2000

Grove Encyclopedias of
European Art

*Encyclopedia of
Italian Renaissance
& Mannerist Art*

Grove Encyclopedias of
European Art

Encyclopedia of
ITALIAN RENAISSANCE
& MANNERIST ART

Volume II
Macagnino to Zucchi

Edited by
JANE TURNER

Grove Encyclopedias of European Art
Encyclopedia of Italian Renaissance & Mannerist Art
Edited by Jane Turner

© **Macmillan Reference Limited, 2000**

Published in the United Kingdom by

MACMILLAN REFERENCE LIMITED, 2000
25 Eccleston Place, London, SW1W 9NF, UK
Basingstoke and Oxford
ISBN: 0–333–76094–8
Associated companies throughout the world
http://www.macmillan-reference.co.uk

British Library Cataloguing in Publication Data
Encyclopedia of Italian Renaissance and Mannerist Art
 1. Art, Renaissance—Italy—Encyclopedias
 2. Mannerism (Art)—Italy—Encyclopedias
 3. Art, Italian—Encyclopedias
 I. Turner, Jane, 1956–
709.4'5'09024
ISBN 0-333-76094-8

Published in the United States and Canada by
GROVE'S DICTIONARIES, INC
345 Park Avenue South, New York, NY 10010-1707, USA
ISBN: 1–884446–02–7

Library of Congress Cataloging-in-Publication Data

Encyclopedia of Italian Renaissance and Mannerist art / editor, Jane Turner
 p. cm – (Grove library of world art)
Includes bibliographical references and index.
ISBN 1–884446–02–7 (alk. paper)
 1. Art, Renaissance—Italy Encyclopedias.
 2. Mannerism (Art)—Italy Encyclopedias.
 I. Turner, Jane Shoaf. II. Series
N6370 .E53 1999
709'.45'03–dc21

 99–41597
 CIP

Typeset in the UK by William Clowes Ltd, Beccles, Suffolk
Printed and bound in the UK by William Clowes Ltd, Beccles, Suffolk

Jacket illustration: Andrea Mantegna: *Parnassus*, tempera on canvas, 1.50x1.92 m, 1495/6–7 (Paris,
Musée du Louvre/photo: Scala, Florence)

Contents

Volume II

M

Macagnino, Angelo del. *See* ANGELO DEL MACAGNINO.

Macchietti, Girolamo (di Francesco di Mariotto) [Girolamo del Crocifissaio] (*b* 1535; *d* Florence, 3 Jan 1592). Italian painter. He trained in Florence with Michele Tosini, whose studio he left in 1555 to work for six years under Vasari on the redecoration of the Palazzo Vecchio, Florence; there he was apparently employed as a designer of tapestries. This was followed by two years of study in Rome. By 1563 he had returned to Florence, where he became a member of the newly founded Accademia del Disegno. Under the academy's auspices he collaborated in 1564 with his friend MIRABELLO CAVALORI on a grisaille painting of *Lorenzo de' Medici Receiving Michelangelo* (untraced) for the catafalque of Michelangelo's funeral in S Lorenzo, Florence. For the academy's next major project, the decorations for Duke Francesco I de' Medici's wedding in 1565 to Joanna of Austria (1547–78), Macchietti contributed a monochrome painting of the *Establishment of the Monastery of Monte Oliveto Maggiore* (untraced) towards a festive 'Arch of Religion'.

Macchietti may have visited Rome again before executing the *Adoration of the Magi* (1568; Florence, S Lorenzo, Cappella della Stufa). This altarpiece chiefly reflects Vasari's elaborate Mannerist style, but numerous details derive from paintings by Parmigianino and the school of Raphael; and the composition was based on a version of the theme by Taddeo Zuccaro (Cambridge, Fitzwilliam). In Macchietti's *Holy Family with St Anne* (*c.* 1568; Budapest, Mus. F.A.) and the *Madonna della cintola* (*c.* 1569; Florence, S Agata), his Mannerism yielded to a more restrained style. This may be due to contemporary works he viewed in Rome, or to pictures conceived in the spirit of the Counter-Reformation in Florence, such as Santi di Tito's *Adoration of the Shepherds with St Francis* (*c.* 1566; Florence, S Giuseppe) and Cavalori's *Pentecost* (*c.* 1567–8; Florence, Badia Fiorentina).

The two paintings Macchietti contributed to the *studiolo* of Francesco I in the Palazzo Vecchio, the *Baths of Pozzuoli* and *Medea and Jason* (*c.* 1570–72), were indebted to Cavalori's *studiolo* pictures in their naturalism of light and space and in the graceful figure-types derived from Pontormo and Andrea del Sarto. The beautiful lighting of these pictures is also found in Macchietti's *Allegory of Wealth* (Venice, Ca' d'Oro). For his *Martyrdom of St Lawrence* (1573; Florence, S Maria Novella, Cappella Giuochi) Macchietti turned to Venetian models, particularly Titian's rendition of the subject in S Maria Assunta

dei Gesuiti, Venice. After completing the *St Lawrence*, the painter travelled to Paris, where he worked for 15 months at the court of Catherine de' Medici. Macchietti's later altarpieces, such as the *St Lawrence in Glory* (1577; Empoli, Mus. S Andrea), were less adventurous and more schematic. His last years were spent mainly in Naples and Benevento (1578–84) and in Spain (1587–9).

BIBLIOGRAPHY

L. Marcucci: 'Girolamo Macchietti disegnatore', *Mitt. Ksthist. Inst. Florenz*, vii (1955), pp. 121–32

P. Pouncey: 'Contributo a Girolamo Macchietti', *Boll. A.*, xlvii (1962), pp. 237–40

V. Pace: 'Contributi al catalogo di alcuni pittori dello studiolo di Francesco I', *Paragone*, xxiv (1973), pp. 69–84

L. Feinberg: *The Works of Mirabello Cavalori* (diss., Cambridge, MA, Harvard U., 1986)

M. Privitera: 'Nuovi disegni di Girolamo Macchietti', *Paragone*, xlv/529–33 (1994), pp. 107–12

——: *Girolamo Macchietti: Un pittore dello Studiolo di Francesco I (Firenze 1535–1592)* (Milan and Rome, 1996)

LARRY J. FEINBERG

Machiavelli, Zanobi (di Jacopo di Piero) (*b* 1418–19; *d* Pisa, 7 March 1479). Italian painter. His birth date is calculated from his 1457 *catasto* (land registry declaration) in which he gave his age as 39. In neither this declaration nor that for 1469 does he mention his occupation. He was formerly confused with a painter named Zanobi who in 1453 entered into a three-year partnership with Piero di Lorenzo di Pratese di Bartolo Zuccheri (1413–87) and Pesellino, but that painter's name was Zanobi di Migliore. However, Zanobi Machiavelli's documented works do show the influence of Pesellino.

Vasari stated that Zanobi was a pupil of Benozzo Gozzoli. This is undocumented, but Zanobi may have assisted Gozzoli in Umbria during the early 1450s. He appears to have worked mainly outside Florence and the only mention of his workshop in the city is in Benedetto Dei's *Pittori nella città di Firenze* (1470). Zanobi is not mentioned in the records of the Arte de' Medici e Speziali, the Florentine painters' guild. In Zanobi's earliest surviving work, a *St James* (1463; Berlin, Gemäldegal.), the influence of Gozzoli is evident, while the strong light effects and rich drapery design recall Pesellino.

On 12 March 1465 Zanobi received 66 lire for three lunette overdoor paintings of the *Pietà*, *St Augustine* and *St Monica* (all untraced) for the recently completed Badia at Fiesole. A signed *Coronation of the Virgin* (Dijon, Mus. B.-A.) was commissioned in 1473 for Santa Croce in Fossabanda, just outside Pisa. It was probably executed in

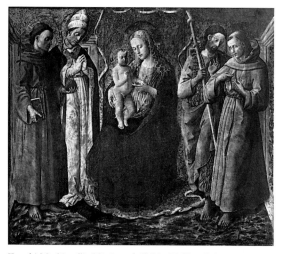

Zanobi Machiavelli: *Virgin and Child with Four Saints*, tempera on panel, 1.54×1.77 m, *c.* 1465 (Pisa, Museo Nazionale di San Matteo)

large part by assistants and is almost a caricature of Zanobi's style. More representative of his talents is a *Virgin and Child with Four Saints* (Pisa, Mus. N. S Matteo; see fig.), also for Santa Croce in Fossabanda. In this work and a slightly earlier *Virgin and Child with Saints* (Dublin, N.G.) the placement of figures, play of light and setting recall the *Virgin and Child with Four Saints* (Paris, Louvre, inv. no. 1661) begun by Pesellino and probably finished in Filippo Lippi's workshop. The figure of St Jerome in the Dublin picture depends on a figure in Lippi's *Coronation of the Virgin* (Rome, Pin. Vaticana). Roughly contemporary with the Dublin and Pisa paintings is a *Virgin and Child with Two Angels* (Rome, Gal. Pallavicini). The inscribed haloes and the dry, almost metallic forms also recall Gozzoli, but the vivacious faces (with almond-shaped eyes, light skin and high foreheads) and the flowing drapery are typical of Zanobi. Machiavelli is mentioned in Pisa in 1475, and on 28 September 1476 he was paid by the administrators of Pisa Cathedral for blue pigment for a painting. Further payments were made in October and November 1476 and also on 12 February 1477.

Padoa Rizzo has made a convincing case for Zanobi's activity as a painter of illuminated manuscripts. Her attributions tally well with the style of Zanobi's *St Jerome* predella panels (untraced, see Padoa Rizzo, 1984, figs 6 and 7) and share that 'sentimental tone of composed yet gentle devotion' that is a trademark of his art.

BIBLIOGRAPHY

G. Vasari: *Vite* (1550, rev. 2/1568); ed. G. Milanesi, vol. iii, pp. 53–4
G. Poggi: 'Zanobi di Iacopo Machiavelli pittore', *Riv. A.*, ix (1916–17), pp. 67–9
P. Bacci: 'Zanobi Machiavelli a Pisa', *Riv. A.*, x (1917–18), pp. 125–7
B. Berenson: 'Zanobi Macchiavelli', *Burl. Mag.*, xcii (1950), pp. 345–9 [with several superseded attributions]
A. Padoa Rizzo: 'Zanobi Machiavelli miniatore?' *Scritti di storia dell'arte in onore di Roberto Salvini* (Florence, 1984), pp. 319–24

ELIOT W. ROWLANDS

Macrino d'Alba. *See* ALBA, MACRINO D'.

Magistris, Simone de (*b* Caldarola, Macerata, 1538; *d c.* 1611). Italian painter. He was the son of a painter, Giovanni Andrea de Magistris (*fl c.* 1510–60), and signed his first works, including the *Adoration of the Magi* (1566; Matelica, S Francesco), with his brother Giovanni Francesco de Magistris (*b* 1540). Simone's earliest independent painting, the *Nativity* (1570; Fabriano, Pin. Civ.), shows the influence of Pellegrino Tibaldi and the Zuccaro brothers. A brief stay at Loreto with Lorenzo Lotto left no trace on his style. Simone executed numerous paintings, mostly signed and dated, of variable quality and formulaic iconography, in small towns of the Marches and Umbria. The frescoes (1580–82) in the sanctuary of Macereto, near Visso, show a knowledge of the contemporary painters in Rome gained from a stay in the city (see Giffi Ponzi). His style did not evolve further, but in his better works there is a definite originality, as in the *Virgin and Child with SS Andrew and James* (1585; Osimo, Baptistery) and the *Death of St Martin* (1594; Caldarola, S Martino). His three canvases in S Maria, San Ginesio (Macerata), depicting the *Last Supper*, the *Road to Calvary* and the *Crucifixion* (all 1594), show an unrestrained expressiveness that suggests knowledge of northern European engravings.

BIBLIOGRAPHY

P. Zampetti: 'I pittori da Caldarola e Simone de Magistris', *Not. Pal. Albani*, ix/1–2 (1980), pp. 90–98
R. Petrangolini Benedetti Panici: 'Simone de Magistris', *Lorenzo Lotto nelle Marche: Il suo tempo, il suo influsso* (exh. cat., Ancona, Il Gesù, Francesco alle Scale e Loggia dei Mercanti, 1981), pp. 480–502
P. Zampetti: 'Simone de Magistris', *Andrea Lilli nella pittura delle Marche tra cinquecento e seicento* (exh. cat., Ancona, Pin. Com., 1985), pp. 175–85
E. Giffi Ponzi: 'Tra Roma e le Marche: Simone de Magistris, Antonio Tempesta e Domenico Malpiedi', *Prospettiva*, 57–60 (1989–90), pp. 99–107

ELISABETTA GIFFI

Magni, Cesare (*b* Milan, *c.* 1495; *d* Milan, 1534). Italian painter. He was the illegitimate son of Francesco Magni, a member of a prominent Milanese family. In 1511, while Fermo Tizoni's apprentice, he joined a protest against the officials of the Scuola di S Luca, Milan. In a will of 1524, Magni indicated that he wished to leave a drawing (untraced) of the Virgin in S Francesco (presumably a copy of all or part of Leonardo da Vinci's *Virgin of the Rocks*) to S Maria delle Grazie, Milan. In 1526 he painted a *St Apollonia* (untraced) for S Maria presso S Celso. An altarpiece of the *Virgin and Child with SS Peter and Jerome* (Milan, Ambrosiana) dates from 1530, while both the *Crucifixion* (Vigevano Cathedral) and the *Virgin and Child with SS Peter Martyr and Vincent Ferrer* (Codogno, S Biagio) are from 1531. Two years later he executed frescoes of *SS George and Martin* (Saronno, S Maria dei Miracoli) and a *Virgin and Child with SS Sebastian and Roch* (ex-Bodemus., Berlin) for the oratory of S Rocco at Codogno.

Magni is often considered one of the Milanese followers of Leonardo; he was, however, a generation younger than the Florentine's Lombard disciples. His surviving works, all from rather late in his short career, are strongly influenced by Bernardino Luini and his circle, by Cesare da Sesto and, indirectly, by Raphael.

BIBLIOGRAPHY

W. Suida: *Leonardo und sein Kreis* (Munich, 1929), pp. 226–7, 304–5
B. Berenson: *Central and North Italian Schools*, i (1968), pp. 86–7
M. T. Fiorio: 'Una scheda per Cesare Magni', *Paragone*, xxxiv (1983), pp. 94–9

J. Shell: *Painters in Milan, 1490–1530* (diss., New York U., 1986), pp. 774–95, *passim*

Disegni e dipinti leonardeschi delle collezioni milanesi (exh. cat., Milan, Pal. Reale, 1987–8)

P. C. Marani: *Leonardo e i leonardeschi a Brera* (Florence, 1987)

Pinacoteca di Brera: Scuole lombarda e piemontese, 1300–1535 (Milan, 1988), pp. 330–34 [entries by M. T. Fiorio and P. C. Marani]

J. Shell and G. Sironi: 'Copies of the *Cenacola* and the *Virgin of the Rocks* by Bramantino, Marco d'Oggiono, Bernardino de' Conti, and Cesare Magni', *Rac. Vinc.*, xxiii (1989), pp. 103–17

JANICE SHELL

Magro, Guglielmo del. *See* GIRALDI, GUGLIELMO.

Maiano [Majano], da. Italian family of artists. The brothers (1) Giuliano da Maiano, Giovanni da Maiano I (*b* Maiano, nr Florence, 1439; *d* Florence, 10 Aug 1478) and (2) Benedetto da Maiano ran one of the most versatile and productive workshops in Florence in the later 15th century. They were sons of the mason Leonardo d'Antonio da Maiano and were brought up in the quarry village of Maiano, outside Florence. Giuliano was the administrative head of the workshop, which produced secular and ecclesiastical furniture and executed sculpture in a wide variety of media, as well as designing and building numerous architectural projects. They worked throughout Tuscany and also in Naples. In a *catasto* (land registry declaration) of 1469 Giuliano gave his own age as 38 and those of Giovanni I and Benedetto as 31 and 28 respectively. Giovanni I is mentioned in payments (1473–7) for work at SS Annunziata, Florence, and is also named in the brothers' *catasti* of 1470 and 1480. Nothing is known of his specific contribution to the family's enterprises. (3) Giovanni da Maiano II was the son of (2) Benedetto da Maiano and was one of the first generation of Italian sculptors to introduce the Renaissance style to the English court at the time of Henry VIII (*reg* 1509–47).

BIBLIOGRAPHY

Thieme–Becker

L. Cèndali: *Giuliano e Benedetto da Maiano* (Sancasciano Val di Pesa, [1926])

M. G. Ciardi Dupré dal Poggetto, ed.: *Bottega di Giuliano e Benedetto Maiano nel Rinascimento fiorentino* (Florence, 1994)

(1) Giuliano da Maiano (*b* Maiano, nr Florence, 1432; *d* Naples, 17 Oct 1490). Architect, wood-carver and intarsia worker. As *capomaestro* of Florence Cathedral and court architect to Alfonso, Duke of Calabria (later Alfonso II, King of Naples), he was recognized in his lifetime as the outstanding architect of his generation. He made an important contribution to spreading the Renaissance style to southern Italy, and his ambition to enlarge the scale and scope of Italian architecture from the smaller scale employed in the early Renaissance, although not entirely successful, paved the way for the next generation's creation of the truly monumental architecture of the High Renaissance.

1. Life and work. 2. Working methods and technique.

1. LIFE AND WORK.

(i) Woodwork and intarsias. Although much of his posthumous fame rests on his work as an architect, Giuliano's earlier work in wood, which included intarsia work, earned him an equally high reputation. His first recorded commissions, for *all'antica* wooden panels and frames, were from the Florentine painters Neri di Bicci (payments from 28 Feb 1454/5–14 Nov 1472) and Cosimo Rosselli (payments, Aug 1456–March 1457 for a wooden frame (destr.) for the *St Barbara* altarpiece, originally in SS Annunziata, now Florence, Accad.). He also made a wooden bench (1455) for S Maria del Carmine in Florence and a wooden cross that was sold to Neri di Bicci on 24 April 1459. In addition, he accepted commissions for more ephemeral objects, including a float for the celebrations of the feast of St John the Baptist in Florence in 1461.

By 1461 Giuliano's workshop was well established, and he began to receive major commissions for entire ensembles of wooden church furnishings, including the choir benches, doors and sacristy cabinets for the Badia at Fiesole (payments 3 July 1461–2 Jan 1462/3) and the completion of panels and cabinets for the north sacristy of Florence Cathedral (commissions dated 20 July 1463 and 19 April 1465). The cathedral woodwork, the earliest complete surviving set of furnishings by Giuliano, shows him to have achieved full mastery of his craft. Five figures in two of the compositions showing the *Annunciation* and *St Zenobius between SS Eugenius and Crescenzo* were designed by Maso Finiguerra and coloured by Alesso Baldovinetti, so it is the design of the architectural settings and architectonic ornament that must be attributed to Giuliano. Indeed, the overall unity of the window wall points to a single designer. Giuliano provided arched frames for the iconic figure of *St Zenobius between SS Eugenius and Crescenzo* on the lower level and employed a deeply foreshortened perspective scheme for an elevated fictive loggia above. In the *Annunciation*, Maso's figures of the Virgin and Angel are not fully consonant with the daring illusionism Giuliano employed on the loggia in which the scene takes place. This only highlights Giuliano's exceptional inventiveness. The fictive architecture—the structural members, the framing panels and their ornament—are typical of the classically inspired architecture and architectural ornament of the generation following Brunelleschi; it also bears a strong resemblance to actual buildings designed or built by Giuliano in the next decade.

Giuliano received other commissions for woodwork, including wooden pulpits for S Maria Nuova, Florence (payment 5 April 1465), and for the collegiate church in San Gimignano (1469); the designs, but not the execution, of choir-stalls for Florence Cathedral (1471) and a similar commission for Pisa Cathedral (1477); and woodwork at SS Annunziata, Florence (1470s). He also provided cassoni, elaborate beds and other furniture for the Strozzi, Rucellai, Pazzi and other families in both Florence and Naples.

A letter of 3 April 1473 from Filippo Strozzi (i) and Lorenzo Strozzi in Florence to Filippo di Matteo Strozzi in Naples states that both Giuliano and his brother Benedetto were eager to take on three-dimensional work as opposed to woodwork. At about this time Benedetto started to work as a marble sculptor, and Giuliano took on major architectural commissions in Siena and Faenza. Giuliano's bottega, however, continued to receive commissions for woodwork throughout his lifetime. With Benedetto and a team of sculptors, he took on the

commission for the new ceiling, doors and marble door-frames of the Sala dei Gigli in the Palazzo Vecchio, Florence (payments 28 Feb 1476–27 Nov 1481). On 8 January 1489–90 Giuliano was paid for the design of the coffered ceiling at S Eligio in Naples, and his name was included in an inscription on the choir-stalls in Perugia Cathedral, although these were executed largely by the del Tasso family, who must have been working to his designs.

(ii) Architecture. In 1461 Giuliano entered a competition for the design of an aedicula for the Madonna della Tavola in Orvieto Cathedral. Giuliano's other early work outside Florence included plans for enlarging the collegiate church in San Gimignano (payment 16 July 1466) and his subsequent erection of the chapel of S Fina in the same church (payment 16 May 1468), where he would seem to have been influenced by Bernardo Rossellino's and Antonio Rossellino's chapel of the Cardinal of Portugal in S Miniato al Monte, Florence.

In the 1460s Giuliano may also have begun work on the Palazzo Strozzino in Florence, which was left unfinished by Michelozzo in 1462. The irregular rustication and bold three-dimensionality of most of the ground storey shows the clear imprint of Michelozzo's style, but the shift to a much tauter surface and distinctly linear articulation in the last two courses of stonework are compatible with the sensibilities one might expect of an intarsia worker. The upper storey is also planar, its minimal rustication delineated into neatly alternating narrow and wide courses that were inspired by the façade of Alberti's Palazzo Rucellai in Florence (*see* ALBERTI, LEON BATTISTA, fig. 2). The Strozzino rustication, however, is much more regular, the façade is not divided into bays, and the horizontal continuity of each storey is emphasized. The Palazzo Pazzi–Quaratesi, Florence , which is also usually attributed to Giuliano, has a similar articulation. Work there may have begun in 1462, when the major purchase of land on which to build was completed, and may have continued to the 1470s, for in 1478 Giuliano claimed that Jacopo de' Pazzi owed him money for some work in the Pazzi house in Florence, at a villa in Montughi and at Santa Croce, Florence. Some of the debt may have been for works in wood, but the design of the Pazzi courtyard shares numerous similarities with the cathedral intarsias (Haines, 1983), and the spare restraint of its façade links it to the Palazzo Spannocchi in Siena, built by Giuliano for Ambrogio Spannocchi, treasurer to Pope Pius II (payments 15 March 1473–1475).

In 1474 Giuliano was commissioned to rebuild Faenza Cathedral (1474–86; see fig.). He attempted to create a building more monumental in conception than earlier Renaissance architecture. He conceived of the nave of the basilica not as a Brunelleschian unity but as a series of ample square bays, each covered by a domical sail vault. Tall pilasters and slightly projecting architraves emphasize the division of space into bays so large that they require intermediate columnar supports. The articulation is severe, and the vaulting and alternating square piers and columns lend an almost neo-medieval aspect to the building. The decoration is minimal, the semi-dome of the apse is in the form of an outsized shell, and the nave capitals are singularly unexpressive. However, despite its large scale

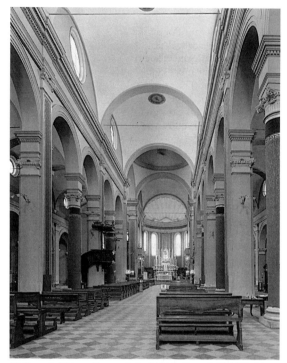

Giuliano da Maiano: Faenza Cathedral, interior, rebuilt 1474–86

and careful articulation, the cathedral fails to live up to its monumental intention.

By the mid-1470s Giuliano was the leading architect of his generation, as his position as *capomaestro* (April 1477–2 May 1488) of Florence Cathedral would suggest. His plan for the placement of the doors on the façade of Brunelleschi's church of Santo Spirito, Florence, was chosen despite the fact that his design of three rather than four doors violated the master's original, much more daring, intentions. His long association with the fortification and perhaps the vaulting of the basilica of S Maria in Loreto (1476–87) assured that his fame spread well beyond Florence. In 1482, for example, the city officials of Macerata sought his advice regarding the repair of the Palazzo Maggiore. He also attracted the attention of Cardinal Anton Giacomo Venieri of Recanati, who commissioned a palace in Recanati (begun 1477, left largely incomplete in 1479).

Giuliano accepted a wide variety of commissions, including the building of a castle at Montepoggiolo (1471), the expansion of one of the Strozzi palaces in Florence (1483) and the erection of a wooden tower at Pontormo (June 1485). He also seems to have provided designs for projects that he did not personally supervise, including those for S Maria del Sasso near Bibbiena (1486). Furthermore, he submitted designs for projects that were not carried out or not completed in his lifetime: the cloister of SS Flora e Lucilla in Arezzo (commissioned 27 April 1470, begun 1489), S Maria delle Carceri in Prato (20 April 1485, later reassigned to Giuliano da Sangallo) and a design (1490, unexecuted) for the façade of Florence Cathedral.

The last years of Giuliano's life were some of his most fruitful. From 1485 to 1490 he stayed largely in Naples in

the service of Alfonso, Duke of Calabria, for whom he designed the elegant Porta Capuana (*see* NAPLES, fig. 2) in Naples, the adjacent Villa Duchesca (unfinished) and, most importantly, the villa at Poggio Reale (begun 1487; destr.), one of the most significant suburban residences of the Renaissance. The villa was a two-storey, rectangular structure with a large, brick-paved, interior courtyard located a few steps below ground-level. Four towers at the corners of the structure were joined to the core of the building by ground-floor porticos and arcaded loggias above, while a large fountain and flanking porticos extended along the axis of the structure into the extensive gardens. Thoroughly Classical in its inspiration, the design of Poggio Reale particularly appealed to architects of the 16th century. It influenced Baldassare Peruzzi's suburban Villa Farnesina in Rome, and Serlio published a plan and description of it in 1544. They must have admired its masterful use of geometry and the singularly successful manner in which it dissolved the usual boundaries between interior and exterior space. Whether the entire design can be credited to Giuliano, however, is not certain. The Duke employed and consulted numerous architects on the project, so the design may have resulted from group consultations. On the other hand, the plan seems surprisingly clear and coherent for a building designed by a committee. At the very least, Giuliano should be given credit for having guided the project to a most felicitous realization. The villa was already in use for a banquet in June 1489, so the speed of construction was also remarkable.

2. WORKING METHODS AND TECHNIQUE. Giuliano was the administrative head of a multifaceted workshop that produced secular and ecclesiastical furniture, sculpture in a wide variety of media and numerous buildings. Early in his career he seems to have engaged in many of these activities himself, but as his fame as an architect grew, he increasingly turned over certain operations to his brothers. Sometimes the brothers worked independently of each other, sometimes as partners; sometimes Giovanni I and Benedetto worked as Giuliano's subordinates, receiving payments on his behalf when he was outside Florence or ensuring that materials were sent to other sites, as, for example, on 24 May 1488, when Benedetto received a payment from the Gondi bank for 20,000 bricks destined for Naples. In addition, Giuliano provided designs for many types of work whose execution was subcontracted to other intarsia workers or builders, while his shop supplied several Florentine artists with panels and frames for their paintings.

Giuliano made great use of models and drawings (untraced), some of which are recorded in documents of the 1480s. In this manner he was able to engage in a large number of projects even when he could not be personally present for every phase of the construction. Through drawings designs could also be more easily explained to patrons, a number of whom took a sophisticated interest in architecture and exchanged drawings of their residences with one another. For instance, Giuliano carried drawings from Lorenzo the Magnificent to the Duke of Calabria.

BIBLIOGRAPHY
N. di Bicci: *Le Ricordanze, 10 Marzo 1453–24 Aprile 1475* (Florence, Bib. Uffizi, MS. 2); ed. B. Santi (Pisa, 1976)
G. Vasari: *Vite* (1550, rev. 2/1568); ed. G. Milanesi (1878–85), ii, pp. 467–75
L. Pecori: *Storia della terra di San Gimignano* (Florence, 1853)
G. Baroni: *La parrocchia di San Martino* (Florence, 1875)
G. Milanesi: *Nuovi documenti per la storia dell'arte toscana dal XII al XV secolo* (Rome, 1893), p. 155
C. von Fabriszy: 'Toscanische und oberitalienische Künstler in Diensten der Aragonesen zu Neapel', *Repert. Kstwissen.*, xx (1897), pp. 85–120 (87–9)
——: 'Giuliano da Maiano in Siena', *Jb. Preuss. Kstsamml.*, xxiv (1903), pp. 320–34
C. Grigioni: 'Il duomo di Faenza: Documenti inediti intorno alla sua costruzione e il documento decisivo sul nome del suo architetto', *Arte*, xxvi (1923), pp. 161–74
R. Mather: 'Documents Mostly New Relating to Florentine Painters and Sculptors of the Fifteenth Century', *A. Bull.*, xxx (1948), pp. 20–65 (37–40)
Mostra documentaria e iconografica di Palazzo Vecchio (exh. cat., Florence, Archv Stato, 1957), doc. 37, 38, 39, 40, 41
G. Marchini: *Giuliano da Maiano* (Florence, 1959)
G. Hersey: *Alfonso II and the Artistic Renewal of Naples, 1485–1495* (New Haven, 1969)
M. Salmi: 'Santa Maria delle Grazie ad Arezzo e il suo piazzale', *Commentari*, xx (1969), pp. 37–51
L. Borgo: 'Giuliano da Maiano's Santa Maria del Sasso', *Burl. Mag.*, cxiv (1972), pp. 448–52
B. Hellerforth: *Der Dom von Faenza: Ein Beitrag zur Problematik der Basilika-Architektur in der 2. Hälfte des Quattrocento* (diss., Bonn, Rhein. Friedrich-Wilhelms U., 1975)
D. Covi: 'A Documented Lettuccio for the Duke of Calabria by Giuliano da Maiano', *Essays Presented to Myron P. Gilmore*, ii (Florence, 1978), pp. 121–30
M. Haines: *The 'Sacrestia delle Messe' of the Florentine Cathedral* (Florence, 1983)
P. Nuttall: '"La Tavele Sinte Barberen": New Documents for Cosimo Rosselli and Giuliano da Maiano', *Burl. Mag.*, cxxvii (1985), pp. 367–72
M. Dezzi Bardeschi: 'I cantieri dei destini incrociati', *La difficile eredità: Architettura a Firenze dalla Repubblica all'assedio*, ed. M. Dezzi Bardeschi (Florence, 1994), pp. 6–36

GARY M. RADKE

(2) Benedetto da Maiano [Benedetto di Leonardo] (*b* Maiano, nr Florence, 1442; *d* Florence, 24 May 1497). Sculptor and wood-carver, brother of (1) Giuliano da Maiano. He was technically one of the most accomplished marble-carvers of the 15th century and the foremost sculptor in Florence of the generation following Bernardo Rossellino. Technical difficulties had been largely overcome by his predecessors, however, and he lacked the innovative qualities of Rossellino's generation. There are close parallels between Benedetto and his contemporary and sometime collaborator Domenico Ghirlandaio in their technical proficiency, powers of narrative expression, excellent portraiture and adherence to traditional techniques.

1. Life and work. 2. Working methods and technique.

1. LIFE AND WORK. Benedetto is first recorded as a woodworker. On 7 March 1467 he received payment for wooden panels that his older brother, Giuliano, had prepared for painters working in the chapel of the Cardinal of Portugal at S Miniato al Monte, Florence. His early training and first artistic activity appear to have been in the workshop of Giuliano. There he learnt the art both of intarsia and of wood-carving, which must have prepared him for his later career as stone-carver. The rich, decorative intarsia designs may also have contributed to the lavish quality of many of his mature works in marble.

Vasari told an apocryphal story that Benedetto abandoned working in wood when the inlaid panels of a pair of large chests (untraced) he had made for Matthias Corvinus, King of Hungary (*reg* 1458–90), fell apart after shipping; in fact he worked in this medium throughout his career, carving wooden angels that were painted and gilded by Neri di Bicci (23 March 1471–2), making a large intarsia chest for the personal papers of Filippo Strozzi (i) (8 May 1479), carving wooden frames for steel mirrors (one documented for the Strozzi family on 28 June 1482) and producing numerous crucifixes: one for Onofrio di Pietro of San Gimignano in 1474, another for the Strozzi Chapel in Lecceto (payment 22 June 1482), yet others listed in the inventory of his workshop after his death, and large crucifixes for the choir-screen of the Certosa di Galluzzo (payment 12 August 1496) and Florence Cathedral (acquired from Giovanni II in 1509). He is also said to have completed Desiderio da Settignano's wooden statue of *St Mary Magdalene* (Florence, Santa Trìnita), and the model he provided of the Palazzo Strozzi on 5 February 1491 must have been made of wood too.

Benedetto's first independent work in marble was the *St Savino* monument (1468–71) in Faenza Cathedral. It is not in a fully mature style, but its six narrative reliefs, two free-standing statues and wide variety of architectural elements suggest something of the early influences on Benedetto. The organization of the monument derives from prototypes developed in the workshop of Bernardo Rossellino and Antonio Rossellino, as do the slight figures in the reliefs; however, the complex is more densely organized than anything produced by the Rossellini, and the conception of space within the narratives is unlike the restricted, even miniaturized settings used by them. Instead, Benedetto followed the example of Donatello and Ghiberti, cutting off figures and parts of his setting at both the top and sides of his scenes, as in *St Savino Heals a Blind Man*. In this monument Benedetto demonstrated his love of the richly ornamented surfaces and spatially complex but narratively clear reliefs that became characteristic of his mature work.

Benedetto's first important commission was the *St Fina* monument in the collegiate church, San Gimignano (1472–7, inscribed 1475, last payment 13 Dec 1493), erected in the chapel of S Fina built by Giuliano da Maiano and frescoed by Domenico Ghirlandaio. The gilt marble monument takes up one wall of the chapel. Above an altar encrusted with rich decorative motifs stands a tabernacle with a relief of angels depicted in an architectural setting shown in raking perspective—possibly Benedetto was aware of the subtle effects achieved by Desiderio da Settignano. The scenes from the *Life of S Fina* in the frieze above may owe their serene quality to the influence of Domenico Ghirlandaio. Above this is the saint's tomb, and still higher the Virgin and Child in high relief are displayed in a mandorla flanked by two flying angels. Illusionistic marble curtains are drawn back to reveal the monument. Originally two free-standing marble statues of kneeling angels flanked the monument (now by the high altar in the same church).

In 1473 Benedetto matriculated in the Arte dei Maestri di Pietra e Legname in Florence and then travelled to Rome, where he delivered an elaborate bed for the Duke of Calabria, before moving on to Naples, where he made preliminary studies for the marble tomb of *Matteo Strozzi* (*d* 1459; see Borsook, *Ant. Viva*, 1970). On 15 June 1475 Benedetto was paid for a marble bust of *Filippo Strozzi* (Paris, Louvre); its terracotta model (Berlin, Skulpgal.) possesses a good deal more life than the rather cool marble rendition. This is the only case in which both model and finished marble bust have survived from the 15th century.

Between 28 February 1476 and 27 November 1481 Giuliano and Benedetto were paid for work in the Palazzo Vecchio, Florence. Benedetto contributed the marble doorframes surmounted by statues between the Sala del Consiglio and the Sala dei Gigli. The elaborately decorative, classicizing doorframes are crowned with semicircular pediments flanked by candelabra and paired putti. Placed before the pediments on either side is a statue, the seated figure of *Justice* on one side and the young *St John the Baptist* on the other. The latter is inspired by Desiderio, but, like all of Benedetto's works, it is more straightforward in its conception and close in spirit to the work of Domenico Ghirlandaio.

In 1474 Benedetto signed and dated a meticulously detailed marble portrait bust of the wealthy Florentine merchant *Pietro Mellini* (Florence, Bargello). In 1478 he was again at work for Mellini, carving a marble tabernacle for holy oil at SS Fiora e Lucilla, Arezzo. A design for the portico of S Maria delle Grazie in the same town may also date from around this time. Mellini's last recorded commission, that for his own simple floor tomb and a magnificent marble pulpit (see fig.) over it in Santa Croce, Florence, is Benedetto's masterpiece. Completed by 19 May 1485, when Pietro Mellini made his final will and testament, the full-scale work was preceded by several models, three of which are preserved (London, V&A). A terracotta model for a relief of the *Dream of Innocent III* (Berlin, Bodemus) was also prepared, but the scene was abandoned in the final project. A model of the entire pulpit that was in the artist's studio at his death has not survived.

The pulpit is cleverly attached to one of the piers in the nave of the church, through which Benedetto excavated a staircase. The five relief scenes from the *Life of St Francis* are powerfully clear and dramatic narratives illustrated with a kind of clear-eyed verism that is usually reserved for painting. The reliefs are separated by Corinthian colonettes, framed by finely carved classicizing mouldings, while below, closer to eye-level, the terminating corbel is overlaid with *tour de force* basketweave carving. The entire ensemble is of extremely high technical quality, one of the most remarkable works of relief sculpture of the later 15th century.

Similar in its complexity and virtuoso workmanship is the altar ciborium for S Domenico in Siena, which may also date from the 1480s. Earlier commissions include a ciborium for the collegiate church in San Gimignano and a holy water font for the Strozzi Chapel in Lecceto (payment 23 Jan 1482). In Loreto a lavabo and two glazed terracotta lunettes of Evangelists, which strongly resemble those in roundels at the base of the Siena ciborium, date from between 1480 and 1483.

Another major commission of the 1480s was the Annunciation Altar and marble furnishings for the Cor-

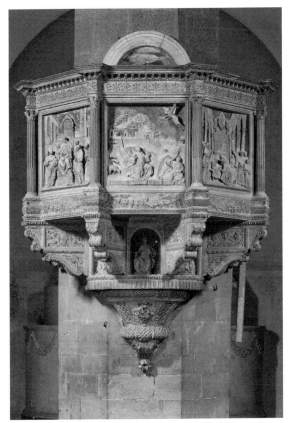

Benedetto da Maiano: marble pulpit, completed 1485 (Florence, Santa Croce)

reale (Terranova Chapel) of the church of Monteoliveto Maggiore (now S Anna dei Lombardi), Naples. It was begun before 16 September 1489, when Joanna, Queen of Naples, requested duty-free passage of the carved marbles from Florence via Pisa to Naples; payments continued until 23 April 1491. The form of the altar, with a relief of the *Annunciation* flanked by niches containing statues of *St John the Baptist* and *St John the Evangelist*, is based on Antonio Rossellino's Piccolomini Altar in the same church. The detail and finishing are only slightly less meticulous than the Santa Croce pulpit, the saints are more substantial than Benedetto's earlier free-standing figures, and the central relief, with high-relief figures of the *Virgin and Angel* and a barrel-vaulted loggia leading to a garden, openly challenges painting's supremacy in the depiction of deep illusionistic space. Also from this period is a nearly 2 m-high relief of a standing *Madonna and Child* in Terranova Sappo Minu'lio (Reggio Calabria), probably commissioned by Marino Correale, Conte di Terranova and patron of the *Annunciation* altar.

In the 1490s Benedetto's individual figures and the settings in which he placed them became increasingly large in scale and spare in detail. The sober dignity of a bust of *Giotto* for Florence Cathedral (*in situ*) and the relative restraint of the tomb monument of *Filippo Strozzi* (*d* 1491) in S Maria Novella (begun by 27 June 1491, payments continuing into 1497) marked a move away from the highly anecdotal and decorative quality of his earlier work

towards more monumental forms and design. This is also evident in the broad figures in the unfinished *Coronation of Ferdinand of Aragon* (frags, Florence, Bargello), which he was working on in 1494 for the Porta Reale in Naples. In the *St Bartolo* monument in S Agostino, San Gimignano (11 May 1492–23 July 1494), Benedetto increased the size of his figures, reduced the number of characters within his reliefs and provided architectural settings free of unnecessary detail. A *St Sebastian* and a *Virgin and Child* (both Florence, Misericordia), both left unfinished at his death, were also conceived along the same lines.

Benedetto's designs for the corner lanterns and torch holders of the Palazzo Strozzi, Florence (payment 12 March 1495), retained the decorative sense for which he was known in the 1480s, and the same may have been true of a design he submitted for a baptismal font in Pistoia (14 May 1497), but these were works intended as decorative fittings. Other surviving late works include a terracotta lunette of *St Lawrence* for the Certosa di Galluzzo near Florence (payment 12 Aug 1496), which the della Robbia workshop glazed for Benedetto, and a bust of *Onofrio di Pietro* for the collegiate church in San Gimignano (commissioned 28 May 1493; San Gimignano, Mus. A. Sacra); both are notably more severe than his earlier, decorative works. His large wooden Crucifix in Florence Cathedral (acquired in 1509 from Giovanni II) is subtle in its rendering and, like a number of his late works, is characterized by a heightened idealization and grander dimensions that place it on the verge of the High Renaissance.

2. WORKING METHODS AND TECHNIQUE. Benedetto's sculptural ensembles show clearly that his workshop participated in their creation. In compositions that include symmetrical elements, one of the two complementary figures or architectural elements is regularly of superior execution and can be credited to the master, while the second has been copied from its pair by an assistant. Full-scale models in terracotta, such as those that survive for the Santa Croce pulpit reliefs, must also have allowed Benedetto to maintain close control over his work while delegating a good deal of carving to assistants. Drawings would have been less useful in this regard, and although no drawings survive that can be firmly attributed to Benedetto, contemporary examples usually associated with Francesco di Simone Ferrucci suggest that they would have been useful for working out the complex interrelationships between the numerous component parts of Benedetto's monuments and altars, as well as suggesting to patrons the overall shape of a commissioned work. Other artists' drawings were also used by the sculptor, as in the case of Benedetto's bust of *Onofrio di Pietro*, which was not carved from life but from a drawing of the deceased.

Vasari claimed that he owned drawings by Benedetto and praised them highly. There is no indication that Benedetto did any carving outside Florence; his works for other cities were shipped in largely finished form and then installed under his supervision. His devotional works were often reproduced in stucco or terracotta: for example a marble relief of the *Virgin and Child* (Washington, DC, N.G.A.) served as a model for numerous terracottas and stuccos. Such artists as Neri di Bicci were engaged to paint

these reliefs. Together with his brothers, Benedetto erected a tabernacle containing a terracotta *Virgin and Child* and a marble relief of the *Man of Sorrows* on their country property near Prato (relief dated 1480; now in Prato Cathedral).

BIBLIOGRAPHY

DBI: 'Benedetto di Leonardo, detto da Maiano'

G. Vasari: *Vite* (1550, rev. 2/1568); ed. G. Milanesi (1878–85), iii, pp. 333–46

P. Bacci: 'Documenti su Benedetto da Maiano e Andrea da Fiesole relative al "Fonte Battesimale" del Duomo di Pistoia', *Riv. A.*, ii (1904), pp. 271–84

A. Marquand: 'A Lunette by Benedetto da Maiano', *Burl. Mag.*, xl (1922), pp. 128–31

L. Dussler: *Benedetto da Maiano: Ein Florentiner Bildhauer des späten Quattrocento* (Munich, 1924)

M. Lisner: 'Zu Benedetto da Maiano und Michelangelo', *Z. Kstwiss.*, xii (1958), pp. 141–56

J. Pope-Hennessy: *Italian Renaissance Sculpture* (London, 1963, rev. 3/1981), pp. 289–92

E. Borsook: 'Documenti relativi alle cappelle di Lecceto e delle Selve di Filippo Strozzi', *Ant. Viva*, ix/3 (1970), pp. 3–20

——: 'Documents for Filippo Strozzi's Chapel in Santa Maria Novella and other Related Papers', *Burl. Mag.*, cxii (1970), pp. 737–45, 800–04

M. Lisner: *Holzkruzifixe in Florenz und in der Toskana von der Zeit um 1300 bis zum frühen Cinquecento* (Munich, 1970), pp. 76–82

D. Carl: 'Der Finaaltar von Benedetto da Maiano in der Collegiata zu S. Gimignano: Datierung, Rekonstruktion, Stil', *Münster*, xxvi (1973), pp. 285–7

A. Paolucci: 'I musici di Benedetto da Maiano e il monumento di Ferdinando d'Aragona', *Paragone*, xxvi/303 (1975), pp. 3–7

A. Tessari: 'Benedetto da Maiano tra il 1490 e il 1497', *Crit. A.*, 2nd ser., xxi/143 (1975), pp. 39–52; xxii/145 (1976), pp. 20–30

J. Russel Sale: *The Strozzi Chapel by Filippino Lippi in Santa Maria Novella* (diss., U. Pennsylvania, 1976), pp. 19, 524–6

D. Carl: 'Der Fina-Altar von Benedetto da Maiano in der Collegiata zu San Gimignano zu seiner Datierung und Rekonstruktion', *Mitt. Ksthist. Inst. Florenz*, xxii (1978), pp. 129–66

P. Morselli: *Corpus of Tuscan Pulpits, 1400–1550* (diss., U. Pittsburgh, 1979)

G. Radke: 'The Sources and Composition of Benedetto da Maiano's San Savino Monument in Faenza', *Stud. Hist. A.*, xviii (1985), pp. 7–27

Italian Renaissance Sculpture in the Time of Donatello (exh. cat., ed. A. Darr and G. Bonsanti; Detroit, MI, Inst. A., 1985), pp. 193–6

G. M. Radke: 'Benedetto da Maiano and the Use of Full Scale Preparatory Models in the Quattrocento', *Verrocchio and Late Quattrocento Italian Sculpture*, ed. S. Bule (Florence, 1992), pp. 217–24

D. Carl: 'Franziskanischer Martyrerkult als Kreuzzugspropaganda an der Kanzel von Benedetto da Maiano in Santa Croce in Florenz', *Mitt. Ksthist. Inst. Florenz*, xxxix/1 (1995), pp. 69–91

F. Caglioti and G. Gentilini: 'Il quinto centenario di Benedetto da Maiano e alcuni marmi dell'artista in Calabria', *Bull. Assoc. Hist. A. It.*, iii (1996–7), pp. 1–4

D. Carl: '*Die Madonna von Nicotera* und ihre Kopien: Vier unerkannte Madonnenstatuen des Benedetto da Maiano in Kalabrien un Sizilien', *Mitt. Ksthist. Inst. Florenz*, xli/1/2 (1997), pp. 93–118

GARY M. RADKE

(3) Giovanni da Maiano II [John de la Mayn; Delamayne; Demayanns; Demyans; Dermyans; Mane] (*b* Florence, 1486–7; *d c*. 1542–3). Sculptor, son of (2) Benedetto da Maiano. It has erroneously been thought by some that he was the son of Giovanni da Maiano I. In 1507 he received a third of the inheritance his father had left him. On 4 August 1509 he rented, as a sculpture workshop, Benedetto da Maiano's (and subsequently Rustici's) old bottega on Via Castellacio in Florence. This was intended to continue for three years; however, on 8 January 1510 he withdrew without reason. He may at this point have accompanied Pietro Torrigiani northward. Alternatively, he may have been recruited by Torrigiani in 1519, together with the sculptor Benedetto da Rovezzano, when Torri-giani contracted with other Florentine sculptors, including Antonio Toto del Nunziata (Darr, 1980), to travel to England with him to assist on the altar of King Henry VII (frags, London, Westminster Abbey, Henry VII's Chapel) and the projected monumental tomb of King Henry VIII and his first wife, Catherine of Aragon, the latter commissioned to Torrigiani in January 1519 but never completed.

Giovanni was certainly in England by 18 June 1521, when he wrote a letter to Cardinal Thomas Wolsey requesting payment for eight life-size painted and gilded terracotta roundels of *Roman Caesars* that he had made for the Cardinal for the exterior of Hampton Court near London (*in situ*; see Higgins). These are among the first evidence of Italian Renaissance style directly incorporated in English architecture. Additional busts of *Caesars* in roundels made of the same London yellow clay and red brick, and by the same hand, survive at The Vyne, Hants, in Hanworth and elsewhere. Presumably they originally formed a series (possibly of *Twelve Caesars*) that decorated three of the Hampton Court gateways (made 1530–32). In the same letter Giovanni demanded payment from Wolsey for three Histories (i.e. Labours) of Hercules (untraced) that were probably also of painted and gilded terracotta. Also installed in a gateway of Hampton Court is a large terracotta relief bearing Wolsey's coat of arms, flanked by two standing putti, formerly bearing Wolsey's monogram and dated 1525, which may be by Giovanni or, more likely, initiated by Torrigiani and completed by Giovanni, possibly in conjunction with Benedetto da Rovezzano.

In 1527 Giovanni modelled and painted stucco and wood decorative furnishings for Henry VIII's Banqueting and Revels houses in Greenwich; he is mentioned working there with Ellys Carmyan and Vincent Volpe of Naples as a gilder for revels and is referred to as an Italian 'graver'—he may be the 'Maister Mane' paid for 'drawing the pictures' (see Auerbach). From 1528 he received an annual salary of £20 from Henry VIII, and in 1530 was paid for six painted, gilded and silvered 'Antique heads'. From 1530 to 1536 he collaborated with Benedetto da Rovezzano and other Italian and northern craftsmen on the revived project of a tomb for Henry VIII at Windsor, parts of the sculpture for which the King had taken over from Wolsey's aborted tomb project (1524–9). In 1536 Giovanni's and Benedetto's involvement on this important royal commission ended, and, despite later work by others, it was never completed. Between 1532 and 1536 Giovanni may have produced the screen of King's College Chapel, Cambridge (Auerbach), and he may have modelled the four terracotta tondi on the façade of the Holbein Gate at Whitehall Palace and various other busts and works in terracotta. He is not mentioned in England after 1536, and it is probable that he returned to Florence with Benedetto da Rovezzano, who was back by May 1543.

BIBLIOGRAPHY

DBI: 'Benedetto di Leonardo, detto da Maiano'; Thieme–Becker

A. Higgins: 'On the Work of Florentine Sculptors in England in the Early Part of the Sixteenth Century: With Special Reference to the Tombs of Cardinal Wolsey and King Henry VIII', *Archaeol. J.*, li (1894), pp. 129–220, 367–70

C. Beard: 'Torrigiano or da Maiano', *Connoisseur*, 84 (1929), pp. 77–86

E. Auerbach: *Tudor Artists* (London, 1954), pp. 17, 157, 176, 190

E. Luporini: *Benedetto da Rovezzano* (Milan, 1964), p. 169

A. Darr: *Pietro Torrigiano and his Sculpture for the Henry VII Chapel, Westminster Abbey* (diss., New York U., 1980)

S. Gunn and P. Lindley: *Cardinal Wolsey: Church, State and Art* (Cambridge, 1991), pp. 34, 47, 267, 280–82, 285

A. Darr: 'New Documents for Pietro Torrigiani and Other Early Cinquecento Florentine Sculptors Active in Italy and England', *Kunst der Cinquecento in der Toskana*, ed. M. Cämmerer (Munich, 1992), pp. 108–38

ALAN PHIPPS DARR

Mainardi, Bastiano [Sebastiano] (*b* San Gimignano, 23 Sept 1466; *d* ?Florence, Sept 1513). Italian painter. Vasari mentioned that Mainardi was a pupil of Domenico Ghirlandaio and that he was still working in the studio at the time of his master's death. Vasari also claimed that Mainardi collaborated with Ghirlandaio on several works between 1475 and 1477, including the fresco decoration of the chapel of S Fina in the Collegiata, the collegiate church in San Gimignano, and on the frescoes in the abbey of Passignano in Val di Pesa, near Florence. Given the dates of these works, it was thought that Mainardi was born between 1450 and 1460 and that he was, if not a contemporary of Ghirlandaio's, certainly one of his earliest collaborators, together with Ghirlandaio's brother Davide. The discovery that Mainardi was born in 1466 would suggest that the two painters' relationship was that of master and pupil, at least until the early 1480s. Certainly Mainardi could not have collaborated on the frescoes in the Collegiata.

Mainardi was the son of a wealthy apothecary in San Gimignano and was probably taken into Domenico Ghirlandaio's studio in the 1470s. From then on, he worked constantly with the Ghirlandaio family and continued to do so after Domenico's death in 1494, when his younger brothers, Davide and Benedetto Ghirlandaio, took over management of the studio. In June 1494 Mainardi married the brothers' half-sister, Alessandra. Although it is difficult to define Mainardi's role in the Ghirlandaio studio, he presumably collaborated on the frescoes (1486–90) in the choir of S Maria Novella, Florence, since his portrait is included in the scene of *Joachim Driven from the Temple*. He was working for the studio in Pisa between the end of 1492 and the summer of 1494, and in 1493 he painted an *Assumption of the Virgin* (destr.) in the Palazzo dei Priori, Pisa.

Mainardi is first recorded working as an independent master on 20 July 1484, when he was paid for painting a screen (destr.) for the high altar in the Collegiata, San Gimignano. In 1487 he frescoed *St Gimignano Blessing Three Noblemen* in S Agostino, San Gimignano; the work (*in situ*) was commissioned by Fra Domenico Strambi, whose tomb beneath the fresco was completed the following year. For the same patron and in the same church, Mainardi frescoed *St Peter Martyr* (1488; destr. 17th century). Two frescoes representing *St Jerome* and the *Virgin and Child* in the chapel in the Bargello, Florence, date from 1490. The surviving early works are heavily influenced by Domenico Ghirlandaio. Vasari attributed the large fresco of the *Assumption of the Virgin with St Thomas* in the Baroncelli Chapel, Santa Croce, Florence, to Mainardi, adding that the cartoon was provided by Ghirlandaio. From these works, it is difficult to define Mainardi's individual style, and numerous disparate products of Ghirlandaio's studio have been attributed to him.

These include portraits (see Davies) and such drawings as the *Study of the Heads of Two Children* (Florence, Uffizi), which is connected to a series of tondi (e.g. Paris, Louvre) often attributed to Mainardi, but which should be regarded rather as products of Ghirlandaio's large bottega.

Mainardi's oeuvre has to be reconstructed around a single fresco cycle in the chapel of S Bartolo in S Agostino, San Gimignano. Originally the frescoes were signed and dated 1500 (Pecori). *The Doctors of the Church* are depicted in the quadripartite vault, and on the left wall *SS Gimignano, Lucy and Nicholas* are shown standing in a fictive loggia with pilasters and a frieze richly decorated with zoomorphic motifs and a landscape in the distance. A number of paintings in San Gimignano can be grouped around these frescoes and would seem to date from the turn of the 16th century. They include a large altarpiece of the *Virgin and Child with Six Saints*, which stylistically belongs to the late 15th century and would seem to have been painted with an assistant's help, two tondi of the *Virgin and Child* and a panel of the *Virgin and Child with SS Jerome and Bernard* dated 1502 (all San Gimignano, Mus. Civ.), all of which came from local monasteries. Other works of this date in San Gimignano include a tabernacle of the *Virgin and Child with Cherubim* in Via S Giovanni, and a series of lunettes of the Virgin and Child and busts of saints in the vestibule of the Ospedale di S Fina. Although he was still under the influence of Ghirlandaio, he seems also to have been influenced by such Florentine masters of the younger generation as Francesco Granacci, who was his fellow pupil in Ghirlandaio's studio. A fresco of a *Sacra Conversazione* in S Lorenzo in Cappiano, near Incisa, echoes some of Raffaellino del Garbo's stylistic traits. A *Pietà with SS John the Baptist and Paul* (Schwerin, Staatl. Mus.), usually attributed to Antonio da Viterbo (*d* 1516), is stylistically very close to the frescoes in the chapel of S Bartolo, San Gimignano, and can be attributed to Mainardi.

Bastiano Mainardi: *Virgin and Child with St Justus and a Female Saint*, oil on panel, 1.61×1.55 m, 1507 (Indianapolis, IN, Museum of Art)

The panel was commissioned by Guglielmo Altoviti in 1500 for the chapel in the Palazzo Vicariato in Certaldo.

The compositions of Mainardi's later works are repetitive, although in an attempt to bring his style up to date he simplified and softened the forms, perhaps influenced by Fra Bartolommeo and Mariotto Albertinelli, but above all under the influence of Ridolfo Ghirlandaio, in whose studio he almost certainly worked in the first years of the 16th century. Examples of this phase are the *Virgin and Child with SS Francis and Julian* (Palermo, Chiaramonte–Bordonaro priv. col., see van Marle, p. 221, fig. 150), painted in 1506 for Pietro Nori, a notary in San Gimignano employed by the Mainardi family, and the *Virgin and Child with St Justus and a Female Saint* (see fig.). A banner of the *Holy Face* (San Gimignano, Mus. A. Sacra and church of the Compagnia della Misericordia) may also date from this period. Mainardi also undertook decorative work: he painted a plaster statue of the *Virgin* (untraced) for the rector of the Ospedale di S Fina, and in 1500 he gilded the marble tomb of *St Bartolo*, sculpted by Benedetto da Maiano, in the church of S Agostino, San Gimignano. In 1501 he frescoed a vault in the Collegiata in San Gimignano with blue sky and stars, and in 1504 and 1507 he decorated banners for the feast of S Fina.

BIBLIOGRAPHY

Thieme–Becker

G. Vasari: *Vite* (1550, rev. 2/1568); ed. G. Milanesi (1878–85), iii, pp. 263, 272, 275–7

L. Pecori: *Storia della terra di San Gimignano* (Florence, 1853), pp. 495–6, 522–3, 539–40, 545, 555

G. B. Cavalcaselle and J. A. Crowe: *Pittori fiorentini del secolo XV e del principio del seguente*, Stor. Pitt. It., vii (Florence, 1897)

R. van Marle: *Italian Schools* (1923–38), xiii, pp. 187–228

G. de Francovich: 'Sebastiano Mainardi', *Cron. A.*, iv (1927), pp. 169–93, 256–70

M. Davies: *The Earlier Italian Schools*, London, N.G. cat. (London, 1951, 2/1961/R 1986), pp. 220, 326

B. Berenson: *Florentine School* (1963), i, pp. 125–8

E. Fahy: *Some Followers of Domenico Ghirlandaio* (New York and London, 1976), pp. 190, 215–19

L. Venturini: *Bastiano Mainardi, pittore di San Gimignano, e altri problemi di pittura fiorentina tra la fine del quattrocento e l'inizio del cinquecento* (diss. U. Florence, 1988–9)

——: 'Tre tabernacoli di Sebastiano Mainardi', *Kermes*, xv (1992), pp. 41–8

Maestri e botteghe: Pittura a Firenze alla fine del quattrocento (exh. cat. by L. Venturini, Florence, Pal. Strozzi, 1992), pp. 151–2, 162, 214–16, *passim*

L. Venturini: 'Il maestro del 1506: La tarda attività di Bastiano Mainardi', *Stud. Stor. A.*, v (in preparation)

LISA VENTURINI

Majano, da. *See* MAIANO, DA.

Majorana, Cristoforo (*b* Naples; *fl c.* 1480–94). Italian illuminator. Two manuscripts by this artist can be identified from surviving payment records in the Aragonese treasury: on 13 October 1480 he was paid for the illustration of 'Agostino super Salamis', a work that has now been identified as St Augustine's *Commentary on the Psalms* (London, BL, MSS Add. 14779–83), while a copy of Aesop's *Fables* (U. Valencia, Bib., MS. 758) has been linked to a payment made in 1481. Analysis of these documented volumes allows the partial reconstruction of the artist's career. Other work for the King of Naples, Ferdinand of Aragon, is recorded in numerous sources, but the manuscripts described in these commissions remain untraced. Majorana's hand has nevertheless been identified in a Breviary that once belonged to Ferdinand (*c.* 1480; Naples, Bib. N., MS. 1. B. 57). This was probably executed while Majorana was in the workshop of the Neapolitan illuminator Cola Rapicano, where he appears to have begun his career, as some pages reveal the hand of Nardo Rapicano, another member of the shop.

Majorana also decorated several volumes for the libraries of both Cardinal Giovanni d'Aragona (1456–85) and Andrea Matteo Aquaviva d'Aragona, Duca d'Atri. His works for the latter include copies of Virgil's *Aeneid*, *Eclogues* and *Georgics*, now bound as one volume (1482–94; Leiden, Bib. Rijksuniv., MS. BPL 6B), and a copy of Ptolemy's *Cosmographia* (Paris, Bib. N., MS. lat. 10764). The Leiden copy of Virgil is an example of the numerous volumes Majorana decorated with frontispieces featuring classicizing architecture in a style that may have had its source in the manuscripts of the Venetian–Roman type that were circulated at the Aragonese court in Naples. It is also possible to detect in them influences from northern European, Florentine and Ferrarese manuscript illumination.

BIBLIOGRAPHY

T. De Marinis: *La biblioteca napoletana dei re d'Aragona*, 6 vols (Milan and Verona, 1947–69)

J. J. G. Alexander and A. C. de la Mare: *The Italian Manuscripts in the Library of Major J. R. Abbey* (Oxford, 1969)

A. Putaturo Murano: *Miniature napoletane del rinascimento* (Naples, 1973), pp. 34–8, 64–9

E. Cassee: 'La miniatura italiana in Olanda: Risultati di ricerche nella collezione della Biblioteca dell'Università di Leida', *La miniatura italiana tra gotico e rinascimento: Atti del II congresso di storia della miniatura italiana: Cortona, 1982*, i, pp. 155–74

A. C. de la Mare: 'The Florentine Scribes of Cardinal Giovanni of Aragon', *Il libro e il testo*, ed. C. Questa and R. Raffaelli (Urbino, 1984), pp. 245–93

J. P. Timmer: *Drie geïllumineerde Napolitaanse manuscripten uit de 15de eeuw, rich bevindende in de Universiteitsbibliothek te Leiden* (diss., U. Leiden, 1984)

Dix siècles d'enluminure italienne (exh. cat., ed. F. Avril; Paris, Bib. N., 1984)

S. Gentile, ed.: *Vita e Favole di Esopo* (Naples, 1988) [on U. Valencia, Bib., MS. 758]

GENNARO TOSCANO

Malatesta. Italian family of rulers and patrons. (1) Sigismondo Pandolfo Malatesta, (2) Novello Malatesta and Galeotto Roberto Malatesta (*d* 1432) were the sons of Pandolfo III Malatesta (1370–1427), a condottiere and ruler of Bergamo, Brescia and Fano. When Pandolfo died, custody of his sons passed to his brother, Carlo Malatesta (1368–1429), ruler of Rimini and Cesena. Before Carlo died, he secured the legitimization of his three nephews from Pope Martin V. The final division of Carlo's estate, as well as that of Pandolfo III, was made between Sigismondo and Novello in 1432 after Galeotto Roberto's death. To Sigismondo went Fano and Rimini, the latter unquestionably the most important possession, while Novello received the less important towns of Cesena and Cervia.

(1) Sigismondo Pandolfo Malatesta (*b* Rimini, 1417; *d* Rimini, 1468). At a very young age he distinguished himself as a condottiere in the service of the papacy, and from the 1430s he was involved in many of the important military engagements on the Italian peninsula. His fortunes

began to wane, however, when in 1447 he deserted Alfonso I, King of Naples and Sicily (*reg* 1416–58). This desertion, his subsequent hostilities toward the Montefeltro and Sforza families, and his disregard in 1459 of peace terms proposed by Pope Pius II severely tarnished his reputation and heralded the eventual decline of his political and military fortunes. Although he continued to provide his services as a condottiere, fighting for Venice against the Turks (1464–5), his enemies had managed to reduce his base of power to Rimini alone by the time of his death.

In addition to his numerous political and military activities, Sigismondo made Rimini into an important, albeit small, centre of Renaissance art, science and learning. As there were few artists of note in 15th-century Rimini, he awarded his commissions to artists from other cities. Initially his patronage was influenced by the artistic direction taken by the Este court in Ferrara, with which he enjoyed a political alliance through his marriage in 1434 to Ginevra d'Este, daughter of Lionello d'Este, Lord of Ferrara; in the mid-1440s Pisanello, then employed by the Este, made medals of both Sigismondo and Novello. Sigismondo was one of the first Renaissance princes to grasp the possibilities of this art form as propaganda, and he commissioned no fewer than 15 medals from Pisanello.

Sigismondo was also interested in the artistic developments in Florence. Filippo Brunelleschi is recorded in Rimini in 1438, and his presence there may have been connected with the construction of the Castel Sigismondo (1437–46), which also served as Sigismondo's residence. In 1449 Sigismondo wrote to Giovanni de' Medici requesting the services of a good painter to decorate the chapels of the Malatesta and their dependants, ostensibly in the Gothic monastic church of S Francesco at Rimini, the burial site of his ancestors. Giovanni de' Medici seems to have recommended Fra Filippo Lippi, who painted for Sigismondo a *St Sigismund* and *St Jerome* (both untraced).

Sigismondo's greatest involvement with Florentine artists came with the reconstruction and decoration of S Francesco (*see* RIMINI, §1). His modest initial plans covered only new memorial chapels (1447–50) for himself and his mistress, Isotta degli Atti, whom he married *c.* 1454. The chapels were decorated by the Florentine sculptor Agostino di Duccio and the Tuscan painter Piero della Francesca, who created the fresco of *Sigismondo Malatesta Venerating St Sigismund* (*see* PIERO DELLA FRANCESCA, fig. 2). Before he left Rimini, probably in 1457, Agostino was also responsible for most of the sculptural decoration inside S Francesco when Sigismondo decided to expand the project. His elegantly linear sculpture, which contemporaries considered antique in style and expression, was particularly well suited to the Renaissance environment established by Sigismondo in Rimini. Another Florentine, Maso di Bartolommeo, made an iron gate (destr.) for Sigismondo's memorial chapel.

The contributions made by these artists and others to the interior of S Francesco were overshadowed when Sigismondo commissioned Leon Battista Alberti, the Florentine architect and theoretician, to renovate the exterior of the church (*c.* 1450). Alberti transformed the Gothic church into the neo-Roman Tempio Malatestiano, but his concept remains unfinished, and Matteo de' Pasti's foundation medal (1450; *see* RIMINI, fig. 3) is the only record of Alberti's original design. The medal indicates the intended construction of the upper storey of the façade, flanked by segmental half pediments and culminating in a single central bay, and a large rotunda surmounted by a hemispherical dome (*see* ALBERTI, LEON BATTISTA, fig. 1). The fidelity of the medal to Alberti's project is supported by Pasti's role as the architect responsible for the actual construction of the Tempio in Alberti's absence. In style and iconography, the Tempio was classical and therefore pagan: Pius II described it as 'so full of pagan images that it seems like a temple for the worshippers of demons, and not for Christians'.

Sigismondo Pandolfo Malatesta has been represented traditionally as one of the most disreputable, though highly cultured, rulers and patrons of the Italian Renaissance: 'Unscrupulousness, impiety, military skill and high culture have been seldom so combined in one individual as in Sigismondo Malatesta' (Burckhardt). More recently, while not fully exonerating him, scholars have begun to question the testimony of his detractors. He was, however, unable to make Rimini a permanent home of the arts, and its cultural distinction lapsed with his death.

(2) Novello (Domenico) Malatesta (*b* 1418; *d* 1465). Brother of (1) Sigismondo Pandolfo Malatesta. Throughout his life he was overshadowed by his elder brother in political, military and cultural activities. A scholar and bibliophile, Novello commissioned and was responsible for the construction of the Biblioteca Malatestiana (1447–52) in the convent of S Francesco, Cesena, to the designs of the Umbrian architect Matteo Nuti. Particularly noteworthy is the scriptorium, with a barrel vault that spans the central of three aisles. The Biblioteca Malatestiana bears a striking resemblance to the library of S Marco, Florence, which Michelozzo di Bartolomeo built for Cosimo de' Medici in the 1430s.

BIBLIOGRAPHY
J. Burckhardt: *Die Kultur der Renaissance in Italien* (Basle, 1860; Eng. trans., London, 1873)
C. Ricci: *Il Tempio Malatestiano* (Rimini, 1925/*R* 1974)
C. Brandi: *Il Tempio Malatestiano* (Turin, 1956)
F. Arduini and others: *Sigismondo Pandolfo Malatesta e il suo tempo* (Vicenza, 1970)
P. J. Jones: *The Malatesta of Rimini and the Papal State: A Political History* (London and New York, 1974)
J. R. Hale, ed.: *A Concise Encyclopaedia of the Italian Renaissance* (London, 1981), pp. 196–7
ROGER J. CRUM

Malosso, il. *See* TROTTI, GIOVANNI BATTISTA.

Manara, Baldassare (*fl* 1526; *d* Faenza, 1546–7). Italian potter. He was a member of an important family of maiolica potters in Faenza; his father Giuliano Manara and his uncle Sebastiano worked in Faenza, as several documents prove. Baldassare was one of the most eminent artists working in Faenza during the first half of the 16th century. A series of documents refer to his workshop in the S Clemente district of the city, and he left many works, signed with the monogram BM or his signature in full, dated between 1532 and 1538. Manara was an exponent of the *istoriato* (narrative) genre, in which despite being inspired by many of Raphael's subjects taken from prints,

he also derived some elements of form and colour from *istoriato* maiolica made in Urbino (as in a shallow bowl decorated with the *Triumph of Time*, 1530–35; Oxford, Ashmolean). Historians often regard Manara as the single greatest influence on maiolica production in Faenza during the second *istoriato* period.

BIBLIOGRAPHY

C. Grigioni: 'Documenti: Serie faentina: Documenti relativi alla famiglia Manara', *Faenza*, xx/3–6 (1932), pp. 152–81
G. Liverani: 'Sul disco di B. Manara con l'effigie di Battistone Castellini', *Faenza*, xxviii/4 (1940), pp. 78–82
C. Ravanelli Guidotti: *Baldassare Manara faentino, pittore di maioliche nel Cinquecento*, intro. by F. Zeri (Ferrara, 1996)

CARMEN RAVANELLI GUIDOTTI

Mancini, Domenico (*fl* Venice, 1511). Italian painter. The only evidence for his existence is an inscription in a painting of the *Virgin and Child with an Angel* (Lendinara Cathedral), which reads *opus • dominicj mancinj/ venetj • p • / • 1511*. The painting was first recorded in 1652 (1984 exh. cat.), in S Francesco, Lendinara. In 1795 Brandolese reported that it was part of a triptych, the side panels of which each contained pairs of apostles (untraced). The Lendinara picture is derived from the central section of Giovanni Bellini's altarpiece (*Virgin and Child Enthroned with Saints*) in S Zaccaria, Venice, dated 1505 (see colour pl. 000). The poses of the Virgin and Child are almost identical in the two pictures, but the musician angel is different from Bellini's in pose and holds a lute rather than a *lira da braccio*. Closer parallels to this figure appear in various pictures by Francesco Bissolo, but these may all be later.

The importance of the Lendinara altarpiece lies less in its dependence on Bellini than in its links with works associated with the circle of Giorgione. The arrangement of folds of the left sleeve of the Virgin and of the lower right section of her robe is identical to that in the corresponding sections of the *Madonna and Child with SS Anthony and Roch* (Madrid, Prado), usually attributed to Giorgione or early Titian. Scholars have suggested that Mancini copied the figure of the Virgin from the S Zaccaria Altarpiece and these drapery sections from the Prado picture. No convincing explanation of why he should have done so has been offered, however, and it could be argued that Mancini himself painted the Prado *Madonna*. The impact of Giorgione's innovations is most evident in the angel, which is painted with saturated colours, very soft modelling and loose brushwork, especially in the curls. Physiognomically the head is close to that of the wife in *Christ and the Woman Taken in Adultery* (Glasgow, A. G. & Mus.), another picture generally given to Titian or Giorgione. Zampetti (1955 exh. cat.) tentatively assigned the Glasgow painting to Mancini, a view that has much to recommend it. Trevisani (1984 exh. cat.), noting that there are pentiments in the head of the angel, argued that it was repainted by Dosso Dossi in or after 1516. This seems implausible, even though the stylistic parallels with Dosso's work are undeniable, but Dosso may well have been influenced by Mancini.

Other pictures have been assigned to Mancini on the basis of their supposed similarity to the Lendinara panel; the most convincing attribution is a *Virgin and Child with Two Saints* (ex-Gamba priv. col., Florence; see Berenson,

pl. 692). Probably because of the lack of documentary evidence of his activity, however, most scholars have been reluctant to suppose that Mancini was more than a minor and unproductive follower of Bellini. Since very few documents survive from this period concerning Venetian painters even of the stature of Giorgione and Titian, the possibility that he was much more important than is now generally supposed cannot be excluded.

BIBLIOGRAPHY

P. Brandolese: *Del genio de' Lendinaresi per la pittura e di alcune pregevoli pitture di Lendinara* (Padua, 1795), pp. 7–9
J. Wilde: 'Die Probleme um Domenico Mancini', *J. Ksthist. Samml. Wien*, vii (1933), pp. 97–135
Giorgione e i Giorgioneschi (exh. cat., ed. P. Zampetti; Venice, Doge's Pal., 1955), pp. 110–13
B. Berenson: *Venetian School* (1957)
The Genius of Venice, 1500–1600 (exh. cat., ed. J. Martineau and C. Hope; London, RA, 1983), pp. 168–70 [entries by F. L. Richardson]
Restauri nel Polesine (exh. cat., ed. A. della Valle; Rovigo, Accad. Concordi, 1984), pp. 133–66 [full discussion and technical report on the Lendinara panel by F. Trevisani]

CHARLES HOPE

Mane, John. *See* MAIANO, DA, (3).

Manetti, Antonio di Ciaccheri (*b* Florence, *c.* 1402; *d* Florence, 8 Nov 1460). Italian carpenter and architect. He was the son of a Florentine merchant and writer, Manetto Ciandi. As early as October 1432 he was paid for wooden models relating to the construction of the dome of Florence Cathedral, a task probably passed to him by Filippo Brunelleschi. Before 1436 he was working on the model for the upper section of the dome and on detailed parts, such as screws and the high scaffolding, for the special crane intended to hoist building material up to the dome. In 1434 he produced two models (destr.) for the high altar of the cathedral, based on a design by Brunelleschi, as well as seven models (destr.) for the side altars. He was also involved, in 1438, with the installation of the organs in their galleries and produced two models for the cathedral lantern competition held in 1436. One of these was from a design by Brunelleschi; the other was Manetti's own, although according to Antonio di Tuccio Manetti this was almost identical with Brunelleschi's design. However, Manetti did make an independent contribution to part of the marquetry cupboards for one of the cathedral sacristies, the Sagrestia delle Messe (1436–42), which were begun by Agnolo de' Cori.

From 1447 Manetti received payments for a model that may have represented Michelozzo da Bartolomeo's restructuring of the church of SS Annunziata, Florence. He also produced models for the small Chiostro dei Voti in front of the church, and for the outer door leading on to the Piazza della SS Annunziata (1453). Several courtyards and cloisters dating from the same period (1446–55) have been attributed to Manetti, including the Canonica at S Lorenzo, the Spinelli Cloister of Santa Croce, both in Florence, as well as at Badia a Settimo, Impruneta and Montepulciano. These are articulated with slender Ionic columns of *pietra serena* and have no cornices or horizontal emphasis. In later cloisters the columns are more slender and support Corinthian or Composite capitals. In 1452, after the dismissal of Michelozzo, Manetti was put in charge of the Opera del Duomo (Cathedral Works) of

Florence Cathedral. He was involved mainly with continuing work on the lantern, for which he had already invented (1444) a revolving crane to hoist the large sections of marble. Manetti also constructed a model for the exterior gallery of the dome and wooden decorations (destr.) such as lamps, tabernacles, processional floats for chapels, as well as stalls for the new choir. Manetti was ordered by the Florentine government to present Francesco Sforza, Duke of Milan, in March 1459/60 with a design for a fortified stronghold at Pisa, but this was considered impractical and 'too splendid'.

In 1455 Manetti was involved with the Villa Medici at Fiesole and at the nearby convent of S Gerolamo, once attributed to Michelozzo. In 1457 he took over the construction of the church of S Lorenzo, particularly the dome and the nave chapels. Both elements were later criticized by Brunelleschi's biographer and by Vasari because they were considered to differ from the original plan. The dome was criticized because it lacked a light source, while the chapels were considered too small and not well proportioned to the rest of the architecture. In 1459 Manetti was put in charge of Brunelleschi's church of Santo Spirito where he is traditionally attributed with covering the convex curves of the original exterior with a straight wall. In the same year at SS Annunziata, he worked on the completion of the large cloister and strengthened the foundations of the choir tribune. In 1460, together with Michelozzo and Giovanni da Gaiole, Manetti was called on by the Ufficiali della Torre to judge a project for an artificial lake at Mantignano, which would contain the waters of the Arno. In 1460 he supplied a model for the chapel of the Cardinal of Portugal in the church of S Miniato, Florence. However, the chapel as executed probably follows the designs of the circle of Antonio Rossellino.

BIBLIOGRAPHY

DBI; Thieme–Becker

A. di Tuccio Manetti: *Vita di Filippo di Ser Brunellesco* (c. 1487); ed. H. Saalman (Pennsylvania and London, 1970), pp. 110–15, 149–53

G. Gaye: *Carteggio inedito d'artisti dei secoli XIV, XV, XVI*, i (Florence, 1839), pp. 169–71

C. Guasti: *La cupola di Santa Maria del Fiore, illustrata con i documenti di archivio dell'opera secolare* (Florence, 1857)

C. Von Fabriczy: 'Brunelleschiana', *Jb. Kön.-Preuss. Kstsamml.*, xxvii (1907), pp. 53–5

G. Poggi: 'Il Duomo di Firenze', *It. Forsch. Kstgesch.*, ii (1909), pp. 208, 214, 234, 239, 240, 270

H. Saalman: 'Tommaso Spinelli, Michelozzo, Manetti and Rosselino', *J. Soc. Archit. Historians*, xxv (1966), pp. 151–64 (155,158)

I. Hyman: 'Toward Rescuing the Lost Reputation of Antonio di Manetto Ciaccheri', *Essays Presented to Myron P. Gilmore*, ii (Florence, 1978), pp. 261–80

F. Borsi, G. Morolli and F. Quinterio: *Brunelleschiani* (Rome, 1979), pp. 34–45, 106–13, 260–76

H. Saalman: *Filippo Brunelleschi: The Cupola of Santa Maria del Fiore* (London, 1980)

I. Hymann: 'Antonio di Manetto Ciaccheri and the Badia Fiesolana, Italy', *Architetura*, xxv/2 (1995), pp. 181–93

FRANCESCO QUINTERIO

Mangone, Giovanni (*b* Caravaggio; *d* Rome, before 27 June 1543). Italian architect and sculptor. He was a pupil of the sculptor Andrea di Piero Ferrucci. From *c.* 1527 to 1532 he was supervisor of the Fonte di S Pietro, Rome. He was conservator of the gilded ceilings of the basilica of S Maria Maggiore until 1541, and from *c.* 1542 he was also the architect to the Camera Apostolica (Vatican Works Office), a post he held until his death. For Angelo Massimo, Mangone constructed the Palazzo di Pirro (initiated *c.* 1533). In this, his first architectural work, he appears as a faithful follower of the severe style of Antonio da Sangallo (ii) with whom he worked on the decorations (1534) for the coronation of Pope Paul III and the fortifications (1537–43) of Rome. In 1535 he worked on the palazzo in Rome of Giacomo Simonetta, Cardinal of Perugia, and in 1536 he planned alterations to the convent of the Serviti attached to the church of S Marcello al Corso. In the same year, he executed the monument to *Cardinal Eckervoirt* in the church of S Maria dell'Anima, Rome, in a style influenced by Andrea Sansovino. This work and the monument (1538) to *Cardinal Magalotti* in the church of S Cecilia in Trastevere, Rome, represent the sculptural production attributed to Mangone.

In his last years Magone carried out valuations and, at an unspecified time, worked on the church of S Luigi dei Francesi (before ?1531), laying out the architectural arrangement (later altered) of the internal decoration. In *c.* 1543 he worked on the fortification of the Sermoneta in Lazio. Other buildings attributed to him, all in Rome, include the Palazzo Alicorni in Borgo (destr. 1931; later rebuilt) and the Palazzetto dei Vellis in Piazza S Maria di Trastevere. Mangone's architecture is characterized by his great attention to proportion and balance, revealing his training as a sculptor in the precise design of the mouldings.

BIBLIOGRAPHY

Thieme–Becker

C. Tolomei: *Delle lettere libri sette* (Venice, 1547), p. 105

G. Vasari: *Vite* (1550, rev. 2/1568); ed. G. Milanesi (1878–85), iv, p. 480

F. de Marchi: *Dell'architettura militare* (Brescia, 1599), ii, 3 vols, p. xxxiv

G. Milanesi: 'Stima di un lavoro di Giovanni Mangone', *G. Erud. A.*, iv (1875), pp. 152–3

A. Bertolotti: *Artisti lombardi a Roma nei secoli XV, XVI e XVII*, i (Milan, 1881), pp. 43–7

G. Caetani: *Domus Caietana*, ii (San Casciano in Val di Pesa), p. 65

A. Venturi: *Storia*, x (1935), pp. 273–6

G. Giovannoni: 'Giovanni Mangone, architetto', *Palladio*, iii (1939), pp. 97–112

P. Portoghesi: *Roma del rinascimento* (Venice, 1970), pp. 237, 498

C. L. Frommel: *Der römische Palastbau der Hochrenaissance*, i (Tübingen, 1973), p. 54

M. Tafuri: 'Antonio da Sangallo il giovane e Jacopo Sansovino: Un conflitto professionale nella Roma medicea', *Antonio da Sangallo il giovane: La vita e l'opera*, ed. G. Spagnesi (Rome, 1986), pp. 90–91

S. Benedetti and G. Zander: *L'arte in Roma nel secolo XVI*, i of *L'architettura* (Bologna, 1990)

M. Tafuri: *Ricerca del rinascimento: Principi, città, architetti* (Turin, 1992), p. 209

ADRIANO GHISETTI GIAVARINA

Mannerism [It. *maniera*]. Name given to the stylistic phase in the art of Europe between the High Renaissance (*see* RENAISSANCE, §4) and the Baroque, covering the period from *c.* 1510–20 to 1600. It is also sometimes referred to as late Renaissance, and the move away from High Renaissance classicism is already evident in the late works of Leonardo da Vinci and Raphael, and in the art of Michelangelo from the middle of his creative career. Although 16th-century artists took the formal vocabulary of the High Renaissance as their point of departure, they used it in ways that were diametrically opposed to the harmonious ideal it originally served. There are thus good grounds for considering Mannerism as a valid and auton-

omous stylistic phase, a status first claimed for it by art historians of the early 20th century.

1. History of the term. 2. Historical context. 3. Formal language. 4. Iconography and theory. 5. Spread and development.

1. HISTORY OF THE TERM. The multitude of opposing tendencies in 16th-century art makes it difficult to categorize by a single term, a difficulty increased by the importance Mannerism placed on conflict and diversity. The word 'maniera' was first applied to the visual arts in 1550 by Giorgio Vasari. He used the words 'maniera greca' to describe the Byzantine style of medieval artists, which yielded to the naturalism of the early Renaissance, and he wrote of the 'maniera' of Michelangelo, which deeply influenced later 16th-century art. This gave rise to the modern concept of Mannerism as a description for the style of the 16th century. Although in 18th- and 19th-century art theory Mannerism was regarded as marking a decline from the High Renaissance, in the early 20th century critics recognized its affinities with contemporary artistic movements, and Mannerist art was highly esteemed. At the same time its importance in leading to the Baroque was appreciated, as were those aspects that opposed the classical stability of the High Renaissance.

2. HISTORICAL CONTEXT. Mannerist art can be understood only in the context of profound social, religious and scientific turmoil. The Reformation officially started when Martin Luther nailed up his theses in 1517; the Counter-Reformation opposition started from the time of the Council of Trent in 1545. The Protestant doctrine of justification by faith challenged fundamental Catholic dogmas, and the Church of Rome could no longer exert its spiritual authority effortlessly, even in areas where the Counter-Reformation prevailed. The Sack of Rome in 1527 was interpreted as a retribution for moral decline and the glorification of luxury and sensuality. North of the Alps the structure of society was destabilized by the Peasants' Wars of 1524–5 in Germany. The discovery of the New World in the late 15th century and the early 16th must have had an equally momentous impact on the Christian West's concept of itself. The Old World could no longer see itself as the centre of the earth, but was revealed as a relatively small area within an immeasurable and largely still unexplored whole with incalculable potential. On top of this came Copernicus's recognition of the heliocentric planetary system (c. 1512). A completely new view of the world came into being. The varied forms of Mannerist art evolved against this background. The art of the 16th century as a whole reflects deep doubts over the classical principles, normative proportions and lucid space of the High Renaissance. Mannerism may be described as the most wilful and perverse of stylistic periods.

3. FORMAL LANGUAGE.

(i) Movement. (ii) Spiritual intensity. (iii) Space. (iv) The fusion of the arts. (v) Anti-classicism and subjective expression.

(i) Movement. For the first time in Western art the painting and sculpture of the 16th century made the optical suggestion of movement a central creative concern. In painting this mainly affected subjects that suggest the passage of time, such as the Assumption of the Virgin or scenes from the Life of Christ, such as the Deposition and the Entombment. Examples include the *Lamentation* by Pontormo (1525–8; Florence, S Felicità; see PONTORMO, JACOPO DA, fig. 2) and Tintoretto's *Bacchus and Ariadne* (c. 1575; Venice, Pal. Ducale). In sculpture this interest in movement inspired the creation of single figures or groups of figures that can be viewed from all sides, rather than from a single point; just as the figure seems to be in perpetual movement, so the spectator is encouraged to keep moving around it. Giorgio Vasari coined the expression 'figura serpentinata' (serpentine line) to describe this concept. The style was developed by Benvenuto Cellini in his *Perseus with the Head of Medusa* (1545–54; Florence, Loggia dei Lanzi; see CELLINI, BENVENUTO, fig. 6) and subsequently by Giambologna in such works as *Mercury* (1580; Florence, Bargello; see GIAMBOLOGNA, fig. 3) and the *Rape of a Sabine* (1582; Florence, Loggia dei Lanzi; see GIAMBOLOGNA, fig. 2).

(ii) Spiritual intensity. Endeavours to depict the spiritual were equally characteristic of Mannerism, especially in the field of painting. Medieval artists set weightless figures against a spaceless gold ground to suggest the realm of the Divine; in the Renaissance an interest in naturalistic description and anatomy subordinated the depiction of the transcendental. In Renaissance art the 'miracle is a process like any other earthly event' (Frey). For example, in Raphael's *Disputa* the heavenly and earthly spheres are bound together by being represented with equal reality. Mannerism, however, developed new means of distinguishing between the earthly and the divine, and in Mannerist art 'the world beyond intrudes into the world below' (Frey). The High Renaissance had paved the way for this process: Raphael, for instance, suggested the miraculous in the *Liberation of St Peter* (1514; Rome, Vatican, Stanza di Eliodoro) through the representation of light.

A new painterly concept was the necessary basis for representing the spiritual. In 15th-century painting line dominated over colour. Line fixes an object on a flat surface, making it appear tangible and real. Leonardo da Vinci countered this with a new emphasis on colour, as in the *Virgin and Child with St Anne* (c. 1515; Paris, Louvre; see LEONARDO DA VINCI, fig. 5). In his art line gave way to the subtle modulation of tone, and this concept deeply influenced 16th-century painting, especially in Venice and Emilia. Forms become less tangible and clearly defined, and while line primarily appeals to the intellect, colour speaks first and foremost to the emotions. Thus the conditions were set for the viewer to be overwhelmed by the miracle made visible in the picture.

This new potential was most fully realized in pictures of apparitions and visions. Titian's *Virgin and Child with SS Francis and Aloysius and the Donor Alvise Gozzi* (1520; Ancona, Pin. Com.), in which the Virgin miraculously appears to saints and to the donor, Alvise Gozzi, was of fundamental importance to the development of this theme. Many of Parmigianino's paintings, such as the *Vision of St Jerome* (commissioned 1526; London, N.G.) and the *Virgin and Child with SS Mary Magdalene, John the Baptist and the Prophet Zachariah* (c. 1530; Florence, Uffizi), were

influenced by this work by Titian. Even the events described in the New Testament as taking place in this world were transposed into the divine realm, as in Titian's late version of the *Annunciation* (before 1566; Venice, S Salvatore) and Tintoretto's *Last Supper* (1592–4; Venice, S Giorgio Maggiore; see colour pl. 2, XXXIV1). Both the interest in movement and the representation of saintly visions and ecstasies were features developed by Baroque artists.

(iii) Space. Closely linked with giving visible expression to the spiritual was the endeavour to represent the infinite. In both architecture and painting the Renaissance had created space that was clearly defined on all sides. The viewer was provided with a definite frame and a fixed viewpoint. In the 16th century this situation was reversed. This development took place in stages. Initially the construction of pictorial space began to dominate over the animation of the surface. Here again the roots of the change can be found in the High Renaissance. Raphael's *School of Athens* (completed 1512; Rome, Vatican, Stanza della Segnatura; *see* ITALY, fig. 15) and the *Expulsion of Heliodorus* (1512–14; Vatican, Stanza di Eliodoro), in compositions based on the same principles, demonstrate the development from the primacy of surface to the primacy of space. In the second stage the space represented in pictures is seemingly extended into infinity: as in Francesco Salviati's fresco *Bathsheba Going to David* (1552–4; Rome, Palazzo Sacchetti), Tintoretto's *Rediscovery of the Body of St Mark* (before 1566; Milan, Brera; *see* TINTORETTO, fig. 3) or Giambologna's relief of the *Rape of a Sabine* (1582; Florence, Loggia dei Lanzi; *see* GIAMBOLOGNA, fig. 2). In the final stage, the side boundaries, too, are made transparent or even removed, as for example in Tintoretto's painting of the *Transportation of the Body of St Mark* (1562; Venice, Accad.) or Parmigianino's *Madonna of the Long Neck* (1534–40; Florence, Uffizi; *see* PARMIGIANINO, fig. 3). This last painting also epitomizes a further defiance of High Renaissance lucidity: the architectural features and figures are no longer rationally united. Data relating to proportion and perspective space are at variance with one another, as is also the case in Pontormo's earlier panels illustrating the *Story of Joseph* (1515–18; London, N.G.).

Developments in architecture were closely bound up with those in painting. The ideal of the centralized plan was abandoned in favour of the elongated axis. The administrative building of the grand duchy of Tuscany, the Uffizi, started in 1560 and designed by Vasari, was laid out according to this principle. The concept of a long gallery building, which was to be a constant component of grand houses and castles until the 19th century, became a favourite element in secular architecture. For example, Rosso Fiorentino created the Galerie François I at Fontainebleau in 1533–40 (5 m wide and 58 m long). In the 1580s Duke Vespasiano Gonzaga had the Palazzo del Giardino built at his residence in Sabbioneta, probably to designs by Vincenzo Scamozzi, on a narrow, seemingly unending axis (*see* SCAMOZZI, (1), fig. 2). The blurring of fixed side limits that can be observed in painting, however, also had parallels in architecture. Michelangelo in particular in his designs (1516) for the façade of S Lorenzo in

Florence (not implemented), the New Sacristy (1519–33) at S Lorenzo and the vestibule of the Biblioteca Laurenziana (both from 1524; *see* MICHELANGELO, fig. 8) treated the wall in a way that defies the normative proportions and clarity of the High Renaissance. Not only is the wall more sculpturally modelled than ever before, but there is no clear surface to act as a point of reference for the projecting and receding architectural elements; where the wall and thus the spatial boundary lies is debatable. In addition, Michelangelo no longer made a precise distinction between the façade and the inner wall; in the vestibule of the Biblioteca Laurenziana and in the New Sacristy the observer is confronted with four inward-turning façades.

Another characteristic of Mannerist art with regard to treatment of space is the lifting of boundaries—or blurring of them—in a variety of ways. This applies especially to the boundary between the artistic space (in the work of art) and the real space. A distinction can be made between the passive and active removal of this aesthetic boundary: when it is lifted passively the artistic space appears to be a continuation of the real space, while when it is lifted actively elements or figures from the artistic space appear to step out into real space. Important preliminary stages of this process are again discernible *c.* 1500 (e.g. the altar wall of the Strozzi Chapel painted by Filippino Lippi at S Maria Novella, Florence). In 1516–17 Baldassare Peruzzi painted the Sala delle Prospettive in the Villa Farnesina in Rome, in which a painted architectural colonnade opens out over a view of Rome. In the Sala dei Cento Giorni (1546; Rome, Pal. Cancelleria) Vasari successfully achieved a disorientating play with the spatial boundaries, while with the Sala dei Cavalli (1525–35; Mantua, Palazzo del Te) GIULIO ROMANO blurred the division between artistic and real space, and between architecture, painting and sculpture. With the frescoes (1561–2) in the Villa Barbaro at Maser, Paolo Veronese went farthest along this path (*see* VERONESE, PAOLO, §I, 3; see colour pl. 2, XXXIX1).

(iv) The fusion of the arts. In all the examples given so far, it is clear that conditions specific to the individual art forms were removed. The possibility of replacing one art form with another—for example, sculpture and architecture with painting, or architecture with sculpture—is most powerfully rooted in the work of Michelangelo (the nude figures that appear to be painted sculptures in the ceiling of the Sistine Chapel in the Vatican, 1508–12; see colour pl. 2, VI1). This trend developed fully in the next generation. When CORREGGIO decorated the Camera de S Paolo at the monastery of S Paolo in Parma (*c.* 1519; *see* CORREGGIO, fig. 2) not only did he make it impossible to see where the ceiling ended, but he also used painting to suggest the presence of sculpture and architectural elements. Veronese opened the boundaries between architecture, sculpture and painting farther than anyone else in his decorations at the Villa Barbaro at Maser.

Boundaries were overstepped in other respects too—here verging on the bizarre: for example, when buildings were created in the form of figural sculptures (*c.* 1580) in the garden at the Villa Orsini in Bomarzo (*see* BOMARZO, SACRO BOSCO), or when sculpture sprang directly out of nature, as in the allegorical figure of the *Apennines* (1570–

80; see colour pl. 1, XXXIII3) by Giambologna in the park at Pratolino, above Florence.

(v) Anti-classicism and subjective expression. 16th-century art rejected the classical principles of the High Renaissance. However, this alone does not make it Mannerist, as this further requires, among others, a predilection for the depiction of the abnormal and an emphasis on the subjective. Indeed, since the reassessment of Mannerism at the beginning of the 20th century, these latter aspects of 16th-century art have been much over-emphasized. In this context, the distortion of the human figure, often with the object of making it more expressive (a trend that is therefore allied with Expressionism), is of primary importance. Thus Rosso Fiorentino had no doubt studied Michelangelo, but he gave to his heroic figures seemingly arbitrary proportions and forms, summarizing and generalizing detail, as in *Moses Defending Jethro's Daughters* (1523; Florence, Uffizi; see fig.) and the *Deposition* (1521; Volterra, Pin. Com.; *see* ROSSO FIORENTINO, fig. 1). In Florentine painting in particular figures were often elongated, while the heads remained relatively small, as in Pontormo's portrait of *Alessandro de' Medici* (*c.* 1525; Lucca, Mus. & Pin.), his *Visitation* (*c.* 1530; Carmignano, S Michele) and his frescoes (1523–5) in the Certosa del Galluzzo, near Florence. In North and Central Italy the same phenomena occurred, as in Parmigianino's *Madonna of the Long Neck* or Tintoretto's *Christ before Pilate* (1566–7; Venice, Scu. Grande di S Rocco).

In general terms between 1400 and 1600 three stages of development in the representation of the human figure

Rosso Fiorentino: *Moses Defending Jethro's Daughters*, oil on canvas, 1.60×1.17 m, 1523 (Florence, Galleria degli Uffizi)

in art can be identified. In the early Renaissance the ideal was to show man as he appears naturally. There followed, in the High Renaissance, a desire to create ideally beautiful figures and to overcome the blemishes of nature. The ideal of Mannerism was to go beyond the natural reality and to distort figures in the interests of subjective expression.

In architecture classical forms are used in a fanciful and complex way that defies the rules of Classical architecture. Typical examples of this are the Palazzo del Te in Mantua, built *c.* 1525–35 by Giulio Romano (*see* GIULIO ROMANO, fig. 3), the courtyard face of which is structured *all'antica*, but with the masonry irregularly divided and with every third triglyph on the frieze threatening to slip out of place; the courtyard façade of the Palazzo Pitti in Florence, which adopts the Classical orders—Doric, Ionic and Corinthian—but where the actual load-bearing members, the columns, are given virtually no visual impact; or Palladio's Villa Rotonda (started in 1553; *see* PALLADIO, ANDREA, fig. 5), Vicenza, which externally embodies the idea of the centrally planned building to perfection, while the central space within is so poorly lit that the visitor has the impression of being drawn outwards by the horizontal shafts of light coming from the four entrances. Thus the centripetal principle of the centrally planned building is reversed into its centrifugal opposite.

4. ICONOGRAPHY AND THEORY. Mannerism is also distinguished by its intellectually complex iconography. Agnolo Bronzino's painting of the *Venus, Cupid, Folly and Time* (*c.* 1544–5; London, N.G.; *see* BRONZINO, AGNOLO, fig. 2) is as typical in this respect as Benvenuto Cellini's salt cellar (Vienna, Ksthist. Mus.; *see* CELLINI, BENVENUTO, fig. 4) with its heavy burden of mythological references, both works made for Francis I (*reg* 1515–47). Cellini himself said that he was well aware that he did not approach his work like many ignorant artists who, although they could produce things that were quite pleasing, were incapable of imbuing them with any meaning.

The art theory of the Mannerist period was concerned with aesthetic problems rather than with the empirical problems of perspective, proportion and anatomy that had absorbed 15th-century writers. Venetian and Florentine theorists debated the primacy of *colore* and *disegno*; PARAGONE, a debate over whether painting or sculpture was the superior art form, raged; and in the late 16th century the question of the relationship between the creative idea (the 'concetto') and the model in nature was discussed by such theorists as Giovanni Paolo Lomazzo.

5. SPREAD AND DEVELOPMENT. In the 1520s Mannerism was established as a style in Rome by the late work of Raphael and that of his followers, Giulio Romano and Perino del Vaga, and in Florence by the work of Pontormo and Rosso Fiorentino. After the Sack of Rome (1527), the style spread to other Italian centres (Giulio Romano worked in Mantua, Sanmicheli in Verona and Parmigianino in Parma) and Florentine art of the mid-16th century may be described as mature Mannerism, the principal exponents of which were Bronzino, Vasari, Salviati and Giambologna. The Fontainebleau School was influential in the spread of Mannerism throughout Europe. The Italians

Rosso, Cellini and Primaticcio were associated with it, and Rosso and Primaticcio, in the Galerie François I (1533–40), created a rich and intricate decorative style. The style was developed by Jean Goujon (*c.* 1510–65) and Germain Pilon (*c.* 1525–90) and, in the reign of Henry II, by such French artists as Jacques Androuet Du Cerceau the elder (1550–1614), who were influenced by developments in the Netherlands. In the Netherlands many artists who had visited Italy, among them Frans Floris (1519/20–70) and Marten de Vos (1532–1603), created a Mannerist style, and pattern-books such as those of Cornelis Floris (*c.* 1513/14–75), combining the Italian grotesque with scrolling and strapwork, had a decisive effect in the second half of the 16th century, especially on architectural decoration north of the Alps. A highly sophisticated Mannerism flourished at the Wittelsbach court of Albert V (*reg* 1550–79) in Munich and the Habsburg court of Rudolf II (*reg* 1576–1612) in Prague.

In northern European art Mannerism continued well into the 17th century, but in Italy the Baroque style was established by *c.* 1600. The Mannerist interests in movement and expression were more prophetic of future developments than the static images of the High Renaissance. In many ways early Baroque art united these elements with High Renaissance clarity and naturalism.

BIBLIOGRAPHY

EWA [with full bibliog. and list of sources]
G. Vasari: *Vite* (1550, rev. 2/1568); ed. G. Milanesi (1878–85)
G. P. Lomazzo: *Trattato dell'arte della pittura, scultura e architettura* (Milan, 1584)
——: *Idea del tempio della pittura* (Milan, 1590)
J. van Schlosser: *Die Kunstliteratur* (Vienna, 1924) [contains most sources]
H. Hofmann: *Hochrenaissance, Manierismus, Frühbarock: Die italienische Kunst des 16. Jahrhunderts* (Zurich and Leipzig, 1939)
R. Zürcher: *Stilprobleme der italienischen Baukunst des Cinquecento* (Basle, 1948)
De triomf van het Manierism (exh. cat., ed. M. van Luttervelt; Amsterdam, Rijksmus., 1955)
W. Friedländer; *Mannerism and Anti-Mannerism in Italian Painting* (New York, 1957)
E. Battisti: *Rinascimento e barocco* (Turin, 1960)
G. Briganti: *La maniera italiana* (Rome, 1961)
F. Württenberger: *Der Manierismus* (Vienna, 1962)
F. Baumgart: *Renaissance und Kunst des Manierismus* (Cologne, 1963)
J. Pope-Hennessy: *Italian High Renaissance and Baroque Sculpture*, 3 vols (London, 1963)
L. van Puyvelde: *Die Welt von Bosch und Breughel: Flämische Malerei im 16. Jahrhundert* (Munich, 1963)
D. Frey: *Manierismus als europäische Stilerscheinung: Studien zur Kunst des 16. und 17. Jahrhunderts* (Stuttgart, 1964)
A. Hauser: *Der Ursprung der modernen Kunst und Literatur: Die Entwicklung des Manierismus seit der Krise der Renaissance* (Munich, 1964); Eng. trans. as *Mannerism*, 2 vols (London, 1965)
J. Shearman: *Mannerism* (Harmondsworth, 1967)
G. Kauffmann: *Die Kunst des 16. Jahrhunderts* (Berlin, 1972)
H. Kozakiewiczowie and S. Kozakiewiczowie: *The Renaissance in Poland* (Warsaw, 1976)
M. Wundram: *Renaissance und Manierismus* (Stuttgart and Zurich, 1985)

MANFRED WUNDRAM

Mansueti, Giovanni (di Niccolò) (*fl* Venice, 1485–1526/7). Italian painter. The large number of signed pictures, several of which are dated, provides a clear idea of his style and forms a firm basis for further attributions. His earliest known work is the *Symbolic Representation of the Crucifixion* (London, N.G.), signed and dated 1492, by which time he was clearly already a mature master. The *Miracle of the True Cross at the Campo di S Lio* (1494;

Venice, Accad.) is one of two works he made for the *Miracles of the True Cross* cycle for the Scuola Grande di S Giovanni Evangelista, Venice. The signature declares the artist to be a pupil of Gentile Bellini, whose influence is evident in the pictorial composition, with its decoratively repetitive treatment of shapes and colours. As in Bellini's paintings for the same cycle, Mansueti provides a topographically accurate record of an actual location in Venice; and with an even greater tendency than Gentile towards pedantic literalness, he packed his scene with stiff ceremonious figures in contemporary costume, and with a wealth of anecdotal detail.

Mansueti also executed a number of altarpieces and smaller devotional works, but his most characteristic and successful productions were narrative canvases of this type, painted for the meeting-rooms of the Venetian confraternities. Apart from the pair for the Scuola di S Giovanni Evangelista, the most important include the *Arrest of St Mark* for the chapel of the silk-weavers in the church of the Crociferi (1499; Vaduz, Samml. Liechtenstein), and three paintings for the *Life of St Mark* cycle for the Scuola Grande di S Marco, Venice (two in Venice, Accad.; one in Milan, Brera), datable on circumstantial evidence to *c.* 1518–26. All four of these works, which portray scenes from St Mark's apostolic activity in Alexandria, include a profusion of pseudo-Islamic elements, reflecting the 'oriental mode' then fashionable in Venice. Most of his narrative paintings include portraits of confraternity officers, and it may be that Mansueti painted more independent portraits than is generally realized. It is difficult, if not impossible, to discern any development in his art: the Scuola Grande di S Marco paintings, although contemporary with Titian's Pesaro Altarpiece (1526; Venice, S Maria Gloriosa dei Frari; see colour pl. 2, XXXV2), are distinguishable from works of the 1490s only to the extent that they appear more tired and repetitive. Many of these late paintings include motifs taken directly from Giovanni Bellini (for whom he seems occasionally to have worked as an assistant), Cima or Vittore Carpaccio. Documents indicate that he remained in Venice throughout his life, dying there between September 1526 and March 1527 (Ludwig).

BIBLIOGRAPHY

A. M. Zanetti: *Della pittura veneziana* (Venice, 1771), pp. 42–4
G. Ludwig: 'Archivalische Beiträge zur Geschichte der venezianischen Malerei', *Jb. Kön.-Preuss. Kstsamml.*, xxvi (1905), pp. 61–9 [doc.]
S. Moschini Marconi: *Gallerie dell'Accademia di Venezia: Opere d'arte dei secoli XIV e XV* (Rome, 1955), pp. 134–9
S. Miller: 'Giovanni Mansueti: A Little Master of the Venetian Quattrocento', *Rev. Roum. Hist. A.*, xv (1978), pp. 77–115 [full bibliog.]
H. W. van Os and others, eds: *The Early Venetian Paintings in Holland* (Maarsen, 1978), pp. 106–9 [entry by B. Groen]
T. Pignatti, ed.: *Le scuole di Venezia* (Milan, 1981)
J. Raby: *Venice, Dürer and the Oriental Mode* (London, 1982)
P. Humfrey: 'The Bellinesque Life of St Mark Cycle for the Scuola Grande di San Marco in Venice in its Original Arrangement', *Z. Kstgesch.*, xlviii (1985), pp. 225–42
P. F. Brown: *Venetian Narrative Painting in the Age of Carpaccio* (New Haven and London, 1988)

PETER HUMFREY

Mantegazza. Italian family of sculptors. The brothers Cristoforo Mantegazza (*d c.* 1481) and Antonio Mantegazza (*d* 1495) were, with Giovanni Antonio Amadeo, major sculptors in Milan during the later 15th century.

Their dates of birth are unknown, and no documented or signed work exists by either. The earliest documentation of their activities records Cristoforo at the Certosa di Pavia (*see* PAVIA, §2) in 1464 working with other sculptors to furnish stones carved as arches, vaults and columns for the walls of the nave (Dell'Acqua, 1948). Also in 1464 he worked in the Certosa's two cloisters, making capitals for the large cloister. In 1465 he designed wooden models for the terracotta capitals in the large cloister, working with the sculptor Rinaldo de' Stauris (*fl* 1461–90; Dell'Acqua, 1948). On 26 August 1467 Cristoforo was given six pieces of marble for works to be made for the Castello Sforzesco, Milan (Dell'Acqua, 1948).

Both brothers were active at the Certosa di Pavia by 1472; its prior repaid their work with a house in Milan at the beginning of the next year. In 1473 they were consulted by Galeazzo Maria Sforza, Duke of Milan, concerning a bronze equestrian sculpture of his father, Francesco I Sforza, a commission eventually given to Leonardo da Vinci. The documentation here refers to them as goldsmiths (*orevexi*). Also in 1473 the brothers, on a recommendation from Galeazzo Maria, were charged on 7 October to execute the façade of the church of the Certosa. On 20 August 1474 the Mantegazza brothers ceded half the work on the façade to Amadeo. In 1476 the Mantegazza presented unspecified works to the Certosa, and in 1478 they, together with Amadeo, presented architectural furniture and sculpture. In 1477 and again in 1480 the Duke reminded the prior to treat the Mantegazza well and not to delay in paying them. Cristoforo Mantegazza had died by February 1482, when his brothers Antonio and Giorgio and his daughter Costanza were paid for his works for the façade. Antonio appears to have kept his studio until 1489, when he gave it up to Alberto Maffiolo da Carrara (*fl* 1488–99). In the succeeding years he remained in contact with the monks, if only as a contractor. In 1495 Antonio was replaced as ducal sculptor by Cristoforo Solari and is presumed to have died.

Attempts to distinguish the individual hands of the brothers have been inconclusive, although scholars have provided some plausible solutions. A particular style of angular, flattened figures and drapery has been associated with both their names. Recalling flattened crumpled paper, the 'cartaceous' style characterizes much Milanese sculpture of the later 15th century. It appears that this style should now be associated only with Antonio; Cristoforo is responsible for some softer and more curving sculptures at the Certosa, including some of the *Old Testament* reliefs on the church façade (Morscheck, 1978).

A document of 12 October 1478 identifies two medallions of the *Doctors of the Church*, sculpted under the Certosa's *tiburio*, as by the Mantegazza brothers and two by Amadeo. The document also refers to a marble *Pietà* in a double chapel and an Angera stone *Madonna* keystone of the same chapel and identifies them as by the Mantegazza (Morscheck, 1984, p. 29). Morscheck (1978, pp.

Antonio Mantegazza: *Lamentation*, marble relief, 1470s (London, Victoria and Albert Museum)

225–9) identified a keystone in a double chapel in the Certosa as the *Madonna* keystone mentioned in the 1478 document and determined that its Late Gothic style must be associated with Cristoforo rather than Antonio Mantegazza. On the basis of this keystone, he then associated Cristoforo with the *St Jerome*, one of the four *Doctors of the Church* carved in the *tiburio*, and a number of similar corbels and capitals in the large cloister (Morscheck, 1984, p. 29; Bernstein, 1972, pp. 79f). He also associated Cristoforo with the triangular relief of *God the Father* (now above the refectory door) from the *Old Testament* cycle for the façade of the Certosa (*in situ*; also examples in Pavia, Mus. Certosa; Milan, Castello Sforzesco). These reliefs were probably placed there no earlier than 1515 (Morscheck) and may not have been intended for their present site.

To Antonio Mantegazza have been attributed many works in the 'cartaceous' style, including the *Lamentation* in the Capitolo dei Fratelli of the Certosa (*see* PAVIA, fig. 2); another *Lamentation* (London, V&A; see fig.), which may be the *Pietà* described in 1478 in the double chapel in the Certosa; Old Testament *Creation* and *Expulsion* scenes for the façade of the Certosa; and some of the *New Testament* scenes on the right side of the façade of the Certosa. Also attributed to Antonio are the Foulc *Madonna* (Philadelphia, PA, Mus. A.) and *Faith*, *Hope* and *Charity* (all Paris, Louvre).

BIBLIOGRAPHY
G. L. Calvi: *Notizie sulle vite e sulle opere dei principali architetti, scultori e pittori che fiorirono in Milano durante il governo dei Visconti e degli Sforza*, ii (Milan, 1865)
C. Magenta: *I Visconti e gli Sforza nel Castello di Pavia*, 2 vols (Milan, 1893)
——: *La Certosa di Pavia* (Milan, 1897)
G. A. Dell'Acqua: 'Problemi di scultura lombarda: Mantegazza e Amadeo', *Proporzione*, ii (1948), pp. 89–108
E. Arslan: 'Sui Mantegazza', *Boll. A.*, xxxv (1950), pp. 27–34
J. Pope-Hennessy: *Italian Renaissance Sculpture* (London, 1958, rev. New York, 1985), pp. 325–6, 364
G. A. Dell'Acqua: *Arte lombarda dai Visconti agli Sforza* (Milan, 1959), p. 91
A. M. Romanini: 'L'incontro tra Cristoforo Mantegazza e il Rizzo nel settimo decennio del quattrocento', *A. Lombarda*, ix (1964), pp. 91–102
J. G. Bernstein: 'The Architectural Sculpture of the Cloisters of the Certosa di Pavia' (diss., New York U., Inst. F.A., 1972)
C. R. Morscheck: *Relief Sculpture for the Façade of the Certosa di Pavia, 1473–1499* (New York and London, 1978), pp. 225–35
M. G. Albertini Ottolonghi: 'Per i Mantegazza: Note sui capitelli pensili dei chiostri della Certosa di Pavia', *La scultura decorativa del primo rinascimento; Atti del I. convegno internazionale di studi: Pavia, 1980*, pp. 113–28
C. R. Morscheck: 'Keystones by Amadeo and Cristoforo Mantegazza in the Church of the Certosa di Pavia', *A. Lombarda*, lxviii–lxix (1984), pp. 27–37

ANDREA S. NORRIS

Mantegna, Andrea (*b* Isola di Carturo, nr Padua, 1430–31; *d* Mantua 13 Sept 1506). Italian painter and printmaker. He occupies a pre-eminent position among Italian artists of the 15th century. The profound enthusiasm for the civilization of ancient Rome that infuses his entire oeuvre was unprecedented in a painter. In addition to its antiquarian content, his art is characterized by brilliant compositional solutions, the bold and innovative use of perspective and foreshortening and a precise and deliberate manner of execution, an aspect that was commented on during his lifetime. He was held in great esteem by his contemporaries for his learning and skill and, significantly, he is the only artist of the period to have left a small corpus of self-portraits: two in the Ovetari Chapel; his presumed self-portrait in the *Presentation in the Temple* (Berlin, Gemäldegal.); one in the Camera Picta (Mantua, Pal. Ducale) and the funerary bust in his burial chapel in S Andrea, Mantua, designed and probably executed by himself. His printmaking activity is technically advanced and of great importance, although certain aspects of the execution remain to be clarified. Due to the survival of both the Paduan and Mantuan archives, Mantegna is one of the best-documented artists of the 15th century.

I. Life and work. II. Working methods and technique.

I. Life and work.

Mantegna's date of birth is gleaned from an inscription (recorded by Scardeone, 1560) on an altarpiece (ex-S Sofia, Padua; untraced) stating that the work was painted in 1448 when the artist was 17. He is presumed to have been born at Isola di Carturo, where the birth of his brother Tommaso is recorded. His father Biagio was a carpenter. By 1442 he had been taken on as a pupil by Franceso Squarcione who legally adopted him. In 1448, following disagreements, Mantegna made himself independent of Squarcione. By this time he probably already knew Jacopo Bellini, whose daughter Nicolosia he was to marry in 1452 or 1453. Mantegna claimed (in 1456) that he had painted many works while in Squarcione's workshop, but none of these is known. From the late 1440s Mantegna was associated with a circle of scholars and professionals in Padua, and they helped form his interest in the civilization of Classical antiquity. Among them were the Venetian notary Ulisse degli Aleotti (1412–68) and the epigrapher and doctor of medicine Giovanni Marcanova (*d* 1467). Mantegna must also have studied the works that Tuscan artists had produced in the Veneto, notably the frescoes of Filippo Lippi (*c.* 1443; untraced) for the chapel of the Podestà in the basilica of S Antonio (Il Santo), Padua; Uccello's series of *Famous Men* (*c.* 1445; Padua, Casa Vitaliani; untraced); Andrea del Castagno's frescoes (1442; Venice, S Zaccaria, chapel of S Tarasio) and the attributed mosaic of the *Death of the Virgin* (early 1440s; Venice, S Marco, Mascoli Chapel) and, most important, the work of Donatello, who was in Padua from 1443 to 1453. Donatello's sculptures for the basilica of the Santo and the equestrian monument of *Gattamelata* (1447–53; Padua, Piazza del Santo; *see* DONATELLO, fig. 4) introduced to the region the modern Florentine manner together with a whole new repertory of forms. In 1448 Mantegna formed a partnership with Niccolò Pizzolo, a talented painter and modeller who had worked as an assistant to Donatello.

1. Paintings and drawings. 2. Engravings.

1. PAINTINGS AND DRAWINGS.

(i) Padua, to 1460. (ii) Mantua, 1460–88. (iii) Rome, 1488–1490. (iv) Mantua, *c.* 1490–1506.

(i) Padua, to 1460.

(a) Youthful easel pictures. (b) Ovetari Chapel decoration. (c) Altarpieces. (d) Other frescoes and easel pictures.

(a) Youthful easel pictures. Mantegna's development was extraordinarily precocious and his earliest securely attributable easel picture, the *St Mark* (Frankfurt am Main, Städel. Kstinst. & Städt. Gal.), dating from the late 1440s, displays many characteristics that became distinctive features of his style. The saint is seen through a round-headed marble window, a pictorial device that permitted the artist to control the relationship between the painted space and the viewer's space. The swag of fruit and foliage, much used by members of Squarcione's workshop, is a variation of an antique motif, and the embroidered edge of the Saint's tunic, embellished with pearls, is executed with studied realism. The fictive *cartellino* is signed in a latinate form, but it was only after his move to Mantua that Mantegna signed in a consistent and accurate Latin form. The *St Jerome* (São Paolo, Mus. A.) is a more problematic attribution, having more in common stylistically with Bolognese or Ferrarese painting, but if it is a work of Mantegna it must date from about the same time as the *St Mark*. Mantegna was in Ferrara, briefly, in 1449; he was commissioned to paint a double-sided portrait of the *Marchese Lionello d'Este and Folco da Villafora* (untraced), a remarkably prestigious commission for such a young artist.

(b) Ovetari Chapel decoration. In May 1448 Mantegna and Pizzolò were commissioned to paint one half of the funerary chapel of Antonio Ovetari in the church of the Eremitani, Padua. The other half was to be executed by the more established Muranese partnership of Antonio Vivarini and Giovanni d'Alemagna. The chapel was bombed in 1944, and all that survives are Mantegna's two *St Christopher* scenes and the *Assumption of the Virgin*, which had been transferred to canvas in the early 1880s because of their poor state of conservation. Fragments of other frescoes remain but are unmounted and not on display. The comments that follow, therefore, are based mainly on photographic evidence. (For colour plates of the destroyed scenes, see G. Fiocco: *Paintings by Mantegna*.)

According to the 1448 contract, Mantegna and Pizzolò were assigned the decoration of the left wall (scenes of *St James*), the chapel tribune and the execution of a terracotta altarpiece. Following a dispute between the two, however, their partnership was dissolved in September 1448 and, according to the arbitration, Mantegna was to execute all the *St James* scenes, excepting that of the saint's martyrdom, three of the five tribune vault figures—*St Paul, St Peter* and *St Christopher*—and the left side of the tribune arch. His tribune figures (1449–50) are characterized by a weightiness and solidity that recalls the similar figures by Castagno (1442) in the tribune of the chapel of S Tarasio at S Zaccaria. Of the six *St James* scenes, which are based on the Gospel narratives and on the account in *The Golden Legend*, the first, at upper left, is the *Calling of SS James and John* (1450). Set in a landscape with an impressive ensemble of rocks towering above the figure group, it gives an early indication of the artist's fascination

1. Andrea Mantegna: *Martyrdom of St Christopher* (1453–7; detail), fresco on the right-hand wall of the Ovetari Chapel, church of the Eremitani, Padua

with geological formations and all types of stone. The adjacent *Preaching of St James* (1450) shows a more developed narrative sense and is Mantegna's earliest attempt at an *all'antica* setting, although the pulpit from which St James preaches could hardly be described as rigorously classical. The two scenes in the middle register (both 1450–51), the *Baptism of Hermogenes* and the *Trial of St James*, are linked by a unified perspectival system and by the putto-bearing swags with the arms of Antonio Ovetari quartering those of his widow, Imperatrice Capodilista, which illusionistically hang across and in front of both pictorial fields. The *Trial of St James* displays a significant advance on the *Preaching* scene above it in terms of its Classical setting and the *all'antica* detail. The triumphal arch in the background is generally modelled on the now-destroyed Arch of the Gavi (Verona) and the inscription on it is taken from an antique slab formerly at Monte Buso, outside Padua. The throne of Herod Agrippa is a classicizing invention, the zoomorphic supports of which probably depend on those that appear on Donatello's sculpture of the *Virgin and Child Enthroned* in Il Santo. The musculated cuirass with cingulum worn by the soldier on the left, sometimes identified as a self-portrait,

shows an accurate understanding of Roman armour. At this date no more convincing rendition of a Classical scene had been realized. The compositional dynamic in the *St James* frescoes owes a debt to Donatello's reliefs for the Santo altar, both in the figure groupings and in the relationship of figures to architecture.

In 1450 Giovanni d'Alemagna died and Vivarini abandoned the Ovetari project soon after. Bono da Ferrara and Ansuino da Forlì were enlisted to execute the *St Christopher* scenes on the right-hand wall, on which no start had been made, and they probably worked under the direction of Pizzolò. During a caesura in the chapel's execution, between 1452 and 1453, Mantegna took on at least two other commissions, the lunette fresco depicting *SS Anthony and Bernardino* for Il Santo and the *St Luke* altarpiece (1453–4; Milan, Brera), both discussed below. In 1453 Pizzolò was killed, and Mantegna acquired sole responsibility for the completion of the Ovetari Chapel decoration. This included the tribune fresco of the *Assumption of the Virgin* (*c*. 1456), the two remaining *St James* scenes and the two remaining *St Christopher* scenes (1453–7). In the bold and ambitious *St James Led to Martyrdom* (probably 1453–4) Mantegna adopted a very

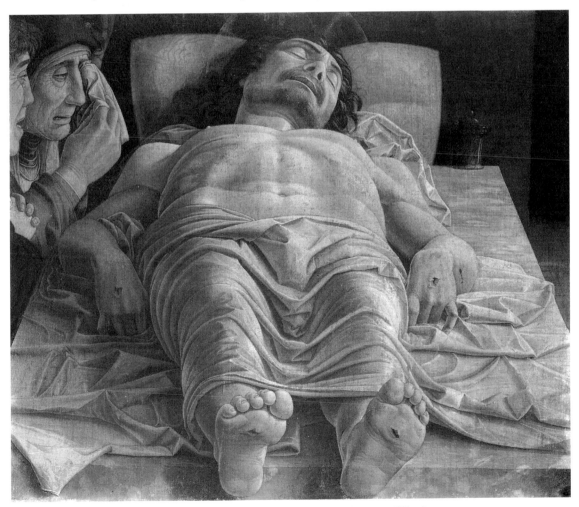

2. Andrea Mantegna: *Dead Christ*, tempera on canvas, 680×810 mm, *c*. 1500 (Milan, Pinacoteca di Brera)

low viewpoint and established the vanishing-point of the perspective beneath the base-line of the composition. This had the effect of making the architectural setting more dominant and impressive. The figural composition was worked out in a pen-and-ink drawing (London, BM) in which, interestingly, the viewpoint is much higher and the pivotal figure of the soldier with a shield is absent. The neighbouring scene of the *Martyrdom of St James* had been allocated to Pizzolò and must therefore have been painted by Mantegna between 1453 and February 1457, when all the parts left unfinished by the former were said to have been completed.

The chronology of the scenes of the *Martyrdom of St Christopher* (see fig. 1) and the *Removal of the Body of St Christopher* on the right-hand wall is more difficult to determine. They are not named in the documents that relate to a dispute of 1457 concerning Mantegna's works in the chapel, and this has led some scholars to conclude that they should be dated later (Davies, Romanini, Paccagnini, Lightbown). The documents do not explicitly exclude a dating of between 1453 and 1457 and stylistically the frescoes fit neatly into this period. The *St Christopher* scenes share a unified perspectival and architectural stage-like setting and are separated visually and notionally by an illusionistically painted Ionic column. King Dagnus's palace is decorated with Classical ornament and carved portrait-bust diptychs and inset with coloured marble medallions reminiscent of Leon Battista Alberti's design for the Tempio Malatestiano at Rimini (*see* RIMINI, fig. 1). Mantegna's figures are in contemporary dress to conform with the scenes above. The saint's body in the right-hand scene is shown in extreme foreshortening, a foretaste of the virtuoso effects later achieved by Mantegna in his decoration of the Camera Picta and in his *Dead Christ* (Milan, Brera; see fig. 2). Vasari, in his description of these frescoes, which derived from a dependable source, identified several portraits.

The *Assumption* (1456–7) was probably the last fresco to be painted by Mantegna. Originally the area behind the altar was to be frescoed with a Christ blessing (possibly an Ascension scene), but Antonio Ovetari's executors decided in 1454 to change the iconography to the Assumption of the Virgin. Mantegna turned to advantage the limitations imposed by the compressed space available, boldly bringing two of the Apostles on to the viewer's side of the painted architectural setting and emphasizing the sense of receding space with a low viewpoint.

Scardeone and Vasari recorded that Mantegna's *St James* frescoes in the Ovetari Chapel were criticized by Squarcione as being dull in colouring and that as a result the artist responded by brightening his palette for the *St Christopher* scenes. From the photographic evidence these do appear less sombre, and it has been argued that this softer mode of expression was due to Mantegna's contact with the Bellini (Cavalcaselle). More serious was Squarcione's claim that Mantegna's figures were characterized by the hardness of antique marble figures and had nothing of the softness of natural and living things, an appraisal that has become a touchstone of negative criticism of the artist ever since (Berenson, Longhi).

(c) Altarpieces. Mantegna painted the high altarpiece of S Sofia, Padua, in 1447–8, for the Paduan master-baker Bartolommeo di Gregorio (*d* 1447). It showed the Virgin and was elaborately and proudly signed *Andreas Mantegna Pat. an. septem & decem natus, sua manu pinxit, M.CCC.XLVIII* (Scardeone). Payments totalling nearly 46 ducats, a very substantial sum, are recorded. The painting was probably removed from the church in the late 16th century and was subsequently lost.

The *St Luke* altarpiece (1453–4; Milan, Brera) executed for the reformed Benedictines of S Giustina, Padua, retains the traditional polyptych format with gilded backgrounds and varying figure-scale common in Veneto altarpieces of the 1430s and 1440s. Indeed, it is likely that Mantegna was instructed to take as his model the polyptych that Vivarini and d'Alemagna painted for the Benedictine abbey of Praglia, outside Padua (1448; Milan, Brera). The two paintings share many features, including the full-length standing saints in the lower register and the central image on a larger scale crowned by a *Pietà*; this is flanked in the upper register by three-quarter-length saints. Mantegna, however, updated the formula by employing a unified perspectival scheme for the marble platform on which all the saints of the lower register, including the larger figure of the titular saint, are placed and achieved an overall sense of chromatic harmony through the gently rhythmical alternation of pink and black draperies. He developed the perspectival logic of the lunette scene of *SS Anthony and Bernardino* (see below) and showed the figures of the upper register (with the exception of the *Pietà* group) in slight *di sotto in sù* perspective. St Luke is shown in full frontal view, seated at a scribe's desk working with the miniaturist's red and black ink: the figures are drawn with subtlety and precision of line. Commissioned by the abbot Mauro dei Folperti on 10 August 1453 and completed in November 1454, the altarpiece originally had a carved and gilded frame, which must surely have made the anomalies of figure scale less apparent. The artist's signature appears illusionistically carved on the marble column supporting St Luke's writing desk ('OPVS/ANDREAE/MANTEGNA').

It may have been the *St Luke* altarpiece commission that brought Mantegna to the attention of Gregorio Correr, nephew of Cardinal Antonio Correr who had sponsored the reform of the Benedictines of S Giustina. Gregorio was the abbot of the Benedictine monastery of S Zeno in Verona and commissioned Mantegna to paint the high altarpiece. The format of the S Zeno Altarpiece (1456–9; *in situ*), a unified scene showing the *Virgin and Child with Saints* and extending over three large panels, also has precedents in the work of Vivarini and d'Alemagna (for example, the triptych for the Scuola della Carità, 1446; Venice, Accad.), but it has frequently been proposed that Donatello's altar in Il Santo, as it was set up in 1450, had a direct bearing on Mantegna's figure groups and their enclosed architectural setting, as well as on the design of the altarpiece's elaborate (surviving) classical frame. In an open pavilion supported by marble piers decorated with carved medallions of Classical subject-matter, the Virgin sits enthroned, with the Christ Child, attended by musician angels. In the left panel stand SS Peter, Paul, John the Evangelist and Zeno, Bishop and patron saint of Verona. A compositonal drawing at Chatsworth, Derbys (inv. no. L.718), shows this group with some slight differences of

pose and viewpoint. In the right panel are SS Benedict, Lawrence, Gregory Nazianzen and John the Baptist. Remarkably, seven out of eight saints hold books in their hands, a fact that undoubtedly reflects the scholarly concerns of the patron, Gregorio Correr, a devout Christian humanist, and the monks of S Zeno. The altarpiece was commissioned from Mantegna in 1456, executed over the next three years in Padua and delivered to Verona in the second half of 1459. The date 1433, which appears on the lower edge of the carpet beneath the Virgin, corresponds to the year in which Correr received the monastery of S Zeno *in commendam*. The altarpiece is impressive for the sheer conceptual logic of its design, and for the complete integration of the figures, sculpture, architecture, multifarious decorative details and carved frame into a unified whole. Mantegna even appears to have arranged for a window to be opened in the choir of the church so that the lighting of the picture, which is from upper right, might correspond to the source of real light and thus appear even more convincing. The three predella scenes show the *Agony in the Garden* (Tours, Mus. B.-A.), the *Crucifixion* (Paris, Louvre; see fig. 3) and the *Resurrection* (Tours, Mus. B.-A.). In the *Crucifixion* the scene is set on a raised rocky plateau with the walled city of Jerusalem in the background. The archaeological detail of costume and armour is impressive, if not completely accurate. Mantegna seems to have been the first artist to realize that the Romans did not have stirrups.

(d) Other frescoes and easel pictures. Mantegna's lunette fresco depicting *SS Anthony and Bernardino* supporting a wreath with the monogram of Christ (1452; Padua, Mus. Antoniano) was painted above the main door of Il Santo. It is noteworthy for the illusionism achieved with the adoption of the low viewpoint. The *St Euphemia* (1454; Naples, Capodimonte) shows a development of some of the characteristics of the Frankfurt *St Mark*, and it, too, is painted on canvas. The saint appears full-length and life-size, exerting a forceful physical presence in the marble arch. The *cartellino* inscribed with the artist's name and the date in Roman majuscules testifies both to Mantegna's increasing skill in illusionistic rendering of materials and to his study of Classical epigraphy. The painting was probably executed as an altarpiece although there is no record of its early provenance.

With the *Presentation in the Temple* (c. 1455; Berlin, Gemäldegal.; see fig. 4) Mantegna established a new and influential pictorial format, the narrative half-length scene. Conceived as a pictorial equivalent to relief sculpture in its horizontal composition and in the absence of background detail, Mantegna played up the illusionism of the picture by setting the figures behind a marble window and arranging for the cushion beneath the Christ Child to protrude into the viewer's space. The inclusion of what is generally accepted as a self-portrait head on the extreme right and the identification of the woman on the left as Nicolosia Bellini may mean that the painting is a votive

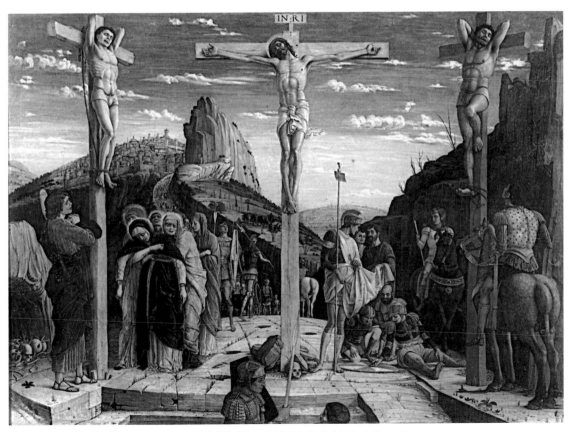

3. Andrea Mantegna: *Crucifixion*, tempera on panel, 670×930 mm, 1456–9 (Paris, Musée du Louvre)

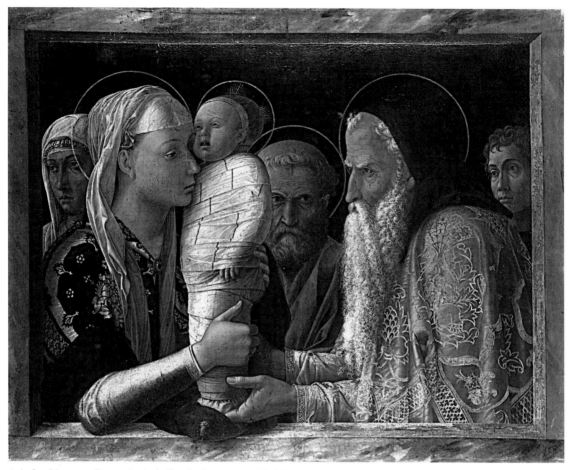

4. Andrea Mantegna: *Presentation in the Temple*, oil on canvas, 670×860 mm, *c.* 1455 (Berlin, Gemäldegalerie)

picture painted to commemorate the safe delivery of a child, perhaps Francesco Mantegna, the artist's first son. The style of the picture would anyway accord well with a date close to that of the *St Euphemia*.

The dating of the *Adoration of the Shepherds* (New York, Met.), a work of which the authorship has been unjustly questioned, is not easy to determine, although there is general agreement that it falls in the decade of the 1450s. The early provenance of the picture, combined with what is purported to be an Este emblem in the picture (the wattle fence), has prompted the suggestion (1992 exh. cat.) that it was painted for Borso d'Este, Duke of Ferrara, in the early 1450s. The painting, originally on panel but transferred to canvas in 1924, is characterized by the miniature-like quality of the execution, particularly apparent in the minute gold brushstrokes employed for the highlights of the Virgin's robe and for the heads of the cherubs that surround her, and the brilliant palette. The slightly uneasy amalgamation into a single composition of what are essentially self-sufficient figural groups would support an early dating for the picture. The shepherds are sometimes said to depend on Netherlandish figure types.

Somewhat similar in character, although a more ambitious and more fully successful composition, is the *Agony in the Garden* (London, N.G.), an image of great narrative tension and clarity. Christ kneels in a *profil perdu* view before a natural rock formation resembling an altar, his form set against a distant view of Jerusalem, conceived as an oriental Classical city with buildings inspired by famous Roman monuments. The Apostles, statue-like, sleep, oblivious to the approach of Judas and the soldiers, while Christ, in a curious deviation from traditional iconography, is visited by putti bearing the instruments of the Passion. It has been proposed (1992 exh. cat.) that since the *Agony in the Garden* probably shares the same early provenance of the *Adoration of the Shepherds* it too may have been a commission from Borso d'Este. Compared with the Tours version of this subject, the London picture would appear to reflect a more sophisticated appreciation of the narrative content of the Gospel episode and its affective potential, which would suggest a later date, at the end of the 1450s, although Tietze-Conrat and Camesasca date it as early as 1450. In March 1459 Mantegna was engaged on a small work for Jacopo Marcello, a work that is sometimes identified with the *St Sebastian* (Vienna, Ksthist. Mus.). Of very refined execution, redolent with Classical learning, from the representation of the ruined architecture to the Greek inscription, the picture illustrates the maturity of Mantegna's classicism

just before his removal to Mantua. Other pictures that can be assigned to the 1450s with some degree of plausibility are the *Infant Redeemer* (Washington, N.G.A.), the Butler *Madonna and Child* (New York, Met.) and another, extraordinarily tender, representation of the *Virgin and Child* (Berlin, Gemäldegal.), which shares some of the characteristics of Donatello's reliefs of the subject.

By the end of the 1450s Mantegna had accepted the invitation from Ludovico II Gonzaga, 2nd Marchese of Mantua, to become his court painter. The invitation was made in 1456 and Mantegna gave a positive response by the end of the year, because in January 1457 Ludovico wrote and thanked him for agreeing to enter his service. The artist, however, was unable to go immediately because of his commitment to complete the S Zeno Altarpiece. There is evidence, too, that he may have had some misgivings about taking up a court post. About March 1458 Ludovico sent his architect Luca Fancelli to Padua to settle the terms on which Andrea would move to Mantua and in January 1459 he granted him the privilege of bearing the Gonzaga device of a sun in splendour with the motto *par un désir*, which Ludovico had used since 1448. It was probably on a visit to Mantua at this time that Mantegna painted the portrait of *Cardinal Ludovico Trevisan*, also known as *Cardinal Mezzarota* (Berlin, Gemäldegal.), who was in the town for the ecumenical council of 1459–60. In this work Mantegna emulated the pose and *gravitas* of Roman portrait busts. He eventually moved permanently to Mantua in 1460.

(ii) Mantua, 1460–88. Mantegna's terms of employment in Mantua were generous. In return, as court painter he was expected to work exclusively for the Gonzaga, overseeing the decoration of their palaces, making portraits, designing tapestries, heraldic devices, vases and whatever else his patrons required.

(a) Castello di S Giorgio and portraits. The artist's first important task in Mantua was the decoration of the new chapel in the Castello di S Giorgio, the late 14th-century fortified residence overlooking the River Mincio. The chapel no longer survives, and the painted elements were dismantled in the 16th century. Although the documentation is incomplete, it is possible to reconstruct the appearance of the chapel partially. It was square in plan and had a small dome resting on four arches; there was a niche rising above the altar. In type it probably resembled the approximately contemporary chapel of the Perdono in the Palazzo Ducale at Urbino. Its decoration engaged Mantegna into the mid-1460s.

Three paintings in the Uffizi are associated with the scheme—the *Adoration of the Magi*, the *Circumcision* and the *Ascension*—together with a fourth in the Prado, Madrid, the *Death of the Virgin* (see colour pl. 2, II1), the upper part of which is the fragment in the Pinacoteca Nazionale at Ferrara showing *Christ with the Virgin's Soul*. These four panels, and there were probably others, would have been set in gilded wooden panelling. Iconographically, the quartet of surviving pictures suggests a combined Marian and Christological cycle. The *Adoration of the Magi*, which is slightly concave in form and lit from the front,

would have been set above the altar, probably opposite a small window. Its hard-edged drawing, brilliant chromatic range and use of gold places it in close stylistic proximity to the *Crucifixion* in the Louvre. The *Circumcision* scene combines three episodes from the Gospels: the Circumcision of Christ, his Presentation in the Temple and the Purification of the Virgin. These scenes are linked typologically to the Old Testament scenes presented in feigned relief in the lunettes. Such a purposeful, many-layered presentation of the story suggests some special significance in a contextual sense, although it is difficult to determine precisely what this might have been. The Temple setting is of extraordinary richness and illustrates an unprecedented confidence in handling architectural elements and devising variegated marble types. The *Death of the Virgin* conforms to the account in *The Golden Legend* and is compositionally close to the Venetian mosaic scene attributed to Castagno mentioned above. It includes Mantegna's only topographical view, showing with a limpid focus the Ponte di S Giorgio, linking the Castello with the Borgo di S Giorgio.

Documents indicate that as court painter Mantegna frequently had to make portraits, both drawn and painted, on canvas and on panel. Among the few that have survived is the small panel portrait of *Francesco Gonzaga* (Naples, Capodimonte), Ludovico's second son, dressed in the robes of a protonotary apostolic and thus dating from before his appointment to the cardinalate in December 1461. Portraiture was one aspect of his work in which Mantegna did not always satisfy his patrons, and even Ludovico admitted in 1475 that although Mantegna was a great artist his portraits were perhaps lacking in grace (Signorini, 1985). In 1466 Mantegna was sent to Florence by Ludovico. It was probably during this visit that he painted the striking *Portrait of a Man* (Florence, Pitti) usually identified as Carlo, the illegitimate son of Cosimo de' Medici.

(b) Camera Picta. Ludovico's principal commission from Mantegna was an historiated portrait gallery for the Palazzo Ducale, Mantua; this mural decoration took the artist nearly ten years to complete. The so-called Camera Picta (1465–74), also known as the Camera degli Sposi, shows the Marchese and his consort, Barbara of Brandenburg, together with their children, friends, courtiers and animals engaged in professional and leisurely pursuits, illustrating the present successes and alluding to the future ambitions of the Gonzaga dynasty. The gallery represents the culmination of a series of secular decorative schemes for palace interiors in North Italy in the 14th and 15th centuries, and the illusionism of the painted vault (see colour pl. 2, I1) establishes its status as the progenitor of Correggio's ceilings and those of the Baroque. The Camera Picta is a room with a square plan (8.1×8.1 m). An inscription, simulating graffiti, on the embrasure of the north window, *1465.d.16.iunii*, indicates the date of the official commencement of the decoration.

Mantegna devised an integrated scheme according to which the room is conceived as a pavilion, open on the sides and topped by an elaborate architectural framework perforated by a Classical oculus. As custom and practical considerations dictated, the ceiling must have been painted

first. Inset within the classical intersecting ribs are roundels with simulated marble busts of the first eight Caesars. The roundels are surrounded by wreaths supported by putti strongly reminiscent of those painted by Castagno on the soffit of the arch of the chapel of S Tarasio in S Zaccaria, Venice. The oculus represents a tour de force of *di sotto in sù* illusionism. Winged putti, drastically foreshortened, play among the openings in the balustrade while women courtiers and domestics look into the room with a mixture of curiosity and amusement.

Over the fireplace on the north wall is the so-called *Court Scene* (see colour pl. 2, I2). Ludovico is shown surrounded by members of his family and to the right stand retainers wearing the Gonzaga colours. The Marchese is shown in conversation with his secretary, Marsilio Andreasi, while his dog Rubino rests comfortably under his chair. This image of the reigning marchese is that of an active paternalist governor, head of a secure dynasty. The figures stand before and behind the painted piers, which are crowned by real stone corbels from which the ceiling vaults spring. Mantegna subtly combined fictive elements with real ones, adapting viewpoints so that the spectator is constantly under pressure to believe the illusion and enter into the fiction of the represented scenes. Although it has been claimed that the *Court Scene* illustrates a specific historical moment (Signorini), it is more likely that it should be understood as an idealized group portrait of the ruler and his family. In 1470 the ambassadors of the Duke of Milan were taken to see the room and they witnessed that this wall was already completed.

On the west wall, adjacent to the *Court Scene* (which is painted largely in secco, hence its poorer state of preservation), is the *Meeting Scene*, representing an open-air encounter between Ludovico and his second son, Cardinal Francesco. Again it is unlikely that a specific moment is intended since among the other figures in the scene are the Holy Roman Emperor Frederick III (*reg* 1452–93), who never visited Mantua, and Christian I, King of Denmark (*reg* 1448–81) and brother-in-law of Barbara of Brandenburg, who was in Mantua in 1474. A Classical city, exquisitely executed, dominates the landscape background behind the figures. In the lunettes are Gonzaga devices and above them are painted simulated reliefs set against painted gold mosaic backgrounds showing scenes from the stories of Arion, Hercules and Orpheus, which symbolically allude to Gonzaga virtues. Above the doorway in the west wall are putti bearing an inscribed stone slab in which Mantegna dedicated 'this slight work' (*OPVS HOC TENVE*) to Ludovico and Barbara. It is dated 1474. Despite the proclaimed modesty, Mantegna was doubtless counting on the viewer's awareness that *'tenue'* could also mean 'subtle' or 'fine' and a few centimetres away amidst the foliage decoration of the pilaster on the right he introduced his self-portrait.

(c) Relationship with the Gonzaga. Mantegna was employed by three generations of Gonzaga and held in great esteem and affection by all of them. Ludovico was a model of patience in dealing with the artist's difficult character and slow work rate. He made him gifts of land, notably a plot just outside the city centre near Alberti's S Sebastiano, where Mantegna set about constructing a grandiose dwelling that still survives; the foundation stone is dated 18 October 1476. Square in plan with a circular courtyard, the house is of considerable architectural interest and reflects Mantegna's desire to emulate a Classical town house. The Gonzaga valued his antiquarian knowledge; there is a letter of 1472 from Cardinal Francesco to Ludovico asking that Mantegna be sent to the baths of Porretta so that Francesco, who was taking the waters, could discuss with him his collection of antique bronzes. The artist had his own collection of antiquities, which Lorenzo de' Medici came to see in 1483, and in 1506 he sold a valuable bust of the *Empress Faustina* (probably the exemplar in the Palazzo Ducale, Mantua) to Isabella d'Este. It was almost certainly Federico I Gonzaga, Ludovico's successor, who commissioned the *St Sebastian* (Paris, Louvre). The picture, painted in the early 1480s, was probably intended as an altarpiece for the Sainte-Chapelle at Aigueperse in the Auvergne (where it hung until the French Revolution), where Chiara Gonzaga, Federico's daughter, went to live after her marriage in 1481. The idealized figure of the saint is set against a temple fragment painted with a masterly sense of the texture of both carved and broken rock. Mantegna juxtaposed the saint's real foot with a foot fragment of a statue, playing on the *paragone* theme in a demonstration of the versatility of painting. The landscape background is close to that in the *Meeting Scene* in the Camera Picta, confirming the works' chronological proximity. Francesco Gonzaga, Federico's successor, was also appreciative of Mantegna's abilities, making him a grant of land in 1492 in recognition of his painted works for the family.

(iii) Rome, 1488–c. 1490. Mantegna was summoned to Rome in 1488 by Pope Innocent VIII to paint the Belvedere Chapel in the Vatican. Unfortunately, the chapel was destroyed in 1780, but a fairly full description of its fresco decoration survives. Above the altar was the *Baptism*, which Vasari described in some detail, while on the entrance wall was a *Virgin and Child with Saints*, life-size, with the Pope being commended to the Virgin's protection by St Peter. The *Beheading of the Baptist* was represented on the wall facing the entrance wall, and there were also small-scale narrative scenes of the *Annunciation*, *Nativity* and the *Adoration of the Magi*, and eight full-length figures representing Virtues. Mantegna included an inscription in which he declared himself a Palatine Count and Knight of the Golden Spur, the former title probably given to him by the Pope and the latter by Federico I Gonzaga. According to the humanist and poet Battista Fiera, the chapel excited the Romans 'for its marvellous minuteness of workmanship'. It was in Rome, according to Vasari, that Mantegna painted the *Madonna of the Quarries* (Florence, Uffizi), a tiny picture of great delicacy of execution in which the Virgin and Child are set against a vast landscape dominated by a fantastic basaltic rock formation at the base of which are quarrymen engaged in carving. The picture was seen by Vasari in the collection of Francesco de' Medici.

Mantegna's sojourn in Rome appears to have had little effect on his art. The only evidence that he made drawings after the antiquities in Rome is an ink-and-chalk drawing, of disputed attribution (Vienna, Albertina; see 1992 exh.

cat., no. 145), the *recto* of which shows a section of a Trajanic relief on the Arch of Constantine and the *verso* a detail of a Greco-Roman relief. There is no significant alteration in the style or content of the *Triumphs of Caesar*, which Mantegna had begun before going to Rome and continued painting after his return.

(iv) Mantua, c. 1490–1506.

(a) *Triumphs of Caesar.* (b) *Studiolo* of Isabella d'Este. (c) Altarpieces. (d) Easel pictures and other works.

(a) Triumphs of Caesar. The series (London, Hampton Court, Royal Col.), the clearest and most potent testimony of Mantegna and his Gonzaga patrons' devotion to the cult of antiquity, is composed of nine large canvases (each 2.66×2.78 m) and has as its principal theme the Gallic triumph of Julius Caesar, an exemplary role model for the Gonzaga. In his depiction of the standard bearers (Canvas I), trophy and bullion bearers (Canvases II and III), sacrificial oxen and elephants (Canvases IV and V), captives (Canvas VII) and musicians (Canvas VIII), Mantegna followed the descriptions of Roman triumphs given in the ancient sources, principally Plutarch, Appian and Suetonius. It seems likely that he made use of the compendium of triumphal literature entitled *Roma triumphans*, published (*c.* 1472) by Flavio Biondo in Mantua, which transcribes or paraphrases the ancient accounts. Mantegna supplemented this information with his own knowledge of antique visual sources for the costumes, arms, siege-engines and buildings. Elsewhere he used his imagination to create motifs that have no textual source. The *Triumphs* should not be understood as an accurate archaeological reconstruction of an antique ovation, but rather as a passionate re-creation of a Roman triumph, which seeks to make the world of antiquity come alive.

The identity of the patron, the precise chronology of the *Triumphs*, their original location, and even whether the series is complete or not (Martindale and Lightbown argue that it is not), are issues that remain unresolved. The canvases are first mentioned in a letter of August 1486, and it has been argued that Mantegna may have completed the last surviving canvas as late as 1505 (Hope). Since the imagery of the *Triumphs* makes no specific allusion to any of the marchesi, or indeed to the Gonzaga family, and because the date of the earliest reference to the pictures does not *per se* exclude any of Mantegna's three Gonzaga patrons, the case for patronage has been made on the basis of trying to match the character of the enterprise to the character and patronage activities of a particular marchese. On balance, the arguments in favour of Francesco seem strongest. The intended location of the series is not known, and the use of some of the canvases as theatrical decoration in the 1490s and early 1500s suggests that they may not have had a permanent site from the beginning. The series was acquired from the Gonzaga by Charles I (*reg* 1625–49) in 1629 and has been in England ever since. The fame of the work was immediate and was propagated by engravings after Mantegna's original drawn designs and subsequently by reproductive woodcuts and painted copies.

(b) Studiolo of Isabella d'Este. Isabella d'Este, consort of Francesco Gonzaga, commissioned from Mantegna two allegories for her first *studiolo*, in the Castello di S Giorgio. Mantegna's first painting for her was the so-called *Parnassus* (Paris, Louvre; see colour pl. 2, II3), begun in 1495–6 and completed in 1497. The combination of the familiar mythological subject-matter of the illicit union of Mars and Venus, the parents of Cupid, with the less familiar dance of the Muses on Mt Helicon and the winged horse Pegasus giving birth to the fount of Hippocrene alludes to the harmony of love and the arts, although the precise meaning of the allegory remains elusive (which may have been intentional). The picture is executed with a fineness of touch and sureness of outline that set the standard of execution for the other painters who contributed pictures to the scheme, Perugino and Lorenzo Costa, whose works did not please Isabella as much as those by Mantegna. A detailed programme drawn up by the Mantuan humanist and Hebrew scholar Paride da Ceresara for Perugino's picture survives and similarly complex literary programmes may have been provided for Mantegna's pictures. Highly sophisticated in their intellectual content, refined in execution and compositionally elaborate, the pictures for Isabella's *studiolo* reflect perfectly the cultivated and elitist courtly milieu for which they were created.

Mantegna's second picture, *Pallas Expelling the Vices from the Garden of Virtue* (1499–1502; Paris, Louvre), is unequivocal in its moralizing intention. The goddess erupts into the Garden of Virtue which has been overtaken by ugly and deformed personifications of the Vices, most of them identified by inscriptions, while in the sky the rightful residents of the Garden, Temperance, Fortitude and Justice, wait to return. Paride da Ceresara's participation in devising the programme of this allegory is suggested by the presence of the Hebrew inscription on the anthropomorphic tree on the left of the composition. Despite the pictorially unpromising theme, Mantegna's unfailing draughtsmanship, his extraordinary attention to minute detail and the brilliance of wit apparent in the grotesque personifications make the picture wholly compelling.

(c) Altarpieces. To celebrate Francesco Gonzaga's victory against the French at Fornovo in 1495, an altarpiece was commissioned from Mantegna to decorate a newly constructed chapel in Mantua dedicated to the Madonna of Victory (1495–6; Paris, Louvre; see fig. 5). The altarpiece was originally to have the iconographic form of a Madonna della Misericordia protecting Francesco, his brothers and his wife, but in the event only Francesco was shown, in full armour, with the warrior saints Michael and George, the patron saints of Mantua, Andrew and Longinus, and SS Elizabeth and John the Baptist. The Virgin is seated with the Child on a raised throne beneath a fruit-laden canopy, extending her hand in protection over the Marchese. Camesasca has accurately characterized the *Madonna of Victory* as a 'colossal miniature'. The heavy theatricality and monumental character of the composition anticipates the altarpieces of the 16th century.

These aspects of the picture were further developed by Mantegna in the so-called *Trivulzio Madonna* (1496–7; Milan, Castello Sforzesco), painted for the Olivetan monks of S Maria in Organo in Verona. Here Mantegna employed

5. Andrea Mantegna: *Madonna of Victory,* ?tempera on canvas, 2.80×1.64 m, 1495–6 (Paris, Musée du Louvre)

the low viewpoint of the *Triumph* scenes, with the foreground figures of St John the Baptist and St Jerome, gracefully elongated, standing on the base-line of the composition on a surface that slopes away from the picture plane. By contrast, the Virgin in her mandorla of cherubs, whose heads dissolve into cloud (an effect that anticipates Correggio and Raphael), is shown frontally. The altarpiece is dated 15 August 1497, the feast of the Assumption, and although not strictly an Assumption scene, allusion to that iconography is implied. The sobriety of this picture, which contrasts sharply with the courtly richness of the *Madonna of Victory,* is entirely appropriate to its monastic context.

The altarpiece showing the *Virgin and Child with Mary Magdalene and St John the Baptist* (London, N.G.) is completely undocumented. The refined classicism of the composition, the elongated figures and the sharply defined folds and *cangiantismo* of the robes suggest a date in the 1490s close to the two large altarpieces.

(d) Easel pictures and other works. Mantegna's late devotional works are characterized by a great depth of feeling and by profoundly meditated pictorial solutions.

The half-length narrative type devised in the 1450s is further developed in the *Adoration of the Magi* of the 1490s (Los Angeles, CA, Getty Mus.) and the contemporary *Ecce homo* (Paris, Mus. Jacquemart-André), both executed in distemper on a cloth support. The *Dead Christ* (Milan, Brera), with the bold foreshortening of the Christ figure and the broken flesh of the stigmata, make this a deeply moving image whose sense of tragedy is heightened by the expressions of the devastated mourners and by the sombre colouring. A painting of this subject, perhaps this very work, was in Mantegna's house at his death, a fact that, taken in conjunction with the style of the picture, the subdued tonalities in particular, and the extreme emotionalism, suggests a date of *c.* 1500. Other late devotional works include the *Descent into Limbo* (Princeton, NJ, Johnson priv. col.), which in its preternatural rendition of the earth and rocks in the foreground is very similar to the *Madonna of the Quarries* and to the *Man of Sorrows with Two Angels* (Copenhagen, Stat. Mus. Kst.). In the latter picture Mantegna imitated the light effects of Bellini in the sky and clouds. The image projects a rarefied sense of dramatic tragedy through the combined effect of the realistically rendered details of the porphyry tomb and the winding sheet and the stylized expressions of grief imprinted on the heads. The same combination of realism and stylization is apparent in the haunting late *St Sebastian* (Venice, Ca' d'Oro), which was also in Mantegna's studio at his death. Abstracted from any narrative context, the elegant elongated figure is about to step out of a marble frame, like that of the *St Euphemia* or the *St George* (probably 1470s; Venice, Accad.), giving rise to a most graceful contrapposto pose. In the lower right-hand corner a snuffed-out candle bears a cartellino with a Latin inscription which states: 'Nothing stands firm except the divine; all else is smoke', a dictum perhaps composed by Mantegna himself and perhaps indicative of the increasing sense of frustration and disillusionment that appears to have marked his final years. Among the Virgin and Child pictures that should be dated late are the one in the Poldi Pezzoli Museum, Milan (probably 1490s), and the Altman *Madonna and Child* (*c.* 1495–1505; New York, Met.).

Mantegna's grisailles were painted to simulate marble or bronze reliefs. They were intended to be appreciated as virtuoso representations, on the model of the *trompe l'oeil* works described by Pliny, but they were also demonstrations of the conceits of art imitating art and painting outdoing sculpture. Their appearance in Mantegna's oeuvre in the 1490s corresponds with the contemporary development of a classicizing relief style in Veneto sculpture. The grisailles are small in scale and show Old Testament or Classical subjects. The distemper on canvas technique, with its dry matt look, was particularly appropriate for the realistic representation of shallow relief sculpture. A fine example of this new category of painting is the *Judith with the Head of Holofernes* (late 1490s; Dublin, N.G.), in which the grey canvas preparation is made to act as the mid-tone between the white highlights and the dark shadows. The figural monochromatic scene is set against a coloured slab of marble, the patterning of which is designed to resemble, but not to imitate, a particular kind of stone, and perhaps here too Mantegna was exercising his powers of invention. Another example is the *Samson*

and Delilah (late 1490s; London, N. G.; see fig. 6), which interprets the subject in a strong moralizing key as an admonition against excessive drinking and combines this with a warning concerning the wiles of evil women. Mantegna's most ambitious monochrome painting is the *Introduction of the Cult of Cybele to Rome* (1505–6; London, N. G.), executed for Francesco Cornaro in Venice. It illustrates an episode from the story of the Roman Cornelia family in imitation of a Classical frieze set against two different types of coloured marble. The scene is presented *di sotto in sù*, and it is clear that the painting was intended to hang high, probably in a small study. Mantegna by this late stage in his career had acquired an extraordinary confidence for dealing with recondite Classical subject-matter in an entirely convincing way.

Mantegna also painted '*bronzi finti*', or fictive bronzes, in which he created the metallic effect by painting the highlights in shell gold over the distemper technique employed for the fictive stone reliefs. A superlative example of this is the *?Sibyl and Prophet* (*c.* 1495; Cincinnati, OH, A. Mus.), which achieves an effect ultimately more pictorial than sculptural. The *Tuccia* and the *Sophonisba* (both *c.* 1500; London, N. G.) are also fictive bronzes but painted in tempera and gold on panel. They may have been intended to decorate furniture.

Mantegna executed some highly finished drawings towards the end of his career; these appear to constitute some of the earliest examples of what have been called 'presentation drawings', drawings made as finished works of art and often intended as gifts. Among them are the *Judith with the Head of Holofernes* (Florence, Uffizi), signed and dated 1491, and the coloured drawing of *Mars, Diana*

6. Andrea Mantegna: *Samson and Delilah*, distemper on canvas, 470×370 mm, late 1490s (London, National Gallery)

and (?)Iris (1490s; London BM). The *Allegory of the Fall of Ignorant Humanity* ('*Virtus combusta*', 1490–1506; London, BM), which is associated in style and subject-matter with the *studiolo* pictures, is probably in the same category. It formed the template for the design of the upper half of the print attributed to Giovanni Antonio da Brescia. The lower half, inscribed *Virtus deserta*, must depend on a lost Mantegna drawing.

Mantegna's burial chapel, dedicated to St John the Baptist, is in S Andrea, Mantua; it has frescoed decoration that was probably executed by his son Francesco. Canvas paintings include a *Baptism*, perhaps designed by Andrea but whose execution is not worthy of him, and a frieze-like altarpiece depicting the *Families of Christ and John the Baptist*. The latter is at least in part by Mantegna. The bronze bust of Mantegna set in a roundel against a porphyry background was probably made by the artist. It is modelled on the Roman *imago clipeata* portraits. The artist is portrayed crowned with a wreath, identifying himself as the 'painter-laureate', or the new Apelles, a title often applied to him by his contemporaries.

2. ENGRAVINGS. Mantegna's prints are the finest examples of copperplate-engraving in 15th century Italy, compositionally elaborate and technically advanced. He was a pioneer in the medium and was probably responsible for the technical innovation of combining drypoint and burin to broaden the tonal range. With the exception of Antonio Pollaiuolo's print of *Battling Nudes* (*c.* 1470), the large dimensions of Mantegna's engravings are unprecedented. Initially he appears to have been interested in the expressive and artistic potential of the medium and only subsequently in its potential for disseminating his '*invenzioni*' and for financial return, at which point he enlisted the services of professional engravers, such as Giovanni Antonio da Brescia and possibly the young Giulio Campagnola.

Although there is disagreement as to whether Mantegna cut his own plates, there is good reason to believe that he did cut some of them, notably the seven prints attributed to the artist by Kristeller; the *Virgin and Child* (B. 8), the two parts of the *Battle of the Sea Gods* (B. 17 and 18), the *Risen Christ with SS Andrew and Longinus* (B. 6), the two *Bacchanals* (B. 19 and 20) and the *Entombment* (B. 3). These are works of extremely high quality and represent what must be the culmination of a process of increasing familiarity with the technical problems of the medium. Recently the case has been made for adding four more engravings to the canon of autograph prints. These are more experimental in character (three of them unfinished) and sometimes clumsy in execution, testifying to the artist's first uncertain steps in the medium. They are the co-called *Flagellation with a Pavement* (B. 1), the *Descent into Limbo* (B. 5; these two were engraved on either side of the same plate), the *Deposition* and the *Entombment with Four Birds* (B. 2A; these two also engraved on either side of the same plate and accepted as Mantegna's by Bartsch; for all the above see 1992 exh. cat.).

It is difficult to establish a chronology for Mantegna's prints, but it seems certain that none predates the artist's move to Mantua. From a letter of 1475 written by an engraver called Simone Ardizzone da Reggio to the

Marchese Ludovico, it appears that at this date Mantegna was considering employing a professional engraver, and so it has been argued that most of his prints date from before that time (Landau). The *Entombment*, which exists in two states, is probably Mantegna's first experiment in using the drypoint technique. The first state shows that the design had been executed wholly in drypoint and the resulting print has poor contrast of tone and is illegible in parts. The much improved second state shows that the plate was recut with a burin, and the clarity and range of tone is far superior (see 1992 exh. cat., cat. nos 38 and 39).

The most ambitious print is the *Battle of the Sea Gods*, which is composed of two sheets and is more than 800 mm long. The Classical subject-matter has been interpreted as an allegory of Envy, since the emaciated hag who presides over the battling Tritons and Icthyocentaurs bears a tablet inscribed with the word INVID (Jacobsen), although the subject may have a specific literary source. Mantegna's intention in designing this composition must have been to create an authentic-looking Classical scene that imitated the appearance and effect of a Roman frieze. The *Bacchanal with a Wine Vat* and the *Bacchanal with Silenus* were conceived in a similar spirit but lack the moralizing content.

Mantegna's prints were recognized as important works from an early date. Albrecht Dürer (1471–1528) made drawn copies of the right half of the *Battle of the Sea Gods* and the *Bacchanal with Silenus* (both 1494; Vienna, Albertina). Engraved copies of some of the prints were made in Mantegna's own lifetime, sometimes in reverse and presumably most of them under his supervision. There are several prints by other engravers after Mantegna's drawings, and these probably date from quite late in his career.

II. Working methods and technique.

Mantegna's painting technique presents some very interesting characteristics. Among them are the frequent use of a canvas support, unusual in 15th-century Italy, the frequent use of distemper (pigment bound in animal size) and his propensity for using gold (usually in the form of shell gold, gold powder bound in size) right up to his death, by which time its use had largely gone out of fashion.

Panel paintings by Mantegna, on the other hand, generally conform to traditions current in Italy in the period. Most of the panels of the *St Luke* altarpiece, for example, are made from the commonly used white poplar, although some are black poplar. On the white gesso layer that was customarily laid on panel supports, Mantegna made quite careful underdrawings, probably with a brush and sometimes with the aid of a cartoon, as can be seen in infra-red reflectograms of some of the figures in his painting of the *Ascension* (Florence, Uffizi). In his tempera paintings on panel Mantegna sometimes made use of oil-glazes, for example in the garland of the *St Mark* (Frankfurt am Main, Städel. Kstinst. and Städt. Gal.) and probably for the copper resinate greens of the foliage in the *Agony in the Garden* (London, N.G.), some of which have turned brown. Mantegna seems to have varnished all his tempera paintings on panel to give them a glossy, reflective finish,

and the letter he wrote to Ludovico Gonzaga in 1464 saying that he 'could not yet varnish the panels because the frames are not gilded' suggests that varnishing was the very last thing he did.

One of the advantages of using canvas was that it was cheaper and could be easily transported, as Mantegna himself acknowledged in a letter to Marchese Ludovico (1477). The pictures for Isabella d'Este's *studiolo* are executed in tempera (pigment bound in an egg medium) on canvas, except for the areas of blue paint, which are in oil, and were varnished with high-quality varnish, purchased in Venice. This had the effect of saturating the colours and gave the surface a precious vitreous quality. Mantegna's propensity for using distemper on canvas was governed by the optical and aesthetic effects that could be achieved using this technique, which gives results very similar to fresco. The low refractive index of the medium means that the pigments are closer in appearance to their dry state than when they are bound in other media. Once settled in Mantua, Mantegna had few opportunities to paint in fresco, a technique in which he excelled, and this may partly account for his frequent use of distemper on canvas. The *Triumphs*, which have the character and are of the scale of wall paintings, appear to be painted in distemper, although their state of preservation is so poor and the pictures have been so mistreated over the centuries that it is hard to be certain. Usually executed on a very fine linen support, the pictures in distemper are executed over a layer of size, sometimes coloured. Occasionally, as in the *Introduction of the Cult of Cybele to Rome* (London, N.G.), the paint is applied over a fine layer of gesso. It is generally accepted that pictures in this technique were never intended to be varnished, although most of them subsequently have been, causing a saturation of colour that the artist never intended and an overall darkening of tone due to the varnish impregnating the paint layer and the support. One picture that has escaped this fate is the *Ecce homo* (Paris, Mus. Jacquemart-André), which also happens to be glued to its original panel backing. As a result, it has preserved its fresh matt appearance and constitutes a touchstone for the intended appearance of Mantegna's paintings in this technique. Most of the late grisailles (e.g. *Samson and Delilah*, London, N.G.; *Judith with the Head of Holofernes*, Dublin, N.G.) are in the distemper technique, which was particularly suited to imitating the dry appearance of carved stone.

Mantegna worked with great precision, leaving very little to chance. He worked methodically and, by all accounts, very slowly. Few pictures reveal significant pentiments, and in general his underdrawing was so carefully executed that when he came to paint he rarely had to make departures from the drawn lines. A drawing for the engraving of the *Risen Christ with SS Andrew and Longinus* in Munich (Staatl. Graph. Samml.; see 1992 exh. cat., no. 44) shows how fastidious he was in preparing the design that was to be engraved on the copperplate. The drawing is highly finished in all its details and includes an important correction to the head of Christ. At a certain point the artist must have decided the inclination of the head was not quite right and so he cut it out of the sheet and pasted it back on at the correct angle. This is not to say that his drawings lack spontaneity; on the contrary, the

preparatory pen studies (U. London, Court. Inst. Gals) for the engraving of the *Flagellation with a Pavement* are vibrant sketches that show a brilliantly inventive mind.

BIBLIOGRAPHY

EARLY SOURCES

G. Vasari: *Vite* (1550, rev. 2/1568); ed. G. Milanesi (1878–85), iii

B. Scardeone: *Historiae de urbis patavinae antiquitate et claries civibus patavini* (Padua, 1560)

MONOGRAPHS AND EXHIBITION CATALOGUES

H. Thode: *Mantegna* (Bielefeld and Leipzig, 1897)

P. Kristeller: *Andrea Mantegna* (London, 1901); 2nd edn, with fuller documentary appendix (Berlin and Leipzig, 1902)

C. Yriarte: *Mantegna* (Paris, 1901)

E. Tietze-Conrat: *Mantegna: Paintings, Drawings, Engravings* (London, 1955)

G. Fiocco: *L'arte di Andrea Mantegna* (Venice, 1959)

Andrea Mantegna (exh. cat., ed. G. Paccagnini; Mantua, Pal. Ducale, 1961)

R. Cipriani: *Tutta la pittura del Mantegna* (Milan, 1962)

E. Camesasca: *Mantegna* (Milan, 1964)

M. Bellonci and N. Garavaglia: *L'opera completa del Mantegna* (Milan, 1967)

G. Fiocco: *Paintings by Mantegna* (London, 1978) [includes colour plates of the Ovetari frescoes]

R. Lightbown: *Mantegna* (Oxford, 1986)

Andrea Mantegna (exh. cat., ed. J. Martineau; London, R.A., 1992); review by M. Hirst, *Burl. Mag.*, cxxxiv (1992), pp. 318–21

MANTEGNA IN PADUA

V. Lazzarini and A. Moschetti: *Documenti relativi alla pittura padovana del secolo XV* (Venice, 1908/*R* Bologna, 1974)

P. Kristeller: 'Francesco Squarcione e le sue relazioni con Andrea Mantegna, *Rass. A.*, ix (1909), no. 10, pp. iv–v; no. 11, pp. iv–v

E. Rigoni: 'Nuovi documenti sul Mantegna' (1927–8), reprinted in *L'arte rinascimentale in Padova. Studi e documenti* (Padua, 1970)

H. Tietze: 'Mantegna and his Companions in Squarcione's Workshop', *A. America* (1942), pp. 54–60

V. Moschini: *Gli affreschi del Mantegna agli Eremitani di Padova* (Padua, 1944)

G. Fiocco: *La Cappella Ovetari* (Milan, 1953; Eng. trans., Oxford, 1979) [See also G. Fiocco exh. cat.]

C. Paccagnini: 'La cronologia della Cappella Ovetari', *Atti del congresso sull'arte e la cultura a Mantova: Mantova, 1961*

L. Puppi: 'Osservazioni sui riflessi dell'arte di Donatello tra Padova e Ferrara', *Atti dell'VIII convegno (Ist. N. Stud. Rinascimento): Firenze 1966*, pp. 307–29

A. M. Romanini: 'L'itinerario pittorico del Mantegna nel primo rinascimento padano-veneto', *Arte in Europa: Scritti in onore di E. Arslan* (1966), pp. 437–64

L. Puppi: *Il trittico di Andrea Mantegna per la Basilica di San Zeno Maggiore in Verona* (Verona, 1972)

——: 'Nuovi documenti (e una postilla) per gli anni padovani del Mantegna', *Ant. Viva*, xiv (1975), pp. 3–11

M. Dunkelman: 'Donatello's Influence on Mantegna's Early Narrative Scenes', *A. Bull.*, lxii (1980), pp. 226–35

S. Bandera Bistoletti : *Il polittico di San Luca di Andrea Mantegna (1453-1454) in occasione del suo restauro* (Florence, 1989)

MANTEGNA IN MANTUA

F. Arcangeli: 'Un nodo problematico nei rapporti fra L. B. Alberti e il Mantegna', *Convegno di studi sul Sant'Andrea di Mantova e L. B. Alberti: Mantova, 1974*, pp. 189–203

C. Elam: 'Mantegna in Mantua', *Splendours of the Gonzaga* (exh. cat., ed. D. Chambers and J. Martineau; London, V&A, 1981), pp. 15–25

L. Ventura: 'La religione privata: Ludovico II, Andrea Mantegna e la Cappella del Castello di San Giorgio', *Quad. Pal. Te*, vii (1987), pp. 23–34

G. Agosti: 'Su Mantegna, 4 (a Mantova nel Cinquecento)', *Prospettiva*, lxxvii (Jan 1995)

The 'Camera degli Sposi'

C. Paccagnini: 'Appunti sulla tecnica della Camera Picta di Andrea Mantegna', *Studi in onore di Mario Salmi* (Rome, 1961), pp. 395–403

C. M. Brown: 'New Documents on Mantegna's Camera degli Sposi', *Burl. Mag.*, cxiv (1972), pp. 861–3

R. Signorini: 'Lettura storica degli affreschi della Camera degli Sposi di A. Mantegna', *J. Warb. & Court. Inst.*, xxxviii (1975), pp. 109–35

——: 'L'autoritratto del Mantegna nella Camera degli Sposi', *Mitt. Ksthist. Inst. Florenz*, xx (1976), pp. 205–12

C. Lloyd: 'An Antique Source for the Narrative Frescoes in the Camera degli Sposi', *Gaz. B.-A.*, xci (1978), pp. 119–22

A. Tissoni Benvenuti: 'Un nuovo documento sulla Camera degli Sposi del Mantegna', *Italia Med. & Uman.*, xxiv (1982), pp. 357–60

R. Signorini: *Opus Hoc Tenue: La Camera dipinta di Andrea Mantegna* (Mantua, 1985)

D. Arasse and C. Cieri Via: 'A proposito della Camera degli Sposi: Una discussione di metodo', *Quad. Pal. Te*, vi (1987), pp. 19–22

M. Cordaro: 'Aspetti del modo di esecuzione della Camera Picta di Andrea Mantegna', *Quad. Pal. Te*, vi (1987), pp. 9–18

The 'Triumphs of Caesar'

E. K. Waterhouse, C. H. Collins-Baker and J. Macintyre: 'Mantegna's Cartoons at Hampton Court', *Burl. Mag.*, lxiv (1934), pp. 103–7

A. Luzio and R. Paribeni: *Il 'Trionfo di Cesare' di Andrea Mantegna* (Rome, 1940)

M. Vickers: 'The Intended Setting of Mantegna's *Triumphs of Caesar*, *Battle of the Sea Gods* and *Bacchanals*', *Burl. Mag.*, cxx (1978), pp. 365–70

A. Martindale: *The 'Triumphs of Caesar', by Andrea Mantegna in the Collection of H.M. The Queen at Hampton Court* (London, 1979)

C. Hope: 'The Chronology of Mantegna's *Triumphs*', *Renaissance Studies in Honour of Craig Hugh Smyth*, ed. A. Morrogh and others (Florence, 1985), ii, pp. 297–316

C. Hope: 'The *Triumphs of Caesar*', *Andrea Mantegna* (exh. cat., ed. J. Martineau; London, RA, 1992), pp. 350–92

The 'Studiolo' of Isabella d'Este

E. Tietze-Conrat: 'Mantegna's *Parnassus*: A Discussion of a Recent Interpretation', *Art. Bull.*, xxxvi (1949), pp. 126–30

E. H. Gombrich: 'An Interpretation of Mantegna's *Parnassus*', *J. Warb. & Court. Inst.*, xxvi (1963), pp. 196–8

A. Martindale: 'The Patronage of Isabella d'Este at Mantua', *Apollo*, lxxix (1964), pp. 183–91

E. Verheyen: *The Paintings in the Studio of Isabella d'Este at Mantua* (New York, 1971)

V. Tátrai: 'Osservazioni circa due allegorie del Mantegna', *Acta Hist. A. Acad. Sci. Hung.*, xviii (1972), pp. 233–50

P. W. Lehmann: 'The Sources and Meaning of Mantegna's *Parnassus*', *Samothracian Reflections: Aspects of the Revival of the Antique*, ed. P. Lehmann and C. Lehmann (Princeton, 1973), pp. 59–178

Lo Studiolo d'Isabella d'Este (exh. cat., ed. S. Béguin; Paris, Louvre, 1975)

R. Jones: 'What Venus Did with Mars: Battista Fiera and Mantegna's *Parnassus*, *J. Warb. & Court. Inst.*, xliv (1981), pp. 193–8

Late works and miscellaneous

A. Portioli: 'La chiesa e la *Madonna della Vittoria* di Andrea Mantegna in Mantova', *Atti & Mem. Accad. N. Virgil. Mantova* (1884)

A. Luzio : 'La *Madonna della Vittoria* del Mantegna', *Emporium*, x (1899), pp. 359

F. Hartt: 'Mantegna's *Madonna of the Rocks*', *Gaz. B.-A.*, xl (1952), pp. 329–42

M. Levi d'Ancona: 'Il Mantegna e la simbologia: Il *S Sebastiano* del Louvre e quello della Ca' d'Oro', *Commentari*, xxiii (1972), pp. 44–52

R. Jones: 'Mantegna and Materials', *I Tatti Studies: Essays in the Renaissance*, ii (Florence, 1987)

C. Gilbert: 'Huldah Solves the Problem: Identifying a Mantegna Subject', *Apollo*, cxliii/412 (June 1996), pp. 11–15

MANTEGNA AND ANTIQUITY

I. Blum: *Mantegna und die Antike* (Strasbourg, 1936)

A. M. Tamassia: 'Visioni di antichità nell'opera di Mantegna', *Atti Pont. Accad. Romana Archeol.*, xxviii (1956), pp. 213–49

F. Saxl: 'Jacopo Bellini and Mantegna as Antiquarians', *Lectures*, i (London, 1957), pp. 150–60

P. D. Knabenshue: 'Ancient and Medieval Elements in Mantegna's *Trial of St James*', *A. Bull.*, xli (1959), pp. 59–73

M. Meiss: 'Towards a More Comprehensive Renaissance Palaeography', *A. Bull.*, xlii (1960), pp. 97–112

V. Fasolo: 'L'inspirazione romana negli sfondi architettonici di Mantegna', *Palladio*, xiii (1963), pp. 79–84

E. Battisti: 'Il Mantegna e la letteratura classica', *Arte, pensiero e cultura a Mantova nel primo rinascimento in rapporto con la Toscana e con il Veneto: Atti del convegno internazionale di studi sul rinascimento: Firenze, 1965*, pp. 103

C. M. Brown: 'A Sketchbook after the Antique Known to Andrea Mantegna', *Mitt. Ksthist. Inst. Florenz*, xvii (1973), pp. 153–9

M. Vickers: 'The Palazzo Santacroce Sketchbook: A New Source for Andrea Mantegna's *Triumphs of Caesar, Bacchanals* and *Battle of the Sea Gods*', *Burl. Mag.*, cxviii (1976), pp. 824–34

M. Billanovich: 'Intorno all'IUBILATIO di Felice Feliciano', *Italia Med. & Uman.*, xxxii (1989), pp. 351–8

DRAWINGS AND ENGRAVINGS

E. Tietze-Conrat: 'Was Mantegna an Engraver?', *Gaz. B.-A.*, xxiv (1943), pp. 375–81

A. E. Popham and P. Pouncey: *Italian Drawings in the Department of Prints and Drawings in the British Museum: The Fourteenth and Fifteenth Centuries*, 2 vols (London, 1950)

Prints by Mantegna and his School (exh. cat. by D. Alston, C. Burman and D. Landau, Oxford, Christ Church, 1979)

D. Landau: 'Mantegna as Printmaker', and S. Boorsch: 'Mantegna and his Printmakers', *Andrea Mantegna* (exh. cat., ed. J. Martineau; London, RA, 1992), pp. 44–54, 56–66

P. Emison: 'The Raucousness of Mantegna's Mythological Engravings', *Gaz. B.-A.*, ser. 6, cxxiv/1510 (1994), pp. 159–76

G. R. Goldner: 'A New Mantegna Drawing for the S Zeno Altarpiece', *Master Drgs*, xxxii/4 (Winter 1994), pp. 371–9

D. Landau: 'Mantegna's Plates', *Prt Q.*, xiv (1997), p. 81

TECHNIQUE AND MATERIALS

Lo Studiolo d'Isabella d'Este (exh. cat., ed. S. Béguin; Paris, Louvre, 1975)

M. Hours and others: 'L'Analyse des peintures du Studiolo d'Isabelle d'Este au Laboratoire de recherche des Musées de France', *An. Lab. Rech. Mus. France* (1975), p. 21

S. Bandera Bistoletti: *Il polittico di San Luca di Andrea Mantegna (1453–1454) in occasione del suo restauro* (Florence, 1989)

K. Christiansen: 'Some Observations on Mantegna's Painting Technique', and A. Rothe: 'Mantegna's Paintings in Distemper', *Andrea Mantegna* (exh. cat., ed. J. Martineau; London, RA, 1992), pp. 68–78, 80–88

J. Dunkerton: 'Mantegna's Painting Techniques', *Mantegna and Fifteenth-century Court Culture*, ed. F. Ames-Lewis (London, 1993), pp. 26–38

A. Rothe: 'Andrea Mantegna's *Adoration of the Magi*', *Historial Painting Techniques, Materials and Studio Practice: Preprints of a Symoposium: Leiden, 1995*, pp. 111–16

GABRIELE FINALDI

Mantovano. *See* SCULTORI.

Mantovano, Marcello. *See* VENUSTI, MARCELLO.

Mantovano, Rinaldo. *See* RINALDO MANTOVANO.

Mantua [It. Mantova]. North Italian city in the Lombard plain, situated on the River Mincio *c.* 16 km north of its confluence with the River Po. Here the Mincio widens into a series of swampy lakes that once surrounded the city but now bound it on the west, north and east. Occupied successively by Etruscans, Gauls and Romans, although never a settlement of any significance, Mantua first claimed fame as the birthplace in 70 BC of the poet Virgil, whose head sometimes appeared on coins (earliest example 1256) and, set within a quarter of St George's cross, is borne on the city's coat of arms.

The city developed only from the 9th century AD. Its proximity to the River Po, the main link between the central Lombard cities and Ferrara and Venice, enabled it to exert some fiscal control over river traffic. It also straddled the land routes from Padua to Cremona and Parma, but Mantua was always relatively isolated, the only town in a flat region, some of which was forest or marsh and much of which subject to flooding. The economy was based on agriculture, although in the 13th century a cloth industry developed, its masters soon dominating the merchants' guild. Later on, silk textiles were manufactured, but on a modest scale, and Mantua remained dependent on its larger neighbours, above all on Venice. The city's heyday came between the 14th century and the early 17th, under the rule of the GONZAGA family. Major patrons of all the arts, the Gonzagas expanded and transformed the city, employing such architects as Leon Battista Alberti and Giulio Romano. To their court they attracted painters, among them Andrea Mantegna, musicians (Claudio Monteverdi) and goldsmiths and metalworkers (Antico). What were probably the earliest tapestry workshops in Italy grew up under Gonzaga patronage (*see* §3 below). In the early 17th century a large part of the family's collections was sold to Charles I (*reg* 1625–49) of England, and after the sack of the city by imperial troops during the War of Succession (1628–31) many of the more portable items from the Gonzaga inventory left Mantua, to be dispersed in collections across Europe, although much of the family's legacy is still to be seen in the city.

1. HISTORY AND URBAN DEVELOPMENT. Mantua began to emerge as an urban community under its own bishops in the 9th century and under the counts of Canossa in the 11th. In 1115 the city threw off the Canossa overlordship and became an independent *commune*, usually loyal to the Holy Roman emperors. By about 1200 communal Mantua was growing rapidly. In 1273 the Bonacolsi family seized power. However, in 1328 the Gonzaga family took control of the city in a *coup d'état*, an event commemorated in the *Expulsion of the Bonacolsi from Mantua* (Mantua, Pal. Ducale; see fig.) painted in 1494 by Domenico Morone.

The Gonzagas, proprietors of large estates in the southern part of the Mantuan dominion, increased their wealth through contracts of military service with such major Italian powers as Venice, Milan, Florence and the Papacy, by marriage with influential dynasties, and by the acquisition of imperial titles (Marchese 1433; Duke 1530). Both lay and ecclesiastical government came under their control, the bishopric being held by members of the family from 1466 over most of the following two centuries. Mantua's urban society and economy were not wholly parasitic on the court; there was some resurgence in the cloth industry by the middle of the 15th century, and the merchants' guild flourished, although it had no political power. The Gonzaga regime offered some degree of stability and the rule of law; it was little troubled by opposition.

The city's urban expansion that had characterized the medieval period continued despite physical disadvantages: Pope Pius II noted it was built on a swamp (*Commentaries*, Book II), dusty in summer, muddy in winter; those who suffered from its fever-bearing mosquitoes included Giulio Romano's assistants and Benvenuto Cellini. The first panoramic view of Mantua is a wall painting from the early 15th century, uncovered in 1981 in a warehouse that may originally have been the office of the *massaro* (economic administrator). It shows a water-girt city of brick houses, towers and churches huddled within its walls, linked to the mainland on the north and east by the Ponte dei Mulini and the Ponte di S Giorgio (destr. 1920), the surrounding landscape studded with castles. The schematic depiction gives no idea of the street layout or identifiable rendering of individual buildings. Under Francesco I Gonzaga (*reg* 1382–1407), Bartolino da Novara built the

Domenico Morone: *Expulsion of the Bonacolsi from Mantua*, oil on canvas, 1.65×3.15 m, 1494 (Mantua, Palazzo Ducale)

Castello S Giorgio by the lake east of the city, which was itself reorganized into 20 districts (*rioni*) and its statutes revised. The façade of the cathedral was added by Pierpaolo and Jacobello dalle Masegne (*fl* 1383–1409) from 1395 to 1403; although now destroyed, it appears in Morone's *Expulsion of the Bonacolsi from Mantua* (see fig. 1).

Under Gianfrancesco Gonzaga (*reg* 1407–44), subsequently the 1st Marchese, the school of Vittorino da Feltre made Mantua a centre of humanistic education and values, and in these years some of the most familiar features of the city centre were established. In the absence of local stone, brick was the principal building material, as for the high bell-tower of S Andrea (1416); terracotta was sometimes used for such details as capitals and doorframes, seen in the house of the Milanese merchant, Giovanni Boniforte da Concorezzo, built in 1455. Over the portico above his shop (facing S Andrea) are curiously fretted terracotta window-cases and carved stone friezes showing woolsacks and items of merchandise, including combs, bowls, gloves, stirrups and saddlebags.

It was, however, Marchese Ludovico Gonzaga (*reg* 1444–78) whose initiatives reflected Renaissance architectural theory emanating from Florence. Although he already had a Florentine architect in LUCA FANCELLI, in 1459–60 he was consulting Leon Battista Alberti over a programme of urban renewal. Mantua's streets were paved, and the votive church of S Sebastiano was begun to an innovative Greek-cross design by Alberti; and in 1472 work began on the rebuilding of S Andrea to a revised design by the same architect (*see* ALBERTI, LEON BATTISTA, §III, 2(iii) and figs 4–8). The latter, a huge new building that dominates the city centre, remains the major monument to Ludovico's architectural patronage. Its portico inspired by Roman triumphal arches and the vast scale of its interior, with coffered vaulting and side chapels instead of aisles, exerted a strong influence upon church design in Rome, Milan, Venice and elsewhere.

Other civic projects sponsored by Ludovico were the rebuilt Palazzo della Ragione, the adjacent tower with its elaborate astrological clock (1473; rest. 1989) by Bartolomeo Manfredi, a new market-hall (Casa del Mercato; destr.), and a civic hospital (now offices of the Polizia Stradale, Piazza Virgiliana) designed by Luca Fancelli, begun in 1450 and in operation by 1472. At this time, too, the streets leading to the market-place beside S Andrea assumed their present character, with prominent merchants' houses surmounting porticoed shop-fronts. Some of the original marble columns with a variety of devices on their capitals and certain of the original buildings survive, although only faint traces remain to suggest the effect produced by painted stucco walls. The porticoed 15th-century exterior to the meeting-house of the merchants' guild has a capital bearing their device of an eagle above a woolsack.

Marchese Federico I (*reg* 1478–84) added the Domus Nova to the Ducal Palace complex, and further urban development occurred under Marchese Federico II (*reg* 1519–40), subsequently the 1st Duke. GIULIO ROMANO, who came to Mantua in 1524, combined the roles of court painter and building overseer. A palace built for Marchese Francesco II (*reg* 1484–1519) near S Sebastiano was superseded after *c.* 1525 by Giulio's project on the site of the Gonzaga stables, the eccentric Palazzo del Te (*see* GIULIO ROMANO, fig. 3); he also designed for Federico's bride the Palazzina Palaeologa (destr.). As supervisor of the city's streets and housing, Giulio is credited with the layout of straight streets and patrician palazzi with gardens that still continued westwards, and he may have been responsible for the porticoed bridge over the Rio at the fish market, and in 1536 for a new meat market building. He also redesigned the interior of the cathedral (1545–6), remodelling the nave along the lines of an Early Christian basilica in Rome. The reign of Duke Guglielmo Gonzaga (1550–87) probably marked Mantua's zenith of prosperity

and efficient government, the population reaching 35,000 in the 1560s. Thereafter the city declined, the direct Gonzaga line ending at the death of Duke Vincenzo II in 1627.

2. ART LIFE AND ORGANIZATION. Virgil, who publicized Mantua's legendary foundation and supposedly historical beginnings as an Etruscan city (*Aeneid* X.196–206), not only brought fame to the city; his works provided painters there with subject-matter. Most artists and other professional experts during Mantua's heyday were brought in from elsewhere. It is remarkable that unlike Padua, Bologna or Ferrara, for example, Mantua seems to have been without its own characteristic workshop traditions of painting. Very little survives at all before 1400, the principal works (in S Francesco and in the Palazzo Ducale) being attributed to Stefano da Verona; no names emerge of Mantuan masters. Yet in 1380 Giangaleazzo Visconti, later 1st Duke of Milan, sent to Mantua for good painters (*bonos depictores*), so there may have been native talent. Even in better recorded times, painters of Mantuan origin were few and undistinguished, for example Rinaldo Mantovano, an assistant of Giulio Romano, or the latter's disciples, such as Lorenzo Costa (ii), who was born and died in Mantua, although his parents were not from there. A similar dearth of native sculptors is rather less surprising, in view of the lack of stone quarries in the region to stimulate a working tradition.

Goldsmiths, whose guild statutes date from 1310, did flourish in Mantua, and they achieved some distinction in the Renaissance. Cristoforo di Geremia, who worked for Marchese Ludovico Gonzaga in the 1460s, appears to have specialized in the design of objects, including medals, based on the Antique. One of his pupils was probably Bartolommeo Melioli (1448–1514), who had a shop near S Lorenzo and was a supervisor of the Mantuan mint *c.* 1492; another remarkable medallist, also an official of the mint, was Gian Marco Cavalli; a third was Sperandio, who also worked for Marchese Francesco II. The Mantuan mint, which lasted from the 10th century until 1785, had already begun producing gold and silver coins of high quality and denomination in the 1430s. It was then that Gianfrancesco, the first Gonzaga marchese, was granted the imperial privilege of having his head represented on coins; these finer coins, imitations of those produced by the Venetian mint, may, like medals, have been principally commemorative. The most distinguished of 15th-century Mantuan goldsmiths was probably Piero Jacopo Alari Bonacolsi, known as 'Antico', a pioneer in the art of small neo-antique bronze-castings.

The related arts of printing and engraving were also practised early in Mantua. Four of the earliest incunabula (1472–4) were printed by Pietro Adamo de' Micheli (*c.* 1441–81), the son of a Mantuan lawyer; he learnt the technique from the Butzbach brothers who had come from near Mainz. Early printed books and book illustrations in Mantua were few and mostly of inferior quality, whereas engravings were pioneered there at an early date. Zoan Andrea was in practice with his friend Simone Ardizone da Reggio, and Simone complained in September 1475 that not only their stock but their persons had been attacked, for which he blamed Mantegna. It may have been that some of Mantegna's drawings were pirated; Mantegna himself was practising engraving in Mantua by the 1490s, and the tradition was continued with great distinction by others such as Giorgio Ghisi.

Art in Mantua was very much the business of the court, and most major works were by distinguished non-Mantuans either invited to work there or given specific commissions by members of the Gonzaga family or their foreign consorts, such as Isabella d'Este (*see* ESTE (6)), a notable collector, who resided in Mantua from 1490 to 1539. Some arts, such as tapestry-weaving, which probably found its first Italian home at Mantua, may have been entirely dependent on court patronage (*see* §3 below). There were important non-Mantuans who remained in Mantua for long periods and whose local influence went far beyond the court apartments they decorated. One was ANDREA MANTEGNA, who arrived as court painter in 1460 and stayed almost without interruption until his death in 1506; he designed not only his own house in the city but also his funerary chapel in the church of S Andrea. The other was Giulio Romano, who arrived as court painter in 1524. Giulio (as well as also leaving his own house behind) inspired many of the city's painters and architects, most notably the Mantuan Giovanni Battista Bertani, who designed the first court theatre (1549, destr. 1591) and painted scenery for its productions. The house Bertani designed for himself also survives. Mantua is exceptional in containing three houses that leading Renaissance artists designed and (at least briefly) themselves inhabited.

BIBLIOGRAPHY

GENERAL

G. Cadioli: *Descrizione delle pitture, sculture ed architetture che si osservano nella città di Mantova e nei suoi contorni* (Mantua, 1763)

L. C. Volta and G. Arrivabene: *Compendio cronologico critico della storia di Mantova dalla sua fondazione sino ai nostri tempi*, 5 vols (Mantua, 1807–33)

C. D'Arco: *Delle arti e degli artifici di Mantova*, 3 vols (Mantua, 1857–9/*R* 1975)

W. Braghirolli: *Lettere inedite di artisti del secolo XV cavate dall'archivio Gonzaga per nozze Cavriani-Sordi* (Mantua, 1878)

P. Torelli and A. Luzio: *L'archivio Gonzaga di Mantova*, i (Ostiglia, 1920), ii (Verona, 1922) [introductory essays and bibliog. as well as lists of the archives]

D. E. Rhodes: 'A Bibliography of Mantua', *La bibliofilia*, lvii–lviii (1955–6, 1964) [for early printed books]

G. Coniglio and L. Mazzoldi, eds: *Mantova: La storia*, 3 vols (Mantua, 1958–63)

E. Faccioli, ed.: *Mantova: Le lettere*, 3 vols (Mantua, 1959–63)

G. Paccagnini and others, eds: *Mantova: Le arti*, 3 vols (Mantua, 1960–65)

[Each of the series has an additional volume of illustrations and extensive bibliog.]

Mantova e i Gonzaga nella civiltà del rinascimento: Atti del convegno organizzato dall'Accademia Nazionale dei Lincei e dall'Accademia Virgiliana: Mantova, 1974

M. Vaini: *Mantova nel Risorgimento: Itinerario bibliografico* (Mantua, 1976)

C. Pecorari: 'La pianta di Mantova disegnata e incisa dal Bertazzolo nel 1596', *Civiltà Mant.*, xi (1977), pp. 325–48

A. Franchini and others, eds: *La scienza a corte* (Rome, 1979)

U. Bazzotti and A. Belluzzi: *Architettura e pittura all'Accademia di Mantova, 1752–1802* (Florence, 1980)

Splendours of the Gonzaga (exh. cat., ed. D. Chambers and J. Martineau; London, V&A, 1981) [full bibliog.]

P. Carpeggiani and I. Pigliari: *Mantova: Materiali per la storia urbana dalle origini all'ottocento* (Mantua, 1983)

M. A. Grignani and others, eds: *Mantova 1430: Pareri a Gian Francesco Gonzaga per il governo*, Fonti per la storia di Mantova e del suo territorio (Mantua, 1990)

R. Signorini, ed.: *Andrea da Schivenoglia, 'Cronaca di Mantova'*, Fonti per la storia di Mantova e del suo territorio (in preparation)

A. Cole: *Virtue and Magnificence: Art of the Italian Renaissance Courts* (New York, 1995)

SPECIALIST STUDIES

A. Magnaguti: *Studi intorno alla zecca di Mantova 1433–1627*, 2 vols (Milan, 1913–15)

P. Carpi: 'Giulio Romano ai servizi di Federico Gonzaga', *Atti & Mem. Accad. N. Virgil. Mantova*, xi–xiii (1918–1920), pp. 35–150

A. Magnaguti: *Le medaglie mantovane* (Mantua, 1921)

E. Rosenthal: 'The House of Andrea Mantegna in Mantua', *Gaz. B.-A.*, xv (1962), pp. 327–48

G. Paccagnini: *Il Palazzo Ducale di Mantova* (Turin, 1969)

K. W. Forster: 'The Palazzo del Te', *J. Soc. Archit. Hist.*, xxx (1971), pp. 267–93

Il Sant'Andrea di Mantova e Leon Battista Alberti: Atti del convegno di studi organizzato dalla città di Mantova con la collaborazione dell'Accademia Virgiliana nel quinto centenario della basilica di Sant'Andrea e della morte dell'Alberti, 1472–1972: Mantova, 1972

K. W. Forster and R. J. Tuttle: 'The Casa Pippi: Giulio Romano's House in Mantua', *Architectura* [Munich], iii (1973), pp. 104–7

C. Perina: 'Bertanus invenit: Considerazioni intorno su alcuni aspetti della cultura figurativa del cinquecento a Mantova', *Ant. Viva*, xiii/4 (1974), pp. 18–23

E. J. Johnson: *S Andrea: The Building History* (University Park, PA, and London, 1975) [some transcripts faulty]

R. Signorini: 'Marmi della casa di mercante', *Civiltà Mant.*, x (1976), pp. 53–68

D. S. Chambers: 'Sant'Andrea at Mantua and Gonzaga Patronage', *J. Warb. & Court. Inst.*, xl (1977), pp. 99–127

C. Vasic Vatovec: *Luca Fancelli architetto: Epistolario gonzaghesco* (Florence, 1979)

E. Marani: *La masseria di Mantova e i suoi affreschi* (Mantua, 1983)

D. Ferrari: *Mantova nelle stampe* (Brescia, 1985)

R. Signorini: *Opus hoc tenue: La camera dipinta di Andrea Mantegna* (Mantua, 1985) [lavish illustrations, documentation and bibliog.]

R. Signorini: *L'ostensorio sognato: Breve guida alla conoscenza del ripristinato orologio pubblico di Mantova* (Mantua, 1989)

A. Cicinelli: 'Pisanello a Mantova: Nuovi Studi', *Stud. Stor. A.* [Todi], v–vi (1994–5), pp. 55–92

L. Ventura, intro.: *I camerini di Isabella d'Este: Uno spazio culturale esemplare* (Modena, 1995)

C. Mozarelli, R. Oresko and L. Ventura, eds: *The Court of the Gonzaga in the Age of Mantegna, 1450–1550* (Rome, 1997)

D. S. CHAMBERS

3. CENTRE OF TAPESTRY PRODUCTION. The earliest published record of a northern European tapestry weaver in Italy is of Nicolò di Francia, who in early 1420 was in Mantua weaving a tapestry for Gianfrancesco Gonzaga, 1st Marchese of Mantua, from a cartoon by Giovanni Corradi; Nicolò seems to have stayed in Mantua for only a year. In 1421–2 Maria di Bologna is recorded as having the qualification of master of hangings, although it is not clear whether she was weaving or repairing tapestries. Zanino di Francia is first recorded in 1422 and worked for the Gonzaga until 1442, weaving several bench-backs.

After working for the Este in Ferrara, the peripatetic Brussels master Rinaldo Boteram (pseud. di Gualtieri; *fl* 1438–81) moved to Mantua in 1449, in one of the earliest of numerous exchanges of tapestries and tapestry weavers between the Gonzaga and Este families. Cartoons were provided by the painter Giacomo Bellanti di Terra d'Otranto. In 1457 Boteram, with a recommendation from Ludovico II Gonzaga, went to Modena and then Venice. Until at least 1480, however, Boteram continued to import northern European tapestries for the Gonzaga. In 1465 Maffeo de Mafeis (*fl* 1462–8) began a set of fine, large tapestries, with silk and gold-thread highlights, from cartoons by Andrea Mantegna (see Kristeller, p. 524). In

1466 the master Zohanne de Franza (pseud. Giovanni or Zanino di Francia; *fl c.* 1466–91; *d* ?1507) was recommended to Marchesa Barbara from Ferrara by Bengarda Gonzaga. Other weavers, Simone (1469) and Lorenzo and Ruggiero (from 1471) who were listed as *tappezzieri*, may have woven either tapestries or rugs. From 1475 to 1478 the upholsterer Francesco degli Acerbi worked for the Gonzaga, and in 1493 Master Bartolomeo had a tapestry workshop in Mantua.

Documents from the 16th century seem to indicate that the Gonzaga attempted to have always at least one tapestry master in their employ. Various weavers are documented as working in Mantua until 1511. Information is then scarce until 1538, when a tapestry weaver called Giuseppe is mentioned. In 1539 Federico II Gonzaga invited Nicolas Karcher (*d* 1562) to come from Ferrara to establish a court workshop. Karcher brought ten other weavers with him, probably including his father, Aluisio Karcher (1455–1540). Until this time 16th-century production of tapestries appears to have been limited, and weavers may have worked mainly on smaller pieces and repairs. An antependium of the *Annunciation* (c. 1509; Chicago, IL, A. Inst.) with the arms of Francesco II Gonzaga is from a cartoon strongly influenced by Mantegna.

Following the lead of his cousin Ercole II d'Este, Federico II Gonzaga doubtless planned a major tapestry-decorating campaign with Karcher's workshop, which under Cardinal Ercole Gonzaga continued the 15-piece *Playing Putti* (five complete tapestries and two fragments, Lisbon, Mus. Gulbenkian; one complete piece and one fragment in other collections) from cartoons by Giulio Romano. After an eight-year sojourn in Florence, Karcher returned to Mantua (1554), and his workshop's major project, probably from cartoons by several different painters, was the six *Stories of Moses* and the accompanying *spalliere* of *Putti with Garlands* (four in Milan, Mus. Duomo; three destr.), which were later given to San Carlo Borromeo (1538–84). No tapestry weavers are documented in Mantua after Karcher's death in 1562. Despite having weavers in Mantua, the Gonzaga never abandoned the tradition of importing tapestries from north of the Alps, some of which were woven from their own cartoons.

BIBLIOGRAPHY

A. Bertolotti: 'Le arti minori alla corte di Mantova nei secoli xv, xvi e xvii: Ricerche storiche negli archivi mantovani', *Archv Stor. Lombardo*, v (1888), pp. 259–318, 980–1075

P. Kristeller: *Andrea Mantegna* (Berlin and Leipzig, 1902)

M. Viale Ferrero: *Arazzi italiani* (Milan, 1961)

D. Heinz: *Europäische Wandteppiche* (Brunswick, 1963), pp. 260–64

M. Viale Ferrero: *Arazzi italiani del cinquecento* (Milan, 1963), pp. 18–22, 50–55

C. H. Brown and G. Delmarcel: 'Les Jeux d'enfants: Tapisseries italiennes et flamandes pour les Gonzague', *RACAR*, xv/2 (1988), pp. 109–21

N. Forti Grazzini: 'Arazzi', *Giulio Romano* (exh. cat., Mantua, Pal. Ducale and Mus. Civ. Pal. Te, 1989), pp. 466–79

C. Adelson: 'On Benedetto Pagni da Pescia and Two Florentine Tapestries: The Allegorical "Portière" with the Medici-Toledo Arms', *Kunst des Cinquecento in der Toskana*, ed. M. Kämmerer (Munich, 1992), pp. 185–96

C. H. Brown and G. Delmarcel: *Tapestries for the Courts of Federico II, Ercole, and Ferrante Gonzaga, 1522–63* (Seattle and London, 1996)

CANDACE J. ADELSON

Manutius, Aldus (*b* Bassiano, ?1450; *d* Venice, 6 Feb 1515). Italian printer, publisher, teacher and translator. He

studied in Rome and Ferrara and spent some time in Mirandola with Giovanni Pico (1463–94). In 1483 he was tutor to the Pio family. He formed a project to publish Greek texts and in 1489–90 moved to Venice, where soon afterwards he published the *Musarum panegyris* (1491). His Greek publications formed the core of his activities: he issued *c.* 30 first editions of literary and philosophical Greek texts including a five-volume Aristotle (1495–8). The first book printed with his own newly cut Greek type was the *Erotemata* (1495) by Constantine Lascaris (1434–?1501). Three further Aldine Greek types were developed, the last in 1502.

Manutius established a pre-eminent position in Venetian publishing and in 1495 entered into a formal partnership with Andrea Torresani, his future father-in-law, and Pierfrancesco Barbarigo. His total output has been estimated at 120,000 or more copies. One of his most significant innovations was the production of small-format editions of Classical texts, starting with those of Virgil in 1501, produced in comparatively large print runs of 1000, the earliest precursor of the modern paperback. Typographically his major achievement was the type cut by Francesco Bologna, il Griffo, for Pietro Bembo's *De Aetna* (February 1495), a truly modern type still used in modified form. His activities as a teacher, scholar and translator were of equal importance to his printing work: his academy included among its associates Erasmus, Pietro Bembo, Andrea Navagero (1483–1529) and Fra Giovanni Giocondo of Verona.

BIBLIOGRAPHY

M. Lowry: *The World of Aldus Manutius: Business and Scholarship in Renaissance Venice* (Oxford, 1979)

N. Barker: *Aldus Manutius and the Development of Greek Script and Type in the Fifteenth Century* (Sandy Hook, 1985)

H. G. Fletcher: *New Aldine Studies. Documentary Essays on the Life and Work of Aldus Manutius* (San Francisco, 1988)

V. Fontana: 'Fra Giocondo, "Consilii X Maximus Architectus", 1506–1514, *Tempi di Giorgione*, ed. R. Maschio (Rome, 1994), pp. 119–27

Aldo Manuzio e l'ambiente veneziano, 1494–1515 (exh. cat., ed. S. Marcon and M. Zorzi; Venice, Lib. Marciana, 1994)

M. Davies: *Aldus Manutius, Printer and Publisher of Renaissance Venice* (Malibu, 1995)

H. K. Szepe: 'The Book as Companion, the Author as Friend: Aldine Octavos Illuminated by Benedetto Bordon', *Word & Image*, xi/1 (1995), pp. 77–99

In Praise of Aldus Manutius: A Quincentenary Exhibition (exh. cat. by H. G. Fletcher, New York, Pierpont Morgan Lib.; Los Angeles, UCLA, Res. Lib.; 1995)

LAURA SUFFIELD

Manzini, Andrea di Giusto. *See* ANDREA DI GIUSTO.

Manzuoli, Tommaso. *See* SAN FRIANO, MASO DA.

Marascalchi [Marescalchi; Mariscalchi], **Pietro de'** [lo Spada] (*b* Feltre, 1522; *d* Feltre, 1589). Italian painter. His first known work, a crowded *Virgin and Saints* (1545–7; Feltre, S Martino), is a curious mixture of traditional elements derived from the Feltre painter Lorenzo Luzzo, with Emilian Mannerist influence, probably from Parma. The youthful phase is almost entirely in the manner of Jacopo Bassano, with Titianesque iconographic revisions. In both the *Madonna with SS Peter and Laurence* of Aune (Sovramonte), which is closely linked to Jacopo's altarpiece for the church of Rasai (1542), and the more articulated *Madonna with SS Martin and Victor, Corona and Mark* in

the church of S Martino at Feltre (1545–7; *in situ*) (with drawings on the reverse, including a St Sebastian), Marascalchi used models from Titian's altarpiece for S Nicolo dei Frari, derived from a print by Nicolò Boldrini (*fl c.* 1530–70). The impact on Marascalchi of the work of the Venetian Jacopo Bassano was also of critical importance. Marascalchi's celebrated altarpiece, the *Adoration of the Shepherds* ('Madonna della Misericordia', *c.* 1552; Feltre Cathedral), also shows the influence of Giovanni Demio. An exercise in pictorial dynamism, it is notable for its rich colours and for the cluster of supplicants spiralling around the Virgin, who is portrayed in equally energetic torsion. The free and vibrant predella scenes from the *Life of the Virgin* are characteristic of the small-scale painting that Marascalchi favoured. The small altarpiece of the *Virgin and Child Enthroned with SS Victor, Michael and Angel Musician* (San Giustina Bellunese, S Michele) dates from the same time.

This successful and creative period ended by 1564, when Marascalchi signed and dated the *Virgin and Child with Saints* (Los Angeles, CA, Getty Mus.). The hieratic *St John the Baptist* (Feltre Cathedral) is of a similar date. Marascalchi's many later altarpieces are conventionally structured, archaic in their composition and often show a repetition of physical types. The altarpiece at S Giustina Bellunese, Meano, showing the *Madonna and SS Bartholomew, John the Baptist and a Donor* (1570; *in situ*) is an episode of precious and sparkling colour seldom repeated in subsequent works in churches (e.g. Lamon, 1571; S M degli Angeli at Feltri; Mugnai, Mellarne etc.). These same mixtures include nevertheless the *Holy Family with SS Agatha and Apollonia*, painted for S Agata at Velai and now in S Marco at Mugnai; the small and intense *Feast of Herod* (1576; Berlin; Gemäldegal.), originally from the parish church of Serro (Sovramonte), and finally the *S Peter Freed from Prison*, formerly in the convent of S Pietro in Vincoli at Feltre. The *Feast of Herod*, with its almost Rococo informality, once led to the suggestion that he was a precursor of El Greco (*c.* 1541–1614). In a late period and leaving the *impresa* incomplete, Marascalchi frescoed the interior of the Monte de Pietà with scenes from the Bible.

BIBLIOGRAPHY

R. Pallucchini: 'Petro de Mariscalchi: Un manierista di provincia', *Da Tiziano a El Greco* (exh. cat., Venice, Doge's Pal., 1981), pp. 208–15

V. Sgarbi: 'Pietro de Mariscalchi', *The Genius of Venice* (exh. cat., ed. C. Hope and J. Martineau; London, RA, 1983), pp. 183–5

S. Claut: '"Regesto" Mariscalchi', *Archv Stor. Belluno, Feltre & Cadore*, ccxlvi (1984), pp 21-7

——: 'Novità, divagazioni e note su Pietro Marascalchi', *A. Ven.*, xxxviii (1984), pp. 46–56

——: 'Feltro e Belluno', *La pittura nel Veneto. Il Cinquecento*, ed. M. Lucco, ii (Milan, 1998), pp. 717–20

SERGIO CLAUT

Marco da Ravenna. *See* DENTE, MARCO.

Marco di Costanzo. *See* COSTANZO, MARCO.

Marconi, Rocco (*fl* Venice, 1504–29). Italian painter. He is mentioned (Ridolfi, Boschini, Zanetti) as being a native of Treviso, but signed himself *venetus* in the contractual document for an altarpiece for Treviso. He may have been born in Venice to parents originating from Bergamo

(Ludwig). He is documented for the first time as a witness in 1504, and then several times until 1529, including in 1517 as an auditor of the Guild of Painters, a sign that by this time he was already established. He spent over 25 years in the workshop of Giovanni Bellini, and during this period, either in the 1490s or perhaps the late 1480s, he produced three paintings of the *Virgin and Child* (Strasbourg, Mus. B.-A.; ex-Czernin priv. col., Vienna), all signed *Rochus de Marchonib*. These are exact copies of Bellini's *Virgin and Child* (*c.* 1485–90; Atlanta, GA, High Mus. A.), on which it is sometimes thought that Marconi collaborated. On the basis of these signed works others have been attributed, most of which are now reattributed to the Venetian Master of the Incredulity of St Thomas. Thus there are only three or four certain works from the years Marconi spent with Bellini.

On Bellini's death (1516), Marconi moved to the workshop of Palma Vecchio and adjusted his style accordingly, although his figures retained some of the rigid quality that was characteristic of Bellini's art. He specialized mainly in paintings of *Christ and the Adulteress* and *Christ with Martha and Mary*, although many that have been attributed to him are undoubtedly not by his hand. From this second phase of his career there is also the signed altarpiece of *Christ Blessing, with Two Saints* (Venice, S Giovanni e Paolo). It is painted in his characteristic mixture of styles derived from Bellini and Palma Vecchio, which cannot be said of two other works that have been attributed to him: the *Christ with SS Peter and John the Baptist* (Venice, Accad.) and the altarpiece in the Alte Pinakothek in Munich. It seems to the present writer that these are unlikely to have been painted by Marconi.

BIBLIOGRAPHY

C. Ridolfi: *Meraviglie* (1648); ed. D. von Hadeln (1914–24), p. 237
M. Boschini: *Le ricche miniere della pittura veneziana* (Venice, 1664), pp. 25, 412, 467, 521, 566
A. M. Zanetti: *Della pittura veneziana* (Venice, 1771), pp. 208–10
G. Ludwig: 'Archivalische Beiträge zur Geschichte der venezianischen Kunst', *Jb. Kön.-Preuss. Kstsamml.* (1905), suppl., pp. 136–42
F. Gibbons: 'Giovanni Bellini and Rocco Marconi', *A. Bull.*, xliv (1962), pp. 127–34
P. L. de Vecchi: 'Rocco Marconi', *I pittori bergamaschi dal XIII al XIX secolo: Il cinquecento*, i (Bergamo, 1975), pp. 345–59
M. Lucco: 'Marconi, Rocco', *La pittura in Italia: Il cinquecento*, ed. G. Briganti, 2 vols (Milan, 1987, rev. 1988), ii, p. 763 [with bibliog.]

MAURO LUCCO

Marescalco, il. *See* BUONCONSIGLIO, GIOVANNI.

Mariani, Camillo (*b* Vicenza, ?1567; *d* Rome, July 1611). Italian sculptor, painter and architect. He received his early training as a sculptor in Vicenza, in the workshop of Lorenzo and Agostino Rubini (*fl* late 16th century). Deeply influenced by the style and method of Alessandro Vittoria, Lorenzo Rubini's brother-in-law, Mariani enjoyed an active career in his native city and beyond from *c.* 1584 until his departure for Rome in 1597. Around 1584 he helped to carry out the stucco figural decoration of Andrea Palladio's Teatro Olimpico, Vicenza, and his most important independent early commission (*c.* 1596) consisted of six elegant life-size stucco statues, representing members of the Cornaro family, for the main salon of Palladio's Villa Cornaro, Piombino Dese. These works, stylistically close

to Vittoria's sculpture, are characterized by a largeness of form, an emotive intensity and expressive movement.

In Rome after 1597 Mariani played a key role, together with Nicolas Cordier (*c.* 1567–1612), Stefano Maderno (1575–1636) and others, in the large architectural and decorative enterprises of Clement VIII and Paul V. Among other works for Clement VIII Mariani modelled the colossal allegorical stucco figures of *Justice* and *Fortitude* (1599–1600) above the nave arch of the Clementina Chapel in St Peter's, and he carved the marble statues of *St Peter*, *St Paul* and *Religion* (1604) for the Aldobrandini Chapel in S Maria sopra Minerva. Paul V employed him as a member of the team of sculptors that carried out the sculptural decoration of the Pauline Chapel in S Maria Maggiore; he contributed models (1609–10) for the bronze angels surrounding the icon of the Virgin on the altar tabernacle, the marble statue of *St John the Evangelist* to the left of the altar, and the large marble relief of the *Siege of Strigonia* on the tomb of *Clement VIII* (both begun 1610).

The masterpieces of Mariani's Roman period are his eight monumental stucco figures of saints (1599–1600) in niches in the church of S Bernardo alle Terme. These figures reveal the sculptor's debt to the style of Vittoria and, more significantly, demonstrate his importance to the development of the early Baroque. The statues have robust three-dimensional volume and weight and are endowed with a profound sense of life and energy. Chiaroscuro effects are achieved through subtle and bold modelling of surfaces, and each of the saints is characterized psychologically and spiritually by means of pose, expression and gesture. Through their dynamic stances and directed glances, these figures engage the spectator and activate the space of the church.

In addition to his work in stucco and marble, Mariani also produced medals and small-scale bronzes, among the latter *St Crescentino and the Dragon* (h. 830 mm, 1596; Urbino, Pal. Mun.). One painting, a *Flight into Egypt* (Florence, Roberto Longhi priv. col.), has been identified by Middeldorf as by Mariani, and Fiocco (1940–41 and 1968) has argued convincingly that the sculptor, a close friend of Vincenzo Scamozzi, designed the façade of S Pietro, Vicenza, and the main salon of the Villa Cornaro, Piombino Dese. Mariani raised the art of stucco sculpture to an unprecedented position in Rome, and his dynamic, pictorial and highly expressive style was of fundamental importance to his pupil, Francesco Mochi, and to the second generation of sculptors in the papal capital.

BIBLIOGRAPHY

G. Baglione: *Vite* (1642); ed. V. Mariani (1935), pp. 113–14
A. Venturi: *Storia*, x/3 (1937), pp. 349–77
G. Fiocco: 'Camillo Mariani', *Arti: Rass. Bimest. A. Ant. & Mod.*, iii (1940–41), pp. 74–86
A. Riccoboni: *Roma nell'arte: La scultura nell'evo moderno dal quattrocento ad oggi*, i (Rome, 1942), pp. 130–34
V. Martinelli: 'Le prime sculture di Camillo Mariani a Roma', *Venezia e l'Europa. Atti del XVIII congresso internazionale di storia dell'arte: Venezia, 1955*, pp. 306–11
M. C. Dorati: 'Gli scultori della Cappella Paolina in Santa Maria Maggiore', *Commentari*, xviii (1967), pp. 231–60
G. Fiocco: 'Camillo Mariani e Palladio', *Boll. Cent. Int. Stud. Archit. Andrea Palladio*, x (1968), pp. 164–9
S. Pressouyre: 'Actes relatifs aux sculptures de la chapelle Aldobrandini à Sainte Marie-de-la-Minerve à Rome', *Bull. Soc. N. Antiqua. France* (1971), pp. 195–206

U. Middeldorf: 'Camillo Mariani, scultore-pittore', *Burl. Mag.*, xcviii (1976), pp. 500–03
R. C. Burns: *Camillo Mariani: Catalyst of the Sculpture of the Roman Baroque* (diss., Baltimore, MD, Johns Hopkins U., 1979)
STEVEN F. OSTROW

Mariano del Buono di Jacopo (*b* Florence, 1433; *d* Florence, ?19 Nov 1504). Italian illuminator. His output appears to be divided into two main phases: the early phase is characterized by an exuberant style; the later (after 1478), for which he is best known, is less vivacious, due to the constant intervention of mediocre collaborators. In 1464 Mariano illuminated Livy's *History of Rome* (Florence, Bib. Riccardiana, MS. 484), formerly attributed to the Master of the White Scrolls because of an incorrect interpretation of the motif of white scrolls, which were seen as a stylistic peculiarity rather than as characteristic of a certain type of book. A feature of Mariano's early work is the use of innovative design, even within traditional graphic schemes. He preferred portraits to narrative scenes and his portraiture reflects a more complex range of influences, including such artists as Piero della Francesca and Antonio del Pollaiuolo, and such Classical motifs as the bust. Pairs of putti, three-dimensional candelabra and a vast assortment of animals can often be seen in the backgrounds.

Among the codices featuring white scrolls is a manuscript of Plutarch's work (1469; Modena, Bib. Estense, MS. lat. 429); the initials frequently contain representations of themes that are typical of *cassone* panels: the journey, the couple, the drama of love. In the depiction of *Theseus and the Minotaur* in the initial of the proem by the translator Antonio da Todi, Mariano shows the suffering minotaur with a bleeding face that is more like that of a dead Christ than the traditional image of sinful brutality; this anticipates Sandro Botticelli's *Pallas and the Centaur* (1480–85; Florence, Uffizi). Another early work is St Augustine's *City of God* (London, BL, Add. MS. 15246). Among the themes used by Mariano during the 1460s is a symbolic *Woman in Profile* with a little dog jumping into her lap, found in a miscellany (Milan, Castello Sforzesca, MS. 817, fol. 1). In a *Fior di virtù* (Florence, Bib. Riccardiana, MS. 1774) a variety of animals are similarly correlated with moral classifications.

The manuscript (finished 1477; Florence, Bargello, MS. 68) illuminated for the Ospedale di S Maria Nuova in Florence reveals the stylistic change in Mariano's work. It also contains work by Gherardo di Giovanni del Foro, Felice di Michele (*d* 1518), Antonio di Domenico and Girolamo da Cremona. The manuscript, presumably executed over a long period, contains examples of Mariano's early and later work, the latter suggesting his acquaintance with Girolamo da Cremona in the new conception of the figure and the transformation of the borders. Similarly, in the copy of Virgil's *Aeneid* (Florence, Bib. Medicea–Laurenziana, MS. Plut. 39.6) illuminated for Francesco Sassetti, Mariano shows his familiarity with the Antique. The Classical subjects—the *Abduction of Helen*, the *Judgement of Paris*, the *Departure of Aeneas*, the *Wooden Horse*—are inserted into 15th-century urban scenes. Classical references also appear in the three-volume *History of Rome* by Livy (Munich, Bayer. Staatsbib., Clm. 15731–3) made for Johannes Vitéz, of which Mariano illuminated the frontispieces. This small book is a celebratory cycle in which the *Labours of Hercules* and *Stories of Ancient Rome* are evoked in terms that later became common in 16th-century iconography. The influence of the art of Girolamo da Cremona emerges in a vernacular version of the *History of Rome* (U. Valencia, Bib., MS. 757). Portraits of famous people are found in this manuscript and are common in the *Scriptores historiae Augustae* and the *Storie di Roma* by Eutropius and Paul the Deacon (Melbourne U., MS. 219) executed for the Medici prince Lorenzo the Magnificent in 1479. The motif of the famous man in a pattern of white scrolls appears again in the *History of Rome* (New York, Pub. Lib., Spencer MS. 27) executed later for Matthias Corvinus, King of Hungary (*reg* 1458–90).

In 1484 Mariano illuminated Nesi's *De moribus* (Florence, Bib. Medicea–Laurenziana, MS. Plut. 77.24), dedicated to Piero de' Medici, son of Lorenzo the Magnificent. The medallions in the frontispiece are related to work by Pollaiuolo, Botticelli and others. The Book of Hours (*c.* 1488; Waddesdon Manor, Bucks, NT, MS. 16), decorated for the wedding of Maddalena de' Medici and Francesco Cybo, has substantial contributions from Mariano's bottega. The importance of his bottega is witnessed by the presence of collaborators throughout his work.

BIBLIOGRAPHY
M. Levi d'Ancona: *Miniatura e miniatori a Firenze dal XIV secolo al XVI secolo* (Florence, 1962), pp. 175–81
A. Garzelli: 'Micropittura su temi virgiliani prima e dopo Apollonio di Giovanni: Apollonio, Giovanni Varnucci, Mariano del Buono e altri', *Scritti di storia dell'arte in onore di Federico Zeri*, i (Milan, 1984), pp. 147–62
——: *Miniatura fiorentina del Rinascimento, 1440–1525*, i (Florence, 1985), pp. 189–215
PATRIZIA FERRETTI

Marigliano [Mariliano; Marliano; Merigliano; Miriliano], **Giovanni** [Giovanni da Napoli; Giovanni da Nola] (*b* Nola, *c.* 1488; *d* Naples, 1558). Italian wood-carver and sculptor. He trained in Naples as a wood-carver under Pietro Belverte (*d* 1513), executing polychromed wooden reliefs (1507; Naples, S Lorenzo; destr.) and crib figures (1507; Naples, S Domenico Maggiore). In 1508 he and Belverte assisted Tommaso Malvito (*fl* 1484–1508) on a frame for an image of *St Anne* and on doors at the Ospizio dell'Annunziata, Naples. Marigliano continued to work almost exclusively in Naples. His first independent commissions were the frame for the *Virgin and Child* (1511; Naples, S Pietro ad Aram) by Antonio da Rimpacta (*fl* 1509–11) and the altar frame for Bartolommeo de Lino's *Virgin and Saints* (1513; Castelluccio, S Francesco). Around 1524 he carved crib figures for S Maria del Parto, Naples, and collaborated on the marble tomb of the Viceroy of Sicily *Don Ramón de Cardona* (*d* 1522; Catalonia, Bellpuig, S Nicolás), a monument that reflects Andrea Sansovino's tomb designs and the decorative style imported by the Spanish sculptor Bartolomé Ordoñez. The lyrical tomb of *Antonia Guadino* (*c.* 1530; Naples, S Chiara) depicts the figure as a sleeping antique Cleopatra.

In 1532 Marigliano completed the altar of the *Madonna del soccorso*, commissioned by the Liguoro family (Naples, S Anna dei Lombardi), a pendant to another altar by Girolamo da Santacroce (*c.* 1502–*c.* 1537) for the del Pezzo

family in the same church. Both follow earlier Tuscan models, and the juxtaposition highlights Marigliano's awkward figure designs and his dependence on other sculptors' formulae. His altar of the *Madonna della neve* (1536; Naples, S Domenico Maggiore) represents a more classical solution, as did his monument to *Guido Fieramosca* (*c.* 1535–6; church of Montecassino Abbey; destr.). These precede the bizarre designs for the three tombs of the brothers Sigismondo, Ascanio and Jacopo Sanseverino (1539–46; Naples, SS Severino e Sossio), who were poisoned (1516) by their uncle. Here Marigliano's training in wood-carving is revealed in the armour-clad figures, like wooden lay-figures perched on their severely architectonic ledges. The grandiose tomb of the Viceroy of Naples (*reg* 1532–53) and his consort, *Don Pedro of Toledo and Maria Ossorio Pimental* (*c.* 1540–46; Naples, S Giacomo degli Spagnoli), combines Lombard influences with Giovanni Angelo Montorsoli's classical style, derived from Michelangelo, detectable also in such later marble figures as the *St Peter* in the Caracciolo Chapel (1547; Naples, S Giovanni Carbonara). Marigliano's last surviving sculpture, the *Deposition* (*c.* 1549; Naples, S Maria delle Grazie a Caponápoli), is a highly emotive scene.

BIBLIOGRAPHY
Thieme–Becker
A. Venturi: *Storia* (1901–40), X, i, pp. 715–44
A. Borzelli: *Giovanni Miriliano o Giovanni da Nola scultore* (Naples, 1921)
M. Collareta: 'Un busto napoletano a Washington', *Paragone*, xxxviii/443 (1987), pp. 53–5
R. Naldi: 'Giovanni da Nola tra il 1514 e il 1516', *Prospettiva*, lxxvii (1995), pp. 84–100

ANTONIA BOSTRÖM

Mariotto di Nardo (*fl* Florence, 1394–1424). Italian painter. He was the son of the sculptor Nardo di Cione (*fl c.* 1480; namesake of the painter) and was probably trained by his father (Boskovits, 1975). Mariotto's interest in sculpture and his almost obsessive rendering of plastic form in painting remain constant factors in his style, which is easily identifiable and markedly different from that of his contemporaries.

Numerous surviving documents relating to Mariotto di Nardo indicate that he was much sought after as a painter for both public and private commissions in Florence. From 1394 to 1404 he may have been working as the principal artist for the cathedral, for which he executed a large number of paintings, most of which have not survived. Three panels from an altarpiece survive, bust-length figures of *Christ*, *St Ambrose* and *St Augustine* (1402–4; Florence Cathedral).

Around 1400 Mariotto was employed on the fresco decoration of two of the most important churches in Florence: S Maria Maggiore and Orsanmichele (fragments of both cycles *in situ*). For the officials of Orsanmichele he also executed frescoes in their residence, including a *Virgin and Child Enthroned with Saints* (*in situ*). At this stage of his career he was also commissioned to paint illuminated manuscripts, which brought him in contact with the manuscript workshop at S Maria degli Angeli, Florence. This contact had a considerable influence on his style. Examples of his work in this medium include two fragments of *St Lawrence* (Cambridge, Fitzwilliam) and *St Mary Magdalene* (Berlin, Kupferstichkab.).

In 1400 Mariotto may have accompanied Lorenzo Ghiberti to Pesaro, possibly at the request of Pandolfo Malatesta, the ruler of the city. Ghiberti mentioned the journey in his *Commentarii* but failed to give the name of his companion. However, the hypothesis that it was Mariotto (Salmi) is substantiated by the existence in Pesaro of a triptych of the *Virgin and Child with SS Michael and Francis* (Pesaro, Mus. Civ.), dated 1400, by Mariotto.

A large number of securely attributed works by Mariotto survive. These include an altarpiece of the *Virgin and Child with Saints* for the church of S Donnino at Villamagna, Bagno a Ripoli (*in situ*); a triptych of the *Assumption of the Virgin* with *St Jerome* and *St John the Evangelist* (1398; Fiesole, Fontelucente Church); a polyptych of the *Virgin and Child with Saints* and a predella with scenes from the *Life of the Virgin* (Florence, Accad.) from the convent of S Gaggio, Florence; the *Coronation of the Virgin* (Florence, Certosa del Galluzzo, Pin.); the *Trinity* (Impruneta, S Maria); and an altarpiece of the *Virgin and Child Enthroned with Saints* for S Leolino at Panzano in Chianti (*in situ*).

As Mariotto's career progressed, so his paintings became increasingly repetitive and acquired traditional traits. Given that his paintings are often of little more than artisan quality, his success in his own day has perplexed critics, but it was evidently based on his works of the late 14th century, which introduced to Florence elements of Late Gothic taste, such as oblique perspective, nervous tension of the figures and deserted, rocky landscapes.

BIBLIOGRAPHY
Colnaghi
L. Ghiberti: *I commentarii* (MS., Florence, Bib. N. Cent. II.1.33, *c.* 1447–8); ed. J. von Schlosser (Berlin, 1912), p. 45
G. Vasari: *Vite* (1550, rev. 2/1568); ed. G. Milanesi (1878–85), i, p. 610
O. Sirèn: 'Alcuni pittori che subirono l'influenza di Lorenzo Monaco', *Arte*, vii (1904), pp. 337–55
O. H. Giglioli: 'Mariotto di Nardo e la sua tavola d'altare per la Pieve di Villamagna presso Firenze', *Illustratore fiorentino*, n. s., iii (1906), pp. 67–70
O. Sirèn: 'Gli affreschi nel Paradiso degli Alberti: Lorenzo di Niccolò e Mariotto di Nardo', *Arte*, xi (1908), pp. 179–86
H. Horne: 'A Commentary upon Vasari's Life of Jacopo del Casentino', *Riv. A.*, vi (1909), pp. 165–84
G. Poggi: *Il duomo di Firenze* (Berlin, 1909)
R. Piattoli: 'Un mercante del trecento e gli artisti del suo tempo', *Riv. A.*, xi (1929), pp. 396–437, 537–79
R. Offner and K. Steinweg: *Corpus* (New York, 1930), section III, ii, iii
——: 'The Mostra del Tesoro di Firenze Sacra', *Burl. Mag.*, lxiii (1933), pp. 166–78
M. Salmi: 'Lorenzo Ghiberti e Mariotto di Nardo', *Riv. A.*, xxx (1955), pp. 147–52
B. Berenson: *Florentine School*, i (1968), pp. 129–34
M. Boskovits: 'Sull'attività giovanile di Mariotto di Nardo', *Ant. Viva*, vii/5 (1968), pp. 3–13
——: 'Mariotto di Nardo e la formazione del linguaggio tardo-gotico a Firenze', *Ant. Viva*, vii/6 (1968), pp. 21–31
U. Procacci: 'L'affresco dell'Oratorio del Bigallo e il suo maestro', *Mitt. Ksthist. Inst. Florenz*, xviii (1973), pp. 135–52
M. Boskovits: *Pittura fiorentina alla vigilia del rinascimento* (Florence, 1975), pp. 139–41, 388–402
R. Fremantle: *Florentine Gothic Painters* (London, 1975), pp. 451–9

CECILIA FROSININI

Marmitta, Francesco (*b c.* 1460; *fl* ?1505). Italian illuminator, painter and gem-engraver. According to Vasari, Marmitta lived in Parma and, after training as a painter, became an engraver of gemstones, 'closely imitating the ancients'. Although no signed work is known, he is

mentioned in verses prefacing a manuscript of Petrarch's *Canzoniere* and *Trionfi* (Kassel, Landesbib., MS. Poet.4°.6) as the illuminator of the accompanying miniatures. This poem, written by Jacobus Lilius, the patron and scribe of the manuscript, praises Marmitta by comparing him with two of the greatest artists of antiquity, Apelles and Lysippos. Marmitta's familiarity with ancient art is particularly evident in the cameos with Classical figures inset in the frames of the miniatures. These are modelled as if in three dimensions and, with other illusionistic devices featuring Classical motifs, suggest his knowledge of illumination of the 1470s and 1480s from the Veneto. An equally important influence is the work of the Ferrarese painter Ercole de' Roberti. Marmitta's highly personal figure style, characterized by slender, slightly elongated forms, well modelled but full of nervous energy, clearly derives from Roberti's work of the 1480s, such as the *Israelites Gathering Manna* (London, N.G.).

Marmitta's distinctive style has been recognized in other manuscripts, including a Book of Hours from the Durazzo collection (Genoa, Bib. Berio) and a Missal commissioned by Cardinal Domenico della Rovere (Turin, Mus. Civ. A. Ant.). The Missal, Marmitta's only clearly datable work, was made as a gift for Turin Cathedral between 1498 and 1501. It appears to be later than the Petrarch. The surer draughtsmanship and less intense compositions may reflect the influence of the calm, idealized style of Lorenzo Costa (ii) in his Bolognese period (1483–1506). The development towards a quieter figure style is taken a stage further in the Durazzo Hours, where the miniatures are free from fussy detail and tranquil settings are effectively used for subjects often treated with genuine pathos. The scribe of this manuscript, Pierantonio Sallando, worked in Bologna after 1483, which confirms the Bolognese connection in Marmitta's work.

An apparent preparatory drawing for the miniature of the *Entombment* in the Durazzo Hours and two drawings of the *Virgin and Child* of the same period (all London, BM) are in a style that strongly suggests knowledge of Raphael's work in Florence of *c.* 1505. Indeed, the *Entombment* drawing was formerly attributed to Raphael. Marmitta's late style, further characterized by an interest in effects of light and shade, may also be seen in a large altarpiece of the *Virgin and Child with SS Benedict and Quentin* (Paris, Louvre). A passage in Francesco Maria Grapaldi's *De partibus aedium* (1506 edn) confirms that Marmitta worked as a painter of altarpieces. One other panel painting, a small *Flagellation* (Edinburgh, N.G.; see fig.), has been attributed to Marmitta. Comparison with the Petrarch suggests that this is an early work. Marmitta's work as a gem-engraver is now known only through the cameos illuminated in his manuscripts. Vasari recorded that he taught the art to his son Ludovico Marmitta (*fl* 1534), who practised it successfully in Rome.

Francesco Marmitta: *Flagellation*, oil on panel, 358×250 mm, ? before 1498 (Edinburgh, National Gallery of Scotland)

P. Pouncey: 'Drawings by Francesco Marmitta', *Proporzioni*, iii (1950), pp. 111–13
L. A. Pettorelli: 'La miniatura a Parma nel rinascimento', *Parma A.*, ii (1952), pp. 107–17
M. Levi D'Ancona: 'Un libro d'ore di Francesco Marmitta da Parma e Martino da Modena al Museo Correr', *Boll. Mus. Civ. Ven.*, xii (1967), pp. 9–28
J. J. G. Alexander: *Italian Renaissance Illuminations* (London, 1977), pp. 26, 34, 118–19
G. Mariani Canova: *Miniature dell'Italia settentrionale nella Fondazione Giorgio Cini* (Vicenza, 1978), pp. 34–5
D. A. Brown: 'Maineri and Marmitta as Devotional Artists', *Prospettiva* [Florence], 52–3 (1988–9), pp. 99–308
A. Bacchim Beatrice and others: *Francesco Marmitta* (Turin, 1996)

THOMAS TOLLEY

Marone, Roberto. *See* RAFFAELLO DA BRESCIA.

Martelli. Italian family of patrons and collectors. Members of the family held important political positions in Florence, especially during the 15th century. One of their most important acts of patronage, recorded by Vasari, was the commissioning by Roberto Martelli (1408–64) of several sculptures from Donatello, including the famous statue of *St John the Baptist as a Youth* (*c.* 1455; Florence, Bargello). Although the accuracy of Vasari's information has been questioned, some recently discovered unpublished documents have enabled a partial confirmation of the attribution (see Civai, 1988–9, pp. 40–59; 1989). During the 16th century the family gave important commissions to Lorenzo di Credi, Giorgio Vasari, Andrea Sansovino and Giovanni Francesco Rustici in connection with the decoration of

BIBLIOGRAPHY
G. Vasari: *Vite* (1550, rev. 2/1568); ed. G. Milanesi (1878–85), v, p. 383
R. Longhi: *Officina ferrarese* (Rome, 1934, rev. Florence, 2/1956), pp. 93–4
P. Toesca: 'Di un pittore e miniatore emiliano: Francesco Marmitta', *L'Arte*, xvii (1948), pp. 33–9
A. E. Popham and P. Pouncey: *Italian Drawings in the Department of Prints and Drawings in the British Museum: The Fourteenth and Fifteenth Centuries* (London, 1950), pp. 106–7

family chapels in the basilica of S Lorenzo and the churches of S Frediano in Florence and S Agostino in Rome.

BIBLIOGRAPHY

G. Vasari: *Vite* (1550; rev. 2/1568); ed. G. Milanesi, ii, vi, vii (1878, 1881, 1881)

A. Civai: 'Donatello e Roberto Martelli: Nuove acquisizioni documentarie' *Donatello-Studien. Atti del convegno, Kunsthistorischen Institut in Florenz: Firenze 1986*, pp. 253–62

——: *Dipinti e sculture in casa Martelli: Storia di una collezione patrizia fiorentina dal quattrocento all'ottocento* (Florence, 1990)

ALESSANDRA CIVAI

Martin V, Pope. *See* COLONNA, (1).

Martinelli, Niccolo. *See* TROMETTA.

Martini, Cristofano di Michele. *See* ROBETTA.

Martini, Francesco di Giorgio. *See* FRANCESCO DI GIORGIO MARTINI.

Martino da Udine. *See* PELLEGRINO DA SAN DANIELE.

Marziale, Marco (*fl* 1492–1507). Italian painter. He was first recorded in 1492 as one of several assistants to Giovanni Bellini in the Doge's Palace in Venice; in an inscription on his earliest known work, a damaged *Virgin and Child with Saints and a Donor* (1495; Zadar, St Mary, Treasury), he called himself a pupil of Gentile Bellini. Visual confirmation of his close association with both Bellini brothers is provided by the rather large number of his signed and dated works, many of which are closely based on compositional motifs by Giovanni, but which in their linearity and angularity more closely resemble the style of Gentile. The influence of German art, and of Albrecht Dürer (1471–1528) in particular, has often been noted in the sharply focused and densely packed details, the harsh modelling and the expressive ugliness found in much of Marziale's work.

In 1500 he seems to have moved to Cremona, perhaps at the behest of the poet and jurist Tommaso Raimondi, who is portrayed with his wife as a donor in Marziale's *Circumcision* altarpiece (1500; London, N.G.), painted for the local church of S Silvestro. The artist's last recorded work, a *Virgin and Child with Saints* (1507; London, N.G.), was also painted for a church in Cremona; it shows the influence of both Lombard painting and Perugino's *Virgin Enthroned with Saints*, painted in 1494 for S Agostino, Cremona. Marziale in turn seems to have stimulated a taste in Cremona for an anti-classical angularity and eccentricity that was later reflected in the work of Altobello Melone.

BIBLIOGRAPHY

Thieme–Becker

G. Ludwig: 'Archivalische Beiträge zur Geschichte der venezianischen Malerei', *Jb. Kön.-Preuss. Kstsamml.*, suppl. xxvi (1905), pp. 34–6 [doc.]

B. Geiger: 'Marco Marziale und der sogenannte nordische Einfluss in seinen Bildern', *Jb. Kön.-Preuss. Kstsamml.*, xxxiii (1912), pp. 1–22, 122–48

B. Berenson: *Venetian School* (1957), i, p. 112

H. W. van Os and others, eds: *The Early Venetian Paintings in Holland* (Maarssen, 1978)

PETER HUMFREY

Masaccio [Tommaso di Ser Giovanni di Mone Cassai] (*b* San Giovanni Val d'Arno, 21 Dec 1401; *d* Rome, before late June 1428). Italian painter. He is regarded as the founder of Italian Renaissance painting, a view established within a decade of his death. Vasari correctly perceived that Masaccio 'always followed as best he could in the footsteps of Brunelleschi and Donatello, even though he worked in a different medium'. Among the painters of his time, he was the first to organize his compositions according to the system of linear perspective developed by Brunelleschi. He thus transposed into painting the mathematically proportioned spaces and Classical architectural vocabulary of Brunelleschi's buildings, as well as the realistic anatomical structure, heavy draperies and human grandeur of Donatello's statues. He was also inspired by the paintings of Giotto and the art of antiquity. Masaccio's revival of Giotto's monumentality and concentration on volume was, like the writings by humanists on Florentine history, an affirmation of the greatness and enduring values of the Florentine past.

The features that distinguish Masaccio's work most sharply from that of Giotto are his rendering of objects and figures as fully three-dimensional solids with gravitational weight; the measurability of his pictorial space; his depiction of light and shadow as if light were entering this space from a single source; and his portrayal of figures as conscious individuals who confront issues of profound moral moment and exist and act in real time as well as real space.

I. Life and work. II. Working methods and technique. III. Critical reception and posthumous reputation.

I. Life and work.

1. Training and early years, to *c.* 1426. 2. *c.* 1427 and after. 3. Lost undated works. 4. Disputed attributions.

1. TRAINING AND EARLY YEARS, TO *c.* 1426. Masaccio's father was the notary Ser Giovanni di Mone (Simone) Cassai (*d* 1406), after whose death his mother, Jacopa di Martinozzo di Dino (*b* 1381), married Tedesco di Feo, an apothecary in Masaccio's native San Giovanni, which is situated between Florence and Arezzo in the upper Arno Valley. By the age of 16 Masaccio was referred to as a painter in Florence in a document of 14 October 1418. On 7 January 1422 he was inscribed in the Florentine painters' guild, the Arte de' Medici e Speziali, giving as his residence the parish of S Niccolò sopr'Arno. In 1424 his name appears in a register of the Compagnia di S Luca, the professional association of Florentine painters. He is documented in Florence twice in 1425: on 5 June he and another painter were paid for gilding processional candlesticks for the canons of Fiesole Cathedral, and on 18 July he was cited for a debt to a sausagemaker.

Writers from Vasari (1568) to van Marle (1928) believed that Masaccio's master was MASOLINO, with whom he later often collaborated. This is hardly possible, however, since Masolino was not registered in the painters' guild —and could therefore not have accepted apprentices —until 1423. Moreover, there are no links between the Late Gothic style of Masolino's early works, such as his *Madonna of Humility* (1423; Bremen, Ksthalle), and the works now regarded as autograph paintings by Masaccio. On the contrary, during the years in which the two artists are believed to have worked together (*c.* 1424–8), Maso-

lino's style clearly shows the influence of the younger Masaccio.

(i) Lost early works. According to 15th- and 16th-century sources, Masaccio painted a fresco of the *Consecration of St Maria del Carmine* (destr. 1598–1600)—Vasari referred to it as the *Sagra*—over the interior portal of the cloister abutting the church of St Maria del Carmine in Florence. The consecration of the church was celebrated on 9 April 1422, and it is probable that the artist executed or began the fresco in that year. Vasari described it as painted in greenish monochrome (*di verde terra*) and as showing the Piazza del Carmine with rows of five or six figures proportionally decreasing in perspective. Groups of these figures were copied in drawings by Michelangelo (Vienna, Albertina), by Michelangelo's assistant Antonio Mini (Florence, Casa Buonarroti) and by four anonymous 16th-century Florentine draughtsmen (priv. col., see Berti, 1962/rev. 1967, fig. 43; Florence, Uffizi and Ugo Procacci priv. col., see Berti, 1988, p. 211; and Folkestone, Mus. & A.G.). Behind the religious procession, according to Vasari, came numerous Florentine citizens, among them Brunelleschi, Donatello, Masolino, Niccolò da Uzzano, Giovanni di Bicci de' Medici, Bartolomeo Valori and Antonio Brancacci, whom Vasari wrongly believed to have commissioned the Brancacci Chapel frescoes (*see* §2(ii) below).

Vasari also reported that there were portraits by Masaccio of the same Florentines in the house of Simone Corsi; they may have been the prototypes for a group of five profile portraits of men wearing *mazzocchi* (turban-like hats) of the second quarter of the 15th century (Boston, MA, Isabella Stewart Gardner Mus.; Chambéry, Mus. Benoit-Molin; Norfolk, VA, Chrysler Mus.; two in Washington, DC, N.G.A.). Three of these (the panels in Boston and Chambéry, and one in Washington) have been stylistically associated with or attributed to Masaccio himself. Of these, the portrait in Boston, which was cleaned in 1980–81, is by far the most consistent with Masaccio's style in breadth of design, solidity of form and distribution of light and shade. Nevertheless, none can confidently be given to him. Another lost work by Masaccio, the *Virgin in a Tabernacle*, is mentioned in a Florentine document dated 23 August 1426; it is not known for whom or where it was painted.

(ii) The S Giovenale Triptych. It is widely believed that Masaccio's earliest extant work is a gold-backed triptych (Regello, nr Florence, S Giovenale di Cascia) with the *Virgin and Child and Two Angels* flanked on the left by *SS Bartholomew and Blaise* and on the right by *SS Giovenale and Anthony Abbot*. Cleaning of the triptych, discovered in the late 1950s, revealed the date 23 April 1422 on the strip below its three panels. The attribution to Masaccio has in its favour the stark three-dimensionality and realism of the Virgin and the nude Child; the broad handling of the pink garments of the angels; the bold perspective construction of the Virgin's throne; and the resemblances in physiognomic type and expression between the Virgin and Child in the triptych and those in the S Ambrogio

Altarpiece (Florence, Uffizi; *see* §(iii) below) and the central panel of the Pisa Altarpiece (London, N.G.; see §(v) below).

The attribution of the S Giovenale Triptych is nevertheless problematic. The pairs of saints are far less three-dimensional than the central *Virgin and Child*, suggesting that they may be by a different author or authors. But even the *Virgin and Child* presents difficulties. Whereas in the later S Ambrogio Altarpiece (see fig. 1 below) and in the *Virgin and Child* from the Pisa Altarpiece light enters the pictorial space as if from a single source, the vanishing-point for the perspective construction is at the level of the Virgin's knees, and the spatial projection of the robes covering her legs is emphasized by the highlight on her left knee, in the S Giovenale *Virgin and Child* light strikes the figures from the left, front and right, the vanishing-point is at the Virgin's chin, and the block of the Virgin's legs placed against the steeply rising throne platform lacks convincing volumetric definition. It has been argued that at the age of 19 Masaccio had not yet attained the mastery of three-dimensional form that he displayed about two years later in the S Ambrogio Altarpiece, but this does not entirely resolve the problem.

(iii) The S Ambrogio Altarpiece. The altarpiece of the *Virgin and Child with St Anne* (Florence, Uffizi) was attributed to Masaccio by Vasari (1568) when it was in the Florentine church of S Ambrogio. An early attempt to clean the painting, probably in the 18th century, caused serious losses that were subsequently repainted. Cleaning and restoration between 1935 and 1954 revealed areas that had survived in nearly their original condition, most notably the Child and the heads of the Virgin and St Anne. These show that the painting was probably executed by at least two hands. It is now widely believed that the throne and its platform, the Virgin and Child and perhaps the angel at the upper right are by Masaccio and that St Anne, the cloth of honour behind her and the other four angels were painted by Masolino. It could also be argued that all five angels, which exhibit stylistic inconsistencies between each other as well as in relation to the main figures, were executed by assistants.

In the picture's present state the Virgin and Child are far more robust and sculpturally rounded than the figure of St Anne (the pose of the Child closely resembles that of an Etruscan bronze votive statue, 3rd century BC; Rome, Vatican, Mus. Gregoriano Etrus.). They seem to be the first known reflections of Masaccio's mature style. Even though this is consistent with the presumed division of labour, the view that Masaccio was the picture's sole author has not been abandoned. The issue is complicated by disagreement concerning the precise role of each artist in the other projects—the Carnesecchi Triptych (*see* §(iv) below), the Brancacci Chapel frescoes and the S Maria Maggiore Altarpiece (*see* §2(iii) below)—in which they are believed to have collaborated. Although it is not known from whom the S Ambrogio Altarpiece was commissioned, it is generally agreed that it was painted between 1423 and 1425, either before 2 November 1424, when Masolino received a payment for frescoes in the chapel of the Compagnia della Croce in S Stefano at Empoli, or between that date and 1 September 1425, when he went

to Hungary. Because the *Pietà* (Empoli, Mus. Collegiata) painted by Masolino in Empoli seems to show the strong influence of Masaccio, the earlier date is the more likely (for the opposite view *see* MASOLINO, §§1–2).

(iv) The Carnesecchi Triptych. Vasari (1568) also attributed to Masaccio a triptych in the Carnesecchi Chapel of S Maria Maggiore, Florence, with the *Virgin and Child, St Catherine* and *St Julian* above a predella with the *Nativity*, a scene from the *Life of St Catherine* and a panel in which 'St Julian kills his mother and father'. (In 1550 he had stated that Masaccio was responsible only for the predella.) However, the *Virgin and Child* (ex-S Maria di Novoli, nr Florence, stolen *c.* 1924) and the *St Julian* (Florence, Pal. Arcivescovile) are now thought to be by Masolino.

The scene from the *Life of St Julian* described by Vasari may well be identical with a severely damaged predella panel of the *Legend of St Julian* (Florence, Mus. Horne). Although the attribution to Masaccio is contested, it is supported by the restriction of the palette to reds, earth colours, grey and black; by the illumination of the figures from a single light source and by the three-dimensional conception and sculptural roundness of the figures. A predella panel of the *Attempted Martyrdom of St Catherine* in an altarpiece of 1437 by Andrea di Giusto (Florence, Accad.) may be a copy based on Masaccio's scene from the *Life of St Catherine*. Masolino's participation in the Carnesecchi Triptych probably ended with his departure for Hungary. If Masaccio painted the predella afterwards, it is likely that he did so before 19 February 1426, when he signed the contract for the Pisa Altarpiece.

(v) The Pisa Altarpiece. The work was commissioned by the Pisan notary Giuliano di Colino degli Scarsi da San Giusto for a chapel in S Maria del Carmine, Pisa. Construction of the chapel by the mason Pippo di Gante began on 29 November 1425. The wooden, gilded framework of the altarpiece was begun on 25 November 1425 by the Sienese wood-carver Antonio di Biagio, whose last payment was recorded on the same day, 19 February 1426, as the first payment to Masaccio. This sequence of payments indicates that the form of the altarpiece (see figs 1–4 below), including the number, placement, size and shape of its compartments, was determined not by Masaccio but by Antonio di Biagio. Masaccio received his final payment on 26 December 1426, but he was recorded in Pisa again on 23 January 1427, when he was a witness to a notarial act.

The altarpiece was dispersed after S Maria del Carmine was remodelled in the late 16th century. Vasari (1568) described the polyptych as containing a *Virgin and Child*, with angels playing music at the Virgin's feet, between figures of SS Peter, John the Baptist, Julian and Nicholas; a predella with scenes from the lives of these saints and an *Adoration of the Magi* in the middle; and above the main storey 'many saints in additional panels' surrounding a *Crucifixion*. The surviving panels of the altarpiece are the *Virgin and Child Enthroned* (London, N.G.; see fig. 1); the predella panels of the *Adoration of the Magi* (see fig. 2), the *Crucifixion of St Peter*, the *Beheading of St John the Baptist*, the *Legend of St Julian* and *St Nicholas and the Poor Man's Daughters* (all Berlin, Gemäldegal.); four small

1. Masaccio: *Virgin and Child Enthroned*, central panel from the Pisa Altarpiece, tempera on panel, 1355×730 mm, 1426 (London, National Gallery)

figures (*St Augustine, St Jerome* and two Carmelite saints) from the pilasters at either side of the main storey (all Berlin, Gemäldegal.); the *Crucifixion* (Naples, Capodimonte; see fig. 3); and half-length figures of *St Paul* (Pisa, Mus. N. S Matteo; see fig. 4) and *St Andrew* (Los Angeles, CA, Getty Mus.) from among the panels on either side of the *Crucifixion*. The predella panels of the *Legend of St Julian* and *St Nicholas and the Poor Man's Daughters* are thought to be by Andrea di Giusto, who on 24 December 1426 was paid for work on the Pisa Altarpiece as Masaccio's apprentice (*garzone*).

In the centre of the *Adoration of the Magi* Masaccio included the standing profile portraits of the donor and his son. The son, swathed in a cloak, with one hand on his hip and the other folded across his chest, assumes the pose of a Classical statue of *Sophocles* (Roman marble copy of a 4th-century BC Greek original; Rome, Vatican, Mus. Gregoriano Profano). Although there is no evidence that Masaccio could have seen this statue or others of the same type, its arm postures could have been transmitted to him through Hellenistic terracotta figurines such as a *Winged Genius* (Munich, Staatl. Antikensamml., 6800).

Shearman (1966) proposed that the enthroned Virgin and Child surrounded by angels and the four standing

2. Masaccio: *Adoration of the Magi*, predella panel from the Pisa Altarpiece, tempera on panel, 210×610 mm, 1426 (Berlin, Gemäldegalerie)

saints in the main storey, instead of being separated by colonettes as was the custom in polyptychs of this date, were placed on three platforms receding into a continuous space, which was unified by a perspective construction consistent with that of the Virgin's throne, the vanishing-point being just below Christ's left foot. However, documentary, technical and stylistic evidence (see Gardner von Teuffel, 1977) conclusively shows that the main storey had the traditional form of compartments divided by colonettes. The question remains whether these colonettes were placed only between the Virgin and Child and the saints, as in polyptychs by Starnina or Piero della Francesca, or whether, as in altarpieces by Giovanni del Biondo or Giovanni di Paolo, they also formed separate compartments for each saint.

2. *c.* 1427 AND AFTER. On 29 July 1427, six months after he was last recorded in Pisa, Masaccio filed a tax declaration with the Florentine *catasto* office in which he stated that he, his mother and his younger brother, the painter Giovanni di Ser Giovanni, called SCHEGGIA, were living in a house in Florence on the Via dei Servi; that he was renting 'part of a workshop' on the Piazza S Apollinare; that his cash assets were 'approximately six soldi'; and that he owed various creditors about forty-five fiorini, including a debt of six fiorini to his apprentice Andrea di Giusto 'for the balance of his salary'. A few weeks before Masaccio

filed this tax declaration, Masolino had returned from Hungary. Documents (see Procacci, 1980) suggest that in August 1427 the two artists probably began the paintings on the walls of the Brancacci Chapel in S Maria del Carmine, Florence. But before that, more likely in the early part of 1427 than during the two preceding years, as the majority of writers have maintained, Masaccio painted the fresco of the *Trinity* (see colour pl. 2, III1) in the third bay of the left aisle of S Maria Novella, Florence.

(i) The *Trinity*. (ii) The Brancacci Chapel frescoes. (iii) The S Maria Maggiore Altarpiece.

(i) The 'Trinity'. The work was first recorded in *Memoriale di molte statue e picture di Florentia* (1510) by Francesco Albertini, who called it 'a Crucifixion, that is a Trinity with death at the foot'. Vasari (1568) described it as a Trinity with the Virgin and St John the Evangelist 'contemplating the crucified Christ' and 'a barrel vault represented in perspective, and divided into squares full of bosses, which diminish and are foreshortened so well that the wall seems to be hollowed out'. The vanishing-point of the foreshortened barrel vault is at the top of the raised step behind the kneeling donors, roughly at the spectator's eye-level, and the Virgin and St John (though not God the Father and Christ) are also rendered as if seen from below. Because the Classical forms and ornaments framing the space of the chapel or mausoleum (left ambiguous by Masaccio)

3. Masaccio: *Crucifixion*, panel from the Pisa Altarpiece, tempera on panel, 770×640 mm, 1426 (Naples, Museo e Gallerie Nazionali di Capodimonte)

4. Masaccio: *St Paul,* panel from the Pisa Altarpiece, tempera on panel, 610×340 mm, 1426 (Pisa, Museo Nazionale di S Matteo)

recall the bays at either side of the Florentine Ospedale degli Innocenti (begun 1420) by Brunelleschi, who is credited with the invention of Renaissance linear perspective, it has been thought that Brunelleschi may have designed or collaborated with Masaccio on a cartoon for the painted architecture. There is, however, no documentary evidence that the two artists ever collaborated.

The *Trinity* is thought to have been commissioned by a member of the Lenzi family. The tombstone of Domenico Lenzi and his family, dated 1426, was formerly in front of the fresco; Domenico's son Benedetto was Prior of S Maria Novella from June 1426 until September 1428; and the kneeling donor at the left wears the red robes of the Florentine *gonfaloniere di giustizia,* an office held in August and September 1425 by Domenico's cousin Lorenzo di Piero Lenzi (*d* 1442), who was buried in the church of Ognisanti, Florence.

At an unknown date after the completion of the fresco, an altar was placed in front of the image of 'death'—a skeleton on a catafalque surmounted by the inscription: IO FU G[I]A QUEL CHE VOI S[I]ETE EQUEL CHISON[O] VOI A[N]CO[RA] SARETE ('I was once that which you are and that which I am you will also be').

In 1570, when redesigning the church's interior, Vasari covered the upper part of the fresco with one of his altarpieces; it was rediscovered during renovations *c.* 1860 and transferred to the entrance wall. The altar in front of the lower part was removed in 1951, and in 1952 the two parts of the fresco were reunited, cleaned and restored.

Masaccio's fresco is unique in Italian painting in its representation of the Trinity within an illusionistic, Classically inspired interior framed by the motif of a triumphal arch instead of against a gilded or landscape background. It may thus have been the prototype for the design by Brunelleschi's adopted son Buggiano for the Cardini Chapel in S Francesco at Pescia (1446), where a triumphal arch similar to Masaccio's frames a barrel-vaulted interior containing a wooden crucifix.

(ii) The Brancacci Chapel frescoes. Neither the commission nor the execution of the frescoes is documented. The Brancacci Chapel in S Maria del Carmine was founded by Pietro Brancacci (*d* 1366–7), and a bequest was left to it in his son Antonio's will dated 16 August 1383. Since between 1422 and 1434 it was owned by Pietro's nephew FELICE BRANCACCI, it has been thought that he commissioned the fresco decorations. Felice's first will (26 June 1422) transferred ownership of the chapel to his sons on his death, designated the chapel as his burial site and extended burial rights to other family members on condition of paying a tribute of 25 fiorini. His second will (5 September 1432) stipulated that if the decoration of the chapel were still unfinished at the time of his death, his heirs should be responsible for its completion. But in 1434 Felice went into exile in Siena, and the frescoes remained incomplete until the intervention 50 years later of Filippino Lippi (*see* LIPPI, (2)).

According to Vasari, the earliest frescoes in the chapel were Masolino's *Four Evangelists* in the vault and the *Calling of SS Peter and Andrew,* the *Denial and Remorse of St Peter* and *Christ Walking on the Water* in the lunettes (all destr. 1746–8). He also attributed to Masolino *St Peter Preaching* on the altar wall and *St Peter Curing a Cripple and the Raising of Tabitha* (*see* MASOLINO, fig. 2) in the upper tier of the wall to the right of the altar. Masaccio, according to Vasari, then painted *St Peter Baptizing Neophytes* and *St Peter Healing with his Shadow* (*see* FLORENCE, fig. 5) on the altar wall, the *Tribute Money* (see fig. 5) in the upper tier of the wall to the left of the altar, and below it the *Raising of the Son of the Prefect of Antioch and St Peter Enthroned as Bishop of Antioch,* which was left unfinished and completed by Lippi between *c.* 1481 and 1485. While Vasari's attributions have stood the test of time, Pope-Hennessy (1990) showed that the landscape in Masaccio's *St Peter Baptizing Neophytes* was painted by Masolino and that Masaccio was responsible for the landscapes in Masolino's *St Peter Preaching.*

In addition to the scenes described by Vasari, the decoration of the chapel includes the *Distribution of the Goods of the Church and the Death of Ananias* on the altar wall (see colour pl. 2, III2) and the *Expulsion from Paradise* in the upper tier of the left entrance pier (see colour pl. 2, II2), both by Masaccio, and opposite it the *Temptation of*

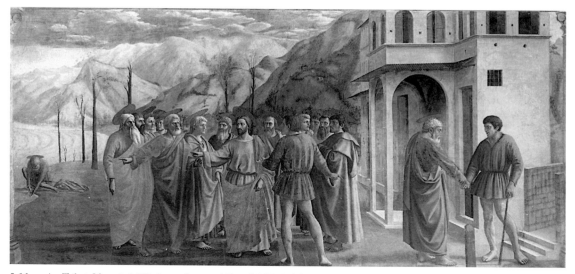

5. Masaccio: *Tribute Money* (*c.* 1427), fresco, Brancacci Chapel, S Maria del Carmine, Florence

Adam and Eve by Masolino. The figure of Eve in the *Expulsion* assumes the arm and hand gestures of the *Venus de' Medici* (Florence, Uffizi), a Roman copy of a Praxitilean original, first recorded in the Villa Medici in Rome in 1638. Masaccio may have known the statue of a similar type that the humanist Benvenuto da Imola saw in a Florentine house in the second half of the 14th century, or he may have derived the gestures from the earlier antique adaptation in the standing, nude figure of *Prudence* at the base of the pulpit (1302–10) in Pisa Cathedral by Giovanni Pisano (*c.* 1245/50–1284).

The chronology of the Brancacci Chapel is problematic. Those writers who follow Vasari believe that Masolino painted all his sections of the chapel in a single campaign between November 1424 and September 1425, working alone on the vault and lunettes and in tandem with Masaccio on the walls (for this view *see* MASOLINO, §2). However, the documentary evidence for the two artists' movements and activities can also be interpreted to suggest that there were two campaigns: one during which Masolino decorated the vault and the lunettes (before Sept 1425), and another in which he and Masaccio jointly executed their frescoes on the walls when he had returned from Hungary (some time after 7 July 1427); the wall frescoes would then have been left unfinished when Masolino and Masaccio went to Rome. (Masolino is thought to have gone in spring 1428, Masaccio after 11 May of that year.) It has been objected that the period from perhaps August 1427 to May 1428 would not have been enough time for the two artists to execute nine frescoes. But even allowing for the suspension of work during winter, when it was too cold to paint on wet plaster, there would have been ample time. The total number of *giornate* (work sessions corresponding to sections of plaster discernible by their rims) is 131, and given the area of Masaccio's contribution (roughly twice that of Masolino's), the frescoes could have been painted in less than a hundred sessions.

The frescoes were restored first *c.* 1565, again in 1782 after they were severely damaged by a fire in the church in 1771 and a third time by Filippo Fiscali in 1902–4. A

fourth conservation campaign (1982–8) brought to light two heads in circular frames between bands of acanthus ornament on the embrasures of the window over the altar, and a small fragment of a landscape and the back of a male figure on the wall above the altar. The left embrasure with the head of a woman has been given to Masolino, and the fragment above the altar and the right embrasure with the head of a man to Masaccio; but there is no consensus over these attributions. Two fragmentary *sinopie* were discovered on the left and right sides of the lunette over the altar wall, although their subjects do not correspond to the *Denial of St Peter* painted there, according to Vasari, by Masolino. All earlier restorations as well as a viscous coat that darkened the colours of the wall paintings were removed (1986–8), revealing previously obscured passages and the original clear, bright colours.

The subjects of the wall paintings appear to have been taken mainly from the Acts of the Apostles and the chapters on the three feasts of St Peter in the *Golden Legend* by Jacopo da Voragine. The account in the *Golden Legend* of the feast of the Chairing of Peter, for example, was probably the source for the frescoes on the lower tier of the left wall, from *St Peter Imprisoned* to his *Enthronement as Bishop of Antioch*. Debold von Kritter (1975) suggested that the combination of the *Temptation* and the *Expulsion* on the entrance piers with the cycle of scenes from the *Life of St Peter* in the interior of the chapel corresponds to comparisons of Peter with Adam and Eve in theological texts by Nicholas of Lyra and Maximus of Turin, according to which the original sinners Adam and Eve have their counterpart in St Peter, the redeemed sinner who through his own example and the institutions of the Church becomes the gatekeeper of paradise and leads mankind to redemption. Interpretations of the wall paintings as reflections of contemporary events are all based on contradictory and inconclusive evidence.

The placement of the Apostles in the *Tribute Money* in a semicircular arc with Christ in the middle, which imparts to the figures of the central group unprecedented spatial unity and psychological concentration, has been convinc-

ingly related (Meiss, 1963) to Brunelleschi's use of the circular plan in the dome of the Old Sacristy of S Lorenzo (begun 1421), Florence, to symbolize in mathematical form the Christian conception of God's grace as radiating from the centre of the perfect form of the circle.

Longhi (1940) recognized that the head of Christ, which covers the fresco's vanishing-point and was the last area to be plastered and painted, is in the style of Masolino, a view supported by the most recent cleaning of the fresco; he also suggested that the perspective and lighting of the architectural background in the *Raising of Tabitha*, which was painted in a single session, are characteristic of Masaccio, but this proposal has been questioned since the cleaning. Watkins (1973) presented technical evidence that the two artists could have worked on the frescoes of the second tier at the same time.

(iii) The S Maria Maggiore Altarpiece. The work, now dispersed, was a double-sided triptych, with the *Foundation of S Maria Maggiore* (Naples, Capodimonte), flanked by *SS Jerome and John the Baptist* (London, N.G.) and *An Evangelist and St Martin of Tours* (Philadelphia, PA, Mus. A.); and on the other side the *Assumption of the Virgin* (Naples, Capodimonte) flanked by *A Pope and St Matthias* (London, N.G.) and *SS Peter and Paul* (Philadelphia, PA, Mus. A.). Vasari saw the altarpiece in a small chapel near the sacristy of the Roman church of S Maria Maggiore and attributed the central panel of the *Virgin of the Snow* (destr.) to Masaccio. The altarpiece was apparently commissioned by Pope Martin V (*reg* 1417–31), probably for the main altar of the church rather than for the small chapel where it was seen by Vasari. The features of St Martin of Tours are believed to be those of the Pope, and a column, the emblem of the Colonna family to which the Pope belonged (*see* COLONNA, (1)), appears six times in the border of St Martin's vestment and in the form of the staff held by St John the Baptist.

Since its rediscovery in 1951, the panel with *SS Jerome and John the Baptist* has been regarded, with some dissent (see Davies, 1961), as the only one of the triptych's six known compartments that was painted, though not completely finished, by Masaccio. The other five are attributed to Masolino. However, technical examination of the two panels in Philadelphia has revealed that they were probably designed by Masaccio, who seems to have painted the hands and feet of SS Peter and Paul. Masolino apparently painted at least the faces of the Evangelist and of St Martin of Tours, after which the programme of the altarpiece and the design of the two panels were altered. The *SS Jerome and John the Baptist*—with its unbroken, regular contours, meticulous rendering of detail and luminous, evenly textured surfaces—is the most refined of Masaccio's paintings. It has been thought an early work, on the grounds that it lacks the formal breadth and robustness of Masaccio's other paintings; this assumption is difficult to sustain, however, considering both the limited knowledge of Masaccio's stylistic evolution and the clear colours and precise execution revealed by the cleaning of the Brancacci Chapel frescoes. Moreover, documentary evidence (Procacci, 1953 and 1980) strongly suggests that the S Maria Maggiore Altarpiece was begun only after Masaccio and Masolino arrived in Rome, probably in spring 1428. The

decorative elegance of Masaccio's panel, rather than indicating an early date, was more likely a response to the aesthetic preferences of the papal court and of Martin V, who in 1427 had commissioned Gentile da Fabriano, the most refined painter of his generation, to fresco the nave (destr.) of S Giovanni in Laterano. Masaccio's work on the altarpiece was cut short by his death, news of which reached Florence before the end of June 1428, and it was finished by Masolino.

3. LOST UNDATED WORKS. Two paintings are listed in the inventory of the Medici collection compiled in 1492 after the death of Lorenzo the Magnificent: a *desco da parto* with a 'skirmish' (*una schermaglia*) and a panel with *SS Peter and Paul*. Albertini (1510) listed a fresco by Masaccio of the *Last Judgement* in the second cloister of S Maria degli Angeli, Florence, which may be reflected in the nude figures of a *Last Judgement* by Giovanni di Paolo (Siena, Pin. N.). Vasari, following earlier sources, attributed to Masaccio a fresco of *St Paul* (destr. 1675–83) on a pier next to the Serragli Chapel in S Maria del Carmine, and he praised the figure's forceful expression and foreshortening from below and identified it as a portrait of Bartolo di Angiolino Angiolini.

Other lost works of Masaccio recorded by Vasari are a fresco in the Badia, Florence, of *St Ivo of Brittany* (destr. 1627) 'in a niche with his feet foreshortened, seen from below', beneath whom there were 'widows, children and poor assisted by him in their want'; a panel with a male and female nude in the Palazzo Rucellai; and a painting of *Christ Exorcizing a Possessed Man* in the house of Ridolfo Ghirlandaio with 'buildings so drawn in perspective that the interior and exterior are represented at the same time'. Vasari's description of the latter fits the architectural setting of Francesco d'Antonio's *Christ and the Apostles in a Temple* (Philadelphia, PA, Mus. A.), which may be a copy or reflection of Masaccio's lost picture. Vasari also noted an *Annunciation* 'painted in tempera' on the rood screen of S Niccolò sopr'Arno, Florence, with 'a building filled with columns drawn in perspective', which he believed to be by Masaccio. The painting is thought to have been the prototype for compositions of the *Annunciation* with symmetrically arranged perspective colonnades by Fra Angelico (Florence, Mus. S Marco), Domenico Veneziano (Cambridge, Fitzwilliam) and Piero della Francesca (Perugia, G.N. Umbria). (It has been identified by some as a late work by Masolino, Washington, DC, N.G.A., although this is not generally accepted.)

4. DISPUTED ATTRIBUTIONS. Among the works formerly attributed to Masaccio since Crowe and Cavalcaselle (1864) is a panel with the *Agony in the Garden* and the *Communion of St Jerome* (Altenburg, Staatl. Lindenau-Mus.), which seems to be by an artist who attempted to imitate but did not fully understand Masaccio's style. A *desco da parto* (Berlin, Gemäldegal.) showing the interior of a convent (not, as is generally claimed, a palace, for the columns of the courtyard rest on a low wall or stylobate, as is usual in convents but not in palaces) is a not wholly successful imitation of Masaccio's style, probably of the late 1430s; it has a birth scene on one side and a courtyard in perspective with figures of a herald, men bearing gifts,

nuns and fashionable ladies on the other. On the back a naked boy who resembles the Child in the S Giovenale Triptych kneels on a meadow of flowers and instructs a sharp-toothed dog. The same anonymous artist may have been responsible for a small panel of the *Virgin and Child* (Florence, Pal. Vecchio), although in the picture's present restored state an attribution seems hazardous. On its back is the coat of arms of Antonio Casini (*d* Florence, 1439), a native of Siena who was made a cardinal on 24 May 1426. The panel was probably painted towards the end of the Cardinal's life. An impressive damaged and restored fresco of *Christ on the Cross* (Florence, S Maria del Carmine) that came to light after the Florentine flood of 1966 would seem to be the work of another Florentine follower of Masaccio active in the 1430s. A crudely painted roundel of *God the Father* (London, N.G.) is by a follower or imitator of Masaccio of uncertain date, while a fresco of the *Virgin and Child with SS Michael and John the Baptist* (Montemarciano, Oratory) has been recognized since the 1950s as a work of *c.* 1425–30 by Francesco d'Antonio. The fresco decoration of the chapel of St Catherine in S Clemente, Rome, given to Masaccio by Vasari, has been attributed to Masolino since the late 19th century, and, although Longhi (1940) proposed that Masaccio may have been responsible for the riders in the middle zone of the *Crucifixion*, there is no compelling stylistic or technical evidence of this, either in the fresco itself or in the *sinopia* discovered when the work was detached in the 1950s. A *Madonna of Humility* (Washington, DC, N.G.A.) is difficult to attribute because of its current repainted state, although photographs taken in 1929–30 before it was restored suggest that it may well have been painted by Masaccio.

II. Working methods and technique.

In fresco as well as in tempera Masaccio followed the methods described in Cennino Cennini's *Libro dell'arte*, although for the underpainting of flesh he employed a greyish tone rather than the greenish *verdaccio* recommended by Cennini. In contrast to the rich colouring of Late Gothic painting, Masaccio's palette is restricted and repetitive. In his figures it is dominated by tonalities of blue and red, generally within close range of a middle value, with a preference for vermilion, and in his architectural and landscape backgrounds by warmer or cooler greys. The chromatic range of the *Virgin and Child* from the Pisa Altarpiece and the *Trinity* at S Maria Novella is composed entirely of gradations of these three colours. In the three predella panels from the Pisa Altarpiece this scheme of colours is augmented sparingly by a golden orange-yellow and an occasional black, and in the Brancacci Chapel frescoes by orange-yellows and muted greens.

The *Trinity* and the frescoes by Masaccio in the Brancacci Chapel were very largely executed in *buon fresco* on sections of wet plaster, with additions in *fresco a secco* (after the plaster had dried) for the gilded haloes and in, the Brancacci Chapel, for the foliage of the trees. Whether Masaccio used *sinopie* is not known. The *intonaco* of the wall frescoes in the Brancacci Chapel has never been detached, and the *arriccio* beneath the *Trinity* was destroyed when it was detached *c.* 1860. Vestiges on the surface of

the *Tribute Money* of vertical plumb lines snapped into the plaster by cords in order to establish the axis of the standing figures—the earliest known example of what later became common studio practice—and of incised lines to mark the straight edges of the architecture have been taken as indications that Masaccio there worked directly on the wall without a cartoon.

Attempts to reconstruct Masaccio's method of painting the foreshortened architecture in the *Trinity* have reached two different conclusions. One is that he first drew a modular ground-plan of the coffered vault, as if he were designing a Brunelleschian building, and then projected this ground-plan in perspective on a squared cartoon from which, when enlarged to full scale, the foreshortened design was transferred to the painting. The other, more likely solution is that by means of a ruler and compass and relatively simple operations of Euclidean geometry he drew the foreshortened forms of the architecture directly on a cartoon, enlarging sections of it for transfer to the wall for each work session and controlling the design of the whole by means of a plumb line and other snapped cords, traces of which remain on the surface of the *intonaco*. Evidence of Masaccio's use of cartoons in the *Trinity* is restricted to *spolveri* (dusted pounce marks) in the entablature of the architecture. An incised grid of squares and rectangles across the face of the Virgin and incised guidelines for foreshortened architectural ornaments, the rear arch and the curved bands of the vault suggest that Masaccio executed at least parts of the fresco directly on the wall, as he also may have done in the Brancacci Chapel.

III. Critical reception and posthumous reputation.

In the dedicatory letter to Brunelleschi at the beginning of *Della pittura* (1436), Leon Battista Alberti declared that when he returned to Florence from exile (*c.* 1429) he perceived in Brunelleschi, Donatello, Lorenzo Ghiberti, Luca della Robbia and Masaccio 'a genius for every laudable enterprise in no way inferior to any of the ancients who gained fame in these arts'. It is widely thought that Alberti had Masaccio's compositions in mind when in the first two books of *Della pittura* he recommended to painters how pictures should be designed and executed in order to command the same admiration as Greek and Roman authors bestowed on paintings of antiquity.

The first Renaissance writer to attempt to characterize Masaccios's style was the Florentine humanist Cristoforo Landino. In his commentary (1481) on Dante's *Divine Comedy*, Landino praised Masaccio for his imitation of the true appearance of objects in nature (*imitazione del vero*), the roundness (*rilievo*) he gave to his figures, the harmony and coherence of his compositions, his dedication to the clarity of three-dimensional form at the cost of ornamental grace (*puro senz'ornato*), his mastery of perspective and his assurance in dealing with technical problems (*facilità*). In its concise definition of the essential components of Masaccio's style, Landino's text has not been surpassed.

Masaccio's work had an immediate and profound impact on his contemporaries. Not only his collaborator Masolino and his apprentice Andrea di Giusto, but also Gentile da Fabriano and minor Florentine masters, such

as Bicci di Lorenzo, Francesco d'Antonio, Giovanni del Ponte, Giovanni Toscani and Paolo Schiavo, accommodated the decorative Giottesque or Late Gothic traditions in which they were trained to the sober, sculptural realism of Masaccio. The principal artists to assimilate Masaccio's innovations were Fra Angelico, Fra Filippo Lippi and Andrea Castagno—who are reported by Vasari to have studied the frescoes in the Brancacci Chapel—as well as Paolo Uccello, Domenico Veneziano, Piero della Francesca and Andrea Mantegna. But it was Leonardo da Vinci who first fully understood and incorporated into his own style Masaccio's depiction of objects under conditions of light and shade as they are observed in nature. In one of his notebooks, Leonardo wrote that Masaccio 'showed by his perfect works how those who take for their standard anyone but nature, mistress of masters, were labouring in vain'.

In his *Vite* Vasari divided the history of Italian painting into three periods and designated Giotto, Masaccio and Leonardo their founders. By then nature was no longer considered painting's sole mistress. The works of Classical antiquity and of Raphael and Michelangelo were thought to rival and surpass nature as the most worthy models, for they were perceived as rectifying nature's imperfections. In Vasari's judgement, the only earlier Italian painter who could still be imitated with profit was Masaccio, because it was he who 'paved the way for the good style of our own day', having understood, among other things, 'that all figures which do not stand with their feet flat and foreshortened, but are on the tips of toes, are destitute of all excellence in style (*maniera*) in essentials, and show an utter ignorance of foreshortening'. Vasari reported that the Brancacci Chapel became the school of Florentine painters, and he named 25, including Leonardo, Michelangelo and Raphael, who studied and copied its wall paintings. The only such copies to have survived are drawings by Michelangelo of *St Peter Paying the Tax Collector* (Munich, Staatl. Graph. Samml.) from the *Tribute Money* and of *Adam and Eve* (Paris, Louvre) from the *Expulsion*, although the attribution is not unanimously accepted.

Vasari placed Raphael at the summit of the 'good style' towards which Masaccio had paved the way. This view, that Masaccio laid the groundwork for what Raphael perfected and that he might have achieved what Raphael did had he been born later or lived longer, prevailed until the end of the 19th century. Joshua Reynolds (1723–92) wrote in his 12th Discourse (1784) that Raphael

had carefully studied the work of Masaccio; . . . [whose] manner was dry and hard, his compositions formal, and not enough diversified according to the custom of painters in that early period, yet his works possess that grandeur and simplicity which accompany, and even sometimes proceed from, regularity and hardness of manner.

In 1830 Eugène Delacroix (1798–1863) wrote in the *Revue de Paris* that, although Masaccio 'wrought by himself the greatest revolution painting ever experienced', posterity has hidden him 'behind the rays with which it had surrounded Raphael'. Yet 'who can say', Delacroix continued, 'what new perfections he might have discovered in later years; and who can affirm that he might not have put even Raphael in the shade'.

Bernard Berenson (1896) finally removed Masaccio from the shadow of Raphael, perceiving in him an artist unrivalled among Italian painters in power of three-dimensional form and in gravity, dignity and resoluteness of expression. Masaccio, according to Berenson, 'gave Florentine painting the direction it pursued to the end' and surpassed all other painters of his age. Although later painters were capable of 'greater science, greater craft, and greater perfection of detail', there was never a 'greater reality' or 'greater significance' than in the works of Masaccio.

Brockhaus (1929–32) was the first scholar who sought to place these works in the context of 15th-century political and social currents. During Masaccio's lifetime Florence was engaged in a series of wars with Milan and other Italian states; the city-state succeeded against great odds in maintaining its independence and republican form of government. Humanist writers, comparing Florence to the Roman republic of antiquity, celebrated the city for its defence of civic freedom and human dignity. Hartt (1964) suggested that the figures in Masaccio's paintings were classically inspired embodiments of these ideals. Masaccio's sober, realistic, unornamented style—in contrast to the ornate, courtly style of Gentile da Fabriano—was interpreted by Antal (1947) as an affirmation of the ascendancy in early 15th-century Florence of a newly influential upper middle-class bourgeoisie. Because these interpretations deal with style, they have the merit of addressing decisions and choices controlled by the artist. The situation is different in the case of attempts to discover in Masaccio's works iconographic allusions to contemporary social or political issues and events, since the determination of subjects and iconographic programmes was in the hands not of the artist but of the patron.

BIBLIOGRAPHY

EARLY SOURCES AND DOCUMENTS

L. B. Alberti: *De pictura* (MS. 1435); It. trans. as *Della pittura* (MS. 1436); ed. L. Mallè (Florence, 1950), p. 54; Eng. trans. by J. Spencer as *On Painting* (London, 1956), p. 39

C. Landino: *Commento di Cristoforo Landino fiorentino sopra la Commedia di Dante* (Florence, 1481); ed. R. Cardini: *Scritti critici e teorici*, i (Rome, 1974), p. 124

G. Santi: *La vita e le geste di Federico da Montefeltro duca d'Urbino* (MS. *c.* 1492); ed. L. Michelini Tocci (Rome, 1985), ii, p. 674

F. Albertini: *Memoriale di molte statue e picture di Florentia* (Florence, 1510)

G. Santi: *Il Codice Magliabechiano* (MS. *c.* 1540); ed. C. Frey (Berlin, 1892), pp. 81–2, 315–19; ed. C. Fabriszy as *Il Codice dell'anonimo Gaddiano* (Florence, 1893)

A. Billi: *Il libro di Antonio Billi* (MS. *c.* 1550); ed. C. Frey (Berlin, 1892), pp. 16–17

G. Vasari: *Vite* (1550, rev. 2/1568); ed. G. Milanesi (1878–85), ii, pp. 305–25

J. Reynolds: *Discourses on Art* (London, 1778); ed. R. R. Wark (San Marino, CA, 1959/*R* New Haven and London, 1975), pp. 216–21

E. Delacroix: *Oeuvres littéraires*; ed. E. Faure (Paris, 1923), ii, pp. 12–13

U. Procacci: 'Documenti e ricerche sopra Masaccio e la sua famiglia', *Riv. A.*, xiv (1932), pp. 489–503; xvii (1935), pp. 91–111

——: 'Sulla cronologia delle opere di Masaccio e di Masolino tra il 1425 e il 1428', *Riv. A.*, xxviii (1953), pp. 3–55

P. Murray: *An Index of Attributions before Vasari* (Florence, 1959), pp. 110–12

U. Procacci: 'Nuove testimonianze su Masaccio', *Commentari*, xxvii (1976), pp. 223–37

J. Beck: *Masaccio, the Documents* (Locust Valley, NY, 1978)

U. Procacci: 'Masaccio e la sua famiglia negli antichi documenti', *Stor. Valdarno*, ii (1981), pp. 553–9

GENERAL

EWA; Thieme–Becker

J. A. Crowe and G. B. Cavalcaselle: *A New History of Painting in Italy*, i (London, 1864), pp. 519–50

B. Berenson: *The Florentine Painters of the Renaissance* (London, 1896), pp. 27–31

M. Dvořák: *Geschichte der italienischen Kunst im Zeitalter der Renaissance* (Munich, 1927), pp. 47–62

R. van Marle: *Italian Schools*, x (1928), pp. 251–307

F. Antal: *Florentine Painting and its Social Background* (London, 1947/R 1986), pp. 305–28

U. Baldini: 'Masaccio', *Mostra di quattro maestri del primo rinascimento* (exh. cat., ed. M. Salmi; Florence, Pal. Strozzi, 1954), pp. 3–17

J. White: *The Birth and Rebirth of Pictorial Space* (London, 1957, rev. Cambridge, 3/1987), pp. 135–41

E. Borsook: *The Mural Painters of Tuscany* (Oxford, 1960, rev. 2/1980), pp. 58–67

F. Hartt: 'Art and Freedom in Quattrocento Florence', *Essays in Memory of Karl Lehmann* (New York, 1964), pp. 114–31

B. Cole: *Masaccio and the Art of the Early Renaissance* (Bloomington, 1980)

P. Hills: *The Light of Early Italian Painting* (New Haven, 1987), pp. 129–45

MONOGRAPHS

A. Schmarsow: *Masaccio-Studien*, 2 vols (Kassel, 1895–99)

E. Somaré: *Masaccio* (Milan, 1924)

O. H. Giglioli: *Masaccio* (Bergamo, 1929)

M. Salmi: *Masaccio* (Rome, 1932, rev. Milan, 2/1948)

M. Pittaluga: *Masaccio* (Florence, 1935)

K. Steinbart: *Masaccio* (Vienna, 1948)

U. Procacci: *Tutta la pittura di Masaccio* (Milan, 1951, rev. 2/1952)

L. Berti: *Masaccio* (Milan, 1962, rev. University Park, PA, 2/1967)

A. Parronchi: *Masaccio*, Diamanti A. (Florence, 1966)

P. Volponi and L. Berti: *L'opera completa di Masaccio*, Class. A. (Milan, 1966)

C. Del Bravo: *Masaccio* (Florence, 1969)

U. Procacci: *Masaccio* (Florence, 1980)

L. Berti: *Masaccio* (Florence, 1988) [with photos of the restored frescoes of the Brancacci Chapel]

J. T. Spike: *Masaccio* (New York and Milan, 1995)

S. Borsi: *Masaccio* (Florence, 1996)

THE S GIOVENALE TRIPTYCH

L. Berti: 'Masaccio 1422', *Commentari*, xii (1961), pp. 84–107

——: 'Masaccio a S Giovenale di Cascia', *Acropoli*, ii (1962), pp. 149–65

J. Stubblebine and others: 'Early Masaccio: A Hypothetical Lost Madonna and a Disattribution', *A. Bull.*, lxii (1980), pp. 217–25

Masaccio e l'Angelico: Due capolavori della diocesi di Fiesole (exh. cat., ed. E. Micheletti and A. Maetzke; Fiesole, Pal. Mangani, 1984), pp. 14–29

A.-S. Göing: *Masaccio?: Die Zuschreibung des Triptychons von San Giovenale* (Hildesheim and New York, 1996)

THE PISA ALTARPIECE

W. Suida: 'L'altare di Masaccio, già nel Carmine a Pisa', *L'Arte*, ix (1906), pp. 125–7

M. Davies: *The Earlier Italian Schools*, London, N.G. cat. (London, 1951, rev. 2/1961/R 1986), pp. 269–72

E. Borsook: 'A Note on Masaccio in Pisa', *Burl. Mag.*, cxxxiii (1961), pp. 212–15

J. Shearman: 'Masaccio's Pisa Altarpiece: An Alternative Reconstruction', *Burl. Mag.*, cviii (1966), pp. 449–55

C. Gardner von Teuffel: 'Masaccio and the Pisa Altarpiece: A New Approach', *Jb. Berlin. Mus.*, xix (1977), pp. 23–68

THE 'TRINITY'

G. J. Kern: 'Das Dreifaltigkeitsfresko von S Maria Novella: Eine perspektivisch architekturgeschichtliche Studie', *Jb. Preuss. Kstsamml.*, xxiv (1913), pp. 36–58

C. de Tolnay: 'Renaissance d'une fresque', *L'Oeil*, xxxvii (1958), pp. 37–41

U. Schlegel: 'Observations on Masaccio's *Trinity* Fresco in Santa Maria Novella', *A. Bull.*, xiv (1963), pp. 19–33

J. Coolidge: 'Further Observations on Masaccio's *Trinity*', *A. Bull.*, xlviii (1966), pp. 382–4

O. von Simson: 'Über die Bedeutung von Masaccios Trinitätsfresko in S Maria Novella', *Jb. Berlin. Mus.*, viii (1966), pp. 119–59

H. W. Janson: 'Ground Plan and Elevation in Masaccio's *Trinity* Fresco', *Essays in the History of Art Presented to Rudolf Wittkower* (London, 1967), pp. 83–8

J. Polzer: 'The Anatomy of Masaccio's *Holy Trinity*', *Jb. Berlin. Mus.*, xiii (1971), pp. 18–59

C. Dempsey: 'Masaccio's *Trinity*: Altarpiece or Tomb', *A. Bull.*, liv (1972), pp. 279–81

E. Hertlein: *Masaccios 'Trinität'* (Florence, 1979)

R. Goffen: 'Masaccio's *Trinity* and the Letter to the Hebrews', *Mem. Domenicane*, xi (1980), pp. 489–504

R. Liebermann: 'Brunelleschi and Masaccio in Santa Maria Novella', *Mem. Domenicane*, xii (1981), pp. 127–39

W. Kemp: 'Masaccios *Trinità* im Kontext', *Marburg. Jb. Kstwiss.*, xxi (1986), pp. 45–72

A. Perrig: 'Masaccios *Trinità* und der Sinn der Zentralperspektive', *Marburg. Jb. Kstwiss.*, xxi (1986), pp. 11–43

J. A. Aiken: 'The Perspective Construction of Masaccio's *Trinity* Fresco and Medieval Astronomical Graphics', *Artibus & Hist.*, xvi/31 (1995), pp. 171–87, 209

THE BRANCACCI CHAPEL FRESCOES

J. Mesnil: 'Per la storia della cappella Brancacci', *Riv. A.*, x (1912), pp. 34–40

H. Brockhaus: 'Die Brancacci-Kapelle in Florenz', *Mitt. Ksthist. Inst. Florenz*, iii (1929–32), pp. 160–82

P. Meller: 'La cappella Brancacci: Problemi rittrattistici e iconografici', *Acropoli*, i (1960–61), pp. 186–227, 273–312

C. de Tolnay: 'Note sur l'iconographie des fresques de la Chapelle Brancacci', *A. Lombarda*, x (1965), pp. 69–74

H. von Einem: *Masaccios Zinsgroschen* (Cologne, 1967)

L. B. Watkins: 'Technical Observations on the Frescoes of the Brancacci Chapel', *Mitt. Ksthist. Inst. Florenz*, xvii (1973), pp. 65–74

A. Debold von Kritter: *Studien zum Petruszyklus in der Brancacci Kapelle* (Berlin, 1975)

A. Molho: 'The Brancacci Chapel: Studies in its Iconography and History', *J. Warb. & Court. Inst.*, xl (1977), pp. 50–98

W. Welliver: 'Narrative Method and Narrative Form in Masaccio's *Tribute Money*', *A.Q.* [Detroit], n. s. 1 (1977–8), pp. 40–58

D. Amory: 'Masaccio's *Expulsion from Paradise*: A Recollection of Antiquity', *Marsyas*, xx (1979–80), pp. 7–10

U. Procacci and U. Baldini: *La cappella Brancacci nella chiesa del Carmine a Firenze* (Milan, 1984)

O. Casazza: 'Il ciclo delle storie di San Pietro e la *Historia salutatis*', *Crit. A.*, ix (1985), pp. 77–82

W. Jacobsen: 'Die Konstruktion der Perspektive bei Masaccio und Masolino in der Brancaccikapelle', *Marburg. Jb. Kstwiss.*, xxi (1986), pp. 73–92

U. Baldini: 'Le figure di Adamo e Eva formate affatto ignude in una cappella di una principal chiesa di Fiorenza', *Crit. A.*, liii/1 (1988), pp. 72–7

O. Casazza: 'La grande gabbia architettonica di Masaccio', *Crit. A.*, liii/1 (1988), pp. 78–97

U. Baldini and O. Casazza: *La cappella Brancacci* (Milan, 1990)

J. Pope-Hennessy: 'Unveiling Masaccio's Radical Masterpiece in Florence', *Archit. Dig.* (March 1990), pp. 27–46

K. Christiansen: 'Some Observations on the Brancacci Chapel Frescoes after their Cleaning', *Burl. Mag.*, cxxxiii (1991), pp. 5–20

THE S MARIA MAGGIORE ALTARPIECE

K. Clark: 'An Early Quattrocento Triptych from Santa Maria Maggiore, Rome', *Burl. Mag.*, cxiii (1951), pp. 339–47

M. Davies: *The Earlier Italian Schools*, London, N.G. cat. (London, 1951, 2/1961/R 1986), pp. 272–80

M. Meiss: 'London's New Masaccio', *ARTnews*, li/2 (1952), pp. 24–5

J. Pope-Hennessy: 'The Sta Maria Maggiore Altarpiece', *Burl. Mag.*, xciv (1952), pp. 31–2

D. Gioseffi: 'Domenico Veneziano: L'esordio masaccesco e la tavola con i SS Girolamo e Giovanni Battista della National Gallery di Londra', *Emporium*, lxviii (1962), pp. 51–72

M. Meiss: 'The Altered Program of the S Maria Maggiore Altarpiece', *Studien zur toskanischen Kunst* (Munich, 1964), pp. 169–89

C. B. Strehlke and M. Tucker: 'The Santa Maria Maggiore Altarpiece: New Observations', *A. Crist.*, lxxv (1987), pp. 105–24

OTHER SPECIALIST STUDIES

J. Mesnil: 'Masaccio and the Antique', *Burl. Mag.*, xlviii (1926), pp. 91–8

——: *Masaccio et les débuts de la Renaissance* (The Hague, 1927)

——: 'Die Kunstlehre der Frührenaissance im Werke Masaccios', *Vorträge der Bibliothek Warburg, 1925–26* (Leipzig, 1928), pp. 122–46

O. H. Giglioli: 'Masaccio: Saggio di bibliografia ragionata', *Boll. Reale. Ist. Archeol. & Stor. A.*, iii/4–6 (1929), pp. 55–101

M. Pittaluga: 'Masaccio e L. B. Alberti', *Rass. It. A.*, xxiv (1929), pp. 779–90

——: 'La critica e i valori romantici di Masaccio', *L'Arte*, xxxiii (1930), pp. 139–64

H. Lindberg: *To the Problem of Masolino and Masaccio*, 2 vols (Stockholm, 1931)

R. Oertel: 'Die Frühwerke des Masaccio', *Marburg. Jb. Kstwiss.*, vii (1933), pp. 191–28

——: 'Masaccio und die Geschichte der Freskotechnik', *Jb. Preuss. Kstsamml.*, lv (1934), pp. 229–40

R. Longhi: 'Fatti di Masolino e di Masaccio', *Crit. A.*, v (1940), pp. 151–66

U. Procacci: 'Il Vasari e la conservazione degli affreschi della cappella Brancacci al Carmine e della Trinità in S Maria Novella', *Scritti di storia dell'arte in onore di Lionello Venturi* (Rome, 1956), pp. 211–22

R. Offner: 'Light on Masaccio's Classicism', *Studies in the History of Art Dedicated to William Suida* (London, 1959), pp. 66–73

M. Meiss: 'Masaccio and the Early Renaissance: The Circular Plan', *Studies in Western Art*, ii (Princeton, 1963), pp. 123–45

M. Boskovits: 'Giotto Born Again', *Z. Kstgesch.*, xxix (1966), pp. 51–66

R. Freemantle: 'Masaccio e l'antico', *Crit. A.*, xxxiii (1969), pp. 39–56

C. Gilbert: 'The Drawings Now Associated with Masaccio's *Sagra*', *Stor. A.*, iii (1969), pp. 260–78

J. Polzer: 'Masaccio and the Late Antique', *A. Bull.*, liii (1971), pp. 36–40

J. Beck: 'Fatti di Masaccio', *Essays in Archaeology and the Humanities in Memoriam Otto Brendel* (Mainz, 1976), pp. 211–14

B. Cinelli and F. Mazzocca: *Fortuna visiva di Masaccio* (Florence, 1979)

E. Maurer: 'Masaccio–Cavallini–Spätantike', *Ars Auro Prior* (Warsaw, 1981), pp. 155–60

——: 'Masaccio: Vom Himmel gefallen?', *15 Aufsätze zur Geschichte der Malerei* (Basle, 1982), pp. 75–89

T. Verdon: 'La Sant'Anna Metterza: Riflessioni, domande, ipotesi', *Uffizi, Stud. & Ric.*, v (1988), pp. 33–58

P. Joannides: *Masaccio and Masolino: A Complete Catalogue* (London, 1993)

HELLMUT WOHL

Mascherino [Mascarino], **Ottaviano** [Ottavio dei Nonni] (*b* Bologna, *bapt* 3 Sept 1536; *d* Rome, 6 Aug 1606). Italian architect, sculptor and painter. He was the son of Giulio Mascherino, a mason who worked with Jacopo Vignola in 1547. Vignola's influence is clear in Ottaviano Mascherino's earliest attributed work, the Porta Pia (Porta di S Isaia) in Bologna (1567–71; destr. 20th century), and it has been suggested that he merely executed Vignola's design (Wasserman, 1966). He is documented in 1568 as the architect supervising the construction of the Fountain of Neptune in Bologna. A year later he joined the Consiglio dei Bombasari e Pittori in Bologna, and his first documented works are paintings. Also in 1569, with Lorenzo Fiorini, in the Cubiculum Artistarum of the Archiginnasio (the university) he painted frescoes representing the *Liberal Arts* (partially destr. 1944) and executed the niche and statue of *Apollo* for the entrance. There are echoes of Parmigianino, Lorenzo Sabatini and Giambologna in these works. In the Villa Guastavillani at Barbiano (nr Bologna), there are frescoes and a statue of *Bacchus* attributed to him (Negro, 1990). He probably also planned this villa, which was begun in 1575 by Cardinal Filippo Guastavillani (1540–87), a nephew of Pope Gregory XIII (*reg* 1572–85).

Mascherino is documented in Rome in 1574, where he was instrumental in introducing the style of the Bolognese school. He was first employed as a painter at the Vatican, working on the loggias of Gregory XIII; he also painted *quadrature* in the Sala del Bologna (Negro, 1990). As a painter, he was elected to the Accademia di S Luca in 1576 and to the Virtuosi al Pantheon in 1580. From 1574 he is

Ottaviano Mascherino: *casino* in the courtyard of the Palazzo del Quirinale, Rome, from 1582

also mentioned as an architect; he probably assisted the papal architect Martino Longhi the elder, whom he succeeded in 1577. At the Vatican he modified the east side of the Cortile di S Damaso and began what became the palace of Pope Sixtus V. Other projects there included the construction of the Galleria delle Carte Geografiche above the west corridor of the Cortile del Belvedere (from 1578), the Torre dei Venti (1578–80), the west loggia in the upper court of the Belvedere (1582–5) and the restructuring of S Marta (1582; destr. 1930). From 1582 to 1585 he planned the restructuring of a summer palace, the Vigna d'Este, on the Quirinal Hill in Rome, for Gregory XIII, including a *casino* with a two-storey loggia and side wings, surmounted by a central tower (now part of the Palazzo del Quirinale; see fig.). His oval staircase in the *casino* was one of the first to be constructed. A predilection for the oval form, and for centrally planned structures in general, is evident in many of his unrealized designs.

Mascherino held the post of papal architect until the death of Gregory XIII (in 1585) and again under Innocent IX (*reg* 1591). This gave him access to a large clientele. Ecclesiastical works in Rome for other important patrons included the Bandini Chapel in S Silvestro al Quirinale (1580–85), the restructuring of S Caterina della Ruota (1585–before 1591), the church and cloister of SS Giovanni Evangelista e Petronio (from 1582), the supervision of the construction of S Maria in Traspontina, designed (1581–7) by Giovanni Sallustio Peruzzi, and the oval steps leading to the cloister of the Ospedale di Santo Spirito in Sassia. In the nave of S Salvatore in Lauro (after 1591) the use of free-standing, paired columns has contributed much to Mascherino's fame, although the attribution is not unanimous (Heydenreich and Lotz, p. 284). He also worked on the reconstruction of Roman palaces, including the Albero (destr.), Alessandrino, Ginnasi, Aldobrandini, Verospi and the Monte di Pietà (Wasserman, 1966). The dates and the extent of his participation in these projects are uncertain, however. Although many aspects of Mascherino's work remain to be clarified, according to Wasserman, he is particularly interesting for his way of organizing interior spaces, for example the use of different designs for the sides of a courtyard, and for the juxtaposition of urban and suburban architectural elements. He was certainly appreciated by his contemporaries, as is clear from his nomination in 1604 as *principe* of the Accademia di S Luca.

BIBLIOGRAPHY

J. S. Ackerman: *The Cortile del Belvedere* (Rome, 1954)
J. Wasserman: 'The Palazzo Sisto V in the Vatican', *J. Soc. Archit. Hist.*, xxi (1962), pp. 26–35
——: 'The Quirinal Palace in Rome', *A. Bull.*, xlv (1963), pp. 205–44
——: *Ottaviano Mascarino and his Drawings in the Accademia Nazionale di San Luca* (Rome, 1966); review by K. Schwager in *Z. Kstgesch.*, xxxi (1968), pp. 246–68
L. H. Heydenreich and W. Lotz: *Architecture in Italy, 1400–1600*, Pelican Hist. A. (Harmondsworth, 1974)
I. Sjöström: *Quadratura: Studies in Italian Ceiling Painting* (Stockholm, 1978)
E. Negro: 'Cubiculum Artistarum et Cubiculum Juristarum: La decorazione pittorica cinquecentesca delle aule', *L'archiginnasio, il palazzo, l'università, la biblioteca*, ed. G. Roversi, i (Bologna, 1988), pp. 145–58
N. Margot: *Gregory XIII's Tower of the Winds in the Vatican* (diss., New York U.; microfilm, Ann Arbor, 1990)
E. Negro: 'Ottaviano Mascherino pittore e scultore', *Lelio Orsi e la cultura del suo tempo*, ed. J. Bentini (Bologna, 1990), pp. 161–72

ALESSANDRA ANSELMI

Maser, Villa Barbaro. Italian villa at Maser, a village in the Veneto between Cornuda on the River Piave and the fortified town of Asolo, in the foothills of the Dolomites *c.* 60 km north-west of Venice. The villa, designed by Andrea Palladio and built in 1554–8 for the Barbaro family, lies to the east of the village and faces south. It incorporates the remains of a medieval *castello* tower as a forward-projecting two-storey central block; this tower may have been built *c.* 1339, when Venice conquered the province of Treviso and the Barbaro family acquired the property. Its rebuilding and enlargement by Palladio (*see* PALLADIO, ANDREA, §I, 1(ii)) were commissioned in 1549 by two of the most important humanist statesmen and artistic patrons of the Venetian republic: Daniele Barbaro, Ambassador to England and Patriarch Elect of Aquileia, and his married brother Marc'Antonio Barbaro, a Venetian senator and Ambassador to Constantinople (*see* BARBARO). Palladio's first plan sketches (London, RIBA) date from May 1549; the villa was definitively designed between 1551 and 1554.

Palladio substituted new vaults for the former beamed ceilings in an intermediate storey of the tower, extending its spaces into the original top storey (which survives only as an unfloored, windowless attic), and covered it with a monumental pitched roof, presenting a pedimented gable towards the long approach avenue of lime trees. This pediment is supported by four giant Ionic half-columns rising through both levels of fenestration to treat the projecting façade as an antique temple-front attached to the entrance wall of the main block, the full form of which thus assumes, in angled or distant views, the three-dimensional aspect of an ancient temple. The villa backs on to a wooded hillside (see fig.), which Palladio concealed with tall lateral arcades ending in high dovecots. These narrow east–west wings function as retaining walls to mask a private garden lying behind residential suites on the upper level of the wings, with service rooms on the lower level, which connect on both floors across the reception

Maser, Villa Barbaro by Andrea Palladio, 1554–8; aerial view looking north-east, showing the Tempietto to the right

rooms of the central block. The south façade thus becomes a five-part composition, its central block connected by lower arcades to terminal pavilions crowned with pedimented frontispieces: that adjoining the entrance forecourt to the east (projected, unfeasibly, for stables) still contains a carriage-house, while wine-cellars and kitchens formerly occupied its twin, opening on to gardens and orchards to the west.

As noted by Vasari, the garden and grotto structures (1552) by Bartolomeo Ammanati at the Villa Giulia in Rome are paralleled at the Villa Barbaro by the nymphaeum, a fountain hemicycle and grotto chamber in the enclosed upper garden. These combine architecture, sculpture and fresco painting in a programmatic reconstruction of a Greek oracular sanctuary described by Pausanias, dedicated to the genius of the place and to beneficent Fortune (Lewis, 1980). The engineering of this element, the structural reworkings of the site and the medieval tower, and Palladio's new wings, must have been executed in 1554–8, as literary references of 1558 and 1559 (see Puppi, 1973) state that the villa was in use, with the decoration of the nymphaeum complete. The most striking feature of the nymphaeum, as well as of the façade pediment, pavilion niches and the chimney-pieces of four of the largest rooms, is a lavish cycle of nearly three-dimensional stucco sculptures; these display the style of a sophisticated amateur in the circle of Alessandro Vittoria, and in fact were contemporaneously attributed to Marc'Antonio Barbaro (Ludovico Roncone, in Scamozzi).

The axial suites of private rooms on the upper storey of Palladio's wings open northwards directly on to the nymphaeum garden and also look south through windows situated under the arcades of the main elevation. These rooms were later frescoed with unexceptional cycles of imagery depicting *Venus and Hercules*, attributed to followers of Battista Zelotti; the westernmost room, with its *Labours of Hercules*, was repainted by Girolamo Pellegrini (*d* 1700) around 1670 (Pallucchini). The upper floor of the central block was arranged by Palladio to provide reception rooms and staircases in its corners, divided by a cruciform hall lit from balconied windows set in the east, south and west façades; on the north side the hall opens through a triumphal arch into the main *salone*, the Sala dell'Olimpo, which, with two flanking vestibules, provides access to the lateral wings. These vestibules (a 'Room of Faith' leading to Daniele Barbaro's eastern suite, a 'Room of Fortune' leading to that of Marc'Antonio Barbaro and his family on the west), the Sala dell'Olimpo, the Crociera and two corner chambers along the main façade (a south-eastern 'Room of the Family' and a south-western room inscribed 'To the Genius of the Place and to the Household Gods') were all painted with a magnificent cycle of frescoes (*c.* 1561–2) by Veronese, his masterpiece in this medium and the most distinguished fresco cycle in any Italian Renaissance private palace (*see* VERONESE, PAOLO, §I, 3(i) and colour pl. 2, XXXIX1).

The painted decoration is organized within an elaborate *trompe l'oeil* architecture of columnar screens, recessed niches, pedimented portals, sculptured attics and projecting cornices, all designed by Palladio (Lewis, 1982). Among these frameworks are illusionistic landscapes with Classical ruins, based on engravings (1561) by Battista Pittoni (*c.*

1520–83) (Oberhuber, 1968), as well as simulated sculptures and reliefs in fictive marble, bronze, gilt and coloured stones. Finally, interspersed within *trompe l'oeil* doorways, balconies and cornices revealing distant vistas of open sky, is a large population of life-like human figures in full colour, occasionally representing real people (among them Marc'Antonio Barbaro's wife, children, servants and friends, including a huntsman traditionally identified as Veronese), but mostly comprising idealized figures of allegories, virtues, and personifications of the Christian and Olympian gods. The overall iconographic theme presented by these emblematic figures, which are mainly derived from *Le imagini de i dei degli antichi* (Venice, 1556) by Vincenzo Cartari, is the immanence of Christian humanism in the moral philosophy of the Classical world (Lewis, 1990).

At the end of his life, Palladio designed a free-standing private chapel for the villa, the chapel of the Redeemer (built 1580–84), as a scaled-down realization of his unexecuted 'rotunda project' (1576) for the votive church of the Redentore in Venice—an alternative design strongly promoted by Marc'Antonio Barbaro. The chapel at Maser has extensive stucco sculptures (1584–8) by Giannantonio da Salo and Pietro di Benvegnudo (both *fl c.* 1584–1603; Lewis, 1981). The plan and elevation of this Tempietto Barbaro, ultimately inspired by the Pantheon in Rome, may even have contributed a long-standing feature to its great model: Palladio's twin bell-towers above the pedimented portico at Maser seem likely to have inspired the similar 'donkey's ears' added to the Pantheon by Bernini.

Because Palladio acted at Maser in large part as an inspired executant of concepts originated by his two most extraordinary patrons (Huse), the residential complex is hardly an independent demonstration of his own ideas: Marc'Antonio Barbaro, in addition to modelling all the sculptures, undoubtedly supervised the villa's complex engineering (his speciality in the Senate); and Daniele Barbaro certainly invented its immensely sophisticated iconographic programme. Nevertheless, Palladio published the plan and elevation of the villa as his own in his treatise *I quattro libri dell'architettura* of 1570, from which its persuasive five-part configuration had a profound influence on the Palladian revivals of the 18th and 19th centuries, especially in northern Europe and Great Britain. Its miraculous cycle of architectural and figural frescoes by Palladio and Veronese contributed to a revolution in the concept of mural painting and indirectly inspired such milestones of *di sotto in sù* illusionism as Roman Baroque ceiling paintings by Cortona and Andrea Pozzo, as well as the late Baroque masterworks of Giambattista Tiepolo and his many followers.

BIBLIOGRAPHY

G. Vasari: *Vite* (1550, rev. 2/1568); ed. G. Milanesi (1878–85), vii, p. 530

A. Palladio: *I quattro libri dell'architettura* (Venice, 1570, 3/1601/*R* Newcastle upon Tyne, 1971; Eng. trans. by I. Ware, London, 1738/*R* New York, 1965), ii, p. 51

G. D. Scamozzi, ed.: *Tutte l'opere d'architettura di Sebastiano Serlio* (Venice, 1584/*R* Bologna, 1978) [introductory letter by Lodovico Roncone]

B. Berenson and others: *Palladio, Veronese e Vittoria a Maser* (Milan, 1960) [unique monograph; fine illus.]

R. Wittkower: *Architectural Principles in the Age of Humanism* (London, 1962), pp. 135–6 [analysis of harmonic proportions of plan]

U. Basso: *Cronaca di Maser: Delle sue chiese e della villa palladiana dei Barbaro* (Montebelluna, 1968)

K. Oberhuber: 'Hieronymous Cock, Battista Pittoni und Paolo Veronese in Villa Maser', *Munuscula discipulorum: Kunsthistorisches Studien Hans Kauffmann* (Berlin, 1968), pp. 207–24 [discovery of engraved sources for landscape frescoes]

D. Lewis: 'Disegni autografi del Palladio', *Boll. Cent. Int. Stud. Archit. Andrea Palladio*, xv (1973), pp. 369–79

L. Puppi: *Andrea Palladio*, 2 vols (Milan, 1973); Eng. trans. as 1 vol. (New York, 1975, London, 2/1986)

N. Huse: 'Palladio und die Villa Barbaro in Maser', *A. Ven.*, xxviii (1974), pp. 106–22

U. Basso: *La villa e il tempietto dei Barbaro a Maser di Andrea Palladio* (Montebelluna, 1976)

R. Pallucchini and others: *Gli affreschi nelle ville venete dal seicento all'ottocento*, 2 vols (Venice, 1978), i, pl. 183, no. 94; ii, figs 147–51

D. Lewis: 'Il significato della decorazione plastica e pittorica a Maser', *Boll. Cent. Int. Stud. Archit. Andrea Palladio*, xxii (1980), pp. 203–13; repr. and rev. as 'Classical Texts and Mystic Meanings: Daniele Barbaro's Program for the Villa Maser', *Klassizismus, Epoche und Probleme: Festschrift für Erik Forssman*, ed. J. Meyer zur Capellen and G. Oberreuter-Kronabel (Hildesheim, 1987), pp. 289–307

——: *The Drawings of Andrea Palladio* (Washington, DC, 1981, rev. 1999), pp. 45–6, 154–8, 192–4

L. Larcher Crosato: 'Considerazioni sul programma iconografico di Maser', *Mitt. Ksthist. Inst. Florenz*, xxvi (1982), pp. 211–56 [excellent general survey]

D. Lewis: 'Palladio's Painted Architecture', *Vierhundert Jahre Andrea Palladio (1580–1980): Colloquium* (Heidelberg, 1982), pp. 59–74 [Palladio's documented drawings for architectural frescoes]

I. J. Reist: 'Divine Love and Veronese's Frescoes at the Villa Barbaro', *A. Bull.*, lxvii (1985), pp. 614–35

D. Lewis: 'The Iconography of Veronese's Frescoes in the Villa Barbaro at Maser', *Nuovi studi su Paolo Veronese*, ed. M. Gemin (Venice, 1990), pp. 317–22

J. Barnes: 'A Villa of Abundance: Villa Barbaro: More than an Architectural Construction', *F.M.R. Mag.*, xiv (1994), pp. 16–25

M. Muraro: 'A Villa of Abundance: Villa Barbaro', *F.M.R. Mag.*, xiv (1994), pp. 28–44

C. Kolb: 'The Sculptures on the Nymphaeum Hermicycle of the Villa Barbara at Maser'; 'Postscript with an Excursus on Recent Historiography', by D. Lewis, *Artibus & Hist.*, 35/xviii (1997), pp. 15–40

DOUGLAS LEWIS

Maso [Tommaso; Masaccio] **di Bartolommeo** (*b* Capannole, nr Valdambra, Arezzo, 1406; *d c.* 1456). Italian sculptor. He is first recorded working with Donatello and Michelozzo between 1434 and 1438 on the installation and decorative relief-carving of the external pulpit of Prato Cathedral. From 1438 to 1442 he executed part of the bronze grille of the Cappella del Sacro Cingolo in the cathedral, until a dispute halted his work. It is gothicizing in style, with a pattern of delicate rosettes and elegantly twisted stems of naturalistic plant forms interspersed with animals and putti. In 1447 Maso made a gilded bronze reliquary inlaid with bone and tortoiseshell for the same chapel. It is decorated with a frieze of leaden putti dancing clumsily behind a colonnade and is ultimately derived from Donatello's *Singing Gallery (Cantoria)* made for Florence Cathedral (Florence, Mus. Opera Duomo; see colour pl. 1, XXVIII2).

Two account-books, which Maso kept between 1447 and 1452, record many of his smaller decorative commissions from important Florentine patrons. For Piero de' Medici he made a pair of candlesticks and two gilded bronze eagles for the Cappella del Crocefisso in S Miniato al Monte and the bronze railings (1447) around the miraculous *Annunciation* in SS Annunziata. For Cosimo de' Medici he designed the frieze (1452) for the courtyard of the Palazzo Medici in Florence; and for the Arte del Cambio a stone tabernacle. Maso worked on a wide variety of projects and employed many assistants. The portal of S

Domenico in Urbino, which he designed in 1449 and whose light architectural forms encrusted with elaborate surface decoration show the influence of Michelozzo, appears to have been entirely executed by assistants, while the reliefs in the lunette and pediment were commissioned from Luca della Robbia. Other commissions included the provision and repair of armaments for Federigo da Montefeltro II and the Republic of Florence.

In 1446 Maso received a joint commission with Luca della Robbia and Michelozzo for the bronze doors of the New Sacristy in Florence Cathedral. Work was suspended after Maso's death until his brother Giovanni took over his part in 1461.

BIBLIOGRAPHY

G. Vasari: *Vite* (1550, rev. 2/1568), ed. G. Milanesi (1878–85), ii, p. 172, n. 1, p. 291, n. 2

C. E. Yriarte: *Le Livre de souvenirs de Maso di Bartolommeo* (Paris, 1894)

G. Marchini: 'Di Maso di Bartolommeo ed altri', *Commentari*, iii (1952), pp. 108–27

——: 'Maso di Bartolommeo', *Donatello e il suo tempo: Atti dell' VIII convegno internazionale di studi sul rinascimento: Firenze, 1966*

ROSIE-ANNE PINNEY

Masolino (da Panicale) [Tommaso di Cristofano Fini] (*b* Panicale, Umbria, 1383; *d* after 1435). Italian painter. He is one of the pivotal figures of Florentine painting. Not only does his career span the two decades during which the basis of Renaissance painting was forged, but for a time he collaborated with its protagonist, MASACCIO, most notably in a cycle of frescoes in the Brancacci Chapel in S Maria del Carmine, Florence, a landmark in the history of European art. Paradoxically, his collaboration with Masaccio has obscured his own achievement. Vasari originated the idea that Masolino was the teacher of Masaccio, and he also attributed a number of Masolino's works to an early phase of Masaccio's. Not until the 20th century was the work of the two artists convincingly distinguished. Masolino's most extensive independent fresco cycle in the Lombard town of Castiglione Olona (a work unknown to Vasari) was recovered in 1843, and a century later the fresco fragments and the *sinopie* of another, documented cycle were discovered in the church of S Stefano, Empoli. These have thrown further light on a career that remains enigmatic and subject to a variety of interpretations.

1. Training and early career, to *c.* 1424. 2. The Brancacci Chapel frescoes and collaboration with Masaccio, *c.* 1424–5. 3. Last years, *c.* 1426 and after.

1. TRAINING AND EARLY CAREER, TO *c.* 1424. His birth date is based on the date given in the 1427 *catasto* (land registry declaration) of his father. (Whether he was born in Panicale di Val d'Elsa, as stated by Vasari, or a suburb of San Giovanni Val d'Arno, the birthplace of Masaccio, has not, however, been established.) He must therefore have been about 39 when he was first recorded as a painter on 7 September 1422; *c.* four months later he matriculated in the Florentine painters' guild, the Arte de' Medici e Speziali, on 18 January 1423, the year of his earliest certain work, the *Madonna of Humility* (Bremen, Ksthalle). Masolino's training and earlier career are largely conjectural: according to Vasari, he was a pupil of Lorenzo Ghiberti, 'and in his youth a very good goldsmith, and the

best assistant Lorenzo had in the work on the [Baptistery] doors . . . He devoted himself to painting at the age of 19 . . . learning colouring from Gherardo Starnina'. Both points remain hypothetical. Payments were made to a 'Maso di Cristofano' for work on Ghiberti's first set of bronze doors for the Baptistery in Florence from 1404 until some time after 1407; whether this was Masolino has been disputed. Starnina returned to Florence from Spain between 1401 and 1404 and was one of the most prominent artists in the city until his death *c.* 1413. Masolino could thus well have been employed by Ghiberti before an apprenticeship with Starnina, which might explain the absence of independent works before 1423. (It has also been suggested that the information in the *catasto* is erroneous and that Masolino was born *c.* 1400; there is, however, no cogent reason for this.) In any case, Ghiberti's sculpture was a source of inspiration for Masolino throughout his career, and there are undeniable affinities between Masolino's earliest paintings and those of Starnina. In the *Madonna of Humility*, for example, the pose of the child and the relationship of his face to that of the Virgin seem to derive from a Ghibertian prototype, possibly a half-length terracotta *Virgin and Child* in which the child stood on a plinth rather than straddled his mother's knee and left hand. The splayed drapery folds of the Virgin's cloak, on the other hand, are not unlike those favoured by Starnina.

An equally important place in Masolino's artistic formation must be accorded to Gentile da Fabriano. Gentile is now known to have been living in Florence by October 1420 and may have been active there as early as late September 1419, two to three years before Masolino joined the painters' guild. The refinement of Gentile's figure types, with their delicately modelled features and naturalistically rendered details are the pre-condition to Masolino's *Madonna of Humility*, which can be compared with Gentile's *Virgin and Child* (*c.* 1420; Washington, DC, N.G.A.). Indeed, Gentile's influence was the determining factor in Masolino's art, far outlasting that of Masaccio. (Earlier comparisons of Masolino's work with Lombard painting are irrelevant in the light of what is now known of Gentile's early activity in Florence.)

Masolino's most significant commission before the Brancacci Chapel fresco cycle was for the decoration of a side chapel in S Stefano, Empoli, belonging to the Compagnia della Croce, for which he was paid 74 florins on 2 November 1424. This is a small chapel, the tall, narrow lateral walls of which are divided into four horizontal fields with the *Story of the True Cross* depicted on the upper three zones and, apparently, portraits of the donors viewed through an arcade on the bottom zones. Of the narrative scenes, only the *sinopie* survive. Considering the available space and the fact that two episodes are shown in some of the individual picture fields, the narrative clarity is remarkable. This is due, above all, to the fact that the compositions were conceived in terms of figural action. Buildings and the suggestion of a spatial setting were peripheral to the creation of simple figure groups invariably placed close to the picture plane. There is no hint in these scenes of the use of a coherent perspective system such as Masolino consistently employed in his subsequent work. Rather, the compositions recall the work of Starnina: the

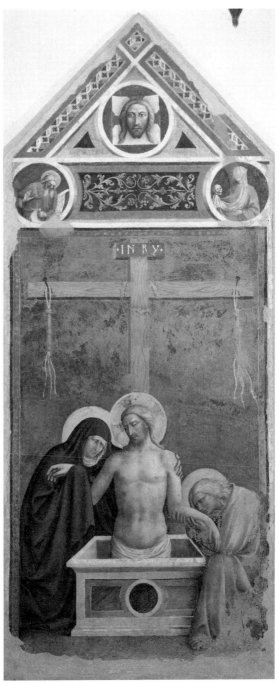

1. Masolino: *Pietà*, detached fresco, 2.8×1.2 m, from the baptistery of the Collegiata, Empoli, *c.* 1424 (Empoli, Museo della Collegiata di Sant'Andrea)

Beheading of Chosroes should be compared with Starnina's fresco of the *Resurrection of Lazarus* (Florence, Mus. Opera Santa Croce), and the scene of *Chosroes Enthroned* with Starnina's *Death of St Jerome*, recorded in an engraving in Séroux d'Agincourt's *L'Histoire de l'art*.

One of the few frescoed portions in the chapel still intact is a recess with, on its back wall, a still-life of liturgical books and two flasks of wine and water on

shelves. Again, there is no hint of perspectival logic, although Masolino's depiction of cast shadows—such as appear in Gentile da Fabriano's *Adoration of the Magi* (1423; Florence, Uffizi; *see* GENTILE DA FABRIANO, fig. 3)—reveals a precocious interest in naturalistic effects. The remains of two other frescoes in the same church, one of the *Virgin and Child with Two Angels* in a lunette over the sacristy door and the other of a saint flanked by young girls, are both contained in highly effective Gothic architectural surrounds for which Starnina's surviving frescoes in the Carmine, Florence, again offer a precedent.

Perhaps the most impressive early work by Masolino is the detached fresco of the *Pietà* painted for the baptistery of the Collegiata in Empoli (Empoli, Mus. S Andrea; see fig. 1), in which the assertive form of the sarcophagus introduces a jarringly realistic note into an otherwise hieratic and planar composition. Masolino's source was, again, a Late Gothic work: Lorenzo Monaco's *Pietà* (1404; Florence, Accad.).

2. THE BRANCACCI CHAPEL FRESCOES AND COLLABORATION WITH MASACCIO, *c.* 1424–5. Whether Masolino had established contact with Masaccio by 1424 is not known. The Empoli frescoes suggest he had not. (Longhi, 1940, argued the contrary case with regard to the *Pietà* at Empoli; *see also* MASACCIO, §I, 1(iii).) Collaboration with Masaccio seems to have begun with the fresco cycle in the Brancacci Chapel. The frescoes, carried out by Masolino and Masaccio in the 1420s and completed by Filippino Lippi *c.* 1481–5, mark a watershed in the history of European art. Originally there were figures of the *Four Evangelists* (destr.) in the vault (attributed by Vasari to Masolino), scenes of the *Temptation of Adam and Eve* and the *Expulsion from Paradise* (see colour pl. 2, II2) on the lateral walls of the entrance (by Masolino and Masaccio respectively) and 17 episodes from the *Life of St Peter* (by Masolino and Masaccio, later added to by Filippino Lippi) in 12 separate picture fields on the lateral and back walls (the back wall is divided by a biforate Gothic window). Individual fields are separated by Corinthian pilasters and a dentilled moulding, a complete novelty at this date. Construction of a new vault and window in 1746–8 destroyed the four uppermost scenes in the lunettes and the figures of the *Evangelists* in the vault. The frescoes were further altered by repeated restorations and the effects of a fire that swept the church in 1771. A full restoration was undertaken in 1982–8. In addition to revealing an unsuspected brilliance of colour in the surviving portions, the restoration campaign recovered *sinopie* for two of the destroyed scenes on the altar wall, the decorations of the window embrasure, and, below the window, fragments of a scene that is not mentioned in any of the early descriptions of the chapel (its identification remains speculative). These discoveries and the clarification of styles resulting from the cleaning bear directly on the conjectures regarding the commission of the cycle, the attribution of the individual scenes and on the iconographic programme.

That the prominent Florentine citizen FELICE BRANCACCI was probably the patron of the chapel is suggested by his two wills, the first dated 26 June 1422 and the second 5 September 1432. There is, however, no known document related to the commission, which is not likely to have been arranged before Brancacci's return from an embassy to Egypt in February 1423. Masaccio would have been available at any time after that, but Masolino can hardly have begun work before completion of the frescoes in Empoli. On 8 July 1425 Masolino was paid by the Compagnia di S Agnese for work on props for the Ascension Day miracle play (Ascension Day actually fell on 17 May 1425). This has reasonably been adduced as evidence that Masolino was already working in the Brancacci Chapel at the time. On 1 September 1425 Masolino gave power of attorney to a banker and entered the service of the condottiere Filippo Scolari (Pippo Spano) in Hungary. He did not return until some time between 7 July 1427 and 11 May 1428 (Molho, 1977). His activity in the Brancacci Chapel is, therefore, confined to the period between November 1424 and September 1425 or, less likely, some time after July 1427 (in Christiansen's opinion the latter date can be excluded for reasons of style; for a different interpretation *see* MASACCIO, §I, 2(ii)). That it was he and not Masaccio who received the commission, as recorded by Vasari and sustained by most recent critics, was confirmed by the recovery of the decoration of the window embrasure. The window extends into the uppermost zone of the original fresco cycle, and its decoration would have been conceived along with those first scenes. It is virtually identical with the border surmounting Masolino's *Pietà* at Empoli and antithetical to the Corinthian pilasters framing the surviving scenes. Moreover, the two *sinopie* that have been recovered from the altar wall, one showing the *Repentance of St Peter* and the other the *Feed my Sheep* (a scene not mentioned by Vasari who, however, attributed all of the uppermost scenes to Masolino), again accord with Masolino's work at Empoli. (The attempt to attribute one of the *sinopie* to Masaccio is without basis.) It is, therefore, probable that Masolino began work on the Brancacci Chapel independently in 1425 and that Masaccio's collaboration was sought on completion of the four scenes in the lunettes. The reason behind the collaboration can only be surmised. Perhaps it was simply an effort to expedite work in view of the far more prestigious commission Masolino had from Pippo Spano. At the time Masaccio was probably relatively unknown, although if he had completed his fresco of the *Consecration of St Maria del Carmine* (the *Sagra*; destr.) in the church's cloister, this may have recommended his services. Whatever the explanation, the results were momentous.

From the outset the two artists took their different styles into account and made an effort to minimize the disparities by alternating the authorship of the frescoes. Thus, Masaccio undertook the large scene of the *Tribute Money* on a lateral wall (*see* MASACCIO, fig. 5), while Masolino painted the adjacent *St Peter Preaching*; (see colour pl. 2, IV1) Masolino painted *St Peter Curing a Cripple and the Raising of Tabitha* on the opposite lateral wall (see fig. 2 below), while Masaccio painted the adjacent *St Peter Baptizing Neophytes*. Interestingly, the recent cleaning suggests that a further effort was made to unify the scenes, Masolino painting the conical hills in *St Peter Baptizing*, while Masaccio continued the naturalistic hills and sky of the *Tribute Money* into Masolino's fresco of *St*

Peter Preaching. Longhi's suggestion that Masolino also painted Christ's head in the *Tribute Money* also seems correct, although the hypothesis that Masaccio painted the background buildings in the *Raising of Tabitha* is no longer tenable. The most important result of this collaboration was in Masolino's adoption of Renaissance pilasters to divide the scenes and a one-point perspective system to organize the narratives. There can be no doubt that these were Masaccio's innovations, and the degree to which Masolino understood their implications is debatable.

In *St Peter Curing a Cripple and the Raising of Tabitha* (see fig. 2), the main lines of the various buildings recede to a point somewhat to the right of the two richly clothed youths in the centre of the composition. Superficially, the scheme seems identical with that employed by Masaccio in the *Tribute Money*, but whereas in Masaccio's scene the vanishing-point coincides with the narrative focus—Christ's head—in Masolino's fresco space and narrative operate independently of each other, with the result that the two miracles of St Peter are reduced to peripheral events. Architecture is used exclusively to generate an expansive (and superfluous) space rather than to clarify the action and the sequence of the narrative, as in Masaccio's scene. Masolino apparently adopted what he perceived as a technical innovation—the use of strings snapped from a single point on the wall at the height of the foreground figures (an improvement on the system recorded in Cennino Cennini's *Libro dell'arte*)—without perceiving that this perspective system was only the scaffolding for a new kind of realistic painting, which was based on the study of modelled figures viewed under controlled lighting conditions and the use of elaborate architectural drawings to ensure structural logic and verisimilitude. Masolino's work in the chapel was less advanced than Sassetta's contemporary predella for his altarpiece for the Arte della Lana in Siena (Siena, Pin. N.), in which figure and setting are perfectly integrated; and it was aesthetically inferior to Gentile's predella panel of the *Presentation in the Temple* (Paris, Louvre) from the *Adoration of the Magi* (Florence, Uffizi). Given Masolino's love of naturalistic detail, it is not surprising that he should lavish such extraordinary attention on genre details in the background. The stones on the ground, which cast shadows, are depicted like elements in a still-life, and the figure behind Tabitha's bed with one hand upraised wears a blue robe that originally had a gilt decoration. Masolino's debt to Gentile was a continuing factor in his art.

The church's Carmelites were staunch supporters of the papacy, and a cycle devoted to St Peter would have met with their approval; members of the Order are shown in the scenes of *St Peter Preaching* (by Masolino) and *St Peter Enthroned as Bishop of Antioch* (by Masaccio). The choice of scenes is not unusual: nine of the episodes represented are listed in Jacopo da Voragine's *Golden Legend*, including the *Tribute Money* (which Meiss, 1963, attempted to relate to the establishment of the *catasto* in 1427). The remaining scenes all underscore Peter's privileged position among the Apostles (except for the scene of his repentance). The inclusion of scenes of the *Temptation* and *Expulsion* indicate that the underlying theme is that of salvation through the Church, whose head is Peter. The scenes are not strictly chronological, but have been arranged to form complementary pairs: the *Calling of St Peter* opposite *Christ Walking on the Water* (both destr.); *St Peter Preaching* next to *St Peter Baptizing*; the *Tribute Money* opposite *St Peter Curing a Cripple and the Raising of Tabitha*; *Peter Imprisoned* opposite *Peter Released by an Angel*. This is the same expedient adopted later by Filippo Lippi in his frescoes in Prato Cathedral and by Piero della Francesca in the cycle in S Francesco, Arezzo, and it points to an exegetical approach to the theme.

That Masolino's collaboration with Masaccio went beyond sharing the commission of the Brancacci Chapel is shown by the contemporary altarpiece for S Ambrogio, Florence, with the *Virgin and Child with St Anne* (Florence, Uffizi), in which Masolino was probably responsible for the figure of St Anne and four angels, while Masaccio painted the Virgin and Child and one angel (Vasari again attributed the work to Masaccio). However, there is no evidence that a formal partnership was established, and,

2. Masolino: *St Peter Curing a Cripple and the Raising of Tabitha* (*c.* 1425), fresco, Brancacci Chapel, S Maria del Carmine, Florence

in Christiansen's opinion, it would be incorrect to postulate an association that extended beyond Masolino's departure for Hungary in September 1425, when he left the Brancacci Chapel frescoes incomplete.

3. LAST YEARS, c. 1426 AND AFTER. Masolino's work in the decade following his collaboration in the Brancacci Chapel, though frequently relegated to a position of secondary importance, is of considerable historical interest and is aesthetically superior to what he produced earlier. Nothing remains of the work in Hungary for Pippo Spano, who died on 28 December 1426. Masolino returned to Florence between 7 July 1427, when his father stated that he was still in Hungary, and 11 May 1428, the day before he was finally emancipated from his father's guardianship at the age of about 45. The only work that can be dated with reasonable certainty to this period is the *Annunciation* (Washington, DC, N.G.A.), now identified (Damiani, 1982) with the altarpiece that Vasari saw in the church of S Niccolò sopr'Arno, Florence, and formerly attributed to Masaccio. The chapel in the rood screen (*tramezzo*) for which it was painted was provided for in the will of Michele Guardini dated 8 March 1427. The scene, framed by a feigned carved stone arch, is depicted in an elaborate, brightly coloured architectural setting with a low viewpoint that has the effect of enhancing the decorative character of the work rather than of generating a sense of realism. The picture marks a retreat from Masaccio's innovations and a renewed interest in the courtly aspects of Gentile da Fabriano's work—the brocade dress of the angel depends on the central panel of the *Virgin and Child* in Gentile's altarpiece for S Niccolò sopr'Arno (British Royal Col., on loan to London, N.G.). This is attributable partly to Masolino's natural predilection and partly to the impact of Late Gothic Bohemian painting that he would have seen in Hungary.

Some time after May 1428, and possibly not until 1429, Masolino was summoned to Rome. The date is a matter of surmise, not fact (no documents can be connected with Masolino's extensive activity in Rome). His three principal patrons in Rome were Martin V (*see* COLONNA, (1)), who was promoting a restoration and redecoration of the Roman basilicas, Cardinal Castiglione Branda and Cardinal Giordano Orsini. For the first Masolino completed a double-sided triptych for S Maria Maggiore that was begun by Masaccio and probably left incomplete at his death in Rome before late June 1428 (central panels, Naples, Capodimonte; side panels, London, N.G., and Philadelphia, PA, Mus. A.; for a different reconstruction *see* MASACCIO, §I, 2(iii)). This altarpiece is sometimes dated as early as 1423 and is also viewed—incorrectly in Christiansen's opinion—as evidence of a continued collaboration between Masolino and Masaccio (for a good analysis, see Meiss, 1964). For Cardinal Branda's titular church of S Clemente, Masolino frescoed a chapel with scenes from the *Life of St Catherine* and the *Life of St Ambrose* as well as a *Crucifixion*. For Orsini's palace on Monte Giordano, Rome he painted a cycle of famous men (destr.), for which related drawings survive (see Mode, 1972). There is evidence that the Orsini commission was finished in 1432, which accords with what little is known of Masolino's movements in these years. In Rome the standard of taste

had been set not by Masaccio, but by Gentile da Fabriano, who at his death in 1427 left several unfinished works. It was in this environment that Masolino took decisive steps in adapting the heroic style of the Brancacci Chapel to the exigencies of courtly art. One-point perspective is used to create tunnelling, box-like interiors or elaborate, stepped exterior views that generate abstract surface patterns and a heightened sense of unreality (most notable in the *Annunciation* over the entrance arch of Branda's chapel in S Clemente). Judged in terms of the naturalism of the Brancacci Chapel, these works are regressive. In the *Foundation of S Maria Maggiore* (see fig. 3), the central panel of the S Maria Maggiore Altarpiece, figures have a doll-like delicacy, despite several recognizable portraits (including that of Martin V), and the landscape background, which includes topographical details of great beauty, lacks substance. In the frescoes of the *Life of St Catherine* in S Clemente, the lighting and space are

3. Masolino: *Foundation of S Maria Maggiore*, central panel from the S Maria Maggiore Altarpiece, tempera and gold on panel, 1.44×0.76 m, after 1428 (Naples, Museo e Gallerie Nazionali di Capodimonte)

surprisingly inconsistent. However, judged as narratives, these works mark a significant advance. They reveal a greater command of expression, and the compositions are more focused.

To carry out this extensive work, Masolino must have hired a number of assistants. Domenico Veneziano has been mentioned in connection with the frescoes at S Clemente, and Paolo Uccello has been proposed as an assistant or collaborator at the Palazzo Orsini. A number of figure types at S Clemente recall the later work of Vecchietta, who certainly later worked with Masolino at Castiglione Olona. Longhi believed Masaccio carried out part of the *Crucifixion* in S Clemente, but this seems highly unlikely (the fresco is in a ruinous state but the detached *sinopia* is consistent with Masolino's work).

In 1432–3 Masolino painted a fresco of the *Virgin and Child and Two Angels* in S Fortunato, Todi, for which he received payments on 17 October 1432 and 30 June 1433. The work is inspired by a fresco of 1426 by Gentile da Fabriano in Orvieto Cathedral, in which the figures are similarly viewed *di sotto in su*, but Masolino rejected the naturalistic premise of Gentile's work, opting instead for a composition of geometric purity. Masolino's last major undertaking was a series of frescoes for Cardinal Branda in his home town of Castiglione Olona, Lombardy. He decorated the ribbed vault of the choir of the Collegiata (the church was consecrated in 1425 and still undecorated in 1431; the frescoes are signed) and the interior of an adjacent small baptistery (the building became a baptistery only in 1431; the frescoes are dated 1435). The Collegiata frescoes appear to have been painted earlier than those in the baptistery. In the triangular, concave surface of the vaults, Masolino returned to the principle of architecture as a foil for figural compositions; the result is a series of unprecedentedly evocative scenes in which carefully de-scribed details (an open cupboard with stacked books in the *Annunciation*; the flock of sheep in the background of the *Nativity*) animate scenes conspicuous for their refined figure types and blond tonality. In the *Marriage of the Virgin* (see colour pl. 2, IV2), in which the steps of the temple fill the awkward spandrels at the base of the vault while an ingeniously conceived second storey accommo-dates the scene in the pointed apex, Masolino was able for the first time to integrate fully figural action and architec-ture. The other scenes show a new awareness of the possibility of using illusionistic space and surface pattern to achieve a unified composition.

Masolino's real stature emerges in the cycle of the *Life of St John the Baptist* in the small baptistery (main area, approximately 5×5.5 m; see fig. 4), in which spatial effects are handled with consummate facility. Even the irregular-ities of the floor-plan are utilized to achieve surprising, illusionistic effects. In *St John's Imprisonment*, for example, the front wall of the prison is shown on the lateral wall, while on the window jamb is depicted a view of the saint through a barred window. A comparison of the scene of the *Banquet of Herod* with *St Catherine on the Wheel* in S Clemente, in which both settings are defined by a receding arcade to the right and back and by a two-storey loggia to the left, reveals Masolino's increased sophistication. Al-though Masolino determined the rate of diminution only approximately, the isocephaly of the *Banquet of Herod*

4. Masolino: *Life of St John the Baptist* (1435), fresco, baptistery, Castiglione Olona, Lombardy

suggests familiarity with the basic tenets of Alberti's perspective system (which assured a greater unification of figure with setting). Coupled with this increased mastery of space, there is a firmer grasp of anatomy, especially evident in the *Baptism*, in which the figure of Christ is based on Ghiberti's bronze relief for the Siena baptismal font, and in the portraits in the scene of *St John Preaching*. The tooled areas of gold and silver leaf (now badly damaged) are brilliantly exploited to imitate rich brocades and cut velvet. It is not surprising that Masolino found favour with a native of Lombardy, where realism and courtly refinement were the basis of Late Gothic art. And yet, if the scene of *St John Preaching* in the baptistery is compared with that of *St Peter Preaching* in the Brancacci Chapel, it is extraordinary the degree to which Masolino abandoned Masaccio's attempt to make painting an exten-sion of the visible world and to imagine biblical events in terms of human experience. The change would seem inexplicable were the same phenomenon not observable in the work of other contemporary Tuscan artists, such as Sassetta and Uccello. Masolino's collaboration with Ma-saccio was a necessary but aberrant prelude to the creation of a new post-Gothic style later in the century.

Vecchietta, Masolino's principal assistant at Castiglione Olona, and Paolo Schiavo completed the decoration of the choir of the Collegiata, presumably after Masolino's death, and it is to Vecchietta, not Masolino, that a landscape decoration in Cardinal Branda's palace is probably due; he also decorated a chapel in the palace. Whereas in Florence Masolino had no significant influence—apart from Paolo Schiavo and, possibly, the young Domenico Veneziano —in Siena, through Vecchietta, his work struck a respon-sive chord.

BIBLIOGRAPHY

G. Vasari: *Vite* (1550, rev. 2/1568); ed. G. Milanesi (1878–85), ii, pp. 305–25

P. Toesca: *Masolino da Panicale* (Bergamo, 1908)

R. Longhi: 'Fatti di Masolino e di Masaccio', *Crit. A.*, xxv–xxvi (1940), pp. 145–80

K. Clark: 'An Early Quattrocento Triptych from Santa Maria Maggiore, Rome', *Burl. Mag.*, xciii (1951), pp. 339–43

U. Procacci: 'Sulla cronologia delle opere di Masaccio e di Masolino tra il 1425 e il 1428', *Riv. A.*, xxviii (1953), pp. 3–55

G. Urbani: 'Restauro di affreschi nella cappella di S Caterina a S Clemente in Roma', *Boll. Ist. Cent. Rest.*, xxi–xxii (1955), pp. 13–20

R. Krautheimer: *Lorenzo Ghiberti* (Princeton, 1956) [incl. analysis of S Clemente frescoes]

E. Micheletti: *Masolino da Panicale* (Milan, 1959)

E. Borsook: *The Mural Painters of Tuscany from Cimabue to Andrea del Sarto* (London, 1960, rev. Oxford, 1980)

M. Meiss: 'Masaccio and the Early Renaissance: The Circular Plan', *Acts of the Twentieth International Congress of the History of Art: Princeton, 1963*, ii, pp. 123–45

R. Oertel: 'Perspective and Imagination', *Acts of the Twentieth International Congress of the History of Art, Princeton, 1963*, ii, pp. 146–59

M. Meiss: 'The Altered Program of the Santa Maria Maggiore Altarpiece', *Festschrift L. Heydenreich* (Munich, 1964), pp. 169–90

B. Cole: 'A Reconstruction of Masolino's True Cross Cycle in Santo Stefano, Empoli', *Mitt. Ksthist. Inst. Florenz*, xiii (1967), pp. 289–300

E. Wakayama: 'Novità di Masolino a Castiglione Olona', *A. Lombarda*, xvi (1971), pp. 1–16

R. Mode: 'Masolino, Uccello, and the Orsini *Uomini Famosi*', *Burl. Mag.*, cxiv (1972), pp. 369–78

L. B. Watkins: 'Technical Observations on the Frescoes of the Brancacci Chapel', *Mitt. Ksthist. Inst. Florenz*, xvii (1973), pp. 65–74

A. Debold-von Kritter: *Studien zum Petruszyklus in der Brancaccikapelle* (Berlin, 1975)

R. Freemantle: 'Some New Masolino Documents', *Burl. Mag.*, cxvii (1975), pp. 658–9

A. Molho: 'The Brancacci Chapel: Studies in its Iconography and History', *J. Warb. & Court. Inst.*, xl (1977), pp. 50–98

E. Wakayama: 'Il programma iconografico degli affreschi di Masolino nel battistero di Castiglione Olona', *A. Lombarda*, l (1978), pp. 20–32

A. Braham: 'The Emperor Sigismund and the Santa Maria Maggiore Altarpiece', *Burl. Mag.*, cxxii (1980), pp. 106–11

G. Damiani: *San Niccolò Oltrarno: La chiesa, una famiglia di antiquari* (Florence, 1982), pp. 29–30, 57–9

F. Santi: 'Momenti della scultura e della pittura', *Il tempio di San Fortunato a Todi* (Milan, 1982), 149–50

U. Baldini: *La Cappella Brancacci nella chiesa del Carmine a Firenze* (Milan, 1984)

A. Natali: 'La chiesa di Villa a Castiglione Olona e gli inizi del Vecchietta', *Paragone*, xxxv/407 (1984), pp. 3–14

P. Joannides: 'A Masolino Partially Reconstructed', *Source: Notes Hist. A.*, iv/4 (1985), pp. 1–5

O. Casazza: 'Il ciclo delle storie di San Pietro e la "Historia Salutis": Nuova lettura della Cappella Brancacci', *Crit. A.*, li (1986), pp. 69–82

M. Boskovits: 'Il percorso di Masolino: Precisazioni sulla cronologia e sul catalogo', *A. Crist.*, 718 (1987), pp. 47–66

J. Manca: 'A Remark by Pliny the Elder as a Source for Masolino's Landscape Mural in Castiglione Olona', *A. Crist.*, 719 (1987), pp. 81–4

F. Mazzini: 'Stacco e ricollocamento di affreschi di Masolino nel battistero di Castiglione Olona: Le sinopie', *A. Crist.*, 719 (1987), pp. 85–98

C. Strehlke and M. Tucker: 'The Santa Maria Maggiore Altarpiece: New Observations', *A. Crist.*, 719 (1987), pp. 105–24

E. Wakayama: 'Masolino o non Masolino: Problemi di attribuzione', *A. Crist.*, 719 (1987), pp. 125–236

U. Baldini and O. Casazza: *La Cappella Brancacci* (Milan, 1990)

K. Christiansen: 'Some Observations on the Brancacci Chapel Frescoes after their Cleaning', *Burl. Mag.*, cxxxiii (1991), pp. 5–20

P. Joannides: *Masaccio and Masolino: A Complete Catalogue* (London, 1993)

S. Tomasi Velli: 'Scipio's Wounds', *J. Warb. & Court. Inst.*, lviii (1995), pp. 216–34

KEITH CHRISTIANSEN

Masone [Massone]**, Giovanni.** *See* MAZONE, GIOVANNI.

Massimo [Massimi; Massimo alle Colonne]. Italian family of nobles, bankers and patrons. It is one of the oldest Roman families, and its members have held important offices in the secular and ecclesiastical administration of Rome and the Church. According to tradition, as recorded by Onofrio Panvinio *c.* 1550, the family owes its origins to the Roman general Fabius Maximus (3rd century BC). By the 12th century they owned a house in the Parione district of Rome, on the site of the present Palazzo Massimo alle Colonne, Corso Vittorio Emanuele. Pietro Massimo (*d* 1489) housed the printing firm of Konrad Sweynheim and Arnold Pannartz in his palazzo in Rome (destr. 1527), and founded the chapel of St Peter Martyr in S Maria della Strada (destr. 16th century), Rome. His son Domenico Massimo (*d* 1531/2) amassed enormous riches and expanded the palazzo. After his death, Domenico's sons Pietro Massimo (*d* 1544), Luca Massimo (*d* 1550) and Angelo Massimo (*d* 1550) divided his properties, and each decided to build new residences on or close to the site of the old palazzo. Pietro had Baldassare Peruzzi erect the Palazzo Massimo alle Colonne, which was begun in 1532 (*see* PERUZZI, BALDASSARE, §3 and fig. 4). Its walls and ceilings were painted under the direction of Perino del Vaga with scenes from Classical history and mythology, while Daniele da Volterra decorated the *sala grande* with a painted frieze showing the Roman ancestors of the family, including Fabius Maximus. Pietro's wife, Faustina Rusticelli (*d* 1571), founded the Massimo Chapel in the basilica of S Giovanni Laterano. Antonio da Sangallo designed another palazzo (destr. *c.* 1880) in Rome (Florence, Uffizi, UA 944) for Luca Massimo, and this became famous for its collection of Classical sculpture and inscriptions.

Successive members of the family were all descended from Angelo and his son Fabrizio Massimo (*d* 1633). Angelo built the Palazzo di Pirro (completed *c.* 1537), Rome, designed by Giovanni Mangone, next to Pietro's palazzo, and had it frescoed by followers of Perino del Vaga, who continued their work for Angelo's son Massimo Massimo (*d* 1579), Archbishop of Amalfi. Angelo also founded the Massimo Chapel in Trinità dei Monti, with decorations by Perino del Vaga (destr.; one fresco London, V&A). In 1574 Fabrizio became Lord of Arsoli (nr Tivoli), where he had various buildings erected, including SS Salvatore, designed by Giacomo della Porta.

BIBLIOGRAPHY

O. Panvinio: *De Fabiorum familia, de Maximorum familia* (MS. *c.* 1550; Rome, Vatican, Bib. Apostolica, Archv Capitolare S Pietro, Cod. Lat. 6168); ed. A. Mai in *Spigilegium romanum*, ix (1843), pp. 543–91

P. Litta: *Famiglie celebri italiane*, IV/xlv (Milan, 1837)

Ceccarius: *I Massimo*, Le Grandi Famiglie Romane, viii (Rome, 1954)

H. Wurm: *Der Palazzo Massimo alle Colonne* (Berlin, 1965)

C. L. Frommel: *Der römische Palastbau der Hochrenaissance*, Römische Forschungen der Bibliotheca Hertziana, xxi, 3 vols (Tübingen, 1973)

J. L. DE JONG

Massina, Pino da. *See* JACOBELLO D'ANTONIO.

Masters, anonymous, and monogrammists. Collective terms for artists who have not been identified with a documented, named individual, but whose oeuvre has been recognized by art historians. The various sources from which their identifying names have been derived is reflected in the subdivision of the following article.

Anonymous masters (§I) covers those artists whose association with, for example, a particular work, place or

patron, or stylistic and iconographic characteristic has led art historians to refer to them by a descriptive name. These are listed alphabetically by the identifying part of the name, ignoring the preliminary 'Master' and intervening prepositions and articles. Dated anonymous masters (§II), who are most usually named from the date of the sample work, are entered chronologically. Anonymous monogrammists (§III) are listed alphabetically by the initials of the monograms that appear on their work.

I. Anonymous masters. II. Dated masters. III. Monogrammists.

I. Anonymous masters.

Master of the Arcimboldi Missal (*fl* Milan, *c.* 1492). Italian illuminator. He is named after the spendidly illuminated Missal (Milan, Bib. Capitolare, MS. X.D.I.13) that bears the coat of arms and the portrait of *Guidantonio Arcimboldi*, Archbishop of Milan (1489–97). The manuscript was probably donated to Arcimboldi by Ludovico Sforza ('il Moro'), Duke of Milan; the frontispiece bears a miniature of the Duke and his court during the coronation ceremony, which took place in S Ambrogio, Milan, on 26 March 1495. The Missal must therefore have been decorated after that date, and it is attributed to a Milanese artist strongly influenced by the work of Ambrogio Bergognone and Cristoforo de Predis.

The Master of the Arcimboldi Missal is also credited with the Hours of Ascanio Sforza (Oxford, Bodleian Lib., MS. Douce 14), produced at a later date than the Milanese manuscript. Here his pictorial language has become less dry and sharp, the modelling is softer and the rendering of landscape more refined; the style partly reflects the new experience of Leonardo da Vinci's painting. Other miniatures have been attributed to the Master, including three initials (Paris, Wildenstein Inst., 25–7), a *St Stephen* (London, Wallace, M. 330) and *St John the Baptist* (Venice, Fond. Cini, inv. 2111). Alexander identified the Master with MATTEO DA MILANO. The Arcimboldi Missal could therefore document Matteo's early career in Milan in the 1490s, before he is first documented in Ferrara in 1502.

BIBLIOGRAPHY
F. Malaguzzi Valeri: *Gli artisti lombardi* (1917), iii of *La corte di Ludovico il Moro*, 3 vols (Milan, 1913–17), pp. 175–82
R. Cipriani: 'Maestro del Messale Arcimboldi', *Arte lombarda dai Visconti agli Sforza* (Milan, 1958), pp. 157–9
O. Pächt and J. J. G. Alexander: *Italian School* (1970), ii of *Illuminated Manuscripts in the Bodleian Library Oxford* (Oxford, 1966–73), p. 97
G. Mariani Canova: *Miniature dell'Italia settentrionale nella Fondazione Giorgio Cini* (Vicenza, 1978), pp. 58–9
J. J. G. Alexander: 'Italian Illuminated Manuscripts in British Collections', *La miniatura italiana tra gotico e rinascimento: Atti del II congresso di storia della miniatura italiana: Cortona, 1983*, i, p. 113
M. P. Lodigiani: 'Per Matteo da Milano', *A. Crist.*, lxxix (1991), pp. 287–300
J. J. G. Alexander: 'Matteo da Milano illuminator', *Pantheon*, l (1992), pp. 32–45

MILVIA BOLLATI

Master of the Bambino Vispo [Master of the Lively Child] (*fl* Florence, early 15th century). Italian painter, possibly identified as STARNINA. Sirén (1904) assembled a group of paintings under the name the Master of the Bambino Vispo. These included the *Virgin and Child with Saints and Angels* (Florence, Accad.), the *Virgin of Humility* (Philadelphia, PA, Mus. A.), a triptych of the *Virgin and*

Child with Music-making Angels and Four Saints (Rome, Pal. Doria–Pamphili) and an altarpiece wing with *SS Mary Magdalene and Lawrence and a Cardinal Donor* (Berlin, Bodemus.). He chose the name on account of the particularly lively expression and movement of the Christ Child in the paintings. He associated the altar wing with a documented altarpiece of *St Lawrence*, which, it was then believed, had been donated to Florence Cathedral by Cardinal Pietro Corsini in 1422. This date provided the starting-point from which to relate the Master to other 15th-century Florentine painters. Sirén believed the painter to be a distant follower of Lorenzo Monaco and noted his apparent interest in the psychology of the figures as well as a marked sense for the decorative that set him apart from his contemporaries. The Master was accepted by art historians, but Sirén's attempts to identify the painter with Pietro di Domenico da Montepulciano or Parri Spinelli were not seriously pursued. The question was raised as to whether the Master's obvious indebtedness to the Late Gothic style could be explained solely by the influence of Lorenzo Monaco, or whether it might result from direct contact with the centres of Late Gothic painting, particularly Valencia.

Pudelko (1938) attempted to chart the Master's stylistic development. He pointed to the close thematic and stylistic similarities between the *Last Judgement* (Munich, Alte Pin.), attributed to the Master, and early 15th-century Valencian painting, such as the retable of the *Crucifixion and Stories of the True Cross* attributed to the Gil Master (*fl* 1408–47) and the retable of the *Crucifixion, Conversion of St Paul* and *Baptism* (both Valencia, Mus. B.A.) by Bonifacio Ferrer. Pudelko concluded that the *Last Judgement* was painted *c.* 1415 in Valencia. This would suggest that the Master was in Valencia before 1422, the date previously proposed for the *St Lawrence* altarpiece. While there, he was deeply influenced by the Late Gothic style before becoming the most important representative of this style in Florence, together with Lorenzo Monaco. Pudelko believed that the *St Lawrence* altarpiece reveals how the Master subsequently evolved a more grandiose style, under the influence of Gentile da Fabriano, that later declined into meaningless mannerisms, as in another triptych of the *Virgin and Child with Music-making Angels and Four Saints* (U. Würzburg, Wagner-Mus.). This development was generally accepted, although scholars could not agree on the Master's identity nor his exact connection with Spanish painting. Longhi ascribed to the Master several Valencian paintings that previously had constituted the oeuvre of the Gil Master (named after an altarpiece donated by Vicente Gil; fragments in New York, Met.; New York, Hisp. Soc. America) and suggested that they had been painted in Spain. Nevertheless, Longhi insisted on the Tuscan, or specifically Florentine, origins of the artist.

De Saralegui suggested that the Gil Master could be identified with the Valencian Miguel Alcanyis (*fl* 1408–47), and at this stage the problem of the identity of the Master of the Bambino Vispo appeared to be resolved. However, Alcanyis is documented in Barcelona, Valencia and Mallorca between 1415 and 1447, and Oertel saw no specific connection between the Master's work and Span-

ish painting and, like Sirén, regarded him as a pupil of Lorenzo Monaco.

Berti and Bellosi noticed the striking similarities between the work of the Master of the Bambino Vispo and that of Starnina, and this prompted van Waadenoijen and Syre to claim the Master and Starnina as the same person. The premise for this identification was new evidence that the *St Lawrence* altarpiece could be dated much earlier than had previously been supposed. It was proved that it was donated by Cardinal Angelo Acciauoli (1349–1408) to a chapel in the Certosa del Galluzzo, near Florence (not by Cardinal Corsini to the Cathedral in 1422). Consequently, the altarpiece was painted in 1404–7 and the oeuvre of the Master has to be dated considerably earlier than had previously been assumed. Van Waadenoijen and Syre attempted to integrate the works of the Master into the documented oeuvre of Starnina and to establish a chronology. This led to a complete reassessment of the Master's style. His indebtedness to Late Gothic style was no longer regarded as retardataire; instead it corresponded to the most advanced artistic currents of the early 15th century. Both scholars believe that not all the works attributed to the Master of the Bambino Vispo are by Starnina: some should be ascribed to his followers and members of his workshop, or even to other masters. The connection with Valencian painting could be explained by the fact that Starnina is documented in Valencia. In general, scholars have accepted van Waadenoijen's and Syre's theory. Boskovits, however, believed the Master to be Miguel Alcanyis, who, he suggested, worked with Starnina in Spain and subsequently followed his master to Florence.

BIBLIOGRAPHY

O. Sirén: 'Di alcuni pittori fiorentini che subirono l'influenza di Lorenzo Monaco: Il Maestro del Vispo Bambino', *L'Arte*, vii (1904), pp. 349–52
——: 'Florentiner Trecentozeichnungen', *Jb. Preuss. Kstsamml.*, xxvii (1906), pp. 208–23
——: 'A Late Gothic Poet of Line', *Burl. Mag.*, xxiv (1913–14), pp. 323–30; xxv (1914), pp. 15–24
G. Pudelko: 'The Maestro del Bambino Vispo', *A. America*, xxvi (1938), pp. 47–63
R. Longhi: 'Fatti di Masolino e di Masaccio', *Crit. A.*, v (1940), pp. 145–91 (183–5)
L. de Saralegui: 'Comentarios sobre algunos pintores y pinturas de Valencia', *Archv Esp. A.*, xxvi (1953), pp. 237–52
L. Berti: *Masaccio* (Milan, 1964), pp. 137–8, n. 152
R. Oertel: 'Der Laurentius-Altar aus dem Florentiner Dom: Zu einem Werk des Maestro del Bambino Vispo', *Studien zur toskanischen Kunst, Festschrift für L. H. Heydenreich* (Munich, 1964), pp. 205–20
L. Bellosi: 'La mostra di affreschi staccati al Forte Belvedere', *Paragone*, xvii/201 (1966), pp. 73–9
J. van Waadenoijen: 'Proposal for Starnina: Exit the Maestro del Bambino Vispo?', *Burl. Mag.*, cxvi (1974), pp. 82–91
M. Boskovits: 'Il Maestro del Bambino Vispo: Gherardo Starnina o Miguel Alcañiz?', *Paragone*, xxvi/307 (1975), pp. 3–15
C. Syre: *Studien zum 'Maestro del Bambino Vispo' und Starnina* (diss., U. Bonn, 1979)
J. van Waadenoijen: *Starnina e il gotico internazionale a Firenze* (Florence, 1983)

CORNELIA SYRE

Master of the Barbarigo Reliefs (*fl c.* 1486–*c.* 1515). Italian sculptor. He is named after the three bronze reliefs of the *Coronation of the Virgin* (see fig.), the *Assumption of the Virgin* and the *Twelve Apostles* (Venice, Ca' d'Oro) that formerly decorated the altar donated by the BARBARIGO family for a double tomb in the church of S Maria della Carità in Venice (now the Galleria dell'Accademia). Other fragments surviving from the tombs (dismantled 1808) include a marble kneeling effigy of *Doge Agostino Barbarigo* (Venice, ante-sacristy of S Maria della Salute) and a limestone relief of the *Resurrection* (Venice, Scu. Grande S Giovanni Evangelista). The Barbarigo tomb is recorded in an engraving of 1692 (Venice, Correr, Raccolta Ghesso, iii, no. 435), which shows that the reliefs decorated the altar of the central barrel-vaulted bay, flanked on either side by the kneeling figures of *Marco Barbarigo* and *Agostino Barbarigo*. In each adjacent bay was a reclining effigy on a bier supported by a console. Documentary evidence suggests that work on the tombs began *c.* 1486, the date of Doge Marco Barbarigo's death, and that the reliefs were completed by 1515.

The attribution of these bronze reliefs has caused much scholarly discussion. Leo Planiscig (1921) coined the anonymous sculptor's present title, suggesting that he may be identified with Tullio Lombardo. Other suggestions have included Alessandro Leopardi (Paoletti, 1893), Antonio Lombardo (Bode, 1907) and Paolo di Matteo Savin (Pope-Hennessy, 1963). The present consensus is that the reliefs are probably the work of a sculptor working within the circle of Antonio Lombardo and Tullio Lombardo. The classicizing modelling of the figures and draperies and

Master of the Barbarigo Reliefs: *Coronation of the Virgin*, bronze relief, *c.* 1515 (Venice, Ca' d'Oro)

the distinctive punching of the grounds of these reliefs have been recognized in a number of other anonymous works, including a bronze half-length relief of *Christ Blessing*, a relief of *Cupid* (both Berlin, Skulpgal.), a bronze statuette of *Charity* (Vienna, Ksthist. Mus.) and a *St Jerome* (Brescia, Mus. Civ. Crist.), all of which bear similarities of facture and modelling.

BIBLIOGRAPHY

P. Paoletti: *L'archittetura e la scultura del rinascimento in Venezia* (Venice, 1893), pp. 184–5

W. Bode: *The Italian Bronze Statuettes of the Renaissance* (English edn 1907, rev. New York, 1980)

L. Planiscig: *Venezianische Bildhauer der Renaissance* (Vienna, 1921), pp. 209–15

E. F. Bange: *Staatliche Museen zu Berlin: Die italianischen Bronzen der Renaissance und des Barock*, ii (Berlin and Leipzig, 1922), pp. 4–5; cat. nos 23–5

G. Fogolari, U. Nebbia and V. Moschini: *La R. Galleria Giorgio Franchetti alla Ca' d'Oro* (Venice, 1929), p. 148

Italian Bronze Statuettes (exh. cat., ed. J. Pope-Hennessy; London, V&A, and elsewhere, 1961), cat. nos 91–2

J. Pope-Hennessy: 'An Exhibition of Italian Bronze Statuettes—I', *Burl. Mag.*, cv (1963), pp. 14–23

A. Markham Schulz: 'Pietro Lombardo's Barbarigo Tomb in the Venetian Church of S Maria della Carità', *Art the Ape of Nature: Studies in Honour of H. W. Janson*, ed. M. Barasch and L. Freeman Sandler (New York, 1981), pp. 171–92

ANTONIA BOSTRÖM

Master of the Barberini Panels (*fl c.* 1445–75). Italian painter. The two eponymous works (New York, Met.; Boston, MA, Mus. F.A.) were painted in Urbino, whence they were removed to Rome by Cardinal Antonio Barberini (1607–71) in 1631. The pictures, which have been the subject of much debate and speculation, are exceptional both for their ambitious architectural settings and their genre-like treatment of narrative. It is now generally conceded that they represent, in a highly unorthodox fashion, the *Birth of the Virgin* and the *Presentation of the Virgin*; that the elaborate architecture, with its wealth of Classical allusion, reflects the influence of Alberti; and that their author was either trained or deeply influenced by Fra Filippo Lippi in Florence *c.* 1445–50 and then fell under the spell of Piero della Francesca, aspects of whose palette and figure types he imitated in a superficial fashion. Other works attributed to the artist include, in their presumed order of execution, an *Annunciation* (Washington, DC, N.G.A.), a second *Annunciation* (Munich, Alte Pin.), a *Crucifixion* (Venice, Fond. Cini), three related panels with saints (Milan, Brera and Pin. Ambrosiana; Loreto, Santa Casa) and a painted alcove (Urbino, Pal. Ducale). The *Annunciation* in Munich bears the arms of the French banker Jacques Coeur (*c.* 1400–56) and was probably painted in Florence during the financier's trip to Italy in 1448. The alcove has, on the basis of its armorial devices, been dated after 1474, but this is by no means certain. It does, however, establish that the artist was employed by Federigo II, Duke of Urbino. The Barberini panels have been presumed to have decorated the Palazzo Ducale; this is unlikely since the panels are not mentioned in any inventory or description of the palace. They have also been supposed, almost certainly incorrectly, to have formed part of a larger series dealing with the Life of the Virgin, but the *Presentation of the Virgin* panel includes subsidiary representations of the Annunciation and the

Visitation, thereby eliminating these two crucial scenes from any hypothetical series.

Alternatively, it has been suggested that one or both of the Barberini panels formed part of an altarpiece of the *Birth of the Virgin* commissioned in 1467 from FRA CARNEVALE for the church of S Maria della Bella in Urbino. Vasari mentioned the altarpiece in his life of Bramante, and it was later confiscated by Cardinal Antonio Barberini. Surprisingly, the identification has been dismissed, despite the fact that both panels are attributed to Fra Carnevale in a 1644 inventory of Barberini's possessions. Even more surprisingly, Zeri's identification of the Master of the Barberini Panels with Giovanni Angelo di Antonio da Camerino (*fl* 1451–61) has been widely accepted, despite the fact that Giovanni's activity as a painter is completely undocumented. Identifications of the anonymous master with Bramante and with Alberti have been rightly dismissed.

BIBLIOGRAPHY

R. Offner: 'The Barberini Panels and their Painter', *Mediaeval Studies in Memory of A. Kingsley Porter* (Cambridge, MA, 1939), pp. 205–53

F. Zeri: *Due dipinti, la filologia e un nome: Il Maestro delle Tavole Barberini* (Turin, 1961)

K. Christiansen: 'For Fra Carnevale', *Apollo*, cix (1979), pp. 198–201

Urbino e le Marche prima e dopo Raffaello (exh. cat., ed. M. G. Ciardi Duprè dal Poggetto and P. dal Poggetto; Urbino, Pal. Ducale, 1983), pp. 43–55

KEITH CHRISTIANSEN

Master of the Beheading of St John the Baptist (*fl* ?Milan, *c.* 1500–*c.* 1525). Italian engraver. Galichon first assembled the small oeuvre of this Master by attributing five engravings, previously ascribed to several different printmakers, to the author of the *Beheading of St John the Baptist*. Four of these engravings form a clearly unified group and are certainly the work of one hand.

Little of substance is known about the Master, although his connections with Milanese art are evident, making it reasonable to assume that he was active in Milan. The most ambitious of his engravings, *Allegorical Theme: Combat of Animals*, is related to a pen drawing of *Animals Fighting and a Man with a Burning Glass* (Paris, Louvre) by Leonardo da Vinci, which is assignable to the first of Leonardo's two Milanese periods (*c.* 1483–99), probably to the early 1490s. The portions of the engraving that are not based directly on the Louvre drawing are related to other works by Leonardo. Scholars have also noted that the figure and drapery style of the *Beheading of St John the Baptist* are comparable to works by Marco d'Oggiono, one of Leonardo's Milanese followers, although the other engravings by the Master are not as close to d'Oggiono's style.

The Master's manner of engraving reflects the stippling technique developed by Giulio Campagnola to achieve a soft, tonal quality in his prints, evident in his *Doe Resting* and *Stag Browsing*. It has been proposed that the Master was also influenced by Andrea Mantegna and that he was responsible for two engravings of the *Man of Sorrows* and *Hercules and the Hydra* now assigned to Mantegna's school, although these attributions have been disputed.

BIBLIOGRAPHY

E. Galichon: 'De quelques estampes milanaises', *Gaz. B.-A.*, xviii (1865), pp. 546–52

A. M. Hind: *Early Italian Engraving: A Critical Catalogue* (London, 1938–48), v, pp. 97–9

J. A. Levenson, K. Oberhuber and J. L. Sheehan: *Early Italian Engravings from the National Gallery of Art* (Washington, DC, 1973), pp. 437–8

M. J. Zucker: *The Early Italian Masters, Commentary (1984)*, 25 [XIII/ii] of *The Illustrated Bartsch*, ed. W. Strauss (New York, 1978–), pp. 108–10, 123–4

JAY A. LEVENSON

Master of the Berlin St Jerome. *See under* GASPARO PADOVANO.

Master of the Birago Hours (*fl c.* 1465). Italian illuminator. He was recognized by Alexander and De La Mare as the illuminator of a Book of Hours formerly in the Abbey Collection (MS. J.A. 6960) that bears the coat of arms of the Birago family. He illuminated all the pages of the manuscript except for folio 125*r*, which is attributed to Belbello da Pavia. The Master's hand is also clearly recognizable in some pages of another Book of Hours (Paris, Bib. N., MS. fond. Smith-Lesouëf 22) and in a manuscript containing a treatise by the jurist Girolamo Mangiaria, *Opusculum de impedimentis matrimonii ratione consanguinitatis et affinitatis* (Paris, Bib. N., MS. Lat. 4586), which was read at Pavia University in 1465. The frontispiece (fol. 1*r*) depicts Galeazzo Maria Sforza, Duke of Milan, to whom the manuscript is dedicated, receiving the book from the author. In both the Birago and the Smith-Lesouëf Hours the Master collaborated with BELBELLO DA PAVIA, and he may have been trained in Belbello's workshop. This would explain the accentuated expressiveness of some of his figures, the strong and brilliant colouring and, above all, the use of certain decorative motifs, such as branches of leaves and flowers against a gold background, which is typical of Belbello and his workshop.

BIBLIOGRAPHY

G. Swarzenski and R. Schilling: *Die illuminierten Handschriften und Einzelminiaturen des Mittelalters und der Renaissance in Frankfurter Besitz* (Frankfurt am Main, 1929), pp. 247–8

J. J. G. Alexander and A. C. De La Mare: *The Italian Manuscripts in the Library of Major J. R. Abbey* (London, 1969), pp. 147–50

F. Avril: *Dix siècles d'enluminure italienne* (Paris, 1984), p. 156

E. Kirsch: *Five Illuminated Manuscripts of Gian Galeazzo Visconti* (Philadephia, PA, 1991), p. 100

MILVIA BOLLATI

Master of the Carrand Triptych. *See* GIOVANNI DI FRANCESCO (i).

Master of the Castello Nativity (*fl* Florence, *c.* 1445–*c.* 1470/75). Italian painter. He was named by Berenson (1913) after the *Nativity* (Florence, Accad.) that came from the Medici villa at Castello. There are no datable works by the Master, but the earliest attributable works indicate stylistically that he was probably a pupil of Fra Filippo Lippi and trained in his studio in Florence in the 1440s, before Lippi's move to Prato. Although there is no definitive documentary evidence, Lachi (1995) has recently identified the Master as Piero di Lorenzo di Pratese (*d* 1487), who collaborated with Filippo Lippi and then became a partner of Pesellino.

The altarpiece of the *Virgin and Child Enthroned with SS Justus and Clement* (Prato, Mus. Opera Duomo) would appear to be an early work by the master, datable to the mid-15th century (Procacci). In its composition, drapery style and architectural setting it is heavily dependent on Lippi's work of the 1440s; the figure of St Clement is derived from Lippi's *Annunciation* (*c.* 1445; Munich, Alte Pin.). Two scenes from the *Lives of SS Justus and Clement* (Philadelphia, PA, Mus. A.) and a *Nativity* (London, N.G.) originally formed the predella of the altarpiece. The iconography of the *Nativity* is based on the *Revelations* of St Bridget, popular in Florence at this date, and shows the Virgin's hands covered by a veil, a detail present in many of the Master's devotional works.

The Master apparently collaborated with Lippi on the predella panel of the *Nativity* (Washington, DC, N.G.A.), which is usually considered to belong to the Munich *Annunciation*: the figure of St Joseph and the typology of the Christ Child, both characteristic of the Master, are almost identical with their counterparts in the London *Nativity*. Also stylistically close to the Prato Altarpiece is the *Virgin of Humility with Two Musician Angels* (Pisa, Mus. N. & Civ. S Matteo).

The Castello *Nativity* cannot, in fact, have been executed for the Medici villa at Castello since it appears in inventories only after 1610 (Shearman). In 1638, however, the coats of arms on the base of the altarpiece (now illegible) were recorded as being those of the Medici and the Tornabuoni families. It is presumed that it was made for Piero de' Medici and his wife Lucrezia Tornabuoni. Certainly, the sumptuous decoration of the Virgin's robe accords with Piero's taste for ornate works of art, while the intense devotional aspect of the work—emphasized by the presence of the young Baptist and God the Father in a glory of seraphim—is consistent with Lucrezia's fervent piety. The painting probably dates from *c.* 1460, contemporary with the work of Domenico Veneziano and with Lippi's and Gozzoli's decoration in the chapel of the Palazzo Medici, Florence. All these artists were favoured by Piero.

The corpus of paintings attributed to the Master is frequently repetitive in subject-matter and composition, yet the works are carefully executed and probably catered for the demands of patrons who were, for the most part, educated as well as rich. This would seem to be confirmed by the existence of several portraits by the Master of apparently noble Florentine women, such as the *Portrait of a Woman* (New York, Met., 49.7.6), strongly influenced by Lippi, and another elegant and decorative female portrait (Boston, MA, Isabella Stewart Gardner Mus.). These portraits seem to date from the end of the Master's career.

BIBLIOGRAPHY

C. Gamba: 'Due opere d'arte nella R. villa di Castello', *Ant. Viva.*, iii (1903), pp. 81–2

B. Berenson: *Catalogue of Italian Paintings in the John G. Johnson Collection, Philadelphia*, i (Philadelphia, 1913), p. 17

——: *Italian Pictures of the Renaissance* (Oxford, 1932), p. 343

U. Procacci: 'Opere sconosciute d'arte toscana', *Riv. A.*, xvii (1935), pp. 405–11

M. Salmi: 'Aggiunte al tre e al quattrocento fiorentino', *Riv. A.*, xvii (1935), pp. 411–21

——: 'Il Maestro della Natività di Castello', *Liburni Civitas*, ii (1938), pp. 217–56

B. Berenson: *Florentine School* (1963), i, pp. 141–2

M. Meiss: 'A Lunette by Master of Castello Nativity', *Gaz. B.-A.*, lxx (1967), pp. 213–18

F. Zeri and E. Gardner: *The Metropolitan Museum of Art: Italian Paintings, Florentine School* (New York, 1971), p. 114
Arte nell'aretino (exh. cat. by L. Boccia and others, Arezzo, S Francesco, 1974), pp. 91–2
E. Carli: *Il Museo di Pisa* (Pisa, 1974), pp. 97–8
G. Marchini: *Filippo Lippi* (Milan, 1975), pp. 119, 234–5
J. Shearman: 'The Collection of the Younger Branch of the Medici', *Burl. Mag.*, cxvii (1975), pp. 12–27 (16, 20)
F. Zeri: *Italian Paintings in the Walters Art Gallery*, i (Baltimore, 1976), pp. 74–6
Early Italian Painting (exh. cat., London, Matthiesen F.A., 1983), pp. 57–8
C. Lachi: *Il Maestro della Natività di Castello* (Florence, 1995)

ANNA PADOA RIZZO

Master of the Chiostro degli Aranci. *See* GIOVANNI DI CONSALVO.

Master of the Codex Coburgensis (*fl* 1550–55). Italian draughtsman. He executed a collection of 282 drawings of antiquities, with a preponderance of reliefs, which was acquired on the Roman art market in 1870 and 1872 by the Frankfurt dealer Jacob Gerson (1821–1903), Consul General for Saxony, and presented by him to Duke Ernst II of Saxe-Coburg and Gotha (*reg* 1844–93) as a gift. It has since been known as the Codex Coburgensis, although it is a portfolio, and is today housed in the Kupferstichkabinett der Kunstsammlungen der Veste Coburg, Coburg (inv. no. Hz 2). Little is known of its history before its acquisition by Gerson; however, watermarks on the paper of the drawings and the locations where the antiquities depicted were earlier preserved both indicate a mid-16th-century origin in Rome and its neighbourhood. It is likely that the collection of drawings was commissioned by Cardinal Marcello Cervini (1501–55), who reigned as Pope Marcellus II for a few days in 1555. He was a great scholar, with an interest in the study of antiquity, who is known to have commissioned editions of antique inscriptions and illustrated works on antique sculpture in connection with the foundation of a Vitruvian academy. The dates of discovery of some of the antiquities depicted in the Codex Coburgensis suggest that the work was undertaken towards the end of his life.

Although the sequence of the drawings was wholly disarranged before Gerson's acquisition of the collection, traces of earlier display and ensuing neglect (before 1806) allow certain conclusions about the original arrangement of the contents. These are confirmed by the Codex Pighianus in the Staatsbibliothek Preussischer Kulturbesitz in Berlin (MS. Lat. 2° 61), which contains a partial, later expanded copy of the Codex Coburgensis, with 172 of its drawings and also 50 sheets bearing copies of originals lost from the Codex Coburgensis. Further evidence suggests that the Coburg collection formerly consisted of considerably more than 300 sheets. It was originally arranged in chapters on genealogies of gods, astronomy and calendrical lore, heroic mythology, death and sacrificial ritual, insignia of office and circus shows. Thus the Codex Coburgensis may be called the first, systematically presented work of archaeological illustration, long predating Johann Joachim Winckelmann.

There has hitherto been no actual certainty concerning the identity of the artist, or several artists, who executed the drawings of the Codex Coburgensis. Examination of the state of preservation of the drawings, very variable in parts, has led to the conclusion that with five exceptions they are all by the same hand. No further drawings by the artist of the Codex Coburgensis have been found elsewhere, other than four contained in the Codex Pighianus, probably placed there in error during the process of copying; hence the name of Master of the Codex Coburgensis must suffice as the artist's designation.

This master is distinguished from all other Renaissance artists who drew antiquities by his understanding of archaeology and stylistic closeness to his models; he is pre-eminent above all in the faithfulness with which he records the state of preservation of his originals and in his rendering of exact detail. His regular procedure was first to depict an object precisely in black chalk and then to execute the drawing with a pen in brown ink, adding grey wash with a brush. The light always falls from above left to below right, proof that the drawings were executed in a workshop, with a theoretical and didactic purpose in mind. Free relief background to the objects depicted is provided by vertical wash strokes. He evolved a special method of presenting extended depictions involving unfolding or unrolling paper. Among his stylistic characteristics are blank eyes, certain details of toe- and fingernails, and the avoidance of crosshatching in pen and arbitrary stippling. Clearly ordered compositions of a classical appearance, with a minimum of receding planes, were most to the liking of this artist; he mastered restless, more complex subjects with somewhat greater difficulty. He had an especial preference for Hellenic reliefs, whose religious content must have held interest for his client. Whether the inscriptions on the monuments depicted are by this artist or whether he engaged a lettering specialist for the task remains to be established.

BIBLIOGRAPHY
F. Matz: 'Über eine dem Herzog von Coburg-Gotha gehörige Sammlung alter Handzeichnungen nach Antiken', *Mber. Kön. Preuss. Akad. Wiss. Berlin* (Sept–Oct 1871)
Der Codex Coburgensis: Das erste systematische Archäologiebuch (exh. cat., ed. H. Wrede and R. Haprath; Coburg, Veste Coburg, 1986)

RICHARD HARPRATH

Master of the Crocifisso dei Bianchi (*fl* 1500–20). Italian painter. The name is given to the painter of the *Mystic Marriage of St Catherine with SS Anthony Abbot and James* (Lucca, Curia Arcivescovile), originally in the church of the Crocifisso dei Bianchi, Lucca, and formerly attributed to the Master of the Lathrop Tondo. However, this painting and others stylistically close to it, such as the *Virgin and Child with SS Stephen and Jerome* (Berlin, Gemäldegal.) and the fresco of *Famous Men and Women* (Lucca, Cathedral Library), are not of the quality of the Master of the Lathrop Tondo (Ferretti) and would seem to be the work of a painter active *c.* 1510 and influenced by the Master and by Amico Aspertini, who was working in Lucca at that date. Baracchini and others have proposed that the Master of the Crocifisso dei Bianchi can be identified as the painter Ranieri di Leonardo da Pisa, documented in Lucca from 1502 to 1521, who painted with Vincenzo Frediani a *Virgin and Child* in S Gennaro di Capannori, near Lucca (see Tazartes). He was a minor painter, active in Frediani's workshop. The *Virgin and*

Child with SS Roch and Frediano (Torre, S Frediano) and the *Virgin and Child with SS John the Baptist, Colombano, Catherine and Sebastian* (S Colombano, parish church) can be attributed to him on stylistic grounds.

BIBLIOGRAPHY

M. Ferretti: 'Percorso lucchese', *An. Scu. Norm. Sup. Pisa*, n.s. 2, v/3 (1975), pp. 1059–60

M. Tazartes: 'Anagrafe lucchese', i, *Ric. Stor. A.*, xxvi (1985), pp. 10–11

C. Baracchini and others: 'Pittori a Lucca tra '400 e '500', *An. Scu. Norm. Sup., Pisa*, n.s. 2, xvi (1986), pp. 769–72, 813–14

G. Concioni, C. Ferri and G. Ghilarducci: *I pittori rinascimentali a Lucca* (Lucca, 1988), pp. 185–95

MAURIZIA TAZARTES

Master of the David and St John Statuettes (*fl* Florence, late 15th century or early 16th). Italian sculptor. Conventional name for the sculptor of two stylistically coherent groups of statuettes produced in terracotta and in some numbers, under the influence of Verrocchio. The group of statuettes of *David* are characterized by elaborately decorated, pseudo-Roman armour reminiscent of that shown on Ghiberti's *Gates of Paradise* (see colour pl. 1, XXXI2) and are derived from Verrocchio's bronze statue of *David* (*c.* 1475; Florence, Bargello; *see* VERROCCHIO, ANDREA DEL, fig. 3). They have the left elbow bent, the right arm hanging down with a sword in its hand, and Goliath's head between the feet. The other group, which is stylistically related and appears with minor variations and in some numbers, comprises statuettes of the *Young St John the Baptist*, who is shown seated on some rocks in the desert. Classic examples of both compositions are in the Victoria and Albert Museum, London; a nude *St Sebastian* in the same collection also appears to originate from the same workshop, together with a superior version located in the Kunstgewerbemuseum, Leipzig. All the statuettes are highly detailed and partially hollowed out for firing, while some bear traces of polychromy; these features indicate that they were not *bozzetti* but finished statuettes, produced commercially for domestic altars or as interior decoration, for example to be displayed on mantelpieces.

'The authorship of the statuettes presents a problem of great difficulty', wrote John Pope-Hennessy (1964, p. 193). He ruled out earlier attributions based on comparisons between the terracottas of St Sebastian and major statues of the same saint by Baccio da Montelupo and Leonardo del Tasso (1466–?1500), arguing that the supposed similarities were 'generic, and not substantiated by other authenticated works' by either sculptor. A connection with the style of the young Jacopo Sansovino has also been suggested. However, there is no record of his having been involved in such productions, although he was a gifted and prolific modeller. Connections with Andrea della Robbia and Giovanni della Robbia, whose workshop was then producing glazed terracotta sculpture in a not dissimilar style, should also be considered.

There may also be links with other series of Florentine terracotta statuettes that are currently grouped by subject, for example those ascribed to the Master of the Unruly Children, including groups of warriors struggling with horsemen in the style of Leonardo da Vinci and a series of recumbent river gods inspired by Michelangelo. The latter sculptures suggest a late date for the work of the Master of the David and St John Statuettes, in the 1520s at the earliest. It has also been argued that Pietro Torrigiani may have been responsible for works attributed to the Master of the David and St John Statuettes or to the Master of the Unruly Children. However, as with Jacopo Sansavino, while there are general affinities of style, there is no evidence that Torrigiani was involved in such commercial replication of statuettes for the retail market. A possible candidate for the authorship of at least some of the loosely defined group associated with the present anonymous master is the recently discovered, secondary (but evidently competent and well-connected) Florentine sculptor Sandro di Lorenzo di Sinibaldo (*fl* 1523), for whom *see also* the MASTER OF THE UNRULY CHILDREN below.

BIBLIOGRAPHY

J. Pope-Hennessy: *Catalogue of Italian Sculpture in the Victoria and Albert Museum* (London 1964), nos 169–72

La civiltà del cotto (exh. cat., ed. A. Paolucci; Impruneta, 1980), pp. 85–6, 96–8, cat. nos 2.7, 2.8

B. Boucher: *The Sculpture of Jacopo Sansovino* (New Haven and London, 1991), p. 313, cat. nos 1, 2

A. P. Darr: 'Verrocchio's Legacy: Observations Regarding his Influence on Pietro Torrigiani and other Florentine Sculptors', *Verrocchio and Late Quattrocento Italian Sculpture*, ed. S. Bule, A. P. Darr and F. S. Gioffredi (Florence, 1992), pp. 125–39

CHARLES AVERY

Dido Master. *See* APOLLONIO DI GIOVANNI.

Master of the Die (*fl c.* 1530–*c.* 1560). Engraver and print designer, active in Italy. Name given to an artist in the workshop of Marcantonio Raimondi in Rome who signed his prints with a small die, or the letters BV. Suggested identifications include Benedetto Verino, Daddi or Dado, Marcantonio's natural son, or, more recently, TOMMASO VINCIDOR, one of Raphael's assistants. The Master collaborated with many of the artists in Marcantonio's studio working on Raphaelesque designs and made scores of prints, mainly reproducing Raphael's decorations for the Vatican (e.g. *Coronation of the Virgin*, B. 29). The Master also produced sheets of grotesque decorative panels in imitation of the antique prototypes reinvented by Raphael (e.g. B. 80–85); these served as patterns for north European decoration. He is best known for a suite of four designs, *Playing Putti* (1532; B. 32–5). These prints were made after tapestry designs by Giovanni da Udine and cartoons by Vincidor (Munich, Staatl. Graph. Samml.), finished in 1521, which expressed the dream of a Golden Age under the pontificate of Leo X. Each shows three winged putti engaged in symbolic play on heavy swags of verdure. The cartoons were sent with Vincidor to Brussels to be woven, and the finished tapestries hung in the Sala di Constantino in the Vatican. The new genre was popular: 20 similar compositions by other artists are known in drawings or engravings. In the 1530s the Master's engravings were themselves used as cartoons for tapestry sets after Raphael's *Life of the Virgin*, ordered by such patrons as the Prince–Bishop of Liège, Cardinal Evrard de la Marck (1472–1538). The Master's works therefore reveal the extraordinary productivity of the Marcantonio workshop at this date and the high standard of craftsmanship used to disseminate Raphael's oeuvre.

BIBLIOGRAPHY
S. Boorsch: *Italian Masters of the Sixteenth Century*, 29 [XV/ii] of *The Illustrated Bartsch*, ed. W. Strauss (New York, 1982), pp. 159–241 [B.]
L. Zentai: 'On Baldassare Peruzzi's Compositions Engraved by the Master of the Die', *Acta Hist. A. Acad. Sci. Hung.*, xxix/1–4 (1983), pp. 51–104
Raphael invenit (exh. cat. by G. B. Pezzini, S. Massari and S. P. V. Rodino, Rome, Ist. N. Graf., 1985), pp. 137–8, 584–6, 805, 820–25
P. Foglia: 'Aggiunte ai cataloghi', *Grafica A.*, xxv (1996), p. 43
A Griffiths: 'False Margins and Fake Collectors Stamps Mixed Together with Prints with Genuine Collectors' Stamps in Two Sets of Engravings by the Master of the Die', *Prt Q.*, xiii (1996), pp. 184–6
LOUISE S. MILNE

Master of the E-Series Tarocchi (*fl* Ferrara, *c.* 1465). Italian engraver. Levenson gave the name to the author of a series of 50 engravings that constitutes one of the finest achievements of Italian printmaking in the 15th century. The series is subdivided into five sets of ten engravings; each image is titled and numbered within its set, and a letter indicates to which set it belongs. The sets consist of the *Conditions of Man* (E), *Apollo and the Muses* (D), the *Liberal Arts* (C), the *Cosmic Principles* (B) and the *Firmaments of the Universe* (A). A second version of the series exists in which the 'E' of the first group is replaced with the letter 'S'. It has been generally accepted that the E-series is the original set and that the S-series is derived from it. Two figures from the E-series were copied in a manuscript of 1467 (Bologna, Archv Stato, *Costituzione dello studio bolognese*), which provides a *terminus ante quem* for the dating of the series.

Both the E-series and the S-series were traditionally referred to as 'Mantegna's Tarocchi', but the engravings cannot have been intended to serve as *tarocchi* (tarot cards), since they do not correspond to the game either in number or in iconography; it is debatable if they formed a game at all, since some examples are bound together in a kind of pictorial encyclopedia (e.g. Paris, Bib. N.). The original designs for the cards can be attributed neither to Mantegna nor to one of his pupils but to an artist active in Ferrara, almost certainly identifiable as the Master of the E-Series Tarocchi who engraved the series. The Master is also responsible for two other engravings, the *Death of Orpheus* and *Cupids at the Vintage*, the latter of which is copied in a manuscript of 1466 (Vienna, Österreich. Nbib., Ser. nov. 4643, frontispiece).

The Master was extremely skilled technically, and his refined style is well suited to the erudite humanist subjects he illustrated. His work has more in common with manuscript illumination than with monumental painting. The plasticity of the figures is emphasized by the use of clear outlines and delicate shading, as can be seen in the *Emperor* of the E-Series Tarocchi. The iconographic programme of this series is particularly complete, and the series has been used as a source of iconographic borrowings. Copies of some of the figures appear in two versions of the poem *De imaginibus gentilium deorum* by the humanist Ludovico Lazzarelli (Rome, Bib. Vaticana, Cod. Urb. Lat. 716, 717), one of which can be dated 1471, and also in the early drawings of Albrecht Dürer (1471–1528).

BIBLIOGRAPHY
P. Kristeller: *Die Tarocchi* (Berlin, 1910)
H. Brockhaus: 'Ein edles Geduldspiel: "Die Leitung der Welt oder die Himmelsleiter", die sogennanten Taroks Mantegnas vom Jahre 1459–

60', *Miscellanea di storia dell'arte in onore di Igino Benvenuto Supino* (Florence, 1933), pp. 397–410
K. Clark: Letter, *Burl. Mag.*, lxii (1933), p. 143
A. M. Hind: *Early Italian Engraving: A Critical Catalogue* (London, 1938–48), i, pp. 221–40
K. Rathe: 'Sulla classificazione cronologica di alcuni incunabuli calcografici italiani', *Maso Finiguerra*, v (1940), pp. 3–13 (7–10)
E. Panofsky: *The Life and Art of Albrecht Dürer* (Princeton, 1943, rev. 2/1948), i, p. 31; ii, pp. 102–3
L. Donati: 'Le fonti iconografiche di alcuni manoscritti urbinati della Biblioteca Vaticana: Osservazioni intorno ai cosiddetti "Tarocchi del Mantegna"', *La Bibliofila*, lx (1958), pp. 48–129
E. Ruhmer: *Francesco del Cossa* (Munich, 1959), pp. 66–8
J. Levenson, K. Oberhuber and J. Sheehan: *Early Italian Engravings from the National Gallery of Art* (Washington, DC, 1973), pp. 81–157
MARCO COLLARETA

Master of the Franciscan Breviary (*fl c.* 1440–60). Italian illuminator. He is named after a two-volume Breviary of Franciscan Use (Bologna, Bib. U., MS. 337), which was probably written *c.* 1446. His work is also found in several other manuscripts, including a splendid Gradual entirely illuminated in his style (Ithaca, NY, Cornell U., Lib., MS. B 50++), a Breviary (Parma, Bib. Palatina, MS. 6) and a Psalter (Rome, Vatican, Bib. Apostolica, MS. Barb. lat. 585), and in many cuttings from choir-books (e.g. Berlin, Kupferstichkab., nos 1234 and 6694; Venice, Fond. Cini, nos 2172 and 2207; Paris, Mus. Marmottan, no. 27). The Vatican Psalter was commissioned by Cardinal Ioannes Bessarion, papal legate for Bologna 1450–55, and is probably part of the great series of choir-books that he commissioned during his residence in Emilia. This series of at least 20 large-format volumes was the work of several artists and was presented to the convent of S Maria Annunziata in Cesena after its foundation in 1458. The Master of the Franciscan Breviary's contribution to this series has been identified in two surviving Antiphonals (Cesena, Bib. Malatestiana, Corale 3; and sold Amsterdam, Mensing–Muller, 5 April 1935, lot 19) and in folios cut from dismembered books (Venice, Fond. Cini, nos 2096–7).

Features of the Master's highly decorative style, such as the smoothly modelled round faces and the flowing contours of figures and drapery, place him among the followers of the Lombard painter Michelino da Besozzo. His identification as Ambrogio da Cermenate or as Jacopino Cietario cannot be sustained. He apparently had access to the designs of Giovannino de Grassi and Belbello da Pavia as he repeated many of their motifs, especially extravagantly structured architectural initials. Notable is his unusual and subtle manipulation of monochrome: black with gold, light brown with white or light blue, pinks and greens. When he used a full palette the results were spectacular, particularly the brilliant, glowing colours of his fluid draperies highlighted with touches of gold. His style is characteristic of the colourful and charming illumination produced in and around Milan throughout the first 60 years of the 15th century.

BIBLIOGRAPHY
Arte lombarda dai Visconti agli Sforza (exh. cat., Milan, Pal. Reale, 1958), pp. 79–80
R. Calkins: 'The Master of the Franciscan Breviary', *A. Lombarda*, 16 (1971), pp. 17–36
G. Mariani Canova: *Miniature dell'Italia settentrionale nella Fondazione Giorgio Cini* (Venice, 1978), pp. 39–44
ROBERT G. CALKINS

Master of the Gardner Annunciation (*fl c.* 1450–1500). Italian painter. In 1927 Longhi assigned this name to an unknown 15th-century Central Italian artist who executed a small group of panel paintings and frescoes, Umbrian in character. The most noteworthy among the group is the *Annunciation* (Boston, MA, Isabella Stewart Gardner Mus.), from which the artist's provisional name is derived. Early paintings attributed to the Master, which include the *Virgin and Child with Two Seraphim* (Baltimore, MD, Walters A.G.) and the *Virgin and Child with a Pomegranate* (1481; Berlin, Gemäldegal), show the influence of Pietro Perugino and Fiorenzo di Lorenzo, while the later works are infused with Roman influences.

Although scholars agree on the oeuvre proposed by Longhi, the identity of the artist has remained controversial. The Boston *Annunciation*, for example, bought by Isabella Stewart Gardner in 1900 through Bernard Berenson as a work by Fiorenzo di Lorenzo, was later catalogued at the Gardner Museum as a work by Antoniazzo Romano. In 1953 Zeri rejected this attribution and instead proposed Piermatteo (Lauro de' Manfredi) d' Amelia (*c.* 1450–1503/8). Subsequent documentary and circumstantial evidence supports Zeri's argument. Archival records found in 1978 show that the Gardner *Annunciation* was originally made for the main altar of the Franciscan church in Amelia, Piermatteo's native city, not for S Maria degli Angeli in the Porziuncola, a district near Assisi, where Berenson acquired it in the late 19th century. Another document, discovered in 1986, identifies the *Virgin and Child Enthroned with Saints* (1485; Terni, Mus. & Pin. Civ.), a major altarpiece traditionally attributed to the Master of the Gardner Annunciation, as a work by Piermatteo d'Amelia.

Piermatteo d'Amelia was a pupil and collaborator of Filippo Lippi at Spoleto between 1467 and 1469. Other influences on his style are reflected by the attributions of the Gardner *Annunciation*: Fiorenzo di Lorenzo during Piermatteo's early period and Antoniazzo Romano during the mid-1480s. He is documented in Rome in 1480, working on the decoration of the Sistine Chapel, and in Civita Castellana in 1502–3. Zeri also observed his style in the fresco depicting the *Mass of St Gregory* at Orvieto Cathedral, where Piermatteo is recorded working in 1480–81. Although Piermatteo's activities are well documented, it was not until the last decades of the 20th century that any of his paintings were successfully identified.

BIBLIOGRAPHY

R. Longhi: 'In favore di Antoniazzo Romano', *Vita artistica*, ii (1927), pp. 226–33 (228)

F. Zeri: 'Il Maestro dell'Annunciazione Gardner', *Boll. A.*, 2nd ser., xxxviii (1953), pp. 125–39, 233–49

B. Berenson: *Central and North Italian Schools* (1968), i, pp. 251–2; iii, pls 1070–72

L. Canonici: 'L'Annunciazione Gardner alla Porziuncola', *Archv Franciscanum Hist.*, lxxi (1978), pp. 459–62

F. Zeri: 'Postilla al Maestro dell'Annunciazione Gardner', *Paragone*, xxxvi/429 (1985), pp. 3–6

A. Ricci: 'Pier Matteo d'Amelia e la pala dei Francescani: Un documento notarile per identicare l'autore dell'opera', *Arte sacra in Umbria e dipinti restaurati nei secoli XIII–XX* (Perugia, 1986), pp. 47–9

GENETTA GARDNER

Master of the Griggs Crucifixion. *See* TOSCANI, GIOVANNI.

Griselda Master (*fl c.* 1490). Italian painter. He was named after a set of three *spalliera* panels (London, N.G.) devoted to Boccaccio's *Story of Patient Griselda* (*Decameron*, X.10). They had been assigned to Pinturicchio, and the Master's style is rightly linked to Umbria, although he was active chiefly in Siena. The tall, spindly figures on the panels show vibrant movement and are dressed in elegant costumes, despite their crude, sticklike, sketchy execution. The artist's personality was established by the discovery of the same hand at work in small background scenes in a set of panels of single figures standing on pedestals with landscape backgrounds. Eight panels of the set by various artists have been identified. Four of the panels are by Sienese painters: Matteo di Giovanni's *Judith* (Bloomington, IN U. A. Mus.); Neroccio de' Landi's *Claudia Quinta* (Washington, DC, N.G.A.; *see* ITALY, fig. 12); Francesco di Giorgio's *Scipio Africanus* (Florence, Bargello); and Pietro Orioli's *Sulpicia* (Baltimore, MD, Walters A.G.). The other four were first attributed to Signorelli but now are given by consensus to an artist dependent on him, plausibly considered to be the Griselda Master himself: *Artemisia* (Milan, Mus. Poldi Pezzoli); *Eunostos* (Washington, DC, N.G.A.); *Alexander* (U. Birmingham, Barber Inst.); and *Tiberius Gracchus the Elder* (Budapest, Mus. F.A.). Though more suave and sculptural, the main figures share the smaller ones' finicky, dancer-like refinement. The shared theme of persons behaving virtuously to the opposite sex is that of the Griselda panels too, and the figures were probably made for a grand house, perhaps for a marriage; the Piccolomini and Spanocchi families of Siena have been suggested.

The frequent comparison with Andrea del Castagno's series of *Nine Famous Men and Women* (Florence, Uffizi; see colour pl. 1, XXI) can be enhanced, in that both sets include one half-length figure, the only Biblical one, in each case an Old Testament heroine (in this case *Judith*, for Castagno *Esther*). Hence *Judith* may, like *Esther*, have been over a door in the middle of the wall, the central and highest-ranking figure. There would then have had to have been a ninth panel. It is consistent that the seven surviving secular panels comprise two male Romans and two male Greeks (in both cases one military, one civil), two female Romans (one virgin, one wife) and one female Greek (a wife). A candidate for a ninth figure, as a Greek virgin, is Hippo. The usual reconstruction regards the set of eight as complete, because there are four men and four women, and assumes that the *Judith* has been cut. That the ethnic clusters are significant is also suggested in that the Greek figures are all by the Griselda Master, whereas the other five are each by a different artist, including one by him; the work is often said to have begun with the better-known artists assisted by the Griselda Master for backgrounds, after which the Master took over and completed the set.

The logical place to seek other work by the Griselda Master is in the backgrounds of paintings by LUCA SIGNORELLI (as Longhi suggested); there are little scenes by him in the background of Signorelli's *Last Days of Moses* in the Sistine Chapel, Rome (1481–2), and some large figures in the foreground of the same scene. The Sistine cycle is notorious for complex collaborations between masters and assistants. Signorelli and his followers

are often credited with parts of Perugino's *Giving of the Keys*, and the Griselda Master seems to have painted the Tribute Money group in the background of that scene and an elegant portrait figure in front of it. Of all the distinctive styles in the chapel, the Griselda Master's is the only one not fitted with an artist's name, and so he may well be the only artist named by Vasari as working in the chapel by whom no works are known, Rocco Zoppo. As confirmation, this man worked with Perugino (so explaining the Umbrian style) but was born in Belforte, close to Siena, thus matching the Master's career. The portrait figure in the *Giving of the Keys* is a clue to the specific origins of his style in the Peruginesque San Bernardino panels (Perugia, G.N. Umbria).

BIBLIOGRAPHY

A. Venturi: 'I quadri di scuola italiana nella Galleria Nazionale di Budapest', *Arte*, iii (1900), pp. 185–240 (237–8)

G. De Nicola: 'Notes on the Museo Nazionale of Florence, v: Fragments of Two Series of Renaissance Representations of Greek and Roman Heroes', *Burl. Mag.*, xxxi (1917), pp. 224–8

F. Canuti: *Il Perugino* (Siena, 1931) [on Rocco Zoppo]

R. Longhi: 'Un intervento raffaelesco nella serie "eroica" di Casa Piccolomini', *Paragone*, xv/175 (1964), pp. 5–8

B. Berenson: *Central and North Italian Schools* (1968), i, p. 252

E. Zafran: *Fifty Old Master Paintings from the Walters Art Gallery* (Baltimore, 1988), no. 13 [for late 20th-century opinions on the Master and important bibliog.]

A. Barriault: *'Spalliera' Paintings of Renaissance Tuscany* (University Park, PA, 1994)

CREIGHTON E. GILBERT

Guinigi Painter. *See* MASTER OF THE LATHROP TONDO below.

Master of the Hamilton Xenophon (*fl* Florence, 1470s and 1480s). Italian illuminator and ?painter. He is named after a manuscript illuminated (after 1475) for Ferdinand I of Aragon (Berlin, Kupferstichkab., MS. Hamilton 78.C.24), a Latin translation of Xenophon's *Kyroupaideia*. The Master was an artist of some note, whose prestigious patrons included the Medici and Federigo II da Montefeltro, and whose work ranged from the illustration of Books of Hours to humanistic texts. His early style is best represented by some folios of two Antiphonaries (begun in 1463; Florence, Bib. Medicea–Laurenziana, MSS Edili 148 and 150), to which Zanobi Strozzi and Francesco di Antonio del Chierico, in whose bottega he worked until 1478, also contributed. Other early collaborative projects include the frontispiece of Jerome's *Commentary on Ezechiel* (Rome, Vatican, Bib. Apostolica, MS. Urb. lat. 57, fol. 2*r*) with Domenico Ghirlandaio and Poggio Bracciolini's *Storia di Firenze* (Rome, Vatican, Bib. Apostolica, MS. Urb. lat. 491) with Francesco Rosselli. Reflections of Ghirlandaio's work emerge again in the Bible for Federigo da Montefeltro (completed 1478; Rome, Vatican, Bib. Apostolica, MSS Urb. lat. 1–2), in which he collaborated with del Chierico; the Master's own unmistakable style has also been recognized in some of its miniatures previously attributed to Attavante Attavanti.

The two main frontispieces of the codex of the vernacular version of Leonardo Bruni's *Historia fiorentini populi* (Florence, Bib. N. Cent., Banco Rari 53) were painted in 1480. These show a combination of monumental composition and minute rendering of surface and volume,

approaching Netherlandish work, while the refined technique is suggestive of goldsmiths' work. This was followed by a series of Books of Hours, probably datable before the end of 1480. The possibility that the Master also worked as a panel painter should not be excluded: some of his illustrations show evidence of a large repertory of portraits and groups of figures, painted in particular colour harmonies that suggest experience in painting on a larger scale.

BIBLIOGRAPHY

A. Garzelli: *La Bibbia di Federico da Montefeltro* (Rome, 1977), pp. 144–56

——: *Miniatura fiorentina del rinascimento, 1440–1525: Un primo censimento*, 2 vols (Florence, 1985), pp. 157–62

PATRIZIA FERRETTI

Master of the Immaculate Conception. *See* FREDIANI, VINCENZO.

Ippolita Master (*fl c.* 1459–65). Italian illuminator. Numerous manuscripts survive by this Master, who was mainly active at the Sforza court in Milan. In 1459 he was employed on the decoration of the *Trattato di caccia e falconeria* (Chantilly, Mus. Condé, MS. 368/1375) for Francesco Sforza, Duke of Milan. In the same and subsequent years he was commissioned to decorate other manuscripts, mostly Classical texts (Paris, Bib. N., MSS lat. 7703 and 7779) for the education of the young Galeazzo Maria Sforza. The *De practica seu arte tripudi* ('Of the practice or art of dancing') by Guglielmo da Pesaro (Paris, Bib. N., MS. it. 973), illuminated in 1463, is also dedicated to Galeazzo.

The Ippolita Master is linked with a group of manuscripts (Paris, Bib. N., MS. it. 1712; U. Valencia, Bib., MS. 780) commissioned in 1465 by Francesco Sforza and Bianca Maria Visconti as a wedding gift for their daughter Ippolita. In these and in the other manuscripts mentioned he shows himself to be much indebted to Late Gothic Lombard illumination, in particular that of the MASTER OF THE VITAE IMPERATORUM (*see* below). His manuscripts also show a decidedly humanistic taste in their more orderly coordination of text and decoration. The Master's predilection for strong, brilliant colours and orderly, symmetrical compositions, in which the landscape is always subsidiary to the narrative, and above all his striking decorative taste mark him as a pleasing and gracious illuminator justly favoured by the ducal family.

BIBLIOGRAPHY

R. Cipriani: 'Maestro di Ippolita', *Arte lombarda dai Visconti agli Sforza* (Milan, 1958), pp. 89–92

E. Pellegrin: *La Bibliothèque des Visconti et des Sforza ducs de Milan* (Florence and Paris, 1969), pp. 56–7

A. C. de la Mare: 'Further Italian Illuminated Manuscripts in the Bodleian Library', *La miniatura italiana tra gotico e rinascimento: Atti del II congreso di storia della miniatura italiana: Cortona, 1983*, pp. 145, 148

F. Avril: *Dix Siècles d'enluminure italienne* (Paris, 1984), pp. 152–5

20 Illuminated Manuscripts from the Celebrated Collection of William Waldorf Astor, First Viscount Astor (sale cat., London, Sotheby, 21 June 1988), pp. 48–54

G. Toscano: 'La librarie des rois d'Aragon à Naples', *Bull. Bibliopolos.*, ii (1993), pp. 265–83

The Painted Page: Italian Renaissance Book Illumination, 1450–1550 (exh. cat., ed. J. J. G. Alexander; London, RA, 1994)

MILVIA BOLLATI

Master of the Jarves Cassoni. *See* APOLLONIO DI GIOVANNI.

Karlsruhe Master (*fl c*. 1440–60). Italian painter. The *Adoration of the Child* (Karlsruhe, Staatl. Ksthalle) was taken by Pudelko (1935) as the stylistic basis on which to build the oeuvre of an unidentified artist active in Florence and Prato in the 1440s and 1450s. In Pudelko's opinion, his career probably began in the workshop of Paolo Uccello. The works attributed to him are strongly influenced by Domenico Veneziano, but later examples make clear reference to Alesso Baldovinetti. The catalogue of frescoes, panels and drawings created by Pudelko for the Karlsruhe Master corresponds very closely to the oeuvre that Salmi (1934) provisionally assigned to the Master of the Quarata Predella, and many of the works attributed to Pudelko's Karlsruhe Master continue to be ascribed to Paolo Uccello or have been claimed for Giovanni di Francesco or the Master of the Castello Nativity. Some have also been described as school of Andrea del Castagno or Florentine school. The frescoes of the *Dispute of St Stephen*, the *Birth of the Virgin* and the *Presentation of the Virgin* in the chapel of the Assunta, Prato Cathedral, were initially acceptable to Pope-Hennessy as part of the Karlsruhe Master's oeuvre, and he therefore renamed the latter the PRATO MASTER (*see* below), dating the Karlsruhe *Adoration* to an earlier phase of the unknown artist's career, long before the Prato frescoes. Later (1969) Pope-Hennessy amalgamated the work of his Prato Master with parts of the oeuvre of Salmi's Master of the Quarata Predella but rejected the Karlsruhe *Adoration* and created around this yet another catalogue of works, whose author, identified as active 1440–60, he now called the Karlsruhe Master, as Pudelko had done in 1935. Owing to the close stylistic links with the work of Paolo Uccello, Parronchi (1974) sought to identify the Karlsruhe Master with Uccello's daughter Antonia (1456–91), whom Vasari and Gaetano Milanesi referred to as a Carmelite nun and painter. Parronchi's argument rests on the inscription SOROR ANTONIA P. on a panel showing a clerical scene, from S Donato, Polverosa (Florence, Uffizi). Parronchi interpreted the inscription as either 'Sister Antonia, daughter of Paolo' or 'painted by Sister Antonia'. To this female artist he attributed the Karlsruhe *Adoration*; the *Thebaid* (Florence, Accad. B.A. & Liceo A.), also in Pudelko's list; the *Virgin and Child* (Greenwich, CT, T. S. Hyland priv. col., see Parronchi, pl. 25a), also in Pope-Hennessy's list; and a triptych of the *Crucifixion* (ex-Knoedler's, New York, see Parronchi, pl. 24a). Parronchi's proposition, particularly with regard to his dating of the works to the second half of the 15th century, remains unconvincing.

BIBLIOGRAPHY

G. Vasari: *Vite* (1550, rev. 2/1568); ed. G. Milanesi (1878–85)
C. Gamba: 'Di alcuni quadri di Paolo Uccello o della sua scuola', *Riv. A.*, vi (1909), pp. 19–30
R. Longhi: 'Ricerche su Giovanni di Francesco', *Pinacotheca*, i (1928), pp. 34–48
M. Marangoni: 'Gli affreschi di Paolo Uccello a San Miniato al Monte a Firenze', *Riv. A.*, xii (1930), pp. 403–17
L. Venturi: 'Paolo Uccello', *L'Arte*, xxxiii (1930), pp. 52–87
R. van Marle: 'Eine unbekannte Madonna von Paolo Uccello', *Pantheon*, ix (1932), pp. 76–80
R. Offner: 'The Mostra del Tesoro di Firenze Sacra', *Burl. Mag.*, lxiii (1933), pp. 72–84, 166–78
M. Salmi: 'Paolo Uccello, Domenico Veneziano, Piero della Francesca e gli affreschi del duomo di Prato', *Boll. A.*, xxviii (1934), pp. 1–27
G. Pudelko: 'Der Meister der Anbetung in Karlsruhe, ein Schüler Paolo Uccellos', *Das siebte Jahrzehnt: Festschrift für Adolph Goldschmidt* (Berlin, 1935), pp. 123–30
J. Pope-Hennessy: *Paolo Uccello* (London, 1950, rev. 1969)
J. Lauts: *Meisterwerke der Staatlichen Kunsthalle Karlsruhe* (Honnef, 1957)
——: *Katalog Alter Meister*, Karlsruhe, Staatl. Ksthalle cat. (Karlsruhe, 1966)
A. Parronchi: *Paolo Uccello* (Bologna, 1974)
D. Lüdke, G. Reising and K. Simons-Kockel: *Ausgewählte Werke der Staatlichen Kunsthalle Karlsruhe: 150 Gemälde vom Mittelalter bis zur Gegenwart* (Stuttgart, 1988)

JOHANNES TRIPPS

Master of the Lathrop Tondo [Guinigi Painter] (*fl c*. 1490–1520). Italian painter. He was named by Berenson (1906) after the tondo of the *Virgin and Child, with SS Jerome and Catherine and a Donor* (*c*. 1496–1502; Los Angeles, CA, Getty Mus.), which from 1906 to 1929 had belonged to Francis Lathrop, a New York collector. The painting was commissioned by the Guinigi and Buonvisi families of Lucca (whose coats of arms are included), probably to commemorate the marriage of Michele Guinigi and Caterina Buonvisi in 1496. Berenson collected a corpus of paintings around this work, suggesting that the Master was active in Lucca and influenced by Domenico Ghirlandaio, Filippino Lippi and Flemish painting. Ragghianti (1955) added five more works to the Master's oeuvre and renamed him the Guinigi Painter. He believed that the artist was particularly influenced by the Bolognese painter Amico Aspertini, who was active in Lucca *c*. 1506–8/9. Fahy (1965) added 23 paintings to the Master's supposed output, but Ferretti (1975) gave a number of them to the MASTER OF THE CROCIFISSO DEI BIANCHI (*see* above). A preliminary chronology for the Master of the Lathrop Tondo was proposed by Natale (1980). A panel of *St Anthony Enthroned with SS Andrew, Dominic, Francis and Bartholomew* (Lucca, S Pietro Somaldi), attributed to him by Ferretti and Kiel (both 1972), was dated to *c*. 1497 and identified as the work of MICHELANGELO DI PIETRO by Tazartes (1985); the Master's chronology, however, remains uncertain.

The earliest works attributed to the Master, such as a pair of panels with *St Blaise and a Male Donor* and *St Lucy and a Female Donor* (*c*. 1490; Lucca, Marchese Pietro Mazzarosa priv. col., see Fahy, pl. 7) show the influence of Florentine painters in the morphology of the saints and in the niche settings, which are tempered by some Lucchese traits, while the unidealized portraits of the kneeling donors have an affinity with Flemish portraiture. The style is decorative and characterized by an enamelled, metallic finish, which is also found in the Lathrop Tondo. The *Virgin of the Girdle* (*c*. 1500; Sarasota, FL, Ringling Mus. A.) has iconographical and stylistic links with other Lucchese works such as Vincenzo Frediani's altarpiece of the *Immaculate Conception* (1503; Lucca, Villa Guinigi) and the wooden altarpiece of the *Assumption of the Virgin* (Lucca, S Frediano) by Masseo di Bartolomeo Civitali (*d* after 1511). It also shows the influence of paintings that were then in Lucca but painted by artists from further afield, such as Sebastiano Mainardi's *Virgin and Child with SS Apollonia and Sebastian* (Philadelphia, PA, Mus. A.) and Perugino's *Virgin and Child with SS Jerome and Peter* (*c*. 1500–05; Chantilly, Mus. Condé). The influence of Perugino is also evident in the *Virgin and Child with SS Lawrence and Jerome* (Lucca, Villa Guinigi), in the *Annunciation* (Lucca, SS Annunziata), which shows more Flemish

influence, and in the *Virgin and Child with SS Cassiano and Blaise* (Lucca, S Cassiano a Vico).

During his last period (1510–20) the Master of the Lathrop Tondo seems to have been influenced by Amico Aspertini, whose eccentric, bizarre manner was grafted on to the Master's earlier classicizing style, transforming it into something harsh, grotesque and exaggerated. These traits are exemplified in the *Virgin and Child with SS James and Christopher* (*c.* 1510; Lammari, nr Lucca, S Cristoforo) and in the *Virgin and Child with SS Augustine, Monica, Anthony of Padua and Jerome* (*c.* 1510; Lucca, Villa Guinigi), from S Agostino in Lucca.

BIBLIOGRAPHY
B. Berenson: 'La pittura in Italia nella raccolta Yerkes', *Ant. Viva.*, vi (1906), pp. 37–8
C. L. Ragghianti: 'Il pittore nei Guinigi', *Crit. A.*, ii/8 (1955), pp. 137–44
R. Longhi: 'Uno sguardo alle fotografie della mostra "Italian Art and Britain" alla Royal Academy di Londra', *Paragone*, xi/125 (1960), p. 61
E. Fahy: 'A Lucchese Follower of Filippino Lippi', *Paragone*, xvi/185 (1965), pp. 9–20
G. Ardinghi: 'Altri dipinti per il Maestro del Tondo Lathrop', *Prov. Lucca*, viii/1 (1968), pp. 85–95
G. Monaco, L. Bertolini Campetti and S. Meloni Trkulja: *Museo Nazionale di Villa Guinigi* (Lucca, 1968), pp. 162–3
G. Ardinghi: 'Una pala d'altare nella parrocchiale di Marlia', *Prov. Lucca*, ix/3 (1969), pp. 99–100
——: 'Madonna col Bambino nella chiesa di Ombreglio', *Prov. Lucca*, xii/1 (1972), pp. 114–15
M. Ferretti: 'Mostra del restauro, Pisa 1972', *An. Scu. Norm. Sup. Pisa*, n.s. 2, ii/2 (1972), p. 1057
H. Kiel: 'Pisa, mostra del restauro 1972', *Pantheon*, xxx (1972), p. 508
M. Ferretti: 'Percorso lucchese', *An. Scu. Norm. Sup. Pisa*, n.s. 2, v/3 (1975), pp. 1055–60
——: 'Di nuovo sul percorso lucchese', *An. Scu. Norm. Sup. Pisa*, n.s. 2, viii/3 (1978), pp. 1248–50
M. Natale: 'Note sulla pittura lucchese alla fine del '400', *Getty Mus. J.*, viii (1980), pp. 37–43
M. Tazartes: 'Committenza popolare in S Frediano di Lucca', *Ric. Stor. A.*, 13–14 (1981), pp. 111–18
——: 'Anagrafe lucchese, I. Vincenzo di Antonio Frediani "pictor de Luca": Il Maestro dell'Immacolata Concezione?', *Ric. Stor. A.*, 26 (1985), pp. 4–17, 28–39
——: 'Anagrafe lucchese, III. Michele Angelo (del fu Pietro "Mencherini")': Il Maestro del Tondo Lathrop?', *Ric. Stor. A.*, 26 (1985), pp. 40ff.

MAURIZIA TAZARTES

Lippi-Pesellino Imitators. *See under* PSEUDO-PIER FRANCESCO FIORENTINO below.

Master of the London Pliny. *See under* GASPARO PADOVANO.

Master of the Louvre Annunciation. *See under* BRACCESCO, CARLO.

Master of the Marble Madonnas (*fl c.* 1470–1500). Italian sculptor or group of sculptors. The name was coined by Bode (1892–1905) for an anonymous sculptor, apparently Tuscan, possibly trained in the workshop of Mino da Fiesole and influenced by Antonio Rossellino. Numerous sculptures have been attributed to him on the basis of related compositions, drapery forms, ornamental motifs and pronounced mannerisms. Chief among the latter is a peculiar feline smile from heavy-lidded eyes and a taut jaw, at its best radiating inward joy but often acerbic or bordering on the manic. The Master's eclectic shop and followers produced marble reliefs of the *Virgin and Child*, busts and reliefs of the suffering Christ and busts of

children. Bode had noted (1886) that many of these were of Florentine or Tuscan provenance.

The chief documented monument that is stylistically associated with the Master's work is the *Numai* tomb (1502) at S Pellegrino, Forlì. This has led to the Master's identification as either Tommaso Fiamberti (de Nicola, 1922) or Giovanni Ricci (*d* after 1523; Balogh, 1933), but whichever of these Lombards made the Forlì reliefs seems, rather, to have been a late, somewhat clumsy follower of the Master. Numerous attributions in Emilia-Romagna, Urbino, Hungary and Dalmatia might indicate that either the Master or a close follower was active in those regions. Balogh (1975) gives the most complete list of attributed works.

The sculptures attributed to the Master are the product of various hands, and several may be collaborative works. Even the best works and most frequent types are not necessarily all by a single hand. Two marble reliefs of the *Virgin and Child* (Florence, Bargello and S Stefano al Ponte) are representative of the most characteristic composition. They reflect a prototype by Mino da Fiesole exemplified by the *Virgin and Child* relief on the monument to *Conte Ugo of Tuscany* (1469–81; Florence, Badia), but Rossellino's influence shows in softer flesh and drapery passages, freer movement, curling hair and background motifs. The Bargello relief is stiff, almost frontal and close to Mino, whereas the S Stefano relief has soft, fluid handling and a warm expression, with signs of Verocchio influence in the smiles. This may be due to a distinct personality in the workshop. In related reliefs the Virgin has an ovoid head with a high plucked forehead and long, pointed chin, with a spreading hood and a mantle with a sinuous, hatched border; the Christ Child is shown seated, holding a bird or orb, and paired background angels proffer a crown or fruit. Good examples include one close to the S Stefano relief (Paris, Louvre) and one with its old polychromy (Ottawa, N.G.), a link to Urbino; a third is in Canberra (N.G.). A bust of the youthful *St John the Baptist* (Washington, DC, N.G.A.) and a half-length youthful *St John the Baptist* (Kansas City, MO, Nelson–Atkins Mus. A.) are close to the Madonna reliefs in expression and the handling of details. Most accomplished of the related works is a bust *Ecce homo* (Switzerland, priv. col., see Middeldorf, 1973), with rich, open and fluid carving, sharply ornamental locks of hair and remarkable expressive intensity.

The three reliefs of the *Virgin and Child* (Urbino, Pal. Ducale) are arguably by at least three sculptors, one of whom (see Rotondi, 1950–51, fig. 445) probably also carved the fine relief of the *Virgin and Child* (Pistoia, Mus. Civ.). A collaborator on the Urbino *Virgin and Child beneath an Arch* (Rotondi, fig. 447) may have carved a related composition of the same subject (U. London, Courtauld Inst. Gals) as well as the strange busts of boys (Budapest, N.G.; Urbino, Pal. Ducale) with harsh smiles and knobbly curls. An important group of works in Hungary, Dalmatia (dated *c.* 1480–92 by Balogh, 1980) and Forlì has stockier figure-types, compositions frequently reflecting the lunette above Desiderio da Settignano's tomb of *Carlo Marsuppini* (*c.* 1453–68; Florence, Santa Croce; *see* DESIDERIO DA SETTIGNANO, fig. 1) and a Child often wearing a short tunic. Striking patterns of

ornament and drillwork occur in these. The *Virgin and Child with Cherubim* (Berlin, Skulpgal., 94) appears close to the works in Dalmatia and Hungary, as does a group of reliefs by yet another hand (e.g. New York, Mortimer Schiff priv. col.), in which the Virgin is shown tenderly caressing the Child; the faces are coarser, and the drapery is brittle and angular.

BIBLIOGRAPHY

Thieme–Becker

W. von Bode: 'Die italienischen Skulpturen der Renaissance in den königlichen Museen zu Berlin, VI: Die Florentiner Marmorbildner in der zweiten Hälfte des Quattrocento', *Jb. Kön.-Preuss. Kstsamml.*, vii (1886), pp. 29–32

——: *Denkmäler der Renaissance: Sculptur toscanas* (Munich, 1892–1905), i, pp. 130–31

G. de Nicola: 'Tommaso Fiamberti: Il Maestro delle Madonne di Marmo', *Rass. A.*, ix (1922), pp. 73–81

J. Balogh: 'Uno sconosciuto scultore italiano presso il Re Mattia Corvino', *Riv. A.*, xv (1933), pp. 272–97

P. Rotondi: *Il Palazzo Ducale di Urbino* (Urbino, 1950–51), i, pp. 392, 467, 473–6; ii, figs 443–51

J. Pope-Hennessy: *Catalogue of Italian Sculpture in the Victoria and Albert Museum*, i (London, 1964), pp. 151–2, 197–8

——: 'Three Marble Reliefs in the Gambier-Parry Collection', *Burl. Mag.*, cix (1967), pp. 117–18

U. Middeldorf: 'An *Ecce homo* by the Master of the Marble Madonnas', *Album Amicorum J. G. van Gelder* (The Hague, 1973), pp. 234–6; also in U. Middeldorf: *Raccolta di scritti*, ii (Florence, 1980), pp. 345–9

J. Balogh: *Die Anfänge der Renaissance in Ungarn: Matthias Corvinus und die Kunst* (Graz, 1975), pp. 179–83 [lists most works attributed to the Master, with references]

U. Middeldorf: *Sculptures from the Samuel H. Kress Collection: European Schools, XIV–XIX Century* (London, 1976), pp. 29–30

J. Balogh: 'A márvanymadonnák mestere: Mátyás király szobrásza' [The Master of the Marble Madonnas: King Mátyás's sculptor], *Épités-Épitészettudomány*, xii (1980), pp. 77–86 [discussion of Hung. and Dalmat. career, reaffirms identity with Ricci]

G. Gentilini: 'Maestro delle Madonne di Marmo: Madonna col Bambino e angeli', *Misericordia di Firenze: Archivio e raccolta d'arte*, ed. C. Toricelli and others (Florence, 1981), pp. 248–9

J. Balogh: 'Der Meister der Marmormadonnen: Giovanni Ricci', *Matthias Corvinus und die Renaissance in Ungarn, 1458–1541* (exh. cat., Schallaburg, Schloss, 1982), pp. 385–91

ALISON LUCHS

Master of the Mascoli Altar (*fl* Venice, *c.* 1430). Italian sculptor. His name is derived from the marble altarpiece of the *Virgin and Child with SS Mark and James* in the Mascoli Chapel, S Marco, Venice (see fig.). An inscription above the altar dates the foundation of the chapel to 1430, and both the figures and the architectural frame of the altar were probably commissioned at that time. Most authors also attribute the relief of the *Virgin and Child with Two Angels* over the exterior portal of the Corner Chapel (after October 1422) in S Maria dei Frari, Venice, to the Master of the Mascoli Altar. In both works the tightly pulled drapery reveals the lines of the body, accenting the pose and movement of the figures; the rather conventional Gothic frames were probably designed and executed by Venetian masons. It appears that the three sections of the Corner Chapel relief and also the figures for the Mascoli Chapel were adapted to fit into their respective frames, suggesting that the carvings did not originate in Venice but were imported and inserted into existing frames.

The style of the works attributed to the Mascoli Master has been the subject of controversy. Most authors have identified him as a Venetian, suggesting a number of well-known sculptors, including Pierpaolo dalle Masegne *fl*

from 1383; *d c.* 1403), Giovanni Buon and Bartolomeo Buon, but Pierpaolo died too early and the strong stylistic similarity to works by Lorenzo Ghiberti indicates instead that the Master was active in Florence. For example, the style of SS Mark and James in the Mascoli Altar is derived from figures in Ghiberti's reliefs for the first bronze door for the Florentine Baptistery, and the Virgin for the Corner Chapel appears to have been modelled on Ghiberti's figures of St John the Evangelist and St Ambrose, also on the Baptistery doors. The Virgin for the Mascoli Altar, however, is based on models from the circle of Nino Pisano (*fl* 1334–60s). The Florentine origin of these figures is particularly clear when works by the Mascoli Master are compared with Venetian copies, such as the Virgin in the south transept of S Marco, and with Venetian works showing his influence, such as the pair of angels on the front of the Mascoli Altar or a figure of Gabriel (New York, Met.).

The Mascoli Master's works in Venice, and through them some of the formal characteristics of Ghiberti's work, influenced a number of artists in Venice during the 1440s, including Bartolomeo Buon. Others translated his style into a calmer mood expressing psychological states through glance and gesture.

BIBLIOGRAPHY

L. Planiscig: 'Die Bildhauer Venedigs in der ersten Hälfte des Quattrocento', *Jb. Ksthist. Samml. Wien*, iv (1930), pp. 47–120 (113)

J. Pope-Hennessy: *Italian Gothic Sculpture* (London, 1955, 3/1985), pp. 49, 221, 286

W. Wolters: *La scultura veneziana gotica, 1300–1600* (Milan, 1976), pp. 110, 276 [gives summary of research, bibliog. and illus.]

WOLFGANG WOLTERS

Master of the Mascoli Altar: *Virgin and Child with SS Mark and James*, marble, h. 1.3 m, *c.* 1430 (Venice, S Marco, Mascoli Chapel)

Master of the Missal of Borso d'Este. *See under* GIORGIO D'ALEMAGNA.

Master of the Novella. *See under* CORTESE, CRISTOFORO.

Master of the Osservanza (*fl ?c.* 1440–80). Italian painter. Longhi recognized that two triptychs, formerly attributed to Sassetta, were the work of another hand. The *Virgin and Child with SS Jerome and Ambrose* (Siena, Osservanza; see fig.) and the *Birth of the Virgin* (Asciano, Mus. A. Sacra), formerly in the Collegiata, Asciano, both have a stylistic affinity with Sassetta's works but, in terms of narrative expression, still belong to the Late Gothic tradition. Longhi observed that a further group of paintings was closely related to these works. This included the predella of the Osservanza Altarpiece (Siena, Pin. N., 216), a predella of *St Bartholomew* (Siena, Pin. N.), scenes of the *Passion* (Rome, Pin. Vaticana; Philadelphia, PA, Mus. A.; Cambridge, MA, Fogg) and the scenes from the *Life of St Anthony Abbot* (dispersed; e.g. panels in Washington, DC, N.G.A.; New York, Met.; Wiesbaden, Mus. Wiesbaden) previously also attributed to Sassetta. These last panels are difficult to integrate into the group. The full-length painting of *St Anthony Abbot* (Paris, Louvre), which scholars have attempted to integrate with the small scenes from the saint's life into a multipartite altarpiece, seems to come from another altarpiece.

Graziani named the painter the Master of the Osservanza after the altarpiece in that church and reconstructed his oeuvre around this work, ranging between the *Pietà*

Master of the Osservanza: *Virgin and Child with SS Jerome and Ambrose*, tempera on panel, 2.16×1.62 m, late 1440s [dated 1436] (Siena, Convent of St Bernardino dell'Osservanza)

with *St Sebaldus and a Devotee* (Siena, Monte Dei Paschi priv. col.), datable 1432–3, and the painted cover of the Gabella (tax records) showing the *Archangel Michael* (Siena, Pal. Piccolomini, Archv Stato), dated 1444. Graziani proposed that the Master took as his models Giovanni da Milano, Gregorio di Cecco and Masolino, thereby combining Sienese and Florentine stylistic elements. Graziani's theory was accepted by Zeri, Carli, Volpe, Laclotte, Benati, Angelini and Christiansen.

A different theory was proposed by Berenson, who suggested that the Master's oeuvre was the early work of SANO DI PIETRO, known to have been active from 1428 but whose earliest dated work is the Gesuati Polyptych of 1444 (Siena, Pin. N.; for illustration *see* SANO DI PIETRO). This was accepted by Brandi (1949), Pope-Hennessy (1956), Torriti and Boskovits.

A third hypothesis was put forward by Alessi and Scapecchi (1985). They established that the Osservanza panel was painted for S Maurizio, Siena, and that the date on the painting, 1436, refers to the foundation of the chapel by its patron, the grocer Manno d'Orlando (*d* 1442), and not necessarily to the year in which the altarpiece was painted. They suggested that the Osservanza Altarpiece and the *Birth of the Virgin* date from the late 1440s and that the Master was active from the 1440s to the 1470s and was influenced by developments in Florentine painting of that date, particularly by Fra Angelico and Uccello. They further proposed that the Master could be identified with FRANCESCO DI BARTOLOMEO ALFEI, a well-documented artist who was associated with Sano di Pietro but whose work has not been identified. While Pope-Hennessy (1987) did not accept the identification of the Master with Alfei, he accepted Alessi's and Scapecchi's attribution of additional works to the Master. These include the *Virgin and Child* (New York, Met.) and two paintings of the *Virgin of Humility* (Altenburg, Staatl. Lindenau-Mus.; New York, Brooklyn Mus. A.).

BIBLIOGRAPHY

R. Longhi: 'Fatti di Masolino e di Masaccio', *Crit. A.*, v (1940), pp. 145–91 (188, n. 26)

B. Berenson: *Sassetta: Un pittore senese della leggenda francescana* (Florence, 1946), pp. 51–2

C. Brandi: 'Introduzione alla pittura senese del primo quattrocento', *Rass. Italia* (1946), p. 31

A. Graziani: 'Il Maestro dell'Osservanza', *Proporzioni*, 2 (1948), pp. 75–88

C. Brandi: *Quattrocentisti senesi* (Milan, 1949), pp. 69–87; review by J. Pope-Hennessy in *A. Bull.*, xxxiii (1951), pp. 141–3

F. Zeri: 'Il Maestro dell'Osservanza: Una crocefissione', *Paragone*, v/49 (1954), pp. 43–4

J. Pope-Hennessy: 'Rethinking Sassetta', *Burl. Mag.*, xcviii (1956), pp. 364–70

E. Carli: *Il Sassetta e il Maestro dell'Osservanza* (Milan, 1957), pp. 89–121; review by C. Volpe in *A. Ant. & Mod.*, 4 (1958), pp. 344–5

M. Laclotte: 'Sassetta, le Maître de l'Observance et Sano di Pietro: Un Problème critique', *Inf. Hist. A.*, ii (1960), pp. 47–53

H. M. von Erffa: 'Der Nürnberger Stadtpatron auf italienischen Gemälden', *Mitt. Ksthist. Inst. Florenz*, xx (1976), pp. 1–12

P. Torriti: *La Pinacoteca Nazionale di Siena: I dipinti dal XII al XV secolo* (Genoa, 1977), pp. 248–52

D. Benati: 'Il Maestro dell'Osservanza', *Il gotico a Siena* (exh. cat., Siena, Pal. Pub., 1982), pp. 393–8; review by M. Boskovits in *A. Crist.*, lxxi (1983), pp. 259–76 (267)

P. Scapecchi: 'Quattrocentisti senesi nelle Marche: Il polittico di Sant'Antonio Abate del Maestro dell'Osservanza', *A. Crist.*, lxxi (1983), pp. 287–90 [with Eng. summary]

C. Alessi and P. Scapecchi: 'Il Maestro dell'Osservanza: Sano di Pietro o Francesco di Bartolomeo', *Prospettiva*, 42 (1985), pp. 13–37

Sassetti e i pittori toscani tra XIII e XV secolo (exh. cat. by A. Angelini, Siena, Col. Chigi-Saracini, 1986), pp. 43–7

J. Pope-Hennessy: *Italian Paintings in the Robert Lehman Collection*, New York, Met. cat. (Princeton, 1987), pp. 105–11

Painting in Renaissance Siena (exh. cat., New York, Met., 1988), pp. 99–136 [entry by K. Christiansen]

Restauri, 1983–1988 (exh. cat., Siena, 1988), pp. 20–27 [entry by C. Alessi]

Catherine de Sienne (exh. cat., Avignon, 1992), pp. 253–4 [entry by C. Alessi]

CECILIA ALESSI

Master of the Pala Sforzesca (*fl* Milan, *c.* 1490–*c.* 1500). Italian painter. The Master's oeuvre centres around the Pala Sforzesca (Milan, Brera), which was painted for the church of S Ambrogio ad Nemus, Milan, on the orders of Ludovico Sforza, il Moro, guardian of the Duke of Milan and, in 1494, Duke of Milan himself. It depicts the Virgin and Child, the four Doctors of the Church, Ludovico il Moro, his wife, Beatrice d'Este, and Ludovico's two sons. The painting is identifiable with an artist's plan that the Duke's secretary Stanga submitted to Ludovico on 22 January 1494 (Malaguzzi Valeri, p. 45). The painter's name is not mentioned, and attempts to identify him with Vincenzo Foppa, Bernardino de Conti, Ambrogio de Predis and others are untenable on stylistic grounds (Malaguzzi Valeri; Romano, Binaghi and Collura, 1978).

In the deliberately archaizing altarpiece, the Master depicted Ludovico and his family in stark profile, kneeling at the feet of the Virgin. He liberally employed gold and lapis lazuli in painting the figures' jewel-encrusted garments. This lavish ostentation was typical of the Milanese court at that date. The Master's paintings take elements from the works of Foppa, Bergognone and Leonardo, from Ferrarese painters *c.* 1475 and from artists working at the Certosa di Pavia in 1490–1500. Stylistically, he was an individual and idiosyncratic painter with considerable skill in depicting space and volume but inept at representing movement and Leonardo's *sfumato*.

About 15 paintings can be grouped around the Pala Sforzesca. Zeri and Romano (1982) have convincingly dated the Master's works, placing them between the *Virgin and Child* (Baltimore, MA, Walters A.G.) and the frescoed chapel with the *Crucifixion with Saints* in S Giorgio in Annone, Brianza, Como, spanning a period from before 1490 to after 1500.

BIBLIOGRAPHY

C. Bianconi: *Nuova guida di Milano per gli amanti delle belle arti* (Milan, 1787), p. 366

F. Malaguzzi Valeri: 'Il Maestro della Pala Sforzesca', *Ant. Viva*, ix (1905), pp. 44–8

L. Giordano: 'Il duomo di Monza e l'arte dall'età viscontea al cinquecento', *Storia di Monza e della Brianza: L'arte dall'età romana al rinascimento*, ii (Milan, 1973), pp. 441–2

F. Zeri: *Italian Paintings in the Walters Art Gallery*, i (Baltimore, 1976), pp. 290–91

G. Romano: 'Il Maestro della Pala Sforzesca', *Processo per il museo* (exh. cat., ed. F. Russoli; Milan, Brera, 1977)

G. Romano, M. T. Binaghi and D. Collura: *Il Maestro della Pala Sforzesca* (Florence, 1978)

G. Mulazzani: 'Un'aggiunta al Maestro della Pala Sforzesca', *A. Lombarda*, 51 (1979), pp. 22–3

G. Romano: 'Maestro della Pala Sforzesca: S Giacomo, S Bartolomeo, e tre Apostoli', *Zenale e Leonardo* (exh. cat., Milan, Mus. Poldi Pezzoli, 1982), pp. 54–7

M. T. BINAGHI OLIVARI

Paris Master (*fl* Florence, *c.* 1440–60). Italian painter. He was named by Schubring after the anonymous painting of the *Judgement of Paris* (Glasgow, A. G. & Mus.) and attributed with 22 other *cassone* paintings of mythological or historical subjects. This is not, however, a stylistically coherent group; only three of the works can be securely given to the same workshop as the *Judgement of Paris*: the *Sleep of Paris* and the *Rape of Helen* (ex-Lanckoronski priv. col., Vienna; see Wohl, pls 185, 186) and a *Diana and Actaeon* (see Wohl, pl. 188). To these four may be added two *cassone* panels of the *Story of Patient Griselda* (Bergamo, Gal. Accad. Carrara). The six panels have at various times been associated with or attributed to Domenico Veneziano, Pesellino and Domenico di Michelino; but, although they share a common pictorial language with these artists, they have an artistic identity of their own. The *Judgement of Paris* and *Diana and Actaeon* were among the first Italian paintings of Classical mythology in which the nude figure predominates, but the new Classical subject-matter was painted in the Gothic style, and the artist probably also drew on Netherlandish illuminations containing nude figures.

BIBLIOGRAPHY

P. Schubring: *Cassoni* (Leipzig, 1915), pp. 109, 260–65

H. Wohl: *The Paintings of Domenico Veneziano, ca. 1410–1461: A Study in Florentine Art of the Early Renaissance* (New York, 1980), pp. 154–8, 192–3

HELLMUT WOHL

Master of the Pellegrini Chapel. See MICHELE DA FIRENZE.

Master of the Piccolomini Madonna [Piccolomini Master] (*fl* Siena, ?1450–1500). Italian sculptor or group of sculptors. A number of reliefs of the Virgin and Child have been collected together under this name. All show the Virgin turned three-quarter face, standing behind a parapet upon which the Infant Christ reclines, raising his hand in benediction. Variations occur in the decoration of the parapet and the presence or absence of candelabra and putti's heads in the sky. In some examples the Virgin holds a cartouche. By the 1990s nine marble examples were known: Siena, Col. Chigi–Saracini; Paris, Louvre, 609; Pesaro, Mus. Civ.; Florence, Mus. Bardini; Paris, Louvre, ex-Arconati Visconti priv. col.; Benneboek, Pannwitz priv. col.; London, V&A; Pianiga (Padua), parish church; and New York, Met. There is also one in stucco (Florence, priv. col.).

The reliefs in the Louvre (609) and Collezione Chigi–Saracini in Siena both have the Piccolomini coat of arms on the parapet, and both originally came from properties belonging to the Chigi family. They would seem to be of higher quality than the others and may be by the same hand. The existence of so many variants of a single composition is rare, and it has been suggested that they may all derive from a common prototype that was originally in Siena, either a lost relief by Donatello of *c.* 1457–8 (Bode, Pope-Hennessy) or the Chigi–Saracini relief itself. This, in turn, has led to the attribution of the latter relief to Vecchietta (Valentiner), to a sculptor in the circle of Giovanni di Stefano (Bode, Schubring), and even to the claim that it is a work of the early 16th century by Lorenzo Marrina (1476–1534; Curajod).

It is extremely unlikely that all the reliefs are the work of a single sculptor. The Chigi–Saracini and the Louvre

(609) reliefs do, however, have the appearance of being Sienese, datable *c.* 1475–1500. Stylistically they are close to paintings by Neroccio de' Landi and Francesco di Giorgio, particularly in the rhythmic outlines of the delicate, semi-transparent drapery and the facial characteristics with fine arched eyebrows and almond-shaped eyes.

BIBLIOGRAPHY

L. Curajod: 'Récentes Acquisitions du Musée de la sculpture moderne au Louvre', *Gaz. B.-A.*, n.s. 1, xxiii (1881), pp. 203–6

W. von Bode: *Denkmäler der Renaissance: Sculptur toscanas*, (Munich, 1892–1905), i, p. 159

P. Schubring: *Die Plastik Sienas in Quattrocento* (Berlin, 1907)

W. Valentiner: 'Marble Reliefs by Lorenzo Vecchietta' *A. America & Elsewhere*, xiii (1924), pp. 55–62

F. Negri Arnoldi: 'Sul Maestro della Madonna Piccolomini', *Commentari*, xiv (1963), pp. 8–16

J. Pope-Hennessy: *Catalogue of Italian Sculpture in the Victoria and Albert Museum*, i (London, 1964), pp. 261–3; review by F. Negri Arnoldi in *Commentari*, xxi (1970), pp. 201–18

M. Salmi: *Il palazzo e la collezione Chigi-Saracini* (Siena, 1967), pp. 230–32

A. Parronchi: 'Une Madonne donatellienne de Jacopo Sansovino', *Rev. A.* [Paris], xxi (1973), pp. 41–3

E. Neri Lusanna and L. Faedo: *Le sculture*, ii of *Il museo Bardini a Firenze* (Milan, 1986), pp. 269–70

G. Gentilini: 'Il Maestro della Madonna Piccolomini', *Collezione Chigi-Saracini. La scultura: Bozzetti in terracotta, piccoli marmi e altre scultura dal XIV al XX secolo*, ed. G. Gentilini and C. Sisi (Siena, 1989), i, pp. 80–98

FRANCESCA PETRUCCI

Prato Master (*fl c.* 1440–50). Italian painter. Pope-Hennessy (1950) assigned this name to an anonymous artist closely allied with Paolo Uccello. In collaboration with another artist, he painted frescoes of the *Lives of the Virgin and St Stephen* in the chapel of the Assunta, Prato Cathedral. Specifically attributed to the Prato Master are the scenes depicting the *Birth of the Virgin*, the *Presentation of the Virgin*, the *Dispute of St Stephen*, most of the figures in the borders surrounding the scenes, images of the *Virtues* on the ceiling and some of the saints on the entrance arch. The fresco of the full-length figure of *Jacopone da Todi*, discovered in 1871 behind a Baroque altar in the same chapel, can also be attributed to him. The mediocre collaborator responsible for the lower scenes on both walls is almost unanimously recognized as Andrea di Giusto.

Suggested dates for the cycle vary considerably. Parronchi, for example, believed they were begun in 1435 or 1436 in order to place the frescoes within the transitional phase of Uccello's career following his return to Florence from Venice in 1430. Pope-Hennessy, on the other hand, attributed the frescoes to an artist trained in Uccello's workshop. They would have been painted after Uccello's clockface of 1443 (Florence Cathedral), since the Prato Master borrowed the heads in it as prototypes for his own work. Because the upper frescoes would have almost certainly been painted first, the death of Andrea di Giusto (1450) provides a *terminus ante quem* for the entire fresco cycle.

Former attributions of the Prato frescoes to Domenico Veneziano or Giovanni di Francesco have been largely discarded, but their inclusion in Uccello's oeuvre is maintained by many. The frescoes, however, display several peculiar qualities. The exaggerated facial expressions in the *Dispute* almost, though perhaps unintentionally, caricature Uccello's interest in physiognomy as a scientific subject. They are contrasted by the more stylized features of other figures. Unusual colours are likewise juxtaposed in original combinations, and the tendency to treat them as flat, large fields intensifies their decorative role. Interest in embellishment is further evident in the smaller details. The artist's shifting attention between decorative line and plastic effect is notable. Unsystematic perspective, inexactly constructed figures and an inconsistent handling of space and volumes all point to an artist who enthusiastically followed the advances being made by his contemporaries but developed none himself.

The Prato Master has at times been identified with the KARLSRUHE MASTER (*see* above) and the Master of the Quarata Predella. Scholarly opinion on the subject is varied and sometimes conflicting. The connections, if any, among these three masters remain unclear and so, too, does the association of the Prato Master with such works as the *Virgin and Child* (Dublin, N.G.), a *Female Saint with Two Children* (Florence, Pitti) and *St George and the Dragon* (London, N.G.). While most scholars assign these works to Uccello, perhaps they should be attributed to the still enigmatic Prato Master.

BIBLIOGRAPHY

R. van Marle: *Italian Schools*, ix (1927)

J. Pope-Hennessy: *Paolo Uccello* (London, 1950, rev. 2/1969)

G. Marchini: *Il duomo di Prato* (Milan, 1957)

E. Borsook: *The Mural Painters of Tuscany: From Cimabue to Andrea del Sarto* (London, 1960, rev. Oxford, 1980), pp. 79–84

C. Shell: 'The Early Style of Fra Filippo Lippi and the Prato Master', *A. Bull.*, xliii (1961), pp. 197–209

M. Meiss: *The Great Age of Fresco: Discoveries, Recoveries and Survivals* (New York, 1970)

A. Parronchi: *Paolo Uccello* (Bologna, 1974)

DONNA T. BAKER

Master of Pratovecchio (*fl* Florence, *c.* 1450). Italian painter. Longhi gave the name to an anonymous Florentine painter active in the mid-15th century who was influenced by Domenico Veneziano and, to a lesser extent, by Andrea del Castagno. His most important surviving work is a dismembered triptych consisting of an *Assumption of the Virgin* (Pratovecchio, S Giovanni Evangelista, on dep. Arezzo, Soprintendenza alle Gallerie), side panels of *SS Michael and John the Baptist* and a *Bishop and Female Martyr* as well as side pilasters, tondi and pinnacles (all London, N.G.). Longhi suggested that the *Death of the Virgin* (Boston, MA, Isabella Stewart Gardner Mus.) originally formed the predella, but this is debatable.

Longhi also attributed to the Master the *Virgin and Child with SS Bridget and Michael*, known as the Poggibonsi Altarpiece (Los Angeles, CA, Getty Mus.), and this has been accepted by later scholars. Using a document of 1439, Fredericksen tried to identify the Poggibonsi Altarpiece with one painted by GIOVANNI DI FRANCESCO for the convent of Paradiso, Pian di Ripoli, near Florence, and suggested that the Master's works were early works by Giovanni di Francesco. However, this identification is difficult to sustain, since the two groups of paintings assigned to the Master and to Giovanni di Francesco are clearly distinct in style. The identification of the Poggibonsi Altarpiece with that mentioned in 1439 also remains unproven: the subject named in the document does not tally with the Poggibonsi painting, which, in any case,

would seem to date to *c.* 1450. Certainly it is very close in style to the *Assumption of the Virgin*. Longhi also attributed other works to the Master. These include *Three Archangels* (Berlin, Gemäldegal.), two panels of the *Virgin and Child* (Cambridge, MA, Fogg; Florence, Vittorio Frascione priv. col.) and a *Virgin and Child with Angels* (New York, Pierpont Morgan Lib.). Also attributable to the Master is a fresco fragment with a frieze of putti heads, part of the decoration of the Lenzi Chapel, Ognissanti, Florence (*in situ*), which was decorated by Bicci di Lorenzo and Neri di Bicci between 1446 and 1451. Presumably the Master completed the work with Neri di Bicci after Bicci di Lorenzo became ill.

Given the quality of the Master's work and the narrow time band into which it apparently falls, Longhi suggested that he may have died young. Padoa Rizzo's hypothesis is that he may be identified with JACOPO DI ANTONIO, who died aged 27 in 1454.

BIBLIOGRAPHY

M. Davies: *The Earlier Italian Schools*, London, N.G. cat. (London, 1951, 2/1961/*R* 1986), pp. 541–4

R. Longhi: 'Il "Maestro di Pratovecchio"', *Paragone*, iii/35 (1952), pp. 10–37

F. Hartt: 'The Earliest Works of Andrea del Castegno, Part Two', *A. Bull.*, xli (1959), p. 234

F. Zeri: *Due dipinti, la filologia e un nome* (Turin, 1961), p. 45

F. Zeri and B. Fredericksen: *Census of Pre-Nineteenth Century Italian Paintings in North American Public Collections* (Cambridge, MA, 1972), p. 135

B. Fredericksen: *Giovanni di Francesco and the Master of Pratovecchio* (Malibu, 1974)

P. Hendy: *European and American Paintings in the Isabella Stewart Gardner Museum* (Boston, 1974), pp. 107–10

Disegni italiani del tempo di Donatello (exh. cat., ed. A. Angelini; Florence, Uffizi, 1986), pp. 32–3

A. De Marchi: 'Maestro di Pratovecchio', *Pitture di luce* (exh. cat., ed. L. Bellosi; Milan, 1990), pp. 149–52

A. Padoa Rizzo: 'Ristudiando i documenti: Proposte per il Maestro di Pratovecchio e la sua tavola eponima', *Studi di storia dell'arte sul medioevo e il rinascimento nel centenario della nascita di Mario Salmi: Atti del convegno internazionale: Arezzo–Firenze, 1989* (Florence, 1993), pp. 579–99

——: *Aggiunte al Maestro di Pratovecchio* (in preparation)

ANNA PADOA RIZZO

Pseudo-Antonio da Monza. *See* BIRAGO, GIOVANNI PIETRO.

Pseudo-Boccaccino. *See* GIOVANNI AGOSTINO DA LODI.

Pseudo-Pier Francesco Fiorentino (*fl* second half of the 15th century). Italian painter or group of painters. The name was given by Berenson (1932) to an unknown artist whose work was previously confused with that of PIER FRANCESCO FIORENTINO, a follower of Benozzo Gozzoli and Neri di Bicci. The numerous pictures attributed to the anonymous master do not in fact resemble Pier Francesco's oeuvre. They are instead well-crafted, albeit mechanical, adaptations of paintings by Pesellino and Filippo Lippi. A few are copies of whole compositions, such as the *Virgin Adoring the Christ Child* in the chapel of the Palazzo Medici–Riccardi, Florence, which replaced Lippi's original (Berlin, Gemäldegal.). The Pseudo-Pier Francesco works derived from Lippi's designs only (all from paintings dating from the 1450s) often combine motifs from more than one composition. Pesellino's Madonnas (e.g. Toledo, OH, Mus. A.; ex-Edouard Aynard priv. col., Lyon) were another frequent resource. Works by Pseudo-Pier Francesco are all marked by a lavish, archaic use of gold leaf, and many include elaborate rose-hedge backgrounds, probably derived from Domenico Veneziano.

Zeri (1958) was the first to suggest that this body of works was not produced by one painter but rather by a workshop. He published a *Virgin and Child* (Italy, art market), in which the figure of the Virgin is taken from Antonello da Messina's *Virgin Annunciate* (Munich, Alte Pin.). He also called attention (1976) to a tondo (Arezzo, Gal. & Mus. Med. & Mod.) derived from Leonardo's Benois *Madonna and Child* (St Petersburg, Hermitage), which is probably one of the last products of the workshop. Zeri's title for the painters of these mass-produced works (who also polychromed stucco reliefs of the Madonna that had been mass-produced; see Middeldorf) is more accurate than Berenson's, namely 'The Lippi–Pesellino Imitators'.

BIBLIOGRAPHY

B. Berenson: 'Quadri senza casa. Il quattrocento fiorentino, II', *Dedalo*, xii/3 (1932), pp. 665–702 (692–7)

F. Zeri: 'Un riflesso di Antonello da Messina a Firenze', *Paragone*, ix/99 (1958), pp. 16–21

B. Berenson: *Florentine School*, i (1963), pp. 171–4

F. Zeri: *Italian Paintings in the Walters Art Gallery* (Baltimore, 1976), pp. 80–85

U. Middeldorf: 'Some Florentine Painted Madonna Reliefs', *Collaboration in Italian Renaissance Art*, ed. W. S. Stead and J. T. Paoletti (New Haven, 1978), pp. 77–90 (80–81)

ELIOT W. ROWLANDS

Master of the Putti (*fl* Venice, *c.* 1469–75). Italian illuminator. Stylistic evidence and visual clues, such as family crests on attributed works, indicate that he decorated printed books for Venetian typographers from 1469 and that he was active in Venice during the first half of the 1470s. The Master of the Putti's manuscripts, for example a copy of Pliny (1472; Padua, Bib. Semin., MS. K.I.), are decorated with imagination and refinement *all'antica*, with touches of tempera, a technique that remained typical of his production. The antiquarian motifs of satyrs, epigraphs, sarcophagi, vases and putti, from which his name is derived, are taken from Classical reliefs of the Imperial period. There are close similarities to the drawings of Jacopo Bellini and to the work of Mantegna and precedents also in the antiquarian interests of the Venetian and Paduan illuminators of the preceding decade. Adopting the faceted initials favoured by the latter group, the Master created splendid mythological scenes. Another Paduan characteristic appears in his illusionistic frontispieces, where the text appears to be inscribed on a parchment scroll supported by architectural elements.

The artist's crisp, nervous style is close to the drawing style of Antonio Pollaiuolo, but even more so to that of Marco Zoppo. The influence of Giovanni Bellini is evident in the energy of the modelling and in the expression and emotional intensity of the figures. The debt to Bellini is still more apparent in the Master's use of colour in the two-volume *Bibbia italica* (1471; New York, Pierpont Morgan Lib., MS. Inc. 26983). The Master of the Putti's late work has not yet been clearly defined.

BIBLIOGRAPHY

G. Mariani Canova: *La miniatura veneta del rinascimento, 1450–1500* (Venice, 1969)

L. Armstrong: *Renaissance Miniature Painters and Classical Imagery: The Master of the Putti and his Venetian Workshop* (London, 1981)
The Painted Page: Italian Renaissance Book Illumination, 1450–1550 (exh. cat., ed. J. J. G. Alexander; London, RA, 1994)

FEDERICA TONIOLO

Master of St Anastasio. *See under* BERNARDINO DEL CASTELLETTO.

Master of St Philip. *See* CIAMPANTI, (2).

Master of San Davino. *See under* GUALTIERI DI GIOVANNI.

Master of S Trovaso (*fl* Venice, *c.* 1470). Italian sculptor. The artist is named after three superlative reliefs of unknown origin now set into an altar frontal in S Trovaso, Venice. Two of the reliefs depict *Angels Playing Musical Instruments* and the third shows *Angels Carrying the Instruments of the Passion* (there are anonymous copies of the reliefs in Berlin, Skulpsamml.). Attempts to attribute the works of the Master of S Trovaso to Agostino di Duccio (Venturi) have not found favour. Pope-Hennessy thought it possible that a relief depicting the *Head of St John the Baptist* in the sacristy of S Maria del Giglio, Venice, was by the same Master. Paoletti (1893) stressed the similarities with works by Antonio Rizzo. Comparison of the S Trovaso panels with Rizzo's reliefs (executed after 1486) for the Scala dei Giganti in the courtyard of the Doge's Palace, Venice, adds weight to the hypothesis that the Master can be identified with Rizzo, but this suggestion—more convincing than any other—has gained little support.

BIBLIOGRAPHY
P. Paoletti: *L'architettura e la scultura del rinascimento a Venezia* (Venice, 1893), p. 159
L. Planiscig: 'Pietro Lombardi ed alcuni bassirilievi veneziani del '400', *Dedalo*, x (1929–30), pp. 461–81
A. Venturi: 'Pietro Lombardi e alcuni bassirilievi veneziani del '400', *L'Arte*, i (1930), pp. 191–205
J. Pope-Hennessy: *Italian Renaissance Sculpture* (London, 1958, 3/1985), pp. 92, 337
N. Huse and W. Wolters: *Venedig, die Kunst der Renaissance: Architektur, Skulptur, Malerei, 1460–1590* (Munich, 1986), p. 161

WOLFGANG WOLTERS

Stratonice Master (*fl c.* 1470–1510). Italian painter. He was named by Berenson (1931) after two *cassone* panels with scenes from the *Story of Antiochus and Stratonice* (San Marino, CA, Huntington A.G.). Berenson also attributed to the Master two large panels of the *Rape of Proserpina* and the *Story of Orpheus and Eurydice* (ex-priv. col., Vienna, see Berenson, 1931, pp. 736–7) and a group of paintings that combine Sienese and Florentine stylistic elements. Berenson's suggestion that he was a Sienese master active from 1475 to 1490, influenced by Francesco di Giorgio Martini, Filippino Lippi and Botticelli, was accepted by van Marle and Waterhouse. However, Fahy (1965) suggested that the Master might have had connections with Lucca and (1966) distinguished three phases in his career. From 1470 to 1480 there was the first, Sienese, phase when he was influenced by Liberale da Verona and Francesco di Giorgio Martini (see fig.). During a second, Florentine, phase (*c.* 1480) the Master absorbed the styles of Filippino Lippi and Botticelli, while in a third, Lucchese,

phase (*c.* 1480 onwards) he had close links with contemporary painters in Lucca.

Meloni Trkulja attributed a triptych of the *Virgin and Child with SS John the Baptist, Vitus, Modestus and Peter* (Montignoso, nr Massa, SS Vito and Modesto) to the Master's Lucchese phase, but Tazartes (1985) found the contract for the triptych, made in 1482 between the Operai of the church and the painter Michele Ciampanti of Lucca (*see* CIAMPANTI, (1)), thus leading to the attribution of some of the Stratonice Master's work to that artist. The Stratonice Master's Florentine and Lucchese phases coincide perfectly, in terms of chronology and style, with Ciampanti's career. The *Virgin and Child with SS Ursula, Agatha and Angels* (Birmingham, AL, Mus. A.), attributed to the Master by Berenson (1931), has echoes of Botticelli and contemporary Lucchese masters such as Vincenzo Frediani (the former Master of the Immaculate Conception), the Master of the Lathrop Tondo and the sculptor Matteo Civitali. The works attributed to the Stratonice Master's early Sienese period (1470–80), however, are hard to reconcile with the works grouped around Ciampanti's Montignoso Triptych, and their chronology is difficult to establish. The Master's last years are also difficult to

Stratonice Master: *Virgin and Child with an Angel*, tempera on canvas, 1470–80 (Vienna, Lederer Collection)

categorize. Ferretti (1975 and 1978) suggested that a group of paintings dependent on Sienese and Umbro-Tuscan sources, including the *Virgin and Child with Saints* (Avignon, Mus. Petit Pal.) and the *Virgin and Child with SS John the Baptist and Mary Magdalene* (Paris, Heim & Cie), date from the last phase of the Master's career at the end of the 15th century. This phase might coincide with Michele Ciampanti's last period. Natale (1980), however, attributed this group of works to the Master of St Philip (later identified as Ciampanti's son, Ansano di Michele Ciampanti; *see* CIAMPANTI, (2)).

BIBLIOGRAPHY

R. van Marle: *Italian Schools* (1923–38), xvi, pp. 509–13
B. Berenson: 'Quadri senza casa: Il quattrocento senese', *Dedalo*, xi (1931), pp. 735–46
E. K. Waterhouse: 'Two Panels from a Cassone by Montagna in the Ashmolean Museum', *Burl. Mag.*, lxxxix (1947), pp. 46–7
F. Zeri: 'The Beginnings of Liberale da Verona', *Burl. Mag.*, xciii (1951), pp. 114–15
E. Fahy: 'A Lucchese Follower of Filippino Lippi', *Paragone*, xvi/185 (1965), pp. 14–16
——: 'Some Notes on the Stratonice Master', *Paragone*, xvii/197 (1966), pp. 17–28
B. Fredericksen: 'The Earliest Painting by the Stratonice Master', *Paragone*, xvii/197 (1966), pp. 53–5
L. Bellosi: 'Un "S Sebastiano" del Maestro di Stratonice', *Paragone*, xviii/207 (1967), pp. 62–3
S. Meloni Trkulja: article in *Boll. A.*, n.s. 5, liii/1 (1968), p. 53
B. Berenson: *Central and North Italian Schools* (1968), vol. ii, pp. 256–7
M. Ferretti: 'Percorso lucchese', *An. Scu. Norm. Sup. Pisa*, n.s. 2, v/3 (1975), pp. 1046–52
——: 'Di nuovo sul percorso lucchese', *An. Scu. Norm. Sup. Pisa*, n.s. 2, viii/3 (1978), pp. 1247–8
M. Natale: 'Note sulla pittura lucchese alla fine del quattrocento', *Getty Mus. J.*, 8 (1980), pp. 5–58
C. Ferri: 'Nuove notizie documentarie su autori e dipinti del'400 lucchese', *Actum Luce*, xi/1–2 (1982), pp. 53–72
M.Tazartes: 'Anagrafe lucchese, II. Michele Ciampanti: Il Maestro di Stratonice?', *Ric. Stor. A.*, 26 (1985), pp. 18–27
——: 'Nouvelles Perspectives sur la peinture lucquoise du quattrocento', *Rev. A.*, 75 (1987), pp. 29–36

MAURIZIA TAZARTES

Master of the Unruly Children (*fl* Florence, early 16th century). Italian sculptor. Conventional name for an anonymous sculptor much influenced by Verrocchio and Benedetto da Maiano, who produced a stylistically coherent group of statuettes in terracotta, the common feature being one or more mischievous children. These were first integrated by Wilhelm von Bode in connection with examples in the Altes Museum in Berlin, while later discussions concentrated on a *Charity* (see fig.) in the Victoria and Albert Museum, London (Pope-Hennessy, 1964), and a *Virgin and Child* in the Fogg Art Museum, Cambridge, MA (Avery, 1981).

The terracottas ascribed to the Master of the Unruly Children are composed with complete assurance and convey a sense of movement and physical presence that indicates an accomplished sculptor. He executed a series of variations on the basic theme of a seated woman with children about her. Some examples with three children conform to the standard iconography of the Christian virtue of Charity. Others, with only one boy, apparently represent the *Virgin and Child*, in some of which he playfully reveals one of his mother's breasts as she reads. The similar facial features of the women, the disposition of their feet with knees swung to their left, their loose

robes and ample cloaks, and the treatment of their drapery folds, especially across their knees and their feet along the bases, relate all of them to the same master. The modelling of the children, with the fleshiness of their cheeks, necks, arms, legs and abdomens, as well as their facial expressions and swirling curls of hair, also relate them to the same hand. In some compositions children appear on their own, quarrelling. All have rocky bases and, where necessary, are hollowed out behind to prevent cracking when being fired in the kiln. They are also often painted naturalistically.

Close in style and subject to the statuettes by the Master of the Unruly Children are the glazed terracotta figures of the Christian Virtues, especially the *Charity*, made for the frieze depicting the *Seven Works of Mercy* on the external loggia of the Ospedale dell Ceppo in Pistoia. The curious ribbed and pointed halo, like an umbrella blown inside out, with which the *Charity* in Pistoia is endowed, frequently features in the work of the Master of the Unruly Children. Santi Buglioni is credited with glazing the figures at Pistoia between 1526 and 1528, but it is not known whether he actually modelled them.

It is unlikely that a sculptor as competent as the Master of the Unruly Children restricted himself to producing such a limited range of subjects, and the particular groups from which he derives his nickname form probably only one facet of a more extensive activity. Two other distinct series of statuettes in terracotta, on much the same scale and in a similar style, should perhaps be attributed to him:

Master of the Unruly Children: *Charity*, terracotta, early 16th century (London, Victoria and Albert Museum)

both manifest a tendency to produce a series of variations on a particular theme, and are clearly not *bozzetti* but finished sculptures made for collectors. One series takes the theme of a mêlée of soldiers fighting around a horseman. These have sometimes been attributed to Giovanni Francesco Rustici, a close associate of Leonardo da Vinci. The terracotta groups are indeed reminiscent of Leonardo's sketches for his fresco, the *Battle of Anghiari* (*c.* 1503–5; Florence, Pal. Vecchio; destr.). According to Vasari, Rustici executed terracotta groups of horses with men on or under them. There is thus ample evidence for an attribution of at least some of these works to Rustici, but others are very close in style, facial types and technique to works by the Master of the Unruly Children.

The other series that is related in style to the *Unruly Children* consists of reclining male figures with various attributes, often upturned urns, signifying that they are river gods. Again, there are the characteristics of form and movement, facial expression, and rendering of flesh, hair and drapery folds that appear in the *Unruly Children*. Examples of the *River Gods* are located in the Museum of Art, Rhode Island School of Design, and the Detroit Institute of Arts: some are reworkings of Michelangelo's models and drawings of the 1520s for the unexecuted *River Gods* intended for the tombs in his New Sacristy in S Lorenzo, Florence. They have sometimes been connected with Jacopo Sansovino, on the strength of their similarities with his Venetian works, especially the statuettes of the *Four Evangelists* on the altar-rail in S Marco's, Venice, and the terracotta *bozzetto* of *St John* in the Staatliche Museen Preussischer Kulturbesitz, Berlin. The work of the Master of the Unruly Children has also been compared with that of the MASTER OF THE DAVID AND ST JOHN STATUETTES (see above), and furthermore it has been suggested that sculptures attributed to these masters may be by Pietro Torrigiani. It has remained difficult to decide between the several distinguished candidates, perhaps because none of them was involved directly in this commercial, serial production of ceramic sculpture, but a gifted minor figure instead, one who was capable of imitating their styles and subjects, with occasional variations. A possible candidate has recently emerged from obscurity in the person of Sandro di Lorenzo di Sinibaldo, qualified as a 'sculptor or statuary', who resided in the Oltrarno district of Florence. His name is associated , in a valuation drawn up in 1523 (with Rustici, Tribolo and Antonio Solosmeo acting as third-party witnesses), with four small sculptures in terracotta or unbaked clay, namely a *Laokoon*, a '*Bambino*', a *Bacchus* and a *Judith* (see Butterfield and Franklin, who did not, however, draw the present conclusion). A terracotta statue of *Bacchus* (Detroit, MI, Inst. A.) is intimately related to the above-mentioned *River Gods*, while the small *Judith* (described as being after Verrocchio) recalls certain glazed terracotta statuettes by della Robbia (e.g. Florence, Mus. Bandini), which are also consistent in style with the wider group proposed here.

BIBLIOGRAPHY

J. Pope-Hennessy: *Catalogue of Italian Sculpture in the Victoria and Albert Museum* (London, 1964), nos 425–6

La civtà del cotto (exh. cat., ed A. Paolucci; Impruneta, 1980), nos 2.16–2.18

C. Avery: *Fingerprints of the Artist: European Terra-cotta Sculpture from the Arthur M. Sackler Collections* (Washington, DC, and Cambridge, MA, 1981), no. 9

B. Boucher: *The Sculpture of Jacopo Sansovino* (New Haven and London, 1991), cat. nos 101, 118, 125–6

A. P. Darr: 'Verrocchio's Legacy: Observations Regarding his Influence on Pietro Torrigiani and other Florentine Sculptors', *Verrocchio and Late Quattrocento Italian Sculpture*, ed. S. Bule, A. P. Darr and F. S. Gioffredi (Florence, 1992), pp. 125–39

M. Ferretti: *Master of the Fretful Children* (Turin, 1992)

CHARLES AVERY

Master of the Vatican Homer. *See under* GASPARO PADOVANO.

Virgil Master. *See* APOLLONIO DI GIOVANNI.

Master of the Vitae Imperatorum (*fl* 1430–50). Italian illuminator. He is named after the manuscript of the Italian translation of Suetonius' *Vitae imperatorum* (Paris, Bib. N., MS. it. 131), copied in 1431 for Filippo Maria Visconti, 3rd Duke of Milan. The artist's style continues the Lombard tradition of the late 14th century and the early 15th, and he may have trained with Tomasino da Vimercate. Both illuminators painted in clear, bright colours, and they shared a repertory of decorative features combined in elaborate initials and borders, incorporating both naturalistic and fantastic foliage. The stylized figures that people the initials and miniatures painted by the Master of the Vitae Imperatorum appear to be direct descendants of those in the work of the earlier illuminator, although they are shown with a more controlled animation and a greater interest in modelling. The influence of Michelino da Besozzo may account for the Master's fluid drapery style, in which deep and curling folds are combined within a simplified contour. In general, his highly finished and precisely painted miniatures are not naturalistic in style, their emphasized lines contributing to an overall sense of pattern and decorativeness.

Although a Missal dated 1413 (New York, H. N. Strauss priv. col.) has been attributed to the Master, the bulk of his extant work dates from the period 1430–50. He was one of the favourite illuminators of Filippo Maria Visconti and painted many manuscripts produced for the Duke and members of his family and court. One of the earliest of these, *c.* 1430–34, is the Breviary (Chambéry, Bib. Mun., MS. 4) made for Filippo Maria's second wife, Maria of Savoy (*d* 1447), which also contains initials (fols 436*v*–438*v*) painted by Belbello da Pavia. The *Vitae imperatorum* is the earliest of the dated manuscripts illustrated by the Master for the Duke. It is the most lavish survival of several Roman histories that Filippo Maria had copied in translation and then illustrated or decorated by this illuminator. Although this style seems to have been favoured by many Lombard humanists for the decoration of their Classical texts, the most remarkable miniatures that the Master produced for the Duke illustrate Dante's *Inferno*. The manuscript of this poem (*c.* 1438; Paris, Bib. N., MS. it. 2017 and Imola, Bib. Com., MS. 32) with the commentary of the Milanese humanist Guiniforte Barzizza (1406–63) and containing Filippo Maria's coat of arms is now dismembered and partly defaced. Originally it had 115 miniatures showing the progress of the Poet and Virgil through Hell. The dramatic compositions, all shown taking

place under the earth's crust, demonstrate an invention, control and expressive range unsurpassed in the Master's work.

Besides working for members of the Visconti court, the Master worked also for prominent Milanese citizens. Between 1433 and 1438 he illuminated a Pontifical (Cambridge, Fitzwilliam, MS. 28) for Francesco Pizolpasso, Archbishop of Milan, and in the 1440s he painted two manuscripts for Cristoforo da Cassano, keeper of the Albergo del Pozzo, an inn that survived until 1918. One of these, Fazio degli Uberti's *Il dittamondo* (1447: Paris, Bib. N., MS. it. 81), contains a series of images of constellations that reveal the Vitae Imperatorum Master as a subtle and accomplished draughtsman with special skill in the representation of animals. A large number of manuscripts has been attributed to the Master, and it has been proposed (Melograni) that he had assistants who worked under his close supervision. He was once thought to be the author of an initial 'C' of the *Communion of the Apostles* (Venice, Fond. Cini, no. 2099) that is inscribed as having been made in 1439 by an Olivetan of Milan. This initial and other works in the same style, however, have been identified as the work of a second illuminator, known as the Olivetan Master. The influence and features of the style of the Master of the Vitae Imperatorum were widespread in Lombardy and persisted into the next generation of Milanese illumination, for example in the work of the Ippolita Master, the anonymous illuminator whose role at the court of Francesco Sforza, Duke of Milan, was analogous to that played by the Vitae Imperatorum Master at the court of the third Duke.

BIBLIOGRAPHY

P. Toesca: *La pittura e la miniatura nella Lombardia dai più antichi monumenti alla metà del quattrocento* (Milan, 1912/R Turin, 1966), pp. 528–32

A. Stones: 'An Italian Miniature in the Gambier-Parry Collection', *Burl. Mag.*, cxi (Jan 1969), pp. 7–12

E. Cappugi: 'Contributo alla conoscenza dell'Inferno Parigi-Imola e del suo miniatore detto il Maestro delle Vitae Imperatorum', *La miniatura italiana tra gotico e rinascimento. Atti del II congresso di storia della miniatura italiana: Cortona 1983*, pp. 285–96

S. Bandera Bistoletti: 'La datazione del ms. *italien* 2017 della Bibliothèque Nationale di Parigi miniato dal "Magister Vitae Imperatorum"', *Scritti di storia dell'arte in onore di Roberto Salvini* (Florence, 1984), pp. 289–92

Dix Siècles d'enluminure italienne (exh. cat., Paris, Bib. N., 1984), pp. 148–51

Arte in Lombardia tra gotico e rinascimento (exh. cat., Milan Pal. Reale, 1988), pp. 122–9

A. Melograni: 'Appunti di miniatura lombarda: Ricerche sul "Maestro delle Vitae Imperatorum"', *Stor. A.*, lxx (1990), pp. 273–314

F. Todini: *Una collezione di miniature italiane dal duecento al cinquecento* (Milan, 1993), pp. 56–99

The Painted Page: Italian Renaissance Book Illumination, 1450–1550 (exh. cat., ed. J. J. G. Alexander; London, RA, 1994)

□

II. Dated masters.

Master of 1419 (*fl* Florence, *c.* 1419–30). Italian painter. The artist was first identified by Pudelko (1938), who constructed a corpus around the *Virgin and Child with Angels* (Cleveland, OH, Mus. A.; see fig.), the central panel of a dismembered triptych. The work is dated 1419, hence the name by which the Master is known. This corpus was not entirely coherent, however, and the artist was more clearly defined by Longhi (1940), who recognized that he

Master of 1419: *Virgin and Child with Angels*, tempera and gold on panel, 1.96×0.68 m, 1419 (Cleveland, OH, Cleveland Museum of Art)

was probably trained in the circle of Lorenzo Monaco, later absorbing the more conservative innovations of the Renaissance represented by Masolino. The triptych of *St Julian Enthroned with Two Saints* (San Gimignano, Mus.

Civ.), originally in the Collegiata, can be dated to this phase in his development and shows an extremely precocious response in the 1420s to Masaccio's early work, such as the S Giovenale Triptych (Reggello, S Giovenale in Cascia) and the *Virgin and Child with St Anne and Angels* (Florence, Uffizi), in its attempt to show the figures in perspective and to render their bodies volumetrically. Critics have emphasized the importance of the Master's role in the development of the Late Gothic style in Florence and have suggested links with Rosello di Jacopo Franchi, Giovanni Toscani and also with some controversial works attributed to Paolo Uccello, such as the frescoed tabernacle of *Lippi and Macia* (Macia, Mater Dei).

Carli suggested that the Master could be identified with Ventura di Moro (*fl* 1419–56), a Florentine painter known chiefly through documents. Ventura is documented working as a painter in San Gimignano around 1427; it has been suggested that the triptych of *St Julian* also dates from this year and might have been part of that campaign of work. Those who have accepted this identification have enlarged the artist's corpus to include documented works attributed to Ventura such as the frescoes on the façade of the oratory of the Bigallo in Florence, now barely legible. However, a comparison between the original nucleus of works attributed to the anonymous Master and those subsequently added makes it apparent that the identification should be rejected. The underlying artistic formation of the two groups of works is so dissimilar that they cannot be the work of the same painter, even in two phases of his career.

BIBLIOGRAPHY

G. Pudelko: 'The Maestro del Bambino Vispo', *A. America*, xxvi (1938), pp. 47–63
R. Longhi: 'Fatti di Masolino e Masaccio', *Crit. A.*, v (1940), pp. 145–91 (177, 183, 185)
B. Nicolson: 'The Master of 1419', *Burl. Mag.*, xcvi (1954), p. 181
P. Pouncey: 'Letters: A New Panel of the Master of 1419', *Burl. Mag.*, xcvi (1954), pp. 291–2
W. Cohn: 'Notizie storiche intorno ad alcune tavole fiorentine del '300 e '400', *Riv. A.*, xxxi (1956), pp. 41–72
H. S. Francis: 'Master of 1419', *Bull. Cleveland Mus. A.*, xliii (1956), pp. 211–13
A. Parronchi: *Studi sulla dolce prospettiva* (Milan, 1964), pp. 132–3
S. Skerl Del Conte: 'Una tesi di laurea su "Il Maestro del 1419 e Paolo Uccello"', *A. Friuli, A. Trieste*, iii (1979), pp. 175–84
E. Carli: *San Gimignano* (Milan, 1982), p. 94
H. W. van Os: 'Discoveries and Rediscoveries in Early Italian Painting', *A. Crist.*, lxxi (1983), pp. 69–80

CECILIA FROSININI

Master of 1515 (*fl c.* 1515). ?Italian engraver and draughtsman. The Master's name is taken from the date on an engraving of *Cleopatra with a Herm*. A further 40 engravings are generally accepted as the work of the same artist; all are characterized by a preference for the depiction of architecture, decorative details and figures inspired by the Antique. Of these engravings, six (presumably the earliest) are executed with the burin alone, while the rest show traces of drypoint burrs. Among the remaining 34 is the *Allegory with Roman Monuments* (possibly an *Allegory of Fortitude*), an unfinished engraving that has traces of drypoint and is a kind of antique architectural caprice: it includes the statue of *Marcus Aurelius* and Trajan's Column. It is the best illustration of the Master's style, a highly personal interpretation of the technique using close parallel lines for shading popularized by Mantegna.

The Master's distinctive originality in terms of style, technique and iconography makes it difficult to place him in the history of engraving. At first he was assumed to be Italian; later he was thought to be a northern European artist, possibly the sculptor Hermann Vischer the younger (*c.* 1486–1517), or a dilettante from the Rechenmeister family of Nuremberg. The discovery that architectural elements in a number of his engravings were taken directly from a sketchbook (Berlin, Kupferstichkab.) plausibly attributed to the Milanese sculptor Agostino Busti seems to have settled the problem of his identity (Dreyer and Winner). Yet, although the engravings certainly reproduce the drawings attributed to Busti, it does not necessarily follow that Busti was the engraver. Moreover, a comparison of the drawings attributed to Busti with the only drawing generally accepted as being by the Master of 1515 (1520; Berlin, Kupferstichkab., with an inscription in old German on the back) highlights their considerable stylistic discrepancies. It would therefore be prudent to consider the Master an anonymous artist, with evident contacts with contemporary north Italian art.

BIBLIOGRAPHY

P. Kristeller: 'Eine Zeichnung des Meisters von 1515', *Amtl. Ber. Kön. Kstsamml.*, xxxii (1910–11), cols 60–62
——: *Der Meister von 1515* (Berlin, 1916)
K. Simon: 'Der Meister von 1515 = Hermann Vischer?', *Italienische Studien, Paul Schubring zum 60. Geburtstag gewidmet* (Leipzig, 1929), pp. 123–37
A. M. Hind: *Early Italian Engraving: A Critical Catalogue* (London, 1938–48), v, pp. 279–90
P. Dreyer and M. Winner: 'Der Meister von 1515 und das Bambaja-Skizzenbuch in Berlin', *Jb. Berlin. Mus.*, vi (1964), pp. 53–94
J. Levenson, K. Oberhuber and J. Sheehan: *Early Italian Engravings from the National Gallery of Art* (Washington, DC, 1973), pp. 456–64
M. J. Zucker: *Early Italian Masters, Commentary (1984)*, 25 [XIII/ii] of *The Illustrated Bartsch*, ed. W. Strauss (New York, 1978–), pp. 571–95
P. Emison: 'Prolegomenon to the Study of Italian Renaissance Prints', *Work & Image*, xi/1 (1995), pp. 1–15

MARCO COLLARETA

III. Monogrammists.

Master B.F. (*fl* Milan, *c.* 1486–1545). Italian illuminator and painter. The initials B.F. appear on a group of miniatures painted by a Lombard artist, clearly a follower of Leonardo da Vinci. They include an *Adoration of the Magi* (New York, Pierpont Morgan Lib., MS. M. 725) and an *Entombment* (London, BM, Add. MS. 18196), as well as a number of other miniatures dispersed in various museums and private collections. A number of different hypotheses have been proposed, and some scholars now tend to accept Wescher's identification of the Master as Francesco Binasco, an illuminator documented at the court of Francesco Maria Sforza, Duke of Milan (*reg* 1521–35). Binasco was also a goldsmith and an engraver, and in 1513 he was working at the Milan mint in the service of Massimiliano Sforza (Levi D'Ancona).

Although many manuscripts have been attributed to the Master, a chronology has not been definitely established. His earliest works certainly include the *Liber hiemalis ordinis SS Ambrosii* (1486; Milan, Archv Capitolare) for Pietro de Casolis, Canon of St Ambrogio, Milan, the *Romanzo di Paolo e Daria* by Gasparo Visconti (Berlin, Kupferstichkab., MS. 78. C. 27) and a three-volume Bible

(Milan, Archv Capitolare), in which the *explicit* bears the date 19 April 1507.

Of somewhat later date is the decoration of the *Lives of the Archbishops of Milan* (Milan, Bib. Ambrosiana, MS. H. 87. Sup.), which shows the arms of Agostino Ferrero, Bishop of Vercelli (1511–36). A number of miniatures cut from choir-books commissioned by the Olivetans of SS Angelo e Nicolò at Villanova Sillaro near Milan and probably illuminated in the years 1500–10 have been traced (London, BL, Add. MSS 18196, 18197b, 39636; Berlin, Kupferstichkab., 626 and 1246; London, Wallace, M. 325–6, 333–5 (miniatures of the *Life of Christ*); Philadelphia, PA, Free Lib., M 72,11, M 28,19, M 72,116, M 72,49–54). Binasco worked for the Olivetan monastery of S Vittore in Corpo, Milan, the provenance of three choir-books decorated after 1542 (Milan, Castello Sforzesco, Biblioteca Trivulziana, corali nos 1–3).

The close link discerned between manuscripts illuminated by this Master and contemporary Lombard painting, especially the work of Leonardo and Bernardino Luini, has been confirmed by the analysis of the panel paintings now attributed to him: a *Circumcision* (Philadelphia, PA, Mus. A.) and two predella panels of the *Nativity* and the *Presentation in the Temple* (Scotland, priv. col., see Frangi, figs 7–8). These works show clear references to the painting of Luini, as well as to that of Martino Piazza of Lodi (*d* 1527).

BIBLIOGRAPHY

DBI

G. Nicodemi: 'I codici miniati dell'Archivio Santambrogiano', *Rass. A.*, i (1914), pp. 91–6
R. Benson: *The Holford Collection: Dorchester House*, i (London, 1927), pp. 35–8
P. Toesca: *Monumenti e studi per la storia della miniatura italiana, I: La collezione di Ulrico Hoepli* (Milan, 1930), pp. 117–19
P. Wescher: *Beschreibendes Verzeichnis der Miniaturen, Handschriften und Einzelblätter des Kupferstichkabinetts der Staatlichen Museen Berlin* (Leipzig, 1931), pp. 133–4
M. Harrsen and G. K. Boyce: *Italian Manuscripts in the Pierpont Morgan Library* (New York, 1953), pp. 55–6
P. Wescher: 'Francesco Binasco Miniaturmaler der Sforza', *Jb. Berlin. Mus.*, ii (1960), pp. 75–91
M. Levi D'Ancona: *The Wildenstein Collection of Illuminations: The Lombard School* (Florence, 1970), pp. 97–105
G. Mariani Canova: *Miniature dell'Italia settentrionale nella Fondazione Giorgio Cini* (Vicenza, 1978), pp. 59–63
Zenale e Leonardo: Tradizione e rinnovamento della pittura lombarda (exh. cat., Milan, Mus. Poldi Pezzoli, 1982), pp. 60–62 [entry by M. Natale and A. Zanni]
F. Frangi: 'Vincenzo Civerchio: Un libro e qualche novità in margine', *A. Crist.*, lxxv (1987), pp. 325–30
J. J. G. Alexander: 'The Livy (MS. 1) Illuminated for Gian Giacomo Trivulzio by the Milanese Artist B. F.', *Yale U. Lib. Gaz.*, lxvi (1991), pp. 219–34
P. G. Mulas: *B. F. et il Maestro di Paolo e Daria* (Pavia, 1991)

MILVIA BOLLATI

Master H.E. *See* MASTER H.F.E. below.

Master H.F.E. [H.E.] (*fl* mid-16th century). Italian engraver. He has often been confused with Domenico Beccafumi. Tietze-Conrat suggested identification of the initials with Hieron

Master IO.FF (*fl c.* 1480–1515). Italian sculptor. Various candidates have been proposed for the bronze plaquette sculptor who signed his works IO.FF, including

Giovanni delle Corniole (*c.* 1470–*c.* 1516), Gian Francesco di Boggio (*fl* 1538) and Giovanni Francesco Ruberti (1486–1526); current opinion favours Giovanni Paolo Fonduli.

The subjects most frequently depicted on this master's plaquettes are allegorical and mythological scenes in circular frames, such as the *Judgement of Paris*, *Ariadne on Naxos* and an *Allegory with a Woman on a Dragon*, and in cartouche frames subjects including the *Trial of Mucius Scaevola*, the *Death of Marcus Curtius* and an *Unidentified Scene with the Breaking of Sticks* (all Washington, DC, N.G.A.). Originally they probably functioned as decorations for sword pommels, and some of these compositions have been recognized in the decoration of daggers and scabbards, including one (*c.* 1493–8; London, V&A) made for Cesare Borgia. They were also used in fine bookbindings produced 1510–15 for Jean Grolier.

BIBLIOGRAPHY
W. Terni de Gregory: 'Giovanni da Crema and his "Seated Goddess"', *Burl. Mag.*, xcii (1950), pp. 159–61
C. B. Fulton: *The Master of IO.FF and the Function of Plaquettes*, Stud. Hist. A., xxii (1982), pp. 143–62 [bibliog. and pls]

□

Mattei. Italian family of patrons and collectors. Claiming descent from Innocent II (*reg* 1130–43), the Mattei were an ancient Roman family of merchants and civic officials who prospered economically in the 16th century. Towards the middle of the 16th century two branches of the family, the Mattei, Dukes of Paganica, and the Mattei, later Duchi di Rocca Sinibaldi and Duchi di Giove, began to erect a formidable group of four contiguous urban palaces that became known as the *isola dei Mattei* in the S Angelo district of Rome. The architectural complex was believed to have been built on the site of the ancient Circus Flaminius: in fact it was located on the site of the Teatro di Balbo and the Crypta Balbi (both 19 BC). Palazzi of the Mattei–Paganica occupied the southern and western portions of the *isola*. The Palazzo Mattei di Paganica, erected by Ludovico Mattei, Duca di Paganica, was constructed in 1540 to designs ascribed to Jacopo Vignola. The interior contains frescoed friezes possibly executed by Taddeo Zuccaro and Federico Zuccaro. The smallest of the new Mattei palaces was erected to designs ascribed to Nanni di Baccio Bigio on a contiguous site, facing the Piazza dei Mattei, in or perhaps a little before 1540 by Giacomo Mattei, younger brother of Ludovico. The austere façade was decorated with chiaroscuro frescoes (destr.) depicting scenes from the *Life of Furio Camillo* executed (1548) by Taddeo Zuccaro (Vasari). Giacomo subsequently commissioned Taddeo Zuccaro to execute frescoes representing the *Passion* (*c.* 1556; *see* ZUCCARO, (1), fig. 1) in the Mattei Chapel, S Maria della Consolazione (*in situ*).

The second branch of the Mattei consisted of Alessandro Mattei (*d* 1580); his brother Paolo Mattei (*d* 2 or 4 March 1592), the Duca di Giove; and Alessandro's three sons: (1) Ciriaco Mattei, Duca di Rocca Sinibaldi; Cardinal Girolamo Mattei (*b* Rome, 1546; *d* Rome, 1603); and Asdrubale Mattei (*b* Rome, 1556; *d* Rome, 1638), Duca di Giove and, after Ciriaco's death, also Duca di Rocca Sinibaldi. Their palazzi occupied the northern and eastern areas of the *isola dei Mattei*. The palazzo of Alessandro

Mattei, now the Palazzo Mattei–Caetani, bears the date 1564 on an inscription above the main entry portal. The architect was formerly identified as Bartolomeo Ammannati, although Claudio Lippi di Caravaggio, the son of Nanni di Baccio Bigio, has also been suggested. Alessandro commissioned ceiling frescoes (1559–60; some *in situ*), from Taddeo Zuccaro, which were executed with Federico Zuccaro and which depict scenes from the *Life of Alexander the Great*. In the *grand salone* there are frescoes by Giovanni Alberti with landscapes by Paul Bril (*c.* 1554–1583). During 1564–5 Alessandro Mattei also had a family burial chapel, subsequently decorated through the patronage of Ciriaco Mattei, constructed in a Tuscan style by Giacomo del Duca in S Maria in Aracoeli.

Paolo Mattei acquired a site on the Palatine in 1552, on which he erected a small villa called the 'Palatina' (destr.), in part frescoed with grotesques and mythological scenes, possibly by Baldassare Peruzzi and subsequently engraved by Marcantonio Raimondi. At the Palatina, Paolo also collected antiquities, some of which were later recorded at his nephew Asdrubale's Palazzo Mattei di Giove. In 1585 Paolo acquired burial rights in and agreed to have decorated the chapel of the Pietà in S Maria in Aracoeli. The fresco scheme (*in situ*) executed (1588–90) for him by Cristoforo Roncalli consists of a complex Christological programme with a doctrinal interpretation of the Passion as its central theme. Girolamo Mattei, of the order of Observant Franciscans, became the first Mattei Cardinal, elevated by Sixtus V. It is thought that Girolamo commissioned the fresco of the *Flagellation* (1573; *see* ZUCCARO, (2), fig. 1) bearing the Mattei coat of arms in conjunction with a cardinal's hat, from Federico Zuccaro in the oratory of the Gonfalone. He was a reserved and austere man, whose patronage was limited; nonetheless, for about two years (1601–*c.* 1603) Caravaggio (1571–1610) was a guest in his palace.

BIBLIOGRAPHY

G. Vasari: *Vite* (1550, rev. 2/1568); ed. G. Milanesi (1878–85), vii, pp. 78, 83–4
G. Baglione: *Vite* (1642); ed. V. Mariani (1935), pp. 50, 56, 87, 289, 309, 343, 346, 379
G. P. Bellori: *Vite* (1672); ed. E. Borea (1976)
F. Titi: *Descrizione delle pitture…in Roma* (Rome, 3/1763), pp. 86–91, 187, 189–96, 469–70, 473
L. Heutter: 'I Mattei custodi dei Ponti', *Capitolium*, vii (1929), pp. 347–55
G. Antici–Mattei: 'Cenni storici sulle nobili e antiche famiglie Antici, Mattei, e Antici–Mattei', *Riv. Coll. Araldica*, xxxix–xlii (1941–4)
C. Benocci: *Il Rione S Angelo* (Rome, 1980), pp. 57–78
——: 'Taddeo Landini e la fontana delle Tartarughe in Piazza Mattei a Roma', *Stor. A.*, lii (1984), pp. 187–203
S. Finocchi Vitale and R. Samperi: 'Nuovi contributi sull'insediamento dei Mattei nel Rione S Angelo e sulla costruzione del Palazzo Mattei Paganica', *Stor. Archit.*, viii (1985), pp. 19–36
F. Cappelletti and L. Testa: *Il trattenimento di virtuosi: Le collezioni secentesche di quadri nei palazzi Mattei di Roma* (Rome, 1994)

(1) Ciriaco Mattei (*b* Rome, 12 Aug 1545; *d* Rome, 10 Oct 1614). He was a distinguished patrician and city official. He had the renowned Villa Celimontana, with its complex garden scheme, constructed (1581–6) on vineyards inherited from Giacomo Mattei on the Monte Celio. The architect of the principal *casino* was Giacomo del Duca. The gardens, much visited by foreign travellers, were arranged in a formal scheme *all'antica*, which included terraces and ramps, avenues and hedges, as well as a labyrinth for amusement. A highly celebrated collection of antique and contemporary statuary and fountains, (destr. and dispersed) in addition to a rich collection of antique inscriptions, were originally part of the design. Only the Capitoline Obelisk given to Ciriaco by the City of Rome in 1582 remains *in situ*. MacDougall's reconstruction of the gardens reveals an allegorical and emblematic scheme organized around the theme of the antique Roman circus, a conspicuous reference to the myth of the Circus Flaminius. The gardens were meant to evoke the glories of ancient Rome, and demonstrate the Mattei's links with that era. During the 17th century they were enlarged and embellished with a series of emblematic fountains (destr.; see Falda; Belli Barsali), probably designed by Bernini.

Ciriaco also assembled a collection of antiquities (see Venuti; Lanciani) at the Palazzo Mattei (now Mattei–Caetani). This was dispersed in the 18th century, and many pieces, including the Mattei *Ceres* (marble; *c.* 3rd century BC; Rome, Vatican, Gal. Candelabri) and the acclaimed *Pudicity* (marble; late 1st century AD; Rome, Vatican, Braccio Nuo.), entered the Museo Pio-Clementino. In 1584 Ciriaco obtained the municipal appointment of Conservatore in Rome. In the Mattei Chapel, S Maria in Aracoeli, he had a decorative scheme executed (1586–9; incomplete) by Girolamo Muziano, with the assistance of Giacomo del Duca. The principal paintings are five large oils (*in situ*) depicting scenes from the *Life of St Matthew*, the family's patron saint.

In 1592 Clement VIII granted jointly to Ciriaco and Asdrubale Mattei the fief of Rocca Sinibaldi. Ciriaco thus obtained the title of marchese along with the estate castle, which was probably designed by Baldassare Peruzzi. Three works by Caravaggio (1571–1610) are documented as having been painted for Ciriaco: the *Supper at Emmaus* (London, N.G.), payment January 1602; *St John the Baptist* (Rome, Pin. Capitolina), payments July and December 1602; and the *Taking of Christ* (Dublin, N.G.), payment 2 January 1603. Baglione stated that the *Incredulity of St Thomas* (Potsdam, Schloss Sanssouci) was painted for him, but it is more likely that this work was painted in the Palazzo Mattei for Vincenzo Giustiniani (1564–1637).

BIBLIOGRAPHY

G. B. Falda: *Le fontane di Roma* (Rome, 1675, rev. 1690–91), iii, pls 18–19
R. Venuti: *Vetera monumenta quae in hortis Caelimontanis et in aedibus Matthaeiorum adservantur*, 3 vols (Rome, 1776–9)
R. Lanciani: *Storia degli scavi di Roma e notizie intorno le collezioni romane di antichità*, iii (Rome, 1907), pp. 83–6, 88–97 [Ciriaco's testament, 1610; the inventory of his possessions, 1614]
L. Hautecoeur: 'La Vente de la collection Mattei et les origines du Musée Pio-Clémentin', *Mél. Archéol. & Hist.*, xxx (1919), pp. 57–75
M. Borda: 'Sculture antiche a villa Celimontana', *Capitolium*, xxxi (1956), pp. 43–54
I. Belli Barsali: *Ville di Roma: Lazio I* (Milan, 1970), pp. 54, 384–5
E. B. MacDougall: *The Villa Mattei and the Development of the Roman Garden Style* (diss., Cambridge, MA, Harvard U., 1970)
F. Haskell and N. Penny: *Taste and the Antique: The Lure of Classical Sculpture, 1500–1900* (New Haven and London, 1981/R 1982), pp. 66, 141–3, 181–2, cats 4, 22, 74
J. Heideman: *The Cinquecento Chapel Decorations in S Maria in Aracoeli in Rome* (Amsterdam, 1982)
E. B. MacDougall: 'A Circus, a Wildman and a Dragon: Family History and the Villa Mattei', *J. Soc. Archit. Historians*, xlii (1983), pp. 121–30
F. Cappelletti and L. Testa: *Identificazione di un Caravaggio: Nuove tecnologie per una rilettura del 'S Giovanni Battista' di Roma* (Rome, 1990)

F. Cappelletti: 'The Documentary Evidence of the Early History of Caravaggio's *Taking of Christ*', *Burl. Mag.*, cxxxv (1993), pp. 742–6

□

Matteo, Pasquino di. *See* PASQUINO DA MONTEPULCIANO.

Matteo, Sano di. *See* SANO DI MATTEO.

Matteo (di Pietro di Giovanni di Ser Bernardo) da Gualdo (*b* Gualdo Tadino, *c.* 1435; *d* Gualdo Tadino, after 20 Jan 1507). Italian painter and notary. He was a minor master who worked on the fringes of the artistic activity in Umbria and the Marches. He was rediscovered in the 19th century, but his original, easily recognizable style, with its tendency to distortion and its lively popular sentiment, has ensured him a popularity that perhaps exceeds his merits.

Matteo is documented in his place of birth between 29 May 1463, when he entered into a marriage contract with Pellegrina di Pietro d'Angelello, and 21 January 1507, when he added a codicil to his will. His first securely attributed work, the *Virgin and Child with St Anne* (*c.* 1460; Gualdo Tadino, S Francesco), derives its compositional structure and linear rhythms from the work of Girolamo di Giovanni da Camerino and Bartolomeo di Tommaso da Foligno respectively. The signed and dated altarpiece depicting the *Virgin and Child Enthroned with SS Francis, Bernard, Margaret and Catherine of Alexandria* (1462; ex-S Margherita, Gualdo Tadino; Gualdo Tadino, Pin. Com.) points to contact with Padua and the work of Mantegna. The same stylistic elements appear in his most significant work, the fresco (1468) on the end wall of the oratory of the Pellegrini, Assisi, depicting the *Virgin and Child Enthroned with SS Anthony Abbot and James and the Annunciation*. Matteo's later activity in and around Gualdo Tadino was very intense. His works include triptychs for S Nicolò (1471) and S Maria di Pastina (1477) (both Gualdo Tadino, Pin. Com.) and another for S Lorenzo in Coldellanoce, as well as numerous frescoes. Although these paintings clearly show his assimilation of the ideas and motifs of such contemporaries as Carlo Crivelli and Niccolò di Liberatori, they also utilize Late Gothic forms and rhythms. The same motifs, more crudely and expressionistically rendered, recur in the *Annunciation* and the *Tree of Jesse* (both Gualdo Tadino, Pin. Com.) and *Meeting of Joachim and Anna* (Nocera Umbra, Pin. Com.), all executed in the last decades of the 15th century. While currently attributed to Matteo, they may have been painted by his son Girolamo da Gualdo (*fl* 1st quarter of 16th century), who, like his father, also practised as a notary, as did his own son, Bernardo da Gualdo (*fl* 1500–30).

BIBLIOGRAPHY
G. B. Cavalcaselle and J. A. Crowe: *Storia della pittura in Italia*, ix (1902), pp. 96–102
P. Scarpellini: 'Un paliotto di Matteo da Gualdo', *Paragone*, xxvii/313 (1976), pp. 54–61
G. Donnini: 'La vicenda pittorica di Matteo da Gualdo', *Gualdo Tadino* (Gualdo Tadino, 1979), pp. 81–107
F. Todini: *La pittura umbra dal duecento al primo cinquecento* (Milan, 1989), i, pp. 211–14; ii, pp. 383–6
P. SCARPELLINI

Matteo da Milano (*b* ?Milan; *fl c.* 1492–1523). Italian illuminator. He is first documented in November 1504 among the artists working on the Breviary of Ercole I d'Este (1502–5; Modena, Bib. Estense, MS. VG. 11, lat. 424). He appears in the Este accounts until 1512. Hermann identified Matteo as the illuminator of numerous historiated initials in the Breviary, as well as four full-page miniatures that were cut out of the manuscript (Zagreb, Yug. Acad. Sci. & A.). Matteo's style is characterized by a late 15th-century Lombard sense of three-dimensional form and modelling, suggesting that his earliest training took place in Milan. His use of Classical motifs is often superficial and decorative. Matteo's familiarity with the prints of Albrecht Dürer (1471–1528) is apparent in quotations in the background of the full-page miniature of the *Calling of SS Peter and Andrew* from the Breviary, in cuttings from the Hours of Alfonso I d'Este (Zagreb, Yug. Acad. Sci & A.) and in the architectural background of the miniature from the Hours of Bonaparte Ghislieri (London, BL, Yates Thompson MS. 29, fol. 74*v*). The last-mentioned manuscript also reveals Matteo's knowledge of northern manuscript traditions and has borders with *trompe l'oeil* flowers and fantastic beasts arrayed against a continuous gold background in the Flemish manner. Alexander attributed a number of manuscripts and cuttings to Matteo, including the Missal of Cardinal Arcimboldi of Milan (Milan, Bib. Capitolare, MS. II.D.I.13; *see* MASTERS, ANONYMOUS, AND MONOGRAMMISTS, §I: MASTER OF THE ARCIMBOLDI MISSAL), which he dated to *c.* 1492, and a Missal written in Rome in 1520 for Cardinal Giulio de' Medici (Berlin, Kupferstichkab., MS. 78. D. 17).

BIBLIOGRAPHY
H. J. Hermann: 'Zur Geschichte der Miniaturmalerei am Hofe der Este in Ferrara', *Jb. Ksthist. Samml. Allhöch. Ksrhaus.*, xxi (1900), pp. 117–271; It. trans. with new material as *La miniatura estense* (Modena, 1994)
J. J. G. Alexander: 'Italian Illuminated Manuscripts in British Collections', *La miniatura italiana tra gotico e rinascimento: Atti del II congresso di storia della miniatura italiana: Cortona, 1983*, i, pp. 110–13
C. M. Rosenberg: 'The Influence of Northern Graphics on Painting in Renaissance Ferrara: Matteo da Milano', *Mus. Ferrar.: Boll. Annu.*, xv (1985–7), pp. 61–74
M. P. Lodigiani: 'Per Matteo da Milano', *A. Crist.*, lxxix/745 (1991), pp. 287–300
J. J. G. Alexander: 'Matteo da Milano, Illuminator', *Pantheon*, l (1992), pp. 32–45
A. Dillon Bussi: *Una serie di ritratti miniati per Leone X* (Florence, 1994)
CHARLES M. ROSENBERG

Matteo de' Pasti. *See* PASTI, MATTEO DE'.

Matteo di Giovanni (*b* Borgo Sansepolcro, *c.* 1430; *d* Siena, 1495). Italian painter. His large surviving oeuvre exemplifies the development of Sienese painting in the 15th century from an emphasis on line and pattern to an early interest in the innovations of contemporary Florentine art. It has been suggested that he was first influenced by Umbrian painting of the mid-15th century, but he was already active in Siena by the early 1450s. This was a decade of transition in the artistic life of the city after the death of Sassetta, Domenico di Bartolo and Pietro di Giovanni d'Ambrogio and before the influx of new ideas during the pontificate of Pius II. Matteo is first documented in Siena in 1452, when he was commissioned to gild an angel carved in wood by Jacopo della Quercia for Siena Cathedral. In 1457 he decorated the chapel of S Bernardino there. The modest nature of these projects

suggests that he was still an apprentice. In this period he collaborated with Giovanni di Pietro, the brother of Vecchietta, which supports the hypothesis that his early training was in the circle of Vecchietta.

Giovanni di Pietro is known mainly through documents, and attempts to establish his artistic identity have involved works traditionally attributed to Matteo in his early period, notably the altarpiece of the *Annunciation with SS John the Baptist and Bernardino* (Siena, S Pietro Ovile; still largely *in situ*), painted in a style close to Vecchietta. The centre panel, a copy of the *Annunciation* (Florence, Uffizi) from Siena Cathedral by Simone Martini (1284–1344), has been attributed to Matteo by some scholars and to Giovanni by others, while the side panels of *St John the Baptist* and *St Bernardino*, which show the strong influence of Domenico di Bartolo and Pietro di Giovanni d'Ambrogio, are generally accepted as by Matteo. The archaic style of the Ovile altarpiece has certain elements in common with Matteo's first dated work, an altarpiece painted in 1460 (Siena, Mus. Opera Duomo).

Stylistic affinities are also apparent between the Ovile altarpiece panels and Matteo's predella with scenes from the *Life of St John the Baptist* and side panels with *St Peter* and *St Paul* (all Sansepolcro, Mus. Civ.), all of which once surrounded Piero della Francesca's *Baptism* (London, N.G.; *see* PIERO DELLA FRANCESCA, fig. 1), works datable on stylistic grounds to the mid-1450s. A slightly later work is the altarpiece of the *Virgin and Child with SS James, Augustine, Bernardino and Margaret* (Asciano, Mus. A. Sacra). The *Annunciation* in the pinnacle, and the predella, include elements derived from Domenico di Bartolo and Vecchietta, as well as details typical of Matteo's later works: geometric paving, fine fabrics and certain facial expressions, often melancholy.

Matteo's first dated work, the signed altarpiece of 1460, the *Virgin and Child Enthroned with SS Anthony of Padua and Bernardino and Angels* (Siena, Mus. Opera Duomo; see fig.), was recorded in 1478 in the chapel of S Antonio in the Baptistery, Siena. The pairs of angels behind the Virgin recall those in Piero della Francesca's *Baptism*, which suggests that the *Baptism* altarpiece was completed earlier. The Siena painting, with its careful depiction of space and sculptural figures, marks perhaps the most intense period in Matteo's artistic career.

Matteo, with masters of the previous generation, Giovanni di Paolo, Sano di Pietro and Vecchietta, was commissioned by Pius II to paint two altarpieces for Pienza Cathedral (*in situ*). The first, the *Virgin and Child with SS Jerome, Ambrose, Augustine and Nicholas* (1462–4), shows a new element of fantasy, with archaeological overtones, in the throne of the Virgin. The second panel, painted somewhat later and signed, the *Virgin and Child with SS Catherine, John, Bartholomew and Lucy*, suggests a broader range of influences, particularly the manuscript illumination of Liberale da Verona, who was in Siena from 1466. The Virgin's throne is surrounded by saints clothed in dazzling colours; the drawing is softer and more flexible, elegantly defining the faces, and the graceful and delicate figures are typical of Matteo's mature works. In the *Flagellation* in the pinnacle, the floggers are an early reference to the Florentine painting of Antonio del Pollai-

Matteo di Giovanni: *Virgin and Child Enthroned with SS Anthony of Padua and Bernardino and Angels*, oil on panel, 1460 (Siena, Museo dell'Opera del Duomo)

uolo; the figure of Christ, seen from below and slightly foreshortened, evokes the work of Piero della Francesca.

The delightful *Virgin and Child with Angels* (1470; Siena, Pin. N.) is still full of youthful freshness and charm, both in the delicate definition of the faces and hands and in the vivacity of the colours. The angels are reminiscent of those painted by Domenico di Bartolo in the *Madonna of Humility* (1433; Siena, Pin. N.; for illustration see DOMENICO DI BARTOLO) but with softer modelling, more fluid forms, enamel-like colours and careful attention to detail. These qualities characterize Matteo's work of the 1470s and 1480s, which is full of charm and elegance but has an increasingly narrow vision. In the 1470s he produced some of his most ambitious works, including the Placidi Altarpiece (1476) and the *St Barbara* altarpiece painted in 1479 for the bakers' guild (both Siena, S Domenico), the *Assumption* (London, N.G.) for S Agostino, Asciano, and the Cinughi Altarpiece (Siena, S Maria della Neve). All these are ornate compositions of great splendour, with a prevalence of decorative, flat forms, rather than the sense of space and volume found in his early works. He seems to have become increasingly conservative in this period, creating works of undoubted charm but somewhat insular and aristocratic in tone. This tendency may reflect the many commissions he received from noble families for pictures for private devotion, for example, two paintings of the *Virgin and Child with Saints* (both Washington, DC, N.G.A.).

In his last phase Matteo made greater use of workshop assistance to execute the increasing number of his com-

missions. Important works of these years include three versions of the *Massacre of the Innocents* (Naples, Capodimonte; Siena, S Maria dei Servi; Siena, S Agostino), in which his late style is clearly defined. These paintings show the high level of Matteo's final phase, the tendency to abstraction, a recurring interest in fictive bas-reliefs inspired by the beautiful stoups in Siena Cathedral attributed to Antonio Federighi, and accents of lively imagination. Among his last works are the *Virgin and Child with Saints* (Siena, Mus. Opera Duomo) for the altar of the Celsi family in Siena Cathedral, the large *St Michael* altarpiece (Montepescali, S Lorenzo), the lunette over Francesco di Giorgio Martini's *Nativity* (Siena, S Domenico) and the *Virgin and Child with Saints* (Anghiari, S Agostino). The number and importance of Matteo's commissions indicate that he was highly esteemed in his lifetime, although his reputation later was overshadowed by such contemporaries as Francesco di Giorgio Martini.

BIBLIOGRAPHY

G. Milanesi: *Documenti per la storia dell'arte senese*, 3 vols (Siena, 1854–6), ii, p. 279

S. Borghesi and L. Banchi: *Nuovi documenti per la storia dell'arte senese* (Pisa, 1898), pp. 254–5

G. F. Hartlaub: *Matteo da Siena und seine Zeit* (Strasbourg, 1910)

P. Bacci: 'I primi ricordi del pittore Matteo di Giovanni in Siena', *Riv. A.*, xi (1929), pp. 128–31

M. Gengaro: 'Matteo di Giovanni', *La Diana*, ix (1934), pp. 149–85

C. Brandi: *Quattrocentisti senesi* (Milan, 1949), pp. 142–8

J. Pope Hennessy: 'Matteo di Giovanni's *Assumption* Altarpiece', *Proporzioni*, iii (1950), pp. 81–5

——: 'A *Crucifixion* by Matteo di Giovanni', *Burl. Mag.*, cii (1960), pp. 63–7

E. Trimpi: '"Johannem Baptistam Hieronymo aequalem et non maiorem": A Predella for Matteo di Giovanni's Placidi Altarpiece', *Burl. Mag.*, cxxv (1983), pp. 457–66

C. B. Strehlke: 'Sienese Paintings in the Johnson Collection', *Paragone*, xxxvi/427 (1985), pp. 8–15

La pittura in Italia: Il quattrocento (Milan, 1987), i, pp. 329–32, 335, 337; ii, pp. 706–7 [entry by A. Angelini]

Painting in Renaissance Siena, 1420–1500 (exh. cat. by K. Christiansen, L. Kanter and C. B. Strehlke, New York, Met., 1988–9), pp. 270–81

La pittura senese del rinascimento (Milan, 1989), pp. 284–95 [entry by C. Strehlke]

P. Torriti: *La Pinacoteca Nazionale di Siena* (Genoa, 1990), pp. 258–65

M. Seidel: 'The Social Status of Patronage and its Impact on Pictorial Language in Fifteenth-century Siena', *Italian Altarpieces, 1250–1550: Function and Design*, ed. E. Borsook and F. S. Gioffredi (Oxford, 1994), pp. 119–38

GIOVANNA DAMIANI

Matteo di Nuccio Vagnoli. *See* NUTI, MATTEO.

Mauro di Codussis. *See* CODUSSI, MAURO.

Mayn, John de la. *See* MAIANO, DA, (3).

Mazone [Masone; Massone; Mazzoni], **Giovanni** (*fl* Liguria, 1453–1510/12). Italian painter and wood-carver. Though originally from Alessandria, he was released from the bonds of *patria potestà* in Genoa in 1453 by his father, Giacomo Mazone (*fl* 1434–53), who was also a painter. Giovanni's first recorded commission dates from 1463, when he was engaged to make a relief-carving on an altar (untraced) for the chapel of S Giovanni Battista in Genoa Cathedral. Wood-carving, mentioned again in 1476 in a contract for the renovation of the main altar of Genoa Cathedral, constantly occupied his workshop, which specialized in polyptych frames. Mazone's earliest activity was

centred on the now dispersed polyptych depicting the *Apotheosis of St Nicholas of Tolentino* (1466; ex-S Maria in Cellis, Sampierdarena; Milan, Bib. Ambrosiana; Zurich, Ksthaus; Italy, priv. cols). The panels are Mediterranean in character with their profusion of tooled gold and decorative relief work. The Late Gothic style is attenuated in the rendering of the flesh, where there is a greater sense of volume. This reflects the influence of the first visit to Liguria (1461) of Vincenzo Foppa, who was specified as a model in Mazone's contract of 1463.

The polyptych of the *Annunciation* (Genoa, Nostra Signora del Monte), formerly attributed to Giacomo Serfolio or to the Master of the Annunciation of the Monte, illustrates a moment in Mazone's complex stylistic development before he had absorbed the new ideas of Foppa. Apart from its Late Gothic Lombard elements, the painting displays a Netherlandish influence in the central scene, which is especially reminiscent of the *Annunciation* (1451; Genoa, S Maria di Castello) by Justus of Ravensburg, and aspects of Provençal art in the treatment of landscape. The polyptych of the *Virgin and Child Enthroned with the Four Evangelists* (Pontremoli, SS Annunziata) presents a similar range of cultural references, with, additionally, some signs of Paduan influence (possibly indirect) and parallel signs of intervention by workshop assistants. In those years assistants such as Galeotto Nebbia da Castellazzo Bormida (*c.* 1446–after 1495) are documented. Mazone's only signed and dated work is the triptych of the *Noli me tangere* (1477; Alençon, Mus. B.-A. & Dentelle), painted around the same time as the signed triptych of the *Nativity* (Savona, Pin. Civ.); these are more unambiguously derived from the Lombard tradition, which was strongly represented in Liguria by such painters as Francesco da Verzate (*fl* 1465–1500) and Cristoforo de' Mottis (*fl* 1460–86). Any Cremonese influence is merged with the Provençal style of Jacques Durandi (*fl* 1454–69).

In a series of works that Mazone probably produced in the 1480s there is a new interest in perspective and the rendering of volume in figure painting. This was fostered by the presence of works by Foppa and his followers, such as de' Mottis, but is also a reflection of Tuscan art, especially that of Andrea del Castagno and Domenico Ghirlandaio. These paintings include the *Virgin and Child Enthroned* (Genoa, S Maria delle Vigne), *St Mark with Four Saints* (Liverpool, Walker A.G.), a polyptych with the *Annunciation* (Genoa, S Maria di Castello), a polyptych with the *Virgin and Child Enthroned with Six Saints* (Miami Beach, FL, Bass Mus. A.) and *St John the Baptist* (Milan, Pin. Ambrosiana). Between 1483 and 1489 Mazone also executed frescoes in the Sistine Chapel, near Savona Cathedral. Some of these have become detached, while others are covered by 18th-century stuccowork. They contained sacred scenes decorated with friezes in the Lombard style. The *Calvary* (ex-S Giuliano d'Albaro, Genoa; Genoa, Gal. Pal. Bianco) is probably contemporaneous. Its figures seem closely related to those of the Liverpool *St Mark*, but they are imbued with a deeper dramatic sense, suggestive of Netherlandish influence, and its landscapes show a heightened sense of spatial depth. This last characteristic has led some scholars to suggest

that part of the painting was done by Nicolò Corso, who is documented in Mazone's workshop around 1484.

A more radical break from Netherlandish and Mediterranean traditions, in favour of a Paduan style of naturalism with elements from the work of Mantegna and Foppa, appears in the triptych of the *Nativity* (main sections, Avignon, Mus. Petit Pal.), which Mazone painted in 1489 at the request of Cardinal Giuliano della Rovere (later Pope Julius II) for the Sistine Chapel, near Savona Cathedral. In the minute rendering of some of the drapery folds and faces, however, the intervention can be discerned of an unknown collaborator, to whom other works painted in the following years and formerly attributed to Mazone can be assigned. These include the polyptych of *St Lawrence* (1492; Cogorno, S Lorenzo), the side panels of the triptych of the *Annunciation* (1493; Savona, Pin. Civ.) and parts of a polyptych for S Giorgio, Moneglia. Among Mazone's last works is the panel depicting the *Four Doctors of the Church* (Paris, Mus. Jacquemart-André), which is probably a section of the altarpiece painted in 1491 for Baldassarre Lomellini in S Teodoro, Genoa.

BIBLIOGRAPHY

G. V. Castelnovi: 'Il quattro e il primo cinquecento', *La pittura a Genova e in Liguria dagli inizi al cinquecento*, ed. C. Bozzo Dufour, i (Genoa, 1970, rev. 1987), pp. 84–95, 143–4
A. M. Folli: 'Giovanni Mazone pittore genovese del quattrocento', *Studi Genuensi*, viii (1970–71), pp. 163–90
M. Migliorini: 'Appunti sugli affreschi del convento di Santa Maria di Castello a Genova', *Argomenti Stor. A.* (1980), pp. 49–63
Zenale e Leonardo (exh. cat., Milan, Mus. Poldi Pezzoli, 1982), pp. 85–90 [entry by M. Natale]
C. Varaldo: 'Giovanni Mazone nella cappella Sistina a Savona', *Sabazia*, iv (1983), pp. 8–12
L. Martini: 'Ricerche sul quattrocento ligure: Nicolò Corso tra lombardi e fiamminghi', *Prospettiva*, xxxviii (1984), pp. 42–58
G. V. Castelnovi: 'Su Giovanni Mazone e il "cosidetto Serfolio" ', *Riv. Ingauna & Intemelia*, xxxix (1984), pp. 1–13
G. Algeri: 'Galleria Nazionale di Palazzo Spinola', *Interv. Rest.: G.N. Pal. Spinola*, 9 (1986), pp. 19–24
O. Bergomi: 'Contributo a Giovanni Mazone', *Paragone*, xxxvii/431–3 (1986), pp. 41–4
M. Boskovits: 'Nicolò Corso e gli altri: Spigolature di pittura lombardo-ligure di secondo quattrocento', *A. Crist.*, lxxv (1987), pp. 351–86
M. Natale: 'Pittura in Liguria nel quattrocento', *La pittura in Italia: Il quattrocento*, ed. F. Zeri, 2 vols (Milan, 1987), i, pp. 15–30 (19–20)
A. De Floriani: 'Verso il rinascimento', *La pittura in Liguria: Il quattrocento*, ed. G. Algeri and A. De Floriani (Genoa, 1991), pp. 238–46, 287–300, 417–24

VITTORIO NATALE

Mazzafirri, Michele (*b* Florence, *c.* 1530; *d* Florence, 1597). Italian medallist, goldsmith, silversmith and sculptor. He worked primarily as a goldsmith for the second and third Medici Grand Dukes of Tuscany, Francesco I and Ferdinand I, as well as for Vincenzo I Gonzaga of Mantua. His works of plate and jewellery, gold reliefs and seals are documented, but have not survived. He was involved in the casting in silver in 1580 of some of the figures from a series of the *Labours of Hercules* (e.g. Florence, Bargello; Dublin, N.G.; Vienna, Ksthist. Mus.), using models by Giambologna. He is also suggested as the author of a stone bust of *Vincenzo I Gonzaga* (Milan, Castello Sforzesca), and he produced a series of wax reliefs showing events from the life of Francesco I (London, BM). Also in wax is a group of models for medals and coins (London, BM), in particular a relief in white wax on black slate showing *Hercules Slaying a Centaur*, based on

one of the series by Giambologna for the Tribuna in the Galleria degli Uffizi, and not on the marble version of 1595–1600 (now Florence, Loggia Lanzi), as stated by Pollard. This scene was subsequently used for the reverse of a medal of Ferdinand I de' Medici (see Armand, i, p. 284), signed by Mazzafirri and dated 1588. It was later re-used, with minor changes, by Gasparo Mola (*c.* 1580–1640) in 1598 for another medal of Ferdinand. Mazzafirri's medals demonstrate an attention to the small details of armour and dress in a style that is dry and precise. His portraits are accurate, but without life, and his reverses are unimaginative and brittle versions of official emblems. Only on some of the well-struck medals (Florence, Bargello) with portraits on the obverse and reverse respectively of Ferdinand I and his consort, Christine of Lorraine, can one appreciate the value of the artist's precision and make some connection with the subject.

BIBLIOGRAPHY
Forrer
A. Armand: *Les Médailleurs italiens* (2/1883–7), i, pp. 283–5
G. Guidetti: 'La breve vita di una medaglia Gonzaghesca del '500', *Medaglia*, ii/3 (1972), pp. 19–21
G. Pollard: *Italian Renaissance Medals in the Museo Nazionale del Bargello*, ii (Florence, 1985), pp. 806–30

STEPHEN K. SCHER

Mazzola [Mazolla; Mazzuoli]. Italian family of painters. They came from Pontremoli, but moved to Parma in 1305. Bartolomeo II Mazzola (*fl* 1461–*c.* 1505), who may have been a painter, had three sons who were painters: Filippo Mazzola (*b* Parma, *c.* 1460; *d* Parma, before 30 June 1505), Pier'Ilario II Mazzola (*b c.* 1476; *d* after 30 May 1545) and Michele Mazzola (*b c.* 1469; *d* after 1529). Filippo may have trained with Francesco Tacconi (*fl* 1458–1500) of Cremona. His signed paintings, which include the *Virgin Enthroned with Saints* (1491; Parma, G.N.), the *Baptism* (1493; Parma Cathedral) and the *Conversion of Saul* (1504; Parma, G.N.), are closely related to the works of contemporary Venetian painters, latterly Alvise Vivarini in particular. He was also an accomplished portrait painter, producing such works as the *Portrait of a Man* (Milan, Brera) and *Alessandro da Richao* (Madrid, Mus. Thyssen-Bornemisza). Pier'Ilario and Michele collaborated on commissions, including frescoes in the chapel of S Niccolò (1515) in S Giovanni Evangelista, Parma. Filippo's son, Girolamo Francesco Maria Mazzola, known as PARMIGIANINO, became a leading Mannerist painter. Parmigianino's pupil, who added the Mazzola surname to his own, was GIROLAMO MAZZOLA BEDOLI. Bedoli's son Alessandro Mazzola Bedoli (*b* 2 Sept 1547; *d* 1612), also a painter, worked mainly in Parma.

BIBLIOGRAPHY
G. Vasari: *Vite* (1550, rev. 2/1568); ed. G. Milanesi (1878–85), v, pp. 217–38
C. Ricci: *Filippo Mazzola* (Trani, 1898)
L. Testi: 'Pier Ilario e Michele Mazzola', *Boll. A.*, iv (1910), pp. 49–67, 81–104
B. Berenson: *Venetian School*, i (1957), pp. 112–14
F. Zeri: 'Filippo Mazzola e non Alvise Vivariani', *Diari di lavoro*, i, (Bergamo, 1971), pp. 54–5
H.-J. Eberhardt: 'Il Giovane con la parrucca: Un ritratto dell'ambito di Cima', *Venezia Cinquecento*, iv/8 (1994), pp. 127–44
A. Ghirardi: 'Exempla per l'iconografia dell'infanzia nel secondo Cinquecento padano', *Carrobbio*, xix–xx (1993–4), pp. 123–39

Mazzola, Girolamo Francesco Maria. *See* PARMIGIANINO.

Mazzola Bedoli, Girolamo. *See* BEDOLI, GIROLAMO MAZZOLA.

Mazzolino, Ludovico (*b* Ferrara, *c.* 1480; *d* Ferrara, after 27 Sept 1528). Italian painter. He may have served an apprenticeship with Ercole de' Roberti (Morelli) before he left Ferrara to study in Bologna with Lorenzo Costa (i). The earliest surviving documentation is from 20 May 1504, when he received a first payment for frescoes (destr. 1604) in eight chapels in S Maria degli Angeli, Ferrara, commissioned by Ercole I d'Este, Duke of Ferrara and Modena. Between 1505 and 1507 he was paid for works, presumably decorative, in the Este *guardaroba* and the *camerini* of the Duchessa Lucrezia Borgia in Ferrara Castle (untraced). His first surviving dated painting is the triptych of the *Virgin and Child with SS Anthony and Mary Magdalene* (1509; Berlin, Gemäldegal.), which shows the influence of his training with Costa and of the German-orientated circle of Jacopo de' Barbari and Lorenzo Lotto.

The archaizing tendency of Mazzolino's work has led to the suggestion (Zamboni) that in his youth, perhaps before 1509, he was in Venice in direct contact with Giorgione. After that year he resided permanently in Ferrara, where he produced mainly small paintings in oil on panel. In 1511 he signed and dated the *Holy Family with SS Sebastian and Roch* (sold London, Christie's, 9 March 1923), which again employs the style of Costa but introduces a new, restless asymmetry. The anti-classical tendency apparent in the work may derive from Albrecht Dürer (1471–1528), who was in Ferrara in 1506 on his way to Bologna. The landscape in the signed and dated *Pietà* (1512; Rome, Gal. Doria–Pamphili), painted for Lucrezia Borgia, shows a strong influence of Giorgione. The diverse components of Mazzolino's artistic background were united in his most important work of this period, the *Adoration of the Magi* (1512; sold London, Sotheby's, 11 March 1964, no. 129).

In the *Holy Family* (1516; Munich, Alte Pin.) the influence of Lotto can still be felt, as well as that of Garofalo and Ortolano, artists to whom he was close stylistically. The *Crossing of the Red Sea* (1521; Dublin, N.G.) also shows evidence of his familiarity with north European prints, particularly of Lucas Cranach the elder (1472–1553). The altarpiece *Christ among the Doctors* (Berlin, Gemäldegal.) for S Francesco in Bologna is signed and dated 1524. Also from that year is the small altarpiece the *Tribute* (Poznań, N. Mus.) painted for the Bolognese writer Gerolamo Casio (1465–1533). Many of Mazzolino's paintings after 1520, such as the *Virgin and Child with St Anthony Abbot* (1525; Chantilly, Mus. Condé), reflect the manner of Dosso Dossi, who dominated Ferrarese painting in this period. Mazzolino's efforts to adopt modern models were not sustained, however, and the *Circumcision* (Vienna, Ksthist. Mus.) and the *Pietà* (St Petersburg, Hermitage), both dated 1526, show that in his last years he returned to the style of Costa. He died of the plague, aged 49 (Baruffaldi).

BIBLIOGRAPHY

G. Vasari: *Vite* (1550, rev. 2/1568); ed. G. Milanesi (1878–85), iii, pp. 138–9

G. Baruffaldi: *Vite de' pittori e scultori ferraresi* (Ferrara, *c.* 1697–1722); ed. G. Boschini (Ferrara, 1844–6), i, pp. 126–30

G. Morelli: *Le opere dei maestri italiani nelle gallerie di Monaco, Dresda e Berlino* (Bologna, 1886), p. 254

A. Venturi: 'Nuovi documenti: Ludovico Mazzolino pittore nella chiesa di Santa Maria degli Angeli', *Archv Stor. A.*, ii (1889), p. 86

——: 'Ludovico Mazzolino', *Archv Stor. A.*, iii (1890), pp. 449–64

R. Longhi: *Officina ferrarese* (1934, rev. Florence, 1956), pp. 68–70

S. Zamboni: *Ludovico Mazzolino* (Milan, 1970)

LUCA LEONCINI

Mazzoni, Guido [Modanino, Paganino] (*b* Modena, ?1450; *d* Modena, 12 Sept 1518). Italian sculptor, painter, mask-maker and festival director. He was brought up by a paternal uncle, Paganino Mazzoni, a Modenese notary and official of the Este bureaucracy. This connection with the ducal court of Ferrara throws some light on the artist's early training, which is otherwise obscure. A document of 1472 refers to him as a painter, and his first sculpture strongly echoes the figural style in Francesco del Cossa's frescoes (1466–the mid-1470s) at the Palazzo Schifanoia outside Ferrara (*see* FERRARA, fig. 2). Mazzoni may have worked at the Palazzo Schifanoia in association with the stucco master Domenico di Paris, where he may have learnt to model papier-mâché props for the court masques that contemporary sources say he directed and designed. A related activity of these years was making the realistic and caricatural festival masks (*volti modenesi*) for which Modena was famous.

It was in the synthesis of these diverse talents that Guido Mazzoni made his name as a master of dramatic ultra-realism in sculpture. He specialized in composing groups of life-size, naturalistically pigmented terracotta figures whose gestures and facial expressions convey intense emotional involvement. His works on the theme of the *Lamentation* include portrait figures of donors as biblical personages and incorporate life casts of the subject's face and hands, often reworked to fit the action of the scene. Mazzoni's standard format for this theme is distinct from the Deposition and Entombment tableaux of Franco-German tradition, and shows seven mourners around the corpse of Christ, expressing varying degrees of grief. The figures of the Virgin Mary, Mary Magdalene, Mary Cleofa, Mary Salome, St John the Evangelist, Joseph of Arimathaea and Nicodemus are usually arranged in a shallow semicircle facing the viewer set within a large and slightly elevated niche, which may originally have been painted to depict Calvary. The groups were designed to be seen from several viewpoints including from below.

In the earliest group attributable to Mazzoni (the *Lamentation*, *c.* 1475; Busseto, nr Parma, S Maria degli Angeli), the broad handling of form and strident characterization betray his beginnings as a mask-maker. By the early 1480s, however, he began using life casts to imbue his figures with a sense of immediacy and to enhance their functional value as *ex votos*. The *Head of a Man* (Modena, Gal. & Mus. Estense) is the earliest example of this shift from allusive naturalism to the use of reality itself, in which every scar and wrinkle, even the roughened skin of the subject's shaved cheeks, is faithfully reproduced. The decisive development that followed is shown in two works of about 1485; the *Adoration of the Virgin and Child* (Modena Cathedral) and *Lamentation* (Modena, S Giovanni Battista). In both works Mazzoni subordinated

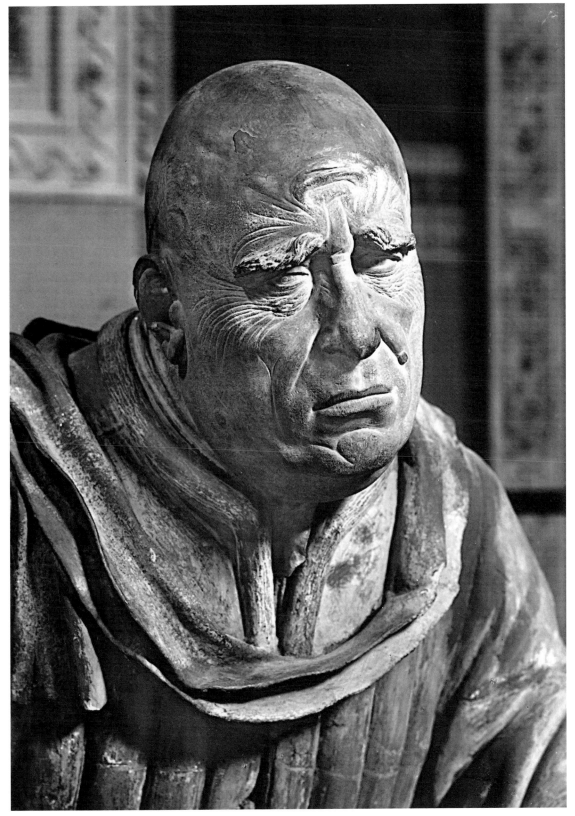

Guido Mazzoni: *Duke of Calabria* [later Alfonso II] *as Joseph of Arimathaea Mourning the Dead Christ*, detail from the *Lamentation* group, terracotta, life-size, 1492 (Naples, S Anna dei Lombardi)

mechanical mimesis to drama, reformulating the inert data furnished by casts into facial expressions and gestures of poetic eloquence. Also apparent in these works, and in the fragments of the *Lamentation* (Padua, Mus. Civ.) made for Venetian patrons, is a fluidity of movement and lyrical introspection reminiscent of Giovanni Bellini. Finally, in the best-known of his groups, the *Lamentation* (1492; Naples, S Anna dei Lombardi) made for the Duke of Calabria (later Alfonso II), Mazzoni achieved a formal monumentality and grandeur of mood that reflects the humanist climate of the Neapolitan court and the artist's exposure to Classical sculpture and contemporary Tuscan art (see fig.).

Like many other Italian artists, Mazzoni emigrated to France when Charles VIII (*reg* 1483–98) returned there in 1496 after his coronation as King of Naples. Mazzoni was court sculptor first to Charles VIII and then to his successor Louis XII of France (*reg* 1498–1515). His major work of this period, the tomb of *Charles VIII* (see Verdon, 1978, figs 87–90) in Saint-Denis, Paris, was destroyed in 1789, but pre-revolutionary illustrations and descriptions confirm that Mazzoni's gift for realism in dramatically activated portrait sculpture was also brought to bear on the royal effigy, made of polychrome enamel and gilded bronze and set on a black marble base. This monument and Mazzoni's project for a two-tier tomb for Henry VII of England (a different design was subsequently commissioned from Pietro Torrigiani in 1512) influenced later French funerary sculpture.

Other works attributable to Mazzoni in these years, all associated with the French court, seem to be collaborative projects. The effigies on the sepulchral monument of *Philippe de Commynes* (ex-Grands Augustins, Paris; fragments Paris, Louvre) and individual figures in the life-size *Death of the Virgin* (Fécamp, Abbaye de la Trinité), which are carved in stone rather than modelled, are close to Mazzoni's style but have many non-Italian features; the same is true of an equestrian statue of *Louis XII* (destr.; see Verdon, 1978, fig. 94), which stood over the entrance of the Château de Blois, Loir-et-Cher, and is known now only from drawings. Mazzoni also acted as consultant and entrepreneur for the decoration of the façade of Château de Gaillon, near Rouen, procuring *all'antica* medallions (Paris, Louvre and Ecole N. Sup. B.-A.) from Italy, and may have directed the decoration with painting and sculpture of the abbot's chapel at the Hôtel de Cluny, Paris (now Paris, Mus. Cluny). In France his role seems to have been that of director of an international workshop, entrusted with fusing the new Italian style with local Late Gothic realism. He had the highest salary of the dozens of Italian artists working at the court and was knighted by Charles VIII. On the death of Louis XII in 1515, Mazzoni returned to Modena, where he had a house and business investments.

Mazzoni had probably already worked outside Modena before his journeys to Naples and France, since he would have accompanied his figures (which were fired in horizontal sections) to be reconstructed and painted on site. He employed assistants, including his wife and daughter, and was well paid and highly regarded. Documents record personal gifts to Mazzoni and his wife from the Dukes of Ferrara, and Vasari said that the Duke of Calabria held Mazzoni in the greatest veneration. His social standing may have been partly due to the special character of his art, which called for intimacy with the patron whose private religious feelings it interpreted. Mazzoni was part-artist, part-confessor and part-stage-director, 'casting' the patron in a key role in this sculptural *sacra rappresentazione*. The increasing psychological subtlety of Mazzoni's interpretation of his themes probably reflects first-hand involvement in religious drama productions.

Mazzoni should be distinguished from Niccolò dell'Arca, whose *Lamentation* group in Bologna (S Maria della Vita) has sometimes been seen as the source of his style. Although it is difficult to establish chronological precedence, Mazzoni's groups bear little resemblance to Niccolò dell'Arca's stylized tableau beyond general similarities of theme and format. Mazzoni strove for an integral illusion of reality in the service of religious sentiment, whereas Niccolò dell'Arca's figures are typically Ferrarese in their expressionism. Mazzoni's appeal lay in his ability to situate patron and viewer in an utterly believable context of shared feeling. He was the most celebrated practitioner of this artistic genre, influencing both the ultra-realistic ensembles of 16th-century northern Italy—the sacromonti ('holy mountains') at Varallo and elsewhere—and the development of the multiple-figure Neapolitan crèche.

BIBLIOGRAPHY

A. Pettorelli: *Guido Mazzoni da Modena, plasticatore* (Turin, 1925)

C. Gnudi: 'L'arte di Guido Mazzoni', *Boll. Stor. A.*, ii (1952), pp. 98–113 [crit. interpretation of earlier lit.]

H. Dow: 'Two Italian Portrait Busts of Henry VIII', *A. Bull.*, xlii (1960), pp. 291–6

M. Beaulieu: 'Note sur la chapelle funéraire de Philippe de Commines au Couvent des Grands Augustins de Paris', *Rev. Louvre Mus. Fr.*, xvi (1966), pp. 65–75

O. Morisani: 'Mazzoni e no', *Scritti in onore di Edoardo Arslan* (Milan, 1966), pp. 475–9

E. Riccòmini: *Guido Mazzoni*, I maestri della scultura (Milan, 1966) [colour pls]

G. Hersey: *Alfonso II and the Artistic Renewal of Naples, 1485–1495* (New Haven, 1969), pp. 112–21

C. Mingardi: 'Problemi mazzoniani', *Contributi dell'Istituto di storia dell'arte medievale e moderna dell'Università Cattolica del Sacro Cuore* (Milan, 1972), pp. 163–87

T. Verdon: *The Art of Guido Mazzoni*, Outstanding Diss. F.A. (New York, 1978) [exhaustive bibliog.]

N. Gramaccini: 'Guido Mazzonis Beweinungsgruppen', *Städel-Jb.*, n. s., ix (1983), pp. 7–40

T. Verdon: 'Guido Mazzoni in Francia: Nuovi contributi', *Mitt. Ksthist. Inst. Florenz*, xxxiv (1990), pp. 139–64

A. Lugli: *Guido Mazzoni e la rinascita della terracotta del quattrocento* (Modena, 1991)

M. Ferretti: 'A Court Artist: Neapolitan Lamentations: Guido Mazzoni in Naples', *F.M.R. Mag.*, lxxxviii (1997), pp. 48–58

P. Tranchina: 'I gruppi scultorei di Guido Mazzoni: Osservazioni sulla tecnica', *Scultura in terracotta: Tecniche e conservazione*, ed. M. G. Vaccari (Florence, 1996), pp. 209–16

TIMOTHY VERDON

Mecarino [Mecherino], **Domenico**. *See* BECCAFUMI, DOMENICO.

Medici, de'. Italian family of merchants, bankers, rulers, patrons and collectors. They dominated the political and cultural life of Florence from the 15th century to the mid-18th. Their name and their coat-of-arms showing five to nine spheres were not derived from medical ancestors,

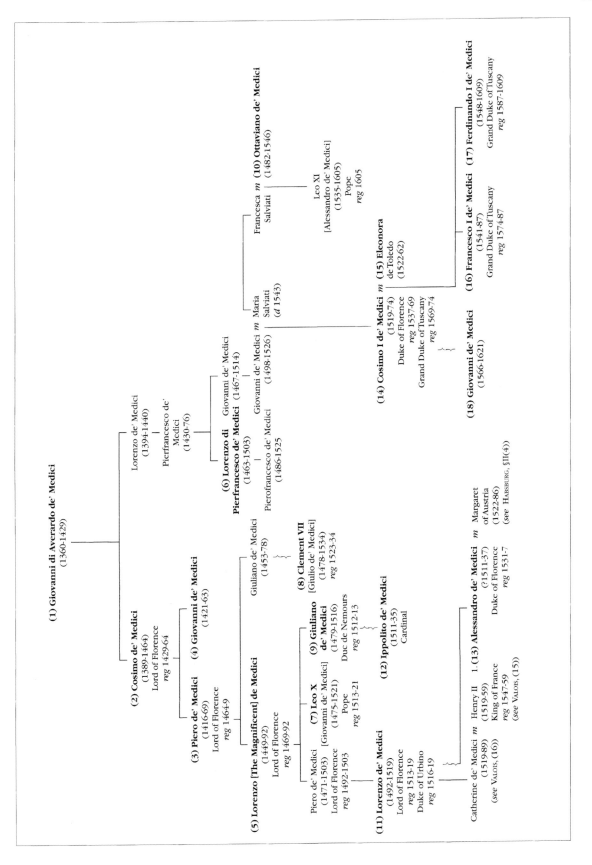

(1) Giovanni di Averardo de' Medici
(1360-1429)

(2) Cosimo de' Medici
(1389-1464)
Lord of Florence
reg 1429-64

(4) Giovanni de' Medici
(1421-63)

(3) Piero de' Medici
(1416-69)
Lord of Florence
reg 1464-9

Lorenzo de' Medici
(1394-1440)

Pierfrancesco de' Medici
(1430-76)

(6) Lorenzo di Pierfrancesco de' Medici
(1463-1503)

Pierofrancesco de' Medici
(1486-1525)

Giovanni de' Medici
(1467-1514)

Giovanni de' Medici *m* Maria Salviati
(1498-1526) (*d* 1543)

Francesca *m* **(10) Ottaviano de' Medici**
Salviati (1482-1546)

Leo XI
[Alessandro de' Medici]
(1535-1605)
Pope
reg 1605

(5) Lorenzo [The Magnificent] de Medici
(1449-92)
Lord of Florence
reg 1469-92

Giuliano de' Medici
(1453-78)

(8) Clement VII
[Giulio de' Medici]
(1478-1534)
reg 1523-34

Piero de' Medici
(1471-1503)
Lord of Florence
reg 1492-1503

(7) Leo X
[Giovanni de' Medici]
(1475-1521)
Pope
reg 1513-21

(9) Giuliano de' Medici
(1479-1516)
Duc de Nemours
reg 1512-13

(12) Ippolito de' Medici
(1511-35)
Cardinal

(11) Lorenzo de' Medici
(1492-1519)
Lord of Florence
reg 1513-19
Duke of Urbino
reg 1516-19

Catherine de' Medici *m* Henry II 1. **(13) Alessandro de' Medici** *m* Margaret
(1519-89) (1519-59) (?1511-37) of Austria
(*see* VALOIS, (16)) King of France Duke of Florence (1522-86)
 reg 1547-59 *reg* 1531-7 (*see* HABSBURG, §II(4))
 (*see* VALOIS, (15))

(14) Cosimo I de' Medici *m* **(15) Eleonora**
(1519-74) de Toledo
Duke of Florence (1522-62)
reg 1537-69
Grand Duke of Tuscany
reg 1569-74

(16) Francesco I de' Medici **(17) Ferdinando I de' Medici**
(1541-87) (1548-1609)
Grand Duke of Tuscany Grand Duke of Tuscany
reg 1574-87 *reg* 1587-1609

(18) Giovanni de' Medici
(1566-1621)

since the family had always been merchants. However, they appropriated this interpretation, making the physicians Cosmas and Damian their patron saints. International trade in wool, silk, metals and spices made them one of the wealthiest and most influential families in Italy. The family seat was in Cafaggiolo in the Mugello region, 25 km north of Florence, but by 1201 several towers belonging to them are mentioned in notarial records in Florence. In 1240 the Medici appears among the financiers of Conte Guido Guerra and of the abbey of Camaldoli and on several occasions thereafter in the list of the ruling council of Florence. They extended their trade by setting up branches in Genoa, Treviso, Nîmes and Gascony and were one of the few Florentine houses that survived the economic crisis of the first half of the 14th century. In 1348 Vieri de' Medici was enrolled in the Arte del Cambio, the guild of bankers and changers. The banking business flourished, the Medici becoming suppliers of credit to the most important Italian courts. Through their financial situation they already belonged to the wealthy class of the *popolo grasso* but continued to support the *popolo minuto* in their political outlook. The rise of the Medici began its final stage with (1) Giovanni di Averardo and his son (2) Cosimo (see fig.). This main line of the Medici family, to which (5) Lorenzo the Magnificent, (7) Leo X, (8) Clement VII and Catherine, Queen of France (*reg* 1559–74), belonged, was especially zealous in patronizing the arts and sciences, making Florence the cultural centre of the Italian Renaissance. Although the Medici were twice expelled from Florence (1494–1512; 1527–30), they were always able to regain their political power and their cultural prestige. After the murder of (13) Alessandro, who was named Duke of Florence in 1532 and was regarded as a tyrant, power passed to a secondary line of the family. With (14) Cosimo I the Medici became Grand Dukes of Tuscany. His successors, (16) Francesco I and (17) Ferdinando I, attempted to maintain the family's role as patrons, but the decline of the once most important Florentine family began in the following generations.

BIBLIOGRAPHY

R. Clayton: *Memoirs of the House of Medici* (London, 1797)
G. F. Young: *The Medici*, 2 vols (London, 1910)
G. Pieraccini: *La stirpe de' Medici di Cafaggiolo*, 3 vols (Florence, 1924–5)
Y. Maguire: *The Women of the Medici* (London, 1927)
R. de Roover: *The Rise and Decline of the Medici Bank, 1397–1494* (Cambridge, MA, 1963)
S. Camerani: *Bibliografia medicea* (Florence, 1964)
N. Rubinstein: *The Government of Florence under the Medici, 1434–1494* (Oxford, 1966)
M. Biron: *Le Siècle des Médicis* (Paris, 1969); Eng. trans. as *The Medici: A Great Florentine Family* (London, 1980)
E. Cochrane: *Florence in the Forgotten Centuries, 1527–1800: A History of Florence and the Florentines in the Age of the Grand Dukes* (Chicago and London, 1973)
C. Hibbert: *The Rise and the Fall of the House of Medici* (London, 1974)
J. Cleugh: *The Medici: A Tale of Fifteen Generations* (New York, 1975)
J. R. Hale: *Florence and the Medici: The Pattern of Control* (London, 1977)
G. Pottinger: *The Court of the Medici* (London, 1977)
R. Brogan: *A Signature of Power and Patronage: The Medici Coat of Arms, 1299–1492* (diss., Tallahassee, FL State U., 1978)
Le arti del principato mediceo (exh. cat., Florence, Pal. Vecchio, 1980)
D. J. B. Ritchie: *Florence and the Medici: Book Lists* (St Andrews, 1981) [biblog.]
K. Langedijk: *The Portraits of the Medici, 15th–18th Centuries*, 3 vols (Florence, 1981–7)
E. L. Goldberg: *Patterns in Late Medici Art Patronage* (Princeton, 1983)
Firenze e la Toscana dei Medici nell'Europa del '500, 3 vols (exh. cat., Florence, Pal. Vecchio, 1983)
J. Cox-Rearick: *Dynasty and Destiny in Medici Art: Pontormo, Leo X and the Two Cosimos* (Princeton, 1984)
E. Marchand and A. Wright: *With and without the Medici: Studies in Tuscan Art and Patronage, 1434–1530* (Aldershot, 1998)
R. Fremantle: *God and Money: Florence and the Medici in the Renaissance* (Florence, 1992)
R. A. Goldthwaite: *Banks, Palaces and Entrepreneurs in Renaissance Florence* (Aldershot, 1995)
Magnificenza alla corte dei Medici: Arte a Firenze alla fine del Cinquecento (exh. cat. by M. Gregory, D. Heikamp and others; Florence, Pal. Pitti, 1997–8)
R. Le-Goff: 'Princely Record-breaker: The Medici Archive Project', *A. Newspaper*, ix/80 (April 1998), p. 34)

MARLIS VON HESSERT

(1) Giovanni di Averardo de' Medici [Giovanni di Bicci] (*b* Florence, 1360; *d* Florence, 20 Feb 1429). He established the financial and political power of the Medici in Florence and was one of the richest bankers in Italy when he turned to public life in 1400. In 1402, 1406 and 1422 he was appointed prior of his guild, the Arte del Cambio, and in 1421 was made gonfaloniere or chief magistrate. His views were democratic, and he sided with the *popolo minuto* against the oligarchical regime of Rainaldo degli Albizzi (1370–1442) and Niccolò da Uzzano (1359–1431). Giovanni was the first Medici to surround himself with and support art. He was one of the few Florentines who had the walls of his house frescoed, and he commissioned Dello Delli to paint the furnishings (untraced) of an entire room. He was on the panel of advisers for the celebrated competition (1401) for the commission to execute the bronze doors for the Baptistery, and as gonfaloniere he was involved in the government's decision to promote the Ospedale degli Innocenti and supported its building financially. In 1418 the rebuilding of S Lorenzo was planned, and Giovanni undertook to finance a chapel and the Old Sacristy, designed by Filippo Brunelleschi (*see* BRUNELLESCHI, FILIPPO, §I, 1(iv) and fig. 2). Finally, he supervised the erection of the tomb (*c.* 1424; Florence, Baptistery) of *Baldassare Coscia, Anti-Pope John XXIII* (*d* 1419) by Donatello and Michelozzo di Bartolomeo. Giovanni had secured Coscia's release from prison during the Council of Constance and later sheltered him in his house. He left a large fortune to his sons, (2) Cosimo and Lorenzo (1394–1440), and was buried with his wife Piccarda de' Bueri in a marble sarcophagus by Buggiano at the centre of the Old Sacristy in S Lorenzo.

BIBLIOGRAPHY

B. Dami: *Giovanni Bicci dei Medici nella vita politica, 1400–1429* (Florence, 1899)
G. F. Young: *The Medici* (London, 1910), i, pp. 19–59
G. Pieraccini: *La stirpe de' Medici di Cafaggiolo* (Florence, 1924), i, pp. 7–13

MARLIS VON HESSERT

(2) Cosimo [il vecchio] de' Medici, Lord of Florence (*b* Florence, 27 Sept 1389; *d* Careggi, 1 Aug 1464). Son of (1) Giovanni di Averardo de' Medici. He was the greatest private patron of his time, who, motivated through ambition for his family, and perhaps through a desire to expiate the sin of usury, introduced a new conception of patronage; a humanist, he fully appreciated the propaganda value of architecture and sculpture, and his ambitions rivalled those of the Comune. Primarily an architectural patron, Cosimo

favoured MICHELOZZO DI BARTOLOMEO, but he also gave generous support to DONATELLO and others. Cosimo increased his father's trading and banking business and became one of the wealthiest men of his time. He dominated Florence from 1434; yet he himself valued his burgher status and constantly emphasized it, and the artistic tradition associated with him is simple and restrained. He was prior of his guild in 1415 and 1417, accompanied the antipope John XXIII to the Council of Constance and then travelled in Germany and France. He was Florentine ambassador to Milan (1420), Lucca (1423), Bologna (1424) and the court of Pope Martin V in Rome. His long association with Michelozzo began in this period: in the 1420s Michelozzo remodelled Cosimo's austere villa at Trebbio and the monastery of S Francesco at Bosco ai Frati, both of which were situated in his patron's native region of the Mugello. Cosimo had mastered the French and German languages on his travels in Europe and had been introduced to Latin and Arabic in the monastery of Camáldoli, and an inventory of his library made in 1418 indicates that from early on he owned an extensive collection of contemporary and Classical literature.

In 1433 Cosimo's support of the people led to his banishment by the dominant Albizzi family, but in Padua and Venice he was received like an honoured visitor rather than a fugitive, and his business interests flourished. He was accompanied by Michelozzo, whom he commissioned to design the library (destr.) of the Benedictine monastery of S Giorgio in gratitude for Venetian hospitality. He then endowed the library with precious manuscripts. In 1434 he was recalled from exile and became the unofficial ruler of Florence until his death. The republican form of government was maintained, but Pius II commented that Cosimo lacked only the title and pomp of royalty. One of Cosimo's great achievements for his native city was the transfer of the Council of Ferrara, a meeting of the Eastern and Western churches, to Florence in February 1439; many contemporary Florentine paintings were enriched by the portrayal of exotic Eastern figures, lavishly clad in gold-embroidered silk garments and elaborate headgear. The Council was attended by such scholars as Gemistos Pletho (1355–1452), who stimulated a profound interest in Platonic philosophy. Cosimo later founded the Platonic Academy, which, under the guidance of Marsilio Ficino, whom Cosimo encouraged to produce Latin translations of Plato, became the centre of humanist thought.

Much of Cosimo's patronage was for churches and monasteries, and in 1436 he initiated the rebuilding of the Dominican monastery of S Marco, whose sole patron he remained until his death. He awarded the commission to Michelozzo. The interior was decorated by Fra Angelico, who executed the high altar, known as the S Marco Altarpiece (Florence, Mus. S Marco), which unites Dominican and Medicean themes, and directed the frescoed decoration of the interior (see ANGELICO, FRA, figs 4–5 and colour pls 1, III1 and 1, III2), where two double cells were reserved for Cosimo's private use. For the library, the monastery's most innovative feature (see MICHELOZZO DI BARTOLOMEO, fig. 2), Cosimo had 200 books copied from other collections within two years, according to Vespasiano da Bisticci, his contemporary bi-

ographer; he also assembled precious manuscripts from all parts of the world and, in repayment of a loan, acquired the collection of the humanist Niccolò Niccoli, donated to the library on the condition that it was made accessible to the public.

Cosimo also supported the continuation of Brunelleschi's work on the Old Sacristy of S Lorenzo (see FLORENCE, §IV, 5 and BRUNELLESCHI, FILIPPO, fig. 2), where he initially acted as joint patron with his brother, Lorenzo de' Medici (1394–1440), and for which Donatello produced the twin pairs of bronze doors, the lunettes above them and eight roundels on the walls and pendentives showing the *Four Evangelists* and scenes from the *Life of St John the Evangelist* (1435–43). From 1442 Cosimo was the dominant patron of the church (see fig.), and from this year, apart from the family chapels, the building was financed by Cosimo alone. Donatello's two pulpits, decorated with bronze panels, date from the 1460s. Cosimo also initiated the building of a dormitory for the novices of Santa Croce and was involved in the alterations to the church of SS Annunziata.

Cosimo's largest building project of the 1440s, however, was the new Palazzo Medici in the Via Larga, Florence. Tradition relates that the first plans were by Brunelleschi, but Cosimo rejected these as too monumental and presumptuous. Nonetheless, the subsequent design by Michelozzo (1444) produced a palazzo of unprecedented grandeur and became the model for many subsequent town palazzi (see MICHELOZZO DI BARTOLOMEO, fig. 3). Cosimo commissioned Donatello to make two large-scale bronzes, *Judith Slaying Holofernes* (Florence, Pal. Vecchio; see ITALY, fig. 18) and *David* (Florence, Bargello; see colour pl. 1, XXXIX1), for this palazzo, and he was probably responsible for the commission to Paolo Uccello for a series of decorative paintings of the *Rout of San Romano* (London, N.G., see UCCELLO, PAOLO, fig. 3; Paris, Louvre, see colour pl. 2, XXXVII1; Florence, Uffizi). In this period Cosimo also had the country villa at Careggi remodelled by Michelozzo, and here, influenced by the classical ideal of villa life, he sought spiritual refreshment in the beauty of the countryside.

Vespasiano emphasized that Cosimo 'had a good knowledge of architecture ... and all those who were about to

Cosimo de' Medici is Presented with a Model of S Lorenzo by Brunelleschi and Ghiberti (c. 1555–72), fresco by Marchetti Marco da Faenza after a design by Giorgio Vasari, Palazzo Vecchio, Florence

build came to him for advice'. Thus it seems likely that he played a significant role in the planning of his palazzo and probably an even larger part in designing the Badia of Fiesole (from 1456). The ample documentation on the latter never mentions the name of an architect, but only that of Cosimo, who inspected the work daily. He is said to have spent 70,000 gold florins on the architecture of this monastery and a further 14,000 florins on the embellishment of its interior; he endowed the library with precious manuscripts. Yet, despite the scale of his involvement, he regretted having started his activity as patron so late in life.

Cosimo was also involved in commissions to Desiderio da Settignano, Andrea del Castagno and Fra Filippo Lippi; he and his brother, Lorenzo, commissioned from Lorenzo Ghiberti the reliquary chest of *SS Protus, Hyacinthus and Nemesius* (c. 1425–8; Florence, S Maria degli Angeli). A number of other cities benefited from Cosimo's interest in art. In Milan he had the courtyard of the Medici bank, a palazzo previously owned by the Sforza family, extended by Michelozzo and commissioned frescoes (mid-1460s; mainly destr.) from Vincenzo Foppa. In Paris he restored the Collegio degl'Italiani (destr.) and in Jerusalem built a hostel for pilgrims. He died on his country estate at Careggi and was carried in state to S Lorenzo and buried in the crypt there. A porphyry ledger by Andrea del Verrocchio before the altar bears the inscription posthumously awarded to him by the Signoria of Florence on 20 March 1465: 'Pater Patriae'. His role as patron was later celebrated in the frescoes designed by Giorgio Vasari in the Sala di Cosimo il Vecchio in the Palazzo Vecchio (*see also* VASARI, (1), fig. 4) and in a portrait painted by Pontormo (see colour pl. 2, XVIII3).

BIBLIOGRAPHY
A. Fabronius: *Magni Cosmi Medicei vita*, 2 vols (Pisa, 1789)
G. Cavalcanti: *Della carcere, dell'ingiusto esilio e del trionfale ritorno di Cosimo padre della patria* (Florence, 1821)
A. Gelli: 'L'esilio di Cosimo de' Medici', *Archv Stor. Ital.*, 4th ser., x (1892), pp. 52–96, 149–69
Vespasiano da Bisticci: 'Cosimo de' Medici', *Vite di uomini illustri del secolo XV* (Bologna, 1893), iii, pp. 37–75
K. D. Ewart: *Cosimo de' Medici* (London, 1899)
C. Gutkind: *Cosimo de' Medici 'pater patriae'* (Oxford, 1938)
E. H. Gombrich: 'The Early Medici as Patrons of Art: A Survey of Primary Sources', *Italian Renaissance Studies*, ed. E. F. Jacob (London, 1960), pp. 279–311 (282–97); repr. in E. H. Gombrich: *Norm and Form* (London, 1966), pp. 35–57
A. M. Brown: 'The Humanist Portrait of Cosimo de' Medici, pater patriae', *J. Warb. & Court. Inst.*, xxiv (1961), pp. 186–221
I. Hyman: *The Palazzo Medici and a Ledger for the Church of S Lorenzo* (diss., U. New York, 1968)
U. Procacci: 'Cosimo de' Medici e la costruzione della Badia Fiesolana', *Commentari*, xix (1968), pp. 80–97
D. Kent: *The Rise of the Medici Faction in Florence, 1426–34* (Oxford, 1978)
G. A. dell'Acqua: 'Le teste all'antica del banco mediceo a Milano', *Paragone*, xxxiv/401–3 (1983), pp. 48–55
B. A. Bennett and D. G. Wilkins: *Donatello* (Oxford, 1984)
D. Kent: 'The Dynamic of Power in Cosimo de' Medici's Florence', *Patronage, Art and Society in Renaissance Italy*, ed. F. W. Kent, P. Simons and J. C. Eade (Oxford, 1987), pp. 63–77
I. Lavin: 'Donatellos Kanzeln in S Lorenzo und das Wiederaufleben frühchristlicher Gebräuche', *Donatello-Studien* (Munich, 1989), pp. 155–69
J. Hawkins: 'Cosimo de' Medici and the Platonic Academy', *J. Warburg & Court. Inst.*, liii (1990), pp. 144–62
F. Ames-Lewis, ed.: *Vecchio de' Medici, 1389–1464* (Oxford, 1992) [with bibliog.]
C. Vasic Vatovec: 'L'impegno di Cosimo I de'Medici nel reperimento dei marmi e il ruolo dell'Ammannati', *Bartolomeo Ammannati, scultore e architetto (1511–1592)*, ed. N. Rosselli del Turco and F. Salvi (Florence, 1995), pp. 329–41

MARLIS VON HESSERT

(3) Piero (di Cosimo) [the Gouty] **de' Medici**, Lord of Florence (*b* Florence, 1416; *reg* 1464–9; *d* Florence, 3 Dec 1469). Son of (2) Cosimo de' Medici. Raised in early humanist Florence, he was trained to assume his father's civic and cultural leadership. His artistic tastes were apparently stimulated less by the aesthetic ideals of Republican Florence, however, than by those manifested in such north Italian centres of patronage as Ferrara and Venice, where the Medici lived in exile in 1433–4. Piero watched over family interests at the Council of Ferrara (1437–9) and responded positively to the style of Este court patronage, which he may have sought to emulate (with the wealth of the Medici bank behind him) in the decorations he commissioned for the new Palazzo Medici in Florence. His aesthetic preferences may be deduced from such commissions, which contrast with the large-scale ecclesiastical projects that his father sponsored: typically they show precise, often minute detailing (as in a bust of Piero by Mino da Fiesole; see colour pl. 2, VIII2), brilliant and resonating colour and rich surface finish.

The best-documented works commissioned by Piero are two small, precious tabernacles built to the designs of MICHELOZZO DI BARTOLOMEO to house miracle-working images: the chapel of the Crucifixion, S Miniato al Monte, Florence (begun 1447; *see also* MASO DI BARTOLOMMEO), and the chapel of the Annunciation, SS Annunziata, Florence (1448–52). In both, high-quality architectural sculpture was carved with intricate richness and variety of detail in the finest marble. Piero's preoccupation with heraldry is evident in the inclusion of his personal device (a falcon holding a diamond ring) on the S Miniato tabernacle and in the glazed terracotta tiles in the white, green and mauve of his livery that Luca della Robbia provided for its roof.

The barrel vault of Piero's study (destr.) in the Palazzo Medici, probably completed by 1456, was also decorated by Luca della Robbia: the 12 enamelled terracotta roundels, the *Labours of the Months* (London, V&A), were set once more against the background of Piero's livery colours. The architect Filarete wrote of this vault that 'it causes greatest admiration in anyone who enters'; early records also emphasize the richness of the study's glazed terracotta floor and of the elaborate intarsia work on the furnishings. The superbly produced books that lined the shelves had bindings coloured according to subject classification: red for books on history, for example, and green for rhetoric. Filarete described how Piero, crippled by gout, was carried into his study to feast his eyes on his books or to rejoice in his collections of Classical gems, coins and other small, highly valued objects.

The two inventories of Piero's possessions, drawn up in 1456–8 and after Cosimo de' Medici's death in 1464, list numerous domestic furnishings, now lost or unidentifiable, including French or Flemish tapestries, silverware, jewellery, tournament apparel and weapons, musical instruments and also the treasures that Piero kept in his study. Among the wide-ranging and valuable collection of

Classical gems and cameos was the *Daedalus and Icarus* (Naples, Capodimonte), which provided the source for one of the medallions decorating the courtyard of the Medici palace. The closely written listings of books show the importance of Piero's manuscript commissions, often placed through the agency of the major *cartolaio* and biographer of Quattrocento Florence, Vespasiano da Bisticci. The descriptions indicate special concern for the binding of each manuscript and for the type of script in which it was written. Most of the books commissioned by Piero survive in the Biblioteca Medicea–Laurenziana, Florence, and the quality of their production and illuminated decoration warrants the high values recorded in the inventories. His patronage stimulated the development of a new type of green-tendril border decoration, evident, for example, in the two-volume Plutarch (Florence, Bib. Medicea–Laurenziana, MSS. Plut. 65.26–7), which from the early 1460s dominated Florentine manuscript illumination for the rest of the 15th century.

Letters written by Benozzo Gozzoli indicate that Piero was also responsible for the decoration of the chapel of the Palazzo Medici, probably completed in 1461. Michelozzo's architectural articulation of this small space is again rich in decorative detail and colour, and the floor and intarsiated seating are emblazoned with Medici heraldic devices. Gozzoli's *Journey of the Magi* frescoes (see colour pl. 1, XXXV2) convincingly blend finely executed surface details (highly individualized portraits and figure-types, splendid costumes and pattern-book bird and animal motifs) with deep recession into beautifully observed, atmospheric landscape vistas. The goal of the Magi's journey, Fra Filippo Lippi's *Adoration of the Magi* altarpiece (Berlin, Gemäldegal.), shows similar aesthetic emphases. Jewel-like colours, brilliant refinement of surface finish—noticeable in the spray of golden dots that link together the persons of the Trinity—and a delicate, expressive sentiment are brought together in this exquisite altarpiece which perhaps quintessentially reflects Piero's artistic sensibilities.

BIBLIOGRAPHY

E. H. Gombrich: 'The Early Medici as Patrons of Art: A Survey of Primary Sources', *Italian Renaissance Studies*, ed. E. F. Jacob (London, 1960), pp. 279–311; repr. in E. H. Gombrich: *Norm and Form* (London, 1966), pp. 35–57

R. Hatfield: 'Some Unknown Descriptions of the Medici Palace in 1459', *A. Bull.*, lii (1970), pp. 232–49

F. Ames-Lewis: *The Library and Manuscripts of Piero di Cosimo de' Medici* (New York, 1984)

A. Beyer and B. Boucher, eds: *Piero de' Medici 'il Gottoso' (1416–1464): Kunst im Dienste der Mediceer* (Berlin, 1993)

F. Caglioti: 'Donatello, i Medici e Gentile de' Becchi: Un po' d'ordine intorno alla *Giuditta* (e al *David*) di via Larga', i*Prospettiva*, lxxv–lxxvi (1994), pp. 14–49

FRANCIS AMES-LEWIS

(4) Giovanni (di Cosimo) de' Medici (*b* Florence, 1421; *d* Florence, 1463). Son of (2) Cosimo de' Medici. Although less well-known to posterity than his older brother (3) Piero, he may actually have been Cosimo's preferred successor in finance and politics. He was enrolled at a young age in the Florentine guilds the Arte del Cambio (1426) and the Arte della Lana (1435). In 1438 he served an apprenticeship in the Ferrara branch of the Medici bank and in 1455 became the manager of the entire bank.

In the political sphere, in addition to holding important guild memberships, he was elected to the Florentine priorate in 1454, and he was one of the Florentine ambassadors sent to Rome in 1455 to congratulate Calixtus III on his elevation to the papacy. Throughout the 1450s Giovanni often spoke in Florentine political councils on behalf of the Medici. He received a humanist education and in 1447 served as an official at the Studio Fiorentino, the university of Florence.

Like Piero, Giovanni was a collector of ancient and contemporary art as well as a patron of art and architecture. His penchant for ancient art may have been a logical result of his humanist education; it must also have been nurtured by his father, himself a collector of antiquities. Giovanni became an avid collector of ancient coins, statues and manuscripts; he also commissioned copies of Classical texts. Giovanni's interest in Classical culture was recognized in a letter of 1443 in which the writer, Alberto Averadi, informed him of the ruined state and contemporary destruction of ancient monuments in Rome and of the unsatisfactory nature of their modern replacements. As a patron of art and architecture, Giovanni may have sought a reconciliation between the Roman past and the Florentine present. In the 1450s he had Michelozzo di Bartolomeo construct the Medici villa at Fiesole and remodel the nearby church and cloister of S Girolamo. The villa, later celebrated in Angelo Poliziano's writings, is located in a position overlooking Florence (*see* GARDEN, fig. 3) that calls to mind Pliny the younger's description of his Tuscan villa. The Classical and the modern were also wedded in the ornamentation of Giovanni's apartments in the Palazzo Medici in Florence: in the portrait bust (*c.* 1456–61) by Mino da Fiesole, Giovanni is shown in a suit of pseudo-antique armour; for his study Giovanni commissioned DESIDERIO DA SETTIGNANO to make reliefs of the heads of the 12 Caesars, most probably modelled after ancient coins.

Giovanni may also have commissioned the paintings by Domenico Veneziano and Pesellino that appear in an inventory of his apartments. Documents of 1454 and 1455 indicate that he commissioned works from Donatello. His artistic interests extended beyond the works of the ancients or his Florentine contemporaries; letters of 1448 and 1460 addressed to him by Medici agents in Bruges indicate his interest in the tapestries and paintings of northern Europe. The Medicean banking establishments in Bruges undoubtedly played a role in his acquisition of these products, just as the family's political commitments explain certain of his transactions with Florentine artists and with other rulers of the Italian peninsula. In 1449 Sigismondo Malatesta of Rimini contacted him for recommendations of painters who might supply works for the church of S Francesco, the so-called Tempio Malatestiano. Giovanni may have recommended either or both Piero della Francesco and Fra Filippo Lippi. It is known that in the late 1450s he arranged for an altarpiece by Lippi to be sent as a diplomatic gift to Alfonso I, King of Naples and Sicily. Giovanni was buried together with Piero di Cosimo, in an elaborate double tomb by Verrocchio (1472; Florence, S Lorenzo, Old Sacristy; *see* VERROCCHIO, ANDREA DEL, fig. 2).

BIBLIOGRAPHY

R. de Roover: *The Rise and Decline of the Medici Bank, 1397–1494* (Cambridge, MA, 1963)

N. Rubinstein: *The Government of Florence under the Medici, 1434–1494* (Oxford, 1966)

C. Bargellini and P. de la Ruffinière du Prey: 'Sources for a Reconstruction of the Villa Medici, Fiesole', *Burl. Mag.*, cxi (1969), pp. 597–605

E. Grassellini and A. Fracassini: *Profili medicei* (Florence, 1982)

K. Langedijk: *The Portraits of the Medici, 15th–18th Centuries*, ii (Florence, 1983)

W. A. Bulst: 'Uso e trasformazione del Palazzo Mediceo fino ai Riccardi', *Il Palazzo Medici Riccardi di Firenze*, ed. G. Cherubini and G. Fanelli (Florence, 1990), pp. 98–129

ROGER J. CRUM

(5) Lorenzo the Magnificent [Lorenzo de' Medici; Lorenzo il Magnifico], Lord of Florence (*b* Florence, Jan 1449; *reg* 1469; *d* Florence, 8 April 1492). Son of (3) Piero de' Medici. In 1469 Piero organized a joust to celebrate Lorenzo's marriage to Clarice Orsini, and in the same year the succession passed, without discord, to Lorenzo. The Pazzi conspiracy (1478) and the following war challenged Medici predominance, yet Lorenzo's leadership was consolidated by constitutional changes and by his securing peace with the papacy in 1480. Traditionally Lorenzo has been regarded as one of the great patrons of the Renaissance, under whom the arts flourished in a golden age. This view has since been rejected by modern writers, on the grounds that to accept it would be to perpetuate a myth created by the Medici themselves. Instead, Lorenzo began to be portrayed as primarily a collector of antiquities, who, unable to afford to commission art on a grand scale, had to satisfy himself with offering amateur advice to others. This view is now, in its turn, being challenged as an oversimplification that underestimates and misunderstands Lorenzo's role as a patron: his patronage was more than a mere matter of political expediency, and his advice was sought by both rulers and civic bodies because he was considered an expert.

Lorenzo was both ruler and scholar. A distinguished vernacular poet, he was also passionately interested in Classical antiquity and became the centre of a humanist circle of poets, artists and philosophers, which included Marsilio Ficino, Pico della Mirandola, Angelo Poliziano, Botticelli, Bertoldo di Giovanni and Michelangelo. His taste in architecture was formed by Leon Battista Alberti, with whom he had studied antiques in Rome in 1465 and whose treatise he read repeatedly. He showed great interest in the architectural projects of his day; this has stimulated a debate on whether he may have been an amateur architect. Even if Lorenzo was not a practising architect, there is no doubt that Giuliano da Sangallo, whom he saw as able to revive the glories of antiquity, worked in close collaboration with him.

Lorenzo continued the Medici patronage of ecclesiastical institutions. He enriched the family church of S Lorenzo, where the tomb of Piero and Giovanni de' Medici was completed by Verrocchio between 1469 and 1472, and had Sangallo build the Augustine Observant Monastery at San Gallo in 1488 (destr.). Lorenzo's position as *de facto* ruler of Florence gave him an added importance as a patron, since little was done by public or semi-public authorities without his approval. He planned to build houses and roads to beautify his quarter of S Giovanni,

although only four houses on the newly proposed Via Laura were erected. His choice of Giuliano da Sangallo for the building of the sacristy of Santo Spirito was accepted in 1489, and he was involved in two decisions concerning the cathedral: to delay the selection of a design to complete the façade and to decorate with mosaic two vaults in the chapel of S Zenobius, a project later abandoned. Even the building boom of the late 1480s was in part due to Lorenzo, as he encouraged the legislation that promoted it. Other patrons were influenced by him, and in this period the Palazzo Strozzi and the house of Bartolommeo Scala were built.

Lorenzo's influence on the patronage of others extended outside Florence. Pistoia's choice of Verrocchio for the cenotaph for *Niccolò Forteguerri* in Pistoia Cathedral in 1476 was the result of his intervention, as was Prato's decision, in 1485, to employ Giuliano da Sangallo to build the church of S Maria delle Carceri (*see* SANGALLO, (1) fig. 1). He also gave artists introductions to foreign courts, both through letters of recommendation and gifts of work, recommending Filippino Lippi to Cardinal Oliviero Carafa in 1488, resulting in Lippi's decoration of the Carafa Chapel in S Maria sopra Minerva, Rome, and Giuliano da Maiano to the Duke of Calabria in 1484, which led to the building of the hugely influential villa of Poggio Reale (begun 1497; destr.). Among Lorenzo's gifts was a palazzo design by Giuliano da Sangallo sent to the King of Naples and two marble reliefs of *Darius* and *Alexander* by Verrocchio sent to the King of Hungary. Lorenzo's manoeuvring in the world of patronage must in part be understood in a political context. At home the results it produced and the work it provided could increase his popularity and his network of clients, on both of which he depended to maintain political control. Outside Florence it could help in his dealings with foreign rulers. His patronage increased in scale in the 1480s, after Florence had made peace with the papacy and the Kingdom of Naples.

Lorenzo's more private interests are best represented by his country retreats, where he indulged a taste for rural life modelled on Classical ideals, and in the collections that he built up at the Palazzo Medici in Florence. His major architectural commission was the Villa Medici at Poggio a Caiano (*c.* 1480; *see* VILLA, fig. 1 and POGGIO A CAIANO, VILLA MEDICI), where Sangallo created a villa *all'antica*, deeply influenced by Lorenzo's ideals. He also commissioned *c.* 1487 an illustrious team of artists—Botticelli, Perugino, Filippino Lippi and Domenico Ghirlandaio—to decorate his villa of Spedaletto (destr.), near Volterra, and ordered two works from Verrocchio, thought to be the *Putto with a Fish* (Florence, Pal. Vecchio) and the *David* (Florence, Bargello; *see* VERROCCHIO, ANDREA DEL, fig. 3) for his villa at Careggi. Both Verrocchio and Botticelli were employed to make ceremonial decorations for jousts.

Lorenzo's interest in antiquity is further underlined by the keenness with which he built up an expensive collection of antiquities, including sculptures, gems, cameos, vases and large-scale marble sculpture (for illustration of Giorgio Vasari's posthumous portrait *see* VASARI, (1), fig. 1); among the most celebrated items were the Farnese Cup (2nd or 1st century BC; Naples, Mus. Archeol. N.), the *Apollo and Marsyas* gem (Naples, Mus. Archeol. N.) and a red jasper

two-handled vase with cover (Florence, Pitti). It has been claimed that this collection was made at the expense of the patronage of contemporary artists, but Lorenzo's role as a collector cannot be wholly divorced from his activities as a patron. He encouraged the revival of the ancient arts of mosaic and gem-engraving, and he consciously used antiquities to inspire modern artists. His collection was cared for by Bertoldo di Giovanni, from whom he commissioned a relief, *The Battle* (Florence, Bargello), inspired by an ancient Roman relief in Pisa, and he possessed Antonio Pollaiuolo's antique-inspired bronze of *Hercules and Antaeus* (c. 1475–80; Florence, Bargello; *see* POLLAIUOLO, (1), fig. 2). Moreover, he established a sculpture garden at S Marco (*see* FLORENCE, §V, 2), where he encouraged Michelangelo to study from the Antique, and before 1492 Michelangelo had carved his *Virgin of the Steps* and the *Battle of the Centaurs* (both Florence, Casa Buonarroti). Both Bertoldo and Michelangelo formed part of Lorenzo's household, and this treatment of artists as the equals of humanist scholars and poets was unprecedented in Republican Florence. It introduced a new type of patronage and was associated with an increasing emphasis on the production of collector's pieces.

BIBLIOGRAPHY
G. Vasari: *Vite* (1550, rev. 2/1568); ed. G. Milanesi (1878–85)
W. Roscoe: *The Life of Lorenzo de' Medici* (London, 1796, rev. Heidelberg, 2/1825–6)
A. Chastel: 'Vasari et la légende médicéenne', *Studi Vasariani: Atti del convegno internazionale per il IV centenario della prima edizione delle Vite di Vasari: Florence, 1952*
C. Ady: *Lorenzo de' Medici and Renaissance Italy* (London, 1955)
E. H. Gombrich: 'The Early Medici as Patrons of Art: A Survey of Primary Sources', *Italian Renaissance Studies*, ed. E. F. Jacob (London, 1960), pp. 279–311; repr. in E. H. Gombrich: *Norm and Form* (London, 1966), pp. 35–57
E. Barfucci: *Lorenzo de' Medici e la società artistica del suo tempo* (Florence, 2/1964)
M. Martelli: 'I pensieri architettonici del Magnifico', *Commentari*, xvii (1966), pp. 107–11
J. R. Hale: *Florence and the Medici: The Pattern of Control* (London, 1977)
C. Elam: 'Lorenzo de' Medici and the Urban Development of Renaissance Florence', *A. Hist.*, i (1978), pp. 43–66
F. W. Kent: 'Lorenzo de' Medici's Acquisition of Poggio a Caiano and the Early Reference to his Architectural Expertise', *J. Warb. & Court. Inst.*, xlii (1979), pp. 250–56
P. Foster: 'Lorenzo de' Medici and the Florence Cathedral Façade', *A. Bull.*, lxiii (1981), pp. 495–500
F. W. Kent: 'New Light on Lorenzo de' Medici's Convent at Porta San Gallo', *Burl. Mag.*, cxxiv (1982), pp. 292–4
P. Morselli and G. Corti: *La chiesa di Santa Maria delle Carceri in Prato* (Florence, 1982)
C. Elam: 'Lorenzo de' Medici's Sculpture Garden', *Mitt. Ksthist. Inst. Florenz*, xxxvi (1992), pp. 41–84
Florentine Drawing at the Time of Lorenzo the Magnificent: Papers from a Colloquium held at the Villa Spelman: Florence, 1992
Lorenzo il Magnifico e il suo mondo: Convegno internazionale di studi: Florence, 1992
L'architettura di Lorenzo il Magnifico (exh. cat., ed. G. Morolli; Florence, Spedale degli Innocenti, 1992)
Il disegno fiorentino del tempo di Lorenzo il Magnifico (exh. cat., ed. A. P. Tofani; Florence, Uffizi, 1992)
Il giardino di San Marco (exh. cat., ed. P. Barocchi; Florence, Casa Buonarroti, 1992)

MARY BONN

(6) Lorenzo di Pierfrancesco de' Medici (*b* 1463; *d* 20 May 1503). Great-grandson of (1) Giovanni di Averardo de' Medici. His father was Pierfrancesco de' Medici (1430–76). Lorenzo di Pierfrancesco was head of the junior line of the Medici. At the age of 13 he was orphaned, and he

and his brother Giovanni (1467–1514) were brought up under the guardianship of their second cousin (5) Lorenzo the Magnificent, who chose as their tutors 'men of excellence in character and letters'. Among them were the poet Naldo Naldi (*d c.* 1470) and the humanist Giorgio Antonio Vespucci (*b* 1435), one of a family closely associated with Sandro Botticelli. Lorenzo also received letters of guidance and instruction in early and later life from the Neo-Platonic philosopher Marsilio Ficino and was a friend and patron of Angelo Poliziano.

After attaining his majority, Lorenzo di Pierfrancesco became hostile to his guardian when he discovered that he had taken 53,643 florins from his and his brother's joint patrimony to counter a threatened bankruptcy of the Medici bank. The two brothers obtained the villa of Cafaggiolo and other properties in compensation, but their lurking hostility broke out in 1494, when they sided with the French to expel Piero de' Medici (1471–1503), Lorenzo the Magnificent's son, from Florence. Their taking of the popular side in this conflict won them the surname of Popolano. After a brief period of self-imposed exile (1498–9), Lorenzo di Pierfrancesco returned to Florence. Like all his family, he engaged in commerce and banking. He was also a poet, writing in the vernacular, and a patron of poets. He and his brother inherited a palazzo in Florence adjoining the Palazzo Medici, the family villa of Trebbio in Mugello and in 1477 acquired the villa of Castello. Inventories of the Florentine palazzo from 1498, 1503 and 1516 survive and have been published (Shearman, 1975).

In art history Lorenzo is important as Botticelli's most significant and constant patron. Botticelli made drawings to illustrate Cristoforo Landino's edition of Dante's *Divine Comedy* published in Florence (1481) at Lorenzo's expense; he also made for Lorenzo an illuminated manuscript of the work (untraced). He painted for him the *Primavera* (*see* BOTTICELLI, SANDRO, fig. 2 and colour pl. 1, XV1) and *Pallas and the Centaur* (both Florence, Uffizi) as decorations for a room in the town palazzo and was still working for Lorenzo at Cafaggiolo in 1495. In the villa of Trebbio there were works from Botticelli's workshop: an altarpiece (Florence, Accad. B.A. & Liceo A.) and a *Madonna* (untraced). Lorenzo was also one of Michelangelo's first patrons: Vasari recorded that Michelangelo carved for him *c.* 1495 a young *St John the Baptist* in marble (untraced). It was Lorenzo who in 1495 gave Michelangelo the famous advice to bury his *Sleeping Cupid* and then pass it off as an antique in Rome, where he would get a much higher price for it, and then gave him commendatory letters for the Cardinal di S Giorgio and others in Rome. Lorenzo is also said to have founded the ceramics factory that was later transferred by him or by his son Pierfrancesco (1486–1525) to Cafaggiolo.

BIBLIOGRAPHY
D. Guasti: *Cafaggiolo e altre fabbriche di ceramiche in Toscana* (Florence, 1902), p. 76
G. Pieraccini: *La stirpe de' Medici di Cafaggiolo*, i (Florence, 1924), pp. 383–7 [fullest account]
R. de Roover: *The Rise and Decline of the Medici Bank, 1397–1494* (Cambridge, MA, 1963)
J. Shearman: 'The Collections of the Younger Branch of the Medici', *Burl. Mag.*, cxvii (1975), pp. 12–27
W. Smith: 'On the Original Location of the *Primavera*', *A. Bull.*, lvii (1975), pp. 31–9

R. W. Lightbown: *Sandro Botticelli* (London, 1978), *passim*
R. Jacoff: 'Charles Eliot Norton's Medicean Dante', *Harvard Lib. Bull.*,
 v/3 (Autumn 1994), pp. 45–52

R. W. LIGHTBOWN

(7) Pope **Leo X** [Giovanni de' Medici] (*b* Florence, 11 Dec 1475; *reg* 1513–21; *d* Rome, 1 Dec 1521). Son of (5) Lorenzo the Magnificent. His mother was Clarice Orsini. His teachers included the humanists who frequented the Palazzo Medici in Florence, such as Angelo Poliziano, Pico della Mirandola (1463–94) and Marsilio Ficino. By the age of eight he was admitted into minor orders, and by 1486 he was Abbot of Montecassino and Morimondo. He spent three years at the University of Pisa, where he was introduced to the study of theology and canon law by Filippo Decio (1454–1535) among others. In 1492 he was made a cardinal by Pope Innocent VIII.

When his brother Piero de' Medici (1471–1503) was expelled from Florence in 1494, Giovanni also went into exile, which he spent mainly in Città di Castello, Perugia, Urbino and Milan; in 1499 he travelled to Germany, the Netherlands and France. In 1500 he went to Rome, occupying the Palazzo di S Eustachio, later the Palazzo Madama, where he gathered around him many of the leading personalities in Rome, including the writers Tommaso Inghirami (1470–1516) and Jacopo Sadoleto (1477–1547) and the artist Baldassare Peruzzi. During his years as cardinal, he commissioned the rebuilding of S Maria in Domenica and the façade of S Cristina in Bolsena, Rome. He was appointed papal legate in Bologna by Pope Julius II, and in 1512, with the support of the Pope, he secured the return of the Medici to Florence. When Julius II died in 1513, the 37-year-old Giovanni was elected pope as Leo X.

Like his father, Leo X devoted much of his time to the arts and sciences. He attracted Paolo Giovio to the Roman university, set up Greek colleges in Rome and Florence, promoted the study of Hebrew and Arabic writings and, not least, gave strong support to printing. By 1508 he had brought the remains of his father's library from Florence and set up a private library in Rome, which, like the Vatican library, he enriched with rare manuscripts and books from Europe and the East. He also supported scholars and poets, including Pietro Bembo, Francesco Guicciardini (1483–1540), Baldassare Castiglione, Giangiorgio Trissino, Jacopo Sannazaro (1456–1530) and Marco Girolamo Vida (1490–1566). Under his aegis, Bernardo Bibbiena's *La Calandria* was performed, and Ludovico Ariosto staged his *Suppositi* in 1519, with décor by Peruzzi and Raphael. He had a large collection of musical instruments and maintained a private orchestra as well as the official papal musicians.

Although his patronage of art did not match that of his predecessor, Leo continued most of the buildings begun under Julius II and their decoration, notably the decoration of the Vatican staterooms, the Stanze, begun by Raphael in 1508. The frescoes in the Stanza della Segnatura were completed before Leo X's election, and those in the two adjoining rooms were painted during his pontificate. In the Stanza di Eliodoro, Leo is depicted on the white horse he rode in the battle of Ravenna. The frescoes in the Stanza dell'Incendio (*see* RAPHAEL, fig. 4) are also designed to demonstrate Leo X's power, as the scenes from the lives of the earlier popes Leo III and IV allude to his own political activities. Another important commission for Raphael was the design of a set of ten tapestries illustrating the *Acts of the Apostles Peter and Paul*, intended for the lower walls of the Sistine Chapel in the Vatican. The tapestries, which were executed in the workshop of Pieter van Aelst (1509–55) in Brussels, are in Rome (Pin. Vaticana); the seven surviving cartoons by Raphael are in London (V&A; *see* RAPHAEL, fig. 5). Although the main fields are devoted to the Apostles, the border scenes glorify Leo X, portraying events from his time as cardinal. From 1513 Leo had open galleries, Logge, built on the east side of the Vatican palace, overlooking the courtyard of S Damaso. In 1518–19 the walls were decorated with frescoes designed by Raphael, 52 biblical scenes and grotesque figures based on antique models. Leo also commissioned several paintings from Raphael, including his portrait, *Leo X with Cardinals Giulio de' Medici and Luigi de' Rossi* (1517–19; Florence, Uffizi; see fig.). He gave no significant commissions to other artists who came to Rome, including Leonardo da Vinci and Sodoma.

Leo's main area of patronage was architecture. To continue the rebuilding of St Peter's, begun by Donato Bramante, he employed Fra Giovanni Giocondo, Giuliano da Sangallo, Raphael, Antonio da Sangallo (ii) and Peruzzi, but the work made little progress. He commissioned a new church in Rome, for his fellow Florentines, S Giovanni dei Fiorentini, begun by Jacopo Sansovino. He had chapels built in the Cortile di Onore of the Castel Sant'Angelo and restored several churches in Rome, including S Maria Maggiore, S Maria sopra Minerva, the baptistery of S

Leo X with Cardinals Giulio de' Medici and Luigi de' Rossi by Raphael, oil on panel, 1.55×1.19 m, 1517–19 (Florence, Galleria degli Uffizi)

Giovanni in Laterano, as well as the monastery of S Cosimato. He also had the streets of Rome widened and improved, commissioned Giuliano da Sangallo to extend the Via Alessandrina and laid out three streets leading to the Piazza del Popolo. To stop the destruction of the remains of ancient Rome, in 1515 he appointed Raphael Romanarum Antiquitatum Praes, a post that entailed the conservation of antiquities in Rome and its environs and the supervision of excavations. One of the most important archaeological discoveries during Leo's pontificate was the excavation of the monumental antique statue of the river-god *Nile* (Rome, Vatican, Braccio Nuo.).

Leo's patronage also extended outside Rome. In 1513 he commissioned the marble-carving on the Santa Casa in the basilica of S Maria at Loreto from Andrea Sansovino, assisted by Baccio Bandinelli, Niccolò Tribolo, Francesco da Sangallo and Raffaello da Montelupo. In Florence in 1516 he commissioned Michelangelo to design a façade for S Lorenzo, which was never built. In 1519 he entrusted Michelangelo with another project, the building and decoration of the New Sacristy of S Lorenzo, including Medici family tombs (*see* FLORENCE, §IV, 5 and MICHELANGELO, fig. 5). His relations with Michelangelo were often strained, and on several occasions Leo withdrew commissions already granted, notably the statue of *Hercules* intended as a pendant for Michelangelo's *David* (*see* ITALY, fig. 22), which was transferred to Baccio Bandinelli. Leo had the Medici Villa at Poggio a Caiano rebuilt and decorated in 1520–21 with frescoes by Andrea del Sarto, Pontormo (*see* PONTORMO, JACOPO DA, fig. 1) and Franciabigio. Leo also collected small *objets d'art*, gems, cameos and medals. He had his papal seal made by Pietro Maria Serbaldi da Pescia and employed other important medallists such as Vittore Gambello, Caradosso and Valerio Belli. The period of Leo X's pontificate was a minor golden age, though as a result of his generous patronage he left not only numerous works of art but debts amounting to 600,000 ducats.

BIBLIOGRAPHY
P. Giovio: *Pauli Iovii de vita Leonis decimi pont. max. libri quatuor* (Florence, 1551)
A. Fabroni: *Leonis X ponteficis maximi vita* (Paris, 1797)
W. Roscoe: *The Life and Pontificat of Leo the Tenth*, 4 vols (London, 1806)
M. Audin: *Histoire de Léon X* (Paris, 1844)
Paride De Grassi: *Diario di Leone X*, ed. M. Armellini (Rome, 1884)
F. Nitti: *Leone X e la sua politica secondo documenti e carteggi inediti* (Florence, 1892)
H. M. Vougham: *The Medici Popes: Leo X and Clement VII* (London, 1908)
L. Pastor: *Geschichte der Päpste seit dem Ausgang des Mittelalters*, IV/i (Freiburg im Breisgau, 1923)
G. B. Picotti: *La giovinezza di Leone X* (Milan, 1927)
E. Rodocanachi: *Histoire de Rome: Le Pontificat de Léon X, 1513–1521* (Paris, 1931)
D. Gnoli: *La Roma di Leone X* (Milan, 1938)
G. Truch: *Léon X et son siècle* (Paris, 1941)
R. Steiner: 'Von Leo X. bis Clemens VII', *Festschrift Arnold Geering zum 70. Geburtstag* (Berne and Stuttgart, 1972), pp. 136–54
J.-M. Kliemann: *Politische und humanistische Ideen der Medici in der Villa Poggio a Caiano*, (diss., U. Berlin, 1976)
J. F. d'Amico: 'Papal History and Curial Reform in the Renaissance: Raffaele Maffei's *Brevis Historia* for Julius II and Leo X', *Archv Hist. Pont.*, xviii (1980), pp. 157–210
A. Boldorini: 'Una stupefacente pinacoteca di Leone X', *Renovatio*, xxxviii (1982), pp. 221–34
V. de Caprio, ed.: *Il ruolo della corte di Leone X* (Rome, 1984) [anthol. & ess., 1846–1919]
J. Cox-Rearick: *Dynasty and Destiny in Medici Art: Pontormo, Leo X and the Two Cosimos* (Princeton, 1984)
C. Falconi: *Leone X, Giovanni de' Medici* (Milan, 1987)
M. Fagiolo: 'Le feste per Leone X: Il gemellagio tra Roma e Firenze', *La difficile eredità: Architettura a Firenze dalla Repubblica all'assedio*, ed. M. Dezzi Bardeschi (Florence, 1994), pp. 68–9
MARLIS VON HESSERT

(8) Pope **Clement VII** [Giulio de' Medici] (*b* Florence, 26 May 1478; *reg* 1523–34; *d* Rome, 25 Sept 1534). Nephew of (5) Lorenzo the Magnificent. He was the illegitimate son of Giuliano de' Medici (1453–78) and Fioretta Gorini. An intellectual and a renowned musician, he was a highly discriminating patron whose circle included Baldassare Castiglione and Paolo Giovio. Educated at Padua University, he travelled extensively in Europe during the Medici exile from Florence (1494–1512). When the Medici were restored to power, Giulio was created Archbishop of Florence and cardinal by his cousin Pope Leo X. He travelled to Rome in 1513 and became Papal Vice-Chancellor in 1517. He is depicted on the left in Raphael's *Leo X with Cardinals Giulio de' Medici and Luigi de' Rossi* (1517–19; Florence, Uffizi; for illustration *see* (7) above). In late 1516 he commissioned Sebastiano del Piombo and Raphael to execute altarpieces for his archiepiscopal church, the cathedral of Narbonne, France: Sebastiano's *Resurrection of Lazarus* (1517–19; London, N.G.; *see* SEBASTIANO DEL PIOMBO, fig. 3) and Raphael's *Transfiguration* (1518–20; Rome, Pin. Vaticana). He continued the Medici patronage of Raphael and requested him to design a villa (later known as Villa Madama) outside Rome (*see* RAPHAEL, fig. 9). Work began *c.* 1518, with the assistance of Giulio Romano and Antonio da Sangallo (ii). Fresco decorations were painted by Giulio Romano, Giovanni da Udine and Giovanni Francesco Penni, and Baccio Bandinelli produced a pair of stucco Herculean *Giants* (destr.) for the gardens. Only part of the villa was completed, and it was largely destroyed in 1527, in the Sack of Rome. Giulio governed Florence from 1519 onwards, and the marble sculpture of *Orpheus* (Florence, Pal. Medici–Riccardi; *in situ*) he ordered from Bandinelli dates from that year. In 1520 he was involved with commissioning Pontormo's lunette fresco of *Vertumnus and Pomona* for the *salone* of the Medici villa at Poggio a Caiano (*in situ*; *see* PONTORMO, JACOPO DA, fig. 1).

Giulio was elected Pope, at the age of 45, on 19 November 1523 and took the title Clement VII: the decorations for his coronation were produced by Bandinelli. Clement continued the decoration by Giulio Romano and Penni of the Sala di Costantino (Rome, Vatican), in which they incorporated a portrait of Clement as Pope Leo I. On 10 December 1523 Clement confirmed the commission given by Leo X to Michelangelo to design a chapel at S Lorenzo in Florence for Medici family tombs. In January 1524 he asked Michelangelo to design a library at S Lorenzo to display the Medici book collection to the public (*see* FLORENCE, §IV, 5 and MICHELANGELO, fig. 8). Numerous drawings exist for these two projects (e.g. Florence, Casa Buonarroti; London, BM), and the surviving correspondence reveals Clement's high degree of involvement: he requested an unusual design with small figures for the ceiling and asked Paolo Giovio to devise an inscription for the entrance to the reading-room of the

Biblioteca Laurenziana; he even specified the type of wood to be used for the desks and ceiling of the library (Barocchi, 1973). By 1525 Sebastiano had produced two further works for Clement; a head of Christ (untraced) and a Holy Family; the latter is identified with the *Holy Family with St John the Baptist* (Prague, N.G., Šternberk Pal.). In 1525 Clement commissioned Bandinelli to produce a statue of *Hercules and Cacus* for the Piazza della Signoria, Florence (*in situ*; *see* BANDINELLI, BACCIO, fig. 2) as a pendant to Michelangelo's *David* (Florence, Accad.; *see* ITALY, fig. 22).

During the Sack of Rome on 6 May 1527, Clement took refuge in Castel Sant'Angelo; he then fled to Orvieto and Viterbo, where he remained in exile. After his return to Rome in October 1528, he vowed, according to Vasari, to order bronze statues of the Deadly Sins for the gate-tower of Castel Sant'Angelo to commemorate this traumatic event. The commission was given to Bandinelli but never executed. Sebastiano's magnificent portrait of *Clement VII* (Naples, Capodimonte) dates from this period. Benvenuto Cellini, who was master of the Papal Mint from 1529 to 1534, produced seals, medals and finely wrought coins bearing the Pope's portrait with the highly personal iconography of the obverses chosen by Clement himself (e.g. 1534; Florence, Bargello; *see* CELLINI, BENVENUTO, fig. 1). Cellini also produced *c.* 1529 a renowned papal morse (destr.; watercolour by Francesco Bartoli, London, BM). After 1529 Clement concentrated his resources on completing the Medici Chapel and the Biblioteca Laurenziana. From November 1529 to March 1530 Clement was in Bologna to crown Charles V as Holy Roman Emperor (*reg* 1519–56), and Sebastiano drew a double portrait of them (London, BM). In 1531 Clement rewarded Sebastiano for his loyalty by appointing him keeper of the papal seal, the *Piombo*. For the marriage of Henry II of France (*reg* 1547–59) to Clement's niece Catherine de' Medici in 1533, Clement commissioned a jewelled unicorn's horn (untraced) as a gift. In August 1533 Clement commissioned Michelangelo to fresco the *Last Judgement* on the altar wall of the Sistine Chapel (Rome, Vatican; *see* colour pl. 2, VII3). Work was started only after Clement's death. His tomb (Rome, S Maria Sopra Minerva) was begun by Bandinelli but completed by assistants after 1540.

DBI

BIBLIOGRAPHY

E. Müntz: 'L'oreficeria sotto Clemente VII, documenti' and 'Gli allievi di Raffaello durante il pontificato di Clemente VII', *Archv Stor. A.*, i (1888), pp. 68ff, pp. 447ff

G. F. Young: *The Medici*, 2 vols (London, 1910), pp. 436–55, 464–92

J. S. Ackerman: *The Architecture of Michelangelo*, 2 vols (London, 1961/*R* 1964), pp. 28–9, 31–43

P. Barocchi, ed.: *Il carteggio di Michelangelo* (Florence, 1973)

M. Hirst: *Sebastiano del Piombo* (Oxford, 1981), pp. 106–8, 110–12, 115–16, 123

K. Langedijk: *The Portraits of the Medici, 15th–18th Centuries*, i (Florence, 1981), pp. 52–5

J. Pope-Hennessy: *Cellini* (London, 1985), pp. 47–54, pls 18, 22–34

K. Schwager: 'L'architecture religieuse à Rome de Pio IV à Clément VII', *L'église dans l'architecture de la Renaissance: Actes du Colloque: Tours, 1990*, pp. 223–44

G. Peretti: 'Due inediti fregi veronesi di soggetto imperiale', *Quad. Pal. Te*, i (1994), pp. 52–69

G. Satzinger: 'Der "Statuenhof" Clemens VII im Garten des Palazzo Medici in Florenz: Zur Laokoon-Zeichnung der Albertina, Inv. 48v, und zu Folio 28v im Codex Geymüller der Uffizien, A 7818v, *Ars*

naturam adiuvans: Festschrift für Matthias Winner, ed. V. V. Flemming and S. Schutze (Mainz, 1996), pp. 208–27

HELEN GEDDES

(9) Giuliano de' Medici, Duc de Nemours (*b* 1479; *reg* 1512–13; *d* Florence, 17 March 1516). Son of (5) Lorenzo the Magnificent. He was the brother of (7) Giovanni de' Medici, who became Pope Leo X, and Piero de' Medici (1471–1503). Domenico Ghirlandaio portrayed Giuliano as a boy (1485; Florence, Santa Trìnita, Sassetti Chapel), standing next to his tutor, Angelo Poliziano. After the Medici were expelled from Florence in 1494, he spent some time in exile in Urbino. He returned to Florence with his brother Giovanni in 1512 and assumed the title of head of state, a position he held without great effect for only one year before handing it over to his nephew (11) Lorenzo. Giuliano was represented as cultured and of a literary bent by Baldassare Castiglione in *The Courtier*, although subsequent descriptions referred to him as feckless and weak. He was awarded the title Duc de Nemours by the French king, Francis I (*reg* 1515–47). His marble tomb in the New Sacristy of S Lorenzo, Florence, was sculpted by Michelangelo (see colour pl. 2, V1), who portrayed Giuliano above the figures of Night and Day, in an 'active' pose, wearing fanciful antique armour and holding coins, perhaps to suggest his liberality.

BIBLIOGRAPHY

G. Fatini, ed.: *Giuliano de' Medici: Poesie* (Florence, 1939)

G. Taborelli: *I Medici a Firenze* (Milan, 1981)

H. Butters: *Governors and Government in Early 16th-century Florence, 1502–1519* (Oxford, 1985)

ANABEL THOMAS

(10) Ottaviano de' Medici (*b* Florence, 14 July 1482; *d* Florence, 28 May 1546). The son of Lorenzo di Bernardetto, he belonged to a cadet branch of the family and assisted the ruling Medici as adviser and artistic administrator. Guardian of the young (12) Ippolito de' Medici and (13) Alessandro de' Medici and a member of the Florentine government, on the accession of (14) Cosimo I de' Medici in 1537 as Duke of Florence he became one of the Duke's most trusted counsellors. He married Francesca Salviati, the sister of Cosimo's mother Maria, and their son Alessandro (1535–1605) had a brief reign as Leo XI in 1605. Heartily disliked by Benvenuto Cellini for his influence, or interference, in artistic affairs, Ottaviano was nevertheless appreciated by other artists, and by the poet and writer on art Pietro Aretino in Venice, for his generous support, and his palazzo by S Marco, Florence, near the Medici sculpture garden, was looked on as home by Giorgio Vasari, whose studies and first visit to Rome had been assisted by Ottaviano. A friend of Michelangelo, Ottaviano was the patron of Titian (from whom he was awaiting, in July 1539, paintings promised by Aretino) and Sebastiano del Piombo and the owner, according to Vasari, of a collection that included a tapestry cartoon by Leonardo da Vinci. In the 1520s he was the supervisor of the decoration of the Villa Medici at Poggio a Caiano, commissioning the painters Franciabigio, Pontormo and Andrea del Sarto. As custodian of Medici property, when Federico I Gonzaga requested Raphael's portrait of *Leo X with Cardinals Giulio de' Medici and Luigi de' Rossi* (1517–19; Florence, Uffizi; for illustration

see (7) above) Ottaviano ordered a copy from Andrea del Sarto and sent the copy, not the original, to Mantua. Vasari later made a copy of Raphael's picture for Ottaviano's collection of Medici portraits, which included Pontormo's *Cosimo il Vecchio* (1519; Florence, Uffizi; see colour pl. 2, XVIII3) and Vasari's *Lorenzo the Magnificent* (Florence, Uffizi; *see* VASARI (1), fig. 1) and constituted a form of archive of the house.

BIBLIOGRAPHY

G. Vasari: *Vite* (1550, rev. 2/1568); ed. G. Milanesi (1878–85)

B. Cellini: *Vita*, ed. A. Cocchi (Cologne, 1728); Eng. trans. by J. A. Symonds, 2 vols (London, 1887, abridged Oxford, 1983)

A. M. Bracciante: *Ottaviano de' Medici e gli artisti* (Florence, 1984)

J. Cox-Rearick: *Dynasty and Destiny in Medici Art: Pontormo, Leo X and the Two Cosimos* (Princeton, 1984)

JANET SOUTHORN

(11) Lorenzo de' Medici, Lord of Florence and Duke of Urbino (*b* Florence, 12 Sept 1492; *reg* 1513–19; *d* Florence, 4 May 1519). Grandson of (5) Lorenzo the Magnificent. He was the son of Piero 'lo Sfortunato' de' Medici (1471–1503) and Alfonsina Orsina. He was reared in Rome during the Medici exile and accepted the government of Florence unwillingly from his uncle, (7) Leo X, in August 1513, taking over from his uncle, (9) Giuliano de' Medici. His rule was frequently clouded by his lack of interest in Florentine affairs and an obvious preference for Rome. He was made Captain General of the Florentine Republic on 6 June 1515, and in the following year the Pope made him Duke of Urbino. Niccolò Machiavelli (1469–1527) dedicated *Il principe* (1513) to Lorenzo in the hope that Italy might be unified under Florentine rule. Lorenzo's tomb was designed by Michelangelo; it stands in the New Sacristy of S Lorenzo, Florence, embellished by a figure of the Duke in a melancholy pose (*see* MICHELANGELO, fig. 4) that contrasts with the vigorous stance of Giuliano de' Medici, whose tomb is opposite. Hopes for a Medici dynasty ended when Lorenzo died without a son; however, his daughter, Catherine de' Medici (*reg* 1559–74), became Queen of France on her marriage to Henry II (*reg* 1547–59) in 1533.

BIBLIOGRAPHY

A. Giorgetti: 'Lorenzo de' Medici, capitano general della Repubblica fiorentino', *Archv. Stor. It.*, iv–xi (1883), pp. 194–215

N. Rubinstein: *The Government of Florence under the Medici (1434–1494)* (Oxford, 1966)

——: 'Lorenzo de' Medici: The Formation of his Statecraft', *Proc. Brit. Acad.*, lxiii (1977)

J. N. Stephens: *The Fall of the Florentine Republic, 1512–1530* (Oxford, 1983)

H. Butters: *Governors and Government in Early 16th-century Florence, 1502–1519* (Oxford, 1985)

J. Hidalgo Ogayar: *Libro de horas de los Médicis de Lorenzo II el Joven* (Madrid, 1994)

ANABEL THOMAS

(12) Cardinal Ippolito de' Medici (*b* Urbino, 19 April 1511; *d* Itri, 10 Aug 1535). Illegitimate son of (9) Giuliano de' Medici. He was considered by the Medici popes (7) Leo X and (8) Clement VII as the possible future head of the family. In the event he was passed over in favour of (13) Alessandro de' Medici and was created a cardinal in January 1529, in which capacity he travelled to Hungary in 1532 as papal legate to Emperor Charles V (*reg* 1519–56), who was then at war with the Turks. Believing himself unfairly treated in the succession, he worked to displace Alessandro as Duke of Florence, dying in southern Italy on the way to present his case to the Emperor on campaign in North Africa. Unsuited by nature to the cardinalate (his friendship with the Venetian courtesan Angela Zaffetta and passion for Giulia Gonzaga were public knowledge), he nevertheless entered readily into the lavish style of living of his peers, to the extent that Clement VII once tried to sack members of his household, which Ippolito resisted on the grounds that while he probably did not need them, they needed him. He was a generous patron of Michelangelo (to whom he gave a horse) and of the poet and art enthusiast Pietro Aretino, with whose help he summoned Titian from Venice to Bologna in 1530 to work for Charles V. When Titian returned to Bologna for the Emperor's second visit in 1533, he painted the portrait of *Ippolito de' Medici in Hungarian Costume* (Florence, Pitti). Other artists enjoying Ippolito's patronage included Benvenuto Cellini, the gem-engraver GIOVANNI BERNARDI, Sebastiano del Piombo (who painted the portrait of *Giulia Gonzaga*; untraced, but known from copies) and the sculptors ALFONSO LOMBARDI and Giovanni Angelo Montorsoli, who on the recommendation of Michelangelo was sent by Ippolito to France in response to a request from Francis I (*reg* 1515–47). Giorgio Vasari acknowledged Ippolito as his first patron and repaid him with the many references in the *Vite* to his generous patronage of the arts.

BIBLIOGRAPHY

G. Vasari: *Vite* (1550, rev. 2/1568); ed. G. Milanesi (1878–85)

B. Cellini: *Vita*, ed. A. Cocchi (Cologne, 1728); Eng. trans. by J. A. Symonds, 2 vols (London, 1887, abridged Oxford, 1983)

G. Moretti: 'Il Cardinale Ippolito dei Medici dal trattato di Barcellona alla morte, 1529–1535', *Archv Stor. It.*, xcviii (1940), pp. 137–78

JANET SOUTHORN

(13) Alessandro de' Medici, Duke of Florence (*b* Florence, ?1511; *reg* 1531–7; *d* Florence, 5–6 Jan 1537). Illegitimate son of (8) Clement VII but officially the illegitimate son of (11) Lorenzo de' Medici. He was not a liberal patron and commissioned little, his patronage guided purely by political motives. The most outstanding sculpture created during his reign, Baccio Bandinelli's colossal marble group of *Hercules and Cacus* (1533–4; Florence, Piazza della Signoria; *see* BANDINELLI, BACCIO, fig. 2), was in fact commissioned by Clement VII. In 1531, the year of his election as head of the Florentine Republic, Alessandro commissioned Pontormo to continue with the decoration of the *gran salone* in the Medici villa of Poggio a Caiano (Vasari), a project that Pontormo had started in 1520 but was never to complete. In 1532 Alessandro was appointed Duke of Florence; emphasizing his absolute power, he had the council bell removed from the Palazzo della Signoria and reduced to coins and weapons. Other small-scale commissions were for gems and medals, the most famous of the latter made in 1534 by Domenico di Polo (1480–1547) and in (?)1535 by Francesco dal Prato, glorifying Alessandro as a peace-maker. In 1534 the Duke had his portrait painted by Giorgio Vasari (Florence, Uffizi), who depicted him as the defender and protector of Florence and a resurgent offshoot of the Medici family. Other portraits were painted by Pontormo (1534; Philadelphia, PA, Mus. A.) and Giulio Romano (Madrid, Mus. Thyssen-Bornemisza).

The commission that was most characteristic of Alessandro was the Fortezza Alessandra (1533–6; now Fortezza da Basso), which was designed by Antonio da Sangallo (ii) (see SANGALLO, (4)). An absolute ruler's citadel against the city, it is architecturally important for its technical and formal achievements. In 1536 Alessandro married Margaret of Parma, the natural daughter of Charles V (reg 1519–56). He was murdered on the night of 5–6 January 1537 on the order of Lorenzino de' Medici (1514–48).

BIBLIOGRAPHY
M. Rastrelli: *Storia d'Alessandro de Medici, Primo Duca di Firenze* (Florence, 1781)
J. Pope-Hennessy: *Italian High Renaissance and Baroque Sculpture* (London, 1963, 3/1985), pp. 362–4, 457, pl. 64
J. R. Hale: *Florence and the Medici: The Pattern of Control* (London, 1977)
K. Langedijk: *The Portraits of the Medici, 15th–18th Centuries*, i (Florence, 1981), pp. 70–77, 221–42
K. Weil-Garris: 'On Pedestals: Michelangelo's *David*, Bandinelli's *Hercules and Cacus* and the Sculpture of the Piazza della Signoria', *Rom. Jb. Kstgesch.*, xx (1983), pp. 393–403
J. Cox-Rearick: *Dynasty and Destiny in Medici Art: Pontormo, Leo X and the Two Cosimos* (Princeton, 1984), pp. 234–5
P. Rubin: 'Vasari, Lorenzo and the Myth of Magnificence', *Lorenzo il Magnifico e il suo mondo: Convegno internazionale di studi: Florence, 1992*, pp. 427–42
C. Acidini Luchinat: 'Il cardinale Alessandro de' Medici e le arti: Qualche considerazione', *Paragone*, xlv/529–33 (1994), pp. 134–40

THOMAS HIRTHE

(14) Cosimo I de' Medici, Grand Duke of Tuscany (*b* Florence, 11 June 1519; *reg* 1569–74; *d* Castello, 21 April 1574). Nephew of (10) Ottaviano de' Medici. His mother, Maria Salviati (*d* 1543), was a granddaughter of (5) Lorenzo the Magnificent; his father, the professional soldier Giovanni delle Bande Nere (1498–1526), was killed when Cosimo was seven. When, in 1537, Lorenzino de' Medici murdered (13) Alessandro de' Medici, the tyrannical Duke of Florence, Cosimo was the only available successor. Initially his power was limited, but he became Duke of Florence in 1537, after his victory at the Battle of Montemurlo, and Grand Duke of Tuscany in 1569.

Cosimo, more powerful than any earlier Medici, strove to create a court whose splendour should rival the proudest European courts and to express the triumphs and ambitions of his dynasty through the architectural magnificence of his palazzi and public works (see FLORENCE, §I, 3). He cultivated the myth of the great tradition of Medici art patronage, restoring the plundered Palazzo Medici, and reassembling and enriching the Biblioteca Laurenziana, founded by Cosimo *il vecchio*. He commissioned from Giorgio Vasari a portrait of *Lorenzo the Magnificent* (Florence, Uffizi; see VASARI, (1), fig. 1) as an act of homage to his ancestors, and the desire for a noble lineage led to his claiming descent from the first Etruscan settlers in Tuscany and the title Ducatus Etruriae. Cosimo supported archaeological excavations at Etruscan sites, where the *Chimaera of Arezzo* was found in 1553 and the *Arringatore* in 1566 (both Florence, Mus. Archeol.). Humanists and poets, such as Vincenzo Borghini, and artists, such as Agnolo Bronzino, Benvenuto Cellini, Pierino da Vinci and Giorgio Vasari, gathered around him and enhanced his glory and power. In 1554 he established the Arazzeria Medicea (see FLORENCE, §III, 3(ii)), and he was joint head, with Michelangelo, of the Accademia del Disegno

(founded 1563; see FLORENCE, §V, 1). Florence again became an important centre for gems and medals (see GEM-ENGRAVING, §I).

AGNOLO BRONZINO was court artist from 1539, and his many state portraits of Cosimo and his family (e.g. *Cosimo in Armour*, 1543; Florence, Uffizi; see FLORENCE, fig. 8) are propagandistic images of power and authority. In 1545 a bust of *Cosimo I* was commissioned from BENVENUTO CELLINI, but this dramatic work was replaced by a more conservative image by BACCIO BANDINELLI (both Florence, Bargello).

The first Medici residence to receive embellishment was the Villa di Castello, where in 1538 Cosimo commissioned Niccolò Tribolo to realize a grandiose garden, adorned with allegorical sculptures glorifying the Medici (for illustration see TRIBOLO, NICCOLÒ), that contrasted with the relative modesty of earlier Medici villa gardens. In 1540 the Duke moved from the Palazzo Medici to the Palazzo della Signoria (which from this time began to be known as the Palazzo Vecchio) and began extending the latter, having the Salone del Cinquecento remodelled by Bandinelli; the Sala dell'Udienza was frescoed (1542–5) by Francesco Salviati (see SALVIATI, FRANCESCO, fig. 2). In 1549 he moved to the former Palazzo Pitti on the other side of the River Arno, which had been bought by his wife, (15) Eleonora of Toledo. Cosimo had this new family palace enlarged and altered by Bartolomeo Ammanati from 1560 to 1568 (although according to Vasari it was Eleonora who made the arrangements for this). Especially noteworthy is the Mannerist treatment of the courtyard (see colour pl. 1, II2), which opens on to the Boboli Gardens (see FLORENCE, §IV, 9(iii) and fig. 14), laid out by Tribolo in 1549–50.

The Palazzo Vecchio was now used exclusively for government business. In 1554 Giorgio Vasari (see VASARI, (1)) replaced Bronzino as the favoured court artist, and he became artistic superintendent (1555–72) of an ambitious project to transform its interior. A series of rooms, with frescoes designed by Vasari, was dedicated to the glorification of the Medici. The sequence opened with a room extolling Cosimo *il vecchio* (for illustration see (2) above) and culminated in the Sala dei Cinquecento; see colour pl. 2, XXXVII3, where the ceiling decoration (1563), whose programme was devised by Borghini, glorifies Cosimo's rule (see VASARI, (1), fig. 5); Cosimo is shown dominating the artists of his court (see fig.). In several rooms frescoed decorations were accompanied by sets of tapestries, most of which were designed for the Arazzeria Medicea by Joannes Stradanus (1523–1605). Cosimo also kept his magnificent collection of bronzes, marble statuettes, curios, medals and miniatures in a small room in the palace, called the Scrittoio di Calliope, which was the first Medici museum of this kind. Ancient works were added to Lorenzo the Magnificent's 15th-century collection of small bronzes and medals, and Cosimo searched for rare Roman, Greek and Egyptian works. In 1562 a show-case (destr.) of medals was presented to him by Conte Orsini di Pitigliano. Cosimo also had medals made with his own image, a series by Domenico Poggini from *c.* 1560 and one by Pietro Paolo Galeotti from *c.* 1569.

Cosimo was also concerned that Florence itself should reflect the triumph of his dynasty, and he enriched the city

Cosimo I de' Medici among the Artists of his Court (1563), fresco ceiling painting by Giorgio Vasari, Sala dei Cinquecento, Palazzo Vecchio, Florence

with buildings and with sculpture. The building of the Uffizi, begun in 1559 by Vasari (*see* FLORENCE, §IV, 10, and VASARI, (1), fig. 6), expressed order and harmony. It was an administrative structure, in the ground-floor of which Cosimo housed the offices (*gli uffici*) of the Florentine state; on the first floor he accommodated the art treasures assembled by the Medici, laying the foundation of one of the most important art collections in Italy. In 1564, to secure a safe passage from the palace of government to his private palace at all times, the Duke commissioned Vasari to construct a long corridor, running from the Palazzo Vecchio, through the Uffizi, to the Ponte Vecchio and thence to the Palazzo Pitti. Cellini's bronze *Perseus with the Head of Medusa* (1543–53; Florence, Loggia Lanzi), perhaps symbolizing Cosimo's leadership (*see* CELLINI, BENVENUTO, §I, 4 and fig. 6), and Ammanati's Fountain of Neptune (*c.* 1560–75; *see* AMMANATI, BARTOLOMEO, fig. 2) were commissioned for the Piazza della Signoria; columns commemorating the Medici were erected in the piazzas of S Marco, Santa Trìnita and S Felice.

Cosimo had a special relationship with Pisa, reinforcing its naval power and founding the Order of the Knights of S Stefano in 1526; he also supported the reopening of the University of Pisa. In place of the earlier republican city centre, he commissioned Vasari to build the church of S Stefano and the Palazzo dei Cavalieri. His interest is commemorated in Pierino da Vinci's marble relief *Pisa Restored* (1552–3; Rome, Pin. Vaticana; for illustration *see* PIERINO DA VINCI). In 1564 Cosimo, in poor health, decided to withdraw from political life in favour of his son (16) Francesco I de' Medici.

For a posthumous equestrian monument of Cosimo I *see* GIAMBOLOGNA, fig. 5.

BIBLIOGRAPHY
A. Mannucci: *Vita di Cosimo de' Medici, primo gran duca di Toscana* (Bologna, 1586)
L. A. Ferrai: *Cosimo de' Medici, duca di Firenze* (Bologna, 1882)
P. E. Giambullari: *Personificazione delle città, paesi e fiumi della Toscana, festeggianti le nozze di Cosimo I ed Eleonora di Toledo*, ed. U. Angeli (Prato, 1898)
V. Maffei: *Dal titolo di Duca di Firenze e di Siena a Granduca di Toscana* (Florence, 1905)
E. Borsook: 'Art and Politics at the Medici Court: The Funeral of Cosimo I de' Medici', *Mitt. Ksthist. Inst. Florenz,* xii (1965–6), pp. 31–54
A. C. Minor and B. Mitchell: *A Renaissance Entertainment: Festivities for the Marriage of Cosimo I, Duke of Florence, in 1539* (Columbia, MO, 1968)
K. W. Forster: 'Metaphors of Rule: Political Ideology and History in the Portraits of Cosimo I de' Medici', *Mitt. Ksthist. Inst. Florenz,* xv (1971), pp. 65–104
P. W. Richelson: *Studies in the Personal Imagery of Cosimo I de' Medici, Duke of Florence* (diss., Princeton U., 1973)
D. R. Wright: *The Medici Villa at Olmo a Castello: Its History and Iconography* (diss., Princeton U., 1976)
Le arti del principato mediceo (exh. cat., Florence, Pal. Vecchio, 1980), pp. 31–45 [article on ant. sculp. col. of Cosimo I de' Medici]
R. Cantagalli: *Cosimo I de' Medici, Granduca di Toscana* (Milan, 1985)
T. Hirthe: 'Die Perseus-und-Medusa-Gruppe des Benvenuto Cellini in Florenz', *Jb. Berlin. Mus.,* xxix–xxx (1987–8), pp. 197–216

MARLIS VON HESSERT

(15) Eleonora de' Medici [Eleanora of Toledo], Grand Duchess of Tuscany (*b* Naples, 1522; *d* Pisa, 1562). First wife of (14) Cosimo I de' Medici. She was the second daughter of the Viceroy of Naples, Don Pedro di Toledo, Marquis of Francavilla, senior lieutenant to Emperor Charles V (*reg* 1519–56). In 1539 Cosimo I married her as part of his policy to strengthen his connections with the Emperor. The union appears to have been happy and resulted in 11 children, two of whom eventually succeeded to the Grand Duchy of Tuscany: (16) Francesco I de' Medici, on Cosimo's death in 1574, and (17) Ferdinando I de' Medici in 1587. Spanish by birth, and notably pious, Eleonora retained the influences—and language—of her upbringing throughout her life. Her physical beauty is attested to by a considerable number of portraits by Agnolo Bronzino (e.g. 1546, Florence, Uffizi; 1560, Berlin, Gemäldegal.; for a portrait of her with her son Giovanni *see* BRONZINO, AGNOLO, fig. 3).

An imperious woman of considerable intelligence, Eleonora was passionately interested in gambling, despite her deeply religious nature. Once settled in Florence, she demonstrated great business acumen and was instrumental in enlarging the Medici fortune by astute dealings in land and property. In 1550, for example, she bought the Palazzo Pitti, which then became the official Medici residence in Florence. According to Vasari, it was Eleonora who arranged for it to be enlarged and for the redesigning of the land attached to it (now the Boboli Gardens; *see* FLORENCE, §IV, 9(iii) and fig. 15).

As a patron, Eleonora embraced both charitable causes and the arts, although, according to Benvenuto Cellini, she was as autocratic and capricious in this respect as she was in most other matters. She was closely associated with many of the major Florentine artists of the period, including Niccolò Tribolo, Bronzino, Pierino da Vinci, Cellini himself and Baccio Bandinelli. Cellini discussed Eleonora's pleasure both in acquiring and wearing jewellery—an interest evident in the Bronzino portraits, in all of which she is extremely richly dressed in heavy brocade robes liberally embroidered with pearls, for which she had a particular passion. The project with which the Duchess is most closely associated is the chapel bearing her name in the Palazzo Vecchio, Florence, which Cosimo commissioned Bronzino to decorate. The small private chapel,

frescoed with scenes from the *Life of Moses* (1540–45), is a major work of Florentine Mannerism, and perhaps the most complete extant indication of Eleonora's own taste. Bronzino's altarpiece, a *Lamentation* (1545; Besançon, Mus. B.-A. & Archéol.; *see* BRONZINO, AGNOLO, fig. 1), includes an idealized portrait of Eleonora in a prominent position within the narrative. She was also involved in the 'Elevati', a literary academy founded by her husband in 1547. The poet Laura Battiferri (1525–89), who, in common with Eleonora, was influenced by Jesuit thought, dedicated the first publication of her poetry to Eleonora in 1560.

BIBLIOGRAPHY

G. Vasari: *Vite* (1550, rev. 2/1568); ed. G. Milanesi (1878–85)
B. Cellini: *Vita*, ed. A. Cocchi (Cologne, 1728); Eng. trans. by J. A. Symonds, 2 vols (London, 1887; abridged Oxford, 1983)
A. Baia: *Leonora di Toledo: Duchessa di Firenze e Siena* (Todi, 1907)
C. McCorquodale: *Bronzino* (London, 1981)
L. von Wilckens: 'Noch einmal: Bronzinos Kleid der Eleonara von Toledo', *Z. Kstgesch.*, lviii/2 (1995), p. 262

WARREN HEARNDEN

(16) Francesco I de' Medici, Grand Duke of Tuscany (*b* Florence, 25 March 1541; *reg* 1574–87; *d* Poggio a Caiano, 19 Oct 1587). Son of (14) Cosimo I de' Medici and (15) Eleonora de' Medici. His education included instruction in science and the decorative arts, and these were to remain his abiding interests. Bronzino painted a portrait of *Eleonora with Francesco* (1549–50; workshop versions, Pisa, Mus. N. S. Matteo; Cincinnati, OH, A. Mus.). He was again painted by Bronzino in 1551 (Florence, Uffizi), the first of a series of *quadretti* of Cosimo's children at the same age. The last image of his youth was the idealized portrait by Bronzino's pupil Alessandro Allori (*c.* 1559; replica in Chicago, IL, A. Inst.) of Francesco with a miniature of his sister Lucrezia (*d* 1561).

In the 1550s Francesco became interested in the art of GIAMBOLOGNA and from 1561 paid him a monthly salary. The Prince's first major commission to the sculptor was for *Samson Slaying a Philistine* (1560–62; London, V&A; *see* ITALY, fig. 23); it marked the beginning of a long patronage. In 1564 Francesco was made Prince Regent, and celebratory medals were struck, the first of many by Pastorino de Pastorini and Domenico Poggini. At about the same time Poggini carved a marble portrait bust of *Francesco de' Medici* (Florence, Uffizi), which, in contrast to Benvenuto Cellini's tensely realistic portrayal of *Cosimo de' Medici* (1548; Florence, Bargello), presents a generic and romanticized image, the forerunner of the idealized rulers of the Baroque.

In 1565 Francesco travelled to Vienna and Innsbruck and returned with the promise of an imperial bride. One result of this trip was a full-length portrait, probably by Allori, showing Francesco standing in armour in the Habsburg manner (studio versions, e.g. Antwerp, Mus. Mayer van den Bergh). The other was the ceremonial arrival in Florence in December 1565 of Joanna of Austria (1547–78), daughter of the Holy Roman Emperor Ferdinand I (*reg* 1558–64); the wedding, celebrated over several weeks, was intended to mark the full grandeur of the new Tuscan state. Some of its lavish features still survive, such as Giorgio Vasari's redecoration of the courtyard of the Palazzo Vecchio, Francesco's residence, with gilded stuc-

coes on the columns and frescoes of Austrian cities on the inner walls (1565; *in situ*). Also associated with these celebrations is Giambologna's marble group *Florence Triumphant over Pisa* (Florence, Bargello).

In the Palazzo Vecchio, Vasari also built Francesco a private apartment, consisting of a bedchamber, a secret closet and a small, richly decorated treasure-room, connected by a hidden stairway to his famous *studiolo* (*see* STUDIOLO, fig. 2 and BANDINI, GIOVANNI). The decoration of the *studiolo* (1570–75; *in situ*) displays, in an arcane programme devised by Vincenzo Borghini, the range of Francesco's interests, expressed in terms of man's dominance of nature through art and science and illustrated by scenes and figures symbolic of the *Four Elements* and the *Four Seasons* and their presiding gods. The scheme, under Vasari's direction, combined frescoes, oil paintings, mosaics and bronze statuettes in an elaborately varied exhibition, on a tiny scale, of the finest examples of Florentine Late Mannerism, employing, besides Vasari himself (*see* VASARI, (1), fig. 8), the talents of Giambologna, Bartolommeo Ammannati, Francesco Poppi, Giovan Battista Naldini (for illustration *see* NALDINI, GIOVAN BATTISTA) and others. Francesco appears as a spectator in such scenes (all *in situ*) as Giovanni Maria Butteri's *Glassblower's Workshop* (1570–71) and Alessandro Fei's *Goldsmith's Workshop* (*c.* 1570), and, more remarkably, as the protagonist in Joannes Stradanus's *The Alchemists* (*see* STRADANUS, JOHANNES, fig. 1). There was indeed a private laboratory in the Palazzo Vecchio, built earlier by Vasari for Cosimo I, in which Francesco was reputed to experiment in alchemy and chemistry, metalwork and crystal-cutting, and developments in the manufacture of fireworks, paste jewellery and porcelain. He certainly encouraged his favoured artist (who was also his art tutor), BERNARDO BUONTALENTI, in the last, and in 1572 he brought Ambrogio and Stefano Caroni from Milan to Florence, followed in 1575 by Giorgio Gaffurri, to set up a workshop specializing in hardstone products (*see* FLORENCE, §III, 1 and 2).

These un-princely activities were unpopular with the Florentines, who were only too aware that Francesco's ten-year apprenticeship had failed to remake him in Cosimo's heroic self-image. His accession in 1574 was marked by disparaging assessments by diplomatic observers, describing his short stature, melancholy mien, graceless bearing and taciturn circumspection. His preference for his various private pursuits over public duties was also noted; these included his notorious affair with the Venetian beauty Bianca Capello, who had become his mistress in 1568. It was for Bianca that Buontalenti created the second masterpiece of Francesco's patronage, the Villa Medici at Pratolino, near Florence. The main building (1569–75; destr.) was on the traditional lines of the Villa Medici at Poggio a Caiano. Buontalenti's inventive artistry was concentrated on the amazing gardens, with their terraces, grottoes, fountains, set-pieces and automata. (For Buontalenti's façade and interior of the great grotto of the Boboli Gardens, carried out for Francesco from 1583, *see* BUONTALENTI, BERNARDO, fig. 1 and colour pl. 1, XVIII1) Most of these were completed by 1581, when Montaigne visited and described them in his *Journal de voyage en Italie par la Suisse et l'Allemagne*, and were still

functioning a century later. Virtually all that remains at Pratolino is the gigantic fountain-figure of the *Appennines* (1580), created by Giambologna (see colour pl. 1, XXXIII3). Francesco appointed Buontalenti as his court artist after Vasari's death in the year of his accession. One of his earliest duties was to arrange the celebrations of the birth of Francesco's heir, Filippo, in 1577. Also being celebrated was the Emperor's belated approval of the title of Grand Duke of Tuscany, originally granted to Cosimo I by Pope Pius V in 1570. In 1578 the death of Joanna of Austria was commemorated in elaborate obsequies; less than two months later Francesco secretly married Bianca. Their union was officially celebrated the following year with the most lavish festivities yet seen in Florence (again designed by Buontalenti). Bianca's new status was recorded in a number of portraits by Allori (all destr.), depicting her with both the Grand Prince Filippo and her own older, illegitimate son Antonio. After Filippo's death in 1582, Antonio was legitimized. Perhaps to emphasize the continuity of his line, Francesco commissioned in 1584–5 a series of paintings of his ancestors, known as the *Serie Aulica*, from various minor artists; a hieratic double portrait of his late wife and son (Florence, Uffizi) by Giovanni Bizzelli (1556–1612) was added to it in 1586. He himself was portrayed with rather more effective dignity by Hans von Aachen (1552–1615), wearing the Order of the Golden Fleece conferred on him in 1585 (Florence, Pitti).

Francesco's extravagance, and his second wife and son, were deeply resented by his subjects; however, he did much to improve the cultural life of Florence. In 1583 he founded the Accademia della Crusca ('chaff') for the purification of the Italian language and the promotion of Tuscan literature. He had already (from 1572) encouraged those decorative arts he loved by grouping craft workshops, particularly those producing jewellery, glass and porcelain, in Buontalenti's Casino de' Medici in Piazza S Marco; he even moved his own laboratory there. In 1581 he ordered the transformation of the upper storey of the Uffizi, newly completed by Buontalenti and Alfonso Parigi, into an art gallery to display his collections, with the choicest pieces grouped in Buontalenti's octagonal, domed Tribuna. In the centre of the latter was placed a tempietto decorated with gold reliefs by Giambologna (Florence, Pitti), five of which showed Francesco supervising building projects: the fortifications of Livorno and of Portoferraio, the villa at Pratolino, the Forte di Belvedere and the façade of Florence Cathedral. In fact, Pratolino was the only one completed by Francesco, and, of the others, only the work at Livorno was begun by him. The competition for the façade of the cathedral was held in 1587, and the various models for it (including Buontalenti's) survive (Florence, Mus. Opera Duomo). But this, like the other projects, was interrupted by the sudden death from malaria, one day apart, of both Francesco and his wife.

BIBLIOGRAPHY
G. Vasari: *Ragionamenti sopra le inventioni da lui dipinte in Firenze . . .* (Florence, 1588); ed. G. Milanesi (1882)
J. Shearman: *Mannerism* (Harmondsworth, 1967)
E. Pucci: *Palazzo Vecchio* (Florence, 1968)
M. Levey: *Painting at Court* (London, 1971)
C. Hibbert: *The Rise and Fall of the House of Medici* (London, 1974)
J. R. Hale: *Florence and the Medici: The Pattern of Control* (London, 1977)
S. J. Schaefer: *The Studiolo of Francesco de' Medici in the Palazzo Vecchio in Florence* (microfilm, Ann Arbor, 1980)
K. Langedijk: *The Portraits of the Medici, 15th–18th Centuries*, 3 vols (Florence, 1981–7)
M. L. Mariotti Masi: *Bianca Capello: Una Veneziana alla corte dei Medici* (Milan, 1986)
NIGEL GAUK-ROGER

(17) Ferdinando I de' Medici, Grand Duke of Tuscany (*b* Florence, 30 July 1548; *reg* 1587–1609; *d* Florence, 7 Feb 1609). Son of (14) Cosimo I de' Medici and (15) Eleanora de' Medici. His future career seemed uncertain until, in 1562, two of his brothers and his mother suddenly died (he was the fourth son). The older of the two, Giovanni, had been a cardinal; Cosimo arranged with Pius IV that Ferdinando should inherit Giovanni's title and benefices (1563). The investiture took place in Rome the following year. For the next decade Ferdinando spent increasingly long periods in Rome, lodging frequently with the Tuscan cardinal Giovanni Ricci, and made numerous influential contacts and alliances. He also began, from 1569, to collect antique sculptures, housing them in a small villa (destr.) outside the Porta del Popolo. In 1572 Cosimo commissioned Bartolomeo Ammannati to remodel and enlarge considerably the Palazzo di Firenze in Campo Marzio, Rome, as Ferdinando's main residence, but little work was done before Cosimo's death (1574) put paid to the scheme. Nevertheless Ferdinando was determined to move permanently to Rome. (His relations with his elder brother (16) Francesco I de' Medici were strained.) In 1576 he completed the purchase of Cardinal Ricci's magnificent villa on the Pincio, which is still known as the Villa Medici. Over the next decade it was rendered even more splendid, with the approaches and entrances regularized and embellished, the gardens enlarged and beautified, and the main building remodelled and redecorated. Two of the new architectural features were especially influential on subsequent Roman villas and palazzi: the crowning of the doubled turrets with decorative belvederes, and the encrustation of the garden front, above a deep loggia, with antique fragments framed in rich stuccowork. The other main new feature was an immense gallery below a raised terrace, built to house Ferdinando's by then superb collection of Classical sculpture, which eventually included the *Venus de' Medici*, the *Wrestlers*, the *Niobids* (all Florence, Uffizi) and the *Spinario* (Rome, Mus. Conserv.).

Ferdinando's fine physical presence, good humour and liberality made him popular both in Florence and Rome; but it was clear from the decisive influence of his intervention in the papal conclaves of 1572 and 1585 that his fellow cardinals recognized more solid qualities beneath his affable exterior. The Florentines too were to discover that he could be both decisive and ruthless. In 1582 Francesco's only legitimate son had died; the son of Francesco's second wife, Bianca Capello, was then legitimized. When both Francesco and Bianca died suddenly in 1587, Ferdinando quickly found witnesses to swear that the boy was not, in fact, Francesco's son (and soon entered him, for good measure, in the celibate Order of the Knights of S Stefano). Ferdinando himself had never taken priestly vows and was thus able, with Pope Sixtus V's permission, to doff his cardinalate (which was conferred

on Francesco Maria del Monte) and become Grand Duke of Tuscany.

Ferdinando's coup was popular with his new subjects, who had come increasingly to detest his brother. He proved an able administrator and with firmness and efficiency secured for Tuscany stability and prosperity at home and independence and respect abroad. He spent as lavishly as Francesco had, but was less resented for it, perhaps because his projects tended to be of a more public and lasting nature, and many more of them were brought to completion. In fact, several were based on his brother's initiatives. He regularized the haphazard grouping of craft workshops in the Casino de' Medici by transferring them, together with painters' studios, to the newly completed Uffizi, under the supervision of a single Soprintendente. In 1588 he founded a workshop, later known as the Opificio di Pietre Dure (see FLORENCE, §III, 2), for the control and encouragement of workers in hardstones. He had Bernardo Buontalenti execute the planned Forte di Belvedere (1590–95) above the Boboli Gardens, and in 1596 he held a second competition for the façade of Florence Cathedral. (This was won by his half-brother (18) Giovanni de' Medici; work was eventually begun to the latter's design, but soon abandoned.)

Above all, Ferdinando continued his predecessor's development of the port of Livorno from virtually nothing into an international trading centre. Even more important was the city's internal rearrangement: in 1594 Francesco had begun the rebuilding of the cathedral by Alessandro Pieroni (1550–1607) to Buontalenti's design; but it was under Ferdinando that the symmetrical Piazza Grande (in the centre of town) in front of it was laid out, with mixed commercial and residential properties encased in a consistent architectural configuration. This was soon imitated by Ferdinando's nephew-in-law, Henry IV, King of France (reg 1589–1610), in the Place Royale (1605; now Place des Vosges), Paris, and subsequently by Inigo Jones (1573–1652) at Covent Garden, London (1631), both with dramatic effect on European urban planning.

Livorno also contained another influential feature, an over life-size marble statue (1595–9) of Ferdinando by Giovanni Bandini in the Piazza Micheli, overlooking the port. Inspired by his love of the Antique and knowledge of Roman monuments, Ferdinando replaced painting with sculpture as the dynastic image-maker. Two other large statues of himself, by Pietro Francavilla to Giambologna's designs, had been set up in Arezzo (1590–95; Piazza del Duomo) and Pisa (1594–5; Piazza Carrara). The latter accompanied a similar figure of *Cosimo I* by the same artists, surmounting a fountain before the Palazzo dei Cavalieri (1593–6). Cosimo had been even more influentially immortalized by his son in Giambologna's superb bronze equestrian statue in Florence (1587–95; Piazza della Signoria; see GIAMBOLOGNA, fig. 5). Ferdinando was portrayed in similar guise, the metal supposedly from Turkish arms captured by his victorious fleet (1601–8; Florence, Piazza SS Annunziata). While Giambologna was working on the latter (completed by Pietro Tacca), he was commissioned to produce comparable statues of *Henry IV* (destr. 1792) and *Philip III* (1606–17; Madrid, Plaza Mayor). These conquering images were to become a staple of Baroque portraiture.

Ferdinando sat for only one official portrait painting, by Scipione Pulzone, a pair with that of his wife (1590; Florence, Uffizi). He had married Christine of Lorraine (Catherine de' Medici's granddaughter) in 1589, with festivities more lavish than any before, including processions, masques, theatrical intermezzi and a mock sea battle in the flooded courtyard of Palazzo Pitti. Equally lavish, though more sober, ceremonies marked the obsequies of Philip II (1598) and the marriage of Marie de' Medici and Henry IV (1600). The true splendour of the Medici, however, was expressed in the Cappella dei Principi at S Lorenzo (begun 1604), a huge octagonal mausoleum in which the tombs of the Grand Dukes were to be preserved in the gloomy opulence of imperishable pietre dure.

BIBLIOGRAPHY
C. Hibbert: *The Rise and Fall of the House of Medici* (London, 1974)
G. M. Andres: *The Villa Medici in Rome*, 2 vols (New York, 1976)
J. R. Hale: *Florence and the Medici: The Pattern of Control* (London, 1977)
Theater Art of the Medici, (exh. cat., Hanover, NH, Dartmouth Coll., Hood Mus. A., 1980)
K. Langedijk: *The Portraits of the Medici, 15th to 18th Centuries*, 3 vols (Florence, 1981–7)
E. L. Goldberg: *Patterns in Late Medici Art Patronage* (Princeton, 1983)

□

(18) Giovanni de' Medici (*b* Florence, 1566; *d* Murano, 1621). Illegitimate son of (14) Cosimo I de' Medici. His mother was Leonora degli Albizzi. Although legitimized, he played no role in Florentine politics and instead embarked on a military and diplomatic career outside Tuscany. His activities as an amateur architect, however, all fell within Tuscany. He studied at the Accademia del Disegno in Florence. In 1590 he designed the Fortezza Nuova at the port of Livorno, his only contribution to military architecture, and in 1593 he designed the façade of S Stefano, Pisa. In 1596 he won the competition for the façade of Florence Cathedral over entries submitted by Bernardo Buontalenti, Giovanni Antonio Dosio, Lodovico Cigoli (1559–1613) and Giovanni da Bologna (1524–1608); work began but was abandoned. In 1602 Giovanni was invited to redesign the cupola and piazza of S Maria di Provenzano, Siena. His major architectural achievement was the monumental Cappella dei Principi at S Lorenzo, Florence, which was built by Matteo Nigetti (1560/70–1648) from 1604 to a revision of Giovanni's design (1597; Florence, Bib. N. Cent.) as a mausoleum to the Medici Grand Dukes (see FLORENCE, §IV, 5). Excepting the lavish marble revetment of the Cappella dei Principi and the utilitarian nature of the Fortezza, the richly decorative and sculptural quality of Giovanni's works have their origins in the architecture of Michelangelo, Vasari and such later 16th-century architects as Buontalenti and Giovanni da Bologna.

BIBLIOGRAPHY
A. Venturi: *Storia* (1901–40), xi, pp. 587–94
K. Langedijk: *The Portraits of the Medici, 15th to 18th centuries*, ii (Florence, 1983), pp. 1020–26
M. Cambell: 'Family Matters: Notes on Don Lorenzo and Don Giovanni de' Medici at Villa della Petraia', *Ars naturam adiuvans: Festschrift für Matthias Winner*, ed. V. V. Flemming and S. Schutze (Mainz, 1996), pp. 505–13

ROGER J. CRUM

Medici, Gian Angelo de'. *See* PIUS IV.

Medici, Jacopo Filippo de'. *See* JACOPO FILIPPO D'ARGENTA.

Medulić, Andrija. *See* SCHIAVONE, ANDREA.

Meglio, Jacopo del. *See* COPPI, GIACOMO.

Meldolla, Andrea. *See* SCHIAVONE, ANDREA.

Meleghino, Jacopo (*b* Ferrara, *c.* 1480; *d* Rome, 17 Nov 1549). Italian administrator and architect. He was the son of a notary and chancellor of the episcopal curia in Ferrara and was educated in law and languages. Around 1520 he entered the service of Cardinal Alessandro Farnese in Parma as treasurer, a position of trust that made him indispensable to Farnese as a general organizer and expert in architectural and antiquarian matters. Once Farnese had ascended the papal throne as Paul III in 1534, Meleghino became supervisor of the Belvedere and its antiquities in the Vatican. He organized and oversaw the restoration of the Belvedere corridor and the extension of the gardens by Baldassare Peruzzi, who bequeathed him some of his drawings and papers on architectural theory. Paul III appointed Meleghino his chief accountant and, later, the architect for the construction of St Peter's, Rome, as well as general administrator of papal buildings. As such, in 1538–40, together with the architect Antonio da Sangallo (ii), he directed the rebuilding and extension of the state rooms of the Vatican Palace (Scala Regia and Sala Regia, Sala Ducale and Capella Paolina; *see also* ROME, §V, 1(iii)(a)).

Meleghino was employed chiefly as a fortifications engineer, notably at the Rocca, or fortress, in Perugia, and in Parma, Castro and Frascati, where in the latter in 1538–45 he had districts of the newly erected town built to his own plans. In 1546 he finally became chief architect for the fortifications of Rome. He was also expert both in the layout of gardens and in the interior decoration of villas and palaces. From 1535 to 1544 he erected in Rome, to his own designs, Paul III's villa near Aracoeli, and its connecting corridor to the Palazzo S Marco (now Palazzo di Venezia), and the garden and palace of Orazio Farnese near San Rocco; he restored the Vigna Carafa on the Quirinal, helped in the furnishing of the Vigna del Monte, and in 1548–9 designed for his superior, Cardinal Guido Ascanio Sforza, the summer palace in Proceno, Viterbo.

The few surviving drawings by Meleghino's hand are of a technical nature, giving no information about his architectural style. His villa palaces near Aracoeli and in Proceno are in the tradition of the Roman High Renaissance, adapting details from the Palazzo Farnese. The palace in Proceno reveals an individualistic combination of stylistic motifs from Tuscany, Emilia-Romagna and, predominantly, Rome. Although he was self-taught and had only modest gifts, he was competent in adapting and combining existing styles.

BIBLIOGRAPHY

A. Ronchini: 'Jacopo Meleghino', *Atti & Mem. RR. Deput. Stor. Patria Prov. Moden. & Parm.*, iv (1868), pp. 125–35

J. S. Ackerman: *The Cortile del Belvedere* (Rome, 1954)

F.-E. Keller: 'Der Palast des Guido Ascanio Sforza in Proceno', *Jahrbuch der Max-Planck-Gesellschaft, 1983* (Göttingen, 1983), pp. 758–60

FRITZ-EUGEN KELLER

Meleto, Evangelista di Pian di. *See* EVANGELISTA DI PIAN DI MELETO.

Melone, Altobello (da) (*b* Cremona, *c.* 1490; *d* before 3 May 1543). Italian painter. With Gian Francesco Bembo, he reacted against the classicism of such Cremonese painters of the preceding generation as Boccaccio Boccaccino and Tommaso Aleni (*fl* 1505–15). His first work, the *Virgin and Child with the Infant St John the Baptist* (Philadelphia, PA, Mus. A.), is similar to compositions by Aleni, with carefully constructed perspective in the manner of Donato Bramante. From 1500 to 1507 the Venetian painter Marco Marziale lived in Cremona; Melone was only superficially affected by him but seems to have been attracted to Marziale's sources: northern European painting, particularly the work of Albrecht Dürer (1471–1528), and the work of Giorgione and Titian, as can be seen in his *Virgin and Child with the Infant St John the Baptist* (Bergamo, Gal. Accad. Carrara).

Melone's *Adoration of the Christ Child with Saints* (U. London, Courtauld Inst. Gals, 39674A) shows the influence of GEROLAMO ROMANINO, and Marcantonio Michiel, who saw a full-length painting of *Lucretia* (untraced) by Melone in the house of the prior of S Antonio in Cremona, described Melone as 'a young man with a good talent and instinct for painting, and a pupil of Armanin [Romanino]'. For almost a decade from *c.* 1508 Melone was closely associated with Romanino, which has, with some works, led to difficulties of attribution. Melone's *Lamentation over the Dead Christ* (Milan, Brera) is a reworking of Romanino's painting of the same subject (1510; Venice, Accad.), painted for S Lorenzo in Brescia. The *Portrait of a Man*, traditionally identified as Cesare Borgia, is influenced equally by Venetian and northern portraiture. Melone was influenced by Romanino's Titian-esque style, as is evident in such works as *The Lovers* (Dresden, Gemäldegal.); *St Prosper* (London, priv. col., see exh. cat., p. 92) and *St Jerome* (Verona, Castelvecchio), the wings of a triptych originally in the former church of S Prospero, Cremona.

In December 1516 Melone was commissioned to work on the series of frescoes in Cremona Cathedral begun by Boccaccio Boccaccino and continued by Bembo: the *Flight into Egypt* and the *Massacre of the Innocents* were executed before 15 August 1517. They are some of Melone's finest works, in which he combined German and Venetian traits with those of Romanino to produce dramatic and dynamic scenes by means of a remarkably expressive use of light and colour. The *Resurrection* (Rome, priv. col.) is extremely close to the work of Albrecht Altdorfer (1480–1538) and belongs to the same period. A second group of frescoes in the cathedral was commissioned on 13 March 1518; the cycle consists of the *Last Supper*, *Christ Washing the Disciples' Feet*, the *Agony in the Garden*, *Christ Taken by the Soldiers* and *Christ before Caiaphas*. They differ considerably from the first frescoes and are more conservative in character. Melone borrowed motifs from northern engravings and employed colder tones, perhaps influenced by the work of Lorenzo Lotto, then living in Bergamo. He returned to using perspectival devices derived from Bramante, took care in the depiction of character and, in

Christ Taken by the Soldiers, was less adventurous with his light effects.

The *Journey to Emmaus* (*c.* 1518; London, N.G.; see fig.) is of the same date. The triptych from Torre dei Picenardi (dismembered; wings, Oxford, Ashmolean; central panel, Columbia, U. MO, Mus. A. & Archaeol.; predella, Algiers, Mus. N. B.-A.) has a 15th-century format, but the still figures and the delicacy with which their expressions are conveyed, create a contemplative and subtle mood. The *Nativity with St Dominic* (Lurago d'Erba, Sormani Andreani Verri priv. col.) is a mature work in which Melone continued his experiments in the use of dramatic light effects started in the frescoes in Cremona Cathedral to the point where he anticipated the proto-Caravaggism of the Campi family. In the late 1520s, however, his allegiance to Romanino was shaken by the arrival of Giulio Romano in Mantua, which resulted in such paintings as the *Annunciation* at Isola Dovarese, Cremona, the *Virgin and Child with SS John the Baptist and Nicholas* (Cremona, Mus. Civ. Ala Ponzone) and *Christ in Limbo* (Cremona Cathedral), in which he attempted to emulate Giulio's Mannerist elegance, unfortunately a style that did not come naturally to him.

BIBLIOGRAPHY
Thieme–Becker
G. Vasari: *Vite* (1550, rev. 2/1568); ed. G. Milanesi (1878–85), iv, p. 583; vi, pp. 459, 492
M. A. Michiel: *Notizie d'opere di disegno* (MS. before 1552); as *Der Anonimo Morelliano*, ed. T. Frimmel (Vienna, 1888), pp. 44–5, 50
L. Grassi: 'Ingegno di Altobello Meloni', *Proporzioni*, iii (1950), pp. 143–63
F. Zeri: 'Altobello Melone: Quattro tavole', *Paragone*, iv (1953), pp. 40–44
F. Bologna: 'Altobello Melone', *Burl. Mag.*, xcvii (1955), pp. 240–50
M. Gregori: 'Altobello, il Romanino e il cinquecento cremonese', *Paragone*, vi (1955), pp. 3–28
——: 'Altobello e G. Francesco Bembo', *Paragone*, viii (1957), pp. 16–40
M. L. Ferrari: 'Un recupero per Altobello', *Paragone*, ix (1958), pp. 48–53
M. Tanzi: 'Novità e revisioni per Altobello Melone e Gianfrancesco Bembo', *Ric. Stor. A.*, xvii (1982), pp. 49–56
——: 'Appunti sulla fortuna visiva degli "eccentrici" cremonesi', *Prospettiva*, 39 (1984), pp. 53–60

Altobello Melone: *Journey to Emmaus*, oil on panel, 1.46×1.44 m, *c.* 1518 (London, National Gallery)

I Campi e la cultura artistica cremonese del cinquecento (exh. cat., ed. M. Gregori; Cremona, Mus. Civ. Ala Ponzone, 1985), pp. 85–98
M. Tanzi: 'Riflessioni sull'attività di Altobello Melone dopo il 1520', *Stud. & Bibliog. An. Bib. Stat. & Lib. Civ. Cremona*, xxxvii (1987), pp. 97–107
M. Gregori, ed.: *Pittura a Cremona dal romanico al settecento* (Milan, 1990), pp. 26–39
F. Moro: 'Per Altobello giovane', *A. Crist.*, lxxxii/760 (1994), pp. 13–20

MARCO TANZI

Melozzo da Forlì [Melozzo degli Ambrogi] (*b* Forlì, 8 June 1438; *d* Forlì, 8 Nov 1494). Italian painter. Melozzo occupied a transitional position between the early and High Renaissance. His contact with Piero della Francesca at the court of Urbino was fundamental to his stylistic development. He rose to prominence in Rome during the papacy of Sixtus IV (*reg* 1471–84) and later worked for the Pope's family. Many of his works have been lost or damaged, but he enjoyed a long and illustrious career and was famed for his skill in the use of illusionistic perspective.

1. LIFE AND WORK. Melozzo was probably trained near Forlì in the Romagna, and it is likely that he was first active in his native town. The fresco known as the '*Pepper Pestle*' (*c.* 1460–65; Forlì, Pin. Civ.), formerly located over the entrance to an apothecary's shop, is traditionally attributed to him. It shows a man energetically pounding pepper. Piero della Francesca is regarded as the major influence on Melozzo during this period and may have introduced him to Rome as early as 1460. Presumably during that visit Melozzo executed two processional banners on canvas. The frontally viewed, enthroned *St Mark, Pope* and a three-quarter view of *St Mark, the Evangelist* (*c.* 1460; both Rome, S Marco) are obviously early works. Despite the constricted banner format, both figures are strongly modelled and seem to project into the viewer's space, evidence that Melozzo had begun to experiment with the foreshortening that later became his hallmark. An anonymous epigram of *c.* 1461 says that Melozzo made a replica (untraced) of the *Madonna of St Luke*, the icon in S Maria del Popolo, Rome, for Lord Alessandro Sforza of Pesaro. The painting is sometimes mistakenly identified as the *Madonna of St Luke* (*c.* 1469–70; Montefalco, Pin.-Mus. Com.).

From *c.* 1465 to *c.* 1475 Melozzo is believed to have been resident at Urbino, painting at the court of Federico da Montefeltro, Duke of Urbino. This period is undocumented, but Melozzo is praised for his skill in perspective by Giovanni Santi in a poem of 1488, and Luca Pacioli, a resident at the court, noted Melozzo's skill and that of his pupil Marco Palmezzano at measuring proportion. At Urbino, Melozzo could have strengthened his ties with Piero della Francesca. A series of paintings of the *Liberal Arts* (*c.* 1475; ex-Kaiser-Friedrich Mus., Berlin, destr.; London, N.G.), a series of *Famous Men* (1476–7; Paris, Louvre; Urbino, Pal. Ducale) and a portrait of *Federico Montefeltro with his Son* (*c.* 1475; Urbino, Pal. Ducale) have in the past been associated with Melozzo, but current opinion favours as the artist the Fleming Justus of Ghent (*fl* 1460–80), who was also employed by the Duke, as was possibly the Spaniard Pedro Berruguete (*c.* 1450–1500).

Melozzo probably returned to Rome *c.* 1475 and must have immediately entered the service of Pope Sixtus IV.

His fresco of *Sixtus IV Founding the Vatican Library* (*c.* 1476–7; Rome, Pin. Vaticana; see fig. 1) was originally located on the north wall of the Vatican Library facing the entrance to the Biblioteca Latina. The scene depicts the Pope surrounded by four nephews: Raffaele Riario, Cardinal Giuliano della Rovere (later Julius II), Giovanni della Rovere and Girolamo Riario. The librarian Platina kneels and points to an inscription praising the Pope's urban renovations. The figures are arranged in the foreground of a deep architectural setting, with grand proportions and classicizing ornament, the space articulated by imposing marble piers and a coffered ceiling. The modelling of form, calculated juxtaposition of individuals, careful delineation of character and use of a low viewpoint recall Mantegna's group portrait of the Gonzaga family in the Camera degli Sposi (*c.* 1465–74; Mantua, Pal. Ducale; see colour pl. 2, I2) which must have been familiar to Melozzo. The artist also demonstrated his debt to Piero della Francesca by emphasizing the harmony between space and the human figure. Melozzo began the work after 15 July 1475 and had finished it by 15 January 1477. He received payments for further work (destr.) on the library with Antoniazzo Romano from June 1480 to April 1481.

In 1478 Melozzo signed the statutes of the Compagnia di S Luca, Rome, by designating himself painter of the pope. Around 1479–80 he was occupied with the decoration of the apse of SS Apostoli, Rome, commissioned by Cardinal Giuliano della Rovere (later Pope Julius II) for his titular church. Only fragments of the fresco of the *Ascension*, which originally occupied the vault, survive; they include *Christ Blessing* (Rome, Pal. Quirinale; see fig. 2) and musical angels (Rome, Pin. Vaticana; see colour pl. 2, IV4). The authenticity of one angel (Madrid, Prado) has

2. Melozzo da Forlì: *Christ Blessing* (1479–80), fresco, Palazzo del Quirinale, Rome

been questioned (Tumidei). Melozzo's expert handling of spatial effects made the fresco of SS Apostoli his most influential work. He represented numerous figures of apostles and angels in steeply foreshortened poses circling the figure of Christ, who was illumined by radiant seraphim and cherubim. The composition was dynamic, conveying the idea of revolving figures ascending towards heaven. Vasari praised its illusionism and provided a description of the work *in situ*.

The frescoes of the vault of the sacristy of the Treasury at the Santa Casa, Loreto, are undocumented. There is general agreement that Melozzo devised the decorative scheme (1477–8) but left its execution to assistants *c.* 1480–84, probably to his leading pupil, Marco Palmezzano, and possibly also to Giovanni Santi. The painted figures of prophets, angels and cherubs ring the interior of the octagonal dome, resting on, or floating before, a simulated architectural framework. The illusion of a heavenly chorus occupying real space demonstrates Melozzo's mastery of foreshortening. However, the stiffness of the figures and their uniformity of expression confirm the intervention of his assistants.

Although Melozzo seems to have been the preferred artist of Sixtus IV and his court, he worked in Rome only until 1481 and was not involved in the decoration of the most important project of the Pope's later years, the Sistine Chapel. Instead, he was engaged in projects in Loreto and Forlì at the behest of Cardinal Girolamo Basso della Rovere, Captain General of the Church and Lord of Forlì. Presumably, he secured Melozzo the title of Painter to the Pope and the patronage of Caterina Sforza of Forlì.

In his later life Melozzo increasingly relied on assistance from his pupils. It is unknown if he received any commissions in Rome during these years. By 1493 he had departed

1. Melozzo da Forlì: *Sixtus IV Founding the Vatican Library*, fresco transferred to canvas, 3.75×3.25 m, *c.* 1476–7 (Rome, Pinacoteca Vaticana)

for the north where he painted in the Palazzo degli Anziani in Ancona. He left in May for Forlì and began work on the fresco decoration of the Feo Chapel, S Biagio (destr. 1944). The narrative scenes in the lunettes, representing miracles from the lives of saints, incorporated portraits of the donors, Giacomo Feo and Caterina Sforza. The vault was painted with prophets and cherubs against a background of illusionistic coffering. The somewhat weak execution of the powerful design is given to Palmezzano who completed the work after his master's death. The architecture of the oratory of S Sebastiano, Forlì, exhibits the classical forms and proportions found in Melozzo's paintings. He probably designed it and left its execution to the local architect and textile artist Pace di Maso, called Bambase (d 1500).

2. WORKING METHODS AND TECHNIQUE. Melozzo's fresco technique conformed to established practice. Examination of the fragments from SS Apostoli has revealed that he used cartoons to transfer his designs. The portions relating to faces and hands were pounced and then dusted with charcoal while other lines were incised. Melozzo's acknowledged ability as a draughtsman has resulted in the attribution of several figural studies associated with large-scale projects, although the attributions are unproven (see Ruhmer, 1968). No large working drawings or cartoons have survived. Melozzo may also have worked in mosaic, directing the design of the chapel of S Elena in Santa Croce in Gerusalemme, Rome c. 1489–92. Melozzo was aware of historical prototypes; he reinterpreted medieval images, and some paintings from his circle were modelled on icons. He also borrowed motifs from Early Christian iconography: for the fresco in SS Apostoli, he placed a row of standing apostles at the base and the heavenly apparition in the curvature of the apse above in imitation of a scheme typical of early medieval chapels and basilicas. The seated prophets decorating the dome at Loreto hold plaques with biblical passages; the prominence of inscriptions in Melozzo's work recalls the practice of incorporating dedicatory texts in medieval church decoration. During his years in Rome, he presumably studied antique works because ancient Roman reliefs, architecture and epigraphy were essential to his development as an artist. It is tempting to see Melozzo as a learned artist, familiar with the theories of Leon Battista Alberti and conversant with the ideas of Piero della Francesca.

3. STUDIO AND INFLUENCE. Melozzo influenced artists of his native Romagna, Urbino and the local school of Rome. His principal pupil was Marco Palmezzano, who imitated the sculptural forms and dramatic devices developed by his master; he may also have worked as an architect. In Urbino, Giovanni Santi perpetuated the discoveries of Melozzo, perhaps transmitting a knowledge of perspective to his own son, Raphael. Antoniazzo Romano worked closely with Melozzo in Rome. Many works formerly attributed to Melozzo should be credited to Antoniazzo or his workshop: the frescoes in S Giovanni Evangelista, Tivoli (c. 1480), long associated with Melozzo on the basis of a dubious inscription, should be attributed to Antoniazzo. Melozzo's work also had an impact on painters of diverse regional schools such as Lorenzo da

Viterbo (c. 1437–70) and Donato Bramante in Milan and Bergamo. There is an obvious relationship between Melozzo's perspective and proportion studies and his dynamic style and other branches of the arts, particularly architectural design, sculpture and decorative objects, including maiolica wares from Pesaro and Faenza. Melozzo's earliest biographer, Leone Cobelli of Forlì, refers to 'la sua brigada', most likely members of his studio who remained active after his death. They included Pace di Maso, Cristoforo Bezzi, an architect, and Bernardino Guiritti (d 1511) of Ravenna, an architect, sculptor and decorator. A document cited in the early 19th century refers to Melozzo as the architect of the Cathedral at Forlì. High Renaissance painters were influenced by Melozzo's apse decoration in particular; Raphael drew inspiration from the papal portrait of Sixtus IV and the apse of SS Apostoli. Later 16th-century painters, particularly in northern Italy, studied Melozzo's illusionistic cupola paintings which opened the way for Baroque effects.

4. CRITICAL RECEPTION AND POSTHUMOUS REPUTATION. Although Melozzo was praised by Giovanni Santi (1488) and Luca Pacioli (1492), Vasari omitted him from the first edition of the *Vite* (1550), but in the second edition he corrected the oversight by praising the frescoes in SS Apostoli. Sebastiano Serlio (*Trattato dell'architettura*, 1540) lauded Melozzo for his mastery of perspective and foreshortening. A resurgence of interest in Melozzo's career took place when the history of Forlì (the birthplace of Mussolini) attracted attention. A major exhibition of Melozzo's work was organized in 1938 on the occasion of the fifth centenary of his birth.

BIBLIOGRAPHY
Thieme–Becker
G. Santi: *La vita e le geste di Federico da Montefeltro duca d'Urbino* (MS., 1488); ed. L. Michelini Tocci, ii (Rome, 1985), pp. 674–5
L. Pacioli: *Summa de arithmetica geometria proportioni et proportionalità* (Venice, 1492), col. 2r
L. Cobelli: *Cronache forlivesi dalla fondazione della città sino all'anno 1498* (1498); ed. G. Carducci and E. Frati (Bologna, 1887), p. 533
G. Vasari: *Vite* (1550, rev. 2/1568); ed. G. Milanesi (1878–85), iii, pp. 51–2, 63–8; vi, p. 82
E. Muntz: *Les Arts à la cour des papes*, iii (Paris, 1882), pp. 95–134
A. Schmarsow: *Melozzo da Forlì: Ein Beitrag zur Kunst und Kulturgeschichte Italiens im 15. Jahrhundert* (Berlin, 1886)
O. Okkonen: *Melozzo da Forlì und seine Schule* (Helsinki, 1910)
A. Schmarsow: *Joos von Ghent und Melozzo da Forlì in Rom und Urbino* (Leipzig, 1912)
R. Buscaroli: *Melozzo da Forlì nei documenti, nelle testimonianze dei contemporanei e nella bibliografia* (Rome, 1938)
A. Pasini: 'Melozzo nei documenti di archivio', *Atti & Mem. Reale Deput. Stor. Patria Emilia & Romagna*, n.s. 5, iii (1938), pp. 121–36
Mostra di Melozzo e del quattrocento romagnolo (exh. cat. by C. Gnudi and L. Becherucci, Forlì, Pal. Mus., 1938)
R. Buscaroli: *Melozzo e il melozzismo* (Bologna, 1955)
E. Ruhmer: 'Melozzo als Zeichner', *Festschrift Ulrich Middeldorf*, i (Berlin, 1968), pp. 201–5
A. Schiavo: 'Melozzo a Roma', *Presenza Romagnola*, ii (1977), pp. 89–110
R. di Paolo: 'L'oratorio di San Sebastiano in Forlì e Pace di Maso, architetto', *Boll. A.*, n. s. 4, lxvii/15 (1982), pp. 1–26
B. Montuschi Simboli: 'Bernardino Guiritti, architetto e decoratore', *Faenza*, lxx/3–4 (1984), pp. 168–77
S. Tumidei: 'Un falso Melozzo: L'angelo musicante del Prado', *Prospettiva* [Florence], 53 (1988), pp. 64–7
N. Clark: *Melozzo da Forlì* (London, 1990)
J. Ruysschaert: 'La Fresque de Melozzo de l'ancienne Bibliothèque Vaticane: Réexamen', *Miscellanea bibliotecae apostolicae vaticanae*, iv (Rome, 1990), pp. 328–41

I. Frank: 'La Passione raccontata da Melozzo nella sagrestia di San Marco', *Santuario di Loreto: Sette secoli di storia arte devozione*, ed. F. Grimaldi (Rome, 1994), pp. 77–88

Melozzo da Forlì[236], la sua citt[224] e il suo tempo (exh. cat. by Marina Foschi and Luciana Prati, Forlì, Oratorio S Sebastiano & Pal. Alberteni, 1994–5); review by L. Michelacci in *Schede Umanistiche*, i (1995), pp. 223–7

I. Frank: 'Cardinal Giuliano della Rovere and Melozzo da Forlì at SS Apostoli, Rome', *Z. Kstgesch.*, lix/1 (1996), pp. 97–122

EUNICE D. HOWE

Melzi, Francesco (*b* Milan, 1491–3; *d* Vaprio d'Adda, *c.* 1570). Italian painter and draughtsman. Belonging to a noble Lombard family, he began to attend the workshop of Leonardo da Vinci around 1508, during Leonardo's second visit to Milan. From that time on he was always associated with Leonardo, whose favourite pupil he became: he followed Leonardo to Rome in 1513 and moved with him to France in 1515, staying with him until his death in 1519. In his will Leonardo entrusted Melzi with all the works he had with him at Cloux—mainly drawings and manuscripts—which Melzi brought back to Italy in 1520 and guarded jealously in his villa at Vaprio, where Leonardo had stayed as a guest in 1512. Vasari visited Melzi at Vaprio during his tour of Lombardy in 1566 and described him as 'a beautiful and kind old man'. Melzi played a crucial role in conserving Leonardo's manuscripts and in ensuring that his theories on painting survived as the *Trattato della pittura*, which Melzi took great pains to organize, using Leonardo's notes as a basis.

Melzi's career as a painter is problematic, given that it is based on only two works, chronologically far apart, and on the unverifiable statement of Lomazzo and Morigia that Melzi was an expert illuminator. The first work is a signed and dated drawing of a *Head of an Old Man* (1510; Milan, Bib. Ambrosiana) obviously inspired by Leonardo. On the drawing Melzi gave his age as 17 on one line and 19 on another; his approximate birthdate is based on this inscription. The second work is a painted panel of a *Youth with a Parrot* (Milan, Gallarati Scotti priv. col.) inscribed OPUSF/MELTIUS/1525, which scholars, with the exception of Salmi, have accepted as being autograph. The picture is, however, devoid of Leonardesque traits, which suggests a later date of execution; Marani has proposed this to be 1555.

Other paintings attributed to Melzi include the *Vertumnus and Pomona* (Berlin, Bodemus.), for which a preparatory drawing of Pomona's foot exists (Milan, Bib. Ambrosiana, fol. Resta; inscribed with autograph writing by Leonardo), the *Holy Family* (Prague, N.G., Šternberk Pal.) and the *Flora* or *Colombina* (untraced; copy, St Petersburg, Hermitage); doubts have been expressed about the *Leda and the Swan* (Rome, Gal. Borghese), previously attributed to Melzi. The list of attributed paintings is still largely that of Suida. However, Pedretti has recognized Melzi's hand on many of Leonardo's autograph drawings, reinforcing outlines and annotating the studies; he has also attributed some copies of lost drawings by Leonardo to Melzi.

BIBLIOGRAPHY
Thieme–Becker

G. Vasari: *Vite* (1550, rev. 2/1568); ed. G. Milanesi (1878–85), iv, p. 39

G. P. Lomazzo: *Trattato dell'arte della pittura* (Milan, 1584); also in *Scritti sulle arti*, ed. R. P. Ciardi, ii (Florence, 1974), p. 96

P. Morigia: *La nobiltà di Milano*, with suppl. by G. Borsieri (Milan, 1619), p. 469

I. Lermolieff [G. Morelli]: *Kunstkritische Studien über italienische Malerei: Die Galerie zu Berlin* (Leipzig, 1893), pp. 141–5

A. Venturi: *Storia* (1901–40), VII/iv, pp. 1061–3

C. J. Ffoulkes: 'Una mezza figura di donna di scuola leonardesca in una collezione privata a Londra', *Ant. Viva*, x (1910), pp. 27–9

E. Möller: 'Leonardo da Vincis *Brustbild eines Engels* und seine Kompositionen des St Johannes-Baptista', *Mhft. Kstwiss.*, iv (1911), pp. 541–5

P. Parente: 'Una vivace polemica su Francesco Melzi e Francesco Neapolitano discepoli del divino Leonardo', *A. & Stor.*, xxxvii (1918), pp. 195–200, 213–19

M. Salmi: 'Una mostra di antica pittura lombarda', *Arte*, xxvi (1923), p. 158

P. D'Ancona: 'Antichi pittori lombardi', *Dedalo*, iv (1923–4), pp. 375–6

W. Suida: *Leonardo und sein Kreis* (Munich, 1929)

A. De Hevesy: 'Un compagno di Leonardo: Francesco Melzi', *Emporium*, cxvi (1952), pp. 243–54

Leonardo da Vinci on Painting: A Lost Book (Libro A), ed. C. Pedretti (Berkeley and Los Angeles, 1964)

K. Clark: 'Francesco Melzi as Preserver of Leonardo da Vinci's Drawings', *Studies in Renaissance and Baroque Art Presented to Anthony Blunt on his 60th Birthday* (London, 1967), pp. 24–5

C. Pedretti: *Leonardo e la lettura del territorio* (1981), i of *Lombardia: Il territorio, l'ambiente, il paesaggio*, ed. C. Pirovano (Milan, 1981–5), pp. 250–51

Leonardo da Vinci: Nature Studies from the Royal Library, Windsor Castle (exh. cat., intro. K. Clark; ed. C. Pedretti; London, RA, 1981; It. trans., Florence, 1982), pp. 7, 9, 11, 40, 45

M. T. Fiorio: *Leonardeschi in Lombardia* (Milan, 1982), pp. 34–6

C. Pedretti: *Landscapes, Plants and Water Studies* (1982), i of *Leonardo da Vinci: Drawings and Miscellaneous Papers at Windsor Castle* (London, 1982–)

Leonardo all'Ambrosiana (exh. cat., ed. A. Marinoni and L. Cogliati Arano, Milan, Ambrosiana, 1982), pp. 136, 155–6

C. Pedretti, ed.: *Leonardo: Studi per il 'Cenacolo' dalla Biblioteca Reale nel Castello di Windsor* (Milan, 1983), pp. 110, 128

Leonardo e il leonardismo a Napoli e a Roma (exh. cat., Naples, Capodimonte; Rome, Pal. Venezia; 1983), pp. 97, 103

Renaissance Drawings from the Ambrosiana (exh. cat., ed. R. Coleman; Washington, DC, N.G.A., and elsewhere; 1984), pp. 58–9

P. C. Marani: 'A New Date for Francesco Melzi's *Young Man with a Parrot*', *Burl. Mag.*, cxxxi (1989), pp. 479–81

MARIA TERESA FIORIO

Meo da Caprino [Amedeo di Francesco; Meo da Settignano; Meo Fiorentino] (*b* Settignano, nr Florence, 1430; *d* 1501). Italian architect. One of the earliest Florentine architects to work in Rome in the Renaissance manner, he is first recorded there in 1462, when he became one of Giuliano da Sangallo's assistants working for Pope Paul II at the Palazzo S Marco (now Palazzo Venezia). The original architect of the palace is not certain, although Alberti and Benedetto da Maiano have been suggested; it is essentially a transitional work, the product of many architects over some decades, and Meo's individual contribution cannot be identified. He is also associated with Giuliano at the Vatican Palace, where he may have assisted on the Benediction Loggia, adjacent to the façade of St Peter's.

Meo's most important work is the rebuilt cathedral of S Giovanni in Turin, which shows the influence of the façade (*c.* 1477) of S Maria del Popolo, Rome, by Baccio Pontelli and Leon Battista Alberti's façade (1456–70) of S Maria Novella in Florence. The cathedral was rebuilt on the instructions of Cardinal Bishop Domenico della Rovere, and it replaced three smaller, much earlier adjacent basilicas. Meo worked with eight other Florentine masons and sculptors; the first stone was laid in July 1491 and the whole church completed with great rapidity by 1497.

Its plan is a Latin cross, with a seven-bay nave and aisles, which are lined with shallow niches forming side

chapels. Above the crossing is a tall, octagonal drum, with a cupola supported by eight Doric columns. The nave and aisles are separated by piers with marble half columns and Doric capitals. On the nave side, these extend vertically, becoming flat pilasters at clerestory level, where they meet the simple barrel vault. The overall appearance of the interior is attractive and well proportioned; the church is not particularly large, and all the detailing is simple to the point of austerity. It is this extreme simplicity that makes the interior imposing. It is significant that at the time of the cathedral's construction Turin was still very small, with a population of only about 5000; the church's scale was thus appropriate to such a settlement.

The exterior is dominated by the white marble west façade, which, however, is less successful than the interior, its proportions being rather squat and the carving shallow and timid. The façade has three vertical sections corresponding to the ground-plan. The central part is capped by a triangular pediment and is connected to the much lower aisles by large simple volutes rather in the manner of Alberti. The central portal is well proportioned and in the form of a triumphal arch; smaller-scale versions lead to the aisles, which, with their chapels, are nearly as wide as the nave and thus contribute to the squat proportions of the whole façade. The two windows above the main portal are still Gothic in detail, and their design is repeated in the tall drum of the dome above the crossing. The dome itself is too small to successfully dominate the exterior.

The cathedral interior is Meo's best work; the east end, however, which was almost certainly originally built with a semicircular apse, was destroyed when work began (1668) on the construction of the extraordinary chapel of S Sindone by Guarino Guarini (1624–83), built to house the Holy Shroud. This elaborate structure stands immediately to the east of Meo's crossing, and its impressive dome (completed 1680) now dominates the exterior of the church, dwarfing Meo's modest cupola.

BIBLIOGRAPHY

Thieme–Becker

F. Rondolino: *Il Duomo di Torino* (Turin, 1898)
A. Venturi: *Storia* (1901–40)
S. Solero: *Il Duomo di Torino* (Turin, 1956)
L. Tamburini: *Le chiese di Torino dal rinascimento al barocco* (Turin, 1968)

☐

Merigliano, Giovanni. *See* MARIGLIANO, GIOVANNI.

Mesastris, Pierantonio. *See* MEZZASTRIS, PIERANTONIO.

Messina, Antonello da. *See* ANTONELLO DA MESSINA.

Messina, Pino da. *See* JACOBELLO D'ANTONIO.

Mezzarisa, Francesco di Antonio [Risino] (*fl* Faenza, 1527–81). Italian potter. He directed one of the most famous ceramic workshops in Faenza during the 16th century. Through its production, it is possible to follow the stylistic evolution of Renaissance maiolica from the 'Severe' style through to the wares known as *bianchi di Faenza*, for the invention of which Mezzarisa is thought to have been largely responsible (*see* FAENZA). He is also noted for a few important *istoriato* (narrative) wares, with skilfully applied decoration, including the large plaque depicting the *Deposition*, signed and dated 1544, and a vase decorated with biblical scenes dated 1558 (both Palermo, Gal. Reg. Sicilia). Mezzarisa was an astute businessman, and from 1540 he was assisted by Pietro di Francesco Zambaldini, a craftsman who specialized in glazes and paints. Among the most important commissions accorded to Mezzarisa was an order (1546) for more than 7000 articles for a Genoese merchant in Palermo. He also worked for the Ferrara court, where he became acquainted with the brothers and court painters Battista Dossi (*d* 1548) and Dosso Dossi (*c.* 1479–*c.* 1542). After *c.* 1550 Mezzarisa discontinued his exuberant narrative designs in favour of the *bianchi di Faenza* decorated with the more sketchy *compendiario* style. Mezzarisa's sons Giovanni Mezzarisa and Antonio Mezzarisa became famous potters, and in 1568 they opened a workshop in Venice.

BIBLIOGRAPHY

G. Ballardini: 'Francesco Mezzarisa alias Risino maiolicaro faentino del cinquecento', *Miscellanea di storia dell'arte in onore di Igino Benvenuto Supino* (Florence, 1933), pp. 519–51
——: 'Giovanni Brame e Francesco Risino', *Faenza*, xxxi (1943–5), pp. 67–9
C. Ravanelli Guidotti: 'Aspetti della cultura maiolicara faentina all'epoca della stesura del trattato piccolpassiano', *Faenza*, lxx (1984), pp. 189–97

LUCIANA ARBACE

Mezzastris [Mesastris], **Pierantonio** (*b* Foligno, *c.* 1430; *d* 1506). Italian painter. A cousin of Bartolomeo di Tommaso, he is first documented in 1458. By 1460 he had a workshop in Foligno. Apart from a banner (Foligno, S Giacomo), he appears to have worked exclusively in fresco. The earliest frescoes attributed to him are those in the Cola delle Casse Chapel in S Maria in Campis, Foligno, executed after 1452 (previously assigned to Niccolò da Foligno). In 1471 Mezzastris frescoed a lunette of the *Virgin and Child with SS Lucy and Clare* (Foligno, Pin. Civ.) in S Lucia, Foligno. In the oratory of the Pellegrini, Assisi, where he is documented in 1477, he painted scenes from the *Lives of SS Anthony Abbot and James* and the *Four Doctors of the Church*. Other frescoes include a *Crucifixion* (1482) in S Damiano, Assisi; the signed *Coronation of the Virgin* (1486; Foligno, Pin. Civ.); those (1487) in S Martin, Trevi; and the *Virgin and Child with SS John and Francis* (1499; Foligno, Pin. Civ.). The principal influence evident in his work is that of Benozzo Gozzoli, in particular Gozzoli's scenes of the *Life of St Francis* (Montefalco, S Francesco), from which Mezzastris's *St Francis* cycle (Narni, S Francesco) is clearly derived. Mezzastris's style is coarser and more expressive than Gozzoli's, however. Mezzastris's son Bernardino was also a painter.

BIBLIOGRAPHY

C. Cenci: *Documentazione di vita assisana, 1300–1530*, ii (Grottaferrata, 1976), pp. 756–7
M. Sensi: 'Nuovi documenti per Niccolò di Liberatore detto l'Alunno', *Paragone*, ccclxxxix (1983), pp. 91–2
La pittura in Italia: Il quattrocento, ii (Milan, 1987), p. 710
F. Todini: *La pittura umbra: Dal duecento al primo cinquecento* (Milan, 1989), i, pp. 226–8; ii, pp. 407–10

☐

Michelangelo (Buonarroti) [Michelagnolo di Lodovico Buonarroti Simoni] (*b* Caprese, ?6 March 1475; *d* Rome, 18 Feb 1564). Italian sculptor, painter, draughtsman and

architect. The elaborate exequies held in Florence after Michelangelo's death celebrated him as the greatest practitioner of the three visual arts of sculpture, painting and architecture and as a respected poet. He is a central figure in the history of art: one of the chief creators of the Roman High Renaissance, and the supreme representative of the Florentine valuation of *disegno* (see DISEGNO E COLORE). As a poet and a student of anatomy, he is often cited as an example of the 'universal genius' supposedly typical of the period. His professional career lasted over 70 years, during which he participated in, and often stimulated, great stylistic changes. The characteristic most closely associated with him is *terribilità*, a term indicative of heroic and awe-inspiring grandeur. Reproductions of the *Creation of Adam* from the Sistine Chapel Ceiling (Rome, Vatican; see colour pl. 2, V2) or the *Moses* from the tomb of *Julius II* (Rome, S Pietro in Vincoli; see colour pl. 2, VII2) have broadcast an image of his art as one almost exclusively expressive of superhuman power. The man himself has been assimilated to this image and represented as the archetype of the brooding, irascible, lonely and tragic figure of the artist. This popular view is drastically oversimplified, except in one respect: the power and originality of his art have guaranteed his prominence as a historical figure for over 400 years since his death, even among those who have not liked the example he gave. For such different artists as Gianlorenzo Bernini (1598–1680), Eugène Delacroix (1798–1863) and Henry Moore (1898–1986), he provided a touchstone of integrity and aesthetic value. Although his reputation as a poet has not been so high, his poetry has been praised by such diverse figures as William Wordsworth (1770–1850) and Eugenio Montale (1896–1981).

WRITINGS

G. Milanesi, ed.: *Le lettere di Michelangelo Buonarroti pubblicate coi ricordi ed i contratti artistici* (Florence, 1875)
E. N. Girardi: *Rime* (Bari, 1960)
P. Barocchi, R. Ristori and G. Poggi, eds: *Il carteggio di Michelangelo*, 5 vols (Florence, 1965–83); Eng. trans. of Michelangelo's letters only in E. H. Ramsden, ed.: *The Letters of Michelangelo*, 2 vols (London, 1963)
P. Barocchi, K. Loach Bramanti and R. Ristori, eds: *Il carteggio indiretto di Michelangelo*, 2 vols (Florence, 1988 and 1995)
J. M. Saslow, trans.: *The Poetry of Michelangelo: An Annotated Translation* (New Haven and London, 1991)

GENERAL BIBLIOGRAPHY

EARLY SOURCES

A. Condivi: *Vita di Michelagnolo Buonarroti* (Rome, 1553); ed. E. Spina Barelli (Milan, 1964); Eng. trans. by A. S. Wohl as *The Life of Michelangelo* (Oxford and Baton Rouge, 1976)
B. Varchi: *Orazione funerale di M. Benedetto Varchi fatta e recitata da lui pubblicamente nell'esequie di Michelagnolo Buonarroti in Firenze, nella chiesa di San Lorenzo* (Florence, 1564)
Esequie del divino Michelagnolo Buonarroti celebrate in Firenze dall'Accademia de pittori, scultori, & architettori, nella chiesa di San Lorenzo il di 14 luglio MDLXIIII (Florence, 1564), facs. and trans. in R. Wittkower and M. W. Wittkower, eds: *The Divine Michelangelo: The Florentine Academy's Homage on his Death in 1564* (London, 1964)
P. Barocchi, ed.: *G. Vasari: La vita di Michelangelo nelle redazioni del 1550 e del 1568*, Documenti di filologia, v, 5 vols (Milan and Naples, 1962)
G. Corti: 'Una ricordanza di Giovan Battista Figiovanni', *Paragone*, xv/175 (1964), pp. 24–31
L. Bardeschi and P. Barocchi, eds: *I ricordi di Michelangelo* (Florence, 1970)
E. Ristori: 'Una lettera a Michelangelo degli operai di S Maria del Fiore, 31 luglio, 1507', *Rinascimento*, xxiii (1983), pp. 167–72
E. Wallace: 'An Unpublished Michelangelo Document', *Burl. Mag.*, cxxix (1987), pp. 181–4

MODERN WORKS

J. A. Symonds: *The Life of Michelangelo Buonarroti: Based on Studies in the Archives of the Buonarroti Family at Florence*, 2 vols (London, 1893)
H. Thode: *Michelangelo: Kritische Untersuchungen über seine Werke: Verzeichnis der Zeichnungen, Kartons und Modelle*, 3 vols (Berlin, 1913)
E. Steinmann and R. W. Steinmann: *Michelangelo-Bibliographie, 1510–1926* (Leipzig, 1927/R Hildesheim, 1967), i of *Römische Forschungen der Bibliotheca Hertziana* (Leipzig, 1927–)
C. de Tolnay: *Michelangelo*, 5 vols (Princeton, 1943–60)
E. N. Girardi: *Studi sulle rime di Michelangelo* (Milan, 1964)
C. de Tolnay: *The Art and Thought of Michelangelo* (New York, 1964)
The Complete Works of Michelangelo, 2 vols (London, 1965)
H. V. Einem: *Michelangelo* (London, 1973)
L. Düssler: *Michelangelo-Bibliographie, 1927–1970* (Weisbaden, 1974)
E. N. Girardi: *Studi su Michelangelo scrittore* (Florence, 1974)
H. Hibbard: *Michelangelo* (London, 1979)
J. Wilde: *Michelangelo: Six Lectures* (Oxford, 1979)
K. Lippincott: 'When Was Michelangelo Born?', *J. Warb. & Court. Inst.*, lii (1989), pp. 282–3
J. K. Cadogan: 'Michelangelo in the Workshop of Domenico Ghirlandaio', *Burl. Mag.*, cxxxv (1993), pp. 30–31
W. E. Wallace, ed.: *Michelangelo: Selected Scholarship in English*, 5 vols (New York and London, 1995)
W. E. Wallace: *Michelangelo: The Complete Sculpture, Painting, Architecture* ([New York], 1998)

ANTHONY HUGHES

I. Life and work. II. Working methods and technique. III. Character and personality. IV. Critical reception and reputation.

I. Life and work.

Michelangelo frequently practised as a painter, sculptor and architect simultaneously, and, like many of his contemporaries, regarded the three arts as manifestations of the fundamental discipline of *disegno* (drawing), itself based on a profound knowledge of the male human form; it is, however, convenient to discuss each art separately.

1. Sculpture. 2. Painting. 3. Drawing. 4. Architecture.

1. SCULPTURE. Michelangelo's reputation as a sculptor was established early and has rarely been questioned. Until the 20th century he was commonly regarded as the most important sculptor of the modern era. His work is idiosyncratic, of exceptional expressive power and of strikingly limited range. It consists in the main of monumental marble statuary. He sometimes worked in media other than marble to oblige friends or especially powerful patrons, but he encouraged the identification of his sculpture with stone.

Michelangelo jokingly told Vasari that he had 'sucked in the chisels and mallet' of his trade with the milk of his wetnurse, a stone-carver's wife from Settignano. Long months spent at the quarries in Carrara in the course of his professional career, choosing pieces of marble, are proof of his care for the materials of the craft. His vision of fashioning colossal figures from the mountains indicates that it was only this aspect of the natural world that could stimulate his art. In his verse, among the conventional metaphors derived from Petrarch, his unconventionally abrasive intellect is signalled by a series of images drawn from the excavation and working of rock.

Attempts have been made to identify a hidden thematic unity in all his work. Notably, it has been argued by Tolnay and others that many projects reflect the ideas of NEO-PLATONISM absorbed by the young artist during his stay in the household of Lorenzo the Magnificent (*see* MEDICI, DE', (5)). From this premise the whole oeuvre has been

interpreted in the light of Neo-Platonic ideas. While there are loose links between Michelangelo's funerary monuments, there is nothing to warrant the elaborate interpretations that have been proposed. These rely too much on speculation about missing elements, and the analysis of symbols cannot be sustained in detail. Passages in Condivi's biography have been used as evidence that Michelangelo incorporated a private symbolism into his work, but his remarks concern Michelangelo's dramatic interpretation of subjects provided by patrons, not hidden programmes.

(i) Training and early work, to c. 1505. (ii) Tomb of *Julius II*: early phases, 1505–19. (iii) New Sacristy, 1519–34. (iv) Late work, 1534–64. (v) Unfinished works.

(i) *Training and early work, to c. 1505.* Michelangelo's training as a carver remains mysterious. His family was from the minor bourgeoisie of Florence, and, unlike most artists of his generation, he had formal schooling until the age of 13. In 1488 he was apprenticed as a painter in the workshop of Domenico Ghirlandaio (*see* GHIRLANDAIO, (1)) in Florence. Only during the following year did he join a group of young sculptors in the garden of the Medici *casino* at S Marco, against the wishes of his father, who believed that sculpture, a manual trade, was beneath the family's standing. At the age of about 17 he simply emerged as the sculptor of a precociously assured relief, the *Battle of the Centaurs* (Florence, Casa Buonarroti).

If formal instruction were offered in the Medici Garden, no information about it has survived. According to Condivi, Michelangelo first taught himself sculpture by borrowing tools from masons working on the S Marco library in order to copy the antique head of a faun. This work supposedly attracted the attention of Lorenzo the Magnificent, who made the teenage sculptor a member of his own household and reconciled Lodovico Buonarroti to his son's chosen career. Condivi's account of his master's youth, however, is characterized throughout by a tendency to deny Michelangelo's dependence on any other artist, including Ghirlandaio. Vasari, by contrast, claimed that BERTOLDO DI GIOVANNI was in charge of the young sculptors at S Marco. Although Bertoldo was not a stone-carver but a maker of small bronzes, this version of events seems more plausible than Condivi's because there is a generic relationship between Bertoldo's plaque of a *Battle* (Florence, Bargello) and Michelangelo's *Battle* scene.

It is a superficial resemblance. The *Battle of the Centaurs* is such a confident piece of sculpture that it has been regarded as more 'Michelangelesque' than many works that immediately followed it. To some extent, this impression is due to its suggestively unfinished state, but the relief undoubtedly exhibits two features characteristic of the mature Michelangelo: the expression of narrative or emotional excitement through the male nude, and an extreme economy of means. As in Bertoldo's *Battle*, the device of stacking figures in layers one above the other was derived directly from Roman sarcophagi of the Antonine era, but the types are less elegant than those of the older master. Michelangelo consulted a wider range of antique prototypes than Bertoldo, aiming at creative paraphrase rather than archaeological exactness. There is no attempt to depict antique costume or to give characters

identifying attributes. The intertwined bodies were packed into a composition far more condensed than any ancient work or its imitation up to that date. The compression of the relief is emphasized by lateral figures which overlap the thin framing rim. A band of rough-hewn marble running across the top dramatizes the way in which the struggling mass below has been squeezed into an area more confined than that of the already small block.

It is probable that the maturity of the *Battle* relief exemplifies the end of a process of learning rather than its beginning. Earlier work may be represented by an even smaller relief, the *Madonna of the Steps* (Florence, Casa Buonarroti). The dating and authenticity of this work have been questioned unnecessarily. One reason for this is that the figures are represented in uncharacteristic shallow relief against an architectural background. As Vasari noted, in the *Madonna* relief Michelangelo imitated and challenged the example of Donatello. This indicates that even Michelangelo experimented in the work of his early maturity. Throughout his late teens and twenties, he also travelled a great deal and worked for a larger range of clients than at any other time in his life. The variety of works produced before 1505 demonstrate a young man's adaptability.

When Lorenzo the Magnificent died in 1492, Michelangelo returned to his father's house for a time during which he carved a figure of *Hercules* (untraced). He studied anatomy by dissecting corpses at the Ospedale di Santo Spirito under the protection of the prior, for whom he made a wooden Crucifix. This work has been identified as the Crucifix (Florence, Casa Buonarroti) found at Santo Spirito (Lisner, 1964). Since it is the only recorded wooden sculpture by Michelangelo, it is difficult to compare with his other work. The smooth transitions of the muscular articulation have caused some writers to doubt the attribution, although a comparison with the *Bacchus* (Florence, Bargello) is instructive, and the painting of flesh bears comparison with that in the Doni Tondo (see colour pl. 2, IV3).

For a brief period Michelangelo returned to the Medici household, where he was employed by Piero de' Medici. Before the Medici were expelled by the Republican government in 1494, Michelangelo had left Florence, moving first to Venice, then settling in Bologna in the house of Giovanni Francesco ALDROVANDI, a patron who encouraged his interest in vernacular literature. In Bologna he provided small statues for the shrine of S Domenico, left incomplete by Niccolò dell'Arca: a kneeling *Angel* bearing a candelabrum, and the figures of *St Proculus* and *St Petronius* (Bologna, S Domenico Maggiore). Each of these sculptures displays a different quality, a fact for which various explanations have been offered. For some writers, the *St Petronius* is said to betray the influence of Jacopo della Quercia, although it is difficult to distinguish here between stylistic borrowing and resemblance due to identity of iconographic type. Others have supposed it to represent a figure begun by another sculptor and completed by Michelangelo, a suggestion that has also been made in connection with the *St Proculus*. Scholarly uncertainty reflects Michelangelo's successful accomplishment of a brief to integrate these works into the existing ensemble. The *Angel*, whose authenticity is not in doubt,

although more stocky than the counterpart completed by Michelangelo's predecessor, is in finish delicately attuned to Niccolò's example.

Late in 1495 Michelangelo returned to Florence, where he carved a figure of *St John the Baptist* and a *Sleeping Cupid* (both untraced). The *Sleeping Cupid* brought him to the attention of Cardinal RAFFAELE RIARIO, who summoned him to Rome in the summer of 1496 and ordered the figure of *Bacchus* (Florence, Bargello). The statue was initially designed to compliment Riario's collection of antiquities, but for unknown reasons it entered the collection of JACOPO GALLI in 1497 and was exhibited in his garden among a group of antique fragments. Galli commissioned two more sculptures, a *Cupid* and a *St John* (both untraced). The armless figure of a *Cupid* (New York, French Embassy Cult. Bldg), carved in part imitation of the Antique, was attributed to the youthful Michelangelo by Kathleen Weil-Garris Brandt (1996), though so far this must remain a speculative attribution.

The *Bacchus* was undoubtedly conceived as an exercise in the Antique. As a garden statue, it is superficially untypical of Michelangelo, being a free-standing group, designed to be viewed in the round; most of Michelangelo's surviving works were conceived for architectural settings with restricted viewpoints. The 'pictorial' finish of the *Bacchus* has been widely disliked, probably because the dull surface sheen of the god's plump flesh, carefully differentiated from the curling goat-hair of the attendant satyr, is seen as suggestive of an unwholesome sensuality unworthy of the artist. The use of contrasting textures is not unusual in Michelangelo's sculpture, however.

Such contrast certainly is a feature of the Roman *Pietà* (Rome, St Peter's; see fig. 1), the work that marked the turning-point in Michelangelo's fortunes. Commissioned in 1497 by the French Cardinal Jean Villiers de La Grolais (*c.* 1430–99) for his own tomb, it was begun the following year and was finished by 1500. It signals the beginning of Michelangelo's maturity as a sculptor. The style of the group does not differ radically from the practice represented by the *Bacchus*, however. Rather it shows even greater textural richness, a characteristic noted by Vasari in his description of the inert body of Christ. This sensitively carved surface is strongly contrasted with the unpolished textures of rock and tree stump. Although the dazzling virtuosity of the carving is less appreciated now than it was in the 16th century, there is general agreement that the *Pietà* is a work of unprecedented elegance. Its grace of contour is most apparent in the drapery: the tight, dampfold loincloth of Christ, the ruches and complex crinkles of Mary's robes and the controlled but generous sweep of the shroud, which both cradles and displays Christ's corpse. Much of the pathos of the group derives from this drapery. The Virgin shows no grief; her features are composed and the gesture of her left hand is designed to draw attention to her dead son.

Following this triumph, Michelangelo returned to Florence, where between 1501 and 1504 he executed four out of fifteen small statues he had contracted to provide for the Piccolomini Altar in Siena Cathedral (*in situ*). Simultaneously, he worked on the gigantic *David* (Florence, Accad.; *see* ITALY, fig. 22), and there seems little doubt that he thought of this as the more important commission.

1. Michelangelo: *Pietà*, marble, 1.74×1.95 m, 1497–1500 (Rome, St Peter's)

The marble block used for the *David* had been roughed out and abandoned by Agostino del Duccio and Michelangelo was thus required to work within predetermined constraints. Some peculiarities of the work, such as the relative shallowness of the lateral views of the figure, may be due to the existing shape of the marble; Vasari claimed that the splayed legs were determined by earlier piercing of the block.

The work's significance does not lie in its technical ingenuity, however. The *David* is the first of Michelangelo's surviving depictions of the heroic male nude in which the entire emotional charge is carried by the articulation and twist of the body and limbs against the head. Stripped of all attributes but the minimal sling, this *David* carries no sword, and not even the head of Goliath distracts from his stark nudity. The figure's authority seems to stem from the swing of the thorax, within which is a dramatic play of intercostal and abdominal muscles, stretched on the left, compressed on the right. But other details—the highly particularized right hand, for example, large, veined, quite unideal—suggest latent power in a figure apparently at rest. In a formal sense, the *David* is a classicizing work recalling the *Dioscuri* (Rome, Quirinale) or nudes found on Roman sarcophagi, perhaps mediated by the Herculean figure of *Fortitude* (Pisa, Baptistery, pulpit) by Nicola Pisano (*c.* 1220/25–before 1284). Conceptually, however, it was unprecedented. Wölfflin's objection to the representation of David as an adolescent 'hobbledehoy' and to the ugliness of the gap between the

figure's legs draws attention to the combination of the heroic with the vulnerable that makes the *David* so foreign to its antique sources.

Work on the marble *David* coincided with an exceptionally busy period of overlapping activity in which, however, Michelangelo left much unfinished or even undone. A second, bronze *David* (untraced), commissioned by the Republican government in 1502 as an ambassadorial gift to the French, was cast only in 1508 in Michelangelo's absence. The scheme initiated in 1503 to provide Florence Cathedral with statues of 12 Apostles resulted in a single unfinished figure of *St Matthew* (Florence, Accad.). A plan to fresco the great hall, the Sala del Gran Consiglio, in the Palazzo Vecchio, Florence, with a depiction of the *Battle of Cascina* certainly interrupted his sculptural activity. A new contract for the remaining statues for the Piccolomini Altar was signed in 1504, but Michelangelo did nothing further for this project. Failure to fulfil his obligations to the Piccolomini family was the first sign of an increasingly reckless ambition that played havoc with his professional life during the following decade. By the time the second Piccolomini contract had been drawn up, he was probably already at work on the Bruges *Madonna* (Bruges, Onze Lieve Vrouw), a finished statue of the *Virgin and Child* bought by the Flemish merchant Alexander Mouscron and shipped to Bruges in 1506. Two marble roundels of the *Virgin and Child*, the Pitti Tondo (Florence, Bargello) and the Taddei Tondo (London, RA) seem to have been begun between 1504 and 1507, but were left incomplete. It seems quite extraordinary that Michelangelo also completed a panel painting during this period, the *Holy Family* (Doni Tondo; Florence, Uffizi; see colour pl. 2, IV3). Around 1504, too, he seems to have made his first experiments as a poet. By this time status, income and force of personality had made him virtual head of the Buonarroti family, though his father survived until 1531.

The Bruges *Madonna* is one of Michelangelo's most accomplished carvings. The apparently simple and compact relationship between Child and Virgin was carefully calculated to take account of its intended position in the church, about which he obviously had reliable information. (Ironically, it was subsequently positioned incorrectly in the niche made for it at Bruges.) The group strikingly contrasts a cool and heiratic figure of the Virgin with an animated Christ Child whose subtly twisting body she encloses and protects as though he were still sheltered within her body. The interplay between infancy and majesty was maintained in the Pitti Tondo while in the Taddei Tondo the contrast between a still Virgin and active child passes over into symbolic narrative, as the infant Christ shrinks from St John's gift, probably a goldfinch signifying the Passion. These two unfinished tondi were the last reliefs Michelangelo carved. The *St Matthew*, which is a relief only by virtue of its incompleteness, often receives more sympathetic attention than Michelangelo's contemporaneous sculpture because, as a figure subjected to powerful torsion, it seems to anticipate later, more famous works.

(ii) Tomb of 'Julius II': early phases, 1505–19. In addition to this remarkable roster of tasks, Michelangelo had other commitments. In 1505 he was called to Rome by Pope Julius II (*see* ROVERE, DELLA, (2)) to plan a magnificent tomb for St Peter's. By 1506 he was making drawings preparatory to painting the vault of the Sistine Chapel (Rome, Vatican), also for Julius. This seemingly perfect match between an ambitious pontiff and an ambitious artist was disastrous for Michelangelo's career in one respect: until 1545 his life was dominated by repeated failures to complete the Julian monument, what Condivi called 'the tragedy of the tomb'. In order to discuss the next stage of Michelangelo's development as a sculptor, it is necessary to outline the events that affected work on the monument from 1505 to 1519.

The most valuable source of information on the first plans for the tomb, is Condivi, who gives convincing measurements, although his description is tantalizingly incomplete. What Michelangelo and Julius proposed was a free-standing, three-storey monument, covering an area of over 70 sq. m. The lowest level, housing the papal sarcophagus, was to be decorated with figures of captives symbolizing the Liberal Arts. Above them, on each corner of the cornice, a large figure was to have been seated, one of them a *Moses*. On the upper level was to be an effigy of Julius, flanked by two angels, one weeping to signify that the world had lost a benefactor, one rejoicing at his translation to heaven. It has been calculated that 47 figures would have been required for the tomb. Given the enormous scale of this commission, it is hardly surprising that Michelangelo's attention shifted to Rome in 1505–6. Marble arrived for the gigantic mausoleum, and he was eager to begin work, but Julius unaccountably cooled towards the project. After the first of a series of disputes with the Pope, Michelangelo fled to Florence. When he was recalled to Rome by Julius, it was for a new project. He spent much of 1507 in Bologna preparing a gigantic bronze statue of the Pope. This apparently menacing image of the city's conqueror was set on the façade of S Petronio, Bologna, and subsequently melted down for cannon when the Bentivoglio regained control of the city in 1511.

For four years, between 1508 and October 1512, Michelangelo was occupied by the Sistine Chapel Ceiling. Following the Pope's death in February 1513, he signed a second contract with Julius's executors for a reduced version of the tomb to be completed within seven years. This still massive undertaking, which is recorded in documents and drawings, was for a three-sided structure attached to the wall. There were to be six figures on the cornice, while above the contract specified a 'capelletta', a tabernacle, with a sculpted image of the Virgin and Child. For this scheme he began the *Moses* as well as the figures known as the *Dying Captive* (see fig. 2) and the *Rebellious Captive* (both Paris, Louvre).

The tomb did not occupy Michelangelo's attention exclusively, however. Following the election of Leo X (*see* MEDICI, DE', (7)), he received a commission to refurbish the façade of the papal chapel in Castel Sant'Angelo, Rome. In 1514, moreover, he signed a contract to make the *Risen Christ* (Rome, S Maria sopra Minerva) for Metello Vari, although it was delivered only in 1521. Finally, from 1515 to 1518, he attempted, with some underhand manoeuvres, to obtain the commission to design the façade

of S Lorenzo, the Medici church in Florence, and to furnish it with an ambitious number of statues and reliefs. The façade project was cancelled by the patrons in 1519.

A third contract for a still smaller Julian monument had been drawn up in 1516, for which he probably began the four *Slaves* (Florence, Accad.). These commitments did not prevent him from undertaking or allow him to refuse the task of designing windows for Palazzo Medici in 1517. Conflicting demands began to take a heavy toll of his work and of his self-esteem. 'I have become a swindler against my will', he wrote in connection with the *Risen Christ*, but the phrase summed up his general predicament at this time and was marginally more honest than some of his subsequent accounts of this period.

Michelangelo's sculptural manner did not develop in a linear fashion, and the figures prepared for the two versions of the Julian monument present special problems for anyone attempting to characterize his style at any time. One difficulty is that these works do not necessarily represent a unified period in the artist's career. Different schemes for the tomb required Michelangelo to conceive statues in varying ways, and items were worked on over considerable periods of time, with frequent interruptions followed by campaigns of intensive labour. Comparisons with his work in other media may be misleading. It has often been said that Michelangelo realized his impossible dreams for the first version of the Julian tomb in the figures painted on the Sistine Chapel Ceiling. The converse also can be argued: that the inventions of the Sistine Ceiling, which grew in scale and power between its inception in 1508 and its completion in 1512, helped to form a new, more massive ideal perceptible in the sculptured figures. The *Moses* (see colour pl. 2, VII2) is the statue most obviously related to the Prophets on the Sistine Ceiling.

Assessment of the *Moses* is further complicated by the fact that it is not in the position for which it was planned. Originally designed to stand some 13 feet above the ground, the statue was incorporated in the central recess of the finished tomb of 1545, only a few feet above floor-level. There are indications that most of the statue had been completed before it was decided to change the intended location. It has been observed that the figure's exaggeratedly long waist and withdrawn left leg would have enabled a viewer below to see the gesture made by the left arm (Wilde, 1954). The resemblance is often noted between this work and Donatello's *St John the Evangelist* (Florence, Mus. Opera Duomo; *see* DONATELLO, fig. 1), the proportions of which were also adapted to be seen from below. Unlike the *St John*, the *Moses* was planned as a corner figure standing free of the architecture and offering a number of subsidiary views. Yet the placement of the statue was Michelangelo's decision. Indeed the effect of confinement was even greater originally, when he set the work further back in the recess. (It was moved forward in 1816 when a cast was taken from it.)

None of these considerations detracts from the magisterial quality of the sculpture. Indeed, by bringing the statue closer to the spectator and squeezing it so uncomfortably within the completed monument, Michelangelo may have enhanced an effect of force and energy that could have been dissipated at longer range. The figure's

large size becomes insistent, and the imperious, but strangely indeterminate, facial expression may be discerned clearly, so altering the psychological charge carried by the work. This cannot happen, for example, with the tall, free-standing figure of *David*, whose similar gaze and furrowed brow create less tension.

Almost the opposite change of context has affected the view of the *Dying Captive* (Paris, Louvre; see fig. 2), a

2. Michelangelo: *Dying Captive*, figure for the tomb of *Julius II*, marble, h. 2.29 m, *c.* 1514 (Paris, Musée du Louvre)

figure intended for a niche, but now exhibited as a free-standing pendant to the *Rebellious Captive*. The traditional titles for these statues serve to differentiate their characters, but they should not control the viewer's response: the figures were not created as a pair but as elements in a large sequence, a theme with variations potentially as rich as those provided by the *ignudi* on the Sistine Chapel Ceiling. The *Dying Captive* in particular suggests the quality of work that was lost through Michelangelo's inability to complete the whole tomb satisfactorily: the statue was brought to an unusually high state of resolution and reveals a moving sensuousness unusual in the conception of the male nude in Western sculpture. As a group, the *Captives* were deliberately differentiated from the *Moses* because they served separate functions and had distinct symbolic roles within the scheme of the monument. All three figures, however, show an increased feeling for the three-dimensionality of sculpture. In the *Dying Captive*, a form made to be seen from a relatively restricted series of viewpoints, there is no contour that may be transcribed simply in two dimensions and no surface plane that is not continuously turned into another.

Although planned for a significantly different version of the tomb project, the four *Slaves* (see fig. 3) from the 1516 campaign also exemplify this principle, and they should not be regarded as a totally new departure. While a certain massiveness characterizes all figures devised for the Julian monument, two in particular, the *Bearded Slave*

and the *Awakening Slave*, with their grosser proportions, may appear to anticipate the ideal of heroic masculinity that appears in the later frescoes. This view is mistaken. In part the effect is created by Michelangelo's distinctive interpretation of the heavy muscularity that conventionally characterizes older men in antique statuary; in part it perhaps arises because some sections were only roughed out.

Because of the demands of the tomb project and the fruitless diversion of the S Lorenzo façade, in the three decades after the completion of the Sistine Chapel Ceiling Michelangelo presented to the public only one finished work, the statue of the *Risen Christ* (Rome, S Maria sopra Minerva). This is the second version of the work. While carving the figure, the artist uncovered an unsightly flaw in the area of the face and he began carving a new block. It has been among the least admired of Michelangelo's statues. Pope-Hennessy regarded it as a replica lacking the vibrant surface expected in an authentic marble. It may be, however, that modern critical taste is simply out of sympathy with the whole concept of this naked, Apollo-like Christ languidly supporting the cross and other instruments of the Passion. As a relaxed male nude, it exhibits a refined elegance at variance with those signs of energy, tension and unrest normally associated with Michelangelo's art. Its success as a devotional image, however, suggests that the faithful are more at ease with the notion of a Lord of perfect beauty than scholars have been.

(iii) New Sacristy, 1519–34. When the façade project for S Lorenzo was abruptly dropped in 1519, Michelangelo was ordered to build a Medici funerary chapel at S Lorenzo (the New Sacristy; *see* §4(i) below). Work on this went ahead rapidly until the death of Leo X in 1521. During the brief pontificate of Adrian VI (*reg* 1522–3), when Michelangelo could no longer count on the protection of a powerful patron, the della Rovere heirs of Julius threatened litigation over the tomb. The election of Pope Clement VII (*see* MEDICI, DE', (8)) in 1523 saved him from the worst consequences, but negotiations with the della Rovere family continued. Work resumed on the New Sacristy at this time, and more projects were added to Michelangelo's workload, notably a library over the cloisters adjoining S Lorenzo and a reliquary tribune on the inside of the church façade.

In 1527 the Medicean government of Florence was expelled from the city, and work at S Lorenzo was suspended. Michelangelo probably continued to carve figures for the Julius tomb, but he also agreed to provide the new Republic with a group of *Samson Slaying the Philistines*. Little was done for this, apart perhaps from a small model, since in 1528 he became military engineer to Florence. Disagreement with the military committee caused a temporary flight to Venice but, following a brief visit to Ferrara where he undertook to provide the Duke, Alfonso I d'Este, with a painting of *Leda* (untraced), Michelangelo returned to his post in November 1529.

The Republic fell in 1530, and for some months after Michelangelo hid from possible Medici reprisals. Pardoned by Clement VII, he worked intensively at S Lorenzo and began a statue of *Apollo* (Florence, Bargello) for Baccio

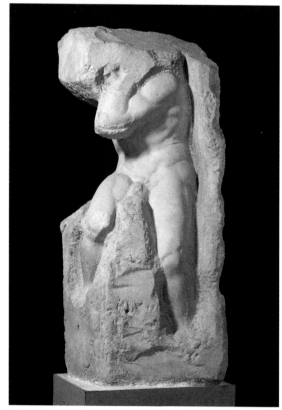

3. Michelangelo: *Atlas Slave*, figure for the tomb of *Julius II*, marble, h. 2.5 m, *c.* 1520 (Florence, Galleria dell'Accademia)

Valori. After bitter negotiations with the della Rovere heirs, in 1532 a fourth contract was drawn up for a yet more modest version of the tomb, planned for Julius's former titular church in Rome, S Pietro in Vincoli. That year Michelangelo fell in love with the young Roman nobleman Tommaso de' Cavalieri (d 1565). Following the death of Clement VII in 1534, he settled permanently in Rome.

In terms of sculpture, this period of Michelangelo's life was dominated by the work for the New Sacristy. The ensemble is lamentably incomplete, and many details planned for it remain unknown, but the Medici tombs give a better sense of the plenitude of Michelangelo's inventive powers than the scattered fragments of successive schemes for the Julius monument. The history of the scheme has parallels with that of the project for Julius. Clement's first idea was to construct a free-standing monument beneath the dome of the chapel to house his own sarcophagus. He then decided to exclude himself from the plans and to build two wall tombs for recently deceased members of the family, Giuliano de' Medici, Duc de Nemours, and Lorenzo de' Medici, Duke of Urbino. The two later became known as the *Capitani* because of the Roman military uniforms worn by their effigies. The marble frameworks and the four allegorical figures of the *Times of Day* for these tombs occupy the lateral walls of the chamber (see fig. 4 and colour pl. 2, V1). The ensemble was to have been completed by a splendid double monument on the entrance wall of the chapel to commemorate

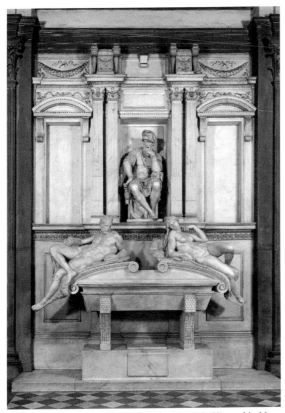

4. Michelangelo: tomb of *Lorenzo de' Medici* (1519–33), marble, New Sacristy, S Lorenzo, Florence

the *Magnifici*, two 15th-century Medici, also named Giuliano and Lorenzo. As the priest offering masses for the dead officiated from the small tribune behind the altar, looking across to the entrance wall, this double tomb was conceived unusually as a displaced altarpiece, to be surmounted by a statue of the *Virgin and Child* (the Medici *Madonna*). No part of this tomb was built, and the only reminder of the original plan is the unfinished *Madonna* flanked by statues of the Medici saints, *Cosmas* and *Damian*. *Cosmas* was carved to Michelangelo's design by Giovanni Angelo Montorsoli (for illustration *see* MONTORSOLI, GIOVANNI ANGELO) and *Damian* by Raffaello da Montelupo. The three figures are mounted on a platform that bears no relation to the original scheme. Additional figures were to have included four river gods beneath the two tombs of the *Capitani*, symbolic figures of a grieving *Earth* and laughing *Heaven* in the niches on either side of Giuliano's effigy and other insecurely identifiable items. According to Condivi, the *Times of Day* symbolized 'the principle of time which consumes everything'. All the autograph carvings for the New Sacristy were executed between 1524 and 1534.

The Medici sculptures represent a distinctly new physical type, also found in Michelangelo's drawings from this period. The aim seems to have been to express great power in the most relaxed and elegant form. The figures have small heads on massive torsos, muscular, tapering thighs and slender ankles, an ideal most clearly articulated in the figure of *Giuliano de' Medici* and that of the youth in a contemporary work, the *Victory* (Florence, Pal. Vecchio). Of the figures prepared for the New Sacristy, only the *Day* departs from this model. Formally, the figures are among the most spatially interesting sculptures in the European tradition. The allegorical figures in particular were designed to be viewed from many different vantage-points within the chapel.

The New Sacristy is also of interest because it contains Michelangelo's only two sculptured female nudes. Unlike comparable figures by other artists, they have been conceived without a trace of eroticism, and it is the absence of obvious sexuality that gives these works their uneasy power. Appropriately, the skin of *Dawn* is sleek and unmarked while the figure of *Night* has a more aged body, marked by greater experience. A similar, less marked contrast is apparent in the two male figures.

The effigies of the *Capitani* partake of these contrasts, the alert figure of Giuliano associated with the positive and negative poles of *Night* and *Day*, Lorenzo with the shadowy allegories of twilight. Michelangelo stated that the *Capitani* figures were not portraits but idealized representations, endowed with the dignity and power that the men should have had. The contrast between the 'melancholic' Lorenzo and the 'sanguine' Giuliano has long been remarked, and Michelangelo seems to have taken great care to place the face of *Lorenzo* in shadow. As a formal invention, this brooding presence is unprecedented. The *Giuliano*, in which sprightliness is mixed with force, remains one of the most original statues of the 16th century.

Of all the unhoused figures carved by Michelangelo, the *Madonna* of the New Sacristy appears the most

awkwardly placed in its setting. Perhaps because the still-unpolished surface of the stone blurs much of the definition of the figures, this, Michelangelo's final sculptured *Virgin and Child*, has an especially insubstantial look. As a devotional object, the group also appears puzzling. The tall figure of the Virgin has the regal, expressionless calm common to all his depictions of this theme, but the infant Christ, dramatically turned to seek his mother's breast, is at once the most actively Herculean and the most withdrawn of Michelangelo's images of the Saviour.

Of the sculptures associated with this period of Michelangelo's life, the *Victory* group poses the greatest difficulty for historians. It has been dated at various times between 1519 and 1530, and its purpose is obscure. The youth kneeling on the body of the bearded old man wears a wreath of oak leaves, and this detail strongly suggests that it is another abandoned work for the Julius tomb. As a model, the *Victory* had a powerful effect in Florence, where younger sculptors including Vincenzio Danti (for illustration see DANTI, (1)) and Giambologna (*see* GIAMBOLOGNA, fig. 1) produced variants. Combining helical motion with a pyramidal construction, the group has been regarded as the epitome of the *figura serpentinata* that Lomazzo claimed Michelangelo advocated as a compositional principle. While the *Victory* can indeed be understood in this way, it should be remembered that the words Lomazzo attributed to Michelangelo related to painting, not sculpture.

(iv) Late work, 1534–64. During the 1530s and 1540s the pattern of the aging Michelangelo's life changed drastically. In 1534 Clement VII decided to have him paint the altar wall of the Sistine Chapel, and his successor, Paul III (*see* FARNESE, (1)), proceeded with this plan. In 1535 Pope Paul appointed Michelangelo 'supreme architect, sculptor and painter' to the Apostolic Court, and in the following year he issued a decree freeing him from all obligations to the della Rovere heirs, although plans to complete Julius's monument continued. During 1536 Michelangelo was introduced to VITTORIA COLONNA, and the influence of her commitment to the Catholic Reformation is detectable in the sacred poetry he wrote over the following decade. In the same year he began painting the *Last Judgement* in the Sistine Chapel (see colour pl. 2, VII3). On its completion in 1541, the Pope commissioned the frescoes for the Pauline Chapel, also in the Vatican. In 1542 a fifth, and final, contract for the Julius tomb was drawn up, and three years later an unsatisfactory monument was erected in S Pietro in Vincoli. It was the end of the 'tragedy of the tomb'. Only three of the statues, the *Moses, Rachel* and *Leah*, were carved by Michelangelo himself. Interrupted by illness, he worked on the Pauline frescoes from 1542 until 1550. During the second half of the 1540s Michelangelo probably began the *Brutus* (Florence, Bargello), his last commissioned sculpture, for Cardinal Niccolò Ridolfi. The Florentine *Pietà* (Florence, Mus. Opera Duomo) and the Rondanini *Pietà* (Milan, Castello Sforzesco) were undertaken on his own initiative. Apart from these works, the final two decades were dominated by an increasingly ramifying architectural practice (*see* §4 below).

The last phase of Michelangelo's sculptural activity comprises the smallest group of works, but the most difficult to assess in conventional terms. These apparently personal sculptures pose the most acute attributional and chronological problems. The figures of *Rachel* and *Leah* are good examples. The final agreement for the Julius tomb specifies that the two statues flanking the *Moses* were to be carved by Raffaello da Montelupo. Condivi and Vasari, however, clearly attributed them to Michelangelo himself, a view that is generally accepted, although it has been suggested that they were conceived at different times. They also show inconsistencies: *Rachel* is noticeably shorter than *Leah* and has a rectangular rather than a rounded base. It is clear, however, that they represent allegories of the Contemplative Life and the Active Life respectively.

Michelangelo gave both the *Brutus* and the Florentine *Pietà* to Tiberio Calcagni (1532–65) for completion. The condition of the *Pietà* is far from ideal. The left leg of Christ is missing and there are obvious repairs to other breaks. Nor is there agreement on the type and scope of Calcagni's intervention. The Palestrina *Pietà* (Florence, Accad.) is of doubtful authenticity. Only the Rondanini *Pietà* is securely authentic and safely datable to the artist's very last years, but it is a shattered fragment. A radical change of plan led Michelangelo to mutilate the group so that the upper parts of the Virgin and Christ were left as shallow, ghostly presences beside a single, substantial right arm, the remnant of a previous more conventional version. A head and part of the torso belonging to the earlier scheme (Florence, Pal. Vecchio) was discovered in 1973. The legs of Christ, which probably date from the earlier composition, also show signs of modification. It is probable that the first carving was begun in the 1550s and the radical cutting back of the two figures took place in the very last years of Michelangelo's life. According to a letter of Daniele da Volterra, he was at work on the group only five days before his death.

The spectral quality of the Rondanini *Pietà* has been used to support the view that at the end of his life Michelangelo inclined towards an aesthetic of renunciation. Allegedly rejecting the full, twisting forms characteristic of his earlier work, he reduced the piece to a pair of stark columnar figures, tensely bent forward. It has been suggested that the compositional scheme shows an affinity with northern, or even with Gothic art. The idea that Michelangelo adopted medieval motifs late in life has become a recurrent theme among writers. The combination of Classical and medieval elements has been noted even in the *Rachel* and *Leah*. But echoes of medieval motifs are not exclusive to work of his last decades. By stressing certain elements in the late figures and linking them with Michelangelo's adherence to the reform movement within the Roman Church, a spurious argument is proposed, falsely associating Gothic with Christian. The private nature of these late uncommissioned works should not be exaggerated, although it is plausible that they reflect Michelangelo's desire for personal redemption and are meditations on salvation akin to his drawings and poems of this period; they also seem to have had a shadowy public purpose. According to Vasari, the Florentine *Pietà* includes a self-portrait of the artist as Nicodemus and had originally been intended to surmount Michelangelo's own tomb. The Rondanini *Pietà*, though kept in Michelangelo's

studio until his death, seems to have been promised to a client.

(v) Unfinished works. Discussion of abandoned works, the '*non-finito*', has been confused by the claim that lack of finish should be regarded as an expressive device essential to Michelangelo's art. This view became especially prominent after Auguste Rodin (1840–1917) had established a taste for images only partly emerging from rough stone. The suggestion that Michelangelo's failure to complete works arose from a dissatisfaction with the expressive limitations of craft perfection is an extreme example of the view that great genius manifests impatience with the limitations of any medium. According to one version of this approach, the incomplete state of Michelangelo's carvings was due to an irresolvable tension between pagan and Christian principles. It is far more likely that much of Michelangelo's sculptured oeuvre was abandoned because he committed himself simultaneously to too many projects. Evidence for this comes from his own criticism of the rough surfaces of Donatello's sculpture, as reported in Vasari's biography, and from what is recorded of his fastidious regard for the quality of marble. His abandonment of the first version of the *Risen Christ* on the revelation of a flaw in the stone is a good example of this. Whenever possible, he crisply articulated surface detail and gave his statuary a final polish. In this respect there is no distinction between early and late work. A more accurate idea of Michelangelo's standards of craftmanship may be gained from a study of the *Rachel* and *Leah* than from the Rondanini *Pietà*. Of the apparently 'unfinished' elements in his completed sculptures, most are deliberate textural differentiation. The remainder are parts that were not meant to be seen at close quarters or seen at all, such as the roughly chiselled patch of neck behind the beard of *Moses*, or the back of the *Risen Christ*.

Admiration for Michelangelo's work ensured that much of his statuary was preserved, even when its condition would have been considered unacceptable as the work of other artists. His work was so highly valued that the slightest sketch was coveted, and it is not surprising that even imperfect sculptures were sought after. When there was a delay in delivering the second version of the *Risen Christ*, Metello Vari demanded the unfinished first version (untraced) and installed it in his garden. Michelangelo himself gave the two abandoned *Captives* to Roberto Strozzi as tokens of affection. His contemporaries were therefore forced to come to terms with the incompleteness of the sculpture. This occurred in three ways. First, Michelangelo's inventive power was so much admired that his unfinished works were regarded by other artists as a legitimate quarry for ideas. Raphael, for example, struck by the mere adumbration of the *St Matthew*, copied it in pen and ink (Chatsworth, Derbys). Second, literary strategies were developed for dealing with aborted statues. Vasari was a pioneer, citing the *St Matthew* as a model of decisive carving. He also gave an influential psychological explanation of Michelangelo's abandoned statuary, suggesting that the sculptor did not give final form to his inventions because of his frustration at the gap between conception and execution. Third, in two cases incompleteness was exploited by controlling the conditions of display.

The *Brutus*, commissioned by a Medici opponent as a symbol of Republican virtue, was acquired after Michelangelo's death by the Grand Duke of Tuscany, Francesco I (*see* MEDICI, DE', (16)). In the Medici collections it was exhibited accompanied by a Latin verse, which claimed: 'As the sculptor carved the portrait of Brutus from the marble, he remembered his crime, and broke off'. Celebration of the tyrant-slayer was thus subverted, and Michelangelo's failure to complete the work was represented as a praiseworthy moral act. It was also under the Medici that Bernardo Buontalenti incorporated the four *Slaves* from the abandoned Julius tomb into the rough masonry of a grotto in the Boboli Gardens in Florence (replicas *in situ*). Seemingly growing from the rock, the figures served as witty representations of the transformation of nature into artifice.

The predominance of unfinished work in Michelangelo's oeuvre has also contributed to the impression that he was at odds with contemporary aesthetic values. In addition, his incomplete or aborted projects have obscured two aspects of his sculpture that might have modified this picture: relief and the design of ornament. No reliefs appear in Michelangelo's work after 1507, although they were planned for earlier projects for the Julius tomb and for the façade of S Lorenzo, according to drawings (New York, Met.; Florence, Uffizi). In one design for the S Lorenzo façade (Florence, Uffizi), Michelangelo began by adapting a compositional type derived from Lorenzo Ghiberti, a source so unexpected as to bring into question conventional ideas about the limits of his art. Fragmentary survivals give a good idea of Michelangelo's preferences in ornament. The lower storey of the Julius tomb, largely constructed from parts begun between 1513 and 16, shows him to have been a designer of fantastic carving firmly rooted in late 15th-century practice. The New Sacristy, although incomplete, reveals an abundance of invention: the fanciful cuirass of Giuliano's effigy, the bat-headed box on which Lorenzo rests his arm, the poppies and owl of *Night* and the frieze of masks that runs behind both sarcophagi (carved by Silvio Cosini and Francesco da Sangallo). Even what was executed of the decoration for the New Sacristy does not survive intact: stucco figuration for the interior of the dome, designed by Michelangelo and executed by Perino del Vaga, was destroyed by Vasari. Michelangelo's three-dimensional work was fashioned to inhabit a more richly inventive world of ornament than is generally considered appropriate to it. Had these frameworks been completed as he envisaged them, they would have revealed Michelangelo as a less austere sculptor, less isolated from his age, but still dominant of it.

BIBLIOGRAPHY

GENERAL

E. Panofsky: *Tomb Sculpture* (New York, 1964)

C. J. Seymour: *Sculpture in Italy, 1400–1500*, Pelican Hist. A. (Harmondsworth, 1966)

M. Weinberger: *Michelangelo the Sculptor*, 2 vols (London and New York, 1967)

F. Hartt: *Michelangelo: The Complete Sculpture* (London, 1969)

J. Pope-Hennessy: *Italian High Renaissance and Baroque Sculpture* (London, 1970, 3/1985)

J. Poeschke: *Michelangelo und seine Zeit* (1992), ii of *Die Skulptur der Renaissance in Italien* (Munich, 1990–92); Eng. trans. by R. Stockton as *Michelangelo and his World: Sculpture of the Italian Renaissance* (New York, 1996)

TRAINING AND EARLY WORK

F. Kriegbaum: 'Michelangelos Statuen am Piccolomini-Altar in Dom zu Siena', *Jb. Preuss. Kstsamml.*, lxiii (1942), pp. 57–78

C. Eisler: 'The *Madonna of the Steps*: Problems of Date and Style', *Stil und Überlieferung in der Kunst des Abendlandes: Akten des 21. internationalen Kongresses für Kunstgeschichte: Bonn, 1964*, ii, pp. 115–21

M. Lisner: 'Michelangelos Crucifix aus S Spirito in Florenz', *Münch. Jb. Bild. Kst*, n. s. 2, xv (1964), pp. 7–37

A. Parronchi: 'Il *Cupido dormiente* di Michelangelo', *Stil und Überlieferung in der Kunst des Abendlandes. Akten des 21. internationalen Kongresses für Kunstgeschichte: Bonn, 1964*, ii, pp. 121–5; repr. in A. Parronchi: *Opere giovanili di Michelangelo, Accademia Toscana di Scienze e Lettere 'La Columbaria': 'Studi'*, x (Florence, 1968)

M. Cali: 'La *Madonna della Scala* di Michelangelo, il Savonarola e la crisi dell'umanesimo', *Boll. A.*, 5th ser., lii (1967), pp. 152–66

C. Seymour: *Michelangelo's 'David': A Search for Identity* (Pittsburgh, 1967)

M. Epton: 'The Taddei Tondi: A Frightened Jesus?', *J. Warb. & Court. Inst.*, xxxii (1969), pp. 391–3

R. Lightbown: 'Michelangelo's Great Tondo: Its Origin and Setting', *Apollo*, lxxxix (1969), pp. 22–31

P. Bargellini: *Michelangelo's 'David': Symbol of Liberty* (Florence, 1971)

H. R. Mancusi-Ungaro: *Michelangelo: The Bruges Madonna and the Piccolomini Altar* (New Haven and London, 1971)

R. de Campos: 'Il restauro della *Pietà* di Michelangelo', *Tutela e conservazione del patrimonio storico e artistico delle chiese in Italia*, xcvii (Rome, 1974), unpaginated insertion

S. Levine: 'The Location of Michelangelo's *David*: The Meeting of January 25, 1504', *A. Bull.*, liv (1974), pp. 31–41

N. R. Park: 'Placement of Michelangelo's *David*: A Review of the Documents', *A. Bull.*, lv (1975), pp. 560–70

D. Ewing: 'Further Observations on the Bruges *Madonna*: Ghiberti as a Source for Michelangelo', *Rev. Belge Archéol. & Hist. A.*, clviii (1979), pp. 77–83

M. Lisner: 'Form und Sinngehalt von Michelangelos *Kentaurenschlacht* mit Notizien zu Bertoldo di Giovanni', *Mitt. Ksthist. Inst. Florenz*, xxiv (1980), pp. 283–344

P. Barocchi: *Il Bacco di Michelangelo* (Florence, 1982)

V. Herzner: 'David Florentinus', *Jb. Berlin. Mus.*, xxiv (1982), pp. 129–34

M. Hirst: 'Michelangelo, Carrara and the Marble for the Cardinal's Pietà', *Burl. Mag.*, cxxvii (1985), pp. 154–9

K. Weil-Garris Brandt: 'Michelangelo's *Pietà* for the Cappella del Re di Francia', *Il se rendit en Italie: Etudes offertes à André Chastel* (Rome, 1987), pp. 77–119

G. Rocchi: 'Tecnica ed espressione nella scultura michelangiolesca con particolare riguardo alla Pietà di San Pietro', *Ant. Viva*, xxviii/5–6 (1989), pp. 45–50

J. M. Massing: 'Michelangelo's *Madonna of the Stairs*, Circa 1492: Art in the Age of Exploration, ed. J. A. Levenson (Washington, 1991), pp. 268–9

C. Elam: 'Lorenzo de' Medici's Sculpture Garden', *Mitt. Ksthist. Inst. Florenz*, xxxvi/1–2 (1992), pp. 41–84

P. Barocchi, ed.: *Il giardino di San Marco: Maestri e compagni del giovane Michelangelo* (Florence, 1992)

W. E. Wallace: 'Michelangelo: In and Out of Florence Between 1500 and 1508', *Leonardo, Michelangelo and Raphael in Renaissance Florence from 1500 to 1508* (Washington, DC, 1992), pp. 54–88 [Michelangelo's patrons]

T. Weddingen: 'Aus der Not eine Tugend: Michelangelos *David* difficilissimamente facile/A Virtue of Necessity: Michelangelo's *David* Difficilissimamente Facile', *Daidalos*, 59 (March 1996), pp. 80–91

K. Weil-Garris Brandt: 'A Marble in Manhattan: The Case for Michelangelo', *Burl. Mag.*, cxxxviii/1123 (1996), pp. 644–59

TOMB OF JULIUS II: EARLY PHASES

K. A. Laux: *Michelangelos Juliusmonument* (Berlin, 1943)

J. Wilde: *Michelangelo's 'Victory'*, Charleton Lectures on Art, 36 (Oxford, 1954)

E. Rosenthal: 'Michelangelo's Moses, dai di sotto in sù', *A. Bull.*, xlvi (1964), pp. 544–50

W. Lotz: 'Zu Michelangelos *Christus* in Santa Maria sopra Minerva', *Festschrift für Herbert von Einem* (Berlin, 1965), pp. 143–50

M. Hirst: 'A Project of Michelangelo's for the Tomb of Julius II', *Master Drgs*, xiv (1976), pp. 375–82

G. S. Panofsky: 'Die Ikonographie von Michelangelos *Christus* in Santa Maria sopra Minerva in Rom', *Münch. Jb. Bild. Kst*, n. s. 2, xxxix (1988), pp. 89–112

M. Hirst: 'Michelangelo in 1505', *Burl. Mag.*, cxxxiii (1991), pp. 760–66

C. Echinger-Maurach, *Studien zu Michelangelos Juliusgrabmal*, 2 vols (Hildesheim, Zurich and New York, 1991)

P. Armour: 'The Prisoner and the Veil: The Symbolism of Michelangelo's Tomb of Julius II', *It. Stud.*, xlix (1994), pp. 40–69

F. J. Verspohl: 'Der *Torso* des Apollonius und der *Moses* des Michelangelo: Von der Genauigkeit des Künstlers/Apollonio's *Torso* and Michelangelo's *Moses*: On the Exactness of the Artist', *Daidalos*, lix (1996), pp. 92–7

NEW SACRISTY

A. E. Popp: *Die Medici-Kapelle Michelangelos* (Munich, 1922)

H. W. Frey: 'Zur Entstehungsgeschichte des Statuenschmuckes der Medici-Kapelle in Florenz', *Z. Kstgesch.*, xiv (1951), pp. 40–96

F. Hartt: 'The Meaning of Michelangelo's Medici Chapel', *Essays in Honour of George Swarzenski* (Chicago, 1951), pp. 145–55

J. Wilde: 'Michelangelo's Designs for the Medici Tombs', *J. War. & Court. Inst.*, xviii (1955), pp. 54–66

W. Goez: 'Annotationen zu Michelangelos Mediceergräbern', *Festschrift für Harald Keller* (Darmstadt, 1963), pp. 235–54

C. Gilbert: 'Texts and Contexts of the Medici Chapel', *A. Q.* [Detroit], xxxiv (1971), pp. 391–407

P. Joannides: 'Michelangelo's Medici Chapel: Some New Suggestions', *Burl. Mag.*, cxiv (1972), pp. 541–51

L. D. Ettlinger: 'The Liturgical Function of Michelangelo's Medici Chapel', *Mitt. Ksthist. Inst. Florenz*, xxii (1978), pp. 285–304

A. Prater: *Michelangelos Medici-Kapelle* (Stiftland, 1979)

G. Neufeld: 'Die Konzeption der Wandgrabmäler der Medici-Kapelle', *Städel-Jb.*, n. s., viii (1981), pp. 247–87

R. C. Trexler and M. E. Lewis: 'Two Captains and Three Kings: New Light on the Medici Chapel', *Stud. Med. & Ren. Hist.*, n. s., iv (1981), pp. 91–177

A. Morrogh: 'The Magnifici Tomb: A Key Project in Michelangelo's Architectural Career', *A. Bull.*, lxxiv/4 (1992), pp. 567–98

W. Wallace: *Michelangelo at San Lorenzo: The Genius as Entrepreneur* (Cambridge, 1994)

P. Joannides: 'Michelangelo: The Magnifici Tomb and the Brazen Serpent', *Master Drgs*, xxxiv/2 (1996), pp. 148–67

LATE WORK

D. J. Gordon: 'Giannotti, Michelangelo and the Cult of Brutus', *Fritz Saxl, 1890–1948* (London, 1957), pp. 281–96

J. Pope-Hennessy: 'The Palestrina *Pietà*', *Stil und Überlieferung in der Kunst des Abendlandes: Akten des 21. internationalen Kongresses für Kunstgeschichte: Bonn, 1964*, ii, pp. 105–14, repr. in J. Pope-Hennessy: *Essays on Italian Sculpture* (London and New York, 1968), pp. 121–31

W. Stechow: 'Joseph of Arimathea or Nicodemus?', *Studien zur toskanischen Kunst: Festschrift für L. H. Heydenreich* (Munich, 1964), pp. 289–302

B. Mantura: 'Il primo Cristo della Pietà Rondanini', *Boll. A.*, lviii (1973), pp. 199–201

F. Hartt: *Michelangelo's Three Pietàs* (London, 1976)

V. Shrimplin-Evangelidis: 'Michelangelo and Nicodemus: The Florentine Pietà', *A. Bull.*, lxxi (1989), pp. 58–66

UNFINISHED WORKS

P. Barocchi: 'Finito e non-finito nella critica vasariana', *A. Ant. & Mod.* (1958), no. 3, pp. 221–35

J. Schulz: 'Michelangelo's Unfinished Works', *A. Bull.*, lvii (1975), pp. 366–73

J. G. Haddad: 'The Sabbatarian Struggle of Michelangelo', *Athanor*, xii (1994), pp. 45–53

ANTHONY HUGHES

2. PAINTING. Michelangelo's history of sporadic activity as a painter seems to support his contention that he was primarily a sculptor, despite his training in Ghirlandaio's workshop. He produced few easel pictures. It was in painting, however, that his ambition was realized most completely. His three monumental fresco cycles in the Vatican (the ceiling of the Sistine Chapel; *see* ROME, fig. 9, its altar wall (the *Last Judgement*; see colour pl. 2, VII3) and the two lateral walls of the Pauline Chapel; see fig. 6 below) are among his greatest achievements. Even in the 16th century these works were treated as representing quite distinct phases in Michelangelo's career.

(i) Early work, to c. *1507.* According to documents, Michelangelo was active as a painter in Rome during the early years of the 16th century, when he produced a cartoon for a painting of *St Francis* and worked on, but did not finish, an unspecified altarpiece for S Agostino. This may have been the *Entombment* (London, N.G.), which, alone among the speculative attributions to his early period, seems likely to be authentic. Of the others, the Manchester *Madonna* (*Virgin and Child with St John and Angels*; London, N.G.) looks more convincing (Hirst and Dunkerton, 1994); the *Pietà* (Rome, Pal. Barberini) has no connection with him.

Michelangelo's first commission for a monumental fresco, the *Battle of Cascina* for the Palazzo Vecchio in Florence, was never realized. His cartoon for the *Battle of Cascina* (1504–7) was highly influential, but was dismembered and disappeared in the 16th century. Only an incomplete copy attributed to Bastiano da Sangallo (Holkham Hall, Norfolk) and some autograph preliminary drawings (e.g. London, BM) remain to show why this closely packed composition of muscular nudes had so inspired his contemporaries. These remnants also suggest how important this work was in Michelangelo's development: it gave him an opportunity to refine the composition of the *Battle of the Centaurs* and to develop motifs that he reworked as late as the *Last Judgement.*

It is difficult, then, to follow Michelangelo's earliest development as a painter. This gives a special importance to the Doni Tondo (*Holy Family*; Florence, Uffizi; see colour pl. 2, IV3) as his only existing documented panel picture. The survival of the original frame, which may have been designed by Michelangelo, makes the tondo doubly important as the sole intact decorative ensemble in his oeuvre. The frame also provides a clue to the date of commission, since it shows the intertwined devices of AGNOLO DONI and his wife, Maddalena Strozzi. It has been suggested that the painting celebrated their marriage in 1503 or the birth of their first male heir in 1507.

The high colour key and predominantly blond tonality of the Doni Tondo were often contrasted with the apparently more markedly tonal style of the Sistine Ceiling. The cleaning of both the tondo and the Sistine vault, however, has revealed considerable continuity of manner between the two. Because the tondo depicts a conventional subject, it emphasizes Michelangelo's formal independence from contemporaries who were developing motifs and treatments derived from Leonardo da Vinci. In colour, tone and handling, the panel is deeply conservative. Its originality lies in the quite exceptional clarity with which Michelangelo designed the three major figures as a compact, yet coherent, group. The pose of the most prominent figure, the Virgin, is particularly complex. The central group is often cited correctly as an extreme example of what *disegno* came to represent. It has been suggested that the group is essentially sculptural in feeling, but this is true only in the sense that each figure is strongly realized as a turning, three-dimensional form. To dwell excessively on its sculptural properties is to ignore the marked fashion in which Michelangelo emphasized two-dimensional patterning by sharply silhouetting the central mass against the

background. Colour plays its part too. The Virgin's rose shift with its brilliant, almost blanched, highlights is the most vibrant element within the pictorial field, and clearly signals her stature as the chief figure of the painting.

Although she is not without tenderness, the Virgin of the Doni Tondo is depicted as muscular, lithe, heroic and unusually authoritative. The relative severity of Michelangelo's conception of the Holy Family has given rise to speculation that this panel had a special significance, a suggestion supported by the puzzling inclusion of a group of naked youths lounging in the background. Similar groups are depicted in tondos by Luca Signorelli (1484–90; Florence, Uffizi; Munich, Alte Pin.), although the meaning of these also remains mysterious. Tolnay's suggestion that the youths represent the epoch before the Law, while the Holy Family stands for the era of Grace and the Baptist an intermediary period, makes sense of the spatial arrangement of the picture in terms of orthodox theology, but it remains speculative. Less credible interpretations include the assertion that two of the youths are homosexual lovers. Whether it commemorates marriage or birth (or both), this exhilarating painting in its magnificent frame is one of the most sumptuous objects to have survived from the Italian Renaissance.

The Doni Tondo was not the last of Michelangelo's panel paintings. Around 1530 he painted a *Leda and the Swan* (untraced) for Alfonso I d'Este, Duke of Ferrara. Alfonso never received the picture, which vanished in France. The power of Michelangelo's conception of the Leda myth is suggested by a number of 16th-century copies, of which the most reliable appear to be a painting often attributed to Rosso Fiorentino (London, N. G.) and an engraving by Cornelis Bos (London, BM).

(ii) Sistine Ceiling, 1508–12. It is difficult to exaggerate the importance of the frescoes on the ceiling of the Sistine Chapel (*see* ROME, fig. 9). They mark the arrival of a new type of heroic painting. Through frequent copy, adaptation and parody, they have become the works most commonly associated with Michelangelo's name, and they are central to any discussion of his achievement.

According to his own account, Michelangelo was originally unwilling to paint the Sistine Ceiling, although his statements on the subject are not entirely reliable. The project was already being discussed in 1506, less than a year after the first negotiations for Julius II's monument. At this stage the Pope wished Michelangelo to replace the original ceiling decoration, blue with gold stars, with a scheme of the 12 Apostles in the spandrels and predominantly geometric ornament on the vault. Two drawings (Detroit, MI, Inst. A.; London, BM) give an idea of early plans. In a later account Michelangelo claimed he told the Pope that this was a 'poor' idea and that Julius then allowed him to do what he chose. In view of the importance of the chapel in the life of the papal court, this cannot be literally true. Nevertheless, the transformation of modest schemes into more ambitious projects was a recurrent feature of Michelangelo's career. It is plausible therefore that the Pope accepted his suggestion to decorate the vault more magnificently, but that the biblical themes of the fresco were chosen by an adviser.

In the final scheme the vault was given a fictive stone framework, with a series of nine narratives from the book of Genesis in the centre, each placed at right angles to the long axis of the chapel. The narrative order begins at the altar end with three depictions of the Creation of the Heavens and Earth; there follow scenes representing the creation of Adam, the creation of Eve and a composite narrative of the Fall and the Expulsion from the Garden of Eden. The final trio begins with a scene of sacrifice (identified by Condivi as that of Abel or, more commonly, that of Noah, although this must mean that it is placed out of sequence); it continues with the Flood, and ends with the Drunkenness of Noah. Figures of nude youths (the famous *ignudi*) sit on the simulated architecture framing these narratives. They bear garlands supporting fictive bronze medallions with reliefs depicting other Old Testament stories. In the spandrels at both ends and down the sides of the chapel are colossal enthroned figures, each labelled as a prophet or sibyl (see colour pls 2, VI1 and 2, VI2). Collectively they represent those who foretold the coming of Christ to the Jews and the Gentiles respectively. Between these, and in the lunettes above the windows beneath, are family groups and paired figures of the Ancestors of Christ. At the four corners, the pendentives are painted with scenes illustrating the salvation of Israel (at the altar end, the *Death of Haman* and the *Brazen Serpent*, at the entrance, *Judith and Holofernes* and *David and Goliath*). Fictive bronze nudes and stone putti add to the wealth of figurative invention.

Michelangelo signed a contract to paint the vault in May 1508. Four years later, in October 1512, the fresco was complete. Considering delays during early stages, when mould developed on the wet plaster, and the interruption of work for almost a year between 1510 and 1511, progress was staggeringly fast. This casts doubt on Condivi's statement that Michelangelo worked without even an assistant to grind colours. The high quality of painting throughout indicates that he exercised the closest supervision, however.

In design, the vault is powerfully articulated by the fictive architecture, which is keyed to that of the chapel itself. This provides a framework for figures and scenes and also distinguishes one part from another, permitting a rational reading of the composition, despite inequalities in scale between the figures. It is this architectural structure that preserves continuity between the first and the last figures Michelangelo painted on the vault. For, in spite of its reputation, the ceiling is not a unified achievement.

While thematically the paintings fall into three contrasting sections, stylistically there are two, the division roughly corresponding to the interruption of work in 1510 and 1511. During the first phase Michelangelo painted everything between the prophet *Zeccharia* and the fifth bay of the vault, representing the *Creation of Eve*. That included Prophets, Sibyls and Ancestors of Christ on either side. The remainder, which took less than a year, comprises the most admired narratives and figures of the ceiling. The break is marked by the discontinuation of gilding on the balusters of the thrones of the Prophets and Sibyls. Later parts of the fresco lack the *a secco* touches that would have given them a rich finish to match the 15th-century paintings below. This is, however, only the most trivial of the distinctions between Michelangelo's two campaigns. More importantly, during the months of interruption, he made major revisions to his designs. All the main figures from the later part of the series are larger and more powerfully presented to the viewer. Prophets and Sibyls were given greater bulk by lowering the base of their thrones, a procedure that may also have suggested changes in the angles from which these platforms ostensibly are seen. The ledges on which the *Persica* and *Jeremiah* are placed tilt forward dramatically in a way quite inconsistent with the projection of the surrounding architecture. The distortion is subtle, although it adds to the sense that these later figures press against a constraining architectural frame, even bearing heavily down upon it. Some, such as the *Daniel*, forcibly burst beyond their confines.

This powerful impression results from Michelangelo's increasing use of illusionism on the vault, culminating in the dramatic figure of *Jonah* placed directly above the altar (see colour pl. 2, VI2). This figure was much admired in the 16th century as a *tour de force* of three-dimensional realization, belying the concavity of the surface on which it is painted. Such effects are now taken for granted, but Michelangelo's inventive use of foreshortening to enhance the dramatic interplay between figure and ground is as striking as his related indifference to the use of more conventional illusions of depth within paintings.

As work on the ceiling progressed, these preferences issued in a novel approach to narrative. The first three biblical scenes executed along the centre of the vault, the *Drunkenness of Noah*, the *Flood* and the *Sacrifice*, recognizably conform to the notion of LEON BATTISTA ALBERTI that a history painting should include many figures displaying variety of action and character. By the standards of Michelangelo's later work, they are also the least successful parts of the ceiling. While the scenes contain many fine passages and single inventions, such as the man climbing the blasted tree in the *Flood*, these brilliant bits and pieces are often unhappily put together. This stems from Michelangelo's lack of interest in another requirement stipulated by Alberti: the creation of a convincingly deep space in which to set figures. Recession is either blocked off, as it is by the building and altar in the *Sacrifice*, or flattened, as by the waters in the *Flood*. Landscape is reduced to formulaic elements. In four instances a frontal plane is represented by a featureless wedge at the lower left-hand corner. Within the compressed spaces of these earlier scenes, figures often seem bunched arbitrarily and the narrative unfocused. Only when Michelangelo began to enlarge his figures within the frame and reduce them in number did the narratives become more concentrated. Then conventional spatial indicators grew progressively more ambiguous, and gaps between figures took on a psychological charge, rather than signifying distance.

As Michelangelo's interest in creating plausible settings diminished, his use of foreshortenings became more marked. The most daring examples are in the very last narrative scenes, which show God alone. This is best explained by contrasting them with the three preceding scenes in Eden, at the centre of the ceiling. Although these contain single figures in poses of great complexity, such as the Eve of the *Temptation*, the narratives are conceived as friezes running parallel to the fresco's surface. The most

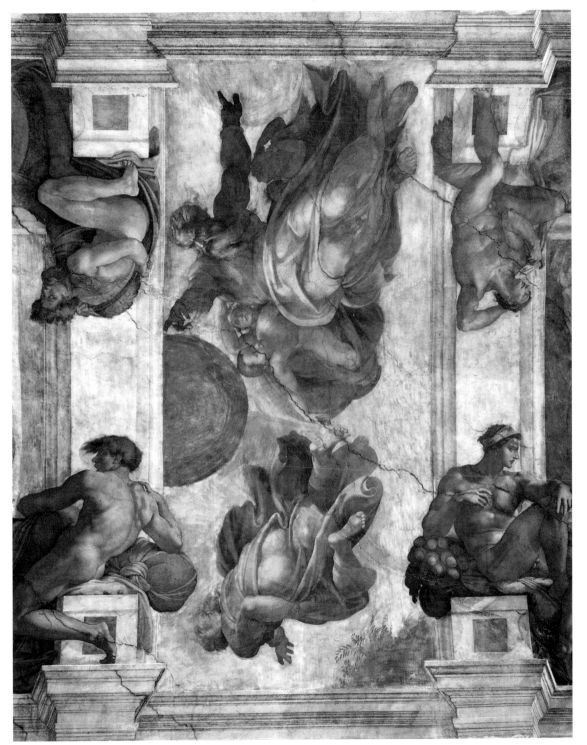

5. Michelangelo: *Creation of the Sun and Moon* (1511–12), fresco, 2.8×5.7 m, Sistine Chapel, Vatican, Rome

magisterial of the scenes, the *Creation of Adam*, also has the simplest construction. The scene that follows marked an immediate break. In the *Separation of the Waters from the Earth*, a steeply foreshortened figure of God hovers above the waters. The palms of his hands, raised in benediction, appear to press against the surface of the picture. Here it is the figure alone that gives definition to the nebulous setting, a device accentuated in the two following works, the *Creation of the Sun and Moon* (see fig. 5) and the *Division of Light from Darkness*. It has been

observed (Hirst, *The Sistine Chapel*, 1986) that the *Division* is the only image on the vault designed to be seen as if from below. It gives the effect of continuous revolving movement, as though the fabric of space itself is being unwound.

What caused the profound differences between the beginning and end of this famous set of paintings? It could be that Michelangelo simply matched style to subject. The biblical scenes were painted in reverse order of the sequence in which they are to be read. It is not difficult to see that some changes in form nicely fit the thematic material of the narratives from Genesis. The stories may have determined the variations in the number of figures depicted between the first and last of the scenes, although the use of simultaneous narrative in the frescoes of the *Fall* and the *Creation of the Sun and Moon* casts doubt on the validity of this argument. It is unlikely, however, that the change was due entirely to the hiatus of 1510.

According to one view, Michelangelo enlarged the size of his figures after the removal of the scaffolding in 1510 when he saw that the biblical scenes were not sufficiently legible from the floor of the chapel. Using the discontinuation of gilding as a guide, however, the first of the newer kind of narrative, the *Fall and Expulsion*, precedes the break between painting campaigns. Moreover, the convincing reconstruction of the scaffolding bridge Michelangelo devised for painting the vault (Mancinelli, 1986) has invalidated the idea that large parts of the fresco remained hidden for lengthy periods. Practical considerations may have played only a small part in these striking transformations.

No single explanation is sufficient. Accounts that stress decorum and legibility alone can apply only to the main series of narratives. As has already been noted, the figures of Prophets and Sibyls also reflect these changes, and there is no logical explanation for this. The increasing grandeur of the section of the ceiling that was painted last demonstrates Michelangelo's increasing confidence as a painter.

The same development may be followed in the figures of the *ignudi*, placed above the thrones of the Prophets and Sibyls. These are among the most admired parts of the ceiling, and admiration has led writers to speculate about their symbolic meaning. It is unlikely that the *ignudi* are symbolic, however. Their function is to support the bronze medallions, and to bear oak leaves and acorns, the heraldic devices of the della Rovere, Julius II's family. Their moods range from grave to playful, although the later ones, painted on a grander scale and more powerfully modelled, perhaps do suggest an emotional complexity that gives them greater significance than their ornamental role would seem to warrant.

A related point could be made about the considerable interpretative literature on the iconology of the Sistine Ceiling as a whole. The greatness of these frescoes and their importance for the subsequent history of the visual arts in Europe are almost inestimable. Their significance is not diminished by the observation that their meaning for the papal retinue was not especially esoteric. The stories at the centre of the ceiling represent the providential history of the world, from Creation through Original Sin to the First Covenant after the Flood. These scenes may be read as the antecedents to the establishment of the Law through Moses and the Redemption of humankind by Christ, depicted in the 15th-century frescoes on the walls beneath. The coming of Christ is celebrated by the Prophets, Sibyls and Ancestors and allegorically foreshadowed by the scenes of Israel's salvation.

Michelangelo's depiction of cosmic mysteries was sufficiently impressive to his contemporaries, but writers have continued to seek a hidden meaning in the work. There have been elaborate attempts to explain the imagery of the ceiling as a coded expression of Michelangelo's adherence to Neo-Platonism (e.g. Hettner, 1879). It has been argued that the ceiling narratives illustrate successively higher states of consciousness, from the forgetfully sensual, signified by Noah's drunkenness, to the direct revelation of divinity in the *Separation of Light from Darkness* (Tolnay). In most Neo-Platonic readings, it is assumed that Michelangelo had sole responsibility for controlling the programme and its subsequent interpretation. This is unlikely, considering his patron. As the ubiquitous della Rovere oak leaves and acorn remind the viewer, the ceiling is also a memorial to its author, not Michelangelo in this context, but Julius II, whose arms were originally placed below the figure of Jonah. Attempts to explain the imagery of the ceiling by reference to Julius or his advisers (Wind, 1944; Hartt, 1951; Sinding-Larsen; Dotson), although in theory more appropriate, have not proved conclusive. It is not implausible, for example, that reflections based on the theology of St Augustine's *City of God* passed through the mind of a cultured 16th-century frequenter of the chapel (Dotson), but biblical exegesis in the early 16th century was so flexible, and allegorical interpretation so easy to manipulate, that writers attempting to identify a hidden key may be in danger of mistaking connotation for denotation.

In another approach, the paintings were analysed according to the principles of structuralist anthropology (Leach). It was suggested that the images reflected not the individual temperaments or beliefs of Michelangelo or Julius, but rather contemporary social structures of which its authors were at best semiconscious. These structures manifested themselves as a language of binary oppositions (sacred and secular, light and dark etc). Although this promised a fresh reading of the paintings, it relied almost exclusively on the earlier interpretations of Tolnay. This approach also implied that any reasonably complex 16th-century Roman artefact should yield similar results, and it is not therefore addressed to the peculiarities of the Sistine Ceiling. Although it has not proved persuasive, the article did at least focus attention on Michelangelo's imagery as a form of language that derived its power by radical reformations and sometimes deformations of a contemporary visual grammar. The authority and force of the frescoes are irreducible to any verbal message.

(iii) Late work, 1534–50. According to Lomazzo, the frescoes on the Sistine Ceiling were the summit of Michelangelo's achievement as a painter, exemplifying the first and best of his three styles; the *Last Judgement* (see colour pl. 2, VII3) and the paintings for the Pauline Chapel represented successive stages of decline. While this view is not universally accepted, the preponderance of writing devoted to the ceiling paintings seems to reflect this bias.

There are many possible reasons for this. The *Last Judgement* quickly acquired a bad reputation. The dialogues of Gilio da Fabriano contained the most detailed attack on the fresco, but many others found the nudity of the figures unseemly. Consequently parts of the fresco were destroyed and parts overpainted so that in appreciable detail it is not the fresco Michelangelo designed. In addition some plaster above the altar was damaged by the fittings for a canopy. Finally, the surface became coated with centuries of fatty candle smoke owing to Michelangelo's decision to restructure the wall with an overhang to prevent dust settling on the fresco. Critical neglect of the Pauline Chapel frescoes, the *Conversion of Saul* (see fig. 6 below) and the *Crucifixion of St Peter*, could be due to their inaccessibility in the pope's private chapel, although they too attracted Gilio's censure for the licence Michelangelo took with holy stories. These complaints have attracted less attention, presumably because they were not linked to sexual scandal. It is, however, stylistic idiosyncrasies that have made both the *Last Judgement* and the Pauline frescoes difficult to understand.

(a) Last Judgement. Michelangelo's commission to decorate the altar wall of the Sistine Chapel dates from 1534, the final year of Clement VII's pontificate. According to Vasari, the project was taken over without alteration by his successor, the Farnese pope Paul III. On the basis of a contemporary letter stating that Michelangelo was preparing to paint a Resurrection in the chapel, it has been suggested that the original scheme was to show Christ rising from the tomb. This proposal would explain a group of drawings of this subject (e.g. London, BM) datable on stylistic grounds to the late 1520s or early 1530s. In other respects, however, the theory does not fit the known facts, and it is probable that the letter referred to a projected Resurrection of the Dead (i.e. a Last Judgement). This is not to imply that the genesis of the fresco was simple. Again, Michelangelo seems to have persuaded his patrons to enlarge the original brief, this time with strange consequences for the decoration of the Sistine Chapel as a whole.

Surviving drawings show that the painting was designed around the existing frescoed altarpiece, Perugino's *Assumption of the Virgin*. The altarpiece frame would have served as a fictive ledge on which angels stood to throw down the damned. This plan was changed when it was decided to destroy the altarpiece and obliterate two lunettes frescoed earlier by Michelangelo. Two windows above the altar were bricked up, depriving the decorative cycles around the lateral walls of their apparent light source.

Damage to the existing decoration was not obviously compensated for by Michelangelo's gigantic fresco, which shouldered its way among the more modest designs of the past. Lacking a framing device like that articulating the vault, the painting has seemed to some observers uncontained, shapeless. It has certainly attracted conflicting compositional analyses. The proposal that the architecture of the chapel determined the organization of the painting (Wilde, 1936) remains the most persuasive. According to this theory, the figure groups in the *Last Judgement* were banded in zones corresponding to the horizontal membering of the lateral walls and the illumination from the

lost windows was symbolically replaced by the representation of Christ.

One factor that complicates attempts at compositional analysis is Michelangelo's curious representation of space, which is more unorthodox in this fresco than in any portion of the ceiling. Condivi's seemingly banal statement that 'the whole is divided into sections, left and right, upper and lower, and central' stresses the conventional symbolic orientation observed in most depictions of the *Last Judgement*; the damned fall on Christ's left, the saved rise on his right; Heaven occupies the top and Hell the lower level of the field. Condivi's words, however, also encourage a reading of the fresco as a two-dimensional surface, rather than a window-like projection. While this fits the subject of the Day of Judgement, when time and space will be abolished, it does not account for certain oddities. Each figure is vigorously modelled, and the painting abounds in the bravura demonstrations of foreshortening celebrated by 16th-century writers, yet the characters inhabit individual spaces that cannot be combined consistently. Spiritual importance, not spatial position, determines the size of the figures of Christ and many saints. Irregular fields mark out the lunettes, and another separates Christ and his mother within a yellow mandorla. This atomization of the pictorial plane makes it difficult to appreciate the overall cohesion to which Wilde drew attention. Vasari concentrated his praise on Michelangelo's impressive representation of individual types and movements. Many 16th-century artists borrowed particular motifs, but only Pontormo appeared interested in its structural principles, and his paintings for the choir of S Lorenzo in Florence were disliked and eventually destroyed. In the best contemporary copy of Michelangelo's fresco, by Marcello Venusti (Naples, Capodimonte), the jarring discrepancies of scale have been subtly toned down, and the intervals between figure groups adjusted to produce a more conventional account of space.

What was admired immediately in the *Last Judgement* was its colour, a feature to which both Vasari and Lomazzo drew attention. Colour in this sense is not the broad, broken brushwork of a Titian, but a high-keyed brilliance that was barely appreciable beneath the surface dirt before the work was cleaned in the late 20th century. Vasari noted a delicacy of effect that he likened to miniature painting. The most intense hue is provided by the azure ground. In some passages, such as those representing the hosts of the blessed in heaven, Michelangelo employed a fluent and allusive brushwork such as he had used two decades earlier for the Ancestors of Christ in the lunettes of the chapel.

Contemporaries also noted the continued vigour of Michelangelo's powers of invention. Many details have become familiar through photographic reproduction, for example the damned man covering one eye with his hand, or the two blessed creatures soaring heavenward, wrapped in winding sheets, variations on one of the most moving drawings for the Resurrection of Christ (London, BM). For some viewers, however, the painting manifests an awkward development in Michelangelo's representation of the human body. The increased girth of the figures lends weight to Dolce's accusation that men and women,

young and old, are hardly distinguishable from one another. The equation of bulk with power is most obvious in the figure of Christ. To take one detail, Michelangelo increased the size of the upper right arm far beyond the line he had traced through from his cartoon. The extravagant attitudes and gestures of many of the figures also caused complaint. The ungainly tumbling of the angels who display the instruments of Christ's Passion seems particularly unwarranted, but it may be a pictorial metaphor for the heaviness of Christ's suffering.

Because of these marked stylistic peculiarities, it is hardly surprising that the painting is sometimes taken as a statement of personal belief. Dolce, writing in the 16th century, seemed to provide evidence for this view when he alleged that Michelangelo had a hidden, although unspecified, allegorical purpose. This was merely a rhetorical ploy, however, to draw attention to the indecency of representing so many nudes in a sacred place. It has been suggested that the painting encodes Michelangelo's secret adherence to Valdesian beliefs, in which the saved are justified by faith alone. Whatever the artist's own views, abstruse points of doctrine would have been difficult to represent in pictorial form. The important question here, as with the ceiling frescoes, is to determine how Michelangelo's patrons would have understood the image within the context of the chapel itself.

For a papal establishment already chastened by the Sack of Rome, it seems likely that the fresco was intended as a powerful reminder of the Four Last Things: Death, Judgement, Heaven and Hell. Two factors contributed to the impact of this message: the fresco's unusual position on the altar wall (representations of the Last Judgement were normally placed on the entrance wall of ecclesiastical buildings) and the removal of Perugino's altarpiece, with its comforting image of the Virgin, as the focal point of the chapel. The painter alone would not have had the power to decide either of these matters, and it is more likely that the attacks on the painting reflected a dramatic swing towards the narrow defence of orthodoxy within the Church. Features acceptable in a devotional image during the 1530s came under more intensive scrutiny during the following two decades, and Michelangelo's art fell victim to the trend.

(b) Pauline Chapel. By contrast to the oppressive appearance of the *Last Judgement*, the Pauline Chapel frescoes (1542–50) seem restrained. They have a lighter tonality and less striking contrasts of colour: violets, greens and blues predominate. Despite this colouristic mildness—which differs from most of Michelangelo's earlier work—these frescoes could not be called serene or lyrical. As scenes of conversion (see fig. 6) and martyrdom they seem unconventional, for reasons it is difficult to specify.

Gilio noted uncanonical illogicalities: Saul is bearded and already aged (which has led to the suggestion that it is

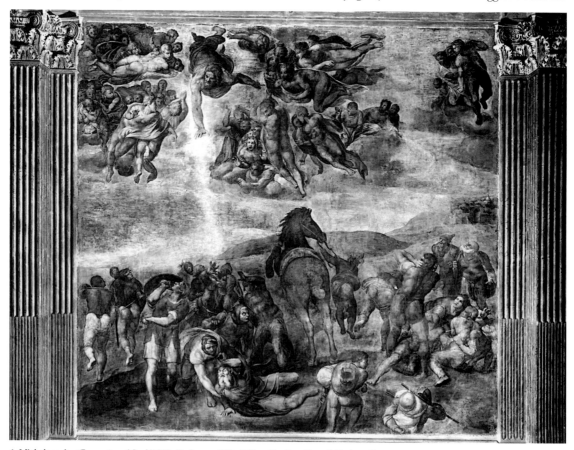

6. Michelangelo: *Conversion of Saul* (1542–5), fresco, 6.20×6.66 m, Pauline Chapel, Vatican, Rome

an idealized portrait of its commissioner, Pope Paul III); Saul's rearing horse has no bit; Peter is unaffected by the pains of martyrdom, and so on. These characteristics typify much of Michelangelo's art, however. Paucity of circumstantial detail and discrepancy between action and facial expression also occur in his earlier painting and sculpture. These traits are merely intensified in the late work. This is also true of his treatment of space. As in the *Last Judgement*, some groups are isolated within map-like patches of ground. Symbolic relation between figure size and narrative importance is also apparent in the *Crucifixion of St Peter*, in which in addition distance is telescoped disconcertingly by the angle of the foreground rock.

Michelangelo's conception of human figures also became more bizarre in these late works, although there was no abrupt departure from the types to be found on the Sistine altar wall. Limb and torso are as gross as before; figures are still conceived in the round; their poses in outline retain all the twisting complexity associated with the earlier painting, but the general effect is insubstantial. Interest has shifted from detailed notation of internal modelling towards forms more generally realized. Bodies have rubbery, tube-like members; enormous eyes stare from broad, flat faces. In late drawings the heavy corporeality of similar figures is disguised by repeated passes of chalk. In the stark clarity demanded by fresco, such shimmering, ambiguous forms are not possible.

Formal asperity is manifested everywhere in these pictures. More than any others in Michelangelo's oeuvre, they upset conventional order. Examples of unorthodox procedure include the many odd repetitions of motif. At the extreme right corner of the *Saul*, a naked angel gestures towards the events beneath. He has a twin in the spectator to the right of the Crucifixion scene. With slight variations, his form is mirrored in turn by a man in a green tunic behind the cross at the upper centre of the *Crucifixion*. By using such repetitions Michelangelo flouted Alberti's requirement of variety in history painting. It is tempting, therefore, to endorse Lomazzo's low opinion and, like him, to see the Pauline frescoes as products of failing powers of invention. This is, however, an unlikely interpretation of their peculiarities, for it was in a letter of 1542, while executing these frescoes, that Michelangelo most forcefully asserted painting to be intellectual rather than manual labour ('you paint by brain, not with your hands'). Besides, during the following decade, he continued to produce powerful drawings. The works' barbarities—if they are that—seem studied. Although 16th-century texts were brief or hostile, visual evidence of borrowing and adaptation shows that the aging Michelangelo's power to impress his artist contemporaries was undiminished. Many 20th-century writers consider the contraventions of rule found in the Pauline Chapel frescoes to be the expressions of a late period of spiritual and formal research. Certainly these last frescoes present the peculiarly modern appearance of powerful, uningratiating works, designed to resist explanation in terms of conventional critical categories.

BIBLIOGRAPHY

GENERAL
F. Hartt: *The Paintings of Michelangelo* (London, 1968)
P. De Vecchi: *Michelangelo pittore* (Milan, 1984)

EARLY WORK
W. Köhler: 'Michelangelos *Schlachtkarton*', *Kstgesch. Jb. Ksr.-Kön. Zent.-Komm. Erforsch. & Erhaltung Kst- & Hist. Dkml.*, i (1907), pp. 115–72
F. Baumgart: 'Contributi a Michelangelo, II: La *Madonna* Doni', *Boll. A.*, 3rd ser., xxviii (1935), pp. 350–53
J. Wilde: 'The Hall of the Great Council in Florence', *J. Warb. & Court. Inst.*, vii (1944), pp. 65–81; repr. in *Renaissance Art* (New York, 1944), pp. 92–132
——: 'Notes on the Genesis of Michelangelo's *Leda*, *Fritz Saxl, 1890–1948*, ed. D. J. Gordon (London, 1957), pp. 270–80
C. Eisler: 'The Athlete of Virtue: The Iconography of Asceticism', *De Artibus Opuscula XL: Essays in Honour of Erwin Panofsky*, ed. M. Meiss (New York, 1961), pp. 82–99
C. Gould: *Michelangelo: 'Battle of Cascina'*, Charlton Lectures on Art (Newcastle-upon-Tyne, 1966)
A. Smart: 'Michelangelo, the Taddei *Madonna* and the National Gallery *Entombment*', *J. Royal Soc. A.*, cxv (1967), pp. 835–62
M. Levi d'Ancona: 'The Doni *Madonna* by Michelangelo: An Iconographic Study', *A. Bull.*, l (1968), pp. 43–50
W. Grohn: 'Michelangelos Darstellung der *Schlacht von Cascina*', *Jb. Hamburg. Kstsamml.*, xvii (1972), pp. 23–42
C. Gould: 'Michelangelo's *Entombment*: A Further Addendum', *Burl. Mag.*, cvi (1974), pp. 31–2
G. Smith: 'A Medici Source for Michelangelo's Doni Tondo', *Z. Kstgesch.*, xxxviii/1 (1975), pp. 84–5
M. Hirst: 'Michelangelo in Rome: An Altarpiece and the *Bacchus*', *Burl. Mag.*, cxxiii (1981), pp. 581–93
Il Tondo Doni di Michelangelo e il suo restauro (Florence, 1985)
M. Hirst: 'I disegni di Michelangelo per la *Battaglia di Cascina*', *Tecnica e stile*, i (Milan, 1986), pp. 43–58
L. Morozzi: 'La *Battaglia di Cascina*: Nuova ipotesi sulla data di commissione', *Prospettiva*, liii (1988–9), pp. 320–24
A. Butterfield: 'A Source for Michelangelo's National Gallery *Entombment*', *Mitt. Ksthist. Inst. Florenz*, xxxiii (1989), pp. 390–93
M. Bailey: 'The Rediscovery of Michelangelo's *Entombment*: The Rescuing of a Masterpiece', *Apollo*, cxl/392 (Oct 1994), pp. 30–33
M. Hirst and J. Dunkerton: *The Young Michelangelo* (London, 1994)
J. Manca: 'Michelangelo as Painter: A Historiographic Perspective', *Artibus & Hist.*, xvi/31 (1995), pp. 111–23

SISTINE CEILING
H. Hettner: 'Michelangelo und die Sixtinische Kapelle', *Italienische Studien zur Geschichte der Renaissance* (Brunswick, 1879), pp. 247–72
E. Steinmann: *Die Sixtinische Kapelle*, 2 vols (Munich, 1905)
E. Wind: 'The *Crucifixion of Haman*', *J. Warb. Inst.*, i (1937–8), pp. 245–8
——: 'Sante Pagnini and Michelangelo: A Study of the Succession of Savonarola', *Gaz. B.-A.*, xxvi (1944), pp. 211–46
F. Hartt: '*Lignum Vitae in Medio Paradisi*: The Stanza d'Eliodoro and the Sistine Ceiling', *A. Bull.*, xxxii (1951), pp. 15–145, 181–218
——: 'Pagnini, Vigerio and the Sistine Ceiling: A Reply', *A. Bull.*, xxxiii (1951), pp. 262–73
J. Wilde: 'The Decoration of the Sistine Chapel', *Proc. Brit. Acad.*, xliv (1958), pp. 61–82
E. Wind: 'Maccabean Histories in the Sistine Ceiling', *Italian Renaissance Studies* (London, 1960), pp. 312–27
S. Sandström: *Levels of Unreality: Studies in Structure and Construction in Italian Mural Painting during the Renaissance* (Stockholm, 1963)
S. Sinding-Larsen: 'A Re-reading of the Sistine Ceiling', *Acta Archaeol. & A. Historiam Pertinentia (Institutum Romanum Norvegiae)*, iv (1969)
C. J. Seymour: *Michelangelo: The Sistine Chapel*, Critical Studies in Art History (London, 1972), pp. 143–58
R. Kuhn: *Michelangelo: Die Sixtinische Decke: Beiträge über ihre Quellen und ihre Auslegung* (Berlin, 1975)
D. Freedberg and C. Hope: 'Structuralism and Michelangelo', *TLS* (22 April 1977), pp. 489–90
E. R. Leach: 'Michelangelo's Genesis: Structuralist Comments on the Paintings on the Sistine Chapel Ceiling', *TLS* (18 March 1977), pp. 311–13
E. G. Dotson: 'An Augustinian Interpretation of Michelangelo's Sistine Ceiling', *A. Bull.*, lxi (1979), pp. 223–56, 405–29
M. Hirst: '*Il modo delle attitudini*: Michelangelo's Oxford Sketchbook for the Ceiling', *The Sistine Chapel: Michelangelo Rediscovered*, ed. A. Chastel (London, 1986), pp. 208–17
F. Mancinelli: 'Michelangelo at Work', *The Sistine Chapel: Michelangelo Rediscovered*, ed. A. Chastel (London, 1986), pp. 218–59

W. E. Wallace: 'Michelangelo's Assistants in the Sistine Chapel', *Gaz. B.-A.*, cx (May–June 1987), pp. 203–16

M. Bull: 'The Iconography of the Sistine Chapel', *Burl. Mag.*, cxxx (1988), pp. 597–605

K. Weil-Garris Brandt: 'The Early Projects for Michelangelo's Sistine Ceiling: Their Practical and Artistic Consequences', *Michelangelo Drawings* (Washington, 1992), pp. 57–87

The Sistine Chapel: A Glorious Restoration (London, 1993)

P. De Vecchi: *The Sistine Chapel: A Glorious Restoration* (New York, 1994)

LAST JUDGEMENT

L. Dolce: *Dialogo della pittura intitolato l'Aretino* (Venice, 1557); repr. in P. Barocchi, ed.: *Trattati d'arte del cinquecento*, i (Bari, 1960); Eng. trans. by M. W. Roskill in *Dolce's 'Aretino' and Venetian Art Theory of the Cinquecento* (New York, 1968)

G. A. Gilio da Fabriano: *Due dialoghi di M. Andrea Gilio da Fabriano* (Camerino, 1564); repr. in P. Barocchi, ed.: *Trattati d'arte del cinquecento*, ii (Bari, 1961)

G. P. Lomazzo: *Idea del tempio della pittura* (Milan, 1590)

F. La Cava: *Il volto di Michelangelo scoperto in 'Giudizio finale': Un dramma psicologico in un ritratto simbolico* (Bologna, 1925)

J. Wilde: 'Der ursprüngliche Plan Michelangelos zum Jüngsten Gericht', *Graph. Kst.*, n. s. 1, i (1936), pp. 7–20

D. Redig de Campos and B. Biagetti: *Il 'Giudizio universale' di Michelangelo*, 2 vols (1943), vii of *Monumenti vaticani di archeologia e d'arte* (Rome)

D. Redig de Campos: *Il 'Giudizio universale' di Michelangelo* (Milan, 1975)

L. Steinberg: 'Michelangelo's *Last Judgement* as Merciful Heresy', *A. America*, lxiii (1975), pp. 48–63

M. Hall: 'Michelangelo's *Last Judgment*: Resurrection of the Body and Predestination', *A. Bull.*, lviii (1976), pp. 85–92

E. Talamo: 'La controriforma interpreta la Sistina di Michelangelo', *Stor. A.*, 1 (1984), pp. 7–26

B. Barnes: 'A Lost Modello for Michelangelo's *Last Judgement*', *Master Drgs*, xxv (1988), pp. 239–48

J. Greenstein: '"How Glorious the Second Coming of Christ": Michelangelo's *Last Judgment* and the Transfiguration', *Artibus & Hist.*, x/19 (1989), pp. 33–57

B. Wyss: 'The *Last Judgment* as Artistic Process: The *Flaying of Marsyas* in the Sistine Chapel', *Res*, 28 (1995), pp. 62–77

PAULINE CHAPEL

D. Redig de Campos: 'La "terza maniera" di Michelangelo nella Cappella Paolina', *Illus. Vatic.*, vii (1936), pp. 212–16

H. van Dam van Isselt: 'Sulla iconografia della *Conversione di Saulo* di Michelangelo', *Boll. A.*, xxxvii (1952), pp. 315–19

L. Steinberg: *Michelangelo's Last Paintings* (Oxford, 1975)

W. E. Wallace: 'Narrative and Religious Expression in Michelangelo's Pauline Chapel', *Artibus & Hist.*, x/19 (1989), pp. 107–12

ANTHONY HUGHES

3. DRAWING. On a sheet of studies containing sketches by his assistant Antonio Mini (*d* 1533), datable to *c.* 1524 (London, BM), Michelangelo wrote, 'Draw Antonio, draw and do not waste time'. This was more than conventional workshop wisdom. Michelangelo himself drew tirelessly, and his draughtsmanship acquired exemplary status for his contemporaries, especially for those who held *disegno* to be the foundational principle of all art. The drawings have become equally important to subsequent critical and historical assessment of the artist because, unlike work in other media, which was often interrupted or left incomplete, they provide a nearly continuous record of Michelangelo's activity.

Initially, as for other artists, drawing was a means of education. In the Ghirlandaio workshop Michelangelo learnt the language of Florentine draughtsmanship. Little survives from the earliest stage of his activity, although two pen drawings after frescoes in Santa Croce, Florence, by Giotto (Paris, Louvre) and in S Maria del Carmine, Florence, by Masaccio (Munich, Staatl. Graph. Samml.) seem to date from the artist's adolescence and demonstrate

both how firmly rooted in the Tuscan past Michelangelo's practice was and how quickly he developed an incisive analytical critique of his native tradition.

That process presumably continued well beyond adolescence. Judging by the wealth of adaptation and reference in the artist's mature work, it must have involved drawing from the Antique, although direct trace of this is relatively rare in the surviving record. Vasari testified that Michelangelo burnt a great number of sheets towards the end of his life, because he did not want anyone to know what pains he had taken. Evidence of self-education may have been among these losses. Interesting survivals are various leaves (Florence, Uffizi; London, BM) that show the novice architect copying details of ancient buildings from drawings included in the Codex Coner (London, Soane Mus.). From surviving examples it seems that Michelangelo used drawing almost exclusively in connection with professional needs. Nothing in his output resembles Leonardo's encyclopedic researches. Although, according to Condivi, he planned to illustrate a textbook of anatomy by Realdo Colombo (*c.* 1510–59), the project never materialized, and there is no reason to suppose that Michelangelo's own anatomical dissections concerned anything more than musculature and the articulation of the skeleton. Even by conventional standards his interests as a draughtsman were narrow. He remained incurious about landscape, and only two portraits are recorded, of which perhaps one survives of *Andrea Quaratesi* (London, BM; see fig. 7). The total effect of his drawn work is one of strict dedication.

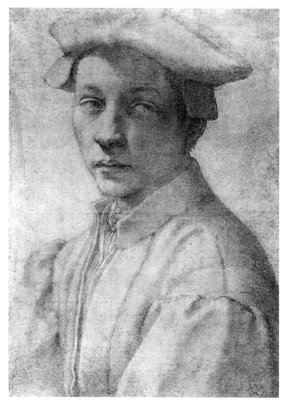

7. Michelangelo: *Andrea Quaratesi*, black chalk, 411×292 mm, 1531 (London, British Museum)

Strictness does not imply monotony. Within his chosen area, approaches were richly varied. Drawings from almost every stage of the compositional process survive, from slight sketches to cartoons (London, BM; Naples, Capodimonte). Most of them are working sheets; on many he appears to have experimented with ideas for several projects almost simultaneously (e.g. Oxford, Ashmolean). Words and images are juxtaposed on some sheets, and some have an almost palimpsest-like character inviting, and rewarding, the most painstaking detective work. There is a tendency to exaggerate the degree to which stylistically they are the product of a sculptor's conception of form. Certainly some are textured with vigorous cross-hatchings, resembling marks left by claw chisels on stone (e.g. Berenson, fig. 657). A dramatic example is the powerful study for the *Risen Christ* (*c.* 1514; London, Brinsley Ford priv. col.; see Hirst, 1988, pl. 131). However if this articulation of the figure derived from a carver's need to map each plane and hollow as bone and muscle play beneath skin, the same impulse had surprising consequences elsewhere. The red chalk study of the *Libyan Sibyl* for the Sistine Chapel Ceiling (New York, Met.; see colour pl. 2, VII1) impresses as much by its luminosity as by its formidable analysis of structure. Part of the effect is due to the relief-like conception of the back, shallowly raked with light. It was achieved, however, by small variations of pressure, clotting or dispersing the red chalk. Saturated colour plays against barely marked areas of paper. Descriptions indicate that the cartoon for the *Battle of Cascina* (destr.) was rich in comparable subtleties of handling observable in some of the surviving preliminary studies for it (London, BM; Oxford, Ashmolean). Such painterly use of chalk may have been stimulated by Leonardo's example. Michelangelo's wash drawings, however, developed from a workshop training shared by Florentine contemporaries. Most of the surviving examples are for architectural projects, but a delicate drapery study for the *Erythrean Sibyl* (London, BM) from the ceiling of the Sistine Chapel may represent a number of lost figurative works. In general, Michelangelo's later drawings are more densely atmospheric. Rubbed black chalk, grey wash and white heightening were often superimposed to blur the sharpness of even measured architectural designs. Function seems to have been forgotten in the drive to make self-sufficient artefacts.

Already during his lifetime Michelangelo's reputation was so great that his slightest sketches became collectors' items. The artist himself often used drawings as a form of diplomatic gift, to seal friendships or to show devotion to social superiors. Discarded preliminary studies or new compositional designs were given to Sebastiano del Piombo, Pontormo, Daniele da Volterra and others to realize as paintings. A design for a salt-cellar (1537; London, BM) was prepared for Francesco Maria I, Duke of Urbino (*see* ROVERE, DELLA, (3)), heir of Julius II, a gift designed to signal Michelangelo's intention to finish the tomb of his relative. More characteristic were the 'presentation drawings' made for Tommaso de' Cavalieri (for illustration *see* PRESENTATION DRAWING) and VITTORIA COLONNA (e.g. London, BM; Boston, MA, Isabella Stewart-Gardner Mus.). These highly worked sheets were offered, with letters and poems, as tokens of courtly love. Although those addressed to Cavalieri seem today among the most enigmatic examples of Michelangelo's art, they were not essentially private documents and quickly became well known through copies, engravings and gem-carvings.

During the 20th century acceptance or rejection of these presentation drawings as the work of Michelangelo became an indicator of shifting views on his artistic personality. For writers in the early part of the century, who believed such daintiness uncharacteristic of Michelangelo, they were regarded as copies of lost originals. Berenson even removed from the oeuvre preliminary studies that bore formal resemblances to the Cavalieri drawings. Following Wilde, most modern connoisseurs have accepted the status of these sheets, emphasizing the variety and richness of Michelangelo's achievement; only Perrig retains an exceptionally sceptical position.

BIBLIOGRAPHY

B. Berenson: *The Drawings of the Florentine Painters*, 3 vols (London, 1903, Chicago and London, 2/1938)

K. Frey: *Die Handzeichnungen Michelagniolos Buonarroti*, 3 vols (Berlin, 1909–11)

H. Thode: *Michelangelo: Kritische Untersuchungen über seine Werke: Verzeichnis der Zeichnungen, Kartons und Modelle*, 3 vols (Berlin, 1913)

A. E. Popham and J. Wilde: *The Italian Drawings of the XV and XVI Centuries . . . at Windsor Castle* (London, 1949)

J. Wilde: *Italian Drawings in the Department of Prints and Drawings in the British Museum: Michelangelo and his School* (London, 1953)

P. Barocchi: *Michelangelo e la sua scuola: I disegni di Casa Buonarroti e degli Uffizi*, Accademia Toscana di Scienza e Lettere, 'La Columbaria', Studi, viii, 2 vols (Florence, 1962)

——: *Michelangelo e la sua scuola: I disegni del Archivio Buonarroti*, Accademia Toscana di Scienza e Lettere, 'La Columbaria', Studi, viii (Florence, 1964)

F. Hartt: *The Drawings of Michelangelo* (London, 1971)

Drawings by Michelangelo from English Collections (exh. cat. by J. A. Gere and N. Turner, London, BM, 1975)

C. de Tolnay: *Corpus dei disegni di Michelangelo*, 4 vols (Novara, 1975–80)

A. Perrig: *Michelangelo-Studien* (Frankfurt am Main, 1976–7); Eng. trans. by M. Joyce as *Michelangelo's Drawings: The Science of Attribution* (New Haven, [1991])

P. d. Poggetto: *I disegni murali di Michelangiolo e della sua scuola nella Sagrestia Nuova di San Lorenzo* (Florence, 1978)

C. Elam: 'The Mural Drawings in Michelangelo's New Sacristy', *Burl. Mag.*, cxxiii (1981), pp. 593–602

M. Hirst: *Michelangelo and his Drawings* (New Haven and London, 1988)

J. Roberts: *A Dictionary of Michelangelo's Watermarks* (Milan, 1988)

C. Fischer: 'Ghirlandaio and the Origins of Cross-hatching', *Florentine Drawing at the time of Lorenzo the Magnificent: Papers from a Colloquium held at the Villa Spelman: Florence, 1992*, pp. 245–53

C. H. Smyth, ed.: *Michelangelo Drawings*, Stud. Hist. A., 33, Center for Advanced Study in the Visual Arts, Symposium Papers, xvii (Washington, DC, 1992)

L. Bardeschi Ciulich: 'I marmi di Michelangelo', *La difficile eredità: Architettura a Firenze dalla Repubblica all'assedio*, ed. M. Dezzi Bardeschi (Florence, 1994), pp. 100–105

P. Joannides: 'Bodies in the Trees: A Mass Martyrdom by Michelangelo', *Apollo*, cxl/393 (1994), pp. 3–14

——: 'A Drawing by Michelangelo for the Lantern of St Peter's', *Apollo*, cxlii/405 (1995), pp. 3–6

W. E. Wallace: 'Instruction and Originality in Michelangelo's Drawings', *Craft of Art: Originality and Industry in the Italian Renaissance and Baroque Workshop*, ed. A. Ladis, C. Wood and W. U. Eiland (Athens, GA, and London, 1995), pp. 113–33

Michelangelo and his Influence: Drawings from Windsor Castle (exh. cat. by P. Joannides, Washington, N.G.A., and elsewhere, 1996–8)

ANTHONY HUGHES

4. ARCHITECTURE. The myth of Michelangelo's reluctance to take on architectural commissions was coloured by his retrospective shame at the 'tragedy of the tomb' of

Julius II (*see* §1(ii) above). In fact, Michelangelo actively manoeuvred to obtain his first major architectural project—the façade of S Lorenzo, Florence—and from then on the design of buildings played an increasingly dominant role in his career. The originality of his architectural language, at a period when Vitruvianism was hardening into dogma, meant that, while his influence on subsequent architecture was profound, he was also blamed for fostering rule-breaking and licence.

(i) Projects in Rome and Florence for the Medici family, 1516–33. (ii) Work in Rome, 1534–64.

(i) Projects in Rome and Florence for the Medici family, 1516–33. Michelangelo's interest in architecture developed from designing complex monumental sculptural ensembles within a coherent architectonic framework. Indeed, the concept of architecture as a grid intended to set off sculpture, as in the Julius tomb, links all his early architectural designs. His first building, the marble façade (*c.* 1515–16) of Leo X's chapel at Castel Sant'Angelo, Rome, is like a pedimented wall tomb without sculpture, and it incorporates the niches, lions' heads and Medici devices found in other Leonine buildings. Leo's triumphal entry into Florence in November 1515 sparked off many architectural projects there, including the insertion (*c.* 1516) of pedimented windows designed by Michelangelo into the corner bays of the Palazzo Medici. Their elongated volute brackets supporting both lintel and sill introduced the fashion for 'kneeling windows' in 16th-century Florence.

(a) S Lorenzo façade. (b) New Sacristy. (c) Biblioteca Laurenziana. (d) Fortification designs.

(a) S Lorenzo façade. Leo's entry prompted thoughts of completing the Medici church of S Lorenzo (started 1418) with a marble façade decked in sculpture (*see* FLORENCE, §IV, 5). Many artists hoped for this commission, which in the winter of 1516 was awarded to Michelangelo in collaboration with BACCIO D'AGNOLO. It was initially intended that the lesser sculpture should be contracted out to others, but as Michelangelo gradually shed his collaborators, his ideas for the façade—envisaged as a 'mirror of all Italy for sculpture and architecture'—grew to unworkable proportions, and, although an agreement with Leo was signed (Jan 1518) and marble quarried (1517–20), the project was shelved by March 1520.

Elevation drawings and some plans survive (*Corpus*, 496–510) as evidence of Michelangelo's successive ideas for the façade. An early idea (Florence, Casa Buonarroti, 45A; *Corpus*, 497*r*) envisaged a two-storey central section with recessed bays for the side doors and high tabernacles over the side chapels. A modified version of this modello, known from copies, probably formed the basis for an initial agreement with the Pope in Rome in December 1516, and for a wooden model (destr.) by Baccio d'Agnolo. By mid-January Michelangelo's second thoughts (*Corpus*, 498*r*) led him towards a more regular rhythm; in March he sacked Baccio and started again from scratch, making a terracotta sketch model of a more ambitious design, embodied in the wooden model (Florence, Casa Buonarroti) presented to the Pope in December. The façade had

now become an immense two-storey screen with single-bay projections at the sides. Vastly more expensive, it involved over 40 pieces of sculpture. It was not built, however, because the structural problems would have been considerable. The detailed vocabulary of the wooden model is relatively conventional, but embodies qualities that were to endure in Michelangelo's architecture—respect for vertical and horizontal continuity and the use of overlapping elements and receding planes, producing a complex and enriched silhouette. The orders are laid against plain pilaster strips, at one remove from the wall, an effect that was fundamental to Michelangelo's architectural thinking.

(b) New Sacristy. The New Sacristy (1519–33; see colour pl. 2, V1) of S Lorenzo, Florence, and the Biblioteca Laurenziana (begun *c.* 1524; see fig. 8) were singled out by Vasari as marking a conscious break with ancient and modern tradition in their use of licentious non-Vitruvian detail. Both projects were conceived by Cardinal Giulio de' Medici (later Pope Clement VII) in summer 1519, although the designs for the library were not produced for another five years (*see* MEDICI, DE', (8)). The New Sacristy was to house the tombs of the recently deceased Medici dukes Lorenzo of Urbino (*d* 1516; see fig. 4) and Giuliano of Nemours (*d* 1519)—the *Capitani*—and their 15th-century forebears Giuliano (*d* 1478) and Lorenzo (*d* 1492) de' Medici—the *Magnifici*. Intermittent plans to introduce additional tombs for the Medici popes were not realized. Again, a large sculptural component was involved. The new chapel was to balance Brunelleschi's Old Sacristy (1421–8; *see* BRUNELLESCHI, FILIPPO, fig. 2) opposite, and its exterior treatment matches the levels and detailing of the 15th-century transept. For the plan and interior elevation, Michelangelo's starting-point was also the Old Sacristy, but he introduced an intermediate level with tabernacle windows, arches and pilasters between the main order and the pendentive zone.

Work began in autumn 1519, and by April 1521 the first interior order was largely in place. The pace of construction slackened after Leo's death that year, but picked up after Clement's election in 1523. In 1525 the exterior was crowned by the innovative marble lantern with its lively broken silhouette and faceted bronze ball, deliberately varied by Michelangelo from the 15th-century example on Florence Cathedral. The marble ornament of the interior was begun in 1524, with the construction of the tombs of the *Capitani* and the doors and tabernacles in the corners. The *Magnifici* tomb opposite the altar was never finished, nor was the sculptural programme, which remained incomplete when Michelangelo moved definitively to Rome in 1534 (*see* §1(iii) above).

The rapid development of Michelangelo's architectural language in these years can be traced in the successive elements of the interior architecture. The *pietra serena* articulation of the first two levels draws on Florentine tradition, but with the layering effect first used on the S Lorenzo façade model. Above the second cornice the more adventurous tabernacle windows with their upwardly converging frames show Michelangelo improvising from an antique motif: the Temple of the Sibyl at Tivoli (2nd century BC). The wholly unorthodox marble architecture

of the tombs and doors seems deliberately contrasted with the sober grey stone pilasters between which it is squeezed. In extending the sacristy upwards to bring in more light (see Elam, 1979) Michelangelo did not entirely succeed in unifying the interior space, which remains rather box-like and planar, but its wealth of invention in detail makes it a pioneering if awkward building (*see also* MANNERISM, §3(iii)).

(*c*) *Biblioteca Laurenziana.* When Cardinal Giulio was elected to the papacy in November 1523, he commissioned Michelangelo to design at S Lorenzo a public library, the Biblioteca Laurenziana, to house the library of his uncle Lorenzo the Magnificent. The result was one of the most beautiful and coherent interior spaces in Western architecture (the reading room) and a vestibule (*ricetto*) that continues to inspire both controversy and artistic emulation.

After various sites had been considered, it was decided to build the library above the west range of the canons' cloister, with an entrance on the upper level. A system of arches supported by stone piers built up from ground level was inserted to support the new structure; the blind arcading (visible at the rear) does not (*pace* Ackerman) determine the rhythm of the window bays. The reading room, complete with its stone membering, was built in 1525, followed by the lower levels of the entrance vestibule. As at the New Sacristy, building was interrupted by the Medici expulsion from Florence in 1527 and the siege of 1529–30. After a flurry of activity in 1533, Michelangelo departed for Rome, again leaving the work unfinished. Under Grand Duke Cosimo I (*see* MEDICI, DE', (14)), most of the missing pieces were filled in, Niccolò Tribolo and Santi Buglioni (*see* BUGLIONI, (2)) making the floor of the reading room (1549–53), Bartolomeo Ammanati building the staircase (1559–62) in consultation with Michelangelo and Vasari supervising the completion of the desks and ceiling. The exterior windows of the vestibule are an early 20th-century pastiche.

The patron was discriminating, demanding and absent; thus we can follow the library's design through letters and drawings (*Corpus*, 523–62), and see how Clement spurred Michelangelo on to unusually inventive solutions. For the reading room ceiling, Clement wanted 'some new idea', asking Michelangelo to avoid the standard deep coffering found in contemporary Roman interiors. Clement said of Michelangelo's design for the library entrance door that 'he had never seen one more beautiful, neither antique nor modern'. He rejected, however, Michelangelo's suggestion of lighting the vestibule with round skylights, which,

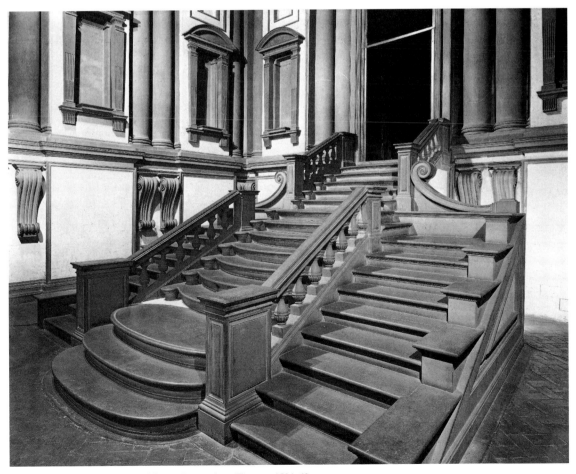

8. Michelangelo: vestibule of the Biblioteca Laurenziana, Florence, 1524–62

although 'beautiful and novel', would have required incessant cleaning.

The reading room interior is one of Michelangelo's most lucid and rigorous designs. The pilaster articulation of the walls begins just above the level of the desks, which thereby provide visual 'support' for the order. The wide central and narrow outer bays of the short walls are reflected in the tripartite divisions of the ceiling, in turn echoed in Tribolo's pavement. The layering of the walls, whereby the windows and blind tabernacles are set into recessed panels, is matched by the subtle recessions of the ceiling. The detailing is outstandingly crisp and lively.

The Pope's unwillingness to entertain the idea of skylights in the vestibule did not entail a change in the proportions and detail of the main order—for the stone membering was already arriving by that date—but it did mean that an upper order to accommodate windows had to be inserted (begun 1533/4). A series of drawings shows Michelangelo working towards the bizarre articulation, with its embedded columns flanking sections of wall that break forward into the room, themselves hollowed out by empty tabernacles. Giant ornamental volutes hang 'like dewdrops' (Wittkower) below the columns. The tabernacle surrounds take the abstract licence of the New Sacristy door bays one stage further, while the capitals of the recessed columns were described in Michelangelo's lifetime as a composite Doric (see §IV, 2 below)—a reading supported by isolated elements of the Doric order, triglyphs and guttae, which punctuate the herm-like frames. The vestibule's function was to house the stairs bridging the level between the upper cloister and the reading room (see fig. 8). After experimenting with double-ramp stairs like those of the Villa Medici at Poggio a Caiano, and with combinations of convex and concave as at the Vatican Belvedere, Michelangelo hit on the notion of three flights meeting and fusing into one at a central landing. The central flight is a series of 'overlapping oval boxes' as Michelangelo himself wrote of it, flanked by side 'wings' (for servants when the central flight was being ceremonially used). As built by Ammanati, the stairs diverge slightly from Michelangelo's intentions, but retain the flowing, dream-like invention evident in his description. The vestibule has been seen as the epitome of Michelangelo's Mannerist architectural style. Although Vasari spoke of its 'resolved grace' in the whole and the parts, subsequent commentators have been disturbed by its tall, cavernous proportions, the compressed tension of the paired columns and the apparently arbitrary detail. Wittkower analysed the vestibule's forms in terms of irreconcilable conflict, ambiguity and inversion, although, as Ackerman pointed out, the recessed columns are in fact more functional than many applied orders of the High Renaissance. It is likely that Michelangelo derived the idea of using large monolithic columns from Giuliano da Sangallo's Sacristy vestibule (begun 1492) at Santo Spirito, Florence, and recessed them to reduce the weight on the chapter house below. But no functionalist analysis can explain away the deliberately fantastic qualities of the vestibule.

The rare-books room planned to open off the opposite end of the reading room from the vestibule was never built, but is recorded in two drawings of 1525 (*Corpus*, 559*r*, 560*r*). The triangular design is a link between Michelangelo's work on the library and his fortification designs for the Florentine government three years later.

(d) Fortification designs. During the short-lived Republican government of 1527–30, Michelangelo, whose political sympathies were guardedly republican despite his close ties to the Medici pope, was ready to harness his design skills to modernizing the city's medieval defences (see FLORENCE, §I, 2). In April 1529 he was appointed governor general of the city's fortifications, and supervised the construction of bastions and bulwarks (destr.). In late September, despairing of the outcome of the war, he fled to Venice and was declared a rebel. Induced to return in October, he resumed his work in a city now under siege to papal and imperial forces. Michelangelo's fortifications were constructed of earth faced with unbaked bricks, and although the whole circuit of walls was strengthened in this way, more is known of his work at S Miniato and the southern circuit, whereas the magnificent series of surviving drawings in the Casa Buonarroti (*Corpus*, 563*r*–83*v*) concentrate mostly on the northern perimeter. The complexity and impracticality of these designs suggests they were not intended for rapid construction under pressure in 1529, but are proposals drawn up the previous year. They are among the most exciting architectural drawings that Michelangelo ever produced—both in their dynamic response to the needs of modern defence against artillery, and in the extraordinary forms themselves. Making them seems to have aided Michelangelo's development from a planar to a plastic conception of architectural space, from a static to a dynamic architecture. In them he incorporated the curving double volutes and dislocated outlines—which up to now had been applied to the wall as sculptural ornament—into spatial solutions. This more liberated approach to space found its consummation in Michelangelo's last works in Rome.

(ii) Works in Rome, 1534–64. Uncomfortable in the new Medici ducal regime in Florence, Michelangelo moved permanently to Rome in 1534. Here two popes in particular—Paul III and Pius IV—had the imagination to entrust him with architectural projects of the greatest importance.

(a) Piazza del Campidoglio. (b) St Peter's. (c) Palazzo Farnese. (d) S Giovanni dei Fiorentini and the Sforza Chapel. (e) S Maria degli Angeli and the Porta Pia.

(a) Piazza del Campidoglio. Redesigning the Piazza del Campidoglio on the Capitoline Hill was one of Michelangelo's most successful architectural achievements and one of the most perfectly realized examples of Renaissance urban planning (see fig. 9). Although the project was only partially completed in his lifetime, the engravings published by Etienne Dupérac (*c.* 1525–1601) in 1568 and 1569 made it possible in later centuries to follow the general lines of his design.

Initially Michelangelo was asked to design a base for the ancient equestrian statue of the Roman emperor *Marcus Aurelius*, which Paul III had moved from the Lateran to the Capitoline in 1538. His choice of an oval base is echoed in the oval pavement (from 1561), and

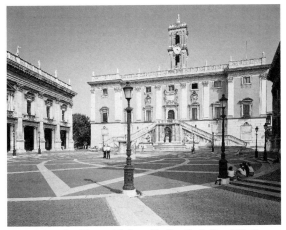

9. Michelangelo: Piazza del Campidoglio, Capitoline Hill, Rome, showing (right) the façade of the Palazzo dei Conservatori (after 1561), with (left) the Palazzo Nuovo (built 1603–60 to the same design) and (centre) the staircase to the Palazzo Senatorio (1544–52); from an early 20th-century photograph

Ackerman argued that Michelangelo produced the designs for the whole piazza, including the façade of the Palazzo dei Conservatori, at this early date, although the latter was not executed until after 1561. Certainly the triangular, double-ramp staircase in front of the Palazzo Senatorio (rest. 1984) was carried out in 1544–52, but it would have been uncharacteristic for Michelangelo to adhere to fixed overall designs for over 30 years. After the election of Pius IV in 1559, the monumental stairway ramp (*cordonata*) up to the Piazza del Campidoglio was built and the oval steps around the piazza put in place. The year before Michelangelo's death, the façade of the Palazzo dei Conservatori was started according to a new set of drawings produced under his supervision, and the building was completed (1568–84) by GIACOMO DELLA PORTA. The construction of a palazzo of the same design across the square, the Palazzo Nuovo, which established the symmetry of the composition, followed in 1603–60.

The Palazzo dei Conservatori's giant order of Corinthian pilasters on high pedestals gives the façade its immensely powerful character, culminating in a sculpture-crowned balustrade, which dissolves the skyline. A minor order of Ionic columns on the ground floor supports monolithic stone beams, the wide intercolumniations producing effects of dense shadow. The composition is a dramatic opposition of verticals and horizontals, in which the pilaster order is laid like a grid over wider brick piers that form the structural support. Few Renaissance buildings convey such a powerful sense of structural forces at work.

As completed according to Michelangelo's design, the trapezoidal piazza has strictly symmetrical flanking façades and an oval central space and statue podium, which serve to divert circulation to left and right towards the Palazzo Senatorio staircase. The pattern on the pavement tends to magnify the effect of the statue. It illustrates Michelangelo's firmly held belief in bilateral symmetry around a prominently marked central axis, affirmed in a celebrated letter (untraced), which states that 'the central elements are always free', but that corresponding parts of a plan must be identical, just as 'one hand is obliged to be like the other' in the human body.

(b) St Peter's. Michelangelo's work at St Peter's is unquestionably the crowing achievement of his architectural career. When he was appointed chief architect by Paul III in November 1546, succeeding Antonio da Sangallo (ii), it seemed to Ascanio Condivi that Judgement Day would come sooner than the completion of the basilica. Since Bramante's first designs of 1506 (*see* ROME, fig. 5), half a dozen architects had worked under five successive popes, all bringing their own revisions with them (*see* ROME, §V, 1(ii)). In the 18 remaining years of his life Michelangelo succeeded in 'uniting into a whole the great body of that machine' (Vasari), ensuring that the crossing and dome would follow his overall design, even though the façade and nave remained unresolved.

Soon after his appointment, Michelangelo outlined in a letter his objections to Sangallo's model, praising Bramante's 'clear, pure and luminous' plan and attacking Sangallo's proposed high ambulatories, which would have deprived the crossing of light. His radical plans for reducing and unifying the building were initially outlined in successive models of terracotta and wood (Millon and Smyth, 1976), then put swiftly into execution. In 1547–8 the north arm walls were constructed; in the following two years the north arm was vaulted and the first and second orders of the south hemicycle erected. The drum was partially built in 1556–7, the southern hemicycle completed in 1557 and the north hemicycle up to the entablature followed in 1558–60 (the vault and attic facing are shown half-finished in an engraving of 1565).

To rationalize Bramante's plan, Michelangelo consolidated the main and subsidiary piers and removed the passages through the latter that had been created for the ambulatories, inserting spiral staircases instead. He demolished the external ambulatory ring and transformed Sangallo's inner transept arms into the external walls, clothing them on the exterior with a system that repeats the internal giant Corinthian order. The rhythm of wide and narrow bays of the exterior elevation is also derived from the interior, but given an added Michelangelesque tension by the multiplication of niches in the narrow bays and the characteristically complex layering of the order. Perhaps most brilliant is the way in which, to make the transition between the rounded apses and the pointed corner chapels, Michelangelo as it were drew between them a diagonal curtain, which both consolidated and unified the plan. Nowhere in his architecture are the expressive results of his habit of squeezing and shaping architectural models out of terracotta to be felt so strongly.

Erection of the present attic facing with its clustered pilaster strips and bizarre detailing began in 1565, the year after Michelangelo's death, and is visible in Dupérac's engraving of 1569 which purports to convey his design (*see* ROME, fig. 6). Behind the attic walls of the transepts are the highly innovative gored vaults of the apses, their three curves swelling out behind the ribs. To Michelangelo's mortification, the foreman on site misunderstood the novel stereometry of the vault, despite the existence of a model, and a great number of stones had to be

removed. Michelangelo wrote to Vasari that the error had occurred because his age made frequent visits to the site impossible.

The cupola was probably not included on Michelangelo's 1547 model, and it was not until 1558 that the carpenters began work on the larger-scale model (1:5; Rome, Vatican, Mus. Stor. A. Tesoro S Pietro) for the drum and dome, which Michelangelo justifiably felt to be the last task of his life (he was then 83). Whereas Bramante and Antonio da Sangallo (ii) had favoured an *all'antica* single-shell dome, Michelangelo's was to be composed of two hemispherical shells. His starting-point for the double shell—and the design in general—was Brunelleschi's cupola of Florence Cathedral (he had made an unexecuted project *c.* 1520 for the completion of its drum; Saalman, 1978). Even closer to Brunelleschi's cupola (*see* BRUNELLESCHI, FILIPPO, fig. 1) was Giacomo della Porta's dome as built, with its pointed profile, but despite the changes he introduced he retained most of the salient features of Michelangelo's concept. Particularly impressive is the vertical correspondence of the 16-sided lantern and drum, connected by the emphatic ribs of the dome.

Michelangelo's plans for the façade are unclear, and the east arm of the basilica remained untouched during his lifetime. Certainly the screen façade (1607–14) by Carlo Maderno (1555/6–1629) and the longitudinal nave behind it have destroyed the unity of Michelangelo's plan. Only from the Vatican gardens is it possible to experience the extraordinary organic power of Michelangelo's design, the

massive verticals of the giant order continued up through attic and drum to lantern, the undulating rhythms of the great slow curtain pulled around the apses.

(c) Palazzo Farnese. Michelangelo also took over from Antonio da Sangallo (ii) as architect to Paul III at the Palazzo Farnese, despite the bitter opposition of Sangallo's relatives and supporters (*see* ROME, §V, 7 and PALAZZO, fig. 2; *see also* SANGALLO, DA, (4), fig. 2). At the Palazzo Farnese, Michelangelo gave the decisive final direction to the exterior cornice and to the upper levels of the courtyard (see fig. 10). The design for the cornice was tested in March 1547 in the form of a full-scale wooden model of one corner hoisted into position. It was strongly attacked by Battista da Sangallo for its failure to accord with Vitruvian proportions and ancient practice. With its frieze of Farnese lilies alternating with acanthus, its dentils, egg and dart and thickly set lions' heads, the cornice is indeed neither Doric, Ionic nor Corinthian, but gives a subtly variegated and powerful termination to Sangallo's façade. Above the central doorway Michelangelo replaced Sangallo's double-arched window with a straight entablature crowned by a gigantic Farnese coat of arms.

In the third order of the courtyard, Michelangelo demonstrated how distant his sensibility was from that of Sangallo. A light order of clustered Corinthian pilasters on high pedestals supports an entablature studded with grinning masks and misplaced triglyphs, while the windows themselves continue the mode of fragmentation and

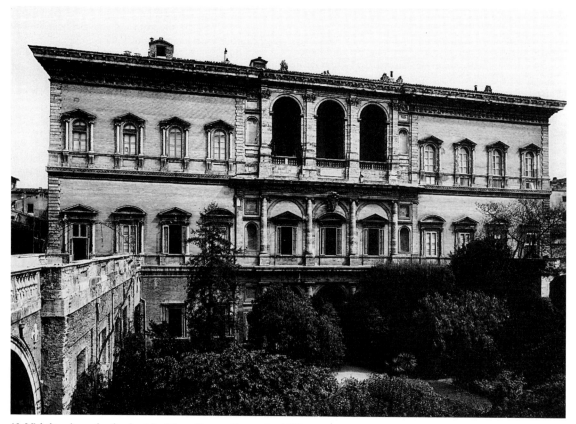

10. Michelangelo: garden façade of the Palazzo Farnese, Rome, after 1547

dislocation found in the Medici Chapel: scaly triglyph brackets slip down the frames to be replaced by bucrania, while the pediment floats above brackets detached from the lintel below.

(d) S Giovanni dei Fiorentini and the Sforza Chapel. In 1559 Michelangelo was asked by the Florentine community in Rome to make fresh designs for their church of S Giovanni dei Fiorentini, begun *c.* 1519 by Jacopo Sansovino and Antonio da Sangallo (ii), but abandoned thereafter. The aging artist agreed, on the condition that he could leave the final drawings and models to others. After one of his five designs had been selected, Antonio Calcagni prepared models in terracotta and wood (the latter destr. 1720; known from engravings), and began to direct the works. In 1562 Michelangelo was replaced, and no further work was done. Michelangelo's designs survive in large pen and wash drawings in the Casa Buonarroti (*Corpus*, 608–12). He seems to have had access to early unexecuted projects by Antonio da Sangallo (ii) and Baldassare Peruzzi, and he returned to the idea of a centralized plan, which was appropriate for a Florentine baptismal church. Perhaps the most original of the surviving designs (*Corpus*, 610) is an octagon or blunted diamond, with semicircular chapels in the corners and diagonally placed piers, which sets up a dynamic of strongly conflicting axes, emphasized in the drawing by construction lines and by four human eyes drawn in to represent the four principal views.

The chosen design (*Corpus*, 612) is redolent of St Peter's in its use of massive masonry piers of irregular contour and softened exterior transitions. From a central circle spokes of space radiate, terminated by oval and rectangular chapels. In the final version represented by the model, the inner ring of paired columns was pushed out and attached to the eight piers. The exterior was to be simply articulated with pilasters at the lower level, while the drum and dome were apparently to be left bare. Inside, however, the detailing is shown as rich, with the verticals of the superimposed orders continued up into the coffering of the dome. The angled window embrasures are very striking, directing light down into the central space as at the New Sacristy of S Lorenzo. Michelangelo's drawings for S Giovanni dei Fiorentini represent his architectural thinking at its most advanced, providing a starting-point for the radical spatial innovations of Francesco Borromini in the next century.

The same is true of the burial chapel (1561–4) he designed for the Sforza family off the nave of S Maria Maggiore, Rome (*see* ROME, §V, 5). Although Michelangelo was not involved in its execution (and some of the detailing is patently not his), the chapel as built owes everything to his vision. The tombs are placed in niches shaped from gently curving concave arcs, and the vault is supported by four columns pushed diagonally out from the piers into the central space, creating an almost explosive spatial experience in a chapel of modest dimensions.

(e) S Maria degli Angeli and the Porta Pia. As part of his urban improvements to this area of Rome, Pope Pius IV took up the campaign of a Sicilian visionary Antonio del Duca (brother of the architect Giacomo del Duca) that a part of the ancient Baths of Diocletian (AD 298–306)

should be re-dedicated for Christian use. Michelangelo was called in to convert the *tepidarium* into the Carthusian church of S Maria degli Angeli (built from 1562). He oriented it north-east/south-west, with the main door and high altar on the short axis and long 'transepts' ending in side-entrances. His interventions were minimal. Because the original groin vaulting and the great rose-granite columns that supported it were largely intact, Michelangelo simply walled off the transepts from the rooms beyond, built a long barrel-vaulted choir behind the altar, whitewashed the vault and tiled the roof. The present opulent interior is the result of a major reworking by Luigi Vanvitelli (1700–73) in the 18th century, which obscures Michelangelo's intentions (for further discussion, *see* DUCA, (1)).

This intensely religious, reforming project went together with Michelangelo's most wilfully eccentric secular design, the Porta Pia (1561–4; *see* ITALY, fig. 10). The function of this city gate was to terminate the vista from the Quirinal to the Aurelian walls down Pius IV's new street the Strada Pia, which was then lined with villas and gardens. In it Michelangelo combined elements of Medieval and Renaissance city-gate tradition with ideas derived from garden and festival architecture, as well as his own rich invention. Thus joky castellation, remnants of rustication and the Doric order are used as metaphors for strength, while the main portal evolved through a series of extraordinary drawings (*Corpus*, 614–21), superimposing and metamorphosing one solution over and into another. The result is a compendium of all the most fantastic elements of Michelangelo's architectural vocabulary—broken pediments, swags, masks, displaced fragments of the orders, overlapping planes and juxtaposed façades and profiles.

There has been a temptation to see Michelangelo's late architecture as an expression of deepening religious feeling and resignation at the end of his life. The Porta Pia shows that in this last decade a tendency to simplification and spareness (as at S Giovanni dei Fiorentini and S Maria degli Angeli) could go alongside a reaffirmation of the most extremely licentious side of his architectural personality. The same contrasts can be seen at St Peter's.

BIBLIOGRAPHY

R. Wittkower: 'Michelangelo's Biblioteca Laurenziana', *A. Bull.*, xvi (1934), pp. 123–218; also in *Idea and Image* (London, 1978), pp. 11–71; review by P. Joannides in *Burl. Mag.*, cxxiii, pp. 620–22

H. Siebenhühner: *Das Kapitol in Rom: Idee und Gestalt* (Munich, 1954); review by J. Ackerman in *A. Bull.*, xxxviii (1956), pp. 53–7

J. Ackerman: *The Architecture of Michelangelo*, 2 vols (London, 1961, rev. 2/1986)

P. Portoghesi: 'Michelangelo fiorentino', *Quad. Ist. Stor. Archit.*, n. s., ii (1964), pp. 27–60

P. Portoghesi and B. Zevi, eds: *Michelangiolo architetto* (Turin, 1964)

G. de Angelis Ossat and C. Pietrangeli: *Il Campidoglio di Michelangelo* (Milan, 1965)

P. Portoghesi: 'Le strutture della Laurenziana', *Boll. Ingeg.*, 2/3 (1965), pp. 29–35

T. Buddensieg: 'Zum Statuenprogramm in Kapitolsplan Pauls III', *Z. Kstgesch.*, xxx (1969), pp. 177–238

D. Summers: 'Michelangelo on Architecture', *A. Bull.*, liv (1972), pp. 146–57

C. de Tolnay: 'I progetti di Michelangelo per la facciata di S Lorenzo a Firenze: Nuove ricerche', *Commentari*, xxiii/1–2 (1972), pp. 53–71

H. Millon and C. H. Smyth: 'A Design by Michelangelo for a City Gate: Further Notes on the Little Sketch', *Burl. Mag.*, cxvii (1975), pp. 162–6

C. de Tolnay: *Corpus dei disegni di Michelangelo*, 4 vols (Novara, 1975–80)

H. Millon and C. H. Smyth: 'Michelangelo and St Peter's: Observations on the Interior of the Apses, a Model of the Apse Vault and Related Drawings', *Rom. Jb. Kstgesch.*, xvi (1976), pp. 137–206

H. Saalman: 'Michelangelo and St Peter's: The Arborio Correspondence', *A. Bull.*, lx (1978), pp. 483–93

S. Sinding Larsen: 'The Laurenziana and Vestibule as a Functional Solution', *Acta Archaeol. & A. Historiam Pertinentia*, Institutum Romanum Norvegiae, viii (1978), pp. 213–22

C. Elam: 'The Site and Early Building History of Michelangelo's New Sacristy', *Mitt. Ksthist. Inst. Florenz*, xxiii (1979), pp. 155–86

R. Manetti: *Michelangiolo: Fortificazioni per l'assedio di Firenze* (Florence, 1980)

H. Thiess: *Michelangelo: Das Kapitol* (Florence, 1982)

M. Hirst: 'A Note on Michelangelo and the S Lorenzo Façade', *A. Bull.*, lxvii (1986), pp. 323–36

H. Millon and C. H. Smyth: *Michelangelo Architect: The Façade of S Lorenzo and the Cupola of St Peter's* (Washington, DC, 1988)

W. Wallace: 'The Lantern of Michelangelo's Medici Chapel', *Mitt. Ksthist. Inst. Florenz*, xxxiii (1989), pp. 17–36

G. C. Argan and B. Contardi: *Michelangelo architetto* (Milan, 1990); Eng. trans. by M. L. Grayson (New York, 1993)

H. Burns: 'Building Against Time: Renaissance Strategies to Secure Large Churches Against Changes to their Design', *L'église dans l'architecture de la Renaissance: Actes du Colloque: Tours, 1990* (Paris, 1995), pp. 107–31

C. Elam: 'Drawings as Documents: Michelangelo's Designs for the Façade of S Lorenzo', *Michelangelo Drawings*, ed. C. H. Smyth (Washington, DC, 1992)

A. Morrogh: 'The Palace of the Roman People: Michelangelo at the Palazzo dei Conservatori', *Röm. Jb. Bib. Hertz.*, xxix (1994), pp. 129–86

CAROLINE ELAM

II. Working methods and technique.

1. SCULPTURE. In sculpture, the expense and physical intractability of marble discourages flexible working methods. Here Michelangelo acted with the care and parsimony of any craftsman. He first made drawings and small models in wax or clay in order to clarify ideas for figures. Only when the design had been concluded did he send specifications for the block to the quarries. Measurements could be accompanied by diagrams, some indicating the form that was ultimately to be 'revealed' by the process of carving. He also spent several weeks at Carrara to ensure the choice of flawless blocks.

Roughing out was done by masons at the quarry; the extent of this process is debated, however. It has been suggested that only two of the four unfinished *Slaves* (Florence, Accad.) should be regarded as authentic (Kriegbaum, 1940), although most scholars see Michelangelo's work in all of them. The notion that he attacked a cube of stone aided only by inspiration is a romantic fallacy, as is the assertion, elaborated from brief accounts by Vasari and Benvenuto Cellini, that he invariably began carving on the front face of the block, only gradually exposing the flanks of the statue. Examination of surviving unfinished statues reveals that work proceeded according to the nature of the figure. Although the *St Matthew* (Florence, Accad.) does seem to have emerged almost as a relief carved from the front, the *Atlas Slave* (Florence, Accad.; see fig. 3 above), devised as a corner figure for the tomb of *Julius II*, was excavated from two adjacent faces of the block simultaneously.

These varied practices indicate that Michelangelo took the greatest pains to predetermine the appearance of his carvings. On at least one occasion, for the New Sacristy (Florence, S Lorenzo), he also made full-scale models for several of the figures. Only one such model, the *River God* (Florence, Accad.), has survived. Pressure to finish the decoration of the chapel may have forced him to act uncharacteristically in this instance since, during this period, he was also assisted by contemporaries including Raffaello da Montelupo and Niccolò Tribolo, who were contracted to carve figures under his direction. This episode in Michelangelo's career may have been unusual, but some degree of studio intervention should be assumed, especially in completed works. Finish was the responsibility of subordinates. When Sebastiano del Piombo wrote that Michelangelo's assistant Pietro Urbano had spoilt the *Risen Christ* (Rome, S Maria sopra Minerva) while giving it the final touches, he did not imply that it was unusual for Michelangelo to entrust the figure to an assistant, but that Urbano had done his job badly.

In spite of the evidence that Michelangelo carefully planned his work and was less unwilling to delegate than has been assumed, it is true that, even as a sculptor, he did alter plans. In parts of the *St Matthew* and the *Taddei Tondo* (London, RA) he deliberately allowed for the adjustment of contour, as might be expected of an experienced carver. There are indications of more radical changes elsewhere, however: in the New Sacristy, the figures of *Night* and *Day* do not fit the curve of the lid of Giuliano de' Medici's sarcophagus; the *Day* was carved from a block of different size from that of the other figures and the left arm of *Night* has been adjusted. From these indications, it has been argued that Michelangelo modified his designs as work proceeded.

A certain willingness to improvise seems to match the description of Michelangelo at work given by the 16th-century French writer Blaise de La Viginère, who vividly described the ferocity with which the artist assaulted the marble. The impression of recklessness, however, may be misleading. Blaise saw Michelangelo as an old man, working without commission. The reliability of this report has been questioned (Steinberg, 1968). It is possible that Blaise saw Michelangelo roughing out a new block. On the other hand his savage treatment of the two late sculptures of the Pietà may indicate that the Frenchman witnessed an expression of Michelangelo's dissatisfaction with himself, or, as hinted in one of the sonnets, with the limitations of his art. A contrary view, that Michelangelo was careless of finish even in his early maturity, has been proposed, based on observation of the forceful use of the chisel on the 'perilously thin skin' of the Taddei Tondo (Larson, 1991). The Tondo may not be a sound basis for generalization, however. Like the *Brutus* (Florence, Bargello) and the Rondanini *Pietà* (Milan, Castello Sforzesca), it was almost certainly worked on after Michelangelo abandoned it. In sculpture, as in painting, Michelangelo's standards of craftsmanship were high. Perhaps, as Vasari hinted, they proved too exacting to allow him to complete many works.

BIBLIOGRAPHY

B. Cellini: *Due trattati alle otto principali arti dell'oreficeria: L'altro in materia dell'arte della scultura* (Florence, 1568); Eng. trans. by C. R. Ashbee as *The Treatises of Benvenuto Cellini on Goldsmithing and Sculpture* (London, 1888/R New York, 1967)

B. de la Viginère: *Les Images ou tableaux de plate peinture* (Paris, 1579)

F. Kriegbaum: *Die Bildwerke* (Berlin, 1940)

L. Goldscheider: *A Survey of Michelangelo's Models in Wax and Clay* (London, 1962)

E. Battisti: 'I "coperchi" delle tombe medicee', *Arte in Europa: Scritti di storia dell'arte in onore di Eduardo Arslan*, ed. E. Arslan (Milan, 1967), pp. 517–30

L. Steinberg: 'Michelangelo's Florentine Pietà: The Missing Leg', *A. Bull.*, l (1968), pp. 343–59

C. Klapisch-Zuber: *Les Maîtres du marbre: Carrara, 1300–1600* (Paris, 1969)

T. Verellen: 'Cosmas and Damian in the New Sacristy', *J. Warb. & Court. Inst.*, xlii (1979), pp. 274–7

C. Avery: '"La cera sempre aspetta": Wax Sketch Models for Sculpture', *Apollo*, cxix (1984), 3–11

J. Larson: 'The Cleaning of Michelangelo's Taddei Tondo', *Burl. Mag.*, cxxxiii (1991), pp. 844–6

ANTHONY HUGHES

2. PAINTING. As a painter, Michelangelo's working procedures were traditionally methodical. Through drawings ranging from first sketches to cartoons, the process of preparation seemingly allowed little room for spontaneity. The unpainted areas of the *Entombment* (London, N.G.) are firmly contoured blanks awaiting colour. While cleaning has revealed the brilliance and, in fresco, the brio of his brushwork, his painting nevertheless was based on controlled analysis of outline and internal modelling. His method was the opposite of the improvisatory approach to image-making developed by Giorgione in Venice, and his reputation as the exemplar of Florentine *disegno* is deserved.

It is characteristic that for mural painting Michelangelo favoured *buon fresco*, a technique demanding unerring swiftness of execution. After Sebastiano del Piombo prepared the altar wall of the Sistine Chapel for oil paint, Michelangelo had the surface demolished, reputedly declaring that oil painting was fit only for women and idlers. For Michelangelo, true fresco, like stone cutting, was manly work because it allowed no correction of errors. Comparing the arts of painting and sculpture, he wrote that he had once thought carving nobler than painting as it represented the fruit of 'greater judgement . . . difficulty, obstacles and labour'.

In spite of Michelangelo's insistence on decisiveness, however, he made important alterations to many of his works at the eleventh hour. The change in style between the earlier and later parts of the Sistine Chapel Ceiling is an example of adjustment on a large scale, but he also often altered details traced from the cartoon. For some of the lunette figures of Christ's Ancestors, he worked without a full-scale drawing. As a rule, the more time he had to spend on a project, the more likely he was to develop it.

BIBLIOGRAPHY

M. Levey and others: *Michelangelo's 'Entombment of Christ': Some New Hypotheses and Some New Facts* (London, 1970)

M. Hirst and J. O'Malley: *The Sistine Chapel: Michelangelo Rediscovered* (London, 1986)

C. B. Cappel: 'Michelangelo's Cartoon for the *Crucifixion of St Peter* Reconsidered', *Master Drgs*, xv (Summer 1987), pp. 131–2

J. Beck: 'The Final Layer: L'ultima mano on Michelangelo's Sistine Ceiling', *A. Bull.*, lxx (1988), pp. 502–3

F. Hartt: '*L'ultima mano* on the Sistine Ceiling', *A. Bull.*, lxxi (1989), pp. 508–9

F. Hartt and G. Colalucci: *La Cappella Sistina*, 3 vols (Milan, 1989–90)

J. Shearman and F. Mancinelli: *Michelangelo e la Sistina: La tecnica, il restauro, il mito* (Rome, 1990)

Atti del convegno 'Michelangelo e la Sistina': Vatican City, 1991

ANTHONY HUGHES

3. ARCHITECTURE. An unusually large body of surviving architectural drawings (*Corpus*, iv) makes it possible to reconstruct Michelangelo's design process from the site plan through to drawn profiles of mouldings to be cut in metal for the stonemasons. Early in his architectural career, *c.* 1515–16, he made copies after the Codex Coner, Bernardo della Volpaia's recently completed model book of studies after ancient buildings. Characteristically, Michelangelo ignored the archaeological identifications and measurements and copied freehand, concentrating especially on lively profiles. The drawings for the rare-books room of the Biblioteca Laurenziana (*see* §I, 4(i)(c) above) show him first sketching over a ruled site-plan, then working up the revised design into a modello in pen and wash, adding a scale and explanatory annotations for his patron. Drawings of this type continued to be a feature of his practice up to the time of the S Giovanni dei Fiorentini project. From the 1520s he increasingly elaborated designs for such details as windows and doors by superimposing ideas one over the other on a single sheet (e.g. the Palazzo Farnese window drawing, *Corpus*, 589; and designs for the Porta Pia). The layered, palimpsest-like character of his finished buildings often owe much to the process of drawing itself. Instructions to the work-force would be conveyed through template profiles, full-scale drawings on walls, wooden models and, above all, by constant personal supervision.

Wooden models had long been used in Italian architectural practice to convey three-dimensional ideas to a patron more effectively than drawings, and to provide an enduring record of the design during building. Michelangelo also made 'study' models from clay, which must have helped him towards the more moulded spatial forms of his later architecture. In addition to the normal small-scale wooden models of complete designs, he liked to make full-scale models of wood to judge the effect of a solution *in situ*—as with the cornice of the Palazzo Farnese and the cornice below the drum of St Peter's. Distrusting proportional systems and preconceived rules, he was quoted as believing that the artist should 'have his compasses in his eyes and not in his hands'. For similar reasons, he tended to design each stage of a building as construction proceeded, rather than working out every detail in advance.

Michelangelo's anxiety to distance himself from workshop practice and the mechanical arts is evident in his angry response to his nephew's demeaning gift of a measuring rod when asked for the length of the Florentine braccio 'as if I were a builder or a woodworker'. However, his belief in design as an intellectual activity did not mean that he confined his contribution to initial designs and models. He was suspicious of such bureaucratic offices of works as those of the St Peter's *fabrica* and the Florentine Opera del Duomo, and liked to gather control of the executant team and the ordering of materials into his own hands, using a small, trusted group of assistants wherever possible. Perhaps because he did not espouse the increasingly sophisticated techniques of architectural drafting, his presence was needed on site, as the débâcle of the St Peter's hemicycle vaults demonstrated. Only at the end of his life did he restrict architectural involvement to the supply of drawings. Thus, despite his role in freeing the Renaissance artist from the workshop, he remained in

many ways faithful to 15th-century Florentine architectural practices.

For bibliography *see* §I, 4 above.

CAROLINE ELAM

III. *Character and personality.*

Michelangelo was below average height, wore a sparse beard and had 'horn-coloured' eyes flecked blue and yellow. Surprisingly, he loved natural scenery and was a good judge of a horse. For years, a kidney stone made urination painful for him. These details were recorded by Condivi in 1553. But the sense of intimacy they promise is false. Michelangelo's personality remains elusive. His words, as Vasari remarked, were often ambiguous: so was his behaviour. There is, for instance, no doubt of his family piety. He lost no chance to promote the status of the Buonarroti clan, even claiming kinship with the counts of Canossa. He hectored his nephew on the need to marry and maintain the family name. Yet he himself remained celibate and solitary.

His difficult character impressed people in different ways. According to anecdote, he overawed Pope Leo X. Battista Figiovanni, prior of S Lorenzo, however, declared that Job would have lost patience with him. Greed for commissions and contempt for peers led him to behave unscrupulously early in his career and he poisoned many friendships. In 1517 Jacopo Sansovino sent a memorably bitter letter, justifiably accusing him of breach of faith about the S Lorenzo façade project. Although he experienced considerable guilt concerning mismanaged transactions and more than once offered to make financial restitution for unfinished work, he remained sensitive to professional rivalry. He accepted admirers, but trained no pupil of merit. Nevertheless he was capable of great generosity, for example towards his assistant Antonio Urbino and his wife.

Michelangelo's sexual history is unknowable. Condivi claimed that he remained perfectly chaste; PIETRO ARETINO perniciously hinted at pederasty. His writings are often used illegitimately to reconstruct a secret life of the affections. Although he undoubtedly experienced a powerful erotic attraction to Cavalieri, the language of letters and poems he sent to him is highly conventional. It no more constitutes evidence of sexual involvement than the Petrarchan courtesies he addressed to VITTORIA COLONNA with whom there is no question of a physical liaison. In both cases, he was engaged in highly publicized exchanges with social superiors: a large element of refined and courtly play is to be expected.

About Michelangelo's religious life, there is no doubt. At all stages of his career Michelangelo was sensitive to climates of piety. According to Condivi, he never forgot the voice of GIROLAMO SAVONAROLA, whose sermons he heard as a youth in Florence. Especially in later years, his commitment to Christian observance deepened. Condivi recorded clandestine works of charity. In letters, poems and drawings he meditated on death and redemption. It is this grand, sombre, secretive adherent of the Catholic reform movement that probably forms the most persistent image of the artist.

BIBLIOGRAPHY

G. Spini: 'Politicità di Michelangelo', *Riv. Stor. It.*, lxxvi (1964), pp. 557–600; repr. in *Atti del convegno di studi michelangioleschi: Florence, 1964*, pp. 110–70

R. De Maio: *Michelangelo e la controriforma* (Bari, 1978)

C. Gilbert, ed. and trans.: *Complete Poems and Selected Letters of Michelangelo* (Princeton, 1980)

ANTHONY HUGHES

IV. *Critical reception and reputation.*

1. GENERAL. The Michelangelo literature is vast, and much material was produced in the artist's lifetime. Throughout the 16th century his name was cited in a variety of documents. Already by 1527, the first biography of him was written, a short account by Paolo Giovio. In the very earliest documents he was not always represented as the intimidating giant familiar from later accounts. He appears, for example, as an unusually urbane and modest authority on Dante in a dialogue by Donato Giannotti. With the first edition of Vasari's *Vite* in 1550, however, the outlines of the Michelangelo myth were already apparent. Michelangelo was virtually the only living artist included in this edition, and he was depicted as the man sent by God to perfect the arts of painting, sculpture and architecture. Although Vasari's tone was adulatory he still portrayed Michelangelo as an artist firmly rooted in Florentine history and culture and this sense of historical placement was given greater emphasis in the second edition of 1568, in which he included other living artists, with Michelangelo as the first among equals. A great deal in Vasari's life is fabulous rather than strictly historical, as Barolski has pointed out, but the Michelangelo myth was created largely by ASCANIO CONDIVI, probably in close consultation with Michelangelo. Condivi's biography was written to 'correct' the first version of Vasari's Life, especially the implication that the artist had behaved badly over the tomb of *Julius II*. Condivi remains a valuable source in some matters of detail, but he deliberately represented Michelangelo as a force of nature, virtually untutored, owing nothing to predecessors or contemporaries. Although his extravagant estimate found echoes, especially in the romantic biographies of the 19th and 20th centuries, Condivi's book is probably the most uncritical evaluation of Michelangelo ever offered.

During his lifetime Michelangelo's authority became very great, and he was frequently invoked by 16th-century artists. He left behind no aesthetic teaching, however, apart from a few, ambiguous remarks, either reported by his biographers or scattered among letters or poems. Attempts have been made to piece together a theory from these fragments (Clements, 1961) and to see how 16th-century terminology was modified by Michelangelo's practice and dicta (Summers, 1981), but as both writers acknowledged, although he was a profoundly reflective artist, Michelangelo held to no particular system. It is difficult, therefore, to determine to what extent certain texts reflect Michelangelo's opinions. The problem is acute in relation to the dialogues on painting recorded by Francisco de Holanda, but it also occurs with later 16th-century literature. 'Michelangelo's' explanation of the *figura serpentinata* in Giovanni Paolo Lomazzo's *Treatise on the Art of Painting* (1584), for example, may derive from some

crumb of table talk, but it is set out in implausibly systematized form by Lomazzo.

Even for 16th-century Italians, Michelangelo's authority was not absolute, but varied according to the art under discussion or a writer's local patriotism. In contemporary opinion he was almost unanimously accorded pre-eminence as a sculptor, but his reputation as a painter came to be higher in central, than in northern, Italy. In Venice his abilities were questioned by Ludovico Dolce (1557) who unfavourably compared Michelangelo's narrow expertise in depicting the male nude with the greater variety displayed by Raphael and Titian. Dolce's attack was part of the dispute about the relative merits of Florentine and Venetian painting (*see* DISEGNO E COLORE), in which Michelangelo was cast as the chief representative of *disegno*, the model for the 'grand manner', an intellectual rather than sensuous style, totally lacking in sweetness.

In Dolce's *Dialogo* these complaints are voiced by Pietro Aretino, who had been among the first to write that Michelangelo's fresco of the *Last Judgement* was a licentious display of skill rather than a proper depiction of a holy subject. Although Aretino's comment separates form from content in a seemingly modern way, it was a malicious appeal to pious sensibilities, and the accusation became a commonplace of clerical literature. Opinion about the *Last Judgement* was never uniform, however. Engravings of the fresco were published throughout the late 16th century, and the inquisitor who interrogated Paolo Veronese remarked that there was nothing that was not 'spiritual' about the nudes of the *Last Judgement*.

Michelangelo continued to be admired throughout the following centuries. For Joshua Reynolds (1723–92), the major proponent of a grand manner in the 18th century, he was a touchstone of value for the visual arts, and while Reynolds's 'classicist' view was conservative, his tone of homage anticipated a more emotional literature that represented Michelangelo as a dark, titanic, often tortured spirit. Alexandre Dumas's *Vie de Michel-Ange* initiated a series of romantic biographies of a kind still popular in the 20th century. Even scholarly works shared characteristics with the novelistic lives. The study by Grimm, in which Michelangelo is presented as the transcendent expression of Renaissance Italy, is the best-grounded historically. In a strictly scholarly sense, Grimm was superseded by Gotti, whose biography was deeply informed by Milanesi's great edition of the letters and contracts. There was dissent from this general hero worship, however. The most dramatic attack was by John Ruskin (1818–1900), who characterized Michelangelo's sculpture as dishonest and violently theatrical.

Romantic interpretations of Michelangelo's life should not be dismissed as vulgar sideshows. The view that his art could be understood as a form of autobiography has continued to inform many of the most ambitious scholarly accounts of the 20th century. Michelangelo's adherence to some form of Neo-Platonism, first argued by Hettner, has had several supporters. Frommel's study of Michelangelo's relationship with Tommaso de' Cavalieri convincingly relates the artist's letters and poems to the circle of Neo-Platonists he met in the household of Lorenzo the Magnificent. J. A. Symonds's *The Life of Michelangelo Buonarroti* was significant as it acknowledged a homosexual Michelangelo. Since then a significant strand of the literature has been psychoanalytic in character: examples include the intelligent popular introduction by Hibbard and the unconvincing clinical study by Liebert. Psychoanalysis also informs the writings of Steinberg. Among the legacies of the 19th-century tradition are the iconological interpretations offered by Panofsky, Tolnay and Hartt that have dominated mid-20th-century Michelangelo studies. Although these were inspired by a genuine desire to explain Michelangelo's imagery historically in 16th-century terms, their claims are often unconvincing. Many such iconological readings now seem fantastic in detail, but they still contain valuable information and comment. Panofsky's interpretation of the presentation drawings is notably persuasive, and the huge monograph of Tolnay, despite its old-fashioned emphasis on the influence of Neo-Platonism, remains the most sustained attempt this century to deal with the total range of Michelangelo's work apart from architecture. The subsequent trend, however, has been towards more cautious, sociologically orientated interpretations, continuations of the scholarly literature that has been devoted to the discovery and editing of sources and to solving particular problems. During the 20th century this genre was best represented by Barocchi, Elam, Frey, Hirst, Steinmann, Wallace and Wilde.

BIBLIOGRAPHY

P. Giovio: *Michaelis Angeli Vita* (1523–7); repr. in P. Barocchi: *Scritti d'arte del cinquecento*, i (Milan and Naples, 1921); Eng. trans. by L. Murray in *Michelangelo: His Life, Work and Times* (London, 1984)

D. Giannotti: *Dialoghi di Donato Giannotti, de' giorni che Dante consumò nel cercare l'inferno e il purgatorio*, ed. D. Redig de Campos (Florence, 1939)

J. de Vasconcelos: *F. de Holanda: Vier Gespräche über die Malerei, geführt zu Rom 1538* (Vienna, 1899); Eng. trans. by C. Holroyd in *Michael Angelo Buonarroti* (London, 1903, London and New York, 2/1911)

L. Dolce: *Dialogo della pittura intitolato l'Aretino* (Venice, 1557); repr. in P. Barocchi: *Trattati d'arte del cinquecento*, i (Bari, 1960); Eng. trans. by M. W. Roskill in *Dolce's 'Aretino' and Venetian Art Theory of the Cinquecento* (New York, 1968)

G. A. Gilio da Fabriano: *Due dialoghi di M. Andrea Gilio da Fabriano* (Camerino, 1564); repr. in P. Barocchi, ed.: *Trattati d'arte nel cinquecento*, ii (Bari, 1961)

G. Paleotti: *Discorso intorno alle immagine sacre e profane* (Rome, 1582); repr. in P. Barocchi, ed.: *Trattati d'arte nel cinquecento*, ii (Bari, 1961), pp. 117–503

G. P. Lomazzo: *Idea del tempio della pittura* (Milan, 1584)

J. Reynolds: *Discourses on Art* (London, 1778); ed. R. R. Wark (San Marino, CA, 1959/*R* New Haven and London, 1975)

H. Grimm: *Leben Michelangelos* (Vienna, 1860–63)

J. Ruskin: *The Relation between Michael Angelo and Tintoret: Seventh of the Course of Lectures on Sculpture Delivered at Oxford, 1870 and 1871* (London, 1872)

A. Gotti: *Vita di Michelangelo Buonarroti con l'aiuto di nuovi documenti*, 2 vols (Florence, 1875)

A. Dumas: *Vie de Michel-Ange* (Paris, 1878)

H. Hettner: 'Michelangelo und die Sixtinische Kapelle', *Italienische Studien zur Geschichte der Renaissance* (Brunswick, 1879), pp. 247–72

J. A. Symonds: *The Life of Michelangelo Buonarroti: Based on Studies in the Archives of the Buonarroti Family at Florence*, 2 vols (London, 1893)

K. Frey: *Michelagniolo Buonarroti: Quellen und Forschungen zu seiner Geschichte und Kunst*, i (Berlin, 1907)

E. Steinmann: *Michelangelo im Spiegel seiner Zeit* (Leipzig, 1930)

E. Panofsky: 'The Neoplatonic Movement and Michelangelo', *Studies in Iconology: Humanistic Themes in the Art of the Renaissance* (New York, 1939, rev. 2/1962), pp. 171–230

R. Clements: *Michelangelo's Theory of Art* (New York, 1961)

L. Steinberg: 'The Metaphors of Love and Birth in Michelangelo's Pietàs', *Studies in Erotic Art* (New York, 1970), 231–85

C. L. Frommel: *Michelangelo und Tommaso dei Cavalieri* (Amsterdam, 1979)

H. Hibbard: *Michelangelo* (London, 1979)
J. Bury: *Two Notes on Francisco de Holanda* (London, 1981)
D. Summers: *Michelangelo and the Language of Art* (Princeton, 1981)
R. S. Liebert: *Michelangelo: A Psychoanalytic Study of his Life and Images* (New Haven and London, 1983)
J. M. Saslow: '"A Veil of Ice between my Heart and Fire": Michelangelo's Sexual Identity and Early Modern Constructs of Homosexuality', *Genders* (1988), pp. 77–90
W. E. Wallace: 'Michelangelo at Work: Bernardino Basso, Friend, Scoundrel and Capomaestro', *I Tatti Stud.*, 3 (1989), pp. 235–77
P. Barolsky: *Michelangelo's Nose: A Myth and its Maker* (University Park and London, 1990)

For further bibliography *see* the relevant sections above.

ANTHONY HUGHES

2. ARCHITECTURE. Responses to Michelangelo's architecture have always been divided between admiration for his originality and distaste at his licence. Even Vasari, whose biography of Michelangelo was the culmination of the first edition of the *Vite*, and who considered his 'grazia' the summit of art as the product of visual judgement rather than rules, was uneasy at the 'grotesque' architectural forms perpetrated by Michelangelo's more presumptuous followers. He tried to assimilate Michelangelo's eccentricities into the Vitruvian language of the orders by classifying his detail as 'composite', and others defended the 'grotesque' as legitimate artistic licence. But Michelangelo's successor at St Peter's, Pirro Ligorio, attacked his use of capricious ornament in sacred buildings as an offence against decorum, and this was the first example in a critical tradition that extended from Inigo Jones (1573–1652) through to Francesco Milizia (1725–98), and as far as Michelangelo's best 19th-century biographer, John Addington Symonds.

Michelangelo did not write an architectural treatise. Neither his drawings nor his finished buildings furnished examples that could be exported or adopted wholesale, and there is no real 'Michelangelesque' movement in architecture although his motifs soon became influential through engravings. In Italy his influence in Florence was enduring but superficial; architects who trained in Rome, such as Galeazzo Alessi, took his ornamental ideas to northern Italy, but it was in the Rome of Borromini (1599–1667) that his spatial inventions were taken up and developed. As the 'father of the Baroque' (Wölfflin, 1964) Michelangelo was further vilified by Neo-classical critics.

A more balanced reconsideration of Michelangelo's architectural achievement came with Heinrich Wölfflin's re-evaluation of the Baroque in 1888. The pioneering monographic studies of Geymueller, Frey and Thode before World War I were followed up by Tolnay's detailed consideration of the Casa Buonarroti drawings, by Wittkower's classic article on the Biblioteca Laurenziana and by Ackerman's exemplary monograph. As Ackerman pointed out, understanding of Michelangelo's architectural ideas has not been greatly enhanced by the 20th-century predilection for 'Mannerism' as a stylistic label.

BIBLIOGRAPHY

H. Wölfflin: *Renaissance und Barock* (Munich, 1888; Eng. trans., London, 1964)
H. Thode: *Michelangelo: Kritische Untersuchungen über seine Werke: Verzeichnis der Zeichnungen, Kartons und Modelle*, 3 vols (Berlin, 1913)

For further bibliography *see* §I, 4 above.

CAROLINE ELAM

Michelangelo di Pietro [Mencherini] (*fl* Lucca, 1489–1521). Italian painter. He painted the *St Anthony Enthroned with SS Andrew, Dominic, Francis and Bartholomew* (*c.* 1497; Lucca, S Pietro Somaldi; see Tazartes), previously attributed (by Ferretti and Kiel) to the MASTER OF THE LATHROP TONDO (*see* MASTERS, ANONYMOUS, AND MONOGRAMMISTS, §I). Michelangelo di Pietro had an active workshop in Lucca and received prestigious commissions, working in close contact with other Lucchese artists such as the painter Vincenzo Frediani and the sculptors Masseo di Bartolomeo Civitali (*d* after 1511) and Matteo Civitali. Some of the paintings previously given to the Master of the Lathrop Tondo may be the work of Michelangelo di Pietro, but his oeuvre has still to be established.

BIBLIOGRAPHY

M. Ferretti: 'Mostra del restauro, Pisa 1972', *An. Scu. Norm. Sup. Pisa*, n.s. 2, ii/2 (1972), p. 1057
H. Kiel: 'Pisa, mostra del restauro 1972', *Pantheon*, xxx/6 (1972), p. 508
M. Tazartes: 'Anagrafe lucchese, III. Michele Angelo (del fu Pietro "Mencherini"): Il Maestro del tondo Lathrop?' *Ric. Stor. A.*, 26 (1985), pp. 28–39
N. Dacos: 'De Pinturicchio à Michelangelo di Pietro da Lucca: Les premiers groteques à Sienne', *Umanesimo a Siena: Letteratura, arti figurative, musica*, ed. E. Cioni and D. Fausti (Siena, 1994), pp. 311–43

MAURIZIA TAZARTES

Michele da Firenze [Michele di Niccolaio; Michele di Niccolò detto Scalcagna; Master of the Pellegrini Chapel] (*fl c.* 1404–43). Italian sculptor. He was an assistant in Lorenzo Ghiberti's workshop during the execution of the north doors of the Baptistery in Florence (1403–24; *see* GHIBERTI, (1), fig. 2), and the influence of Ghiberti is apparent throughout his work, which largely consists of small-scale terracotta sculpture. He remained in Florence during the 1420s and probably established his own workshop, producing a vast number of small devotional reliefs in terracotta, originally polychromed and gilt, such as the *Virgin and Child with Angels beneath a Niche* (*c.* 1420; Prato, Mus. Com.). These almost certainly were executed in serial fashion for sale to private clients. Michele is credited with the terracotta tomb of *Francesco Roselli* (*c.* 1430; Arezzo, S Francesco), but by 1433–5 he had left Tuscany for the Veneto, where he has been identified with the sculptor of the Pellegrini Chapel in S Anastasia, Verona (executed in 1433–8). This is Michele's first independently documented work and is considered to be his masterpiece. In place of the customarily frescoed narrative scenes, Michele encased the chapel walls with an impressive terracotta revetment, originally polychromed, consisting of 24 individual panels depicting the *Life, Passion and Death of Christ*. Among the most notable are the *Kiss of Judas* and the *Adoration of the Magi*, the latter particularly showing an intrinsic debt in its gentle style and architectural motifs to Ghiberti's bronze panels for the north doors of the Baptistery in Florence.

By 1440–41 Michele was in Emilia, where he worked at S Maria degli Angeli di Belfiore, Ferrara. Around 1442–3 he was in Modena, where he was responsible for the terracotta *Virgin and Child* on the altar delle Statuine in the cathedral. This statuette and that of the *Virgin 'della Rondini'* (terracotta, *c.* 1442–3) in S Adriano Spilamberto, Modena (both originally polychromed), are among his latest known works. Along with a *Virgin* of *c.* 1442

(Florence, Bargello), they exhibit the continuing high quality and inventiveness of his statuary and the mature expressive forms of his late career. In the absence of an up-to-date critical catalogue of the artist, his oeuvre remains subject to revision, and the attribution to him of some pieces has been questioned.

BIBLIOGRAPHY

G. Fiocco: 'Michele da Firenze', *Dedalo*, xii (1932), pp. 542–63
E. Baglioni: 'La Porta Nord (Parri Spinelli e Michele da Firenze)', *Lorenzo Ghiberti: Materia e ragionamenti* (exh. cat., Florence, Accad. and Mus. S Marco, 1978), pp. 116–17
L. Righi: 'Una *Madonna* di Michele da Firenze nel Modenese', *Mus. Ferrar.: Boll. Annu.*, ix–x (1979–80), pp. 67–75
G. P. Marchini: *Sta. Anastasia* (Verona, 1982)
G. Bonsanti: 'Michele da Firenze', *Donatello e i suoi: Scultura fiorentina del primo rinascimento* (exh. cat., ed. A. Darr and G. Bonsanti; Florence, Forte Belvedere, 1986), pp. 198–200
F. Piccinini: 'Uno scultore quercesco–donatelliano ad Adria', *Ric. Stor. A.*, xxx (1986), pp. 99–103

Michele di Matteo da Bologna [da Calcina; da Fornace] (*fl* 1410–69). Italian painter. Not to be confused with the painter Michele di Matteo recorded in Bologna in 1393, nor with the fictitious Michele di Matteo Lambertini, he is first documented in 1410, when he collaborated with Francesco Lola (1393–1419) in the design of decorations to celebrate the arrival of the anti-pope Alexander V (*reg* 1409–10) in Bologna. His name appears on the register of the Quattro Arti in 1415 and various minor works by him are documented in the following years, including the decoration, in 1418, of a flag (untraced). In 1426 he executed his first important work, a polyptych (untraced) for the Compagnia dei Calzolari, Bologna. In 1428 Michele was working with Giovanni da Modena and Pietro Lianori (*fl* 1446–60), and their influence is reflected in the dry, incisive drawing style and harshness of expression in both face and gesture that can be seen, for example, in the *Death of the Virgin* and *St Bartholomew and the Emperor Constantine* (both Pesaro, Mus. Civ.), the *Coronation of the Virgin* (Pisa, Mus. N. & Civ. S Matteo) and the frescoes of the *Road to Calvary* and the *Crucifixion* in S Stefano, Bologna.

From around 1430 to 1437 Michele was in Venice, where he executed a polyptych depicting the *Virgin and Child with Saints and Scenes from the Cross* (Venice, Accad.), one of his most characteristic works, in which his earlier harshness is tempered by a more lyrical vision and a more meticulously crafted quality inspired by Michele Giambono and the Venetian followers of Gentile da Fabriano. In 1443 Michele signed a fresco (destr.) in the portico of S Matteo delle Pescherie, Bologna, and in 1447 he frescoed the tribune of the baptistery in Siena with scenes from the *Life of Christ*. Among the many surviving works by Michele in Bologna are the panels of *St Petronius* and the *Virgin and Child* (both Bologna, Mus. S Stefano). He was, however, unable to adapt to the Renaissance style that dominated the artistic scene in Emilia from the middle of the 15th century, and he continued to work in a severe, old-fashioned Late Gothic style, repeating his tested formulae for a conservative clientele.

BIBLIOGRAPHY
Bolaffi
S. Bottari: *La pittura in Emilia nella prima metà del '400* (Bologna, 1958)
L. Castelfranchi Vegas: *Il gotico internazionale in Italia* (Rome, 1966)

F. Filippini and G. Zucchini: *Miniatori e pittori a Bologna: Documenti nel secolo XV* (Rome, 1968)
R. Longhi: 'Il tramonto della pittura medievale nell'Italia del Nord', *Lavori in Valpadana dal '300 al primo '500, 1934–1964* (Florence, 1973), pp. 91–153
MARIA CRISTINA CHIUSA

Micheli [Michieli]**, Parrasio** (*b* ?Venice, *c.* 1516; *d* Venice, 19 May 1578). Italian painter and draughtsman. The natural son of a Venetian aristocrat, Salvador Michiel, he pursued his early training in the workshop of Titian and later in his career was associated with Paolo Veronese, who provided him with drawings for his paintings. He is known to have been in Rome before 1547. Micheli's earliest work is an altarpiece depicting the *Virgin and Child with SS Lorenzo and Ursula* (1535; Murano, S Pietro Martire), which was commissioned by Ursula Pasqualigo in memory of her deceased husband, the former Procurator Lorenzo Pasqualigo. There is also a *Venus and Cupid* (*c.* 1547; London, priv. col.) and a *Lucrezia* (*c.* 1547; London, Mond priv. col.). In 1550 he married the daughter of a German baker. Several documented paintings have been destroyed or are untraced: the painting of *Doge Lorenzo Priuli Accompanied by Ten Senators with Personifications of Fortune and Venice* (1563), for which he received 225 ducats, was destroyed in the fire in the Doge's Palace of 1574. The work is known from a preparatory study (Berlin, Kupferstichkab.) and a contract of 22 October 1563. Five paintings known to have been in the Libreria Marciana that same year are also untraced. The large painting depicting the *Adoration of the Dead Christ* (Venice, S Giuseppe), signed and dated *parrhasio Micheli dipinse nel 1573*, includes a self-portrait. Micheli also painted portraits of Venetian noblemen (e.g. *Girolamo Zane*, Venice, Accademia; *Tommaso Contarini*, Venice, Doge's Palace) and associated with prominent men of letters including Paolo Giovio and Pietro Aretino. He corresponded with Philip II, King of Spain (*reg* 1556–98), and two signed paintings by Micheli are in the Prado. He left a will dated 17 April 1578 (Venice, Archv Stato).

BIBLIOGRAPHY
Thieme–Becker
D. von Hadeln: 'Parrasio Micheli', *Jb. Kön.-Preuss. Kstsamml.*, xxxiii (1912), pp. 149–72
——: 'Parrasio Michieli', *Apollo*, vii (1928), pp. 17–21
A. Venturi: *Storia*, ix/4 (1929), pp. 1047–54
EDWARD J. OLSZEWSKI

Michelino, Domenico di. *See* DOMENICO DI MICHELINO.

Michelino (de' Molinari) da Besozzo (*fl* 1388; *d* after 1450). Italian painter and illuminator. Milanese writers from the humanist Uberto Decembrio (1350–1427) to Giovanni Paolo Lomazzo in the 16th century described Michelino as the greatest artist of his time. He was especially praised for his skill and prodigious talent in the naturalistic portrayal of animals and birds. Records of payments made in 1388 to a 'Michelino pictore' who painted scenes from the *Life of St Augustine* in the second cloister of the Augustinian convent of S Pietro in Ciel d'Oro, Pavia, are thought to be the earliest references to the artist. He was still resident in Pavia in 1404, when the Fabbrica (Cathedral Works) of Milan Cathedral decided to consult him as 'the greatest in the arts of painting and

design'. The frescoes in S Pietro in Ciel d'Oro and a panel by Michelino dated 1394 that was in S Mustiola, Pavia, in the 17th century have not survived, but two of the manuscripts with illumination firmly attributed to Michelino date from his time in Pavia: St Augustine's *Commentary on the Psalms* (Rome, Vatican, Bib. Apostolica, MS. Vat. lat. 451), which was probably made for Marco Gallina, an Augustinian professor of theology at Pavia University, in 1396, and the *Funeral Eulogy and Genealogy of Giangaleazzo Visconti* (Paris, Bib. N., MS. lat. 5888), dated 1403. Similarities in the style of illuminated initials and in the scale and layout of the foliate borders painted by Michelino with those of the Augustinian friar Pietro da Pavia suggest a direct relationship between the two artists at the beginning of Michelino's career. Stylistic analogies with the work of Stefano da Verona, now known to be the son of Jean d'Arbois, painter to Philip the Bold, Duke of Burgundy from 1373 to 1375, raise the question of whether both artists may have trained with the French painter, who is thought to have been in Pavia from 1385.

Michelino is not recorded in either Pavia or Milan between 1404 and 1418, and he may have left Lombardy during the unstable years of Giovanni Maria Visconti's rule (1402–14). In 1410 he was in Venice, where he gave a recipe for ultramarine to Johannes Alcherius, who wrote of him as 'the most excellent painter among all the painters of the world'. Michelino may have moved to the city, where major artistic projects underway in S Marco and the Doge's Palace had attracted other artists from North and Central Italy, including Gentile da Fabriano and Pisanello. The damaged fresco decoration of the tombs of *Giovanni Thiene* and *Marco Thiene* in S Corona, Vicenza, is the only work attributable to Michelino that survives in the Veneto. He was, however, also responsible for some of the illumination in the *Epistles of St Jerome* (London, BL, Egerton MS. 3266), a manuscript that is likely to have been produced in Venice around 1414, the date of an additional index. One frontispiece (fol. 8*r*) is painted in a distinctly Venetian style, except for the marginal drawing of an archer and a deer; the other frontispiece (fol. 15*r*) contains the arms of the Cornaro family of Venice. The drawing of the hunt and the entire second frontispiece exemplify the fluidity of line and subtle colouring fundamental to the style of Michelino.

From 1418 all references to Michelino place him in Milan. In that year he was paid for the first of many undertakings for the cathedral when he ornamented the marble boss of the vault behind the high altar. Subsequent entries in the Fabbrica accounts are explicit about Michelino's supremacy as a master of glass, and he not only adjudicated the work of others but also designed and painted glass himself. In 1425 he was paid for 24 panels of glass for the window next to the altar dedicated to SS Quirico and Giulitta. Michelino, whose assistants included his son Leonardo da Besozzo, had been paid for the pictorial decoration of this altar in 1421. Six trefoils with half-length *Prophets* (Milan Cathedral, south transept, window 15) have been identified as from this window, and, although heavily restored, they are Michelino's only surviving documented work in glass. These figures are types readily recognizable in the attributed manuscripts.

The artist rented a house close to the Castello Visconteo in 1428, and he may have worked for the Duke of Milan: Pier Candido Decembrio in his *Life* of Filippo Maria Visconti recounted how highly the Duke valued the portrait of his brother by Michelino. The artist does not appear in the cathedral accounts between 1429, when he painted a standard, and 1439, when he painted a *Crucifix*. In 1441 he was at work on more stained glass for the cathedral, and his final documented activity was in 1445, when he painted frescoes in the palace of the Borromeo family.

Only damaged or repainted fragments survive from these documented works, and the corpus of attributions to Michelino centres on a panel, the *Mystic Marriage of St Catherine* (Siena, Pin. N.), with the signature *Michelinus fecit*. The painting combines high quality and rich colouring with a very distinctive style: the figures have simplified, curved contours, often enveloped in flowing drapery with curling folds; female faces are smooth and round with small features, while the men have large bent noses and deep-set eyes; heads tend to crane forward on long necks. A comparison with the securely datable works shows that these qualities remained characteristic of Michelino's style throughout his career; consequently there has been no consensus on the dating of other works attributed to the artist. Furthermore, his influence on his contemporaries and the ease with which such idiosyncratic features could be adopted have led to an expanded body of attributions, few of which are universally accepted.

One of the undisputed works, although placed by different scholars at dates varying from the first to the fourth decade of the 15th century, is a prayerbook (New York, Pierpont Morgan Lib., MS. M. 944), which best demonstrates the sophistication of design and delicacy of handling that distinguishes Michelino from his followers. The manuscript contains 47 prayers for Church feasts from both the Temporal and Sanctoral, mostly arranged according to the calendar. Originally the opening of each prayer was faced by a full-page miniature, and both miniature and text were surrounded by matching borders with flowering tendrils springing from golden roots and entwined around golden supports. Most of the flowers are identifiable, and the borders appear to be a stylized evocation of contemporary botanical illustrations. The coherence of the decorative scheme often extends to the gold background of the miniature, which is patterned with the same flower depicted in the border. All the prayer openings with borders and 22 of the full-page miniatures survive. The subtle combinations of pastel and saturated shades, burnished gold and silver and the decoration with gold paint give these pages a sumptuous and scintillating appearance resembling that of contemporary enamelled goldsmiths' work.

The precise and naturalistic treatment of St Martin's horse (fol. 80*v*; see fig.) and St Luke's ox (fol. 75*v*) in the Pierpont Morgan Library prayerbook and the portrait busts of the Visconti genealogy give some indication of Michelino's accomplishment in two of the areas for which he was praised. Otherwise the surviving works do little to reflect the wide range in subject-matter as well as in technique that the early sources indicate were produced during the artist's long and highly successful career.

Michelino da Besozzo: *St Martin Dividing his Cloak*; miniature from a prayerbook, first half of the 15th century (New York, Pierpont Morgan Library, MS. M. 944, fol. 80*v*)

Nothing survives, for example, that is remotely comparable to the lewd genre scene of four peasants described by Lomazzo. It was presumably the combination of the rich variety of his invention with a polished and distinctive style that accounts for Michelino's renown and influence.

BIBLIOGRAPHY
P. Toesca: *La pittura e la miniatura nella Lombardia dai più antichi monumenti alla metà del quattrocento* (Milan, 1912/*R* Turin, 1966), pp. 185–93
G. Biscaro: 'Note di storia dell'arte e della cultura a Milano dai Libri Mastri Borromeo (1427–78)', *Archv Stor. Lombardo*, 5th ser., i (1914), pp. 71–108
O. Pächt: 'Early Italian Nature Studies and Early Calendar Illustration', *J. Warb. & Court. Inst.*, xiii (1950), pp. 13–47
R. Schilling: 'Ein Gebetbuch des Michelino da Besozzo', *Münchn. Jb. Bild. Kst*, n. s. 1, viii (1957), pp. 65–80
Arte lombarda dai Visconti agli Sforza (exh. cat., ed. R. Longhi; Milan, Pal. Reale, 1959), pp. 52–8
S. Matalon: *Michelino da Besozzo e 'l'ouvraige de Lombardie'*, Maestri Colore, 219 (Milan, 1966)
D. Sellin: *Michelino da Besozzo* (diss. University Park, PA State U., 1968; microfilm, Ann Arbor, 1969)
C. Eisler: *The Prayer Book of Michelino da Besozzo* (New York, 1981) [pls]
Dix Siècles d'enluminure italienne (exh. cat., ed. Y. Zatuska and others; Paris, Bib. N., 1984), pp. 107–8
C. Pirana: *Le vetrate del duomo di Milano*, Corp. Vitrearum Med. Aevi (Milan, 1986), pp. 97–118
G. Algeri: 'L'attività di Michelino da Besozzo in Veneto', *A. Crist.*, 718 (1987), pp. 17–32
M. Dachs: 'Neue Überlegungen zum sogennanten Studienblatt des Michelino da Besozzo in der Graphischen Sammlung Albertina in Wien', *Mitt. Ksthist. Inst. Florenz*, xxxv (1991), pp. 1–20
——: 'Zur künstlerischen Herkunft Michelinos da Besozzo', *Wien. Jb. Kstgesch.* (in preparation)

L. Migliaccio: 'Leonardo "auctor" del genere comico', *Achademia Leonardi Vinci: J. Leonardo Stud. & Bibliog. Vinciana*, viii (1995), pp. 158–61
F. Paliaga: '*Quattro persone che ridono con un gatto*', *Achademia Leonardi Vinci: J. Leonardo Stud. & Bibliog. Vinciana*, viii (1995), pp. 143–57
KAY SUTTON

Michelozzo di Bartolomeo (*b* Florence, 1396; *d* Florence, 7 Oct 1472). Italian sculptor and architect. He was both an extremely talented sculptor and one of the pioneers of Renaissance architecture. He was extensively employed by the Medici family, especially Cosimo I de' Medici (*see* MEDICI, DE', (14)), becoming in effect his personal architect. His success can be attributed to an enthusiasm for innovation and a willingness to tailor his designs to his clients' wishes. Characteristic of his work is the variety of styles, sometimes with medieval and Renaissance elements placed together in the same design.

1. Life and career. 2. Work. 3. Critical reception and posthumous reputation.

1. LIFE AND CAREER.

(i) 1420–40. Michelozzo was the son of Bartolomeo di Gherardo Borgognone, a tailor of French origin but a Florentine citizen for 20 years, who lived in the Via Larga. Michelozzo must have trained as a workshop apprentice, because in 1410 he is recorded in the registers of the Fiorinaio (coinmakers' guild) as an engraver working for the Florentine mint. His apprenticeship in metalwork would have qualified him to assist Lorenzo Ghiberti on the north doors (1403–24; *see* GHIBERTI, (1), fig. 2) of the Baptistery of Florence Cathedral. In 1420 he became a member of the Arte dei Maestri di Pietra e Legname (Stonemasons' and Carpenters' guild), and in the following year his employment with Ghiberti became a genuine collaboration when he was called on for the second casting of the statue of *St Matthew* destined for the tabernacle of the Arte del Cambio (Money-changers' guild) in Orsanmichele. As a direct employee of the Calimala (Cloth finishers' guild), he participated in the initial work on the final set of Baptistery doors, the *Gates of Paradise* (1426–52; see colour pl. 1, XXXI2).

In 1424–5, possibly after a visit to Venice, Michelozzo entered into partnership with DONATELLO and opened a workshop, principally to carry out private commissions. Michelozzo's role was both that of working artist and administrator. The need to work extensively in marble, which in Florence was supplied exclusively through the Opera del Duomo, encouraged them to open a second workshop in Pisa, nearer to the Carrara quarries and the port. The workshop received important commissions from both private and public patrons. Some works were executed by Donatello alone, such as the bronze *Feast of Herod* panel (1423–5) on the font of the Siena Baptistery and the *Prophets* on the exterior of the Campanile (1416–35), Siena, but several were genuine collaborations, notably the tomb monuments of *Cardinal Baldassare Coscia* (the anti-pope John XXIII; 1424–8; Florence Cathedral, Baptistery), *Cardinal Rinaldo Brancaccio* (1426–8; Naples, S Angelo a Nilo; see fig. 1) and *Bartolomeo Aragazzi* (1427–38; dismantled after 1616; fragments in Montepulciano Cathedral and London, V&A), and the pulpit of the Sacro Cingolo (1433–8; exterior of Prato Cathedral). The work-

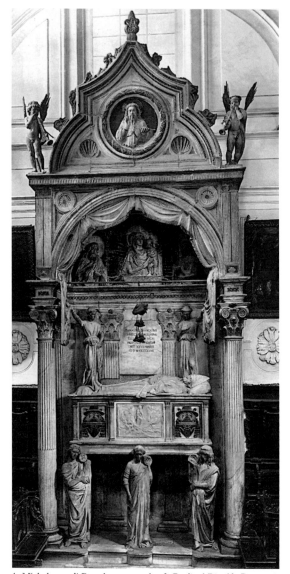

1. Michelozzo di Bartolomeo: tomb of *Cardinal Rinaldo Brancaccio*, marble and bronze, h. 9.1 m, 1426–8 (Naples, S Angelo a Nilo)

Michelozzo eventually returned to Florence and was placed in charge of the mint in 1435; his transformation of the Medici Villa at Cafaggiolo, which was then owned by Averardo, may date from this period. He was also by then in contact with Cosimo de' Medici, who had been a consul of the Arte del Cambio when the statue of *St Matthew* was commissioned, and who was the official responsible for the Coscia tomb. According to Vasari, Michelozzo accompanied Cosimo in his brief exile in Venice (1433–4) and built a library, financed by Cosimo, for the monastery of S Giorgio Maggiore (destr.). Three major buildings from this period are linked with the patronage of Cosimo and have been attributed to Michelozzo: the monastery at Bosco ai Frati in the Mugello (perhaps 1420s), the nearby villa of Trebbio, which was already complete and inhabited by 1427, and the monastery of S Marco, Florence (begun *c*. 1436).

In 1437 Michelozzo returned to Montepulciano to complete the *Aragazzi* tomb; the project involved litigation, and he was not paid until at least 1469. In Montepulciano he supplied a design, his first documented work as an architect, to the *priori*, the governors of the town, for the façade of the Palazzo Comunale (1440), which was built in travertine stone and supervised by a Florentine mason. Michelozzo was probably also responsible for the restructuring of the interior, which included the main staircase, courtyard and loggias, and some upper rooms. Meanwhile, perhaps from 1437, and certainly from 1439, he recommenced work (having been involved from 1425) on the casting of panels for the east doors of the Florence Baptistery, perhaps also contributing to their design: until at least 1443 he is referred to as 'sculptor of the doors of S Giovanni'.

(ii) 1441–72. During the 1440s Michelozzo's architectural career was at its peak. From 1441 he probably supervised the construction of Brunelleschi's S Lorenzo for Cosimo de' Medici (he appears in the accounts of 1444 and 1454), and he undoubtedly designed the Palazzo Medici (from 1444; *see* PALAZZO, fig. 1) as Vasari claims. At around the same time Michelozzo probably also designed Cosimo's villa at Careggi and was involved in the reconstruction of the monastic buildings at Santa Croce, which were partly financed by Cosimo. In 1444 work began on the tribune of SS Annunziata (*see* FLORENCE, §IV, 3); designed and initially supervised by Michelozzo, it was financed by Ludovico II Gonzaga, 2nd Marchese of Mantua. Work was interrupted when the Servite Order took possession of the monastery (1447), although it was they who initiated the reconstruction of the monastery, still under Michelozzo's control. The elaborate monastery tabernacle (1448), to house the miraculous painting of the *Annunciation*, was paid for by Cosimo's son Piero de' Medici, who also paid for a tabernacle (1447) in S Miniato al Monte that is probably also the work of Michelozzo. In 1445 Michelozzo married Francesca Galigari and purchased first a vineyard and then a house near San Donnino a Brozzi, west of Florence. He joined the Compagnia de' Magi (Company of Magi), whose members included some of the highest officials of the Florentine government, for which he organized a grand celebration (1446).

shop was well run, although there were financial irregularities, and in 1428 Michelozzo ran into money difficulties, as he was to do several times subsequently.

Michelozzo's first documented construction project was in 1430 when, together with Brunelleschi, Donatello and other Florentine artists, he was involved in the plans to excavate dykes in order to divert the River Serchio and flood the besieged city of Lucca. In 1432 he was employed as a military engineer at Montepulciano. During this period he became increasingly close to the Medici family. In 1430 he travelled with Averardo, Cosimo de' Medici's cousin, to Venice, Padua and Verona, where he executed 'a small work' as a gift for an influential friend of the Medici. He took the opportunity of asking Averardo to intercede with the Florence mint to have his post left open until the following year.

After 1444 Michelozzo established himself with the Opera del Duomo (Cathedral Works), as a supervisor of bronze fixings such as lamps, gratings and bells, as well as other articles of liturgical furniture. In 1446 the Opera del Duomo commissioned Michelozzo, Luca della Robbia and Maso di Bartolommeo to make bronze doors for the north sacristy in the cathedral, but the project was beset with problems and was eventually completed by Luca alone. The problems partly resulted from Michelozzo's many other commitments, especially his appointment as Master of the Cathedral Works after the death of Brunelleschi in 1446. The appointment represented the official recognition of Michelozzo as Florence's leading architect and principally involved the construction of Brunelleschi's project for the cathedral lantern. He designed its component parts and decoration, as well as the complex machinery required to hoist the sections of marble to a height of almost 100 m. As head of the Cathedral Works, he also supervised the defences of the Florentine Republic, in this case the castle of Castellina in Chianti, and also such hydraulic engineering projects as the lake at Castiglione della Pescaia (1447–8) and the fisheries at Mantignano (1460). He was particularly talented in this type of specialized work: in both Venice and Florence he is said to have eliminated the damaging effects of water penetration in buildings. In Florence this concerned the replacement of three disintegrating columns in the Palazzo Vecchio courtyard; this ultimately led to the transformation and extension of the building (from 1457), although this was mostly carried out by his successors.

Various other works dating between 1445 and 1455 have been attributed to Michelozzo, but with no documentary foundation, although it is possible that he was involved with S Girolamo at Volterra, S Girolamo at Fiesole, the monastery at S Miniato (see FLORENCE, §IV, 7), the Palazzo dello Strozzino (1458–65), Florence, and the Medici villa at Fiesole (c. 1466). During the 1450s, however, his career gradually declined. He was increasingly involved in litigation relating to the payment of securities or to disputes on site, as at SS Annunziata in 1455. He also became less active as a designer: only a few payments are recorded for his 'design' for the hospital of S Paolo (1455), Florence, and he was not closely involved in the building of the Ceppo Hospital at Pistoia, for which he provided designs (1451). He appears instead to have concentrated on the cathedral, but his contract with the cathedral authorities was not renewed from 1460. In the following year, possibly after a visit to Milan, where he is said by Vasari to have left designs for the Medici Bank (1454–9), he accepted a post offered by the city of Ragusa (now Dubrovnik) to supervise the strengthening of the city walls.

Among Michelozzo's other projects was an unspecified commission (begun 1464) from the powerful Venetian Giustiniani family on the island of Chios in the Aegean, but it was abandoned, and his payments were withheld. In 1464, after repeated requests, his son Niccolò joined him on Chios, and, although not in the best of health, Michelozzo wrote to Matthias Corvinus, King of Hungary (reg 1458–90), offering to provide him with a hydraulic machine for his copper mines. Michelozzo and his son set out to return to Florence in 1467, stopping at Crete to visit the ruins at Knossos, but their ship was blockaded in Ancona and did not reach Florence until 1469. After an illness in 1470, he was appointed to the commission supervising the completion of the cathedral choir in the following year. He was buried two years later at S Marco, Florence.

2. WORK.

(i) Sculpture. Michelozzo's contribution to Ghiberti's first Baptistery doors remains unclear. Attempts have been made to recognize Michelozzo's influence in the simple architectural backgrounds and especially in their distinctive early Renaissance details, but their design should instead be associated with Ghiberti himself, who also worked as an architect during this period. The culmination of Michelozzo's technical development as a metalworker came with the casting of the St Matthew, Ghiberti's initial casting having proved defective. The hybrid style of this monumental statue, with its Classical and Gothic elements, has much in common with Michelozzo's subsequent work, which reveals a strong tendency to emulate the Antique, as is particularly noticeable in the three great funerary monuments executed in partnership with Donatello.

The Coscia monument (1424), being wall-mounted and surmounted by a draped canopy, is derived from such Venetian prototypes as that of Tomaso Mocenigo (1423; Venice, SS Giovanni e Paolo) by the Florentine Piero di Niccolò Lamberti. Michelozzo's monument, which is inserted between two of the Baptistery's interior columns, has a high base decorated with garlands and putti heads, upon which stand three theological Virtues in shell niches and framed by pilasters. The sarcophagus above is supported by corbels and bears a commemorative inscription on a scroll, held open by two putti. Above this, lying on an all'antica bier supported by lions, is the gilt-bronze figure of the cardinal with a singularly youthful face similar to Donatello's St Louis (1423; Florence, Mus. Opera Santa Croce), and above this in turn is a bust of the Virgin and Child set against a lunette filled by a large shell, and finally a marble drape apparently hanging by a ring from the architrave of the Baptistery's lower storey. Although it is not clear what Michelozzo's particular contribution to the work may have been, it is likely that he was at least involved in the general design and that he was responsible for some of the carving. Usually attributed to him is the bust of the Virgin and Child, which with its flowing composition and formal simplification is reminiscent of Ghiberti.

The Brancaccio tomb (1426–8; see fig. 1, above) in S Angelo a Nilo, Naples, by contrast, is an example of the floor-standing baldacchino type, based on Angevin tombs such as that of Ladislas, King of Naples (after 1414; Naples, S Giovanni a Carbonara) as well as Roman examples, such as the tomb of Philippe d'Alençon. These models, however, are reinterpreted in an early Renaissance architectural vocabulary usually attributed to Michelozzo, but which is comparable with other works of the period, for example Donatello's St Louis tabernacle (c. 1423; Florence, Orsanmichele). The sarcophagus, surmounted by a canopy supported by composite columns, is carried by marble caryatids—a favourite motif in Neapolitan tombs, for example the monument of Catherine of Austria (after 1323;

Naples, S Lorenzo Maggiore) by Tino di Camaino (*c.* 1280–1377)—which are probably the work of Michelozzo. Their identities are still uncertain, being either Christian Virtues or Classical Fates, although they appear to derive from Roman reliefs of religious processions but with an added movement that appears to capture an instant in the funeral ceremony. The simplification of the angular figures recalls both classical prototypes, especially their idealized heads, and the work of other 14th-century artists such as Giovanni Pisano (*c.* 1245/50–1319).

The dismembered *Aragazzi* monument at Montepulciano (1427) is almost exclusively the work of Michelozzo and would have been still more classicizing and archaeological in spirit. The two reliefs that decorated the sarcophagus (still in the church, now Montepulciano Cathedral) are closely based on Roman processional reliefs. More dynamic are two reliefs of angels (London, V&A) once flanking a full-length male figure, perhaps the risen Christ in Montepulciano Cathedral. The antiquarianism can be related to the cultural background of the patron, Bartolomeo Aragazzi (whose effigy by Michelozzo is also in the cathedral), who, as secretary and then chancellor to Pope Martin V, was a pioneering researcher of Classical texts. The *Aragazzi* monument anticipates Bernardo Rossellino's *Bruni* monument (1444; Florence, Santa Croce; for illustration *see* ROSSELLINO, BERNARDO) and Desiderio da Settignano's *Marsuppini* monument (*c.* 1453; Florence, Santa Croce; *see* DESIDERIO DA SETTIGNANO, fig. 1) in associating sculptural antiquarianism with the humanist avant-garde. Although the reliefs of the Prato pulpit (1428) were largely the work of Donatello, the architectural elements, especially the elaborate bronze supporting capital, were possibly Michelozzo's and are characteristic of his creative and fanciful approach to *all'antica* design. There is little evidence that he contributed to the design of Ghiberti's *Gates of Paradise* (completed 1452; Florence Cathedral, Baptistery), although he has been connected with the panels of *Isaac* and *Jacob*. His silver statuette of *St John the Baptist* (1452; Florence, Mus. Opera Duomo), however, is a masterpiece of metalwork.

(ii) Architecture.

(a) Early work. Michelozzo's earliest buildings reveal that he was capable of operating in a wide range of styles. What they have in common is an emphasis on form and volume, a sparing articulation and a willingness to mix stylistic elements. The façade of the Palazzo Comunale at Montepulciano (1440) is so closely based on the late medieval Palazzo Vecchio in Florence that, although it is arranged into a symmetrical composition, it can be considered as a quotation.

The monastery of S Francesco at Bosco ai Frati (1420s) rises from the ruins of a hermitage and, although somewhat marred by the insistent use of the Medici *palle* (their coat of arms) as a decorative motif, it was restructured without the loss of its sober medieval austerity. The dormitory was enlarged, loggias were built over the garden, and the church was lengthened and splendidly vaulted. Work on the Trebbio villa (1420s), also for the Medici, involved alterations to a medieval tower-fortress of a compact and regular shape, strategically positioned high above the

Mugello valley north of Florence. The medieval appearance of the villa, with its castellations, is difficult to reconcile with the spirit of humanist architecture but is appropriate for the country residence of a family with social aspirations. The Cafaggiolo villa (1420s), not far from Trebbio, has all the qualities of a palazzo, with a courtyard and loggias, fortified walls and moat. The use of plaster on the exterior is characteristic of Michelozzo, as are the simple volumetric elements of the design, especially the dominant central tower, a feature typical of fortresses that gives dignity to the villa. The irregularly arranged windows with their dark frames contrast with the light walls and lend the building a medieval character, and architectural elements such as the cornices of the doors (similar to those of the later Noviciate at Santa Croce) and the triangular corbels are certainly of medieval form. More unusual, however, is the sophisticated combination of volume with surrounding space and garden, which is no longer an enclosed medieval *hortus* but a synthesis of utility and ornament.

The monastery of S Marco (*c.* 1436), Florence, develops on a larger scale the ideas initiated at Bosco ai Frati. Cosimo de' Medici's motives for financing the rebuilding, rather than hoarding his money like other merchants and bankers, would have been faithful to the moral stance of Dominican theologians as well as to Ciceronian ethics. Early writers attributed an initial design for the new monastery to Brunelleschi, who then entrusted the project

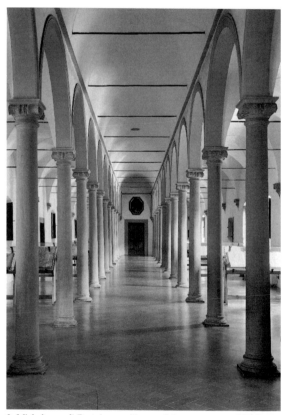

2. Michelozzo di Bartolomeo: library of the monastery of S Marco, Florence, begun *c.* 1436

to Michelozzo because he had too much work in hand. Michelozzo's design did not greatly change the original building. In the church he added a vaulted choir to the existing presbytery and framed it with fluted Corinthian pilasters, applied to piers. The body of the church was subdivided according to Dominican tradition into three areas, for the monks, for laymen and for women, and Michelozzo added the gabled bell-tower. The basic layout of the adjoining monastery, which Vasari judged 'the most comfortable and beautiful ... in all Italy', was retained, with the pilgrims' guest wing along the front aligned with the unadorned façade of the church (replaced 1780). The cloister at the side of the church was rebuilt in Renaissance style, with stone Ionic columns and slightly flattened arches. Around the courtyard on the upper floor are the simple monks' cells, many of which were frescoed by Fra Angelico (see colour pls 1, III1 and 1, III2).

The main innovation of the monastery complex is the library (see fig. 2), the first purpose-built example in the Renaissance, which occupies the upper floor of a wing facing on to a second cloister to the north. The library has three aisles, a layout derived from 14th-century dormitories—as, for example, at S Maria Novella—but here they are divided by slender Ionic columns with a central barrel vault and groin vaults at either side. The windows are small and situated at the reader's eye-level. In this library were kept the precious Greek and Latin manuscripts acquired in 1437 by Cosimo de' Medici from the heirs of the humanist Niccolò Niccoli as well as texts recom-

mended by Tommaso Parentucelli (later Pope Nicholas V).

(b) Mature work. The Medici Chapel at Santa Croce, Florence (1440s), is a simple design that became a model for many other buildings. The body of the chapel has two square bays with groin vaults supported on corbels, and an altar space at the end, framed by pilasters, which is flanked by service areas as in Brunelleschi's Old Sacristy for S Lorenzo. The tall vaulted corridor nearby that links the medieval church with new monastic buildings is lit by three elegant tripartite arched windows, of a basically medieval type but reinterpreted in Renaissance style. The monastic buildings at Santa Croce, which incorporate the Pazzi Chapel (perhaps under construction at the same time and perhaps, according to Trachtenberg, actually by Michelozzo rather than Brunelleschi to whom it is traditionally attributed), have a similar layout to those at S Marco, with spacious barrel- or groin-vaulted stairways, and sleeping wings divided into small cells with white walls and simple stone cornices. At S Lorenzo it has been suggested that alterations made by Michelozzo (after Cosimo's return in 1434) to Brunelleschi's design can be seen in the transept ends, the dome, and even the nave colonnades.

Michelozzo's design for the Palazzo Medici (now Palazzo Medici–Riccardi; 1444; see fig. 3), Florence, may have been inspired by Brunelleschi's grandiose design, which had been rejected, perhaps because it was consid-

3. Michelozzo di Bartolomeo: courtyard of the Palazzo Medici (new Palazzo Medici–Riccardi), Florence, begun 1444

ered incompatible with Cosimo de' Medici's political and cultural image. Michelozzo's design, however, with its relatively regular plan organized around a central colon-naded courtyard, its rear garden flanked by loggias, and with its three-storey façades crowned by massive cornices, became a model for early Renaissance architecture. The graduated stone facing, from the rusticated basement to the smooth masonry of the second floor, and the round-headed mullioned windows can be traced to 14th-century palaces, for example the Palazzo Vecchio and Palazzo Davanzati. The Corinthian cornice, however, is derived from Roman examples, and the rustication may have been thought evocative of such ancient monuments as the Etruscan walls at Fiesole. The interior of the palace was splendidly decorated, especially the chapel with the fresco cycle by Benozzo Gozzoli (see colour pl. 1, XXXV2) and its elaborately carved wooden fittings and coffered ceilings, which perhaps follow Michelozzo's designs.

Unlike Trebbio and Cafaggiolo, the Careggi villa, about three miles from Florence, was not a fortified stronghold, despite its external castellations, but a suburban residence with courtyards and open loggias overlooking a garden. Its curious plan is due to the irregular shape of the site and to its being a remodelling of an earlier structure. Careggi marks the revival of the Classical ideal of villa life. The Medici villa (c. 1460) at Fiesole is also attributed to Michelozzo, although its construction was supervised by Antonio Manetti Ciaccheri (1405–60). The design, a simple block with a loggia overlooking a terraced garden, reflects a new interest in the villa as a place of rest and culture as described by Cicero and Pliny.

The most extraordinary and fascinating of Michelozzo's architectural projects was the tribune of SS Annunziata, Florence. Its unprecedented circular plan with nine radi-ating chapels served as a presbytery, choir and funerary chapel (see fig. 4). From the start of work (1444) the building was criticized by Brunelleschi and other architects, who suggested it was an unsuitable attachment to a basilican church. The design of the tribune is apparently derived from the Temple of Minerva Medica in Rome and would be one of the earliest, as well as one of the most far-reaching, instances of this sort of revivalism in the 15th century. Michelozzo's transformation of the rest of the church under the new administration of the Servites (1447) involved the conversion of the side aisles into chapels and the construction of a new sacristy. Other work at SS Annunziata included the rebuilding of the large cloister and the building of a forecourt, the Chiostro dei Voti, the neighbouring oratory of S Sebastiano dei Pucci, and the creation of the elaborately carved marble taber-nacle (1448) supported by four columns, two Corinthian and two Composite, to house the miraculous painting of the *Annunciation*. The tabernacle was executed by Pagno di Lapo (Portigiani) and Maso di Bartolommeo, two former colleagues from the workshop who also worked at S Lorenzo.

The Ceppo Hospital (1451) at Pistoia and the Ospedale di S Paolo (1455), with their spacious courtyards and columns carrying arches without intermediate mouldings, were both only routine work for Michelozzo. In each case the front loggia dates from the late 15th century, and it is therefore unclear whether the design, which is based on

Brunelleschi's Ospedale degli Innocenti in Florence (see colour pl. 1, XVI2), may be attributed to Michelozzo.

3. CRITICAL RECEPTION AND POSTHUMOUS REPUTATION. Michelozzo was almost totally ignored by 15th-century treatise and chronicle writers, although he was mentioned by Benedetto Dei, who described him as an 'architect and sculptor of all things', while Filarete included him with other sculptors who turned to architec-ture, such as Pagno di Lapo and Bernardo Rossellino. The first catalogue of Michelozzo's work (1516–20) was by Antonio Billi, who incorrectly referred to him as Miche-lozzo Michelozzi. This was Vasari's primary source in the first edition of his *Vite* (Florence, 1550), although in the second edition he attempted to distinguish Michelozzo's personality as a sculptor from that of his 'master' Dona-tello, emphasizing Michelozzo's administrative role in the partnership and in particular his work as an architect. For the first time the Palazzo Medici, the modernization of Palazzo Vecchio and the fortifications outside Florence

4. Michelozzo di Bartolomeo: plan of SS Annunziata, Florence, begun 1444

were added to the list of attributions. Vasari's account forms the basis of those by Borghini, Scamozzi and the comprehensive guide of Bocchi. The view that Michelozzo's design for Palazzo Medici was a mere fall-back to replace the destroyed project of Brunelleschi became particularly popular (del Migliore), and the number of erroneous attributions increased. Milizia was more critically objective, praising some of the formal solutions of Palazzo Medici but condemning the strongly decorative trends of the Annunziata tabernacle.

Perhaps the first attempt to define the architectural personality of Michelozzo was that of Rau and Rastrelli, who saw Michelozzo as an imitator of Brunelleschi but one who strove 'to abandon ... the barbarous German style', a view underlying the writings of Quatremère de Quincy and others. The reappraisal of Michelozzo's career, based on documentary material, began with Milanesi and culminated with Fabriczy (1904) and the first monographs on Michelozzo by Wolff and Folnesics. At the same time critical assessment and typological comparison became an increasingly important aspect of the study of Michelozzo, and his work began to be seen as having had a formative influence on building in Florence from 1440 to 1460. Once Michelozzo had been elevated to the rank of an independent artist, especially in studies dating from between the two world wars, attempts began to be made to characterize his style more precisely (notably in works of particular importance, such as the SS Annunziata tribune), recognizing both his classical and gothicizing designs, such as the church at Bosco ai Frati, and his apparent ability to adapt his style in accordance with his various patrons. Despite a number of excellent studies, Michelozzo regained his due recognition as one of the great sculptors of the Renaissance only with Janson's thesis (1942). Subsequent studies have reaffirmed this view, and his formative influence has been recognized, particularly in the evolution of the Renaissance tomb monument.

BIBLIOGRAPHY

EARLY SOURCES

A. Filarete: *Trattato di architettura* (1451–64); ed. A. M. Finoli and L. Grassi (Milan, 1973), p. 171

B. Dei: *Descrizione de Firenze* (1472); ed. G. C. Romby, *Descrizioni e rappresentazioni della città di Firenze nel XV secolo* (Florence, 1976), p. 72

A. Billi: *Il libro di Antonio Billi* (MS.; *c.* 1516–20; Florence, Bib. N. Cent.); ed. C. von Fabriczy (Florence, 1891), p. 27

G. Vasari: *Vite* (Florence, 1550, rev. 2/1568); ed. G. Milanesi (1878–85), ii, pp. 431–51

R. Borghini: *Il riposo di Raffaello Borghini, in cui della pittura, e della scultura si favella* (Florence, 1584); ed. M. Rosci (Milan, 1967), p. 322

F. Bocchi: *Le bellezze della città di Fiorenza* (Florence, 1591); ed. G. Cinelli (Florence, 1677), p. 87

V. Scamozzi: *L'idea della architettura universale* (Venice, 1615), p. 29

F. Baldinucci: *Notizie* (Florence, 1681–1728); ed. F. Rinalli (1845–7), i, p. 406

F. L. del Migliore: *Firenze città nobilissima* (Florence, 1684), p. 199

GENERAL WORKS

F. Milizia: *Le vite de' più celebri architetti d'ogni tempo* (Rome, 1768), pp. 169–70; rev. as *Memorie degli architetti antichi e moderni* (Bassano, 4/1785), i, pp. 127–9

A. Rau and M. Rastrelli: *Serie degli uomini più illustri nella pittura, scultura, e architettura . . .* (Florence, 1769–76), xiii, p. 50

A. C. Quatremère de Quincy: *Histoire de la vie et des ouvrages des plus célèbres architectes du XIe siècle jusqu'à la fin du XVIIIe*, i (Paris, 1830), p. 72

MONOGRAPHIC STUDIES

F. Wolff: *Michelozzo di Bartolomeo: Ein Beitrag zur Geschichte der Architektur und Plastik im Quattrocento* (Strasbourg, 1900)

C. von Fabriczy: 'Michelozzo di Bartolomeo', *Jb. Kön.-Preuss. Kstsamml.*, xxv (1904), pp. 34–110

O. Morisani: *Michelozzo architetto* (Turin, 1951) [full bibliog.]

L. Gori Montanelli: *Brunelleschi e Michelozzo* (Florence, 1957)

H. McNeal Caplow: *Michelozzo*, 2 vols (New York, 1977)

A. Natali: *L'umanesimo di Michelozzo* (Florence, 1980)

M. Ferrara and F. Quinterio: *Michelozzo di Bartolomeo* (Florence, 1984)

G. Morelli, ed.: *Michelozzo: Scultore e architetto (1396–1472)* (Florence, 1998)

SCULPTURE

H. W. Janson: *The Sculpted Works of Michelozzo di Bartolomeo* (diss., Cambridge, MA, Harvard U., 1942)

——: *The Sculpture of Donatello*, 2 vols (Princeton, 1957)

O. Morisani: 'Il monumento Brancacci nell'ambiente napoletano del quattrocento', *Atti dell'VIII convegno internazionale di studi sul rinascimento: Donatello e il suo tempo: Firenze, 1968*, pp. 207–13

F. Gurrieri: *Donatello e Michelozzo nel pulpito di Prato* (Florence, 1970)

F. Finiello Zervas: *Systems of Design and Proportion used by Ghiberti, Donatello and Michelozzo in their Large-scale Sculptural Ensembles between 1412–1434* (Baltimore, 1973)

H. McNeal Caplow: 'Sculptors' Partnerships in Michelozzo's Florence', *Stud. Ren.*, xxi (1974), pp. 145–75

R. W. Lightbown: *Donatello and Michelozzo: An Artistic Partnership and its Patrons in the Early Renaissance*, 2 vols (London, 1980)

J. Beck: 'New Notices for Michelozzo', *Renaissance Studies in Honour of Craig Hugh Smith* (Florence, 1985), ii, pp. 23–36

ARCHITECTURE

H. Folnesics: 'Der Anteil Michelozzos an der Mailander Renaissancearchitektur', *Repert. Kstwiss.*, xl (1917), pp. 129–37

H. Saalman: 'The Palazzo Comunale in Montepulciano: An Unknown Work by Michelozzo', *Z. Kstgesch.*, xxviii (1965), pp. 1–46

——: 'Michelozzo Studies: I. Michelozzo at Santa Croce', *Burl. Mag.*, cviii (1966), pp. 242–50

——: 'Michelozzo Studies: The Florentine Mint', *Festschrift Ulrich Middeldorf* (Berlin, 1968), i, pp. 140–42

P. Roselli: *Coro e cupola della SS Annunziata a Firenze* (Pisa, 1971)

H. McNeal Caplow: 'Michelozzo at Ragusa: New Documents and Revaluations', *J. Soc. Archit. Hist.*, xxxi/2 (1972), pp. 108–19

M. Gori Sassoli: 'Michelozzo e l'architettura di villa del primo rinascimento', *Stor. A.*, xxiii (1975), pp. 5–51

E. Casalini: 'Brunelleschi e Michelozzo all'Annunziata', *Le due cupole: Firenze, 1977*, pp. 29–63

R. A. Goldthwaite and W. Rearick: 'Michelozzo and the Ospedale di San Paolo in Florence', *Mitt. Ksthist. Inst. Florenz*, xxi (1977), pp. 221–306

H. Saalman: 'Documenti inediti sulla cappella della SS Annunziata', *Scritti di storia dell'arte in onore di U. Procacci* (Milan, 1977), pp. 225–7

H. Teubner: 'Das Langhaus der SS Annunziata in Florenz: Studien zu Michelozzo und Giuliano da Sangallo', *Mitt. Ksthist. Inst. Florenz*, xxii (1978), pp. 27–60

——: 'San Marco: Umbauten vor 1500 ein Beitrag zum Werk des Michelozzo', *Mitt. Ksthist. Inst. Florenz*, xxiii (1979), pp. 239–72

B. L. Brown: *The Tribuna di SS Annunziata in Florence* (diss., New York U., 1980)

P. Jacks: 'Michelozzo di Bartolomeo and the Domus Pulcra of Tommaso Spinelli in Florence: History of the Authorship of Spinelli Palace in Fifteenth-century Florence, with Appendices of Archival Letters', *Architectura*, xxvi/1 (1996), pp. 47–83

M. Trachtenberg: 'Michelozzo and the Pazzi Chapel, Santa Croce, Florence', *Casabella*, lxi (1997), pp. 56–75

FRANCESCO QUINTERIO

Michiel, Marcantonio (*b* Venice, *c.* 1484; *d* Venice, 9 May 1552). Italian writer and collector. He was an important Venetian dilettante and connoisseur whose surviving writings constitute a valuable source of information on 16th-century art patronage in the Veneto. He received his education from the renowned scholar Giovanni Battista Egnazio (1473/8–1553), Canon of S Marina, whose own active interest in the arts and literature no doubt had a formative influence on him. In his youth Michiel travelled to Dalmatia and Corfu; in 1514 he visited Florence and in

1516 Bergamo, of which he wrote a Latin description, his only work published in his lifetime. In 1518 he travelled to Rome, where he stayed for two years.

Michiel's diary, which he kept from 1511, reveals his increasing interest in art and architecture, no doubt stimulated by his experience of the papal court, where he came into contact with Baldassare Peruzzi and possibly Sebastiano del Piombo and Raphael. Michiel also explored the ancient ruins of Rome and Naples. While in Rome, he maintained contact with his Venetian friends, to whom he wrote about current affairs and major events in the city's art life, such as Raphael's death, the decoration of the Vatican Loggie, the display of seven of Raphael's tapestries and the praise received by Sebastiano del Piombo's *Raising of Lazarus* (1519; London, N.G.; *see* SEBASTIANO DEL PIOMBO, fig. 3) when it was displayed in the Vatican in December 1519.

Soon after his return to Venice, Michiel began assembling concise notes describing civic buildings, churches and their contents and, most importantly, private collections located in the Veneto; now arranged geographically, the largest sections are devoted to Padua and Venice. These notes (Venice, Bib. N. Marciana, Ital. XI.67 (7351)), which were compiled intermittently between 1521 and 1543, were discovered in 1800 by Jacopo Morelli (1745–1819) and were known as the *Anonimo Morelliano* until the identification of their author by Daniele Francesconi (*d* 1835). Michiel used a variety of sources: written, oral and personal visits. His description of Milan was taken directly from Cesare Cesariano's *Di Lucio Vitruvio Pollione de Architectura Libri Dece* (Como, 1521), and he frequently cited the authority of Hieronimo Campagnola (*d* 1522). While undertaking his research, Michiel also consulted personal friends, such as the Paduan sculptor Andrea Riccio, whose opinion he quoted regarding the authorship of various Paduan fresco cycles, and the Neapolitan humanist Pietro Summonte, who sent him letters describing both ancient and modern works of art in Naples. Michiel also corresponded with Pietro Aretino, Guido Celere and possibly knew the sculptor Giovanni Maria Mosca Padovano. The notes, which were probably made for Michiel's own interest rather than with a view to publication, provide a first-hand insight into the richness and diversity of private collections in the Veneto, to which, as a patrician and collector, he had access; many were owned by his acquaintances. His information must, however, be used with caution, for the succinct accounts are by no means exhaustive; nor was he wholly reliable with regard to attribution or the identification of religious iconography, and gaps remain in the text where he was unable to discover the identity of certain artists. In Padua he visited Niccolò Leonico Tomeo (1456–1531), Pietro Bembo and Marco di Mantova Benavides, and in Venice he viewed some major collections, including those of Cardinal Domenico Grimani (1521), Gabriele Vendramin (1530) and Andrea Odoni (1532). Michiel's notes attest to connoisseurs' admiration for landscapes, portraits, antiquities and early Netherlandish paintings and to one of the earliest recorded instances of an attributional problem: the debate as to whether a painting owned by Antonio Pasqualino, identified as Antonello da Messina's *St Jerome in his Study* (*c*. 1474–6; London, N.G.), was an Italian or

Flemish work (*see* ANTONELLO DA MESSINA, fig. 1). The notes also contain the earliest existing description of Mantegna's frescoes (1454–7; partly destr. 1844; remnants *in situ*; *see* MANTEGNA, ANDREA, fig. 1) in the Ovetari Chapel (Padua, Eremitani) and are an important source for studies of Giorgione; though there is no evidence that they were acquainted, Michiel owned at least one work by Giorgione. The works of art acquired and commissioned by Michiel were probably kept in his family palazzo at S Marina, where he had a *studiolo*. Although not described in his notes, at least some of its contents can be determined from an undated inventory (Venice, Bib. Corror, MS PD C 1267 [8]). It included marble sculptures, paintings (mostly portraits), reliefs, drawings and small bronze statuettes of *all'antica* subjects similar to those produced by Riccio. Also itemized is the marble statuette of a running *Mercury* (London, V&A) that Michiel commissioned from Antonio Minello in 1527, with a bronze horoscope set in the base.

Although Michiel's writings on artistic matters are significant, most of his work was devoted to current affairs and politics. He regarded himself primarily as a historian and prepared notes for studies of Venetian history and Pisan/Venetian relations. In February 1527 he married Maffea Soranzo (*d* 1576), a member of a powerful family, and after several attempts to secure public office he was elected to the Venetian senate on 28 September 1527, but his political ambitions were never fully realized.

UNPUBLISHED SOURCES

Venice, Bib. Corror, MS. Cicogna 2848 [diary, 1511–20]

WRITINGS

Agri et Urbis Bergomatis descriptio anno 1516 (Bergamo, 1516); *R* in F. Bellafina: *De origine et temporibus Urbis Bergomi* (Venice, 1532)

Venice, Bib. N. Marciana, Ital. XI 67 (7351), pub. as *Notizia d'opere di disegno nella prima metà del secolo XVI* (MS.; 1521–43), ed. J. Morelli (Bassano, 1800, rev. Bologna, 1884); *Notizie d'opere di disegno* (MS.; *c*. 1520–40), ed. G. Frizzoni (Bologna, 1884); Eng. trans. by P. Mussi, ed. G. C. Williamson, as *The Anonimo* (London, 1903/*R* New York, 1969); *Der Anonimo Morelliano*, Quellenschr. Kstgesch. & Ksttech., ed. T. Frimmel (Vienna, 1896)

BIBLIOGRAPHY

E. A. Cicogna: 'Intorno la vita e le opere di Marcantonio Michiel Patrizio veneto della prima metà del secolo XVI', *Mem. Ist. Ven. Sci., Lett. & A.*, ix (1861), pp. 359–425

C. von Fabriczy: 'Summonte's Brief an Marcantonio Michiel', *Repert. Kstwiss.*, xxx (1907), pp. 143–68

F. Nicolini: *L'arte napoletana del rinascimento e la lettera di Pietro Summonte a Marcantonio Michiel* (Naples, 1925)

W. Hartner: 'The Mercury Horoscope of Marcantonio Michiel of Venice', *Vistas in Astronomy*, ed. A. Beer, i (London and New York, 1955), pp. 83–138; *R* in *Oriens–Occidens* (Hildesheim, 1968), pp. 440–95

J. Fletcher: 'Marcantonio Michiel's Collection', *J. Warb. & Court. Inst.*, xxxvi (1973), pp. 382–5

J. Eade: 'Marcantonio Michiel's Mercury Statue: Astronomical or Astrological?', *J. Warb. & Court. Inst.*, xliv (1981), pp. 207–9

J. Fletcher: 'Marcantonio Michiel: His Friends and Collection', *Burl. Mag.*, cxxiii, no. 941 (1981), pp. 453–67

L. Campbell: 'Notes on Netherlandish Pictures in the Veneto in the Fifteenth and Sixteenth Centuries', *Burl. Mag.*, cxxiii, no. 941 (1981), pp. 467–75

J. Fletcher: 'Marcantonio Michiel, "che ha veduto assai"', *Burl. Mag.*, cxxiii, no. 941 (1981), pp. 602–8

L. Olivato: 'Con il Serlio tra i "dilettanti di architettura" veneziani della prima metà del '500: Il ruolo di Marcantonio Michiel', *Les Traités d'architecture de la Renaissance. Actes du colloque: Tours, 1981*, pp. 247–54

Collezioni di antichità a Venezia nei secoli della Repubblica (exh. cat., ed. M. Zorzi; Venice, Bib. N. Marciana, 1988), pp. 41–50

HELEN GEDDES

Michieli, Andrea. *See* VICENTINO, ANDREA.

Milan [It. Milano; Lat. Mediolanum]. Italian city and capital of Lombardy. A Celtic settlement that became a Roman colony in 89 BC, it served as the capital of the Western Empire from AD 280 to 402 and also became a prominent Early Christian centre under Archbishop Ambrose (*reg* AD 374–97). By the mid-11th century it had developed into one of the early Italian communes and from 1257 to 1499 was ruled by a succession of powerful families: the Torriani, the Visconti and the Sforzas.

BIBLIOGRAPHY
A. Bosisio: *Storia di Milano* (Milan, 1958)
P. Mezzanotte and G. C. Bascapè: *Milano nell'arte e nella storia* (Milan, 1968)
G. Bologna: *Milano nei libri e nei documenti del suo archivio storico* (Milan, 1980)
M. Mirabella Roberti, A. Vincenti and G. M. Tabarelli: *Milano città fortificata* (Rome, 1983) □

I. History and urban development. II. Art life and organization. III. Centre of rock crystal production.

I. History and urban development.

1. Introduction. 2. To 1499. 3. 1500 and after.

1. INTRODUCTION. The name Mediolanum is of Celtic origin, indicating a central place or point of convergence, and it reflects the town's location on a plain at the junction of early trade routes by land and water, including the route from the Alps to the north. The first permanent settlement was established by the Gauls, who crossed into Italy in 388 BC and recognized its favourable geographical position. Owing to the local importance of pig farming, a tradition arose that the name was derived from a sow with hair on her back only (Lat. *medio-lanum*, 'half-woolly'); the animal appears on oil lamps (e.g. 4th century AD; Milan, Civ. Mus. Archeol.).

The town was conquered by the Romans in 222 BC and granted the status of a Latin colony in 89 BC. From AD 280 to AD 402 Milan was the capital of the Western Roman Empire. A period of building activity began with the appointment of Ambrose as archbishop in 374. In 538 the city was half destroyed by the Ostrogoths. Following a brief period of Byzantine rule (553–69), the city fell to the Lombards, who in turn were eventually overthrown by Charlemagne in 774.

In the 9th century the city began to acquire greater autonomy, particularly under Archbishop Ansperto da Biasono (*reg* 868–81). The affirmation of episcopal authority reached its culmination with Archbishop Ariberto d'Antimiano (*reg* 1018–45), who united the citizens against Emperor Conrad II (*reg* 1024–39). A symbol of this union was the so-called 'Caroccio'—an ox-drawn war cart bearing the cross and the standard of the city. Between the 9th and 10th centuries the organization of the city underwent a change: communities gathered around the houses of the most powerful citizens, who exercised patronage and charity to the poor. Merchants and bankers resided in the city centre, artisans in the suburbs, and the area in between was occupied by convents, hospitals and charitable institutions.

On 1 March 1162, after a seven-month siege, the Milanese were forced to capitulate to Frederick I, who had invaded northern Italy. The walls, towers and palaces of the beautiful medieval city were completely demolished: only the churches were left standing. The inhabitants were forced to evacuate the city and lived in four districts of poor housing built outside the city walls (Nosedo, Vigentino, Siro alla Vepra and Lambrate). Five years later, however, in defiance of the imperial decree that prohibited their return to the city, the Milanese began to reconstruct it with the help of the Paduan Commune. After the defeat of Frederick at the Battle of Legnano (1176), the Milanese Commune reverted to a life characterized by opposition between the aristocracy, who belonged to the Motta party, and the emerging mercantile and artisan classes, who formed a political organization called the Credenza di S Ambrogio. The continuing disputes gradually pushed the city towards a form of monarchical government. The first skirmishes at the Signoria occurred when Martino della Torre (*d* 1263) was elected Anziano Perpetuo del Popolo di Milano (1257), which effectively sanctioned the rule of the Torriani. In 1277 the Guelph Torriano party was defeated by the aristocratic pro-Ghibelline party headed by Archbishop Ottone Visconti (*d* 1295) after a bloody battle at Desio, near Milan. The VISCONTI quickly pacified the city's factions and consolidated their rule. Ottone appointed his great-nephew Matteo I (*reg* 1310–22) as Captain of the People. Despite resistance from the Torriani (1302–11) and disputes with the imperial authorities, the dominion of the Visconti family became absolute. Under Galeazzo I (*reg* 1322–8), Azzo (*reg* 1328–39), Galeazzo II (*reg* 1354–78) and Bernabò (*reg* 1354–85) numerous other cities became subject to Visconti Milan, which thus became the capital of a state.

BIBLIOGRAPHY
M. Mirabella Roberti: *Milano romana e paleocristiana* (Milan, 1972/*R* 1984)
R. Krautheimer: *Three Christian Capitals: Topography and Politics* (London, 1983)
C. Bertelli, ed.: *Milano: Una capitale da Ambrogio ai Carolingi* (1987), i of *Il millennio ambrosiano*, 3 vols (Milan, 1987) [with extensive bibliog.]
ALESSANDRA ANSELMI

2. TO 1499. The political and economic expansion that took place in the 13th and 14th centuries naturally led to a surge of building and urban development. The city conquered by the Visconti had numerous ecclesiastical buildings, many of which were Early Christian basilicas rebuilt in the Romanesque style. The canal system was expanded, which, in addition to being defensive, allowed the transport of goods and food and providing running water for the workshops of dyers, tanners, smiths, millers and papermakers.

The Visconti were associated with a series of building projects that testified to their power and largesse. Bernabò Visconti reinforced the Porta Romana and the Porta Nuova (1358), while Giangaleazzo Visconti (*reg* 1378–1402) fortified the Rocca di Porta Giovia (1358–68), thus founding the Castello di Porta Giovia (later Castello Sforzesco; see fig. 1 below), which he made his official seat. His withdrawal from the Palazzo di Corte Ducale was symbolic of his increasing detachment from the people. A practical reason for the move was the construction of a new cathedral (begun 1306), which was to occupy

1. Milan, Castello Sforzesco, from 1358

part of the palace's site. Giangaleazzo was created Duke of Milan in 1395. His death in 1402 not only meant that work on the cathedral was halted, but had important repercussions throughout the state of Milan. Under Giangaleazzo the city's dominion had extended to nearly all of North Italy and the area beyond the Apennines, including Pisa, Perugia and Siena. Following his death, the republics of Florence and Venice now formed a coalition against Milan and reduced its territories to Lombardy. Giovanni Maria (*reg* 1402–12) and Filippo Maria (*reg* 1412–47) were forced to defend themselves against repeated attacks by the two republics and the Papal State.

Filippo Maria employed as condottiere Francesco Attendolo (known as Francesco Sforza I; *see* SFORZA, (1)), who married the Duke's daughter, Bianca Maria (*see* SFORZA, (3)). When Filippo Maria died without a male heir, the Milanese proclaimed the Golden Ambrosian Republic, inspired by the city states. The new yet rather anachronistic system failed to consolidate power or to prevent the desertion of the Lombard cities. Venice in particular began to threaten Milan, and the 24 heads of the republic turned for help to Francesco Sforza, who made an agreement first with the Milanese, and then with Venice; he successfully besieged Milan (1450) and claimed the duchy. He presided over a period of prosperity and renewal, aided by the peace that was confirmed with the

Treaties of Lodi (1454). Francesco encouraged the city's flourishing production of tapestries, goldwork, armour and precious silks. While Milanese merchants exploited new trade routes, the city became the market for the surrounding plain's agricultural produce.

In 1455 the cylindrical towers of the Castello Sforzesco were begun (see fig. 1), and in 1456 Francesco commissioned the Ospedale Maggiore (now university; *see* FILARETE and fig. 2): its construction dragged on for centuries. Francesco also initiated the paving of the main streets.

Francesco's son Galeazzo Maria (*reg* 1466–76) inherited a flourishing city that played host to humanists and scholars, such as Luca Pacioli. When Galeazzo Maria was assassinated, his son Giangaleazzo (*reg* 1476–94) was too young to rule, and so his uncle Ludovico Sforza ('il Moro') gradually took control. Under Ludovico and his wife, Beatrice d'Este, the city flourished. Ludovico surrounded himself with the finest artists, in emulation of Lorenzo de' Medici: he brought Leonardo da Vinci to Milan, and Bramante designed S Maria presso S Satiro (from 1478; *see* BRAMANTE, DONATO, §I, 2(ii)(a), and fig. 1), S Maria delle Grazie (from 1492; *see* BRAMANTE, DONATO, fig. 2) and parts of the S Ambrogio monastic complex. Ludovico also added a lantern (1470–1500) to the cathedral, commissioned the Lazzaretto (1488–1513) and ordered the

excavation of one of the canals, the Naviglio della Marte-sana, from the River Adda to Milan. Among other works, GIOVANNI DI DOMENICO BATTAGGIO designed S Maria della Passione (begun before 1486) in a style heavily influenced by that of Bramante. At the end of the 15th century Louis XII of France (*reg* 1498–1515) asserted his claim to Milan in alliance with the Aragonese rulers of Naples, Venice and the Pope. In 1499 Ludovico was forced to abandon the city and was captured by the French.

BIBLIOGRAPHY

B. Corio: *Patria historia* (Milan, 1503)
F. Cognasso: 'Note e documenti sulla formazione dello stato visconteo', *Boll. Soc. Pavese Stor. Patria*, xxiii (1923), pp. 23–169
C. Santoro: *Gli offici del comune di Milano e del dominio visconteo-sforzesco, 1216–1515* (Milan, 1968)
L. Cerioni: *La diplomazia sforzesca nella seconda metà del quattrocento*, 2 vols (Rome, 1970)
Popolo e stato in Italia nell'età di Federico Barbarossa: Alessandria e la Lega Lombarda (Turin, 1970)
N. Raponi: *Lo stato di Milano nell'età sforzesca* (Milan, 1971)
G. Martini: 'La battaglia di Legnano: Realtà e mito', *Nuova Antol.*, cxi (1976), pp. 357–71
M. Bellonci, G. A. dell'Acqua and C. Perogalli: *I Visconti a Milano* (Milan, 1977)
G. Lopez: *Gli Sforza a Milano* (Milan, 1978)
P. Zerbi: *Tra Milano e Cluny: Momenti di vita e cultura ecclesiastica nel XII secolo* (Rome, 1978)
La città nell'età di Ludovico il Moro: Atti del convegno su Leonardo a Milano, 1482–1982: Milano, 1983
Ludovico il Moro: La sua città e la sua corte, 1480–1499 (exh. cat., Milan, Archv Stato, 1983)

MARCO CARMINATI

3. 1500 AND AFTER. Louis XII of France initially gained the trust of the Milanese by restoring the Senate, an assembly of noble citizens elected by the French crown. He also reduced taxation by instituting protectionist measures in favour of some categories of craftsmen. The numerous wars fought by the French monarch, however, led to an increase in taxation and a decrease in his popularity. The church of S Maurizio Maggiore (rest.) at the Monasterio Maggiore was erected from 1503, possibly to a design by Giovanni Giacomo Dolcebuono, while the pro-French condottiere GIAN GIACOMO TRIVULZIO commissioned Bramantino to build a large family funerary chapel (*c.* 1512) in front of the church of S Nazaro Maggiore. Between 1508 and 1509 the French governor, Charles d'Amboise II, commissioned the sanctuary of S Maria alla Fontana (rest.); Leonardo da Vinci was possibly involved in the project.

The creation of the Holy League, which aimed to expel the French from the Italian peninsula, resulted in Louis's defeat at Ravenna in 1513 and the restoration of the Sforzas. Massimiliano Sforza (*reg* 1512–15), however, was beaten by Francis I of France (*reg* 1515–47) at the Battle of Marignano (1515). During the second period of French rule, Milan was involved in the dispute between France and Habsburg Spain and Austria. Francis allowed the existing citizens' council to continue to function, but he ruled through greedy and unpopular governors. In 1521

2. Milan, Villa Gonzaga (now Villa Simonetta) by Domenico Giunti, 1547–52; engraving by Marc'Antonio dal Re from his *Ville di Delizia o siano Palagi Camparecci nello stato di Milano* (Milan, 1726) (London, Victoria and Albert Museum)

the Spanish troops of Emperor Charles V (*reg* 1519–56) reclaimed Milan for the Habsburgs. Charles established Francesco Sforza II (*d* 1535) as Governor of Milan and took direct possession of the city on the latter's death.

CRISTOFORO LOMBARDO worked on a number of buildings: he participated in the construction of S Maria presso S Celso from 1530; he rebuilt the Palazzo Stampa di Soncino (from 1534), which culminated in a tower decorated with the heraldic devices of Charles V; and he designed the lantern (1550–51) of S Maria della Passione. DOMENICO GIUNTI was architect to the Spanish governor, Ferrante Gonzaga (*reg* 1546–55), for whom he executed a number of commissions, including the transformation of the suburban Villa Gonzaga (now Villa Simonetta; 1547–52; see fig. 2). The new city fortifications (mostly destr.), often known as the Spanish bastions, were commissioned by Ferrante Gonzaga in 1548 and largely completed before 1560. The nine-pointed bastions closely followed the outline of the Visconti ditches, with gateways aligned with existing city gates. Built from spolia, the ramparts had irregular, battered walls and a rough surface. The gates had two pilasters covered by a pitched roof and were flanked by tollhouses. In the city, Galeazzo Alessi designed a number of churches and the influential Palazzo Marino (begun 1558; *see* ALESSI, GALEAZZO and fig. 3).

Spanish rule was recognized by the other great powers in the treaty of Cateau-Cambrésis (1559). Milan declined from the capital of an independent duchy to a provincial capital within an empire. The Spanish governor made his headquarters in the Palazzo Ducale. A little administrative autonomy was granted to the 60 noble members of the citizens' council, but in general the city suffered from the political and economic rigidity of Spanish rule. There was a considerable decline in building activity and few notable building projects, although from 1560 a programme of modernization was carried out in the medieval city centre. The Piazza dei Mercanti was enriched with a series of monumental palazzi containing public offices, the Palazzo dei Giureconsulti (1561; for illustration *see* SEREGNI, VINCENZO) and the Tribunale di Provvisione.

Spanish misgovernment was counteracted by the strength of the Church, particularly under Archbishop Carlo Borromeo (*reg* 1563–84). He was extremely active during the Council of Trent (1545–65), the decrees of which he rigorously applied. He wished to make Milan a stronghold of the Catholic Counter-Reformation and tried to prevent Protestant infiltration. His charitable works included the foundation of institutions to educate clergymen and, indirectly, the lay rulers: the Seminario Arcivescovile (from 1565), Collegio Elvetico and Colle-

3. Milan, Canonica of the Palazzo Arcivescovile, by Pellegrino Tibaldi, 1572

gio dei Nobili. He took strict control of the conduct of the clergy, sponsoring new religious orders such as the Theatines, Barnabites and Oblates of St Ambrose, and suppressing those that he deemed corrupt (e.g. the Humiliati; suppressed 1571). Several times he was involved in direct clashes with the Spanish authorities and Philip II of Spain (*reg* 1556–98) concerning public order and the arrival in Milan of the Spanish Inquisition, which was strongly supported by Philip and equally opposed by Carlo.

Carlo's moral and political jurisdiction was sustained by his cousin, Archbishop Federico Borromeo (*reg* 1595–1631), who continued Carlo's reforming work. The age of the Borromei left its mark on the city in the form of the numerous buildings erected by the two archbishops. In the old centre they continued the work on the cathedral and built the Canonica (designed 1565; built 1572; see fig. 3) at the Palazzo Arcivescovile, S Fedele (from 1569) and S Sebastiano (from 1577), all by Pellegrino Tibaldi (*see* TIBALDI, (1) and fig. 2), as well as S Raffaele (from 1575); MARTINO BASSI worked on a number of churches in the city. The archbishops also completed the remodelling of the Piazza dei Giureconsulti. The archbishops built various schools, including the Collegio di Brera (from 1591). Stations of the Cross (columns supporting a cross or the statue of a saint) were erected in the piazzas and the streets to commemorate the makeshift altars set up during the plague of 1576.

Many churches and monasteries were built or rebuilt (e.g. S Antonio Abate, from 1582) during this period. By contrast, civic building activity was limited by economic difficulties to a few notable works: the Palazzo del Capitano di Giustizia, or delle Carceri Nuove (*c*. 1570–after 1624, by Pietro Antonio Barca), the great arch of the Porta Romana (1598), and the completion of the fortification of the former Castello Sforzesco with the construction of a series of angle bastions.

BIBLIOGRAPHY
C. Torre: *Il ritratto di Milano* (Milan, 1674, rev. 2/1714)
L. Beltrami: *Relazione di Don Ferrante Gonzaga, Governante di Milano, inviata all'imperatore Carlo V, nel 1552 in difesa della progettata cinta dei bastioni* (Milan, 1897)
C. Baroni: *Documenti per la storia dell'architettura a Milano nel rinascimento e nel barocco*, 2 vols (Florence and Rome, 1940–68)
A. Ballo and B. Caizzi: *Milano nell'età spagnola* (Rome, 1960)
C. Bascapè: *Vita e opere di Carlo, Arcivescovo di Milano, Cardinale di Santa Prassede* (Milan, 1965)
F. Chabod: *Lo stato e la vita religiosa a Milano all'epoca di Carlo V* (Turin, 1971)
——: *Storia di Milano all'epoca di Carlo V* (Turin, 1971)
H. Jedin: *Carlo Borromeo* (Rome, 1971)
U. Petronio: *Il senato di Milano: Istituzioni giuridiche ed esercizio del potere nel ducato di Milano da Carlo V a Giuseppe II* (Milan, 1972)
L. Ferrarino: *La guerra e la peste nella Milano dei Promessi Sposi: Documenti inediti tratti dagli Archivi spagnoli* (Madrid, 1975)
A. Buratti: *La città rituale: La città e lo stato di Milano nell'età dei Borromeo* (Milan, 1982)
A. de Maddalena: *Dalla città al borgo: Avvio di una metamorfosi economica e sociale nella Lombardia spagnola* (Milan, 1982)
D. Sella: *L'economia lombarda durante la dominazione spagnola* (Bologna, 1982)

MARCO CARMINATI

II. Art life and organization.

1. Introduction. 2. To 1499. 3. 1500 and after.

1. INTRODUCTION. Milanese artists, like members of other professions, were organized into corporations, of which the oldest surviving statutes date from the 14th century. The three types of corporation that artists could join were the *paratici*, *università* and *scuole*. The differences among these organizations are not entirely clear, particularly as the terms are often used interchangeably in corporation documents. It would appear that *scuole* were fraternal organizations devoid of any legal status; they were similar to religious confraternities, but created for workers in a particular trade or craft. The *scuola* aspiring to the status of *università* was required to draw up, or revise, its statutes and submit them for approval to the Ufficio di Provvisione, whence they would be passed to the duke for final confirmation. The corporation would then become a legally recognized *università*, entitled to the duke's protection; in addition to privileges, recognition brought with it certain obligations, mostly financial, to the State. The *paratico* differed from the *università* chiefly in that its privileges were greater and its civic obligations correspondingly heavier.

Of the artists' corporations, perhaps the oldest is the goldsmiths', which was established as a *scuola* as early as 1311 and had its statutes formulated in 1343; by the end of the century at least, it had requested and received official confirmation as a *paratico*. Other artists' organizations were less ambitious, or perhaps less willing to shoulder the financial burden imposed on the *paratici*. The painters and woodworkers first formed *scuole*, then (reluctantly at that) *università*, but did not choose to advance further. These bodies were intended to regulate the activities of their members and so ensure a high standard of craftsmanship. It should be noted that in Milan, unlike Florence, for example, there was no legal limit on the number of corporations that might exist, and so no *arti* operated under the control of larger and more important organizations. Neither did the Milanese corporations have significant political power or influence: the rules of commerce were fixed by the Ufficio di Provvisione, technically an organ of the Commune but actually subservient to the State.

The painters' *arte* was probably founded towards the end of the 14th century, although there is no documentary information regarding its establishment. The earliest reference to its activity is a notarial act from 1438 concerning the election of officials for the Scuola di S Luca. In 1481 the painters drew up statutes and—under pressure from the duke—requested recognition as a *università*. This was presumably granted (in later documents the organization is always referred to as a *università*), although no record of the event or the statutes, said to consist of 29 articles, has survived. It is clear, however, that the corporation was governed by an annually elected prior and a board of 12 syndics, who were appointed for life. These officers were assisted by a *canepario* (a kind of treasurer), a notary and a messenger. Members, all qualified masters, were obliged to pay annual dues, inscribe their names in the *matricola* and doubtless to inform the prior if they decided to take an apprentice (in all the surviving artisans' statutes, the number of apprentices that any single master could employ is strictly limited). The prior was empowered to settle disputes among members or between a member and his client, and fine any member who contravened the corporation's statutes.

The sculptors had no universal professional organization, although stonecutters employed by the cathedral workshop were members of the Scuola dei Quattro Coronati. Major figure sculptors, however, whether they worked at the cathedral or not, did not belong, perhaps because the demand for sculpture was limited, other than for the most important projects, and the number of independent figure sculptors active at any one time was correspondingly small.

JANICE SHELL

2. TO 1499. Giotto painted frescoes (c. 1335; destr.) in Azzo Visconti's palace, and this artistic discernment was continued by succeeding members of the Visconti family, including Bernabò Visconti and Galeazzo II Visconti. In the late 14th century Giangaleazzo Visconti presided over an influx of artists employed to work on the cathedral, not only Italians, but also foreigners. In the 15th century sculpture at the cathedral was dominated by Italians, including Matteo Raverti and Giovanni Antonio Amadeo, who were active at the beginning and end of the century respectively, and whose work demonstrates how Milanese sculptors turned from Gothic to Renaissance forms.

A similar development also occurred in the work of Milanese painters in this period. The Late Gothic style is exemplified by wall paintings of ball games and other activities (first half of the 15th century; Milan, Pal. Borromeo). As the century progressed, however, the new Renaissance style was encouraged by various patrons, including the Florentine Pigello Portinari (d 1468), the representative of the Medici Bank in Milan. Between 1462 and 1466 he built the Portinari Chapel in S Eustorgio, which is decorated with remarkable frescoes of the *Life of St Peter Martyr* (late 1460s; *see* FOPPA, VINCENZO, §1 and fig. 1). Portinari also helped finance the building of S Pietro in Gessate (1447–75). Its other patrons included Ambrogio Grifi (d 1493), whose burial chapel contains a fresco cycle depicting the *Life of St Ambrose* (1490–93) by Bernardino Butinone and Bernardo Zenale, and the coloured marble tomb of *Ambrogio Grifi* by BENEDETTO BRIOSCO.

The Sforza family were particularly important patrons. Their commissions included the decoration of the Castello Sforzesco by such artists as Bonifacio Bembo (*see* BEMBO, (1)) and Stefano de Fedeli (*fl* 1472–81), including frescoes in the ducal chapel (1473). As well as his architectural projects (*see* §I, 2 above), Bramante produced a number of decorative designs, including a coloured terracotta frieze of putti and male busts (executed by Agostino Fonduli in 1483) for the baptistery of S Maria presso S Satiro and the wall painting of the *Argus* (c. 1490–93) in the Cortile della Rocchetta of the Castello Sforzesco.

Apart from Bramante, the most significant artist in Milan during the late 15th century was Leonardo da Vinci, who by 1483 had arrived at the court of Ludovico Sforza (*see* LEONARDO DA VINCI, §I, 2). He was involved in designing various spectacles, such as the *Festa del paradiso*, staged as a wedding celebration in 1490, and was also able to pursue his diverse intellectual interests. Despite the range of his activities, Leonardo executed a number of important paintings in Milan, most notably the fresco of the *Last Supper* (c. 1495–c. 1497; unveiled after recent cleaning, June 1999) in the refectory of S Maria delle Grazie. He also designed a bronze equestrian monument to *Francesco Sforza* (unexecuted). The clay model (untraced) that he displayed in 1494 seems to have been one of the many casualties of the French conquest of Milan in 1499, and Leonardo himself left the city in December of that year.

BIBLIOGRAPHY

L. Beltrami: *Il castello di Milano sotto il dominio dei Visconti e degli Sforza* (Milan, 1894)
F. Malaguzzi-Valeri: *Milano*, i–ii (Bergamo, 1906)
——: *Bramante e Leonardo* (1915), ii of *La corte di Ludovico il Moro* (Milan, 1913–23)
C. Ponzoni: *Le chiese di Milano* (Milan, 1930)
R. Cipriani, G. A. Dell'Acqua and F. Russoli: *La cappella Portinari in Sant'Eustorgio a Milano* (Milan, 1963)
G. Lise: *Santa Maria presso San Satiro* (Milan, 1974)
E. Brivio and A. Majo: *Il duomo di Milano nella storia e nell'arte* (Milan, 1977)
E. Brivio: *La scultura del duomo di Milano: La fede narrata nel marmo di Candoglia* (Milan, 1982)
M. T. Fiorio, ed.: *Le chiese di Milano* (Milan, 1985)
G. Lopez, A. S. Tosini and L. M. Rossi: *Il Castello Sforzesco di Milano* (Milan, 1986)
P. C. Marani, R. Cecchi and G. Mulazzani: *Il Cenacolo e Santa Maria delle Grazie* (Milan, 1986)
E. L. Longsworth: 'The Monument to Ambrogio Grifi in San Pietro in Gessate in Milan', *Verrocchio and Late Quattrocento Italian Sculpture*, ed. S. Bule, A. P. Darr and F. Superbi Gioffredi (Florence, 1992), pp. 291–301
M. Hollinsworth: *Patronage in Renaissance Italy from 1400 to the Early Sixteenth Century* (London, 1994)
E. S. Welch: *Art and Authority in Renaissance Milan* (New Haven and London, 1995)
D. C. Ahl, ed.: *Leonardo da Vinci's Sforza Monument Horse: The Art and the Engineering* (Bethlehem, PA and London, 1995)

□

3. 1500 AND AFTER. In the opening years of the 16th century the brilliant Renaissance culture of the Sforza court remained important. Vincenzo Foppa, dominant in the reign of Ludovico Sforza, was succeeded by Ambrogio Bergognone. With the arrival of the French, Bramantino served the Francophile general Gian Giacomo Trivulzio, for whom he made cartoons for 12 tapestries of *The Months* (1501–8; Milan, Castello Sforzesco), woven in Vigevano; in 1525 Bramantino became official architect and painter to Francesco Maria Sforza, who also patronized Giovanni Girolamo Savoldo. Leonardo da Vinci was again in Milan from 1508 to 1513, where he completed the *Virgin of the Rocks* (London, N.G.; *see* LEONARD DA VINCI, fig. 2) and served the French and Trivulzio. Leonardo's writings stimulated an interest in art theory, which later found expression in the writings of Giovanni Paolo Lomazzo and Gregorio Comanini. The most distinguished of Leonardo's heirs were Giovanni Antonio Boltraffio, Andrea Solario, Cesare de Sesto and Bernardo Luini (see colour pl. 1, XXXIX4). The large family workshop headed by Luini, together with that of the Piedmontese artist Guadenzio Ferrari, dominated Milanese painting in the mid-16th century.

Under Spanish rule artists from outside Milan were favoured. Charles V gave a house in Milan to LEONE LEONI, where the sculptor created what was perhaps the first private art gallery in Milan (*see* LEONI, (1), fig. 1). Leoni executed several imperial commissions in Milan, and his monument to *Gian Giacomo de' Medici* (completed

1563; Milan Cathedral) brought an awareness of Michelangelo's classicism to the city. The Spanish governor of Milan, Alfonso d'Avalos (1502–46), commissioned from Titian the *Marques del Vasto Addressing his Soldiers* (Madrid, Prado), which Titian himself brought to Milan in 1541; Titian was also commissioned (1540) by the Confraternity of the Santa Corona to paint the *Christ Crowned with Thorns* (1540–42; Paris, Louvre) for a chapel in the church of S Maria delle Grazie, Milan. Other Venetian works in Milan were Jacopo Tintoretto's *Christ among the Doctors* (Milan, Mus. Duomo) and canvases by Paris Bordone and Moretto in S Maria presso S Celso.

Carlo Borromeo and his cousin Federico Borromeo left a deep imprint on the cultural and artistic history of the city. Carlo Borromeo brought Pellegrino Tibaldi with him from Rome in 1565, and with him the influence of Michelangelo. His patronage, informed by his belief in the didactic purpose of art, encouraged the production of clear and direct religious narratives, drawn from the Bible or lives of the saints. Scenes from the *Life of Christ* (1578–82) were painted for the Certosa di Garegnano by the Bergamese Simone Peterzano, while the Cremonese brothers Antonio Campi and Vincenzo Campi, who directed a large family studio, were active in the church of S Paolo Converso (1586–9; see colour pl. 1, XVIII2). Caravaggio (1571–1610) was apprenticed to Peterzano in 1584. In the 1580s the Procaccini family moved from Bologna to Milan. The cathedral workshop remained a powerful patron. The high altar in the cathedral was designed by Tibaldi, the organ shutters (for which a competition was held in 1590) painted by Giuseppe Meda (*d* 1599), Ambrogio Figino and Camillo Procaccini (*c.* 1555–1629), and the marble enclosure around the presbytery decorated with carvings by Francesco Brambilla the younger.

BIBLIOGRAPHY
A. Santagostino: *L'immortalità del pennello, ovvero catalogo delle pitture insigni che stanno esposte al pubblico nella città di Milano* (Milan, 1671); ed. M. Bona Castellotti (Milan, 1980)
C. Torre: *Ritratto di Milano* (Milan, 1714)
G. Mongeri: *L'arte in Milano* (Milan, 1872)
A. Paredi, G. A. dell' Acqua and L. Vitali: *L'Ambrosiana* (Milan, 1968)
M. Valsecchi: *Gli arazzi dei 'Mesi' del Bramantino* (Milan, 1968)
Il seicento lombardo, 3 vols (exh. cat., Milan, Pal. Reale, 1973)
Omaggio a Tiziano: La cultura artistica milanese nell' età di Carlo V (exh. cat. by B. W. Meijer, Milan, Pal. Reale, 1977)
A. Paredi: *Storia dell' Ambrosiana* (Milan, 1981)
La Ca' Granda: Cinque secoli di storia e d'arte dell'Ospedale Maggiore di Milano (exh. cat. by G. Testori and others, Milan, Pal. Reale, 1981)
M. Bona Castellotti: *La pittura lombarda del seicento* (Milan, 1985)
J. Shell: *Painters in Milan, 1490–1530* (diss., New York U., 1986)
I Piazza da Lodi: Una tradizione di pittori del cinquecento (Milan, 1989)
G. A. Dell' Acqua: *La maniera nella pittura lombarda dal 1550 al 1630* (Milan, n.d.)

MARCO CARMINATI, JANICE SHELL

III. Centre of rock crystal production.

In the course of the 16th century Milan became the most important centre in Europe for the production of vases and plaques of rock crystal, a material that was readily available near the St Gotthard Pass. Whole families of artisans specialized in this craft and from the mid-16th century were patronized by the most important courts of Europe.

Production consisted mostly of engraved plaques decorated with complex religious or mythological scenes,

plant motifs and portraits, used to embellish furniture and vases. Carved and engraved vases, however, made not only of rock crystal but also of pietre dure formed the most important production of these craftsmen, who could create bizarre designs inspired by the natural form of the rock crystal. The most frequent forms were those of fantastic animals, birds, fish and ships. Ewers and goblets could also be adorned with whimsical handles in the shape of monsters and lids decorated with bird heads or lions (see colour pl. 2, VIII1). These splendid ornamental vases were often further embellished with elaborate enamelled gold mounts.

In most instances it remains difficult to identify the production of individual workshops; despite the large number of surviving vases, there is little documentation. The stylistic criteria adopted by Kris in 1929 are still the fundamental point of departure, although some of these have been called into question by recent archival work.

The workshop of the Saracchi brothers (Giovanni Ambrogio, *b* 1540; Simone, *b* 1547; Stefano, *b* 1550; Michele; Raffaello) produced many objects (see fig. 4), but is particularly associated with vessels in the form of a ship. A ewer decorated with engraved scenes from the *Life of Moses* (Munich, Residenzmus.) was made for Albert V, Duke of Bavaria (*reg* 1550–79), and was still in his possession in 1579. Another, made by the same family in Florence, was probably created for the marriage of Ferdinand I de' Medici and Christine of Lorraine in 1589. This also has scenes of the *Life of Moses*, with additional images of knights and a figure of *Neptune* on the lid. It has splendid enamelled gold mounts, with handles in the form of *termini*, and a carved, enamelled border set with cameos.

Ambrogio and Stefano Caroni (*d* 1611) moved from Milan to Florence in 1572, followed in 1575 by Giorgio

4. Milanese rock crystal tazza and cover, attributed to the Saracchi brothers, h. 315 mm, *c.* 1589 (Florence, Palazzo Pitti, Museo degli Argenti)

Gafurri and his sons Cristofano and Bernardino (*d* 1606), who had been invited by the Medici to set up specialized workshops for the Florentine court; these artisans produced many important vases, which are documented in the Medici inventories of the second half of the 16th century (*see* FLORENCE, §III, 2(i)). The sculptor ANNIBALE FONTANA produced vases decorated with complex mythological scenes and carved plant motifs and crystal plaques with allegories of *The Seasons* for a small chest (Madrid, Pal. Real). His two panels with figures of *Jove* and *Juno* recall the decoration of a jug from the Saracchi workshop, carved with allegories of *The Elements* (Florence, Pitti). The production of Milanese craftsmen, while largely linked to commissions from Italian and European courts, also included some interesting pieces made for the local clergy, for example the Castiglioni Monstrance with pearl and enamelled gold mounts (Milan, Tesoro Duomo).

BIBLIOGRAPHY

DBI: 'Caroni'

E. Kris: *Meister und Meisterwerke der Steinschneidekunst in der italienische Renaissance*, 2 vols (Vienna, 1929/*R* 1979)

B. Heinzel-Wied: 'Studi sull'arte della scultura in pietre dure durante il rinascimento: I fratelli Sarachi', *Ant. Viva*, 6 (1973), pp. 37–58

R. Distelberger: 'Die Sarachi Werkstatt und Annibale Fontana', *Jb. Ksthist. Samml. Wien*, lxxi (1975), pp. 150–78

A. M. Massinelli and F. Tuena: *Treasures of the Medici* (London, 1992)

ANNA MARIA MASSINELLI

Milan, Dukes of. *See under* SFORZA.

Minello (de' Bardi). Italian family of masons and sculptors. (1) Giovanni Minello was active in Padua for almost 60 years, notably at the basilica of S Antonio (Il Santo), where he was assisted by his son (2) Antonio Minello. Their work ensured the continuing influence of the Lombardo family into the early 16th century.

(1) Giovanni (d'Antonio) Minello (de' Bardi) (*b* Padua, *c.* 1440; *d* Padua, 1528). Mason and sculptor. Although his talent was mediocre, he was one of the principal figures in Paduan sculpture after Donatello, primarily as a contractor and specialist in decorative work. Described in 1467 as 'magister', he was head of a workshop three years later. That he had enough capital to run his own shop by 1470 indicates he was born before 1450 and perhaps as early as 1440. Pietro Lombardo was in Padua from 1463 to 1468 and employed Giovanni Minello then (Rigoni); he and not Bartolomeo Bellano must be considered Minello's master. This theory is further supported by the many features of Lombardo's style present in Giovanni Minello's work, especially the tomb of *Cristoforo da Recanati* (1483–9; destr.; fragment in Padua, Mus. Civ.), in which he followed the Tuscan format established in Padua by Lombardo's tomb for *Antonio Roselli* (1464–7; Padua, Il Santo). Giovanni Minello's presentation drawing of this tomb survives in the Museo Civico, Padua.

Giovanni Minello's earliest known commission (1471) was for decorative work in the Leoni Chapel of S Bernardino (destr.). His association with Il Santo, for which most of his work was done thereafter, began in 1482 when he was commissioned to ornament the choir-screen around the sides of the high altar with statues, candelabra, a marble revetment of pilasters and a frieze of seraphim heads. In 1490 he also contracted to make the marble for Bellano's bronze reliefs for the choir. This complex was dismantled in the 17th century, and the architectural members are all that survive of Giovanni Minello's work. They, like the fragment of the *Recanati* tomb, show his style to be dry, hard and linear, lacking in animation or corporeality.

Fabriczy attributed several terracottas to Giovanni Minello; Moschetti and Planiscig added more. Carpi, however, disproved some of these attributions on documentary evidence, and none can be securely given to Minello. These forceful, if sometimes crude, terracottas find no echo in Giovanni Minello's works in stone, and it is more reasonable to reject them than try, as earlier scholars did, to reconcile two opposing styles. It is very doubtful that Giovanni Minello was a major figure in Paduan terracotta sculpture.

In 1500 Giovanni Minello was named *protomaestro* of the project to rework the funerary chapel of S Antonio in Il Santo. He has been called the designer of the complex, but this honour more likely belongs to Tullio Lombardo. In 1501 Giovanni Minello and his son (2) Antonio Minello were commissioned to carve a relief of the *Miracle of the Ass* (unexecuted). Over the next 20 years Giovanni Minello, often assisted by Antonio, continued to work on the chapel, carving figures in the friezes, small reliefs of prophets, modillions, steps, rosettes and other details, together with three holy water stoups and a well for the cloister. He was released from his duties as *protomaestro* in 1521, but continued to work: in 1522 he recarved an inscription his son had bungled. In 1527 he set up his own epitaph.

The tomb of *Giovanni Calfurnio* (1512), now in the Novitiates' cloister of Il Santo, speaks for Giovanni Minello's meagre gifts as a figural sculptor: he always signed himself as a *tagiapietra* (stone mason). Although he was previously considered a prime exponent of 'post-Donatellian naturalism' (Planiscig) in Padua, his importance lies in the lower level of codifying a classical decorative language at Il Santo and in running the largest workshop in Padua, where such artists as Giovanni Maria Mosca Padovano and Giovanni Rubino were trained.

BIBLIOGRAPHY

Thieme–Becker

C. von Fabriczy: 'Giovanni Minello: Ein Paduaner Bildner vom Ausgang des Quattrocento', *Jb. Kön.-Preuss. Kstsamml.*, xxviii (1907), pp. 53–89

L. Planiscig: *Der venezianische Bildhauer der Renaissance* (Vienna, 1921), pp. 155–70

P. Carpi: 'Nuove notizie e documenti intorno a Giovanni Minello e all'arte del suo tempo', *Boll. Mus. Civ. Padova*, n. s., vi (1930), pp. 40–91

E. Rigoni: 'Giovanni Minello e la cappella dell'Arca di S Antonio', *Atti & Mem. Accad. Patavina Sci., Lett. & A.*, xlv (1953–4), pp. 90–96; also in *L'arte rinascimentale in Padova: Studi e documenti*, Med. & Uman., ix (Padua, 1970), pp. 259–64

——: 'Notizie riguardanti Bartolomeo Bellano e altri scultori padovani', *L'arte rinascimentale in Padova: Studi e documenti*, Med. & Uman., ix (Padua, 1970), pp. 123–39

A. Sartori: *Documenti per la storia dell'arte a Padova* (Vincenza, 1976), pp. 148–59

Dopo Mantegna (exh. cat., Milan, 1976), no. 87, p. 128

S. Wilk: 'La decorazione cinquecentesca della cappella dell'Arca di S Antonio', *Le sculture del Santo di Padova*, ed. G. Lorenzoni (Padua, 1984), pp. 115–17, 123–4

THOMAS MARTIN

(2) Antonio (di Giovanni) Minello (de' Bardi) (*b* Padua, *c.* 1465; *d* Venice, ?1529). Italian sculptor, son of

(1) Giovanni Minello. He worked in a stolid, classicizing style influenced by the Lombardo family of sculptors and architects. Antonio is first recorded working as an assistant to his father on 10 April 1483. They worked together on the choir-screen of Il Santo in Padua and, after 1500, on the chapel of S Antonio in the basilica. During 1510–11 he carved 15 half-length *Prophets* on the portal of S Petronio, Bologna, together with Antonio da Ostiglia. On his return to Padua, Minello completed the statue of *St Justina* in the leftmost niche above the entrance to the chapel of S Antonio in 1512 and in 1517 delivered the *Investiture of St Anthony*, the first relief on the left in the chapel. From 1523 to 1529 he worked on the relief of the *Miracle of the Parrasio Boy*, which was finished by Jacopo Sansovino in 1536. Schulz also attributed to him the tombs of *Nicolo Orsini*, *Leonardo da Prato* and *Dionigi Naldi* (1513–15; Venice, SS Giovanni e Paolo). In the early 1520s Minello moved to Venice, where, in 1524, he purchased the contents of the workshop of Lorenzo Bregno. He completed a *Virgin* (Montagnana Cathedral) begun by Bregno and also took over Bregno's commission for statues of saints on the Trevisian altar (Venice, S Maria Mater Domini). In 1527 Minello executed a statuette of *Mercury* (London, V&A) for Marcantonio Michiel. A head of *Hercules* (untraced), recorded by Michiel as in Andrea Odoni's collection, is probably depicted on the right in Odoni's portrait by Lorenzo Lotto (London, Hampton Court, Royal Col.; *see* LOTTO, LORENZO, fig. 3). Minello was last documented in January 1529 and presumably he died that year.

BIBLIOGRAPHY

E. Rigoni: 'Giovanni Minello e la cappella dell'Arca di S Antonio', *Atti & Mem. Accad. Patavina Sci., Lett. & A.*, xlv (1953–4), pp. 90–96; also in *L'arte rinascimentale in Padova: Studi e documenti, med. & uman.*, ix (Padua, 1970), pp. 259–64

A. Sartori: *Documenti per la storia dell'arte a Padova* (Vicenza, 1976), pp. 150–51, 156–63

J. Eade: 'Marcantonio Michiel's *Mercury* Statue: Astronomical or Astrological?', *J. Warb. & Court. Inst.*, lxiv (1981), pp. 207–9

S. Wilk: 'La decorazione cinquecentesca della cappella dell'Arca di S Antonio', *Le sculture del Santo di Padova*, ed. G. Lorenzoni (Padua, 1984), pp. 128–9, 137–9, 161–2

A. Schulz: 'Four New Works by Antonio Minello', *Mitt. Ksthist. Inst. Florenz*, xxi (1987), pp. 291–325 [with full bibliog.]

——: 'Two New Works by Antonio Minello', *Burl. Mag.*, cxxxvii/1113 (1995), pp. 799–808

THOMAS MARTIN

Miniato, Giovanni [Nanni]. *See under* FORA, DEL.

Minio, Tiziano (*b* Padua, *c.* 1511–12; *d* Padua, 1552). Italian stuccoist and sculptor. He probably trained as a founder under his father, Guido Minio (*fl* 1511–16), called Lizzaro, and later alternated this trade with his work as a sculptor. His first documented activity is as a stuccoist in 1533, employed on the vault of the chapel of S Antonio in Il Santo, Padua, under the architect Giovanni Maria Falconetto and alongside two members of Jacopo Sansovino's circle, Silvio Cosini and Danese Cattaneo. In 1535–6 Minio executed his first independent work, the stucco altar (now Padua, Mus. Civ.) for the Confraternity of S Rocco in Padua. Large and ungainly, this altar has the crude vigour often associated with provincial workmanship; its female saints show, nonetheless, the influence of Sansovino's style, while the deployment of the sculptures in general is indebted to arrangements at Sansovino's Loggetta, Venice.

Minio began working for Sansovino in 1536 at Venice, where he made stucco decorations for the atrium of S Marco and helped cast Sansovino's first bronze reliefs for the choir. Minio was clearly valued by Sansovino for his skill as a stuccoist and founder, while receiving from Sansovino a new formal language for his own work. This influence can be seen in all of Minio's subsequent figural designs, especially in the plasterwork of the Odeo Cornaro, built in Padua for Alvise Cornaro, and in the bronze reliefs for the baptismal font in S Marco.

The stucco decorations of the Odeo Cornaro (1539–43) furnish the best index of Minio's abilities in this field. As Wolters has shown, they combine direct quotations from Sansovino's bronze reliefs in S Marco with reflections of the work of Donatello and of Giulio Romano's Palazzo del Te, Mantua. The transformation from Minio's earlier altar for S Rocco is almost beyond recognition. During these years he also became a member of Alvise Cornaro's household, thus gaining access to one of the Veneto's most notable artistic and intellectual circles. Cornaro advanced his career on several occasions, most notably when he stood surety for Minio's execution of a bronze cover for S Marco's baptismal font. The contract for this work, drawn up in 1545, was also signed by Desiderio da Firenze, a protégé of Pietro Bembo. Sansovino seems to have exercised an editorial authority over this project, but the bulk of the design reflects Minio's idiom as found in the Odeo's stucco panels. Desiderio's role may have been confined to decorative frames; these frames were lost by the 19th century. The main panels consist of four scenes from the *Life of St John the Baptist* and the four *Evangelists*. The narrative panels are peopled with the same types as are found in the Odeo, along with stylistic allusions to Lorenzo Ghiberti and Donatello. Recent cleaning has shown them to be outstanding examples of Venetian bronze-casting of the period and a testimonial to Minio's skill in low relief. Vasari implied that Minio was to have executed a statue of *St John the Baptist* for the baptistery, but this was pre-empted by the sculptor's death.

Minio contributed stucco decorations for the performance of Pietro Aretino's *La Talenta*, mounted by Giorgio Vasari in Venice in 1542. Vasari also stated that Minio carved 'alcune figurette', by which he probably meant the minor figural elements on Sansovino's Loggetta. In 1543 Minio and Cattaneo contracted to furnish a series of bronze gates for the entrance arcade of the chapel of S Antonio in Il Santo, Padua; but although some portions were cast, the whole was left unfinished at Minio's death. His extant late works include the Contarini arms (1541) and the figure of *Justice* (1552) on the façade of the Palazzo del Podestà (now Palazzo Municipale), Padua, which once again are indebted to the influence of Sansovino.

Minio's early death and the ephemeral nature of many of his creations pose problems for an exact estimation of his abilities as a sculptor. In addition, the promiscuous attribution of small bronzes to him by Planiscig has severely distorted the picture; few, if any, of these small bronzes can be by him. By concentrating on his documented pieces, it can be seen that Minio was an artist of high decorative ability, capable of translating Sansovino's

style into the media of stucco and bronze. His position in Padua made him central to the dissemination of the master's style there, and his association with Agostino Zoppo (*fl* 1555–9) and, indirectly, with his own nephew Tiziano Aspetti (*c.* 1559–1606) fostered the continuation of that style into the latter part of the 16th century.

BIBLIOGRAPHY

G. Vasari: *Vite* (1550, rev. 2/1568); ed. G. Milanesi (1878–85), vii, pp. 515–16

B. Scardenone: *De antiquitate urbis Patavii* (Padua, 1560), pp. 376–7

A. Venturi: *Storia* (1901–40), X/iii, pp. 36–57

L. Planiscig: *Venezianische Bildhauer der Renaissance* (Vienna, 1921), pp. 389–408

G. Fiocco: 'La prima opera di Tiziano Minio', *Dedalo*, xi/1 (1931), pp. 600–10

W. Wolters: 'Tiziano Minio als Stukator in Odeo Cornaro zu Padua', *Pantheon*, xxi (1963), pp. 20–28, 222–30

P. Sambin: 'I testamenti di Alvise Cornaro', *Italia Med. & Uman.*, ix (1966), pp. 295–385

E. Rigoni: 'Notizie sulla vita e la famiglia dello scultore Tiziano Aspetti detto Minio', *L'arte rinascimentale in Padova* (Padua, 1970), pp. 201–15 [fundamental source material]

C. Fillarin, ed.: *Documenti per la storia dell'arte a Padova* (Vicenza, 1976), pp. 164–5

Alvise Cornaro e il suo tempo (exh. cat., ed. L. Puppi; Padua, Loggia Cornaro; Odeo Cornaro; Pal. Ragione; 1980)

BRUCE BOUCHER

Mino da Fiesole [Mino di Giovanni] (*b* Papiano, nr Poppi in Casentino, 1429; *d* Florence, 1484). Italian sculptor. He worked in both Florence and Rome and apparently established large workshops in both cities, producing many important tombs, altars and tabernacles; he was also one of the first Renaissance sculptors in Florence to carve portrait busts, and his revival of this antique form gave expression to the humanism of Medicean Florence. The majority of his Florentine works are dated or datable, but there is little solid evidence for the dating of his Roman projects, and consequently there is some confusion over his chronology. Because of his familiarity with two distinct sculptural traditions he became a transmitter of ideas between Rome and Florence.

1. LIFE AND WORK.

(i) Training and early career. Mino's first documented work, the portrait bust of *Piero de' Medici* (1453; Florence, Bargello; see colour pl. 2, VIII2), is also the first securely dated portrait bust of the Renaissance. The head is derived from antique Roman busts, but the carving of the patterned tunic and the inclusion of the shoulders and part of the torso are 15th-century innovations. Although nothing is known about his training, the importance of this early commission suggests that Mino may have trained in the workshop of one of the major artists working for Piero de' Medici during the 1450s. Vasari's description of Mino as a hapless student of Desiderio da Settignano can be refuted on stylistic and chronological grounds, since the two sculptors were probably born within a year of each other. However, an association with Michelozzo di Bartolommeo might account for the attention of Piero de' Medici (Carrara, 1956); there are also reflections of Michelozzo in Mino's later works.

During the 1450s Mino produced a steady stream of portrait busts that benefited from his study of antique busts in Rome; the inscription on the marble bust of

Niccolò Strozzi (Berlin, Skulpgal.; see fig. 1) records that it was carved in Rome in 1454. The almost brutal naturalism of the portrait, the alert expression of the subject, with the head set at an angle to the torso, and the elegant surface finish of both flesh and cloth are sophisticated solutions to the problem of bust portraiture, not the work of a tentative beginner. It is generally assumed that Mino's next bust, of *Astorgio Manfredi II* (1455; Washington, DC, N.G.A.), was made in Naples; Mino used the pattern of the sitter's chain-mail armour to frame and accentuate the face, which exaggerates the lifelike qualities of the features. These early busts show a remarkably sensitive appreciation of the dual nature of portraits as both a record of individual features and a commemoration of the sitters' status. Mino's insistence on a sense of movement and on an almost palpable link between viewer and bust is present in all his portraits.

Mino was again in Rome in the early 1460s: a single payment was made to him for work on Pius II's Benediction Loggia (destr.) on 5 July 1463. It would seem probable that he was already in Rome working on an important commission from Cardinal Guillaume d'Estouteville for the ciborium for the high altar of S Maria Maggiore (destr.; fragments in apse and sacristy), originally inscribed with the date 1461. The attribution and dating of this work are of critical importance in establishing a coherent chronology for Mino. The ciborium has also been attributed to MINO DEL REAME, but it is difficult to make a firm association. If the design and some of the carving are the work of Mino da Fiesole, with the participation of his workshop, the dating of the monument becomes even more significant. A date of *c.* 1461–3 would make the ciborium Mino's first large-scale project; thus his first relief-carving would have been done in Rome, and his style defined by his experiences there. The apparent disparity between the ciborium reliefs and his later Florentine reliefs may reflect a deliberate adjustment of his Roman style to Florentine taste. The innovative design is based in part on 13th-century prototypes by Arnolfo di Cambio (*fl* 1265–1302) but incorporates details taken from Michelozzo. This skilful synthesis of Early Christian

1. Mino da Fiesole: *Niccolò Strozzi*, marble, h. 490 mm, 1454 (Berlin, Skulpturengalerie mit Frühchristlich–Byzantinischer Sammlung)

elements with 13th-century and contemporary Florentine forms to satisfy the new demands of function and scale is also apparent in his other sacrament tabernacles and carved altarpieces. The reliefs for the d'Estouteville altar of *St Jerome* (destr.; fragments, Rome, Pal. Venezia), also for S Maria Maggiore, were probably made around the same time. These two projects may have necessitated the establishment of a large workshop that could have continued to function after Mino returned to Florence in 1464.

(ii) Mature work. On 28 July 1464 Mino was inscribed in the Arte della Pietra in Florence, and he began to accept commissions from Florentines in the Medici circle. In 1464 Diotisalvi Neroni commissioned a marble altar in half relief with the *Virgin and Child with SS Leonard and Lawrence* (Florence, Badia Fiorentina) for his family chapel in S Lorenzo, and he also had Mino carve his portrait (1464; Paris, Louvre). The altar was not completed in the four months stipulated in the contract, since in 1466, when Neroni was exiled from Florence, the marble was still in Mino's possession; it was only in 1470 that he sold the completed altar to the Badia, Florence. Within a Brunelleschian architectural frame, appropriate for the altar's intended setting, the saints' figures are shown frontally; the stylized linearity of the drapery, the inconsistencies of scale between the figures and the shifts in relief depth reflect the influence of Isaia da Pisa and other sculptors active in Rome, while the format and style are based on Early Christian ivories.

Some time before Bishop Leonardo Salutati's death in 1466, Mino carved his portrait and probably began plans for the marble decoration of his funerary chapel in Fiesole Cathedral, comprising a tomb into which the Bishop's portrait bust was set and an elaborate marble altarpiece with the Virgin and SS Leonard and Martin in half relief and, in front of them, in much higher relief, the Holy Children and St Martin's beggar. The tomb of *Bernardo Giugni* (*d* 1466; Florence, Badia Fiorentina), which includes a powerful profile portrait of the deceased, and a Sacrament tabernacle (1467–71; Volterra Cathedral) share a marked interest in the articulation of the architectural structure and a tendency to abstract the human form through the use of repetition and pattern, particularly in the tabernacle, where identical pairs of angels support symbols of the Passion on all four sides.

In 1469 Mino began work on the tomb of *Count Hugo of Tuscany* (*d* 1001; Florence, Badia Fiorentina), probably completing at that time the recumbent effigy on the bier and the high-relief personification of *Charity*. In this work Mino's style of figural relief-carving achieved a high level of linear abstraction; the tomb's size and solidity seems far removed from the decorative emphasis of Mino's model, Desiderio da Settignano's *Marsuppini* tomb (*c.* 1453–60; Florence, Santa Croce; *see* DESIDERIO DA SETTIGNANO, fig. 1). The marble tondo of the *Virgin and Child* (*c.* 1470; Florence, Bargello; see fig. 2) was designed to be set above the doorway of the Badia. It is in an elaborate frame that, together with the minute costume details, helps to emphasize the surface of the relief, while the linear pattern formed by the drapery defines the radius of the circle. Seen from below, the direction of the glances and the angles of the haloes intensify the projection of the

2. Mino da Fiesole: *Virgin and Child*, marble, diam. *c.* 900 mm, *c.* 1470 (Florence, Museo Nazionale del Bargello)

forms into space, creating a strong sense of three-dimensionality; the work is also skilfully undercut to compensate for the steep angle at which it was intended to be viewed. Mino discarded the popular 15th-century image of the embracing Mother and Child in favour of a frontal, almost iconic presentation. In 1473 Mino contributed two reliefs, the *Feast of Herod* and the *Beheading of St John the Baptist*, to the circular marble interior pulpit in Prato Cathedral, the overall design of which has been attributed to Mino and to Antonio Rossellino, among others.

It is assumed that between 1474 and 1480 Mino was working chiefly in Rome. He probably went there specifically to work on the tomb of *Paul II* (*d* 1471; destr.; fragments, Rome, Grotte Vaticane), a commission that he shared with Giovanni Dalmata (*c.* 1440–after 1509). Cardinal Marco Barbo, the Pope's nephew, employed both sculptors in order to complete the tomb quickly, perhaps in time for the Holy Year of 1475; Vasari wrote that it was finished in two years. It was the largest 15th-century tomb in Rome, and responsibility for the reliefs was divided equally between the two sculptors and their workshops. The overall design, which emphasizes the architectural frame, may have been Mino's work. Mino and his assistants carved reliefs of the *Fall of Man, Faith, Charity, St John, St Luke* and the large lunette of the *Last Judgement*. Mino's style is more delicate and stereotyped than Giovanni's. Mino worked on a series of important tombs in Rome, sometimes collaborating with Andrea Bregno, as on that of *Cristoforo della Rovere* (Rome, S Maria del Popolo). In the monuments to *Cardinal Forteguerri* (*d* 1473; Rome, S Cecilia) and to *Cardinal Giacomo Ammanati–Piccolomini* (*d* 1479; Rome, S Agostino, cloister), Mino refined ideas

he had previously developed for the papal tomb and that of *Count Hugo*.

In 1480 Mino returned to Florence and resumed work on *Count Hugo*'s tomb (finished 1481); the elaborately carved, classicizing lunette decorated with palmettes and egg-and-dart moulding framing a tondo of the *Virgin and Child*, and the base, with its elegantly lettered inscription, probably date from this time. His final project was the large marble reliquary altar for S Ambrogio, Florence (1481; *in situ*), which, in form and iconography, combines altar and tabernacle. Within a fanciful architectural framework crowned with a pediment with a relief of *God the Father in Glory*, the main scene, with the *Christ Child and Saints*, is in high relief, while the low-relief predella scene is set at a strongly raking angle. This was the second time that Mino had worked in association with Cosimo Rosselli, who painted the chapel frescoes (the first occasion was in the Salutati Chapel in Fiesole Cathedral; see Padoa Rizzo, 1977). Mino was buried in the entrance of S Ambrogio.

2. WORKING METHODS AND TECHNIQUE. When designing his major monuments, Mino must have used drawings that could later be modified as required. This practice may have been necessitated by his dependence on a large workshop from the time he was engaged on the d'Estouteville projects in the 1460s. The broad, linear quality of these reliefs reflects Mino's attempt to create a standardized, legible pattern for his assistants to follow. The likelihood that drawings remained in the workshop and were reused is suggested by comparing the angels on the Volterra tabernacle with those on a small tabernacle (Florence, Bargello, 264) that is obviously a workshop production. Mino frequently adapted designs from one type of monument for use in another context. It is probable that he designed his compositions in two dimensions and not with three-dimensional models.

The number of signed works in Rome that are apparently not autograph may be accounted for by Mino's practice of supplying drawings for his assistants in Rome, leaving the carving and the control of the shop to an assistant in his absence. The relationship between Mino da Fiesole and Mino del Reame can probably be explained by this workshop system. He presumably had another shop in Florence organized in a similar fashion.

BIBLIOGRAPHY

EARLY SOURCES

F. Albertini: *Opusculum de mirabilibus novae urbis Romae* (Rome, 1510), ed. A. Schmarsow (Heilbronn, 1886), pp. 16–17

G. Vasari: *Vite* (1550, rev. 2/1568); ed. G. Milanesi (1878–85), vol. iii, pp. 115–27

GENERAL

Thieme–Becker

A. Venturi: *Storia* (1901–40/*R* 1967), vol. vi, pp. 634–7

F. Burger: *Geschichte des florentinischen Grabmals von den ältesten Zeiten bis Michelangelo* (Strasbourg, 1904)

G. Davies: *Renascence: The Sculptured Tombs of the Fifteenth Century in Rome* (London, 1910)

R. Mather: 'Documents Mostly New Relating to Florentine Painters and Sculptors of the Fifteenth Century', *A. Bull.*, xxx (1948), pp. 20–66 (60–64)

J. Pope-Hennessy: *Italian Renaissance Sculpture* (London, 1963, rev. Oxford, 3/1985)

C. Seymour jr: *Sculpture in Italy, 1400–1500*, Pelican Hist. A. (Harmondsworth, 1966)

I. Lavin: 'On the Sources and Meaning of the Renaissance Portrait Bust', *A. Q.* [Detroit], xxxiii (1970), pp. 207–26

Palazzo Venezia: Paolo II e le fabbriche di S Marco (exh. cat., ed. M. L. Casanova Uccella; Rome, Pal. Venezia, 1980), pp. 33–6

Italian Renaissance Sculpture in the Time of Donatello (exh. cat., ed. A. Darr; Detroit, MI, Inst. A., 1985), pp. 185–9

MONOGRAPHS

D. Angeli: *Mino da Fiesole* (Florence, 1905)

H. Lange: *Mino da Fiesole: Ein Beitrag zur Geschichte der florentinischen und römischen Plastik des Quattrocentos* (Greifswald, 1928)

J. Rusconi: *Mino da Fiesole* (Rome, 1931)

M. Cionini Visani: *Mino da Fiesole*, I Maestri della Scultura (Milan, 1962)

G. C. Sciolla: *La scultura di Mino da Fiesole* (Turin, 1970); review by A. Markham Schulz in *A. Bull.*, liv (1972), pp. 208–9

SPECIALIST STUDIES

L. Courajod: 'Un Bas-relief de Mino da Fiesole', *Mus. Archeol.*, ii (1877), pp. 47–69

H. von Tschudi: 'Ein Madonnenrelief von Mino da Fiesole', *Jb. Kön.-Preuss. Kstsamml.*, vii (1886), pp. 122–8

D. Gnoli: 'Le opere di Mino da Fiesole in Roma', *Archv Stor. A.*, ii (1889), pp. 455–67; iii (1890), pp. 89–106, 175–86, 258–71, 424–40

G. Poggi: 'Mino da Fiesole e la Badia Fiorentina', *Riv. A.*, i (1903), pp. 98–103

C. Fabriczy: 'Alcuni documenti su Mino da Fiesole', *Riv. A.*, ii (1904), pp. 40–45

C. Ricci: 'Il tabernacolo e gli angeli di Mino da Fiesole in Volterra', *Riv. A.*, ii (1904), pp. 260–67

C. Fabriczy: 'Portate al catasto di Mino da Fiesole', *Riv. A.*, iii (1905), pp. 265–7

U. Dorini: 'La casa di Mino e i disegni murali di essa recentemente scoperti', *Riv. A.*, iv (1906), pp. 49–55

D. Cavalleni: 'Il tabernacolo del Corpo di Nostro Signor Gesù Cristo di Maestro Mino da Fiesole, scultore di pietra', *A. Crist.*, iv/1 (1916), pp. 6–13

J. Alazard: 'Mino da Fiesole à Rome', *Gaz. B.-A.*, 4th ser., xiv (1918), pp. 75–86

G. Biasiotto: 'Di alcune opere scultorie conservate in S Maria Maggiore di Roma', *Rass. A.*, xviii (1918), pp. 42–57 (52–6)

W. R. Valentiner: 'A Portrait Bust of Alfonso I of Naples', *A. Q.* [Detroit], i (1938), pp. 61–88 (76–88)

E. Marrucchi: 'Dove nacque Mino da Fiesole', *Riv. A.*, xxi (1939), pp. 324–6

W. R. Valentiner: 'Mino da Fiesole', *A. Q.* [Detroit], vii (1944), pp. 151–80; also in W. R. Valentiner: *Studies in Italian Renaissance Sculpture* (London, 1950), pp. 70–96

J. Phillips: 'The Case of the Seven Madonnas', *Bull. Met.*, iv/1 (1945), pp. 18–28

L. Carrara: 'Nota sulla formazione di Mino da Fiesole', *Crit. A.*, iii (1956), pp. 76–83

G. Corti and F. Hartt: 'New Documents concerning Donatello, Luca and Andrea della Robbia, Desiderio, Mino, Uccello, Pollaiuolo, Filippo Lippi, Baldovinetti and Others', *A. Bull.*, xliv (1962), pp. 155–67 (166–7)

M. Pepe: 'Sul soggiorno napoletano di Mino da Fiesole', *Napoli Nob.*, v (1966), pp. 116–20

G. C. Sciolla: 'L'ultima attività di Mino da Fiesole', *Crit. A.*, xciv (1968), pp. 35–44

F. Negri Arnoldi: 'Il monumento sepolcrale del Card. Niccolò Forteguerri in Santa Cecilia a Roma e il suo cenotafio nella cattedrale di Pistoia', *Egemonia fiorentina ed automonie locali nella Toscana nord-occidentale del primo rinascimento: Vita, arte, cultura: Pistoia, 1975*, pp. 211–33

A. Padoa Rizzo: 'La cappella Salutati nel duomo di Fiesole e l'attività giovanile di Cosimo Rosselli', *Ant. Viva*, xvi (1977), pp. 3–12

E. Carli: *Il pulpito interno della cattedrale di Prato* (Prato, 1981)

G. Zander: 'Considerazioni su un tipo di ciborio in uso a Roma nel rinascimento', *Boll. A.*, 4th ser., lxix (1984), pp. 99–106

B. Cassidy: 'Two Trecento Angels at Volterra Disguised by Mino da Fiesole', *Burl. Mag.*, cxxxvi/1101 (1994), pp. 802–8

F. Cagliotti: 'Ancora sulle traversie vaticane del giovane Mino, sulla committenza statuaria di Pio II e su Leon Battista Alberti', *Dial. Stor. A.*, i (1995), pp. 126–31

S. E. Zuraw: 'The Public Commemorative Monument: Mino da Fiesole's Tombs in the Florentine Badia', *A. Bull.*, lxxx/3 (1998), pp. 452–77

SHELLEY E. ZURAW

Mino del Reame [Mino del Regno] (*fl* Rome, *c.* 1460–80). Name given by Vasari to an Italian sculptor who

worked in Rome during the second half of the 15th century. The name, which means 'from the Kingdom [of Naples]', suggests that Mino was from Naples. No documentation except for Vasari's *Vita* has been discovered to support the existence of this artist. The confusion between Mino del Reame and MINO DA FIESOLE was already evident in Vasari's writings and resurfaced in the early 20th century (Fraschetti, Angeli). The majority of works at present attributed to the Neapolitan sculptor have traditional associations—some as early as the 16th century—with the Florentine Mino.

The name Mino del Reame first appeared in Vasari's description of a competition between the sculptor and Paolo Romano to make a statue for Pius II, which would imply that Mino was already working in Rome in the early 1460s. In fact, two of the sculptures that Vasari stated were the work of Mino del Reame are documented works by Paolo Romano: the marble statues of *St Peter* and *St Paul* for the stairs leading to Old St Peter's, Rome (both Rome, St Peter's; see Rubinstein). Reliefs of two angels decorating the portal of S Giacomo degli Spagnuoli, Rome, one signed OPUS PAULI, the other OPUS MINI (the signature used by Mino da Fiesole), are cited as examples of the rivalry between the two sculptors. Vasari's suggestion that Mino del Reame was also active in Naples has led critics to associate the sculptor with Jacopo della Pila (*fl* Naples, 1472–1502), whose works resemble those attributed to Mino del Reame in Rome (Causa). However, the affinities in their carving styles do not necessarily confirm the identification, especially since Mino da Fiesole produced reliefs with similar qualities.

Vasari attributed the tomb of *Paul II* (*d* 1471; destr., frags in Rome, St Peter's) to Mino del Reame in that artist's biography; however, in his *Vita* of Mino da Fiesole, he contradicted himself and correctly said it was the work of the latter. Despite Vasari's confusion, however, he clearly identified them as two different sculptors.

Vasari's account suggests that Mino del Reame arrived in Rome *c.* 1460 and was active there in the 1460s and 1470s, years in which Mino da Fiesole is also presumed to have been working in the same city. Some scholars have interpreted the identical signatures and the stylistic similarities as evidence to deny the existence of Mino del Reame altogether (Langton Douglas). Others assume that Mino del Reame was a separate personality (Pope-Hennessy). By removing from Mino da Fiesole's canon of works those sculptures that seem inimical to his Florentine manner, and assigning them to Mino del Reame, a limited oeuvre has been established. Some of these works—the angel relief, a Sacrament tabernacle (Rome, S Maria in Trastevere) and the marble ciborium of Cardinal d'Estouteville for S Maria Maggiore, Rome (destr.; frags *in situ* and Cleveland, OH, Mus. A.)—are signed OPUS MINI, but none is mentioned by Vasari. The most elaborate project in the group, the ciborium, is properly to be attributed to Mino da Fiesole. The flat, decorative carving technique and abstracted, simplified forms can be linked to his documented works (Caglioti).

A series of smaller works have also been attributed to Mino del Reame, including a *Crucifixion* relief (Rome, S Balbina), the monument of *Antonio Rido* (Rome, S Francesca Romana) and *St John the Baptist* (Rome, S Giovanni dei Fiorentini). It has been assumed that he either returned to Naples or died in Rome in the 1480s. The stylistic cohesion of the works attributed to Mino derives more from their resemblance to Mino da Fiesole's designs than from any internal unity.

BIBLIOGRAPHY

Thieme–Becker

F. Albertini: *Opusculum de mirabilibus novae urbis Romae* (Rome, 1510); ed. A. Schmarsow (Heilbronn, 1886), pp. 16–17

G. Vasari: *Vite* (1550, rev. 2/1568); ed. G. Milanesi (1878–85), ii, pp. 647–55; iii, pp. 115–27

S. Fraschetti: 'Una disfida artistica a Roma nel quattrocento', *Emporium*, xiv (1901), pp. 101–16

A. Venturi: *Storia* (1901–40), vi, pp. 658–71

D. Angeli: 'I due Mino', *Nuova Antol.*, n. s. 4., lxiii (1904), pp. 423–35

S. A. Callisen: 'A Bust of a Prelate in the Metropolitan Museum, New York', *A. Bull.*, xviii (1936), pp. 401–6

U. Middeldorf: [review of A. Grisebach: *Römische Porträtbüsten der Gegenreformation* (Leipzig, 1936)], *A. Bull.*, xx (1938), pp. 111–17

Italian Gothic and Early Renaissance Sculpture (exh. cat. by W. R. Valentiner, Detroit, MI, Inst. A., 1938), no. 100

W. R. Valentiner: 'Mino da Fiesole', *A. Q.* [Detroit], vii (1944), pp. 151–80; also in W. R. Valentiner: *Studies in Italian Renaissance Sculpture* (London, 1950), pp. 70–96

R. Langton Douglas: 'Mino del Reame', *Burl. Mag.*, lxxxvii (1945), pp. 217–24

——: *Burl. Mag.*, lxxxviii (1946), p. 23 [letter]

R. Causa: 'Contributi all conoscenza della scultura dell '400 a Napoli', *Scultura lignee nella Campania* (exh. cat., ed. F. Bologna and R. Causa; Naples, Pal. Reale, 1950), pp. 105–21 (116–21)

S. Nodelman: *Mino del Reame* (diss., New Haven, CT, Yale U., 1959)

H. Leppien: *Die neapolitanische Skulptur des späteren Quattrocento*, 2 vols (diss., Tübingen, Eberhard-Karls-U., 1960), pp. 132–43

J. Pope-Hennessy: *Italian Renaissance Sculpture* (London, 1963, rev. 3/Oxford, 1985) pp. 287–8, 321–2

A. Riccoboni: 'Nuovi apporti all'arte di Mino del Regno a Roma', *L'Urbe*, xxix/1 (1966), pp. 16–23

V. Golzio and G. Zander: *L'arte in Roma nel secolo XV*, Storia di Roma, xxviii (Bologna, 1968), pp. 323–5, 429–30, 479

R. Rubinstein: 'Pius II's Piazza S Pietro and St. Andrew's Head', *Enea Silvio Piccolomini, Papa Pio II; Atti del convegno per il quinto centenario della morte e altri scritti: Siena, 1968*, pp. 221–44 (230–35)

Italian Renaissance Sculpture in the Time of Donatello (exh. cat., ed. A. Darr; Detroit, MI, Inst. A., 1985), pp. 190–92

F. Caglioti: 'Per il recupero della giovinezza romana di Mino da Fiesole: Il 'ciborio' della neve', *Prospettiva* [Florence], 49 (1987), pp. 15–32

For further bibliography *see* MINO DA FIESOLE.

SHELLEY E. ZURAW

Mio, Giovanni de. *See* DEMIO, GIOVANNI.

Mirabello di Salincorno. *See* CAVALORI, MIRABELLO.

Miriliano, Giovanni. *See* MARIGLIANO, GIOVANNI.

Mocenigo. Italian family of statesmen, patrons and collectors. Six members of the family occupied the office of Doge of Venice. The first of these was Tommaso Mocenigo (*b* 1343; *d* 3 April 1423), whose rule was characterized by continued peace and the promotion of commercial prosperity through maritime trade. His marble tomb (*c.* 1425) by Pietro di Niccolò Lamberti and Giovanni di Martino da Fiesole (*fl c.* 1425–60) is in the church of SS Giovanni e Paolo and typifies an emerging Renaissance style in Venetian monumental sculpture and tomb architecture. Its unresolved amalgamation of Late Gothic and early Renaissance devices is augmented by a relief depicting *Prudence* and two figures representing *Faith* and *Charity*, almost certainly derived from Donatello. The tombs of

two other Mocenigo doges are also in SS Giovanni e Paolo. The marble tomb of Tommaso's nephew *Pietro Mocenigo* (*b* 1406; *d* 23 Feb 1476) was executed *c.* 1476–81 by Pietro Lombardo and is considered the earliest example of the artist's mature style. Iconographically, its decorative elements emphasize Pietro's career as a naval commander prior to his election as Doge. The tomb of his brother *Giovanni Mocenigo* (*b* 1408; *d* 4 Nov 1485), executed by Tullio Lombardo *c.* 1500–10, exhibits an increasingly sympathetic assimilation of antique prototypes and is perhaps the best known of the three Renaissance *Mocenigo* tombs in the church. Giovanni is also the subject of two important portraits, both generally attributed to Gentile Bellini: the votive picture of *Doge Giovanni Mocenigo before the Virgin and Child* (late 15th century; London, N.G.) and the profile portrait of *Doge Giovanni Mocenigo* (late 15th century; Venice, Correr).

The Mocenigo family owned numerous palaces and properties along the Grand Canal in the parish of S Samuele, of which the oldest was the 'Casa Vecchia'. During the 16th century sites contiguous to it were acquired and their existing structures largely demolished to construct three new palaces, thereby creating an imposing sequence of four family edifices along the Grand Canal. The grandest of the new palaces, the 'Casa Nuova' (completed *c.* 1579), has been attributed to Palladio, who had clearly designed a residence for this pyramidal site by *c.* 1570, but some exterior elements suggest that the author was a follower of Palladio, perhaps Mauro Bergamasco. The 'Casa Nuova' and the 'Casa Vecchia' were connected by two palazzetti of lower elevation, whose canal façades were subsequently painted with scenes of Roman subjects by Giuseppe Albardi (see Bassi, fig. 136).

The 'Casa Nuova' was probably built for, and possibly even by, Doge Alvise I Mocenigo (*b* 1507; *d* 4 June 1577), whose portrait was executed by Tintoretto (*c.* 1570–75; Venice, Accad.) and by an anonymous Venetian master (*c.* 1575; Venice, Correr). Alvise is thought to have been highly influential in determining the Giudecca as the site for Palladio's new votive church, Il Redentore (begun 1576; see PALLADIO, ANDREA, fig. 7), and was prominently portrayed with a possible model for the Redentore in an anonymous painting (?mid-1570s; ex-A. di Robilant priv. col., see Timofiewitsch, fig. xvii). He also initiated the enlargement of the Palazzo Mocenigo at S Stae, although most work there dates from *c.* 1590 to 1600; its structure recalls the architectural ideas of Sebastiano Serlio. Alvise also began the reconstruction of the family's 15th-century palazzetto on the Giudecca, later rebuilt by an unidentified architect who had closely studied the works of Palladio. Leonardo Mocenigo (?1522–75), who may have been the brother of Alvise, was among Palladio's most important Venetian patrons, employing him from 1558 in the construction of his new residence in the S Sofia district of Padua. He also commissioned Palladio *c.* 1561–2 to design a large country villa (incomplete) at Marocco (Treviso), for which three sketches (*c.* 1561–2; Venice, Archv Stato), plans and façade elevations (Palladio: *I quattri libri*) survive, and a villa on the River Brenta, for which there are two pen-and-ink sketches (*c.* 1570; London, RIBA); it remains unclear, however, whether any portion of this structure was ever executed.

BIBLIOGRAPHY

A. Palladio: *I quattri libri dell'architettura* (Venice, 1570)
P. Zampetti: 'Il Palazzo Mocenigo', *A. Ven.*, viii (1954), pp. 330–33
W. Timofiewitsch: *La chiesa del Redentore. Corpus Palladianum*, iii (Vicenza, 1969)
O. Logan: *Culture and Society in Venice, 1470–1790: The Renaissance and its Heritage* (London, 1972), pp. 148–219, 314–15
G. Goldner: 'The Tomb of Tommaso Mocenigo and the Date of Donatello's *Zuccone* and of the Coscia Tomb', *Gaz. B.-A.*, lxxxiii (1974), pp. 187–92
E. Bassi: *Palazzi di Venezia* (Venice, 1976, 2/1978)
A. Foscari: 'L'invenzione di Palladio per un "sito piramidale" in Venezia', *A. Ven.*, xxxiii (1979), pp. 136–41
L. Puppi: 'Palladio e Leonardo Mocenigo: Un palazzo a Padova, una villa "per un . . . sito sopra la Brenta", e una questione di metodo', *Klassizimus: Epoche und Probleme: Festschrift für Erik Forssman zum 70. Geburtstag*, ed. J. M. zur Capellen and G. Oberreuter-Kronabel (Hildesheim, 1987), pp. 337–62

□

Mocetto [Moceto; Mozeto; Mozetto], **Girolamo** (*b* Murano, *c.* 1470; *d* ?Venice, after 21 Aug 1531). Italian engraver, painter and designer of stained glass. He was born into a family of glass painters, and, although there is no documentary evidence that he worked outside Venice, his early paintings and engravings show the influence of Domenico Morone and of Mantegna and his circle, which would suggest that Mocetto's training may not have been exclusively Venetian. His artistic evolution is most clearly seen in a comparison of early works still close to Morone, such as a series of three engravings of the *Battle between Israel and the Amalekites* (see Hind, nos 719–20) or the painting of the *Battle* (Pavia, Pin. Malaspina), to works of a few years later, such as the two small paintings of the *Massacre of the Innocents* (London, N.G.; see fig.) and the engravings of *Pagan Sacrifices* (H 726–7), the *Metamorphosis of Amymone* (H 728) and the *Calumny of Apelles* (H. 727), all datable to *c.* 1500. In the later works, whole passages or motifs are copied or adapted from drawings and engravings by Mantegna. Mocetto may have had direct contact with the court of Mantua (the *Metamorphosis of Amymone* is an allegory of the city of Mantua); two engravings dating from the first years of the 16th century, *St John the Baptist* (H 724) and *Judith with the Head of Holofernes* (H 725), both bear a close resemblance to the contemporary work of Giulio Campagnola, who was in Mantua in 1499.

From *c.* 1500 Mocetto began to study the work of other artists from Venice and the Veneto. In his engraving of *Bacchus* (H 726), the pose of the god is derived from a soldier in Giovanni Bellini's *Resurrection* (Berlin, Gemäldegal.), while Bellini's *Assumption of the Virgin* (Murano, S Pietro Martine) inspired Mocetto's mediocre engraving of the same subject (H 717). Mocetto's several engravings of the *Virgin and Child Enthroned* (H 730–32) are derived from prototypes by Bartolomeo Montagna, Cima da Conegliano and possibly also Bellini. Mocetto's paintings of the *Virgin between Joachim and Anne* (*c.* 1500–10; Amsterdam, Rijksdienst Beeld. Kst., on dep. Maastricht, Bonnefantemus.) and *Virgin and Child* (*c.* 1500–10; Vicenza, Mus. Civ. A. & Stor.) mark the high point of his interest in Cima and Montagna. His engraving of the *Baptism of Christ* (*c.* 1515; H 729) is a pastiche of Cima's *Baptism of Christ* (Venice, S Giovanni in Brágora) and Bellini's painting of the same subject (Vicenza, S Corona). In this engraving, atmospheric effects are obtained by

Girolamo Mocetto: *Massacre of the Innocents* (fragment), oil on canvas (?transferred from panel), 679×445 mm, *c.* 1500 (London, National Gallery)

BIBLIOGRAPHY

E. Galichon: 'Girolamo Mocetto, peintre et graveur vénitien', *Gaz. B.-A.*, ii (1859), pp. 321–36
P. Nanin: *Disegni di varie dipinture a fresco che sono in Verona* (Verona, 1864)
C. Von Fabriczy: 'Über Heimat und Namen G. Mocettos und Bonifazios von Verona', *Repert. Kstwiss.*, xii (1889), p. 15
G. Ludwig: 'Archivalische Beiträge zur Geschichte der venezianischen Malerei', *Jb. Kön.-Preuss. Kstsamml.*, xxiv (1903), pp. 44–57
J. Guibert: 'Notes sur une *Resurrection* du Musée Royal de Berlin: Giovanni Bellini et le graveur Mocetto', *Gaz. B.-A.*, xxxiv (1905), pp. 380–83
A. Venturi: 'Appunti sul Museo Civico di Verona', *Madonna Verona*, i/1 (1907), pp. 49–50
E. Waldmann: 'Zu Mocetto', *Mhft. Kstwiss.*, i (1908), pp. 193–5
B. Baron: 'Girolamo Mocetto: Painter-engraver', *Madonna Verona*, iii/1 (1909), pp. 61–6
G. Fiocco: 'Il primo dipinto di Girolamo Mocetto', *Madonna Verona*, viii/2–3 (1914), pp. 81–4
A. M. Hind: *Early Italian Engravings*, v (London, 1948) [H]
L. Puppi: 'Di Benedetto Montagna, del Mocetto e di altri problemi', *A. Ant. & Mod.*, 11 (1960), pp. 281–90
——: 'Schedule per la storia della pittura veronese tra la fine del '400 e l'inizio del '500', *A. Ant. & Mod.*, 28 (1964), pp. 416–27
Early Italian Drawings from the National Gallery of Art (exh. cat., ed. K. Oberhuber, J. Levenson and J. Sheehan; Washington, DC, N.G.A,, 1973), pp. 382–9
L. Zecchin: 'I Mozetto, vetrai muranesi del quattrocento', *Riv. Staz. Spermntl Vetro* (1978), pp. 111–15
S. Romano: 'La vetrata dei SS Giovanni e Paolo: Esercizi di attribuzione', *A. Ven.*, xxxvi (1982), pp. 41–51
La grande vetrata di S Giovanni e Paolo (exh. cat., Venice, Ala Napoleonica, 1982)
S. Romano: *Girolamo Mocetto* (Modena, 1985) [with full bibliog.]

SERENA ROMANO

Modanino, Paganino. *See* MAZZONI, GUIDO.

Modena, Giovanni da. *See* GIOVANNI DA MODENA.

Modena, Nicoletto da. *See* NICOLETTO DA MODENA.

Moderno [Mondella, Galeazzo] (*b* Verona, 1467; *d* Verona, 1528). Italian plaquette designer and gem-engraver. A coherent group of 12 plaquette designs (from some 45 currently credited to this master; Washington, DC, N.G.A.; Vienna, Ksthist. Mus.) are signed with initials or contractions of MODERNUS FECIT or OPUS MODERNI: both the signed and attributed groups establish a claim for the recognition of their author as the most accomplished designer of plaquettes in Italy in the Renaissance. References to the art of the western Veneto in the early work and to that of Venice in later examples make it virtually certain that Moderno was Galeazzo Mondella of Verona. The plaquettes display an intimate awareness of preceding and contemporary Veronese art, with special loyalties to Andrea Mantegna, the Falconetto family, Francesco Bonsignori and Liberale da Verona. Galeazzo's brother Girolamo Mondella (1464–1512) was a painter and an intimate of the Este court at Ferrara. Moderno's earliest works (from about 1485) reflect both Ferrarese painting and a disposition towards the humanist themes favoured by the court. Ferrara also gave him the opportunity to see Bolognese art; in his early years he may have known Emilian art mainly from drawings. The same was true of Lombard art: he knew of Vincenzo Foppa in Brescia (which was then Venetian), but of art in Milan and Pavia perhaps only through Foppa's involvement there.

means of dense cross-hatching, a characteristic device of his.

One of Mocetto's most successful works was the lower band of stained-glass panels (*c.* 1515) for a window in SS Giovanni e Paolo, Venice. The figures of *St Theodore*, *SS John and Paul* and *St George and the Princess* are shown in a continuous landscape setting that runs behind the stone divisions of the Gothic window; this contrasts with the upper part of the window, in which the four saints are conceived in isolation. Within the contours of the forms delineated by the leading, Mocetto modelled the figures and created subtle chiaroscuro effects by using a technique of fine cross-hatching similar to that used in his drawings and engravings. The fresco cycle formerly on the façade of a house at Acqua Morta, Verona (*c.* 1517; four fragments in Verona, Castelvecchio), is probably correctly attributed to Mocetto and his workshop.

Only a few works can be ascribed to the last phase of the artist's career. They include panels of *St Helen* (Milan, Castello Sforzesco) and *St Catherine* (Padua, Mus. Civ.), both of which are inspired by Cima and Bellini. A drawing of *Children Playing with Masks* (Paris, Louvre) is executed in a somewhat academic style and reverts to the antiquarian taste of Mocetto's early work but is free of any trace of Mantegna's style.

Within the Veneto, Moderno was attracted to Bartolomeo Montagna and his pupil Cima, as well as to the Vivarini family, Antonello da Messina, the Bellini family, and Carlo Crivelli in Venice. His main inspiration came from Mantegna, above all during Mantegna's period in Mantua, where Moderno may have had access to his studio. It is striking that his work has virtually no parallels with the art of Padua.

Moderno appears to have chosen his pseudonym as early as 1487 at Mantua, where he evidently worked as a medallist; thereafter he must have frequented the Mantuan court regularly. Within the Verona–Ferrara–Mantua area he seems to have been almost as peripatetic as a contemporary engraver, Nicoletto da Modena (*fl* 1480–1507), whom he may well have known: many of Nicoletto's prints reflect Moderno's plaquettes, and they are often the sources of later copies by Giovanni Antonio da Brescia (*fl* 1490). From about 1500 Moderno's work suggests he had first-hand experience of the expressive terracotta sculpture groups that were characteristic of Modena and Bologna. Contacts at Mantua may have introduced him to the greatest patron of his late years, Cardinal Domenico Grimani of Venice: through this connection he seems to have developed a considerable Venetian clientele and perhaps turned more to gem-engraving.

Moderno's work moves from a tentative provincial eclecticism based mostly on Mantegna to a confident and authoritative Roman Renaissance classicism based on Raphael and the Antique, often interpreted in forms similar to those of Tullio Lombardo and Antonio Lombardo in Venice and Ferrara. He may not have travelled far from the Veneto during the discernible years of his working life (1485–1515), although it is likely that Cardinal Grimani helped him to visit Rome in the latter part of that period, perhaps during the invasions of the Veneto (1509–16). There seem to be no new designs by Moderno after about 1512, the year he became head of the Mondella family workshop. Moderno may have turned from art to civic affairs after the restoration of his family to the council of nobles in Verona in 1517, or he may have travelled to France, as Vasari supposed; there are no records of his whereabouts from 1517 until 1527, when he is documented in Verona. After his death, the family shop was inherited by his son Giambattista Mondella (1506–*c.* 1572), who was also a metalworker. Moderno's designs continued to be reissued for some time, as well as augmented, adapted and further developed. Their inclusion in fine castings on Paduan utensils around 1530 and later (perhaps by Desiderio da Firenze) suggests that a few of his most popular matrices may have been transferred to Padua. His plaquettes were widely admired and conspicuously influential in the Veneto, Emilia and Lombardy; farther afield, his designs were sketched by Albrecht Dürer (1471–1528) and Hans Holbein the younger (1460/65–1534) and incorporated into French Renaissance sculpture; one of the best, *David and a Companion with the Dead Goliath* (*c.* 1504/5; e.g. Washington, DC, N.G.A.), provided Michelangelo with the model of a figure for his *Last Judgement* in the Sistine Chapel (Rome, Vatican; see colour pl. 2, VII3).

BIBLIOGRAPHY

G. Vasari: *Vite* (1550, rev. 2/1568); ed. G. Milanesi (1878–85), v, pp. 375–6

L. Rognini: 'Galeazzo e Girolamo Mondella, artisti del rinascimento veronese', *Atti Mem. Accad. Agric., Sci. & Lett. Verona*, ser. 6, xxv (1975), pp. 95–119

D. Lewis: 'The Medallic Oeuvre of "Moderno": His Development at Mantua in the Circle of "Antico"', *Italian Medals*, ed. J. G. Pollard, 'Studies in the History of Art', xxi (Washington, DC, 1987), pp. 77–97

——: 'The Plaquettes of "Moderno" and his Followers', *Italian Plaquettes*, ed. A. Luchs, 'Studies in the History of Art', xxii (Washington, DC, 1989), pp. 105–41

DOUGLAS LEWIS

Molinari, Leonardo de'. *See* LEONARDO DA BESOZZO.

Monaco, Lorenzo. *See* LORENZO MONACO.

Mondella, Galeazzo. *See* MODERNO.

Monópoli, Reginaldo Piramo da. *See* PIRAMO DA MONÓPOLI, REGINALDO.

Monsignori, Francesco. *See* BONSIGNORI, FRANCESCO.

Montagna [Cincani]. Italian family of artists. (1) Bartolomeo Montagna was the leading painter in Vicenza during the last quarter of the 15th century and the first quarter of the 16th. His son (2) Benedetto Montagna, who continued his father's style of painting, is more significant for his engravings, some of which are based on his father's work, often combined with German influences.

(1) Bartolomeo Montagna (*b* Orzinuovi, nr Brescia, or Biron, nr Vicenza, *c.* 1450; *d* Vicenza, 11 Oct 1523). Painter and draughtsman.

1. LIFE AND WORK.

(i) Early work, to c. 1485. Montagna is first documented in 1459 in Vicenza as a minor and, still a minor, in 1467. In 1469 he is recorded as a resident of Venice. In 1474 he was living in Vicenza where, in 1476 and 1478, he was commissioned to paint altarpieces (now lost). He has variously been considered a pupil of Andrea Mantegna (Vasari), Giovanni Bellini, Antonello da Messina, Alvise Vivarini, Domenico Morone and Vittore Carpaccio. While none of these artists, except Carpaccio, was irrelevant to Montagna's stylistic formation, scholars agree that Giovanni Bellini was the primary influence on his art. He may have worked in Bellini's shop around 1470. Several of Montagna's paintings of the *Virgin and Child* in which the influence of Antonello da Messina is especially marked (e.g. two in Belluno, Mus. Civ.; London, N.G., see Davies, no. 802) are likely to be close in date to Antonello's sojourn in Venice (1475–6); they are therefore best considered Montagna's earliest extant works (Gilbert, 1967) rather than as an unexplained parenthesis around 1485 between two Bellinesque phases (Puppi, 1962). These early paintings appear to be followed by others in which the geometrically rounded forms derived from Antonello become more slender and sharper-edged. Their figures are imbued with a deeply felt, individual humanity, sometimes austere and minatory, sometimes tender. Among them are some larger-scale works, for example the *Virgin and Child Enthroned with SS Nicholas and Lucy* (Philadelphia, PA, Mus. A.) and a *Virgin and Child with SS Ansanus, Anthony Abbot, Francis and Jerome* (often but wrongly attributed to

Carpaccio; Vicenza, Mus. Civ. A. & Stor.). This group also includes a fresco fragment depicting the *Virgin and Child* (London, N.G.), the modern frame of which is inscribed, 'Painted 1481 in the choir of the church of Magrè near Schio-Vicenza'. The date seems plausible on stylistic grounds, and the work thus provides a chronological point of reference for the rest of the group. In 1482, again in Venice, Montagna undertook to paint canvases of the *Flood* and the *Creation* for the Scuola di S Marco; the former was completed in 1485–6 by Benedetto Diana, and both were subsequently destroyed by fire.

(ii) Maturity, c. 1485–1509. Having returned to Vicenza, Montagna supplied designs (after 1484) for the intarsie of the choir-stalls (*in situ*) of the sanctuary of Monte Berico, executed by the intarsiatore of note Pierantonio da Lendinara (*c.* 1430–97). In 1486 he made an agreement with Giovanni di Magrè about a *Virgin and Child with Saints*, which could be (but more likely is not) that in the parish church of S Giovanni Ilarione.

Montagna's mature style is ushered in by two superb altarpieces for S Bartolomeo, Vicenza, the *Virgin and Child with SS Monica and Mary Magdalene* (see fig. 1) and the monumental high altarpiece of the *Virgin and Child with Four Saints and Music-making Angels* (both Vicenza, Mus. Civ. A. & Stor.), both of which are datable to the mid-1480s. The former sets its trenchantly characterized protagonists outdoors in a landscape whose pitted, fossil-embossed limestone, entwined roots and seething grass combine Bellinesque observation with an element of fantasy reminiscent of Francesco Squarcione's school. The air is clear, the light cool. The latter painting (see colour pl. 2, VIII3) is a *plein-air* variant of Bellini's great Venetian altarpieces, with figures arranged in a spacious vaulted

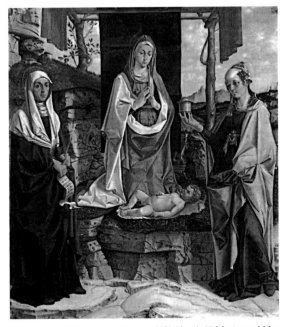

1. Bartolomeo Montagna: *Virgin and Child with SS Monica and Mary Magdalene*, tempera on canvas, 1.69×1.21 m, mid-1480s (Vicenza, Museo Civico d'Arte e Storia)

porch brimming with morning light. Here the landscape bespeaks the beauty of the everyday while fantasy finds play in the architecture of the Virgin's tall throne. Colour again is cool, dominated by sky blue, silver and cream. Besides Bellini, further sources of influence for this work may be Ercole de' Roberti (as Puppi suggests) and Benedetto Diana, whose *Virgin and Child with Two Saints and Donors* (1486; Venice, Ca' d'Oro) similarly exploits architectural oddity, a high ratio of void to mass, and subtle, silvery tonality. Montagna's style in these altarpieces is, however, very much his own, with invention and control in perfect balance. In his small *Virgin and Child with SS Sebastian and Roch* (1487; Bergamo, Gal. Accad. Carrara) the sophisticated interplay of colour and light depends still further on the variegated colouring of the marble in the architecture, a device he increasingly exploited thereafter. An inscription on the back of this painting states that he painted it in September 1487 for Gerolamo Roberto Bresciano; it is thus Montagna's first extant securely dated painting.

In 1488 and again in 1492 Bartolomeo was in Padua. A notation made by one of the Certosa di Pavia's monks between 1634 and 1637 states that in 1490 he painted an altarpiece depicting the *Virgin and Child Enthroned with SS John the Baptist and Jerome* (Pavia, Mus. Certosa) for the Certosa. Between 1496 and 1500 he was paid for an altarpiece for S Michele, Vicenza; it is dated 1499 and depicts the *Virgin and Child with Four Saints and Music-making Angels* (Milan, Brera). He is also documented as receiving payment between 1499 and 1504 for a *Virgin and Child with Eight Saints* (destr.) for Vicenza Cathedral. Dated paintings of this period include a *Virgin and Child with SS James and John the Evangelist* (1499; Glasgow, A.G. & Mus.), a *Nativity* (1500; Orgiano, parish church), a frescoed *Pietà* (5 Apr 1500; Vicenza, sanctuary of Monte Berico), a *Christ Blessing* (1502; Turin, Gal. Sabauda) and three paintings of the *Virgin and Child* (all 1503; ex-Lugano, Donati priv. col.; Modena, Gal. & Mus. Estense; Paris, de Noailles priv. col.).

During the 1490s and into the next decade Montagna held aloof from the general mellowing of Venetian art. He cultivated complications of cutting edge and angular junction, prismatic drapery, bizarrely decorative architecture, and quarried landscapes that memorably blend the domestic and the fantastic. These ever more anachronistic features, though, are combined with increasingly ample figures and, from the mid-1490s, often with darkened tonalities that, however, entail no atmospheric softening or indistinctness. Paradoxical though this style became, it produced impressive paintings: *St Jerome* and *St Paul* (*c.* 1490; Milan, Mus. Poldi Pezzoli; see fig. 2), *St Peter* (early 1490s; Venice, Accad.), the twilit *Virgin and Child with SS Francis and John the Baptist* (later 1490s; Venice, Fond. Cini), the Monte Berico *Pietà*, the ruined but splendidly spacious and monumental frescoes of scenes from the *Life of St Biagio* (1504–6; Verona, SS Nazaro e Celso) and the majestic *Virgin and Child with Four Saints and Music-making Angels* (1499; Milan, Brera). This last represents a summit of achievement not only within Montagna's art but among High Renaissance altarpieces in North Italy. The imposing figures are integrated with monumental architecture in a colour scheme of extraor-

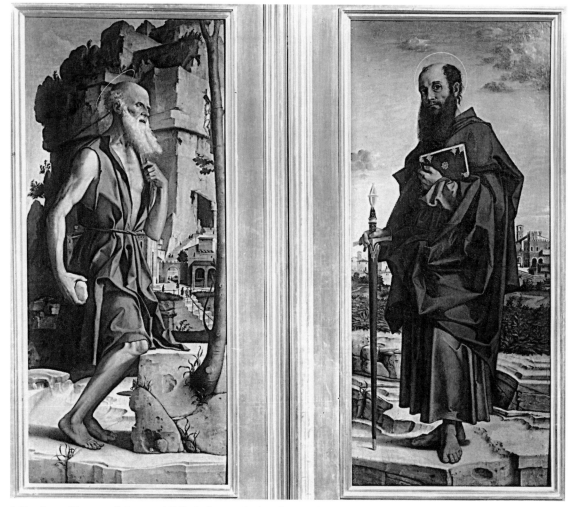

2. Bartolomeo Montagna: *St Jerome* and *St Paul*, oil on panel, wings from an altarpiece, each panel 1.12×0.50 m, *c.* 1490s (Milan, Museo Poldi Pezzoli)

dinary intricacy that is given coherence by the slightly lowered tonality. The composition balances massive solids against deep, light-filled space, and complexity of detail against overall symmetry.

(iii) Late works, 1509–23. Montagna is documented in Vicenza again in 1509. The last 15 years of his career are often considered a period of decline (Borenius; Puppi, 1962), although Gilbert (1956) persuasively argued against so simple a view. In these years Montagna was less often able to resolve with complete success the contradictions implicit in his mature style, but the successes remain works of great individual distinction. He was working against increasing odds: his own advancing years; a move to Padua (1509–14), probably enforced by the ravages of war in Vicenza; and the rapid ascendancy of a style and taste very unlike his own, that promulgated by Giorgione and Titian. His adjustments to this last factor included lusher land-scapes, more rotund figures, warm tonalities and, some-times, fiery sunset skies. He ingeniously fused these elements with the complex geometric architecture and

coloured marbles of his earlier works in paintings that, at their best, achieve a new, more romantic and poetic quality.

Outstanding examples are the fresco of the *Exhumation of St Anthony* (1512; Padua, Scuola S Antonio), in which eventful landscape, eccentric architecture, tumultuous crowds and striking portraits vie for the viewer's attention; and the crepuscular and nostalgic *Virgin and Child with Four Saints* (*c.* 1514; Padua, S Maria in Vanzo). Having returned to Vicenza by 1517, when he was paid for work by his son (2) Benedetto Montagna, he was commissioned in 1520 to paint an altarpiece depicting the *Nativity* for the Scuola di S Giuseppe, Cologna Veneta, which was executed in 1522. In 1523 he made his last will.

2. CRITICAL RECEPTION AND POSTHUMOUS REPUTATION. Despite the number of dated works, no chronology of Montagna's oeuvre yet published can be considered definitive. He was clearly responsive to stimuli from diverse sources. Scholars disagree as to when these responses occurred, and hence in their dating of many individual paintings. For example the severely damaged

Virgin and Child (London, N.G., see Davies, no. 1098) is dated by Puppi 1504–6, by Berenson *c.* 1489 and by Borenius as early as the 1470s.

Montagna's art was overwhelmingly influential for his contemporaries in Vicenza, but far less so elsewhere. Among Venetian painters, Cima da Conegliano and Vittore Carpaccio apparently consulted his art early in their careers; it had more lasting importance for Benedetto Diana and for contemporary artists active in Padua and Verona. Among Vicentines, Montagna's example determined the styles of his son Benedetto and Giovanni Battista Speranza and, with Perugino, that of Francesco Verla (*fl* 1490–1520). It was also highly significant for Giovanni Buonconsiglio. Montagna is chiefly important, however, for his own idiosyncratic achievement. Unsurpassed, even in a generation of virtuosos, at using colour to evoke varying intensities and qualities of light, he also devised colouristic counterpoints, fascinating in their own right. Masterly and often daring in his compositions, he was also a fine draughtsman, as several surviving drawings attest (e.g. the *Drunkenness of Noah*, New York, Pierpoint Morgan Lib.; the *Risen Christ*, Paris, Louvre; and the two related *Heads* of the Virgin, Windsor Castle, Royal Lib., and Oxford, Christ Church; see 1983 exh. cat.). His formal skills used to expressive ends. He had a deep feeling for landscape and for the human figure, face and posture as expressive agents. In many of his works all these elements combine to produce compelling realizations of a personal vision of life: sombre, truthful and compassionate.

BIBLIOGRAPHY

G. Vasari: *Vite* (1550, rev. 2/1568); ed. G. Milanesi (1878–85), iii, pp. 649–50; 672–4; vii, p. 526

C. Ridolfi: *Meraviglie* (1648); ed. D. von Hadeln, i (1914), pp. 109–11

M. Boschini: *I gioielli pittoreschi* (Vicenza, 1676)

A. Magrini: *Elogio di Bartolomeo Montagna* (Venice, 1863)

J. A. Crowe and G. B. Cavalcaselle: *A History of Painting in North Italy*, 3 vols (London, 1871); ed. T. Borenius, ii (London, 1912), pp. 121–8 [important especially for Borenius's notes]

T. Borenius: *The Painters of Vicenza: 1480–1550* (London, 1909)

A. Venturi: *Storia*, VII/iv (1915), pp. 436–500

B. Berenson: *Venetian Painting in America* (New York, 1916), pp. 173–85, 189–94

G. G. Zorzi: *Contributo alla storia dell'arte vicentina* (Venice, 1916)

M. Davies: *The Earlier Italian Schools*, London, N.G. cat. (London, 1951, rev. 1961/*R* 1986)

F. Barbieri: *Il Montagna al Museo di Vicenza* (Vicenza, 1954)

E. Arslan: *Vicenza: Le chiese* (Rome, 1956)

C. Gilbert: 'Alvise e compagni', *Scritti di storia dell'arte in onore di Lionello Venturi* (Rome, 1956), pp. 277–308

B. Berenson: *Venetian School* (1957)

L. Puppi: *Bartolomeo Montagna* (Vicenza, 1962) [standard mod. monograph]

G. Mantese: *Memorie storiche della chiesa vicentina*, III/ii (Vicenza, 1964)

C. Gilbert: [review of L. Puppi, *Bartolomeo Montagna* (Vicenza, 1962)], *A. Bull.*, xlix (1967), pp. 184–9

L. Puppi: 'Un integrazione al catalogo e al regesto di Bartolomeo Montagna', *Ant. Viva*, xiv/3 (1975), pp. 23–9

P. Humfrey: 'Cima da Conegliano at San Bartolomeo in Vicenza', *A. Ven.*, xxxi (1977), pp. 176–81

F. Barbieri: *I pittori di Vicenza, 1480–1521* (Vicenza, 1981), pp. 16–31

Drawing in the Italian Renaissance Workshop (exh. cat. by F. Ames-Lewis and J. Wright; Nottingham, A.G.; London, V&A; 1983), pp. 76–7, 168–9, 318–21

M. Lucco: 'La pittura del secondo quattrocento nel Veneto occidentale', *La pittura in Italia: Il quattrocento*, ed. F. Zeri (Milan, 1986), i, pp. 152–6; ii, p. 712 [incl. concise biog. of Montagna]

M. Tanzi: 'Vincenza', *La pittura nel Veneto: Il quattrocento*, ed. M. Lucco (Milan, 1990), ii, pp. 606–21, p. 760 [incl. concise biog. of Montagna by M. Lucco]

S. Claut: 'La pala di Cima da Conegliano nella chiesa di S Dionisio a Zermen a la cultura montagnesca nell'area bellunese', *Venezia Cinquecento*, iv/7 (1994), pp. 81–101

S. Lodi: 'La fabbrica della cappella di San Biagio', *Verona Illus.*, vii (1994), pp. 33–50

FRANCIS L. RICHARDSON

(2) Benedetto Montagna (*b* Vicenza, *c.* 1480; *d* Vicenza, 1556–8). Engraver and painter, son of (1) Bartolomeo Montagna. His approximate date of birth is derived from the fact that he was given power of attorney in 1504. In 1517 his father received payment for work (untraced) done by Benedetto in the Palazzo del Podestà, Vicenza, and in 1522 Benedetto was paid for frescoes (destr.) in S Agostino, Padua. After this date altarpieces by Benedetto are documented at intervals until 1541. As a painter, he is of merely local significance. His style is based on his father's, with some admixture from contemporaries such as Moretto, Pordenone and Domenico Campagnola. He is more important, however, as an engraver. His earliest engravings are usually dated *c.* 1500 but could be somewhat earlier. They often seem to be based directly on drawings, or in one case a painting, by his father and reflect the austere beauty of these. Almost from the beginning, however, he embellished his father's style with motifs and technical borrowings from the prints of Albrecht Dürer (1471–1528), five of which he is known to have copied between *c.* 1500 and 1505. The unlikely amalgamation of Bartolomeo with Dürer is startlingly exemplified in *St Jerome* (B. 14). Around 1505 Benedetto was apparently in contact with Girolamo Mocetto, a contact that benefited both artists; thereafter Benedetto's technique and artistic orientation were strongly affected by the example of Giulio Campagnola. As a result, his latest engravings recall Giorgione in character, not least in regard to their subject-matter. They include seven illustrations of Ovid and other mythological, arcadian and genre scenes. Benedetto was the most prolific engraver of his generation in North Italy and influenced others such as Girolamo Mocetto and Nicoletto da Modena (*fl* before 1500–12): 52 engravings are unmistakably his, 47 of them signed or monogrammed.

BIBLIOGRAPHY

A. von Bartsch: *Le Peintre-graveur* (1803–21), xiii, pp. 332–52 [B.]

T. Borenius: *The Painters of Vicenza: 1480–1550* (London, 1909), pp. 115–25

F. Carrington: 'Benedetto Montagna and the *Metamorphoses* of Ovid', *Prt Colr Q.*, xxviii (1941), pp. 206–32

A. M. Hind: *Early Italian Engravings: A Critical Catalogue with Complete Reproduction of all the Prints Described* (London, 1948), v, pp. 173–88; vii, pls 736–69

L. Puppi: 'Appunti su Benedetto Montagna pittore', *A. Ven.*, xii (1958), pp. 53–62

Early Italian Engravings from the National Gallery of Art (exh. cat., ed. J. A. Levenson, K. Oberhuber and J. L. Sheehan; Washington, DC, N.G.A., 1973), pp. 307–32 [entries by J. L. Sheehan]

M. J. Zucker: *Early Italian Masters* (1980), 25 [XIII/ii] of *The Illustrated Bartsch*, ed. W. Strauss (New York, 1978–), pp. 198–230; *Commentary* (1984), pp. 385–432

FRANCIS L. RICHARDSON

Montagnana, Jacopo da. *See* JACOPO DA MONTAGNANA.

Monte, del. Italian family of lawyers, ecclesiastics and patrons. The family, whose ancestral town was Monte San Savino, 20 km south-west of Arezzo, established itself in the 16th century under Antonio Maria Ciocchi del Monte

(1462–1533). His nephew Giovanni Maria Ciocchi del Monte was the future pope (1) Julius III, During the reign of Julius III, the del Monte family continued to prosper, with numerous male and female relatives receiving the benefits of ecclesiastical incomes, titles and property. Baldovino del Monte (*d* 1556), created Conte di Monte San Savino, inherited from his brother Julius III the Villa Giulia in Rome and had a palazzo there (now the Palazzo Firenze) and the family palazzo in Monte San Savino extended and further embellished for his use.

(1) Pope **Julius III** [Giovanni Maria Ciocchi del Monte] (*b* Rome, 10 Sept 1487; elected 7 Feb 1550; *d* Rome, 23 March 1555). He studied law in Perugia and Bologna before undertaking theological studies under the direction of the Dominican Ambrosius Catharinus (*c.* 1484–1553). In his early career he benefited from the patronage of his uncle Antonio Maria Ciocchi del Monte, receiving a number of ecclesiastical preferments. After his uncle's death (1533), he continued to prosper and was appointed successively vice-legate to Bologna (1534), Cardinal Presbyter (1536), Cardinal Bishop (1543) and co-president of the Council of Trent (1545). During his pontificate, Julius made continuous efforts towards Church reform, ordering the resumption of the Council of Trent and initiating a programme to control the conferment of benefices and to change the administration of the curia. He nevertheless ensured that his relatives were granted lucrative benefices, titles and properties.

A generous patron, Julius placed several eminent humanists in his chancery, appointed Marcello Cervini (1501–55, later Pope Marcellus II) as Vatican librarian and reformed La Sapienza, the University of Rome. He was an important patron of the composer Palestrina, who dedicated his *Missarum liber primus* (Rome, 1554) to him. He also took a lively and informed interest in architecture. As he tended to be difficult and exacting, his relationships with artists were often fraught. He appointed Giorgio Vasari in 1550 to design and oversee a decorative scheme (completed 1552) for the funerary chapel of his uncles, Antonio and Fabiano del Monte, in S Pietro in Montorio, Rome. It contains an altarpiece, the *Baptism of St Paul*, and, in the vault, scenes from the *Life of St Paul*, painted by Vasari and his assistants, and two tomb monuments by BARTOLOMEO AMMANATI, one with a statue of *Theology*, the other with a statue of *Justice*. Ammanati was probably also responsible for the marble balustrade and the fine stucco decoration in the vault of the chapel.

Julius had inherited from his uncle a property outside the Porta del Popolo, Rome, which as pope he expanded and rebuilt as the luxurious Villa Giulia (1551–3). As he changed his mind countless times in the course of construction, the chronology and attribution of the various phases of design and construction are both complex and insecure. Vasari claimed that he responded to the Pope's ideas and executed the original designs (which were shown to Michelangelo for comment, and which formed the basis for work done afterwards by himself, Ammanati and Jacopo Vignola; *see* VIGNOLA, JACOPO, fig. 3). In its present form, the architectural scheme unfolds in an orderly and ingeniously integrated sequence: the two-storey villa; the first semicircular courtyard; another loggia;

and the second courtyard which encloses, on a lower level, the profusely decorated nymphaeum. The centrepiece of the nymphaeum is a fountain decorated by colossal statues of the *Tiber* and the *Arno*. Nearly all the rich interior decoration of the villa (on which Giovanni da Udine as stuccoist and Taddeo Zuccaro and Federico Zuccaro as painters collaborated) has now disappeared. The magnificent collection of antique sculptures housed there was removed to the Vatican in the late 16th century. In its scale, scenographic design and combination of artificial and natural features, the villa presented a grandiose emulation of the imperial villas of antiquity, consonant with Julius's aspirations. In the vicinity of the new villa, he also commissioned Vignola to erect (1550–*c.* 1553) the tiny votive church of S Andrea in Via Flaminia as thanksgiving for his escape from death during the Sack of Rome (1527). Its oval dome anticipates the first use of an oval plan for a church, in his S Anna degli Palafrenieri (1565) in the Vatican.

Under the auspices of Julius III, Girolamo da Carpi supervised the modifications of the Villa Belvedere at the Vatican Palace. Michelangelo replaced the circular staircase of DONATO BRAMANTE's Belvedere exedra with a double flight of stairs and conceived the idea of adding two upper storeys to it, subsequently carried out by Pirro Ligorio under Pope Pius IV. Julius also commissioned the decoration of the Stanza della Cleopatra (the present Atrio del Torso) with a scheme which embraced rich stuccowork and a series of murals on themes close to Julius's heart by Daniele da Volterra.

Shortly after his election, Julius III asked Vasari to prepare a new urban scheme for his family home-town, Monte San Savino. Although the scheme was never carried out, several smaller projects were, including the paving of the central portion of the city in brick, renovating the Palazzo Pretorio and the Porta Fiorentina, and adding a new loggia to the sanctuary of S Maria delle Vertighe outside the town's walls. Work also resumed on the Palazzo del Monte at Monte San Savino in order to furnish Baldovino del Monte with a suitable country residence. The architect was Nanni di Baccio Bigio who was apparently also responsible for building the garden loggia. The palazzo bears a striking resemblance to Michelangelo's rejected project of *c.* 1546–8 to link by bridge the Palazzo Farnese, Rome, to the grounds of the Villa Farnesina across the Tiber. It is possible that the Pope personally urged Nanni to complete the palazzo in this manner. Work was still being executed there in the 1560s.

BIBLIOGRAPHY

G. de Angelis d'Ossat: 'La vicenda architettonica del manierismo', *Atti del XIV congresso di storia dell'architettura: Brescia, Mantova, Cremona, 1965*, pp. 95–113

N. W. Canedy: 'The Decoration of the Stanza della Cleopatra', *Essays in the History of Art Presented to Rudolf Wittkower* (London, 1967), pp. 110–18

F. L. Moore: 'A Contribution to the Study of the Villa Giulia', *Röm. Jb. Kstgesch.*, xii (1969), pp. 171–94

T. Falk: 'Studien zur Topographie und Geschichte der Villa Giulia in Rom', *Röm. Jb. Kstgesch.*, xiii (1971), pp. 101–78

C. Davis: 'Ammanati, Michelangelo, and the Tomb of Francesco del Nero', *Burl. Mag.*, cxviii (1976), pp. 472–84

D. Coffin: *The Villa in the Life of Renaissance Rome* (Princeton, 1979)

B. F. Davidson: 'The Landscapes of the Vatican Logge from the Reign of Pope Julius III', *A. Bull.*, lxv (1983), pp. 587–602

A. Nova: 'Bartolomeo Ammanati e Prospero Fontana a Palazzo Firenze: Architettura e emblemi per Giulio III Del Monte', *Ric. Stor. A.*, 21 (1983), pp. 53–76
——: 'The Chronology of the Del Monte Chapel in S Pietro in Montorio in Rome', *A. Bull.*, lxvi (1984), pp. 150–54
L. Satkowski: 'The Palazzo del Monte in Monte San Savino and the Codex Geymüller', *Studies in Honour of Craig Hugh Smyth*, ii (Florence, 1985), pp. 653–60

<div style="text-align: right">DIANA NORMAN</div>

Monte di Giovanni del Fora. *See* FORA, DEL, (2).

Montefeltro. Italian dynasty of rulers and patrons. Buonconte, Lord of Montefeltro (*reg* 1213–41), gained control of Urbino in 1234, and for more than two centuries the family were important condottieri, often in the service of Siena or Arezzo. The wealth and lands gained by (1) Federigo II da Montefeltro financed the patronage of one of the most enlightened rulers of the early Renaissance. The power of the duchy declined under his only son, (2) Guidobaldo da Montefeltro.

(1) Federigo [Federico] **II da Montefeltro**, 1st Duke of Urbino (*b* Gubbio, 1422; *reg* 1444–82; *d* Ferrara, 10 Sept 1482). He was the illegitimate son of Guidantonio da Montefeltro, Count of Urbino (*reg* 1404–43). In his youth he spent two years at the Gonzaga court in Mantua, attended the humanist school of Vittorino da Feltre and served as a condottiere from 1437. He became Count of Urbino after the assassination of his half-brother, Oddantonio (*reg* 1443–4). Federigo's mastery of warfare was renowned throughout Europe. In 1444 he served the Sforzas of Milan and was later employed by Florence and Naples (1451). He was infrequently engaged after the peace of Lodi (1454), although various city-states retained the promise of his service. In 1469 he headed the alliance of Naples, Milan and Florence against Pope Paul II (*reg* 1464–71). In 1474, however, he was created Duke of Urbino by Sixtus IV (*reg* 1471–84) and granted the rights to land in Romagna. He fought for the papacy against Florence in 1479.

The two facets of Federigo's life, the cunning warrior and the enlightened patron, were celebrated in biographies by VESPASIANO DA BISTICCI and GIOVANNI SANTI. They were also captured by Justus of Ghent (*fl c.* 1460–80) in his portrait of *Federigo da Montefeltro and his Son Guidobaldo* (*c.* 1476; Urbino, Pal. Ducale; *see* URBINO, fig. 1), depicted examining a manuscript while dressed in armour. Especially during the later years of his reign, Federigo had a surplus of funds and time available for art and architectural patronage: from the late 1460s he may have invested more money in patronage than any other Italian ruler of his day. He built or refurbished residences throughout his lands, including the Palazzo Comunale (rebuilt 1463), Cagli; the Corte Alta (1464–70), Fossombrone; the Palazzo Ducale (from 1472), Urbania; and the Palazzo Ducale (from 1476; *see* FRANCESCO DI GIORGIO MARTINI, §1), Gubbio. The court at Urbino, however, remained the centre of his attentions (*see* URBINO, §2).

Baldassare Castiglione wrote that the commanding Palazzo Ducale at Urbino was 'thought by many the most beautiful to be found anywhere in all Italy and he furnished it so well with every suitable thing that it seemed not a palace but a city in the form of a palace'. It was built in

several campaigns from the 1440s to the 1470s (*see* URBINO, §4 and fig. 3). Construction was directed successively by several architects, including the Florentine Maso di Bartolommeo, the Dalmatian Luciano Laurana (1466–72; for discussion and illustration *see* LAURANA, LUCIANO) and the Sienese Francesco di Giorgio Martini (from 1476). The three-storey, classically articulated façade facing the city was decorated with 72 stone reliefs by AMBROGIO BAROCCI showing ancient and modern instruments of war. The interior, however, was intended to display the achievements of the remarkable array of progressive artists, scholars and theoreticians who were drawn to the Duke's court, including Leon Battista Alberti. By 1482 the palace library contained some 1100 volumes, many purchased from Vespasiano, who also advised on acquisitions. Local artists were employed to provide illuminations for many of the manuscripts and decorate certain rooms in the palace.

According to Vespasiano, Federigo could not find Italian oil painters to his taste and brought Justus of Ghent to Urbino, where his work included the 28 portraits of *Famous Men* (*c.* 1473–6; Paris, Louvre; Urbino, Pal. Ducale) for the Duke's *studiolo*, a painting called *Federigo, Guidobaldo and Others Listening to a Discourse* (*c.* 1480; London, Hampton Court, Royal Col.) and a further seven paintings of the *Liberal Arts* (*Music* and *?Rhetoric* (London, N.G.) for the *studiolo* in the Palazzo Ducale, Gubbio. Both *studioli* were decorated with some of the most elaborate surviving 15th-century intarsia designs (*see* STUDIOLO, fig. 1; Gubbio intarsia now in New York, Met.).

The artist with the greatest hold on Federigo's patronage, however, would appear to have been Piero della Francesca, who dedicated *De prospectiva pingendi* (Parma, Bib. Palatina, MS. 1576) to the Duke (*see* PIERO DELLA FRANCESCA, §§I and III). Some scholars have suggested that he may have served as an artistic adviser, and others have even given him partial credit for the design of the Urbino palace. The extent and identity of Piero's work for Federigo remain uncertain, but it includes the double portrait of *Federigo da Montefeltro* and *Battista Sforza* (*c.* 1472; Florence, Uffizi), with their *Triumphs* shown on the reverse. Federigo's sense of loss on his wife's death in 1472 is poignantly illustrated in his lone presence kneeling before the Virgin and Child in the Brera Altarpiece (mid-1470s; Milan, Brera; see colour pl. 2, XVI2).

(2) Guidobaldo da Montefeltro, 2nd Duke of Urbino (*b* Urbino, 24 Jan 1472; *reg* 1482–1508; *d* Fossombrone, 23 April 1508). Son of (1) Federigo da Montefeltro. Guidobaldo was less successful as a condottiere than his father and seriously impoverished, reducing his opportunity for patronage. He completed the construction of the Palazzo Ducale, Gubbio, and added manuscripts and printed books to the ducal library. Piero della Francesca dedicated to the Duke his *Libellus de quinque corporibus regularibus* (after 1485; Rome, Vatican, Bib. Apostolica, Cod. Urb. 273), and Giovanni Santi had been appointed court painter by 1488. Guidobaldo seems to have been an early patron of Santi's son, Raphael (*see* RAPHAEL, §I, 1(i)). BALDASSARE CASTIGLIONE provided an idealized account of life at Urbino from 1504, although he complained that his stipends often went unpaid. Guidobaldo and his wife,

Elisabetta Gonzaga, remained childless, and he adopted his nephew Francesco Maria I della Rovere as his heir in 1504 (*see* ROVERE, DELLA, (3)).

BIBLIOGRAPHY
Vespasiano da Bisticci: *Vite di uomini illustri* (1480s; Bologna, Bib. U., MS. 1452); ed. A. Greco (Florence, 1970); Eng. trans. by W. G. Waters and E. Waters as *Renaissance Princes, Popes and Prelates: The Vespasiano Memoirs* (London, 1926/*R* New York, 1963), pp. 83–114
G. Santi: *La vita e la gesta di Federico da Montefeltro duca d'Urbino: Cronaca* (1482–7; Rome, Vatican, Bib. Apostolica, MS. Vat. Ottob. lat. 1305); ed. L. Michelini Tocci (Rome, 1985)
B. Castiglione: *Il libro del cortegiano* (Venice, 1528); Eng. trans. by T. Hoby as *The Courtyer* (London, 1561) and by C. Singleton as *The Book of the Courtier by Baldesar Castiglione* (Garden City, NY, 1959)
P. Rotondi: *Il Palazzo Ducale di Urbino*, 2 vols (Urbino, 1950–51; Eng. trans., London, 1969)
C. H. Clough: *The Duchy of Urbino in the Renaissance* (London, 1981)
G. Cerboni Baiardi, G. Chittolini and P. Floriani, ed.: *Federico di Montefeltro: Lo stato/le arti/la cultura*, 3 vols (Rome, 1986)
L. Cheles: *The Studiolo of Urbino: An Iconographic Investigation* (Wiesbaden, 1986)

ROGER J. CRUM

Montelupo. Italian centre of maiolica production. This small town near Florence was an important centre of ceramics production from the mid-15th century. The potters of Montelupo, many of whom originally came from other Italian centres of maiolica production, must have found favourable working conditions, and from the end of the 15th century their pottery was held in such high regard that some of them were able to move their kilns to the countryside around Florence or even, as in the case of the family known as the Fattorini (*see* SCHIAVON), to the Cafaggiolo ceramic factory, which was under the patronage of the Grand Dukes of Tuscany. During the Renaissance the maiolica from Montelupo reflected typical Italian themes, including East Asian and Gothic floral decoration and portraits. The colour range was very striking, particularly during the 16th century. An outstanding group of wares known as *arlecchini* were so called because they were decorated with a vivid, multi-coloured palette dominated by yellow. This technique was used for painting characters from the *commedia dell'arte*, Spanish soldiers and swashbuckling bullies.

BIBLIOGRAPHY
G. Cora and A. Fanfani: 'Vasai di Montelupo', *Faenza*, lxix (1983), pp. 289–306, 401–8; lxx (1984), pp. 58–113, 235–77, 507–55: lxxi (1985), pp. 129–71, 350–91
F. Berti: *La maiolica di Montelupo* (Milan, 1986)

CARMEN RAVANELLI GUIDOTTI

Montelupo, da [Sinibaldi]. Italian family of sculptors and architects. They were active in Central and North Italy from the end of the 15th century to the mid-16th.

(1) Baccio da Montelupo [Bartolomeo Sinibaldi] (*b* Montelupo, 1469; *d* Lucca, 1535). According to Vasari, he studied antique sculpture in the gardens of Lorenzo de' Medici in Florence with Michelangelo and others. His career was linked to Dominican patronage and the supporters of Girolamo Savonarola. His first documented work is a terracotta *Pietà* group (1495), from which four figures survive at S Domenico, Bologna. His wooden Crucifix (*in situ*) for S Marco, Florence, dates from 1496. With other followers of Savonarola, Baccio fled in 1498 to Bologna and Venice. A wooden figure of *St Sebastian*

(Bologna, S Maria del Baraccano) attributed to him may date from this period. He also carved a *Christ and the Twelve Apostles* (untraced; those in Ferrara Cathedral are not by Baccio). For S Lorenzo in Florence he carved a wooden Crucifix (*c.* 1500; untraced; the cork Crucifix in S Lorenzo is not by Baccio), and the figure of the *Christ Child* (*in situ*) for the tympanum of the marble tabernacle by DESIDERIO DA SETTIGNANO has been attributed to him (Verdier, 1983). In the following years Baccio's workshop specialized in the production of wooden Crucifixes, including those in S Maria Novella, Florence, and SS Flora e Lucilla, Arezzo.

Between 1504 and 1510 Baccio made a number of works for S Godenzo, Val di Sieve, Mugello; a polychrome wood *St Sebastian* (1506) survives there. He often worked with Michelangelo and may have assisted him on figures for the Piccolomini Altar (Siena Cathedral). The carved frame of Michelangelo's Doni Tondo (*Holy Family*; 1503 or 1507; Florence, Uffizi; see colour pl. 2, IV3) has been convincingly attributed to him (Lisner, 1965). He supplied the marble figure of *Mars* (and possibly also *Neptune*) for the monument of *Benedetto Pesaro* (1506) in S Maria dei Frari, Venice. In 1515 he completed his finest sculpture, the bronze statue of *St John the Evangelist* for Orsanmichele, Florence, made in competition for the guild of silk merchants. In this period he began a long association with the city of Lucca, where Dominican influence was strong. Three enamelled busts, a *Virgin and Child*, *St Romano* and *St Pellegrino* (all Lucca, S Concordio in Contrada), are attributed to him. The influence of Savonarolan ideas may be felt in a marble altar with the figure of the *Redeemer* (1518; Lucca, Segromigno Monte, S Lorenzo). Michelangelo may have helped Baccio to win his most important commission, to design S Paolino, Lucca (begun 1518). An important commission for the tomb of *Bishop Niccolò Pandolfini* (*d* 1519) in the Badia of Pistoia remained unfinished.

The last years of Baccio's life are not well documented. As he probably employed many assistants, it is difficult to gauge the stylistic range of his workshop. He has been identified with the Master of the David and St John Statuettes. While his art demonstrates an affinity to Donatello, it is even more closely related to that of the della Robbia workshop and of Benedetto da Maiano. His later style also shows an awareness of the work of Andrea Sansovino.

BIBLIOGRAPHY
F. Albertini: *Memoriale di molte statue e pitture della città di Firenze* (Florence, 1510); repr. in *Five Early Guides to Rome and Florence*, intro. P. Murray (Farnborough, 1972)
G. Vasari: *Vite* (1550, rev. 2/1568); ed. G. Milanesi (1878–85), iv, pp. 258, 539–62
F. Sansovino: *Venetia, città nobilissima et singolare* (Venice, 1581), p. 66a
C. de Fabriczy: 'Scultura in legno di Baccio da Montelupo', *Riv. A.*, i (1903), pp. 67–8
A. del Vita: 'Un crucifisso di Baccio da Montelupo ritrovato nella chiesa di S. Flora e Lucilla in Arezzo', *Riv. A.*, vii (1910), pp. 90–92
F. Filippino: 'Baccio da Montelupo in Bologna', *Dedalo*, iii (1927–8), pp. 527–42
M. Weinberger: 'A Bronze Statuette in the Frick Collection and its Connections with Michelangelo', *Gaz. B.-A.*, xxxix (1952), pp. 103–14
M. Lisner: 'Zum Rahmen von Michelangelos Madonna Doni', *Studien zur Geschichte der europäischen Plastik: Festschrift Theodor Müller* (Munich, 1965), pp. 167–78
J. Pope-Hennessy and A. Radcliffe: *Italian Sculpture* (New York, 1970), pp. 54–8; iii of *The Frick Collection*

P. Verdier: 'Il putto ignoto', *Bull. Cleveland Mus. A.*, lxx/7 (1983), pp. 303–11

F. Petrucci: 'Baccio da Montelupo a Lucca', *Paragone*, xxxv (1984), pp. 3–22

TILL R. VERELLEN

(2) Raffaello [Raffaele] **da Montelupo** [Sinibaldi] (*b* Florence, 9 July 1504; *d* Orvieto, before 26 Dec 1566). Son of (1) Baccio da Montelupo. Trained by his father and the goldsmith Michelangelo Viviani in Florence, he worked briefly in Carrara in 1521 and entered the workshop of Lorenzo Lotti in Rome in 1523. There he assisted on projects including the tomb of the poet *Bernardino Capella* (*c.* 1460–1524) in S Stefano Rotondo, the tomb of *Raphael* (Pantheon) and in the Chigi Chapel (S Maria del Popolo). It was probably through the circle of Raphael that he met influential supporters, such as Baldassare Turini and Antonio da Sangallo (ii). He also made drawings after the Antique (destr.) during this formative period, which ended in 1527 with the Sack of Rome. His first major commission was to assist in the execution of the marble decoration designed by Andrea Sansovino for the Santa Casa (1530–33) at Loreto, where he worked with Niccolò Tribolo, Giovan Francesco da Sangallo, Simone Mosca and others under the direction of Antonio da Sangallo (i). He carved the relief of the *Adoration of the Magi*, the left half of the *Birth of the Virgin*, the *Visitation* and some putti. In 1533–4 for Michelangelo he carved the statue of *St Damian* for the New Sacristy in S Lorenzo, Florence. Influence from his period in Loreto is apparent in his relief of the *Adoration of the Magi* (1538–41) for Simone Mosca's altar of the *Magi* in Orvieto Cathedral. In 1541–2 Raffaelo completed the seated figure of *Leo X*, left unfinished by Baccio Bandinelli, for the Pope's tomb (Rome, S Maria sopra Minerva). Between 1542 and 1545 for Michelangelo's tomb of *Julius II* (Rome, S Pietro in Vincoli; see colour pl. 2, VII2) he worked on the over life-size statues of the *Virgin and Child*, on the *Prophet* and *Sibyl* and possibly on *Leah* and *Rachel*.

In 1544 Raffaello executed the colossal marble statue of the *Archangel Michael* for the top of Castel Sant'Angelo, Rome, to replace one lost during the Sack of Rome; it in turn was replaced in 1753. Other works from the 1540s include the funerary monument to *Sigismondo Dondolo* (1543; Rome, S Maria della Consolazione) and the tomb of *Girolamo de' Giustini* (1548–9; Rome, S Maria della Pace). He also worked as an architect for Tiberio Crispi (1497–1566), papal castellan of Castel Sant'Angelo, where he built the Loggia of Paul III, the vestibule of the Sala Paolina and the new papal apartments (1542–5). During the same period he constructed Crispi's palace at Bolsena (begun by Mosca). In 1553 he completed the tomb of *Baldassare Turini*, begun by Pierino da Vinci, for Pescia Cathedral. In that year also he succeeded Mosca as *capomaestro* of the cathedral works at Orvieto, where his work included statues of the *Risen Christ*, *Adam* and *Eve* and the Apostle programmes for the nave and the façade; most of these were completed after his death. In the 1550s he supervised the construction of Crispi's palace and of S Lorenzo in Vineis, both in Orvieto. Raffaello often worked collaboratively and completed projects begun by others, which did not encourage the development of a distinctive personal style. His sculpture was influenced by the Ra-phaelesque style of Lotti and the classicism of Andrea Sansovino, his architecture by Antonio da Sangallo (ii).

BIBLIOGRAPHY

Thieme–Becker

G. Vasari: *Vite* (1550, rev. 2/1568); ed. G. Milanesi (1878–85), iv, pp. 539ff

R. Borghini: *Il riposo* (Florence, 1584), pp. 407ff

J. W. Gaye: *Carteggio*, iii (Florence, 1840), pp. 581ff [autobiographical fragments]

A. Venturi: *Storia* (1901–40), x

K. Weil-Garris: *The Santa Casa di Loreto: Problems in Cinquecento Sculpture* (New York and London, 1977)

T. R. Verellen: *Raffaello da Montelupo als Bildhauer und Architekt* (diss., U. Hamburg, 1981)

C. Gilbert: *Michelangelo: On and Off the Sistine Ceiling: Selected Essays* (New York, 1994)

F. Lemerle: 'Le codex Italien du Musée des Beaux-Arts de Lille: Les modeles d'architecture antiques et modernes de Raffaello da Montelupo (1504–1566)', *Rev. Louvre*, xlvii (April 1997), pp. 47–57

TILL R. VERELLEN

Montepulciano, Pasquino da. *See* PASQUINO DA MONTEPULCIANO.

Montorfano. Italian family of painters. Paolino da Montorfano (*fl* Milan, 1402–30) worked in Milan Cathedral as a painter and as a painter of stained glass. Abramo (di Alberto) da Montorfano (*fl* Milan, 1430–38), in 1430 also employed in Milan Cathedral, apparently worked regularly for the Visconti and was a member of the painters' guild, as was his son Alberto (di Abraam) de Montorfano (*fl* Milan, *c.* 1450–81). Giovanni da Montorfano (*fl* 1452–70) worked in Milan Cathedral in 1452 and 1454, and in Genoa from 1457; a signed *St Martin and the Beggar* exists (Cernuschi sale, Paris, Gal. Petit, 25–6 May 1900, lot 65). Giovanni Donato (di Alberto) da Montorfano (*b* Milan, *c.* 1460; *d* Milan, 1502/3), who may have been active from the late 1470s, is best known for his fresco of the *Crucifixion* (signed and dated 1495; Milan, S Maria delle Grazie). Several frescoes in S Pietro in Gessate, Milan, in the chapels of St Anthony, St John the Baptist and the Virgin, are attributed to him, but their dating and attribution are problematic; his hand is most plausibly seen in the St Anthony frescoes. Frescoes of scenes from the *Life of St Catherine* in S Maria delle Grazie, long attributed to him, have recently been tentatively reassigned to Cristoforo de Mottis (*fl* 1461; *d* 1493). Four fresco fragments of saints (ex-S Maria della Rosa, Milan; Milan, Pin. Ambrosiana) are from around the same time as the *Crucifixion*. It is likely that Giovanni Donato's brother Vincenzo (di Alberto) da Montorfano (*d* after 1484) was also a painter and that the pair first worked with their father Alberto. One of Giovanni Donato's three sons, Alberto (di Giovanni Donato) da Montorfano (*b* Milan, 1491/2; *d* Milan, 1524) was also a painter, though none of his works has been identified. In 1513 Bernardino (or Bernardo) da Montorfano was a painter in Genoa.

BIBLIOGRAPHY

Thieme–Becker

Annali della Fabbrica del Duomo (Milan, 1877–85), i, ii, app. II, app. III [Paolino, Abramo and Giovanni da Montorfano]

F. Mazzini: *Affreschi lombardi del quattrocento* (Milan, 1965) [Giovanni Donato da Montorfano, illustrations, bibliography]

A. Frattini: 'Documenti per la committenza nella chiesa di S Pietro in Gessate', *A. Lombarda*, vi/65 (1983), pp. 27–48

G. Mulazzani: 'La decorazione pittorica: il quattrocento', *S Maria delle Grazie in Milano* (Milan, 1983), pp. 112–39 [Giovanni Donato da Montorfano, bibliography, illustrations]

J. Shell: *Painters in Milan, 1490–1530* (diss., U. New York, 1986), pp. 375, 381–7, 838–57 [Abramo, Alberto (di Abraam) and Alberto (di Giovanni Donato) da Montorfano]

JANICE SHELL

Montorsoli, Giovanni Angelo (*b* Montorsoli, nr Florence, ?1507; *d* Florence, 31 Aug 1563). Italian sculptor and architect. After a three-year apprenticeship with Andrea di Piero Ferrucci, he worked as an assistant in Rome (producing rosettes on the cornices of St Peter's), Perugia and Volterra. He then went to Florence to work on the New Sacristy (Medici Chapel) and the Biblioteca Laurenziana at S Lorenzo, probably from 1524; the influence of Michelangelo was to prove decisive. Work at S Lorenzo was suspended as a result of the expulsion of the Medici in 1527, and Montorsoli decided to enter a religious order; he was inducted into the Servite Order at SS Annunziata in 1530, taking his vows in 1531. For his monastery church he restored the wax portraits of the Medici family, which had been destroyed in 1527, and modelled new ones of *Leo X, Clement VII, Matthias Corvinus* and *Giacomo V d'Appiano, Duke of Piombino* (untraced). In 1532 Michelangelo recommended him to Clement VII to restore antique statues in the Vatican; his restorations of the *Laokoon* group and the *Apollo Belvedere* (both Rome, Vatican, Mus. Pio-Clementino) ensured their enduring fame. In Rome, Montorsoli also produced a marble portrait of *Clement VII* (untraced) and assisted Michelangelo on the tomb of *Julius II* (see colour pl. 2, VII2).

From the end of 1533 Montorsoli again contributed to work on the Medici Chapel at S Lorenzo, producing a model for the statue of *St Cosmas*, which, after revision by Michelangelo, he carved in marble (completed 1536–7; see fig.). Late in 1534 he was again in Rome, working on the tomb of *Julius II*, and then briefly in Paris, working for Francis I (*reg* 1515–47). On his journey through northern Italy, he studied the work of Giulio Romano in Mantua and Jacopo Sansovino in Venice.

Back in Florence, Montorsoli contributed to the ephemeral decorations for the entry of Charles V (*reg* 1519–56) in 1536; he then completed the tomb of *Angelo Aretino* (Arezzo, S Pier Piccolo). In 1536 he probably also received the prestigious commission for the marble tomb of the poet *Jacopo Sannazaro*, which was erected in 1541 in the Servite church of S Maria del Parto, Naples. It consists of a portrait bust on an antique-style sarcophagus, beneath which is a finely worked relief flanked by smoothly polished seated statues of *Apollo* and *Minerva*; the niche sculpture of *St James* is based on a model by Jacopo Sansovino, indicating that Montorsoli was able to adapt his style according to the nature of the contract.

Shortly after receiving the Sannazaro commission, Montorsoli was asked by Cosimo I de' Medici to produce a marble statue of *Hercules and Antaeus* intended to surmount Niccolò Tribolo's Fountain of Hercules (for illustration see TRIBOLO, NICCOLÒ) at his villa at Castello (the *bozzetto* was destroyed by Baccio Bandinelli in 1547). In 1538 Montorsoli was commissioned to complete Bandinelli's statue of *Andrea Doria* to stand in front of the Palazzo Ducale, Genoa. The marble statue, badly damaged

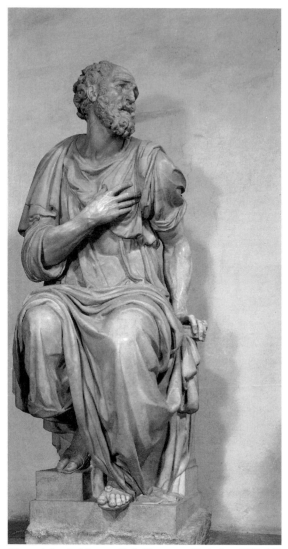

Giovanni Angelo Montorsoli: *St Cosmas*, marble, h. 2 m, 1533–6/7 (Florence, S Lorenzo)

in 1797, depicted the *pater patriae* in Roman armour standing above vanquished Turks. Further works in Genoa include a marble statue of *St John the Evangelist* (1540–41) for one of the apse niches of the cathedral and the decoration (1541) of the Doria family church, S Matteo. There he furnished the apse with five niche figures and the presbytery walls with polychrome marble incrustation and reliefs of the Evangelists beside the tombs of saints; the ceiling and cupola were decorated with figural stuccowork. He also executed the marble tomb of *Andrea Doria* for the crypt. Two marble portrait busts of *Charles V* (Naples, Capodimonte; Madrid, Prado) date from the Emperor's visit to Genoa in 1541. After completing the decoration of S Matteo, Montorsoli produced plans for the garden behind the Palazzo Doria, rising in terraces to a colossal stucco statue of *Neptune*. All that survives of his work there is an antique-inspired marble fountain group of a triton and a dolphin; standing on an island in a

pool, it is an early example of sculpture erected in close harmony with nature.

In September 1547 Montorsoli travelled to Messina to produce the Fountain of Orion in front of the cathedral. The elaborately carved marble basin supports four reclining river-gods, the first use of such a formula in Renaissance art and also the first example of an urban fountain with symbolism directly related to water; a statue of the city's founder, *Orion*, surmounts two further basins. Before the fountain could be erected in 1553, the church of S Lorenzo had to be demolished to make way for it. It was rebuilt elsewhere to plans by Montorsoli (destr. 1783). Montorsoli's second outstanding work in Messina is the marble Fountain of Neptune (1553–7) at the harbour. This consists of a colossal statue of *Neptune* on a high socle above a basin from which rise the fettered *Scylla* and *Charybdis*, the sea monsters of the Straits of Messina. Once again his work introduced a new fountain type, that with a single central figure. In 1550 he designed the interior of Messina Cathedral, which has 12 chapels with statues of the Apostles; he himself supplied the marble *St Peter* in 1555. That year he also designed his second architectural work, the lighthouse in the harbour. Fragments of the monument for *Andrea Sluiti*, once at Domenico, are now in the Museo Regionale in Messina.

Having remained in Messina for ten years, in 1557 Montorsoli went to Rome in response to Paul IV's appeal that all who had left the monastic life (Montorsoli had ceased wearing the habit in 1533) should return to their orders. His last important work was the free-standing marble high altar of S Maria dei Servi in Bologna (1558/9–61). Its many sculptures are set into a polychrome marble architectural setting with three niches separated by columns; Vasari particularly singled out for praise the central statue of the *Risen Christ*. At the end of his life Montorsoli's main interest was in the foundation of the Accademia del Disegno in Florence and the conversion of the former chapter house of his monastery church into a memorial chapel for artists, the chapel of S Luca.

BIBLIOGRAPHY

G. Vasari: *Vite* (1550, rev. 2/1568); ed. G. Milanesi, vi (1881), pp. 629–60

S. Boscarino: 'L'opera di Giovanni Angelo Montorsoli a Messina (1547–1557)', *Quad. Ist. Stor. Archit.*, xx–xxi (1957), pp. 1–12

C. Manara: *Montorsoli e la sua opera genovese* (Genoa, 1959)

M. Weinberger: 'Portrait Busts by Montorsoli', *Scritti di storia dell' arte in onore di Maria Salmi*, iii (Rome, 1963), pp. 39–48

S. Ffolliott: *Civic Sculpture in the Renaissance: Montorsoli's Fountains at Messina* (diss., University Park, PA State U., 1979; microfilm, Ann Arbor, 1984)

K. Möseneder: *Montorsoli: Die Brunnen* (Mittenwald, 1979)

C. Elam: 'The Mural Drawings in Michelangelo's New Sacristy', *Burl. Mag.*, cxxiii (1981), p. 601

P. Boccardo: *Andrea Doria e le arti: Committenza e mecendismo a Genova* (Rome, 1989)

B. Daschke: *Fra Giovan Angelo da Montorsoli: Ein Florentiner Bildhauer des 16. Jarhunderts* (Berlin, 1994)

B. Laschke: 'Le invenzioni dello scultore servita Giovan Angelo da Montorsoli: Il confronto fra opere religiose e profane', *A. Crist.*, lxxxii/764–5 (1994), pp. 411–20

A. W. Vetter: 'Zeichen göttlichen Wesens: Überlegungen zum Apoll vom Belvedere', *Archäo. Anz.*, iii (1995), pp. 451–62

KARL MÖSENEDER

Morandi. *See* TERRIBILIA.

Morandini (da Poppi), Francesco. *See* POPPI.

Morando, Paolo. *See* CAVAZZOLA, PAOLO.

Moretti, Cristoforo (*fl* 1450–75). Italian painter. A minor but prolific Milanese artist, he first appears as a creditor of the Borromeo family in Milan in 1450 and 1451. The following year, several letters addressed to Duke Francesco Sforza (*reg* 1450–66) show him as painter primarily of pennants and horse trappings. Moretti continued to work for the Sforza family during the 1450s. In 1462, however, he was banished from Milan for writing a defamatory letter about the wife of the court physician Cristoforo da Soncino.

Documents after 1463 indicate that the artist then moved into the nearby region of Piedmont, where he painted coats of arms and the communal tower in Turin. In 1467 he decorated a chapel in Casale Monferrato for William VI, Margrave of Monferrat (*reg* 1464–83), and three years later he provided an altarpiece for S Marco, Vercelli. He left incomplete fresco decorations in this same church when he returned to Milan in 1469, after his banishment had been lifted. He rejoined the group of artists working for the Sforza court, and notarial deeds suggest that he became a wealthy man.

Moretti's only signed work is a triptych of the *Virgin and Child with SS Gervase and Lawrence* from S Aquilino, Milan (Milan, Mus. Poldi Pezzoli). On the basis of this work, which shows the strong influence of Michelino da Besozzo, numerous other pictures, miniatures and a painted glass reliquary have been attributed to Moretti. The most convincing attributions include the *Crucifixion* (Berlin, Gemäldegal.) and the *Virgin with Saints* (Munich, Alte Pin.).

BIBLIOGRAPHY

E. Motta: 'Una lettera di Cristoforo Moretti', *Boll. Svizzera It.*, vii (1885), p. 176

——: 'Ancora una supplica del pittore Cristoforo Moretti', *Boll. Svizzera It.*, vii (1885), p. 246

F. Malaguzzi-Valeri: *Pittori lombardi del quattrocento* (Milan, 1902), pp. 79–88

G. Biscaro: 'Note di storia dell'arte e della cultura a Milano dai libri mastri Borromeo, 1427–1478', *Archv. Stor. Lombardo*, xvi (1914), pp. 71, 108

R. Longhi: 'I resti del polittico di Cristoforo Moretti già in Sant' Aquilino di Milano', *Pinacotheca*, i (1928), pp. 75–9

M. Natale: *Museo Poldi-Pezzoli: Dipinti* (Milan, 1982), pp. 67–71

E. S. WELCH

Moretto (da Brescia) [Bonvicino, Alessandro] (*b* Brescia, *c.* 1498; *d* Brescia, between 9 Nov and 22 Dec 1554). Italian painter. Together with Romanino and Giovanni Girolamo Savoldo, he was one of the most distinguished painters of Brescia of the 16th century. Influenced by both Lombard verism and contemporary Venetian painters, Moretto created an individual style in which realism and Venetian light and colour were perfectly balanced. He was personally involved in the local movement of Roman Catholic reform, and this is reflected in his direct, solemn and often moving depictions of religious subjects. He was also an innovative portrait painter.

1. Before 1530. 2. 1530–54.

1. BEFORE 1530. Moretto's birthdate is calculated from a document of 1548 in which he declared that he

was about 50 years old, but another document (Boselli, 1976), which names Moretto as early as 1514, suggests that the traditional date may not be strictly accurate. Moretto was born to a family of local artists originating in the town of Ardesio. His father, Pietro Bonvicino (*d* before Aug 1515), and his uncle Alessandro Bonvicino (*d* before Nov 1484) both worked on projects in the Loggia in Brescia and painted heraldic devices throughout the 1480s and 1490s. Although much of Moretto's later career is well documented, his development from 1516 to 1520 cannot be precisely charted.

Despite the attributional confusion outlined by Panazza (see 1965 exh. cat.), the organ shutters with *SS Faustino and Giovita* (Lovere, S Maria in Valvendra), commissioned for the Old Cathedral, Brescia, are securely dated early works. The shutters were begun in August 1515 by Floriano Ferramola (1480–1528), who painted the exterior scenes of the *Annunciation*, and Moretto received his first payment in November 1516 for the equestrian saints in fashionable contemporary dress. A lunette of the *Coronation of the Virgin with Saints* (Brescia, S Giovanni Evangelista) signed *Alexander. Brix.* is clearly by the same hand, although Morelli, followed by Nicodemi, thought it so close to Romanino that they attributed it, along with a small group of additional works, to Romanino's hypothetical 'brother or cousin' Alessandro. Boselli (1943) convincingly attributed it to Moretto and dated it *c.* 1516. The impressive *Christ Carrying the Cross with Donor* (Bergamo, Gal. Accad. Carrara) was once dated 1518. Three smaller paintings, *Christ and the Samaritan Woman* (Bergamo, Gal. Accad. Carrara), *Christ among the Animals* (New York, Met.) and *Christ Blessing St John the Baptist* (London, N.G.), the latter two possibly fragments, should also be dated *c.* 1518. Several other high-quality works have been attributed to the youthful Moretto: of these, the most interesting are the *St Roch with other Saints* (S Euphemia della Fonte, parish church; on dep. Brescia, Pin. Civ. Tosio–Martinengo), traditionally given to Romanino but probably by Moretto deeply under the influence of Romanino (A. Ballarin, unpublished lecture); and an attribution of a *Virgin between SS Gregory and Valentine* in S Gregorio delle Alpi, near Feltre (Fiocco, 1948).

Moretto's training and early travels are undocumented, but this body of work of *c.* 1515–20 demonstrates that he quickly outstripped his first collaborator, Ferramola. While Ridolfi's assertion (1648) that Moretto studied with Titian cannot be confirmed, his works of *c.* 1518 are so deeply influenced by Venetian art, above all that of Titian, that it is reasonable to assume he made a journey to Venice or at least to Padua. That Moretto was closely attentive to the work of Romanino is clear as early as 1516 in the organ shutters (A. Ballarin, unpublished lecture). Other Lombard artists, especially Vincenzo Foppa, also influenced him.

By 1517 Moretto was an important figure in Brescia; that year he attended a meeting of local artists in the church of S Luca, and after 1520 he played a leading role in such local organizations as the Scuola del Sacramento of the cathedral, where he was elected to the council, and received a string of important commissions. In March 1520 Mattia Ugoni, Bishop of Famagosta, requested money at a meeting of the city council for a *gonfalone* (processional banner) commemorating the relics of the True Cross housed in Brescia Cathedral. This banner, only one side of which is extant (Brescia, Pin. Civ. Tosio–Martinengo), shows the *Exaltation of the Reliquary of the Holy Cross between SS Faustino and Giovita*; the worshippers below include identifiable portraits. Although the cartellino is now blank, Ridolfi said that Moretto's signature was then legible. The connection with Ugoni was fruitful for Moretto, who later painted frescoes of *Moses and the Burning Bush* and the *Prophets* for the Bishop's private chapel in the family palazzo (Brescia, Pin. Civ. Tosio–Martinengo).

Perhaps Moretto's most important commission of the 1520s came from the deputies of the Confraternity of the Sacrament and the prior of the Augustinian canons of S Giovanni Evangelista, Brescia, for the decoration of the Chapel of the Sacrament in their church. The contract is dated 21 March 1521. The decorative scheme was shared with Romanino, and their canvases were arranged around Bernardo Zenale's pre-existent altarpiece of the *Deposition* (*c.* 1505), set in an elaborate framework carved by the local sculptor Stefano Lamberti in 1509. Moretto's contribution includes a lunette of the *Last Supper*, *Elias and the Angel*, the *Gathering of Manna*, the *Evangelist Luke*, the *Evangelist Mark* and a series of *Prophets*. The theme of the cycle is Christ as the food of life: it is a significant early example of a complex decorative scheme for a sacrament chapel of a type that became common in Italy only later in the 16th century.

A standard (untraced) for the guild of the Mercanzia was dated 1523, while the *Portrait of a Monk* (Verona, Castelvecchio), which, according to Guazzoni (1981), represents Girolamo Savonarola, and the contract for the *Assumption* for the high altar of the Old Cathedral of Brescia both date from 1524. Moretto's inventive approach to portraiture, already apparent in the intense posthumous portrait of Savonarola, is seen again in the full-length *Portrait of a Gentleman*, dated 1526 (London, N.G.), which may depict Gerolamo II Avogadro. The format and the presentation of the subject are similar to those made famous by Titian in his portrayal of *Charles V with his Dog* (1533; Madrid, Prado), but Moretto's painting antedates that work by some seven years. It is therefore seminal in the development in Italy of this type of portrait, possibly originating in Germany. In 1526 Moretto received an important commission from the Comune of Brescia for a fresco of the *Translation of the Remains of SS Faustino and Giovita* (destr.; copy by Pietro Maria Bagnadore, 1603; Brescia, Loggia). It was painted on an exterior wall of the Porta Brusata to mark the location of a miracle and typifies the emphasis Moretto's patrons placed on local religious themes.

By 1528 Moretto's reputation in Brescia was secure, and he began to make contacts in other Lombard towns. A letter of December 1528 from Lorenzo Lotto in Bergamo invited Moretto to continue Lotto's work decorating the choir of S Maria Maggiore for the society of the Misericordia of that city and demonstrated his admiration for Moretto's painting. Moretto went to Bergamo and was paid for his trip and for various drawings for intarsias on 26 January 1529, but any work he may have done there is unidentified.

2. 1530–54. Moretto continued to travel in the 1530s: on 23 December 1530 he wrote from Milan to Monsignor Savello in Salò about the work of G. G. Antegnati, the organ builder. In 1535 he joined the court of Isabella d'Este at Solarolo, and he was again in Milan in 1541. Correspondents included Pietro Aretino, who wrote thanking him for a portrait (untraced) in 1544. But above all Moretto continued to work in Brescia, buying a house in the S Clemente district in 1533 and becoming increasingly involved in local affairs.

A group of paintings from the 1530s exemplifies the various directions that Moretto's work was taking. The altarpiece of *St Margaret of Antioch with SS Jerome and Francis of Assisi* (Brescia, S Francesco) is dated 1530, and the *Massacre of the Innocents* (Brescia, S Giovanni Evangelista) was commissioned the same year, by two members of the Casari family in honour of their young nephew, and was consecrated in December 1532. The first documents for the decoration of the Chapel of the Sacrament in the Old Cathedral date from 1531, and between then and 1534 Moretto probably produced four paintings for it, including the important lunette of the *Sacrifice of Isaac*. (The project was taken up again in the 1550s and continued after Moretto's death.) The altarpiece of the *Apparition of the Virgin to the Deaf-mute Filippo Viotti* for the sanctuary at Paitone (*in situ*), commemorating the appearance of the Virgin to a young peasant, is usually dated 1533–4, a convincing date stylistically and also tied to that of the miracle and the foundation of the church. According to Boselli (1954), the *Coronation of the Virgin with Saints* (Brescia, SS Nazaro e Celso) was executed in 1534, and in June 1536 a group of Bergamask patricians commissioned the altarpiece of the *Virgin and Child with SS Andrew, Eusebia, Domno and Domneone* (Bergamo, S Andrea). *St Nicholas of Bari Presenting Pupils of Galeazzo Rovelli to the Virgin and Child* (the Rovelli Altarpiece; Brescia, Pin. Civ. Tosio–Martinengo; see colour pl. 2, IX1) was painted for the church of S Maria dei Miracoli in 1539; the cartouche includes the name of the patron, Galeazzo Rovelli, a Brescian schoolmaster.

Each of this impressive series of paintings illustrates a variation on Moretto's shifting combination of elements drawn both from the local tradition and from the Veneto and Central Italy. In the *St Margaret* altar the forms are of an amplitude reminiscent of Palma Vecchio, while Moretto's reputation as the 'Raphael of Brescia' rests on the classicizing *Massacre of the Innocents*. His continuing strong interest in Venetian art is exemplified by the Rovelli Altarpiece, which evidently refers to Titian's Pesaro *Madonna* (Venice, S Maria Gloriosa dei Frari; see colour pl. 2, XXXV2), and by the sumptuous *St Giustina with a Donor* (Vienna, Ksthist. Mus.), which is undated but related to various paintings of the 1530s. Such works as the *Virgin* at Paitone belong to a local, Lombard tradition and draw on the example of Vincenzo Foppa. In this painting, the strong colouring is softened by the silvery greys and rust colours found in Foppa's late works, and there is a subdued, even sombre mood derived from the same source. As in Moretto's earlier works, those of the 1530s contain poetic depictions of landscape and a distinctive manipulation of light that exaggerates the surface qualities of textiles; both are evident in the *Coronation* in SS Nazaro e Celso. The naturalistic detail and rough figure types in such paintings as the altarpiece in S Andrea, Bergamo, or the earlier *Supper at Emmaus* (*c.* 1526; Brescia, Pin. Civ. Tosio–Martinengo; see fig. 1) led Longhi (1929) to see Moretto as a predecessor of Caravaggio (1571–1610).

By the end of the 1530s Moretto increasingly avoided narrative and showed a marked preference for static and iconic forms: ideological changes in the religious community of Brescia partially account for this shift to simple, legible and forceful images (Guazzoni, 1981). Altars of the Sacrament were in demand—four by Moretto date from the 1540s—commissioned for rural churches throughout the large diocese. These include two of Moretto's most striking works, *Christ with Symbols of the*

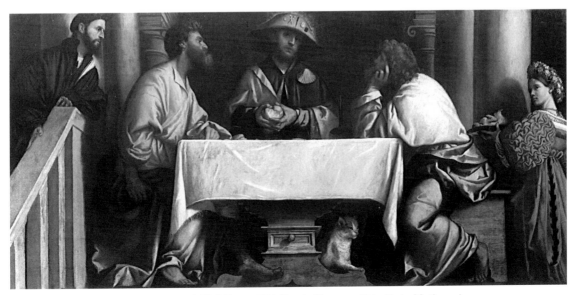

1. Moretto: *Supper at Emmaus*, oil on canvas, 1.47×3.05 m, *c.* 1526 (Brescia, Pinacoteca Civica Tosio–Martinengo)

Passion and the Eucharist and SS Cosmas and Damian (Marmentino, SS Cosma e Damiano) and *Christ with Symbols of the Passion and the Eucharist and SS Bartholomew and Roch* (Castenedolo, S Bartolomeo), in which figures, symbols and architecture are arranged with symmetry and geometric order in spare, but powerful compositions. The Sacrament altar of *Christ with Moses and Solomon* (1541; Brescia, SS Nazaro e Celso) is a good example of the imagery of this decade: Moses and Solomon lean on stelae carved with inscriptions below the resurrected Christ, whose blood flows into a chalice held by an angel with a tablet reading 'Hic est sangus novis testamentum'. This urge to illustrate Roman Catholic dogma reached its high-point late in Moretto's career in a pair of organ shutters of *SS Peter and Paul Supporting the Church* (Brescia, Seminario di S Angelo). Here, behind raised red curtains, the two muscular apostles literally hoist a church on to their shoulders.

Works from Moretto's studio continued to be in great demand throughout the 1540s: altarpieces were sent to S Giorgio in Braida at Verona (1540), the church of the Umiliati at Verona (1541; ex-Kaiser-Friedrich Mus., Berlin; destr.), S Maria presso S Celso in Milan (1540–41) and S Stefano in Bergamo (1544; Milan, Ambrosiana). Moretto continued to produce a remarkable series of portraits as well, culminating in the *Portrait of a Young Man* (London, N.G.; see fig. 2), probably painted to commemorate the wedding of Fortunato Martinengo in 1542 (Boselli, 1978). This depiction of a richly dressed, pensive gentleman, with a Greek inscription on his velvet hat, surrounded by inkwells and other accoutrements, is a significant contribution to a genre of portraiture started by Lorenzo Lotto. Unique in Moretto's oeuvre is his design for the decoration of a small room in the Palazzo Salvadego, Brescia, com-missioned on the occasion of a marriage between a Martinengo and a Gonzaga in 1543. Although the poor state of preservation of the mixed-technique frescoes makes it difficult to discuss style or quality, this is a festive and unusual scheme, showing young women seated on balustrades set in landscapes with towns, hills and lakes.

There is an unmistakable decline in the execution of many works from the later 1540s, and many of the paintings produced in Moretto's studio are marred by the intervention of students. The series of altarpieces painted for St Clemente, Brescia, exhibit a certain awkwardness typical of many of these later canvases, while in the *Virgin and Child with St Bernardino and other Saints* (London, N.G.) all five male saints are adapted from earlier works. However, in these years Moretto also created some of his most profound and deeply felt images. In the *Christ with an Angel* (Brescia, Pin. Civ. Tosio–Martinengo) he banished all accessories and almost all colour, concentrating attention on the grief-stricken angel and tortured figure of Christ. His last painting, the *Entombment* (New York, Met.), is dated October 1554.

Moretto seems to have been most comfortable working in oil or tempera on canvas, although a number of his works up to *c.* 1530 are on panel (e.g. *St Margaret of Antioch with SS Jerome and Francis of Assisi*). Several of his later paintings, particularly those in tempera, are extremely fragile and have lost paint layers; this should not obscure Moretto's move to a more muted palette later in his career. Only a handful of drawings can be attributed to him with any degree of certainty (see the list in 1988 exh. cat.). Many questions also remain regarding Moretto's studio: he took on a number of pupils, the most important of whom was Giovanni Battista Moroni.

2. Moretto: *Portrait of a Young Man*, oil on canvas, 1.14×0.94 m, *c.* 1542 (London, National Gallery)

BIBLIOGRAPHY

EARLY SOURCES

G. Vasari: *Vite* (1550, rev. 2/1568); ed. G. Milanesi (1878–85), vi, pp. 505–6

P. Aretino: *Lettere sull'arte di Pietro Aretino* (before 1556), ed. E. Camesasca (Milan, 1957), i, p. 231; ii, p. 24

B. Faino: *Catalogo delle chiese di Brescia: MSS E.VII.6 e E.I.10 della Biblioteca Queriniana di Brescia, 1630–1669*; ed. C. Boselli (Brescia, 1961)

C. Ridolfi: *Meraviglie* (1648), ed. D. von Hadeln (1914–24), i, pp. 147, 262–7, 415

F. Paglia: *Il giardino della pittura: MSS G.IV.9 e Di Rosa 8 della Biblioteca Queriniana di Brescia, c. 1667–1675*; ed. C. Boselli (Brescia, 1967)

G. A. Averoldi: *Le scelte pitture di Brescia additate al forestiere* (Brescia, 1700)

F. Maccarinelli: *Le glorie di Brescia: MS. della Biblioteca Queriniana di Brescia, 1747–1751*; ed. C. Boselli (Brescia, 1959)

G. B. Carboni: *Le pitture e le sculture di Brescia* (Brescia, 1760)

B. Zamboni: *Memorie intorno alle pubbliche fabbriche di Brescia* (Brescia, 1778)

P. Sgulmero: *Il Moretto a Verona: Per le nozze Boschetti–Musato* (Verona, 1899)

C. Boselli: 'Documenti inediti di storia d'arte bresciana', *Comment. Ateneo Brescia* (1946–7), pp. 1–15

L. Chiodi: 'Lettere inedite di Lorenzo Lotto', *Bergomum*, n. s. 2, lxii (1968), p. 137

C. Boselli: *Regesto artistico dei notai roganti in Brescia dall'anno 1500 all'anno 1560* (Brescia, 1976)

M. C. Rodeschini: 'Note sulle due pale del Moretto a Bergamo', *Not. Pal. Albani*, x (1981), pp. 23–35

S. Guerrini: 'Note e documenti per la storia dell'arte bresciana dal XVI al XVIII secolo', *Brixia Sacra*, xxi (1986), pp. 3–85

GENERAL

DBI: 'Bonvicino, Alessandro'; Thieme–Becker

S. Fenaroli: *Dizionario degli artisti bresciani* (Brescia, 1877)

I. Lermolieff [G. Morelli]: *Die Werke italienischer Meister in den Galerien von München, Dresden und Berlin* (Leipzig, 1880)

B. Berenson: *Central and North Italian Schools*, i (1968), pp. 274–9

S. Freedberg: *Painting in Italy, 1500–1600*, Pelican Hist. A. (Harmondsworth, 1971, 2/1983), pp. 367–72

M. Gregori: *Pittura del duecento a Brescia* (Milan, 1986)

G. Briganti, ed.: *La pittura in Italia: Il cinquecento* (Milan, 1987)

MONOGRAPHS

S. Feraroli: *Alessandro Bonvicino soprannominato il Moretto* (Brescia, 1875)

P. Molmenti: *Il Moretto da Brescia* (Brescia, 1898)

P. da Ponte: *L'opere del Moretto*, 2 vols (Brescia, 1898)

G. Gombosi: *Moretto da Brescia* (Basle, 1943) [standard monograph]

C. Boselli: *Moretto* (Brescia, 1954)

E. Cassa Salvi: *Moretto* (Milan, 1966)

V. Guazzoni: *Moretto: Il tema sacro* (Brescia, 1981) [excellent intro.]

P. V. Begni Redona: *Alessandro Bonvicino, il Moretto da Brescia* (Brescia, 1988)

Alessandro Bonvicino, il Moretto (exh. cat., Brescia, Monastero S Giulia, 1988)

SPECIALIST STUDIES

P. Guerrini: 'L'altare dei SS Innocenti in S Giovanni e la famiglia Casari', *Illus. Bresc.* (1 Jan 1907), pp. 7–9

R. Longhi: 'Cose bresciana del cinquecento', *L'Arte*, xx (1917), pp. 99–114; also in *Scritti giovanile* (Florence, 1961)

E. Lovarini: *Le sontuossime nozze di Hieronimo Martinengo: Pubblicate per le nozze Caponi–Benati* (Cividale del Friuli, 1922)

G. Nicodemi: 'Per un libro sul Romanino', *L'Arte*, xxix (1926), pp. 277–80

R. Longhi: 'Quesiti caravaggeschi: I precedenti', *Pinacotheca*, v–vi (1929), pp. 258–320; also in *Me pinxit e quesiti caravaggeschi* (Florence, 1968)

R. Eisler: 'Jesus among the Animals', *A. America*, xxiii (1935), pp. 137–9

A. Morassi: *Catalogo delle cose d'arte e d'antichità d'Italia: Brescia* (Rome, 1939)

La pittura bresciana del Rinascimento (exh. cat., ed. F. Lechi; Brescia, Pin. Civ. Tosio-Martinengo, 1939)

C. Boselli: 'Alexander Brixiensis', *L'Arte*, xiv (1943), pp. 95–129

Pittura in Brescia dall'ottocento (exh. cat., ed. G. Panazza and C. Boselli; Brescia, Ist. Cult., 1946)

C. Boselli: 'Asterischi morettiani', *A. Ven.*, ii (1948), pp. 85–98

G. Fiocco: 'Un'opera giovanile del Moretto', *Boll. A.*, xxxiii (1948), pp. 330–34

P. Guerrini: 'La scuola del duomo', *Mem. Stor. Dioc. Brescia*, xix (1952), pp. 29–52

C. Boselli: 'Il gonfalone delle SS Croci', *Comment. Ateneo Brescia* (1953), pp. 101–9

——: 'Noterella bresciana', *A. Ven.*, xi (1957), pp. 204–5

R. Bossaglia: 'La pittura bresciana del cinquecento', *Storia di Brescia*, ii (Brescia, 1963)

Mostra di Girolamo Romanino (exh. cat., ed. G. Panazza; Brescia, Duomo Vecchio, 1965)

C. Gould: *The Sixteenth-century Italian Schools*, London, N.G. cat. (London, 1975), pp. 155–65

G. Testori: *Romanino e Moretto alla cappella del Sacramento* (Brescia, 1975)

C. Boselli: 'Noterella morettiana: Il presunto Sciarra Martinengo di Londra e la sua datazione', *A. Lombarda*, il (1978), pp. 83–4

Bergamo per Lorenzo Lotto (exh. cat., ed. G. Mascherpa and others; Bergamo, Gall. Accad. Carrara, 1980)

ANDREA BAYER

Moretto da Bergamo [Moro di Martino]. *See* CODUSSI, MAURO.

Moro, Cristoforo, Doge of Venice (*b* Venice, *c.* 1390; *d* Venice, 9 Nov 1471). Italian ruler and patron. Born into a noble Venetian family, he studied at the University of Padua and then steadily climbed the conventional round of official positions: Captain of Brescia, then of Padua, Ambassador in Rome, *Savio del Consiglio*, Ducal Counsellor, Procurator of S Marco and finally Doge (elected 12 May 1462). His contemporaries considered him harsh and avaricious; nevertheless two Venetian churches owe important works to his generosity. He had three altars built by ANTONIO RIZZO at S Marco between 1465 and 1469;

those of St James and St Paul still stand against the first piers of the south and north transepts, respectively; of the third there remains only a relief of the *Virgin and Child* set in the altarpiece of the chapel of St Clement. He also presented to the basilica two large silver-gilt candlesticks in Venetian Gothic style (Venice, Tesoro S Marco). He was patron to the new hospital of S Giobbe and actively promoted its construction; since he had no direct heir, he left all his possessions for the completion of the church, where he had had a tomb for himself and his wife, Cristina Sanudo, built below the sanctuary in 1470. He recommended that Antonio Gambello should be entrusted with the work, but Pietro Lombardo was employed instead. Only the doge's generosity, therefore, and not his taste, was responsible for the carved portal and the presbytery with a cupola supported on pendentives, which were influential in the development of Renaissance forms in Venice. Under his rule, work continued on the Arco Foscari in the Doge's Palace (*see* VENICE, fig. 9): it incorporated his arms and his statue (destr. 1797), although it is not clear whether he was personally involved in the project. His face is known from a portrait (Venice, S Giobbe) painted by a member of the school of Gentile Bellini and a medal (see G.F. Hill: *Corpus*, 1930, no. 411) by Antonello della Moneta (*fl* 1454–84). He can thus be recognized as the doge adoring the infant Christ in a *Nativity* (Philadelphia, PA, Mus. A.) attributed to Lazzaro Bastiani, which he must have commissioned.

BIBLIOGRAPHY

P. Paoletti: *L'architettura e la scultura del rinascimento in Venezia* (Venice, 1893)

A. da Mosto: *I dogi di Venezia* (Milan, 1960), pp. 220–26

D. Pincus: *The Arco Foscari* (New York and London, 1976)

BERTRAND JESTAZ

Moro, il. *See* TORBIDO, FRANCESCO.

Morone. Italian family of painters. (1) Domenico Morone was the leading early Renaissance painter of Verona, and his son (2) Francesco Morone was similarly important for Veronese High Renaissance painting.

(1) Domenico Morone (*b* Verona, *c.* 1442; *d* Verona, *c.* 1518). Vasari—exceptionally well informed on Veronese artists—asserted that Domenico was taught by students of the Gothic painter Stefano da Verona. His earliest signed work, a fine *Virgin and Child* dated 29 April 1483 (Berlin, Gemäldegal.), reveals his conversion to Andrea Mantegna's ideas, partly as filtered through Giovanni Bellini and Francesco Benaglio. His next, the signed and dated *Expulsion of the Bonacolsi from Mantua* (1494; Mantua, Pal. Ducale; for illustration *see* MANTUA), parallels the Venetian panoramic narratives of Gentile Bellini and Vittore Carpaccio and may owe much to Giovanni Bellini's lost battle paintings for the Doge's Palace in Venice. Though damaged and repainted (the distant landscape, for example, is new), this spirited narrative remains valuable both for its detailed description of 15th-century Mantua and as the most convincing large-scale Quattrocento battle-piece that survives. Around 1500 Domenico's workshop executed major fresco cycles in Verona's churches: the crossing and lantern of S Maria in Organo (payments

1495–9), the Medici Chapel in S Bernadino and the upper zones of the chapel of S Biagio in SS Nazaro e Celso (with G. M. Falconetto, (2) Francesco Morone, Girolamo Mocetto and others). All are much damaged, and scholars differ as to which portions Domenico himself painted, but all display a large-scale mastery of Mantegnesque perspectival and decorative effects.

Unenterprising by comparison are Domenico's signed and dated frescoes from the oratory of S Nicola at Paladon (*Standing Saints*, 1502; Verona, Castelvecchio). Not so the workshop's best-preserved fresco cycle, dated 1503, in the monastery library of S Bernadino. It depicts Franciscan saints and doctors as life-size friars on illusionistic pedestals and gives one whole wall to a panoramic, quasi-narrative *Virgin and Child with Saints and Donors in a Landscape*. The concept's originality and the figures' homely naturalism are both remarkable. The few paintings attributable to Domenico after this date show a decline in quality, and he seemingly painted little in his last years. Domenico Morone is traditionally and rightly considered a pioneer of Renaissance painting in Verona. His personal contribution is difficult to appraise more precisely because so few documented works survive, most of them seriously damaged and many of them collaborative. They suggest a capable and versatile practitioner who infused a basically Mantegnesque style with a distinctively earthy realism. He established points of departure for the next generation of Veronese painters: his son Francesco, Michele da Verona, the brothers Caroto and Girolamo dai Libri.

(2) Francesco Morone (*b* Verona, 1471; *d* Verona, 16 May 1529). Son of (1) Domenico Morone. He was taught by his father, with whom he collaborated *c.* 1500–05. His imposing *Crucifixion* (1498; Verona, S Bernadino), however, owes more to Bartolommeo Montagna and Giovanni Buonconsiglio from nearby Vicenza in its dark, lofty sky and lyrical expressiveness. Dated altarpieces of 1502 (Milan, Brera) and 1503 (Verona, S Maria in Organo), both depicting the *Virgin and Child Enthroned with Saints*, show the geometric rounding off of figures and the symmetry of arrangement characteristic of Francesco's mature art, as well as a subtle interplay of lights and colours. They reflect a study both of Mantegna's high altarpiece for S Maria in Organo (1496) and of Venetian models. Mantegnesque too is the illusionistic cupola Francesco painted in fresco for S Maria in Organo's sacristy (payments 1505–7), lauded by Vasari and still startling in its perspectival virtuosity. Giovanni Bellini's predawn *Resurrection* (Berlin, Gemäldegal.) furnished a precedent for the marvellously observed and calibrated sunset skies that transfigure several of Francesco Morone's panels, for instance the *Stigmatization of St Francis* (Verona, Castelvecchio) or the *Virgin and Child* (Verona, Bib. Capitolare). Those skies, overarching dusky crags, fir trees and valleys inspired by the prints of Albrecht Dürer (1471–1528) produce effects unique to this artist in his time and curiously prophetic of Caspar David Friedrich (1774–1840).

Francesco Morone's style did not change radically during the three decades of his career. He was impervious to the innovations of Giorgione and Titian in Venice, but his later art does exhibit—in the idealized regularity of figures and faces, the symmetrical harmony of compositions and the usual tenor of dignified calm—a distant approach to some aspects of Raphaelesque classicism. This approach appears especially in his occasional collaborations with his close friend Girolamo dai Libri, notably the organ shutters for S Maria in Organo (1515; Marcellise, parish church). These depict paired *Saints*, paired *Prophets* and a *Nativity* set against deep, sub-alpine landscapes. Some modern scholars have considered Francesco Morone essentially a continuer of his father's presumed innovations. Vasari was more accurate: 'He was taught the principles of art by his father, but so exerted himself as shortly to become a much better artist.' Nothing in Domenico's surviving work foreshadows the subtle luminism, the understated monumentality or the poetic sensibility that make Francesco's a decidedly personal statement. Francesco's art moreover consolidated in the High Renaissance generation certain distinctively Veronese aesthetic preferences, for example for slightly phosphorescent colours in particular combinations and for firm, rounded forms. These determined the style of Francesco's pupil Paolo Cavazzola and can still be seen two generations later in that of Paolo Veronese.

BIBLIOGRAPHY

G. Vasari: *Vite* (1550, rev. 2/1568); ed. G. Milanesi (1878–85), v, pp. 307–14

V. Cipolla: 'Il testamento di Francesco Morone', *Archv Ven.*, xxiii (1882), pp. 213–16

G. Gerola: 'Questioni storiche d'arte veronese: 4. Per la biografia di Liberale da Verona; 7. Intorno a Domenico Morone', *Madonna Verona*, iii (1909), no. 1, pp. 24–34; no. 2, pp. 104–13

L. Simeoni: *Verona: Guida storico-artistica della città e della provincia* (Verona, 1909)

R. Wittkower: 'Studien zur Geschichte der Malerei in Verona', *Jb. Kstwiss.*, ii (1924–5), pp. 185–222, 269–89

R. Brenzoni: *Domenico Morone* (Florence, 1956)

C. del Bravo: 'Francesco Morone', *Paragone*, xiii/151 (1962), pp. 3–23

H. J. Eberhardt: 'Domenico Morone', *Maestri della pittura veronese*, ed. P. Brugnoli (Verona, 1974), pp. 91–100

M. T. Cuppini: 'Verona nel quattrocento: L'arte', *Verona e il suo territorio*, iv/1 (Verona, 1981), pp. 381–401

H. J. Eberhardt: 'Nuovi studi su Domenico Morone', *Miniatura veronese del rinascimento* (exh. cat., Verona, 1986), pp. 103–16, 144–6

M. Lucco: *La pittura in Italia: Il quattrocento*, ed. F. Zeri (Milan, 1987), i, pp. 148–50, 166; ii, p. 713

M. Lucco, ed.: *La pittura nel Veneto: Il quattrocento* (Milan, 1990) [esp. writings by S. Marinelli: ii, pp. 641–53, 760–61]

E. M. Guzzo: 'Museo canonicale di Verona: Pittura del Rinascimento restaurata', *A. Ven.*, xlvi (1994), pp. 101–4

T. Henry: 'The Subject of Domenico Morone's Tournament Panels in the National Gallery, London', *Burl. Mag.*, cxxxvi/1090 (1994), pp. 21–2

FRANCIS L. RICHARDSON

Moroni, Andrea (*b* Albino, Bergamo; *fl* 1532; *d* ?Padua, 1560). Italian architect. He was active mainly in and around Padua, where he became the leading architect of the generation after Giovanni Maria Falconetto and was a contemporary of Palladio. He is closely associated with several important buildings in the city after 1532, although in the past his identity has been confused with that of his protégé Andrea da Valle. In July 1532 Moroni was appointed *proto* (chief surveyor) to S Giustina, Padua, a post that he retained until his death. The church has a complex building history. Before 1532 several architects had been asked to submit designs and make models, and initially it seems that Alessandro Leopardi's proposals were to be followed. Leopardi's model formed the basis

for the earliest work on site, but little had been achieved by the time of his death in 1522. In 1532 Moroni was asked to produce his own model and to comment on Leopardi's scheme. In 1532–3 work recommenced on the choir walls and sacristy; by 1536 it was possible to vault the chapels of S Massimo and S Giuliano; after 1541 the vaulting of the choir began, and the chapels of the Innocenti and S Arnaldo were completed. After 1550 the vault to the crossing was in place, but only after Moroni's death were the other chapels vaulted and the nave piers and vaults built. The façade was never completed. After Moroni's death, Andrea da Valle became *proto* and completed the nave, cupolas and the sanctuary. The church was completed only in 1580. Although da Valle's later contribution was important (he had assisted Moroni for many years), the basic plan and form are Moroni's; the imposing church has a rigorous and highly disciplined architectural language to the interior. The spatial arrangements of the east end are particularly complex, with many subsidiary chapels clustered around the chancel and sanctuary, but all is clearly articulated and ordered.

As Padua's leading architect, Moroni also had other commitments, and it is significant that because of these his original annual salary as *proto* of S Giustina was gradually reduced from 120 ducats to only 36 ducats. One such project was the Palazzo del Podestà (now Palazzo Municipale); this is almost exclusively his own work, and it was begun in 1539–40. Rapid early progress was made, and the large pilasters of the portico were erected up to the first-floor windows. However, completion took many years as a result of erratic funding by the Venetian government. The imposing façade on to Piazza delle Erbe is on four storeys and is rusticated. The strong ground-floor colonnade is reminiscent of Jacopo Sansovino's Palazzo Corner (from *c.* 1545) in Venice. Above the colonnade is the *piano nobile*, and above that a continuous balcony to the second floor, above which is a low attic. The balcony thus divides the façade into two approximately equal parts, with the upper part unified by a giant order of pilasters. The colonnade in the main courtyard again has echoes of Sansovino, while the two upper *piani nobili* have fine windows in a disciplined, rather Palladian manner. The smaller courtyard is simpler, with minimal windows to the *piano nobile* and attic but with complex, rather heavy arcading to the ground floor. The interior has a particularly fine doorway on the first floor, perhaps influenced by Falconetto. The palace was nearly complete by Moroni's death, and a local builder completed the Doric courtyard to his design.

Moroni also made an important contribution to the main university building, the Palazzo del Bò, although other architects worked there both before and after him.

Andrea Moroni: central courtyard, Palazzo del Bò, Padua, 1546–59

The most notable feature by Moroni is the fine central courtyard (see fig.) with two superimposed colonnades, Doric below and Ionic above, with careful classical trabeation. This work has been variously ascribed to Palladio, Michele Sanmicheli and da Valle. However, Moroni had been city *proto* since 1540, and as the university was a public, city-owned building, it is now accepted as his work. The courtyard is perhaps the finest Renaissance work in Padua, and its three wings can be dated: north wing, 1546–7; east wing, 1555; west wing, 1558–9. The main façade is probably also Moroni's work, again with a rusticated ground-floor colonnade and two superimposed *piani nobili*, with large windows surmounted by triangular pediments on the first floor and segmental on the second. Moroni was also responsible for the establishment in 1545 of the university's Orto Botanico; founded by decree of the Venetian Senate, it was the first such scientific collection in Europe. It was not completed until after 1554 and still survives, but Moroni's rusticated gateway has been lost.

Two further works in Padua, and another near by, deserve mention. The Palazzo Zacco on Prato della Valle is a substantial house with a ground-floor colonnade and a typically Venetian bay-structure. The façade is of a simple, stripped-down classical appearance, but the house has a complex roof-line, with a row of obelisks alternating with semicircular gables above the windows, and it has a central aedicula. The Loggia della Corte Capitaniato is another official work, in Moroni's capacity as city *proto*; it is a small, three-bay structure, noble and dignified in appearance, again with a strongly moulded, rusticated ground-floor. The fine *piano nobile* has large, well-proportioned windows with triangular pediments. The Certosa di Vigodarzere also contains work by Moroni, chiefly in the two cloisters. The larger is restrained and elegant, but the smaller—unusually—is fully rusticated, including the Doric columns. Moroni also probably designed the portal to the church façade. Moroni's style exhibits the early influence of Falconetto and, perhaps, Alvise Cornaro; some of his work shows a refined sense of proportion, particularly in colonnades and fenestration. His was a pure classicism, showing little of the Mannerism that followed. An architect of considerable local importance, he showed a sensitivity often lacking in such figures; this may be partly attributed to the refined taste of his Paduan patrons and to the influence of nearby Venice.

BIBLIOGRAPHY

J. Cavacci: *Historiarum Coenobii D. Justinae Patavinae*, 6 vols (Venice, 1606)
P. Selvatico: *Guida di Padova* (Padua, 1869)
N. Baldoria: 'Il Riccio e il Leopardi architetti della chiesa di S Giustina di Padova', *Stor. A.* (1891)
A. Venturi: *Storia* (1901–40)
G. Lorenzetti: 'Il cortile e la loggia dell' Università di Padova', *Boll. Mus. Civ. Padova*, xi (1908), pp. 124–56
E. Lovarini: 'Di Andrea da Valle, architetto', *Riv. Italia* (June 1910)
E. Rigoni: *L'architetto Andrea Moroni* (Padua, 1939)
R. Pepi: *L'abbazia di S Giustina* (Padua, 1966)
N. Gallimberti: *Il volto di Padova* (Padua, 1968)
G. Bresciani Alvarez: *La basilica di S Giustina* (Castelfranco Veneto, 1970)
L. Curti: 'L'Orto botanico tra le glorie del passato e le prospettive del futuro', *Padova & Territ.*, x/54 (1995), pp. 12–15

RICHARD J. GOY

Moroni, Giovanni [Giovan] **Battista** (*b* Albino, ?1520–24; *d* Albino, ?after 5 March 1578). Italian painter. He was the most significant painter of the 16th-century school of Bergamo and is best known for his portraits, which feature a naturalistic rendering of both faces and costume and an objective approach to character.

1. EARLY CAREER, TO *c.* 1560. A document dated 6 March 1549 refers to Moroni as an administrative procurator, which implies that he was then at least 25 years old. He was trained in Brescia, in the workshop of Moretto. Moroni's religious paintings, particularly the early works, are characterized by explicit borrowings from Moretto's pictures. Two drawings by Moroni (both 1543; Brescia, Pin. Civ. Tosio–Martinengo), his first securely dated works, show figures of saints copied from paintings by Moretto. It is likely that Moroni collaborated with the Brescian painter in some of his works: for instance, some scholars have identified his hand in Moretto's *St Roch and the Angel* (Budapest, Mus. F.A.) and the *Coronation of the Virgin* (Brescia, S Angelo). Others have attributed outright to Moroni paintings once given to Moretto, for example the two *Angels* (London, N.G.; see fig. 1) and the *Assumption of the Virgin* (Orzivecchi, SS Pietro e Paolo).

In the second half of the 1540s Moroni was working in Trent, contemporaneously with the first session of the Council. In 1548 he executed an *Annunciation* (Trent, Congregazione di Carità, on dep. Osp. Riuniti) and a *St Clare* (Trent, Mus. Dioc.; on dep.) for the church of S Chiara there. In 1549 he is documented in Brescia and his native Albino, and in that year, according to Tassi (1793), he also executed the frescoes (destr.) in the Palazzo Spini in Bergamo. The portraits of the poet *Isotta Brembati* (Bergamo, Gal. Accad. Carrara) and *Marco Antonio Savelli* (Lisbon, Mus. Gulbenkian), presumably early works, show Moroni's impressive qualities as a portrait painter. He was still in Trent in the early 1550s, and the portraits of *Ludovico Madruzzo* (Chicago, IL, A. Inst.) and *Gianfederico Madruzzo* (Washington, DC, N.G.A.), nephews of Cristoforo Madruzzo, Prince Bishop of Trent, can be dated to these years. According to Bartoli (1780), the altarpiece of the *Virgin in Glory with the Four Fathers of the Church and St John the Evangelist* (Trent, S Maria Maggiore) dates from 1551, and this is confirmed by stylistic considerations. The picture, which is modelled on Moretto's altarpiece of the same subject (Frankfurt am Main, Städel. Kstinst. & Städt. Gal.), is exemplary in the severity of its formal arrangement, in its clear exposition of the doctrinal content and in the kind of image required by the Counter-Reformation, to which Moroni remained faithful in all his religious works.

For the rest of the 1550s Moroni's activity was concentrated in the Bergamo region. Two paintings of the *Assumption of the Virgin* (Cenate Sopra, parish church; Oneta, parish church) and the *Crucifixion with SS Francis and Anthony* (Bergamo, Suore della Beata Capitanio) probably date from this period. In these works Moroni's treatment of formulae derived from Moretto is more academic, characterized by colours of an enamel-like brightness and a greater clarity of design. Dated and datable portraits of these years include the *Portrait of a Young Nobleman* (1553; Honolulu, HI, Acad. A.), the *Portrait of ?Michel de l'Hôpital* (1554; Milan, Ambrosiana)

1. Giovanni Battista Moroni (attrib.): *An Angel*, oil on panel, 1.51×0.53 m, after 1543 (London, National Gallery)

and *Lucrezia Vertova* (1556–7; New York, Met.). It is probably in this period that he executed the full-length *Portrait of a Gentleman* (London, N.G.), which depicts a member of the Avogadro family; the unadorned setting and direct representation of the sitter testify to Moroni's divergence from the canons of portraiture as developed by Titian.

The date 1560 appears on the portraits of the *Duke of Albuquerque* (Berlin, Bodemus.), *The Poet* (Brescia, Pin. Civ. Tosio–Martinengo) and the celebrated '*Cavaliere in Rosa*' (*Gian Girolamo Grumelli*; Bergamo, Moroni priv. col., see Pope-Hennessy, p. 223). The sharp colouring of the Cavaliere's costume indicates Moroni's rejection of Venetian tonal harmonies in favour of dazzling, metallic tones used by contemporary Brescian painters. The sitter is portrayed against a background of Classical ruins, a device Moroni used on several occasions, often (as in this case) with reliefs and inscriptions of a moralizing or celebratory tone.

2. MATURE WORK, *c.* 1561 and after. Numerous documents testify to Moroni's presence in Albino after 1561 and particularly in the 1570s, when he was employed in the town council's administration. During the 1560s he executed the *Crucifixion with SS Bernard and Anthony of Padua* (Albino, S Giuliano), the *Virgin and Child with SS Barbara and Catherine* (Bondo Petello, S Barbara) and *Christ Carrying the Cross* (Albino, Santuario della Madonna del Pianto). The unpretentious and melancholic tenor of these paintings and their engaging naturalistic immediacy make them among the artist's finest religious works.

Moroni's style became more austere during the 1560s, as is evident from the many dated works of the period. The standard he executed for the parish church of Pradalunga, with *St Christopher* on one side and the *Glory of the Eucharist* on the other, was valued on 1 July 1562, indicating that it had just been completed. The altarpiece of the *Assumption of the Virgin* (Palazzago, S Giovanni Battista) dates from 1564 according to Calvi (1676–7), and the date 1566 is inscribed on the *Deposition* (Bergamo, Gal. Accad. Carrara) from the church of the Zoccolanti in Gandino. The altarpiece of the *Virgin and Child with SS Peter, Paul and John the Evangelist* in S Pietro at Parre was completed in 1567. Compositionally it recalls Moretto's Rovelli Altarpiece (Brescia, Pin. Civ. Tosio–Martinengo; see colour pl. 2, IX1), but its pale Mannerist inflections link it to works by the Cremonese painters Camillo Boccaccino and Bernardino Campi. The *Virgin and Child* (1567; Bergamo, Gal. Accad. Carrara) for the church of the Madonna della Ripa at Desenzano al Serio is a variant of Giovanni Bellini's panel of the same subject and date (Bergamo, Gal. Accad. Carrara), which once hung in the convent of the Monache di Alzano. The painting by Bellini was copied by Moroni, probably earlier, in another canvas (Brescia, priv. col.; see Rossi, 1977, p. 56). One of Moroni's most praised works, the *Last Supper* (Romano di Lombardia, S Maria Assunta), was commissioned in 1565 but delivered only in 1569.

Among the portraits of the early 1560s are those of *Giovanni Bressani* (1562; Edinburgh, N.G.) and *Pietro Secco Suardo* (1563; Florence, Uffizi). In 1565 Moroni executed the *Portrait of a Member of the Mosca Family* (Amsterdam, Rijksmus.) and *Antonio Navagero* (Milan, Brera; see colour pl. 1, IX3), which in its directness and intimacy typifies Moroni's refusal to engage in the rhetoric of display. A similarly unconventional treatment of the sitter can be seen in the portrait of *Giovanni Antonio Pantera* (Florence, Uffizi), of uncertain date. The date 1567 has been uncovered on the *Portrait of a 29-year-old Nobleman* (Bergamo,

Gal. Accad. Carrara), the intensity of which makes it one of Moroni's portrait masterpieces. The lively *Portrait of a Young Girl of the Redetti Family* (Bergamo, Gal. Accad. Carrara) and '*The Tailor*' (*c.* 1570; London, N.G.; see fig. 2), aspects of which imitate the work of Caravaggio (Longhi), also belong to this period.

Among the most typical works in Moroni's vast oeuvre are devotional portraits, in which the sitter is depicted with a religious scene in the background. Examples of this genre are *Two Devotees of the Virgin and Child and St Michael* (Richmond, VA, Mus. F.A.) and the *Crucified Christ with SS John the Baptist and Sebastian with a Donor* (Bergamo, S Alessandro della Croce), which is later in date. Even in the late religious works Moroni displays an immunity to the formal complexities of the Mannerist style, preferring to present religious scenes in a simple, straightforward manner. This purposefully conservative attitude is most apparent in his continued use of the polyptych format into the 1560s (e.g. in S Bernardo in Roncola) and the 1570s (S Giorgio in Fiorano al Serio, begun 1575; S Vittore in Gaverina, dated 1576).

Moroni's late portraits, on the other hand, show a development in the direction of softer, more atmospheric effects, in which the objective and naturalistic rendering characteristic of the earlier works is replaced by a more full-bodied treatment, apparent, for example, in the pair of Spini portraits (Bergamo, Gal. Accad. Carrara), datable to the early 1570s on the basis of the sitters' ages. Similar stylistic characteristics are evident in the portraits of *Vincenzo Guarinoni* (1572; Cleveland, OH, Mus. A.), *Jacopo Foscarini* (1575; Budapest, Mus. F.A.), *Paolo Vidoni Ced-*

relli (1576; Bergamo, Gal. Accad. Carrara) and in the *Portrait of ?Francesco Spini* (1576; Boston, MA, Isabella Stewart Gardner Mus.). Moroni's late religious works include the *Coronation of the Virgin* (Bergamo, S Alessandro alla Croce), the altarpiece of the *Virgin and Saints* in Bergamo Cathedral, both dated 1576, the altarpiece of the *Virgin and Child with SS Peter and Andrew* (1577) in S Andrea in Fino del Monte and the incomplete *Last Judgement* (Goriago, S Pancrazio), commissioned in 1577.

UNPUBLISHED SOURCES

Trent, Bib. Com., MS. 1207 [F. Bartoli: *La pitture, sculture ed architetture che adornano le chiese ed altri pubblici luoghi della città di Trento*, 1780]

BIBLIOGRAPHY

D. Calvi: *Effemeride sacro profana di quanto di memorabile sia successo in Bergamo, sua diocese et territorio*, 3 vols (Milan, 1676–7)

F. M. Tassi: *Vite de' pittori, scultori e architetti bergamaschi* (Bergamo, 1793), i, pp. 162–72

C. von Lutzow: 'Giovanni Battista Moroni', *Graph. Kst.*, xiv (1891), pp. 21–6

G. Lafenestre: 'Les Portraits des Madruzzi par Titian et G. B. Moroni', *Rev. A. Anc. & Mod.*, xxi (1907), pp. 351–60

F. Frizzoni: 'Moretto und Moroni: Eine Charakterisierung auf Grund zweier massgebender Studienblätter', *Münchn. Jb. Bild. Kst*, vii (1912), pp. 28–38

M. Biancale: 'Giovanni Battista Moroni e i pittori bresciani', *L'Arte*, xvii (1914), pp. 289–300, 321–2

A. Locatelli Milesi: 'Un grande ritrattista: G. B. Moroni', *Emporium*, xliv (1916), pp. 376–87

H. Merten: *Giovanni Battista Moroni: Des Meisters Gemälde und Zeichnungen* (Marburg, 1928)

R. Longhi: 'Quesiti caravaggeschi. II: I precedenti', *Pinacoteca*, v–vi (1929), pp. 258–320; also in *Me pinxit e quesiti cava vaggeschi* (Florence, 1968)

G. Lendorff: *G. B. Moroni der Porträt-Maler von Bergamo* (Winterthur, 1933)

D. Cugini: *Moroni pittore* (Bergamo, 1939)

G. Gombosi: *Il Moretto da Brescia* (Basle, 1943)

W. Suida: 'Aggiunte all'opera di Giovanni Battista Moroni', *Emporium*, cix (1949), pp. 51–7

I pittori della realtà in Lombardia (exh. cat. by R. Longhi, R. Cipriani and G. Testori, Milan, Pal. Reale, 1953)

J. Pope-Hennessy: *The Portrait in the Renaissance* (New York and London, 1966), pp. 205, 207, 223, 321

M. Gregori: 'Il ritratto di Alessandro Vittoria del Moroni a Vienna', *Paragone*, xxvii/317–19 (1976), pp. 91–100

F. Rossi: 'Giovan Battista Moroni nel quarto centenario della morte', *Not. Pal. Albani*, vi (1977), pp. 50–59

H. Brigstocke: 'A Moroni Portrait for Edinburgh', *Burl. Mag.*, cxx (1978), pp. 457–61

C. Gould: 'G. B. Moroni and the Genre Portrait in the Cinquecento', *Apollo*, cviii (1978), pp. 316–21

G. Testori and G. Frangi: *Moroni in Val Seriana* (Brescia, 1978)

Giovanni Battista Moroni: 400th Anniversary Exhibition (exh. cat. by A. Braham, London, N.G., 1978)

M. Gregori: 'Giovanni Battista Moroni', *I pittori bergamaschi: Il cinquecento* (Bergamo, 1979), iii, pp. 95–377 [with list of works and bibliog.]

M. Cali: '"Verità" e "Religione" nella pittura di Giovan Battista Moroni (a proposito della mostra di Bergamo)', *Prospettiva*, xxiii (1980), pp. 11–23

G. Previtali: 'Il bernoccolo del conoscitore (a proposito del presunto *Ritratto di Gian Girolamo Albani* attribuito al Moroni)', *Prospettiva*, xxiv (1981), pp. 24–31

The Genius of Venice, 1500–1600 (exh. cat., ed. C. Hope and J. Martineau; London, RA, 1983), pp. 186–92 [entries by M. Gregori]

Seicento a Bergamo (exh. cat., Bergamo, Pal. Ragione, 1987), pp. 47–50, 227–8 [entries by V. Guazzoni]

F. Rossi: 'Giovan Battista Moroni: Ritratti di famiglia', *Osservatorio A.*, iv (1990), pp. 68–73

M. Previto: '"Un nuovo documento per Giovan Battista Moroni", *Paragone*, xlv/527 (1994), pp. 65–8

M. Di Tanna: '*Il ritratto di Bartolomeo Bonghi* nel Metropolitan Museum di New York', *Bergomum*, lxxxix/3 (1994), pp. 73–88

FRANCESCO FRANGI

2. Giovanni Battista Moroni: '*The Tailor*', oil on canvas, 970×740 mm, *c.* 1570 (London, National Gallery)

Morto da Feltre. *See under* LUZZO, LORENZO.

Mosca. Italian family of artists. The earliest known family members, both masons, were Francesco di Simone Mosca, also known as Francesco delle Pecore (*b* nr Settignano, early 1470s; last documented 1504), and his brother Jacopo di Simone delle Pecore, who is documented as having matriculated in October 1506. They and three subsequent generations of the family were active in Central Italy. Francesco's son, (1) Simone Mosca, also known as 'il Moschini', was a sculptor, as was his son (2) Francesco Mosca, also known as 'il Moschino'. It was the latter's son (3) Simone Mosca Moschino, however, that had the strongest artistic personality.

(1) Simone Mosca [il Moschini] (*b* Settignano, 1492; *d* Orvieto, April 1553). Sculptor. He went to Rome with Antonio da Sangallo (ii) and participated in the building and decoration of S Giovanni dei Fiorentini and the Cesia Chapel in S Maria della Pace. He was also associated with the workshop of Andrea Sansovino and assisted in the decoration of the Santa Casa of Loreto. Around 1525 he travelled to Bologna with Niccolò Tribolo and assisted with reliefs for churches there. Simone's free use of garlands, richly carved cornices and friezes and other classicizing motifs was highly praised by contemporaries. During the late 1520s and early 1530s he assisted Michelangelo on the decoration of the Medici Chapel, Florence. Some time after 1533 Vasari unsuccessfully attempted to obtain for him the commission for the *Del Monte* monument for S Pietro in Montorio, Rome. In collaboration with Benedetto da Rovezzano, Simone carved the base for Baccio Bandinelli's statue of *Orpheus* (Florence, Pal. Medici–Riccardi, main courtyard). His last years were spent mainly in Orvieto, where he executed altars and decorative carvings for the cathedral.

BIBLIOGRAPHY
S. Bellesi: 'Simone Mosca, scultore ornatista e architetto', *Ant. Viva*, xxxiv/1–2 (1995), pp. 22–8

STEVEN BULE

(2) Francesco Mosca [il Moschino] (*b* ?1546; *d* Pisa, 28 Sept 1578). Sculptor, son of (1) Simone Mosca. He also worked in Orvieto, and he may have completed his father's unfinished commissions. For the cathedral there he executed a nude statue of *St Sebastian* and figures for *St Peter* and *St Paul*. He also executed statues for Pisa Cathedral (a *Virgin and Child* and *Angel* in the chapel of the Annunciation) and in 1577 travelled to Parma, where he was employed briefly by the Farnese as court sculptor. A marble relief of *Diane and Acteon* (Florence, Bargello) and a free-standing group of *Atalanta and Meleager* (Kansas City, MO, Nelson–Atkins Mus. A.) reflect Francesco's indebtedness to mid-16th-century Mannerism.

BIBLIOGRAPHY
G. Vasari: *Vite* (1550, rev. 2/1568); ed. G. Milanesi (1878–85)
J. Burckhardt: *Il Cicerone* (Basle, 1855)
K. Weil-Garris: *The Santa Casa di Loreto: Problems in Cinquecento Sculpture* (New York, 1977)
M. Butzek: *Die kommunalen Repräsentationsstatuen der Päpste des 16. Jahrhunderts in Bologna, Perugia und Rom* (Bad Honnef, 1978)
G. Magnani: *Abbazia benedettina di S Giovanni Evangelista a Parma*, ed. B. Adorni (Milan, 1979)

STEVEN BULE

(3) Simone Mosca Moschino (*bapt* Orvieto, 12 Nov 1553; *d* Parma, 20 June 1610). Sculptor and architect, son of (2) Francesco Mosca. He gained experience at an early age, working for Pier Francesco ('Vicino') Orsini (*d* 1585) as a sculptor at Bomarzo (see BOMARZO, SACRO BOSCO). In 1578 he was recommended by Orsini to Ottavio Farnese, 2nd Duke of Parma, who appointed him to succeed his father as court sculptor. While he was employed at Bomarzo and during his visits to Rome in 1594, 1597 and 1599–1600, Moschino had the opportunity to become acquainted at first hand with the works of Michelangelo, and this had a personal if superficial impact on his sculpture. Together with his experience at Bomarzo and his youthful contact, through his family, with Florentine Mannerism, and in particular with Bartolomeo Ammanati and Bernardo Buontalenti, this new influence contributed to the evolution of his style towards a determined anti-classicism, which disconcerted his contemporaries (and later also Burckhardt).

Under Ottavio Farnese, Moschino was responsible in particular for the sculptural decoration of Giovanni Boscoli's great fountain, which backs on to the Palazzo del Giardino, Parma. His activity broadened at the end of the century under Ranuccio I, 4th Duke of Parma, who appointed him general superintendent of art and architecture. For Ranuccio he enlarged the Palazzo del Giardino built by Jacopo Vignola, and he probably (under the Duke's precise instructions) also designed the Pilotta next to the ducal palace. This immense construction was a service building housing stables, the wardrobe, armoury and several courtyards for playing pelota and *archetto*. Moschino was responsible for the entrance stairway (1604) to the armoury; the armoury itself was later converted into the Teatro Farnese (1618–19) by Giovanni Battista Aleotti. This grand and complex staircase has a large, domed octagonal space on the main landing, which once possessed a lantern, almost as if it were a large, centralized chapel. Other works by Moschino include the funerary monument of *Margaret of Parma* (*d* 1586) in S Sisto, Piacenza; the enlargement of the Benedictine convent of S Alessandro (1593; destr.) at Parma; a statue of *Duke Alessandro Farnese* (1594; Caserta, Pal. Reale); and a great marble door (from 1596) for the citadel of Parma. From 1604 to 1607 he built the façade of the church of S Giovanni Evangelista, Parma, begun in 1490; here the rigid skeleton of superimposed orders is contrasted with an assortment of niches with statues, small pediments, frames and various motifs taken from Michelangelo; a lively exterior profile supports a medallion with the eagle of St John the Evangelist. Also attributable to Moschino is the bell-tower (1616; also attributed to Giovanni Battista Trotti) of S Sepolcro, Parma, where his anti-classical and anti-architectonic style assumed a particularly violent character.

UNPUBLISHED SOURCES
Munich, Staatl. Graph. Samml. [drawings by Moschino]

BIBLIOGRAPHY
J. Burckhardt: *Il Cicerone* (Basle, 1855)
A. Ronchini: 'Francesco e Simone Moschini', *Atti & Mem. RR. Deput. Stor. Patria Prov. Moden. & Parmen.*, viii (1876), pp. 97–111
A. Sorrentino: 'L'autore del gruppo marmoreo "Alessandro Farnese incoronato dalla vittoria"', *Aurea Parma*, xxiii (1939), pp. 20–25
B. Adorni: *L'architettura farnesiana a Parma, 1545–1630* (Parma, 1974), pp. 45–7, 55–62, 167–83

——: *L'architettura farnesiana a Piacenza, 1545–1600* (Parma, 1982), pp. 409–12

H. Bredekamp: *Vicino Orsini e il sacro bosco di Bomarzo* (Rome, 1989), pp. 66, 69, 71, 76, 120, 123, 128, 131, 143, 152–3, 155, 179, 256, 274, 302, 340–1

B. Adorni: 'I giardini farnesiani a Parma e a Piacenza', *Gli arti farnesiani sul Palatino* (Rome, 1990), pp. 516–17

——: 'La costruzione della Pilotta', *Il Palazzo della Pilotta a Parma*, ed. L. Fornari Schianchi (Milan, 1996), pp. 13–33

BRUNO ADORNI

Mosca Padovano, Giovanni Maria [Gianmaria] [Padoan, Zuan Maria; Padovano, Jan Maria] (*b* Padua, *c.* 1493/5; *d* Kraków, after 31 March 1574). Italian sculptor, medallist and architect, active also in Poland. He is first documented in 1507, when he was apprenticed for six years to the Paduan sculptor Giovanni d'Antonio Minello de' Bardi. Released early from this contract, he also trained with the sculptor Bartolomeo Mantello (*fl* early 16th century). His first documented work is a bronze relief of the *Beheading of St John the Baptist* (1516; Padua Cathedral). In Padua he also executed a marble relief of the *Judgement of Solomon* (Paris, Louvre) for Giambattista Leon. However, a commission dated 28 April 1520 for a marble relief of the *Miracle of the Unbroken Goblet* (Padua, Santo, Chapel of St Anthony) describes him as a resident of Venice, working on the high altar of S Rocco in that city. Mosca's work on the relief proceeded from 1523 to 1529, when the almost completed relief was finished by Paolo Stella after Mosca's final departure. In S Rocco, the lower register of the high altar contains two small marble works by Mosca, *St John the Baptist* (often identified as *St Pantaleon*) and *St Sebastian*. The powerfully contorted and pathetic *St Sebastian* is his first mature statement departing from the calm, static manner of earlier reliefs by Minello and the influential Tullio Lombardo. Mosca is documented in Venice in 1522, when he received payments for a *Virgin* (untraced) on the house of Paolo de Monte. Other works of this period include several marble reliefs, such as *Venus Anadyomene* (London, V&A), *Portia* (Venice, Ca' d'Oro) and *Mucius Scaevola* (Florence, Bargello).

In 1529 Mosca left Venice, possibly because of ill-will between himself and Jacopo Sansovino. He was given patronage by Sigismund I (*reg* 1506–48), King of Poland, and his Italian wife Bona Sforza. He set up a workshop in Kraków and spent the rest of his career introducing the influence of the classicizing art of Tullio Lombardo to Poland. His funerary monuments, based on the rectangular aedicule, are without ornaments. The artist modelled his saints and allegorical figures *all'antica*, while portraying the deceased more naturalistically, reclining as if asleep, after the type popularized by Jacopo Sansovino, which Mosca himself also brought to Poland. Mosca also popularized the use of the Classical orders in Poland.

BIBLIOGRAPHY

PSB; Thieme–Becker [with bibliog. to date]

A. Venturi: *Storia* (1901–40)

E. Rigoni: 'Notizie riguardanti Bartolomeo Bellano e altri scultori padovani', *Atti & Mem. Reale Accad., Sci., Lett. & A. Padova*, n. s., xlix (1932–3); also in *L'arte rinascimentale in Padova: Studi e documenti, Medioevo e umanesimo*, ix (Padua, 1970), pp. 127–8, 138–9

F. Kopera: 'Jan Maria Padovano', *Prac. Kom. Hist. Sztuki*, vii (1937), pp. 219–61

J. Zarnecki: 'Renaissance Sculpture in Poland: Padovano and Michałowicz', *Burl. Mag.*, lxxxvi (1945), pp. 10–16

H. Kozakiewicz: 'Jan Maria Padovano: Życie i działalność we Włoszech' [Life and activity in Italy], *Biul. Hist. Sztuki*, xxiv (1964), pp. 153–68 [with It. summary]

G. Fiocco: 'Il Mosca a Padova', *Venezia e la Polonia nei secoli dal XVII al XIX*, xix (Venice and Rome, 1968), pp. 43–52

J. Białostocki: *The Art of the Renaissance in Eastern Europe* (Oxford, 1976)

S. Wilk: 'La decorazione cinquecentesca della Cappella dell'Arca di S Antonio', *Le sculture del Santo di Padova*, ed. G. Lorenzoni (Padua, 1984), pp. 134–6

A. M. Schulz: 'Paolo Stella Milanese', *Mitt. Ksthist. Inst. Florenz*, xxix (1985), pp. 79–110

——: *Gianmaria Mosca Called Padovano*, 2 vols (University Park, 1998)

JERZY KOWALCZYK, THOMAS MARTIN

Motta, Raffaello. *See* REGGIO, RAFFAELLINO DA.

Moysis, Costanzo de. *See* COSTANZO DA FERRARA.

Mozetto, Girolamo. *See* MOCETTO, GIROLAMO

Murano. *See under* VENICE, §III, 3.

Musi, Agostino dei [Agostino Veneziano] (*b* Venice, *c.* 1490; *d* ?Rome, after 1536). Italian engraver and draughtsman. His monogram ('A.V.') and in five instances his full name appear on 141 prints. Of these 85 are dated from 1514 to 1536. He began his career in Venice. His earliest dated prints (1514) are copies after Giulio Campagnola (*The Astrologer*, B. 411) and Albrecht Dürer (1471–1528) (*Last Supper*, B. 25). A print dated 1515 after Baccio Bandinelli (*Cleopatra*, B. 193) and another dated 1516 after Andrea del Sarto (the *Dead Christ Supported by Three Angels*, B. 40) indicate his presence in Florence in these years.

In 1516 Agostino went to Rome, where over the next ten years he produced numerous prints after Raphael (e.g. *Blinding of Elymas*, 1516; B. 43), Michelangelo, Giulio Romano and Rosso Fiorentino. He left Rome at the time of the Sack in 1527 and went to Venice, where he worked on illustrations (later rejected; B. 525–33) for a book on architecture by Sebastiano Serlio (unpublished); he also visited Mantua, where he engraved prints after Giulio Romano (e.g. *Hercules and the Nemean Lion*, 1528; B. 287), and Florence. Between 1531 and 1536 he worked in Rome, where he produced numerous prints, including a set of 12 *Antique Vases* (1531; B. 541–52) and several contemporary portraits (e.g. *Francis I, King of France*, 1536; B. 519).

BIBLIOGRAPHY

DBI: 'De' Musi, Agostini'

B. Hedergott: 'Eine Braunschweiger Zeichnung von Agostino Veneziano: Gedanken zur Physiognomik der Groteske', *Beitr. Kstgesch.* (1960), pp. 126–54

K. Oberhuber: *Graphische Sammlung Albertina: Die Kunst der Graphik III: Renaissance in Italien 16. Jahrhundert* (Vienna, 1966)

——: *Marcantonio Raimondi*, 2 vols (New York, 1978), 26 [14–1] and 27 [14–2] of *The Illustrated Bartsch*, ed. W. Strauss (New York, 1978–) [B.]

D. Minonzio: 'Novità e apporti per Agostino Veneziano', *Rass. Stud. & Not.*, viii (1980), pp. 273–320

S. Massari: *Tra mito e allegoria* (Rome, 1989)

CHRISTOPHER L. C. E. WITCOMBE

Muziano, Girolamo (*b* Brescia, 1532; *d* Rome, 27 April 1592). Italian painter and draughtsman. He trained as a landscape painter in Padua and Venice, but from 1549 he worked in Rome. In 1550–51 he skilfully completed the background of Battista Franco's altarpiece of the *Resurrec-*

tion in the Gabrielli Chapel, S Maria sopra Minerva, Rome, with a rustic scene of woods, mill and stream in the style of Titian and of Domenico Campagnola, rendered in rhythmic, luminous strokes reminiscent of Tintoretto and Andrea Schiavone; on the entrance pilasters he executed the rather laboured frescoes of *Prophets* and *Seers*, derived from Michelangelo. Around 1554–5 he frescoed the *Prophets* and *Dream of Joseph* (Rome, S Caterina della Rota). The angel in the latter is related to elaborate Mannerist figures by Taddeo Zuccaro and Pellegrino Tibaldi, but Muziano's clear illustration of the subject and careful characterization of the protagonists reflect the sombre classicizing style of Girolamo Siciolante da Sermoneta and the artistic tenets of the Counter-Reformation. The monumental forest setting and dramatic lighting, reminiscent of Titian, do not seem to have been appreciated in Rome; for a few years Muziano worked only outside the city, and subsequently he reduced the role of landscape in his religious paintings.

In Subiaco, Muziano painted a *Raising of Lazarus* (Rome, Pin. Vaticana; see fig.), which was exhibited in Rome in 1555. Its large dimensions, dramatic light effects and varied textures still show Venetian influence, but he used an eloquent background of Classical ruins and wove sufficient variety and complexity into his design and use of colour to please the sophisticated Mannerist taste of his Roman audience without compromising the solemnity of the subject. The picture earned him Michelangelo's praise (Turner, p. 131) and brought him other major commissions. Between 1555 and 1558 for Orvieto Cathedral Muziano painted two large altarpieces, another *Raising of Lazarus* and a *Road to Calvary* (*in situ*), and chapel decorations (destr.). An altarpiece (untraced) for Foligno Cathedral also dates from this period. He declined to collaborate with Zuccaro and others on the decoration of Villa Farnese at Caprarola, and, after refusing further commissions in Orvieto, he returned to Rome.

Between 1560 and 1566 Muziano painted original and highly influential landscape frescoes in Cardinal Ippolito II d'Este's villas in Rome and Tivoli. None survives, but drawings, such as one in the Uffizi, Florence (512), suggest that in these landscapes he initiated the revival of the Classical genre of the idealized landscape, adapting it to contemporary Roman taste with a picturesque blend of natural forms and evocative antique ruins in scenes derived from the local countryside and accented with Venetian contrasts of scale.

Subsequently Muziano concentrated on religious subjects, further developing his interpretation of the spiritual values of the Counter-Reformation. Responding to the growing market for popular devotional images, he designed many engravings, notably nine scenes from the *Life of Christ* and two versions of the *Stigmatization of St Francis*, all issued by Cornelis Cort (1533–78) in 1567–8, and seven plates of *Penitent Saints* in large landscapes, issued by Cort in 1573–5 (London, BM; Hollstein, nos 77, 80–81, 83, 86–7, 128–9, 135). All in vertical format, the *Penitent Saints* are tightly organized on the surface and in depth, using both aerial perspective and a series of overlapping planes; framing and accentuating the tiny

Girolamo Muziano: *Raising of Lazarus*, oil on canvas, 2.95×4.40 m, exh. 1555 (Rome, Pinacoteca Vaticana)

figures are richly varied landscape forms, some boldly exaggerated but naturalistically described, which create dramatic contrasts and a moody play of light and shade and which evoke the awesome aspects of the wilderness.

In his many small devotional paintings (for which he received high prices) Muziano relied on vibrant atmospheric effects rather than detailed descriptions of figures or background to communicate mood. Even in large paintings, such as *St Francis* (Rome, S Maria della Concezione) and *St Jerome* (Bologna, Pin. N.), where the figures dominate the landscape, shifting coloured lights and shadow convey a sense of brooding and expectation. For narrative subjects in the early 1560s, such as *Christ Raising the Daughter of Jairus* (Madrid, Escorial), painted for Philip II of Spain (*reg* 1556–98), Muziano had developed a style of classically balanced composition and naturalistic representation of action similar to that of Zuccaro, but he later turned towards a more poetic form of communication. Beginning with his paintings (*c*. 1569) in the Ruiz Chapel, S Caterina dei Funari, Rome, he limited action to a few grave gestures and arranged his figures in simple planar designs of graceful geometric shapes connected in gentle rhythms. Later treatments of narrative subjects, for example *Christ Receiving Envoys from John the Baptist* (*c*. 1570–75; Loreto, Santa Casa), are enlivened with soft colours and textures and flickering rose and gold light.

In the late 1570s and the 1580s the patronage of Gregory XIII ensured that Muziano was the foremost religious artist in Rome, and in 1577 he persuaded the Pope to establish the Accademia di S Luca. From 1576 Muziano painted numerous canvases for the papal court and supervised the making of mosaics from his own designs in the Cappella Gregoriana, the first chapel completed in the new St Peter's. He did not participate in the decoration of the Galleria Geografica in the Vatican, another of the collaborative projects he disliked. His altarpieces were in great demand, especially among Roman families ordered by the Pope to improve their chapels: the *Ascension* (1580–81; Rome, S Maria in Vallicella); the *Donation of the Keys to St Peter* (*c*. 1584; Rome, S Maria degli Angeli); the *Ascension*, *St Paul* and the *Immaculate Conception* (*c*. 1581–4; all now Rome, Carmelite Coll.); and in the Mattei Chapel (*c*. 1582–9; Rome, S Maria d'Aracoeli). The only commission Muziano received after Gregory XIII's death (1585) was the *Circumcision* for the high altar of Il Gesù (1587–9; Rome, Pal. Gesù). He died after a long illness, leaving many paintings unfinished. His altarpieces for St Peter's were completed by artists he had inspired, the *Mass of St Gregory* (untraced) by his former pupil Cesare Nebbia and the *Six Hermit Saints* (Rome, S Maria degli Angeli) by Paul Bril (*c*. 1554–1626).

BIBLIOGRAPHY

Hollstein: *Dut. & Flem.*; Thieme–Becker

G. Vasari: *Vite* (1550, rev. 2/1568); ed. G. Milanesi (1878–85), v, p. 432; vi, p. 508; vii, p. 87

R. Borghini: *Il riposo*, iii (Florence, 1584/*R* 1807), pp. 145–9; 2nd edn A. M. Biscioni and G. G. Bottari (Florence, 1730), pp. 469–72

G. Baglione: *Vite* (1642); ed. V. Mariani (1935), pp. 49–52

U. da Como: *Girolamo Muziano, 1528–1592: Note e documenti* (Bergamo, 1930)

U. Procacci: 'Una *Vita* inedita del Muziano', *A. Ven.*, viii (1954), pp. 242–64

F. da Morrovalle: 'Girolamo Muziano a Loreto', *A. Ant. & Mod.*, viii (1965), pp. 385f

A. R. Turner: *The Vision of Landscape in Renaissance Italy* (Princeton, 1966), pp. 116–18, 131–2, 175–8

R. E. Mack: 'Girolamo Muziano and Cesare Nebbia at Orvieto', *A. Bull.*, lvi (1974), pp. 410–13

G. L. Masetti Zannini: *Pittori della seconda metà del cinquecento* (Rome, 1974), pp. 61–9

J. Heideman: 'Observations on Girolamo Muziano's Decoration of the Mattei Chapel in S Maria in Aracoeli', *Burl. Mag.*, cxix (1977), pp. 686–94

G. Fusconi and S. Prosperi Valenti Rodinò: 'Note in margine ad una schedatura: I disegni del Fondo Corsini nel Gabinetto Nazionale delle Stampe', *Boll. A.*, xvi (1982), pp. 81–118

J. A. Gere and P. M. R. Pouncey: *Italian Drawings in the Department of Prints and Drawings in the British Museum*, i (London, 1983), pp. 129–31

J. M. Ruiz Manero: 'Obras y noticias de Girolamo Muziano, Marcello Venusti y Scipione', *Archv Esp. A.*, lxviii/272 (Oct–Dec 1995), pp. 365–80

P. di Giammaria: *Girolamo Muziano* (Montichiari, 1997)

ROSAMOND E. MACK

N

Naldini, Giovan Battista [Giovanbattista] (*b* Fiesole, *c.*
1537; *d* Florence, 18 Feb 1591). Italian painter and
draughtsman. He was the artistic heir of Jacopo Pontormo,
with whom he trained from 1549 to 1556. While maintain-
ing an allegiance to the ideals of Andrea del Sarto and
Pontormo, he also worked in the vocabularies of Bronzino
and Vasari. From these sources he forged an individual
style of drawing indebted to del Sarto in its loose handling
of chalk and reminiscent of Pontormo in its schematic
figures defined by firm contours and modelled with loose
hatching or spots of wash. There are an analogous
stylization and an expressive freedom in his treatment of
serpentine figures, which are sculptural in form but
painterly in detail, arranged in compact compositions with
concentrated lights revealing passages of warm yellows,
reds and greens. Particularly characteristic is the *Christ
Carrying the Cross* (1566; Florence, S Maria Assunta),
which is distinguished in its colouring and expressive
figures from the chill linearity and metallic forms of
Bronzino, Vasari and Alessandro Allori.

Naldini had numerous patrons in Florence and else-
where in Tuscany, but he worked largely for the Medici as
one of the artists under Vasari's supervision. He was in
Rome after Pontormo's death in 1557 but returned to
Florence *c.* 1562 to assist Vasari in the decorations for the
Palazzo Vecchio, working in the *studiolo* (e.g. *Allegory of
Dreams* and *Gathering Ambergris*, both 1570–71; see fig.)
and in the Sala del Cinquecento. His work with Vasari
included decorations for the obsequies of Michelangelo in
1564 and for the marriage of Francesco I de' Medici,
Grand Duke of Tuscany, in 1565, as well as participation
in the renovations of Santa Croce (*Pietà*, tomb of Michel-
angelo) and of S Maria Novella (*Pietà*, 1572; *Nativity*,
1573; *Presentation in the Temple*, 1577). He was in Rome
again in the late 1570s, painting frescoes with Giovanni
Balducci of scenes from the *Life of St John the Baptist*
(1577–80) in the Altoviti Chapel, Santa Trinità dei Monti.
Contemporary and later examples of his painting, reflect-
ing the influence of the Council of Trent, are the *Pietà* (*c.*
1577; Bologna, Col. Molinari Pradelli, see 1980 exh. cat.,
ed. L. Berti, p. 150), the *Virgin and Child with Saints*
(1580s; Granaiolo, nr Castelfiorentino, S Matteo) and the
Calling of St Matthew (1588; Florence, S Marco, Salviati
Chapel). In 1590, again with Balducci, he worked on the
Presentation of the Virgin in Volterra Cathedral (*in situ*).
Although responsive to late Mannerism and to the reforms
of the Council of Trent, Naldini remained an anomaly, a
highly individual Mannerist. He was a founder-member in

Giovan Battista Naldini: *Gathering Ambergris*, oil on slate, 1270×890
mm, 1570–71 (Florence, Palazzo Vecchio, *studiolo*)

1563 of the Accademia del Disegno, in which he was
active throughout his career, and he had pupils who
influenced 17th-century Florentine art: Giovanni Balducci
(*c.* 1560–1631), Valerio Marucelli (1563–1620), Cosimo
Gamberucci (*d* 1620), Francesco Curradi (1570–1661) and
Domenico Passignano (1559–1638).

BIBLIOGRAPHY
Colnaghi; Thieme–Becker
G. Vasari: *Vite* (1550, rev. 2/1568); ed. G. Milanesi (1878–85), vi, p. 288;
 vii, pp. 99, 308, 610; viii, pp. 619–20
R. Borghini: *Il riposo* (Florence, 1584); ed. M. Rosci (Milan, 1968), esp.
 pp. 613–19
F. Baldinucci: *Notizie* (1681–1728); ed. F. Ranalli (1845–7); rev. P.
 Barocchi (1974), esp. iii, pp. 511–19
D. E. Colnaghi: *Dictionary of Florentine Painters from the 13th to the 17th
 Centuries* (London, 1928/*R* Florence, 1986)

P. Barocchi: 'Itinerario di Giovan Battista Naldini', *A. Ant. & Mod.*, 31–2 (1965), pp. 244–88

A. Forlani Tempesti: 'Alcuni disegni di Giovanbattista Naldini', *Festschrift Ulrich Middeldorf* (Berlin, 1968), pp. 294–300

G. Thiem: 'Neuentdeckte Zeichnungen Vasaris und Naldinis für die Sala Grande des Palazzo Vecchio in Florenz', *Z. Kstgesch.*, xxxi (1968), pp. 143–50

E. Pillsbury: 'The Sala Grande Drawings by Vasari and his Workshop: Some Documents and New Attributions', *Master Drgs*, xiv (1976), pp. 127–46

Palazzo Vecchio: Committenza e collezionismo medici (exh. cat., ed. P. Barocchi; Florence, Pal. Vecchio, 1980), pp. 280–81 [entries by M. Collareta]

Il primato del disegno (exh. cat., ed. L. Berti; Florence, Pal. Strozzi, 1980), pp. 148–52 [entries by A. Petrioli Tofani]

The Draftsman's Eye: Late Renaissance Schools and Styles (exh. cat. by E. J. Olszewski, Cleveland, OH, Mus. A., 1981)

S. Schaefer: 'The Studiolo of Francesco I de' Medici: A Checklist of the Known Drawings', *Master Drgs*, xx/2 (1982), pp. 125–30

B. Santi: 'Nota su Giovanni Battista Naldini: La *Pala di Collebarucci* in Mugello', *Ant. Viva*, xxiv/1–3 (1985), pp. 56–7

Florentine Drawings of the Sixteenth Century (exh. cat. by N. Turner, London, BM, 1986), pp. 210–14

Sixteenth-century Tuscan Drawings from the Uffizi (exh. cat. by A. Petrioli Tofani and G. Smith, Detroit, MI, Inst. A., 1988–9), pp. 128–35

G. Gruitrooy: 'A New Drawing by Giovanni Battista Naldini', *J. Paul Getty Mus. J.*, xvii (1989), pp. 15–20

From Studio to Studiolo: Florentine Draftsmanship under the First Medici Grand Dukes (exh. cat. by L. J. Feinberg and K.-E. Barrman, Oberlin Coll., OH, Allen Mem. A. Mus., 1991), pp. 129–39

S. Gregory: 'Invenzione, Disegno e Fatica: Two Drawings by Giovanbattista Naldini for an Altarpiece in post-Tridentine Florence', *Drawing, 1400–1600: Invention and Innovation* (Aldershot and Brookfield, VT, 1998)

MILES L. CHAPPELL

Naldo, Niccolò di. *See* NICCOLÒ DI NALDO.

Nanni, Giovanni. *See* GIOVANNI DA UDINE.

Nanni, Ser Ricciardo di. *See* RICCIARDO DI NANNI, SER.

Nanni di Baccio Bigio. *See* BIGIO, NANNI DI BACCIO.

Nanni di Banco (*b* Florence, *c.* 1380–85; *d* Florence, 1421). Italian sculptor. His father, Antonio di Banco (*d* 1415), a stone-carver at Florence Cathedral with whom he trained, was married in 1368, which provides a *terminus post quem* for Nanni's birth. On 2 February 1405 Nanni matriculated in the Arte di Pietra e Legname, the masons' guild, presumably to allow him into the cathedral workshops. He is first documented there on 31 December 1407, working with his father on the archivolt sculpture of the Porta della Mandorla.

On 24 January 1408 Nanni and his father were both commissioned to carve a figure of *Isaiah* for the exterior of the north tribune of the cathedral (now inside). Despite both names on the document, it is likely that the statue was intended to be by Nanni alone, since his father seems to have been a *lastraiuolo* (stone-carver), not a figural sculptor. Nanni and his father probably operated a joint workshop. Nanni is first referred to by the title *magister* in a document of February 1408, in which Donatello was commissioned to carve a marble *David* (Florence, Bargello) as a companion figure to the *Isaiah*, which itself was completed by 15 December 1408, when Nanni's father received payment for his son. Despite the long, curving lines of the Late Gothic style, there is a hint in the *Isaiah*,

as in Donatello's *David*, of an active contrapposto pose derived from antique sculpture.

On 19 December 1408 Nanni was commissioned to carve a seated marble *St Luke* for one of the niches flanking the main doors of the cathedral, while Donatello was assigned a companion figure of *St John the Evangelist* (*see* DONATELLO, fig. 1) and Niccolò di Piero Lamberti a figure of *St Mark* (for illustration *see* LAMBERTI, NICCOLÒ DI PIERO; all Florence, Mus. Opera Duomo). Work on these statues progressed fitfully, and the *St Luke* was not completed and paid for until 16 February 1413. It also owes much to Nanni's study of Classical prototypes and, with Donatello's *St John*, marks a turning-point towards the early Renaissance style. Nanni's only other known documented figural work is the high relief of the *Assumption of the Virgin* for the tympanum of the Porta della Mandorla, a work that is full of robust movement and was much admired by Vasari. Begun in 1414, the relief was substantially complete by the sculptor's death in 1421. Taking into account the intervention of pupils (among whom may have been Luca della Robbia) in the carving, the relief features gothicizing drapery patterns that may reflect Nanni's response to the style of the portal into which it was to be inserted, rather than any significant shift in his late style.

Three other figures in marble are universally accepted as Nanni's work, though their dating and ordering are controversial: the *St Philip*, the *Four Crowned Saints* (see fig.) and the *St Eligius*, all for the trade guild niches on the exterior of Orsanmichele, Florence (*in situ*). Given the delays in the carving of the *St Luke*, it is possible that Nanni's work at Orsanmichele was competing for his

Nanni di Banco: *Four Crowned Saints* (*c.* 1416), marble, Orsanmichele, Florence

attention. The *St Philip* (c. 1412–15) for the Arte dei Calzolai is comparable in pose to Donatello's nearby *St Mark* (1411), just as the two artists' *Isaiah* and *David* for the tribune are essentially mirror images. Since they worked closely together in the cathedral workshops, they undoubtedly also shared ideas for their sculpture at Orsanmichele. Their sculpture seems to have developed along parallel lines, even though Nanni may have been older and may well have initiated the stylistic changes normally ascribed to Donatello's fertile imagination. Nanni's *Four Crowned Saints*, with its overtly classicizing forms, is important as the first sculptural group in Renaissance Florence. The relief beneath the group showing stone-carvers at work is instructive for collaborative workshop practices during the early 15th century.

From May to August 1414 Nanni served as consul for the guild of the Maestri di Pietra e Legname, the guild that commissioned the *Four Crowned Saints*. He also held the civic office of podestà of Montagna for six months from 22 August 1414 and of Castelfranco di Sopra from 9 July 1416. He was proposed for the same office for Tizzana (1414) and Buggiano (1415) but was not elected.

Nanni's shop must have been active, although records remain only for six carved coats of arms of the wool guild in 1419: two for S Maria Novella and four for their guildhall. The same year, with Donatello and Brunelleschi, Nanni provided a model for the new dome of Florence Cathedral, a fact that further testifies to the active collaboration between the leading sculptural workshops of the city.

BIBLIOGRAPHY

G. Vasari: *Vite* (1550, rev. 2/1568); ed. G. Milanesi (1878–85), ii, pp. 161–5, 344, 351
H. Semper: *Donatello, seine Zeit und Schule*, Quellenschr. Kstgesch. & Ksttech., ix (Vienna, 1875)
G. Poggi: *Il Duomo di Firenze*, It. Forsch. Kstgesch., ii (Berlin, 1909/R Florence, 1988)
O. Wulff: 'Nanni d'Antonio di Banco und sein Verhältnis zu Donatello', *Kstgesch. Ges.*, v (1909), pp. 27–9
——: 'Giovanni d'Antonio di Banco und die Anfänge der Renaissanceplastik in Florenz', *Jb. Kön.-Preuss. Kstsamml.*, xxxiii (1913), pp. 99–164
G. Brunetti: 'Un'opera sconosciuta di Nanni di Banco e nuovi documenti relativi all'artista', *Riv. A.*, xii (1930), pp. 229–37
J. Lanyi: 'Il Profeta Isaia di Nanni di Banco', *Riv. A.*, xviii (1936), pp. 137–78
——: 'Zur Pragmatik der Florentiner Quattrocentoplastik', *Krit. Ber.*, vi (1937), p. 128
W. R. Valentiner: 'Donatello and Ghiberti', *A. Q.* [Detroit], iii (1940), pp. 182–215
L. Planiscig: 'I profeti sulla Porta della Mandorla del Duomo fiorentino', *Riv. A.*, xxiv (1942), pp. 125–42
——: *Nanni di Banco* (Florence, 1946)
W. R. Valentiner: 'Donatello or Nanni di Banco', *Crit. A.*, xxvii (1949), pp. 25–31
P. Vaccarino: *Nanni* (Florence, 1950)
W. R. Valentiner: 'Notes on the Early Works of Donatello', *A. Q.* [Detroit], xiv (1951), pp. 307–25
M. Wundram: 'Antonio di Banco', *Mitt. Ksthist. Inst. Florenz*, x (1961), pp. 23–32
H. von Einem: 'Bemerkungen zur Bildhauerdarstellung des Nanni di Banco', *Festschrift für Hans Sedlmayr* (Munich, 1962), pp. 68–79
M. Phillips: 'A New Interpretation of the Early Style of Nanni di Banco', *Marsyas*, xi (1962–4), pp. 63–6
H. W. Janson: 'Nanni di Banco's *Assumption of the Virgin* on the Porta della Mandorla', *Studies in Western Art: Acts of the Twentieth Congress of the History of Art: Princeton, 1963*, ii, pp. 98–107; also in H. W. Janson: *Sixteen Studies* (New York, 1973), pp. 91–7
M. Wundram: *Donatello und Nanni di Banco* (Berlin, 1969)
V. Herzner: 'Donatello und Nanni di Banco', *Mitt. Ksthist. Inst. Florenz*, xvii (1973), pp. 1–28
M. Lisner: 'Josua und David—Nannis und Donatellos Statuen für den Tribuna-Zyklus des Florentiner Doms', *Pantheon*, xxxii (1974), pp. 232–43
A. Parronchi: 'L'autore del Crocifisso di Santa Croce: Nanni di Banco', *Prospettiva*, vi (1976), pp. 50–55
J. T. Paoletti: '"Nella mia giovanile età mi partì . . . da Firenze"', *Lorenzo Ghiberti nel suo tempo: Atti del convegno internazionale di studi, Firenze, 1978*, i, pp. 99–110
R. Munman: 'The Evangelists from the Cathedral of Florence: A Renaissance Arrangement Recovered', *A. Bull.*, lxii (1980), pp. 207–17
M. L. Dunkelman: 'Nanni di Banco', *Italian Renaissance Sculpture in the Time of Donatello* (exh. cat., ed. A. Darr and G. Bonsanti; Detroit, MI, Inst. A; Fort Worth, TX, Kimbell A. Mus.; Florence, Forte Belvedere; 1985–6), pp. 83–5 (103–4, It. ed.)
M Bergstein: 'La vita civica di Nanni di Banco', *Riv. A.*, xxxix (1987), pp. 55–82
——: 'The Date of Nanni di Banco's "Quattro santi coronati"', *Burl. Mag.*, cxxx (1988), pp. 910–13
C. King: 'Narrative in the Representation of the Four Crowned Martyrs: Or San Michele and the Doge's Palace', *A. Crist.*, dccxliii (1991), pp. 81–9

JOHN T. PAOLETTI

Nanni [Giovanni] **di Bartolo** [il Rosso] (*fl* 1419–35). Italian sculptor. He was the son of a Fra Bartolo. From 1419 to 1424 he worked on various figures for the façade and campanile of Florence Cathedral. In July 1419, with Pietro Uberti Baldassarre degli Albizzi as his guarantor, he was commissioned to sculpt a figure for the cathedral façade, which was completed in March 1420. Its subject is not stated, but it may perhaps be identified as the *St John the Baptist* (Florence, Mus. Opera Duomo). On 30 April 1420 Nanni was asked to complete a statue of *Joshua* begun by Bernardo Ciuffagni in 1415 for the east side of the campanile. The identity of this figure is uncertain.

It has been suggested that Nanni was trained in the workshop of Niccolò di Pietro Lamberti, who, with Antonio di Banco and his son Nanni, completed the Porta della Mandorla on the north side of Florence Cathedral (1406–9). Brunetti (1934–5) attributed some of the reliefs in the frieze to the left of the door to Nanni, but they have also been attributed to Nanni di Banco or Jacopo della Quercia. The attribution (Brunetti, 1934–5) to Nanni of two small prophets (Florence, Mus. Opera Duomo), originally on pinnacles flanking the door of the campanile, has also been questioned. These figures, with their thickly curled hair and beards, undulating borders to their cloaks, hooked folds in their robes and exaggerated curvature of their posture, resemble the figure style of Ghiberti's contemporary relief panels on the north door of the Baptistery. A group of terracotta sculptures, stylistically dependent on Ghiberti, has also been attributed to Nanni. It includes a standing *Virgin and Child* (ex-Kaiser-Friedrich Mus., Berlin; destr.) and a half-length *Virgin and Child* (Berlin, Skulpgal.) and can probably be dated between 1415 and 1420.

In 1421–2 Nanni collaborated with Donatello on the group of *Abraham and Isaac* (Florence, Mus. Opera Duomo) for the east side of the campanile. Donatello's strong artistic personality inspired a change in Nanni's style, which is visible in his only signed Florentine work, the *Obadiah* (Florence, Mus. Opera Duomo, see fig.), originally on the west side of the campanile. The youthful prophet is well characterized, and his movement graceful and balanced, but the figure lacks Donatello's dramatic power.

Nanni di Bartolo: *Obadiah* (Florence, Museo Opera Duomo)

stucco versions of the *Virgin and Child* (e.g. Florence, Mus. Stibbert), presumably made from the same prototype (see Bellini and Schlegel).

Nanni di Bartolo had left Florence before 11 February 1424 leaving unpaid debts behind him and, according to a document of that date, was engaged on a project in Venice that would take a long time to complete. This project has not been identified, but he may have worked on three gargoyles on the north face of S Marco. The document also says that he was resident in Volterra, but this was probably a mistake on the part of the scribe, for on 14 May 1424 Nanni was present when the Venetian Doge received Rinaldo degli Albizzi, the Florentine ambassador in Venice (Gilbert).

Nanni's only certain work in north Italy is the signed Brenzoni monument (*c.* 1426) in S Fermo, Verona. The harmonious relationship between Nanni's sculpted scene of the *Resurrection of Christ* and Pisanello's fresco of the *Annunciation* above it gives the impression that the two artists formed a well-integrated team (Longhi and Del Bravo). It seems probable that Nanni designed the highly pictorial scene, based on Ghiberti's relief of the same subject on the north doors of the Florentine Baptistery, but left part of the execution to an assistant. Several works in Venice are attributed to Nanni; among the most probable attributions are the four statues on the left of the façade of S Maria dell'Orto and the large group depicting the *Judgement of Solomon* above the capital of Justice on the exterior of the Doge's Palace.

Nanni di Bartolo was in the Veneto again in 1435, as is shown by the inscription over the portal of S Niccolò at Tolentino, in the Marches, erected by him. It seems, however, that his role there was limited to assembling various pieces of statuary, which had been carved by other artists in the Veneto and brought to Tolentino by the brother of the condottiere Niccolò da Tolentino after the latter's death in 1435. The *Virgin and Child* and the two saints in the lunette show the influence of Jacopo della Quercia and have been attributed to Nanni, but they bear no stylistic relationship to his certain works. The relief of the *Baptism* in the lunette above the tomb of the Blessed Pacifico (1437; S Maria dei Frari) has also been attributed to him (see Wolters).

Nanni's date of death is uncertain. A document of 1451 has been used to prove that he was active in Carrara at that date, but Gilbert believed that it provides no evidence to suggest that he was still alive.

BIBLIOGRAPHY

Thieme–Becker
R. Longhi: 'Recensione: Lettera pittorica a Giuseppe Fiocco', *Vita Artistica*, i (1926), pp. 127–39
F. Schottmüller: 'Nanni di Bartolo, il Rosso', *Miscellanea di storia dell'arte in onore di Igino Benvenuto Supino* (Florence, 1933), pp. 295–304
G. Brunetti: 'Ricerche su Nanni di Bartolo "il Rosso"', *Boll. A.*, xxviii (1934–5), pp. 258–72
J. Lányi: 'Le statue quattrocentesche dei profeti nel campanile e nell'antica facciata di Santa Maria del Fiore', *Riv. A.*, xvii (1935), pp. 120–59, 245–80
M. Wundram: 'Donatello und Ciuffagni', *Z. Kstgesch.*, xxii (1959), pp. 85–101
C. Del Bravo: 'Proposte e appunti per Nanni di Bartolo', *Paragone*, xii/137 (1961), pp. 26–32
R. Stang and N. Stang: 'Donatello il Giosuè', *Acta Archaeol. & A. Hist. Pertinentia*, i (1962), pp. 113–30

Another group of terracotta and stucco figures attributed to Nanni combines features taken from Ghiberti with the rhythmic quality of Donatello's early works. This includes the *Virgin and Child* (Florence, Mus. Ognissanti), originally in S Miniato, Florence, the beautiful *Virgin and Child Enthroned* (Krefeld, Kaiser Wilhelm Mus.) and five

L. Becherucci and G. Brunetti: *Il Museo dell'Opera del Duomo a Firenze*, i (Milan, 1970), pp. 258–60, 264–7

R. Chiarelli: 'Note pisanelliane', *Ant. Viva*, ii (1972), pp. 3–25

C. Gilbert: 'La presenza a Venezia di Nanni di Bartolo il Rosso', *Studi di storia dell'arte in onore di Antonio Morassi* (Venice, 1972), pp. 35–9

F. Bellini: 'Da Federighi a Nanni di Bartolo? Riesame di un gruppo di terracotte fiorentine', *Jacopo della Quercia fra gotico e rinascimento. Atti del convegno di studi: Siena, 1975*, pp. 180–88

G. Brunetti: 'Sull'attività di Nanni di Bartolo nell'Italia settentrionale', *Jacopo della Quercia fra gotico e rinascimento. Atti del convegno di studi: Siena, 1975*, pp. 189–200

W. Wolters: *La scultura veneziana gotica, 1300–1460* (Venice, 1976), pp. 90–93, 267–71

U. Schlegel: 'Dalla cerchia del Ghiberti: Rappresentazione della Madonna di Nanni di Bartolo', *Ant. Viva*, xviii/1 (1979), pp. 21–6

G. C. Gentilini: 'Nella rinascita delle antichità', *La civiltà del cotto* (exh. cat., Impruneta, 1980), pp. 93–4

E. Neri Lusanna and L. Faedo: *Il Museo Bardini a Firenze: Le sculture* (Milan, 1986), pp. 247–8

L. Bellosi: 'Da una costola di Donatello: Nanni di Bartolo', *Prospettiva* [Florence], 53–6 (1988–9), pp. 22–13

F. Landi: 'Per Nanni di Bartolo, il Rosso', *Ant. Viva*, xxxi/2 (1992), pp. 27–31

FRANCESCA PETRUCCI

Nanni di Pietro. *See* GIOVANNI DI PIETRO (ii).

Nanto, Francesco de [da] (*fl c.* 1520–32). Italian woodcutter. He was active in the Venice area, but his origins in the Savoy are indicated by the signature FRANCISCVS/DE NANTO/DE SABAVDIA on the print of the *Healing of the Gouty Man* (London, BM). Stylistic comparisons suggest a date between 1520 and 1525 for a series of 13 woodcuts of scenes from the *Life of Christ* (London, BM), taken from designs by Girolamo da Treviso the younger. A few other prints by him are known, after works by Amico Aspertini and Francesco Francia. The frame decorated with grotesques and allegorical motifs, signed DE NANTO, in the edition of Ludovico Ariosto's *Orlando furioso* published in Ferrara in 1532 by Francesco Rosso da Valenza indicates his activity in book production. This frame is used for the title-page and again for the portrait of *Ariosto*, reputedly based on a design by Titian. The portrait itself was once considered to be the work of de Nanto, but it does not show the traces of wormholes that are apparent in the frame, which has led to the suggestion (see exh. cat.) that it may have been cut after the frame. The elegant and refined technique of the portrait also contrasts strongly with de Nanto's sometimes harsh and irregular manner.

BIBLIOGRAPHY

F. Zava Boccazzi: 'Tracce per Girolamo da Treviso il Giovane in alcune xilografie di Francesco de Nanto', *A. Ven.*, xii (1958), pp. 70–78

N. Nanni: 'Uno xilografo italiano del cinquecento: Francesco da Nanto', *Rass. Graf.*, 118 (1963), pp. 24ff

Tiziano e la silografia veneziana del cinquecento (exh. cat. by M. Muraro and D. Rosand, Venice, Fond. Cini; Washington, DC, N.G.A.; 1976–7), pp. 84, 109, 117

FELICIANO BENVENUTI

Naples [Napoli]. Italian city. The largest and most important city in South Italy, Naples is situated on the Bay of Naples, overlooking the Tyrrhenian Sea, to the west of Mt Vesuvius. It had a varied and lively history before the Renaissance period, starting as a Greek colony and being ruled by the Romans, the Norman kings of Sicily, the Ghibelline house of Hohenstaufen and the Angevins.

BIBLIOGRAPHY

B. Capasso *Napoli greco-romano* (Naples, 1905)

G. Galasso *Mezzogiorno medievale e moderno* (Torino, 1965)

G. Doria *Storia di una capitale. Napoli dalle origine al 1860* (Naples, 1968)

C. De Seta *Storia della città di Napoli. Dalle origini al Settecento* (Rome, 1973)

V. Gleijeses *La storia di Napoli: dalle origini ai nostri giorni* (Naples, 1974)

Storia di Napoli 10 vols.; Società editrice storia di Napoli (Naples, 1975–81)

A. Ryder *The Kingdom of Naples under Alfonso the Magnanimous: The Making of a Modern State* (Oxford, 1976)

A. Cruciani, ed. *Napoli e il golfo tra vestigia e storia* (Naples, 1977)

V. Gleijeses *La Guida storica, artistica, monumentale, turistica della città di Napoli e dei suoi dintorni* (Naples, 1979)

C. De Seta *Napoli. La Città nella storia d'Italia* (Rome, 1981)

V. Gleijeses *La storia di Napoli* (Naples, 1981)

□

1. History and urban development. 2. Art life and organization. 3. Castelnuovo.

1. HISTORY AND URBAN DEVELOPMENT.

(i) Introduction. Naples began as a Greek settlement. When the Greek colony of Cumae reached its optimum size in the mid-6th century BC, the residents established a new settlement to the south. This settlement on the Bay of Naples was known either as Parthenope in honour of the siren or as Palaiopolis (Gr.: 'the old city'). When more immigrants arrived in the mid-5th century BC, they established Neapolis ('the new city') to the north-east; Palaiopolis became a mere suburb. With an excellent harbour, Neapolis assumed a leading role among the colonies of South Italy. The Greek town covered approximately 60 ha and had a population of *c.* 30,000. In 326 BC the Romans occupied Palaiopolis; Neapolis surrendered without resistance and became a favoured ally of Rome, though Hellenic influence remained strong. Wealthy citizens from Rome spent winters in the pleasant environment of Naples. The surrounding areas boasts hundreds of villas, including that of L. Licinius Lucullus with its famous fishponds in the area of Palaiopolis. In AD 79 the eruption of Vesuvius damaged the town. Soon after, Rome settled a contingent of veterans on the site and awarded Neapolis the title and benefits of a Roman colony. The Imperial city spread over 100 ha with a population of *c.* 35,000. During the late Empire repeated barbarian onslaughts compelled the residents to strengthen the city walls. In AD 552 Neapolis came under Byzantine suzerainty.

Naples was the seat of a Byzantine duchy from 554 to 1139. During the 10th century sizeable population growth, arising from peace with the Lombards and the Arabs, led to a revival of trade and manufacturing. This resulted in the construction of appropriate new defence structures, the modernization of port facilities and the emergence of small, built-up urban nuclei. From the 10th to the 12th century the ducal city had a high concentration of urban churches and monasteries, which regulated the activity of farmers in the surrounding countryside.

The extraordinary development of Naples in the Angevin period (1266–1442) continued some of the initiatives made by the Norman Hauteville dynasty and the Swabian kings (1139–94 and 1194–1266 respectively), which were dictated by strategic necessities, but which nevertheless opened the city to its hinterland and created a new upsurge of building development out towards the plain. After the

conquest of the Duchy of Naples by King Roger II of Sicily in 1139, one of the first Norman works undertaken was the Castel Capuano (c. 1165), built by William I (reg 1154–66) to replace a Byzantine fort on the edge of the plain to the west of the city. It was completed by Emperor Frederick II (reg 1194–1250), and since 1540 it has been the Court of Justice. The other was the occupation of the islet of Salvatore, previously inhabited by a monastic community, which was transferred to Naples to allow the construction of Castel dell'Ovo, a fortified stronghold built on the foundations of the Roman villa of L. Licinius Lucullus, where the court was installed before it moved to the royal residence of Castel Capuano. With these fortresses, the Normans established two points of surveillance, one facing the hinterland and the other looking out to sea, working together in a defensive system based on strongpoints around the city at Pozzuoli, Aversa, Acerra and Afragola. Due to tensions between Norman and Swabian dynasties and the papacy, little religious architecture was built in Naples in the 12th and 13th centuries. Under the Hohenstaufen emperor Frederick II (reg 1212–50), Naples regained its position as a major city. He founded the University of Naples in 1224, which helped to reconfirm the city's cultural status.

With the succession of the Angevins in 1266, Naples was the capital of a great kingdom, and there are records of a further increase in the population: in 1278 there were nearly 30,000 inhabitants. Under Charles I (reg 1266–85) Castel Capuano was restored, and the southern stretch of city walls was enlarged, while Castel dell'Ovo was transformed into a public building and became the seat of the Treasury. Between 1279 and 1283 construction work began on a new royal palace: Castelnuovo (see fig. 1 and §3 below). The strong tie between the Angevins and the papacy paved the way for a religious revival. The old city centre increasingly assumed the character of a religious, conventual area, while the commercial and governmental district moved to the surroundings of Castelnuovo. Under kings Charles II (reg 1285–1304) and Robert (reg 1309–43) the enlargement of the western walls continued, as did a vast programme of public works: streets, manufacturing businesses, harbour works (from 1302), a market-place and exchanges. During the 14th century a number of important Gothic churches were started. A seaquake in 1343 did not damage the city, but it necessitated repairs

to the harbour structures, which were carried out in 1347. Between 1348 and 1411 repeated plague epidemics led to a decline in public investment in urban planning and development. Furthermore, Naples and its strongholds suffered immense damage in the course of dynastic struggles between the Angevins and Aragonese, resulting in a lengthy siege that ended in 1442 with the city's capitulation to the Aragon king Alfonso I (reg 1435–58).

BIBLIOGRAPHY

G. M. Fusco: *Riflessioni sulla topografia della città di Napoli nel medio evo* (Naples, 1865)
B. Capasso: *Topografia della città di Napoli nell'XI secolo* (Naples, 1895)
M. Schipa: *Storia del ducato napolitano* (Naples, 1895)
M. Napoli: *Napoli greco-romana* (Naples, 1959)
A. G. McKay: *Naples and Campania* (Exeter, NH, 1962)
G. Russo: *Napoli come città* (Naples, 1966)
J. D'Arms: *Romans on the Bay of Naples* (Cambridge, MA, 1970)
C. De Seta: *Storia della città di Napoli* (Rome and Bari, 1973)
S. De Caro and A. Greco: *Campania*, Guide archeologiche Laterza (Bari, 1981)
L. Santoro: *Le mura di Napoli* (Rome, 1984)

DIANE FAVRO, ROBERTO CORONEO

(ii) 1443 and after. Naples recovered quickly from the siege of 1442 to become the principal Aragonese military and commercial power in the Mediterranean. Between 1443 and 1458 Alfonso I rebuilt Castelnuovo to repair damage and to meet new military requirements, thus creating the actual and symbolic highpoint of Renaissance Naples. An earthquake in 1450 devastated the old centre of the city, but the reconstruction of the harbour areas and the restoration of the Castel dell'Ovo were complete by the time of Alfonso's death in 1458. Naples was already substantially the city that in 1464 was to be depicted in the Tavola Strozzi (see fig. 1).

Alfonso's successor King Ferdinand I (reg 1458–94) and his son Alfonso, Duke of Calabria (later King Alfonso II), further strengthened the city's defences with a modern system of wall construction. Under Alfonso's supervision, two major extensions were effected. In the first (1484) the whole eastern range was moved forwards from the Castello del Carmine (formerly Forte dello Sperona) to Porta S Gennaro, involving the construction of 22 round towers. Alfonso also commissioned the court architect, Giuliano da Maiano, to construct a large triumphal arch (1484; see fig. 2) for the Porta Capuana. The second extension (1499–1501) ran from the Porta Reale (now Piazza del Gesù)

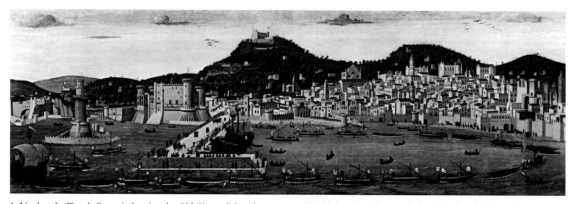

1. Naples, the Tavola Strozzi, showing the Old City and Castelnuovo, panel, 1464 (Naples, Museo e Gallerie Nazionali di Capodimonte)

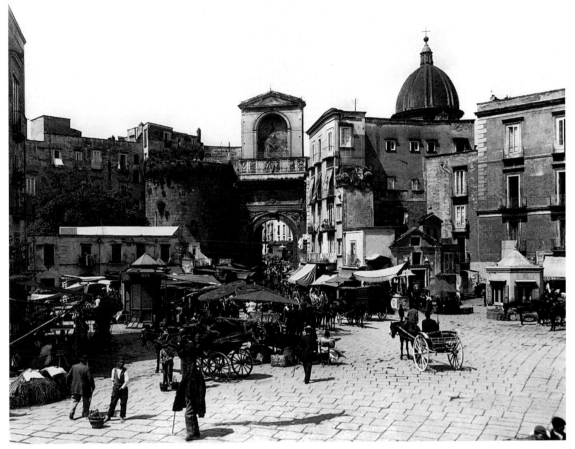

2. Naples, Porta Capuana, by Giuliano da Maiano, 1484; from a 19th-century photograph

part of the way down the present Via Toledo and ended at Castelnuovo. Areas of the Greco-Roman city were also redeveloped, and restorations were made to the fabric of the city that had been damaged during the Angevin–Durazzo wars, filling the old centre with magnificent residences in a Catalan Durazzo-Renaissance style (e.g. Palazzo Carafa Santangelo, 1466; the portal of Palazzo Bonifacio at Porta Nuova, early 15th century; rusticated façade of Palazzo Sanseverino, begun 1470, remodelled 1584–1601, now the Gesù Nuovo).

Many Neapolitan buildings from the late 15th century demonstrate an influx of Tuscan influences, due mainly to the intensification of political and cultural ties between the Kingdom of Naples and Florence. Tuscan styles later permeated the city's whole artistic output of the early 16th century, even after the Kingdom of Naples passed under Spanish imperial dominion (1504). This can be seen in the Palazzo Cuomo (begun 1466), designed probably by Giuliano da Maiano on Florentine lines; again at Palazzo Orsini di Gravina (begun 1513) by Neapolitan craftsmen; and even at the Pontano chapel (1492), or the cathedral crypt (1497–1506) by Tommaso Malvito. Alfonso built a number of royal villas on the outskirts of Naples, including one at Poggio Reale (from 1487; destr. late 18th century) to designs by Giuliano da Maiano, and La Duchesca (destr. ?16th century), which was a *casino* built in the gardens of the Castel Capuano.

The arrival of the Spaniards in Naples brought the greatest expansion of the urban fabric. They governed under a system of viceroys. The Viceroy Don Pedro Alvarez de Toledo, Marqués de Villafranca (*reg* 1532–53), created a new road, the Via Toledo, which connected the area of Porta Reale (now Piazza Dante) and the open space around Castelnuovo. He also planned the layout of the Spanish Quarter, where troops and administrative personnel were accommodated. Thus the directional centre of the city was created, between the Collina di Pizzofalcone, the later Palazzo Reale, Castelnuovo and the Aragonese port, all of which were defended by the new star-shaped ramparts of the fortress of Sant'Elmo (1537–46). Under Don Pedro, Naples became the western fulcrum of the Mediterranean military politics of imperial Spain, and it was transformed into a great administrative capital, characterized by high urban density due to the influx of immigrants from the provinces.

The ever increasing presence of the religious orders in the social life of the metropolis led to the expansion or foundation of dozens of monastic complexes, mostly situated near the Greco-Roman *polis*. It was during this time that such complexes as S Gregorio Armeno, S Maria di Montevergine, S Caterina at Formiello and many others were enlarged. At the same time the Neapolitan aristocracy were producing buildings that were manifestly influenced

by Tuscan styles (e.g. Palazzo Marigliano, *c.* 1512; Palazzo del Panormita, late 16th century).

BIBLIOGRAPHY

N. Cortese: *Cultura e politica a Napoli dal cinquecento al settecento* (Naples, 1965)

G. L. Hersey: *Alfonso II and the Artistic Renewal of Naples, 1485–95* (New Haven and London, 1969)

A. Ryder: *The Kingdom of Naples under Alfonso the Magnificent* (Oxford, 1976)

RICCARDO LATTUADA

2. ART LIFE AND ORGANIZATION. The ascension of Alfonso V of Aragon as King Alfonso I of Naples ushered in a new period of Neapolitan artistic life. The Renaissance in Naples tied the city even more closely to Italian and Mediterranean currents and turned its back on the French and Gothic influences of its deposed Angevin rulers. These tendencies also coincided with the growing role of the Neapolitan nobility—native, North Italian and Iberian—in patronage within the city. Perhaps the best-known monument of the age was the Castelnuovo, rebuilt from 1443 as both palace and fortress to reflect Alfonso's new rule (see fig. 3 and *see* §3 below). The renovation (1454–67) was completed by the Triumphal Arch commemorating Alfonso's entry into the city in 1443. Framing the castle's main gate, the arch was the work of Francesco Laurana, Domenico Gagini and others. Royal patronage also rebuilt the city, expanding ports, walls, streets and fountains in keeping with Renaissance urban theory and Naples' growing role as the centre of a Mediterranean empire. The famed cityscape of the Tavola Strozzi (see fig. 1 above) accurately reflects the beauty and importance of the city in the late 15th century.

The general shift within Naples towards Renaissance forms can be seen in a variety of that includes the courtyard of the Palazzo di Diomede Carafa's transition from Late Gothic to Renaissance and the Tuscan classicism of Giuliano da Maiano's designs for the new Porta Capuana (1490) and the palace at Poggio Reale (1487–90; destr.). While most of Naples' churches have undergone Baroque and Rococo interventions since the 17th century, the city retains several notable examples of the Renaissance style, especially the work done in the last quarter of the 15th century in S Anna dei Lombardi (from 1411; now Monteoliveto). Here the Terranova, Piccolomini and Tolosa chapels reflect the crisp classicism of Tuscan architecture and funerary sculpture and, in turn, demonstrate the patronage of native, North Italian and Spanish nobility. In fact, Antonio Rossellino's altarpiece of the *Nativity* (1475; see fig. 4) in the Piccolomini Chapel was actually carved in Florence and shipped to Naples. The nobility's desire for the new Renaissance style also found expression in such palaces as the Panormita, Gravina, Penna, Cuomo and Sanseverino.

With the transfer of the remains of S Gennaro to the cathedral in 1497, a new chapel to house the relics was commissioned. The Succorpo was completed in 1506 after a design by Tommaso Malvito of Como. The chapel, its attendant sculpture and its wall decoration mark a high-point of Renaissance style in Naples. In painting the city also saw a shift from the Late Gothic and Flemish work of the Neapolitan Niccolò Colantonio (*c.* 1352–1442) to that of Antonio Solario and his student Andrea da Salerno

3. Naples, Castelnuovo, detail of the marble reliefs (*c.* 1465) on the triumphal arch of Alfonso I, *c.* 1452–71

4. Naples, church of Monteoliveto, Piccolomini Chapel, carved altarpiece of the *Nativity* (1475), by Antonio Rossellino

(*c.* 1490–1530) in the Venetian style, seen in such works as Solario's cycle of 20 scenes from the *Life of St Benedict* (*c.* 1515; now in Naples, Archv Stato) in the cloister of SS Severino e Sosio (now the State Archives).

Aragonese rule in Naples ended with the Spanish conquest in 1506. Under the first viceroys, especially Consalvo de Cordoba (1502–6) and Pedro de Toledo (1532–53), the city's ports, walls and infrastructure were greatly expanded and modernized to fit its new status as a southern capital of the Habsburg empire. Throughout the 16th century one development that went hand-in-hand with new imperial patronage and the Late Renaissance style was the emergence of southern Italian and native Neapolitan artists who worked for both foreign masters and the native nobility. This coincided with the patronage of such new and reformed religious orders as the Theatines, Oratorian Fathers and Jesuits, as the Catholic Reformation sought to match the austerity of Protestant reform with a new sensuality of colour, material and form that well fitted the sensibilities of the south.

Examples of the collaboration between northerners and regional artists include Malvito's designs and Giovanni Marigliano da Nola's sculpture (1517) in the Caracciolo Chapel (S Giovanni a Carbonara). The sculpture of such Spanish artists as Bartolomé Ordoñez (*d* 1520), who carved the marble altarpiece in the Caracciolo Chapel, helped to create a Neapolitan art that mirrored the cosmopolitan nature of its political rule and patronage. Yet this very hybridization of artistic currents led to something of a decline in Neapolitan arts at the end of the 16th century as reform turned into the formulae of Mannerism and orthodoxy into a reliance on often archaizing trends. The arrival in Naples of the sculptor Pietro Bernini (1598–1680) *c.* 1584, the painter Caravaggio (1571–1610) in 1606 and the architect Cosimo Fanzago (1591–1678) in 1608 coincided with Domenico Fontana's completion of the massive Palazzo Reale in 1602. These all served to consolidate the end of the Renaissance impulse and to give fresh impetus to the Baroque.

BIBLIOGRAPHY

R. Pane: *Architettura dell'età barocca in Napoli* (Naples, 1939)
P. Causa: *Pittura napoletana dal XV al XIX secolo* (Bergamo, 1957)
N. Cortese: *Cultura e politica a Napoli del cinque al settecento* (Naples, 1965)
G. L. H. Hersey: *Renewal of Naples, 1485–1495* (New Haven and London, 1969)
A. Blunt: *Neapolitan and Baroque Architecture* (London, 1975)
G. d'Agostino: *La capitale ambigua: Napoli dal 1458 al 1580* (Naples, 1979)
G. Labrot *Baroni in città. Residenza e comportamenti dell'aristocrazia napoletana, 1570–1734* (Naples, 1979)
Civiltà del Seicento a Napoli (Naples, 1984)
Ricerche sul '600 Napoletano: dedicato a Ulisse Prota-Giurleo nel centenario nascita (Milan, 1986)
S. Cassani, D, Campanelli and F. Chiuazzi, eds *Napoli Città d'arte* (Naples, 1986)
G. Cautela, ed. *Napoli sacra: Realta e proposte per il centro storico* (Naples, 1986)
J. H. Bentley: *Politics and Culture in Renaissance Naples* (Princeton, NJ, 1987)
A. Ryder: *Alfonso the Magnanimous, King of Aragon, Naples and Sicily, 1396–1458* (Oxford and New York, 1990)

RONALD G. MUSTO

3. CASTELNUOVO. The fortified residence was built in 1281 by the architects Pierre de Chaule and Pierre d'Agincourt for Charles I of Anjou (*reg* 1266–85), who elevated Naples to the status of capital of the Kingdom of Sicily and Naples. The site combined proximity to the city with direct access to the sea. The original structure must have resembled contemporary French castles in Provence, which were characterized by extremely high towers and walls crowned with crenellations, embrasures, a moat and all the other defensive devices of the period. Total remodelling during the 15th century retained only the basic square plan around a large central courtyard; the chapel of St Barbara, or Palatine Chapel, is the only surviving part of the original castle. Constructed in the Gothic style under the supervision of Giovanni Caracciolo (1578–1635) and Gualtiero Seripando (1493–1563), it was decorated throughout with frescoes by Giotto and Maso di Banco (*fl* 1335–50), but this work had already been destroyed by the mid-15th century. Only the medallions of *Angels* and *Saints* remain in the splayed jambs of the high, single-light windows.

Castelnuovo was inhabited by the Angevins until 1382, when Charles III di Durazzo took it as Pretender to the succession of Joanna. Two low-arched gateways constructed in peperino stone remain from the Durazzo era. The castle was the stage for various dynastic struggles that endured until 1442, when Alfonso V of Aragon (later Alfonso I, King of Naples and Sicily) conquered Naples. From 1443 he began the demolition of a large part of Castelnuovo (already seriously damaged during the hostilities) in order to rebuild it on a trapezoidal plan within the same area encircled by the moats. Another motive for the reconstruction was the evolution of warfare: the use of bombards and subsequently of gunpowder necessitated low and bulky towers able to resist the grazing fire of the cannonballs.

At first the work did not follow a unified plan, and it was only with the arrival of Guillem Sagrera in 1447 and his introduction of military engineering technology based on the practice of Catalan fortification specialists in Mallorca (derived ultimately from Burgundy) that a radical transformation of the castle was carried out to a predetermined plan. Sagrera devised the system of five massive round towers, their bases decorated with scale-like tiles and concave spiral grooves, to prevent scaling-ladders from being placed against the walls and to present a fearsome appearance. His finest achievement at Castelnuovo is the Great Hall, or Barons' Hall, a superb room on a square plan, covered by an octagonal stellar vault with ribbing that dies into the wall without the intervention of corbels. In the place of a keystone, an oculus admits the light in an analogy of the domes of the Roman baths at Baia and Tripergola in the nearby Phlegrean Fields.

The triumphal arch (*c.* 1452–71; see fig. 5), built in marble to celebrate and immortalize Alfonso's triumphal entry into Naples (26 Feb 1443), is both the frontispiece and the entrance to the castle. Squeezed in between the two towers faced in peperino on the western wall looking towards Naples, the monument comprises four superimposed zones, including two distinct arches, which belong to separate periods. The first zone consists of a triumphal arch resting on paired Corinthian columns and decorated in the pendentives by two rampant griffins bearing the Aragon royal coat of arms over the centre of the arch. In

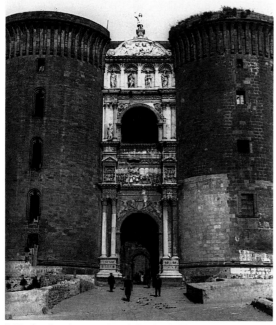

5. Naples, Castelnuovo, triumphal arch of Alfonso I, c. 1452–71

also added, including an arsenal, a foundry and an armoury.

BIBLIOGRAPHY

G. Ceci: *Bibliografia per la storia delle arti figurative nell'Italia meridionale* (Bari, 1911, 2/1937) [with complete bibliog. to date]
R. Filangieri: 'La città della aragonese e il recinto bastionato di Castelnuovo', *Atti Accad. Pontaniana*, n. s. 1, xxxiv (1929), pp. 49–73
——: *Castelnuovo: Reggia angioina ed aragonese di Napoli* (Naples, 1934)
——: 'Rassegna critica delle fonti per la storia di Castelnuovo', *Archv Stor. Prov. Napolet.*, lxi (1936), pp. 251–3; lxii (1937), pp. 267–333; lxiii (1938), pp. 258–342
G. Rosi: 'Il restauro del Castelnuovo a Napoli', *Arti: Rass. Bimest. A. Ant. & Mod.*, iv (1942), pp. 284–7
F. Bologna: *I pittori alla corte angioina di Napoli* (Rome, 1969)
G. Alomar: *Guillem Sagrera y la arquitectura gotica de siglo XV* (Barcelona, 1970)
R. Causa: 'Sagrera, Fouquet, Laurana e l'arco di Castelnuovo', *Atti del IX congresso di storia della corona d'Aragona: Napoli, 1973*
G. L. Hersey: *The Aragonese Arch at Naples, 1443–1475* (New Haven, 1973) [with comprehensive bibliog. and doc.]
H. W. Kruft and M. Malmanger: *Der Triumphbogen Alfonsos in Neapel, Acta Archaeol. & A. Hist. Pertinentia*, vi (Rome, 1976), pp. 213–88
F. Bologna: *Napoli e le Rotte Mediterranee della pittura da Alfonso il Magnanimo a Ferdinando il Cattolico* (Naples, 1977)
L. Santoro: *Castelli angioini e aragonesi* (Milan, 1982)
G. Cassese: 'Il dibattito storico-critico sull'arco di Alfonso d'Aragona: Problemi generali e questioni di metodo', *Quad. Ist. N. Stud. Rinascimento Merid.*, ii (1985), pp. 7–44
A. Alabiso and others: *L'arco di trionfo di Alfonso d'Aragona e il suo restauro* (Rome, 1987)

GIOVANNA CASSESE

the second zone a frieze in high relief depicts the *Triumph of King Alfonso*. The third zone is composed of another open arch flanked by paired columns with *Winged Victories* in the pendentives. Four shell niches, separated by plaster strips and containing statues of the *Cardinal Virtues*, make up the fourth zone. The arch culminates in a curved pediment with two allegorical figures of *Rivers* and, at the very top, a statue of *St Michael*. From the vestibule, the entrance arch opens into the castle, and above this is a high relief of the *Coronation of Ferrante*. The sculpture of the triumphal arch was executed by at least nine different artists, including Domenico Gagini, Isaia da Pisa and Paolo Romano, and their numerous assistants. The design of the arch itself has been attributed to Pietro di Martino da Milano, who was also responsible for several of the reliefs. Inspired by Classical models such as the Arch of Trajan at Benevento and the Arch of the Sergi at Pola, and by medieval examples such as the Gate of Frederick II at Capua, the arch at Castelnuovo is a complex work of architecture and sculpture that represents an extremely rich interweaving of Late Gothic and humanistic cultures.

From 1453 Castelnuovo was protected by a low solid barbican, an enclosure of crenellated walls with towers, but in 1494 Francesco di Giorgio Martini, and subsequently his pupil Antonio Marchesi da Settignano (1451–1522), redesigned the outer defences of the castle by constructing a proper fortified enclosure, which was to render the castle impregnable (destr.). After the Kingdom of Naples became a province of the Spanish empire in 1503, Castelnuovo served as the temporary seat of the viceroys, who continued work on the fortifications until 1537. From the late 16th century it was used as a military store and as a barracks. In successive centuries further work was carried out to rebuild and repair the defensive walls and the castle itself, and many new buildings were

Napoli, Giovanni da. *See* MARIGLIANO, GIOVANNI.

Nardo, Mariotto di. *See* MARIOTTO DI NARDO.

Nebbia, Cesare (*b* Orvieto, *c.* 1536; *d* Orvieto, 1614). Italian painter and draughtsman. He was a pupil of GIROLAMO MUZIANO and much influenced by Federico Zuccaro, and Vasari cited him as a promising painter. Between 1562 and 1575 Nebbia was continuously employed in Orvieto, producing altarpieces and frescoes in the cathedral, for example the *Marriage at Cana* (1569), the *Crucifixion* (1574) and the *Crowning with Thorns* (1575; all Orvieto, Mus. Opera Duomo). In Rome, where from 1579 his name appeared in the register of the Accademia di S Luca, he executed an *Ecce homo* and another *Crowning with Thorns* (1576; oratory of the Gonfalone), a *Noli me tangere* (1579; S Maria degli Angeli), decorations in the Sforza Chapel, S Maria Maggiore (1582), *Heraclius Taking the Cross* (1582–4; Santissimo Crocifisso), the *Martyrdom of St Lawrence* (1589; S Susanna) and decorations in the Borghese Chapel, Trinità dei Monti (*c.* 1590). Under Pope Sixtus V he was responsible, with Giovanni Guerra, for the decorations in the Sistine Library, and he also worked on the Scala Santa, in the Vatican Palace and in the Lateran Palace. In 1597 he was principal of the Accademia di S Luca. Two years later he received payment for the cartoons of *St Matthew* and *St Mark* for the mosaics in the cupola of St Peter's. The following year he painted the *Dream of Constantine* (S Giovanni in Laterano). In 1603–4 he decorated, with Zuccaro, the hall in the Collegio Borromeo, Pavia. He retired to Orvieto in 1609. His works are executed in pale colours, and the Mannerist compositions, complex, but unoriginal and filled with stiff, heavy draperies, show the influence of Muziano and Zuccaro, the former at the beginning and again towards the end of his

career. A prolific artist, Nebbia was a typical interpreter of the age of the Counter-Reformation in Rome.

BIBLIOGRAPHY

Thieme–Becker

G. Baglione: *Le vite de' pittori, scultori et architetti* (1642); ed. V. Mariani (1925), pp. 116–17

U. Procacci: 'Una *Vita* inedita del Muziano', *A. Ven.*, viii (1954), pp. 249–64

A. Peroni: 'Il Collegio Borromeo: Architettura e decorazione', *I quattro secoli del Collegio Borromeo di Pavia* (Pavia, 1961)

J. Hess: 'Some Notes on Paintings in the Vatican Library', *Kunstgeschichtliche Studien zu Renaissance und Barock* (1967), pp. 163–79

R. E. Mack: 'Girolamo Muziano and Cesare Nebbia at Orvieto', *A. Bull.*, lvi/3 (1974), pp. 410–13

A. Satolli: 'La pittura dell'eccellenza: Prolegomeni ad uno studio su Cesare Nebbia nel suo tempo', *Boll. Ist. Stor. A. Orviet.*, xxxvi (1980) [1987], pp. 17–222

M. C. Abromson: *Painting in Rome during the Papacy of Clement VIII (1592–1605): A Documented Study* (New York, 1981)

Oltre Raffaello: Aspetti della cultura figurativa del '500 romano (exh. cat., ed. L. Cassanelli and S. Rossi; Rome, Villa Giulia; and elsewhere; 1984), pp. 162–4 [entries by A. Vannugli]

A. Zuccari: *I pittori di Sisto V* (Rome, 1992)

Roma di Sisto V (exh. cat., ed. M. L. Madonna; Rome, Pal. Venezia, 1993) [exh. pamphlet & subsequent book]

R. Eitel Porter and A. Satolli: 'Cesare Nebbia's Work for the Palazzo Simoncelli: Drawings and Frescoes', *Burl. Mag.*, cxxxvi (1994), pp. 433–8

C. Mandel: *Sixtus V and the Lateran Palace* (Rome, 1994)

R. Eitel Porter: 'Cesare Nebbia at the Vatican, the "Sale dei Foconi"', *Apollo* (1995), pp. 19–24 [bibliog.]

L. Gambi, M. Milanesi and A. Pinelli: *La Galleria delle Corte Geografiche in Vaticano: Storia e iconografia* (Modena, 1996)

R. Eitel Porter: 'Artistic Co-operation in Late Sixteenth-century Rome: The Sistine Chapel in S Maria Maggiore and the Scale Santa', *Burl. Mag.*, cxxxix (1997), pp. 452–62

R. Eitel Porter: *Das graphische Oeuvre des Cesare Nebbia* (diss., U. Vienna, in preparation)

ANTONIO VANNUGLI

Nebridio da Cremona, Frate (*fl* 1463; *d* before 1503). Italian illuminator and painter. In 1463 he wrote to the Duke of Milan's agent in Cremona requesting consideration for a commission to paint an altarpiece for a memorial altar erected in S Agostino, Cremona; this would suggest that he was a painter as well as an illuminator. In 1503, in a payment made to his nephew Marchino for the illumination of a Gradual, Nebridio is referred to as deceased. Two signed illuminations survive: a cutting in Bologna with a representation of *St Augustine* (Bologna, Mus. Civ., Palagi, no. 130) and another showing the *Resurrection* (Cambridge, MA, Fogg, MS. 1916.28). On the Bolognese cutting, Nebridio identifies himself on a scroll as a 'son of the saint', that is, an Augustinian. His style displays a density of decoration characterized by courtliness and elegance and shows the survival of Late Gothic influences in Cremonese art. Levi d'Ancona detected a reflection of the style of Bonifacio Bembo and of the later work of Belbello da Pavia in Nebridio's illuminations and suggested a Venetian connection between Nebridio and Belbello, an idea that was rejected by Bandera. A number of works have been attributed to Nebridio, including a Breviary dated 1467 (Rome, Bib. Casanatense, B.VI.5, MS. 1182), another in Oxford (Oxford, Bodleian Lib., MS. Can. Lit. 368), an Antiphonal completed before 1480 (Cremona, Mus. Civ. Ponzone, Cod. IX) and the Mainardi Missal, illuminated after 1491 (Cremona, Bib. Stat. & Lib. Civ., MS. 188).

BIBLIOGRAPHY

M. Levi d'Ancona: 'Frate Nebridio: Il maestro del messale Mainardi', *A. Lombarda*, vii/2 (1963), pp. 87–92

S. Bandera: 'Persistenze tardogotiche a Cremona: Frate Nebridio e altri episodi', *Paragone*, 323 (1977), pp. 34–72

CHARLES M. ROSENBERG

Negretti. *See* PALMA.

Negroponte, Antonio da. *See* FALIER, ANTONIO.

Nelli (di Nello), Ottaviano (di Martino) (*b* Gubbio, *c.* 1370; *d* Gubbio, ?1444). Italian painter. His brother Tommaso and his father, Martino Nelli (or Melli), are both documented as painters. His grandfather Mello di Gubbio is undocumented but signed the *Virgin and Child in Glory* (Gubbio, Mus. Duomo), a panel previously attributed to Guiduccio Palmerucci (*fl* 1315–49). In 1403 Nelli signed a polyptych of the *Virgin and Child with Saints* (ex-S Agostino, Pietralunga; Perugia, G.N. Umbria), a work that shows the influence both of local stylistic traditions (Matteo di Ser Cambio) and of Orvietan painting (Cola Petruccioli). Later, Nelli was influenced by Sienese and Bolognese painters and, more importantly, by Lombard and Burgundian styles. He interpreted the decorative, Late Gothic style in a humorous and homely way, showing lively narrative treatment. His rustic figures are painted in bright colours but also have a certain elegance of line. These characteristics are evident in the fresco cycle of the *Life of the Virgin* (1410–20; Gubbio, S Francesco). He also painted a polyptych (dispersed) of a later date, probably for the same church. This once comprised the *Adoration of the Magi* (Worcester, MA, A. Mus.), *St Jerome* (Avignon, Mus. Petit Pal.), the *Circumcision* and the *Mystic Marriage of St Francis* (both Rome, Pin. Vaticana). As well as the important fresco cycle of the *Life of the Virgin*, dated 1424 and influenced by Gentile de Fabriano, in the chapel of the Palazzo Trinci at Foligno, Nelli executed fresco cycles in Gubbio for S Agostino and S Domenico, while in the Palazzo Beni, Gubbio, he frescoed a secular cycle, including personifications of the Virtues and Vices. Nelli is also recorded in the Romagna (the banner of Covignano, S Maria delle Grazie), at Assisi and Fano, and at Urbino, where he is first documented in 1417 and was evidently influenced by the Salimbeni brothers' frescoes in the oratory of S Giovanni Battista (completed 1416).

Fewer of Nelli's panel paintings survive: four panels of *Saints* (Florence, priv. col.) and the central panel of the *Madonna of Humility* (Avignon, Mus. Petit Pal.) and the predella panel of *St John the Baptist Rebuking Herod* (Florence, Fond. Longhi), close in style to the Foligno frescoes.

BIBLIOGRAPHY

Bolaffi; Thieme–Becker

L. Bonfatti: *Memorie storiche di Ottaviano Nelli* (Gubbio, 1843)

F. Santi: 'Un capolavoro giovanile di Ottaviano Nelli', *A. Ant. & Mod.*, iii/12 (1960), pp. 373–84

R. Roli: 'Considerazioni sull'opera di Ottaviano Nelli', *A. Ant. & Mod.*, iv/13 (1961), pp. 114–24

L. Castelfranchi Vegas: *Il gotico internazionale in Italia* (Rome, 1966), p. 43

F. Rossi: 'Un ciclo d'affreschi allegorici di Ottaviano Nelli', *A. Ant. & Mod.*, ix/34 (1966), pp. 197–208

B. Berenson: *Central and North Italian Schools* (London, 1968), i, pp. 289–91; ii, pl. 511

M. R. Silvestrelli: 'Nelli Ottaviano', *La pittura in Italia: Il quattrocento*, ii (Milan, 1987), p. 715

B. Toscano: 'La pittura umbra del quattrocento', *La pittura in Italia: Il quattrocento* (Milan, 1987), pp. 322–4

F. Todini: *La pittura umbra*, 2 vols (Milan, 1989)

C. Vadee: 'Note sugli affreschi della cappella di Palazzo Trinci a Foligno', *Boll. Stor. Foligno*, xiv (1990), pp. 183–98

A. De Marchi: *Gentile de Fabriano* (Milan, 1992), pp. 11–12, 116–17, 122–3, 130–33, 217

F. Todini: 'Polittico di Pietralunga', *Galleria Nazionale dell'Umbria: Dipinti sculture e ceramiche: Studi e restauri*, ed. C. Bon Valsassina and V. Garibaldi (Florence, 1994), pp. 167–8

F. Marcelli: *La Maestà di S Maria del Piangato: Ottaviano Nelli, sec. XV* (n.p., 1995)

ENRICA NERI LUSANNA

Nelli, Suor Plautilla [Pulisena] (*b* Florence, 1523; *d* Florence, 7 May 1588). Italian painter. Daughter of a painter, Luca Nelli, she entered the convent of S Caterina di Siena in Florence in 1537. She studied painting with Fra Paolino, a pupil of Fra Bartolommeo, and executed works, including altarpieces, for her convent and outside patrons. In the *Last Supper* (Florence, S Maria Novella), executed from a cartoon by Agnolo Bronzino and reminiscent of Fra Bartolommeo's restrained early style, the still-life and the starched tablecloth are carefully observed. For the *Deposition* (Florence, Mus. S Marco), probably executed after a design by Andrea del Sarto, she was reputed to have used the corpse of a nun for the figure of Christ. The *Adoration of the Magi* (Parma, Gal. N.), her own composition, is again reminiscent of del Sarto with its graceful drapery and harmony of light and shade. Nelli's solemn and undramatic compositions had gone out of fashion by the mid-16th century. She inherited Fra Paolino's important collection of drawings by Fra Bartolommeo and is said to have trained other nuns in painting, including Agata Traballesi and Maria Ruggieri.

BIBLIOGRAPHY
Thieme–Becker

G. Vasari: *Vite* (1550, rev. 2/1568); ed. G. Milanesi (1878–85), v, pp. 79–80

G. Greer: *The Obstacle Race: The Fortunes of Women Painters and their Work* (London, 1979), pp. 185, 228

□

Neri di Bicci (*b* Florence, 1418; *d* Florence, 4 Jan 1492). Italian painter, son of Bicci di Lorenzo (*c.* 1350–?1427). He was the last artist member of the family, whose workshop can be traced back to his grandfather LORENZO DI BICCI. Under Neri's direction, the workshop was extremely successful and catered to a wide variety of patrons. The details of its activity, including the names of the many pupils and assistants that passed through it, are recorded between 1453 and 1475 in the workshop diary, the *Ricordanze*, the most extensive surviving document relating to a 15th-century painter.

1. Life and work. 2. Style and patronage. 3. The *Ricordanze*.

1. LIFE AND WORK.

(i) To 1452. (ii) After 1452.

(i) To 1452. He was enrolled in 1434 in the Compagnia di S Luca and began to make his way as a painter in the thriving family workshop. Vasari described Neri as the second son of Lorenzo, to whom he attributed works now given to Neri's father Bicci. The confusion was first pointed out by Domenico M. Manni in his edition (1768) of Baldinucci's *Notizie dei professori del disegno* and then by Gaetano Milanesi in his commentary to Vasari's *Vite* (1878). Milanesi's analysis restored the real relationships between the three painters and reconstructed the pictorial production of Bicci di Lorenzo and his son Neri. In June 1438 Neri is named along with Bicci as a witness in a dispute between Bastiano di Giovanni, a gold-beater, and Domenico di Giovanni Lapi. On 15 December of the same year he delivered to his father a payment of 15 florins on account, for a panel painting commissioned by Donato Barbadori for the chapel of S Frediano in S Felicita, Florence. In 1439–40 Neri worked with his father on the *trompe-l'oeil* funerary monument to *Luigi Marsili* (1342–94) frescoed in Florence Cathedral and in 1440 he painted and dated an *Annunciation* in S Angelo a Legnaia. In these early works his style was virtually indistinguishable from that of Bicci and the other painters of the workshop. Documents indicate that in 1444 he painted a triptych (untraced) depicting the *Virgin and Child Enthroned with Six Saints* for the chapel of S Giacomo in SS Annunziata, Florence (reconstructed by Zeri: central panel, sold before 1980, London, Colnaghi's; side panels, Florence, Accad. and Oberlin Coll., OH, Allen Mem. A. Mus.). In these panels the style is more developed, showing similarities of detail with the painting of Fra Filippo Lippi and Paolo Schiavo.

In this period Neri not only began to achieve an autonomy of form in his painting, but also probably took over the management of the workshop. In April 1447 he painted a predella (untraced) for S Martino, Maiano, paid for on 27 August 1460. In 1452, the year of his father's death, Neri dated a painting of the *Virgin and Child with Four Saints* (San Miniato, Mus. Dioc. A. Sacra), commissioned by Nicoluccio d'Antonio from Canneto in Valdelsa, near Empoli, for the church of S Giorgio there. In the same year Neri was entrusted with an important project for one of the most eminent Florentine families: a fresco cycle illustrating scenes from the *Life of St Giovanni Gualberto*, commissioned by Giovanni Spini and Salvestro Spini for the family chapel in Santa Trìnita. Only the *Annunciation* over the entrance arch survives.

(ii) After 1452. From the *Ricordanze* the most important events of Neri's life and his most important works can be reconstructed. The first information regarding the presence of a pupil in the workshop, Cosimo Rosselli, dates from 4 May 1453. The first work mentioned is a frescoed tabernacle at Ponte di Stagno near Florence depicting the *Virgin and Child with Four Saints* (Santa Maria a Castagnolo, nr Lastra a Signa) painted for Luca da San Colombano at Settimo on 15 June 1453. The most prestigious commission of this period was a tabernacle depicting *Moses and the Four Evangelists* (destr.) for the Sala dell'Udienza, in the Palazzo della Signoria. This tabernacle was to house a copy of Justinian's *Digest* in Greek. The commission, from the Gonfaloniere Tommaso di Lorenzo Soderini, was begun on 15 August 1454. In another project for the Republic, commissioned on 24 January 1455, Neri collaborated with Vittorio di Lorenzo Ghiberti, Piero del Massaio and four other painters on the decoration of a

model for a tapestry *spalliera* (untraced) for the Palazzo della Signoria.

The workshop's activity in the Spini Chapel of Santa Trìnita, Florence, resumed with the execution of the altarpiece depicting the *Assumption of the Virgin* (begun 28 February 1455; Ottawa, N.G.; see fig. 1). On 1 March 1455 Neri started work in the Vallombrosan monastery of Pancrazio on the fresco commissioned by the abbot Benedetto Toschi and now considered his masterpiece; the large lunette, depicting *St Giovanni Gualberto Enthroned with Saints and Blessed Persons of his Order* (Florence, Santa Trìnita), contains curious echoes of Piero della Francesca, Fra Filippo Lippi and Domenico Veneziano. On 1 March 1456 a new contract with Cosimo Rosselli was drawn up. On 5 March 1457 Michele Agnolo di Papi of Arezzo commissioned an altarpiece depicting the *Madonna of Mercy* for S Maria delle Grazie, Arezzo (Arezzo, Gal. & Mus. Med. & Mod.). In this painting Neri returned to traditional schemes. The frames and other carpentry work were provided for the painting by Giuliano da Maiano. On 5 June 1457 Neri settled a few financial matters with Stefano d'Antonio Vanni that went back to his father's partnership with him (1426–34). On 8 November 1457 he was commissioned by Giovanni Spinellini, at the suggestion of the Florentine Cathedral authorities, to produce a *Virgin and Saints* for S Sisto, Viterbo (*in situ*). The finished altarpiece was delivered on 28 July 1459.

On 3 June 1458, commissioned by Antonio di Berto Cardini, Neri began to fresco a chapel in S Francesco, Pescia (*in situ*). He painted four saints on the wall, an epigraph and a wooden Crucifix carved by Giuliano da Maiano. This is considered one of the most interesting and noteworthy of the painter's works, precisely because of its composite nature. On 19 October 1458 Giusto d'Andrea arrived in the workshop and remained intermittently until 6 February 1461. Francesco Botticini was taken on as a pupil on 22 October 1459 and left the workshop on 24 July 1460. The workload continued to increase and

1. Neri di Bicci: *Assumption of the Virgin*, tempera on panel, 2.43×2.23 m, 1455 (Ottawa, National Gallery of Canada)

on 22 November 1458 Neri rented a second workshop at the Porta Rossa in the centre of Florence. A further important project was the fresco depicting scenes from the *Passion* (untraced) in the refectory of the Florentine monastery of S Onofrio, known as di Fuligno. These pictorial cycles were finished on 20 March 1462.

On 25 November 1459 Neri received the commission for an altarpiece depicting the *Coronation of the Virgin with Eleven Saints* (Florence, Accad.; see fig. 2) for the church of the monastery of S Felice, Piacenza. This work is notable for its monumental composition and for the unusually large number of figures, though it shows very few changes of style. Against the old medieval background Neri placed modern elements, decorative and architectural, borrowed from Fra Filippo Lippi and Domenico Veneziano. Neri's faces are typically immobile, harsh and wooden and the images of the Infant Christ are most often doll-like. Nonetheless, he never lacked commissions. On 6 June 1460 he began an altarpiece, commissioned by Bartolommeo Lenzi, for the church of the Innocenti, depicting the *Coronation of the Virgin with Saints* (Florence, Gal. Osp. Innocenti; see colour pl. 2, IX2). In this panel the poses of the figures are freer and there are stylistic references to Andrea del Castagno. On 29 October 1460 Giovanni d'Antonio was taken on as a *garzone* (shop boy) in the workshop, where he remained until 1469. On 4 November 1460 Bernardo di Stefano Rosselli began collaborating with Neri.

The workshop's activity continued at a lively rate. An important *Assumption of the Virgin* (untraced), dated 25 August 1462, was painted for the sacristy of the church of the Hermit, Camáldoli (nr Arezzo), commissioned by the general of the Camaldolensians, Mariotto Allegri. On 19 November Neri painted a wooden crucifix carved by Romualdo di Candeli for the church of S Cristoforo, Strada (*in situ*). On 8 October 1463 Benedetto di Domenico d'Andrea entered the workshop as a pupil, to remain until 1 January 1470. On 10 December 1463 Neri painted an altarpiece depicting the *Virgin and Saints* for Antonio, parish priest of San Miniato, to be sent to the parish church of San Verano, Pèccioli, near Pisa (*in situ*). On 9 January 1464 he began for Agnolo di Neri Vettori an *Annunciation* (Florence, Accad.; see fig. 3) for the church of the monastery of the Càmpora (destr.). On 30 May 1464 he painted for Tanai de' Nerli, a prominent Florentine citizen, an altarpiece depicting *St Felicity and her Seven Sons* (Florence, S Felicita). A fresco with scenes from the *Life of St Benedict* (untraced), painted for the abbot Jacopo in the upper cloister of the Camaldolese Monastery in Florence, was begun on 10 April 1465.

Commissions from important Florentine families continued with, on 17 May 1465, the painting of stone coats of arms in the convent of S Maria del Carmine for Tommaso di Lorenzo Soderini. These are still *in situ*, although the colours have disappeared. On 19 June 1465 Neri and Baldovinetti gave an assessment of the panel depicting *Dante Alighieri Holding a Volume of the 'Divine Comedy'* painted by Domenico di Michelino for Florence Cathedral (*in situ*). On 5 November the contract of another pupil terminated: Giosuè di Santi (1427–84), who had apparently been working with Neri for some time, though the date of his arrival is not known. On 20 January 1466

2. Neri di Bicci: *Coronation of the Virgin with Eleven Saints*, tempera on panel, 1459 (Florence, Galleria dell'Accademia)

Neri's nephew Dionigi d'Andrea di Bernardo di Lottino (*b* 1455), the son of his wife Costanza's brother, came to work in the shop. On 10 July Neri was commissioned by a devout lady who lived in the monastery at Candeli to paint a *Coronation of the Virgin* (Cintoia, near Florence, S Bartolo). This was a favourite subject, which he repeated over many years without noticeable variations in composition.

On 6 March 1467 Neri recorded the final episode of a complicated affair. An altarpiece (untraced) was valued for him by Strozzi and Baldovinetti. The panel, begun much earlier in 1438 by Bicci di Lorenzo for Bartolommeo Lapacci, formerly bishop of Cortona and prior of S Romolo, Florence, had been completed by Neri. When the prelate's heirs had difficulty paying for the work, it was deposited with the painter Giovanni d'Antonio and valued again on 17 November by Strozzi and Domenico di Michelino. On 24 November Neri finally received payment from Amedeo, the new prior of S Romolo, and the panel was placed on the altar of the church.

On 7 May 1471 a monumental altarpiece was begun, another *Coronation of the Virgin*, the only one still pre-served with its predella and the original frame made by Giuliano da Maiano, for the Camaldolese abbey of S Pietro a Ruoti, in Valdambra near Arezzo. It was finished on 14 October 1472 and placed on the altar on 25 October. On 31 October 1471, commissioned by Tommaso di Lorenzo Soderini, Neri repaired and repainted an earlier polyptych for S Maria del Carmine. Only one section of this remains, a *St Margaret* painted over a *St Frediano* (Cambridge, MA, Fogg). On 27 September 1474 Neri recorded the last surviving painting mentioned in the *Ricordanze*: an altar-piece depicting the *Virgin and Child with Saints* (Radda in Chianti, S Maria al Prato), painted for Mariotto Gondi and Niccolò di Goro of Radda. The carpentry and the frame (untraced) were executed by Zanobi di Domenico. Two other works (untraced) are mentioned in a contract dated 30 January 1475 with Ser Amedeo, procurator of the convent of S Niccolò di Cafaggio (destr.) in the former Via del Cocomero in Florence. One of these two panels was completed on 31 October, the other on 3 November 1475.

The diary ends on 24 April 1475, with a note on the purchase of a piece of cloth for a cloak for Neri's son

3. Neri di Bicci: *Annunciation*, tempera on panel, 1464 (Florence, Galleria dell'Accademia)

Bicci. But the latest date, written in the margin, is 18 February 1484, when the painter appointed the notary Ser Domenico Bonsi to act for him in the purchase of a house. An altarpiece with *St Sebastian with SS Bartholomew and Nicholas* (Volterra, Pin. Com.), commissioned by the *contrada* (district) of Prato Marzio, Volterra, and painted for the church of S Marco there, is dated 1478. Another panel depicting the *Virgin and Child with Four Saints* (Siena, Pin. N., formerly at Casole, Valdelsa) is dated 1482.

In 1488 Neri was active in the convent of S Maria, Monticelli, near Florence, where he received (1 April) 8 bushels of grain for painting done there; on 10 May he was paid for a frontal (untraced) depicting the *Legend of St Francis* and the *Building of S Maria degli Angeli*; on 1 November he painted a door panel for Suor Cecilia, the mother superior of the convent. The last information on Neri, then over 70 years old, is dated 14 May 1491 and concerns a valuation he carried out, together with Domenico Ghirlandaio, Filippo di Giuliano (*fl* 1480–91) and Baldovinetti, of the altarpiece painted by his old pupil Botticini for the Compagnia di S Andrea dalla Veste Bianca of the Collegiata di Empoli (*in situ*).

Though active throughout most of the 15th century, Neri remained faithful, at least in content, to the tradition established by his father and grandfather and with his death on 4 January 1492 came also the demise of a workshop that had stood out for over a century for the wealth of its production. He was buried in S Maria del Carmine. Of his four sons and two daughters, none were artists: Neri's mercantile aspirations probably induced his sons to abandon the vocation of their father, grandfather and great-grandfather.

2. STYLE AND PATRONAGE. Neri's work was decorative, two-dimensional and technically accomplished but entirely devoid of inspiration. The compositions, for example his countless *Annunciations* and *Coronations*, are inexpressive and repetitive, and the figure drawing is awkward. Until the 1450s Neri's paintings had a rather unsophisticated but carefully worked freshness. A typical example is the Pisa *Coronation* (Pisa, Mus. N. S Matteo) painted between 1444 and 1452, which teems with figures and lively ornamental motifs. After the 1450s he adopted forms learnt from the artists associated with Renaissance painting, from Fra Filippo Lippi (but with results more obviously reminiscent of Paolo Schiavo) to Fra Angelico and Domenico Veneziano. A certain dryness of outline has been compared with the harsh style of Andrea del Castagno, but this is probably due rather to their shared taste for incisive drawing. Neri's later works were, however, rather tired and repetitive.

Despite shortcomings, Neri's paintings, with their simple and clearly identifiable style, lavishly adorned with gold, azurite and lakes, were keenly sought after throughout his career by the most varied clientele, representing every stratum of society from the ruling class of Florence to the artisans of the Chianti region; from noble families like the Spini, Soderini and Rucellai to small Florentine shopkeepers; from the abbots of powerful religious orders like the Vallombrosans of Santa Trinita and S Pancrazio to ordinary parish priests from the surrounding countryside. This capacity to satisfy the demands and tastes of the most varied patrons is the most outstanding characteristic of Neri as an artist. With the preservation of his *Ricordanze*, it has made him one of the best-known painters of 15th-century Florence, notwithstanding his clearly rather modest artistic talents.

3. THE 'RICORDANZE'. On 10 March 1453 Neri began his *Ricordanze* (Florence, Uffizi, MS. 2), a workshop diary, which is the most extensive surviving original document to record the activity of a 15th-century painter. The 189 sheet volume is almost certainly the fourth such diary kept in the workshop (the MS. is marked with the letter D, and there is reference to a C volume for 1452). Until 24 April 1475 Neri recorded both workshop and family affairs: commissions for paintings, the names and often the profession and social status of patrons, descriptions and dimensions of works, techniques and colours used, the type of carpentry, the style of frames, the scenes depicted in predella panels, and prices. The whole provides an exhaustive account of the activity of a medieval painter's workshop.

While commissions for altarpieces were the most prestigious, the workshop also produced or coloured small panels for private patrons. These were made of wood, gesso, stucco or even marble carved in relief, and some were the work of renowned artists such as Desiderio da Settignano or Luca della Robbia. The diary also mentions the gilding of wooden or metal articles such as chandeliers, torch holders and various items for religious use. They also painted fabrics, frontals and shop signs, relief sculpture in stone, terracotta and gesso, coats of arms, portrait busts and statues. They painted wooden statues carved by artists such as Giuliano da Maiano (who as a carpenter also provided the workshop, between 1455 and 1472, with picture frames) or by the Camaldolese monk Romualdo di Candeli, an obscure sculptor who produced wooden crucifixes of various sizes and other religious articles.

Another area of activity was the restoration, adaptation and modernization of paintings from earlier periods.

The diary lists the workshop's paint suppliers by name; usually they were apothecaries, with occasionally a religious organization such as the Compagnia degli Gesuati. Neri also recorded the names of painters and artists with whom he came into contact through his work. These included Fra Filippo Lippi, Desiderio da Settignano, Giuliano da Maiano, Benedetto da Maiano, Maso Finiguerra, Masaccio's brother, known as Scheggia, Domenico di Michelino, Zanobi Strozzi and Alesso Baldovinetti.

The business was carried on in two different locations —the diary mentions one shop in Via S Salvadore in the Oltrarno district and another, more central, at the Porta Rossa, near Piazza della Signoria. The intense, varied work of the organization must have required a considerable number of assistants. 22 pupils were registered by Neri during the period of the *Ricordanze*, but only three of these are well known: Cosimo Rosselli, Giusto d'Andrea and Francesco Botticini. Others, who came and went rather quickly, are mentioned only by their baptismal names. Neri noted the dates when they entered the workshop, the time they remained there, the day they left and the wages they received. He also recorded family affairs: the birth of his children, marriages of relatives, illnesses and epidemics, rentals of houses and lands, harvests of crops and production of wine, oil and firewood. His business transactions, disputes with insolvent customers, investments and loans of money and goods are also documented in the *Ricordanze*, which thus provide a complete and detailed record of a full personal and professional life, diligently registered in the author's laconic lines. An active, versatile personality is revealed; artistic life was only one aspect of Neri's numerous, mainly commercial, interests.

Furthermore, from the minute detail of the painter's day-to-day activity over more than 20 years, a picture emerges of the social environment in which a 16th century Florentine painter worked and the transformations in style and taste that took place in that century. Notwithstanding his failure to keep abreast of artistic developments, the large capacity and high technical standards of the workshop kept Neri's paintings in demand both from the less cultivated classes and the influential ruling groups in the city.

<div align="center">WRITINGS</div>

Ricordanze (1453–75; Florence, Uffizi, MS. 2); ed. B. Santi (Pisa, 1976)

<div align="center">BIBLIOGRAPHY</div>

<div align="center">EARLY SOURCES</div>

G. Vasari: *Vite* (1550; rev. 2/1568); ed. G. Milanesi (1878–85), ii, pp. 58–60 [also contains G. Milanesi: 'Commentario alla vita di Lorenzo Bicci' (1878), pp. 63–8]
F. Baldinucci: *Notizie* (1681–1728); ed. D. M. Manni (1768), iii, pp. 110–21
J. W. Gaye: *Careggio* (1839–40), ii, p. vi

<div align="center">GENERAL</div>

Colnaghi; Thieme–Becker
A. Venturi: *Storia* (1901–40), i, pp. 431–2
R. van Marle: *Italian Schools* (1923–38), x, pp. 523–46
M. Wackernagel: *Der Lebensraum des Künstlers in der florentinischen Renaissance* (Leipzig, 1938)
A. Chastel: *L'arte italiana*, i (Florence, 1962), p. 341
B. Berenson: *Florentine School* (1963), i, pp. 152–8

P. Dal Poggeto: *Arte in Valdelsa dal sec. XII al sec. XVII* (Certaldo, 1963), pp. 54–5
A. Chastel: *I centri del rinascimento: Arte italiana, 1460–1500* (Milan, 1965), p. 72
A. Thomas: *The Painter's Practice in Renaissance Tuscany* (Cambridge, 1995)

<div align="center">SPECIALIST STUDIES</div>
<div align="center">'Ricordanze'</div>

G. Poggi: 'Le Ricordanze di Neri di Bicci (1453–1475)', *Il Vasari*, i (1928), pp. 317–38
——: 'Le Ricordanze di Neri di Bicci (1453–1475)', *Il Vasari*, iii (1930), pp. 133–53, 222–34
——: 'Le Ricordanze di Neri di Bicci (1453–1475)', *Il Vasari*, iv (1931), pp. 189–202
B. Santi: 'Dalle Ricordanze di Neri di Bicci', *An. Scu. Norm. Sup. Pisa*, n. s. 2, iii/1 (1973), pp. 169–88

<div align="center">Specific works</div>

G. Poggi: 'Della tavola di Francesco di Giovanni Botticini per la Compagnia di S Andrea in Empoli', *Riv. A.*, iii (1905), pp. 258–64
G. Carocci: 'Un dipinto di Neri di Bicci nella chiesa di S Verano a Péccioli (Pisa)', *Illus. Fiorentino*, iii (1906), pp. 31–2
——: 'Un quadro di Neri di Bicci nella chiesa di S Lucia al Borghetto (Tavarnelle)', *Illus. Fiorentino*, iii (1907), pp. 46–7
A. Del Vita: 'La Pinacoteca d'Arezzo', *Rass. A.*, xv (1915), pp. 75–88 (87)
I. Vavasour Elder: 'Alcuni dipinti e oggetti d'arte nei dintorni di Firenze', *Rass. A.*, xvi (1916), pp. 257–64 (259)
F. Tarani: *La Badia di S Pancrazio a Firenze* (Pescia, 1923), p. 54
W. R. V.: 'The Three Archangels by Neri di Bicci', *Bull. Detroit Inst. A.*, viii (1926), pp. 13–16
L. Pescetti: 'La Pinacoteca di Volterra', *Emporium*, lxxi (1930), pp. 208–20 (219)
G. Gronau: 'Das Erzengebild des Neri di Bicci aus der Kirche S Spirito: Kleine wissenschaftliche Beiträge', *Mitt. Ksthist. Inst. Florenz*, iii (1931), pp. 430–34
P. Torriti: *La Pinacoteca nazionale di Siena: I dipinti dal XII al XV secolo* (Genoa, 1977), p. 418
E. Carli: *La Pinacoteca di Volterra* (Pisa, 1980), pp. 42–3
B. Santi: 'Due dipinti recuperati di Neri di Bicci', *Scritti di storia dell'arte in onore di Roberto Salvini* (Florence, 1984), pp. 329–34
A. Paolucci: *La Pinacoteca di Volterra* (Florence, 1989), pp. 131–2
L. Venturini: 'Restauri quattrocenteschi: Neri di Bicci, Domenico Ghirlandaio', *Kermes*, vii/19 (1994), pp. 28–34 [discussion of the *Crucifixion with Saints* S Sisto, Viterbo]
A. Thomas: 'Neri di Bicci's *Young St. John the Baptist Going into the Desert*: A Predella Re-connected to its Panel', *Apollo*, cxliii/411 (1996), pp. 3–7
——: 'A New Date for Neri di Bicci's S Giovannino dei Cavalieri *Coronation of the Virgin*', *Burl. Mag.*, cxxxiv (1997), pp. 103–6
——: 'Neri di Bicci's *Assumption of the Virgin* for S Trinita, Florence', *Apollo*, cxlvi (1997), pp. 42–51

<div align="center">Other</div>

L. Manzoni: *Statuti e matricole dell'arte dei pittori della città di Firenze, Perugia e Siena* (Rome, 1904), p. 130
G. Poggi: 'Neri di Bicci e Giuliano da Maiano', *Riv. A.*, iii (1905), pp. 128–9
A. Colasanti: 'Opere d'arte ignote o poco note', *Boll. A.*, iv (1910), pp. 184–92 (188–9)
R. Longhi: 'Ricerche su Giovanni di Francesco', *Pinacotheca*, i (1928), pp. 34–48 (36., n. 1)
Catalogo della mostra del tesoro di Firenze sacra (Florence, 1933), pp. 73, 121
R. Graves Mather: 'Documents Mostly New Relating to Florentine Painters and Sculptors of the Fifteenth Century', *A. Bull.*, xxx (1948), pp. 20–65 (43–44)
Mostra d'arte sacra della diocesi e della provincia dal sec. XI al XVIII (Arezzo, 1950)
R. Longhi: 'Il Maestro di Pratovecchio', *Paragone*, iii/35 (1952), pp. 10–37 (22, 35)
L. Bartolini Campetti: 'Opere d'arte toscane ignote o poco note', *An. Scu. Norm. Sup. Pisa*, n. s. 1, xxii (1954)
W. Cohn: 'Notizie storiche intorno ad alcune tavole fiorentine del '300 e del '400', *Riv. A.*, xxxi (1956), pp. 41–72
A. M. Maetzke: *Arte nell'Aretino: Recuperi e restauri dal 1968 al 1974* (Florence, 1974), pp. 92–4
——: *Arte nell'Aretino: Dipinti e sculture restaurati dal XIII al XVIII secolo* (Florence, 1979), pp. 48–9

B. Santi: *Tesori d'arte antica a San Miniato* (Genoa, 1979), pp. 79–83

C. Frosinini: 'Il passaggio di gestione in una bottega fiorentina del primo '400: Bicci di Lorenzo e Neri di Bicci', *Ant. Viva*, xxvi/1 (1987), pp. 5–14

——: 'Neri di Bicci', *La pittura in Italia nel quattrocento*, ii (Milan, 1987), pp. 715–16

F. Petrucci: 'La pittura a Firenze nel quattrocento', *La pittura in Italia nel quattrocento*, i (Milan, 1987), p. 291

BRUNO SANTI

Neroccio de' Landi. *See* LANDI, NEROCCIO DE'.

Neroni, Bartolommeo (di Sebastiano) [il Riccio] (*b* ?Siena, 1505–15; *d* before 12 July 1571). Italian painter, illuminator, architect, stage designer and engineer. His earliest surviving documented works, illuminations for an Antiphonal, signed and dated 1531–2 (ex-Olivetan convent, Finalpia; Genoa, Bib. Berio), suggest training with Sodoma, but he seems to have been drawn relatively quickly into the orbit of other influential painters in Siena, such as Domenico Beccafumi and Baldassare Peruzzi, the latter having returned there after the Sack of Rome (1527). Although he shows an affinity with all three at one time or another, the breadth of Neroni's activities, from painting to engineering and especially his architectural work, most closely resembles Peruzzi's career, and Vasari describes him as a follower of Peruzzi.

Neroni's first independent large-scale commission, in which he was strongly influenced by Sodoma, is the fresco depicting the *Departure of SS Maurus and Placid*, executed in 1534 for the cloister of the convent of Monte Oliveto Maggiore. In the same year he was also commissioned to decorate the chapel of the master masons in the cathedral, Siena. Fragments of the fresco survive, notably scenes depicting the *Martyrdom of the Four Crowned Martyrs* (Siena, Mus. Opera Duomo). The design of the chapel is based on Peruzzi's frescoes (1516) in the Ponzetti Chapel, S Maria della Pace, Rome, and the figure style reflects aspects of Sodoma, Beccafumi and Peruzzi. The figures have the sharp-nosed features of those of Beccafumi, the eyes are soft and limpid as in Sodoma's figures, and the bodies and full, monumental spatial composition recall Peruzzi's work. In later works the links with Sodoma are strengthened. In the *Lamentation at the Cross* (Siena, Col. Chigi–Saraceni), executed (1537–9) for the Compagnia di S Giovanni Battista della Morte, the dark tonalities and fleshy, solid figures mark a turning away from Peruzzi's style. The *Coronation of the Virgin* (Siena, Pin. N.), possibly dating from the mid-1540s, also strongly reveals the influence of Sodoma in the twisting figures and the dark tonality. Another example of Sodoma's influence can be seen in the *Dead Christ* (1554–6; Siena, Col. Monte dei Paschi). Neroni's artistic relationship to Sodoma was probably reinforced by his marriage to Sodoma's daughter in 1542. He is also cited as Sodoma's heir. Nonetheless, elements emerge to recall the work of Beccafumi, as in the Fondi tomb frescoes (1547–8) in the Azzoni Chapel for the church of S Agostino, Siena.

Neroni is recorded as providing *apparati* (temporary architectural decorations) for the entry of Pope Paul III into Siena (1538, 1540). His name is associated with several buildings in Siena. He may have been responsible for designing the Palazzo Chigi alla Postierla (?1548), with its rusticated quoining, and for completing the Palazzo Tantucci alla Dogana (1548–9). In 1554–6 he built the Conservatorio delle Derelitte. The relatively plain, brick panelled façade with stark pilasters recalls Peruzzi. The garden façade of the Palazzo Guglielmi nel Casato, Siena, its storeys linked by giant pilasters, recalls Peruzzi's façade for the Villa Farnesina, Rome (*see* PERUZZI, BALDASSARE, fig. 1). In 1560 he designed a stage set (untraced) for the Teatro degli Intronati, Siena. From the end of 1552 until the surrender of Siena to Florence in 1555, Neroni was active building fortifications and making military models and drawings (destr.). He is documented working at Sinalunga, Chiusi and Massa Marittima (1552) and Monterotondo Marittima and Chiusdino (1553). In January 1555 he was forced to move from his workshop so that a guard house could be built there. After the fall of the Republic, he went to Lucca, where he taught drawing and perspective and military architecture. He returned to Siena definitively in 1568.

A collection of drawings by Neroni (Siena, Bib. Com. Intronati, S. IV. 6), consisting largely of machines, mills, pumps and siphons, are largely copied from the earlier Sienese engineers Mariano Taccola and Francesco di Giorgio Martini. Copies after military drawings by Francesco di Giorgio (Turin, Bib. Reale, MS. Ser. Mil. 238) have been attributed to Neroni. Whether his interest in these matters was spontaneous or the result of a commission is not known. Neroni's last years were relatively difficult. Designs for the lectern and choir-stalls to be executed in wood in the cathedral, Siena, date from 1567, but Neroni had to take his claim for salary to court. He was responsible for the bishop's chair (1567), and a wooden lectern behind the main altar was designed by him. Designs for these works are in the Museo dell'Opera del Duomo, Siena. Through ill-health he was forced to renounce commissions as early as 1567. Among the artists who worked for him at various times are Girolamo Mazzei, Crescenzio Gambarelli, Tiberio Billo (*fl* 1574), Michelangelo d'Antonio Anselmi and, possibly, Bartolommeo di Francesco Almi. Almost all his work is located in Siena and on Sienese territory.

UNPUBLISHED SOURCES

Siena, Bib. Com. Intronati, MS. L.II.6 [E. Romagnoli: *Biografia cronologica de' bellartisti senesi dal secolo XII a tutto il XVIII*, vii [before 1835]], pp. 711–805

BIBLIOGRAPHY

Thieme–Becker

P. Torriti: *Le miniature antifonali di Finalpia* (Genoa, 1953)

F. Secchi-Tarugi: 'Aspetti del manierismo nell'architettura senese del cinquecento', *Palladio*, xvi (1966), pp. 103–30

A. Cornice: *Indagine per un catalogo dell'opera di Riccio* (diss., U. Genoa, 1973–4)

P. A. Riedl: *Das Fondi-Grabmal in S Agostino zu Siena* (Heidelberg, 1979)

A. Cornice: 'Bartolommeo Neroni', *L'arte a Siena sotto i Medici, 1555–1609* (Rome, 1980), pp. 27–47

F. S. Santoro, ed.: *Da Sodoma a Marco Pino* (Siena, 1988), pp. 147–69

G. Scaglia: *Francesco di Giorgio: Checklist and History of Manuscripts and Drawings in Autographs and Copies from c. 1470 to 1687 and Renewed Copies, 1764–1839* (Bethlehem, PA, 1992)

NICHOLAS ADAMS

Niccolaio [Niccolò detto Scalcagna]**, Michele di.** *See* MICHELE DA FIRENZE.

Niccoli, Niccolò (*b* Florence, *c.* 1364; *d* Florence, 3 Feb 1437). Italian humanist and calligrapher. The son of a

wealthy wool merchant, he abandoned trade for a scholarly pursuit of the values and artefacts of the ancient world as a touchstone of the present. He attained eminence as the catalyst for and guardian of Florentine letters, while leaving no writings of his own. With others he was responsible for the introduction in Florence of the teaching of Greek, and he stimulated such friends as Leonardo Bruni and Ambrogio Traversari to do what he could not do himself, that is, to spread Greek learning in stylish translations. He was a central figure in the organized search for Classical texts. Niccoli's unrivalled library was enriched by the spectacular discoveries of Roman manuscripts by POGGIO BRACCIOLINI and Aurispa, and his home became a magnet for the learned of Italy and elsewhere and for the dissemination of the new finds. By the terms of his will the manuscripts went to form a public library, installed in the Dominican convent of S Marco with the aid of Cosimo de' Medici, il Vecchio. Recovery of ancient texts implied also purging them of corruption, the removal of centuries of accumulated error, without which Niccoli saw no prospect of ancient wisdom being comprehended and revived. With this went an open contempt for medieval scholasticism and even for the barbarous Latinity of the great writers of the Tuscan Trecento. His concern for the minutiae of linguistic usage was ridiculed, but it was a positive step in the emergence both of philological method and of the supple purity of style that was the achievement of 15th-century humanism.

The clarity of view demanded by Niccoli had its counterpart in the reform of script and decoration and in the production of manuscripts. He probably cooperated with Poggio Bracciolini, its first recognized practitioner, in the formation of the humanistic *littera antiqua* (see SCRIPT), which harked back to the beautifully legible late-Carolingian handwriting, and examples of his formal script from the early years of the Quattrocento have been identified. His later manuscripts are generally written in a freer cursive hand, from which derive italic fonts. Bartolomeo Facio called him the 'inventor of book decoration', which surely means that he at least inspired the Florentine white-vine initials that frequently accompany humanistic script.

Vespasiano da Bisticci's *Vite* gives us a memorable portrait of Niccoli at home, dining off the finest 'antique' tableware, surrounded by his art collection: inscriptions, gemstones, medals, sculptures and pictures. His interest in the visual arts was not merely theoretical and antiquarian, and he may have encouraged the development of a Classical style; he cultivated the leading Florentine artists of the day, specifically Brunelleschi, Donatello, Luca della Robbia and Ghiberti. The way that the worlds of learning and art interacted is shown by a recently rediscovered letter (de la Mare, pp. 59ff), in which Niccoli asks his friend Michelozzo, then working on the Aragazzi tomb at Montepulciano, Siena, to seek from the Bishop of Arezzo an ancient manuscript of Cato and a copy of the tomb inscription of Vitruvius.

BIBLIOGRAPHY

Vite uomini de illustri (MS.; 1480s); ed. A. Greco (Florence, 1970); Eng. trans. by W. G. Waters and E. Waters as *Renaissance Princes, Popes and Prelates: The Vespasiano Memoirs* (London, 1926/R New York, 1963), pp. 395–403

G. Zippel: *Niccolò Niccoli* (Florence, 1890), R in *Storia e cultura del rinascimento italiano* (Padua, 1979)

A. C. de la Mare: *The Handwriting of Italian Humanists*, I/i (London, 1973), pp. 44–61

E. H. Gombrich: 'From the Revival of Learning to the Reform of the Arts', *The Heritage of Apelles* (London, 1976), pp. 93–110

M. C. DAVIES

Niccolò, Andrea di. *See* ANDREA DI NICCOLÒ.

Niccolò, Domenico di. *See* DOMENICO DI NICCOLÒ.

Niccolò da Foligno [Niccolò di Liberatore; l'Alunno] (*b* Foligno, *c.* 1420–30; *d* 1502). Italian painter. He probably trained with his father-in-law, Pietro Mazzaforte (*fl* 1440–95), who may have worked with him on frescoes (1456–8) in S Maria-in-Campis, near Foligno. Their continuing association is confirmed by documents. His earliest surviving signed panel, dated 1457, the *Virgin and Child Enthroned with Saints and Jacobus Rubeus* (Deruta, Pin. Com.), recalls the work of Benozzo Gozzoli. Niccolò was long considered Gozzoli's pupil, but the attribution of another early work, the *Virgin and Child Enthroned with Saints* (New Haven, CT, Yale U. A. G.), suggests rather that they were contemporaries (Vertova). In 1461 he frescoed the chapel of S Anna, Spello, and painted a *Crucifixion* (Spello, Pin. Com.). The *Virgin and Child with Saints* for the high altar of Assisi Cathedral (Assisi, S Rufino, Mus. Capitolare) was executed in 1462. Both Niccolò and Mazzaforte were commissioned to execute a polyptych (1465, Milan, Brera) that bears only Niccolò's name, however.

Dated works by Niccolò include a banner of the *Annunciation* (1466; Perugia, G.N. Umbria), a polyptych (1466; Rome, Pin. Vaticana) for S Angelo, Montelpare, and a triptych (1468; San Severino Marche, Pin. Com. 'P. Tacchi Venturi'). From 1468 to 1471 he executed works in and around Assisi, including a polyptych of *St Francis* (1471; Gualdo Tadino, Pin. Com.). Niccolò's mature style shows the influence of Bartolomeo Vivarini, Antonio Vivarini and Carlo Crivelli. After 1480 he executed works with his son Lattanzio di Niccolò (*fl* 1480–1527), notably the high altarpiece of S Francesco, Cannara (1482). Late works include a polyptych (1483; Nocera Umbra, Pin. Com.), frescoes (destr.) on the façade of the Porziuncola, S Maria degli Angeli (Assisi), a *Crucifixion with Saints* (1497; Terni, Mus. & Pin. Civ.) and a *St Bernardino of Siena* (1497; Budapest, Mus. F.A.). After his death, the *Martyrdom of St Bartholomew* (Foligno, S Bartolomeo) was completed by Lattanzio.

BIBLIOGRAPHY

G. Vasari: *Vite* (1550, rev. 2/1568); ed. G. Milanesi (1878–85), iii, pp. 508–10

J. Ferrata Omelia: *Niccolò da Foligno and his Frescoes for S. Maria-in-Campis* (diss., New York U., 1975; microfilm, Ann Arbor, 1977)

L. Vertova: 'The Earliest Known Painting by Niccolò da Foligno', *Studies in Late Medieval and Renaissance Painting in Honor of Millard Meiss*, ed. I. Lavin and J. Plummer (New York, 1977), pp. 455–61

E. Lunghi and F. Todini: *Niccolò di Liberatore detto l'Alunno* (Spoleto, 1987)

La pittura in Italia: Il quattrocento (Milan, 1987), ii, pp. 718–19 [with bibliog.]

C. Galassi: 'Niccolò di Liberatore: Il crocifisso ligneo del museo di S Francesco a Montefalco e altre opere giovanili: Considerazioni sulla formazione', *Stor. A.*, lxxxi (1994), pp. 194–206

HELEN GEDDES

Niccolò dell'Arca: *Lamentation*, painted terracotta, *c.* 1460–90 (Bologna, S Maria della Vita)

Niccolò dell'Arca [Niccolò da Ragusa; Nichollò de Bari; Nicolaus de Apulia] (*fl* 1462; *d* Bologna, 2 March 1494). Sculptor, probably of Italian origin. The name 'dell'Arca' derives from the Arca, or shrine, of St Dominic in S Domenico, Bologna, by Nicola Pisano (*c.* 1220/25–before 1284) on which Niccolò worked during the 1470s. The earliest surviving reference to him dates from September 1462, when the artist was residing in Bologna. Later documents refer to him as 'Nicolaus de Apulia', 'Niccolò da Ragusa' and 'Nichollò de Bari', suggesting that he was probably born in Apulia in south-eastern Italy and perhaps migrated to Dalmatia or was of Slav origin. Gnudi (1973) contended that Niccolò was trained by the Dalmatian sculptor Giorgio da Sebenico (*fl c.* 1441–73). Contemporary accounts of Niccolò describe him as difficult, withdrawn and stubborn, but his sculpture reveals him to have been among the most original and unique sculptors of his generation working in Emilia.

Some critics have suggested that Niccolò participated on the triumphal arch of the Castel Nuovo, Naples (*see* NAPLES, §3), during the 1450s, and that his exposure to the art of various non-Italian sculptors working there, among whom was the Catalan sculptor Guillem Sagrera (*fl c.* 1397–1454), explains the Hispano-Burgundian elements in his style. A few scholars have regarded the Burgundian elements in Niccolò's art as the result of a subsequent trip to France. Although none of these proposals can be substantiated, it is clear that by 1462, when Niccolò is documented in Bologna, he already possessed a very mature, powerful and individual style.

In 1469 Niccolò received the commission to complete and modernize the marble Arca of St Dominic (*see* BOLOGNA, §IV, 1). The contract specified that the decorated sarcophagus lid was to include figures of God the Father, angels, the Four Evangelists, a *Pietà* with adoring angels, a *Resurrection* relief and figures of SS Petronius, Dominic, Francis, Florian, Vitale, Agricola, Thomas Aquinas and Vincent Ferrer, and two angels with candelabra. The lid was installed in 1473, but Niccolò never completed the terms of the contract, although he probably continued to work on the shrine until his death. It is not clear why certain elements of the project were left unfinished. In 1494 Michelangelo was commissioned to sculpt a few

remaining figures, including *St Proculus*, which Niccolò may have already begun. Niccolò's figural sculpture and decorative architectural elements for the Arca reflect a curious blend of influences, including features that are Burgundian, Florentine (the work of Desiderio da Settignano and Antonio Rossellino) and non-Tuscan (the expressive elements and details of clothing and headdress); the last has caused some scholars to propose that Niccolò made a trip to northern Europe in the late 1460s. The statuettes, though small in scale, are powerful and dramatic in expression and pose, with draperies, beards and hair flowing in crisply carved patterns, recalling works by Jacopo della Quercia. *God the Father* at the top of the monument is the most impressive figure; its dramatic, pivoting axial movement and subtly shifting, massive drapery folds (as well as its position and function) are derived from Jacopo della Quercia's figure of *St John the Baptist* on the top of the font in the baptistery of Siena Cathedral.

Niccolò's terracotta *Madonna di Piazza* (1478) on the exterior of the Palazzo del Comune, Bologna, also reflects the eclectic nature of his stylistic sources. In this high relief, Jacopo della Quercia's heavy drapery folds and powerful bulk can be seen, as well as traces of Andrea del Verrocchio's sculpture, perhaps transmitted to Bologna in the late 1470s by Francesco di Simone Ferrucci—although the influence of Tuscan art on Niccolò's sculpture and the way in which it was transmitted are debated.

Among Niccolò's most important contributions to Renaissance sculpture is his signed painted terracotta *Lamentation* in S Maria della Vita, Bologna (see fig.). The group is composed of six free-standing figures placed in a semicircle around the recumbent figure of the dead Christ. The scene's intensity is magnified by the verism of the facial details and the highly dramatic poses, reflecting profound grief and inner spiritual torment. The date of the work is uncertain, so it is unclear whether it influenced, or was influenced by, the similar terracotta groups by GUIDO MAZZONI and the equally dramatic paintings of the *Lamentation* by late 15th-century Ferrarese artists including Cosimo Tura, Francesco del Cossa and Ercole de' Roberti. While some scholars date Niccolò's *Lamentation* to the early 1460s, others prefer a date between

1485 and 1490. As early as 1462–3, Niccolò is mentioned in Bologna as a 'master of terracotta figures', yet for some scholars the energy, freedom of form and sense of uncontrolled frenzy present in the figures have supported the later date. Those who propose the earlier dating generally discount the notion that Niccolò trained in Naples during the 1450s and contend that his artistic development probably took place in Siena and was derived from the art of Jacopo della Quercia and Donatello. Whatever the dating, Niccolò was a significant contributor to an innovative and evocative genre, the legacy of which can be seen in 16th-century sculpture in both North Italy and Spain.

Other important works by Niccolò include a marble statue of *St John the Baptist*, signed NICOLAVS (Madrid, Escorial), a terracotta bust of *St Dominic* (1474; Bologna, S Domenico) and a terracotta figure of *St Monica* datable to 1478–80 (Modena, Gal. & Mus. Estense). Less widely accepted is Beck's attribution of the tomb of *Andrea Manfredi* in S Maria dei Servi, Bologna, to Niccolò. The effigy, executed in black and white marble, certainly indicates the intervention of a highly skilled master, but his identity cannot be established.

BIBLIOGRAPHY

C. Gnudi: *Niccolò dell'Arca* (Turin, 1942)
J. Pope-Hennessy: 'The Arca di San Domenico—A Hypothesis', *Burl. Mag.*, xciii (1951), pp. 347–51
——: *Italian Renaissance Sculpture* (London, 1958, rev. New York, 1985)
P. Belli d'Elia: 'Niccolò dell'Arca: Aggiunte e precisazioni', *Commentari*, xv (1964), pp. 52–61
S. Bottari: *L'Arca di S Domenico in Bologna* (Bologna, 1964)
J. Beck: 'Niccolò dell'Arca: A Re-examination', *A. Bull.*, xlvii (1965), pp. 335–44
C. Gnudi: *Nuove ricerche su Niccolò dell'Arca* (Rome, 1973)
C. Del Bravo: 'Niccolò dell'Arca', *Paragone*, xxv (1974), pp. 26–40
T. Verdon: *The Art of Guido Mazzoni* (New York, 1978)

STEVEN BULE

Niccolò di Forzore Spinelli. See SPINELLI, (2).

Niccolò di Naldo (da Norcia) (*b* Norcia, ?1370; *d* after 1410). Italian painter. Together with Gualtieri di Giovanni he painted the vaults and decorative framework of the three chapels in the sacristy of Siena Cathedral. On 26 June 1410 he was paid for decorating a canopy (destr.) for the chapel of the Madonna del Campo, Siena, and on 25 August 1410 for making two cope cowls and two designs for a choir in the cathedral, probably in the chapel of S Victor or that of S Ansano. Niccolò was last recorded on 15 November 1410, when he was paid for more work in the sacristy. One of the group of painters known as the Masters of the Sacristy of Siena Cathedral, he was formerly believed to have frescoed the scenes in the Cappella dei Liri (or Libri), but it has emerged that his role there was extremely minor. Niccolò di Naldo was previously confused with a Niccolò da Siena (*fl* Norcia, 1457–63), who has subsequently been identified as Niccolò di Ulisse.

BIBLIOGRAPHY

V. Lusini: *Il duomo di Siena*, i (Siena, 1911), pp. 299–300
B. Toscano: 'Bartolomeo di Tommaso e Niccolò da Siena', *Commentari*, xv (1964), pp. 37–51
E. Carli: *Il duomo di Siena* (Siena, 1979), p. 92
J. Mongellaz: 'A propos d'une fresque peu connue de la cathédrale de Sienne', *Fond. Stud. Stor. A. Roberto Longhi, Firenze: An.*, i (1984), pp. 27–34
——: 'Reconsidération de la distribution des rôles à l'intérieur du groupe des Maîtres de la Sacristie de la Cathédrale de Sienne', *Paragone*, xxxvi/2 (1985), pp. 73–89

JACQUELINE MONGELLAZ

Niccolò di Pietro [Paradisi, Niccolò] (*fl* Venice, 1394–1430). Italian painter. His father, Pietro (*fl* 1365–89), and grandfather Niccolò (*fl* 1365) were both painters. Niccolò appears to have been an independent master by 1394, when he signed a panel depicting the *Virgin and Child Enthroned* (Venice, Accad.). In 1404 he signed and dated a *Crucifix* (Verucchio, SS Martino e Francesco), and between 1414 and 1416 he executed a processional banner (untraced) for the Scuola Grande della Misericordia in Venice. He is last documented on 4 October 1430.

The subtly shaded modelling that softens the forms of the 1394 *Virgin and Child* suggests that this work belongs to a more advanced phase of Niccolò's career than a small group of works that includes the *Coronation of the Virgin* (Milan, Brera) and two panels with *Busts of the Twelve Apostles* (Rome, Pal. Barberini). With their expressive qualities and outlines that are vigorously defined in a darker colour, these works closely resemble the Veneto-Bolognese painting of Jacopo d'Avanzo or Giovanni da Bologna (*fl* 1377–89) and could therefore date to around 1390 or earlier. The *Coronation of the Virgin*, which is more flexible in its drawing and more carefully elaborated in its details, and other similar works including the *Virgin and Child* (Cambridge, MA, Fogg) and fragments of frescoes in SS Maria e Donato, Murano, show how far, in the last years of the 14th century, Niccolò had absorbed the ideals of the Late Gothic style. In the first years of the 15th century he was the major Venetian exponent of this lyrical and elegant style and thus prepared the way for Gentile da Fabriano as well as anticipating ideas that were later developed in the art of Pisanello. The *Coronation of the Virgin with Donors* (Rovigo, Accad. Concordi), two scenes from the *Life of the Virgin* (Vittorio Veneto, Mus. Cenedese) and the panel depicting the *Journey of the Magi* (Venice, Accad.) all show similarities to the 1404 *Crucifix* and probably date from the first years of the 15th century.

Subsequently Niccolò looked towards northern European works, and this influence is revealed, for example, in the childlike innocence and grace of his scenes from the *Life of St Augustine* (Rome, Pin. Vaticana) and in the luminous pallor of the faces and pathetic gestural elegance of *SS Nicholas of Tolentino, Lawrence, Paul and Peter* (Pesaro, Mus. Civ.), *St John the Baptist* (Chicago, IL, A. Inst.) and *St Bonaventure* (Saint-Lô, Mus. B.-A.), all probably once part of a single work. In his most important work, the panel depicting *St Ursula and her Companions* (New York, Met.; see fig.), the outlines are even more refined and the rhythms and colour harmonies even more exquisite. This work, with the *Virgin with Two Saints* and *St Lawrence* (both Venice, Accad.) and perhaps the rather badly preserved frescoes in the chapel of the Innocenti, S Caterina, Treviso (attributed by Coletti to the Maestro degli Innocenti), represents Niccolò's last phase of activity and is datable, as are the others, to the second decade of the 15th century or even the early 1420s.

BIBLIOGRAPHY

Bolaffi
L. Coletti: 'Il Maestro degli Innocenti', *A. Ven.*, ii (1948), pp. 30–40

Niccolò di Pietro: *St Ursula and her Companions*, tempera and gold on panel, 940×787 mm, *c.* 1410–25 (New York, Metropolitan Museum of Art)

G. Fiocco: 'Niccolò di Pietro, Pisanello, Venceslao', *Boll. A.*, n. s. 3, xxxvii (1952), pp. 13–20
O. Ferrari: 'Un'opera di Niccolò di Pietro', *Commentari*, iv/3 (1953), pp. 228–30
R. Pallucchini: 'Nuove proposte per Niccolò di Pietro', *A. Ven.*, x (1956), pp. 37–55
F. Valcanover: 'Un'opera tarda di Niccolò di Pietro', *Paragone*, xi (1960), no. 123, pp. 27–30
L. Cuppini: 'Niccolò di Pietro: L'Arrivo dei Magi', *A. Ven.*, xviii (1964), pp. 160–61
U. Ruggeri: 'Le collezioni pittoriche rodigine', *L'Accademia dei Concordi di Rovigo* (Vicenza, 1972), pp. 29–112

MARIA CRISTINA CHIUSA

Niccolò Fiorentino. *See* SPINELLI, (3).

Niccolò Pisano [de Brusis; dell'Abrugia; di Bartolomeo] (*b* Pisa, 13 March 1470; *d* ?1538). Italian painter. His first recorded work was in Pisa, where he produced the altarpiece of the *Virgin and Child Enthroned with Saints* and the associated predella of the *Adoration of the Magi* and *Slaughter of the Innocents* (?1493; ex-S Matteo, Pisa; Pisa, Mus. N. S Matteo). In 1499 he was commissioned to participate in the decoration of the choir of Ferrara Cathedral and subsequently he was one of the painters who received a salary from Alfonso I d'Este, Duke of Ferrara. In Ferrara he also executed an altarpiece of the *Virgin and Child Enthroned between SS James and Helen* (1512–14; Milan, Brera). On the basis of stylistic comparisons with this, he has been attributed with several works, including the altarpiece of the *Holy Family with Four Crowned Saints* (1520; ex-S Niccolò, Ferrara; Worcester, MA, A. Mus.). In 1526 he moved to Budrio, near Bologna, where he produced the *Virgin and Child in the Clouds with Saints* (1526; Bologna, S Donnino), showing links with Raphael's classicism, the *Deposition* (ex-S Maria Maddalena, Bologna; Bologna, Pin. N.), the *Virgin and Child in Clouds with SS John, Eleutropius and Petronius* (1534; ex-S Giovanni in Monte, Bologna; sold Milan, Finarte, 4 Nov 1986) and the attributed (1988) *Virgin and Child with Saints* (Buenos Aires, Mus. N. B.A.). In 1537 Niccolò Pisano returned to Pisa, where he painted the panel depicting the *Punishment of the Sons of Aaron* (*in situ*) for the cathedral.

BIBLIOGRAPHY
I. B. Supino: 'Niccolò Pisano pittore', *Riv. A.*, ix (1916), pp. 1–9
R. Longhi: *Officina ferrarese* (1934, rev. Florence, 1956), pp. 72, 74, 118, 152, 166
G. Bargellesi: 'Opere di Niccolò Pisano', *Notizie d'opere d'arte ferrarese* (Rovigo, 1955), pp. 71–5
M. Ferretti: 'Pisa 1493: Inizi di Niccolò pittore', *Studi di storia dell'arte in onore di Federico Zeri* (Milan, 1984), pp. 249–62
E. Sambo: 'Niccolò Pisano tra Ferrara e Bologna', *Paragone*, cdlv (1988), pp. 3–20
E. Sambo: *Niccolò Pisano pittore (1470–post 1536): Catalogo generale* (Rimini, 1995)

ELISABETTA SAMBO

Nicholas V, Pope [Parentucelli, Tommaso] (*b* Sarzana, nr La Spezia, 15 Nov 1397; elected 1447; *d* Rome, 24 March 1455). Italian pope and patron. He was the first humanist pope of the Renaissance and the first to conceive of Rome as the cultural capital of Europe, putting the authority and wealth of the papacy at the service of a long-term plan for its architectural renovation. According to the biography composed by Gianozzo Manetti (1396–1459), he would have liked to have spent all of the papal wealth on books and buildings. In this spirit, he began the collection that became the Vatican Library and devised a coherent project for the restoration of Rome, which promoted architecture in the grand manner, subordinating the other arts. In 1449 he brought about the abdication of the last anti-pope, Felix V (*reg* 1391–1434), dissolved the Council of Basle and, thus, officially ended the Great Schism. To commemorate the restored unity of the Church, he declared 1450 a jubilee year. Thousands of pilgrims flocked to Rome, replenishing the papal treasury and validating Nicholas's concept of Rome as the centre of Christendom.

According to Manetti, the Pope's ambition for the renovation of Rome had five objectives: the repair of the city walls; the restoration of Rome's principal churches; the transformation of the Borgo, the zone between St Peter's and the Castel Sant'Angelo, from a medieval conglomerate of crooked streets into a rational plan facilitating traffic and allowing for the construction of palaces by members of the curia; the enlargement of the Vatican Palace; and the rebuilding of St Peter's, which he envisaged as the most magnificent church in Christendom. Not long before his death, Nicholas delivered an address defending his programme of reconstruction on the grounds that magnificent buildings enhanced the authority of the Holy See in the eyes of the uneducated. Few of his architectural schemes, however, were realized during his lifetime, and his successor, Calixtus III, suspended Nicholas's plans. Nicholas V rebuilt the walls of Rome, a project begun by his predecessor Eugenius IV, restored the Trevi Fountain and the churches of S Stefano Rotondo, SS Apostoli, S Celso and S Maria Maggiore (*see* ROME, §V, 5), rebuilt the Palazzo de' Conservatori on the Capitoline

Hill and constructed the corner bastions and the rectangular superstructure of the Castel Sant'Angelo. At the Vatican Palace (*see* ROME, §V, 1(iii)), where he was the first resident pope since the beginning of the 14th century, he built the tower associated with his name, a series of rooms on the ground-floor of the Cortile Belvedere, in which Sixtus IV later installed the Vatican Library, and a new wing on the north side of the Cortile del Papagallo, which includes the rooms that became the apartments of Alexander VI and the *stanze* of Julius II. The designers involved included the Florentine Bernardo Rossellino, whom Manetti named as the Pope's architectural adviser and who reinforced the walls of the transept of St Peter's, lined the nave of the basilica with chapels and in 1452 began the construction of a new monumental choir. Other contemporary writers and later Vasari attributed Nicholas's projects for the transformation of the Borgo and the rebuilding of St Peter's to LEON BATTISTA ALBERTI, who in 1452 dedicated to the Pope his *De re aedificatoria*. Much as the pontiff may have been influenced by Alberti's ideas, however, none of the plans that Alberti may have drawn up was put into execution, and this makes it difficult to estimate his contribution.

Like the majority of Renaissance popes, Nicholas V favoured the sumptuous, decorative style of painting introduced to Rome during the pontificate of Martin V (*reg* 1417–31) by Gentile da Fabriano and Pisanello; he commissioned from one of their followers frescoes depicting the personifications of the *Virtues*, of which only fragments have survived in the Sala Vecchia degli Svizzeri in the Vatican. Nicholas also continued the patronage of Fra Angelico: of the four fresco cycles that he painted at the Vatican between 1446 and 1449, only the cycle executed in 1448–9 in the Pope's private chapel survives. Its narrative scenes abound in references to the city of Rome: the scene depicted in the *Martyrdom of St Stephen* is divided by a representation of a section of Rome's city wall; the architectural background of the *Ordination of St Stephen* is probably derived from Alberti's project for the rebuilding of St Peter's; and the scene of *St Lawrence Distributing Alms* (*see* ANGELICO, FRA, §I, 4(i) and fig. 6) is staged in front of a fanciful version of the *porta argentea*, the original central doorway of the Constantinian basilica.

BIBLIOGRAPHY

G. Manetti: 'Vita Nicolai V summi pontificis', repr. in *Rerum italicorum scriptores*, iii, ed. L. A. Muratori (Mediolani, 1734)

E. Muentz: *Les Arts à la cour des papes pendant le XVe et le XVIe siècle*, i (Paris, 1878), pp. 68–189

L. Pastor: *Geschichte der Päpste seit dem Ausgang des Mittelalters*, i (Freiburg, 1885, 12/1955), pp. 371–652

T. Magnuson: 'The Project of Nicholas V for Rebuilding the Borgo Leonino in Rome', *A. Bull.*, xxxvi (1954), pp. 89–115

——: *Studies in Roman Quattrocento Architecture* (Rome, 1958), pp. 3–97

C. W. Westfall: *In This Most Perfect Paradise: Alberti, Nicholas V, and the Invention of Conscious Urban Planning in Rome, 1447–55* (University Park, 1974)

C. Gilbert: 'Fra Angelico's Fresco Cycles in Rome: Their Number and Dates', *Z. Kstgesch.*, xxxviii (1975), pp. 245–65

R. Krautheimer: 'Fra Angelico and—perhaps—Alberti', *Studies in Late Medieval and Renaissance Painting in Honor of Millard Meiss* (New York, 1978), pp. 290–96

H. Wohl: 'Papal Patronage and the Language of Art: The Pontificates of Martin V, Eugene IV and Nicholas V', *Umanesimo a Roma nel quattrocento* (Rome, 1984), pp. 240–43

HELLMUT WOHL

Nicola da Guardiagrele. *See* GALLUCCI, NICOLA.

Nicola da Urbino [Sbraghe, Nicola di Gabriele; Sbraga di Gabriele; Pellipario, Nicolò] (*fl* 1520–37/8; *d* Urbino, ?1537/8). Italian maiolica painter. He has long been confused with Nicolò Pellipario from Castel Durante, who was the father of the maiolica painter Guido Durantino (later Fontana) of Urbino. Nicola was documented as being in Urbino in 1520, by which time he was already referred to as *maestro*. He was head of his own workshop but also collaborated with others. One of his finest pieces is a large signed plate (1528; Florence, Bargello) decorated with the *Story of St Cecilia*. Four other signed pieces are in the Hermitage Museum, St Petersburg (1521), the Louvre, Paris (*c.* 1525–8), the church of S Stefano, Novellara (*c.* 1530), and the British Museum, London (*c.* 1535).

Several magnificent armorial services have been attributed to him on the basis of these works. The 'Correr' service (*c.* 1520; Venice, Correr) is noted for its lyrical scenes drawn from mythology and contemporary romances and for its graceful figures and sophisticated colour harmonies. A service of *c.* 1525 for Isabella d'Este, Marchesa of Mantua, was his most prestigious commission, and he also produced another set around the same time for the Calini family of Brescia. Both sets feature imaginative architectural settings. In the 1530s he made services for Isabella's son, Federico Gonzaga, 1st Duke of Mantua, and his wife, Margherita Paleologo.

Nicola was a pre-eminent figure in the production of Italian Renaissance maiolica and was a major influence on other *istoriato* painters in and around Urbino and Pesaro. Like other artists, such as Francesco Xanto Avelli, he drew on prints for inspiration, using woodcuts from Ovid's *Metamorphoses* (Venice, 1497) and engravings by such artists as Marcantonio Raimondi. Nicola's compositions, however, are imbued with a freshness and originality that set them apart from those of his contemporaries and followers. He is often regarded as the most gifted and inventive of the 16th-century *istoriato* artists and was largely responsible for establishing what is thought of as the classic style of Renaissance maiolica.

BIBLIOGRAPHY

H. Wallis: *XVII Plates by Nicola Fontana da Urbino at the Correr Museum, Venice: A Study in Early XVIth Century Maiolica* (London, 1905)

G. Liverani: 'Le "Credenze" maiolicate di Isabella d'Esta Gonzaga e di Federico II Duca di Mantova', *Corriere Cer.*, xvii (1939), pp. 1–17

B. Wallen: 'A Maiolica Panel in the Widener Collection', *National Gallery of Art: Report and Studies in the History of Art* (Washington, DC, 1968), pp. 94–105

J. Rasmussen: 'Zum Werk des Majolikamalers Nicolo da Urbino', *Keramos*, lviii (1972), pp. 51–64

F. Negroni: 'Nicolo Pellipario: Ceramista fantasma', *Not. Pal. Albani*, xiv/1 (1985), pp. 13–20

M. R. Palvarni Gobio Casali: 'Un episodio della storia di Giuseppe ed i fratelli in un piatto di maiolica di Nicola Urbino a Novellara', *Faenza*, lxxx/1–2 (1994), pp. 10–19

WENDY M. WATSON

Nicola di Maestro Antonio (di Ancona) (*fl* Ancona, 1472–1510). Italian painter. His only autograph work is the signed and dated altarpiece of the *Virgin and Child Enthroned with Saints* (1472; Pittsburgh, PA, Carnegie Inst.) from S Francesco delle Scale, Ancona. Other paintings attributed to him on the basis of this work include

the Massimo Altarpiece (main panel, Rome, Pal. Massimo alle Colonne), a lunette of *SS Lucy, Anthony and Bernardino* (Montefortino, Pin. Com.), *St Mary Magdalene, St Francis* (both Oxford, Ashmolean), a *Pietà* (Jesi, Pin. Civ.) and an *Annunciation with Saints* (Urbino, Pal. Ducale). His works are indebted to Francesco Squarcione, Carlo Crivelli, Marco Zoppo and Cosimo Tura. The influence of Piero della Francesca is also apparent in the light and landscape of the autograph altarpiece, which has figures of great inner tension and strange beauty.

BIBLIOGRAPHY

G. Hedberg: 'In Favour of Nicola di Maestro Antonio d'Ancona [sic]', *Minneapolis Inst. A. Bull.*, lxii (1975–6), pp. 84–99
D. Pennacchioli: *Nicola di Maestro Antonio* (diss., U. Bologna, 1987)
P. Zampetti: *Pittura nelle Marche*, i (Florence, 1988), pp. 330–33, 340–41, 366–73

HELEN GEDDES

Nicoletto da Modena [Nicoletto Rosex] (*b* Modena; *fl c.* 1500–*c.*1520). Italian painter and engraver. It is not certain whether he is identifiable with the Nicoletto mentioned in some Ferrarese court documents (1481–91; see Cittadella). Lodovico Vedriani described Nicoletto in 1662 as a 'painter most illustrious in perspective and an excellent engraver of copper'. No examples remain of his painting, but there are at least 78 engravings signed 'OPVS NICOLETI MODENENSIS ROSEX, OP NICOLETI DE MUTINA, OP. NI. MODENENSIS'. Two works are dated: the *Judgement of Paris* or *Four Nude Women* (1500; B. 110), a copy of the engraving of 1497 by Albrecht Dürer (1471–1528), and the *St Anthony Abbot* (1512; B. 48). The engravings that have been dated before 1500 are those connected with Andrea Mantegna and his circle, for example *Hercules and Antaeus* (B. 1) and *Vulcan Forging the Wings of Eros* (B. 2). These are characterized by dense diagonal hatching and iconographic models derived from Mantegna.

It is known from documents (see Sambin) that by 1506 Nicoletto was in Padua, where he is said to have decorated a chapel in an unspecified location with paintings (destr.), of which even the subjects are unknown. In Padua, Nicoletto must have become familiar with Venetian painting. This taught him to brighten and soften his style, which previously had been based on a rigid, rather dark Mantegnesque technique. The masterpiece of this second phase is the *Orpheus* (1500–06; B. 22–3), unsigned but certainly attributable to Nicoletto, in which the stylistic features are already those of his mature period. In 1507 he was certainly in Rome, as is proven by an inscription incised in a wall of the Domus Aurea: 'Nicholetto da Modena/Ferrara 1507'. It is not clear, however, whether he was living there or, as seems more likely, only passing through. In any case, on that occasion he saw the frescoes of Filippino Lippi in the Carafa Chapel in S Maria sopra Minerva (1489–93); a figure of a philosopher on the right side of the *Triumph of St Thomas Aquinas* was in fact used for his engraving *Apelles* (*c.* 1507; B. 31). He undoubtedly also looked at antique statues, such as the *Apollo Belvedere* (Rome, Vatican, Mus. Pio-Clementino), discovered in 1506, a copy of which was clearly used in his *Mercury* (B. 16), as well as in the *Apollo* (B. 34), the *Marcus Aurelius* (B. 35) and the *Quirinale Dioscuri* (B. 91), all datable to *c.* 1507. Above all, Nicoletto must have seen the grotesque decoration of the Domus Aurea and its contemporary imitations in the

works of Filippino Lippi, Jacopo Ripanda (frescoes in the Palazzo dei Conservatori) and Bernardino Pinturicchio (frescoes in S Maria in Aracoeli and S Maria della Vittoria), which inspired a rich series of engravings on that theme (B. 90–103). In some of his late engravings there are signs of Marcantonio Raimondi's mature style, and in fact the *St Anthony Abbot* (B. 64) is nothing but a readaptation of Marcantonio's engraving of the same subject (1515–20).

BIBLIOGRAPHY

L. Vedriani: *Raccolta de' pittori, scultori ed architetti modenesi più celebri* (Modena, 1662), p. 44
L. N. Cittadella: *Documenti ed illustrazioni riguardante la storia antica ferrarese* (Ferrara, 1869), p. 138
A. M. Hind: *Early Italian Engraving: A Critical Catalogue with Complete Reproduction of All the Prints Described*, v (London, 1948), pp. 107–40
P. Sambin: 'Nuovi documenti per la storia della pittura in Padova dal XIV al XVI secolo', *Boll. Mus. Civ. Padova*, li (1962), pp. 124–6
J. L. Sheehan and others: *Early Italian Engravings from the National Gallery of Art* (Washington, DC, 1973), pp. 466–88
M. Zucker, ed.: *Early Italian Masters, Commentary (1984)*, 25 [XIII/ii] of *The Illustrated Bartsch*, ed. W. Strauss (New York, 1978–), pp. 157–253 [B.]
J. Manca: 'Martin Schongauer et l'Italie, *Le beau Martin: Études et mises au point*, ed. A. Chatelet (Colmar, 1994), pp. 223–8
M. Munarini: 'Il periodo d'oro dell'arte ceramica a Padova', *Padova Territ.*, ix/48 (1994), pp. 8–9
J. M. Gonzalez de Zarate: 'Una breve nota sobre la fachada da la Universidad de Salamanca', *Homenaje al profesor Martín González* (Valladolid, 1995), pp. 625–30
S. Cohen: 'Virtuousness and Wisdom in the Giorgionesque Fresco of Castelfranco', *Gaz. B.-A.*, cxxviii/1530–31 (1996), pp. 1–20

LUCA LEONCINI

Nicolò da Voltri (*fl* Genoa, 1394–1417). Italian painter. He was the most important Ligurian painter in a period when the region was dominated by foreign, especially Tuscan, artists. His early development took place, probably in the 1370s, in the circle of Barnaba da Modena (*fl* 1361–83), who was active in Liguria between 1361 and 1383. On iconographic and stylistic grounds most scholars assign the *Virgin and Child* (Genoa, S Rocco) to this early period. Soon Nicolò became interested in Sienese painting, particularly that of Taddeo di Bartolo (1362/3–1422), who was in Liguria between 1393 and 1398. Records show that the two were in direct contact in 1394. Taddeo's influence is apparent in the signed *Virgin and Child* (Genoa, S Donato). In 1401, while working in Genoa on a tabernacle (untraced) for Nice Cathedral, Nicolò signed and dated the polyptych of the *Annunciation* (ex-S Maria delle Vigne, Genoa; Rome, Pin. Vaticana). The signed *St George and the Dragon* (?1402–4; Termini Imerese, church of the Minorites) must date from shortly afterwards. A date after 1401 has also been proposed for the dismembered polyptych of *St Columbanus* (Genoa, Mus. Osp. Civ.) and the signed polyptych of *St Peter* (ex-S Pietro in Vesima, Genoa; Gabiano, Castello Negrotto Cambiaso). Two predella fragments depicting *Apostles* (Genoa, Mus. Accad. Ligustica B.A.; Albenga, Mus. Dioc.) and the *Virgin Suckling the Infant Christ* (Baltimore, MD, Walters A.G.) have also been attributed to him. The last of these, a late work, shows very clearly the influence of the Pisan painters working in Liguria between 1410 and 1420.

BIBLIOGRAPHY

L. Venturi: 'Nicolò da Voltri', *L'Arte*, xxi (1918), pp. 269–76
F. R. Pesenti: 'Un apporto emiliano e la situazione figurativa locale', *La pittura a Genova e in Liguria dagli inizi al cinquecento*, i (Genoa, 1970, rev. 1987), pp. 60, 69–70

M. Migliorini: 'Aggiunte a Nicolò da Voltri', *Stud. Stor. A*, i (1977), pp. 55–63

E. Rossetti Brezzi: 'Pittura ligure del trecento', *La pittura in Italia: Il duecento e il trecento*, ed. E. Castelnuovo, 2 vols (Milan, 1986), pp. 40, 643

G. Algeri: 'Nuove proposte per Giovanni da Pisa', *Boll. A.*, xlvii (1988), pp. 35–48 (42–3, 48)

VITTORIO NATALE

Nicolò di Lombarduccio. *See* CORSO, NICOLÒ.

Nigreti. *See* PALMA.

Nofri, Andrea. *See under* ANDREA DA FIRENZE.

Nola, Giovanni da. *See* MARIGLIANO, GIOVANNI.

Nuti, Matteo [Matteo di Nuccio Vagnoli] (*b* Colfiorito, nr Foligno, *fl* 1423; *d* ?Cesena, 1470). Italian architect. He worked initially for Pandolfo III Malatesta (1370–1427) at the court of Fano (1423) and subsequently in various localities in the Malatesta domains. He directed work on the fortresses at Rimini (1438) and Fano (from 1439), where he also later worked on the city walls and gates (1443–4). After moving to Cesena, Nuti was put in charge of the fortifications and the Biblioteca Malatestiana (1447–52). The exterior of the latter, which may have been based on ideas supplied by Leon Battista Alberti, has a somewhat monastic appearance, with a series of pointed single-light windows on the first floor. The reading room is both spacious and intimate, with a barrel-vaulted nave marked off by columns from the flanking groin-vaulted aisles, in the manner of the library of the convent of S Marco, Florence, which was completed by Michelozzo di Bartolomeo in 1444.

In 1454 Nuti was in Rimini, working on the Tempio Malatestiano, where he directed work on the facing in Istrian stone and the roof, as well as executing decorative work in the chapel of the Martyrs. The same year he also worked on the broad spiral staircase and the chapel for the Castel Sismondo, Rimini (partly destr. 1626), the complex of buildings that served as Sismondo Malatesta's residence. In 1465 he returned to Cesena, which was then in papal hands, as superintendent of the fortifications. He took charge of rebuilding the fortress, strengthening it with a large circular tower in keeping with the fortifications that he built downhill. Meanwhile, in Fano he directed work on the Porta Maggiore and the nearby angled bastion (destr. 1944). In 1466 he inspected the fortifications of Ronciglione (Viterbo), proof of the regard in which he was held for his technical prowess in military architecture; yet although his work displays an awareness of contemporary developments, he cannot be considered an innovator.

BIBLIOGRAPHY
G. Volpe: *Matteo Nuti: Architetto dei Malatesta* (Venice, 1989)

ADRIANO GHISETTI GIAVARINA

O

Odoni, Andrea (*b* Milan, 1488; *d* Venice, 1545). Italian collector. The son of a Milanese merchant who settled in Venice, he spent his life in Venice as an administrator on the fringes of business and owned a fine house (now disfigured) on the Rio di Gaffaro. Girolamo da Treviso (ii) embellished the façade and courtyard with frescoes but the decoration, praised by Giorgio Vasari and Carlo Ridolfi (1594–1658), was already ruined by the time of Antonio Maria Zanetti (1680–1767). The details of Odoni's collection are known from notes taken by Marcantonio Michiel after a visit to the house in 1532 and from the inventory drawn up on the death of Odone's son, Alvise, in 1555; in addition, a letter survives from 1538 in which Pietro Aretino compliments Odoni on the artistic treasures in his house. Among these were a number of works and precious objects left to Odoni in 1523 on the death of his uncle, Francesco Zio, himself a distinguished collector, together with many items collected by Odoni. There were many genuine antique sculptures together with contemporary copies by Simone Bianco and modern bronzes. Odoni commissioned from Lorenzo Lotto a portrait of himself (1527; London, Hampton Court, Royal Col.; *see* LOTTO, LORENZO, fig. 3), in which he is shown three-quarter-length holding out an Egyptian-style statuette and surrounded by apparently ancient sculptures.

The paintings in the collection included the portrait of the 26-month-old dauphin *Charles-Orland* (Paris, Louvre), son of Charles VIII (*reg* 1483–98), by the Master of Moulins (*fl c.* 1480–*c.* 1500); this had been captured from King Charles's baggage train at the Battle of Fornovo. There were also a Flemish painting of *Hell* and works by principal masters of the Venetian school: a *Virgin and Child with Two Saints* by Titian (probably the *Virgin and Child with SS John the Baptist and Alexandria*; London, N.G.), a *Justice (?) of Trajan* and a *Hell* by Cariani, and a *Continence of Scipio* and a nude by Giovanni Girolamo Savoldo. In addition there was a *Transfiguration of St Paul* by Bonifazio de' Pitati (possibly the *Conversion of St Paul*; Florence, Uffizi), a *Young Woman with an Old Woman* by Palma Vecchio, a *St Jerome* after Giorgione and portraits of *Francesco Zio* (untraced) by Vincenzo Catena.

BIBLIOGRAPHY

M. Michiel: *Notizie d'opere di disegno* (MS.; *c.* 1520–40); ed. G. Frizzoni (Bologna, 1884); Eng. trans. by P. Mussi, ed. G. C. Williamson, as *The Anonimo* (London, 1903/*R* New York, 1969)
E. Cicogna: *Delle iscrizioni veneziane*, iii (Venice, 1833), pp. 434–7
G. Ludwig: 'Archivalische Beiträge zur Geschichte der venezianischen Kunst', *It. Forsch. Kstgesch.*, iv (1911), pp. 55–71
L. O. Larsson: 'Lorenzo Lottos Bildnis des Andrea Odoni', *Ksthist. Tidskr.*, xxxvii (1968), pp. 21–33
L. Beschi: 'Collezioni d'antichità a Venezia ai tempi di Tiziano', *Aquileia Nostra*, xlvii (1976), pp. 6–7
I. Favaretto: 'Simon Bianco', *Numi. & Ant. Class.*, xiv (1985), pp. 405–22

BERTRAND JESTAZ

Oggiono, Marco d' (*b* ?Milan, *c.* 1467; *d* Milan, 1524). Italian painter. He is first documented in Milan in a contract of apprenticeship of 1487, when he undertook to teach Protasio Crivelli (*d* after 1516) the art of painting miniatures; Marco must by that time have been a qualified master with a shop of his own. During the early 1490s he was in some way associated with Leonardo da Vinci: in September 1490 Leonardo's assistant Salai stole a valuable silverpoint pencil from Marco, who was then staying in the Florentine's house. In 1491 d'Oggiono and Giovanni Antonio Boltraffio were commissioned by the brothers of the late Archbishop Leonardo Griffi to paint an altarpiece for the newly constructed chapel of S Leonardo, attached to S Giovanni sul Muro, Milan; only the centrepiece of the work, a *Resurrection with SS Leonardo and Lucy* (Berlin, Bodemus.), survives. The Griffi Altarpiece was not finished until 1494.

In 1498 Marco worked for a confraternity in Venice, and in 1501 for the church of S Niccolò in Lecco. Between 1500 and 1510 he worked on several occasions in Liguria; most notably, he and Ambrogio Zaffaroni, another Milanese painter, were hired in 1501 by Cardinal Giuliano della Rovere (later Pope Julius II; *see* ROVERE, (2)) to execute frescoes in Savona Cathedral. Though Marco maintained his contacts in Savona for several years, he must have returned to Milan in 1504 or shortly thereafter, as from that time until his death he painted a number of large altarpieces for the churches and convents of Milan and its environs, as well as a considerable number of small-scale pictures.

Like Boltraffio, d'Oggiono was strongly and permanently affected by his association with Leonardo. Unlike Boltraffio, he lacked originality and taste; his compositions are repetitive and formulaic, and his colour sense unfortunate. At his best, however, he was capable of a high level of technical accomplishment, as works such as the small *Blessing Christ Child* (Rome, Gal. Borghese) reveal. He was highly regarded by his clients and contemporaries, and died a wealthy man.

BIBLIOGRAPHY

W. Suida: *Leonardo und sein Kreis* (Munich, 1929), pp. 201–9, 293–6
——: 'Marco d'Oggiono: Anmerkungen und Beiträge', *Rac. Vinc.*, xv–xvi (1935–9), pp. 129–55

B. Berenson: *Central and North Italian Schools*, i (1968), pp. 242–4
C. Marcora: *Marco d'Oggiono* (Lecco, 1976)
J. Shell: *Painters in Milan, 1490–1530* (diss., New York U., 1987), pp. 970–1043, *passim*
F. Caroli: 'Marco d'Oggiono: Un modello per Lucia Anguissola', *Achad. Leonardi Vinci: J. Leonardo Stud. & Bibliog. Vinciana*, viii (1995), p. 247
G. Sironi and J. Shell: 'Giovanni Antonio Boltraffio and Marco d'Oggiono: The Berlin *Resurrection with Sts Leonard and Lucy*' (in preparation)

JANICE SHELL

Olivieri, Maffeo (*b* Brescia, 1484; *d* Brescia, 1543–4). Italian sculptor, bronze-caster and medallist. His only signed work is the pair of candlesticks (h. 1.89 m) at the entrance to the chapel of the Sacrament of S Marco, Venice. They were evidently donated in 1527, on Christmas Eve, by Altobello Averoldo (*c.* 1465–1531), Bishop of Pola (now Pula, Croatia) and Papal Legate at Venice. Both candlesticks bear the inscription ALTOBELLVS. AVEROLDVS. BRIXIANVS.EPIS[copus]. POLEN [sis]. VENET (ia). LEGAT[us]. APOSTOLICVS.DEO.OPT[imo].MAX[imo]. DICAVIT —MAPHEVS OLIVERIVS FACIEBAT. In spite of the lack of documentary evidence, Hill attributed to Olivieri a group of twelve unsigned medals, formerly assigned to the 'Medallist of 1523' (two of the pieces bear that date). Hill drew attention to the analogy in design between the reverse representation on the *Averoldo* medal (e.g. London, V&A), which bears two figures 'unveiling Truth', and scenes on the signed candlesticks. He also noted the similar legends on both works. The reverse of the *Renier* medal (e.g. London, BM) showing 'Venetia waving the banner of St Mark', another piece from the group of twelve, bears close affinity to the bronze statue of *Adam with his Spade* (ex-Kaiser-Friedrich Mus., Berlin, destr.), which in turn resembles the nude youths on the candlesticks.

These figures emphasize a progression from Lombardic classicism towards a freer and more fluent treatment of the human body. The portraits of the Olivieri group are notable for their restrained elegance in design and technical refinement, their bold relief and sharp cameo-like truncations. The ductus of the lettering is assured, and good casts show the incised guiding lines for the legend.

A number of bronze statuettes have also been attributed to Olivieri, including *Venus and Cupid* and *Bust of a Woman* (both Paris, Louvre), as well as some marble and wood sculpture. A wooden altarpiece for Tione (untraced) was commissioned in 1515, another for the high altar of S Maria in Condino in 1538, and a wooden Crucifix for the church in Sarezzo; all are towns near Brescia. The attribution to Olivieri of the *Martinengo* monument (Brescia) has so far not been established.

BIBLIOGRAPHY
Forrer; Thieme–Becker
A. Armand: *Les Médailleurs italiens* (Paris, 1879, rev. 2/1883–7), i, pp. 124–5; iii, p. 51
W. von Bode: *Die italienischen Bronzestatuetten*, i (1907), p. 38; also in *Jb. Preuss. Kstsamml.*, xxx (1909), pp. 81–8
Exhibition of Italian Sculpture (exh. cat. by M. Rosenheim, London, Burlington F. A. Club, 1910–11), p. 50 [cat. of medals, plaquettes, gems etc]
K. Regling: 'Vier venezianische Medaillen', *Archv Medaillen- & Plakettenknd.*, ii (1920–21), pp. 1–9
G. F. Hill: *A Corpus of Italian Medals of the Renaissance before Cellini*, 2 vols (London, 1930/*R* Florence, 1984), pp. 126–30
A. Morassi: 'Per la ricostruzione di Maffeo Olivieri', *Boll. A.*, iii (1936), pp. 237–49

C. Boselli: 'Regesto artistico dei notai roganti in Brescia dall'anno 1500 all'anno 1560', *Supplemento ai commentari dell'Ateneo di Brescia per il 1976* (Brescia, 1977)
P. G. Redona: *Maffeo Olivieri e il crucifisso di Sarezzo* (Brescia, 1985)
V. Pialorsi: 'Medaglie relative a personaggi, avvenimenti e istituzioni di Brescia Provincia', *Medaglia*, xvii/24 (1989), pp. 7–34
The Currency of Fame: Portrait Medals of the Renaissance (exh. cat., ed. S. K. Scher, New York, Frick, 1994), pp. 108–11

MARK M. SALTON

Olivieri, Pietro Paolo (*b* Rome, 1551; *d* Rome, 6 July 1599). Italian sculptor and architect. Few details of his life are known, but his small oeuvre includes commissions for important public works that show he was successful in his time. Documents also seem to indicate his activity as an architect in the building site of S Andrea della Valle, and in the planning of the Sacramento altar in S Giovanni in Laterano. His religious sculptures in Rome show a classicizing type of late Roman Mannerism absorbed from the city's churches and workshops, where many Lombard masters of the time worked. Some of his allegorical figures and statues of saints, for instance *Gregory XIII* (*c.* 1585; Rome, S Maria d'Aracoeli), are markedly cold and didactic, with an exasperating minuteness of detail, qualities that his first biographer Baglione rather chose to emphasize as 'diligenza'. In the *Cleopatra* (marble, 1574; Rome, Pal. Corsini) and the *Andromeda* (*c.* 1570–80; priv. col.), however, the Tuscan influence of sculptors such as Baccio Bandinelli, Bernardo Buontalenti and Giambologna can be seen.

Olivieri, like many sculptors of the time, worked on the restoration of antique statues and fragments and all his work bears the stamp of his archaeological interests. Another current in his style is an archaizing interest in Late Gothic sculpture, as seen in the funerary relief *Husband and Wife in Huguenot Costume* (*c.* 1590; New York, Met.) and in the figures, recently attributed to him, of the *Virgin and Child* (*c.* 1587–8) completing the *Praesepe* (1285–7) of Arnolfo di Cambio in S Maria Maggiore, Rome.

BIBLIOGRAPHY
Thieme–Becker
G. Baglione: *Vite* (1642); ed. V. Mariani (1935), pp. 76–7
E. Borsellino: 'Una nuova acquisizione sulla collezione Corsini: La *Cleopatra* di Pietro Paolo Olivieri', *Paragone*, lx/475 (1989), pp. 3–14
R. Barbiellini Amidei: 'Pietro Paolo Olivieri', *Roma di Sisto V: Le arti e la cultura*, ed. M. L. Madonna (Rome, 1993), pp. 561–2

ENZO BORSELLINO

Onofrio, Andrea di. *See* ANDREA DA FIRENZE.

Opera, Giovanni dell'. *See* BANDINI, GIOVANNI.

Opificio delle Pietre Dure. *See under* FLORENCE, §III, 2.

Oriolo, Giovanni da. *See* GIOVANNI DA ORIOLO.

Ornament and pattern. Decorative devices applied or incorporated as embellishment. Ornament and pattern are not generally essential to the structure of an object, but they can serve a number of other purposes: they can emphasize or disguise structural elements, particularly in architecture, and they can fulfil an iconographic role. The repertory of Classical ornament and the concept of decorum, the theory of appropriate degree and type of orna-

ment, influenced the application of ornament and pattern in all European classical revival styles from the Renaissance period onwards.

BIBLIOGRAPHY

J. Evans: *Pattern: A Study of Ornament in Western Europe from 1180 to 1900* (London, 1931)
——: *Style in Ornament* (Oxford, 1950)
A. H. Christie: *Pattern Design: An Introduction to the Study of Formal Ornament* (New York, 1969)
R. Wittkower: *Allegory and the Migration of Symbols* (London, 1977)
J. C. Cooper: *An Illustrated Encyclopedia of Traditional Symbols* (London, 1978)
J. Fleming and H. Honour: *The Penguin Dictionary of Decorative Arts* (Harmondsworth, 1979)
E. H. Gombrich: *The Sense of Order: A Study in the Psychology of Decorative Art* (Oxford, 1979)
S. Lambert, ed.: *Pattern and Design: Designs for the Decorative Arts, 1480–1980* (London, 1983)
S. Jervis: *The Penguin Dictionary of Design and Designers* (Harmondsworth, 1984)
P. Lewis and G. Darley: *Dictionary of Ornament* (Moffat, 1986)
J. Hall: *Dictionary of Subjects and Symbols in Art* (London, 1987)
E. Wilson: *8000 Years of Ornament: An Illustrated Handbook of Motifs* (London, 1994)

□

1. Architectural. 2. Other.

1. ARCHITECTURAL. With the rise of humanism and the rebirth of Classical ideals in the 15th century came a corresponding revival of antique forms and decoration, derived principally from Roman buildings, triumphal arches, sarcophagi, bronzes and gems. Initially, at least, Classically-inspired ornament was simpler than its Gothic predecessor.

In the early years of the Renaissance in Florence (1420s) the architect FILIPPO BRUNELLESCHI introduced Classical features to Tuscan buildings: traditional arcading was raised on slender, unfluted columns, and walls were enriched with pedimented windows, roundels and rustication (*see* RENAISSANCE, §2). Roman monuments and the writings of Vitruvius were important influences on the work of LEON BATTISTA ALBERTI. However, whereas Vitruvius had considered ornament (by which he meant the architectural orders) as integral to a building, Alberti treated structure and decoration as separate entities. He applied the orders correctly, but employed them mainly as surface wall ornament, detaching them from their original context. He transformed Gothic churches by superimposing triumphal arch and pedimented temple motifs; the façade of S Francesco (*c.* 1450–60) in Rimini (*see* RIMINI, fig. 1), for example, incorporates a triumphal arch with composite half-columns and details from the nearby Arch of Augustus (*c.* 27 BC). Alberti's belief that the orders should be employed according to their status is illustrated on the façade of Florence's Palazzo Rucellai (begun 1446; *see* ALBERTI, LEON BATTISTA, fig. 2), where plain Tuscan columns feature on the ground floor and elaborate Corinthian examples enrich the *piano nobile* (for further discussion *see* RUCELLAI). In Rome, Donato Bramante's use of restrained ornament strictly confined to architectural features marked the complete re-establishment of the grammar of antiquity (*see* BRAMANTE, DONATO and fig. 4), although he also employed balustrading, unknown to the ancient world and possibly deriving from sculptural sources, and may have developed the so-called Serlian window.

As the 16th century progressed, buildings became more ornate, with portrait roundels and beribboned swags of fruit and drapery applied to their façades. Michelangelo inverted or dispensed with many Renaissance conventions: by massing together capital-less pilasters and elaborate tabernacles on the walls, he created a multi-layered effect of advancing and receding surfaces. Such Mannerist motifs as giant orders, a notable break from the Roman tradition, heavy quoins and voussoirs, rusticated columns and frames, and enormous voluted brackets, were used by both Michelangelo (*see* MICHELANGELO, §I, 4) and Giulio Romano, a pupil of Raphael. Each brought an expressive quality and wit to architecture, with complex rhythms or ornament and distortion of forms and scale. At the Palazzo del Te, Mantua (mid-1520s–1531; *see* GIULIO ROMANO, §I, 3(ii) and fig. 3), Giulio preferred instability to Renaissance harmony, employing dropped keystones and sliding triglyphs; the twisted columns were derived from a Raphael cartoon. Throughout the 16th century richer textural effects were obtained with different types of rustication —vermiculated, congelated, diamond-pointed—and with carved and stuccoed detailing. The extravagant façade of the Palazzo Negrone (*c.* 1560; attributed to Giovanni Battista Castello), Genoa, is encrusted with cartouches, naked figures, herms, masks and abundant fruit.

2. OTHER. Following excavations of the Domus Aurea, Rome, in the late 15th century, grotesques—non-naturalistic confections of scrolling acanthus and candelabra incorporating masks, putti, dolphins and mythical creatures—appeared in painted and stuccoed decoration (*see* GROTESQUE and fig. 1). Originally contained within architectural frameworks, grotesques later covered entire surfaces in delicate, filigree patterns. Doorways, cornices and chimney-pieces featured more orthodox Classical decoration, particularly egg and dart mouldings, scrolling acanthus, vases, trophies, putti and cherubs' heads. Throughout the 16th century designs became heavier, the Classical repertory was more freely interpreted, and Mannerist influences became apparent in dense arrangements of broken and scrolled pediments, caryatids, ewers, helmets and mythological figures. Interior ornament echoed and reinforced the painted themes of rooms, including hunting scenes and historical and allegorical cycles.

Ornamental sources in the decorative arts were especially diverse. Grotesques and prints after paintings were copied on silks, tapestries and maiolica (*see* ITALY, fig. 27 and colour pl. 1, XXVII3). Elaborate sculpture and naturalistic motifs enhanced both carved furniture (*see* ITALY, §VI and fig. 26 and colour pl. 1, XXXIV4) and metalwork, as in the work of Benvenuto Cellini (e.g. gold and enamel salt, 1540–43; *see* CELLINI, BENVENUTO, fig. 4) and the designs by Giulio Romano (e.g. design for ewer, *c.* 1540–50; London, V&A; *see* fig.); these combined Classical motifs, monsters and studies from nature and became a source for Mannerist designers. Intarsia inlay on panelling, doorways and furniture depicted *trompe l'oeil* and illusionistic schemes, (see colour pl. 1, XXXIV4) musical and scientific instruments, faceted cups and hourglasses.

BIBLIOGRAPHY

M. Levey: *High Renaissance* (Harmondsworth, 1975)
P. Murray: *The Architecture of the Italian Renaissance* (London, 1979)

Mannerist design for a ewer, attributed to Giulio Romano, pen and ink and wash, 305×150 mm, *c.* 1540–50 (London, Victoria and Albert Museum)

J. Shearman: *Mannerism* (Harmondsworth, 1979)
P. Bray Bober and R. Rubinstein: *Renaissance Artists and Antique Sculpture* (Oxford, 1986)
E. Miller: *16th-century Italian Ornament Prints in the Victoria and Albert Museum* (London, 1999)

SARA PETERSON

Orsi, Lelio (*b* Novellara, 1508 or 1511; *d* Novellara, 3 May 1587). Italian painter and draughtsman. A prominent Emilian artist of the mid-16th century, he was influenced by Correggio as well as by the late Mannerist style of Giulio Romano. His large-scale works seem to have been mainly secular decorations, notably illusionistic façades, of which only fragments are extant. Their energy and expressiveness are apparent, however, in the surviving paintings of smaller dimensions. Orsi's sole documented architectural work is the Collegiata di S Stefano, Novellara (1567; study, Windsor Castle, Berks, Royal Lib.).

Orsi was the son of a painter, Bernardino Orsi (*d* 1532). His earliest securely attributed work is the fresco decora-

tion *c.* 1535 of the Castello della Querciola (Reggio Emilia) with grotesque motifs, including putti, satyrs and fantastic animals, executed in monochrome ochre with white highlights. The athletic nudes, expressive distortions and the shafts of light animating the figures derive from such local painters as Bernardino Zacchetti (1472–after 1525) and Nicolò Patarazzi (1495–before 1562), with whom Orsi was in contact in 1536. The caricature-like quality of his monstrous figures suggests he was already familiar with Giulio Romano's decorations in the Palazzo del Te, Mantua (*see* GIULIO ROMANO, figs 4 and 5).

In 1538 Orsi was living in Reggio Emilia. His decorations (destr.) on the façade of the Torre dell'Orologio there are documented in 1544. The subject of these paintings has been identified as *Apollo and the Chariot of the Sun* (Pirondini and Monducci, 1985), based on two series of preparatory drawings featuring this subject (Windsor Castle, Berks, Royal Lib.; Paris, Louvre). The influence of the Mantuan school is evident in the drawings, as are elements derived from Michelangelo and Raphael. This has led to the suggestion that Orsi made a first visit to Rome in the 1540s (Romani). From the early 1540s there is evidence of the influence of Francesco Primaticcio, who was living in France but maintained links with the Emilia region, and of northern painters with their predilection for landscapes and dramatically lit nocturnal scenes. The dominant model for his work, however, remained the late Roman Mannerism derived from the works of Giulio Romano in Mantua. Works from this period include the *Agony in the Garden* (priv. col., see 1987 exh. cat., no. 156).

Accused of involvement in a murder, Orsi fled to Novellara in 1546. He remained there until 1557, apart from a stay in Venice in 1553 and in Rome in 1554–5. Only fragments of his decorations in the Rocca di Novellara survive (Modena, Gal. & Mus. Estense). These include the *Rape of Ganymede* and *Putti with Garlands*, probably from the *camerino* of Costanza di Correggio, widow of Alessandro I Gonzaga, Count of Novellara (*d* 1530). This room and its decorative theme were probably inspired by such precedents as the *studiolo* of Isabella d'Este in the Palazzo Ducale, Mantua. Also from the early years in Novellara are fragments of monochrome frescoes, including the *Great Flood, Stories of Deucalion and Pirra, Homage to Diana* and *Constellations and Gods* (all Modena, Gal. & Mus. Estense), which echo paintings done at Fontainebleau by Rosso Fiorentino and Primaticcio. Other fresco fragments (Modena Gal. & Mus. Estense) date from almost a decade later (Bonsanti; see 1978 exh. cat.). These also depict mythological themes, here derived from the early years of Ovid's *Metamorphoses*: the *Great Flood, Zeus and Lycaon, Deucalion and Pirra at the Temple of Temi* and *Apollo and the Serpent*.

Orsi's largest decorative project was for the Casino di Sotto, a villa near Novellara commissioned in 1563 by Alfonso Gonzaga, Count of Novellara; for this the artist provided everything from architectural drawings to decorative partitions. He also may have been involved in the Casino di Sopra, decorated about 1558. As only fragments of his large-scale decorative schemes survive, and no altarpieces, inferences about Orsi's monumental style are drawn from easel paintings, which became his speciality. These include the *Sacrifice of Isaac* and *St George and the*

1. Lelio Orsi: *Journey to Emmaus*, oil on canvas, 700×560 mm, after 1550 (London, National Gallery)

Dragon (both Naples, Capodimonte; see colour pl. 2, X1) and *Leda and the Swan* (priv. col., see Romani, fig. 23), attributable to the early 1560s. Slightly later in date, the *Annunciation* (priv. col., see Romani, fig. 45), identified by Zeri, shows the decided influence of Michelangelo, but tempered by the example of Daniele da Volterra. These new elements enriched the development of Orsi's own style. In a similar mould are the *Journey to Emmaus* (London, N.G.; see fig. 1) and the *Martyrdom of St Catherine* (Modena, Gal. & Mus. Estense; preparatory drawing, London, BM).

Orsi's drawings are characterized by a very high level of technique and by a stylistic sophistication inspired by Parmigianino. They are also notable for their visionary quality and the sometimes mysterious iconography of his subjects, for example the complex *Creation of the World at the Spring Equinox* (Paris, Louvre, Cab. Dessins; see fig. 2) and the enigmatic *Trinity and Pagan Deities* (Paris, priv. col.; see 1987 exh. cat., no. 139), datable to 1565. In his studies for the *Conversion of St Paul* (Cleveland, OH, Mus. A.; London, BM; Oxford, Ashmolean), attributable to the 1560s, the pen is used incisively, defining volumes in the manner of an engraving tool. Stylistically, the influence of Michelangelo is predominant. The only securely dated two-dimensional work by Orsi is the preparatory drawing (1569; Reggio Emilia, Beata Vergine della Ghiara) for his painting (1575–80; untraced) of the *Madonna della Ghiara*. This is the clearest example of his mature style, a reinterpretation of Raphael, in the manner of Correggio and Perino del Voga.

From the 1570s there are few records of Orsi's activities. The painting of *SS Cecilia and Valerian* (Rome, Gal.

Borghese) may date from this decade. He was probably living in Reggio Emilia in 1576, when he was paid ten scudi for frescoes proposed for the apse of S Prospero there, subsequently executed by Camillo Procaccini. One of the last references to Orsi relates to a commission received in 1580, for an altarpiece for the chapel of the Scaruffi in S Francesco, Reggio Emilia. This was never executed.

Orsi is first mentioned in the 17th century, by Malvasia, but the reconstruction of his oeuvre was undertaken only in the 18th century (Tiraboschi). Although he was the subject of several studies in the 1980s, many aspects of his work remain to be clarified, notably his links with humanist circles in Modena and Ferrara and his appreciation of antiquity.

BIBLIOGRAPHY

C. C. Malvasia: *Felsina pittrice* (1678); ed. G. Zanotti (1841)

G. Tiraboschi: *Biblioteca modenese* (Modena, 1786), pp. 493–502

Lelio Orsi (exh. cat. by R. Salvini and A. M. Chiodi, Reggio Emilia, Civ. Gal. Fontanesi, 1950)

F. Zeri: 'Lelio Orsi: Una Annunciazione', *Paragone*, 27 (1952), pp. 59–62

E. Panofsky: '"Sol Aequinoctialis fuit creatus": Notes on a Composition by Lelio Orsi and its Possible Connection with the Gregorian Calendar Reform', *Mélanges Alexander Koyce* (Paris, 1964), pp. 358–80

J. R. Hoffman: *Lelio Orsi da Novellara: A Stylistic Chronology* (diss., Madison, U. WI, 1975)

M. S. Verzelloni: *L'opera grafica di Lelio Orsi fino al soggiorno romano* (diss., U. Bologna, 1978)

Restauri fra Modena e Reggio (exh. cat. by G. Bonsanti, Modena, Pal. Musei, 1978), pp. 59, 93–100

S. Leonelli: *L'opera grafica di Lelio Orsi dal 1554 al 1587* (diss., U. Bologna, 1980)

J. Hoffman: 'Lelio Orsi and Thomas à Kempis' *Imitatio Christi*', *A. Crist.* (1984), pp. 135–42, n. 702

2. Lelio Orsi: *Creation of the World at the Spring Equinox*, pen and brown ink, 450×350 mm, 1565 (Paris, Musée du Louvre, Cabinet des Dessins)

V. Romani: *Lelio Orsi* (Modena, 1984)

M. Pirondini and E. Monducci: *La pittura del '500 a Reggio Emilia* (Milan and Reggio Emilia, 1985)

M. R. Bentini: 'Lelio Orsi alla corte Gonzaga di Novellara: Una proposta per il Cristo fra le croci', *Il Carrobbio*, xii (1986), pp. 34–48

Lelio Orsi, 1511–1587: Dipinti e disegni (exh. cat. by M. Pirondini and E. Monducci, Reggio Emilia, Teatro Municipale, 1987)

Lelio Orsi e la cultura del suo tempo: Atti del convegno internazionale di studi: Novellara, 1988

FRANCESCA CAPPELLETTI

Orsini. Italian family of patrons. One of the greatest Roman dynasties, the Orsini are documented from the 11th century and rose to prominence under the pontificate of Pope Celestine III (*reg* 1191–8). The founder proper of the Orsini dynasty was Matteo Rosso Orsini (*d* after 1254). In 1241 they defended Rome from the assault of the Holy Roman Emperor, Frederick II (*reg* 1212–50), and as a consequence began their traditional enmity with the Colonna family. By the 13th century they had had two popes: Celestine III and Nicholas III (*reg* 1277–80). The latter's emblem, also that of the family, was a standing bear (It. *orso*). At the close of the 13th century the Orsini began to divide into numerous branches, the principal ones being those of Monterotondo, the Conti di Nola and Pitigliano and the Duce di Bracciano and Gravina. So extensive was the family that it is not possible to reconstruct a comprehensive genealogy. The French family of Jouvenel des Ursins claimed kinship with them, and they were connected by marriage to the Medici and Farnese families.

From the 14th century until 1696 the Orsini family was associated with the small town of Bracciano (32 km northwest of Rome). Their castle (now Castello Odescalchi) still contains frescoes (finished by 1493) by Antoniazzo Romano depicting episodes from the *Life of the Orsini Family*. In Rome, they patronized a number of churches and commissioned mosaic decoration (destr.) from Pietro Cavallini. The wealthy and powerful Cardinal Giordano Orsini (1360–1438) was an eminent humanist at the Roman court whose circle included the leading scholars of the day. He bequeathed his library, which included many rare Classical texts, to St Peter's and commissioned an extensive fresco cycle (destr.) of *Famous Men* (not before 1432) for the fortified palace at Monte Giordano (now Palazzo Taverna), his residence from the 1430s. From this stronghold the Orsini ruled the approaches from Rome to the Borgo of the Vatican. According to Poggio Bracciolini, Giordano also had painted a fresco cycle of *Sibyls* in the Orsini palace in Via Papale, Rome.

In the 16th century the family achieved great prominence and counted among their members a number of important condottieri, statesmen and ecclesiastics. Between 1520 and 1540 the famous Orsini–Colonna set of maiolica pharmaceutical vessels (dispersed) was produced in Castelli. During the 16th century, patrons included an illegitimate son FULVIO ORSINI and the military leader Pier Francesco (Vicino) Orsini (1523–85), Duke of Bomarzo, who in 1552 commissioned the extraordinary Parco dei Mostri at Bomarzo. Other notable secular patrons included the illegitimate daughter of Archbishop Aldobrandini Orsini, Elena Orsini, Baroness of Filacciano. DANIELE DA VOLTERRA painted a chapel for her in the 1540s (Rome, Trinità dei Monti, Orsini Chapel). Corradino Orsini (*fl* 1580–93) employed Cavaliere d'Arpino (1568–

1640) and the architect Giacomo del Duca on the Palazzetto of Sixtus V (*c.* 1592–3) in Via di Parione. D'Arpino also frescoed the loggia of the Palazzo del Pio Sodalizio dei Piceni (1594–5) for Corradino. Another family member, the condottiere Giordano Orsini (1525–64), was in the service of Cosimo I, Grand Duke of Tuscany (1548), and the King of France (1551). Titian painted his portrait (*c.* 1562–4; destr.), the appearance of which is thought to be preserved in a volume on the history of the Orsini (see Sansovino, p. 85). The soldier Paolo Giordano I Orsini, Duca di Bracciano (*d* 1585), who gained notoriety by having his wife Isabella de' Medici strangled for adultery, owned a large collection of antiquities, the content of which is preserved in an inventory (?1582). Giacomo del Duca designed a garden for him at Bracciano.

BIBLIOGRAPHY

F. Sansovino: *De gli huomini illustri della casa Orsini* (Venice, 1565)

P. Litta: *Famiglie celebri italiane*, iv (Milan, 1839), pls XVI, XVII

C. A. Willemsen: *Kardinal Napoleon Orsini (1263–1342)* (Berlin, 1927)

G. Brigante Colonna: *Gli Orsini* (Milan, 1955)

V. Celletti: *Gli Orsini di Bracciano* (Rome, 1963)

W. A. Simpson: 'Cardinal Giordano Orsini (+1438) as a Prince of the Church and a Patron of the Arts', *J. Warb. & Court. Inst.*, xxix (1966), pp. 135–59

H. Rottgen: 'Giuseppe Cesaris Fresken in der Loggia Orsini: Eine Hochzeitsallegorie aus dem Geist Torquato Tasso', *Stor. A.*, 3 (1969), pp. 279–95

R. Mode: 'Masolino, Uccello, and the Orsini "Uomini famosi"', *Burl. Mag.*, cxiv (1972), pp. 369–78

G. Rubsamen: *The Orsini Inventories* (California, 1980)

C. Valone: 'Elena Orsini, Daniele da Volterra, and the Orsini Chapel', *Artibus & Hist.*, xi/22 (1990), pp. 79–87

☐

Orsini, Fulvio (*b* Rome, 11 Dec 1529; *d* Rome, 18 May 1600). Italian antiquarian and collector. He was an illegitimate son of the Orsini family. He devoted himself early to the study of manuscripts under the guidance of Gentile Delfini, Cardinal Ranuccio Farnese's *Vicario* at S Giovanni in Laterano, Rome. In 1554 he became a canon of the same church, and on Delfini's death in 1559 entered Farnese service, in which he remained for the rest of his career.

Orsini was secretary and librarian to Ranuccio Farnese until the latter's death in 1565. He was then 'inherited' by Cardinal Alessandro Farnese (*see* FARNESE, (3)) as librarian and as keeper of the antiques and works of art in the Palazzo Farnese. Orsini fulfilled his duties with care, acquiring many new works for the Farnese collection and advising his patron on the choice of artists for several commissions. He also composed inscriptions for the Cardinal's frescoes and devised iconographic programmes, including that for the Sala d'Ercole in the Villa Farnese at Caprarola.

Orsini's antiquarian interests made him a friend to many artists. He was especially close to Giulio Clovio and Pirro Ligorio. He amassed a considerable collection of antiques, paintings and drawings, including works that he attributed to Michelangelo (many drawings), Raphael (several portraits and many drawings), Francesco Salviati (a *St Francis*), Sebastiano del Piombo (several portraits) and Daniele da Volterra (copies after Raphael and Sebastiano). These have not been identified. He owned two paintings by Sofonisba Anguissola, *Game of Chess* (1555; Poznán, N. Mus.) and *Self-portrait* (1559; Naples, Capodimonte), and several by

El Greco (*c.* 1541–1614), including the portrait of *Giulio Clovio* (1570–72; Naples, Capodimonte). Many of the works may have been gifts from the artists in gratitude for Orsini's help in obtaining commissions. Orsini's interest in Classical iconography is shown by the publication of his *Imagines et elogia* (Rome, 1570), a study of portraits of famous men.

On the death of Cardinal Alessandro (1589), Orsini became tutor to his heir, Cardinal Odoardo Farnese, and continued to look after the family collections. He also acted as artistic adviser to his new patron, composing the programme for the Camerino frescoes in the Palazzo Farnese by Annibale Carracci (1560–1609). It has been suggested that Orsini also wrote the programme for the Farnese Gallery, but this remains conjectural. He bequeathed most of his collection to Odoardo Farnese, and many of his possessions are still to be found in the Farnese collection (Naples, Capodimonte and Mus. Archeol. N.).

BIBLIOGRAPHY

A. Ronchini and V. Poggi: 'Lettere di Fulvio Orsini ai Farnese', *Atti & Mem. RR. Deput. Stor. Patria Prov. Emilia*, iv (1879), pp. 6–74
P. de Nolhac: *La Bibliothèque de Fulvio Orsini* (Paris, 1887)
——: 'Les Collections de Fulvio Orsini', *Mél. Ecole Fr., Rome; Moyen Age, Temps Mod.*, iv (1888), pp. 139–231
J. R. Martin: *The Farnese Gallery* (Princeton, 1965), pp. 39–48
L. W. Partridge: 'The Sala d'Ercole at Caprarola', *A. Bull.*, liii (1971), pp. 467–86; liv (1972), pp. 50–62
C. Robertson: *Il Gran Cardinale: Alessandro Farnese, Patron of the Arts* (New Haven and London, 1992), pp. 223–31
M. Hochmann: 'Les peintures et les dessins de Fulvio Orsini et la collection Farnese', *Mél. Ecole Fr. Rome: It. & Med.*, 105 (1993), pp. 49–91
 CLARE ROBERTSON

Ortolano [Benvenuti, Giovanni Battista] (*b* Ferrara; *fl c.* 1500–after 1527). Italian painter. The name by which he is known is derived from his father's occupation as a gardener (It. *ortolano*). A document of 1512, according to which he was then more than 25 years old, supports the hypothesis that Ortolano began his career in Ferrara around 1500. Initially he was influenced by the Quattrocento style of devotional paintings by Domenico Panetti (*c.* 1460–before 1513) and Michele di Luca dei Coltellini. Subsequently he was drawn to the classicism of Boccaccio Boccaccino and Garofalo, which gave his painting a particular gentleness and clarity of form equally reminiscent of Perugino, as is evident in Ortolano's *Virgin and Child* (Paris, Louvre) and *Holy Family* (Rome, priv. col.).

Another work dated to this early period is a lunette depicting the *Pietà* (1505–6; Ferrara, Pin. N.). Probably as a result of a journey to Venice with Garofalo, he introduced warmer colours and a greater emphasis on naturalism into his painting.

Contact with Fra Bartolommeo, possibly in 1508, proved decisive in establishing Ortolano's commitment to his style of religious painting: essentially simple yet sensitive to realistic and descriptive details, as in his *Sacra conversazione* (Potsdam; Schloss Sanssouci) and the *Presentation in the Temple* (Tempe, AZ State U., Northlight Gal.). Around 1515 several works by Raphael arrived in Emilia, after which Ortolano turned his attention firmly towards Roman classicism. Both his altarpiece of *SS Sebastian, Roch and Demetrius* (London, N.G.) and his *St Margaret* (1524; Copenhagen, Nmus.) are stylistically close to Raphael. In his two versions of the *Deposition* (Rome, Gal. Borghese; Naples, Capodimonte), which are considered to be painted around the same time (the Naples version is dated 1521), the Raphaelesque classicism softens the compositional arrangement, which is still tied to the manner of Fra Bartolommeo. Ortolano's last dated work, the *Nativity* (1527; Rome, Gal. Doria–Pamphili), shows a further assimilation of Raphael's influence in the sculptural clarity and monumental simplicity of the forms.

BIBLIOGRAPHY
AKL
G. Baruffaldi: *Vite de' pittori e scultori ferraresi* (MS., 1697–1722); pubd in 2 vols (Ferrara, 1844–6/*R* 1971), i, pp. 165–80
C. Cittadella: *Catalogo istorico de' pittori e scultori ferraresi*, i (Ferrara, 1782), pp. 151–61
C. Laderchi: *Descrizione della quadreria Costabili* (Ferrara, 1838), pp. 6–12
B. Berenson: *North Italian Painters of the Renaissance* (New York and London, 1907), p. 276
A. Venturi: *Storia*, ix/4 (1929), pp. 320–43
R. Longhi: *Officina ferrarese* (Rome, 1934/*R* Florence, 1968), pp. 75–7
G. Frabetti: *L'Ortolano* (Ferrara, 1966)
E. Sambo: 'Ortolano: Giovanni Battista Benvenuti detto l'Ortolano', *La pittura in Italia: Il Cinquecento*, ii (Milan, 1987), p. 787
F. Ciani Passeri and others: '*Compianto sul Cristo morto*, Giovan Battista Benvenuti, detto l'Ortolano, datato 1521: Napoli, Pinacoteca del Museo Nazionale di Capodimonte', *Restauro*, vi (1994), pp. 180–87
A. M. Fioravanti Baraldi: 'Ludovico Pittorio e la cultura figurativa a Ferrara nel primo Cinquecento', *Alla corte degli Estensi: Atti del convegno internazionale di studi: Ferrara, 1992* (Ferrara, 1994), pp. 216–46
V. Romani: 'Giovanni Battista Benvenuti detto l'Ortolano', *Dosso Dossi: La pittura a Ferrara negli anni del ducato di Alfonso I*, ed. A. Ballarin, ii (Padua, 1995), pp. 262–78
 ANNA MARIA FIORAVANTI BARALDI

Ottavio dei Nonni. *See* MASCHERINO, OTTAVIANO.

P Q

Pacchiarotti, Giacomo (*b* Siena, 1474; *d* Viterbo, 1539–40). Italian painter. His style was influenced by Bernardino Fungai, who was possibly his teacher, and by Matteo di Giovanni, Perugino and Signorelli. His works include the *Visitation with SS Michael and Francis* (*c.* 1510; Siena, Pin. N.) and the *Ascension* (1530; Siena, Pin. N.), the *Virgin and Child with Saints* (1520; Casole d'Elsa, Pal. Com.) and the decorations executed between 1507 and 1514 for the Cappella Piccolomini, S Francesco, Siena (destr.). Often characterized as an imitator of 15th-century models, he is more significant for his synthesis of High Renaissance tendencies into a distinctly Sienese pattern of eclecticism. His linear definition, sculptural figures, selfconscious displays of perspective and harmony of design exemplify the traditional Sienese stylistic background against which Beccafumi's Mannerism was formed. Pacchiarotti is also documented as a designer of pageants and was active in the resistance against Florence.

BIBLIOGRAPHY
Thieme–Becker
F. Baldinucci: *Notizie* (1681–1728); ed. F. Ranalli (1845–7), ii, p. 115
L. de Angelis: *Elogio storico di Giacomo Pacchiarotti, pittor senese, del secolo sesto, recitato nella sala dell'esposizione dell'Accademia delle Belle carti di Siena, il 11 di settembre 1820* (Siena, 1820)
J. Burckhardt: *Der Cicerone* (Basle, 1855/*R* Stuttgart, 1964), p. 896
B. Berenson: *The Central Italian Painters of the Renaissance* (New York, 1909), pp. 212–14
G. Rosenthal, ed.: *Italian Paintings, XIV–XVIIIth Centuries, from the Collection of the Baltimore Museum of Art* (Baltimore, 1981), pp. 117–28
A. Angelini: 'Da Giacomo Pacchiarotti a Pietro Orioli', *Prospettiva*, 29 (1982), pp. 72–8
F. Sricchia Santoro: 'Ricerche senesi: 1. Pacchiarotto e Pacchia; 2. Il Palazzo del magnifico Pandolfo Petrucci', *Prospettiva*, 29 (1982), pp. 14–31

MILES L. CHAPPELL

Paciotto [Pacciotto; Pachote; Paciotti], **Francesco** (*b* Urbino, 1521; *d* Urbino, 13 July 1591). Italian architect. He was one of the most important military architects of the 16th century, as well as an interesting civil architect. A man of strong and violent character, he was on confidential terms with many of the princes for whom he worked. This is shown, for example, by the scurrilous language of his numerous letters to Ottavio Farnese, 2nd Duke of Parma and Piacenza, which were adorned with pornographic sketches. According to Vernaccia, his biographer, Paciotto studied civil and military architecture in Urbino with Girolamo Genga. In the 1540s he went to Rome, where he worked for the cardinals Alessandro Farnese and Ranuccio Farnese and formed a close friendship with Annibale Caro. He worked with the Accademia Vitruviana

della Virtù surveying the Baths of Caracalla and other ancient monuments. In 1549 he produced a scheme (unexecuted) for a monument to Pope *Paul III* in St Peter's, Rome. Other works in this period probably include a map of Rome printed by Antoine Lafréry (1512–77) in *Speculum romanae magnificentiae* (Rome, 1567). In 1550 Pope Julius III appointed him chief engineer of the Papal States and sent him to Ancona to rebuild the fortress.

In 1551 Paciotto entered the service of Duke Ottavio Farnese, for whom he reinforced or rebuilt the fortifications of Montecchio, Scandiano, Correggio and Guastalla (all 1557) and planned the fortifications of Borgo S Donnino (now Fidenza; 1557 or 1558; see below). During this period he also taught civil and military architecture and arithmetic to Prince Alessandro Farnese. When Piacenza was restored to the Farnese in 1556, Paciotto was appointed architect of the city's planning committee, in which capacity he completed the present Via delle Benedettine in 1558 and began construction of the Palazzo Farnese to a plan that he must have worked on from 1556. This was completely reworked by Jacopo Vignola, who produced more costly plans in the winter of 1560–61. Little is known of Paciotto's design, except that it included a wooden theatre in the courtyard, but this was probably more a semicircular extension to increase the courtyard's apparent depth than a real theatre in Vignola's antique style. A surviving preliminary scheme for the palazzo (see fig.) re-elaborates the plan for a villa derived from Poggio Reale in Naples, shown in *Delle antichità* (Venice, 1540), the third book of Serlio's *Il trattato di architettura*, with the addition of four bastions with embrasures, the latter even placed in the four loggias; this extreme form of flanking defence recalls the Palazzo del Tiranno in Serlio's then unpublished sixth book.

Also in 1558, at the request of Cardinal Alessandro Farnese, Paciotto produced a written opinion and two drawings (Naples, Archv Stato) on Vignola's design for the new Villa Farnese at Caprarola. Vignola, while naturally critical of Paciotto's opinion, adopted his suggestion of a large internal spiral stairway. Later that year Paciotto accompanied Ottavio Farnese on his visit to Philip II (*reg* 1556–98) in the Netherlands and remained there as 'chief engineer of all Flanders', enabling Philip to assess Paciotto's talents, both as a military architect at Béthune, Arras and Gravelines and through his plans for palaces in Piacenza and Brussels.

In November 1559 Paciotto entered the service of Emanuel-Philibert, Duke of Savoy, who retained him by

Francesco Paciotto: preliminary scheme for the Palazzo Farnese, Piacenza, 1556–8 (Parma, Archivio di Stato)

paying him well and finding him a wife. He was called to Genoa in 1560 to inspect the fortresses there and in Piedmont, and he fortified Savigliano. In 1561 he produced plans for the fortress of Vercelli and for the splendid walls of Lucca, on which construction began in 1562. His intentions are illustrated in a drawing (Windsor Castle, Berks, Royal Lib., fol. 10176). The curtain walls faithfully follow the drawing, but the bastions were built with rounded orillions at the suggestion of the military architect Genesio Bressani. Only the bastion of S Maria was built to Paciotto's plan.

In 1561 Philip II conferred on Paciotto the position of Chief Engineer for the State of Milan and soon after requested his presence in Spain to discuss certain fortifications and the Escorial. Paciotto remained in Spain for about a year and, by his own account as reported by Vernaccia, produced a design for the church and monastery of the Escorial, 'which was later carried out'. This is also documented by Fray José de Sigüenza, according to whom the church was the work of Paciotto. Paciotto stated that in 1561 he built the church of the Descalzas Reales in Madrid, at the request of Princess Joanna of Portugal. The church (destr. 1862) was remodelled in 1756 by Diego de Villanueva (1715–74) and Paciotto's authorship is difficult to prove. In 1562 he planned an irrigation canal from Aranjuez to Toledo, fed by the River Tagus, that would also serve the royal villa of Aranjuez and carry water to the upper part of Toledo with a fountain in the Alcázar; the project was not carried out on account of its cost and difficulty (Simancas, Archv Gen., leg. 251, 2°).

In autumn 1562 Paciotto returned to the service of Emanuel-Philibert and made improvements (destr.) to the Castello Sforzesco in Milan. In 1563 he restored the castles of Nice (destr. 1706) and Cisterna d'Asti. The regular pentagonal citadel at Turin (1563–6; destr.; see TURIN, §I) followed Paciotto's plan rather than that produced in 1560 by Giacomo Orologi. Paciotto also built the fortress of Cuneo in 1566, and his citadels at Turin and, especially, Antwerp (begun 1567; destr. 1874) mark a high-point in

16th-century fortification, both for their pentagonal form and for their position between the city walls, which enabled them to exert effective command over the city and surrounding countryside.

Paciotto became a citizen of Turin in 1568 and the next year he produced plans for other Piedmontese fortresses and went to Rome. In 1570 he prepared the temporary decorations for the wedding of Francesco Maria II della Rovere, Duke of Urbino, and Lucrezia d'Este in Urbino. His alleged involvement, together with his brother Orazio Paciotto, in a case of military espionage in 1571 led to his dismissal by Emanuel-Philibert, but in 1572 Pope Pius V nominated him as general engineer of the Papal States, an appointment confirmed by Gregory XIII, for whom he did further work on the fortifications of Ancona and a land reclamation scheme near Ravenna (1577–8). Probably in 1573 he became a member of the Accademia del Disegno in Perugia. In 1574 he returned to Parma to work on his designs for the fortifications of Borgo S Donnino (begun 1575; destr. 1603) in the form of a heptagonal shield with large bastions topped with rounded merlons and set-back flanks. Further work at Parma in 1580 probably concerned plans for the 'corridor', a large gallery intended to give a princely aspect to the rather unprepossessing Farnese court palace; after c. 1600 it was incorporated in the gigantic Palazzo della Pilotta. In 1589 he was asked by Vincenzo Gonzaga I to work on the fortifications of Mantua and perhaps also the citadel of Casale Monferrato, designed by Germanico Savorgnan (1554–1600). According to his memoirs, Paciotto began work in 1590 on the Fortezza Nuova at Livorno. His work for his many noble patrons earned him fortune and honours, and he became a count in 1578.

UNPUBLISHED SOURCES

Urbino, Bib. U. [P. G. Vernaccia: *Notizie del Conte Francesco Paciotto d'Urbino architetto militare e civile raccolte l'anno 1738*]

BIBLIOGRAPHY

J. de Sigüenza: *Historia de la Orden de San Jeronimo*, iii (Madrid, 1605/*R* 1905; as *Fundación del monasterio de El Escorial*, Madrid, 1963/*R* 1986)

C. Promis: 'La vita di Francesco Paciotto d'Urbino', *Misc. Stor. It.*, iv (1863), pp. 361–442

A. Ronchini: 'Francesco Paciotti', *Atti & Mem. RR. Deput. Stor. Patria Prov. Moden. & Parm.*, iii (1865), pp. 299–318

G. Kubler: 'Francesco Paciotto, Architect', *Essays in Memory of Karl Lehemann* (New York, 1964), pp. 176–89

P. Dreyer: 'Beiträge zur Planungsgeschichte des Palazzo Farnese in Piacenza', *Jb. Berlin. Mus.*, viii (1966), pp. 160–65

F. Manlio: *Lucca: Le mura* (Lucca, 1968)

B. Adorni: *L'architettura farnesiana a Parma, 1545–1630* (Parma, 1974), pp. 48–53, 146–9

——: *L'architettura farnesiana a Piacenza, 1545–1600* (Parma, 1982)

G. Kubler: *Building the Escorial* (Princeton, 1982)

BRUNO ADORNI

Padovano, Alessandro [Alessandro da Padova] (*fl* 1507–29). Italian painter. Born into a family of painters documented in Syracuse from 1481, he was a prominent follower of Antoniazzo Romano, whose style he interpreted in a sensitive, personal manner. His only surviving documented work, executed with Giovanni Maria da Treviso (*fl* 1506–13), is a signed and dated altarpiece of the *Virgin of Loreto* (1507; Syracuse, Pal. Bellomo); Alessandro was responsible for the group of the Virgin and Child, whose archaic forms reveal the additional influence of Antonello da Palermo (*fl* 1497–1528). The panel is

similar in style to the heavily overpainted *Virgin and Child* in the sacristy of the Chiesa Madre, Piazza Armerina. He painted the frescoes (destr. 1693) that decorated Mdina Cathedral, Malta. The *Last Judgement* (Palermo, S Nicolò da Tolentino) is a less certain attribution, perhaps also in collaboration with Giovanni Maria da Treviso. The main figures of the *Virgin of Loreto* in the Capuchin church, Savoca, sometimes attributed to Antonio de Saliba, are perceptibly similar to the dated altarpiece, indicating that this also was probably executed by Alessandro. The *Virgin Enthroned with SS John the Evangelist and John the Baptist* (Messina, Mus. Reg.) seems to be by the same hand, although some attribute it to Antonio de Saliba. Despite problems of attribution, Alessandro emerges as a provincial artist but not a crude one, as a certain elegance in the clean line and apparent naivety of his figures testify.

BIBLIOGRAPHY

G. Di Marzo: *La pittura in Palermo nel rinascimento* (Palermo, 1899)
E. Mauceri: 'Su alcuni pittori vissuti in Siracusa nel rinascimento', *L'Arte*, vii (1904), pp. 161–4
R. van Marle: *Italian Schools* (1923–38), xv, pp. 442–4
V. Bonello: *La Madonna nell'arte* (Malta, 1949)
S. Bottari: *La cultura figurativa in Sicilia* (Messina and Florence, 1954)

UGO RUGGERI

Padovano, Benedetto. *See* BORDON, BENEDETTO.

Padovano, Gasparo. *See* GASPARO PADOVANO.

Padovano, Giovanni. *See* RUBINO, GIOVANNI.

Padovano, Jan Maria [Padoan, Zuan Maria]. *See* MOSCA PADOVANO, GIOVANNI MARIA.

Padua [It. Padova; Lat. Patavium]. Italian university city on the River Bacchiglione, the provincial capital of Veneto.

1. History and urban development. 2. Art life and organization. 3. Centre of ceramics production. 4. Arena Chapel.

1. HISTORY AND URBAN DEVELOPMENT.

(i) Before 1405. According to a legend that goes back to Virgil and Livy, Padua, like Rome, was founded by Trojan refugees, in this case led by Antenor. The first settlements, in an oxbow of the River Brenta, probably date from the 11th to the 10th century BC. Archaeological evidence shows that between the 5th and 4th centuries BC there was a busy palaeo-Venetian town, a centre of trade and agriculture. It maintained increasingly close contacts with Rome, which it aided in the Gallic wars in the 3rd century BC, and came under Roman power in 49 BC. In the first two centuries of the Empire, favoured by a well-organized network of roads and rivers and a solid economy based mainly on the wool industry, Padua (Patavium) became one of the most important Roman cities. Christianity arrived by the middle of the 3rd century AD; the cult of the martyr St Justina (*d c.* AD 300) developed soon afterwards.

Padua was only marginally affected by the barbarian invasions, which began in the early 5th century, but the wars between the Ostrogoths and the Byzantines in the following century were followed by several difficult decades. The exodus towards the Venetian lagoon began,

aggravated by the Lombard siege and conquest of the city in 602. The combination of a shift in the course of the River Brenta, caused by flooding that replaced it with the River Bacchiglione, and the Lombard invasion virtually erased Roman Padua.

The history of Padua under the Lombard occupation is obscure. The civil authority was transferred to the nearby town of Monselice. The bishop may have remained, maintaining a settlement around the cathedral. After the Franks came 150 years later, this settlement formed the nucleus of the urban revival. The bishop was still highly influential when Padua became the county seat in 969, and this continued during the subsequent development of the Commune, which by the early 12th century was well established. Two significant events occurred in the 1220s: in 1222 a group of Bolognese students and professors of law founded the university, which soon became one of the most famous in Europe; and Anthony of Padua (1195–1231; *can* 1232) arrived. The popularity of his cult resulted in the construction of Il Santo, begun soon after his death. There were incessant wars between Padua and the nearby communes, which culminated in the rule of Ezzelino III (*reg* 1237–56), the son-in-law of Emperor Frederick II.

In 1318 Giovanni da Carrara was appointed Capitaneus et Dominus Generalis to conduct the war against the della Scala family of Verona, disputing possession of Vicenza, which Padua had annexed. This essentially ended the republic. After the short rule of the della Scala (1328–37), the princely DA CARRARA family took over. They were enlightened patrons. They fortified the Borghi quarter and built the Reggia (14th century; mostly destr.).

(ii) 1405 and later. Padua was conquered by the Venetians in 1405, after a long war that practically halved the population. In the 15th century Padua was allowed to retain its old administrative practices. At the beginning of the 16th century, however, Venice imposed its rule more firmly after recapturing territories lost to the League of Cambrai (a coalition of major European and Italian states). Since Padua, which was conquered in June 1509 and recaptured a month later, was extremely important for the defence of Venice, a strong ring of bastioned walls (1517–40; see fig. 1), roughly following the line of those built in the 14th century, was built. Both Michele Sanmicheli and Giovanni Maria Falconetto participated in their construction. Numerous buildings inside and outside the walls were demolished to form a wide band of open ground (the *guasto*) that blocked the expansion of the city, which had already begun to spread along main roads.

In the central public spaces the Venetian government began to assert its dominance using classical and triumphal architecture and figurative art. In 1539 work began on the Palazzo del Podestà (now Palazzo Municipale) and the nearby Palazzo del Bò (for illustration *see* MORONI, ANDREA) for the university. At the end of the 16th century the old Carrara palace was converted into the Palazzo del Capitano (1599–1605); the entrance was moved and framed by a triumphal arch below a clock-tower. Private building, however, remained faithful to the traditional style with porticos imitative of the city's public buildings. Dramatic emphasis tended to be given to the interiors of the houses of important families, as, for example, in

1. Padua, plan of the city showing the bastioned walls (1517–40); from an engraving by Giovanni Valle, 1.77×2.00 m, 1782–4 (Padua, Museo Civico)

Giovanni Maria Falconetto's Loggia Cornaro (1524; for illustration *see* FALCONETTO, GIOVANNI MARIA) and the Odeo (1524; see colour pl. 1, XXIX2).

BIBLIOGRAPHY

J. K. Hyde: *Padua in the Age of Dante* (Manchester, NY, 1966)
C. Aymonino, ed.: *La città di Padova* (Rome, 1970)
G. Lorenzoni and L. Puppi: *Padova: Ritratto di una città* (Vicenza, 1973)
C. Bellinati and L. Puppi, eds: *Padova: Basiliche e chiese* (Vicenza, 1975)
D. Torresini: *Padova, 1509–1969: Gli effetti della prassi urbana borghese* (Padua and Venice, 1975)
L. Puppi and F. Zuliani, eds: *Padova: Case e palazzi* (Vicenza, 1977)
I Benedettini a Padova e nel territorio padovano attraverso i secoli (exh. cat., ed. A. de Nicolò Salmazo and F. G. Trolese; Padua, S Giustina, 1980)
S Antonio, 1231–1981: Il suo tempo, il suo culto e la sua città (exh. cat., ed. G. Gorini; Padua, Pal. Ragione and Il Santo, 1981)
L. Puppi and M. Universo: *Padova* (Bari, 1982) [with a full bibliog.]
S. Ghironi: *Padova: Piante e vedute, 1449–1865* (Padua, 1985)
P. Maretto: *I portici della città di Padova* (Milan, 1986)
G. Croce, R. Castelli and R. Gonzato: *Padova: I rilievi del centro storico* (Padua, 1988)
A. Verdi, ed.: *Le mura ritrovate: Fortificazioni di Padova in età comunale e carrarese* (Padua, 1988)
A. Ventura: *Padova* (Rome and Bari, 1989)

DONATA BATTILOTTI

2. ART LIFE AND ORGANIZATION. The artistic life of Padua was at its most vital and its artistic products most influential during the later Middle Ages and the early Renaissance period. The city is particularly important for its painting. The Carrara court provided important humanist patronage throughout the 14th century, as Padua became one of the leading centres of North Italian painting. More than 100 painters are recorded working there, about half of whom were native Paduans. Of the outsiders, over 20 came from Venice and Bologna, the rest from other Italian towns and a few from France and Germany. The painters' guild met at the church of S Andrea. Following the work of GIOTTO in Padua, Paduan painting seems to have been in demand throughout the region.

After the mid-14th century the greatest achievements, which constitute the 'Paduan proto-Renaissance', were, however, largely by painters from outside Padua such as Nicoletto Semitecolo (*fl* 1353–70), Giusto de' Menabuoi (*fl* 1349–*c*. 1390) and Altichiero (*fl* 1369–93). The extent to which their innovations, in combination with the perspectival researches (*Quaestiones Perspectivae c*. 1390) of Biagio Pelacani, professor of astrology at Padua University, may have been transmitted to Florence via Brunelleschi's associate, the astronomer Paolo Toscanelli, or by Leon Battista Alberti, a student at Padua in the early 15th century, is unclear. Given the shared humanist interests of the two cities, some such connection is probable. The fine Paduan school of manuscript illumination was essentially dominated by Bolognese styles, perhaps transmitted at university level, and several Bolognese illuminators were recorded working in Padua. Sculpture was largely dominated by Venetian models.

In the 15th century Paduan commissions were given to members of the BELLINI family and to Antonio Vivarini (*see* VIVARINI, (1)) in collaboration with Giovanni d'Alemagna (*d* 1450), among others. Fra Filippo Lippi was active in Padua in the 1430s. From 1431 FRANCESCO SQUARCIONE taught over 100 pupils in his Paduan school, including Michele di Bartolommeo, ANDREA MANTEGNA, MARCO ZOPPO, GIORGIO SCHIAVONE, Dario da Trenso, and the illuminator GIROLAMO DA CREMONA. PAOLO UCCELLO executed several frescoes in Padua from 1445 to 1446. The Florentine Donatello lived in Padua from 1443 to 1453; his statue of Erasmo da Narni, the so-called *Gattamelata* (1447–53; for illustration and discussion *see* DONATELLO, §I, and fig. 4), was the first monumental equestrian bronze to be cast in Italy since Roman times. Donatello's work, together with that of the Paduan Mantegna, maintained the city's importance as an artistic centre. A succession of important sculptors worked in Padua or executed commissions for the city in the 15th century and after, including BARTOLOMEO AMMANATI, GIROLAMO CAMPAGNA, JACOPO SANSOVINO, FRANCESCO SEGALA, TIZIANO MINIO, his nephew Tiziano Aspetti (*c*. 1559–1606), Giovanni d'Antonio Minelli de' Bardi (*see* MINELLO, (1)), GIOVANNI MARIA MOSCA PADOVANO, GIOVANNI RUBINO, Vincenzo Grandi and Giovanni Girolamo Grandi (*see* GRANDI).

Yet the city increasingly became a cultural outpost of the Venetian state. Comparison between the young Titian's Paduan frescoes of the *Life of St Anthony* in the Scuola del Santo (1510–11; *see* TITIAN, §I) and those by local artists emphasizes the generally provincial nature of Paduan painting in the High Renaissance period. In the 16th century BERNARDINO SCARDEONE published a book detailing Padua's cultural heritage.

BIBLIOGRAPHY

H. Moschini: *Dell'origine e delle vicende della pittura in Padova* (Padua, 1826)
Da Giotto a Mantegna (exh. cat., ed. L. Grossato; Padua, Pal. Ragione, 1974)
A. Sartori: *Documenti per la storia dell'arte a Padova* (Vicenza, 1976)
C. Semenzato, ed.: *Le pitture del Santo di Padova* (Vicenza, 1984)
C. Karpinski: 'Il Tionfo della fede: L'"affresco" di Tiziano e la silografia di Lucantonio degli Uberti', *A. Ven.*, xlvi (1994), pp. 6–13
D. Norman, ed.: *Siena, Florence and Padua: Art, Society and Religion, 1280–1400* (New Haven and London, 1995)

JOHN RICHARDS

3. CENTRE OF CERAMICS PRODUCTION. As in many other North Italian centres of ceramic production during

the 15th and 16th centuries, the pottery in Padua was decorated with *sgrafitto* designs; the decorative motifs and shapes of these wares were quite conventional. Occasionally local artists produced work of such quality that it is often difficult to establish whether it is the work of local craftsmen or imported from Ferrara, the most famous centre of *sgraffito* production at that time. From the mid-16th century, maiolica wares decorated with *istoriato* (narrative) designs were being produced. Although they were greatly influenced by and are stylistically almost indistinguishable from contemporary Venetian products, some are dated and stamped A PADOA (e.g. plate, 1563; London, BM). At the end of the 15th century and during the 16th, Paduan potters introduced a special type of ware known as *Candiana*, which was produced for a convent near Padua. Characteristic of this maiolica are the decorative motifs derived from the multicoloured, floral wares from Iznik in Anatolia, which were brought to the Veneto through trade links with Venice.

BIBLIOGRAPHY

A. Moschetti: *Della ceramica graffita padovana* (Padua, 1931)

G. Morazzoni: *Antica maiolica veneta* (Milan, 1955)

M. Munarini: 'Il periodo d'oro dell'arte ceramica a Padova', *Padova & Territ.*, ix/48 (April 1994), pp. 8–9

CARMEN RAVANELLI GUIDOTTI

4. ARENA CHAPEL. This small brick structure (interior 29.26×8.48×12.8 m to the apex of the vault) consists of a single-cell nave, the walls and vault of which are entirely covered with paintings (rest.) by Giotto (see fig. 2 and colour pl. 1, XXXIV2), and a choir with paintings by an imitator. The cycle by Giotto is widely accepted to represent the pinnacle of his achievement and to be one

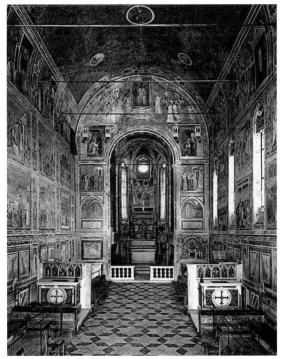

2. Padua, Arena Chapel, interior view looking east, begun 1303

of the most important Italian pictorial cycles (for a discussion of the paintings *see* GIOTTO, §I, 3(i)).

The chapel is the sole remaining fragment of a house built by a leading citizen, Enrico Scrovegni (*d* 1336), on a site just outside the city walls in an area marked by the remains of the elliptical Roman amphitheatre or arena (hence the names of Cappella dell'Arena and degli Scrovegni). Scrovegni purchased the land from another leading family on 8 February 1300. The contract details the houses and orchards then standing on the land. Their presence seems to preclude the idea that the chapel was preceded by a smaller church. An annual procession and play of the Annunciation took place mostly within the elliptical space, perhaps even in the previous century. Outside that space a small church of the Annunciation is recorded by 1325, with a confraternity devoted to supporting the play. Documents concerning it have often been presumed to refer to the Arena Chapel, which from the next century was sometimes alluded to as of the Annunciation, but in all formal records from 1304 to the 19th century its name is S Maria della Carità. Scrovegni built a grand but undocumented house; the chapel, with its own outside entrance, abutted the south side. The façades of house and chapel faced inwards at the line of the amphitheatre wall. A quite good sense of the scale and the layout of the complex can be had from a bird's-eye view in a city plan published by Portenari in 1623 (p. 91).

According to a document of 1305 (see below), permission to build the chapel was obtained from a bishop who died in March 1302. A lost inscription on Scrovegni's tomb in the chapel noted that he 'dedicated' it to the Virgin in 1303; a more specific date, often said to be 25 March, is not implied. A papal bull of 1 March 1304 granted indulgences at the Annunciation and three other great feasts of the Virgin to visitors. On 9 January 1305 clergy of the nearby parish church lodged a complaint that, contrary to the authorization given by the previous bishop for a modest family chapel, Scrovegni had included with 'pomp and vainglory' a large bell-tower and several altars. On 16 March 1305 the city council of Venice voted to lend Scrovegni 'cloths of S Marco' for the forthcoming consecration, perhaps of an altar, often presumed to be scheduled for 25 March. This loan has been thought to imply that Giotto's frescoes were not yet ready; but the cloths may have been hung in the choir or even outside the building. In 1306 payments were made for some volumes in a set of choir-books (antiphonaries B14–16 and A14–16 in Padua, Bib. Capitolare) for Padua Cathedral, some of which are very close copies of Giotto's Arena frescoes. This *terminus ad quem* confirms as very probable the dating arrived at on the basis of the records of the events of 1304–5. The painting surely required at least two years, i.e. 1304–5, and was possibly under way in 1303. It is often suggested that Giotto was also the architect of the chapel, but the blocking of a door and a window required by his design argues against this view, which is supported only on general stylistic grounds.

In the lower part of the *Last Judgement* in Giotto's cycle is an image of the kneeling Scrovegni offering the chapel to the Virgin and two other saints (variously identified; probably *SS John the Evangelist* and *Mary Magdalene*, to whom the two secondary altars of the chapel were

dedicated according to 15th century records). Scrovegni is assisted by a priest who also holds up the building. A full-time priest was on duty by 1309, and a staff of 12 was endowed in 1317. In his endowment and elsewhere Scrovegni cites the following as the purpose of his building: honour to the Virgin and to his city and help and salvation for his forefathers' souls and his own. He thus regarded the soul of his usurious father as in Purgatory, as did other Paduans. If, as Dante wrote (*Inferno* xx, 64–75), it had been in Hell, he would have been beyond possible help; the idea that the chapel was mainly meant to expiate the usury of the father in Hell is modern. Such expiation was obtained not by building but by returning money, as Scrovegni did in his will and earlier.

The chronicler Michele Savonarola (1384–1468) wrote that he was omitting descriptions of the city's fine private houses because his readers would never believe how splendid they were, but that he would make an exception for the Scrovegni house, evidently the finest of all. The house passed through many changes of ownership until it was destroyed in the early 19th century; the chapel, preserved by a conservation campaign, was bought by the city in 1880.

BIBLIOGRAPHY

A. Portenari: *Della felicità di Padova* (Padua, 1623)
M. Savonarola: *Libellus de magnificis ornamentis regie civitatis Padue* (1477); ed. L. Muratori in *Rerum Italicarum scriptores* (Città di Castello, 1902)
J. Stubblebine, ed.: *Giotto: The Arena Chapel Frescoes* (New York, 1969) [the only nearly complete assemblage of the docs; in Eng. trans.]
R. H. Rough: 'Enrico Scrovegni, the *Cavalieri Gaudenti*, and the Arena Chapel in Padua', *A. Bull.*, lxii (1980), pp. 24–35
P. Pelagatti and E. Riccomini: 'Studi sullo stato di conservazione della Cappella degli Scrovegni in Padova', *Boll. A.*, lxvii/2 (1982) [special issue with extensive bibliog.]
G. Toffanin: *Cento chiese padovane scomparse* (Padua, 1988)
F. D'Arcais: 'Precisazioni e proposte per la datazione della decorazione dell'abside della cappella degli Scrovegni', *Studi di Storia dell'Arte in Onore di Mina Gregori* ([Milan], 1994), pp. 13–14
A. M. Spiazzi: *La Chapelle des Scrovegni à Padoue* (Milan, 1994)
L. Jacobus: 'Giotto's Design of the Arena Chapel, Padua, Italy', *Apollo*, cxli (1995), pp. 37–42
R. Simon: 'Giotto and after: Altars and Alterations at the Arena Chapel, Padua, Italy', *Apollo*, cxli (1995), pp. 24–36
C. Bellinati: *Padua Felix: Atlante iconografico della cappella di Giotto, 1300–1305* ([Ponzano], 1997)

CREIGHTON E. GILBERT

Pagno di Lapo (Portigiani) (*b* Fiesole, nr Florence, 1408; *d* Florence, 1470). Italian sculptor and architect. He spent much of his early career working for Donatello and Michelozzo: he is documented in connection with the font in the Siena Baptistery (1428) and the external pulpit of Prato Cathedral (1430–33). He was engaged on mainly decorative work in S Lorenzo, Florence, *c.* 1440 and in 1442 supplied the bronze for the doors of the north sacristy in Florence Cathedral. About 1445 he supervised the decoration of the courtyard and perhaps the chapel of the Palazzo Medici and then worked on the tabernacle of the *Annunciation* in SS Annunziata, Florence. In 1447, together with Giovanni Rossellino (1417–?1496), he executed the tabernacle over the baptismal font in Massa Marittima Cathedral.

For almost a decade from 1451 Pagno was in Bologna, where he was involved in the decoration (1453; 1459–61) of chapels in S Petronio and supervised the decoration of the Palazzo Bolognini (destr. 1507), perhaps also carrying

out structural work. He designed the Palazzo Bentivoglio (begun 1460; destr. before 1551) and may also have been responsible for the Bentivoglio family chapel in S Giacomo Maggiore. Two corbels and the side slabs of the tomb of *Antongaleazzo Bentivoglio* (completed *c.* 1451) in the same church are also attributed to him. In 1462 he supervised the last phase of building at S Lorenzo, Florence. About 1467 he was commissioned to build a portico (destr. *c.* 1600) in front of S Pietro, Bologna, and to make statues of *St Peter* and *St Paul* (destr.). Among the works attributed to him by Vasari are 'an enormous bronze lily in a vase', a great bronze candlestick and a marble basin for holy water with a figure of *St John* (all ex-Florence, SS Annunziata). Vasari's attribution to Pagno of two marble figures of the *Virgin and Child* (Florence, SS Annunziata and Mus. Opera Duomo) is disputed. Pagno's son, Lapo di Pagno Portigiani (*c.* 1448–*c.* 1511), is documented as working in Faenza from 1484 as a sculptor and perhaps an architect.

BIBLIOGRAPHY

Thieme–Becker
G. Vasari: *Vite* (1550; rev. 2/1568); ed. G. Milanesi (1878–85), ii, pp. 445–7
C. von Fabriczy: 'Pagno di Lapo Portigiani', *Jb. Kön.-Preuss. Kstsamml.*, xxiv (1903), pp. 119–36
H. W. Janson: 'Two Problems in Florentine Renaissance Sculpture', *A. Bull.*, xxiv (1942), pp. 326–35 (326–9)
C. Volpe, ed.: *Il tempio di San Giacomo Maggiore in Bologna* (Bologna, 1967) [with bibliog.]
M. Ferrara and F. Quinterio: *Michelozzo di Bartolomeo* (Florence, 1984)

ANTONIO NATALI

Palazzo [It.: 'palace']. Italian term originally applied to large or residential buildings but now used more broadly to describe any large secular or urban structure. Although the early medieval Italian palazzo contained residential space, it was primarily civic in purpose, providing the seat of government during the era of the independent city-republics, communes and later rule by individuals. The terms Palazzo Pubblico, Palazzo Comunale, Palazzo del Podestà and Palazzo dei Priori all indicate types of designated government at the time of a particular civic building's construction. Residential palazzi, on the other hand, are identified by the names of the families who built or remodelled them, as in the Palazzo Rucellai and the Palazzo Medici (later Palazzo Medici–Riccardi).

The residential function of the medieval civic palazzo derived from the legal stipulation that the chosen municipal leader, who was by law a resident of another city, must live in the designated civic palazzo during his term. The same regulation applied to other elected officials. Optimum spaces on the upper floors were reserved for their living areas. Such civic buildings often included several apartments, many with an elegance equal to or exceeding the panelled and frescoed meeting-chambers below. The dual-purpose civic palazzo set a precedent for the division of the private palazzo into separate commercial and residential levels. Merchant palazzi, for example the 14th-century Palazzo Baldovinetti and Palazzo Bardi in Florence, developed certain common characteristics, including a sturdy, blocklike form punctuated by a central courtyard. Austere palazzo exteriors of three to six floors showed a continuing preference for heavy, rusticated stone construction at the lower levels, with brick, often stuccoed, above.

Small window openings with iron grates appeared at street-level, where civil disturbances might occur. Larger window openings, generally arched, were arranged across the upper façade and provided with wooden shutters to protect the interior from extremes of heat and cold.

The ground-floor contained a place of business, a shop or a warehouse area behind a large, arched doorway. Grouped around the small interior courtyard beyond the entrance were the service areas, storage for wood, horse stalls and some of the retainers' quarters. A narrower door in the façade gave access to a stairway that rose to the upper family floors, where the residents could enjoy more light, air and freedom from street noise. The first of the private levels, the *piano nobile*, contained a foyer, grand salon, studies, wardrobe-rooms and, in some instances, balconies and loggias. Bedrooms and their antechambers were assigned to the floor above, with servants' quarters and storerooms for bread and grain at attic level. Occasionally, kitchens were also located on the top floor, from which heat and smoke could escape through an opening in the slate or tile roof, but cooking more typically took place in a separate building. When chimneys ascending exterior walls became common, it was possible to incorporate the kitchen safely into the palazzo proper. The entire palazzo rested on a low, vaulted subterranean space, which was used as a storage and cooling area.

As the 15th century advanced and artistic workshops flourished, private urban palazzi lost much of their exterior severity and acquired more refined masonry and decoration. The palazzo became increasingly horizontal in emphasis, and exterior string courses, usually two in number, delineated the public and private areas. Classical antiquity provided a ready source of decorative motifs: inner courtyards surrounded by Roman arcades became ubiquitous, and round-headed arches and classical pilasters articulated façades in a variety of harmonious compositions.

A major exponent of the post-medieval attitude towards the palazzo was the Florentine Filippo Brunelleschi, whose rejected but influential model of the Palazzo Medici for the family patriarch, Cosimo de' Medici, relied on mathematics to order form and provided an extended Classical architectural vocabulary. Traces of his ideas can be observed in the Palazzo Medici (now the Palazzo Medici–Riccardi; see fig. 1), designed by Michelozzo di Bartolomeo in 1444 after the conservative Cosimo rejected Brunelleschi's design as too ostentatious (*see* MICHELOZZO DI BARTOLOMEO, §3(ii)). In the Palazzo Rucellai (begun *c.* 1453), Florence, by Leon Battista Alberti, the façade is divided by three superimposed orders of shallow pilasters, following the example of the ancient Roman Colosseum, with entablatures across the building to divide it horizontally. With mathematical accuracy, Alberti determined the façade design according to theories of harmonic proportions (*see* ALBERTI, LEON BATTISTA, fig. 2).

During the later 15th century and the 16th, Italian architects continued their refinements of the urban residential palazzo, with an increasing emphasis on open spaces, such as courtyards (see fig. 2), and including an ever-increasing number of classical devices. RAPHAEL, who designed the Palazzo Pandolfini (*c.* 1516) in Florence and the residential Villa Madama (begun 1518) in Rome

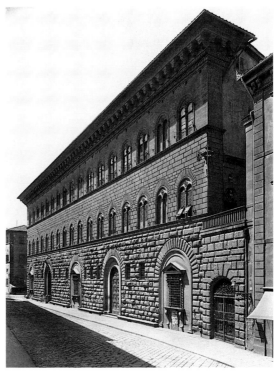

1. Palazzo Medici (now Palazzo Medici–Riccardi), Florence, by Michelozzo di Bartolomeo, 1444–60

(*see* RAPHAEL, fig. 9), employed a variety of Classical elements, including alternating triangular and segmental window pediments, balustrades and paired columns. More delicate string courses delineated the horizontality of the storeys, and rustication was confined to doorways. Across Italy during the 16th century, architects continued to expand on the residential palazzo, tailoring it to meet clients' individual tastes and needs, and expressing their own creativity. Raphael's former assistant Giulio Romano designed the huge, rambling, one-storey Palazzo del Te in Mantua in 1525, complete with grottoes, heavy door and window surrounds, and with unexpected proportions throughout (*see* GIULIO ROMANO, FIG. 3). Bartolomeo Ammanati used similar large-scale rustication on the Palazzo Micheletti (*c.* 1550) in Lucca and added the heavily rusticated extensions with massive corner quoins to the Palazzo Pitti in Florence in 1557 (see colour pl. 1, II2). These architects, together with the other Mannerists, manipulated existing palazzo forms in an idiosyncratic fashion.

The Roman architecture of Michelangelo, particularly the Palazzo dei Conservatori (completed by Giacomo della Porta, 1568–84) and the Palazzo Senatorio (designed in 1546 and completed by della Porta in the 1590s), influenced the development of many subsequent buildings. The devices of Giant pilasters unifying two storeys, balustrades, acroterian sculptures adorning the horizontal roof cornice and the double staircase are, if not inventions of Michelangelo, indelibly associated with his name and continued to influence palazzo façades. Andrea Palladio exerted an even more direct influence on centuries of later

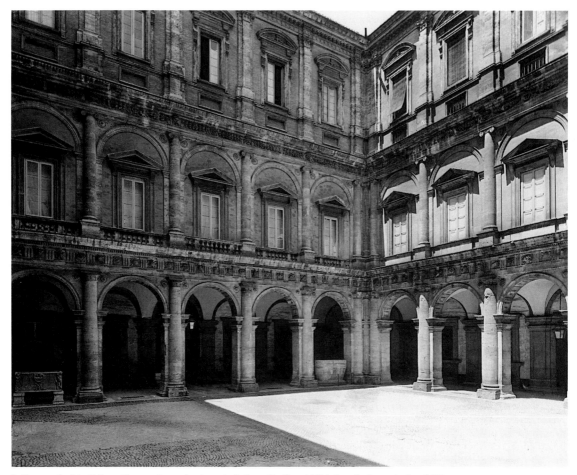

2. Courtyard of the Palazzo Farnese, Rome, by Antonio da Sangallo (ii) and Michelangelo, begun before 1495

domestic design. His Palazzo Chiericati (begun *c.* 1547) in Vicenza turned the urban palazzo outwards towards the street rather than inwards towards its protected courtyard as in earlier designs. The open loggia on the façade presented an airy, delicate expanse embellished with restrained classical elements (*see* PALLADIO, ANDREA, fig. 2). His influential designs, published in *I quattro libri dell'architettura* (1570), were based on his study of ancient monuments and the writings of Vitruvius.

As private ownership of the palazzo became more common than municipal ownership, the residential function gradually replaced that of the civic and eventually that of the commercial. The Italian palazzo became to its citizens what it had previously been to the municipal city-states: a visible symbol of power and wealth that called on the finest talents of the most discriminating artists of the day.

BIBLIOGRAPHY
H. Wölfflin: *Renaissance und Barock* (Basle, 1888; Eng. trans., London, 1964)
R. Wittkower: *Art and Architecture in Italy, 1650–1750*, Pelican Hist. A. (Harmondsworth, 1958; rev. 5/1982)
——: *Architectural Principles in the Age of Humanism* (New York, 1962, rev. 3/1971)
G. Chierici: *Il palazzo italiano* (Milan, 1964)
J. White: *Art and Architecture in Italy, 1250–1400*, Pelican Hist. A. (Harmondsworth, 1966, rev. 3/1993)
F. Godfrey: *Italian Architecture up to 1750* (New York, 1971)
G. Fanelli: *Firenze: Architettura e città* (Florence, 1973)
L. Heydenrich and W. Lotz: *Architecture in Italy, 1400–1600*, Pelican Hist. A. (Harmondsworth, 1974)
R. Goldthwaite: *The Buildings of Renaissance Florence* (Baltimore, 1981)
G. Mazzariol and A. Dorigato: *Venetian Palazzi* (New York, 1998)

PHILANCY N. HOLDER

Palermo [anc. Gr. Panormos; Arab. Burlima]. Italian city, capital of Sicily. It is situated in a small plain at the foot of Mt Pellegrino on the north-west coast and has served as a port since the 8th century BC.

1. BEFORE 1282. A series of incised drawings of human figures and animals (*c.* 10,000 BC) in one of the ADDAURA caves at the foot of Mt Pellegrino provides some of the earliest evidence of Upper Palaeolithic art in Sicily. Neolithic remains (*c.* 3000 BC; Palermo, Mus. Reg.) have also been found here, and during the 3rd millennium BC the area was settled by the Sicani, Cretans and Elymi. The city itself was founded by the Phoenicians in the 8th century BC on a tongue of land between the rivers Papireto and Kemonia, to the west and south-east respectively. The Greeks, who named it Panormos ('all harbour'), had established trading links with the inhabitants by the mid-7th century BC. The ancient city centre, which occupied

the highest ground near the present Piazza della Vittoria, was surrounded by walls in the 6th century BC; this area was known from the 3rd century BC as Palaeapolis in order to distinguish it from Neapolis, which had developed to the north between the eastern defences and the sea.

During the First Punic War (264–241 BC), Panormos became the focal-point of the struggle between Carthage and Rome, eventually succumbing to the Romans in 254 BC. The city surrendered to the Vandals and Ostrogoths early in the 5th century AD, but was reconquered in AD 536 by the Byzantine general Belisarius (*d* 565). It remained in Byzantine hands until the Arab conquest of AD 831, when it was renamed Burlima.

As the capital of an emirate, the city became a vital commercial, administrative and military centre, second among European cities only to Constantinople (now Istanbul), functioning as an emporium between various Muslim cities and between the Muslim and Christian worlds. With its capital at Syracuse, facing the Ionian Sea, Sicily had gravitated towards Greece; now, with Palermo as capital, the western Mediterranean became its focus. In 1072 Palermo fell to the Normans, led by Roger de Hauteville (*reg* 1072–1101) and Robert Guiscard, Duke of Apulia (*reg* 1057–85). Under Norman rule, especially in the reign of Roger II in the first half of the 12th century, Palermo reached great prosperity and splendour, but paradoxically this was because the invaders were not strong enough to impose their own way of life, but allowed Arabic, north European, Roman and Greek traditions to subsist, creating a cultural richness in the city comparable to the agricultural fertility all around.

The dynastic crises that followed the death of William II (*reg* 1166–89) prompted the emigration of many Arabs and led to economic difficulties within the city. Although Emperor Frederick II revitalized the royal court, the subordination of Sicily to his empire required stronger links with north Europe than with Africa and the East. This undermined Palermo's supremacy, causing urban stagnation, marked by the transfer of the capital to Naples in 1282. In 1282 the rebellion known as the Sicilian Vespers deposed the oppressive papal vassal Charles I of Anjou (*reg* 1266–82), and Peter III of Aragon (*reg* 1276–85) was summoned to become King Peter I of Sicily.

2. LATER HISTORY. During the 14th century the most significant new buildings erected in Palermo were the grandly isolated palaces of the powerful Alagona, Chiaramonte, Peralta and Ventimiglia families, which deliberately disrupted the medieval urban fabric. Close ties between the aristocracy and mendicant orders resulted in the creation of powerful monastic centres during the late 13th century and the early 14th: the Dominicans in the commercial centre, the Franciscans, Augustinians and Carmelites near S Maria dell'Ammiraglio (the Martorana).

During the 15th century the increasing number of workhouses, hospitals and slums marked the existence of an impoverished working class, while the growth of the aristocracy was reflected in palace building and urbanization. The rebuilding in stone of the Palazzo Pretorio (1463) and the laying out of the Piazza della Cattedrale (1452) indicate the consolidation of the city's institutions; the Piano della Corte, the Piazza Ballarò (1467–8) and the

Piazza S Domenico (1458) were reorganized, and new roads were built, among them Via Alloro in the Kalsa (the Arab quarter), which had the highest concentration of prestigious civil and religious architecture.

Tension between the Spanish rulers and the Turks determined most of the changes to Palermo during the 16th century. At this time, too, the systematic idealization and mythologizing of the city began, initiating the era of rule by propaganda and reflecting the growing gap between the city's real significance and the pretentions of its most powerful inhabitants. As their reputation depended on it, the Spanish viceroys undertook conspicuous urban embellishments, including the construction of the Via Toledo from the Royal Palace to the sea (1560s) and the Via Maqueda (1590s), which divided Palermo into four.

BIBLIOGRAPHY

G. Palermo: *Guida istruttiva per potersi conoscere . . .* , 2 vols (Palermo, 1816); ed. G. di Marzo-Ferro as *Guida istruttiva per Palermo e suoi dintorni* (Palermo, 1858/*R* 1984)

R. Romano and C. Vivanti, eds: *Storia d'Italia*, 6 vols (Turin, 1970–77)

C. de Seta and L. di Mauro: *Palermo* (Bari, 1988)

HELEN HILLS

Palla, Giovanbattista della (*b* Florence, *c.* 1485; *d* Pisa, 1531). Italian diplomat and agent. As a young man he was part of the sophisticated group around Bernardo Rucellai (*see* RUCELLAI, (2)) at the Orti Oricellari in Florence. He was a close friend of Giuliano de' Medici and entered the service of Pope Leo X (*reg* 1513–21), although he subsequently joined the opposing Soderini faction. He went to France, where he won favour with Francis I (*reg* 1515–47), and in 1522 took part, from a distance, in the plot against Giulio de' Medici, the future Pope Clement VII. After the Sack of Rome and the fall of the Medici in 1527, he acted as intermediary between the new government of Florence and Francis I, whose support was essential to the republic's survival. Well informed about the King's tastes in art, he procured for him 'all kinds of antique objects and a variety of paintings, all by great masters'. Vasari, who related this in his *Vita* of Niccolò Tribolo, stressed that 'every day he sent caseloads of them'. Contemporary chroniclers, Jacopo Nardi (1476–after 1563) and Benedetto Varchi in particular, also accused him of having 'plundered Florence' for the King and even of having had 'several marble statues' removed from the house of the Rucellai, his former hosts. Vasari for his part mentioned commissions passed by della Palla to Tribolo, Pontormo, Andrea del Sarto and Ridolfo Ghirlandaio, as well as the purchase from Baccio Bandinelli of a statue of *Mercury* and from the Strozzi of a *Hercules* by Michelangelo.

Of those works that are known to have reached Francis I, only one survives: a statue of the goddess *Nature* by Tribolo (*c.* 1528; Paris, Louvre). Michelangelo's *Hercules*, the *Mercury* by Bandinelli and Pontormo's *Resurrection of Lazarus* are all lost. Political events and the death of della Palla annulled the contract signed with del Sarto for *Charity* (Washington, DC, N.G.A.) and the *Sacrifice of Abraham* (Dresden, Gemäldegal. Alte Meister). It appears that the paintings commissioned from Ghirlandaio remained in Florence. Della Palla also attempted to acquire for Francis I 'in the name of the Signoria' a series of

paintings of the *Story of Joseph*. Executed by Francesco Granacci (Florence, Uffizi and Pal. Davanzati), Bacchiacca (Rome, Gal. Borghese, and London, N.G.), Pontormo (London, N.G.) and del Sarto (Florence, Pitti), these decorated the bedroom of PIERFRANCESCO BORGHERINI. However, della Palla left empty-handed, having been rebuffed with a vehement torrent of words from Borgherini's wife, an episode that Vasari retold with evident satisfaction in his *Vita* of Pontormo.

Art historians specializing in the formation of the French royal collections have been unable to add to the names provided by Vasari. They can only suggest that della Palla acted as an intermediary in the purchase of antique statues or 'contemporary' works that are presumed, in the absence of contrary evidence, to have entered the Fontainebleau collections in the 16th century. There is therefore no basis to consider him, as some have proposed, as 'the first art dealer, in the modern sense of the term'. Della Palla's letters (1529) to Michelangelo beseeching him to return to Florence, which was then under siege by imperial troops, bear witness to his attachment to the republican cause. This is probably the reason for his short-lived activity in the 'art market' for the sole benefit of Francis I, whom he had hoped, in vain, would come to the aid of Florence. Della Palla was arrested after the fall of Florence and imprisoned at Pisa. He died there the following year, poisoned—it is said—on the orders of Clement VII.

BIBLIOGRAPHY

G. Vasari: *Vite* (1550, rev. 2/1568); ed. G. Milanesi (1878–85), iv, p. 188; v, pp. 27, 50; vi, pp. 61, 140, 263, 540, 619; vii, p. 145

J. Nardi: *Istorie della città di Firenze*, ed. A. Gelli (Florence, 1842)

B. Varchi: *Storia fiorentina*, ed. G. Milanesi (Florence, 1857–8)

G. B. Busini: *Lettere a Benedetto Varchi sopra l'assedio di Firenze* (Florence, 1861)

H. Hauvette: *Luigi Alamanni, sa vie, son oeuvre* (Paris, 1903)

M. Wackernagel: *Der Lebenstraum des Künstlers in der florentinischen Renaissance: Aufgaben und Auftraggeber, Werkstatt und Kunstmarkt* (Leipzig, 1938; Eng. trans., Princeton, 1981), pp. 283–4

La Collection de François I (exh. cat. by J. Cox-Rearick, Paris, Louvre, 1972)

A. Braham: 'The Bed of Pierfrancesco Borgherini', *Burl. Mag.*, cdxxi (1979), pp. 754–65

M.-G. de La Coste-Messelière: 'Pour la république florentine et pour le roi de France: Giovanbattista della Palla, des "Orti Oricellari" aux cachots de Pise', *Il se rendit en Italie: Etudes offertes à André Chastel* (Rome and Paris, 1987), pp. 195–208

MARIE-GENEVIÈVE DE LA COSTE-MESSELIÈRE

Palladio, Andrea [Gondola, Andrea di Pietro della] (*b* Padua, 8 Nov 1508; *d* Vicenza or Maser, 19 Aug 1580). Italian architect, theorist and writer. More than any other Italian architect, he shaped the building culture of the following generations. As the last of the great Renaissance architects, he based his designs on Classical architecture, the idiom of which he converted with increasing virtuosity and independence into a repertory that was subsequently developed into the distinctive style that bears his name, Palladianism (*see* §II below). In his buildings, which profoundly influenced the physical appearance of the Veneto region of North Italy (the terra firma), the social and cultural characteristics of his time are epitomized (*see* VICENZA, §1; *see also* VILLA, §2). From them, the specific ambitions and interests of his patrons can be discerned no less than Palladio's endeavour to derive a contemporary

form of building from the study of ancient architecture. His solution is an impressive monument to the last phase of the High Renaissance. His imposing oeuvre includes town palaces, villas, public buildings and churches; much of it is documented in his *Quattro libri dell'architettura* (1570; *see* §I, 2 below), which contributed decisively to the spread of his fame. The study of his work has long been a special preoccupation of architectural historians; the Centro Internazionale di Studi di Architettura Andrea Palladio in Vicenza has become one of the most important centres of specialist discussion on architectural history.

I. Life and work. II. Critical reception and posthumous reputation.

I. Life and work.

1. Architecture. 2. *I quattro libri* and other publications.

1. ARCHITECTURE. The earliest biography of Palladio, Paolo Gualdo's *Vita di Andrea Palladio* (1616), presents him above all as an extremely social man and architect, and it thus inaugurated a continuing critical concern with Palladio and his work that is biographically orientated to an unusual degree. He was apprenticed to a mason at the age of 13, but he broke his contract in 1524 and left his native city of Padua to settle in neighbouring Vicenza. He worked first in the masons' workshop of Giovanni and Girolamo da Pedemuro. No work definitely attributable to Palladio has survived from this period. The workshop produced mainly decorative sculptures for Vicenza, recruiting its patrons from the wealthiest noble families of the town and its environs. Contacts with this powerful circle of clients, so important to Palladio subsequently, were thus made at an early stage of his career.

About 1537 the workshop was engaged in extending the villa of Giangiorgio Trissino at Cricoli, outside the gates of Vicenza (*see* TRISSINO, GIANGIORGIO). Here Palladio first came into contact with an exponent of Classical learning and humanism, and Trissino in turn must have recognized in Andrea a potential student and collaborator whose practical knowledge and experience would help him realize his own architectural ambitions. In 1540 Trissino bestowed on Andrea the name Palladio, an allusion to an angelic messenger from the epic poem he was writing, *Italia liberata dai Goti* (1547).

No less important to Palladio's development must have been the influence of the patron and theorist Alvise Cornaro and his circle in Padua. With the Loggia (1524, *see* FALCONETTO, GIOVANNI MARIA, fig. 2) and Odeo (1530; *see* colour pl. 1, XXIX2) at his palace in Padua, both designed with Giovanni Maria Falconetto, Cornaro had introduced the first Renaissance buildings on the Roman model to the Veneto; he later produced a theory of his own (*c.* 1555), concerned mainly with reducing the cost of building.

Palladio's initial period of Classical and humanist studies with Trissino culminated in his first visit to Rome (1541) in the company of Trissino; he returned there in 1545, 1546–7, 1549 and 1554. On the last journey he was possibly accompanied by the humanist Daniele Barbaro, with whom Palladio was then working on a translation of and commentary on Vitruvius, *I dieci libri dell'architettura di M. Vitruvio* (Venice, 1556), for which he provided the

illustrations (*see* Barbaro, (1)). In Rome and elsewhere Palladio sketched the remains of ancient buildings, architectural drawing being the indispensable basis of his work.

(i) Early work, before 1548. (ii) Basilica and mature work, 1548–59. (iii) Villa Rotonda, S Giorgio Maggiore, Il Redentore and late works, 1560 and after.

(i) Early work, before 1548. Palladio's first independent work was the Villa Godi–Malinverni (1537–42) in Lonedo di Lugo, north of Vicenza. Although he was involved in humanist studies at this time, his design for Girolamo de' Godi reflects his reaction to the contemporary vernacular architecture of the region. An open central loggia is flanked by two solid, tower-like wings (see fig. 1); while the layout of the central section, driven like a wedge between the projecting wings, may carry echoes of the villa of his patron Trissino at Cricoli, it is clear from the heavy accentuation of the massive side sections that Palladio was trying to reinterpret in a contemporary manner the type of rural building with twin towers that was common to the Veneto. Its formal severity and lack of ornamentation also conform to the tradition of the country house in the Veneto. His combination of this theme with a quotation from antiquity—the arcades of the ancient Roman villa—created a new type that he went on to vary richly and effectively in subsequent buildings. This approach was developed further in the Villa Valmarana (1541–3), Vigardolo, north-east of Vicenza, probably the first building constructed after his initial visit to Rome, although it differs slightly from his drawing (*see* Architectural Drawing, fig. 3). While the ground-plan is very similar to that of Trissino's villa, its stark, geometric elevation clearly anticipates the pedimented solutions typical of his later work, and the Serliana proposed for the entry is echoed in the later Villa Poiana (*see* §(ii) below).

In the Villa Pisani (1542) at Bagnolo, south of Vicenza, Palladio for the first time devised a form of country house in which agricultural use and prestigious appearance complement each other. The villa, built for counts Vittore, Marco and Daniele Pisani, although probably begun by their father Giovanni Pisani, consists of a basement used for the kitchens and store-rooms, a *piano nobile* and an upper level intended for grain storage. Since, therefore, the internal stairs would be used only rarely by the owners, Palladio gave the external stairs, leading directly to the *piano nobile*, a design function greater than that in any previous domestic architecture. The Villa Pisani was originally situated at the bottom end of a courtyard bordered by utility wings. The *barchesse* (partly destr.), the arcaded farm buildings so typical of his villas, were for Palladio an integral part of the building, the concept of which incorporated not only the main house but also the whole complex, including the surrounding terrain (*see* §(iii) below). The façade facing the River Guà has a twin-tower format, although the towers project only slightly above the cubic body of the building and seem like a cautious quotation from local idiom. More imposing is the omission of the upper storey on this side and the rusticated, triple-arcaded entrance at the centre, surmounted by a pediment and framed by the towers. The plan of the villa reveals Palladio's intensive study of antiquity: the cruciform central *sala* was influenced by ancient Roman baths and was originally lit from above by two thermal windows.

Also in 1542 Palladio began rebuilding the Palazzo Thiene (only partly completed) in Vicenza. Scholars are not unanimous in attributing this building to Palladio, although Palladio himself claimed authorship of it by including it in his *Quattro libri*, an attribution supported by Vasari. For some scholars, however, Vincenzo Scamozzi's assertion that the building was originally started

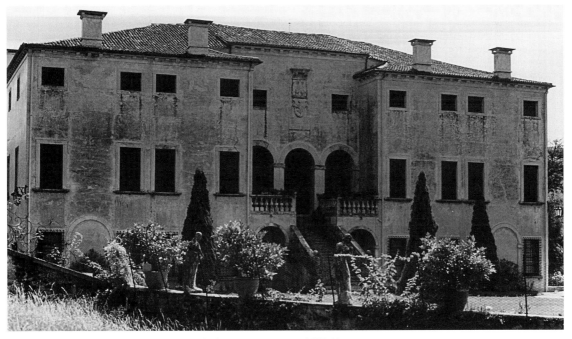

1. Andrea Palladio: Villa Godi–Malinverni, Lonedo di Lugo, near Vicenza, 1537–42

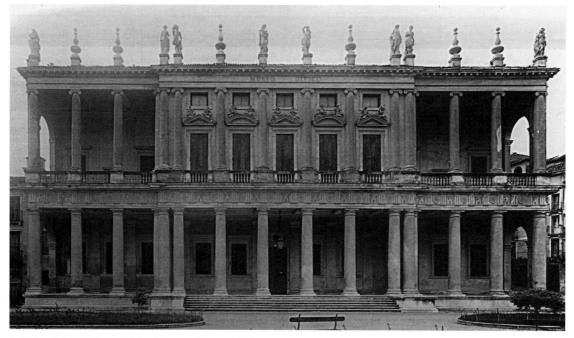

2. Andrea Palladio: Palazzo Chiericati, Vicenza, begun *c.* 1547

by the Roman architect Giulio Romano, and the rusticated treatment of the parts of the façade that were executed, are reason enough to attribute the building to the latter. The structure is a massive palace rising directly from ground-level and recalling a fortress rather than a Renaissance town palace. The rock-faced rusticated masonry of the ground floor, in which the windows look as if they are cut out, is continued in smoother and shallower form on the *piano nobile*. The upper storey is articulated by a series of pilasters in a regular rhythm and enlivened by windows surmounted alternately by triangular and segmental pediments. The columns flanking the windows are clad with small blocks that interrupt the curvature of the column, a further allusion to the fortress quality of the palace. The tripartite composition of the whole consists of a sequence of façade, atrium and inner courtyard, each expressed as clearly distinct zones. The richly varied forms designed by Palladio for the axially linked room plans in the self-contained wings of the palace are derived directly from the architecture of Roman baths.

The Palazzo da Porto–Festa (begun *c.* 1547) in Vicenza, built for Iseppo DA PORTO, the brother-in-law of Marc'Antonio Thiene, was originally planned as a double site reconstructing the antique Roman house as conceived by Palladio, with two residential blocks linked by a peristyle court with colossal columns, although only the front portion was completed. The façade combines various motifs to demonstrate Palladio's mastery of both traditional and innovative forms. He derived the façade from house-types developed by Raphael and Donato Bramante; it comprises two floors and an attic. On the *piano nobile* engaged columns alternate with tall, balconied windows, which in turn are crowned alternately by segmental and triangular pediments; the façades of all Palladio's urban palaces subsequently used variations on this type, which

emphasizes the horizontal articulation. In the original plan for the Palazzo da Porto, the owner's quarters were intended to occupy the part of the site towards the street, while the guest-rooms were to be in the rear block, in the manner of the ancient Roman residence as reconstructed by Vitruvius. The main house was to have been emphasized by two blocks projecting out each side of the central range, although in plan their rooms were not connected to those of the palace. The rooms of the palace, of progressively smaller volume, are grouped at right angles to one another around two staircases, giving rise to two virtually self-contained residential suites facing each other on either side of the central entrance atrium and reflecting Palladio's preference for an axially symmetrical plan.

Also begun by Palladio *c.* 1547 was the Palazzo Chiericati, Vicenza (completed *c.* 1680), which has motifs echoing villa architecture. Its main axis runs parallel to the street, incorporating the surrounding space by means of a loggia (see fig. 2). The tripartite division of the two-storey façade, with the solid middle section of the upper floor (accommodating a large *sala* built over the colonnade) surrounded by loggias, exemplifies the increasing emphasis in Palladio's work on the centre of a building, further expressed in the groups of four columns placed at the corners of the slightly projecting middle section. The ground-floor order is Tuscan and the upper floor Ionic, a combination that Palladio used in other buildings of this period, and the rhythm of the colonnade is repeated in the wall of the solid middle section with the use of engaged columns. The special feature of this façade is the use of the loggia, which was unusual in an urban palace (*see* PALAZZO). The site of the Palazzo Chiericati, on a large open piazza on the River Bacchiglione, may have led Palladio to treat the structure not as a house set into a confined urban environment but as an isolated building in the manner of one of his villas.

A further reason for the use of such an open façade may lie in Palladio's study of antiquity. In his *Quattro libri* he reconstructed the typical Roman square as a two-storey loggia open on all four sides; its lower level served as protection from sun and rain, while the upper level afforded a view of the square. In the Palazzo Chiericati, therefore, Palladio did not so much provide a variation of a palace façade or even a villa type; rather, the façade alludes subtly to the idea of an urban piazza.

The plan of the Palazzo Chiericati is strictly symmetrical about a rectangular court at the rear, parallel to the street. The transverse vestibule in the centre of the ground floor is not matched on the upper floor; there the large *sala* reflected the importance of the *piano nobile* and the role of the *sala* as the site of public functions. The vestibule gives access to living-quarters at the sides; opposite the entrance a four-column arcade flanked by two staircases leads to the garden loggia. On this side, too, the size of the rooms in terms of floor area diminishes along the central axis.

This principle of dividing up the space of a house was methodically developed and followed by Palladio in his work. In particular, it is possible to attest the use of a geometrical system in his villas, although its strict application is not as unremittingly demonstrable as Rudolf Wittkower sought to claim in his influential *Architectural Principles in the Age of Humanism*. Wittkower asserted that these plans, derived from the simple requirements of the Italian country house, showed the open loggia, a central hall with smaller adjoining rooms, and space for stairs and ancillary accommodation, to be indispensable components. Palladio compressed them into a geometrical formula, which in outline served as the point of departure for numerous schemes and, with few modifications, could be adapted to the specific conditions of any particular commission. Wittkower's overemphasis of the aspect of harmonic proportion may perhaps lead to what is ultimately a reductive view of Palladio's design practice.

Nevertheless, it remains incontestable that it is precisely the use of rational building principles that gives Palladio's plans just that quality that makes the proportional relationship between man and building so successful.

(ii) Basilica and mature work, 1548–59. In 1548 Palladio received his first public commission from the town of Vicenza. The reconstruction of the original loggia surrounding the medieval town hall had collapsed in 1496, and after gathering proposals for its replacement from many of the well-known architects of the time, including Jacopo Sansovino, Sebastiano Serlio, Michele Sanmicheli and Giulio Romano, the town council decided in favour of the design by the local architect Palladio, thus firmly establishing his reputation. Palladio's solution for the loggia of the Palazzo della Ragione (also known as the Basilica; see fig. 3) is brilliantly convincing, not least because of the use of the Serlian motif with which he concealed the irregularities of the inner structure, particularly the different widths of the bays, by varying the side openings while giving the building a harmonious general appearance. The idea of a double skin for the building derives from the structure of ancient Roman theatre walls, the vertical axes of which are articulated by equal-sized openings on the different floors and by engaged columns set in front of the walls. In addition, Palladio projected the Serliana—subsequently also called the Palladian motif—in the third dimension, since its columns are duplicated towards the interior of the loggia. The boundary between the building and the piazza was thus made permeable, as befitted the building's function as the seat of the town council. Palladio's design combines various elements derived from the same historical source, but without producing a sense of monotony. The model for the two-storey casing was the Palazzo della Ragione, Padua, which was surrounded by two-storey arcades in the first half of the 15th century. There, however, each arch on the ground floor is matched by two openings with slender marble

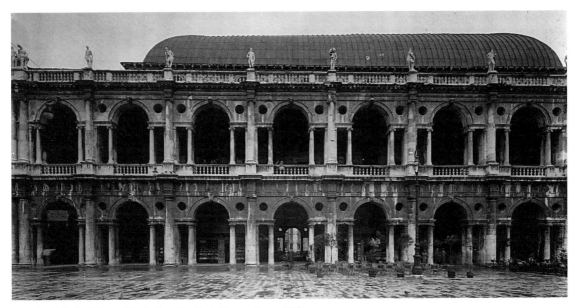

3. Andrea Palladio: Palazzo della Ragione (Basilica), Vicenza, begun 1548

columns on the upper floor. In the Basilica, instead of differentiating between the two levels, Palladio offered a uniform structure, albeit one that gives a general impression of variety despite its rigorous discipline. This effect results not least from the masons' virtuoso handling of the many details of the building, which was not completed until 1617.

In 1548–9 Palladio was commissioned by Bonifacio Poiana to design the Villa Poiana in Poiana Maggiore, south of Vicenza. Here, again, he sought to respect the two fundamental conditions of villa construction: agricultural utility and prestigious appearance. The appearance of the façade is determined by the very slightly projecting central section, in which Palladio used a broken-bed pediment that provided an organic link between the tympanum and the wall surface of the projecting section. Both the main and garden façades are embellished with a Serliana, here encompassed within a round arch punctuated by five oculi. Despite this unusual and attractive motif, the façade is otherwise rather plain. A noteworthy feature of the villa is the use of the loggia: because the residential rooms are disposed either side of the main axis, the view through the loggia, which does not project in front of the building but is set within the main block, allows a view through the whole building. This complete penetration of the building seems to integrate it organically into its natural surroundings. Palladio repeated this approach in his subsequent buildings with many variations that aimed for a complete harmonization of architecture and nature (*see* §(iii) below).

About 1549 Palladio produced the first designs for the Villa Barbaro in Maser, near Treviso (completed by 1558), which was built on the remains of a medieval castello for Daniele and Marc'Antonio Barbaro, who must have had a significant influence on the design (*see* BARBARO). The main house, projecting far in front of outstretched utility wings surmounted by dovecots, is a pedimented structure inspired by antiquity, with a strong vertical emphasis, and it became one of his most influential villas (for illustration *see* MASER, VILLA BARBARO and colour pl. 2, XII1). The triangular pediment surmounting the entire façade of the house, supported by four giant engaged Ionic columns, is a motif taken from ancient temple design, which Palladio believed had been based on private houses, and it had only rarely been used in Renaissance villa design before this time (*see* VILLA, §3). Here, the pediment serves primarily to impart dignity, to designate the status of the noble residence. A magnificent series of frescoes by Veronese celebrates rural life (*see* VERONESE, PAOLO, §I, 3(i) and colour pl. 2, XXXIX1), and a nymphaeum, unique in Palladio's work, is set into the hill at the rear of the house on its central axis, a clear indication of the co-existence of practical agricultural factors and idyllic humanist values in villa design. He later designed the Tempietto Barbaro (1580–83) at Maser, probably intended as the Barbaro family mausoleum.

The temple-front motif is still more prominent in Palladio's Villa Cornaro (1551–3; see fig. 4) in Piombino Dese, the urban nature of which is expressed in two-storey pedimented porticos on both façades: projecting on the façade facing the street, but flush with the wall plane on the garden side. In this building the porticos are dominant,

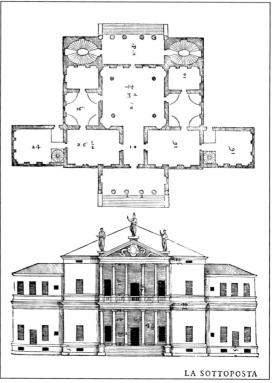

4. Andrea Palladio: Villa Cornaro, Piombino Dese, near Treviso, 1551–3; woodcut from *I quattro libri dell'architettura* (Venice, 1570)

adorning the otherwise rather plain building like part of a stage design. Here also is manifested Palladio's desire to combine harmoniously the residential and prestigious elements of the house, already seen at the Villa Poiana. The main house has an almost square plan focused on a large central atrium or *sala*, also square; this has four columns supporting the structure of the upper level. The *sala* is subordinated to the development of the room sequence, mediating between the entrance hall and the inset garden portico, which is flanked by two oval staircases. The short side wings are harmoniously incorporated in the room layout, being exactly as wide as the two rooms beside the entrance hall, thereby allowing an entirely new fusion of the residential and utilitarian elements of the villa. The doubling of the *piano nobile*, apparent from the superimposition of storeys in the porticos, was echoed in Palladio's design for the Villa Pisani–Placco (1552–5) at Montagnana. Here, too, he made use of an atrium with four columns, a main theme of his understanding of Vitruvius; it was also the starting-point for a sequence of progressively larger rooms in his Palazzo Antonini (*c.* 1552–6) in Udine.

The Villa Serego (1552–69) at Santa Sofia di Pedemonte, near Verona, seems a curious exception in Palladio's oeuvre, particularly because of its rusticated surface, although the plan provides yet stronger evidence of his preoccupation with ancient Roman houses. The villa, of which only the left part of the main building, with its attendant loggias, was completed, was originally conceived as a complex arranged around an extensive courtyard, with

no dominant central pavilion. In this courtyard, Palladio may have been trying to combine two elements from texts by Vitruvius and Alberti: the atrium and the peristyle courtyard. The very large columns of the giant order used in the courtyard give it a disproportionately massive appearance. The Villa Serego must be regarded as an unresolved compromise between the demands of contemporary villa design and the desire to revive antiquity.

Around 1556 Palladio was commissioned by Francesco Badoer to build his villa in Fratta Polesine, south-west of Rovigo (*see* VILLA, fig. 4). Palladio, who was skilled at adapting his designs to client and location, was flexible in his approach to the Villa Badoer, the plan of which incorporates three longitudinal axes. The apparent single-storey configuration identifies the building clearly as a country villa, and the *barchesse*—incorporating the only curved loggias in Palladio's built works—not only define the entry court but also set off the elevated central pavilion. The difference in height between these utility wings and the main house is accentuated by the high podium and staircase in several flights leading to the front portico. Its pediment, acting as a symbol of prestige, emphasizes the whole structure, not, as in the Villa Cornaro, the arrangement of rooms behind it. In the cohesiveness of its design, the Villa Badoer must be considered one of Palladio's most successful attempts to harmonize room layout, architectural function and residential qualities.

The Villa Foscari (begun *c.* 1558) at Malcontenta di Mira, close to Venice, is another of Palladio's villas with strongly scenographic qualities. The building is raised on an unusually high base, giving it an urban character, while the rustication running all round it contributes to its rural character. The portico of the façade facing the river, crowned by a massive pediment, is balanced on the rear façade facing the surrounding countryside by a large thermal window inscribed in a broken-bed pediment, a device that occurs in other buildings by Palladio and indicates both his study of antiquity and his independent treatment of the idiom derived from it.

The Villa Emo (begun *c.* 1559) at Fanzolo di Vedelago, near Treviso, is regarded as one of Palladio's most successful villas, celebrating the house both as a centre of agricultural production and as an arcadian retreat for the landlord. The raised central block, similar to that at the Villa Badoer, is joined at the sides by low, elongated arcaded *barchesse*, which are closed at the ends by dovecotes as at the Villa Barbaro. Each part of the Villa Emo not only serves a practical purpose but also has a clear visual and symbolic role. The pediment of the main house again combines ostentation with a play on architectural forms. The simplicity of the building's exterior gives way to a sumptuous interior, with frescoes by Battista Zelotti.

(iii) Villa Rotonda, S Giorgio Maggiore, Il Redentore and late works, 1560 and after. In 1560 Palladio began a series of works in the city of Venice. His refectory (1560–63) at the Benedictine monastery of S Giorgio Maggiore on the island of San Giorgio Maggiore (*see* VENICE, §IV, 1(i)) is in every sense a monumental testimony to Palladio's urge to create a style in the manner of Classical antiquity that was both severe and imposing. The unusually high-placed windows, like the dimensions of other individual parts

from the portal to the cornice around the building, celebrate architectural form as an end in itself, almost regardless of the building's function. The success of this work resulted in Palladio's commission (1564) to rebuild the monastery church of S Giorgio Maggiore (see below). Another commission in Venice, although never fully realized, was the monastery of S Maria della Carità (begun 1560; partly destr. 1630). On the evidence of Palladio's illustrations for the *Quattro libri*, it is clear that here, too, he took as his theme the house of Classical antiquity with its sequence of atrium, refectory and peristyle. The allusion to the model Roman house, however, should be understood only in a general sense.

Although Palladio never succeeded in producing a secular building in Venice, nor in having his costly plan to reconstruct the Rialto Bridge adopted, he was nevertheless engaged for further ecclesiastical works there, including a new façade (1562–*c.* 1570) for S Francesco della Vigna (*see* ITALY, fig. 11). Here, he achieved a unified composition by employing a variety of scales, a technique he later adopted in the Palazzo Valmarana. At S Francesco della Vigna, the use of corresponding pediments over the nave and aisles allowed Palladio not only to resolve their difference in scale but also to make visible the hierarchy of the different parts with one architectural motif. This invention was to play a decisive part in the later church façades of S Giorgio Maggiore and Il Redentore, also in Venice (see below).

The building that probably bears most lasting witness to Palladio's longing for antiquity is the Villa Almerico–Valmarana, the so-called Villa Rotonda or Villa Capra (begun *c.* 1565–6; see fig. 5), near Vicenza, the last of Palladio's villas to be built (*see* VICENZA, §2). It is a simple, centralized structure of the kind repeatedly conceived but seldom realized in the Renaissance. At its centre is a circular *sala*, to which lead four narrow passages from four massive temple-front porticos approached by flights of steps. The cupola of the central room was originally based on that at the Pantheon, Rome, but in its final execution, supervised by Vincenzo Scamozzi, it was made shallower and thus less sacred in appearance. In its relationship to the surrounding countryside the Villa Rotonda is one of Palladio's masterpieces and was enormously influential (*see* §II below). Set on a low hill with gentle approaches, it appears to draw in nature from every direction, just as, from inside, the building seems to push out into the surrounding landscape. It is an almost pure celebration of the dream of life in the country.

The Villa Rotonda exemplifies the way in which Palladio linked architecture with landscape in a wholly new way in his villas. The type of site to be chosen for laying out villas was dealt with by Palladio in chapter 12 of the second book of his *Quattro libri* (*see* §2 below; *see also* VILLA, §4). In addition to various practical requirements, Palladio stressed the aesthetic categories that should determine how the villa is placed in its setting. Thus he advised against building in valleys as this would deprive the structure of its importance in being seen from a distance. Palladio contrived in different ways to tie his villas to their surrounding landscape. Sometimes he used arcaded wings or curved colonnades, as in the Villa Badoer, which embrace whoever approaches and at the same time stretch

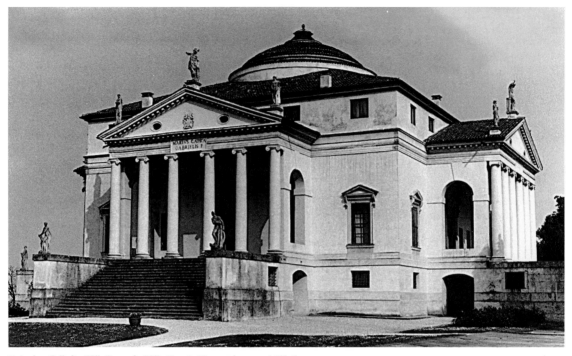

5. Andrea Palladio: Villa Rotonda (Villa Capra), Vicenza, begun *c.* 1565–6

out to open the building to nature. Elsewhere, as at the Villa Emo, steps from the landscape penetrate the building, whence the axis of vision takes up that of the steps and is released from the building again. Always a crucial point in this connection is the fact that the territory surrounding and belonging to the villa can be overseen or kept under surveillance. This way of embedding the villa in its surroundings is hence determined both by aesthetic and economic requirements. The complete idealization of this type of panorama, however, was first achieved at the Villa Rotonda. Here the *mise en scène* of nature and architecture is achieved above and beyond the requirements of mere utility. From the hill crowned by the villa the view extends far beyond the garden of the estate, giving the beholder a sense of being at one with the whole of nature.

In 1565 Palladio was commissioned by the VALMARANA family to design the Palazzo Valmarana (now Palazzo Braga) in Vicenza; it was built in several phases and completed in 1571, although only a part of Palladio's planned project was executed. Its street façade in particular makes it one of Palladio's most interesting buildings (see fig. 6). The giant order of its pilasters gives the palace a monumentality that must have had an oppressive effect in the narrow street setting. Inscribed within it is a smaller order extending the full width of the façade at the lower level, a device possibly derived from Michelangelo's plan for St Peter's, Rome. The rhythmical articulation of the façade nevertheless results from Palladio's ingenious idea of marking the end bays not with giant pilasters but with statues placed above the interpolated order, thus providing a sense of compression towards the centre of the façade, which in turn gives additional emphasis to the entrance. As a result, the building has something of a contrapuntal effect that runs counter to the tectonic laws of the classical

orders, and it is thus an impressive example of Palladio's increasingly independent manipulation of traditional idiom.

In 1566 work began on the new church of S Giorgio Maggiore on the island of San Giorgio Maggiore, Venice (*see* VENICE, §IV, 1(i) and colour pl. 2, XI2). The façade was not completed until 1610, and it has been suggested that deviations from Palladio's original plan resulted from the protracted building process. The articulation of the façade, which was intended to be seen at a distance from

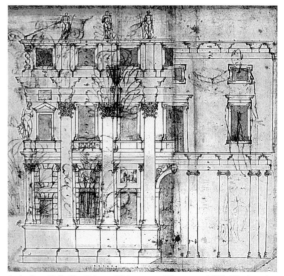

6. Andrea Palladio: Palazzo Valmarana, Vicenza, *c.* 1565–71; elevation and courtyard study, pen and ink on paper (London, Royal Institute of British Architects)

the city, is intensified dynamically towards the centre. The part of the façade in front of the nave resembles an open temple portico attached to a closed wall, its four engaged columns considerably thicker than the pilasters framing the lower aisle sections of the façade. The question of the authenticity of the façade design, particularly the high pedestal zone, remains unresolved. If the effect from the city is considered, however, the weaknesses of the façade apparent at close quarters are more easily explained. The main internal space comprises a longitudinal nave with side aisles and a domed crossing, with tall, projecting lateral apses abutting the aisles at the crossing; a square presbytery; and an elongated apsidal monks' choir. Each part is set on a different level and is individually articulated. S Giorgio often has been equated with Michelangelo's concept for rebuilding St Peter's, Rome. The spatial interpenetration of all parts of the interior and the sculptural ornamentation, which appears to evolve from the walls instead of being placed in front of them, introduce a sense of movement that in many respects looks forward to the Baroque.

Although Palladio settled in Venice in 1570, becoming Jacopo Sansovino's unofficial successor as municipal architect, he continued to build in Vicenza. At the beginning of the 1570s, commissioned by the Venetian government, he built the official seat of the Venetian military, the Loggia del Capitaniato, in the Piazza dei Signori, Vicenza, opposite his earlier Basilica. The design originally comprised a monumental loggia, probably of five bays, with giant engaged columns, although only three of the bays were completed. Particularly noteworthy in this building is Palladio's adoption of an unrestrained monumentality, which serves both to emphasize the building's functional importance and to make the parts appear more clearly as elements of a total design. The side elevation is designed as a triumphal arch to commemorate the Venetian victory over the Turks at Lepanto (1571). Otherwise, a tendency towards increasing simplicity is evident, as it is also in Palladio's design for the Palazzo Barbarano–da Porto (1570–75) in Vicenza. Here, he again used the motif of a two-storey palace façade with corresponding bays, the horizontal emphasis of which respects the narrow street setting. A striking feature, also evident in the Loggia del Capitaniato, is the increasing use of decorative elements on the wall surfaces, which, in their *horror vacui*, display clear characteristics of Mannerism.

The increasing virtuosity of Palladio's late style culminated in the votive church Il Redentore (begun 1576; see fig. 7) in Venice, in the façade of which Palladio refined ideas developed in earlier churches, particularly the tightly interlocking, layered series of pediments echoing the structure behind. The functions of Il Redentore as a votive and processional church as well as a monastery church called for a unifying concept. In his plan Palladio developed a sequence of three distinct spaces: a nave with side chapels but without aisles; a square, domed presbytery with side apses; and a longitudinal and brilliantly lit choir that is visually isolated from the rest of the church by an exedra formed by four columns. Despite their conceptual distinction, however, the relationship of the individual architectural zones to one another is clearly specified, forming an

7. Andrea Palladio: Il Redentore, Venice, begun 1576

effective whole held together and reinforced by the uninterrupted horizontal cornice.

Probably the last imposing example of Palladio's late work is the Palazzo da Porto–Breganze (after 1571), Vicenza, although its attribution to him is not uncontested; only two bays remain of the original façade, probably in seven bays. The giant engaged columns are surmounted by a deeply projecting cornice; the rustication of the high plinth storey and the decorative elements of the façade contain echoes of earlier palace façades such as that of the Palazzo da Porto–Festa, but here such elements have been subordinated to the monumental scale and plasticity of the architecture. Palladio's design for the Teatro Olimpico (1580) in Vicenza, a reconstruction of ancient theatre types, is another such statement of artistic identity inspired by humanism. It features a semi-elliptical auditorium with a colonnade behind. The classical *scaenae frons* echoes the form of the triumphal arch, with a tall, central arched opening flanked by two lower openings; there are also two levels of aedicular niches filled with statues, and an attic level above with relief panels. The openings were intended to give on to a set of flats painted illusionistically to depict different types of theatre. This design was altered by Vincenzo Scamozzi, who completed the building in 1584 and, for its first performance (*Oedipus Rex*), constructed steeply foreshortened streets behind the proscenium, thus making the stage set unalterable.

2. 'I QUATTRO LIBRI' AND OTHER PUBLICATIONS. Palladio's real fame is founded on *I quattro libri dell'architettura*, published in two instalments in 1570. In this treatise Palladio presents a summary of his own work, various buildings of Roman antiquity and some reflec-

tions on basic principles of architecture. The books are clearly only a part of a much larger work that was planned but never completed, which was intended above all to present works from Classical antiquity as a guide for the construction of useful buildings. Palladio's treatise is organized in a similar way to the ones by Sebastiano Serlio and Jacopo Vignola, but it was distinguished fundamentally from those more discursive texts by the prominence given to his own work. Palladio consciously avoided lengthy definitions and descriptions and used only terms familiar to contemporary architects and craftsmen. While this work, like those of other practising architects, therefore differs from the works of Vitruvius or Alberti, the conciseness of his language and his logical and straightforward descriptions certainly result from a close knowledge of Vitruvius and from a concern to avoid the latter's complexities. The clarity of the writing is matched by the woodcut illustrations (see fig. 4 above), which include a plan and elevation of each building discussed as well as some axial cross-sections and larger-scale plates depicting individual details, particularly the different orders (for further discussion and illustration *see* ARCHITECTURAL DRAWING). Figures indicate the different proportions, and a scale for the absolute dimensions of the buildings enables the reader to gain comprehensive knowledge of each work with a visual clarity seldom found in earlier architectural books.

The four books are devoted respectively to building principles and techniques; private residential buildings; public secular buildings; and temples of Classical antiquity. In the second and third books Palladio presents almost exclusively his own buildings, not chronologically but as types that correspond to their Classical models. The fourth and longest book is devoted entirely to buildings of antiquity, with the single exception of the Tempietto (1502), Rome, by Bramante, the only contemporary architect whose work is discussed, appreciatively and at length, by Palladio, who considered him the first architect able to revive the beauty of Classical buildings (*see* BRAMANTE, DONATO, §II and fig. 4). For Palladio, the architecture of antiquity was the paradigm by which all subsequent buildings, including those of his contemporaries, were to be measured. This did not signify blind allegiance to an authority sanctioned by tradition but reflected Palladio's proclamation of general, almost supra-historical, 'natural' architectural laws, of which he considered ancient buildings to be the hitherto unrivalled example. In his reconstructions, using Vitruvius, of Classical temples and other antique buildings, however, Palladio frequently deviated from the specific evidence of the ruins studied, thus synthesizing a relatively unified, idealized ancient 'style' in order to make the works better fit the rules of proportion that he considered ideal.

Moreover, Palladio did not exclude his own work from such treatment: the plans and elevations of his projects often differ considerably from the executed buildings because he idealized site irregularities and amended the designs to suit his didactic aims. In addition, while occasionally the laws governing the appearance of his buildings are spelt out, albeit briefly, they are usually presented through the drawings, and the informed reader must recognize their logic. The same

applies to the beauty of a building, which Palladio defines as the unity of the individual parts in relation to one another and to the whole, and which is determined by fine proportion and the correct use of the Classical orders. The latter determines above all the articulation of a façade and the extent to which all the parts and surfaces of a building are finally both unified and subtly distinguished, and Palladio applied this principle with a novel consistency. The façades of his villas demonstrate admirably how a hierarchy of forms expressing the iconographic value of the building and its parts evolved from the fully developed temple-front portico. The 'order' of a building attained in this way was, for Palladio, not simply a special system of organizing architectural form but also reflected the purpose and significance of a building for both the patron and the observer. It was taken for granted, however, that variations were possible within the fixed limits laid down by the general principles of architecture: the peculiarities of architectural forms, as well as the intrinsic functionality of ancient buildings, interested Palladio so much because both were relevant to the tasks facing Renaissance architects. In the *Quattro libri* Palladio therefore canonized both the traditional architectural rules of antiquity and the revived and modernized idiom that he had created.

Following his last trip to Rome, in 1554, Palladio published an archaeological guide to the city, *Le antichità di Roma*, as well as the *Descritione delle chiese di Roma*, both of which were highly successful and replaced the traditional works on Rome and its treasures. As well as his collaboration with Daniele Barbaro on an edition of Vitruvius (*see* §1 above), several texts by Palladio have survived (see Puppi, 1988): four on church architecture include his suggestions for the new cathedral at Brescia (1567) and the façade of S Petronio in Bologna (1572–9), in addition to his inspector's report on the cathedral at Milan (1570). He discussed the design of the *palazzo pubblico*, which had a prominent place in his own work, in his building instructions for the new city palace at Brescia (1562–75) and in his suggestions for remodelling the Doge's Palace in Venice, extensively damaged by fire in 1577. The position and nature of sites always particularly interested Palladio; two texts on the construction of watermills along the River Brenta (1566) and a bridge design for Belluno (1579) reflect the special quality of the Venetian hinterland, dominated by water, and show Palladio once more as an attentive observer of technical matters. No less than his discussion of Vitruvius in the *Quattro libri*, Palladio's dedication and preface to Caesar's *Commentaries* (1575) and his introduction to a planned edition of the works of Polybius (1579) bear witness to his search for architectural principles and models in antiquity. Undoubtedly, all the efforts of his time to reconcile humanistic learning and the practicalities of everyday living in architecture are condensed in Palladio. In addition, however, he was an experienced and well-qualified builder who was able to put into practice the inspired architectural theories of his mentors, particularly Giangiorgio Trissino and Daniele Barbaro. In his works he presents not so much his own *summa teorica* as its practical correlative, exemplified above all in the buildings produced for his humanist patrons.

II. Critical reception and posthumous reputation.

Soon after Palladio's death his buildings became models for new constructions. The architect Vincenzo Scamozzi (*see* SCAMOZZI, (2)) was commissioned to complete a number of Palladio's buildings, and he adopted Palladio's architectural models, particularly in his villas and usually in simplified form, which he also illustrated in his own treatise *Idea dell'architettura universale* (Venice, 1615). This treatise is, far more than that by Palladio, a compendium of contemporary architectural theory and practice, and it was one of the principal channels through which Palladio's ideas were mediated to northern Europe. Scamozzi also met Inigo Jones (1573–1642) in 1613/14 on the latter's visit to Italy; Jones acquired a large number of Palladio's drawings and subsequently became Palladio's first English interpreter. Palladio's immediate legacy in Italy was the start of a debate on his work that ultimately embraced the whole of Europe and North America. It was first pursued among the nobility and gentry of Protestant countries, especially the Netherlands, England and Sweden, where new solutions were being sought particularly in secular architecture. The decorative elegance and clear spatial conceptions of Palladio's buildings were considered exemplary for house and villa design, offering a middle way between the plainness of bourgeois houses and the ornamental splendour of princely palaces; this gave rise to a Palladian architecture that exactly matched the ideals of these groups.

Palladio's reception in the two centuries following his death was not consistent, however, and the development of Palladianism varied considerably from country to country and from architect to architect. It is significant, for example, that Palladio's influence is barely detectable in the great royal palaces of France, or in the country retreats of the nobility there, including those designed by Claude-Nicolas Ledoux (1736–1806) at the end of the 18th century. In the countries most receptive to the development of Palladianism, however, such as England, Ireland and North America, there were direct imitations of Palladio's buildings as well as free variations, stimulated by the first complete English edition of *I quattro libri* (1715) by James Leoni (*c.* 1686–1746) and a later one (1738) by Isaac Ware (1704–66); the latter was encouraged by Richard Boyle, 3rd Earl of Burlington (1694–1753), who had purchased some drawings by Palladio in Italy in 1719 and later acquired Inigo Jones's collection (most in London, RIBA). Other 18th-century editions of *I quattro libri* included that by Ottavio Bertotti Scamozzi (1719–1790) of 1776–83, intended to clarify Palladio's ideas for an international audience.

The many replicas of the Villa Rotonda, for example Mereworth, Kent (*c.* 1723), by Colen Campbell, and Chiswick House, London (1725–9, by Burlington and William Kent, are probably the only cases of imitation in the form of a direct copy. Generally it was not a single building that served as a model; instead, a basic type was taken over and modified, although Palladio's attempt to derive individual building types from their origins in Classical antiquity, and to renew them in terms of the ancient ideal, was not related by his imitators to the factors of time and place that underlay his own architecture.

Rather, the guiding framework for Palladian architecture continued to be the generally accepted model of antiquity itself, not least because of its diverse moral and political content. In changing formulations it continued to hold sway through the 19th century and even into the 20th.

That Palladian designs conveyed a sense of order as well as power helped to determine their wide influence within the aristocratic culture of Europe. The economic foundation of this culture was agriculture, and landscape was therefore the foil of aristocratic life and identity. The way in which Palladio's architecture drew the visitor and the landscape together, using flights of steps, entrance porticos and arcades, especially matched the needs of a specific group within the aristocracy. Around 1800, however, a different kind of Palladianism developed, which defined the heritage of Palladio in a manner that persisted into the 20th century. In his *Précis des leçons d'architecture données à l'Ecole polytechnique* (Paris, 1802–5) Jean-Nicolas-Louis Durand (1760–1834) described a new method of design that used schematic, dimensioned, geometrical grids in developing ground-plans and elevations in place of the traditional modular conceptions derived from the theory of the Classical orders. It is notable how frequently Durand referred to Palladio's villas to illustrate his ideas; again, the Villa Rotonda is the preferred example. The procedure entirely eliminates the historical context of Palladio's buildings, concentrating exclusively on the logic of architectural forms and spatial arrangements, not their function.

Palladian country houses and villas were built as late as the 19th century, although criticism of their precise aesthetic calculations began to set in with John Ruskin (1819–1900). The concept of the house as a place for living, subsequently considered the primary task of all architecture, is in opposition to the formal architecture of Palladio and Inigo Jones. For the adherents of 20th-century movements that followed the traditions of the Arts and Crafts Movement and the Deutscher Werkbund, Palladio was a peripheral figure, particularly as they were not centrally concerned with large public buildings. In the late 20th century, however, architects who deliberately rejected the International Style of modern architecture began to draw on elements from the Renaissance, Baroque and Neo-classicism, and they also developed certain motifs and effects derived primarily from the façades of Palladio's palazzi. Nevertheless, such architecture is not a legitimate development of Palladio's own work, nor even of Palladianism, both of which serve in such cases merely as sources of individual formal motifs, not of architectural concepts.

WRITINGS

Le antichità di Roma (Rome, 1554)
Descritione de le chiese, stationi, indulgenze & reliquie de corpi sancti, che sonno in la città di Roma (Rome, 1554)
I quattro libri dell'architettura (Venice, 1570, 3/1601/*R* Newcastle upon Tyne, 1971); Eng. trans. by I. Ware (London, 1738/*R* New York, 1965)
I commentarij di C. Giulio Cesare con le figure in rame de gli alloggiamenti, de fatti d'arme, delle circonvallationi, delle città . . . (Venice, 1575)
L. Puppi, ed.: *Andrea Palladio: Scritti sull'architettura (1554–1579)* (Vicenza, 1988) [incl. *L'antichità di Roma*, *Descritione de le chiese di Roma* and other writings]

BIBLIOGRAPHY
EARLY SOURCES
Vasari: *Vite* (1550, rev. 2/1568); ed. G. Milanesi (1878–85) [Palladio discussed under the life of Jacopo Sansovino]

P. Gualdo: *Vita di Andrea Palladio* (1616); ed. C. G. Zorzi in *Saggi & Mem. Stor. A.*, xi (1959), pp. 93–104

MONOGRAPHS

O. Bertotti Scamozzi: *Le fabbriche e i disegni di Andrea Palladio raccolti e illustrati*, 4 vols (Vicenza, 1776–83/R 1968)
A. Venturi: *Storia* (1901–40), xi, pp. 320–517
A. Dalla Pozza: *Palladio* (Vicenza, 1943)
R. Pane: *Andrea Palladio* (Turin, 1961)
J. S. Ackerman: *Palladio*, The Architect and Society (Harmondsworth, 1966)
N. Ivanoff: *Palladio* (Milan, 1967)
Corpus Palladianum (Vicenza, 1968–) [continuing surv. of Palladio's works]
L. Puppi: *Andrea Palladio: L'opera completa*, 2 vols (Milan, 1973; Eng. trans., London, 1975)
M. Zocconi: 'Il Palladio nel processo produttivo del cinquecento veneto', *Boll. Cent. Int. Stud. Archit. Andrea Palladio*, xx (1978), pp. 171–201
Atti del convegno internazionale su Palladio e il Palladianesimo: Venice, 1980
D. Howard: 'Four Centuries of Literature on Palladio', *J. Soc. Archit. Hist.*, xxxix (1980), pp. 224–41
D. Lewis: *The Drawings of Andrea Palladio* (Washington, 1981)
L. Puppi: *Palladio e Venezia* (Florence, 1982)
C. Constant: *The Palladio Guide* (Princeton, 1985)
F. Barbieri: *Architteture Palladiane* (Vicenza, 1992)
B. Boucher: *Andrea Palladio: The Architect in his Time* (New York, 1994)

VILLAS

F. Burger: *Die Villen des Andrea Palladios* (Leipzig, 1909)
G. Masson: 'Palladian Villas as Rural Centres', *Archit. Rev.* [London], cxviii (1955), pp. 17–20
G. Mazzotti: *Palladian and Other Venetian Villas* (London, 1958)
W. Lotz: 'La Rotonda, edificio civile con cupola', *Boll. Cent. Int. Stud. Archit. Andrea Palladio*, iv (1962), pp. 69–73
G. Mazzariol: *Palladio a Maser* (Venice, 1965)
J. S. Ackerman: *Palladio's Villas* (Locust Valley, 1967)
C. Semenzato: *La Rotonda* (1968)
G. G. Zorzi: *Le ville e i teatri di Andrea Palladio* (Venice, 1968)
G. Bordignon Favero: *La Villa Emo di Fanzolo* (Vicenza, 1972)
L. Puppi: *La Villa Badoer di Fratta Polesine* (Vicenza, 1972)
D. Battilotti: 'Villa Barbaro a Maser: Un difficile cantiere', *Stor. A.*, liii (1985), pp. 33–48
I. J. Reist: *Renaissance Harmony: The Villa Barbaro at Maser* (diss., New York, Columbia U., 1985)
R. Freedman: 'A Computer Recreation of Palladian Villa Plans', *Architectura* [Munich], xvii (1987), pp. 58–66
M. Morresi: *Villa Porto Colleoni a Thiene: Architettura e commitenza nel rinascimento vicentino* (Milan, 1988)
P. Holberton: *Palladio's Villas: Life in the Renaissance Countryside* (London, 1990)

PUBLIC BUILDINGS AND PALACES

H. Pée: *Die Palastbauten des Andrea Palladios* (Würzburg, 1941)
R. Cevese: *I palazzi dei Thiene* (Vicenza, 1952)
F. Barbieri: *Il museo civico di Vicenza* (Venice, 1962) [Palazzo Chiericati]
G. G. Zorzi: *Le opere pubbliche e i palazzi privati di Andrea Palladio* (Venice, 1965)
F. Barbieri: *La Basilica Palladiana* (Vicenza, 1968)
A. Vendetti: *La Loggia del Capitaniato* (Vicenza, 1969)

CHURCHES

G. Damerini: *L'isola e il cenobio di San Giorgio Maggiore* (Venice, 1956)
R. Wittkower: 'Le chiese di Andrea Palladio e l'arte veneta', *Barocco europeo e barocco veneziano: Florence, 1962*, pp. 77–87
H. Lund: 'The Façade of S Giorgio Maggiore', *Archit. Rev.* [London], cxxxiii (1963), pp. 282–4
W. Timofiewitsch: 'S Giorgio Maggiore', *Boll. Cent. Int. Stud. Archit. Andrea Palladio*, v (1963), pp. 330–37
S. Sinding-Larsen: 'Palladio's Redentore: A Compromise in Composition', *A. Bull.*, xlvii (1965), pp. 419–37
W. Timofiewitsch: *Die sakrale Architektur Palladios* (Munich, 1968)
G. G. Zorzi: *Le chiese e i ponti di Andrea Palladio* (Venice, 1968)
R. Timofiewitsch: *La chiesa del Redentore* (Vicenza, 1969)

THEATRES

L. Magagnato: 'The Genesis of the Teatro Olimpico', *J. Warb. & Court. Inst.*, xiv (1951), pp. 209–20
G. G. Zorzi: 'Le prospettive del Teatro Olimpico di Vicenza', *A. Lombarda*, x/2 (1965), pp. 70–97
——: *Le ville e i teatri di Andrea Palladio* (Venice, 1968)

J. T. Oosting: *Andrea Palladio's Teatro Olimpico* (Ann Arbor, 1981)
A. Beyer: *Andrea Palladio, Teatro Olimpico: Triumpharchitektur für eine humanistische Gesellschaft* (Frankfurt am Main, 1987)
F. Rigon: 'Il Teatro Olimpico di Vicenza: Identità di un monumento', *Venezia A.*, ii (1988), pp. 47–63

THEORY OF DESIGN

R. Wittkower: *Architectural Principles in the Age of Humanism* (London, 1949, rev. 1962)
G. Forssman: *Palladios Lehrgebäude* (Stockholm, 1965)
——: 'Palladio e le colonne', *Boll. Cent. Int. Stud. Archit. Andrea Palladio*, xx (1978), pp. 71–87
D. Howard and M. Longair: 'Harmonic Proportion and Palladio's "Quattro Libri"', *J. Soc. Archit. Hist.*, xli (1982), pp. 116–43

For further bibliography see VICENZA, §2; VENICE, §IV, 1; and MASER, VILLA BARBARO.

ANDREAS BEYER

Palma [Negretti; Nigreti]. Italian family of painters and draughtsmen. They were active in Venice from the early 16th century to the first quarter of the 17th. (1) Palma Vecchio was the most talented of a number of painters of his generation from the Bergamo region who worked in Venice. His nephew (2) Antonio Palma was a pupil of Bonifazio de' Pitati. Antonio's son (3) Palma Giovane was the leading painter in Venice in the last years of the 16th century and the early 17th century. Despite the continuity of the generations, there was no stylistic continuity founded on workshop training between the three artists, other than that perceptible in 16th-century Venetian painting as a whole. Antonio Palma moved to Venice at an early age, but probably only in 1528, at the time of his uncle's death, and he conveyed nothing of his own practice to his son.

(1) (Jacopo) [Giacomo] **Palma (il) Vecchio** (*b* Serina, nr Bergamo, ?1479–80; *d* Venice, 28 July 1528). His birthdate is calculated on Vasari's testimony (1550) that he died aged 48. By March 1510 he was in Venice, where he spent his working life. The stylistic evidence of his earliest works suggests that he was apprenticed to fellow Bergamasque artist Andrea Previtali, who had studied under Giovanni Bellini. A signed *Virgin Reading* (1508–10; Berlin, Gemäldegal.), which may be Palma Vecchio's earliest surviving painting, is strongly reminiscent of his teacher. Previtali returned to Bergamo in 1511, and the main corpus of Palma's work can be dated from this time. Palma Vecchio's oeuvre reflects the change from an early to a High Renaissance conception of the human figure in secular and religious art. He specialized in certain themes that became established in the repertory of genres of the Venetian school in the generation after him. The principal of these were the wide-format SACRA CONVERSAZIONE—that is, paintings of the Virgin and saints in a rural setting, for private piety but not devotional use—and half-length paintings of idealized women with some erotic intent.

Palma Vecchio's early work shares the imagery of late paintings by Bellini, of bust-length portraits (e.g. Budapest, Mus. F.A.) and of half-length *Virgin and Saints* (Prague, N. Mus.; Rovigo, Accad. Concordi). Conspicuous among early works with a lingering late 15th-century mood is a documented *Assumption of the Virgin* (Venice, Accad.), for which he was paid early in 1514. However, already by *c.* 1513, in a *Sacra Conversazione* (Dresden, Gemäldegal.,

1. Palma Vecchio: *Virgin and Child with Saints*, oil on canvas, 1.33×1.98 m, 1520–22 (Vienna, Kunsthistorisches Museum)

Alte Meister), he had begun to develop one of his characteristic themes, animating the figure groups and breaking with the contemplative postures of his first works. Alvise Vivarini's *Virgin and Child with Saints* (Caen, Mus. B.-A.) is the earliest example of this new spirit, while the immediate inspiration was Titian, from whom Palma derived the arcadian mood of his paintings of the Virgins in landscape settings.

Palma Vecchio's tendency to modernize his art became more marked in the period between 1515 and 1520, during which he was attentive to Central Italian art, as well as to recent Venetian work. In the *Rest on the Flight into Egypt with Mary Magdelene* (1514–15; Florence, Uffizi), the most vital figure in the composition, St Joseph, is derived from a soldier in Michelangelo's cartoon of the *Battle of Cascina* (1504; destr.). In the same period, the *St Sebastian* in a polyptych by Palma in the parish church of Peghera di Taleggio (near Bergamo) is copied from a print by Marcantonio Raimondi.

In the field of portraiture, the '*Violante*' (1516–18; Vienna, Ksthist. Mus.) reveals a new assurance in the relation of the half-length figure to the pictorial field. The sources for this are Titian and possibly Giorgione, to whom Palma's *Self-portrait in a Fur Coat* (1516–18; Munich, Alte Pin.) is still sometimes attributed. The latter was among the Venetian paintings most highly commended by Vasari in both editions of his *Vite*.

The period closes, from 1518 to 1520, with a group of works in which Palma Vecchio's mature style emerges for the first time. In the painting *Sacra Conversazione* (Madrid, Mus. Thyssen-Bornemisza), elements from Raphael and

Titian are combined in Palma's first successful work of this genre. The *Nymph* (Dresden, Gemäldegal., Alte Meister) has an overt eroticism exemplary of the new secularity of Venetian art collecting. In his altarpiece depicting the *Virgin and Child Enthroned with Saints* (1518–20) for the parish church of Zerman (near Treviso), Palma successfully absorbed lessons in figure style from Titian and Sebastiano del Piombo, as well as from Albrecht Dürer (1471–1528) and Giovanni Bellini.

The 1520s were the period of Palma Vecchio's maturity and of a steadily growing success. By this time he had come to the attention of the group of patricians whose collections were recorded (1521–43) by Marcantonio Michiel. The Dresden *Nymph*, for example, may have been in the collection of Francesco Zio by 1521 together with the artist's *Adam and Eve*, which may be identical with a surviving life-size double nude (Brunswick, Herzog Anton Ulrich-Mus.), a subject without precedent in Venetian painting. The monumental classicism of the painting derives from Tullio Lombardo's tomb of *Andrea Vendramin* (Venice, SS Giovanni e Paolo).

A series of majestic *sacre conversazioni* constitutes some of Palma's most characteristic work, beginning with a *Virgin and Child with Saints* (1520–22; Vienna, Ksthist. Mus.; see fig. 1) and continuing with examples from the middle of the decade (Moscow, Pushkin Mus. F.A.; Penrhyn Castle, Gwynedd, NT; and Naples, Capodimonte; see colour pl. 2, XII1). The series closes with the unfinished *Sacra Conversazione* (1527–8; Venice Accad.), indebted to Titian's *Pesaro Madonna* (1526; Venice, S Maria Gloriosa dei Frari; see colour pl. 2, XXXV2). A group of half-length

portraits of blonde women clad only in loose shirts also dates from the 1520s. These were not intended as portraits of individuals but as generalized and profane statements of feminine beauty, inspired by courtesans, in the spirit of the Petrarchan poetry revival then in vogue in Venice. Titian's *Flora* (Florence, Uffizi) is an early example of this genre, which originated in the circle of Leonardo da Vinci. Palma Vecchio and subsequently Paris Bordone adopted it as their own. Noble and well-preserved examples by Palma are the *Flora* (1522–4; London, N.G.; see fig. 2) and the *Woman with Bared Breast* (1524–6; Berlin, Gemäldegal.).

Palma Vecchio's success in the 1520s was also marked by a series of commissions for altarpieces for Venetian churches. Notable among these is the polyptych of *St Barbara* painted in 1523–4 for the altar of the Scuola dei Bombardieri in S Maria Formosa (*in situ*). The regal figure of the saint, patroness of the artillery, is a skilled variant of Titian's Virgin in the *Assumption of the Virgin* (Venice, S Maria Gloriosa dei Frari) and is a classic example of Venetian High Renaissance art. In 1525 Palma was commissioned for the first time to paint a high altar for a Venetian church, the *Adoration of the Magi* (Milan, Brera) for S Elena. Its large scale and festive mood were influential in the Venetian school and hence on European painting in general. He also continued to receive altarpiece commissions outside Venice. Polyptychs for SS Annunziata, Serina (the *Resurrection*; *in situ*), and for Gerosa (the triptych of *St Helen and Constantine*; Milan, Brera) indicate his continuing ties with the valleys near Bergamo. His *Death of St Peter Martyr* in S Martino, Alzano Lombardo (near Bergamo) was a novel subject for an altarpiece in Venetian art and was probably related to his failure to win a competition (*c.* 1526) against Titian for an altarpiece of

the same subject (destr.) for SS Giovanni e Paolo, Venice. Around 1527–8 Palma painted a *Virgin and Child with SS George and Lucy* for the Capra family chapel in S Stefano, Vicenza, which draws on the same aristocratic mood of rich material, idealized humanity and noble piety as the *St Barbara* polyptych and the private *sacre conversazioni*. A *Portrait of a Man* (1527–8; Madrid, Pal. Liria, Col. Casa Alba) may be of Palma's Vicentine patron, Girolamo Capra. It was probably in 1527 that Palma was commissioned to paint a large canvas of *St Mark Saving Venice from the Ship of Demons* (*in situ*) for the Scuola Grande di S Marco, Venice. This composition, inspired by Lorenzo Lotto (Palma's friend, according to Vasari), has traditionally been associated with Giorgione. Vasari (1568) praised the work as one of the greatest achievements of the Venetian school. Palma left the canvas incomplete at his sudden death in 1528, and it was subsequently worked on by Paris Bordone and several later hands.

Palma's paintings of the 1520s reveal a mature High Renaissance style, characterized by his mastery of contrapposto, the enrichment of his high-keyed palette and the development of a dignified and diverse repertory of ideal human types in conservative compositions. These qualities dominated his work to the exclusion of dramatic chiaroscuro, spatial experiment, expressionism and innovative composition. Nevertheless, the continuing development of his art is hinted at in some late paintings, revealing the influence of Pordenone (the *Death of St Peter Martyr*; Alzano Lombardo, Mus. Basilica S Martino) or contemporary Central Italian art (*Bathing Nymphs*; Vienna, Ksthist. Mus.).

Palma Vecchio is traditionally considered to have taught Bonifazio de' Pitati in the 1520s. There is, however, no documentary evidence concerning the operation of his workshop, although his impact on minor painters in Venice at this time is considerable. A large number of paintings in his style, which are usually designated 'workshop', are indistinguishable from damaged and repainted works or from imitations. A small corpus of chalk-and-pen drawings, including a signed *Holy Family* (London, BM), offers insights into Palma's working methods but not into workshop practice. Surviving drawings suggest he used pen and ink for compositional sketches, but chalk for studies of details. Certain drawings, e.g. *Head of a Young Woman* (*c.* 1520s; Paris, Louvre), seem to have served for several paintings. The use of hatching with strong contours in the Louvre sketch is also characteristic of more highly finished pen drawings, such as parts of the *Holy Family* (Cambridge, Fitzwilliam).

2. Palma Vecchio: *Flora*, oil on panel, 775×641 mm, 1522–4 (London, National Gallery)

BIBLIOGRAPHY

Thieme–Becker

M. Michiel: *Notizie d'opere di disegno* (MS.; 1521–43); ed. J. Morelli (Bassano, 1800)

G. Vasari: *Vite* (1550,rev. 2/1568); ed. G. Milanesi (1878–85), v, pp. 243–8

C. Ridolfi: *Meraviglie* (1648); ed. D. von Hadeln (1914–24)

E. Fornoni: *Notizie biografiche su Jacopo Palma Vecchio* (Bergamo, 1886)

G. Ludwig: 'Bonifazio de' Pitati', *Jb. Preuss. Kstsamml.*, xxii (1901), pp. 61–78, 180–200; xxiii (1902), pp. 36–66

——: 'Archivalische Beiträge zur Geschichte der venezianischen Malerei', *Jb. Preuss. Kstsamml.*, xxiv (Beihft), 1903, pp. 66–71

G. Gombosi: 'Les origines artistiques de Palma Vecchio', *Gaz. B.-A.*, vii (1932), pp. 172–82

——: *Palma Vecchio*, Klass. Kst Gesamtausgaben (Stuttgart and Berlin, 1937)

T. Borenius: 'A Masterpiece of Palma Vecchio', *Burl. Mag.*, ii (1939), pp. 141–2

H. Tietze and E. Tietze-Conrat: *The Drawings of the Venetian Painters in the 15th and 16th Centuries* (New York, 1944), p. 229

G. Fiocco: 'Un' opera magistrale di Palma il Vecchio', *Emporium* (1954), pp. 243–6

J. Held: 'Flora, Goddess and Courtesan', *Essays in Honor of Erwin Panofsky*, i (New York, 1961), pp. 201ff

A. Ballarin: *Palma il Vecchio* (Milan, 1965)

G. Mariacher: *Palma il Vecchio* (Milan, 1968)

C. Gould: *National Gallery Catalogues: The Sixteenth-century Italian Schools* (London, 1975, rev. 1987), pp. 184–9

G. Mariacher: 'Jacopo Negretti detto Palma il Vecchio', *I pittori bergamaschi: Il cinquecento*, i (Bergamo, 1975), pp. 171–247 [full bibliog.]

D. Rosand: *Painting in Cinquecento Venice* (London, 1982), pp. 20, 249

The Genius of Venice (exh. cat., ed. C. Hope and J. Martineau; London, RA, 1983), pp. 194–9, 265–7

P. Rylands: *Palma il Vecchio, Opera Completa* (Milan, 1988)

(2) Antonio Palma (*b* Serina, nr Bergamo, ?1515; *d* Venice, after 1574). Nephew of (1) Palma Vecchio. He was apprenticed to Bonifazio de' Pitati, whose niece Giulia he married *c.* 1545. He probably assisted Bonifazio in the decoration of the Palazzo dei Camerlenghi, Venice, and the sacristy of S Sebastiano, Venice. A signed *Pietà* (Serina, SS Annunziata), a processional banner dated 1565, is too damaged to be indicative of his style. One other signed work, the *Resurrection* (Stuttgart, Staatsgal.), forms the basis for gathering a small number of stylistically similar works under Antonio's name. The remainder of what must have been a substantial oeuvre is submerged in the proliferation of painting influenced by Bonifazio in the mid-16th century. A late painting, *Esther and Ahasuerus* (1574; Sarasota, FL, Ringling Mus. A.), testifies to the longevity of the style of Bonifazio. Titian's *Portrait of a Man with a Palm* (1561; Dresden, Gemäldegal. Alte Meister) is generally thought to represent Antonio Palma.

BIBLIOGRAPHY

Thieme–Becker

N. Ivanoff: 'Antonio Palma e Jacopo Palma il Giovane', *Not. Pal. Albani*, i (1975), pp. 24–8

——: 'Antonio Negretti detto Antonio Palma', *I pittori bergamaschi: Il cinquecento*, iii (Bergamo, 1979), pp. 379–99

(3) (Giacomo) [Jacopo] Palma (il) Giovane (*b* Venice, *c.* 1548; *d* Venice, 1628). Son of (2) Antonio Palma. A greater artist than his father, his vast oeuvre represents the impact of Central Italian Mannerism but principally of Jacopo Tintoretto on Venetian painting in the generation after Titian, Tintoretto and Paolo Veronese. He died in his late seventies and was occasionally referred to as 'il vecchio', but since the 17th century he has been known as 'il giovane' to distinguish him from his great uncle. He was virtually self-taught, apart from a presumed acquaintance with his father's workshop. In 1567 he came to the attention of Guidobaldo II della Rovere, Duke of Urbino, who was to support him for four years. A possible knowledge of Federico Barocci's art at the court of Urbino left little trace on his surviving early works. The Duke sent him to Rome for study, where he spent a few months apprenticed to an unknown artist. There his sympathy was with Taddeo Zuccaro and Federico Zuccaro, who influenced the graphic style of the drawing of *Matteo da Lecce* (1568; New York, Pierpont Morgan Lib.), his first dated work. His Roman sojourn, which lasted until *c.* 1573–4, made a direct impact on some of his Venetian works and indirectly made him receptive to Tintoretto's style. A tendency in Rome in the 1560s to retreat from the most artificial and decorative aspects of Mannerism in favour of naturalism was also to affect Palma's attitude to style in his mature works, in which the degree of *maniera* would be determined by subject-matter and the taste of the patron.

After the 1577 fire at the Doge's Palace in Venice, Palma Giovane received his first major public commission, three canvases for the ceiling of the Sala del Maggior Consiglio (see colour pl. 2, XII2). The largest of these, *Venice, Crowned by Victory* (*c.* 1578; *in situ*), depends on Veronese for its compositional order, while the figure style and the palette are strongly indebted to Roman Mannerism. In the early 1580s Roman influences gave way to more thickly impasted surfaces, more emphasis on light and a looser brushstroke. The direct cause of this seems to have been his contact with the *Pietà* (Venice, Accad.) Titian left unfinished at his death, which Palma worked on in this period. Although there is no evidence that Palma was apprenticed to Titian, he was the source of a famous description of Titian's working methods (Boschini). Palma's cycle of paintings on a eucharistic theme for S Giacomo dall'Orio, Venice, reflecting for the first time in Venice Tridentine doctrine on this subject, is exemplary of this shift in his style. A second painting in the Sala del Maggior Consiglio, *Pope Alexander III and the Doge Charge Otto to Negotiate for Peace with Frederick Barbarossa* (*c.* 1583), is a pendant in both setting and style to Federico Zuccaro's adjacent canvas, completed in the previous year. By the mid-1580s, however, Palma had absorbed a Venetian technique and apprehended the versatile figure postures of Tintoretto, predicated less on static and decorative arabesques than on rolling contrapposto with dynamic spatial implications.

Palma Giovane's decoration of the oratory of the Crociferi, Venice, between 1583 and 1592, occasioned some of his finest works. The cycle exemplifies his choice of naturalism, amounting in places to genre for lay subjects (e.g. *Pasquale Cicogna Attending Mass in the Church of the Crociferi*, 1586–7), contrasting with a manner reminiscent of Tintoretto for scenes from the *Passion*, including the *Assumption* on the ceiling of the oratory. His realism partakes of a general trend in Italy in the last quarter of the 16th century to modify late Mannerism with credible figure postures and structured spatial settings. Another major work of this period is the *St Julian in Glory* (*c.* 1588) on the ceiling of S Giuliano, Venice, which mediates between Tintoretto's manner for the figures and a soaring infinity of space anticipating Baroque effects. Several portraits included in the Crociferi paintings testify to Palma's considerable accomplishment in this field. His few surviving independent portraits are characterized by their directness and simplicity. They seem not to have been official commissions. The *Portrait of a Collector* (Birmingham, Mus. & A.G.) may represent his friend Bartolomeo della Nave. He also painted a portrait of his friend the sculptor *Alessandro Vittoria* (1600–05; Vienna, Ksthist. Mus.). There are three self-portraits (Florence, Uffizi; Venice, Gal. Querini–Stampalia; Milan, Brera), the best of which is that (*c.* 1590; *see* VENICE, fig. 4) in Milan.

After the death of Tintoretto in 1594, Palma Giovane became the most esteemed artist in Venice, and this seems to have given him greater impulse to perpetuate the late master's style. He became even more prolific, and his catalogue of surviving paintings numbers over 600. His patrons were primarily ecclesiastical, while secular patronage diminished in importance as Venice suffered economic decline in the period of the plague (1576) and the war of Cyprus (1575–7). The redecoration of the Doge's Palace continued, and Palma's primacy was acknowledged in an important commission for four votive Ducal paintings in the Sala del Senato, including that of *Doge Pasquale Cicogna* (*c.* 1595; see fig.). These show an assured and personal combination of naturalism for landscapes and portraits with a felicitous *maniera* for allegorical and visionary figures. Palma's status as a painter by this time was equivalent to that of the sculptor Vittoria, with whom he worked on several chapel decorations, for example in S Giuliano, Venice. From 1600 onwards his oeuvre is dominated by Marian and Passion themes, as well as dolorous martyrdoms. Counter-Reformationary doctrine is reflected in the scenes of *Purgatory* (*c.* 1600) for the ceiling of the Ateneo Veneto, Venice, and in the decoration (*c.* 1604) of the Scuola del Sacramento in S Giacomo dall'Orio, Venice. After 1610 he painted a few mythologies for a small circle of intellectuals that included the poet Giambattista Marino. His fame led to innumerable commissions outside Venice, in various regions of Italy, the Dalmatian coast and including the courts of the Emperor Rudolf II (*reg* 1576–1612) and of King Sigismund III of Poland (*reg* 1587–1632).

Despite his success, Palma Giovane was aware that the Venetian pictorial tradition, based on the broken brushwork and tenebrism of Titian with Tintoretto's figure style, was exhausted. His remedy was to collaborate in the publication of two primers of *disegno* (Odoardo Fialetti: *Il vero modo et ordine per dissegnar tutte le parti et membra del corpo humano*, Venice, 1608; Giacomo Franco: *De excellen-*

tia et nobilitate delineationis libri duo, Venice, 1611), treating it in the manner of the Bolognese Academy, and these were the earliest to be published in Italy. He was himself a draughtsman of great facility. Major holdings of his drawings are in Bergamo (Accad. Carrara), London (BM), Munich (Alte Pin.) and Venice (Correr). Some of them have been confused with those of Hans Rottenhammer I, a close friend of Palma. Palma designed the monument to himself, Palma Vecchio and Titian (*in situ*) over his burial place in the church of SS Giovanni e Paolo, Venice.

BIBLIOGRAPHY

Thieme–Becker
R. Borghini: *Il Riposo* (Florence, 1584); ed. M. Rosci (Milan, 1967), p. 559
M. Boschini: *Le ricche minere della pittura veneziana* (Venice, 1674)
F. Bartoli: *Notizie della pitture, sculture ed architetture d'Italia* (Venice, 1777)
T. Temanza: *Vite dei più celebri architetti e scultori veneziani del secolo XVI* (Venice, 1778)
G. Ludwig: 'Bonifazio de' Pitati', *Jb. Preuss. Kstsamml.*, xxii (1901), pp. 180–200
G. Gronau: *Documenti artistici urbinati* (Florence, 1936)
D. Rosand: 'Jacopo Palma il Giovane: Disegni inediti dell'Accademia Carrara di Bergamo e del Museo Fantoni di Rovetta', *Master Drgs*, iv (1966), pp. 182–4
——: *Palma Giovane and Venetian Mannerism* (diss.; Ann Arbor, 1967)
L. Grassi: *Il libro dei disegni di Jacopo Palma il Giovane all'Accademia di San Luca* (Rome, 1968)
D. Rosand: 'The Crisis of the Venetian Renaissance Tradition', *L'Arte*, xi–xii (1970), pp. 5–53
——: 'Palma Giovane as Draughtsman', *Master Drgs*, ii (1970), pp. 148–61
S. J. Freedberg: *Painting in Italy, 1500–1600*, Pelican Hist. A. (Harmondsworth, 1971), pp. 560–62
S. Mason Rinaldi: 'Disegni preparati per dipinti di Jacopo Palma il Giovane', *A. Ven.*, xxvi (1972), pp. 92–110
P. Zampetti: 'Ancora su Palma il Giovane nelle Marche', *Not. Pal. Albani*, 2 (1976), pp. 45–52
N. Ivanoff and P. Zampetti: 'Giacomo Negretti detto Palma il Giovane', *I pittori bergamaschi: il cinquecento*, iii (Bergamo, 1979), pp. 401–739 [full bibliog.]
D. Rosand: *Painting in Cinquecento Venice* (London, 1982), pp. 77–80
The Genius of Venice (exh. cat., ed. C. Hope and J. Martineau; London, RA, 1983), pp. 192–4, 264–5
S. Mason Rinaldi: *Palma il Giovane*, Opera Completa (Milan, 1984)
M. Amaturo: 'Un episodio di committenza cremasca: *L'Assunta* di Palma il Giovane per la chiesa di Sant'Agostino', *Insula Pulcheria*, xxv (Dec 1995), pp. 107–19
A. J. Elen: *Italian Late-Medieval and Renaissance Drawing-books from Giovannino de'Grassi to Palma Giovane: A Codicological Approach* (diss., Leiden, Rijksuniv., 1995)

PHILIP RYLANDS

Palmanova. Italian town in the province of Friuli, 17 km south of Udine. It was built on flat ground from 1593 to 1598 by the Republic of Venice to house a military garrison as a protection from Turkish attack on its north-eastern land frontier. Designed for a single purpose, with no conventional social substructure, Palmanova could be laid out as an ideal city according to an Italian urban-planning tradition that had hitherto been confined to theoretical treatises. A group of Venetian engineers was responsible for designing Palmanova, the main contributor being Giulio Savorgnano (1516–95), but Bonaiuto Lorini (*c.* 1540–1611) and Vincenzo Scamozzi, authors of books on fortification and urban planning, were involved. An original plan was for a nine-sided central piazza from which streets radiated to nine bastions, those from the three gates in the middle of curtains being blocked off for safety before they reached the piazza. Savorgnano favoured gates

Palma Giovane: *Doge Pasquale Cicogna*, oil on canvas, 3.69×3.62 m, *c.* 1595 (Venice, Doge's Palace, Sala del Senato)

tucked into the flanks of the bastions, a practice not uncommon with Venetian engineers.

The plan that was realized was similarly based on a regular geometrical figure, a nine-pointed star, forming a polygon of eighteen sides, with a central hexagonal piazza, a design that satisfied both humanists and generals. Six streets radiated in an alternating pattern to three gates and three bastions. However, the later street pattern, not designed by the engineers, displayed a complexity at odds with military demands. The geometrical street pattern facilitated rapid communications from the core to any threatened sector of curtain or bastion. The greater the number of sides to a geometrical plan, the larger the internal space enclosed within the bastions; but this advantage had to be set against the comparatively high cost of constructing bastions (more of which were needed as the number of sides was increased) as against the cost of curtain walls. There was also an optimum distance from the flank of one bastion to the tip of its neighbour that depended on the effective range of artillery. During the Napoleonic Wars (1803–14) numerous outworks were added to extend the depth of the fortifications. Palmanova remains a somewhat unattractive garrison town, its piazza too large and desolate and its symmetrical plan dull except when seen from the air or rendered in drawings, when its geometry becomes appealing.

BIBLIOGRAPHY

H. de la Croix: *Military Considerations in City Planning* (New York, 1972)
P. Marchesi: *La fortezza veneziana di Palma la Nuova* (Reana del Rojale, 1980)
——: *Fortezze veneziane: 1508–1797* (Milan, 1984)
Q. Hughes: *Military Architecture* (Liphook, 1991), pp. 95, 102–3

QUENTIN HUGHES

Palmezzano, Marco (*b* Forlì, *c.* 1459–63; *d* Forlì, before 25 May 1539). Italian painter. His earliest work was probably on the fresco decoration (*c.* 1480–84) of the vault of the sacristy of the treasury in the Santa Casa, Loreto, designed by Melozzo da Forlì. He then probably went to Rome, where he may have painted the fresco in the apse of Santa Croce in Gerusalemme (Longhi). In 1493 Palmezzano is documented working with Melozzo on the fresco decoration in the Feo Chapel, S Biagio (destr. 1944), Forlì. Melozzo's influence—with a few references, also, to Venetian art—continues to be seen in his works of the 1490s.

A document dated 30 May 1495, relating to the division of property between Marco and his two brothers, endows the painter with a house in Venice and all its furnishings. This suggests his presence there around that time, and the figure of St Sebastian in the altarpiece depicting *St Anthony Abbot and other Saints* (Forlì, Pin. Civ.) clearly shows the painter's familiarity with Giovanni Bellini's S Giobbe Altarpiece (*c.* 1480; Venice, Accad.; *see* BELLINI, (3), fig. 3). In this work, however, one can already see a certain weakening of Palmezzano's inventive powers, which perhaps is what led him to experiment with all the artistic trends of the time. His desire to keep up to date increased as his work became more successful in the Romagna and along the Adriatic coast. His prolific output, which continued until 1539, evolved towards an easily identifiable, sparse, dry style. While he continually strove to utilize a modern pictorial vocabulary, his work shows no awareness of the true direction of 16th-century painting. Although Palmezzano continued painting into the first four decades of the 16th century, he is a distinctly late 15th-century artist, superficially modern but in reality limited by an arid preoccupation with the past.

BIBLIOGRAPHY

Thieme–Becker

R. Longhi: *In favore di Antoniazzo Romano* (Florence, 1927); repr. in *Saggi e ricerche*, ii (Florence, 1967), pp. 245–6
C. Grigioni: *Marco Palmezzano pittore forlivese* (Faenza, 1956)
E. Golfieri: 'In margine al V centenario della nascita di Marco Palmezzano', *A. Ven.*, xi (1957), pp. 246–7
Mostra delle opere del Palmezzano in Romagna (exh. cat., ed. L. Becherucci and C. Gnudi; Forlì, Pin. Civ., 1957)
F. Heinemann: *Giovanni Bellini e i Belliniani* (Venice, 1962), pp. 264–5
G. Viroli: *La Pinacoteca Civica di Forlì* (Forlì, 1980), pp. 50–75
A. Mazza: 'Marco Palmezzano', *Luca Longhi e la pittura su tavola in Romagna nel '500* (exh. cat., ed. J. Bentini; Ravenna, Loggetta Lombard., 1982), pp. 124–7
M. Lucco: 'Palmezzano, Marco', *La pittura in Italia: Il quattrocento*, ed. F. Zeri, ii (Milan, 1987), p. 723

GENNARO TOSCANO

Pandolfini. Italian family of patrons and collectors. Originally from Signa, the family became established during the 13th century in Florence and subsequently played a significant part in the city's political and cultural life. Filippo Pandolfini, son of the notary Giovanni Pandolfini, was a prior of the Commune in 1381 and gonfalonier in 1392. His son Agnolo Pandolfini (1360/63–1446) distinguished himself as a soldier and a diplomat in the service of the Florentine Republic and was a friend of Leon Battista Alberti. Agnolo's son Giannozzo Pandolfini (1396–1456) allied himself with Cosimo de' Medici, and his services to the Republic were rewarded with a tomb in Badia Fiorentina, where the Pandolfini also founded their family chapel, begun in 1503 to the design of Benedetto da Rovezzano and decorated in the 17th century with an altarpiece commissioned from Giovanni Bilivert. Giannozzo's son Pandolfo Pandolfini (1424–65) owned the Villa Carducci–Pandolfini at Legnaia, to the west of Florence, the loggia of which was originally decorated with the series of frescoes of *Famous Men and Women* (Florence, Uffizi) painted by Andrea del Castagno *c.* 1450 (see colour pl. 1, XXI1) and removed in 1850. Pier Filippo Pandolfini (1437–97) was responsible for beginning the family library.

Giannozzo Pandolfini the younger (*d* 13 Dec 1525), Pandolfo's son, was created Bishop of Tróia in 1484. He spent much of his time in Rome, however, at the court of Pope Leo X, who made him castellan of the Castel Sant'Angelo and contributed to his collection of antiquities. Giannozzo was also on friendly terms with Raphael, who produced a design (*c.* 1518) for the Palazzo Pandolfini in Florence. It was begun *c.* 1520 under the supervision of Giovan Francesco da Sangallo and continued under Bastiano da Sangallo when it was inherited by Giannozzo's nephew Ferdinando Pandolfini (*d* 1560).

BIBLIOGRAPHY

G. Vasari: *Vite* (1550, rev. 2/1568); ed. G. Milanesi (1878–85), ii, pp. 670–71
G. B. di Crollalanza: *Dizionario storico blasonico delle famiglie nobili e notabili italiane*, ii (Pisa, 1888), p. 268
V. Spreti: *Enciclopedia storico-nobiliare italiana* (Milan, 1931), pp. 98–100
L. Ginori: *I palazzi di Firenze nelle storie e nell'arte*, i (Florence, 1972), pp. 507–12
M. Bucci: *Palazzi di Firenze*, iii (Florence, 1973), pp. 77–87

JANET SOUTHORN

Panicale, Masolino da. *See* MASOLINO.

Panico, Ugo da. *See* CARPI, UGO DA.

Paolino, Fra [Paolo di Bernardino d'Antonio] (*b* Pistoia ?1490; *d* Pistoia, 3 Aug 1547). Italian sculptor, painter and draughtsman. He was the son of Bernardino del Signoraccio (Bernardino d'Antonio; 1460–after 1532), a minor Pistoian painter, and is first recorded in 1513 as a monk of the Dominican convent of S Marco in Florence. In that year he made two clay statues of *St Dominic* and *St Mary Magdalene* (both untraced) that in 1516 were placed in S Maria Maddalena in Pian di Mugnone.

His first documented painting is a fresco of the *Crucifixion* (1516; Siena, Santo Spirito), done with the assistance of Fra Agostino, showing a type of composition invented by Fra Bartolommeo for miniaturized painting. The figure of Christ, however, is derived from Albertinelli's *Crucifixion* (Florence, Certosa del Galluzzo (also known as di Val d'Ema)). During these years Fra Paolino must have worked as an assistant to Fra Bartolommeo, but his precise contributions remain difficult to isolate. He was obviously admired within S Marco, however, since, on Fra Bartolommeo's death in 1517, the vast collection of the latter's drawings was consigned to him.

All Fra Paolino's paintings demonstrate strong dependence on Fra Bartolommeo's drawings, beginning with the *Pietà* (1519; Florence, Mus. S Marco), painted for the high altar in S Maria Maddalena in Pian di Mugnone. By 1525 Fra Paolino was painting altarpieces combining figures with architecture derived from Fra Bartolommeo's *sacre conversazioni* of 1510–13. Most of these were destined for provincial convents affiliated with the congregation of S Marco, the earliest being the *Virgin and Child with SS Dominic, Antonino, Lucy, Catherine, Vincent Ferrer and Thomas Aquinas* (1525; Bibbiena, S Maria del Sasso) and the *Virgin and Child with SS Gimignano, Dominic, Lucy, Mary Magdalene and Two other Saints* (1525; San Gimignano, S Lucia), originally painted for S Domenico, San Gimignano.

In these evocations of Fra Bartolommeo's style, Fra Paolino kept the chiaroscuro modelling to a minimum; his figures appear to have the consistency of wax and to exist in a denatured ambient. This is evident in the altarpiece for the high altar of S Domenico of Pistoia (1528; Pistoia, S Paolo), in which 15 saints are arranged around the Virgin and Child under a canopy held by flying angels, where none of the figures has a hint of spontaneous animation. However, the *Adoration of the Magi* (1526; Pistoia, S Domenico) and the *Assumption of the Virgin* (1532–3; Bibbiena, S Maria del Sasso) both retain some of the formal complexities of Fra Bartolommeo's original drawings.

Fra Paolino's development as a draughtsman is obscure. It is uncertain if a group of studies in pen or black chalk copied after Fra Bartolommeo's drawings and paintings are by him. The first drawing unquestionably by Fra Paolino is the study (Florence, Uffizi, 1402E) for the *Crucifixion* fresco of 1516. It is in black chalk, his favourite medium, and, like many of his drawings, it is far superior to the painting because of its sincerity of feeling.

Fra Paolino settled in S Domenico, Pistoia, in the late 1520s and produced altarpieces that disseminated his style throughout the provincial towns of Tuscany. In 1543–4 he visited Viterbo to finish the *Coronation of the Virgin* (Viterbo, S Maria della Quercia) begun by Fra Bartolommeo and Albertinelli in 1513–14 and left unfinished. He died of sunstroke suffered during a procession. His collection of Fra Bartolommeo's drawings was passed to his pupil Plautilla Nelli (1523–88), a nun and painter of S Caterina da Siena, Florence.

BIBLIOGRAPHY
G. Vasari: *Vite* (1550, rev. 2/1568); ed. G. Milanesi (1878–85), iv, p. 212
F. Tolomei: *Guida di Pistoia* (Pistoia, 1821), p. 111
V. Marchese: *Memorie dei più insigni pittori, scultori e architetti domenicani* (Florence, 1845–6, rev. Bologna, 4/1879), ii, p. 244
J. A. Crowe and G. B. Cavalcaselle: *A History of Painting in Italy* (London, 1864–6; ed. T. Borenius, 1914), vi, p. 99
V. Capponi: *Biografia pistoiese* (Pistoia, 1878)
A. Venturi: *Storia* (1901–40/*R* 1967), IX/i, p. 386
B. Berenson: *The Drawings of the Florentine Painters* (London, 1903, rev. Chicago, 2/1938), i, p. 163
F. Knapp: *Fra Bartolommeo della Porta und die Schule von San Marco* (Halle, 1903), p. 235
H. von der Gabelentz: *Fra Bartolommeo* (Leipzig, 1922), i, p. 100
B. Berenson: *Florentine School*, i (London, 1963), p. 164
Disegni toscani e umbri del primo rinascimento dalle collezioni del Gabinetto Nazionale delle Stampe (exh. cat., ed. E. Beltrame Quattrocchi; Rome, Farnesina, 1979), p. 52
B. Giardano: *Santa Maria del Sasso* (Cortona, 1984), p. 223
A. M. Petrioli Tofani: *Gabinetto Disegni e Stampe degli Uffizi: Disegni esposti* (Florence, 1986), p. 215
Disegni di Fra Bartolommeo e della sua scuola (exh. cat., ed. C. Fischer; Florence, Uffizi, 1986), p. 151
 LUDOVICO BORGO, MARGOT BORGO

Paolo, Giovanni di. *See* GIOVANNI DI PAOLO.

Paolo di Matteo Savin. *See* SAVIN, PAOLO DI MATTEO.

Paolo Romano [Paolo di Mariani di Tuccio Taccone da Sezze; Paolo da Gualdo; Paolo di Mariano] (*b* ?Sezze, nr Velletri; *fl* 1451; *d* Rome ?1470). Italian sculptor. His earliest documented works are three windows for the Palazzo del Campidoglio, Rome, for which he was paid on 1 January 1451 (Corbo, 1966). He worked with his father, Mariani di Tuccio Taccone, a mason, and Piero d'Albino da Castiglione on the construction of two chapels (destr.) dedicated to St Mary Magdalene and the Holy Innocents near the Ponte S Angelo and commissioned by Nicholas V. From 1453 to 1458 he was one of the team of sculptors working on the Arch at Castelnuovo, Naples (*see* NAPLES, §3), for King Alfonso I. Several sections have been convincingly attributed to him, including the river god on the left side of the tympanum and the mask beside it, the spandrel reliefs of Victories with putti below and, probably, the free-standing figures of *St Anthony* and *St George*. Hersey has argued that Paolo played only a minor role, assisting with the carving of the narrative reliefs, but stylistically the *Victory* is close to his later Roman works, and he would seem to have been given some independence in its carving. Isaia da Pisa was also working on the arch at Castelnuovo, and some works, including the *Fortitude* and the female genius guiding Alfonso's chariot in the frieze, have been attributed to both sculptors, although stylistically they seem closer to Isaia. Paolo's style at this

date may have been, to some extent, shaped under Isaia's influence; they worked together again in Rome.

Between 1460 and 1464 Paolo Romano ran the largest workshop in Rome; he seems to have been the preferred sculptor of Pius II. An angel on the left of the tympanum over the portal of S Giacomo degli Spagnuoli, a relief that can be dated c. 1460, is signed OPUS PAULI; the angel on the right is signed OPUS MINI and is the work of Mino da Fiesole (although it has been traditionally attributed to MINO DEL REAME). According to Vasari, Paolo Romano and Mino del Reame worked in competition on two colossal statues of *St Peter* and *St Paul* intended for the base of a monumental staircase leading to Old St Peter's. The resultant statues (both Rome, Vatican, Aula del Sinodo) are the work of Paolo Romano. Another colossal marble statue of *St Paul* (1463–4; Rome, Ponte Sant'Angelo) was made by Paolo for the top of the staircase near the Benediction Loggia (destr.), on which he was also working at the time. The remarkably successful classicism of the *St Paul* is indicative of the sophistication of the revival of the Antique in Rome during these years, and its over life-size scale is in keeping with Pius II's ambition to restore Rome to its ancient splendour. In 1462 Paolo carved a marble standing figure of *St Andrew* (Rome, cemetery at Ponte Molle) to stand in a tabernacle erected by Pius near the Ponte Milvio, and Paolo and Isaia da Pisa both carved reliefs (1463; Rome, Grotte Vaticane) for a second monumental marble tabernacle of St Andrew in St Peter's to hold the Apostle's head. The tabernacle formed the centrepiece of the Pope's funerary chapel (destr.) in St Peter's. For the same Pope, Paolo carved the first series of reliefs (destr.) for the ciborium over the high altar of St Peter's (Raggio).

Other works documented between 1465 and 1470 cannot be associated with extant sculpture. Evidence of a late style can be deduced from a drawing (see Corbo, 1973; Giuliano and Fusconi) of a tabernacle (destr.) originally in S Lorenzo in Damaso, Rome. Paolo Romano wrote his will in 1470 (Corbo, 1966), at which time he seems to have been working on the effigy of Pius II (d 1464) for his tomb (Rome, S Andrea della Valle); it is possible that he designed it as well (Valentiner).

Paolo Romano was formerly confused with another sculptor named Paolo active in Rome in the first decades of the 15th century (Leonardi; Muñoz). In the second edition (1568) of the *Vite*, Vasari mentioned that there were 'some works' by Paolo in S Maria in Trastevere, but he was confusing him with an earlier master of the same name. Filarete's report that Paolo was also a goldsmith responsible for 12 silver statues of the apostles on the altar of the papal chapel (destr.) may also be due to a confusion of names.

BIBLIOGRAPHY

Thieme–Becker

Filarete [A. Averlino]: *Trattato d'architettura* (MS. c. 1460–65); ed. and trans. by J. Spencer as *Treatise on Architecture*, i (New Haven, 1965), p. 251

G. Vasari: *Vite* (1550, rev. 2/1568); ed. G. Milanesi (1878–85), ii, pp. 647–9; see also ed. G. Previtali, ii (Milan, 1962), pp. 485–9

E. Müntz: *Martin V–Pie II, 1417–1464* (1878), i of *Les Arts à la cour des papes pendant le XVe et le XVIe siècle: Recueil de documents inédits*, ed. E. Thorin (Paris, 1878–82)

A. Bertolotti: 'Paolo di Mariano, scultore nel secolo XV', *Archv. Stor. A. Archeol. & Lett. Città Prov. Roma*, iv/7 (1882), pp. 291–317

V. Leonardi: 'Paolo di Mariano, marmorario', *L'Arte*, iii (1900), pp. 86–106, 259–74

C. von Fabriczy: 'La statua di S Andrea all'ingresso della Sagrestia de S Pietro', *L'Arte*, iv (1901), pp. 67–9

A. Venturi: *Storia*, vi (1906) , pp. 1110–20

A. Muñoz: 'Maestro Paolo da Gualdo, detto "Paolo Romano" ', *Rass. A. Umbra*, ii/2–3 (1911), pp. 29–35

A. Riccoboni: *Roma nell'arte: La scultura nell'evo moderno dal quattrocento ad oggi* (Rome, 1942), pp. 14–15

W. R. Valentiner: 'The Florentine Master of the Tomb of Pope Pius II', *A.Q.* [Detroit], xxi (1958), pp. 117–50

J. Pope-Hennessy: *Italian Renaissance Sculpture* (London, 1958, rev. 3/1985), pp. 65–7, 287, 316–17, 319–20, 332

A. M. Corbo: 'L'attività di Paolo di Mariano a Roma', *Commentari*, xvii (1966), pp. 195–226

C. Seymour jr: *Sculpture in Italy, 1400–1500*, Pelican Hist. A. (Harmondsworth, 1966), pp. 137–8, 155–7, 160, 261, 265, 270

R. Rubinstein: 'Pius II's Piazza S Pietro and St Andrew's Head', *Essays in the History of Architecture Presented to Rudolf Wittkower* (London, 1967), pp. 22–33

V. Golzio and G. Zander: *L'arte in Roma nel secolo XV*, Storia di Roma, xxviii (Bologna, 1968)

G. C. Sciolla: 'Fucina aragonese a Castelnuovo, 2', *Crit. A.*, n. s., xix/126 (1972), pp. 19–38

A. M. Corbo: 'Un'opera sconosciuta e perduta di Paolo Romano: Il tabernacolo di S Lorenzo in Damaso', *Commentari*, xxiv/1–2 (1973), pp. 120–21

G. Hersey: *The Aragonese Arch at Naples, 1443–1475* (New Haven, 1973)

H.-W. Kruft and M. Malmanger: *Der Triumphbogen Alfonsos in Neapel: Das Monument und seine politische Bedeutung*, Acta Archaeol. & A. Hist. Pertinentia, vi (1975), pp. 213–305

A. Chastel: 'Two Roman Statues: Saints Peter and Paul', *Collaboration in Italian Renaissance Art*, ed. W. Stedman Sheard and J. T. Paoletti (New Haven, 1978), pp. 59–76

The Vatican Collections, the Papacy and Art (exh. cat. by O. Raggio, New York, Met., 1982), pp. 40–41

C. L. Frommel: 'Francesco del Borgo: Architekt Pius' II und Pauls II, der Petersplatz und weitere romische Bauten Pius' II Piccolomini', *Röm. Jb. Kstgesch.*, xx (1983), pp. 127–74

A. Giuliano and G. Fusconi: 'Disegni da un taccuino con monumenti del XV secolo a Roma', *Scritti di storia dell'arte in onore di Federico Zeri*, i (Milan, 1984), pp. 183–8

□

Paradisi, Niccolò. *See* NICCOLÒ DI PIETRO.

Paragone [It.: 'comparison': figuratively, a test or trial]. Term used to refer specifically to the rivalry of the arts of painting and sculpture. In 1817 in Manzi's edition of Leonardo da Vinci's *Trattato della pittura* the word appeared as the title to Leonardo's witty defence of painting against the arts of poetry, music and sculpture, although it had not had this association before. Polemical comparisons of the arts are widely documented in 16th-century sources, yet a comprehensive work on the subject has never been attempted.

Many historians have viewed the arguments as merely superficial, rhetorical formulae. However, the writings associated with the term *paragone* are significant because they provided an arena to discuss artistic procedures in theoretical terms. Major personalities such as Leon Battista Alberti, Leonardo and Giorgio Vasari recorded opinions that anticipate the modern classification of the fine arts, systematized in the 18th century (Kristeller).

Renaissance *paragoni* extend the Classical literary theory of parallels between the arts of painting and poetry to the visual arts (*see also* UT PICTURA POESIS). The literary forms are varied but derive primarily from epideictic rhetoric, the oratory of display, which is divided into the categories of praise and blame. Immediate sources of Renaissance

types include medieval poetic contests. One of the earliest comparisons of painting and sculpture appears in Alberti's *De pictura*, written in 1435, the second part of which begins with an extensive panegyric praising painting as a liberal art. Leonardo, who studied Alberti's treatise and defended the status of painting as natural philosophy, set out the major topics of later arguments in the 1490s. His views were broadly disseminated in Baldassare Castiglione's *Il libro del cortegiano* (Venice, 1528), a fiction about ideal courtly conduct. There is little evidence of any widespread literary dispute, however, until the middle years of the 16th century.

Notions of artistic competition are an important ingredient of the *paragone* tradition. Lodovico Dolce, in his 1557 dialogue on painting, cast Leonardo, Raphael and Titian as Michelangelo's rivals. It is assumed that *paragoni* were often enacted in practice, and Giambologna's sculpture *Rape of a Sabine* (1583; Florence, Loggia Lanzi; *see* GIAMBOLOGNA, fig. 2) is one of the rare documented visual examples. The fundamental issue, that painters and sculptors emulate each other to outdo nature, can probably be traced to sculpture simulated in painting and experiments with pictorial effects in relief sculpture beginning in the early 15th century and perhaps even earlier. Donatello's reinterpretation of low relief, or Lorenzo Ghiberti's panels for the Florence Baptistery, may record early claims for the supremacy of one visual art form over another. In 1456 Bartolomeo Fazio described a painting (untraced) by Jan van Eyck (*c.* 1395–1441) of a nude reflected in a mirror, in terms that anticipate the familiar *paragone* question as to which medium, painting or sculpture, exhibits the figure from all sides more effectively. Anecdotes on the same theme are recorded by Paolo Pino and Vasari about Giorgione's painting of *St George* (untraced).

The tenor of discussion changed considerably when the arguments moved out of a courtly environment, but the central problem of selecting criteria by which to judge artifice unifies the literature. Writings by Pino, Dolce, Antonio Francesco Doni, Benedetto Varchi, Vincenzo Borghini, Benvenuto Cellini, Francisco de Holanda and Vasari—to name only the best-known authors—testify to the popularity of the subject during the middle years of the 16th century, when disputes concerning literature and the visual arts ran parallel courses in defining new art forms autonomously. The most famous document connected with the rivalry of painting and sculpture is the questionnaire circulated by Varchi, published in 1550 along with Neo-Platonizing arguments of his own. His respondents were seven prominent artists and literary figures including Pontormo, Cellini and Michelangelo, each of whom praised the superiority of his own respective profession by addressing ubiquitous themes, such as the figure seen from all sides, mental versus physical labour, conspicuous versus natural *varietà*, the longevity of the work and so on. (These and other texts are reprinted by Barocchi.)

Paragoni document the struggle of artists to achieve intellectual status paralleling that of men of letters, a topic that has often been discussed in connection with Cosimo I de' Medici's support of the Accademia del Disegno (*see* FLORENCE, §V, 1), formed in 1563 under Vasari's leadership. Continued rivalries are recorded in connection with the elaborate funeral service for Michelangelo planned in 1564 by Varchi, Vasari and their associates at the Accademia. The ceremony and attendant publication eulogized Michelangelo's mastery of painting, sculpture, architecture and poetry with poems and visual personifications of the individual arts, an obvious sign that painting and sculpture were no longer considered menial or mechanical labours. The Accademia adopted as their emblem the theme of *disegno* (*see* DISEGNO E COLORE), related to the Trinity and also a civic metaphor for the unity of Cosimo I's reformed state. Vasari, in his second edition (1568) of the *Vite*, predictably resolved the rivalry in favour of the common foundation of painting, sculpture and architecture in *disegno*, and disputes about the relative status of painting and sculpture in a revised hierarchy of the liberal arts diminished during the following years. Raffaello Borghini's *Il riposo* of 1584 includes one of the last literary debates on the subject, gathered in an encyclopedic review of familiar arguments.

BIBLIOGRAPHY

Leonardo da Vinci: *Trattato della pittura*; ed. G. Manzi (Rome, 1817)
I. Richter: *Paragone: A Comparison of the Arts by Leonardo da Vinci* (London and New York, 1939; rev. London and Toronto, 1949)
P. O. Kristeller: 'The Modern System of the Arts: A Study in the History of Aesthetics', *J. Hist. Ideas*, xii (1951), pp. 496–527; xiii (1952), pp. 17–46
P. Barocchi, ed.: *Scritti d'arte del cinquecento*, 9 vols (Turin, 1977)
D. Summers: *Michelangelo and the Language of Art* (Princeton, NJ, 1981)
L. Mendelsohn: *Paragoni: Benedetto Varchi's 'Due lezzioni' and Cinquecento Art Theory* (Ann Arbor, 1982)
L. Freedman: '"The Schiavona": Titian's Response to the *Paragone* between Painting and Sculpture', *A. Ven.*, xliv (1984), pp. 31–40
P. Hecht: 'The Paragone Debate: Ten Illustrations and a Comment', *Semiolus*, xiv/2 (1984), pp. 125–36
C. Farago: *Leonardo da Vinci's Paragone: A Critical Interpretation with a New Edition of the Text in the Codex Urbinas* (Leiden, 1992)
L. Wolk-Simon: 'Fame, Paragone and the Cartoon: The Case of Perino del Vaga', *Master Drgs*, xxx (1992), pp. 61–82
M. Boudon: 'Le Relief d'*Ugolin* de Perino da Vinci: Une Réponse sculptée au problème du Paragone', *Gaz. B.–A.*, ser. 6, cxxxii (1998), pp. 1–18
 CLAIRE FARAGO

Parentino [Parenzano], **Bernardino**. *See* BERNARDINO DA PARENZO.

Parentucelli, Tommaso. *See* NICHOLAS V.

Parma. Italian city in Emilia-Romagna in the Po Valley at the confluence of the rivers Baganza and Parma.

1. History and urban development. 2. Buildings.

1. HISTORY AND URBAN DEVELOPMENT. A midBronze Age Terramara settlement was discovered in 1864 in the east of the city, and a crematory necropolis lying beneath the Piazzale della Macina is datable to the late Bronze Age. A network of foundations built of stones without mortar between Via d'Azeglio and Piazza dell'Annunciata dates to the second Iron Age. The orientation of this settlement, which was possibly Etruscan, may have influenced the Roman and subsequent layout of the city. There are no surviving traces of the Celtic settlement, but it was probably built about the 3rd century BC on the earlier structures on the river banks. According to Livy, the Roman Colonia Parmensis was founded in 183 BC, four years before the building of the Via Emilia.

At the end of the 4th century and in the 5th Parma probably endured raids and a reduction in population. Under Theodoric the Great (*reg* 489–526) maintenance of the canals and restoration of the walls are documented. During the Byzantine–Ostrogothic War (535–53) the Roman imperial amphitheatre was apparently in use as a defensive structure. By the 7th century the city was under the rule of Lombard kings. In 877 the rule of the count–bishops began. Bishop Guidobodo (*reg* 860–95) re-established the Orthodox church in the Early Christian cathedral, but in 1037 Bishop Ugo and Emperor Conrad II (*reg* 1024–39) were besieged in their enclosure by the rebellious population.

The city's period as a Comune (1106–1303) began when the first consuls were appointed, and in 1181 the Podestà and the Capitano del Popolo were installed. The city came under the control of Lucchino Visconti, ruler of Milan (*reg* 1339–49), who built bridges, canals and fortifications. In 1356 under Bernabo Visconti two towers, the Rocchette, were constructed at either end of the Ponte di Galeria (now Ponte Verdi); the east one still exists, incorporated in the Palazzo della Pilotta. Under Niccolo III d'Este, ruler of Ferrara and Modena, followed by the Sforza government and the Peace of Lodi (*c.* 1454–1500), the city's population stabilized at *c.* 12,000–14,000 and its expansion halted. The establishment of the Farnese court from 1545 led to a gradual increase in population despite the outbreak of plague (1630).

In the 15th and 16th centuries the first maps of Parma were made. The painter Cristoforo Caselli worked in the city in the late 15th century and the early 16th. Important military, civil and religious buildings were erected, including the pentagonal bastions (1450) along the walls; l'Ospedale Vecchio (1476); the Sforza Rocchetta (1478); the rebuilding (begun 1490) and decoration by CORREGGIO, PARMIGIANINO, FRANCESCO MARIA RONDANI, GIROLAMO MAZZOLA BEDOLI, and MICHELANGELO ANSELMI of S Giovanni Evangelista; S Maria della Steccata (*see* §2(iii) below); the Palazzo Ducale (1545; rest.; now a police station) and the Palazzo del Giardino (1561; destr.) by Jacopo Vignola in 1561; and the pentagonal Cittadella Farnesiana (begun 1591) designed by Alessandro Farnese.

BIBLIOGRAPHY
I. Affo: *Storia della città di Parma*, 4 vols (Parma, 1792–5/*R* 1956–7)
M. Corradi Cervi: *Guida di Parma artistica* (Parma, 1967)
G. Capelli: 'Porte e bastioni della città fortificata', *Parma Econ.*, ci (1969), pp. 26–33
L. Gambrara, M. Pellegri and M. de Grazia: *Palazzi e casate di Parma* (Parma, 1971)
B. Adorni: *L'Architettura farnesiana a Parma, 1545–1630* (Parma, 1974)
F. da Mareto, ed.; *Parma e Piacenza nei secoli: Piante e vedute cittadine delle antiche e nuove province parmensi* (Parma, 1975)
V. Banzola, ed.: *Parma: La città storica* (Parma, 1978)
P. Conforti: *Le mura di Parma*, 3 vols (Parma, 1979–80)
L. Farinelli and P. P. Mendogni: *Guida di Parma* (Parma, 1981)
G. Ferraguti: *I borghi di Parma* (Parma, 1981)
F. Miani Uluhogian: *Le immagini di una città: Parma, secoli XV–XIX: Dalla figurazione simbolica alla rappresentazione topografica* (Parma, 1984)
ROBERTO CORONEO

2. S MARIA DELLA STECCATA. The 16th-century church of the Steccata (see fig.) replaced a 14th-century oratory dedicated to a miraculous image of *St John the*

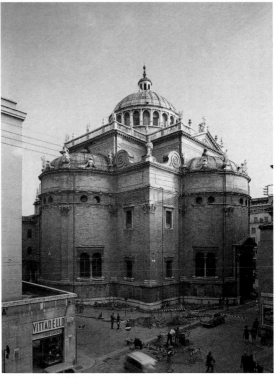

Parma, S Maria della Steccata, from 1521

Baptist. Cult origins can be traced for the oratory of S Giovanni Battisti, established *c.* 1392, under the Knights Hospitaller. Between 1466 and 1483 St John was supplanted as an object of devotion by an image of the Virgin, the efficacy of which proved so great that the oratory became known as the 'Beate Virginis Mariae de la Stechata'. A confraternity connected with the oratory was established *c.* 1490–93; the Knights Hospitaller, who still owned the property, gave it to the confraternity for perpetual use in 1502. The decision to build a more imposing structure dated from about this time, coming to fruition in 1515, when the confraternity was permitted to raise construction money and the property adjacent became available for purchase.

The first reference, dated 1521, mentions a building based upon a Greek-cross-and-square plan with corner towers; Bernardino ZACCAGNI is named as architect, assisted by his son, Gian Francesco Zaccagni. Disputes over the church's appearance arose almost immediately, resulting in the dismissal of the Zaccagni in 1526. When consecrated in 1539, S Maria had undergone alterations that included the substitution of corner towers by low, square chapels, and a new dome designed by Antonio da Sangallo the younger, who submitted a detailed report proposing to create entrances in three of the four apses. The Greek-cross plan remained, its austerity unbroken until the 17th-century addition of a choir to the eastern apse. (This project, as well as exterior ornamentation in the form of balustrade, statues, vases and volutes extending above chapels, was initiated by Mauro Oddi (1639–1702) around 1660 and completed by Adalberto Nave (1681–1742) in 1730). The interior preserves the symmetry of

the cruciform plan. High barrel vaults roof the arms between the central dome and the individual, semicircular apses. Four corner chapels are reached through pedimented doorways that suggest that they are hollowed out of piers rather than integral to the principal church area. The windows are disposed to provide natural lighting adjusted to the iconographic programme of the frescoes, culminating in the radiant brilliance of the dome soffit. The exterior displays a crescendo from the apses and chapels, which share a unified pilaster order, simplified entablature and attic, via a higher level of walls that marks the arms of the Greek cross, to the drummed dome in the centre.

The decorative programme, devoted to the Virgin, provides a compendium of mid-16th-century Emilian painting. The first contract was awarded to Parmigianino in 1531 for a *Coronation of the Virgin* above the high altar and vaulting decorations between eastern apse and central dome (see PARMIGIANINO, §1(iv)). Parmigianino failed to fulfill his contract; only the vaulting decorations were completed. As evidenced by drawings (London, BM), he designed the ornamental scheme of the vault as well as the figures of the *Wise and Foolish Virgins, Moses* (see PARMIGIANINO, fig. 2) and *Adam* on the left side, and *Aaron* and *Eve* on the right. The images painted on the left are considered autograph; the *Virgins* on the right were executed by assistants, while the figures of *Aaron* and *Eve* are subject to debate.

Parmigianino's frescoes strike the only original note in S Maria's decoration; narratives by MICHELANGELO ANSELMI, Girolamo Mazzola Bedoli and Bernardino Gatti follow largely in the wake of Correggio's stylistic innovations, despite their quality. After Parmigianino's dismissal, Anselmi undertook the *Coronation of the Virgin* (1541–2, altered 1547), rendered from a design by Giulio Romano. When the *Coronation* was approved in 1548, Anselmi was commissioned for an *Adoration of the Magi* in the west apse. The *Adoration* was completed by Gatti after Anselmi's death. The following year Gatti was recorded painting the *Assumption of the Virgin* in the cupola. Bedoli was entrusted with the two remaining narratives, the *Descent of the Holy Ghost* (1547–53) in the north apse and a combined *Nativity* and *Adoration of the Shepherds* (1547–53) in the south apse; Vasari viewed this work from scaffolding as it neared completion in 1566.

BIBLIOGRAPHY

G. Vasari: *Vite* (1550, rev. 2/1568); ed. G. Milanesi (1878–85)

I. Affo: *Il Parmigianino: Servitor di piazza* (Parma, 1796)

A. Ronchini: 'La Steccata di Parma', *Atti & Mem. RR. Deput. Stor. Patria Prov. Moden. & Parm.*, i (1863), pp. 169–21

L. Testi: *Santa Maria della Steccata in Parma* (Florence, 1922)

E. Marseglia: *The Architecture of Santa Maria della Steccata in Parma* (diss., Baltimore, MD, Johns Hopkins U., 1966)

M. di Giampaolo: 'Girolamo Bedoli: Tre disegni per la "Discesa dello Spirito Santo" alla Steccata', *Ant. Viva*, xviii (1979), pp. 10–11

B. Adorni, ed.: *Santa Maria della Steccata a Parma* (Parma, 1982)

MAUREEN PELTA

Parmigianino [Mazzola, Girolamo Francesco Maria] (*b* Parma, 11 Jan 1503; *d* Casalmaggiore, 24 Aug 1540). Italian painter, draughtsman and printmaker. Beginning a career that was to last only two decades, he moved from precocious success in the shadow of Correggio in Parma to be hailed in the Rome of Clement VII as Raphael reborn. There he executed few large-scale works but was introduced to printmaking. After the Sack of Rome in 1527, he returned to North Italy, where in his final decade he created some of his most markedly Mannerist works. Equally gifted as a painter of small panels and large-scale frescoes both sacred and profane, he was also one of the most penetrating portrait painters of his age. Throughout his career he was a compulsive draughtsman, not only of preparatory studies for paintings and prints, but also of scenes from everyday life and of erotica.

1. Life and work. 2. Working methods and technique. 3. Critical reception and posthumous reputation.

1. LIFE AND WORK.

(i) Parma, 1503–24. (ii) Rome, 1524–7. (iii) Bologna, 1527–30. (iv) Parma and Casalmaggiore, 1530–40.

(i) Parma, 1503–24. Parmigianino's father, Filippo Mazzola (see MAZZOLA), was an unremarkable provincial painter, as were his uncles Pier'Ilario Mazzola (*c.* 1476–after 1544) and Michele Mazzola (*c.* 1469–after 1528). They presumably taught him the rudiments of his art but can take no credit for the style of his earliest drawings and paintings. At the age of 16 he painted a *Baptism* (Berlin, Bodemus.) for SS Annunziata in Parma; this altarpiece already reveals elegant proportions in the main figures, allied to an awareness of Correggio in the putti. His next altarpiece, the more personal and eccentric *Mystic Marriage of St Catherine with SS John the Evangelist and John the Baptist* (*c.* 1521; Bardi, S Maria) was executed for S Pietro in Viadana, where he fled in 1521 to avoid the warring Papal and French troops. He also painted *SS Francis and Clare* (untraced) for the Franciscan church in Viadana.

On his return to Parma in 1522, Parmigianino painted an altarpiece of the *Virgin and Child with St Jerome and the Blessed Bernardino da Feltre* (untraced; copy in Parma, G.N.) and began work in S Giovanni Evangelista, where Correggio was frescoing the dome and apse. Opinions differ as to how many chapels Parmigianino frescoed, but the first two on the left of the nave are invariably accepted as his. These chapels were not in private hands at this date but were still the property of the Benedictines, and their iconography relates to this monastic patronage. The second chapel (1522) shows *SS Stephen and Lawrence* on the left and *St Vitalis* on the right, the latter in particular revealing the influence of Pordenone's frescoes of the *Passion* (1520–21; Cremona Cathedral; see PORDENONE, fig. 1). The decoration of the first (*c.* 1523–4), which has *St Agatha* on the left and *SS Lucy and Apollonia* on the right, is more polished and also more in tune with Correggio, through whom he was aware of the Roman works of Raphael and Michelangelo. It is known that Parmigianino copied Correggio's drawings for the dome and drum of the cupola of S Giovanni, but it now appears that he may also have assisted him with the frescoing of the lower zone of decoration. In 1522 he received an important commission, never executed, to fresco the vault and apse of the north transept of Parma Cathedral. About 1523 he painted *David* and *St Cecilia* for the organ shutters (much repainted and with later additions) of S Maria della Steccata, Parma (see PARMA, §2).

In addition to these public works, Parmigianino was in demand as a painter of domestic devotional pictures. Two paintings of the *Nativity* (*c.* 1521–2, priv. col., see Gould, fig. 2; *c.* 1523–4, U. London, Courtauld Inst. Gals) roughly correspond in style to the chapels in S Giovanni Evangelista, while a *St Catherine with Two Angels* (damaged; Frankfurt am Main, Städel. Kstinst. & Städt. Gal.) and a half-length *St Barbara* (Madrid, Prado) point to a growing sophistication of handling, as does a *Mystic Marriage of St Catherine with SS Peter and Joseph* (untraced; copy Parma, G.N.). A lunette fresco in grisaille of the *Virgin and Child* (Fontanellato, Mus. Rocca Sanvitale) also dates from this time and was painted for the palazzo of Scipione Montino della Rosa, Correggio's great protector. The palazzo passed in 1526 to Galeazzo Sanvitale, Parmigianino's major patron in his first period in Parma. It was for Sanvitale that he painted the frescoes of *Diana and Actaeon* (*c.* 1523–4; Fontanellato, Mus. Rocca Sanvitale), one of the most seductive Renaissance decorations, which reveals a profound debt, especially in its putti playing among foliage, to Correggio's Camera di S Paolo (*c.* 1519; Parma, S Paolo; *see* CORREGGIO, fig. 2). He also executed a portrait of *Galeazzo Sanvitale* (1524; Naples, Capodimonte), the latest of his three early male portraits (the others are in London, N.G., and York, C.A.G.). All are characterized by the directness of the sitter's gaze and by an enigmatic element in their surroundings or attributes. Iconographic obscurity, which became more pronounced in his work, is not a notable feature of this first period.

(ii) Rome, 1524–7. When Giulio de' Medici was elected Clement VII in November 1523, Parmigianino was one of many artists who determined to go to Rome. Accompanied by his uncle Pier'Ilario, he probably travelled via Florence, delaying his journey until the end of the summer of 1524 in order to avoid the plague. On his arrival in Rome, he was presented to the Pope, to whom he subsequently gave three paintings: a night scene of the *Circumcision* (Detroit, MI, Inst. A.), a *Holy Family* (Madrid, Prado; see colour pl. 2, XIII1) and the remarkable *Self-portrait in a Convex Mirror* (1524; Vienna, Ksthist. Mus.; see fig. 1), a virtuoso *tour de force* that also conveys a profound impression of Parmigianino's personal style and grace. As a consequence, he was given a commission to fresco the walls of the Sala dei Pontefici in the Vatican. Various drawings (e.g. Angers, Mus. B.-A.; Florence, Uffizi; Popham, 1971, pls 189, 200) for large-scale narrative paintings in the tradition of Raphael's frescoes in the Stanze (Rome, Vatican) have been plausibly associated with this project, but the murals were never executed. In fact Parmigianino produced very few finished paintings in Rome. Exceptions include the portrait of the Captain of the Papal Guard, *Lorenzo Cybo* (*c.* 1525; Copenhagen, Stat. Mus. Kst), very much in the manner of the *Sanvitale* portrait, and a pair of panels of the *Virgin and Child* and the *Adoration of the Shepherds* (both Rome, Gal. Doria–Pamphili). These paintings, and even more the *Mystic Marriage of St Catherine* (*c.* 1526–7 but sometimes dated to the Bolognese period; London, N.G.), show Parmigianino using a very free and fluid touch, something hinted at earlier. From this period his work alternates between a sketchy manner and a more finished marmoreal effect.

1. Parmigianino: *Self-portrait in a Convex Mirror*, oil on panel, diam. 244 mm, 1524 (Vienna, Kunsthistorisches Museum)

The culmination of Parmigianino's years in Rome is the *Virgin and Child with SS John the Baptist and Jerome* (the *Vision of St Jerome*; London, N.G.; *see* ITALY, fig. 17). According to Vasari, Parmigianino was at work during the Sack of Rome on the altarpiece when German soldiers broke into his house, and it was only by making innumerable drawings for one of them that he escaped with his life. Recently published documents show that the contract was given to Parmigianino and his uncle on 3 January 1526 and reveal that additional images, perhaps in fresco, of the Immaculate Conception and Joachim and Anna were originally intended to flank it. The painting was commissioned by Maria Bufalini for S Salvatore in Lauro, Rome, but was deposited first in S Maria della Pace, Rome, and then installed in S Agostino, Città di Castello. With its colossal, elongated Baptist and withdrawn, sleeping Jerome, as well as a monumental Virgin in which elements from Raphael and Michelangelo are combined, it is one of the most mysterious of Parmigianino's works.

During these years Parmigianino was close to such artists as Rosso Fiorentino, Perino del Vaga and Polidoro da Caravaggio. When the same motifs appear in their works, it is sometimes difficult to determine whose invention they were. They had such patrons in common as Angelo Cesi, for whom Parmigianino executed a tondo of the *Virgin Annunciate* (untraced) and for whom Rosso frescoed a chapel (1524; Rome, S Maria della Pace). Rosso, Perino and Parmigianino also collaborated with the printmaker Giovanni Jacopo Caraglio. The engraving by Caraglio of the *Adoration of the Shepherds* (B. 4) after Parmigianino's design is dated 1526, and the prints of *Diogenes* (B. 61), the *Marriage of the Virgin* (B. 1) and the *Martyrdom of SS Peter and Paul* (B. 8) must be roughly contemporary. Parmigianino also collaborated with Ugo da Carpi, who made a woodcut of his *Diogenes* (B. 10; see colour pl. 1, XX1). His experiments with etching include the *Entombment* (B. xvi, p. 8, n. 5 and xviii, p. 300, n. 46),

for which there is also a sketch painted in grisaille (priv. col.). He appears to have pursued his interest in etching in Bologna.

(iii) Bologna, 1527–30. Despite the turmoil of the Sack, there is no evidence of stylistic change in Parmigianino's first work in Bologna, the *St Roch and a Donor*, his only altarpiece still *in situ* (Bologna, S Petronio), in which the protagonist is identical in type to the Baptist in the *Vision of St Jerome*. Also in a similar style is the *Conversion of Saul* (Vienna, Ksthist. Mus.), painted for a doctor from Parma, Giovanni Andrea Bianchi, known as Albio. The very different, meticulously detailed execution of this canvas shows that, in spite of its large scale, it was intended for a domestic setting. The other altarpiece of these years, the *Virgin and Child with SS Margaret, Benedict, Jerome and an Angel* (Bologna, Pin. N.), originally on the high altar of S Margherita, Bologna, reveals a renewed interest in Correggio, especially his *Virgin of St Jerome* (*Il Giorno*; 1523–8; Parma, G.N.).

In Bologna, Parmigianino continued to paint mainly small pictures of the Virgin and portraits. There are three paintings of the *Virgin and Child*: a panel (Kedleston Hall, Derbys), an unfinished picture (U. London, Courtauld Inst. Gals), possibly one Vasari acquired in Bologna, and the celebrated *Virgin of the Rose* (Dresden, Gemäldegal. Alte Meister). Two small panels with several figures date from these years: the *Virgin and Child with SS Mary Magdalene, John the Baptist and the Prophet Zachariah* (Florence, Uffizi; see colour pl. 2, XIII3), commissioned by Bonifazio Gozzadini, and a *Virgin and Child with SS Mary Magdalene and John the Baptist* (priv. col., see Whitfield, fig. 12), possibly painted for the saddler from Parma who was Parmigianino's close friend and landlord. All these works, which are closely interrelated, with the same models clearly being used for the children, show the exceptional refinement, even artificiality, of his technique at this period. It is typical of Parmigianino, however, that one of the first sketches for the highly rarefied *Virgin of the Rose* (Chatsworth, Derbys, see Popham, 1971, no. 702) shows the Virgin rolling up her sleeve in preparation for giving her wriggling son a bath. The evidence of surviving works suggests it was in this period that he began painting in tempera on canvas, employing a thin medium and notably free brushstrokes. The *Holy Family with St John the Baptist* (Naples, Capodimonte) is the prime example of this technique, but a *St Roch* (Bologna, priv. col., on dep. Parma, G.N.), presumably either a sketch or part of a larger picture, is an important addition.

Apart from the donor portrait in *St Roch and a Donor* in S Petronio, three portraits may be dated to these years. One (Vienna, Ksthist. Mus.) represents a bearded young man, holding an open book but apparently lost in thought. The second (Vienna, Ksthist. Mus.) shows a stylish young lady in a hat, looking directly out. Her costume is only sketched in, and the square format suggests that the panel may have been cut down. The sitter is probably the wife of his patron Gozzadini: Vasari records that her portrait was unfinished. The third, an allegorical portrait of *Charles V* (untraced, see 1986–7 exh. cat., p. 173), executed at the time of his coronation by Clement VII in 1530, shows the Emperor being crowned by a figure of Fame. The portrait

was never delivered, because Parmigianino was not satisfied with it, a problem that was to increase in his final period. Another commission from the emperor, to decorate a projected chapel of St Maurice in S Petronio, Bologna, was not executed.

Parmigianino continued his printmaking activities in Bologna, making designs for engravings and chiaroscuro woodcuts, executed by various artists, including Antonio da Trento. Many of these designs were for single prints, whereas the *Apostles* and *Pan* groups (Popham, 1971, pls 128–32, 167–74) were designed as series.

(iv) Parma and Casalmaggiore, 1530–40. The occasion of Parmigianino's return to Parma was probably the commission, dated 20 April 1530, to paint two altarpieces for S Maria della Steccata. Nothing further is heard of this plan, and no drawings can be connected with it, but a year later (10 May 1531) Parmigianino contracted to paint the vault and apse of the Steccata, and it was this work that was to dominate the remainder of his career. Numerous documents chart the slow progress of the project, which led to his arrest and imprisonment in 1539. Forfeiting the bail provided by his patron Francesco Baiardi and the architect Damiano de Pleta, he fled to Casalmaggiore, which was under the jurisdiction of Cremona. On 19 December 1539 he was dismissed by the trustees of the Steccata, and the commission for the decoration of the apse was given to Giulio Romano.

Parmigianino produced numerous preparatory schemes for the vault of the Steccata, many featuring such Old

2. Parmigianino: Studies for the grisaille *Moses* in S Maria della Steccata, Parma, pen and brown ink and wash over traces of black chalk, 210×153 mm, 1531 (New York, Metropolitan Museum of Art)

Testament episodes as Daniel in the Lions' Den (e.g. London, BM, 1905–11–10–37), and eventually painted *Three Wise Virgins* and *Three Foolish Virgins*, set against a red and blue coffered background studded with gilded three-dimensional rosettes. At the outer edges of the vault, flanking the Virgins, are grisaille figures of *Moses* (see fig. 2) and *Adam* (l.) and *Aaron* and *Eve* (r.). His drawings for the projected fresco of the *Coronation of the Virgin* for the Steccata apse reveal that he planned to break with the traditional static, balanced treatment of the subject, represented by Correggio's apse fresco in S Giovanni Evangelista, Parma, by having the Virgin floating upwards towards Christ. The apse fresco painted by Michelangelo Anselmi, using the designs of Giulio Romano, reverted to the traditional type. Parmigianino's decoration of the vault, even though it is only part of the complete design, and regardless of possible workshop intervention in the right half, is an extraordinary work. The vase-bearing virgins, a cross between Raphael's *Eve* from the Logge (Rome, Vatican) and the vase-bearing woman in his *Fire in the Borgo* (Rome, Vatican, Stanze; *see* RAPHAEL, fig. 4), are models of elegance yet not devoid of feeling. These figures, together with the equally elongated and graceful *Madonna of the Long Neck* (1534–40; Florence, Uffizi; see fig. 3),

3. Parmigianino: *Madonna of the Long Neck*, oil on panel, 2.16×1.32 m, 1534–40 (Florence, Galleria degli Uffizi)

have come to be regarded as Parmigianino's artistic testament.

The *Madonna of the Long Neck* was commissioned on 23 December 1534 by Elena Tagliaferri, the sister of Francesco Baiardi, and was placed in the funerary chapel of her husband Francesco in S Maria dei Servi, Parma, in 1542, bearing an inscription stating that it had been left unfinished. The drawings (see Popham, 1971, pls 345–60) show that it started out as a conventional Virgin and Child enthroned between SS Francis and Jerome, but the figures of the saints were pushed into the background and were eventually supplanted by angels in the foreground. One of the angels holds a crystal urn, in which there was once visible a cross, which echoed the pose of the sleeping Christ Child. The exceptional refinement of the Virgin's head and the elaboration of her bejewelled coiffure, not to mention the extreme elongation of the proportions, are entirely typical of Parmigianino's slightly frigid appeal.

The other major painting of these years in Parma, the *Cupid* (*c.* 1531–4; Vienna, Ksthist. Mus.; see fig. 4), was commissioned by Baiardi himself. It shows Cupid cutting his bow, while one putto torments another. Baiardi also owned the *Minerva* (London, Hampton Court, Royal Col.), and numerous untraced paintings are recorded in his inventory (see Popham, 1971, pp. 264–70). Works from this period include a *Saturn and Phillyra* (priv. col.; also known through copies; see Popham, 1971, fig. 46) and *Lucretia* (untraced; probably known through a drawing, Washington, DC, N.G.A., and a print by Enea Vico [B. xv, p. 289, n. 17]).

No small religious paintings seem to date from these years, but there are a number of portraits. One, apparently a *Self-portrait* (Florence, Uffizi), perhaps originally dated 1530, is certainly the earliest. Others are the *Turkish Slave Girl* (Parma, G.N.; see colour pl. 2, XIII2), a title presumably suggested by her spectacular hat, and one known as *Antea* (Naples, Capodimonte), the name of a celebrated Roman courtesan, although there is no reason to associate her with the picture. *Antea* has the features of one of the angels in the *Madonna of the Long Neck*, which suggests the relation between real and ideal in Parmigianino's work. Two male portraits (London, Hampton Court, Royal Col.; Vienna, Ksthist. Mus.) probably also date from these years, although they have sometimes been placed in the Bolognese period. His last portraits were the *Conte di San Secondo* and the *Contessa di San Secondo with her Three Sons* (both Madrid, Prado). Since one of the sons appears to be by another hand, the painting was presumably left unfinished when Parmigianino fled Parma. During his last year, in Casalmaggiore, in addition to the *Lucretia* he executed an altarpiece of the *Virgin and Child with SS John the Baptist and Stephen and a Donor* (Dresden, Gemäldegal. Alte Meister), according to Vasari for S Stefano there. The painting shows no slackening of Parmigianino's powers and calls into question Vasari's lurid account of the artist's decline from the beautiful youth of the *Self-portrait* into a dishevelled melancholic, who abandoned painting for alchemy.

2. WORKING METHODS AND TECHNIQUE. Parmigianino was one of the most instinctive and most prolific draughtsmen of the 16th century. Popham's catalogue

4. Parmigianino: *Cupid*, oil on panel, 1.35×0.65 m, *c.* 1531–4 (Vienna, Kunsthistorisches Museum, Gemäldegalerie)

the extant drawings, it would seem he did few life drawings or studies for heads, hands and drapery. There are no extant cartoons for large-scale works.

By no means were all of Parmigianino's drawings done as preparation for paintings and prints. Some are finished drawings in their own right, while others represent subjects that could not have been intended for finished pictures. Scenes from everyday life—the artist with his dog, people on a boat, a woman working on a cushion—are an important category here. Many are erotic—especially homoerotic—images, ranging from the merely indecent to the psychologically profound. The production of these may have been connected with Francesco Baiardi, as the inventory of his possessions indicates that he owned some of them, in addition to the *Cupid*. The huge number of his drawings listed in the inventory suggests that Baiardi acquired Parmigianino's studio property, which the painter had lovingly preserved as a resource. Parmigianino's drawings reveal that, more than any artist of his time, he responded to a new commission by looking into his own creative past, not out on to the world.

3. CRITICAL RECEPTION AND POSTHUMOUS REPUTATION. Parmigianino was much admired by such nearly contemporary writers as Vasari and Lodovico Dolce, and his critical reputation tended to remain high in the late 16th century. It declined gradually as his works became of less interest to practising artists. There has been a new appreciation of his work in the 20th century, in part because his experiences during the Sack of Rome and his allegedly deranged end have given the misleading impression that he is the ideal representative of a style in crisis.

In addition to the complex interrelations with his Roman contemporaries and a possible influence on late works by Correggio, Parmigianino's most obvious effect was on Girolamo Mazzola Bedoli, who copied his drawings and adapted them. For example, Bedoli's *Virgin and Child with St Bruno* (1540s; Munich, Alte Pin.) is derived from a Parmigianino drawing (see Popham, 1971, pl. 354). Parmigianino's drawings and prints were crucial in making him a dominant power of the mid-16th century; their effect is seen on artists as diverse as Francesco Salviati, the Campi, Andrea Schiavone, Jacopo Bertoia, and particularly on Nicolò dell'Abate and Francesco Primaticcio, and through them on the school of Fontainebleau. Similarly, the artists of the court of Rudolf II (*reg* 1576–1612) in Prague around the end of the 16th century, such as Bartholomäus Spranger, were profoundly indebted to him. Although Parmigianino's influence began to wane after 1600, copies of the *Cupid* (Vienna, Ksthist. Mus.) by Peter Paul Rubens (1577–1640) and its adaptation in the *Abduction of Helen* (Paris, Louvre) by Guido Reni (1575–1642) underline the fact that it did not disappear.

(1971) of his drawings numbers 819 sheets, many double-sided, and about 100 additions have been made since its publication. Whereas the majority of his contemporaries had a marked preference for pen or chalk, Parmigianino used a variety of techniques, including pen, pen and wash (even coloured washes), red chalk, black chalk, metalpoint and white heightening, as well as coloured grounds and blue paper. Again, unlike most Renaissance masters, he does not seem habitually to have used pen for his first ideas and chalk for more finished or detailed studies. In such cases as the Steccata decoration or the *Madonna of the Long Neck*, for which a substantial number of studies survives, a variety of techniques is employed; there is a tendency for drawings to document possible changes of iconography as much as adjustments to the overall composition or to the poses of individual figures. Judging from

BIBLIOGRAPHY
M. Biondo: *Della nobilissima pittura* (Venice, 1549)
G. Vasari: *Vite* (1550, rev. 2/1568); ed. G. Milanesi (1878–85), v, pp. 217–42
L. Dolce: *Dialogo della pittura intitolato L'Aretino* (Venice, 1557); repr. and trans. in *Dolce's 'Aretino' and Venetian Art Theory of the Cinquecento*, ed. M. Roskill (New York, 1968), pp. 182–3
P. Lamo: *Graticola di Bologna* (MS.; 1560; Bologna, 1844)
I. Affò: *Vita del graziosissimo pittore Francesco Mazzola detto il Parmigianino* (Parma, 1784)

A. von Bartsch: *Le Peintre-graveur* (1803–21), xii, xv, xvi, xviii [B.]

L. Fröhlich-Bum: *Parmigianino und der Manierismus* (Vienna, 1921)

G. Copertini: *Il Parmigianino*, 2 vols (Parma, 1932)

A. O. Quintavalle: *Il Parmigianino* (Milan, 1948)

S. Freedberg: *Parmigianino: His Works in Painting* (Cambridge, MA, 1950)

A. E. Popham: *The Drawings of Parmigianino* (London, 1953)

Parmigianino und sein Kreis (exh. cat. by K. Oberhuber, Vienna, Albertina, 1963)

A. E. Popham: *Artists Working in Parma in the Sixteenth Century*, London, BM cat., 2 vols (London, 1967), pp. 36–107

A. Ghidiglia Quintavalle: *Gli affreschi del Parmigianino* (Milan, 1968)

M. Fagiolo dell'Arco: *Parmigianino: Un saggio sull'ermetismo nel cinquecento* (Rome, 1970)

A. Ghidiglia Quintavalle: *Gli ultimi affreschi del Parmigianino* (Milan, 1971)

A. E. Popham: *Catalogue of the Drawings of Parmigianino*, 3 vols (New Haven and London, 1971); review by P. Pouncey in *Master Drgs*, xv (1977)

B. Adorni, ed.: *L'Abbazia benedettina di San Giovanni Evangelista a Parma* (Parma, 1979)

P. Rossi: *L'Opera completa del Parmigianino* (Milan, 1980)

B. Adorni, ed.: *Santa Maria della Steccata a Parma* (Parma, 1982)

C. Whitfield: 'A Parmigianino Discovery', *Burl. Mag.*, cxxiv (1982), pp. 276–80

Correggio and his Legacy (exh. cat. by D. DeGrazia, Washington, DC, N.G.A.; Parma, G.N.; 1984), pp. 141–82

The Age of Correggio and the Carracci (exh. cat., Bologna, Pin. N.; Washington, DC, N.G.A.; New York, Met.; 1986–7)

D. Ekserdjian: 'Parmigianino in San Giovanni Evangelista', *Florence and Italy: Renaissance Studies in Honour of Nicolai Rubinstein*, ed. P. Denley and C. Elam (London, 1988), pp. 443–54

M. di Giampaolo: *Parmigianino* (Florence, 1991)

C. Gould: 'A Parmigianino *Madonna and Child* and His Uncommissioned Paintings', *Apollo*, cxxxv (1992), pp. 151–6

M. Vaccaro: 'Documents for Parmigianino's "Vision of St Jerome", *Burl. Mag.*, cxxxv (1993), pp. 22–7

S. Corradini: 'Parmigianino's Contract for the Caccialupi Chapel in S Salvatore in Lauro', *Burl. Mag.* cxxxv (1993), pp. 27–9

K. Adachi: 'Parumijanino no "Bara no sebio" o megutte/*La Madonna della Rosa di Parmigianino*', *Bijutsushigaku*, xvi (1994), pp. 67–91

G. Finaldi: '*The Conversion of St Paul* and Other Works by Parmigianino in Pompeo Leoni's Collection', *Burl. Mag.*, cxxxvi (Feb 1994), pp. 110–12

C. Gould: *Parmigianino* (New York, London and Paris, 1994)

D. Posner: 'Parmigianino's *Conversion of Paul*', *Burl. Mag.*, cxxxvi/1098 (Sept 1994), p. 621

B. Bohn: 'Felsina collezionista: The Creation of Finished Drawings in Sixteenth-century Bologna', *Stud. Stor. A.* [Todi], v–vi (1994–5), pp. 193–211

R. Stefaniak: 'Amazing Grace: Parmigianino's *Vision of Saint Jerome*', *Z. Kstgesch.*, lviii/1 (1995), pp. 105–15

C. Bambach: 'Francesco Mazzola, called Il Parmigianino: *Bishop-saint in Prayer*', *Bull. Met.*, liv (1996), p. 24

A. Gnann: 'Parmigianino's Projekte fur die Cesi-Kapelle: Decoration of the Cesi Chapel, ca. 1525', *Z. Kstgesch.*, lix/3 (1996), pp. 360–80

J. Stock: 'An Early Drawing by Parmigianino', *Ars naturam adiuvans: Festschrift für Matthias Winner*, ed. V. V. Flemming and S. Schutze (Mainz, 1996), pp. 228–9

DAVID EKSERDJIAN

Parrasio, Angelo. *See* ANGELO DEL MACAGNINO.

Parri Spinelli. *See* SPINELLI, (2).

Pasqualino Veneto [Pasqualino da Venezia] (*fl* 1496–1504). Italian painter. Several signed works by Pasqualino are known, two of which are also inscribed with dates. They are a *Virgin and Child with St Mary Magdalene* (1496; Venice, Correr) and a *Virgin and Child with St John the Baptist* (1502; priv. col., see Pallucchini, 1980). All are half-length pictures of the Virgin and Child, with or without accompanying saints, and they provide a stylistic basis for further attributions to the painter. With the single exception of a *Virgin and Child* (Maastricht, Bonnefantenmus.), which corresponds to a design by Giovanni Bellini of the 1480s, Pasqualino's works are closely dependent in style and composition on the art of Cima da Conegliano, whose pupil or assistant he must have been. The Correr picture is freely based on several of Cima's works of the early to mid-1490s, in particular the *Madonna of the Orange Tree* (Venice, Accad.); however, the elongated, tubular forms, rigid modelling, fussily detailed landscape background and opaque colours are typical features of Pasqualino's own style. Unlike Cima's other known associates such as Andrea Busati or Girolamo da Udine, Pasqualino does not seem to have been employed in Cima's workshop merely as an executant of the master's designs. By 1504 he evidently had sufficient reputation to be entrusted with the important commission to decorate the main wall of the *albergo* of the Scuola della Carità in Venice. The documents show, however, that he died in the same year without having painted anything and the commission later went to Titian.

BIBLIOGRAPHY

Thieme–Becker

G. Ludwig: 'Archivalische Beiträge zur Geschichte der venezianischen Malerei', *Jb. Kön.-Preuss. Kstsamml.*, Beiheft, xxvi (1905), pp. 52–6

B. Berenson: *Venetian School*, i (1957), pp. 137–8

R. Pallucchini: 'Giunte al catalogo di Pasqualino', *A. Veneta*, xi (1957), pp. 199–200

L. Coletti: *Cima da Conegliano* (Venice, 1959), pp. 66, 97–8

L. Puppi: 'Per Pasqualino Veneto', *Crit. A.*, xliv (1961), pp. 36–47

H. W. van Os and others, eds: *The Early Venetian Painters in Holland* (Maarssen, 1978), pp. 123–7

R. Pallucchini: 'Un'altra aggiunta a Pasqualino Veneto', *Stor. A.*, xxxix–xl (1980), pp. 215–16

L. Menegazzi: *Cima da Conegliano* (Treviso, 1981)

P. Humfrey: *Cima da Conegliano* (Cambridge, 1983)

PETER HUMFREY

Pasquino (di Matteo) da Montepulciano (*b* Montepulciano, *c.* 1425; *d* Florence, *bur* 15 Jan 1485). Italian sculptor and bronze caster. His date of birth is calculated from the *catasto* (land registry declaration) returns of 1457 and 1480 (that of 1470 erroneously implies that he was born in 1428). In August 1435 he matriculated into the Arte dei Maestri di Pietra e di Legname. In 1445 he collaborated with Antonio Filarete on the bronze doors of St Peter's, Rome; Filarete stated in his *Trattato d'architettura* that he trained Pasquino. From 1449 Pasquino was working as Maso di Bartolommeo's assistant, and on behalf of his master he completed the portal of S Domenico, Urbino, from 1450 to 1454. On 12 June 1453 he was elected choirmaster to the clerics of Florence Cathedral. In 1460 he began working on the bronze screen and gates of the chapel of the Sacro Cingolo in Prato Cathedral, a commission originally given to Maso di Bartolommeo and then to Antonio di ser Cola. Maso was responsible for the overall design, and both he and Antonio di ser Cola executed some of the delicate, openwork screen; Pasquino may have been responsible for the classicizing acanthus-leaf frieze. On 25 April 1461 Pasquino undertook to complete the work within three years. However, in 1467 the decorative frieze of candelabra and palmettes was being put into place, and the gates were finished only in 1468 or even later.

Between 1465 and 1467 Pasquino made frequent visits to Florence, sometimes at the request of Piero di Cosimo de' Medici, Lord of Florence, and helped to clean the

bronze door of the north sacristy in Florence Cathedral. In 1469 the Operai del Sacro Cingolo of Prato Cathedral bought the marble for the internal pulpit, and in a document of 4 December Pasquino was reported to be making the pulpit. For this reason, some of the carving on its tall base has been attributed to him. He was still working on the pulpit in 1470–71. In 1473, together with Verrocchio, he witnessed the payment made to Antonio Rossellino for the marble reliefs decorating the pulpit that he had sculpted with Mino da Fiesole. In 1475 Pasquino bought a house in Borgo la Croce in the S Lorenzo quarter of Florence. In the *catasto* of 1480 he stated that he had given up working as a sculptor.

A number of stylistically disparate works have been attributed to Pasquino. They include the funerary monument of *Pius II* in S Andrea della Valle, Rome (which Vasari says he executed in collaboration with Ciuffagni), the funerary monument of *Sigismondo Malatesta* (see Costa) and the monument of the *Ancestors* (see Schubring), both in the Tempio Malatestiano, Rimini; a baptismal font in the Museo della Collegiata in Empoli (Burckhardt), the terracotta lunette of the *Virgin with SS John the Baptist and Augustine* over the portal of S Agostino, Montepulciano (see Fumi, also attributed to Michelozzo), and the relief of the *Rediscovery of the Image of the Virgin* for the left tabernacle in S Maria all'Impruneta, near Florence (see Proto Pisani).

BIBLIOGRAPHY
Thieme–Becker
Filarete [A. Averlino]: *Trattato d'architettura* (MS. *c.* 1460–65); Eng. trans., ed. J. Spencer as *Treatise on Architecture*, i (New Haven, 1965), p. 172
G. Vasari: *Vite* (1550, rev. 2/1568); ed. G. Milanesi (1878–85), vol. ii, pp. 363 n., 460 n., 462
G. B. Costa: 'Il tempio di S Francesco di Rimini', *Misc. Var. Lett.*, v (Lucca, 1765), p. 90
E. Fumi: *Guida di Montepulciano e dei bagni di Chianciano* (Montepulciano, 1894), p. 28
C. Yriarte: *Livre de souvenirs de Maso di Bartolomeo dit Masaccio* (Paris, 1894)
J. Burckhardt: *Der Cicerone*, ii/1 (Leipzig, 1901), p. 185
C. de Fabriczy: 'Pasquino di Matteo da Montepulciano (1425–1485)', *Riv. A.*, iv (1906), pp. 127–31
O. H. Giglioli: *Empoli artistica* (Florence, 1906), pp. 41–2
P. Schubring: 'Matteo de' Pasti', *Kunstwissenschaftliche Beiträge August Schmarsow gewidmet* (Leipzig, 1907), pp. 103–14 (107)
M. Lazzaroni and A. Muñoz: *Filarete, scultore e architetto del secolo XV* (Rome, 1908), pp. 6, 82, 120, 152–3, 251
C. Ricci: *Il tempio malatestiano* (Milan, [1925]), pp. 341, 362, 406, 505
R. Nuti: 'Pasquino di Matteo da Montepulciano e le sue sculture nel duomo di Prato', *Bull. Senese Stor. Patria*, x (1939), pp. 338–41
G. Marchini: 'Di Maso di Bartolomeo e d'altri', *Commentari*, iii (1952), pp. 108–27 (108, 109, 117, 120–26)
——: *Il duomo di Prato* (Milan, 1957), pp. 16, 62–6
E. Carli: *Il pulpito interno della cattedrale di Prato* (Prato, 1981)
F. Mazzini: *I mattoni e le pietre di Urbino* (Urbino, 1982), pp. 100–03, 134, 138, 148, 185–6, 190
M. Ferrara and F. Quinterio: *Michelozzo di Bartolomeo* (Florence, 1984), pp. 198–200, 239, 284
A. Paolucci: *Il museo della collegiata di S Andrea in Empoli* (Florence, 1985), pp. 100–03
R. C. Proto Pisani: 'Catalogo del tesoro', *Il tesoro di Santa Maria all'Impruneta* (Florence, 1987), pp. 33–62 (33–4)
ANTONIO NATALI

Passarotti [Passerotti], **Bartolomeo** (*bapt* Bologna, 28 June 1529; *d* Bologna, 3 June 1592). Italian painter, draughtsman, engraver and collector. His first biographer, Raffaele Borghini, records that he travelled to Rome with Giacomo Barozzi da Vignola, returned briefly to Bologna, then made a second visit to Rome and stayed with Taddeo Zuccaro. Documentary evidence attests to his presence in Rome in June 1551. By 1560 Passarotti was established in Bologna, where he opened a workshop and joined the Compagnia delle Quattro Arti. His activity in these years as a prestigious portraitist of popes (e.g. portrait of *Pope Gregory XIII Boncompagni*; *c.* 1572; Gotha, Mus. Nat.) and Roman cardinals, mentioned by Borghini, and his interest in *anticaglie* (miscellaneous antiquities), for example those sent to him from Rome on 9 September 1572, indicate his continued links with the capital.

The earliest documented Bolognese paintings by Passarotti show a pictorial language rooted in Emilian soil, clearly influenced by Correggio and Parmigianino, and his anatomical interest in powerful, acrobatic figures appears to be derived from the Bolognese works of Pellegrino Tibaldi. On the other hand, his minute, lively illustration of detail is reminiscent of the Flemish tradition. During his youthful visits to Rome, he may have encountered northern Romanists such as Marten de Vos (1532–1603), active there in the 1550s. In Bologna the painting school opened by Denys Calvaert in 1565 was an important centre for the distribution of northern European prints, and Bartholomeus Spranger (1546–1611) was in Parma around 1566.

The influence of Correggio is evident in the dated panel depicting the *Virgin and Child Enthroned with SS Anthony Abbot, Nicholas, Augustine, Stephen and Donors* (1564–5; Bologna, S Giacomo Maggiore). Passarotti's interest in the Parma school is evident from other works produced around the same time, for example the *Adoration of the Magi* (Bologna, Pal. Arcivescovile), and the signed and dated *Portrait of a Man* (1566; Marseille, Mus. B.-A.). The latter serves as a point of departure for the reconstruction of Passarotti's portraiture, a field in which he earned a considerable reputation.

Passarotti's painting reflects his active participation in Bologna's cultural life during the latter half of the 16th century. Naturalist Ulisse Aldovrandi's scientific curiosity and the aspirations for social and moral renewal inspired by Cardinal Gabriele Paleotti's pastoral activity are reflected in paintings such as the *Perracchini Family* (1569; Rome, Gal. Colonna), *The Botanist* (Rome, Gal. Spada; see colour pl. 2, XIII4), and the *Family Group* (Vienna, Ksthist. Mus.). The restless vivacity of the artist's cultural interests can also be seen in his graphic works (e.g. drawings of *crocodiles*, Hamburg, Ksthalle; London, J. Witt Collection; *cock*, Florence, Uffizi; *eagle*, priv. col.; *dogs*, Windsor Castle, Berks, Royal Lib.). Passarotti was praised as a draughtsman and engraver by his first biographers. Vasari also mentioned him and commented on a pen-and-ink portrait of *Primaticcio*.

Passarotti established a museum to display his collection of *anticaglie* (in his case, fragments of ancient statues, drawings and engravings, paintings, coins and medals, cameos and precious stones etc). This museum was later enlarged by his son Tiburzio Passarotti. No traveller of any consequence, passing through Bologna, would miss the chance to visit Passarotti's famous museum. His interest in collecting is reflected in his portraits. During the 1570s he favoured a style in which the subject is presented as a three-quarter-length figure, in the act of

Bartolomeo Passarotti: *Monaldini Brothers*, oil on canvas, 0.93×1.48 m, *c.* 1578–80 (Hopetoun House, Lothian)

displaying or pointing to some object and often standing near a table on which books, medals, sculptures etc. are set out. This formula was used in the portrait of *Sertorio Sertori* (1577; Modena, Gal. & Mus. Estense), which also presents some other recurrent features of Passarotti's painting: the lively oratorical gestures and the presence of a dog. Two other portraits of collectors have recently been identified: one in London (It. Embassy) is probably of *Ercole Basso*, the other (Milan, priv. col.) is perhaps of *Giulio Cesare Veli.* They were both Bolognese antiquarians famous for their collections of antique coins, and both had a relationship with Passerotti. Passarotti's cordial, narrative manner of describing his subjects and the details of their environment, as in the portrait of the Domenican friar *Ignazio Danti* (*c.* 1577; Brest, Mus. Mun.), painted during the stay in Bologna of this most important character of the age of Pope Gregory XIII, is derived from the portraiture of Parmigianino and Girolamo Mazzola Bedoli but has a dimension of spirited naturalism reminiscent of works by Giovanni Battista Moroni. Passarotti's greater attention to chromatic values betrays an interest in the painters of the Veneto region, especially the Bassano family. The Venetian influence also emerges in Passarotti's altarpieces. Those of the early 1570s reflect the Mannerism of Pellegrino Tibaldi and Vasari, represented in Bologna by Prospero Fontana, Orazio Samacchini and Lorenzo Sabatini. Passarotti's work in this vein includes the *Virgin and Child Enthroned with SS Petronius and Peter Martyr* (Bologna, S Petronio).

Between 1575 and the early 1580s Passarotti was the pre-eminent painter in Bologna. His first experiments with genre painting, at which he arrived by two different routes,

portraiture and privately commissioned satirical allegories, probably date from this period. The portrait of the *Monaldini Brothers* (Hopetoun House, Lothian; see fig.) marks a watershed between the courtly and aristocratic tradition of Niccolò dell'Abate and the newer genre scenes based on popular themes. The stylistic language, grotesque and humorous intonation and didactic intentions of the *Merry Company* (*c.* 1577; Paris, P. Rosenberg priv. col.) are typical of this kind of genre scene. Exaggeratedly grotesque accents can also be seen in some of Passarotti's drawings (e.g. *Man with Wide Open Mouth*, sold New York, Sotheby's, 3 June 1981; *Old Laughing Woman*, Berlin, Kupferstichkab.) and even in his religious paintings, for example the deformed, ugly faces of the figures of common people in the *Ecce homo* (Bologna, S Maria del Borgo). Passarotti's known and securely attributed genre scenes are the *Butcher's Shop*, the *Fishmonger's Shop*, (both Rome, Pal. Barberini), the *Chicken Sellers* (Florence, Longhi priv. col.) and *Women Selling Chickens and Greengrocery with a Child* (Berlin, Gemäldegal.); the last work, painted about 1578–80, probably belonged to the same series mentioned in an inventory (1614) of the Villa Celimontana of the Mattei of Calcarara family, in Rome. A later genre painting, the so-called *Dog Breeder* (1585–90; Rome, Pal. Barberini), in which a free representation of the Five Senses can be recognized, dates from the period when the naturalistic reform of the Carraccis had already imposed itself in Bologna. Related figurative ideas can be seen in the paintings of kitchens and markets, well known in Italy, of the Flemish painters Pieter Aertsen (1507/8–75) and Joachim Beuckelaer (*c.* 1534–74) and in the biblical-pastoral scenes produced in the Venetian workshop of the

Bassano family. Passarotti, in parallel with Vincenzo Campi, led the field in the production of such genre scenes, and his work served as an important point of reference for the young Annibale Carracci (1560–1609). The genre scenes have been seen in terms of moralistic satire on human vices, expressed through a didactic visual presentation of the everyday life of the lower classes, in accord with post-Tridentine cultural prescriptions.

Around 1580 Passarotti painted several outstanding altarpieces: *St Dominic and the Albigeans* (Bologna, Pin. Nat.), the *Coronation of the Virgin with St John the Evangelist and St Luke* (sold New York, Sotheby's, 30 January 1998) and the *Madonna of the Rosary with Saints and devout figures* (Modena, Semin.). In 1583 he painted the *Presentation of the Virgin* (Bologna, Pin. N.). The figures of the two women encapsulate the popular element then favoured by the Church, representing the life of the common people as composed and decorous. Passarotti's last securely datable work is the recently rediscovered painting of *St Catherine* (1588; Scandiano, nr Reggio Emilia, parish church). Like many of his works it is signed with a sparrow, the symbol of Passarotti's name. At his death, the painter left a thriving workshop, inherited by his many sons (Tiburzio, Passarotto, Ventura and Aurelio) and grandsons (Gaspare and Arcangelo). Their activities continued into the first decades of the 17th century.

BIBLIOGRAPHY

G. Vasari: *Vite* (1550, rev. 2/1568); ed. G. Milanesi (1878–85)
R. Borghini: *Il riposo* (Florence, 1584); ed. M. Rosci (Milan, 1967)
C. C. Malvasia: *Felsina pittrice* (1678); ed. M. Brascaglia (1971)
A. Venturi: *Storia* (1901–40), IX/vi, pp. 731–51
R. Pallucchini: 'Ritratti di Bartolomeo Passarotti nella Regia Galleria Estense di Modena', *Riv. A.*, n. s., ix (1937), pp. 46–52
H. Bodmer: 'Die Kunst des Bartolomeo Passarotti', *Belvedere*, xiii (1938–9), pp. 66–73
G. Heinz: 'Realismus und Rhetorik im Werk des Bartolomeo Passarotti', *Jb. Ksthist. Samml. Wien*, lxviii (1972), pp. 153–69
B. Wind: 'Pitture ridicole: Some Late Cinquecento Genre Painting', *Stor. A.*, 20 (1974), pp. 25–35
——: 'Annibale Carracci "Scherzo": The Christ Church Butcher Shop', *A. Bull.*, lviii (1976), pp. 93–6
D. Benati: 'Una "Lucrezia" e altre proposte per Bartolomeo Passerotti', *Paragone*, xxxii/379 (1981), pp. 26–35
A. Ghirardi: 'Per una lettura di due ritratti di famiglia di Bartolomeo Passerotti', *Itinerari*, ii (1981), pp. 57–65
F. Porzio: 'Tre ritratti di Bartolomeo Passerotti', *Scritti di storia dell'arte in onore di Federico Zeri*, ed. M. Natale (Milan, 1984), i, pp. 427–33
Correggio e il suo lascito: Disegni del cinquecento emiliano (exh. cat., ed. D. Degrazia; Parma, Pal. Pilotta, 1984), pp. 347–50
G. Poletti: 'Alcuni ritratti inediti di Bartolomeo Passerotti e i manoscritti di Marcello Oretti ad esso relativi', *Antol. B. A.*, 25–6 (1985), pp. 85–9
A. Ghirardi: 'Bartolomeo Passerotti', *Pittura bolognese del cinquecento*, ed. V. Fortunati Pietrantonio (Bologna, 1986), ii, pp. 543–94
Nell'età di Correggio e dei Carracci (exh. cat., Bologna, Pin. N., 1986), pp. 177–84 [entry by A. Ghirardi]
C. Höper: *Bartolomeo Passarotti* (Worms, 1987)
A. Ghirardi: *Bartolomeo Passerotti* (Rimini, 1990)
——: 'I Bolognesi illustri: Disegni di Bartolomeo Passerotti', *Grafica d'Arte*, xiv (1993), pp. 28–31
——: 'Note su Bartolomeo Passerotti, nell'età dei Carracci', *Atti & Mem. Accad. Clementina Bologna*, n.s., xxxii (1993), pp. 153–68
B. Bohn: 'Felsina collezionista: The Creation of Finished Drawings in Sixteenth-century Bologna', *Stud. Stor. A.* [Todi], v–vi (1994–5), pp. 193–211
F. Missere Fontana: 'Raccolte numismatiche e scambi antiquari a Bologna tra Quattrocento e Seicento', *Boll. Numi.*, xxv (1995), pp. 161–209
C. Monbeig Goguel: 'Une version inédite de la *Madone du silence* de Michel–Ange et une proposition pour Barolomeo Passerotti', *Ars naturam adiuvans: Festschrift für Matthias Winner*, ed. V. V. Flemming and S. Schutze (Mainz, 1996), pp. 311–26
A. Ghirardi: 'In margine ad una mostra: Un'interpretazione del cosiddetto *Allevatore di cani* di Bartolomeo Passerotti', *Atti & Mem. Accad. Clementina Bologna*, n.s., xxxviii (in preparation)

ANGELA GHIRARDI

Pasti, Matteo de' (*b* Verona, *c.* 1420; *d* Rimini, after 15 May 1467). Italian medallist, architect, painter and illuminator. He came from a good Veronese family (his father was a doctor, two of his brothers were in the church and three others were merchants). He is first documented in 1441, when he was working in Venice as painter to Piero di Cosimo de' Medici illustrating Petrarch's *Trionfi* (untraced). Subsequently (1444–6), he worked as an illuminator for the Este court, under the direction of Giorgio d'Alemagna. None of his works from this period is known.

By 1449 he was resident in Rimini, where he married Elisa di Giovanni Baldigara. There he was joined by Agostino di Duccio and other Venetian sculptors, working on the construction and decoration of two large funerary chapels (1447–*c.* 1452) for Sigismondo Pandolfo Malatesta, Lord of Rimini, and his mistress, Isotta degli Atti, in S Francesco (known as the Tempio Malatestiano). Initially Matteo was probably the organizer and supervisor of this project, but *c.* 1450 Sigismondo decided to rebuild the church and entrusted the project to Leon Battista Alberti (*see* RIMINI, fig. 1). Matteo, however, continued to work there, and the scheme for the interior decoration, in a gothicizing, Venetian style, is his work; originally an inscription naming de' Pasti as architect ran across an architrave.

Matteo won the confidence of Sigismondo, and by 1454 he was referred to as 'noble' and was entrusted with responsibility for all architectural and artistic work within the state. This brought him into contact with Piero della Francesca, Leon Battista Alberti, Agostino di Duccio and many other artists working at the court. In 1461 he was sent by Sigismondo on a diplomatic mission to Constantinople, ostensibly to paint the portrait of the Ottoman sultan, Mehmed II (*reg* 1444–6 and 1451–81), but he was arrested at Candia by the Venetians and repatriated.

Matteo de' Pasti was also active as a medallist at the Rimini court; Pisanello had executed three medals for the Malatesta (*c.* 1445) and his work had a profound influence on Matteo. His are dated 1446, 1447 and 1450, but these dates are commemorative and do not necessarily record the years the medals were cast, particularly since Matteo was first recorded in Rimini in 1449.

All Matteo's early medals carry the profile of Sigismondo Pandolfo Malatesta on the obverse, while on the reverse various subjects are depicted: an arm holding a palm of victory (Hill, *Corpus*, no. 182); the personal emblem of Sigismondo (Hill, *Corpus*, no. 165); an allegory of Strength (Hill, *Corpus*, nos 184, 178); and the castle of Rimini (Hill, *Corpus*, no. 174). They possess a controlled naturalism, precise modelling and simple, harmonious compositions. The first medal of *Isotta degli Atti*, with an angel on the reverse, can be dated *c.* 1450 (Hill, *Corpus*, no. 170). Dating from 1453–4 are the medal commemorating the *Foundation of the Tempio Malatestiano*, which records Alberti's unrealized plan for the façade (Hill, *Corpus*, no. 183; *see* RIMINI, fig. 3), and one of Isotta with an elephant on the reverse (Hill, *Corpus*, no. 167); the latter is Matteo's greatest

work. Between 1454 and 1456, Matteo must have cast the medals of his brother *Benedetto de' Pasti* (Hill, *Corpus*, no. 160), *Timoteo Maffei* (Hill, *Corpus*, no. 159), the humanist *Guarino of Verona* (Hill, *Corpus*, no. 158) and *Leon Battista Alberti* (Hill, *Corpus*, no. 161; *see* ALBERTI, LEON BATTISTA, fig. 1); all are signed and show a considerable stylistic evolution and the influence of Alberti's humanistic innovations and of Piero della Francesca. Matteo's last medal (*c.* 1466) shows on the obverse the bust of the Saviour, the first Renaissance medal of the subject, and the Pietà on the reverse (Hill, *Corpus*, no. 162). About 150 of Matteo de' Pasti's medals have been found buried in the walls of Malatesta buildings, particularly the Tempio and the castle of Rimini. During the last decade of his life the artist probably returned to his earlier activity as a miniaturist.

BIBLIOGRAPHY

Thieme–Becker

A. Heiss: *Les Médailleurs de la Renaissance: Léon-Baptiste Alberti, Matteo de' Pasti* (Paris, 1881)

D. Friedländer: *Die italienischen Schaumünzen des fünfzehnten Jahrhunderts* (Berlin, 1882)

A. Armand: *Les Médailleurs italiens du quinzième siècle*, i (Paris, 1883)

P. Schubring: 'Matteo de' Pasti', *Kunstwissenschaftliche Beiträge August Schmarsow gewidmet* (Leipzig, 1907)

C. Grigioni: 'I costruttori del Tempio Malatestiano', *Rass. Bibliog. A. It.*, xi (1908), pp. 117–28, 154–63, 196–8

G. Soranzo: 'Una missione di Sigismondo Pandolfo Malatesta a Maometto II nel 1461', *La Romagna*, iv (1909), pp. 43–95

C. Ricci: *Il Tempio Malatestiano* (Milan, [1924]), pp. 38–60

A. Calabi and G. Cornaggia: *Matteo de' Pasti* (Milan, [1926])

G. F. Hill: *Corpus*, i (London, 1930), pp. 37–43

J. Pope-Hennessy: *The Portrait in the Renaissance* (London, 1966), p. 155

G. F. Hill and G. Pollard: *Renaissance Medals from the Samuel H. Kress Collection at the National Gallery of Art* (London, 1967)

F. Panvini Rosati: *Medaglie e placchette italiane dal rinascimento al XVIII secolo* (Rome, 1968), pp. 22–3

P. G. Pasini: 'Note su Matteo de' Pasti e la medaglistica malatestiana', *La medaglia d'arte, atti del I. convegno internazionale di studio, Udine 1970*, pp. 41–75

Sigismondo Pandolfo Malatesta e il suo tempo (exh. cat., ed. F. Arduini and others; Rimini, Pal. Arengo, 1970), pp. 105–22, 168–76

U. Middeldorf: 'On the Dilettante Sculptor', *Apollo*, cvii (1978), pp. 310–22, 316–19

G. Pollard: *Italian Renaissance Medals in the Museo Nazionale del Bargello*, i (Florence, 1984), pp. 92–119

P. G. Pasini: 'Matteo de' Pasti: Problems of Style and Chronology', *Stud. Hist. A.*, xxi (1987), pp. 143–59

Le Muse e il principe: Arte di corte nel rinascimento padano (exh. cat., Milan, Mus. Poldi Pezzoli, 1991)

A testa o croce: Immagini d'arte nelle monete e nelle medaglie del rinascimento (exh. cat. by R. Parise Labadessa, Padua, Mus. Civ., 1991)

P. G. Pasini: *Cortesia e geometria: Arte malatestiana fra Pisanello e Piero della Francesca* (Rimini, 1992)

E. Luciano: 'Diva Isotta and the Medals of Mateo de' Pasti: A Success Story', *Medal*, xxix (1996), pp. 3–17

PIER GIORGIO PASINI

Pastiglia [*pasta di muschio*]. Italian term used to describe a form of decoration applied to furniture (*see* CASSONE, §2 and fig. 5) and, in particular, small caskets. Pastiglia decoration was made from white powder formed when ground lead was exposed to vinegar vapour in a sealed jar (Pliny: *Natural History* IX.vi.6). It was then mixed with egg white to make a malleable paste; and lead matrices (moulds) were used to stamp out relief figures or decorative motifs, which were applied with rabbit-skin glue to the gilding. There are at least two examples (*c.* 1500, London, V&A; *c.* 1500, Venice, Fond. Cini) where pastiglia was applied to a casket surface of coloured-glass fragments.

The gilt surface of the casket was built up from a layer of *gesso sottile*, then Armenian bole, and finally gold leaf; it was punched with either palmette or lozenge-shaped patterns (imitating *opus reticulatum*), which possibly gave the pastiglia a better grip. The pastiglia was left in white or highlighted with gilding or paint. A matrix was made for each element of the composition: figures, buildings, trees, and the decorative motifs applied to the mouldings and lids. The matrices were reused and recognizable figures reappear on various caskets.

There is documentary evidence of pastiglia or *pasta di muschio* (the contemporary term) in the mid- and late 15th century in Ferrara, where Carlo di Monlione, a craftsman originally from Brittany, is recorded in the 1450s as a specialist of this type of decoration. Pastiglia decoration also appears to have flourished in the Veneto in the early 16th century: the inventory of Bianca Maria di Challant (1522) refers to 'five little caskets gilt in the Venetian style'; this is possibly a description of pastiglia boxes. Other factors that make this likely are that the Venetians controlled the monopoly of lead and had a taste for luxurious gilt furniture and objects, and that the wood used for the carcass of the caskets was mainly alder, commonly found in the Veneto. One surviving casket (*c.* 1535; London, V&A; see fig.), which can be dated from the coat of arms on the lid, was made for Cardinal Bernhard von Cles of Trent.

There were several popular decorative themes used on pastiglia caskets: Greek myths from Ovid's *Metamorphoses* or early Roman legends from Livy such as the torture of Regulus or the story of Marcus Curtius. The casket designs may have been taken from engravings by Mantegna (e.g. casket, *c.* 1500; London, V&A), his plagiarist Zoan Andrea, or Benedetto Montagna. Illustrations to Classical texts such as Giovanni Rosso's edition of the *Metamorphoses* (1497) and the 1509 edition of Livy (Venice, Fond. Cini) were also available. Biblical stories of a heroic nature, such as Judith and Holofernes, and David and Goliath (e.g. casket, *c.* 1500; London, V&A), were also used, as were the scenes from bronze medallions or plaquettes. Six pastiglia workshops have been identified (de Winter); of these, the workshops of the Moral and Love themes, possibly Ferrarese (Manni), were the most prolific.

The term pastiglia has also been used to describe a technique employed in the Gothic painter's workshop in

Pastiglia decoration on the lid of a casket showing the coat of arms of Cardinal Bernhard von Cles, 89×229 mm, North Italian, *c.* 1535 (London, Victoria and Albert Museum)

which *gesso sottile* was used as a form of surface decoration, but late 20th-century research (de Winter and Manni) has shown that gesso and pastiglia are two different things in contemporary accounts. *Cassone* decoration, described in books from the late 19th century onwards as pastiglia, is in fact gilt gesso. Pastiglia would be too small and fragile for a large *cassone*.

BIBLIOGRAPHY

W. L. Hildburgh: 'On Some Italian Renaissance Caskets', *Antiqua. J.*, xxvi (1946), pp. 118–22

A. M. Marien-Dugardin: 'Un Coffret italien', *Bull. Mus. Royaux A. & Hist.*, n.s. 4, xxv (1953), pp. 37–41

P. M. de Winter: 'A Little-known Creation of Renaissance Decorative Arts: The White Lead Pastiglia Box', *Saggi & Mem. Stor. A.*, xiv (1984), pp. 7–42

G. Manni: *Il mobile emiliano* (Modena, 1986)

JAMES YORKE

Pastorini, Pastorino (di Giovan Michele de') [Pastorino da Siena] (*b* Castelnuovo della Berardenga, *c.* 1508; *d* Florence, 6 Dec 1592). Italian medallist, glass painter and die engraver. He was one of the most prolific and able medallists of the Italian Renaissance, producing around 200 medals. He held various official positions including several in the mints of Emilian courts: in Ferrara (1554–9), in Bologna (1572), in Novellara (1574) and in Florence (1576). In Florence he was 'maestro di stucchi' under Grand Duke Francesco de' Medici (1541; 1574; 1587). He was also renowned as a portraitist in coloured wax for which he apparently developed new materials and techniques to represent hair and skin.

Pastorini trained as a glass painter under Guillaume de Marcillat (1467/70–1529), who worked in Arezzo until his death in 1529. He practised this craft through the 1530s and 1540s, first at Siena Cathedral (1531–7) and later in the Sala Regia in the Vatican and in San Marco (1541–8).

Pastorini continued to work in Siena, and gained a reputation for his achievements in portraiture in wax and stucco and on medals and coins. His dated medals fall between 1548 and 1578. In 1552 he was active in the mint at Reggio Emilia, but the following year fled to Parma, having been unjustly accused of counterfeiting coins. He worked in the mint there for a short time and in various other Emilian towns thereafter. In 1554 he moved to Ferrara, where he directed the Este mint until 1559; coins of 1558 and 1559 bear his signature. In 1561 he was in Mantua, and in 1574 he was working for Camillo Gonzaga in the mint at Novellara. In 1576 he entered the service of Francesco de' Medici as a master of stucco work. His oeuvre includes portraits of members of many of the most illustrious families of central Italy, especially the Este, Gonzaga and Medici (see fig.). He generally signed his pieces with the single initial P and rarely included a reverse, concentrating solely on the portraiture that was the basis of his immense popularity. The reverses that do exist by Pastorini are singularly barren, and it seems he made a wise decision not to include them in his medals. His portraits are placid, precise, refined, accurate without being unflattering and certainly non-committal. In the best specimens of the finest medals, for example those of *Margherita Paleologo Gonzaga* (lead, 1561; London, BM), *Alberto Lollio* (bronze, 1562; Florence, Bargello), *Francesco*

Pastorino Pastorini: *Lucrezia de'Medici* (uniface), cast lead, diam. 69 mm, 16th century (private collection)

I de' Medici, Grand Duke of Tuscany (bronze, 1560; Florence, Bargello) and *Camillo Castiglione* (bronze, 1561; Washington, DC, N.G.A.), Pastorini combined a fine and sensitive portrait with a meticulous and elaborate representation of the minutest details of dress, armour and ornamentation. His work is uneven, however, and much of it is superficial.

His medals divide, roughly, into two groups. The finest work is in large format (usually 56–69 mm), is marked by a border composed of a raised, flat band with large pearls, and is mostly signed and dated. The medals of the second, earlier group are much smaller (35–45 mm), seldom signed or dated and often lack the pearled border; the artist's facility and technical ability are less in evidence. He spent the last years of his career in Florence and was dismissed from his post in 1589. His brother, Guido Pastorini (*d* 1592), was also a painter and glass painter.

BIBLIOGRAPHY

A. Armand: *Les Médailleurs italiens des quinzième et seizième siècles*, i (Paris, 1883/*R* Bologna, 1966), pp. 188–211

I. B. Supino: *Il medagliere mediceo del R. Museo Nazionale di Firenze* (Florence, 1899), pp. 120–25

L. Forrer: *Biographical Dictionary of Medallists*, iv (London, 1909), pp. 408–22

G. F. Hill: *Medals of the Renaissance* (Oxford, 1920); rev. J. G. Pollard (London, 1978), pp. 85–7

G. Habich: *Die Medaillen der italienischen Renaissance* (Stuttgart and Berlin, 1924), pp. 122–4

G. F. Hill and J. G. Pollard: *Renaissance Medals from the Samuel H. Kress Collection at the National Gallery of Art* (London, 1967), pp. 60–63

V. Johnson: 'La medaglia italiana in Europa durante i secoli XV e XVI (parte seconda)', *Dieci anni di studi di medaglisti, 1968–78* (Milan, 1979), pp. 62–4

J. G. Pollard: *Italian Renaissance Medals in the Museo Nazionale del Bargello*, ii (Florence, 1985), pp. 681–715

G. Boccolari: *Le medaglie di Casa d'Este* (Modena, 1987), pp. 330–31

The Currency of Fame: Portrait Medals of the Renaissance (exh. cat., ed. S. K. Scher; Washington, DC, N.G.A.; New York, Frick; 1994), pp. 177–80, 385–6

STEPHEN K. SCHER

Patanazzi. Italian family of potters. They were a dominant force in the production of maiolica in Urbino during the

late 16th century and early 17th. Four members of the family signed their work, and dates range from 1580 to 1620. Antonio, Alfonso, Francesco and Vincenzo were involved in the family business, although Alfonso is also known to have painted in another workshop. The Patanazzi succeeded the renowned workshop belonging to the Fontana family and it is often difficult to differentiate between their wares, especially those of the period 1570 to 1585. Maiolica decorated with *istoriato* (narrative) scenes or figures with grotesque borders on a white ground rose in popularity during the mid-16th century. By the 1580s these were the most popular ceramics in the Urbino area, overshadowing the earlier, purely narrative wares. The Patanazzi embraced this decorative style, developed by Raphael, which combined human figures with fanciful monsters, cameos, garlands and other motifs found in the recently discovered ruins of ancient Rome.

The wares of the Patanazzi, which are remarkably consistent in style, are characterized by cursorily drawn, seemingly boneless figures, a palette dominated by blue and brownish orange and strong, dark outlines. Their work never reached the artistic heights of the *istoriato* maiolica of the 1530s and 1540s, however, and the standard of the later wares deteriorated significantly. In addition to plates and jars, the Patanazzi produced such elaborate modelled items as wine cisterns (e.g. of 1608 from the workshop of Francesco Patanazzi; London, BM), inkstands and salts, which imitated the increasingly Baroque forms of contemporary silverware. They also manufactured large sets of apothecary jars for the pharmacies of Roccavaldina, near Messina, Sicily, and the Santuario della Santa Casa in Loreto, as well as the important 'Ardet Aeternum' service (part destr.; some items in London, BM), which was probably made for Alfonso II d'Este, Duke of Ferrara and Modena, and Margherita Gonzaga at the time of their marriage (1579).

BIBLIOGRAPHY

Italienische Majolika (exh. cat. by J. Lessmann, Brunswick, Herzog Anton Ulrich-Mus., 1979)
C. Ravanelli Guidotti: *Ceramiche occidentali del Museo Civico Medievale di Bologna* (Bologna, 1985)
T. Wilson: *Ceramic Art of the Italian Renaissance* (London, 1987)

WENDY M. WATSON

Patavium. *See* PADUA.

Paul II, Pope [Barbo, Pietro] (*b* Venice, 23 Feb 1417; elected 30 Aug 1464; *d* Rome, 26 July 1471). Italian pope and patron. He was made a cardinal in 1440 by his uncle, Pope Eugenius IV (*reg* 1431–47). His reign was spent attempting to check the Turkish advance into Europe and to establish effective rule in the papal territories. He was also concerned to promote the magnificence of Rome and the status of the papacy by various means, including a programme of building and restoration. In 1455, while still a cardinal, he began to rebuild his titular church of S Marco and the adjoining palace (later renamed the Palazzo Venezia) that became his principal residence in 1466 and was completed in 1471. He also installed a private bronze foundry for the manufacture of bronze plaquettes. Together with the benediction loggia at St Peter's (*c.* 1461–95), begun by Pius II, these were the first buildings in Rome where the rules of Vitruvius were applied, and the

Gothic tradition was broken. In the benediction loggia, the façade of S Marco (*c.* 1460–65) and the few bays that were built of the courtyard (*c.* 1470) of the Palazzo Venezia, a system of arcades inspired by antique prototypes made its first appearance in Rome. Though the designer of this system is not known—a case has been made for Bernardo Rossellino and Giuliano da Maiano—the concept was probably Leon Battista Alberti's. The Palazzo Venezia marked the transition in Rome from medieval fortress to Renaissance palace. Although its exterior is severe and forbidding, its magnificent and luxurious interior housed collections of Byzantine icons, ivory-carvings, mosaics and vestments; Flemish tapestries; Florentine goldsmiths' works and an extensive hoard of antiquities: cameos, intaglios, gold and silver coins and bronzes. Much of this last later came into the possession of Lorenzo de' Medici ('il Magnifico').

Paul II surrounded himself with scholars and in 1467 installed the first printing press in Rome, operated by German printers, who with the encouragement of Niccolò da Cusa (1401–64) had come to the Benedictine abbey of Subiaco. The Pope made available manuscripts from the Vatican library. While in such ways he encouraged learning, the Pope was nervous of the increased influence of humanist studies and in 1468 suppressed the Roman academy (instituted *c.* 1458 by Pomponio Leto) because he suspected its members of promoting pagan ideas. He imprisoned the historian and papal biographer Platina (Bartolomeo Sacchi, 1421–81) for challenging papal policy. Platina's career recovered, however, under Paul's successor Sixtus IV, when he became the first papal librarian, depicted in *Sixtus IV Founding the Vatican Library* (*c.* 1476–7; Rome, Pin. Vaticana; *see* MELOZZO DA FORLÌ, fig. 1).

As the first pontiff actively to pursue the preservation of antique monuments, Paul II commissioned restorations of the Pantheon, the arches of Titus and Septimius Severus, the *Alexander and Bucephalus* (Piazza del Quirinale) and the equestrian statue of *Marcus Aurelius* (Rome, Mus. Capitolino). He also continued the restoration of S Giovanni in Laterano, S Maria in Aracoeli, S Maria Maggiore, S Maria sopra Minerva and of the bridges, city gates and fortifications of Rome. His building activities extended as far as Tivoli, Ostia, Civitavecchia, Terracina, Viterbo and Monte Cassino. During the papacy of Paul II a refined, classicizing style of sculpture was introduced in Rome under the leadership of Andrea Bregno, a native of Lombardy, and the Dalmatian-born Giovanni Dalmata (*c.* 1440–1509), who collaborated with the Florentine Mino da Fiesole on the Pope's tomb (?1471–7; destr.; fragments, Rome, Grotte Vaticane; Paris, Louvre), the largest and most richly composed papal tomb of its date.

BIBLIOGRAPHY

E. Muentz: *Les Arts à la cour des papes pendant le XVe et le XVIe siècle*, ii (Paris, 1879)
Ludwig, Freiherr von Pastor: *Geschichte der Päpste* (1886–9), i, pp. 293–447
R. Weiss: *Un umanista veneziano: Papa Paolo II* (Rome, 1958)
C. L. Frommel: *Der Palazzo Venezia in Rom* (Opladen, 1982)

HELLMUT WOHL

Paul III, Pope. *See* FARNESE, (1).

Paul IV, Pope. *See* CARAFA, (2).

Pavia. Italian city on the River Ticino in Lombardy.

1. History and urban development. 2. Certosa.

1. HISTORY AND URBAN DEVELOPMENT. The site was founded by Ligurians and later settled by Celts. The Romans conquered the area *c.* 220 BC and created the military colony of Ticinum, which later grew into a town when the Via Aemilia was extended beyond the River Po. The town was well placed for trading and flourished as a result. In the 5th century AD the town was sacked and burnt by barbarians. When the Ostrogoths conquered the district in 493, Pavia became one of the favourite residences of Theodoric the Great (*reg* 489–526). Pavia resisted the Lombard invasions for three years, finally yielding in 571. The city became the capital of the Lombard kings, and the new name of Pavia appeared towards the end of the 7th century.

In 774 the Franks conquered the city, which remained a political and military centre, and increased in importance as a commercial centre. The Hungarians sacked the city in 924 and destroyed most of the old Lombard city. Pavia became a Commune in 1024. In the struggles between the Holy Roman Emperor and the cities of Lombardy, Pavia allied itself with the Emperor and against its great rival, Milan, the increasing wealth and power of which constituted a considerable threat. Wars were fought between the two cities in the 11th, 12th and 13th centuries. During this period Pavia began to lose its political pre-eminence, though it retained its wealth and commercial importance.

In 1359 Pavia became part of the Duchy of Milan under the Visconti and later the Sforza families. During this period the castle (from 1360; *see* VISCONTI , (3)), the university (from 1485), the Certosa (begun 1396; *see* §2 below) and other secular and religious buildings were erected. The ornately sculpted Arca di St Agostino (1362) serves as the altarpiece of S Pietro in Ciel d'Oro. Parts of the city were replanned, including the new centre, and the Piazza Grande was laid out. The cathedral was reconstructed from 1487, largely to a design by Bramante (*see* BRAMANTE, DONATO, §I, 2(ii)(a)); it is a notable product of the Lombard Renaissance.

The domination of the Spanish from 1535 to 1714 initiated a period of decline for the city, although the university regained its importance. In the 16th century the Spanish erected ramparts around the city that still stand.

BIBLIOGRAPHY
R. Soriga: *Pavia e la Certosa* (Bergamo, 1926)
A. Poroni and others, eds: *Pavia: Architetture dell'età Sforzesca* (Turin, 1978)
P. Hudson and M. C. La Rocca Hudson: 'Lombard Immigration and its Effects on North Italian Rural and Urban Settlement', *Papers in Italian Archaeology IV: The Cambridge Conference*, ed. C. Malone and S. Stoddart, iv (Oxford, 1985), pp. 225–46

SARAH MORGAN

2. CERTOSA. Giangaleazzo Visconti, 1st Duke of Milan, founded the Carthusian monastery, the Certosa, in fulfilment of his wife's will of 1390. The monastery church, dedicated to S Maria delle Grazie, was to serve as a mausoleum for the Visconti, and Giangaleazzo donated land on the edge of his private park for the project. The cornerstone of the Certosa was laid on 27 August 1396, with Bernardo da Venezia (*fl* 1391–1403) supervising the layout of the monastic complex. Work progressed slowly after Giangaleazzo's death in 1402, but Francesco Sforza revitalized the project after becoming Duke of Milan in 1450. Guiniforte Solari guided construction through the period of its most concentrated activity in the second half of the 15th century. The church was consecrated on 3 May 1497, although work continued until the French invasion of Lombardy in 1523, resuming on the façade only in 1550.

(i) *Architecture.* The fabric of the Certosa reflected the various artistic influences in Lombardy in the 15th century, with its idiosyncratic blend of Romanesque tradition, Gothic detail and Renaissance organization, and this eclectic approach was ultimately more influential in the region than the homogeneous design of Milan Cathedral. The monastery was conceived on a grand scale with an imposing church and conventual buildings arranged around two cloisters, one large and one small. Both cloisters are decorated with white marble columns and capitals supporting an arcade with bands of terracotta relief, a popular form of ornament in the region. The east end of the church is visible above the roofs of the claustral buildings, and the red of the outer brick walls harmonizes with the terracotta accents of the cloisters. The build-up of volumes, the extensive use of dwarf galleries and the presence of a stepped tower over the crossing are all traditional features of Lombard Romanesque architecture. Even the choice of brick as the principal medium reflects regional practices in use for centuries. The only concessions to the Gothic aesthetic are the pier buttresses topped with stone pinnacles, which resemble those used at S Maria del Carmine in Pavia (begun 1370).

The interior of the church combines a squat profile derived from Romanesque architecture with sexpartite ribbed vaulting and uniform clustered piers of Gothic type. The square bays with flattened vaults recall the preference for discrete, centralized spaces found in such Lombard Romanesque churches as S Ambrogio, Milan. The combination of semicircular transverse arches and pointed rib vaults in the side aisles was an equally archaic feature. Ackerman has interpreted this use of Romanesque features at the Certosa as the conscious revival of a pre-Gothic aesthetic akin to the imitation of Tuscan Romanesque architecture by Early Renaissance architects in 15th-century Florence. The interior, then, may be viewed as the first step in exploring a non-Gothic aesthetic, which is more fully exploited in the façade.

The west façade (see fig. 1) was realized in two successive campaigns, from 1473 to the 1480s and then from *c.* 1491 (the façade is shown under construction in the background of Bergonone's *Christ Carrying the Cross with Carthusian Monks*, Pavia, Pin. Malaspina; for illustration *see* BERGONONE, AMBROGIO). It resembles the screen façades of Lombard Romanesque churches in its general relationship to the main body of the church, but contemporary Renaissance design has clearly influenced the use of marble sheathing. It is articulated in five bays below and three above by pilasters penetrated by a succession of superimposed niches holding statues. From 1473 Giovanni

1. Pavia, Certosa, west façade, begun 1473

Antonio Amadeo, Antonio Mantegazza and Cristoforo Mantegazza were among the sculptors who worked on the lower façade. Simple, enclosed volumes of Renaissance inspiration are juxtaposed against richly coloured inlay and an exuberant profusion of compact, sculptural ornament (most notably the mullions of the biforate windows, in the shape of candelabrum shafts; *see* AMADEO, GIOVANNI ANTONIO, fig. 2). Such a combination of classic form and the precious treatment of surfaces, related to the aesthetic of Gothic metalwork, had appeared in one of Amadeo's earlier commissions, the Colleoni Chapel in Bergamo (*see* AMADEO, GIOVANNI ANTONIO, fig. 1). Commissions were given to such painters as Bernardino de Rossi.

The organization of the upper façade presents a subdued interplay of voids and planar solids in contrast to the lively sculptural decoration of the lower part. Cristoforo Lombardo directed this later campaign with its more severe composition of arcades and inlaid panels. Sculpture was used sparingly and was subordinated to the architectonic design. A clearly defined order and a balance of horizontal and vertical elements control the organization of the three galleries. The sober elegance of the upper façade reflects not only the acceptance of Florentine Renaissance ideals but also the reduced financial resources of the monastery after the French occupation of Lombardy. Cristoforo's death in 1555 effectively halted construction on the façade, and a crowning section with shaped gable and candelabra was never executed. The conditions that had originally made such a grandiloquent testimony to ducal patronage possible no longer existed, and subsequent 16th-century projects in Lombardy were smaller in scale and less elaborately decorated.

BIBLIOGRAPHY
G. Durelli and F. Durelli: *La Certosa di Pavia* (Milan, 1863)
C. Magenta: *I Visconti e gli Sforza nel Castello di Pavia e loro attinenze con la Certosa e la storia cittadina*, 2 vols (Milan, 1883)
L. Beltrami: *La Certosa di Pavia* (Milan, 1891, rev. 3/1924)
——: *Storia documentata della Certosa di Pavia, 1389–1402* (Milan, 1896)
C. Magenta: *La Certosa di Pavia* (Milan, 1897)
A. Meyer: *Pavia e la sua Certosa* (Pavia, 1911)
R. Maiocchi: *Codice diplomatico artistico di Pavia dall'anno 1330 all'anno 1550*, 2 vols (Pavia, 1937–49); index by R. Cipriani (Pavia, 1966)
J. S. Ackerman: 'The Certosa of Pavia and the Renaissance in Milan', *Marsyas*, v (1947–49), pp. 23–38
M. Salmi: *La Certosa di Pavia* (Milan, 1949)
G. Borlini: 'The Façade of the Certosa in Pavia', *A. Bull.*, xlv (1963), pp. 326–36
A. M. Romanini: *L'architettura gotica in Lombardia*, 2 vols (Milan, 1964)
M. G. Albertini Ottolenghi, R. Bossaglia and F. R. Pasenti: *La Certosa di Pavia* (Milan, 1968)

KATHRYN MARIE McCLINTOCK

(ii) Sculpture. There is sculptural decoration in the church interior, the cloisters and the façade. The construction of the church was accomplished largely between 1450 and 1485; the cloisters were decorated in the 1460s, and the campaigns on the façade followed from 1473.

Shortly after 1396, the Certosa acquired a fine marble altar (now in Carpiano, S Martino), carved by Campionese sculptors. It was probably first used in the hospice in Torre del Mangano and later in the temporary church in the refectory. Between 1400 and 1409 the monastery purchased an elaborate, Gothic ivory triptych from Baldassare degli Embriachi, which was transferred to the main altar when the church was consecrated in 1497 (for illustration *see* EMBRIACHI).

The Gothic corbels supporting the vaults in the twin sacristies of the church were probably carved in the 1450s. The keystones in the nave and aisles bear reliefs of saints by Cristoforo Mantegazza and Giovanni Antonio Amadeo, datable between 1467 and 1473. A document of 1478 shows that the medallions of the *Doctors of the Church* below the *tiburio* were completed, two by Amadeo and two by Cristoforo Mantegazza and Antonio Mantegazza. The Mantegazza brothers also made a marble *Pietà* and a keystone of the *Virgin*, which has been identified in a chapel in the nave. The marble altarpiece of the *Adoration of the Magi* in the Capitolo dei Padri is probably a late work of Cristoforo Mantegazza, while the stupendous marble *Lamentation* (late 1480s; see fig. 2) in the Capitolo dei Fratelli is attributed to Antonio Mantegazza. In 1489 Alberto Maffioli da Carrara contracted to make a marble lavabo for the sacristy. Its lunette, however, is filled with *Passion* reliefs by Lombard sculptors. The northern sacristy portal, with medallions of the Visconti and Sforza dukes, was carved by Cristoforo Solari, Benedetto Briosco and others in the 1490s. Solari also carved effigies of *Ludovico Sforza* and *Beatrice d'Este*, intended for S Maria delle Grazie in Milan (for illustration *see* SOLARI, (5)). The contemporary portal of the sacristy of the lavabo, with medallions of the Visconti and Sforza duchesses, can be attributed to Tommaso Cazzaniga with some medallions by Gian Cristoforo Romano and Benedetto Briosco. The tomb of *Giangaleazzo Visconti* (*d* 1402) was made in the 1490s by Gian Cristoforo, Briosco and others. Its iconography is surprisingly secular, emphasizing the deeds of Giangaleazzo but lacking the New Testament reliefs that characterized contemporary Lombard tombs (see below). The tabernacle to the left of the altar was finished by Biagio Vairone and the brothers Giovanni Battista da Sesto and Giovanni Stefano da Sesto in 1513, and the piscina on the right was finished in the same year by Antonio della Porta and Pace Gaggini.

The corbels and terracottas (*c.* 1463–5) in the small cloister are by several sculptors including Francesco Solari and Cristoforo Mantegazza; some of the pier capitals may also be attributed to Cristoforo. A new, classicizing or Renaissance influence is evident in many of these corbels

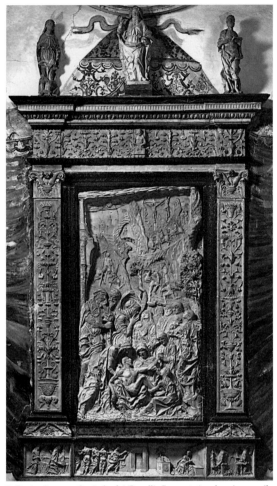

2. Pavia, Certosa, Capitolo dei Fratelli, *Lamentation* altarpiece attributed to Antonio Mantegazza, marble, late 1480s

and terracottas, and particularly in the small cloister lavabo (mid-1460s) by Amadeo and Francesco Solari, and in Amadeo's small cloister marble portal. Although the latter is crowded with miniaturistic detail, some of its motifs, for example the vivacious nude putti and the *Hercules and Antaeus* relief of the jambs, and many of its architectural elements, are classical in both content and style. Amadeo's reliefs display a naturalism and a perspectival virtuosity that are far more Renaissance than Gothic. In the large cloister, corbels (1460s) attributable to Cristoforo Mantegazza and Amadeo are carved with figures of saints that collectively constitute an image of Heaven. This is a common theme at the Certosa, repeated in the cloister terracottas, the painted and carved decoration of the church vaults, on the intarsiated choir-stalls and in the statues within the church and on the façade.

The first campaign on the façade, from 1473, produced at least 34 *Old Testament* panels attributable to Cristoforo Mantegazza and Antonio Mantegazza (for discussion of attributions *see* MANTEGAZZA). A Florentine ambassador, Giovanni Ridolfi, saw biblical stories and heads of emperors on the façade in 1480. When a new design was adopted *c.* 1491 the earlier sculpture was taken down, although

many of the *Old Testament* panels were mounted high on the façade in the mid-16th century, and others now decorate portals in the cloisters and in the church. The new design included over 60 large, classicizing, medallions in imitation of ancient Roman coins and a programme of large *New Testament* reliefs. As such medallions and New Testament scenes, together with heraldic crests and swags of fruit, are common features on Lombard tombs, the façade is literally a pendant to Giangaleazzo Visconti's tomb. The medallions were made by Amadeo, Antonio Mantegazza, Antonio della Porta, Cristoforo Solari, Benedetto Briosco and others. The *New Testament* panels are attributable to Antonio della Porta, Antonio Mantegazza and others, while the statues flanking them were also made in the 1490s by followers of Amadeo and Antonio Mantegazza. The four elaborate façade windows, installed by 1497, contain reliefs and statuettes by several sculptors of the same school.

Amadeo resigned from the façade project in 1499, having already made the socle reliefs for the façade portal in collaboration with Benedetto Briosco. Briosco continued the portal with the assistance of the da Sesto brothers and Biagio Vairone, finishing most of it by 1506. The pilaster-panels flanking the portal, with portraits of bishop saints, were carved *c.* 1506–07 by Biagio Vairone and Giovanni Stefano da Sesto. Many of the statues and roundels with saints and prophets were executed between 1510 and 1523 by Briosco, Antonio della Porta, and the da Sesto brothers.

After the French invasion of Lombardy in 1523, no further important sculptural work was done at the Certosa until 1550, when a contract to finish the façade was made with Giovanni Orsolino and Jacopo Orsolino according to designs by Cristoforo Lombardo. Angelo Marini (*fl* 1550–84) made 15 statues between 1554 and 1559, most of which are identifiable on the façade.

BIBLIOGRAPHY

A. G. Meyer: *Oberitalienische Frührenaissance: Bauten und Bildwerke der Lombardei*, 2 vols (Berlin, 1897–1900)

F. Malaguzzi-Valeri: *Gio. Antonio Amadeo: scultore e architetto lombardo, 1447–1522* (Bergamo, 1904)

G. Treccani degli Alfieri, ed.: *Storia di Milano*, vii (Milan, 1956), pp. 691–746

M. G. Albertini Ottolenghi, R. Bossaglia and F. R. Pesenti: *La Certosa di Pavia* (Milan, 1968)

J. G. Bernstein: *The Architectural Sculpture of the Cloisters of the Certosa di Pavia* (diss., New York U., Inst. F.A., 1972)

C. R. Morscheck jr: *Relief Sculpture for the Façade of the Certosa di Pavia, 1473–1499* (New York and London, 1978)

——: 'Early Works by Cristoforo Solari for the Certosa di Pavia', *La scultura decorativa del primo rinascimento: Atti del I Convegno Internazionale di Studi: Pavia, 1980*, pp. 123–8

M. G. Albertini Ottolenghi: 'Per i Mantegazza: Note sui capitelli pensili dei chiostri della Certosa di Pavia', *La scultura decorativa del primo rinascimento: Atti del I Convegno Internazionale di Studi: Pavia, 1980*, pp. 113–21

R. Schofield: 'Giovanni Ridolfi's Description of the Façade of the Certosa di Pavia', *La scultura decorativa del primo rinascimento: Atti del I Convegno Internazionale di Studi: Pavia, 1980*, pp. 95–102

C. R. Morscheck jr: 'Keystones by Amadeo and Cristoforo Mantegazza in the Church of the Certosa di Pavia', *A. Lombarda*, 78/79 (1984), pp. 27–37

R. Schofield and A. Burnett: 'The Medallions of the *Basamento* of the Certosa di Pavia. Sources and Influence', *A. Lombarda*, 120 (1997), pp. 5–28

C. R. Morscheck jr: 'The Certosa Medallions in Perspective', *A. Lombarda*, 123 (1998), pp. 5–10

CHARLES R. MORSCHECK JR

Pavia, Belbello da. *See* BELBELLO DA PAVIA.

Pazzi. Italian family of merchants, bankers and patrons. They were established as merchants in Florence by the late 13th century. Andrea di Guglielmo Pazzi (1372–1445) made his fortune as a banker, initially working for the Medici bank in Rome in the 1420s (*see* MEDICI, DE'), and had a successful diplomatic and political career. When René I, King of Naples (*reg* 1434–80), came to Florence in 1442, he stayed with the Pazzi and conferred a knighthood on Andrea. Andrea's major artistic commission was the Pazzi Chapel, Florence, traditionally thought to have been designed by Filippo Brunelleschi (*see* BRUNELLESCHI, FILIPPO, §I, 1(v) and figs 4, 5 and 6), though Trachtenberg has argued in favour of an alternative attribution to MICHELOZZO DI BARTOLOMEO. In 1429 Andrea Pazzi made a contract with the friars of the church of Santa Croce (*see* FLORENCE, §IV, 4) to rebuild their chapter house, which would also serve as a family chapel for the Pazzi. He deposited funds with the Florentine public debt (*monte comune*) so that the interest could be spent on the chapel. The main structure of the chapel was established during Andrea's lifetime since the date 10 May 1443 is inscribed on one of the walls. It is likely that Luca della Robbia began the roundels of *Apostles* on the chapel walls (*see* ROBBIA, DELLA, (1), fig. 2) before the deaths of Andrea Pazzi and Brunelleschi.

By 1457 Andrea's heirs were members of the wealthiest family in Florence after the Medici. His three sons, Antonio Pazzi (1412–1450/8), Piero Pazzi (1416–*c.* 1465) and Jacopo Pazzi (1422–78), were active patrons of the arts. Antonio seems to have taken over the chapel project first. His enthusiasm for antiquity is attested by the accusation in 1447 that he had stolen slabs of ancient porphyry in Rome. Piero, who received a humanist education, commissioned fine manuscripts and kept scribes in his service. He inherited the Castello del Trebbio, north-east of Florence, and probably rebuilt the courtyard. The fresco by an assistant of Andrea Castagno of the *Virgin and Child with SS Jerome and John the Baptist* (Florence, Pitti), with portraits of two children identified as Piero's daughter Oretta Pazzi (*b* 1437) and his son Renato Pazzi (1442–78), was originally in a chapel of the castle.

After the death of Antonio, his younger brother Jacopo was in charge of the completion of the Pazzi Chapel while also proceeding with two other architectural schemes. Jacopo had inherited the family house on the south side of the Canto de' Pazzi (where the modern Via del Proconsolo meets the Borgo degli Albizi), and between *c.* 1458 and *c.* 1469 he demolished it and built a magnificent new palace (now Palazzo Pazzi–Quaratesi) on the site. Emblems of the Pazzi family are incorporated into the architecture, with sails of fortune on the windows of the façade and dolphins forming the volutes of the capitals in the courtyard. Jacopo also renovated his villa at Montughi (now Villa La Loggia, Via Bolognese). Documentary and visual evidence points to Giuliano da Maiano (*see* MAIANO, DA, (1)) as the architect for both projects. A pair of roundels by Luca della Robbia with the arms of Jacopo and his wife Maddalena Serristori that were still in the palace in the 19th century are now in the Palazzo Serristori, Florence, while the one with the arms of René I from the

villa at Montughi is now in the Victoria and Albert Museum, London.

In 1478 Jacopo was persuaded by his nephew Francesco d'Antonio Pazzi, with the support of Pope Sixtus IV and Ferdinand I, King of Naples (*reg* 1458–94), to participate in a conspiracy against the Medici. His violent death and the gruesome treatment of his corpse were in sharp contrast to the great respect and honour he had previously enjoyed in the city.

BIBLIOGRAPHY

V. da Bisticci: *Vite di uomini illustri del secolo XV* (1480s; Bologna, Bib. U., MS. 1452), ed. A. Greco (Florence, 1970); Eng. trans. by W. G. Waters and E. Waters as *Renaissance Princes, Popes and Prelates: The Vespasiano Memoirs* (London, 1926/*R* New York, 1963)

P. Litta: *Famiglie celebri italiane* (Milan, 1819–99), iv

A. Moscato: *Il Palazzo Pazzi a Firenze* (Rome, 1963)

H. Saalman: 'The Authorship of the Pazzi Palace', *A. Bull.*, xlvi (1964), pp. 388–94

V. Herzner: 'Die Segel-Imprese der Familie Pazzi', *Mitt. Ksthist. Inst. Florenz*, xix (1975), pp. 13–32

J. Pope-Hennessy: *Luca della Robbia* (Oxford, 1980)

M. Haines: *The 'Sacrestia delle Messe' of the Florentine Cathedral* (Florence, 1983)

H. Saalman: *Filippo Brunelleschi. The Buildings* (London, 1993)

M. Trachtenberg: 'Why the Pazzi Chapel is not by Brunelleschi', *Casabella*, lx (1996), pl. 58–77

——: 'Michelozzo and the Pazzi Chapel', *Casabella*, lxi (1997), pp. 56–75

AMANDA LILLIE

Pedrini, Giovanni. *See under* RIZZOLI, GIOVANNI PIETRO.

Pela, il. *See* LAMBERTI, (1).

Pellegrini. *See* TIBALDI.

Pellegrino da San Daniele [Martino da Udine] (*b* Udine or San Daniele del Friuli (Udine), 1467; *d* Udine, 17 Dec 1547). Italian painter. He trained in Udine and by 1490 was already a master. He was influenced by Giovanni Bellini, Vittore Carpaccio, Giovanni Battista Cima and Bartolommeo Montagna. His earliest surviving work is a *Virgin and Child Enthroned* (Udine, Mus. Civ.), painted in 1494 for the parish church of Osoppo (Udine). In 1497 he began the frescoes, including episodes from the *Life of Christ*, for S Antonio Abate at San Daniele del Friuli. Works executed between 1500 and 1503 include the altarpiece of *St Joseph* for Udine Cathedral and the polyptych of saints for the main altar of the basilica of Aquileia.

From 1503 to 1513 Pellegrino was painter to the Este court at Ferrara, where he worked for Ercole I, Alfonso I, Cardinal Ippolito I and Lucrezia Borgia. His works from this period, all lost or untraced, included scenery, notably for the first performance of Ludovico Ariosto's *La cassaria*, in 1508. He also supervised the decoration of the Este theatre and, with Bernardino Fiorini (*fl* 1505, *bur* 23 Dec 1523), painted the frescoes in the loggias of the Archbishop's Palace at Ferrara.

On his return to Friuli, Pellegrino continued the fresco decoration in S Antonio Abate, completed in 1522. He also painted an altarpiece of the *Virgin Enthroned between SS Roch and Sebastian* (1514–15; Udine, Pal. Arcivescovile), an *Annunciation* (1519; Udine, Mus. Civ.) and the organ doors for Udine Cathedral (1519–21). His last extant work is a polyptych of the *Virgin and Child Enthroned* (1526–

8; Cividale del Friuli, Mus. Archeol. N.), painted with the assistance of his pupil Sebastiano Florigerio. In the past, writers have been generous in their attributions to Pellegrino, but a more accurate assessment of his oeuvre has now been established, based on documents and the many surviving works.

BIBLIOGRAPHY

G. Vasari: *Vite* (1550, rev. 2/1568); ed. G. Milanesi (1878–85), v, pp. 105–7
J. A. Crowe and G. B. Cavalcaselle: *A History of Painting in North Italy*, 2 vols (London, 1871); rev. T. Borenius, 3 vols (London, 1912), iii, pp. 81–110
A. Tempestini: *Martino da Udine detto Pellegrino da San Daniele* (Udine, 1979)
M. Bonelli and R. Fabiani: *Pellegrino da San Daniele del Friuli: Gli affreschi di Sant'Antonio Abate* (Milan, 1988)
G. Fossaluzza: 'Pittori friulani alla bottega di Alvise Vivarini e del Cima', *Saggi & Mem. Stor. A.*, xx (1996), pp. 35–94
A. Tempestini: 'Pellegrino da San Daniele tra '400 e maniera moderna', *Quad. Guarneriani*, n.s., i (1998), pp. 5–19
——: 'La *Sacra Conversazione* nella pittura veneta dal 1500 al 1516', *La pittura nel Veneto: Il Cinquecento*, iii (Milan, 1999) (in preparation)

ANCHISE TEMPESTINI

Pellipario, Nicolò. *See* NICOLA DA URBINO.

Peloro [Pelori], Giovanni Battista (*b* Siena, 1483; *d* ?Rome, 1558). Italian architect and sculptor. He was probably trained as a sculptor; Vannuccio Biringucci's *Pirotechnia* (Venice, 1550) refers to his invention of a papier-mâché technique for copying ancient sculpture. He may also have been trained in architecture, since he is referred to by Vasari as Baldassare Peruzzi's 'creation'. Although Peloro worked primarily as a military architect, two works of civil architecture can be securely attributed to him: the fish-pond at the monastery of Monte Oliveto Maggiore (1532) and the interior of the church of S Martino, Siena (1537). The latter has a single, barrel-vaulted nave and a severe Doric order and orthodox frieze; it is clearly the work of a distinguished designer, well trained in the Roman idiom of Bramante and Antonio da Sangallo the younger.

Peloro served the Sienese government extensively as ambassador to Genoa (1526) and Spain (1528–9), and as a fortifications expert. He was Commissioner of the Fortifications at Sinalunga in 1542–5. On behalf of the Sienese, he travelled to the imperial court in Augsburg in 1549. Three years later he was appointed architect to the Sienese Republic, although he had been waiting in Florence hoping for work from Cosimo de' Medici (soon to be Siena's enemy). Peloro had major responsibility for the Sienese defences against Cosimo and the Habsburg army (1552–5), notably the design of the defences for the Camollia ridge (1553). He also provided plans and oversaw work on the fortifications of many smaller towns in the Sienese Republic, such as Lucignano, Monticchiello, Montalcino and Chiusi. Although Peloro was a man of wide-ranging talents, Vasari says that he specialized in mathematics. His career is poorly chronicled, and some Sienese sources confuse him with a Roman mason/architect with the same Christian names who was responsible for the Spanish Citadel in Siena (1550).

BIBLIOGRAPHY

G. Vasari: *Vite* (1550, rev. 2/1568); ed. G. Milanesi (1878–85), iv, pp. 608–9
E. Romagnoli: *Biografia cronologica de' bellartisti senesi, 1200–1800* (MS.; 1835), vi (Siena, 1835/*R* Florence, 1976), pp. 385–490
I Medici e lo stato senese, 1555–1609: Storia e territorio (exh. cat. by L. Rombai and others, Grosseto, Mus. Archeol., 1980), p. 105
N. Adams and S. Pepper: *Firearms and Fortifications: Military Architecture and Siege Warfare in Sixteenth-century Siena* (Chicago, 1986), pp. 81, 173, 190, 193

NICHOLAS ADAMS

Pennacchi, Girolamo di Giovanni. *See under* GIROLAMO DA TREVISO (i).

Pennacchi, Pier Maria (*b* ?Treviso, 1464; *d* Treviso, before 15 March 1515). Italian painter. He was a significant figure in the artistic life of Treviso, and, as he is recorded there almost annually from 1483, he could not have been a pupil with Giovanni Bellini in Venice from 1490 to 1500, as has been suggested. Many works by him are documented, the earliest in 1495, but only one documented work survives: the fresco of *Christ* in the semi-dome of the chapel of the Santissimo in Treviso Cathedral, commissioned in 1511. The chronology of his oeuvre is thus highly problematic. Among his presumed early works were the *Virgin and Child with Saints*, influenced by Girolamo da Treviso the elder and Antonello da Messina, and the *Dead Christ with Angels* (both Berlin, Kaiser-Friedrich Mus.; both destr.). These reflected northern art, including engravings by Albrecht Dürer (1471–1528). His works from the early 16th century probably include the *Sacra conversazione* (Treviso, Mus. Civ. Bailo), *Christ the Redeemer* (Parma, G.N.), the *Virgin and Child with Donor* (Venice, Ca' d'Oro) and the *Holy Family with Donor* (Bassano, Mus. Civ.). The attribution of the ceiling of S Maria dei Miracoli, Venice, considered a very late work, is uncertain. The iconography lacks unity, and it is difficult to identify Pennacchi's hand. In addition to the influences of Bellini, Antonello and Girolamo, his secure works reflect northern and Lombard elements and early paintings by Lorenzo Lotto. The use of colour in such late works as the *Death of the Virgin* (Venice, Accad.) shows a knowledge of Giorgione.

BIBLIOGRAPHY

V. Sgarbi: 'Pier Maria Pennacchi e Lorenzo Lotto', *Prospettiva*, x (10 July 1977), pp. 39–50
——: 'Il fregio di Castelfranco e la cultura bramantesca', *Giorgione. Atti del convegno: Castelfranco, 1979*, pp. 273–89
G. Nepi Scirè: 'Pier Maria Pennacchi, regesti, documenti e proposte', *Boll. A.*, vi (1980), pp. 37–48
——: 'Il pittore trevigiano Pier Maria Pennacchi', *Lorenzo Lotto. Atti del convegno: Venice, 1981*, pp. 37–42
E. Negro: 'Pier Maria Pennachi', *La pittura nel Veneto: Il quattrocento*, ed. M. Lucco, ii (Milan, 1990)

GIOVANNA NEPI SCIRÈ

Penni. Italian family of artists.

(1) Giovan Francesco Penni [il Fattore] (*b* Florence, *c.* 1496; *d* Naples, after 1528). Painter and draughtsman. He worked for Raphael in Rome, possibly as early as 1510–11; some drawings datable to this period are either later copies of designs by Raphael, or were drawn by Penni on behalf of his master. According to Vasari, his role in Raphael's workshop was that of secretary, hence his nickname Fattore. He was responsible for working up Raphael's ideas and showed great skill at imitating his style. In 1515–16 he assisted in the preparation of the cartoons

(Royal Col., on loan to London, V&A) for the Vatican tapestries (Rome, Pin. Vaticana), and subsequently with the work (1516) for the *stufetta* (bathroom) and *loggetta* for Cardinal Bibbiena. Both *Venus Rising from the Waves* and *Minerva and Vulcan* (*in situ*) correspond to what is known of Penni's own work.

During work on the Vatican Loggie (1518–19) of Leo X, Penni's role increased in importance. He demonstrated such affinity with Raphael that the attribution of many drawings oscillates between the two. Vasari confirmed Penni's role in the work on the Loggie: he was responsible for giving final form to Raphael's ideas and then passing on these *modelli* to the various assistants. The scenes (*in situ*) depicting *God Separating the Land from the Waters*, *Abraham and the Angels* and *Joseph Explaining Pharaoh's Dreams* are almost certainly by his own hand.

In addition to Penni's role in the Loggie scenes, scholars have identified his hand in other works from Raphael's workshop: the *Madonna of the Fish*, the *Spasimo di Sicilia* (*c.* 1516) and the Branconio *Visitation* (all Madrid, Prado), as well as the *Transfiguration* (1517–20; Rome, Pin. Vaticana). Before 1520 Penni must also have completed the *Holy Family* (Cava dei Tirreni, Mus. Badia Santa Trinità; see fig.). The original composition recalls Raphael's ideas of *c.* 1512–13, when he produced drawings in which the group forming the *Adoration of the Child* was organized in circular format.

After Raphael's death in 1520, Penni collaborated with Giulio Romano in the Sala di Costantino (1521–4; Rome, Vatican) and the Monteluce *Coronation of the Virgin* (1524; Rome, Pin. Vaticana). Under the influence of Giulio, his style became simpler, with a heightened emphasis on chiaroscuro. He followed Giulio to Mantua, where he is recorded in 1528, working at the Palazzo del Te. His attempt to re-establish a partnership with Giulio failed, however, and Penni moved to Naples. As is evident in the modest copy of the *Transfiguration* (Madrid, Prado) begun

Giovan Francesco Penni: *Holy Family*, oil on canvas, tondo, diam. 750 mm, before 1520 (Cava dei Tirreni, Museo della Badia della Santa Trinità di Cava)

in Rome and probably completed on Ischia, his late work is characterized by a crude and dull simplification of the style of his master.

BIBLIOGRAPHY
G. Vasari: *Vite* (1550, rev. 2/1568); ed. G. Milanesi (1878–85), iv, pp. 643–9
F. Hartt: *Giulio Romano*, 2 vols (New Haven, 1958), pp. 42–51, 126–7, 317
P. Pouncey and J. A. Gere: *Italian Drawings in the Department of Prints and Drawings in the British Museum: Raphael and his Circle* (London, 1962)
N. Dacos: *Le Logge di Raffaello: Maestro e bottega di fronte all'antico* (Rome, 1977, rev. 1986)
B. F. Davidson: *Raphael's Bible: A Study of the Vatican Loggie* (London, 1985)
Andrea da Salerno nel rinascimento meridionale (exh. cat., ed. G. Previtali; Padula, Certosa di San Lorenzo, 1986), pp. 108–10 [entry no. 14 by N. Dacos]
G. Briganti, ed.: *La pittura in Italia: Il cinquecento*, 2 vols (Milan, 1988), pp. 424–9, 797
P. Giusti and P. Leone de Castris: *Pittura del cinquecento a Napoli: 1510–1540 forestieri e regnicoli* (Naples, 1988), pp. 61–75
GENNARO TOSCANO

(2) Luca Penni [Romanus] (*b* Florence, 1500–04; *d* Paris, 12 April 1557). Painter and designer, brother of (1) Giovan Francesco Penni. According to Orlandi, he was a pupil of Raphael in Rome. In 1528 he assisted his brother-in-law Perino del Vaga in the decoration of the Palazzo Doria, Genoa. He moved to Paris *c.* 1530 and from 1538 to 1547/8 he worked with Rosso Fiorentino and Primaticcio at Fontainebleau. From *c.* 1544 he executed designs for engravers, including Léon Davent (*fl* 1540–56), Etienne Delaune (*c.* 1519–83) and Giorgio Ghisi, for example Ghisi's *Allegory of Birth* (Paris, Bib. N., B.L.L. 26) and *Calumny of Apelles* (Paris, Bib. N., B.L.L. 27). His designs were widely reproduced by engravers in France, Italy and Flanders.

Although no signed painting survives, his documented works include portraits and religious subjects. Among those paintings attributed to him is the *?Justice of Otto* (Paris, Louvre), a composition comparable to his *Calumny of Apelles* for Giorgio Ghisi. He produced designs for tapestries, and his drawings of the *Story of Diana* (Paris, Ecole B.-A. and Louvre; Rouen, Mus. B.-A.) may have served as models for a set of tapestries of *Diana and Orion* (Anet, Château; New York, Met.; Rouen, Mus. B.-A.) produced for King Henry II (*reg* 1547–59). His son Lorenzo Penni (*b* ?1538) was apprenticed to the engraver René Boyvin (*c.* 1525–*c.* 1625).

BIBLIOGRAPHY
P. A. Orlandi: *Abecedario pittorico* (Bologna, 1704, rev. 1719, 1731, 1753, etc), p. 298
P. Vanaise: 'Nouvelles précisions concernant la biographie et l'oeuvre de Luca Penni', *Gaz. B.-A.*, 67 (1966), pp. 79–90
S. Béguin: 'Un Tableau de Luca Penni', *Rev. Louvre*, xxv/5–6 (1975), pp. 359–66
——: 'Luca Penni peintre: Nouvelles attributions', *Il se rendit en Italie: Etudes offertes à André Chastel* (Paris, 1987), pp. 243–57
K. Wilson-Chevalier: 'Sebastian Brant: The Key to Understanding Luca Penni's *Justice and the Seven Deadly Sins*', *A. Bull.*, lxxviii/2 (June 1996), pp. 236–63

Percaccino. *See* PROCACCINI.

Peregrino da Cesena (*fl c.* 1490–1520). Italian engraver and draughtsman. Among the Italian engravings datable

to c. 1500 is a *Resurrection* known in two different states, the first signed OPVS PEREGRINO and the other DE OPUS PEREGRINI CE⁵. Scholars are generally agreed in accepting this as the signature of Peregrino da Cesena, despite the fact that no artist by this name is known from documents or other sources. About 40 marked engravings have been attributed to Peregrino, and about 35 unsigned or unmarked engravings appear to be by the same hand. Peregrino appears to have been the pupil, in Bologna, of Francesco Francia, to whom are attributed several nielli, which are stylistically close to the works bearing Peregrino's mark. These latter have generally been described as niello prints, but the fact that the inscriptions—as well as the relationship between right and left—are the correct way round, identifies them as proper engravings, albeit executed in the manner of nielli. Certain drawings bound into a volume containing three of Peregrino's engravings (Paris, Louvre, Cab. Estampes) have also been attributed to him.

BIBLIOGRAPHY

E. Dutuit: *Manuel de l'amateur d'estampes*, i (Paris, 1888), pp. 293–333
P. Kristeller: 'R. Pinacoteca di Bologna: Nielli del Francia', *Le gallerie nazionali italiane*, iii (1897), pp. 186–94 (190–91)
A. M. Hind: *Nielli in the British Museum* (London, 1936), pp. 14, 42–60
A. Blum: *Les Nielles du quattrocento* (Paris, 1950), pp. 18–28, 39
L. J. Rosenwald: 'Appendix B: Niello Prints', *Early Italian Engravings from the National Gallery of Art* (Washington, DC, 1973), pp. 528–49
M. J. Zucker: *Early Italian Masters, Commentary (1984)*, 25 [XIII/ii] of *The Illustrated Bartsch*, ed. W. Strauss (New York, 1978–)

MARCO COLLARETA

Peretti. Italian family of ecclesiastics and patrons. They came from the Marches and in the final quarter of the 16th century and the first half of the 17th produced a pope and several cardinals. They were prominent principally in Rome. Felice Peretti was the most important patron of the family; as (1) Pope Sixtus V he began a huge programme of building work between 1585 and 1590. In 1586 he handed over the Villa Montalto (destr.), Rome, which he had started to build, to his sister Camilla Peretti (1519–1605). However, the initiative for the extensions and decorations seems to have come from the Pope himself or from his great-nephew Cardinal Alessandro Peretti–Montalto (1570–1623).

MATTHIAS QUAST

(1) Pope **Sixtus V** [Felice Peretti] (*b* Grottamare, nr Pescara, 13 Dec 1520; elected 25 April 1585; *d* Rome, 27 Aug 1590). Known as the 'Iron Pope', he was a resolute, energetic and ruthless ruler. During his years in Rome before being elected pope, Sixtus V familiarized himself with the main problems besetting the city, both from an administrative point of view and from that of a pilgrim wishing to visit the principal churches. Under Gregory XIII, Sixtus V's predecessor, lawlessness prevailed both in Rome and the Campagna, the treasury was empty and the administration flagging. Sixtus V was elected by an indecisive Sacred College and was not expected to achieve much; but within a short time he had restored order in the papal state, reorganized the central administration and replenished the treasury. He regulated food prices, drained marshes and encouraged agriculture and the wool and silk industries.

Sixtus V's patronage of art and architecture sprang from his belief in the traditional concept of Rome as the seat of all temporal and spiritual power on earth, and he transformed the city more decisively than any other pope in history. The day he took office the Pope ordered the architects Domenico Fontana (1543–1607) and Matteo Castello (1525–1616) to begin the reconstruction of the Acqua Alessandrina, an aqueduct renamed the Acqua Felice in his honour. This provided Rome with a new supply of water. The aqueduct was hailed as a triumph for the papacy. For lack of water all new building in Rome since the early Middle Ages had been concentrated in the low-lying terrain on either side of the Tiber. The new water supply regained Rome's hills and permitted Sixtus to extend the city to the high ground enclosed by the Aurelian walls. The end of the aqueduct at the Baths of Diocletian in the Piazza S Susanna was a wall fountain (1587–8; *in situ*) designed by Domenico Fontana and Giovanni Fontana in the form of a Roman triumphal arch. Its two side niches contain reliefs, *Aaron Leading the Jews to a Well* and *Gideon Leading the Jews over the Jordan*. In the central niche a colossal figure of *Moses Striking the Rock* holds the tablets of the law in one hand and with the other points downward towards the water.

The campaigns of urban planning envisaged and carried out by earlier Renaissance popes, most notably Nicholas V (*reg* 1447–55), Sixtus IV (*reg* 1471–84) and Julius II (*reg* 1503–13), had provided solutions to specific problems of access, traffic and beautification along the Tiber and in the *borgo* (the zone between the Vatican and the Castel Sant'Angelo). The Acqua Felice now made it possible for Sixtus to approach the replanning of Rome on a citywide scale. Under the direction of Domenico Fontana, he laid out a system of straight thoroughfares, with obelisks at their ends as visual guides, linking Rome's principal churches. The first, begun in the summer of 1585 and open to traffic in the autumn of the following year, was the Via Felice, joining S Maria Maggiore and the Trinità dei Monti. It appears, with an extension as far as S Maria del Popolo, in the famous engraving in Giovanni Francesco Mercati's *De rebus praeclare gestis a Sisto V Pont. Max.* (Rome, 1588). The engraving also shows straight roads leading from S Maria Maggiore to S Giovanni in Laterano, Santa Croce in Gerusalemme, S Lorenzo fuori le Mura, S Maria del Popolo and the column of Trajan (not executed because the ruins of the Forum of Trajan were in the way), and from S Giovanni in Laterano to S Paolo fuori le Mura and to the Colosseum. He installed as focal points obelisks surmounted by a cross at S Maria Maggiore (1587), S Giovanni in Laterano (1587) and S Maria del Popolo (1589) and projected an obelisk at Santa Croce in Gerusalemme.

These obelisks were also celebrations of the triumph of Christianity over paganism, in line with Sixtus's desire to subsume ancient monuments to the glorification of the cross. The first and most spectacular implementation of this wish was the installation in front of St Peter's of an obelisk that throughout the Middle Ages had stood next to the basilica's south sacristy. The transport (1586) of the obelisk under the direction of Domenico Fontana covered approximately 4 m a day and took 130 days. Described and illustrated in Fontana's *Della trasportatione dell'obelisco*

(1590), it overshadowed all his other architectural achievements. Before rededicating the obelisk to the faith on 14 September 1586, Sixtus exorcized it and had the sphere at its summit, which was believed to contain the ashes of Julius Caesar, replaced by the *monti* of the papacy, a gilt ten-pronged star and the cross. In the same vein Sixtus had statues of *St Peter* and *St Paul* placed, respectively, on the columns of Trajan (1587) and Marcus Aurelius (1588), and commissioned Tommaso Laureti to decorate the ceiling of the Sala di Costantino in the Vatican with an architectural fresco of the *Triumph of Christian Faith* (1585–6; *in situ*). Aligned with the central axis of the mural's perspective system are a smashed statue of *Mercury* and a Crucifix mounted on the pedestal formerly occupied by the pagan god. In the spirit of the Counter-Reformation, Sixtus preserved those ancient monuments that he could convert to the service of the faith or of which he could make practical use. For example he wanted to transform the Colosseum into a wool factory and home for poor labourers. He restored the *Dioscuri* on the Quirinal Hill, moved them so that they provided a focus for the Via Pia that Pope Pius IV had built between the Montecavallo and Michelangelo's Porta Pia, and placed a fountain in front of them. In 1590 he had the Trophies of Marius transported from a site near S Eusebio to the balustrade of the Campidoglio.

The association between the Pope and Domenico Fontana began 11 years before Sixtus V's election. In 1574, as Cardinal Felice Peretti, he commissioned from Fontana a tomb in S Maria Maggiore for *Pope Nicholas IV*. In 1577 he employed him to design a small mansion in the Piazza Pasquino, then in 1579 to design the Villa Montalto (destr.) on the Esquiline Hill, near S Maria Maggiore, which he used after 1581 as his official residence. It was a three-storey block with an open arcade on the ground-floor, surrounded by a large formal garden and was the first project of its scale and importance on any of Rome's hills since antiquity. The site is occupied today by the Stazione Termine, Rome's main railway station. After Sixtus's elevation to the papacy, Fontana remained in his service and executed all of his architectural commissions except the church of S Girolamo degli Schiavoni (1587–90), designed by Martino Longhi the elder, and the dome of St Peter's (1588–90), which was completed under the direction of Giacomo della Porta. Domenico Fontana, an architect of a practical rather than theoretical bent, and with a preference for the imitation and simplification of proven models, was ideally suited to the Pope's requirements.

At the Lateran, Sixtus V destroyed all medieval structures except the chapel of S Lorenzo, also known as the Sancta Sanctorum, in front of which Fontana designed a two-storey structure with arcades on the façade to house the Scala Santa (1586–9), according to a medieval tradition the staircase of the praetorium of Pontius Pilate that Christ mounted at the time of his trial. Fontana also built three palaces for Sixtus on the model of the Palazzo Farnese in Rome: a new Lateran Palace (1585–9; *see* ROME, §V, 2), a five-storey palace at the Vatican (begun 1580; *see* ROME, §V, 1(iii)), east of Bramante's Cortile di S Damaso, and the Palazzo Quirinale, begun as a villa for Gregory XIII by Ottaviano Mascherino. Fontana designed the Benediction Loggia at S Giovanni in Laterano (1586–8) and directed the construction and decoration of the Sistine Chapel at S Maria Maggiore, which contains the tombs in the form of Roman triumphal arches of *Sixtus V* and his patron *Pius V* (*reg* 1566–72). The chapel has a simple, severe and dignified design, but its interior surfaces are rich in polychromy, with inlaid marbles, many of them taken from antique buildings, mosaics, frescoes, statuary and reliefs.

The public works of Sixtus V's reign are among the subjects of the frescoes with which Cesare Nebbia and Giovanni Guerra decorated the Salone Sisto of the new Vatican Library (1585–9) that Fontana constructed across Bramante's Cortile del Belvedere (*see* BRAMANTE, DONATO, fig. 5 and colour pl. 1, XVI1). To the papal library that had been begun by Nicholas V, Sixtus added his own collection of books, many of them on the history of Rome, its traditions and its divine mission as the centre of Christendom. The murals in the Salone Sisto have an iconographic programme glorifying the achievements of the Pope that was devised by the humanists Federico Ranaldi and Silvio Antoniani. In addition to representing Sixtus's architectural projects, the frescoes depict the nine famous libraries of the world, the inventors of language, the founders of religion and the sixteen ecumenical councils from Nicea to Trent.

BIBLIOGRAPHY

J. D. de Huebner: *Sixte V*, 3 vols (Paris, 1870)

L. von Pastor: *Geschichte der Päpste seit dem Ausgang des Mittelalters* (1886–1933)

E. Stevenson: 'Topografia e monumenti di Roma nelle pitture a fresco di Sisto V della Biblioteca Vaticana', *Al sommo pontificie Leone XIII omaggio giubilare della Biblioteca Vaticana* (Rome, 1887)

J. A. F. Orbaan: 'La Roma di Sisto V negli *avvisi*', *Archv Soc. Roman. Stor. Patria*, xxxiii (1910), pp. 277–312

——: *Sistine Rome* (London, 1911)

A. Dupront: 'Art et contre-réforme: Les Fresques de la bibliothèque de Sixte-Quint', *Mél. Archéol. & Hist.: Ecole Fr. Rome*, xlviii (1931), pp. 282–307

L. M. Persone: *Sisto Quinto* (Florence, 1935)

R. Canestrari: *Sisto V* (Turin, 1954)

K. Schwager: 'Zur Bautätigkeit Sixtus' V. an Santa Maria Maggiore in Rom', *Miscellanea Bibliothecae Hertzianae*, ed. L. Bruhus, F. G. W. Metternich and L. Schudt (Munich, 1961), pp. 324–54

C. D'Onofrio: *Gli obelischi di Roma* (Rome, 1965, rev. 2/1967), pp. 69–202

H. Hibbard: *Carlo Maderno and Roman Architecture, 1580–1630* (London, 1971), pp. 12–38

C. Aikin: *The Capitoline Hill during the Reign of Sixtus V* (diss., Berkeley, U. CA, 1977), pp. 43–72

T. Magnuson: *Rome in the Age of Bernini*, i (Stockholm, 1982), pp. 1–38

R. Schiffmann: *Roma felix: Aspekte der städtebaulichen Gestaltung Roms unter Papst Sixtus V* (Frankfurt am Main, 1985)

H. Wohl: 'New Light on the Artistic Patronage of Sixtus V', *A. Christ.*, lxxx (1992), pp. 123–34

For further bibliography *see* ROME, §II, 3.

HELLMUT WOHL

Perino [Perin] **del Vaga** [Buonaccorsi, Pietro] (*b* Florence, 1501; *d* Rome, 20 Oct 1547). Italian painter and draughtsman. He trained in Florence, first with Andrea de' Ceri and from the age of 11 with Ridolfo Ghirlandaio. According to Vasari, he practised drawing by copying Michelangelo's cartoon for the *Battle of Cascina* (destr.). For Pope Leo X's entry into Florence in November 1515 he painted an allegorical figure on one of the twelve triumphal arches. Soon after, an obscure Florentine painter called Vaga took

Perino to Rome, where he became known as del Vaga. There he continued his drawing studies, copying from works of antiquity and Michelangelo's ceiling in the Sistine Chapel. On the recommendation of Giulio Romano and Giovanni Francesco Penni, he joined Raphael's workshop, where he learnt stuccowork and how to design grotesques, through assisting Giovanni da Udine in the Vatican Logge. Soon he was painting scenes from Raphael's designs, and five or six ceiling frescoes in the Logge, including the *Story of Joshua* and the *Story of David*, are generally accepted as his. Vasari drew particular attention to scenes under the windows that are painted to look like bronze reliefs (badly damaged). Pictures of this kind became a speciality of Perino's. Before the death of Leo X in 1521, he worked with Giovanni da Udine again, on the ceiling frescoes in the Sala dei Pontefici at the Vatican.

Perino also received several private commissions in Rome at this time: a *Lamentation with Woman Donor* (1520–21; S Stefano del Cacco, ruinous); the frescoes in the chapel of the Madonna in S Marcello al Corso (most destr.; preliminary study, London, BM); an altarpiece of the *Deposition* (*c.* 1521–5) for S Maria sopra Minerva (two fragments: the *Good Thief* and the *Bad Thief*, oil on panel, London, Hampton Court, Royal Col.; drawing, London, BM); the Pucci Chapel frescoes in Trinità dei Monti (begun *c.* 1521, continued 1523, completed 1560s by Taddeo and Federico Zuccaro). He also began work on his first major independent commission, decorating the interior of the Palazzo Baldassini, which probably ended in 1525 with the death of his patron, the lawyer Melchiorre Baldassini. The decoration of the *salone* with antique subjects alluding to the patron's profession is particularly noteworthy (part destr., two wall friezes in Florence, Uffizi). After Raphael's death (1520), Perino's prospects declined, and when Leo X was succeeded by the austere Pope Adrian VI (*reg* 1522) in 1522, there was little hope of employment at the papal court. Plague broke out in Rome in the spring of 1522, and Perino returned to Florence. There he designed a wall fresco of the *Martyrdom of the Ten Thousand* for the Camaldoli Compagnia de' Martiri. This never progressed beyond the cartoon (drawing, Vienna, Albertina), which was acclaimed and compared with Michelangelo's *Cascina* cartoon. He left Florence when the plague reached there in 1523, presenting his host, the chaplain of S Lorenzo, with a monochrome canvas of *Moses Commanding the Red Sea* (Florence, Uffizi) that simulates a bronze relief.

Perino spent several months travelling before returning to Rome. In the period between the start of Clement VII's papacy (19 Nov 1523) and the Sack of Rome (6 May 1527) he worked on the frescoes in Pucci Chapel and received many new commissions. In 1525 he married Penni's sister, Caterina. At this time he must have begun his other major chapel decoration of this period, the ceiling frescoes in the chapel of the Crucifixion in S Marcello al Corso (abandoned 1527, resumed in the late 1530s and continued in 1539 or shortly after by Daniele da Volterra; drawings by Perino in Paris, Louvre). During the Sack of Rome, Perino and his wife and daughter were imprisoned, and he had to pay a heavy ransom. Vasari mentioned only one work by him dating from the subsequent period, a series of preparatory drawings for the *Loves of the Gods* (Florence,

Uffizi; London, BM), which were engraved by Giovanni Jacopo Caraglio (B. 9–23).

In 1528 Perino was asked to go to Genoa in the service of Andrea Doria I to redecorate his palazzo at Fassolo (*see* DORIA, (1)). Executed in an energetic and elegant classicist manner, these works were designed to express Doria's role as defender of the republican state, with references to Roman gods and heroes (see colour pl. 2, XIV1). They include the entrance atrium with ceiling frescoes of scenes from Roman history, stuccowork on the stairway, the Loggia degli Eroi depicting ancestors of the Doria family, with ceiling stuccos, and the two large halls with ceiling painting in oil of the *Fall of the Giants* (*in situ*) and the *Shipwreck of Aeneas*, in which Doria was shown as Neptune (destr.). Designs for an unexecuted façade survive (Amsterdam, Rijksmus.; Chantilly, Mus. Condé). Perino employed many assistants in Genoa, including Luca Penni, Luzio Romano, Prospero Fontana and the sculptors Giovanni da Fiesole, Silvio Cosini and Guglielmo della Porta.

Emperor Charles V (*reg* 1519–58) stayed in the palazzo on the occasions of his two entries to Genoa, for which Perino designed triumphal arches (drawings in Berlin, Kupferstichkab.; U. London, Courtauld Inst. Gals). In 1534 he bought a house in Pisa and began work on a decorating commission for the cathedral there (only a few remains extant). In 1536 he was elected one of the two consuls of the Genoese guild of painters. During his decade in Genoa he also undertook a number of religious commissions, notably an altarpiece of the *Nativity*, the Pala Baciadonne, from S Maria della Consolazione, dated 1534 (panel transferred to canvas; Washington, DC, N.G.A.), a polyptych of *St Michael* (Celle Ligure, S Michele) and a polyptych of *St Erasmus* (Genoa, Mus. Accad. Ligustica B.A.). The conservatism of these religious works contrasts strongly with the Palazzo Doria decorations, which suggests that the sophisticated Roman style introduced by Perino did not find favour with other Genoese patrons.

Back in Rome by 1538 at the latest, Perino painted a frieze in the Palazzo Massimo alle Colonne and decorated the Massimi Chapel (destr.; one fresco in London, V&A) in Trinità dei Monti. Cardinal Alessandro Farnese, nephew of Pope Paul III, commissioned him to design engraved crystal plaques for a gilded silver casket (Naples, Capodimonte). This brought him to the attention of the Pope, who ordered decorations for the *spalliera* below Michelangelo's *Last Judgement* (tempera on canvas; Rome, Gal. Spada) and for the *basamento* of Raphael's frescoes in the Stanza della Segnatura. The stanza *basamento* is in the form of simulated bronze reliefs. Paul III also commissioned him to paint the ceiling of the Sala Regia in the Vatican from 1542 and to decorate the papal suite at Castel Sant'Angelo starting in 1545. The work at Sala Regia offered Perino the possibility of creating a monumental narrative series in the tradition of Raphael, but due to his preoccupation with the Castel Sant'Angelo decorations only the stuccowork was executed. He employed many assistants at Castel Sant'Angelo, including Marco Pino, Luzio Romano, Pellegrino Tibaldi and Girolamo Siciolante. In the vast Sala Paolina (see fig.) the decorative programme refers to Pope Paul by depicting those who

Perino del Vaga: *Alexander the Great Consecrating the Twelve Altars* (*c.* 1546), fresco, Sala Paolina, Museo Nazionale di Castel Sant'Angelo, Rome

shared his names (the Apostle Paul and Alexander the Great) or were associated with Castel Sant'Angelo before him (Emperor Hadrian and the Archangel Michael). Both the fictive architectural setting and the muscular figures show the influence of Michelangelo, but there is an innovative integration of the narrative scenes with their decorative framework more akin to the school of Fontainebleau. The Sala Paolina is the culmination of the development of the Mannerist decorative style, in which Perino played a major role, providing a formative example for the next generation.

BIBLIOGRAPHY

DBI: 'Buonaccorsi, Pietro'; Thieme–Becker: 'Vaga, eigentlich Pietro Buonaccorsi'

G. Vasari: *Vite* (1550, rev. 2/1568); ed. G. Milanesi (1878–85), v, pp. 587–632

G. Baglione: *Vite* (1642); ed. V. Mariani (1935), pp. 13, 19–20, 23, 30–31, 151

A. von Bartsch: *Le Peintre-graveur* (1803–21), xv [B.]

G. Fiocco: 'La Cappella del Crocifisso in San Marcello', *Boll. A.*, vii (1913), pp. 87–94

A. E. Popham: 'On Some Works by Perino del Vaga', *Burl. Mag.*, lxxxvi (1945), pp. 56–66

——: 'Sogliani and Perino del Vaga at Pisa', *Burl. Mag.*, lxxxvi (1945), pp. 85–90

P. Askew: 'Perino del Vaga's Decorations for the Palazzo Doria, Genoa', *Burl. Mag.*, xcviii (1956), pp. 46–53

J. A. Gere: 'Two Late Fresco Cycles by Perino del Vaga: The Massimi Chapel and the Sala Paolina', *Burl. Mag.*, cii (1960), pp. 9–19

M. V. Brugnoli: 'Gli affreschi di Perin del Vaga nella Cappella Pucci', *Boll. A.*, xlvii (1962), pp. 327–50

Mostra di disegni di Perino del Vaga e la sua cerchia (exh. cat., ed. B. Davidson; Florence, Uffizi, 1966)

R. Harprath: *Papst Paul III. als Alexander der Grosse: Das Freskenprogramm der Sala Paolina in der Engelsburg* (Berlin and New York, 1978); review by L. Partridge in *A. Bull.*, lxii (1980), pp. 661–3

Gli affreschi di Paolo III a Castel Sant'Angelo: Progetto ed esecuzione, 2 vols (exh. cat., ed. F. M. Aliberti Gaudioso, E. Gaudioso and others; Rome, Mus. N. Castel Sant'Angelo, 1981–2)

E. Parma Armani: *Perino del Vaga, l'anello mancante: Studi sul manierismo* (Genoa, 1986); review by L. Wolk-Simon in *A. Bull.*, lxxi (1989), pp. 515–23

P. Boccardo: *Andrea Doria e le arti* (Milan, 1989)

RICHARD HARPRATH

Perugia [anc. Perusia]. Italian hilltop city and capital of Umbria. Situated *c.* 80 km south-east of Arezzo and *c.* 170 km north of Rome, the city stands on the hills above the River Tiber. An important medieval city, Perugia was also the chief centre of Umbrian painting, particularly in the 15th century.

Although traces of prehistoric settlements have been found in Perugia, significant urban development began only under Etruscan domination from about the 6th century BC. As Perusia it became one of 12 cities of the Etruscan league and was the last to be engulfed by the expansion of Roman influence. Perugia received Roman citizenship in 90 BC but was destroyed after a siege in 40 BC during the struggles for power in Rome. It was rebuilt by Emperor Augustus, who renamed the city Augusta Perusia.

The existence of the Early Christian Diocese of Perugia was recorded in the 5th century AD, and in the following century its bishop was invested with civic as well as religious authority. In AD 548 the city fell to the Goths under Totila, and Bishop Ercolano, who later became the city's patron, suffered martyrdom. Subsequently, Perugia returned to Byzantine rule, becoming a strategic stronghold between Rome and Ravenna. After AD 1000 Perugia benefited from the general revival of Umbria. It is recorded as a free *comune* in 1139 and soon began to dominate the surrounding towns, spreading its influence to the west, north and east. It became more closely aligned with Rome and the papal cause, and in 1198 Innocent III became its protector. Throughout the 13th century its power increased. The town outgrew its old fortifications, and new suburbs appeared along the access roads, which followed the ridge of the surrounding hills. In addition to agriculture, new commercial activities and industries developed, producing a new group of middle-class artisans who soon became dominant and, together with the upper middle classes, formed the Repubblica delle Arti, which lasted until the early 15th century and sought to maintain the political and economic autonomy of the city. Towards the end of the 13th century the university was founded, achieving official recognition by Clement V (*reg* 1305–16) in 1308. At that time the city had a population of *c.* 28,000, with a further 45,000 in the surrounding countryside.

During the 14th century both the climax and the downfall of the free *comune* of Perugia took place. Its expansion necessitated the construction of a second city wall to protect the suburbs, producing the city's characteristic star-shaped plan. Artistic and commercial life continued to develop, and painting flourished, particularly the art of miniatures. The plague of 1348, however, and the gradual restoration of ecclesiastical power heralded Perugia's decline. The second half of the 14th century was marked by increasing conflict, both internally, between the nobles and the people, and externally. Under the Treaty

of Bologna (1370), Perugia formally recognized its subservience to papal rule; it rebelled again but never regained the social and economic stability that had made it one of the principal cities in medieval Italy. Instead, social and political conflict continued into the early years of the 15th century, when Braccio Fortebraccio conquered the city (1416). After his death (1424), the Baglioni family achieved pre-eminence. During this period building work continued, notably on the cathedral and the Palazzo dei Priori, together with the sumptuous headquarters of the two major guilds: the Collegio del Cambio (bankers) and the Collegio della Mercanzia (merchants). The new palace of the Studium (Università Vecchia; 1453) was built in the Piazza del Sopramuro (now Piazza Matteotti) to the designs of Gasparino di Antonio (*fl* 1473–81) and Bartolomeo Mattioli di Torgiano (*d* 1473). AGOSTINO DI DUCCIO built the ornate, sculpted façade of the Renaissance oratory of S Bernardino (1457–61) and the Porta S Pietro (1475–80; unfinished), an elegant example of a Renaissance city gate. Several important painters also worked in Perugia's churches in the 15th century, including FRA ANGELICO, who painted the Guidalotti Altarpiece (*c.* 1437) in S Domenico; PIERO DELLA FRANCESCA, who painted the *Virgin and Child between SS Anthony of Padua, John the Baptist, Francis and Elizabeth of Hungary* (before 1447; Perugia, G.N. Umbria) for S Antonio delle Monache; and Domenico Veneziano, who painted a series of frescoes (1438; fragments Perugia, G.N. Umbria) for the Palazzo Baglioni (destr. 1540).

In the late 15th century an important local school of painting developed in Perugia, its principal exponents including BENEDETTO BONFIGLI, Bartolomeo Caporali (*see* CAPORALI, (1)), FIORENZO DI LORENZO, BERNARDINO PINTURICCHIO and PERUGINO. Many works by Perugino survive in Perugia, the most important being the fresco decoration (1496–1500) in the Sala dell'Udienza of the Collegio del Cambio, where he produced one of the most extensive iconographic displays of the Renaissance period. One of Perugino's pupils was Raphael, who established himself in Perugia from 1500 to 1504, producing a series of altarpieces that were later exported to various museums in Italy and abroad. The only work by Raphael remaining in Perugia is a fresco of the *Trinity* (1505) for the church of S Severo (*see* RAPHAEL, §II).

In 1540 Pope Paul III occupied Perugia to reassert papal authority, destroying the Baglioni family buildings together with a substantial quarter of the city. In their place he built a large fortress, the Rocca Paolina (1540–43; destr. 1860), to designs by Antonio da Sangallo (ii); this remarkable monument, full of costly works of art, was embellished with the Etruscan Porta Marzia. GALEAZZO ALESSI was also active in Perugia in the 1540s, his buildings including the Loggia dell'Angelo della Pace (1545–8) and the church of S Maria del Popolo (1547). Art life in the city was stimulated by Vincenzio Danti (*see* DANTI, (1)), who became city architect in 1573 and in the same year helped to establish the Accademia del Disegno. However, papal domination of Perugia, which lasted for more than three centuries, eventually led to economic, social and cultural stagnation. The artists' guilds lost their independence, and there was a halt in population growth: for three

centuries the city remained within the limits of the 14th-century walls. At this time the 12th-century tower houses, with the exception of the Torre degli Sciri in Via dei Priori, were demolished, and several Mannerist and Baroque palaces were incorporated into the medieval fabric of the city.

BIBLIOGRAPHY

C. Pellini: *Dell'historia di Perugia*, 2 vols (Venice, 1664/*R* Bologna, 1968, 3/Perugia, 1970)

S. Siepi: *Descrizione topologica-istorica della città di Perugia* (Perugia, 1822)

L. Bonazzi: *Storia di Perugia* (Perugia, 1875)

U. Gnoli: *Pittori e miniatori nell'Umbria* (Spoleto, 1923)

U. Tarchi: *L'arte nell'Umbria e nella Sabina*, 4 vols (Milan, 1936–40); *Appendix* (Milan, 1956)

F. Santi: *La Galleria Nazionale dell'Umbria*, 2 vols (Rome, 1969–85)

A. Grohomann: *Città e territorio tra medioevo ed età moderna: Perugia sec. XIII–XVI* (Perugia, 1981)

P. SCARPELLINI

Perugino [Vannucci, Pietro di Cristoforo] (*b* Città della Pieve, *c.* 1450; *d* Fontignano, ?Feb 1523). Italian painter and draughtsman. He was active in Perugia, Florence and Rome in the late 15th century and early 16th. Although he is now known mainly as the teacher of Raphael, he made a significant contribution to the development of painting from the style of the early Renaissance to the High Renaissance. The compositional model he introduced, combining the Florentine figural style with an Umbrian use of structure and space, was taken up by Raphael and became widely influential throughout Europe.

I. Life and work. II. Character and personality. III. Critical reception and posthumous reputation.

I. Life and work.

1. To 1478. 2. *c.* 1479–82. 3. 1482–*c.* 1495. 4. *c.* 1495–1500. 5. 1500–23.

1. TO 1478. It is generally accepted that Perugino was born about 1450. The verse chronicle by Giovanni Santi, Raphael's father, states that he was the same age as Leonardo da Vinci, who was born in 1452. Documents show that by 1469 he was old enough to pay taxes and that in 1472 he was a member of the Florentine artists' guild, the Compagnia di S Luca. In 1475 he received payments for works (destr.) in the council chamber of the Palazzo dei Priori in Perugia. According to Vasari, he trained first in the workshop of an insignificant painter from Perugia and then moved to Florence, where in the studio of Andrea Verrocchio he met other artists, including Leonardo. In his life of Piero della Francesca, Vasari mentioned that Perugino was Piero's pupil and ascribed some paintings in Arezzo to him. There is no agreement as to whether he was taught by Piero before or after his training in Florence (Oberhuber, 1978; Scarpellini).

The earliest works attributed to Perugino, which date from the 1470s, show the influence of both masters: the figural style recalls Verrocchio, particularly the elegant poses and affected gestures, while the structural organization and the bright, luminous palette, especially in the frescoes, may derive from Piero. In the over 500 documents on Perugino (Canuti, 1931) there is little mention of his early works, and few of these are extant. Most of his 60–70 surviving drawings (e.g. Florence, Uffizi; London, BM) date from the earlier part of his career, however, thus helping the reconstruction of that period (Fischel,

1917). Works attributed to him from the 1470s include two of eight small panels by various artists illustrating scenes from the *Life of St Bernardino of Siena* (Perugia, G.N. Umbria).

The panels, perhaps originally ten in number, decorated a cupboard or recess housing the processional banner of St Bernardino (Santi, 1963) in the oratory of S Bernardino, Perugia. The scenes ascribed to Perugino depict the *Healing of Giovanni Antonio da Rieti's Daughter*, inscribed 1473, and the *Curing of a Blind Man* (Riccardo di Micuzio dall'Aquila). The architectonic design, with great emphasis on decorative detail, and the affected figural style are completely consonant with other early works attributed to him such as *St Peter* (Hannover, Niedersächs. Landesmus.), the predella panels of *St Jerome* and *Christ in the Tomb* (both Paris, Louvre) and the *Lamentation* (Perugia, G.N. Umbria). He also may have been involved in the overall planning of the *St Bernardino* scenes; the panels he painted contain important elements, namely the date and the possible identification of the donor, in the medallions on the second small panel (Vasco).

Perugino's *Adoration of the Magi* (Perugia, G.N. Umbria), painted for the church of the Servites in Colle Landone and transferred to S Maria Nuova, Perugia, after 1542, is generally dated *c.* 1475 (a date supported by the self-portrait included). This is the first work in his early monumental style: confident design influenced by Verrocchio is coupled with a structural approach to composing figures in a sculptural landscape typical of Umbrian painters. The strong use of local colour and the dense surface treatment make the figures and objects almost appear to be made of wood and heighten the sense of realism. Another signed work, datable to 1478 (Scarpellini; Wood), is

the fresco of *SS Roch, Sebastian and Peter* for the parish church in Cerqueto, which survives only in fragments (*in situ*). This was once regarded as the key work of Perugino's early period, although it already shows the qualities he displayed with such mastery a few years later in his frescoes in the Sistine Chapel (Rome, Vatican): clear, confident figure drawing and bright, festive colouring.

2. *c.* 1479–82. In Rome *c.* 1479 Perugino executed a fresco in Pope Sixtus IV's Cappella della Concezione in Old St Peter's. The work was destroyed, probably when the church was rebuilt, but, according to documents, it depicted the *Virgin and Child with Angels*; on the Virgin's left were St Peter and St Francis presenting the kneeling Pope Sixtus IV, and St Paul and St Anthony of Padua were on her right. The Pope was evidently pleased with this painting as he immediately engaged Perugino to work on the decoration of the recently restored Sistine Chapel. Although, according to Vasari, Sandro Botticelli was responsible for the overall decorative scheme of the chapel, surviving documents and stylistic indications in the plan suggest that Perugino not only made the main contribution to the execution of the decoration but perhaps also planned it.

The walls of the chapel are divided horizontally into three sections: in the plinth area painted pilasters define bays containing fictive tapestries; above them, also flanked by pilasters, are scenes depicting stories from the Old and New Testaments, and above these, at the sides of the double windows, is a series of martyr popes. Perugino's paintings on the altar wall were destroyed in preparation for Michelangelo's *Last Judgement* (see colour pl. 2, VII3). The altarpiece depicted the *Assumption of the Virgin* and

1. Perugino: *Christ Giving the Keys to St Peter* (*c.* 1480–82), fresco, Sistine Chapel, Vatican, Rome

included a kneeling figure of Sixtus IV; it is recorded in a drawing (Vienna, Albertina). Above it, according to Vasari, were the *Birth of Christ* on the right and the *Finding of Moses* on the left. He also painted the two immediately adjacent scenes on the long walls, as well as the thematically most important fresco, *Christ Giving the Keys to St Peter* (see fig. 1), and was involved in painting the portraits of the popes (Ferino Pagden, 1985).

It is possible that Perugino was originally commissioned to carry out the decoration of the chapel on his own and that other artists were brought in at a later stage. In a contract dated October 1481, Botticelli, Domenico Ghirlandaio and Cosimo Rosselli undertook to paint ten frescoes by 15 March 1482. No doubt in order to complete the project in time, Luca Signorelli and Bartolomeo della Gatta were engaged to collaborate on the last scenes. According to a eulogistic poem, the painting of the chapel was completed by the spring of 1482 (Monfasani), and this account is supported by the fact that Botticelli, Ghirlandaio and Perugino were working on other projects in Florence in the autumn of 1482.

The scenes of the *Circumcision of Moses*, the *Baptism* and *Christ Giving the Keys to St Peter* show Perugino's feeling for clear compositions of figures; he preferred a symmetrical arrangement with a central perspective, particularly in paintings that included subsidiary scenes. In the background of *Christ Giving the Keys*, for example, are scenes of the tribute money and the stoning of Christ. Perugino also executed frescoes (destr.) in S Marco in Rome, which can be reconstructed from drawings (Ferino Pagden, 1985); these too were widely copied.

3. 1482–*c.* 1495. Few of Perugino's documented works from the 1480s have been preserved, and it is difficult to form a coherent picture of his artistic development during that decade. He was engaged to paint one of the walls in the Palazzo Vecchio, Florence, as early as October 1482, but when he did not fulfil the contract, it was given to Filippino Lippi. In 1483 a commission for an altar panel for the Cappella dei Priori in the Palazzo dei Priori, Perugia, was also withdrawn when he failed to execute it. He made ephemeral paintings for the coronation of Pope Innocent VIII in Rome in 1484. In 1485 he was again commissioned to produce the altar panel for the Priori of Perugia and was made a citizen of that town. In 1486 he painted a monumental, multifigured fresco of the *Crucifixion* for S Maria degli Angeli, Perugia; it is preserved only in fragments and has been overpainted, but it can be reconstructed from the many drawings made after it (Scarpellini). Records show that Perugino was in Florence in 1486–7. Works datable on stylistic grounds to the 1480s probably include the *Crucifixion* triptych (Washington, DC, N.G.A.) and such decorative tempera pictures as the *Virgin and Child with the Infant St John the Baptist* (London, N.G.), the tondo of the *Virgin and Child Enthroned with Angels and Saints* (Paris, Louvre), as well as such works as the *Crucifixion with Four Saints* (Florence, Uffizi), possibly painted with Signorelli, and the poetic cabinet picture *Apollo and Daphnis* (Paris, Louvre; see fig. 2), which may have been made for Lorenzo the Magnificent.

In 1488 Perugino accepted two commissions for altarpieces for S Maria Nuova, near San Lazzaro (both Fano,

2. Perugino: *Apollo and Daphnis*, panel, 390×290 mm, 1480s (Paris, Musée du Louvre)

S Maria Nuova): an *Annunciation*, dated ?1489, and a *Sacra conversazione*, which he did not complete until 1497 (see below). The *Vision of St Bernard* (Munich, Alte Pin.; see fig. 3) for S Maria Maddalena dei Pazzi, Florence, was commissioned in 1490 and probably executed the following year. The *Annunciation* and the *Vision of St Bernard* exemplify Perugino's work in the late 1480s, leading to the 'classical' style of his altarpieces of the 1490s. The architectural settings are clearly defined, with perspectival views through arches opening on to delightful Umbrian landscapes. The figures are solemn and dignified, in contrapposto poses derived from antique sculpture, suggesting an aspiration towards a harmonious idyll, a Christian Arcadia. This impression is reinforced by the use of a restricted palette of deep, luminous colours in harmonious tones, and by the reduction to essentials of the setting, implements and attributes. The way in which the contours of the figures in the *Vision of St Bernard* seem almost to vibrate makes this picture one of Perugino's indisputable masterpieces, anticipating the enchantment of Raphael's Florentine Madonnas.

Perugino's works from the 1490s in this 'classical' style include a *Virgin and Child with Saints* for S Domenico in Fiesole, the *Pietà* and the *Agony in the Garden* for the monastery of the Gesuati outside Florence (all Florence, Uffizi), a *Virgin and Child with Saints* dated 1493 (Vienna, Ksthist. Mus.), a *Virgin and Child with Saints* for S Agostino in Cremona (*in situ*) dated 1494 and the *Lamentation* for the nuns of S Chiara in Florence (1495;

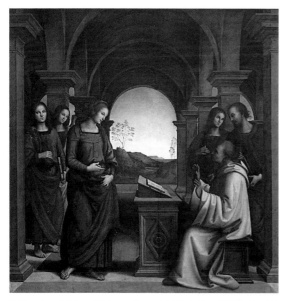

3. Perugino: *Vision of St Bernard*, panel, 1.73×1.60 m, ?1491 (Munich, Alte Pinakothek)

Florence, Pitti; see colour pl. 2, XIV3). Perugino was also working on large-scale fresco commissions in this period. Shortly after 1487 he may have collaborated with Botticelli, Filippino Lippi and Ghirlandaio on a cycle of mythological scenes (destr.) in Lorenzo the Magnificent's Villa Lo Spedaletto. The fresco of the *Last Supper* (the *Cenacolo di Fuligno*), in the refectory of the former monastery of S Onofrio, Florence, may also date from the late 1480s.

In 1489 Perugino was invited to Orvieto to complete the frescoes started by Fra Angelico in the chapel of S Brizio in the cathedral. After initial negotiations, he travelled on to Rome, where he carried out work for Cardinal Giuliano della Rovere (who subsequently became Pope Julius II). He never executed the Orvieto commission, which was eventually given to Signorelli. The works he made for Cardinal della Rovere probably include the altarpiece of the *Nativity with Saints* (Rome, Albani Torlonia priv. col.; see Scarpellini, fig. 78). It is dated 1491 but may have been started earlier, as in comparison with the *Vision of St Bernard* the figural style and the tempera technique seem archaic. It is highly probable that he collaborated with Bernardino Pinturicchio in this period in decorating palazzi of the della Rovere family (Ferino Pagden, 1985).

Perugino's reputation was high outside Rome, as well. In 1494 he agreed to paint a wall in the Sala del Gran Consiglio in the Palazzo Ducale, Venice, for the considerable sum of 400 ducats. He never fulfilled the commission, however, and more than 20 years later Titian accepted it for a much smaller fee. He did paint a picture (untraced) for the Scuola di S Giovanni Evangelista in Venice in 1496. Some writers (e.g. Russell, 1986) detect Venetian influence in the luminous palette he used in such works from this period as the *Pietà* (Williamstown, MA, Clark A. Inst.). His services were sought for the cathedral in Lucca in 1494, apparently in vain. From 1496 Ludovico Sforza, Duke of Milan, tried to entice Perugino into his service,

and in 1497 Isabella d'Este enquired about a picture for her *studiolo* in the Castello di S Giorgio in Mantua.

Although Perugino was sought after throughout Italy, in the first half of the 1490s he still worked primarily in Florence; after his marriage in 1493 to Chiara Fancelli, daughter of the architect Luca Fancelli, he had his main residence and studio there. He also executed his best-known Florentine altar pictures there, such as the *Lamentation* (Florence, Pitti) for the nuns of S Chiara, which was praised by Vasari. This work is thought to be the direct inspiration for Raphael's *Entombment* (1507; Rome, Gal. Borghese; see colour pl. 2, XX2), although it conveys contemplation and repressed grief rather than drama and pathos. Each figure participates through individualized poses and gestures, yet they combine to form an ordered composition. Even the landscape and sky underline the elegiac mood. His monumental fresco of the *Crucifixion* in the chapter house of S Maria Maddalena dei Pazzi in Florence (*in situ*) has similar expressive power. He exploited the architecture of the room by painting a triple-arched framework with fictive columns to receive the real ribs of the vaulting; this serves as a *trompe l'oeil* setting for the landscape in which the figures appear convincingly behind the arches. The *Crucifixion* demonstrates Perugino's mastery in creating a three-dimensional setting using perspective.

4. *c.* 1495–1500. In the second half of the 1490s Perugino increasingly shifted his activity to Perugia. In 1495 he signed another contract for the altarpiece in the Cappella dei Priori in the Palazzo dei Priori and one for the huge polyptych for the high altar of S Pietro, for which he negotiated a very high fee. In 1496 he is presumed to have been entrusted with the decoration of the Perugian money-changers' guild, the Collegio del Cambio. Other lesser patrons, both religious and secular, also vied for his services.

Perugino continued to divide his time between Florence and Perugia, but by now the political and economic situation in Florence had altered significantly. The city was in financial difficulty, and the preaching of Girolamo Savonarola against 'vanities' had restrained the enthusiasm for art. There was a shortage of new commissions in Florence, and most of the works that Perugino produced there after this were for places outside Florence, including the Badia di Vallombrosa, the Certosa di Pavia and S Giovanni al Monte in Bologna. In Perugia, on the other hand, his return instigated an upsurge of commissions as every guild, order and institution felt that its prestige required a work by him. It was only after he had become established in Perugia that he ran a large studio on a commercial basis, for which he was criticized by Vasari and later writers. The works that he produced in Perugia in the late 1490s nevertheless demonstrate that he had reached full artistic maturity and was capable of handling a varied range of commissions. In technique and formal inventiveness these works were models for the young Raphael.

The framework for the S Pietro Polyptych (dispersed) was completed in 1495, and Perugino probably began painting it that year. The *Ascension* is depicted in the centre

panel, with a lunette of *God the Father* above (both Lyon, Mus. B.-A.). The predella has three scenes (the *Adoration of the Magi*, the *Baptism* and the *Resurrection*; all Rouen, Mus. B.-A.), with half-length figures of Benedictine saints (dispersed). In 1496 there was a second contract for the side sections, the prophets *Isaiah* and *Jeremiah* in two large tondi (both Nantes, Mus. B.-A.). The composition of the *Ascension* is conceived in two horizontal planes, with the Apostles grouped around the Virgin below Christ attended by angels. Despite the careful balance of forces in the composition, the predominant impression is of the rhythmic undulation of the ribbons and the edges of the robes, heightening the festive character of the scene. The keen observation evident in the heads and gestures of the Apostles as they evince wonder and astonishment suggests that he made detailed preliminary studies. Eusebio da San Giorgio and Giovanni di Francesco Ciambella (*fl* 1495–1510) acted as witnesses to the contract, which supports the suggestion that they collaborated on the project. The overall impression is of such high quality, however, that they certainly subordinated their work to Perugino's style. The polyptych was dismembered as early as 1591, destroying the interplay between the gilded framework and the paintings, as is also the case with the even more splendid altarpiece he created for S Agostino (*see* below).

(i) Collegio del Cambio. The Collegio del Cambio in Perugia also acted quickly, probably in 1496, to entrust Perugino with the pictorial decoration of its audience chamber. The date MD on the pilaster opposite Perugino's self-portrait is now generally accepted as the date for the completion of all the paintings in this large room. The ambitious programme is attributed to the Perugian scholar Francesco Maturanzio, who wrote the couplets featured in the frescoes (as can be deduced from a manuscript compendium containing his poetry, *In audientia cambii perusiae* (Perugia, Bib. Augusta, MS. Cod. LX)). There were five large arched wall areas available in the irregular room: two were used to depict the four worldly virtues, the other three show Christian scenes. The figures of the virtues Fortitude, Justice, Temperance and Wisdom, distinguished by their attributes, sit in pairs on banks of clouds, flanked by putti holding inscribed tablets. Each virtue is illustrated by three figures from Roman and Greek antiquity, identified by inscription, arranged in a row in the area below.

In two of the arched areas the *Adoration* and the *Transfiguration* are depicted. According to Bombe (1914, p. xxii), these illustrate the Christian virtues of Faith and Love, while the six prophets and six Sibyls below the figure of God the Father represent Hope, as they foretold Redemption through Christ. The figure of Cato in a niche near the entrance doors, representing civic virtue and the administration of justice, is the most important in the audience chamber. On the ceiling are the planetary gods who direct human destiny, inscribed in tondi and surrounded by lavish frescoed decorations: Apollo in the centre, Saturn, Jupiter, Mars, Venus, Mercury and Diana as the moon. Perugino found the models for the planetary gods in the *Astrolabium planum* (Augsburg, 1488, and Venice, 1494) by Johannes Angelus. The grotesques may have been inspired by Nero's Domus Aurea in Rome, which also influenced other Umbrian artists at the time,

notably Pinturicchio (Dacos, 1969). The portrayal of the ancient heroes and their arrangement may derive from his earlier scheme in the Palazzo Vecchio in Florence, and Ghirlandaio presented his portraits of distinguished men there in a comparable way.

The superb structuring within the Collegio paintings is equally innovative: the monumental figures are ranged against a landscape setting that is only roughly sketched in (Oberhuber, 1977). Each scene occupies a complete section of the wall, an arrangement later used by Raphael in the Stanze (Rome, Vatican). Perugino included a self-portrait in the hall, a small fictive picture on a pilaster with an inscription vaunting his artistic skills. The Collegio project, for which he implemented a humanist programme in simple, clear forms on a large scale and in a short timespan, won him great acclaim in Perugia. He also produced altar pictures for private patrons in this period (e.g. the *Resurrection*, Rome, Vatican, Appartamenti Papali, and the *Madonna della consolazione*, Perugia, G.N. Umbria) and processional banners for fraternal orders: *St Francis* (Perugia, G.N. Umbria) and *St Augustine* (Pittsburgh, PA, Carnegie Inst.).

(ii) Florentine works. There is a difference between the Perugian works and the pictures Perugino produced around the same time in his studio in Florence. He seems to have taken into account the style prevailing in the locality for which the work was made. Thus his most important Perugian altarpieces, for S Pietro and the Priori (Rome, Vatican), are characterized by chiselled clarity, powerfully luminous colours and accentuated modelling, qualities that typified the 15th-century Umbrian style. In the altarpieces that are presumed to have been painted in Florence, such as those for the Badia di Vallombrosa (Florence, Accad.) and for the Certosa di Pavia (London, N.G.; see fig. 4), there is a less colourful palette, and a soft *sfumato* brushstroke is more in evidence, imparting vibrant life to his figures. These differences may also derive from assistants who had been trained in different schools. Vasari grouped Perugino's assistants into those who worked in Perugia and those in Florence. The most famous (apart from Raphael and Pinturicchio) were Rocco Zoppo, Roberto da Montevarchi, Gerino da Pistoia (1480–after 1529) and Bacchiacca in Florence, and Giovanni Spagna (after 1450–1528), Andrea d'Assisi ('l'Ingegno'; *fl* 1480–1500), Eusebio San Giorgio and Giovan Battista Caporali in Perugia.

(iii) Works possibly executed with Raphael. Controversy continues about the possible contribution made by the young Raphael to Perugino's works between 1495 and 1504. Raphael is recorded as a master in 1500, when he was 17. It is not clear whether he was apprenticed to Perugino between 1494 and 1500, or only after 1500, or indeed whether he ever worked for Perugino at all. It is certain, however, that he imitated and assimilated Perugino's style in a unique way, refreshing and animating it in the process. A key work in this question is the predella of the *Sacra conversazione* (Fano, S Maria Nuova), completed in 1497, and the sketches relating to it (Ferino Pagden, 1982). It has been suggested that Raphael's hand can be detected either only in the drawings, only in the predella,

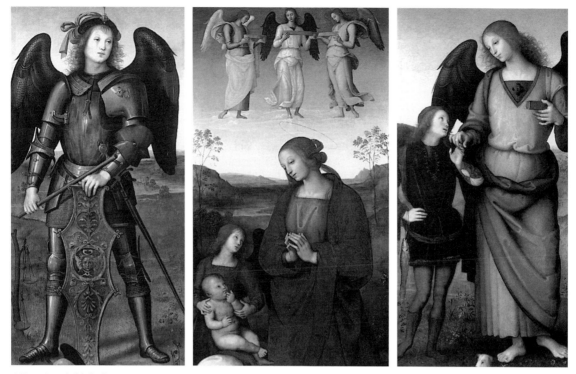

4. Perugino: *St Michael* (1150×563 mm), *Virgin and Child* (1137×638 mm) and *St Raphael with Tobias* (1133×565 mm), surviving panels of an altarpiece from the Certosa di Pavia, oil on panel, *c.* 1499 (London, National Gallery)

or in both (Gregori, 1984). Attempts have also been made to detect Raphael's hand in the frescoes in the Collegio del Cambio, and in almost all works dating from this period, but with little success. The hazards of such attempts were demonstrated by Haskell (1978).

5. 1500–23. Perugino's fame reached its pinnacle about 1500. In a letter of that year Agostino Chigi described him as the finest master in Italy. His artistic powers were beginning to wane, however, and after 1500 he worked primarily in Perugia and increasingly in the provincial towns of Umbria, although he kept his studio in Florence and also carried out commissions in Siena, Rome and elsewhere. Among the most celebrated of the altar pictures he painted in this period are: the monumental *Crucifixion with Augustinian Saints*, commissioned by Chigi for S Agostino, Siena (1502–6; *in situ*); the *Holy Family* (Marseille, Mus. B.-A.) for S Maria degli Angeli, Perugia; and the *Marriage of the Virgin* (Caen, Mus. B.-A.) painted for the brothers of St Joseph in Perugia Cathedral. All still display his clear, masterly method of composition, but the figures are prettier and less powerful in style. The same is true of Perugino's wall paintings, although the cheerful, lively, briskly painted fresco of the *Adoration of the Magi* for the oratory of S Maria dei Bianchi in Città della Pieve, his native town, shows his technical bravura, and the *Martyrdom of St Sebastian*, dated 1505 (Panicale, S Sebastiano), in which the rhythmic movements of the Floggers almost suggest a ritual dance, has tremendous appeal. Later paintings in Montefalco, Fontignano, Foligno and other Umbrian towns follow the same symmetrical pattern.

These works show that Perugino's inventive powers had started to decline and that his supreme technical skill had begun to atrophy into routine. Although superbly painted and attractive in an almost pretty way, they indicate that he was no longer in the vanguard of artistic innovation, even compared with his own work from the previous decade. They seem almost archaic in relation to such contemporary Florentine works as Leonardo's cartoon of the *Virgin and Child with St Anne* (London, N.G.), Michelangelo's Doni Tondo (Florence, Uffizi; see colour pl. 2, IV3) or Fra Bartolomeo's altar pictures. Nevertheless, Perugino continued to have important patrons in the first decade of the 16th century: Pope Julius II engaged him *c.* 1508 with Sodoma, Signorelli, Cesare da Sesto, Jacopo Ripanda and others to decorate his new suite of rooms, the Stanze (Rome, Vatican), and it is significant that Perugino's ceiling frescoes in the Sala dell'Incendio are the only paintings from the first phase of the decoration to have been preserved; the others were repainted by Raphael soon after they were completed. According to Vasari, Raphael refused to destroy Perugino's frescoes out of respect for his teacher, but their preservation must also be due to their refined elegance and imitation of costly materials. Inspired by Early Christian mosaics in Roman churches, Perugino simulated a gold mosaic ground with tendrils of acanthus, with scenes showing Christ in fictive oculi.

Perugino's *Assumption of the Virgin with St Januarius and Cardinal Carafa* for Naples Cathedral (*in situ*), painted for Oliviero Carafa, may also date from this period, as may the frescoes of *Apollo and the Muses* (fragments

Rome, Pal. Braschi) from the papal hunting-lodge of La Magliana. The execution of the figures in the fragments of the latter work, however, is typical of his pupil Gerino da Pistoia (Ferino Pagden, see 1982 exh. cat.). After 1510 Perugino worked almost exclusively in Perugia and Umbria. His main work from this period is the altarpiece for S Agostino, Perugia. The work was intended to surpass the superb S Pietro altarpiece. He agreed to paint it in 1502, for 500 ducats, but it was incomplete at his death. As the vast work was soon dismantled (26 elements survive in various museums), reconstruction of the original arrangement is difficult (Camesasca, 1969). The panels, which were executed over a long period, offer no notable innovations either in composition or in figural style. The only striking change is in the colouring: the colours became thin and transparent, increasingly light in tone. In an ironic twist of fate, Perugino completed the altarpiece in S Severo, Perugia, left unfinished by Raphael on his death in 1520. The dignified, static, isolated figures of saints in the lower part, typifying the late style of Perugino, are in sharp contrast with the energy-filled composition of the upper part, where Raphael's delight in experiment can be seen in the depiction of the *Trinity with Benedictine Saints*. Perugino died of the plague while working on a fresco in Fontignano.

Unlike his teacher Verrocchio or his pupil Raphael, Perugino was exclusively a painter. His designs for other artistic media, for example banners, embroidery, stained glass (Florence, S Gesuati; Florence, Santo Spirito) and miniatures (*St Sebastian*, Ghislieri Book of Hours; London, BM, MS. Yates Thompson, 23) were always two-dimensional. Writers since Vasari have remarked on the superficiality of religious feeling expressed by his figures of saints, gazing humbly heavenwards. According to Baxandall (1972), this apparent lack of spiritual intensity was due to the fact that artists in the late 15th century were trying to create an ideal framework for contemplation by the individual believer. Perhaps it was the result of his depicting saints according to an ideal inspired by the Antique, which proved a difficult vehicle for expressing inner Christian intensity. Raphael was the first to achieve it. Perugino also painted subjects from antiquity, as in the Collegio del Cambio or for Isabella d'Este (*see* below), and even battle scenes, of which only drawings survive (Ferino Pagden, 1985). In addition, his portraits are of outstanding quality, for example that of *Francesco delle Opere* (see colour pl. 2, XIV2) or the two profile heads of monks from Vallombrosa (all Florence, Uffizi).

II. Character and personality.

Perugino worked as an independent painter, refusing invitations to become a court artist. His gifts were entrepreneurial as well as artistic, and he appears to have been reluctant to turn down any commission, however difficult or far away. In negotiating contracts, he always seemed anxious not to lose out financially. Vasari attributed Perugino's commercialism to his having suffered acute poverty as a child, but this is unfounded as his father was a respected property owner and a member of the town council of Città della Pieve. Perugino knew how to exploit his artistic success: having achieved fame through his work

in the Sistine Chapel, he managed to marry Chiara Fancelli, who brought him a dowry of 500 gold florins. He then settled in Florence, bought houses and rented Ghiberti's studio near S Maria Nuova. Although he was not a Florentine citizen, he was a member of two artists' guilds, the Compagnia di S Luca and the Arti de' Medici e Speziali. He was repeatedly chosen by the city as an adviser on artistic affairs (e.g. the installation of Michelangelo's *David* in Florence and the judging of a competition for the cathedral façade). He held political office in Città della Pieve and served as a *priore* of Perugia in 1500.

Perugino lived on a lavish scale, had agents managing his financial and commercial affairs in Florence and always behaved with self-assurance. How much he enjoyed public respect is particularly apparent in the many surviving letters between him and Isabella d'Este and their agents in Florence, dating from the period 1500–5. Isabella struggled for five years to obtain the picture she wanted from him, the *Battle between Love and Chastity* (Paris, Louvre). The correspondence mentions that he would not accept correction and behaved as if he were Giotto, or another great master. Vasari's account of Perugino's quarrel with Michelangelo, who dismissed him as a 'goffo nell'arte' (artistic clodhopper), is also significant. Perugino did not see the artist as an intellectual, a genius superior to society; he did not meet Vasari's Platonic ideal of the artist, as Michelangelo had done. He demonstrated his professionalism by carrying out a large number of important commissions, rather than in the originality of his pictorial designs.

III. Critical reception and posthumous reputation.

According to Vasari, Perugino achieved success only because he had studied day and night in his youth. His works were in demand not only in Italy but also in France, Spain and other countries. For a time he ran at least two successful studios simultaneously, one in Florence and the other in Perugia, both with a considerable number of assistants in order to deal with the plethora of commissions. With the great demand for his services, it is understandable that he was not able to base each work on a new pictorial idea and reused cartoons from earlier works. In 15th-century studio practice this tended to be the rule; there are, for example, many replicas of Botticelli's pictures of the Virgin.

Varsari's account of the criticism of Perugino in Florence *c.* 1506, when he finished an altarpiece left incomplete by Filippino Lippi, is doubly illuminating. He was criticized for repeating figures from earlier works, that is for lack of originality, which was already the established criterion for artistic excellence by Vasari's day. It is clear from Vasari's story that Perugino did not understand this criticism, replying that it was not his fault if figures that had met with approval earlier had suddenly lost their appeal. Vasari did not portray Perugino as a representative of an earlier phase of the social status of the artist but as an individual victim of his own acquisitiveness. He also reproached him for his lack of faith.

In his assessment of Perugino's artistic importance Vasari was considerably more magnanimous. He regarded

Perugino and Francesco Francia, alone among the 15th-century masters, as direct precursors of the third, mature style because of their 'bellezza nuova e più viva' (new and more vivid beauty), which others, including Giovanni Bellini and Andrea Mantegna, did not achieve. In the introduction to the section on painting he placed Perugino alongside Leonardo and Raphael. Perugino's fame as the finest master in Italy was short-lived; displaced by Raphael, he was soon mentioned mainly as the latter's teacher. His reputation revived briefly in the Romantic period, but in the 20th century, when taste has tended to be anti-classical, and even Raphael has been considered insufficiently dramatic, Perugino has been little understood.

BIBLIOGRAPHY

EARLY SOURCES

G. Santi: *La vita e le gesta di Federico di Montefeltro, duca di Urbino, poema in terza rima* (Codice Vat. Ottob. lat. 1305); ed. L. Michelini Tocci (Vatican City, 1985)

G. Vasari: *Vite* (1550, rev. 2/1568); ed. G. Milanesi (1878–85), iii, pp. 565–99

GENERAL

K. F. von Rumohr: *Italienische Forschungen* (Berlin, 1827–31); ed. J. von Schlosser (Frankfurt am Main, 1920)

J. A. Crowe and G. B. Cavalcaselle: *Umbrian and Sienese Masters of the Fifteenth Century*, v of *A History of Painting in North Italy* (London, 1864, 2/1912)

G. Morelli: *Kunstkritische Studien über italienische Malerei*, 3 vols (Leipzig, 1890–93); Eng. trans. by C. J. Foulkes as *Italian Painters: Critical Studies of their Works* (London, 1893)

A. Venturi: *Storia* (1901–40), vii

E. Jacobson: *Umbrische Malerei* (Strasbourg, 1914)

O. Fischel: 'Die Zeichnungen der Umbrer', *Jb. Kön.-Preuss. Kstsamml.*, xxxvii (1917), pp. 1–72, suppl. 1–188

U. Gnoli: *Pittori e miniatori nell'Umbria* (Spoleto, 1923/*R* Foligno, 1980)

R. van Marle: *Italian Schools* (1923–38), xiv

H. Wackernagel: *Der Lebensraum des Künstlers in der florentinischen Renaissance* (Leipzig, 1938); Eng. trans. by A. Luchs as *The World of the Florentine Renaissance Artist* (Princeton, 1981)

C. Gamba: *Pittura umbra del rinascimento* (Novara, 1949)

A. E. Popham and J. Wilde: *The Italian Drawings of the XV and XVI Centuries in the Collection of His Majesty the King at Windsor Castle* (London, 1949)

A. E. Popham and P. Pouncey: *Italian Drawings in the Department of Prints and Drawings in the British Museum: The Fourteenth and Fifteenth Centuries*, 2 vols (London, 1950)

M. Baxandall: *Painting and Experience in Fifteenth-century Italy* (Oxford, 1972)

Disegni umbri del rinascimento da Perugino a Raffaello (exh. cat., ed. S. Ferino Pagden; Florence, Uffizi, 1982)

Pittura in Umbria tra il 1480 e il 1540, premesse e sviluppi nei tempi di Perugino e Raffaello (exh. cat., ed. F. F. Mancini and P. Scarpellini; Città di Castello, Pin. Com., 1983)

Urbino e le Marche prima e dopo Raffaello (exh. cat., ed. M. Grazia Ciardi Duprè and P. dal Poggetto; Urbino, Pal. Ducale; Urbino, S Domenico; 1983)

MONOGRAPHS

B. Orsini: *Vita, elogio e memorie dell' egregio pittore Pietro Perugino e degli scolari di esso* (Perugia, 1804)

A. Mezzanotte: *Della vita e delle opere di Pietro Vannucci* (Perugia, 1836)

J. C. Broussolle: *La Jeunesse du Pérugin* (Paris, 1901)

G. C. Williamson: *Pietro Vannucci called Perugino* (London, 1903)

F. Knapp: *Perugino* (Bielefeld and Leipzig, 1907)

W. Bombe: *Geschichte der Peruginer Malerei bis zu Perugino und Pinturicchio: Italienische Forschungen*, v (Berlin, 1912)

——: *Perugino* (Stuttgart and Berlin, 1914)

U. Gnoli: *I documenti su Pietro Perugino* (Perugia, 1923)

——: *Pietro Perugino* (Spoleto, 1923)

F. Canuti: *Il Perugino*, 2 vols (Siena, 1931)

L. Venturi and G. Caradente: *Il Perugino (Gli affreschi del Collegio del Cambio)* (Turin, 1955)

E. Camesasca: *Tutta la pittura del Perugino* (Milan, 1959)

——: *Perugino*, Opera Completa (Milan, 1969)

P. Scarpellini: *Perugino* (Milan, 1984)

J. M. Wood: *The Early Paintings of Perugino* (diss., U. Virginia, 1985)

SPECIALIST STUDIES

Sistine Chapel

E. Steinmann: *Die Sixtinische Kapelle*, 2 vols (Munich, 1901–5)

J. Wilde: 'The Decorations of the Sistine Chapel', *Proc. Brit. Acad.* (London, 1958), pp. 61–81

L. S. Ettlinger: *The Sistine Chapel before Michelangelo* (Oxford, 1965)

R. Salvini: *La Cappella Sistina in Vaticano*, 2 vols (Rome, 1965)

D. Redig de Campos: 'I titoli degli affreschi del quattrocento nella Cappella Sistina', *Studi di storia dell'arte in onore di Valerio Mariani* (Naples, 1972), pp. 113–21

J. Monfasani: 'A Description of the Sistine Chapel under Pope Sixtus IV', *Artibus Hist.*, 7 (1985), pp. 9–18

J. Shearman: 'La costruzione della cappella e la prima decorazione al tempo di Sisto IV', *La Cappella Sistina* (Novara, 1986), pp. 22–85

Other

F. Zeri: 'Il Maestro dell'Annunciazione Gardner', *Boll. A.*, 4th ser., xxxviii (1953), pp. 125–39, 233–49

F. Santi: *La Nicchia di San Bernardino a Perugia* (Milan, 1963)

N. Dacos: *La Découverte de la Domus Aurea et la formation des grotesques à la renaissance*, Stud. Warb. Inst., xxxi (London, 1969)

F. Battistelli: 'Notizie e documenti sull' attività del Perugino a Fano', *Ant. Viva*, xii/13 (1974), pp. 65–8

F. Russell: 'Towards a Reassessment of Perugino's Lost Fresco of the *Adoration of the Magi* at San Giusto alle Mura', *Burl. Mag.*, cxvi (1974), pp. 646–52

S. Vasco: 'Le tavolette di San Bernardino a Perugia', *Commentari*, xxv/1–2 (1974), pp. 64–7

K. Oberhuber: 'The Colonna Altarpiece in the Metropolitan Museum and Problems of Early Style of Raphael', *Met. Mus. J.*, xii (1977), pp. 55–90

F. Russell: 'A Late Drawing by Perugino', *Master Drgs*, xv (1977), pp. 257–8

F. Santi: 'Ancora sulle architetture dei Miracoli del 1473 e sui rapporti tra l'ambiente urbinate e la scuola perugina', *Rapporti artistici fra le Marche e l'Umbria* (Perugia, 1977), pp. 49–53

F. Haskell: 'Un Martyr de l'attribution: Morris Moore et l'*Appolon et Marsyas* du Louvre', *Rev. A.* [Paris], 42 (1978), pp. 78–88

K. Oberhuber: 'Le Problème des premières oeuvres de Verrocchio', *Rev. A.* [Paris], 42 (1978), pp. 63–75

S. Ferino Pagden: 'A Master Painter and his Pupils: Perugino and his Umbrian Workshops', *Oxford A. J.*, 3 (1979), pp. 9–14

C. H. Smyth: 'Venice and the Emergence of the High Renaissance in Florence: Observations and Questions', *Florence and Venice: Comparisons and Relations: Quattrocento* (Florence, 1979), pp. 209–49

D. Thiébaut and M. Debout: *Le Pérugin et l'école ombrienne*, Cahiers d'Art et d'Essai (Paris, 1979)

S. Ferino Pagden: 'Gli affreschi della "Madonnuccia" in San Martino in Campo e l'enigma di Andrea d'Assisi detto l'Ingegno', *Esercizi*, 4 (1980), pp. 68–85

R. Guerrini: 'Valerio Massimo e l'iconografia umanistica: Perugino, Beccafumi, Pordenone', *Studi su Valerio Massimo* (Pisa, 1981), pp. 61–136

G. Romano: 'Verso la maniera moderna da Mantegna a Raffaello', *Storia dell'arte italiana*, II/i (Turin, 1981), pp. 5–85

F. Russell: 'A Lost Fresco of Perugino and a Drawing at Bayonne', *Per A.E. Popham* (Parma, 1981), pp. 11–13

S. Ferino Pagden: 'Pintoricchio, Perugino or the Young Raphael? A Problem of Connoisseurship', *Burl. Mag.*, cxxv (Feb 1983), pp. 87–8

M. Gregori: 'Raffaello fino a Firenze e oltre', *Raffaello a Firenze* (Florence, 1984), pp. 17–34

S. Ferino Pagden: 'Perugino al servizio dei della Rovere: Sisto IV e il Cardinale Giuliano (Appunti per l'attività di Perugino a Roma)', *Sisto IV e Giulio II—mecenati e promotori di cultura, Atti del convegno internazionale di studi: Savona, 1985*, pp. 53–72, 203–16

F. Russell: 'Perugino and the Early Experience of Raphael', *Raphael before Rome*, Studies in the History of Art, 17 (Washington, DC, 1986), pp. 189–201

Perugino, Lippi e la bottega di San Marco alla Certosa di Pavia, 1495–1511 (exh. cat., ed. B. Fabjan; Milan, Brera, 1986)

S. Ferino Pagden: 'Perugino's Use of Drawing: Convention and Invention', *Drawings Defined*, ed. W. Strauss and T. Felker (New York, 1987), pp. 77–102

G. Goldner: 'New Drawings by Perugino and Pontormo', *Burl. Mag.*, cxxxvi/1095 (June 1994), pp. 36–57

F. Russell: 'An Overlooked Perugino Drawing at Saltram', *Apollo*, cxli/398 (April 1995), pp. 12–14
C. G. von Teuffel: 'The Contract for Perugino's *Assumption of the Virgin* at Vallombrosa', *Burl. Mag.*, cxxxvii/1106 (1995), pp. 307–12
P. Dreyer: 'A Forgotten Drawing by Perugino', *Burl. Mag.*, cxxxix (1997), pp. 465–9
Pietro Perugino: Master of the Italian Renaissance (exh. cat. by J. Antennuci Becherer, Grand Rapids, MI, A. Mus., 1997–8)
A. Ladis: 'Perugino and the Wages of Fortune', *Gaz. B.-A.*, 6th ser., cxxxi (1998), pp. 221–34

SYLVIA FERINO PAGDEN

Peruzzi, Baldassare (*b* Ancaiano, nr Siena, 15 Jan 1481; *d* Rome, 6 Jan 1536). Italian architect, painter and draughtsman. Although his mature career lay wholly within the 16th century and on his death he was honoured by burial in the Pantheon in Rome next to Raphael, he was a transitional figure between the early Renaissance and the High Renaissance in Italy. Yet certain of his works had a strong influence on later architects in the 16th century, and his architectural theories can be said to have been extremely forward-looking. It is the balance between traditional and advanced thinking that characterizes Peruzzi's life and career.

Consider, for example, the nature of his architectural practice. He was brought up in Siena. He was, when circumstances demanded, capable of serving as the practical architectural all-rounder: he seems to have moved easily from minting coins to building palaces, from military architecture to figural painting, in a way that was characteristic of artistic practice in the 15th century (see, for example, the career of Michelozzo di Bartolomeo or Francesco di Giorgio Martini). Yet Peruzzi was also an artist and architect of great erudition, without equal as a draughtsman and noted for his extraordinary studies of antique buildings. Like Raphael and Leonardo da Vinci he frequented the highest levels of Roman and papal artistic culture. That Peruzzi's name is not better known was due, according to Giorgio Vasari, to the fact that he was too timid. But that timidity may also reflect Peruzzi's discomfort among such society. In short, Peruzzi offers a multifaceted career and a personality that resists easy interpretation.

In no aspect of his work does he seem to have been so prolific as in the production of graphic material. Like Francesco di Giorgio Martini, Peruzzi would appear to have found drawing the most congenial mode of expression. That he preserved his own drawings is even more remarkable. Well over 500 architectural drawings survive in the Gabinetto dei Disegni, Galleria degli Uffizi, Florence, alone. He had, in effect, a painter's touch as a draughtsman. His line is light, quick and economical, and he was not afraid to add touches of wash to give relief to his work. He was one of the first to experiment with axonometric drawing, and his perspective drawing (Florence, Uffizi) of St Peter's, Rome—one of the most beautiful of Italian architectural drawings—is a masterpiece of visual insight, for it succeeded in arranging the pieces of the plan in a way that could be instantly comprehended. Elsewhere he showed a willingness to use drawing as an investigative tool; a drawing (Florence, Uffizi) for the church of S Giovanni dei Fiorentini competition of 1519 in Rome reveals multiple variant chapels around the central core. The structure cannot have been planned with such diversity to its parts; rather the drawing shows Peruzzi's fertile experimentation and invention. Elsewhere he used drawing to show a technique for the construction of ovals, used extensively, for example, in the site planning of the Villa Trivulzio in Salone, near Tivoli. Peruzzi is generally credited as having been the first Renaissance architect to experiment with this non-regular geometrical form.

1. Training and early work, to 1503. 2. Rome and elsewhere, 1503–27. 3. Siena and elsewhere, 1527–32. 4. Rome, 1532–6.

1. TRAINING AND EARLY WORK, TO 1503. It is not known where he received his training. Vasari reported that Peruzzi studied with a goldsmith, but the first notice of his independent activity is as the painter of a group of frescoes (destr.) in the chapel of S Giovanni in Siena Cathedral, where he was paid over a two-year period (1501–2). He also received a significant architectural commission from the Sienese banker–merchant Sigismondo Chigi (1449–78), building him a villa known as Le Volte (1500–05) on the outskirts of Siena. Erected on the foundations of an earlier structure, it has a U-shaped plan, with the projecting wings facing the countryside and the more formal façade directed towards the road. The building is divided into two storeys horizontally by a frieze entablature and vertically into bays by a regular series of pilasters. In all respects it adheres to the principles of 15th-century architectural composition that had been elaborated by Francesco di Giorgio Martini, also Sienese, during the later years of the 15th century; it has been noted (see Frommel, 1961; Fiore in Fagiolo and Madonna, pp. 133–68; and Fiore, 1994) that the articulation of pilasters of the loggia derives from the lateral chapel of Francesco di Giorgio's church of S Maria del Calcinaio, Cortona (see colour pl. 1, XXXI1). At a very early age, therefore, Peruzzi demonstrated his mastery of Francesco's style and came into contact with the family that later provided significant employment for him in Rome. Although he was probably too young to have worked for long with Francesco di Giorgio himself, it is likely that he came into close contact with the latter's workshop and its architectural methods. From the first, therefore, Peruzzi showed an understanding of the principles of regularity that, in Siena, could only have come from Francesco di Giorgio. Like him, Peruzzi was an architect and a painter and had a strong interest in classical antiquity, later strengthened through contact with Raphael and Antonio da Sangallo (ii). Finally, Peruzzi's faith in the power of drawing as a means of exploration and experiment can only have come from experience with the traditions of Francesco di Giorgio Martini.

2. ROME AND ELSEWHERE, 1503–27. The events that led to Peruzzi's move from Siena to Rome—according to Vasari, with the painter Pietro Andrea da Volterra (*fl* 1503–29)—are not clear. Possibly he moved there spontaneously with the election of Pius III, the Sienese pope, in October 1503, possibly he was there already. In any case, in 1503 he is noted as working in the Stanze of the Vatican, helping Raphael in the decoration of the ceiling partitions. In 1504–6 he received an independent commission for the fresco decorations for the apse of S Onofrio,

Rome (his work there shows the influence of Pinturicchio and Sodoma from his native Siena), and in 1508 he joined the confraternity of the Compagnia di S Rocco, a sign that he was by then well established in Rome.

By 1506, if not earlier, Peruzzi was employed on the design and construction of a suburban villa for AGOSTINO CHIGI), the brother of Sigismondo Chigi, on the newly opened Via della Lungara. Modelled after Villa le Volte in plan, the Villa Farnesina (see fig. 1), as it is now called after its 17th-century owners, the Farnese family, was the most sophisticated dwelling of the Roman High Renaissance. The land was purchased in 1505. The villa is a compact encyclopedia of antique references and motifs on the theme of pleasure and fame. Decorated by Raphael and his workshop, Sebastiano del Piombo, Sodoma and Peruzzi, the villa displays the sophisticated taste of its patron. In the garden was his collection of ancient sculpture, and facing it was a loggia decorated as if it were an arbour. Painted on the ceiling are fictive tapestries on which are depicted the *Wedding Banquet of Cupid and Psyche* and the *Council of the Gods* (*c.* 1517–18) by Raphael and his workshop. In the spandrels of the walls around the side are scenes from the *Life of Psyche*. On the ground floor are also found the *Triumph of Galatea* (*c.* 1511; see colour pl. 2, XXII1) by Raphael and a painted ceiling for the Sala di Galatea executed by Peruzzi; it represents the sky and stars on the day Agostino Chigi was born. Peruzzi also painted the small-scale grisaille frieze on Ovidian themes in the so-called Sala del Fregio. In his major work

of painting at the Farnesina, in the Sala delle Prospettive on the upper floor, he revived illusionistic Classical techniques of mural painting and decorated the surfaces with a fictive perspective scene showing some of the major sites of ancient Rome (1516–17; see colour pl. 2, XV1). His skill was much admired by later artists. Vasari, for example, took Titian to see the work and reported that he was amazed 'and could not believe that it was really just a painting'.

Other works of this period include the Ponzetti Chapel (1516–17) in S Maria della Pace, Rome. With its combination of illusionistic painting, sculpture (not executed) and architecture, it was intended to recall Raphael's recently completed Chigi Chapel in S Maria del Popolo. Also for S Maria della Pace was the huge fresco of the *Presentation of the Virgin* (see fig. 2). The subject is represented in a fictive panel painting, and the narrative sequence recalls the spatial complexity of Raphael's later images, such as the fresco of the *Fire in the Borgo* (*see* RAPHAEL, fig. 4) or the tapestry cartoon for the Sistine Chapel *Paul at Lystra* (London, V&A). Much respected for his decorative work with its sophisticated classical imagery, Peruzzi was also responsible for work on Trajanic themes for Cardinal Raffaele Riario at the bishop's palace in Ostia (1511–13) as well as for work in the Cancelleria, Rome, and at the Villa Mills and the Villa Madama.

In these years Peruzzi also painted theatre perspectives. In 1513, most notably, he participated in the construction of the wooden theatre on the Capitoline that Leo X had

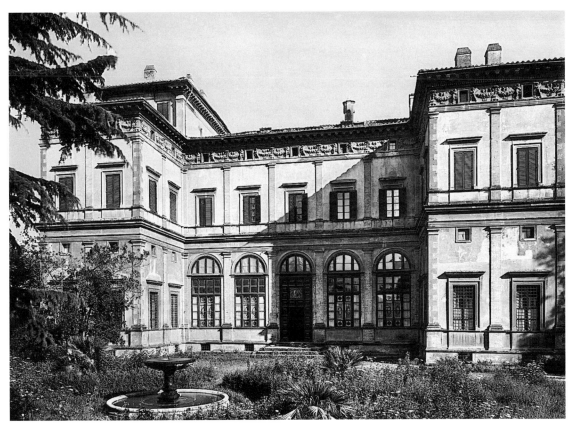

1. Baldassare Peruzzi: rear façade of the Villa Farnesina, Rome, begun ?1506

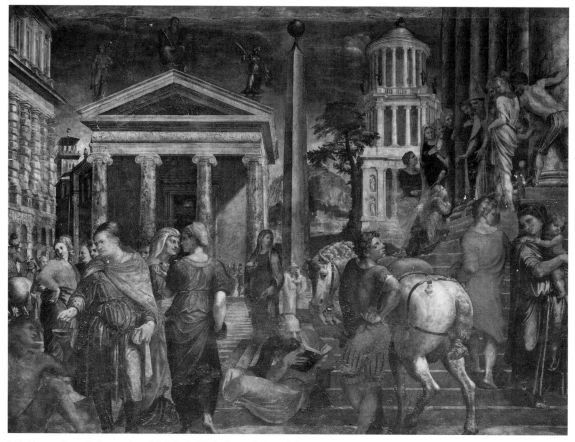

2. Baldassare Peruzzi: *Presentation of the Virgin* (1523), fresco, S Maria della Pace, Rome

erected on the admission of Giuliano de' Medici and Lorenzo de' Medici to the Roman patriciate. In December 1514, or during the carnival of 1515, Peruzzi provided scenes for a production of Niccolò Machiavelli's *Calandria*. A sketch of 1515 (Turin, Bib. Reale) survives for theatrical work, and Peruzzi's theatrical work was used by Sebastiano Serlio as the basis for his designs for Book II of his architectural treatise (*see* SERLIO, SEBASTIANO, §1(ii)).

Peruzzi's next major architectural work seems to have come from Agostino Chigi's neighbour, the imperial ambassador Alberto III Pio. Peruzzi probably travelled to Carpi on two occasions, in 1514 to visit the site and in 1515 as part of Pope Julius II's entourage on a trip to Bologna. Early in 1515 a contract was signed for a new façade for the cathedral, and within the year a model was prepared for the church itself. Peruzzi based the façade on that of a small church by Donato Bramante, the parish church of Roccaverano, but his experience at the Villa Farnesina seems to have taught him to articulate the junction of the large and small orders in a new way. For the interior Peruzzi provided a design that reflected the current thinking about St Peter's, Rome, and suggests the continuing influence of Bramante at this point in Peruzzi's career. In the crossing, for example, Peruzzi used piers that are quite similar to those employed by Bramante at the Vatican; Peruzzi, however, turns his piers diagonally.

In the clerestory Peruzzi used Serlianas, borrowed possibly from Bramante's choir at S Maria del Popolo, in an effort to provide a new kind of classically inspired lighting solution. This urgent curiosity, the desire to renew and reform the nature of Renaissance style, is characteristic of Peruzzi.

In addition he was responsible for the design of the church of S Nicolò, Carpi. Begun in 1493 under the patronage of Alberto III Pio, the church had made slow progress. During the years 1518 to 1522, when work again commenced, Peruzzi contributed to the remodelling of the nave bays. During the years 1522 to 1523 Peruzzi worked in Bologna, where he prepared designs for the church of S Petronio, a chapel for the Ghisilardi family in the church of S Domenico, as well as designs for the Palazzo Lambertini, and a door for S Michele in Bosco. The designs for the church of S Petronio represent an effort by the works to update the Gothic building with a modern, classically inspired façade (Tuttle, 1994). Four of Peruzzi's designs, up to 2 m high, survive in the Museo di S Petronio, Bologna.

Peruzzi's contribution to St Peter's, Rome, is not yet fully understood. Following the death of Raphael in 1520 Peruzzi was given the position of *coadjutore* at St Peter's. It was a period of relative inactivity on the great building site. Severe structural and design problems with the original scheme by Bramante had been identified, many of which

neither Raphael nor Antonio da Sangallo had been able to resolve. Peruzzi's many drawings from this period went well beyond the specific problem of the constructional details; he experimented with multiple chapels and various forms of centralized plan. A number of drawings exist that seem to represent efforts by Peruzzi and Antonio da Sangallo to clarify what it was that Bramante had done and how the project could or should be carried forward. Whether Peruzzi's fertile invention in fact became part of the problem for construction is unclear. After 1521 and after the acceptance of Antonio da Sangallo's longitudinal plan, Peruzzi dedicated himself to the resolution of specific matters associated with that proposal, although nothing, as far as has been determined, survives in the building itself to reflect any direct contribution by Peruzzi.

3. Siena and elsewhere, 1527–32. It was Peruzzi's misfortune during the Sack of Rome in 1527 to be imprisoned by the soldiers of Charles V (*reg* 1519–56). Through Sienese contacts, however, he sent word to the Sienese government and was ransomed. Whether because of the ransom or his simple longing to return to his homeland, he is next found in Siena. Vasari reported that on his way back to Siena Peruzzi was robbed and entered the city wearing only his shirt. In any case, in July 1527 he was given the position of architect to the Republic of Siena. Peruzzi's career underwent a radical change, returning in essence to the more traditional varied practice of the early Renaissance all-rounder. His major design activity centred on the reconstruction of the Sienese fortifications, but he was also employed to advise the Republic on the state of the walls of some of the smaller towns of the outlying district and as military adviser to the imperial generals at the siege of Florence. In addition he undertook to improve the Sienese coinage and devised a new minting machine.

The improvement to the walls reflected an updating and strengthening of the medieval wall system. In particular Peruzzi built bastions to go alongside the gates at Porta Camollia, Porta S Marco, Porta S Viene (Pispini), Porta S Prospero and Porta Laterina. Only those at S Viene, Laterina and Camollia are still standing. Peruzzi employed the careful siting techniques and free, responsive plan used by Francesco di Giorgio Martini in his fortresses in the Marches for the Duke of Urbino. It has been shown (see Pepper and Adams), for example, that while the bastion at Porta S Viene (see fig. 3) seems to have a high, unstable profile derived from the medieval tower, it is in fact arranged to take maximum advantage of its site: the embrasures are set so that fire can be easily directed towards the zones liable to receive enemy attack. Yet Peruzzi was also capable of inflecting the military necessity of these practical works in a way that shows his skilled knowledge of ancient architecture. Thus the Porta S Viene has a heavy cordon about one-third of the way up, with a smaller cordon nearer the top that divides the work into a balanced tripartite composition. At the top, Peruzzi's classically inspired frieze has alternatively grooved and feathered corbels supporting the cornice.

In addition to his work within the city of Siena, Peruzzi also travelled extensively on behalf of the Sienese Republic. He is recorded in the area of Chiusi in 1528–9 and in the

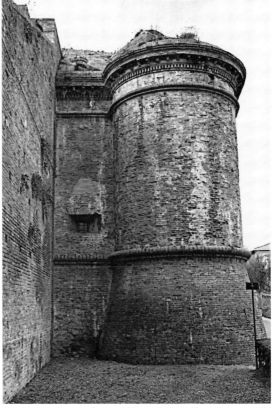

3. Baldassare Peruzzi: bastion of Porta S Viene, Siena, begun *c.* 1530

Maremma area in the summer of 1532. For the towns in these areas he prepared plans for fortification of the city walls; many of these plans survive as drawings (Florence, Uffizi). One of Peruzzi's most unusual projects was for the reconstruction of a dam on the River Bruna near Giuncarico. Originally built by a series of masons and with the advice of the estimator Pietro dell'Abbaco, the dam was superintended by Francesco di Giorgio Martini before it collapsed in 1492 (Adams, 1984). Although there is no direct documentary evidence to date Peruzzi's activity at the dam site, it seems likely that the six surviving drawings (Florence, Uffizi) date from *c.* 1532, when Peruzzi was in the area. Not only do the drawings reveal his skill as a practical architect (all of the sketches are structurally overbuilt), they also reveal Peruzzi's faith in classical antiquity even in a structure for which there could be no precise classical precedent known to him. On two of the sheets Peruzzi recorded that he modelled his structures on an isosceles triangle that he had identified in the slope of ancient theatres. Elsewhere imagery was recognizably borrowed from Roman aqueducts.

Peruzzi's presence in Siena brought new Roman influences into the city. This can be seen in works probably designed by Peruzzi himself and also in those by his local followers. His non-governmental design in the city has been relatively poorly studied, and most works remain only attributions. The Palazzo Neri–Pollini, for example, was probably begun during his stay in Siena and finished in the mid-1530s. Sited at an awkward corner where two

streets meet, one coming directly down a steep slope, the other following the lines of the topography, the palace mediates between two strong axes with a dramatic, almost military front. The vertical divisions of the tripartite façade and the battered base recall the bastion at Porta S Viene. Peruzzi also built a series of houses in the Via dei Fusari for the cathedral works.

While in Siena, Peruzzi was consulted about a number of ecclesiastical commissions. A fire had destroyed much of the Gothic church of S Domenico at the end of 1531. Using the walls of the old structure, Peruzzi referred back to St Peter's, Rome, to create a series of domed spaces and barrel-vaulted halls. Although nothing built to Peruzzi's design survives, the drawings represent a remarkable re-adaptation of the imagery of St Peter's to the old mendicant church. Other attributions of church designs, more or less traditional, such as the cloister of the house of S Caterina, the oratory of S Giuseppe and the bell-tower and courtyard of S Niccolò al Carmine tend now to be assigned to Peruzzi followers. The only church plan that may reflect his hand is that of S Sebastiano in Vallepiatta, but the construction dates, from as early as 1507 and possibly earlier, until c. 1525, and the absence of documentary confirmation have made attribution difficult. In addition to Peruzzi, scholars have suggested Giacomo Cozzarelli and even Francesco di Giorgio Martini (Tafuri, 1994). Peruzzi was also called in to help with the reorganization of Siena Cathedral. He provided a design for a high altar of multicoloured marble in a restrained series of abstract blocks and proposed construction of a new dome that would renovate and update the Gothic cathedral. Motifs were borrowed to evoke the great sources of the new St Peter's: the Pantheon, S Costanza, the Basilica of Constantine.

Peruzzi was responsible for the construction or remodelling of a number of villas in the immediate vicinity of Siena, including the Villa Petrucci at Santa Colomba (nr Monteriggioni) and the Villa of S Regina (nr Due Ponti, Siena). For the Castello di Belcaro, drawings datable to c. 1533 reveal the transformation of this fortified farmhouse into a country residence for the Turamini family. Only a small section of the eastern edge of the main courtyard of Peruzzi's project corresponds directly to the Uffizi drawings, but the use of shallow pilasters on high pedestals elsewhere seems to speak of Peruzzi's hand. The fresco of the *Judgement of Paris* (in situ) on the ground floor of the loggia is probably by a Peruzzi follower. The façade was renovated in 1802 by the architect Serafino Belli and in 1865 by Giuseppe Partini, so that it is extremely difficult to distinguish any 16th-century work.

Working under Peruzzi in Siena was a group of architects and artists who were responsible for the diffusion of his style in the area. Among the Sienese architects who worked for him and were, in effect, trained in his style were Giovanni Battista Peloro, Antonio Maria Lari and Pietro Cataneo. Buildings still lacking a secure attribution but that seem to reflect Peruzzi's influence, in addition to those already mentioned, are the cloister of S Martino, the Villa di Fratta, Sinalunga, the Villa Apparita, Siena, the church of San Sepolcro, Siena, the Palazzo Palmieri and S Giovanni in Panteneto, Siena.

Following the Sack of Rome, there is relatively little painted work from Peruzzi's hand. The *Augustus and the Sibyl* (Siena, S Maria di Fontegiusta) has recently been attributed by Santoro (in Fagiolo and Madonna, pp. 433–68) to Daniele da Volterra. The work has always been a doubtful addition to Peruzzi's oeuvre. While the design seems to reflect precisely the kind of late Raphaelesque spatial design that Peruzzi had explored in the *Entry of Mary into the Temple*, the surface is not convincing: the colours are higher than normal, and the figures are weakly modelled. The boldness of the caption on the canvas itself—BALTHASAR PERUZZI SENEN. DELINEAVIT ET PINXIT—suggests, possibly, that the work was incomplete on Peruzzi's departure from Siena and was finished by one of Peruzzi's assistants, possibly even in Rome. The 'signature', testimony to the painting's authenticity, may have been placed there by Peruzzi to ensure payment.

4. ROME, 1532–6. Around 1532–3 Peruzzi began to spend more time in Rome. His salary was again paid at St Peter's in 1531, and in April 1532 questions were raised by the Sienese government concerning his whereabouts. An ambassador was sent to track him down and elicited from Peruzzi a promise to return—a promise that seems not to have been kept.

Peruzzi's final work, begun in 1532 and completed after his death, was the Palazzo Massimo alle Colonne (see fig. 4) in Rome. The intention was to provide a home for Pietro Massimo (d 1544) on a key location along the Via Papalis (now Corso Vittorio Emanuele). The site alone was problematic, for at that point the road curves sharply on its route between the Vatican and the Capitoline Hill, but Peruzzi also had to accommodate the distinction between the brothers' sites. His solution, evolved slowly and visible in a number of drawings, was to bend the

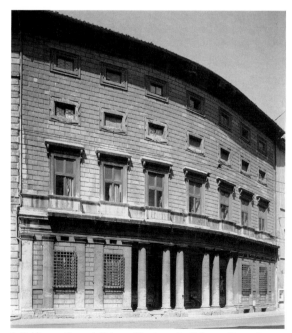

4. Baldassare Peruzzi: Palazzo Massimo alle Colonne, Rome, begun 1532

façade itself, taking account not only of the road's curve but also of the axial lane that meets it. From the lane it can be read as a symmetrical unit in which pilaster piers are paired across the open front with columns. From the main street, however, the palazzo is a sequential discovery leading to the raised loggia above street level. Yet the Palazzo Massimo alle Colonne contains many surprising elements. There is, for example, no centralizing focus over the main portal as in most Renaissance palaces and no vertical linkage to the floors above. Peruzzi thus abandoned the traditional organizing system favoured by Renaissance architects for one in which the elements of the façade establish their own natural relationship. Above, for example, Peruzzi designed small rectangular windows surrounded by delicate curved frames. The wall surface itself has a lightly textured rustication.

BIBLIOGRAPHY

G. Vasari: *Vite* (1550, rev. 2/1568); ed. G. Milanesi (1878–85)

C. L. Frommel: *Die Farnesina und Peruzzis architektonisches Frühwerk* (Berlin, 1961)

H. Wurm: *Der Palazzo Massimo alle Colonne* (Berlin, 1965)

C. L. Frommel: *Baldassare Peruzzi als Maler und Zeichner* (Vienna, 1967)

A. Biagi, ed.: *Baldassarre Peruzzi architetto (quinto centenario della nascita di Baldassarre Peruzzi)* (Soviciille, 1981)

M. F. Conti, ed.: *Rilievi di fabbriche attribuite a Baldassarre Peruzzi* (Siena, 1982)

P. C. Marani: 'A Reworking by Baldassare Peruzzi of Francesco di Giorgio's Plan of a Villa', *J. Soc. Archit. Historians*, xli (1982), pp. 181–8

N. Adams: 'Architecture for Fish: The Sienese Dam on the Bruna River—Structures and Designs, 1468–c. 1530', *Technol. & Cult.*, xxv (1984), pp. 768–97

M. Quinlan-McGrath: 'The Astrological Vault of the Villa Farnesina: Agostino Chigi's Rising Sun', *J. Warb. & Court. Inst.*, xlvii (1984), pp. 98–105

S. Pepper and N. Adams: *Firearms and Fortifications: Military Architecture and Siege Warfare in Siena in the Sixteenth Century* (Chicago, 1986)

M. Quinlan-McGrath: 'A Proposal for the Foundation Date of the Villa Farnesina', *J. Warb. & Court. Inst.*, xlix (1986), pp. 245–50

M. Fagiolo and M. L. Madonna, eds: *Baldassarre Peruzzi: Pittura scena e architettura nel cinquecento* (Rome, 1987)

F. P. Fiore: 'Villa Chigi a le Volte', *Francesco di Giorgio architetto*, ed. F. P. Fiore and M. Tafuri (Milan, 1994), pp. 338–45

M. Tafuri: 'La chiesa di San Sebastiano in Vallepiatta a Siena', *Francesco di Giorgio architetto*, ed. F. P. Fiore and M. Tafuri (Milan, 1994), pp. 322–47

R. Tuttle: 'Baldasarre Peruzzi e il suo progetto di completamento della basilica petroniana', *Una basilica per una città: Atti del convegno di studi per il sesto centenario di fondazione della basilica di S Petronio, 1390–1990: Bologna, 1994*, pp. 243–50

U. Kiby: 'Poggioreale: Das erste Nymphäum der Renaissance', *Gartenkst* [Worms], vii/1 (1995), pp. 68–79

M. Quinlan-McGrath: 'The Villa Farnesina: Time-telling Conventions and Renaissance Astrological Practice', *J. Warb. & Court. Inst.*, lviii (1995), pp. 52–71

C. Tessari with H. Burns: *Baldassare Peruzzi: Il progetto dell'antico* (Milan, 1995)

J. Wojciechowski: 'Ubi Apollo, Ibi Marsyas: Un dessin reconstitué de Peruzzi (1481–1536), *Rev. Louvre*, xliii/2 (1995), pp. 42–3

A. M. Orazi: 'Baldassarre Peruzzi in area padana: Il Mausoleo Pio a Carpi', *Duca Ercole e il suo architetto Biagio Rossetti: Architettura e città nella Padania tra Quattro e Cinquecento* (Rome, 1995), pp. 57–76

G. Pochat: '*Les Bacchides* de Peruzzi: La reconstitution d'un théâtre à Rome, 1531', *Iconographie et arts du spectacle*, ed. J. de la Gorce (Paris, 1996), pp. 11–28

B. Gopnik: 'Physiognomic Theory and a Drawing by Baldassare Peruzzi', *Ksthist. Tidskr.*, lxvi/2–3 (1997), pp. 133–41

NICHOLAS ADAMS

Pesaro (i) [Lat. Pisaurum]. Italian city and port, capital of Pesaro and Urbino province. The city, noted for its production of maiolica, is located on the Adriatic coast 22 km south-east of Rimini.

1. History and urban development. 2. Centre of maiolica production. 3. Villa Imperiale.

1. HISTORY AND URBAN DEVELOPMENT. It was founded as the Roman colony Pisaurum in 184 BC. Like nearby Fano, Pisaurum was orientated with regard to the shoreline rather than the points of the compass. Approximately 2 sq. km in area, it was divided into unequal quarters by the *decumanus* and *cardo*, the latter subsequently linked to the Via Flaminia. Throughout history these streets have been its principal thoroughfares, and the site of the original forum is preserved in the city's main square. After the fall of the Roman Empire, Pesaro was ruled alternately by the Goths, Byzantines and Lombards until 755, when Pepin III vanquished Aistulf, King of the Lombards (*reg* 749–56), and donated the occupied towns to the Church. In the 12th century Pesaro became a *comune*.

By 1285 the first Malatesta had entered the political scene, as *podestà*, and when the dynasty came to power, Pesaro had not expanded significantly beyond the limits of the Roman settlement. Created papal vicars of Pesaro in 1355, the Malatesta ruled as such until 1445, when the pusillanimous Galeazzo sold the town to Francesco I Sforza, Duke of Milan (*reg* 1450–66), for 20,000 florins. Francesco immediately entrusted the government to his brother, Alessandro Sforza, who ruled as Lord of Pesaro until his death in 1473 (*see* SFORZA, (2)); the Sforza seignory of Pesaro lasted until 1512, when the direct male line died out.

Beginning in the 1450s, the town walls were totally rebuilt and increased by Alessandro Sforza, but the whole system was finished only at the beginning of the 16th century by Giovanni Sforza. In 1512 Pope Julius II reclaimed Pesaro as part of the Papal States and assigned it to his nephew Francesco Maria I della Rovere, Duke of Urbino. From 1528 the fortifications underwent a second enlargement ordered by Francesco Maria I della Rovere and supervised by Pier Francesco da Viterbo (*see* ROVERE, DELLA, (3)). This circuit was completed by the 5th Duke of Urbino, Guidobaldo II della Rovere. At about the time that the periphery of the town was being extended, its centre was also substantially transformed. The Palazzo Ducale (1450–1510) was enlarged in the 1520s, with the construction of new apartments (altered) and a temporary amphitheatre in the main salon, supervised by the architect Niccolò Sabbatini (1574–1654).

In 1564, under Guidobaldo II, the ancient Palazzo Comunale on the main square was razed, the square increased to almost double its original size, and a new town hall built along the edge of the square (the present building dates from 1954), at right angles to the Palazzo Ducale. Under the Sforza and della Rovere families, Pesaro became a highly important centre of maiolica production (*see* §2 below).

Although façades and individual buildings in Pesaro have changed with the centuries, the general urban appearance within the former circle of walls still corresponds

Bird's-eye view of Pesaro; engraving from J. Blaeu and P. Mortier: *Nuovum Italiae theatrum* (Amsterdam, 1705–24), ii, pl. XLIX (London, British Library)

to the 16th–17th-century layout (see fig.). A reconstruction of the details of the earlier townscape is possible by way of information in notarial documents and the town statutes: the documents describe buildings and locations, the statutes spell out building regulations. The average house was small (minimum size 7.00×5.25 m), so that courtyards were most often behind or adjacent to the structure. Along the main streets the walls of houses were to be of stone up to a height of 5.25 m, and their porticos, loggias and balconies were also to be built of stone rather than wood. One of the principal arteries is still lined with a stretch of 14th- and 15th-century arcades. Judging by what has survived of the early architectural decoration—the 14th- and 15th-century portals of S Francesco (1356–78), S Domenico (destr.) and S Agostino (1413), and some doors and windows of private houses—the main influences on the urban fabric of the city came from the Veneto and Lombardy. There was, in fact, a large colony of Lombard stonecutters in Pesaro in the 15th century. By the mid-15th century, Tuscany had begun to exert a strong influence, both direct and indirect, on local architecture and its decoration. As far as architectural planning at the time of the della Rovere is concerned, the influence of Francesco di Giorgio Martini's *Trattati* cannot be over-emphasized. The principal building material of Pesaro was light-coloured brick. Sandstone, used for decorative details, was widely quarried, especially around Fossombrone. The area was also rich in limestone, another important material for architectural decoration, although occasionally it was imported from Istria (e.g. the limestone used for the portal of S Agostino).

BIBLIOGRAPHY

Statuta civitatis Pisauri (Pesaro, 1531; *R* Bologna, 1985)

A. Olivieri: *Memorie del porto di Pesaro* (Pesaro, 1774)

——: *Memorie per la storia della chiesa pesarese nel secolo XIII* (Pesaro, 1779)

C. Marcolini: *Notizie storiche della provincia di Pesaro e Urbino* (Pesaro, 1868)

L. Celli: 'Le fortificazioni militari di Urbino, Pesaro e Senigallia del secolo XVI', *Nuova Riv. Misena*, iii (1895), pp. 67–158

G. Vaccaj: *Pesaro: Pagine di storia e di topografia* (Pesaro, 1909)

——: *La vita municipale sotto i Malatesta, gli Sforza e i della Rovere, signori di Pesaro* (Pesaro, 1928)

O. T. Locchi: *La provincia di Pesaro ed Urbino* (Rome, 1934)

M. R. Valazzi: *Indagine sull'urbanistica di Pesaro, 1513–1631* (diss., Rome, La Sapienza, 1974–5)

G. G. Scorza: *Pesaro fine secolo XVI* (Venice, 1980)

S. Eiche: *Alessandro Sforza and Pesaro: A Study in Urbanism and Architectural Patronage* (diss., Princeton, U., NJ, 1982)

M. R. Valazzi, ed.: *Pesaro nell'antichità, Historica Pisaurensia*, i (Venice, 1984)

M. Frenquellucci: 'Il Palazzo Ducale sulla scena della piazza di Pesaro all'epoca dei Malatesta e degli Sforza', in *La Corte di Pesaro*, ed. M. R. Valazzi (Modena, 1986)

T. Scalesse: 'Le fortificazioni roveresche', *Pesaro nell'età dei Della Rovere, Historica Pisaurensia*, III/i, ed. G. Arbizzoni and others (Venice, 1998), pp. 213–29

M. R. Valazzi: 'La città dei duchi', *Pesaro nell'età dei Della Rovere, Historica Pisaurensia*, III/i, ed. G. Arbizzoni and others (Venice, 1998), pp. 193–212

SABINE EICHE

2. CENTRE OF MAIOLICA PRODUCTION. During the Renaissance, Pesaro was one of the most important centres of maiolica production. Important patrons included the Sforza family and Isabella d'Este, who decorated her apartments at the Palazzo Ducale in Mantua with tiles from Pesaro (now Paris, Louvre; London, V&A). Pesaro's fame as a centre for maiolica was consolidated by Giovanni Battista Passeri's book *Istorie delle pitture in majolica fatte in Pesaro e ne' luoghi circonvicini* (Venice, 1758), in which the Pesaro workshops were equalled to those of Faenza, Urbino and Venice. From 1540 the workshop of Girolamo di Lanfranco delle Gabicce (*c.* 1500–78) produced excellent work in the *istoriato* (narrative) genre (dish, 1544; London, V&A). His family continued the business, and in 1569 Guidobaldo II, Duke of Urbino (*reg* 1538–74), permitted Girolamo's son Giacomo (*fl* 1567–98) to lustre his wares.

BIBLIOGRAPHY

P. Berardi: *L'antica maiolica di Pesaro* (Florence, 1984)

G. Albarelli: *Ceramisti pesaresi nei documenti notarili dell'archivio di stato di Pesaro—secc. XV–XVII* (Bologna, 1986)

G. Biscontini Ugolini: *Ceramiche pesaresi dal XVIII al XX secolo* (Bologna, 1986)

P. Bonali and R. Gresta: *Girolamo e Lanfranco Dalle Gabicce: Maiolicari a Pesaro nel secolo XVI* (Rimini, 1987)

C. Giardini: *Ceramica pesarese nel XVIII secolo: La manifattura Casali e Callegari* (Ferrara, 1995)

T. Wilson: 'Mailoche del tardo Rinascimento dipinte a grottesche: Nuove testimonianze della produzione di Pesaro', *Fimantiquari*, iv/7 (1995), pp. 33–9

C. Giardini: *Pesaro, Museo delle ceramiche* (Bologna, 1996)

C. Leonardi, ed.: *Maiolica metaurense rinascimentale, barocca, neoclassica* (Urbania, 1996)

G. C. Bojani, ed.: *Fatti di ceramiche nelle Marche dal Trecento al Novecento* (Milan, 1997)

C. Leonardi, ed.: *La collezione di maioliche della Fondazione Cassa di Risparmio di Pesaro e collezioni private in Pesaro* (Urbania, 1998)

CARMEN RAVANELLI GUIDOTTI

3. VILLA IMPERIALE. Villa complex on San Bartolo hill, outside Pesaro, composed of two adjacent structures. Frederick III, Holy Roman Emperor (*reg* 1440–93), laid the foundation stone in January 1469 and bestowed his title on the villa under construction for Alessandro Sforza, Lord of Pesaro. No architect is named in the surviving documents, and it is believed that Alessandro Sforza was himself involved with the design. The distinctive form of the chimneys points to a Venetian origin for the master builder. The design of the 15th-century Imperiale—four wings around a colonnaded courtyard—was inspired by Tuscan palaces, and the layout of spaces around the court—one wing nar-

rower than the rest, fully open as a loggia at ground level—is similar to the plans of the Palazzo Medici (1444–60; now Palazzo Medici–Riccardi; for illustration *see* PALAZZO, fig. 1) in Florence and the Palazzo Piccolomini (1459–64) in Pienza. Two other palaces also influenced the design: the Palazzetto of the Palazzo di Venezia (begun 1455) in Rome provided the model for some of the capitals, and the Palazzo Ducale in Urbino inspired the handling of the corners in the courtyard.

In the late 1520s Eleonora Gonzaga, Duchess of Urbino, decided to commission a country retreat for her husband, Francesco Maria I della Rovere. Girolamo Genga was engaged to decorate the Sforza Imperiale with frescoes (*c.* 1529–32), and to build a new villa with gardens, up the hill of San Bartolo, behind the earlier one. Genga directed a team of artists, including the brothers Dosso Dossi and Battista Dossi, Francesco Menzocchi da Forlì (*c.* 1502–84), Agnolo Bronzino, Raffaello dal Colle and Camillo Mantovano, in decorating eight rooms on the top floor of the Sforza villa. The fresco cycle displays two main themes. One refers to the Imperiale's rustic setting, and is expressed primarily through pastoral landscapes and references to plentiful harvest; the other alludes to the villa's role as a monument to the Duke, and is developed in the historical and allegorical scenes.

Although the first document referring specifically to the della Rovere Imperiale is from 1532, work probably began earlier, shortly after commencement of the fresco painting. Genga's villa is rectangular in plan, laid out as a series of terraces up the hillside and completely enclosed by walls. The lowest side of the rectangle is a wing with a pavilion at the left end of the exterior façade, which faces the Sforza villa (for illustration *see* GENGA, (1)). The interior façade of the wing faces a courtyard, which forms the first terrace. Across the courtyard is a grotto supporting a hanging garden, which constitutes the second terrace. The uppermost level of the Imperiale is occupied by a large, square garden. At the same height is a balustraded walkway that runs over the side walls of the hanging garden and courtyard, and the whole top of the villa. There are two storeys of rooms in the 16th-century Imperiale, and the first floor, which corresponds to the courtyard level on the interior façade and to the *piano nobile* on the exterior, has two sets of four rooms either side of a central loggia, which opens on to the courtyard. The second storey is composed of a line of small rooms with a central chapel. In his designs Genga drew heavily on ancient and modern Roman architecture. The villa shows variously the influence of the Basilica of Maxentius (*c.* AD 307–12), Bramante's Cortile del Belvedere (from 1505; see colour pl. 1, XVI1) in the Vatican Palace and Raphael's Villa Madama (from 1518; *see* RAPHAEL, fig. 9) near Rome.

The most curious aspect of Genga's villa is its position with respect to the Sforza Imperiale. Its main façade is at right angles to that of the earlier building, and the villas are juxtaposed in such a way that the Sforza Imperiale always blocks a part, and sometimes the whole, view of the della Rovere Imperiale. Adding to the general bewilderment is the absence of an obvious entrance into the later villa. The principal façade appears sealed, except for two windows on the *piano nobile*. Similarly, inside the courtyard of the 16th-century villa, passageways are con-

cealed, and there are no clear means of access to such areas as the gardens and roof walkways. The stairs are hidden in the side walls, accessible by means of simple apertures cut into two of the four convex corners of the courtyard. Although incomplete at the death of Francesco Maria I in October 1538, the gardens had been planted, and Genga was working on the fountains. The Duke's son turned his attention to other architectural projects, and the Imperiale was neglected for nearly 50 years. Though a major restoration was undertaken at the beginning of the 20th century, some of the interior spaces in the villa remain unfinished.

BIBLIOGRAPHY

B. Patzak: *Die Villa Imperiale in Pesaro* (Leipzig, 1908)

C. H. Smyth: 'The Sunken Courts at the Villa Giulia and the Villa Imperiale', *Essays in Honor of Karl Lehmann*, ed. L. F. Sandler (New York, 1964), pp. 304–13

A. Pinelli and O. Rossi: *Genga architetto* (Rome, 1971)

S. Eiche: 'The Villa Imperiale of Alessandro Sforza at Pesaro', *Mitt. Ksthist. Inst. Florenz*, xxix (1985), pp. 229–74

——: 'Architetture sforzesche', *Pesaro tra medioevo e rinascimento*, Historica Pisaurensia, ii, ed. M. R. Valazzi (Venice, 1989), pp. 269–303

——: 'I Della Rovere mecenati dell'architettura', *Pesaro nell'età dei Della Rovere, Historica Pisaurensia*, III/i, ed. G. Arbizzoni and others (Venice, 1998), pp. 231–63

F. Panzini: 'Giardini rovereschi nella Pesaro del Cinquecento', *Pesaro nell'età dei Della Rovere, Historica Pisaurensia*, III/i, ed. G. Arbizzoni and others (Venice, 1998), pp. 266–73

C. H. Smyth: 'On Dosso Dossi at Pesaro', *Dosso's Fate: Painting and Court Culture in Renaissance Italy*, ed. L. Ciammitti and others (Los Angeles, 1998), pp. 241–62

SABINE EICHE

Pesaro (ii). Italian family of statesmen, diplomats and patrons. The family was first recorded in Venice at the beginning of the 13th century, and in 1297 it appeared in the Maggior Consiglio. The construction of a palazzo, later the Fondaco dei Turchi (rebuilt; now Mus. Civ. Stor. Nat.), in Venice in the 13th century has been attributed to the family, which by the 15th century was one of the most eminent in Venice; Benedetto Pesaro (1433–1503), for example, was a commander of the Venetian naval forces. The four branches of the family—S Giacomo dall'Orio, S Stae, S Sofia and S Benedetto—contributed seven procurators of S Marco and one doge, Giovanni Pesaro (1568–1659), who is commemorated in a large monument, designed (1659–69) by Baldassare Longhena and sculpted (1665–9) by Melchior Barthel, in the church of S Maria Gloriosa dei Frari, Venice.

Jacopo Pesaro (1466–1547), the titular bishop of Paphos, Cyprus, who commanded the papal fleet of Alexander VI in the victory over the Turks in the Battle of Santa Maura in 1502, was the most prominent patron of the family, notably of Titian. His first commission from this artist was an altarpiece depicting *Pope Alexander VI Presenting Jacopo Pesaro to St Peter* (begun 1502–3; completed ?1515; Antwerp, Kon. Mus. S. Kst.). He then commissioned Titian to execute an altarpiece (1519–26; *in situ*), known as the Pesaro Madonna, for the church of S Maria Gloriosa dei Frari, Venice (see colour pl. 2, XXXV2), which depicts members of the Pesaro family and which, like the earlier altarpiece, is a votive picture relating to the 1502 victory. The Pesaro Madonna, remarkable for its asymmetrical composition, is full of symbolic elements, for example a captive Turk and a battle-flag, with Jacopo,

on the left. Other members of the Pesaro family gathered on the bottom right have been tentatively identified as Benedetto Pesaro, Vittorio Pesaro, Antonio Pesaro, Fantini Pesaro and Lunardo Pesaro, son of Antonio, from the S Giacomo dall'Orio branch.

Members of the family from the S Benedetto branch (which died out in 1687) have also been identified in two paintings: the *Lady as Lucretia* by Lorenzo Lotto (*c.* 1530; London, N.G.) represents Lucrezia Valier, the wife of Benedetto Pesaro (*b* 1512), and a double portrait of two boys by Titian (1540s; priv. col., see 1983 exh. cat., p. 224), their sons Gerolamo Melchiorre Pesaro (1536–95) and Francesco Santo Pesaro (*b* 1537). Both paintings were probably commissioned by Benedetto's father Gerolamo Pesaro, a Procurator.

BIBLIOGRAPHY
J. A. Crowe and G. B. Cavalcaselle: *Life of Titian*, i (London, 1877)
H. E. Wethey: *The Paintings of Titian*, i (London, 1969)
M. Jaffé: 'Pesaro Family Portraits: Pordenone, Lotto and Titian', *Burl. Mag.*, cxiii (1971), pp. 696–702
J. Meyer zur Capellen: 'Beobachtungen zu Jacopo Pesaro exvoto in Antwerpen', *Pantheon*, xxxviii (1980), pp. 144–52
D. Rosand: *Paintings in Cinquecento Venice: Titian, Veronese, Tintoretto* (London, 1982)
The Genius of Venice (exh. cat., ed. C. Hope and J. Martineau; London, RA, 1983)

☐

Pesaro, Lord of. *See* SFORZA, (2).

Pescara, Marchesa di. *See* COLONNA, VITTORIA.

Pesellino [Francesco di Stefano] (*b* Florence, *c.* 1422; *d* Florence, 29 July 1457). Italian painter. According to the *catasto* (land registry declaration) return of his grandfather PESELLO, Francesco di Stefano was five years old in 1427. He was the son of the painter Stefano di Francesco (*d* 1427), who married Pesello's eldest daughter. By the early 1440s, perhaps after initial training in his grandfather's workshop on the Corso degli Adimari, Florence, Pesellino appears to have joined Fra Filippo Lippi's workshop. He may have been the 'Franciesco di Stefano pittore' who enrolled in the Compagnia di S Luca in 1447. In August 1453 Pesellino went into partnership with Piero di Lorenzo di Pratese (*d* 1487) and Zanobi di Migliore, and numerous replicas of popular Virgin and Child compositions by Pesellino were probably produced in this joint workshop for sale on the open market.

The five predella panels (Florence, Uffizi; Paris, Louvre) for Filippo Lippi's altarpiece (Florence, Uffizi) for the Novitiates' Chapel in Santa Croce, Florence, are generally regarded as Pesellino's earliest works. These show Pesellino's ability at the outset of his career to evolve narrative compositions that are succinct and direct, almost to the point of brusqueness, as is appropriate in small panels that have to convey the stories tellingly over some distance. Although they lack the vigour and anecdotal nature of Lippi's narrative treatment, Pesellino's predella panels nonetheless reflect his master's style and handling. Clearly constructed figures, robed in thick draperies that fall in angular, pleated folds, are often placed in symmetrical or mirror-image poses, as in the *Martyrdom of SS Cosmas and Damian* (Florence, Uffizi). They occupy simplified, unornamented interiors or cursory landscape settings indicated by a few sharp-edged, slanting rocks or slender trees. The style contrasts with both the complex space and the linearity of the main panel of Lippi's altarpiece.

Pesellino's quality as a painter of small, brilliantly executed panels, reminiscent of miniature painting, is fully developed in a group of works of delicate intricacy and sentiment. An *Annunciation* diptych (U. London, Courtauld Inst. Gals; see fig.), of simple pictorial design and jewel-like craftsmanship, is an outstanding example. The two figures are variants of a well-established Annunciation type derived from Lippi but cast in a gentler mould. They kneel in placid intercommunication within logically constructed spaces: an Ionic colonnade reminiscent of Fra Angelico's Annunciation settings, and a tastefully furnished bedchamber. The narrative mood, undramatic but sincere, is reflected in radiant colours which are offset by occasional touches of gold on haloes, wings and drapery borders. Characteristic of Pesellino's reinterpretation of Lippi's linearity is his rhythmic stress on outline and light modelling of the forms. Details of curling hair, crisp features and elegant, quietly expressive hand gestures are unobtrusively emphasized by fluent, dark contours. The same refined grace typifies the finest of Pesellino's small altarpieces, from the *Virgin and Child with SS Julian and Francis* (ex-Methuen Col.; sold London, Christie's, 1 Dec 1978), which is strongly influenced by Lippi, to the *Virgin and Child with Saints* (New York, Met.), with its more independent treatment of forms and expression, evolved by perhaps 1450–55.

Pesellino's growing reputation in the mid-15th century brought him the commission for his only surviving large-scale work, the altarpiece of the *Trinity with Saints* (London, N.G.) for the Compagnia della Santissima Trinità in Pistoia. This important work, ordered on 10 September 1455, was dismembered in the early 19th century but later reconstructed. To choose to paint the Trinity in a landscape setting was as yet very unusual, and the landscape itself is perceived and rendered with a naturalistic freedom remarkable for the date. This area of the panel may not, however, have been painted by Pesellino himself. Extensive documentation indicates that the altarpiece was only about half completed when it was appraised by Filippo Lippi and Domenico Veneziano on 10 July 1457, about three weeks before Pesellino died. It was completed between October 1458 and June 1460 in Lippi's Prato workshop, which certainly provided the predella panels. The over-elaborated forms and details of these panels contrast with the predella that Pesellino had provided for Lippi's altarpiece for the Novitiates' Chapel, Santa Croce. Inconsistencies in handling suggest that Lippi's assistants, such as Fra Diamante, also finished the main panel of the *Trinity with Saints*, which was designed by Pesellino but may in parts have been little more than sketched in at the time of his death. The contrasting treatment of the forms and draperies of the flying angels, later copied into a *Nativity* (Paris, Louvre) from Lippi's workshop, and of the pairs of saints suggests that differing artistic temperaments were at work. The difficulties of distinguishing Pesellino's hand from those of Lippi's assistants are exacerbated by the large size of the altarpiece, exceptional in Pesellino's short career.

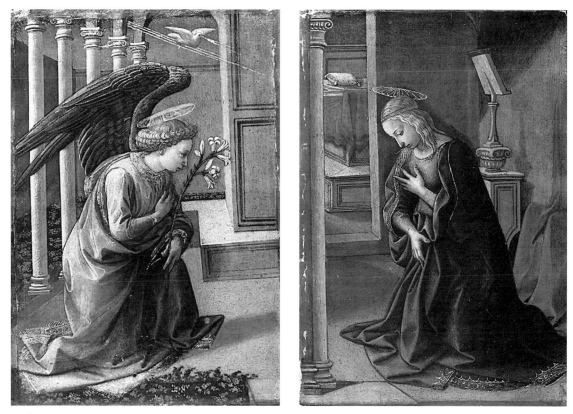

Pesellino: *Annunciation*, diptych, tempera on panel, each panel 200×146 mm, *c.* 1450–55 (London, University of London, Courtauld Institute Galleries)

Pesellino contributed two panels (untraced), one representing a hunt and the other a cage of lions, to the decoration respectively of a room on the ground floor and of the the Sala Grande of the new Palazzo Medici. Painted *c.* 1455, these important commissions were recorded in the palace inventory of 1492. They signal Pesellino's place in the development of Florentine secular painting, now evident only from his *cassone* decorations. His controlled treatment of elaborate scenes is revealed in the pair of *cassone* panels of Petrarch's *Trionfi* (Boston, MA, Isabella Stewart Gardner Mus.), in which stately, fashionably dressed figures are set in a verdant landscape alive with birds and animals. These richly detailed panels foreshadow the complex pictorial organization of two *cassone* panels (Loyd Trustees, on loan to London, N.G.) that show *David and Goliath* and the *Triumph of David*. The episodes are arranged in a rhythmically active, easily readable sequence, set coherently within a minutely detailed landscape. Their precision and finesse, worthy of a manuscript illuminator, suggest that these panels decorated a pair of unusually expensive *cassoni*. This is a further indication that Florentine patrons of the 1450s held Pesellino's polished style in high esteem.

BIBLIOGRAPHY

C. Landino: *Comento di Cristoforo Landino fiorentino sopra la Comedia di Dante Alighieri* (Florence, 1481); also in *Scritti critici e teorici*, ed. R. Cardini, ii (Rome, 1974), p. 167

Il codice dell'anonimo Gaddiano (*c.* 1540; Florence, Bib. N. Cent., Cod. Magliabechiano xvii.17); ed. C. Fabriczy (Florence, 1893), p. 69

A. Billi: *Il libro di Antonio Billi* (MS.; *c.* 1550); ed. K. Frey (Berlin, 1892), p. 27

G. Vasari: *Vite* (1550, rev. 2/1568); ed. G. Milanesi (1878–85), iii, pp. 35–40

W. Weisbach: *Francesco Pesellino und die Romantik der Renaissance* (Berlin, 1900)

A. Scharf: 'Zur Kunst des Francesco Pesellino', *Pantheon*, xiv (1934), pp. 211–21

G. Gronau: 'In margine a Francesco Pesellino', *Riv. A.*, xx (1938), pp. 123–46

P. Bacci: *Documenti e commenti per la storia dell'arte* (Florence, 1944), pp. 111–51

M. Davies: *The Earlier Italian Schools*, London, N.G. cat. (London, 1951, 2/1961/R 1986), pp. 413–19

D. Gordon: 'The "Missing" Predella Panel from Pesellino's *Trinity* Altarpiece', *Burl. Mag.*, cxxxviii/1115 (1996), pp. 87–8

FRANCIS AMES-LEWIS

Pesello [Giuliano d'Arrigo] (*b* Florence, *c.* 1367; *d* Florence, 6 April 1446). Italian painter and designer. An extensively documented Florentine painter to whom no work can be securely attributed, he was greatly esteemed by his contemporaries. The chronicler Giovanni Cavalcanti considered him on a par with Gentile da Fabriano, Filippo Brunelleschi and Lorenzo Ghiberti. Cosimo de' Medici was one of his patrons and loaned him a considerable sum in gold florins when his daughter was married (Procacci, p. 20).

Pesello matriculated in the Florentine painters' guild on 25 June 1385. He was consulted several times by the Cathedral Works' committee about the construction of

the cathedral dome, for which in 1419 he produced a model (untraced). In 1420 he was nominated to stand in for Brunelleschi in the event of his absence or resignation, and he made several other models for the cathedral authorities (Guasti). In 1430 he completed a painting of the *Annunciation* (untraced) left unfinished by Giovanni Toscani. He also produced works of an artisan nature. From 1416 until his death he ran a workshop in the Corso degli Adimari which produced flags and processional banners (e.g. a banner for the Calimala guild in 1424; untraced) and decorated armour, painted leather objects and other similar work (Guasti, Weisbach, Procacci).

Pesello's most important commissions were to provide, with Agnolo Gaddi, designs for the frescoed funerary monuments in Florence Cathedral for two condottieri who had worked for the Florentine Republic, *Piero Farnese* (1390; destr.) and *Sir John Hawkwood* (1395; destr.); the latter was later replaced by Uccello's fresco of the same subject (*see* UCCELLO, PAOLO, fig. 1). Together with Ghiberti he frescoed the Papal Chamber (1419; destr.) in S Maria Novella.

Zeri suggested that a group of high-quality panels might be attributed to Pesello. The corpus is grouped around two works, a *Virgin of Humility* (Florence, Pal. Vecchio), formerly attributed to Masolino, and a *Virgin and Child with Two Angels* (Rotterdam, Boymans–van Beuningen), previously ascribed to Arcangelo di Cola da Camerino. The artist who produced these panels must have emerged from the circle of Gaddi and, in his mature works, shows the influence of Ghiberti; this would tie in with Pesello's documented collaborations. The panels also have much in common with Lorenzo Monaco's Late Gothic style.

Zeri's hypothesis was accepted by Parronchi, who added several interesting works to the corpus, including the frescoes in the cupola of the Old Sacristy, S Lorenzo, Florence, showing the constellations of the heavens. Pesello's considerable skill in painting animals was recognized in the 15th century (Filarete, Landino, Billi, the Anonimo Gaddiano or Magliabechiano) and later by Vasari. The frescoes date from *c.* 1427 and are remarkable for their skilled draughtsmanship. Pesello was the master of his grandson, PESELLINO.

BIBLIOGRAPHY
Colnaghi
C. Landino: *Comento di Cristoforo Landino fiorentino sopra la Comedia di Dante Alighieri* (Florence, 1481); ed. R. Cardini in *Scritti critici e teorici*, i (Rome, 1974), p. 124
G. Cavalcanti: *Istorie fiorentine* (MS.; 1420–52); ed. F. Polidori (Florence, 1839), p. 499
A. Filarete: *Trattato di architettura* (MS.; 1464); ed. A. Finoli and L. Grassi, i (Milan, 1972), p. 265
Il codice dell'anonimo Gaddiano (*c.* 1540; Florence, Bib. N. Cent., Cod. Magliabechiano xvii.17); ed. C. Fabriszy (Florence, 1893), p. 69
A. Billi: *Il libro di Antonio Billi* (MS.; *c.* 1550); ed. C. Frey (Berlin, 1892), p. 27
G. Vasari: *Vite* (1550, rev. 2/1568); ed. G. Milanesi (1878–85), iii, pp. 35–40
C. Guasti: *La cupola di Santa Maria del Fiore* (Florence, 1857)
G. Milanesi: 'Le vite di alcuni artefici fiorentini, scritte da Giorgio Vasari, corrette ed accresciute coll'aiuto dei documenti', *G. Stor. Archv Tosc.*, iv (1860), pp. 170–210 (189–91, 205–10)
W. Weisbach: 'Der Meister der Carrandschen Triptychons', *J. Kön.-Preuss. Kstsamml.*, xxii (1901), pp. 35–55 (45–8)
G. Gronau: 'In margine a Francesco Pesellino', *Riv. A.*, xx (1938), pp. 123–46
U. Procacci: 'Di Jacopo d'Antonio e delle compagnie di pittori del Corso degli Adimari nel XV secolo', *Riv. A.*, xxxv (1960), pp. 3–70
F. Zeri: 'Opere maggiori di Arcangelo di Cola', *Ant. Viva*, viii/6 (1969), pp. 12–15
A. Parronchi: 'L'emisfero della Sagrestia Vecchia: Giuliano Pesello?', *Scritti di storia dell'arte in onore di Federico Zeri* (Milan, 1984), pp. 134–46
Y. Even: 'Paolo Uccello's *John Hawkwood*: Reflections of a Collaboration between Agnolo Gaddi and Giuliano Pesello', *Source*, iv/4 (1985), pp. 6–8

CECILIA FROSININI

Peter, Master, the Florentine carver [Magistro Petro scarpelino florentino]. *See* TORRIGIANI, PIETRO.

Peterzano, Simone (*b* ?Bergamo, *c.* 1540; *d* Milan, *c.* 1596). Italian painter. He claimed to have trained with Titian in Venice, but his first known works, the scenes from the *Lives of SS Paul and Barnabas* (1573; Milan, S Barnaba), were painted in Milan, where he was established by 1575; these works indicate closer contacts with Jacopo Tintoretto, Brescian Renaissance artists, particularly Moretto, and Milanese Mannerist painters. Between 1578 and 1582 he painted frescoes and altarpieces for the charterhouse of Garegnano, near Milan, and in these established his mature style, which developed very little. He united elements of Antonio Campi's naturalism with Mannerist formulas partly influenced by Giovanni Demio (at Garegnano most marked in the angels he depicted on the dome), and thus achieved a lively narrative style, as in the *Adoration of the Shepherds* and the *Adoration of the Magi*. His *Deposition* (Milan, S Fedele) perhaps dates from 1583–4, but, although it is signed *S Petrazanus Titiani Al[umnus]* (i.e. pupil of Titian), it is closer to the work of Moretto. In 1584 Caravaggio (1571–1610) entered his workshop on a four-year contract. The absence of any works or documents between 19 Feb 1585 and 26 Sept 1589 has led scholars to suggest a long stay in Rome.

In 1589 Peterzano is recorded in Milan, when he took part in the competition for the cathedral organ doors, a commission won by himself and Camillo Procaccini. His cycle of frescoes depicting scenes from the *Life of St Anthony* (Milan, S Angelo), painted after 1591, accentuated the interest in narrative already evident at Garegnano, and this was developed with greater monumentalism in his frescoes of biblical stories in the Monastero Maggiore, Milan, which are indebted to the colossal art of Ambrogio Figino and Giuseppe Meda (*d* 1599). His altarpiece depicting *St Ambrose between SS Gervase and Protase* (1592; Milan, Ambrosiana) exemplifies the clarity and directness of his late art, which fulfilled the propaganda demands of the reformed Milanese church, led by Carlo and Federigo Borromeo.

BIBLIOGRAPHY
M. Calvesi: 'Simone Peterzano, maestro di Caravaggio', *Boll. A.*, i (1954), pp. 114–33
M. Gregori: *Gli affreschi della Certosa di Garegnano* (Milan, 1973)
M. T. Franco Fioro: 'Note su alcuni disegni inediti di Simone Peterzano', *A. Lombarda*, xix (1974), pp. 87–100
E. Baccheschi and M. Calvesi: 'Simone Peterzano', *Il cinquecento: IV* (1978), iv of *I pittori bergamaschi dal xiii al xix secolo*, ed. G. A. dell'Acqua (Bergamo, 1975–90), pp. 473–557
V. Natale: 'Un quadro di Tibaldi–Peterzano', *Paragone*, xlix/457 (1988), pp. 15–28

UGO RUGGERI

Petrarch [Petrarca], **Francesco** (*b* Arezzo, 20 July 1304; *d* Arquà, nr Padua, 19 July 1374). Italian poet and humanist. He was the central figure of Italian literary culture in the

mid-14th century. The son of an exiled Florentine notary who moved to Avignon in 1312, Petrarch led a peripatetic career as a man of letters; after studying law at Montpellier (1316) and Bologna (1320), he alternated residence between France and the Italian courts until 1353, when he finally settled in Italy. He often acted as an ambassador and orator on state occasions. His work largely initiated the transition from the fragmentary humanism of the late Middle Ages to the more systematic classicism of the Renaissance. His observations on art were sporadic and usually marginal, but they are crucially important for the understanding of the development of a critical vocabulary for art, and for revealing the way in which an appreciation of the visual arts began to be absorbed into the concerns of literary humanism. Petrarch also has an important place in art history owing to his known connections with contemporary artists, the visual interpretation or illustration of his work in the Trecento, and the unusually large number of portraits made of him during or just after his lifetime.

Petrarch's name can be associated with three major painters: Simone Martini, (*c.* 1284–1344) 'il mio Simon', whom he met at the papal court in Avignon in 1336, Giotto and Altichiero (*fl* 1369–93). In a letter (*Familiari* v, 17) he mentioned 'two outstanding painters who were not handsome: Giotto, a Florentine citizen whose reputation is very high among the moderns, and Simone of Siena . . .', observing that the painting of the period was superior to its sculpture, 'since our age is truly mediocre in that art form'. In April 1338 Petrarch had Simone paint, on a new folio inserted into his recovered manuscript of the works of Virgil (Milan, Bib. Ambrosiana), a frontispiece showing Virgil, Servius and Aeneas in a pastoral setting. Two of Petrarch's sonnets (lxxvii and lxxviii) mention Simone by name and reveal that he also painted a portrait (untraced) of Petrarch's muse Laura.

Petrarch's admiration for Giotto was evidently profound. He possessed a *Virgin and Child* (untraced) by him, which he bequeathed to his last patron Francesco I da Carrara, ruler of Padua, and in his *Itinerarium syriacum* of 1358 he recommended a visit to the 'great memorials of [Giotto's] hand and talent [*ingenium*]' in the royal chapel of Naples (frescoes on biblical subjects; destr.). The concept of *ingenium* and the wording of the bequest to Francesco da Carrara reveals that Petrarch admired Giotto's art because it appealed to the knowledgeable but not to the ignorant. The idea, later amplified by Giovanni Boccaccio, Filippo Villani and others, of an informed appreciation of art by non-artists, and for its specifically artistic merits, appears here for the first time in Renaissance literature.

Altichiero almost certainly collaborated on the Sala Virorum Illustrium (Hall of Famous Men; now the Sala dei Giganti; 1367–79) in the Palazzo Carrara, Padua, which was based on Petrarch's *De viris illustribus*, and possibly executed under his supervision. Altichiero also executed two headpieces of posthumous Petrarch manuscripts for Francesco da Carrara (Paris, Bib. N., MS. Lat. 6069F and 6069G), and his workshop illuminated another (Paris, Bib. N., MS. Lat. 6069I). The first and last of these represent the *Triumph of Fame*, derived from Petrarch's *Trionfo della fama*. The *Triumphs* as a set were the most extensively

illustrated of Petrarch's works throughout the Renaissance, appearing in manuscripts as well as on *cassone* panels and as independent paintings. Altichiero painted four surviving portraits of Petrarch; although all posthumous, they must have been based on observation from life: the burnt fresco in the Sala Virorum Illustrium, which shows Petrarch in his study; a profile grisaille on the flyleaf of a Carrarese manuscript of the *De viris illustribus* (Jan 1379; Paris, Bib. N., MS. Lat. 6069F); and one each in his Paduan fresco cycles, in the chapel of S Giacomo (now S Felice; *c.* 1376–9) in the Santo and in the nearby oratory of S Giorgio (1379–84). A portrait of *Petrarch* made during his lifetime appears in Nardo di Cione's *Last Judgement* in S Maria Novella, Florence, and a letter written by Petrarch in 1356 mentions two sittings for unnamed artists on behalf of Pandolfo Malatesta of Rimini.

The exact criteria by which Petrarch judged art are hard to determine, and his comments on individual pieces are few and rather vague. His only description of a surviving work of art (*Familiari* xvi, 11) is of a 12th-century stucco tondo of *St Ambrose* in S Ambrogio, Milan. In a letter (*Familiari* i, 5) he described the half-built Cologne Cathedral as 'a very beautiful temple'. His letter on his walks through the ruins of Rome (*Familiari* vi, 2), important in a humanist context, gives little sense of any aesthetic appreciation of antiquity, and this is broadly true of Petrarch's attitude to antiquity in general. The section on the visual arts in the *De remediis utriusque fortunae* (between 1354 and 1366; for illustration of frontispiece of first German edition (1532), assembles a series of familiar arguments in favour of the appreciation of art without attempting to add any original theory of aesthetics. It is, nevertheless, Petrarch's concept of *ingenium* that stands at the head of the critical and analytical tradition of understanding art.

WRITINGS

Opera omnia (Basle, 1581)
V. Rossi, ed.: *Le familiari*, 4 vols (Florence, 1933–42)
G. Martelloti, ed.: *De viris illustribus* (Florence, 1964)

BIBLIOGRAPHY

D. Shorr: 'Some Notes on the Iconography of Petrarch's *Triumph of Fame*', *A. Bull.*, xx (1938), pp. 100–07
T. E. Mommsen: 'Petrarch and the Decoration of the Sala Virorum Illustrium in Padua', *A. Bull.*, xxxiv (1952), pp. 95–116
E. H. Wilkins: *Petrarch's Eight Years in Milan* (Cambridge, MA, 1958)
——: *Petrarch's Later Years* (Cambridge, MA, 1959)
——: *Life of Petrarch* (Chicago, 1961)
M. Bishop: *Petrarch and his World* (London, 1964)
M. Baxandall: *Giotto and the Orators* (Oxford, 1971)
G. Frasso: *Travels with Francesco Petrarca* (Padua, 1974)
G. Mardersteig: 'I ritratti del Petrarca e dei suoi amici di Padova', *Italia Med. & Uman.*, xvii (1974), pp. 251–80
C. Gilbert: 'The Fresco by Giotto in Milan', *A. Lombarda*, 47–8 (1977), pp. 31–72

JOHN RICHARDS

Petrucci, Pandolfo (*b* Siena, 1451; *d* San Quirico d'Orcia, nr Siena, 21 May 1512). Italian patron. He led a faction that seized power in Siena in 1487. Known as *il Magnifico*, Pandolfo ruled the city absolutely from 1502 to 1512, not only controlling the city's foreign alliances and domestic policies but also wielding considerable influence over artistic production. His interest in renovating the architectural fabric of Siena, much like that of Lorenzo de' Medici in Florence, was far-reaching; they both avidly promoted

Classical taste in architecture as well as in painting and sculpture. Although he seems to have had no particular hostility to medieval art, Pandolfo attempted to stamp his own taste on Siena's public buildings by changing two key works in the city. As a member of the Opera del Duomo, the commission responsible for the cathedral, in 1505 he arranged for the removal from the high altar of the *Maestà* (most panels now Siena, Mus. Opera Duomo by Duccio (*fl* 1278–1319) and for the movement of the high altar itself from its site under the dome to its present location in the choir. In 1508 he advocated the construction of a series of porticos to ring the Campo, Siena's main piazza, for which Baldassare Peruzzi provided a design. The Petrucci houses, a group of small medieval buildings on the Via dei Pellegrini, were united by Giacomo Cozzarelli and transformed into a single massive block, the Palazzo del Magnifico (Palazzo Petrucci), early in the 16th century. The interior decorations, on mainly Classical themes, included work by Luca Signorelli (the *Calumny of Apelles* and the *Festival of Pan*, both *in situ*; the *Triumph of Chastity*, London, N.G.), Bernardino Pinturicchio (*Scenes from the Odyssey*, London, N.G.) and Girolamo Genga (the *Ransoming of Prisoners* and *Aeneas' Flight from Troy*, both Siena, Pin. N.). The overall design of the decorative programme has not been explained. Although his sons, Borghese, Fabio and later Raffaello Petrucci, attempted to fulfil Pandolfo's dynastic goals, they were unable to maintain themselves in power and their artistic patronage is negligible. Borghese took power in 1512 but was forced to flee in 1516; Raffaello died in 1522 and Fabio was killed in 1524, bringing an end to the influence of the Petrucci.

BIBLIOGRAPHY

G. A. Pecci: *Memorie storico-critiche della città di Siena che servano alla vita civile di Pandolfo Petrucci dal MCCCCLXXX al MDXII* (Siena, 1755)

M. Davies: *The Earlier Italian Schools*, London, N.G. cat. (London, 1951, 2/1961/R 1986), pp. 437–9, 472–9

D. L. Hicks: *The Rise of Pandolfo Petrucci* (diss., New York, Columbia U., 1959)

——: 'Sienese Society in the Renaissance', *Comp. Stud. Soc. & Hist.*, ii (1960), pp. 412–20

J. Hook: *Siena: A City and its History* (London, 1979)

NICHOLAS ADAMS

Piacenza [anc. Placentia]. Italian city and provincial capital of Emilia-Romagna, situated about 68 km south-east of Milan. An agricultural and industrial centre, the city is a communication hub close to the River Po, and it contains a splendid legacy of medieval and Renaissance art. The original settlement became a Roman colony of Cisalpine Gaul in 218 BC as the *municipium* of Placentia, and its commercial importance developed as a direct result of its position at the end of the Roman Via Emilia. The regular layout of the Roman settlement still dominates the urban plan of Piacenza, while its commercial importance continued under subsequent rule by the Lombards (AD 570) and Franks (AD 774).

In 1090 Piacenza became a free commune. It was victorious as a member of the Lombard League of Cities in its battle (1176) with Frederick I, Holy Roman Emperor (*reg* 1152–90), and the city appointed a popular government in 1250. From 1332 Piacenza was dominated by the Visconti family, and it remained a Milanese possession until 1512, when it was taken by Pope Julius II and

incorporated into the Papal States. The works of Alessio Tramello, whose style was derived from Bramante, are among the most important Renaissance buildings in Piacenza; they include S Sisto (1499–?1511), S Sepolcro (?1498–1510/11) and S Maria di Campagna (1522–6; for illustration *see* TRAMELLO, ALESSIO); the latter was planned as a domed Greek cross, and in 1530–32 its interior was decorated by PORDENONE, who executed important frescoes in the dome. In 1545 Paul III instituted the dukedom of Parma and Piacenza, which he bestowed on his son Pier Luigi Farnese. The enormous Palazzo Farnese, based on the remains of the 14th-century Rocca Viscontea, was begun in 1558 by Francesco Paciotto for Ottavio Farnese, 2nd Duke of Parma and Piacenza (for illustration *see* PACIOTTO, FRANCESCO). JACOPO VIGNOLA took over in 1564 as director of the works, which were halted in 1593 although the project remained uncompleted; the building now houses the important collections of the Museo Civico.

BIBLIOGRAPHY

B. Adorni: *L'architettura farnesiana a Piacenza, 1545–1600* (Parma, 1982)

B. Adorni: 'I giardini farnesiani a Parma e a Piacenza', *Orti farnesiani sul Palatino* (Rome, 1990), pp. 505–21

GIUSEPPE PINNA

Piazza. Italian family of painters. Their workshop dominated art in Lodi in the 16th century. Martino Piazza (*b c.* 1475–80; *d c.* 1530) and Albertino Piazza (*b* 1490; *d* 1528/9) were brothers, who frequently collaborated; both are documented at the Incoronata at Lodi in 1514. Martino's oeuvre has been reconstructed (Moro) on the basis of two pictures, *St John the Baptist* (London, N.G.) and an *Adoration of the Shepherds* (Milan, Ambrosiana), which bear the monogram MPP; he was an eclectic artist, indebted to Leonardo da Vinci. Albertino's more classical style is revealed in his *Coronation of the Virgin* (1519; Lodi, Incoronata). Martino had three sons: Cesare Piazza (*fl* 1523; *d* ?1562), (1) Callisto Piazza and Scipione Piazza, who was the youngest. Callisto was the dominant figure, and Cesare and Scipione worked with him in Brescia and Lodi. Fulvio (*b* 1536; *d* after 1579) was the son of Callisto, and collaborated with him at the Incoronata, Lodi, and elsewhere.

(1) Callisto Piazza [da Lodi; de Toccagni] (*b* Lodi, *c.* 1500; *d* Lodi, 1561–2). Early collaborative projects with Martino and Albertino remain problematic. He probably moved to Brescia in 1523; the first major extant dated work is a *Nativity* (1524; Brescia, Pin. Civ. Tosio–Martinengo), painted for S Clemente, Brescia. In Brescia he studied the work of Moretto da Brescia and of Gerolamo Romanino, with whom he may have collaborated. Their influence is seen in the *Visitation* (1525; Brescia, S Maria Calchera) and especially in the group of works painted for churches in the Valcamonica. These include a *Deposition* (1527; Esine parish church); a *Virgin Enthroned with Saints* (Breno, S Antonio); a frescoed lunette of the *Virgin Enthroned with Saints* (Borno, oratory of S Antonio), and three frescoes—the *Beheading of St John the Baptist*, the *Assumption* and the *Life of St George* (all Erbanno, S Maria del Restello). These have a freshness and vigour that has sometimes led scholars to attribute them to Romanino. One of his best-known works, a genre scene, *The Concert*

(Philadelphia, PA, Mus. A.), is more Venetian in style. In 1529 Callisto returned to Lodi to complete a polyptych of the *Massacre of the Innocents* for the cathedral. This had been left unfinished by Albertino. This same year he was commissioned to paint the chapel containing the organ in the church of the Incoronata, Lodi. Throughout the rest of his career, alone or with his brothers and son, he worked in this church, on the chapel of St John the Baptist (1530–32); the chapel of the Crucifixion (1534–8); the chapel of St Anthony (1552); and the chapel of St Anne (1558). The scenes he painted demonstrate a growing interest in the art of Pordenone and in Cremonese art, a trend also evident in the *Assumption* of 1533 (Codogno, S Biagio). The later years of Callisto's career show him to have been very well established, working frequently in Milan in the major churches of S Maria presso S Celso (1542, 1546, 1554), S Ambrogio (*c.* 1545) and S Maurizio Maggiore (1555).

UNPUBLISHED SOURCES

Lodi, Tesoro Incoronata [P. C. Cernuscolo: *Annali o sia diario delle cose occorse nella chiesa della Santiss. Incoronata et Sacro Monte di Pietà della citta di Lodi dalla loro fondazione all'anno corrente 1642*]

BIBLIOGRAPHY

C. Ridolfi: *Meraviglie* (1648); ed. D. von Hadeln (1914–24)
R. Bossaglia: 'Le fonti di Callisto Piazza e le parafrasi dureriane', *Arte lombarda: Studi in onore di Giusta Nicco Fasola I*, ix (1964), pp. 106–12
M. L. Ferrari: 'Calisto de la Piaza', *Paragone*, xvi/183 (1965), pp. 17–49
A. Novasconi and G. C. Sciolla: *I Piazza* (Lodi, 1971)
A. Novasconi: *L'Incoronata di Lodi* (Lodi, 1974)
F. Moro: 'Lodi, Treviglio, Caravaggio, Crema', *Pittura tra Adda e Serio*, ed. M. Gregori (Milan, 1987), pp. 25–6, 107–10
I Piazzi da Lodi: Una tradizione di pittori nel cinquecento (exh. cat., ed. G. C. Sciolla; Lodi, Mus. Civ., S Cristoforo and Santuario Incoronata, 1987)
C. Fraccaro: 'Due nuovi documenti per Callisto Piazza e Pellegrino Tibaldi a Lodi', *Archv Stor. Lodi.*, cxiii (1994), pp. 301–10
C. Parisio: 'Di un libro sul Romanino e dei rapporti fra il pittore e Callisto Piazza', *A. Crist.*, lxxxiv/773 (1996), pp. 153–5

ANDREA BAYER

Piccinelli, Andrea. *See* BRESCIANINO.

Piccolomini. Italian family of ecclesiastics and patrons.

(1) Pope **Pius II** [Aeneas Silvius Piccolomini] (*b* Corsignano [now Pienza], nr Siena, 18 Oct 1405; elected 1458; *d* Ancona, 15 Aug 1464). Born of a Sienese noble family in exile, he studied classics and law in Siena, and travelled north of the Alps as secretary and diplomatic envoy to the cardinals at the Council of Basle, the anti-pope Felix V and the emperor Frederick III (*reg* 1452–93). He took holy orders in 1446, and returned to Italy to become bishop of Trieste (1447), bishop of Siena (1450) and cardinal (1456). A humanist gifted with an insatiable curiosity for history, travel and current events, with a penetrating eye for character and a love for landscape, he felt compelled to record his experiences and the results of his topographical studies in elegant Latin. Of all his many literary works, the *Commentaries*, written like Caesar's in the third person, remain the most vivid source for his life and times. Though composed at the end of his life, he recalls in Book I early travels that took him as far as Scotland. His letters also record the visual impressions that later influenced his patronage. In Germany he admired the wide squares, orderly layouts of towns and Gothic cathedrals, and in England at York, the Lady Chapel, describing its 'walls of glass held together by very slender columns'.

Having succeeded Calixtus III in 1458, Pius II had the primary goal as pope to launch a crusade against the Turks. To promote it, he organized a council in Mantua (1459), and a ceremony in Rome to welcome the relic of St Andrew's head brought from Patras under Turkish threat (1462). Both events furthered Pius's patronage. On the way to Mantua and back, he stopped at his birthplace and planned a small city there to be renamed PIENZA, and also he commissioned new buildings at Siena.

In Rome preparations for the reception of St Andrew's head included clearing (from 1460) the Piazza S Pietro of houses and rebuilding the Constantinian steps in front of Old St Peter's, at the foot of which were placed Paolo Romano's colossal marble statues of *St Peter* and *St Paul* (1461–2). After the ceremony, a tabernacle, marble ciborium (with lunettes by Paolo and Isaia da Pisa, now in the Vatican *Grotte*) and a silver-gilt reliquary (Pienza, Mus. Cattedrale) by the Florentine goldsmith Simone di Giovanni Ghini (1407–91) were made for a new chapel in the basilica to house the saint's head. Paolo's statue of *St Andrew* at Ponte Milvio marked the point where the relic entered Rome. A colossal *St Paul* (1463) destined for the top of the new steps is the most powerful of the statues Paolo made for Pius. It was moved to the Ponte S Angelo by Clement VII in 1530.

Paolo's colossal Apostles reflect Late Antique and Early Christian traditions, and Pius's buildings in Rome also reflect antique models. The Benediction Loggia (destr. 1600), the most monumental innovation of Pius's papacy, was based on the Colosseum. Leon Battista Alberti, Pius's apostolic secretary, was probably behind this innovative choice of model, which he praised in his *De re aedificatoria* (*c.* 1450). The loggia was begun on top of the new steps at the end of 1462, to the right of the atrium façade. The work was supervised by Francesco del Borgo, and the bulk of payments were to the architect Pagno di Antonio di Berti da Settignano (*c.* 1436–*c.* 1511). Nearly four bays were finished by Pius; Paul II and Alexander VI each added a storey above them. Originally the loggia seems to have been planned to extend across the façade. Of Pius's work in Rome, only the sculptures remain. Many manuscripts were also illuminated for him, and a number are in the Biblioteca Apostolica Vaticana, Rome, decorated by Andrea da Firenze and Jacopo da Fabriano (*fl* 1452–*c.* 1474), both of whom went to Rome in 1458 and worked in the current humanist style.

Disturbances in Rome and the Papal States caused Pius to strengthen various fortifications. He added a tower to the citadel at Assisi (1459–60), and at Tivoli built a new fortress (1461–2; by Manfredino da Como, *fl* 1460–*c.* 1497), using the remains of a Roman amphitheatre. Payments of 1463 exist for a new fortified tower entrance to the Vatican palace (destr.). Paolo Romano's bust of *Pius* (1463), which was over the portal (Vatican, Appartamento Borgia), vividly characterizes this man of determination, perspicacity and wit.

In Siena, Pius built the elegant Palazzo Piccolomini (now the Banco di Roma) for his sister (begun in 1461 by Antonio Federighi and Bernardo Rossellino). Based on the Palazzo Medici, Florence, it was modified to suit the

conservative Gothic taste of the Sienese. The tall and elegant Piccolomini Loggia (1460–62; designed by Federighi) is based on the Rucellai Loggia in Florence. Pius provided the site for the huge family palace opposite (now the Archivio di Stato), but the cornerstone was laid only in 1469.

With the building of Pienza (begun in 1459), Pius had more freedom. He had consulted Alberti and a copy of Vitruvius, but was also able to introduce elements he had admired in the north, which are combined with antique and contemporary Roman ones. His love of light and landscape is evident in the Piazza with views of Monte Amiata to the south across the Val d'Orcia visible between the cathedral and its flanking buildings. The cathedral has an interior 'remarkable for the clarity of the light', owing to the huge Gothic windows at the south, and the aisles and nave being of equal height, an arrangement like the hall-churches that had impressed Pius in Austria; the façade, however, is resolutely classical. The altarpieces, by contemporary Sienese artists, all depict the Virgin to whom the cathedral is dedicated. Vecchietta's altarpiece of the *Assumption of the Virgin with Four Saints* (*c.* 1462; *in situ*) must have appealed particularly to Pius, who wrote a Latin hymn to the Virgin, *Assunta*. The adjacent Palazzo Piccolomini, modelled on that of the Rucellai in Florence, but with larger windows, is a block with four façades, the rear a triple loggia overlooking the view, and a large central courtyard. Pius urged members of the papal curia and the Piccolomini family to add their palaces to the main axis of the town; those built include the palaces of cardinals Rodrigo Borgia (later Alexander VI), Jean Jouffroy (cardinal, 1461–73) and Jacopo Ammannati (1422–79). Pius wrote a minutely detailed description of Pienza, which he inspected in September 1462, in Book IX of his *Commentaries*.

In May 1462 alum was discovered at Tolfa in the Papal States, greatly increasing the papal revenue. This windfall may explain Pius's equanimity when faced by a bill for Pienza far higher than the estimate made by his architect, Bernardo Rossellino. In the summer of 1464 Pius left the Vatican to embark on the crusade, the banners of church and crusade flying from the newly restored campanile rising above the new Benediction Loggia. He died at Ancona, however; the mercenaries were dispersed, and the crusade was instantly abandoned.

WRITINGS

Opera omnia (Basle, 1571)
F. A. Gragg, trans., abridged: *Memoirs of a Renaissance Pope (The Commentaries of Pius II)* (New York, 1959, rev. London, 1960)
A. von Heck, ed.: *Commentarii*, 2 vols (Vatican City, 1984) [based on the autograph, Rome, Vatican, Bib. Apostolica, MS.Vat.Reg.Lat.1995]
L. Totaro, ed.: *Commentarii*, 2 vols (Milan, 1984) [based on the clean copy approved by Pius in 1464, Rome, Accad. N. Lincei, Cod. Corsiniano. 147; with It. trans.]

BIBLIOGRAPHY

E. Müntz: *Les Arts à la cour des papes*, i (Paris, 1878) [payments, documents and contemporary texts related to Pius's patronage]
C. M. Ady: *Pius II: The Humanist Pope* (London, 1913)
E. Carli: *Pienza: La città di Pio II* (Siena, 1967)
D. Maffei, ed.: *Enea Silvio Piccolomini, Papa Pio II Atti del Convegno per il quinto centenario della morte* (Siena, 1968) [with illustrated articles by R. O. Rubinstein on Pius's work in Rome and by J. Ruysschaert on Pius's MSS]
C. L. Frommel: 'Francesco del Borgo Architekt Pius' II und Pauls II', *Röm. Jb. Kstgesch.*, xx (1983), pp. 127–54
R. Rubinstein: 'Pius II and Roman Ruins', *Ren. Stud.*, ii/2 (1988), pp. 197–203

RUTH OLITSKY RUBINSTEIN

(2) Pope **Pius III** [Francesco Todeschini Piccolomini] (*b* Siena, *c.* 1440; elected 1503; *d* Rome, 18 Oct 1503). Nephew of (1) Pius II. He became Archbishop of Siena (1460), Cardinal Deacon of S Eustachio (1460) and reigned as Pope from 22 September 1503 for a few weeks before his death. As cardinal, he built a palace in Rome on the site of part of the present church of S Andrea della Valle. There he collected a group of ancient sculptures, one of which—the *Three Graces*—he presented in 1502 to his native Siena as the centrepiece of the Biblioteca Piccolomini, the foundation stone of which he laid in 1492. The library, part of Siena Cathedral, was intended specifically to house his uncle's extensive collection of books and was embellished by the Sienese sculptors Lorenzo di Mariano Marrina (1476–1534) and Antonio Ormanni (1457–1519), who executed the bronze entrance doors. The cycle of frescoes commissioned from Bernardino Pinturicchio in 1502 was executed between 1503 and 1508, after the patron's death. The subject of the painted scheme is the life and achievements of Pius II with Pius III's coronation depicted over the entrance to the Biblioteca.

At Cardinal Piccolomini's instigation, Siena Cathedral was embellished by a sculpted altar (*in situ*), executed by Andrea Bregno, for which Pietro Torrigiani was subsequently commissioned (1501) to sculpt the life-size *St Francis*. Torrigiani left this statue unfinished, and on 5 June 1502, Cardinal Piccolomini contracted Michelangelo to carve, within three years, fifteen statues for this monument. Michelangelo finished *St Francis* in June 1501 and in October 1504 delivered four more statues: *St Peter*, *St Paul*, *Gregory the Great* and *Pius I*. The project never appealed to Michelangelo, however, and it was only in 1561 that the sculptor was finally absolved by Pius III's heirs of his legal obligation to complete this grandiose project.

BIBLIOGRAPHY

E. Carli: *Il Museo dell'Opera e la Libreria Piccolomini di Siena* (Siena, 1946)
J. Pope-Hennessy: *Italian High Renaissance and Baroque Sculpture*, ii (London, 1963), pp. 7–8

DIANA NORMAN

Piccolpasso, Cipriano di Michele (*b* Castel Durante, 1523–4; *d* Castel Durante, 1579). Italian writer and maiolica painter. He came from a patrician family of Bolognese descent and was a humanist by education and an amateur devotee of the arts. He was also active as a dilettante poet, land surveyor, civil and military engineer and draughtsman. Between 1556 and 1559 he wrote *Li tre libri dell'arte del vasaio*—the earliest European treatise on maiolica production—at the request of Cardinal François de Tournon (1489–1562), who may have intended the treatise to help improve the quality of faience being manufactured in his native France. In this three-part treatise, Piccolpasso explained and illustrated in lively detail the basic procedures required for maiolica production; these procedures have remained largely unchanged during the ensuing centuries. He described the composition of glazes, pigments and lustres, the location and preparation of the raw materials, the methods for constructing the tools—includ-

ing the wheel and kiln—and for forming, trimming, drying, painting and firing the wares. He also included a selection of designs for plate decoration that were popular during the first half of the 16th century. His other major literary work was a topographical description of Umbria entitled *Le piante e i ritratti delle città e terre dell'Umbria sottoposte al governo di Perugia* commissioned by Pope Pius IV in the mid-1560s. Shortly after this commission, Piccolpasso became a member of the Accademia degli Eccentrici, a literary group based in Perugia, and in 1573 he helped found the Accademia del Disegno, one of the earliest academies for Italian artists. He was knighted and is cited as a cavalier in the records of Castel Durante of 1575.

WRITINGS

Le piante et i ritratti delle città e terre dell'Umbria sottoposte al governo di Perugia (1560s; Rome, 1963)
Li tre libri dell'arte del vasaio (1557–9; London, V&A, MS. L 7446–1861); ed. G. Conti (Florence, 1976); Eng. trans. and ed. by R. Lightbown and A. Caiger-Smith as *The Three Books of the Potter's Art* (London, 1980)

BIBLIOGRAPHY

E. Liburdi: 'Cipriano Piccolpasso (1524–1579)', *Faenza*, xviii (1930), pp. 42–8
B. Rackham: 'La data del trattato del Piccolpasso: "I tre libri dell'arte del vasaio"', *Faenza*, xxii (1934), pp. 16–20
G. Cecchini: 'La famiglia Piccolpasso di Bologna', *Archiginnasio*, 57 (1962), pp. 299–306
A. Caiger-Smith: *Tin Glaze Pottery in Europe and the Islamic World: The Tradition of 1,000 Years in Maiolica, Faience and Delftware* (London, 1973)
W. Watson: *Italian Renaissance Maiolica from the William A. Clark Collection* (London, 1986)

CATHERINE HESS

Pienza. Italian city in Tuscany, 50 km south of Siena. The small hamlet of Corsignano (birthplace of Pius II; *see* PICCOLOMINI, (1)) was transformed into the beautiful city of Pienza during one of the most intense periods of urban renewal in Renaissance Italy. The newly elected Pope made a return visit there in February 1459 and found it peopled by individuals who were 'bowed down by old age and illness'. He determined to 'build there a new church and a palace . . . to leave as lasting as possible a memorial of his birth'. In June 1462 Pius requested the senate in Rome to rename the town Pienza (a name deriving from his own) and to raise it to the level of a city state. During the mid-15th century the town was officially in the possession of the Sienese, but with its elevation and change of name it effectively came under the rule of Rome.

Between 1459 and 1464 some 40 buildings were either erected or refurbished in Pienza, including a huge papal palace (the Palazzo Piccolomini), a new cathedral, government offices and homes for the officials and members of the papal retinue and family. The centre of Pienza reflects the humanist ideals of such architectural theorists as Leon Battista Alberti, who was probably among the papal party on its visit to Corsignano in 1459. In his *De re aedificatoria* (Florence, 1485) Alberti, basing much of his advice on Vitruvius, proposed that the main palace in a city should be in a central piazza, adjacent to the temple, the theatre and the houses of other noblemen: the central square at Pienza is notable for its combination of secular and ecclesiastical architecture. The cathedral is positioned on the south side of the irregularly shaped piazza, flanked on the west by the Palazzo Piccolomini and on the east by

the episcopal palace (see fig. 1). The town hall (Palazzo Comunale) faces the cathedral on the northern side. The façades of the two palaces slope inwards to the cathedral in a way that exaggerates the monumentality of the square and the width of the cathedral façade in particular. This device was later adopted by Michelangelo for the Campidoglio in Rome (begun 1563).

Pius chose as his chief architect the Florentine Bernardo Rossellino, who was currently directing work on the cupola and lantern of Florence Cathedral. His design for the Palazzo Piccolomini façade is a variant of Alberti's Palazzo Rucellai in Florence (begun *c.* 1453; *see* ALBERTI, LEON BATTISTA, fig. 2), on which Rossellino had worked as executant architect. The rustication at the Palazzo Piccolomini is carried on through the pilaster shafts of the ground-floor order. The internal arrangements diverge from those of a town palace, as the central courtyard is opened up on the south side in three superimposed loggias, giving a view on to the hanging gardens below and across the Tuscan landscape to Monte Amiata beyond (*see* GARDEN, fig. 4). Pius referred to the distant view from the upper floors of his palace in his *Commentaries* (1462). This new awareness of the interaction between an interior and an exterior reflected a trend in architecture already introduced by Nicholas V in his proposed loggia at the Vatican, which was specifically designed to have a view over the papal gardens and surrounding city. In the *Commentaries* Pius gives detailed descriptions of the building works at Pienza and reveals his interest in both the aesthetic and practical. Constant reference is made to the changing effects of light from dawn to sunset in the Palazzo Piccolomini, the importance of the evenness of floors when moving from one part of the building to another (a matter in which Alberti was especially interested), varying temperatures and the convenience of having kitchen quarters on each of the three floors of the palace.

Pius's preoccupation with the quality of light as it enters a building no doubt played an important part in his choice of design for the north–south orientated cathedral. In

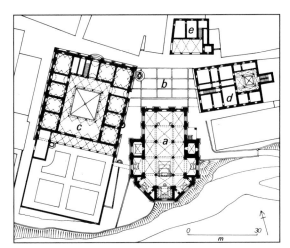

1. Pienza, plan of the cathedral square (now Piazza Pio II), 1459–64: (a) cathedral; (b) piazza; (c) Palazzo Piccolomini; (d) episcopal palace; (e) Palazzo Comunale

siting the (predominantly) glass wall of the altar end towards the sun, however, Rossellino had also to contend with the lie of the surrounding land. The southern end of the church had to be built out over the hillside surrounding the town, and ensuing foundation problems led to severe cracking in the fabric very shortly after its completion. The cathedral is unusual in being arranged on the lines of a German Late Gothic hall church of the type Pius had admired on his travels as a young apostolic secretary and ambassador. To comply with his client's wish, Rossellino adapted the hall-like structure to be found in the transept of Siena Cathedral to produce a church with three aisles of equal height, detailed in a Renaissance vocabulary. Similar ingenuity is shown in the design of the main elevation, the north front (see fig. 2), which is articulated by four colossal pilasters on pedestals, reaching to the horizontal cornice of the pediment without any intervening entablature. These pilasters embrace superimposed minor orders supporting three arches. Pius described the façade as being 'modelled on those Ancient temples and richly decorated with columns and arches and semicircular niches designed to hold statues'.

The episcopal palace is built in a Roman style comparable to that of the Palazzo Capranica, Rome (begun in 1450 for Cardinal Domenico Capranica, a former patron of the Pope), while the Palazzo Comunale has a loggia and tower designed in the Tuscan tradition. The architectural ensemble of the piazza in Pienza thus presents an anthology of early Renaissance architecture *c.* 1460. The city is also remarkable for having retained, virtually unchanged, the radical transformations introduced by Pius II. He ordained that the newly completed cathedral, dedicated to the Immaculate Virgin, should not be changed structurally, nor should its interior decoration be altered. The row of houses erected on the Via delle Nuove Case in the northeast sector suggest the beginnings of an overall urban plan,

as does also the relationship of the street system to the piazza. Pius ordered the cardinals of Mantua, Pavia and Artois and others to build palaces at Pienza and even planned to appropriate the land around the city. His untimely death in 1464 thwarted plans to flood the flat valley floor of the River Orcia below the city in order to create a vast lake intended to serve both as a natural defence and as a supply of fish for local consumption and trade. After his death, the city inhabitants returned to their former (mainly) agricultural pursuits, unable or unwilling to change the architectural fabric of Pienza further in the absence of powerful patronage and external finance.

BIBLIOGRAPHY

Pius II: *Commentarii* (Rome, 1462); Eng. trans., abridged, by F. A. Gragg as *Memoirs of a Renaissance Pope: The Commentaries of Pius II* (London, 1960)

O. S. van Henk: 'Painting in a House of Glass: The Altarpieces of Pienza', *Simiolus*, xvii (1987), pp. 23–8

C. R. Mack: *Pienza: The Creation of a Renaissance City* (Ithaca, NY, and London, 1987)

A. Tönnesmann: *Pienza–Städtebau und Humanismus* (Munich, 1992)

S. Stefanac: 'I maestri transalpini alla costruzione del Duomo di Pienza', *Mitt. Ksthist. Inst. Florenz*, xli/1/2 (1997), pp. 177–87

ANABEL THOMAS

Pier Francesco [Florenzuoli; Fiorenzuoli] **da Viterbo** (*b* Viterbo, 1470; *d* Viterbo, before Sept 1537). Italian architect. Along with Antonio da Sangallo (ii) and Michele Sanmicheli, he was one of the most distinguished military architects of the first half of the 16th century in Italy. Although material evidence of his military architecture is lacking, and his drawing style has not been identified, his reputation as a military figure was prodigious. According to Francesco Maria della Rovere I, Duke of Urbino, he was one of the few military architects able to judge the quality of a site. In the early years of the development of the angle bastion, and in the absence of scientific techniques for measuring vertical differences in topography, this skill was highly prized. He was subsequently engaged by Clement VII in 1523 as an engineer with responsibility for the papal fortresses at an annual salary of 300 scudi, and his fame was such that other rulers, including Alfonso I, Duke of Ferrara, requested his services.

Between 1525 and 1526 Pier Francesco conducted surveys of the fortresses in the Marches as well as proposing additions to the walls of Ferrara (1525), Piacenza (bastions of S Antonio and S Benedetto, 1525–47; destr.), Verona, Crema, Pesaro and Lodi. A drawing by Antonio da Sangallo (ii) of a section of the wall at Verona shows a sketch of a bastion by Pier Francesco (Florence, Uffizi). He seems to have supplied the first plans for the Fortezza da Basso, Florence (1528–34), completed by Antonio da Sangallo (ii), and in 1528 was also active in Pesaro. For Pope Paul III he supplied early designs for the Rocca Paolina, Perugia (1540–43; partly destr. 1860), and the Citadel Ancona (1535–7); the degree of his influence on plans such as these, in the past attributed wholly to Sangallo, appears substantial.

BIBLIOGRAPHY

F. M. della Rovere: *Discorsi militari* (Ferrara, 1583)

L. Celli: *Le fortificazioni militari di Urbino, Pesaro e Sinigallia del secolo XVI costruite dai Rovereschi* (Castelpiano, 1895)

E. Concina: *La macchina territoriale: La progettazione della difesa nel cinquecento Veneto* (Bari, 1983)

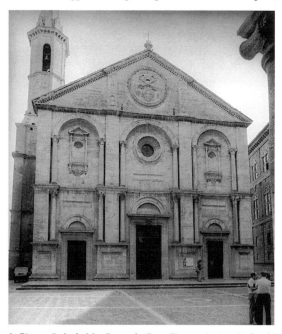

2. Pienza Cathedral by Bernardo Rossellino, main (north) façade, 1459–64

B. Adorni: 'Progetti e interventi di Pier Francesco da Viterbo, Antonio da Sangallo il Giovane e Baldassare Peruzzi per le fortificazioni di Piacenza e Parma', *Antonio da Sangallo il Giovane, la vita e l'opera: Atti del XXII congresso di storia dell'architettura: Roma, 1986*, pp. 349–72

NICHOLAS ADAMS

Pier Francesco Fiorentino [Pier Francesco di Bartolomeo di Donato] (*b* Florence, 1444–5; *d* after 1497). Italian painter. A fairly large corpus of works can be attributed to Pier Francesco grouped around one documented altarpiece, the *Virgin and Child with Saints* (1474; Empoli, Mus. Dioc.) and two signed and dated works: the *Virgin and Child with Saints* (1494; San Gimignano, S Agostino) and *Virgin and Child with Saints* (1497; Montefortino, Pin. Com.). The stylistically homogeneous group consists mostly of small-scale works, many of which bear dated inscriptions, sometimes including the name of the patron, who is often shown at prayer. They reveal Pier Francesco to have been an artisan–painter of high quality, somewhat lacking in invention but with a sound technique. His devotional paintings have a serene order and an air of humility completely devoid of rhetoric. The fact that he worked mostly for a provincial clientele somewhat limited his scope, but it also allowed him to express his own simple vein of piety derived from an unsophisticated pictorial culture that he gradually enriched through his technical virtuosity.

Pier Francesco probably trained in the workshop of his father, Bartolomeo di Donato, also an artist. There he would have acquired sufficient technical knowledge to enable him to become independent at an early age. The detached fresco with scenes from the *Life of St Eustace* (Florence, Cenacolo S Apollonia; see fig.) is certainly a youthful work, although its inscribed date of 1462 is suspect. It reveals a mature technique and a confident approach to spatial problems, modelled on Andrea del Castagno's work at the Villa Pandolfini, Legnaia, outside Florence. The lateral scenes are inspired by Benozzo Gozzoli's Florentine works and also by the coffer ('*forzieri*')

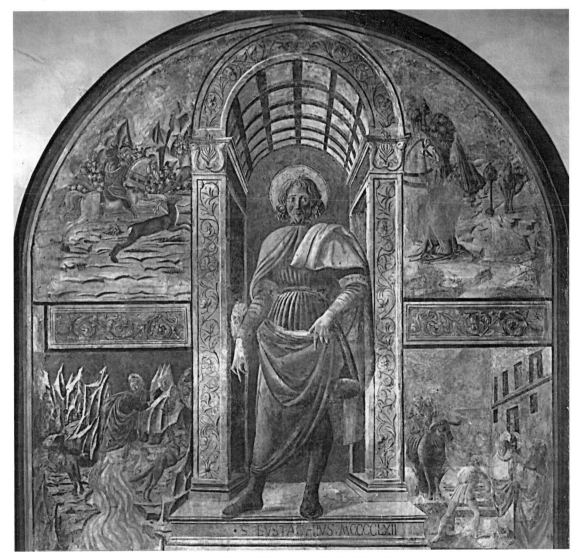

Pier Francesco Fiorentino: *Life of St Eustace* (?1462), detached fresco, Cenacolo S Apollonia, Florence

paintings of the followers of Domenico Veneziano. Certain stylistic features of the fresco such as its luminosity, the articulation of perspective and the linear treatment of the figures also suggest comparisons with Giovanni di Francesco, with whom it is likely that Pier Francesco collaborated on the *terra verde* frescoes of biblical stories in the loggia of the Palazzo Rucellai, Florence.

There are no documents concerning Pier Francesco's activity between 1461 and 1474, but stylistic evidence, supported by the large number of works attributed to him in the Val d'Elsa region, suggests he joined Benozzo Gozzoli's studio when the latter moved to San Gimignano around 1463–4. He may even have painted parts of Gozzoli's frescoes in S Agostino, San Gimignano. From this time Gozzoli's influence is increasingly evident in Pier Francesco's work, although he also borrowed from other artists such as Botticelli, Baldovinetti, Piero della Francesca and Perugino, whose Infant Christ type Pier Francesco used in his numerous representations of the Virgin and Child. His years in the Val d'Elsa, a territory caught between the political and cultural influences of Siena and Florence, caused him to assimilate elements from Sienese painters, particularly Vecchietta. This is most apparent in the predella of the *Virgin and Saints* altarpiece (Colle Val d'Elsa, S Maria in Canonica).

The Dominicans were an important source of patronage for Pier Francesco: many of his works in and around San Gimignano, such as the fresco of the *Crucifixion* (S Lucia, near San Gimignano) and the altarpiece of the *Virgin and Saints* (Avignon, Mus. Petit Pal.) were commissioned by members of the Order. His frescoes in the Palazzo Vicariale in Certaldo and in the Palazzo Pretorio in Volterra demonstrate the degree of respect also accorded to him by civic patrons. Pier Francesco's last dated works are of 1497: they include the *Trinity* (San Gimignano, Mus. Civ.) and a *Sacra conversazione* (Montefortino, Pin. Com.). His lucid manner was readily accessible to a public of different cultural levels and probably accounts for his continuing success. For PSEUDO-PIER FRANCESCO FIORENTINO *see* MASTERS, ANONYMOUS, AND MONOGRAMMISTS, §I.

BIBLIOGRAPHY
Thieme-Becker

L. Pecori: *Storia di San Gimignano* (Siena, 1853)
G. Poggi: 'Una tavola di Pier Francesco Fiorentino nella Collegiata di Empoli', *Riv. A.*, vi (1909), pp. 65–7
I. Vavasour Elder: 'Spigolature di Val d'Elsa', *Ant. Viva*, ix (1909), p. 160
G. Soulier: 'Pier Francesco Fiorentino pittore di Maddone', *Dedalo*, vii (1926–7), pp. 86–101
B. Berenson: *Florentine School* (1963), i, pp. 169–70
Arte in Valdelsa (exh. cat., ed. P. Dal Poggetto; Certaldo, Pal. Pretorio, 1963), pp. 61–4
Mostra di opere d'arte restaurate nelle provincie di Siena e Grosseto (exh. cat. by G. Borghini, Siena, Pin. N., 1979), pp. 164–5
R. Salvini: 'The Frescoes in the *Altana* of the Rucellai Palace', *Giovanni Rucellai e il suo Zibaldone*, ii: *A Florentine Patrician and his Palace*, Stud. Warb. Inst., xxiv (London, 1981), pp. 241–52
A. Padoa Rizzo and F. Nannelli: 'Pier Francesco Fiorentino a Pontorme', *Ant. Viva*, xxiv (1985) [triple issue dedicated to Luise Becherucci]
A. Paolucci: *Il museo della Collegiata di Sant'Andrea in Empoli* (Florence, 1985), pp. 111–13
A. Padoa Rizzo, ed.: *Arte e committenza in Valdelsa e Valdera* (Florence, 1997), pp. 34–45, 66–7

ANNA PADOA RIZZO

Pierino da Vinci [Pierfrancesco di Bartolomeo di Ser Piero da Vinci] (*b* Vinci, *c.* 1529; *d* Pisa, 1553). Italian sculptor, nephew of LEONARDO DA VINCI. His brief life was characterized by a precocious and promising sculptural career. He began his apprenticeship in Baccio Bandinelli's Florence workshop when he was about 12 but transferred shortly afterwards to that of Niccolò Tribolo; at the time Tribolo was working on the monumental fountains for the gardens of the Medici villa at Castello, near Florence. Pierino's first works, which can be dated after 1544, are a series of putti so similar in style to Tribolo's as to cause frequent misattributions. Among them are the *Putto with a Mask* (marble, h. 560 mm; Arezzo, Gal. & Mus. Med. & Mod.) made for a fountain; the *Putti Holding a Coat of Arms* (pietra serena, h. 430 mm; fragments, London, V&A); and two *Putti with a Fish* (terracotta, h. 650 mm; London, V&A).

Around 1545, after a brief trip to Rome, Pierino and other assistants were entrusted by Tribolo with the carving of the marble shaft of the Fountain of the Labyrinth for Castello (h. *c.* 1.2 m; moved 1788 to the nearby Villa di Petraia). On it satyrs, aquatic animals, putti and grotesque masks are carved in relief and in the round. From the same period, or shortly afterward, is the 'lost' grey-stone *Bacchus* of the Capponi family; a reference to it is in the *Portrait of a Youth* (London, N.G.) by Bronzino, identified as the portrait of Pierino da Vincio. In 1546 Pierino supplied the terracotta models (cast in 1547 by Zanobi Lastricati) for the four bronze putti (h. *c.* 700 mm) then positioned on the rim of the lower basin of Tribolo's Fountain of Hercules (for illustration *see* TRIBOLO, NICCOLÒ) at Castello. During casting one of Pierino's putti broke and was replaced by one executed by Tribolo.

In 1546–7 Pierino met his patron, Luca Martini, who commissioned a marble bas-relief of *Christ at the Column* (untraced). Pierino then left for Rome, where he stayed for about a year. During this time Pierino produced a Crucifix in bas-relief, from a drawing by Michelangelo, and for Cardinal Ridolfi he made a bronze bust for an antique head, and a marble low relief of *Venus*. He also restored an antique horse for Francesco Bandini and made a three-quarter size wax reproduction of Michelangelo's statue of *Moses* (see colour pl. 2, VII2), which he sent as a gift to Martini (all untraced). The only surviving works that can reasonably be ascribed to Pierino's Roman period, although possibly begun in Florence, are the pair of bronze statuettes of *Pomona* (h. 170 mm) and *Bacchus* (h. 166 mm), on a bronze base (h. 130 mm) that carries the inscription MDXLVII–OPERA DI PIERO DA VINCI, in the Ca' d'Oro, Venice (see Meller, 1974).

In 1548 Luca Martini, who had been appointed *Provveditore* at the Ufficio dei Fossi in Pisa by Cosimo I de' Medici, summoned Pierino to Pisa to carve a marble statue of a *River God* (l. 1.36 m; Paris, Louvre), which Martini later presented to Cosimo's wife, Eleonora of Toledo, and she to her brother, Don Garcia, who put it in the gardens of Chiara, Naples. Meanwhile, Pierino began a relief of the *Death of Count Ugolino and his Sons*, a subject at once Pisan and Dantesque suggested to him by Martini. Already known through numerous versions in different materials (wax and terracotta, *c.* 620×440 mm, Oxford, Ashmolean; terracotta, *c.* 620×440 mm, Florence, Antinori priv. col.), the original bronze version, mentioned by Vasari, has been identified in the exemplar at Chatsworth, Derbys. For the

inauguration in 1550 of Pisa's market-place, Pierino executed an allegorical statue of *Abundance* (travertine, h. 2.0 m; Pisa, Piazza Cairoli), the contrapposto theme of which is a variation of the earlier *River God*. It was followed in 1551–2 by a marble group of *Samson Slaying a Philistine* (h. 2.23 m; Florence, Pal. Vecchio), reminiscent of Michelangelo's marble *Genius of Victory* (Florence, Pal. Vecchio). At the same time Pierino also made a relief of the *Virgin and Child with the Infant St John and SS Elizabeth and Zacharias* (marble, 420×270 mm; ex-Bargello, Florence), which demonstrates the influence of Michelangelo, of Donatello, and of the engravings of Lucas van Leyden. Another of Pierino's works is the bas-relief of the *Holy Family with the Infant St John*, known through a bronze copy (London, V&A). Pierino's most famous and compositionally complex relief is the so-called *Pisa Restored* (Rome, Pin. Vaticana; see fig.). This is an allegorical marble relief in which Cosimo I is shown chasing out vices and promoting virtues in the city of Pisa. Two preparatory drawings for it are preserved (Florence, Uffizi and Chatsworth, Derbys.). It was the property of the art dealer and restorer Bartolomeo Cavaceppi until 1792, when it was passed to the Pio-Clementine Museum in the Vatican. From the same period are two marble reliefs attributed to Pierino: *Pan and Olympus* (430×570 mm; Florence, Bargello) and the *Profile of a Young Woman* (Lawrence, U. KS, Spencer Mus. Art). Pierino's last and unfinished work is the marble funerary monument of *Baldassare Turini* in Pescia Cathedral to which a candlestick base (bronze, h. 128 mm; London, BM) may be stylistically related.

BIBLIOGRAPHY

Thieme–Becker: 'Vinci, Pierino da'
G. Vasari: *Vite* (1550, rev. 2/1568); ed. G. Milanesi (1878–85), vi, pp. 119–32
U. Middeldorf: 'Additions to the Works of Pierino da Vinci', *Burl. Mag.*, liii (1928), pp. 299–306
M. Vandelli: 'Contributo alla cronologia della vita di Pierino da Vinci', *Riv. A.*, xv (1933), pp. 109–13
J. Wilde: 'An Illustration of the Ugolino Episode by Pierino da Vinci', *J. Warb. & Court. Inst.*, xiv (1951), pp. 125–7
H. Utz: 'Pierino da Vinci e Stoldo Lorenzi', *Paragone*, xviii/211 (1967), pp. 47–69
——: 'Neue Dokumente und Anmerkungen zu einigen Werken des Pierino da Vinci', *Stor. A.*, xiv (1972), pp. 101–25
P. Meller: 'Un gruppo di bronzetti di Pierino da Vinci del 1547', *Mitt. Ksthist. Inst. Florenz*, xviii (1974), pp. 251–72

Pierino da Vinci: *Pisa Restored*, marble relief, 0.75×1.08 m, 1552–3 (Rome, Pinacoteca Vaticana)

R. P. Ciardi: 'Uno stemma e una statua', *El Artista*, iii (1991), pp. 38–47
M. Cianchi: 'Pierino da Vinci: His Life and Works in Brief', *It. Cult.*, i (1995), pp. 81–110
M. Cianchi, ed.: *Pierino da Vinci* (Florence, 1995) [includes bibliog.]
——: 'Ripetizioni del Conte Ugolino di Pierino da Vinci ed il ritrovamento del rilievo Franchetti', *Tutte le opere non son per istancarmi: Raccolta di scritti per i settant'anni di Carlo Pedretti*, ed. F. Frosini (Rome, 1998), pp. 35–48
J. Fenton: *Leonardo's Nephew: Essays on Art and Artists* (London, 1998), pp. 68–87

<div style="text-align:right">MARCO CIANCHI</div>

Piermatteo (Lauro de' Manfredi) d'Amelia. *See* MASTERS, ANONYMOUS, AND MONOGRAMMISTS, §I: MASTER OF THE GARDNER ANNUNCIATION.

Piero [Pietro di Benedetto di Pietro] **della Francesca** [de' Franceschi] (*b* Borgo San Sepolcro [now Sansepolcro], *c.* 1415; *bur* Borgo San Sepolcro, 12 Oct 1492). Italian painter and theorist. His work is the embodiment of rational, calm, monumental painting in the Italian early Renaissance, an age in which art and science were indissolubly linked through the writings of Leon Battista Alberti. Born two generations before Leonardo da Vinci, Piero was similarly interested in the scientific application of the recently discovered rules of perspective to narrative or devotional painting, especially in fresco, of which he was an imaginative master; and although he was less universally creative than Leonardo and worked in an earlier idiom, he was equally keen to experiment with painting technique. Piero was as adept at resolving problems in Euclid, whose modern rediscovery is largely due to him, as he was at creating serene, memorable figures, whose gestures are as telling and spare as those in the frescoes of Giotto or Masaccio. His tactile, gravely convincing figures are also indebted to the sculpture of Donatello, an equally attentive observer of Classical antiquity. In his best works, such as the frescoes in the Bacci Chapel in S Francesco, Arezzo, there is an ideal balance between his serene, classical compositions and the figures that inhabit them, the whole depicted in a distinctive and economical language. In his autograph works Piero was a perfectionist, creating precise, logical and light-filled images (although analysis of their perspective schemes shows that these were always subordinated to narrative effect). However, he often delegated important passages of works (e.g. the Arezzo frescoes) to an ordinary, even incompetent, assistant.

I. Life and painted work. II. Style, working methods and technique. III. Theoretical works. IV. Critical reception and posthumous reputation.

I. Life and painted work.

1. Early works. 2. Mature works. 3. Late works.

1. EARLY WORKS.

(i) Background and collaborative works. Piero's birthplace, Borgo San Sepolcro, was at one of the crossroads between Tuscany, the Marches and Umbria. A flourishing town in the upper Tiber Valley, it passed from Malatesta rule to the Papacy in 1431 and was ceded to Florence in 1441. Piero was the son of a tanner and wool merchant, and his early study of mathematics doubtless had a mercantile purpose (*see* §III below).

Documents (Dabell, 1984; Banker, 1990, 1991, 1993) provide clues about Piero's earliest artistic activity. He was paid in Borgo San Sepolcro in June 1431 for painting processional candle poles, and he is recorded there on 29 December 1432 as having assisted Antonio da Anghiari, a local Late Gothic painter, with initial work on the high altarpiece of S Francesco since June 1432. The commission was later abandoned and passed on to Sassetta, whose celebrated altarpiece, completed in 1444, was an important influence on Piero. This early payment (a substantial 56 florins) and others for painting pennants with the insignia of Pope Eugenius IV (*reg* 1431–47) in 1436 were made through his father (recorded elsewhere in dealings with Antonio), indicating Piero's youth but also his precocious involvement in local artistic commissions. He is recorded several times in Borgo San Sepolcro until 1438.

Florence must have provided a fundamental stimulus for Piero's development, although there is only one record of his presence there. On 12 September 1439 he is documented with Domenico Veneziano in a payment relating to the decoration (destr.) of S Egidio (now S Maria Nuova), then the most important Florentine fresco cycle since the Brancacci Chapel (Florence, S Maria del Carmine; see colour pls 2, II2, 2, III2 and 2, IV1). Piero was inspired by Domenico's ordered, rationally lit compositions (especially his *St Lucy* altarpiece of the 1440s; *see* DOMENICO VENEZIANO, fig. 2 and colour pl. 1, XXVIII1), as well as by his calm, pale Madonnas, whose ovoid heads and almond eyes reappear in Piero's figures. It is intriguing to imagine the appearance of the work (untraced) that Domenico is documented as having produced in 1450 in Arezzo, where the two painters may have met again.

(ii) The 'Misericordia' altarpiece. In 1442 Piero's name was drawn from a list of citizens eligible for membership of the town council of Borgo San Sepolcro (not necessarily indicating his actual presence there), the first of many references to his participation in civic affairs. He received a significant commission in the town a year after Sassetta's altarpiece was set up there. On 11 June 1445 a leading charitable confraternity contracted him to paint a large altarpiece for its church/oratory. The *Misericordia* altarpiece (Sansepolcro, Pin.) was probably the first major work in the town by a non-Sienese artist. The commission had been in preparation since 1430 (Dabell, 1984), and Piero's contract specified that the work was to be completed within three years. As with many of Piero's works, however, there were years of delay, and he interrupted the execution of this polyptych more than once; in early 1455 he was admonished by the patrons. The work was not finished until about 1460. Although the panels of the *Misericordia* altarpiece are poorly preserved, they reveal the early development of Piero's style from the loose modelling reminiscent of Masaccio, seen in *SS Sebastian and John the Baptist* on the left, to the monumental, subtly defined *SS John the Evangelist and Bernardino* on the right, all of them standing solidly in space, despite the gold background required for this conservative commission. The central figure of the Virgin epitomizes Piero's concern for statuesque, scrupulously modelled form and is a perfect

conjunction of iconography and volumetric description. The supplicants gathered around her typify Piero's non-individualizing approach to figures, here depicted with a restrained but telling use of gesture.

(iii) The 'Baptism'. The *Baptism* (London, N.G.; see fig. 1) is also an early work, probably begun in the late 1440s; it was the centre of an altarpiece (Sansepolcro Cathedral) that appears archaic when viewed according to Piero's luminous idiom. The morning light, open sky and distinctive clouds in the *Baptism* are all characteristic of Piero, while the trees in the landscape background punctuate space like bars of music and provide the same compositional scansion as they do in many of his later works. His interest in light is prominently displayed in the reflective surface of the river. The arrangement of the foreground figures and their deliberate juxtaposition with inanimate, regular bodies (e.g. the cylinder of the tree) are early indications of Piero's enduring interest in rigorously constructed compositions. Here and elsewhere, however, narrative expression always takes precedence over perspectival construction.

The remaining part of the altarpiece was entrusted in the mid-1450s to the Sienese workshop of Matteo di Giovanni (also a native of Borgo San Sepolcro) and Giovanni di Pietro, who painted the lateral panels with figures of *SS Peter and Paul*, pilaster saints and a narrative predella relating to the Baptist, one end of which bears the arms of the Graziani family (all Sansepolcro, Mus.

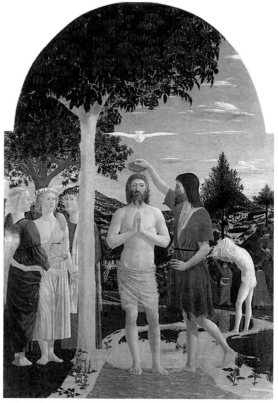

1. Piero della Francesca: *Baptism*, egg tempera on panel, 1.67×1.16 m, ?late 1440s (London, National Gallery)

Civ.). A roundel with *God the Father* (untraced) above the central scene may have been painted by Piero. The altarpiece appears to have been constructed by Antonio d'Anghiari (Dabell, 1984) and commissioned for a church dedicated to S Giovanni Battista, either in Val d'Afra or the Pieve (Lightbown).

(iv) Work for courtly patrons. The signed and dated *Penitent St Jerome* (1450; Berlin, Gemäldegal.), a small painting in its original frame, is a refined work of the kind Piero provided for his first courtly patrons. These were perhaps the Este in Ferrara, where he painted frescoes (destr.) in S Agostino *c.* 1449 and where he doubtless saw examples of work by Rogier van der Weyden (*c.* 1399–1464) or other early Netherlandish painters. Despite the loss of its surface glazes, this work demonstrates Piero's clarity of composition and depiction of cool, morning light. Its poetic, river-crossed landscape, similar to that of the *Baptism*, precedes that painted by Bono da Ferrara in the Ovetari Chapel (Padua, Eremitani). A slightly later version of the same subject (Venice, Accad.) depicts a donor and a view of a town like Borgo San Sepolcro. Both works have an intensity of feeling entirely befitting the spiritual subject.

Sigismondo Pandolfo Malatesta was one of Piero's most important courtly patrons. His transformation of S Francesco in Rimini into the dynastic Tempio Malatestiano involved Alberti (*see* RIMINI, figs 1–3), who may have proposed Piero's services for the votive fresco of *Sigismondo Malatesta Venerating St Sigismund* (1451; detached,

in situ; see fig. 2). The careful profile of Sigismondo, repeated in a portrait by Piero (Paris, Louvre), contrasts with the relaxed pose of the saint and with the contrapuntal figures of the two greyhounds, in which courtly and symbolic iconography and natural description are merged. The saint's hand and orb reveal the painter's skill in depicting both regular and irregular solids. As in the *Baptism* and all of Piero's most successful compositions, there is a visually satisfying sense of interval between the figures here, a remarkable and idiosyncratic feeling for the rhythmical arrangement of solids and voids.

(v) The Perugia altarpiece. The altarpiece painted for the Franciscan nuns of S Antonio delle Monache, Perugia (Perugia, G.N. Umbria), has been associated with documents of 1469 (Lightbown) but appears to be an earlier work, datable to before the Arezzo frescoes and showing the strong influence of Domenico Veneziano (e.g. his *Virgin and Child*; Bucharest, N. Mus. A.). The setting and frame of the main register, the *Virgin and Child between SS Anthony of Padua, John the Baptist, Francis and Elizabeth of Hungary*, are redolent of the courtly Late Gothic world of Central Italy, while its more modern double predella and unusual gable with the *Annunciation*, certainly planned from the start, display Piero's freedom when faced by less restricted sections of a painting. The virtuosity of the architectural description recalls the Urbino *Flagellation* and the *Solomon and Sheba* scene in Arezzo, both roughly contemporary.

2. Piero della Francesca: *Sigismondo Malatesta Venerating St Sigismund* (1451), fresco, 2.57×3.45 m, Tempio Malatestiano, Rimini

2. MATURE WORKS.

(i) Frescoes for S Francesco, Arezzo. Piero's greatest achievement is the fresco cycle of the *Legend of the True Cross* (Arezzo, S Francesco; see colour pl. 2, XVI1) illustrating Man's redemption through the story of the wood from the Garden of Eden that became Christ's Cross. These narrative scenes contain some of the most original and memorable images of the Renaissance, and their arrangement, which diverges from the traditional chronology of the *Golden Legend*, is adapted to Franciscan liturgy. The sophistication of these paintings is the result of the learned Franciscan programme and the lucid inspiration of Piero.

In the initial phase of decoration, the chapel vault and the *Last Judgement* over the arch facing the nave were painted by the workshop of Bicci di Lorenzo c. 1447. Piero may have begun work very soon thereafter. The commission was the result of a bequest by the Bacci family (the involvement of the humanist Giovanni Bacci, postulated by Ginzburg, is entirely hypothetical). The fresco cycle is undocumented and can be dated only to after 1447, when a partial payment was made by the Bacci to an unnamed painter (usually identified as Bicci); most of the chapel was painted during the early to mid-1450s, and it was certainly finished by 1465.

The frescoes may be dated stylistically to a period beginning in the late 1440s (by comparison with the early parts of Piero's own *Misericordia* altarpiece) and are reflected in works by other artists painted by the late 1450s (Bellosi, Bertelli). One comparable work is by Giovanni da Piamonte, an assistant of Piero whose hand is recognizable in parts of the frescoes. His *Virgin and Child with Saints* (Città di Castello, S Maria dei Servi) is signed and dated 1456, which proves that this little-known painter was an independent master by then. Another work that reflects knowledge of the lowest tier of frescoes in Arezzo is the *St Nicholas* predella by Giovanni di Francesco (Florence, Casa Buonarroti), who died in 1459, so adding to the chronological framework. In sizeable sections of the frescoes Piero's design is more evident than his execution; qualitative unevenness reveals that important passages were delegated to an ordinary, even incompetent, assistant. The *Raising of the Jew from the Well*, for example, was designed by Piero and painted by an assistant (probably Giovanni da Piamonte), but with the correct light-source—such a significant part of Piero's cerebral approach to art—reversed.

Although Vasari's account of the frescoes in the *Vite* (1550, rev. 2/1568) is somewhat confused and historically inaccurate, his description is often detailed and perceptive. He noted (*Vite*, 1568; Eng. trans. by G. de Vere, London, 1912–14, iii, p. 20):

> a row of Corinthian columns, divinely well proportioned [in the *Solomon and Sheba* scene]; and a peasant who, leaning with his hands on his spade, stands listening [in the *Discovery of the Cross* scene].... But above every other consideration.. .is his painting of Night, with an angel in foreshortening who is flying with his head downwards.. .and with his own light.. .illuminates the pavilion, the men-at-arms, and all the surroundings [the *Dream of Constantine*].... Piero gives us to know in this darkness how important it is to copy things as they are.

Three essential aspects of Piero's art are touched on here: his interest in perspective, his unaffected naturalism and his skill with light.

(ii) The 'Flagellation'. The signed *Flagellation* (Urbino, Pal. Ducale; see fig. 3) is in a sense a summation of Piero's artistic interests: a rigorous construction based on modular measurements, a conception of composition and *istoria* worthy of Alberti and the use of Classical figures and architecture, all depicted with his precise and extraordinary command of light. The figure of the man in Turkish dress, whose turban is described with the aid of minuscule pouncing and whose Classical drapery is lit by separate sources of light (the underside of his left hand catches the natural light in a manner reminiscent of Jan van Eyck (c. 1395–1441), represents the summit of Piero's art. From the 18th century, when the *Flagellation* was recorded in the sacristy of Urbino Cathedral, descriptions of this enigmatic panel have focused on the identity of the three figures on the right. These were once thought to portray members of the Montefeltro family or to allude to the assassination in 1444 of Oddantonio da Montefeltro by his half-brother Federigo da Montefeltro, later Duke of Urbino and an important patron of Piero. Uncertainty about the date of this picture (probably mid-1450s) and its destination has led to many interpretations. Analyses of its function and meaning have ranged from themes related to the Crusades, in which Christ's Passion was echoed in contemporary events (Clark, Ginzburg), often with specific identifications of the secular figures with princes or patrons (Lavin, Lightbown, Calvesi), to anti-Semitic themes (Lollini). An original interpretation of the scene as the flagellation of St Jerome (Pope-Hennessy, *Apollo*, 1986), in which much iconographical inconsistency is resolved, sets the painting in the context of a highly cultured court.

(iii) The 'Resurrection'. One of Piero's most celebrated paintings, the *Resurrection* (after 1458; Sansepolcro, Mus. Civ.; see colour pl. 2, XV2), is undocumented but is related stylistically to the later Arezzo frescoes. It was frescoed in the Residenza, one of the official chambers of government in Borgo San Sepolcro, in the Sala dei Conservatori, a room completed in 1458. It was clearly modelled on the image of the *Resurrection* seen in the 14th-century Sienese altarpiece still in the cathedral there. The fresco was probably moved soon after its execution when the room was altered, and it suffered some damage, including the loss of framing elements and parts of the inscription. The commanding figure of the Risen Christ is one of the enduring images of Christian victory in Western art, and the disarray of the slumbering Roman soldiers provides a stirring contrast. As at Arezzo, the setting of the figures close to the foreground lends a dramatic immediacy to the scene.

(iv) Work for S Agostino, Borgo San Sepolcro and the 'Madonna del parto'. On 4 October 1454 Piero had been commissioned by the Augustinian friars of Borgo San Sepolcro and the family of Angelo di Giovanni di Simone and his late brother, Simone di Giovanni di Simone, to paint the high altarpiece of S Agostino. The unusual time limit of eight years suggests that Piero was involved elsewhere at the time. The principal surviving panels of this altarpiece (dispersed), each about 1.33×0.59 m, are linked by a Classical parapet running behind the figures.

3. Piero della Francesca: *Flagellation*, tempera on panel, 590×815 mm, ?mid-1450s (Urbino, Palazzo Ducale)

These include a solemn depiction of *St Augustine* (Lisbon, Mus. N. A. Ant.), who bears a crystal crozier and whose cope is decorated with freely handled New Testament scenes; a quietly heroic and dazzlingly bejewelled *St Michael* (London, N.G.), in which part of the throne base and drapery are visible; *St John the Evangelist* (New York, Frick), with a corresponding element of the throne at his feet; and a corpulent portrait-like image of *St Nicholas of Tolentino* (Milan, Mus. Poldi Pezzoli). Smaller panels executed by Piero's workshop and possibly associated with the altarpiece include *St Apollonia* (Washington, DC, N.G.A.) and two Augustinian saints and a damaged *Crucifixion* (all three New York, Frick). The *Crucifixion* contains beautifully depicted horses, which are as monumental as their counterparts in Arezzo and may well be by Piero. Like the *Raising of the Jew from the Well* scene of the Arezzo frescoes, *St Apollonia* seems to have been painted by an assistant, as it is lit from the 'wrong' side. Archival research has revealed more information about the patrons involved in this altarpiece commission (Banker, 1987) and evidence of the untraced central panel, a *Virgin and Child* (Polcri, 1990). The work was not completed until at least 1469, and once again stylistic contrasts within its evolution are apparent, from the *St John*, contemporary with the Arezzo frescoes, to the luminosity of the *St Augustine* inspired by the Urbino *Flagellation*.

A figure of a youthful saint, usually identified as *St Julian* (Sansepolcro, Mus. Civ.), which Piero had frescoed earlier in S Agostino, was discovered in 1954. Only the upper part of the body survives, but this fragment beautifully illustrates his skilful use of lighting and the technique of pouncing. These qualities are also evident in a calm image of incomparable devotional strength, the *'Madonna del parto'* (*Virgin with Two Angels*; see colour pl. 2, XVII1), which adorns a small reconstructed cemetery chapel (formerly S Maria a Momentana) near Monterchi. The angels revealing the pregnant Virgin were painted from the same cartoon reversed, a device also used in the contemporary Arezzo frescoes, which provides a powerful symmetry. A more monumental female figure, also undocumented and perhaps painted somewhat later, is the frescoed *St Mary Magdalene* (Arezzo Cathedral), which is partly cropped.

3. LATE WORKS. Piero is recorded in Urbino only once, as the guest of Giovanni Santi on 8 April 1469, when he came to discuss a projected altarpiece for the confraternity of the Corpus Domini, a commission that had passed to Justus of Ghent (*fl c.* 1460–80) by 1473. He must have been in frequent contact with the court of Federigo da Montefeltro, however, which provided him with at least two other commissions. The first of these was probably the candid double portrait of *Federigo da Montefeltro* and his wife *Battista Sforza* (both Florence, Uffizi), no doubt painted after Battista's premature death in 1472 and partly a celebration of the ruling couple's virtues. These are extolled in the elegant humanist texts on the reverse of each of the bust-length portraits, which

have in the background one of the most beautiful, airy landscape views of the 15th century. The Brera Altarpiece (*Virgin and Child*; Milan, Brera; see colour pl. 2, XVI2), possibly a work of the mid-1470s, was in some ways modelled on a Late Gothic altarpiece (1439; Urbino, Pal. Ducale) commissioned from Antonio Alberti by the father of Federigo, Guidantonio da Montefeltro (*reg* 1404–43). Both works have a funerary function (Lightbown), and it seems clear that Piero's altarpiece is a votive work, relating Federigo to his heavenly intercessors. Its beauty derives from the extraordinary union of Renaissance architecture (reflecting the style current in Urbino) and figures in an idealized, ecclesiastical setting. The suspended egg, which has elicited much exaggerated exegesis, is sometimes found in funerary chapels; it provides both a symbol of the Resurrection and a formal parallel to the ovoid head of the Virgin.

Among Piero's last works are the poetic *Nativity* (London, N.G.), abraded by old, over zealous cleaning but also damaged by a candle-burn, which suggests that it did once stand as a completed altarpiece, and the Senigallia *Madonna* (Urbino, Pal. Ducale; ex-Senigallia), an intimate depiction of the Virgin and Child between two silvery-blue and pink angels with a view into a background room. The extraordinary effect of reflected light from the shuttered window there is a distant prelude to Dutch 17th-century painting.

II. Style, working methods and technique.

Since the execution of many of Piero's paintings was spread over many years, and since his figure types and mode of composition changed little during his long career, it is challenging to provide an accurate chronology of his works. Close scrutiny of certain characteristics, however, provides evidence for some of the change in his style. In physiognomy, there was a gradual shift from rosier to paler flesh tints and a move from fuller, rounder faces with large, expressive eyes and fleshier lips towards smaller eyes and less deeply modelled features. In Piero's approach to colour, there was a move from saturated tonalities, laid on in broad brushstrokes, to more luminous ones, handled in the latest works with a miniaturist's fine technique. Some of this shift in use of colour occurred early and may have been the result of a similar development in the work of Domenico Veneziano. The extremes of Piero's figure style may be perceived by comparing the left-hand saints in the *Misericordia* altarpiece or the frescoed *St Julian* in Sansepolcro with the figures in the Brera altarpiece or the Senigallia *Madonna*. The late change in handling was perhaps the result of failing eyesight, alluded to by Vasari, but which probably occurred very gradually, as the clear handwriting of Piero's will of 1487 suggests.

It is evident that Piero began experimenting with fresco technique early on. His association in Florence in 1439 with Domenico Veneziano, who was using an oil-based medium for at least part of the frescoes in S Egidio, already suggests a move away from traditional *buon fresco* technique. This may not be as unusual as it has seemed, however. An oil technique in wall painting is mentioned in Cennino Cennini's *Il libro dell'arte*, a handbook used by many 15th-century Central Italian painters, and analysis of

the Arezzo frescoes proves that Piero's approach to painting there was complex and varied.

Piero's frequent use of pricked cartoons, even for the smallest parts of a composition, is at the heart of his attempt to achieve pictorial perfection. Evidence of their use is visible in both panels and frescoes, for example in the *Baptism*, the *Flagellation* and throughout the frescoes in Rimini, Arezzo and Monterchi. In these last two works, symmetry of pose is achieved by the reversing of the cartoon, a method that could also be used to repeat a design and thus save time. This general use of pouncing indicates that Piero was a key figure in the changing application of this technique in the Renaissance, from earlier frescoes, when it was usually used for repeated decorative motifs, to the full-scale cartoons used by Raphael and others. Far from implying a loss of artistic spontaneity, this method could convey the most sophisticated, artfully achieved designs from the workshop to the wall without a loss in quality such as one might risk by using a *sinopia*, in which the underdrawing is covered with plaster.

Within several passages of the Arezzo frescoes (the marquetry door of the *Annunciation*, for instance) changes of medium are apparent, as if the painter experimented on the spot. Some patches of wall bear marks left by the application of a damp cloth to keep the plaster damp, while many other passages show evidence of retouching *a secco*, necessary with certain metal pigments, to refine effects of light and shade. Some of the pigmented forms painted after the plaster had dried were later lost, such as leaves on the large tree in the *Adamites* in the Arezzo frescoes or the left-hand tree in the *Resurrection* in Sansepolcro (leading writers to misinterpret them as symbolic, withered trees).

For bibliography *see* §IV below.

FRANK DABELL

III. Theoretical works.

Throughout the 15th century in Tuscany there was an increasing use of more sophisticated mathematical techniques in many crafts. An examination of artists' practice in this period, however, strongly suggests that Leon Battista Alberti was over-stating his case when he implied, in *De pictura* (1435), that painting generally involved a considerable quantity of exact mathematics. Only one leading artist of the 15th century seems to have had an independent reputation as a mathematician: Piero della Francesca. The identification of manuscripts of mathematical works by Piero and their publication confirm Vasari's characterization of him as an able mathematician, much of whose work was incorporated into treatises published after his death by his countryman, and possibly pupil, Luca Pacioli. Vasari's charges that Pacioli was guilty of plagiarism, which thus lowered Piero's later reputation, must be viewed with caution. Notions of copyright took root only slowly with the advent of printing: even in the 1520s, what should now be regarded as a piece of intellectual property, namely a method of solving cubic equations, seems to have been considered to be heritable. Most 15th-century mathematical treatises, including two of Piero's, contained numerous problems taken from

earlier treatises. Mathematics, particularly algebra, developed very rapidly in the period immediately after Piero's death, a fact that no doubt contributed to the rapid decline of his reputation as a mathematician; the fortune of Piero's mathematics was not unlike that of his art.

Vasari said that Piero wrote 'many' mathematical treatises. Three have been identified: *De prospectiva pingendi* ('On perspective for painting'), *Trattato d'abaco* ('Abacus treatise') and *De quinque corporibus regularibus* ('On the five regular bodies', i.e. the five regular solids described in Euclid's *Elements*). The treatise on perspective and the abacus book are both in Italian. The work on the regular solids survives in Latin, but may have been written originally in Italian. The dates of composition are not known exactly, but it is clear, from Piero's own borrowings and references, that the abacus book (probably written in the 1450s) preceded the work on the regular solids and that the latter was completed after the perspective treatise, probably in the decade after 1482. Partly on account of Pacioli's 'plagiarism' the contents of all three treatises have rather complicated publishing histories. Complete editions have appeared only in modern times.

The treatise least used by Pacioli is the one of most obvious concern to the historian of art, namely *De prospectiva pingendi*. A manuscript with exquisitely neat diagrams, believed by Nicco Fasola to be autograph, is preserved in Parma (Bib. Palatina, MS. 1576). Several later manuscripts are known (some in Latin), confirming other evidence that the work circulated quite widely in the 16th century. Parts of it were incorporated, with acknowledgement, in Daniele Barbaro's *La Prattica della perspettiva* (Venice, 1569). *De prospectiva pingendi* is intended as a practical instruction manual. The reader is presumably regarded as an apprentice, since he is called 'tu' throughout and is generally addressed in the imperative while being given detailed instructions for drawing the diagrams. Proofs mainly take the form of merely checking that the result is what Piero asserted. They are usually very brief, much briefer than the drawing instructions. Some proofs are only approximate, suggesting that the successful drawing of the diagram was seen as proof enough. However, a few proofs are fairly elaborate, involving long series of similar triangles and manipulation of ratios. While these techniques are standard for the time, they are not entirely elementary. The apprentice would need to have attended an abacus school to be able to follow such proofs with the fluency Piero seems to expect. (It is probably on account of the level of mathematical skill expected in the reader that *De prospectiva pingendi* did not find its way into print in the Renaissance.) In the manner of all practical treatises of the time, Piero's work proceeds almost entirely by means of worked examples. Its first book deals with flat patterns (tiled floors and the plans of simple bodies), the second considers various simple solid figures (such as houses, idealized as cuboids), and the third handles more elaborate objects, such as column capitals and human heads. Several diagrams correspond closely with elements found in the fresco cycle the *Legend of the True Cross* (Arezzo, S Francesco) and presumably reflect Piero's preliminary drawings.

Piero's treatise on perspective seems to have been the first of its kind, and it set the pattern for later treatises, although Piero no doubt saw it as part of an established tradition of workshop manuals. The *Trattato d'abaco* belongs in another tradition of practical texts, that of the elementary mathematical treatises used in abacus schools. These treatises—which derive their name from the *Liber abaci* (1202) of Leonardo of Pisa (*c.* 1170–?1250)—are largely concerned with arithmetic, but usually also contain a little algebra and may sometimes include a few geometrical problems. The exposition is by series of worked examples. Piero's *Trattato* is written in this way, though the introduction makes it clear that the work was not written for use in a school, but at the request of a friend or patron. It was probably a manual for merchants and was dedicated to a member of a local family, the Pichi (related to Piero's own family). There are two known manuscripts of the work; the one Arrighi believes to be autograph is in Florence (Bib. Medicea–Laurenziana, MS. Ashb. 280/359–291). Most of Piero's arithmetical and algebraic problems can be found in earlier treatises, but his geometrical problems, of which there is an unusually large number, show considerable originality, notably in dealing with three-dimensional figures. In particular, Piero gives descriptions of four of the polyhedra whose discovery Pappus of Alexandria (5th century AD) ascribes to Archimedes (*c.* 287–212 BC). Pappus' account merely lists the number of faces of each type. Piero shows what the solids actually look like, by describing how the faces are distributed round each corner of the solid. He is thus to be credited with having rediscovered the solids. Many of the problems in Piero's *Trattato* were printed, verbatim or with very minor changes, in Pacioli's *Summa de arithmetica* (Venice, 1494).

Piero's treatise *De quinque corporibus regularibus* is dedicated to Guidobaldo I, Duke of Urbino. This dedication must date from after Guidobaldo's accession to the title, in 1482, so it is probable that the treatise was at least finished in the last decade of Piero's life. The single surviving manuscript is in Rome (Vatican, Bib. Apostolica, Cod. Urb. 273). The text is in Latin, but the work nonetheless has much in common with the vernacular *Trattato d'abaco*, including many repeated problems (usually treated in a more detailed manner in the later work). The later treatise is original in being concerned only with geometry, however. Its first part deals with problems of plane figures, the second considers the five regular polyhedra individually, the third solves the problems involved in inscribing one regular polyhedron inside another (with numerous references to *Elements*, XV, a book formerly considered to be by Euclid). The fourth part of Piero's work deals with bodies that Piero calls 'irregular', though most of them (such as his Archimedean polyhedra, already discussed in the *Trattato*) can be inscribed in a sphere, and almost all show considerable symmetry. Several of Piero's geometrical problems are original in requiring the construction of a sphere with volume equal to that of a given solid. Piero's treatise on the regular solids was printed, complete but in Italian translation, as the third part of Pacioli's *De divina proportione* (Venice, 1509).

Piero was undoubtedly a very able mathematician. His mathematical works are not only unusually orderly in their presentation but also show an unusual degree of originality (for their time) both in the extent to which they deal with

geometrical problems and in the choice of the problems themselves. It is, however, difficult to establish any simple connection between Piero's mathematics and his paintings. His use of perspective seems to be broadly similar to that of most of his contemporaries, although he is exceptional in his adeptness at balancing composition in space with composition in the plane, and the famous 'stillness' of his works may be due to his having made exact perspective calculations for an unusually large number of elements (thus, for example, making all heads appear exactly equal). Piero's strong sense of order and of symmetry certainly should be seen as links between his mathematics and his art, although they by no means provide complete characterizations of either.

WRITINGS

G. Mancini, ed.: *Libellus de quinque corporibus regularibus* (Rome, 1916); also in G. Mancini: 'L'opera "De corporibus regularibus" di Pietro Franceschi detto della Francesca usurpata da Fra Luca Pacioli', *Mem. Accad. Lincei*, 15th ser., xiv, pp. 441–580
G. Nicco Fasola, ed.: *De prospectiva pingendi* (Florence, 1942/R Florence, 1984)
G. Arrighi, ed.: *Trattato d'abaco* (Pisa, 1970)

BIBLIOGRAPHY

S. A. Jaywardene: 'The "Trattato d'abaco" of Piero della Francesca', *Cultural Aspects of the Italian Renaissance*, ed. C. H. Clough (Manchester, 1976)
M. D. Davis: *Piero della Francesca's Mathematical Treatises: The 'Trattato d'abaco' and 'Libellus de quinque corporibus regularibus'* (Ravenna, 1977)
O. Calabrese, ed.: *Piero teorico d'arte* (Rome, 1985)
R. Franci and L. Toti Rigatelli: 'Towards a History of Algebra from Leonardo of Pisa to Luca Pacioli', *Janus*, lxxii (1985), pp. 17–82

IV. Critical reception and posthumous reputation.

Piero is first mentioned during his own lifetime, but only in passing, by Filarete in his *Trattato* and by Giovanni Santi in his life of *Federigo da Montefeltro*. Luca Pacioli, who called him a 'monarch' of painting and was mainly concerned with his theoretical works, was the first to state that Piero worked in Bologna, Ferrara (specified later by Vasari as decoration in the Palazzo Ducale and a chapel in S Agostino), Rimini and Urbino. Although several of the works mentioned are untraced, there is no reason to doubt the accounts of Pacioli or Vasari. Vasari, who also stressed Piero's skill as mathematician, referred to his work in Pesaro (the *Flagellation*, according to Lightbown), Ancona (a *Marriage of the Virgin* in S Ciriaco) and Loreto (in the sacristy, S Casa, with Domenico Veneziano).

Piero's reputation as painter declined after the 16th century, and it was only in local studies of the early 19th century, such as F. Gherardi Dragomanni's edition (1835) of Vasari's 1550 biography, that his oeuvre began to be examined critically. J. Crowe and G. Cavalcaselle, in the *New History of Painting in Italy* (London, 1864), and soon after them Bernard Berenson in the *Central Italian Painters of the Renaissance* (London, 1897), led the way to a modern reappraisal. In the 20th century early local studies of Piero and his impact around Arezzo by Salmi and others (summarized in 1979) were followed by landmark publications by Roberto Longhi (reassembled in 1963), whose fundamental and poetic appreciation of Piero in the context of his contemporaries set the stage for his reception in Italy. Berenson, who employed a connoisseur's approach to Piero in 1897, later wrote an essay,

Piero della Francesca or the Ineloquent in Art (London, 1954), in which Piero's classical restraint is equated with essential form. In the Anglo-Saxon world, Piero's name became more familiar after the *Baptism* was acquired by the National Gallery in London in 1861, and the *Resurrection* was acclaimed by John Addington Symonds as 'by far the grandest, most poetic and most awe-inspiring picture of the Resurrection' (*Renaissance in Italy*, 1875–86). Aldous Huxley declared in an essay of 1925 that the *Resurrection* was 'the best picture', and Piero was championed in 1951 by Kenneth Clark, who endorsed Huxley's view in the television series *Civilisation* (1969). An extensive text by Battisti (1971) contains a large but unevenly transcribed body of documents assembled by Settesoldi. In the fifth centenary of Piero's death a number of penetrating but idiosyncratic monographs were issued, and archival discoveries were matched by the publication of important technical data.

BIBLIOGRAPHY
EARLY SOURCES

Filarete [Antonio Averlino]: *Trattato del architettura* (MS.; early 1460s); ed. J. R. Spencer (New Haven, 1965), ii
G. Santi: *La vita e le gesta di Federico di Montefeltro, Duca d'Urbino* (MS.; c. 1482); ed. L. Michelini Tocci (Vatican City, 1985), ii, pp. 673–4
L. Pacioli: *Summa de arithmetica* (Venice, 1494), fols 2r, 68v
——: *De divina proportione . . .* (Venice, 1509), fols 23r, 33r
G. Vasari: *Le vite di più eccelenti [sic] architetti, pittori, et scultori* (Florence, 1550); ed. L. Bellosi and A. Rossi (Turin, 1986), pp. 337–43
——: *Vite* (1550, rev. 2/1568); ed. G. Milanesi (1878–85), ii, pp. 487–501

GENERAL

J. Crowe and G. Cavalcaselle: *New History of Painting in Italy* (London, 1864)
E. Borsook: *The Mural Painters of Tuscany from Cimabue to Andrea del Castagno* (London, 1960, rev. Oxford, 2/1980)
B. Berenson: *Central and North Italian Schools* (1968)
M. Aronberg Lavin: *The Place of Narrative: Mural Decoration in Italian Churches, 431–1600* (Chicago, 1990), pp. 167–94

MONOGRAPHS

K. Clark: *Piero della Francesca* (London, 1951, rev. 2/1969)
B. Berenson: *Piero della Francesca or the Ineloquent in Art* (London, 1954)
R. Longhi: *Piero della Francesca* (1963), iii of *Opere complete di Roberto Longhi* (Florence, 1963)
G. Gilbert: *Change in Piero della Francesca* (Locust Valley, 1968)
P. Hendy: *Piero della Francesca and the Early Renaissance* (London, 1968)
P. de Vecchi: *The Complete Paintings of Piero della Francesca* (London, 1970/R Harmondsworth, 1985)
E. Battisti: *Piero della Francesca*, 2 vols (Milan, 1971, rev. 2/1992)
M. Salmi: *La pittura di Piero della Francesca* (Novara, 1979)
B. Cole: *Piero della Francesca: Tradition and Innovation in Renaissance Art* (New York, 1991)
J. Pope-Hennessy: *The Piero della Francesca Trail* (London, 1991)
M. Aronberg Lavin: *Piero della Francesca* (London and New York, 1992)
C. Bertelli: *Piero della Francesca* (London and New Haven, 1992)
R. Lightbown: *Piero della Francesca* (New York, London and Paris, 1992)

EXHIBITION CATALOGUES AND SYMPOSIA

Federico di Montefeltro, lo stato, le arti, la cultura: Atti del convegno di studi organizzato dallo centro studi sulle società dell'antico regime: Urbino, 1982
Piero della Francesca e il novecento (exh. cat., Sansepolcro, Mus. Civ., 1991)
Monarco della pintura: Piero and his Legacy: Washington, DC, 1992
La 'Madonna del parto' in restauro (exh. cat., ed. G. Centauro; Monterchi, Scu. Via Reglia, 1992)
Nel raggio di Piero (exh. cat., ed. L. Berti; Sansepolcro, Mus. Civ., 1992)
Piero e Urbino, Piero e le corti rinascimentali (exh. cat., ed. P. dal Poggetto; Urbino, Pal. Ducale, 1992)
Una scuola per Piero: Luce, colore e prospettiva nella formazione fiorentina di Piero della Francesca (exh. cat., ed. L. Bellosi; Florence, Uffizi, 1992–3)

SPECIALIST STUDIES
Specific paintings

M. Aronberg Lavin: *Piero della Francesca: The 'Flagellation'* (Chicago and London, 1972, rev. Chicago, 2/1990)

——: *Piero della Francesca's 'Baptism of Christ'* (New Haven, 1981)

P. Scapecchi: 'Enea Silvio Piccolomini, Piero della Francesca e gli affreschi di Arezzo', *Prospettiva* [Florence], 32 (1983), pp. 71–6

M. Aronberg Lavin and M. Laclotte: *Piero della Francesca a Rimini: L'affresco nel Tempio Malatestiano* (Bologna, 1984)

C. Ginzburg: *The Enigma of Piero: The 'Baptism', the Arezzo Cycle, the 'Flagellation'* (London, 1985); review by P. Black in *Oxford A. J.*, ix/2 (1986)

J. Pope-Hennessy: 'Whose *Flagellation*?', *Apollo*, cxxiv (1986), pp. 162–5

J. R. Banker: 'Piero della Francesca's S Agostino Altarpiece: Some New Documents', *Burl. Mag.*, cxxix (1987), pp. 642–51

L. Bellosi: 'Giovanni di Piamonte e gli affreschi di Piero ad Arezzo', *Prospettiva* [Florence], 50 (1987), pp. 15–35

J. Guillaud and M. Guillaud: *Piero della Francesca, Poet of Form: The Frescoes of San Francesco in Arezzo* (Paris and New York, 1988)

M. G. Paolini, ed.: *Ricerche su Piero* (Siena, 1989) [essays on the *Resurrection, St Louis of Toulouse* and Perugia]

Progetto per Piero della Francesca: Indagini diagnostico-conoscitive per la conservazione della 'Leggenda della Vera Croce' e della 'Madonna del parto' (Florence, 1989)

G. Centauro: *Dipinti murali di Piero della Francesca. La basilica di S Francesco ad Arezzo: Indagini su sette secoli* (Milan, 1990)

F. Lollini: 'Ancora la *Flagellazione*: Addenda di bibliografia (e di metodo)', *Boll. A.*, 67 (1991), pp. 149–50

——: 'Una possibile connotazione antiebraica della *Flagellazione* di Piero della Francesca', *Boll. A.*, 65 (1991), pp. 1–28

E. F. Londei: 'La scena della *Flagellazione* di Piero della Francesca: La sua identificazione con un luogo di Urbino del quattrocento', *Boll. A.*, 65 (1991), pp. 29–66

A. S. Tessari: 'La *Flagellazione* di Piero della Francesca: Ovvero l'instaurazione del Regno di Cristo', *A. Crist.*, 745 (1991), pp. 277–86

M. Calvesi: 'La *Flagellazione* di Piero della Francesca: Identikit di un enigma', *A. & Dossier*, 70 (1992), pp. 22–7

Piero della Francesca: Il polittico di Sant'Antonio (exh. cat., ed. V. Garibaldi; Perugia, Rocca Paolina, 1993)

M. A. Lavin: *Piero della Francesca: San Francesco, Arezzo* (New York, 1994)

S. Nessi: 'Il Sant'Antonio di Padova di Piero della Francesca nel polittico di Perugia', *Santo*, xxxiv/1 (Jan–April 1994), pp. 95–8

J. R. Banker: 'The Altarpiece of the Confraternity of Santa Maria della Misericordia in Borgo Sansepolcro', *Piero della Francesca and his Legacy* (Washington, DC, 1995), pp. 21–35

B. Diemling: 'The *Meeting of the Queen of Sheba with Solomon*: Crusade Propaganda in the Fresco Cycle of Piero della Francesca in Arezzo', *Bruckmanns Pantheon*, liii (1995), pp. 18–28

M. Michael: *Piero della Francesca: The Arezzo Frescoes* (London, 1996)

D. Arasse: 'Piero della Francesca: La Legende d'Arezzo: Restoration of Mural Paintings at Basilica di San Francesco, Italy', *L'Oeil*, 487 (1997), pp. 44–57

Other

M. Salmi: 'Perchè "Piero della Francesca"?', *Commentari*, 27 (1976), pp. 121–6

J. Beck: 'Una data per Piero della Francesca', *Prospettiva* [Florence], 25 (1978), p. 53

R. Cocke: 'Piero della Francesca and the Development of Italian Landscape Painting', *Burl. Mag.*, cxxii (1980), pp. 627–31

G. Agosti and V. Farinella: 'Calore del marmo. Pratica e tipologia delle deduzioni iconografiche. Un artista: Piero della Francesca, per esempio', *Memoria dell' antico nell' arte italiana*, ed. S. Settis, i (Turin, 1984), pp. 427–40

F. Dabell: 'Antonio d'Anghiari e gli inizi di Piero della Francesca', *Paragone*, 417 (1984), pp. 71–94

P. Scapecchi: 'Tu celebras burgi iam cuncta per oppida nomen: Appunti per Piero della Francesca', *A. Crist.* (1984), pp. 209–21

J. Triolo: 'Aggiunte bibliografiche a "Piero della Francesca", 1970–83', *Piero teorico dell'arte*, ed. O. Calabrese (Rome, 1985), pp. 287–99

J. Pope-Hennessy: 'The Mystery of a Master', *New Repub.*, 3715 (1986), pp. 38–41

A. Turchini: 'L'imperatore, il santo e il cavaliere: Note su Sigismondo Pandolfo Malatesta e Piero della Francesca', *A. Crist.*, 714 (1986), pp. 165–80

F. Polcri: 'A proposito di Piero della Francesca: Nuove fonti archivistiche a Sansepolcro', *Prop. & Ric.*, 21 (1988), pp. 39–54

J. R. Banker: 'Un documento inedito del 1432 sull'attività di Piero della Francesca per la chiesa di San Francesco in Borgo S Sepolcro', *Riv. A.*, 4th ser., vi (1990), pp. 245–7

F. Polcri: *Due ritrovamenti d'archivio a Sansepolcro: Un inedito sul polittico degli Agostiniani di Piero della Francesca* (Sansepolcro, 1990)

——: 'Ritrovamenti pierfrancescani nell'archivio giudiziario di Sansepolcro', *Atti Mem. Accad. Petrarca Lett., A. & Sci.*, n. s., i (1990), pp. 203–17

F. Dabell: 'New Documents for the History and Patronage of the Compagnia della SS Trinità in Arezzo', *A. Crist.*, 747 (1991), pp. 412–17

D. Franklin: 'An Unrecorded Commission for Piero della Francesca in Arezzo', *Burl. Mag.*, cxxxiii (1991), pp. 193–4

L. B. Kanter: 'Luca Signorelli, Piero della Francesca, and Pietro Perugino', *Stud. Stor. A.*, i (1991), pp. 95–111

J. R. Banker: 'Piero della Francesca, il fratello Don Francesco di Benedetto e Francesco dal Borgo', *Prospettiva*, 68 (1992), pp. 54–6

C. B. Cappel: 'On "la testa proportionalmente degradata": Luca Signorelli, Leonardo, and Piero della Francesca's *De prospectiva pingendi*', *Florentine Drawing at the Time of Lorenzo the Magnificent: Papers from a Colloquium held at the Villa Spelman: Florence, 1992*, pp. 17–43

P. G. Pasini: *Piero e i Malatesti: L'attività di Piero della Francesca per le corti romagnole* (Milan, 1992)

J. R. Banker: 'Piero della Francesca as Assistant to Antonio d'Anghiari in the 1430s: Some Unpublished Documents', *Burl. Mag.*, cxxxv (1993), pp. 16–21

C. E. Gilbert: *Piero della Francesca et Giorgione: Problèmes d'interprétation* (Paris, 1994)

M. Aronberg Lavin, ed.: *Piero della Francesca and his Legacy* (Washington, DC, 1995)

C. Cieri Via and M. Emiliani Dalai, eds: *Piero 500 anni* (Venice, 1995)

M. Kemp: 'In the Light of Dante: Meditations on Natural and Divine Light in Piero della Francesca, Raphael and Michelangelo', *Ars naturam adiuvans: Festschrift für Matthias Winner*, ed. V. V. Flemming and S. Schutze (Mainz, 1996), pp. 160–77

FRANK DABELL

Piero di Cosimo [Piero di Lorenzo di Piero d'Antonio] (*b* ?Florence, 1461–2; *d* Florence ?1521). Italian painter and draughtsman.

1. Life and work. 2. Working methods and technique. 3. Personality and posthumous reputation.

1. LIFE AND WORK. Tax declarations made by Piero di Cosimo's father suggest that the artist was born in either 1461 or 1462. According to the first, he was eight years old in 1469, while a *catasto* (land registry declaration) of 1480 gives his age as 18. A document of 1457 establishes that his father, Lorenzo di Piero d'Antonio, was a maker of small tools (*succhiellinaio*) rather than a goldsmith, as Vasari claimed. By 1480 Piero appears no longer to have been living at the family house in the Via della Scala, Florence, but was an unsalaried apprentice or workshop assistant to Cosimo Rosselli, from whom he received room and board and eventually took the name of Piero di Cosimo.

When his teacher was summoned to Rome by Pope Sixtus IV in 1481–2, Piero di Cosimo seems to have gone with him, and Vasari asserted that during the two years he spent there Piero executed the landscape background in Rosselli's fresco of the *Sermon on the Mount* in the Sistine Chapel, as well as a number of still unidentified portraits of notable Romans, both in fresco and on panel. Although the precise duration of Piero's attachment to Rosselli's studio is uncertain, it is conceivable that he maintained close ties with the workshop until his master's death in 1507 and that he directly influenced Fra Bartolommeo and Mariotto Albertinelli, both pupils of Rosselli's. But by the second half of the 1480s Piero di Cosimo must have been established as an independent artist, since even the earliest of his extant works seem to be entirely by his hand

and there is no reason to suppose that they were not commissioned directly from him.

The chronology of Piero di Cosimo's work is problematic. A document of 1489 apparently refers to the frame made by Chimenti del Tasso for Piero's *Visitation with SS Nicholas of Bari and Anthony Abbot* (Washington, DC, N.G.A.; see fig. 1), implying a date of *c.* 1489–90 for the picture itself. Only the *Virgin and Child with SS Peter, Rose of Viterbo, Catherine of Alexandria and John the Evangelist* (Florence, Gal. Osp. Innocenti), possibly installed in the chapel of the del Pugliese family in the church of the Ospedale degli Innocenti in 1493, is similarly datable on the basis of documentary evidence discovered in the 1970s (see Bellosi). Other works, including *cassone* panels and *spalliere*—pictures destined for the decoration of rooms in private houses and often painted with the imaginatively conceived mythological compositions for which the artist is renowned (*see* SPALLIERA)—were executed for members of the prominent del Pugliese, Vespucci, Strozzi and Tedaldi families. Piero was also successful as a designer of public spectacles (*trionfi*), which were extremely popular in Florence at the end of the 15th century.

Since documentary evidence on Piero's work is scarce, his oeuvre must be reconstructed on stylistic grounds. In what are presumably his first paintings, the influence of Cosimo Rosselli is tempered by the younger artist's much greater sensitivity to atmosphere and light, as well as by a profound receptivity to the innovations of his contemporaries. A *Virgin and Child with SS Lazarus and Sebastian* (Montevettolini, Pistoia, SS Michele e Lorenzo) may be Piero's earliest surviving work, probably executed not long after his return from Rome in 1482. While the wooden physiognomy of the Virgin recalls a figure type current in Rosselli's workshop, the composition is close to that of such altarpieces as Domenico Ghirlandaio's *Virgin and Child with the Archangels Michael and Raphael and SS Zenobius and Justus* (*c.* 1483; Florence, Uffizi). Other

1. Piero di Cosimo: *Visitation with SS Nicholas of Bari and Anthony Abbot*, oil on panel, 1.84×1.89 m, *c.* 1489–90 (Washington, DC, National Gallery of Art)

motifs, such as the design of the windows opening on to a panoramic landscape behind the figures, were evidently inspired by Leonardo da Vinci's Benois *Madonna and Child* (St Petersburg, Hermitage). Piero's *Virgin and Child* (Stockholm, Nmus.) similarly combines Leonardesque and Netherlandish elements in a composition that paraphrases Filippino Lippi's painting of the same subject (New York, Met.). The latter artist had a long-lasting impact on Piero di Cosimo, which can be seen in the portrait said to be of *Simonetta Vespucci* (Chantilly, Mus. Condé). Possibly identifiable with a painting of Cleopatra seen by Vasari in the collection of Francesco da Sangallo, the subject of this picture appears to have been changed by the later addition of an inscription SIMONETTA IANUENSIS VESPUCCIA, presumably after it had become the property of the Vespucci family. The facial type and handling recall Filippino Lippi, but the elaborate hairstyle and the restless quality of the landscape are equally indebted to works by Leonardo.

After *c.* 1490 Piero's interest began to shift away from the stylistic traits of artists trained in the circle of Andrea del Verrocchio towards the bulky, plastic forms of Luca Signorelli and the meticulous rendering of detail characteristic of Netherlandish painting; the most important example of the latter in Florence was the Portinari Altarpiece (Florence, Uffizi) by Hugo van der Goes (*c.* 1440–82). The *Visitation*, lauded by Vasari for its precision in suggesting the texture of the vellum pages of a manuscript in St Nicholas's hands and the play of light on the three golden balls by his side, is a highly eclectic work. In three panels representing successive stages in the evolution of primitive man—the *Hunting Scene* and *Return from the Hunt* (both New York, Met.) and the *Forest Fire* (Oxford, Ashmolean)—the lingering influence of Signorelli, the Pollaiuoli and especially Filippino Lippi is marked, together with evidence of Piero's familiarity with works such as Leonardo's *Battle of Anghiari* (destr.), executed around 1503–5. As much as any other late 15th-century painter, with the notable exception of Leonardo, Piero understood the expressive potential of landscape and not only studied meteorological effects but even convincingly represented the colour and intensity of the light peculiar to different times of day.

Except for references to his involvement in organizing festivals and a few allusions to unspecified compositions, Piero's name seldom appears in documents written after 1500. In 1503–5 he was a member of the Compagnia di S Luca, and on 8 May 1504 he enrolled in the Florentine painters' guild. In 1504 he also served on the committee convened to select an appropriate site for Michelangelo's recently completed statue of *David* (Florence, Accad.; *see* ITALY, fig. 22). In the archives of the Strozzi family, Piero's name appears in connection with both the Glovemakers' Pageant and the famous *Triumph of Death*, performed in 1506 and vividly described by Vasari. Piero also helped in the preparations for the entry of the Medici pope, Leo X, into Florence on 20 November 1515.

Both the *Battle of Lapiths and Centaurs* (London, N.G.), where the central group was inspired by a marble relief by Michelangelo (Florence, Casa Buonarroti), and the elegaic *Death of Procris* (London, N.G.; see fig. 2) probably date from between about 1500 and 1505. The presence of a faun or satyr in the latter suggests that it was inspired not

2. Piero di Cosimo: *Death of Procris*, oil on panel, 654×1842 mm, ?1500–05 (London, National Gallery)

directly by Ovid but by Niccolò da Correggio's *Fabula di Caephalo*, written in the 1480s. The sensitively rendered dog in the foreground of the painting and the dogs and shore birds near the body of water in the middle distance reflect the same unusual interest in animals as do the creatures in the slightly earlier *Hunting Scene* and *Forest Fire* and those in a drawing probably by Piero di Cosimo (Rotterdam, Mus. Boymans–van Beuningen, I.242).

A large *Incarnation of Christ with SS John the Evangelist, Filippo Benizzi, Catherine of Alexandria, Margaret, Antoninus and Peter* (Florence, Uffizi), admired by Vasari in the Tedaldi Chapel in SS Annunziata, Florence, appears to date from around 1505/6–7. In that altarpiece Leonardesque *sfumato* and the profound, but as yet imperfectly assimilated, impression made on Piero di Cosimo by Fra Bartolommeo's *Vision of St Bernard* (Florence, Uffizi; *see* BARTOLOMMEO, FRA, fig. 2) dominate not only the handling of details but also the geometrical organization of the composition. Around 1510 Piero turned away from his preoccupation with Leonardo's intricacies of form and the compositions of Raphael's Florentine Madonnas (still evident in Piero's *Virgin and Child with Two Musician Angels*; Venice, Fond. Cini) and began to emulate Fra Bartolommeo's simpler and more accessible style. Two scenes from the *Legend of Prometheus and Epimetheus* (Munich, Alte Pin. and Strasbourg, Mus. B.-A.) reveal an interest in compositional symmetry and the suppression of detail, which is carried to an extreme degree in the hieratic *Immaculate Conception with SS Bonaventure, Bernard, Francis, Jerome, Thomas Aquinas and Augustine* (Fiesole, S Francesco). This work, inscribed with the apocryphal date of 1480, is one of Piero's last works (*c.* 1515–20). Yet the fairy-tale *Liberation of Andromeda* (Florence, Uffizi; see colour pl. 2, XVII3) demonstrates that the artist's fertile imagination was undiminished even at the very end of his life. According to Vasari, he was buried in the church of S Pier Maggiore, Florence.

2. WORKING METHODS AND TECHNIQUE. Except for his contribution to the Sistine Chapel frescoes, Piero worked primarily in tempera on panel, although he appears frequently to have used both egg and oil media in the same picture. His drawings, occasionally executed in metalpoint or black and even red chalk, but mostly using

pen and ink, often in combination with wash and white heightening, pose a problem. Five sheets are studies for known compositions. One drawing (Florence, Uffizi, 286 E), executed in pen and ink over preliminary indications in black chalk on ochre tinted paper, is a study for the Capponi *Visitation* (*c.* 1489–90; Washington, DC, N.G.A.). Two red and black chalk studies in the same collection (Florence, Uffizi, 552 E and 555 E) are related to the S Francesco *Immaculate Conception*, while a fourth (176 E) is a Leonardesque study for the Cini *Virgin and Child*. A preparatory drawing for the Tedaldi Altarpiece was at Bremen (destr. World War II). Other sheets by Piero are studies for devotional images, although a few represent mythological subjects (e.g. *Mars and Rhea Silvia*; Florence, Uffizi, 1257 E, and *Ariadne on Naxos*; London, BM, 1902–8–22–6).

3. PERSONALITY AND POSTHUMOUS REPUTATION. Despite Piero di Cosimo's significant contribution to landscape painting, his imaginative, unorthodox and often poignant treatment of pagan as well as Christian subjects and the vital role he played in the formation of some of the most important artists working in Florence in the first quarter of the 16th century (Fra Bartolommeo, Mariotto Albertinelli, Jacopo Pontormo and possibly Andrea del Sarto were among his pupils), he was for centuries better known for the personal eccentricity that constitutes the focus of Vasari's biography. According to Vasari, he was a peculiar and absent-minded genius who preferred to live and work by himself, eating only the hard-boiled eggs that he prepared 50 at a time while boiling the glue he used for making size. Irritated by flies, church music, screaming children and the coughing of old men, frightened of thunderstorms and intent on allowing his property to fall into disrepair, he died in self-imposed solitude, afflicted by a partial paralysis that had prevented him from working for some time.

Vasari's colourful and anecdotal account, to some extent responsible for almost 300 years of critical neglect of the artist's work, was ironically the principal reason for which Piero di Cosimo was championed first by the Romantics, whose interpretation of the painter's allegedly bohemian character is embodied in George Eliot's *Romola* (1863), and subsequently by the Surrealists, who saw in his pictures

the antecedents of their own work. At the end of the 19th century serious attention was finally devoted to Piero's oeuvre; Morelli, followed by Ulmann, Knapp and Berenson, made the first steps towards unravelling the painter's career and sorting out the many stylistically dissimilar pictures that had previously been attributed to him. However, Piero's importance in the development of Florentine painting around 1500, a role touched on by Langton Douglas and further explored by Grassi, was not finally established until the publication of Bacci's two monographs (1966, 1976) and of Fahy's examination (1965) of some of the artist's later works.

BIBLIOGRAPHY

Thieme–Becker

G. Vasari: *Vite* (1550, rev. 2/1568); ed. G. Milanesi (1878–85), iv, pp. 131–44

J. A. Crowe and G. B. Cavalcaselle: *A History of Painting in Italy* (London, 1864–6, rev. 2/1903–14/*R* 1972)

G. Morelli: *Kunstkritische Studien über italienische Malerei*, 3 vols (Leipzig, 1890–93; Eng. trans., i–ii, 1892–3)

H. Ulmann: 'Piero di Cosimo', *Jb. Kön.-Preuss. Kstsamml.*, xvii (1896), pp. 42–64, 120–42

F. Knapp: *Piero di Cosimo: Ein Übergangsmeister vom Florentiner quattrocento zum cinquecento* (Halle, 1899)

H. Haberfeld: *Piero di Cosimo* (diss., U. Breslau, 1900)

A. Venturi: *Storia* (1901–40), VII/i, pp. 581, 586, 680, 687, 696–712; VII/ii, pp. 442–3, 440; IX/i

B. Berenson: *Drawings of the Florentine Painters*, 2 vols (London, 1903, rev. 3 vols, Chicago, 2/1938/*R* 1970)

R. van Marle: *Italian Schools* (1923–38), xii, pp. 69, 70, 114, 441

E. Panofsky: 'The Early History of Man in a Cycle of Paintings by Piero di Cosimo', *J. Warb. & Court. Insts*, i (1937), pp. 12–30

G. Pudelko: 'Piero di Cosimo, pittore "bizzarro"', *Rif. Lett.*, xvi (1938), pp. 112–32

R. Langton Douglas: *Piero di Cosimo* (Chicago, 1946)

Mostra di disegni di Filippino Lippi e Piero di Cosimo (exh. cat., ed. M. Fossi; Florence, Uffizi, 1955)

P. Morselli: 'Ragioni di un pittore fiorentino: Piero di Cosimo', *Arte*, lvi (1957), pp. 125–76

——: 'Piero di Cosimo, saggio di un catalogo delle opere', *Arte*, lvii (1958), pp. 67–92

F. Zeri: 'Rivedendo Piero di Cosimo', *Paragone*, x (1959), pp. 36–50

B. Berenson: *Florentine School* (1963), i, pp. 175–7

L. Grassi: *Piero di Cosimo e il problema della conversione al cinquecento nella pittura fiorentina ed emiliana* (Rome, 1963)

E. Fahy: 'Some Later Works of Piero di Cosimo', *Gaz. B.-A.*, lxv (1965), pp. 201–12

M. Bacci: *Piero di Cosimo* (Milan, 1966)

K. G. Boon: 'Een studieblad toegeschreven aan Piero di Cosimo', *Bull. Rijksmus.*, xvii (1969), pp. 159–70

G. Dalli Regoli: 'Piero di Cosimo, disegni noti e ignoti', *Crit. A.*, xxxix (1974), no. 133, pp. 49–65; no. 134, pp. 62–80

S. J. Craven: 'Three Dates for Piero di Cosimo', *Burl. Mag.*, cxvii (1975), pp. 572–6

M. Bacci: *L'opera completa di Piero di Cosimo*, Class. A. (Milan, 1976)

L. Bellosi, ed.: *Il Museo dello Spedale degli Innocenti a Firenze* (Milan, 1977), pp. 12, 235–6

A. Jouffroy: *Piero di Cosimo ou la forêt sacrilège* (Paris, 1982) [good colour illus.]

W. Griswold: *The Drawings of Piero di Cosimo* (diss., U. London, Courtauld Inst., 1988)

S. Fermor: *Piero di Cosimo: Fiction, Invention and Fantasia* (London, 1993)

L. Venturini: 'Piero di Cosimo e la pala della Compagnia di San Vincenzo', *Paragone*, xlv/529–33 (1994), pp. 60–67

WILLIAM GRISWOLD

Piero di Giovanni. *See* LORENZO MONACO.

Pietrasanta, Jacopo da (*fl* 1452; *d* ?1490). Italian stonemason and architect. He is first recorded in 1452, working in Rome as a stonemason, cutting door and window architraves for the Palazzo Brandesi on the Capitoline

Hill. Thereafter he is recorded as working for the papacy on a number of building projects including the Vatican Palace and the Benediction Loggia (1463–4; destr.). In 1467 he is mentioned as supervising stonemasons on the Palazzo Venezia. In 1472 he was sent to inspect the church of S Francesco at Assisi.

The only building that is known to be by Pietrasanta is the church of S Agostino, Rome (1479–83), built for Cardinal Guillaume d'Estouteville. By the summer of 1481 the aisles and nave were vaulted and by the following winter the façade was almost completed. An inscription on the façade records a completion date of 1483. The plan is simple with vaulted nave, aisles and side chapels, and the square crossing is surmounted by a cupola, one of the earliest examples of its type in Rome. The scooped-out side chapels echo those by Filippo Brunelleschi at Santo Spirito, Florence. The façade, made from travertine taken from the Colosseum, follows Leon Battista Alberti's composition in his prototype antique façade at the church of S Maria Novella, Florence (see colour pl. 1, I2). However, due to the insertion of compressed half pediments below the volutes and a clumsy handling of the architectural elements, the effect is awkward and does not compare with the sophistication of the interior.

Pietrasanta's brother Lorenzo is recorded as working as a stonemason on the Palazzo Venezia, Rome, and at the fortifications at Civitavecchia (1481–2).

BIBLIOGRAPHY

P. Tomei: *L'architettura a Roma nel quattrocento* (Rome, 1942)

L. Heydenreich and W. Lotz: *Architecture in Italy, 1400–1600*, Pelican Hist. A. (London, 1974)

ALICE DUGDALE

Pietro, Alvaro di. *See* PIREZ, ALVARO.

Pietro, Michelangelo di. *See* MICHELANGELO DI PIETRO.

Pietro, Niccolò di. *See* NICCOLÒ DI PIETRO.

Pietro, Sano di. *See* SANO DI PIETRO.

Pietro, Zanino di. *See* ZANINO DI PIETRO.

Pietro d'Angelo, Jacopo di. *See* JACOPO DELLA QUERCIA.

Pietro del Donzello. *See* DONZELLO, (1).

Pietro delle Campane. *See* CAMPANATO, PIETRO DI GIOVANNI BATTISTA.

Pietro de Saliba. *See* SALIBA, DE, (2).

Pietro di Antonio Dei. *See* BARTOLOMEO DELLA GATTA.

Pietro di Domenico da Montepulciano [Pietro da Recanati] (*b* ?the Marches, *fl* 1418; *d* after 1422). Italian painter. He probably took his name from the village of Montepulciano in the Marches and not from the town in Tuscany. The polyptych of the *Virgin and Child with Saints* (1418; Osimo, Mus. Sacro Dioc.), painted for the baptistery at Osimo, is his first dated work; its composition is still in the style characteristic of 14th-century painting

of Umbria and the Marches, although it also suggests that the artist may have been influenced by the Venetian figurative style. This is confirmed by other panels, such as the *Coronation of the Virgin* (Washington, DC, Howard U., Gal. A.), the *Virgin and Child with Saints* (Hannover, Niedersächs. Landesmus.) and the *Madonna of Mercy* (Avignon, Mus. Petit Pal.). These paintings, in which form is created by means of soft shading, recall the work of Jacobello del Fiore in the Marches.

Pietro's later style is characterized by an attempt to create rich and elegant effects through the use of serpentine outlines and decorative, sumptuously embroidered materials, as in the *Madonna of Humility with Music-making Angels* (1420; New York, Met.), formerly in the Camaldolese monastery in Naples. The influence of the Late Gothic style of the Marches, particularly the work of the Salimbeni brothers, is evident in the polyptych of the *Madonna of Humility with Saints* (1422; Recanati, Pin. Civ.), Pietro's last documented work. In subject and style it is close to the polyptych of the *Virgin and Child with Saints and Angels* (Switzerland, priv. col., see Berenson, vol. ii, pls 525–7) from Potenza Picena. The gable panel of *St John the Evangelist* (Italy, priv. col.; see Rotondi, pl. 25) is of the same date. More doubtful attributions are the frescoes in the oratory of the Annunziata at Riofreddo (near Tivoli), those in the convent of S Niccolò at Osimo and the Farneto Triptych (Perugia, G. N. Umbria).

BIBLIOGRAPHY

Bolaffi; Thieme–Becker

U. Gnoli: 'Pietro di Domenico e Giacomo da Recanati', *Boll. A.*, xv (1922), pp. 574–80

R. van Marle: *Italian schools* (1923–38), vol. viii, pp. 264–70

R. Longhi: 'Una coronazione di Pietro di Domenico da Montepulciano', *Vita artistica*, ii (1927), pp. 18–20

P. Rotondi: *Studi e ricerche intorno a Lorenzo e Jacopo Salimbeni da Sanseverino, Pietro di Domenico da Montepulciano e Giacomo da Recanati* (Fabriano, 1936)

I. Patrizi: 'Un affresco di Pietro di Domenico da Montepulciano', *Paragone*, v/51 (1954), pp. 26–32

B. Berenson: *Central and North Italian Schools* (1968), vol. i, pp. 342–3; vol. ii, pls 525–7

F. Rossi: 'Appunti sulla pittura gotica tra Ancona e Macerata', *Boll. A.*, liii (1968), pp. 197–206

P. Zampetti: *La pittura marchigiana del '400* (Milan, [c. 1970]), pp. 15, 34, 42–3, 238

F. Bisogni: 'Per Giacomo di Nicola da Recanati', *Paragone*, xxiv/227 (1973), pp. 44–69

Fioritura tardogotica nelle Marche (exh. cat., Urbino, 1998), pp. 30–39, 274–81

ENRICA NERI LUSANNA

Pietro di Domenico da Siena (*b* ?1457; *d* ?1533). Italian painter. He was a minor Sienese painter, and his works reflect the dominant pictorial styles of the era, especially showing the influence of Bernardino Fungai, Matteo di Giovanni, Francesco di Giorgio Martini and Neroccio de' Landi. The impact of Luca Signorelli and Bernardino Pinturicchio, both of whom worked in Siena for a time, is evident in Pietro's interest in landscape and the distribution in space of firmly modelled figures. A small body of attributed works has grown up around his one signed work, an *Adoration of the Shepherds with SS Martin and Galganus* (Siena; Pin. N.); its date (MCCCCC...) is now illegible. Given the large number of motifs juxtaposed by the artist in this painting and the lack of any other

documentation, such attributions should be treated with caution.

BIBLIOGRAPHY

E. Romagnoli: *Biografia cronologica de' bell'artisti senesi del secolo XII a tutto il XVIII*, v (MS. *c.* 1835; Siena, Bib. Com. Intronati); ed. (Florence, 1976)

F. Brogi: *Inventario generale degli oggetti d'arte della provincia di Siena* (Siena, 1897)

R. van Marle: *Italian Schools* (1923–38), xvi

R. Morrison: 'An Elusive Minor Sienese Master of the Fifteenth Century', *A. America*, xviii (1930), pp. 305–9

E. Sandberg-Vavala: *Sienese Studies* (Florence, 1953)

B. Berenson: *Central and North Italian Schools* (1968)

P. Torriti: *La Pinacoteca Nazionale di Siena: I dipinti dal XV al XVIII secolo* (Genoa, 1978)

E. Carli: *Sienese Painting* (New York, 1983)

B. Cole: *Sienese Painting in the Age of the Renaissance* (Bloomington, 1985)

LINDA CARON

Pietro di Galeotto (di Ercolano) (*b* Perugia, *c.* 1450; *d* Perugia, May 1483). Italian painter. He is first documented in 1476, when he was commissioned to paint an altarpiece (untraced) for S Corona, Vicenza. He enrolled in the painters' guild of Perugia in 1479, the year he undertook to paint an altarpiece for the Palazzo dei Priori there; the commission was later executed by Pietro Perugino. A banner of the *Flagellation* (Perugia, oratory of S Francesco), documented in 1480, is the only work securely attributed to Pietro. It shows an original style, reflecting the influence of Piero della Francesca, and also that of Flemish and Ferrarese painters, and also perhaps that of artists from the Alto Adige, such as Hans Multscher (*c.* 1400–67) and Michael Pacher (*fl* 1462–98). The marble pavement and the landscape are reminiscent of the small panels showing the *Miracles of St Bernardino* (1473), now in the Galleria Nazionale dell'Umbria, Perugia, to which some critics believe Pietro contributed. He was working on the lunette fresco of the *Virgin and Child*, for S Pietro in Perugia, when he died; the work was completed by Bartolomeo Caporali in 1488. Pietro's influence is apparent in only one painting, a copy of the Perugia *Flagellation* in S Francesco di Costacciaro, possibly painted by his assistant for the fresco in S Pietro in Perugia, Niccolò da Gubbio.

BIBLIOGRAPHY

F. F. Mancini: 'Identificazione di Pietro di Galeotto', *Esercizi*, 2 (1979), pp. 43–55

A. Sannipoli: 'Un seguace di Pietro di Galeotto a Costacciaro', *Esercizi*, 8 (1985), pp. 17–19

G. Briganti, ed.: *La pittura in Italia: Il quattrocento* (Milan, 1987), ii, pp. 376, 739

F. Todini: *La pittura umbra dal duecento al primo cinquecento* (Milan, 1989), i, p. 288; ii, p. 490

P. SCARPELLINI

Pietro di Giovanni Battista Campanato. *See* CAMPANATO, PIETRO DI GIOVANNI BATTISTA.

Pietro di Giovanni d'Ambrogio [Ambrosi] (*b* Siena, *bapt* 7 Oct 1410; *d* Siena, *bur* 4 Sept 1449). Italian painter. In a period during which commissions to Sienese painters often demanded adherence to 14th-century precedents, Pietro di Giovanni produced some of the most individual and imaginative solutions, combining local tradition with elements of progressive Florentine style. A member of the Sienese painters' guild in 1428, he had probably trained

with Sassetta, whose influence on him was fundamental. Only the last ten years of his brief career are documented.

In the 1430s, during which he no doubt visited Florence, he matured into one of the most exquisitely eccentric of Late Gothic painters in Italy. A *St Paul* (sold Milan, Finarte, 24 Oct 1989, lot 71) appears to date from the late 1430s. Payments in 1440 record a work (untraced) in Città di Castello and two frescoes (destr.) in the infirmary of the hospital of S Maria della Scala, Siena. Panels from an altarpiece (dispersed) of *c*. 1440, possibly for the Azzoni Chapel in S Agostino, Siena, reveal inspiration from Ambrogio Lorenzetti (*fl c.* 1317–48) and Sassetta. These included a central panel of the *Virgin and Child* (New York, Brooklyn Mus. A.; see fig.) dependent on Sassetta's *Madonna of the Cherries* (Grosseto, Mus. Archeol.), and a *St Augustine* (Altenburg, Staatl. Lindenau-Mus.). The predella consists of a *Miracle of St Monica (?)* (Berlin, Gemäldegal.), an enchanting, implausibly constructed scene with the *Birth of St Nicholas of Bari* (Basle, Kstmus.), and the *Entry into Jerusalem* (Parma, Pin. Stuard), which combines a reflection on the work of Duccio with the increased spatial and tonal sophistication of Sassetta's predella panels of the early 1430s. The anecdotal garden

Pietro di Giovanni d'Ambrogio: *Virgin and Child*, tempera on panel, 978×575 mm, *c*. 1440 (New York, Brooklyn Museum of Art)

scene on the left is like a glimpse into the world of the Limbourg brothers, while the group of Apostles on the right derives from Masaccio's *Tribute Money* in the Brancacci Chapel in S Maria del Carmine, Florence (*see* MASACCIO, FIG. 5). Pietro di Giovanni's use of perspective was intuitive, but always attentive, as the foreshortened wall in this panel attests.

Pietro di Giovanni's notable, intense depictions of St Bernardino include the panel in the church of the Osservanza, Siena, signed and dated 1444. In 1445 he is recorded in Florence and then in Siena again, assisting Vecchietta in the decoration of the reliquary cupboard (Siena, Pin. Civ.) for the Ospedale di S Maria della Scala. The *Virgin and Child* (Florence, Acton priv. col.) is datable to the mid-1440s and seems to reflect an awareness of Domenico Veneziano's recent *St Lucy* altarpiece (dispersed; *see* DOMENICO VENEZIANO, fig. 2 and colour pl. 1, XXVIII1). The double-sided canvas banner with *St Catherine with Six Virtues* and the *Crucifixion* (signed and dated 1444; Paris, Mus. Jacquemart-André), painted for the confraternity of St Catherine in Sansepolcro (Dabell), shows a further refinement of design and colour that must be indebted to Sassetta's celebrated altarpiece (dispersed) erected in S Francesco, Sansepolcro, that year. A miniature of the *Virgin and Child* (1446–7; Milan, Castello Sforzesco, Cod. 138), executed for Filippo Maria Visconti, 3rd Duke of Milan, probably derives from an untraced *Madonna of Humility* by Sassetta (Christiansen, 1989).

The sense of powerful, mystical reality that informs many of Pietro di Giovanni's scenes is achieved in part through minutely described detail and bold, patterned abstraction. This is evident in several depictions of the *Crucifixion*: the starkly poetic panel (Venice, Col. Cini), the more elaborate image on the banner of 1444 in Paris and a small fresco dated 1446 (Siena, Pal. Pub.). The painter's eccentricity is also displayed in such details as the face of the *Virgin* on a small panel (Esztergom, Mus. Christ.).

The *Adoration of the Shepherds with SS Augustine and Galganus* (Asciano, Mus. A. Sacra) was probably commissioned during the mid-1440s in emulation of Bartolommeo Bulgarini's altarpiece of the *Adoration* (1351) for Siena Cathedral. The nocturnal setting of this late masterpiece resembles the almost surreal approaches of Giovanni di Paolo and Paolo Uccello. Small dispersed elements of this altarpiece probably included the pinnacles with *St Anthony Abbot* and *St Bartholomew* (ex-Harris priv. col., London; see Gregori), those with *St Catherine of Siena* and *St Bernardino* (Poznań, N. Mus.), and possibly the beautifully described *St Agatha* and *St Ursula* (Florence, Mus. Horne).

BIBLIOGRAPHY

M. Gregori: 'Un'opera giovanile di Pietro di Giovanni d'Ambrogio', *Paragone*, 75 (1956), pp. 46–51

C. Volpe: 'Per Pietro di Giovanni d'Ambrogio', *Paragone*, 75 (1956), pp. 51–5

Il gotico a Siena (exh. cat., Siena, Pal. Pub., 1982), pp. 405–8 [entry by C. Volpe]

F. Dabell: 'Un senese a Sansepolcro: Documenti per Pietro di Giovanni d'Ambrogio', *Riv. A.*, xxxvii (1984), pp. 361–71

M. Laclotte: 'Une prédelle de Pietro di Giovanni d'Ambrogio', *Paragone*, 419/421/423 (1985), pp. 107–12

La pittura in Italia: Il quattrocento (Milan, 1986, rev. 2/1987), pp. 739–40 [entry by C. Alessi]

Painting in Renaissance Siena, 1420–1500 (exh. cat. by K. Christiansen, L. Kanter and C. Strehlke, New York, Met., 1988–9), pp. 91–8

K. Christiansen: 'Three Dates for Sassetta', *Gaz. B.-A.*, n.s. 5, cxiv (1989), pp. 263–70

——: 'Notes on "Painting in Renaissance Siena"', *Burl. Mag.*, cxxxii (1990), pp. 205–13

FRANK DABELL

Pietro di Martino da Milano [Pietro da Milano] (*b* Milan, *c.* 1410; *d* Naples, 1473). Italian sculptor, architect and medallist. He began his career in Dalmatia and was active at an important bottega in Ragusa (now Dubrovnik) from 1431. His friendship and collaboration with the Dalmatian sculptor FRANCESCO LAURANA may have begun at this time. Many of the works produced by Pietro in Ragusa were lost in the earthquake of 1667: all that survives are the reliefs of the Small Fountain (1437–8) and the capitals of the Rector's Palace (1445), which show a restrained style with geometric, blocklike forms. Other documented works (destr.) were the Large Fountain (1437–41), a statue for the Franciscan Monastery (1441), the fountain of the monastery of S Chiara (1449) and the Tabernacle for the monastery of S Blasio (1456). In 1452 he went to Castel Nuovo in Naples, to work on the Triumphal Arch of Alfonso of Aragon with Laurana and numerous other sculptors (*see* NAPLES, §3). He and Laurana are documented in France from 1461 to 1464 at the court of René I, King of Naples, Duke of Anjou (*reg* 1434–80). There Pietro came into contact with the tradition of Burgundian sculpture and also worked as medallist, producing portraits of *René* and other medals. In 1463 he executed *Les Images et le mystère de St Magdalen* (lost) for the church of St Maxe in Bar-le-duc and a relief of *Two Dogs Fighting* (*in situ*) for a room in the castle of Bar-le-duc. In 1464 he returned to Italy, to complete the Triumphal Arch. The Arch was the most important sculptural monument in southern Italy in the second half of the 15th century. Many scholars believe that Pietro da Milano himself was the architect of the Arch; he undoubtedly coordinated this great collaborative scheme during 1465–71 and was responsible for some of the reliefs. Despite the absence of reliable sources, he has been attributed with the central relief depicting the *Triumph of King Alfonso* and the relief on the intrados of the lower arch with the *Departure of Alfonso for the War*. The most significant work for the understanding of his style is the high relief with the *Coronation of Ferrante*, which Pietro carved between 1465 and 1468 after the death of Alfonso (1458).

There is abundant documentation of the work he produced during this last Neapolitan period, but much of it has been lost or dispersed. In 1468 he was commissioned by Giovanni Battista Caracciolo to carve ornaments for the family chapel in the Cathedral of S Gennaro, Naples, and also produced numerous other funerary monuments at this time, in a style of rigidly constructed geometrical forms, evidently influenced by Laurana, whose work was always an important point of reference for him. Pietro may also have carved a few parts of the composite altar of Giovanni Miroballo in S Giovanni at Carbonara (Naples). His final commission was for seven windows for the great hall of Castel Nuovo (1472).

BIBLIOGRAPHY

Thieme–Becker

A. Heiss: *Francesco Laurana et Pietro da Milano* (Paris, 1882)

A. Max Werley: 'Un Sculpteur italien à Bar-le-duc', *Acad. Inscr. & B.-Lett.: C. R. Séances*, iv/24 (1896), pp. 54–62

C. von Fabriczy: 'Pietro di Martino da Milano in Ragusa', *Repert. Kstwiss.*, xxviii (1905), pp. 192–3

W. Rolfs: 'Der Stil Peter Martins von Mailand', *Mhft. Kstwiss.*, i (1908), pp. 303–5

G. F. Hill: *A Corpus of Italian Medals of the Renaissance* (London, 1930)

I. Mazzoleni, ed.: *Fonti aragonesi*, i (Naples, 1957), pp. 76–8

F. Strazzullo: 'Documenti sull'attività napoletana dello scultore milanese Pietro de Martino (1453–1473)', *Archv Stor. Prov. Napoletane*, lxxxi (1963), pp. 325–41

V. Gvordanovic: 'The Dalmatian Works of Pietro da Milano and the Beginnings of Francesco Laurana', *A. Lombarda*, 42–3 (1974), pp. 113–223

V. P. Goss: 'I due rilievi di Pietro da Milano e Francesco Laurana in Castelnuovo', *Napoli Nob.*, xx (1981), pp. 102–13

F. Abbate: 'Appunti su Pietro da Milano scultore e la colonia lombarda a Napoli', *Boll. A.*, n. s. 3, xxvi (1984), pp. 73–86

G. Cassese: 'Il dibattito storico-critico sull'Arco di Alfonso d'Aragona: Problemi generali e questioni di metodo', *Quad. Ist. N. Stud. Rinascimento Merid.*, ii (1985), pp. 7–45

For further bibliography *see* NAPLES, §3.

GIOVANNA CASSESE

Pietro Falloppi, Giovanni di. *See* GIOVANNI DA MODENA.

Pini, Biagio (de'). *See* PUPINI, BIAGIO.

Pino, Marco [Marco da Siena] (*b* Costa del Pino, Siena, *c.* 1525; *d* Naples, *c.* 1587). Italian painter. He was an apprentice of Domenico Beccafumi in Siena (1537–42), and by 1543 was in Rome. His Mannerist formula was already evident in the *Visitation* (1545; Rome, Santo Spirito in Sassia). Through his collaborations with Perino del Vaga on frescoes in the Castel Sant'Angelo (1546) and Daniele da Volterra on frescoes in Trinità de' Monti (1548–53), he combined the grace of Perino with the twisting poses of Michelangelo. He may have travelled to Spain (Borea) and by 1557 had settled in Naples, where he executed frescoes (destr.) at Montecassino and the *Baptism of Christ* (1564; Naples, S Domenico Maggiore). In Rome in 1568 he painted a *Resurrection* in the oratory of the Gonfalone and a *Pietà* for S Maria in Aracoeli. After returning to Naples, he executed such works there as the *Adoration of the Magi* and the *Assumption of the Virgin* (1571; both SS Severino e Sossio) and the *Archangel Michael* (1573; S Angelo a Nilo), which reflected Counter-Reformation tendencies. Among his paintings exported from Naples is the *Conversion of Saul* (1574; Palermo, Gal. Reg. Sicilia). The devotional aspect is accentuated in his Neapolitan works of 1577–8: a *Crucifixion* (Naples, SS Severino e Sossio) and a *Transfiguration* (Naples, Gesù Vecchio).

BIBLIOGRAPHY

Thieme–Becker

B. de Dominici: *Vite* (1742–5), ii, pp. 193–204

E. Borea: 'Grazia e furia in Marco Pino', *Paragone*, xiii/151 (1962), pp. 24–52

G. Previtali: *La pittura del cinquecento a Napoli e nel Vicereame* (Turin, 1978), pp. 53–60, 77–81 [documents and full bibliog.]

R. Harprath: 'Marco Pino e il ciclo di Alessandro Magno nel Castel Sant'Angelo a Roma', *Umanesimo a Siena: Letteratura, arti figurative, musica*, ed. E. Cioni and D. Fausti (Siena, 1994), pp. 437–52

P. Leone de Castris: 'Marco Pino: Il ventennio oscuro', *Boll. A.*, lxxix (1994), pp. 71–86

A. Zezza: 'Tra Perin del Vaga e Daniele da Volterra: Alcune proposte, e qualche conferma, per Marco Pino a Roma', *Prospettiva*, lxxiiilxxiv (1994), pp. 144–58

——: 'Precisazioni per Marco Pino al Gesù Vecchio', *Dial. Stor. A.*, i (1995), pp. 104–25

CARMELA VARGAS

Pino, Paolo (*b* Venice; *fl* 1534–65). Italian painter and writer. He is chiefly known for his *Dialogo di pittura* (1548), in which he referred to Giovanni Girolamo Savoldo as his teacher. Three signed paintings by him survive, all of which show him to have been influenced by Bergamese painting and the school of Giorgione: the *Portrait of a Man* (1534; Chambéry, Mus. B.-A.), the *Portrait of Dr Coignati* (?1534; Florence, Uffizi) and the *Virgin and Child with Four Saints and a Donor* (1565; Padua, S Francesco). R. Pallucchini (1946) attributed to Pino another *Portrait of a Man* (Rome, Gal. Doria–Pamphili). In 1548 he designed the marble base of a commemorative column in the town of Noale, between Padua and Treviso; this remains *in situ*, but the frescoes he is thought to have painted in the loggia of the same town are untraced.

In his *Dialogo* Pino emerges as the first Venetian theorist of painting and the first writer to explore theoretical questions through dialogue form. Although it draws on such sources as Pliny, Leon Battista Alberti, Pomponius Gauricus and Albrecht Dürer (1471–1528), it is entirely original for its discursive tone. In the dialogue two painters, a Tuscan and a Venetian, hold a discussion that is dialectical rather than polemical (the divergence of views over the relative importance of DISEGNO E COLORE not yet having become as sharp as it was soon to do). The Tuscan is the more abstract and didactic, the Venetian disagreeing with him good-humouredly. The conversation begins with remarks on feminine beauty and then broadens to a general definition of beauty and its intermediate position between art and nature. The connection between art and nature justifies the need for rules of perspective and proportion. The Venetian, Lauro, recognizes the value of rules but declares that in his city they are considered dated and not to be rigorously observed. There follows a declaration that painting should be accepted as one of the liberal arts, based on the nobility of the art of drawing (*disegno*), which the Tuscan school had proclaimed at least since Cennino Cennini (*c.* 1400).

Painting is divided into three essential parts: *disegno* (which in turn is made up of judgement, contour, execution and correct composition), *invenzione* and *colore*. This modification of Alberti's scheme (in which *disegno*, 'circonscrizione', is singled out but invention is not mentioned) exactly reproduces the traditional rhetorical scheme of *inventio, compositio* and *elocutio*; it went on to have great success, from Ludovico Dolce's *Dialogo della pittura intitolato l'Aretino* (1557) onwards. A more direct opposition to Alberti was Pino's rejection of the perspective grid or 'velo' (dividing the sheet into geometric squares to facilitate the orderly composition of the scene). Pino shared with Tuscan Mannerists an admiration for daring foreshortenings and for grace and ease. His passionate praise of colour, and especially of the atmospheric blending of colours, is, however, typically Venetian; hence a preference for oil, which can better convey natural effects. Next there is a summary of art history, which includes a survey of contemporary painting. Here his admiration for Giorgione is apparent, but he also appreciated Tuscan artists, such as Jacopo Pontormo, Agnolo Bronzino, Andrea del Sarto and Giorgio Vasari (whose forthcoming *Vite*, 1550, is mentioned).

Pino defined the perfect painter as one who unites the drawing of Michelangelo with the colours of Titian. Yet on entering the famous PARAGONE debate, over the superiority of painting or sculpture, he proclaimed the superiority of painting, considering it more natural, more captivating and with a greater claim to the status of liberal art. Leonardo, too, maintained this view, yet it was always upheld by the Venetians against the Tuscan preference for sculpture. The dialogue concludes with some practical advice for the education and the life of a good painter.

WRITINGS
Dialogo di pittura (Venice, 1548), ed. R. Pallucchini and A. Pallucchini (Venice, 1946); also in *Trattati d'arte del cinquecento tra manierismo e controriforma*, ed. P. Barocchi, i (Bari, 1960), pp. 95–139

BIBLIOGRAPHY
F. Sansovino: *Venetia città nobilissima* (Venice, 1581), xiii, p. 257*v*
Federici: *Memorie trevigiane sulle opere di disegno* (Venice, 1803), ii, p. 54
S. Ortolani: 'Le origini della critica d'arte a Venezia', *L'Arte* (1923), pp. 1–17
J. Schlosser Magnino: *La letteratura artistica* (Florence, 1924, 3/1964), pp. 239–43
M. L. Gengaro: *Orientamenti della critica d'arte nel rinascimento cinquecentesco* (Milan and Messina, 1941)
R. Pallucchini: *La critica d'arte a Venezia nel cinquecento* (Venice, 1943)
F. Bernabei: 'L'ombra, la cosa, il lavoro', *A. Ven.*, xxxii (1978), pp. 147–52
A. Mazza: *Paolo Pino, teorico d'arte e artista: Il restauro della pala di Scorzè* (Venice, 1992)

FRANCO BERNABEI

Pino da Messina. *See* JACOBELLO D'ANTONIO.

Pinturicchio [**Pintoricchio**], **Bernardino (di Betto)** (*b* Perugia, *c.* 1452; *d* Siena, 11 Dec 1513). Italian painter. He collaborated with Perugino in 1481–2 in the Sistine Chapel, Rome, and quickly established his reputation as a painter of distinctive and picturesque decorative cycles. His most important commissions included the decoration (1492–4) of the Borgia Apartments in the Vatican Palace, Rome, for Pope Alexander VI and the large fresco cycle (1502–1507/8) in the library of Siena Cathedral, depicting the *Life of Aeneas Silvius Piccolomini*, for Cardinal Francesco Todeschini Piccolomini (later Pope Pius III).

1. To early 1492. 2. Mid-1492–1499. 3. From 1500.

1. TO EARLY 1492. Pinturicchio, whose nickname refers to his small stature and unprepossessing appearance, was probably a pupil of Bartolomeo Caporali or Fiorenzo di Lorenzo, whose style is reflected in the first work usually attributed to him, the *Virgin and Child* (*c.* 1470, London, N.G.; see fig. 1). The *Resurrection of the Dead Man* and the *Liberation of a Prisoner* from the series of eight small panels (one dated 1473) representing the *Miracles of St Bernardino of Siena* (ex-oratory of S Bernardino, Perugia; Perugia, G.N. Umbria) have been assigned to Pinturicchio. His participation may also have extended to other sections where a link with Andrea del Verrocchio and perhaps also with Florentine illuminators such as Gherardo di Giovanni (1444/5–1497) and Monte di Giovanni (1448–1529) can be discerned.

1. Bernardino Pinturicchio: *Virgin and Child*, oil on panel, 535×355 mm, *c.* 1470 (London, National Gallery)

In 1481 Pinturicchio enrolled in the painters' guild of Perugia, and throughout his career he maintained contact with the city. In 1481–2 he collaborated with Pietro Perugino on the frescoes on the walls of the Sistine Chapel in the Vatican Palace, Rome, painting large parts of the *Journey of Moses* and the *Baptism*. The various portraits, groups of figures in the middle distance and, especially, background landscapes show his familiarity with Flemish painting. In these paintings Pinturicchio's characteristically poetic style is already established. Distinct from the work of his Umbrian and Tuscan contemporaries and of Perugino, his varied and picturesque scenes, full of Late Gothic detail and rich colour grafted on to Renaissance forms, soon established his reputation in Rome.

Around this time Pinturicchio received his first important independent commission, to fresco the chapel of S Bernardino, S Maria d'Aracoeli, Rome, for Niccolò di Manno Bufalini (*c.* 1430–1506), a prominent consistorial advocate in the papal court. On the ceiling he painted the four *Evangelists* (badly deteriorated) and on the walls scenes from the *Lives of SS Francis and Bernardino of Siena*. The scheme, including the various ornamental motifs, is almost entirely by Pinturicchio. Festive and lively, it is executed with lightness and imagination in a rapid, delicate style.

In some other Roman commissions, however, a certain heaviness of handling is evident, owing to the intervention of assistants and collaborators. This can be seen in the decoration of the Palazzo dei Penitenzieri (*c.* 1490) of Cardinal Domenico della Rovere (1442–1501), where the ceiling of the *Demi Gods* provides one of the first examples of profane decoration in a cardinal's residence. Between 1488 and 1491, again with assistants, Pinturicchio frescoed a ceiling in the palazzo of Cardinal Giuliano della Rovere (1443–1513) and four chapels in the right aisle of S Maria del Popolo, Rome. In the first of these, built for Domenico della Rovere, the *Nativity* is autograph. Pinturicchio's designs for the grotesques were directly inspired by those on the ceiling of Nero's recently rediscovered Domus Aurea.

Among Pinturicchio's few panel paintings of this period, the most outstanding is the *Virgin of Peace* (*Virgin and Child with Two Angels and a Donor*) executed around 1490 for the apostolic protonotary Liberato Bartelli, who presented it to Sanseverino Cathedral (*in situ*). The painting's fairy-tale landscape is reminiscent of manuscript illumination, and the donor portrait of Bartelli is skilfully executed. In 1491 Pinturicchio is documented in Perugia, and the following year he was in Orvieto, where the cathedral authorities commissioned him to repaint two *Evangelists* (of which *St Mark* survives) and two *Doctors of the Church*, originally frescoed by Ugolino di Prete Ilario (*fl* 1370–80) in the ceiling of the apse. The two *Evangelists*, painted with considerable workshop participation, were badly received, and a dispute arose over the payment. Work on the apse was eventually completed by Lorenzo da Viterbo (?1437–76).

2. MID-1492–1499. With the election of the Borgia Pope Alexander VI on 11 Aug 1492, Pinturicchio received the commission to decorate the new pope's living-quarters, the Appartamento Borgia, in the former apartments of Nicholas V and in the Torre Borgia. Pinturicchio was working in Rome by November 1492 and remained there until the end of 1494, when the project was completed. In the first room, the Sala delle Sibille, the lunettes contain 12 pairs of *Sibyls and Prophets*. In the second room, the Sala del Credo, the *Prophets* reappear, linked with the *Apostles*. In the third room, the Sala delle Arti Liberali, the *Seven Liberal Arts* are depicted, and in the fourth, the Sala dei Santi, are the *Visitation* and scenes from the *Lives of the Saints* including Elizabeth, Anthony, Paul, Catherine of Alexandria, Barbara and Sebastian, together with a detailed exposition and exaltation of the Borgia emblem and other mythological themes. In the fifth room, the Sala dei Misteri della Fede, are the *Annunciation*, the *Adoration of the Magi*, the *Nativity*, the *Ascension*, the *Pentecost*, the *Assumption of the Virgin* and the *Resurrection*. Although Pinturicchio planned and supervised the entire project, his direct participation was limited. His intervention is usually recognized in the Sala dei Santi, where, in the large lunettes, his rich narrative vein, poetic passion for details and imaginative feeling for the Antique are discernible. In the other rooms such freshness and facility of execution are much less evident. The *Resurrection*, which includes a profile portrait of Alexander VI, is generally agreed to be wholly by Pinturicchio (*see* ROME, fig. 9). Lorenzo da Viterbo appears to have been among the most active of the assistants.

Between 1495 and 1500 Pinturicchio was again in Perugia. On 14 February he signed the contract to paint

his largest and most important surviving panel, the altarpiece for S Maria dei Fossi, Perugia (Perugia, G.N. Umbria). The central panel depicts the *Virgin and Child with St John* with, in the side compartments, the *Annunciation* and *SS Jerome and Augustine*. The *Pietà* is featured above, and in the predella (central section untraced) are the *Vision of St Augustine* and the *Penitence of St Jerome*. The execution of the panels is minute and rich in ornamentation, as is the frame, which, perfectly preserved, adds to the magnificence of the whole. During this period Pinturicchio's career prospered. Second in fame only to Perugino, he was inundated with commissions, executing numerous works for Umbrian patrons and enjoying the support and protection of Alexander VI and his son Cesare Borgia. In 1497 he painted the unfinished frescoes in the Eroli Chapel in Spoleto Cathedral.

3. FROM 1500. In 1500–01 Pinturicchio worked on another great decorative project, to paint scenes from the *Life of the Virgin and the Young Christ* for the Baglioni Chapel, S Maria Maggiore, Spello. In the segments of the crossed vault over the wide, square nave the four *Sibyls* appear to be by an assistant, but on the walls the *Annunciation*, the *Adoration of the Shepherds* and the *Christ among the Doctors* seem to be almost entirely by Pinturicchio. Here he toned down the overpowering decorative richness of the Roman projects, and instead of the crowding and superabundance of the Borgia Apartments there is a return to the limpid, serene narrative style of his early works. The large scene of the *Adoration*, with its lyrical, mysterious and picturesque landscape, is one of the highest achievements of 15th-century Umbrian painting. The *Annunciation* (signed BERNARDINUS PICTORICIUS PERUSINUS) is depicted in the atrium of an aristocratic palazzo, with a view of the countryside at the centre, while *Christ among the Doctors* (see fig. 2) is set in a large open square, with a varied assortment of figures and characters including the patron, Troilo di Rodolfo Baglioni (1463–1506), Bishop of Perugia.

In Siena, on 25 June 1502, Pinturicchio contracted with Cardinal Francesco Todeschini Piccolomini, later Pope Pius III, to decorate the library annexed to the cathedral with stories from the life of the patron's maternal uncle, the humanist Aeneas Silvius Piccolomini (Pope Pius II). He probably spent the rest of 1502 and much of 1503 in Perugia, fulfilling other commissions but mainly working on the drawings for individual episodes, and perhaps also on the cartoons, for the Piccolomini project. Raphael is thought to have taken part in this work, giving the older master some ideas for the compositions, as can be seen in certain drawings (Florence, Uffizi; New York, Pierpont Morgan Lib.; Chatsworth, Derbys). In Siena meanwhile, during this preparatory phase, Pinturicchio's assistants, including Matteo Balducci (*fl* before 1554), Giovanni Francesco Ciambella (*fl* 1495–1510), Eusebio da San Giorgio, Girolamo del Pacchia and Giacomo Pacchiarotti, painted the ceiling of the library with various mythological scenes inspired by the 'golden vault' of the Domus Aurea. At the same time Pinturicchio continued to paint in Umbria; for example, his *Coronation of the Virgin* for S Maria della Pietà (Umbertide) was painted in 1503–5 (panel; Rome, Pin. Vaticana).

2. Bernardino Pinturicchio: *Christ among the Doctors* (1500–01), fresco, Baglioni Chapel, S Maria Maggiore, Spello

From 1504 until his death Pinturicchio lived in Siena, although he made a few brief visits to Perugia and Rome. He did not immediately start work in the library but was instead commissioned by the rector of the Cathedral Works, Alberto Aringhieri, to paint eight scenes from the *Life of St John the Baptist* for the baptistery (three destr.). The series, especially the two scenes containing donor portraits, is characterized by the minute, almost Flemish style of Pinturicchio's later work.

After the death of Pius III, Pinturicchio made a new contract with Andrea di Nanni Piccolomini (*d* 1508), the brother and heir of the late pope. To the ten scenes from the *Life of Pius II* already planned, another painting was now added on the outside of the library, showing the *Coronation of Pius III*. A rather mechanical composition, this may have been painted last, in late 1507 or 1508. In the two preceding years Pinturicchio, who was required by his contract to 'make all the heads by his own hand and retouch them *in secco*', executed, on the walls, ten scenes from the *Life of Aeneas Silvius Piccolomini*. A series of large, *trompe l'oeil* arches frames the scenes, giving the viewer the impression of looking towards the outside world. One of the largest fresco cycles of the Renaissance, its theme is Man, who (in the person of Aeneas Silvius) triumphs through his moral and intellectual virtues, determines the course of history and imposes himself on it. Although undoubtedly impressive, the cycle is less satisfactory than Pinturicchio's earlier works. It is mostly filled with a rather external kind of description rendered in

excessively gaudy colours, and the whole is undermined by even more extensive intervention by assistants than in the Roman frescoes.

The *Allegory of Fortune* (1505–6) designed for the inlaid marble floor of Siena Cathedral similarly shows the decline of Pinturicchio's artistic powers, as do the ceiling (New York, Met.) and a scene depicting the *Return of Ulysses* (London, N.G.) painted in 1509 for a room in the palazzo of Pandolfo Petrucci in Siena. Another somewhat disappointing work is the decoration of the vault of the presbytery, S Maria del Popolo, Rome, featuring the *Coronation of the Virgin*, in a complicated pattern of squares and ornaments intended to imitate mosaic (see colour pl. 2, XVII2). This was Pinturicchio's last work, in which his main assistant was probably Giovanni Battista Caporali.

In his last years, as his health began to fail, Pinturicchio supervised the production of a few panel paintings, for example the altarpiece (1507–8; Spello, S Andrea) depicting the *Virgin and Child Enthroned with Saints*, mostly executed by Eusebio da San Giorgio, and the *Assumption of the Virgin* (Naples, Capodimonte), a rather weak composition, with little evidence of Pinturicchio's intervention, that shows a return to Perugino's motifs. Pinturicchio's role is more evident in the panel of the *Assumption of the Virgin, with SS Gregory the Great and Bernard* (1512; San Gimignano, Pin. Civ.). While the figures are somewhat formal and academic, the bright landscape, which recalls manuscript illumination, contains passages worthy of Pinturicchio at his best. The finest works of his last period, however, are the smaller paintings, such as the tondo of the *Holy Family with St John* (Siena, Pin. N.) and the *Road to Calvary* (Isola Bella, Mus. Borromeo), signed and dated 1513. The latter presents a fantastic procession of little figures that sparkle against the dark vegetation, almost a recollection, crepuscular and romantic, of the flowery fantasy of the early small panels by Pinturicchio in Perugia.

On 7 May 1513 Pinturicchio made his third will (the first dates from 1502, the second from 1509), and a few months later, after dying apparently in poverty, he was buried in SS Vincenzo ed Anastasio, Siena. Pinturicchio's reputation suffered after Giorgio Vasari's negative evaluation of him as an artist who 'enjoyed greater fame than his works merited' and produced works that were most pleasing to 'princes and lords', that is to say 'people who had little understanding of art'. He was long relegated to the margins of the Renaissance and mentioned only amid the dense ranks of decorators, but since the 19th century there has been a revival of interest in his art, although a full critical re-evaluation has yet to appear.

BIBLIOGRAPHY

Thieme–Becker

G. Vasari: *Vite* (1550, rev. 2/1568); ed. G. Milanesi (1878–85), iii, pp. 493–511

F. Baldinucci: *Notizie* (1681–1728); ed. F. Ranalli (1845–7), iii

G. B. Vermiglioli: *Memorie di Bernardino Pintoricchio* (Perugia, 1837)

J. A. Crowe and G. B. Cavalcaselle: *A New History of Painting in Italy*, iii (London, 1866)

A. Schmarsow: *Rafael und Pintoricchio in Siena* (Stuttgart, 1880)

——: *Bernardino Pintoricchio in Rom* (Stuttgart, 1882)

E. Steinmann: *Pinturicchio* (Bielefeld and Leipzig, 1898)

C. Ricci: *Pinturicchio* (London, 1902)

W. Bombe: *Geschichte der Peruginer Malerei bis zum Perugino und Pinturicchio* (Berlin, 1912), pp. 230–40

A. Venturi: *Storia*, VII/ii (Milan, 1913), pp. 586–661

U. Gnoli: *Pittori e miniatori nell'Umbria* (Spoleto, 1923), pp. 284–98

R. van Marle: *Italian Schools*, xiv (1933), pp. 202–98

U. Carli: *Il Pinturicchio* (Milan, 1960)

D. Redig de Campos: 'Il "Soffitto dei Semidei" del Pinturicchio e altri dipinti suoi restaurati nel palazzo di Domenico della Rovere', *Scritti di storia dell'arte in onore di M. Salmi*, ii (1962), pp. 363–75

J. Schulz: 'Pinturicchio and the Revival of Antiquity', *J. Warb. & Court. Inst.*, xxv (1962), pp. 35–55

P. Scarpellini: *Pintoricchio alla Libreria Piccolomini* (Milan, 1965)

S. Ferino Pagden: *Disegni umbri del rinascimento da Perugino a Raffaello* (Florence, 1982), pp. 74–97

J. Beck: 'A New Date for Pinturicchio's Piccolomini Library', *Paragone*, xxxvi/419–425 (1985), pp. 140–43

K. Oberhuber: 'Raphael and Pinturicchio', *Stud. Hist. A.*, xvii (1985), pp. 155–72

F. Santi: *Galleria Nazionale dell'Umbria: Dipinti, sculture e oggetti dei secoli XV–XVI*, Perugia, G.N. Umbria cat. (Rome, 1985), pp. 90–96

A. Cavallaro: 'Pinturicchio a Roma: Il Soffitto dei Semidei nel Palazzo di Domenico della Rovere', *Stor. A.*, lx (1987), pp. 155–70

S. Poeschel: 'Age itaque Alexander, das Appartamento Borgia und die Erwartungen an Alexander VI', *Röm. Jb. Kstgesch.*, xxv (1989), pp. 129–65

F. Todini: *La pittura umbra dal duecento al primo cinquecento* (Milan, 1989), i, pp. 290–300; ii, pp. 527–36

S. Poeschel: 'A Hitherto Unknown Portrait of a Well-known Roman Humanist', *Ren. Q.*, xliii/1 (1990), pp. 146–54

P. SCARPELLINI

Pio [Pio da Carpi; Pio di Savoia]. Italian family of patrons and collectors. They were the rulers of Carpi, Emilia, and the history of the Pio family is closely linked with that of the neighbouring families of Este of Ferrara and Pico of Mirandola. In 1500 Giberto III Pio exchanged with Alfonso I d'Este the fief of Carpi for that of Sassuolo. In 1512 Giberto's cousin (1) Alberto III Pio regained Carpi, but his subsequent alliance with France led to the confiscation of the fief by the Holy Roman Emperor, Charles V (*reg* 1519–56), in 1525. In 1527 Carpi was awarded to the Este, and the Pio family transferred to Sassuolo, remaining there until 1599. The main branch of the Pio family then settled in Ferrara and assumed the name Pio di Savoia. In 1750 Pope Benedict XIV bought 126 paintings from the Pio collection for the Pinacoteca Capitolina, Rome.

BIBLIOGRAPHY

U. Fiorina: *Inventario dell'archivio Falcò Pio di Savoia* (Vicenza, 1980) [Pio archvs in Milan, Bib. Ambrosiana]

(1) **Alberto III Pio** (*b* Carpi, 23 July 1475; *d* Paris, 8 Jan 1531). Son of Leonello I Pio (*d* 1477) and Caterina Pico, he was instrumental in making Carpi an intellectual centre of the Renaissance. He and his brother Leonello II Pio were pupils (1485–*c.* 1488) of the scholar Aldus Manutius, the protégé of their uncle the humanist Giovanni Pico della Mirandola (1463–94). Alberto was subsequently a patron of Aldus's printing house and set up a printing press in Carpi. He was also a patron of the poet Ludovico Ariosto, who in *Orlando furioso* (xlvi, 17) praised as 'sublime, godlike geniuses' Alberto and his cousin Gianfrancesco Pico della Mirandola. As a patron of architecture in Carpi, Alberto commissioned a new façade for the Palazzo Pio and in 1515 gave a contract for a new façade for the cathedral to BALDASSARE PERUZZI. Peruzzi also remodelled the nave of the church of S Nicolò between 1518 and 1522. Painters who worked for Alberto include Bernardino Loschi (*c.* 1460–1540) of Parma, to

whom the portrait of *Alberto Pio* (London, N.G.) is attributed.

BIBLIOGRAPHY

G. Tiraboschi: *Biblioteca modenese*, iv (Modena, 1783)
A. Morselli: *Notizie e documenti sulla vita di Alberto Pio* (Carpi, 1932)
O. Rombaldi, ed.: *Alberto Pio III, Signore di Carpi, 1475–1975* (Modena, 1977)
C. Vasoli: *Alberto Pio da Carpi* (Carpi, 1978)
Presenza del Pio in Carpi, 1327–1525 (exh. cat., Carpi, Mus. Civ., 1978)
Atti del convegno internazionale: Società, politica e cultura a Carpi ai tempi di Alberto III Pio: Padova, 1981

JANET SOUTHORN

(2) Cardinal **Rodolfo Pio** (*b* Carpi, 6 May 1500; *d* Rome, 7 May 1564). Nephew of (1) Alberto III Pio. He was one of the most influential prelates in the age of Church reform. Bishop of Faenza in 1528 and nuncio to France in 1535, he was made a cardinal in December 1536 by Pope Paul III. A *papabile* contender in the conclaves of 1549, 1555 and 1559, Rodolfo narrowly missed election to the papacy, but his influence was felt through his membership of many papal commissions and congregations, including the Inquisition and on the Fabbrica (Cathedral Works) of St Peter's, Rome. It was he who advised Michelangelo to make a model of his design for the dome of St Peter's. Rodolfo was admired for his learning and for his collection of antiquities. His library was housed in his palace (the Palazzo Cardelli) in the Campo Marzio district of Rome, together with a collection of paintings, marble heads and busts, epitaph slabs, Greek vases, glass, weapons and curiosities. His larger Classical sculptures were displayed at the villa (destr.) on the Quirinale, which Rodolfo ordered to be laid out in the 1540s. Comprising also a vineyard, woods, gardens and fountains, the villa's was the first of the great statuary gardens; particularly influential was its grotto with the fountain of the *Sleeping Nymph*.

BIBLIOGRAPHY

U. Aldovrandi: *Delle statue antiche che in Roma da ogni parte si vedono* (Venice, 1566)
Ludwig, Freiherr von Pastor: *Geschichte der Päpste* (1886–9), xi–xvi
C. C. F. Hülsen: 'Römische Antikengarten des XVI. Jahrhunderts', *Abh. Heidelberg. Akad. Wiss., Philos.-Hist. Kl.*, iv (1917), pp. 55–76 [illustrations of statuary]
P. G. Baroni: *La nunziatura in Francia di Rodolfo Pio, 1535–1537* (Bologna, 1962)
D. R. Coffin: *The Villa in the Life of Renaissance Rome* (Princeton, 1979)

JANET SOUTHORN

Piombo, Sebastiano del. *See* SEBASTIANO DEL PIOMBO.

Pippi, Giulio. *See* GIULIO ROMANO.

Piramo da Monópoli, Reginaldo (*fl* 1496–1524). Italian illuminator. He was one of the last great Renaissance illuminators active in Naples and worked in the service of Andrea Matteo III, Duca di Atri. A number of manuscripts known to have been in the Duke's collection are attributed both to him and to his followers. Between 1496 and 1504 he decorated a copy of Seneca's *Epistulae morales* (Vienna, Österreich. Nbib., Cod. Phil. lat. 7). Dating to the beginning of the 16th century and the most splendid of his commissions for Andrea Matteo is the *Ethics* of Aristotle (Vienna, Österreich. Nbib., Cod. Phil. gr. 4). The frontispiece to each of the ten books is elaborately decorated with scenes synthesizing the content of each book, as well as with mythological scenes and figures; the iconography was almost certainly directed by the Duke. On the frontispiece of the sixth book are inscribed the initials R. F., probably 'Reginaldus fecit', and on fol. 80 of the same book the artist signed his name in full. Piramo's work draws on a number of diverse influences; his classicizing style owes much to the Paduan school, while Ferrarese and Netherlandish–Neapolitan influences may also be noted. Towards the end of his career Piramo returned to Monópoli, in Apulia. In 1524 he signed the frontispiece of the Libro dei Soci della Confraternità del SS Sacramento (Monópoli, Confraternità SS Sacramento), his last known work. The stiff and repetitive nature of the illumination is in marked contrast to the exquisite and inventive ornamentation of his earlier work.

BIBLIOGRAPHY

Thieme–Becker
H. J. Hermann: 'Miniaturhandschriften aus der Bibliothek des Herzogs Andrea Matteo III Acquaviva', *Jb. Ksthist. Samml. Allhöch. Ksrhaus.*, xix (1898), pp. 147–216
——: *Die Handschriften und Inkunabeln der italienischen Renaissance* (Leipzig, 1933), p. 79
Arte in Puglia dal tardo antico al rococo (exh. cat., ed. M. d'Elia; Bari, Pin. Prov., 1964), pp. 123–4
M. Rotili: *L'arte del cinquecento nel regno di Napoli* (Naples, 1972), pp. 160–61

□

Pirez (d'Évora), Alvaro [Alvaro di Pietro; Alvaro Portoghese] (*b* Évora, Portugal, before 1411; *d* Italy, after 1434). Italian painter of Portuguese birth. He is first recorded in Pisa, where he arrived some time before 1411; on the evidence of his halo designs Frinta suggested that he was trained in Valencia. He was influenced by Turino di Vanni and Taddeo di Bartolo and evolved a style that reflects a combination of Pisan, Florentine and Sienese trends in Late Gothic painting. In 1411 he and Niccolò di Pietro Gerini painted frescoes on the façade of the Palazzo del Ceppo in Prato (destr.). His two signed and dated works are an altarpiece with the *Virgin and Child with Four Saints* (1423; Volterra, Pin. Com.), and a triptych (1434; Brunswick, Herzog Anton Ulrich-Mus.) with the *Annunciation, Crucifixion* and *Resurrection*. He also signed panels of the *Virgin and Child with Angels* in Santa Croce a Fossabanda, Pisa, and in the Franciscan church in Nicosia, Sicily. Paintings attributed to Alvaro Pirez include two side panels from a dispersed altarpiece, *SS Michael and John the Evangelist* (Warsaw, N. Mus.) and *SS Catherine and James* (Münster, Westfäl. Landesmus.); two panels of *Four Apostles* (two on each panel; Altenburg, Staatl. Lindenau-Mus.); panels of the *Virgin and Child* (Livorno, church of the Casa di Riposo; Cagliari, Mus. Archeol. N.); and fragments of a *St Catherine* (Berne, Kstmus.) and a *St Francis* (ex-Platt priv. col., Englewood Cliffs, NJ). He had no imitators or followers.

BIBLIOGRAPHY

R. dos Santos: *Alvaro Pirez d'Évora: Pintor quatrocentista em Itália* (Lisbon, 1922)
R. van Marle: *Italian Schools*, ix (1927), pp. 581–6
M. Salmi: 'Un'opera di Alvaro Pirez a Livorno', *Liburni Civitas*, ii (1929), pp. 267–81
R. Piattoli: 'Un mercante del trecento e gli artisti del tempo suo', *Riv. A.*, xii (1930), pp. 120–9
F. Zeri: 'Alvaro Pirez: Tre tavole', *Paragone*, v/59 (1954), pp. 44–7

K. Steinweg: 'Opere sconosciute di Alvaro di Pietro', *Riv. A.*, xxxii (1957), pp. 39–55

E. Carli: *Pittura pisana del trecento: La seconda metà* (Milan, 1961), p. 33

R. Oertel: *Frühe italienische Malerei in Altenburg* (E. Berlin, 1961), pp. 138–40

F. Zeri: 'Qualche appunto su Alvaro Pirez', *Mitt. Ksthist. Inst. Florenz*, xvii (1973), pp. 361–70

R. Freemantle: *Florentine Gothic Painters* (London, 1975), pp. 433–40

M. S. Frinta: 'A New Work by Alvaro Pirez', *Bull. Mus. N. Varsovie/Biul. Muz. N. Warszaw.*, xvii (1976), pp. 33–47

HELLMUT WOHL

Pirotti. Italian family of potters. Pietro ('Pirotto') Paterni was already working as a potter by 1460. His four sons, Matteo, Negro, Gianlorenzo and Gianfrancesco, all of whom were skilful maiolica painters, took their surname (Pirotti) and the name of their shop, Casa Pirota, from the nickname of their father. Their workshop was among the best known in Faenza during the first half of the 16th century. It was situated in the S Vitale district of the town, in the area of greatest concentration of the maiolica workshops. They specialized in the most refined, decorative techniques including the use of the *berettino* (blue) glaze and the production of articles decorated with grotesques on a dark-blue ground. They also produced work in the *istoriato* (narrative) style, the most outstanding of which is the goblet (1535; Bologna, Mus. Civ. Med.) depicting the *Coronation of Charles V*, inscribed underneath FATA IN CAXA PIROTA. Documents referring to individual members of the family are plentiful: for example, Domenico rented part of the workshop to his cousin Sebastiano in 1544; Gianfrancesco was elected prior of the Compagnia di S Sebastiano and Gianlorenzo was nominated Console dell'arte in 1507.

BIBLIOGRAPHY
G. Ballardini: 'Fatto in Faenza in Caxa Pirota', *Faenza*, xxii (1934), pp. 167–73

C. Grigoni: 'La Casa Pirota: Documenti', *Faenza*, xxv (1937), pp. 35–42; xxvi (1938), pp. 133–5; xxviii (1940), pp. 25–7; xxx (1942), pp. 27–9, 60–63

CARMEN RAVANELLI GUIDOTTI

Pisa. Italian city in Tuscany. An important medieval trading port at the mouth of the River Arno, Pisa was the centre of a distinctive and influential style of Romanesque architecture, and its wealth, derived from commercial activity all over the Mediterranean area, attracted a number of important artists to the city.

I. History and urban development. II. Art life.

I. History and urban development.

The city's name, Etruscan in origin, means 'mouth' or 'outlet'. The earliest settlement grew up near the sea, probably in the 6th century BC, on islands in the lagoon on the river plain at the junction of the rivers Arno and Auser (now Serchio). By the 10th century AD the coastline had already receded by 6 km; Pisa is now 12 km inland. The accumulation of alluvial deposits did not, however, prevent the development of a flourishing maritime trade. The settlement was conquered by the Romans in 230 BC. After the fall of the Roman Empire, Pisa declined, although the harbour continued to develop and the city retained partial autonomy. A Lombard necropolis has been excavated, as has an octagonal building with an apse, which

has been identified as the 4th–5th-century baptistery. During the Carolingian period Pisa continued to be both a naval base and trading port. The town gradually shifted towards the Arno, consolidated *c.* 1000 by the development of the *forisportam* (outside the gates) quarter on the right bank and the so-called Kinzica quarter on the left.

In the 11th century the city chose to be governed by a *comune* and became an archbishopric in 1092. With intensified efforts to curb Arab advances into the Mediterranean, Pisa reached the height of its political and commercial power. Later the support of the Holy Roman Emperors was crucial in the city's struggles against Lucca, Florence, Genoa and Amalfi, enabling it also to establish small mercantile colonies on the main Mediterranean coasts. In 1162 Frederick Barbarossa granted Pisa a vast area of coastal territory between Porto Venere and Civitavecchia. During the 13th century the population reached 40,000, its highest level before modern times. Part of the city's accumulated wealth was used to build the cathedral and adjacent episcopal complex on an extensive, less marshy piece of land on the northern edge of the new urban nucleus (see fig. (a)). The choice of site, atypical of a medieval city, was partly dictated by the desire for continuity with the old baptistery (and almost certainly with the old cathedral). The present cathedral was started in 1064, the baptistery in 1152 and the bell-tower (campanile), which started leaning during construction because of the marshy terrain, in 1174. In the early 13th century the clergy house was built, followed by the hospital (now the Museo della Sinopie del Camposanto Monumentale) in 1257 and the Camposanto in 1278. The episcopal palace was built in the early 14th century.

By the end of the 13th century the weakened *comune* and defeat by the Genoese in the naval battle at Meloria in 1284 led to the city's political and economic decline; almost all the colonies were lost in the 14th century, and by 1405, when the Florentines took Pisa after a long siege, the population was reduced to 7330. Apart from a brief period of French domination (1494–1509), the Medici and (from 1735) the Austrian grand dukes of the house of Lorraine were to control Pisa, until the citizens voted in 1860 to join the Kingdom of Italy.

The Florentines immediately strengthened the city's defences, work beginning in 1406 on the Cittadella Nuova (c), to which a fortified bastion was added in 1509–12 by Giuliano da Sangallo. They concentrated on specific areas of the city: the university (Palazzo della Sapienza, 1471–1543, the Piazza dei Cavalieri (begun 1562 from plans by Giorgio Vasari, when Cosimo I de' Medici instituted the Order of the Knights of St Stephen to combat coastal piracy) and the market loggias (1603–9). The botanical garden (d), the oldest in Europe, was established in 1540. The Medici brought their own architects to Pisa, among them Bernardo Buontalenti and Francesco Salviati. Many of the churches and palaces that they rebuilt, though decorated in marble, reflect very sober Florentine tastes, the most stylistically eccentric episode being represented by the academic Mannerist façade of S Stefano dei Cavalieri, designed in 1594 by Giovanni de' Medici. The desire for staircases, courtyards and gardens had to be adapted to the many small, irregular spaces of existing buildings, and only on the façades could the architects

Pisa, plan of the city: (a) cathedral complex; (b) S Michele in Borgo; (c) Cittadella Nuova; (d) botanical garden; (e) university

express themselves without constraint. The Palazzo Granducale (now the Soprintendenza per i Beni Ambientali, Architettonici ed Artistici) was begun in 1583 by Buontalenti: its moderate, balanced proportions were the model for later buildings. As Pisa changed from an economic centre into a showplace, the Lungarno in particular became a favourite location for houses of the nobility. The Palazzo Lanfreducci (now Upezzinghi), built in the late 16th century to a design by Cosimo Pugliani (*d* 1618), has a marble-clad façade, and is inscribed on the doorway *Alla giornata*.

BIBLIOGRAPHY
Portoghesi
D. H. Herlihy: *Pisa in the Early Renaissance: A Study of Urban Growth* (New Haven, CT, 1958)
A. R. Masetti: *Pisa storia urbana* (Pisa, 1964)
E. A. Gutkind: *International History of City Development*, iv (London, 1969), pp. 96–9, 314–16
E. Tolaini: *Forma pisarum* (Pisa, 1979)
Livorno e Pisa: Due città e un territorio nella politica dei Medici (exh. cat. by M. Mirri and others, Pisa, Arsenale Galee, Arsenale Mediceo, 1980)
L. Nuti: *I lungarni di Pisa* (Pisa, 1981)
E. Tolaini: 'Campo Santo di Pisa: Progetto e cantiere', *Riv. Ist. N. Archeol. & Stor. A.*, xvii (1994), pp. 101–46

II. Art life.

Little evidence of Pisa's art life from before the 10th century AD survives. The Pisan desire to show an awareness of the city's Roman heritage ('romanitas pisana') led to the inclusion in the Piazza del Duomo (now Piazza dei Miracoli) of fragments of ancient objects (some incorporated into buildings) and large numbers of sarcophagi. These items formed the nucleus of an early collection, which in the mid-14th century was placed in the Camposanto. From the 11th century onwards the city's art life was dominated by the cathedral and its related buildings, for which numerous sculptors and painters were employed. Although during the medieval period artists may have been organized, there are no known sources referring to artists' guilds or similar organizations.

During the 15th century Pisa's loss of political and economic power was matched by a loss of artistic autonomy, although important artists were still active in the city: in 1426 Masaccio received his last payment for the altarpiece for S Maria del Carmine (dispersed; *see* MASACCIO, §I, 1(v) and fig. 1); and between 1468 and

1484 Benozzo Gozzoli worked in the Camposanto. Pisa, however, was no longer to the forefront of artistic developments. The sculptors active in Pisa during the 16th century were all trained in Tuscany: for example STAGIO STAGI, Francesco Mosca, Stoldo Lorenzi and Pietro Francavilla. Following the destruction of the cathedral doors in the fire of 1595, new ones were designed by Raffaello Pagni (*fl* 1588–97) and executed at the beginning of the 17th century by artists working in the manner of Giambologna. In painting, the most eloquent works of this period were the paintings in the apse of the cathedral, completed between 1528 and 1541. Between the 16th and 17th centuries the figurative arts of Pisa broadly reflected two levels of taste: the Medici tended to patronize Florentine artists, while the local aristocracy favoured the Sienese.

<div align="center">BIBLIOGRAPHY</div>

Enc. A. Ant.

M. Salmi: 'Pisa nell'arte dal medioevo ai tempi moderni', *Pisa nella storia e nell'arte* (Milan and Rome, 1929), pp. 71–127

P. Toesca: *Storia dell'arte italiana* (Turin, 1951)

P. Vigo, ed.: *Statuto inedito dell'arte degli speziali di Pisa nel secolo XV* (Bologna, 1969)

E. Carli: *Il museo di Pisa* (Pisa, 1974)

M. Fanucci Lovitch and E. Virgili: 'I Vasai di Pisa ed i loro accordi corporativi del 1419 e del 1421', *Boll. Stor. Pisa.*, liii (1984), pp. 291–300

G. De Angelis d'Ossat, ed.: *Il museo dell'Opera del Duomo a Pisa* (Pisa, 1986)

R. P. Ciardi, C. Casini and L. Tongiorgi Tommasi: *Scultura a Pisa tra quattro e seicento* (Pisa, 1987)

E. Carli: *La pittura a Pisa dalle origini alla bella maniera* (Pisa, 1994)

D. Dringoli and P. Primavori: *All'ombre della torre: Immagini dalle chiese di Pisa* (Lucca, 1994)

F. Redi, ed.: *Arte vetraria a Pisa: Dallo scavo di una vetreria rinascimentale* (Ospedaletto, 1994)

For further bibliography *see* §I above.

<div align="right">ALESSANDRA ANSELMI</div>

Pisa, Giovanni da. *See* GIOVANNI DA PISA (i).

Pisa, Isaia da. *See* ISAIA DA PISA.

Pisanello [Pisano, Antonio] (*b* Pisa or Verona, by 1395; *d* ?*c.* Oct 1455). Italian painter, draughtsman and medallist. His richly decorative frescoes, courtly and elegant painted portraits and highly original portrait medals made him one of the most popular artists of the day. He travelled extensively and worked for several Italian courts, at Mantua, Ferrara, Pavia, Milan and Naples. Many of his paintings have been lost or damaged, making a reconstruction of his career difficult. He is now better known as a medallist.

The personal commemorative medal, which enjoyed great popularity in the Renaissance, was invented by him, and in making medals he displayed an unsurpassed refinement of technique. He was also a brilliant and innovative draughtsman. Many drawings of animals, birds, people and costumes survive, often, as in the case of *Hunting Dog in Profile* (Paris, Louvre; see fig. 1), distinguished by detailed yet poetic naturalism. The central critical question raised by Pisanello's highly original art is whether it should be seen as the inspired finale not only of a school of painting, but of a whole culture that, to borrow Huizinga's word, was waning or whether, instead, his work anticipates the more advanced tendencies and achievements of Renaissance art.

1. Life, painted work and drawings. 2. Medals.

1. LIFE, PAINTED WORK AND DRAWINGS.

(i) *Early career, to 1432*. He was erroneously called Vittore by Vasari; his real name, Antonio, was discovered by Biadego (1908–13). His father, Puccio di Cerreto, went to Verona with many other Tuscan emigrés towards the end of the 14th century; there he married Isabetta, daughter of Niccolò Zuperio. Puccio's will, in favour of his son Antonio, was drawn up in Pisa on 22 November 1395, and it seems probable that Pisanello was born shortly before the will was written. Although there is little evidence on his early artistic activity, it is clear that his style was formed by the traditions of Veronese painting from around the turn of the century. Altichiero (*fl* 1369–93) remained influential, as did the dominant and still problematic Stefano da Verona (1374/5–1438). Recent studies have suggested, with some plausibility, an early contact with Tuscan art.

A first possible result of his early training in Verona can be seen in the charming small panel of the *Virgin and Child with a Quail* (Verona, Castelvecchio). This painting, which is also influenced by Lombard art, has been dated to *c.* 1420 by some scholars. Others (including Longhi, 1928) have disputed the attribution, ascribing the work instead to Cristoforo Moretti together with the *Virgin and Child* (Rome, Pal. Venezia). It was probably between 1415 and 1422 that Pisanello began a fruitful collaboration with Gentile da Fabriano, who had invited him to continue the decoration of the Palazzo Ducale in Venice. There, in the Sala del Maggior Consiglio, he painted frescoes representing the struggle between the emperor Frederick Barbarossa and Pope Alexander III. These frescoes were covered with others painted by Alvise Vivarini in 1479 and were irretrievably lost in the fire of 1557.

In 1422 Pisanello was documented as a resident of Mantua. He was employed by Ludovico Gonzaga (then aged 13), son of the ruler Gianfrancesco Gonzaga, 1st Marchese of Mantua, and was to continue working for the Gonzagas until the end of his career. There has been some speculation that Pisanello was in Florence in 1423, because Gentile da Fabriano was there that year, painting a panel, which he signed, showing the *Adoration of the Magi* (Florence, Uffizi; *see* GENTILE DA FABRIANO, fig. 3) for Santa Trinita. The close relationship between this painting and some of Pisanello's drawings led Degenhart (1941) to suggest a possible collaboration between the two artists, but this remains controversial. Vasari gave some grounds for the notion that Pisanello himself was actually working in Florence, but the evidence is not reliable.

Administrative and family documents show that the artist was in Verona in 1424. Some scholars assign the frescoes that he painted in Pavia to the same year. According to early commentators (Michiel, Breventano), these depicted hunting and fishing scenes as well as jousts and various other courtly amusements. No trace now remains of the frescoes, which were commissioned by Filippo Maria Visconti, 3rd Duke of Milan, in anticipation of the visit of Emperor John VIII Palaeologus (*reg* 1425–

1. Pisanello: *Hunting Dog in Profile*, pen and ink, 162×196 mm (Paris, Musée du Louvre)

48). It is known, however, that Pisanello here collaborated with Lombard painters.

Between 1424 and 1426 the artist was again with the Gonzagas in Mantua. One of his most famous surviving works belongs to this period. It is the charming fresco of the *Annunciation* around the funeral monument of *Nicolò di Brenzoni* (d 1422) in S Fermo, Verona, by the Florentine sculptor Nanni di Bartolo. The fresco (signed PISANUS PINSIT) was highly praised by Vasari, and this dating is widely accepted.

Between August and October of 1427 Gentile da Fabriano died in Rome, leaving incomplete his fresco decorations for S Giovanni in Laterano. He bequeathed his painting equipment to Pisanello, who, it is documented, completed the work between 1431 and 1432. The documents refer to him as *Pictor ecclesie sancti Johannis lateranensis*. The frescoes, which depicted scenes from the *Life of St John the Baptist*, were completely destroyed in Francesco Borromini's 17th-century rebuilding of the Basilica; all that remains is a pale sketch (Berlin, Kupferstichkab.) made by Borromini himself.

(ii) Later career, 1432–55. After his long stay in Rome, which critics consider encouraged him to create a more

classical style, in harmony with Renaissance art, Pisanello travelled through several Italian cities and may have stayed in Florence (Chiarelli, 1972 *L'opera*). He was already a famous painter and was presented at a number of Italian courts. To this central period in his activity some critics (Degenhart, Coletti, Marcenaro, Brenzoni) assign the famous portrait of the *Emperor Sigismund* (Vienna, Ksthist. Mus.). The attribution of this work to Pisanello, however, is much contested. It was formerly thought to be the work of Conrad Laib (Wilde, 1930); and Rasmo (1955) claimed that it was painted by a Bohemian artist close to the Master of the Capuchins in Prague (c. 1434). The fine *Portrait of a Man* (Genoa, Pal. Rosso), generally accepted as an autograph work, was painted at around the same time (Marcenaro, 1959).

Between 1433 and 1438 Pisanello is documented in the S Paolo quarter of Verona with his wife and daughter. Most critics assign one of his greatest works, *St George and the Princess of Trebizond*, painted over the Gothic arch of the Pellegrini Chapel in S Anastasia, Verona (see fig. 2), to this central period of his career. The painting was badly damaged by water seepage at the end of the last century and consequently restored; today it can be seen in the sacristy of the basilica. Vasari's mention of other frescoes

2. Pisanello: *St George and the Princess of Trebizond* (*c.* 1433–8), fresco, S Anastasia, Verona

by Pisanello in the same chapel, of which no memory or concrete evidence remains, has led to much debate (Chiarelli, 1958, 1966, 1972 *L'opera*; Mellini, 1961). Many of Pisanello's drawings, including many from the Codex Vallardi in the Louvre, Paris, are related to this fresco. In the background of the fresco two hanged men dangle from gallows, and the sheets of studies for these figures are among the artist's most famous drawings (Edinburgh, N.G.; London, BM; see fig. 3). The fascinating small panel painting of the *Vision of St Eustace* (London, N.G.), one of his most poetic renderings of the natural world, enriched by lovingly observed detail, may date from the same period.

In 1435 Pisanello sent an image of Julius Caesar (untraced) as a gift to Lionello d'Este, Marchese of Ferrara. From that year he became increasingly interested in portraiture as well as in medalmaking. To this period belongs the charming *Portrait of an Este Princess* (Paris, Louvre; see fig. 4), first attributed to Pisanello by Venturi in 1939. The sitter is shown in profile, half-length and cut off at the elbows against a decorative background of columbines and butterflies. She may be Ginevra d'Este, Margherita Gonzaga (*d* 1439), the wife of Lionello d'Este, or Cecilia Gonzaga; her identity remains uncertain.

In 1438 Pisanello was in Ferrara on the occasion of the Council of Emperor John VIII Palaeologus; he struck a medal of the Emperor and thus initiated his career as a medallist (*see* §2 below). He also drew portraits of the Emperor and his exotic retinue and annotated the drawings that survive (e.g. Paris, Louvre) with careful notes on

3. Pisanello: *Studies of Hanging Corpses*, pen and brown ink, over black chalk, 283 x 193 mm, *c.* 1430s (London, British Museum)

4. Pisanello: *Portrait of an Este Princess*, panel, 430×300 mm, *c.* 1436–8 (Paris, Musée du Louvre)

costume and colour. This may suggest that the occasion of the conference was to be commemorated by a painting or a fresco decoration for the Este palazzo. The same year marked the beginning of the war between Filippo Maria Visconti and the Republic of Venice, in which Pisanello found himself dangerously entangled. He was in Mantua with Gianfrancesco Gonzaga and rashly participated in the capture and sack of Verona. The Venetians considered him a 'rebel', and in 1441–2 he was threatened with a heavy sentence, from which he was saved by powerful intercessors.

After that the painter vigorously resumed his activity, especially in the fields of portraiture and medalmaking. He was in Milan in 1440 and 1441. In Ferrara in 1441 he painted the celebrated portrait of *Lionello d'Este* (Bergamo, Gal. Accad. Carrara; see colour pl. 2, XVIII1) in competition with JACOPO BELLINI. The sitter is shown in profile against wild roses, which glow in a dark background. His only signed work, the *Virgin and SS Anthony the Abbot and George* (London, N.G.), may also belong to that period. The great frescoes depicting *Scenes of War and Chivalry* (Mantua, Pal. Ducale) have been assigned to 1447, on the basis of their stylistic affinities with drawings that are considered preparatory (Fossi Todorow). This dating is, however, not at all certain. The Mantua fresco cycle is the grandest and most impressive surviving example of Pisanello's painting.

In December 1448 Pisanello arrived in Naples and is documented in 1449 at the Aragon court, where an ode in

his honour was written by the poet Porcellio. After that year there is no further mention of him, although it has been suggested on the basis of various documents that he may have lived another five or six years.

RENZO CHIARELLI

2. MEDALS. It is difficult to celebrate with sufficient eloquence the originality of the invention of the personal commemorative medal by Pisanello. Much mystery still surrounds the invention, for although sources of inspiration can be suggested, the actual spring for the invention of the first medal can only be guessed at, and the time and location remain in dispute. Pisanello's first medal portrays *John VIII Palaeologus, Emperor of Byzantium* (1439–40; e.g. London, V&A; see fig. 5), in Italy with his retinue of 700 followers in 1438–9 to attend the ecumenical conference of the Greek and Latin Churches at Ferrara. The visitors were the guests of Pope Eugenius IV (reg 1431–47), who paid for them, and of Niccolo III d'Este, Marquese of Ferrara. The Byzantine state was threatened by the Turkish empire and John VIII was seeking the support of the Pope against the danger. This first medal has a profile portrait head of the Emperor on its obverse, with the imperial titles correctly rendered in Greek. The reverse of the medal depicts the Emperor on horseback, praying at a wayside shrine and accompanied by a mounted squire. The inscription reads simply: 'The work of Pisanello the painter'. This medal reveals much about the character of the earliest medals. Medalmaking was a court art, to illustrate a ruler and his achievements, and it was invented by a painter. While the specific reason for this invention is not known, the Emperor and his exotic retinue had certainly greatly interested Pisanello. A threat of war and an outbreak of pestilence forced the conference to retreat to Florence in January 1439. It is thus not certain whether the first medal was made in Ferrara or in Florence.

For his design Pisanello may have been indebted to ancient Roman coins, which were widely excavated and

5. Pisanello: portrait medal of *John VIII Palaeologus, Emperor of Byzantium*, bronze, diam. 104 mm, probably struck in Florence, 1439–40 (London, Victoria and Albert Museum)

collected in Italy; they bore portraits of rulers and had allegorical representations on the reverses. The Duc de Berry acquired for his collections in Paris large commemorative gold medals of Emperors Constantine and Heraclius in 1402. The medals were part of a series on the history of Christianity made by a local goldsmith to catch the eye of the Duc. Each medal measured 950 mm in diameter, a size convenient to pass from hand to hand. Reproductions of these medals would certainly have been known to Pisanello, giving him the hint as to the size of his invention. The new medals had the same function at the courts of Italy as had the ancient coins that were so much collected; they formed a contemporary record of rulers and they could be presented as personal marks of favour. The enforced removal of the conference to Florence perhaps crystallized for Pisanello the need for a convenient form of commemoration that was easy to make, easy to reproduce by casting, and portable. The technical accomplishment of Pisanello's first medal is not surprising, as he was trained as a goldsmith and would have been experienced in the techniques of modelling and casting. He designed his medals in drawings, several of which have survived (e.g. Paris, Louvre). The drawings, having been approved by the patron, would then be translated into a wax model for casting in lead or bronze. The contents of the medal designs would have been invented by Pisanello himself, for he was not only the grandest painter of his day, he was an accomplished humanist courtier.

It was while he was in Milan, during 1441 and 1442, that Pisanello made medals of *Filippo Maria Visconti* and his condottiere *Niccolò Piccinino* and *Francesco Sforza*. The most enthusiastic of his patrons for the medal was Lionello d'Este at Ferrara, with five small uniform pieces of probably 1443 and a superb medal to commemorate his marriage in 1444. For the Mantuan court, between 1446 and 1448, Pisanello made medals of *Ludovico II Gonzaga*, the reigning marchese, a commemorative medal of his father, *Gianfrancesco Gonzaga*, an especially beautiful medal of Ludovico's daughter *Cecilia Gonzaga* and another of her famous tutor *Vittorino da Feltre*. In 1448 he designed the medal of *Pier Candido Decembrio*, commissioned by Lionello d'Este. When, finally, Pisanello settled at the court of Alfonso I, King of Naples and Sicily, in 1448, after wresting from the Gonzaga court settlement for his work, he was treated with the dignity and generosity for which the Neapolitan court was famous. Here he made three medals of Alfonso and a medal of his court chamberlain, *Alfonso d'Avalos*.

The conventional portrait type in Pisanello's medals is a profile, based on a life study of the sitter, for some of whom the portrait drawings have survived (e.g. Paris, Louvre). The effigies are either cut-off at a short bust length, just below the shoulder, or imitate Pisanello's own convention for the painted panel portrait, a half-length figure cut off at the elbows, as in the medals of *Gianfrancesco Gonzaga* and *Cecilia Gonzaga*.

The reverses of the medals are all original inventions by Pisanello and can be classified in three groups: (1) realistic scenic illustrations (*John VIII Palaeologus*, *Filippo Maria Visconti*, *Gianfrancesco Gonzaga* and *Ludovico Gonzaga*, the

Malatesta medals); (2) humanist inventions (the *Lionello d'Este* marriage medal, the *Cecilia Gonzaga* and *Alfonso I of Naples as Meleager*, a type taken directly from an antique sarcophagus then in Mantua); (3) personal imprese of the sitters. Those of *Lionello d'Este* have a simple political message to record the good government conducted by Lionello.

As remarkable as the invention itself is the fact that the conventional format of the medal made by Pisanello, the placing of a portrait on the obverse and an illustrative type on the reverse, the scale of the relief employed and the exquisite attention to geometrical form in the handling of all of these elements within a roundel have remained valid in the making of medals to the present time.

J. G. POLLARD

BIBLIOGRAPHY

EARLY SOURCES

B. Fazio: *De viris illustribus* (MS. 1456; Florence, 1745); Eng. trans. in M. Baxandall: 'Bartolomaeus Facius on Painting: A Fifteenth-century Manuscript of *De viris illustribus*', *J. Warb. & Court. Inst.*, xxvii (1964), pp. 90–107
G. Vasari: *Vite* (1550, rev. 2/1568); ed. G. Milanesi (1878–85)
S. Breventano: *Istoria della antichità, nobiltà, et delle cose notabili della città di Pavia* (Pavia, 1570/R Bologna, 1972)
B. C. dal Pozzo: *Le vite de' pittori . . .* (Verona, 1718)
M. A. Michiel: *Notizie d'opere di disegno . . .pubblicate e illustrate da G. Morelli* (Bassano, 1880; rev. Bologna, 2/1884)
O. Fischer and L. Planiscig: 'Zwei Beiträge zu Pisanello: I. Zwei Bildnisse des deutschen Kaisers Sigismund von Pisanello; II. Ein Entwurf von den Triumphbogen um Castelnuovo zu Neapel', *Jb. Kön.-Preuss. Kstsamml.*, cccci (1933), pp. 5–28

MONOGRAPHS, EXHIBITION CATALOGUES

G. F Hill: *Pisanello* (London, 1905)
G. Biadego: 'Pisanus Pictor', *Atti Reale Ist. Ven. Sci., Lett. & A.*, i (1908); ii, iii (1909); iv, v (1910), vi (1913)
G. F. Hill: *Drawings by Pisanello* (Paris, 1929/R New York, 1965)
A. Venturi: *Pisanello* (Rome, 1939)
B. Degenhart: *Pisanello* (Vienna, 1941; It. trans., Turin, 1945)
R. Brenzoni: *Pisanello* (Florence, 1952)
L. Coletti: *Pisanello* (Milan, 1953)
R. Chiarelli: *Pisanello* (Milan, 1958)
Da Altichiero a Pisanello (exh. cat. by L. Magagnato, Verona, Castelvecchio, 1958); review by R. Longhi in *L'Approdo Letterario*, iv/4 (1958)
E. Sindona: *Pisanello* (Milan, 1961)
R. Chiarelli: *Pisanello* (Florence, 1966)
——: *L'opera completa di Pisanello* (Rome, 1972)
Pisanello alla corte dei Gonzaga (exh. cat., ed. G. Paccagnini and M. Figlioli; Mantua, Pal. Ducale, 1972)
L. Pupi, ed.: *Pisanello* (Paris, 1996)
Pisanello: Le peintre aux sept vertus (exh. cat. by D. Cordellier and others, Paris, Louvre, 1996)
Pisanello (exh. cat., ed. P. Marini; Verona, Musei Civ., 1996)

MEDALS

G. F. Hill: *Medals of the Renaissance* (Oxford, 1920, rev. London, 1978)
——: *A Corpus of Italian Medals of the Renaissance before Cellini* (Oxford, 1930)
——: 'A Lost Medal by Pisanello', *Pantheon*, viii (1931), pp. 487–8
M. Salmi: 'Riflessioni sul Pisanello medaglista', *An. Ist. It. Num.*, iv (1957), pp. 13–23
J. A. Fasanelli: 'Some Notes on Pisanello and the Council of Florence', *Master Drgs*, iii (1965), pp. 36–47
R. Weiss: *Pisanello's Medallion of the Emperor John VIII Palaeologus* (London, 1966)
F. P. Rosati: 'Inspirazione classica nella medaglia italiana del rinascimento', *La medaglia d'arte: Atti del primo convegno internazionale di studio: Udine, 1970*, pp. 95–105
R. Chiarelli: *L'opera completa di Pisanello* (Milan, 1972), pp. 96–7, 99, 101 [for convenient grouping of the medals]
M. Vickers: 'Some Preparatory Drawings for Pisanello's Medallion of John VIII Palaeologus', *A. Bull.*, lx (1978), pp. 417–24

M. Jones: *A Catalogue of French Medals in the British Museum: 1: AD 1402–1610* (London, 1982), nos 1, 5 [for the medals of Constantine and Heraclius]

J. R. Spencer: 'Speculations on the Origins of the Italian Renaissance Medal', *Stud. Hist. A.*, xxi (1987), pp. 197–203

M. G. T. Antonelli: 'Il ruolo della medaglia nella cultura umanistica', *Le muse e il Principe: Arte di corte nel rinascimento padano* (exh. cat., ed. A. M. Molfino and M. Natale; Milan, Mus. Poldi Pezzoli, 1991–2), i, pp. 25–35

A. N. Stone: 'Pisanus pictor: A Self-portrait Medal?', *Medal*, xxv (1994), pp. 3–5

M. Jones, ed.: *Designs on Posterity: Drawings for Medals* (n.p., 1994)

R. Waddington: 'Pisanello's *Paragoni*, *Perspectives on the Renaissance Medal*, ed. S. K. Scher (in preparation)

Currency of Fame: Portrait Medals of the Renaissance (exh. cat. by S. K. Scher, New York, Frick, 1991)

SPECIALIST STUDIES

U. Bode: *Die Anbetung der Könige von Vittore Pisanello* (1885)

M. Krasceninnikova: 'Catalogo dei disegni del Pisanello nel Codice Vallardi del Louvre', *Arte*, xxiii (1920), pp. 5–23

R. Longhi: '"Me pinxit". I resti del politico di Cristoforo Moretti già in Sant'Aquilino di Milano', *Pinacotheca*, ii (Sept/Oct 1928), pp. 75–9

J. Wilde: 'Ein zeitgenössisches Bildnis des Kaisers Sigismund', *Jb. Ksthist. Samml. Wien*, n.s., iv (1930), pp. 213–22

B. Degenhart: 'Das Wiener Bildnis Kaiser Sigismunds, ein Werk Pisanellos', *Jb. Ksthist. Samml. Wien*, n.s., xiii (1944), pp. 359–76

N. Rasmo: 'Il Pisanello e il ritratto dell'imperatore Sigismondo a Vienna', *Cult Atesina*, ix (1955), pp. 11–16

C. Marcenaro: 'Un ritratto del Pisanello ritrovato a Genova', *Studies in the History of Art Dedicated to W. E. Suida on his Eightieth Birthday* (London, 1959), pp. 73–80

B. Degenhart and A. Schmitt: 'Gentile da Fabriano in Rom und die Anfänge des Antikenstudiums', *Münch. Jb. Bild. Kst.*, iii/40 (1960), pp. 59–151

G. L. Mellini: 'Problemi di archeologia pisanelliana', *Crit. A.*, xlvii (1961), pp. 53–6

M. Fossi Todorow: *I disegni del Pisanello e della sua cerchia* (Florence, 1966)

R. Chiarelli: 'Due questioni pisanelliane', *Atti & Mem. Accad. Agric., Sci., & Lett. Verona*, cxliii–cxliv (1967), pp. 373–81

G. Paccagnini: 'Il Pisanello ritrovato a Mantova', *Commentari*, iv (1968), pp. 253–8

——: *Il Palazzo Ducale di Mantova* (Turin and Rome, 1969)

R. Chiarelli: 'Note pisanelliane', *Ant. Viva*, xi/2 (1972), pp. 3–25

G. Paccagnini: *Pisanello e il ciclo cavalleresco di Mantova* (Milan, 1972)

B. Degenhart: 'Pisanello in Mantua', *Pantheon* (1973), pp. 364–411

I. Toesca: 'Lancaster Gonzaga: Il fregio della Sala del Pisanello nel Palazzo Ducale di Mantova', *Civiltà Mant.* (1973), pp. 361–77

A. Zanoli: 'Sugli affreschi del Pisanello nel Palazzo Ducale di Mantova', *Paragone*, xxiv/277 (1973), pp. 23–44

I. Toesca: 'More about the Pisanello Murals at Mantua', *Burl. Mag.*, cxviii (1976), pp. 622–9

S. Osano: 'Giovanni Badile collaboratore del Pisanello? Contributo alla datazione del ciclo cavalleresco di Mantova', *Quad. Pal. Te*, iv/7 (1987), pp. 9–22

J. Woods-Marsden: *The Gonzaga of Mantua and Pisanello's Arthurian Frescoes* (Princeton, 1988); review by A. Martindale in *Burl. Mag.*, cxxxii (1990), pp. 719–21

L. Bellosi: 'The Chronology of Pisanello's Mantuan Frescoes Reconsidered', *Burl. Mag.*, cxxxiv (1992), pp. 657–60

A. Cicinelli: 'Pisanello a Mantova: Nuovi studi', *Stud. Stor. A. [Todi]*, v–vi (1994–5), pp. 55–92

B. Degenhart and A. Schmitt: *Pisanello und Bono da Ferrara* (Munich, 1995)

D. Cordellier: *Pisanello: La princesse au brin de genévrier* (Paris, 1996)

RENZO CHIARELLI, J. G. POLLARD

Pisano, Niccolò. *See* NICCOLÒ PISANO.

Pisaurum. *See* PESARO (i).

Pitati, Bonifazio [Bonifacio] **de'** [Veneziano, Bonifazio; Veronese, Bonifazio] (*b* Verona, 1487; *d* Venice, 19 Oct 1553). Italian painter. He was the son of Marco, an armourer from Verona. Between 1505 and 1515 the family moved to Venice where Bonifazio is first recorded in 1528, when he had probably long been active as a painter, perhaps in the workshop of Palma Vecchio. Works attributable to this period (*c.* 1515–28) indicate his thorough understanding of the stylistic idioms dominant in Venice in the early 16th century. In his paintings of the *Virgin and Child with Saints* (Paris, Louvre; Los Angeles, CA, Co. Mus. A.; Florence, Pitti) Bonifazio responded intelligently to contemporary works of this type by Titian and Palma. He also took note of the styles of older Venetian masters such as Giovanni Bellini and Giorgione: the early versions are characterized by compositional symmetry and a tripartite division of the landscape backgrounds that is reminiscent of Bellini, while the tone of quiet introspection of the assembled saints recalls Giorgione.

Bonifazio's independent, if unstable, artistic identity emerged only after 1528, the year of Palma's death. In the *Virgin of the Tailors* (1533; Venice, Accad.; see fig.) the archaic symmetry of the composition is offset by the dynamic figure of St Homobonus, patron saint of tailors, approaching a crouching beggar. The complex poses, use of space and narrative interest introduced here were to become prominent features in Bonifazio's mature work. Other aspects of the altarpiece, however, demonstrate the painter's continuing adherence to a more traditional Venetian idiom. The bulky figure, voluminous draperies and warm coloration show that Bonifazio practised a conservative style reminiscent of Palma's, well into the 1530s.

In 1529 Bonifazio began work at the Palazzo dei Camerlenghi in Venice, a state building housing various financial magistracies, for which he was commissioned by a succession of retiring magistrates to produced wall paintings. These included groups of saints (e.g. *SS Lawrence and Alvise*, oil on canvas, *c.* 1532–3; Venice, Accad.), allegorical figures (e.g. *Prudence and Fortitude*, oil on canvas, *c.* 1533–4; Modena, Gal. & Mus. Estense) and larger biblical narratives. Bonifazio and his workshop were

Bonifazio de' Pitati: *Virgin of the Tailors*, oil on canvas, 1.30×1.49 m, 1533 (Venice, Galleria dell'Accademia)

engaged at the Camerlenghi until his death in 1553. Fifty-seven works survive from the cycle. One strand of Bonifazio's development can be followed in a series of large-scale biblical paintings from this commission. In the *Adoration of the Magi* (*c.* 1530; Venice, Accad.) there is little sense of narrative movement across the pictorial field, and the painting is effectively bisected by a column placed between the lunettes. The static arrangement demonstrates a traditional Venetian interest in the organization of form according to the picture shape. The panoramic landscape, typical of Bonifazio, has no powerful movement into depth but provides instead a decorative horizon line that connects at the picture surface with the architecture to the right. In the later *Judgement of Solomon* (*c.* 1533–5; Venice, Accad.), the unified movement across the picture space gives a greater dramatic emphasis, but this horizontal thrust is countered by a series of powerful receding forms. The resulting tension between surface and depth suggests Bonifazio's awareness of Central Italian Mannerist painting.

Bonifazio's precocious response to Central Italian styles in the 1530s influenced the younger generation of painters in Venice, particularly Andrea Schiavone and Jacopo Tintoretto. His knowledge of Mannerism, however, was probably derived from the innovative work at Venice of more widely travelled painters, such as Lorenzo Lotto and Pordenone. Moreover, his use of the new formal vocabularies was typically limited, and the hybrid quality of many of his mature paintings is due to his attempt to assimilate progressive, foreign elements into a conservative Venetian style. In *Christ among the Doctors* (*c.* 1536; Florence, Pitti), the deep plunge to an off-centre vanishing point and the placement of the protagonist in the middle distance reflect Bonifazio's interest in Mannerist innovations. The still, Giorgionesque figures of Christ's parents, however, contradict the potential dynamism of the composition. Despite the bustling energy of later Camerlenghi paintings such as the *Conversion of St Paul* (*c.* 1545; Florence, Uffizi) and the *Massacre of the Innocents* (*c.* 1545–6; Venice, Accad.), both closely dependent on compositions by Raphael, Bonifazio's response to Central Italian painting was neither continuous nor coherent.

Apart from the Camerlenghi, Bonifazio's style moved in a very different direction. His *Dives and Lazarus* (1543–5; Venice, Accad.) combines the naturalism already apparent in such works as the *Supper at Emmaus* (1536–8; Milan, Brera) with a new strain of intellectuality. Bonifazio's model for the genre treatment of a sacred theme was undoubtedly the narrative cycles painted for Venetian *scuole* by Vittore Carpaccio, Gentile Bellini and others. In his detailed description of aristocratic pleasures, however, Bonifazio anticipated the preoccupation of his young compatriot Paolo Veronese. The moralistic theme of *Dives and Lazarus* is typical of Bonifazio's later works (e.g. *Lot and his Daughters*, *c.* 1545; Norfolk, VA, Chrysler Mus.). The picture is carefully structured to convey the theme: a fire raging in the background has hellish overtones, and the column dividing the foreground at the right emphasizes visually the exclusion of Lazarus from the luxurious life beneath the portico. Veronese subsequently employed columns in an analogous manner.

Despite his flirtation with progressive developments in mid-16th-century painting, Bonifazio produced private devotional pictures of a more traditional type until the end of his career. The *Rest on the Flight into Egypt* (1545–53; Adelaide, A.G. S. Australia), apart from its strong lighting and formal fluidity, is still dependent on works painted decades earlier by Palma and Titian. Bonifazio's continued production of such old-fashioned painting types probably reflects the limited range of his patronage. His busy workshop attracted gifted pupils such as Jacopo Bassano (before 1534) but never rivalled the status, social or artistic, of that of his contemporary Titian. His patrons were usually local and probably from the less fashionable sections of Venetian society, for example the *Virgin of the Tailors* was commissioned by the tailors' *scuola*, a confraternity with little social prestige. Bonifazio also produced many small-scale paintings to decorate furniture and *cassoni* (e.g. two allegories, *c.* 1540; Berlin, Gemäldegal.), a type of picture disparaged by contemporary artists and theorists in aristocratic circles. The low prices paid for his large narrative paintings at the Palazzo dei Camerlenghi (10–30 ducats) contrast with the high fees commanded by Titian and Palma. Bonifazio's work at the Palazzo was little known in his day, and it was only in the 17th century that his significant contribution to Venetian painting in its most creative period was fully recognized.

BIBLIOGRAPHY

G. Vasari: *Vite* (1550, rev. 2/1568); ed. G. Milanesi (1878–85), vii, p. 531

C. Ridolfi: *Meraviglie* (1648); ed. D. von Hadeln (1914–24), i, pp. 284–95

G. Ludwig: 'Bonifacio de' Pitati da Verona, eine archivalische Untersuchung', *Jb. Kön.-Preuss. Kstsamml.*, xxii (1901), pp. 61–78, 180–200; xxiii (1902), pp. 36–66

D. Westphal: *Bonifazio Veronese* (Munich, 1931)

G. Faggin: 'Bonifacio ai Camerlenghi', *A. Ven.*, xvii (1963), pp. 79–95

R. Gaston: 'Bonifazio Veronese's *Rest on the Flight to Egypt*', *Bull. A.G. S. Australia*, xxxv (1977), pp. 36–41

S. Simonetti: 'Bonifacio de' Pitati', *The Genius of Venice* (exh. cat., ed. J. Martineau and C. Hope; London, RA, 1983), pp. 151–3

——: 'Profilo di Bonifacio de' Pitati', *Saggi & Mem. Stor. A.*, xv (1986), pp. 83–134 [full bibliog. and many good illus.]

TOM NICHOLS

Pitti, Luca di Bonaccorso (*b* Florence, 1395; *d* Florence, 1472). Italian merchant, politician and patron. One of the wealthiest and most influential citizens of 15th-century Florence, he was the builder and first owner of the Palazzo Pitti in Florence, which later became the residence of the Medici dukes of Tuscany and is now the home of one of Italy's most important museums. Pitti was a staunch supporter of Cosimo de' Medici, and the planning and early construction of the Palazzo Pitti coincided with the period of his involvement with the Medici. From 1418 he acquired land on a piecemeal basis for the eventual construction, which began *c.* 1457. In the 15th century the palace was the largest private residence in Florence, comparable in size only to the public Palazzo della Signoria. Its original seven-bay façade gave it a compact, cubic and distinctly Renaissance massing that was lost in the course of subsequent enlargements (*see* FLORENCE, §IV, 9). The bond of *amicizia* or reciprocal loyalty between Pitti and Cosimo de' Medici ensured that the former would be chosen for high political office, and in 1458 he was elected the city's Gonfalonier of Justice. His adherence to the Medici was not unfaltering, however. In 1466 he led a

faction of disgruntled patricians in planning a revolt against Piero I de' Medici, intended to introduce a more republican form of government. The plan was thwarted and the Medici hegemony preserved, but whereas the other conspirators faced exile or execution, Pitti managed to effect a reconciliation with Piero.

BIBLIOGRAPHY

N. Rubinstein: *The Government of Florence under the Medici, 1434 to 1494* (Oxford, 1966)
D. Kent: *The Rise of the Medici Faction in Florence, 1426–1434* (Oxford, 1978)
L. Guisti and F. Bottai: 'Documento sulle prime fasi costruttive di Palazzo Pitti', *Filippo Brunelleschi: La sua opera e il suo tempo*, ii (Florence, 1980), pp. 703–31

ROGER J. CRUM

Pittoni, Battista (*b* Vicenza, *c.* 1520; *d c.* 1583). Italian printmaker. He settled in Venice in 1558 and from 1561 made etchings of maps ('50 maps of diverse beautiful landscapes', see Vasari, p. 423), as well as of series of ornaments (inspired by the plates of Antonio Fantuzzi) and, above all, landscapes of the surroundings of Rome and Naples. In particular he copied the romantic views by Hieronymus Cock (*c.* 1510–70) in *Praecipua aliquot romanae antiquitatis ruinarum monumenta* (Venice, 1561) to illustrate the treatise by Vincenzo Scamozzi *Discorsi sopra le antichità di Roma* (Venice, 1582). In 1562 Pittoni began to publish two volumes of a collection entitled *Imprese di diversi principi, duchi, signori* (1578; Paris, Bib. N.), which was an immediate success and went through several editions in the late 16th century. For a long time he was confused with Battista dell'Angolo del Moro, with whom he worked in very close collaboration, and with Andrea Schiavone. His prints are usually signed B.P.V. (Battista Pittoni Vicentino).

BIBLIOGRAPHY

G. Vasari: *Vite* (1550, rev. 2/1568); ed. G. Milanesi (1878–85)
J. D. Passavant: *Le Peintre-graveur*, vi (Leipzig, 1864), p. 169
K. Oberhuber: *Renaissance in Italien. 16. Jahrhundert* (Vienna, 1966), pp. 162–3
Palladio e Verona (exh. cat., ed. P. Marini; Verona, Gran Guardia, 1980), p. 291
I. Artemieva: 'Alcune precisazioni sulla storia di un ciclo di Giovanni Battista Pittoni dell'Ermitage', *A. Ven.*, xlvi (1994), pp. 54–61

FRANÇOISE JESTAZ

Pittori, Giovanni Battista dei. *See* BERTUCCI, (1).

Pius II, Pope. *See* PICCOLOMINI, (1).

Pius III, Pope. *See* PICCOLOMINI, (2).

Pius IV, Pope [Medici, Gian Angelo de'] (*b* Milan, 31 March 1499; elected 26 Dec 1559; *d* Rome, 1565). Italian pope and patron. His respectable, but not noble, family were of Milanese origin and were almost certainly unconnected to the famous Florentine de' Medici dynasty. He became a cardinal in 1549, and Cosimo I de' Medici then granted him permission to use the coat of arms of the Florentine de' Medici family. During his pontificate, Pius IV evidently intended to emulate the architectural achievements of two Florentine Medici popes, Leo X and Clement VII. Pius IV revived Leo's plans for the regularization of the streets of Rome, creating a magnificent new thoroughfare, the Strada Pia (completed 1561), from the Piazza del

Quirinale to the old Porta Nomentana, replacing the latter with Michelangelo's superb Porta Pia (1561–4). Pius IV also continued Julius III's beautification of the Via Flaminia to the north of the city and commissioned Julius's architect, Jacopo Vignola, to design the outer façade of the Porta del Popolo as its culmination (1561–3). From 1561 Pius IV also improved the fortifications of the city, strengthening the ramparts of the Castel Sant'Angelo, and building a new wall north of the restored tunnel linking the castle with the Vatican Palace; he was commemorated by both the main gate in this wall, the Porta Angelica, and the residential area to which it led, the Borgo Pio. The coastal defences of Ostia and Civitavecchia were also improved, as were the fortifications of Bologna, Ancona, Ravenna and Anagni, where Giovanni Antonio Dosio was employed.

These public works, which so clearly prefigure the extensive achievements of Sixtus V, did not prevent Pius from further imitating his Medici predecessors in more private artistic indulgence. In the Vatican Palace he employed Pirro Ligorio to complete Bramante's semicircular exedra in the Cortile del Belvedere, to which he added a half-dome and a loggia (1562; see colour pl. 1, XVI1), fronting an apartment frescoed with biblical scenes by Federico Barocci, Federico Zuccaro, Santi di Tito and Niccolò Pomarancio. Pius also improved the lower Court, completing the tiers of loggias on the west side to correspond with those of Bramante on the east and adding a semicircular exedra or *teatro* abutting the old Palace at the south end (1560–65). The uppermost of Bramante's loggias, the Loggia della Cosmografia, was decorated with frescoed maps by Ligorio and with grotesques and the coat of arms of the Medici by Giovanni da Udine, who had been employed on similar work half a century before by Leo X in Raphael's loggias and whom Pius IV had recalled to Rome from Udine in 1560. He commissioned a team of artists, including Francesco Salviati, Girolamo Siciolante da Sermoneta, Taddeo Zuccaro and Orazio Samacchini, to execute the vast yet gloomy frescoes in the huge Sala Regia, the theme of which was the *Defence of the Faith*.

The jewel of Pius IV's patronage was the Casino of Pio IV in the gardens of the Vatican, designed by Pirro Ligorio (for discussion and illustration *see* LIGORIO, PIRRO and fig. 1). This was an extension and elaboration of a modest project begun by Paul IV in 1558. It was refounded and built between 1560 and 1562; the decoration continued until 1564. The Casino, frescoed internally by Santi di Tito and Federico Barocci, faces a free-standing loggia, with a vault painted by Federico Zuccaro. Both these façades have been adorned with Ligorio's exquisite low-relief stuccos, the theme of which is a celebration of Pius as Apollo Medicus.

Equally important were some of Pius IV's ecclesiastical projects. He restored a number of Roman churches, including the Pantheon and SS Apostoli, and provided the great carved and coffered wooden ceiling in the nave of S Giovanni in Laterano that bears his coat of arms. He commissioned Michelangelo to convert the great hall of the Baths of Diocletian into the church of S Maria degli Angeli, an idea that took the Pope's fancy as yet another echo of his baptismal name. This magnificent and influential structure (1561–3) can be identified as Pius's mon-

ument; his tomb (*in situ*) was erected there by his nephew Cardinal Altemps in 1583.

BIBLIOGRAPHY

Ludwig, Freiherr von Pastor: *Geschichte der Päpste* (1886–9)

R. Lanciani: *Storia degli scavi di Roma*, iii (Rome, 1908)

J. S. Ackerman: *The Cortile del Belvedere* (Vatican, 1954)

A. G. Dickens: *The Counter Reformation* (London, 1968)

G. Smith: *The Casino of Pius IV* (Princeton, 1977)

L. Cellauro: 'The Casino of Pius IV in the Vatican', *Pap. Brit. Sch. Rome*, lxiii (1995), pp. 183–214, 262

P. Tosini: 'Federico Zuccari, Pirro Ligorio e Pio IV: La Sala del Buon Governo nell'appartamento di Belvedere in Vaticano', *Stor. A.*, 86 (1996), pp. 13–38

□

Pius V, Pope [Michele Ghislieri] (*b* Bosco Marengo, nr Alessandria, 17 Jan 1504; *reg* 1566–72; *d* Rome, 1 May 1572; *can* 1712). Italian saint, pope, collector and patron. He is remembered mainly for his efforts in the struggle against Protestantism and Islam. His distaste for art not subject to Catholic interpretation caused him to rid the Belvedere, Rome, of its collection of antique statues, some of which were transferred to the Capitol, others given away. As a patron, he favoured schemes that interpreted the Church's programmes after the Council of Trent, as exemplified by his foundation (1566) of the church and monastery of Santa Croce in Bosco Marengo, probably designed by Nanni di Baccio Bigio, which contained paintings by Giorgio Vasari and works by Giovanni Antonio Buzzi (*fl* 1569–79), including the Pope's tomb.

Among works commissioned by Pius V are silver reliquaries by Antonio Gentili and Pier Antonio di Benvenuto Tati after a design by Guglielmo della Porta and the 34 *Corali* (books of anthems; Alessandria, Pin. Civ.) decorated with miniatures by the circle of Giulio Clovio with the assistance of northern European and Lombard artists. Objects sent to Bosco Marengo for the Pope's private devotional use included several gifts, such as the *Passion* (*c.* 1475; Turin, Gal. Sabauda) by Hans Memling (1430/40–94), from Cosimo I de' Medici. Pius V was the patron of Bartholomäus Spranger (1546–1611), who during his stay in Rome was a guest in the Belvedere, where he executed his *Last Judgement* (Turin, Gal. Sabauda) copied from the work (*c.* 1431; Florence, Mus. S Marco) by Fra Angelico. The paintings decorating the small *All Saints* altarpiece-cum-reliquary (Bosco Marengo, Santa Croce) are reminiscent of Spranger's work.

BIBLIOGRAPHY

S Pio V e la problematica del suo tempo (Alessandria, 1972), rev. as *Pio V e S Croce di Bosco: Aspetti di una committenza papale* (exh. cat., ed. G. Ieni and C. Spantigati; Alessandria, Pal. Cuttica; Bosco Marengo, Santa Croce; 1985)

CARLENRICA SPANTIGATI

Pizzicolli, Ciriaco di Filippo de'. *See* CYRIAC OF ANCONA.

Pizzolo [Pizolo]**, Niccolò** [Nicolò] (*b* Padua, ?1421; *d* Padua, before 18 Dec 1453). Italian painter and sculptor. The son of Pietro da Villaganzerla, he came from a wealthy family and dealt in commerce throughout his life. Vasari said that he was a pupil of Francesco Squarcione. According to tradition, he collaborated with Filippo Lippi and Ansuino da Forlì on the fresco decoration (destr.) in the chapel of the Podestà, Padua, for which he painted a *God*

the Father in the vault (Vasari). Given his extreme youth at the time that Filippo Lippi was working there (1434–7), it seems likely that Pizzolo's work in the chapel dated from slightly later, but certainly he was influenced by Lippi's Tuscan Renaissance style. A panel of a *Bishop Saint* (Paris, Mus. Jacquemart-André) is usually considered to be an early work. Between 1446 and 1449 Pizzolo worked as an assistant to Donatello while he was casting the bronze high altar of S Antonio, Padua. Pizzolo is documented as having made one of the ten reliefs of angels (now mounted on the base of the altar), but it is impossible to distinguish which. Under Donatello's influence, Pizzolo developed his powers of expression, particularly in the use of line and realistic detail.

On 16 May 1448 Pizzolo, in partnership with Andrea Mantegna, and together with Antonio Vivarini and Giovanni d'Alemagna, was commissioned to decorate the Ovetari Chapel in the church of the Eremitani, Padua. Pizzolo and Mantegna were assigned the frescoes in the apse, those on the left wall of the chapel and on the right-hand side of the entrance arch. In addition, Pizzolo was to make the terracotta altarpiece of the *Virgin and Child with Six Saints* (*in situ*, badly damaged), which shows, in its modelling, composition and iconography, that Pizzolo was still strongly influenced by Donatello. Previously, it was suggested that it was a collaborative work of Pizzolo with Mantegna and Giovanni da Pisa (i), but this was evidently not the case. Pizzolo also painted the frescoes of *God the Father* and tondi of the four *Doctors of the Church* in the apse (all destr., 1944) and some decorative red cherubim (*in situ*). In July 1449 Mantegna and Pizzolo were in dispute; as a result of an arbitration, it was decided that Mantegna was to paint all the scenes of St James on the left-hand wall of the chapel except one, which was to be done by Pizzolo. Because of Pizzolo's premature death, this scene was eventually painted by Mantegna too. Pizzolo's lively, well-characterized Doctors of the Church were shown sitting at desks in interiors drawn in steep perspective. Perhaps even more apparent than the influence of Donatello is that of Andrea del Castagno (particularly his frescoes in S Zaccaria, Venice), of Filippo Lippi and of Paolo Uccello, who also worked in Padua. The surviving fresco fragments of the cherubim show Pizzolo's effective use of brilliant colour. According to Vasari, Pizzolo was excessively fond of arms, always went armed and died as a result of a treacherous attack on his way home from work.

BIBLIOGRAPHY

Thieme–Becker

G. Vasari: *Vite* (1550, rev. 2/1568); ed. G. Milanesi (1878–85), iii, pp. 386–8

G. Fiocco: *Mantegna* (Milan, 1937), pp. 19–24

E. Rigoni: 'Il pittore Nicolò Pizolo', *A. Ven.*, ii (1948), pp. 141–7

S. Bettini and L. Puppi: *La chiesa degli Eremitani di Padova* (Vicenza, 1970), pp. 74–9

A. Dani: 'Il polittico della Pieve di Santa Maria in Castello ad Arzignano', *Valle del Chiampo*, ed. V. Nori (Vicenza, 1974), pp. 51–87

G. Mariani Canova: 'Alle origini del rinascimento padovano: Nicolò Pizolo', *Da Giotto a Mantegna* (exh. cat., ed. L. Grossato; Padua, Pal. Ragione, 1974), pp. 75–80

MASSIMO GEMIN

Placentia. *See* PIACENZA.

Poccetti, Bernardino [Barbatelli, Bernardo] (*b* San Marino di Valdelsa, nr Florence, 27 Aug 1548; *d* Florence, 9

Nov 1612). Italian painter and draughtsman. He was trained in Florence by Michele Tosini, a pupil of Ridolfo Ghirlandaio, and at 22 was admitted to the Compagnia di S Luca and later the Accademia del Disegno. His skill as a fresco painter of façades earned him the sobriquets 'Bernardino delle facciate', '…delle muse' and '…delle grottesche'. Surviving examples include the façade of the Palazzo di Bianca Capello, Florence. His six lunettes of the *Life of St Dominic* (*c*. 1582–4; Florence, S Maria Novella, Chiostro Grande) owe much to Andrea del Sarto for the clear compositions and individual figures and to the new emphasis on naturalism of Santi di Tito for the narrative simplicity. Poccetti's progress from small-scale *sgraffito* decorations to large-scale compositions was aided by drawings supplied by Alessandro Allori. The frescoes celebrating the Capponi family (1583–7; Florence, Pal. Capponi, Sala Grande) refer to some of the 132 tapestry designs of Joannes Stradanus (e.g. Florence, Pal. Vecchio) and to his engraved series of the *Medicae familiae*. Northern sources are also apparent in Poccetti's work. The lunettes of the *Martyrdom of the Apostles* (*c*. 1585–90; Florence, S Pier Maggiore, courtyard) show the influence of Lucas Cranach the elder (1472–1553) and Hendrik Goltzius (1558–1617). *Small Woodcut Passion* by Albrecht Dürer (1510–11) inspired the *Calvary* and *Christ Nailed to the Cross* (Florence, S Pier Maggiore, vestibule).

Poccetti's private patrons, including the Medici and Strozzi, prized his ability to create realistic, legible compositions with stylized figures. Ecclesiastical and corporate patrons appreciated the drama and comprehensibility of his narratives, and they provided a continuous stream of commissions aimed at promoting Florentine saints and encouraging piety. In 1590 Poccetti began a series of commissions for the Carthusians of Florence and Siena (for whom, as an exception, he travelled outside Florence). The most notable of these is the group of scenes from the *Life of St Bruno* (1592–3; Florence, Certosa del Galluzzo, Pin.). In the *Coronation of the Virgin* in the Neri Chapel (*c*. 1599; Florence, S Maria Maddalena dei Pazzi), the large-scale, visionary images of saints, angels and putti recall Lodovico Cigoli's *Madonna of the Rosary* (Cortona Cathedral); but Cigoli's tenebrist manner of oil painting was inappropriate for frescoes, and Poccetti reverted to more even lighting for the scenes from the *Life of St Antonino* (1601–2; Florence, S Marco, cloister) and the decorations of the Chiostro dei Morti and the Pucci Chapel in SS Annunziata, Florence. The characteristically warm, vivid pastel colours of his frescoes are exemplified in *Deeds of the First Medici Grand Dukes* (*c*. 1608; Florence, Pitti).

Poccetti's drawings (over 800 in Florence, Uffizi; others in London, BM, and Vienna, Albertina) were avidly collected by Filippo Baldinucci (1625–97) for Cardinal Leopoldo de' Medici (1617–75). They range from compositional sketches, such as the *Virgin Appearing to a Saintly Monk* (*c*. 1599; Florence, Uffizi; see fig.), individual figure studies (typically in charcoal, or red and black chalk on blue or white paper) to a fresco cartoon. In his late drawings, such as the preparatory sketches for the decorations of the Ospedale degli Innocenti, Florence (for illustration of fresco *see* FLORENCE, fig. 15), the technique is extraordinary: form is dissolved in light-filled mist; exact contours appear, if at all, only in final pen strokes.

Bernardino Poccetti: *Virgin Appearing to a Saintly Monk*, black chalk, pen, wash and whiting on tan paper, 265×197 mm, *c*.1599 (Florence, Uffizi, Gabinetto dei Disegni)

Poccetti's very few paintings on canvas differ significantly from his frescoes; chiaroscural values rather than a play of bright colour predominate in the *Adoration of the Shepherds* (1597; under restoration at Florence, Fortezza Basso, from S Elizabetta delle Convertite) and in *St Andrew Healing a Blind Man in Avignon* (*c*. 1599; Florence, S Maria del Carmine, sacristy). Poccetti left no vital workshop, although about 40 of his designs were engraved, some by Jacques Callot (1592–1635); his inspiration touched artists including Agostino Ciampelli (1565–1630) and particularly Matteo Rosselli (1578–1650). Pietro da Cortona (1596–1669) admired his skill (F. Baldinucci: *Notizie* (1846), iii, p. 138) and perhaps also his early unification of painting, sculpture and architecture (e.g. Florence, S Pier Maggiore).

BIBLIOGRAPHY

DBI: 'Barbatelli, Bernardo'; Thieme–Becker
C. Thiem: *Florentiner Zeichner des Frühbarock* (Munich, 1977), pp. 265–71 [bibliog.]
Disegni di Bernardino Poccetti (exh. cat., ed. P. C. Hamilton; Florence, Uffizi, 1980)
P. Dreyer, ed.: *Ex Bibliotheca Regia Berolinensi* (Berlin, 1982), pp. 34–5, pl 52–5
Florentine Drawings of the Sixteenth Century (exh. cat. by N. Turner, London, BM, 1986), pp. 242–52
Dessins toscans, XVIe–XVIIIe s. (exh. cat., ed. F. Viatte; Paris, Louvre, 1988), i, pp. 174–97
Sixteenth-century Tuscan Drawings from the Uffizi (exh. cat., ed. A. Petrioli Tofani and G. Smith; Oxford, Ashmolean, 1988), pp. 172–9
S. Ferrone: 'La parola e l'immagine: Lelio bandito e santo', *Valore del falso: Errori, inganni, equivoci sulle scene europee in epoca barocca*, ed. S. Carandini (Rome, 1994), pp. 105–19
S. Vasetti: *Bernardino Poccetti e gli Strazzi: Committenze a Firenze nel primo decennio del Seicento* (Florence, 1994)

——: 'La "guccia" di Bernardino Poccetti da San Gimignano', *Paragone*, xlv/529–33 (1994), pp. 154–9
M. Maddii: 'Cenni sul restauro del Palazzo Ramirez de Montalvo', *Bartolomeo Ammannati, scultore e architetto (1511–1592)*, ed. N. Rosselli del Turco and D. Salvi (Florence, 1995), pp. 343–8

PAUL C. HAMILTON

Poggini. Italian family of artists. Michele Poggini (1487–1527) was a gem-engraver whose two sons (1) Giampaolo Poggini and (2) Domenico Poggini worked together in Florence as goldsmiths and gem-carvers at the court of Cosimo I de' Medici. In 1556 the two brothers were appointed die-engravers at the Florentine Mint.

(1) Giampaolo Poggini (*b* Florence, 1518; *d* Madrid, ?1582). Medallist and coin-engraver. In 1557 he attached himself to the court of Philip II (*reg* 1556–98) in Brussels, one year after Philip's accession to the kingdom of Spain with its dependencies. There he was commissioned to improve coin-engraving in the Spanish Netherlands. An ordinance dated 21 July 1557 introduced the Philippus daalder, which was issued in many varieties by many mints. Poggini's medallic work began during his time at Brussels with two portrayals of *Philip II*, both quite similar in their overall design. His style demonstrates a trend in 16th-century art towards more elaborate ornament, notably in his reverse designs. When, after the Peace of Cateau-Cambrésis (1559), Philip left Brussels for Madrid, Poggini went too and never returned to Italy. In commemoration of the Treaty, Poggini executed a medal dated 1559 showing Pax setting fire to a pile of armaments in front of the closed Temple of Janus.

In 1563 Poggini was raised to the position of Royal Sculptor. His most productive years as a medallist date to his Spanish period, when besides Philip he also portrayed *Elizabeth of Valois* and *Anne of Austria*, third and fourth wives of the King. The dies for his medal of *Joan of Portugal* (1564), widow of the Portuguese heir and sister of Philip, are preserved at the Vienna Mint. Most of his medals are signed I.PAVL.POG.F. or G.P.F., either on obverse or reverse.

BIBLIOGRAPHY
Forrer; Thieme–Becker
A. Armand: *Les Médailleurs italiens* (2/1883–7), i, pp. 237–40
J. Simonis: *L'Art du médailleur en Belgique: Contributions à l'étude de son histoire* (Brussels, 1900)
C. von Fabriczy: *Medaillen der italienischen Renaissance* (Stuttgart, 1903)
G. Habich: *Die Medaillen der italienischen Renaissance* (Stuttgart and Berlin, 1922), p. 118
G. Pollard: *Medaglie italiane del rinascimento*, Florence, Bargello cat., ii (Florence, 1985), pp. 759ff
The Currency of Fame: Portrait Medals of the Renaissance (exh. cat. ed. S. K. Scher, New York, Frick, 1994), pp. 165–8

MARK M. SALTON

(2) Domenico Poggini (*b* Florence, 24 Aug 1520; *d* Rome, 28 Oct 1590). Sculptor, medallist, die-engraver, goldsmith, bronze-caster and poet, brother of (1) Giampaolo Poggini. His earliest training probably came from his father Michele. Benvenuto Cellini (*Vita*) describes a gold cup with low reliefs made *c.* 1545–6 by Domenico and his brother under his direction for Cosimo I de' Medici. A letter of 1548 from Domenico to Cosimo mentions a sword hilt and the reverse of a medal he had been working on for Cosimo. Domenico worked mostly with his brother until Giampaolo's departure between 1553 and 1555 to work for Philip II, King of Spain (*reg* 1556–98), in the Netherlands and Spain. In 1554 Domenico made a pair of silver candlesticks for Cosimo, and in 1556 he was appointed diecutter for the Florentine mint.

His earliest signed and dated marble sculpture, the *Bacchus* (1554; New York, Met.), is from this period. It is recorded in a 1560 inventory of Cosimo's cloakroom. A youthful, energetic work, its frontal viewpoint and contrapposto stance reflect classicizing influences and also the vigour of Cellini's works. Domenico composed a sonnet for the unveiling of Cellini's *Perseus* (1554; Florence, Piazza della Signoria; *see* CELLINI, BENVENUTO, fig. 6) that same year. His signed and dated marble *Apollo* (1559; Florence, Boboli Gdns) is stylistically less indebted to Cellini and perhaps owes more to the stolid classicism of Baccio Bandinelli. A paraphrase of Michelangelo's *David* (1504; Florence, Accad.; *see* ITALY, fig. 22), it is a monumental work whose meaning is explained by a sonnet Domenico wrote glorifying Duke Cosimo as Apollo the Sun God. Domenico also reproduced the statue on the reverse of one of his struck medals of Cosimo (e.g. Florence, Bargello). In 1564 he modelled a terracotta *Poetry*, which, along with similar figures of *Painting*, *Sculpture* and *Architecture* by three other sculptors, formed part of the temporary decorations for Michelangelo's catafalque. Later that year Domenico was a candidate to execute the figure of *Sculpture* for Michelangelo's permanent tomb (Florence, Santa Croce), but Valerio Cioli (1529–99) was chosen by Cosimo instead. Domenico also made temporary decorations for the wedding in 1565 of Cosimo's son Francesco I de' Medici to Joanna of Austria; Vasari praised these works, which included terracotta statues of two Holy Roman Emperors, depictions of *Active Life* and *Contemplative Life* and a relief of the *Birth of the Virgin*. A bust of *Francesco* (Florence, Uffizi), which is convincingly attributed to Domenico, probably dates from shortly before this time.

In 1570 eight bronzes were commissioned for Francesco's *studiolo* (Florence, Pal. Vecchio). Domenico's signed *Pluto*, made between February 1572 and July 1573, was one of these. It reflects an influence from the circle of Bartolomeo Ammannati, especially in the attempt to capture movement. Like the other works for the *studiolo*, especially Giambologna's *Apollo* (1572–5; *in situ*), it is an attempt at the conventional *figura serpentinata* but is designed essentially for a single viewpoint. His seeming reluctance to abandon a singular viewpoint is also reflected in his *Muse* (Florence, Bargello), signed and dated to 1579. The uncomfortable stance of the work seems to imply and deny at the same time the contrapposto that would give it movement. The large figure is covered with tiny, carefully carved drapery folds, a reflection of Domenico's characteristic attention to subtleties of surface detail, part of his heritage as a goldsmith and medallist.

Domenico's skill as a medallist was praised by Vasari. His medals, some struck and some cast, number about 40. They include a series of struck depictions of *Cosimo* (*c.* 1560; London, BM) that seem to have been the basis for Pietro Galeotti's series of Cosimo medals (*c.* 1569; London, BM). Domenico also struck medals of *Francesco I de' Medici* and *Joanna of Austria* (London, BM). His cast

medals include two depicting the Florentine historian *Benedetto Varchi* (Florence, Bargello), who had honoured Domenico by associating him with Donatello in a sonnet of 1555. One or both of these probably date from just after Varchi's death in 1565, since such a medal is described by Annibale Caro in a letter of 20 April 1566 and since the reverse of one features a phoenix on a pyre, a common funeral symbol. The Varchi medal is the basis of the identification of Titian's portrait of him (Vienna, Ksthist. Mus.). Among Domenico's last works was a series of struck medals of *Pope Sixtus V*, as well as one of the Pope's sister *Camilla Peretti* (London, BM). These were made in Rome, where the Pope called him around 1585 and where he became chief engraver of the mint. Other widely-accepted attributions to Domenico include a marble statue of *Lex* (Florence, Pal. Medici–Riccardi) and a marble bust of *Virginia Pucci–Ridolfi* (Florence, Bargello).

BIBLIOGRAPHY

Forrer; Thieme–Becker

G. Vasari: *Vite* (1550, rev. 2/1568); ed. G. Milanesi (1878–85), v, p. 391; vii, p. 305; viii, pp. 618, 620

B. Cellini: *Vita di Benvenuto Cellini* (Naples, 1728), pp. 252, 260

A. Armand: *Les Médailleurs italiens* (2/1883–7), i, pp. 254–61

M. Weinberger: 'Marmorskulpturen von Domenico Poggini', *Z. Bild. Kst*, lviii (1924), pp. 233–5

U. Middeldorf and F. Kriegbaum: 'Forgotten Sculpture by Domenico Poggini', *Burl. Mag.*, liii (1928), pp. 9–17

H. Utz: 'Sculptures by Domenico Poggini', *Met. Mus. J.*, x (1975), pp. 63–78

R. Schiffmann-Baur: 'Zwei Medaillen Papst Sixtus V. zum römischen Stadtbau', *Medal*, xxviii (1996), pp. 17–20

DONALD MYERS

Poggio a Caiano, Villa Medici. Italian villa situated 18 km north-west of Florence, near Prato. One of the few 15th-century villas surrounding Florence to survive the Spanish siege of 1529, it was designed for Lorenzo de' Medici by Giuliano da Sangallo (*see* SANGALLO, (1)) and begun in 1485. Only the front third of the villa was completed by 1494 when the Medici were expelled from Florence, and the large central *salone* and rear third of the villa were completed to Sangallo's design in 1515–19 by the Medici pope Leo X (*reg* 1513–21). Monumental in scale, the villa is raised on a balustraded podium with a groin-vaulted arcade. Above the podium the *piano nobile* is reached by two semicircular staircases built in the 17th century to replace the original horse-ramps that ran at angles to the entrance. The façade is articulated by a pedimented temple front set on four widely spaced Ionic columns *in antis*. This Classical feature, here applied to the Renaissance villa for the first time, later became the hallmark of Palladio's villas, though in a more architecturally integrated form. The terracotta frieze of the portico may be by Bertoldo di Giovanni (it has also been attributed to Andrea Sansovino). The plan is strictly symmetrical (also a feature of Palladio's villas), with the barrel-vaulted *salone* at its centre having curved terracotta coffering, cast using a technique adapted from ancient Roman practice and, according to Vasari, first tried out in Sangallo's own house in Florence. Also of Classical inspiration are the clear geometry of the exterior massing, the harmonic ratios used in designing the elevations, the room plans, and the layout of the surrounding walled garden, known from a view (*c.* 1599; Florence, Mus. Firenze com'era; *see* VILLA, fig. 1) by Giusto Utens (*d* 1609).

The decoration of the central *salone* glorifying the Medici family is one of the most important fresco cycles of 16th-century Florentine art. Begun in 1520 by Andrea del Sarto (*Tribute to Caesar*), FRANCIABIGIO (*Triumph of Cicero*) and Jacopo Pontormo (*Vertumnus and Pomona*; *see* PONTORMO, JACOPO DA, fig. 1), following a programme by Paolo Giovio, work stopped with Leo X's death in 1521. In 1531 Pope Clement VII (*reg* 1523–34) commissioned Pontormo to complete the frescoes, but beyond drawings little was done. Following a revised programme by Vincenzo Borghini, the decoration was completed for Grand Duke Francesco I de' Medici from 1578–82 by Alessandro Allori (*Scipio Africanus and Hasdrubal at the Court of Syphax, Titus Flaminius at the Council of the Achaeans, Hercules and Fortuna in the Garden of the Hesperides* and twelve allegories of virtues).

BIBLIOGRAPHY

G. Vasari: *Vite* (1550, rev. 2/1568); ed. G. Milanesi (1878–85), iv, pp. 267–91

P. Hamberg: 'The Villa of Lorenzo il Magnifico at Poggio a Caiano and the Origin of Palladianism', *Idea and Form: Studies in the History of Art*, i (Stockholm, 1959), pp. 76–87

P. Foster: 'Lorenzo de' Medici's Cascina at Poggio a Caiano', *Mitt. Ksthist. Inst. Florenz*, xxvi (1969), pp. 47–52

M. Winner: 'Pontormos Fresko in Poggio a Caiano: Hinweise zu seiner Deutung', *Z. Kstgesch.*, xxxv (1972), pp. 153–97

J. Kliemann: *Politische und humanistische Ideen der Medici in der Villa Poggio a Caiano: Untersuchungen zu den Fresken der Sala grande* (Bamberg, 1976)

P. Foster: *A Study of Lorenzo de' Medici's Villa at Poggio a Caiano* (New York, 1978) [fundamental study of architecture]

S. Bardazzi and E. Castellani: *La Villa medicea di Poggio a Caiano*, 2 vols (Prato, 1981) [excellent colour pls]

J. Cox-Rearick: 'Themes of Time and Rule at Poggio a Caiano: The Portico Frieze of Lorenzo il Magnifico', *Mitt. Ksthist. Inst. Florenz*, xxvi (1982), pp. 42–68

——: *Dynasty and Destiny in Medici Art: Pontormo, Leo X, and the Two Cosimos* (Princeton, 1984) [study of villa's iconography]

C. Dempsey: 'Lorenzo de' Medici's *Ambra*', *Renaissance Studies in Honor of Craig Hugh Smyth* (Florence, 1985), pp. 177–89

J. D. Draper: *Bertoldo di Giovanni: Sculptor of the Medici Household* (Columbia, MO and London, 1992) [for the terracotta frieze]

J. Nelson: 'Filippino Lippi at the Medici Villa of Poggio a Caiano', *Florentine Drawing at the Time of Lorenzo the Magnificent: Papers from a Colloquium held at the Villa Spelman: Florence, 1992*, pp. 159–74

L. Meoni: '"I panni d'arazzo" con le cacce per la villa di Poggio a Caiano', *Paragone*, xlv/529–33 (1994), pp. 94–100

A. Wright: 'Renaissance Florence: The Age of Lorenzo de' Medici, 1449–1492', *Ren. Stud.*, viii/3 (1994), pp. 334–7

L. M. Medri: *Pontormo a Poggio a Caiano* (Florence, 1995)

LOREN PARTRIDGE

Polidoro da Caravaggio [Caldara, Polidoro] (*b* Caravaggio, nr Bergamo, *c.* 1499; *d* Messina, *c.* 1543). Italian painter and draughtsman. He moved from Lombardy to Rome around 1515 and soon joined Raphael's workshop, which was then occupied with the frescoes in the Vatican Palace. A few rough, expressive details in Raphael's frescoes in the Stanza dell'Incendio and in the Loggetta of Cardinal Bernardo Bibbiena as well as in the tapestry cartoons of the *Acts of the Apostles* (London, V&A) are probably by Polidoro. In 1517–18 he began working with Giulio Romano and Perino del Vaga on the frescoes in the Vatican Logge of Leo X, where he can be credited with the scenes of *Joseph Sold by his Brothers* and the *Crossing of the Jordan*. He formed a close friendship with Perino

and with the Spanish painter Pedro Machuca (*c*. 1490–1550), who was also working on the Logge. Perino probably executed the plan (Donnington Priory, Berks) for Polidoro's fresco cycle of scenes from the *Passion* (early 1520s; Rome, Vatican, S Maria della Pietà, Cappella degli Svizzeri). These frescoes, which have been restored, are considered the earliest coherent expression of his eccentric and dramatic conception of nature and of classicism.

During these early years Polidoro began a fruitful collaboration with other artists interested in ancient Roman art, notably Giulio Romano; he also worked with Maturino da Firenze, a little known painter in Baldassare Peruzzi's circle. With them Polidoro contributed to the chiaroscuro decorations in the Sala di Costantino in the Vatican and the frescoes in the *salone* of the Villa Lante, the first of the large fresco decorations based on Classical themes that made his reputation in Rome during the pontificates of Leo X and Clement VII. Working mainly with Maturino, *c*. 1523–4, he began to paint panoramic friezes of Roman histories on numerous façades in Rome, using a chiaroscuro fresco technique to imitate reliefs on antique columns and tombs, thus lending an ephemeral dignity and splendour even to modest buildings. Very little of this work survives: a fresco depicting *Roman Triumphs over the Barbarians* in the Palazzo Barberini; a damaged fresco of *Mythological Scenes* in the Palazzo Braschi; and a few faded traces on the façades of the Palazzo Milesi and the Palazzo Ricci. Polidoro also painted façades (all destr.) in Naples *c*. 1523–4, as artistic commissions in Rome had decreased during the papacy of the austere Adrian VI (1495–1523). Many of his façade decorations are known from drawings and engravings, particularly by Baroque artists, to whom Polidoro's restless, dramatic style was especially pleasing.

Polidoro studied and admired Michelangelo's frescoes on the ceiling of the Sistine Chapel and also had an affinity with the artists later known as Mannerist who were then converging on Rome: Rosso Fiorentino, Parmigianino and the Netherlandish Jan van Scorel (1495–1562). These influences are apparent in the masterpiece of Polidoro's last years in Rome, the decoration of the chapel of Fra' Mariano in S Silvestro al Quirinale. Painted around 1526, perhaps with the help of Maturino, it has large figures of female saints, lively putti and Classical ruins set in broad landscapes in which untamed nature is depicted with great originality. These scenes, which approach pure landscape, are strikingly innovative and foreshadow the work of 17th-century artists such as Claude Lorrain (1604/5–82) and Nicolas Poussin (1594–1665).

In 1527, at the height of his fame as a decorator, Polidoro was driven from Rome by the Sack. He fled to Naples, where he found employment with ecclesiastical patrons. Surviving works from this period include a few parts of the great altarpiece of *SS Peter and Andrew and Souls in Purgatory* (Naples, Capodimonte), which originally framed an ancient panel of the *Virgin and Child* in S Maria della Grazie at the Pescheria. This painting demonstrates a grandiose, naturalistic and highly dramatic interpretation of the early Mannerist style, in which his study of Michelangelo and contacts with Perino, Rosso, Parmigianino and van Scorel are evident but are fused in an individual language.

By October 1528 Polidoro had settled in Messina. There, isolated from Roman influences, his style developed with formidable consistency, and he painted sacred images of great strength and expressiveness. Among surviving works from his years in Messina are the *Adoration of the Shepherds* (Messina, Mus. Reg.), commissioned in 1533; the *Incredulity of Thomas* (U. London, Courtauld Inst. Gals); and *St Albert* (Turin, Gal. Sabauda) and *St Angelo the Carmelite* (England, priv. col.), these two panels being all that remains of the monumental polyptych executed for the church of the Carmine. The use of colour, the Classical allusions and the sculptural quality of these works are all apparent in the *Road to Calvary* (Naples, Capodimonte), painted before 1534 for SS Annunziata dei Catalani, Messina. Polidoro made lengthy preparations for this large panel, reworking the compositions of Raphael and Lucas van Leyden (*c*. 1494–1553) in a series of vigorous and fluent oil sketches (Rome, Pal. Cancelleria; Naples, Capodimonte; London, Pouncey priv. col.). Works that probably date from the last decade of Polidoro's activity show an even stronger expressive quality. They include the *Transfiguration* (U. London, Courtauld Inst. Gals; see fig.), the *Marriage at Cana* (Messina, Mus. Reg.), *Salome*

Polidoro da Caravaggio: *Transfiguration*, oil on panel, 652×420 mm, 1530s (London, University of London, Courtauld Institute Galleries)

and the *Calling of St Matthew* (both Naples, Capodimonte). In some late works, such as the *Crucifixion* (1536; Valletta, St John's Cathedral), there are passages of less fluent execution, which slip from the dramatic into the grotesque, an effect probably due to the collaboration of Stefano Giordano (*fl* 1538–41), Polidoro's main assistant in Messina.

BIBLIOGRAPHY

G. Vasari: *Vite* (1550, rev. 2/1568); ed. G. Milanesi (1878–85), v, pp. 141–54

A. Marabottini: *Polidoro da Caravaggio* (Rome, 1969) [with good bibliog.]

R. Longhi: 'Un apice di Polidoro da Caravaggio', *Paragone*, xxi/245 (1970), pp. 3–7

A. Marabottini: 'Una postilla a Polidoro', *Commentari*, xxiii (1972), pp. 366–75

L. Ravelli: *Polidoro Caldara da Caravaggio* (Bergamo, 1978)

P. Leone de Castris: 'Polidoro alla Pietra del Pesce', *Ric. Stor. A.*, 21 (1983), pp. 21–52

Polidoro da Caravaggio fra Napoli e Messina (exh. cat., ed. P. Leone de Castris; Naples, Capodimonte, 1988) [with full bibliog.]

M. G. Aurigemma: 'Un disegno polidoresco per l'Andata al Calvario', *Ric. Stor. A.*, liii (1994), pp. 67–73

C. Limentani Virdis: 'Percorsi grafici e sentimentali: Il crocevia fra Italia e Paesi Bassi nella prima metà del Cinquecento', *Incontri*, ix/1 (1994), pp. 21–30

F. Vossilla: 'Un piatto di Cafaggiolo, Polidoro, il Cellini, il Bandinelli e Cosimo I', *Faenza*, lxxx/5–6 (1994), pp. 239–48

A. Zezza: 'Documenti per la *Cona magna* di Sant'Agostino alla Zecca (Girolamo Santacroce, Polidoro da Caravaggio, Bartolomeo Guelfo, Marco Cardisco)', *Prospettiva*, 75–6 (1994), pp. 136–52

Aspetti della pittura a Messina nel Cinquecento: Interventi di restauro e acquisizioni culturali (exh. cat. by F. Campagna Cicala, Messina, Mus. Reg., 1996)

PIERLUIGI LEONE DE CASTRIS

Polidoro da Lanciano [Polidoro, Lanzani; Polidoro de Renzi di Lanzano; Polidoro Veneziano] (*b* Lanciano, *c.* 1515; *d* Venice, 21 July 1565). Italian painter. Documented in Venice before 1536, he specialized in paintings showing various combinations of the Holy Family and saints in informal, outdoor settings. Although Polidoro was not a pupil of Titian, his works are closely dependent on the older Master's paintings of this type and have often been mistakenly attributed to him. The *Holy Family with the Infant St John the Baptist* (*c.* 1550; Paris, Louvre) is typical of Polidoro's work. A delicately handled figure group is set in a spacious wooded landscape, where the foliage is treated with literal precision. The Christ Child leans forward to accept a lamb offered by St John. The motif was often used by Polidoro but is found earlier in Titian's *Virgin and Child with St Agnes and the Infant St John the Baptist* (*c.* 1535; Dijon, Mus. B.-A.).

Despite his continuing allegiance to the lyricism of the early Titian, Polidoro was also receptive to the increasingly ornamental style of Bonifazio de' Pitati in the 1540s and to Veronese's decorative classicism in the 1550s. The *Holy Family with the Infant St John the Baptist, Mary Magdalene and a Donor* (*c.* 1560; Dresden, Gemäldegal. Alte Meister) is characterized by a new stress on elegant costume and richly patterned surfaces. The figure group is placed in a forward plane against prominent Classical architecture to give added monumentality to the composition. Polidoro occasionally executed altarpieces (e.g. the *Pentecost*, 1546; Venice, Accad.), ceiling paintings (e.g. Venice, S Salvatore, refectory, destr.) and portraits (e.g. *Isabella d'Este, Marchesa of Mantua*, Boston, MA, Isabella Stewart Gardner Mus.), but he was less successful in these genres. None-

theless, Ridolfi's report that Polidoro was little regarded in his day appears to be contradicted by Dolce's inclusion of him in a list of the 12 greatest painters in Italy.

BIBLIOGRAPHY

L. Dolce: *Vita dell'invittiss. e gloriosiss. imperador Carlo Quinto* (Venice, 1561), p. 171

C. Ridolfi: *Meraviglie* (1648); ed. D. von Hadeln (1914–24), i, pp. 226–7

C. Marciani: 'Polidoro da Lanciano, sua patria e suoi familiari', *A. Ven.*, xi (1957), pp. 181–5

H. E. Wethey: 'Polidoro Lanzani, Problems of Titianesque Attributions', *Pantheon*, xxxiv/3 (1976), pp. 190–99

TOM NICHOLS

Poliziano [Ambrogini; Politian], **Angelo** (*b* Montepulciano, Tuscany, 14 July 1454; *d* Florence, 29 Sept 1494). Italian humanist and writer. His precocious talents as a Classical scholar and poet attracted the patronage of Lorenzo de' Medici, whose household he entered in 1473. From 1475 to 1479 he was tutor to Piero de' Medici. In 1479 he spent several months in self-imposed exile, mostly in Mantua, where he composed *La favola d'Orfeo*, the first secular Italian drama, for Francesco Gonzaga. He returned to Florence in 1480 and for the rest of his life lectured on Latin literature and Greek philosophy at the Florentine Studio (the university).

Since the late 19th century a number of scholars have suggested that Poliziano acted as the adviser for some of Botticelli's mythological paintings. Both had strong ties with Lorenzo de' Medici and with his second cousin, Lorenzo di Pierfrancesco de' Medici, a patron of Botticelli and the dedicatee of Poliziano's *Manto* (*Prose*, pp. 287–8). His uncompleted *Stanze per la giostra* describes a relief on the door of the palace of Venus (I.xcix–ci). Although this scene, based on one of the Homeric *Hymns*, bears some resemblance to Botticelli's *Birth of Venus* (Florence, Uffizi; *see* BOTTICELLI, SANDRO, fig. 3), there are also a number of differences: for example, in the painting the position of the goddess's hands is reversed and the number of Hours, waiting expectantly on the shore, is reduced from three to one. Therefore, as Lightbown has argued, Poliziano's *Stanze* should be envisaged as erudite iconographical advice from the humanist to the painter rather than as the direct literary source of Botticelli's work. The same can be said in relation to Botticelli's *Primavera* (Florence, Uffizi; *see* BOTTICELLI, SANDRO, fig. 2), which has certain similarities not only with Poliziano's *Stanze* but also with his *Rusticus* (*Prose*, pp. 315–16, lines 210–21). Although it is possible that Poliziano played a role in devising the programme of the *Primavera*, the resemblance between his poems and the painting is not exact. Wittkower suggested that there is an affinity between Poliziano's reconciliation of Cupid and Minerva in the *Stanze* (II.xli–xlii) and Botticelli's *Pallas and the Centaur* (Florence, Uffizi). Juřen found a direct connection between the learned discussion of Pan's panic-inducing conch shell in Poliziano's *Miscellanea* (*Opera*, pp. 249–51) and Botticelli's depiction of a little satyr blowing on a conch in *Mars and Venus* (London, N.G.; *see* BOTTICELLI, SANDRO, fig. 6). Poliziano's excursus does not, however, fit the mood of the painting (Lightbown), although it may be the source for Correggio's *Pan Blowing the Conch* in the Camera di S Paolo in Parma. Meltzoff argued that Poliziano suggested the iconographic programme for Botticelli's *Calumny of*

Apelles (Florence, Uffizi) as a response to Fra Girolamo Savonarola's attacks on the value of humanist literary culture.

According to Condivi and Vasari, Poliziano suggested to Michelangelo the subject for his marble relief, the *Battle of the Centaurs* (Florence, Casa Buonarroti). Vasari also recorded that Poliziano wrote the Latin epigram (*Opera*, p. 593) carved on the tomb of Filippo Lippi in Spoleto Cathedral. There are two portraits of Poliziano by Domenico Ghirlandaio, one (*c.* 1483) in the Sassetti Chapel of Santa Trinita and the other (1486–90) in the Tornabuoni Chapel of S Maria Novella, both in Florence.

WRITINGS

Stanze cominciate per la giostra di Giuliano de' Medici (Bologna, 1494), ed. V. Perticone (Turin, 1954) [written 1476–8; uncompleted]
Opera . . . omnia (Basle, 1553), ed. I. Maïer (Turin, 1971)
Prose volgari inedite e poesie latine e greche edite e inedite, ed. I. Del Lungo (Florence, 1867/*R* Turin, 1970)

BIBLIOGRAPHY

DBI: 'Ambrogini, Angelo'
G. Vasari: *Vite* (1550, rev. 2/1568); ed. G. Milanesi (1878–85), ii, p. 630; vii, p. 143
A. Condivi: *Vita di Michelangelo Buonarroti* (Rome, 1553); ed. E. Spina Barelli (Milan, 1964), pp. 28–9
R. Wittkower: 'Transformations of Minerva in Renaissance Literature', *J. Warb. Inst.*, ii (1938–9), pp. 194–205
V. Juřen: '"Pan Terrificus" de Politien', *Bib. Humanisme & Ren.*, xxxiii (1971), pp. 641–5
R. Lightbown: *Sandro Botticelli*, i (London, 1978), pp. 88–9, 92–3, 122–6
P. Holberton: 'Botticelli's *Primavera*: Che volea s'intendesse', *J. Warb. & Court. Inst.*, xlv (1982), pp. 202–10
S. Meltzoff: *Botticelli, Signorelli and Savonarola: 'Theologia poetica' and Painting from Boccaccio to Poliziano* (Florence, 1987), pp. 13–283
C. Dempsey: *The Portrayal of Love: Botticelli's 'Primavera' and Humanist Culture at the Time of Lorenzo the Magnificent* (Princeton, 1992)
JILL KRAYE

Pollaiuolo [Pollaiolo; Pollajuolo]. Italian family of artists. The brothers (1) Antonio Pollaiuolo and (2) Piero Pollaiuolo were the sons of Jacopo d'Antonio di Giovanni Benci, a Florentine poulterer (hence their nickname). Between *c.* 1460 and 1484 their Florentine workshop was second only to Andrea del Verrocchio's in size, prestige and range of output in a variety of media. Antonio Pollaiuolo, the elder brother, was trained as a goldsmith but was also influential as a painter. He developed an enduring preoccupation with the representation of the human form, which shows in his work in all media, and he was an important stimulus to High Renaissance painters and sculptors, not least Michelangelo and Raphael. Between 1484 and his death in 1498, he designed and produced in Rome the two grandest papal tombs of the 15th century; these made a major contribution to the development of Renaissance bronze sculpture, as did his small bronzes produced in Florence.

Piero Pollaiuolo worked primarily as a panel painter like his brother and developed new skills in handling the medium of oil paint, particularly in landscape representation. Probably shortly after the Pollaiuolo workshop transferred from Florence to Rome in 1484, the Florentine humanist Ugolino Verino wrote: 'There are two brothers, remarkable twins, Pollaiuolo by name, one a painter, the other a good sculptor. Antonio casts his breathing faces in bronze, and models vigorous images from soft clay.' The implications of a clear demarcation in responsibilities

between the two brothers and of the superior quality of Antonio's abilities are probably intentional, but oversimplify their respective roles. It seems clear that Antonio was the leader of the workshop and was primarily a draughtsman and a sculptor in metal, but he also enjoyed a reputation as a painter. Piero Pollaiuolo collaborated with his brother on painted and sculpted works but also worked independently, principally as a painter.

I. Family members. II. Working methods and technique. III. Critical reception and posthumous reputation.

I. Family members.

(1) Antonio (di Jacopo d'Antonio Benci del) Pollaiuolo (*b* Florence, *c.* 1432; *d* Rome, ?4 Feb 1498). Sculptor, painter, designer and engraver. He was trained as a goldsmith and bronze sculptor, probably in Lorenzo Ghiberti's workshop, and is recorded in Militarro Dei's workshop in 1457. In 1466 he joined the Arte della Seta, the silkworkers' guild (to which goldsmiths traditionally belonged), and he listed himself as a goldsmith and painter in the membership records of the Compagnia di S Luca in 1473; this is the only documented reference to him as a painter. In his tax return in 1480, he reported that he was renting a workshop specifically for goldsmiths' work. He still described himself as a goldsmith, and not as a painter, in his last tax return in 1498.

1. Paintings and drawings. 2. Small bronzes. 3. The papal tombs. 4. Designs for goldsmiths' work and embroideries. 5. Engravings.

1. PAINTINGS AND DRAWINGS. Antonio's overriding concern in painting was with the human figure as a dynamic and expressive force; this dominated his Florentine career and generated a tight network of stylistic interrelationships between his works in all media. This is well demonstrated by a pen drawing of a *Nude Man Seen from Front, Side and Back* (Paris, Louvre), for which Antonio closely observed his model from three angles, as though he sought to reconstruct on paper its three-dimensionality. This was a celebrated and widely utilized study of male anatomy, as is shown by the sizeable group of surviving copies. It is lauded in a contemporary inscription on the drawing itself: 'When he depicts man, look how marvellously he shows the limbs.' The principle of the pivoted or mirrored figure is central to nearly all Antonio's two-dimensional figural compositions.

Antonio Pollaiuolo's single-minded use of this system of figure construction helps to explain the somewhat contrived appearance of the figure-group in the large-scale altarpiece of the *Martyrdom of St Sebastian* (London, N.G.; see fig. 1). This altarpiece, perhaps the largest and most important produced in the Pollaiuolo workshop, was, according to Vasari, painted in 1475 for the Pucci family for their oratory dedicated to St Sebastian adjoining SS Annunziata, Florence. Set before an extensive and brilliantly described landscape of the Arno Valley, the pyramidal figure group consists of subgroups of figures pivoted about the vertical axis defined by the figure of St Sebastian bound to his tree of martyrdom. The poses of the pair of figures reloading their crossbows in the centre foreground were generated by pivoting a model through 180° before drawing the figure again with only slight adaptation.

1. Antonio Pollaiuolo: *Martyrdom of St Sebastian*, oil on panel, 2.19×2.03 m, 1475 (London, National Gallery)

Similarly, the two archers in the left and right foreground and the archer behind the saint to the right share an almost identical pose pivoted through *c.* 45° in both directions, so that these figures form a quasi-symmetrical triad, which helps to establish the depth of space occupied by the archers. The final archer, also a crossbowman, is based on a sculptural model derived from one of the ancient Dioscuri in Rome. Pollaiuolo also made use of a *Marsyas* model which exists in several bronze versions, none of which is securely attributable to him. The figure group is pulled together by the use of an overall compositional triangle that imposes a coherent pictorial framework on a highly charged depiction of martyrdom. An additional expressive force is provided by the contrast in treatment between the soft, pallid fleshiness and relatively undifferentiated musculature of St Sebastian and the determined concentration and wiry vigour of the archers' strained arms and legs. Although early sources (Anonimo Magliabecchiano, Billi) attribute the execution of the painting to Piero, it is more probably a joint work. Certainly the preparatory drawings for the archers must have been Antonio's, for the figures demonstrate his keen observation of the surface anatomical structure of a male nude under muscular tension.

Antonio's concern with the antique and with classical motifs is indicated by the ruined triumphal arch in the left middle ground of the altarpiece and in particular by the relief sculpture that decorates it. Inside the arch, a battle relief resembles antique battle sarcophagi both in general

terms and in specific figure poses, and on the front of the arch a roundel is carved with a relief that in subject-matter reflects Antonio's 'presentation drawing' of a *Prisoner Led before a Judge* (London, BM). This drawing is exceptional for its time in its large scale and detailed finish. In this carefully contrived, elaborate composition, the figures are silhouetted against a neutral background, as though the composition was intended as a pictorial echo of Classical sarcophagus reliefs. Three figures are directly derived from a sarcophagus with the *Triumph of Bacchus* (Florence, Uffizi) that was in Rome in the 15th century. Characteristically, Pollaiuolo did not copy his source slavishly but rather pivoted, reversed and altered the figures' poses to generate fresh interrelationships of grouping and movement. Two other figures are adapted from the sheet of a *Nude Man Seen from Front, Side and Back*.

The fragmentary frescoes of *Dancing Figures* in the Villa Gallina outside Florence are usually dated to the later 1460s or 1470s. Although in poor condition, they show Antonio's enthusiasm for the Antique in the frieze-like arrangement of dancing nude men and a woman and the decorative festoons of fruit above them. Antonio's figure poses frequently recur in slightly changed form: one of the Villa Gallina dancers is, for example, in essentially the same pose as Antaeus in the small bronze of *Hercules and Antaeus* (Florence, Bargello; see fig. 2 below). This further demonstrates Pollaiuolo's preoccupation with dynamic three-dimensional figures, often generically based on antique patterns, and emphasizes the close interrelationship that exists between his two-dimensional and three-dimensional representations of the human form.

A number of portraits of women in profile have been attributed to Antonio or to his brother. Those by Antonio in the Museo Poldi Pezzoli, Milan, and in the Gemäldegalerie, Berlin, reveal an ability to depict individual textures that is indebted to Netherlandish art.

2. SMALL BRONZES. The small bronze *Hercules* (Berlin, Bodemus.) resembles in pose and plastic treatment of surface musculature the archer loading his crossbow in the foreground of the *Martyrdom of St Sebastian* (see fig. 1 above); this figure may in turn have corresponded to a figure of Hercules (untraced) cast in 1472 as the crest for a silver-gilt helmet given by the Florentine State to Federigo da Montefeltro, Duke of Urbino, after he suppressed the uprising of Volterra. The bronze statuette was intended to be held in the hand and pivoted and to be enjoyed for its surface textural qualities. This was a new form that as a revival of an ancient type greatly appealed to humanist patrons in the second half of the 15th century. Apparently first developed by Filarete, Pollaiuolo exploited the genre in representations of mythological and other heroes associated with civic pride.

A small bronze of *Hercules and Antaeus* (*c.* 1475–80; Florence, Bargello; see fig. 2), also the subject of one of the lost canvases for the Palazzo Medici (*see* (2) below), was modelled and cast by Antonio, probably to Lorenzo de' Medici's commission. According to his letter of 1494 (Rome, Casa Orsini, Archv. Capitolino), Antonio had painted three *Labours of Hercules* (destr.) with his brother *c.* 1460; these large canvases, each six *braccia* (*c.* 3.3 m) square, hung in the Sala Grande of the Palazzo Medici. In

2. Antonio Pollaiuolo: *Hercules and Antaeus*, statuette, h. 450 mm, *c.* 1475–80 (Florence, Museo Nazionale del Bargello)

the small-scale panel replica of *Hercules and Antaeus* (Florence, Uffizi) the group is dynamically, three-dimensionally disposed in the foreground against a distant landscape. Despite setting himself complicated casting problems in the matching bronze, Pollaiuolo imaginatively exploited the tensile strength of his material. As though by centrifugal force, Antaeus' legs flail outwards from the group's central vertical core, and his head is raised at a sharp angle to his tensed neck to emphasize dramatically his agony. Both here and in the panel painting, Antonio's treatment of his figures' strained anatomy gives the group and the narrative a formidable expressive strength.

The strident aggressiveness of facial characterization in the *Hercules and Antaeus* group is emphasized by the vigorous surface of the bronze, which in some areas was left in a rough, expressively unfinished state. As in the other *Hercules* bronzes, Pollaiuolo stressed the group's pivoting movement by providing a triangular base. The sides of the base dictate the best three viewing angles, but the observer is also encouraged to turn the bronze around and inspect the interlocked figures from other angles. The two single-figure *Hercules* bronzes (Berlin, Bodemus.; New York, Frick) similarly demand to be rotated. The expressive effect of their surface texture, so different from the smooth polish of Verrocchio's bronzes, echoes the contained energy inherent in the pose and crisply detailed features of each figure.

Medicean patronage probably continued to be a source of commissions and recommendations. Antonio may have benefited from Lorenzo de' Medici's recommendations both to Ludovico Sforza, Duke of Milan, for whom he probably made two designs (Munich, Staatl. Graph. Samml.; New York, Met.) for the projected equestrian monument to *Francesco Sforza* in the 1480s (the commission was awarded to Leonardo da Vinci), and to Cardinal Giuliano della Rovere (later Pope Julius II), who called him to Rome in 1484 to make the tomb of his uncle, Pope Sixtus IV.

3. THE PAPAL TOMBS. The two bronze papal tombs executed between 1484 and 1496 by the Pollaiuolo workshop for St Peter's, Rome, were the grandest of the 15th century, and the only tombs to be transferred into the new basilica when Old St Peter's was demolished in 1506. Contrary to convention, the tomb of *Sixtus IV* (Rome, Grotte Vaticane), made between 1484 and 1493, was not set against a wall but was designed as a free-standing structure to be placed in the centre of a new chapel built by Sixtus IV on the south aisle of Old St Peter's. Around the recumbent effigy of the Pope, whose face was evidently modelled on a death mask, reliefs of seven *Virtues* decorate the top of the tomb. This rests on a base with steeply sloping sides, which are decorated with personifications of the *Liberal Arts* in high relief separated by rich acanthus decoration. The iconography was unprecedented: the Liberal Arts had never before been included on an ecclesiastic's tomb, although they were appropriate for Sixtus' wide-ranging intellectual interests. Ingeniously using the variety in the shapes of the field available for each figure, Antonio pivoted a recumbent female figure to create a variety of poses and gestures appropriate for each personification and exploited a fluid drapery style to convey a vitality of pose and expression. Most of the seated *Virtues* derived from workshop patterns used earlier for Piero Pollaiuolo's paintings of *Virtues* (Florence, Uffizi) for the Mercanzia (the Merchants' tribunal); they were used yet again for the tomb of *Innocent VIII* (Rome, St Peter's).

Innocent VIII's tomb was placed against a wall but, exceptionally for its date, it incorporated two statues of the Pope: one showing him recumbent in death, and the other enthroned and vividly triumphant. Originally, the effigy of the seated Pope, holding aloft the relic of the head of Longinus' lance with a powerfully theatrical gesture, was placed beneath the recumbent effigy. However, only the bronzes from the tomb were moved to the new St Peter's, and they were later reassembled differently; the original design is preserved in an anonymous 17th-century drawing (Berlin, Kupferstichkab.).

4. DESIGNS FOR GOLDSMITHS' WORK AND EMBROIDERIES. Antonio Pollaiuolo's major works as a goldsmith and embroidery designer were made for the Baptistery in Florence. His earliest recorded commission was for work on the great silver reliquary cross (Florence, Mus. Opera Duomo) ordered by the Arte di Calimala (the Cloth Guild) on 22 February 1457 to house a relic of the True Cross belonging to the Baptistery. Final payments were made to Pollaiuolo and his collaborator, Betto di Francesco Betti, in 1459, although the cross was still incomplete; further work was recorded in May 1468.

Antonio's share of the project consisted of making the foot of the cross, decorated with silver plaques engraved with scenes from the *Life of St John the Baptist, Prophets* and *Virtues* (which originally, perhaps, were to have been enamelled), and above this a tempietto, which derives in design from Brunelleschi's lantern for the cathedral cupola. The engraved plaques demonstrate the dynamic vigour of Antonio Pollaiuolo's draughtsmanship early in his career; he built up forms using wiry contour lines. The designs of several of the seated *Virtues* anticipate Piero Pollaiuolo's Mercanzia *Virtues* and are the earliest in the sequence of designs for seated female figures in fluent, expressive poses. Other documented liturgical silverwork includes two candelabra (1460s; untraced) for Pistoia Cathedral, two (1470; untraced) for the Baptistery, Florence, and another reliquary cross (1478; Florence, Bargello) for the monastery of S Gaggio, near Florence. Antonio also made silver jewellery (untraced) for Cino Rinuccini in 1461–2.

Another important commission was for a silver relief of the *Birth of St John the Baptist*, one of a group of four ordered by the Calimala on 24 July 1477 to complete the decoration of the silver altar of the Baptistery (Florence, Mus. Opera Duomo). As in Piero Pollaiuolo's *Annunciation* (Berlin, Gemäldegal.; *see* (2), fig. 1 below), the scene is set in an elaborate contemporary interior in which the slim figures, clothed in loosely flowing robes, move and gesticulate gracefully; stylistically the relief blends well with the Late Gothic character of the scenes on the front of the altar, unlike the more dramatic, but less appropriate, treatment of the *Beheading of St John the Baptist* cast in silver by Verrocchio as his contribution to the same project.

The series of 27 embroideries of scenes from the *Life of St John the Baptist* (*c.* 1469–80; Florence, Mus. Opera Duomo) were designed by Antonio Pollaiuolo to decorate a new set of liturgical vestments (a chasuble, two dalmatics and a cope) of white brocade, used on high feast days, for the Baptistery. The first record of Pollaiuolo's involvement in this project was on 9 August 1469, but work had already started on the embroideries in August 1466, by which date Antonio may already have supplied the first of his designs. Payment for the designs was still being made in 1480, and the final payment to the embroiderers was made in 1487, three years after the Pollaiuolo workshop had moved to Rome.

These designs form one of the most extensive narrative cycles in 15th-century Florentine art and demonstrate better than any other of Antonio's works his strengths as a narrative artist. Architectural and landscape settings are imaginatively varied to suit the nature and context of each episode. Large-scale settings, defined by a sophisticated use of geometric perspective and Renaissance architectural articulation, distinguish the interiors of Herod's palace from the simpler domestic furnishings of St Elizabeth's bedroom in the scene of the *Birth of St John the Baptist*. The setting for scenes showing St John in the wilderness, characterized by an inhospitable terrain of conventional Late Gothic rocks and boulders, contrasts with the atmospheric vista of the Arno landscape familiar from Pollaiuolo workshop paintings, in *St John Baptizing the Neophytes*. Similarly, in the figure treatment, Antonio effectively contrasted the sinewy contours of the Baptist's lean,

muscular form with more robust figures clothed in robes with fanciful details and heavy folds. Dynamic interaction between the figures is treated energetically. These simple but vigorous compositions admirably fulfil their purpose by the vivid clarity and legibility of the narrative (*see* ITALY, fig. 38).

5. ENGRAVINGS. That Antonio Pollaiuolo regarded his engraved plate of the *Battle of the Ten Nudes* (London, BM; see fig. 3), usually dated to *c.* 1470–75, as one of his most important works, is indicated by the signature *Opus Antonii Pollaioli Fiorenttini* inscribed on a tablet ostentatiously displayed hanging from a tree at the left of the composition. This engraving, measuring 383×595 mm, was the largest produced in Florence in the 15th century. With this work, which was probably not commissioned, Pollaiuolo intended to demonstrate his skill in rendering muscular anatomy in a print, large numbers of which could be disseminated to other artists' studios. Pollaiuolo's work later became known both in Italy and abroad through the extensive circulation of engravings: just as German engravings stimulated the imaginations of late 15th-century Florentine artists, so such artists as Albrecht Dürer (1471–1528) knew and made use of Pollaiuolo's engraving.

Given the engraving's essentially demonstrative purpose, it is probably mistaken to attempt to identify an established iconography in the battle portrayed; rather, its subject may be a moral allegory invented for the purpose. It can also be seen as the equivalent in terms of human anatomy of late 15th-century Florentine engraved pattern sheets of animals and other natural forms. The carefully posed, artificially interrelated fighting figures are represented as if in battle, a convention adopted to provide them with energetic activities to display their animated musculature. The battle may suggest a relationship with Classical battle reliefs, but Pollaiuolo contrived the composition specifically to show his abilities in representing the human form in movement.

The idea of producing prints on paper of engraved designs probably evolved in Florentine goldsmiths' workshops as a result of their niello work. Linear designs were engraved on sheets of silver, and the grooves were filled with a sulphur compound, which when fired produced strong, permanent black contours. Antonio's proven skill as a silver engraver enabled him to control his engraver's burin to produce rhythmically tense outlines around his forms. A similar, although less flexible and less expressive, drawing style was developed by MASO FINIGUERRA; Pollaiuolo may have provided designs for Finiguerra early in his career: according to Benvenuto Cellini, Pollaiuolo designed a *Crucifixion* (untraced) that Finiguerra nielloed for a pax in the Baptistery, Florence. The exact character of the artistic relationship between Pollaiuolo and Finiguerra is obscure but was probably mutually beneficial. Just as Pollaiuolo was influenced by Finiguerra's work, so also many of the numerous drawings and engravings attributable to Finiguerra may have been based on patterns by Pollaiuolo.

In some of his pen-and-ink drawings Pollaiuolo was able to demonstrate clearly the figures' forms and movements through the use of vibrant, elastic contour lines alone. In the *Battle of the Ten Nudes*, however, he supplied

3. Antonio Pollaiuolo: *Battle of the Ten Nudes*, engraving, 383×595 mm, *c.* 1470–75 (London, British Museum)

extensive additional information about surface anatomy by using hatched shading in a manner unique to Florentine engravers of the 1470s. The internal modelling varies between occasional cross-hatching and fine zigzag strokes of the burin. Pollaiuolo was thereby able to show convincingly, if exaggeratedly, the articulation of muscles under the stress of violent activity. Vasari claimed that Antonio dissected human corpses, but it is unlikely that he did so, since the flaccid musculature of a cadaver could have provided virtually none of the information he needed to portray tensed muscles. Moreover, Pollaiuolo quite consistently represented the positions and interrelations of muscles incorrectly.

The emphasis on active nude form is reinforced by the battle's undefined setting. Intentionally, the screen of bushes cuts out all but the shallow foreground. Different phases of the activity are shown by different groups of figures: thereby within a single composition the various sequences of the fight could be illustrated, from initial engagement to victory on the death of the adversary. As in the *Martyrdom of St Sebastian*, the composition is dominated by the use of a pivoted figure. The main foreground figures are drawn from a single model pivoted through 180° to produce two aggressively confronted poses. Other figures are based on models familiar from other products of the Pollaiuolo workshop: the archer, for instance, is a 180° pivot of the figure used for Hercules in the painting of *Hercules and Deianira* (New Haven, CT, Yale U. A.G.).

(2) Piero (di Jacopo d'Antonio Benci del) Pollaiuolo (*b* Florence, *c.* 1441; *d* Rome, *c.* 1496). Painter, brother of (1) Antonio Pollaiuolo. He was described as a painter in the membership records of the Compagnia di S Luca, which he joined in 1472. According to tradition, he initially trained under Andrea del Castagno. In his 1480 tax return Piero reported that he had a small house adjoining the family home '. . .which I use when I have painting to do'. He produced many paintings for the Florentine workshop, often jointly with Antonio, whose greater fame overshadowed him.

The first paintings known to have been produced by the Pollaiuolo workshop were the three canvases of the *Labours of Hercules* (*c.* 1460; destr.) for the Palazzo Medici, Florence. These were probably painted by both brothers to Antonio's designs. It is generally agreed that two of them are closely reflected in small panels by Antonio of *Hercules and the Hydra* (see colour pl. 2, XVIII2) and *Hercules and Antaeus* (both Florence, Uffizi). Piero is first documented working from 1466 to 1468 on the decoration of the chapel of the Cardinal of Portugal in S Miniato al Monte, Florence, again producing paintings probably partly based on drawings provided by his elder brother. He collected the payments for these works on behalf of both brothers, and this may suggest that he was primarily responsible for the execution of the paintings, both in fresco and on panel. F. Albertini (*Memoriale di molte statue et picture sono nella inclyta cipta di Firenze*; 1510), the Anonimo Magliabecchiano and Billi attributed to Piero

the chapel's altarpiece of *SS James, Vincent and Eustace* (Florence, Uffizi), although the documents make clear that the design emanated from the joint workshop; it may not be possible, however, to define precisely the brothers' separate contributions. The elongated proportions of the figures, the refined hand gestures and the brilliant treatment of surface textures associate the execution with Piero, yet the anatomically coherent poses, wiry contours and expressive features suggest either Antonio's participation or that Piero was working to Antonio's figure drawings.

The only independent documented Florentine commission completed by Piero Pollaiuolo was for six *Virtues* (Florence, Uffizi) of a set of seven painted in 1469–70 to decorate the meeting room of the Mercanzia (the Merchants' tribunal). They conspicuously lack an articulate sense of anatomical form and structure. This series of six panels was Piero's major work in Florence. The commission for the seventh was transferred to Botticelli in June 1470, perhaps because Piero's progress was slow. Documents show that the trial piece, presumably the full-scale drawing (in charcoal, heightened with white, on the unprimed back of the panel) by Antonio for the figure of *Charity*, was accepted by the patrons on 18 August 1469. The prestigious commission for the whole series was awarded to Piero on 18 December that year, after the final version of *Charity* (Florence, Uffizi) had been painted on the other side of the trial panel. If Botticelli's *Fortitude* (Florence, Uffizi) can be seen as a critique of Piero's first contributions to the cycle, it may be that he was attempting to correct the exaggerated perspectival recession of the thrones, the thick-set, inexpressive faces and the anatomical disproportions that give Piero's monumental, shapeless figures relatively small torsos and heads. As variations on the theme of the seated female figure, however, the Mercanzia *Virtues* stand as an important and successful sequence of designs, good enough to be reused in the Roman tomb monuments. The panels are in a poor state of preservation, which makes it impossible to judge the quality of their execution, but Piero's principal concern seems to have been for rich patterning and textural definition of surfaces.

A similar preoccupation with surface detail characterizes the treatment of the interior setting and of the landscape background in Piero's *Annunciation* (Berlin, Gemäldegal.; see fig. 1). This attributed work may be dated to the 1470s because of the resemblance to the Mercanzia *Virtues* and to Antonio's Baptistery altar relief. Her response to the angel's muted greeting is restrained; both figures appear weighed down by their rich, jewel-trimmed garments and overawed by their opulent environment. They are set against the elaborately decorated pilasters and ornate wall panelling of a grand contemporary bourgeois interior. At the end of extensive perspectival spaces, biforate windows give views, on the left, of Florence (seen from the foothills to the north of the city) and, on the right, of the Arno Valley receding behind a group of rural buildings that includes a 15th-century Florentine villa not unlike the Villa Medici at Fiesole.

The ability to paint recognizable landscape vistas using aerial perspective is a major feature of the painter of the *Annunciation*; and Piero should perhaps be credited with

1. Piero Pollaiuolo: *Annunciation*, ?oil on panel, 1.50×1.74 m, *c.* 1470 (Berlin, Gemäldegalerie)

advances in this field as significant as his brother's. Building on the developments in topographical landscape representation of Benozzo Gozzoli and especially of Baldovinetti, Piero Pollaiuolo was perhaps the earliest Florentine painter to make his landscape vignettes recognizable views of the Arno valley downstream from Florence by including the city itself. The view of Florence reappears in the painting of *Hercules and Deianira* (New Haven, CT, Yale U. A.G.), perhaps also dating from the 1470s. Characteristically, Piero avoided the difficulty of indicating recession from foreground to middle ground by showing the landscape from the high viewpoint of the upper floor windows of the Virgin's bedroom: in the altarpiece for the Cardinal of Portugal's Chapel, the balustrade behind the saints serves the same purpose. The recession from middle ground to the far distance was easily defined by lines of trees of diminishing size, by the winding river and by the interfolding hillsides shown in increasingly reduced tonal density. The atmospheric delicacy with which fine details and colours are gradually dissolved in the haziness of the distant horizon demonstrates a sensitive response to Netherlandish landscape painting. In this respect, developments in paintings from the Pollaiuolo workshop bear comparison with the contemporaneous observations of landscape forms and atmosphere made by Leonardo da Vinci in Verrocchio's workshop.

A noteworthy three-quarter face portrait of *Galeazzo Maria Sforza* (Florence, Uffizi) was painted by Piero for Lorenzo de' Medici during the sitter's visit to Florence in 1471. Piero's only recorded work in a medium other than painting was the model (untraced) that he submitted in 1477 in competition for the monument to *Cardinal Niccolò Forteguerri* (1419–73) in Pistoia Cathedral. His candidacy may have been suggested by his previous completion of a Corpus Domini altar for the same church. The Forteguerri monument commission is another example of the rivalry between the Pollaiuolo workshop and that of Verrocchio; it was awarded to Verrocchio on Lorenzo de' Medici's advice, although the authorities of Pistoia preferred Piero Pollaiuolo's design. A commission from the Florentine

2. Piero Pollaiuolo: *Coronation of the Virgin*, oil on panel, 3.12×2.50 m, 1483 (San Gimignano, San Agostino)

Signoria in 1478 for an altarpiece for the chapel of St Bernard in the Palazzo Vecchio, originally awarded to Piero, was transferred to Leonardo da Vinci.

The altarpiece of the *Coronation of the Virgin* (1483; San Gimignano, S Agostino; see fig. 2) is Piero's only signed and dated work. The figure proportions, especially of the Virgin and Christ, are (like those of the Mercanzia *Virtues*) unnaturally elongated, but the anatomical observation and internal modelling of St Jerome's nude torso are relatively accomplished, and the saints' facial features express a wide range of pious feelings. The sophisticated treatment of fabrics and gemstones is consistent with Piero's artistic temperament and again indicates his awareness of Netherlandish practice. His talents were peculiarly suited to portraying the textural characteristics of brocades and velvets, the immaculate detail of the crown, the chalice and the instruments played by the music-making angels, and to the keen observation of light reflected from gemstones or refracted through the rock crystal of the bishop-saints' croziers. Piero appears to have transferred to Rome in 1484 with the Pollaiuolo workshop, but no record of his life or work thereafter survives.

II. Working methods and technique.

Only one drawing by Piero Pollaiuolo survives, the cartoon for the head of the Mercanzia *Faith* (Florence, Uffizi); pricked for transfer, it served a practical purpose in the execution of the painting. However, a large group of pen-and-ink and some black chalk drawings attributable to Antonio Pollaiuolo survives; he made these to practise his skills in recording the human figure, both at rest and as a rhythmically tensed form in movement, and to provide others (as Cellini suggested) with patterns to incorporate into their own works or to stimulate their own studies of formal problems. Some may even have been kept by patrons. Antonio made drawings of figures at rest from the live model: a good example is a pen-and-ink study of a *Standing Nude* (Bayonne, Mus. Bonnat); but for others, such as the *Nude Man Seen from Front, Side and Back*, he may have used a wax or clay (or sometimes perhaps even a cast bronze) sculptural model, which he could pivot around its vertical axis and draw from a variety of angles. By exploiting the working practice of reusing designs, particularly of pivoted figures, more vigorously than did his contemporaries, Antonio led the field in that quintessentially Renaissance preoccupation, the investigation of the anatomy of the human figure.

The Pollaiuolo workshop was in the forefront of experimentation in the use of oil as a binding medium for panel painting. There is evidence that Piero used an oil medium to capture the atmospheric gradients of tone and colour in the sky and in the misty, grey-blue plains and hills in the landscapes of the Berlin *Annunciation*. Technical analysis of the *Martyrdom of St Sebastian*, the landscape of which is probably by Antonio, also indicates the presence of a significant amount of oil in the medium. Tonally moderating and unifying oil glazes could best produce the naturalistic mistiness and lack of definition of detail and colour that has led the landscape at the horizon to be compared with Jan van Eyck's treatment of distant landscape. Furthermore, the handling of relatively translucent pigment in the colourful sashes worn by the crossbowmen shows the fluency of application and brush movement possible with an oil medium. Finally, the rich variety of surface texture, typical of the Pollaiuolo brothers, especially in the treatment of fabrics, also suggests that they exploited the ease of manipulation offered by the oil medium to expand their textural range. Such techniques had been described at the beginning of the century by Cennino Cennini in his *Libro dell'arte*, but the increase in their use later in the 15th century had been further stimulated by the example of Netherlandish paintings that had been imported to Florence. Antonio Pollaiuolo's bronze-casting technique has yet to be systematically studied.

III. Critical reception and posthumous reputation.

In the early 1460s Antonio was described in a letter (Florence, Archv Stato) by Jacopo Lanfredini as '…the leading master of this city, and perhaps of all time: this is the view commonly held by all who know about such things'. Both Giovanni Rucellai and Giovanni Santi (Raphael's father) commended Antonio and Piero as masterful draughtsmen, and shortly before 1500 Luca Landucci wrote that 'around 1450 … Master Antonio and Piero his brother called del Pollaiuolo, goldsmiths, sculptors and painters, became notable …' (*Diario Fiorentino (1450–1516)*, ed. J. del Badia (Florence, 1883), p. 3).

There is no evidence that the Pollaiuolo workshop was of the size or of the significance as a training ground for the next generation of painters and sculptors that Verroc-

chio's was. Like him, however, the brothers ran a workshop that produced works in a wide variety of materials: bronze sculpture both small and monumental, goldsmiths' work, paintings (in fresco and on panel), processional banners, tournament apparel, embroidery designs, drawings and engravings.

Although the large-scale works were of greatest importance to the workshop in terms of patronage, Antonio Pollaiuolo's later reputation rested on his engravings and drawings of the human figure. Indeed, beyond his immediate circle, Antonio was best known for his drawings and engravings. By about 1464 a *cartonum* (probably a drawing rather than an engraving) 'with nudes by Pollaiuolo' was among the property in the workshop of Francesco Squarcione. Benvenuto Cellini wrote in his treatise of 1568 that Antonio was 'a goldsmith and a draughtsman of such skill that all the goldsmiths made use of his beautiful designs, which were of such excellence that many of the best sculptors and painters also use them . . .', adding that he 'did little else but admirable drawing, and always kept faith with that great *disegno*'. Both the praise bestowed on Antonio by Cellini and the frequency with which his figure patterns were copied and imitated at the end of the 15th century indicate that it was in this field that he made his most significant contribution to the development of Florentine Renaissance art.

BIBLIOGRAPHY

EARLY SOURCES

G. Rucellai: *Zibaldone* (MS.; before 1481), ed. A. Perosa as *Giovanni Rucellai e il suo Zibaldone*, i (London, 1960), pp. 24, 144

C. Landino: *Comento di Christoforo Landino Fiorentino sopra la Comedia di Dante . . .* (Florence, 1481), in *Scritti critici e teorici*, ed. R. Cardini, ii (Rome, 1974), p. 167

U. Verino: *De illustratione urbis florentiae* (MS.; *c.* 1485), i (Paris, 1790), pp. 132–3

G. Santi: *La vita e le gesta di Federico di Montefeltro, Duca d'Urbino* (MS.; *c.* 1492), ed. L. Michelini Tocci, ii (Rome, 1985), pp. 406, 674

Il codice dell'anonimo Gaddiano (*c.* 1540; Florence, Bib. N. Cent., Cod. Magliabechiano xvii.17), ed. C. Fabriczy (Florence, 1893), p. 72

A. Billi: *Il libro di A. Billi* (*c.* 1550; Florence, Bib. N. Cent., Cod. Strozz. xiii.89), ed. K. Frey (Berlin, 1892), pp. 27–9

G. Vasari: *Vite* (1550, rev. 2/1568), ed. G. Milanesi (1878–85), iii, pp. 285–300

B. Cellini: *Trattati dell'oreficeria e della scultura* (Florence, 1568), ed. C. Milanesi (Florence, 1857), pp. 7, 13, 14

GENERAL

EWA; Thieme–Becker

E. Müntz: *Les Arts à la cour des papes pendant le XVe et le XVIe siècle* (Paris, 1878–82), iii, p. 86; iv, pp. 89–90

W. Bode: *Die italienischen Bronzestatuetten der Renaissance* (Berlin, 1923)

B. Berenson: *The Drawings of the Florentine Painters of the Renaissance* (Chicago, 1938)

A. M. Hind: *Early Italian Engraving* (London, 1938–48)

E. Steingräber: 'Studien zur Florentiner Goldschmiedekunst', *Mitt. Ksthist. Inst. Florenz*, vii (1955), pp. 87–110

B. Berenson: *Florentine School*, i (1963), pp. 178–9

J. Pope-Hennessy: *Italian Renaissance Sculpture* (London, 1963, rev. Oxford, 3/1985), pp. 299–302, 358–60

A. Mayor: 'Artists as Anatomists', *Bull. Met.*, xxii (1964), pp. 201–10

MONOGRAPHS

M. Cruttwell: *Antonio Pollaiuolo* (London, 1907)

A. Sabatini: *Antonio e Piero del Pollaiolo* (Florence, 1944)

S. Ortolani: *Il Pollaiuolo* (Milan, 1948)

A. Busignani: *Pollaiolo* (Florence, 1970)

L. D. Ettlinger: *Antonio and Piero Pollaiuolo* (London, 1978); review by E. Frank, *Apollo*, xcii (1980), pp. 358–60

N. Pons: *I Pollaiolo* (Florence, 1994)

SPECIALIST STUDIES

E. Müntz: 'Nuovi documenti: La tomba di Innocenzo VIII', *Archv Stor. A.*, iv (1891), pp. 367–8

J. Mesnil: 'Les Figures de Vertus de la Mercanzia', *Misc. A.*, iii (1905), pp. 42–6

C. Guasti: *Gli affreschi del secolo XV scoperti in una villa ad Arcetri* (Florence, 1910)

G. de Nicola: 'Opere perdute del Pollaiolo', *Rass. A.*, xviii (1918), pp. 210–14

B. Degenhart: 'Francesco di Giorgio und Pollaiuolo', *Z. Kstgesch.*, viii (1939), pp. 125–35

L. D. Ettlinger: 'Pollaiuolo's Tomb of Sixtus IV', *J. Warb. & Court. Inst.*, xvi (1953), pp. 239–74

F. Hartt, G. Corti and C. Kennedy: *The Chapel of the Cardinal of Portugal* (Philadelphia, 1964)

L. D. Ettlinger: 'Hercules Florentinus', *Mitt. Ksthist. Inst. Florenz*, xvi (1972), pp. 119–42

E. Borsook: 'Two Letters Concerning Antonio Pollaiuolo', *Burl. Mag.*, cxv (1973), pp. 464–8

L. S. Fusco: 'Battle of the Nudes', *Early Italian Engravings from the National Gallery of Art* (exh. cat., ed. J. A. Levenson, K. Oberhuber and J. L. Sheehan; Washington, DC, N.G.A., 1973), pp. 66–80

M. Vickers: 'A Greek Source for Antonio Pollaiuolo's *Battle of the Nudes* and *Hercules and the Twelve Giants*', *A. Bull.*, lix (1977), pp. 182–7

L. S. Fusco: 'Antonio Pollaiuolo's Use of the Antique', *J. Warb. & Court. Inst.*, xlii (1979), pp. 257–63

E. Frank: 'Comments on Pollaiuolo in Rome', *Verrocchio and Late Quattrocento Italian Sculpture*, ed. S. Bule, A. P. Darr and F. Superbi Gioffredi (Florence, 1992), pp. 353–6

A. J. Wright: *Studies in the Paintings of the Pollaiuolo* (PhD thesis, U. London, Courtauld Inst., 1992)

A. Wright: 'Piero de' Medici and the Pollaiuolo', *Piero de' Medici "il Gottoso" (1416-1469)*, ed. A. Beyer and B. Boucher (Berlin, 1993), pp. 129-49

——: 'Antonio del Pollaiuolo, *maestro di disegno*', *Florentine Drawing at the Time of Lorenzo the Magnificent*, ed. E. Cropper (Florence, 1994), pp. 131–46

——: 'The Myth of Hercules', *Lorenzo il Magnifico e il suo mondo*, ed. G. C. Garfagnini (Florence, 1995), pp. 323–9

——: 'Dimensional Tension in the Work of Antonio del Pollaiuolo', *The Sculpted Object, 1400–1700*, ed. S. Currie and P. Motture (Aldershot, 1997), pp. 65–79

——: 'Pollaiuolo's *Elevation of the Magdalen* Altarpeice and an Early Patron', *Burl. Mag.*, cxxxix (1997), pp. 444–51

——: 'Mantegna and Pollaiuolo: Artistic Personality and the Marketing of Invention', *Drawing 1400–1700*, ed. S. Currie (Aldershot, 1998), pp. 72–90

FRANCIS AMES-LEWIS

Pollaiuolo, Simone di Tomaso del. *See* CRONACA.

Polo, Agnolo di. *See* AGNOLO DI POLO.

Pomarancio [Circignani], Niccolò (*b* Pomarance, Volterra, ?between 1517 and 1524; *d* before 9 Oct 1596). Italian painter. He may have been a pupil of Daniele da Volterra and later of Santi di Tito. In 1564 he was in Rome working on frescoes of Old Testament narratives in the Sala Grande of the Vatican Belvedere. Next, in Perugia, he formed a partnership with Hendrick van den Broeck (*c.* 1530–1597) and in 1565 replaced him in the painting of frescoes (destr.) for Orvieto Cathedral. His paintings of this period—including the frescoes (1568) in the church of the Maestà delle Volte, Perugia, the *Resurrection* (1569; Mongiovino, Sanctuary) and the *Annunciation* (1577; Città di Castello, Pin. Com.)—are strongly influenced by late Florentine and Roman Mannerism. From 1579 he was again in Rome, working in the Vatican, where, with Matthijs Bril (1550–83), he decorated the Sala della Meridiana in the Torre dei Venti (finished before the end of 1580) and supervised works on the third floor of the

Logge (1580–83). In 1581–2 he executed huge fresco cycles in S Apollinare and S Stefano Rotondo, Rome, following the didactic style recommended in the post-Tridentine treatise of Gabriele Paleotti. In scenes of great emotional impact Pomarancio depicted the tortures of Christian martyrs with insistent emphasis on the cruel details. His next works—frescoes in the chapel of S Francesco Borgia at Il Gesù (1584–7), the *Angelic Concert with the Eternal Father* in SS Giovanni e Paolo and the *Celestial Glory* in S Pudenziana, all in Rome—show a stylistic evolution from late Roman Mannerism towards a more unified and monumental type of composition. His last work, the *Ascension* (Cascia, S Francesco), is dated 1596.

BIBLIOGRAPHY

DBI; Thieme–Becker

G. Vasari: *Vite* (1550, rev. 2/1568); ed. G. Milanesi (1878–85), vii, p. 578

F. Lessi and V. Bavoni: *Arte a Volterra* (Pisa, 1980), pp. 24–7

M. Nimmo: 'L'età perfetta della virilità di Niccolò Circignani dalle Pomarance', *Stud. Romani*, xxxii (1984), pp. 194–214

G. Belardinelli: 'La "Sancti Francisci historia" negli affreschi di Circignani e Lombardelli a San Pietro in Montorio e nelle incisioni di Villamena e Thomassin', *Boll. A.*, 6th ser., lxxvi (1991), pp. 131–146

R. P. Ciardi: *Niccolò Circignani, Cristoforo Roncalli: Pittori di Pomarance*, contrib. J. Spirelli and F. A. Lessi (Volterra, 1992)

MARINA GAROFOLI

Ponchino [Bazzacco; Bozzato; Brazzacco]**, Giambattista** [Giovanni Battista] (*b* Castelfranco Veneto, *c.* 1500; *d* ?1570). Italian painter. He was known to contemporaries as Bazzacco, Bozzato or Brazzacco. Between 1537, when he is first recorded as living in Borgo Bastia Nova, Castelfranco Veneto, and probably 1543, when his protector Cardinal Francesco Cornaro died, Ponchino was in Rome. During this Roman sojourn he studied Michelangelo's works and later boastfully claimed to have been his pupil. Ponchino is first recorded in the Veneto in 1546, and in 1548 he is documented at the Villa Barbaro in Maser, near Treviso, home of Daniele Barbaro and Marc'Antonio Barbaro. In 1551 he was in Castelfranco Veneto, where he designed and executed an altarpiece for the high altar of the church of the Pieve (destr.), depicting *Christ Liberating the Souls from Purgatory* (Castelfranco Veneto, S Liberale), for which a contract dated 21 July 1551 exists. Associated with this work are the *St George* and *St Liberale* (both Castelfranco Veneto, S Liberale). Further lost frescoes executed in Castelfranco Veneto and attributed to Ponchino are recorded by Melchiori (*b* 1671; *d* after 1735): a *Judgement of Paris* on the façade of the Palazzo Piacentini, *Venus with Three Amorini* in one of the rooms, and frescoes in the Palazzo Soranzo.

In 1553 Ponchino was in Venice, where he was commissioned to paint the decorations in the Doge's Palace. Vasari stated that he gained this important commission because of his connection with the influential Grimani family, but then, at Ponchino's invitation, Paolo Veronese and Battista Zelotti became involved in the project. His work in the Sala del Consiglio dei Dieci (1553–5) comprises *Mercury and Minerva*, *Neptune Drawn by Sea Horses* and grisailles of a personification of *Venice* and male nudes (all *in situ*). In the Stanza dei tre Capi dei Dieci, Ponchino executed the *Allegory of the Expulsion of Heresy* and *Allegory of Justice* (both *c.* 1555–6). In 1556 he was again in Rome, where in 1558 he was paid for work on a panel

for Pope Paul IV; of this work nothing further is known. By 1560 he had returned to Venice and was documented again at the Villa Maser on 11 November of that year. In 1564 he received a payment of 21 gold ducats for frescoes (destr.) on the façade of S Monte di Pietà, Castelfranco Veneto, for which church he also executed two canvases: *St Mark the Evangelist* and *St Liberale* (both destr.). Also attributed to Ponchino (Battilotti and Puppi) are a *Self-portrait* and a *Portrait of an Architect* (both Treviso, Mus. Civ. Bailo). Ponchino's importance lies in his supposed role in introducing Veronese and Zelotti to Venice and transmitting Michelangelo's style in the Veneto.

BIBLIOGRAPHY

G. Vasari: *Vite* (1550; rev. 2/1568); ed. G. Milanesi (1878–85)

N. Melchiori: *Notizie di pittori e altri scritti* (1720), ed. G. P. Bordignon Favero (Florence, 1969), pp. 62–6

G. Bordignon Favero: *Le opere d'arte e il tesoro del duomo di S Maria e S Liberale di Castelfranco Veneto* (Castelfranco Veneto, 1965), pp. 101, 131

D. Battilotti and L. Puppi: 'Prime approssimazioni su Giambattista Ponchino', *Ric. Stor. A.*, 19 (1983), pp. 77–83

☐

Ponte, Antonio da (*b* Venice, ?1512; *d* Venice, 20 March 1597). Italian architect. He came from a family of carpenters and architects. In 1554 he took part in the competition for the vacant post of *proto al sal*, a lifetime appointment as superintendent of public building works controlled by the Magistratura del Sale in Venice, but he was evidently unsuccessful, and two years later he was working as a superintendent in the building of the church of the Incurabili (destr.) designed by Jacopo Sansovino. He was also associated with the planning and construction of the men's infirmary (partly destr.) annexed to the hospice adjoining the Incurabili. He eventually became *proto al sal* in 1563, on the death of his predecessor Piero de'Guberni, and began his public activity by assuming the direction of restoration works on the Fondaco dei Tedeschi, and the purchase of materials.

Da Ponte's first important activity was in the reconstruction, after the fire of 11 May 1574, of rooms in the Palazzo Ducale, including the halls of the Senato, the Collegio, the Anti-collegio and the Sala dell Quattro Porte. Da Ponte's role seems to have been limited to the direction of the works, following plans by Andrea Palladio and Giovanni Antonio Rusconi. His relationship with Palladio continued in the building of the church of the Redentore (1577–92; *see* PALLADIO, ANDREA, fig. 7). Da Ponte directed the works, in the absence of Palladio, who settled in Vicenza in 1579. On 20 December 1577 a second, more serious fire broke out in the Palazzo Ducale, which destroyed the two upper floors of the building overlooking the wharf and the Piazzetta di S Marco. Da Ponte, together with other architects, was consulted about the restoration of the palace. In opposition to Palladio, who recommended a total reconstruction of the building, da Ponte maintained that it could be restored without substantial modifications. The Venetian government chose da Ponte's solution, and, together with Francesco Zamberlan, he supervised the rebuilding.

From 1579 da Ponte worked within the Arsenal, the Venetian state shipyard. His first work there was the reconstruction of the Corderie, an austere structure of

enormous size (l. 316 m) for rope manufacture. From 1582 the Arsenal was placed entirely under his supervision. In those years he also presented a series of projects for hydraulic machines (Venice, Archv Stato), which show his competence as an engineer. In 1580 he was appointed, together with Zamaria dei Piombi, to study plans for the Palazzo delle Prigioni on the Rio di Palazzo across the canal that runs beside the Palazzo Ducale. The prison was moved out of the palace itself after the fire of 1577, but it was not until 1591, after the presentation of a second plan, that work began on the new building, which is of an architectural severity appropriate to its function.

Da Ponte's participation in the complex project of rebuilding the Rialto Bridge on the Grand Canal is amply documented. In December 1587 he presented a proposal for a triple arch surmounted by a level containing two arcades of shops and three uncovered roadways. Later, in 1588, he produced another plan (Venice, Archv Stato), opting for the present arrangement of a bridge with a single span of 28 m. This is surmounted by two footpaths and by two arcaded ranges of shops that face on to the central passageway and are interrupted at the apex by an open loggia that affords views along the canal (see VENICE, fig. 3). Da Ponte's proposal won the firm approval of the Venetian Senate, which therefore rejected proposals by Palladio and Sansovino, among others. Da Ponte invented an original system for the underwater foundations and was put in charge of the work on the bridge.

BIBLIOGRAPHY

T. Temanza: *Vita dei più celebri architetti e scultori veneziani che fiorirono nel secolo decimosesto* (Venice, 1778), pp. 499–518
A. Alberti and R. Cessi: *Rialto: L'isola, il ponte, il mercato* (Bologna, 1934), pp. 191–202, 213–20
L. Puppi: *Andrea Palladio* (Milan, 1973)
D. Calabi and P. Morachiello: *Rialto: Le fabbriche e il ponte* (Turin, 1987)

MANUELA MORRESI

Ponte, da. *See* BASSANO.

Pontelli, Baccio (*b* Florence, 1450; *d* Urbino, after Nov 1494). Italian intaglio and intarsia artist, architect and military engineer. He was one of the leading architects of the early Renaissance, receiving commissions from Italian princely patrons and from within the circle of the papal court. Pontelli demonstrated, particularly in the later Roman works, a sophisticated integration of antique ideals of function with explorations in mathematically derived proportions. This mature period suggested the immediate legacy of Leon Battista Alberti and heralded the achievements of Donato Bramante.

Pontelli was born to a family of Florentine carpenters and studied under the Florentine intarsia master Francione. From 1471 he undertook, with his brother Piero, his earliest known project, intarsia work for the choir of Pisa Cathedral, where he was resident in 1475. In the same year, with Francione, he also began work in the Campo Santo, Pisa, in the funerary chapel (destr.) of Archbishop Filippo de' Medici. In 1479 he travelled to Urbino where he came into close collaborative contact with Luciano Laurana and Francesco di Giorgio Martini in connection with the building of the Palazzo Ducale for Federigo da Montefeltro. He may have executed intarsia for the Duke's *studiolo* (*see* STUDIOLO, fig. 1). From Urbino he was

requested by Lorenzo de' Medici to send drawings (untraced) of the palace, as a letter signed by Pontelli and dated June 1481 attests, and in which he describes himself as 'lignaiolo discepulo de francione'. From Urbino, and probably after Federigo's death in 1482, Pontelli appears to have gone to Rome, where he was employed by Sixtus IV and his relations, including the pope's nephew, Giuliano della Rovere, the future Julius II. This period in Pontelli's career is less well documented, since the only securely attributable work is the *rocca* or fortress at the strategic Roman port of Ostia, which bears inscriptions with his name, that of his patron and the date. The design and rebuilding of the stronghold were initiated by Giuliano, who had been Cardinal Bishop of Ostia since early 1483, and the project was completed in 1486. At Ostia (where he was recorded again in 1488) Pontelli also created the small cathedral of S Aurea (see fig.) for the same patron, and he probably played a role in the design of the *borgo* or small town situated between the *rocca* and the church. He may thus have been an early innovator in the history of Renaissance urbanism, although today, apart from the traces of several late medieval houses, very little of his contribution remains. In 1488 he designed fortifications for the basilica of S Maria, Loreto (*see* LORETO, fig. 2).

In Rome, Pontelli was the leading disseminator of Tuscan-derived ideas, which he adapted to the Roman context. This imaginative combination is expressed in several contemporaneous projects and exemplified in the porticos of SS Apostoli and S Pietro in Vincoli and, most maturely, in the Palazzo della Cancelleria (*c.* 1485–*c.* 1511; attrib. to Pontelli), all of which were built for members of the extended della Rovere family. The southern façade of the Cancelleria, comparable to S Aurea in its finely calculated system of applied orders rising from a high, pedestal base, recalls the decorative language of the Roman past (and most conspicuously, the Colosseum), while the symmetrical relations of the inner courtyard allude to the palace at Urbino.

Pontelli's fame during his own lifetime rested largely, according to surviving documents, on his abilities as an engineer, where his accomplishments as an inventive military designer, most evident at Ostia, must have been inspired by Francesco di Giorgio. Sixtus IV sent Pontelli as military inspector to Civitavecchia in July 1483, and in

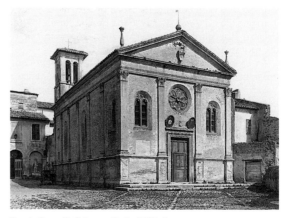

Baccio Pontelli: S Aurea, Ostia, 1483–8

a brief of Innocent VIII, dated November 1487, he is described as 'familiaris et serviens armorum' and 'ingenerius universalis'. In December 1490 the Pope referred to him as 'serviens armorum et architectus ac commissarius noster' when creating him inspector general of fortifications in the Marches, where Pontelli played a significant role in the construction of the fortresses, later significantly altered, of Osimo (1487–8), Iesi (c. 1488–92) and Offida (c. 1488). For Giovanni della Rovere, the brother of Giuliano, Pontelli appears also to have designed S Maria di Castro in Orciano (1491), S Maria delle Grazie near Senigallia, and, again for Giuliano, the portal (c. 1492) of the main tower of Grottaferrata Abbey, and perhaps the entire *rocca*. He was involved in the construction of the *rocca* of Senigallia in 1492. It is likely that he died between late 1494 and 1495, because the last notice of him is in November 1494 when Alfonso II, King of Naples, invited him to Sessa Aurunca. That Pontelli died in Urbino is suggested by a late 16th-century tomb inscription, sponsored by a nephew, in S Domenico, Urbino.

Ever since Vasari's attribution to him of most of the architectural programmes under Sixtus IV, Pontelli has been one of the most critically discussed, controversial and yet elusive figures in Renaissance artistic life. Milanesi's extended commentary and documentary additions, drawing partly on Gaye, contributed vital revisions to Vasari's image of the over-prolific and reliable architect–builder. More recent scholarship has accomplished much in accurately modifying and reducing the number of works ascribed to Pontelli; the attribution of several of these, most notably the important Roman churches of S Maria della Pace and S Pietro in Montorio, remains at issue.

BIBLIOGRAPHY

G. Vasari: *Vite* (1550, rev. 2/1568); ed. G. Milanesi (1878–85), ii, pp. 652–65

F. Baldinucci: *Notizie*, ii (Turin, 1770), pp. 107–10

G. Gaye: *Carteggio* (1839–40), i, pp. 274–7

E. Müntz: *Les Arts à la cour des papes pendant le XVe et le XVIe siècle, recueil de documents inédits*, iii (Paris, 1882), pp. 75–6; iv (Paris, 1898), pp. 47–8

I. B. Supino: 'L'arte del rinascimento nella primaziale di Pisa, i maestri d'intaglio e di tarsia in legno, i pittori e gli scultori', *Archv Stor. A.*, vi (1893), pp. 156–64

P. Tomei: *L'architettura a Roma nel quattrocento* (Rome, 1942/R 1977)

T. Magnuson: *Studies in Roman Quattrocento Architecture* (Stockholm, 1958)

G. Urban: 'Die Kirchenbaukunst des Quattrocento in Rom: Eine bau- und stilgeschichtliche Untersuchung', *Röm. Jb. Kstgesch.*, ix–x (1961–2), pp. 214–19

G. de Fiore: *Baccio Pontelli, architetto fiorentino* (Rome, 1963) [with bibliog.]

C. L. Frommel: 'Francesco del Borgo: Architekt Pius II. und Pauls II.', *Röm. Jb. Kstgesch.*, xx (1983), pp. 127–74; xxi (1984), pp. 71–164

——: '"Il palazzo della Cancelleria", Palazzo dal rinascimento a oggi', *Italia nel regno di Napoli in Calabria: Storia e attualità: Atti del convegno internazionale Reggio Calabria, 1988* (1988), pp. 29–54

——: 'Giuliano della Roveres Kathedrale Sant'Aurea in Ostia', *Festschrift für Nikolaus Himmelmann* (Mainz am Rhein, 1989), pp. 491–505

P. N. Pagliara: 'Grottaferrata e Giuliano della Rovere', *Quad. Ist. Stor. Archit.*, n. s., xiii (1989), pp. 19–42 [with bibliog.]

MEREDITH J. GILL

Pontormo, Jacopo da [Carucci, Jacopo] (*b* Pontormo, nr Empoli, 26 May 1494; *d* Florence, 31 Dec 1556). Italian painter and draughtsman. He was the leading painter in mid-16th-century Florence and one of the most original and extraordinary of Mannerist artists. His eccentric personality, solitary and slow working habits and capricious

attitude towards his patrons are described by Vasari; his own diary, which covers the years 1554–6, further reveals a character with neurotic and secretive aspects. Pontormo enjoyed the protection of the Medici family throughout his career but, unlike Agnolo Bronzino and Giorgio Vasari, did not become court painter. His subjective portrait style did not lend itself to the state portrait. He produced few mythological works and after 1540 devoted himself almost exclusively to religious subjects. His drawings, mainly figure studies in red and black chalk, are among the highest expressions of the great Florentine tradition of draughtsmanship; close to 400 survive, forming arguably the most important body of drawings by a Mannerist painter. His highly personal style was much influenced by Michelangelo, though he also drew on northern art, primarily the prints of Albrecht Dürer (1471–1528).

1. Life and works. 2. Influence and posthumous reputation.

1. LIFE AND WORKS.

(i) Formative years: Classicism to Mannerism, before 1520. Pontormo probably studied with Leonardo da Vinci in 1508 (Vasari), then with Piero di Cosimo, and by 1510 with Mariotto Albertinelli. Around 1512 he was an assistant of Andrea del Sarto and painted his earliest surviving work, *St Catherine of Alexandria* (1512; Florence, Uffizi; see Proto Pisani). In his first independent paintings, all frescoes (now detached), he followed the High Renaissance classical style of Fra Bartolommeo and del Sarto. These include a *Faith and Charity* (1513–14; Florence, Gallerie), originally surrounding the arms of Pope Leo X over the portico of SS Annunziata, Florence, the *Hospital of St Matteo* (c. 1514; Florence, Accad.) and the *Virgin and Child with Saints* (c. 1514; Florence, SS Annunziata) for S Ruffillo. Two further frescoes demonstrate a fully developed High Renaissance style: the lunette fresco of *St Veronica* (with the vault frescoes of *God the Father*, *Putti with the Instruments of the Passion* and *Putti with the Arms of Leo X*; all Florence, S Maria Novella), which was executed to honour the Medici pope's visit to Florence in 1515 and marked Pontormo's début in the service of the Medici family; and the *Visitation*, part of the cycle of the *Life of the Virgin* (1514–16; Florence, SS Annunziata). The latter is notable for its dramatic rhetoric and classical amplitude of form. Among his earliest works on panel were three (1515–17; London, N.G.) of a series of scenes from the *Story of Joseph*, painted for the bridal chamber of Pierfrancesco Borgherini. His *Portrait of a Jeweller* (c. 1518; Paris, Louvre) and *Portrait of a Musician* (c. 1515–16; Florence, Uffizi), were similarly based on del Sarto's classical style. *Cosimo de' Medici il Vecchio* (1519; Florence, Uffizi; see colour pl. 2, XVIII3) is an emblematic profile image commemorating the founder of Medici power in Florence and allegorizing the family's political ambitions.

Around 1517 Pontormo broke with the classicism of his teachers and of his own early paintings and started creating radically experimental works in the new Mannerist style. This change is most clearly apparent in his major early work, the Visdomini Altarpiece, which depicts the *Virgin and Child with Saints* (1518; Florence, S Michele Visdomini). The design is based on the *sacra conversazione* composition as formulated by Fra Bartolommeo, but its

classical stability and harmony are undermined by a nervously complex fragmentation of form, an intense projection of emotional states and an implausible spatial construction. Another experimental work is the last of the Borgherini panels, *Joseph in Egypt* (*c*. 1518; London, N.G.), in which his treatment of space and light is irrational and complex, the background Germanic and the figure types and draperies increasingly individual. According to Vasari, the small boy dressed in contemporary style in the foreground is Bronzino.

(ii) Mature works, 1520–30. During the 1520s a further series of experimental works established Pontormo's mature style. The first was the lunette fresco of *Vertumnus and Pomona* (see fig. 1) painted in the Gran Salone of the Medici villa at Poggio a Caiano (1520–21; *in situ*) as part of a collaborative project (never completed) with del Sarto and Franciabigio. Vertumnus, the Roman god of harvests, and Pomona, the goddess of fruit trees, are shown with other gods in an idyllic pastoral scene on a sunlit wall. The design is novel and depends on subtle, abstract relationships of shape and colour, combined with precisely described realistic details that are quite contrary to classical notions of idealization. The preparatory drawings (Florence, Uffizi) show that Pontormo moved away from first

ideas for rhythmically interrelated, Michelangelesque nudes towards the delicate patterns and bucolic mood of the final version. The individual figure studies for Vertumnus and for the goddess on the wall are among those that possess a striking psychological intensity and reveal his interest in experimental, angular shapes.

In the fresco series of the *Passion* (1523–6; Florence, Certosa del Galluzzo, Pin.) and a *Supper at Emmaus* for the same monastery (1525; Florence, Uffizi), Pontormo drew inspiration from the prints of Dürer, whose Late Gothic art suggested the power of a more abstract, spiritual style. This influence, the psychological intimacy of the figures and Pontormo's characteristic pale tonalities give these pictures an emphatically unclassical character. Many figures and poses are adapted from Dürer's *Small Passion* series, as for example in the *Agony in the Garden*, which takes figures from Dürer's woodcut of that subject. The graphic style, too, is borrowed from the woodcuts, as in the broken line and angular draperies of the study of *St John* (Florence, Uffizi) for the *Agony in the Garden*.

In the mid-1520s Pontormo's renewed contact with Michelangelo resulted in a reaccommodation of his art to the classical notion of harmony. In 1525–8 he painted the most important ensemble of his maturity, the decoration of the Capponi Chapel in S Felicita, Florence (*in situ*). The

1. Jacopo da Pontormo: *Vertumnus and Pomona* (1520–21), fresco, Gran Salone of the Medici villa, Poggio a Caiano

altarpiece shows the *Lamentation* (see fig. 2); in the pendentives of the dome are tondi of *St John the Evangelist, St Matthew, St Luke*, and *St Mark*, and on the side wall is a fresco of the *Annunciation* (see colour pl. 2, XIX2). In the *Lamentation*, generally acknowledged to be his masterpiece, Pontormo combined a new sense of ornamental beauty, polished surfaces and exquisitely refined line with the insubstantial, floating forms, the spatial irrationality and the poignant communication of feeling that are hallmarks of his Mannerism. The colours—high-keyed, clear blues, acid greens and pinks, with little light and shade—intensify the picture's strange and haunting grace. The drawings for the *Lamentation*, such as the sculptural, precisely modelled study for the *Dead Christ* (Florence, Uffizi), are mainly in red chalk and are characterized by a new feeling for the beauty of line and light.

Most of Pontormo's paintings of the late 1520s, such as the *Visitation* (Carmignano, S Michele), are in a similar style to that of his work at the Capponi Chapel, though there are also some, such as the monumental altarpiece depicting the *Virgin and Child with St Anne and other Saints* (c. 1529; Paris, Louvre), in a more delicate manner. In the portraits of these years Pontormo broke with his early style, based on the portraits of del Sarto, to create

2. Jacopo da Pontormo: *Lamentation*, oil on panel, 3.13×1.92 m, 1525–8 (Florence, S Felicita, Capponi Chapel)

the typical Florentine Mannerist image, with its lengthened format and strict frontality; the *Portrait of a Young Man in a Pink Satin Cloak* (c. 1509–30; Lucca, Villa Guinigi), which is thought to depict Alessandro de' Medici but more likely represented Amerigo Antinori (Costamagna), and *Maria Salviati and Cosimo de' Medici* (c. 1527/?1537; Baltimore, MD, Walters A.G.) are of this type. The *Portrait of Two Friends* (c. 1523–4; Venice, Col. Cini) is a penetrating study of the relationship between the two male sitters.

(iii) Late works, 1530–56. The *Legend of the Ten Thousand Martyrs* (c. 1529–30; Florence, Pitti), in which Pontormo experimented with complex male nude poses, both concludes the development of the 1520s and looks forward to the increasing influence of Michelangelo. This influence is evident in the ornamental works that have an affinity with, but are distinct from, those of his Mannerist contemporaries Bronzino, Francesco Salviati and Vasari. In the early 1530s Pontormo executed two paintings from cartoons by Michelangelo: the *Noli me tangere* (1531–2; ex-Milan, priv. col., see Berti, fig. 115) and *Venus and Cupid* (1532–4; Florence, Accad. B.A. Liceo A.). He painted fresco decorations (destr.) in the loggias of the Medici villas at Careggi (1535–6) and Castello (1537–43), for which preparatory drawings survive (Florence, Uffizi; see also Cox-Rearick, 1964), and in 1545 contributed to another decorative project for the Medici: the tapestries of the *Story of Joseph*. These were largely by Bronzino, but Pontormo designed the *Lament of Jacob, Joseph Capturing Benjamin* (both Rome, Pal. Quirinale) and the *Temptation of Joseph* (Florence, Pal. Vecchio).

In 1546 Pontormo was one of the artists who wrote to BENEDETTO VARCHI in response to his request to enter the PARAGONE (debate) on the primacy of painting or sculpture; these letters, defending Florentine *disegno*, were published in Varchi's *Due lezioni* (1549). Around this time Pontormo began work on his frescoes, mainly of Old Testament subjects but also including a *Resurrection* and *Last Judgement* (1546–56, destr. 1742), in the choir of S Lorenzo, Florence. Painted for Cosimo I de' Medici, they were the major work of his last years and were completed by Bronzino after Pontormo's death. The preparatory black chalk drawings (mainly Florence, Uffizi) are the only testimony to Pontormo's late style: that for *Christ in Glory* (Florence, Uffizi) fuses the influence of Michelangelo with a most eccentric personal grace.

The elongation and spirituality of Pontormo's late portraits, such as the sombre *Alessandro de' Medici* (1534; Philadelphia, PA, Mus. A.) and *Giovanni della Casa* (1540–44; Washington, DC, N.G.A.), coincide with the rarefied atmosphere of these late religious works. The *Portrait of a Halberdier* (?1530–7; Los Angeles, CA, Getty Mus.) probably depicts Cosimo I de' Medici (Keutner; Forster; Cox-Rearick; Costamagna) but is also thought to represent Francesco Guardi Berti. Pontormo's portraits differ from those of his contemporaries in their subtle and complex psychological communication.

2. INFLUENCE AND POSTHUMOUS REPUTATION. Pontormo's major follower was Bronzino, his pupil in the 1520s, who transformed his master's early Mannerism into the mid-century *maniera*. Also influenced by Pontormo

were Pier Francesco Foschi, Jacone and, later, Battista Naldini, Pontormo's pupil between 1549 and 1556. After Pontormo's death, his reputation declined with the advent of late Mannerism, although in the 1570s some Florentine artists, including Maso da San Friano, Mirabello Cavalleri (1510/20–72) and Girolamo Macchietti, tried to free themselves from the formulae of this style by imitating aspects of his work. But the Counter-Reformation demand for realism in religious art soon eclipsed his influence. None of his paintings was engraved; even his portraits were not admired. The destruction in 1738 of his fresco cycle in S Lorenzo was symptomatic of the low repute of his work. His reputation was not restored until the 20th century, with the publication of Clapp's monographs on his drawings (1914) and paintings (1916); an exhibition marking the 400th anniversary of his death (1956) initiated further specialized studies (e.g. Berti, Cox-Rearick, Forster), and the celebration of the 500th anniversary of his birth initiated a cluster of further publications in 1993–4.

WRITINGS

B. Varchi: *Due lezioni di M. Benedetto Varchi* (Florence, 1549), pp. 132–5 [letters from Pontormo to Varchi]
Diary (1554–6; Florence, Bib. N. Cant., Misc. Magl. cl. VII, 1490); ed. E. Cecchi as *Jacopo da Pontormo: Diario* (Florence, 1956); Eng. trans., ed. R. Mayer, as *Pontormo's Diary* (New York, 1982)

BIBLIOGRAPHY

G. Vasari: *Vite* (1550, rev. 2/1568); ed. G. Milanesi (1878–85), vi
F. M. Clapp: *Les Dessins de Pontormo* (Paris, 1914)
——: *Jacopo Carucci da Pontormo: His Life and Work* (New Haven, 1916)
B. Berenson: *The Drawings of the Florentine Painters*, 3 vols (Chicago, 1938); rev., 2 vols (Milan, 1961)
C. Tolnay: 'Les Fresques de Pontormo dans le choeur de San Lorenzo à Florence', *Crit. A.*, xxxiii (1950), pp. 38–52
Mostra di disegni dei primi manieristi italiani (exh. cat., ed. L. Marcucci; Florence, Uffizi, 1954)
Mostra del Pontormo e del primo manierismo fiorentino (exh. cat., ed. U. Baldini, L. Berti and L. Marcucci; Florence, Pal. Strozzi, 1956)
H. Keutner: 'Zu einigen Bildnissen des frühen Florentiner Manierismus', *Mitt. Ksthist. Inst. Florenz.*, viii (1959), pp. 139–54
J. Cox-Rearick: *The Drawings of Pontormo*, 2 vols (Cambridge, MA, 1964/ R 1981 with addns)
K. W. Forster: *Pontormo: Monographie mit kritischem Katalog* (Munich, 1966)
J. Shearman: *Pontormo's Altarpiece in S Felicita: The 51st Charlton Lecture, U. Newcastle-upon-Tyne* (Westerham, 1968)
S. J. Freedberg: *Painting in Italy, 1500–1600*, Pelican Hist. A. (Harmondsworth, 1971, rev. 1983)
J. Kliemann: '*Vertumnus und Pomona*: Zum Program von Pontormos Fresko in Poggio a Caiano', *Mitt. Ksthist. Inst. Florenz*, xvi (1972), pp. 293–328
M. Winner: 'Pontormos Fresko in Poggio a Caiano', *Z. Kstgesch.*, xxxv (1972), pp. 153–97
L. Berti: *L'opera completa del Pontormo* (Milan, 1973)
L. Steinberg: 'Pontormo's Capponi Chapel', *A. Bull.*, lvi (1974), pp. 385–99
G. Smith: 'On the Original Arrangement of Pontormo's Passion Cycle', *Z. Kstgesch.*, xli (1979), pp. 61–4
A. Braham: 'Pontormo and the Influence of Northern Art in Sixteenth-century Italy', *J. Royal Soc. A.*, cxxx (Summer 1982), pp. 624–41
J. Cox-Rearick: *Dynasty and Destiny in Medici Art: Pontormo, Leo X and the Two Cosimos* (Princeton, 1984)
R. B. Simon: *Bronzino's Portraits of Cosimo I de' Medici* (diss., New York, Columbia U., 1982; microfilm, Ann Arbor, 1985)
C. B. Strehlke: 'Pontormo, Alessandro de' Medici and the Palazzo Pazzi', *Bull. Philadelphia Mus. A.*, lxxxi (1985), pp. 3–15
J. Cox-Rearick: 'An Important Painting by Pontormo from the Collection of Chauncey D. Stillman', *Portrait of Duke Cosimo I de' Medici* (sale cat., New York, Christie's, 1989)
——: 'Pontormo, Bronzino, Allori and the lost *Deluge* at S Lorenzo', *Burl. Mag.*, cxxxiv (1992), pp. 239–248
E. Pilliod: 'Pontormo and Bronzino at the Certosa', *Getty Mus. J.*, xx (1992), pp. 77–88
L. Berti: *Pontormo e il suo tempo* (Florence, 1993)
M. Bietti: 'Una *Pietà* dal Pontormo', *Paragone*, xlv/529–33 (1994), pp. 119–27
P. Costamagna: *Pontormo* (Paris and Milan, 1994)
A. Forlani Tempesti and A. Giovannetti: *Pontormo* (Florence, 1994)
G. Goldner: 'New Drawings by Perugino and Pontormo', *Burl. Mag.*, cxxxvi/1095 (1994), pp. 365–7
R. Proto Pisani and others: *Il Pontormo a Empoli* (Empoli, 1994)
H. van der Velden: 'De verdwijning van een meesterwerk/The Disappearance of a Masterpiece', *Kunstschrift*, xxxviii/3 (1994), pp. 36–40
L. M. Medri: *Pontormo a Poggio a Caiano* (Florence, 1995)
E. Pilliod: 'The Earliest Collaborations of Pontormo and Bronzino: The Certosa, the Capponi Chapel and the *Dead Christ with the Virgin and Magdalen*', *Craft of Art: Originality and Industry in the Italian Renaissance and Baroque Workshop*, ed. A. Ladis, C. Wood and W. U. Eiland (Athens, GA and London, 1995)
Pontormo e Rosso: La 'maniera moderna' in Toscana: Empoli and Volterra, 1994 (Florence, 1996)

JANET COX-REARICK

Ponzello. Italian family of architects. Its best-known members are Domenico Ponzello (*b* Caravonica, nr Oneglia; *fl* 1548–71) and his brother Giovanni (*b* Caravonica, nr Oneglia; *fl* 1549–96), who practised primarily in Genoa in the second half of the 16th century. Domenico was elected Console dell'Arte dei Maestri Antelami Genovesi in 1550; Giovanni received this honour twice, in 1557 and 1572. Domenico was involved in the workshop of Galeazzo Alessi at Carignano (1555–6) during construction of the Sauli family's church of S Maria Assunta. He was then sent to Corsica by the Genoese Republic in 1560 to strengthen the fortifications at Recco and other outposts. Shortly afterwards he entered the service of the Duke of Savoy to rebuild forts at Montealbano and Villafranca (near Nice). During this period Giovanni received commissions for Genoese suburban villas, including one for Paolo Spinola at Cornigliano (1559–63, altered) and one for Vincenzo Imperiale at S Pier d'Arena (1560–63). Giovanni's Villa Imperiale, known as La Bellezza (now the Istituto Casaregis), continued Alessi's Roman villa style in Genoa by placing the building block on the main axis at the head of a formal garden affording views of the sea. It incorporates a dense decorative scheme with paired half-columns and pilasters, paired consoles topped by a frieze, balustrades and mezzanine cartouche window-frames. This greater decorative intricacy parallels Bernardo a Spazio's frescoed exterior of the Villa Grimaldi (1559–64). The contrast between Giovanni's Alessi-inspired geometric control of plastic decoration at the Villa Imperiale and Giovanni Battista Castello's Raphaelesque treatment of the façade of the Palazzo Imperiale, Genoa, reveals two distinct stylistic modes suiting the taste of the same patron.

Domenico and Giovanni collaborated on the monumental Palazzo Grimaldi (now the Municipio) built for Nicolò Grimaldi between 1565 and 1575 on the Strada Nuova (now Via Garibaldi), Genoa. Documents indicate that Giovanni designed the palazzo while Domenico oversaw building operations. The first part of the scheme involved the placing of terraces into a steep hillside (h. 12 m) rising from the street towards S Francesco a Castelletto (destr.). The palazzo was conceived in scenographic terms and was influenced by Giovanni's earlier work at the Villa Imperiale Scassi (*c.* 1560) at S Pier d'Arena. From the large

entrance vestibule a staircase ascends through a screen of Doric columns to a light-filled courtyard. This is completely surrounded by a two-tier loggia articulated with Doric and Ionic columns. The colonnades with their dramatic play of light and shade act as an open circulation system for the different levels of the palazzo. At the end of the courtyard an open T-shaped double-ramped staircase rises through two floors to a garden entrance (destr.) into S Francesco. This perspective staircase design adapted ideas from contemporary and early 16th-century Spanish open hall staircases.

Giovanni's later commissions included the addition of end-loggias to Giovanni Andrea Doria's Genoese suburban villa in Fassolo and the expansion and systematization of its gardens (1577–80). Based on the earlier gardens of the Villa Imperiale, the colossal sculptures of *Neptune* and *Jupiter* (destr.) served as focal-points for the garden design. For the Villa Doria (1575) at Loano, Giovanni again designed end-loggias and formal terraced gardens. While serving as Architetto Camerale to the Genoese Republic from 1576 until 1596, he planned and cleared the Piazza Soziglia (1578) and modernized the Darsena (Arsenal) and Molo, all in Genoa.

BIBLIOGRAPHY

M. P. Gauthier: *Les Plus Beaux Édifices de la ville de Gênes et de ses environs*, 2 vols (Paris, 1818–32)
Il catalogo delle ville genovesi (Genoa, 1967)
M. Labò: *I palazzi di Genova di Pietro Paolo Rubens e altri scritti d'architettura* (Genoa, 1970)
E. Poleggi: *Strada Nuova: Una lottizzazione del cinquecento a Genova* (Genoa, 1972)
F. Caraceni: *Palazzo Tursi (Municipio)*, Guide di Genova (Genoa, 1976), x
L. Magnani: *Il tempio di Venere: Giardino e villa nella cultura genovese* (Genoa, 1987)

GEORGE L. GORSE

Poppi [Morandini (da Poppi), Francesco] (*b* Poppi, 1544; *d* Florence, 8 April 1597). Italian painter. He went to Florence at an early age and became a protégé of Vincenzo Borghini. He was trained by Giorgio Vasari, whose team of artists he joined in the work of remodelling the Palazzo Vecchio for Cosimo I de' Medici, Duke of Florence, later Grand Duke of Tuscany.

Although still occasionally influenced by Vasari, Poppi's work subsequently showed a greater affinity with that of Giovanni Battista Naldini, another of Vasari's assistants. Poppi imitated and even exaggerated Naldini's very painterly, colouristic manner, and some of his paintings of the mid-1560s are based directly on compositions by Naldini. The *Sacrifice of Isaac* and *St Antoninus Healing a Possessed Man* (*c.* 1566; both Bosco Marengo, Santa Croce) depend on designs and figure types by Naldini, although the latter work reflects also the strange and introverted emotions of the early Mannerist works of Jacopo Pontormo and Rosso Fiorentino.

Despite these influences, Poppi maintained a working relationship with Vasari throughout the late 1560s and early 1570s. With Naldini he worked on Vasari's altarpiece depicting the *Adoration of the Magi* (1567–8) for Boscomarengo, and Poppi's *Vision of Count Ugo* (Florence, Pitti), which shows the influence of Joannes Stradanus as well as of Vasari, probably formed part of the predella of Vasari's altarpiece depicting the *Assumption of the Virgin*

with Two Saints (Florence, Badia Fiorentina). Around 1570 Poppi was commissioned by Francesco I de' Medici, Grand Duke of Tuscany, to execute the *Golden Age* (Edinburgh, N.G.) after a drawing by Vasari (Paris, Louvre). The painting has the rich texture and compositional flow of Naldini's *Gathering of Ambergris* in the *studiolo* of Francesco I in the Palazzo Vecchio (for illustration *see* NALDINI, GIOVAN BATTISTA).

In his own works for the *studiolo*, Poppi followed several of his colleagues, notably Mirabello Cavalori, Girolamo Macchietti, Maso da San Friano and Naldini, in reviving the style of Pontormo. Poppi's ceiling frescoes depicting allegories of *Prometheus and Nature* and the *Elements* and his panels depicting *Alexander Giving Campaspe to Apelles* (1571) and the *Bronze Foundry* (1572) derive from Pontormo's late works and exploit their attentuations and pliancy of form for effects of sheer fantasy. The influence of Parmigianino is also detectable, along with stylistic elements from Naldini and Andrea del Sarto. The complexities of light and colour that play across these whimsical compositions establish Poppi among the more progressive artists then working in Florence.

From the mid-1570s, probably in response to the demands of the Counter-Reformation, Poppi's works became less optically indulgent and, with few exceptions, compositionally more restrained. In his two versions of *Tobias and the Angel* (*c.* 1572–3; Florence, S Niccolò; Prato, Mus. Com.) he tempered his Mannerism with further references to the work of del Sarto. However, in *Christ Healing the Leper* (*c.* 1584–5; Florence, S Marco, Salviati Chapel) he returned to the decidedly Mannerist style of the early works of Pontormo, Rosso and Domenico Beccafumi. In his religious works of the mid-1580s to 1590s Poppi strove to assimilate the naturalism of such Florentine artistic reformers as Santi di Tito and to recall the principles of High Renaissance classicism (e.g. *Last Supper*, *c.* 1584–6; Castiglion Fiorentino, Chiesa del Gesù). In the *Crucifixion* (1594; Castel Fiorentino, S Francesco) the naturalism is modified by archaicizing tendencies that are meant to convey a sense of unsophisticated (and thus sincere) piety to a Counter-Reformation viewer.

BIBLIOGRAPHY

P. Barocchi: 'Appunti su Francesco Morandini da Poppi', *Mitt. Ksthist. Inst. Florenz*, xi (1963–5), pp. 117–48
L. Berti: *Il principe dello studiolo* (Florence, 1967)
V. Pace: 'Contributi al catalogo di alcuni pittori dello studiolo di Francesco I', *Paragone*, xxiv/285 (1973), pp. 69–84
S. Schaefer: *The Studiolo of Francesco I de' Medici in the Palazzo Vecchio in Florence*, 2 vols (Ann Arbor, 1976)
A. Giovannetti, ed.: *Francesco Morandini detto il Poppi: i disegni. I dipinti di Poppi e Castiglion Fiorentino* (Poppi, 1991)
E. Acanfora: 'Un'aggiunta a Francesco Morandini detto Il Poppi', *Paragone*, xlv/529–33 (1994), pp. 113–18

LARRY J. FEINBERG

Porcaccino. *See* PROCACCINI.

Pordenone [Sacchis, de] **(, Giovanni Antonio)** (*b* Pordenone, ?1483; *d* Ferrara, ?13 Jan 1539). Italian painter and draughtsman. Early historians mistakenly called him Licinio. He was the son of Angelo de Lodensanis, master mason from Corticelle (Brescia). He was active mainly as a fresco painter and became one of the most innovative and influential individual artists in North Italy in the early

to mid-16th century. His work shows a broad range of influences, including Mannerism and Venetian art, particularly that of Giorgione. In Venice in the 1530s Pordenone was Titian's chief rival, and the expressive intensity of his painting anticipates the art of Tintoretto.

1. EARLY WORKS, *c.* 1500–19. Pordenone's earliest signed and dated work, a fresco from 1506, *St Michael the Archangel with SS Valerian and John the Baptist* (Valeriano, Spilimbergo, S Stefano), has echoes of Gianfrancesco da Tolmezzo (*fl* 1482–1511), who may have been his master, as well as Bartolommeo Montagna and Pellegrino da San Daniele. Between 1506 and 1510 Pordenone executed the fresco decoration in the apse of S Lorenzo in Vacile, Spilimbergo, including the *Doctors of the Church* and the *Risen Christ* on the ceiling. This work reveals complex formal influences, from Mantegna to Vittore Carpaccio and the late works of Giovanni Bellini. The resemblance of the *Doctors of the Church* to figures by Luca Signorelli suggests that Pordenone may have had contact with the art of Central Italy early on in his career. His second securely dated work, from 1511, is the small altarpiece of the *Virgin and Child with Saints* (ex-Castello, Collalto; Venice, Accad.). From 1514 he was greatly influenced by Giorgione, as is apparent in frescoes executed in that year in S Ulderico in Villanova, Pordenone, including the *Doctors of the Church*, on the ceiling, and scenes from the *Passion*, and in the altarpiece of 1516, the *Virgin of Mercy with SS Joseph and Christopher with the Donor, Francesco da Tiezzo, and his Family* (Pordenone Cathedral), which also reveals the influence of the early works of Titian. It was probably at this time (1515–16) that Pordenone decorated a room in the Casa Tonon-Calzolari in Pordenone (near the Dom) with mythological subjects in a landscape (discovered 1989). The house was owned by the family of Giovanni Antonio de Sacchis, and the room was probably the studio of the painter (see Magri and Testa). Pordenone's characteristic intimate, dramatic scenes can be seen in the frescoes, including scenes of the *Life of St Peter* (1516–17), on the ceiling in the apse of the parish church of Travesio, Pordenone.

Pordenone had direct contact with the art of Central Italy when he worked at Alviano, Terni, where he painted a fresco of the *Virgin and Child, with Saints and a Donor* (1518, sometimes dated a decade later) in the parish church. Another decisive influence on his work was the painting of Raphael and Michelangelo, which Pordenone studied in Rome sometime before 1520, probably in 1518. The works of Leonardo da Vinci and Andrea del Sarto were also probably among the formative elements of his distinctive, dramatic style, which reached maturity towards the end of the decade.

2. MATURE PERIOD, 1519–33. Pordenone became known for his façade decorations from 1519–20, when he frescoed the façade (destr.) of the palazzo of the poet Paride Ceresara (*b* 1466) in Mantua. In 1520 he signed the cycle of frescoes in the chapel of the Annunziata in Treviso Cathedral, including the *Adoration of the Magi* and the *Visitation*. Also in 1520 he took over from Gerolamo Romanino the decoration of Cremona Cathedral, where his frescoes of *Christ before Pilate, Christ Nailed to the*

Cross, the *Crucifixion* (see fig. 1) and *Mourning at the Tomb* attracted considerable attention for their dramatic intensity. The rendering of light and the feeling of pathos that he achieved here reveal his knowledge of works by such northern artists as Albrecht Altdorfer (*c.* 1480–1538) and Martin Schongauer (*c.* 1435/50–1491). The numerous preparatory drawings for the Cremona frescoes (e.g. London, BM) show that Pordenone, more than any other painter born in the area dominated by Venice, regarded drawing as fundamental to his art. Links with Central Italian painting practice are also indicated by the style of his drawings and by his use of red chalk. On his return to Friuli, in 1523, he painted the organ balcony at Spilimbergo Cathedral with scenes from the *Childhood of Christ* and the organ shutters with the *Assumption of the Virgin*, the *Conversion of Saul* (see colour pl. 2, XIX1) and the *Fall of Simon Magus*. These works of daring illusionism were praised by Vasari.

Between 1525 and 1529, in Friuli, Pordenone painted a number of frescoes in an old-fashioned style, probably to satisfy the provincial clientele; examples can be seen in S Maria dei Battuti in Valeriano and in S Martino in Pinzano al Tagliamento. In the same period he revitalized the Friulian altarpiece, notably in the *Virgin and Child with Saints* (1526–9) for S Lorenzo di Varmo, Udine, which is still in the frame he designed. His frame for the altarpiece of *St Gothard with SS Roch and Sebastian* (1525; Pordenone, Mus. Civ. Pal. Ricchieri), painted for the Capuchin church of Pordenone, is untraced.

From 1528 Pordenone executed significant commissions outside Friuli. In Venice in that year he painted

1. Pordenone: *Crucifixion* (*c.* 1520–21), fresco, Cremona Cathedral

illusionistic frescoes (mostly destr.) in S Rocco. Between 1529 and 1530 he painted frescoes of the *Prophets, Sibyls, God the Father* and *Angels* in the Pallavicino Chapel in the Franciscan church of Cortemaggiore, Piacenza, in which actual and fictive architecture are integrated. For the same church he also painted the *Deposition* (*in situ*; see fig. 2) and the altarpiece of the *Immaculate Conception* (Naples, Capodimonte). From 1530 to 1532 Pordenone decorated the interior of S Maria di Campagna in Piacenza. The frescoes in the dome represent *God the Father with Angels, Prophets and Sibyls*; in monochrome are episodes from the *Old Testament*; in the chapel of St Catherine are stories from the *Life of St Catherine* and the altarpiece of the *Mystic Marriage of St Catherine*; the frescoes in the chapel of the Magi illustrate the *Childhood of Christ*. Bernardino Gatti later completed the decoration.

Pordenone's works in Piacenza and Cortemaggiore reveal his contact with the painting of Correggio (and of Parmigianino), although his frescoes in S Maria di Campagna were conceived before Correggio had completed the dome of Parma Cathedral (1530). He adopted the refined Parmesan style in an original manner, for example in the later Venetian altarpieces with *St Lawrence of Giustiniani and Saints* (Venice, Accad.) and *SS Roch, Sebastian and Catherine* (Venice, S Giovanni Elemosinario). Pordenone was probably in Genoa in 1533 to paint the frescoes of the *Stories of Jason* (destr.), in the Palazzo Doria; here he saw the work of Perino del Vaga, which stimulated the striking virtuosity of his late work.

3. LATE WORKS, 1534–9. Manneristic elements in Pordenone's work became more marked from 1534; examples of this were in his façade decorations on the Palazzo d'Anna (destr.), on the Grand Canal in Venice, celebrated for the bravura of the illusionistic rendering of space, and on the Palazzo Tinghi in Udine (completed in 1534; partially preserved), which was painted with allegorical and mythological subjects. In these decorations the artist achieved a brilliant synthesis of the Roman taste for illusionistic monochrome relief and the Veneto tradition of painted façades.

Pordenone's contact with Friuli ended after his move to Venice in 1535. On his departure, he left incomplete a number of works. Some were finished by his pupil and son-in-law Pomponio Amalteo, including frescoes in the Loggia di Ceneda (1535–6), frescoes in S Maria Assunta in Lestans, Spilimbergo (executed almost completely by Amalteo in 1548), and the organ shutters (1549) of Valvasone Cathedral, Pordenone. Others, such as the altarpiece for Pordenone Cathedral, *St Mark Consecrating St Ermacora as Bishop of Aquileia* (1535), were left unfinished.

Pordenone had influential supporters in Venice, including the Doge Andrea Gritti, the Pesaro family and such writers as Pietro Aretino and Lodovico Dolce. He painted the ceiling of the Sala della Libreria (later Sala dello Scrutinio) in the Palazzo Ducale and executed paintings for the Sala del Maggior Consiglio (destr. by fire 1577). In 1538 he was invited to Ferrara by Ercole II d'Este to execute the cartoons for tapestries illustrating the *Stories of Ulysses* (untraced), and there he died.

BIBLIOGRAPHY

G. Vasari: *Vite* (1550, rev. 2/1568); ed. G. Milanesi (1878–85), v, pp. 111–32
C. Ridolfi: *Meraviglie* (1648); ed. D. von Hadeln (1914–24), i, pp. 112–32
J. A. Crowe and G. B. Cavalcaselle: *A History of Painting in North Italy* (London, 1864–6), ed. T. Borenius (London, 1912), iii, pp. 132–84
A. Venturi: *Storia* (1901–40), ix, iii, pp. 630–739
K. Schwarzweller: *Giovanni Antonio Pordenone* (diss., U. Göttingen, 1935)
G. Fiocco: *Giovanni Antonio Pordenone* (Udine, 1939, 2/Padua, 1943, rev. 3/Pordenone, 1969)
H. Tietze and E. Tietze Conrat: *The Drawings of the Venetian Painters in the 15th and 16th Centuries* (New York, 1944), pp. 35, 173, 235–41
A. Morassi: 'L'arte del Pordenone', *Mem. Stor. Forogiuliesi*, xlii (1956–7), pp. 123–38
C. Gilbert: 'The Earliest Work of Pordenone', *A. Ven.*, xvi (1962), pp. 152–4
W. Friedländer: 'Titian and Pordenone', *A. Bull.*, xlvii (1965), pp. 118–21
C. Furlan: *Giovanni Antonio Pordenone* (Bergamo, 1966)
J. Schulz: 'Pordenone's Cupolas', *Studies in Renaissance and Baroque Art Presented to Anthony Blunt* (London, 1967), pp. 44–50
P. Goi and F. Metz: 'Alla riscoparta del Pordenone: Ricerche sull'attività di Giovanni Antonio Pordenone in Friuli', *Noncello*, 33 (1971), pp. 103–48; 34 (1972), pp. 3–42
M. Muraro: 'Del Pordenone e della principale linea di sviluppo della sua arte', *Ateneo Ven.*, ix (1971), pp. 163–80
L. dell'Agnese Tenente: 'Sull'attività giovanile del Pordenone: La formazione e le esperienze romane', *A. Ven.*, xxvi (1972), pp. 39–50
C. Gould: 'The Cinquecento at Venice IV: Pordenone versus Titian', *Apollo*, xcvi/126 (1972), pp. 106–10
C. E. Cohen: 'Pordenone's Painted Façade on the Palazzo Tinghi in Udine', *Burl. Mag.*, cxvi (1974), pp. 445–57
——: 'Pordenone's Cremona Passion Scenes and German Art', *A. Lombarda*, xlii–xliii (1975), pp. 74–96
G. Pantaleoni: *Affreschi e dipinti del Pordenone a Piacenza e a Cortemaggiore* (Piacenza, 1978)
Giorgione a Venezia (exh. cat., ed. T. Pignatti and R. Pallucchini; Venice, Accad., 1978), pp. 177–89

2. Pordenone: *Deposition*, oil on canvas, 1529–30 (Cortemaggiore, Franciscan church)

C. E. Cohen: *The Drawings of Giovanni Antonio Pordenone* (Florence, 1980)

P. Ceschi Lavagetto, ed.: *Giornata di studio per il Pordenone* (Piacenza, 1981), pp. 12–23

The Genius of Venice (exh. cat., ed. C. Hope and J. Martineau; London, RA, 1983), pp. 268–75, 335–7, 345

Il Pordenone (exh. cat., ed. C. Furlan; Passariano, Villa Manin; Pordenone, S Francesco; 1984)

Il Pordenone: Atti del Convegno Internazionale di Studi: Pordenone, 1984

C. Furlan: *Il Pordenone* (Milan, 1988)

G. C. Magri and G. C. Testa: 'Lo studiolo del Pordenone', *Noncello*, 63 (1989–94), pp. 19–81

A. D. Basso: 'Sui ritrovati affreschi di Giovanni Antonio da Pordenone nella chiesa veneziana di San Giovanni Elemosinario', *Boll. A.*, lxxviii/ 80–81 (1993), pp. 9–24

J. Biscontin: 'Problemi iconografici: Il fregio decorativo del Pordenone nella cappella dell'Immacolata Concezione a Cortemaggiore', *A. Ven.*, 45 (1993), pp. 51–62

C. Furlan: '"Per dar maggiore vaghezza et spendore alla chiesa": La decorazione pittorica dalla metà del Quattrocento alla fine del Cinquecento', *San Marco di Pordenone*, ed. P. Goi (Pordenone, 1993), pp. 227–73

Le siècle de Titien: L'âge d'or de la peinture à Venise (exh. cat. ed. M. Laclotte; Paris, Grand Pal., 1993), pp. 436–7, 701

P. Ceschi Lavagetto: 'Una *Pietà* del Pordenone ritrovata', *A. Ven.*, 46 (1994), pp. 15–27

G. Rodella: 'Un affresco del Pordenone scoperto nel Duomo di Cremona', *Quad. Pal. Tè*, ii (1995), pp. 87–92

C. E. Cohen: *The Art of Giovanni Antonio da Pordenone between Dialect and Language* (Cambridge, 1996)

——: 'Pordenone's Working Methods in Light of a Group of Copies after Lost Designs', *Master Drgs*, xxxiv/2 (1996), pp. 168–91

PAOLO CASADIO

Pordenone, Dario da. *See* DARIO DA TREVISO.

Porta, della. Italian family of sculptors, stone masons and architects, active from the 15th century to the 17th. Originally they came from Porlezza on Lake Lugano, but they were active in the masons' lodges of Milan Cathedral and the Certosa di Pavia from the 1470s. Around 1500, (1) Antonio della Porta set up a workshop in Genoa, where he collaborated with, among others, his nephew Pace Gagini of the GAGINI family of sculptors and stone masons, producing sculpture that was exported to France. (3) Guglielmo della Porta moved *c.* 1537 to Rome, where his descendants continued to work until the early 17th century.

BIBLIOGRAPHY

S. Varni: 'Delle opere di Gian Giacomo e Guglielmo della Porta e Niccolò da Corte in Genova', *Atti Soc. Ligure Stor. Patria*, iv (1866), pp. 35–78

F. Alizeri: *Notizie dei professori del disegno in Liguria dalle origini al secolo XVI*, iv and v (Genoa, 1876–77)

A. Bertolotti: *Artisti lombardi a Roma nei secoli XV, XVI, XVII*, 2 vols (Milan, 1881)

A. Venturi: *Storia* (1909–40/R 1967), vi, pp. 840, 847, 921, 1922; vii, pp. 251; x, pp. 678

R. Maiocchi: *Codice diplomatico artistico di Pavia*, 2 vols (Pavia, 1937–49)

H.-W. Kruft and A. Roth: 'The della Porta Workshop in Genoa', *An. Scu. Norm. Sup. Pisa*, n. s. 3, iii/3 (1973), pp. 893–954

K. Schwager: 'Giacomo della Portas Herkunft und Anfänge in Rom', *Röm. Jb. Kstgesch.*, xv (1975), pp. 109–41

(1) Antonio della Porta [Antonio Tamagnino] (*b* Porlezza, nr Como, *fl* 1489–1519). He was the son of the master stone mason Giacomo della Porta, who worked at the Certosa di Pavia between 1477 and 1481. With his older brothers Guglielmo and Bartolomeo, Antonio was trained at the Certosa where he worked mostly in collaboration with other sculptors. His individual style is therefore rather difficult to isolate. His earliest documented

works are twelve figures of angels, three reliefs of church fathers and two medallions, all in S Maria dei Miracoli, Brescia, for which he was paid in 1489. Stylistically they are closely related to the sculpture at the Certosa. The graceful music-playing angels, with their elaborate, stylized draperies, recall Giovanni Antonio Amadeo's angels on the façade of the Certosa di Pavia, and the circular reliefs of the church fathers, set into the pendentives of the cupola, are also closely modelled on similar reliefs at the Certosa. In 1493 and 1499 he worked again in Brescia.

Between 1491 and 1499 Antonio was active at the Certosa, although no specific works by him can be identified. In 1493 his nephew, Pace Gagini, and Girolamo Viscardi joined the workshop. Around 1500 Antonio transferred some of his activity to Genoa; the signed portrait bust of the Genoese politician and banker *Acellino Salvago* is dated 1500 (Berlin, Bode Mus.; damaged during World War II). The strikingly realistic head, with its piercing gaze and alert expression, represents an almost isolated example of such portraiture in Genoese sculpture. A medallion portrait of Salvago (New York, Met.) can also be ascribed to Antonio. In 1501 Francesco Lomellini commissioned Antonio and Pace Gagini to build a family chapel in S Teodoro, Genoa. The only remains of this chapel in the present church of S Teodoro (rebuilt after 1870) are Lomellini's tomb and the altar retable. From 1505 to 1508 Antonio worked on two doorways for the Palazzo Grillo–Cattaneo, Genoa, one of which survives. In this work he showed himself a master of ornament in the Lombard style. In 1506, with Agostino Solari and Pace Gagini, he was commissioned to construct a fountain (dismantled 1759) for the Château de Gaillon, near Rouen. Jacques Androuet Du Cerceau I (1515–85) recorded the appearance of the fountain in a drawing (*c.* 1575; London, BM) and an engraving. It consisted of an octagonal basin decorated with reliefs of *St George and the Dragon* and the arms of Louis XII and Cardinal d'Amboise. Two circular basins were supported on a central stem, which was richly carved with nude female figures, satyrs and classical ornament, the whole surmounted by the figure of a man. Jets of water flowed from masks set into the circular basins. A fountain-basin now in the Château de La Rochefoucauld, near Angoulême, may have formed part of the fountain at Gaillon.

In 1508 Antonio worked on a seated figure of *Francesco Lomellini* in the Palazzo S Giorgio, Genoa, but it was completed the same year by Pace Gagini and signed by him alone. In 1509 Antonio received the final payment for a standing figure of *Antonio Doria* for the same palace. The tomb of *Raoul de Lannoy and Jeanne de Poix* in the parish church of Folleville in Picardy was the joint work of Antonio and Gagini. The recumbent effigy of *Raoul de Lannoy* is signed by Gagini, and that of *Jeanne de Poix* is signed by Antonio. The tomb is set in a highly decorated Late Gothic recess, adapted for the purpose. The broad and naturalistic carving of the recumbent figures suggests that the sculptors were familiar with Cristoforo Solari's effigies of *Lodovico Sforza* and *Beatrice d'Este* (1498; Pavia, Certosa; for illustration *see* SOLARI, (5)). The Classical spirit of the tomb front, with inscription plate flanked by mourning putti, is stylistically related to the Lomellini tomb relief in S Teodoro, Genoa, but cannot be positively

attributed to either sculptor. It is probably the most significant piece of Italian sculpture to be exported to France at this date. A statuette of the *Virgin and Child* in the parish church of Ruisseauville, Pas-de-Calais, is signed by both sculptors.

Before 1513 Antonio returned to the Certosa di Pavia, where he and Pace Gagini executed the right-hand tabernacle (1513) in the church choir. The tabernacle, surmounted by the Virgin in a mandorla surrounded by music-playing angels, is arranged on six tiers with an elaborate architectural frame housing narrative reliefs and niches with angels. Between 1517 and 1519 Antonio worked on the façade of the Certosa. He produced two half-figures of prophets and nine other figures, some of which were completed later or reworked. His personal contribution is extremely hard to identify. Antonio was brought up in the tradition of stonemasons' lodges organized on late medieval lines, and in his later career he reverted to this way of working. His individual style, which is inextricably bound up with a collective Lombard style, is discernible only in the works he produced during his time in Genoa. But even here, given his collaboration with Pace Gagini, his artistic individuality is obscured.

BIBLIOGRAPHY

R. Bossaglia: 'La scultura', *La Certosa di Pavia* (Milan, 1968), pp. 40–80

H.-W. Kruft: 'Genuesische Skulpturen der Renaissance in Frankreich', *Actes du XXII Congrès International d'Histoire de l'Art, Budapest, 1969*, pp. 697–704

——: 'Antonio della Porta, genannt Tamagnino', *Pantheon*, xxviii (1970), pp. 401–14

——: *Portali genovesi del rinascimento* (Florence, 1971)

B. Barbero: 'Antonio della Porta a Savona: Una postilla', *Boll. Ligustico Stor. & Cult. Regionale*, xxvi (1974), pp. 11–18

C. R. Morscheck jr: *Relief Sculpture for the Façade of the Certosa di Pavia, 1473–1499* (New York, 1978)

HANNO-WALTER KRUFT

(2) Gian Giacomo della Porta (*fl* 1513; *d* Genoa, 1554–5). Nephew of (1) Antonio della Porta. There is evidence that Gian Giacomo was working as a sculptor in Genoa from 1513, but the works mentioned in the documents have not survived. At the same time, he began his association with the Certosa di Pavia, where in 1514 his uncle Antonio declared him fully qualified. In documents he is often described as 'engineer and sculptor'. Stylistic factors suggest that Gian Giacomo assisted in the work on the right-hand tabernacle on the south wall of the choir in the Certosa undertaken by Antonio della Porta and Pace Gagini in 1513.

From 1524 to 1530 Gian Giacomo worked as engineer and sculptor in the stonemasons' lodge of Milan Cathedral, although it is impossible to identify specific works by him. In 1525 he was commissioned to work on a shrine for the relics of SS Marcellinus and Peter in S Tommaso, Cremona, but this was never completed. A single relief depicting a scene from the lives of these saints was incorporated into the 17th-century reliquary in the crypt of Cremona Cathedral. Stereotyped movements and heavy garments are characteristic features of Gian Giacomo's relief style. The influence of Bambaia is also apparent. Three further undocumented reliefs, executed in the same style, can be ascribed to Gian Giacomo: the *Virgin and Child with St Anne and St John the Baptist* ('*Anna Selbdritt*'; Berlin, Bode Mus.); a tomb relief of a *Humanist with the Theological Virtues* (London, V&A); and a *Penitent St Jerome* (Prague, N.G., Convent of St George).

In 1530 Gian Giacomo transferred his studio to Genoa, where, from 1532, he collaborated with Niccolò da Corte. The partnership was formalized in 1534, when Gian Giacomo, his son (or nephew) Guglielmo and da Corte set up a studio together, and it continued until 1537 when da Corte went to Spain and Guglielmo presumably went to Rome. The most important commissions undertaken by this partnership were the baldacchino in the chapel of S Giovanni Battista (1530–32) and the funerary monument to *Giuliano Cybo*, Bishop of Agrigento (both Genoa Cathedral). The rectangular marble baldacchino is raised on a platform, with a richly carved canopy supported on four porphyry columns. These rest on tall socles carved in high relief on each face with figures of the prophets. Gian Giacomo contributed a considerable amount to this monument, in particular, some of the prophets on the socles of the baldacchino. The *Cybo* monument is composed as a serliana with the seated figure of Christ in the central niche, flanked by over life-size figures of saints and prophets. The upper and lower faces are decorated with reliefs depicting the Virtues, funereal symbols and scenes from the lives of the saints and prophets. Before the monument is placed the kneeling figure of *Giuliano Cybo*, which was removed from its original situation after the completion of the tomb.

From 1537 until his death, Gian Giacomo ran his studio in Genoa mostly by himself. His somewhat ponderous and doughy style is evident in the following documented works: a group of *Christ and St Thomas* (1540; Genoa, S Tommaso), four marble figures of *Giovanni Gioacchino* and *Ansaldo Grimaldi* (seated) and *Gerolamo Gentile* and *Giovanni Grillo* (standing) in the Palazzo S Giorgio, Genoa, produced between 1539 and 1553. In 1544 Gian Giacomo was paid for the elaborate fireplace in the Palazzo S Giorgio, in which the figure style shows the influence of Perino del Vaga and Giovanni Angelo Montorsoli. Between 1551 and 1553 he made statues of *St Mark* and *St Luke* for the choir of Genoa Cathedral. In all his works produced in Genoa, Gian Giacomo strove to create a new monumentality, but failed to give the figures necessary psychological depth.

BIBLIOGRAPHY

Annali della fabbrica del Duomo di Milano dall'origine fino al presente, iii (Milan, 1880)

H.-W. Kruft and A. Roth: 'The della Porta Workshop in Genoa', *An. Scu. Norm. Sup. Pisa*, n. s. 3, iii/3 (1973), pp. 893–954

HANNO-WALTER KRUFT

(3) Guglielmo della Porta (*b* Porlezza, nr Como, *fl* 1534; *d* Rome, 6 Jan 1577). Son or nephew of (2) Gian Giacomo della Porta. He also signed himself 'Mediolanensis' (i.e. of Milan): both signatures are found on the base of the seated figure of the tomb of *Paul III*. His father's identity is still in dispute. Vasari describes him as the nephew of Gian Giacomo, a statement which biographers (Baglione, Soprani, Ratti) and later scholars have accepted; a document of 1561 identifies him as the son of a certain Cristoforo. However, in Genoese documents dated 1534–6, he repeatedly appears as the son of Gian Giacomo della Porta. This statement is the most convincing because it

confirms that father and son worked together as partners, and because the style of works in Genoa known to be by Guglielmo continues in his works in Rome. The suggestion that a second Guglielmo della Porta was working in Genoa at the same time is untenable.

Guglielmo must have learnt his craft in Milan in the 1520s, at the time when Gian Giacomo was a member of the stonemasons' lodge of Milan Cathedral. Vasari also says he was apprenticed in Milan. Around 1530, in Genoa, Guglielmo must have met Perino del Vaga, who had a decisive influence on his style. Guglielmo probably worked on the stuccowork in the Galleria degli Eroi, Palazzo Doria, Genoa, under Perino's guidance. This collaboration was later continued in Rome.

Guglielmo is first mentioned in 1534 in a partnership agreement between himself, Gian Giacomo and the sculptor Niccolò da Corte in connection with the tomb of *Giuliano Cybo*, Bishop of Agrigento, in Genoa Cathedral. In August 1536 and in 1538 Guglielmo is recorded as absent from Genoa, although his presence in Genoa is mentioned in both years. With Gian Giacomo and Niccolò da Corte he worked on the baldacchino, completed in 1532, in the chapel of S Giovanni Battista, Genoa Cathedral. A number of reliefs of prophets on the socles of the baldacchino have been identified as Guglielmo's earliest works. However, only the unidentified figure on the rear side of the right-hand socle can be attributed wholly to Guglielmo. As an independent sculptor, Guglielmo worked on several figures for the *Cybo* monument, a commission begun in 1533. Guglielmo's contributions to this monument are the figures of *Giuliano Cybo* (rediscovered in 1955) and of *Abraham* (see fig.). *Abraham* is Guglielmo's first masterpiece. In this figure, which is located on the left projecting socle of the monument, the heavy drapery, flowing beard and musculature show detailed attention to texture and volume. Abraham's sharp and forceful contrapposto movement creates a tension absent in the other figures on the monument.

According to Vasari, Guglielmo moved to Rome in 1537. However, his name does not feature on any documents there until 1546. Initially, he worked with Perino del Vaga and produced designs for stucco decorations, now lost, for the Cappella Massimi in Trinità dei Monti. The Farnese family commissioned him to restore antique sculptures, including the Farnese *Hercules*, which he restored in 1547 after its discovery by Cardinal Alessandro Farnese in 1540. In the same year he was nominated 'Piombatore Apostolico'—officially in charge of the lead used for making papal bulls—in succession to Sebastiano del Piombo, and thereafter is known as Fra Guglielmo della Porta.

One of Guglielmo's first commissions in Rome was the bronze tomb of *Bishop Francesco de Solis* (d 1545). A workshop drawing in Turin shows the overall design of the monument. The tomb was partly executed, but it was never erected in Rome. The recumbent figure was sold to Spain, where it was used on the tomb of *Archbishop Lodovico de Torre* in Malaga Cathedral. Paul III purchased the base of the monument and had it incorporated into the design of his own tomb.

From *c.* 1544 Guglielmo was patronized by the Farnese pope Paul III, producing bronze and marble busts of him

Guglielmo della Porta: *Abraham*, marble, detail from the monument to *Giuliano Cybo*, *c.* 1535 (Genoa Cathedral)

(Hamburg, Mus. Kst & Gew.; Naples, Capodimonte and Mus. N. S Martino). Guglielmo was probably commissioned to construct the funerary monument to *Paul III* in 1547. In 1575 his ambitious free-standing tomb was temporarily erected in the nave of St Peter's, but by 1588 it had been dismantled and reconstructed in a different form, in a recess in a crossing pier. In 1629 it was finally placed against the wall in the choir of St Peter's. In this arrangement, the bronze seated figure of the Pope is raised on a high pedestal, with inscription, above the two marble reclining figures of *Justice* and *Prudence*. The influence of Michelangelo, who occasionally supported Guglielmo, is particularly evident in these figures, which are still on the tomb (allegories of *Roman Peace* and *Public Wealth* were removed in 1628 and now flank a fireplace by Vignola in a salon on the *piano nobile* of the Palazzo Farnese, Rome). The figures for the monument reveal a perfect combination of Guglielmo's Lombard style with the influence of Classical antiquity and of Michelangelo. In the seated figure of the Pope the overall impression of the figure and a minute attention to detail are finely balanced.

Guglielmo was probably responsible for at least the design of a number of other funerary monuments in Rome, including the tomb of *Cardinal Gregorio Magalotti* (d 1538) in S Cecilia in Trastevere, the tomb of *Bernardino Elvino* (d 1548) in S Maria del Popolo and the tombs of *Cardinal Paolo Cesi* (d 1537) and *Cardinal Federigo Cesi* (d 1565) in S Maria Maggiore.

Two sketchbooks (Düsseldorf, Kstakad.; MS. 64 Disegni 37–8) give valuable information about Guglielmo's

work in bronze, a medium he only began to use when he first came to Rome. His numerous bronze sculptures include 16 mythological reliefs after Ovid and are held in several collections (e.g. *Judgement of Paris*, Vienna, Ksthist. Mus.; *Bacchanalian Feast*, New York, Met.) as well as crucifixes and representations of scenes from the Passion. The Farnese Table (New York, Met.), which was once attributed to Jacopo Vignola, is probably by Guglielmo.

After Guglielmo's death, a number of moulds and original models were stored in the 'Ufficio del Piombo'. In 1585 Guglielmo's son, Fidias, stole several such items from the workshop and sold them for re-use. Guglielmo also produced some architectural designs for S Silvestro al Quirinale in Rome. An outline for a treatise on architecture shows that Guglielmo had a thorough knowledge of architectural matters.

BIBLIOGRAPHY

E. Steinmann: *Das Grabmal Pauls III in St Peter in Rom* (Rome, 1912)

A. Borzelli: *Il capolavoro di Guglielmo della Porta: La tomba di Paolo III in S Pietro in Vaticano* (Naples, 1920)

G. Matthiae: 'L'attività romana di Guglielmo della Porta', *Capitolium*, xi (1935), pp. 313–26

U. Middeldorf: 'Two Wax Reliefs by Guglielmo della Porta', *A. Bull.*, xvii (1935), pp. 90–97

W. Gramberg: 'Der Veroneser Bildhauer Giuseppe de Levis und Guglielmo della Porta', *Jb. Ksthist. Samml.*, n. s. xi (1937), pp. 179–88

M. Gibellino Krasceninnicowa: *Guglielmo della Porta: Scultore del Papa Paolo III Farnese* (Rome, 1944)

W. Gramberg: 'Die Hamburger Bronzebüste Pauls III Farnese von Guglielmo della Porta', *Festschrift für Erich Meyer* (Hamburg, 1959), pp. 160–72

J. Pope-Hennessy: *Italian High Renaissance and Baroque Sculpture* (London, 1963, rev. 1970)

W. Gramberg: *Die Düsseldorfer Skizzenbücher des Guglielmo della Porta*, 3 vols (Berlin, 1964)

D. Kaczmarzyk: 'Deux Sculptures de Guglielmo della Porta et un dessin de son fils Teodoro della Porta au Musée national de Varsovie', *Bull. Mus. N. Varsovie*, v (1964), pp. 94–103

W. Gramberg: 'Guglielmo della Portas verlorene Prophetenstatuen für San Pietro in Vaticano', *Festschrift Walter Friedlaender* (Berlin, 1965), pp. 79–84

R. Roli: 'Le sculture di Guglielmo della Porta nella cattedrale di Genova', *A. Ant. & Mod.*, xxxiv–xxxvi (1966), pp. 209–22

S. Howard: 'Pulling Herakles' Leg: Della Porta, Algardi and Others', *Festschrift Ulrich Middeldorf* (Berlin, 1968), pp. 402–7

W. Gramberg: 'Vier Zeichnungen des Guglielmo della Porta zu seiner Serie mythologischen Reliefs', *Jb. Hamburger Kstsamml.*, xiii (1968), pp. 69–94

——: 'Die Liegestatue des Gregorio Magalotti: Ein römisches Frühwerk des Guglielmo della Porta', *Jb. Hamburger Kstsamml.*, xvii (1972), pp. 43–52

G. L. Masetti Zannini: 'Notizie biografiche di Guglielmo della Porta in documenti notarili romani', *Commentari*, xxiii (1972), pp. 449–60

W. Gramberg: 'Das Kalvarienberk-Relief des Guglielmo della Porta', *Festschrift für Hanns Swarzenski* (Berlin, 1973), pp. 449–60

H.-W. Kruft and A. Roth: 'The della Porta Workshop in Genoa', *An. Scu. Norm. Sup. Pisa*, n. s. 3, iii/3 (1973), pp. 893–954

U. Middeldorf: 'A Renaissance Jewel in a Baroque Setting', *Burl. Mag.*, cxviii (1976), pp. 157–8

C. Valone: 'Paul IV, Guglielmo della Porta and the Rebuilding of San Silvestro al Quirinale', *Master Drgs*, xv (1977), pp. 243–55

W. Gramberg: 'Notizen zu den Kruzifixen des Guglielmo della Porta und zur Entstehungsgeschichte des Hochaltarkreuzes in S Pietro in Vaticano', *Münch. Jb. Bild. Kst*, n. s. 3, xxxii (1981), pp. 95–114

——: 'Guglielmo della Portas Grabmal für Paul III Farnese in S Pietro in Vaticano', *Röm. Jb. Kstgesch.*, xxi (1984), pp. 253–364

W. M. Griswold: 'Some Newly-discovered Drawings in the Metropolitan Museum of Art', *Apollo*, cxl/393 (1994), pp. 24–8

C. Riebesell: 'Eine *Herkulesstatuette* des Guglielmo della Porta', *Ars naturam adiuvans: Festschrift fr Matthias Winner*, ed. V. V. Flemming and S. Schutze (Mainz, 1996), pp. 352–66

HANNO-WALTER KRUFT

(4) Teodoro della Porta (*b* Rome, 1567; *d* Rome, 23 March 1638). Son of (3) Guglielmo della Porta. He was the only one of Guglielmo's sons to work as a sculptor, but very few examples of his work survive. In 1594 he executed the bronze drapery for the allegory of *Justice* on the tomb of Paul III designed by Guglielmo. A gilded terracotta relief of the *Entombment* (1602; Rome, Gal. Spada) is signed by a monogram that was recently deciphered as Teodoro's. He evidently used models from his father's studio and attempted to improve on their style. In 1625, in collaboration with Giacomo Laurenziano (*fl* 1607; *d* 1650), he made the funerary monument for *Lucrezia Tomacelli* in S Giovanni in Laterano.

In 1609 Teodoro charged several Roman goldsmiths with having illegally reproduced models that had been stolen from his father's workshop.

BIBLIOGRAPHY

A. Bertolotti: 'Guglielmo della Porta scultore milanese', *Archv Stor. Lombardo*, ii (1875), pp. 295–322

U. Middeldorf: 'In the Wake of Guglielmo della Porta', *Connoisseur*, cxciv (1977), pp. 75–84

HANNO-WALTER KRUFT

(5) Giovanni Battista della Porta (*d* Rome, 4 Oct 1597). He was the son of Alessio della Porta from Porlezza and occasionally collaborated with his brother (6) Tomaso della Porta. Giovanni Battista's first documented commission (1567) was for ten stuccoed figures of nymphs for the Oval Fountain in the park of the Villa d'Este, Tivoli, which he was to execute following the designs of Pirro Ligorio. In the 1570s Giovanni Battista worked with his brother Tomaso on the Santa Casa, Loreto. Giovanni Battista contributed the sibyls, which combine the style of antique robed figures with that of (3) Guglielmo della Porta's female allegories from the tomb of *Paul III*. The two brothers also made the statues of *Faith* and *Charity* on the tomb of *Cardinal Niccolò Caetani* (1579; Loreto, Santuario Santa Casa). After the death of Vespasiano Gonzaga in 1591, Giovanni Battista erected an almost identical tomb in the Chiesa dell'Incoronata in Sabbioneta, with the figures of *Justice* and *Fortitude*. The seated bronze figure of *Vespasian*, by Leone Leoni, was inserted later into the central recess. Giovanni Battista also restored antique sculptures and was active as an art dealer.

(6) Tomaso della Porta (*d* Rome, 1618). Brother of (5) Giovanni Battista della Porta. Apart from the works he carried out jointly with his brother Giovanni Battista, Tomaso made two seated marble angels and gable-figures (1580) for the chapel of St Gregory in St Peter's, Rome. From 1585 he collaborated with Leonardo Sormani on a model for the bronze figure of *St Peter* placed on top of Trajan's Column, Rome, in 1587 (cast by Bastiano Torrigiani). The design for the figure of *St Paul* on the Column of Marcus Aurelius, erected in 1589, is also ascribed to him. A large marble altar in the oratory of the Lombardi of S Carlo al Corso, Rome, showing a *Deposition* and two sibyls, is a late documented work. Stylistically he was strongly influenced by Michelangelo and Guglielmo della Porta. Like his brother Giovanni Battista, Tomaso was also active as a dealer in antique sculpture.

BIBLIOGRAPHY

A. Bertolotti: 'Tommaso della Porta, scultore milanese e vari artisti lombardi', *Archv Stor. Lombardo*, iii (1876), pp. 270–95

P. Rotondi: 'Tommaso della Porta nella scultura romana dalla controriforma', *Boll. R. Ist. Archeol. & Stor. A.*, vi (1933), pp. 33–8

HANNO-WALTER KRUFT

Porta, Baccio della. *See* BARTOLOMMEO, FRA.

Porta, Giacomo della (*b* Porlezza, 1532; *d* Rome, 3 Sept 1602). Italian architect. He was the dominant architect in Rome in the last quarter of the 16th century, working on most of the major projects of the period. In many cases he completed work begun by others, notably Michelangelo, after whose death he became surveyor of the works on the Capitoline Hill, and Jacopo Vignola, whom he succeeded as architect at Il Gesù, St Peter's and the Palazzo Farnese. A highly practical architect, his style was influenced both by Michelangelo's Mannerism and Vignola's more classicizing approach. His most important design was the façade of Il Gesù, which was highly influential.

1. Early works and the Capitoline Hill. 2. Other public works in Rome. 3. Private commissions, Il Gesù and St Peter's. 4. Palazzi and late works.

1. EARLY WORKS AND THE CAPITOLINE HILL. Della Porta is first recorded in Rome in 1559 as a sculptor interested in the acquisition and sale of excavated artefacts. He probably served his apprenticeship as an architect with Guidetto Guidetti. The earliest architectural work attributed to him was the portal (1560–61) of the Vigna Grimani on the Quirinale. From 1561 to 1568 he was architect at the oratory of the SS Crocifisso di S Marcello, supervising work that had been entrusted initially to Guidetti. On Guidetti's death (1564), della Porta completed the church of S Caterina dei Funari and the Cesi Chapel in S Maria Maggiore, and from 1562 to at least 1573 he worked in S Maria Maggiore on alterations to the transept and choir commissioned by Cardinal Guido Ascanio Sforza to accord with the dictates of the Council of Trent. Some elements in Michelangelo's Sforza Chapel in S Maria Maggiore are attributed to della Porta: the internal decoration, the windows in the vault and the external façade facing the nave (the latter was demolished, or perhaps sold to Cardinal Alessandro Albani, in the 18th century).

In 1563 della Porta was engaged in restoration work at the Palazzo Senatorio on the Piazza del Campidoglio. He was introduced to the work on the Capitoline Hill either by Guidetti, who had been commissioned to oversee the construction of Michelangelo's façade for the Palazzo dei Conservatori, or by Tommaso de' Cavalieri, master of the works at the Palazzo Senatorio. Della Porta would have met the latter during the construction of the oratory of the SS Crocifisso, as Cavalieri was a member of the brotherhood responsible for the fabric.

In October 1564, following the deaths of both Michelangelo and Guidetti, della Porta was elected Architetto del Popolo Romano and became responsible for supervising the Capitoline works, which he continued until his death. Various elements of the work had already been completed by 1564 in accordance with Michelangelo's designs (*see* MICHELANGELO, §I, 4 and fig. 9), notably the podium for the antique equestrian statue of *Marcus Aurelius*, the stairway to the Palazzo Senatorio and the first bay of the Palazzo dei Conservatori, and the *cordonata*, or monumental stairway ramp leading up to the piazza, had been begun. Although Michelangelo's designs determined the overall appearance of the complex, there is no concrete evidence that he left drawings or other instructions for the continuation of the work, nor that any such drawings—if they existed—were followed. Under della Porta's supervision the following works were completed: the façade of the Palazzo dei Conservatori (1586), the interior layout of the Palazzo Senatorio (begun 1573/4) and the continuation of its façade (subsequently completed by Girolamo Rainaldi), and the *cordonata*. Detailed designs by della Porta include the large window (1568–9) in the central bay of the Palazzo dei Conservatori, the windows (1576–7) and door surround (1598) of the Palazzo Senatorio, and the balustraded parapet (1581–2) of the *cordonata*, the slope of which he reduced, extending it right into the piazza.

2. OTHER PUBLIC WORKS IN ROME. As Architetto del Popolo Romano, della Porta was also responsible for the supervision of other projects under the city's jurisdiction, notably alteration and restoration work at S Maria in Aracoeli, which had begun in 1563 and included a new high altar, the addition of a monks' choir (1564) and the design and construction of the Armentieri and Paluzzi–Albertoni chapels (1572). This latter work was part of a much larger transformation of the nave, raising the height of the walls and renewing the roof, ceiling and transept arch (completed 1584). Della Porta also designed commemorative plaques to *Duke Alessandro Farnese* (1585), located on the door to the sacristy, and to *General Giovan Francesco Aldobrandini* and *Cardinal Pietro Aldobrandini* (1602).

Other public works included responsibility for the restoration to working order (1563) of the Trevi Fountain, the construction of a new fountain (*c.* 1563) at S Giorgio in Velabro and supervising the re-leading (1600–01) of the roof of the Pantheon. As public architect, della Porta also supervised projects for the *Congregazione cardinalizia super viis, pontibus, fontibus*, a body created by Pius V in 1567 with responsibility for the construction and maintenance of the urban infrastructure. This work included the construction of a bridge (1569; with Giacinto Barozzi) on the Via Portuense, the selection of a site for the Vatican Obelisk (1585), which was moved and erected by Domenico Fontana (1543–1607); supervising the erection of the obelisk at S Maria Maggiore (1587); and the layout of Campo Vaccino (1595; with Flaminio Ponzio). All these undertakings were interspersed with such activities as surveys of roads and the construction of sewers. The same cardinals also controlled a council for the reclamation of the Acqua Vergine, to which della Porta was appointed (1568) in place of Nanni di Baccio Bigio. In addition to works related to the channelling of water, completed in 1570 when water reached the basin of the Trevi Fountain, his responsibilities included the construction of public fountains, and he designed those in Piazza Navona (from 1574; see fig. 1), Piazza Colonna (from 1575), Piazza del Pantheon (begun 1575; remodelled 1711 by Filippo Barigioni) and Piazza S Marco (from 1588).

1. Giacomo della Porta: Moro Fountain, Piazza Navona, Rome, from 1574

3. PRIVATE COMMISSIONS, IL GESÙ AND ST PETER'S. In addition to his public responsibilities, della Porta also carried out private commissions. In 1565–71 he constructed the chapel for Faustina Rusticelli in S Giovanni in Laterano. In 1565 he began work on a palazzo (completed 1582) in Via del Gesù for Carlo Muti. For the convent of S Ambrogio at the Massima he designed a dormitory (1568), and for the Dominican nuns of S Sisto at Magnanapoli he refurbished the whole convent (completed by 1575) and constructed the enclosed church.

In July 1571 work began on the façade of Il Gesù (completed 1573; see ROME, §V, 3), for which Cardinal Alessandro Farnese had favoured della Porta's design over those of Jacopo Vignola—who had largely designed the rest of the church—and Galeazzo Alessi. Vignola had designed a façade with a balanced rhythm, which is rooted in classical tradition as interpreted in the Renaissance (see ROME, fig. 13). Della Porta's design, however, by abandoning niches and statues in the outer bays, concentrating openings in the central portion, and doubling the pediment over the main entrance, accentuated the verticality of the façade, thereby creating a strong central climax (see ROME, fig. 14); this provided a precedent for successive Baroque façades. Della Porta also designed the high altar (1582) and the crossing (1584) of Il Gesù.

On Vignola's death (1573), della Porta succeeded him as architect to the Farnese family and as architect of St Peter's. At the Palazzo Farnese (see ROME, §V, 7), he finished the wing facing the garden (1574–89), thus completing Michelangelo's scheme, and he built the rear façade of the loggia overlooking the Tiber, where his patron insisted he follow the same bay rhythm as the courtyard, with the result that the relationship with the side wings by Antonio da Sangallo (ii) is not altogether a happy one (see Lotz). He was also involved in the construction of the Villa Farnese at Caprarola.

Della Porta received his first payment as architect to St Peter's on 13 July 1574. Initially he supervised the construction and decoration of the Gregorian Chapel (completed c. 1584). In 1578 he began work on the Clementine Chapel (completed 1601), and after the destruction (1585–7) of the choir by Bernardo Rossellino and Bramante, the new apse (completed 1588) began to take shape. In 1586 della Porta received approval for his designs for the dome, built between 1588 and 1590 (with Domenico Fontana; see ROME, §V, 1(ii)(a)); the lantern was completed in 1603. Della Porta's slightly pointed dome with raised ribs has been the subject of heated critical debate; the majority of scholars now agree that the wooden model preserved in the basilica corresponds to Michelangelo's design only in

its hemispherical inner skin, the outer skin, as built, being probably a modification under Sixtus V, which must therefore have been introduced by della Porta. He was also responsible for other modifications to the design of the dome, including the reduction in width and projection of the ribs and the adjustment of the dormer windows: in Michelangelo's design these reduced in size towards the top, whereas the existing shapes vary within their horizontal dispositions. Even the lantern was modified and simplified by della Porta. On the completion of the dome, work started on the new Confessio (sepulchre of St Peter) and the high altar (consecrated 26 June 1594). While della Porta was architect to the fabric, work also commenced on the internal decoration of the basilica.

4. PALAZZI AND LATE WORKS. Della Porta's prestigious position as architect to St Peter's and his support from Cardinal Farnese allowed him to monopolize Roman patronage. His activities were further assisted by a papal bull (1573) that gave those who built large palaces the right to expropriate adjoining owners, thus encouraging the expansion of the construction industry. Palaces designed by della Porta include Palazzo Fani (now Pecci–Blunt), Palazzo Crescenzi on the Via del Seminario, and Palazzo Maffei.

In 1577 della Porta was commissioned to recommence the works begun by Pirro Ligorio at La Sapienza (University of Rome), which had been suspended in 1566. In 1580 work began on the construction of della Porta's designs for S Maria dei Monti (completed 1588), which was financed by Gregory XIII, and S Atanasio dei Greci (1580–83; see fig. 2); and from 1581 to 1586 he built the façade of S Luigi dei Francesi. In 1583 della Porta continued the work begun by Antonio da Sangallo (ii) at S Giovanni dei Fiorentini, where he added eight side chapels and vaulted the nave and aisles. After the death of Gregory XIII, who had involved him in all his major schemes, and with the election of Sixtus V, della Porta was eclipsed as a public architect by Domenico Fontana. He nevertheless remained architect to St Peter's and continued to undertake private commissions, building the Palazzo Muti all'Aracoeli and a palazzo for himself in Piazza dell'Aracoeli, which became the nucleus of the Palazzo Massimo. Della Porta regained a dominant position under Clement VIII, however, and important works from the last decade of his life include the restoration of the crossing in S Giovanni in Laterano, the completion of the Clementine Chapel in St Peter's and the Aldobrandini Chapel in S Maria sopra Minerva. His last commission was the construction of the Villa Aldobrandini (begun 1601) at FRASCATI. In 1602 the main body of the villa was almost finished; it was completed after his death by Carlo Maderno.

2. Giacomo della Porta: façade of S Atanasio dei Greci, Rome, 1580–83; engraving from Joachim von Sandrart: *Insignium Romae templorum prospectus* (1690)

BIBLIOGRAPHY

DBI

G. Baglione: *Vite* (1642); ed. V. Mariani (1935)

O. Pollak: 'Ausgewählte Akten zur Geschichte der Römischen Peterskirche, 1535–1621', *Jb. Kon. Preuss. Kstsamml.*, xxxvi (1915), pp. 74, 84, 111–15

G. Giovannoni: *Saggi sull'architettura del rinascimento* (Milan, 1935), pp. 179–235

A. Nava: 'La storia della chiesa di S Giovanni dei Fiorentini nei documenti del suo archivio', *Archv. Real. Deput. Romana Stor. Patria*, lix (1936), pp. 337–62

P. Pecchiai: *Acquedotti e fontane di Roma nel cinquecento* (Rome, 1944)

——: *Il Gesù di Roma* (Rome, 1952)

K. Schwager: 'Kardinal Pietro Aldobrandinis Villa di Belvedere in Frascati', *Röm. Jb. Kstgesch.*, ix (1961–2), pp. 291–382

C. D'Onofrio: *La villa aldobrandini a Frascati* (Rome, 1963)

J. S. Ackermann and W. Lotz: 'Vignoliana', *Essays in Memory of Karl Lehmann*, ed. L. Freeman Sandler (New York, 1964), pp. 1–24

J. Wasserman: 'Giacomo della Porta's Church for the Sapienza in Rome and Other Matters Relating to the Palace', *A. Bull.*, xlvi (1964), pp. 501–10

J. S. Ackermann: 'Della Porta's Gesù Altar', *Essays in Honor of Walter Friedlaender* (New York, 1965), pp. 1–2

C. D'Onofrio: *Gli obelischi di Roma* (Rome, 1967)

H. Hibbard: 'Giacomo della Porta on Roman Architects', *Burl. Mag.*, cix (1967), pp. 713–14

L. W. Partridge: 'Vignola and the Villa Farnese at Caprarola', *A. Bull.*, lii (1970), p. 86, n. 44

L. Chappel and W. C. Kirvin: 'A Petrine Triumph: The Decoration of the Navi Piccole in S Pietro under Clement VIII', *Stor. A.*, 21 (1974), pp. 150–54

C. von Henneberg: *L'oratorio dell'arciconfraternità del Santissimo Crocifisso di San Marcello* (Rome, 1974)

L. H. Heydenreich and W. Lotz: *Architecture in Italy, 1400 to 1600*, Pelican Hist. A. (Harmondsworth, 1974)

V. Tiberia: *Giacomo della Porta: Un architetto tra manierismo e barocco* (Rome, 1974)

K. Schwager: 'Giacomo della Porta: Herkunft und Anfänge in Rom', *Röm. Jb. Kstgesch.*, xv (1975), pp. 111–14

C. D'Onofrio: *Acque e fontane di Roma* (Rome, 1977)

J. von Henneberg: 'Emilio dei Cavalieri, Giacomo della Porta and B. G. Montano', *J. Soc. Archit. Hist.*, 36 (1977), pp. 252–5

W. Lotz: 'Vignola et Giacomo della Porta', *Le Palais Farnèse*, i (Rome, 1981), pp. 225–41

A. Bedon: 'Uniatismo apostolato e colonialismo religioso nell'età di Gregorio XIII: La chiesa di S Atanasio di rito greco', *Ant. Viva*, xxii (1983), pp. 87–96

K. Schwager: 'Die architektonische Erneuerung von S Maria Maggiore unter Paul V', *Röm. Jb. Kstgesch.*, xx (1983), pp. 223–6, 286–8

B. Boesel: *Jesuitenarchitektur in Italien, 1540–1773* (Vienna, 1985)

G. C. Argan and B. Contardi: *Michelangelo architetto* (Milan, 1990)

ALESSANDRA ANSELMI

Porta, Giuseppe. *See* SALVIATI, GIUSEPPE.

Portelli (da Loro), Carlo (*b* Loro Ciuffenna, before ?1510; *d* Florence, 15 Oct 1574). Italian draughtsman and painter. Though little known today, he had an active career in Florence alongside such Mannerist artists as Pontormo, Bronzino and Francesco Salviati. Trained by Ridolfo Ghirlandaio, he developed a Mannerist style, best seen in his drawings, in which figures in the style of Michelangelo are defined by flowing, thin contours and faint washes, articulated with nervous curves and given character with stylized faces and pronounced, Pontormo-like round eyes. The documents of his life, examined by Colnaghi, are the basis for the oeuvre proposed by Barocchi, Pace and others. Portelli was active in the Arte de' Medici e Speziali by 1545 and in the Accademia del Disegno from its foundation in 1563 until his death; he is mentioned briefly by Vasari as having painted some panels and a great number of other paintings in Florentine churches. Most notable among his Florentine patrons were the Medici: for example, he produced decorations (with Salviati) for the wedding of Cosimo I to Eleonora de Toledo (1539) and for that of Francesco I to Joanna of Austria (1565). His paintings included a work (untraced) for the *studiolo* of Francesco I (1570–73; Florence, Pal. Vecchio), for which a drawing has been proposed (Smith). Other works include two lost pictures of the *Crucifixion* after a design by Salviati (Colnaghi), a *Martyrdom of St Romulus* (Florence, S Maria Maddalena de' Pazzi) and the *Crucifixion with the Virgin, SS John, Anthony Abbot and Francis, and Donors* (Florence, Mus. S Salvi). Writing from the viewpoint of Tridentine reforms, Raffaele Borghini highly criticized Portelli's painting and observed that he was surpassed by his pupil Tommaso Manzuoli, better known as Maso da San Friano.

BIBLIOGRAPHY

Colnaghi

G. Vasari: *Vite* (rev. 2/1568); ed. A. Salani (1963), vi, pp. 126–7, *passim*

Il riposo di Raffaele Borghini (Florence, 1584); facs. ed. M. Rosci (Milan, 1967), 2 vols, pp. 202, 539

D. E. Colnaghi: *Dictionary of Florentine Painters from the 13th to the 17th Centuries* (London, 1928/*R* Florence, 1986)

L. Hendel Sarsini: 'Un'opera di Carlo Portelli nello studiolo di Francesco I', *Riv. A.*, xxxv (1960), pp. 99–102

P. Barocchi: 'Proposte per Carlo Portelli', *Festschrift Ulrich Middeldorf* (Berlin, 1968), pp. 283–9

V. Pace: 'Carlo Portelli', *Boll. A.*, 3rd ser., lviii (1973), pp. 27–33

G. Corti: 'Notizie inedite sui pittori fiorentini Carlo Portelli, Maso da San Friano, Tiberio Titi, Francesco Furini, Fabrizio e Francesco Boschi, Giovanni Rosi', *Paragone*, xxviii/331 (1977), pp. 55–66

E. Pillsbury: 'A Medici Portrait by Carlo Portelli', *Essays Presented to Myron P. Gilmore*, ii (Florence, 1978), pp. 289–300

S. Padovani and S. Meloni: *Il cenacolo di Andrea del Sarto a San Salvi: Guida del museo* (Florence, 1982)

G. Smith: 'Carlo Portelli', *Sixteenth-century Tuscan Drawings from the Uffizi* (exh. cat., ed. A. Petriole Tofani and G. Smith; Detroit, MI, Inst. A., 1988), pp. 102–3

B. Santi: 'La predella della Lamentazione di Lucco di Mugello: Una proposta per Carlo Portelli', *Ant. Viva*, xxviii/2–3 (1989), pp. 8–14

L. Hendel Sarsini: 'Intorno a due tavole di Carlo Portelli', *Riv. A.*, xlii (1990), pp. 261–71

MILES L. CHAPPELL

Portigiani, Pagno di Lapo. *See* PAGNO DI LAPO.

Portinari, Tommaso (*b* Florence, 1428; *d* Florence, 15 Feb 1501). Italian banker and patron of the arts. The best-known Florentine patron of Netherlandish painting, Portinari spent over 40 years in Bruges, in the course of which he achieved pre-eminence in its Italian mercantile colony. He went to the Bruges branch of the Medici bank as a junior employee *c.* 1440, a position he held for many years, during which he built up lucrative contacts and gained a foothold at the Burgundian court. Egotistical and ambitious, he came to resent his subordinate position and eventually, in 1465, persuaded the Medici to appoint him manager. This proved to be disastrous. So gravely did he mismanage its finances that by 1478 the Bruges branch was bankrupt.

Portinari abused his position as head of the most prestigious bank in Bruges to further his career at the Burgundian court, the magnificence and refinement of which fascinated him, and which he emulated in his own patronage. His headquarters was the Bladelinhof, one of the most splendid houses in Bruges; he erected a chapel in the St Jakobskerk and was a prominent member of the prestigious Confraternity of the Dry Tree, and he dressed himself and his wife, Maria Maddalena Baroncelli, in the costliest Burgundian fashion. He was adviser to two dukes of Burgundy, Philip the Good (1396–1467) and Charles the Bold (1433–77), advancing to the latter loans that were largely responsible for crippling the bank. Portinari returned to Florence in 1477 but was forced to take on the debts of the liquidated Bruges branch in 1480. He returned to the Netherlands in connection with this, and with diplomatic missions for Lorenzo de' Medici and Maximilian I of Austria (1459–1519).

Portinari owned three outstanding works by Netherlandish painters. The first two, datable to shortly after his marriage in 1470, were by Hans Memling (1430/40–1494), a favourite of the Italians in Bruges: the *Passion* (Turin, Gal. Sabauda) and a half-length triptych, of which only the wings with portraits of Tommaso and Maria survive (New York, Met.). The third was by Hugo van der Goes (*c.* 1440–1482), the great triptych of the *Adoration of the Shepherds* (Florence, Uffizi), with portraits of Tommaso and his family on the wings, destined for the Portinari Chapel in the choir of S Egidio, the church of the hospital of S Maria Nuova, Florence. It was probably painted between 1473 and 1478, but did not reach Florence until 1483, its shipment delayed perhaps by Portinari's precarious position at this time.

Portinari's sensitivity to the individual capacities of the painters he employed is manifest in these works. The minute scenes in the *Passion* were the perfect vehicle for Memling, gifted in recording microscopic detail. Memling was also the obvious choice for the half-length triptych, being a specialist in this format and the leading portrait painter in Bruges. Hugo van der Goes, on the other hand, was the only painter then active capable of producing an

imposing work on the vast scale of the Portinari Altarpiece. One of the masterpieces of early Netherlandish painting, it is a fitting monument to a patron motivated in equal measure by connoisseurship and the love of extravagant display.

BIBLIOGRAPHY

A. Grunzweig: *Correspondence de la filiale de Bruges des Medici* (Brussels, 1931)
A. Warburg: 'Flandrische Kunst und florentinische Frührenaissance', *Gesammelte Schriften*, 2 vols (Leipzig and Berlin, 1932), i, pp. 185–206, 370–80
R. De Roover: *The Rise and Decline of the Medici Bank (1397–1494)*, Harvard Studies in Business History (Cambridge, MA, 1963)
B. Hatfield Strens: 'L'arrivo del trittico Portinari a Firenze', *Commentari*, xix, n. s. 1 (1968), pp. 315–19
R. Salvini: *Banchieri fiorentini e pittori di fiandra* (Modena, 1984)
R. Strohm: *Music in Late Medieval Bruges* (Oxford, 1985/*R* 1990), pp. 37, 38, 56, 65, 72, 123, 138
B. G. Lane: 'The Patron and the Pirate: The Mystery of Memling's Gdansk *Last Judgment*', *A. Bull.*, lxxiii/4 (Dec 1991), pp. 623–40
P. Nuttall: 'Memlinc's *Last Judgement*, Angelo Tani and the Florentine Colony at Bruges', *Polish and English Responses to French Art and Architecture: Contrasts and Similarities: London, 1993*, pp. 155–65

PAULA NUTTALL

Porto, da. Italian family of nobles and patrons. Known in Vicenza from the 11th century, it was among the oldest and most powerful of the ruling families there; its members held prominent positions in military, judicial and intellectual circles. In 1532 the family received the title of Count from Emperor Charles V (*reg* 1519–56) and was subsequently one of the most cohesive nuclei supporting the Reformist doctrines of John Calvin (1509–64). The Palazzo da Porto–Colleone, Contrà Porti, was the family's principal residence in Vicenza. A famous theatrical performance, with a wooden theatre designed by Sebastiano Serlio, took place in its courtyard in 1539. Several important palazzi and villas in Vicenza attributed to ANDREA PALLADIO are connected to various branches of the family, most importantly the Palazzo Porto (see below); others were the Villa Porto, Vivaro di Dueville (later Villa Filotto, Villa Bressan and Villa Mencato, 1554), for Paolo da Porto, and the Palazzo Porto al Castello (now Palazzo da Porto–Breganze, after 1571) for Alessandro da Porto or possibly Canon Simone da Porto, later partly finished by Vincenzo Scamozzi.

Iseppo [Giuseppe] da Porto (*d* Vicenza, 8 Nov 1580), the most notable patron of the family, was the son of Gerolamo da Porto and distinguished himself as a commander in the Venetian forces. Sometime between 1542 and 1545 he married Livia Thiene, the sister of Marcantonio Thiene. In 1547 he was among the Vicentine nobles accused of heresy, but he subsequently re-entered public life and was appointed to high posts. A patron of Palladio and Paolo Veronese, Iseppo is shown in two portraits (*c.* 1554) by Veronese, with his eldest son, Adriano (Florence, Pitti), and with Livia together with her daughter Porzia (Baltimore, MD, Walters A.G.). The Palazzo Porto, Contrà Porti (now Palazzo da Porto–Festa, begun *c.* 1547), adjacent to the Palazzo Porto–Colleone, was Iseppo's principal act of patronage and is one of Palladio's most important palazzi in Vicenza. It was designed to run from the Contrà Porti to the Strada della Stalli, enclosing a magnificent peristyle courtyard; the front, the only part to be built, was intended for family use, and the rear for guests and independent apartments for the sons. The interior decoration is by Veronese. Iseppo was apparently also the client for the Villa Porta–Colleone (later Villa Thiene, *c.* 1572; destr.) in Molina, attributed to Palladio. He was also involved in other works of Palladio in Vicenza: he was *provveditore* (1561–2) for the works of the Palazzo della Ragione Basilica (begun 1548) and, as *deputato* (1571–2), authorized work on the Loggia del Capitaniato (early 1570s); he also supported the construction of the Teatro Olimpico (1580).

BIBLIOGRAPHY

DBI
E. Forssman: *The Palazzo da Porto Festa in Vicenza*, Corpus Palladianum, viii (Pennsylvania, 1973)
G. Cracco, ed.: *Storia di Vicenza*, iii (Vicenza, 1989)

For further bibliography see PALLADIO, ANDREA.

Portoghese, Alvaro. *See* PIREZ, ALVARO.

Pouncing [Fr.: *poncer*; It.: *spolvero*]. Transfer process in which powder or dust is rubbed through a pricked design, creating a dotted underdrawing on the surface beneath. Though primarily known as an Italian Renaissance technique for translating designs from a CARTOON to the moist plaster in FRESCO painting, pouncing had a wide application in the work of artists, craftsmen and amateurs. Draughtsmen, easel painters, illuminators, embroiderers, lacemakers, ceramicists, printmakers and writing-masters used pouncing to duplicate their designs. The drawing to be reproduced was placed over the working surface (paper, cloth, wall or panel), and the outlines of the design were pricked with a pointed implement such as a needle or stylus and rubbed with pounce (powder or dust of black chalk, charcoal or pumice if the support was light; of white chalk, gesso or light pumice powder if the support was dark) contained in a pouncing bag (a small cloth pouch with its end tied). The advantages of pouncing compensated for the laboriousness of the task: precise correspondence between drawing and final work was assured; a painter could delegate the task to an assistant; and once a drawing was pricked it could be reused to repeat designs or, by pouncing the verso, to create symmetrical patterns and complementary figures. Armenini described in his *De' veri precetti della pittura* (1586) how artists also used pouncing to reduce the effort of drawing the chiaroscuro in a cartoon. The areas representing shadows were tapped with the pouncing bag, so that the settled pounce gave the impression of shaded preliminary drawing.

The earliest written references to pouncing occur in Cennini's *Libro dell'arte* (*c.* 1390), which includes instructions on how to replicate complex gold brocade patterns in panel paintings by means of pounced patterns. Between 1450 and 1520 the pouncing of drawings became routine practice in painters' workshops, but the technique is relatively undocumented in 15th- and 16th-century primary sources. Leonardo's notes of *c.* 1490 for his treatise on painting contain a passing recommendation to use a pricked drawing (cartoon) to pounce designs for panel paintings. For frescoes Armenini described the process of laying a second cartoon ('sub-cartoon' or 'substitute cartoon') underneath the drawn cartoon, pricking both with

Pouncing, method used by Raphael to transfer the design of his cartoon in pen and brown ink over black chalk underdrawing (left), 183×215 mm, to the panel of his tempera painting (right) of the *Vision of a Knight* (*Dream of Scipio*), 171×171 mm, *c*. 1504 (both London, National Gallery)

the needle and using pieces of the substitute cartoon to pounce the design onto the wall. This refinement of the technique spared valuable fresco cartoons from damage or possible destruction. Although both Giorgio Vasari and Vincenzo Borghini possessed pounced drawings in their collections, neither commented on pouncing figural fresco cartoons, probably because the advantages of the technique were mainly those of replication, and it was considered assistants' work, too laborious to be described. Fortunately 16th-century Venetian pattern-books on embroidery and treatises by Paganino, Tagliente, Ostaus and Vecellio document aspects of the practice that would otherwise be lost.

The technique of pouncing appears to have been known by the the mid-10th century in China. Yet the technique emerged in the West only during the late Middle Ages, probably making its way along the Silk Route during the period of trade established between Europe and the Orient, after Marco Polo's return to Venice in 1295. A dissemination of the technique through the Silk Route might especially explain Cennino's allusion to pouncing in connection with painting gold brocade patterns.

Pounce marks first appear in the ornamental parts of mid-14th-century Central Italian frescoes and panels. The earliest function of pouncing in European art was exclusively replicative, to enable the multiple repetition of ornamental motifs. Gradually artists began applying the technique selectively within figural compositions as a means of preparing their design. By the 1430s and 1440s, the practice of pouncing figural cartoons for fresco compositions (often combined with a sinopia underdrawing) became common in the workshops of Italian painters. Among the pioneers of pounced figural cartoons were Paolo Uccello, Domenico Veneziano, Andrea del Castagno and Piero della Francesca. Between 1475 and 1520 pouncing enjoyed its highest popularity among painters and draughtsmen in Italy, especially in Tuscany and Umbria. Nearly all Central Italian painters working in this period seem to have produced pricked and/or pounced

drawings. Leonardo was probably one of the first artists to exploit pouncing creatively in drawing symmetrical or nearly symmetrical designs (e.g. *Study of the Organs of a Woman*, Windsor Castle, Berks, Royal Lib., 12281*r*; *Perspective Study of a Mazzocchio*, Milan, Bib. Ambrosiana, Cod. Atlanticus, VIII, fol. 710b). The exceptional number of pricked and/or pounced drawings by Raphael (see fig; *see also* RAPHAEL, fig. 2; for further illustration *see* CARTOON) bears witness to his systematic use of pouncing in many phases of the artistic process (e.g. Paris, Louvre, 3860; Oxford, Ashmolean, KTP 530*r*, 530*v* and 568*r*; and Chatsworth, Derbys, 67). Even Armenini's description of how a pounced substitute cartoon was produced seems to stem from knowledge of Raphael's workshop practice through his acquaintance with Raphael's assistant Giulio Romano. Between 1520 and 1550 pouncing suffered virtual extinction among painters and draughtsmen, though some artists of the older generation and from provincial outposts stubbornly clung to the technique.

BIBLIOGRAPHY

EARLY SOURCES

C. Cennino: *Il libro dell'arte* (*c*. 1390); Eng. trans. and notes by D. V. Thompson jr as *The Craftsman's Handbook: 'Il libro dell'arte'* (New Haven, 1933/*R* New York, 1954), pp. 3, 6–7, 86–7, 89

A. Paganino: *De rechami pelquale se impara in diversi modi l'ordine e il modo de recamare . . .* (Venice, 1527/*R* 1875–91) [see 'Allessandro Paganino al lettore', *r* and *v*]

G. Tagliente: *Esemplario nuovo che insegna a le donne a cuscire, a reccamare, et a disegnare a ciascuno . . .* (Venice, [?1527], 1531/*R* 1875–91) [see last two pages]

G. Ostaus: *La vera perfettione del disegno di varie sorti di ricami et di cucire punti a fogliami punti tagliati* (Venice, 1567/*R* 1875–91) [see 'Alli saggi et giuditiosi lettori', *r*]

G. B. Armenini: *De' veri precetti della pittura* (Ravenna, 1586/*R* New York, 1971; Eng. trans., New York, 1977), pp. 172–4

C. Vecellio: *Corona delle nobili et virtuose donne . . .* (Venice, 1591/*R* 1875–91)

V. Carducho: *Diálogos de la pintura, su defensa, origen, esencia, definición, modos y diferencias* (Madrid, 1633); ed. F. Calvo Serraller (Madrid, 1979), pp. 385–6

F. Pacheco: *Arte de la pintura, su antigüedad, y grandezas* (MS., 1638; Seville, 1649); ed. F. J. Sánchez Cantón (Madrid, 1956), ii, pp. 2–3, 26–7, 52–3, 76–7

C. Boutet: *Traité de mignature, pour apprendre aisément à peindre sans maître* (Paris, 1676, Eng. trans., 1752), pp. 6–7

F. Baldinucci: *Vocabolario toscano dell'arte del disegno* (Florence, 1681); rev. in *Opere di Filippo Baldinucci*, ed. D. M. Manni (Milan, 1809), ii, pp. 114–15; iii, p. 157

A. Pozzo: 'Breve instruttione per dipingere a fresco', *Perspectiva pictorum et architectorum*, ii (Rome, 1700) [see 'Settione settima: ricalcare']

A. Palomino de Castro y Velasco: *El museo pictórico y escala óptica* (Madrid, 1715–24); ed. M. Aguilar, intro. J. A. Ceán y Bermúdez (Madrid, 1947), pp. 78, 518, 545–6, 579–81, 1152, 1159

F. Milizia: *Dizionario delle belle arti del disegno* (Bassano, 1771; rev. in *Opere complete di Francesco Milizia*, ii, Bologna, 1827), p. 231 [see 'cartoni']

J. P. Richter, ed.: *The Literary Works of Leonardo da Vinci*, i (London, 1888, rev. 1970), p. 319

GENERAL

O. Fischel: 'Raphael's Auxiliary Cartoons', *Burl. Mag.*, lxxi (1937), pp. 167–8

R. Oertel: 'Wandmalerei und Zeichnung in Italien', *Mitt. Ksthist. Inst. Florenz*, v (1940), pp. 217–314

S. A. Ives and H. Lehmann-Haupt: *An English 13th-century Bestiary: A New Discovery in the Technique of Medieval Illumination* (New York, 1942)

E. Borsook: *The Mural Painters of Tuscany* (London, 1960, rev. Oxford, 2/1980), pp. xxxiv–xxxvi, xliv–xlvi, 72–3, 91, 95–7, 107–8, 114–15, 119–20

D. Miner: 'More about Medieval Pouncing', *Homage to a Bookman: Essays . . . for Hans P. Kraus on his 60th Birthday* (Berlin, 1967), pp. 87–107

B. Degenhart and A. Schmitt: *Süd- und Mittelitalien* (1968), i of *Corpus der italienischen Zeichnungen, 1300–1450* (Berlin, 1968–90), pp. xxxvii–xxxix

J. Taubert: 'Pauspunkte in Tafelbildern des 15. und 16. Jahrhunderts', *Bull. Inst. Royal Patrm. A.*, xv (1975), pp. 387–401

J. Meder and W. Ames: *The Mastery of Drawing*, i (New York, 1978), pp. 391–9

B. Degenhart and A. Schmitt: *Venedig: Addenda zu Süd- und Mittelitalien* (1980), ii of *Corpus der italienischen Zeichnungen, 1300–1450* (Berlin, 1968–90), pp. 136–72

M. Koller: 'Die technische Entwicklung und künstlerische Funktion der Unterzeichnung in der europäische Malerei vom 16. bis zum 18. Jahrhundert', *Colloque IV pour l'étude du dessin sous-jacent dans la peinture: Louvain, 1981*, pp. 173–89

C. Bambach Cappel: 'Michelangelo's Cartoon for the *Crucifixion of St Peter* Reconsidered', *Master Drgs*, xxv (1987), pp. 131–42

——: *The Tradition of Pouncing Drawings in the Italian Renaissance Workshop: Innovation and Derivation* (diss., New Haven, CT, Yale U., 1988)

——: 'Leonardo, Tagliente, and Dürer: 'La scienza del far di groppi', *Achad. Leonardi Vinci: J. Leonardo Stud. & Bibliog. Vinciana*, iv (1991), pp. 72–98

——: 'A Substitute Cartoon for Raphael's *Disputa*', *Master Drgs*, xxx (1992), pp. 9–30

——: 'Pounced Drawings in Leonardo's *Codex Atlanticus*', *Achad. Leonardi Vinci: J. Leonardo Stud. & Bibliog. Vinciana* (in preparation)

——: *The Pouncer's Art: Design Theory and Workshop Practice in Renaissance Italy* (New York, in preparation)

CARMEN BAMBACH CAPPEL

Prato. Italian city in Tuscany. It lies on the River Bisenzio, *c.* 14 km north-west of Florence. It is a centre of the textiles industry, which was begun in the Middle Ages. The area was inhabited from the Bronze Age: signs of an Etrusco-Roman settlement have been found in the city centre, and there was a military settlement here during the Roman period. In the 10th century Prato was part of the vast domain ruled by the Alberti family, Counts of Prato. From *c.* 1000 Prato expanded as its commercial and industrial activities developed, despite numerous internal struggles and wars with neighbouring cities. From early medieval times Prato was famous for its textiles, particularly the production of woollen fabrics; by the 13th century cloth was being exported all over Europe.

As Prato expanded and grew wealthier, new churches were built and existing ones remodelled, beginning with the cathedral in the 14th century. The crossing and transepts were added, together with Gothic arches and vaulting, the presbytery and its five chapels and the five-storey campanile. The external pulpit of the Sacro Cingolo (1433–8) was later designed by Donatello and Michelozzo di Bartolomeo and decorated with reliefs by Donatello (originals now in Prato, Mus. Opera Duomo). Prato came under Florentine rule in 1351, and the numerous building projects of the period generated intense artistic activity, involving both local artists and those from Pisa, Siena and Florence. Fra Filippo Lippi painted a celebrated fresco cycle (1452–66) of the *Evangelists* and scenes from the *Lives of SS John the Baptist and Stephen* in the cathedral choir (*see* LIPPI, (1)). Maso di Bartolommeo and Pasquino da Montepulciano had workshops in Prato producing high-quality work in bronze, gold and silver. An outstanding architectural work of the period was Giuliano da Sangallo's S Maria delle Carceri (1485–99), designed for Lorenzo de' Medici (for further discussion and illustration *see* SANGALLO, (1), and fig. 1).

BIBLIOGRAPHY

I. Origo: *The Merchant of Prato* (London, 1957)

P. Vestri and S. Bardazzi: *Prato: Nascita e sviluppo di una città di mercanti* (Turin, 1983)

R. Fantappiè: *Il bel Prato*, 2 vols (Prato, 1984)

G. Mugnaini: *Prato* (Prato, 1988) [bibliog. of works on local history, art and archit.]

□

Prato, Francesco (di Girolamo Ortensi) dal (*b* Caravaggio, 1512; *d* Florence, 13 Oct 1562). Italian medallist, painter, sculptor, goldsmith and armourer. The son of Girolamo d'Andrea degli Ortensi (Girolamo dal Prato), a goldsmith and medallist, he was called 'dal Prato' after the location of his dwelling on the Prato d'Ognissanti in Florence. Vasari described him as the best goldsmith of his time and mentioned that he had made a fine medal of *Alessandro de' Medici, Duke of Florence* (untraced), which was placed in the foundations of the gate at Faenza, and another, a struck piece, of *Pope Clement VII* (?1529–30; Florence, Bargello) with a reverse of Christ bound to a column for the flagellation, commemorating the Pope's imprisonment during the Sack of Rome (1527). His identity as a medallist, however, is precarious, as his work and that of DOMENICO DE' VETRI have long been confused, and, since there are no signed medals, his oeuvre has not yet been established. Aside from the surviving *Clement VII* mentioned by Vasari, the only other medal generally attributed to him, another of *Alessandro de' Medici* (1534; Kress, no. 317), exists in cast examples, although it was probably originally struck; the portrait is without distinction, and the reverse shows a figure of *Peace* setting fire to a pile of arms.

BIBLIOGRAPHY

Forrer

G. F. Hill and G. Pollard: *Renaissance Medals from the Samuel H. Kress Collection at the National Gallery of Art* (London, 1967), p. 60 [Kress]

G. Pollard: *Italian Renaissance Medals in the Museo Nazionale del Bargello*, ii (Florence, 1985), pp. 673–6

STEPHEN K. SCHER

Prato, Giovanni di Gherardo da. *See* GIOVANNI DI GHERARDO DA PRATO.

Pratolino. Villa and gardens 12 km north-east of Florence, Italy. They were created between *c.* 1569 and 1581 for

Francesco I de' Medici by BERNARDO BUONTALENTI. By the end of the 16th century the garden was probably the most famous in Europe, because of its grottoes, *giochi d'acqua* and automata. It undoubtedly expressed an iconographic programme, but no totally convincing one has yet been proposed.

According to Montaigne (*Voyage à l'Italie. . .*), the Prince chose (mid-November 1580) a barren, very mountainous and waterless site (of 250 ha) in order to demonstrate his mastery over nature. Its water displays, which especially intrigued English visitors from Fynes Moryson (1617) onwards, were designed to excel those of the Villa d'Este (*see* TIVOLI, §1).

The house was sited halfway up a hill, which sloped southwards, with the main garden on the south side. Because of the nature of the ground, it was not possible to construct a series of terraces, making the garden seem rather old-fashioned compared to Roman designs of the same period. Around the house was a broad platform with a balustrade, under which lay one of the chief attractions, the grottoes—the first and biggest was that of the Flood, and there were seven others. Here were the *giochi d'acqua*. In the first, when you sat down on an inviting bench to admire the sculpture, 'by a single movement the whole grotto is filled with water, and all the seats squirt water to your backside' (Montaigne). As you ran up the stairs outside to escape, the gardener 'may let loose a thousand jets of water from every two steps of that staircase'.

Automata made music and noises of every kind and gave the illusion of moving men and beasts—Pan, Silenus and Syrinx—and 'numerous animals that dive to drink' (Montaigne). They served not only to represent an allegory (for an easy interpretation see de Vieri) but also to demonstrate scientific ingenuity in imitation of the mechanical marvels described by Hero of Alexandria (1st century AD) in his *Pneumatica*, a work that circulated in manuscript before its first printing (in Latin, 1575; in Italian, 1589) and influenced Italian Renaissance garden design.

From the centre of the balustrade ran a long avenue, '50 feet wide and about 500 paces long' (Montaigue), bordered on both sides by a free-stone wall, from which at every 5 or 10 paces sprang fountains, so that all along the walk nothing but jets could be seen. This did not act as a central axis, however, for fountains, aviaries, grottoes, fish-tanks and mounds were scattered quite randomly around the garden. At the end of the walk there was a fountain that discharged its water into a great *bassin* via a marble statue of a woman doing her washing. She squeezed out a 'tablecloth' of white marble, from which the water fell; beneath this was another vessel, where the water seemed to be boiling. Behind the house, the rising ground was cut out in the form of an amphitheatre, which was dominated by the colossal statue of the *Appenines* (1570–80) by Giambologna (see colour pl. 1, XXXIII3) in the shape of an old man seated on a rock, pressing his hand on the head of a monster so that the water gushes out of its mouth and falls into a semicircular *bassin*. Behind the statue were three avenues leading to a round labyrinth, at the extreme end of which was a fountain acting as a reservoir. The garden was destroyed to make a *giardino*

inglese in 1819, and the only suriving features are the retaining wall and the statue of the *Appenines*.

BIBLIOGRAPHY

F. de Vieri: *Discorsi. . .della maravgliose opere di Pratolino e d'amore* (Florence, 1586)

F. Moryson: *Itinerary*, 4 vols (1617/R Glasgow, 1907–8)

B. Sgrilli: *Descrizione della regia villa, fontane e fabbriche di Pratolino* (Florence, 1742)

M. de Montaigne: *Journal de voyage à l'Italie. . .en 1580–81*, ed. C. Dedeyan (Paris, 1946), pp. 185–6

W. Smith: 'Pratolino', *J. Soc. Archit. Historians.*, xx (1961), pp. 155–68

D. Heikamp: 'Pratolino, suoi giorni splendidi', *Ant. Viva*, viii (1969), pp. 14–34

L. Zangheri: 'L'acqua a Pratolino, da elemento naturale ad artifizio "maraviglioso"', *Il giardino storico italiano*, ed. G. Ragionieri (Florence, 1981), pp. 355–61

PATRICK GOODE

Predis [Preda]**, de.** Italian family of artists. The family is first documented in Lombardy in 1467 and was repeatedly cited at least until 1508. Leonardo de Predis married three times and had six sons, of whom (1) Cristoforo de Predis, (2) Giovanni Ambrogio de Predis and Evangelista de Predis (*b* 1440–50; *d* 1490–91) were those mainly involved in artistic activity. Another son, Bernardino, collaborated with Giovanni Ambrogio, but no independent work by him is known. Evangelista, Cristoforo's brother, is mentioned in a document dated 1472. He lived with Giovanni Ambrogio in the Porta Ticinese quarter of Milan, in a house where Leonardo da Vinci stayed for some time during his residence in the city. The contract for the altarpiece commissioned by the Confraternità dell' Immacolata Concezione for S Francesco Grande, Milan, which contained Leonardo's *Virgin of the Rocks* (London, N.G.; *see* LEONARDO DA VINCI, fig. 2), mentions him as collaborating with Leonardo and Giovanni Ambrogio.

(1) Cristoforo de Predis (*b c.* 1440; *d* before 1486). Illuminator. His oeuvre has been reconstructed on the basis of four signed works, the chronology of which remains controversial. The first mention of Cristoforo is in a notarial act of September 1467, concerning the division of the paternal inheritance, in which he is described as 'mutus' (mute). His name is mentioned again, in the same connection, in a letter dated 1472. Cristoforo worked as an illuminator at least from 1471, when a payment to him is recorded in the archives of the Borromeo family: he received money or gifts, especially articles of clothing, from the family until 1474. It was probably in this period that he decorated the Borromeo Book of Hours (Milan, Bib. Ambrosiana). The work is signed but not dated. In this work his elegant and refined style is combined with Renaissance motifs, and these became more substantial in his mature works.

Cristoforo's training was based on the study of miniatures painted by the French artist Jean Colombe (*fl* 1463–98) and the Flemish masters active in the Burgundian court, such as Philippe de Mazerolles (*c.* 1420–1479) and Jean Hennecart (*fl* 1454–70). His contact with these artists came not only through the importation of their works into Italy but also through the presence of northern European artists in Lombardy. Cristoforo established a reputation in Milan, and won important commissions from noble Milanese families and from the Duke of Milan Galeazzo

Maria Sforza himself, as witnessed by two miniatures (London, Wallace) that are fragments of a codex decorated for the Duke. The larger of these (see fig.) bears an inscription with the signature (OPUS. XPOFORI. DE. PREDIS. MUTI) and the partly effaced date (DIE. APR. 147.). It depicts Galeazzo Maria Sforza praying in the background of a scene of war, an allusion to the Duke's military expedition into France (1465). The style strongly reflects a Flemish influence and probably also that of the court portraits of Zanetto Bugatto. Cristoforo was also influenced by Lombard miniatures, especially those of Belbello da Pavia, and also by the north European tradition, with its emphasis on minute detail.

In 1476 Cristoforo decorated the *Missal of the Madonna del Monte* (Varese, Mus. S Maria del Monte) for the Bishop of Piacenza, Fabrizio Marliani, whose arms are reproduced on the first page and who donated it to the monastery of the Sacromonte in Varese. In this Cristoforo moved away from the influence of Flemish art and began to use linear perspective. His play of fantasy unites with the new directions present in Lombard art in his masterpiece, the New Testament (Turin, Bib. Reale; cod. var. 124). This ambitious work shows the lives of SS Anne and Joachim, the Virgin Mary, Jesus and St John the Baptist, and scenes of the Apocalypse. It is signed and dated 6 April 1476. In some pages, illuminated with the help of collaborators, the artist shows a familiarity with the works of Giovanni Antonio Amadeo, Ambrogio Bergognone and the artisans then working on the windows of Milan Cathedral.

Cristoforo de Predis: miniature and arms of Galeazzo Maria Sforza, Duke of Milan, 230×194 mm, 147(?) (London, Wallace Collection)

Cristoforo can probably also be credited with the *Biblical Commentary of Nicolò de Lira* (Milan, Bib. Ambrosiana), which was decorated before 1486 and belonged to Cardinal Federico Fregoso. The finesse of the style and the influence of fable are combined with the features already present in his certainly attributed works. Also attributed to him are the decoration of the Choir-book of the chapel of Ercole I (Modena, Bib. Estense, cod. lat. P.I.6) and of the *De Sphaera* (Modena, Bib. Estense, cod. lat. 209). The miniatures for these codices were painted mainly by Cristoforo's pupils, probably under the supervision of the master, who himself executed only a few initials. Cristoforo headed an important workshop, where his brother Giovanni Ambrogio trained, as did Ambrogio da Marliano and Giovanni Pietro Birago.

(2) Giovanni Ambrogio de Predis (*b* Milan, *c.* 1455; *d* after 1508). Painter and illuminator, half-brother of (1) Cristoforo de Predis. He began his career as an illuminator, working with Cristoforo. His first documented works are seven miniatures for a Book of Hours (1472; destr.) for Vitaliano Borromeo (1451–95) and a Book of Hours for Francesco Borromeo. He was paid for the latter in 1474, and the codex can probably be identified with the *Horae Beatae Virginis Mariae* (ex-H. P. Kraus, New York, 1987; Suida, 1959). From 1479 he artist worked in the Milanese mint, together with his brother Bernardino. For some years Giovanni Ambrogio also worked at the court of Ludovico Sforza ('il Moro'), especially as a portrait painter. This is borne out by the charcoal drawing of *Bianca Maria Sforza* (1492; Venice, Accad.), which dates from a period before her marriage to Emperor Maximilian I (*reg* 1493–1519). The portrait was ordered by her future husband, through Frederick III, Duke of Saxony, to give him an idea of her appearance. It was favourably received, and later a painting of the same subject (Washington, DC, N.G.A.) was commissioned from Giovanni Ambrogio. In 1482 the artist travelled to Ferrara on orders of Ludovico Sforza to paint a portrait of *Duchess Eleonora d'Este*.

As court artist, Giovanni Ambrogio gave hospitality to Leonardo da Vinci on his arrival in Milan in 1483. In this year Leonardo, Giovanni Ambrogio and Evangelista de Predis were commissioned by the Confraternità dell'Immacolata Concezione to complete the altarpiece and paint three pictures for their chapel in S Francesco Grande, Milan. While Leonardo painted the central panel with the *Virgin of the Rocks* (London, N.G.), the two de Predis brothers worked on the side panels. The left-hand panel shows an *Angel in Green with a Vielle* and the right one an *Angel in Red Playing the Lute* (both London, N.G.). Giovanni Ambrogio probably also contributed to the painting of the central part of the altarpiece, which shows a certain awkwardness in places and some harsh colours. The angels at the sides are unsuccessful as pendants. They may be by both Evangelista and Giovanni Ambrogio, or by one of them at different dates (Davies, 1951); alternatively, it has been suggested that the one on the left, painted in a more modern, dramatic style, is by Francesco Napoletano, a disciple of Leonardo (Brown, 1984). Several documents attest that Leonardo and Giovanni Ambrogio (without Evangelista, who had probably died) worked

together for the Confraternità until the 1490s (*see* LEONARDO DA VINCI, §I, 2).

When Bianca Maria Sforza went to Innsbruck, already married by proxy to Emperor Maximilian I, she took with her a *Maestà* painted by Giovanni Ambrogio, who in 1493 followed her in person to the German court. In the meantime he continued to work for the Este court, as evidenced by correspondence from Anna Maria d'Este in Ferrara concerning a portrait commission and by his portrait of *Ludovico Sforza, il Moro* made at this time. At the imperial court he carried out several commissions, including the portrait of the *Duchess Caterina with a Lady of the Court*, which was later sent to Beatrice d'Este. In 1494, together with Francesco Galli and Accino da Lecco, who were already active in the imperial mint, Giovanni Ambrogio was appointed by Emperor Maximilian I to work on the design of new coins. He then returned to Milan, where he was treated after, an accident, by Ludovico Sforza's personal physician (who was also de Predis's brother-in-law). In 1497–8 he illuminated two portraits in profile of *Ludovico Sforza, il Moro* and his son *Maximilian* in the *Grammatica di Elio Donato* (Milan, Castello Sforzesco).

Meanwhile imperial commissions continued to keep Giovanni Ambrogio busy. In 1498 and for some years afterwards, together with his brother Bernardino, he supervised the execution of six tapestries designed by himself, a project supported by two Milanese bankers, Giovan Pietro Porro and Costanzo da Ello. He also made designs for dress fabrics and took part in the preparation of stage scenery. In 1502 he produced the only signed and dated work that has survived, the portrait of *Emperor Maximilian* (Vienna, Ksthist. Mus.), which conforms to a 15th-century tradition of the profile portrait against a dark background. The outdated approach and the uneven quality of the work have cast doubt on the attribution to de Predis of other works, which are in a more modern style and reveal a response to the innovations of Leonardo da Vinci. In 1509 he had not yet been finally paid for these works.

Giovanni Ambrogio is not mentioned after 23 October 1508; his death probably occurred near that date, unless he was the 'magistro Ambrosio Pictore' mentioned in a document of 7 March 1522 as residing in Milan in the parish of S Eufemia. His oeuvre, which consists exclusively of portraits, remains disputed. All his religious works are lost, except possibly for a *Virgin* (Cleveland, OH, Mus. A.). Along with the one certain work there are various controversial attributions. Among those most widely accepted is the *Portrait of a Young Man* (Milan, Brera), which shows the painter's effort to meet the new challenges posed by Leonardo. Its clear drawing and effects of light and shade bring this painting close to the portrait of *Francesco di Bartolomeo Archinto* (1494; London, N.G.; see fig.), which is inscribed with the monogram *Am Pr F* and thus seems to be securely attributable to Ambrogio. Other convincing attributions are the portrait of *Bianca Maria Sforza* (Paris, Louvre) and the portrait of *Beatrice d'Este* (Milan, Ambrosiana). Other works connected with his name are the portrait of *Francesco Sforza as a Child* (Bristol, Mus. & A.G.), the *Portrait of a Woman* (Paris, Mus. Jacquemart-André), the *Portrait of an Old Man* (Philadel-

Giovanni Ambrogio de Predis: *Francesco di Bartolomeo Archinto*, tempera on panel, 533×381 mm, 1494 (London, National Gallery)

phia, PA, Mus. A.) and the *Profile of a Young Man* (Cambridge, MA, Fogg).

BIBLIOGRAPHY

F. Malaguzzi Valeri: 'Ambrogio Preda e un ritratto di Bianca Maria Sforza', *Rass. A.*, 2 (1902), pp. 93–4

W. von Seidlitz: 'Ambrogio Preda und Leonardo da Vinci', *Jb. Ksthist. Samml. Allhöch. Ksrhaus.*, xxxvi (1906), pp. 1–48

G. Biscaro: 'Intorno a Cristoforo Preda, miniatore milanese del secolo XV', *Archv Stor. Lombardo*, xxxvii (1910), pp. 223–6

F. Malaguzzi Valeri: *La corte di Ludovico il Moro*, 4 vols (Milan, 1915–20), ii, pp. 256, 372, 374, 388, 390–93; iii, pp. 5–6

A. Venturi: *Leonardo da Vinci pittore* (Bologna, 1920), pp. 15–16

F. Wittgens: 'Cristoforo De Predis', *La Bibliofilia*, xxxvi (1934), pp. 341–70

M. Davies: *The Earlier Italian Schools*, London, N.G. cat. (London, 1951, 2/1961/*R* 1986)

W. Suida: 'Giovanni Ambrogio De Predis miniatore', *A. Lombarda*, iv (1959), pp. 67–73

B. Berenson: *Central and North Italian Schools*, i (1968), p. 108

D. A. Brown: 'A Leonardesque Madonna in Cleveland', *Scritti di storia dell'arte in onore di Federico Zeri*, ed. M. Natale (Milan, 1984), pp. 291, 302

F. Russoli: 'Ritratto di musico', *Leonardo: La pittura*, ed. G. C. Argan (Florence, 1985), pp. 63–5

M. Chirico de Biasi: 'Giovanni Ambrogio de Predis', *La pittura in Italia: Il quattrocento*, ed. F. Zeri (Milan, 1986, rev. 1987), p. 615

R. Passoni: 'Il Codice Varia 124 della Biblioteca Reale di Torino e Cristoforo De Predis', *Il Codice Varia 124 della Biblioteca Reale di Torino, miniato da Cristoforo De Predis (Milano, 1476)*, ed. A. Vitale-Brovarone (Turin, 1987), pp. 85–113

M. T. Fiorio: 'Giovanni Ambrogio de' Predis', *Pinacoteca di Brera: Scuola lombarda e piemontese, 1300–1535*, ed. C. Pirovano (Milan, 1988), pp. 158–60

J. Shell and G. Sironi: 'Ambrogio de' Predis, Cristoforo Solari and the Monument to Erasmo Brasca', *Rac. Vinc.*, xxvi (1995), pp. 159–83

ENRICA BANTI

Presentation drawing. Art form developed in Renaissance Italy. It refers to a drawing created as a finished work of art, rather than as a stage in the preparation or development of a work in another medium. The term was invented by Johannes Wilde to describe certain specific works by Michelangelo, but examples by other artists are known, and, as a whole, the existence of the type constitutes an interesting and important stage in the history of drawing.

The earliest known instances of Renaissance drawings apparently created as finished works are two scenes of religious narrative, datable to the early 1420s, by Lorenzo Monaco: the *Visitation* and the *Journey of the Magi* (both Berlin, Kupferstichkab.), in pen and ink with coloured washes and some heightening. (The *Visitation* even has a painted frame to emphasize its autonomy.) These drawings may have been linked with Lorenzo's training as a manuscript illuminator; certainly they remained isolated examples in Central Italy for several decades. Studio practice in North Italy was fundamentally different and led directly to an appreciation of the independent existence of drawings. Pattern- or model-books, usually containing a range of drawings often created for future reference, became valuable studio heirlooms, for example that begun by Gentile da Fabriano and continued by his successor in Venice and Rome, Pisanello (Paris, Louvre). The sketchbooks of Jacopo Bellini contain compositional drawings not only unrelated to known works but also in a variety of media—the *Crucifixion* in brush and ink, the *Stigmatization of St Francis* in silverpoint and pen (both Paris, Louvre)—which suggests a forthright joy in artistic creation. That such creations were already being appreciated outside the professional studio is indicated by the will (1466) of the Paduan humanist (and amateur draughtsman) Felice Feliciano (*d* after 1479), which cites 'drawings and pictures on paper' among his specified bequests. The portrait drawings of Giovanni Bellini (some of which, however, are also attributed to his brother-in-law Andrea Mantegna) are of such extraordinary quality as to be defined as a new type, the portrait commissioned as a drawing, as in the *Portrait of a Man* (Oxford, Christ Church Pict. Gal.), with its realization of form and of character achieved through the superb handling of the materials (black chalk with a faint grey wash).

In Florence the only comparable works are Domenico Ghirlandaio's characteristically literal portraits, such as the *Portrait of a Woman* (Chatsworth, Derbys) in black chalk, pricked for transfer, and the *Old Woman* (Windsor Castle, Berks, Royal Lib.) in silverpoint, both relics of the elaborate preparations for the fresco of the *Birth of the Virgin* (1485–90) in the Tornabuoni Chapel in S Maria Novella; their survival suggests that they were 'presented' to their subjects afterwards. Other survivals among Florentine workshop drawings perhaps indicate an increasing contemporary appreciation of such works *per se*. A famous example is Antonio Pollaiuolo's *Nude Man, Seen from the Front, Side and Back* (1486; Paris, Louvre), identified and dated probably because it had become an exemplar of anatomical study for sculpture. The development of the independent drawing in North Italy took on a new dimension in Mantegna's tortuous relationship with painting; his signed and dated drawing, in brush and wash slightly heightened,

of *Judith with the Head of Holofernes* (1491; Florence, Uffizi) is an exact equivalent of his *grisaille* painting of the same subject (Dublin, N.G.). A similar recognition of the new status of drawing may be seen in the finished studies, in black chalk and coloured wash, made by Luca Signorelli after his own apocalyptic masterpieces in Orvieto Cathedral (*see* SIGNORELLI, LUCA, fig. 4). The drawings, such as the *Nude Man* (Bayonne, Mus. Bonnat), were presumably worked up from the final stages of preparation for the frescoes, apparently as souvenirs of his virtuoso performance.

The final boost to the position of drawing in Florence was given by Leonardo da Vinci. His highly finished silverpoint *Bust of a Warrior* (London, BM) is clearly an exercise dating from his time in Verrocchio's workshop, but its superb quality would easily have justified its presentation to a distinguished friend. It is Leonardo who was first recorded, by Vasari, as making a drawing, of *Neptune* (untraced), specifically for such a presentation, to Antonio Segni, after his own return to Florence in 1500. He had already while in North Italy drawn an exquisite portrait of *Isabella d'Este* (1500; Paris, Louvre; for illustration *see* ESTE, (6)), which, though pricked for transfer to a painted version, was itself coloured (with a novel form of pastel) probably in order to stand as a finished work.

Chalk was the medium to which Michelangelo turned in the 1520s when he began to produce his presentation drawings. They were intimately connected with the development in his middle age of attachments to aristocratic young men, and the first of these was probably Gherardo Perini, for whom he drew a number of the so-called *teste divine*: images of idealized beauty decked in fantastic headdresses, in red chalk (e.g. the androgynous head at Oxford, Ashmolean) or black (the explicitly female half-lengths in the Uffizi, Florence, and the BM, London). In 1532 Michelangelo formed the most profound of such attachments, with Tommaso de' Cavalieri, for whom he created a series of increasingly elaborate and personal mythologies and allegories, from the *Rape of Ganymede* (Cambridge, MA, Fogg) and *Tityus* (Windsor Castle, Berks, Royal Lib.) to the extraordinary *'Dream of Human Life'* (*c*. 1533; U. London, Courtauld Inst. Gals; see fig.) and *The Archers* (Windsor Castle, Berks, Royal Lib.). Michelangelo's letters reveal that early stages of such compositions were submitted to the recipient for approval, and then finished or redrawn; different versions of the *Fall of Phaëthon* (London, BM, and Windsor Castle, Berks, Royal Lib.) confirm this process. The earlier portrait of *Andrea Quaratesi* (*c*. 1531; London, BM; *see* MICHELANGELO, fig. 7) is the only surviving example of his portrayals of specific male beauty. The delicate, elaborately stippled chalk technique, typical of these presentation drawings, was revived several years later during Michelangelo's entirely spiritual devotion to the pious widow, VITTORIA COLONNA, for whom he created (again submitting them for approval) such exquisite drawings as the *Resurrection* (Windsor Castle, Berks, Royal Lib.), the *Crucifixion* (London, BM) and the *Pietà* (Boston, MA, Isabella Stewart Gardner Mus.).

This whole aspect of Michelangelo's career indicates that drawings were by then thought worthy of absolute

Presentation drawing by Michelangelo: *'Dream of Human Life'*, black chalk, 396×279 mm, *c.* 1533 (London, University of London, Courtauld Institute Galleries)

consideration. By contrast, Raphael never produced a non-utilitarian drawing, even though the deliberation of his compositional processes inspired a still greater variety of type, including such highly finished examples as his 'auxiliary cartoons'. The legacy of both Michelangelo and Raphael to their Mannerist followers suggested the idea that various stages in the artistic process were of such completeness and power as to constitute finished works. Indeed, the influence of presentation drawings developed a reaction to Leonardesque freedom: the working drawings of Francesco Salviati, for instance, are often highly finished. The height of Mannerist theorizing was represented by Federigo Zuccaro's definition of *disegno* as *segno di Dio*.

BIBLIOGRAPHY
C. de Tolnay: *History and Technique of Old Master Drawings* (New York, 1943)
A. E. Popham and J. Wilde: *The Italian Drawings of the XV and XVI Centuries . . . at Windsor Castle* (London, 1949)
J. Wilde: *Italian Drawings in the . . . British Museum: Michelangelo and his Studio* (London, 1953)
D. S. Chambers: *Patrons and Artists in the Italian Renaissance* (London, 1970)
F. Ames-Lewis: *Drawings in Early Renaissance Italy* (New Haven and London, 1981)
R. S. Liebert: *Michelangelo* (New Haven, 1983)
Andrea Mantegna (exh. cat., ed. J. Martineau; London, RA, 1992)

□

Previtali, Andrea [Cordeliaghi, Andrea] (*b* Berbenno, nr Bergamo, *c.* 1480; *d* Bergamo, 1528). Italian painter. He is first recorded in 1502, when he signed and dated a *Virgin and Child with Donor* (Padua, Mus. Civ.), stating in the inscription that he was a 'disciple' of Giovanni Bellini. The painting confirms this description but is exceptionally forward-looking for its date, foreshadowing Palma Vecchio and Titian in the amplitude of the forms, and perhaps reflecting Giorgione's influence in the free and painterly rendering of the landscape. In other approximately contemporary signed paintings of the *Virgin and Child* (such as that in Detroit, MI, Inst. A.), figures deriving in pose and type from Bellini are similarly set against landscapes whose darker and more sylvan character recalls Giorgione.

Hereafter a series of dated paintings— *Virgin and Child with Saints* (1504; London, N.G.); *Virgin and Child with Donor* (1506; Scotland, priv. col.; see fig.); *Virgin Enthroned with Saints* (1506; Bergamo, Gal. Accad. Carrara); *Virgin and Child with the Infant St John* (1510; Mönchengladbach, Schloss Rheydt)—document Previtali's lively responses to various artists active in Venice during this decade, including Lorenzo Lotto, Marco Basaiti, Albrecht Dürer (1471–1528), Boccaccio Boccaccino and (in the painting of 1510) Titian. Especially extraordinary is the *Virgin and Child with Donor*, which, with its twilight tonality, vine-encrusted ruined basilica and thundery sky, adumbrates the tradition of romantic landscape. To this period also belong the four small paintings of stories of *Damon and Thyrsis* (London, N.G.), so Giorgionesque in character that they were bought by the gallery in the 1930s as being by Giorgione, and the beautiful *Annunciation* altarpiece (Vittorio Veneto, S Maria Annunziata del Meschino), with its overtones of Cima and Carpaccio, that was much admired by Titian (Ridolfi).

About 1511 Previtali left Venice to establish himself in Bergamo, where he remained for the rest of his life and where he was the most important resident painter together with Lotto, who joined him there in 1513. In this provincial environment he gradually relinquished the vanguard position he had occupied during the previous decade, but continued for some years to produce paintings of uniformly high quality, exploiting his personal amalgam of Giorgionesque and Bellinesque elements. These include the striking, crepuscular *Virgin and Child Reading* (1514; Bergamo, Gal. Accad. Carrara) with its sunset sky and darkening landscape, the large-scale altarpiece of *St John the Baptist with Saints* (1515; Bergamo, Santo Spirito) and the beautiful *Christ and the Holy Spirit in a Landscape* (1513; Milan, Brera), whose unique iconography suggests it may be a highly unorthodox rendering of the Transfiguration. Other paintings of this period take more from the local Lombard tradition, both in subject-matter and in their informality of the style; these include the frescoes of the *Trades, Crafts and Professions* in the Villa Suardi at Trescore, near Bergamo, and his panoramic version of the *Rest on the Flight into Egypt* (Buscot Park, Oxon, NT), in which the Holy Family are helped to a realistic picnic not by angels but by a sharp-featured peasant.

After *c.* 1518 the quality of Previtali's work became more uneven; his execution is often summary and workshop participation more apparent, while the influence of Lotto (with whom he was friendly, and whose designs for the intarsias of the choir-stalls in S Maria Maggiore he transcribed on to the panels after Lotto left Bergamo in 1524) is more marked and not invariably beneficial.

Andrea Previtali: *Virgin and Child with Donor*, panel, 495×647 mm, 1506 (Scotland, private collection)

Nonetheless, this period produced some fine works in a more overtly mystical vein, such as the *Annunciation* (Memphis, TN, Brooks Mus. A.), the quasi-nocturnal *Crucifixion* (1523; Bergamo, S Alessandro della Croce), the nocturnal *Nativity* (Venice, Accad.), and the splendid altarpiece *St Benedict Enthroned* (1524; Bergamo Cathedral).

The earliest of Previtali's portraits, straightforward but sensitive in treatment and in the mode of Giovanni Bellini, are two portraits of young men (Milan, Mus. Poldi Pezzoli, and Rovigo, Accad. Concordi). Later portraits such as *Family before a Coastal Landscape* (Bergamo, Conte Moroni priv. col.; see Zampetti and Chiappini, 1975, p. 162) take suggestions from Lotto and Giovanni Cariani.

Not one of the great innovators of his time, Previtali nevertheless commands respect as an artist who was both responsive to those who were innovators and true to his own perceptions. Most of his works are religious paintings in which landscape plays an essential part. Of Giovanni Bellini's last generation of pupils, Previtali best understood Bellini's conception of the natural world as deeply imbued with holiness, and he carried it almost intact into the realm of 16th-century style in works such as *Christ and the Holy Spirit* (Milan, Brera). But for Previtali that conception did not preclude a sense, perhaps inspired by Giorgione, of nature's potential for mystery of a darker, more uncertain

kind. His best work is therefore subtly distinctive and deserving of serious regard.

BIBLIOGRAPHY

C. Ridolfi: *Meraviglie* (1648), ed. D. von Hadeln (Berlin, 1914–24/*R* 1965), i, pp. 141–2
F. M. Tassi: *Le vite de' pittori, scultori, e architetti bergamaschi* (Bergamo, 1793/rev. F. Mazzini, Milan, 1969), i, pp. 39–44
I. Kunze: 'A Rediscovered Picture by Andrea Cordeliaghi', *Burl. Mag.*, lxxi (1937), pp. 261–7
B. Berenson: *Venetian School* (1957), i, pp. 147–9; ii, pls 742–51
F. Gibbons: *The Late Giovanni Bellini and his Workshop* (diss., Cambridge, MA, Harvard U., 1961)
F. Heinemann: *Giovanni Bellini e i Belliniani*, 2 vols (Venice, 1962), i, pp. 232–48; ii, pls 486–531 [very unreliable for attributions but useful for plates]
J. Meyer zur Cappellen: *Andrea Previtali* (diss., Würzburg, Julius Maximilians U., 1972)
P. Zampetti and I. Chiappini: 'Andrea Previtali': *I pittori bergamaschi dal XIII al XIX secolo: Il cinquecento*, i (Bergamo, 1975), pp. 87–167
A. Morandotti: *Pittura lombarda, 1450–1650* (Milan, 1994)

FRANCIS L. RICHARDSON

Primaticcio, Francesco (*b* Bologna, 1504–5; *d* Paris, between 2 March and 14 Sept 1570). Italian painter, draughtsman, stuccoist and architect, active in France. He was in France from 1532 and was the most influential Italian artist there in the 16th century. With Rosso Fiorentino, he developed a style of interior decoration, combining Mannerist painting and stucco relief, that became known as the Fontainebleau school.

1. TO *c*. 1540. He trained in Bologna, first with Innocenzo da Imola and then Bagnacavallo, in a milieu predominantly influenced by the style of Raphael and his pupils. A formative influence was Giulio Romano, with whom he worked from 1526 on the decoration of the Palazzo del Te in Mantua. The scale of the project and the lack of documentary evidence make it difficult to attribute specific works to Primaticcio, although the stucco of the *Triumph of Emperor Sigismond* in the Sala degli Stucchi has traditionally been attributed to him, and, according to Vasari, he designed all the stuccowork in that room. Vasari also claimed that Primaticcio executed the first stuccowork in France, where he went in 1532 at the invitation of Francis I (*reg* 1515–47), who had already succeeded in enticing Rosso Fiorentino to the French court. The move to France proved decisive for Primaticcio and, it has been suggested, for French art (Dimier 1900 and 1928). Except for sojourns in Italy, he worked there for the rest of his life, mostly at the royal château of Fontainebleau.

For Primaticcio, as for Rosso, Fontainebleau offered creative opportunities far greater than those available in Italy. At first somewhat in the shadow of Rosso, he soon developed his own style, a version of Mannerism showing various influences, including Correggio, Parmigianino and Michelangelo as well as Giulio Romano. His main responsibility was for decorative programmes, assimilating and developing the solution formulated by Rosso for the Galerie François I in the 1530s. Rosso's scheme served as a model for much of the work done at the château and for the aesthetic language associated with the Fontainebleau school. Although stucco decorations survive in fair condition at Fontainebleau, many of the paintings have been extensively reworked, restored or, in some cases, destroyed. Often preparatory drawings and prints made after the works are the only means of judging their original state. For example, Primaticcio's decorations for the Chambre du Roi (1533–5; destr.), which included frescoes illustrating such ancient legends as *Achilles at the House of Lycomedes*, are recorded in engravings made in the 18th century by Guérineau.

Primaticcio probably executed the stuccowork for the Galerie François I as well as for other rooms, and the use of motifs from Mantua suggests that in this area he made an original contribution to the embellishment of the château. In most of the decoration done at Fontainebleau at this time the ornamental elements are dominant. The frames, for example, are so elaborate as to make the paintings almost irrelevant. In the Chambre de la Reine (1534–7) the decoration over the fireplace is a complex construction of stucco figures, garlands, masks and rams' heads surrounding a frame within a frame. The inner frame contains a painting of *Venus and Adonis* that is overshadowed by its setting. This ensemble includes several motifs from the Sala degli Stucchi at Mantua. For the Porte Dorée (*c*. 1535–41), Primaticcio developed a different solution: there is an increased emphasis on the paintings. Drawings from this period (Paris, Louvre) display his interest in the monumental musculature of Michelangelo's nudes as well as the softer, more elegant contours of those by Parmigianino. Another possible influence is the exquisitely graceful forms in works by

Benvenuto Cellini, who was at the French court in this period.

Throughout the château, the theme of the Antique and of *all'antica* decoration, inspired by Italian precedents, is predominant. Francis I also collected works of art, including copies of antique statues, prompting Vasari to call Fontainebleau the 'new Rome'. Primaticcio made several trips to Italy to obtain works of art for the King, beginning in 1540, when he was sent to Rome to make casts of ancient statues, mainly from the Cortile del Belvedere at the Vatican, for bronze copies to be cast in the foundry at Fontainebleau. While he was away in 1540, Rosso died, and Primaticcio assumed full control of the works at the château.

2. AFTER *c*. 1540. In Primaticcio's scheme for the Chambre de la Duchesse d'Etampes (1541–4; see colour pl. 2, XX1), which is decorated with scenes from the *Life of Alexander the Great*, the paintings are again overwhelmed by their surround (see fig. 1). This room survives as part of the Escalier du Roi, and the stuccowork is well preserved. A small oval scene of *Apelles Painting Campaspe* has a relatively simple frame, flanked by two high-relief stucco female nudes with elongated bodies reminiscent of Parmigianino. Their role as caryatids, supporting the elegant strapwork derived from the Galerie François I, is belied by their animated postures. Other stucco details, including ripe fruit and rams' heads, also occur in the Galerie, where they may have been Primaticcio's designs. Three putti recline luxuriously at the top of the *Apelles* painting, and the abundance of elements, richly executed in high relief, gives a sensual effect.

While Primaticcio focused on large-scale decorative schemes, there is evidence that he also executed smaller works. A painting of the *Holy Family* (St Petersburg, Hermitage), datable to the early 1540s, has been attributed to him. Although the subject is unfamiliar in his oeuvre, the style has his refinement. The informality of the figure group recalls similar compositions by Correggio and Parmigianino, derived from Raphael; the architectural setting has more in common with Pontormo. This work, if it is by Primaticcio, shows his efforts to emulate the grace of his counterparts in Italy and also demonstrates a softness of handling that is not apparent in his frescoes, many of which were painted by assistants or are damaged.

Work on the Galerie d'Ulysse, a project even larger than the Galerie François I, began at the end of the 1530s. Given Primaticcio's absences in the 1540s, however, and his other projects (e.g. frescoes of the *Olympian Gods* (part destr.) in the vestibule of the Porte Dorée, and Tondi (destr.) in the Grotte du Jardin des Pins), it is likely that the decoration of the walls began only towards the end of the 1540s (Béguin, Guillaume and Roy, 1985). The gallery, which was destroyed in 1738 by Louis XV, was about 150 m long, with 16 bays and a barrel vault. The vault was probably decorated first, as some sections bore the mark of Francis I, who died in 1547. The decoration of the gallery is recorded in descriptions, drawings and prints, including an important series of 17th-century prints by Théodore van Thulden (1606–69). The scheme was very complex, again incorporating a variety of means to produce a rich effect, strongly reminiscent of Raphael's loggias in

1. Francesco Primaticcio: *Wedding of Alexander and Roxana*, detail of the stucco and fresco decoration for the Chambre de la Duchesse d'Etampes at Fontainebleau, 1541–4 (Fontainebleau, Musée National du Château de Fontainebleau)

Rome. The barrel vault was thickly covered in frescoes, grotesques and gilded stucco, in a *horror vacui* of antique motifs. The walls were frescoed with scenes from the *Story of Ulysses* in simple stucco frames, and the five fireplaces also included paintings, a total of 60 scenes.

There are numerous drawings by Primaticcio for the Galerie d'Ulysse. Several *di sotto in sù* drawings for the vault are very reminiscent of the work of Correggio, as in the *Parnassus* (Florence, Uffizi), which derives from Correggio's decoration of the dome of S Giovanni Evangelista in Parma (1521), although the body types are closer to Rosso and Parmigianino. The elaborate surface decoration on the vault perhaps served to isolate the larger scenes, emphasizing the illusionism of the figures and architecture. In the drawing for the scene of *Minerva Visiting Jupiter and Juno* (Florence, Uffizi; see fig. 2), the *trompe l'oeil* effect is very notable, with dramatic foreshortening recalling Giulio Romano's designs for the cycle of *Cupid and Psyche* at the Palazzo del Te (*see* GIULIO ROMANO, fig. 4). It is difficult to identify a precedent for the illusionistic architectural setting, which seems rather to anticipate the work of Paolo Veronese, or the great ceilings of the Baroque era. An important model for Primaticcio may have been the contemporary work of Pellegrino Tibaldi, who painted a *Ulysses* cycle for the Palazzo Poggi in Bologna. The vault of the Galerie d'Ulysse was decorated with a dense web of grotesques, with illusionistic openings, while the wall scenes formed a long, dramatic narrative.

The engravings after the wall frescoes indicate that the scenes were arranged in pairs, side by side, the two often related formally, with sequential narratives and backgrounds. The effect of the whole gallery must have been exciting, with its rich combination of stuccowork, grotesques and illusionistic paintings. The Galerie d'Ulysse was undoubtedly Primaticcio's masterpiece, as the Galerie François I was Rosso's. While it had only a limited influence on French art, it does seem to have been a precedent for Ignazio Danti's Galleria della Carte Geografiche (1580) at the Vatican in Rome.

Although Primaticcio did work elsewhere in France, notably for the Guise family at Paris and Meudon, the majority of his work was at Fontainebleau. He worked on an astonishing number of projects there, commissioned by successive kings, possibly to rival such contemporary palaces as the Vatican. The enormous programme gave him the opportunity to create decorations for many different environments, including a suite of baths (1544–7; destr.), presumably reflecting the taste for the Antique. After the death of Francis I, he worked for Henry II (*reg* 1547–59), for whom he designed the Galerie Henri II, a ballroom (1552–6), with scenes of the gods feasting and musical motifs. His powerful position permitted him to concentrate on design and delegate the execution to numerous assistants, including Nicolò dell'Abate, who brought ideas from Modena and Bologna. Other artists who visited France during Primaticcio's time there, and

2. Francesco Primaticcio: *Minerva Visiting Jupiter and Juno*, black and white chalk on pink prepared paper, 388×285 mm, study for the Galerie d'Ulysse at Fontainebleau, *c.* 1547–59 (Florence, Galleria degli Uffizi)

who may have influenced him, were Jacopo Vignola and Sebastiano Serlio. Primaticcio also seems to have turned his hand to architecture, designing the Grotte des Pins and the wing of the Belle Cheminée (destr.), although the extent of his responsibility is not clear, nor is the role played by Serlio. Certainly Serlio's knowledge of ancient and contemporary architecture in Italy helped Primaticcio to follow trends there. With the death of Henry II in 1559, Primaticcio was appointed Surveyor of Works to the new king, Francis II (*reg* 1559–60). The mausoleum he designed for Henri II, commissioned by his widow Catherine de' Medici, was not completed. In addition to architecture and decorative schemes, he supervised the execution of a set of tapestries of scenes from the Galerie François I (Vienna, Ksthist. Mus.) and created designs for court masques and other celebrations. The archetypal court artist, he was comparable to Raphael in his versatility, if not in originality. Although he is regarded more as a decorator than a painter, the concept of interior design and the style of decoration he helped to develop at Fontainebleau were widely influential.

BIBLIOGRAPHY
G. Vasari: *Vite* (1550, rev. 2/1568); ed. G. Milanesi, vii (1878–85), pp. 405–24
T. van Thulden: *Les Travaux d'Ulysse peints à Fontainebleau par le Primatice* (Paris, 1633)
L. Dimier: *Le Primatice, peintre, sculpteur et architecte des rois de France* (Paris, 1900)
——: *Le Primatice* (Paris, 1928)
P. Barocchi: 'Precisazioni sul Primaticcio', *Commentari*, ii (1951), pp. 203–23
E. Panofsky and D. Panofsky: 'The Iconography of the Galerie François I at Fontainebleau', *Gaz. B.-A.*, n. s. 5, lii (1958), pp. 113–90
F. Herbet: *Les Graveurs de l'Ecole de Fontainebleau* (Amsterdam, 1969)
L. Golson: 'Serlio, Primaticcio and the Architectural Grotto', *Gaz. B.-A.*, n. s. 5, lxxvii (1971), pp. 95–108
Actes du colloque international sur l'art de Fontainebleau: Fontainebleau and Paris, 1972
S. Béguin and others: 'La Galerie François I au Château de Fontainebleau', *Rev. A.*, 16–17 (1972) [whole issue]
L'Ecole de Fontainebleau (exh. cat., ed. S. Béguin; Paris, Grand Pal., 1972)
Fontainebleau: L'Art en France, 1528–1610 (exh. cat., ed. S. Béguin; Ottawa, N.G., 1973)
K. Wilson-Chevalier: 'La Postérité de l'école de Fontainebleau dans la gravure du XVIIe siècle', *Nouv. Est.*, 62 (1982), pp. 5–16
S. Béguin, J. Guillaume and A. Roy: *La Galerie d'Ulysse à Fontainebleau* (Paris, 1985)
V. Juren: 'Un Nouveau Fragment de la correspondance de Primatice', *Il se rendit en Italie: Etudes offertes à André Chastel* (Rome, 1987), pp. 231–4
C. Eschenfelder: 'Les Bains de Fontainebleau: Nouveaux documents sur les décors du Primatice', *Rev. A.* (1993), pp. 45–52
N. J. Vickers: 'Courting the Female Subject', *French Renaissance in Prints from the Bibliothèque Nationale de France* (Los Angeles, 1994), pp. 94–107

DORIGEN CALDWELL

Procaccini [Percaccino; Porcaccino]. Italian family of artists. It comprised three generations of artists: (1) Ercole Procaccini I, three of his sons—Camillo Procaccini (*c.* 1555–1629), Carlantonio Procaccini (1571–?1630) and Giulio Cesare Procaccini (1574–1625)—and a grandson, Ercole Procaccini II (1605–75/80). Their activity covered over 100 years, from Ercole I's beginnings in Bologna in the 1550s through a collective move to Milan in the mid-1580s to continued success in Lombardy well into the 1670s.

BIBLIOGRAPHY
C. C. Malvasia: *Felsina pittrice* (1678); ed. G. Zanotti (1841)
A. Arfelli: 'Per la cronologia dei Procaccini (e dei figli di Bartolomeo Passarotti)', *A. Ant. & Mod.*, 7 (1959), pp. 457–61
V. Caprara: 'Nuovi reperimenti intorno ai Procaccini', *Paragone*, xxviii/300 (1977), pp. 95–100
M. Bona Castellotti: *La pittura lombarda del '600* (Milan, 1985)

(1) Ercole Procaccini I [*il vecchio*] (*b* Bologna, bapt 23 Feb 1520; *d* Milan, 13 Jan 1595). Painter. He studied with Prospero Fontana and the two artists worked together in Rome in 1551. Active in Parma before 1560 and during part of that decade, in 1569 Ercole is documented back in Bologna, where a number of his altarpieces survive. The *Virgin and Child with the Four Patron Saints of Bologna* (1570; Bologna, S Giovanni in Monte) is a simple, symmetrical composition. Later in the 1570s his work became more sophisticated. His best-known altarpiece, the *Conversion of Saul* (1573; Bologna, S Giacomo Maggiore), is heavy yet elegant, reflecting the influence of Central Italian Mannerism, as represented in Bologna by Lorenzo Sabbatini and Orazio Samacchini.

Ercole was active as an officer in the newly formed painters' guild Compagnia dei Pittori between 1569 and 1585 and its head from January to April 1585, just before he left Bologna. The Procaccini family moved to Milan in the mid-1580s, but, except for Torre's statement that Ercole and Camillo frescoed the chapel of the Immaculate Conception in S Francesco, Milan (destr.), there is no record of Ercole's work in Lombardy. Malvasia summed him up accurately as a mediocre painter, best remembered as the teacher of his more gifted sons.

BIBLIOGRAPHY

G. P. Lomazzo: *Idea del tempio della pittura* (Milan, 1590); ed. R. Klein, 2 vols (Florence, 1974)

C. Torre: *Il ritratto di Milano* (Milan, 1674, 2/1714/*R* 1973)

D. Benati: 'Ercole Procaccini', *Pittura bolognese del '500*, ed. V. F. Pietrantonio, 2 vols (Bologna, 1986)

A. Mazza: 'Un San Giovanni Battista di Camillo Provaccini diciannovenne nella Galleria Estense. Dipinti di Ercole e Camillo Procaccini per i territori estensi,' *Pittura a Modena e a Reggio Emilia Tura Cinque e Seicento* (Modena, 1998)

NANCY WARD NEILSON

Prospero da Brescia. *See* ANTICHI, PROSPERO.

Pucci. Italian family of patrons. The family was putatively descended from Puccio di Benintendi, a mason in Florence in the second half of the 13th century, and for several generations members belonged to the guild of woodworkers. Although the family lived near S Michele Visdomini, Puccio's son Benintendi di Puccio (*d* 1325) commissioned a family tomb in Santa Croce, Florence, *c.* 1320. The latter's grandson, Antonio Pucci I, may have been an architect and was one of three contractors who built the vaults and roof (1380–82) of the Loggia dei Signori. The family's connection with SS Annunziata, Florence, began in 1384 when he built a wooden model (destr.). He held high office in the guild of woodworkers between 1390 and 1417 and was twice selected a prior of Florence.

From the 15th century the family's fortunes were linked with those of the Medici. They were ardent supporters of Cosimo de' Medici, who arranged for two of Antonio's sons, Puccio Pucci (*b* 1389) and Saracino Pucci (1405–80), to matriculate into the Arte del Cambio and the Arte della Seta, respectively, in 1436. Vasari stated that Puccio Pucci was among the politically active Florentines depicted in Andrea del Castagno's frescoes of the *Life of the Virgin* (1451–3; destr. 17th century) in the choir of S Egidio. The chapel of S Sebastiano (completed 1452) in SS Annunziata was commissioned by Puccio, his brothers Giovanni (1392–1445) and Saracino, and his son Antonio Pucci II (1418–84). It contained the tomb of *Saracino Pucci* (1469; destr.) by Francesco di Simone Ferrucci and the *Martyrdom of St Sebastian* (1475; London, N.G.) by Antonio Pollaiuolo and Piero Pollaiuolo (*see* POLLAIUOLO, (1) and (2)). About 1483 Antonio Pucci II commissioned Botticelli to paint four *cassone* or *spalliera* panels depicting Boccaccio's *Story of Nastagio degli Onesti* (London, Watney Col.; Madrid, Prado, see colour pl. 1, XIV2) for the bridal chamber of his son Giannozzo Pucci (1460–97) and Lucrezia di Piero Bini, and a tondo of the *Adoration of the Magi* (probably London, N.G.). The political alliance with the Medici is indicated by their coat of arms on one of the panels and the choice of a favourite subject of the Medici for the tondo. Antonio's portrait appears alongside that of Lorenzo de' Medici in Domenico Ghirlandaio's *Confirmation of the Rule* (*c.* 1485; Florence, Santa Trìnita, Sassetti Chapel). Pietro Perugino's *Crucifixion* (1493–6; Florence, S Maria Maddalena dei Pazzi, Certosa) was commissioned by Antonio's elder son, Dionigi Pucci (1442–94).

In the early 16th century the Pucci further embellished the chapel of S Sebastiano with a mosaic *Annunciation* (1509) by Davide Ghirlandaio and a coat of arms (*c.* 1513; destr.) by Rosso Fiorentino. Francesco di Giovanni Pucci (1437–1518) established a burial chapel at S Michele Visdomini with an altarpiece of the *Virgin and Child with Saints* (1518) by Jacopo da Pontormo. The new façade and cloister of S Agata (begun 1592) was commissioned by Lorenzo di Piero Pucci (1520–92) to designs by Alessandro Allori (1535–1607), who also supplied the *Wedding at Cana* (Florence, Uffizi) for the high altar to a commission by Ascanio di Pandolfo Pucci (*d* 1596). The chapel of S Sebastiano was renovated in 1601–4 with architectural and sculptural additions by Giovanni Battista Caccini, frescoes by Bernardino Poccetti and mother-of-pearl rosettes by Mariotto Tosini.

The Palazzo Pucci was originally commissioned by Lorenzo Pucci (1458–1531) and Roberto Pucci (1463–1525) in the early 16th century; the coat of arms of Pope Leo X (*reg* 1513–21) carved on the exterior by Baccio da Montelupo indicates the family's support for the Medici regimes in both Florence and Rome. On the initiative of Pandolfo di Roberto Pucci (1509–60) the palazzo was remodelled in the mid-16th century, most probably by Bartolomeo Ammanati. Its present form follows a further renovation (after 1688) by Paolo Falconieri (*fl* 1670–1702) for Orazio Roberto Pucci (1625–97).

BIBLIOGRAPHY

G. Vasari: *Vite* (1550, rev. 2/1568); ed. G. Milanesi (1878–85)

P. Litta: *Famiglie celebri italiane*, x (Milan, 1874)

W. Paatz and E. Paatz: *Kirchen* (1940–54)

L. Ginori: *I palazzi di Firenze*, 2 vols (Florence, 1972)

D. Kent: *The Rise of the Medici: Faction in Florence, 1426–1434* (Oxford, 1978)

R. Goldthwaite: *The Building of Renaissance Florence* (Baltimore and London, 1980)

ROGER J. CRUM

Puligo, Domenico (*b* Florence, 1492; *d* Florence, Sept 1527). Italian painter. He trained in Florence with Ridolfo Ghirlandaio and in the workshops of Antonio del Ceraiuolo (*fl* 1st half 16th century) and Andrea del Sarto. What may be his earliest surviving work, the *Virgin and Child with St John* (*c.* 1513; Rome, Pal. Venezia), reflects the style of Ghirlandaio. Other early paintings, however, such as the *Holy Family* (Florence, Gal. Corsini), show the influence of Fra Bartolommeo and Andrea del Sarto and are little affected by Ghirlandaio. The *Virgin and Child with the Infant St John* (*c.* 1522; Florence, Pitti) clearly reflects the examples of Fra Bartolommeo and Raphael, with the figures in the manner of Andrea del Sarto. The figure of the Christ Child may derive from Raphael's *Madonna of the Pinks* (*c.* 1507–8; Alnwick Castle, Northumb., on loan to London, N.G.). Over a dozen drawings have been attributed to Puligo, but none relates to his extant work or resembles his style of painting. Vasari described him as a particularly lazy artist, which may account for this scarcity of drawings and for the frequency of borrowed motifs and repeated compositions in his smaller religious paintings. Such borrowing often resulted in a lack of harmony in his compositions, as in the Pitti *Virgin and Child*. The influence of the more sculptural forms of Andrea del Sarto's work of the 1520s can be seen in the *Mary Magdalene* (*c.* 1525; Ottawa, N.G.). One of Puligo's most important large-scale works of this period is the *Vision of St Bernard* (*c.* 1525; Baltimore, MD, Walters A.G.).

In 1525 Puligo's name appears on the roll of the Compagnia di S Luca, and in the same year he painted the

Presentation of the Virgin (Florence, S Maria Maddalena dei Pazzi) for S Maria degli Angiolini, Cestello. The largest surviving altarpiece by him is the *Deposition* (*c.* 1526; Anghiari, S Maria delle Grazie). His only surviving fresco dates from 1525–6 (Florence, corner of Via S Zanobi and Via delle Ruote). Almost entirely repainted, it is recorded in an engraving published by Galvani.

Unlike his religious paintings, Puligo's portraits show an interest in the latest models, particularly by Raphael and Titian. Their influence can be seen in his portraits of the 1520s, when he painted several three-quarter-length standing figures, such as the *Fattore of S Marco* (*c.* 1524; Firle Place, E. Sussex). The only dated work by Puligo, *Portrait of a Man Writing* (1523; Firle Place, E. Sussex), suggests he knew Raphael's portrait of *Tommaso Inghirami* (e.g. Boston, MA, Isabella Stewart Gardner Mus.). Other portraits indicate study of the Venetian genre established by Titian. The portrait of *Barbara* (*c.* 1525; Wilts, priv. col., see Bruce Lockhart) includes such details as a volume of Petrarch, which are typical of Venetian portraits of courtesans.

BIBLIOGRAPHY

Thieme–Becker
G. Vasari: *Vite* (1550, rev. 2/1568); ed. G. Milanesi (1878–85), v, pp. 247–54
C. Gamba: 'Di alcuni ritratti del Puligo', *Riv. A.*, vi (1909), pp. 277–80
B. Berenson: *The Drawings of the Florentine Painters*, 3 vols (London, 1948)
S. M. Bruce Lockhart: *The Work of Domenico Puligo* (MA thesis, U. London, Courtauld Inst., 1973)

☐

Pulzone, Scipione [il Gaetano] (*b* Gaeta, 1544; *d* Rome, 1 Feb 1598). Italian painter. He is thought to have been a pupil of Jacopino del Conte in Rome. His talent was already evident in his early portraits, such as *Cardinal Ricci* (1569; Cambridge, MA, Fogg) and *Cardinal Santorio* (or *Cardinal Granvella*, 1576; U. London, Courtauld Inst. Gals). He was influenced by Italian court portraiture, particularly that of Raphael, and also by Flemish stylistic traits, which he must have absorbed through seeing the works (untraced) left in Rome by Antonis Mor (1516/20–?1576). His brilliant palette was further enriched through contact with Venetian painting. The naturalism of the early portraits sets them apart from Mannerist portraiture; the careful rendering of details of physiognomy and dress was as important to Pulzone as expressing the personality of his sitter.

Having established himself as a portrait painter, Pulzone turned to sacred subjects. His approach to this genre was innovative, both formally and psychologically, and his religious paintings have a simplicity and clarity that contrasts with the extravagant designs of Mannerist painters in Rome. His first known painting of a religious subject is an altarpiece intended to be placed by the tomb of *Pope Martin V* in S Giovanni in Laterano, Rome. It was commissioned in 1574 by the Colonna family, of which Martin V (*reg* 1417–31) was a member. Pulzone painted a portrait of *Martin V* on one side and a *Mary Magdalene* on the other; the two parts, now separated, are kept elsewhere in the basilica, in the Coro dei Canonici. The papal portrait is in an archaic style; the *Magdalene* has numerous allusions to such Roman painters as Girolamo Siciolante and Marcello Venusti and to such Venetians as

Sebastiano del Piombo. The greatest debt, however, is to Titian, one of whose paintings of the *Magdalene* (Naples, Capodimonte) was then in the residence of Cardinal Alessandro Farnese in Rome. Blending these various influences, Pulzone produced an image of clear, inspiring serenity. Other artistic models are apparent in the *Immaculate Conception with Angels, Saints and Donor* (Ronciglione, Cappuccini), painted in 1581–4 for S Maria della Concezione in Rome. By reinterpreting elements borrowed from Girolamo Muziano and Giulo Romano and Marco Pino, he created a work that conveys religious feeling without mystic passion. Among his portraits of these years is that of *Lucrezia Colonna* (1584; Munich, Alte Pin.). In 1584, on the strength of his reputation as a portrait painter, Pulzone was summoned first to the Aragon court at Naples, where he painted not only portraits but also the *Martyrdom of St John the Evangelist* (Naples, S Domenico Maggiore), and then to the Medici court at Florence. His work shows no significant impression from his contact with these two centres apart from a move towards the style of Andrea del Sarto in the composition of the *Assumption* (1585; Rome, S Silvestro al Quirinale).

Around 1588 Pulzone began collaborating with Giuseppe Valeriano, a Jesuit painter and architect, on the decoration of the chapel of S Maria della Strada in the Gesù in Rome, for which they produced scenes from the *Life of the Virgin* (oil on panel). The contact with Valeriano, who advocated a rational approach to art, free of any excess, proved of fundamental importance to Pulzone's stylistic development. Combining this with a Venetian use of colour and Flemish attention to detail, Pulzone went on to produce paintings that were perfectly in tune with the popular, conservative, religious style prescribed by the Council of Trent (e.g. *Virgin and Child*, 1592, Rome, Gal. Borghese; *Virgin of Divine Providence*, Rome, S Carlo ai Catinari). In the *Holy Family* (*c.* 1590; Rome, Gal. Borghese; see fig.) the blend of dull colours, the balanced composition, the minute recording of detail and the facial expressions contribute to creating an image of calm devotion. The painting suggests a universe in which everything has a moral significance: old age is venerated, the good are happy, the bad are marked by deformity and ugliness.

Among Pulzone's other late works are three altarpieces: the *Pietà* (New York, priv. col., see Zeri, fig. 90), painted for the Cappella della Passione in the Gesù, Rome; the *Assumption of the Virgin* (Rome, S Caterina dei Funari); and the *Crucifixion* (1585–90; Rome, S Maria in Vallicella), based on Titian's *Crucifixion* in S Domenico, Ancona (*in situ*). The references to the art of the 15th century evident in Pulzone's picture again accord with the Council of Trent, which advocated a return to traditional devotional imagery and condemned Mannerist distortions. In these works Pulzone's style moved beyond Mannerism towards a personal version of classicism, which developed in parallel with the classicism of the Caracci family in Bologna. Pulzone remained in demand as a portrait painter, and late examples, such as the *Portrait of a Cardinal* (London, N.G.) and *Portrait of a Woman* (New York, Spark priv. col., see Zeri, fig. 86), are lively and expressive.

Scipione Pulzone: *Holy Family*, oil on panel, 1.35×1.05 m, *c.* 1590 (Rome, Galleria Borghese)

BIBLIOGRAPHY
G. Baglione: *Vite* (1642); ed. V. Mariani (1935), pp. 52, 76, 83, 124, 127, 169
L. Mariotti: 'Cenni su Scipione Pulzone detto Gaetano ritrattista', *L'Arte*, xxvii (1924), pp. 27–38
F. Tomassetti: 'Il pittore Scipione Pulzone detto "Il Gaetano" e il ritratto di Marcantonio Colonna', *Roma*, vi (1928), pp. 537–44
F. Zeri: *Pittura e Controriforma: L'arte senza tempo di Scipione da Gaeta* (Turin, 1957)
A. Marabottini: 'Un dipinto di Scipione Pulzone in Sicilia', *Commentari*, 13 (1962), pp. 48–51
M. Chiarini: 'A Drawing by Scipione Pulzone', *Master Drgs*, xiv (1976), pp. 383–4
E. Vaudo: *Scipione Pulzone da Gaeta, pittore* (Gaeta, [1976])
M. Di Giampaolo: 'A Study by Scipione Pulzone', *Master Drgs*, xviii (1980), p. 47
J. M. Ruiz Manero: 'Obras y noticias de Girolamo Muziano, Marcello Venusti y Scipione Pulzone en España', *Archv Esp. A.*, lxviii/272 (1995), pp. 365–80

FIORENZA RANGONI

Pupini [dalle Lame; de' Pini; Pini], **Biagio** (*b* Bologna; *fl* 1511–51). Italian painter and draughtsman. He was probably a pupil of Francesco Francia. In 1511 he collaborated with Bagnacavallo on frescoes (destr.) in S Pietro in Vincoli, Faenza, and in 1519 on a stained-glass window for the Cappella della Pace, S Petronio, Bologna. In 1524 Pupini painted the *Virgin and Child with Saints*—a copy of Raphael's *Holy Family* (Paris, Louvre)—in the upper cloister of the Collegio di Spagna, Bologna. In 1525 he participated, with Girolamo da Carpi and Giovanni Borghese, in the decoration of the sacristy of S Michele in Bosco, Bologna. Thereafter he produced works that have Ferrarese elements and echoes of Parmigianino, evidently also influenced by the works of Girolamo da Carpi, as in the *Nativity* (Bologna, Pin. N.), the *Virgin and Child with*

Saints (Baltimore, MD, Walters A.G.) and the *Virgin and Child with Saints* (Bologna, S Giuliano). In 1536 Pupini worked with Girolamo da Carpi, Garofalo, Battista Dossi, Camillo Filippi and others on the decoration of the Este Villa at Belriguardo. In 1539 he was again in Bologna. His altarpiece depicting the *Virgin and Child with Saints* and three predella scenes for Fabriano Cathedral were executed in 1545. Shortly afterwards he painted *St Ursula and her Companions* for S Giacomo, Bologna. Pupini was a prolific draughtsman. His numerous drawings, influenced by Polidoro da Caravaggio and Parmigianino, are characterized by a technique that combines watercolour with white lead highlights and by a swift, *sfumato* brushstroke. He is last documented in 1551.

BIBLIOGRAPHY
G. Vasari: *Vite* (1550, rev. 2/1568); ed. G. Milanesi (1878–85), v, pp. 177–83; vi, p. 473; vii, p. 666
F. Filippini: 'Un affresco di Biagio nel Collegio di Spagna', *Archiginnasio*, xi (1916), pp. 170–72
G. Zucchini: 'Una vetrata per S. Petronio commessa a Biagio Pupini e al Bagnacavallo', *Archiginnasio*, xxix (1934), pp. 116–17
A. E. Popham and S. Wilde: *Italian Drawings of the XV and XVI Centuries in the Collection of His Majesty the King at Windsor Castle* (London, 1946)
R. Roli: *Quattro secoli di pittura in S. Michele in Bosco* (Bologna, 1971), pp. 204–9
Correggio and his Legacy: Sixteenth-century Emilian Drawings (exh. cat., ed. D. De Grazia; Washington, DC, N.G.A., 1984), pp. 308–10
M. Lucco: 'La cultura figurativa padana al tempo del Codice Hammer', *Leonardo: Il Codice Hammer e la Mappa di Imola presentati da Carlo Pedretti* (exh. cat., ed. J. Roberts; Bologna, Pal. Podestà, 1985), pp. 143–75 (150–52, 161)
A. M. Fioravanti Baraldi: 'Biagio Pupini detto dalle Lame', *Pittura bolognese del '500*, ed. V. Fortunati Pietrantonio, i (Bologna, 1986), pp. 185–208

ANNA MARIA FIORAVANTI BARALDI

Pyrgoteles [Lascaris, Giovanni Giorgio; Lascaris, Zuan Zorzi] *fl* before 1496; *d* ?Padua, Sept 1531). Italian sculptor of Greek birth or descent. He adopted the name of a celebrated Greek gem cutter who served Alexander the Great. He was active in Venice, Padua, Verona and possibly Ferrara and is first mentioned in an epigram of 1496 by the humanist Giambattista Guarino, who praised his *Venus flagillifera* (destr.). Pomponius Gauricus also praised the same work in *De sculptura* (1504).

Of his recorded sculptures, only one survives: a half-length marble *Virgin and Child* in the tympanum on the façade of S Maria dei Miracoli, Venice, is signed on a plaque embedded in the wall behind the sculpture. The full-bodied Virgin, in a layered veil, encompasses the energetic child within the rounded contour of her arms. The long drapery folds model her figure and unify the composition. Pyrgoteles shared his classicizing approach with his contemporaries Tullio and Antonio Lombardo. The child's contrapposto pose and backward gaze towards his mother's face suggest that Pyrgoteles was familiar with Leonardo da Vinci's *Virgin of the Rocks* (Paris, Louvre; see colour pl. 1, XXXVII1), if only indirectly, and points to a date of *c.* 1510.

BIBLIOGRAPHY
P. Paoletti: *L'architettura e la scultura del rinascimento in Venezia: Ricerche storico-artistiche*, 2 vols (Venice, 1893–7), ii, pp. 217, 225
L. Planiscig: *Venezianische Bildhauer der Renaissance* (Vienna, 1921), pp. 177–206
A. Moncrief and K. F. B. Hempel: 'Conservation of Sculptural Stonework: *Virgin & Child* on S Maria dei Miracoli and the Loggetta of the Campanile, Venice', *Stud. Conserv.*, xxii (1977), pp. 1–11

A. M. Schulz: 'The Giustiniani Chapel and the Art of the Lombardo', *Ant. Viva*, xvi/2 (1977), pp. 38–9, 44

——: *Giambattista and Lorenzo Bregno, Venetian Sculpture in the High Renaissance* (Cambridge and New York, 1991), pp. 10–11, 43, 81, 92, 194–5

M. T. Fiorio: 'Between Milan and Venice: The Role of Sculpture', *Leonardo & Venice* (exh. cat., Venice, Pal. Grassi, 1992), pp. 147–8, 152

ALISON LUCHS

Quercia, Jacopo della. *See* JACOPO DELLA QUERCIA.

R

R, del. *See* ERRI.

Rabicano, Cola. *See* RAPICANO, COLA.

Raffaellino da Reggio. *See* REGGIO, RAFFAELLINO DA.

Raffaellino del Garbo [Raffaelle de' Capponi; Raffaelle de' Carli; Raffaelle de Florentia] (*b* Florence, ?1466; *d* Florence, 1524). Italian painter and draughtsman. According to Vasari, he began as the most gifted assistant of Filippino Lippi and the most promising painter of the new generation but never fulfilled expectations, deteriorating into mediocrity and worse. Raffaellino's first known work is the frescoed vault of a small antechamber off Filippino Lippi's Carafa Chapel in S Maria sopra Minerva, Rome, uncovered during restoration in the 1960s. It was decorated with pagan themes, to Filippino's designs, apparently after the main chapel was completed in 1493. Filippino's influence is evident in the *all'antica* detail and animated figure style, to which Raffaellino brought a youthful freshness and charm. Vasari, in his account of the vault, likened it to an illuminator's work. It has been suggested that Raffaellino remained in Rome and worked with Bernardino Pinturicchio in the Borgia apartments in the Vatican, where some frescoes of 1495 show stylistic affinities with Raffaellino's work in S Maria sopra Minerva. This would explain the increasingly Umbrian orientation of his work, although he must also have studied Perugino in Florence.

By 1498 Raffaellino had returned to Florence and was working independently; his *catasto* (land registry declaration) shows he rented two workshops, and in 1499 he matriculated in the painters' guild. It is generally thought that his two major panel paintings date from around this time: the *Resurrection*, painted for the Capponi Chapel, S Bartolomeo a Monteoliveto, Florence, and the *Pietà* (see fig.), for the Nasi Chapel, Santo Spirito, Florence. Both works were mentioned by Vasari and by the Anonimo Magliabecchiano. The spontaneity of the Carafa vault has been replaced by the eclecticism that was to become a hallmark of Raffaellino's work. Elements from Filippino, Perugino, Piero di Cosimo and others combine to create competent, up-to-date but somewhat laboured works. The *Resurrection* still has a vestige of charm, particularly in the fanciful costumes and airy landscape, but the composition is fussy and the poses and spatial relationships uncomfortable. The *Pietà* is more elegant, although somewhat mannered and slick, with a bold, effective design based on

Raffaellino del Garbo: *Pietà*, oil on panel, 187×197 mm, *c.* 1499 (Munich, Alte Pinakothek)

Perugino's *Pietà* for S Giusto (Florence, Uffizi), well-constructed figures and unusually sculptural drapery.

By 1500, when he signed and dated the *Virgin and Child with SS Francis, Zenobius and Donors* (Florence, Uffizi), Raffaellino's style had become more stilted. The stiffly grouped figures are ranged somewhat two-dimensionally against an architectural framework opening on to a distant vista, a late 15th-century formula that Raffaellino often repeated, for example in the relatively sophisticated *Virgin and Child with SS John the Evangelist, Lawrence, Stephen and Bernard* (1505; Florence, Santo Spirito) or in the more monotonous altarpiece of *St Giovanni Gualberto* (1507–9; Vallombrosa, Abbey). Although this is his last datable work, it is possible that the *Coronation of the Virgin* (Paris, Louvre) from S Salvi, Florence, may be as late as 1511, although it is extremely close to Filippino; the four saints standing in a landscape and the angels encircling the Virgin and Christ in glory have a graceful beauty rarely encountered in Raffaellino, making this one of his most attractive works.

Five stylistically related paintings dated from between 1500 and 1503—of which three are signed or documented as by Raffaelle de' Carli, one signed *Raphael de Capponibus* and another *Raphael de Florentia*—appear inferior in style and execution to the so-called 'Garbo' group, centred on

the *Resurrection* and the *Pietà*. Some critics, notably Berenson, held that the inferior group was the work of a separate painter, Carli, and perhaps of two others as well. For some time, however, it has been acknowledged that these were names variously used by Raffaellino del Garbo. Carli was his family name, and Capponi that of a foster-parent, while del Garbo was a nickname deriving from the street in which the painter had his workshop. *Raphael de Florentia* was presumably a signature he used outside Florence.

Raffaellino's mature work is a blend of Florentine and Umbrian styles, with Filippino and Perugino the dominant influences. The resonant colour in the works of these painters became slightly garish in Raffaellino's paintings, which include bright violets, carmines and yellows. His modelling is bold, his contours strong and occasionally harsh. The quality of Raffaellino's work is erratic, but this cannot be explained simply in terms of a progressive decline; for example, the Uffizi altarpiece of 1500 is weaker than either the Santo Spirito altarpiece of 1505 or the *Coronation of the Virgin*. Raffaellino's oscillation between the Florentine and Umbrian styles and his often careless execution seem to be the manifestation of a restless impatience that may have been at the root of his decline. He was also perhaps a victim of his times, too limited in imagination to keep pace with the artistic developments of the early 16th century.

Raffaellino was last documented in 1517 as a tenant of the Florentine Badia; for over a decade before his death in 1524 (the date given by Vasari), there is scant indication of his activity. If, as is thought, he was the Raffaellino who offered his services in 1508 as an assistant to Michelangelo on the Sistine Chapel ceiling, he may already have fallen on hard times, although his workshop must have operated well into the next decade, as he is known to have been the master of Agnolo Bronzino and perhaps also of Andrea del Sarto. However, Vasari recounts that Raffaellino was eventually compelled, through straitened circumstances, to undertake all sorts of inferior work, which may explain the absence of late panel paintings. He certainly produced designs for embroideries, including part of the Passerini *paramento* (Cortona, Mus. Dioc.), datable to *c.* 1515 or later. His drawings were admired by Vasari, who purchased several from Raffaellino's son, including a fine study of the *Risen Christ* (London, BM).

BIBLIOGRAPHY

Thieme–Becker: 'Capponi, Raffaello de'; 'Carli, Raffaello de'; 'Garbo, Raffaellino del'

G. Vasari: *Vite* (1550, rev. 2/1568); ed. G. Milanesi (1878–85), iv, pp. 223–53

H. Ulmann: 'Raffaellino del Garbo', *Repert. Kstwiss.*, xvii (1894), pp. 90–115; xix (1896), pp. 186–7

B. Berenson: *The Drawings of the Florentine Painters*, i (New York, 1903), pp. 80–100

C. Gamba: 'Dipinti ignoti di Raffaele Carli', *Ant. Viva*, vii (1907), pp. 104–9

A. Scharf: 'Die frühen Gemälde des Raffaellino del Garbo', *Jb. Kön.-Preuss. Kstsamml.*, liv (1933), pp. 151–66

K. B. Nielson: *Filippino Lippi* (Cambridge, MA, 1938)

C. H. Smyth: 'The Earliest Works of Bronzino', *A. Bull.*, xxxi (1949), pp. 184–210

B. Berenson: *Florentine School* (1963), i, pp. 185–9

M. Carpaneto: 'Raffaellino del Garbo', *Ant. Viva*, ix/4 (1970), pp. 3–23; x/1 (1971), pp. 3–19

G. L. Geiger: *Filippino Lippi's Carafa Chapel* (Kirksville, MO, 1986)

PAULA NUTTALL

Raffaello da Brescia, Fra [Marone, Roberto] (*b* Brescia, 1479; *d* Rome, 1538). Italian wood-carver. He took the name Fra Raffaello when he entered the Olivetan Order at S Niccolò di Rodegno near Brescia in 1501. The Olivetans produced an impressive series of wood-carvers during the 15th century, including Fra Giovanni da Verona, under whom Fra Raffaello trained and served as assistant. In 1502 the two worked together on the intarsia of the choir of the abbey church of Monte Oliveto Maggiore, the mother house of the Order, near Siena. Shortly after this commission, Fra Raffaello assisted Fra Giovanni in the inlay of the sacristy cupboards and the choir for the Olivetan church in Naples (now S Anna dei Lombardi). Fra Raffaello returned to Brescia in 1509, working in S Niccolò di Rodegno, where his style became independent and individual, reflecting a fresh vitality and originality in the choice of themes. He moved to S Michele in Bosco near Bologna in 1513 and remained there until 1537, when he transferred to the Olivetan foundation in Rome. At S Michele in Bosco he was responsible for the carving and inlay work for the church and sacristy. Among his known surviving works are a signed and dated lectern for the church of Monte Oliveto Maggiore (1520), a panel from a cupboard (London, V&A) and various panels from a lectern from S Niccolò di Rodegno (Brescia, Mus. Civ. Cristiano). Fra Raffaello's inlay work is characterized by precise details, often whimsical depictions of genre, still-life scenes (fruit, musical instruments, liturgical vessels and animals) and remarkable perspective views of townscapes and landscapes, clearly in emulation of contemporary painting.

BIBLIOGRAPHY

M. Caffi: 'Fra Raffaele, maestro di legname', *Archv Stor. Lombardo*, ix (1882), pp. 661–71

F. Malaguzzi-Valeri: *La chiesa di S Michele in Bosco* (Bologna, 1895)

M. J. Thornton: 'Three Unrecorded Panels by Fra Raffaele da Brescia', *Connoisseur*, cxcvii (1978), pp. 240–48

STEVEN BULE

Raffaello [Raffaellino] dal Colle. *See* COLLE, RAFFAELLO DAL.

Ragusa, Niccolò da. *See* NICCOLÒ DELL'ARCA.

Raibolini. *See* FRANCIA.

Raimondi, Eliseo (*b* Cremona; *d* Cremona, 19 May 1512). Italian nobleman, patron and ?architect. He belonged to a rich commercial family whose members had held prestigious positions in Cremona from the 13th century. In 1482, as executor of his uncle Andrea Raimondi's will, he commissioned the master builder Guglielmo de Lera (*d* 1490), of a noted family of Cremonese builders, to construct the church and oratory of S Monica, Cremona, for the order of Augustinian nuns. In 1508 he commissioned Guglielmo's brother, Bernardino de Lera (*fl c.* 1477–1518), to renovate the choir and two adjacent chapels in the ancient church of S Francesco, Cremona, where he wished to be buried. The documents do not show who actually carried out the project, but some critics have attributed it to Eliseo himself, giving him the reputation of an architect. Two inscriptions (dated 1496) over the portal of Eliseo's Palazzo Raimondi (completed

1490–99; façade begun 1495) in Cremona have always been interpreted as proof that Eliseo authored the building. Bernardino de Lera was also involved in the construction of the palace in 1495 (see Visoli). According to Antonio Campi's map of the city of Cremona (see Campi), the palazzo was a typical Renaissance building laid out around two courts: a *cour d'honneur*, surrounded by a portico with two tiers of columns, and a small service court. The façade is entirely covered in marble, with a double order of paired pilaster-strips. The interior of the building was drastically impaired by 19th-century alterations. Eliseo is alleged to have written a treatise on architecture, *De re aedificatoria*, according to Arisi (1702). His brother, Tommaso Raimondi (*d* 1523), commissioned an altarpiece (London, N.G.) in 1500 from Marco Marziale for S Silvestro, Cremona.

UNPUBLISHED SOURCES

Cremona, Bib. Stat. & Lib. Civ., MS. AA.8.16 [D. Bordigallo: *Inclitae urbis Cremonae*, 1515]

BIBLIOGRAPHY

A. Campi: *Cremona fedelissima* (Cremona, 1585), p. liiij

F. Arisi: *Cremona literata*, i (Parma, 1702), pp. 375–6

F. Sacchi: *Notizie pittoriche cremonesi* (Cremona, 1872), pp. 165–71

A. Scotti: 'Architetti e cantieri: Una traccia per l'architettura cremonese del cinquecento', *I Campi e la cultura artistica cremonese del cinquecento* (exh. cat., Cremona, Mus. Civ. Ala Ponzone, 1985), pp. 371–408

O. A. Biandra: 'Un esempio di fedecommesso cinquecentesco: Il Palazzo Raimondi di Cremona', *Riv. Stor. Diritto It.*, lxi (1988), pp. 341–50

M. Visoli: 'Documenti per Palazzo Raimondi', *Artes* [Pavia], i (1993), pp. 84–7

MONICA VISIOLI

Raimondi, Marcantonio (*b* ?Argini, nr Bologna, *c.* 1470–82; *d* ?Bologna, 1527–34). Italian printmaker. One of the most important printmakers of the Renaissance, he helped to establish engraving as a reproductive medium. He made over 300 prints, all apparently based on designs of other artists, though he is best known for his prints after Raphael and the Antique. His creative contribution to his models is suggested by the apparent freedom with which he modified the compositions he engraved. The widespread dissemination of Raphael's designs was due to his prints.

1. TO *c.* 1510. Most information about Raimondi derives from the biography by Vasari, who did not know him personally. He spent his early years in Bologna, where he studied with Francesco Francia. His first engravings, including *Pyramus and Thisbe* (B. 322) of 1505 and the contemporary *Serpent Speaking to a Young Man* (B. 396), date from *c.* 1500–05. The models for many of his early prints are unknown; they probably reflect a combination of sources, including the works of Francia, Albrecht Dürer (1471–1528) and the Antique. Some subjects may derive from Classical texts. His earliest engravings are indebted technically to niello prints and to the engravings of Mantegna. The figure style shows the influence of Bolognese painters such as Francia and Lorenzo Costa (i). Like many early Italian engravers, he often set figures in extensive landscapes, some based on prints by Dürer or Lucas van Leyden (*c.* 1494–1533). By 1505, the year of *Pyramus and Thisbe* (B. 322), his rendering of space and figures in motion shows significant improvement. It was also about 1505 that he began copying the prints of Dürer (e.g. the *Offer of Love*, B. 650), which suggested more varied means of graphic expression.

Raimondi was exposed early to antique art, mythology and history in the rich intellectual life of Bologna. A body of drawings ascribed to him (Bayonne, Mus. Bonnat; Berlin, Kupferstichkab.; New York, Pierpont Morgan Lib.), probably dating from the beginning of his career, testifies to his early responsiveness to antique and 15th-century models, and his sensitivity to light, volume and Classical grace. He was a friend of the Bolognese poet Giovanni Achillini (1466–1538), who owned a collection of medals and other antique works and whose portrait he engraved (B. 469). Achillini's poem *El Viridario*, published in Bologna in 1513 but written in 1504, includes the first published reference to Raimondi. His interest in the Antique throughout his career is manifest in such prints as the *Equestrian Statue of Marcus Aurelius* (B. 514) and *Orpheus and Eurydice* (B. 282 and 295).

Between *c.* 1506 and *c.* 1508 Raimondi was in Venice, where he engraved copies after prints by Dürer, including those (B. 88) after the latter's woodcut series of the *Life of the Virgin*. Raimondi made a total of some 74 engraved copies after woodcuts and engravings by Dürer, making him the most prolific copyist of the German's work up to that time (Dürer, in fact, brought legal proceedings against him in 1506), and Dürer's varied linework inspired Raimondi throughout his career. During his Venetian sojourn he engraved more painterly models. The *Dream of Raphael* (B. 359) of *c.* 1508, possibly after a lost work by Giorgione, is his most pictorial early engraving, successfully approximating the tonal and atmospheric effects of a stormy landscape punctuated by fire, smoke and dramatic contrasts of light and shadow. Evidence that Raimondi visited Florence after his stay in Venice is provided by two engravings after Michelangelo's cartoon for the *Battle of Cascina* (destr.), which was then on exhibition in the Palazzo Vecchio. *The Climber* (B. 488) shows one figure from the cartoon, while *The Climbers* (1510; B. 487), his last dated print, shows three figures from it placed in front of a landscape derived from Lucas van Leyden's engraving *Mohammed and the Monk* (1508).

2. FROM *c.* 1510. Raimondi was probably in Rome by 1510 or 1511 and had met Raphael by 1513, when the latter included Raimondi's portrait in the fresco depicting the *Expulsion of Heliodorus* in the Stanza d'Eliodoro in the Vatican. Raimondi's earliest engraving after Raphael is probably *Dido* (B. 187) of *c.* 1510 and from this date until the latter's death in 1520 he primarily engraved the designs of Raphael and his circle. According to Vasari, he collaborated with Raphael's assistant Baviera, who handled the printing and marketing. He did not undertake a systematic reproduction of Raphael's works, but engraved only selections from the works in the Villa Farnesina, the Vatican Stanze and the Logge. Some engravings depict only portions of a larger composition, for example *Poetry* (B. 382) from the Stanza della Segnatura.

It was not until *c.* 1511–12, after his arrival in Rome and his exposure to Raphael's drawings, that Raimondi achieved the systematic graphic vocabulary of his mature style. This is evident in his *Lucretia* (B. 192; see fig. 1) and the *Massacre of the Innocents* (B. 18), in which he employed a logical system of hatching and highlighting, concentrating on essential areas of shadow rather than dispersing shad-

1. Marcantonio Raimondi: *Lucretia*, engraving, 212×130 mm, *c.* 1511 (Amsterdam, Rijksprentenkabinet)

ows over the figure. The result is a clearer articulation of forms that are more sculptural and easily readable. In the *Massacre of the Innocents* there is also a new fluency in depicting the figure in motion. This engraving and several of his other works after Raphael, including the *Morbetto* (B. 417), *Quos ego* (B. 352) and the *Judgement of Paris* (*c.* 1517–20, B. 245), were probably designed explicitly to be engraved. Many other engravings after Raphael were probably worked from preliminary drawings rather than finished pictures. This is suggested by the discrepancies between the prints and the paintings in such works as *Apollo* (B. 334), *Poetry* (B. 382) and *Parnassus* (B. 247), all related to frescoes in Raphael's Stanza della Segnatura. Some discrepancies may also reflect Raimondi's considerable liberty in interpreting some of his drawn models. A few exceptions, for instance *Galatea* (B. 350), correspond closely to their painted counterparts and may have been based directly on the painted model (see colour pl. 2, XXII1). The style of certain prints has been related to the impact of finished wash drawings by Raphael and his circle. The strong contrasts in light and shadow in the *Morbetto* (*see* RAPHAEL, fig. 7) (B. 417) and the *St Cecilia* (B. 116) were connected by Davidson with analogous chiaroscuro effects in wash drawings heightened with white.

Vasari noted that Raimondi's collaboration with Baviera was extremely profitable, as is suggested by the many plates that were duplicated in Raimondi's workshop, presumably to meet the continuing demand for prints after the original plates had worn out (e.g. the *Massacre of the Innocents*, B. 18 and 19). After Raphael's death, Raimondi continued to engrave designs by artists from his workshop, especially Giulio Romano. His prints after Giulio include *Hercules and Antaeus* (B. 346) and the *Virgin of the Long Thigh* (B. 57). The latter shows his continued commitment to clear sculptural forms. The portrait of *Pietro Aretino* (B. 513), however, demonstrates a new sensitivity to tactile values and effects of light. Vasari credited Raimondi with the design for this portrait engraving, but it is generally attributed to Sebastiano del Piombo. Around 1524 Raimondi engraved *I modi*, 16 erotic engravings after Giulio's designs, and Pope Clement VII ordered Raimondi's imprisonment as punishment. Cardinal Ippolito de' Medici and the sculptor Baccio Bandinelli secured his release, after which he completed his engraving of Bandinelli's *Martyrdom of St Lawrence* (B. 104; see fig. 2). This shows his response to a different type of model, Bandinelli's complex, multi-figured, Mannerist composition. The Sack of Rome in 1527 ruined Raimondi. According to Vasari, he was forced to ransom himself from the Spaniards and departed from the city reduced to beggary. He probably returned to Bologna, though there are no documented accounts of his presence there at this time, and he is referred to as deceased in the revised version (1534) of Pietro Aretino's *La Cortigiana*. With Raphael's death, his own imprisonment and the Sack of Rome, Raimondi's productivity diminished, and none of his prints can be securely dated after 1527.

Although best known as an engraver, Raimondi was one of the first Italian printmakers to experiment with etching. In some 30 small plates (e.g. *A Woman Tearing her Hair*, B. 437), he combined engraving with etching, although his use of etched lines so closely resembles the technique of engraving that it is difficult to distinguish the etched from the engraved lines. It was the later Italian etchers, notably Parmigianino, who exploited the potential of etching for greater freedom.

In 1510 there was no school of engraving in Rome. Raimondi took advantage of this opportunity to create a financially and artistically successful commerce in prints, and to found a school of engravers that included Marco Dente, Agostino dei Musi and Giovanni Jacopo Caraglio. The engraving techniques developed and taught by Raimondi produced accurate copies of works of art and permitted the rapid dissemination of stylistic and iconographic knowledge throughout Europe.

BIBLIOGRAPHY

Thieme–Becker

G. Achillini: *El Viridario* (Bologna, 1513)

P. Aretino: *La Cortigiana* (Rome, 1525, rev. 1534)

G. Vasari: *Vite* (1550, rev. 2/1568); ed. G. Milanesi (1878–85), v, pp. 395–446

A. von Bartsch: *Le Peintre-graveur* (1803–21), xiv/[B.]

J. D. Passavant: *Le Peintre-graveur* (Leipzig, 1860–64), i, pp. 248–9; vi, pp. 1–49

B. F. Davidson: *Marcantonio Raimondi: The Engravings of his Roman Period* (diss, Cambridge, MA, Harvard U., 1954)

A. Petrucci: *Panorama della incisione italiana: Il cinquecento* (Rome, 1964), pp. 19–35

2. Marcantonio Raimondi: *Martyrdom of St Lawrence*, engraving, 438×580 mm, *c.* 1525 (London, British Museum)

K. Oberhuber: *Die Kunst der Graphik*, iii (Vienna, 1966), pp. 84–103
——: *Raphaels Zeichnungen* (Berlin, 1972)
K. Oberhuber and others: *Rome and Venice: Prints of the High Renaissance* (Cambridge, MA, 1974), pp. 9–47
S. Ferrara and G. Gaeta Bertelà: *Incisori bolognesi ed emiliani del sec. XVI* (Bologna, 1975), nos 319–473a
K. Oberhuber: *The Works of Marcantonio Raimondi and of his School* (1978), 26–7 [XIV/i–ii] of *The Illustrated Bartsch*, ed. W. Strauss (New York, 1978–)
I. H. Shoemaker and E. Broun: *The Engravings of Marcantonio Raimondi* (Lawrence, KS, 1981) [with good bibliog.]
K. Oberhuber: *Raffaello* (Milan, 1982)
P. Joannides: *The Drawings of Raphael* (Berkeley and Los Angeles, 1983)
R. Jones and N. Penny: *Raphael* (New Haven and London, 1983), pp. 81–4, 151–2, 179–85
E. Knab, E. Mitsch, K. Oberhuber and others: *Raphael: Die Zeichnungen* (Stuttgart, 1983)
G. Bernini Pezzini, S. Massari and S. Prosperi Valenti Rodinò: *Raphael invenit* (Rome, 1985)
G. V. Dillon: 'Il vero Marcantonio', *Studi su Raffaello, Atti del Congresso internazionale di studi*: Milan, 1987, pp. 551–561
Bologna e l'umanesimo, 1490–1510 (exh. cat., ed. M. Faietti and K. Oberhuber; Bologna, Pin. N., 1988), pp. 45–236
R. van Straten: *Marcantonio Raimondi and his School: An Iconographic Index to A. von Bartsch, Le Peintre-graveur, vols. 14, 15, and 16* (Doornspijk, 1988)
B. Bohn: 'Felsina collezionista: The Creation of Finished Drawings in Sixteenth-century Bologna', *Stud. Stor. A.* [Todi], v–vi (1994–5), pp. 193–211

BABETTE BOHN

Raimondi [Raimondo], **Vincenzo.** *See* RAYMOND, VINCENT.

Rainieri di Leonardo da Pisa. *See* MASTERS, ANONYMOUS, AND MONOGRAMMISTS, §I: MASTER OF THE CROCIFISSO DEI BIANCHI.

Ramenghi, Bartolomeo, I. *See* BAGNACAVALLO.

Rangone [Giannotti; Philologo; da Ravenna]**, Tommaso** [Tomaso] (*b* Ravenna, 18 Aug 1493; *d* Venice, 10 Sept 1577). Italian physician, philologist and patron. He received his doctorate in arts and medicine from the university of Bologna and was appointed to a chair in mathematics at the university of Padua in 1520. He taught in Rome and Bologna and also served as a private physician, in which capacity he was granted the right to adopt the name Rangone, an aristocratic family of Emilia. He settled in Venice and amassed a fortune through his medical practice and publications. His acts of public charity began in 1552, when he founded a college at the university of Padua. In 1553 the Venetian Senate approved Rangone's proposal to pay for the façade and restoration of S Giuliano and for a bronze statue of himself to be placed on the façade. The statue (1554–7; *in situ*) was executed to Jacopo Sansovino's model, reworked by Alessandro Vittoria. Sansovino also provided the model for the façade, which was begun in 1554 and is generally considered to have been completed by Vittoria and/or Giovanni Antonio

Rusconi. In 1558 Rangone signed a contract to contribute to the rebuilding of the nave, provided that his tomb be placed in the high altar chapel (he was eventually buried in the chancel). Vittoria designed three medals (1556–60; Venice, Correr) to commemorate Rangone's patronage of S Giuliano. He also designed two bronze portrait medals of Rangone (1552–9; 1556–8) from a series of five, of which two (*c.* 1562) are by Matteo Pagano della Fede (*fl* 1543–62) and one (*c.* 1562) by Martino da Bergamo (*fl* 1562–8). There is a complete series in Venice (Correr); three are in Washington, DC (N.G.A.).

Rangone promoted artistic projects for the Scuola di S Marco during his two terms (1562–3; 1568–9) as Guardiano Grande. In 1562 the Scuola accepted his proposal to pay for paintings by Jacopo Tintoretto in the Sala Grande. This comprised the frescoes of the *Virtues and Vices* (or *Prophets and Sibyls*; destr.) and three paintings of the *Miracles of St Mark* (1562–6), which originally hung opposite the frescoes. The latter works—*St Mark Saving the Saracen*, the *Removal of the Body of St Mark* (both Venice, Accad.) and the *Finding of the Body of St Mark* (Milan, Brera)—all prominently include depictions of Rangone. He ended his relationship with the Scuola after the chapter rejected his offer of self-commemorative objects in 1571. Rangone became procurator of S Geminiano in 1564, and Vittoria's gilded bronze bust of *Tommaso Rangone* (*c.* 1575) was placed over the exterior door to the sacristy; when the church was demolished (1807) the bust was moved to the Ateneo Veneto. In 1570 he became procurator for life of the convent of S Sepolcro, Venice, for which he commissioned a portal facing the Riva degli Schiavoni from Sansovino, designed by Vittoria after Sansovino's death. The portal was crowned by a marble statue by Vittoria's workshop of *St Thomas* (1560s; Venice, Semin. Patriarcale) with Rangone's features.

An inventory (*c.* 1561) of Rangone's possessions lists works of art in addition to books, manuscripts and maps. These included antique vases, a drawing by Giulio Romano of *Duke Federico Gonzaga of Mantua* (untraced), a design by Raphael for a weapon for Duke Federico (untraced), as well as 41 statues and reliefs. A few of the objects have been identified with surviving works: Tintoretto's *Tommaso Rangone and ?his Son Marius* (Stockholm, Ake Wilberg bequest) and a portrait of *Tommaso Rangone* (New York, Heimann) thought to be by Domenico Molino. The inventory also mentions a gilded stucco relief by Sansovino of the *Virgin and Child* (possibly that in Venice, Correr). In his will Rangone provided for the founding of a public library and museum near S Giuliano to be endowed with his books and collections. These were never realized, and his possessions are in various collections, libraries and museums in Venice, notably the gilded terracotta bust of *Tommaso Rangone* (Venice, Correr) by Vittoria, which was intended for the library.

BIBLIOGRAPHY

P. Aretino: *Lettere*, 6 vols (Venice, 1538–57); ed. E. Camesasca, 3 vols (Milan, 1957–60), ii, pp. 204–5

G. Vasari: *Vite* (1550, rev. 2/1568); ed. G. Milanesi (1878–85), vi, pp. 592–3

G. Astegiano: 'Su la vita e le opere di Tommaso da Ravenna', *Boll. Mus. Civ. Padova*, xviii (1925), pp. 240–57

P. Paoletti: *La Scuola Grande di San Marco* (Venice, 1929), pp. 13–64, 166, 168–74, 177–80, 182

D. Giordano: 'Un ospite dell'Ateneo Veneto di Venezia, Tomaso Rangone', *Ateneo Ven.*, cxxix (1941), pp. 291–303

E. Weddigen: 'Thomas Philologus Ravennas: Gelehrter, Wohltäter und Mäzen', *Saggi & Mem. Stor. A.*, ix (1974), pp. 7–76

J. Bialostocki: 'Die Kirchenfassade als Ruhmesdenkmal des Stifters: Ein Besonderheit der Baukunst Venedigs', *Röm. Jb. Kstgesch.*, xx (1983), pp. 1–16 (7–11)

JILL E. CARRINGTON

Raphael [Santi, Raffaello; Sanzio, Raffaello] (*b* Urbino, 28 March or 6 April 1483; *d* Rome, 6 April 1520). Italian painter, draughtsman and architect. He has always been acknowledged as one of the greatest European artists. With Leonardo da Vinci, Michelangelo and Titian, he was one of the most famous painters working in Italy in the period from 1500 to 1520, often identified as the High Renaissance, and in this period he was perhaps the most important figure. His early altarpieces (of 1500–07) were made for Città di Castello and Perugia; in Florence between 1504 and 1508 he created some of his finest portraits and a series of devotional paintings of the Holy Family. In 1508 he moved to Rome, where he decorated in fresco the *Stanze* of the papal apartments in the Vatican Palace —perhaps his most celebrated works—as well as executing smaller paintings in oil (including portraits) and a series of major altarpieces, some of which were sent from Rome to other centres. In Rome, Raphael came to run a large workshop. He also diversified, working as an architect and designer of prints.

I. Life and work. II. Working methods and technique. III. Character and personality. IV. Critical reception and posthumous reputation.

I. Life and work.

1. Paintings and drawings. 2. Architecture.

1. PAINTINGS AND DRAWINGS.

(i) Urbino, to 1504. (ii) Florence, 1504–8. (iii) Rome, 1508–20.

(i) Urbino, to 1504. Raphael was the son of GIOVANNI SANTI, a competent painter attached to the Montefeltro court in Urbino. Giovanni was esteemed by the court as a poet, chronicler and deviser of masques as well as a painter. Although Raphael was only 11 when his father died, it is significant that he spent his first years near a court, for he was to become a court artist himself. In his early years he enjoyed the patronage of Elisabetta Gonzaga, the Duchess of Urbino, and of the Duke's sister-in-law Giovanna della Rovere, known as the Prefetessa. Raphael first received commissions for major altarpieces in Città di Castello and Perugia, not far from Urbino. Most remarkably, he also made detailed compositional drawings (Florence, Uffizi; New York, priv. col.) for a series of frescoes in the Biblioteca Piccolomini in Siena commissioned from Bernardo Pinturicchio, then the most successful artist in Italy. That Pinturicchio should have delegated the invention of such works to a junior artist outside his own circle who had probably never worked in fresco is an astonishing tribute to Raphael's precocious genius.

Raphael is said by Vasari to have been a pupil of Perugino, the master of Pinturicchio, who about 1500 was at the height of his powers and whose reputation would have been pre-eminent in the area near his native Perugia, where he retained a workshop. What seems to be Raphael's earliest intact altarpiece, the Mond *Crucifixion* (*Crucifixion*

with the *Virgin, SS Mary Magdalene, John the Baptist and Jerome*, London, N.G.; see fig. 1), which was painted for a chapel (consecrated 1503) in S Domenico, Città di Castello, is remarkably close to Perugino, in the lightly posed figures, which are meek and decorous in gesture and sweet in expression, in its linear elegance and atmospheric distant hills, which are bare but for soft clumps and individual trees as light as columns of smoke. All details of the formal language—crooked little fingers, solid scaly wings, hooked drapery folds—derive from Perugino, and Raphael also imitated Perugino's technique of painting, largely in an oil medium. An earlier altarpiece, of *St Nicholas of Tolentino*, which was commissioned in 1500 for S Agostino, Città di Castello (surviving fragments Brescia, Pin. Civ. Tosio–Martinengo; Naples, Capodimonte; Paris, Louvre), is also influenced by Perugino, but to a lesser extent (the flesh in particular is painted in a very different way). Thus if Raphael was closely associated with Perugino it may not have been in the late 1490s, at the age implied by Vasari's account.

Perugino is no less dominant as an influence in the *Coronation of the Virgin* (Rome, Pin. Vaticana), which is probably only a little later in date than the Mond *Crucifixion*, and in the *Sposalizio* (Marriage of the Virgin) dated 1504 (Milan, Brera) made for Città di Castello. Indeed the latter is, in some respects, a revised version of Perugino's painting of the same subject begun in 1500 for Perugia Cathedral. Raphael's Ansidei *Madonna* (*Madonna and Child with SS John the Baptist and Nicholas of Bari*), apparently dated 1505 (London, N.G.), also recalls many of Perugino's altarpieces of the Virgin and Child enthroned with saints, in particular the great altarpiece completed in 1495 for the Magistrates of Perugia (Rome, Pin. Vaticana). There is an advance in Raphael's altarpieces towards more concern for the lucid articulation of pictorial space. The earliest of them, the Mond *Crucifixion*, is remarkable rather for its two-dimensional geometry: little is made of the fact that the standing saints are placed behind the kneeling ones. The puzzle among these early altarpieces is the *Pala Colonna* (New York, Met.), which is relatively gauche in its architectural structure, turgid in its patterned surfaces and clumsy in its overlapping forms. It may be a work of collaboration and perhaps dates in conception from as early as 1501.

These altarpieces were not the young Raphael's only important commissions, nor perhaps those by which his reputation was chiefly made. His commissions from the court of Urbino were confined, it seems, to small finely finished paintings. Some of these are untraced: an *Agony in the Garden*, commissioned by the Duchess, which was being completed in 1507, or small Madonnas probably of earlier date belonging to the Duke, Guidobaldo I. Of his surviving small courtly works the most notable are a pair of paintings of *St George* and *St Michael* (both Paris, Louvre), another, later, painting of *St George* (Washington, DC, N.G.A.), probably connected with the Duke's election to the Order of the Garter in 1504, and another pair of paintings, evidently allegorical, of *c.* 1504, showing a dreaming hero, the *Vision of a Knight* (or *Dream of Scipio*; London, N.G.; see fig. 2; for illustration of a drawing of this work *see* POUNCING) and the *Three Graces* (Chantilly,

1. Raphael: Mond *Crucifixion* (*Crucifixion with the Virgin, SS Mary Magdalene, John the Baptist and Jerome*), oil on panel, 2.80×1.65 m, *c.* 1503 (London, National Gallery)

2. Raphael: *Vision of a Knight* (or *Dream of Scipio*), tempera on panel, 171×171 mm, *c.* 1504 (London, National Gallery)

Mus. Condé). In these paintings sources are evident that are not apparent in Raphael's altarpieces: the influence of imported Netherlandish oil paintings (the background of the *St George* in Washington is taken from a Hans Memling (1430/40–1494)) and of the Antique (the *Three Graces* are derived from an ancient Roman marble group).

(ii) Florence, 1504–8. Raphael probably arrived in Florence late in 1504, although the letter that purports to document this is probably a forgery. He evidently remained there on and off until 1508, but he also continued to work for Umbrian patrons. The Ansidei *Madonna*, which seems to be dated 1505 (it may be later), was made for Perugia, and in S Severo, also in Perugia, Raphael completed a lunette in fresco, apparently his first work in that medium, dated by a later inscription to *c.* 1505. In that year also he is likely to have received the commission for the *Entombment* (Rome, Gal. Borghese; see colour pl. 2, XX2) from Perugia's ruling family, the Baglioni, which he completed in 1507. Raphael's only large altarpiece commissioned in Florence was the *Madonna and Child Enthroned with Saints* (the '*Madonna del Baldacchino*'; Florence, Pitti), which he abandoned in 1508 when he was called to Rome to work for the Pope. He did, however, receive important commissions from Florentines, for portraits and for domestic devotional paintings of the Virgin and Child (larger in format than such works generally were elsewhere in Italy). The most important portraits are those of *Agnolo Doni* and his wife *Maddalena* (both *c.* 1507–8; Florence, Pitti); of the devotional works the most important are the series of full-length groups of the Virgin and Child with St John in a landscape setting: the *Madonna of the Meadow*, apparently dated 1505 (Vienna, Ksthist. Mus.; see fig. 3), the badly damaged *Madonna del Cardellino* of about 1506 (Florence, Uffizi) and the *Belle Jardinière* dated 1507 (Paris, Louvre).

In Florence, Raphael made friends with local artists, most notably Fra Bartolommeo, whose influence is most obvious in the S Severo fresco and in the '*Madonna del Baldacchino*'. From him Raphael learnt to replace the fragile grace of Perugino with a more measured movement, far ampler draperies, more gravity and grandeur. He also studied two great Florentine artists of the past, significantly both sculptors. There is, for example, a remarkable drawing by him (Oxford, Ashmolean) of Donatello's *St George* (Florence, Bargello; *see* FLORENCE, fig. 11), and he adapted the pose of the Child in Michelangelo's *Madonna and Child* (Bruges, Notre Dame) for his *Madonna del Cardellino* and made a drawing (Oxford, Ashmolean) of Michelangelo's newly erected *David* (Florence, Accad.; *see* ITALY, fig. 22). In addition, Raphael studied work, both new and old, by Leonardo. In some of the smaller panels he painted in these years, notably the *Holy Family with the Lamb* (*c.* 1505; Madrid, Prado) and the *Madonna dei Garofani* (1507–8; Alnwick Castle, Northumb., on loan to London, N.G.), he adapted inventions that connoisseurs would have immediately recognized as Leonardo's. Moreover, the example of Leonardo's compositional ideas lies behind not only Raphael's portrait of *Maddalena Doni* (close to the *Mona Lisa*; Paris, Louvre; see colour pl. 1, XXXVI3) but the Florentine paintings of the full-length groups of

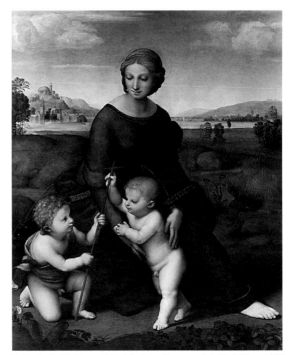

3. Raphael: *Madonna of the Meadow*, oil on panel, 1.13×0.88 m, 1505 (Vienna, Kunsthistorisches Museum)

the Holy Family in a landscape (listed above) in which the figures are arranged into a pyramid or cone with each part retaining a dynamic and organic relationship to the others. The physical movement and psychological interplay within these groups is further developed in the Canigiani *Holy Family* (*c.* 1507; Munich, Alte Pin.), where other figures are added and the spiralling movement is extended into the angels in the clouds (revealed by cleaning).

The prestige accorded by Leonardo and other Florentine artists to the depiction of action and a variety of emotions in art, and the priority (in consequence) of narrative in painting, explains how Raphael's ideas evolved for the *Entombment* which he painted in these years. His first compositional drawings for this commission (Oxford, Ashmolean) suggest that he envisaged a scene not dissimilar to the *Lamentation* (Florence, Pitti; see colour pl. 2, XIV3) made by Perugino for S Chiara in Florence in the mid-1490s, in which the figures were stationary around the dead body. He concluded by painting every figure in movement.

Raphael's drawing style changed in Florence: more of his work was in pen and ink and it was often rough, a means of generating and exploring his ideas as well as defining them. Only from this period are there drawings by him that seem to have been made for their own sake rather than as preparation for other works. His sketches, perhaps made from memory, of work by Donatello, Michelangelo and Leonardo belong to this category and probably also a series of drawings of struggling male nude warriors (Oxford, Ashmolean). There is some echo of those compositions in the *Entombment*, but they relate more closely to works he executed later in Rome.

(iii) Rome, 1508–20.

(a) Works for the Vatican Palace. (b) Altarpieces. (c) Engravings by Marcantonio Raimondi and frescoes outside the Vatican. (d) Portraits and smaller devotional works.

(a) *Works for the Vatican Palace.*

The 'Stanze'. Raphael left Florence to work in Rome in 1508, probably in the autumn, summoned by Pope Julius II who would have heard of him through his relatives at the court of Urbino and through his architect Donato Bramante, a compatriot and distant kinsman of Raphael. From this date, until his death, Raphael was employed by the popes—successively Julius II and (from 1513) Leo X—and engaged more or less continuously on the decoration of the Vatican Palace. A review of his work in the Palace provides valuable points of reference for a survey of the astonishing achievements of his brief maturity as an artist.

Raphael's first commission at the Vatican was to decorate the Stanza della Segnatura, a room that was almost certainly designed as the library of Pope Julius. He painted first the *Disputa* (disputation), a composition on three tiers representing the Church, on earth and in heaven, with the Trinity above an altar displaying the Eucharist. In the golden vault is God the Father, on the middle tier is Christ enthroned, flanked by the Virgin and St John the Baptist, with a hemicircle of seated prophets and martyrs ranged on a cloud bank. Below, surrounding the altar, are groups of disputants, including the Fathers of the Church.

Raphael's next work in this room was probably the *Parnassus* on an adjacent wall (see colour pl. 2, XXI1). It depicts great poets assembled on the slopes of the hill where Apollo's music enraptures the Muses. By the time Raphael had completed this wall—perhaps before—it must have been decided that he should decorate the whole room and modify the earlier decoration of the vault by Sodoma.

Opposite the *Disputa* Raphael painted the *School of Athens* (see ITALY, fig. 15), an ideal assembly of ancient sages with Plato and Aristotle at the centre, framed by an arch. On the fourth wall, scenes of Pope Gregory IX (*reg* 1227–41) and Justinian I, Emperor of Byzantium, delivering decrees were placed to either side of a window with the Three Cardinal Virtues above. The lower part of the wall looks hastily composed and was certainly not executed entirely by Raphael. It is evidence of the immense pressure his patrons now placed on him.

The decoration of the whole room is based on a complex intellectual structure (*see* ROME, §V, 1(iii)(b)). The tondi on the ceiling, with personifications of Theology, Poetry, Philosophy and Jurisprudence, are placed in relation to the subjects on the walls below. Between each tondo is a rectangular composition depicting a subject relating to the contiguous virtues (thus, for example, the *Judgement of Solomon* is placed between Jurisprudence and Philosophy). The fact that Raphael's work on the ceiling may not have been envisaged originally and the evidence of his numerous surviving drawings, however, suggest that the programme

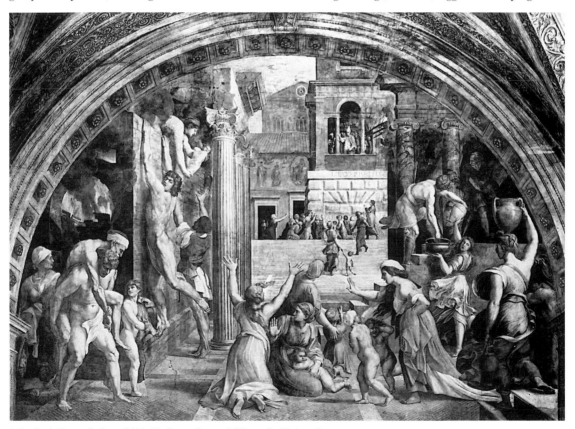

4. Raphael: *Fire in the Borgo* (1514–17), fresco, Stanza dell'Incendio, Vatican, Rome

was not fixed, but evolved in response to the artist's own ideas, the patron's changing ambitions and the opportunities offered by the space.

Work on the Stanza della Segnatura was probably completed in 1512: in that year Raphael began work on another room, the Stanza d'Eliodoro, apparently completed in 1514. Here the intellectual structure was less complex. Each wall was painted with an historical or legendary narrative that had a special significance for the devotions and political aspirations of the Pope: the miraculous bleeding of a eucharistic wafer during the *Mass at Bolsena*, the *Expulsion of Heliodorus* (*see* ROME, fig. 11) from the Temple of Jerusalem, the *Repulse of Attila* by Pope Leo I, the *Deliverance of St Peter from Prison*. Julius II had, for example, venerated the relic from the mass at Bolsena in Orvieto on his march against Bologna in 1506. The episode of Leo I halting the Huns, attractive to Julius, who was determined to expel the French from Italy, was of no less significance for his far less belligerent successor Leo X. Raphael adapted the composition, making the first Leo a portrait of the tenth.

When the last frescoes in the Stanza d'Eliodoro, the Old Testament scenes on the ceiling, were complete in 1514, Raphael was one of the most celebrated artists in Europe. Remarkable evidence of the esteem he enjoyed at court is supplied by the fact that Leo X's chief minister, the papal treasurer Cardinal Bernardo Bibbiena, offered Raphael his niece as a wife. Still more remarkable is the reason that Vasari gave for Raphael's hesitation to accept her hand: the possibility that the Pope would make him a cardinal. Leo greatly extended the range of work that Raphael undertook in Rome, above all by appointing him one of the architects of St Peter's (*see* ROME, §V, 1(ii)(a)) in succession to Bramante. In consequence, Raphael's workshop enlarged, and associates as well as assistants began to play a greater part in his paintings.

Like the Stanza d'Eliodoro, the Stanza dell'Incendio, decorated between 1514 and 1517, features large narratives of permanent significance to the papacy as a spiritual and temporal power but also of topical relevance for the ruling pontiff. They show Leo III taking the oath in St Peter's, Leo III crowning Charlemagne Holy Roman Emperor in the same basilica, Leo IV (*reg* 847–55) thanking God for victory over the Saracens at Ostia and ordering that the captives be used as labourers to rebuild the Vatican, and Leo IV extinguishing by the sign of the cross the fire in the area near the Vatican, the Borgo, that had threatened St Peter's itself. Every scene relates to St Peter's, which Leo X and Raphael were rebuilding. Raphael only painted a part of these scenes, and perhaps no part at all of some of them. He may not have made the cartoons for all of them, although he certainly made studies for each and was responsible for all the designs. The scene of the extinction of the *Fire in the Borgo* (see fig. 4), which gives its name to the room, is much the finest in execution and most remarkable in composition. The action is largely at right angles to the picture plane, an innovation that later attracted Jacopo Tintoretto.

The tapestry cartoons, loggias and the Sala di Costantino. During the same years in which he was at work on the commission for the Stanza dell'Incendio, Raphael was making designs for tapestries to hang on the lowest stage of the walls of the Sistine Chapel, the chapel of the Vatican Palace. Payments for this work are recorded in June 1515 and December 1516. The tapestries (Rome, Pin. Vaticana) were made in the Brussels workshop of Pieter van Aelst; of Raphael's ten cartoons eight survive (British Royal Collection, on loan to London, V&A). They depict the Acts of the Apostles. The scenes from the *Life of Peter* were intended to emphasize the authority of the pope, Peter's successor as Christ's vicar on earth. The authority of the Church was stressed by reference to the works of Paul, its most active early minister, in, for example, *Paul Preaching at Athens* (see fig. 5). It is difficult to establish quite how much of the cartoons Raphael himself painted. Certainly he took care that the compositions, the expressions and the gestures were clear and forceful, in anticipation of their translation into the less subtle medium of tapestry.

Also in 1516 Raphael's workshop painted the bathroom (the *stufetta*) and loggia (the *loggetta*) of Cardinal Bibbiena in the Vatican Palace (for illustration *see* GIOVANNI DA UDINE and colour pl. 2, XXI2). These were decorated in an extraordinarily accomplished imitation of ancient Roman painting—in some ways a rehearsal for the decoration of the Loggie, the private Vatican loggias of Leo X, which Raphael supervised in 1518–19. The pilasters of the Loggie were decorated with grotesque ornaments, both painted and in low-relief stucco, closely modelled on the interiors of ancient Roman palaces and tombs (*see* GROTESQUE, fig. 1). The decoration of the vault of each of the 13 bays included narrative paintings drawn (with the exception of the final bay) from the Old Testament. The project involved associates as well as assistants. His associates included Giovanni da Udine, who worked for Raphael as a still-life expert, a specialist in the painting of animals and flowers, and as a painter and modeller of ornament. Encouraged by Raphael, he perfected his imitation of ancient white stucco technique and grotesque ornament. GIULIO ROMANO and Giovan Francesco Penni (*see* PENNI, (1)), who probably painted the narratives, were assistants, trained by Raphael, but now highly accomplished and given considerable independence. Raphael's contribution was probably confined to compositional drawings.

At the time of his death in 1520, Raphael had started work on the Sala di Costantino, a great audience hall in the Vatican Palace. He had planned the decorative scheme and completed drawings for the *Battle of the Milvian Bridge* and for some of the enthroned virtues before he died, and painting of two of the enthroned virtues had, it seems, already begun.

(b) *Altarpieces.* Raphael's career before his arrival in Rome is generally charted through his altarpieces, which were his most important commissions. He continued to paint major altarpieces in Rome, many of them destined for sites outside the city. The first was the *Madonna di Foligno* (*c.* 1512; Rome, Pin. Vaticana), commissioned by the private chamberlain of Julius II, Sigismondo de' Conti, to serve as the high altarpiece of S Maria in Aracoeli, a major Franciscan church in Rome. This work reveals Raphael as a great colourist. In the majority of his earlier paintings the colour, however effective, impresses as

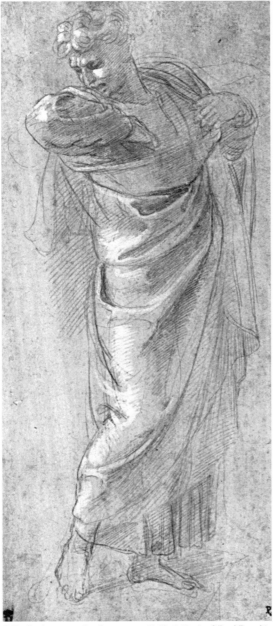

5. Raphael: cartoon for the tapestry (3.43×4.42 m) of *Paul Preaching at Athens*, gouache on paper, 1515–16 (British Royal Collection: on loan to London, Victoria and Albert Museum)

In 1513 and 1514 Raphael was probably working on three major altarpieces, the *Madonna of the Fish* (Madrid, Prado), the *Sistine Madonna* (Dresden, Gemäldegal. Alte Meister) and the *St Cecilia* altarpiece (Bologna, Pin. N.)—although this last was probably not completed before 1516. The *Sistine Madonna*, which was presented by Pope Julius II to S Sisto in Piacenza, a city newly incorporated into the Papal States, is the most remarkable of these, on account of its visionary power. The Virgin and Child appear to float forward through the picture frame. They seem to be extraordinarily tangible and yet at the same time 'to be made of air and of light and without mortal weight', as Bellori remarked of the radiant angel in the *Deliverance of St Peter* painted at the same date. The *St Cecilia* altarpiece made for S Giovanni in Monte, Bologna, at the behest of Canon Antonio Pucci, nephew of the powerful Cardinal Lorenzo Pucci, is utterly different and no less original. Here Raphael insinuated novel ideas of beauty and grandeur into an image in which the realism, the depiction of light on different textures, and the meticulous detail of the still-life (apparently largely painted by Giovanni da Udine) and of the still figures is dazzling.

In the altarpiece known as the *Spasimo di Sicilia* (the Road to Calvary; Madrid, Prado), which Raphael completed for the Olivetan Monks of S Maria dello Spasimo in Palermo in 1517 or soon afterwards, studio assistance is as obvious as in the tapestry cartoons. There is also some discordance in the composition, reminiscent of some

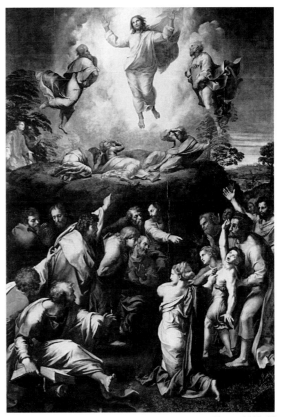

6. Raphael: *Transfiguration*, oil on panel, 4.05×2.78 m, 1517–20 (Rome, Pinacoteca Vaticana)

something added after the composition was worked out. In this painting, as in the Stanza d'Eliodoro, the colour seems an integral part of the composition. There is also a remarkable development of some of the most expressive figures in the *Disputa*, most notable in the head of St Francis with its open mouth, watery eye and melting profile against the flickering lights of the distant landscape. Light indeed is now a major agent in the picture, as it is in the *Repulse of Attila* (with its dawn and fires) or the *Deliverance of St Peter* by moonlight, in the Stanza d'Eliodoro.

of the frescoes in the Stanza dell'Incendio. There are no such problems with the large devotional paintings sent by Raphael to the French court, most notably the *Holy Family of Francis I* and the *St Michael* (both 1518; Paris, Louvre), despite the large participation of his workshop. Nor, certainly, is there any unevenness in the most ambitious and largest of all his paintings in oil, his last altarpiece, the *Transfiguration* (Rome, Pin. Vaticana; see fig. 6), commissioned by the Pope's cousin, Cardinal Giulio de' Medici, by January 1517 and exhibited as a finished work just after Raphael's death. This too was intended for export, to Narbonne Cathedral of which Giulio was archbishop. Like the *Spasimo* and the Borghese *Entombment*, it was a narrative with numerous figures.

The *Transfiguration* was created in competition with Sebastiano del Piombo, whose *Raising of Lazarus* (London, N.G.; *see* SEBASTIANO DEL PIOMBO, fig. 3), painted with the help of drawings supplied by Michelangelo, was intended for the same cathedral. The subject of Raphael's painting is not simply the Transfiguration, the manifestation of Christ's divinity to his disciples, but a subsequent event, the failure of the disciples to heal a boy possessed by demons. This extension of the subject was perhaps prompted in order to provide a composition that was closer in character to Sebastiano's. Nowhere more than in this last work does Raphael reveal himself as the student of Leonardo. Some of his expressive heads seem to recall those of Leonardo's unfinished *Adoration of the Magi* (Florence, Uffizi; *see* LEONARDO DA VINCI, fig. 1). The dynamic wheeling composition of agitated figures and the use of dark shadows and complex lighting (including, for example, the back lighting of hands) both to unify and dramatize are also derived from Leonardo.

It is striking that Raphael's debt to Leonardo should emerge when he was engaged in competition, if indirectly, with Michelangelo. He had come closest to Michelangelo when he was able to study, before it was complete, the ceiling of the Sistine Chapel. Imitation of the sublime expression, heavy musculature, massive drapery and powerful movement of Michelangelo's prophets is strong in the later parts of Raphael's work in the Stanza della Segnatura. It is most obvious, appropriately, in the fresco of the prophet *Isaiah* that he painted for the curial prelate Johann Goritz in 1512 on one of the piers of S Agostino in Rome (*see* SANSOVINO, ANDREA). After this near mimicry of Michelangelo, Raphael drew away from his example, but he had learnt something that he could not forget—and that Michelangelo may well have found it hard to forgive.

(c) Engravings by Marcantonio Raimondi and frescoes outside the Vatican. Although the *Transfiguration* was not in fact sent to Narbonne (it was erected instead in Rome,

7. Marcantonio Raimondi (after Raphael): *Morbetto*, engraving, 195×248 mm, *c.* 1512–13 (London, British Museum)

in S Pietro in Montorio), most of the altarpieces Raphael painted in Rome were sent out of the city and they did much to broadcast his fame and extend his influence. Even more influential, however, were the engravings made after his works by MARCANTONIO RAIMONDI, an artist who may be considered as an associate (although a less close one than Giovanni da Udine). Raphael permitted, perhaps encouraged, Raimondi to reproduce his designs (for example his first idea for his *St Cecilia* altarpiece; B. 116), and in a few but very important cases he made designs for this purpose. In the first of these, the *Massacre of the Innocents* (*c.* 1511–12; B. 18), Raphael devised complicated but symmetrical choreographic schemata for the theme of nude warriors in combat, which had so preoccupied him in Florence. Although a biblical subject, the nudity of the figures is more obviously appropriate to ancient Greek and Roman myths or legends. These sources in fact supplied the other subjects that Raphael seems to have designed especially as prints: the *Morbetto* (*c.* 1512–13; B. 417; e.g. London, BM; see fig. 7), from Virgil's *Aeneid*; the *Judgement of Paris* (*c.* 1517–20; B. 245) and the *Quos ego* (1518; B. 352), also from Virgil.

Raphael not only moved in the papal court's circle of poets and scholars who prized ancient art and literature but himself developed a scholarly attitude towards the remains to be found in Rome. In about 1515, with the help of Baldassare Castiglione, he wrote a remarkable public letter (Munich, Bayer. Staatsbib.) to Leo X. This is not only an eloquent appeal against the destruction of inscribed and carved stones, which were essential archaeological evidence, but also includes an outstandingly acute analysis of the styles of ancient sculpture on the Arch of Constantine in Rome. It reveals that Raphael had thought systematically about the best methods of describing and surveying the remains of ancient Rome. The *Judgement of Paris* and the *Quos ego* exhibit a profound study of Roman relief carving, and the latter also suggests that Raphael had given much thought as to the different possibilities open to artists working in other media; it may even be claimed that the artist's style is to some extent a subject of the work of art.

After the fresco of *Isaiah* (1512), Raphael worked in fresco only for the popes and those closest to them. In the villa (now Villa Farnesina) built by the Tiber in Rome for the immensely wealthy banker AGOSTINO CHIGI I), an intimate of both Julius and Leo, Raphael painted the fresco of the *Triumph of Galatea* (see colour pl. 2, XXII1) *c.* 1512. He also decorated Chigi's chapels in S Maria della Pace and in S Maria del Popolo in Rome, providing a fresco of prophets and sibyls for the former, and designs for sculpture, architecture and mosaics in the latter. In 1518 his workshop painted the entrance loggia of Chigi's villa with scenes from the *Story of Cupid and Psyche*. Such work could not have been undertaken without the Pope's consent. This is also true of the decoration (1516) of Cardinal Bibbiena's bathroom and loggia in the Vatican Palace.

The frescoes for Chigi and Bibbiena demonstrate the same learned and imaginative re-creation of antique art that is characteristic of Raphael's designs for prints, and in Chigi's frescoes, as in the prints, the influence of sculpture is also evident. The balletic symmetry of com-

position and highly sculptural poses (some of them repeated from behind, as if the figure was rotated) are characteristic of both the *Massacre of the Innocents* and the *Galatea*. The imitation of relief style that is found in parts of the *Judgement of Paris* and in the *Quos ego* is found also in the two central narratives of Chigi's loggia but contrasted there (as in the *Quos ego*) with scenes of complete spatial freedom. The concern with the novel and ingenious division of successive narrative episodes is common to the *Morbetto* and the *Quos ego* and to the loggia frescoes. In the *Galatea* Raphael's knowledge of the female nude seems derived from ancient sculpture. In the *Judgement*, as in the loggia and above all in the red chalk preparatory drawings for the latter (Paris, Louvre; Windsor Castle, Berks, Royal Lib.), the nude is studied from the life, perhaps from the mistress whose company is said to have detained Raphael when working on the decoration of the villa.

(d) Portraits and smaller devotional works. Raphael was under constant pressure from great patrons to supply them with paintings, and his inability to oblige, coupled with his courteous disinclination to refuse, drove some of them to frenzy. Yet he continued to paint independent portraits at more or less the rate that he had done during the five or so years before he came to Rome. He painted both of the popes, of course. The portrait of *Julius II* (*c.* 1512; London, N.G.), less vigorously characterized than the portraits of him incorporated into the frescoes of the Stanza d'Eliodoro, nevertheless established a formula for papal portraits that endured for more than two centuries. The portrait of *Leo X* (1518; Florence, Uffizi; for illustration *see* MEDICI, DE', (7)) includes two of the Pope's

8. Raphael: *Baldassare Castiglione*, oil on canvas, 820×660 mm, *c.* 1514–15 (Paris, Musée du Louvre)

relatives and still-life elements (an illuminated missal, a magnifying glass and an elegant bell).

Raphael also painted his own circle of friends: *Tommaso Inghirami* (Florence, Pitti), *Baldassare Castiglione* (c. 1514–15; Paris, Louvre; see fig. 8), *Andrea Navagero and Agostino Beazzano* (before April 1516, Rome, Gal. Doria–Pamphili) and another double portrait, probably a self-portrait with a friend (c. 1518; Paris, Louvre). The *Donna Velata* (c. 1514; Florence, Pitti; see colour pl. 2, XXIII2) may well also belong to this category, although no one knows who the sitter is. His other famous female portraits, of *Joanna of Aragon* (Paris, Louvre) and the *Fornarina* (Rome, Pal. Barberini), are not wholly autograph; indeed the latter, though an intimate study of a nude woman who wears Raphael's name on her bracelet, must have been largely, if not entirely, painted by Giulio Romano.

All of the portraits listed above as by Raphael himself, except those of the Pope and the versions (neither of them certainly autograph) of *Inghirami*, are painted on canvas. Raphael employed a richness of textures in the paint to enhance awareness of the textures depicted, fabrics, fur and hair especially. This is most remarkable in the portraits of *Leo X* and the *Donna Velata*, but softness of handling, making much use of the canvas texture, is no less remarkable, especially in the portrait of *Castiglione*. The way that many of these paintings implicate the beholder, by seeming to respond to him or her; their drama —whether subtle, as in Castiglione, or explicit, as in the Louvre double portrait—develops the psychological dimension of Leonardo's portraiture and anticipates that of Titian's. Indeed, Titian seems to have seen Raphael's *Castiglione* and to have responded to its subtlety of subdued colour and quiet mood and to its composition, which (thanks to its influence) seems so natural. On the other hand the icy detachment and cool monumentality of *Joanna of Aragon*, which owes its conception at least to Raphael, anticipates the very different ideals of Agnolo Bronzino.

In Rome, Raphael painted fewer devotional works for domestic settings such as had played so important a part in his oeuvre in Florence, but two paintings of the Virgin and Child with St John, the Garvagh *Madonna* (London, N.G.) and the Alba *Madonna* (Washington, DC, N.G.A.), are superb examples of this type, dating from about 1511: in both, the harmonious figurative architecture of the Stanza della Segnatura seems to be epitomized. In the Alba *Madonna* especially, the relationship between the tondo format and the diagonals of foreshortened limbs, the gracious curves and forceful geometry, both the spatial conception and the finely calculated balance of the volumes are especially impressive. Raphael's other great devotional painting of this type, the *Madonna della Sedia* (c. 1514; Florence, Pitti; see colour pl. 2, XXIII1), also a tondo, is completely different. It shows the richness of colour and surface typical of his portraiture of the same date and an intimacy, enhanced by the way forms seem to grow out of darkness and to press against and swell out of the picture plane. It embodies a more sensuous idea and a more organic compositional scheme, albeit one no less cunningly transgressive of anatomical and logical correctness.

2. ARCHITECTURE.

(i) Drawn and painted. (ii) Planned and built.

(i) Drawn and painted architecture. Among Raphael's earliest drawings are some that reveal a close interest in architecture. The most notable of these is a fine drawing of the Pantheon in Rome (Florence, Uffizi), which is sometimes claimed as a copy of a drawing by him, sometimes regarded as a copy by him of another of his drawings, and is evidence for a visit to Rome made long before he settled there. Such a visit is also suggested by some of the echoes of ancient sculpture found in his early paintings and by the studies in one of his drawings (Oxford, Ashmolean) of the ornamental frames in Filippino Lippi's Caraffa Chapel in S Maria Sopra Minerva, Rome. On the verso of the compositional study (Lille, Mus. B.-A.) for the altarpiece of *St Nicholas of Tolentino* there is a sketch that may be inspired by the courtyard of the Palazzo Ducale in his native Urbino, a reminder that he grew up near one of the finest works of 15th-century architecture in Italy. Undoubtedly the achievements, perhaps also the projects, of Francesco di Giorgio Martini, architect to the Montefeltro court, were known to Raphael, and he may also have been given some training as an architect.

Certainly an exceptional knowledge of architecture is a feature of Raphael's early paintings. The distant temple in the scene of the crowning of Aeneas Silvius Piccolomini (Pius II) in the library frescoes in Siena Cathedral (painted after Raphael's design of c. 1502) and above all the exquisite circular temple in the *Sposalizio* (dated 1504; Milan, Brera) may not be notably practical buildings, but they are structurally plausible; they could be built. This is seldom true of Perugino's architecture, which nonetheless strongly influenced Raphael's. Such architecture is clean in outlines, with sharp mouldings, and is both uniform in colour and unencrusted with coloured inlays or reliefs, which were so beloved by other painters in Italy in this period. Although there is no evidence of Raphael's work on any actual building during his Florentine period, Vasari noted that he participated actively in the discussions about architecture that took place in the house of the Florentine architect Baccio d'Agnolo. Vasari also mentioned his expert knowledge of perspective (from which Fra Bartolommeo is said to have benefited).

When Raphael came to paint the *School of Athens* in the Stanza della Segnatura, he responded to the power and magnificence of ancient Roman architecture as no painter before him had done. The great vaulted interior behind the figures (ingeniously designed so that they appear to be within it) is reminiscent not only of such great buildings as the Basilica of Maxentius in the Roman Forum (whence its coffering is derived) but also of the work of Donato Bramante, who was re-creating such structures in his own rebuilding of St Peter's. Vasari indeed credits Bramante with the invention of this painted structure, and it is highly likely that Raphael worked closely with him.

(ii) Planned and built architecture. It was Bramante's death in April 1514 that turned Raphael into an architect, for Leo X promoted him to Bramante's office as architect of St Peter's, to work with Fra Giovanni Giocondo and Giuliano da Sangallo. It is likely that Raphael was profoundly involved in every aspect of the architect's work

but he was no less active as a painter and it is clear that he depended, to a far greater extent than had Bramante, on the assistance of expert draughtsmen with much more practical experience of building. In particular, the talented nephew of Giuliano da Sangallo, Antonio da Sangallo (ii), who succeeded Raphael at St Peter's, occupied a position that was in some respects comparable to those of Giulio Romano and Giovan Francesco Penni in Raphael's painting studio. The extent of Raphael's responsibility is not easy to assess for this reason, especially in the case of the Palazzo Pandolfini, which was erected in Florence from *c.* 1516 by the Sangallo family using designs by Raphael. Vasari relates that without Antonio's prompt intervention the Vatican Loggie for which Raphael was responsible would have crumbled—a significant story even if probably a garbled one.

Raphael was asked to submit designs for the façade of the Medici church in Florence, S Lorenzo (1515–16), and for the Florentine church in Rome, S Giovanni dei Fiorentini (1518). He also designed a small Roman church of the goldsmiths, S Eligio degli Orefici (*c.* 1515). His designs for the first two were never executed and his work for S Eligio was largely obliterated by subsequent modifications. At St Peter's much of what was built under his supervision was demolished. Project drawings (New York, Pierpont Morgan Lib.), however, give a clear idea of how he intended to modify Bramante's plan for the façade: surprisingly, he multiplied distinct and relatively small architectural parts into a design with a complex pattern, in some respects a gothic treatment of classical architectural elements.

Raphael himself lived in a building designed by Bramante, the Palazzo Caprini (destr.), and he used its paired pilasters in one of the first buildings he designed in Rome, the huge stable block (begun 1512–14; destr.) for Agostino Chigi's villa, where he applied them in two stages. He also used the rusticated ground floor of the Palazzo Caprini for the palazzo (completed *c.* 1519) that he designed in the Borgo for the Pope's doctor, Jacopo da Brescia. The rich textural effects and powerful metaphorical ideas implicit in this type of stonework (or imitation stonework) were developed in his fresco of the *Fire in the Borgo*. Partly through the influence of Giulio Romano, it then entered the mainstream of European architecture.

Agostino Chigi's burial chapel in S Maria del Popolo, Rome, is the most complete example of an interior built to Raphael's design. In plan, elevation and structure it might have been designed by Bramante, and indeed it follows his scheme for the dome of St Peter's, but the treatment of the detail, most notably the Corinthian capitals and the frieze connecting them, is both original and erudite (see CHIGI, (1)). The same applies to Raphael's use of many varieties of coloured and patterned marbles for the cladding of the walls (as well as the paving, where it would have been expected). Such cladding, which was unprecedented in the Renaissance, was directly inspired by Raphael's study of ancient Roman practice; indeed the materials were all recycled from Roman ruins. His interest in colour—a marked contrast with the taste of Perugino and Bramante, his previous models—is also well illustrated by the architecture in Raphael's later paintings, especially that of the tapestry cartoons.

The use of coloured marbles in this way was to prove highly influential, not only in the later 16th century but even more so in the 17th century when continued interest in the Chigi Chapel was guaranteed by the respectful embellishments it received from Gianlorenzo Bernini (1598–1680). Even more influential, however, was Raphael's façade for the Palazzo Branconio dell'Aquila (destr.), which he designed *c.* 1518. Perhaps for the first time in Rome a palace street façade was entirely emancipated from the character of a fortified house and was given instead the ornamental appearance of a triumphal arch—assuming permanently the look that many palaces were given during temporary festive displays. Moreover, the rhythm of framing and openings on different floors, in addition to the relationship between solid and void, niche and window aedicule and painted and sculptured relief, were novel and witty, and the order achieved must have seemed highly complex and even dissonant to many viewers. The Palazzo Spada (originally Palazzo Capodiferro; designed *c.* 1550 by Bartolomeo Baronino (*b* 1511)) is the most conspicuous of the 16th-century urban palaces in Rome that the Palazzo Branconio dell'Aquila inspired, but its influence is even more evident in numerous villas and casinos built in or near Rome in the 16th and 17th centuries.

Raphael's greatest work as an architect was the villa he began on the Monte Mario just outside Rome for Cardinal Giulio de' Medici, now known as the Villa Madama. The plan, which was worked out by 1518, was described very fully in a letter by Raphael (copy in Florence, Archv Stato), a letter that reveals his profound study of Vitruvius and Pliny, his knowledge of such Roman remains as Emperor Hadrian's villa near Tivoli and, of course, the somewhat similar schemes of Bramante in the Belvedere of the Vatican. It reveals that Raphael was no mere paper architect: he enjoyed solving practical planning problems, making ingenious accommodations both to the site and to the user's needs—for air, cool, quiet, privacy, views, defence, advertisement. The round courtyard of the villa was partially built, showing its extraordinary arrangement of large and small brick columns, almost entirely concealing the wall to which they are applied.

It is the great tripartite loggia, which was vaulted and decorated soon after his death by his workshop, that most impresses; there is no more magnificent room built in the Renaissance (see fig. 9). Yet, for all its grandeur, the loggia is convivial in feeling and social in character, perhaps because of the small scale and playful nature of its crisp stucco ornament: the pilasters articulate the wall but are part of its low-relief pattern so that the surfaces flow unbroken from space to space, from walls into domes and semi-domes and apses. Although every other major aspect of Raphael's genius was well known in previous centuries, his achievement as an architect has been reappreciated fully only in the 20th century. This reappraisal is, however, confined to those who have visited this villa, which is not open to the public. Standing in this room, no less than in front of the *Transfiguration*, one is most acutely aware of how much was lost by Raphael's early death.

II. Working methods and technique.

Raphael's career coincided with a rapid increase in the use of oil paint in Italy, and all his early paintings on panel

9. Raphael: garden loggia of the Villa Madama, Rome, begun *c.* 1518; decorations by Giovanni da Udine and Giulio Romano

seem to include work in oil. In most of the earliest examples that have been analysed egg tempera was used as well; a mixture is characteristic of other artists at that date, among them Perugino. By the time he settled in Rome, however, Raphael's panel paintings were executed entirely in oil. In Rome his oil technique developed, perhaps partly in consequence of his contact with Venetian painting, doubtless also in response to his increasing familiarity with fresco painting, but above all as part of his growing interest in colour and light as pictorial elements independent of line and form. The range of textural relief and the impasto in some of his oil paintings have few parallels in the work of earlier artists. It is particularly evident in his paintings on canvas, and his increasing use of this support is one of the aspects of his work that suggests his knowledge of Venetian art (his use of blue paper for drawing is another). Before coming to Rome he seems to have employed canvas only for the two paintings he made for a confraternity standard (or standards) of about 1500 (Città di Castello, Pin. Com.). It would not be surprising if Raphael occasionally executed paintings on vellum, although none has been identified. He certainly painted on paper: each of his tapestry cartoons consists of numerous sheets of paper glued together. The medium employed in these was a type of gouache in which the pigment was bound in animal glue.

Raphael's earliest known painting in fresco, the lunette for S Severo in Perugia of *c.* 1505, is highly proficient technically (the assurance with which the white robes are painted is particularly striking) and cannot have been his earliest work in this medium. Two developments in his use of fresco in Rome are worth noting. The first is that

after his work in the Stanza della Segnatura he greatly reduced the use of gilding. (This had played a particularly conspicuous part in the upper celestial part of the *Disputa*, where the gilding is employed over relief projections in the intonaco, a device much favoured by Pinturicchio.) He did, however, continue to favour secco additions of one sort or another in his frescoes. A second notable development is that when he was painting the Sala di Costantino at the end of his life, Raphael seems to have experimented with an oil medium, perhaps recalling Leonardo's novel methods of mural painting. Doubtless he wished to achieve the greater depth of shadow and richer colours associated with the oil medium, but another consideration may have been the fact that it would have been easier for him to revise his assistants' work in oil than it was in fresco.

Raphael's earliest documented work, the altarpiece of *St Nicholas of Tolentino*, was commissioned in December 1500 from him together with Evangelista di Pian di Meleto, an older artist mentioned in the household of Raphael's father in 1483. What part Evangelista played in the work is unclear; he may have been merely a legal convenience, and the preparatory drawings reveal that the composition was certainly Raphael's invention. Nevertheless, it is striking that from the start of his career Raphael was an artist who worked for and with other artists. Given that his precocious gifts were most obvious in his draughtsmanship, he may often have supplied other artists with drawings as he did Pinturicchio for the Piccolomini library in Siena (*see* §I, 1(i) above). It is not clear that he had any permanent studio assistance during the first decade of the 16th century, but some work was certainly delegated to junior, or at least lesser, artists—most notably, the lunette painted by Domenico Alfani with God the Father, which formed a very important part of his *Entombment* of 1507 when it served as an altarpiece in Perugia.

Once he was established in Rome and working on large frescoes, Raphael must have employed assistants, and within a few years of settling there he had talented pupils and associates, as noted above. Among the works in which their contribution is obvious are the frescoes in the Stanza dell'Incendio and the tapestry cartoons. Nevertheless, the exact nature of their contribution is often hard to discern, and it is unlikely that the division of labour was either consistent or systematic. Raphael seems to have intervened in preliminary, intermediary and final stages of a work and to have interested himself in both central and marginal parts.

If discordances in design and discrepancies in quality can result from this style of work—for example, an imperfect register between the festoons of fruit (by Giovanni da Udine) and the figure groups (largely by Giulio Romano) on the vault of the loggia of the Villa Farnesina or very dull passages next to brilliant ones in the cartoons—there are also astonishing successes. Vasari noted that Giovanni da Udine was responsible for the still-life of musical instruments in the foreground of the *St Cecilia* altarpiece, yet without this testimony no connoisseur would guess that another hand was responsible for this part of the painting. It is also the case that both Giulio Romano and Giovan Francesco Penni had by the end of Raphael's life achieved a standard in execution, and, in

10. Raphael: study of head and hands for the *Transfiguration*, black chalk, 499×364 mm, *c.* 1519 (Oxford, Ashmolean Museum)

and other changes, Raphael's methods as a draughtsman were remarkably consistent. A compositional study (Lille, Mus. B.-A.) for the early *St Nicholas of Tolentino* altarpiece shows his concern for underlying geometric structure in composition and his practice of studying each figure separately from a living model; there are examples made soon afterwards of studies of nude or nearly nude figures and separate studies of draped figures (or simply drapery) and also more detailed studies of heads and hands, some of the same size as those to be painted, which could supplement the basic linear cartoon transferred to the panel as a guide to the painter. Every one of these procedures (e.g. see fig. 10) was still observed by Raphael at the end of his life when he was preparing to paint the *Transfiguration*.

III. *Character and personality.*

Although Raphael's art is relatively well documented, few of the surviving records provide specific evidence about his character and personality. Considering his enormous and precocious success in a highly competitive profession, it is significant (if negative) evidence in support of his good nature that no hostile report of him is known, apart from the sour and cryptic insinuations of his rival, Sebastiano del Piombo, in letters written to gratify Michelangelo. The letter of recommendation written by the Prefetessa in 1504 describes Raphael as 'discreto, e gentile giovane', a sensible and well-mannered youth. Vasari, the chief source, repeatedly emphasizes his gracious, genial, generous, obliging and sweet nature.

Vasari's notions of graciousness and sweetness would not have excluded high ambition, nor did they imply a saintly private life since he also dwelt on the artist's sexual excesses. That Raphael was generous is suggested by the way he permitted other artists access to his drawings and by his unpossessive attitude to his inventions (in which he contrasts greatly with Michelangelo). The encouragement he gave to pupils and associates also suggests a generous nature. Doubtless the harmony that characterized his workshop also reflects this, although the efficient organisation of such a business suggests toughness as well as sweetness. That Raphael was obliging is certainly suggested by his preparedness to abandon his original, and superior, composition for the *Repulse of Attila* in order to flatter Leo X, as well as by his reluctance to refuse commissions.

One document that does reveal Raphael in an unobliging mood is his response in 1514 to his maternal uncle Simone, in Urbino, who seems to have selected a suitable local girl for Raphael to marry. Raphael replied rather tartly that he was very grateful that he had not married before because it would have impeded his career. He spelt out his worth: his property in Rome valued at 3,000 gold ducats and his monthly stipend of 50 ducats from his position at St Peter's. The possibility of marriage with Cardinal Bibbiena's niece is mentioned, or of finding a suitable Roman bride with a dowry of 3,000 gold ducats. This reveals Raphael's concern to impress his family with what he had achieved and to stop their meddling in his affairs. The boasting probably indicates more about his estimate of their values than about his own; it is not indicative of his attitude towards women. According to

Giulio's case, in design, which neither of them was able to sustain for long after Raphael's death.

The fact that Raphael's paintings were always carefully prepared for by drawings obviously meant that their execution by others was made easier, but his assistants also played a part in the process of making such preparatory drawings. There are, for example, compositional drawings in pen and wash that appear to have been made by his assistants using rapid chalk or pen sketches made by Raphael (the drawings (e.g. London, BM) for the biblical narratives painted on the vaults of the Loggie of Leo X are the best examples of this, although some scholars now give some, if not all, of these to Raphael himself). There are also drawings for the figures on the loggia vault of the Farnesina that seem to copy two separate life studies made by Raphael, combining them into a group.

Extraordinary changes in style and technique may be observed in Raphael's drawings: there is, for example, his development, in Florence and inspired by Leonardo, of a loose and at times ferocious manner of compositional invention or exploration using the pen (e.g. London, BM); there is his gradual abandonment in Rome of the metalpoint in favour of chalk, his use of the new medium of red chalk especially for the studies (e.g. Paris, Louvre) for the female nudes in the Farnesina. The very fact of using a female nude model was unusual (Raphael himself had previously employed boys as models for female figures), and these studies for the Farnesina anticipate the female nude studies in red chalk by Peter Paul Rubens and François Boucher in subsequent centuries. Despite these

Vasari, Raphael was 'molto amoroso e affezionato alle donne'. This does not mean that he was a 'womaniser', as is sometimes alleged, only that he loved women and enjoyed female company. It was a mistress who is recorded as keeping this very industrious artist from his work and it was excessive sexual indulgence that was said to have precipitated the fever that terminated his brief life.

IV. Critical reception and posthumous reputation.

Raphael has been one of the most admired of European artists, and his greatness is most easily measured by the diversity of the art he influenced or inspired. In the first half of the 16th century many of his pictorial ideas were widely disseminated in somewhat coarsened form by his pupil Giulio Romano; they were also developed into new ornamental directions by some of his younger workshop assistants, notably Polidoro da Caravaggio and Perino del Vaga. His art provided a crucial ingredient in the elegant aesthetic of Parmigianino (who was described as his reincarnation). Raphael thus became one of the progenitors of Mannerism. In addition, profound study of two or three of his inventions determined the astonishing innovations of Correggio, especially in the painting of domes, which were adopted by Baroque artists in the following century. The finest of Titian's early portraits, which were repeatedly imitated for several centuries, seem to depend upon knowledge of Raphael's portrait of *Castiglione*.

Raphael's methods of preparing to paint, his practice of drawing from the nude model, of adjusting his ideas by reference to nature, of studying drapery and extremities separately, were largely abandoned after his death by his pupils and were indeed followed by few leading 16th-century artists (with the notable exception of Federico Barocci). At the end of the century, however, those methods became exemplary in the artistic teaching established by the Carracci family in Bologna. They were then incorporated into the discipline of the art academies that spread over Europe in the following centuries. The ideal of heroic narrative painting—the very idea of history painting—which such academies propounded was exemplified by the rhetoric of Raphael's *Transfiguration* and his tapestry cartoons. The most authoritative writers on art in the 17th and 18th centuries—Bellori (1613–96), Joshua Reynolds (1723–92), Richardson (1665–1745), Johann Joachim Winckelmann (1717–68)—revered his work almost without qualification.

The impact of Raphael's greatest inventions has been dulled by association with academic art. Although he was the hero of Rubens as well as Nicolas Poussin (1594–1665), and later of Eugène Delacroix (1798–1863) as well as Jean-Auguste-Dominique Ingres (1780–1867), the normative status that Poussin and Ingres and their followers gave to his art has certainly done much to diminish its popularity. Moreover, what is known of his life has not always helped his reputation; his genial and obliging character, his efficient assimilation of the innovations of others, and his remarkable managerial skills do not accord with modern notions of artistic genius. Such notions are better exemplified by Leonardo and Michelangelo, with whom Raphael is inevitably compared.

BIBLIOGRAPHY

The bibliography for Raphael is vast and this list can be only a highly selective one.

G. Vasari: *Vite* (1550, rev. 2/1568); ed. G. Milanesi (1878–85), iv, pp. 311–86

G. P. Bellori: *Descrizione delle immagini dipinte da Raffaelle d'Urbino* (Rome, 1695)

J. Richardson and J. Richardson: *An Account of the Statues, Bas-reliefs, Drawings and Pictures in Italy, France etc. with Remarks* (London, 1722)

J. D. Passavant: *Rafael von Urbino und sein Vater Giovanni Santi*, 2 vols (Leipzig, 1839, rev. 1858; Eng. trans., London and New York, 1872/R 1978)

J. C. Robinson: *A Critical Account of the Drawings by Michel Angelo and Raffaello in the University Galleries, Oxford* (Oxford, 1870)

E. Müntz: *Raphaël, sa vie, son oeuvre et son temps* (Paris, 1881, rev. 2/1886; Eng. trans., London, 1882)

J. A. Crowe and G. B. Cavalcaselle: *Raphael: His Life and Works*, 2 vols (London, 1882–3)

O. Fischel: *Raffaels Zeichnungen*, 8 vols (Berlin, 1913–41)

V. Golzio: *Raffaello nei documenti, nelle testimonianze dei contemporanei e nella letteratura del suo secolo* (Vatican, 1936)

J. Shearman: 'Die Loggie der Psyche in der Villa Farnesina', *Jb. Ksthist. Samml. Wien*, xxiv (1964), pp. 59–100

M. Salmi, ed.: *Raffaello, l'opera: Le fonti, la fortuna*, 2 vols (Novara, 1968)

L. Dussler: *Raphael* (London, 1971)

J. Shearman: *Raphael's Cartoons in the Collection of Her Majesty the Queen and the Tapestries for the Sistine Chapel* (London, 1972)

——: *The Vatican Stanza: Functions and Decoration* (London, 1972)

K. Oberhuber: *The Works of Marcantonio Raimondi and his School* (1978), 26–7 [XIV/i–ii] of *The Illustrated Bartsch*, ed. W. Strauss (New York, 1978–)

P. De Vecchi: *Raffaello: La pittura* (Florence, 1981)

K. Oberhuber: *Raffaello* (Milan, 1982)

S. Béguin: 'Raphaël', *Giorgio Vasari: Les Vies des meilleurs peintres*, ed. A. Chastel, v (Paris, 1983), pp. 187–242

J.-P. Cuzin: *Raphaël: Vie et oeuvre* (Paris, 1983)

P. Joannides: *The Drawings of Raphael with a Complete Catalogue* (Oxford, 1983)

R. Jones and N. Penny: *Raphael* (New Haven and London, 1983)

Acts of the Princeton Raphael Symposium. Science in the Service of Art History: Princeton, 1983

Raphael before Rome. Acts of the Symposium: Washington, DC, 1983

Drawings by Raphael from the Royal Library, the Ashmolean, the British Museum, Chatsworth and other English Collections (exh. cat. by J. A. Gere and N. Turner, London, BM, 1983)

Autour de Raphaël: Dessins et peintures du Musée du Louvre (exh. cat., ed. R. Bacou; Paris, Louvre, 1983–4)

Raphaël dans des collections françaises (exh. cat., Paris, Grand Pal., 1983–4)

L. Frommel, S. Ray and M. Tafuri, eds: *Raffaello architetto* (Milan, 1984)

Raffaello a Firenze (exh. cat., Florence, Pitti, 1984)

Raffaello in Vaticano (exh. cat., Rome, Musei Vaticani, 1984–5)

D. Cordellier and B. Py: *Raphaël, son atelier, ses copistes* (1992), v of *Inventaire général des dessins italiens, Musée du Louvre* (Paris, 1992)

J. H. Beck: *Raphael* (New York, 1994)

H. Locher: *Raffael und das Altarbild der Renaissance: Die 'Pala Baglioni' als Kunstwerk im sakralen Kontext* (Berlin, 1994)

Raphel: The Pursuit of Perfection (exh. cat. by T. Clifford, J. Dick and A. Weston-Lewis, Edinburgh, N.G., 1994)

D. O. Bell: 'New Identifications in Raphael's *School of Athens*', *A. Bull.*, lxxvii/4 (1995), pp. 638–46

J. Bell: 'Re-visioning Raphael as a Scientific Painter', *Reframing the Renaissance: Visual Culture in Europe and Latin America, 1450–1650*, ed. C. Farago (New Haven and London, 1995), pp. 901–11, 316–19

J. Shearman: 'On Raphael's Chronology: 1503–1508', *Ars naturam adiuvans: Festchrisft fr Matthias Winner*, ed. V. V. Flemming and S. Schutze (Mainz, 1996), pp. 201–7

Raphael and his Circle: Drawings from Windsor Castle (exh. cat. by M. Clayton; London, Queen's Gal.; Washington, DC, N.G.A.; and Los Angeles, CA, Getty Mus.; 1999–2000)

NICHOLAS PENNY

Rapicano [Rabicano; Ripicano; Rubicano], **Cola** [Niccola] (*b* Amantea, Calabria; *fl* 1451; *d* Naples, 1488). Italian illuminator. He is cited in the records of the Aragonese treasury as the official illuminator to the court of Aragon in Naples from 1451 to 1488. From 1455 he received a regular stipend, but the books illuminated by him are not specifically identified in the documents until 1471, although there are general references to Graduals, Missals etc, most of which are untraced. Numerous manuscripts have been attributed to Rapicano on the basis of style. His earliest documented works include a copy of Aesop's *Fables* (30 Oct 1473; Berlin, Dt. Staatsbib., MS. Hamilton 6), a copy of Strabo's *Geography* (1473–4; Rome, Vatican, Bib. Apostolica, MS. Ottob. 14448) and a copy of Andrea Contario's *Obiurgatio in Platonis calumniatorum* (1471; Paris, Bib. N., MS. lat. 12947), in which Angiolillo Arcuccio (*fl* 1464–92) also collaborated. Attributed works for the years *c.* 1474–81 include the statutes of the Ordine del Toson d'oro (Naples, Bib. N., MS. ii D 20) and the *Letters* of St Cyprian (Naples, Bib. N., MS. vi C 4); the latter closely resembles the documented *Cancionero* (1481; Rome, Bib. Casanatense, MS. 1098).

Rapicano's style is characterized by the prolific use of friezes with small multicoloured flowers and small gold bosses surrounded by rays, fantastic animals, white scrolls and little putti with ecstatic expressions. He also shows a strong interest in perspective. The work of his mature period, for example copies of the works of St Thomas Aquinas (U. Valencia, Bib., MSS 750 and 794), a copy of Albertus Magnus' *De mirabili scientia dei* (U. Valencia, Bib., MS. 830) and five leaves with noble coats of arms in the Codex of S Maria (Naples, Archv Stato, MS. 99. C.I.), shows a sophisticated blend of Catalan, Franco-Flemish and Florentine styles, and it formed the foundation of the typical Neapolitan manner of illumination in the years of Aragonese rule. One of Rapicano's most important works is St Thomas Aquinas's *Super quarto libro sententiarum* (Naples, Bib. N., MS. vii. B. 4), in which he adopted motifs from the work of the Florentine illuminator Filippo di Matteo Torelli, handling them in a softer manner; the elegant frontispiece, representing *St Thomas in his Study*, has exquisite friezes and a Renaissance architectural setting with a landscape background that shows the artist's understanding of perspective.

Rapicano also worked for aristocratic patrons in Naples, such as the humanists Giovanni d'Aragona, Diomede Carafa and Andrea Matteo III, Duca di Atri. He had a very active workshop, and his sons Filippo and Nardo occasionally collaborated with him. Many Neapolitan illuminators followed his style, including Cristoforo Majorana and Matteo Felice, as well as the painter Angiolillo Arcuccio.

BIBLIOGRAPHY

Thieme–Becker

T. De Marinis: *La biblioteca napoletana dei re d'Aragona*, 6 vols (Milan, 1947–69), i, pp. 145–9

J. J. G. Alexander and A. C. De La Mare: *The Italian Manuscripts in the Library of Major Abbey* (Oxford, 1969)

A. Putaturo Murano: *Miniature napoletane del rinascimento* (Naples, 1973), pp. 25–9, 57–60

A. C. De La Mare: 'The Florentine Scribes of Cardinal Giovanni of Aragon', *Il libro e il testo*, ed. C. Queta and R. Raffaelli (Urbino, 1984), pp. 245–93 (254 and 287–8)

Dix Siècles d'enluminure italienne (exh. cat., ed. F. Avril; Paris, Bib. N., 1984), pp. 175–7

J. J. G. Alexander and E. Temple: *Illuminated Manuscripts in Oxford College Libraries: The University Archives and the Taylor Institution* (Oxford, 1985)

The Painted Page: Italian Renaissance Book Illumination, 1450–1550 (exh. cat., ed. J. J. G. Alexander; London, RA, 1994)

GIOVANNA CASSESE

Ravenna, Marco da. *See* DENTE, MARCO.

Ravenna, Severo da. *See* SEVERO DA RAVENNA.

Raverti, Matteo (*fl* 1398–1436). Italian sculptor. He was first mentioned in 1398, when he was active in the workshop of Milan Cathedral. He remained there until 1409, and three statues are documented as his work: the *Incense-bearing Angel* (1403) the *Giant in Armour* and *St Babila* (1404; all Milan Cathedral). *St Babila* is Raverti's best work but was criticized for departing from the design provided. His style is linked to naturalism of the Lombard Gothic tradition, tempered by proto-Renaissance traits. In May 1421 Raverti was in Venice, where he contracted with Marino Contarini to make certain works for the Ca' d'Oro, then under construction. He was probably responsible for the open staircase, the courtyard arcade, the large window facing the court and the door giving on to the street. These elements, however, were drastically modified or rebuilt in the course of 19th-century restorations. The design for the funerary monument to *Bonromeo Borromei* (destr.) in the church of S Elena dated from 1422. Raverti was in Venice in 1436, when his daughter was married. He has been credited with several works in Venice, but none of them is certain. They include the *St Christopher* on the portal of S Maria dell'Orto, numerous capitals and the *Drunkenness of Noah* on the façade of the Doge's Palace, and the *St Simeon* in S Simeone. The attribution of the cenotaph of *Vitaliano Borromeo* on Isola Bella is also open to doubt.

BIBLIOGRAPHY

U. Nebbia: *La scultura nel duomo di Milano* (Milan, 1908)

G. Mariacher: 'Matteo Raverti nell'arte veneziana del primo rinascimento', *Riv. A.*, xxi (1939), pp. 23–40

G. Mariacher: 'Aggiunta a Matteo Raverti', *Riv. A.*, xxii (1940), pp. 101–7

C. Baroni: *Scultura gotica lombarda* (Milan, 1944), pp. 53, 127, 139, 140, 144, 150, 161, 164

M. Cionini Visani: 'Proposta per Matteo Raverti', *A. Ven.*, xvi (1962), pp. 31–41

W. Wolters: *La scultura veneziana gotica, 1300–1460*, i (Venice, 1976), pp. 235–6

R. J. Goy: 'Matteo Raverti at the Cà d'Oro: Geometry and Order in Venetian Gothic Tracery', *Ren. Stud.*, viii/2 (June 1994), pp. 115–37

FILIPPO PEDROCCO

Raymond, Vincent [Raimondi, Vincenzo; Raimondo, Vincenzo] (*b* ?Lodève; *fl* 1535; *d* Rome, 10 Feb 1557). French illuminator, active in Italy. He is thought to have come from Lodève in Languedoc and worked on the decoration of liturgical manuscripts for the Sistine Chapel

during the pontificates of Leo X, Clement VII and Paul III. He is the only illuminator mentioned between 1535 and 1549 in the Vatican registers of the *Tesoreria secreta*. Although his output must have been large, by the late 20th century little had been firmly attributed to him. One of the most important works agreed to be his is the Psalter (Paris, Bib. N., MS. lat. 8880) illuminated for Pope Paul III and dated 1542. The miniatures are minutely worked but lacking in inventiveness; he evidently borrowed freely from the work of such contemporary painters as Raphael and Michelangelo. The only full-page miniature in the Psalter, *God Creating the Stars*, is strikingly similar to Michelangelo's representation of the same subject on the Sistine chapel ceiling. Most of the border motifs are taken from the decorative schemes of Giovanni da Udine and Perino del Vaga, particularly those of the papal apartments in the Castel Sant'Angelo, Rome. Unusually, some of the historiated initials in the Psalter contain scenes resembling cameos. A number of musical codices in the Sistine Chapel library can also be attributed to Raymond. He is documented as having contributed to the lavish decoration of the 'uffiziolo di Madonna' (untraced), which was bound by Benvenuto Cellini and presented to the Emperor Charles V (*reg* 1519–56) by Pope Paul III in 1536. In 1549 after many years in the service of Paul III, the Pope declared him official illuminator to the papal chapel.

BIBLIOGRAPHY

A. Bertolotti: *Artisti veneti in Roma nei secoli XV, XVI e XVII: Studi e ricerche negli archivi romani* (Venice, 1884), p. 17
——: *Artisti francesi in Roma nei secoli XV, XVI e XVII: Ricerche e studi negli archivi romani* (Mantua, 1886), pp. 28–9
E. Müntz: *La Bibliothèque du Vatican au XVIe siècle: Notes et documents* (Paris, 1886), pp. 104–8
L. Dorez: *Psautier de Paul III: Reproduction des peintures et des initiales du manuscrit latin 8880 de la Bibliothèque Nationale, précédée d'un essai sur le peintre et le copiste du Psautier* (Paris, 1909)
N. Vian: 'Disavventure e morte di Vincent Raymond, miniatore papale', *La Bibliofilia*, lx (1958), pp. 356–60
The Painted Page: Italian Renaissance Book Illumination, 1450–1550 (exh. cat., ed. J. J. G. Alexander; London, RA, 1994)

□

Reame, Mino del. *See* MINO DEL REAME.

Reggio, Baldassare da. *See* BALDASSARE D'ESTE.

Reggio, Raffaellino da [Motta, Raffaello] (*b* 1550; *d* Rome, May 1578). Italian painter and draughtsman. He probably trained under Lelio Orsi, although his work shows none of Orsi's affinity with Correggio. His style was mainly influenced by his contact with painters working in Rome, where he lived from 1572 until his death. As an assistant to Federico Zuccaro, he collaborated on the frescoes depicting scenes from the *Life of St Catherine* (1572; Rome, S Caterina dei Funari), also absorbing the influence of the recently deceased Taddeo Zuccaro. In 1573 he assisted Lorenzo Sabatini in the Vatican. The following year he worked under Giovanni de Vecchi in the Sala del Mappamondo at Cardinal Alessandro Farnese's villa at Caprarola (*see* CAPRAROLA, VILLA FARNESE, §1). His independent projects include frescoes (1573–4) in the chapel of S Silvestro in SS Quattro Coronati, a *Christ before Pilate* (*c.* 1574–5; in the oratory of S Lucia del Gonfalone), frescoes (1576–7) for Pope Gregory XIII in

the Vatican and a chapel vault (*c.* 1577) in S Silvestro al Quirinale. Only one oil painting is securely attributed to Raffaellino, *Tobias and the Angel* (*c.* 1575–6; Rome, Gal. Borghese). Most of his surviving drawings are in pen and wash over chalk. The study of *Hercules, Minerva and Mars* (London, BM) is also characteristic in its use of a *sfumato* technique that reveals the influence of Taddeo Zuccaro. Raffaellino's drawings, like his frescoes, only slightly resemble the style of his Emilian predecessors. Apart from two studies of the *Lamentation* (Chatsworth, Derbys; Florence, Uffizi), which are stylistically close to Parmigianino, his designs are indebted to Taddeo Zuccaro and Perino del Vaga.

BIBLIOGRAPHY

Thieme–Becker
L. Collobi: 'Raffaello Motta detto Raffaellino da Reggio', *Riv. Reale Ist. Archeol. & Stor. A.*, vi/3 (1938), pp. 266f
I. Faldi: 'Contributi a Raffaellino da Reggio', *Boll. A.*, 2nd ser., xxxvi (1951), pp. 324–33
J. A. Gere and P. Pouncey: *Italian Drawings in the Department of Prints and Drawings in the British Museum: Artists Working in Rome c. 1550 to c. 1640*, i (London, 1983), pp. 145–9
Correggio and his Legacy: Sixteenth Century Emilian Drawings (exh. cat. by D. De Grazia, Washington, DC, N.G.A., 1984), pp. 340–43
L. Partridge: 'The Room of Maps at Caprarola, 1573–5', *A. Bull.*, lxxvii/3 (1995), pp. 413–44

□

Regno, Mino del. *See* MINO DEL REAME.

Renaissance [Fr.: 'rebirth']. Term generally used for periods that hark back to the culture of Classical antiquity. Though it has applications elsewhere, it is most often used to refer to that era in Europe, beginning approximately in the 14th century, in which a new style in painting, sculpture and architecture was forged in succession to that of Gothic and in which, in a broader cultural sense, the transition from the Middle Ages to the modern age was made. This period culminated in the High Renaissance, a brief phenomenon confined essentially to Italy in about the first two decades of the 16th century and supremely embodied in some of the work of that time by Leonardo da Vinci, Michelangelo and Raphael. Following this came that phase of the late Renaissance called MANNERISM.

1. Application and history of the term. 2. Early Renaissance, *c.* 1300–1450. 3. Renaissance, 1450–*c.* 1500. 4. High Renaissance.

1. APPLICATION AND HISTORY OF THE TERM. As early as the beginning of the Christian era, Augustan artists drew on the Greek art of the 5th and 4th centuries BC. Later, a Carolingian *renovatio* or renaissance is seen as having occurred in the early Middle Ages. In the architecture of Tuscany there was a 'proto-Renaissance' in the 11th and 12th centuries represented by the Florentine church of S Miniato al Monte, in which Classical orders and tranquil rhythms anticipate the Florentine Renaissance, and the Baptistery of S Giovanni, probably remodelled in the 11th century. In the same period architecture and sculpture inspired by antiquity were being created in Provence, for example the abbey church of St Gilles, and St Trophîme in Arles. The 13th century culminated in the classicizing art created in the Hohenstaufen imperial workshops of Emperor Frederick II (*reg* 1212–50), who collected antique sculpture and erected buildings and

statues in imitation of antiquity, for example the Capua Gate (1234–40).

The term Renaissance in its narrower sense developed under the influence of 19th-century French art theory and was originally applied to the period 1400–1600. In this context it refers to the actual rebirth of art by its drawing on the spirit of antiquity, a one-sided concept that is still widely prevalent. However, this use of the word has older and wider roots: as early as 1550 Giorgio Vasari spoke of the 'rinascità' of art from the 14th century, meaning the re-emergence of 'good art' after the medieval period (i.e. of art modelled on nature again for the first time since antiquity). The intention was not that art should copy nature, however, rather that it should give visible expression to its perfect idealized form, and here lies the connection with antiquity. It is impossible to speak of the Renaissance comprising a rediscovery of the repertory of form used in antiquity, because in Italian medieval art the antique tradition had never been broken. For example, the figures derived from antique sources on the pulpit by Nicola Pisano (*c*. 1220/25–before 1284) in the Baptistery at Pisa (*c*. 1257–64) are more faithful than any ever achieved in the Renaissance. The return to antique sources was not in itself the moving force behind the Renaissance, rather it was the other way round: the endeavour to comprehend all the phenomena of reality in this world reopened artists' eyes to the works of antiquity. Writing in the 18th century the French encyclopedist Denis Diderot (1713–84) put it thus: it is necessary to study antiquity in order to recognize reality.

The Renaissance refers not only to a stylistic period succeeding that of the Gothic but also to the crucial turning-point between the Middle Ages and the modern age. We can talk in general terms of a change from the medieval theocentric (God-centred) image of the world to an anthropocentric (man-centred) concept of the world. This change, the most radical since the end of the antique period, impinged on every area of life.

2. EARLY RENAISSANCE, *c*. 1300–1450. The transition from the Late Gothic to the Renaissance is extremely varied. In Italian art *c*. 1300 the works of Giotto and his contemporaries already indicate a first surge of interest in the phenomena of the temporal world, for example Giotto's frescoes (*c*. 1305–10) in the Arena Chapel in Padua (see GIOTTO, figs 1 and 4) or the cycle of scenes from the *Life of St Francis* (*c*. 1290) by unknown masters in the Upper Church of S Francesco at Assisi. Vasari correctly saw this as a first stage in the 'rinascità'. In the fresco by Ambrogio Lorenzetti (*fl c*. 1317), the *Effects of Good Government* (1338–9; Siena, Pal. Pub.), buildings and landscape attain a realism unrivalled until the second quarter of the 15th century.

The mendicant orders played an important role in the emergence of the Renaissance. Their call for personal devotion and direct imitation of the life and sufferings of Christ resulted in a higher value being placed on the individual. Devotional pictures, such as Pietàs, began to appear from *c*. 1300, and independent panel paintings emerged a little earlier. In literature, especially in Italy, there was a new interest, in the 14th century, in Classical writers. The poetry of Francesco Petrarch and his knowl-

edge of Classical literature are associated with the early development of HUMANISM, which took place, especially in Florence, towards the end of the 14th century.

The starting and focal-point of early Renaissance art was republican Florence, where the precedence of sculpture in displaying new and different forms is significant. By its very three-dimensionality sculpture comes closest to reality, and in a period of the 'discovery of the world and of man' (Burckhardt) it is logical that sculpture should be especially prominent. In early 15th-century Florence Nanni di Banco and Donatello created the modern concept of the statue, in which the drapery is no longer expressive, the emphasis falling instead on the form of the human body, with the drapery serving to articulate its structure. The Classical device of contrapposto was recreated in such works as Nanni di Banco's *St Philip* (*c*. 1410) and *Four Crowned Saints* (*c*. 1416; for illustration see NANNI DI BANCO) and Donatello's *St Mark* (between 1411 and 1413; all Florence, Orsanmichele) and *St George* (*c*. 1414; Florence, Bargello; see FLORENCE, fig. 11) and remained influential in the history of the statue until the late 19th century.

In relief sculpture Lorenzo Ghiberti developed a concept that remained valid for centuries. He took Andrea Pisano's approach to relief as his starting-point for the north doors of the Baptistery in Florence, but as he worked on the project (1403–24; see GHIBERTI, (1), fig. 2) he developed a sense of tension between foreground figures, projecting ever more prominently, and the receding background, achieved by differentiated gradations in the depth of the relief. This led to the 'pictorial' opening up of the background in the Baptistery's *Gates of Paradise* (1426–52; see colour pl. 1, XXXI2), the last set to be completed. Donatello created a less influential form of shallow relief, the *rilievo schiacciato* (It.: 'flattened-out relief'), of which the earliest example is the marble relief showing *St George and the Dragon* (1417; Florence, Bargello), formerly on the lintel beneath the statue of *St George* at Orsanmichele.

A towering figure laid the foundations for Renaissance architecture: Filippo Brunelleschi. From 1420 he was in charge of vaulting the dome of Florence Cathedral (see BRUNELLESCHI, FILIPPO, fig. 1), primarily a brilliant piece of engineering. In the same period he built the loggia of the Ospedale degli Innocenti (see colour pl. 1, XVI2) and the Old Sacristy at S Lorenzo (both from 1419), and evolved designs for S Lorenzo (from *c*. 1421) and Santo Spirito (from 1436; see fig. 1).

What is crucial about his buildings is less the adoption of individual antique-inspired forms, already anticipated in the Romanesque buildings of the Tuscan proto-Renaissance, than the human-inspired measure of the whole and its parts. The column is employed as the architectural component most closely related to the human body; each individual element is placed in a carefully calculated, immediately perceptible relationship with the element adjoining it and the building as a whole. Brunelleschi thus achieved a harmony of proportion intended to be attuned to man, rather than soaring beyond him as in the Gothic cathedral.

The work of Masaccio, whose figural style was influenced equally by contemporary sculpture and Giotto's painting, forms the prelude to early Renaissance painting.

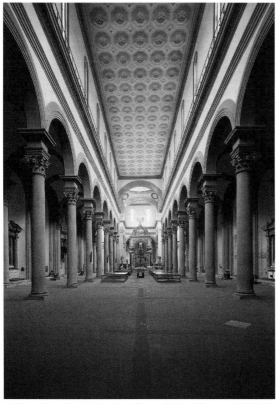

1. Filippo Brunelleschi: interior of Santo Spirito, Florence, 1436–82

His fresco of the *Trinity* at S Maria Novella in Florence (*c.* 1425; see colour pl. 2, III1) demonstrates new artistic objectives, for the first time since antiquity creating a three-dimensional space on a flat surface by use of the newly discovered science of mathematical perspective. His painted figures are life-size and the eye level of the viewer is at the same height as the eye level from which the perspective is constructed, so that the donors appear to be kneeling in front of the painted architecture. Thus, the space in the picture and the space occupied by the viewer merge into one.

This fresco is at the root of all subsequent illusionistic painting until the start of the Baroque period. Masaccio, working with the older artist Masolino, created his masterpiece in the frescoes of scenes from the *Life of St Peter* in the Brancacci Chapel (started *c.* 1424; Florence, S Maria del Carmine; see colour pls 2, II2, 2, III2 and 2, IV1), in which he proved himself to be the true heir of Giotto. With his skill in composition, the power of his figural modelling, the freedom of his grouping, the new possibilities of conveying space and the first attempts to reproduce atmospheric effects, he left behind him an artistic legacy, the development of which absorbed the following generations. Foremost among these later painters were Paolo Uccello, who in his frescoed equestrian monument to *Sir John Hawkwood* (1436) in Florence Cathedral and fresco (after 1440) of the *Flood* in the Chiostro Verde of S Maria Novella, Florence (*see* UCCELLO, PAOLO, figs 1–2), refined the science of perspective; Andrea del Castagno, whose frescoed equestrian monument to *Niccolò da Tolentino*

(1456; Florence Cathedral; *see* CASTAGNO, ANDREA DEL, fig. 4), *Last Supper* (1447; Florence, S Apollonia; see fig. 2) and cycle of *Famous Men and Women* (Florence, Uffizi) attempted to convey the painted figure as a polychrome sculpture; Domenico Veneziano, whose *St Lucy* altarpiece (mid-1440s; Florence, Uffizi; *see* DOMENICO VENEZIANO, fig. 2 and colour pl. 1, XXVIII1) revealed a new response to reproducing sunlight; and finally, in pride of place, Fra Angelico, who can be regarded as Masaccio's heir with such works as the frescoes (1439–47) in the monastery of S Marco (see colour pls 1, III1 and 1, III2), Florence, and those (1448–9) in the chapel of Nicholas V, Vatican, Rome (*see* ANGELICO, FRA, fig. 6).

The extent to which 15th-century art, overriding different regional artistic traditions, was determined by the same cultural shifts is illustrated by a new genre of painting that came into being independently in Italy as well as north of the Alps: the portrait in its modern sense as a reproduction of the unique, unmistakable, individual appearance. This phenomenon again reflects the anthropocentric basis of the Renaissance. Nonetheless, differences in the early Renaissance north and south of the Alps should not be overlooked: first of all, the artistic perception of reality in the north was still completely intuitive, whereas Italian perspective and theories of proportion are an attempt to discover how appearances conformed to rules. Secondly, the north was initially concerned with the accurate rendering of detail, with the whole being the sum of precisely observed parts, while in the south a concept of the whole determined the arrangement and form of the detail. It is in this, rather than in individual borrowed forms, that the real relationship of the Italian Renaissance with antiquity lies.

The difference between north and south is particularly evident in the portrait. In northern Europe, especially in the southern Netherlands, artists developed the three-quarter view in which the profile and full face merge, so conveying a greater measure of individuality; until the third quarter of the 15th century the south on the other hand preferred the severe profile, influenced by the portrait medallions of such artists as Pisanello (for an example, *see* PISANELLO, fig. 4). In the north the sitter looks out of the painting, creating a relationship with the spectator; in the south the portrait remains self-contained, and the sitter makes no contact with the viewer. The three-quarter view shows the sitter in space, while the profile ties him to the flat surface.

In the north the emphasis fell on a painterly treatment of surface and texture, in the south line dominated. The transformation of the picture of the donor on altarpieces is part of the same reappraisal of the individual. In medieval art, which graded figures in size according to importance, donors are shown in very small proportions, yet in the Renaissance they were painted on the same scale as the sacred figures.

However, the new emphasis on the visible world did not affect every artistic region equally, either south or north of the Alps. Initially the early Renaissance in Italy emanated only from Florence, where middle-class patrons were to be found, who welcomed the new creative possibilities. Where feudal and church patrons were predominant, on the other hand (for instance Venice and

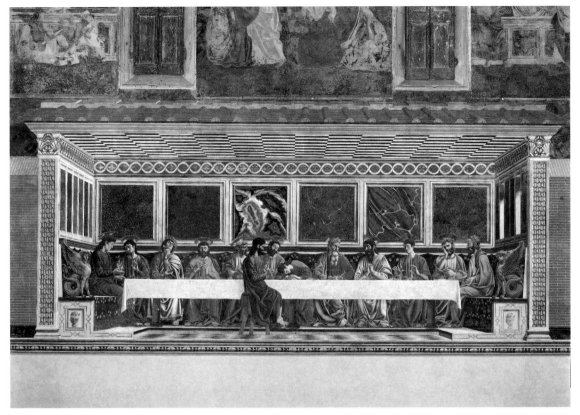

2. Andrea del Castagno: *Last Supper* (1447), fresco, 4.53×9.75 m, S Apollonia, Florence

Milan), the Late Gothic tradition persisted well into the 15th century. Consequently, the early Renaissance can be described as the first great cultural achievement of the middle classes. They created their own forms of expression, while the church and the nobility, backed by tradition, at first rejected the new realism.

3. RENAISSANCE, 1450–c. 1500. In the second half of the 15th century, three major developments took place. First, Tuscan artists spread the early Renaissance into Central and North Italy. Donatello's activity in Padua between 1443 and 1453, where he created the high altar in S Antonio (1446–50) and the equestrian statue of *Gattamelata* (1447–53) in the Piazza del Santo (*see* DONATELLO, fig. 4), had a decisive impact on painting, particularly on Andrea Mantegna. The latter in turn became a master of realistic figure depiction and virtuoso perspective construction, as displayed in the S Zeno Altarpiece (1456–9; Verona, S Zeno) and in the Camera Picta or Camera degli Sposi in the Palazzo Ducale at Mantua (1465–74; see colour pl. 2, I1). Mantegna profoundly influenced Venetian painting, especially that of his brother-in-law Giovanni Bellini. The humanist and architect Leon Battista Alberti developed his style by studying antique Roman buildings, already anticipating the High Renaissance, and added a classically inspired Renaissance façade to S Maria Novella in Florence (*c.* 1458–70; see colour pl. 1, I2). He brought a Renaissance style to Upper Italy with his masterpiece, S Andrea in Mantua (begun 1472; *see*

ALBERTI, LEON BATTISTA, figs 6–8). In the early 1480s Tuscan and Umbrian painters decorated the walls of the Sistine Chapel at the Vatican with the first large Renaissance fresco cycle in Rome; those collaborating on it included Sandro Botticelli, Domenico Ghirlandaio, Pietro Perugino and Luca Signorelli.

A lively exchange between north and south got under way, with Italy initially being the more receptive. Rogier van der Weyden (*c.* 1399–1464) is said to have visited Rome in 1450, and the display of the Portinari Altarpiece (*c.* 1473–9; Florence, Uffizi) by Hugo van der Goes (1440–82) in Florence in 1483 was a milestone. Nevertheless, it was, above all, Antonello da Messina, through his study of works from the Netherlands at the court in Naples, who united Italian achievements with the painterly qualities of the southern Netherlands (as in, for example, his *St Jerome in his Study, c.* 1460–65; London, N.G.; *see* ANTONELLO DA MESSINA, fig. 1). His visit to Venice in 1475–6 and the influence of Mantegna were of fundamental importance to Venetian painting, particularly to that of Giovanni Bellini.

Over wide areas north and south of the Alps from *c.* 1450 there was a reversion to Late Gothic forms, such as the elongated figures, the predominance of vibrantly lively lines over sculptural modelling and the inclusion of decorative detail. This shift started in Italian painting with Benozzo Gozzoli's decoration (1459–63) of the chapel in the Palazzo Medici, Florence (see colour pl. 1, XXXV2). In the following period Sandro Botticelli and Filippino

Lippi were outstanding representatives of this courtly, refined trend. There was a comparable phenomenon in sculpture in the works of Andrea Verrocchio, Desiderio da Settignano and Antonio Pollaiuolo, for example. Even so, new creative possibilities did emerge amid this return to Gothic forms. Especially in the field of sculpture the idea of a single, fixed viewpoint gave way to multiple viewpoints, as in Verrocchio's bronze equestrian statue of *Bartolomeo Colleoni* (1483–94; Venice, Campo SS Giovanni e Paolo; *see* VERROCCHIO, ANDREA DEL, fig. 4).

Only a brief outline of the reasons for this change in style can be given here. Obviously the rich middle classes were increasingly striving to emulate a courtly way of life, as exemplified by the Medici family. In contrast to the early 15th century, it was problems of assimilation rather than demarcation that were at issue. At the same time, especially north of the Alps, a change in the form of individual piety may have played an important role.

Not everything that was happening in Italian art during the 15th century can be classified as a return to Late Gothic forms. Venetian painting, with Giovanni Bellini as its leading figure, moved towards the High Renaissance uninterrupted, with harmoniously balanced composition and an equilibrium between colour and line. These qualities can be seen in the S Giobbe Altarpiece of *c*. 1480 (Venice, Accad.; *see* BELLINI, (3), fig. 3) and in the S Zaccaria Altarpiece (1505; Venice, S Zaccaria; see colour pl. 1, XII2). Another innovative artist *c*. 1500 was Piero della Francesca, with his emphasis on a clear outline and the integration of three-dimensional representation into the conditions imposed by the two-dimensional surface.

4. HIGH RENAISSANCE. All the artistic trends of the 15th century culminated around 1500 in the short-lived High Renaissance whichHeinrich Wölfflin, in *Klassische Kunst* (introduction, 1898), described as the Classic Art of the modern age. It is as hard to give precise time limits to the period as it is to give a comprehensive definition of it. It is generally accepted that artists of the High Renaissance developed more monumental forms and created unified and harmonious compositions that reject the decorative details of 15th-century art.

In terms of the geography of art, there were important shifts in the period from *c*. 1490 to *c*. 1510. Florence lost its cultural ascendancy owing to the fall of the Medici in 1494 and the subsequent influence of the Dominican monk Girolamo Savonarola. After Savonarola was executed in 1498, Florence alternately fell into the hands of rival forces before the Medici returned to power in 1512. Those two decades were the climax of the High Renaissance, but Florence lacked influential patrons. The papacy with its restored power, on the other hand, attracted leading artists to Rome. In 1506 Pope Julius II appointed Donato Bramante architect for the new St Peter's, in 1505 he commissioned Michelangelo to build his tomb, and in 1508 he appointed Raphael to provide paintings for his private rooms, the Stanze. Rome once again became the centre of the Christian West. At the same time Venice—which retained a powerful and wealthy feudal aristocracy who became enthusiastic patrons of art, particularly of painting—developed as a second important centre whose influence spread throughout 16th-century Europe.

At the start of the 16th century an intense dialogue began between the art of the Italian Renaissance and that of northern Europe, which surpassed earlier isolated, albeit significant, exchanges, and with northern Europe now the main recipient. After *c*. 1500 most important German and Netherlandish painters spent some years as apprentices in Italy as part of their training, and a wider knowledge of Italian art was spread through woodcuts and engravings.

(i) Architecture. In architecture Rome acted as a catalyst, enabling architects to mature their talents through a study of Classical antiquity. The centrally planned building, contained within itself and developed symmetrically round a centre, was preferred. Donato Bramante's Tempietto in the courtyard of the monastery of S Pietro in Montorio (*see* BRAMANTE, DONATO, fig. 4), which is not only a pure centrally planned building but a completely unified structure, is comparable to sculpture with perfectly harmonious proportions. The additive composition of earlier centrally planned buildings, such as Giuliano da Sangallo's Madonna delle Carceri (1485–91; *see* SANGALLO, DA, (1), fig. 1) in Prato, was here discarded in favour of a more unified structure. Bramante intended to enclose the building within a circular colonnade, which would have emphasized its centrality and related it to its surroundings. The new St Peter's (*see* ROME, §V, 1(ii)) was also laid out as a pure centrally planned building, possibly a symbolic reference to its position as the centre of Christendom. In keeping with the size of the project, Bramante designed a richly organized structure, the many spatial compartments of which were brought together in the ground-plan as a square. The extent to which the inspiration of antiquity was at work is indicated by Bramante's proud declaration that in his design for St Peter's he wanted to put the Pantheon on top of Constantine's basilica (the Lateran Basilica). Bramante's scheme, still at its initial stages on his death in 1514, was modified by his successors, who included Raphael, Baldassare Peruzzi and Antonio da Sangallo the younger, and transformed by Michelangelo from 1547 when the sculptor shifted it in a more sculptural direction and incorporated more detail.

Only a few of the great architectural projects of the early 16th century were implemented. The extent to which variants on the idea of the centrally planned building occupied artists' imaginations can be recognized particularly from painted background buildings and design drawings, especially those of Leonardo da Vinci. Of the large church projects that were realized, S Maria della Consolazione in Todi, conceived under Bramante's influence, is the purest incarnation of the spirit of the High Renaissance: no longer is the building assembled from independent cubes, instead the central structure and the transepts blend into one another, with the half-cylinders and half-domes of the transepts serving as a preparation for the circular form and hemisphere of the dominant central dome.

(ii) Sculpture. The complexity and detail of the work of the preceding generation gave way to a new, unified concept of the statue. There were of course preliminary stages, such as the *Virgin Enthroned* and *St Sebastian* by Benedetto da Maiano (both Florence, Misericordia, left unfinished on the sculptor's death in 1497). They form part of the

foundations of the work of Michelangelo, the most important sculptor of the High Renaissance, who also contributed decisively towards bringing this brief stylistic period to an end. A series of monumental commissions given to Michelangelo, which included Julius II's tomb (a commission awarded in 1505, then constantly reduced in scale; see colour pl. 2, VII2), the cycle of 12 larger-than-lifesize statues for the choir of Florence Cathedral, started in 1506 (only *St Matthew* was executed; Florence, Accad.), the sculptural programme for the façade of S Lorenzo in Florence, which never got beyond the design stage (1516), and the enrichment (from 1524) of the New Sacristy in S Lorenzo, Florence, were on an unprecedented scale and made new demands. Antiquity now played a crucial role as a source of inspiration. The importance of Roman ruins to architecture was paralleled in sculpture by the many antique works that were being excavated in Rome and that came to form the foundations of the Vatican collections. In 1506 the *Laokoon* (Rome, Vatican, Mus. Pio-Clementino) was found, supposedly in the presence of Michelangelo. In 1515 Pope Leo X appointed Raphael overseer of the antique buildings of Rome.

(iii) Painting and graphic art. Around 1500 Italian painting is notable for its wide range of varied possibilities, some contradictory and some complementing one another. Lively lines could be used as a means of heightening expression, as in the art of Botticelli, but the line could also be exaggerated to virtuosic brilliance, with no inhibitions about effect, as by Filippino Lippi. At the same time the Umbrian school (led by Pietro Perugino) and Venetian painters (particularly Giovanni Bellini) cultivated the modelling of figures and objects by means of light and colour. Alongside the ability of Mantegna and Melozzo da Forlì to achieve powerful illusionistic effects was Piero della Francesca's doctrine of the constitutive importance of the surface. Artists such as Luca Signorelli developed a detailed realism, barely imaginable in the early 15th century, and associated with mastery in conveying the human body in extremes of movement. There are also examples of large-scale and imposing, multi-figured compositions, such as Domenico Ghirlandaio's frescoes of the *Life of the Virgin* and *Life of St John the Baptist* (1486–90) in the choir of S Maria Novella, Florence (see SPALLIERA, fig. 1). The subject-matter of the early 15th century had been expanded by a wide range of mythological, secular themes.

Against all probability and expectation, elements that had to some extent appeared irreconcilable came together in a synthesis *c*. 1500, beginning with Leonardo da Vinci's *Last Supper* for the refectory of S Maria delle Grazie in Milan in 1496–7. The viewer is initially overwhelmed by apparently being able to identify with the painted figures but is in fact held at a distance by the various perspective systems governing real and artistic space, the ideal nature of the composition, which has been thought through to the last detail, and the monumental scale of the figures. In Leonardo's panel paintings his compositional skill is combined with a revolutionary approach to painterly qualities. Increasingly line was replaced by the modulation of colour, and the transitions between figures and landscapes became fluid. Space came to be conveyed not primarily by the use of mathematical perspective, but by lightening the colour and gradually softening the outlines. Leonardo, the perfect embodiment of the ideal of an artist able to work in every artistic sphere and at the same time possessing universal knowledge, did not receive the recognition and understanding that were his due in either Florence or Rome. His move to North Italy, justified in worldly terms by a large number of prestigious commissions from Ludovico Sforza, Duke of Milan, was ultimately sanctioned by an internal logic: close to Venice, he was able both to develop and to spread his influence. The Venetian approach to colour, created by Giorgione and the young Titian, is inconceivable without knowledge of Leonardo.

Next to Leonardo, Raphael most perfectly represents the ideals of the High Renaissance. Born in Urbino, he was exposed to the works and theories of Leon Battista Alberti and Piero della Francesca while still very young. His feeling for the painterly treatment of contours and his gift for depicting landscape were developed in Umbria in Perugino's studio. During the years he spent in Florence his drawing became more precise, he acquired an understanding of how to convey the human body in movement, and at the same time the works of Fra Bartolomeo provided him with a model for the large-scale organization of monumental compositions, which he then perfected on Roman soil in his own frescoes under the influence of antique monuments. As with Leonardo's *Last Supper*, the *Disputà* and the *School of Athens*, both in the Stanze at the Vatican (for an illustration of the latter *see* ITALY, fig. 15), do not at first sight reveal the artistic intelligence with which the tension between the painted space and the flat surface is resolved, or how the unpromising, badly lit wall surfaces, asymmetrically interrupted by doors, are seemingly transformed into virtually 'ideal' formats; or how the unforced and apparently casual figure groupings are in fact thought out down to the smallest detail and are extensively prepared in a long series of studies; or, finally, how the complicated iconographical programmes are made readily comprehensible.

(iv) The move towards Mannerism. The High Renaissance period could only last a short time. The integration of the real into the ideal, of the utmost fullness of life into something strictly composed, of the spontaneous into the intellectual, of the extremely individualistic into the typical, of the perfect, illusionistic representation of space into a flat surface and of the secular into the sacred could not be surpassed. It was in fact the very people who had participated in the High Renaissance who introduced new developments: Michelangelo when he painted the ceiling of the Sistine chapel in the Vatican (1508–12; see colour pl. 2, V2) by the passionate sweep of movement in his figures and the blurring of the boundaries between painting and sculpture; Raphael in the later Stanze in the Vatican and his final panel paintings (e.g. *Transfiguration*, 1517–19; Rome, Pin. Vaticana; *see* RAPHAEL, fig. 6) by his emphasis on spatial depth at the expense of surface, on colour at the expense of line, on the contrasts of light and shade at the expense of an even spread of light, and on the free equilibrium of forces at the expense of a balance achieved by near symmetry; and finally Leonardo by the *sfumato* of his late works causing figures and objects to retreat as it were behind a veil. They opened the way to the late

Renaissance phase now generally referred to as Mannerism.

BIBLIOGRAPHY

EARLY SOURCES

L. B. Alberti: *Della pittura* (Florence, 1435); ed. L. Mallé (Florence, 1950)

P. della Francesca: *De prospectiva pingendi* (MS.; before 1482); ed. G. Nicco Fasola, 2 vols (Florence, 1942/*R* 1984)

L. B. Alberti: *De re aedificatoria libri X* (Florence, 1485); ed. G. Orlandi (Milan, 1966)

G. Vasari: *Vite* (1550; rev. 2/1568); ed. G. Milanesi (1878–85)

CULTURAL HISTORY

J. Burckhardt: *Die Kultur der Renaissance in Italien* (Basle, 1860)

J. Huizinga: *Herfsttij der Middeleeuwen:* . . . (Haarlem, 1919); Eng. trans. as *The Waning of the Middle Ages: A Study of the Forms of Life, Thought and Art in France and the Netherlands in the 14th and 15th Centuries* (London, 1924/*R* 1980)

D. Frey: *Gotik und Renaissance als Grundlagen der modernen Weltanschauung* (Augsburg, 1929)

A. Warburg: *Gesammelte Schriften*, ed. G. Bing, 2 vols (Leipzig and Berlin, 1932/*R* Nedeln, 1969)

M. Wackernagel: *Der Lebensraum des Künstlers in der florentinischen Renaissance: Aufgaben und Auftraggeber, Werkstatt und Kunstmarkt* (Leipzig, 1938; Eng. trans., Princeton, 1981)

E. Panofsky: *Studies in Iconology: Humanist Themes in the Art of the Renaissance* (New York, 1939/*R* 1962)

F. Antal: *Florentine Painting and its Social Background* (London, 1943)

A. Chastel and R. Klein: *L'Age de l'humanisme* (Paris, 1963)

H. Bauer: *Kunst und Utopie: Studien über das Kunst- und Staatsdenken in der Renaissance* (Berlin, 1965)

GENERAL SURVEYS

J. Burckhardt: *Der Cicerone: Eine Anleitung zum Genuss der Kunstwerke Italiens* (Basle, 1855)

H. Wölfflin: *Renaissance und Barock* (Munich, 1888; Eng. trans., London, 1964)

——: *Die klassische Kunst: Eine Einführung in die italienische Renaissance* (Munich, 1899; Eng. trans., Oxford, 1953)

M. Dvořák: *Geschichte der italienischen Kunst im Zeitalter der Renaissance*, 2 vols (Munich, 1927–9)

H. Wölfflin: *Italien und das deutsche Formgefühl* (Munich, 1931)

W. Pinder: *Die deutsche Kunst der Dürer-Zeit* (Leipzig, 1940)

E. Panofsky: *Renaissance and Renascences in Western Art*, 2 vols (Stockholm, 1960)

The Renaissance and Mannerism: Studies in Western Art. Acts of the 20th International Congress of the History of Art: Princeton, 1963

A. Chastel: *Italienische Renaissance: Die grossen Kunstzentren* (Munich, 1965)

——: *Italienische Renaissance: Die Ausdrucksformen der Künste* (Munich, 1966)

E. H. Gombrich: *Norm and Form: Studies in the Art of the Renaissance* (London, 1966)

A. Chastel: *Der Mythos der Renaissance, 1420–1520* (Geneva, 1969)

M. Wundram: *Frührenaissance* (Baden-Baden, 1970)

F. W. Fischer and J. J. Timmers: *Spätgotik: Zwischen Mystik und Reformation* (Baden-Baden, 1971)

J. Białostocki: *Spätmittelalter und Beginn der Neuzeit* (Berlin, 1972)

P. Burke: *Tradition and Innovation in Renaissance Italy* (London, 1972)

F. Seibt, ed.: *Renaissance in Böhmen* (Munich, 1985)

ARCHITECTURE

J. Burckhardt and W. Lübke: *Geschichte der Renaissance in Italien* (Stuttgart, 1878, 3/1891)

C. von Stegmann and H. von Geymüller: *Die Architektur der Renaissance in Toscana*, 11 vols (Munich, 1885–1909)

H. Willich and P. Zucker: *Die Baukunst der Renaissance in Italien*, 2 vols (Potsdam, 1914–29)

A. Haupt: *Baukunst der Renaissance in Frankreich und Deutschland* (Berlin and Neubabelsberg, 1923)

R. Wittkower: *Architectural Principles in the Age of Humanism* (London, 1952)

P. Murray: *The Architecture of the Italian Renaissance* (London, 1969/*R* 1981)

H. A. Milton and V. M. Lampugnani, eds: *The Renaissance from Brunelleschi to Michelangelo: The Representation of Architecture* (London, 1994)

SCULPTURE

W. Pinder: *Die deutsche Plastik vom Mittelalter bis zum Ende der Renaissance*, 2 vols (Potsdam, 1914–29)

J. Pope-Hennessy: *Italian Renaissance Sculpture* (London, 1958)

C. Seymour jr: *Sculpture in Italy, 1400–1500*, Pelican Hist. A. (Harmondsworth, 1966)

PAINTING

K. Escher: *Die Malerei des 14.–16. Jahrhunderts in Mittel- und Unteritalien* (Potsdam, 1922)

R. van Marle: *Italian Schools* (1923–38)

E. van der Bercken: *Malerei der Früh- und Hochrenaissance in Oberitalien* (Potsdam, 1927)

L. Venturi: *La Peinture italienne*, 3 vols (Geneva, 1950–)

J. White: *Birth and Rebirth of Pictorial Space* (London, 1957, rev. 1975)

S. Freedberg: *Painting of the High Renaissance in Rome and Florence*, 2 vols (Cambridge, MA, 1961)

R. Salvini: *Pittura italiana II: Quattrocento* (Munich, 1962)

MANFRED WUNDRAM

Resaliba, de. *See* SALIBA, DE.

Rho [de Raude]. Italian family of sculptors. Gabriele da Rho (*fl* Milan, 1467–89) and Giovanni Pietro da Rho (*b* 1464/5; *fl* Milan, 1481–1513) were sons of Paganino da Rho. From 1464 the family lived in the parish of S Babila in Milan as neighbours of the Solari family of sculptors and architects. Gabriele was a stonecutter at Milan Cathedral in 1467, and in 1469 he was apprenticed to the sculptor Giovanni Antonio Amadeo, whose assistant he still was in 1475. In 1477 and 1478 he received payments for decorative reliefs for the altar of S Giuseppe (dismantled) in the cathedral, a project supervised by Guiniforte Solari on which Amadeo was the leading sculptor. In 1481 Gabriele and Giovanni Pietro rented from the heirs of the defunct Cristoforo Mantegazza the right of executing Cristoforo's share of the façade of the Certosa di Pavia. In 1482 Giovanni Pietro, already called *magister*, and Gabriele contracted with Conte Manfredo Landi to make a marble portal (still extant) for his house in Piacenza; they received payments for it in 1482 and 1483. Gabriele was a *magister* and a member of the Quattro Incoronati, the association of stonecutters of Milan Cathedral, in 1489. Also in 1489 Cristoforo Stanga and his son Marchesino Stanga ordered marble from Milan Cathedral in the name of Giovanni Pietro for work they were having done in Cremona. Much of this marble must have been for the marble portal of the Palazzo Stanga. This portal is now in the Louvre, and Gabriele and Giovanni Pietro were probably among its sculptors.

The works of the two brothers have not been sorted out, but they both probably assisted Amadeo in his works for Cremona in the 1480s and probably also worked for the Certosa di Pavia in the 1480s and 1490s. Many sculptures attributed to Amadeo working under the influence of the Mantegazza brothers may in fact have been carved by Gabriele or Giovanni Pietro. In 1495 Giovanni Pietro, living in Cremona, made a pact with Amadeo to collaborate in providing coloured stone for projects within the dominions of the Duke of Milan. Between 1501 and 1513 Giovanni Pietro worked on Cremona Cathedral, making statues for its façade. In 1509 he gave his age as 44 or 45. A relief depicting *St Anthony the Hermit*, signed by Giovanni Pietro, for the Casa Fassati (now Parravicini) is in Cremona (for illustration see Malaguzzi-Valeri, p. 306).

BIBLIOGRAPHY

F. Malaguzzi-Valeri: *Giovanni Antonio Amadeo: Scultore e architetto lombardo, 1447–1552* (Bergamo, 1904)

A. Venturi: *Storia*, vi (1908)

A. Monteverdi: 'A proposito dell'Arca dei Martiri Persiani a Cremona', *Archv Stor. Lombardo*, 4th ser., xi (1909), pp. 183–97

G. Fiori: 'Le sconosciute opere piacentine di Guiniforte Solari e di Gian Pietro da Rho i portali di S Francesco e del palazzo Landi', *Archv Stor. Lombardo*, xcii–xciv (1968), pp. 127–39

R. V. Schofield, J. Shell and G. Sironi: *Giovanni Antonio Amadeo, Documents/i documenti* (Como, 1989), nos 5, 21, 380

J. Shell: 'Amadeo, the Mantegazza and the Façade of the Certosa di Pavia', *Giovanni Antonio Amadeo, scultura e architettura del suo tempo* (Milan, 1993), pp. 189–222

CHARLES R. MORSCHECK JR

Riario, Raffaele (Sansoni), Cardinal (*b* Savona, 3 May 1460; *d* Naples, 9 July 1521). Italian cardinal and patron, great-nephew of Pope Sixtus IV (*see* ROVERE, DELLA, (1). He was created a cardinal in 1477 and is included in Melozzo da Forlì's fresco of *Sixtus IV Founding the Vatican Library* (*c.* 1476–7; Rome, Pin. Vaticana; *see* MELOZZO DA FORLÌ, fig. 1); he is also depicted in Raphael's *Miracle of the Mass at Bolsena* (1512; Rome, Vatican, Stanza d'Eliodoro) and in a number of portrait medals (Milan, Brera; London, BM). Shortly after his appointment (1483) to the title of S Lorenzo in Damaso, Riario had the church and the mid-15th-century palace attached to it entirely demolished and rebuilt. The construction, over a number of different phases, began *c.* 1485 and ended *c.* 1511, by which time Riario had attained the title of Cardinal Bishop of Ostia. The architectural scheme is grandiose, encompassing a church, a series of ground-floor shops and a magnificent arcaded central courtyard; it was originally called the Palazzo di S Giorgio (after Riario's first title, Cardinal Deacon of S Giorgio in Velabro), but was renamed the Cancelleria when it came to be used as the papal chancery. Within the courtyard Riario placed pieces from his collection of ancient sculptures, one of the most celebrated being the colossal statue of the *Muse Melpomene* (Roman copy of a Greek original, Paris, Louvre), recorded in the courtyard in the Roman sketchbook of the Portuguese artist Francisco de Holanda (1517–84). In 1496 Riario purchased Michelangelo's *Sleeping Cupid*, in the belief that it was an antique statue. It is possible that this was the *Bacchus* (Florence, Bargello) that later became the property of Jacopo Gallo, a close neighbour of Riario's.

BIBLIOGRAPHY

A. Schiavo: 'Profilo e testamento di Raffaele Riario', *Stud. Romani*, viii (1960), pp. 414–29

DIANA NORMAN

Ricamatori, Giovanni dei. *See* GIOVANNI DA UDINE.

Ricciardo di Nanni [Giovanni], **Ser** (*fl* 1449–80). Italian illuminator. He was trained between 1449 and 1452 by Battista di Niccolò da Padova (*fl* from 1425; *d* 1452) and after Battista's death collaborated occasionally with Filippo di Matteo Torelli. Ricciardo was one of the first Florentine artists to be concerned with archaeological discoveries, and this is consistently reflected in his painting. A copy of Plautus's *Comedies* (Florence, Bib. Medicea–Laurenziana, MS. Plut. 36.41), datable before 1450, and belonging to Piero de' Medici, is thought to be his first autograph work. In early commissions from the Medici, Ricciardo shows a strong interest in a wide range of Classical ideas, partly derived from gems and cameos in the Medici collections. He was also sensitive to Florentine painting, from the work of Domenico Veneziano to that of the Master of Pratovecchio, and to the narrative style typical of paintings on *cassoni*. His illustrations are full of biblical symbolism, providing a rich pictorial commentary on the text. This tendency characterizes the works of his early period (1456–9): for example a copy of the work of Lactantius (Malibu, CA, Getty Mus., MS. Ludwig XII 7), Seneca's *On Anger* (Paris, Bib. N., MS. lat. 6376), a copy of Pliny and Seneca's *Letters* (Florence, Bib. Medicea–Laurenziana, MSS Plut. 82.4, fol. 6, and 45.33, respectively). The Pliny manuscript (1458), the masterpiece of his Medicean phase, is perhaps the best example of his iconographic innovations. It includes such images as a *Venus* enthroned under a pavilion with draperies held by angels, set within white-vine decoration.

An important document for the reconstruction of Ricciardo's activity from 1456 is the payment (27 April 1461) for the illumination of a choir-book (*Ecce homo*; Florence, Archivio Capitolo di S Lorenzo, Corale L. 210, fols 3*v*, 24*r*, 67*v* and 88*v*). Certain elements of these illustrations are inspired by devotional altarpieces; most of the illustrative programme, however, is the work of Francesco d'Antonio del Chierico. Stylistically related to this manuscript are some pages in other choir-books (Florence, H. 207, fols 4*r*, 22*r*, 36*r*, 53*v*; K. 206, fols 2*v*, 20*v*, 31*r*, 72*v*, 92*v*; X. 220, fols 4*v*, 42*r*, 69*v*) from the Badia in Fiesole. The Fiesole choir-books mark another important stage in Ricciardo's development, in which the influences of Domenico Veneziano and Fra Filippo Lippi can be seen in the architectural styles and perspective studies. Among the artist's Books of Hours are two (Venice, Bib. N. Marciana, MSS lat. I.91 and III.103) that he produced in collaboration with the bottega of Mariano del Buono.

From 1468 Ricciardo's style became more intensely expressionistic with the volumes and contours of his figures less clearly defined and the faces drawn in rapid strokes. In addition, the archaeological backgrounds are conceived in a distorted perspective. This style is found in an Evangeliary (Florence, Bib. Medicea–Laurenziana, MS. Edili 115), which Ricciardo illuminated in 1468 for the Opera del Duomo of Florence. Formerly commissioned from Torelli (who contributed only the friezes before his death in 1468), the work was executed almost entirely by Ricciardo. Here his constant interest in the Antique is particularly evident in the scenes representing the *Calling of Matthew* (fol. 97*r*) and the *Dance of Salome* (fol. 95*r*). This interest is also apparent in the architectural scheme in the *Presentation in the Temple* in a Book of Hours (sold Paris): the frontal double stairway seems to anticipate that of the Villa Medici (begun *c.* 1485) at Poggio a Caiano. Ricciardo again collaborated with Mariano del Buono on two frontispieces for a Livy manuscript (Munich, Bayer. Staatsbib., Clm. 15731 and 15733), executed for the Hungarian humanist Johannes Vitéz around 1469. On 27 March 1473 he was paid for two miniatures in choir-books for SS Annunziata, Florence. One of these (Florence, Bib. Convento dei Servi all'Annunziata, Graduale D, fol. 71*r*) marks another decisive phase in Ricciardo's work, particularly in his original treatment of the Corpus Domini in *Christ with the Chalice*. In the 1480s the artist's interest in apocalyptic themes intensified, and his treatment of sacred subjects became ironic. Significant expressions of this last

phase are found in a Book of Hours (Florence, Bib. Ricciardiana, MS. 373) and in a copy of Petrarch's *Trionfi* (Madrid, Bib. U. Complutense, MS. Vit. 22.4), in which there is a continuous interplay between the animate and inanimate. The *Triumph of Death* (fol. 41*v*) shows experiments with sacred and profane themes, including a *danse macabre*.

BIBLIOGRAPHY

M. Levi d'Ancona: *Miniatura e miniatori a Firenze dal XIV al XVI secolo* (Florence, 1962), pp. 229–32

M. G. Giardi Duprè Dal Poggetto: 'Contributi a ser Ricciardo Nanni', *Prospettiva*, x (1977), pp. 54–7

A. Garzelli: 'Note su artisti nell'orbita dei primi Medici: Individuazioni e congetture dai libri di pagamento della Badia fiesolana, 1440–1485', *Stud. Med.*, n.s. 2, xxv (1984), pp. 439–46

——: *Miniatura fiorentina del rinascimento, 1440–1525: Un primo censimento*, i (Florence, 1985), pp. 55–66, 71–4

The Painted Page: Italian Renaissance Book Illumination, 1450–1550 (exh. cat., ed. J. J. G. Alexander; London, RA, 1994)

PATRIZIA FERRETTI

Ricciarelli, Daniele. *See* DANIELE DA VOLTERRA.

Riccio [Briosco], **Andrea** (*b* Trent, April 1470; *d* Padua, 8 July 1532). Italian sculptor. He worked in terracotta and bronze, mostly on the small scale of statuettes, plaquettes and elegant domestic items such as inkstands and oil lamps. Usually regarded as the greatest exponent of this kind of work, he was a specialist in rendering themes of Classical mythology to the satisfaction of the erudite humanist professors of Padua University. His oeuvre is often neglected because of its small scale, but it constitutes one of the loftiest and most fascinating manifestations of the poetic paganism of the High Renaissance: the equivalent, and sometimes perhaps the inspiration, of the great Venetian mythological paintings of the period, by Giovanni Bellini, Cima, Giorgione and Titian. Riccio acted as an intermediary for the tradition of Donatello in bronze sculpture in Padua, a tradition that he learnt from his own master, Bartolomeo Bellano, and passed on to Jacopo Sansovino in Venice.

1. Life and work. 2. Posthumous reputation.

1. LIFE AND WORK.

(i) Training and early work, to 1507. (ii) Paschal candlestick, 1507–16. (iii) Della Torre tomb and contemporary works. (iv) Terracottas, 1520–30. (v) Trombetta monument and late bronze statuettes, *c*. 1518–1520s.

(i) Training and early work, to 1507. Riccio ('curly head') trained first in the workshop of his father, Ambrogio di Cristoforo Briosco, an itinerant Milanese goldsmith who had moved to Padua by 1492. Then, according to his friend Pomponius Gauricus (*De sculptura*; Padua, 1504), he had to give up his work as a goldsmith because of 'podagra' (gout, or perhaps arthritis) and turned instead to sculpture in bronze, probably because it principally involved modelling readily ductile materials such as clay and wax, rather than beating or chasing precious metal. This new craft he learnt, apparently, from Bellano, whose series of ten Old Testament narrative reliefs (1484–90) for the interior of the choir enclosure of the Santo, Padua (for illustration *see* BELLANO, BARTOLOMEO), he eventually completed with two more bronze reliefs in 1506–7. According to Marcantonio Michiel, a reliable source, his first work was to finish the monument to *Pietro Roccabo-*

nella, left incomplete at Bellano's death (*c.* 1497), with three small figures of the theological virtues, *Faith, Hope* and *Charity*, as well as to clean and chase Bellano's relief of the *Virgin and Child with Saints* (both Padua, S Francesco). Riccio's *Virtues* are more elegantly classical than most of Bellano's figures, with intricate patterns of intersecting drapery folds which, in the style of Andrea Mantegna, serve to emphasize the underlying anatomy of the figures, notably marking their bent knees with oval shapes. In their proportions, and careful division into obvious segments on their vertical axes, they also recall contemporaneous full-size terracotta statues by Giovanni d'Antonio Minelli de' Bardi, a sculptor with whom Riccio is documented as being in contact in 1500. Minelli was paid for supplying wax models for figures and a relief to go on a wooden model of Riccio's for the Cappella del Santo, the shrine of S Antonio (Padua, Il Santo).

The Santo shrine was a major commission, to which Severo da Ravenna contributed a rather stiff marble statue of *St John the Baptist* (*in situ*; signed and dated 1500). Severo was very influential on Riccio: he was highly praised by Gauricus in 1504, especially for his work as a bronze-sculptor, and rated far above Bellano. He worked in Padua only between the date of the commission for the Santo and 1509, when he returned to Ravenna. A bronze reduction of the *St John the Baptist* (Oxford, Ashmolean), and a *Crucified Christ* (Cleveland, OH, Mus. A.) and a *St Sebastian* (Paris, Louvre) that are associable with it in terms of style and facture, as well as a *Dragon* and a *Kneeling Satyr* (both in private collections, see Avery and Radcliffe, figs 3, 5, 7) that are signed by Severo, may have been among the bronzes that so impressed Gauricus: if so, they pre-date most of Riccio's major work and must have had a profound influence on it. Especially important for Riccio's development was Severo's use of unusual, secular and typically Classical subjects exemplified by the *Dragon* and *Satyr*. He pioneered a daringly novel, because essentially non-Christian, range of subjects that later intrigued, almost obsessed, Riccio and his learned patrons. Severo also paved the way for the integration of such statuettes into functional artefacts, which heretofore had been decorated only with rather crude renderings of figures and ornaments. Riccio later raised such artefacts to a completely new level: that of works of art with a meaning as profound as any painting. The tradition that they established of bronze ornamental artefacts enlivened with mythological figures, either human or monstrous, or religious figures, flourished for over a century in the Veneto, which enjoyed a virtual monopoly of such artefacts throughout Italy.

While Bellano adopted the more violently expressionist techniques of the elderly Donatello on his pulpits for S Lorenzo, Florence, and exploited a strain of naturalism, Riccio appreciated the innate classicism of Donatello's statues and reliefs in Padua, as well as its interpretation by Mantegna. Indeed, Mantegna was celebrated in his day not only as a painter, but also as a sculptor. Riccio also would have known one of the greatest and most immediately classical of all Florentine bronze statuettes, the *Bellerophon and Pegasus* by Bertoldo di Giovanni (Vienna, Ksthist. Mus.; *see* BERTOLDO DI GIOVANNI, fig. 2), which was then in a Paduan collection. This work, essentially a

reduction and idealized completion of one of the ancient Roman colossal statues of *Horse-tamers* (Rome, Piazza del Quirinale), proved seminal for Riccio's avid imagination. It found an immediate echo in a splendid rearing knight in the battle that occupies most of the relief of the *Story of Judith*, made by Riccio for the Santo in 1506: indeed, the city in the middle ground is characterized as ancient Rome, with its great monuments, the Pantheon, the Colosseum, Trajan's Column and the statue of *Marcus Aurelius*. The musculature of the male figures in the left foreground is rendered with the clear divisions typical of Classical statuary. The heroine is an impassive Roman matron; in the left corner she calmly hands the decapitated head of Holofernes to her servant, while at the right she passes it to the people of Israel. The ranks of the charging cavalry are handled as in a Roman relief, with the foremost figure repeated into the fictive depths, conveying a kinetic impression, and the grimacing or shouting faces reflect a knowledge of Leonardo da Vinci's studies for his contemporaneous fresco of the *Battle of Anghiari* (Florence, Pal. Vecchio; destr.). Riccio himself appears on the right, with tight curly hair and a fashionable beret, just as he is shown on an inscribed self-portrait medal and on a miniature bust (Vienna, Ksthist. Mus.). He also appears in the other relief for the Santo, showing *David and the Ark of the Covenant*, in the crowd at lower left; these portraits constitute Riccio's signature. The *David* relief has overtones of Mantegna's painted series, the *Triumph of Caesar* (London, Hampton Court, Royal Col.), and the same fascination with archaeological reconstructions of ancient artefacts, in this case notably the ark itself on its elaborate carriage. A sacrificial scene in the right foreground, with a kneeling youth holding a lamb or kid, prompted the attribution to Riccio of several works, including a fine independent group of a *Curete Milking the Goat Amalthea* (Florence, Bargello). A statuette of *Moses* (Paris, Mus. Jacquemart-André), from a fountain in the refectory of S Giustina, Padua, also resembles the figure of King David on the relief.

Two significant commissions seem to date from between 1500 and 1507, when the Santo reliefs were finished: the earlier was the completion with three terracotta statues of saints of a cycle begun with a single figure of *St Anne* by Bellano in the altar wall of S Canziano, Padua. Like the *Roccabonella* monument, this is likely to have followed reasonably soon after the demise of Bellano: however, the style of drapery on the *St Agnes* is suaver, more like Mantegna and more classical than that on the three Roccabonella statuettes, and closer to that on the *Judith* of the Santo relief, which suggests that some years elapsed

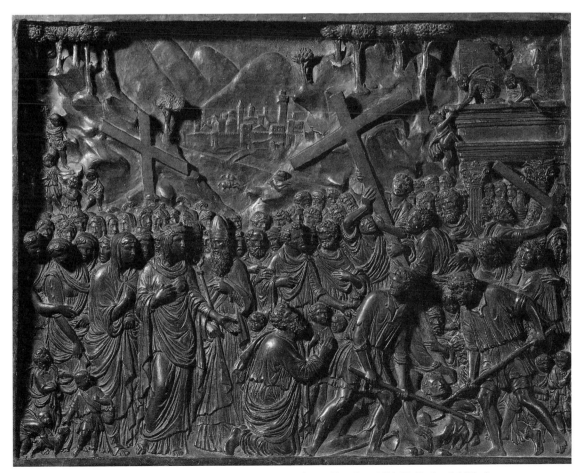

1. Andrea Riccio: *Finding of the True Cross*, bronze relief from the *Legend of the True Cross*, 1500–07 (Venice, Ca' d'Oro)

between the commissions. Furthermore, the *St Henry*, bare-legged and clad in Roman armour, corresponds closely with the many figures of Roman soldiers in the other commission that probably dates from this period, a series of four bronze reliefs showing the *Legend of the True Cross* (Venice, Ca' d'Oro; see fig. 1). They were originally built into the altar of the Holy Cross in S Maria dei Servi, Venice, which housed a shrine for a relic of the True Cross presented to the church in 1492 by Girolamo Donato (1454–1511), a diplomat who was active in Venice principally between 1501 and 1509. These dates indicate the range of years for Riccio's early work in bronze, although there is some discussion as to whether it was earlier or later within the span. The doors of the tabernacle, which form a triumphal arch when closed, are covered with numerous figures and scenes in low relief and on a small scale. They seem less well-resolved than those in the narrative panels of the shrine, let alone the Santo reliefs, and are probably the earliest part of the commission, possibly dating from before 1500. The overtones of Donatello, Bellano and Mantegna are still very strong, both in the finely delineated architectural setting and in the population of angels, Virtues and putti. The lowest zone of each door leaf consists of a distinct, rectangular plaque, one with the *Entombment* and one with the *Lamentation*; these later appeared with minor variations as independent plaquettes—a new class of sculpture for which Riccio became justly famous.

(ii) Paschal candlestick, 1507–16. In March 1507, the month he finished the reliefs for the choir of the Santo in Padua, Riccio received another commission from the same church for the work which is his masterpiece, a monumental bronze Paschal candlestick (h. 3.92 m, *in situ*; see fig. 2). It was not completed until 1516, after interruptions caused by the war of the League of Cambrai. Riccio designed it as a steeply tapering pyramidal pedestal of two main figurated zones—each with a plinth decorated with smaller reliefs, as well as engaged statuettes projecting diagonally from the corners—while a cylindrical form prevails above, with two superimposed drums intercalated with baluster shapes, again with multiple reliefs, ornaments and addorsed statuettes. The whole is capped with a gadrooned drip-pan. It is thus divided into eight principal zones, incorporating an amazing compendium of a few Christian narrative and allegorical themes interspersed with myriad mythological figures, and, what is most remarkable in such a sacred context, its profile is enlivened with such pagan and suggestive creatures as sphinxes, satyrs, griffins and centaurs. The incorporation of pagan motifs in the work is explained by the Neo-Platonic, humanist environment of the university town of Padua in which it was conceived: the commission was proposed by a philosopher, Giambattista Leone, who owned Riccio's drawing for it and persuaded Antonio Trombetta (*d* 1518), the abbot of the adjacent monastery, to countenance its totally unorthodox iconography.

The candlestick rests on an ornamentally carved marble base, so that the bottom plinth is at eye level; it is unashamedly pagan, with four friezes of marine scenes very like Mantegna, other mythological scenes with monstrous creatures, and four large winged sphinxes at the

2. Andrea Riccio: Paschal candlestick, bronze, h. 3.92 m, 1507–16 (Padua, Il Santo)

angles. According to a later 16th-century interpretation, the sphinxes represented *Astrology, Music, Historiography* and *Cosmography* (geography). Above them are four large panels, three of which show standard themes appropriate to a candlestick that was to be lit on Easter Day: the *Adoration of the Magi, Entombment* and *Descent into Limbo*. The last panel, however, depicts a most peculiar, pagan-looking *Sacrifice at an Altar Crowned with a Statuette of the Risen Christ*, rather than a straightforward depiction of the Resurrection, the event that is crucial in Christian belief and that occurred at Easter.

The plinth of the next zone has satyrs tethered at its corners, and above are four vertical rectangular fields showing the *Cardinal Virtues* (Fortitude, Justice, Prudence and Temperance) in the standard form of allegorical draped female figures, although with unusual attributes. Round the base of the zone above are four seated putti holding attributes such as lyres, a mirror and a mask, while on its drum are four convex panels with Classical figures, which may represent *Poetry, Theology, Philosophy* and *History*.

The foreparts of addorsed centaurs project from the baluster above, which seems to rest on their backs, with four rams' heads at its apex. The drum above bears a continuous frieze of sportive putti, while the upper baluster is decorated with harpies and eagles, and the underside of the drip-pan is adorned with cherubim. All these heterogeneous elements are locked together visually by a firm matrix of well-proportioned Classical architectural forms,

enlivened with details and ornaments, such as swags of fruit and flowers depending from a variety of heads, and acanthus volutes.

The bravura of Riccio's modelling in the original wax is preserved by very accurate casting and enhanced by superb chasing of details and by toning of surface with filing and, the artist's favourite technique, hammering. It was his wont to convey the texture of skin by faceting the salient forms and projecting muscles with strokes of the gold-smith's hammer, thus dulling the reflections and leaving a more vibrant surface: this is just the opposite of Antico's unrelenting buffing to a high polish of the flesh parts on his pseudo-antique statuettes. As a result, Riccio's bronze figures have the equivalent of Leonardo's *sfumato* effect, which, in the half-light of a sanctuary, makes them seem almost alive and implies mood in a way that was quite foreign to Antico's emotionless statuettes, with their brittle gleams of cold metal, set off like precious gems amidst the unrealistic gilding of their details. These surprisingly diverse ends were achieved by artists trained in exactly the same tradition.

Riccio's Paschal candlestick is one of the most ingeniously composed and intellectually enigmatic artistic complexes of all time. It is not as widely known as it deserves, nor has it been properly studied, probably just because of a traditional prejudice that bronze artefacts, because they have a function, do not qualify as works of 'fine art'. With its multiplicity of reliefs, figures and ornamental motifs, the candlestick also provides the touchstone for attributing to Riccio's hand a good number of independent and otherwise undocumented statuettes, plaquettes and artefacts. Most of these prove on grounds of quality to be unique, but few of the large range of such pieces, which generically may be associated with Padua or Venice, measure up to the standard set by his masterpiece. A multitude of copies and derivatives was produced on a commercial basis in Veneto–Paduan foundries well into the 16th century, and possibly later, until, towards the middle of the 19th century, forgeries were made to satisfy the demands of collectors; such fakes were often based on aftercasts taken from originals that had been sent for repair by trusting owners.

Following the lead of Severo, Riccio particularly favoured the satyr as a subject, imparting to it quasi-human emotions, for it was supposed to embody the unbridled lust that is man's natural state; on the basis of comparison with the satyrs on the candlestick, a number of statuettes showing satyrs seated and drinking, tethered, or making love, may be reliably attributed to him: most evocative of all is a pair of *Satyr and Satyress* (London, V&A) making up to one another, originally beneath a tree (untraced).

(iii) Della Torre tomb and contemporary works. Riccio's next major project, the joint tomb of *Girolamo and Marcantonio della Torre* (d 1506 and 1511 respectively), in S Fermo Maggiore, Verona, is of uncertain date. The tomb was of a novel, specifically humanist form, with no overtly Christian iconography: a rectangular pedestal with a laudatory commemorative inscription beneath a table-like structure with four baluster legs and a top with an ornamented frieze. On it are seated four bronze sphinxes—similar to those on the Paschal candlestick—that

support upon their backs a plain marble sarcophagus decorated only with eight rectangular narrative reliefs, and it is crowned with a curious double-sided bronze finial presenting death-masks of the two individuals countersunk into ornamentally framed oval recesses. The reliefs are copies; the originals (Paris, Louvre) were removed by the French in 1796. They relate in a thoroughly classical narrative sequence the end of the career, the death, after-life and posthumous fame of a medical professor: a theme that could apply equally to either the older or younger of the deceased. The compositions are in some instances lifted from ancient Roman sarcophagi, and the *dramatis personae* are universally idealized, tall, slim and elegant, whether nude or draped, and accompanied with a number of playful putti. Elsewhere, winged infants represent the soul of the deceased being ferried across the River Styx and being led into the Elysian Fields. The architectural backgrounds are austerely Classical; the tomb itself features in one scene, which shows that the finial was originally flanked by six bronze seated putti (untraced). The final panel shows a gorgeous winged figure of Fame balancing on a globe, trumpeting in triumph over Death, shown as a skeleton, with Pegasus striking the ground with his hoof and creating the spring Hippocrene, fount of the Muses. This particularly vivacious rendering of a horse provides a criterion for dating to about the same period a splendid relief of *St Martin and the Beggar* (Venice, Ca' d'Oro), from S Maria dei Servi, Venice, and an independent figure of a *Shouting Horseman* (c. 1505–10; London, V&A; see fig. 3), which is generally acknowledged to be Riccio's masterpiece in the field of the statuette. Very different in mood, one contemplative and sympathetic, the other aggressive, with its panic-stricken rider inspired by Leonardo's studies of men in combat (*see* LEONARDO DA VINCI, fig. 9), these images convey the sheer breadth of Riccio's sensitivity to the human predicament, which makes him one of the greatest sculptors of the Renaissance.

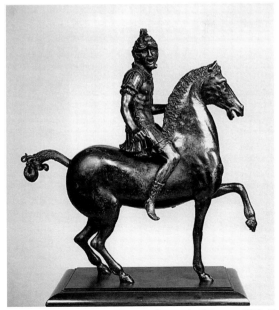

3. Andrea Riccio: *Shouting Horseman*, bronze, h. 335 mm, *c.* 1505–10 (London, Victoria and Albert Museum)

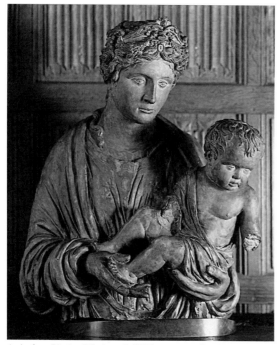

4. Andrea Riccio: *Virgin and Child*, terracotta, h. 590 mm, 1520s (Madrid, Mus. Thyssen–Bornemisza); surviving section of a life-size statue

(iv) Terracottas, 1520–30. Riccio's modelling in clay has been mentioned. In 1520 he was paid for a life-size terracotta group of the *Virgin and Child* to go behind the altar in the Scuola del Santo, Padua. The Virgin resembles an ancient Roman matron or deity, an image that was in theory historically correct for New Testament times. The last dated example was exactly a decade later, a great group of life-size figures enacting the *Entombment* in S Canziano, Padua. Only three half-length fragments survive of the dead Christ and two Marys. Round these fixed points have been arranged chronologically various other surviving terracottas, most in fragmentary condition and stripped of their polychromy: notably the upper section of a life-size standing *Virgin and Child* (Madrid, Mus. Thyssen–Bornemisza; see fig. 4) and the head of a female figure (Padua, Mus. Civ.), probably the Virgin, that was excavated near Padua. Both have serenely classical features and a beautifully detailed coiffure, with symmetrical, wavy strands of hair entwined with an elaborate diadem with central cherub and pendant medallion. These heads are directly comparable with those of the Virtues on the Paschal candlestick, and are even more minutely detailed, on account of their larger size. Riccio's *Entombment* in S Canziano must have been one of the most moving of such tableaux in Italy, comparable with those of Niccolò dell'Arca and Guido Mazzoni.

(v) Trombetta monument and late bronze statuettes, c. 1518–1520s. Antonio Trombetta, the abbot who had sanctioned the Paschal candlestick, died in 1518 and a wall monument in the Santo was commissioned from Riccio. He designed a coherent architectural and sculptural ensemble, its upper part consisting of a cross between a triumphal arch and a Serlian window, with a waist-length bronze bust of Trombetta, holding a bible, in the central aperture, with a basement below housing a laudatory inscription. This rectilinear ensemble was supported by a much more sculptural bracket, formed out of a pair of scrolls tied centrally below and curving outwards and upwards, with human torsos and heads growing out of their acanthus forms, only to have their arms revert once again into acanthus leaves, scrolling back towards the centre. The area contained within the scrolls is enlivened with superimposed layers of strapwork, a very early example, cut to reveal the abbot's heraldic device in the centre, and this is flanked by a pattern of knotted ropes, based on the monastic girdle. The stone carving was executed by Gian Matteo and Vincenzo Grandi to Riccio's design by 1521, and Riccio created the bust soon after, receiving a final payment in 1524. In the two embrasures on either side of the abbot are piles of books, with a globe on the left and an hour-glass on the right, symbolizing his humanistic learning and the passage of time until his death. The bust itself, focus of the whole elaborate composition, is an isosceles triangle, with the monastic habit indicated only by very generalized modelling, in order to act visually as a pedestal and as a foil for the strongly defined portrait head, with wizened and emaciated features deeply incised: they recall, probably deliberately, Donatello's portrait of *St Francis* on the high altar of the Santo. The funereal mood was echoed in the life-size terracotta mourners of the *Lamentation* group in S Canziano of 1530, Riccio's last dated work.

It has been suggested that a number of bronze statuettes date from the 1520s, although there is no firm evidence. As Riccio was over 60 when he died, and had long suffered from gout, or arthritis, his productivity may well have been curtailed severely in the last decade of his life.

2. POSTHUMOUS REPUTATION. Rarely remembered, Andrea Riccio is an example of an artist who rose by his own efforts from the rank of an artisan to be on good terms with the greatest minds of the day. The intellectual and spiritual qualities he developed led him to create sculptures that are the epitome of the Italian High Renaissance: not only did he revive ancient Roman imagery, but he also revitalized it into a sublime expression of the spirit of his own age. If his monumental sculpture had been executed in a less fragile medium than terracotta and had survived intact, Riccio probably would have assumed long since his rightful place as one of the great inventive artists of his day, alongside such sculptors as Antonio and Tullio Lombardo, and painters of the stature of Giorgione and Titian.

BIBLIOGRAPHY

T. Frimmel: *Der Anonimo Morelliano: Michiels 'Notizie d'opere del disegno'* (Vienna, 1888)
L. Planiscig: *Venezianische Bildhauer der Renaissance* (Vienna, 1921), pp. 111–52
——: *Andrea Riccio* (Vienna, 1927)
J. Pope-Hennessy: *Italian Renaissance Sculpture* (Oxford, 1958, 2/1971, 3/1985), pp. 104–6, pls 123–6, figs 147–52
F. Cessi: *Andrea Briosco detto il Riccio scultore (1470–1532)* (Trent, 1965)
M. G. Ciardi Duprè: *Il Riccio* (Milan, 1966)
A. F. Radcliffe: *European Bronze Statuettes* (London, 1966), pp. 39–45

H. R. Weihrauch: *Europäische Bronzestatuetten* (Braunschweig, 1967), pp. 99–112

A. F. Radcliffe: 'Bronze Oil Lamps by Riccio', *V&A Mus. Yb.*, iii (1972), pp. 29–58

B. Jestaz: 'Un Bronze inédit de Riccio', *Rev. Louvre*, iii (1975), pp. 156–62

C. Avery and A. F. Radcliffe: 'Severo Calzetta da Ravenna: New Discoveries', *Studien zum europäischen Kunsthandwerk: Festschrift Yvonne Hackenbroch* (Munich, 1983), pp. 107–22

A. F. Radcliffe: 'Ricciana', *Burl. Mag.*, cxxiv (1982), pp. 412–24

——: 'A Forgotten Masterpiece in Terracotta by Riccio', *Apollo*, cxviii (1983), pp. 40–48

——: 'Riccio', *The Genius of Venice* (exh. cat., ed. C. Hope and J. Martineau; London, R.A., 1983), pp. 371–80, nos S16–26

B. Jestaz: 'Un Groupe de bronze érotique de Riccio', *Mnmts Piot*, 66 (1983), pp. 25–54

Renaissance Master Bronzes from the Collection of the Kunsthistorisches Museum, Vienna (exh. cat., Washington, DC, N.G.A., 1986), nos 20, 21

The Thyssen-Bornemisza Collection: Renaissance and Later Sculpture with Works of Art in Bronze (London, 1992), pp. 74–9, no. 6, 212–17, no. 35

J. R. Bliss: 'A Renaissance Acrobat Lamp by Andrea Riccio: Its Mistaken History as an Ancient Bronze', *Source*, xiv/3 (1995), pp. 13–20

Von allen Seiten Schön: Bronzen der Renaissance und des Barock (exh. cat., Berlin, Staatl. Museen Preuss. Kultbes., 1995), nos 25–30

CHARLES AVERY

Riccio, Domenico. *See* BRUSASORCI, (1).

Riccio, il. *See* NERONI, BARTOLOMMEO.

Rimini [Lat. Ariminum]. Italian town at the mouth of the River Marecchia, about 1 km from the sea, capital of the province of Rimini in Emilia-Romagna. Important in antiquity as a military, naval and commercial centre, Rimini lies at the junction of the Via Emilia and the Via Flaminia; a triumphal arch in honour of Augustus (27 BC) and a five-arched marble bridge (14–21 BC) remain from the Roman period, as well as the ruins of an amphitheatre, which held about 12,000 spectators.

In AD 538 Rimini fell to the Byzantines, and it was subsequently held by the Lombards and the Franks (751), who yielded it to the papacy (757). By the 13th century it was an independent commune, intermittently at war with neighbouring city states. In 1216 Giovanni Malatesta (*d* 1247), a condottiere from Pennabilli in the Appenines, was summoned to Rimini by the Podestà to defend it against the rival town of Cesena. Before he died, Malatesta made himself Podestà of Rimini. Two of his four sons were tragically involved with Francesca da Rimini (*d* between 1283 and 1286), one as husband, the other, Paolo, as lover, and were placed by Dante with her (unnamed) companion in the second circle of Hell.

Rimini was at its peak under the rule of Sigismondo Pandolfo Malatesta (*see* MALATESTA, (1)), who rose above the martial achievements of a condottiere to become a dedicated patron of art and scholarship. Sigismondo overreached himself in his conflicts with his enemies, and in particular with Pope Pius II. He was unable to make a second Florence or Urbino of Rimini, which after his death was wrested from the Malatesta family by Cesare Borgia in 1500 and was ultimately incorporated in the Papal States (1528), where it fell into obscurity.

BIBLIOGRAPHY

Guida d'Italia: Emilia-Romagna, x (Milan, 1971), pp. 676–96

A. Macadam, ed.: *Northern Italy: From the Alps to Rome* (London, 1984), pp. 425–8

1. S FRANCESCO. The church, built by the Franciscans in the second half of the 13th century, was chosen by the lords of Rimini as their burial place. Around 1450 it was enlarged and embellished by Sigismondo Malatesta: carved inscriptions in the building record that this work was in fulfilment of a vow taken during the Italic Wars, when Sigismondo's troops served as mercenaries in the armies of Venice and Florence. This official motive must, however, have been accompanied by a strong desire for self-glorification. The work came to a halt in 1461. It was completed by the Franciscans over subsequent centuries but not to the intended scheme. The two easternmost chapels and the apse were added in the 18th century, and from about this period the church was also known as the 'Tempio Malatestiano'. The building, particularly the east end, was seriously damaged by bombing in 1944. Post-war restoration involved the reconstruction of the apse and the dismantling and reassembly of much of the external marble facing.

(i) Architecture. The original church was a modest structure, comprising a nave without aisles, a few side chapels and three chapels at the east end, the largest of which contained frescoes by Giotto (destr.). In 1447 Sigismondo began to build a large memorial chapel in a simple Gothic style on the south side of the nave, and in the same year Isotta degli Atti (*d* 1474), his mistress and later his wife (*c.* 1454), obtained papal permission to construct a chapel for herself close to this one. By spring 1449 the construction work on the two chapels was complete. A decision was then taken to transform and remodel the whole church. This more ambitious scheme involved the cladding of the exterior in marble and the enlargement and embellishment of the interior, adding further chapels and facing them all with marble and low reliefs. Sigismondo sought the advice of LEON BATTISTA ALBERTI, who provided designs and a wooden model (destr.). A damaged inscription on an architrave on the north side of the nave named the architect of the project as MATTEO DE' PASTI, who had probably already supervised the building of the two chapels begun

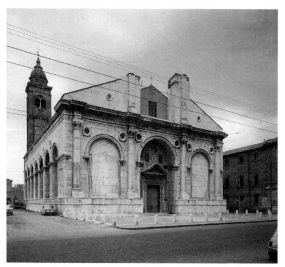

1. Rimini, S Francesco ('Tempio Malatestiano'), façade built to a design by Leon Battista Alberti, *c.* 1450–60

in 1447. De' Pasti directed the construction, which was probably carried out by local builders, as well as the supply of materials, and maintained contact with Alberti in Rome. Alberti designed the exterior of the church and its unexecuted eastern termination (the form of which is disputed, some scholars having proposed a domed rotunda and others a transept with crossing dome). De' Pasti was responsible for the reworking of the interior, which is extremely simple, in accordance with contemporary north Italian taste, with large, pointed arches giving access to the side chapels. There is now an open truss roof, but a timber barrel vault was apparently intended.

Alberti's classicizing design for the exterior of the church (see fig. 1) contrasts strongly with the Gothic interior. He covered the brick fabric with a marble cladding that concealed the irregular outline of the structure and that was independent of it. This gave him the opportunity of putting his theories on architecture into practice; in a letter of 1454 to Matteo de' Pasti, he shows his concern that the proportions of the new work should not be compromised by respecting the dimensions of the old (there is a gap between Alberti's piers and the walls, and

3. Rimini, S Francesco ('Tempio Malatestiano'), intended façade on the reverse of a medal by Matteo de' Pasti, c. 1450 (Washington, DC, National Gallery of Art)

the openings are not lined up; see fig. 2). The design, in which Alberti attempted to apply the elements of Roman architecture to the façade of a church (a building type unknown in Classical antiquity), was of entirely new conception and anticipated his scheme for S Maria Novella, Florence. The first storey, set on a high base, is articulated by half-columns carrying three arches, the central one framing the portal. The design is clearly inspired by Roman imperial architecture, particularly the Arch of Augustus in Rimini, and the frieze bears an inscription in Classical lettering recording Sigismondo's name and the date, 1450. The second storey is incomplete, but a medal by de' Pasti of c. 1450 (see fig. 3) indicates the intended scheme: it was to have terminated in a great semicircular arch containing a three-light window, flanked by two side-pieces linking it to the lower storey; these are shown as quadrants in the medal, but Alberti's letter of 1454 indicates that they were to be triangular, surmounted by scrolls. The domed east end would have been the crowning feature of the design and would have eased the present stylistic incongruity between the interior and the exterior of the church. Only the design for part of the south flank of the church was carried out, but it is extraordinarily harmonious and severe in its simplicity, composed of a series of arches carried on piers, under which the sarcophagi of illustrious members of Sigismondo's court were to be placed.

(ii) *Sculptural decoration.* Although Alberti provided advice on the interior decoration of the church and the materials to be employed for it, the creation of the overall scheme must be attributed to Matteo de' Pasti, who appears prominently in all the few surviving documents relating to the church. (Additional advice was probably received from Agostino di Duccio and Piero della Francesca; in 1451 the latter painted the fresco of *Sigismondo Malatesta Kneeling before St Sigismund* on the south of the nave.) De' Pasti

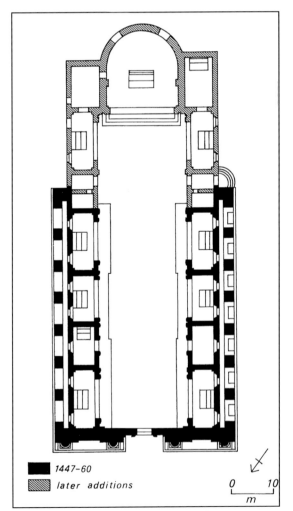

1447–60

later additions

0 10

m

2. Rimini, S Francesco ('Tempio Malatestiano'), plan

seems not to have been responsible for the execution of the work, however, either in stone or metal; this was entrusted instead to Venetian and Tuscan artists.

Documents give some indication of the progress of the work. The Florentine sculptor AGOSTINO DI DUCCIO, whose signature also appeared in an inscription in the nave, and the Venetians Giovanni di Francesco and Pellegrino di Giacomo are documented in Rimini from 1449. Their presence there has justifiably been linked to the decoration of the first two chapels (i.e. those built 1447–9), but in the execution of work for the enlarged scheme, they were assisted by many other sculptors and stonecutters, most of whom remain anonymous. On 15 October 1450 the pair of elephants supporting a pilaster in the first chapel on the right (S Sigismondo) was put in place, and the chapel was dedicated on 1 May 1452. In December 1454 work was proceeding on the decoration of the north chapels, and Agostino di Duccio was required to give the finishing touches to the cover of the Malatesta family sarcophagus (the 'Arca degli Antenati'), which was to have been placed under one of the façade niches (it was instead housed in the first chapel on the left). From 1455 to 1460 Agostino's brother Ottaviano di Antonio di Duccio (*b* 1422; *d* after 1478) and the Florentine Antonio Camarotti (*fl* 1455–75) were collaborating on the sculpture, but Agostino himself had left the site by 17 July 1457, when he is recorded in Perugia. Much of the work on the marbles for the north chapels must have been carried out after his departure, but it comprised the execution of only a few new pieces, carved according to existing models.

The decoration, executed in marble and stucco, is superimposed on the simple Gothic structure. It is typically Venetian in taste, with an abundance of heraldic symbols and elements drawn from civic display, such as festoons, shields and canopies. The polychrome and gilding, of which only traces remain, gave life and splendour to the decoration as a whole and increased its picturesque, profane quality: in 1460 Pius II commented that the building was full of 'gentile works' to the extent that it seemed a temple of 'pagan worshippers of demons' (Ricci, p. 554). The sculptures are mostly executed in low relief, and many employ the *stiacciato* (scratched relief) technique, which Alberti recommended in his treatise on architecture. There are also some sculptures in the round, representing cherubs and youths bearing coats of arms.

The decoration as a whole is symmetrical, both from a conceptual and a formal point of view. The first chapel on the right (S Sigismondo), decorated with figures of the Christian *Virtues* (see fig. 4), is reflected on the left by a chapel dedicated to the Martyrs and bearing figures of *Prophets* and *Sibyls*. Next is a sacristy doorway with figures of *Evangelists*, which is matched by another doorway featuring biblical heroes. Then comes the chapel of the Archangel Michael (also known as the chapel of Isotta) on the right, with music-making cherubs, opposite a chapel with singing angels. Finally, a chapel on the right (S Girolamo) with the *Signs of the Zodiac*, alluding to the perfection of the heavens, corresponds to a chapel on the left (S Gaudenzio) featuring the *Liberal Arts*, referring to the earthly realm.

With its many allusions to Classical literature and philosophy, the sculptural decoration of S Francesco

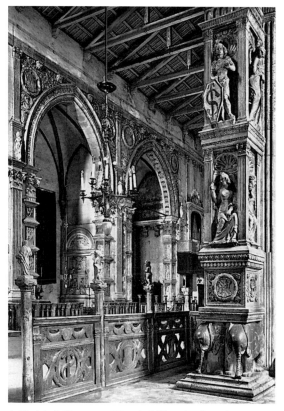

4. Rimini, S Francesco ('Tempio Malatestiano'), sculpture in the chapel of S Sigismondo, showing a pair of elephants and figures of the *Virtues*, 1446–52

manifests the culture of the Malatesta court. The military engineer Roberto Valturio (*d* 1475), who played a prominent part in formulating its iconographic programme (supervising the decoration of the left-hand chapels), explicitly declared that the scheme was inspired 'by the innermost secrets of philosophy' (Mitchell, 1951, p. 77). Poggio Bracciolini advised on the iconography of the prophets and sibyls carved on the pilasters of the first chapel. The project was interrupted in its final stages, however, and it remains difficult to understand the overall meaning of the sculptural cycles. Widely differing interpretations have been proposed: the representation of the history of man's religious beliefs, some of the mysteries of Christianity, and the glorification of Malatesta himself, identified with the sun-god Apollo. Some critics have considered it to be a 'temple of love' built exclusively to celebrate the passion of Sigismondo for Isotta. This last interpretation is based on the monogram formed by the interwoven letters S and I, which is present both on the exterior and interior of the building; these are not, however, the initials of Sigismondo and Isotta but the monogram of Sigismondo alone.

BIBLIOGRAPHY
C. von Stegmann and H. von Geymüller: *Die Architektur der Renaissance in Toscana* (Munich, 1888–1908), iii
I. B. Supino: 'Leon Battista Alberti e il Tempio Malatestiano', *Mem. Reale Accad. Sci. Ist. Bologna*, 2nd ser., viii–ix (1923–5), pp. 1–16
C. Ricci: *Il Tempio Malatestiano* (Milan and Rome, 1924, rev. Rimini, 1974)
A. Tosi: 'Alcune note sul Tempio Malatestiano', *La Romagna*, xvi/1–2 (1927), pp. 213–35

G. Del Piano: *L'enigma filosofico del Tempio Malatestiano* (Forlì, 1928)

R. Wittkower: *Architectural Principles in the Age of Humanism* (London, 1949, 3/R 1962)

E. Lavagnino: 'Restauro del Tempio Malatestiano', *Boll. A.*, xxxv/2 (1950), pp. 176–84

A. Campana: 'Per la storia delle cappelle trecentesche della chiesa malatestiana di San Francesco', *Stud. Romagnoli*, ii (1951), pp. 18–37

C. Mitchell: 'The Imagery of the Tempio Malatestiano', *Stud. Romagnoli*, ii (1951), pp. 77–90

M. Salmi: 'Il Tempio Malatestiano', *Stud. Romagnoli*, ii (1951), pp. 150–57

C. Brandi: *Il Tempio Malatestiano* (Turin, 1956)

C. Grayson: *An Autograph Letter from Leon Battista Alberti to Matteo de' Pasti* (New York, 1957)

P. Portoghesi: *Il Tempio Malatestiano* (Florence, 1965)

C. L. Ragghianti: 'Tempio Malatestiano', *Crit. A.*, xii/71 (1965), pp. 23–31; xii/74 (1965), pp. 27–39

M. Bacci: *Agostino di Duccio* (Milan, 1966)

P. G. Pasini: 'Le arti', and 'Il Tempio Malatestiano', *Sigismondo Pandolfo Malatesta e il suo tempo* (exh. cat., ed. F. Arduini and others; Rimini, Pal. Arengo, 1970), pp. 75–164, 125–66

C. Mitchell: 'An Early Christian Model for the Tempio Malatestiano', *Intuition und Kunstwissenschaft: Festschrift für Hanns Swarzenski* (Berlin, 1973), pp. 427–38

F. Borsi: *Leon Battista Alberti* (Milan, 1975)

C. Mitchell: 'Il Tempio Malatestiano: Studi Malatestiani', *Stud. Stor.*, 110–11 (Rome, 1978), pp. 71–103

P. G. Pasini: 'La facciata prospettica del Tempio Malatestiano', *Romagna A. & Stor.*, i/2 (1981), pp. 23–34

G. Petrini: 'Ricerche sui sistemi proporzionali del Tempio Malatestiano', *Romagna A. & Storia*, i/2 (1981), pp. 35–41

P. Meldini and P. G. Pasini: *La cappella dei pianeti del Tempio Malatestiano* (Milan, 1983)

P. G. Pasini: *I Malatesti e l'arte* (Milan, 1983)

M. A. Lavin and others: *Piero della Francesca a Rimini: L'affresco del Tempio Malatestiano* (Bologna, 1984)

C. Hope: 'The Early History of the Tempio Malatestiano', *J. Warb. & Court. Inst.*, lv (1992), pp. 51–154

P. G. Pasini: *Piero e i Malatesti* (Milan, 1992)

Leon Battista Alberti (exh. cat., ed. J. Rykwert and A. Engel; Milan, 1994)

Rinascimento da Brunelleschi a Michelangelo: La rappresentazione dell'architettura (exh. cat., ed. H. Millon and V. Magnago Lampugnani; Milan, 1994)

PIER GIORGIO PASINI

Rimiteri, Filippo. *See under* SCHIAVON.

Rimpacta, Jacopo. *See* RIPANDA, JACOPO.

Rinaldo Mantovano (*fl* Mantua, *c.* 1527–39). Italian painter. According to Vasari, he was the best pupil of Giulio Romano. He is documented in the workshop of the Palazzo del Te in Mantua, where he collaborated on the decoration of the Sala dei Venti, the Camera delle Aquile (1527) and the Loggia di David (1531). His work with Giulio is documented from 1531, when he participated in the decoration of the Castello di San Giorgio, Mantua, for the wedding of Federico II Gonzaga, Duke of Mantua, and Margherita Paleologa, and in that of the apartment built for the bride in the Palazzo Ducale. From 1532 to *c.* 1536 he worked in the Sala dei Giganti of the Palazzo del Te, where his somewhat flat decorative style can be identified in most of the wall paintings and part of the ceiling. From 1536 to 1539 he worked with Giulio's group in the Palazzo Ducale, decorating the Appartamento di Troia and the Camerino dei Falconi. In S Andrea, Mantua, he executed frescoes designed by Giulio in the Boschetti Chapel. Such scenes as the *Rediscovery of the Precious Blood* show his tendency to flatten figures, thus diminishing the effect of space. The attribution to him of

the decoration of the chapel of S Sebastiano, also in S Andrea, is doubtful.

BIBLIOGRAPHY

G. Vasari: *Vite* (1550, rev. 2/1568); ed. G. Milanesi (1878–85), vi, p. 489

F. Hartt: *Giulio Romano* (New Haven, 1958)

E. Marani and C. Perina: *Mantova: Le arti*, ii (Mantua, 1961), iii (Mantua, 1965), pp. 327–30

P. Carpeggiani and C. Tellini Perina: *Sant' Andrea in Mantova* (Mantua, 1987), pp. 40, 42, 102, 108

Giulio Romano (exh. cat. by A. Belluzzi and others, Mantua, Mus. Civ. Pal. Tè, Pal. Ducale, 1989), pp. 343, 346, 364, 370, 385, 396

MATILDE AMATURO

Ripanda [Rimpacta], Jacopo (*b* ?Bologna, *fl c.* 1500–16). Italian painter and engraver. He went to Rome during the pontificate of Alexander VI to study Classical antiquities. An apparatus he made in order to see and make detailed drawings of the reliefs on Trajan's Column at close hand caused a furore and procured him the commission to paint four *sale* of the Palazzo dei Conservatori with scenes from Classical history. Completed under the pontificate of Julius II, the frescoes of the Sala di Annibale and the Sala della Lupa are still partly *in situ*. In 1505–7 Ripanda painted the chiaroscuro frescoes (destr.) of scenes from the lives of Julius Caesar and Trajan for the palace of Cardinal Fazio Santorio (1447–1510), now the Palazzo Doria–Pamphili. According to a document of 1513, Ripanda executed some decorations for the funeral of Julius II. His last documented work is a sketchbook (1516; Lille, Mus. B.-A.).

Ripanda's style is basically Emilian, influenced by Ercole Grandi and Lorenzo Costa (i), but adapted to the style of painters such as Bernardo Pinturicchio and Girolamo Genga. The result closely resembles the work of Amico Aspertini and the young Baldassare Peruzzi. Contemporary sources indicate that the attraction of Ripanda's work lay in his meticulous description of classical details. Though a mediocre painter, in his turn he influenced such artists as Peruzzi, as is evidenced by the latter's rediscovered chiaroscuro frescoes of the *Life of Trajan* in the episcopal palace, Ostia. It is not clear whether he is the 'Iacobus de Runpare bononiensis pictor' mentioned in a Roman document of 1516. Giulio Mancini, in his *Viaggio per Roma* (1624/R Rome, 1956–7), mentions other church and façade paintings by Ripanda, but these have either been lost or are no longer attributed to him.

According to the Bolognese chronicler Marcello Oretti in his *Notizie de' professori del disegno* (1760–80; Bologna, Bibl. Com., MS.B.123), Ripanda was also an engraver. However, no prints by him are known, and those by the Master I.B., formerly ascribed to Ripanda, are now attributed to Giovanni Battista Palumba.

BIBLIOGRAPHY

G. Fiocco: 'Jacopo Ripanda', *L'Arte*, xxiii (1920), pp. 27–48

P. Venturoli: 'Nota su Jacopo Ripanda e il giovane Baldassare Peruzzi', *Storia dell'arte*, iv (1969), pp. 432–8

V. Farinella: 'Jacopo Ripanda a Palazzo Santoro: Un ciclo di storia romana e le sue fonti classiche', *Stud. Class. & Orient.*, xxxvi (1986), pp. 209–37

S. Ebert-Schifferer: 'Ripandas kapitolinischer Freskenzyklus und die Selbstdarstellung der Konservatoren um 1500', *Röm. Jb. Kstgesch.*, xxiii–xxiv (1988), pp. 75–218

M. Faietti and K. Oberhuber: 'Jacopo Ripanda e il suo collaboratore (il maestro di Oxford) in alcuni cantieri romani del primo cinquecento', *Ric. Stor. A.*, xxxiv (1988), pp. 55–72

V. Farinella: *Archeologia e pittura a Roma tra quattrocento e cinquecento. Il caso di Jacopo Ripanda* (Turin, 1992)

S. Guarino: 'L'antiquario sfegatato: Nuovi studi su Jacopo Ripanda', *Roma Moderna e Contemporanea*, I/i (1993), pp. 191–8

J. L. DE JONG

Ripicano, Cola. *See* RAPICANO, COLA.

Risaliba [Risaliva]**, de.** *See* SALIBA, DE.

Risino. *See* MEZZARISA, FRANCESCO DI ANTONIO.

Rizzo, Antonio (*b* Verona, before 1440; *d* 1499 or after). Italian sculptor, architect and engineer. He seems to have shown his skill as a sculptor in Verona by the 1460s, since the Protonotary Apostolic, Gregorio Correr (*d* 1464), praised him, together with Andrea Mantegna, in two epigrams and a poem. Also in the 1460s he probably visited Padua, where he could have studied Donatello's sculptures and Mantegna's frescoes in the Ovetari Chapel in the Eremitani. The Antonio Rizzo whom documents mention as being responsible for various works (1465–7) at the Certosa di Pavia was probably a different person. Markham Schulz's suggestion (1983), based on stylistic analysis, that Rizzo worked in Florence is controversial.

There is evidence that in 1465 Rizzo was in Venice, where Doge Cristoforo Moro gave him a prestigious commission to carve three marble altars (completed 1469) in S Marco. The altars of St James and St Paul have survived virtually unchanged, but that of St Clement was altered in the 16th century. The slender proportions of the tabernacles decorated with *all'antica* ornament put Rizzo in the vanguard of Venetian artists who took their inspiration from the Antique. He may have been in contact with Jacopo Bellini, who in his sketchbooks endeavoured to combine Classical and traditional Venetian forms. The standing figures of the Saints, framed in the tabernacles, show the influence of Mantegna's early style in their unornamented, angular drapery and severe demeanour, very different in style from the monument to *Doge Francesco Foscari* (*c.* 1457–60; Venice, S Maria Gloriosa dei Frari) usually attributed to Antonio Bregno and Paolo Bregno.

All attributions to Rizzo in his early years in Venice must be compared to the S Marco altars. There are essentially two conflicting views of his oeuvre: Pohlandt, following Paoletti's fundamental research (1893), confined his oeuvre to a few superlatively executed works, whereas Markham Schulz attributed a large body of work to Rizzo. Some of the works she attributed are of indifferent quality, such as the figures at the summit of the Arco Foscari in the courtyard of the Doge's Palace. By 1460 several sculptors active in Venice were imitating and developing the style of the Foscari monument, and in the past scholars have attributed the works of these imitative sculptors to the young Rizzo. These include the *Annunciation* group on the portal of S Maria dell'Orto, the tomb of *Orsato Giustiniani* (*d* 1464; ex-S Eufemia; fragments New York, Met., El Paso, TX, Mus. A.; Padua, Cassa di Risparmio) and the lunette showing Vittore Capello kneeling before St Helena over the portal of S Elena in Isola. Francesco Sansovino (1581) attributed some of these works to a certain Antonio Dentone, sometimes identified as Rizzo (Munman, 1973).

Three full-length marble statues (Venice, Doge's Pal.) that originally stood in niches in the Arco Foscari are probably among Rizzo's earliest Venetian works and may have been finished by 1471, although their dating is controversial. They are of a man in antique Roman armour, usually called *Mars*, and of *Adam* and *Eve*, two of the earliest nude statues of the Venetian Renaissance. In 1474 and 1479 Rizzo served as a military engineer at the two sieges of the Venetian city of Scutari in Albania. In 1476 he executed for the Scuola Grande di S Marco a spiral staircase and a pentagonal pulpit (both destr. 1485) from designs provided by Gentile Bellini.

The monument to *Doge Niccolò Tron* (*c.* 1476–80; Venice, S Maria Gloriosa dei Frari) is undocumented but is unanimously accepted as Rizzo's design. The gigantic wall tomb, which contains twenty-two free-standing statues and four reliefs, is in the form of a vast arch with five tiers of sculpture and standing figures ranged in niches on either side. Such a scheme had been used earlier in Rome for the tomb of *Paul II* (*d* 1471; destr., fragments, Rome, Grotte Vaticane) by Giovanni Dalmata and Mino da Fiesole, and at virtually the same time in Venice for the monument to *Doge Pietro Mocenigo* (*d* 1476; Venice, SS Giovanni e Paolo) by Pietro Lombardo. On the lowest tier of the Tron tomb, the standing effigy of the Doge is flanked by two magnificent figures of *Prudence* (see fig.) and *Charity*, all three statues contained in niches. These exceptionally beautiful figures, with delicate drapery clinging closely to the form of the bodies, show that Rizzo had turned away from the early influences of Donatello and Mantegna towards the Antique, although the relief ornament on the tomb is still close to that on the altars for S Marco. It is probable that Rizzo himself executed only the portraits of the Doge for the standing and recumbent effigies and the figures of *Prudence* and *Charity*; the authorship of the other sculpture is controversial, but it is probably the work of anonymous assistants, although some scholars think that it is the collaborative work of Rizzo and his studio. It is difficult to accept the attribution to Rizzo of the monument to *Giovanni Emo* (*d* 1483; dispersed; effigy of Emo in Vicenza, Mus. Civ. A. & Stor.; two shield-bearers, Paris, Louvre) originally in S Maria dei Servi, Venice. The portrait is of inferior quality and radically different in approach from the Tron portraits. It is much closer to Pietro Lombardo's Mocenigo monument.

In 1483 the east wing of the Doge's Palace burnt down, and in May 1484 after presenting a model Rizzo won a competition to supervise the new building. He was appointed *capomaestro*, and his contract forbade him to accept any other commissions in his own name. The façades overlooking the courtyard and the Rio di Palazzo are some of the most ornate of 15th-century Venice. Most scholars have assumed that the designs of both façades are by Rizzo, but the use of columns and the forms of the windows have much in common with Mauro Codussi's works (Hirthe, 1982). Other decorative details can be attributed to the Lombard masons employed there (Markham Schulz, 1983).

The external ceremonial staircase in the courtyard of the Doge's Palace, known as the Scala dei Giganti, is unanimously attributed to Rizzo. To place a staircase so

Antonio Rizzo: *Prudence*, marble statue from the tomb of *Doge Niccolò Tron*, h. 1.70 m, *c.* 1476–80 (Venice, S Maria Gloriosa dei Frari)

stone enclosed in a grid of marble strips fantastically carved with ornamental and figurative designs in *rilievo schiacciato*; even the risers of the steps are of white marble inlaid with niello patterning. Rizzo seems to have executed parts of it himself. The best of the staircase reliefs are close in style to Rizzo's antependium relief of the *Conversion of St Paul* on the altar of St Paul in S Marco, though they also share characteristics with reliefs by the Master of San Trovaso.

In 1496 Rizzo was summoned to Vicenza to advise on the reconstruction and strengthening of the basilica (later undertaken by Palladio), which was in danger of collapse, but his proposals came to nothing. In 1498, suspected of embezzling money intended for the rebuilding of the Doge's Palace, he fled from Venice to the Marches. He was last recorded in Cesena in 1499. Rizzo was the friend of several outstanding humanists, including Rafaello Regio, Professor of Rhetoric at Padua University, and of Niccolò Leonico Tomeo, the Greek scholar and collector of ancient and modern art. The Triestine poet Raffaele Zovenzoni (*d* 1485) wrote poems in praise of his work, including his statue of *Adam*.

BIBLIOGRAPHY

Thieme–Becker

G. Vasari: *Vite* (1550, rev. 2/1568); ed. G. Milanesi (1878–85), ii, pp. 572–3

F. Sansovino: *Venetia, città nobilissima et singolare* (Venice, 1581), p. 80a

P. Paoletti: *L'architettura e la scultura del rinascimento a Venezia*, i (Venice, 1893), pp. 141–63 [doc.]

P. L. Rambaldi: 'La Scala dei Giganti nel Palazzo Ducale di Venezia', *Ateneo Ven.*, xxxiii/2 (1910), pp. 87–121, 193–239

L. Planiscig: *Venezianische Bildhauer der Renaissance* (Vienna, 1921), pp. 56–72

——: 'Das Grabdenkmal des Orsato Giustiniani: Ein Beitrag zur Geschichte der venezianischen Skulptur im Quattrocento', *Jb. Ksthist. Samml. Wien*, 2nd ser., i (1926), pp. 93–102

G. Mariacher: 'Antonio da Righeggio e Antonio Rizzo', *Arti: Rass. Bimest. Ant. & Mod.*, ii (1941), pp. 193–8

——: 'Profilo di Antonio Rizzo', *A. Ven.*, ii (1948), pp. 67–84

——: 'Due inedite sculture di Antonio Rizzo', *Riv. A.*, xxvii (1951–2), pp. 185–9

E. Arslan: 'Oeuvres de jeunesse d'Antonio Rizzo', *Gaz. B.-A.*, 6th ser., xlii (1953), pp. 104–14

M. Muraro: 'La Scala senza Giganti', *De artibus opuscula, xl: Essays in Honor of Erwin Panofsky*, i (Zurich, 1960), pp. 350–70

G. Zorzi: 'Notizie di arte e di artisti nei diari di Marino Sanudo', *Atti Ist. Veneto Sci., Lett. & A.*, cxix (1960–61), pp. 471–604

J. Pope-Hennessy: *Italian Renaissance Sculpture* (London, 1963, rev. 3/1985), pp. 107–8, 348–50, 367

A. M. Romanini: 'L'incontro fra Cristoforo Mantegazza e il Rizzo nel settimo decennio del quattrocento', *A. Lombarda*, ix (1964), pp. 91–102

U. Franzoi: 'La Scala dei Giganti', *Boll. Mus. Civ. Ven.*, x/4 (1965), pp. 8–30

G. Mariacher: *Rizzo, I Maestri della scultura* (Milan, 1966)

R. Munman: 'The Monument to Vittore Cappello of Antonio Rizzo', *Burl. Mag.*, cxiii (1971), pp. 138–45

W. Pohlandt: 'Antonio Rizzo', *Jb. Berliner Mus.*, xiii (1971), pp. 162–207

R. Munman: 'Antonio Rizzo's Sarcophagus for Nicolò Tron: A Closer Look', *A. Bull.*, lv (1973), pp. 77–85

——: 'The Last Work of Antonio Rizzo', *A. Lombarda*, xvii (1977), pp. 89–98

J. McAndrew: *Venetian Architecture of the Early Renaissance* (Cambridge, MA, 1980), pp. 82–109

D. Pincus: 'The Tomb of the Doge Nicolò Tron and Venetian Renaissance Ruler Imagery', *Art, the Ape of Nature: Studies in Honor of H. W. Janson*, ed. M. Barasch and L. Freeman Sandler (New York, 1981), pp. 127–50

T. Hirthe: 'Mauro Codussi als Architekt des Dogenpalasts', *A. Ven.*, xxxvi (1982), pp. 31–44

A. Markham Schulz: *Antonio Rizzo: Sculptor and Architect* (Princeton, 1983); review by W. Stedman Sheard in *A. Bull.*, lxix (1987), pp. 473–9

that both sides are free-standing was a daring innovation in Venice in the 1480s; it is possible that it may owe something to a drawing (London, BM) in one of Jacopo Bellini's sketchbooks for a similar staircase, or that it followed an earlier staircase in the courtyard. The staircase is subtly skewed to the left to make its axes align with the loggia behind and the two gates—the Arco Foscari and the Porta della Carta—before it. It has a double ramp with a half-landing and is flanked by elegant balustrades. The sides are decorated with squares of multicoloured breccia

W. Wolters: 'Antonio Rizzo', *Venedig, die Kunst der Renaissance: Architektur, Skulptur, Malerei, 1460–1590* (Munich, 1986), pp. 152–62

WOLFGANG WOLTERS

Rizzoli, Giovanni Pietro [il Giampietrino] (*fl c.* 1495–40). Italian painter. He may be identifiable with the 'gian petro' jotted down in a list by Leonardo between 1497 and 1500 (Milan, Bib. Ambrosiana, Codex Atlanticus, fol. 713*r*; ex. fol. 264 *r–b*) and thus may have been present in or near Leonardo's Milanese workshop before the end of the 15th century, although the surviving paintings usually connected with him belong stylistically to the period between 1510 and 1530. The recent discovery of documents and paintings (Marani, 1989; Shell and Sironi) related to his presence in Savona in 1537 excludes the previous identifications of the artists with Giovanni Pedrini or Pietro Rizzo. His paintings include the altarpiece of the *Virgin and Child with Saints* dated 1521 for the church of S Marino, Pavia, and a series of small pictures of the *Virgin and Child, Mary Magdalene, Lucrezia, Cleopatra, Sophonisba* and *Diana* (the latter New York, Met.), probably almost all privately commissioned. These paintings are strongly influenced by the work of Leonardo, often deriving, with variations, from his lost *Leda* or from other late drawings and compositions by Leonardo, thus suggesting a close relationship of the artist with Leonardo during the latter's second Milanese period (mid-1508–1513).

Rizzoli's technique is generally refined and precise, his pale flesh tones barely tinged with pink. The intense, luminous colours of the draperies often contrast with dark backgrounds depicting rocky landscapes, also reminiscent of Leonardo. Many replicas and copies of Rizzoli's works exist, for example the painting (Verona, Castelvecchio) by Gian Francesco Caroto after Rizzoli's *Sophonisba* (Isola Bella, Mus. Borromeo). The autograph paintings, however, are characterized by a small white vase that may be the symbolic signature of the artist. Rizzoli's work also shows the influence of Bernardino Luini's paintings of the second and third decades of the 16th century. Four drawings are securely attributable to Rizzoli: a study for the Pavia altarpiece (Paris, Louvre), a cartoon of the *Holy Family* (New York, Pierpont Morgan Lib.), a large preparatory study for a *Mary Magdalene* (study and painting both Milan, Castello Sforzesco) and a study (Sacramento, CA, Crocker A.G.) for a late altarpiece, recently published by Marani and Bora. Rizzoli's art, with its ambiguous balance between religious asceticism and subtle but quite evident eroticism, was highly successful in the early 17th century in Lombardy. Its influence can be traced in the works of Giulio Cesare Procaccini (1574–1625) and Daniele Crespi (1597/1600–1630).

BIBLIOGRAPHY

Thieme–Becker

G. P. Lomazzo: *Trattato dell'arte della pittura* (Milan, 1584–5)

W. Suida: *Leonardo und sein Kreis* (Munich, 1929), pp. 298–302

B. Berenson: *Central and North Italian Schools* (1968)

Capolavori d'arte lombarda: I Leonardeschi ai raggi "X" (exh. cat., ed. M. Precerruti Garberi and L. Mucchi; Milan, Castello Sforzesco, 1972), pp. 131–45

S. J. Freedberg: *Painting in Italy, 1500 to 1600* (Harmondsworth, 1975), pp. 383, 697

M. T. Fiorio: *Leonardeschi in Lombardia* (Milan, 1982), p. 93

Leonardo e il leonardismo a Napoli e a Roma (exh. cat., ed. A. Vezzosi; Rome, Pal. Espos.; Naples, Capodimonte; 1983), pp. 106, 107, 151, 152

P. C. Marani: *Leonardo e i leonardeschi a Brera* (Florence, 1987), nos 36–9

Disegni e dipinti leonardeschi dalle collezioni milanesi (exh. cat., ed. G. Bora and others; Milan, Pal. Reale, 1987–8), pp. 24, 102–4, 148–9

J. Shell: 'Dati storici', *Giampietrino e una copia cinquecentesca dell'ultima cena di Leonardo* (Milan, 1988), pp. 9–16

P. C. Marani: 'Per il Giampietrino: Nuove analisi nella Pinacoteca di Brera e un grande inedito', *Rac. Vinc.*, xxiii (1989), pp. 33–56

C. Geddo: 'Le pale d'altare del Giampetrino: Ipotesi per un percorso stilistico', *A. Lombarda*, 101 (1992), pp. 67–82

F. Moro: 'Divinità femminili del Giampietrino', *Achad. Leonardi Vinci: J. Leonardo Stud. & Bibliog. Vinciana*, vi (1993), pp. 90–94

J. Shell and G. Sironi: 'Some Documents for Giovanni Pietro Rizzoli: Il Giampietrino, *Rac. Vinc.*, xxv (1993), pp. 121–46

C. Geddo: '*La Madonna di Castel Vitoni* del Giampietrino', *Achad. Leonardi Vinci: J. Leonardo Stud. & Bibliog. Vinciana*, vii (1994), pp. 57–67

L. Keith and A. Roy: 'Giampietrino, Boltraffio and the Influence of Leonardo', *N.G. Tech. Bull.*, xvii (1996), pp. 4–19

G. Bora: 'I leonardeschi e il disegno', *I leonardeschi: L'eredità di Leonardo in Lombardia*, ed. G. Bora and others (Milan, 1998), pp. 93–120

C. Geddo: 'Disegni leonardeschi dal Cenacolo: Un nuovo nome per le teste di Strasburgo', *Tutte le opere non son per istancarmi: Raccolta di scritti per i settant'anni di Carlo Pedretti*, ed. F. Frosini (Rome, 1998), pp. 159–88

P. C. Marani: 'Giovan Pietro Rizzoli detto il Giampietrino', *I leonardeschi: L'eredità di Leonardo in Lombardia*, ed. G. Bora and others (Milan, 1998), pp. 371–84

PIETRO C. MARANI

Robbia, della. Italian family of sculptors and potters. They were active in Florence from the early 15th century and elsewhere in Italy and France well into the 16th. Family members were traditionally employed in the textile industry, and their name derives from *rubia tinctorum*, a red dye. (1) Luca della Robbia founded the family sculpture workshop in Florence and was regarded by contemporaries as a leading artistic innovator, comparable to Donatello and Masaccio. The influence of antique art and his characteristic liveliness and charm are evident in such works as the marble singing-gallery for Florence Cathedral. He is credited with the invention of the tin-glazed terracotta sculpture for which the family became well known. His nephew (2) Andrea della Robbia, who inherited the workshop, tended to use more complex compositions and polychrome glazing rather than the simple blue-and-white schemes favoured by his uncle.

Several of Andrea's sons worked in the shop. Marco della Robbia (*b* 6 April 1468; *d* 1529–34), perhaps the least talented of the sons, became a Dominican monk in 1496 but continued to execute sculpture, for example the lunette of the *Annunciation* (1510–15; Lucca, S Frediano). Andrea's sons (3) Giovanni della Robbia and Luca della Robbia the younger (*b* 25 Aug 1475; *d* before 6 Nov 1548) inherited the workshop and were responsible for adapting its production to 16th-century taste, influenced by contemporary Florentine painting. Another son, Francesco della Robbia (*b* 23 July 1477; *d* 1527–8) joined the Dominican convent of S Marco in Florence in 1495 but maintained links with the family shop. His work included plastic groups such as the *Nativity* of Santo Spirito in Siena (1504), and terracotta altarpieces, some executed in collaboration with his brother Marco. In the 1520s Marco and Francesco spent some time in the Marches, near Macerata, where they realized numerous glazed terracotta works. (4) Girolamo della Robbia was the only son of Andrea to continue the reputation of the family's terracotta works beyond the mid-16th century. He spent much of his life

in France, working for the royal court, often in collaboration with Luca the younger, who joined him there in 1529.

BIBLIOGRAPHY

DBI, Thieme–Becker

P. Gaurico: *De Sculptura* (1504), ed. A. Chastel and R. Klein (Geneva and Paris, 1969), pp. 241–91

G. Vasari: *Vite* (1550, 2/1568), ed. G. Milanesi (1878–85)

F. Baldinucci: *Notizie* (1681–1728), ed. F. Ranalli (1845–7)

E. Cavallucci and E. Molinier: *Les Della Robbia: Leur vie et leur oeuvre* (Paris, 1884)

M. Reymond: *Les Della Robbia* (Florence, 1897)

M. Cruttwell: *Luca and Andrea della Robbia and their Successors* (New York, 1902)

P. Schubring: *Luca della Robbia und seine Familie* (Bielefeld and Leipzig, 1905)

A Marquand: *The Brothers of Giovanni della Robbia* (Princeton, 1928/R New York, 1972)

G. Gentilini: *I Della Robbia: La scultura invetriata nel rinascimento* (Florence, 1992)

☐

(1) Luca (di Simone) della Robbia (*b* ?Florence, July 1399–July 1400; *d* Florence, 20 Feb 1482). He was the son of Simone di Marco della Robbia, a member of the Arte della Lana, the wool-workers' guild. According to Vasari, Luca was apprenticed to the goldsmith Leonardo di Ser Giovanni and at about the age of 15 was taken to Rimini where he made bas-reliefs for Sigismondo Pandolfo Malatesta; however this information is partly contradicted by chronology. Gaurico also indicated that Luca was trained as a goldsmith, and it is possible that he worked on the Adriatic with a Florentine master such as Niccolò di Piero Lamberti, who went to Venice in 1416. It has also been suggested that he was apprenticed to Nanni di Banco, with whom he may have worked (*c.* 1420) on the decoration of the Porta della Mandorla in Florence Cathedral (Bellosi, 1981).

Luca is first documented in 1427, when he enrolled in the Arte della Lana and was mentioned as a collaborator of Lorenzo Ghiberti (*see* GHIBERTI, (1)) on the east door of the Baptistery in Florence. According to Antonio Billi, he also assisted on the earlier, north door. His work for the Baptistery, coupled with the fluid style and meticulous execution of his sculpture have convinced many writers, following Baldinucci, that he was trained by Ghiberti himself. In the late 1520s, during a period of strong interest in the art of DONATELLO, which was fundamental to his development, he may have executed the *Bearded Prophet* (Florence, Bargello) on a window of the east tribune of Florence Cathedral (Gentilini, 1992). Donatello's influence is apparent in works executed *c.* 1430, including small *schiacciato* reliefs of the *Virgin and Child with Two Angels* (1429; Oxford, Ashmolean) and versions of the *Virgin and Child with Six Angels* (e.g. Detroit, MI, Inst. A.; New York, Met.; Paris, Louvre). He joined the Arte dei Maestri di Pietra e Legname (the stone and woodworkers' guild) only in 1532, listed as a sculptor.

During the 1420s Luca became friendly with FILIPPO BRUNELLESCHI who began using della Robbia works to decorate his buildings. According to Vespasiano da Bisticci, he frequented the home of the humanist Niccolò Niccoli with Brunelleschi, Donatello and Ghiberti. His association with learned circles in Florence is suggested also by his friendship with the writers LEON BATTISTA ALBERTI and Antonio Manetti, and by the fact that his first patron was the banker Niccolò di Vieri de' Medici, a close friend of Alberti and Niccoli.

According to Vasari, it was through Medici family influence that Luca, perhaps as early as 1428, received the important commission for the marble *Singing Gallery* (*Cantoria*) for the organ loft of Florence Cathedral (see fig. 1 and colour pl. 2, XXIV2). His first documented independent work, it was executed under the supervision of Brunelleschi, whose influence is evident in the structure, and was installed above the portal of the North Sacristy

1. Luca della Robbia: *Singing Gallery* (*Cantoria*) for the organ loft of Florence Cathedral, marble, 1431–8 (Florence, Museo dell'Opera del Duomo)

in 1438 (removed in 1688, now Florence, Mus. Opera Duomo). The *Cantoria* includes ten high-relief panels carved with groups of young musicians and dancers illustrating verses from psalm 150, which are inscribed on the cornices. The reliefs were carved between 1432 and 1437; in the earliest, the compositions are static and symmetrical, while the later ones are reminiscent of the lively dancing putti that Donatello was then carving for a second *Singing Gallery* (Florence, Mus. Opera Duomo; see colour pl. 1, XXVIII2) for the cathedral. The work included two gilt-bronze angels holding candelabra, identified with a pair in the Musée Jacquemart-André, Paris. These are sometimes attributed to Luca but were probably the work of a sculptor in Donatello's circle. The *Cantoria* reveals Luca as a sculptor of extraordinary skill and maturity and, as Alberti wrote in 1436, one of the major figures of the Florentine artistic 'rebirth'. Luca's *Cantoria* is generally regarded as a masterpiece of Renaissance naturalism, achieved through a profound understanding of antique art, which Luca studied in Pisa and perhaps also in Rome.

The success of the *Cantoria* and the influence of Brunelleschi assured Luca a primary role in the decoration of Florence Cathedral: in 1434 he was invited to compete with Donatello to design a stone head (perhaps never realized) for the top of the dome. Between 1437 and 1439 he carved five marble hexagons of the *Inventors of the Liberal Arts* (Florence, Mus. Opera Duomo) for the campanile. He received a commission in 1437 for two marble altars with narrative scenes for the tribune of S Zanobi (formerly entrusted to Donatello); he executed only two reliefs of *St Peter Freed from Prison* and the *Crucifixion of St Peter* (Florence, Bargello), in which references to Masaccio are evident. Other important commissions included a funeral monument for *Count Ugo of Tuscany* (*d* 1001) for the Florentine Badia, an early project for a humanist tomb. In 1440 Luca prepared a terracotta model (untraced); the tomb was built to a design by Mino da Fiesole in 1481. For Brunelleschi he produced terracotta friezes for the Old Sacristy of S Lorenzo, Florence (*see* BRUNELLESCHI, FILIPPO, fig. 2), and for the interior and the portico of the Pazzi Chapel of Santa Croce, Florence (*see* BRUNELLESCHI, FILIPPO, fig. 6).

Probably from the early 1420s, Luca also worked on sculpture in terracotta, a genre revived by Donatello and Ghiberti. He specialized in images of the *Virgin and Child* for private devotion, often reproducing them by casting (examples, London, V&A; Vienna, Ksthist. Mus.). His more ambitious terracotta statuary included the *Virgin* (*c.* 1435) of S Maria a Palaia, Pisa (Gentilini, 1992). Luca is celebrated as the inventor of tin-glazed terracotta, of which the first documented sculpture dates from 1441: decorations for a marble tabernacle executed by himself for S Egidio, Florence (now Florence, S Maria a Peretola). In this technique the terracotta is covered with vitreous glazes (blue and white or polychrome). The intense colours and the luminosity of the glazes enhance the expressive effects of the sculptural forms as well as the symbolic meaning of the images, and the glazes also protect the surface. Luca's first monumental works in the technique were commissioned for Florence Cathedral: two large lunettes above the sacristy doors (*Resurrection*, 1442–4; *Ascension*, 1446–

51) and two *Angels Holding Candelabra* (1448; chapel of S Zanobi). Other works in this technique produced in this period include the group of the *Visitation* (1448; Pistoia, S Giovanni Fuorcivitas) and numerous half-length reliefs of the *Virgin and Child* (Florence, Bargello; Paris, Mus. Jacquemart-André; Florence, Mus. Osp. Innocenti), some of which were reproduced by casting (examples in Tulsa, OK, Philbrook A. Cent.; New York, Met.; Vienna, Ksthist. Mus.).

From the mid-15th century, Luca worked almost exclusively in tin-glazed terracotta, collaborating with his nephew (2) Andrea di Marco della Robbia. These works were rapidly successful throughout Europe, in part because of their moderate cost and ease of transport (they could be sent disassembled). In 1446 Luca was able to buy a large house with a garden in Via Guelfa, Florence, which until the 1520s included the workshop. One of the most important works in tin-glazed terracotta is the decoration of the Pazzi Chapel in Santa Croce (1445–*c.* 1470; *see* BRUNELLESCHI, FILIPPO, fig. 6), comprising 13 roundels with *Apostles* (see fig. 2), some attributable to (2) Andrea della Robbia, four reliefs with the *Evangelists* (by another hand) and the ceiling of the small cupola in the portico. According to Vasari and Billi, Luca executed a tomb (untraced) in Naples, perhaps for Pedro de Aragon (bur. 1445). Other works for important Neapolitan, Spanish and Portuguese patrons are recorded, but these have not been identified.

In 1445 Luca formed a partnership with MICHELOZZO DI BARTOLOMEO and Maso di Bartolomeo for the execution of the bronze doors of the North Sacristy of Florence Cathedral, formerly commissioned from Donatello. Completed in 1475, the doors have ten relief panels modelled by Luca in 1464–5, which show the archaizing tendencies of his late work. Other products of his collaboration with Michelozzo and Maso, which continued at least until 1451, include two painted terracotta *Mourners* (1445; Florence, SS Annunziata, Villani Chapel) and the tin-glazed terra-

2. Luca della Robbia: roundel of *St Matthew*, tin-glazed terracotta, *c.* 1450–*c.* 1460 (Florence, Santa Croce, Cappella dei Pazzi)

cotta lunette of the *Virgin and Child with Saints* (1450–51; Urbino, Pal. Ducale). Luca's relationship with Michelozzo is attested by the patronage of Piero de' Medici, who commissioned the maiolica decoration of the chapel of the Crocifisso in S Miniato al Monte, Florence (1448), glazed sculptures including the lunette of the *Virgin and Child with Angels* (Berlin, Bodemus.) for the chapel of the Castello del Trebbio, Florence, and decorations for his *studiolo* (c. 1450; destr. 1659) in the Medici Palace, from which remain 12 ceiling panels depicting the *Labours of the Months* (London, V&A) in white on a blue ground. This unusual technique was also used for the festive polychrome cornice of the otherwise austere tomb of *Bishop Benozzo Federighi* (1454–6; Florence, Santa Trinita), Luca's last marble sculpture.

In the following years Luca, in collaboration with Andrea, developed new uses for tin-glazed terracotta: the ceiling of the chapel of the Cardinal of Portugal (Florence, S Miniato al Monte; *see* FLORENCE, fig. 6), with medallions showing the *Cardinal Virtues* (1461); altarpieces including the Capponi *Virgin and Child with SS Blaise and James* (Pescia, Pal. Vescovile); the tomb of *Bishop Guillaume II Filastre* (1463–9); and numerous *stemmi* (coats of arms) with fruit and flower garlands, for example of Jacopo Pazzi and Maddalena Serristori (c. 1465; Florence, Pal. Serristori) and of René d'Anjou (c. 1470; London, V&A).

The della Robbias' art was soon taken up by other members of the Medici circle, including the humanist bishop Antonio degli Agli, who commissioned enamelled decoration for two apsidal aediculae in S Maria a Impruneta, Florence (1450–c. 1465) and Francesco Sassetti, who commissioned an enamelled altarpiece of the *Virgin and Child with SS Cosmas and Damian* for the Badia of Fiesole (1466; Florence, Misericordia).

In the works of his last ten years, Luca employed a more abstract and symbolic language based on the revival of Gothic elements, as seen in for example a *Nativity* (London, V&A), two lunettes (Florence, Pal. Parte Guelfa and Bargello), and a roundel of the *Virgin and Child with Two Angels* (Florence, Bargello).

BIBLIOGRAPHY

L. B. Alberti: *Della pittura* (1436), ed. C. Grayson (Bari, 1973), p. 7
Vespasiano da Bisticci: *Vite di uomini illustri del secolo XV* (c. 1480–98), ed. P. D'Ancona and E. Aeschlimann (Milan, 1951), p. 441
A. Manetti: *XIV huomini singhulari in Firenze* (c. 1485); ed. G. Milanesi (Florence, 1887), p. 168
Il libro di Antonio Billi (c. 1516–20), ed. C. von Fabriczy (Florence, 1891), pp. 316, 321–2
A. Marquand: *Luca della Robbia* (Princeton, 1914/*R* New York, 1972)
C. Del Bravo: 'L'umanesimo di Luca della Robbia', *Paragone*, xxiv (1973), pp. 3–34, 285
J. Pope-Hennessy: *Luca della Robbia* (Oxford, 1980)
L. Bellosi: 'Per Luca della Robbia', *Prospettiva*, xxvii (1981), pp. 67–71
M. Haines: *La sacrestia delle Messe del Duomo di Firenze* (Florence, 1983), pp. 58, 119–29, 221–5
A. Padoa Rizzo: 'Luca della Robbia e Verrocchio: Un nuovo documento e una nuova interpretazione iconografica del tabernacolo di Peretola', *Mitt. Ksthist. Inst. Florenz*, xxxviii/1 (1994), pp. 48–68

GIANCARLO GENTILINI

(2) Andrea (di Marco) della Robbia (*b* Florence, 20 Oct 1435; *d* Florence, 4 Aug 1525). Nephew of (1) Luca della Robbia. He trained with his uncle and assisted in his workshop. In 1458 he enrolled in the Arte dei Maestri di Pietra e Legname (stone and woodworkers' guild) as an

intagliatore (carver), although he continued working with his uncle. His early works, including the altarpiece of the *Virgin and Child with Saints* (1466; Florence, Misericordia), reflect styles codified by Luca, which makes them difficult to identify among workshop products of the mid-15th century.

By c. 1470 Andrea had taken over the running of the workshop. One of his first substantially autonomous works seems to have been the triptych of the *Coronation of the Virgin* (c. 1464) for the church of SS Fiora e Lucilla in Monte Amiata. His works are more complex and ornate than Luca's, with more expressive figures and compositions; they also show the synthesis of sculptural and pictorial values that characterized the later production of the workshop.

Works datable c. 1470 include portrait busts of particular intensity (e.g. *Youth*, Berlin, Bodemus.; *Boy*, Florence, Bargello); a group of *Tobias and the Angel* (1465–70; Prato, Bib. Roncioniana); the ceiling (c. 1474) of the Martini Chapel in S Giobbe, Venice; and a half-length bas-relief *Virgin and Child* in S Gaetano, Florence. In the same period he also made the first examples of the *Virgin of the Cushion* (Palermo, Gal. Reg. Sicilia) and the *Virgin Adoring the Child* (examples in Oxford, Ashmolean; Genoa, S Maria della Consolazione; and elsewhere). The earliest known documented work by Andrea is a tabernacle of the *Virgin and Child with Cherubim* (1475; Florence, Bargello). Other works produced around that year include the altarpiece of *St Francis Receiving the Stigmata* and *Tobias and the Angel* for the S Bartolomeo Chapel in Santa Croce, Florence, and a lunette with *St Michael the Archangel* (New York, Met.).

In the mid-1470s Andrea worked on three important decorative commissions, which were closely linked with the Franciscan cult. For the church of the Osservanza in Siena he made the large altarpiece depicting the *Coronation of the Virgin*, statues of the *Angel of the Annunciation* and the *Virgin Annunciate* and two ceiling medallions. For S Maria degli Angeli in Assisi he made a triptych and a statue of *St Francis*, one of the best-known images of the saint. He also began a series of tin-glazed terracotta altarpieces for the Franciscan convent at La Verna. The earliest, the *Annunciation* (c. 1477) and the *Adoration of the Child* (1479) in the Chiesa Maggiore, have the appealing naturalism typical of his art. His most imposing work there, the monumental *Crucifixion with SS Francis and Jerome* (see fig. 1) in the church of the Stigmata, is documented in 1481. Its more vivid realism and fuller forms are paralleled in the style of Benedetto da Maiano, but the segmented, symmetrical composition and expressive clarity are characteristic of the della Robbia workshop. Among other altarpieces at La Verna, the *Virgin Giving the Girdle to St Thomas* (before 1486) and the *Ascension* (c. 1490) are largely autograph.

By the 1480s there were della Robbia works throughout southern Tuscany and Umbria, including *Angels Adoring the Child* (1484; Montepulciano, Mus. Civ.), *Trinity with SS Donatus and Bernard* (1485; Arezzo Cathedral) and the *Nativity* (Sansepolcro, Pin. Com.), and also in the Aragonese south, such as the *Nativity* (1486–7; Militello, Catania, S Maria della Stella). Also during this period Andrea executed a series of works for Florence Cathedral, includ-

1. Andrea della Robbia: *Crucifixion with SS Francis and Jerome*, tin-glazed terracotta, 1481 (La Verna, Chiesa della Stimmate)

ing a painted lunette of *God the Father with Angels* (1488; Florence, Mus. Opera Duomo) and his only documented work in wood, a *Crucifix* (1491; untraced).

Andrea's tin-glazed works were very successful in the late 15th century. For the Ospedale degli Innocenti, *c.* 1487, he created the roundels depicting *Foundling Infants* on the loggia, and *c.* 1490 he made a lunette with the *Annunciation* (now in the cloister; see colour pl. 2, XXIV1). For Prato Cathedral he executed a lunette of the *Virgin and Child with SS Stephen and Lawrence* (dated 1489) for the portal, and in 1491 executed the tin-glazed decoration of S Maria delle Carceri (*see* SANGALLO, DA, (1), fig. 1), one of the most important buildings of the Renaissance. Andrea's decorations, which include a frieze and four roundels of the *Evangelists*, have a formal vivacity recalling the work of Filippino Lippi. In the workshop several works destined for the Aragon Kingdom of Naples were executed, notably a series of clypeate heads (1492; most untraced; one Naples, Capodimonte) for the palace of Poggioreale, designed in part by Giuliano da Maiano (*see* MAIANO, DA, (1)). Tin-glazed pavements for buildings by Giuliano in S Gimignano, the chapel of S Fina in the collegiata (1475) and the chapel of S Bartolo in S Agostino (1500) were also made.

The della Robbia production of tin-glazed terracotta developed considerably in the second half of the 15th century, and their works were imitated by such artists as Benedetto da Maiano and Andrea Sansovino. Their wide range of products included church furnishings (tabernacles, pulpits, fonts, lavabos), architectural elements (niches, cornices, friezes, corbels, pavements), *stemmi* and decorative objects (vases and baskets of fruit, mirrors). Above all

there were altarpieces and relief sculptures for private devotions, representing the *Virgin and Child* and the *Adoration*, framed by cherubim or garlands. Andrea also worked in stone, e.g. his imposing marble altar (1487–93) for the sanctuary of S Maria delle Grazie near Arezzo. The quality of workshop production declined towards the end of the century, due to the employment of numerous assistants to cope with the increasing demand (e.g. the altarpiece of the *Virgin and Child*, Arezzo, Gal. & Mus. Med. & Mod.), although innovative autograph works were produced by Andrea and his most able assistants, including five of his sons.

One of Andrea's most important commissions during this period was the decoration of the Ospedale di S Paolo dei Convalescenti in Florence (1493–5), including seven tin-glazed roundels of *Franciscan Saints*, two *Acts of Mercy* (e.g. *Christ Healing a Sick Man*; see fig. 2), two portraits of the Bernino Bernini and a lunette of the *Meeting of SS Francis and Dominic*. These have the naturalistic polychrome glazes favoured by Andrea's sons, rather than the white-on-blue scheme associated with Luca. Among the polychrome altarpieces made by the workshop at this time are the *Virgin and Child Enthroned with Saints* (Arezzo Cathedral) and the *Adoration of the Magi* commissioned by the Albizzi family (London, V&A).

Andrea became a follower of Girolamo Savonarola in the early 1490s, and Savonarolan ideas are reflected in the simplified static figures of reliefs executed in that decade (e.g. Arezzo, Mus. Dioc.) and in later works, including the majestic *Virgin and Child Crowned by Angels* on the portal of Pistoia Cathedral (1504–5), and above all the three lunettes on the portals of S Maria della Quercia, Viterbo (1507–8). Andrea's adherence to the Savonarolan style is also evident in the altarpiece of the *Virgin and Child Enthroned with Angels and Saints* (1507; Montalcino, Mus. Dioc. A. Sacra; Siena, Mus. Civ.), a schematic, archaicized composition, which was often repeated.

2. Andrea della Robbia and workshop: *Christ Healing a Sick Man*, tin-glazed terracotta, 1493–5 (Florence, Ospedale di S Paolo dei Convalescenti, Loggia)

These characteristics can also be seen in della Robbia figures of this period, of which the autograph examples probably include the *St Sebastian* (Montalcino, Mus. Civ.) and the *Virgin and Child Enthroned* (Pistoia, S Maria a Lizzano). In a large tabernacle with *Angels*, built under the supervision of Andrea in 1512 for the Acciaiuoli Chapel in SS Apostoli in Florence, the increased spatial articulation of the figures reflects contemporary Florentine painting, probably due to the family's friendship with the young ANDREA DEL SARTO (Vasari). Some notable examples of glazed terracotta produced in the workshop in this period, maybe by the sons Luca and Girolamo, are of problematic attribution: for example an altarpiece in the style of Raphael, the *Virgin and Child with Saints* (Florence, S Mauro a Signa); the *St Francis Receiving the Stigmata* (Barga, Lucca, S Francesco) with references to the work of Sarto; and the extraordinary predellas of the two altarpieces in S Lorenzo a Bibbiena, Arezzo (1513–20), in the style of Jacopo Sansovino.

In his last works Andrea returned to simplified, static compositions in the canonical della Robbia tradition, e.g. the *Adoration of the Shepherds* and the *Pietà* (1513–20; Bibbiena, Arezzo, S Lorenzo), the *Pietà* (Florence, Mus. S Marco) and the *Crucifixion with Saints* (Fiesole, S Maria Primerana). Andrea's continued relationship with the Dominicans of S Marco, Florence, where Savonarola had been prior, is attested by the *Nativity* with painted terracotta figures in the monastery of S Mara Maddalena at Pian del Mugnone, Florence (1515).

BIBLIOGRAPHY

A. Marquand: *Andrea della Robbia and his Atelier* (Princeton, 1922/*R* New York, 1972)

J. Pope-Hennessy: 'Thoughts on Andrea della Robbia', *Apollo*, cix (1979), pp. 176–97

G. Gentilini: *Museo nazionale del Bargello: Andrea della Robbia, I, Madonne* (Florence, 1983)

C. del Bravo: 'Andrea della Robbia, da giovane e da vecchio', *Artista* (1995), pp. 58–71

A. Basso, M. Rossetti and S. Vianello: 'La volta in terracotta maiolicata di Andrea della Robbia nella chiesa di San Giobbe a Venezia', *Scultura in terracotta: Tecniche e conservazione*, ed. M. G. Vaccari (Florence, 1996), pp. 310–17

GIANCARLO GENTILINI

(3) Giovanni (Antonio) della Robbia (*b* Florence, 19 May 1469; *d* ?Florence, 14 July 1529–24 March 1530). Son of (2) Andrea della Robbia. He trained with his father and is documented in the family workshop from 1487, where he collaborated on projects including the marble altar of S Maria delle Grazie in Arezzo (1487–93). By *c.* 1495 he also worked independently. His first documented work, the lavabo in the sacristy of S Maria Novella (Florence), completed in 1498, already shows his characteristic decorative exuberance and it has a particularly beautiful river landscape painted in the lunette. Giovanni's individual style is more apparent in two altarpieces for the convent of S Girolamo in Volterra (*Last Judgement*, 1501, and *St Francis Giving the Rule to St Louis and St Elizabeth of Hungary*), in which the figures are very lively. He also produced decorative jars, vases and *stemmi*, for example 36 jars ordered for the hospital of S Maria Nuova, Florence, of which one example is known (1507; Sèvres, Mus. N. Cér.).

As heir to the family workshop, Giovanni had the task of renewing its famous production to accord with changing tastes. He was particularly receptive to the influence of contemporary painting, and beginning in the second decade of the 16th century, his works were characterized by vivid polychrome glazes, complex ornamentation and picturesque scenes with intensely expressive figures.

Between 1510 and 1521 Giovanni executed a series of works for S Giovanni Battista in Galatrona, Arezzo, including a baptismal font, a monumental ciborium, a statue of *John the Baptist* and four statuettes of the *Evangelists*. A complex altar (Arezzo, S Medardo), in the style of Andrea Sansovino, was made between 1510 and 1513 for S Girolamo del Sasso Rosso at Arcevia. In 1514 he produced an imposing polychrome tin-glazed altarpiece for the Ospedale di S Maria della Scala in Florence, depicting the *Pietà with SS John and Mary Magdalene* (Florence, Bargello). Painted terracotta reliefs produced by the workshop in this period include the *Virgin Swooning* for the Sacro Monte di S Vivaldo, Florence, the *Pietà* in S Maria a Terranuova Bracciolini, Arezzo, and the *Nativity* in S Marco, Florence (Gentilini, 1992).

From 1515 Giovanni began to use polychrome glazing instead of the traditional blue and white. This intensified the exuberant effect of his compositions, for example two works executed *c.* 1515 for the Buondelmonti–Salviati: a niche (*Assumption of the Virgin*; San Giovanni Valdarno, S Maria delle Grazie) and an altarpiece (*Temptation of Adam*; Baltimore, MD, Walters A. G.); and the large altar with statues in S Lucchese near Poggibonsi, dated 1517. In his altarpiece for S Marco a Calcesana (1520; Pisa, Camposanto), the figures are painted in oil. Two important works were signed and dated in 1521: a lunette with the *Entombment* and a monumental *Nativity* (both Florence, Bargello). The eloborate Fonticine Tabernacle, the *Virgin and Child Enthroned with Saints* (Florence, Via Nazionale), dates from 1522. Among the many minor works produced by the shop were such statuettes as *Abundance* (Minneapolis, MN, Inst. A.) and *Judith* (Florence, Mus. Bardini) and busts, of for example *Bacchus* (Florence, Bargello). His most ambitious sculptural work, 66 clypeate heads for the monks' cloister in the Certosa del Galluzzo, near Florence, was completed in 1523. It has been suggested that the project involved other artists, including Giovanni Francesco Rustici (Chiarelli).

Giovanni enrolled in the Arte dei Medici e Speziali only in 1525, when his father died. An important late work, five medallions on the portico of the Ospedale del Ceppo in Pistoia, dates from 1525 to 1529. Three of his five sons probably worked in his shop: Marco della Robbia, Lucantonio della Robbia and Simone della Robbia; according to Vasari, all died of the plague in 1527. The second son, Filippo della Robbia, appears to have been a painter.

BIBLIOGRAPHY

A. Marquand: *Giovanni della Robbia* (Princeton, 1920/*R* New York, 1972)

C. Chiarelli: *La Certosa del Galluzzo a Firenze* (Milan, 1982), pp. 289–92

W. Tschermak Von Seysenegg: 'Die Judith von Giovanni della Robbia', *Keramos*, cxiv (1986), pp. 27–36

G. Gentilini: *Sculture robbiane a Figline* (Figline, 1990)

R. Spinelli: 'Giovanni della Robbia, Domenico Puligo e i "Compagni del Paiuolo" alla Badia del Buonsollazzo', *Mitt. Ksthist. Inst. Florenz*, xxxviii/1 (1994), pp. 118–29

GIANCARLO GENTILINI

(4) Girolamo (Domenico) della Robbia (*b* Florence, 9 March 1488; *d* Nesle, Paris, 4 Aug 1566). Son of (2) Andrea della Robbia. His early work in glazed terracotta was executed in collaboration with his father and older brothers, e.g. *Christ Carrying the Cross* (1513–14; Florence, Certosa del Galluzzo), but according to Vasari he then devoted himself to sculpture, with his brother Luca the younger. Their works, which were much praised, have not been identified with certainty. The brothers were friendly with Andrea del Sarto, who may have been the source of the influence of early Florentine Mannerism in some glazed terracottas produced in the workshop in this period, including the *Christ and the Woman of Samaria* (1511) for the fountain of the Palazzo Pretorio of Pieve Santo Stefano (Arezzo), with a landscape inspired by del Sarto and the sculptural version (Florence, Bib. N. Cent.) of Raphael's *Belle Jardinière* (Paris, Louvre).

At the end of 1517 Girolamo went to France (Vasari), where he entered the service of the King, Francis I (*reg* 1515–47). He had returned to Florence by 1525, perhaps after his father's death, and that year enrolled in the Arte dei Medici e Speziali. In 1527, however, he was again working for Francis I, on the château de Madrid (destr. 1792) in the Bois de Boulogne, Paris, where his activity, which was probably limited to decorative work, is documented until 1564. A few minor fragments of the maiolica decoration survive (Sèvres, Mus. N. Cér.).

Girolamo and Luca, who joined him in 1529, executed other glazed terracotta works for the French court: the altarpiece (Sèvres, Mus. N. Cér.) of the chapel of the château of Cognac; the bust of *Francis I* (1529; New York, Met.), from the château of Sansac; and portrait roundels (1526–35; New Haven, CT, Yale U. A.G.; Paris, Louvre), for the château of Assier. The della Robbias' works were less popular during the reign of Henry II (*reg* 1547–59), when Girolamo returned to Florence, briefly in 1548, and from 1553 to 1556. He was in Paris again later, among numerous Italian artists employed by Henry II's widow Catherine de' Medici. As part of the group led by Francesco Primaticcio, Girolamo executed works in marble including a *gisant* of *Catherine de' Medici* (1565; Paris, Louvre) intended for the tomb of *Henry II* in St Denis, Paris. This unfinished statue, the only certain work of Girolamo, has a vigorous and dramatic realism foreign to the della Robbia tradition.

BIBLIOGRAPHY

H. Delange: *Notice biographique sur Girolamo della Robbia* (Paris, 1847)

P. Leseur: 'Arrivée de Girolamo della Robbia en France', *Bull. Soc. Hist. A. Fr.*, lxiii (1937), pp. 194–203

F. Gebelin: 'Girolamo della Robbia à Bordeaux en 1520', *Bull. Soc. Hist. A. Fr.*, lxiv (1938), pp. 127–32

P. McGrow: 'Terracotta Bust', *Bull. Assoc. F.A. Yale U.*, xx (1955), pp. 4–7

M. Chatenet: *Le Château de Madrid au Bois de Boulogne* (Paris, 1987)

GIANCARLO GENTILINI

Roberti, Ercole (d'Antonio) de' [Grandi, Ercole (di Giulio Cesare) de'] (*b* Ferrara, *c.* 1455–6; *d* 18 May–1 July 1496). Italian painter and draughtsman. He was, together with Cosimo Tura and Francesco del Cossa, one of the most important painters working in Ferrara and Bologna in the 15th century. Although many of his works have been destroyed, those that survive show that he raised the depiction of human emotion and narrative drama to remarkable heights. From 1486 he worked as court painter to Ercole I d'Este, Duke of Ferrara.

1. Early work, 1473–82. 2. Bologna, 1482–6. 3. Ferrara, 1486–96.

1. EARLY WORK, 1473–82. He appears in documents both as Ercole di Giulio Cesare de' Grandi and Ercole d'Antonio de' Roberti. This has prompted some critics to suggest there were two near-contemporary painters working in Ferrara whose Christian name was Ercole. The elder of these, usually designated 'de Roberti', was thought to paint in a style close to that of Cosimo Tura, while the younger, 'Grandi', painted more like the mature Lorenzo Costa. However, a notarial act of 1530 naming 'Hieronimo, son of the deceased Master Ercole de Roberti, alias de Grandis, a painter and a citizen of Ferrara' makes it clear that the two names refer to one artist. Roberti's father, Antonio, is recorded as a doorkeeper at the Este castle in Ferrara.

Roberti's birthdate has been set before 1456, on the basis of a letter he wrote to Ercole I d'Este, Duke of Ferrara, on 19 March 1491, in which he described himself as having passed the middle years of his life. Vasari's comment that Roberti lived to the age of 40 seems to confirm this.

The identification of Ercole's first work remains controversial. In 1473 he was working in Bologna in Francesco del Cossa's workshop, but the extent of his earlier training in Ferrara is unclear. Longhi (1934) attributed to Roberti a large section of the frescoes in the Salone dei Mesi in the Palazzo Schifanoia, Ferrara (*see* FERRARA, §4). He isolated the *Triumph of Luxury* (or the *Triumph of Vulcan*) in the upper register of the Libra section as particularly indicative of the 'personal cubism' of the young artist. Longhi's suggestions have been generally accepted. Bargellesi (1945), developing his own previous attribution to Roberti of the section of the St George's Day horse race in the lower part of the Taurus section, also attributed several sections of the north wall (the lower part of Leo, middle and lower zone of Virgo and all of Libra) to the same hand. Cossa's complaint that he had been forced to work alongside apprentice painters while painting in the *salone* supports the idea that Roberti, as one of these apprentices, could conceivably have been responsible for large sections of the decoration. This may explain how the two painters might have met, and the circumstances under which Roberti might have left Ferrara. Against these arguments, however, it is difficult to imagine how Roberti could be the author of the sections of the Salone dei Mesi most often attributed to him, which seem so heavily influenced by Tura, when his first certain works show little indication of this influence but instead seem almost wholly dependent on the art of his master, Francesco del Cossa. It has been suggested that what Longhi cited as the visual 'madness' of the Libra panel may result from the calculated and mannered effects of a mature painter rather than from the effusions of a dynamic youth. The possibility that Ercole painted in the Salone dei Mesi should not be dismissed, but perhaps should be treated more tentatively.

Roberti's first secure works are the predella and saints on the lateral pilasters painted for the altarpiece (1473)

1. Ercole de' Roberti: detail from the predella of the Griffoni Altarpiece showing scenes from the *Life of St Vincent Ferrer*, oil on panel, 270×2140 mm, 1473 (Rome, Pinacoteca Vaticana)

commissioned from FRANCESCO DEL COSSA for the Griffoni Chapel in S Petronio, Bologna. The predella depicts scenes from the *Life of St Vincent Ferrer* (Rome, Pin. Vaticana; see fig. 1) and relates to Cossa's central panel of *St Vincent* (London, N.G.). A number of small oil panels depicting standing saints are usually identified with the Griffoni Altarpiece: *St Michael* and *St Apollonia* (both Paris, Louvre), *St Anthony Abbot* (Rotterdam, Boymans–van Beuningen), *St Petronius* (Ferrara, Pin. N.) and *St George, St Jerome* and *St Catherine of Alexandria* (all Venice, Col. Cini). Estimates of the degree of Ercole's participation in these works vary from the claim that he filled in only minor details according to a plan and composition that were essentially Cossa's, to the assertion that Roberti was fully responsible for the invention and execution of the predella and of several of the saints. As a member of a workshop, Roberti would naturally be expected to adhere to its stylistic vocabulary. Nevertheless, the compositions of both the individual figures and the predella betray a certain grandeur of vision unlike anything in Cossa's extant oeuvre. Vasari's claim that Roberti surpassed the work of his master in this predella seems to be borne out. Other works that can be dated to this period are the pendant portraits of *Giovanni II Bentivoglio* and his wife, *Ginevra Bentivoglio* (Washington, DC, N.G.A.), *St John the Baptist* (Berlin, Gemäldegal.), *St Jerome* (London, Barlow priv. col.) and the altarpiece for the Lateran canons of S Lazzaro in Borgo delle Pioppe, near Ferrara (Berlin, Kaiser-Friedrich Mus., destr.). Some scholars have suggested that the S Lazzaro Altarpiece was a collaborative work, perhaps begun by Cossa and finished in Ferrara by Roberti after Cossa's death in 1478.

On 5 February 1479 Roberti entered into a contract between himself, his brother Polidoro (a woodworker) and the goldsmith Giovanni di Giuliano da Piacenza. The goldsmith was obliged to make gold and silver leaf for the brothers, and in return they agreed to provide him with tools, half the shop and a share in the profits. The document implies that Ercole intended to remain in Ferrara, but this did not happen. By the end of 1480, perhaps after a trip to Venice, he was probably in Ravenna, painting an altarpiece for S Maria in Porto Fuori. The painting, a *Virgin and Child Enthroned with SS Anne, Elizabeth and Augustine and the Blessed Pietro degli Onesti*, commonly known as the '*Pala Portuense*' (Milan, Brera; see fig. 2), is the masterpiece of Ercole's early career and his only extant documented work. On 26 March and 7 May 1481 Ercole received payments for the altarpiece and Bernardino da Venezia was paid for work on its frame. Between these dates, Ercole apparently returned to Ferrara via Bologna so that the final payment for the altarpiece had to be sent to him in Ferrara. The composition of the '*Pala Portuense*' is heavily dependent on the S Lazzaro Altarpiece, but much of the decorative fussiness found in the latter painting's architecture and costumes has been simplified. In addition, the figures seem more substantial, and the '*Pala Portuense*' composition is permeated with a classical calm reminiscent of the contemporary work of Giovanni Bellini.

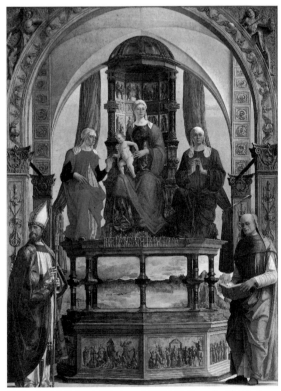

2. Ercole de' Roberti: *Virgin and Child Enthroned with SS Anne, Elizabeth and Augustine and the Blessed Pietro degli Onesti* (the '*Pala Portuense*'), oil on canvas, 3.23×2.40 m, *c.* 1480 (Milan, Pinacoteca di Brera)

2. BOLOGNA, 1482–6. In 1482 Roberti returned to Bologna, where he stood as godfather at the baptism of Bartolomeo Garganelli's son Giovanni Battista. Between this time and 1486, Ercole was involved in the completion of the decoration of the Garganelli Chapel in S Pietro, Bologna, a commission left unfinished by Cossa at his death. The church was demolished in 1605–6, and only a few fresco fragments in a poor state survive (Bologna, Pin. N.). However, it is possible to reconstruct the original decoration of the chapel from copies, drawings and descriptions.

On the right wall of the chapel was a large fresco of the *Crucifixion* (destr.). An autograph pen drawing of the figures at the foot of the cross (Berlin, Kupferstichkab.) is an early compositional plan for this picture. A drawing of *St Longinus and a Young Page* (Munich, Staatl. Graph. Samml.) probably records the area to the lower left of the central crucifix. The only extant autograph fragment, the head of the *Weeping Magdalene* (Bologna, Pin. N.; see fig. 3), belonged to the lower section of the *Crucifixion*. It is possible that the panel of a *Mourning Woman* (Baltimore, MD, Walters A.G.) may also be connected with this section of the fresco. The scene of the *Death of the Virgin* on the left wall of the chapel can be reconstructed from two early partial copies; a canvas showing *Four Standing Men* (Paris, Louvre) records the lower left half of the wall, while the *Death of the Virgin* (Sarasota, FL, Ringling Mus. A.) shows the right. Traditionally, the figure standing at the extreme left of the Louvre picture has been identified as a portrait of Ercole's patron, Bartolomeo Garganelli, while the young man standing to Garganelli's right is believed to be a self-portrait of the artist. The juxtaposition between the highly charged, emotionally turbulent *Crucifixion* and the refined, elegantly restrained pathos of the *Death of the Virgin* must have been striking. In scale and power the Garganelli Chapel decoration was totally unlike any contemporary north Italian painting, its monumental figures knitted together with a compositional density paralleled only by works of the High Renaissance in Rome. Indeed, Michelangelo found Roberti's paintings almost Roman in their character and quality (Lamo, 1560).

Three panels that originally formed the predella to the high altar of S Giovanni in Monte, Bologna, probably date from the early 1480s. The *Agony in the Garden and Betrayal of Christ* and the *Road to Calvary* (both Dresden, Gemäldegal.) flanked the *Pietà* (Liverpool, Walker A.G.; see fig. 4). Several autograph drawings exist for this composition (e.g. Florence, Uffizi, 1444E, 1444F; London, BM, 542). Some scholars have seen the London drawing as a variant on the Liverpool *Pietà*, but the majority of those who have accepted this drawing as autograph have assigned it to an earlier date.

3. FERRARA, 1486–96. By 6 March 1486 Roberti had returned to Ferrara. On 21 August and 20 October he was paid for the cost of gold and colours for a small panel (*tavoletta*) for Eleanora of Aragon, Duchess of Ferrara, and received the gift of a length of black damask. In 1487 Ercole is listed on the court payroll at a salary of 240 lire a year (a substantial amount equalling that paid to the ducal estate manager). On 28 May 1487 Ercole was paid for the gold for, and the painting of, a picture for Ippolito I d'Este, Archbishop of Esztergom, who was about to set out on a journey to Hungary. Rafaele Maffei da Volterra (il Volterrano) stated that Ercole accompanied Ippolito on his trip. Scholars have noted certain elements derived from Roberti in contemporary Hungarian manuscript illuminations and have suggested that perhaps he had been summoned by Matthias Corvinus, King of Hungary (*reg* 1458–90), on receiving the portrait of Ippolito d'Este. If Roberti did travel to Hungary, he had returned to Ferrara by 27 June 1488, when he is recorded as receiving a gift of some satin.

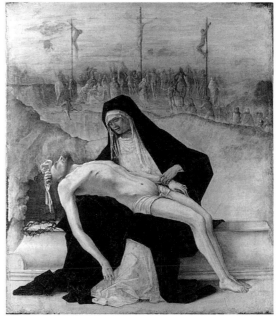

4. Ercole de' Roberti: *Pietà*, oil on canvas, 760×490 mm, *c.* 1482–6 (Liverpool, Walker Art Gallery)

Other paintings probably dating from Roberti's second Bolognese period are the Vendeghini *Virgin and Child* (Ferrara, Pin. N.), the *Virgin and Child* (Berlin, Gemäldegal.), the *Last Supper* and the *Israelites Gathering Manna* (both London, N.G.) and *Melchisedek Blessing Abraham* (untraced; these may have originally been part of the same predella), the *Virgin and Child* (Chicago, IL, A. Inst.), and the *Adoration of the Shepherds* and *Pietà with St Jerome* (both London, N.G.). During this period Ercole seems to have made an intensive study of the art of Andrea Mantegna. Certain figures in the Garganelli Chapel, in a *Battle Scene* (Venice, Correr) and in a number of drawings attributed to Roberti (e.g. Windsor Castle, Royal Lib., 12795; Rotterdam, Boymans–van Beuningen, 574) seem derived from prints and drawings by Mantegna.

3. Ercole de' Roberti: *Weeping Magdalene*, fresco fragment transferred to panel, 230×280 mm *c.* 1482–6 (Bologna, Pinacoteca Nazionale)

In 1489 Roberti was painting in a small room (*camerino*) used by Alfonso I d'Este in the garden of his mother, the Duchess Eleanora. In the same year Eleanora sent Roberti to Venice to buy gold to gild coffers (*forzieri*) for the trousseau of her daughter Isabella d'Este. A payment of 20 March 1490 lists some of the items Ercole constructed for the wedding festivities, including 13 coffers, the nuptial bed and the triumphal chariot on which Isabella entered Mantua for her marriage to Francesco Gonzaga. Roberti accompanied Isabella to Mantua as manager of her wardrobe, but a letter dated 12 March 1490, in which Ercole begged forgiveness from the Duchess, states that he fled the city a few days after arriving and returned to Ferrara without permission. In a letter of 19 March 1491 to Ercole I d'Este, Roberti complained that he had yet to be fully paid for his labour and expenses. On 30 December 1491 he received 50 gold leaves from the Duchess to gild an image of the Virgin painted on a pilaster near the tax office in the Piazza del Duomo in Ferrara.

Between March and August 1492 Roberti directed work on the decoration of the buildings in the Duchess's garden. His part in this seems to have been confined to the oratory and three small rooms near her private loggia. He also gilded and painted devices on some rose windows. Later in the year he was paid for six trumpet banners made for Alfonso d'Este. Presumably these banners were carried by Alfonso's entourage on the journey he made in 1492 to Rome to pay homage to Pope Alexander VI. Ercole accompanied Alfonso on the trip to Rome, stopping in Florence on his return.

Back in Ferrara, Roberti continued to supervise and paint in Eleanora's garden. It is possible that three panels attributed to him, the *Brutus and Portia* (Fort Worth, TX, Kimbell A. Mus.), the *Wife of Hasdrubal* (Washington, DC, N.G.A.) and the *Death of Lucretia* (Modena, Gal. & Mus. Estense), apparently from a series of paintings of *Virtuous Women*, may have been part of this decoration. In 1493 Roberti also began a series of paintings for Ercole I d'Este at Belriguardo (buildings and decoration destr.). In a letter dated 13 February 1493 Siverio Siveri, the ducal secretary, complained about the extent to which the Duke had abandoned his usual pastimes, hunting and playing chess, in order to discuss the projects with Roberti. Siveri described Roberti preparing large drawings, having been

> in the most illustrious Duke's own room from morning till night for the past four days, seated on the far side of the Duke's desk, while the Duke is seated on the inner side, which he never leaves. . … For two or three hours every night he [the Duke] has been reading a section from a book in Italian called Josephus, which mentions matters and stories from the Old Testament.

The letter testifies to an unexpected level of collaboration between patron and artist. Giovanni Sabadino degli Arienti, in his *De triumphis religonis* (see Gundersheimer, 1972), recorded an elaborate cycle based on the story of Cupid and Psyche made for one of the Este residences, which he attributed to an 'excellent Ferrarese painter'. This may have been Ercole. It is also possible that the series of paintings depicting scenes of *Jason and the Argonauts* (Padua, Mus. Civ.; Florence, Rucellai priv. col.; Lugano, Col. Thyssen-Bornemisza) was painted for Belriguardo.

In April 1494 Roberti paid a number of artists for painting devices for Cardinal Ippolito d'Este. In May he was commissioned by Isabella d'Este to paint a portrait of her father, Ercole I d'Este. In a letter dated 28 May 1494 Bernardo Prosperi explained to Isabella that Roberti was unable to devote himself to painting the portrait because Alfonso d'Este was keeping him busy with other work. One document may suggest that these tasks included salami-making. The portrait (untraced) was begun but was left unfinished at Roberti's death and was sent to Mantua in that state by Alfonso in January 1497. It is possible that the portrait for which Dosso Dossi was paid on 4 April 1526, often identified with Dosso's portrait of *Ercole d'Este* (Modena, Gal. & Mus. Estense), might be a copy of Roberti's unfinished portrait. Also in 1494 Chiara Clavell commissioned Roberti to paint an altarpiece for Santo Spirito, Ferrara. The contract stipulates an Annunciation with God the Father and the Holy Spirit on a gable and a predella with the Nativity, Adoration of the Magi and Presentation in the Temple (all untraced). This is the only record of Roberti's being allowed to work for a patron outside the Este household during the last decade of his life.

From 1494 until his death Roberti provided a number of designs for sculptural commissions. The colossal equestrian monument of Ercole I d'Este to be placed in the Piazza Nuova is thought to be based on a design by Roberti (for illustration see A. Maresti: *Teatro geneologico et istorico dell'antiche et illustri famiglie di Ferrara* (Ferrara, 1671), ii, p. 152). Similarly, it is known that he furnished drawings for the façade and interior architectural sculpture for Biagio Rosetti's church of S Maria in Vado, Ferrara. Roberti was last documented supplying an estimate for an altarpiece for Fino Marsigli in 1496. He was buried in S Domenico, Ferrara.

BIBLIOGRAPHY

EARLY SOURCES

G. Santi: *La vita e le gesta di Federico di Montefeltro, duca d'Urbino* (c. 1492); ed. L. Michelini Tocci (Rome, 1985), p. 674

G. Vasari: *Vite* (1550, rev. 2/1568); ed. G. Milanesi (1878–85), iii, pp. 141–8

P. Lamo: *Graticola di Bologna ossia descrizione delle pitture, sculture e architettura di detta città* (1560); ed. G. P. Cavanozzi Zanotti (Bologna, 1844), pp. 30–31

R. Borghini: *Il riposo* (Florence, 1584), p. 340

M. A. Guarini: *Compendio historico . . . l'origine e accrescimento delle chiese di Ferrara* (Ferrara, 1621)

GENERAL

EWA; Thieme–Becker

A. Venturi: 'Beiträge zur Geschichte der ferrarischen Kunst', *Jb. Kön.-Preuss. Kstsamml.*, viii (1887), pp. 71–9

F. Filippini: 'Pittori ferrarese del rinascimento in Bologna', *Com. Bologna*, xx/9 (1933), pp. 7–20

R. Longhi: *Officina ferrarese* (Florence, 1934, rev. with suppls 3/1956/R 1975), pp. 36–47, 128–34, 180–82 [pp. nos for 1956 edn]

F. Mazzini: 'Contributi alla pittura lombarda tardo-gotica', *Studies in the History of Art Dedicated to William E. Suida on his Eightieth Birthday* (London, 1959), pp. 86–9

W. L. Gundersheimer: *Art and Life at the Court of Ercole I d'Este: The 'De triumphis religionis' of Giovanni Sabadino degli Arienti* (Geneva, 1972)

——: 'The Patronage of Ercole I d'Este', *J. Med. & Ren. Stud.*, vi (1976), pp. 1–18

MONOGRAPHS

F. Filippini: *Ercole da Ferrara* (Florence, 1922)

S. Ortolani: *Cosmè Tura, Francesco del Cossa, Ercole de' Roberti* (Milan, 1941)

M. Salmi: *Ercole de' Roberti* (Milan, 1960)

L. Puppi: *Ercole de' Roberti* (Milan, 1966)

J. P. Manca: *The Life and Art of Ercole de' Roberti* (diss., New York, Columbia U., 1986)

——: *The Art of Ercole de' Roberti* (Cambridge, 1992)

M. Molteni: *Ercole de' Roberti* (Milan, 1995)

SPECIALIST STUDIES

A. Venturi: 'Das Toderdatum Ercole de Robertis', *Kunstfreund*, i (1885), cols 165–8

——: 'Ercole Grandi', *Archv. Stor. A.*, i (1888), pp. 193–201

——: 'Ercole de'Roberti fa cartoni per le nuove pitture della delizia di Belriguardo', 'Ercole de'Roberti', 'La Galleria del Campidoglio', *Archv. Stor. A.*, ii (1889), pp. 85, 339–60, 447

C. Ricci: 'La *Pala Portuense* d'Ercole Roberti', *Rass. A.*, iv (1904), pp. 11–12

——: 'Un dipinto di Ercole Roberti in Bologna', *Rass. A.*, xiv (1914), pp. 15–17

C. Gamba: 'Ercole Ferrarese', *Rass. A.*, ix (1915), pp. 191–8

F. Filippini: 'Ercole da Ferrara ed Ercole da Bologna', *Boll. A.*, xi (1917), pp. 49–63

D. Zaccarini: 'Il disegno di Ercole Grandi per il monumento ad Ercole I d'Este', *L'Arte*, xx (1917), pp. 159–67

G. Zucchini: 'La distruzione degli affreschi della Cappella Garganelli (S Pietro di Bologna)', *L'Arte*, xxiii (1920), pp. 275–8

C. Holmes: 'A Lost Picture by Ercole de' Roberti', *Burl. Mag.*, l (1927), pp. 171–2

L. Dussler: 'A Rediscovered Picture by Ercole de'Roberti', *Burl. Mag.*, liv (1929), pp. 199–200

E. Mauceri: 'Ercole de'Roberti e la *Deposizione* della R. Pinacoteca di Bologna', *Boll. A.*, xxvi (1932–3), pp. 482–7

D. G. Fornasini: *I Garganelli* (Bergamo, 1933), pp. 25–7

A. E. Popham: 'Ercole de'Roberti', *Old Master Drgs*, viii/30 (1933), pp. 23–5

G. Bargellesi: 'Ercole da Ferrara', *Riv. Ferrara*, xii (1934), pp. 3–19

A. Busuioceanu: 'Dipinti sconosciuti di Ercole Roberti e della sua scuola', *L'Arte*, n. s. 8, xl (1937), pp. 161–82

H. Bodmer: 'Ercole Grandi und Ercole de Roberti', *Pantheon*, xxv (1940), pp. 59–62, 72

G. Zucchini: 'Un frammento degli affreschi di Ercole da Ferrara per la Cappella Garganelli', *Proporzioni*, i (1943), pp. 81–4

G. Bargellesi: *Palazzo Schifanoia: Gli affreschi nel 'Salone dei Mesi' in Ferrara* (Bergamo, 1945)

E. Arslan: 'Contributi a Ercole de'Roberti, Parmagianino, Primaticcio', *Emporium*, liii (1947), pp. 65–9

G. Bargellesi: 'Due frammenti di Ercole de'Roberti e uno del Maineri', *Emporium*, liii (1947), pp. 61–4

G. Zucchini: 'Un'opera di Ercole da Bologna', *Belle Arti*, i (1948), pp. 339–41

H. D. Gronau: 'Ercole Roberti's *Saint Jerome*', *Burl. Mag.*, xci (1949), pp. 243–4

C. Savonuzzi: 'Una scultura di Ercole de' Roberti', *Crit. A.*, xviii (1956), pp. 567–70

C. B.: 'Ercole Roberti: Frammento degli affreschi della Cappella Garganelli in S Pietro a Bologna. Roma, Coll. V. Grottanelli', *Boll. Ist. Cent. Rest.*, xxxi–ii (1957), p. 148

——: 'Acquisiti della Pinacoteca di Bologna: Ercole de'Roberti, testa femminile', *Boll. A.*, n. s. 4, xliii (1958), p. 375

J. Balogh: 'Ercole de Roberti a Buda', *Act. Hist. A.*, vi (1959), pp. 277–81

E. Ruhmer: 'Ergänzendes zur Zeichenkunst des Ercole de'Roberti', *Pantheon*, xx (1962), pp. 241–7

F. Zeri: 'Appunti per Ercole de'Roberti', *Boll. A.*, n.s. 5, l (1965), pp. 72–9

E. C. G. Packard: 'Close-up: Italian style', *Bull. Walters A.G.*, xx/5 (1968), pp. 1–2

R. Benatti: 'Ercole de'Roberti: Un esempio di paesaggio come "fabula" religiosa nella pittura del quattrocento ferrarese', *Paesaggio: Immagine e realtà* (exh. cat., Bologna, Gal. A. Mod., 1981), pp. 116–20

A. Gentili: 'Mito cristiano e storia ferraresi nel "Polittico Griffoni"', *La corte e lo spazio: Ferrara Estense*, ed. G. Papagno and A. Quondam, ii (Rome, 1982), pp. 563–76

D. Benati: 'Il polittico Griffoni', *La basilica di San Petronio in Bologna*, ii (Bologna, 1984), pp. 156–74

——: 'Per la ricomposizione del polittico Griffoni', *Da Borso a Cesare d' Este: La scuola di Ferrara, 1450–1682* (Ferrara, 1985), pp. 172–5

J. Manca: 'Ercole de' Roberti's Garganelli Chapel Frescoes: A Reconstruction and Analysis', *Z. Kstgesch.*, xlviii/2 (1985), pp. 147–64

Ercole Roberti: La cappella Garganelli in San Pietro (exh. cat., ed. L. Ciammitti; Bologna, Pin. N., 1985)

C. Turrill: *Ercole de' Roberti's Altarpieces for the Lateran Canons* (diss., Newark, U. DE, 1986)

K. Lippincott: 'Gli affreschi del Salone dei Mesi e il problema dell' attribuzione', *Atlante di Schifanoia*, ed. R. Varese (Modena, 1989), pp. 111–39

R. W. Sullivan: 'Three Ferrarese Panels on the Theme of "Death rather than Dishonour" and the Neapolitan Connection', *Z. Kstgesch.*, lvii/4 (1994), pp. 610–25

Ercole de' Roberti: The Renaissance in Ferrara (exh. cat. by D. Allen and L. Syson, Los Angeles, CA, Getty Mus., 1999); exh. cat. pubd as suppl. to *Burl. Mag.*, cxli (1999), pp. i–xl

KRISTEN LIPPINCOTT

Robetta [Cristofano di Michele Martini] (*b* Florence, *bapt* 17 Nov 1462; *d* ?Florence, after 1534). Italian goldsmith and engraver. Vasari mentioned an artist named 'Robetta the Goldsmith', who has been identified through documents with a certain Cristofano, or Cristoforo, di Michele Martini. In 1480, he was still working in his father's shop as a hosier. From 1498 onwards he is recorded as a goldsmith, and between 1517 and 1522 he was paid for three seals (untraced). He was last mentioned in a deed of sale dated 1535.

Robetta is known today exclusively as an engraver: 17 surviving engravings bear his signature, most in the form RBTA; in addition, between 19 and 29 other prints have been attributed to him. None of the signed or universally accepted prints is dated, and it is difficult to chart Robetta's stylistic development. Accordingly, his engravings are usually classified by subject: episodes from the Old and New Testaments, devotional subjects, allegories, episodes from Classical mythology and ancient history.

Robetta's figurative style is deeply indebted to late 15th-century Florentine painters, particularly Antonio Pollaiuolo, Pietro Perugino, Lorenzo di Credi, and above all Filippino Lippi, as is evident in his engraving of the *Adoration of the Magi*. Yet he rarely made slavish copies of his models, and only in the case of Filippino is there any likelihood that he may have worked directly from the painter's drawings. Robetta's technique is dependent on that of Martin Schongauer (*c.* 1435/50–1491) and of Albrecht Dürer (1471–1528), from whom he copied the method of modelling with curved crossed lines. In some cases Robetta made direct copies of engravings by Schongauer, and practically all his landscapes include adaptations of features taken from Dürer's prints, as in Robetta's *Allegory of Envy*.

BIBLIOGRAPHY

G. Vasari: *Vite* (1550, rev. 2/1568), ed. G. Milanesi (1878–85), vi, p. 609

P. Minucci del Rosso: 'Di alcuni personaggi ricordati dal Vasari nella vita di Gio. Francesco Rustici', *Archv Stor. It.*, 4th ser., iii (1879), pp. 475–82

J. Walker: 'A Note on Cristofano Robetta and Filippino Lippi', *Bull. Fogg A. Mus.*, ii (1933), pp. 33–7

A. M. Hind: *Early Italian Engraving*, i (London, 1938), pp. 197–209

P. Bellini: *Catalogo completo dell' opera grafica del Robetta* (Milan, 1973)

J. A. Levenson, K. Oberhuber and J. Sheehan: *Early Italian Engravings from the National Gallery of Art*, Washington, DC, N.G.A. cat. (Washington, 1973), pp. 289–305

M. J. Zucker: *Early Italian Masters, Commentary* (New York, 1984), pp. 527–70; 25 [XIII/ii] of *The Illustrated Bartsch*, ed. W. Strauss (New York, 1978–)

MARCO COLLARETA

Robusti. *See* TINTORETTO.

Rodari, Tommaso [Tomaso] (*b* Maroggi, Lake Como; *fl* Como, 1484–1526). Italian sculptor and architect. He was the most important member of a family of sculptors and architects that worked on the architecture and sculpture of Como Cathedral. His father, Giovanni Rodari (*d*?1493), had four sons, whose order of birth is unknown. Apart from Tommaso, Giacomo Rodari (*fl* 1487–1509), Bernardino Rodari (*fl* 1500–08) and Donato Rodari (*fl* 1500–13) are documented. They all worked in the elaborately decorative Late Gothic style developed by Cristoforo Mantegazza and Giovanni Antonio Amadeo.

In 1484 Tommaso Rodari was paid for carving statues for the façade of Como Cathedral (all *in situ*): the *Resurrection*, the *Angel Gabriel* and the *Virgin Annunciate*, and the *Virgin and Four Saints* that crowns the central portal. In 1486 he was mentioned as sculptor and structural engineer of the cathedral; at this date the north and south façades were being constructed, and the design of the chancel was being planned. One of a pair of elaborately ornate aediculae decorated with music-making angels, sphinxes and other *all'antica* ornament on the cathedral façade is dated 1498 and signed by Tommaso and Giacomo Rodari; evidently the brothers were also responsible for the companion aedicula. However, the seated statues of *Pliny the Elder* and *Pliny the Younger* housed in the aediculae are in an earlier style and have been attributed to the brothers' father, Giovanni (Arslan; Cogliati Arano). Tommaso and Giacomo also together signed the large north door overloaded with ornament, known as the Porta della Rana, and the internal (1491) and external (1509) decoration of the south door. Also attributed to the brothers and their workshop are the three sculptural lunettes over the portals of the main façade of the *Adoration of the Shepherds*, the *Adoration of the Magi* (over the central portal) and the *Presentation in the Temple* with their crowded groups of almost free-standing figures set against backgrounds carved in very low relief. Tommaso also carved three marble altarpieces in the form of polyptychs inside the cathedral known as the altarpieces of *St Lucy* (1492), *St Apollonia* (1493) and the *Deposition* (1498).

In 1498 Tommaso Rodari was commissioned by the town authorities of Ponte in the Valtellina to produce designs for the main chapel of the parish church of S Maurizio. His brother Giacomo was also involved in the project and was required to live in the town while working on the sculpture. The other two brothers, Bernardino and Donato, signed (1508) the portal of S Stefano di Mazzo, Valtellina. At the same date they were also working at Como Cathedral.

In 1510 the committee of the works at Como Cathedral decided to construct the chancel 'according to the most recent model in the workshop of Tommaso da Maroggia [Rodari]'; this model was certainly revised by Giovanni Antonio Amadeo, who was in Como at that date. A plaque records that the chancel's foundation stone was laid on 22 December 1513. Soon after, responsibility for the chancel design was given to Cristoforo Solari, but Rodari was again put in charge of its building in 1519, and responsibility for the design may be given to both artists. Although the giant order used in the chancel suggests the influence of Bramante, the overall style is closer to Pavia Cathedral.

In 1514 Tommaso was in charge of the demolition of S Pietro, Bellinzona, which he replaced with a new church. In 1515 he and Ambrogio Ghisolfi (*fl* 1497–1517) signed a contract for the decoration of part (possibly the façade) of the sanctuary of the Assunta at Morbegno. In 1517 the sculptor Giovanni Gaggini specified in his will that the carved shrine destined for his family's funerary monument at Mendrisio should be completed by Tommaso. In 1522 Tommaso was paid for work at S Maria di Piazzo at Busto Arsizio, probably for work on the portals, the loggia around the exterior of the cupola and its internal niches.

Numerous architectural and sculptural works in Como and in the confines of the old diocese have been attributed to the Rodari workshop. A typical example is the sanctuary of the Madonna at Tirano. Not all of these attributions, however, are convincing. Tommaso Rodari and his workshop evolved a style that was diffused throughout the region of the Lombard lakes and lasted until the end of the 16th century. Although surfaces are highly decorated with candelabra, grotesques and other detail, they are treated more delicately than by Amadeo and Mantegazza and produce a less hard sculptural effect. The style owed something to the influence of Leonardo da Vinci and to Solari's classicism, yet it lacks the force of Bramante's strong architectural plasticity and articulation of space.

BIBLIOGRAPHY

Thieme–Becker

C. F. Ciceri: *Selva di notizie autentiche risguardanti la fabbrica della cattedrale di Como* (Como, 1811)

G. F. Damiani: 'Tomaso Rodari e il rinascimento in Valtellina', *Period. Soc. Stor. Prov. & Ant. Dioc. Como*, xii (1897), pp. 7–16

S. Monti: *Storia e arte nella Provincia e antica diocesi di Como* (Como, 1902)

L. Brentani: 'Nuove opere di Tomaso e Giacomo Rodari', *Emporium*, xliii/253 (1916), pp. 31–8

——: *La storia artistica della collegiata di Bellinzona* (Lugano, 1916)

P. Bondioli: *Arte e storia in Santa Maria di Piazza a Busto Arsizio* (Busto Arsizio, 1931)

M. L. Perer: 'Aspetti della scultura lombarda: Tomaso Rodari', *An. Fac. Filos. & Lett. U. Milano*, vi/2 (1953), pp. 281–308

E. Arslan: *La scultura nella seconda metà del quattrocento, Storia di Milano*, vii (Milan, 1956), pp. 705–6, 732–3

F. Mastropietro: 'La pala della Passione di Tommaso Rodari nel duomo di Como', *A. Lombarda*, xvi (1971), pp. 71–7

O. Bernasconi: 'L'architettura', *Il duomo di Como* (Milan, 1972), pp. 51–63

L. Cogliati Arano: 'La scultura', *Il duomo di Como* (Milan, 1972), pp. 122–34, 146–52

Collezioni Civiche di Como: Proposte, scoperte, restauri (exh. cat., Como, S Francesco, 1981), pp. 118–19

DANIELE PESCARMONA

Romanelli, Gaspare (*b* L'Aquila; *fl* 1560–1609). Italian medallist and goldsmith. He was the son of the goldsmith Bartolomeo Romanelli (*fl c.* 1550) and the brother of Raffaele Romanelli, who was also a goldsmith. The Florentine writer Antonio Francesco Doni wrote a letter to Romanelli (see Armand and Pollard), included in an edition of the sonnets of Burchiello, in which he thanked him for a medal, which is recorded by Armand as being in the Mazzuchelli collection (Brescia, Gian Maria Mazzuchelli priv. col., see Armand, ii, pp. 24, 200; iii, p. 103). The most commonly found medals of the artist are of the Florentine scholar Pietro Vettori the younger (1499–1585; examples, London, BM, and Florence, Bargello). There are five such medals, only one of which is signed with the initials 'G. R. F.'. In good examples of these pieces the portraiture is

adequate but not distinguished, and the reverses show a singular lack of invention. Pollard adds two medals to Romanelli's oeuvre: one (examples, London, BM, and Florence, Bargello), dedicated to Carlo Pitti, a Florentine senator, is a convincing attribution. The second (Florence, Bargello), of Nicholas de Lange of Lyon (1525–1606), dated 1603, although close in style to Romanelli's other medals, is sufficiently different in the handling of the portrait, the lettering and the concept of the reverse, especially in the figure of Apollo, to raise a question regarding the attribution. Pollard also mentions the existence of a specimen of a medal of Cardinal Santacroce signed RF (London, Gere priv. col.), which could also be added to Romanelli's oeuvre. Romanelli's last recorded work was a monstrance for the church of S Maria di Collemaggio in L'Aquila in 1609.

BIBLIOGRAPHY

Forrer
A. Armand: *Les Médailleurs italiens* (2/1883–7)
I. B. Supino: *Il medagliere mediceo nel R. Museo Nazionale di Firenze* (Florence, 1899), p. 162
G. Pollard: *Italian Renaissance Medals in the Museo Nazionale del Bargello*, ii (Florence, 1985), pp. 843–9

STEPHEN K. SCHER

Romanino, Gerolamo [Girolamo di Romano] (*b* Brescia, 1484–7; *d* Brescia, ?1560). Italian painter and draughtsman. The catalogue of his early works is controversial, owing to the intricate problem of his relationship with Altobello Melone. As a result of their prolonged association, which lasted almost a decade from *c.* 1508, a group of works is assigned sometimes to one artist, sometimes to the other. The Rabinowitz Triptych, the three fragments of which are today in three different private collections in Rome and Brescia (see 1965 exh. cat., fig. 153, and 1985 Cremona exh. cat., p. 85), the *Transfiguration* (Budapest, Mus. F.A.) and the *St Catherine* (Frankfurt, Städel. Kstinst. & Städt. Gal.) fall into this category.

Following a probable apprenticeship in Brescia, Romanino completed his education in Venice and Milan. He was attracted to Venice by the innovations of Giorgione, and while there also saw and was influenced by the *Virgin of the Rose Garlands* (1506; Prague, N.G., Šternberk Pal.) by Albrecht Dürer (1471–1528). In Milan he was impressed by the works of Bramante and Bramantino. These three elements—Lombard perspective, Venetian painting (first Giorgione and subsequently Titian) and the influence of German art—contributed to the formation of his pictorial language, the different phases of which were characterized by the emergence sometimes of one, sometimes of another of them, or by a bold mixture.

Romanino's earliest signed and dated work, the *Pietà* (1510; Venice, Accad.), reveals Lombard influences fused with a use of colour that derives from Giorgione; while in the fresco cycle executed (?1509) in the Palazzo Orsini-Mondella, Ghedi, for the condottiere Nicolò Orsini, Conte di Pitigliano (1442–1510), figures drawn from Giorgione's repertory are inserted into a framework that is typical of Bramantino (fragments, Budapest, Mus. F.A.—attributed by some to Bartolomeo Montagna—and Brescia, Pin. Civ. Tosio–Martinengo). The sack of Brescia (1512) and Romanino's consequent move to Padua marked a new phase in his career. He no longer oscillated between Milan and

Venice and became decisively orientated towards the work of Titian, whose frescoes in the Scuola del Santo in Padua had a marked influence on Romanino's paintings between 1510 and 1520. These include two altarpieces depicting the *Virgin and Child Enthroned with Saints*, one (1513–14; Padua, Mus. Civ.) for S Giustina, Padua, the other (1516–17; *in situ*) for S Francesco, Brescia, numerous depictions of the *Virgin and Child* and the *Salome* (Berlin, Bodemus.), the latter influenced by treatments of the same theme by Titian and Sebastiano del Piombo.

Despite the high regard in which he was held by the Gonzaga family of Mantua, Romanino chose, in 1519, to accept a commission offered to him by the *massari* of Cremona Cathedral, and by 1520 he had frescoed four scenes from the *Passion, Christ before Pilate*, the *Flagellation*, the *Crowning with Thorns* and *Ecce homo*, as part of a cycle executed on the walls of the cathedral nave by various artists over a number of years. Among his most famous works, they are characterized by a violent expressionism that is northern European in origin. This change of style was inspired by the study of the graphic works of northern masters and affected both his figure types and his technique. He was also influenced by Altobello Melone's earlier experiments in a similar vein on the walls of the cathedral. This was a conscious stylistic change and must be viewed against the background of the complex phenomenon of Italian anticlassicism. The frescoes, however, did not please the patrons, who expected the pictorial language to be more in line with the innovations of Central Italian painting. Romanino was dismissed, and his place taken by Pordenone. He returned to Brescia and between 1521 and 1524 collaborated with MORETTO on the decoration of the chapel of the SS Sacramento in S Giovanni Evangelista, an experience that had had prolonged, if not always positive, repercussions on his style. This cycle was completed in the early 1540s, and Romanino was responsible for the scenes depicting the *Adoration of the Blessed Sacrament*, the *Feast in the House of Levi*, the *Raising of Lazarus* (see colour pl. 2, XXV1) and *SS Matthew and John the Evangelist*. Troubled by his lack of success in Cremona, he sought to adapt his style to the measured classicism of Moretto, which was uncongenial to him but much admired by his patrons. Yet, though he received numerous commissions in the 1520s in the province of Brescia, it was difficult for him to reassume a central role in his native town.

In 1531, uncertain of which direction to take, Romanino offered his services to Cardinal Bernhard von Cles (1485–1539), who had been engaged for some time in renovating the city of Trent, including BUONCONSIGLIO CASTLE. In the castle he worked with the brothers Dosso Dossi and Battista Dossi, Marcello Fogolino and German masters such as Bartolomäus Tilman Riemenschneider (active 1530s). He exploited a wide range of styles to suit the varying functions and layouts of the rooms: from Venetian classicism enriched with elements derived from Correggio in the Loggia (see fig.) to northern realism in the corridors and anterooms. However, the renewed contact with German art stimulated him to challenge the courtly pictorial language that he had hitherto adopted and led him to produce the daring frescoes executed between *c.* 1533 and *c.* 1543 at Pisogne, Breno and Bienno in Val Camonica, where Romanino gave free rein to his violent

Gerolamo Romanino: *Knights and Ladies* (*c.* 1531), fresco, Loggia of Buonconsiglio Castle, Trent

and grotesque expressionistic tendencies. Such a change of style did not prevent him from receiving important public commissions. Among these were the organ shutters for S Maria Maggiore, Trent, of which two fragments (Trent, Castello Buonconsiglio and Mus. Dioc.) enable the identification of two full-size copies in the church of Our Lady of Týn, Prague; organ shutters (1540) for S Giorgio in Braida, Verona, and organ shutters (1539–41; Brescia, New Cathedral) for the Old Cathedral of Brescia.

During the 1540s Romanino executed many canvases (for example, the *Last Supper*, Montichiari parish church, and the *Mystic Marriage of St Catherine with Saints*, Memphis, TN, Brooks Mus. A.). It is likely that the numerous fresco cycles noted in Brescian sources but destroyed date from this period. On 26 February 1549 he signed a contract to employ Lattanzio Gambara, who had been trained in the Campi family workshop in Cremona, as an assistant. The agreement marked the last important turning-point in his career and proved advantageous for both painters. Romanino, now aged 65, found a capable collaborator who could take his place on the scaffolding for the tiring work of fresco painting and who could keep him up to date with the particular form of Mannerism practised by the Campi. Gambara, not quite 20 years old, could count on his future father-in-law to help him rapidly become established among a rich Brescian clientele. The working relationship was sealed by Gambara's marriage to one of Romanino's daughters in 1556, and the agreement, initially made for a year, evolved into a full partnership that lasted until Romanino's death.

From 1549, therefore, it is impossible to speak of a pure Romanino oeuvre. With the exception of the late and

profoundly Emilian *Calling of Peter* (1558; Modena, S Pietro), the works of his last decade reveal the collaboration of Gambara. This is especially evident in the many Brescian fresco cycles (e.g. in the Palazzo Averoldi, the Palazzo Bargnani–Lechi and the library of the S Eufemia Monastery) but can also be seen in the canvases (for example, the *Gathering of the Manna, c.* 1558; Brescia, Old Cathedral). Despite the uneven quality of his works and his eclectic and contradictory artistic personality, ready to assimilate or reject without compromise the many figurative styles of his time, Romanino was one of the most important eccentric figures of the 16th century.

BIBLIOGRAPHY

R. Longhi: 'Cose bresciane del cinquecento', *L'Arte*, xx (1917), pp. 99–114; also in *Scritti giovanili, 1912–1922* (Florence, 1961), pp. 327–43

G. Panazza: *Affreschi di Girolamo Romanino* (Milan, 1965)

Girolamo Romanino (exh. cat., ed. G. Panazza and others; Brescia, Old Cathedral; Breno, S Antonio; 1965) [comprehensive bibliog.]

A. Ballarin: 'La *Salomé* del Romanino', *Storia dell'arte mediovale e moderna* (Ferrara, 1970–71)

C. Boselli: *Regesto artistico dei notai roganti in Brescia dall'anno 1500 all'anno 1560*, 2 vols (Brescia, 1977)

G. Panazza: 'Aggiunte al catalogo di G. Romanino e V. Foppa', *Brixia Sacra*, xii (1977), pp. 65–81

C. Cook: 'The Lost Last Works by Romanino and Gambara', *A. Lombarda*, 70–71 (1984), pp. 134–8

Bernardo Cles e l'arte del rinascimento nel Trentino (exh. cat., ed. E. Chini; Trent, Castello Buonconsiglio, 1985)

I Campi e la cultura artistica cremonese del cinquecento (exh. cat., ed. M. Gregori; Cremona, S Maria della Pietà, Vecchio Osp. and Mus. Civ. Ala Ponzone, 1985)

M. Gregori, ed.: *Pittura del cinquecento a Brescia* (Milan, 1986)

A. Nova: *Girolamo Romanino: Introduzione a un catalogo ragionato* (diss., U. Milan, 1986)

E. Chini: *Il Romanino a Trento: Gli affreschi nella Loggia del Buonconsiglio* (Milan, 1988)

O. Frantoni: *Romanino in Sant'Antonio a Breno* (Breno, 1992)

Le Siècle de Titien: L'Age d'or de la peinture à Venise (Paris, 1993), pp. 391–7

<div align="right">ALESSANDRO NOVA</div>

Romano, Antoniazzo. *See* ANTONIAZZO ROMANO.

Romano, Gian Cristoforo. *See* GIAN CRISTOFORO ROMANO.

Romano, Giulio. *See* GIULIO ROMANO.

Romano, Paolo. *See* PAOLO ROMANO.

Romano, Pietro Paolo. *See* GALEOTTI, PIETRO PAOLO.

Romanus. *See* PENNI, (2).

Rome [It. Roma]. Capital city of Italy and the metropolis of the Roman Catholic Church, half-way down the Italian peninsula and *c.* 35 km from the mouth of the River Tiber. The early city spread over the seven traditional hills (Palatine, Capitoline, Aventine, Celian, Esquiline, Viminal and Quirinal). Its role as capital, first of the Roman Empire, then of the Papal State and finally of the Italian State, has accorded the city huge historical and artistic importance. Rome's heritage has inspired and fascinated generations of artists and architects, both native and foreign.

I. History. II. Urban development. III. Art life and organization. IV. Centre of production. V. Buildings and monuments. VI. Accademia di S Luca. VII. Antiquarian revivals.

I. History.

Roman historians established 21 April 753 BC as the date of Rome's foundation, when, according to the myth, Romulus founded a city on the Palatine Hill. Virgil, in the *Aeneid*, also followed tradition by linking Romulus and Aeneas, the famous hero who survived the Trojan War and settled in Latium after an eventful journey. In fact a settlement on the Palatine and small villages on the other hills probably started to appear around the 9th century BC; when they united and elected their own king, Rome was founded. The traditional list of Roman kings (753–509 BC) comprises one group of Latin kings (Romulus, Numa Pompilius, Tullus Hostilius and Ancus Marcius); they were followed by three Etruscans, Tarquinius Priscus, Servius Tullius and Tarquinius Superbus. In this second phase Rome seems to have peacefully submitted to Etruscan control, which resulted in the development of crafts and trades and some prosperity. The crisis of monarchy and the attainment of public offices by the plebs led to the birth of the Republic (509–27 BC). The city gradually became supreme as head of a confederacy of all Italians, and after successful wars against Carthage (3rd–2nd centuries BC) became a world power. The city itself continued its irregular growth and, at the end of the Republican era, the population reached one million. Roman culture was rapidly hellenized after the conquest of Greece in 146 BC. Simple Roman values were confronted by the refined Greek world, and wealthy Romans competed for the most skilled Hellenistic artists to increase their power and status.

The Republican era ended in civil war between Julius Caesar and Gnaeus Pompey, Octavian and Mark Antony, and in social and moral collapse.

Once Octavian had attained absolute power in 27 BC and proclaimed himself Augustus, he developed a wide-ranging cultural programme to underpin his government; he renewed morals and religion and reorganized and embellished the city. In the following centuries Rome was the capital of an empire, and it reached the peak of its extent and power. Every emperor linked his name to splendid buildings. From the 3rd century AD Rome became more and more isolated, owing to radical changes in army organization; the emperors transferred both their wealth and their interest abroad and left the city to the senatorial class. Social changes were hastened by a religious crisis due to the spread of Christianity. Under Constantine the Great, the city lost its role as political capital of the Empire, but it became the heart of the Christian world: after the Edict of Milan (AD 313), Constantine established the first organized structure for the Roman Church. The early churches became new poles of attraction in the old Imperial urban system.

In AD 395 Rome lost its role as capital of the Western Empire. In the Middle Ages, with barbarian invasions, pillages and wars with the Goths, the city's monuments were damaged and scattered and her population shrank rapidly. The Byzantine rulers imposed heavy taxation and military obligations. At the beginning of the 7th century the Romans, in fear of the Lombards, entrusted the municipal administration to the Pope. Thus the temporal power of the papacy was born, later strengthened by the alliance with the Franks; the Papal State was founded in 756. The population, which in the 9th century amounted to less than 20,000, was confined to the Tiber loop, the site of Rome's first settlement. The history of Rome in the era of the Comunes is one of the struggle between papacy, empire, municipality and aristocracy. The Roman Comune, which emerged in 1144, was unable to assert its own autonomy, unlike the Comunes of some other Italian cities. When the papal seat was transferred to Avignon (from 1308 to 1378), the city was left in the hands of the most important families (above all the feuding Orsini and Colonna), who turned some of the greatest monuments of the past into fortified mansions. Only in 1417, with Pope Martin V, was Rome firmly established as the seat of the papal court and centre of Christendom. The city grew in cultural and artistic importance: Rome under the popes of the Renaissance, from Julius II to Sixtus V, claimed to be the head of the world, *caput mundi*. Sixtus V planned the transformation of the city into the capital of an absolute state; he restored pagan and Christian buildings, linking them with a road network for the streams of pilgrims that arrived during the Holy Years and the main religious events.

BIBLIOGRAPHY

E. Gibbon: *History of the Decline and Fall of the Roman Empire* (London, 1776–82)

F. Gregorovius: *Geschichte der Stadt Rom im Mittelalter* (Stuttgart, 1859–72; Eng. trans., London, 1906/*R* New York, 1967)

L. von Pastor: *Geschichte der Päpste* (Freiburg im Breisgau, 1886–1933)

Storia di Roma, Istituto di Studi Romani, 31 vols (Bologna, 1954–87)

R. Bianchi Bandinelli: *L'arte romana al centro del potere* (Milan, 1969)

R. Krautheimer: *Rome: Profile of a City, 312–1308* (Princeton, 1980)

C. Hibbert: *Rome: The Biography of a City* (Harmondsworth, 1985)
P. Zanker: *Augustus und die Macht der Bilder* (Munich, 1987)

ANNA MENICHELLA

II. Urban development.

1. 1420–1500. 2. 1500–1600.

1. 1420–1500 Following the disorder, loss of population and general decline occasioned by the withdrawal of the papacy to Avignon and the Great Schism, Rome in the early 15th century was a shadow of its illustrious past. Without the papacy, Rome had lost most of its *raison d'être*. The city, with an area of 13.66 sq. km, had only around 17,000 inhabitants, clustered in the small *abitato* that comprised only one third of the imperial capital; the rest (the *disabitato*) was abandoned or used for agriculture. Most people lived near the Tiber, which, together with a small amount of Acqua Vergine water from the ancient aqueduct and a few wells, provided the only source of potable water. In 1417 Martin V (*see* COLONNA, (1)) was elected pope at the Council of Konstanz. When he made his solemn entry into Rome in 1420, he found that the absence of the popes had proved disastrous to the Eternal City. Martin restored several churches, including the Lateran Basilica and SS Apostoli, parts of the city walls, the Ponte Milvio and the Capitoline Hill, but he concentrated primarily on making necessary repairs rather than large-scale improvements. His successor, Eugenius IV (*reg* 1431–47), also restored a few buildings, but financial restraints precluded any large-scale planning.

NICHOLAS V initiated a substantial amount of building shortly after his election in 1447. The papal residence had been moved from the outlying Lateran to the more central Vatican, and a large wing was added to the Vatican Palace, although its exterior still had a medieval fortress-like appearance (*see* §V, 1(iii)(a) below). In 1451 Bernardo Rossellino (*see* ROSSELLINO, (1), §2) began significant alterations to St Peter's, an audacious step that ultimately led to the complete reconstruction of the basilica (*see* §V, 1(ii)(a) below). Nicholas, heeding the ideas of Leon Battista Alberti, conceived of architecture as an expression of the greatness of the Church: it was only fitting that the capital of Christendom should have its greatest churches. This attitude was to permeate papal building plans until the 18th century. A major improvement to the city was effected by the repair of the Acqua Vergine, which allowed the population to move to areas away from the river. During the reign of Nicholas's successor, Calixtus III (*see* BORGIA, (1)), the first important post-medieval palace of Rome was built, the Palazzo Sforza–Cesarini.

In 1460 Pius II (*see* PICCOLOMINI, (1)) commissioned the renewal of the Piazza S Pietro with the benediction loggia (destr. 1600), which evoked the city's ancient architecture (*see* FRANCESCO DEL BORGO). His successor, PAUL II, did not concentrate on St Peter's but centred his attention on the Palazzo S Marco (completed 1471; now Palazzo Venezia), where he had resided as a cardinal and which he established as a second papal residence. He cleared and widened the ancient Via Flaminia (now the Via del Corso) to provide access from his palace to the northern gate of the city, the Porta del Popolo. Later in his reign, probably in anticipation of the Holy Year of 1475, he continued his predecessors' work at the benediction loggia and the choir of St Peter's.

Sixtus IV (*see* ROVERE, DELLA, (1)) began to create an efficient infrastructure, built the Ponte Sisto to ease traffic on the Ponte Sant'Angelo, laid out the Borgo Sant'Angelo and added the Sistine Chapel (1477–86) to the Vatican. He also altered the character of the city by ordering the enclosure of most of the city's porticos, which were viewed as a threat to public safety. He supported the substantial building activities of his many kinsmen, who constructed major palaces in various parts of the city, each with its own large square. It was during his reign that Cardinal Raffaele Riario began the first great Renaissance palace in Rome, the Cancelleria (*c.* 1483–1514; *see* §V, 6(i) below).

The greatest contribution of Alexander VI (*see* BORGIA, (2)) to the planning of Rome was the construction of the Via Alessandrina, connecting the Castel Sant'Angelo with the entrance of the Vatican Palace, built for the Holy Year of 1500. Although planned by Nicholas V, expropriation of the considerable land required was attempted only by Alexander. This method of cutting through existing buildings to create straight streets would become the model for the construction of major thoroughfares in central Rome from the 16th century until the 20th. On the whole, however, Rome still remained a medieval city at the end of the 15th century. The popes had improved the city, but these ameliorations were more maintenance than new construction. The planning of early Renaissance Rome nevertheless shows three specific goals: improving communications between the Vatican and the city centre, developing the Vatican Borgo and improving the flow of traffic from the Porta del Popolo. Streets radiated from the Ponte Sant'Angelo (the main bridge leading to the Vatican), the Vatican Palace and the Porta del Popolo.

2. 1500–1600. Under Julius II and Leo X, Rome entered a golden age of art and architecture. Julius II (*see* ROVERE, DELLA, (2)) made substantial alterations to Rome and planned several major buildings that were not completed; many of these schemes were designed by Bramante (*see* BRAMANTE, DONATO, §I, 3(ii)). The largest undertaking was the demolition and reconstruction of St Peter's, a project that would continue for more than a century (*see* §V, 1(ii) below). He also constructed the large Cortile del Belvedere (see fig. 8 below and colour pl. 1, XVI1) at the Vatican. The Via Giulia was transformed into an important thoroughfare, and new streets were built off it; the Via della Lungara was laid out roughly parallel to it on the west bank of the river, where important families, including the Chigi and Riario, built *ville suburbane*. A new law court building, the Palazzo dei Tribunali, was begun by Bramante on the Via Giulia but left unfinished in 1511. Julius also planned to rebuild the bridge at the north end of the Lungara.

Julius's successor, Leo X (*see* MEDICI, DE', (7)), followed the tradition that each newly elected pope would begin his own projects and leave many of his predecessor's uncompleted. Under Leo, many students of Bramante were commissioned by various patrons to build palaces, churches and oratories, and Rome began to attain a more urban character. Leo continued work on St Peter's, but in a much grander style; on the site of Julius's law court he

substituted for it the Florentine national church of S Giovanni dei Fiorentini, designed by Jacopo Sansovino (completed 1614). The southern end of the Via Giulia was enriched by the construction of the Palazzo Farnese (*see* §V, 7 below; *see also* PALAZZO, fig. 2), built by Alessandro Farnese (later Paul III; *see* FARNESE, (1)), who had close ties with the Medici. The Via Ripetta was a major straight street that extended from the Piazza del Popolo to the small river port (the *ripetta*). Although begun by Julius II, it was continued by Leo, no doubt because the Medici family palace (the Palazzo Madama) was located near its southern end, as was the Palazzo Lante (owned by Giuliano de' Medici, Duc de Nemours), constituting a centre of Medici influence in the city. Also in this area were the Sapienza college, which Leo subsidized, and the church of S Luigi dei Francesi (begun 1518), which his family patronized.

After the short reign of Adrian VI (*reg* 1522–3), Giulio de' Medici was elected Pope Clement VII. He contributed less than Leo X to the alterations of Rome, although he did complete the trident of streets at the Piazza del Popolo by adding the Via del Babuino to the east, balancing the Via Ripetta, with the Via del Corso in the centre (see fig. 1). The Pope's chamberlain, Francesco Armellini, built the façade of the Banco di Santo Spirito (1523–4; designed by Antonio da Sangallo (ii)), which greeted a visitor crossing the Ponte Sant'Angelo and past which lay the area's two principal streets, the Via del Governo Vecchio and the Via dei Banchi Vecchi. The façade is more a visual than an architectural statement, since it exists independently of the buildings behind it.

1. Rome, plan showing the trident of streets from the Piazza del Popolo; detail from Giovanni Battista Nolli: *Pianta di Roma*, 1748 (London, British Library)

Clement commissioned little after the Sack of Rome in 1527, but his successor, Paul III, was quite active. He had the Torre Paolina (destr. 19th century) built on the Capitoline Hill and transferred the equestrian statue of *Marcus Aurelius* (now Rome, Mus. Capitolino) to the Piazza del Campidoglio. Work again began at St Peter's, this time in accordance with a plan by Michelangelo that necessitated the demolition of much of the new building (*see* §V, 1(ii)(a) below; *see also* MICHELANGELO, §I, 4). Construction continued on the Palazzo Farnese: owing to the family's increased importance, the interior was improved, and the massive Piazza Farnese and the Via dei Baulari were laid out in front of it. The Via del Corso and Via del Babuino (renamed the Via Paolina) were improved, enhancing the importance of the Piazza del Popolo trident. The three streets were connected by a new street from the Piazza di Spagna to the Tiber, leading to the Ponte Sant'Angelo. Michelangelo's work on the Capitoline Hill was probably planned during Paul's reign but executed later. Two pre-existing buildings (the Palazzo del Senatore and Palazzo dei Conservatori) and one new structure (the Palazzo Nuovo), constructed primarily for purposes of symmetry, formed a unified whole. The project was the symbolic statement of the absolute ascendancy of the pope over the city. The Capitoline had been the symbol of the Roman Republic, but the new Piazza del Campidoglio (*see* MICHELANGELO, fig. 9), with the Christian emperor at its centre (the statue of *Marcus Aurelius* was then thought to be *Constantine*), made a clear declaration of the supremacy of the papacy.

The most significant of the contributions of GREGORY XIII to the urban history of Rome was the reinstitution of the Maestri delle Strade (documented from 1233 but possibly founded earlier), the body that authorized and regulated changes to the streets, including the construction and alteration of buildings. Gregory encouraged the construction of colleges, including the Jesuit Collegio Romano (begun 1582), a vast structure that actually altered a district of the city. In preparation for the Holy Year of 1575, he built a wide and relatively straight street from S Maria Maggiore to the Lateran, the Via Merulana; visiting the basilicas was a major activity of the Holy Year, and Gregory did not wish the throngs of pilgrims to see the unkept rural road between these two major churches, located as it was within the walls of the city. Other important streets constructed during his reign included the Via della Ferratella (now Via dell'Amba Arandam), the Via della Rupe Tarpeia (destr.) on the Capitoline, and the completion of the Borgo Pio, begun by Pius IV. In addition to physical improvements to the city, Gregory enacted (1574) the law *De aedificiis*, dealing with city planning and building codes, which facilitated the establishment of new streets and the widening and straightening of ancient narrow, twisting passages. Walls were to be built to conceal ruined or unfinished buildings. Small gaps between houses, which tended to collect rubbish, had to be closed in by neighbouring landowners. To encourage the construction of larger buildings, the owners of surrounding property could be forced to sell if a neighbouring building was to be enlarged.

The five-year reign of Sixtus V (*see* PERETTI, (1)) witnessed a continuation and intensification of the work

begun by Gregory. A major project was the reconstruction of the ruined Acqua Alessandrina. Rome still lacked an adequate water supply, and because of this, large parts of the *disabitato* could not support a substantial population. Under the management of Giovanni Fontana, the aqueduct, renamed the Acqua Felice in Sixtus's honour, opened up vast areas of the city for development, especially near the Villa Montalto (1579; destr. 1861–89), the papal villa, near S Maria Maggiore.

Sixtus's most important contribution was the construction of wide, straight streets leading to the principal basilicas; much of the work for this was executed by Domenico Fontana (1543–1607). The centre of attention was S Maria Maggiore, from which four new streets were built to other basilicas, imitating the Via Merulana of Gregory XIII. The Pope encouraged new construction on these streets, and slowly the former *disabitato* increased in importance. A new papal residence, originally planned by Gregory XIII, was built in this region on the Quirinal, which was thought to be a more salubrious location than the Vatican, especially in the summer.

Other major thoroughfares were constructed to connect important parts of the city, generally churches and gates. Even though it was easier to build new streets in the *disabitato*, on which Sixtus concentrated, the amount of new construction is extraordinary, given his brief papacy. Numerous other streets were planned, and had Sixtus lived longer the urban development of Rome doubtlessly would have proceeded much further. Some of his plans extended into the populated centre of the city, including the construction of a street leading to the Cancelleria and the enlargement of the Piazza Colonna. Work of this nature in the centre, however, was considerably more expensive and time-consuming than that in the *disabitato*, and virtually nothing was accomplished there during his reign.

Obelisks, many of which had been transported to Rome from Egypt during the Empire, became an important element of Sixtus's planning. The only one still in place was located south of St Peter's, on the *spina* of the Circus of Nero. Earlier popes had considered moving it to the piazza in front of the basilica, but only the audacious Sixtus attempted it; the mechanism that successfully moved the massive granite monolith, an engineering feat that had not been attempted for well over a millennium, was designed by Domenico Fontana. After this success, Sixtus ordered the excavation of other obelisks to be erected in front of major basilicas, including S Giovanni in Laterano, S Maria Maggiore, S Maria del Popolo and Santa Croce in Gerusalemme. These obelisks became the visual termini of the new streets leading to the basilicas, for which task an obelisk is well suited by virtue of its long, narrow shape, making it fully visible from far away, whereas a wider fountain or building façade could be seen only in part. At the Piazza del Popolo the obelisk was placed so that it was the visual terminus of the three streets of the trident (see fig. 1 above).

BIBLIOGRAPHY

Philippe-Camille-Casimir-Marcellin, Comte de Tournon: *Etudes statistiques sur Rome et la partie occidentale des états romains* (Rome, 1831, 2/ Paris, 1855)
L. Dall'Olio: *Di alcuni allineamenti e allargamenti delle strade e piazze della città* (Rome, 1865)
P. Cacchiatelli and G. Cleter: *Le scienze e le arti sotto il pontificato di Pio IX*, 2 vols (Rome, 1863–7)
L. Schiaparelli: 'Alcuni documenti dei Magistri Aedificorum Urbis', *Archv Soc. Romana Stor. Patria*, xxv (1902), pp. 5–60
E. Re: 'Maestri di strade', *Archv Soc. Romana Stor. Patria*, xliii (1920), pp. 5–102
T. Ashby and S. R. Pierce: 'Piazza del Popolo, Rome', *Town Planning Rev.*, xi (1924), pp. 75–96
J. A. F. Orbaan: 'How Sixtus V Lost a Road', *Town Planning Rev.*, xiii (1928–9), pp. 121–5
J. Delameau: *Vie économique et sociale de Rome dans la seconde moitié du XVI siècle*, 2 vols (Paris, 1957–9)
F. Castagnoli and others, eds: *Topografia e urbanistica di Roma* (Bologna, 1958)
A. M. Corbo: 'Appunti su una fonte per la storia urbanistica e edilizia di Roma: La serie "fabbriche" del camerale I', *Rass. Archv Stato*, xxv (1965), pp. 45–58
C. W. Westfall: *In this Most Perfect Paradise: Alberti, Nicholas V and the Invention of Conscious Urban Planning in Rome, 1447–55* (University Park, PA, 1974)
A. Ceen: *The Quartiere de' Banchi: Urban Planning in Rome in the First Half of the Cinquecento* (University Park, PA, 1977)
T. A. Marder: 'Sixtus V and the Quirinal', *J. Soc. Archit. Hist.*, xxxvii (1978), pp. 283–94
I. Insolera: *Le città nella storia d'Italia: Roma* (Bari, 1980)
S. Benedetti: 'Il tridente romano di Piazza del Popolo', *Quad. Ist. Stor. Archit.*, xxvi (1981), pp. 91–120
C. Burrough: 'Below the Angel: An Urbanistic Project in the Rome of Pope Nicholas V', *J. Warb. & Court. Inst.*, xlv (1982), pp. 94–124
P. A. Ramsey, ed.: *Rome in the Renaissance: The City and the Myth* (New York, 1982) [esp. articles by J. Ackerman and C. Burrough]
P. Partner: 'Finanze e urbanistica a Roma, 1420–1623', *Chieron*, i/2 (1983), pp. 59–71
C. L. Frommel: 'L'urbanistica della Roma rinascimentale', *Le città capitale* (Bari, 1985)
R. Schiffmann: *Roma felix: Aspekte der stätebaulichen Gestaltung Roms unter Papst Sixtus V* (Bonn, 1985)
H. Gamrath: *Roma sancta renovata: Studi sull'urbanistica di Roma nella seconda meta del sec. XVI con particolare riferimento al pontificato di Sisto V, 1585–1590* (Rome, 1987)
C. L. Frommel: 'Papal Policy: The Planning of Rome during the Renaissance', *Art and History: Images and their Meaning* (Cambridge, 1988)
P. Waddy: 'The Roman Apartment from the Sixteenth to the Seventeenth-century', *Architecture et vie sociale: L'organisation intérieure des grandes demeures à la fin du Moyen Age et à la Renaissance: Actes du colloque: Tours, 1988* (Paris, 1994), pp. 155–96
C. Valone: 'Women on the Quirinal Hill: Patronage in Rome, 1560–1630', *A. Bull.*, lxxvi/1 (March 1994), pp. 129–46

For further bibliography see FONTANA (iv), (2) and PERETTI, (1).

WILLIAM McGUIRE

III. Art life and organization.

1. 1420–1502. 2. 1503–1600.

1. 1420–1502 Martin V (*see* COLONNA, (1)) entered a Rome devastated by anarchy and with a population of only about 17,000; his first concern was to restore and embellish the principal basilicas and churches (*see* §II, 1 above). A fresco cycle (destr.) in the Lateran Basilica, begun by Gentile da Fabriano in 1427 and completed in 1431–2 by Pisanello (*see* GENTILE DA FABRIANO, §1(iii) and PISANELLO, §1(i)), expressed a papal taste for richly decorative art. The importance of Florentine art in Rome was established by Masaccio and Masolino, from whom Martin commissioned (*c.* 1428) a double-sided triptych for S Maria Maggiore (central panels Naples, Capodimonte; side panels London, N.G., and Philadelphia, PA, Mus. A.).

In the middle years of the century successive popes summoned the most distinguished Italian artists to Rome, and the city's fame drew painters from elsewhere in

Europe. Jean Fouquet (1415–81) painted an influential portrait of *Pope Eugenius IV* (1446–8; untraced), and Rogier van der Weyden (*c.* 1399–1464) is said to have visited the city in 1450. The Vatican became the papal residence under Nicholas V, who added a large wing to the palace. Artists from throughout Europe contributed to the Vatican's decoration in the 15th century, among them such leading Italian masters as Benedetto Buonfigli, Fra Angelico, Andrea del Castagno, Piero della Francesca and Andrea Mantegna. The chief surviving 15th-century work is the chapel of Nicholas V, frescoed (1448–9) by Fra Angelico and three assistants (*see* ANGELICO, FRA, fig. 6), one of whom was Benozzo Gozzoli. Fra Angelico received a much greater payment for this work than did his assistants, suggesting that by this date skill could command high prices (see Baxandall). Pope Sixtus IV (*see* ROVERE, DELLA , (1)), whose official painter was Melozzo da Forlì (*see* MELOZZO DA FORLÌ, fig. 1), was therefore following an established tradition when he employed a team of Tuscan and Umbrian artists to decorate the Sistine Chapel (1481–3). The decoration may have been planned by Perugino (see PERUGINO, fig. 1), assisted by Bernardino Pinturicchio, whom he brought with him to Rome as a member of his workshop. Although Domenico Ghirlandaio employed a local painter, Antoniazzo Romano, it was more common for artists to bring their most trusted assistants with them, as they could not expect local Roman artists to be familiar with new stylistic developments. In the late years of the century Pinturicchio was the dominant painter in Rome, and his decoration (1492–4) of the Appartamento Borgia in the Vatican Palace (*see* PINTURICCHIO, BERNARDINO, §2) marks the culmination of a papal taste for the sumptuous and ornate.

The Roman nobility and cardinals followed the pope in their patronage of Florentine artists. Masolino was patronized by the cardinals Castiglione Branda and Giordano Orsini, while Cardinal Oliviero Carafa employed Filippino Lippi to decorate his chapel in S Maria sopra Minerva (completed 1493; *see* LIPPI, (2), §1(iii)). Evidently artists could command a higher remuneration in Rome than in their native cities. Ghirlandaio was paid for one Sistine Chapel fresco more than twice the fee he received for each fresco in the Tornabuoni Chapel in S Maria Novella, Florence (see colour pl. 1, XXXII2). Filippino Lippi received 250 large gold florins for the marble decoration of the altar alone in the Carafa Chapel, but the 1487 contract to fresco the Strozzi Chapel in S Maria Novella, Florence, stipulated only 300 florins for the entire chapel.

The role of local Roman artists throughout the period was relatively minor. In the first half of the century only two Roman names, Pietro di Giovenale (*d* 1464) and Pietro Paolo Paolini, recur in the archives (see Corbo). Devotional images were imported from Germany and Central Italy, but increasingly, from the middle years of the century, Roman artists were employed on ephemera, on the painting of banners and standards, and on the creation of religious images for pilgrims. Papal coronations, jubilee years and ceremonial occasions, such as the entry into Rome of Emperor Frederick III (*reg* 1452–93) for his coronation in 1452 or the reception by Pius II in 1462 of St Andrew's head, were occasions for vast expenditure on decoration, with the erection of temporary triumphal arches and the display of decorative hangings from palaces on the processional routes.

The most distinguished Roman artist of the period was Antoniazzo Romano, who was patronized by Sixtus IV but also produced copies of icons and archaizing religious images for confraternities, religious houses and private patrons. He controlled a large studio, and towards the end of the century his cartoons were used by his assistants to produce many variants of his compositions. Antoniazzo was also the first head of the re-established Università dei Pittori e Miniatori, whose medieval rules, intended to protect the artist, were revised in 1478; the frontispiece to the statutes (Rome, Accad. N. S Luca) shows Antoniazzo, Cola Sacoccia, Giovanni Mancini and Jacopo Rivaldi presenting the rules to St Luke, patron saint of the guild.

The situation was similar for sculptors. The celebrated families of marble-cutters of medieval Rome had gone, and only one marble-cutter is documented during the reign of Martin V. In the early years of the century a privileged role was given to Florentine sculptors: Martin commissioned a mitre with six gold figures from Lorenzo Ghiberti, and Eugenius IV (*reg* 1431–47) also favoured Florentine goldsmiths. Donatello and Michelozzo di Bartolomeo were in Rome between 1431 and 1433, and they were succeeded as leading sculptors by the Florentine Filarete. Eugenius IV commissioned Filarete to create the central bronze doors (inscribed and dated 1445; *see* FILARETE, fig. 1) for Old St Peter's. A relief on the interior of the doors shows the sculptor and his assistants, each identified by their first names and nicknames and arranged according to their role in the studio. This relief bears witness to the presence of large workshops in Rome during the 15th century, in which a master sculptor directed teams of assistants. Filarete established the first bronze foundry in Renaissance Rome, and after his departure his workshop continued to produce bronze plaquettes and medals.

The patronage of Pius II gave a new impetus to sculpture, and in the period from 1460 to 1490 several large workshops emerged. The rival workshops of Mino da Fiesole and Paolo Romano, the latter a rare example of a Roman sculptor, were prominent in the 1460s and 1470s; the large and well-organized workshop of Andrea Bregno dominated the 1480s. Most sculptural commissions, from popes, cardinals and nobles, were for funerary monuments, altars and ciboria. The sudden rise in demand and consequent necessity for speed led to the collaboration of sculptors on single projects, after first establishing the sections for which each was responsible. Mino da Fiesole shared a commission with Giovanni Dalmata for the tomb of *Paul II* (*d* 1471; fragments in Rome, Grotte Vaticane), where the responsibility for the reliefs was divided equally between the two sculptors and their workshops. Mino also collaborated with Andrea Bregno on a series of tombs, and at the end of the 1470s Mino, Bregno and Dalmata worked together on the transennae of the Sistine Chapel.

Throughout this period the ruins of ancient Rome exerted a powerful fascination over artists and scholars and were much studied and surveyed. Pisanello's sketchbook (Paris, Louvre) and that of Cyriac of Ancona were among the earliest of these, but by the end of the century they had become more numerous as the study of the ruins

became more informed. Serious study of the antiquities of Rome was initiated in this period, and the papal court became a flourishing centre of antiquarian learning. Such humanist scholars as the Anonimo Magliabecchiano, Poggio Bracciolini and Flavio Biondo studied Roman archaeology and topography, and antiquarian topographical handbooks, such as the learned *Antiquitates urbis* (1537) by Andrea Fulvio, were produced. Many artists and scholars were keen collectors of antiquities, coins and medals; Cardinal Prospero Colonna, owner of the Belvedere *Torso* (Rome, Vatican, Mus. Pio-Clementino), was a passionate antiquarian, and Cardinal Oliviero Carafa's Roman villa contained a display of ancient funerary monuments inscribed with epigrams. PAUL II was also an avid collector and possessed a remarkable collection of ancient coins, cameos, engraved gems and small bronzes. Admiration of antiquities did not prevent their being plundered, however, even by those popes who issued bulls to protect them, of whom Paul II was the first.

The court of Sixtus IV also attracted humanist scholars. Sixtus increased the holdings of the Vatican library and established its collection of antiquities; moreover, he donated to the Palazzo dei Conservatori on the Capitoline a number of celebrated ancient bronzes, among them the *She-Wolf* and the *Spinario*, believing that these works (both Rome, Mus. Conserv.), so deeply part of Roman heritage, should be available to the Roman people. He thus created the nucleus of the first public museum in Rome, which stimulated both artists and collectors. Several important discoveries were made in excavations (in which Andrea Bregno participated) carried out in the years around 1500, among them the *Apollo Belvedere* (Rome, Vatican, Mus. Pio-Clementino) and the Domus Aurea of Nero, which had a deep impact on the artistic imagination of the time, visible in such works as Filippino Lippi's frescoes in the Carafa Chapel in S Maria sopra Minerva.

BIBLIOGRAPHY

F. Albertini: *Opusculum de mirabilibus novae et veteris urbis Romae* (Rome, 1510)

S. Infessura: *Diario della città di Roma*, ed. O. Tommassini (Rome, 1723, 2/1890)

F. Gregorovius: *Geschichte der Stadt Rom im Mittelalter*, 8 vols (Stuttgart, 1859–72; Eng. trans of 4th Ger. edn by G. W. Hamilton, New York, 1967)

E. Muenz: *Les Arts à la cour des papes pendant le XV et le XVI siècles*, 3 vols (Paris, 1881)

J. Capgrave: *Ye Solace of Pilgrimes: A Description of Rome circa AD 1450*, ed. C. A. Mills (Oxford, 1911)

R. Valentini and G. Zucchetti, eds: *Codice topografico della città di Roma*, 4 vols (Rome, 1946)

T. Magnuson: *Studies in Roman Quattrocento Architecture* (Stockholm, 1958)

Rome in the Renaissance: The City and the Myth. Papers of the 13th Annual Conference, Medieval and Renaissance Texts and Studies: Binghamton, NY, 1964

Builders and Humanists: The Renaissance Popes as Patrons of the Arts (exh. cat., ed. D. de Mesnil; Houston, TX, U. St Thomas, 1966)

A. M. Corbo: *Artisti e artigiani a Roma al tempo di Martino V e di Eugenio IV* (Rome, 1969)

M. Baxandall: *Painting and Experience in Fifteenth-century Italy* (Oxford, 1972)

A. D. Esch: 'Die Grabplätte Martinus V und andere Importstücke in den römischen Zollregistern der Frührenaissance', *Röm. Jb. Kstgesch.*, xvii (1978), pp. 211–17

C. L. Stinger: *The Renaissance in Rome* (Bloomington, 1985)

Roma, 1300–1875: La città degli anni santi (exh. cat., ed. M. Fagiolo and M. L. Madonna; Rome, Pal. Venezia, 1985)

Da Pisanello alla nascità dei Musei Capitolini: L'antico a Roma alla vigilia del rinascimento (exh. cat., ed. A. Cavallaro and E. Parlato; Rome, Mus. Capitolino, 1988)

A. Cavallero: *Antoniazzo Romano e gli Antoniazzeschi* (Udine, 1992)

P. Jacks: *The Antiquarian and the Myth of Antiquity* (Cambridge, 1993)

LYNDA STEPHENS

2. 1503–1600. During the 16th century Rome attracted artists from throughout Europe, many of whom remained undistinguished in comparison to the masters whose creative furore dominated the century. One such artist, Giovanni Battista Armenini (*c.* 1525–1609), who arrived in Rome in the early 1550s, outlined the reasons that lured generations of artists there (1587; Eng. trans. 1977, pp. 81–2):

> In our times countless youths from almost every part of the world went to Rome moved by the wish to learn good draftsmanship [*disegno*] together with painting, which they hoped to do in that city where works and craftsmen of highest excellence flowered in this profession. Some of the youths busied themselves drawing from good paintings, others imitated in clay or wax the work of learned and excellent sculptors, and others worked hard to reproduce temples and ancient palaces on paper. . . . Many were dismayed by the greatness and difficulty of the enterprise, . . . but I can truthfully say that for a long time I was associated with the best and rarest draftsmen and painters of our times, and especially while in the studio of Rome.

Throughout the 16th century the whole of Rome was a 'studio'. As the study of antiquity took on a religious fervour, no other location offered such an abundance of Classical remains. The discovery of previously lost works, such as the *Laokoon* (Rome, Vatican, Cortile Belvedere) in 1506, intensified an already vigorous artistic climate. The practices of observing, measuring, drawing, excavating, reconstructing and collecting antiquities established in the 15th century burgeoned throughout the 16th. In 1548 Francisco de Holanda (1517–84) wrote in *Da pintura antigua* (1928, pp. 3–4), 'What immortal buildings or mighty statues of this city have I not stolen . . . on thin sheets of paper? What painting in stucco or grotesque is discovered in the grottoes and antiquities of Rome . . . but the best of them is sketched in my notebooks?' In his *Vite* Giorgio Vasari saw contemporary Roman artistic achievements as a response to antique art.

The developing public and private collections of antiquities became informal 'schools' for young artists who were inspired by Classical art (*see* §VII, 1 below). The collections of Paul II and Sixtus IV, notably the bronzes housed in the Palazzo dei Conservatori on the Capitoline Hill, were significant resources for artists. In 1503 Julius II (nephew of Sixtus IV) commissioned Donato Bramante to create the Cortile del Belvedere (*see* BRAMANTE, DONATO, fig. 5 and colour pl. 1, XVI1; *see also* §V, 1(iii)(a) and fig. 8 below) for the display of the Vatican's collection of antique sculpture. Other important private collections of antique sculpture frequented by artists were found in the palazzi of the Farnese, della Valle (see fig. 2), Cesi and Fusconi families and on the estate of Cardinal Rodolfo Pio da Carpi. To these displays of monumental sculpture must be added other collections of gems, coins and bronzes, as well as ancient paintings and the city's famous buildings,

2. *Courtyard of the Palazzo della Valle, Rome*, engraving after Maarten van Heemskerck, published by Hieronymus Cock, Antwerp, after 1553

all of which provided 16th-century artists with a source of forms, compositions and concepts.

Knowledge of Rome's antiquities was disseminated by means of copies, prints and sketchbooks; a bronze copy (1540) of the *Laokoon*, for instance, was commissioned by Francis I (*reg* 1515–47) for the château of Fontainebleau. Marcantonio Raimondi was one of a number of printmakers who popularized both ancient and contemporary art in Rome, while artists' sketchbooks, for example those of Amico Aspertini and Maarten van Heemskerck (1498–1574) and fig. 4 below), preserve invaluable 16th-century views of works of art and vistas in Rome (see fig. 16 below). In these ways the city became accessible even to those artists who could not visit it. But 16th-century art life in Rome was bound to the present as well as the past. The authority of enthusiastic patrons coincided and, at times, collided with the epic talent of artists whose grand conceptions guided an artistic golden age. Throughout the century artists working in Rome contributed to the definition of the High Renaissance and Mannerist styles. This contribution, which also affected the patronage system, the status of the artist and, by the end of the century, the formation of European art academies, was made amid the momentous and often tumultuous history of 16th-century Rome.

(i) 1503–49. Six popes ruled from 1503 to 1549; except for Adrian VI (*reg* 1522–3), they were the most significant patrons in Rome. The indomitable Julius II (*see* ROVERE, DELLA, (2)) furthered the aims of Sixtus IV in reforming Rome and aggrandizing the Vatican. In 1505 Michelangelo

was summoned to Rome to design a grand tomb for the pontiff (1545; Rome, S Pietro in Vincoli; *see* MICHELANGELO, §I, 1). A year later Bramante received his most important commission from the pope, namely the rebuilding of St Peter's; the foundation stone was laid for the new church in 1506 (*see* §V, 1(ii)(a) below). The works of Bramante (*see* BRAMANTE, DONATO, §I, 3), Michelangelo's Sistine Chapel Ceiling (see fig. 9 below and colour pls 2, V2–2, VI2) and Raphael's Vatican Stanze (see fig. 11 below and colour pl. 2, XXI1; *see also* RAPHAEL, fig. 4) reflected the heroic vision of Julius and the genius of their creators; the sublimity of the Roman High Renaissance style, which influenced artists throughout the century, resulted from the productive relationship between Julius II and these artists. Although papal patronage dominated the first half of the century, many private patrons, including women, also employed leading architects, artists and numerous craftspeople to build and decorate houses and to create objects of vertu. For example Agostino Chigi (*see* CHIGI, (1)) commissioned Baldassare Peruzzi (*see* PERUZZI, BALDASSARE, and fig. 1), Raphael (and assistants) and SEBASTIANO DEL PIOMBO to create a villa (1508–11; now Villa Farnesina) that was one of the finest examples of High Renaissance palazzo design and decoration.

Leo X (*see* MEDICI, DE', (7)) was a cultivated scholar and lavish patron; Leonardo may have begun his last painting, the *Virgin and Child with St Anne and a Lamb* (*c.* 1515; Paris, Louvre; *see* LEONARDO DA VINCI, fig. 5) in Leo's Rome. Raphael's artistic leadership was assured when he was appointed Superintendent of Antiquities and

Papal Architect in 1514. A member of Raphael's workshop, GIULIO ROMANO, gained increasing recognition. Leo X helped to increase the status of Renaissance artists when in 1520 he allowed the burial of Raphael in the Pantheon. Clement VII (see MEDICI, DE', (9)) continued the humanist and artistic patronage of his cousin, Leo X. BENVENUTO CELLINI was among the artists favoured with papal commissions. The *Vita di Benvenuto Cellini* (Cologne, 1728) remains a valuable source for understanding the production of art as well as the fierce competition and passionate intrigues of art life in Rome. It also describes the devastating Sack of Rome in 1527 by Emperor Charles V (*reg* 1519–58), an event that left the city impoverished, a physical and psychological shadow of its former self. The idealism of the High Renaissance style ended, challenged by the subjective aesthetic of Mannerism. Such artists as ROSSO FIORENTINO and PARMIGIANINO joined the exodus from the city, taking their Mannerist style across Europe.

The conjunction of the artistic climate of the Renaissance with an economic revival provided opportunities for artists and craftspeople, who permeated the whole of society throughout the 16th century. Before the Counter-Reformation, they enjoyed a fairly liberal and supportive environment; for example, in 1525 a papal tax levied on artists was opposed by the Roman Comune. Wealthier artists invested in real estate and obtained papal offices. Many of the most talented and influential artists from Italy and northern Europe studied or worked in Rome early in the century, including Galeazzo Alessi, Bartolomeo Ammanati, Baccio Bandinelli, Fra Bartolommeo, Domenico Beccafumi, Agnolo Bronzino, Girolamo da Carpi, Giovanni da Udine, Leone Leoni, Perino del Vaga, Pontormo, Pordenone, Guglielmo della Porta, Francesco Salviati, Antonio da Sangallo (ii), Andrea Sansovino, Jacopo Sansovino, Pellegrini Tibaldi, Titian, Giorgio Vasari and Jacopo Vignola. Thousands of artisans, many from northern Europe, worked in Rome in increasingly large numbers. They were involved in such activities as printing, tapestry weaving (see §IV, 1 below), embroidery and metalworking, and they contributed to the city's artistic and economic vitality.

In the second quarter of the century groups of artists began to gather to discuss the practice and theory of art. Such meetings of artists as those convened by Baccio Bandinelli in 1531 in the Cortile del Belvedere represented significant steps towards the development of art academies (see ITALY, fig. 42). The initially sporadic (but from 1533 permanent) presence of Michelangelo enhanced the intellectual ambience; Francisco de Holanda recorded erudite discussions between Michelangelo and Vittoria Colonna, who used to meet in 1538 in the cloister of S Silvestro al Quirinale (see de Holanda, 1928). As in other cities, guilds, societies and 'national' groups of artists, such as the Florentines, created the opportunity for collective community involvement. The Congregazione di S Giuseppe di Terra Santa alla Rotonda, for example, was a confraternity dedicated to St Joseph, founded in 1543 to promote charitable works and glorify religion through art. The membership of the confraternity, commonly called the Virtuosi al Pantheon, included most of the noted artists of the period.

The zeal of Paul III (see FARNESE, (1)) to reassert papal authority, introduce reform within the Church and revive Rome in the decades following the Sack was equalled by his enthusiastic patronage of the arts. Michelangelo had settled in Rome, and his pre-eminence was secured with the completion of the *Last Judgement* in the Sistine Chapel in 1541 (see §V, 1(iii)(b) below and colour pl. 2, VII3; see also MICHELANGELO, §I, 2) and various architectural works, such as the new St Peter's (from 1546; see §V, 1(ii)(a) below; see also MICHELANGELO, §I, 4). Michelangelo's architectural vocabulary introduced to Rome a new vitality and lucidity on a monumental scale.

(ii) 1550–1600. Art life in Rome during the second half of the 16th century responded to a complex network of diverse influences. The Sack of 1527 and the Counter-Reformation fed social and religious conservatism, although economic recovery in the later decades supported a renewed surge of building activity. The popes continued to be influential in matters of art, despite relatively brief reigns; 11 popes reigned from 1550 to 1605, facing the religious and political consequences of the continuing spread of Protestantism. Artistic licence was severely restricted by Paul IV (see CARAFA, (2)), who, among other intolerant acts, issued an *Index* of forbidden books; he also entrusted DANIELE DA VOLTERRA to conceal with painted drapery much of the aggressive nudity of the Sistine Chapel *Last Judgement*. This 'repainting', however, was carried out primarily during the reign of another stringent reformer, Pius V, by Daniele, Girolamo da Fano and Domenico Carnevali (*fl* 1553–75). The Counter-Reformation also affected the Vatican collection. Pius V sought to dispose of what were seen as the idols in the Cortile del Belvedere. He was dissuaded from this plan, but the Belvedere was closed to artists and public alike until his death.

Later popes proved less restrictive: GREGORY XIII and especially Sixtus V (see PERETTI, (1)) brought a new vitality to the Church and the city of Rome. Like his Renaissance predecessors, Sixtus V began to transform Rome into a majestic architectural and urban environment with the assistance of Domenico Fontana (1543–1607). Sixtus was also responsible for commissioning GIACOMO DELLA PORTA to complete the commanding dome of St Peter's. Members of the Vatican bureaucracy continued to be active patrons: such cardinals as Odoardo Farnese (see FARNESE, (5)) and Federico Borromeo were generous in their support of artists and artisans.

Antiquarianism remained a vital part of Rome's art experience; just after mid-century Pirro Ligorio completed extensive studies of the ruins of ancient Rome. Ligorio's own architectural and artistic designs, such as the gardens of the Villa d'Este at TIVOLI, built for Cardinal Ippolito II d'Este (see LIGORIO, PIRRO, fig. 2), and the Casino of Pius IV (1558; see LIGORIO, PIRRO, fig. 1) in the Vatican gardens (with ceiling paintings by Federico Barocci and Federico Zuccaro), revealed the influence of his studies. The work of Michelangelo and Raphael continued to influence later generations of artists. Taddeo Zuccaro, one of the most gifted painters of mid-16th century Rome, synthesized elements of their work (see fig. 3) with his early North Italian experience, evolving a unique Manner-

one Pulzone, Perino del Vaga, Cristoforo Roncalli (*c.* 1553–1626), Francesco Salviati, Giuseppe Valeriano, Otto van Veen (*c.* 1556–1629), Marcello Venusti and Enea Vico.

In the closing years of the 16th century art life in Rome centred on the newly formed Accademia di S Luca (*see* §VI below). Rome's foremost artists and architects were members of the Accademia, and its curriculum was the foundation of subsequent European art academies. Perhaps the best testament to the diversity of art life in Rome at the close of the century is the recognition that the Eternal City supported artists as different as Federico Zuccaro and Caravaggio (1571–1610), who had arrived by 1592. While Zuccaro was formulating his conviction of the divine nature of artistic creativity, Caravaggio was, in his own tempestuous way, drawing on the continuing fertility of art life in Rome and pushing forward with his insistent naturalism.

BIBLIOGRAPHY

G. B. Armenini: *De' veri precetti della pittura* (Ravenna, 1587; Eng. trans., New York, 1977)

B. Cellini: *Vita di Benvenuto Cellini* (Cologne, 1728); ed. O. Bacci (Florence, 1901); Eng. trans by J. A. Symonds, 2 vols (London, 1887); abridged by C. Hope and A. Nova as *The Autobiography of Benvenuto Cellini* (Oxford, 1983)

F. de Holanda: *Da pintura antigua* (1548); Eng. trans. of bk II as *Four Dialogues on Painting* (London, 1928)

R. Wittkower and M. Wittkower: *Born Under Saturn: The Character and Conduct of Artists. A Documented History from Antiquity to the French Revolution* (New York, 1963)

R. Klein and H. Zerner, eds: *Italian Art, 1500–1600: Sources and Documents* (Englewood Cliffs, NJ, 1966)

F. Hartt: *History of Italian Renaissance Art* (New York, 1969, rev. 4/1994)

S. J. Freedberg: *Painting in Italy, 1500–1600,* Pelican Hist. A. (Harmondsworth, 1971, rev. 3/1993)

C. L. Frommel: *Der römische Palastbau der Hochrenaissance* (Tübingen, 1973)

C. Gilbert: *History of Renaissance Art throughout Europe* (New York, 1973)

N. Pevsner: *Academies of Art: Past and Present* (New York, 1973)

P. Partner: *Renaissance Rome, 1500–1559* (Berkeley and Los Angeles, 1976)

F. Haskell and N. Penny: *Taste and the Antique: The Lure of Classical Sculpture, 1500–1900* (New Haven, 1981)

E. Olszewski: *The Draftsman's Eye: Late Italian Renaissance Schools and Styles* (Cleveland, 1981)

A. Chastel: *The Sack of Rome, 1527* (Princeton, 1983)

P. P. Bober and R. O. Rubinstein: *Renaissance Artists and Antique Sculpture: A Handbook of Sources* (London, 1986)

BERNARD SCHULTZ

IV. Centre of production.

The position of Rome as a centre of production declined after the transfer of the capital of the Roman Empire to Byzantium; when ceramics, metalworking, mosaic and other crafts and industries began to develop and expand during the Middle Ages and the Renaissance, they tended to do so in North Italian cities. Nevertheless, Rome did possess tapestry workshops, and it was known as well for its marble inlay and furniture designers.

1. Tapestry. 2. Marble inlay. 3. Furniture and design.

1. TAPESTRY. Documents indicate that tapestries were probably used on official occasions for the decoration of chapels and basilicas in Rome from early in papal history, although there are no records of actual tapestry weaving there until the 15th century. Nicholas V first attracted northern masters to Rome: in 1451 the Arras weaver

3. *Taddeo Zuccaro Copying the Last Judgement by Michelangelo*, copy after Federico Zuccaro, pen and ink and wash, 424×182 mm, 1550s (Florence, Uffizi, Gabinetto dei Disegni)

ist style suited to the conservative aims of the Counter-Reformation. His brother, Federico Zuccaro, later became one of Rome's dominant artists and personalities (*see* ZUCCARO, (2)). Other artists working in Rome from the mid-16th century included Cherubino Alberti, Giovanni Baglione (*c.* 1566–1643), Jacopo Bertoia, Jan Breughel I (1568–1625), the Cavaliere d'Arpino (1568–1640), Niccolo Pomarancio, Vincenzo Danti, Etienne Dupérac (*c.* 1525–1601), Battista Franco, Ambrigio Figino, Girolamo da Carpi, Girolamo Siciolante, Jacopino del Conte, Tommaso Laureti, Raffaellino da Reggio, Girolamo Muziano, Scipi-

Giachetto di Benedetto da Razzo (*fl* 1441–57) began weaving the *Life of St Peter* (destr.) in the city, and in 1455 the Paris master Renaud de Maincourt (*fl* 1451–7) also set up a workshop. Patronage continued briefly under Calixtus III, but both Benedetto da Razzo and Renaud left Rome the following year. Paul IV revived the idea of a papal factory and commissioned Jan Rost (*fl* 1535–64) to organize it in 1557–8; the Pope's death prevented its realization, however.

BIBLIOGRAPHY
J. Shearman: *Raphael's Cartoons in the Collection of Her Majesty the Queen and the Tapestries for the Sistine Chapel* (London, 1972)

CANDACE J. ADELSON

2. MARBLE INLAY. In the early 16th century in Rome the cult of the Antique gave rise to an intense campaign of archaeological excavations. These unearthed some admirable examples of intarsia decorations, including those of the Basilica of Junius Bassus. It was probably due to these discoveries and to the persistence in Rome of a tradition of marble craftsmanship that had survived through the Middle Ages that a vogue arose around the middle of the 16th century for polychrome marble inlay work (pietre dure), in both architecture and furniture. Documents show that Cosimo I ordered table-tops *ex-lapide mixto* from Rome, which in the mid-16th century seems to have been the main centre of trade in antique marbles and of interest in stone inlay work and its technical development. Giovanni Mynard (*d c.* 1582), known as 'Il Franciosino', was the most highly regarded marble inlay worker of the time and worked in Rome from at least 1552. He refused Francesco I de' Medici's invitation to visit Florence but accepted that of Catherine de' Medici to move to France.

In a letter written in 1555, the Florentine Bartolomeo Ammannati described 'great marble tables . . . with friezes around the edge in various mixed stones', which he had seen in Julius II's suburban villa on the Via Flaminia. Another table on three piers (New York, Met.) is attributed to Jacopo Vignola and is dated 1565 on the base. This table (formerly in the Palazzo Farnese, Rome) is notable for the subtly elegant design of its rectangular top, with a band of varied scroll ornaments symmetrically arranged around a central slab of alabaster. Made almost entirely of ancient marble spolia, with some inserts of precious stones, the Farnese table offers a firm point of reference for determining the Roman origin of other marble table-tops of similar design, with decorative motifs (scrolls, palmettes, small corollas) symmetrically arranged around a large central slab of a single material. This is the scheme followed, for example, in several table-tops in the Museo degli Argenti, Florence, and a great table with an oval centre in Spanish emerald, formerly in the Roman residence of Ferdinand I (all Florence, Pitti). Another table (Florence, Poggio Imp.) was mentioned in 1588 in the same residence. Among the archaeological marbles that form the geometrical design, this unique piece includes inserts of alabaster underneath which drawings in the style of Raphael's Roman followers can be seen.

Towards the end of the 16th century the use of Roman polychrome marble decoration was extended from furniture to architectural ornamentation; precious antique mar-

bles were used, for example, in the decoration of the Gregorian Chapel in St Peter's and the Sistine Chapel in S Maria Maggiore. Inlays not unlike those of many marble tables appear in the Aldobrandini Chapel in S Maria sopra Minerva, in the Altemps Chapel in S Cecilia in Trastevere and in the grandiose transept with the Altar of the Holy Sacrament in the Lateran basilica, ordered by Clement VIII, on which the intarsia artist Pompeo Targone worked. Another famous marble inlay workshop was that of Giovanni Battista della Porta, who in the early 1590s worked on the wall decorations of the Caetani Chapel in S Pudenziana, using a fine collection of ancient marbles and great inlaid vases that seem to prefigure the ones in the Principi Chapel, Florence.

BIBLIOGRAPHY
O. Raggio: 'The Farnese Table', *Bull. Met.*, xix (1960), pp. 213–31
U. Baldini, A. M. Giusti and A. Pampaloni Martelli: *La Cappella dei Principi e le pietre dure a Firenze* (Milan, 1979)
A. González-Palacios: *Mosaici e pietre dure*, ii (Milan, 1981), pp. 11–20
F. M. Tuena: 'Appunti per la storia del commesso romano: Il "Franciosino maestro di tavole" e il cardinale Giovanni Ricci', *Antol. B.A.*, 33–4 (1988), pp. 54–9
Splendori di pietre dure: L'arte di corte nella Firenze dei granduchi (exh. cat., ed. A. M. Giusti; Florence, Pitti, 1988–9), pp. 43–52
A. di Castro, P. Peccolo and V. Gazzaniga: *Marmorari e argentieri a Roma e nel Lazio tra Cinquecento e Seicento: I committenti, i documenti, le opere* (Rome, 1994)

ANNAMARIA GIUSTI

3. FURNITURE AND DESIGN. Roman furniture in the 15th century and early 16th does not display a distinctive character but was inspired by what was happening in other centres, especially Florence. For example, the doors of the loggias of Raphael at the Vatican were carved and inlaid in a purely Tuscan style by Giovanni Barile (*fl* 1514–29). Later in the 16th century Roman furniture evolved its own vocabulary, as exemplified in several chests bearing the coats of arms of the Colonna and Massimo families (e.g. Florence, Pitti; Rome, Gal. Colonna), which betray a return to Classical art in their carving, choice of subjects and sarcophagus shape.

BIBLIOGRAPHY
F. Passarini: *Nuovi inventioni di ornamenti d'architettura e d'intagli diversi* (Rome, 1698)
G. Lizzani: *Il mobile romano* (Milan, 1970)

DANIELA DI CASTRO MOSCATI

V. Buildings and monuments.

1. Vatican. 2. Lateran. 3. Il Gesù. 4. S Clemente. 5. S Maria Maggiore. 6. Palazzo della Cancelleria. 7. Palazzo Farnese.

1. VATICAN. The Vatican City, covering an area of less than half a square kilometre, was created an independent sovereign state under the terms of the Lateran Treaty of 1929. Surrounded by a high wall, it includes St Peter's Basilica, with its later piazza by Gianlorenzo Bernini (1598–1680), and the Vatican Palace and gardens, official residence of the pope and administrative centre of the state. Within the Vatican Palace are the world famous Vatican museums.

St Peter's Basilica, the most important church of Catholic Christendom, traditionally was first consecrated on 18 November AD 326, built above the tomb of the Apostle Peter. Lavishly decorated with frescoes, mosaics and papal monuments, it drew religious pilgrims from across Europe

and was the site of the crowning of Charlemagne (*reg* 768–814) as Holy Roman Emperor by Leo III (elected 795–816) in AD 800. The structural deterioration of Old St Peter's became a matter of urgency in the 15th century, and Nicholas V decided it would be rebuilt. Work was sporadic, however, until the reign of Julius II, under whom Bramante began dismantling (and greatly destroying) the old church in 1506. Succeeding popes and the artists they employed to continue work on the church proposed conflicting designs (Greek cross vs Latin cross), until in 1546 Michelangelo was summoned by Paul III; he decided to return to Bramante's original Greek-cross plan (see fig. 5 below), with daring modifications; nevertheless, in 1605 Paul V ordered that the nave be lengthened toward the Piazza S Pietro, ensuring that when the church was finally consecrated on 18 November 1626, it was in the form of a Latin cross.

The Vatican Palace began as a house built beside Old St Peter's, used for State occasions (e.g. by Charlemagne in 800) but not as the papal residence, which was the Lateran Palace. Repaired and restored by numerous popes, it became the residence of the pope under Gregory XI in 1378, on his return from Avignon. The house began its transformation into a palace in the 12th century and was complete by the papacy of Nicholas V in the mid-15th century, with additions by succeeding popes: Sixtus IV rebuilt the Sistine Chapel (1477–*c.* 1480); Alexander VI had the Appartamento Borgia decorated and added the Torre Borgia (late 15th century); Julius II began the formation of the Vatican's world-renowned collection of Classical sculpture in the early 16th century, exhibiting it in the Cortile del Statue leading to the Belvedere, now the Museo Pio-Clementino; and Leo X erected the Raphael loggia. □

(i) Old St Peter's. (ii) St Peter's. (iii) Palace.

(i) Old St Peter's. In AD 64 the Apostle Peter was buried on the north-west side of the Circus of Caligula and Nero, where there was already a cemetery. Owing to the circumstances of his death by crucifixion, St Peter's first burial-place would have been an earth tomb. Among the earliest sources, the late 2nd-century presbyter Gaius, quoted by Eusebios of Caesarea in the *Ecclesiastical History* (early 4th century), gives an account based on direct knowledge of the *tropaea*, or glorious burial-places, of both SS Peter and Paul (the latter now covered by S Paolo fuori le Mura). The exact locations must have been known in the early 4th century, when the emperor Constantine decided to build basilicas directly over the sites of their tombs. The basilicas were to be martyria, sanctuaries that enclosed the original burial-places and the Apostles' remains. Excavations in the grottoes beneath the present basilica of St Peter have confirmed the existence of a tomb early associated with the saint in a pagan–Christian necropolis. The *tropaeum* has been identified as a tabernacle composed of two superimposed niches, with, below them, a trench leading to the tomb itself. The lower niche survives in the present crypt of St Peter's, in the so-called Niche of the Pallium. During the 3rd century two walls were added north and south of it, the northern one bearing graffiti invoking St Peter. The basilica was built between *c.* 324

and 329–30 to provide a monumental superstructure for the memorial to the apostle and to encourage the practice of his cult. To accommodate the new building, it was necessary to bury the necropolis and to cut into the hillside to the north, with containing walls on the valley side.

(a) Architecture. (b) Decoration.

(a) Architecture. Although elements remain hypothetical, the appearance of Constantine's basilica can be reconstructed through documentary, archaeological, literary and graphic evidence (see fig. 4), in particular the plans drawn up by Bramante (*see* BRAMANTE, DONATO, §I, 3(ii)(b)) and Tiberio Alfarano (*fl* 1571–90) and the drawings of Domenico Tasselli (*fl c.* 1610) and Giacomo Grimaldi. Owing to the difficulties of the site, the church was occidented. It had a nave with four aisles, divided by rows of twenty-two reused ancient columns supporting a richly decorated architrave; the nave and each pair of aisles were separately roofed in timber, the nave being particularly well lit, with windows in the façade as well as in the side walls. There was a continuous transept at the west end, internally divided into three by colonnades, and terminating to north and south in projecting exedrae that were lower than the transept itself. The aisles ended in pairs of trabeated columns, but the nave opened to the transept through a triumphal arch. The building terminated to the west in a semicircular apse and to the east with the narthex. The façade was fronted by an atrium (*parodisus*), the entrance to which was approached by a flight of steps leading directly from the square in front of the church. Certainly by the 4th century a fountain stood in the centre of the atrium, with the *pigna*, the bronze pine-cone, crowned by an elegant canopy (Rome, Vatican, Cortile Pigna), all made of ancient materials.

The focal-point of the building was the memorial of the Apostle. The *tropaeum* was encased in a tabernacle in the form of a parallelepiped covered with slabs of Phrygian marble alternated with bands of porphyry. A small door or metal railings fixed to the front allowed worshippers to

4. Vatican, Old St Peter's, interior during rebuilding; drawing by Maarten van Heemskerck, pen and brown ink with grey-brown wash, 1534–6 (Berlin, Kupferstichkabinett)

catch a glimpse of the tomb and to lower into it small pieces of cloth or other objects that, through contact with the tomb, would themselves become relics. A bronze canopy placed above the tomb was supported by spiral columns that were brought by Constantine from Greece; these survive in the niches cut into the piers of the present dome.

The building was probably not finished until after Constantine's death in AD 337. Owing to its historical importance, it was frequently modified to suit changes in the cult and in aesthetic taste over the years, culminating in the rebuilding from 1506 (*see* §(ii)(a) below). Alterations were made throughout the Middle Ages. Pope Leo I decorated the façade; Symmachus (*reg* 498–514) built two reception halls next to the entrance steps. Over the centuries mausolea and other buildings were erected around the basilica; two early mausolea were converted to chapels dedicated to St Andrew (498–514) and St Petronilla (*c.* 757). Stephen II (*reg* 752–7) built the first bell-tower. Inside, the most significant change was made by the future Pope Gregory I, who constructed a confessio crypt around the saint's tomb and fixed the main altar directly over the shrine. Both interior and exterior were redecorated during the 13th century (*see* §(b) below).

Despite the modifications, however, Constantine's building maintained its structural integrity until the end of the Middle Ages. During the 15th century a new building was urgently needed, and Nicholas V, perhaps with the Holy Year of 1450 in mind, initiated plans to rebuild the church. Once the necessary emergency measures had been taken, Bramante began to demolish the old building in 1506, under Julius II. The last traces were cleared in 1608, when Carlo Maderno (1555/6–1629) began the new façade.

UNPUBLISHED SOURCES

Rome, Vatican, Bib. Apostolica, Archv Capitolare S Pietro, fols 10–13, 17 [drawings by Tasselli] (*c.* 1605)

BIBLIOGRAPHY

Eusebios of Caesarea: *Ecclesiastical History* (early 4th century); Eng. trans., ed. K. Lake, J. E. L. Oulton and H. J. Lawlor (London, 1926–32), i, p. 182

T. Alfarano: *De Basilicae Vaticanae antiquissima et nova structura* (*c.* 1570–82); ed. M. Cerrati (Rome, 1914)

G. Grimaldi: *Descrizione della basilica antica di S Pietro in Vaticano* (1613; Rome, Vatican, Bib. Apostolica, MS. Barb. Lat. 2733); ed. R. Niggl (Rome, 1972)

Liber Pontificalis, 3 vols (Paris, 1886–1957) [i–ii, ed. L. Duchesne (1886–92/*R* 1955); iii, ed. C. Vogel (1957)]

J. P. Kirsch: 'Beiträge zur Baugeschichte der alten Peterkirche', *Röm. Qschr.*, ii (1890), pp. 110–24

M. Armellini: *Le chiese di Roma dal secolo IV al XIX*, ed. C. Cecchelli, 2 vols (Rome, 1942)

F. W. Deichmann: *Frühchristliche Kirchen in Rom* (Basle, 1948)

B. M. Apollonj-Ghetti and others: *Esplorazioni sotto la confessione di San Pietro in Vaticano eseguite negli anni 1940–1949* (Rome, 1951)

G. H. Forsyth jr: 'The Transept of Old St Peter's at Rome', *Late Classical and Medieval Studies in Honor of A. Mathias Friend, Jr* (Princeton, 1955), pp. 56–70

J. Toynbee and J. Ward-Perkins: *The Shrine of St Peter and the Vatican Excavations* (London, New York and Toronto, 1956)

G. Matthiae: *Le chiese di Roma dal IV al X secolo* (Bologna, 1962)

J. Christern: 'Der Aufriss von Alt-St Peter', *Röm. Qschr.*, lxii (1967), pp. 133–83

G. Bovini: *Edifici cristiani di culto d'età constantiniana a Roma* (Bologna, 1968)

J. Christern and K. Thiersch: 'Der Aufriss von Alt-St Peter', *Röm. Qschr.*, lxiv (1969), pp. 1–34

J. C. Picard: 'Le Quadriportique de Saint-Pierre-du-Vatican', *Mél. Archéol. & Hist.: Ecole Fr. Rome*, lxxxvi/1 (1974), pp. 851–90

H. Geertmann: *'More veterum': Il 'Liber Pontificalis' e gli edifici ecclesiastici di Roma nella tarda antichità e nell'alto medioevo* (Groningen, 1975)

R. Krautheimer and others: *Corpus basilicarum christianarum Romae*, v (Rome, 1977) [with early sources]

R. Krautheimer: *Rome: Profile of a City, 312–1308* (Princeton, 1980)

S. de Blaauw: *Cultus et decor* (Slochteren, 1987)

A. Arbeiter: *Alt-St Peter in Geschichte und Wissenschaft: Abfolge der Bauten, Rekonstruktion, Architekturprogramm* (Berlin, 1988)

C. Pietrangeli, ed.: *La basilica di San Pietro* (Florence, 1989)

MARIO D'ONOFRIO

(b) Decoration. The chief source of information on the decoration of Old St Peter's is the manuscript prepared by the archivist Giacomo Grimaldi (1613; Rome, Vatican, Bib. Apostolica, MS. Barb. Lat. 2733). This records the state of the old basilica at a time when the west end had already been demolished and the decision had been made to tear down what remained. Much of the dating evidence is based on inscriptions that no longer survive (De Rossi, 1857–85).

The decoration of the original apse, almost 18 m wide and 10 m deep, was attested by an inscription referring to the completion of the basilica by Constantine and his son. Depending on which son is intended, this dates the original mosaic to between AD 337 (death of Constantine) and 340–61. It was restored by Pope Severinus (*reg* 640) and completely remade by Innocent III in the early 13th century.

The state of this mosaic in 1592 was recorded in a drawing (Rome, Vatican, Bib. Apostolica, Archv Capitolare S Pietro, Album, fol. 50) made by Grimaldi for Clement VIII. It shows a composition arranged in two registers. Above was *Christ Enthroned*, his right hand raised in blessing and his left supporting a closed book resting on his thigh. He was flanked by standing figures of *St Paul* (left) and *St Peter* (right), both identified by inscriptions in Latin and Greek, and by texts on the scrolls each held in his left hand. At the top of the composition was the *Hand of God*. The figures were set against a starry sky, in a landscape with animals, rustic scenes and small architectural structures, bounded at left and right by two large trees. In the centre of the foreground was depicted a hill from which issued the four rivers of Paradise, with stags drinking from them. Grimaldi recorded and reproduced other works of importance in the atrium of the basilica, including Giotto's *Navicella* mosaic of *c.* 1310, of which only two angels survive (Boville Ernica, nr Frosinone, S Pietro Ispano; Rome, Grotte Vaticane); the mosaic within the portico of St Peter's is a poor copy.

BIBLIOGRAPHY

G. B. De Rossi: *Inscriptiones christianae urbis Romae septimo saeculo antiquiores*, 2 vols (Rome, 1857–85, 2/1915)

——: *Mosaici christiani: Saggi dei pavimenti delle chiese di Roma anteriori al secolo XV* (Rome, 1872–99)

S. Bettini: *Pitture delle origini cristiane* (Novara, 1942)

G. Matthiae: *Mosaici medioevali delle chiese di Roma* (Rome, 1967)

T. C. Bannister: 'The Constantinian Basilica of St Peter at Rome', *J. Soc. Archit. Hist.*, xxvi/1 (1968), pp. 3–32

G. Bovini: *Mosaici paleocristiani di Roma* (Bologna, 1971)

RONALD BAXTER

(ii) St Peter's.

(a) Architecture. (b) Decoration.

(a) Architecture.

Before 1504. When, after the return from Avignon, the Vatican became the papal residence (*see* §(iii) below), St Peter's acquired the character of a palace church. The building was in urgent need of renovation, owing to the imminent Holy Year (1450), lack of space and deterioration of the structure. NICHOLAS V, probably with the collaboration of Leon Battista Alberti, included St Peter's in his building projects for the whole city, envisaging a reorganized piazza in front of the church, with the Vatican obelisk on the central axis, and an extension of the basilica to the west. An extended transept with squared ends was to be built to the west of the old nave and aisles, the nave width serving as the module for the square of the crossing; this dimension also consequently applied to the long, apsidal-ended arm of the choir. The tomb of St Peter would have lain under the domed crossing. Thus the numerous clergy could be located in the choir and the streams of pilgrims granted better access to the grave site. The extension was conceived in the manner of ancient bath buildings. These provided the model for the columns that, at least in the transept, articulate the massive wall and carry the groin vaults; barrel vaulting was envisaged for the choir. The mighty extension would have stood in extreme contrast, in both dimensions and structure, to the fragile nave and aisles of the Early Christian basilica, which presumably was also meant to be replaced by a monumental vaulted structure.

Work began in 1452 under Bernardo Rossellino (*see* ROSSELLINO, (1), §2). It continued until the Pope's death in 1455 and was briefly resumed under Paul II; only the choir foundations were executed. Nevertheless, Nicholas's project remained important as the first attempt in post-medieval Rome to build a large-scale building based explicitly on Classical architecture and intended to compete with older, ambitious ecclesiastical buildings in Milan, Bologna and Florence. Apart from the general effect on Roman church architecture, certain elements of the planning and the foundation walls had a lasting influence on the subsequent building history of St Peter's.

1505–90. The project was resumed by Julius II in connection with his tomb (*see* ROVERE, DELLA, (2)). Bramante was hired to begin a radical reconstruction (*see* BRAMANTE, DONATO, §I, 3(ii)(b)), and intensive planning by Bramante, Giuliano da Sangallo and Fra Giovanni Giocondo preceded the laying of the foundation stone on 18 April 1506. Bramante's first design—unique in its inventiveness—envisaged a centralized building erected on a Greek-cross plan, with a dominating main dome and four subsidiary ones (Florence, Uffizi, 1A; see fig. 5). The completely symmetrical plan is inscribed within a square, the angles of which are accentuated by corner towers. Only the apsidal ends of the cross arms, squared externally with masonry, project beyond them. The mass of the wall, articulated by pilasters, seems to have been extensively hollowed out by a series of niches. An important innovation was the extension of the dome area into the cross arms by bevelling the piers towards the centre. The design was developed into a structurally realizable second draft (Florence, Uffizi, 20A) after further planning (Florence, Uffizi, 7945A) and criticism by Giuliano da Sangallo (Florence, Uffizi, 8A). This second design again envisaged a centrally disposed group of main and subsidiary domes; but the building was extended by spacious ambulatories round the choir and transepts and a nave and aisles towards the east. The change of plan from a centralized to a longitudinal building therefore must have been made by Bramante himself before the foundation stone was laid. Eventually only the piers (much reduced) and arches of the dome were completed, along with the choir; this

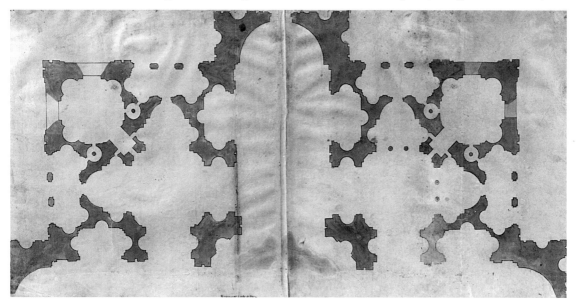

5. Vatican, St Peter's; plan for first design by Donato Bramante, brown ink and orange-ochre wash on parchment, 1506 (Florence, Galleria degli Uffizi, Uff. 1A)

element was erected above Nicholas V's foundations at the request of Julius, who wanted to place his tomb in it. The choir as built could not, however, be integrated structurally with further plans for the church, and from 1585 to 1587 it was demolished in favour of Michelangelo's project (see below). Preliminary studies and views show that the main elevation, under the influence of such ancient precursors as the Pantheon and the Basilica of Maxentius was articulated by enormous semicircular windows, which were to be framed by colonnades bearing an entablature. The uncanonical external articulation with Doric pilasters resulted from the existing wall projections of the earlier choir foundations; in consequence, the layout of the triglyphs was idiosyncratic and unclassical. The interior was decorated with Corinthian pilasters on the model of the Pantheon. The coffered barrel vaulting (1514) was interrupted by window penetrations, and the apse terminated by a shell calotte.

It is uncertain how Bramante's scheme for the longitudinal extension of the nave and aisles was to be completed. Frommel (1976 and 1977) suggested that Bramante produced a reduced plan in 1506 for the financially hard-pressed Pope of transepts without ambulatories, as in the choir, and an aisled nave of three bays. When Fra Giocondo and Sangallo joined Bramante after Julius's death in 1513, under Leo X, the three men extended the plan to include a double-aisled nave with side chapels and ambulatories round the transepts. Metternich and Thoenes (1987), however, argued that this large-scale project (Florence, Uffizi, 7A and 9A; Rome, Vatican, Bib. Apostolica, MS. Barb. Lat. 4424, fol. 64v) was envisaged by Bramante already in 1506.

After Bramante's death in 1514, and on his recommendation, the young Raphael assumed overall charge of the project (see RAPHAEL, §I, 2(ii)), along with the experienced Fra Giocondo, and with Giuliano da Sangallo as second architect. Fra Giocondo added the southern sacristy to Bramante's choir fragment. Raphael, however, envisaged subsidiary domes at this point and proposed the demolition of Bramante's choir. Antonio da Sangallo (ii), trained on the site under Bramante, assisted Raphael from the departure of Fra Giocondo and Giuliano in 1515. Three stages may be reconstructed for Raphael's plan, which was closely related to Bramante's large-scale design, projecting a composite building with transept ambulatories and a five-bay nave and aisles. Alternatives mainly involved the nature of the façade and the articulation of the exterior. Here Raphael abandoned Bramante's giant pilasters in favour of small Doric half-columns alternating with small aediculae. From 1519 the south choir ambulatory and the pilaster articulation of the pier niches were built, together with the coffered barrel vaulting between the north-west dome pier and its counter-pier to the south-west.

After Raphael's death in 1520, Antonio da Sangallo (see SANGALLO, (4)) assumed the supervision of the building works, with Baldassare Peruzzi as second architect. Sangallo criticized Raphael's scheme in the so-called *Memoriale* (see Giovannoni) and was asked for new plans. He eventually decided on a longitudinal building, but Peruzzi designed numerous variations on a centralized theme, among them a perspective sectional drawing (*c.* 1534; Florence, Uffizi, 2A) and the plan published by Sebastiano

Serlio (Book IV). By starting the ambulatories from the main piers, he reverted to Bramante's original ideas. The most essential characteristic of Sangallo's richly varied alternative schemes is the substitution of a series of domes for the continuous barrel vault in the nave.

The last substantial revision was prepared by Antonio in the form of a costly wooden model (1539–46; Rome, Vatican, Mus. Stor. A. Tesoro S Pietro). Many designs have survived from these years, but owing to the poor financial situation of the papacy and the Sack of Rome in 1527, very little was actually built. Nevertheless, the counter-piers with their pilaster decoration were erected in the south transept, and important, enduring interventions by Sangallo are represented by the closing up of the large pier niches and, in particular, the raising of the floor level by about 3.5 m. As a result of this the pedestals of the pilasters articulating the walls were omitted, and the delicate proportions of the entire building were impaired. Sangallo's wooden model took these alterations into account. It shows a centralized building once again barrel-vaulted over a Greek-cross plan with ambulatories, connected to the distant two-tower façade by a vaulted hall open at the sides, producing a clear directionality. A steeply raised drummed dome crowns the church. The exterior design envisaged, above the Doric order begun by Raphael, a fenestrated intermediate zone, closed off by an arcade of piers faced with Ionic half columns. This motif, derived from the Colosseum, continues in the two-storey drum zone. Although the articulation follows strictly Vitruvian rules, its intricate detail and innumerable pinnacle-like pyramids produce an almost Gothic effect.

The appointment of Michelangelo after Sangallo's death in 1546 prevented this monstrosity from being executed (see MICHELANGELO, §I, 4). His new design, as presented in the engravings (1569) by Etienne Dupérac (see fig. 6), took the form of a centralized building over a Greek cross, in front of which was to be a ten-column portico façade with a pedimented, four-column central projection. Although the absence of ambulatories markedly diminished the extent of the building in plan, the powerful modelling of the exterior wall articulation, with a giant order of pilasters, endowed it with impressive clarity and grandeur. After the demolition (1548–9) of the south ambulatory already erected by Raphael and Antonio da Sangallo (ii), Michelangelo built the south cross-arm (1551–8), followed in the 1560s by the north arm. The external articulation of pairs of colossal Corinthian pilasters alternating with aediculae and smaller niches is in keeping with the structural system of the mass of the building, articulated by curves, chamfers and salient angles. Formally, it was inspired by Bramante's choir, which was still standing. The attic of the south arm was intended to be quite plain and thus divided the main body of the building optically from the dome. Only the windows of the apsidal calotte broke through the smoothly finished attic zone, reflecting outwards through their skewed reveal the coffered vault within, as shown in an anonymous engraving (1564; New York, Met.) published by Vincenzo Luchino (*fl* 1552–66).

From the outset, Michelangelo's drawings show his concern with the problem of the dome. His early designs are reminiscent of Brunelleschi's dome for Florence Cathedral (see BRUNELLESCHI, FILIPPO, fig. 1), but, as exe-

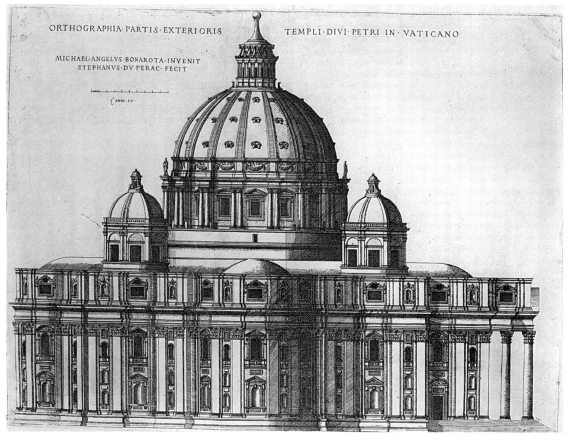

6. Vatican, St Peter's, façade, as designed by Michelangelo; engraving by Etienne Dupérac, from Antoine Lafréry: *Speculum romanae magnificentiae*, iii (1569), pl. 24 (New York, Metropolitan Museum of Art)

cuted, the dome is very substantially articulated (wooden model, 1558–61; Rome, Vatican, Mus. Stor. A. Tesoro S Pietro). It has a cylindrical drum, articulated three-dimensionally by the alternation of windows and powerful buttresses faced with paired columns. Above them, volutes in the attic lead up to the double-shell dome, crowned by a lantern. Only the drum had been executed, as far as the entablature, by the time of Michelangelo's death in 1564. The inner shell of the dome was intended to be semicircular, the outer one slightly stilted.

In 1564 Pirro Ligorio and Jacopo Vignola took over supervision. Although Pius IV instructed that Michelangelo's plans were to be carried out unaltered, controversy immediately arose. On his own initiative, Ligorio completed the attic articulated by pilasters and decorated niches, as it is seen today, and was hence demoted. By designing towering subsidiary domes not envisaged by Michelangelo, Vignola modified the paramount importance of the main dome, as shown by Dupérac. Vignola's successor, Giacomo della Porta, built the smaller domes above the Gregorian and Clementine chapels to his own designs (before 1585 and 1593–1600, respectively). Under his supervision, Bramante's choir was demolished to make way for the western arm of Michelangelo's plan. From 1588 to 1593, together with the engineer Domenico Fontana (1543–1607), della Porta vaulted the dome, which

he markedly stilted on the basis of Michelangelo's model. By raising the apex by some 8 m, he gave the inner shell an ovoid form (*see* PORTA, GIACOMO DELLA, §3). Compared to Michelangelo's broad dome, this created a much steeper effect for the outer shell. The dome of St Peter's, which dominates the cityscape, was widely emulated in Rome, and it was freely imitated in numerous ecclesiastical buildings in Europe.

BIBLIOGRAPHY

GENERAL

M. Ferrabosco: *Libro de l'architettura di San Pietro nel Vaticano* (Rome, 1620); ed. G. B. Costaguti (Rome, 1684)

C. Fontana: *Il tempio Vaticano e sua origine con gli edifici più conspicui antichi e moderni* (Rome, 1694)

H. von Geymüller: *Die ursprünglichen Entwürfe für St. Peter in Rom*, 2 vols (Paris, 1875)

C. A. Jovanovits: *Forschungen über den Bau der Peterskirche zu Rom* (Vienna, 1877)

P.-M. Letarouilly: *Le Vatican et la basilique de Saint-Pierre de Rome*, 2 vols (Paris, 1878–82; Eng. trans., London, 1963)

K. Frey: 'Zur Baugeschichte des St. Peter: Mitteilungen aus der Reverendissima Fabbrica di S Pietro', *Jb. Kön.-Preuss. Kstsamml.*, xxxi (1911), pp. 1–95; xxxiii (1913), pp. 1–153; xxxvii (1916), pp. 22–136 [suppl. vols]

D. Frey: *Bramantes St. Peter-Entwurf und seine Apokryphen* (Vienna, 1915)

O. Pollak: 'Ausgewählte Akten zur Geschichte der römischen Peterskirche, 1535–1621', *Jb. Kön.-Preuss. Kstsamml.*, xxxvi (1915), pp. 21–117 [suppl.]

T. Hofmann: *Entstehungsgeschichte des St. Peter in Rom* (Zittau an der Saale, 1928)

T. Magnusson: 'Studies in Roman Quattrocento Architecture', *Acta U. Upsaliensis: Figura*, 9 (1958) [whole issue]

C. Galassi-Paluzzi: *S Pietro in Vaticano*, Chiese di Roma, lxxiv–lxxviii (Rome, 1963)

C. Thoenes: 'Studien zur Geschichte des Petersplatzes', *Z. Kstgesch.*, xxvi (1963), pp. 97–145

G. Urban: 'Zum Neubau-Projekt von St. Peter unter Papst Nikolaus V.', *Festschrift für Harald Keller* (Darmstadt, 1963), pp. 131–73

F. Graf Wolff Metternich: *Die Erbauung der Peterskirche zu Rom im 16. Jahrhundert* (Vienna, 1972)

C. Galassi-Paluzzi: *La basilica di S Pietro* (Bologna, 1975)

C. L. Frommel: 'Die Peterskirche unter Julius II. im Licht neuer Dokumente', *Röm. Jb. Kstgesch.*, xvi (1976), pp. 57–136

F.-E. Keller: 'Zur Planung am Bau der römischen Peterskirche im Jahre 1564–1565', *Jb. Berlin. Mus.*, xviii (1976), pp. 24–56

E. Francia: *1505–1606: Storia della costruzione del nuovo San Pietro* (Rome, 1977)

L. H. Heydenreich: *Studien zur Architektur der Renaissance: Ausgewählte Aufsätze* (Munich, 1981), pp. 43–7, 180–86

C. Thoenes: 'St Peter: Erste Skizzen', *Daidalos*, v (1982), pp. 81–98

M. Guarducci: *San Pietro in Vaticano* (Rome, 1983)

C. L. Frommel: 'San Pietro: Storia della sua costruzione', *Raffaello architetto* (exh. cat., ed. C. L. Frommel, S. Ray and M. Tafuri; Rome, Pal. Conserv., 1984), pp. 241–310

F. Graf Wolff Metternich and C. Thoenes: *Die frühen St.-Peter-Entwürfe, 1505–1514*, Röm. Forsch. Bib. Hertziana, xxv (Tübingen, 1987); review by H. Hubert in *Z. Kstgesch.*, liv (1990), pp. 226–39

C. Thoenes: 'S Lorenzo a Milano, S Pietro a Roma: Ipotesi sul "piano di pergamena"', *A. Lombarda*, 86–7 (1988), pp. 94–100

H. Saalman: 'Die Planung Neu St. Peters: Kritische Bemerkungen zum Stand der Forschung', *Münch. Jb. Bild. Kst*, xl (1989), pp. 102–40

C. L. Frommel: 'San Piero', *Rinascimento: Da Brunelleschi a Michelangelo—la rappresentazione dell'architettura*, ed. H. Millon and V. M. Lampugnani (Milan, 1994), pp. 399–423

SPECIALIST STUDIES

J. Coolidge: 'Vignola and the Little Domes of St. Peter's', *Marsyas*, ii (1942), pp. 63–123

G. Giovannoni: *Antonio da Sangallo il giovane* (Rome, 1959)

R. Wittkower: *La cupola di S Pietro di Michelangelo* (Florence, 1964)

C. Thoenes: 'Bemerkungen zur Petersfassade Michelangelos', *Munuscula discipulorum: Festschrift für Hans Kauffmann* (Berlin, 1968), pp. 331–41

H. Millon and C. H. Smyth: 'Michelangelo and St. Peter's, I: Notes on a Plan of the Attic as Originally Built in the South Hemicycle', *Burl. Mag.*, cxi (1969), pp. 484–501

F. Graf Wolff Metternich: *Bramante und St. Peter* (Munich, 1975)

H. Saalman: 'Michelangelo: S Maria del Fiore and St. Peter's', *A. Bull.*, lvii (1975), pp. 374–409

H. A. Millon and C. H. Smyth: 'Michelangelo and St. Peter's: Observations on the Interior of the Apses, a Model of the Apse Vault, and Related Drawings', *Röm. Jb. Kstgesch.*, xvi (1976), pp. 137–206

C. L. Frommel: '"Capella Julia": Die Grabkapelle Papst Julius II. in Neu St. Peter', *Z. Kstgesch.*, xl (1977), pp. 26–62

A. Bruschi: 'Problemi del S Pietro bramantesco', *Saggi in onore di Guglielmo De Angelis d'Ossat* (Rome, 1987), pp. 273–90

H. Hubert: 'Bramantes St. Peter-Entwürfe und die Stellung des Apostelgrabes', *Z. Kstgesch.*, li (1988), pp. 195–221

H. A. Millon and C. H. Smyth: *Michelangelo architetto: La facciata di San Lorenzo e la cupola di San Pietro* (Milan, 1988), pp. 91–184

C. Thoenes: 'I tre progetti di Bramante per S Pietro', *Quad. Ist. Stor. Archit.*, n. s., 15–20 (1990–92), pp. 439–46

H. Hubert: 'Bramante, Peruzzi, Serlio und die Peterskuppel', *Z. Kstgesch.*, lxi (1992), pp. 353–71

——: C. Thoenes: 'Neue Beobachtungen an Bramantes St-Peter-Entwürfe', *Münch. Jb. Bild. Kst*, xlv (1994), pp. 103–10

C. L. Frommel: 'Il San Pietro di Nicolò V', *Quad. Ist. Stor. Archit.*, xxv–xxx (1995–7), pp. 103–10

H. Günther: 'Als wäre die Peterskirche mutwillig in Flammen gesetzt: Zeitgenössische Kommentare zum Neubau der Peterskirch und ihre Maßstäbe', *Münch. Jb. Bild. Kst*, xlv (1997), pp. 67–112

HANS HUBERT

(b) Decoration.

Before 1504. Little of the 15th-century decoration of St Peter's has survived; most of the monuments were moved to the Grotte Vaticane, transferred to other churches or left dismantled in the so-called octagons of the basilica. The oldest surviving monument is the large bronze door made by Filarete (*see* FILARETE and fig. 1), which was moved to its present position in St Peter's in 1619. It is signed *Ant[o]nius Petri de Florentia* and dated *Die ultima Iuli 1445* on the right-hand valve, on the back of which is an image of the sculptor and his assistants. The decorative frieze shows Greek myths curiously mingled with episodes from Roman history and characters drawn from the fables of Phaedrus and Christian iconography.

The influential tomb of *Eugenius IV* (?before 1453; Rome, S Salvatore in Lauro) was executed by Isaia da Pisa in the form of an architraved cell with a conch-shaped top. Eugenius's nephew, Cardinal Pietro Barbo (later Paul II), commissioned Isaia da Pisa to create the altar of SS Peter and Paul (1451); the relief of the *Virgin*, traditionally known as the Orsini *Madonna* (Rome, Grotte Vaticane), has been plausibly attributed to this commission. Also in the Grotte Vaticane are the surviving fragments of the tomb of *Nicholas V*, which was modelled on that of Eugenius but executed by a less talented local sculptor.

Two large statues depicting *St Peter* and *St Paul* (both 1461–2; Rome, Vatican, Aula del Sinodo), attributed to Paolo Romano and his workshop, were carved for the steps of the basilica. In collaboration with Isaia da Pisa he also created the S Andrea Chapel (1463–4); fragments of the saint's tabernacle survive in the Grotte Vaticane. The complex monument to *Pius II* (1470–75) was erected in the S Andrea Chapel and rebuilt (1605) in S Andrea della Valle, next to the very similar tomb of *Pius III* (1503). It is thought that the former was designed by Paolo Romano and completed after his death by Nicolò della Guardia and Pietro Paolo da Todi.

The most grandiose tomb was that of *Paul II* (1474–7; fragments in Paris, Louvre; Rome, Grotte Vaticane), designed, according to Vasari, by Mino da Fiesole and Giovanni Dalmata (*c.* 1440–after 1509). Above and behind the sarcophagus and effigy was a relief of the *Resurrection*, above which was the *Last Judgement* in a lunette, the whole surmounted by the *Eternal Father in Glory*, while the base had images of *Faith*, *Hope* (signed by Dalmata) and *Charity* (signed by Mino), alternating with the *Creation of Eve* and the *Tree of Life*.

An imposing ciborium (1470s; dismantled 17th century) built for the main altar incorporated corner reliefs, attributed to Paolo Romano, of the *Trials of SS Peter and Paul* (Rome, Grotte Vaticane) taken from a simpler ciborium commissioned *c.* 1460–64 by Pius II. The other reliefs were carved in the 1470s, perhaps by a Florentine sculptor associated with Bernardo Rossellino.

The tombs of *Sixtus IV* (1493; Rome, Vatican, Mus. Stor. A. Tesoro S Pietro) and *Innocent VIII* (completed 1598; Rome, Vatican, St Peter's) were both designed by Antonio Pollaiuolo (*see* POLLAIUOLO, (1), §3); the latter is the only tomb that was reinstated in St Peter's (*see* INNOCENT VIII). Michelangelo's marble *Pietà* (1498–1500; *see* MICHELANGELO, fig. 1) was commissioned for the rotunda of S Petronilla; in 1749 it was moved to the first chapel to the right of the entrance.

1504 and after. Until the third quarter of the 16th century, while building work on the new basilica continued

(see §(a) above), most of the few decorative commissions were intended for temporary arrangements. A series of small painted altarpieces was needed, for example, after the so-called 'temporary wall' was built and the altars in the transept area were moved. These included Ugo da Carpi's *St Veronica* (*c.* 1524–7) and the *Virgin and Child with SS Anne, Peter and Paul* (Rome, St Peter's, Sagrestia dei Canonici), now generally attributed to Jacopino del Conte. The *Feed My Sheep* (1574; destr. 1608) by Donato da Formello and Riccardo Sassi (*fl* 1573–99), over the central portal, was among the works lost with the demolition of Constantine's basilica. The tomb of *Paul III*, commissioned from Guglielmo della Porta *c.* 1547 (*see* PORTA, DELLA, (3)), was permanently erected *c.* 1629 with fewer allegorical figures than originally intended.

A mosaic workshop was established by Gregory XIII to carry out the decorative programme. Technical innovations developed here included the use of oil putty, which allowed longer periods for the application of the tesserae. The cupola of the chapel of Gregory XIII was decorated (1578–80) to designs by Girolamo Muziano, assisted by Cesare Nebbia and Paolo Manenti. The mosaic decoration of the central dome began under Clement VIII: the *Evangelists* (1598–1600) in the pendentives are by Giovanni de' Vecchi and Nebbia, and the angels on the sides by Cesare Roncalli.

BIBLIOGRAPHY

F. R. Difederico: *The Mosaics of Saint Peter's: Decorating the New Basilica* (University Park, PA, 1983)

For further bibliography see §(ii)(a) above.

FABRIZIO MANCINELLI

(iii) Palace. After their exile in Avignon, the popes moved their official residence to the Vatican from the old Lateran Palace (*see* §2 below), which had been badly damaged during their absence (*see* §II, 2 above). Since then, the Vatican has served primarily as the official and administrative seat of the popes and as their private living quarters. The secretary of state, high-ranking prelates and numerous court officials also live there. Many important architects were involved in expanding the papal residence into a huge palace providing the accommodation necessary for the enactment of papal ceremonial (e.g. the Sala Regia, Sala Ducale, Cappella Magna, Cappella Parva, Camera Paramenti and Camera Papagalli), government affairs, the administration of justice and the various court offices. The building's history, architecture and, not least, its incomparable artistic furnishings, supplemented by inscriptions, views and vast archival material on the palace's origins, role, history and function, have conferred on it a unique historical and art-historical importance. As the most important secular building in Rome, it was a frequent source of inspiration and had particular influence on the Mannerist architecture of villas and palazzi in Rome and other Italian cities.

(a) Architecture. (b) Decoration.

(a) Architecture. The Vatican Palace comprises an enormous, extremely irregular complex of buildings successively appended to one another (see fig. 7). The range of

buildings, which cannot be seen in its entirety from any one point, is some 460 m in length and roughly 230 m at its widest, spreading northwards from St Peter's over the uneven terrain of the Vatican Hill. The relatively insignificant main entrance (Portone di Bronzo; 7a) is located on the Piazza S Pietro, where the north colonnade meets an enclosed passageway. The Scala Regia (7b), a continuation of the passageway, leads into the oldest, southernmost part of the palace, an irregular building consisting of four wings around an inner courtyard (Cortile del Pappagallo; 7c). This is linked with the Belvedere (7d) at the northernmost point of the complex by Bramante's Cortile del Belvedere (see fig. 8 below; *see also* BRAMANTE, DONATO, fig. 5 and colour pl. 1, XVI1), an extended court with several terraces, enclosed on both of its long sides by gallery-like corridors several storeys high (7e). To the south-east it joins the loggia architecture of the Cortile di S Damaso (7f), which leads across to the blocklike palace built by Sixtus V (7g); these are the only two elements of the palace that can be seen from the Piazza S Pietro.

The earliest, unpretentious buildings in the vicinity of St Peter's Basilica are mentioned in mid-5th-century documents from the reign of Leo I (elected 440–61). Excavations have revealed the remains of the Carolingian *triclinium* of the palace, lying south of the church and dating from the pontificates of LEO III (elected 795–816) and Gregory IV (*reg* 827–44). Leo IV (*reg* 847–55) fortified the whole hill area (the Città Leonina) by building a wall around it as protection against the Saracens; papal buildings later spread on to the hilly ground north of the basilica, a strategically more advantageous position.

The *palatium novum*, with aula and loggia, built by Eugenius III (*reg* 1145–53) on the north side of the atrium of St Peter's, is thought to have been the origin of the present residence. Innocent III (*reg* 1198–1216) rebuilt Eugenius's 'palace' and extended it into a genuine residence by means of *domus novae* and business and administrative buildings. According to A. M. Voci (1992), he also established the first palace chapel, the predecessor of the current Sistine Chapel (*see* §(b) below). The donjon with a tower, previously associated with Innocent IV (*reg* 1243–54), may also date from the time of Innocent III. Nicholas III, whose family (the Orsini) owned the Castel Sant'Angelo, which controlled the only crossing of the Tiber, had a passageway built linking his castle with the Vatican Palace; he also laid out gardens protected by walls with watch-towers, eventually enabling the forerunner of the Belvedere to be built in a protected position on the highest point at the north of the site. Nicholas also enlarged the existing buildings on the hill, erecting another chapel (the Cappella Parva or chapel of S Niccolò; destr.) and the north-east wing of the palace, with monumental storeys and loggias that overlooked the surrounding area.

Urban V (*reg* 1362–70) completely renovated the palace when he returned from Avignon. A wooden loggia overlooking the Piazza S Pietro, from which the Pope could give his blessing, is also attested from this period. It is assumed that Boniface IX (*reg* 1389–1404) had the palace extended by adding a great hall (the Sala dei Pontefici) to the north. Extensive renovations were initiated in the reign of NICHOLAS V, probably acting on the advice of Leon Battista Alberti (*see* §(ii)(a) above). A residence with four

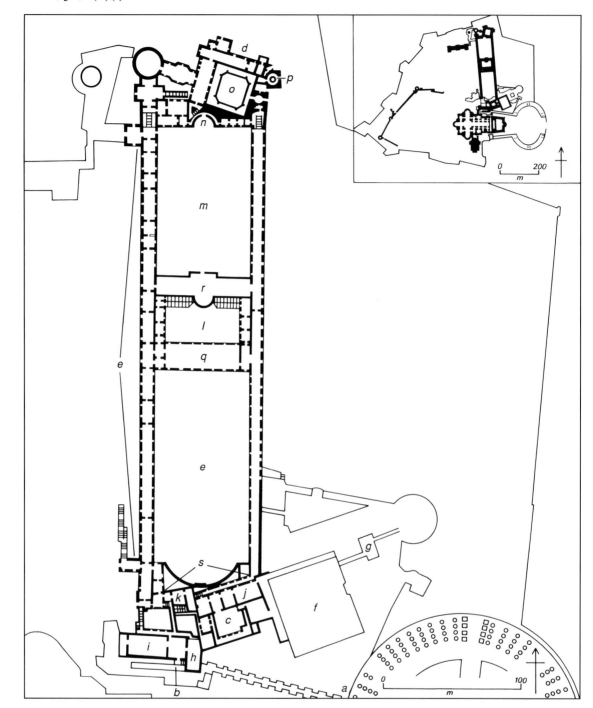

7. Vatican Palace, plan: (a) Portone di Bronzo; (b) Scala Regia; (c) Cortile del Pappagalli; (d) Belvedere; (e) Cortile del Belvedere; (f) Cortile di S Damaso; (g) palace of Sixtus V; (h) Sala Regia; (i) Sistine Chapel; (j) palace of Nicholas V; (k) Torre Borgia; (l) Cortila della Biblioteca; (m) Cortile della Pigna; (n) exedra; (o) Cortile Ottagono; (p) spiral staircase; (q) Sistine Salon; (r) Braccio Nuovo; (s) papal apartments

wings and an inner courtyard was projected, but all that was completed before the Pope's death was the three-storey north wing with a few staterooms (7j), and the fortified wall with its round tower shielding the palace's secret garden on the north-east side.

In 1460 Pius II started work, employing FRANCESCO DEL BORGO to renew the atrium front with a benediction loggia that dominated the whole of the Piazza S Pietro; in front of it was a broad, external flight of steps. Of the eleven arcades planned, only the four at the north end were executed; the third storey was not added until the early 16th century. The motif of arcades with half columns,

as used in the Colosseum, was here copied for the first time in a monumental style.

Paul II constructed a small courtyard loggia on the south side of the Cortile del Maresciallo, which was altered by Paul III (see below). Sixtus IV established the public library (*see* MELOZZO DA FORLÌ, fig. 1), renovated the large palace chapel (7i) and started work on a crenellated wing some 75 m long on the north side of the atrium containing the Sacra Rota audience hall; this was completed by his successor, INNOCENT VIII, who also constructed the Villa di Belvedere (completed 1487 by Giacomo da Pietrasanta) on the most northerly of the Vatican hills, looking on the Monte Mario. The main storey of the Belvedere, set on a high substructure, has an arcaded loggia articulated by pilasters, above which is a mezzanine floor with a crenellated parapet. Alexander VI added the massive Torre Borgia (7k) to provide the missing corner tower of the four-wing palace (*see* BORGIA, (2)).

For Julius II (*see* ROVERE, DELLA , (2)), who wanted to link the range of buildings near St Peter's with Innocent VIII's Belvedere, Bramante designed the Cortile del Belvedere, an enormous courtyard framed by parallel loggias of brick (completely altered; *see* BRAMANTE, DONATO, §I, 3(ii)(a) and fig. 5; see also colour pl. 1, XVI1). The hilly terrain was originally laid out in three tiered terraces, linked by stairs and ramps (see fig. 8). One of the uses of the lower courtyard (see fig. 7e above) was as the setting for plays and tournaments, while the broad steps served as seating for the audience. The loggias, three storeys high at the lowest point, were enclosed and structurally reinforced with boldly projecting buttresses. Only the topmost corridor carries on to the more elevated Cortile della Pigna (7m). The courtyard walls are articulated by a Classical order of superimposed pilasters in travertine marble; the external façade is undecorated.

Until it was later altered (see below), the focal-point of the longitudinal axis was a large exedra at the northern end (7n) with semicircular steps in convex and concave curves. Behind, and set at an angle, is the Cortile Ottagono (7o), intended for Julius's collection of antiquities. This leads to the Belvedere, which can also be entered by a spiral staircase (that can be negotiated on horseback) built on to the exterior in 1510 (7p). This stair is ornamented

8. Vatican, Cortile del Belvedere by Donato Bramante; drawing attributed to Giovanni Battista Naldini, pen and brown ink, 1558–61 (Florence, Galleria degli Uffizi, Uff. 2559 A)

with 36 free-standing columns; the four orders are disposed in an alternating manner from Tuscan to Corinthian. The south side of the courtyard was formed by the slanting outside wall of the papal palace with the Torre Borgia, which was not positioned axially. Bramante capped this tower with an octagonal cupola (1510). He also proposed (Florence, Uffizi, 287A) a spacious council hall, a round chapel constructed on top of Nicholas V's tower and riding stables east of the Belvedere, but these were never built.

Despite later drastic alterations, this range of buildings, partly inspired by the newly discovered Domus Aurea and the Temple of Fortuna in Praeneste (now Palestrina), substantially determined the appearance of the palace and embodied Julius's imperial pretensions. Bramante and his successor, Raphael, replaced the medieval garden loggia on the Cortile di S Damaso with a wide, four-storey loggia façade. In 1516 Raphael installed an apartment with a bathroom and a richly decorated, west-facing loggia for Cardinal Bernardo Bibbiena.

Paul III employed Baldassare Peruzzi and Antonio da Sangallo (ii) to complete the unfinished parts of the east gallery (*see* FARNESE, (1)), although Bramante's wall articulation was not retained, and the superimposed Classical orders were altered. Antonio da Sangallo together with Jacopo Meleghino also regularized and renovated the Scala Regia and the state apartments (Sala Ducale, Sala Regia; 7h). He demolished the medieval chapel of S Niccolò to make room for the broader steps from the Cortile del Maresciallo, replacing the old chapel with the Pauline Chapel (completed 1540). Under Julius III, Girolamo da Carpi added a storey to the great exedra at the north side of the Cortile della Pigna, and Michelangelo replaced Bramante's flight of circular stairs in the exedra with a double ramp.

In 1558 Pirro Ligorio started to build a villa for Paul IV in the secluded slopes west of the Cortile del Belvedere. The building was completed under PIUS IV and named after him; it consists of a pavilion and a loggia linked by a transverse oval courtyard. The whole group is over-lavishly decorated with stucco, mosaics and shells (*see* LIGORIO, PIRRO and fig. 1). In 1560 Ligorio started work, based on Bramante's proposals, on the three-storey corridor wall at the western side of the Cortile del Belvedere and vaulted over Bramante's exedra at the Belvedere end with a large calotte (1562) topped by a semicircular peristyle structure. Ligorio's architectural alterations show his interest in archaeology and antiquity and do not always fit in happily with Bramante's strict Classical architecture. An exception is the faithful copy of the Bramante–Raphael loggias on the north side of the Cortile di S Damaso. This was begun in 1563 and continued by Martino Longhi the elder; the loggias and the apartment behind were completed *c.* 1577. The top gallery of the western Belvedere corridor, the Galleria delle Carte Geografiche, was finally completed after 1578 by Ottaviano Mascherino for GREGORY XIII. Mascherino planned a large, two-storey exedra at the south end of the courtyard, corresponding with the northern focal point, but only the first storey was built. Facing the gardens he also built a tower observatory, the Torre dei Venti (1576–9).

BIBLIOGRAPHY

A. Taja: *Descrizione del Palazzo Apostolico Vaticano* (Rome, 1750)

G. P. Chattard: *Nuova descrizione del Vaticano*, 3 vols (Rome, 1762–7)

P.-M. Letarouilly: *Les Bâtiments du Vatican* (Paris, 1882/*R* London, 1963)

W. Friedländer: *Das Kasino Pius des Vierten* (Leipzig, 1912)

E. Panofsky: 'Die Scala Regia im Vatikan und die Kunstanschauungen Berninis', *Jb. Preuss. Kstsamml.*, xl (1919), pp. 241–78

F. Ehrle and H. Egger: *Der vatikanische Palast in seiner Entwicklung bis zur Mitte des 15. Jahrhunderts*, Stud. & Doc. Stor. Pal. Apostol. Vatic., ii (Rome, 1935)

J. Hess: 'Le logge di Gregorio XIII: L'architettura ed i caratteri della decorazione', *Illus. Vatic.*, vi (1935), pp. 1270–75

——: 'La Bibliotheca Vaticana: Storia della costruzione', *Illus. Vatic.*, ix (1938), pp. 233–41

J. S. Ackerman: 'Bramante and the Torre Borgia', *Rendi. Pont. Accad. Romana Archeol.*, xxv–xxvi (1949–51), pp. 247–65

——: 'The Belvedere as a Classical Villa', *J. Warb. & Court. Inst.*, iv (1951), pp. 70–91

——: *The Cortile del Belvedere*, Stud. & Doc. Stor. Pal. Apostol. Vatic., iii (Rome, 1954)

T. Magnusson: 'The Project of Nicholas V for Rebuilding the Borgo Leonino in Rome', *A. Bull.*, xxxvi (1954), pp. 89–115

A. M. Frutaz: *Il Torrione di Niccolò V. in Vaticano* (Rome, 1956)

E. Battisti: 'Il significato simbolico della Cappella Sistina', *Commentari*, viii (1957), pp. 96–104

T. Magnusson: *Studies in Roman Quattrocento Architecture* (Rome, 1958)

J. Wasserman: 'The Palazzo Sisto V in the Vatican', *J. Soc. Archit. Hist.*, xxi (1962), pp. 25–35

C. L. Frommel: 'Antonio da Sangallos Cappella Paolina: Ein Beitrag zur Baugeschichte des Vatikanischen Palastes', *Z. Kstgesch.*, xxvii (1964), pp. 1–42

J. Hess: 'La Biblioteca Vaticana: Storia della costruzione', *Kunstgeschichtliche Studien zu Renaissance und Barock*, 2 vols (Rome, 1967), i, pp. 143–52, 163–79

D. Redig de Campos: *I palazzi vaticani*, Roma Cristiana, xviii (Bologna, 1967)

H. H. Brummer: *The Statue Court in the Vatican Belvedere* (Stockholm, 1970)

C. W. Westfall: *In this Most Perfect Paradise: Alberti, Nicholas V, and the Invention of Conscious Urban Planning in Rome, 1447–1455* (University Park, PA, 1974)

——: 'Alberti and the Vatican Palace Type', *J. Soc. Archit. Hist.*, xxxiii (1974), pp. 101–21

C. L. Frommel: 'Bramantes "disegno grandissimo" für den Vatikanpalast', *Kstchronik*, xxx (1977), pp. 63–4

——: 'Francesco del Borgo: Architekt Pius' II. und Pauls I.', *Röm. Jb. Kstgesch.*, xx (1983), pp. 107–54

K. B. Steinke: *Die mittelalterlichen Vatikanpaläste und ihre Kapellen: Baugeschichtliche Untersuchung anhand der schriftlichen Quellen*, Stud. & Doc. Stor. Pal. Apostol. Vatic., v (Rome, 1984)

C. Pietrangeli, ed.: *Il palazzo apostolico vaticano* (Florence, 1992)

A. M. Voci: *Nord o sud? Note per la storia del medioevale 'Palatium Apostolicum apud Sanctum Petrum' e delle sue cappelle* (Rome, Vatican, 1992)

C. L. Frommel: 'I tre progetti bramanteschi per il Cortile del Belvedere', *Il Cortile delle Statue: Der Statuenhof des Belvedere im Vatikan: Akten des internationalen Kongresses zu Ehren von Richard Krautheimer: Rome, 1992* (Mainz, 1998), pp. 17–66

F. E. Keller: 'Die Umwandlung des Antikengartens zum Statuenhof durch das architektonische Ornament Pirro Ligorios', *Il Cortile delle Statue: Der Statuenhof des Belvedere im Vatikan: Akten des internationalen Kongresses zu Ehren von Richard Krautheimer: Rome, 1992* (Mainz, 1998), pp. 411–20

HANS HUBERT

(b) Decoration.

Sistine Chapel. Dedicated to the Assumption of the Virgin, the Vatican Palace Chapel was created to meet the requirements of the ceremonial calendar of the pope and his court, and the conclave for the election of a new pope is still held there. The present structure is a palimpsest, created by the remodelling carried out under Sixtus IV, after whom it is named (*see* ROVERE, DELLA, (1)). Up to the level of the windows it incorporates the perimeter

walls of a large palace chapel, first mentioned in documents from 1368, which was probably built after Urban V's return to Rome from Avignon. None of the old chapel's decoration survives, but documents indicate that in 1369 an important project was carried out there by Giottino (*fl* mid-14th century), Giovanni da Milano (*fl c.* 1346–69) and others, including frescoes of the *Four Evangelists*.

Sixtus IV began the reconstruction of the chapel in early 1477 and entrusted the project to Giovannino de' Dolci (*d* before 1486) as 'superstans sive commissarius fabrice palaci apostolici'. According to Sixtus's secretary, Andrea da Trebisonda, the architectural work, including the replacement of the original coffered wooden ceiling with the present low barrel vault, continued throughout the conflict with Florence; thus it must have been finished around the end of 1480 (see fig. 9).

The pictorial decoration began immediately on the altar wall. Its execution, following a plan that was later extended to all the chapel walls, was entrusted to Perugino and his workshop (*see* PERUGINO, §I, 2). At the top were portraits of the *First Four Popes*, in the centre the *Nativity* and the *Finding of Moses*, and at the lowest level two painted draperies framing a frescoed altarpiece depicting the *Assumption of the Virgin*. The ceiling, the lunettes below (which were also ornamented in some way) and probably the whole series of popes also must have been finished or near completion by the autumn of 1481. The ceiling decoration is known from a wash drawing (Florence, Uffizi) by Piermatteo d'Amelia (*c.* 1450–1503/8) and from Vasari. The first four scenes of the *Life of Christ* on the north wall were already painted by 17 January 1482, on

9. Vatican, Sistine Chapel, interior looking west, rebuilt 1477–80

which date they formed the basis of a settlement fixing a payment of 250 scudi per painted section. The programme for each section was to include two popes, a narrative scene and painted drapery below.

The contract for the remaining ten scenes from the *Lives of Moses and Christ* was signed on 17 October 1481 by Cosimo Rosselli, Botticelli, Domenico Ghirlandaio and Perugino, who undertook, with the help of their bottegas, to complete the work by 15 March 1482, with a penalty of 50 ducats if they failed to meet the deadline. The work was probably coordinated by Perugino, who was the first artist to work on the project and is the only one whose signature appears (*Opus Petri Perusini Castro Plebis*) on one of the frescoes, namely on the frame of the *Baptism*, but the overall decorative plan may be the work of Melozzo da Forlì.

Of the narrative scenes, Perugino painted the *Journey of Moses*, the *Baptism* (see PINTURICCHIO, BERNARDINO, §1) and *Christ Giving the Keys to St Peter* (see PERUGINO, fig. 1). Botticelli painted the *Flight of Moses from Egypt*, the *Temptations of Christ* (see colour pl. 1, XIII2) and the *Punishment of Korah*, while Rosselli painted the *Giving of the Law*, the *Sermon on the Mount* and the *Last Supper*. Ghirlandaio (see GHIRLANDAIO, (1), §I, 2(i)(b)) was responsible for the *Calling of SS Peter and Andrew* and the *Resurrection*, which was completely repainted between 1571 and 1575 by Hendrik van den Broeck (c. 1530–97). The *Crossing of the Red Sea* (see colour pl. 2, XXV2) is thought by some critics to be a collaboration between Rosselli and Ghirlandaio, while others attribute it to Ghirlandaio and his workshop. The papal portraits were painted by Perugino, Botticelli, Rosselli and Ghirlandaio. (The portraits of *Marcellus* and *Sixtus I* are unattributable, as they were completely repainted in the 16th and the 20th century, respectively.)

Despite the heavy penalty, the decoration was not completed by the signatories of the contract, and perhaps not within the stipulated time: the last scenes, the *Testament of Moses* (originally assigned to Perugino) and the *Dispute over the Body of Moses* (completely repainted by Mateo Pérez de Alesio in 1571) were actually the work of Luca Signorelli, who had earlier collaborated with Perugino on *Christ Giving the Keys to St Peter* (see SIGNORELLI, LUCA, §I). Work continued well beyond the spring of 1482, at least in regard to the Cosmatesque mosaic pavement and Mino da Fiesole's reliefs on the chancel railing (moved to its present position perhaps in the late 1550s).

The chapel was used for the first time on 9 August 1483, the anniversary of the election of Sixtus IV. In May 1504 a large diagonal crack split the ceiling, causing such serious damage that the chapel could not be used for half the year. Julius II's plans to commission Michelangelo to redecorate the ceiling were first spoken of in 1506, but work did not begin until 10 May 1508 (*see* MICHELANGELO, §I, 2). The initial contract specified 12 *Apostles* in the pendentives and, on the rest of the surface, 'a certain division filled with adornments'. Later, as Michelangelo felt that the plan was a 'poor thing', the Pope told him to do whatever he liked in the ceiling and to carry the decoration 'down to the histories on the lower part'. The sum agreed for the first project was 3000 ducats; the exact fee for the second is not known, but Michelangelo said that it 'came to roughly the same'.

In the centre of the ceiling are nine scenes from Genesis: five, beginning from the altar wall, are dedicated to the Creation: the *Division of Light from Darkness*, the *Creation of Heavenly Bodies and Vegetation* (see MICHELANGELO, fig. 5), the *Separation of the Waters*, the *Creation of Adam* (see colour pl. 2, V2) and the *Creation of Eve*. The *Fall and Expulsion*, serves as a cesura, and *Noah's Sacrifice*, the *Flood* and the *Drunkenness of Noah* close the sequence near the entrance wall. At the side of the smaller panels he painted pairs of *Nudes*, with chiaroscuro medallions and festoons of oak-leaves, a reference to the punning arms of the della Rovere family; in the pendentives, instead of the Apostles, are seven *Prophets* and five *Sibyls* (see colour pls 2, VI2 and 2, VI1). In the lunettes and spandrels are groups of Christ's ancestors, while in the large corner spandrels are four miraculous salvations of the elect: *Judith and Holofernes*, *David and Goliath*, the *Chastisement of Haman* and the *Brazen Serpent*.

Between May and July 1508 a suspended scaffold was erected that allowed the chapel to be used for services, the existing plaster was removed, and the floating coat applied. Decoration began in the autumn with the central framework and the *Flood*. Michelangelo called a series of assistants from Florence, mostly pupils of Ghirlandaio, including Francesco Granacci, Giuliano Bugiardini, Bastiano da Sangallo, Agnolo di Domenico di Donnino (1466–1513) and Iacopo di Sandro (*fl* 1500–54); the last left the project in January 1509 and was replaced by Jacopo di Lazzaro di Pietro Torni (1476–1526). Beginning with the *Fall and Expulsion* Michelangelo drastically reduced the number of assistants, limiting them to the purely decorative parts, and carried on the work practically alone. By August 1510 he had finished half the ceiling, including the lunettes, up to the *Creation of Eve*. Julius's departure for Bologna delayed the work because Michelangelo had no money and needed approval to continue. When Julius returned the scaffold was dismantled, and on 15 August 1511 he was shown the painted half and gave his consent to continue. Work resumed with the *Creation of Adam*, probably in October, and Vespers was finally celebrated in the newly decorated chapel on 31 October 1512.

Michelangelo's frescoes made an enormous impression on contemporary artists, notably Raphael and the so-called Florentine Mannerists. The chapel was further enriched under Leo X, who in 1515 (or a little earlier) commissioned Raphael to provide cartoons for ten tapestries illustrating the *Acts of the Apostles* (seven now in London, V&A; *see* RAPHAEL, fig. 5), executed between June 1515 and October 1516; the tapestries (Rome, Vatican, Gal. Arazzi) were woven in the workshop of Pieter van Edingen Aelst (*d* after 1532 and exhibited for the first time at the pontifical mass of 26 December 1579.

Clement VII first discussed the commission for the *Last Judgement* with Michelangelo in September 1533, although the project actually started in April 1535 under Paul III; painting began in the late spring or early summer of 1536. The work (see colour pl. 2, VII3) was unveiled in 1541, arousing great wonder and admiration but also disputes, for all the previous decoration of the altar wall had been demolished, including two lunettes Michelangelo had painted in 1512 and Perugino's *Assumption*. The position of the Virgin alongside Christ in Judgement was

iconographically irregular, as was the representation of the *Last Judgement* behind the altar; Clement VII had expressly specified this as a warning of punishment for the Sack of Rome (1527) and an indication of his horror and anguish at the changing times.

In his representation of the theme Michelangelo was accused of paganism, and the painting provoked violent reactions even during its execution: Michelangelo punished the papal Master of Ceremonies, Biagio da Cesena, who had made particularly sharp criticisms, by depicting him as Minos. Pietro Aretino, whose iconographic plan Michelangelo had rejected, was later savagely critical. Under Paul IV, there was even talk of destroying the work, and finally, on 21 January 1564, the Congregation of the Council of Trent decided to censor it. In 1565 Daniele da Volterra frescoed the first *braghe* (breeches) and repainted the whole of *St Blaise* and part of *St Catherine*. When Daniele died, Girolamo Gambatelli continued his work, painting the first of the numerous *braghe* in tempera; others were added in later centuries. Immediately after the intervention of Daniele and Gambatelli, the ceiling was restored by Domenico Carnevali (*fl* 1553–75) and the walls beside the entrance by Hendrik van den Broeck and Mateo Pérez de Alesio (*c.* 1545–50–?1616). Under Urban VIII the chapel was restored (1623–8) by Lagi, and under Clement XI by Giuseppe Mazzuoli, between 1710 and 1712.

The *Last Judgement* does not seem to have been touched on these occasions, although Paul III appointed a *mundator* (cleanser) as early as 1542. The plaster was repaired in 1903 by Ludovico Seitz and during the 1920s and 1930s by Biagio Biagetti (1877–1948). Work in the late 20th century included the cleaning of the *Lives of Moses and Christ* (1964–74), the frescoes on the entrance wall (1979–80), the series of popes and Michelangelo's frescoes in the lunettes (1980–84), the ceiling (1985–90) and the *Last Judgement* (1990–93).

BIBLIOGRAPHY

E. Steinmann: *Die sixtinische Kapelle*, 2 vols (Munich, 1901–5)

D. Redig de Campos: *Il giudizio universale di Michelangelo* (Rome, 1944)

C. de Tolnay: *Michelangelo: The Sistine Ceiling* (Princeton, 1945)

R. Salvini and E. Camesasca: *La Cappella Sistina in Vaticano* (Milan, 1965)

Michelangelo e la Sistina: La tecnica, il restauro, il mito (exh. cat., Rome, Vatican, Braccio Carlo Magno, 1990)

P. Crenshaw: 'Face to Face with the Last Judgment', *A. & Ant.*, xvii/4 (April 1994), pp. 81–3

C. Gilbert: *Michelangelo: On and Off the Sistine Ceiling: Selected Essays* (New York, 1994)

C. Pietrangeli and others: *Sistine Chapel: A Glorious Restoration* (New York, 1994)

M. Franklin: 'Forgotten Images: Papal Images in the Sistine Chapel', *A. Crist.*, lxxxix/775 (July–Aug 1996), pp. 263–9

FABRIZIO MANCINELLI

Papal apartments. Only slight traces remain of the decoration of the medieval papal apartments: friezes with griffins and plant motifs (*c.* 1277–80), originally in the Sala della Falda and the bedchamber of Nicholas V (now Rome, Pin. Vaticana), fragmentary frescoes from the same period in the first-floor room of the Torre Innocent III, and 13th-century frescoes in the hollow space above the wooden ceiling of the Sala dei Chiaroscuri and the Sala Vecchia degli Svizzeri.

There is more extensive surviving evidence of the 15th-century decoration, including the *Lives of SS Stephen and Lawrence* (1448–9) by Fra Angelico in the chapel of Nicholas V (see ANGELICO, FRA, §I, 4 and fig. 6). The only remaining frescoes in Nicholas's apartment on the second floor are fragments of a frieze with allegorical figures, still *in situ* above the ceiling of the Sala Vecchia degli Svizzeri (*see* NICHOLAS V). Nothing remains of the paintings said by Vasari to have been produced by Piero della Francesca in one of the 'secret' (private) rooms, probably the Stanza di Eliodoro (see below).

The 'secret' rooms of the first-floor Appartamento Borgia were decorated for Alexander VI (*see* BORGIA, (2)) between 1492 and 1495 by PINTURICCHIO and his workshop, including Pietro d'Andrea da Volterra and Antonio del Massaro (*c.* 1450–1516), known as il Pastura. The lunettes in the Sala delle Sibylle and the Sala del Credo bear, in the former, paired sibyls and prophets and in the latter, prophets and apostles holding scrolls with lines from the Credo. The first room in the Nicholas V wing, the Sala delle Arti Liberali, was used as a study and dining-room. There Pinturicchio and his workshop painted the seven personifications of the *Liberal Arts*. Pinturicchio's hand is perhaps most evident in the Sala dei Santi, where he painted the *Martyrdom of St Sebastian*, *Susanna and the Elders*, the *Life of St Barbara*, *St Catherine of Alexandria Disputing with Pagan Philosophers before the Emperor Maximian*, the *Visit of St Anthony Abbot to St Paul the Hermit* and the *Visitation*. In the vault, following a programme devised by Antonio del Massaro, he painted the myths of *Isis and Osiris* and *Io and Argos*. The series ends in the Sala dei Misteri della Fede: the *Annunciation*, *Nativity*, *Adoration of the Magi*, *Resurrection* (see fig. 10), *Ascension*, *Pentecost* and *Assumption of the Virgin*.

The present decoration of the more 'official' rooms of the Appartamento Borgia dates from much later. The Sala dei Pontefici was frescoed by Perino del Vaga and Giovanni da Udine for Leo X, while the Galleriola (Audience Chamber) dates from the time of Gregory XIII (*reg* 1572–85). The adjacent room (now the Sala dei Paramenti) has, in the centre of the carved and gilded ceiling, a canvas by Girolamo Muziano depicting the *Pentecost* (1576–7).

Julius II moved the papal apartments to the upper floor in 1507 (*see* ROVERE, DELLA, (2)). The decoration of the 'secret' rooms was first entrusted to a team including SODOMA, Bramantino and Perugino, but in 1508 the young RAPHAEL took over and instituted a completely new programme, destroying most of the pre-existing decoration. The first room to be frescoed was the Pope's study (now the Stanza della Segnatura), done by Raphael almost single-handedly between 1508 and 1511. The iconographic programme, possibly planned by Egidio da Viterbo (1469–1532), illustrates the Neoplatonic idea of the three most important concepts of the human spirit: the True, the Good and the Beautiful. Supernatural Truth is illustrated by the *Triumph of the Church* (the *Disputà*); rational Truth by the *School of Athens* (see ITALY, fig. 15). The *Virtues* and the *Giving of the Civil and Canonical Laws* represent the Good, while the Beautiful finds expression in the scene of *Parnassus* (see colour pl. 2, XXI1). Closely linked with the themes of the wall frescoes are those of the ceiling, where the tondi contain depictions of *Theology*,

10. Vatican, Sala dei Misteri della Fede, fresco of *Alexander VI*, detail from the *Resurrection* by Pinturicchio, 1492–4

Philosophy, *Justice* and *Poetry*. The central octagon, by Bramantino, survives from the earlier decoration, while the chiaroscuros on the lower walls were painted by Perino del Vaga under Paul III.

Between 1512 and 1514 the Stanza di Eliodoro, the vestibule of the 'secret' rooms, was decorated by Raphael with the aid of a few assistants, including Giovan Francesco Penni. Here the programme is political, documenting God's protection of the Church when it is threatened in its patrimony (the *Expulsion of Heliodorus*; see fig. 11), in the faith (the *Mass of Bolsena*), in its seat (the *Meeting of Leo the Great with Attila*) and in the person of the pontiff (the *Liberation of St Peter*). The four Old Testament scenes in the ceiling, by Raphael himself, reflect the impression made on him by the recent unveiling of the Sistine ceiling.

Between 1514 and 1517 frescoes were painted in the Stanza dell'Incendio, which Leo X used as an everyday dining-room (*see* MEDICI, DE', (7)): the *Fire in the Borgo* (*see* RAPHAEL, fig. 4, as well as FRESCO, figs 1 and 2) refers to the will for peace of Leo X; the hidden theme of the *Coronation of Charlemagne*, who has the features of Francis I, King of France (*reg* 1515–47), is the Bolognese concordat between France and the Church; the *Justification of Leo III* alludes to the Lateran Council of 1516, and the *Battle of Ostia* to the plan for a crusade against the Turks. These were largely executed by Raphael's workshop although under the strict control of the master. The ceiling frescoes, commissioned by Julius II in an earlier phase of decoration *c.* 1508, depict allegories of the *Trinity* (*see* PERUGINO, §I, 5).

The Sala di Costantino (1517–24) and the Sala dei Chiaroscuri (formerly the Sala del Pappagallo), although partly designed by Raphael, were painted after his death. The former room, which later served for official receptions and ceremonies, contains the *Vision of Constantine* and the *Battle of the Milvian Bridge* (*see* GIULIO ROMANO, §I, 2(i)), while Penni painted the *Baptism* and the *Donation of Constantine*. The latter room was decorated under Clement VII with images of the *Apostles*; it was later restored several times, in particular by Taddeo and Federico Zuccaro. In the Sala Vecchia degli Svizzeri, which was the atrium of the papal apartment, nothing remains of the frescoes painted for Julius II and Leo X. The present decoration, with 15 allegorical figures of *Virtues* (1582) was painted by Jacopo Zucchi, Giovanni Battista Lombardelli (*d* 1592), Paris Nogari (*c.* 1536–1601), Antonio Tempesta, Giacomo Stella (*c.* 1545–1630) and the Cavaliere d'Arpino (1568–1640), under the supervision of Marco da Faenza (*d* 1588). However, the frescoes in the loggias that linked the different areas and levels of the official wing of the building date from the papacy of Leo X. Raphael decorated the second loggia (*see* GROTESQUE, fig. 1) between 1518 and 1519 with the aid of Giulio Romano, Penni, Perino del Vaga, GIOVANNI DA UDINE, POLIDORO DA CARAVAGGIO and others; Giovanni da Udine completed the first loggia in 1519 and decorated the third between 1560 and 1564.

The public audience halls on the first floor took their final shape between the pontificates of Paul III and

11. Vatican, Stanza di Eliodoro, fresco of *Raphael, Marcantonio Raimondi and Julius II*, detail from the *Expulsion of Heliodorus* by Raphael, 1512

12. Rome, Lateran Palace and benediction loggia, by Domenico Fontana, 1585–90; view from the north-west

Gregory XIII. The *aula magna vel prima* (the Sala Regia) was frescoed by Vasari (1571–3; *see* VASARI, (1), §I, 3), Lorenzo Sabatini, Giuseppe Salviati, Livio Agresti (*c.* 1508–79), Giovanni Maria Zoppelli, Girolamo Siciolante (for discussion and illustration *see* SICIOLANTE, GIROLAMO) and Federico and Taddeo Zuccaro, with stuccowork (1542–9) by Perino del Vaga and Daniele da Volterra. The *aula secunda* and the *aula tertia*, which make up the present Sala Ducale, were decorated by Matteo da Siena (1533–88), Girolamo Gambatelli, Domenico Carnevali (*fl* 1553–75) and others.

BIBLIOGRAPHY
F. Ehrle and E. Stevenson: *Gli affreschi del Pinturicchio nell'appartamento Borgia del palazzo apostolico vaticano* (Rome, 1897)
F. Ehrle and H. Egger: *Der vatikanische Palast in seiner Entwicklung bis zur Mitte des XV. Jahrhunderts* (Rome, 1935)
D. Redig de Campos: *I palazzi vaticani* (Bologna, 1967)
J. Shearman: 'The Vatican Stanze: Function and Decoration', *Proc. Brit. Acad.*, lviii (1972), pp. 369–424

FABRIZIO MANCINELLI

2. LATERAN. Situated near the Porta S Giovanni, the Lateran is a complex comprising the former papal palace, and two buildings dating from the reign of Emperor Constantine (*reg* 306–37), the 4th-century basilica of S Giovanni in Laterano and the 4th-century baptistery, perhaps the first in the West. It was the popes' main residence before their departure to Avignon in 1308.

The medieval papal residence at the Lateran was abandoned by the popes on their return from Avignon in favour of the Vatican and was derelict by the late 16th century. Sixtus V removed all traces of the medieval buildings just two months after his enthronement in 1585, except for the Scala Sancta, the Sancta Sanctorum (the papal private chapel of S Lorenzo), both of which were incorporated into a new building (1586–9) by Domenico Fontana (1543–1607). Fontana's original plan for the palace envisaged the construction of only the west and north wings, as well as the staircase wing to the south running parallel to the church. A low corridor on the east side was intended to link the new building with the narthex of the basilica. When the plans were amended in 1586 the elevation of the four northern bays of the corridor was altered to resemble the palace façade. A fire wall was built above the remaining bays of the corridor to the height of three courtyard storeys, thus creating a four-sided, regularly shaped courtyard. Visitors coming from the city received the impression of a palace elevation that was the same on all sides. The new building, completed in just four years, was part of the Pope's overall plan of urban renewal (*see* §II, 2 above).

In the Lateran, Fontana created a cubelike palace typical of the second half of the 16th century, derived, as were many other Roman palazzi, from the Palazzo Farnese (*see* §7 below). The façades are framed by rusticated quoins, not articulated by orders, and are capped by a powerful cornice. The top floor was designed to be markedly lower than the preceding ones; in conjunction with the conspicuously rusticated quoins this serves to draw together the powerful mass of the palace by giving it a clear outline, an important feature because a visitor approaching from the

city first saw the north-west angle of the palace, taking in both the north and west façades (see fig. 12). Fontana, however, made the mass of the building disappear behind the façade. The walls appear to be skins stretched taut between the rusticated quoins, and the regular rhythm of the rows of windows underlines this impression.

Whereas the detailing of the façade mainly reveals Fontana's familiarity with the work of Giacomo della Porta, Vignola's influence is evident in the courtyard. Here, instead of drawing on the Palazzo Farnese, Fontana used an order of terms on the top storey; this was without precedent in Rome, and the inspiration probably came from Galeazzo Alessi's Palazzo Marino (begun 1558; *see* ALESSI GALEAZZO, fig. 3) in Milan. In the ground-plan the architect adhered to the typology of the papal palace, bringing together all the traditions of its predecessors (the medieval Lateran, the Palais des Papes at Avignon and the Vatican) and bonded them into a single programme. After completion, the building was used for only one official papal ceremony. It was handed over to the chapter of S Giovanni in 1608, and 17th-century travellers reported that the palace was empty and neglected.

BIBLIOGRAPHY

P. E. Lauer: *Le Palais de Latran* (Paris, 1911)
A. Muñoz: *Domenico Fontana, architetto, 1543–1607*, Quad. Italo-Sviz., iii (Rome and Bellinzona, 1944)
H. Gamrath: 'Roma sancta renovata: Studi sull'urbanistica di Roma', *Anlct. Romana Inst. Dan.*, xii (1987) [suppl.]
A. Ippoliti: 'Nuove acquisizione sul Palazzo Laterano: La "scala pontificale"', *Quad. Ist. Stor. Archit.*, n. s., xi (1988), pp. 51–60
B. Burkart: *Der Lateran Sixtus' V. und sein Architekt Domenico Fontana* (Bonn, 1989)
C. Pietrangeli, ed.: *Il palazzo apostolico lateranese* (Florence, 1991)

BETTINA BURKART

3. IL GESÙ. The construction of a worthy seat for the emerging Society of Jesus was delayed by the opposition of the families (especially the Altieri) who owned the land on which the church was to be built. The first plan for Il Gesù (SS Nome di Gesù), produced in 1549–50 by Nanni di Baccio Bigio, was for a longitudinal scheme with six chapels flanking the nave and a short transept. The work was soon interrupted, however, and the efforts of Cardinal della Cueva to have it resumed had little effect, although he had obtained a new plan free of charge in 1554 from Michelangelo.

In 1568 building began in earnest thanks to the lavish patronage of Cardinal Alessandro Farnese, later Pope Paul III, who put Jacopo Vignola in charge along with the Jesuit Giovanni Tristano (*d* 1575). Vignola adopted the longitudinal scheme with stubby transepts and three interconnected chapels at each side of the nave, respecting the wishes of Farnese, who considered the plan most suitable for the devotional requirements of the Counter-Reformation liturgy. Two additional chapels were set into the sides of the apse. The strong spatial unity of the interior (*see* VIGNOLA, JACOPO, §3(ii)), enhanced by the unusual barrel-vaulted roof of the nave, the large dome and the apse, all of which had specific acoustic, lighting and symbolic functions, was originally articulated, with great austerity, by features that were clad in precious marbles only in the 19th century. The nave has coupled

Corinthian columns, the arcades between which are comparatively low so as not to distract attention from the line of the deep entablature and attic decoration directed towards the altar. An even, subdued light falls on the nave from the windows above the chapels. The last bay before the dome is shorter, less open and hence darker than the others. The Corinthian pilasters are stepped forward and then set back below the springing of the pendentives, contracting space and light in a deliberate build-up before the drama of the high altar, bathed in floods of light.

While Vignola's solution established an innovative model that strongly influenced church design in the late 16th century, it also developed Classical modules dear to Renaissance architecture, as in Alberti's S Andrea (1470; *see* ALBERTI, LEON BATTISTA, figs 6–8) at Mantua. Similar sources of inspiration appeared in the façade proposed in the 1568 scheme; yet surprisingly this and a second design (1570; see fig. 13) were discarded in favour of another (1571) by GIACOMO DELLA PORTA (see fig. 14), who had overcome the competition of Galeazzo Alessi. The new elevation basically followed Vignola's version, articulated in two orders with a triangular pediment above; della Porta introduced large volutes to link the high nave with the lower aisles, a device invented by Alberti for S Maria Novella, Florence, but given fresh currency by della Porta.

Alessandro Farnese intended the decoration of Il Gesù to be as important and exemplary as the architecture. In full conformity with the Jesuit Order's idea of art, the paintings and sculpture in the church were conceived and organized as a unit, to reinforce the sermons and liturgical rites. The devotion and involvement of the congregation were promoted by art works of great mystical suggestivity and spectacular effect, combining Late Mannerist and emerging Baroque aesthetic tastes with those of the Society of Jesus.

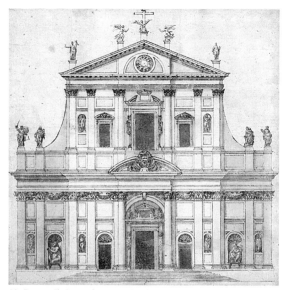

13. Rome, Il Gesù, design (1570) by Jacopo Vignola for the façade (unexecuted); engraving (1573) by Mario Cartari after a drawing by Giacinto Vignola (Berlin, Kunstbibliothek Berlin mit Museum für Architektur, Modebild und Grafik-Design)

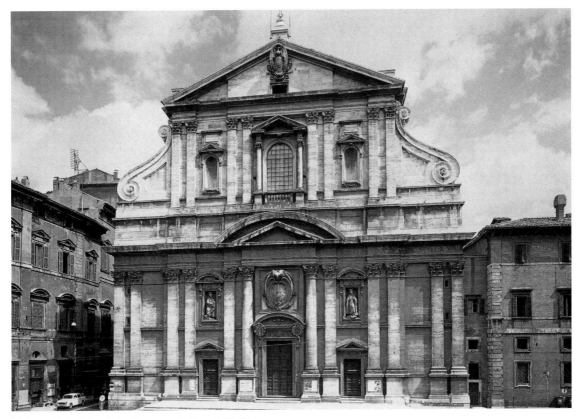

14. Rome, Il Gesù, façade by Giacomo della Porta, 1571–84

In the period just after the consecration by Pope Gregory XIII on 25 November 1584, the interior had a very different appearance from that of four centuries later. The main paintings were done by rising artists: Giovanni de' Vecchi and Gaspare Celio (1571–1640) painted the pendentives depicting the *Four Doctors of the Church* (1583) in the dome, later overpainted by Giovanni Battista Gaulli (1639–shortly after 1709). Girolamo Muziano, Farnese's protégé, painted the *Circumcision* for the high altar (1587–9; Rome, Pal. Gesù). The chapels were decorated with a symmetrical series of frescoes representing stages in the mystery of salvation: its beginning (the chapels of SS Trinità and the Angeli), its fulfilment (the chapels of the Natività di Maria and the Passione) and its perpetuation (the chapels of SS Apostoli and S Andrea). These chapels were painted by some notable exponents of Roman late Mannerism, whose work typified the new artistic approach after the Council of Trent: Federico Zuccaro in the chapel of the Angeli (1592), Celio, following a design by Giuseppe Valeriano, in the chapel of the Passione, Durante Alberti (1538–1613) in the chapel of SS Trinità, Niccolò Pomarancio in the chapel of S Francesco Borgia and Ventura Salimbeni, who painted parts of the chapels of SS Trinità and the Angeli (1590–91).

BIBLIOGRAPHY

P. Pecchiai: *Il Gesù di Roma* (Rome, 1957)
J. S. Ackerman: 'The Gesù in the Light of Contemporary Church Design', *Baroque Art: The Jesuit Contribution*, ed. R. Wittkower and M. Jaffé (New York, 1972), pp. 15–28
M. Stankowski: 'Der Römische und die Jesuiten: Ein methodischer Versuch', *A. Bavar.*, xxii–xxiv (1981), pp. 89–122
A. Dionisi: *Il Gesù a Roma: Breve storia e illustrazione della prima chiesa eretta dalla Compagnia di Gesù* (Rome, 1982)
U. Kutermann: 'Alberti's S Andrea in Mantua: The Prototype of the Renaissance Church', *Pantheon*, xlii/2 (1984), pp. 107–13
E. D. Howe: 'The Church of Il Gesù Explicated in a Guidebook of 1588', *Gaz. B.-A.*, cvi (Dec 1985), pp. 195–202

GIUSEPPE PINNA

4. S CLEMENTE. Dedicated to St Clement, the fourth pope (*reg c.* AD 88–97), S Clemente consists of a 12th-century basilica (the upper church), one of the best-preserved medieval churches in Rome, superimposed on an Early Christian basilica (the lower church). This in turn had been constructed on top of structures dating to the 1st century AD. Below the apse of the lower church are the remains of a Mithraeum (2nd–3rd century AD) that had been inserted into the earlier Imperial building. The early 15th-century chapel of St Catherine of Alexandria (*c.* 1427/8–31) off the south aisle of the upper church is one of the finest early Renaissance frescoed chapels ever executed. Commissioned by Branda di Castiglione, Cardinal of S Clemente (*reg* 1411–31), the frescoes have been attributed to Masolino (see fig. 15) and Masaccio and were much admired by many artists, including Raphael. Subjects include the *Annunciation, St Christopher*, the *Apostles*, the *Crucifixion* and, in the vault, the *Evangelists* and the *Fathers of the Church*. Restoration (1954–6) revealed the artists' original *sinopie* sketches, which are now displayed separately. In the baptistery are frescoes (late 16th century) attributed to Jacopo Zucchi, who also painted the *Virgin and Child with St John* (1570–90; chapel of the Rosary).

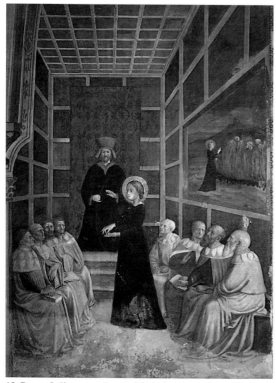

15. Rome, S Clemente, chapel of St Catherine of Alexandria, fresco of *St Catherine of Alexandria and the Philosophers* (1411–13), attributed to Masolino

BIBLIOGRAPHY

G. Urbani: 'Restauro di affreschi nella cappella di S Caterina a S Clemente in Roma', *Boll. Ist. Cent. Rest.*, xxi–xxii (1955), pp. 35–6
L. Boyle: *A Short Guide to St Clement's, Rome* (Rome, 1972)
E. Kane: 'The Painted Decoration of the Church of San Clemente', *Art and Archaeology*, ii of *San Clemente Miscellany*, ed. L. E. Boyle, E. M. C. Kane and F. Guidobaldi (Rome, 1978), pp. 60–151 [esp. pp. 112 onward]

□

5. S MARIA MAGGIORE. Situated at the end of the Esquiline Hill and formerly known as S Maria ad Praesepem, S Maria Maggiore was traditionally founded by Pope Liberius (*reg* 352–66) and financed by Johannes, a rich citizen, after a miraculous summer snowfall. It is more likely, however, that it was founded in the early 5th century by Sixtus III (elected 432–40), whose name appears in the mosaics of the triumphal arch in front of the apse. Until the 12th century, when Eugenius III (*reg* 1145–53) built the narthex, work on the church was mainly limited to maintenance.

The first important changes were made in the late 13th century, when the transept was built with a new polygonal apse, as part of Nicholas IV's policy of improving Rome's churches. In the 15th century Cardinal Guillaume d'Estouteville (*c.* 1412–83) completed the campanile, the tallest in Rome, and Alexander VI built the gilded, coffered ceiling (completed 1498). New chapels were added to the aisles, and Gregory XIII commissioned a new portico for the façade, designed by Martino Longhi the elder.

The two aisles of the present church end in cruciform spaces that open on to the Piazza dell'Esquilino. What was essentially a basilica plan was modified into a Latin cross by the chapels of Sixtus V and Paul V, which are reached through large arches, supported by coupled columns, that interrupt the rhythm of the nave colonnade. The Sistine Chapel (or chapel of the Holy Sacrament), in the north transept, was founded in 1585 by Sixtus V and designed by Domenico Fontana (1543–1607). The Pauline (or Borghese) Chapel (completed 1611) was built by Flaminio Ponzio for Paul V. Along the aisles, in addition to the baptistery (1605, by Ponzio), are the Sforza Chapel (see MICHELANGELO, §I, 4 and PORTA, DELLA, (2)) and the Cesi Chapel (attributed to Guidetto Guidetti). The marble pavement (1581–7), begun by Cardinal Felice Peatti and continued through his papacy as Sixtus V, is subdivided into rectangular compartments with *cosmati* decoration (polychrome marble and mosaic inlay).

BIBLIOGRAPHY

R. Krautheimer and others: *Corpus basilicarum christianarum Romae*, iii (Rome, 1971), pp. 1–60
H. Ost: 'Die Kapelle Sistina in S Maria Maggiore', *Kunst als Bedeutungsträger: Gedenkschrift für Gunter Bandmann* (Berlin, 1978), pp. 279–303
C. Pietrangeli, ed.: *La basilica romana di Santa Maria Maggiore a Roma* (Florence, 1987)
S. F. Ostrow: *The Sistine Chapel at S Maria Maggiore: Sixtus V and the Art of the Counter-Reformation* (diss., Princeton U., NJ, 1987)
M. J. Gill: 'Where the Danger was Greatest: A Gallic Legacy in Santa Maria Maggiore, Rome: G. d'Estouteville's Decoration of the Chapel of S. Michele', *Z. Kstgesch.*, lix/4 (1996), pp. 498–522
R. Eitel Porter: 'Artistic Co-operation in Late Sixteenth-century Rome: The Sistine Chapel in S. Maria Maggiore and the Scala Santa', *Burl. Mag.*, cxxxix (July 1997), pp. 452–62

MASSIMILIANO DAVID

6. PALAZZO DELLA CANCELLERIA. Built *c.* 1485–*c.* 1511 as the palace of Cardinal RAFFAELE RIARIO, the Palazzo della Cancelleria was later used as the offices of the papal chancery and, under Napoleon, as law courts. It stands on the Piazza della Cancelleria and is now the residence of the Cardinal-Vicar of Rome.

(i) Architecture. The palace is one of the most important and influential examples of 15th-century Roman architecture, but no documentation identifies its architects. Suggestions have included BACCIO PONTELLI, Antonio da Sangallo (i), Francesco di Giorgio Martini and Andrea Bregno. Vasari attributed a share in it to Bramante, but Bramante did not arrive in Rome until 1499 and could not have been the original architect; some scholars see his influence in the courtyard. Raffaele Riario, great-nephew of Sixtus IV, traditionally financed the palace with the winnings of one night's gambling. It was taken from the Riario family after they were involved in a plot against Pope Leo X; the offices of the papal chancery were then installed. The church of S Lorenzo in Damaso, rebuilt with the palace, was incorporated into its fabric.

The long travertine façade, probably completed by 1495, is an elegant and delicate combination of flat rustication with paired pilasters on the first and second storeys; it is framed with slight protruding end bays. The windows are based on an ancient Roman prototype. The design, which reflects the influence of Alberti's Palazzo Rucellai, Florence (see ALBERTI, LEON BATTISTA, §III, 2(ii)(a) and fig. 2), has been interpreted as combining elements typical of Florence, Urbino and Rome. The wild

rose, the Riario family emblem, is used in the decoration. The large portal, designed by Domenico Fontana (1543–1607), was added in 1589. The ground floor of the side flank incorporates shops; the Cancelleria was the first Renaissance palace to revive this ancient Roman tradition. The simple and harmonious courtyard (*see* ITALY, fig. 7) features superimposed open loggias and a closed second storey decorated with pilasters. It is said that the 44 granite columns were taken from the Theatre of Pompey (ded. 55 BC) and that stones from the Colosseum were used for general building purposes.

DAVID G. WILKINS

(ii) Decoration. The palace contains decorations from every century since its completion, the principal ones dating from the cardinalates of Raffaele Riario and Alessandro Farnese. The original wooden coffered ceilings and painted friezes with the Riario coat of arms are found in various rooms; in one room Baldassare Peruzzi painted the Volta Dorata (Golden Vault) with grotesques and scenes from the Old Testament (*c.* 1519). Vasari decorated the Sala dei Cento Giorni (*see* VASARI, (1), §I, 2(iii)), and Francesco Salviati the Pallio Chapel (*c.* 1550; *see* SALVIATI, FRANCESCO, §1(v)). Cardinal Alessandro Peretti-Montalto commissioned friezes of plants and animals from Paul Bril (*c.* 1554–1626), Cesare Nebbia and others.

BIBLIOGRAPHY
A. Schiavo: *Il Palazzo della Cancelleria* (Rome, 1964)
C. L. Frommel: 'Baldassare Peruzzi als Maler und Zeichner', *Röm. Jb. Kstgesch.*, xi (1967–8) [supplement]
C. Pericoli Ridolfini: *Guide rionali di Roma: Rione VI, Parione*, ii (Rome, 1971, rev. 3/1980)
C. Robertson: *Il gran cardinale: Alessandro Farnese, Patron of the Arts* (New Haven and London, 1992)
M. Pentiricci: 'Palazzo della Cancelleria: Notizie preliminari sui materiali ceramici dello scavo', *Ceramiche di Roma e del Lazio in età medievale e moderna: Atti del convegno di studi: Rome, 1993*, pp. 30–39
J. L. DE JONG

7. PALAZZO FARNESE. Standing on the Piazza Farnese, the Palazzo Farnese is the most important 16th-century palace in Rome. In 1495 Cardinal Alessandro Farnese bought a small house from the Augustinian monks of S Maria del Popolo, and from 1514 to 1516 it was restored by Antonio da Sangallo (ii), who was later to direct its complete reconstruction. By 1523 the surrounding buildings had been demolished, and under Sangallo the first floor and its courtyard were completed. After Farnese was elected Pope Paul III, he instructed Sangallo to expand the palace (*see* SANGALLO, (4) and fig. 2). The façade was extended from eleven to thirteen bays; the court (*see* PALAZZO, fig. 2) acquired two new arcades, making five in total, and the entrance stairway was rebuilt.

When Sangallo died in 1546, the direction of the project was passed to Michelangelo (*see* MICHELANGELO, §I, 4). Although he was involved only briefly, his contribution was decisive. He raised the height of the first floor and duplicated it above with another, equally high, to create the *ricetto*, or first floor gallery, roofed by vaults half-oval in section, which made space in the side ranges for servants' quarters. He also designed the majestic cornice and the treatment of the central window over the entrance, recessed into the wall plane to give an inverted emphasis. Famous Roman statues (Naples, Mus. Archeol. N.)—the

Farnese Hercules, the *Urania*, the *Genius of the Roman People* and the *Flora*—were placed in Sangallo's courtyard. The *Farnese Bull* (3rd century AD), which Michelangelo wanted to transform into a fountain, was installed in the later second court.

After an interruption following the death of Paul III (1549), construction was resumed under cardinals Ranuccio and Alessandro Farnese (*see* FARNESE, (3) and (4)). From 1550 the project was directed by Vignola (*see* VIGNOLA, JACOPO, §3), who concerned himself mainly with the rear elevation, including a three-bay central loggia on the first floor. This loggia, overlooking the Tiber, was closed by Giacomo della Porta (*see* PORTA, DELLA, (2)) when he succeeded Vignola after the latter's death in 1573, and replaced with one above it, which was closed on the court side of the building. When Ranuccio Farnese became the first of the family to make the Palazzo Farnese his permanent residence, he began the decoration of the interior with the north rooms on the façade and the front of the right wing.

FRANCESCO SALVIATI was commissioned to fresco the Sala dei Fasti Farnesiani, but he finished only the ceiling (1549–56; *see* SALVIATI, FRANCESCO, fig. 4); the cycle was continued (1563–4) by Taddeo and Federico Zuccaro and is a brilliant example of Roman Mannerist historical painting. Alessandro Farnese commissioned the decoration by Daniele da Volterra of the corner room on the first floor (1566).

BIBLIOGRAPHY
C. F. Uginet: *Le Palais Farnèse à traverse les documents financiers, 1535–1612* (Rome, 1980)
I. Cheney: 'Les Premières Décorations: Daniele da Volterra, Salviati e les frères Zuccari', *Le Palais Farnèse*, 3 vols (Rome, 1981), pp. 243–67
Le Palais Farnèse, 3 vols (Rome, 1981)
A. Puaux: *Introduction au Palais Farnèse* (Rome, 1983)
M. Burbon: 'Restauration au Palais Farnèse', *Mnmts Hist. France*, cxlix (Jan–Feb 1987), pp. 67–70
C. Mignot: 'Michel-Ange et la France: Libertinage architectural et classicisme', *Il se rendit en Italie: Etudes offertes à André Chastel* (Paris, 1987), pp. 523–36
L. D. Mauro: 'Domus Farnesia amplificata est atque exornata', *Palladio*, i (1988), pp. 27–44
F. Gennari Santori: 'La decorazione del Palazzo Farnese di Gradoli', *Stor. A.*, lxxxiii (1995), pp. 82–110
GIUSEPPE PINNA

VI. Accademia di S Luca.

Professional institution established in 1577 to replace the old artists' guild in Rome, the Università dei Pittori, and to provide for the education of young artists.

A papal brief issued by Gregory XIII on 13 October 1577 decreed the creation of an academy of fine arts named after St Luke to replace the Università dei Pittori (*see* §III, 1 above), then over a century old. The initiative behind the establishment of the Accademia di S Luca, however, came from Girolamo Muziano, who was entrusted with defining the broad aims on which the activities of the new institution were to be based. On 11 May 1588, Sixtus V donated premises to the Accademia, including the church of S Martina at the foot of the Capitol and an adjoining building where its first headquarters were set up. In 1593 Federico Zuccaro was elected *principe* or president of the assembly of artists and began to draw up the statutes that were adopted on 26 February 1594 and officially

approved in 1595, the year in which the Accademia di S Luca began its regular activities.

At first the Accademia welcomed all those connected with drawing or painting. During the first half of the 17th century, however, the practitioners of such 'mechanical' activities as embroidery and ornamental plaster- and stuccowork were excluded, as were art dealers who were also restorers, and even painters working in the 'minor' genres. During the earliest years of the Accademia's existence, when it was extremely diverse in the professions and specialities it represented, a committee of 12 artist-members was elected to direct the new institution. When the Accademia later became more homogeneous, officials were still elected annually to assist the *principe* or were appointed by him to carry out such duties as visiting the sick, assisting foreigners or preparing festivals. The *principe*'s term of office was one year, but there was no limit on the number of times an individual could hold the post. Despite the predominance of painters among the Accademia's membership, it was obligatory to alternate the three arts of painting, sculpture and architecture when choosing a new *principe*.

The first objective assigned to the Accademia di S Luca by Gregory XIII was to 'train studious youth in the profession of the arts'. Federico Zuccaro drew up the details of the means by which this was to be achieved. There were to be debates on theoretical matters; 12 academicians were entrusted exclusively with teaching duties and would remain in charge for one month each in turn; young artists were excused the obligation of adhering to an apprenticeship contract with strict conditions; and they could only enter the competitions run by the Accademia, intended to judge them and to motivate them, on condition that they took part in weekly classes at the institution.

BIBLIOGRAPHY

M. Missirini: *Memorie per servire alla storia della romana Accademia di S Luca* (Rome, 1823)
J. Arnaud: *L'Académie de Saint-Luc à Rome* (Rome, 1886)
L. Borgese: *Annuario dell'Accademia nazionale di San Luca* (Rome, 1967) [with historical notes and bibliography]
K. Noehles: *La chiesa dei SS Luca e Martina* (Rome, 1970)
P. Marconi, A. Cipriani and E. Valeriani: *I disegni di architettura dell'archivio storico dell'Accademia di San Luca*, 2 vols (Rome, 1974)
L'Accademia nazionale di S Luca (Rome, 1974)
G. Incisa della Rocchetta: *La collezione dei ritratti dell'Accademia di San Luca* (Rome, 1979)
A. Cipriani and E. Valeriani: *I disegni di figura nell'archivio storico dell'Accademia di San Luca*, 3 vols (Rome, 1988–91)

OLIVIER MICHEL

VII. Antiquarian revivals.

1. Sculpture gardens. 2. Descriptions.

1. SCULPTURE GARDENS.

(i) 15th century and early 16th. Although the possession and display of ancient sculpture did not cease at the end of Roman civilization, true collections were not formed again until the 15th century, a manifestation of the Renaissance revival of interest in antiquity. At first the simple possession of antiquities was sufficient, and neither their condition nor the manner of their display was important. Fragments and inscriptions were affixed haphazardly on stair and garden walls, and statues and

fragments were piled in courtyards or in gardens. By the beginning of the 16th century collectors had begun to view and treat antiquities as works of art rather than as a testimony of the past, so damaged reliefs and statues were commonly restored with fragments or newly carved parts. Many were adapted for use in fountains, and elaborate groupings were made to create decorative or iconographic ensembles. Identification of the ancient statue types, needed to provide the narrative or symbolic content of these ensembles, was made, often erroneously, by comparison with coins, gems and descriptions in ancient literature. These same sources enabled collectors to identify the Greek sources of their Roman copies and to claim that their statues were by Pheidias or other noted Greek sculptors.

At the same time that serious collecting of antiquities became prevalent, Romans began to create small suburban gardens just within or just outside the city walls. Unlike true country estates, which provided food and goods for trade, these gardens were used primarily for relaxation and the display of antique sculpture. From ancient writings, for instance Pliny's *Natural History*, Renaissance patrons knew that statues were used in gardens, a knowledge confirmed by the discovery of large statue groups, such as the Medici *Niobe* group (Florence, Uffizi), in sites known to have been villas in antiquity.

Starting with the modest gardens of humanists and officials of the papal court, it became customary to use reliefs, sarcophagi and statues as decorations in the garden. A drawing made by the north Netherlandish artist Maarten van Heemskerck (1498–1574) in the 1530s shows statues in the garden of Cardinal Emilio Cesi (1481–1537) displayed in the haphazard arrangement characteristic of the first decades of the century (see fig. 16). Despite the apparent lack of aesthetic purpose or symbolic content in these arrangements, statues deemed appropriate for out-door settings were preferred: woodland deities, such as satyrs and nymphs; Pan, a symbol of fertility; Flora and Pomona, patron goddesses of gardens and orchards; and even statues of animals. Later in the 16th century, statues of Muses and fountains with a figure of Pegasus, both associated with the creation of poetry and the arts, were often used.

Pope Julius II and his successors, Leo X and Clement VIII, created an architectural and formal setting for the papal statue collection at the Vatican. The most famous ancient statues then known, the *Apollo Belvedere*, the *Laokoon* group, statues of river gods personifying the *Nile*, the *Tigris* and the *Tiber*, and a figure of a *Reclining Woman*, then believed to be Cleopatra, were displayed in a courtyard there. It occupied a space between a 15th-century *casino* on the ridge of the Vatican Hill and the exedral terminus of the Cortile del Belvedere, which connected the Vatican Palace to the ridge. The statues were in niches set symmetrically in the walls of the garden court, and two of the niches were piped for water, with the *Nile* and the *Reclining Woman* serving as fountain figures. The concept and design of the courtyard were undoubtedly believed to be a replica of an ancient statue display and set the pattern for almost all later statue collections in gardens in Rome.

16. Maarten van Heemskerck: *View of Cardinal Cesi's Garden in the Borgo, Rome*, pen and ink, 134×208 mm, 1532–4 (Berlin, Kupferstichkabinett)

(ii) Mid- to late 16th century. By the mid-16th century, statue collections were organized in formal arrangements at the corners or the centre of planting beds: Dupérac's map of Rome of 1576 shows the Cesi collection reorganized in this way. Another form of display was to group statues in 'rooms' created by hedges or pergolas. An example was the collection of the Villa d'Este (1550s; examples in Rome, Mus. N. Romano) on the Quirinale, which had several different groupings. One was a U-shaped grotto that terminated in a rocky mount on which lay the figure of a shepherd pouring water from a flask. Below him was a statue of *Venus and Cupid*, and the pool of the fountain contained a *Boy with a Swan*. A forecourt with pergolas had statues in the niches, and a grotto under one of the palace terraces held statues of the nine *Muses* and an *Apollo Musagetes*. Elaborate fountains and nymphaea, such as the one in the Casino Pio IV (1560s) at the Vatican, were decorated with ancient statues, or the statues themselves, drilled and piped for water, were used as fountains. The Villa Medici (1576–88) on the Pincio represents the high point of these elaborate displays (see fig. 17). The garden façade of the *casino* was covered with reliefs, statues and busts that Ferdinando I de' Medici had purchased from the della Valle and CESI collections. One long wing of the *casino* contained a sculpture gallery, while additional statues were placed at regular intervals along the garden façade. At the far end of the axis that divided the garden, the *Niobe* group was arranged on a mound in what was believed to be a replica of its grouping in antiquity. A reclining figure believed to be Cleopatra, now recognized as *Ariadne* (Florence, Uffizi), was set in an open pavilion placed over the ancient city walls. Only elaborate fountains, common to most gardens of the period, were missing.

With Julius II's Cortile del Belvedere (see fig. 8 above), the garden evolved into an outdoor museum; Julius III elaborated on the precedent at his suburban villa, the Villa Giulia. Behind the *casino* were two courtyards separated by a pavilion. The side walls of the first court were divided into niches or panels by an elaborate architectural framework, and the second had niches for sculptures of river gods and a lower nymphaeum. There were statues in the niches of the first courtyard, with busts in the tondi above and reliefs in the panels, a grouping of decorations that may have had symbolic significance (see MacDougall, 1983). Rooted in Roman and Greek mythology, the nine Muses, for instance, referred to the inspiration of poetry in a garden setting, while woodland and pastoral deities represented the idyllic poetry of ancient writers; many decorations, however, were barely disguised encomia to the patron and his family (Coffin, 1960; *see* TIVOLI). Ultimately, the demand for a symbolic content outran the available supply of ancient statues, and the 'text' was augmented by commissioning new statues to fill in. This was the case at the Villa Mattei in Rome, begun in 1585, where the celebration of the Mattei family and its virtues was created by the strategic placement of ancient statues from their vast collection and of new ones made for the villa.

BIBLIOGRAPHY
D. Coffin: *The Villa d'Este at Tivoli* (Princeton, 1960)
R. Weiss: *The Renaissance Discovery of Classical Antiquity* (Oxford, 1969)

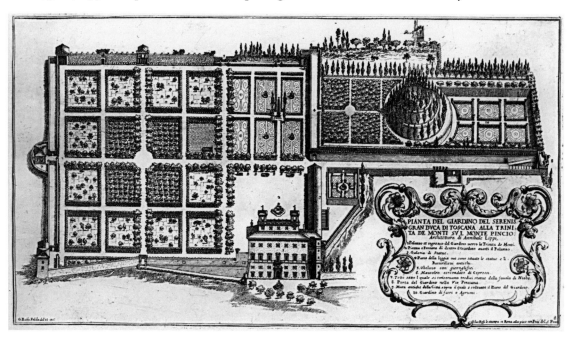

17. Giovanni Battista Falda: *Bird's-eye View of the Villa Medici on the Pincian Hill, Rome*, engraving, 236×432 mm, 1680s (London, British Library)

H. Brummer: *The Statue Court in the Vatican Belvedere* (Stockholm, 1970)
E. MacDougall: 'L'ingegnoso artifizio: Sixteenth Century Garden Fountains in Rome', *Fons Sapientiae: Renaissance Garden Fountains. Dumbarton Oaks Colloquium on the History of Landscape Architecture: Washington, DC, 1978*, v, pp. 85–114
D. Coffin: *The Villa in the Life of Renaissance Rome* (Princeton, 1979)
E. MacDougall: 'A Circus, a Wild Man and a Dragon: Family History and the Villa Mattei', *J. Soc. Archit. Hist.*, xlii (1983), pp. 121–30
——: 'Imitation and Invention: Language and Decoration in Roman Renaissance Gardens', *J. Gdn Hist.*, v (1985), pp. 119–34
——: 'Il giardino all'antica: Roman Statuary and Italian Renaissance Gardens', *Studia Pompeiana and Classica, in Honor of Wilhelmina F. Jashemski*, ed. R. I. Curtis (New Rochelle, 1989), ii, pp. 139–54
D. Coffin: *Gardens and Gardening in Papal Rome* (Princeton, 1991)

ELISABETH BLAIR MacDOUGALL

2. DESCRIPTIONS.

(i) Medieval to 15th century. The standard medieval guidebook to Rome, the 12th-century *Mirabilia urbis Romae* (Valentini and Zucchetti, iii, pp. 17–65), provides evidence of interest in Classical remains as well as Christian monuments. It survives in several redactions in countless manuscripts and was printed and reprinted throughout the Renaissance, despite considerable competition. It has three main sections, the first cataloguing buildings by type, such as palaces, temples etc. There follows a collection of legends on pagan and Christian Rome, and lastly an itinerary listing the monuments encountered on a route beginning at St Peter's, crossing the Tiber at Ponte Sant'Angelo, passing through the city proper and ending in Trastevere. Amid the fables, the *Mirabilia* contains nuggets of fact still relevant today.

After 1420, when Pope Martin V re-established a united papacy in Rome, humanists interested in the physical remains of antiquity gravitated there. Among those employed in the Curia were POGGIO BRACCIOLINI and FLAVIO BIONDO. The former's *De varietate fortunae* (begun *c.* 1431, released 1448) begins with a passage describing the dilapidated state of many ancient remains in Rome. Although not a systematic guide, it is remarkable for its empirical approach, refuting the medieval identifications of the Pyramid of Cestius and the Secretarium Senatus simply by deciphering the inscriptions on them, and distinguishing different building phases in the Aurelian Wall. Bracciolini's achievement, however, is overshadowed by Biondo's. In *Roma instaurata* (1446), the title reflecting the *renovatio Romae*, the movement to restore at least the Christian antiquities of the city, Biondo made use of evidence from coins, reliefs, brick stamps etc to identify monuments, but his principal method was to collect quotations from an impressive range of Classical and later written sources, describing or referring to the situation of buildings in ancient Rome, and to link them to extant ruins or specific locations in 15th-century Rome. He also often resorted to the then standard tool of inquiry, derived ultimately from Varro: the morphology of names. Hence he correctly recognized the Ponte Molle as the Pons Milvius, although over-reliance on the method led to many elementary mistakes, such as confusing the extant Porta Flaminia (Porta del Popolo) with the entirely different Porta Flumentana. Despite the novelty of Biondo's methods he did not entirely repudiate the legacy of the *Mirabilia*, retaining its categorization of monuments by type and beginning the treatment by location at the Vatican. Whatever Biondo's faults in jumping to over-hasty conclusions, he established the standard methodology for Classical topographers virtually single-handedly. Later topographers often corrected him, but only by using refinements of his method and in the light of new information.

The dominating figure of the late Quattrocento was Pomponio Leto (1428–98), who taught at Rome's univer-

sity and edited Classical authors. He left no systematic guide; his erudition is best revealed by his work on the 4th-century AD catalogue of buildings and monuments in the 14 regions of ancient Rome, which survives in two redactions known as the *Notitia urbis Romae* and the *Curiosum urbis Romae*. Leto began amplifying the lists with information culled from other sources, chiefly literary and epigraphical. A version of the interpolated regionary was published between 1502 and 1505, attributed to the spurious Publius Victor. A major topographer still underrated was Bernardo Rucellai (*see* RUCELLAI, (2)), who accompanied Leon Battista Alberti and Lorenzo de' Medici around Rome in 1471. His *De urbe Roma*, a perceptive commentary on the regionary, was not printed until 1748.

(ii) 16th century. The first notable 16th-century guide was the *Opusculum de mirabilibus novae et veteris urbis Romae* (1510) of Francesco Albertini (*d* 1517–21), which claims to be no more than an updated *Mirabilia* but includes an innovative section on works of art both antique and modern. The greatest topographer to follow Biondo's model strictly was Andrea Fulvio (*c.* 1440–1527), a pupil of Leto, whose poem *Antiquaria urbis* (1513) and treatise *Antiquitates urbis* (1527) are extremely erudite works, profiting from the greater accessibility of Greek sources.

After the Sack of Rome in 1527, the first guide to appear was the *Topographia antiquae Romae* (1534) of Giovanni Bartolomeo Marliani (1488–1566). It abandoned the grouping of monuments by type, with the exception of the opening chapter on the walls and gates, thereby avoiding awkward decisions as to what a monument was (the 'Minerva Medica' had been classed as a bath because of its popular name, 'Terme di Caluce', but identified as a basilica by Biondo and his followers). Marliani also began his description by area at the Capitoline, acknowledging a shift of interest away from Christian antiquity. Otherwise the content remains very similar to Fulvio's, belying Weiss's assertion (p. 89) that the book evinces a 'new consciousness'. Such can be more plausibly said of Marliani's *Urbis Romae topographia* (1544), which is much more than a revised edition. The biggest difference is that it is illustrated with a plan of Rome and woodcuts of statues and buildings, many lifted directly from the *Libro terzo dell'architettura* of SEBASTIANO SERLIO (Venice, 1540), the first printed work to illustrate Roman antiquities. The text too displays a new interest in the appearance of monuments, such as which architectural orders are used. Nevertheless, it is significant that his 1534 work and its epitome are reprinted more often than the revolutionary 1544 volume. Among Cinquecento scholarly topographers his only follower was Bernardo Gamucci, whose 1565 guidebook was illustrated by Giovanni Antonio Dosio.

No other published Cinquecento guide approached Marliani's in erudition. Lucio Fauno's *Delle antichità della città di Roma* (1548), the first scholarly guide to appear first in Italian, is basically a translation of Marliani, but the revised edition of 1552 is more descriptive, perhaps to compensate for the lack of illustrations. Andrea Palladio's *L'antichità di Roma* (1554), which gives the most cursory treatment for seeing Rome in three days, succeeded in capturing the popular market, as its 38 reprints before 1600 testify. Lucio Mauro's 1556 guide (*Le antichità della*

città di Roma) is wholly derivative and only remembered for being published with *Le statue antiche di Roma* of Ulisse Aldrovandi (1522–1605). Onofrio Panvinio's *Reipublicae Romanae commentariorum* (1558) provided for the first time both versions of the 4th-century AD regionary and makes a promising start on a commentary, but this rapidly fades out, possibly because Panvinio's energies were diverted elsewhere.

The significance of the most industrious Cinquecento topographer is hidden by the fact that only a fraction of his work is published. *Delle antichità di Roma* (1553) of PIRRO LIGORIO was intended to refute the errors of other topographers and in many cases (although not always) shows real insight. Much of the unpublished material is preserved in two of Ligorio's manuscripts (*c.* 1500; Oxford, Bodleian Lib., MS. Canon. lat. 138, and Paris, Bib. N., MS. ital. 1129), but his 18-volume encyclopedia compiled after 1568 (Turin, Archv Stato, Cod. J.a.III.3–J.a.II.5) contains his topographical *magna opera*, one an unfinished commentary on the interpolated regionaries and the other an essay solely on temples in Rome. Ligorio kept literary references and the morphological method to the minimum, typical entries concentrating instead on brief descriptions of monuments, including their form, number of columns, building materials, physical evidence found to support identifications, images on coins etc. Where remains survive, his testimony usually proves accurate, but in the case of some vanished monuments entirely contrary descriptions can be found in different places. As ever with Ligorio, each description must be treated on its own merits.

By now foreigners were entering the field. In 1550 the Saxon Georg Fabricius published his *Roma: Eiusdem itinerarium liber unus*, which is scholarly, but designed for the visitor with limited time, and was possibly an influence on Palladio's guide. At the end of the century the Frenchman Jean-Jacques Boissard (1528–1602) and the Fleming Justus Lipsius also published guides, both within more general works on antiquities: Boissard (*Pars Romanae urbis topographia*, 1597–1602) included the interpolated regionaries and a four-day tour, while Lipsius (*Admiranda: Sive de magnitudine Romana*, 1598) 'recorded' the conversation between two or three persons visiting selected sites. Both men had acted as tutors to Transalpine youths, and their works look forward to the heyday of the Grand Tour.

BIBLIOGRAPHY

H. Jordan and C. Huelsen: *Topographie der Stadt Rom in Alterthum*, 3 vols (Berlin, 1885–1907)
L. Schudt: *Le guide di Roma: Materialen zu einer Geschichte der römischen Topographie: Unter Benutzung des handschriftlichen Nachlasses von Oskar Pollak* (Vienna and Augsburg, 1930) [the essential bibliographical reference work]
R. Valentini and G. Zucchetti: *Codice topografico della città di Roma*, 4 vols (Rome, 1940–53) [anthology of topographical material from antiquity to Albertini]
R. Weiss: *The Renaissance Discovery of Classical Antiquity* (Oxford, 1969)
D. M. Robathan: 'Flavio Biondo's *Roma instaurata*', *Med. & Human.*, n. s., i (1970), pp. 203–16
P. Spring: *The Topographical and Archaeological Study of the Antiquities of the City of Rome, 1420–47* (PhD diss., U. Edinburgh, 1972)
I. Campbell: *Reconstructions of Roman Temples Made in Italy between 1450 and 1600* (PhD diss., Oxford, 1984), i, pp. 61–102
C. L. Stinger: *The Renaissance in Rome* (Bloomington, 1985), ch. 2
I. Campbell: 'Pirro Ligorio and the Temples of Rome on Coins', *Pirro Ligorio: Artist and Antiquarian*, ed. R. Gaston (Milan, 1988)

IAN CAMPBELL

Rondani, Francesco Maria (*b* Parma, 15 July 1490; *d* Parma, 1550). Italian painter. He may have been a pupil of Correggio. Most of his work, largely fresco painting, was done in Parma. On stylistic grounds he is credited with the monochrome friezes and candelabra (1520–23; probably based on drawings by Correggio) in the nave of S Giovanni Evangelista in Parma. In 1525 Rondani, with Correggio and Michelangelo Anselmi, was asked to survey damage to the church of the Madonna della Steccata. Between 1527 and 1531 he decorated the lower part of the Centoni Chapel in Parma Cathedral with monochrome frescoes representing scenes from the *Life of St Anthony Abbot*, and the upper part with the *Capture of Christ* and *Christ Shown to the People*. In the treatment of these subjects he was evidently influenced by a northern Mannerist style. He frescoed the *Miracles of St Benedict* in the cloister of the Novices in S Giovanni Evangelista. In the church itself he is credited with painting a scene showing the *Eternal Father* on the soffits of an arch in the del Bono Chapel, in collaboration with Anselmi. In 1532 he contributed to the celebratory decorations for the arrival of Emperor Charles V in Parma, and in the same year he worked with Anselmi on the ceiling of the oratory of the Concezione in the church of S Francesco, where his debt to Correggio is apparent. In 1541 he is documented in the cathedral, and in 1550 he is mentioned among the artists working on the triumphal arch for the wedding of Margaret of Austria and Ottavio Farnese, 2nd Duke of Parma and Piacenza. His altarpieces include the *Visitation* and the *Assumption* (Parma, G.N.), the (signed) *Virgin and Child in Glory with SS Augustine and Jerome* (Parma, G.N.) and the *Virgin between SS Peter and Catherine* (Naples, Capodimonte).

BIBLIOGRAPHY
M. G. Diana: 'Francesco Maria Rondani', *La pittura in Italia: Il cinquecento*, ed. G. Briganti, ii (Milan, 1987, rev. 1988), p. 824 [with earlier bibliog.]

MARIO DI GIAMPAOLO

Rondinelli, Niccolò (*fl c.* 1490–1510). Italian painter. He may have been born in Ravenna, but he is first documented in the studio of Giovanni Bellini in Venice *c.* 1490 and was one of his master's more important pupils. He probably collaborated with Bellini on major projects; his own works of this period are small altarpieces derived from types established by Bellini, such as the *Virgin and Child Watching a Bird*, falsely signed *Iohannes Bellinus* (untraced; see Berenson, pl. 385). He is recorded as being married in Venice in 1495 and shortly afterwards moved to Ravenna, where he undertook a number of important commissions in and around that city, while continuing to produce works for private devotion. His paintings continued to be strongly influenced by Bellini, often using his formula of the Virgin enthroned in an architectural setting and flanked by saints and donors, but he was able to draw on the style of other artists, such as Cima da Conegliano, Vittore Carpaccio and Marco Palmezzano and yet produce works that reveal a personal idiom distinct from that of his contemporaries. His most celebrated work, and one of the few that can be securely dated, is *St Sebastian*, made for the cathedral at Forlì (1497; *in situ*), whose suave elegance clearly shows Rondinelli's individuality. Closer to Bellini are the *Virgin and Child with SS Nicholas, Peter,*

Bartholomew and Augustine, made for the church of S Domenico in Ravenna, and *St John the Evangelist Appearing to Galla Placidia*, formerly in the church of S Giovanni Evangelista, Ravenna (both Milan, Brera). Rondinelli is last recorded in Ravenna in 1502, but such pictures as the *Virgin between SS Catherine and Jerome* (Ravenna, Accad. B.A.), which show a knowledge of Bellini's work of the early 1500s, suggest that he lived until *c.* 1510.

BIBLIOGRAPHY
Mostra di Melozzo e del quattrocento romagnolo (exh. cat., ed. C. Gnudi and L. Becherucci; Forlì, Pal. Mus., 1938), pp. 111–15
B. Berenson: *Venetian School* (1957), i, pp. 150–51, pls 384–94
F. Heinemann: *Giovanni Bellini e i belliniani*, 3 vols, Saggi & Stud. Stor. A. (Venice and Hildesheim, 1962–91), i, pp. 148–9; ii, pp. 277–8; iii, p. 54

Rosa. Italian family of painters. The brothers Cristoforo Rosa (*b* Brescia, 1517–18; *d* Brescia, before 1579) and Stefano Rosa (*b* Brescia, 1524–5; *d* after 1572) appear to have undertaken all their major works in partnership. They were renowned in the 16th century as masters of illusionistic ceiling decorations on a large scale, particularly in Venice and Brescia, and exercised an important influence on the development of Baroque ceiling painting. Their skill attracted favourable notice from many of the major writers on the visual arts in the 16th and 17th centuries, including Giorgio Vasari, and the innovative nature of their methods won particular praise from Cristoforo Sorte (1580) and Gioseffe Viola Zanini (1629).

The Rosa brothers' artistic education is not adequately documented. Stefano appears to have been taught by Gerolamo Romanino, but the roots of their skill as decorative painters seem to have lain with Giulio Romano's work in Mantua, particularly in the lost decorations in the Castello executed by Sorte, probably on Giulio's designs. The brothers must have made adequate demonstrations of their abilities, either individually or collectively, before their first documented work, the much-admired decorations on the vaults of the nave and aisles (destr. 1864) in S Maria dell'Orto, Venice, in 1556. Descriptions of the paintings indicate that they contained virtuoso displays of illusionistic architecture, including twisted solomonic columns, a motif foreshadowed by Giulio in Mantua that was to become one of the set-pieces for illusionists in later generations. The fictive architecture provided the support for roundels displaying New and Old Testament scenes. The method employed in S Maria dell'Orto represented a departure from the orthodox system of ceiling illusion, which had been tied to a single vanishing point and therefore to a fixed viewing point. Zanini illustrated the way in which they responded to the problems of perspectival illusion in a long vault by foreshortening the elements along the shorter and longer sides as if viewed from different positions. The internal inconsistencies were ingeniously concealed within the geometrical design, while the rigidities of the orthodox system were circumvented.

The most famous surviving example of the Rosa brothers' skill is the highly effective illusionistic painting of lofty architecture surrounding Titian's octagonal picture of the *Allegory of Wisdom* on the ceiling of the entrance vestibule in the Libreria Marciana in Venice, commissioned in autumn 1559 and completed by the following spring.

Operating in a more compact space, they reverted to the standard system with a single vanishing point. By 1563 they were employed in their native Brescia, where they undertook a series of religious and secular decorations during the following decade. Much of this work has been lost, and it is particularly to be regretted that, following a fire in 1575, nothing remains of their five-and-a-half years' work on the Council Hall of the Palazzo Comunale, for which Titian also provided paintings.

The Rosas' departure from perspectival orthodoxy in their larger vault decorations played a significant role in the development of dynamic illusionism in Baroque ceiling designs. The techniques of Angelo Michele Colonna (1604–87) and Agostino Mitelli (1609–60), leading specialists in this kind of decoration in the 17th century, depended for their mixture of spatial clarities and ambiguities on the ingenuity of the brothers' methods. Stefano was the father of Pietro Rosa (*b c.* 1541), a relatively prominent pupil of Titian.

BIBLIOGRAPHY
C. Sorte: *Osservatione della pittura* (Venice, 1580)
G. V. Zanini: *Della architettura* (Padua, 1629)
J. Schulz: 'A Forgotten Chapter in the Early History of *Quadratura* Painting: The Fratelli Rosa', *Burl. Mag.*, ciii (1961), pp. 90–102
——: *Venetian Painted Ceilings of the Renaissance* (Berkeley and Los Angeles, 1968)
Pittura del cinquecento a Brescia (Milan, 1986)

MARTIN KEMP

Rosex, Nicoletto. *See* NICOLETTO DA MODENA.

Rosselli [Roselli]. Italian family of artists. The family was active in Florence during the 15th and 16th centuries. The brothers Jacopo Rosselli (*b* 1389) and Lorenzo Rosselli (*b* 1390), sons of Filippo Rosselli, were both masons. Jacopo's descendants, with the exception of his grandson, the painter Bernardo Rosselli (1450–1526), all became masons and/or architects. Lorenzo's descendants, however, mostly became painters, a field in which his sons (1) Cosimo Rosselli and (2) Francesco Rosselli became famous. Cosimo's son Giuliano Rosselli (*b* 1471) was an architect and Francesco's son Alessandro Rosselli (*d* 1525) was a printer and poet. The presence of other families in Florence at the same time, with the same name and also active as artists has led to some confusion.

BIBLIOGRAPHY
Thieme–Becker
G. Vasari: *Vite* (1550, rev. 2/1568); ed. G. Milanesi (1878–85), iii, pp. 192–3
A. Gotti: *Ricordanze della nobile famiglia Rosselli-Del Turco* (Florence, 1890), pp. 65–145

MARCO COLLARETA

(1) Cosimo Rosselli (*b* Florence, 1439; *d* Florence, ?7 Jan 1507). Painter. He was documented in Neri di Bicci's workshop between May 1453 and October 1456; in 1459 he received his first known commission, for an altarpiece in Santa Trinita, Florence (untraced). It is thought that he subsequently worked with Benozzo Gozzoli, whose influence is evident in his early work, but Cosimo was receptive to the styles of almost all his more gifted contemporaries, including Alesso Baldovinetti (said by Baldinucci to have been his master), Andrea del Verrocchio and the Pollaiuolo brothers. Cosimo's first surviving works of importance

are the frescoes in the style of Baldovinetti in the Salutati Chapel, Fiesole Cathedral, datable to between 1462 and 1466, but these are heavily restored. A better illustration of his early style is the *St Barbara* altarpiece (1468–9; Florence, Accad.) from the Flemish and German confraternity's chapel in SS Annunziata, Florence; it has hard forms, incised outlines and stiff, slightly ungainly figures.

The essentials of Cosimo's mature style were established in the fresco of the *Investiture of St Filippo Benizzi* (before 1475; Florence, SS Annunziata). The figures have small heads and elongated torsos, their copious draperies concealing weaknesses in anatomical drawing. The design lacks invention but is redeemed by adept perspective construction and up-to-date architectural features. It is the first of several frescoes from his middle years, which are among his best works. From 1481 to 1482 he was in Rome decorating the Sistine Chapel with Sandro Botticelli, Domenico Ghirlandaio and Perugino. He was responsible for four frescoes: the *Sermon on the Mount*, the *Last Supper*, the *Crossing of the Red Sea* and the *Giving of the Law*. Working in proximity to his distinguished colleagues had a salutary effect on Cosimo; although his frescoes cannot equal theirs, they are more sophisticated than his earlier work and contain numerous pleasing details, especially in the crowds of bystanders, which bear testimony to his proficiency in portraiture.

The fresco of the *Procession of the Bishop with the Ampule of Blood in the Piazza S Ambrogio* (see fig.) in the Cappella del Miracolo, S Ambrogio, Florence, begun after July 1484 and completed by August 1486, is Cosimo's most skilful and attractive work, acknowledged since Vasari to be his masterpiece. It is a large group scene, set in the Piazza S Ambrogio; the exact event portrayed is not clear, but it concerns the miraculous Eucharistic relic housed in the chapel. The clusters of worshippers and spectators, deployed with unusual care, include some of Cosimo's most appealing inventions, such as the young girl with two children in the right-hand foreground. In its charm and vivacity, topographical accuracy and genre-like detail it approaches Domenico Ghirlandaio's almost contemporary frescoes in Santa Trinita, Florence, as an evocation of life in the city.

The last two decades of Cosimo's activity were devoted almost exclusively to altarpieces. The best of these is the *Virgin and Child with SS James, Peter and John the Baptist* (1492; Florence, Accad.) from the Salviati Chapel in the Cestello (now S Maria Maddalena dei Pazzi). The monumental Virgin, on her imposing *all'antica* throne, has a languorous expression reminiscent of Filippino Lippi. Her melancholy facial type is characteristic of Cosimo's late work, where downcast eyelids and small but full lips replace the long, somewhat thin lips and eyes of his earlier types. His earlier linear style has also softened, due to new developments in technique and modelling. In such late works as the *Virgin and Child in Glory with SS Ambrose and Francis* (1498–1501; Florence, S Ambrogio) the drapery falls gently in curved swathes, the figures, more elegant than before, engage in wistfully pious attitudes recalling Perugino and stand in verdant landscapes based on Netherlandish models, which were then in fashion. Cosimo's last datable work is the *Coronation of the Virgin* (Florence, S Maria Maddalena dei Pazzi) painted for the del Giglio

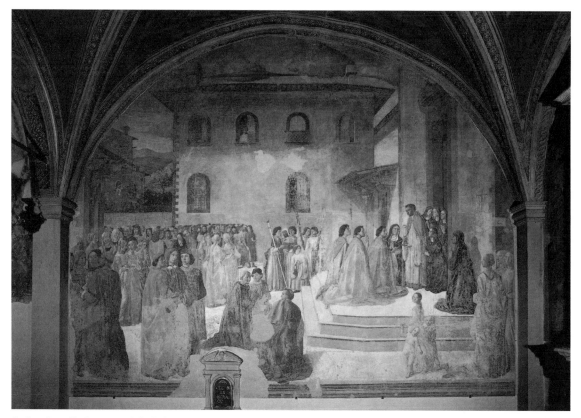

Cosimo Rosselli: *Procession of the Bishop with the Ampule of Blood in the Piazza S Ambrogio* (1484–6), fresco, Cappella del Miracolo, S Ambrogio, Florence

family in 1505; it is a monotonous multi-figure composition and, like so much of his work, accomplished but uninspired. Cosimo has excited little scholarly controversy. Berenson attributed the exquisite *Combat of Love and Chastity* (London, N.G.) and other related works to Cosimo, but this is now rejected; the Sistine Chapel *Crossing of the Red Sea* (see colour pl. 2, XXV2), for some time excluded, has been restored to his oeuvre, although considerable workshop collaboration is admitted. Extensive workshop participation in some of his uncontested works could explain the sometimes great discrepancies in style and execution between paintings close in date, for instance the *St Anne* altarpiece (1471; Berlin, Bodemus.) and the *Annunciation with Saints* (1473; Paris, Louvre). A few drawings have been attributed to him (Cambridge, Fitzwilliam; London, BM) but too tenuously to enrich our understanding. Confusion has recently arisen over his date of death, the accepted documentary evidence for this in 1507 (cited by Milanesi and Lorenzoni) conflicting with Luchs's evidence for his being alive in 1510.

Vasari, more generous than many later critics, summed up Cosimo as neither remarkable nor excellent but capable of producing reasonable works. Cosimo nevertheless found favour in his own lifetime. Private individuals and church bodies supplied him with plentiful commissions in Florence and the outlying regions and, with the best of his contemporaries, he contributed to some important late 15th-century decorative programmes. His opinion was sought on artistic matters in Florence, such as the competition for the cathedral façade, of which he was a judge (1491). He must also have been considered a good teacher; Piero di Cosimo, Fra Bartolommeo and Mariotto Albertinelli were among his pupils. He was presumably a conscientious, reliable worker and, because his style was derivative of whichever artists were currently in fashion, his lack of originality may have contributed to his success.

BIBLIOGRAPHY

Thieme–Becker

G. Vasari: *Vite* (1550, rev. 2/1568); ed. G. Milanesi (1878–85), iii, pp. 183–93
F. Baldinucci: *Notizie* (1681–1728); ed. F. Ranalli (1845–7), i, pp. 522–4
A. Lorenzoni: *Cosimo Rosselli* (Florence, 1921)
R. van Marle: *Italian Schools* (1923–38), xi, pp. 586–618
R. Musatti: 'Catalogo giovanile di Cosimo Rosselli', *Riv. A.*, xxvi, n. s., 3 (1950), pp. 103–30
A. Busignani: 'Cosimo Rosselli e il gusto della tarsia', *Ant. Viva*, i (1962), pp. 41–5
B. Berenson: *Florentine School* (1963), i, pp. 189–92
L. D. Ettlinger: *The Sistine Chapel before Michelangelo: Religious Imagery and Papal Primacy* (Oxford, 1965)
D. A. Covi: 'A Documented Altarpiece by Cosimo Rosselli', *A. Bull.*, liii (1971), pp. 236–8
A. Luchs: *Cestello: A Cistercian Church of the Florentine Renaissance* (New York, 1977)
A. Padoa Rizzo: 'La Cappella Salutati nel duomo di Fiesole e l'attività giovanile di Cosimo Rosselli', *Ant. Viva*, xvi (1977), pp. 3–12
O. Pujmanová: 'Italian Primitives in Czechoslovakian Collections', *Burl. Mag.*, cxix (1977), pp. 536–51
E. Borsook: 'Cults and Imagery at S Ambrogio in Florence', *Mitt. Ksthist. Inst. Florenz*, xxv (1981), pp. 147–202

P. Nuttall: '"La tavele Sinte Barberen": New Documents for Cosimo Rosselli and Giuliano da Maiano', *Burl. Mag.*, cxxvii (1985), pp. 367–72

W. Griswold: 'A Drawing by Cosimo Rosselli', *Burl. Mag.*, cxxix (1987), pp. 514–16

A. Padoa Rizzo: 'La Cappella della Compagnia di Santa Barbara della "Nazione Tedesca" alla SS Annunziata di Firenze nel secolo XV: Cosimo Rosselli e la sua "impressa" artistica', *Ant. Viva*, xxvi (1987), pp. 3–18

PAULA NUTTALL

(2) Francesco Rosselli (*b* Florence, 1448; *d* Florence, before 1513). Engraver, illuminator and painter, brother of (1) Cosimo Rosselli. He apparently trained as an illuminator; in 1470 he was paid for three historiated initials for a Gradual for Siena Cathedral (Siena, Bib. Piccolomini, MS. 25.10, fols 7*v*, 33*v*). Stylistically, these are close to the work of Francesco di Antonio del Chierico, who may have been Francesco's master. In 1480 Francesco was in Hungary, possibly working for Matthias Corvinus, King of Hungary (*reg* 1458–90) and a great patron of books and manuscripts. By 1482 he was apparently back in Florence. He may have fallen under the influence of the Dominican preacher Girolamo Savonarola in the 1490s (Brockhaus). He was recorded in Venice in 1505, and again in 1508, when he attended a lecture given by Luca Pacioli on Euclid.

Although an inventory lists prints and plates found in the shop of Francesco's son Alessandro, Francesco's only signed and dated print is a *Map of the World* of 1506, significant also because it records the discoveries of Columbus and his contemporaries. On the basis of this work, a large number of engravings in the Florentine Broad Manner have been convincingly attributed to him, including a fragment of a *Large View of Florence*, originally engraved on six plates, engravings of *The Deluge* after Maso Finiguerra and of the *Assumption of the Virgin* after Sandro Botticelli, as well as a *Crucifixion* apparently after his own pen drawing (Florence, Uffizi). A woodcut of the *Map of the World* in a 1532 edition of Bartolomeo da li Sonnetti's *Isolario* bears the inscription *F. Rosello fiorentino fecit* and may be based on a lost engraving by Francesco. Oberhuber (see Levenson, Oberhuber and Sheehan) has attributed a series of 15 engravings of the *Life of the Virgin and of Christ* in the Florentine Broad Manner to Francesco and dated them between *c.* 1470 and 1495. The attribution has been generally accepted, but the dating has been questioned (see Cirillo Archer). Enamels and paintings have also been attributed to Francesco (see Garzelli; Ettlinger; Levenson, Oberhuber and Sheehan).

BIBLIOGRAPHY

A. von Bartsch: *Le Peintre-graveur* (1803–21)

J. del Badia: 'La bottega di Alessandro di Francesco Rosselli merciaio e stampatore', *Misc. Fiorent. Erud. & Stor.*, ii (1895), pp. 24–30

H. Brockhaus: 'Ein altflorentiner Kunstverlag', *Mitt. Ksthist. Inst. Florenz*, i (1908–11), pp. 97–110

C. Hülsen: 'Die alte Ansicht von Florenz im Kgl. Kupferstichkabinett und ihr Vorbild', *Jb. Preuss. Kstsamml.*, xxxv (1914), pp. 90–102

A. M. Hind: *Early Italian Engraving*, i (London, 1938)

L. D. Ettlinger: 'A Fifteenth-century View of Florence', *Burl. Mag.*, xciv (1952), pp. 160–67

J. Godsmith Phillips: *Early Florentine Designers and Engravers* (Cambridge, MA, 1955), pp. 68–75

M. Levi D'Ancona: 'Francesco Rosselli', *Commentari*, xvi (1965), pp. 56–76

J. Levenson, K. Oberhuber and J. Sheehan: *Early Italian Engravings from the National Gallery*, Washington, DC, N.G.A. cat. (Washington, DC, 1973), pp. 47–62

A. Garzelli: 'Smalti nelle botteghe fiorentine del quattrocento', *An. Scu. Norm. Sup. Pisa, Lett., Stor. & Filos.*, xiv/2 (1984), pp. 689–701 (695–8)

——: *Miniatura fiorentina del rinascimento, 1440–1525: Un primo censimento*, i (Florence, 1985), pp. 173–88

M. Cirillo Archer: 'The Dating of a Florentine *Life of the Virgin and Christ*', *Print Q.*, v (1988), pp. 395–402

The Painted Page: Italian Renaissance Book Illumination, 1450–1550 (exh. cat., ed. J. J. G. Alexander; London, RA, 1994)

MARCO COLLARETA

Rosselli, Domenico (di Giovanni) (*b* in or nr Pistoia, *c.* 1439; *d* Fossombrone, Marches, 1497–8). Italian sculptor. Works attributed to the earliest period of his career markedly exhibit the influence of Florentine art of the mid-15th century, and it is clear that his initial training was within the environs of Florence, probably in the workshop of Bernardo Rossellino and Antonio Rossellino. He appears to have worked at S Petronio in Bologna in 1460–61, and then in Pisa in 1462, but by the late 1460s he was working in and around Florence. His baptismal font ornamented with stone reliefs in S Maria in Monte, near Empoli, was executed in 1468 and is his only securely dated work from this period. A marble tondo *Nativity* of slightly later date in the Palazzo Budini–Gattai, Florence, closely recalls, in details of its landscape and surface treatment, Rosselli's earlier oeuvre; however, it also resembles Antonio Rossellino's *Nativity* for the altar of S Anna dei Lombardi, Naples (1470–75), and may be a copy of it.

Rosselli moved from Florence to the Marches, perhaps *c.* 1472–3 but at the latest by 1476. It was thought that he executed some minor ornaments in the Palazzo Ducale at Pesaro *c.* 1472–3, afterwards working as a designer and decorative sculptor at the Palazzo Ducale in Urbino between *c.* 1476 and 1480. Volpe, however, has reversed this chronology, suggesting that Rosselli began working in Urbino *c.* 1474, going there at the behest of his patron Geronimo Santucci (*b* 1427), who in 1478 became Bishop of Fossombrone; he may have commissioned from Rosselli, around 1468, a memorial in Santa Croce, Florence, and subsequently prompted Rosselli to move to the Marches, promoting his work by providing further commissions. Rosselli's activity in Urbino is attested by a notable series of reliefs and stucco decorations in the Palazzo Ducale.

From the late 1470s until his death Rosselli lived and worked in Fossombrone. The large number of stone and marble reliefs of the *Virgin* or *Virgin and Child* and of various saints that he produced during this period display, like his earlier work, continuing reliance on Florentine precedents and also suggest the influence of Francesco Laurana. Rosselli's best-known work is the large stone retable (Fossombrone, Cathedral), signed and dated 1480; it was originally gilded and polychromed. The altar was probably commissioned by Santucci and consists of sculptured niches containing figures of the *Virgin and Child* with four attendant saints. It displays a delicate overlay of architectural motifs *all'antica*, clearly dependent on Tuscan art. It is probable that Santucci at the same time commissioned Rosselli to design and execute architectural ornament for the reconstruction of the Bishop's palace in Fossombrone (begun 1479). Rosselli's career as decorative sculptor has not been thoroughly explored, but he certainly

exerted a significant influence in both Urbino and Fossombrone and was largely responsible for bringing the style and motifs of 15th-century Florentine art to the Marches region during the second half of that century.

BIBLIOGRAPHY

Thieme–Becker

U. Middeldorf: 'Some New Works by Domenico Rosselli', *Burl. Mag.*, lxii (1933), pp. 165–72

J. Pope-Hennessy: *Catalogue of Italian Sculpture in the Victoria and Albert Museum* (London, 1964), cat. nos 123–6; pp. 146–51

C. Seymour jr: *Sculpture in Italy, 1400–1500*, Pelican Hist. A. (Harmondsworth, 1966), pp. 166, 169, 273

A. Cesarini: 'Il Palazzo Vescovile', *Fossombrone nel ducato di Federico: Segni di un'epoca e di una cultura* (Fossombrone, 1982), pp. 135–53

F. Mazzini: *I mattoni e le pietre di Urbino* (Urbino, 1982) [summarizes the prob. of Rosselli's oeuvre at the Palazzo Ducale]

G. Volpe: 'Aspetti della cultura architettonica quattrocentesca nella città ducale di Fossombrone', *Federico di Montefeltro: Lo stato, le arte, la cultura* (Rome, 1986), pp. 187–98

☐

Rosselli, Pietro di Giacomo (*b* Florence, ?1474; *d* ?1531). Italian architect. He came from a family of master builders in Florence but was active in Rome where he was a friend of Michelangelo, with whom he collaborated. Although his most notable works were undertaken as a capomastro and esecutore, he was also an independent architect, working mostly on residential buildings. He was strongly influenced by the architecture of the Palazzo della Cancelleria, Rome, although his work was more modest in intent. Rosselli acted as Michelangelo's assistant throughout his works on the ceiling of the Sistine Chapel (1508–12) in the Vatican Palace; he was in charge of the scaffolding and the preparation of the ceiling. He later collaborated with Michelangelo on the tabernacle for the church of S Silvestro in Capite (1518–20), and between 1528 and 1531 he was an estimatore on St Peter's. He was responsible for the construction of the Teatro Capitolino, a temporary theatre in the ancient Roman manner erected to the designs of Giuliano da Sangallo or Baldassare Peruzzi in the Piazza del Campidoglio for a masque staged by Pope Leo X in September 1513 to celebrate the admission of his nephews Giuliano and Lorenzo de' Medici to the Roman patriciate.

Several buildings in Rome have been attributed to Rosselli, including the Palazzo Picchi (1505–8) in the Via del Paradiso; the Casa Sander (1508) in the Via dell'Anima; the Casa di Prospero Mocchi (1516) in the Via dei Coronari; the Casa Rosselli in the Via dei Coronari; and, probably, the early 16th-century renovation of the Palazzo Sora. These showed a development of the manner of the Palazzo della Cancelleria, with massive brick walls relieved by pronounced string courses and windows set within decorative surrounds. The initial stages (1512–15) of the Palazzo Alberini, featuring a finely incised rusticated basement and *piano nobile* articulated by flat pilasters, have also been attributed to Rosselli.

BIBLIOGRAPHY

A. Bruschi: 'Il teatro capitolino del 1513', *Boll. Cent. Int. Stud. Andrea Palladio*, xvi (1974), pp. 189–218

W. E. Wallace: 'Michelangelo's Assistants in the Sistine Chapel', *Gaz. B.-A.*, cx (1987), pp. 205–13

S. Benedetti and G. Zander: *L'arte in Roma nel secolo XVI*, Storia di Roma, xxix/1 (Bologna, 1990)

☐

Rossellino [Gamberelli]. Italian family of artists. The brothers (1) Bernardo Rossellino and (2) Antonio Rossellino were responsible for some of the most important sculptural projects in Florence between 1440 and 1470. Although both artists are now referred to as Rossellino ('little redhead'), this nickname was applied specifically to Antonio; the family name used by both brothers in documents is Gamberelli. By 1399 their father, Matteo Gamberelli, was living in Settignano, where his five sons were born. Matteo and his brothers were masons, and all his sons were trained as such. The eldest son, Domenico Gamberelli (*b* ?1402–5), was approximately five years older than Bernardo; Giovanni Gamberelli was born in 1412 or 1413 and Tomaso Gamberelli sometime between 1415 and 1422. Antonio was the youngest.

In 1451 the elder brothers filed an *estimo* at the death of their father; at this point they were all living together near S Ambrogio, Florence. In the same year Antonio filed an *estimo* separately with two nephews, both sons of Bernardo, in the quarter of Santo Spirito. It is, however, generally presumed that all five brothers usually worked together under the management of Bernardo, although some evidence suggests they occasionally worked separately: in 1448–9 Tomaso and Antonio were paid for work on the seraphim frieze above the capitals of the nave in S Lorenzo, Florence (Hyman, 1977). In 1447 Giovanni and Pagno di Lapo Portigiani (1408–70) carved a baptismal font for Massa Maritima Cathedral. Nevertheless, most of the sculpture associated with the Rossellino family before Bernardo's death in 1464 seems to have been produced by a single workshop, which presumably included the brothers as well as other sculptors. By the 1450s Bernardo increasingly accepted commissions that were finished by Antonio with the assistance of the workshop (Schulz, 1977). Some time after 1451 responsibility for the sculptural output from the Rossellino workshop passed to Antonio, largely because Bernardo became increasingly engaged on architectural commissions.

BIBLIOGRAPHY

V. da Bisticci: *Le vite* (Florence, 1493); ed. A. Greco, 2 vols (Florence, 1976)

G. Vasari: *Vite* (1550, rev. 2/1568); ed. G. Milanesi (1878–85), iii, pp. 93–105

A. Billi: *Il libro di Antonio Billi*, ed. C. Frey (Berlin, 1892)

Il Codice Magliabechiano: Scritto da Anonimo Fiorentino, ed. C. Frey (Berlin, 1892), pp. 93, 120

M. Weinberger and U. Middeldorf: 'Unbeachtete Werke der Brüder Rossellino', *Münchn. Jb. Bild. Kst*, v (1928), pp. 85–92; repr. in U. Middeldorf: *Raccolta di scritti, I: 1924–1938* (Florence, 1979–80), pp. 55–68

L. Planiscig: *Antonio and Bernardo Rossellino* (Vienna, 1942)

F. Hartt: 'New Light on the Rossellino Family', *Burl. Mag.*, ciii (1961), pp. 387–92

J. Pope-Hennessy: *Italian Renaissance Sculpture: An Introduction to Italian Sculpture*, ii (London, 1963, rev. Oxford, 3/1985), pp. 29–30, 37–8, 49–50, 283–7, 355–6 [with selected bibliog.]

SHELLEY E. ZURAW

(1) Bernardo Rossellino (*b* Settignano, ?1407–10; *d* Florence, 1464). Sculptor and architect. He was among the most distinguished Florentine marble sculptors in the second half of the 15th century. Extremely proficient technically, he was able to draw on a variety of sources, contemporary and antique, to create refined and sophisticated images. His architectural style is severely classical,

and he was skilled in designing complex monuments, in which sculptured figures and architecture are harmoniously integrated.

1. Sculpture. 2. Architecture.

1. SCULPTURE.

(i) Life and sculpted works. Brunelleschi, Donatello, Michelozzo and Ghiberti have all been suggested as Bernardo's masters (Schulz, 1977). There is, however, a striking relationship between Bernardo's sculptural style and that of Jacopo della Quercia. Bernardo probably served his initial apprenticeship with his father and uncles in Settignano. His first two documented commissions were both made for Arezzo (Salmi, 1977): in 1433 he carved a tabernacle (destr.) for the abbey of SS Fiora and Lucilla, and in the same year he was hired to complete the façade of the Palazzo della Fraternità. In 1434 he was commissioned to carve the relief of the *Virgin of Mercy* for the façade; he also made the two saints in the flanking niches. In the summer of 1433 he may have been in the Vatican, where documents tantalizingly refer to a certain 'magistro Bernardo architectori'. Between 1436 and 1438 he carved a eucharistic tabernacle for the Badia Fiorentina, of which only fragments remain (Florence, Badia Fiorentina, cloister).

In his early work Bernardo oscillated between traditional imagery and classical formulations, as in the group of the *Annunciation* (*c.* 1447–*c.* 1458; Empoli, Mus. S Andrea). While the general configuration recalls the *Annunciation* group from Florence Cathedral, evocations of antique statuary are apparent both in faces and in the pose of the Virgin, which seems to reflect the Knidian Aphrodite type.

In other projects of the period Bernardo united his skill as a sculptor with the sharp precision of his carving in architectural works. A major commission, in which the Signoria of Florence may have been involved, was for the tomb of *Leonardo Bruni* (*c.* 1446–8; Florence, Santa Croce; see fig.), the humanist chancellor and historian of Florence. Bruni was awarded a state funeral, and elements of the tomb recall the elaborate classical ceremony in Santa Croce, which was described by Vespasiano da Bisticci. This was the first and definitive example of the humanist tomb, and its conception may reflect the ideas of Alberti. The effigy of Bruno, crowned in laurel, is shown on a draped funeral bier, his history of Florence in his hands; on the austere sarcophagus beneath, winged angels support a Latin inscription. The effigy and sarcophagus are framed by the clear lines of a classical triumphal arch, and the elements of the tomb are built up in simple geometric forms, rising from the coloured base. Above, the *Virgin and Child* in a tondo intercede for Bruni's soul. Numerous assistants participated in the execution, most obviously in the two angels in the lunette, which seem to have been carved by two different assistants. The high quality of the portrait of Bruni, and of the Virgin and Child, and the precise rendering of the brocade of cloth reflect the participation of Bernardo.

In 1449 Bernardo received a commission for a tabernacle of the sacrament in S Egidio, Florence, for which Ghiberti made the bronze door behind which the sacrament is reserved. Bernardo employed the centralized

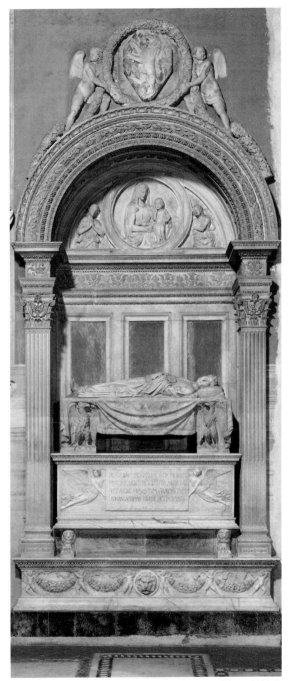

Bernardo Rossellino: tomb of *Leonardo Bruni*, marble, *c.* 1446–8 (Florence, Santa Croce)

perspective that Brunelleschi had used in his sacrament tabernacle (1427; destr.) in S Jacopo in Campo Corbellini, Florence, and his controlled depiction of a recessed niche, with its coffered ceiling and stately procession of adoring angels who seem to enter from side chapels, marks this work as one of the most innovative examples of church furnishing of its date.

From 1451 until 1453 Bernardo was in Rome, working as an architect for Pope Nicholas V (*see* §2 below). No

sculpture in Rome has been connected with him, although his Florentine workshop continued to receive commissions, and in 1451 he contracted to complete the tomb of the *Beata Villana* (Florence, S Maria Novella) and six months later agreed to make further additions to this project. At least four other tomb projects date from the following years (Schulz, 1977). He was probably directly involved in the execution of the tombs of *Orlando de' Medici* (d 1455) in SS Annunziata, Florence, and of *Neri Capponi* (d 1457) in Santo Spirito, Florence. They are extremely innovative reinterpretations of Classical models and display the powerful, severe architectural style of Bernardo's late period. In both, Christian iconography is obliquely articulated in the form of the tomb. The arcosolium format of the tomb of *Orlando de' Medici* recalls the configuration of Christian tombs in the Roman catacombs, while the profile relief on the tomb of *Neri Capponi* evokes associations with Roman sarcophagi. The tomb of *Giovanni Chellini* (d 1462), part of which survives in S Domenico at San Miniato al Tedesco, near Florence, and of *Filippo Lazzari* (d 1462) in S Domenico at Pistoia, are largely workshop productions. In 1461 Bernardo's name appears on the contract for the Cardinal of Portugal's Chapel in S Miniato al Monte, Florence.

(ii) The Rossellino workshop under Bernardo. Bernardo's numerous activities resulted in the growth of a large and semi-independent workshop, which was primarily engaged in the production of sculpture. From a fairly early date small works, such as Virgin and Child reliefs and portrait busts, were taken on by Bernardo's brothers, especially Antonio. Numerous assistants were employed in the workshop, and in several works the visible variations in figure style reflect the contribution of more than one sculptor. A likely arrangement may have been that single blocks of stone were assigned to individual carvers, but the important elements of each monument were carved by Bernardo. Working from models, the secondary sculptors would have been expected to follow closely their master's style. It seems probable that scale drawings left by Bernardo were used for the late tombs, such as those of *Chellini* and *Lazzari*, and the model for the tomb of *Orlando de' Medici* was reused several times by the workshop for other tombs of the same type. Between 1450 and 1464 the large-scale sculptural commissions undertaken by the workshop include distinguishable contributions by Bernardo and Antonio. The tomb of the *Beato Marcolino da Forlì* (1457; Forlì, Pin. Civ.) is probably based on a design by Bernardo, but the carving was done by Antonio and a second assistant. Until the commission for the funerary chapel of the Cardinal of Portugal (1461–6), Bernardo remained the principal master, but from this time onwards Antonio decisively established his independence and in 1469 began to rent his own workshop.

SHELLEY E. ZURAW

2. ARCHITECTURE. Bernardo was commissioned (1433) by the Fraternity of S Maria della Misericordia in Arezzo to complete the façade (begun 1375–6) of the Palazzo della Fraternità. Bernardo supplied the plans, workers and materials. His design for the façade (completed 1435) included four niches inserted into the existing lower part, with a cornice at ceiling level. This was surmounted at the sides by two niches (with statues of *SS Donatus and Gregory*) set between spiral columns and coupled fluted pilasters with Composite capitals, and a central relief of the *Virgin of Mercy* framed by a mixtilinear cornice, surmounted by a frieze with festoons and putti, and a series of corbels carrying a small arcaded loggia with a perforated balustrade. These classically inspired elements and the modelling of the statues and the relief show that Bernardo accepted and shared the interests and ideas of such contemporaries as Brunelleschi and Donatello. Between 1436 and 1438 Bernardo was among the masons working on the Chiostro degli Aranci and the dormitory at the Badia Fiorentina in Florence. Although this project has been attributed to Antonio di Domenico, Mack (1972, pp. 39–50) believes that Bernardo contributed the fluted pilasters that link the cloister's two orders of columns. These pilasters, each crossed by a string course, mark a geometric division of the walls, reflecting the principles of harmony and mathematical proportion that were then being propounded. Bernardo definitely designed the dormitory window overlooking Via Condotta, a combination of the medieval mullion window and the northern Guelph cross window.

Bernardo also worked as a mason and supplier of materials (from 1441) on the cloister (1436–7) of S Maria della Campora in Florence Cathedral and in S Miniato al Monte (1443–50). But Mack (1972, pp. 50–54) believes that in S Maria della Campora he also designed such details as the corbels with unusually long necks, similar to those found in Pienza. Moreover, Bernardo was a member of a commission (1443), which also included Brunelleschi, to decide on the colour of the glass in the oculi of the tribune of the cathedral, which proves that he was acting as more than just a mason. For the Palazzo Pubblico in Siena, he created a doorframe (1446; now in the Sala del Concistoro) in Carrara marble composed of two fluted columns with Corinthian capitals, surmounted by a frieze with two putti holding the coat of arms of the Sienese Republic. At the sides are two red shells with the lion rampant (the coat of arms of the Sienese people), while the doorposts are decorated with bunches of flowers and fruit. Originally some details were gilded, but overall the pictorial effects are subordinate to the architectural structure. Two other works with important architectural features are the tomb (c. 1446–8) of *Leonardo Bruni* (see fig.) in Santa Croce and the tabernacle of the Sacrament (1449–50) in S Egidio, Florence (*see* §1 above). The latter has interesting 'freeform' Composite capitals (Mack, 1972, p. 107), while the Bruni monument presents a new typology that influenced later artists. The use of the triumphal arch as a unifying element, with its classical dignity and allusion to triumph and celestial glory, is of particular interest. Mack (1972, pp. 116–32) attributes to Bernardo the Spinelli cloister (?1448–52) in Santa Croce and also (Mack, 1974) the Palazzo Rucellai. The latter attribution is problematical and much contested, as this is one of the most important 15th-century palazzi, cited by Vasari as the work of Alberti and widely accepted as such. Both the attribution and the dating (interior, 1448–55; façade, after 1461) were rejected by Preyer (1981), believing Alberti to be the author of a plan realized between 1450 and 1458. Saalman (*J. Soc.*

Archit. Historians, xxxxvii, 1988, pp. 82–90) believes that Alberti planned the project and Bernardo executed the first five bays of the façade (*c.* 1450–64); this was completed by others after his death, before 1470.

From 1451 to 1453 Bernardo was in Rome as an Ingenere di Palazzo to Pope Nicholas V. Among the numerous projects attributed to Bernardo by the Papal biographer Giannozzo Manetti (1396–1459) and by Vasari, only two are securely documented: hoists for the new tower situated at the west end of the Covered Way as a defensive counterpart of Castel Sant'Angelo, and the remodelling of S Stefano Rotondo, where he carried out reinforcement works and roofing, and built windows, marble doors and altars in a sober, classical style to harmonize with the old building. Mack (1982 and 1987) raised doubts about the attribution of the so-called 'Rossellino choir', the apse (begun 1452; destr. ?1580–85) of St Peter's in Rome, which was left unfinished in 1455. This structure, visible in many later plans for the basilica and in views by Maarten van Heemskerck (1498–1574), was polygonal outside and semicircular within. For Pope Nicholas V, Bernardo built the Palazzo delle Terme (1453–4; destr. 1527) in Viterbo. He is also credited with the remodelling (1451) of Palazzo Lunense in Viterbo (Valtieri, 1972).

His next and most important architectural project was the reconstruction (1460–64) of Corsignano, the birthplace of Pope Pius II, which was renamed PIENZA in 1461. Here the most important feature was a new town centre with a piazza bordered by the cathedral, Palazzo Piccolomini, the Episcopal Palace, the Palazzo Communale and the rectory. The whole complex was designed to create a unified perspective effect, reinforced by the geometric pattern of the pavement. It is undoubtedly one of the most important works of 15th-century urban planning. While Bernardo certainly supervised the whole project, Mack's opinion (1972, 1987) that he designed it has not been unanimously accepted; some critics maintain that Alberti also played a role. This problem is related to those of the date and attribution of the façade of the Palazzo Rucellai, with which the Palazzo Piccolomini shows obvious connections. In 1461 Bernardo was appointed Capomastro of Florence Cathedral, where he supervised work on the lantern. He also built the octagonal campanile (1463) of S Pietro, Perugia, set on the existing Romanesque base. Mack (1973) also attributes to him the Palazzo Spinelli (1459–64) in Florence. Bernardo's role as an architect is thus very problematic, although the works securely attributed to him demonstrate that he 'participated in the creation of a Renaissance language of form' (Finelli, 1984). Major contributions such as the Bruni monument, and his appointments as Ingenere di Palazzo and Capomastro of the cathedral, show the high esteem that some of his contemporaries had for his professional abilities.

ALESSANDRA ANSELMI

BIBLIOGRAPHY

Thieme–Becker

C. von Fabriczy: 'Ein Jugendwerk Bernardo Rossellinos und spätere unbeachtete Schöpfungen seines Meissels', *Jb. Kön.-Preuss. Kstsamml.*, xxi (1900), pp. 33–54, 99–113

——: 'Neues über Bernardo Rossellino', *Repert. Kstwiss.*, xxv (1902), pp. 475–7

G. Poggi: 'Bernardo Rossellino e l'opera del duomo', *Riv. A.*, i (1903), p. 146

——: *Il Duomo di Firenze: Documenti sulla decorazione della chiesa e del campanile tratti dall'archivio dell'opera*, 2 vols (Florence, 1909); rev., ed. M. Haines (Florence, 1988)

M. Tyszkiewicz: *Bernardo Rossellino* (Florence, 1928); Eng. trans. by R. Rosmaryn, ed. A. Markham (Florence, 1966); reviewed by C. Kennedy in *Riv. A.*, xv (1933), pp. 115–27

——: 'Il Chiostro degli Aranci della Badia Fiorentina', *Riv. A.*, xxvii (1951–2), pp. 203–9

A. M. Schulz: 'The Tomb of Giovanni Chellini at San Miniato al Tedesco', *A. Bull.*, li (1969), pp. 317–32

C. R. Mack: *Studies in the Architectural Career of Bernardo di Matteo Ghamberelli, called Rossellino* (PhD diss., Chapel Hill, U. NC, 1972)

S. Valtieri: 'Rinascimento a Viterbo: Bernardo Rossellino', *L'Architettura*, xvii (1972), pp. 686–94

C. R. Mack: 'The Building Programme of the Cloister of San Miniato', *Burl. Mag.*, cxv (1973), pp. 447–52

L. H. Heydenreich and W. Lotz: *Architecture in Italy, 1400 to 1600*, Pelican Hist. A. (Harmondsworth, 1974)

C. R. Mack: 'The Rucellai Palace: Some New Proposals', *A. Bull.*, lvi (1974), pp. 517–29

C. W. Westfall: *In This Most Perfect Paradise: Alberti, Nicholas V and the Invention of Conscious Urban Planning in Rome, 1447–55* (Pennsylvania, 1974)

K. W. Forster: 'The Palazzo Rucellai and Questions of Typology in the Development of Renaissance Buildings', *A. Bull.*, lviii (1976), pp. 109–13

S. Valtieri Bentivoglio: 'Il coro di S M. del Popolo e il coro detto "del Rossellino" di S Pietro', *Mitt. Ksthist. Inst. Florenz*, xx/2 (1976), pp. 197–204

M. Salmi: 'Bernardo Rossellino ad Arezzo', *Scritti di storia dell'arte in onore di Ugo Procacci*, ed. M. G. Ciardi Dupre dal Poggetto and P. dal Poggetto (Milan, 1977), pp. 254–61

A. M. Schulz: *The Sculpture of Bernardo Rossellino and his Workshop* (Princeton, 1977) [the most complete collection of documents and fullest bibliog.]; reviews by D. Pincus in *Racar*, v/1 (1978), pp. 76–9; M. Chappell in *Ren. Q.*, xxxii/1 (1979), pp. 117–21; G. Passavant in *Kunstchronik*, xxxii/7 (1979), pp. 251–8

M. Mercantini: *Il Palazzo di Fraternità in Piazza Grande ad Arezzo: Contributi storico-critici per una precisazione dell'opera del Rossellino e per una nuova attribuzione a Vasari* (Arezzo, 1980)

B. Preyer and others: *Giovanni Rucellai ed il suo Zibaldone II: A Florentine Patrician and his Palace* (London, 1981)

C. R. Mack: 'Bernardo Rossellino, L.-B. Alberti and the Rome of Pope Nicholas V', *SECAC Rev.*, x/2 (1982)

——: 'Building a Florentine Palace: The Palazzo Spinelli', *Mitt. Ksthist. Inst. Florenz*, xxvii (1983), pp. 261–84

L. Finelli: *L'Umanesimo Giovane, Bernardo Rossellino a Roma e a Pienza* (Rome, 1984)

C. R. Mack: 'Nicholas the Fifth and the Rebuilding of Rome: Reality and Legacy', *Light on the Eternal City*, Papers in Art History from the Pennsylvania State University, ii (University Park, PA, 1987), pp. 31–48

——: *Pienza: The Creation of a Renaissance City* (Ithaca, 1987)

H. W. van Os: 'Painting in a House of Glass: The Altarpieces of Pienza', *Simiolus*, xvii (1987), pp. 23–40 [contains 'A Note on Rossellino's Design for Pienza Cathedral' by K. van der Ploeg]

J. Pieper: 'Architektur wächst aus den Steinen Metaphern der Verwandlung am Palast Pius II in Pienza', *Daedalus* (1989), pp. 76–86

A. Tönnesmann: *Pienza Städtebau und Humanismus* (Munich, 1990)

E. Oy-Marra: *Florentiner Ehrengrabmäler der Frührenaissance* (Berlin, 1994)

(2) Antonio Rossellino (*b* Settignano, 1427–8; *d* Florence, 1479). Sculptor, brother of (1) Bernardo Rossellino. He belonged to the same generation as Desiderio da Settignano and Mino da Fiesole; his development more closely parallels theirs than it does that of his brother, and his style is softer and more fluid. Yet it should be assumed that Antonio received his formal training from his brother, and there are clearly similarities in their work, especially from the 1450s.

1. LIFE AND WORKS. Antonio's first signed and dated work, a portrait bust of the distinguished physician *Gio-*

vanni Chellini (1456; London, V&A), follows the mode established by Mino da Fiesole's bust of *Piero de' Medici* (Florence, Bargello; see colour pl. 2, VIII2). The rendition of the facial features suggests the influence of Roman Republican portraiture (Lightbown, 1962), and the only comparable work from the Rossellino workshop, the portrait medallion on the tomb of *Neri Capponi* (Florence, Santo Spirito), may also be an early work by Antonio (Schulz, 1977). The detailing of Chellini's features is balanced by the simplicity of the base and by the forceful outline; the symmetrical, planar arrangement of the head is further emphasized by the tightly compressed hair. Even in profile, the head is presented as an oval, and the features are aligned with an almost geometrical precision. A similar abstraction of shape can be seen in the *Portrait of a Woman* (Berlin, Skulpgal.). While the typical idealization of the portrait is different from the harsh realism of the Chellini bust, the hard folds of the drapery and the sharp distinction between head and body suggest this was also an early work. The freer and livelier marble bust portrait of *Matteo Palmieri* (Florence, Bargello), which has been considerably damaged owing to its original placement on the exterior of the sitter's home, is inscribed 1468.

The central monument of Antonio's career is the funerary chapel of the Cardinal of Portugal in S Miniato al Monte, Florence (1461–6; *see* FLORENCE, §IV, 7). Cardinal James of Portugal, who died in Florence in 1459 aged 25, had requested to be buried in the Florentine church and, according to the account of Vespasiano da Bisticci, left the commissioning of his tomb to the Bishop of Silves. Two contracts are known: the first of December 1461 is with Antonio alone; the second, made three weeks later, includes Bernardo. It appears, however, that Antonio was chiefly responsible for the sculpture, most of which is his own work, although workshop participation can be assumed. The chapel opens from the north aisle of the church, through a triumphal arch entrance, a motif repeated in the interior. To the right of the altar is the marble tomb, and opposite this is a marble episcopal throne below a frescoed *Annunciation* by Alesso Baldovinetti. The altarpiece was painted by Antonio and Piero Pollaiuolo in 1466, and the domed vault is decorated with terracotta reliefs by Luca della Robbia. The original architect, Antonio Manetti, died in 1460 and was succeeded by Giovanni Rossellino; Antonio was probably responsible for the overall design of the decoration of the chapel, for which, in accordance with his original contracts, a model was submitted. The combination of a variety of media was unprecedented at that date and a important innovation.

The tomb fills the right-hand niche of the chapel, and feigned marble curtains are drawn back to reveal the sarcophagus and effigy, which lies on a bier, the head supported on a pillow from which hang swinging tassels. The bier is supported by two weeping putti, precariously perched on a tomb inspired by an antique prototype. A pair of angels, who seem to have just alighted on the cornice above, lead the eye to a roundel with the *Virgin and Child*, supported by flying angels. The Virgin, with light, fluttering drapery on her right shoulder, leans forward and gazes tenderly at the effigy. The angels and the Virgin and Child are sharply carved, animated figures, while the base of the tomb reveals Antonio's control of

soft, delicate relief-carving. The use of Classical motifs, the concern for an idealized, but still recognizable naturalism and a surface finish that produces an effect of almost gem-like brilliance reveal Antonio's mastery of the dominant trends in mid-15th-century Florentine sculpture. To these he added a new interest in the depiction of movement, most obviously in the angels that surround the tondo of the Virgin and Child, but also in the swinging tassels that hang from the pillow beneath the Cardinal's head, the fluttering drapery on the Virgin's right shoulder and the seated putti, precariously perched on the sarcophagus. The overall integration of the chapel depends on its use of a single, pervasive scale, and Antonio's figures are neither so monumental that they overwhelm the viewer nor so delicate that they retreat into the background. The *Virgin and Child* in the chapel of the Cardinal of Portugal is his only securely datable relief of this subject; other marble reliefs attributed to him are difficult to arrange chronologically. The *Virgin and Child* (New York, Met.) was probably earlier and is one of the most successful.

In 1467 the tomb of *Filippo Lazzari* (d 1462) was installed in S Domenico, Pistoia, a commission that Giovanni and Antonio had inherited from Bernardo. The relief of *Lazzari Teaching* is a notable example of Antonio's interest in perspective. In 1473 Antonio was paid for three reliefs—the *Presentation of the Virgin's Girdle to St Thomas*, the *Stoning of St Stephen* and the *Funeral of St Stephen*—for the interior pulpit in Prato Cathedral, a project underway by 1469. These reliefs reveal his interest in the Antique, both in the heavy reliance on undercutting and in the deeply drilled passages of hair evident in the St Stephen reliefs. The decorated column in the *Stoning of St Stephen* must also have been derived from the columns of Trajan and Marcus Aurelius in Rome. Antonio is not known to have visited Rome, and his numerous quotations from antique images may have been inspired by coins, gems, sarcophagi and sketchbooks. The reliefs were also influenced by Filippo Lippi's frescoes in the same church as well as reflecting Antonio's study of Ghiberti, in the relationship of figure to architecture, and of Donatello, in the intense dramatic quality of the poses and gestures.

The life-size marble statue of *St Sebastian* (Empoli, Mus. S Andrea), the central image in a painted altarpiece by Francesco Botticini, is without parallel in Antonio's work. Two marble angels placed above the gilt wooden frame are workshop versions of similar figures in the chapel of the Cardinal of Portugal. Most critics have dated it *c.* 1470–75, the date of Botticini's painted angels, but the date remains controversial (Pope-Hennessy, 1963; Apfelstadt, 1987). The elegance of the finish is combined with a sure knowledge of anatomy, and the expression and placement of the head, which reflect Hellenistic models (Pope-Hennessy, 1970–71), are especially telling.

Antonio's late works reveal a growing fascination with the depiction of movement and an increasingly sophisticated ability not only to depict the individual elements of a face or body but also to imbue these features with emotional depth. The *Running Infant St John the Baptist* (1477; Florence, Bargello), which was made for the lunette over the doorway of the Palazzo dell'Opera di S Giovanni, illustrates Antonio's interest in the activated figure. Its apparent coarseness reflects only its elevated position,

while the complicated pose suggests a Classical source, possibly one of the groups known as *Alexander and Bucephalus* (Rome, Piazza del Quirinale). There is also a striking resemblance between this figure and the young John the Baptist in Filippo Lippi's painting of the *Adoration* (Florence, Uffizi; *see* LIPPI, (1), fig. 3). Lippi's influence is also apparent in a tondo of the *Nativity* (Florence, Bargello), which, in its narrative complexity and variety of images, is a strikingly pictorial work.

The tomb monument of *Francesco Nori* (Florence, Santa Croce; see fig.), probably commissioned and completed before the patron's death in 1478, is a highly unusual work. The monument consists of a tomb slab on the floor and a holy water font and relief of the *Virgin and Child* in a mandorla fixed to the south side of the first pier on the right side of the nave. The elegance of the surface treatment

Antonio Rossellino: tomb monument of *Francesco Nori*, marble, *c.* 1478 (Florence, Santa Croce)

demonstrates the high quality of Antonio's late productions.

2. WORKSHOP. Although Antonio became responsible for the sculptural output of his brother's workshop sometime after 1451, he did not rent his own workshop until 1469, while his surviving brothers stayed at the first workshop. In the 1470s Antonio shipped many tombs and altars to cities outside Tuscany, and his repetition of images, especially from the chapel of the Cardinal of Portugal, suggests that he kept scale models both of his three-dimensional sculpture and of his reliefs. He probably learnt to do so from Bernardo. Among these works, the chapel of St John the Baptist (1471–6) in S Giobbe, Venice, built for the Martini family (Schmarsow, 1891), is a simplified reduction of the chapel in S Miniato, with a marble altarpiece produced in the Rossellino workshop in Florence. The statue of *St John the Baptist* is attributable to Antonio. In 1475 Antonio received payment for work on the tomb of *Bishop Lorenzo Roverella* in S Giorgio, Ferrara. Although the monument is signed by Ambrogio da Milano alone, the head of the effigy, the lunette decoration and the free-standing statuettes are the work of Antonio and his workshop. Antonio also intervened in the arrangement of the upper half of the monument.

The largest late workshop commission was for the tomb of *Maria of Aragon* in the Piccolomini Chapel of the church of Monteoliveto (also known as S Anna dei Lombardi) in Naples. The work was still unfinished at Antonio's death, and in 1481 the patron requested the return of 50 florins from the sculptor's heirs. The project then passed into the hands of Benedetto da Maiano. The monument imitates the tomb of the *Cardinal of Portugal*, although the compression of the sarcophagus and effigy and the loss of the coloured inlays suggest a deliberate reduction of the original. Antonio's direct intervention can be seen in the tondo of the *Virgin and Child*, where the rounder forms are close to those of the Virgin in the Nori monument. For this chapel Antonio also carved an altarpiece of the *Nativity* (*see* NAPLES, fig. 4), in which the Nativity itself forms the central image with statues of *St James* and *St John the Evangelist* flanking it, while a predella below depicts scenes from the *Life of Christ and of the Virgin*. The *Nativity* relief is an autograph work, and its richly pictorial style is close to that of the tondo of the *Nativity* (Florence, Bargello). The *St James* and the *St John the Evangelist* represent a logical progression from the figures sent to Venice and Ferrara; the *Ascension* relief on the predella, which was probably completed by Benedetto, also seems to have originated with Antonio. The half-length figures in the tondi are more problematic (Hersey, 1969): an attribution to Benedetto da Maiano is unlikely, however, since they appear so different from the figures carved by Benedetto for the Terranuova Chapel in the same church. The young prophet on the right bears notable comparisons both with Antonio's relief figures from Prato and with the *St Sebastian* at Empoli. Antonio was still alive in 1478 and probably died the following year from the plague (Carl, 1983).

BIBLIOGRAPHY
A. Schmarsow: 'Un capolavoro di scultura del quattrocento a Venezia', *Archv Stor. A.*, iv (1891), pp. 225–35

C. von Fabriczy: 'Documenti su due opere di Antonio Rossellino', *Riv. A.*, v (1907), pp. 162–6

H. Gottschalk: *Antonio Rossellino: Inaugural Dissertation des Christian-Albrechts Universität zu Kiel* (Liegnitz, 1930)

J. Pope-Hennessy: *The Virgin with the Laughing Child* (London, 1957); repr. in *Essays on Italian Sculpture* (London, 1969), pp. 72–7

——: 'The Martelli David (Here Attributed to Antonio Rossellino)', *Burl. Mag.*, ci (1959), pp. 134–9

R. W. Lightbown: 'Giovanni Chellini, Donatello and Antonio Rossellino', *Burl. Mag.*, civ (1962), pp. 102–4

——: 'Il busto di Giovanni Chellini al Museo Victoria e Albert di Londra', *Boll. Accad. Euteleti Città San Miniato*, xxvi (1962–3), pp. 13–24

F. Hartt, G. Corti and C. Kennedy: *The Chapel of the Cardinal of Portugal, 1434–1459, at San Miniato in Florence* (Philadelphia, 1964)

J. Pope-Hennessy: 'Three Marble Reliefs in the Gambier-Perry Collection', *Burl. Mag.*, cix (1967), pp. 117–21

G. L. Hersey: *Alfonso II and the Artistic Revival of Naples, 1485–1495* (New Haven, 1969)

J. Pope-Hennessy: 'The Altman Madonna by Antonio Rossellino', *Met. Mus. J.*, iii (1970–71), pp. 133–48; also in J. Pope-Hennessy: *The Study and Criticism of Renaissance Sculpture* (New York, 1980), pp. 135–54

D. Kaczmarzyk: 'La *Madonna dei Candelabri* d'Antonio Rossellino', *Bull. Mus. N. Varsovie/Biul. Muz. N. Warszaw.*, xii (1971), pp. 55–8

D. Covi: 'Nuovi documenti per Antonio e Piero Pollaiuolo e Antonio Rossellino', *Prospettiva*, xii (1978), pp. 61–72

J. Beck: 'An Effigy Tomb Slab by Antonio Rossellino', *Gaz. B.-A.*, n. s. 6, xcv (1980), pp. 213–17

E. Carli: *Il pulpito interno della cattedrale di Prato* (Prato, 1981)

D. Carl: 'A Document for the Death of Antonio Rossellino', *Burl. Mag.*, cxxv (1983), pp. 612–14

D. S. Pines: *The Tomb Slabs of Santa Croce: A New 'Sepoltuario'* (diss., New York, Columbia U., 1985)

G. Radke: 'The Sources and Composition of Benedetto da Maiano's San Savino Monument in Faenza', *Stud. Hist. A.*, xviii (1985), pp. 7–27

E. Apfelstadt: *The Later Sculptures of Antonio Rossellino* (PhD diss., Princeton U., 1987)

A. V. Coonin: 'Portrait Busts of Children in Quattrocento Florence', *Met. Mus. J.*, xxx (1995), pp. 61–71

D. Carl: 'New Documents for Antonio Rossellino's Altar in the S Anna dei Lombardi, Naples', *Burl. Mag.*, cxxxviii/1118 (1996), pp. 318–20

SHELLEY E. ZURAW

Rossello di Jacopo Franchi. *See* FRANCHI, ROSSELLO DI JACOPO.

Rossetti, Biagio (*b* Ferrara, *c.* 1447; *d* Ferrara, Sept 1516). Italian architect and engineer. He was one of the main exponents of the architectural language derived from the Tuscan Renaissance and worked mostly in Ferrara, where he realized the project for which he is best known: the Addizione Erculea, a plan of expansion carried out under Ercole I d'Este, Duke of Ferrara and Modena. He also built numerous churches and palazzi, in which his main sources of inspiration were the works of Brunelleschi, modernized through the influence of subsequent Venetian architecture. He gave these ideas a highly personal interpretation, however, based on Ferrara's own architectural tradition.

1. EARLY WORK, BEFORE 1494. The earliest documentation of Rossetti concerns his part in the building of additional storeys on the Palazzo Schifanoia, where he worked between 1466–7 and 1471 as a *muradore* (mason) under Duke Borso d'Este's architect Pietro Benvenuti dagli Ordini (*fl* 1458–84). There he followed the latter's architectural language, which was characteristic of the transition from Gothic to Renaissance. Rossetti was probably responsible for designing the portal, and in particular for its asymmetrical placement. Between 1474 and 1476, in Rovigo, he may have carried out the restorations and

extension of the Olivetan convent of S Bartolomeo and the initial phase of the Palazzo Roverella, both of which show a complete adherence to the Tuscan Renaissance style. Between 1482 and 1484 he worked as a military engineer in Modena and elsewhere, and in 1483 he succeeded Benvenuti as ducal architect and engineer of the Munizione, the office responsible for fortifications and such other public works as bridges and roads in Ferrara and the Este lands. In the following year, and again in 1487, he worked on the fortress of Argenta near Ferrara.

In 1485 work began on the campanile of the church of S Giorgio in Ferrara, where Rossetti must have been working since 1479 (if not earlier) on the convent belonging to the Olivetan Order. The campanile, built of brick, is four storeys high with architectural orders in terracotta units; it terminates in a spire (partly destr.) flanked by four pinnacles. This is a particular version of the typical Renaissance architecture of the Po Valley. Again in 1485, after the Venetian–Ferrarese War, Rossetti visited Venice several times to carry out works in the Este palace there (now the Fondaco dei Turchi). In the following years he worked on other Este residences in Ferrara, such as the Barco di Belfiore and the Palazzo di Porto (both in 1488), the Palazzo di Ghiara (completed 1491), and the Loggia di Piazza (1491–3; destr. 1532), which surrounded the Palazzo Estense and joined the Arco del Cavallo (attributed to Alberti) opposite the façade of Ferrara Cathedral. In 1491 he directed the restoration of the tower of Modena Town Hall. Despite these commitments, in the preceding year he had begun building a house (completed *c.* 1500) for his own family, also in Ferrara. This included some new layout solutions (for example the three-part plan inspired by Venetian building) that were soon imitated in other houses in the city.

In August 1492 Rossetti was appointed by Ercole I to plan an extension north of the city, later known as the Addizione Erculea. Eschewing both the abstract rationalism of the ideal cities of 15th-century treatise writers and the idea of spontaneous growth characteristic of medieval town planning, he fixed the new perimeter of the city, taking account of certain points that had to be included within the new walls and of the new defensive requirements. He continued to supervise the construction of the new walls until 1510. The resulting form of the city is that of an irregular pentagon, within which he laid out the lines of two straight main thoroughfares. Wherever possible he arranged for the streets of the medieval town to run on into the new roads, so that the two sectors of the city would be firmly linked together. Because of this approach, his plan continued to exert a favourable influence on the development of Ferrara even in later centuries to the extent that Burckhardt described it as the first modern European city.

Inside the Addizione, Rossetti was responsible for the siting of the main buildings, the plans of which he personally devised and some of which he followed through all the stages of construction. At the crossing of the two main streets he placed palazzi of different degrees of importance, determining their size in relation to the overall plan. Work began on these buildings in 1493. The Palazzo dei Diamanti (remodelled 1565; damaged 1943; see fig. 1), built for Sigismondo d'Este on one of the corners formed

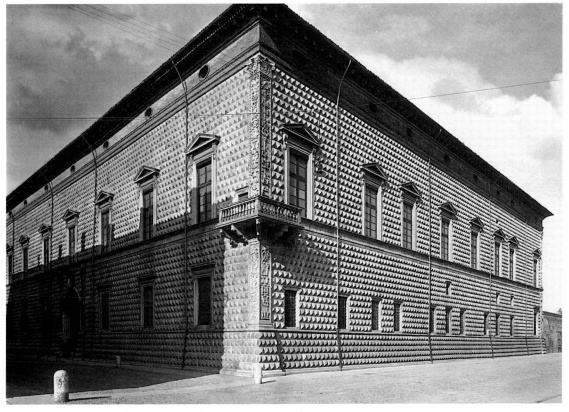

1. Biagio Rossetti: Palazzo dei Diamanti, Ferrara, begun 1493; remodelled 1565

by this crossing, has two façades of three storeys over a sloping base, clad over all with 8500 faceted blocks of Istrian stone. The axes of the facets are tilted upwards in the first storey, downwards in the third and are level in between to take account of perspective and afford the optical corrections necessary to give a vibrant aesthetic effect to the mass of the building. The angles of the long façade are articulated by clasping pilasters, their shafts carved with superimposed candelabra, which support a corner balcony at first-floor level and a deep brick entablature at the top, in effect, a Bolognese mezzanine pierced by oval lucarnes. This corner was clearly intended by Rossetti to serve as an important urban feature, to which the corners of the three other palazzi at the other angles of the crossroads respond. One of these, the Palazzo Prosperi–Sacrati (c. 1493), may have been modified by Rossetti in the early 16th century (work was interrupted in 1511); he was probably responsible for the corner treatment with the overhanging balcony, and the design of the rich portal-balcony flanked by two Corinthian columns, corresponding to which, the entablature crowning the entrance arch on the wall behind, projects deeply. Both these decorative stone features add elegance to the simple brick walls of the palazzo, accentuating its townscape importance at the junction of the two main axial streets. In the Palazzo Turchi–di Bagno and the Palazzo Mosti, situated on the other two corners of the crossing, only the angle features in Istrian stone can be attributed to Rossetti, who again strove to enhance the scenic perspective effect of the buildings facing the two new streets.

2. 1494 AND AFTER. Between 1494 and 1498 Rossetti also erected four churches at the edges of the old city and in the Addizione. In 1494 he began rebuilding the church of S Francesco (1227), in which the plan of nave and aisles with chapels, transept and semicircular apse reveals the inspiration of Brunelleschi's church of S Lorenzo (begun 1421) in Florence, but the façade shows the influence of late 15th-century Lombard taste (see fig. 2). The overall result is an original sense of space and a pleasing equilibrium created by the light from the windows and the proportions of the structural elements and volumes. The church of S Maria in Vado dates from the following year. It has a Latin-cross plan, a flat-roofed nave divided from the aisles by an arcade on tall pedestals, a deep semicircular apse and a dome (destr. early 19th century) at the crossing: here the absence of side chapels, which are replaced by niches in the outer wall, suggests the spatial effect of Brunelleschi's church of Santo Spirito (begun 1436), Florence.

In 1496 Rossetti began the church of S Benedetto. This has a longitudinal plan with nave and aisles, but with the arms of the transept equal to the apse to reconcile, as it were, the centralized plan with the Latin-cross type, as in other 15th-century churches. The arm corresponding to the nave and aisles, flanked by semicircular chapels as in Santo Spirito (their shape is also visible from the outside),

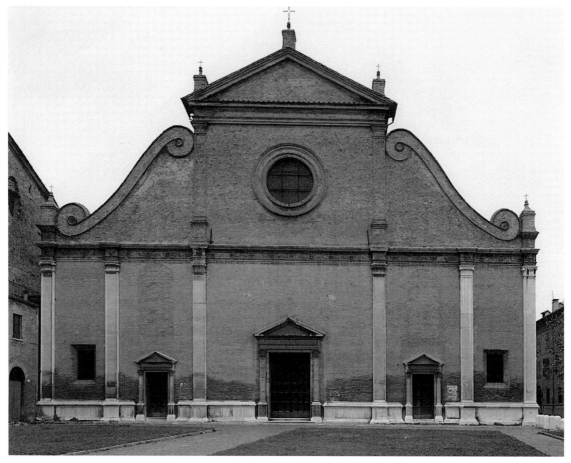

2. Biagio Rossetti: façade of S Francesco, Ferrara, begun 1494

has a bay rhythm that looks to the Romanesque but is embellished with Renaissance architectural orders. Over the centre of the nave is a shallow hemispherical vault: the crossing on the other hand is emphasized by a dome enclosed externally by a *tiburio*. The effectiveness of the spatial solution is increased by the arrangement of the windows. The church was destroyed during World War II, however, and then faithfully reconstructed. The Carthusian church of S Cristoforo (1498) has an aisleless nave with rectangular chapels and transept and a very deep presbytery ending in a semicircular apse. Here too the nave is divided into three bays, each covered by a sail vault; the vault over the crossing (hidden outside by a rise in the roof) is followed by a lower one that covers the presbytery space, separated from the transept by a diaphragm wall with a wide arched opening. This original solution means that the altar zone is flooded with a great light and is hence symbolically enhanced in contrast with the area occupied by the worshippers.

Also in 1498 Rossetti began rebuilding the apse of Ferrara Cathedral (at that time it had double aisles; altered to a nave with single aisles and chapels, 1712). Here, after demolishing the 14th-century structure, he substituted a quadrangular space covered with a groined vault, to which was abutted a new semicircular apse articulated externally

with two orders of pilasters and pierced at the lower level by six single-light windows. Inside, again light determines the effect of the composition, while externally decorations of terracotta and Istrian stone are applied to a simple brick curtain wall. On the street that forms the boundary between the old city and the new, the 'Giovecca', stands the palazzo (later Palazzo Roverella) built between 1497 and 1509 for Gaetano Magagnini. The façade fronting the street has a double order of pilasters flanked by architraved windows on the ground floor and arched windows surmounted by triangular tympani on the *piano nobile*. Shafts and friezes are richly decorated in terracotta and harmonize well with the brick walls on which they are superimposed: this decorative apparatus is attributed to the craftsmen who completed the building, while its compositional scheme is assigned (with some uncertainty) to Rossetti.

In the south-east part of Ferrara, the palazzo of Antonio Costabili (popularly and incorrectly called the 'palazzo of Ludovico il Moro'; now the Museo Archeologico Nazionale di Spina) was under construction in 1502. It was never finished. From the street it looks like a severe brick building relieved by arched windows on the *piano nobile*; but its main interest is in the courtyard, of which only two sides were completed, where each ground-floor arcade bay is surmounted on the first floor by two smaller arches

side by side. Until the restoration of 1930 these were not all open, forming a loggia: every other pair was walled up, and at the corner only did four open arches meet. This solution was a compositional motif that formed an original elaboration of Rossetti's habitual preference for paired openings. In 1503 Rossetti went to Milan to survey the condition of the building housing the Este legation. The following year he was sent to Florence because the Florentines, at war with Pisa, wanted advice on the possibility of diverting the course of the River Arno. Between 1512 and 1516 he carried out works for Cardinal Ippolito I d'Este at various places in the territory of Ferrara. Other works in Ferrara that can be attributed to Rossetti include the apse of the church of S Giovanni Battista, the *loggetta* in the hanging garden of the Este castle, the Palazzo Montecatino and the church of S Maria della Consolazione.

See also FERRARA, §1.

BIBLIOGRAPHY

J. Burckhardt: *Die Kultur der Renaissance in Italien* (Basle, 1860; Eng. trans., London, 1949)
G. Campori: 'Gli architetti e gli ingegneri civili e militari degli Estensi dal secolo XIII al XVI', *Atti & Mem. Reale Deput. Stor. Patria Prov. Moden.*, iii/1 (1883)
A. Venturi: *Storia* (1901–40)
G. Padovani: 'Biagio Rossetti', *Atti & Mem. Deput. Ferrar. Stor. Patria*, xxix (1931)
——: *Architetti ferraresi* (Rovigo, 1955)
B. Zevi: *Biagio Rossetti architetto ferrarese il primo urbanista moderno europeo* (Turin, 1960)
C. M. Rosenberg: 'The Erculean Addition to Ferrara', *Acta*, v (1978)
A. Farinelli Toselli: 'Riparazione delle mura estensi in una lettera di Biagio Rossetti del 1513', *Mus. Ferrar.: Boll. Annu.*, xv (1985–7), pp. 99–102
A. F. Marcianò: *L'età di Biagio Rossetti: Rinascimenti di casa d'Este* (Ferrara and Rome, 1991)
T. Tuohy: *Herculean Ferrara: Ercole d'Este, 1471–1505, and the Invention of a Ducal Capital* (Cambridge, 1996)

ADRIANO GHISETTI GIAVARINA

Rossi, Bernardino de (*b* S Colombano, Pavia, *c.* 1465; *d* after Sept 1514). Italian painter. He was first documented in 1484, as a painter, and in 1485 he was cited in connection with the decoration of the women's infirmaries in the hospital of S Matteo, Pavia. The earliest known signed work is the fresco of the *Virgin and Child with St Benedict and Two Donors* (1491; Pavia, Semin. Vescovile) for the cloister of S Maria Teodote, Pavia. Between 1494 and 1513 he worked mainly with Ambrogio Bergognone, the chief painter employed at the Certosa di Pavia. There de Rossi's work included paintings in the prior's apartment (1494), in the friars' cells and the *Annunciation* (1508) in the vestibule. He also worked in other places linked with the Certosa, producing frescoes in 1505–6 for the nave of the monastery church of Pancarana on the Po, and in 1511 for the façade of the parish church of Vigano Certosino, Milan. Among his last frescoes are those in the Berzio Chapel of S Marino, Pavia, datable to 1512 (Giordano, 1981). In that year he also prepared the festive decorations for the entry into Pavia of Massimiliano Sforza, Duke of Milan. The last documentary evidence regarding the artist is his will, dated September 1514. In the 19th century de Rossi was erroneously identified with the painter Bernardino Lanzani (*fl* 1490–1526) (Calvi, 1865); his identity was clarified by Pezzini (1955).

BIBLIOGRAPHY

G. L. Calvi: *Notizie sulla vita e sulle opere dei principali architetti, scultori e pittori che fiorirono in Milano durante il governo dei Visconti e degli Sforza*, xi (Milan, 1865), pp. 261–3
A. Pezzini: 'Bernardino de Rossi e Bernardino Lanzani a S Colombano', *Boll. Soc. Pavese Stor. Patria*, vii (1955), pp. 65–82
L. Giordano: 'Un'aggiunta a Bernardino de Rossi: La cappella Berzio', *Stor. A.*, 42 (1981), pp. 117–38
M. T. Chirico de Biasi: 'De Rossi, Bernardino', *La pittura in Italia: Il quattrocento*, ii (Milan, 1987), p. 616 [with bibliog.]
A. Battaglia: 'Bernardino de Rossi', *Pittura a Pavia dal Romanico al settecento* (Cinisello Balsamo, 1988), p. 220

MARCO CARMINATI

Rossi, Francesco de'. *See* SALVIATI, FRANCESCO.

Rossi, Franco dei. *See* FRANCO DEI RUSSI.

Rossi, Giovanni Antonio de' (*b* Milan, 1517; *d* after 1575). Italian medallist and gem-engraver. Beginning his career in Milan, he moved to Venice in the early 1540s and to Rome in 1546, to work for the papal mint. On stylistic grounds a medal of *Pope Julius III* (1550–55; Kress, no. 369A) is attributed to de Rossi, but his first signed medal is of *Pope Marcellus II* (1555; Kress, no. 370). From 1557 to 1560 de Rossi resided in Florence, and in 1557 he accepted a commission to carve a large cameo showing *Cosimo I de' Medici, Grand Duke of Tuscany, and his Family* (Florence, Pitti; *see* ITALY, fig. 34), from a preliminary drawing (Oxford, Christ Church) attributed to Vasari; the cameo admirably displays de Rossi's technical brilliance. In 1560 he returned to Rome, and in 1561 he became warden of the papal mint, a position he retained until his death. In this post he produced not only papal medals but a medal of *St Carlo Borromeo, Archbishop of Milan*.

De Rossi's large, cast pieces are not without quality: the portraits are competent and even quite sensitive in cases in which the artist may have had more direct contact with the subject and no obligation to adhere to official standards, as in the medal of *Vincenzo Bovio of Bologna* (1550; Kress, no. 371). The small, struck papal medals, on the other hand, follow a familiar pattern with their dry, official portraits and brittle allegorical or narrative reverses. An exception is the ascetic intensity captured in the expressive portrait of *Pius V* (1571; Pollard, no. 590) for the medal commemorating the victory over the Turkish fleet in the Battle of Lepanto.

BIBLIOGRAPHY

Forrer
A. Armand: *Les Médailleurs italiens*, i (Paris, 1883/R Bologna, 1966), pp. 243–7
G. F. Hill and G. Pollard: *Renaissance Medals from the Samuel H. Kress Collection at the National Gallery of Art* (London, 1967), pp. 69–70 [Kress]
Roma Resurgens: Papal Medals from the Age of the Baroque (exh. cat., ed. N. T. Whitman and J. L. Varriano; South Hadley, MA, Mount Holyoke Coll. A. Mus., 1981), p. 29, no. 10; p. 30, no. 12
G. Pollard: *Italian Renaissance Medals in the Museo Nazionale del Bargello* (Florence, 1985), ii, pp. 1036, 1060, 1068–70, 1073, 1075, 1096, 1125; iii, pp. 1262–3

STEPHEN K. SCHER

Rossi, Properzia de' (*b* Bologna, *c.* 1490; *d* Bologna, 1530). Italian sculptor. She is referred to in a document dated 1516 as the daughter of Girolamo de' Rossi of Bologna. Among the few recorded women artists in the

16th century, she was unusual in working as a sculptor. According to Vasari, she began by carving peach stones: a peach stone he described as engraved with the entire *Passion* has been identified as that forming part of a necklace (Pesaro, Pal. Bonamini–Pepoli). An engraved cherry stone (Florence, Uffizi) has been attributed to her, as well as 11 carved peach stones set in a device of filigree silver (Bologna, Mus. Civ.). Her work in marble includes a portrait of *Conte Guido de' Pepoli* (Bologna, Pal. Pepoli Campogrande), two angels in high relief (believed to be those placed on either side of the *Annunciation* by Domenico Brusasorci in S Petronio) and a relief panel, *Joseph and Potiphar's Wife*, carved for the portal of S Petronio (Bologna, Mus. S Petronio). For the same portal, documents dating to 1525 and 1526 indicate that de' Rossi carved a second panel (believed to be that of the *Visit of the Queen of Sheba to Solomon*), as well as two sibyls and an angel. Vasari also recorded that she produced engravings and made drawings after Raphael.

BIBLIOGRAPHY

Thieme–Becker

G. Vasari: *Vite* (1550, rev. 2/1568); ed. G. Milanesi (1878–85), v, pp. 73–81

L. Ragg: *The Women Artists of Bologna* (London, 1907), pp. 167–86

F. H. Jacobs: 'The Construction of a Life: Madonna Properzia de'Rossi "Schultrice" Bolognese', *Word & Image*, ix (1993), pp. 122–32

N. H. Bluestone: 'The Female Gaze: Women's Interpretations of the Life and Work of Properzia de' Rossi, Renaissance Sculptor', *Double Vision: Perspectives on Gender and the Visual Arts*, ed. N. H. Bluestone (London, 1995), pp. 38–64

CHRISTOPHER L. C. E. WITCOMBE

Rossi, Vincenzo (di Raffaello) de' (*b* Fiesole, 1525; *d* Florence, 1587). Italian sculptor. He began his career as an apprentice to Baccio Bandinelli, possibly in 1534. By 1546 he had completed his training and moved to Rome. In 1547 he received his first independent commission, from the society of artists known as the Pontificia Accademia dei Virtuosi al Pantheon, to execute the *Young Christ with St Joseph* for the chapel in the Pantheon. St Joseph, the society's patron saint, is twice life-size and rendered with almost excessive attention to detail, particularly in the decorative cape that falls over his shoulders. His toga is deeply undercut, exaggerating the effects of light hitting the form, and his face is similarly chiselled to accentuate the eyes and decorative plaits of hair and beard. These effects, as well as the extremely long torso of the saint and almost gargantuan left hand, suggest that de' Rossi was endeavouring to compensate for the viewing angle of the spectator. The figure of Christ is life-size and accordingly looks diminutive beside St Joseph. Nevertheless, the composition of the group is balanced in that St Joseph's stance and gesture and the inclination of his head are mirrored in the pose of his son. This practice and the adoption of a frontal viewpoint (derived from Bandinelli) is repeated in de' Rossi's subsequent figural groupings in progressively more sophisticated ways.

The course of events between 1547 and 1558 is unclear. Vasari stated in his *Vita* of Bandinelli that de' Rossi was recalled from Rome to Florence by his former master in 1554, principally to work on the high altar of the cathedral. Borghini mentioned that early in his career de' Rossi executed the male herm that flanks the main portal of the Palazzo Vecchio, Florence, and that he also made a marble

copy of the *Laokoon* (Switzerland, priv. col.). In 1558 Vincenzo is documented in Rome, having completed a marble statue of *Pope Paul IV* (destr. 1559; head in Rome, Mus. N. Castel S Angelo) and two of the four youths that surrounded the seated figure. While in Rome he executed a number of marble reliefs and portrait busts for secular and religious patrons, as well as a *Bacchus and Satyr* (untraced) for Pope Julius III. By 1558 Vincenzo had also begun two important works in Rome, the marble tombs, figural bronzes and stuccoed reliefs of the Cesi Chapel in S Maria della Pace and the marble group depicting *Paris and Helen* (1558–60; Florence, Boboli Gdns). Ignoring Bandinelli's exhortations to return to Florence, de' Rossi remained in Rome to complete these works, as well as the monument to *Paul IV*. According to Vasari, the Cesi Chapel established his reputation, while according to Borghini it was *Paris and Helen*, which was purchased by Cosimo I de' Medici and transported to Florence in 1560, that gained him entry into Cosimo's court and hence to Medicean patronage. Sculpted from a single block of marble, the latter group (see fig.) is a vital reference point in the assessment of de' Rossi's stylistic development. It comprises the Trojan prince, Helen and a boar. The human figures are positioned above the boar in a manner that recalls Michelangelo's *Victory* (1527–30; Florence, Pal. Vecchio) or Bandinelli's *Hercules and Cacus* (1534; Florence, Piazza della Signoria), but de' Rossi's use of three components better satisfies mid-century notions of *difficoltà* and *sprezzatura* (effortless ability) (*see*

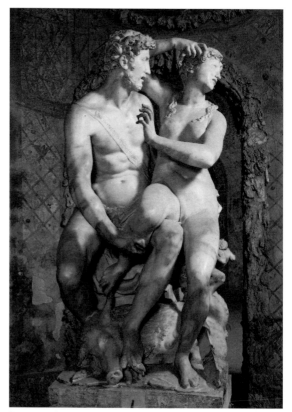

Vincenzo de' Rossi: *Paris and Helen*, marble, 1558–60 (Florence, Boboli Gardens)

MANNERISM). The figures of Paris and Helen are often compared with Bandinelli's *Adam and Eve* (1549–51; Florence, Bargello) and may also have been inspired by a figural grouping such as the Roman copy of the *Satyr and a Youth* (Rome, Mus. N. Romano) attributed to Heliodoros, which was then in the collection of the Cesi family. De' Rossi's grouping, even more than the possible antique source, focuses on Helen's struggle with her abductor, her sensuous, writhing body and pained expression contrasting strongly with those of Paris. The strap worn by Paris is inscribed VINCENTIUS DE RUBEIS CIVIS FLOREN.[TINUS] OPUS and echoes the strap on the Virgin's garment in Michelangelo's *Pietà* (1497–1500; Rome, St Peter's).

At the end of December 1560, following Bandinelli's death, Vincenzo returned to Florence, apparently with Cosimo, to take up permanent residence. He completed the statue of *Leo X* and possibly also that of *Cosimo I* for the Udienza built by Bandinelli at the north end of the Sala Grande in the Palazzo Vecchio. Between 1561 and 1563 he worked on the choir of the cathedral, and in 1565 he contributed to the ephemeral decorations for the nuptials of Francesco de' Medici and Joanna of Austria, in collaboration with other artists. At this time he executed a *Dying Adonis*, which was sent to Isabella de' Medici at the Medici villa at Poggio Imperiale. The *Dying Adonis* (marble; Florence, Bargello) was attributed to Michelangelo from the mid-17th century and is clearly inspired by his art, particularly the figure of *Night* in the Medici Chapel (Florence, S Lorenzo). Among his other works datable to this period are the marble group of *Bacchus and a Satyr* (*c.* 1565; Florence, Boboli Gdns) formerly attributed to Pierino da Vinci, and some of the bronze satyrs on Bartolomeo Ammanati's *Neptune Fountain* (*c.* 1565; Florence, Piazza della Signoria).

By 1568 de' Rossi had executed the over life-size marble groups of *Hercules and Nessus* and *Hercules and Cacus* for a monumental fountain (unfinished). Possibly commissioned in December 1560 and begun as early as 1561–2, the fountain was to have symbolized the fortitude and virtue of Cosimo I. A preparatory drawing (New York, Cooper-Hewitt Mus.) shows that it was intended to have twelve such groups showing the *Labours of Hercules* ranged in tiers above eight bronze reliefs and punctuated on the rim of the basin by Cosimo de' Medici's capricorns. Of the seven marbles executed, at least three are generally ascribed to de' Rossi: the two mentioned above and *Hercules and Antaeus* (all Florence, Pal. Vecchio). Utz (1981) added *Hercules Upholding the Celestial Globe* (Florence, Pal. Vecchio), while Venturi and Muccini attributed all seven to de' Rossi. Venturi justified this assertion by charting a development from the thin and wiry works of the 1560s through the more serpentine and dramatic sculptures finished by 1584, a development similar to that characterized by Utz. While work proceeded on the *Hercules* groups, de' Rossi created the small-scale bronze *Vulcan at the Forge* (1572; Florence, Pal. Vecchio) for Francesco I, Grand Duke of Tuscany's Scrittoio, and the over life-size marble statues of *St Matthew* and *St Thomas*, installed in the cathedral by 1580. From 1584 until his death de' Rossi was evidently occupied solely with the five remaining *Hercules* groups. He was buried in his family tomb in the church of SS Annunziata, Florence.

De' Rossi was highly regarded by his early biographers (according to whom he was also an architect), but by the mid-17th century his reputation had declined, and his subsequent obscurity resulted in many of his works being assigned to other artists, most notably Michelangelo. Research in the 20th century has resulted in the identification of his oeuvre as well as a more critical assessment of his style. Middeldorf stated that nearly all his works exhibit a 'brutality of invention and execution'. Pope-Hennessy considered that he 'was not, even by Florentine standards, a very good sculptor', concluding that the system of patronage in 16th-century Tuscany was largely responsible for the 'clumsiness' and 'childish expressive repertory' of de' Rossi's sculpture.

BIBLIOGRAPHY

G. Vasari: *Vite* (1550, rev. 2/1568); ed. G. Milanesi (1878–85), vii, pp. 626–7
R. Borghini: *Il riposo* (Florence, 1584); ed. M. Rosci (Milan, 1967), i, pp. 595-8; ii, p 125
F. Baldinucci: *Notizie* (1681–1728); ed. F. Ranalli (1845–7), iii, pp. 495–8
U. Middeldorf: 'An Erroneous Donatello Attribution', *Burl. Mag.*, liv (1929), pp. 184–8
A. Venturi: *Storia*, xiv (1936)
J. Pope-Hennessy: *Italian High Renaissance and Baroque Sculpture: An Introduction to Italian Sculpture* (New York, 1963/*R* 1985)
D. Heikamp: 'Vincenzo de' Rossi disegnatore', *Paragone*, xv/169 (1964), pp. 38–42
H. Utz: 'Vincenzo de' Rossi', *Paragone*, xvii/197 (1966), pp. 29–36
V. Bush: *The Colossal Sculpture of the Cinquecento* (New York and London, 1976)
J. Pope-Hennessy: 'The Relations between Florentine and Venetian Sculpture in the 16th Century', *Florence and Venice: Comparisons and Relations*, ed. S. Bertelli, N. Rubinstein and C. H. Smyth, ii (Florence, 1980), pp. 323–35
H. Utz: 'The *Labors of Hercules* and Other Works by Vincenzo de' Rossi', *A. Bull.*, liii/3 (1981), pp. 344–66
A. Boström: 'A Bronze Group of the *Rape of Proserpina* at Cliveden House in Buckinghamshire', *Burl. Mag.*, cxxxii (1990), pp. 829–40
D. Heikamp: 'Die Laokoongruppe des Vicenzo de "Rossi"', *Mitt. Ksthist. Inst. Florenz*, xxxiv/3 (1990), pp. 342–78
U. Muccini: *The Salone dei Cinquecento of Palazzo Vecchio* (Florence, 1990)
R. Galleni: 'Per una ipostesi interpretativa del gruppo scultoreo di Vincenzo de' Rossi nella Grotta Grande di Boboli', *Boboli '90. Atti del convegno internazionale di studi per la salvaguardia e la valorizzazione del giardino: Firenze, 1991*, pp. 47–56
C. Mandel: 'An Autograph Satyr by Vincenzo de' Rossi on the Neptune Fountain in Florence', *Source*, xiv/4 (Summer 1995), pp. 26–33
A, Böstrum: 'The Florentine sculptor Raffaello Peri', *Burl. Mag.* cx1/1141, pp. 263–4

CORINNE MANDEL

Rosso, il. *See* NANNI DI BARTOLO.

Rosso Fiorentino [Giovanni Battista di Jacopo Rosso] (*b* Florence, 8 March 1494; *d* ?Fontainebleau, 14 Nov 1540). Italian painter and draughtsman, active also in France. He was a major Florentine Mannerist (*see* MANNERISM, §5), whose art is both elegant and emotionally intense. He was influential in Rome, and in Paris and Fontainebleau became one of a group of Italian artists who were instrumental in pioneering a northern, more secular Mannerism.

1. Training and early work in Florence and Volterra, before 1524. 2. Rome, 1524–7. 3. Central Italy and Venice, 1527–30. 4. Fontainebleau, 1530–40.

1. TRAINING AND EARLY WORK IN FLORENCE AND VOLTERRA, BEFORE 1524. Rosso was either a pupil of Andrea del Sarto or he worked as an independent artist in del Sarto's studio in Florence. Apparently he had

studied art at an early age; he had copied Masaccio's frescoes in the Brancacci Chapel in S Maria del Carmine, Florence (see colour pls 2, II2 and 2, III2), and Vasari noted that in 1513 he drew from Michelangelo's cartoon of the *Battle of Cascina* (untraced). The other great pillar of Florentine Mannerism, Jacopo Pontormo, was certainly a pupil in del Sarto's studio. Arguably, Rosso's early development was as much influenced by Pontormo (and vice versa) as it was by del Sarto himself.

Rosso's early work in Florence reflected the expressive classicism of del Sarto and Fra Bartolommeo. In 1513–14 he contributed a fresco, the *Assumption*, to the cycle in the atrium of SS Annunziata, Florence, in which del Sarto and Pontormo collaborated. Rosso's fresco (*in situ*), violent and dissonant in colour, and filled with powerful and idiosyncratic forms, differed sharply from the mature classicism of his contemporaries, and it was not well received. Indeed, del Sarto was commissioned to overpaint it, although he never did so. Rosso received other commissions from the Annunziata between 1513 and 1517 (Shearman, 1960), but the incident contributed to his growing reputation as a difficult character and an unpredictable painter.

Rosso's interest in macabre imagery and his development of a novel, highly personal figure style, is evident in the drawing, *Allegory of Death and Fame* (1517; Florence, Uffizi), which was engraved by Agostino Veneziano (B. 14). A bizarre group of shrivelled, almost *écorché* figures bend over a skeleton whose head is held by an ancient bearded man, suggesting a Lamentation or Pietà. On 30 January 1518 Rosso was commissioned by Leonardo di Giovanni Buonafe (*c.* 1450–1545) to paint an altarpiece, the *Virgin and Child Enthroned with Four Saints* (Florence, Uffizi; see colour pl. 2, XXVI1), for the Ospedale di S Maria Nuova, Florence. Buonafe saw the altarpiece before it was finished, and was horrified by the harshness of the saints, who seemed to him like devils; Vasari remarked that the finished painting would have been softer in effect. The picture was rejected, and it has been suggested that it was modified and sent to a church dedicated to S Stefano at Grezzano, outside Borgo San Lorenzo (Franklin). In the altarpiece space is compressed, and the saints appear argumentative, and somewhat demented, rather than devilish, but there is already something of Rosso's later style in the stylized poses and consciously shocking treatment of the subject.

This dispute damaged Rosso's Florentine career, and in 1521 he is documented in Volterra (Battistini), where he painted the *Deposition* (Volterra, Pin. Com.; see fig. 1) for the chapel of the Compagnia della Croce di Giorno in the church of S Francesco and the disquieting *Virgin and Child Enthroned with Two Saints* (Volterra, Mus. Dioc. A. Sacra) for the Pieve at Villamagna. In the *Deposition* he further distanced himself from the conventions of Renaissance classicism. The picture pursues an emotional response through its striking and original use of bright, artificial colours, of unnatural, sharp light, of frozen figures and of drama in the apparent difficulty of lowering Christ's body to the ground.

In late 1521 or early 1522 Rosso returned to Florence, and in 1522 painted the Dei altarpiece (Florence, Pitti) and in 1523 the elegant and spirited *Marriage of the Virgin*

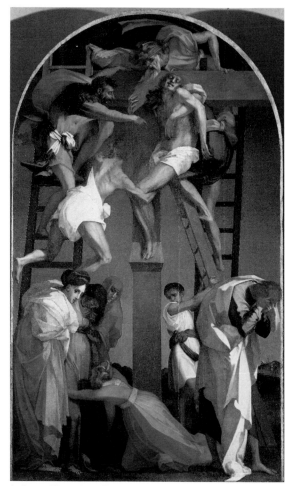

1. Rosso Fiorentino: *Deposition*, oil on panel, 3.41×2.01 m, 1521 (Volterra, Pinacoteca Comunale)

(Florence, S Lorenzo; see colour pl. 2, XXVI2). His *Moses Defending the Daughters of Jethro* (Florence, Uffizi; for illustration *see* MANNERISM) was probably painted in Florence, although the date is disputed by some scholars and the appeal of Michelangelo is very evident in the handling of the naked male forms, the extensive foreshortening and the physicality of the struggle. From the impossible jumble of battling men, terrified sheep and a semi-clothed daughter, gesturing horror, Rosso created a strange and contrived drama. He does not hesitate to shock, placing Moses's, admittedly diminutive, genitals right at the centre of the picture.

2. ROME, 1524–7. In early 1524 Rosso set out for Rome, where he is first recorded on 26 April 1524. He was deeply influenced by the grandeur and nobility of Michelangelo's work, in particular his painting on the ceiling of the Sistine Chapel (see colour pls 2, V2, 2, VI1 and 2, VI2). However, Rosso's sharp tongue and arrogant behaviour continued to make enemies; he antagonized Michelangelo's studio by criticizing his frescoes; Benvenuto Cellini tells us that he had to protect Rosso from Raphael's pupils after other disparaging remarks. In 1524

he completed two powerfully Michelangelesque frescoes, the *Creation of Eve* and the *Fall of Adam*, both in the Cesi Chapel in S Maria della Pace, Rome, but antagonized Antonio da Sangallo, the architect of the chapel, before this decoration was completed. In the summer of that year Rosso was in Cerveteri, where he met Cellini, who tells us that Rosso won a commission for a series of frescoes on the life of St Roch from the Count of Anguillara. This was never completed, but a complex drawing of *St Roch Distributing his Inheritance* (Paris, Jean-Jacques Lebel priv. col.; see 1987–8 exh. cat., p. 69) shows a sophistication and narrative power that is absent from his drawings for engravings. It was possibly also in Rome *c.* 1524 (1987–8 exh. cat.) that Rosso painted the signed *Portrait of a Man* (Liverpool, Walker A.G.). Other portraits include the *Portrait of a Young Man* (Washington, DC, N.G.A.), and his work in this genre is distinguished by the expressive poses and melancholy mood of the sitter. Rosso's *Dead Christ* (1525–6; Boston, MA, Mus. F.A.) was painted for Bishop Lorenzo Tornabuoni of Borgo San Sepolcro. The dead figure of Christ is supported by three curly-haired, handsome adolescent angels. Christ's body, in exquisite contrapposto, is unscarred but for the clean hole of the lance, and his head, in three-quarter-profile, could be modelled on one of Michelangelo's drawings of idealized heads. Only the instruments of the Passion prevent us from believing this to be a *Dead Adonis* (Shearman, 1967).

Much of Rosso's time in Rome was spent in drawing; he was commissioned by the publisher, Baviera, to make drawings for engraving. In 1526 he executed a series of 20 drawings, later engraved, of *Gods in Niches* (1987–8 exh. cat. nos 21–40), which include Juno, who, like her peacock, is drawn from the rear, both being of similar shape, and the goddess Ops, demure amid her baleful animals. Two original drawings survive, for *Pluto* (Lyon, Mus. A. Déc.) and *Bacchus* (Besançon, Mus. B.-A. & Archéol.). In early 1527 Baviera invited him to contribute, with Perino del Vaga, to a series, the *Loves of the Gods* (1987–8 exh. cat. nos 42–3), to be engraved by Giovanni Jacopo Caraglio, and to form a more discrete sequel to Giulio Romano and Marcantonio Raimondi's *I modi*, which depicted the love-makings of the gods. Rosso contributed *Pluto and Proserpina* and *Saturn and Philyra*, with Saturn as an engaging lovesick horse. Rosso's inventions sparkle with wit and complexity, with conceits and playful perversities, with joy in refinement for its own sake, all combined with a deep appreciation of the power and limitations of engraving, which in turn enthused and inspired his engravers. During the Sack of Rome (1527), Rosso was captured by the Duke of Bourbon's *landsknechte*, but he escaped, apparently unscathed, and there followed a period of wandering around Tuscany and Umbria.

3. CENTRAL ITALY AND VENICE, 1527–30. Rosso was given hospitality by the painter Domenico Alfani in Perugia, and in 1527 went to Borgo San Sepolcro, where, through the mediation of Lorenzo Tornabuoni, he was commissioned to paint the *Pietà* (*in situ*) for the Compagnia dei Battuti in S Lorenzo. Here the renewed influence of Pontormo is evident, and he may have returned to Florence before this; Rosso was certainly in Florence sometime between 1527 and 1530. In 1528 he was commissioned to

2. Rosso Fiorentino: *Mars and Venus*, pen and ink with white highlights on blue-grey paper, 430×340 mm, 1530 (Paris, Musée du Louvre)

paint a *Christ in Glory* for Città di Castello Cathedral (*in situ*); in the same year he stayed in Arezzo with Benedetto Spadari, where he met Giorgio Vasari, and was commissioned to fresco the church of S Maria delle Lagrime. This commission was not fulfilled, and he moved to Borgo San Sepolcro, where between 1529 and 1530 he completed the *Christ in Glory*, which is distinguished by its cold and austere colours, and by its eccentric and nervous figure style. Eventually Rosso reached Venice, where he was received by Pietro Aretino. His mind was already set on joining the band of artists and craftsmen centred at the French court in Fontainebleau. Whether it was Aretino who arranged the invitation from the French king, Francis I (*reg* 1515–47), is unknown; certainly Aretino was in touch with the court. A drawing, *Mars and Venus* (Paris, Louvre; see fig. 2) was probably made during Rosso's short visit to Venice; it may have been executed on Aretino's suggestion as evidence of his skills for forwarding to the King. Francis I was about to marry the emperor's sister, Eleanor (1498–1555), and this may be a sort of pictorial epithalamium in praise of the royal bridegroom. Venus is being undressed and Mars unarmed, she by her Graces, he by Cupid. They are surrounded by tumbling putti, scattering the roses of Venus and the lilies of France, playing at soldiers with Mars's armour or firing love darts.

4. FONTAINEBLEAU, 1530–40. By November 1530 Rosso was established at Fontainebleau. The King gave him a large salary, a house in Paris, French citizenship and eventually a lucrative canonship at Sainte-Chapelle, Paris. Few easel pictures from this period survive (Vasari men-

tions only a *St Michael* and a *Dead Christ*) but Rosso was closely involved with the life of the court, designing costumes and scenery for masques as well as triumphal arches and decorations both for Emperor Charles V's visit to Fontainebleau in 1539 and, probably, for the King's entries to provincial cities. He also produced architectural drawings, and designs for tombs, tableware and horse trappings. A series of designs for masks (London, BM) are reminiscent, again, of Michelangelo's idealized heads, but the ringlets have been transformed into a fantasy of leaf, putto, beast and plumed helmet. Other patrons included Cardinal Jean de Lorraine (1498–1540), for whom he drew tapestry cartoons, the Constable, Duc de Montmorency, and the cathedral of Notre Dame, Paris.

Rosso's greatest project was the decoration of the Galerie François I (*in situ*) at the château of Fontainebleau, the plan for which was conceived in 1532, and the stuccowork and painting carried out under Rosso's supervision from 1536 to 1539. Allegorical, mythological and occasionally historical frescoes, celebrating the power of the King, are framed by extravagant stucco grotesqueries (*see* GROTESQUE)—scrolls, armoury, trophies, garlands, goddesses, nymphs and putti—and employ a technique probably brought by Primaticcio from Mantua, where he had worked at the Palazzo del Te. Although Rosso probably expected to provide all 16 principal frescoes, the gallery has only 12, including the *Royal Elephant*, a complex allegorical tribute to the King. He apparently painted the *Nymph of Fontainebleau* for one end wall (engraved Pierre Milan; see 1987–8 exh. cat., p. 253), but this was replaced by a work by Primaticcio, though whether before or after Rosso's death is unclear. Rosso also decorated the Pavillon de Pomone (destr.) with two large frescoes of scenes from the *Loves of Vertumnus and Pomona* (1532–3; etched by Antonio Fantuzzi, see 1987–8 exh. cat., p. 203), the Galerie Basse, the Grande Salle, the steambaths, and the Salle Haute in the Pavillon des Poètes (1537–8; no longer *in situ*), which was described by Vasari. It is possible that Rosso also worked as an architect at Fontainebleau (see Chastel, Guillaume).

Some of Rosso's drawings from this period were intended for engraving by such famed practitioners as Fantuzzi, Milan and René Boyvin (*c.* 1525–*c.* 1625); others appear to be finished works of art, such as his copy after Michelangelo's *Leda* (London, RA). Carroll remarks on the enlargement of the figures and the greater energy after 1535, which 'reflect a serious renewal of interest in Michelangelo's art'. The drawings show an enhanced dramatic intensity and emotion, for which he is prepared to sacrifice some of his customary grace and elegance.

There is no hard evidence to contradict Vasari's account of Rosso's death by suicide, other than the fact that he received a Christian burial. Vasari tells of how Rosso had accused a friend and assistant, Francesco Pellegrino, of stealing some money, and had him arrested and tortured. When the accusation proved unfounded, Francesco was released and pressed charges against Rosso, who 'perceiving that he had not only falsely shamed his friend but also stained his own honour, and to retract what he had said or embark on any other shameful course would likewise proclaim him as a disloyal and evil man' resolved to kill himself.

EWA

BIBLIOGRAPHY

G. Vasari: *Vite* (1550, rev. 2/1568); ed. G. Milanesi (1878–85)

O. Bacci, ed.: *Vita di Benvenuto Cellini* (MS. 1567; Florence, 1901)

M. Battistini: 'Il Rosso fiorentino pittore', *Misc. Volterrana*, iv/1 (1928), p. 16

K. Kusenberg: *Le Rosso* (Paris, 1931)

P. Barrocchi: *Il Rosso fiorentino* (Rome, 1950)

Fontainebleau e la maniera italiana (exh. cat. by F. Bologna and R. Causa, Florence and Naples, 1952)

J. Adhémar: 'Aretino: Artistic Advisor to Francis I', *J. Warb. & Court. Inst.*, xvii (1954), pp. 311–18

E. Panofsky: 'The Iconography of the Gallery of François Ier at Fontainebleau', *Gaz. B.-A.*, lii (1958), pp. 113–90

J. Shearman: 'Rosso, Pontormo, Bandinelli and Others at SS Annunziata', *Burl. Mag.*, cii (1960), pp. 152–6

G. Briganti: *La maniera italiana* (Rome, 1961; Eng. trans., Leipzig, 1962)

M. Hirst: 'Rosso: A Document and a Drawing', *Burl. Mag.*, cvi (1964), pp. 120–26

E. Panofsky: 'Mars Vitae Testimonium, the Positive Aspect of Death in Renaissance and Baroque Iconography', *Studien zur toskanischen Kunst: Festschrift für Ludwig Heinrich Heydenreich* (Munich, 1964), pp. 221–36

J. Shearman: *Mannerism* (Harmondsworth, 1967)

A. Chastel: 'L'Escalier du Cour Ovale à Fontainebleau', *Essays in the History of Art Presented to Rudolf Wittkower*, ed. D. Fraser, H. Hibbard and M. J. Lewine (London, 1967), pp. 74–80

J. Peluso: 'Rosso Fiorentino's *Moses Defending the Daughters of Jethro* and its Pendant', *Mitt. Ksthist. Inst. Florenz* (1976), pp. 87–106

G. Smith: '*Moses and the Daughters of Jethro* by Rosso Fiorentino', *Pantheon*, xxxv (1977), pp. 198–204

J. Guillaume: 'Fontainebleau 1530: Le Pavillon des Armes et sa Porte Egyptienne', *Bull. Mnmtl.*, cxxxvii/3 (1979), pp. 225–40

E. Darragon: 'Maniérisme en crise: Le *Christ en gloire* de Rosso Fiorentino à Citta di Castello', *Corr. Dir. Acad. France*, vi (1983)

D. Franklin: 'Rosso, Leonardo Buonafe and the Francesca de Ripoi Altarpiece', *Burl. Mag.*, cxxix (1987), pp. 650–62

Rosso Fiorentino: Drawings, Prints and Decorative Arts (exh. cat. by E. A. Carroll, Washington, DC, N.G.A., 1987–8) [with bibliog.]

V. Gaston: 'The Prophet Armed: Machiavelli, Savonarola and Rosso Fiorentino's *Moses Defending the Daughters of Jethro*', *J. Warb. & Court. Inst.*, li (1988), pp. 220–25

R. P. Ciardi and A. Mugnaini: *Rosso Fiorentino* (Florence, 1991) [with catalogue and full bibliog.]

P. Rubin: 'The Art of Colour in Florentine Painting of the Early 16th Century: Fiorentino and Jacopo Pontormo', *A. Hist.*, xiv/2 (1991), pp. 175–91

C. Falciani: 'Il Rosso Fiorentino per Carlo Ginori', *Artista* (1994), pp. 8–25

D. Franklin: *Rosso in Italy: The Italian Career of Rosso Fiorentino* (New Haven and London, 1994)

D. Haitovsky: 'Rosso's *Rebecca and Eliezer at the Well* Reconsidered', *Gaz. B.-A.*, cxxiii/1502 (1994), pp. 111–22

J. Stumpel: 'Rosso en Pontormo/Rosso and Pontormo', *Kunstschrift*, xxxviii/3 (1994), pp. 12–27

Il Rosso e Volterra (exh. cat. by R. P. Ciardi and A. Mugnaini, Volterra, Pin. Com., 1994)

C. Falciani: 'Memoria di Rosso negli stucchi della cappella Cesi', *Artista* (1995), pp. 126–37

MICHAEL DAVENPORT

Rovere, della. Italian family of rulers, popes and patrons. It originated in Savona, of humble stock, and rose to power in 1471 when Francesco della Rovere was elected (1) Pope Sixtus IV.

(1) Pope Sixtus IV [Francesco della Rovere] (*b* Celle, nr Savona, 21 July 1414; elected 1471; *d* Rome, 12 Aug 1484). Of humble origin, he rose through the Franciscan Order to become its general in 1464. His reign as pope was marked by his promotion of his della Rovere relatives and his aggressive pursuit of Italian politics. He was the first pope to act on the programme of renovation of Rome that had been conceived by Nicholas V, and his projects of urban planning, building and artistic patronage had a

more lasting impact on the city than those of any Renaissance pontiff except his nephew (2) Julius II. To facilitate the anticipated flow of traffic during the papal jubilee year of 1475, and to encourage the construction of palaces that would confer dignity on the approaches to the Vatican, he laid out the Borgo Sant'Angelo, a straight thoroughfare connecting the Castel Sant'Angelo with the Vatican Palace. In 1473, also in preparation for the jubilee, he rebuilt the Pons Agrippae, one of the Roman bridges over the Tiber, and renamed it the Ponte Sisto.

Sixtus' two major ecclesiastical foundations were the church of the Augustinian monastery of S Maria del Popolo (1472–80), the unknown designer of which applied the new classical style of the Renaissance to the scheme of a Gothic basilica, and S Maria della Pace (1478–83), built as a thanks offering to the Virgin for the end of the war with Florence provoked by della Rovere's part in the Pazzi conspiracy against the Medici. Sixtus' largest and most remarkable public building was the Ospedale di Santo Spirito in Sassia (1473–82), surmounted at the centre by a tower on an octagonal drum. In its main corridor he commissioned frescoes (1477–81) of scenes from his life from an anonymous Roman painter.

In 1471 Sixtus installed in the Palazzo dei Conservatori on the Capitol a group of antique sculptures kept throughout the Middle Ages at S Giovanni in Laterano, including the bronze *She Wolf* (Rome, Mus. Conserv.; the figures of the infants Romulus and Remus were added in the late 15th century), the *Spinario* (Rome, Mus. Capitolino), an over life-size *Hercules* and the colossal head of *Constantine* (both Rome, Mus. Conserv.), thus creating the first public museum of Classical sculpture since antiquity. An inscription declares that by moving them to their new site Sixtus 'restored' them to the Roman people.

In December 1471 Sixtus began renovating two large rooms on the ground floor of the wing of the Vatican Palace that had been built by Nicholas V to house the two branches of the Vatican Library: the Bibliotheca Graeca and the Bibliotheca Latina. The latter was the original site of Melozzo da Forlì's stately fresco of *Sixtus IV Founding the Vatican Library* (now Rome, Pin. Vaticana; *see* MELOZZO DA FORLÌ, fig. 1). Sixtus' most important project at the Vatican, however, was the construction and decoration (1477–86) of the eponymous Sistine Chapel. The chapel was dedicated to the Assumption of the Virgin, the subject of a fresco over the altar by Pietro Perugino (destroyed when Michelangelo painted the *Last Judgement*; see colour pl. 2, VII3). Perugino supervised a team of Florentine and Umbrian painters, composed of Botticelli (see colour pl. 1, XIII2), Domenico Ghirlandaio, Piero di Cosimo, Cosimo Rosselli (see colour pl. 2, XXV2), Luca Signorelli and Bernardino Pinturicchio, who between 1481 and 1483 decorated the chapel's walls. Here scenes of the *Life of Moses*, representing the written law of the Old Testament, are juxtaposed with scenes from the *Life of Christ*, representing the law of the New Dispensation. It has been demonstrated (Goffen) that in keeping with Sixtus' fervent espousal of Franciscan doctrines, the iconography follows the writings of St Bonaventura, according to which Moses is the antetype of St Francis as well as Christ, and his law anticipates not only the New Dispensation but the Franciscan Rule. Thus while the murals stress the common role of Moses and Christ as lawgiver, priest and ruler, thereby stressing the supremacy of the Pope, their successor and representative, they also express the demand for obedience to the Rule of St Francis.

For the main altar of St Peter's, Sixtus commissioned from Mino da Fiesole, Giovanni Dalmata (*c.* 1440–1509) and other sculptors a marble ciborium on porphyry columns with scenes from the *Lives of SS Peter and Paul* (destr.; five reliefs Rome, Grotte Vaticane) carved in the style of Roman Imperial relief. In 1479 Sixtus designated the Cappella del Coro in the south aisle of St Peter's his burial place, and commissioned Perugino to paint a fresco over its altar showing the *Pope Presented to the Virgin by SS Peter, Paul, Francis and Anthony* (destr.). Antonio Pollaiuolo's splendid bronze tomb of *Sixtus IV* (1484–93; St Peter's, Sacristy) was commissioned after the Pope's death by his nephew Cardinal Giuliano della Rovere.

BIBLIOGRAPHY

E. Muentz: *Les Arts à la cour des papes pendant le XVe et le XVIe siècle*, iii (Paris, 1882)
Ludwig, Freiherr von Pastor: *Geschichte der Päpste*, ii (Freiburg, 1886–9), pp. 451–710
W. S. Heckscher: *Sixtus IIII aeneas insignes statuas romano populo restituendas censuit* (The Hague, 1955)
L. D. Ettlinger: *The Sistine Chapel before Michelangelo* (London, 1966)
J. Ruysschaert: 'Sixtus IV, fondateur de la bibliothèque Vaticane (15 Juin 1475)', *Archv Hist. Pont.*, vii (1969), pp. 513–24
E. D. Howe: *The Hospital of Santo Spirito and Pope Sixtus IV* (New York and London, 1978)
E. Lee: *Sixtus IV and Men of Letters* (Rome, 1978)
R. Starn and L. Partridge: *A Renaissance Likeness: Art and Culture in Raphael's Julius II* (Berkeley, 1980)
J. Monfasani: 'A Description of the Sistine Chapel under Pope Sixtus IV', *Artibus & Hist.*, vii (1983), pp. 9–18
R. Goffen: 'Friar Sixtus IV and the Sistine Chapel', *Ren. Q.*, xxxix (1986), pp. 218–62
J. Shearman: 'La costruzione della Cappella Sistina e la prima decorazione al tempo di Sisto IV', *La Cappella Sistina, i primi restauri: La scoperta del colore* (Novara, 1986), pp. 22–87

HELLMUT WOHL

(2) Pope Julius II [Giuliano della Rovere] (*b* Albissola [Savona], 5 Dec 1443; elected 1503; *d* Rome, 20–21 Feb 1513). Nephew of (1) Pope Sixtus IV. The great patron of the High Renaissance in Rome, he commissioned Donato Bramante to build the new St Peter's (*see* ROME, fig. 5), Michelangelo to paint the Sistine Chapel ceiling (see colour pls 2, V2, 2, VI1 and 2, VI2) and Raphael to decorate his private apartments, the *stanze* (all Rome, Vatican; see colour pl. 2, XXI1). He was born into a noble but impoverished family, the son of Raffaele della Rovere (*d* 1477) and Theodora Manerola. Following the example of his uncle Francesco della Rovere, he entered the Franciscan Order, and from 1468 he studied law at Perugia. With the election of Francesco as Pope Sixtus IV in 1471 Giuliano became titular Cardinal of S Pietro in Vincoli, Rome, and Cardinal of SS Apostoli there the following year. He undertook the restoration and embellishment of the two churches. At S Pietro in Vincoli he financed the renewal of the interior and a new portico designed by BACCIO PONTELLI, as well as gilt-bronze doors for the reliquary containing the chains of St Peter (*in situ*), attributed to Caradosso. For SS Apostoli he commissioned a two-storey portico (1473–8) from Pontelli (reputedly designed by Giuliano), choir frescoes from MELOZZO DA FORLÌ (detached: Rome, Pin. Vaticana, Pal. Quirinale;

Madrid, Prado) and an altarpiece of the *Nativity with Saints* from Perugino (1491; Rome, Albani–Torlonia priv. col.; see P. Scarpellini: *Perugino* (Milan, 1984), fig. 78). The funeral monuments he built there for his father and his cousin, Cardinal Pietro Riario (1445–74), are attributed to the school of Andrea Bregno. He also restored S Agnese fuori le mura, Rome.

The earliest known portrait of Giuliano is included in Melozzo's fresco of *Sixtus IV Founding the Vatican Library* (c. 1476–7; Rome, Pin. Vaticana; see MELOZZO DA FORLÌ, fig. 1). His most important early sculpture commission was the lavish bronze tomb of *Sixtus IV* (1484–93; Rome, Grotte Vaticane) by Antonio and Piero Pollaiuolo (see POLLAIUOLO, (1) and (2)). A bold free-standing design, it incorporated relief decoration for which the unorthodox iconography—including figures of the Liberal Arts—may have been devised by Giuliano. As Bishop of Ostia, he commissioned Pontelli to design the episcopal palace complex (1483–6) and a small cathedral, S Aurea (for illustration see PONTELLI, BACCIO). In 1483 he was made Bishop of Bologna, where he lived in 1487–8. Commemorative medals were made for him by Sperandio and Giovanni Candida, and he commissioned a triptych of the *Nativity with Saints* from Giovanni Mazone (1489; Avignon, Mus. Pet. Pal.) for the Sistine Chapel of Savona Cathedral. His portrait was included in the altarpiece he commissioned from Vincenzo Foppa of the *Virgin and Child with Saints* (1490; Savona, oratory of S Maria di Castello).

Adjacent to SS Apostoli in Rome, Cardinal Giuliano built a magnificent Palazzo della Rovere and an adjoining Palazzina della Rovere (most destr.; remnants incorporated in Pal. Colonna). The lavish decoration included frescoes (destr.) by Bernardino Pinturicchio (1488–91) and Perugino (1491–2). He built a more modest residence next to S Pietro in Vincoli, as well as a monastery (both destr.). The antique marble statue, the Apollo Belvedere (Rome, Vatican, Mus. Pio-Clementino), found c. 1500 on one of his estates, was displayed in his garden there..

With the election of a Borgia pope, Alexander VI, in 1492, Giuliano left Rome and spent the years 1492–8 in France. In 1494 he was joined there by Giuliano da Sangallo, who entered his service as principal architect. Sangallo designed the façade (1495–6) of the Palazzo della Rovere in Savona (see SANGALLO, DA, (1), fig. 4). He continued to work for Giuliano after he became pope, designing a loggia (1504) in the Castel Sant'Angelo, Rome, and working on the Pope's villa at La Magliana, outside Rome

Giuliano was elected pope, as Julius II, on 31 October 1503. During his pontificate the Papal States became dominant in Italy and were again a major European power. His choice of the papal name Julius was intended to evoke the Roman emperor Julius Caesar, whose military leadership and ambitious building programmes he emulated. He personally led military campaigns to consolidate and expand the Papal States in northern Italy. After the expulsion of the Bentivoglio rulers of Bologna in 1507, he entered Rome through a series of triumphal arches and was hailed as a second Caesar. A new silver coin, the Giulio, was produced in a design imitating antique examples. His military conquests provided revenue for the depleted treasury inherited from his predecessor, and further funds were raised through economic reforms he introduced with the help of the papal banker AGOSTINO CHIGI. Julius II's contribution to the financial stability of the papacy was countered by his lavish expenditure on art and building projects. Inspired by the monuments of Imperial Rome, he initiated a programme of urban renewal designed to create a city of unrivalled splendour to assert the power of the papacy.

The realization of Julius' vision was largely the responsibility of Bramante, who entered his service c. 1504 and soon replaced Sangallo as his principal architect. From 1507, under Bramante's direction, roads were improved and new ones built, including the Via Giulia and the Via della Lungara. Bramante designed the Palazzo dei Tribunali, an immense complex intended to house civil and ecclesiastical courts and including a church, S Biagio della Pagnotta. Construction of the complex began in 1508 (abandoned 1511; most destr.). Other churches in Rome were rebuilt or enlarged, notably S Maria del Popolo, where Bramante extended the choir as a funeral chapel for Julius' confidant Cardinal Ascanio Sforza and his cousin Cardinal Girolamo Basso della Rovere (d 1507), with tombs designed by Andrea Sansovino, stained glass by Guillaume de Marcillat (1467/70–1529) and frescoes by Pinturicchio (all *in situ*). In 1508 Julius commissioned Bramante to design an elaborate marble covering for the shrine of the Santa Casa at Loreto (see LORETO, §II, 1(ii)(a)). Julius devoted particular attention to the extension and decoration of buildings in the Vatican. In addition to designing the new St Peter's (begun 1506), Bramante planned the Cortile del Belvedere, a vast terraced courtyard linking the palace and the Villa Belvedere (see BRAMANTE, DONATO, §I, 3(ii)(a) and fig. 5 and colour pl. 1, XVI1). The Cortile incorporated an antiquarium for the display of Julius' collection of antique sculpture, which included the Laokoon (*in situ*) and the *Tiber* (Paris, Louvre) as well as the *Apollo Belvedere* (*in situ*).

Julius was also the most important patron of Michelangelo, although their relations were often strained. He summoned Michelangelo to Rome in 1505 to design his funerary monument, but interrupted the project when he transferred his attention to the construction of St Peter's. He then persuaded the reluctant Michelangelo to fresco the ceiling of the Sistine Chapel (1508–12; see MICHELANGELO, §I, 2(ii) and colour pls 2, V2, 2, VI1 and 2, VI2). The monumental bronze statue of himself he commissioned from Michelangelo for the façade of S Petronio, Bologna, was completed in 1508; it was destroyed three years later, when the papal forces lost control of the city. From 1508 Julius employed artists including Perugino, Bramantino, Sodoma and Lorenzo Lotto to decorate his private apartments in the Vatican, the *stanze*. Much of their work was later painted over by Raphael, whom he invited to Rome in 1508 (see RAPHAEL, §I, 1(iii)(a)). According to Paolo Giovio's *Elogia* (Basle, 1525–89), Julius himself devised the personal iconography included in Raphael's decorations of the *stanze*, and his portrait appears in several scenes. It has been suggested that the Stanza della Segnatura was intended as Julius' private library, although he was not a notable bibliophile and only 220 volumes were recorded in the inventory

made after his death. Raphael's portrait of *Julius II* (London, NG), executed after his defeat in Bologna and two years before his death, shows him aged but still forceful. He is buried in S Pietro in Vincoli, in a drastically reduced version of the tomb planned by Michelangelo that includes the famous statue of *Moses* (see colour pl. 2, VII2).

BIBLIOGRAPHY

T. Magnuson: 'The Palaces of Cardinal Guiliano della Rovere', *Acta U. Upsaliensis: Figura*, ix (1958), pp. 312–31

M. Floriani Squarciapino: 'La rocca di Giulio II ad Ostia antica', *Stud. Romani*, 4 (1964), pp. 407–14

R. Weiss: 'The Medals of Julius II, 1503–1513', *J Warb. & Court. Inst.*, xxviii (1965), pp. 163–82

E. Bentivoglio and S. Valtieri: 'I lavori nella Rocca di Viterbo prima e durante il pontificato di Giulio II', *L'arte*, iv (1971), pp. 15–16, 75–109

K. Oberhuber: 'Raphael and the State Portrait, I: The Portrait of Julius II', *Burl. Mag.*, cxiii (1971), pp. 124–30

G. Malandra: 'Documenti sulla Cappella Sistina e sul Palazzo della Rovere a Savona', *Atti & Mem. Soc. Savon. Stor. Patria*, n. s., viii (1974), pp. 131–41

D. Coffin: *The Villa in the Life of Renaissance Rome* (Princeton, 1979)

R. Tuttle: 'Julius II and Bramante in Bologna', *Le arti a Bologna e in Emilia dal XVI al XVIII secolo: Atti del XXIV congresso internazionale di storia dell'arte: Bologna, 1979*, pp. 3–8

C. L. Stinger: 'Roma Triumphans: Triumphs in the Thought and Ceremonies of Renaissance Rome', *Med. & Human.*, n. s., 10 (1981), pp. 189–201

F. Mancinelli: 'Il cubicolo di Giulio II', *Boll. Mnmt., Mus. & Gal. Pont.*, iii (1982), pp. 63–103

S. Ferino Pagden: 'Perugino al servizio dei della Rovere: Sisto IV e il Cardinale Giuliano (appunti per l'attività di Perugino a Roma)', *Sisto IV e Giulio II: Mecenati e promotori di cultura: Atti del convegno internazionale di studi: Savona, 1985*, pp. 53–72, 203–16

D. Brown: 'The Apollo Belvedere and the Garden of Giuliano della Rovere at SS Apostoli', *J. Warburg & Court. Inst.*, xlix (1986), pp. 235–8

I. Cloulas: *Jules II: Le Pape terrible* (Paris, 1989)

C. Shaw: *Julius II: The Warrior Pope* (Oxford, 1993)

M. Compagnucci: 'La cittadella della fede: Sviluppo dell'insediamento lauretano', *Santuario di Loreto: Sette secoli di storia arte devozione*, ed. F. Grimaldi (Rome, 1994), pp. 17–21

B. Kempers: 'Occupation visualized: Julius II and the Bentivoglio in Bologna, 1504–1509', *Incontri*, ix/2–3 (1994), pp. 161–93

M. C. Marzoni: 'Un capolavoro incompiuto: Il maestoso edificio apostolico', *Santuario di Loreto: Sette secoli di storia arte devozione*, ed. F. Grimaldi (Rome, 1994), pp. 155–64

O. Klodt: 'Bramantes Entwürfe für die Peterskirche in Rom: Die Metamorphose des Zentralbaus', *Festschrift für Fritz Jacobs*, ed. O. Klodt and others (Münster, 1996), pp. 119–52

□

(3) Francesco Maria I della Rovere, Duke of Urbino (*b* Senigallia, 25 March 1490; *d* Pesaro, 22 Oct 1538). Nephew of (2) Pope Julius II. He was the son of Giovanni della Rovere, appointed Lord of Senigallia in 1474, and Giovanna da Montefeltro, daughter of Federigo II, Duke of Urbino. In 1498 he was adopted by Federigo's son, Guidobaldo I, who had remained childless, in order to prevent the duchy from lapsing to the Holy See. After he became Duke, his claims were disputed in 1513 by Pope Leo X, and in 1516 he was excommunicated. It was only after he regained his state (when Leo died in 1521) that the artistic patronage of the Duke and his wife, Eleonora Gonzaga, gained momentum.

Initially architecture had priority over painting. From 1523 to the late 1520s new apartments were built at the Palazzo Ducale in Pesaro by Girolamo Genga, who had become court artist and architect in August 1522. Genga was then required to restructure some older houses in Fossombrone as the Corte Bassa, a residence for the Duchess. From *c*. 1529 to 1532 Genga was employed at the Sforza Villa Imperiale, on a hill outside Pesaro, to devise a programme of frescoes. According to Vasari, he was assisted by Francesco Menzocchi da Forlì (*c*. 1502–84), Camillo Mantovano (*d* 1568), Dosso Dossi, Battista Dossi, Raffaello dal Colle and Agnolo Bronzino. In the 1530s a new villa was constructed by Genga on the slope behind the Imperiale (for illustration *see* GENGA, (1)). This was in a sense a response to Raphael's Villa Madama in Rome (*see* RAPHAEL, fig. 9), for besides the apparent similarities, we know that some years earlier Francesco Maria had requested a copy of Raphael's letter describing the Roman villa. In the 1530s Genga also worked on an urban garden in Pesaro, known as the Barchetto (destr.). Vasari mentioned that he added a small house simulating a ruin. Although Genga remained ducal architect for his lifetime, others occasionally sought employment at the court, including Sebastiano Serlio who applied unsuccessfully in the 1530s. The Duke also employed such military engineers as Pier Francesco da Viterbo and Michele Sanmicheli.

The ducal couple's favourite painter was Titian, from whom at least seven paintings were acquired, including the *Adoration of the Shepherds* (Florence, Uffizi), the *Christ* (Florence, Pitti), a portrait of *Hannibal* (untraced), *La Bella* (Florence, Pitti) and portraits of the Duke and Duchess themselves (mid-1530s; Florence, Uffizi).

BIBLIOGRAPHY

G. Vasari: *Vite* (1550, rev. 2/1568); ed. G. Milanesi (1878–85)

J. Dennistoun: *Memoirs of the Dukes of Urbino*, ii–iii (London, 1851, rev. 2/London, 1909)

G. Gronau: *Documenti artistici urbinati* (Florence, [1936])

A. Pinelli and O. Rossi: *Genga architetto* (Rome, 1971)

Tiziano per i Duchi di Urbino (exh. cat. by P. Zampetti, D. Bernini and G. Bernini Pezzini, Urbino, Pal. Ducale, 1976)

Tiziano nelle Gallerie fiorentine (exh. cat., Florence, Pitti, 1978)

Urbino e le Marche prima e dopo Raffaello (exh. cat., ed. M. G. Ciardi Duprè Dal Poggetto and P. Dal Poggetto; Urbino, Pal. Ducale, 1983)

S. Eiche: 'La corte di Pesaro dalle case malatestiane alla residenza roveresca', *La corte di Pesaro*, ed. M. R. Valazzi (Modena, 1986), pp. 13–55

A. Fucili Bartolucci: 'Architettura e plastica ornamentale nell'età roveresca dal Genga al Brandani', *Arte e cultura nella provincia di Pesaro e Urbino*, ed. F. Battistelli (Venice, 1986), pp. 281–92

S. Eiche: 'I della Rovere mecenati dell'architettura', *Pesaro nell'età dei della Rovere, Historica Pisaurensia*, III/i, ed. G. Arizzoni and others (Venice, 1998), pp. 231–55

SABINE EICHE

(4) Guidobaldo II della Rovere, Duke of Urbino (*b* Urbino, 2 April 1514; *d* Pesaro, 28 Sept 1574). Son of (3) Francesco Maria I della Rovere. He was a conscientious, if uninspired patron. He commissioned his first painting, a portrait of himself by Bronzino (Florence, Pitti), in 1532. In 1538 he acquired his first, and most important, work by Titian, the *Venus of Urbino* (Florence, Uffizi; see colour pl. 2, XXXV3), which was to hang in his *guardaroba* in the Palazzo Ducale, Pesaro. Throughout his life he assembled a substantial body of work by Titian, consisting mainly of portraits of his family, rulers and popes, and devotional subjects. Titian's last painting for the Duke was the *Madonna della misericordia* (1573; Florence, Pitti), intended for one of the ducal chapels. Guidobaldo's first architectural commission was for the church of S Giovanni Battista in Pesaro, begun 1543 by Girolamo Genga, and carried

on but not completed by Bartolommeo Genga. Bartolommeo also introduced the Duke to Battista Franco, whose work included a vault fresco of the *Assumption of the Virgin* (1545–6; destr.) in Urbino Cathedral. From *c.* 1548 Bartolommeo remodelled the Palazzo Ducale at Pesaro, in honour of the arrival of Guidobaldo's second wife, Vittoria Farnese. The work included the construction of new apartments, in which some of the fireplaces may have been designed by Federico Brandani. Genga also remodelled an apartment (1554–7) in the Palazzo Ducale, Urbino, where Brandani executed some of the stucco decorations.

Another important artist employed by the Duke was Taddeo Zuccaro, who was at Pesaro between 1551 and 1553, where, according to Vasari, his work included a *studiolo*, recently identified with the room traditionally called the Bagno di Lucrezia. At Pesaro, Guidobaldo also continued but did not finish the work on the Villa Imperiale undertaken by Francesco Maria I. He was probably more interested in his new villa, Miralfiore, outside Pesaro, which incorporated a 15th-century Sforza property, purchased by Guidobaldo in 1559, and also had remarkable gardens. Filippo Terzi, who had succeeded Genga as ducal architect by 1558, is usually credited with the villa's design. Guidobaldo was also interested in large-scale urban projects. In 1556 he finished the fortress and town walls of Senigallia, and in the 1560s he enlarged the central square in Pesaro. In 1567 the Duke sent Palma Giovane to study in Rome, where he lived with one of the ducal ministers until *c.* 1570. Guidobaldo also employed Federico Zuccaro, who, among other things, participated in the decorations for the entry into Pesaro in 1571 of Lucrezia d'Este, bride of (5) Francesco Maria II della Rovere. At about the same time the Duke commissioned a *Rest on the Flight into Egypt* (untraced) from Federico Barocci, which he presented to Lucrezia.

BIBLIOGRAPHY

D. Bernini: 'Decorazioni a grottesche del tempo di Guidobaldo II nel Palazzo Ducale di Urbino', *1631–1981: Un omaggio ai della Rovere* (Urbino, 1981), pp. 13–21
P. Zampetti: 'Guidobaldo II, Francesco Maria II e Palma il Giovane', *1631–1981: Un omaggio ai della Rovere* (Urbino, 1981), pp. 22–32
G. Marchini: 'Per Taddeo Zuccari', *Scritti in onore di Roberto Salvini*, ed. C. De Benedictis (Florence, 1984), pp. 413–16
D. J. Sikorsky: 'Il Palazzo Ducale di Urbino sotto Guidobaldo II (1538–74), Bartolomeo Genga, Filippo Terzi e Federico Brandani', *Il Palazzo di Federico da Montefeltro*, ed. M. L. Polichetti (Urbino, 1985), pp. 67–90

SABINE EICHE

(5) Francesco Maria II della Rovere, Duke of Urbino (*b* Pesaro, 20 Feb 1549; *d* Urbania, 28 April 1631). Son of (4) Guidobaldo II della Rovere. He was the most active patron of the three della Rovere dukes, engaging numerous artists and artisans. In the 1570s he began constructing ten botteghe in the Palazzo Ducale in Pesaro, to house goldsmiths, silversmiths, watchmakers, painters and illuminators. He is best known as the protector of Federico Barocci, from *c.* 1572, when Barocci painted his portrait (Florence, Uffizi; see colour pl. 1, VI2). Most of the works Barocci produced for the Duke were either donated to religious institutions or presented to important personages. Federico Zuccaro's style also appealed to the Duke's pious tastes. His work included the decoration of the ducal chapel in the Santa Casa, Loreto, in the 1580s. He was

also occasionally asked to paint devotional scenes for the Duke, none of which is known to have survived, although documents mention a *Crucifixion* (1593–4), a *Paradise* (1603; formerly in the chapel of his villa at Monte Berticchio) and a *Holy Spirit* (1607). The Duke's ministers in Rome were frequently instructed to recruit suitable artists for specific tasks: for example in the 1580s Francesco Maria commissioned two artists to copy portraits in the Villa Medici, Rome, for his own gallery in Pesaro. Francesco Maria also commissioned full-scale statues of his most illustrious predecessors, *Francesco Maria I* (1585; Venice, Doge's Pal.) by Giovanni Bandini, which stood in the courtyard of the Palazzo Ducale of Pesaro until 1624, and *Federigo II* (1604–6; Urbino, Pal. Ducale) by Girolamo Campagna.

As a patron of architecture, Francesco Maria's first concern was the Palazzo Ducale at Pesaro, which he continued to enlarge and modernize until the 1620s. He also continued work at the suburban villas Imperiale and Miralfiore, his particular concern being the fountains and water supply, about which he probably consulted Bernardo Buontalenti in 1581. Francesco Maria also employed various other architects, including Filippo Terzi, Girolamo Arduini (*d* 1601), Muzio Oddi and Niccolo Sabbatini. In 1583 the Duke, who was himself an architectural draughtsman, designed, together with Arduini, a house known as the Vedetta (destr.), overlooking the sea near the Villa Imperiale. The house served as a retreat from mundane affairs, as did the Portanile, next to the Barchetto in Pesaro. In the 1580s Francesco Maria also laid out a vast garden in Urbino, where he stayed only occasionally. In the early 17th century, when the Duke had transferred his court from Pesaro to Urbania, he designed another villa (destr.), on the peak of nearby Monte Berticchio. He also modernized the Palazzo Ducale of Urbania, where he built, as at Pesaro, a spacious room to house his library.

BIBLIOGRAPHY

J. Dennistoun: *Memoirs of the Dukes of Urbino*, iii (London, 1851, rev. 2/London, 1909)
G. Gronau: *Documenti artistici urbinati* (Florence, [1936])
H. Olsen: *Federico Barocci* (Copenhagen, 1962)
S. Eiche: 'The Vedetta of the Villa Imperiale at Pesaro', *Archit.: Z. Gesch. Baukst*, viii (1978), pp. 150–65
S. Meloni Trkulja: 'I miniatori di Francesco Maria II della Rovere', *1631–1981: Un omaggio ai della Rovere* (Urbino, 1981), pp. 33–8
S. Eiche: 'Federico Zuccari and Federico Barocci at Loreto and Urbino', *Mitt. Ksthist. Inst. Florenz*, xxvi (1982), pp. 398–400
——: 'Francesco Maria II della Rovere as a Patron of Architecture and his Villa at Monte Berticchio', *Mitt. Ksthist. Inst. Florenz*, xxviii (1984), pp. 77–108
——: 'Francesco Maria II della Rovere's *Delizia* in Urbino: The Giardino di S. Lucia', *J. Gdn Hist.*, v (1985), pp. 154–83
——: 'La corte di Pesaro dalle case malatestiane alla residenza roveresca', *La corte di Pesaro*, ed. M. R. Valazzi (Modena, 1986), pp. 13–55
——: *La Villa di Monteberticchio di Francesco Maria II della Rovere a Casteldurante* (Urbania, 1995)
S. Eiche: 'I della Rovere mecenati dell'architettura', *Pesaro nell'età dei della Rovere, Historica Pisaurensia*, III/i, ed. G. Arizzoni and others (Venice, 1998), pp. 255–63
——: *Il giardino di S Lucia: Delizia di Francesco Maria II della Rovere in Urbino* (Urbino, 1998)
——: 'Il Palazzo ducale di Urbania', *Urbania Casteldurante Museo Civico*, ed. B. Cleri and F. Paoli (Bologna, 1998), pp. vii–xvi

SABINE EICHE

Rovezzano, Benedetto da. *See* BENEDETTO DA ROVEZZANO.

Roviale, Francesco (*fl c.* 1544–6). Spanish painter, active in Italy. Giorgio Vasari wrote of 'the Spaniard Roviale', a disciple of Francesco Salviati, who executed an altarpiece depicting the *Conversion of St Paul* (1545; *in situ*) for the church of Santo Spirito in Sassia in Rome. Roviale collaborated with Vasari in the Roman Palazzo della Cancelleria (1546) and probably on the frescoes (1544; *in situ*) of the Sala del Fregio in the Palazzo dei Conservatori, also in Rome. According to Bernardo de Dominici, Francesco Roviale (or Roviale Spagnolo), a Neapolitan collaborator of Polidoro da Caravaggio, executed works including the *Pietà* (after 1545) in the Cappella della Sommaria in Castel Capuano in Naples and the frescoes (*in situ*) in the Cappella del Compianto in Monteoliveto.

Roviale's oeuvre is characterized by a type of Roman Mannerism that shows the influence of Salviati and Perino del Vaga. The *Conversion of St Paul* was based on a drawing (1545) by Salviati engraved by Enea Vico, and the *Pietà* shows strong similarities with Salviati's *Deposition* (*c.* 1547; Florence, Mus. Opera Santa Croce; *see* SALVIATI, FRANCESCO, fig. 3). However, the painter 'created' by Salviati could hardly have been trained in Naples by Polidoro, as Neapolitan sources allege. As the style of the works cited is closer to Salviati than to Polidoro, there might have been two Spanish painters called Roviale, or, before being 'created' by Salviati in Rome, Roviale might have known Polidoro in Sicily. A further identification has tentatively been made with Pedro de Rubiales (*b* Estremadura, 1511; *d* Rome, 1582), who in 1540 produced a polyptych of scenes from the *Life of St Ursula* (*in situ*) for the convent of La Puritad in Valencia.

BIBLIOGRAPHY

G. Vasari: *Vite* (1550, rev. 2/1568); ed. G. Milanesi, vii (1881), p. 43
B. de Dominici: *Vite*, ii (1742–5), pp. 143–4
C. Campos: 'El retablo de Santa Ursula o de las virgenes del convento de la Puritad de Valencia', *An. U. Valencia*, xi (1930–31), pp. 187–202
F. Bologna: *Roviale Spagnolo e la pittura napoletana del cinquecento* (Naples, 1959)
E. Gaudioso: 'I lavori farnesiani a Castel Sant'Angelo: Precisazioni ed ipotesi', *Boll. A.*, 5th ser., lxi/1–2 (1976), pp. 21–42

GENNARO TOSCANO

Rubicano, Cola. *See* RAPICANO, COLA.

Rubino [Padovano], **Giovanni** [il Dentone; Zuan da Milano] (*b* ?Padua, *c.* 1498; *d* Padua, between May 1529 and Feb 1530). Italian sculptor. Of Lombard stock, he entered the Paduan workshop of Giovanni d'Antonio Minello on 29 January 1513. All his known works remain in Padua. According to Michiel, he executed several statues in Giovanni Maria Falconetto's Loggia Cornaro (*c.* 1524). The *Victories* over the central arch of the loggia and perhaps the statues on the lower storey of the Odeo Cornaro (1530; see colour pl. 1, XXIX2) are from his hand and mark him as part of the classicizing avant-garde in Padua. The statues on the second storey of the loggia, *Diana*, *Venus* and *Apollo*, have traditionally been ascribed either to him or to Giovanni Maria Mosca but are probably by Giacomo Fantoni. Minello was *proto* (overseer) of the project to refurbish the chapel of S Antonio in the basilica, where Rubino was commissioned in August 1524 to depict the *Miracle of the Jealous Husband* (Padua, Scuola S Antonio), the second relief on the left. Like all reliefs in

the chapel, it is composed of two blocks. Rubino carved the main scene on the right, the smaller block on the left being finished by Silvio Cosini in 1535. As Titian had done in his fresco of the same subject (1511; Padua, Scuola S Antonio), Rubino depicted the husband stabbing his wife while onlookers desperately try to stop him. The relief is full of impetuous movement and adds an element of drama to the static classicism of Tullio Lombardo's work in the basilica.

BIBLIOGRAPHY

M. Michiel: *Notizia d'opere di disegno* (MS.; 1525–43); ed. G. Frizzoni (Bologna, 1884), p. 22
B. Gonzati: *La basilica di S Antonio di Padova*, i (Padua, 1852), p. 164, doc. xcii
E. Rigoni: *L'arte rinascimentale in Padova: Studi e documenti*, Medioevo e umanesimo, ix (Padua, 1970), pp. 128, 139, 239–53
G. Mariacher: 'Scultura e decorazione plastica esterna della Loggia e dell'Odeo Cornaro', *Alvise Cornaro e il suo tempo* (exh. cat., ed. L. Puppi; Padua, Pal. Ragione; and elsewhere; 1980), pp. 80–85
S. Wilk: 'La decorazione cinquecentesca della cappella dell'arca di S Antonio', *Le sculture del Santo di Padova*, ed. G. Lorenzoni (Padua, 1984), pp. 139–41

THOMAS MARTIN

Rucellai. Italian family of merchants, bankers and patrons. Early members of the family commissioned several chapels, tombs and other works for their church of S Pancrazio, Florence, and for S Maria Novella, the principal church of the quarter in which S Pancrazio is situated, including the *Madonna and Child* (Florence, Uffizi) by Duccio (*fl* 1278) for the Rucellai Chapel in S Maria Novella. The most distinguished members were (1) Giovanni Rucellai and his son (2) Bernardo Rucellai.

(1) Giovanni (di Paolo di Messer Paolo) Rucellai (*b* Florence, 26 Dec 1403; *d* Florence, *bur* 28 Oct 1481). Through discriminating and energetic use of his wealth he became, after the Medici family, perhaps the leading patron in Florence in the 15th century. His patronage far outstripped that of his kinsmen in magnificence and imagination. This is most notable in his commissions for buildings that have been plausibly attributed to Leon Battista Alberti (*see* ALBERTI, LEON BATTISTA, §III and figs 2 and 3). When Giovanni was three, his father died. Giovanni had to struggle to establish himself, helped in 1428 by an alliance with the Strozzi family through his marriage with Iacopa, daughter of Palla Strozzi. In this environment he came into contact with the leading avant-garde intellectual circles of the period.

In 1434 Palla Strozzi was exiled by the Medici regime, and there began a time of adversity lasting 27 years during which Giovanni was under suspicion. Despite this, he was by 1458 not only the third richest Florentine but also already in the process of becoming one of the city's most outstanding patrons. He was aided by his wider family and his connections, repaying them through his local patronage. He continued to support the cause of the exiled Palla Strozzi, with whose agreement a deal was struck that released Strozzi funds for Rucellai ecclesiastical buildings. Giovanni's political rehabilitation came to fruition after 1461, when his younger son (2) Bernardo Rucellai become betrothed to Nannina, the sister of Lorenzo the Magnificent.

Giovanni Rucellai followed a genuine architectural programme, from 1442 buying up properties adjoining his

ancestral home on the Via Vigna Nuova. He transformed the interior of the Palazzo Rucellai before turning his attention to its celebrated façade (begun *c.* 1453), attributed to Alberti. This was designed *all'antica* and is notable for its employment of the Classical orders in the form of superimposed pilasters, articulating a lightly rusticated wall surface. By *c.* 1464 his villa and pleasure garden at Quaracchi, a family estate near Florence, were also finished, although little is known of the history of this building (still standing but utterly transformed). Work on the Rucellai Chapel in S Pancrazio, which was to be dedicated to the Holy Sepulchre and which Giovanni decided to build in 1448, is better documented. He was at first undecided as to which of his ancestral churches should receive the commission but by 1458 had settled on S Pancrazio, directly behind his new palazzo, and construction was probably completed in 1467. In 1457 he again showed his interest in this parish through his plan to build a loggia (completed 1466) opposite the Palazzo Rucellai, for ceremonial use. This allowed a better view of the palazzo, the façade of which Giovanni now extended from its original five bays. Giovanni's last major act of patronage was to commission Alberti to provide a façade for S Maria Novella (see colour pl. 1, I2). Work on the façade was begun *c.* 1458 and was substantially completed by 1470.

Though not a learned man, in his famous commonplace book *Lo zibaldone quaresimale* Giovanni was able through his Strozzi connections to give an eloquent account of the atmosphere of artistic and intellectual ferment in which he lived. In the *Zibaldone* he is somewhat vague on architectural matters. However, he is more precise when it comes to naming the 11 contemporary artists, including Paolo Uccello and Fra Filippo Lippi, whose works he had in his collection, although he does not specify any particular paintings or sculptures. Both Giovanni's building programme and his collecting of paintings were marked by a joyous spirit that was in marked contrast to cautious traditional attitudes. By the late 1450s he had resolved his doubts about the propriety of pursuing his magnificent programme of patronage, though with an air of self-congratulation that has irritated scholars, as it did several of his contemporaries.

WRITINGS
Giovanni Rucellai ed il suo zibaldone, 2 vols (London, 1960–81); i, ed. A. Perosa; ii, ed. F. W. Kent and others; review of ii by R. A. Goldthwaite in *Burl. Mag.* (Jan 1983), pp. 34–5

BIBLIOGRAPHY
S. I. Camporeale: 'Giovanni Caroli e le "Vitae fratrum S. M. Novellae": Umanesimo e crisi religiosa (1460–1480)', *Mem. Domenicane*, n. s., xii (1981), pp. 141–267
D. V. Kent and F. W. Kent: *Neighbours and Neighbourhood in Renaissance Florence* (Locust Valley, 1982)
A. Wright: 'Antonio Pollaiuolo, "maestro di disegno"', *Florentine Drawing at the Time of Lorenzo the Magnificent: Papers from a Colloquium held at the Villa Spelman: Florence, 1992*, pp. 131–46
A. Malquori: *Tempo d'aversità: Gli affreschi dell'Altana di Palazzo Rucellai* (Florence, 1993)

F. W. KENT

(2) Bernardo (di Giovanni) Rucellai (*b* Florence, 11 Aug 1448; *d* Florence, 7 Oct 1514). Son of (1) Giovanni Rucellai. He visited Rome in 1471, together with his brother-in-law Lorenzo the Magnificent and with Alberti as a guide. He was a gifted historian (*De bello Italico, c.*

1505–6) and antiquarian (*De urbe Roma, c.* 1500–05), with a passion for porphyry. His interest in contemporary architecture is revealed in a letter he wrote to Lorenzo in 1474; there is also the intriguing but probably mistaken suggestion that he was an amateur painter. Certainly he was acquainted with artists as various as Stefano d'Antonio (1405–83), a minor Florentine painter, and Leonardo da Vinci, from whom he commissioned a hydraulic machine. It is usually assumed, without direct proof, that he played a prominent role in the design of the suburban house and garden near Florence called the Orti Oricellari (destr.), the site of which his wife Nannina acquired from her brother, Lorenzo, early in 1483: this was to become a meeting place for Florentine intellectuals early in the next century. A marble head of Bernardo was later included among the collection of his son, Palla Rucellai (1473–1543), which also included an unnamed painting by Masaccio.

WRITINGS
De urbe Roma (MS.; ed. J. Tartinius *c.* 1500–05) in *Rerum Italicarum scriptores*, ii (Florence, 1770)
De bello Italico commentarius (MS.; *c.* 1505–6) (London, 1733)

BIBLIOGRAPHY
F. Gilbert: 'Bernardo Rucellai and the Orti Oricellari', *J. Warb. & Court. Inst.*, xii (1949), pp. 101–31
F. W. Kent: 'Lorenzo de' Medici's Acquisition of Poggio a Caiano in 1474 and an Early Reference to his Architectural Expertise', *J. Warb. & Court. Inst.*, xlii (1979), pp. 250–57
W. McCuaig: 'Bernardo Rucellai and Sallust', *Rinascimento*, xxii (1982), pp. 75–98
S. B. Butters: *The Triumph of Vulcan: Sculptor's Tools, Porphyry and the Prince in Ducal Florence*, i (Florence, 1996)
R. M. Comanducci: *Il carteggio di Bernardo Rucellai: Inventario* (Florence, 1996)

F. W. KENT

Rusconi, Giovanni Antonio (*b* ?Como or ?Venice, *c.* 1520; *d* Venice, 1587). Italian architect, decorator and writer. Rusconi was a pupil of the mathematician Niccolò Tartaglia (Tafuri, 1989). In his early years he seems to have been chiefly a military architect in the service of the Venetian Republic in Dalmatia. He returned to Venice to become *proto* (overseer) to the Provveditori al Sal, in which post he was responsible in 1563 for the design of the new prisons across the canal east of the Doge's Palace. The first stage, the rear section, was begun in 1566 and completed to his design, although it was enlarged in 1589 and re-faced with a new block by Antonio da Ponte, facing the Riva degli Schiavoni. Around 1573–5 Rusconi worked on Michele Sanmicheli's monumental Palazzo Grimani (see SANMICHELI, MICHELE, fig. 2) at S Luca, taking over from Giovanni Giacomo de' Grigi in supervising the completion of the second *piano nobile* and the roof. Also about this time he advised Doge Alvise I Mocenigo on the rebuilding of his villa on the Giudecca, damaged by fire in 1574. The house survives but has been badly altered.

Rusconi's most important architectural work was again the result of fire, at the Doge's Palace in 1574. Under the supervision of Palladio, Rusconi, as *proto* of the works, completed much of the reconstruction of the Sala delle Quattro Porte, the Ante-Collegio and the Sala del Collegio. The Sala delle Quattro Porte (the senate ante-chamber) is notable chiefly for the elaborate Roman style of the stucco ceiling and the four richly decorated doorways with columns of rare marbles. The work was completed by da

Ponte *c.* 1590. The Ante-Collegio was restored with marble, stucco and fresco work to designs by Palladio and Rusconi. The Sala del Collegio, the seat of one of the Republic's highest magistracies, is the most imposing of these three rooms. There is a marked contrast between the restrained, classical wall panelling and the richly coffered gilded ceiling, with panel paintings by Veronese and his school. Rusconi's precise contribution to the three rooms is difficult to define, although as *proto* he must have exercised considerable control, and he was probably also responsible for dictating the style of the ceilings, which foreshadow the Baroque. Other works attributed to Rusconi include the chapel of the Holy Sacrament and high altar at S Giuliano; Palazzo Mocenigo at S Samuele; and Palazzo Trevisan at Murano (1554–7).

Rusconi's contemporary reputation was based chiefly on the Doge's Palace and on his writings. Although he worked with Palladio, relations between them were not close: Rusconi replied to Palladio's *Quattro libri* (1570) with his own treatise, published posthumously as *Dell'architettura di Gio Antonio Rusconi.* This did not achieve the fame of Palladio's, and Rusconi's reputation declined with the rise of Palladianism in the 18th century. According to some Palladians, Rusconi misrepresented several passages of Vitruvius, particularly in the fanciful reconstruction of the Tower of the Winds in Athens. This criticism reached a peak in the mid-18th century with Antonio Visentini's pamphlet *Il contro Rusconi.*

UNPUBLISHED SOURCES
Venice, Correr, Cod. Cicogna 3656 [A. Visentini: *Il contro Rusconi ò sia l'esame sopra l'architettura di Giovantonio Rusconi* (n.d.)]

WRITINGS
Dell'architettura di Gio Antonio Rusconi . . .secondi i precetti di Vitruvio . . .libri dieci (Venice, 1590, 2/1660)

BIBLIOGRAPHY
F. Zanotto: *Il palazzo ducale di Venezia*, 4 vols (Venice, 1853)
G. B. Lorenzetti: *Monumenti per servire alla storia del palazzo ducale di Venezia* (Venice, 1869)
A. Venturi: *Storia* (1901–40), ix/3, pp. 202–10
G. Mariacher: *Il palazzo ducale di Venezia* (Florence, 1950)
M. Tafuri: *Jacopo Sansovino e l'architettura del '500 a Venezia* (Padua, 1969)
E. Bassi: *Palazzi di Venezia* (Venice, 1976)
M. Tafuri: *Venice and the Renaissance* (Cambridge, MA, and London, 1989)

□

Ruspagiari, Alfonso (di Tommaso) (*b* Reggio Emilia, 1521; *d* Reggio Emilia, 1576). Italian medallist. He held various prominent positions in the city's administration, and in 1571 he was appointed Superintendent of the Reggio Mint. Together with such artists as Agostino Ardenti, Andrea Cambi ('Bombarda', *fl c.* 1560) and Gian Antonio Signoretti (*d* 1602), he ranks among the foremost medallists of the Emilian school in the 16th century. The work of these artists is closely related though Ruspagiari's modelling is perhaps the finest. His medals are uniface, of low relief, and cast in lead or a lead alloy. A characteristic of his portraits, and Emilian portraiture in general during that period, is that the arms are cut abruptly at or just below the shoulders. The artist's signature is sometimes placed on the exposed truncation. Sitters are portrayed in elaborate, eccentric costumes and exuberant coiffures. Ruspagiari's earliest work probably dates to *c.* 1536 with the portrait of *Ercole II d'Este.* Two self-portraits form

part of Ruspagiari's oeuvre. On the larger he refers to himself not only in the legend ALF[ONSI]RVSPAGIARII REGIEN[sis], but again below the bust with the word IDEM plus his signature A.R. This may have been a way of emphasizing that the sitter and the medallist are the same person, and of ensuring that his work would not be mistaken for that of another artist who also signed A.R. (?Alessandro Ardenti). Other portrayals by Ruspagiari include: *Camilla Ruggieri, Alessandro Ardenti* (painter in Faenza), *Agostino Ardenti* and *Claudia Pancalieri.*

BIBLIOGRAPHY
Forrer; Thieme–Becker
A. Armand: *Les Médailleurs italiens* (2/1883–7), i, p. 215; iii, p. 99
A. Balletti: 'Alfonso Ruspagiari, medalista del secolo XVII', *Rass. A.*, 1 (1901), p. 107; 4 (1904), pp. 44–6
G. F. Hill: 'Some Italian Medals', *Burl. Mag.*, xii (1907–8), p. 141
——: *Portrait Medals of Italian Artists of the Renaissance* (1912), p. 64
A. Balletti: 'Alfonso Ruspagiari e Gian Antonio Signoretti, medaglisti del secolo XVI', *Rass. A.*, 14 (1914), pp. 46–8
G. Habich: *Die Medaillen der italienischen Renaissance* (Stuttgart and Berlin, 1922), pp. 138–9
G. F. Hill and G. Pollard: *Renaissance Medals in the National Gallery of Art* (London, 1967), pp. 85–6
A. S. Norris and I. Weber: *Medals and Plaquettes from the Molinari Collection at Bowdoin College* (Brunswick, ME, 1976), p. 28
M. L. Levkoff: 'Portrait Medals of the Renaissance', *The Currency of Fame*, ed. S. K. Scher (New York, 1994), pp. 185–9

MARK M. SALTON

Russi, Franco dei. *See* FRANCO DEI RUSSI.

Rustici. Italian family of artists. Members of the family were active in Siena from the 15th to the 17th century. Information on their lives is sparse. The founder of the family, Lorenzo Brazzi, was from Piacenza. Cristoforo di Lorenzo Brazzi (*b* Piacenza; *d* Siena, 16 Nov 1545), an architect, worked mainly in Siena according to 16th-century documents. The painter Lorenzo Rustici (*b* Siena, 1521; *d* after 1573) was his son, and the family name probably derives from Lorenzo's nickname, 'il Rustico'. A pupil of Sodoma, Lorenzo was known principally as a stuccoist and painter of grotesques. He worked in Siena for Venanzio Paccinelli (1551) and executed frescoes (1555) in the oratory of the Compagnia di S Michele. In 1563 Lorenzo received the commission to decorate two arcades of the Loggia della Mercanzia. This work, much repainted, is composed of elaborate stuccowork and paintings and betrays a typically Mannerist style, which recalls Baldassare Peruzzi, Perino del Vaga and the work of Vasari in the Palazzo Vecchio, Florence. The decoration of the chapel of Scipione Chigi's Villa (now Chigi–Saracini) near Siena dates from 1563 and the *Pietà* for the Monte dei Paschi, Siena, dates from 1571–2.

BIBLIOGRAPHY
DBI: 'Brazzi'; Thieme–Becker
E. Romagnoli: *Biografia cronologica de' bellartisti senesi, 1200–1800* (MS. and facs. edn, Siena, 1835; Florence, 1976), vii, pp. 139–55
P. Rossi: 'Le antiche pitture della "Pietà" nel palazzo del Monte dei Paschi', *Rass. A. Sen.*, xviii (1925), pp. 5–18 (8)
M. Salmi: *Il palazzo e la collezione Chigi-Saracini* (Siena, 1967)
C. Acidini Luchinat: 'Due episodi della conquista cosimiana di Siena', *Paragone*, xxix/345 (1978), pp. 3–26
Mostra di opere d'arte restaurate nelle provincie di Siena e Grosseto (exh. cat., Genoa, 1981), pp. 166–7

MARINA GAROFOLI

Rustici, Giovanni Francesco (*b* Florence, ?13 Nov 1474; *d* Tours, 1554). Italian sculptor and painter, active also in

France. He was of noble birth, and his artistic activities were those of a dilettante. No formal apprenticeship is recorded: although Vasari called him a pupil of Verrocchio, this can only have been indirectly, for Verrocchio died in Venice in 1488, when Rustici was 14. His later collaboration with Leonardo da Vinci does suggest a mutual familiarity with Verrocchio's workshop, which continued to operate after the master's death. Certainly, the well-informed Pomponius Gauricus, in *De sculptura* (Padua, 1504), named him as one of the principal sculptors of Tuscany, with Benedetto da Maiano, Andrea Sansovino and Michelangelo. Rustici also studied the Medici sculpture collection in the garden at S Marco in Florence, where, as an aristocrat, he would have been particularly welcome.

Probably because his social position made him more independent than the average artist, few of Rustici's works are documented, although many have been identified from descriptions by Vasari, corroborated by stylistic comparisons. The earliest is a tightly designed marble bust of *Giovanni Boccaccio*, cowled and clasping a volume of his works, datable to 1503 (Certaldo, collegiate church). This is a competent portrait (made long after the death of the subject, and hence largely imaginary), analogous with busts of *Christ* (San Gimignano, Mus. A. Sacra) and *St Fina* and *St Gregory* (both San Gimignano, S Fina) made seven years earlier by Pietro Torrigiani, a fellow student in the Medici sculpture garden and admirer of Verrocchio. The only other datable works of Rustici are his group in bronze of *St John the Baptist Preaching* executed for Florence Cathedral Baptistery, 1506–11, and a statuette of *Mercury*, datable from 1515. Thereafter there is a long gap until 1528, when he departed to serve Francis I (*reg* 1515–47) in France, where he stayed until his death.

Rustici's independent means permitted him to remain free of the normal ties of a particular master or workshop and, judging from the heterogeneous sculptures that may reasonably be associated with him, to change his style at will. Probably one of the earliest of the undated works is a large altarpiece of *Noli me tangere*, with a lunette of *St Augustine*, made in terracotta for S Lucia (Florence, Bargello). This was glazed by Giovanni della Robbia, but the unique yellow sky distinguishes it from Giovanni's own oeuvre. Its poses are rather angular, the modelling is hard, and there is little discernible stylistic influence from Verrocchio or Leonardo, so it probably dates from before the Baptistery commission of 1506, on which Leonardo collaborated.

Presumably also from the first decade of the 16th century is a roundel of the *Virgin and Child with the Infant St John* (Florence, Bargello) that, according to Vasari, Rustici carved in marble for the guild of silk merchants, the Arte della Seta. It seems to be a commentary on Michelangelo's marble tondi of the *Virgin and Child*, especially the one for Taddeo Taddei (London, R.A.), but, unlike them, it is fully resolved and carefully finished. It also reflects a 15th-century source, Desiderio da Settignano's relief of the *Virgin and Child* (Turin, Gal. Sabauda; see colour pl. 1, XXVII2), and emulates painted tondi by Raphael. Vasari wrote that Rustici liked Leonardo's style, the psychological atmosphere of his faces and the grace of his compositions, and 'attached himself to him', learning how to cast bronze, draw in perspective and carve marble,

although the last skill was not one that he could have learnt from Leonardo. On his major commission, the *St John the Baptist Preaching* (1506–11; see fig.), Rustici worked closely with the master. The work comprises three separate bronze statues, designed as a psychological interactive group, set against the patterned, external wall of the Baptistery, over the north portal. The two artists were guests in the same house at the time, and must have collaborated closely, for the bronze statues are composed, modelled and characterized with all the confidence and vigour of Leonardo. The contrasting heads of John's audience, Levite and Pharisee, are unforgettable: the one gross and bald (deliberately recalling Donatello's *Habakkuk* on the Campanile near by), and the other with a magnificently tousled mane of hair and beard, which he tugs in a gesture of annoyance (like Michelangelo's slightly later statue of *Moses*; Rome, S Pietro in Vincoli; see colour pl. 2, VII2).

Vasari also recorded that Rustici modelled in terracotta some groups of horses with men on or under them, and several survive (Florence, Bargello and Pal. Vecchio; Paris, Louvre). They recall studies made by Leonardo for his fresco of the *Battle of Anghiari* (Florence, Pal. Vecchio, destr.); some have scowling faces that closely reflect his studies of faces distorted by the rage of battle. At the Villa Salviati on the outskirts of Florence, the courtyard is decorated with a series of large roundels in terracotta by Rustici, many of which are derived (like the corresponding cycle in the Palazzo Medici, Florence) from Classical sources, while several recall designs by Leonardo (e.g. an equestrian monument, and Neptune in his chariot); there are also studies of horses, one of which is seen in mid-air and from below. These were part of a campaign of refurbishment at the villa in 1522–6, as was a marble altarpiece for the chapel carved by Rustici in shallow relief like that of Donatello. It depicts the *Annunciation*, with the angel Gabriel and the Virgin in the foreground, flanking a curious central void, which has an architectural background of a triumphal arch.

Similar in style is another shallow relief in marble, *St George and the Dragon* (Budapest, Mus. F.A.), which betrays in its subject a specific debt to Donatello's relief (Florence, Bargello). From this period of collaboration must date a painting of the *Conversion of St Paul* (London, V&A), for its groups of turbulent horsemen recall studies for the *Battle of Anghiari*. Rustici evidently loved animals, and he kept some unusual pets; Vasari recorded a painting of a hunt.

Cardinal Giulio de' Medici, in appreciation of Rustici's role in the decoration of Florence for the entry of Pope Leo X in 1515, commissioned a bronze statuette of *Mercury* for a fountain in the Palazzo Medici (Geneva, priv. col., see Pope-Hennessy, pl. 40). According to Vasari, water spurted upwards from its pursed lips and rotated a device like a toy windmill that it held in one hand; this may have been characterized as a caduceus, one of the normal attributes of Mercury. The style of the figure reflects an admiration for the vigorous, muscular, male nude statuettes of Antonio Pollaiuolo, for example the *Hercules and Antaeus* (Florence, Bargello; *see* POLLAIUOLO, (1), fig. 2) which belonged to the Medici, rather than the suaver figures of Verrocchio or Leonardo.

Giovanni Francesco Rustici: *St John the Baptist Preaching*, bronze, h. 2.65 m, 1506–11 (Florence Cathedral, Baptistery)

Vasari recorded a number of mythological subjects by Rustici in '*quadri*', but this word can mean sculptural reliefs, as well as paintings. Two reliefs modelled in terracotta and glazed in the della Robbia technique may be attributed to Rustici on stylistic grounds: *Europa and the Bull* (London, V&A), strongly reminiscent of Verrocchio, and *Leda and the Swan* (Frankfurt am Main, Liebieghaus). It is not clear whether these reliefs were produced in Florence, or during Rustici's stay in France after the defeat of the Medici in 1528. Rustici arrived at the court of Francis I with an introduction from the diplomat and art dealer Giambattista della Palla, and was given a salary. He had been preceded there by Leonardo, who had died in 1519. He spent much time on a major project, a twice life-size equestrian monument to Francis I: the horse was cast in 1529–31, but the rider had not been executed by the time of the King's death in 1547. There is no visual record of Rustici's design, but almost certainly it reflected Leonardo's plans for monuments for Francesco Sforza and Gian Giacomo Trivulzio, which were known to the French, from their invasions of Milan earlier in the century, and also to Rustici. The new king, Henry II (*reg* 1547–59),

cancelled Rustici's salary and gave his residence to Piero Strozzi, who looked after the sculptor until his death.

BIBLIOGRAPHY

G. Vasari: *Vite* (1550, rev. 2/1568); ed. G. Milanesi (1878–85), iv, p. 50; vi, pp. 136, 147

W. R. Valentiner: 'Rustici in France', *Studies in the History of Art Dedicated to William E. Suida on his Eightieth Birthday* (London, 1959), pp. 205–17

J. Pope-Hennessy: *Italian High Renaissance and Baroque Sculpture* (London, 1963), pp. 41–3

M. G. Ciardi Duprè: 'Giovan Francesco Rustici', *Paragone*, xiii/157 (1963), pp. 29–50, pls 33–56

C. Avery: *Florentine Renaissance Sculpture* (London, 1970), pp. 149–53

Italian Renaissance Sculpture in the Time of Donatello (exh. cat., ed. A. P. Darr; Detroit, MI, Inst. A., 1985), pp. 242–3

Il giardino di San Marco: Maestri e compagni del giovane Michelangelo (exh. cat. by P. Barocchi, Florence, Casa Buonarroti, 1992), pp. 128–9, 143–7, nos 34–5

L. A. Waldman: 'The Date of Rustici's *Madonna* Relief for the Florentine Silk Guild', *Burl. Mag.*, cxxxix (Dec 1997), pp. 869–72

'The Boscawen Collection at the Fitzwilliam Museum, Cambridge', *Burl. Mag.*, cxxxix (1997), pp. i–ii

A. Butterfield and D. Franklin: 'A Documented Episode in the History of Renaissance *Terracruda* Sculpture', *Burl. Mag.*, cxl/1149 (1998), pp. 819–24

CHARLES AVERY

S

Sabatini [da Salerno], **Andrea** (*b* Salerno, *c.* 1480; *d* Gaeta, 1530–31). Italian painter. He is first documented in 1510, but his triptych of the *Virgin and Child with Saints* (1508; Teggiano, S Andrea) is his earliest known work. His polyptych painted for S Antonio, Buccino (Salerno, Mus. Prov.), commissioned in 1512, reveals the influence of the Lombard and Raphaelesque art of Cesare da Sesto. Two panels that he painted for the abbey of Montecassino (1513–16) survive: *St Bertharius* (Montserrat, Mus. Abadia) and another showing *St Nicholas* (Naples, Capodimonte). There followed a period in which Sabatini was deeply influenced by Raphael's Roman works, and he became the principal disseminator of Raphael's style in the Spanish viceroyalty. His *Pietà* (Salerno, Mus. Duomo) and the *Deposition* (Naples, Capodimonte) are indebted to the first Vatican *stanze*, while the *Adoration of the Magi* (Naples, Capodimonte) echoes the assured compositions of a Fra Bartolomeo or a Ridolfo Ghirlandaio. Around 1519–20, in such works as the triptych in S Francesco, Nocera (1519), Sabatini responded to the personal elaboration of Raphael's style by such minor collaborators in the Vatican Logge as Pedro Machuca (*c.* 1490–1550). In his final decade he created such calmly classical compositions as *Virgin and Child with Saints* (1523; Salerno, S Giorgio). It is probable that from 1526 Sabatini worked with Giovan Filippo Criscuolo, whose hand, it seems, can be identified in the large altarpiece (1529–31), painted on both sides, showing scenes from the *Life of St Benedict* (ex-parish church, Montecassino; Montserrat, Mus. Abadio, and Naples, Capodimonte).

BIBLIOGRAPHY
A. Pantoni: 'L'opera di Andrea Sabatini a Montecassino', *Rass. Stor. Salernitana*, xxiii (1962), pp. 133–54
G. Previtali: *La pittura del cinquecento a Napoli e nel vicereame* (Turin, 1978), pp. 14–17
P. Giusti and P. Leone de Castris: *'Forastieri e regnicoli': La pittura moderna a Napoli nel primo cinquecento* (Naples, 1985), pp. 115–99
Andrea da Salerno nel rinascimento meridionale (exh. cat., ed. G. Previtali; Padula, Certosa di San Lorenzo, 1986), pp. 96–9, 112–20, 124–7, 140–60, 192–5, 210–15
G. Briganti, ed.: *La pittura in Italia: Il cinquecento*, 2 vols (Milan, 1987, rev. 1988), ii, p. 827 [with bibliog.]

RICCARDO NALDI

Sabatini [Sabadini; Sabattini; Sabbatini], **Lorenzo** [Lorenzino da Bologna] (*b* Bologna, *c.* 1530; *d* Rome, 2 Aug 1576). Italian painter. His early education is linked to the Maniera of Pellegrino Tibaldi, Nicolò dell'Abate and Prospero Fontana, who was probably his teacher and collaborator. His chief characteristics as a painter are a Tusco-Roman plasticity derived from Vasari and a lively Emilian Mannerism absorbed through the study of Parmigianino. The most important work from his controversial early career is the *Last Supper* (oil on canvas; Bologna, S Girolamo alla Certosa), which must have functioned almost as a pendant to another painting, the (untraced) *Marriage at Cana*, known through a print by Cornelis Cort (1533–78). Both appear to date from the 1560s. The fresco depicting *Artemisia* (Bologna, Pal. Poggi), the *Holy Family with Saints* (Bologna, S Egidio) and the canvas of *Judith with the Head of Holofernes* (*c.* 1562; Bologna, Banca del Monte di Bologna e Ravenna, Coll. A.) have also been assigned to this early period (Winkelmann, 1986).

In 1565 Lorenzo was registered at the Florentine Accademia del Disegno and in that year he executed six *Virtues* for the Ricetto (vestibule off the Sala dei Cinquecento) in the Palazzo Vecchio, Florence, in a style that is strongly dependent upon Vasari. In 1566 he participated in the decorative preparations for the wedding of Francesco I de' Medici, Grand Duke of Tuscany, and Joanna of Austria. A rare signed work also belongs to this period, the *Virgin and Child with a Citron* (ex-Woerhoren priv. col., The Hague). Between 1566 and 1573 he produced a number of works in Bologna: the *Dispute of St Catherine* (oil on canvas; Bologna, Pin. N.), which makes numerous references to Tuscan tradition, the frescoes (1569; destr. 1913, except for a detached fresco of *God the Father*) in the apse of S Clemente, Collegio di Spagna, Bologna, and probably the untraced altarpiece from the same church depicting *St Peter Handing the Keys to St Clement with SS James the Greater, Jerome, Lawrence and Stephen*. Between 1566 and 1570 he decorated the Malvasia Chapel, S Giacomo Maggiore, Bologna, painting frescoes of the *Doctors of the Church* and the *Evangelists* and, with Denys Calvaert (*c.* 1540–1619), an altarpiece canvas of the *Virgin and Child with St Michael*. The *Virgin and Child Enthroned with Four Saints* (*c.* 1570; ex-Bodemus., Berlin) demonstrates a continuing interest in a rigorous classicism derived from Raphael. Finally, Vasari's late Mannerist formulae are the source for the signed and dated *Virgin and Child with the Infant St John the Baptist* (1572; Paris, Louvre) and *Christ in Glory with SS Louis of France, Bartholomew and Anthony of Padua* (Bologna, Mus. S Domenico).

In 1573 Lorenzo was invited to Rome by Pope Gregory XIII, to assist Vasari in the execution of the frescoes depicting the *Battle of Lepanto* (Rome, Vatican, Sala Regia). He also collaborated in the decoration of the Sala Paolina (finished after his death by Federico Zuccaro in 1580),

and records of payment testify to his activity in other rooms of the Vatican. His last signed work is a *Pietà* in the sacristy of St Peter's, Rome. Documents record his registration in the Compagnia di S Luca on 18 October 1575 and establish the place and date of his death.

BIBLIOGRAPHY

G. Vasari: *Vite* (1550, rev. 2/1568); ed. G. Milanesi (1878–83), pp. 415–16

C. C. Malvasia: *Felsina pittrice* (1678); ed. G. Zanotti (1941), ii, pp. 182–3

J. Winkelmann: 'Un frammento di affresco di Lorenzo Sabatini', *Stud. Albornot.*, xxxvi (1979), pp. 203–14

Bologna 1584: Gli esordi dei Carracci e gli affreschi di Palazzo Fava (exh. cat., Bologna, 1985), pp. 25–8

J. Winkelmann: 'Lorenzo Sabatini', *Pittura bolognese del '500*, ii (Bologna, 1986), pp. 595–630

——: 'Lorenzo Sabatini', *Nell'età di Correggio e dei Carracci* (exh. cat., Bologna, Pin. N., 1986), pp. 188–90

G. Briganti, ed.: *La pittura in Italia: Il cinquecento* (Milan, 1987), pp. 827–8

MATILDE AMATURO

Sabbioneta. Model city in the Po Valley in North Italy. Lying 31 km south-west of Mantua, it was the capital of the small duchy of Vespasiano Gonzaga, the last prince of a cadet branch of the family that ruled Mantua. It was laid out in the 16th century on a modified grid-plan and planned largely by Duke Vespasiano Gonzaga as a monument to himself. In 1554 Vespasiano began to fortify the town. In this project, completed in 1579, Gerolamo Cattaneo (*c.* 1500–*c.* 1558) and Giovan Pietro Bottaccio (*fl* 1558–84) served as military engineers. The old castle, which was all that survived of the original medieval settlement, became the citadel of a complex defensive system designed according to the most advanced principles of military architecture: polygonal perimeter, steeply sloping brick walls reinforced inside by earth embankments, and protruding wedge-shaped bastions.

In its basic plan Sabbioneta is almost unchanged today. Two gates lead into the town: the Porta della Vittoria (*c.* 1560), built mostly of brick in the style of Michele Sanmicheli's Porta di San Zeno in Verona, and the Porta Imperiale (1579), faced in white marble ashlar. Within the walls the streets are laid out on a modified grid plan, creating about 30 rectangular blocks. The scheme is based on the principles of Vitruvius, as illustrated in the editions of Fra Giovanni Giocondo (1511), Cesare di Lorenzo Cesariano (1521) and Daniele Barbaro (1556) and expounded by various theorists such as Francesco di Giorgio Martini and Pietro Cataneo (1554). The main street, which crosses the city from east to west, has the character of a true *decumanus major*, though it does not line up with the two gates but breaks twice at right angles before connecting with them, following a principle laid down by Leon Battista Alberti in his *De re aedificatoria*.

Sabbioneta is the result of a proper town plan, the realization of an ideal city in the manner of the ancients. Unlike Palmanova, however, which was basically a fortress, Sabbioneta displayed a balance between military, civil and cultural functions. In addition to palaces, churches and schools were built, together with a hospital, a mint, a gallery of antiquities, a theatre and a printing office, from which Tobias ben Eliezer Foa published Hebrew books. Forster (1969) suggests that the layout of Sabbioneta may have been the work of Domenico di Giovanni Giunti, an architect and planner in the service of Ferrante Gonzaga, the Duke of the nearby town of Guastalla, for which in 1549 Giunti had drawn up a development plan that in some ways prefigured that of Sabbioneta.

Whatever his precise role, Giunti's responsibility did not go beyond the technical and executive; the real designer of Sabbioneta was Vespasiano himself. The Duke conceived the form of 'his' city as an unconventional self-portrait, using the layout of the town, the design of the buildings and the iconography of the painted and sculptured decorations as expressions of his prestige. Vespasiano's designs show clearly this self-aggrandizement: the Vitruvian street plan; the white marble antique statue of *Minerva* standing on a Corinthian column, which originally marked the centre of the *decumanus major*, the iconographic themes in the decorations of the Palazzo Ducale, which exalt variously the figure of the founding hero (the *Stories of Aeneas* in a drawing-room of the Palazzo del Giardino, Vespasiano's private residence) and the history of ancient Rome (elsewhere in the Palazzo del Giardino and in the theatre); and finally the bronze statue of Vespasiano portrayed as a Roman emperor, modelled by Leone Leoni in 1588, which originally stood on a pedestal in front of the Palazzo Ducale and was later incorporated in the Duke's monumental tomb in the church of the Incoronata. All the elements of this iconographic programme glorify the figure of the Duke, who is seen as both founder and emperor.

Sabbioneta's buildings reflect a precise hierarchical order according to their functions. The ducal palaces and religious buildings are monumental in scale, while the dwellings of the Duke's subjects—who were forced to move into the town on pain of heavy sanctions—are low and uniform, in harmony with the narrow streets of the town centre. The residences of court functionaries (the *palazzetto* del Capitano and the *palazzetto* del Cavalleggero) are of intermediate size.

The centres of political and religious power, the Palazzo Ducale (now the town hall) and the church of the Assunta, overlook the Piazza Maggiore (see fig.) with porticos on three sides, which is off-centre in relation to the plan of the city. The Palazzo Ducale was built in two stages (1554–68 and from 1577), possibly by the architects Paolo and Bassano Tusardi. A rusticated portico on its ground-floor façade is based on Giulio Romano's triforia in the Palazzo del Te in Mantua. Above the cornice, situated on the central axis, rises a tall, slender roof-level loggia. Many rooms in the Palazzo preserve the original decorations, wholly or in part: the Galleria degli Antenati with its bas-relief portraits of members of the Gonzaga house and its Flemish-style landscapes in the ceiling vault, the Gabinetto di Diana with fresco decorations attributed to Bernardino Campi, and two reception rooms where the family's ancient splendour is attested by wooden ceilings covered in sheets of pure gold. The church of the Assunta (before 1582) by Pietro Martire Pesenti (*d* after 1594), with its aisleless nave and side chapels, has a polychrome façade in pink and white marble tesserae. Close to the Palazzo Ducale stands the church of the Incoronata (1586–8), which served as the palace chapel. Its octagonal plan came from the Lombard Renaissance architectural tradition; its prototype was Giovanni di Domenico Battagio's church

Sabbioneta, Piazza Maggiore, viewed from the Palazzo Ducale, with the church of the Assunta

of the Incoronata at Lodi, which in turn was inspired by the style of Donato Bramante. Inside the church is Vespasiano Gonzaga's tomb, designed by Giovanni Battista della Porta with his statue by Leone Leoni.

A second and larger square, now altered in size and shape because of the demolition of the castle (1794) and the unfortunate siting of a 20th-century school building, faces the *decumanus major*. This square is overlooked by Vespasiano's private residence, the Palazzo del Giardino (known as the Villa or Casino; completed in 1588) and the Galleria degli Antichi or Corridor Grande (1583–4). The Palazzo del Giardino is a two-storey building in the form of a very long rectangle. Some of the ground-floor rooms and all the rooms on the *piano nobile* are decorated with frescoes and stucco ornaments. The decoration of the Gabinetto di Venere, and the four landscapes with scenes of courtly life in the Hall of Mirrors, are attributed to Bernardino Campi. Other painters working in the palace were Alberto Cavalli, the brothers Francesco, Pietro Martire and Vincenzo Pesenti and Fornaretto Mantovano for the grotesques. In the Sala dei Venti some fragments of fresco decoration show the influence of Flemish painting, especially that of Hieronymus Bosch (*c.* 1450–1516): in his effort to speed up the decorations Vespasiano commissioned work from a heterogeneous group of artists. Next to the Palazzo del Giardino, and connected by an overhead passage, is the Galleria degli Antichi, a building nearly 100 m long. Its ground-floor consists entirely of porticos; above is a corridor that held the Duke's collection of antiques. The imposing exterior recalls the Palazzo della Pilotta in Parma.

The most important, and progressive, building in Sabbioneta is the theatre, which overlooks the *decumanus major*. It was designed in 1588 by Vincenzo Scamozzi, whose autograph drawing is preserved in the Galleria degli Uffizi in Florence (Gabinetto dei Disegni e delle Stampe, 191 A). The theatre of Sabbioneta contrasts with Andrea Palladio's Teatro Olimpico in Vicenza, which was intended

to revive the theatre of the ancients. Scamozzi's theatre, on the other hand, inspired by the research of BALDASSARE PERUZZI and the theories of SEBASTIANO SERLIO, was presented as a modern theatre and is claimed by Lotz (in Heydenreich and Lotz) as the 'first real theatre in modern architecture'. The monumental *scenae frons* or backdrop was eliminated, and the stage was set up as a townscape with a square and street portrayed in realistic perspective. As in the Teatro Olimpico, behind the stepped auditorium stands a semicircle of columns with an entablature bearing statues of Olympian deities, but in the theatre of Sabbioneta the colonnade becomes a loggia from which the Duke could watch the spectacle on the stage (*see* SCAMOZZI, (2), fig. 2). His entourage sat on the semicircular steps below, while the rank and file stood in the pit.

BIBLIOGRAPHY
L. H. Heydenreich and W. Lotz: *Architecture in Italy: 1400–1600*, Pelican Hist. A. (Harmondsworth, 1954, rev. 1986)
K. W. Forster: 'From "Rocca" to "Civitas": Urban Planning at Sabbioneta', *L'Arte*, ii/5 (1969), pp. 5–41
P. Carpeggiani: *Sabbioneta* (Quistello and Mantua, 1972)
L. Micara and T. Scalesse: *Sabbioneta* (Rome, 1979)
J. P. Neraudau: 'Sabbioneta: "Nouvelle Rome" et "Petite Athènes"', *Présence de l'architecture et de l'urbanisme romains*, ed. R. Chevallier (Paris, 1983), pp. 231–44
G. Confurius: *Sabbioneta oder die schöne Kunst der Stadtgründung* (Munich and Vienna, 1984)
S. Mazzoni and O. Guaita: *Il teatro di Sabbioneta* (Florence, 1985)
G. Rugarli, ed.: *Sabbioneta: Una stella e una pianura* (Milan, 1985)
Città dei signori (exh. cat., 1989)
H.-W. Kruft: *Le città utopiche: La città ideale dal XV al XVIII secolo fra utopia e realtà* (Bari, 1990), pp. 35–56, 174–7, 208–9
——: 'Una "nuova Roma": Sabbioneta', *Le città utopiche* (Rome and Bari, 1990)
U. Bazzotti, D. Ferrari and C. Mozzarelli, eds: *Atti del convegno. Sabbioneta: Mantova, 1991*
C. Tellini Perina: *Sabbioneta* (Milan, 1991)
A. Gozzi and A. Medici: *Sabbioneta, Guastalla, Gualtieri, Pomponesco: Città dei Gonzaga* (Milan, 1993)
S. Grötz: *Sabbioneta: Die Selbstinszenierung eines Herrschers* (Marburg, 1993)
——: 'La SS Incoronata, mausoleo di Vespasiano Gonzaga', *Civiltà Mant.*, xxviii/9 (Dec 1993), pp. 17–39
M. Bini: *Sabbioneta, piccola reggia padana* (Modena, 1994)
PAOLO CARPEGGIANI

Sacchis, Giovanni Antonio de. *See* PORDENONE.

Sacra conversazione [It.: 'sacred conversation']. Term applied to a type of religious painting, depicting the Virgin and Child flanked on either side by saints, which developed during the 15th and 16th centuries and is associated primarily with the Italian Renaissance. The specific characteristics of the genre are that the figures, who are of comparable physical dimensions, seem to co-exist within the same space and light, are aware of each other and share a common emotion. This relationship is conveyed, with greater or lesser emphasis, by gesture and expression. The compositions are usually frontal and centralized, and are distinguished by an aura of stillness and meditation.

In late medieval and early Renaissance art Central Italian polyptychs had generally consisted of a main panel of the Virgin and Child enthroned, flanked by smaller panels showing individual figures of saints; large altarpieces often had small scenes of related narrative below (predellas) and sometimes also above. Usually the panels were divided and surrounded by a frame of a consistent architectonic

pattern. Main and lesser figures were differentiated in terms of size and, set against a gold background, seemed to exist beyond space and time.

The reduction of the framing elements, and the creation of naturalistic figures who exist within a unified space and light, took place in Florence in the middle decades of the 15th century. The desire to create a more unified architectural space for the Virgin and Child is evident in Filippo Lippi's *Virgin and Child with SS Fredianus and Augustine*, known as the Barbadori Altarpiece (1437; Paris, Louvre; *see* LIPPI, (1), fig. 1), in which three arches frame the upper part of the composition, marshalling the whole arrangement of figures—Virgin and Child, adoring saints and attendant angels—without controlling, however, the details of the architectural setting. Nevertheless, the old-fashioned disparity in figure sizes is maintained. The disparity is less obvious in Fra Angelico's *Virgin and Child Enthroned with Eight Saints* (*c*. 1438–40; Florence, S Marco), in which the architectural elements are relegated to the background but the figure groupings (though untrammelled by framing) are still disposed in three groups, yet with a luminous clarity and calm that was to be an important characteristic of the genre.

The first true *sacra conversazione* was almost certainly Domenico Veneziano's *St Lucy* altarpiece (*c*. 1445–7; main panel, Florence, Uffizi; *see* DOMENICO VENEZIANO, fig. 2 and colour pl. 1, XXVIII1). The architectural background still has a tripartite composition reflecting the arrangement of the figures, but also acts as a naturalistic framework to the spatial perspective that contains them. The blonde tonality graces the mostly introspective, stately figures with an elegant calm; the exception, the bare-limbed, strongly coloured St John, gazes firmly, if sadly, out of the picture, while gesturing towards the Child in the Virgin's arms. This psychological and indeed aesthetic appeal to the spectator was to become a feature of this, as of other genres.

Domenico's pupil Piero della Francesca developed his master's limpid and stately style, adding his own qualities of physical grandeur and intellectual poetry. His main contribution to the genre was the Brera Altarpiece (*c*. 1475; Milan, Brera; *see* colour pl. 2, XVI2), in which hardly differentiated saints and angels are disposed, with a naivety reminiscent of Fra Angelico, around a statuesque Virgin adored by a lifelike Federico da Montefeltro; the whole group is surmounted and surrounded by the most consistent and sophisticated depiction of progressive Renaissance architecture yet seen.

The centralized compositions within an architectural perspective created by Florentine artists inspired Venetian and north Italian artists in the mid-15th century. Antonio Vivarini, in collaboration with Giovanni d'Alemagna, painted the *Virgin and Child with SS Jerome and Gregory, Ambrose and Augustine* (1446; Venice, Accad.) as a triptych, and yet the three panels form a single scene, united within a rich Gothic setting. The scheme was elaborated in Andrea Mantegna's *Virgin and Child with Saints* (1456–9; Verona, S Zeno), in which the panels are divided by the four fluted classical columns of the frame. These columns are reflected by similar forms in the fictive space, which define the area occupied by Mantegna's stony and self-absorbed figures (*see* MANTEGNA, ANDREA, §I).

Later in the century, *c*. 1475, the monumental Venetian altarpiece was transformed by Antonello da Messina's S Cassiano Altarpiece (1475–6; ex-S Cassiano, Venice; fragments, Vienna, Ksthist. Mus.; *see* ANTONELLO DA MESSINA, fig. 2) and Giovanni Bellini's altarpiece in SS Giovanni e Paolo, Venice (destr. 19th century): it is not clear which artist took precedence, but these two works were fundamental to the later development of the altarpiece in Venice. Antonello was evidently dependent on Piero's Brera Altarpiece; he imitated Piero's consistently realistic architectural space, but peopled it differently, raising the Virgin's throne high above the attendant saints, who were reduced in number and carefully characterized in type, after the manner of Domenico Veneziano. These models were developed, with more harmonious compositions, by Giovanni Bellini in a series that culminated in the *Virgin and Child with Saints* (1505; Venice, S Zaccaria; *see* colour pl. 1, XII2), perhaps the apogee of the large *sacra conversazione* altarpiece. Here the impressive architecture seems effortlessly to continue the spectator's space, and contains dignified, self-absorbed figures, who, described in exquisite colours and bathed in golden light, embody in their symmetrical grace the music played by the angel at the foot of the Virgin's throne.

From this epitome of the contemplative beauty of 15th-century art subsequent examples varied in different ways. The next genius of Venetian art, Giorgione, applied his newly sensuous descriptive mode to the Castelfranco Altarpiece (*c*. 1505; Castelfranco Veneto, S Liberale; *see* GIORGIONE, fig. 5), outdoing Antonello by raising the Virgin's throne so high that the scene, although conveyed with powerful naturalistic immediacy, is in fact thoroughly unrealistic. In Florence Fra Bartolommeo responded, as in the *Virgin and Child with Saints and Angels* (1510; Florence, S Marco), by investing his figures with individually strong but generally undirected movement, to exciting but distancing effect. The dynamism of the High Renaissance was inimical to the static quality of 15th-century art. Thus in a work such as Andrea del Sarto's *Madonna of the Harpies* (1517; Florence, Uffizi), a composition of fundamentally classical purity is animated by a nervous energy in the figures to produce an unsettling impression of variety. By contrast, the epic dignity of Raphael's *Sistine Madonna* (*c*. 1513; Dresden, Gemäldegal. Alte Meister) describes in warmly human terms a paradoxically hieratic image that is adored, rather than conversed with, by the attendant saints.

Raphael's human warmth links the demise of the *sacra conversazione* altarpiece with the emergence of works on a similar theme intended for private devotion. Bellini probably initiated this development of the genre when he extended his half-length Virgins to include subsidiary figures, as in the *Virgin and Child with SS Catherine and Mary Magdalene* (Venice, Accad.), which is as much a depiction of three types of female beauty as a devotional image. The type of Bellini's St Catherine was taken up by Titian, for example in his realization of the same saint in the *Virgin with the Rabbit* (*c*. 1530; Paris, Louvre). With this painting he probably originated the iconography of the full-length Virgin, seated in a landscape and attended by lesser figures. Lorenzo Lotto also favoured this iconography, as in the typically idiosyncratic, highly charged

atmosphere of the *Virgin and Child with Saints and an Angel* (*c.* 1530; Vienna, Ksthist. Mus.); and Palma Vecchio became a specialist in this type of composition, the most poignant example being perhaps one of his last such works, the *Virgin and Child with SS Catherine and John* (*c.* 1527; London, Hampton Court, Royal Col.), with its concerted exchange of melancholy glances.

Even Palma sometimes found it necessary to rework this type of composition around themes longer established, such as the *Rest on the Flight into Egypt* (*c.* 1514; Florence, Uffizi) and the *Adoration of the Shepherds* (*c.* 1525; Paris, Louvre). In Correggio's *Virgin of St Jerome*, also known as *Il giorno* (1523–8; Parma, Pin. Stuard), the protagonists are so busy entertaining or adoring the Child that there is no room for mere *conversazione*.

BIBLIOGRAPHY

P. Kristeller: *Andrea Mantegna* (London, 1901), pp. 149–52
J. Wilde: 'Die Pala di San Cassiano von Antonello da Messina, ein Rekonstruktionversuch', *Jb. Ksthist. Samml. Wien*, iii (1929)
G. Robertson: 'The Earlier Work of Giovanni Bellini', *J. Warb. & Court. Inst.*, xxiii (1960), pp. 45–59
S. J. Freedberg: *Painting of the High Renaissance in Rome and Florence*, 2 vols (Cambridge, MA, 1961)
J. Shearman: 'Masaccio's Pisa Altarpiece: An Alternative Reconstruction', *Burl. Mag.*, cviii (1966), pp. 449–55
E. Hubbala: *Giovanni Bellini: Madonna mit Kind, Die Pala di S. Giobbe* (Stuttgart, 1969)
J. White: 'Donatello's High Altar in the Santo at Padua. Part Two: The Reconstruction', *A. Bull.*, li (1969), pp. 119–41
S. J. Freedberg: *Painting in Italy, 1500–1600*, Pelican Hist. A. (Harmondsworth, 1971, rev. 2/1983)
H. Wohl: *The Paintings of Domenico Veneziano* (Oxford, 1980)
D. Rosand: *Painting in Cinquecento Venice* (New Haven and London, 1982), pp. 29–39
R. Lightbown: *Andrea Mantegna* (Oxford, 1986), pp. 66–76, 177–85

NIGEL GAUK-ROGER

Salaì. *See* CAPROTTI, GIAN GIACOMO.

Salamanca, Antonio (Martínez [Martini; Martino] **de)** (*b* ?Salamanca, Spain, 1478; *d* Rome, 5 July, 1562). Spanish book and print publisher, active in Italy. Salamanca was in Rome by 1519 when he published *Amadis de Gaula*. Subsequently he published *Ordo perpetuus divini officii secundu*[*m*] *Romana*[*m*] *Curia*[*m*] (1520; printed by Antonio Blado), *Esplandian* (1525), *La Celestina* (*c.* 1525; with Jacopo Giunta), Antonio de Guevara's *Libro aureo de Marco Aurelio* (1531), a Quignon Breviary (1535; with Giunta and Blado), Hernando da Salazar's *Las yglesias & indulgentias de Roma* (1539), *Las obras de Boscan* (1547), a writing manual (1548; printed by the Dorico brothers) and Juan de Valverde's *Historia de la composicion del cuerpo humano* (1556; with Antoine Lafréry). In 1538 he began also to publish prints. His address, often abbreviated (*Ant. Sal. exc.*), appears on the second or later state of over 250 prints. Of this number, at least 150 are by Marcantonio Raimondi and his school. Another 60 or so are by the Master of the Die, Nicolaus Beatrizet (who engraved Salamanca's portrait), Enea Vico, Giulio di Antonio Bonasone and others. The majority are reproductive engravings, but there are also numerous prints of antique sculpture and architecture, and several maps. His name appears in a census taken in Rome just before 1527, and he is listed as a member of the Virtuosi del Pantheon on 9 May 1546. On 20 December 1553 he went into partnership with the French publisher Antoine Lafréry. The partnership was dissolved in September 1563, a year after Salamanca's death, by his son and heir Francesco Salamanca. A number of Salamanca's plates were acquired by Lafréry.

BIBLIOGRAPHY

F. Ehrle: *Roma prima di Sisto V: La pianta di Roma du Pérac-Lafréry del 1577* (Rome, 1908)
A. M. Hind: *A History of Engraving and Etching from the 15th Century to the Year 1914* (New York, 1909, rev. 3/1923/*R* 1963), pp. 118, 132, 361
F. Borroni Salvadori: *Carte, piante e stampe storiche delle raccolte lafreriane della Biblioteca Nazionale di Firenze* (Florence, 1980)
S. Deswarte-Rosa: 'Les Gravures de monuments antiques d'Antonio Salamanca: A l'origine du *Speculum romanae magnificentiae*, Annali di Architettura: Rivista del Centro Internazionale di Studi di Architettura Andrea Palladio, i (1989), pp. 47–62

CHRISTOPHER L. C. E. WITCOMBE

Saliba [Resaliba; Risaliba; Risaliva]**, de.** Italian family of painters. They were active in Sicily. Although Antonio was apprenticed to his cousin Jacobello d'Antonio in January 1480, his painting more closely imitates that of his uncle, ANTONELLO DA MESSINA. This fact, and the similarity of their names, led to the two artists being confused with each other, a situation perhaps intentionally encouraged by de Saliba who used various forms of his uncle's signature on his works.

(1) Antonio de Saliba [Antonello da Messina] (*b* Messina, ?1466–7; *d* ?1535). Antonio is well documented in Sicily up to 1535, the presumed year of his death, except for a period between his apprenticeship in 1480 and 1497; on the basis of stylistic evidence and the presence of various works associated with him in and around Venice, it is generally supposed that he travelled to the north of Italy at that time. Several works connected with this probable visit form the basis for a description of his early style. A *Virgin and Child* (ex-Kaiser-Friedrich Mus., Berlin, destr.) was compositionally very similar to Giovanni Bellini's *Virgin and Child* (São Paulo, Mus. A. Assis Châteaubriand), and it is possible that both reflect a lost composition by Antonello. The *Virgin and Child* (Spoleto, Mus. Civ.) is also connected with this period and mechanically imitates the central motif of Antonello's S Cassiano Altarpiece (1475; fragments, Vienna, Ksthist. Mus.; *see* ANTONELLO DA MESSINA, fig. 2).

A number of Antonio's documented Sicilian commissions are lost, but the *Virgin and Child Enthroned* (1497; Catania, Mus. Civ. Castello Ursino) characterizes his style at its best. Originally for the church of S Maria del Gesù, Catania, and probably the central panel of a polyptych, it shows him at his most Venetian, influenced by Antonello's Virgins in the altarpieces of *St Gregorio* (1473; Messina, Mus. Reg.) and *St Cassiano*, by Bellinesque prototypes, Cima da Conegliano and Bartolommeo Montagna. It was painted the year he is presumed to have returned to Sicily. Thereafter he is documented producing numerous paintings for provincial churches, which, in a repetitive and often laborious way, offer modernized reworkings of Antonello's prototypes. The variable quality of surviving examples suggests a considerable degree of workshop participation.

(2) Pietro de Saliba [Pietro da Messina] (*fl* 1497–1530). Brother of (1) Antonio de Saliba. He is documented only twice: in Messina in 1497 and in Genoa in 1501. He is thought to have travelled to Venice with his brother in the early 1490s. His extant oeuvre includes a *Virgin and Child with a Donor* (sold Florence, Sotheby's, 1975), a *Virgin Adoring the Child* (Venice, S Maria Formosa; replica, Padua Mus. Civ.) and a *Christ at the Column* (Budapest, Mus. F. A.). Like his brother, he was chiefly inspired by his uncle Antonello and by Giovanni Bellini and Cima da Conegliano.

BIBLIOGRAPHY

G. Di Marzo: *Di Antonello da Messina e dei suoi congiunti*, Documenti per servire alla storia di Sicilia, ix (Palermo, 1903), pp. 80–83, 109–35 and app.

Antonello e la pittura del '400 in Sicilia (exh. cat., ed G. Vigni and G. Carandente; Messina, Pal. Com., 1953), pp. 79–81, 85–8

S. Bottari: *La pittura del quattrocento in Sicilia* (Messina and Florence, 1954), pp. 63–7, 88–9

M. G. Paolini: 'Antonello e la sua scuola', *Stor. Sicilia*, v (1979), pp. 51–3

Antonello da Messina (exh. cat., ed A. Marabottini and F. Sricchia Santoro; Messina, Mus. Reg., 1981), pp. 217–18

F. Sricchia Santoro: *Antonello e l'Europa* (Milan, 1986), pp. 142–3

JOANNE WRIGHT

Salimbeni, Ventura [Bevilacqua] (*b* Siena, 20 Jan 1568; *d* Siena, before 23 Nov 1613). Italian painter, draughtsman and engraver. The son of Arcangelo Salimbeni (*fl* 1567–80/89) and Battista Focari, widow of Eugenio Vanni, he was first taught painting in his native Siena by his father, as was his half-brother Francesco Vanni, with whom he was often confused. Ventura possibly spent some time in North Italy before going to Rome, where he worked from 1588, collaborating on the fresco decoration of the Biblioteca Apostolica Vaticana (the Vatican Library) during the reign of Pope Sixtus V (*reg* 1585–90). Salimbeni's painting during 1590–91, when he worked in Il Gesù and S Maria Maggiore, Rome, reflects the influence of the Cavaliere d'Arpino (1568–1640), Cherubino Alberti (1553–1615) and Andrea Lilli (*c.* 1570–1635). The few engravings that Salimbeni executed were made in Rome. Of these, seven survive, dated between 1589 and 1594 (B. 190–97).

After his return to Siena in 1595, Salimbeni was influenced by Federico Barocci (as shown by the *Birth of the Virgin* (*c.* 1607–8; Ferrara, S Domenico)) and became one of the leading personalities in Sienese art in the transitional period between Mannerism and Baroque. The decoration (1595–1602) of the oratory of the Santa Trinità, Siena, is one of his most outstanding achievements. Angels, apostles, virgins, saints, monks and Doctors of the Church fill the vaulted area, while interspersed among them are 12 scenes from the *Apocalypse* (two by Alessandro Casolani, 1552–1606). A series of detailed preparatory drawings in chalk and ink wash (Riedl, 1978) has survived in connection with this project. Around 1600, Salimbeni painted the scenes from the *Life of St Hyacinth* in Santo Spirito, Siena. The scenes from the popular legend are inserted into a rich backdrop of buildings and landscape and reveal Salimbeni's assimilation of the Mannerism of Beccafumi. Preparatory studies exist (Florence, Uffizi) for *St Hyacinth Healing the Blind Twins*. The frescoes in the vault of the chapel of S Massimino in S Maria degli Angeli, Assisi, were also painted around 1600 and include the *Investiture and Death of St Clare* and the *Ascension*, which has an illusionistically painted balustrade (preparatory drawing, Florence, Uffizi). In 1603 Salimbeni frescoed SS Quirico e Giulietta, Siena, with scenes from the lives of the church's patron saints (preparatory drawing, Florence, Uffizi). Salimbeni executed three paintings, the *Donation of the Keys* (1599), the *Disputa* (1600) and the *Crucifixion* (1604) for S Lorenzo in San Pietro in Montalcino (all *in situ*). Around 1600 he was also working in Perugia, where the papal legate, Cardinal Bonifazio Bevilacqua (1571–1627), commissioned two paintings for the basilica of S Pietro (both *in situ*), the *Vision of Gregory the Great*, which has an interesting diagonal composition, and the *Punishment of David* (preparatory drawing, Florence, Uffizi). Bevilacqua invested Salimbeni with the Order of the Golden Spur and authorized him to use his name.

Between 1605 and 1608 Salimbeni painted frescoes for the Chiostro dei Morti, SS Annunziata, Florence, and in 1606–7 executed several oil paintings for S Frediano, Pisa. While in Florence, he was influenced by Lodovico Cigoli's use of colour. Salimbeni is recorded in Genoa in 1610–11, the years in which he also executed his most important commission in Siena, the two large frescoes for the cathedral apse (both *in situ*), depicting the *Gathering of Manna* and *Esther before Ahasuerus*, notable for the skill with which he handled the large number of figures and the distant landscape and buildings. Salimbeni's talent is shown to greater effect, however, in the small intimate scenes from the *Life of St Galganus* (1612; Chiesa del Santuccio). The fairy-tale, wooded landscapes create the perfect atmosphere for the Tuscan knight and saint who became a hermit. In Salimbeni's final painting, the *Marriage of the Virgin* (1613; Foligno, Seminario), he once again demonstrated his links with Mannerism, of which he was the last great representative in Siena after Beccafumi.

BIBLIOGRAPHY

G. Scavizzi: 'Note sull'attività romana del Lilio e del Salimbeni', *Boll. A.*, n. s. 3, lxiv (1959), pp. 33–40

——: 'Su Ventura Salimbeni', *Commentari*, x (1959), pp. 115–36

P. A. Riedl: 'Zu Francesco Vanni und Ventura Salimbeni', *Mitt. Ksthist. Inst. Florenz*, ix (1959–60), pp. 60–70

——: 'Zum Oeuvre des Ventura Salimbeni', *Mitt. Ksthist. Inst. Florenz*, ix (1959–60), pp. 221–48

Disegni dei baroccheschi senesi (Francesco Vanni e Ventura Salimbeni) (exh. cat. by P. A. Riedl, Florence, Uffizi, 1976–7)

S. Gatti: 'Un disegno e un quadro di Ventura Salimbeni: La '*Madonna del Rosario*' in San Martino a Carvico (Bergamo)', *A. Lombarda*, 49 (1978), pp. 28–30

P. A. Riedl: 'Die Fresken der Gewölbezone des Oratorio della Santissima Trinità in Siena: Ein Beitrag zur Dürer-Rezeption in Italien', *Abh. Heidelberg. Akad. Wiss.* (Heidelberg, 1978)

——: 'Zu einigen Studienblättern des Ventura Salimbeni', *Festschrift E. Trier* (Berlin, 1981), pp. 151–63

S. Buffa: *Italian Artists of the Sixteenth Century* (1983), 38 [XVII/v] of *The Illustrated Bartsch*, ed. W. Strauss (New York, 1978–)

C. HÖPER

Salincorno, Mirabello di. *See* CAVALORI, MIRABELLO.

Salò, (Grazioli) da. Italian family of sculptors. Pietro di Lorenzo da Salò (*fl* 4 July 1535; *d* Venice, after 22 Dec 1561, before 1563) worked in Venice and Padua. His style principally shows the influence of his teacher, Jacopo Sansovino, but also derives from that of Alessandro Vittoria and Danese Cattaneo. Two records of payment exist, from 4 July 1535 and 5 July 1549, for some

unspecified works carried out at the Scuola Grande di San Rocco, Venice, and in 1536 he executed and signed the statue of *Mars* for Doge Andrea Gritti's balcony at the Doge's Palace. Further works there include two chimneys executed in 1553–4 in collaboration with Danese Cattaneo. From 1557 Pietro also worked on figural decorations on the façade of the library of St Mark's. In 1554 he competed unsuccessfully for the prestigious office of Proto al Sal (Master Builder of the Doge's Palace). Besides state commissions he executed a portrait bust for the tomb of *Pietro Lando* (*c*. 1545; ex-S Antonio, Venice; untraced) and some of the figure sculpture for the tomb of *Alessandro Contarini* (1555–8; Padua, S Antonio).

Pietro's son Domenico di Pietro da Salò (*fl* Venice, 1542–71) was also a pupil of Sansovino. His earliest identifiable work is the sculpture for the tomb of *Vincenzo Cappello* above the main portal of S Maria Formosa, Venice. In 1556 he received payment from Sansovino for his collaboration on the statues of *Mars* and *Neptune* (Venice, Doge's Pal., Scala dei Giganti). Besides portrait sculptures of the *Ruzzini Family* (Venice, Pal. Ruzzini–Priuli, S Maria Formosa), he executed and signed a marble relief dated 1571 for an altar in S Giuseppe, Venice. In comparison with his father's work, Domenico's appears more wooden and lifeless. The violin-maker Gasparo da Salò (*b* Salò, *bapt* 20 May 1540; *d* ?Brescia, 14 April 1609) was a member of this family, but it is uncertain whether the military architect Donato Grazioli (*fl* Brescia, late 16th century) and Francesco di Tommaso da Salò (*fl* Venice, mid-16th century), who engraved a view of Venice in 1567, also belonged to it.

BIBLIOGRAPHY
S. Fenaroli: *Dizionario degli artisti bresciani* (Brescia, 1877)
L. Planiscig: *Venezianische Bildhauer der Renaissance* (Vienna, 1921)
G. Lorenzetti: *Venezia e il suo estuario* (Venice, 1926, rev. 1963/*R* Trieste, 1974)
L. Gerö: 'Włoskie fortyfikacje bastionowe na Węgrzech' [Italian bastion fortifications in Hungary], *Kwart. Arkhit. & Urb.*, iv (1959), pp. 23–42
L. Rognini: 'Lorenzo da Salò, "eccellente intagliatore", ed il coro di Sant'Anastasia a Verona', *Verona Illus.*, vii (1994), pp. 15–31
THOMAS HIRTHE

Salviati. Italian family of patrons. The family was of Florentine origin, and some of its members held important civic and religious positions. Cardinal Giovanni Salviati (1490–1553) took into his service in Rome the painter Francesco de' Rossi, who, as a sign of his attachment, used the name FRANCESCO SALVIATI. Francesco executed numerous works for the Cardinal (all untraced) and also worked for the Cardinal's brother, Alamanno Salviati, in Florence and for Cardinal Bernardo Salviati (*d* 1568) in Rome. Cardinal Giovanni ordered numerous works from Benvenuto Cellini, including a silver salt-cellar (*c*. 1550; untraced). Among other artists employed by the Salviati were the architects Battista da Sangallo, Nanni di Baccio Bigio and Francesco da Volterra, the painter Santi di Tito and the sculptor Battista Casella (*fl c*. 1550), all of whom worked on the decoration of the family palace in Via della Lungara, Rome. Their palazzo in the Piazza del Collegio Romano in Rome was designed by Carlo Maderno.

Jacopo Salviati, Cardinal Giovanni's nephew, was probably responsible for hiring Bartolomeo Ammanati to enlarge the family palace (1572–80) in Via del Corso, Florence. Jacopo employed his friend and protégé, Alessandro Allori (1535–1607), to contribute to the interior decoration of the palace and for many other commissions. Allori also worked for Alamanno Salviati. In the Via del Corso palace there were works by Baccio Bandinelli, Andrea del Sarto, Correggio, Santi di Tito and Bronzino, and sculptures by Giambologna, Donatello and Ammanati, as well as antique statues, according to Francesco Bocchi's *Bellezze della città di Firenze* (Florence, 1592). Battista Lorenzi (*see* LORENZI, (1)) executed several sculptures for the garden of the Salviati palace, including a *Perseus* fountain (1588; now Florence, Pal. Nonfinito) and a personification of the *River Mugnone* (now Florence, Pal. Salviati).

BIBLIOGRAPHY
P. della Pergola: 'Gli inventari Salviati', *A. Ant. & Mod.* (1966), pp. 192–200, 308–21
H. Utz: 'Skulpturen und andere Arbeiten des Battista Lorenzi', *Met. Mus. J.*, vii (1973), pp. 37–70
P. Hurtubise: *Une Famille-témoin: Les Salviati* (Rome, 1985)
CHIARA STEFANI

Salviati, Francesco (Cecchino) [Rossi, Francesco de'] (*b* Florence, 1510; *d* Rome, 11 Nov 1563). Italian painter and draughtsman. With Bronzino and Vasari, he was a leading member of the generation of Florentine painters succeeding Jacopo Pontormo and Rosso Fiorentino who developed a High Mannerist style of great elegance and complexity. His work includes paintings of mythological and religious subjects and portraiture as well as designs for tapestries and metalwork, but above all he is known as a creator of large-scale decorative schemes.

1. Life and work. 2. Working methods and techniques.

1. LIFE AND WORK.

(i) Florence, 1510–30. (ii) Rome, 1531–8. (iii) Florence, north Italy and Rome, 1539–43. (iv) Florence, 1544–8. (v) Rome, 1548–53. (vi) France and Rome, 1554–63.

(i) Florence, 1510–30. Salviati was the son of a weaver, Michelangelo de' Rossi, but at an early age he refused to follow his father's profession, showing a natural inclination to the arts. He was first apprenticed to a goldsmith cousin, then to the painter Giuliano Bugiardini. Around 1524 he trained with Baccio Bandinelli, the sculptor; three years later, with a friend he had made there, Giorgio Vasari, he moved to the workshop of another painter, Roberto Marone. Finally, in 1529, he became a pupil of Vasari's erstwhile master Andrea del Sarto for two years. None of these masters seems to have had a lasting effect on Salviati's style. The influence of Bandinelli can be detected in the dry and laboured anatomies of some of his early drawings, while that of del Sarto dominates his earliest attributed work, a *Virgin and Child* (*c*. 1530; London, Hampton Court, Royal Col.), with its smooth forms and warm *sfumato*.

(ii) Rome, 1531–8. By 1531 Salviati (then still known as Francesco de' Rossi) had gained a sufficiently promising reputation to be invited to Rome to continue his studies at the expense of Cardinal Giovanni Salviati, of the noble Florentine family, who paid him a stipend and lodged him

1. Francesco Salviati: *Visitation* (1538), fresco, Oratory of S Giovanni Decollato, Rome

in Palazzo Salviati, and by whose name he was thereafter known. For Cardinal Salviati he executed various works, including the painting of a mythological *Hunting Scene*, the design of an *Anointing of David* for a marquetry table, and frescoes in the chapel of the Palazzo Salviati (all untraced). In 1532 he was joined in Rome by Vasari, and they studied avidly together, particularly the works of Michelangelo. Soon, however, they fell ill, and Vasari returned to his home in Arezzo. Salviati recovered more quickly and stayed. His precocious talent found other patrons in the Florentine community there, such as Filippo Sergardi (1466–*c*. 1545) and also Bindo Altoviti, the façade of whose palace he frescoed with decorative motifs (destr. 1888). At this time he also painted an *Annunciation* (before 1534; Rome, S Francesco a Ripa): this simple yet not entirely convincing composition shows a graceful appreciation of the developed Roman classicism of the Raphael school, especially as exemplified by Perino del Vaga, but its smoothly painted surface, realistic details and small fantastic landscape recall the Flemish paintings then much admired in Florence.

In 1535 Salviati was commissioned to provide two grisaille scenes for the ceremonial entry of Emperor Charles V (*reg* 1519–56) into Rome, and two years later to arrange all the decoration for that of Pier Luigi Farnese, son of Pope Paul III, into the newly created dukedom of Castro; it is probable that he had been working for Farnese, lodged in the Vatican Belvedere, for some time previously. Salviati's new renown was consolidated by his contribution to the fresco cycle, begun by Jacopino del Conte in *c*. 1537, in the chapel of a pious Florentine confraternity in Rome. The *Visitation* (1538; Rome, Oratory of S Giovanni Decollato; see fig. 1) is his most significant early work, in which a certain immaturity does not disguise the assimilation of his sources and the development of his own interests. Single figures and groups based on his experience

of del Sarto and on the new influence of Raphael are disposed in an elaborate composition recalling the current Roman example of Perino, with an architectural background derived from Baldassare Peruzzi. All these elements are controlled by Salviati's translation of formal and narrative values into decorative elaboration through the application, not yet entirely consistent, of ornamental linear effects. This translation is made particularly apparent by the comparison of Salviati's vivid and lively compositional sketch (pen, ink and wash; London, BM, 5211–27) with the stately artificiality of the executed fresco. The artificial effect of the scene, framed by fictive architectural features, is emphasized by the introduction in the lower section of portraits of two members of the confraternity, who, seemingly gesturing at the event depicted, interpolate another layer of illusory reality between the spectator and the subject.

(iii) Florence, North Italy and Rome, 1539–43. News of Francesco's success and remarkable development reached Florence, where Cardinal Salviati's nephew, Cosimo I de' Medici, had recently (1537) seized power. Francesco himself followed, soon enough to contribute to the decorations for Cosimo's marriage in 1539. He departed quickly, however, possibly discouraged by Bronzino's dominant position at the Florentine court, leaving his contribution unfinished, and joined Vasari in Bologna. He stayed there only briefly, failing to find immediate patronage; he moved on to Venice, where he was welcomed by the Patriarch of Aquileia, Giovanni Grimani, and the latter's brother Vettor. For them he executed two ceiling decorations in oil for the Palazzo Grimani. The *Homage to Psyche*, known only through engravings, was clearly connected to the rich classicism of the Roman works; the *Myths of Apollo* (*in situ*), set in an elaborate stucco framework by Giovanni da Udine, show Salviati's powerful

complexity overlaid with a new fluency derived from Parmigianino. Both decorations were much admired in Venice, not least by Pietro Aretino, but had little influence there. The other surviving works of Salviati's Venetian period reveal him recapitulating his Florentine heritage while trying to assimilate his new experiences. The altarpiece of the *Virgin and Child Enthroned with Saints*, sent from Venice to the Camaldolese convent of S Cristina in Bologna (1540; *in situ*), combines aspects of Venetian colour, subtle shades disposed naturalistically but in a distinctive chromatic harmony, with the influence of Parmigianino, as in the elegant distraction of the Virgin; but elements of some figures clearly recall those of Leonardo, while the hieratic composition reflects older Florentine examples. The sometimes unsatisfactory results of his use of varied stylistic sources perhaps indicate Salviati's readiness for further development.

By 1541 Salviati had left Venice. After a short stay in Mantua, where he was again unsuccessful in gaining court commissions (despite the encouragement of Paolo Giovio) but was able to study fruitfully the superb decorations of the current court painter Giulio Romano, he returned to Rome. There he signalled a renewed allegiance to the classical mode in his decoration of the Cappella del Margravio in S Maria dell'Anima (begun *c.* 1541, possibly completed after 1548; *in situ*). Its sombre altarpiece of the *Pietà* is flanked by curved walls delightfully frescoed with a combination of miniature fantastic architecture with grotesques and other antique motifs that clearly demonstrates a knowledge not only of the work of Raphael and Giovanni da Udine in the Vatican Loggias and Loggetta but also of the excavations of Palatine palaces and the Domus Aurea of Nero; the scheme also includes lifelike portraits as vivid as those in the S Giovanni Decollato *Visitation*, but more conventionally placed in roundels.

Portraiture first became an important interest for Salviati at this time, perhaps in response to his exposure to the triumphant examples of Bronzino, Parmigianino and the Venetian school. He depicted various notable Tuscans, including Aretino and Annibale Caro, with formal dignity and specific likeness. Later, in this genre, he gradually dispensed with insistent details and compositional distractions in order to portray his sitters, especially youthful males, in direct images with an apparently artless guise of ingenious artificiality. His well-known drawing of the *Head of a Youth* (black chalk; London, V&A) reveals his ability to combine delicacy and even tenderness with purely aesthetic beauty in what is clearly a realistically individual characterization.

During the early 1540s in Rome, Salviati also produced a variety of accomplished designs, both religious and mythological, that were published by several engravers; examples include the *Crucifixion* (1541) and *Birth of Adonis* (1544) by Antoine Lafréry and Antonio Salamanca, a *Holy Family* (1542) and a *Conversion of St Paul* (1545) by Enea Vico, and the *Death of Meleager* (1543) by Nicolaus Beatrizet (1507/15–*c.* 1565). Francesco's dissatisfaction with his position there can be measured by the alacrity

2. Francesco Salviati: *Triumph of Furius Camillus* (1543–5), fresco, Sala dell'Udienza, Palazzo Vecchio, Florence

with which he accepted the invitation of Alamanno Salviati (Cardinal Giovanni's brother) to return to Florence in the service of Duke Cosimo I de' Medici.

(iv) Florence, 1544–8. Salviati's main work for Cosimo I was the superb fresco decoration (1543–5) of the Sala dell'Udienza in the Palazzo Vecchio, Florence, with a series of scenes from the *Life of Furius Camillus* (see fig. 2) and various interpolated *Allegories*. The ensemble represents one of the high points of Salviati's brilliantly distilled transformation of apparently realistic figures and scenes into insistently artificial ornamentation. Scenes of battle and of triumphal procession are realized by equally decorative effects. Forms crowd towards the picture plane, while the landscape settings are reduced to theatrical backdrops, and archaeologically accurate details proliferate; passages of compelling naturalism alternate with those of evident artificiality, and all the protagonists are halted in poses of dramatic grace, described in coldly vivid colours. Over all presides the grisaille allegory of *Peace*, an astonishingly inventive composition, which embodies perhaps the apogee of Salviati's combination of ornamental appearance with intellectual content. The total effect of the Sala dell'Udienza decoration is sadly muted, not only by its unfinished and damaged state, but also by its compromise with existing architectural features, with which it combines scarcely adequately. Cosimo I may also have been surprised to find the subject, presumably intended as a reference to his rejection of French support (Furius Camillus twice defeated the Gauls) in favour of a Spanish alliance (Cosimo's marriage to the daughter of the Viceroy of Naples), treated as a decorative scheme in which the superbly painted forms, though of a sculptural solidity, describe a liveliness wholly internal and aesthetic.

Salviati was also employed on other, minor commissions for the Florentine court. He decorated the ceiling of the study in the Palazzo Vecchio apartment of Cosimo I's wife Eleonora de Toledo with delicately charming grotesques. He then provided an elaborate design for the *Dream of Pharaoh*, the last of a series of tapestries illustrating the *Story of Joseph* (the others by Bronzino and Pontormo) that still hangs in the Sala dei Dugento of the same palace. During the later 1540s Salviati produced further designs for Cosimo I's newly established tapestry factory, including an *Ecce homo*, a *Deposition* and a *Resurrection* (all Florence, Uffizi). He also portrayed members of Cosimo's family, including his son *Don Garzia de' Medici* (Florence, Pitti), though in a somewhat mechanical manner. Perhaps for the same patron, and certainly to greater effect, Salviati painted the sumptuous allegorical group of *Charity* (*c.* 1545; Florence, Uffizi; see colour pl. 2, XXVI3), which is clearly dependent compositionally on Michelangelo's *Holy Family* tondo (*c.* 1504; Florence, Uffizi; see colour pl. 2, IV3). In the treatment he achieved both a naturalistic sensuality and an artificial polish higher than that of the Palazzo Vecchio *Peace*, in response partly, no doubt, to the different medium (oil) but probably, too, to the icy brilliance of Bronzino's contemporary allegory with *Venus, Cupid, Folly and Time* (*c.* 1544–5; London, N.G.; *see* BRONZINO, AGNOLO, fig. 2).

Salviati's highly wrought style differed markedly from those of the established court painters in Florence, both

3. Francesco Salviati: *Deposition*, oil on canvas, 4.3×2.6 m, *c.* 1547 (Florence, Museo dell'Opera di Santa Croce)

then also working in the Palazzo Vecchio: from Bronzino's controlled directness as well as from Vasari's derivative turgidity. Salviati's dazzling effects may have shocked as much as impressed his Florentine audience, and the comparative naturalism of the *Charity* was possibly an attempt at compromise. A similar quality pervades his most important easel painting of the period, the *Deposition* (*c.* 1547; Florence, Mus. Opera Santa Croce; see fig. 3); but here it is more probably due to the contrasting type of commission, for a monumental altarpiece rather than a secular decoration. The *Deposition* is Salviati's grandest and most considered religious work. It was commissioned by Giovanni and Pietro Dini for the altar of their father Agostino's chapel in Santa Croce and constitutes a major contribution to the important series of 16th-century Central Italian explorations of the theme. The earliest of these was Rosso's expressive yet stylized example (1521; Volterra, Pal. Priori, Gal. Pittorica). This very personal interpretation was characteristically classicized in High Mannerist versions, such as Daniele da Volterra's powerful fresco (1541–5; Rome, Trinità dei Monti, Orsini Chapel; see colour pl. 1, XXVI1) and Vasari's typically lifeless altarpiece (1540; Camáldoli, SS Donato & Ilariano). Vasari's *Deposition*, however, has some compositional inventions which, together with specific references to the

Daniele, are clearly reflected in Salviati's work. To Vasari's vacuity and Daniele's force Salviati presented a display of sheer beauty of style. His composition is as static as Vasari's, but it is the deliberate stasis of a balletic tableau, a decorous contrast of naturalism and grace. The detail of the figures encompasses both antique dignity and serpentine grace, while patterns of light and colour counterpoint strong compositional curves and diagonals. The atmosphere is sombre, but the dominant effect is still that of forcefully ornamental line, although it here describes passages of inventively expressed emotion as well as of classical pathos. The result is a moving combination of mannered artifice and religious truth.

(v) Rome, 1548–53. In 1548, disappointed at his inability to dominate the scene, Salviati left Florence for Rome, where Annibale Caro had secured for him the important commission from Cardinal Alessandro Farnese to decorate the chapel of the Pallio in the Cancelleria. Salviati's frescoes, embedded in a lavish scheme of patterned panelling and stuccoed ornament, represent a retreat from the height of his Florentine Mannerism to the standard classicism of Rome. In the scenes of the *Martyrdom of St Lawrence* and the *Beheading of St John the Baptist* the powerfully clear yet gracefully arranged compositions are vitiated by the flaccid depiction of form, and some obvious borrowings from Michelangelo and Raphael.

Salviati's second contribution to the oratory of S Giovanni Decollato, the *Birth of the Baptist* of 1551, was even more conservative. Reflections of earlier examples of this type of scene, perennially popular in Florence from Fra Filippo Lippi and Ghirlandaio to del Sarto, appear without liveliness or his customary elegance; the only original elements are those derived from his own works, including a figure directly quoted from the *Deposition*. He attempted more in the figures of *St Andrew* and *St Bartholomew* flanking the high altar of the oratory, but the uneasy combination of Michelangelesque breadth with fanciful Mannerist contortion strikes a somewhat absurd note. He contributed more successfully to the purely decorative parts of the scheme, painting tautly vivid figures, garlands, masks and small framed scenes around the windows (one real, one fictive) that flank the *Birth*, a treatment recalling the more lavish but less vivid dado decoration of the Sala dell'Udienza (Florence, Pal. Vecchio). Decorative vividness also characterizes some minor but highly inventive frescoes Salviati painted, probably at about this time, in S Marcello al Corso, Rome. Small scenes from the *Life of the Virgin* are described with balletic freshness amid large, artificially disposed repoussoir figures, strong reminiscences of Venice and Emilia lightening the graver Roman elements in compositions of delightful fantasy.

Fantasy was again the keynote in Salviati's extraordinary but superbly effective fresco decoration (*c.* 1553) of the Gran Salone of Cardinal Giovanni Ricci's Roman palace

4. Francesco Salviati: detail from the frescoes (1549–56) in the Sala dei Fasti Farnesiani, Palazzo Farnese, Rome

(now Palazzo Sacchetti, Via Giulia). For the first time he used specific illusionistic effects to emphasize both his artistry and its content, and with consummate ease: languid male nudes recline over real windows, painted columns disappear behind apparently framed pictures, fictive inlaid panels and architraves vie with actual marble doorframes. This rich decorative complexity, encompassing several supposed layers of reality, illustrated the *Story of David* (see colour pl. 1, XXVI4). The small scenes in the corners and on the frieze have a sprightly inventiveness, ranging in mood from the graceful humour of *David Dancing before the Ark* to the dignified chiaroscuro of the *Witch of Endor*, which recalls the work of Perino del Vaga and Pellegrino Tibaldi. A different mood is created by the classical poise of the *Bath of Bathsheba*; but the dominant one is of sombre magnificence, evoked by the large lateral narratives, the *Death of Absalom* and, especially, the *Death of Saul and Jonathan*, where boldly sculptural figures are set in slightly asymmetrical compositions against crowded backgrounds and vast landscape settings.

Less inventively varied but equally complex, and even denser with ornamental forms, are Salviati's contemporary frescoes, for Cardinal Ranuccio Farnese, in the Sala dei Fasti Farnesiani of the Cardinal's family palace (1549–56; Rome, Pal. Farnese; see fig. 4). The *Fasti* concerned were historic moments in the lives of the Cardinal's father, Pier Luigi Farnese, Duke of Castro, Parma and Piacenza, and of his grandfather, Pope Paul III. Portraits of the two, seated amid emblematic figures and devices and surmounted by allegorical scenes on simulated hangings, dominate the centres of the main walls; larger and more elaborate allegorical figures in the corners flank intervening narratives of battle, ceremony and political intrigue, framed by purely decorative dados and friezes. The feigned architectural elements are cleverly combined with the real, and the different levels of illusion are invested with distinct levels of meaning, and also expressed in consistently varied treatment: the single allegories fancifully, the groups more simply pictorially, the portraits in strongly sculptural terms and the narratives, 'viewed' through painted pilasters, with comparatively sober, if densely detailed, naturalism. The spectacular and grandiose result, while less obviously decorative than Salviati's previous large-scale fresco schemes, far exceeds in inventive subtlety and vigour the work of Vasari, for the same patron, in the Sala dei Cento Giorni in the Cancelleria (1546), just as both incorporate illusionistic effects of considerably greater sophistication than those of Perino in the otherwise comparably ambitious Sala Paolina in Castel Sant'Angelo (1545–7), for Paul III.

(vi) France and Rome, 1554–63. In 1554, while still working on the *Fasti*, Salviati left Rome suddenly for France, perhaps as a result of some slight imagined by his impatient and quarrelsome nature. Probably for a similar reason he returned to Italy after little more than a year; during that time he executed decorations (destr.) for Charles de Guise, Cardinal of Lorraine, in the château of Dampierre, but received few other commissions. Travelling via Milan and Florence, Salviati returned to Rome in 1556. He resumed his work in the Palazzo Farnese, apparently without rancour from the autocratic Cardinal Alessandro. The scheme was finished only after Salviati's death, by Taddeo Zuccaro. Salviati also completed Sebastiano del Piombo's altarpiece of the *Birth of the Virgin* begun in 1532 for the Chigi Chapel in S Maria del Popolo, designed by Raphael; the composition (*in situ*) is one of the least interesting fruits of the collaboration of Sebastiano with Michelangelo, and Salviati's attempt to accommodate his style to that of an almost entirely dissimilar artist intrudes an inappropriate air of vigour into the melancholy scene.

Salviati's restlessness may have been caused by dissatisfaction with his position at the papal court. After the death of Paul III (1549), his patronage by the Farnese family might presumably have been unfavourably viewed there. The accession of Pius IV in 1559, however, brought Salviati a commission he had long coveted: a share in the decoration of the Sala Regia in the Vatican. This vast and gloomy room is chiefly memorable for its lively stuccos by Perino and Daniele da Volterra; but it also contains a series of huge fresco panels, one of which was allocated to Salviati. Soon his difficult behaviour recurred, this time, perhaps, due to the strain of working alongside rivals, and he retired briefly to Florence. By 1562 he was again in the Vatican, at work on his fresco of the *Meeting of Alexander III and Frederick Barbarossa*. He died before it was more than half finished, and it was completed by his pupil Giuseppe Salviati (Giuseppe Porta); enough remains evident of his conception of the elaborately dignified scene to bear eloquent testimony that Salviati was to the end the most accomplished High Mannerist painter in Rome.

2. WORKING METHODS AND TECHNIQUES. Salviati was a prolific draughtsman, and there are numerous preparatory drawings by him from almost every aspect and period of his work. These include compositional sketches as well as individual figure studies and designs for elements of his decorative schemes. His first drawings, many of them copies of sculpture, are in the red chalk medium introduced to Florence by Leonardo. This study of sculpture is reflected in certain characteristics of Salviati's paintings, including his predilection for compositions resembling reliefs and for the sharp definition of forms by line. The drawings, like his paintings, suggest the wide variety of his sources. His earliest known drawing in ink, a loose, lively compositional sketch for the *Visitation* fresco (London, BM, 5211-27), shows the influence of Roman Mannerists, with its elongated figures reminiscent of Perino and the rapid pen strokes recalling Polidoro da Caravaggio. By the 1540s Salviati was adept at many drawing styles and produced highly finished ink-and-wash studies such as that for the *Triumph of Camillus* (London, BM, Pp. 2-183), in which both the shading and the tendency to caricature evoke his experience of the work of Giulio Romano in Mantua. The complex and detailed drawing is a much simplified version of the ornate painting with its cold, intense colouring. An increased decorativeness and subtlety in the use of wash is evident in his ink sketch of the *Allegory of Peace* (London, BM, 1946-7-13-52) for the frescoes in the Sala dell'Udienza in the Palazzo Vecchio, Florence, one of his most elegant and sophisticated designs. His stay in Rome, from 1548, is reflected in a new monumentality derived from Michelangelo, as in the bold gesturing figure of the *Roman Soldier* (London,

BM, 1946-7-13-54 *recto*), a study for the *Martyrdom of St Lawrence* in the chapel of the Pallio in the Cancelleria in Rome. The tendency to conservatism of Salviati's late works is shown by the classical proportions and smooth sculptural surfaces of his black chalk drawing of a *Reclining Female Figure* (London, BM, 1946-7-13-520), although there is a return to his loose, sketchy style in some of the studies for the Sala Regia project.

Unlike Vasari, Salviati never ran a large school and was not significant as a teacher. Only four pupils are associated with him, including Giuseppe Porta, and none became an important artist. Salviati's difficult temperament affected both his productivity and his influence, as he alienated other artists and also patrons. Virtually every major project was disrupted by his artistic rivalry and arrogance, or by his relentless search for a better position. Vasari acknowledged this when he wrote about his friend 'if he had found a prince who would have recognized his temperament and given him works to do that would have suited his fancy, he would have made the most wonderful things, because he was ... rich, abundant and most fertile in invention of everything, and universal in all parts of painting'.

BIBLIOGRAPHY
Thieme–Becker

G. Vasari: *Vite* (1550, rev. 2/1568); ed. G. Milanesi (1878–85), vii, pp. 1–47

A. Salviati: 'Il pittore Cecchino Salviati a Bologna', *Archiginnasio*, viii (1913), pp. 79–84

H. Voss: *Die Malerei der Spätrenaissance in Rom und Florenz* (Berlin, 1920), pp. 234–49

A. Venturi: *Storia* (1901–40), ix/vi (Milan, 1933), pp. 147–214

M. Hirst: 'Francesco Salviati's "Visitation"', *Burl. Mag.*, ciii (1961), pp. 236–40

I. H. Cheney: *Francesco Salviati* (diss., New York U., 1963; microfilm, Ann Arbor, 1983)

———: 'Francesco Salviati's North Italian Journey', *A. Bull.*, xlv (1963), pp. 337–49

M. Hirst: 'Three Ceiling Decorations by Francesco Salviati', *Z. Kstgesch.*, xxvi (1963), pp. 146–65

H. Bussmann: *Vorzeichnungen Francesco Salviatis* (diss., Berlin, Freie U., 1969)

S. J. Freedberg: *Painting in Italy, 1500–1600*, Pelican Hist. A. (Harmondsworth, 1971), pp. 299–303, 334–5

C. Dumont: *Francesco Salviati au Palais Sacchetti de Rome et la décoration murale italienne (1520–1560)* (Rome, 1973)

R. H. Keller: *Das Oratorium von San Giovanni Decollato in Rom: Eine Studie seiner Fresken* (Rome, 1976)

R. Cocke: 'Francesco Salviati's "David" Cycle in Palazzo Sacchetti', *A. Hist.*, iii/2 (1980), pp. 194–201

A. Nova: 'Francesco Salviati and the "Markgrafen" Chapel in S Maria dell'Anima', *Mitt. Ksthist. Inst. Florenz*, xxv/3 (1981), pp. 355–72

J. Weisz: *Pittura e Misericordia: The Oratory of S Giovanni Decollato in Rome* (Ann Arbor, 1984)

I. H. Cheney: *The Parallel Lives of Vasari and Salviati* (Florence, 1985)

S. J. Freedberg: 'The Formation of Salviati: An Early "Caritas"', *Burl. Mag.*, cxxvii (1985), pp. 768–75

G. S. Geiger: 'Francesco Salviati e gli affreschi della cappella del Cardinale del Brandenburgo a Roma', *A. Crist.*, lxxiii/708 (1985), pp. 181–94

P. Hurtubise: *Une Famille-témoin: Les Salviati* (Vatican City, 1985), pp. 277–466

Florentine Drawings of the Sixteenth Century (exh. cat. by N. Turner, London, BM, 1986), pp. 124–33

P. Rubin: 'The Private Chapel of Cardinal Alessandro Farnese in the Cancelleria, Rome', *J. Warb. & Court. Inst.*, l (1987), pp. 82–112

P. Joannides: 'Drawings by Francesco Salviati and Daniele da Volterra: Additions and Subtractions', *Master Drgs*, xxxii/3 (1992), pp. 230–51

A. Stabile: 'Miniature di Francesco Salviati', *Prospettiva*, 75–6 (1994), pp. 153–60

Francesco Salviati (1510–1563), o La bella maniera (exh. cat. by C. M. Goguel, Rome, Villa Medici, and Paris, Louvre, 1998)

NIGEL GAUK-ROGER

Salviati [Porta]**, Giuseppe** (*b* Castelnuovo di Garfagnana, *c.* 1520; *d* Venice, *c.* 1575). Italian painter. He was apprenticed to Francesco Salviati in Rome from 1535 and apparently assisted him in the decoration of a number of façades there. The gravitas and sculptural quality of the Roman figural style are reflected in Giuseppe's later work. In 1539, with Francesco, he left Rome, stopping in Florence and Bologna, where he met Giorgio Vasari, and arriving in Venice by 11 July. Giuseppe's earliest known independent works are illustrations for *Le sorti*, a book on fortune-telling published by Francesco Marcolini (Venice, 1540). The frontispiece, traditionally attributed to him, is copied from an engraving by Marco Dente (Witcombe).

Francesco left Venice by 1541, but Giuseppe remained, and he soon had a network of powerful patrons, eventually including the Doge, Francesco Donà (*reg* 1545–53). Giuseppe acquired fame initially for his frescoed decorations on palazzo façades, beginning with the Villa Priuli at Treville (1542). These were highly praised by contemporaries, including Vasari. None is extant, but some are recorded in preliminary drawings (see Molino) and contemporary descriptions. On the Casa Loredan in Venice, for example, he painted scenes from Roman history, surrounded by *grotteschi*, festoons and vegetable forms. He seems to have eschewed the Roman practice of executing such designs in grisaille, adapting to the Venetian preference for colour.

Giuseppe also worked for important ecclesiastical establishments. For the monastery refectory of Santo Spirito in Isola in Venice, he painted the organ shutters with the *Triumph of David*, the *Last Supper* (both mid-1540s; Venice, S Maria della Salute, main sacristy) and also carried out three ceiling paintings: *Elijah Fed by the Angel*, the *Gathering of Manna* and *Habakkuk Brought to David* (Venice, S Maria della Salute, apse ceiling). Titian's influence is evident here, particularly in the lighting effects and the illusionistic projection of the figures. Giuseppe's other religious works, primarily altarpieces in oil on canvas, provide evidence of his stylistic development. He achieved a synthesis of sorts between Central Italian Mannerism and Venetian art, influenced by Titian, Tintoretto and Sansovino, among others. He also adopted the traditional Venetian oil technique of modelling figures by using many layers of paint. In his Valier Altarpiece, the *Presentation of Christ in the Temple* (*c.* 1548; Venice, S Maria Gloriosa dei Frari; see fig.), he used dramatic chiaroscuro to highlight the figures contained within a monumental architectural setting. By the 1550s he had assumed the name of his teacher, Salviati, and his style had altered in favour of more modulated colours, subtler lighting effects and more straightforward narration. Among the most significant of these later works are the *Baptism* (Venice, Accad.), for the high altar of S Caterina in Mazzorbo, and the *Deposition* (Murano, S Pietro Martire).

The artist's mature decorative expression is exemplified in the three roundels he created in 1556 for the ceiling of the reading room of Sansovino's Libreria Marciana, Venice: *Minerva between Prudence and Fortitude*, *Mercury and Pluto* (or *Neptune with the Arts*) and *Minerva and Hercules*. Although most of his frescoes are in Venice, he did go to Rome in 1565 to work on the decoration of the Sala Regia in the Vatican. For this room he painted the *Seven Kings*

Giuseppe Salviati: *Presentation of Christ in the Temple* (the Valier Altarpiece), oil on canvas, 4.43×2.47 m, *c.* 1548 (Venice, S Maria Gloriosa dei Frari)

(destr.) and the *Meeting of Alexander III and Frederick Barbarossa*, a work begun by Francesco Salviati but left incomplete at his death. In 1566 Giuseppe was elected to the Accademia del Disegno in Florence. The same year he executed his most important commission as a frescoist, an ambitious ceiling painting for the Sala dell'Antipregodi (Sala dell'Anticollegio) in the Palazzo Ducale, Venice. The work, an allegorical panegyric to Venice, was destroyed by fire in 1574.

Through much of his career Giuseppe also provided cartoons for Venetian mosaics. Those in S Marco, perhaps designed with Pordenone, include the *Raising of Lazarus*, the *Crucifixion* and the *Entombment* in the central bay of the atrium. In his later years he devoted increasing attention to other interests, perhaps at the expense of his painting. He was an accomplished mathematician (his treatise on Ionic volutes was published in Venice in 1552). Although he did not develop a convincing individual style of painting, he is at least partially responsible for bringing Central Italian Mannerism to Venice. His work influenced Palma Giovane, and his students included Girolamo Gambarato (*d* 1628), Pietro Malombra (1556–*c.* 1617) and possibly Giovanni Contarini (1549–*c.* 1604).

BIBLIOGRAPHY

G. Vasari: *Vite* (1550, rev. 2/1568); ed. G. Milanesi (1878–85), vii, pp. 45–6

C. Ridolfi: *Meraviglie* (1648); ed. D. von Hadeln (1914–24), i, pp. 242–3

J. Molino: 'Riconoscibili decorazioni ad affresco di Giuseppe Porta detto Salviati', *A. Ven.*, xvii (1963), pp. 164–8

R. Pallucchini: 'Per gli inizi veneziani di Giuseppe Porta', *A. Ven.*, xxix (1975), pp. 159–66

B. Boucher: 'Giuseppe Salviati, pittore e matematico', *A. Ven.*, xxx (1976), pp. 219–24

D. McTavish: *Giuseppe Porta Called Giuseppe Salviati* (New York, 1981) [extensive bibliog.]

Da Tiziano a El Greco: Per la storia del manierismo a Venezia (exh. cat., ed. S. Mason Rinaldi; Venice, Pal. Ducale, 1981), pp. 17–19, 88–97, 287–98, 322

C. Witcombe: 'Giuseppe Porta's Frontispiece for Francesco Marcolini's *Sorti*', *A. Ven.*, xxxvii (1983), pp. 170–74

L. Simonetto: 'Giuseppe Porta', *La pittura in Italia: Il Cinquecento*, ii (Milan, 1988), p. 811

ROBIN A. BRANSTATOR

Salvi d'Andrea (*b* ?1438; *d* Florence, 1503). Italian mason and architect. He is first recorded in Pisa (1462–3) with other Lombard stonecutters employed to carve the marble tracery for the Gothic windows of the Camposanto (cemetery), adjacent to the cathedral. From 1472 he is recorded as a master mason, responsible for the completion of the church of Santo Spirito, Florence (begun 1436; *see* RENAISSANCE, fig. 1), in accordance with the design by Brunelleschi; Salvi was also responsible for the supply of materials and the repair of tools. In 1475 he was appointed principal mason for the outstanding decorative work of the church, including the upper cornice of the nave, the dome and the façade. He constructed a working model of the dome of Santo Spirito, based on the original model by Brunelleschi, for the office of works. This was the first dome in Florence to have a hemispherical external profile. In May 1482 Salvi was commissioned to decorate the interior of the façade of Santo Spirito, and in May 1486 an unsuccessful attempt, supported by Giuliano da Sangallo, was made to modify the plan, and return to Brunelleschi's concept of a façade with four entrances. In 1489 he was appointed master of the works at the sacristy of Santo Spirito, designed by Giuliano da Sangallo. Andrea Sansovino, still at the beginning of his career, collaborated with Salvi in carving the richly decorated *all'antica* capitals. The ribbed, octagonal dome of the sacristy collapsed, however, as soon as the scaffolding was removed. Salvi was among those blamed for the disaster and took part in the rebuilding, although at half his normal salary. In 1492 he was invited, with Cronaca, Pagno d'Antonio Berti (1436–*c.* 1511) and Sangallo, to judge the model for the vestibule of the sacristy; Cronaca later won the commission.

BIBLIOGRAPHY

G. Vasari: *Vite* (1550, rev. 2/1568); ed. G. Milanesi (1878–85)

L. Tanfani Centofanti: *Notizie di artisti tratte da documenti pisani* (Pisa, 1898), pp. 452, 460–62

C. von Fabriczy: 'Brunelleschiana', *Jb. Kön.-Preuss. Kstsamml.*, xxvii (1907), pp. 53–5

PLATE I

1. Andrea Mantegna: frescoed vault (1465–74) of the Camera degli Sposi, Palazzo Ducale, Mantua

2. Andrea Mantegna: *Court Scene* (1465–74), fresco, Camera degli Sposi, Palazzo Ducale, Mantua

PLATE II

1. Andrea Mantegna: *Death of the Virgin*, tempera on panel, 540×420 mm, 1462 (Madrid, Museo del Prado)

2. Masaccio: *Expulsion from Paradise* (*c.* 1427), fresco, Brancacci Chapel, S Maria del Carmine, Florence

3. Andrea Mantegna: *Parnassus*, tempera on canvas, 1.50×1.92 m, 1495/6–7 (Paris, Musée du Louvre)

PLATE III

2. Masaccio: *Distribution of the Goods of the Church* (*c.* 1427), fresco, Brancacci Chapel, S Maria del Carmine, Florence

1. Masaccio: *Trinity* (*c.* 1425–7), fresco, S Maria Novella, Florence

3. Maso di Bartolomeo: gilded bronze reliquary, inlaid with bone and tortoiseshell, for the Cappella del Sacro Cingo, Prato Cathedral (Prato, Museo Opera del Duomo)

PLATE IV

2. Masolino: *Marriage of the Virgin* (1435), fresco, Collegiata, Castiglione Olona, Lombardy

1. Masolino: *St Peter Preaching* (*c.* 1425), fresco, Brancacci Chapel, S Maria del Carmine, Florence

3. Michelangelo: *Holy Family* (Doni Tondo), tempera on panel, diam. 1.2 m, 1503 or 1507 (Florence, Galleria degli Uffizi)

4. Melozzo da Forlì: *Music-making Angels*, fresco transferred to canvas, 1479–80 (Rome, Pinacoteca Vaticana)

PLATE V

1. Michelangelo: tomb of *Giuliano de' Medici* (1519–33), marble, h. 1.73 m, New Sacristy, S Lorenzo, Florence

2. Michelangelo: *Creation of Adam* (1508–10), fresco, Sistine Chapel, Vatican, Rome

PLATE VI

1. Michelangelo: *Delphic Sibyl* (1511–12), fresco, Sistine Chapel, Vatican, Rome

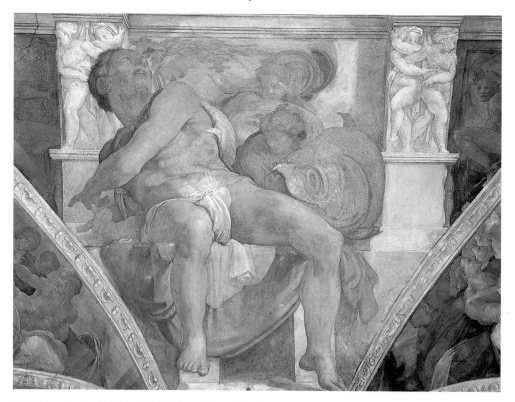

2. Michelangelo: *Prophet Jonah* (1511–12), fresco, Sistine Chapel, Vatican, Rome

PLATE VII

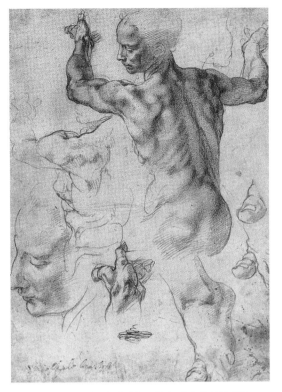

1. Michelangelo: *Studies for the Libyan Sibyl*, red chalk, 289×214 mm, 1508–12 (New York, Metropolitan Museum of Art)

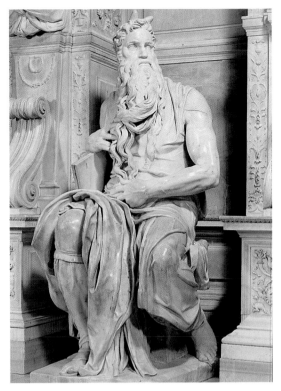

2. Michelangelo: *Moses*, marble, h. 2.35 m, from the tomb of *Julius II*, *c.* 1515–16 (Rome, S Pietro in Vincoli)

3. Michelangelo: *Last Judgement* (1536–41), fresco, Sistine Chapel, Vatican, Rome

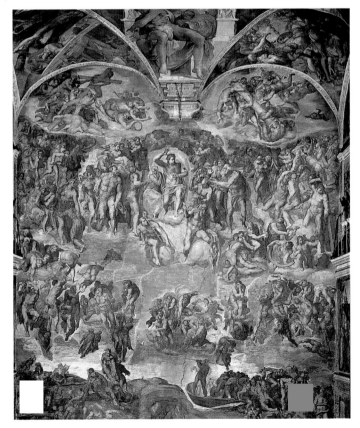

PLATE VIII

1. Milanese rock crystal vase by Annibale Fontana, enamelled gold with gilt metal mounts, 394×184 mm (Florence, Palazzo Pitti)

2. Mino da Fiesole: *Piero de' Medici,* marble, h. 500 mm, 1453 (Florence, Museo Nazionale del Bargello)

3. Bartolomeo Montagna: *Virgin and Child with Four Saints and Music-making Angels*, panel transferred to canvas, 4.60×2.40 m, mid-1480s (Vicenza, Museo Civico d'Arte e Storia)

4. Monte di Giovanni del Fora: illumination from the *Life of Lorenzo the Magnificent* (Florence, Biblioteca Laurenziana, MS. Plut. 61-3, fol. 2*r*)

PLATE IX

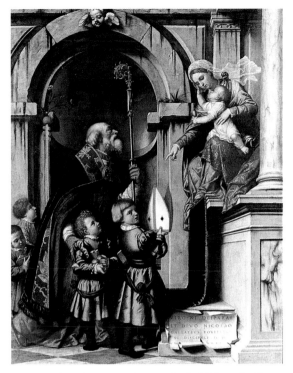

1. Moretto: *St Nicholas of Bari Presenting Pupils of Galeazzo Rovelli to the Virgin and Child* (the Rovelli Altarpiece), oil on canvas, 2.45×1.92 m, 1539 (Brescia, Pinacoteca Civica Tosio–Martinengo)

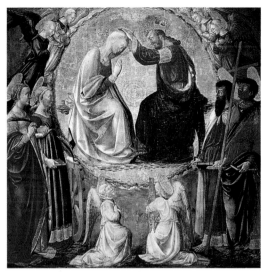

2. Neri di Bicci: *Coronation of the Virgin with Saints*, panel, 1560 (Florence, Galleria dell'Ospedale degli Innocenti)

3. Giovanni Battista Moroni: *Antonio Navagero*, oil on canvas, 900×1150 mm, 1565 (Milan, Pinacoteca di Brera)

4. Niccolò di Forzore Spinelli: bronze medal with portrait of *Lorenzo the Magnificent*, diam. 91.6 mm, 1450 (Florence, Museo Nazionale del Bargello)

PLATE X

1. Lelio Orsi: *St George and the Dragon*, oil on canvas, 600×485 mm, early 1560s (Naples, Museo e Gallerie Nazionali di Capodimonte)

2. Gasparo Padovano (attrib.): *Aristotle Seated*, frontispiece (367×257mm) from Aristotle: *Historia animalium, De partibus animalium, De generatione animalium*, translated by Theodore of Gaza, written by Bartolomeo Sanvito, from Rome, *c.* 1473/4–80 (Rome, Vatican, Biblioteca Apostolica, MS. Vat. Lat. 2094, fol. 8*r*)

PLATE XI

1. Andrea Palladio: Villa Barbaro, Maser, 1554–8

2. Andrea Palladio: S Giorgio Maggiore, Venice, 1566–75; façade 1599–1610

PLATE XII

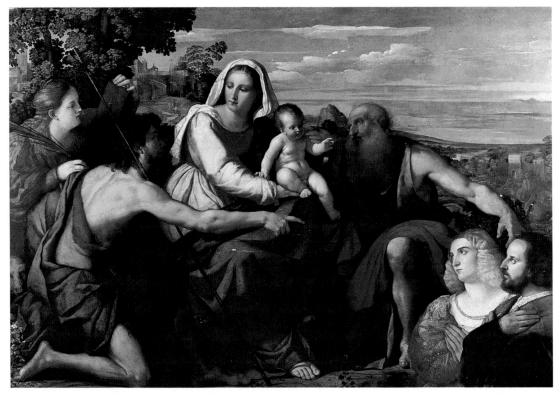

1. Palma Vecchio: *Virgin and Child with Saints and Two Donors*, oil on panel, 1.34×2.10 m, mid-1520s (Naples, Museo e Gallerie Nazionali di Capodimonte)

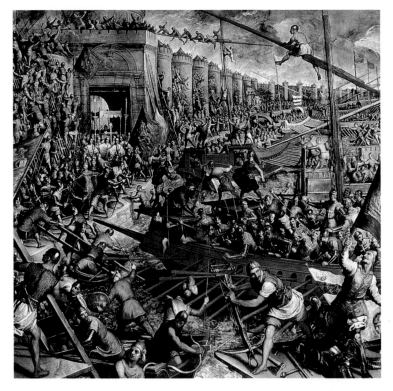

2. Palma Giovane: *Conquest of Constantinople*, oil on canvas, 5.75×6.25 m, *c.* 1578 (Venice, Doge's Palace, Sala del Maggior Consiglio)

PLATE XIII

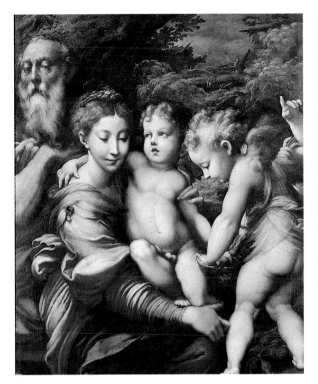

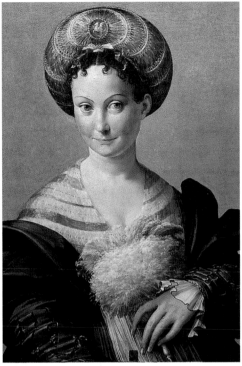

1. Parmigianino: *Holy Family*, oil on panel, 1192×889 mm, *c.* 1524 (Madrid, Museo del Prado)

2. Parmigianino: *Turkish Slave Girl*, oil on panel, 680×530 mm, 1530s (Parma, Galleria Nazionale)

4. Bartolomeo Passarotti: *The Botanist*, oil on canvas, 1010×828 mm, late 1560s (Rome, Galleria Spada)

3. Parmigianino: *Virgin and Child with SS Mary Magdalene, St John the Baptist and the Prophet Zachariah*, oil on panel, 730×600 mm, late 1520s (Florence, Galleria degli Uffizi)

PLATE XIV

1. Perino del Vaga: *Jove Hurling Thunderbolts at the Giants* (*c.* 1530), fresco, Palazzo Doria–Pamphili, Genoa

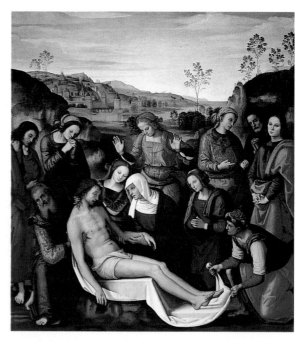

2. Perugino: *Francesco delle Opere*, tempera on panel, 520×440 mm, 1494 (Florence, Galleria degli Uffizi)

3. Perugino: *Lamentation*, oil on panel, 2.14×1.95 m, 1495 (Florence, Palazzo Pitti)

PLATE XV

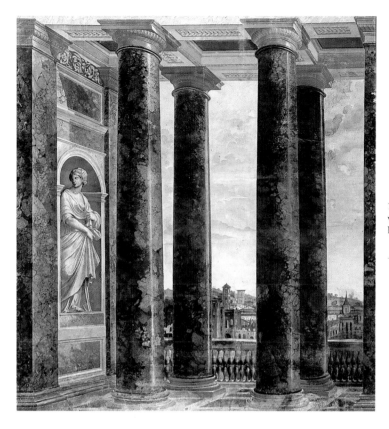

1. Baldassare Peruzzi: fictive perspective view (1517–18), fresco, Sala delle Prospettive, Villa Farnesina, Rome

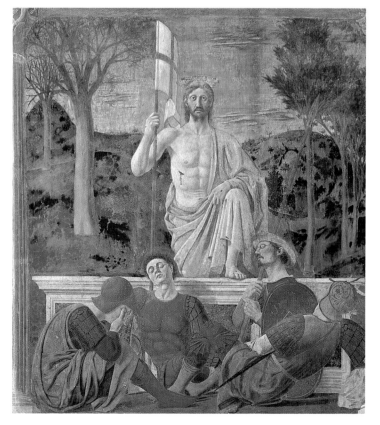

2. Piero della Francesca: *Resurrection*, fresco, 2.80×2.25 m, after 1458 (Sansepolcro, Museo Civico)

PLATE XVI

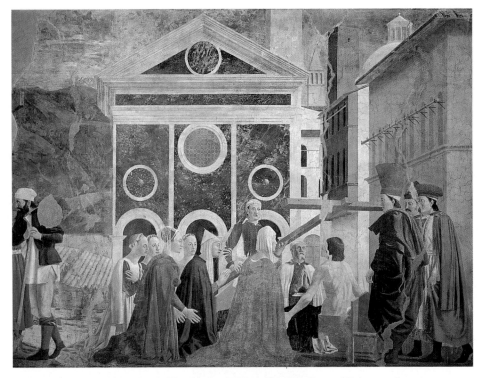

1. Piero della Francesca: *Legend of the True Cross* (late 1440s–mid-1450s), fresco, S Francesco, Arezzo

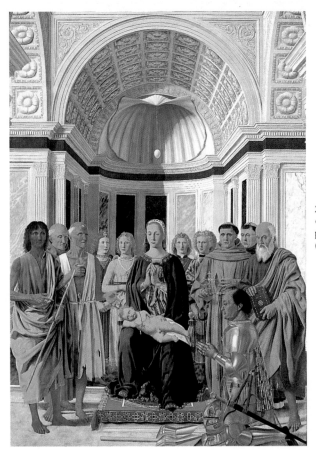

2. Piero della Francesca: *Virgin and Child* (the Brera Altarpiece), oil on panel, 2.48×1.70 m, ?mid-1470s (Milan, Pinacoteca di Brera)

PLATE XVII

1. Piero della Francesca: *'Madonna del Parto'* (Virgin with Two Angels; ?late 1450s), detached fresco, cemetary chapel (formerly S Maria a Momentana), Monterchi

2. Bernardino Pinturicchio: *Delphic Sibyl* (*c.* 1509), ceiling decoration, vault of the presbytery, S Maria del Popolo, Rome

3. Piero di Cosimo: *Liberation of Andromeda*, oil on panel, 710×1230 mm, *c.* 1515–20 (Florence, Galleria degli Uffizi)

PLATE XVIII

1. Pisanello: *Lionello d'Este*, tempera on panel, 295×184 mm, 1441 (Bergamo, Galleria dell'Accademia Carrara)

2. Antonio Pollaiuolo: *Hercules and the Hydra*, tempera on panel, 170×120 mm, after *c*. 1460 (Florence, Galleria degli Uffizi)

3. Jacopo da Pontormo: *Cosimo de' Medici il Vecchio*, oil on panel, 870×650 mm, 1519 (Florence, Galleria degli Uffizi)

PLATE XIX

1. Pordenone: *Conversion of Saul* (1523), tempera on canvas, 4.48×2.24 m, organ shutter, Spilimbergo Cathedral

2. Jacopo da Pontormo: *Annunciation* (1525–8), fresco, Capponi Chapel, S Felicita, Florence

PLATE XX

1. Francesco Primaticcio: fresco decoration for the Chambre de la Duchesse d'Etampes at Fontainebleau, 1541–4 (Fontainebleau, Musée National du Château de Fontainebleau)

2. Raphael: Borghese *Entombment*, oil on panel, 1.84×1.76 m, 1507 (Rome, Galleria Borghese)

PLATE XXI

1. Raphael: *Parnassus* (*c.* 1508–10), fresco, Stanza della Segnatura, Vatican, Rome

2. Raphael and Giovanni da Udine: fresco decoration (1516) in the bathroom (*Stufetta*) of Cardinal Bernardo Bibbiena, Vatican, Rome

PLATE XXII

1. Raphael: *Triumph of Galatea* (*c.* 1512), fresco, Villa Farnesina, Rome

PLATE XXIII

1. Raphael: *Madonna della Sedia*, oil on panel, diam. 710 mm, *c.* 1514 (Florence, Palazzo Pitti)

2. Raphael: *Donna Velata*, oil on canvas, 850×640 mm, *c.* 1514 (Florence, Palazzo Pitti)

PLATE XXIV

1. Andrea della Robbia: *Annunciation*, tin-glazed terracotta, 1.54×2.85 m, *c.* 1490 (Florence, Ospedale degli Innocenti, cloister)

2. Luca della Robbia: *Singing Gallery* (*Cantoria*; detail), marble, 3.28×5.60 m (whole), from the organ loft of Florence Cathedral, 1431–8 (Florence, Museo dell'Opera del Duomo)

1. Gerolamo Romanino: *Raising of Lazarus* (early 1540s), fresco, chapel of the SS Sacramento, S Giovanni Evangelista, Brescia

2. Cosimo Rosselli (attrib.): *Crossing of the Red Sea* (*c.* 1482), fresco, Sistine Chapel, Vatican, Rome

PLATE XXVI

1. Rosso Fiorentino: *Virgin and Child Enthroned with Four Saints*, tempera on panel, 1.72×1.41 m, 1518 (Florence, Galleria degli Uffizi)

2. Rosso Fiorentino: *Marriage of the Virgin*, oil on panel, 3.25×2.47 m, 1523 (Florence, S Lorenzo)

3. Francesco Salviati: *Charity*, oil on panel, 1.56×1.22 m, *c.* 1545 (Florence, Galleria degli Uffizi)

4. Franscesco Salviati: *Story of David* (*c.* 1553), fresco, Gran Salone, Palazzo Sacchetti, Rome

PLATE XXVII

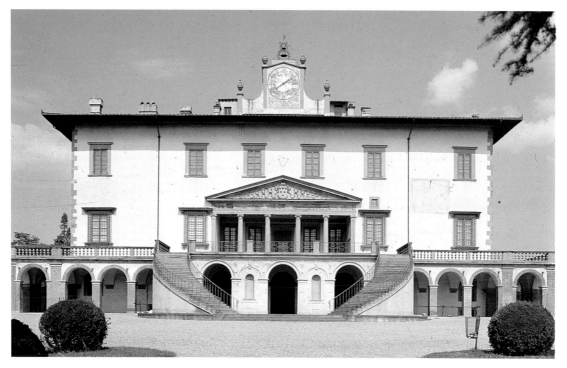

1. Giuliano da Sangallo: Villa Medici, Poggio a Caiano, begun *c.* 1485

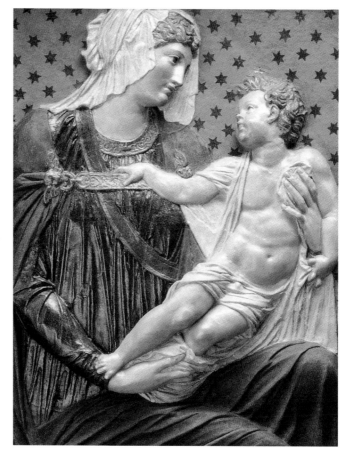

2. Jacopo Sansovino: *Virgin and Child*, polychromed papier mâché relief with gilding, 1133×838 mm, *c.* 1527–50 (Fort Worth, TX, Kimbell Art Museum)

PLATE XXVIII

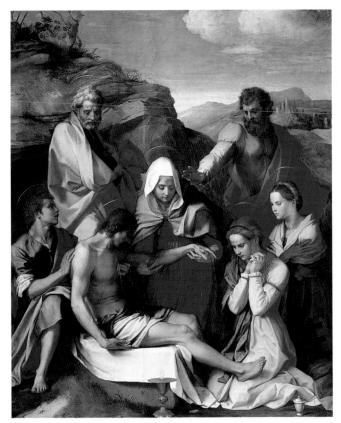

1. Andrea del Sarto: *Lamentation*, oil on panel, 2.39×1.99 m, 1524 (Florence, Palazzo Pitti)

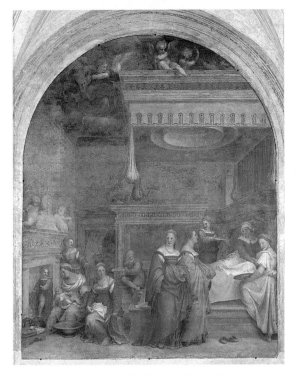

2. Andrea del Sarto: *Birth of the Virgin* (1513–14), fresco, atrium, SS Annunziata, Florence

3. Andrea del Sarto: *Girl Reading Petrarch*, oil on panel, 870x690 mm, *c.* 1528 (Florence, Galleria degli Uffizi)

PLATE XXIX

1. Sassetta: *St Francis in Glory*, panel, 1.90×1.22 m (central panel), 1.79×0.58 m (wings), back of the main panel of the S Francesco Altarpiece, 1437–44 (Florence, Villa I Tatti)

2. Giovanni Girolamo Savoldo: *Tobias and the Angel*, oil on canvas, 960×1240 m, 1534–5 (Rome, Galleria Borghese)

PLATE XXX

1. Andrea Schiavone: *Adoration of the Magi*, oil on canvas, 1.85×2.22 m, *c.* 1547 (Milan, Pinacoteca Ambrosiana)

2. Siena Cathedral, inlaid mosaic pavement showing *Abdis Bringing Elia's Message to Acab*, after Domenico Beccafumi, 1524

PLATE XXXI

1. Sebastiano del Piombo: *Dead Adonis*, oil on canvas, 1.89×2.95 m, 1512 (Florence, Galleria degli Uffizi)

2. Sebastiano del Piombo: *St Giovanni Crisostomo with Saints*, oil on canvas, 2.00×1.65 m, begun 1510 (Venice, S Giovanni Crisostomo)

PLATE XXXII

1. Luca Signorelli: *Damned* (1500–03), fresco, chapel of S Brizio, Orvieto Cathedral

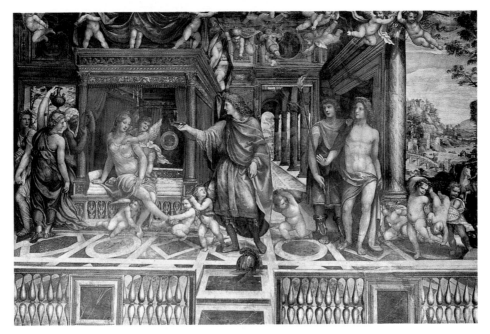

2. Sodoma: *Marriage of Alexander and Roxanne* (between 1509 and 1516), fresco, Villa Farnesina, Rome

PLATE XXXIII

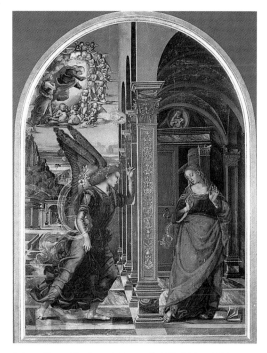

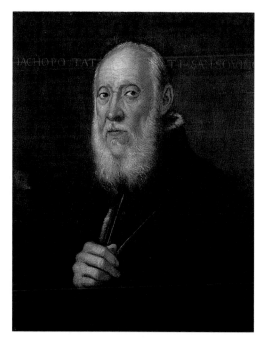

1. Luca Signorelli: *Annunciation*, panel, 2.58×2.06 m, 1491, (Volterra, Pinacoteca Comunale)

2. Tintoretto: *Jacopo Sansovino*, oil on canvas, 700×650 mm, *c*. 1566 (Florence, Galleria degli Uffizi)

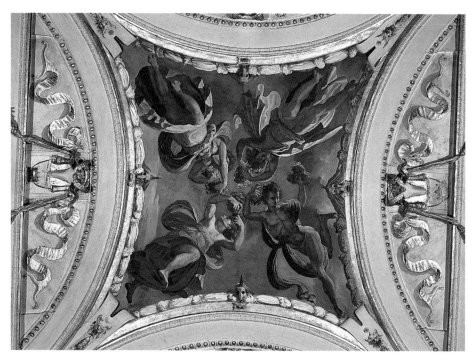

3. Pellegrino Tibaldi: *Four Genii*, ceiling decoration (*c*. 1555), fresco and stucco, the smaller Sala d'Ulisse, Palazzo Poggi, Bologna

PLATE XXXIV

1. Jacopo Tintoretto: *Last Supper* (1592–4), fresco, choir of S Giorgio Maggiore, Venice

2. Jacopo Tintoretto: *Pool of Bethesda* (1578–81), fresco, meeting-house, Scuola Grande di S Rocco, Venice

PLATE XXXV

1. Titian: *Federico II Gonzaga, Duke of Mantua*, oil on panel, 1250×990 mm, 1520s (Madrid, Museo del Prado)

2. Titian: *Virgin and Child Enthroned with Saints and Members of the Pesaro Family* (the Pesaro *Madonna*), oil on canvas, 4.78×2.66 m, 1519–26 (Venice, S Maria Gloriosa dei Frari)

3. Titian: *Venus of Urbino*, oil on canvas, 1.19×1.65 m, 1530s (Florence, Galleria degli Uffizi)

PLATE XXXVI

▲ 1. Titian: *Diana and Callisto*, oil on canvas, 1.87×2.05 m, 1559 (Duke of
Sutherland, on loan to Edinburgh, National Gallery of Scotland)

2. Cosimo Tura: *Angel of the Annunciation*, tempera on canvas, 4.13×1.68
m, from the inside of the organ shutters of Ferrara Cathedral, 1469
(Ferrara, Museo del Duomo) ▶

3. Titian (?attrib.): *Concert champêtre*, oil on canvas, 1.05×1.36 m, *c.* 1510 (Paris, Musée du Louvre)

PLATE XXXVII

1. Paolo Uccello: *Rout of San Romano*, tempera on panel, 1.82×3.17 m, mid-1450s (Paris, Musée du Louvre)

2. Paolo Uccello: *St George and the Dragon*, ▲ oil on canvas, 565×743 mm, *c.* 1465 (Paris, Musée Jacquemart-André)

3. Giorgio Vasari and assistants: Salone ▶ del Cinquecento, Palazzo Vecchio, Florence, 1563–71

PLATE XXXVIII

1. Vecchietta: *Assumption of the Virgin with Four Saints*, tempera on panel, 3.6×2.7 m, *c.* 1462 (Pienza Cathedral)

2. Andrea del Verrocchio: *Putto with a Dolphin*, bronze, h. 1.25 m, late 1460s or early 1470s (Florence, Palazzo Vecchio)

3. Venetian 'chalcedony' glass jug, h. 333 mm, from Murano, *c.* 1500 (London, British Museum)

4. Paolo Veronese: *Portrait of a Man in Fur (?Daniele Barbaro)*, oil on canvas, 1.40×1.07 m, *c.* 1550 (Florence, Palazzo Pitti)

PLATE XXXIX

1. Paolo Veronese: illusionistic frescoes (*c.* 1561), Villa Barbaro, Maser

2. Alvise Vivarini (and Marco Basaiti): *St Ambrose Enthroned with Saints*, panel, 5.0×2.5 m, 1503 (Venice, S Maria Gloriosa dei Frari)

3. Antonio Vivarini: polyptych with *St Anthony Abbot and other Saints*, tempera on panel, 530×300 mm (upper lateral part), 800×500 mm, (upper central part), 1.05×1.3 m (lower part), 1464 (Rome, Pinacoteca Vaticana)

PLATE XL

OCTAVIVS·FARNESIVS·CAMERINI·DVX
MARGARITAM·CAROLI·V·IMP·FILIAM
PAVLO·III·PONTIFICE·MAX·AV SPICE
SIBI·DESPONDET·ANNO·SAL·∞DXXXIX

1. Taddeo Zuccaro: *Marriage of Ottavio Farnese* (begun *c.* 1559), fresco, Villa Farnese, Caprarola

2. Federico Zuccaro: *Wisdom* (begun *c.* 1592), fresco, Casa Zuccaro (now Biblioteca Hertziana), Pincian Hill, Rome

C. Botto: 'L'edificazione della chiesa di Santo Spirito in Firenze', *Riv. A.*, xiv (1932), pp. 23–53

E. Luporini: *Filippo Brunelleschi: Forma e ragione* (Milan, 1964), pp. 193–4

F. Borsi, G. Morolli and F. Quinterio: *Brunelleschiani* (Rome, 1979), pp. 64–9, 322–31

FRANCESCO QUINTERIO

Salvo [Salvatore] **d'Antonio** [Salvo, Giovan] (*b* after 1461; *d* before 1526). Italian painter. He was the son of Antonello da Messina's brother Giordano (*d* March 1488), who was also a painter. Salvo seems to have been the most interesting and able painter working in Sicily in the last years of the 15th century. He is associated with Antonello's workshop, but may have received some of his training on the mainland. If, as seems possible, his cousin Jacobello (Antonello's heir) died in the early to mid-1480s, the family workshop, which probably passed first into the hands of Salvo's father, would have been inherited by Salvo on his father's death in March 1488.

Salvo is first documented in 1493 and is recorded in connection with numerous commissions throughout Sicily, in Calabria and in Malta. Unfortunately, most of his documented work is lost, and there is strong disagreement about attributions. His greatest painting seems to have been the *Dormition of the Virgin* (destr. 1908), commissioned for Messina Cathedral in 1509; it is known only through a small surviving fragment and a photograph, which reveal him to have developed a personal idiom based on Antonello's artistic vocabulary coupled with an awareness of developments from Lombardy, Umbria, Naples and Rome, thus strengthening the hypothesis of a sojourn on the mainland.

A *St Peter* and a predella of *Christ and the Apostles*, signed and dated 1510 (Mdina, Cathedral Mus.), survive from a commission of 1505 from the monks of S Pietro, as does a monumental *Cross* (Calatabiano, S Filippo), commissioned in October 1502. Although stylistically similar to the few other documented works, weak passages in the execution suggest that these are probably workshop productions. A painting of *St John the Evangelist* (Syracuse Cathedral) has been plausibly attributed to Salvo; it is a panel from a series executed by several painters, including probably Marco Costanzo and perhaps also Antonello's son Jacobello. The attribution to Salvo of the *Redeemer* from the group is less convincing (Bologna). The *St John*, which seems to be Salvo's earliest surviving work (certainly before 1500 and probably from the early to mid-1480s, if Jacobello was involved in the commission), demonstrates his debt to Antonello's late style in the crisp yet sensitive handling, the atmospheric lighting and the monumental form set off against the low horizon of the landscape.

BIBLIOGRAPHY

G. Di Marzo: *Di Antonello e dei suoi congiunti*, Documenti per servire alla storia di Sicilia, ix (Palermo, 1903/*R* 1983), pp. 87–107 [app. contains docs]

Antonello e la pittura del '400 in Sicilia (exh. cat., ed. G. Vigni and G. Carandente; Messina, Pal. Com., 1953), pp. 90–92

S. Bottari: *La pittura del '400 in Sicilia* (Messina and Florence, 1954), pp. 71–2, 90–91

F. Bologna: *Napoli e le rotte mediterranee della pittura da Alfonso il Magnanimo a Ferdinando il Cattolico* (Naples, 1977), pp. 213–14

Antonello da Messina (exh. cat., ed. A. Marabottini and F. Sricchia Santoro; Messina, Mus. Reg., 1981), pp. 223–5

G. Previtali: 'Alcune opere di Salvo d'Antonio da ritrovare', *Prospettiva*, xxxiii–xxxvi (1983–4), pp. 124–34

F. Sricchia Santoro: *Antonello e l'Europa* (Milan, 1986), pp. 143–8

JOANNE WRIGHT

Samacchini [Sammacchini; Sammachini]**, Orazio** (*b* Bologna, 20 Dec 1532; *d* Bologna, 12 June 1577). Italian painter. Although a pupil of Pellegrino Tibaldi, his early work mainly reflects the classicism of Raphael as interpreted by Bagnacavallo and the Mannerism of Innocenzo da Imola and Prospero Fontana. Simplicity of form, limpid colours and purity of line characterize such early works as the *Marriage of the Virgin* (*c.* 1555–60; Bologna, S Giuseppe). Also datable to this early period is the *Mystic Marriage of St Catherine* (Bologna, Ferrari-Boschetto priv. col., see 1986 exh. cat., p. 192), which unites the style and typological elements of Fontana with a highly refined use of colour reminiscent of early 16th-century south Netherlandish painting.

In 1563 Samacchini participated in the decoration of the Belvedere and the Sala Regia in the Vatican. This Roman experience resulted in works characterized by complicated compositional solutions and spaces teeming with lively, clearly articulated figures. The influence of Michelangelo can be seen in the *Crucifixion* (1568; Bologna, S Maria dei Servi) and in frescoes depicting the *Brazen Serpent* and *Moses Striking the Rock* (1570–77) in Parma Cathedral. The influence of Federico Zuccaro appears in the fresco of *Paolo Vitelli Driving the Venetian Army from the Casentino* (*c.* 1574) in the Palazzo Vitelli a Sant'Egidio, Città di Castello, while the *Presentation in the Temple* (1575; Bologna, S Giacomo Maggiore) reflects the late work of Vasari. Certain features of the school of Parma, however, can be traced as early as 1569, for example in the *Transfiguration* (Bologna, Corpus Domini), which shows the influence of Parmigianino, and in the later frescoes of *Virtues*, *Prophets* and *Angels* in S Abbondio, Cremona, which include suggestions of Correggio. A more discreet Mannerism characterizes his last altarpiece, which depicts the *Virgin and Child with Saints* (1576–7; Bologna, S Maria Maggiore).

BIBLIOGRAPHY

A. Bolognini Amorini: *Vite dei pittori ed artefici bolognesi* (Bologna, 1840–43), iii, pp. 78–81

G. Smith: 'A Drawing by Orazio Samacchini for his *Presentation in the Temple* in San Giacomo Maggiore', *Master Drgs*, xiii/4 (1975), pp. 370–72

J. Winckelmann: 'Orazio Samacchini (Bologna 1532–Bologna 1577)', *Pittura bolognese del cinquecento*, ii (Bologna, 1986), pp. 631–47

———: 'Vicende di un dipinto di Orazio Samacchini', *Paragone*, xxxvii/431–3 (1986), pp. 66–74

Nell'età di Correggio e dei Carracci: Pittura in Emilia dei secoli XVI e XVII (exh. cat., Bologna, Pin. N., 1986), pp. 191–5

U. Bazzotti: 'Laureati e Samacchini: Due tele nel Palazzo Ducale di Mantova', *Paragone*, xxxix/459–63 (1988), pp. 75–80

M. C. Basteri and P. Rota: 'Alcune precisazioni sull'opera del pittore bolognese Orazio Samacchini nella Rocca di San Secondo', *QUASAR*, 1 (1989), p. 59

MARINA GAROFOLI

Sammicheli (da Verona), Michele. *See* SANMICHELI, MICHELE.

Sanctis, Orazio de (*fl* 1568–84). Italian engraver and etcher. He produced prints almost exclusively after works by Pompeo Cesura, known as Aquilano (*d* 1571). Adam

von Bartsch attributed 17 plates to him, and Le Blanc 18, solely on religious themes. To these, G. K. Nagler added the 74 plates engraved in collaboration with Cherubino Alberti to illustrate the book *Antiquarum statuarum urbis Romae quae in publicis privatisque locis visuntur icones* ('Images of ancient statues in the city of Rome that can be seen in public and private places'; Rome, 1584). De Sanctis is an intriguing artist, due to the originality of his style, characterized by an extreme freedom of line and high level of elegance.

BIBLIOGRAPHY

A. von Bartsch: *Le Peintre-graveur*, xvii (1815), pp. 5–14

G. K. Nagler: *Neues allgemeines Künstlerlexicon oder Nachrichten von dem Leben und den Werken der Maler, Bildhauer, Baumeister, Kupferstecher, Formschneider, Zeichner, Medailleure, Elfenbeinarbeiter, etc.*, xv (Munich, 1845), pp. 4–5

C. Le Blanc: *Manuel de l'amateur d'estampes*, iii (Paris, 1888), pp. 420–21

FRANÇOISE JESTAZ

San Daniele, Pellegrino da. *See* PELLEGRINO DA SAN DANIELE.

San Friano, Maso da [Manzuoli, Tommaso (d'Antonio)] (*b* Florence, 4 Nov 1531; *d* Florence, *bur* 2 Oct 1571). Italian painter. He received his initial training from either Pier Francesco Foschi or Carlo Portelli. The style of his earliest known work, the signed and dated *Portrait of Two Architects* (1556; Rome, Pal. Venezia), suggests Foschi. By 1560 Maso's reputation was such that he received two important commissions for altarpieces. For the de' Pesci Chapel in S Pier Maggiore, Florence, he painted a *Visitation* (1560; Cambridge, Trinity Hall), revealing his intense fascination with the art of Andrea del Sarto. In its High Renaissance compositional structure and grandeur of movement, the work pays homage to del Sarto's large altarpieces, such as the Passerini *Assumption of the Virgin* (1526; Florence, Pitti). Maso's *Virgin and Child with Saints* (Cortona, Convento della Trinità) is primarily a simplification and abstraction of works by del Sarto, whose influence is particularly evident in the male saints, but it also contains elements from the works of Foschi (the faces of the women) and Jacopo Pontormo, particularly the cursive, pliant figure of Mary Magdalene.

Maso was one of the principal participants in a revival of the styles of Pontormo and del Sarto in Florence and, in his religious works of the mid-1560s, he vacillated between the two. Some, such as the *Trinity with Saints* (Florence, Accad.), continued to be strongly influenced by del Sarto while others, such as the *Ascension of Christ* (Oxford, Ashmolean) and a drawing of the *Entombment* (Chatsworth, Derbys), depended more on works by Pontormo, especially those of the late 1520s with their subtle and dynamic light effects. This interest had already been apparent in Maso's drawing of the *Nativity of Christ* (*c.* 1560; Florence, Uffizi). In his *Adoration of the Shepherds* (*c.* 1566; Florence, SS Apostoli; see fig.) virtually every figure was derived from del Sarto and the central angel was copied, with few alterations, from del Sarto's *Birth of the Virgin* (Florence, SS Annunziata; see colour pl. 2, XXVIII2).

Maso's interest in the restrained, classical aspects of del Sarto's art was probably a response to the demand for pictorial clarity advocated by the Council of Trent and

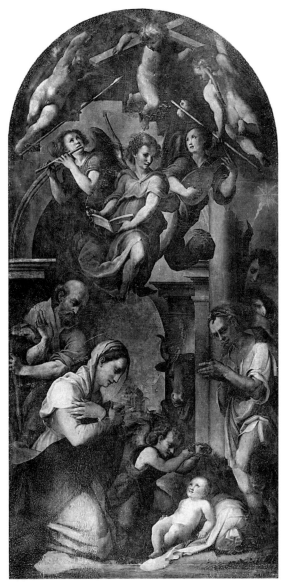

Maso da San Friano: *Adoration of the Shepherds*, oil on panel, 3.09×1.58 m, *c.* 1566 (Florence, SS Apostoli)

Counter-Reformation writers. However, his *Holy Family with St John the Baptist* (*c.* 1569; Oxford, Ashmolean) and *Virgin and Child with St John the Baptist and Two Angels* (*c.* 1570; St Petersburg, Hermitage) imitated the broad, sweeping shapes and the quality of irrational excitement in the later, proto-Mannerist pictures of del Sarto and in the paintings of Pontormo. The restless temper of these works is also found in Maso's *Annunciation with St Nicholas and St Catherine of Siena* (*c.* 1570; Arezzo, Mus. Casa Vasari) and in the two paintings he produced for the *studiolo* of Grand Duke Francesco I de' Medici in the Palazzo Vecchio, Florence: the *Diamond Mines* and *Fall of Icarus* (1570–71; *in situ*). The *Diamond Mines* shows a careful study of the earlier works of Pontormo, such as the *Joseph in Egypt* (*c.* 1518; London, N.G.), in the eccentric anatomical construction and sprightly movement of the

figures, and even recalls Rosso Fiorentino. Maso was given the prestigious commission for a state portrait of *Francesco I de' Medici* (1570; Prato, Mus. Com., Sala del Consiglio), and the work is representative of a trend towards greater naturalism in Florentine court portraiture, at a time when the influence of Agnolo Bronzino, court artist for over 20 years (1539–60), was waning.

BIBLIOGRAPHY

L. Berti: 'Nota a Maso da S Friano', *Scritti di storia dell'arte in onore di Mario Salmi*, ed. G. de Francovich and others, ii (Rome, 1963), pp. 77–88

P. Cannon Brookes: 'Three Notes on Maso da San Friano', *Burl. Mag.*, cvii (1965), pp. 192–6

——: 'The Portraits of Maso da San Friano', *Burl. Mag.*, cviii (1966), pp. 560–68

V. Pace: 'Maso da S Friano', *Boll. A.*, lxi (1976), pp. 74–99

LARRY J. FEINBERG

Sangallo, da [Giamberti]. Italian family of artists. Francesco Giamberti (1404–80) was a woodworker active in the artistic circle around the Medici family in Florence in the 15th century. He was also put in charge of the education of Giulio de' Medici, the future Pope Clement VII (*reg* 1523–34). From Francesco descended two generations of important artists, who took the name 'da Sangallo' from his property near the San Gallo gate in Florence. (1) Giuliano da Sangallo ran a woodworking shop with his brother (2) Antonio da Sangallo (i). Their sister Maddalena Giamberti was the mother of (3) Bastiano da Sangallo and of (5) Giovan Francesco da Sangallo. Another sister, Smeralda Giamberti, married Bartolomeo di Antonio di Meo Cordiani, a cooper, and was the mother of (4) Antonio da Sangallo (ii) and (7) Battista da Sangallo, who worked closely together on some projects. (6) Francesco da Sangallo was the son of Giuliano. Bastiano, Antonio (ii), Giovan Francesco, Francesco and Battista were all members of the group of artists labelled by Vasari the Setta Sangallesca, along with Antonio Labacco, Pietro di Giacomo Rosselli and others.

BIBLIOGRAPHY

DBI; *Macmillan Enc. Architects*; Thieme–Becker

G. Vasari: *Vite* (1550, rev. 2/1568); ed. G. Milanesi (1878–85)

G. Clausse: *Les San Gallo: Architectes, peintres, sculpteurs, medailleurs, le XVeme et XVIeme siècles* (Paris, 1900–02)

CAROLINE ELAM

(1) Giuliano da Sangallo (*b* Florence, *c.* 1445; *d* Florence, 20 Oct 1516). Architect and woodworker. He was the most innovative Florentine architect of the last third of the 15th century and the favoured designer of Lorenzo de' Medici, for whom he produced the Villa Medici at Poggio a Caiano, one of the key buildings of the Florentine Renaissance (see colour pl. 2, XXVII1). Although loyal to the basic forms and ideas of Brunelleschi, Giuliano learnt from Alberti the importance of close study of ancient architecture (*see* ARCHITECTURAL DRAWINGS, fig. 2) and left sketchbooks (Siena, Bib. Com. Intronati; Rome, Vatican, Bib. Apostolica, Barberini Codex) recording a vast array of ancient buildings and architectural details, elements of which he incorporated into his own work. He was essentially a woodworker architect and throughout his life continued an active woodworking partnership with his brother (2) Antonio da Sangallo (i), producing choir-stalls, sacristy cupboards, picture frames

and, above all, architectural models. Although somewhat left behind by the momentous architectural changes wrought by Bramante and Raphael in Rome during the High Renaissance, Giuliano remained a respected figure with considerable influence on his friend Michelangelo.

1. Life and work. 2. Working practice.

1. LIFE AND WORK.

(i) Early career, before *c.* 1485. (ii) Patronage of Lorenzo de' Medici, *c.* 1485–92. (iii) Late work, from 1492.

(i) Early career, before c. *1485.* After presumably training with his father, Giuliano was then, according to Vasari, placed with Francione, whose partner he is documented as being in 1480, the year of his marriage. The choir-stalls (*c.* 1465) in the chapel of the Palazzo Medici can be attributed to Giuliano on the basis of an erased drawing in the Barberini Codex (fol. 1*r*), and he probably worked with Francione on the stalls in Pisa Cathedral during the 1460s. By his own account (Barberini Codex, fol. 1*r*), he was in Rome by 1465, beginning his studies of the Antique. Giuliano spent several years in Rome, returning to Florence during the 1470s. His first commission in Florence may have been the Palazzo Scala, the original parts of which are unmistakably attributable to him. Designed for the Florentine Chancellor Bartolomeo Scala (1430–97) as a kind of urban villa with elaborate gardens, it was completed by 1480. It has the barrel vaults, *all'antica* stuccowork and use of the Roman system of arches supported by piers and pilasters with a flat entablature characteristic of Giuliano's later architecture. Another building probably from the 1470s that may be by him is the façade of the Palazzo Cocchi, Florence, which is articulated with blind arches and piers on the ground-floor; arches, piers and pilasters (doubled at the sides) on the *piano nobile*; and pilasters with flat entablatures on the top floor flanking rectangular windows divided by a single column. The Doric capitals on the top floor, with feathered decoration on the necks, resemble the two surviving original capitals in the Palazzo Scala courtyard. This façade has the quality of partially digested refinement characteristic of many of Giuliano's buildings. During the war after the Pazzi conspiracy in 1478, he had his first experience as a military architect, assisting (according to Vasari) with the siege of Castellina in Chianti and working with Francione and Francesco d'Angelo Cecca (1447–88) on the fortifications of Colle Val d'Elsa the following year.

Giuliano's first documented work is from 1480, when he produced, with Francione, a model of part of the church of SS Annunziata, Florence. His role here (1480–83) appears to have been to design the new junction between the nave and the round tribune added to the church by Michelozzo di Bartolomeo and Alberti (from 1444 and from 1470), to raise and re-roof the nave up to the height required by the new junction and to design wooden racks for painted wax votive images. Here Giuliano's graduation to architecture is evident, but he also produced a wooden crucifix for the high altar of the church in 1481 (in collaboration with his brother Antonio) and made its sacristy cupboards. He carried out a similar range of work for the Badia in Florence in 1482.

(ii) Patronage of Lorenzo de' Medici, c. 1485–92. In the 1480s Lorenzo de' Medici (*see* MEDICI, DE', (5)) selected Giuliano to design not only the buildings he commissioned directly (the Villa Medici at Poggio a Caiano and S Gallo, Florence) but also others on which he had a decisive influence (S Maria delle Carceri, Prato; the sacristy of Santo Spirito, Florence). In addition, Giuliano was one of the agents of Lorenzo's cultural diplomacy. At Lorenzo's death in 1492, Giuliano was engaged on at least four building projects for him.

The church of S Maria delle Carceri (see fig. 1) in Prato is one of the jewels of Renaissance architecture. It was a votive church, commemorating a miracle-working image in the city prisons. After an architectural competition, a project by Giuliano da Maiano had been chosen in 1484, but Lorenzo de' Medici is said to have intervened to impose Sangallo, who then both supplied the wooden model and supervised construction from 1485 to 1499 (*see* §2 below). The Greek cross ground-plan has entrances on three sides. The simple mathematical proportions and the interior spaces crowned with an umbrella dome on pendentives are strongly reminiscent of Brunelleschi. Giuliano's loyalty to the latter is documented in a letter of 1486, in which he begged Lorenzo de' Medici to intervene at Santo Spirito to restore Brunelleschi's four-door solution for the façade. Wholly characteristic of Giuliano, however, is the treatment of the decorative detail at S Maria delle Carceri. The pilaster capitals are inventive variants on the Pegasus capitals of the temple of Mars Ultor, Rome, with the volutes being replaced by winged symbols of the four evangelists, while the exuberant central foliage is shaped into the fleur-de-lis of Prato's civic insignia. The green and white marble cladding of the exterior is unfinished,

only the lower storey being executed in Giuliano's time. Typical also of Giuliano is the use of balustrades, both at the base of the drum inside and outside around the lantern.

The VILLA MEDICI POGGIO A CAIANO, (see colour pl. 2, XXVII1) was probably designed in the same year as S Maria delle Carceri. The foundations of the villa were in place by *c.* 1486, and the building is described as one-third finished by 1494, when the Medici were expelled from Florence; it was completed under Pope Leo X in 1515–19. In its programmatic quality—its symmetricality, its use of triadic planning, its enfilade openings and its incorporation of Vitruvian and Albertian theory along with ancient architectural detail—Poggio is a completely new departure in Florentine villa design. The H-shaped plan is inscribed within a perfect square, the parallel blocks at front and back joined by a two-storey, barrel-vaulted *salone*. The *piano nobile* is raised above an arcaded platform, with vaulted service rooms behind providing a balustraded balcony around the central villa block, affording views of the surrounding countryside and Florence in the distance. Four private apartments in the four corners cluster around the central public spaces.

For the first time in Renaissance architecture a classical temple-front portico is used to mark the entrance, the triangular pediment serving to display the Medici coat of arms. The columns have fanciful Ionic capitals, the central two with bulging necks. Behind is a transverse barrel-vaulted vestibule with the *all'antica* coffering in which Giuliano specialized. The tripartite rhythm of the façade, in which the central openings are bunched and the side windows pushed out to the edges, is both reminiscent of Venetian architecture and prophetic of Palladio's villas. Alberti had recommended the villa as offering options for rational planning unavailable in congested city sites, and Poggio seems to be a conscious attempt to rethink this building type along Albertian lines, incorporating ideas from Vitruvius, Pliny the younger and surviving ancient monuments. The literary ideas were no doubt supplied by Lorenzo, for Giuliano could not read Latin, but it was Sangallo who had accumulated a visual repertory of ancient ground-plans and motifs, whereas Lorenzo had visited Rome only rarely. Their collaboration was one between a patron of exceptional architectural acumen and an architect combining practical skills with a wide knowledge of ancient models.

With his brother Antonio, Giuliano continued to receive woodworking commissions, including the frame (1485) for the altarpiece of the high altar of Florence Cathedral, the frame for the *Innocenti* altarpiece (1488) by Domenico Ghirlandaio and the door (1489) of the Judges and Notaries Guildhall, as well as executing architectural models. From before 1487 the two brothers kept a woodworking shop near the cathedral workshop in Florence. Giuliano's most important commissions, however, continued to be for architectural projects, under Lorenzo's patronage. In 1488 work began at the church and convent of S Gallo (destr. 1529), Florence, which Lorenzo had Giuliano redesign. The buildings were just outside the S Gallo gate, and two ground-plans in the Uffizi (1573A and 1574A), although not in Giuliano's hand, may record projects for the scheme. A letter of 1492 gives a generic eulogy of the complex, which included an elaborate library.

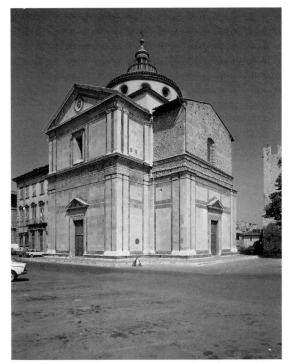

1. Giuliano da Sangallo: S Maria delle Carceri, Prato, begun 1485

The Uffizi projects, for a single nave church with interconnecting side chapels and large friars' choir behind the altar chapel, are quite similar to S Salvatore al Monte (1490–1504), Florence, by CRONACA, reflecting the same kind of reforming ideas.

Because Lorenzo dominated the building committee at Santo Spirito, Florence, Giuliano was given the commission to design the sacristy (1489–96) added to Brunelleschi's church. The octagonal ground-plan makes a generic reference to the Baptistery in Florence but, with its semicircular niches in the corners, is closer to an ancient building at the Baths of Viterbo, which was a favourite of Giuliano's. Two levels of paired pilasters articulate the interior, carrying the most elaborate and beautiful Composite capitals of the 15th century. The transverse vestibule (begun 1492) is modelled on the entrance loggia at Poggia a Caiano, but here the barrel vault is stone, and the supporting monolithic columns are powerful, if oppressive.

Giuliano's other major ecclesiastical building in Florence was the Cestello (now S Maria Maddalena dei Pazzi; see fig. 2), gradually transformed internally for the Observant Cistercians from 1479. The interior, with an aisleless flat-roofed nave and side chapels opening from semicircular arches on square piers, can be seen as a transition between SS Annunziata and S Gallo. Giuliano and his brother Antonio were paid for a wooden model in February 1491, almost certainly for the Ionic cloister between the church and the street. This, most unusually for Florence, has trabeated columns, interrupted only on the main axes by arches carried on square piers. The effect is similar to the Romanesque portico of the cathedral at Civita Castellana, but in an Albertian, *all'antica* mode, emphasized by the distinctive Ionic capitals with their droopy volutes.

In 1489 Giuliano and Antonio made a wooden model for Filippo Strozzi's new palace in Florence, subsequently built (1489–1504; *see* ITALY, fig. 5) under Cronaca's direction. The model (Florence, Pal. Strozzi) establishes the basic, bilaterally symmetrical plan but has a lower, unvaulted main storey, a plainer bracket cornice and façade masonry graduated (as at the Palazzo Medici) from large

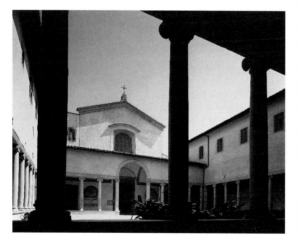

2. Giuliano da Sangallo: S Maria Maddalena dei Pazzi (formerly the Cestello), Florence, early 1490s

rounded blocks on the ground-floor to smooth ashlar at the very top. For Giuliano Gondi in 1490, Sangallo designed the Palazzo Gondi, left unfinished at the patron's death and later enlarged (1871–4) by Giuseppe Poggi. The façade has the most refined graduated rustication of any Florentine Renaissance palace: the voussoirs of the arched windows are keyed into the masonry courses, producing an elegant overall pattern. From the courtyard (see fig. 3)—which, unusually for Giuliano, has columns carrying arches—opens a balustraded staircase occupying one of the arcades, allowing for a comfortable ascent in a confined site. The quality of the carving of the decorative stonework is exceptionally high throughout, especially the chimney-piece in the *sala grande* (1501–3), with its baluster supports, Nereid and triton frieze, and crowning statues of *Hercules* and *Samson*.

Although Lorenzo needed him at home and did not generally recommend him for distant projects, in 1488 Giuliano was sent to Naples with the model of a palace for King Ferdinand I (*reg* 1458–94), the plan of which he recorded three times in his sketchbooks. The square perimeter, bilateral symmetry, use of transverse spaces and corner apartments relate it to Poggio a Caiano, but the Naples plan is for a much larger and more complex city residence, incorporating a triumphal arch entrance, a *salone* based on Roman baths and an axially placed *all'antica* chapel. The sunken courtyard surrounded by theatre seating relates it to Giuliano da Maiano's villa (destr.) at Poggio Reale, Naples, then under construction, the model for which had also been supplied by Lorenzo. The palace plan remained unbuilt, but it was not the last model of a building inspired by Lorenzo that Giuliano presented to a foreign ruler. After Lorenzo's death, his son Piero de' Medici was asked by Duke Ludovico of Milan to supply a model of Poggio a Caiano; Giuliano took it to Milan in autumn 1492. According to Vasari, he also gave the French king Charles VIII (*reg* 1483–98) a palace model when he was in Lyon with Cardinal Giuliano della Rovere (later Pope Julius II, *reg* 1503–13) three years later.

Giuliano and Antonio also benefited from Lorenzo's plans to develop vacant areas within Florence, acquiring land from Cestello in 1490 to build an ambitious town house (Palazzo Panciatichi–Ximenes; altered, 17th century, by Gherardo Silvani), which originally had a transverse barrel-vaulted hall, said by Vasari to have served as a demonstration for the *salone* at Poggio. At least one smaller, vaulted room survives. In the grounds of Cestello near by, Bartolomeo Scala built an oratory (destr.) on the axis of Lorenzo's new street, the Via Laura (now Colonna). Constructed in 1491 the plan resembled a round version of the Santo Spirito sacristy, justifying the attribution to Giuliano. A drawing (*c.* 1515) in the Uffizi (282A), signed by Antonio (i) but with annotations by Giuliano, is for a reduced version of King Ferdinand's palace plan on the Palazzo Scala site, with extensive gardens and an impressive entrance and exedra on the Via Laura.

According to Vasari, Lorenzo planned to build a new town at Poggio Imperiale, Tuscany, for which Giuliano prepared designs. The walls were left unfinished, and a settlement never developed, but the fortress and bastioned circuit are of great interest. Giuliano's participation is not documented, but we know that his brother Antonio was

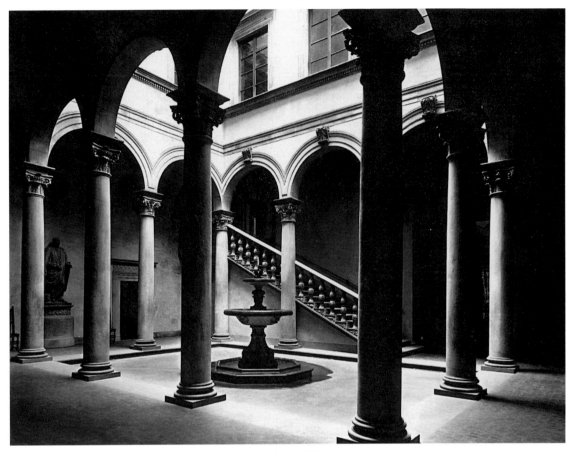

3. Giuliano da Sangallo: courtyard of the Palazzo Gondi, Florence, begun 1490

involved after 1495. The zoomorphic plan of the fortress with its angle bastions recalls the city plans of Francesco di Giorgio Martini. In the same year (1488) Giuliano and Antonio were encouraged by Lorenzo to propose a new model for the fortress of Sarzana, then being constructed by Francione and Cecca, but their plans were rejected. Vasari's attribution to Giuliano in these years of the Rocca d'Ostia (1479–86) is contradicted by the inscribed signature of Baccio Pontelli, and there is no explicit evidence that Giuliano was involved in the fine defences of Brolio in Chianti.

Unfortunately, no accounts survive for any of Lorenzo de' Medici's building projects. In addition to the terms of his employment, Giuliano may have enjoyed substantial peripheral benefits; Ferdinand I paid him 100 florins for his palace model in February 1489. Giuliano became reasonably wealthy: he and his brother built themselves an unusually ambitious house for the period and are said in Francesco Albertini's guidebook to Florence of 1510 to have had a fine collection of ancient sculpture.

(iii) Late work, from 1492. After the death of Lorenzo de' Medici in 1492, his son Piero de' Medici (1471–1503) initiated nothing new, and Giuliano was forced to look elsewhere for patronage, producing for Cardinal Francesco Piccolomini (later Pope Pius III, *reg* 1503) a plan (unexecuted) for the hall of residence of Siena University and a

model (1492–4) for the votive church of S Maria dell'Umiltà in Pistoia. The church of S Chiara (main chapel now in London, V&A), Florence, attributed to him by Marchini (1950), is dated *c.* 1493–5.

After the expulsion of the Medici from Florence in 1494, Giuliano entered the service of Cardinal Giuliano della Rovere. He journeyed to France with the Cardinal in 1495–6, working at Avignon and studying Roman antiquities in Provence. On his way to and from France, Giuliano designed the Palazzo della Rovere at Savona, where he is mentioned in a document of May 1496 for the marble cladding of the façade. The stucco barrel vault of the vestibule, very close in form to the *salone* vault at Poggio, would be enough to identify Giuliano as the architect of the Savona palazzo. The façade (see fig. 4), intended to be faced entirely in stone, is articulated with three superimposed orders of pilasters; the beautiful Doric capitals with egg-and-dart abacus and fluted necks had already appeared in painted form in Filippino Lippi's fresco of *Laokoon* at the Villa Medici.

From 1497 to 1504 Giuliano worked mainly in Florence, although his most important work of these years was the vaulting (1499–1500) of the cupola of S Maria at Loreto. The fortresses he designed in these years show a growing confidence in the use of angle bastions after his early experiences with Francione, who favoured regular, round-towered fortresses with machicolations. For example,

4. Giuliano da Sangallo: façade of the Palazzo della Rovere, Savona, 1496

those at Borgo San Sepolcro (now Sansepolcro; planned 1500; built 1502–3) and Arezzo (from 1503) have round shoulders to protect flanking batteries. Giuliano continued to work at S Maria delle Carceri and at the Palazzo Gondi, and for Giuliano Gondi's sons he designed the Gondi Chapel (from 1504) in S Maria Novella, Florence, an influential early example of the polychromatic marble chapel. The altar wall takes the form of a triumphal arch with paired Doric pilasters, roundels and niches. The side walls are articulated up to half this height with stone benches and a marble backrest, divided by voluted arms supporting a smaller order of attached columns with broken out entablature above. The idea of triumph over death is conveyed through the enduring materials and antique references.

The election of Pope Julius II in 1503 brought Giuliano the hope of major commissions in Rome, and in 1505 he moved his family there. Around this time Giuliano also commissioned from Piero di Cosimo two portraits, of himself and his father (Amsterdam, Rijksmus.). They are both shown behind ledges: on Francesco's rests a sheet of music, and on Giuliano's are the pen and compasses of the designer–architect. In Rome, however, Giuliano was denied the best jobs by Bramante. He designed the elegant Doric loggia in the Castel Sant'Angelo for Julius in 1504 and worked on the Villa La Magliana and the Palazzo Penitenzieri for Cardinal Alidosi, but his design (1505) for a Doric loggia for the papal musicians in the form of a triumphal arch was unexecuted, and his drawings (1506) for St Peter's did not win him the post of chief architect. Instead he designed the tiny church of S Caterina delle Cavallerotte (1508; destr.). Nonetheless Giuliano was an influential figure at the papal court, not least for his ability to mediate between the irascible Pope and the no less choleric Michelangelo. Giuliano's son (6) Francesco da Sangallo later recalled his trip with his father and Michelangelo in 1506 to visit a newly excavated statue, which

Giuliano immediately identified as the '*Laokoon*, which Pliny mentions'.

Giuliano returned to Florence, where military architecture offered the only chance of large-scale civic commissions. He designed the Florentine fortress of Pisa (1509–12; destr.), perhaps his most important achievement as a military architect. Even at this late date Giuliano was being instructed by Piero Soderini in the principles of modern fortress design, and throughout his career military experts and politicians played an important part in this aspect of his work. At Pisa, for example, Machiavelli and others criticized his design. In 1512 the Medici returned to Florence, and the next year Cardinal Giovanni de' Medici was elected Pope Leo X (*reg* 1513–21). Giuliano immediately presented him with a grandiose project for a huge Medici palace on the site of the future Palazzo Madama in Rome, using the Piazza Navona as a forecourt (Florence, Uffizi, 7949A). Leo named Giuliano co-architect at St Peter's in 1514 (Barberini Codex, fol. 64*v*), but Giuliano was rapidly overtaken by Raphael and by his own nephew, (4) Antonio da Sangallo (ii). Giuliano's health was now failing; he worked for Leo on the extension of the Borgo Nuovo (destr.) leading from Castel Sant' Angelo to St Peter's but returned to Florence in July 1515. His last designs were a splendid series of projects for the façade of S Lorenzo in the wake of Leo X's triumphal entry into Florence in autumn 1515. For the competition Giuliano submitted not only fresh drawings (Florence, Uffizi, 276A, 280A, 281A) but also three recycled della Rovere projects (277A, 278A, 279A), which later influenced Michelangelo's first ideas for the façade. Three of the drawings show Giuliano using for the first time the whole apparatus of the Doric order, with triglyph and metope frieze. Vasari noted the improvements Giuliano and Antonio made to the Doric: it had been Giuliano's preferred order since the 1490s.

2. WORKING PRACTICE. Giuliano's career is particularly useful for the study of architectural practice in the early Italian Renaissance. In the preamble to his life of Baccio d'Agnolo, Vasari notes that 'woodworkers. . .in course of time become architects'. This was especially true in 15th-century Florence, where a number of artists not only made a natural transition from model-making to architecture but also continued to work with wood throughout their careers. Writing to Lorenzo de' Medici in 1486 about the façade of Santo Spirito, Giuliano disclaimed the title of architect. However, although there was no architectural profession or training at this period, he was entitled to claim the status of a designer. In fact he is almost always described as either a woodworker (*legnaiuolo*) or an architect in documents; the one exception is the stone contract for the Palazzo Rovere in Savona, where he is called *magister petrarum* (master mason), an understandable mistake in this context. Giuliano only matriculated into the Arte di Pietra e Legname (Guild of Stonemasons and Woodworkers) in 1502, however, an indication of the weakening of guild ties in the 15th century.

The contract for S Maria delle Carceri offers a rare insight into the architectural working methods of the period. Giuliano, who is described as a man of exceptional

natural gifts, was appointed architect and chief master builder. He had already supplied the building committee with a wooden model of the church. Because he was engaged on other projects and was neither able nor required to attend on site all the time, he was paid by the day, together with living and travel expenses. The entire workforce was hired individually by the building committee (normal practice in Florence, where large-scale contracting was rare), but Giuliano controlled the hiring of one mason and one builder at the committee's expense. Interestingly, he reserved the right to execute all the major work in wood—roofs, doors and windows—with separate payment arrangements.

Because Giuliano was paid by the day, the building accounts document his work in unusual detail. He supervised construction, worked on the foundations, quantity surveyed completed work, went to the quarries and provided equipment. In addition to the model, for which he was given an ex gratia payment of 100 lire on completion of the main structure in 1490, he continually supplied designs when needed, in the form of drawings, metal templates or—most often—wooden models, for cornices, altars, lanterns, balustrades and even façade cladding. His instructions to the masons for the complex pilaster capitals were supplied as both 'a design of wood and also drawn on a large sheet of paper'.

Although the documents in Prato are unusually precise, the design process and division of labour they describe is typical of Florentine practice. As for the architect's role, in other contexts Giuliano's contribution might be limited to providing a wooden model (for example at the Palazzo Strozzi), or he might work to a monthly salary (Florence Cathedral, Palazzo Signoria). In other cities the arrangements could be quite different: in Loreto, for example, Giuliano was both designer and contractor, taking on the vaulting of the cupola as a fixed price contract for 1000 florins, from which he had to produce the workforce, while the office of works supplied materials. In Rome, Giuliano worked as a salaried papal architect, but remuneration could be uncertain. The plot on the Borgo Nuovo was probably payment in kind, and full payment for his work under Leo X was received only by Giuliano's heirs after his death.

BIBLIOGRAPHY

R. Falb: *Il taccuino senese di Giuliano da Sangallo* (Siena, 1902) [facs. of Siena sketchbook]
C. von Fabriczy: 'Giuliano da Sangallo', *Jb. Kön.-Preuss. Kstsamml.*, xxiii (1902), pp. 1–41
C. Hulsen: *Il libro di Giuliano da Sangallo*, 2 vols (Leipzig, 1910, R/1985) [facs. of Barberini sketchbook, with full crit. cat.]
I. M. Botto: 'Documenti sull'edificazione di Sto Spirito', *Riv. A.*, i (1932), pp. 23–53
G. Marchini: 'L'incrostazione marmorea della Cappella Gondi in Santa Maria Novella', *Palladio*, iii (1939), pp. 205–11
——: *Giuliano da Sangallo* (Florence, 1942)
——: 'Aggiunte a Giuliano da Sangallo', *Commentari*, i (1950), pp. 34–48
C. L. Frommel: 'S. Caterina alle Cavallerotte: Un possibile contributo alla tarda attività romana di Giuliano da Sangallo', *Palladio*, n.s., xii (1962), pp. 18–25
M. Dezzi Bardeschi: 'La SS Annunziata di Arezzo nella continuità creativa di Giuliano e di Antonio da Sangallo', *Marmo*, iv (1965), pp. 52–100
P. Marconi: 'Una chiave per l'urbanistica rinascimentale: La cittadella come microcosmo', *Quad. Ist. Stor. A. Med. & Mod.*, xv/85–90 (1968), pp. 53–94
M. Lisner: 'Zum bildhauerischen Werk der Sangallo', *Pantheon*, xxvii/2, 3 (1969), pp. 99–119, 190–207

H. Biermann: 'Das Palastmodell Giuliano da Sangallos für Ferdinand I, König von Neapel', *Wien. Jb. Kstgesch.*, xxiii (1970), pp. 154–95
G. Severini: *Architetture militari di Giuliano da Sangallo* (Pisa, 1970)
E. Bentivoglio: 'Un palazzo "barocco" nella Roma di Leone X', *L'Architettura*, xviii (1972), pp. 196–204
H. Utz: 'Giuliano da Sangallo und Andrea Sansovino', *Stor. A.*, xix (1973), pp. 209–16
A. Bruschi: 'Il teatro capitolino del 1513', *Boll. Cent. Int. Stud. Archit. Andrea Palladio*, xvi (1974), pp. 189–218
G. Malandra: 'Documenti sulla Cappella Sistina, e sul Palazzo della Rovere a Savona', *Atti & Mem. Soc. Savon. Stor. Patria*, n.s., viii (1974), pp. 135–42
A. Luchs: *Cestello: A Cistercian Church of the Florentine Renaissance* (New York and London, 1975)
D. Taddei: *L'opera di Giuliano da Sangallo nella Fortezza di Sansepolcro e l'architettura militare del periodo di transito* (Sansepolcro, 1977)
H. Teubner: 'Das Langhaus der SS Annunziata in Florenz: Studien zu Michelozzo und Giuliano da Sangallo', *Mitt. Ksthist. Inst. Florenz*, 22 (1978), pp. 27–60
H. Biermann and E.Worgull: 'Das Palastmodell Giuliano da Sangallos für Ferdinand I König von Neapel: Versuch einer Rekonstruktion', *Jb. Berlin. Mus.*, xxi (1979), pp. 91–118
Firenze e la Toscana dei Medici nell'Europa del cinquecento, 4 vols (exh. cat., Florence, Pal. Strozzi, Forte Belvedere, Pal. Medici–Riccardi, 1980)
G. Corti and P. Morselli: *La Chiesa di S Maria delle Carceri in Prato* (Florence, 1982)
F. W. Kent: 'New Light on Lorenzo de' Medici's Convent at Porta San Gallo', *Burl. Mag.*, cxxiv (1982), pp. 292–4
B. L. Brown and D. E. E. Kleiner: 'Giuliano da Sangallo's Drawings after Ciriaco d'Ancona: Transformations of Greek and Roman Antiquities in Athens', *J. Soc. Archit. Historians*, xlii/4 (1983), pp. 321–5
A. Tönnesmann: *Der Palazzo Gondi in Florenz* (Worms, 1983)
S. Borsi: *Giuliano da Sangallo: I disegni di architettura e dell'antico* (Rome, 1985)
L. Masi: 'La fortificazione di Poggio Imperiale', *An. Archit. Cent. Int. Stud. Archit. Andrea Palladio*, i (1989), pp. 85–90
L. Pellecchia: 'The Patron's Role in the Production of Architecture: Bartolomeo Scala and the Scala Palace', *Ren. Q.*, xlvii (1989)
P. N. Pagliara: 'Grottaferrata e Giuliano della Rovere', *Quad. Ist. Stor. Archit.*, n.s., xiii (1991), pp. 19–42
A. Belluzzi: 'Chiese a pianta centrale di Giuliano da Sangallo', *Lorenzo il Magnifico e il suo mondo: Convegno internazionale di studi: Florence, 1992*, pp. 385–406
D. Hemsoll: 'Giuliano da Sangallo and the New Renaissance of Lorenzo de'Medici', *Early Medici and their Artists*, ed. F. Ames-Lewis (London, 1995), pp. 187–205
I. Moretti: 'Aspetti dell'architettura militare nella Valtiberina toscana alla fine del Medioevo', *Valtiberina, Lorenzo e i Medici*, ed. G. Renzi (Florence, 1995), pp. 249–62
G. Scaglia: 'Eleven Facsimile Drawings of the Pantheon's Vestibule and the Interior in Relation to the Codex Escurialensis and Giuliano da Sangallo's Libro Drawings', *Architectura*, xxv/1 (1995), pp. 9–28

CAROLINE ELAM

(2) Antonio da Sangallo (i) [Antonio di Francesco di Bartolo Giamberti] (*b* Florence, *c.* 1460; *d* Florence, 27 Dec 1534). Architect, woodworker, sculptor and engineer, brother of (1) Giuliano da Sangallo. The earlier part of his career was overshadowed by that of his brother, with whom he ran a workshop in Florence for nearly 40 years until the latter's death. Their first known work of collaboration is the Crucifix (1481) for the high altar of SS Annunziata, Florence. This was followed by a model (1482) for the church and monastery of the Badia, Florence, the seating (1487–8) in the refectory of S Pietro, Perugia, and a model (1491) for S Maria Maddalena dei Pazzi, Florence. Antonio was also active as a military engineer, occasionally representing his brother on the construction sites of fortifications. The first independent work attributed to him (*c.* 1490) is the Crucifix for the church of S Gallo (destr.), which is now kept in SS Annunziata, Florence.

After the expulsion of the Medici from Florence in 1494, Antonio entered the service of the Pope, Alexander VI (*reg* 1492–1503); according to Vasari, he submitted a design to him for converting Castel Sant'Angelo, Rome, into a modern fortress with an integrated palace and garden loggia. On his return to Florence in 1495, Antonio took over from Giuliano as architect of S Maria dell'Umiltà in Pistoia. From 1495 to 1499, in addition to tasks involving fortifications, he was responsible for the design and execution of the Sala del Gran Consiglio in the Palazzo Vecchio, Florence (rest.): the splendid coffered ceiling he built there won him the papal commission to design the coffered ceiling (1499–1503) at S Maria Maggiore, Rome. Between 1499 and 1501 Antonio was also working as a building contractor with others on the fortresses of Civita Castellana and Nepi, both in Latium. The *cour d'honneur* that he designed at Civita Castellana is an exceptionally important example of the use of superimposed orders of pilasters, as well as an expression of Antonio's very individual attitude to the Antique. At the end of 1502 he assumed control of work at SS Annunziata in Arezzo, begun in 1490 by Bartolomeo della Gatta. The exterior is still unfaced; the interior starts with an elegant domed vestibule (designed 1515), its central bay framed by columns supporting an entablature. The arch that prefaces the nave rests on piers, their capitals decorated with masks and dolphins, while the barrel vault of the nave rests on a clerestory above the nave arcade, the piers of which are faced with pilasters. There is a low dome over the crossing. Between 1504 and 1513 Antonio was active mainly as a fortifications engineer in Florence, but in 1504 he and Cronaca were entrusted with the design and construction of the pedestal for Michelangelo's *David* (see ITALY, fig. 22). He may also have collaborated (1505–6) with his brother on the planning of St Peter's, Rome. In 1508 he was involved in planning the gallery beneath the dome of Florence Cathedral.

By 1514 Antonio and Giuliano were back in papal service with Leo X (*reg* 1513–21; *see* MEDICI, DE, (7)). On Leo's arrival in Florence at the end of 1515, Antonio received one of his most prestigious commissions: the construction of an octagonal triumphal arch on the Piazza della Signoria. He made an equally significant contribution to the subsequent planning and building initiated by the Medici, for example a project for the Cappella Medicea before Michelangelo (Florence, Uffizi, 1567A). According to Vasari, he was involved in the competition for the façade (not executed) of S Lorenzo, Florence. His drawing (Florence, Uffizi, 1567 A) is a project for the Cappella Medicea before Michelangelo. From 1516 to 1520, with Baccio d'Agnolo, he designed and built the Loggia dei Servi on the Piazza SS Annunziata, subtly adapting the scheme to echo Filippo Brunelleschi's Ospedale degli Innocenti (1419; see colour pl. 1, XVI2), which is situated opposite: by increasing the number of arcades and omitting the lateral projections of the Ospedale, he reinterpreted the latter as if it were the side of a forum. At the Palazzo del Monte in Monte S Savino, near Arezzo, begun *c.* 1515 for Cardinal Antonio del Monte (*d* 1533), Antonio displayed his originality by freely combining ideas derived from Bramante's Palazzo Caprini (*c.* 1510) and Raphael's Palazzo Jacopo da Brescia (*c.* 1515), both in Rome, with a

systematically devised plan. Antonio's palazzo is characterized by its plain, powerfully three-dimensional language of form. The Palazzo del Monte (begun before 1519), Montepulciano, is a simpler version of the palazzo in Monte S Savino; its façade, modelled on a conventional Florentine example, is particularly outstanding.

Antonio's most important work is the pilgrimage church of the Madonna di S Biagio (begun 1518; see fig.), near Montepulciano. The dome was completed in 1543, the east tower in 1564, and the west tower (not completed) was added in 1574. The lantern and the upper floor of the tower were designed in 1543 by Baccio d'Agnolo. Antonio's numerous drawings of the project (Florence, Uffizi) are evidence of a careful process of planning. Taking the model of his brother's S Maria delle Carceri, Prato, as a starting-point, he created a vast centralized building. The plan is a Greek cross, without aisles. A square block projects above the crossing to form a base for the drum, pilastered inside and out, which supports a hemispherical dome. The arms of the cross are barrel-vaulted, and the four supporting arches at the crossing spring from a jutting entablature borne on ensembles of deeply modelled Doric pilasters and engaged columns on a low plinth, which project well forward into the crossing space. The church is designed into its landscape setting and, while enhancing the significance of its site, defers to the ambient buildings. Antonio's designs (1518) for S Giovanni dei Fiorentini, Rome, with their insistence on the principles of articulated structure, are further evidence of his individuality. In the 1520s he produced suggestions for consolidating the crossing in S Maria della Santa Casa, Loreto, but these were not executed. His drawings, especially the Codex Geymüller (Florence, Uffizi, 7792–7907 A), are a valuable and extensive record of his many different projects. Although he is traditionally regarded as a lesser figure than his brother and subordinate to him, designs and buildings by Antonio dating from as early as the 1490s reveal a major artist of great originality.

BIBLIOGRAPHY
C. Stegmann and H. von Geymüller: *Die Architektur der Renaissance in Toscana*, v (Munich, n.d.)

Antonio da Sangallo (i): church of the Madonna di S Biagio, near Montepulciano, begun 1518

A. Lambert: *Madonna di San Biagio près Montepulciano bâtie par Antonio di San Gallo de 1519 à 1528* (Stuttgart, 1884)

M. Lisner: 'Zum bildhauerischen Werk der Sangallo', *Pantheon*, xxvii/2, 3 (1969), pp. 99–119; 190–208

O. Speciale: 'Antonio da Sangallo il Vecchio: Il cortile della rocca di Civita Castellana', *Annu. Ist. Stor. A.* [Rome] (1973–4), pp. 199–210

L. H. Heydenreich and W. Lotz: *Architecture in Italy, 1400 to 1600*, Pelican Hist. A. (Harmondsworth, 1974)

G. Miarelli Mariani: 'Due infondate attribuzioni ad Antonio da Sangallo il Vecchio: I palazzi Cervini e Del Pecora a Montepulciano', *Quad. Ist. Stor. Archit.*, cxxxix–cl (1977–8), pp. 69–88

P. Jacks: 'Alexander VI's Ceiling for S Maria Maggiore in Rome', *Röm. Jb. Kstgesch.*, xxii (1985), pp. 63–82

L. Satkowski: 'The Palazzo del Monte in Monte San Savino and the Codex Geymüller', *Renaissance Studies in Honour of C. H. Smyth*, ii (Florence, 1985), pp. 653–66

E. Andreatta and F. Quinterio: 'La Loggia die Servi in Piazza SS. Annunziata a Firenze', *Riv. A.*, xl (1988), pp. 169–331

G. Satzinger: 'Ein unbekanntes Projekt für die Neue Sakristei von San Lorenzo vor Michelangelo', *Studien zur Künstlerzeichnung: K. Schwager zum 65. Geburtstag* (Stuttgart, 1990), pp. 78–95

R. Pacciani: 'Nuove ricerche su Antonio da Sangallo il Vecchio ad Arezzo e a Monte Savino, 1504–1532', *An. Archit.*, iii (1991), pp. 40–57

G. Satzinger: *Antonio da Sangallo der Ältere und die Madonna di San Biagio bei Montepulciano* (Tübingen, 1991)

M. Cozzi: *Antonio da Sangallo il Vecchio e l'architettura del Cinquecento in Valdichiana* (Genoa, 1992)

G. Satzinger: 'Der 'Statuenhof' Clemens' VII. im Garten des Palazzo Medici in Florenz. Zur Laokoon-Zeichnung der Albertina (Inv 48v) und zu Folio 28v im Codex Geymüller der Uffizien (A 7818v)', *Ars naturam adiuvans: Festschrift für Matthias Winner* (Mainz 1996), pp. 208–27

GEORG SATZINGER

(3) Bastiano [Aristotile] da Sangallo

(3) Bastiano [Aristotile] **da Sangallo** (*b* Florence, 1481; *d* Florence, 31 May 1551). Architect, painter, draughtsman and stage designer, nephew of (1) Giuliano da Sangallo and (2) Antonio da Sangallo (i). His nickname derived from his serious way of talking and a supposed resemblance to an antique portrait bust of Aristotle. He was a pupil of Perugino, whom he assisted in his work on the main altarpiece for SS Annunziata in Florence. Around 1505 he made a copy (untraced) of Michelangelo's cartoon of the *Battle of Cascina* (destr.), presenting an oil painting (Holkham Hall, Norfolk) based on it to Francis I, King of France (*reg* 1515–47), in 1542. In 1508 Bastiano was called to Rome, where he was among the five artists who assisted Michelangelo during the first phase of the decoration of the ceiling of the Sistine Chapel in the Vatican and who taught him the technique of fresco painting. He also became a regular visitor at the house of Raphael, whom he may have met in Florence, and became acquainted with Bramante; he was also an occasional assistant to the Fabbrica (Cathedral Works) of St Peter's in 1526–8.

By 1515 Bastiano had returned to Florence, where he painted copies of works by Raphael and Michelangelo but obtained little recognition. In 1515 he collaborated with Francesco Granacci on a temporary triumphal arch for the visit of Pope Leo X (*reg* 1513–21). In 1518 he began a career as a stage designer when he collaborated with Ridolfo Ghirlandaio and Franciabigio on the design of scenery and machinery for the theatrical programmes presented at the Palazzo Medici for the marriage of Lorenzo de' Medici, Duke of Urbino (*reg* 1512–19). Throughout the 1520s and 1530s he produced designs for productions of such works as Machiavelli's *La mandragola* (1525; in collaboration with Andrea del Sarto) and *Aridosia* by Lorenzino de' Medici (1536), which was remarkable for the introduction of important new technical solutions in the placing of the musicians. During preparations for the latter, a plot was uncovered to kill Alessandro de' Medici, Duke of Florence (*reg* 1531–7), who was to have been the victim of the extremely unstable scenery ordered by Lorenzino. In 1539 Bastiano produced scenery for the production of the *Commodo* by Antonio Giuseppe Landi. This production was staged in the second courtyard of the Palazzo Medici on the marriage of Cosimo I de' Medici, Grand Duke of Tuscany (*reg* 1569–74). All of Bastiano's stage designs displayed great technical invention, and he was the first to introduce revolving sets and to provide a rostrum for the orchestra, separate from the action on stage.

Bastiano's activities during the 1530s in Florence (where he became a member of the painters' guild in 1535–6) were the supervision of the construction of Raphael's Palazzo Pandolfini during 1530–32 and participation in 1535 in the construction of the Fortezza Alessandra (1533–6; now Fortezza da Basso). From 1540 he assisted his cousin (4) Antonio da Sangallo (ii) not only in Rome but also in Perugia (1540–43), where he was second architect on the works at the Rocca Paolina (1540–43; largely destr.), and at Castro, where he worked on the construction of the new town (also destr.) for Pier Luigi Farnese. He continued, however, to execute theatrical designs, including a revolving stage (*c.* 1542–3) in Castro and a fixed stage (1546) in the Palazzo Cancelleria, Rome, for Cardinal Alessandro Farnese. Around 1547 Michelangelo may have sought his assistance in his work on the Campidoglio in Rome, perhaps to supervise the construction of the staircase of the Senators' Palace, but in 1547 Bastiano returned to settle in Florence, spending his last years there as an engineer in charge of a municipal department. The exact extent of Bastiano's contributions to the architectural projects on which he worked is unclear, especially where he worked with his cousin Antonio (ii), who always treated him with condescension, and despite the information provided by Vasari, his principal biographer, none of his paintings has been definitely identified.

BIBLIOGRAPHY

Enc. Spettacolo

A. Ghisetti Giavarina: *Aristotile da Sangallo: Architettura, scenografia e pittura tra Roma e Firenze nella prima metà del cinquecento* (Rome, 1990)

ADRIANO GHISETTI GIAVARINA

(4) Antonio da Sangallo (ii)

(4) Antonio da Sangallo (ii) [Antonio Cordiani] (*b* Florence, 12 April 1484; *d* Terni, 3 Aug 1546). Architect, engineer, urban planner, landscape designer, draughtsman and theorist, nephew of (1) Giuliano da Sangallo and (2) Antonio da Sangallo (i). Through his contact with the most renowned artists and patrons of his day, he built and restored many important buildings, while also trying to establish himself as an intellectual. His military architecture is notable for its adoption of new defensive techniques and for its highly artistic quality, while in his civil architecture he developed and redefined the palazzo type in a series of designs tailored to the individual needs of a wide range of clients. His religious buildings are interesting for their façades, using superimposed orders of architecture or towers, and for his use of domed, centralized or oval spaces alternating with hall-type spaces. Here, however,

his architectural ambitions were clearly curbed by practical restrictions.

1. Life and work. 2. Working methods and technique. 3. Critical reception and posthumous reputation.

1. LIFE AND WORK.

(i) Before 1520. (ii) 1520–35. (iii) From 1536.

(i) Before 1520. Antonio spent his early youth in Florence in poverty, in the turbulent political and religious atmosphere of the late 15th century. He probably served his apprenticeship as a woodworker (*legnaiolo*) in the workshop of his uncle Giuliano, who had a profound influence on his early career. In 1503 he was summoned to Rome by Giuliano to undertake mostly carpentry work as well as masonry for a papal commission. About 1506 Antonio began his profitable collaboration with Bramante, who valued him highly and largely delegated to him the preparation of drawings (accurately represented in orthogonal projection), even allowing him (according to Vasari) to do some of the design work on minor schemes in the fortress of Ostia, the Castel Sant'Angelo and the Vatican. During this decade he acquired a reputation, mainly for his technical ability, but also for his artistic sensitivity.

The pontificate of Leo X (1513–21) was particularly productive for Antonio; his contact with the great artistic figures of his day (especially Raphael and Baldassare Peruzzi and perhaps Fra Giocondo) enabled him to give concrete form to many of his own architectural ideas, which reflected his studies of antiquity as much as the traditions of the Florentine Renaissance. One of the best examples is the palazzo for the jurist Melchiorre Baldassini (des. 1514–16; completed 1521–2; see fig. 1). A middle-class version of a modest but well-organized palazzo, this anticipated Antonio's later palazzo schemes. In addition to its exquisite reception-rooms, the Palazzo Baldassini is interesting for the brilliant architecture of its courtyard. The sequence of circulatory spaces at ground level along the main axis starts with the main entrance, framed by a Doric order supporting an architrave, and it leads into a vestibule placed symmetrically on the axis of the courtyard with a loggia and abbreviated portico on the entrance side. On the other sides a Doric order of pilaster strips recalls the theme of the main entrance.

During the same period Leo X commissioned Antonio to work on the fortifications and the alterations to the old dockyard in the port of Civitavecchia. Here he demonstrated remarkable artistic qualities but remained nevertheless firmly anchored in the traditions of the late 15th century. In 1516 at Montefiascone and at Marino (for Ascanio Colonna), and a little earlier at Capodimonte, however, Antonio experimented with virtually square continuous ramparts, demonstrating the keen interest in the application of geometric devices (circular, triangular, square or polygonal patterns) that he was later to develop and perfect.

Antonio received his principal encouragement during this period not from Pope Leo, however, but from Cardinal

1. Antonio da Sangallo (ii): courtyard of the Palazzo Baldassini, Rome, completed 1521–2

Alessandro Farnese (later Pope Paul III, *reg* 1536–50). It was Farnese who commissioned what was probably Antonio's first independent work, the fortress of Capodimonte (entrance and courtyard; 1513–15) on Lake Bolsena. This was followed (1514–16) by the remodelling of a house in Campo dei Fiori, which became his undisputed masterpiece: the Palazzo Farnese (*see* PALAZZO, fig. 2). The project is well documented, with drawings of the pre-existing building, and it was intended to provide apartments for the Cardinal's sons Pier Luigi Farnese (later Duke of Parma and Piacenza) and Ranuccio (later Cardinal) Farnese. In the disposition of architectural orders in the courtyard, inspired by the external ambulatory of the theatre of Marcellus, Antonio demonstrated his maturity, sensitivity and originality as an architect. Again for the Farnese family, *c.* 1513, he began the Palazzo Farnese at Gradoli and two tempietti on the Isola Bisentina on Lake Bolsena. These graceful, centralized works built to ancient models, reveal Antonio's clear interest in landscape architecture.

In 1516 Pope Leo, at the suggestion of Cardinal Farnese, appointed Antonio as assistant to Raphael in the construction of St Peter's, for which he prepared designs. The initial relationship of subordination forced Antonio to compromise at times, but more often it provoked a search for his own architectural identity. If in certain aspects of his work at St Peter's and elsewhere he was influenced by Raphael because of his obligations towards his patrons, Antonio nevertheless always asserted his own style, for example in the project for the Villa Madama (from 1517) for Cardinal Giulio de' Medici (later Pope Clement VII, *reg* 1523–34). Here, where he was once more working under Raphael, Antonio again showed his interest in landscape architecture, subtly allowing the built elements (such as large terraces, hydraulic works and retaining walls) to impose their geometry on the natural vegetation. The design of the villa itself showed Antonio's originality and inventiveness, and the villa's theatre displayed his own compositional choices, which were diametrically opposed to those of Raphael. This process of maturation culminated in Antonio's *Memoriale* (Giovannoni, i, pp. 132–3), an unrelenting critique of Raphael's designs for St Peter's in comparison with the design and partial realization of the Villa Madama.

Around this time Antonio collaborated with several other eminent architects, with some of whom (such as Baldassare Peruzzi) he managed to establish an harmonious working relationship; more often, however, he became their rival, as with Jacopo Sansovino. Around 1519 he entered the competition for the church of Giovanni de' Fiorentini in Rome, founded to celebrate the rebirth of Medici Florence and its close links with the papacy. Although the commission went to Sansovino, Antonio was consulted on technical problems relating to the foundations adjacent to the Tiber, and this gave him an opportunity to modify the designs, in which he compressed longitudinal and centralized ground-plans, and later to supplant Sansovino when the latter left Rome in 1527. Antonio proposed an altogether different solution for the church, but this remained unexecuted. The competition between Antonio and Sansovino nevertheless marked an important and lively debate on church design, to which

2. Antonio da Sangallo (ii): S Maria di Monserrato, Rome, interior, 1518–20

several of Antonio's other designs of this period also contributed.

During 1518–20 Antonio proposed two alternative solutions for the church of S Maria di Monserrato (see fig. 2): one with a centralized ground-plan; the other longitudinal with intercommunicating chapels. A single nave scheme with chapels was built, foreshadowing Jesuit structures of the Counter-Reformation. Around 1519, with Peruzzi, he also began work on the Ospedale degli Incurabili di S Giacomo in Augusta in Rome, proposing centralized and longitudinal alternatives for the design of the mortuary chapel of S Maria Porta Paradisi (1519–24). The built design is octagonal in plan, roofed by a domical vault with an atrium and a vaulted, square choir (originally linked to the circulation corridor of the hospital) covered by a sail vault, and it has a façade recalling the triumphal arch motif. The theme of centralized versus longitudinal ground-plan also recurred both at S Giacomo at Scossacavalli (with (7) Battista da Sangallo; destr.) in the Borgo of the Vatican and at S Maria di Loreto (1518–22) in the Forum of Trajan, which have centralized plans, inscribed respectively in a rectangular and a square perimeter. Similar to these is the reconstruction (from 1519) of the church of S Marcello al Corso, an initial plan for which was drawn up by Sansovino. Furthermore, Antonio became consultant to the Curatores Viarum, a committee directly under the pope's control that was responsible for the superintendence of urban streets and squares in Rome.

(ii) 1520–35. In 1520 Antonio became architect to the Fabbrica of St Peter's, a position he retained until his death. He was assisted by Peruzzi until 1536. The early 1520s were his most mature and original creative period.

Important works from this time include the restoration of S Giacomo degli Spagnoli and the Serra Chapel in Santa Croce in Gerusalemme; the continuation of work at S Maria di Monte d'Oro (from 1523) near Montefiascone, and S Maria di Loreto; an aedicula with niche and tabernacle known as the *Imagine di Ponte* (corner of the Casa Serra on Via dei Coronari, 1524), an original solution of urban scenography illustrating Antonio's interest in visual backdrops; and the Zecca (Mint; from 1524; see fig. 3) in Rome, considered to be one of his masterpieces. The Zecca reveals his already highly developed mastery of architectural language, rooted in his work with Bramante, Raphael and Peruzzi but also anticipating especially in the façade, some tendencies, later described as Mannerist. He also worked on the partly finished complex of the sanctuary of Loreto, building the dome and Palazzo Apostolico (courtyard and loggias, from 1525) and then the piazza and church façade. Antonio also acted as an adviser on such technical or architectural problems as the dome of Foligno Cathedral as well as completing the loggias di S Damaso in the Vatican and working with his pupil Antonio Labacco and Michele Sanmicheli on the fortifications of Parma and Piacenza.

Antonio's works of this period still display a predilection for the imposition of geometric patterns, well documented in numerous drawings in which he expresses himself in studies of complex geometrical interrelationships. This line of research is best represented by his designs for the fortified palace of Caprarola (1520–21; later Villa Farnese; *see* CAPRAROLA, VILLA FARNESE, §1), in collaboration with Peruzzi. Antonio's close links with other military architects, however, and above all with Sanmicheli—with whom

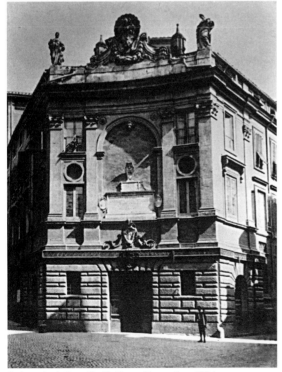

3. Antonio da Sangallo (ii): Zecca, Rome, from 1524

he compiled an important report following their systematic study (1526) of the castles of the Papal States—were instrumental in his developing a taste for all things modern. This transitional phase, which was in advance of much subsequent practice, can be observed in the Capodimonte fortress (1532–43) at Ancona, the intricate drawing for which illustrates the special demands imposed by the ramparts and by the entire fortified bastion and Antonio's innovative architectural solutions, particularly in the ground-plan.

After the sack of Rome (1527), Antonio's economic situation became critical as work opportunities diminished. He used the time to intensify his studies of Vitruvius (*see* VITRUVIUS, §2), and this resulted in the first drafting (the second is dated 1539) of the preface to a proposed commentary on Vitruvius' *On Architecture*. During this period he also produced an extremely interesting group of designs for palazzi, inspired by the antique houses contained in Vitruvius. Only a few of these were built, however, such as the palazzo (much altered) for Giacomo Bernardino Ferrari in Rome. He also made important developments in his designs for funerary monuments. In 1531 he produced a model for the funerary chapel of Piero de' Medici (1471–1503) in the Benedictine abbey of Montecassino, with an octagonal ground-plan, thermal windows influenced by Roman baths and a dome. The internal space is articulated with a sturdy Doric order, a feature that Antonio often used, possibly to demonstrate his dexterity in resolving difficulties described by Vitruvius and also because it satisfied his desire for contrasts and masculine strength. However, as executed, a simple triumphal arch tomb replaced the chapel, a solution that he had developed for the twin tombs of *Leo X* and *Clement VII* in S Maria sopra Minerva. Here a conventional mausoleum had been proposed at the design stage, requiring the total reconstruction of the choir on a horseshoe-plan.

From 1531 to 1532 Antonio worked on S Maria della Consolazione in Todi and the completion of the Late Gothic façade of Orvieto Cathedral. He also undertook numerous fortification works during this period, the most interesting of which was without doubt the Fortezza Alessandra (1533–6; now Fortezza da Basso), built for Duke Alessandro de' Medici (*reg* 1531–7) in Florence. Its interest lies not only in its spectacularly imposing monumentality and military technical functionality but also in its technical and formal achievements (polygonal angle bastions vaulted to support artillery), its well-planned galleried courtyard and the magnificent diamond point and hemispherical rustications used to emphasize the most important bastion. In 1535 Antonio began work on his own house in the Via Giulia. Completed in 1543 and still well preserved, the Casa del Sangallo is particularly interesting for its freedom of invention in contrast with the basic and characteristic decorum of the simple façade.

(iii) From 1536. When Paul III became Pope in 1536, he immediately appointed Antonio as papal architect, instigating a period of great maturity and intense activity. Antonio continued the papal apartments in the Castel Sant'Angelo, and with others he worked intensively on the restoration and strengthening of the entire defensive

system for the walls of Rome. Among the studies for this work, documented by a series of very interesting drawings, notable for their high architectural quality, is the double bastion at Porta Ardeatina with its double flank, in which from 1537 onwards a series of functional spaces were created as well as modernized defences. A different character is evident in the Bastione della Colonnella near Porta San Paolo, an innovative design with a steep escarpment, a device later widely adopted by the Spanish. The Bastione was never completed, partly because of the need to concentrate on the defences of the Leonine walls, a task once again assigned to Antonio in 1542. Meanwhile the strengthening of the fortifications of the Borghi and of Castel Sant'Angelo had become a major point of discussion, which in his unexecuted schemes Antonio designed as closely linked to the Torrione (keep) of Nicholas V (*reg* 1447–55) via the so-called Passetto (destr.). The particular conditions at the different sites required alternative solutions that demonstrated the depth of Antonio's experience and his understanding of expressive architectural values. A particularly interesting solution can be seen at the Porta Santo Spirito, Rome, which again failed to reach completion due to disagreements with Michelangelo, who had become the Pope's military consultant in 1545. This architectural solution, even in its incomplete state, would appear to follow the style already visible in the Zecca, showing a 'mature and energetic classicism' (Bruschi). The same style can be observed in several unexecuted designs for the fortifications of the town of Castro for Pier Luigi Farnese, for which Antonio nevertheless partly built modest but effective defensive works (destr. 17th century). Antonio's gradual maturing as a military architect culminated in the imposing Rocca Paolina (1540–43; destr. 1860) at Perugia, where, despite the practical needs and economic limitations of the project, an efficient system of defence was achieved while retaining a high standard of architecture. Another contemporary work was the fortress at Ascoli.

In 1536 Antonio built 'classical' triumphal arches (designs in Florence, Uffizi) in honour of Emperor Charles V (*reg* 1519–56). Such ephemeral works were characterized by the same subtle use of architectural context displayed in the urban setting of the Palazzo Farnese or of the Zecca in Rome, or again at Castro. Perhaps one of the most obvious characteristics of his work in this respect is the use of streets from which the view is closed by a townscape feature on their axis (for example using the Porta Santo Spirito as a backdrop to the Via della Lungara). Other important works of the late 1530s include the proposed fortress, ducal palace and mint (partially built, from 1538; destr. 1649) at Castro and the project for the church of S Tolomeo (from 1539) at Nepi, a centralized ground-plan (octagonal with crypt), which was abandoned shortly after construction commenced. In 1539 Antonio commissioned Labacco to undertake the famous wooden model (Rome, St Peter's) of St Peter's, a demanding job that required at least seven years to execute. In the meantime he himself constructed the domes for the octagons of St Peter's using the Brunelleschian system of spiral herringbone construction. Completed in 1545, the result, perhaps due to its tardiness, was not altogether convincing, particularly in Michelangelo's view. Work on other projects nevertheless

continued to intensify. In the Vatican Palace Antonio undertook two major rebuilding schemes besides the Cortile del Maresciallo, which acted as a *cour d'honneur*, and the east Corridor of the Belvedere: the Sala Regia (1538–1540) and the new Pauline Chapel (completed 1540). In the Sala Regia, Antonio dispensed with any articulation that used the orders, concentrating instead on the proportioning of the parts in relation to the coffered vault and on the light transmitted by the thermal windows, also used in the Pauline Chapel. This proportional interplay uses a simple geometry based on rectangles and squares under the unifying influence of a great cloister vault.

In the meantime Paul III decided to complete the Palazzo Farnese, dedicated to his only surviving son, Pier Luigi: Antonio was engaged in this work from 1541 until his death. He achieved quite excellent, albeit partial, results, particularly in the spatial design within an urban context, in the disposition of the internal accommodation, in the façade (completed by Michelangelo), in the splendid colonnaded vestibule with its perspective effects, in the majestic courtyard and in the magnificent staircase. Besides many interesting designs for villas, other notable late works include the church of Santo Spirito in Sassia, noted mainly for its façade, which is a forerunner of later Counter-Reformation solutions, and further work on the façade (1540–41) of Orvieto Cathedral. Antonio's last scheme was for the hydraulic works to the River Velino, which involved the resolution of a dispute between the inhabitants of Terni and Rieti, and for which he moved to Piediluco. After his death he was accorded a burial place in St Peter's in Rome, and his coffin was subsequently transferred to S Giovanni dei Fiorentini.

2. Working methods and technique. Countless drawings survive, many of them in Antonio's own hand, others carried out or embellished by others of his circle. Most of these are now in the Galleria degli Uffizi, Florence. They reveal more than any other document his very personal way of describing and communicating architectural forms. In his drawings Antonio expressed himself fundamentally through brief plans often taken at various levels with projections of the significant elements in order to show the relevant architectural features; in the organization of space he used devices including symmetry, studies of geometry scaling, proportion, structural elements, the system of the orders and various building types. His working method was developed through the patient comparison of alternative, even at times diametrically opposed, proposals, generally conceived with creative flair and economy of line, a method that occasionally led, however, to somewhat unsatisfactory results.

During this process new inventions and references to the Antique (with particular interest in theatres, amphitheatres and baths), to the traditions of 15th-century Florence and reminiscences or sympathy for the medieval tradition are tied inextricably to each other in a complex web of stimuli and reflections. For his open-minded use of original details, for his search for effects of contrast and contradiction, Antonio has often been described as Mannerist. Some of his major design schemes, for instance the wooden model for St Peter's or the complex of Villa Madama and its garden, or S Giovanni dei Fiorentini, have

been the subject of continuous study and in themselves have become a precise reference point in the history of architecture and typological research.

Antonio devoted a great deal of time to the study of Vitruvius, most intensely between 1513 and 1530, with particular reference to the geometric and typological aspects of Vitruvian practice. This concentrated interest of his is evident in the numerous studies of an exclusively geometrical nature and from the continual efforts made in order to visualize buildings simply in a planimetric and two-dimensional form.

3. CRITICAL RECEPTION AND POSTHUMOUS REPUTATION. Opinions on the work of Antonio have always been heavily influenced, to some extent negatively, by the judgement of Vasari, who, although he appreciated his gifts as a practising architect and as a flawless master of building technology and of restoration, placed Antonio on a lower level than such figures as Brunelleschi, Peruzzi, Raphael and Michelangelo, particularly because his background did not include any formal study of the art of drawing. The influence of Vasari's critique was felt up to Gustavo Giovannoni and beyond. More recently, however, it has been considered important to re-evalute the logic of Vasari's conclusions and to set Antonio in the context of his own cultural climate.

After the dissolution of the Setta Sangallesca, Antonio did not have a successor. His followers, however, included Nanni di Baccio Bigio, Guidetto Guidetti and perhaps Giacomo della Porta. Despite the doubts expressed by numerous critics, Antonio exercised an enormous, albeit diffuse, influence on generations of architects. His pragmatic and essential approach was highly regarded in the 19th century especially, appropriate as it was for a bourgeois architectural taste that was sensitive to the value of 'utilitas' and 'firmitas', while lacking in neither 'decor' nor 'venustas'. Many other architectural developments have been inspired by the ideals of typological simplification and the paradigms set out by Sangallo. In the 20th century many art historians re-examined Antonio's work from new angles, and these important reassessments in turn paved the way for new studies to be carried out.

BIBLIOGRAPHY

DBI

A. Bertolotti: 'Nuovi documenti intorno all'architetto Antonio di Sangallo il Giovane e alla sua famiglia', *Buonarotti*, iv (1892), pp. 278–86
G. Giovannoni: *Antonio da Sangallo il Giovane*, 2 vols (Rome, 1959)
C. L. Frommel: *Der römische Palastbau der Hochrenaissance* (Tübingen, 1973)
F. P. Fiore: 'Castro, capitale farnesiana, 1537–1649: Un programma di "instauratio" urbana', *Quad. Ist. Stor. Archit.*, xxii (1975), pp. 127–32
M. Heinz: 'Das Hospital S Giacomo in Augusta in Rom: Peruzzi und Sangallo', *Stor. A.*, 41 (1981), pp. 31–49
S. Benedetti: *Fuori dal classicismo: Sintetismo, tipologia, ragione nell' architettura del cinquecento* (Rome, 1984)
F. H. Jacobs: *Studies in the Patronage and Iconography of Pope Paul III, 1534–49* (London, 1984)
Atti del XXII congresso di storia dell'architettura, Centro di Studi per la Storia dell'Architettura. Antonio da Sangallo il Giovane, la vita e l'opera: Roma, 1986
L. Di Mauro: 'Domus Farnesiana amplificata est atque exornata', *Palladio*, n. s. 1 (1988), pp. 27–44
S. Benedetti: 'L'officina architettonica di Antonio da San Gallo: La cupola per il San Pietro di Roma', *Quad. Ist. Stor. Archit.*, n.s., fasc. 15–20 (1990–92)

C. Jobst: 'La ricostruzione dell'Arco di Tito a Roma nei disegni del primo Cinquecento: Il Codex Coner e Antonio da Sangallo il Giovane', *Disegni d'archivio negli studi di storia dell'architettura: Napoli, 1991*, pp. 31–7
P. N. Pagliara: 'Antonio da Sangallo e gli ordini', *L'Emploi des ordres à la Renaissance* (Paris, 1992)
M. Tafuri: *La ricerca del rinascimento: Principi, città, architetti* (Turin, 1992)
C. Frommel and N. Adams, eds: *The Drawings of Antonio da Sangallo the Younger and his Circle* (New York, 1994)
C. L. Frommel: *Palazzi Romani del rinascimento* (in preparation)
R. Schofield: 'Frommel sul disegno di Antonio da Sangallo il Giovane', *Dis. Archit.*, x (1994), pp. 27–9

ANNAROSA CERUTTI FUSCO

(5) Giovan Francesco da Sangallo (*b* Florence, 1484; *d* Florence, 1530). Architect, brother of (3) Bastiano da Sangallo and nephew of (1) Giuliano da Sangallo and (2) Antonio da Sangallo (i). He was probably educated by Giuliano, whose heir he became. He no doubt followed his uncle to Rome on the election of Pope Leo X (*reg* 1513–21), since from October 1513 he worked as an overseer and surveyor for Giuliano Leno at St Peter's. Here, in 1519, he also worked as an architect on the adaptation of the lantern (1513; destr. 1592) built by Bramante to protect the high altar. In the meantime, he prepared a careful measured survey of the monuments of ancient Rome, a practice common to all the members of his family. He also carried out estimates for building work both private (such as the Chigi stables, 1518) and public (S Maria della Navicella, 1519). From 1515 he worked on the Villa dei Papi at La Magliana, near Rome, initially preparing estimates for work executed by Leno and, in 1519, completing the Aviary. He then worked, still with Leno, until March 1520 on the Papal Stables at Palo.

Around this time Giovan Francesco became friendly with and also possibly assisted Raphael, probably through the intervention of the Florentine cardinal Giannozzo Pandolfini; drawings in Giovan Francesco's hand exist of such architectural works by Raphael as the Palazzo Alberini and Villa Madama, both in Rome. On Raphael's death (1520) Giovan Francesco returned to Florence to direct the first phase of works on the palazzo that Raphael had designed for Cardinal Pandolfini. After returning to Rome in January 1521, he worked from March to November again at La Magliana, principally on the completion of the plumbing and waterworks. However, in April he travelled to Campiglia in the Apuan Alps to choose marble for use at St Peter's. This journey may have been the catalyst for the launch, with the help of his brother Bastiano, of a lucrative business supplying building materials for St Peter's.

In 1525, Giovan Francesco had a disagreement with Leno, and the following year he was replaced by Bastiano as quantity surveyor at St Peter's, where his cousin (4) Antonio de Sangallo (ii) had taken over as architect. After the sack of Rome in 1527 work in the city, including that at St Peter's, began to slow down, and Giovan Francesco returned to Florence, where he began working intensely, primarily on military architecture but also devoting much time to the study of Vitruvius. In December of that year he was engaged firstly on the fortress of Montepulciano and then on the restoration of the bridge at Valiano. In February 1528 he visited the fortress at Livorno, and in June he was called to Cortona to complete two large towers. During the spring of the same year he resumed

work at the Palazzo Pandolfini, overseeing the construction of the façade on to Via San Gallo and perhaps drawing up a design for a reduced scheme compared with Raphael's original proposals. The typically Florentine loggia facing the courtyard is probably by him.

In January 1529 Giovan Francesco visited the fortifications of Borgo San Sepolcro (now Sansepolcro), and in May he was in Pisa dealing with the damage caused by the flood of the River Arno. Meanwhile, with the help of Bastiano, he continued to direct the construction of the Palazzo Pandolfini. However, probably due to a life spent in much travelling and hard work, he fell ill and died, leaving the completion of the Palazzo to his brother. On the basis of stylistic considerations and the fact that in 1519 he prepared an estimate of the almost completed work, the Palazzo Balami–Galitzin in Rome has been attributed to Giovan Francesco. This would confirm the view that he was one of the first to continue the architectural tastes created by Raphael, although he had no great creativity of his own. He was nevertheless an able draughtsman and, as a military engineer, a good builder, hardened by long experience at St Peter's.

UNPUBLISHED SOURCES

Florence, Uffizi [architectural drgs]
Lisbon, Mus. N. A. Ant. [architectural drgs]

BIBLIOGRAPHY

G. Gaye: *Carteggio inedito d'artisti dal sec. XIV al XVI*, ii (Florence, 1840), pp 165–88
K. Frey: 'Zur Baugeschichte des St. Peter', *Jb. Kön.-Preuss. Kstsamml.*, xxxi (1910)
M. Dezzi Bardeschi: 'L'opera di Giuliano da Sangallo e di Donato Bramante nella fabbrica della villa papale della Magliana', *L'Arte*, iv/15–16 (1971), pp. 136, 141, 171–3
T. Buddensieg: 'Bernardo della Volpaia und Giovanni Francesco da Sangallo: Der Autor des Codex Coner, und seine Stellung im Sangallo-Kreis', *Röm. Jb. Kstgesch.*, xv (1975), pp. 89–108
G. Spini: 'I primi libri sopra l'instituzioni de' greci et latini architettori . . .', in *Il disegno interrotto: Trattati medicei d'architettura*, ed. C. Acidini (Florence, 1980), p. 51
P. Ruschi: 'Vicende costruttive del Palazzo Pandolfini nell'arco del cinquecento: Documenti e ipotesi', *Raffaello e l'architettura a Firenze nella prima metà del cinquecento* (exh. cat., ed. A. Calvani; Florence, Pal. Pitti, 1984), pp. 27–64
C. L. Frommel: 'Giovanfrancesco da Sangallo, architetto di Palazzo Balami-Galitzin', *Antonio da Sangallo il Giovane: La vita e l'opera*, ed. G. Spagnesi (Rome, 1986), pp. 63–9
C. L. Frommel and N. Adams, eds: *Fortifications, Machines and Festival Architecture*, i of *The Architectural Drawings of Antonio da Sangallo the Younger and his Circle* (New York, Cambridge, MA, and London, 1994), pp. 40–43

ADRIANO GHISETTI GIAVARINA

(6) Francesco da Sangallo (*b* 1 March 1494; *d* 17 Feb 1576). Sculptor and architect, son of (1) Giuliano da Sangallo. In 1504 he accompanied his father to Rome, where he was present with his father and Michelangelo in 1506 at the discovery of the *Laokoon* (now Rome, Vatican, Mus. Pio-Clementino). This experience had a significant impact on the formation of his style, which was uncharacteristic among Italian 16th-century sculptors because of its physiognomic and textural realism and emotional expressionism. In the 1520s Francesco worked as an assistant to Michelangelo in the New Sacristy, S Lorenzo, Florence, for which he carved the marble friezes of decorative masks on the walls behind the sarcophagi (*in situ*). His earliest independent and dated work is the marble

group of the *Virgin and Child with St Anne* (1522–6; see fig.) in Orsanmichele, Florence. His subsequent Florentine works include an undated marble bust of *Giovanni de' Medici* (Florence, Bargello), the marble tomb of the *Abbess Colomba Ghezzi* (commissioned 1540; Florence, Mus. Bardini), the marble funerary monument to *Angelo Marzi, Bishop of Assisi* (1546; Florence, SS Annunziata) and the marble monument of *Paolo Giovio* (1560) in the cloister of S Lorenzo (now Florence, Bib. Medicea–Laurenziana). There is also a self-portrait relief (1542) in S Maria Primerana at Fiesole.

Francesco also worked in Loreto and Naples, collaborating with Niccolò Tribolo and Domenico Aimo from 1531 to 1533 on a relief of the *Death of the Virgin* for the Santa Casa, Loreto Cathedral (*see* LORETO, fig. 3), and with Matteo da Quaranta on the decoration (1546) of the Sanseverini Chapel in SS Severino e Sosio, Naples. As an architect, he worked on the fortifications of Prato and Pistoia in 1528 and at Fucecchio in 1530; after 1529 he served as the Capomaestro Generale of the fortifications of Florence. Around 1542 he was working in St Peter's, Rome, either as a sculptor or an architect, and in 1543 he succeeded Baccio d'Agnolo as the Capomaestro of Florence Cathedral. He designed a campanile for Santa Croce, Florence, in 1549, but only the first storey was constructed (destr. 1854), and in the 1560s he provided the designs for the monumental altar tabernacles that formed part of Vasari's renovation of the same church. Around this time he was also one of the founder-members of the Accademia del Disegno in Florence. His last known work is the marble portrait relief of *Francesco del Fede* (1575; Fiesole, S Maria Primerana).

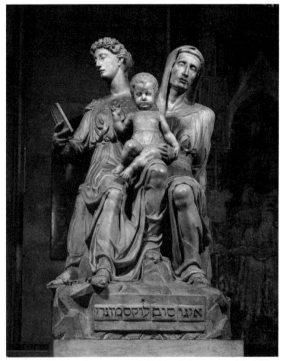

Francesco da Sangallo: *Virgin and Child with St Anne*, marble, 1522–6 (Florence, Orsanmichele)

BIBLIOGRAPHY

U. Middeldorf: 'Portraits by Francesco da Sangallo', *A.Q.* [Detroit], i (1938), pp. 109–38

D. Heilkamp: 'Ein Madonnenrelief von Francesco da Sangallo', *Berlin Mus.: Ber. Staatl. Mus. Preuss. Kultbes.*, n. s., viii (1958), pp. 34–40

J. Pope-Hennessy: *Italian High Renaissance and Baroque Sculpture* (New York, 1985), pp. 255–6

ROGER J. CRUM

(7) (Giovanni) Battista da Sangallo [Giovanni Battista Cordiani] (*b* Florence, 1496; *d* Rome, ?20 Oct 1548). Architect and theorist, brother of (4) Antonio da Sangallo (ii) and nephew of (1) Giuliano da Sangallo and (2) Antonio da Sangallo (i). Known as 'il Gobbo' (It.: 'the hunchback'), he acted as a quantity surveyor and builder's estimator on a wide variety of schemes, ranging from the construction of St Peter's, Rome, to small private commissions. The few architectural works that have been recorded as entirely his work have all, with one exception, been altered or destroyed. Above all, however, he was of invaluable assistance to his brother Antonio, who according to Vasari never fully appreciated Battista's contribution. It is through this collaboration, and his study of Vitruvius (*see* VITRUVIUS, §2), that Battista's artistic achievement can be judged.

1. ARCHITECTURAL PROJECTS. Battista began working with his brother Antonio in Rome *c.* 1515. During his apprenticeship he played an ill-defined role in projects for which Antonio had been commissioned. In 1526 Battista may have joined his brother, along with Michele Sanmicheli, Antonio Labacco and others, in inspecting the castles of Romagna. One of the finished drawings relating to these castles is in Battista's hand, but he may have drawn it later in Rome. Vasari records that between 1527 and 1534 Antonio was engaged in 'five major projects ... in various locations' and was able to handle the work only 'with the help given him by Battista'. From 1528 to 1529, for example, Battista was in Loreto, supervising the lead cladding of the dome of the basilica, a job that Antonio had previously undertaken. For the Fortezza Alessandra (now Fortezza da Basso) in Florence, where Antonio was employed in 1533, a sketch in Battista's hand (Florence, Uffizi, A779) survives, as well as a few finished drawings.

During the early 1530s Battista also worked in Rome as a surveyor and estimator, beginning with St Peter's, where his brother, in his capacity as architect, introduced him. During the same period he began occasionally to undertake projects independently for Roman branches of such Florentine families as the Salviati and the Strozzi. These families were related to the Medici, to whom the Sangallo family was closely linked. In 1532 he produced designs for the tomb of *Ludovico Grati Margani* (see fig. 1) in S Maria in Aracoeli in Rome. It is the only surviving recorded architectural work that Battista carried out on his own. In the same year he designed a tomb to be executed by the mason Bernardino di Giacomo da Morco. The ensemble is formed by three superimposed prisms, resulting in a stepped pyramid reminiscent of Roman funeral pyres and certain ancient mausolea, and the individual parts—in particular the upper section, which supports a *Risen Christ*—are a paraphrase of an ancient funeral altar that was then preserved in the church. Battista and Antonio

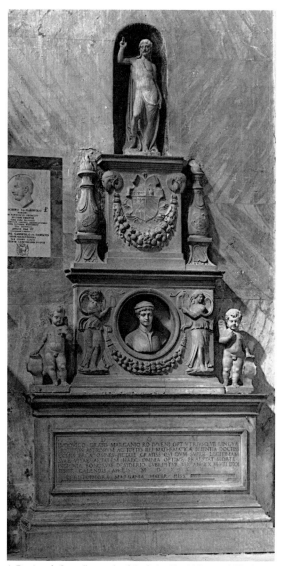

1. Battista da Sangallo: tomb of *Ludovico Grati Margani*, 1532 (Rome, S Maria in Aracoeli)

later developed this theme in their studies for the tomb of *Clement VII*.

In 1533–4 Lorenzo Salviati had converted into a residence for his own use a house that he had recently bought in Rome, and in 1535 he paid Battista for drawings prepared for works here. For the Strozzi family Battista provided further drawings (1540) for alterations to the Castello di Lunghezza, near Rome, formerly owned by the Salviati. Still visible there are windows with surrounds similar to those designed by Antonio for his own house in Via Giulia, Rome. Battista was also highly regarded as a specialist in fortification works and as an expert builder: a fragment of a study for the fortifications of Rome (Rome, Bib. Accad. N. Lincei & Corsiniana) proves his involvement in this project (begun 1537), controlled by Antonio.

The nature of Battista's collaboration with his brother can be better understood through the designs (before

2. Battista da Sangallo: designs for the Medici tombs, S Maria sopra Minerva, Rome, before 1536 (Florence, Galleria degli Uffizi)

1536; see fig. 2) for the Medici tombs in the Roman church of S Maria sopra Minerva. Battista surveyed and drew up a plan (Florence, Uffizi, A1661) of the choir, where it had initially been intended to raise a free-standing monument. The sketch for this (Florence, Uffizi, 185) is in Antonio's hand. Meanwhile Battista worked in Rome, drawing and measuring antique bowls to be included as urns in the Medici monument (Florence, Uffizi, A184), and he executed the finished drawing for his brother's design (Florence, Uffizi, 183). He also continued occasionally to work alongside his brother at the Vatican Palace. From 1542 Battista was paid as chief master builder in partnership with Giacomo da Brescia for the execution of the large barrel vault of the Aula Regia and from then until 1547 for works in other parts of the palaces and in the archives of the apostolic see. With his brother Battista was a member of the group of artists who in 1542 founded the Congregazione di S Giuseppe based in one of the chapels in the Pantheon. The aims of this brotherhood were religious devotion and mutual assistance, as well as providing a focus for discussing antiquarian subjects.

2. STUDY OF VITRUVIUS . For many years Battista laboured on Vitruvius' *On Architecture*. He made one almost complete translation, and then, dissatisfied with the result, he started again, translating more than half the treatise afresh. He also made a copy of the first printed edition of Vitruvius (*c.* 1486), which he annotated and

enlarged in the margins and on separate sheets, with accurate diagrams, towards the end of the 1530s at the latest. Since Antonio prepared in 1539 the preface to a translation of Vitruvius that he intended to undertake, the studies of the two brothers were obviously closely linked. However, Battista frequently interpreted Vitruvius in a different way from Antonio, at least with regard to detail, for example in basilicas, Greek houses and Ionic trabeation.

Although the translation reveals Battista's difficulties in understanding the Latin text, his drawings demonstrate the way in which his knowledge of ancient architecture assisted him in interpreting Vitruvius. Less diagrammatic than those in Fra Giocondo's edition (1511), Battista's drawings frequently have a classical nuance lacking in Cesare di Cesariano's work (1521), and they anticipate the edition prepared by Daniele di Barbaro in 1556. The Doric temples, for example, correctly have columns without bases and with single fascia architraves. Battista's main interest lay in Books III–VI, dealing with temples, the orders, types of dwellings, theatres and other public buildings, all subjects through which he sought with the aid of Vitruvius to create a new architecture based on antiquity. The same desire for studying antique architecture in order to understand, supplement and rationalize Vitruvius is evident in his survey drawings (Florence, Uffizi) of monuments, where his interest lies in the plans and elevations of particular building types rather than in the

decorative details. These drawings also demonstrate Battista's collaboration with Antonio, who at times referred to his brother's research in order to check a Vitruvian rule.

One of Battista's last writings on Vitruvius is a letter to Pope Paul III (*reg* 1536–49) after Antonio's death (1546) berating proposals by Michelangelo—although he is not mentioned by name—for his cornice added to Antonio's Palazzo Farnese, Rome. Battista uses pedantically Vitruvian arguments derived from his own translation of *On Architecture* to request that his brother's work be maintained. In his will Battista left all his Vitruvian papers to the Confraternità della Misericordia in S Giovanni Decollato, from where they were subsequently passed to the Biblioteca Corsiniana in the 18th century.

UNPUBLISHED SOURCES

Florence, Uffizi [drgs]
Rome, Bib. Accad. N. Lincei & Corsiniana, MSS Cors. 1846 and 2093 [trans. of Vitruvius]; Inc. 50–F–1 [annotated copy of Vitruvius]

BIBLIOGRAPHY

G. Philandri: *...in decem libros M. Vitruvii de architectura annotationes* (Rome, 1544), p. 169
C. Ravioli: *Notizie sui lavori d'architettura dei nove da Sangallo* (Rome, 1863), pp. 16, 35–46
P. N. Ferri: *Indice dei disegni di architettura ... nella Galleria degli Uffizi* (Rome, 1885)
C. Pinzi: 'Memorie e documenti inediti sulla basilica di S Maria della Quercia in Viterbo', *Archv Stor. A.*, ii (1890), pp. 300–32
A. Bartoli: *I monumenti antichi di Roma nei disegni degli Uffizi di Firenze*, 6 vols (Rome, 1914–22), iv, pls 301–40; vi, pp. 92–104
G. De Angelis d'Ossat: 'L'autore del codice londinese attribuito ad Andrea Coner', *Palladio*, n. s., i (1951), pp. 94–8
G. S. Hamberg: 'G. B. da Sangallo detto il Gobbo e Vitruvio', *Palladio*, n. s., viii (1958), pp. 15–21
O. Fasolo: 'Contributo ad Antonio e G. B. da Sangallo', *Quad. Ist. Stor. Archit.*, 31–48 (1961), pp. 159–68
R. E. Keller: *Das Oratorium von S. Giovanni Decollato in Rom* (Rome, 1976), pp. 16, 32
O. Vasori: *I monumenti antichi in Italia nei disegni degli Uffizi* (Rome, 1981), pp. 156–79
P. N. Pagliara: 'Alcune minute autografe di G. B. da Sangallo', *Archit. Archiv*, i (1982), pp. 25–51
——: 'Vitruvio da testo a canone', *Memoria dell'antico nell'arte italiana*, ed. S. Settis, 3 vols (Turin, 1984–6), iii, pp. 3–85
G. Morolli: *L'architettura di Vitruvio: Una guida illustrata* (Florence, 1988)
P. N. Pagliara: 'Studi e pratica vitruviana di Antonio da Sangallo il Giovane e di suo fratello Giovanni Battista', *Les Traités d'architecture de la Renaissance* (Paris, 1988), pp. 179–206

PIER NICOLA PAGLIARA

San Gimignano. Town in Tuscany, Italy. It overlooks the valley of the River Elsa, *c.* 37 km south-west of Florence and *c.* 28 km north-west of Siena, and straddles the ancient Via Francigena, an important trading and pilgrimage route from Lombardy to Rome. San Gimignano flourished during the 13th and 14th centuries and still retains the character of a medieval walled hill-town dominated by tall towers. Fine works by 14th-century Sienese and 15th-century Florentine artists are preserved in the town.

There were Etruscan settlements in the area of San Gimignano, but the earliest dated record of a place of that name is a document of AD 929 granting Abelardo, Bishop of Volterra, rights over a hill at San Gimignano. According to legend, the name derived from a miraculous vision of St Giminianus, Bishop of Modena (*d* 387), that saved the inhabitants of the area from marauders (*c.* 5th century AD). Popular devotion to the saint probably led to the

founding of an oratory dedicated to him, around which a settlement grew. A mercantile economy based on wool, wine and saffron ensured the town's growth.

In the 12th century the people of San Gimignano challenged the Bishop of Volterra's rule and established the Commune. The wealthier families exercised considerable corporate influence through the Commune, which became responsible for the town's main civic and religious buildings and introduced strict regulations to control the type and scale of buildings. Materials used included local travertine stone, bricks manufactured in the valley and imported marble. Private patronage was also linked with public interest, for example in the construction of palaces and the endowment of chapels in churches of the mendicant orders.

Important families built fortified tower houses that fulfilled practical and prestigious ends and provided effective defence against attack from without and within the town walls. The towers of such families as the Ardinghelli (Ghibelline) and the Salvucci (Guelph) reflected their continual rivalry. In the 14th century San Gimignano boasted 72 towers, of which 15 have survived. When Florence annexed the town in 1353, a new castle, the Rocca, was built on the west side. This was later extended and the town walls reinforced at the behest of Cosimo I de' Medici, Grand Duke of Tuscany (*reg* 1569–74).

During the 15th century the emphasis in art patronage shifted from Sienese artists, who had been favoured in the 14th century, to Florentine masters. Giuliano da Maiano redesigned the east end of the Collegiata Pieve (1466–8) to accommodate a larger choir, transept and chapels. His brother Benedetto da Maiano sculpted the ciborium for the high altar and the altar for the chapel of St Fina (*see* MAIANO, DA, (2)). Frescoes of the *Life of St Fina* were painted in the chapel (1477–8) by Domenico Ghirlandaio (*see* GHIRLANDAIO, (1), fig. 1) assisted by his brother-in-law Sebastiano Mainardi. An outbreak of plague in 1464 prompted the Commune to commission from Benozzo Gozzoli a votive image of *St Sebastian* below the *Last Judgement* on the inside wall of the façade. Gozzoli painted another *St Sebastian* in S Agostino (1280–98), in the north of the town, which is the only mendicant church and monastery to remain intact. Here he also painted a fresco cycle of the *Life of St Augustine* (1463–5) in the choir (*see* GOZZOLI, BENOZZO, fig. 2), and Piero del Pollaiuolo painted the high altarpiece of the *Coronation of the Virgin* (1483, *see* POLLAIUOLO, (2), fig. 2). Benedetto da Maiano designed a new chapel (1492–4) to house the relics of St Bartholomew (1228–1300). Mainardi and Vincenzo Tamagni were the most celebrated San Gimignanese artists. In addition to frescoes throughout the town, such as those by Mainardi in the chapel of St Bartholomew in S Agostino, examples of their work, some of which were removed when the town's convents and monasteries were suppressed in the Napoleonic era, are displayed in the Pinacoteca Civica and the Museo d'Arte Sacra.

San Gimignano began to decline after its annexation by Florence. As Florentine citizens, San Gimignanese could matriculate freely into that city's guilds, which encouraged the steady migration of the working population from the town. As a result, the character of the town changed little

from that established in the 14th century, the period of its greatest prosperity.

BIBLIOGRAPHY

G. V. Coppi: *Annali, memorie et huomini illustri di San Gimignano* (Florence, 1695)

L. Pecori: *Storia della terra di San Gimignano* (Florence, 1853)

E. Fiumi: *Storia economica e sociale di San Gimignano* (Florence, 1961)

E. Carli and J. V. Imberciadori: *San Gimignano* (Milan, 1987)

D. Krohn: *Civic Patronage of Art in Renaissance San Gimignano* (diss., Cambridge, MA, Harvard U.)

AILSA TURNER

San Giorgio, Eusebio da. *See* EUSEBIO DA SAN GIORGIO.

Sanmicheli [Sammicheli; Sanmichele; da San Michiel] **(da Verona), Michele** (*b* Verona, *c.* 1487; *d* Verona, Aug 1559). Italian architect and engineer. He was one of the most gifted and versatile architects of the generation to follow Bramante, and together with Giulio Romano and Sansovino he brought to North Italy the *all'antica* High Renaissance style of architecture established in Rome during the early 16th century. He adapted this style to traditions in domestic and ecclesiastical architecture that were prevalent in his native Verona and in Venice. He was much employed as a military architect, and his gateway designs, which gave towns a modern and dignified outward appearance, helped considerably to revitalize the image of the Venetian state after the damaging wars of the League of Cambrai (1508–17). Almost all Sanmicheli's buildings reveal a new sensitivity to the possibilities of stonework, with a subtlety and refinement of detailing usually contrasted to great effect with bold, massive forms conceived in terms of receding planes, and a wide variety of surface textures together with a judicious but liberal application of sculptural ornament.

1. Life and work. 2. Critical reception and posthumous reputation.

1. LIFE AND WORK.

(i) Rome and Orvieto, before *c.* 1526. (ii) Verona and Venice, *c.* 1526–59.

(i) Rome and Orvieto, before c. *1526.* Sanmicheli was born into a family of Lombard masons originally from the vicinity of Porlezza, near Lake Como. His father, Giovanni Sanmicheli, and his uncle, Bartolomeo Sanmicheli, worked on the sculptural decoration of the Loggia del Consiglio (begun 1476), Verona. Vasari implied that Sanmicheli was born in 1483/4 when claiming that he moved to Rome in 1500 at the age of 16, but documentary evidence suggests a slightly later date of birth and a transfer to Rome in 1505 at the earliest. By this time Sanmicheli had probably become an accomplished mason, and he may have been lured to Rome in the hope of becoming involved in the major commissions that Pope Julius II awarded to Bramante from 1505. At the outbreak of the wars of the League of Cambrai, Sanmicheli chose to remain in Central Italy, and in 1509 he was working at Orvieto, where he was subsequently appointed *capomaestro* to the cathedral.

Sanmicheli's contribution to Orvieto Cathedral was limited to the upper reaches of the façade, in particular to the crowning gable (begun 1513), which he continued in the style of the pre-existing Gothic work below. This work drew more on his skills as a mason and as a manager of a large workforce than as a designing architect. In the right-hand aisle of the cathedral, however, he designed the ornate architectural framework to the sculpted altarpiece of the *Adoration of the Magi* by Raffaello da Montelupo, known as the Cappella dei Magi (begun 1514; completed after 1528). Both its composition and decoration reveal Sanmicheli's affinities with Lombard masons. The paired pilasters rising to the springing level of the central arch, the attic above crowned with a pediment restricted to the central bay, and the geometric inlay work all recall contemporary works by the leading Lombard architects active in Venice, such as Pietro Buon's high-altar tabernacle in S Rocco (*c.* 1520). Yet the greater rigour of composition and greater orthodoxy in the exquisitely carved detailing and sculptural ornamentation are much more indebted to the contemporary architecture of Rome.

Among other works in and around Orvieto, Sanmicheli designed an elaborate floor-tomb (1516; frags in Orvieto, Mus. Opera Duomo) for the Petrucci family in S Domenico, and the subterranean chapel constructed beneath it. The chapel has an octagonal plan with folded pilasters in the corners and an arrangement of round- and square-ended niches, which he was later to employ again for the chapel at the Villa della Torre at Fumane, near Verona, and for the Madonna di Campagna, Verona. Soon afterwards Sanmicheli was involved in the construction of the cathedral church of S Margherita (*c.* 1519; restored after a fire by Carlo Fontana, 1670–74) at Montefiascone. The church, which rises from an octagonal substructure built in the late 15th century, has an enormous domed interior also of octagonal layout with semicircular chapels, folded Doric pilasters in the angles, and an arrangement very similar to that of S Maria di Loreto (1518–22), Rome, by Antonio da Sangallo (ii).

While working on schemes at Orvieto, Sanmicheli probably gained some experience as a military architect, because by 1526 he was sufficiently well respected to be appointed a member of a commission led by Antonio da Sangallo (ii) to inspect the defences of the Papal States. Soon afterwards, according to Vasari, Sanmicheli decided to examine the fortifications of the Veneto, where he was promptly arrested on suspicion of spying, but once the Venetians had appreciated his capabilities as a military engineer they offered him employment (*see* §(ii)(c) below).

(ii) Verona and Venice, c. 1526–59.

(a) Domestic and public buildings. (b) Ecclesiastical buildings. (c) Fortifications and gateways.

(a) Domestic and public buildings. Meanwhile, Sanmicheli had settled in Verona by the winter of 1526–7 and was immediately in demand as an architect for private commissions. Among his early patrons was Ludovico Canossa, Bishop of Bayeux and a prominent figure at the court of Pope Leo X in Rome, who was undoubtedly one of the most enthusiastic supporters of Sanmicheli's Rome-inspired architecture. Canossa commissioned Sanmicheli to design a new palace for his family, built from *c.* 1530 on one of Verona's main thoroughfares (now Corso Cavour; *see* VERONA, §1). As completed (1667–75; see fig. 1), the Palazzo Canossa is U-shaped in plan, backing on to the

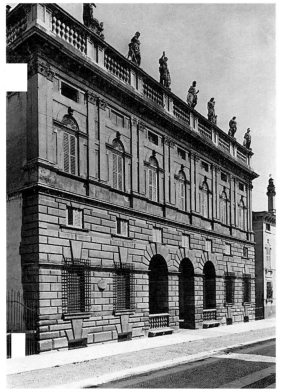

1. Michele Sanmicheli: façade of the Palazzo Canossa, Verona, from *c*. 1530 (completed 1667–75)

River Adige. This arrangement need not, however, reflect the intentions of Sanmicheli, who may well have proposed a block layout with a fully enclosed courtyard of either square or rectangular shape. The symmetrical planning at the front, with a triple-arched vestibule preceding a spacious open entrance hall, closely resembles Sangallo's unexecuted design (*c*. 1530; Florence, Uffizi, MS. A969) for the Palazzo Pucci in Orvieto. With its apartment suites to either side of a *salone* located at the centre of the façade, such a model would presumably have appealed to a Veronese patron accustomed to the traditional tripartite plan of the Veneto region. The monumental two-storey, seven-bay façade of stuccoed brickwork follows the basic format of Bramante's pioneering Palazzo Caprini (*c*. 1510) in Rome, although the design is more complex and varied, reflecting the influence of Giulio Romano. The basement is clad in channelled ashlar-work, with slightly projecting keystones and with small sections at the mezzanine level omitted. The *piano nobile* is also conceived as a number of superimposed planes; the impost mouldings of the arched windows continue on either side as far as the paired Composite pilasters and, in a simplified form, between them, to create a series of recessed panels. Compared with the Palazzo Caprini, the upper storey has been monumentalized by raising the order to incorporate a mezzanine level, as in Raphael's Villa Madama (begun 1518), Rome, and Giulio Romano's Palazzo del Te (begun 1525), Mantua. The pilasters themselves are coupled more closely together for the three central bays of the *salone*, while at either end the terminal corner pilasters project forwards

slightly further and overlap their partners: an unusual arrangement reflecting the integration of the façade-type of Bramante with a Veneto tripartite plan. The superimposed Doric order of the courtyard elevations is derived from the local Roman arena, and the distinctive capitals have their models in the same building. A dependence on the imposing but often highly unorthodox local antiquities, monuments that locally were held in the highest esteem but that appalled such critics as Serlio, continued to play an important part in Sanmicheli's later work.

Soon after his work on the Palazzo Canossa, before 1534, Sanmicheli was commissioned to redevelop the frontal section of the Palazzo Bevilacqua in Verona, an enormous medieval complex also facing on to the present Corso Cavour. The patrons were Antonio Bevilacqua and his brother Gregorio, who had married Ludovico Canossa's niece. The medieval layout, with a forecourt bounded at the right by a residential wing and at the front by a curtain wall, was mostly retained, although an upper-floor *salone* was added to the rear of the frontal wall, to which was applied a new seven-bay façade. The original intention was probably to acquire the adjoining site so as to extend the façade to 15 bays and provide suites of matching accommodation for the joint patrons, a scheme with precedents locally and elsewhere. Even as built, the façade, which was the first in Verona to be faced entirely in stone, is one of the most spectacular and rhythmically complex of the period (for illustration *see* VERONA). The arched bays of the rusticated lower storey alternate in width and are divided by banded Doric pilasters that support an entablature, with triglyphs ingeniously made into corbels to support a continuous balcony, an idea derived from Baldassare Peruzzi or Serlio. The outlandish *piano nobile* above is close in composition to that of Sansovino's elaborate design for the Scuola della Misericordia (1531), Venice, with its alternating large and small arched openings, although rhythmically it is much more complex, with pairs of half columns that have alternately straight and spiral fluting, and arches in the minor bays that are crowned with either triangular or segmental pediments. In its detailing and overall complexity the design of the façade is heavily indebted to the Roman Porta dei Borsari near by, with its elaborate combinations of vertically and spirally fluted shafts, arched openings and triangular and segmental pediments that alternate, like those of the Palazzo Bevilacqua, not singly but, most unusually, in pairs.

Perhaps a little later than the Palazzo Bevilacqua was the Palazzo Pompei (previously Lavezola; ?1530s), Verona; the restrained seven-bay stone-faced façade of which has a rusticated basement with arched openings and an upper floor with fluted Doric half columns, a combination that appears in Giovanni Caroto's drawn reconstruction (1540) of the Roman theatre in Verona. The half columns are paired with pilasters at the corners, a favourite device of Sanmicheli borrowed from the Basilica Aemilia in Rome, and the arched windows between them are embellished with keystones carved as grotesque masks. From the slightly wider central bay a splendid lunette-vaulted entrance hall leads through to a courtyard, bordered on three sides by arcades, carried rather uncanonically by freestanding columns, with an upper storey where tall arched

windows with massive rough-hewn keystones repeat the shape of the more refined windows of the façade.

In Venice, where Sansovino was *de facto* official architect, Sanmicheli began to receive private commissions only in the 1540s. He redesigned the entrance hall (1542) of the Palazzo Corner-Spinelli, then owned by Giovanni Cornaro, for whom he subsequently designed a new palace, the Palazzo Corner (Campo S Polo; *c*. 1550). The unusual but resourceful composition of its façade derives in part from its tall proportions and from an internal plan that may well reflect that of the previous palace (destr. 1535). Three main storeys in height (the standard in Venice), the scheme of rusticated basement with Ionic and Corinthian storeys above recalls that of Sansovino's Palazzo Corner at San Maurizio, begun in 1545 for Giovanni's nephew. Here, however, the architectural embellishment is applied to the main storeys, leaving the mezzanines above them unadorned. At basement level three arched portals, brought forward slightly, alternate with windows with rusticated Doric tabernacles. The Doric entablature is also exposed at the corners of the portal surrounds, as it is in the vestibule portals of Sansovino's palace. The two upper storeys follow a different design, with arched windows in tabernacles and a Serliana arrangement corresponding with the central *salone*.

Sanmicheli's majestic Palazzo Grimani (1556), Venice, is much dependent in its layout on the shape and size of the obliquely angled site, although the frontal portion is symmetrically arranged about the central entrance hall, or atrium, of square plan with free-standing columns, and the *saloni* above. The design of the enormous stone façade, which fronts on to the Grand Canal, was altered after Sanmicheli's death, when the two upper storeys were reduced in height (see fig. 2). In format, the façade is very similar to that of the earlier Palazzo Loredan (later Vendramin–Calergi; begun *c*. 1502), attributed to Mauro Codussi (*see* CODUSSI, MAURO, fig. 2). In both, a Corinthian order, paired for the end bays, articulates all three storeys, with pilasters for the basement and half columns above; a smaller order is used for the main openings. Sanmicheli here achieved greater cohesion than in his Palazzo Cornaro by using two interlocking orders on each storey in order to separate the principal windows from the mezzanines. The magnificent three-arched Serliana that marks the entrance is one of Sanmicheli's most delightful devices.

Sanmicheli designed several villas. His Villa Canossa (before 1532), Venice, also commissioned by Ludovico Canossa, survives as an enormous symmetrical complex organized around a huge *casa* (rebuilt 1769–76, after a fire, by Adriano Cristofali), the arrangement of which may reflect something of its predecessor. At around the same time he may have worked at nearby Corte Spinosa for Carlo Bologna, the powerful Chancellor of Mantua, modernizing the *casa* and adding to it an elegant loggia. He also modernized the medieval castle at Bevilacqua for the eldest of the Bevilacqua brothers, Giovanni Francesco (*d* 1549), redesigning the interior with a two-storey arcaded courtyard, reorganizing the attached enclosure and constructing an imposing entrance gate. For the Venetian Alvise Soranzo he designed the splendid villa known as La Soranza (before 1540; largely destr. early 19th century) at Treville, near Castelfranco, which comprised a central

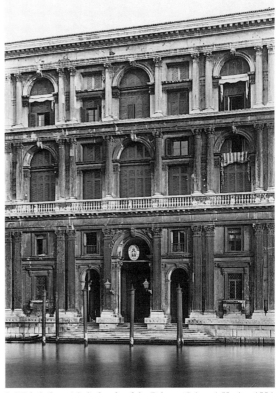

2. Michele Sanmicheli: façade of the Palazzo Grimani, Venice, 1556

casa, in layout based on a design by Peruzzi (Vienna, Österreich. Nbib., Cod. 10,935, fol. 136*ar*); the *casa* is flanked by long *barchesse* with frontal loggias (one surviving, the other possibly unexecuted). Subsequently, for Girolamo Cornaro, Giovanni's brother, he built a villa (*c*. 1545; destr. 18th century) at Piombino Dese; this was a two-storey *casa* with little external embellishment, similar to other Cornaro villas such as the late 15th-century Villa dall'Aglio at Lughignano, near Treviso.

For both domestic and public buildings Sanmicheli produced designs for stone portals and other fixtures. He supplied various items (*c*. 1533–4), including a number of elegant door frames, for the Villa Imperiale at Pesaro, designed from *c*. 1530 by Girolamo Genga for Francesco Maria I della Rovere, Duke of Urbino. He designed the sumptuously carved portal of his own house in Verona, modelled on the ancient portal of S Salvatore at Spoleto. For the Venetian governors of Verona he designed a Corinthian portal (*c*. 1533) for the Palazzo del Capitano in the city's main civic square, with half columns raised upon pedestals; and a more elaborate and learned one (1533) for the Palazzo del Podestà using the Ionic order, which here closely follows Vitruvius. It was the first to do so in the Veneto, as the portal predates Sansovino's Marciana Libreria (begun *c*. 1537) in Venice. The profile of the corner pilasters unusually matches the entasis of the inner half columns, a theoretical nicety that became a standard feature of Sanmicheli's work; and the pediment is placed over the central bay in a manner ultimately derived from the Roman Arco dei Gavi in Verona, a building considered by some to have been designed by Vitruvius himself.

Sanmicheli's project for the Lazzaretto (designed c. 1540, completed 1628; largely destr.), an enormous complex outside Verona to house those suffering from infectious diseases, was commissioned by the city council. The complex, which, as realized, seems certainly to follow Sanmicheli's design at least in outline, is organized as an enormous enclosure (125×250 m) with cells around all four sides and a circular chapel at the centre. The prototype is the Lazzaretto (1488–1513) in Milan, but the planning is also apparently derived from such Roman buildings as Aurelian's Temple of the Sun in Rome. The circular chapel (partly extant) is treated as a fusion of Vitruvius' peripteral and open monopteral temples, with a twelve-column arrangement that is fittingly associated, in Daniele Barbaro's edition of Vitruvius (Venice, 1556), with temples dedicated to Aesculapius.

(b) *Ecclesiastical buildings*. One of Sanmicheli's most sophisticated and admired buildings is the Pellegrini Chapel (c. 1527), attached to the church of S Bernardino, Verona. Approached from a short vestibule, the tall chapel is of circular plan, with a dome concealed externally by a drum in the North Italian manner. The interior (see fig. 3) was inspired by that of the Pantheon, having a radial plan with large recesses on the main axes and tabernacled niches between them. The upper storey has a balcony, perhaps intended for a choir; with its trabeated three-bay windows, it is much indebted to Bramante's design for the dome of St Peter's, Rome. Where the coffered dome is now lit by a lantern, there was originally a large rosette, a motif mentioned by Vitruvius (IV.viii.3) in connection with circular temples. The wall design is of considerable intricacy, especially in the lower storey, where the main

order of Corinthian half columns, their slender 1:11 proportions perhaps derived from those of the Temple of Vesta in Rome, is coupled with a smaller pilaster order that extends into the recesses and connects with the niche tabernacles. Further complexities anticipate the Palazzo Bevilacqua, with straight-fluted half columns for the entrance and end recesses, and spirally-fluted half columns at the sides, while triangular pediments over the main recesses alternate with segmental pediments for the tabernacles. Richly embellished with exquisite carving, the execution, as Vasari observed, appears to defy the immense technical difficulty of adapting so complex a design to a curving wall surface and realizing it in stonework.

As part of the renovation of Verona Cathedral, which included a fresco scheme commissioned from Giulio Romano for the apse, Sanmicheli designed a semicircular choir (*tornacoro*) surrounded by a sumptuous marble screen with Ionic columns and an entrance arch (c. 1534), and he later prepared a scheme for the campanile (c. 1555; unfinished). For S Giorgio in Braida, Verona, he designed (c. 1535) the arcaded drum with coffered dome as well as a campanile (unfinished). For S Maria in Organo he designed a stone façade (1547) that was completed only up to the level of the main entablature; above it there would probably have been an attic storey with a pediment at the centre. The composition, with a central portal and side windows, is common to other Veronese churches, such as S Anastasia (1422–81). However, the openings are treated as arches recessed within larger arches, a device much favoured by Sanmicheli; they are separated by Composite half columns in a three-bay disposition similar to Porta Santo Spirito (1543–4), Rome, by Antonio da Sangallo (ii). Other ecclesiastical works by Sanmicheli include the octagonal chapel (c. 1547) at the Villa della Torre at Fumane, the monastery of SS Biagio e Cataldo (c. 1553; destr.) in Venice and the unusual and richly carved funerary monument (1556) to *Alessandro Contarini* in S Antonio, Padua.

Sanmicheli's most ambitious church is the Madonna di Campagna (1559), just outside Verona. The layout comprises an enormous domed rotunda, circular outside but octagonal inside, with a peripteral portico interrupted by a smaller domed area with subsidiary spaces attached. The basic arrangement of twin domed spaces, which is well suited to the building's function as a pilgrimage church built to house a miraculous image, follows Sangallo's S Maria di Monte d'Oro (begun 1523), near Montefiascone, which was designed for a similar purpose. The larger space is intended for pilgrims and congregation, with additional portals on the cross axis to facilitate processions, while the smaller one, mostly hidden from outside, accommodates the precious image and altar separately. The main space has folded pilasters in the corners with arches between them, providing shallow chapels on the diagonals, and a short arcaded upper storey with windows of three bays to each side. Externally, the portico, with its Tuscan Doric columns, looks too low in relation to the tall cylinder it embraces, perhaps reflecting changes made to Sanmicheli's design after his death.

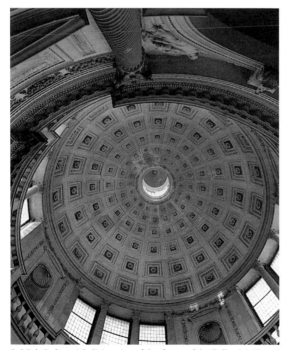

3. Michele Sanmicheli: interior of the dome of the Pellegrini Chapel, Verona, c. 1527

(c) *Fortifications and gateways*. Sanmicheli was involved with fortification work from the moment he returned to

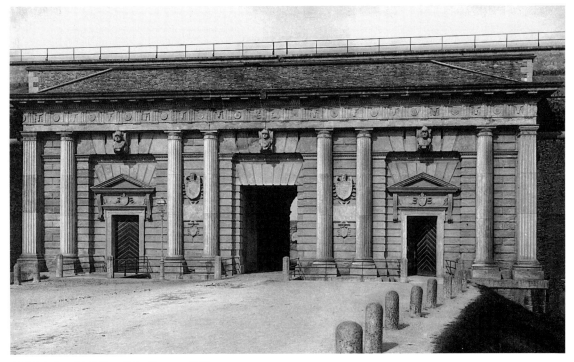

4. Michele Sanmicheli: Porta Palio, Verona, *c.* 1547

northern Italy. Certainly by 1528–9 he was designing fortifications at the strategic town of Legnago, and in 1530 he began making improvements to the fortifications of Verona (*see* VERONA, §1). For the innovative Porta Nuova (*c.* 1530), a gateway in the city walls of Verona, Sanmicheli rejected the tall format employed by Giovanni Maria Falconetto and others in favour of one of lower proportions, used previously in the Porta S Giorgio (1525), Verona, which made the gateway less vulnerable to artillery fire and which was therefore preferable in an exposed position. The Porta Nuova was the first fortified gateway to be rusticated, a practice later recommended for gateways by Serlio (IV.V, fols, 130*r*, 133*v*), and it was the earliest to carry a full Doric order. This combination, together with the sophisticated handling of the detailing, may have been inspired by Giulio Romano's Palazzo del Te, Mantua, but it is one also suggested by the Roman arena in Verona. On both the outer and inner façades, the main archway, crowned with a pediment, is framed by a portal of half columns paired with pilasters of matching profile, both banded, the horizontal joints aligned with those of the wall rustication. At the corners of the entablature Sanmicheli followed Vitruvius' preference in contriving to end the Doric frieze with half a metope, a problem that later preoccupied Sansovino when designing the Marciana Libreria, Venice. On the outer façade, beyond the central portal, the capitals of further pilasters are embedded in rusticated stonework, and the entablature is continued in simplified form with the triglyphs and metopes merely roughed out. The cavern-like interior has rusticated piers with pilasters carrying rusticated ribs across the barrel-vaulted central aisle, an idea derived from the passageways of the Roman arena.

Also in 1530 Sanmicheli was given official responsibility for the defences of Corfu. The following year he was dispatched on a tour of inspection of the mainland fortifications of Venice in the company of Francesco Maria I della Rovere, Duke of Urbino and Commander-in-Chief of Venetian forces, and in 1534 he visited the fortifications of Venetian Dalmatia. Sanmicheli then submitted proposals for the defences of Venice itself, after which he was appointed the state's official military architect (1535). In this capacity he later made other tours of inspection, including an extended journey down the Adriatic and beyond to Crete in 1537–40 and another to the Adriatic in 1550, and he also made designs and recommendations for most of the major towns of the Venetian terra firma. For the imposing rusticated entrance gate to his Fortezza di S Andrea (1535), Venice, he employed a three-bay arrangement with a central arch and smaller openings recessed within blind arches to either side, and half columns paired with pilasters at the corners. For the Porta S Martino (*c.* 1535; destr.), Legnago, he adopted a similar arrangement, but with an attic storey above and no side arches. For the Porta di Terraferma (*c.* 1537–9) at Zadar in Dalmatia, he dispensed with the attic and instead raised the order on to tall pedestals so that the base aligned with the springing-point of the central arch, in a manner similar to earlier gateway designs such as the Porta di S Tommaso (attrib. Bergamasco; *c.* 1518), Treviso, and the Roman Porta Marzia at Perugia. For the Porta S Zeno (*c.* 1540), Verona, he chose a similar arrangement but with Composite pilasters and restricted rustication, which is set against areas of smooth brickwork.

By far the most magnificent and elaborate of Sanmicheli's gates, the Porta Palio (*c.* 1547; see fig. 4), Verona,

stands on the main entrance to the city from beyond the Venetian territories. The exceptionally wide façade is faced with flat rustication that emphasizes the horizontal joints but not the vertical, and which contrasts to great effect with the delicate carving of the elegant pedimented portals and the slender, fluted Roman Doric half columns. The composition of the façade, modelled on one of the terrace walls of the Roman theatre at Verona, is treated as a series of receding planes that lends the design an impression of great strength, as does the treatment of the voussoirs in the flat arches of each plane, which seem to bear down on those below. The rear elevation, in contrast, is much simpler in composition, with five bays of paired Doric half columns and arches, corresponding to a rear loggia running the full width of the gate, the horizontal rustication of the wall face continuing across the column shafts in contrast to the fluting on the other side. The internal façade has paired pilasters and arches framing smaller arched window surrounds, a recurrent motif of Sanmicheli's style.

2. CRITICAL RECEPTION AND POSTHUMOUS REPUTATION. Sanmicheli's influence was considerable. His style was continued in Verona by his immediate followers, who cultivated a particular liking for rustication and the Doric order, evident, for example, in the impressive Palazzo della Gran Guardia (1610) by his nephew Domenico Curtoni (1556–1627). Sanmicheli's designs for gateways were particularly influential, and derivatives were soon erected in other Venetian towns, including Orzinuovi and Bergamo. His influence was felt particularly strongly in nearby Vicenza by the young Andrea Palladio. From Sanmicheli, Palladio derived plan types and elevational formulae, and he paid particular attention to Sanmicheli's mastery of detail. Indeed, he absorbed much of Sanmicheli's architectural vocabulary into his own, including such motifs as half columns coupled with corner pilasters, pilaster shafts of curving profile, and arches recessed within larger arches. It was, in fact, largely through Palladio that Sanmicheli's influence was exerted on later centuries.

In the Neo-classical period of the 18th and early 19th centuries, however, Sanmicheli's own buildings were rediscovered and his style was re-evaluated. In Verona a revival of his style was effected in the works of Alessandro Pompei (1705–72), Adriano Cristofali (1717–88) and, above all, Luigi Trezza (1752–1824). At the same time, his designs began to be circulated in illustrated books, beginning with Scipione Maffei's *Verona illustrata* (Verona, 1731–2). Subsequently, the British entrepreneur Consul Joseph Smith (c. 1674–1770) encouraged Trezza to embark on a systematic record of the Sanmicheli corpus (Verona, Bib. Civ.), a labour that bore fruit in Ferdinando Albertolli's publication (1815), although this was soon superseded by that of Ronzani and Luciolli (1823). At the same time, architects from elsewhere, especially from Britain, visited Verona to see Sanmicheli's buildings for themselves, among them the Adam brothers, John Soane (1753–1837) and Charles Barry (1795–1860). They rightly recognized in Sanmicheli's work a style quite distinct from that of Palladio and a creative mind of the first order.

BIBLIOGRAPHY
S. Serlio: *Tutte l'opere d'architettura et prospettiva di Sebastiano Serlio bolognese* (Venice, 1619/*R* Farnborough, 1964)

F. Albertolli: *Porte di città . . . ed altre principali fabbriche . . . di Michele Sanmicheli veronese* (Milan, 1815)
F. Ronzani and G. Luciolli: *Le fabbriche civili, ecclesiastiche e militari di Michele Sanmicheli* (Verona, 1823)
E. Langenskiöld: *Michele Sanmicheli, the Architect of Verona* (Uppsala, 1938)
P. Gazzola and M. Kahnemann: *Michele Sanmicheli, architetto veronese del cinquecento* (Venice, 1960)
M. Cavaliere, ed.: *Michele Sanmicheli*, Accademia di Agricoltura di Verona (Verona, 1960)
L. Puppi: *Michele Sanmicheli, architetto di Verona* (Padua, 1971)
D. Lewis: 'The Rediscovery of Sanmicheli's Palace for Girolamo Corner at Piombino: A Vindication of Vasari', *Architectura*, vi (1976), pp. 29–35
P. Marini and others: *Palladio e Verona* (Venice, 1980)
L. Puppi: *Michele Sanmicheli, architetto* (Rome, 1986)
P. Davies and D. Hemsoll: 'Palazzo Bevilacqua e la tipologia del palazzo veronese', *An. Archit.*, iii (1991), pp. 58–69
——: 'Sanmicheli through British Eyes', *English Architecture Public and Private: Essays for Kerry Downes*, ed. J. Bold and E. Chaney (London, 1993), pp. 121–34

PAUL DAVIES, DAVID HEMSOLL

Sano, Turino di. *See* TURINO DI SANO.

Sano [Ansano] **di Matteo** (*b* Siena, *fl* 1392; *d* ?Perugia, after 27 July 1434). Italian sculptor and architect. First mentioned in 1392, he was paid for executing a frieze in Siena Cathedral in 1398. Between 1407 and 1425 he served as *capomaestro* of the workshop at Orvieto Cathedral. He made the octagonal cover for the baptismal font and also worked on the Cappella Nuova in the cathedral. Sano's individual style is difficult to isolate, since he often worked in collaboration with other Sienese masters. On 10 November 1413 he contracted with Jacopo della Quercia to carve marble elements for the Fonte Gaia in Siena, and in 1416, while still documented as working on the Fonte Gaia, he was also working on the baptismal font in the Baptistery in Siena together with Nanni da Lucca and Giacomo di Corso (*c.* 1382–after 1427), colleagues with whom he seems to have collaborated on many projects. Sano is also documented in 1428 as one of many masters who assisted in the decoration of the Loggia di S Paolo in Siena. The precise nature of his contribution to these commissions, however, is not specified. As architect and engineer, Sano was involved with the construction of the façade of S Fortunato, Todi, during the early 1430s, and was also responsible for the building of canals and wells in Perugia in 1425–6. He is last mentioned on 27 July 1434 when he had completed work on a vault in the Campione in Perugia.

BIBLIOGRAPHY
Thieme–Becker
G. Milanesi: *Documenti per la storia dell'arte senese*, 3 vols (Siena, 1856)
L. Fumi: *Il Duomo di Orvieto e i suoi restauri* (Rome, 1891)
J. Paoletti: *The Siena Baptistry Font* (New York, 1979), pp. 2, 8, 10–11

STEVEN BULE

Sano di Pietro [Ansano di Pietro di Mencio] (*b* Siena, *bapt* 2 Dec 1405; *d* Siena, 1481). Italian painter and illuminator. In 1428 he was listed in the guild of painters in Siena just before Sassetta, with whom he probably trained. The same year he was paid for gilding and colouring a *Baptism* (untraced), possibly Sassetta's design for the Siena Baptistery font made in 1427. In 1432 he assessed Sassetta's *Virgin and Child with Saints* (the '*Madonna of the Snow*'; Florence, Pitti), and after Sassetta's

death in 1450, Sano completed works left unfinished by him, including the fresco of the *Coronation of the Virgin* over the Porta Romana (1458–66), Siena, and the *St Francis* (Siena, Pin. N., 240; see Pietrasanta, 1971).

From the 1440s Sano's career is copiously documented, and many of his works are dated. In 1446, for example, he was paid to add a figure of the Emperor Barbarossa to Spinello Aretino's fresco of the *Pardon of Frederick Barbarossa* of 1407–8 in the Sala di Balía, Palazzo Pubblico, Siena (Siena, Pal. Piccolomini, Archv Stato, Concistoro, MS. 464, fol. 36*v*; Concistoro, MS. 2498, fol. 393; *see* SIENA, §III, 3). The works of the 1440s—including his masterpiece, the polyptych of the *Virgin and Child with Saints Adored by the Blessed John Colombini*, called the Gesuati Polyptych, dated 1444 (Siena, Pin. N.; see fig.; predella, Paris, Louvre), and perhaps the miniatures in the *Breviarum fratrum minorum* (Siena, Bib. Com. Intronati, MS. X.IV.2), which Ciardi Dupré has identified as early works—show obvious stylistic links with Sassetta. He was also obviously influenced by Domenico di Bartolo, and it also seems probable that he was aware of the work of Paolo Uccello and Fra Angelico. This is evident in the Gesuati Polyptych, in the two paintings of *St Bernardino Preaching* (both Siena Cathedral, Chapter House), as well as in various works commissioned by the Comune of Siena—such as the predella of scenes from the *Life of the Virgin* (Rome, Pin. Vaticana; Altenberg, Staatl. Lindenau-Mus.; Ann Arbor, U. MI Mus. A.) for the altarpiece in the chapel of the Palazzo Pubblico, Siena, of 1448 (Eisenberg, 1981); the fresco of *St Peter of Alexandria* (1448; Siena, Pal. Pub.); and the painting of the *Apparition of the Virgin to Pope Calixtus III* (1450 or 1456; Siena, Pin. N.). A triptych of the *Virgin and Child with SS Lucy and Bartholomew* (1447; Siena, Pin. N.) was originally in S

Maurizio, Siena, which also contained an altarpiece (Siena, Osservanza) by the MASTER OF THE OSSERVANZA (*see* MASTERS, ANONYMOUS, AND MONOGRAMMISTS, §I). The strong similarities in the carpentry of the altarpieces and in their compositions would seem to confirm the close link between the two artists. The hypothesis that the paintings attributed to the anonymous master are early works by Sano di Pietro has been generally rejected, and it is now thought that they may have shared a workshop. A careful comparison of the two altarpieces demonstrates the extent of their stylistic differences.

From the early 1450s Sano was producing many large-scale works; his style became repetitive, and the quality of his works was uneven, the consequence of his extensive use of assistants. This can be observed in the polyptych of the *Virgin and Child with SS George, Peter, Lawrence and Anthony of Padua* (1458; Montemerano, S Giorgio), the altarpiece of the *Virgin and Child with SS Mary Magdalene, James, Philip and Anne* completed in 1462 for Pienza Cathedral, the triptych of the *Virgin and Child with Saints and Angels* (S Quirico in Orcia, Collegiata) and that of 1471 at Badia a Isola, Monteriggioni.

By contrast, Sano's work as an illuminator, documented from the end of 1445 when he decorated a Psalter (untraced) for Siena Cathedral (Milanesi), is distinguished by its consistently high quality. His fresh narrative vein and clear, rich colouring is evident in the Franciscan Breviary (Siena, Bib. Com. Intronati, MS. X.IV.2), illuminated for the Clarissan nuns of S Niccolò, Siena, and probably datable to the 1440s, when Sano was most open to Florentine innovations. The same compositional and colouristic quality is found in three psalters (Chiusi Cathedral, Sala Capitolare, MSS U, V and X) decorated between 1459 and 1463 for Francesco Ringhieri, Abbot General of Monteoliveto Maggiore, near Siena (Gaillard). Probably dating from the same time are three miniatures from an Antiphonal (Bologna, Mus. Civ. Med.), commissioned by the monastery of S Michele in Bosco, Bologna (Milanesi). The miniatures are conceived as framed pictures, rather than decorated initials, and mark the high-point of his work in the medium: the *Baptism of Christ* reflects the traditional composition for the subject set by Ghiberti's relief for the font of Siena Baptistery. Using large colour fields, Sano created fully three-dimensional figures set in ample spaces.

Around the same date Sano was commissioned to illuminate an Antiphonal (Pienza, Mus. Cattedrale, MS. 62), the first choir-book made for Pienza Cathedral, which indicates the high esteem in which he was held, even in the humanist circle of Pope Pius II. Between 1460 and 1463 he was commissioned by the Ospedale di S Maria della Scala, Siena, to illuminate three graduals (Siena, Bib. Piccolomini, MSS 95.1; 96.2; 97.3; 107.13) and, together with Liberale da Verona and Girolamo da Cremona, he is said to have contributed to the choir-books for Siena Cathedral. His illumination in another gradual (Siena, Bib. Piccolomini, MS. 27.11) was paid for in January 1472. The same year he decorated the *Statute of the magistratura di mercanzia* (Siena, Pal. Piccolomini, Archv Stato). Sano was buried in the cloister of S Domenico, Siena.

Sano di Pietro: *Virgin and Child with Saints Adored by the Blessed John Colombini* (the Gesuati Polyptych), panel, 3.20×2.82 m, 1444 (Siena, Pinacoteca Nazionale)

BIBLIOGRAPHY

Thieme–Becker

G. Vasari: *Vite* (1550, rev. 2/1568); ed. F. Le Monnier (Florence, 1846–56), vi, p. 183

E. Romagnoli: *Biografia cronologica de bellartisti senesi* (MS, *c.* 1835; Siena, Bib. Com., MS. L.II.4); facs. (Florence, 1976), pt iv, pp. 273–354

G. Milanesi: *Documenti per la storia dell'arte senesi* (Siena, 1854), i, p. 48; ii, pp. 243, 256–9, 276–9, 301, 308, 327–9, 355–6, 380, 382, 385, 389–90, 465

S. Borghesi and L. Banchi: *Nuovi documenti per la storia dell'arte senese* (Siena, 1898), pp. 159, 162–3, 210, 226, 229–32, 252–3

E. Gaillard: *Un Peintre siennois du XVème siècle: Sano di Pietro* (Chambery, 1923)

R. Trubner: *Die stilistische Entwicklung der Tafelbilder des Sano di Pietro* (Strasbourg, 1925)

B. Berenson: *Sassetta: Un pittore senese della leggenda francescana* (Florence, 1946), pp. 51–3, n. 32

C. Brandi: *Quattrocentisti senesi* (Milan, 1949), pp. 69–87

J. Pope-Hennessy: 'Rethinking Sassetta . . .', *Burl. Mag.*, xcviii (1956), pp. 254–6

E. Carli: *I pittori senesi* (Milan, 1971), p. 26

A. Pietrasanta: 'A "Lavorii rimasti" by Stefano di Giovanni, called Sassetta', *Connoisseur*, clxxvii (1971), pp. 95–9

P. Torriti: *La Pinacoteca Nazionale di Siena: I dipinti dal XII al XV secolo* (Genoa, 1977), pp. 254–99

M. Eisenberg: 'The First Altar-piece for the Cappella de' Signori of the Palazzo Pubblico of Siena', *Burl. Mag.*, cxxiii (1981), pp. 134–48

Sano di Pietro (exh. cat., Siena, Magazzini del Sale, 1982)

M. Boskovits: 'Il gotico senese rivisitato: Proposte e commenti', *A. Crist.*, dcxcviii (1983), p. 267

M. G. Ciardi Dupre Dal Poggetto: 'La libreria di coro dell'Osservanza e la miniatura senese del quattrocento', *L'Osservanza di Siena: La basilica e i suoi codici miniati* (Milan, 1984), pp. 123, 131, 139–40, 145–6

C. Alessi and P. Scapecchi: 'Il Maestro dell'Osservanza: Sano di Pietro o Francesco di Bartolomeo?', *Prospettiva*, xlii (1985), pp. 14, 20–22, 26, 28

J. Pope-Hennessy: *Italian Paintings in the Robert Lehman Collection*, New York, Met., cat. (Princeton, 1987), pp. 105–11

Renaissance Painting in Siena (exh. cat. by K. Christiansen, L. Kanter and C. Strehlke, New York, Met., 1989), pp. 138–67

G. Freuler: 'Sienese Quattrocento Painting in the Service of Spiritual Propaganda', *Italian Altarpieces, 1250–1550: Function and Design*, ed. E. Borsook and F. S. Gioffredi (Oxford, 1994), pp. 81–118

M. Israels: 'New Documents for Sassetta and Sano di Pietro at the Porta Romana, Siena', *Burl. Mag.*, cxl/1144 (1998), pp. 436–44

CECILIA ALESSI

Sansovino. Italian family. (1) Jacopo Sansovino was a dominant figure in the artistic life of Venice in the mid-16th century. His son (2) Francesco Sansovino wrote some of the first guidebooks to the city.

(1) Jacopo (d'Antonio) Sansovino [Tatti] (*b* Florence, *bapt* 2 July 1486; *d* Venice, 27 Nov 1570). Sculptor and architect. After establishing his reputation in Florence and Rome, he moved to Venice following the Sack of Rome (1527) and remained active there until his death. His most important architectural works were buildings that transformed the Piazza S Marco. The influence of his sculptural style continued well into the 17th century.

1. Life and work. 2. Working methods and technique.

1. LIFE AND WORK.

(i) Training and early career, to 1517. (ii) Rome, 1518–27. (iii) Venice, after 1527.

(i) Training and early career, to 1517. He was the eldest son of a mattressmaker and grandson of a cabinetmaker. Vasari stated that Jacopo's mother encouraged his inclination towards art in emulation of Michelangelo, but it is more likely that family connections led to his apprenticeship with Andrea Sansovino, whose name he subsequently adopted. This occurred around 1502, when Andrea was among the most highly regarded sculptors in Florence and

at work on the marble group of the *Baptism* for the Baptistery of Florence Cathedral. Andrea received a number of significant commissions during the first years of the 16th century, and in his studio Jacopo could observe the development of the High Renaissance style from a central vantage-point. Like other young Florentine artists, Jacopo studied Michelangelo's cartoon for the *Battle of Cascina* (destr.) and probably made terracotta models in the style of Leonardo da Vinci, an example of which may be an ecstatic *St Giovannino* (Florence, Bargello). Jacopo also frequented the circles of the artist Giovanni Francesco Rustici and of Baccio d'Agnolo, then the influential *capomaestro* of Florence Cathedral.

Jacopo's studies were interrupted in 1505, when Andrea was called to Rome to execute the tombs of *Cardinal Ascanio Sforza* and *Cardinal Girolamo Basso della Rovere* in the choir of S Maria del Popolo. Jacopo followed soon after in the train of Giuliano da Sangallo, whose protégé he became. In Rome he studied and copied Classical sculptures and may have collaborated with Andrea at S Maria del Popolo; certainly the speed with which the tombs were completed would endorse such a conclusion, and the resemblance between the figure of *Temperance* on the Basso monument and Jacopo's later *Bacchus* (Florence, Bargello) suggests that the affinity between the two sculptors continued through this period.

Vasari related that Jacopo attracted the attention of Donato Bramante in Rome, and that in 1507 or 1508 he won a competition, organized by Bramante and judged by Raphael, for the best copy of the recently unearthed antique sculpture of the *Laokoon* (Rome, Vatican, Mus. Pio-Clementino). A bronze version (untraced) of his wax model was cast for Cardinal Domenico Grimani. This was

1. Jacopo Sansovino: *St James the Greater*, marble, 1511–18 (Florence Cathedral)

the first link between Jacopo and Venice and may have had a bearing on his settling there after the Sack of Rome. One surviving work from this first Roman period, the ambitious *Descent from the Cross* (1508; London, V&A), was conceived as a studio model for the painter Perugino and modelled in wax with great bravura. The musculature and poses of the figures call attention to the artist's absorption of the Antique and his inventiveness. It was the first of a series of works made for other artists, and it signalled the end of his apprenticeship.

Sansovino returned to Florence *c.* 1510 and almost immediately assumed a position of prominence. Possibly through Baccio d'Agnolo, he gained the two commissions for marble statuary that confirmed his reputation as a serious rival to Michelangelo, the *Bacchus* (Florence, Bargello) and *St James the Greater* (see fig. 1) for the cathedral. The *Bacchus*, probably Sansovino's most celebrated work, is one of the best-known Renaissance sculptures. Finished by 1512, it was designed for the garden of Giovanni Bartolini's suburban palace at Gualfonda, where it stood on a plinth carved by Benedetto da Rovezzano. Although Sansovino may have been asked to copy a Classical sculpture, no single convincing prototype has ever been found. His creation seems to have been a synthesis of several Classical works, and it captures the spirit of antiquity far better than any previous modern work. It displays a dazzling virtuosity in its extended left arm and sinuous, serpentine movement. Although damaged by fire in 1762, the *Bacchus* still retains the power to entrance spectators. The *St James* represents, in contrast, Sansovino's response to the Florentine tradition of public statuary, in which overtones of Lorenzo Ghiberti are tempered by an awareness of Michelangelo's unfinished *St Matthew* (Florence, Accad. B.A. & Liceo A.), commissioned for the cathedral almost a decade earlier. For the *St James* Sansovino adapted a modified version of the serpentine contrapposto of *St Matthew*, while he endowed the saint with a more restrained and accessible personality. He also gave the figure elaborate drapery, which Vasari pronounced miraculous in its carving.

The *St James* occupied Sansovino between 1511 and 1518, and in that period he shared a studio with Andrea del Sarto. Their workshop was frequented by a number of artists and sometime pupils, including Niccolò Tribolo and Jacopo Pontormo. In addition Sansovino was in contact with such older artists as Andrea della Robbia and Rustici as well as such patrons as the patricians Giovanni de' Gaddi and Bindo Altoviti. Vasari listed a number of works (no longer in existence) from this period, of which the most important were the colossal equestrian monument and temporary façade for Florence Cathedral, which Sansovino and del Sarto jointly produced for the entry of Pope Leo X into the city in November 1515. The temporary façade was the first instance of Sansovino's talent for architecture, which became the predominant aspect of his career in later years. Vasari also stated that del Sarto and Sansovino evolved a common style during this decade, and his observation can be corroborated by comparing del Sarto's Scalzi frescoes of *St John the Baptist* (1508–26; Florence, Chiostro Scalzo; detached but *in situ*) and the Porta Pinti *Madonna* (lost 19th century; known

through copies, e.g. U. Birmingham, Barber Inst.) with surviving works by Sansovino before 1521.

(ii) Rome, 1518–27. In 1518 the limited opportunities available in Florence led Sansovino back to Rome, which he may have visited briefly in May 1516 to sign the contract for his most famous work of the period, the marble Martelli *Virgin and Child*, or *Madonna del parto* (Rome, S Agostino). He had ample grounds for leaving Florence after his disappointment about the proposed façade for S Lorenzo, in which he expected but was denied a share in Michelangelo's project. In Rome, Sansovino was taken up by the Florentine community, winning the competition (*c.* 1519) to design their church, S Giovanni dei Fiorentini, against Raphael, Baldassare Peruzzi and Antonio da Sangallo the younger. According to Vasari, Sansovino's project called for central and four corner domed spaces, derived from Bramante; the project probably resembled a similar centralized church plan reproduced in Sebastiano Serlio's *L'Architettura*, Book V. The project foundered through technical and financial difficulties, and in January 1521 Sansovino was effectively replaced by Sangallo. Sansovino also gained the commission to rebuild the Servite church of S Marcello in Rome after a fire in 1519, probably helped by his Florentine connections and by his friend and patron Cardinal Antonio de' Monte (*d* 1533), who was protector of the Servite order. Although Sangallo replaced him in this project as well, perhaps as early as 1521, Sansovino made one very significant contribution to the new church: he reversed its orientation to face the present-day Via del Corso rather than SS Apostoli. This showed a sensitivity to urban planning, which became a notable feature of Sansovino's Venetian career. One of his three major buildings from this period survives, the Palazzo Gaddi, planned *c.* 1518 for his Florentine patron Giovanni de' Gaddi and his brothers on the Via del Banco, Rome. The palace has a compact plan, which successfully exploits its narrow site, and its façade demonstrates a Florentine sobriety with rustication inspired by Raphael's Palazzo Pandolfini in Florence, a building Sansovino would have observed under construction shortly before.

During these years Sansovino executed only two major pieces of sculpture, both private commissions obtained through the Florentine community and his connections with the papal curia. The marble *Madonna del parto* (Rome, S Agostino; see fig. 2), made for Giovan Francesco Martelli, is one of Sansovino's most popular sculptures and a rare example of a Renaissance work of art that became a cult image. It also marks a further stage in the evolution of his style in the direction of Michelangelo. The Virgin's full and rounded form and the emphatic gesture of her right arm recall such figures as the *Delphic Sibyl* on the Sistine Chapel ceiling, Rome (see colour pl. 2, VI1), or the *Moses* (Rome, S Pietro in Vincoli; see colour pl. 2, VII2); and at the same time the work conveys clearly the human tenderness between mother and child. The figures are framed by an aedicula originally surmounted by frescoes of putti holding a baldacchino, executed by Polidoro da Caravaggio probably after a design by the sculptor. The *St James of Compostella* (Rome, S Maria di Monserrato), also of marble, amounts to a paraphrase of a motif from Michelangelo's projects for S Lorenzo, Florence. Finished

2. Jacopo Sansovino: *Madonna del parto*, marble, h. 1.88 m, 1518–21 (Rome, S Agostino)

by January 1520, the statue formed the centrepiece of a funerary chapel for Cardinal Giacomo Serra in S Giacomo degli Spagnoli, where the sculptor worked with Antonio da Sangallo the younger under Cardinal Antonio de' Monte as executor of the Spanish cardinal's will. Sansovino conceived the figure as an Apollonian god, less graceful than the Florentine *St James* but more imposing. The saint is close in spirit to Michelangelo's *Risen Christ* (Rome, S Maria sopra Minerva), but beneath the Classical and Michelangelesque overtones a Florentine substratum is still discernible. Sansovino's sculptures from his Florentine and Roman years made him a major figure in the High Renaissance.

(iii) Venice, after 1527. Sansovino's career probably would have remained within the Florentine–Roman axis had it not been for the Sack of Rome in 1527, which sent him and many other artists away from central Italy. His son (2) Francesco Sansovino recorded that Sansovino's original intention was to travel to France to serve Francis I (*reg* 1515–47). During a brief stop in Venice he was persuaded to stay by Doge Andrea Gritti and a small group of noblemen, some of whom he knew from Rome. In 1529 Sansovino became *proto* (chief architect) to the Procurators of S Marco, and he held this office over the next four decades. As *proto*, Sansovino supervised the fabric of the Doge's chapel of S Marco and other properties owned by the church, including the Piazza S Marco. The Procurators of S Marco were drawn from the wealthiest and most powerful patricians, and they could bring Sansovino major public commissions. His talent and conspicuous position

earned him further commissions from private patrons. As a result, he enjoyed a monopoly of the main architectural and sculptural commissions for most of his Venetian career, much like Gianlorenzo Bernini (1598–1680) in Rome the following century. Together with his close friends Titian and Pietro Aretino, Sansovino dominated the artistic life of Venice in the mid-16th century. (For an illustration of a work from this period see colour pl. 2, XXVII2.)

(a) Architecture. Sansovino's major architectural contribution to Venice was in transforming the appearance of the Piazza S Marco through the planning of three buildings, the Zecca (public mint), the Library and the Loggetta. All three were conceived between 1535 and 1537 and were ordered by small, interlocking civic committees. The first was the Zecca, which was designed for the Council of Ten and replaced an older building on its site. Sansovino's design could be built in stages from the waterfront façade with its shops and foundries to the rear courtyard, where coins were made. The Zecca was originally a two-storey building. Entirely of stone, it is a study in rustication: the ground-floor façade is an arcade of finely cut masonry blocks, while Tuscan half-columns of banded rustication define the bays above. The whole gains great power from the tightness with which lintels have been wedged between the columns and from the projecting Doric entablature above. A third storey with an Ionic order was added in the 1550s, probably not by Sansovino. The entrance, by the Piazzetta or a canal, led through a vaulted corridor to a large courtyard, where the themes of the main façade were continued in a less aggressive manner.

The Library and Loggetta were conceived for the Procurators of S Marco, and the former originated as the model for the Procurators' new houses on the south side of the square. Sansovino persuaded his patrons to begin construction at the intersection of the Piazza and Piazzetta rather than at the far end of the Piazza, as had been intended. In this way he was able to widen and regularize the Piazza by starting the new lines of houses some 5 m south of the campanile. The first phase of the new project, the Marciana Libreria (*see* VENICE, §IV, 5(i)), was planned as a multipurpose building with shops on the ground floor and Procurators' offices and the library of S Marco above. Sansovino created a uniform façade in the contemporary Central Italian manner with a ground-floor arcade of Doric half-columns and an Ionic order for the *piano nobile*. Although not finished in his lifetime, the Library is generally held to be Sansovino's architectural masterpiece, and it was praised by Palladio as 'the richest and most ornate building since ancient times' (*Quattro libri dell'architettura*; Venice, 1570). Francesco Sansovino reported his father's intention to extend the façade around three sides of the Piazza: a utopian proposal, no doubt, comparable to Michelangelo's redesigning of the Piazza del Campidoglio in Rome.

The Loggetta (see fig. 3), at the base of the campanile, coincided with the initial phase of the Library and was clearly designed to complement it. Finished *c.* 1542, it was the first of Sansovino's works completed in Venice, and it served as a manifesto of his architectural style. The Loggetta is divided into three arched sections flanked by

3. Jacopo Sansovino: polychrome marble façade of the Loggetta, with bronze figures, Piazza S Marco, Venice, c. 1537–42

pseudo-oval plan, reminiscent, perhaps, of Baldassare Peruzzi's similar essays for S Giacomo degli Incurabili in Rome.

(b) Sculpture. Sansovino continued his practice of sculpture in Venice, where his arrival coincided with the decline of the Lombardo family school, and he had no serious rivals there until his former pupils Danese Cattaneo and Alessandro Vittoria emerged from his shadow in the 1550s. No single line of stylistic development can be traced in his Venetian sculpture, because Sansovino sought to accommodate his work to local taste and he employed a new medium, bronze, for several major commissions. The marble *St John the Baptist* (Venice, S Maria Gloriosa dei Frari), begun *c.* 1534, typifies the break with his earlier Michelangelesque phase by its reversion to a late 15th-century style; Sansovino endowed the seated figure with an intensely spiritual quality while exploiting his facility for carving in a manner reminiscent of his *Bacchus.* Another work of the early 1530s, the statue of the *Virgin and Child* (Venice, Arsenale), bears a pronouncedly archaic stamp and must represent a conscious attempt to create an image comparable to Giovanni Bellini's numerous paintings of the Virgin and Child.

As Sansovino grew more involved in his work as Proto of S Marco he embarked on a variety of sculptural commissions for the Procurators as well as for private patrons. Bronze was the ideal medium for his Venetian sculpture and became increasingly his chosen mode, for example in the six reliefs (*c.* 1537 and *c.* 1542) in the choir of S Marco, the sacristy door there (commissioned 1546; installed 1572; for illustration *see* DOOR) and the statues of gods for the Loggetta. The common thread running through these works was a return to Florentine models, chiefly Ghiberti and Donatello. With his bronze reliefs Sansovino delighted in reproducing the malleability of wax in bronze and achieved a painterly style, praised by his son, Francesco, in the S Marco sacristy door reliefs. The Loggetta gods (*Apollo, Mercury, Pallas Athene* and *Peace*) are attenuated, slightly androgynous figures; they have a self-consciously artificial manner not unlike Giambologna's small bronzes.

After 1550 the pace of Sansovino's sculptural activity slackened, as can be seen by the length of time he took to complete his largely autograph marble relief, the *Miracle of the Maiden Carilla*, for S Antonio in Padua (commissioned 1536; installed 1563). He was entering old age, and as he confessed in a letter to Ercole II, Duke of Ferrara (*reg* 1534–59), he rarely touched a chisel, 'not having the time to cure with my hands because of the buildings which I supervise' (see Boucher, i, pp. 220–21, no. 204). Late Venetian projects, such as the tomb of *Doge Francesco Venier* (*reg* 1577–8) in S Salvatore or the huge marble *Mars* and *Neptune* at the top of the Scala dei Giganti in the courtyard of the Doge's Palace (see fig. 4), were largely workshop productions, designed by Sansovino. The figures of *Mars* and *Neptune* were carved by nine men generally working in groups of three or four over a period of twelve years from 1554. They bear Sansovino's distinctive stamp nonetheless and appear as convincingly bold despite the narrowness of their original blocks. Here, too, Sansovino showed his Tuscan roots, turning to Donatello's

free-standing columns. The two window bays and the central entrance, which were originally open, have been filled in. Its boxlike structure is embellished with polychrome marble, which compensates for its small scale, and the richness of its decoration was, as Aretino noted, appropriate for a meeting-place of the nobility. Neither these features nor the integration of sculpture (*see* (b) below) with architecture was entirely new to Venice, but Sansovino orchestrated these elements into a coherent celebration of the Republic, something that proved influential on Palladio's Venetian projects.

Sansovino also designed two major palaces on the Grand Canal, the Palazzo Dolfin (begun 1538) and the Palazzo Corner at San Maurizio (begun 1545). His use of the orders to regularize the traditional Venetian palace façade conformed to the example of Mauro Codussi, but with the Palazzo Corner Sansovino drew on his own experience of designing the Zecca and the Library to achieve a monumental style anticipating that of Baldassare Longhena a century later.

The Villa Garzoni at Pontecasale, near Padua, under construction in the 1540s, was less influential but equally impressive as an example of the villa–palazzo, a substantial building with three wings about a courtyard, reminiscent both of Florentine palaces and of older Venetian palaces such as the Fondaco dei Turchi.

During his Venetian career, Sansovino also designed two monastic churches (S Francesco della Vigna and Santo Spirito) and three parish churches (S Giuliano, S Martino and S Geminiano), although with less success. He tended to use traditional ground-plans with façades reminiscent of Codussi or of Roman projects, such as Antonio da Sangallo the younger's Santo Spirito in Sassia. This deficiency was recognized by such patrons as Tommaso Rangone, who brought in Alessandro Vittoria to improve the façade of S Giuliano, after Sansovino had designed the model and the lower storeys (the bronze figure of *Rangone* on the façade is almost certainly the work of Vittoria rather than of Sansovino), and by Giovanni Grimani, who dropped Sansovino's project for S Francesco della Vigna in favour of Palladio's more imposing proposal. Only the hospital church S Salvatore degli Incurabili (destr.) showed imagination in its use of a

4. Jacopo Sansovino (workshop): colossal figure of *Neptune* (1554–66), marble, from the Scala dei Giganti, courtyard of the Doge's Palace, Venice

St George (Florence, Bargello; *see* FLORENCE, fig. 11) for the pose of *Mars* and to Baccio Bandinelli's *Hercules and Cacus* (Florence, Piazza della Signoria; *see* BANDINELLI, fig. 2) for the raw power that informs *Neptune*. The *Francesco Venier* monument, Sansovino's only ducal tomb, can be seen as the culmination of a type developed by Tullio Lombardo in the tomb of *Doge Andrea Vendramin* (Venice, SS Giovanni e Paolo; *see* LOMBARDO, (2), fig.). Sansovino's artistic personality manifested itself less in the architecture of the tomb than in the evocative presentation of the Istrian stone figures of *Charity* and *Hope*; the latter not only represents a quality, as in the case of a Quattrocento tomb, but actually *embodies* it. The sweetness of *Hope* preserves more than a hint of the style Sansovino evolved with Andrea del Sarto 40 years before.

In the decade before his death Sansovino withdrew from the frenetic activity so characteristic of his earlier years. Although Palladio was already beginning to supplant him as the major architect in Venice, Sansovino still

exercised considerable influence over Venetian sculpture through such pupils as Cattaneo and Vittoria and such followers as Tiziano Minio and Pietro da Salò; their pupils carried Sansovino's style well into the 17th century. As architect and as sculptor Sansovino's Venetian career showed that he did not have one style but several, on which he drew according to the nature of the task. Thus he could be learned and Roman in the Library and Loggetta and yet indulge in Venetian vernacular with the Palazzo Dolfin or the Palazzo Corner. He could enter into the spirit of Donatello when designing the Loggetta gods, fashioning bronzes that could almost be mistaken for 15th-century Florentine works; at the same time he could create public statuary that recalled the *gravitas* of his work in Florence and Rome. This flexibility or 'visual opportunism' served Sansovino well, although it sometimes led to a superficiality in his architecture that made his eclipse by Palladio inevitable, as a comparison of Sansovino's façade for S Martino (*c.* 1540), Venice, with Palladio's for S Francesco della Vigna makes clear. Nevertheless Sansovino usually gave his patrons what they required, and, as Vasari noted, he was capable of excelling Michelangelo in the expressive qualities of his female figures and in his miraculous handling of drapery.

2. WORKING METHODS AND TECHNIQUE. Sansovino's major early works were marble sculptures, which he carved himself. His move to Venice and increasing success led to the use of bronze, a material new to him, and to a rationalization of his working procedure: the slow creation of autograph works was generally replaced by a system in which he designed models and turned them over to others for execution. He ran his later sculptural practice on proto-industrial lines, and pressures of time forced him to concentrate on the initial stages of many projects, as a number of surviving models indicate. Clay tended to be his preferred medium for sketching, although he also employed wax and stucco. Once the definitive model was established, it could be left to assistants for enlarging into a full-scale model for a statue, or for the making of piece-moulds and a wax cast if the final medium was bronze. With marble, Sansovino generally relied on a number of journeymen labourers for blocking out and carving, while he would limit his own efforts to touching up major passages; with bronzes, Sansovino could make corrections to the wax model before dispatching it to the foundry. Bronze also offered the advantage over stone of a minimal input on his part as well as a higher degree of predictability about the outcome. None of his architectural drawings survives.

See also under VENICE, §V, 5.

BIBLIOGRAPHY
Thieme–Becker: 'Tatti, Jacopo d'Antonio'
P. Aretino: *Lettere*, 6 vols (Venice, 1538–77); ed. F. Petrile and E. Camesasca as *Lettere sull'arte di Pietro Aretino*, 3 vols (Milan, 1957–60)
G. Vasari: *Vite* (1550, rev. 2/1568); ed. G. Milanesi (1878–85), vii, pp. 485–533
T. Temanza: 'Vita di Jacopo Sansovino', *Vite dei più celebri architetti e scultori veneziani* (Venice, 1778); ed. L. Grassi, pp. 198–268
L. Cicognara: *Storia della scultura* (Prato, 1823–4), pp. 262–75
P. Selvatico: *Sulla architettura e sulla scultura in Venezia* (Venice, 1847), pp. 278–307

J. Burckhardt: *Der Cicerone [Gesamtausgabe]* (Basle, 1855), ed. F. Stahelin and H. Wölfflin, iv (Stuttgart, 1929–34), pp. 61–4

G. Lorenzetti: 'La Loggetta al campanile di San Marco', *L'Arte*, xii (1910), pp. 108–33

L. Planiscig: *Venezianische Bildhauer der Renaissance* (Vienna, 1921), pp. 349–86 [chiefly for pls]

H. R. Weihrauch: *Studien zum bildnerischen Werke des Jacopo Sansovino* (Strasbourg, 1935)

R. Gallo: 'Contributi su Jacopo Sansovino', *Saggi & Mem. Stor. A.*, i (1957), pp. 83–105

W. Lotz: 'The Roman Legacy in Sansovino's Venetian Buildings', *J. Soc. Archit. Hist.*, xxii (1963), pp. 3–12

M. Tafuri: *Jacopo Sansovino e l'architettura del '500 a Venezia* (Padua, 1969, rev. 1972)

M. Garrard: *The Early Sculpture of Jacopo Sansovino: Florence and Rome* (diss., Baltimore, Johns Hopkins U., 1970)

J. Pope-Hennessy: *Italian High Renaissance and Baroque Sculpture* (London, 1970), pp. 42–3, 78–85, 350–53, 404–10

M. Garrard: 'Jacopo Sansovino's *Madonna* in Sant'Agostino: An Antique Source Rediscovered', *J. Warb. & Court. Inst.*, xxxviii (1975), pp. 333–8

D. Howard: *Jacopo Sansovino: Architecture and Patronage in Renaissance Venice* (New Haven and London, 1975)

——: 'Le chiese di Jacopo Sansovino a Venezia', *Boll. Cent. Int. Stud. Archit. Andrea Palladio*, xix (1977), pp. 49–67

A. Foscari: 'Schede veneziane su Jacopo Sansovino', *Not. Pal. Albani*, x/1 (1981), pp. 22–34

D. Stott: '"Fatte a sembianza di Pittura": Jacopo Sansovino's Bronze Reliefs in S. Marco', *A. Bull.*, lxiv (1982), pp. 370–88

A. Foscari and M. Tafuri: *L'armonia e i conflitti: La chiesa di San Francesco della Vigna nella Venezia del '500* (Turin, 1983)

A. Foscari: 'Appunti di lavoro su Jacopo Sansovino', *Not. Pal. Albani*, xiii/2 (1984), pp. 35–56

C. Davis: 'Jacopo Sansovino's "Loggetta di San Marco" and Two Problems of Iconography', *Mitt. Ksthist. Inst. Florenz*, xxix (1985), pp. 396–400

T. Hirthe: 'Il "foro all'antica" di Venezia: La transformazione di Piazza San Marco nel cinquecento', *Cent. Ted. Stud. Ven.: Quad.*, xxxv (1986), pp. 3–30

——: 'Die Libreria des Jacopo Sansovino', *Münchn. Jb. Bild. Kst*, n. s. 3, xxxvii (1986), pp. 131–76

N. Huse and W. Wolters: *The Art of Renaissance Venice* (Chicago, 1990) [excellent account of Sansovino's archit.]

B. Boucher: *The Sculpture of Jacopo Sansovino*, 2 vols (New Haven and London, 1991) [with cat. rais. and docs]

E. Lein: 'J Sansovinos sogennante *Madonna del Prato* in Rom und ihre Beziehung zur Florentinischen Skulptur der zwetien Hälfte des 15 Jahrhunderts', *Mitt. Ksthist. Inst. Florenz*, xxxv (1991), pp. 19–201

C. David: 'Jacopo Sansovino and the Engraved Memorials of the Cappella Badoer-Giustiniani in San Francesco dalla Vigna in Venice', *Münchn. Jb. Bild. Kst*, 3rd ser., xlv (1994), pp. 133–64

P. Davies: 'A Project Drawing by Jacopo Sansovino for the Loggetta in Venice, Italy', *Burl. Mag.*, cxxxvi (Aug 1994), pp. 487–97

M. Morresi: 'Co-operation and Collaboration in Vicenza before Palladio: Jacopo Sansovino and the Pedermuro Masters at the High Altar of the Cathedral of Vicenza', *J. Soc. Archit. Hist.*, lv (June 1996), pp. 158–77

J. Poeschke: *Michelangelo and his World: Sculpture of the Italian Renaissance* (New York, 1996), pp. 143–57

BRUCE BOUCHER

(2) Francesco Sansovino (*b* Rome, 1521; *d* Venice, 28 Sept 1583). Writer, son of (1) Jacopo Sansovino. He received his early humanistic education in the school of Stefano Piazzone da Asola in Venice. Between 1536 and 1542 he studied law in Padua, Florence and Bologna, but showed no aptitude for the subject, and after a short period of service at the court of Pope Julius III (his godfather), he settled in Venice, where he embarked on a career as a writer. He wrote prolifically and on many subjects: he was interested in all areas of history, wrote verse and prose and edited translations and editions of Classical works, commentaries, collections of letters, rhetoric and *novelle*. During the 1560s and again between 1578 and 1581 he even had his own press.

Sansovino's guides to Venice enjoyed particular success, and his *Tutte le cose notabili che sono in Venetia* (1556) ran to ten editions during his lifetime (he used the pseudonym Anselmo Guisconi in the first two editions). This work is in the form of a dialogue in which a Venetian gives an outsider detailed information on such subjects as the city's origins, its government and, in particular, its works of art. For example there is a very useful description (included only in the second and later editions) of the pictures in the Palazzo Ducale, which were later destroyed in the fire of 1577. Sansovino had himself compiled the programme for the paintings in the Sala delle Quattro Porte. The book acknowledged Venice's character as a tourist city and was a counterpart to similar Roman guides, which were in turn directly derived from the ancient *Mirabilia*. Equally successful was the *Venetia città nobilissima*, published in 14 books in 1581. The first six volumes are each dedicated to a separate section of the city, describing in each case the most important buildings. Subsequent volumes deal with such aspects of Venetian life as the *scuole* or confraternities (vol. vii), public ceremonies (vol. xii) and the lives of doges and men of letters (vol. xiii). Considerable attention is given throughout to descriptions of churches, palazzi and their various works of art. Such detailed information contributes to a fine overall picture of the city, even if on some points Sansovino is superficial and even inaccurate; indeed he has been criticized for being too broad and insufficiently detailed in his coverage. During the 17th century the guide was provided with important supplements by Giovanni Stringa (1604) and Giustiniano Martinioni (1663).

Other writings by Sansovino on the history of art include his continuation of the catalogue of Florentine artists that Cristoforo Landino had prefixed to his 1481 commentary on Dante. He also attempted to produce surveys of other important Italian cities modelled on the guide to Venice. These drew heavily on the work of Leandro Alberti and covered some 115 cities, both large and small, arranged alphabetically.

WRITINGS

Tutte le cose notabili che sono in Venetia, cioè usanze antiche, pitture e pittori, sculture e scultori, fabriche e palazzi, huomini virtuosi, principi di Venetia e tutti i patriarchi (Venice, 1556)

ed., with C. Landino: D. Alighieri: *La commedia* (Venice, 1564) [with cat. of artists by Sansovino]

Ritratto delle più notabili et famose città d'Italia (Venice, 1576)

Venetia città nobilissima et singolare descritta in XIV libri (Venice, 1581, rev. 1663/R Farnborough, 1968)

BIBLIOGRAPHY

E. A. Cicogna: *Delle iscrizioni veneziane*, iv (Venice, 1834), pp. 31–91

G. Sforza: 'Francesco Sansovino e le sue opere storiche', *Mem. Reale Accad. Sci. Torino*, n. s. 2, xlvii (1897), pp. 27–40

D. von Hadeln: 'Sansovinos "Venetia" als Quelle für die Geschichte der venezianischen Malerei', *Jb. Kön.-Preuss. Kstsamml.*, xxxi (1910), pp. 159–68

G. Pusinich: 'Un poligrafo veneziano del cinquecento', *Pagine Istria*, viii (1910), pp. 121–30, 145–51

P. F. Grendler: 'Francesco Sansovino and Italian Popular History, 1560–1600', *Stud. Ren.*, xvi (1969), pp. 139–80

M. L. Doglio: 'La letteratura ufficiale e l'oratoria celebrativa', *Stor. Cult. Ven.*, iv/1 (1983), pp. 163–87

F. Gaeta: 'Venezia da stato misto ad aristocrazia esemplare', *Stor. Cult. Ven.*, iv/2 (1984), pp. 437–94

DONATA BATTILOTTI

Sansovino, Andrea [Andrea dal Monte Sansovino] (*b* Monte Sansovino, *c.* 1467; *d* Monte Sansovino, 1529).

Italian sculptor. A contemporary of Leonardo da Vinci, he formulated the rubric of High Renaissance form for sculpture as Leonardo did for painting. His style and technique as well as his association with the della Robbia workshop place him firmly in the mainstream of late 15th-century Florentine art. According to Vasari, he was an important architect and a sculptor in bronze as well as marble, but the bronzes and architectural projects mentioned are untraced. A number of drawings (e.g. London, V&A), principally for altars and wall-tomb projects, are attributed to Sansovino, but none can be related to particular extant works.

1. Life and work. 2. Critical reception, influence and posthumous reputation.

1. LIFE AND WORK.

(i) Florence and Portugal, to 1505. The conjectural year of Sansovino's birth is derived from documents indicating that his parents were married in June 1465 (his father was called Niccolo di Menco de' Mucci) and that he had an elder brother. He was enrolled in the Florentine guild the Arte dei Maestri di Pietra e Legname on 13 February 1491. As artistic emissary from Lorenzo de' Medici to King John II (*reg* 1481–95), he made two trips to Portugal between 1491 and 1500, returning to Florence for the period 1493–6.

The identification of Sansovino's work before 1491 rests principally on Vasari's statements. Among the earliest works are two altarpieces in terracotta, the *Virgin and Child with Four Saints*, which was probably glazed in the della Robbia workshop, and *SS Lawrence, Roch and Sebastian*, perhaps originally polychromed (both Monte Sansovino, S Chiara). A terracotta *Head of Galba* (Arezzo, Mus. Casa Vasari), apparently glazed at Cafaggiolo, belonged to Vasari, who also owned a *Head of Nero* (untraced). The glazed terracotta frieze for the portico of the Villa Medici at Poggio a Caiano (*in situ*), designed by Giuliano da Sangallo, may have been executed by Sansovino; other sources attribute it to Bertoldo di Giovanni and the della Robbia workshop. A marble *Tabernacle of the Oil* at S Margherita in Montici, near Florence, is also from this period. These early works are marked by a tension between verisimilitude and classical idealization which is characteristic of late 15th-century art. They indicate familiarity not only with Antonio Pollaiuolo, with whom Vasari asserted that Andrea trained, but with the narrative relief style, figural grace and techniques of the marble sculptors Benedetto da Maiano and Andrea del Verrocchio.

The outstanding achievement of Sansovino's early period is the Corbinelli Altar (Florence, Santo Spirito), a commission he received soon after the chapel was granted to the family in 1485. The triumphal arch motif of the altar is closely related to that in Benedetto da Maiano's contemporary *Annunciation* altar (Naples, S Anna dei Lombardi) but with much bolder reference to the Arch of Constantine in Rome. In the Corbinelli Altar, Sansovino demonstrated his great versatility as a sculptor, employing a variety of styles and figure types in the carving of the reliefs and sculpture in the round. This work established him as the successor to the 15th-century masters Donatello and Desiderio da Settignano.

1. Andrea Sansovino: *Virgin and Child*, marble, over life-size, 1501–3 (Genoa Cathedral, Chapel of St John the Baptist)

Efforts to identify Sansovino's work in Portugal (Justi and Battelli) have yielded little critical consensus, and it may be that all trace was destroyed in the Lisbon earthquakes. Among the works cited by Vasari are a palace with four towers, a clay model of a battle scene and a marble

2. Andrea Sansovino: *St John the Baptist*, marble, over life-size, 1501–3 (Genoa Cathedral, Chapel of St John the Baptist)

figure of *St Mark*. If nothing remains of Sansovino's work in Portugal, evidence of his influence there may be attested in the superbly carved marbles and alabasters of sculptors such as Nicolau Chanterene.

In the period following his return to Italy, Sansovino became established as a sculptor of large-scale figures. In Florence in 1501 he was considered for the colossal block that was ultimately given to Michelangelo for the *David* (Florence, Accad.; *see* ITALY, fig. 22). Soon after this, he

gained two important commissions for monumental marble figural groups, a *Baptism* (1502; *see also* ANDREA DEL VERROCCHIO, fig. 5) for the east doors of the Baptistery of Florence Cathedral (*in situ*) and at about the same time a *Virgin and Child* and *St John the Baptist*, both for Genoa Cathedral (*in situ; see* figs 1 and 2). These figures, his first to demonstrate the Classical canon of anatomical proportion and pose, are notable for their nobility, dignity and grace.

(ii) Rome, 1505–13. Sansovino abandoned important commissions in Florence, for the cathedral and the Palazzo Vecchio, on being summoned to Rome by Pope Julius II to design and carve tombs for Cardinal Ascanio Sforza and Cardinal Girolamo Basso della Rovere, commissioned in 1505 and 1507 respectively. The tombs were carefully integrated into Donato Bramante's new choir for S Maria del Popolo, prompting debate as to Bramante's possible role in the design of the framing motif of a triumphal arch. Sansovino's use of the motif in the Corbinelli Altar, however, suggests that the design is his. For the tomb sculpture he referred to ancient funerary and architectural sculpture, introducing a semi-reclining figure in place of the traditional effigy, and setting personifications of Virtues into the triumphal arch frame.

Sansovino's next Roman commission, the marble group of the *Virgin and Child with St Anne* (1512; Rome, S Agostino), was instigated by one of the leading humanists in Rome, the curial prelate Johann Goritz. Goritz, who entertained literary and artistic friends on the feast of St Anne, commissioned the work as part of an altar that was intended to unite the arts of sculpture, painting and poetry. Sansovino collaborated with Raphael, whose fresco of the *Prophet Isaiah* is on the pier above the altar ensemble. An annual poetry contest was held to celebrate the saint, the statue and the patron. The statue, possibly the first life-size, multi-figure group carved out of a single block of marble since antiquity, might have been executed in response to the discovery in Rome in 1506 of the *Laokoon* (Rome, Vatican, Mus. Pio-Clementino), an antique sculptural group reputedly carved from one block. To give equal emphasis to the three figures, Sansovino created three principal views for the group; that featuring St Anne approximates most closely the compositional solutions that Leonardo adopted in his series of the same subject (e.g. cartoon, London, N.G.).

(iii) Loreto and Florence, 1513–29. Sansovino received a second papal commission in 1513, to supervise the architectural projects and the erection of the marble revetment for the sanctuary of the Santa Casa at Loreto, popularly believed to be the site of the Annunciation (*see* LORETO, §II, 1,(ii)(a) and fig. 3). The shrine complex was designed *c.* 1509–10 by Bramante, who began its construction and provided a model for the revetment. From 1513 onwards Sansovino worked mainly on this project, moving between Loreto, Rome and Monte Sansovino. By 1517 he was concentrating on the carving and assembly of the revetment, which features numerous reliefs and sculptures. Among contemporary works the monumental scale of the revetment relief sculpture was equalled only in Michelangelo's thwarted projects for the tomb of Julius II. Sanso-

vino carved the principal relief, the *Annunciation* (1518–22; *in situ*), and two others, the *Adoration of the Shepherds* (1518–24) and the *Marriage of the Virgin* (completed in 1533 by Niccolò Tribolo). The *Annunciation*, generally considered to be his masterpiece, represents the culmination of Renaissance narrative relief-carving in its handling of pictorial effects, complex perspective schemes, extraordinary undercutting and numerous figures, many carved almost in the round. The story is dramatically presented: the focus on the Virgin's room is emphasized by the perspective of the arcaded halls of the Temple, the gestures of the Archangel Gabriel and the heavenly host, and by the shaft of divine light sent by God the Father with the dove of the Holy Spirit.

In 1516 Sansovino was asked to submit a design for another architectural project meant to carry a rich programme of sculpture, the façade of S Lorenzo, Florence. Other architectural projects attributed to him include the vestibule for the sacristy of Santo Spirito, Florence, several religious and civic structures in Monte Sansovino and Jesi, and the façade of S Maria dell'Anima in Rome. (The traditional attribution to him of the pedimental figures on that façade is, however, incorrect, according to documents in the church archive.) Although Sansovino's role in these projects is not clear, his close association with architects of his generation, notably Cronaca, the Sangallo brothers and Bramante, lends support to Vasari's assertion of his architectural skills. Sansovino left Loreto in 1527; he spent his last years in Monte Sansovino.

2. CRITICAL RECEPTION, INFLUENCE AND POSTHUMOUS REPUTATION. Sansovino's extant work is informed by an astute understanding of perspective and by a conversancy with the architectural vocabulary of antiquity and the Renaissance. His personal style is also marked by his mastery as a carver of marble. Critical appraisal of his technique has followed Vasari's observation 'that the point of a brush could scarcely do what Andrea did with his chisel'. In technique and design he set new standards, developing carving methods of the greatest 15th-century Florentine sculptors to create a High Renaissance vocabulary of form.

Sansovino's most important pupil was Jacopo Sansovino, who became his apprentice *c.* 1502 and adopted his master's surname in deference. Jacopo may have assisted in carving the Florence Baptistery and Genoa Cathedral statues as well as the tombs in S Maria del Popolo, Rome, but it is difficult to identify his hand in Andrea's work. The influence of Andrea is clear, however, in Jacopo's early sculptures, such as his *St James the Greater* (1511–18; Florence Cathedral; *see* SANSOVINO, (1), fig. 1). At Loreto, Andrea supervised gifted younger sculptors, including Baccio Bandinelli and Raffaello da Montelupo, who assisted in the carving of the revetment for the Santa Casa. This was not a workshop in the 15th-century sense, but a group of young artists guided by a master in an atmosphere conducive to the exchange of ideas important for sculptors of the next generation.

Sansovino's tombs in S Maria del Popolo and the *Virgin and Child with St Anne* are particularly praised in Roman guidebooks of the 16th to 18th centuries. The *St Anne* group drew special acclaim in contemporary poetry (*Cor-*

yciana, Rome, 1524), an appraisal that must be viewed in the context of the PARAGONE, the comparison between sculpture and painting, and the development of art theory in the 16th century.

BIBLIOGRAPHY
Thieme–Becker
G. Vasari: *Vite* (1550, rev. 2/1568); ed. G. Milanesi (1878–85), iv, pp. 509–27
P. Schonfeld: *Andrea Sansovino und seine Schule* (Stuttgart, 1881)
C. Justi: 'Die portugiesische Malerei des XVI. Jahrhunderts', *Jb. Kön.-Preuss. Kstsamml.*, ix (1888), p. 234
C. von Fabriczy: 'Ein unbekanntes Jugendwerk Andrea Sansovinos', *Jb. Kön.-Preuss. Kstsamml.*, xxvii (1906), pp. 79–105
G. Battelli: *Il Sansovino in Portogallo* (Coimbra, 1929)
G. H. Huntley: *Andrea Sansovino* (Cambridge, 1935)
C. Girolami: 'In margine ad una monografia su Andrea Sansovino', *Atti & Mem. Accad. Petrarca Lett., A. & Sci.*, xxx–xxxi (1941)
J. Pope-Hennessy: *Italian High Renaissance and Baroque Sculpture* (Oxford, 1963, rev. New York, 3/1986)
H. Keutner: 'Andrea Sansovino e Vincenzo Danti: Il gruppo del Battesimo di Cristo sopra la Porta del Paradiso', *Scritti di storia dell'arte in onore di Ugo Procacci* (Milan, 1977), pp. 370–80
K. Weil-Garris: *The Santa Casa at Loreto* (New York, 1977)
U. Middeldorf: *Raccolta di scritti*, i (Florence, 1979) [essays of 1924–38, incl. 'Unknown Drawings of the Two Sansovinos', pp. 107–16; 'Eine Zeichnung von Andrea Sansovino in München', pp. 121–8; 'Two Sansovino Drawings', pp. 147–53; 'Giuliano da Sangallo and Andrea Sansovino', pp. 155–65]
C. Avery: *Florentine Renaissance Sculpture* (London, 1980)
V. A. Bonito: 'The Saint Anne Altar in Sant'Agostino, a New Discovery', *Burl. Mag.*, cxxii (1980), pp. 805–11
——: 'The Saint Anne Altar in Sant'Agostino: Restoration and Interpretation', *Burl. Mag.*, cxxiv (1982), pp. 268–75
VIRGINIA ANNE BONITO

Santacroce, Girolamo da (*b* Santa Croce, Bergamo, 1480–85; *d* Venice, after 9 July 1556). Italian painter. He was a pupil of Gentile Bellini, who in his will (1507) left him half of the drawings of oriental figures that he had lent to Bernardino Pinturicchio. Afterwards Santacroce was probably employed in the workshops of Giovanni Bellini and Cima and was evidently influenced by Titian and by Palma Vecchio. He was typical of the jobbing painters who produced copies of the works of the great contemporary masters for sale to sometimes quite discerning clients. There are many signed and often dated examples of his prolific output. The earliest of these is the Ryerson *Madonna and Child* (1516; Chicago, IL, A. Inst.), the latest the *Last Supper* (Venice, S Martino) and a polyptych depicting the *Virgin and Child with Saints* (Split, Our Lady of Poljud), both dated 1549. Many other paintings are traceable to his workshop or attributable to either Girolamo or his son Francesco (1516–84) with whom he is easily confused in his last phase. Among his lost works is the *Virgin and Child with St Lorenzo Giustiniani*, painted for the church of the Madonna dell'Orto, Venice, in 1525 and two paintings of the *Head of the Saviour*, executed in collaboration with Lorenzo Lotto for SS Giovanni e Paolo, Venice, in 1542.

BIBLIOGRAPHY
Thieme–Becker
J. A. Crowe and G. B. Cavalcaselle: *A History of Painting in North Italy*, ii (London, 1871), pp. 544–6; ed. T. Borenius, iii (London, 1912), pp. 444–8
A. Venturi: 'Documenti storico artistici: Il libro dei conti di Lorenzo Lotto', *Gallerie nazionali italiane*, i (1895), pp. 115–224 (124)
G. Ludwig: 'Archivalische Beiträge zur Geschichte der venezianischen Malerei: Die Bergamasken in Venedig', *Jb. König.-Preuss. Kstsamml.*, xxiv (1903), pp. 10–20 [suppl.]

G. Fiocco: 'I pittori da Santacroce: ii, Gerolamo da Santacroce', *Arte*, xix (1916), pp. 187–92, 200–03

B. Berenson: *Venetian School*, i (London, 1957), pp. 153–7

F. Heinemann: *Giovanni Bellini e i Belliniani*, i (Venice, 1962), pp. 160–77

R. Stadiotti: 'Per un catalogo delle pitture di Girolamo da Santacroce', *Atti Ist. Ven. Sci., Lett. & A.*, cxxxiv (1975–6), pp. 569–91

B. della Chiesa and E. Baccheschi: 'I pittori da Santa Croce', *I pittori bergamaschi dal XIII al XIX secolo: Il cinquecento*, ii (Bergamo, 1976), pp. 4–19, 28–35, 52–65

L. P. Gnaccolini: 'La donazione Pyrker', *A. Lombarda*, cxvii/2 (1996), pp. 116–21

A. Tempestini: 'La *Sacra Conversazione* nella pittura veneta dal 1500 al 1516', *La pittura nel Veneto: Il Cinquecento*, iii (Milan, 1999) (in preparation)

ANCHISE TEMPESTINI

Sant'Agata, Francesco (di Giacomo) da (*fl* 1491–1528). Italian goldsmith and sculptor. Documents dating from between 1491 and 1528 record his activity as a goldsmith in the area near the church of Sant'Agata in Padua, from which he derives his name. His one securely documented work to survive, a boxwood *Hercules with a Club* (London, Wallace), signed OPVS. FRANCISCI. AVRIFICIS, was highly praised in 1560 by Bernardino Scardeone, who stated that it was in the collection of Marc'Antonio Massimo in Padua. This sleek and highly finished statuette of a muscular Hercules wielding his club established the standard against which a number of similar boxwood and bronze figures have been compared. The analogies between the work's posture and modelling and those of another statuette of *Hercules* (Oxford, Ashmolean) prompted some critics to ascribe this to da Sant'Agata as well, although it has been reattributed to Vittore Gambello.

Other bronzes associated with da Sant'Agata include statuettes of a languid *Niobe* and a *Narcissus* (both London, Wallace) and a *Naked Youth with Raised Arms* (New York, Frick), of which there is also a boxwood version, identified as *St Sebastian* (Berlin, Skulpgal.). A graceful group of *Hercules and Antaeus* (Washington, DC, N.G.A.) has also been assigned to da Sant'Agata. Later attributions included such bronzes as a *Horse and Rider* (New York, Met.), *Europa and the Bull* (Budapest, Mus. F.A.) and a grimacing *Susanna* (New York, Frick). These were ascribed to da Sant'Agata on account of their jewel-like surfaces and chasing, suggesting the work of a goldsmith who was aware of the sculpture of Andrea Riccio.

BIBLIOGRAPHY

B. Scardeone: *De antiquitate urbis Patavii et claris civibus Patavinis* (Basle, 1560)

W. Bode: *The Italian Bronze Statuettes of the Renaissance* (Eng. edn, London, 1907, rev. New York, 1980), pp. 34–7, 95, pls LXXVIII–LXXXI

L. Planiscig: *Venezianische Bildhauer der Renaissance* (Vienna, 1921), pp. 297–306

J. G. Mann: *Wallace Collection Catalogues: Sculpture* (London, 1931, suppl. 1981), p. 101, pls 68, 75

J. Pope-Hennessy: 'An Exhibition of Italian Bronze Statuettes', *Burl. Mag.*, cv (1963), pp. 14–23

A. Sartori: *Documenti per la storia dell'arte a Padova* (Padua, 1976), pp. 323–4

J. D. Draper: 'Andrea Riccio and his Colleagues in the Untermeyer Collection: Speculations on the Chronology of his Statuettes and on Attributions to Francesco da Sant'Agata and Moderno', *Apollo*, cvii (1978), pp. 170–80

ANTONIA BOSTRÖM

Santi, Raffaello. *See* RAPHAEL.

Santi di Tito *See* TITO, SANTI DI.

Santo, Girolamo del. *See* TESSARI, GIROLAMO.

Sanvito [San Vito], **Bartolomeo** (*b* Padua, 1435 or 1438; *d* Padua, after 1518). Italian scribe and illuminator. He was also the most important humanist scribe in Padua, whose monumental epigraphic style was influential also in Rome and Naples. He is first documented as 'scriptor' at the end of the 1450s in Padua, where he was in contact with academic circles and in particular with Bernardo Bembo (1422–1519), a Venetian patrician, who in those years was a student in Padua and for whom Sanvito produced splendid manuscripts (e.g. the *Oratio gratulatoria*, London, BL, Add. MS. 14787). In these, as in other works executed in Padua in the late 1450s and early 1460s, script and decoration were revived in a humanist and antiquarian vein, aimed at recreating the Classical codex. From 1469 to 1501 Sanvito was in Rome at the papal court, where he transcribed numerous books, some signed with the monogram B.S., for such illustrious patrons as the humanist Bartolomeo Sacchi or il Platina (1421–81) and cardinals Francesco Gonzaga and Giovanni d'Aragona (1456–85). Sanvito's writing, recognizable by certain graphic features and other idiosyncracies, clearly shows his role in the spread of italic script, a cursive variant of the 'littera antiqua'. Another feature of his work is the inclusion of beautiful *tituli* in gold, red, blue and green capital letters, which reveal his knowledge of Latin epigraphic script, partly acquired through his friendship with the Veronese epigraphist Fra Giovanni Giocondo. In later codices, beginning in the 1490s, Sanvito's writing appears shaky as a result of arthritis.

Sanvito's diary, written in 1505–11, when he returned to live in Padua and became a canon at Monsélice (near Padua), makes it clear that he was not only a copyist but also passionately interested in Classical culture and art, which he collected. He knew Francesco Squarcione and possessed works by Gasparo Padovano (see colour pl. 2, X2) and Lauro Padovano. Sanvito collaborated with such artists as Franco dei Russi, but in a substantial group of codices both illumination and script have been attributed to him. These books, for example a Suetonius manuscript (Paris, Bib. N., MS. lat. 5814), a copy of Petrarch (ex-Major J. R. Abbey priv. col.; sold London, Sotheby's, 20 June 1978, lot 2989) and Eusebius of Caesarea's *Chronicon* (London, BM, MS. Royal 14 c. 3; see fig.) have architectural frontispieces or friezes with trophies, candelabra, medals and putti derived from antique sculpture and reliefs. Both here and in the rest of the illustrations, especially in the use of colour, Veneto–Paduan influence of the 1450s and 1460s, in particular that of Mantegna and Giovanni Bellini, can be seen.

On the basis of the links between the script and painting in these manuscripts and, above all, the stylistic affinity between them and the miniatures in an Epistolary and an Evangeliary (both Padua, Bib. Capitolare, Cods E. 26–7 respectively), it has been suggested that Sanvito may have been the illuminator of the latter two books. Both were donated by Sanvito in 1509 to the collegiate church of Monsélice and carry his inscription declaring them to be 'manu sua impensaque conscripta ornataque'. On the

Bartolomeo Sanvito: frontispiece for Eusebius of Caesarea: *Chronicon*, translated from the Greek by St Jerome, 15th century (London, British Museum, MS. Royal 14 c. 3)

other hand, the notes written in the Monsélice manuscripts and other Roman documents, which indicate that Sanvito was paid not only for the script but for the paper and decoration of the codices, might suggest that, having copied the text, he was asked to arrange for their ornamentation by another illuminator. Following this hypothesis, the corpus of manuscripts with illumination attributed to Sanvito has been variously ascribed to the Master of the Vatican Homer (Rome, Vatican, Bib. Apostolica, MS. Vat. gr. 1626), who is possibly to be identified as Gasparo Padovano, and to Lauro Padovano.

BIBLIOGRAPHY

S. De Kunert: 'Un padovano ignoto ed un suo memoriale de' primi anni del Cinquecento (1505–1511)', *Boll. Mus. Civ. Padova*, x (1907), pp. 1–16

J. Wardrop: *The Script of Humanism: Some Aspects of Humanistic Script, 1460–1560* (Oxford, 1963), pp. 19–35, 50–51

J. J. G. Alexander and A. C. De La Mare: *The Italian Manuscripts in the Library of Major J. R. Abbey* (London, 1969), pp. 104–10

Renaissance Painting in Manuscripts: Treasures from the British Library (exh. cat., ed. T. Kren; London, BL, 1983), no. 13

J. Ruysschaert: 'Il copista Bartolomeo San Vito, miniatore padovano a Roma dal 1469 al 1501', *Archv Soc. Romana Stor. Patria*, cix (1986), pp. 37–47

U. Bauer Eberhardt: 'Lauro Padovano und Leonardo Bellini als Maler, Miniatoren und Zeichner', *Pantheon*, xlvii (1989), pp. 49–82

The Painted Page: Italian Renaissance Book Illumination, 1450–1550 (exh. cat., ed J. J. G. Alexander; London, RA, 1994)

P. Gwynne: 'A Renaissance Image of Jupiter Stator', *J. Warb. Court. Inst.*, lviii (1995), pp. 249–52

FEDERICA TONIOLO

Sanzio, Raffaello. *See* RAPHAEL.

Saracchi [Sarachi]. Italian family of hardstone engravers, active in Milan from the mid-16th century to the early 17th. Bartolomeo Saracco, a hardstone engraver, is mentioned in documents between 1561 and 1578, and had five sons who worked as glyptic artists: Giovanni Ambrogio Saracco (*b* 1540–41), Simone Saracco (*b* 1547–8), Stefano Saracco (*b* 1550–51; *d* before 1595), Michele Saracco (*b* after 1550) and Raffaello Saracco (*b* after 1550; *d* before 1595). In early 1573 Giovanni Ambrogio, Simone and Stefano offered to go to Munich to work for Albert V, Duke of Bavaria (*reg* 1550–79). Giovanni Ambrogio and Stefano specialized in producing vessels of sculptural form for which they actually ground the material. Simone's art, which was rated more highly, consisted in carving the intaglio decoration. The move to Munich did not come about, however, and the family workshop remained in Milan.

The Saracchi's letter to the Munich court provides the first reliable information on the oeuvre of the workshop. An accompanying drawing shows a rock crystal bowl (*c.* 1571; w. 298 mm; Vienna, Ksthist. Mus.), made by Giovanni Ambrogio and Simone, depicting the *Abduction of Helen* and the *Trojan Horse*. The intaglio decoration within the circular bottom of the bowl is of the *Four Seasons* and is copied from intaglios attributed to ANNIBALE FONTANA, the brother-in-law of the Saracchi brothers. The Saracchi never fully mastered the anatomy of the human body, and produced instead rather stylized figures and narrative scenes. They were influenced by Fontana's new principles for depicting figural scenes, which took into account the transparency of rock crystal, by widely separating figures set within a narrow area to show their profiles as clearly as possible against the polished planes. The Saracchi's best pieces with figural intaglios were produced between 1575 and 1587, during which period Fontana supplied them with designs, or let them copy preliminary drawings for his own works.

From 1579 Giovanni Ambrogio was in charge of the business as head of the family. In that year Albert V acquired two important rock crystal works by the Saracchi: the covered ewer with a depiction of *Joseph and his Brothers*, and the 'Galley of Moses' (both Munich, Residenzmus.). A preliminary drawing of the ewer by Annibale Fontana survives (Vienna, Österreich. Mus. Angewandte Kst). The lion foot and body of the galley survive, the body depicting scenes from the *Life of Moses*. The costly gold mounts, inlaid with gemstones, comprising galley slaves, soldiers, cannon, masts and sails, have been lost. These two works are securely attributed through invoices, and a number of other important pieces may be linked to them on stylistic grounds: a covered ewer with a depiction of the *Story of Callisto*, another galley, carved with the *Judgement of Paris* and the *Abduction of Helen* (both Munich, Residenzmus.), and a covered cylindrical vessel (Vienna, Ksthist. Mus.) with a bacchanalian procession. A table-fountain (Florence, Pitti) in the form of a ship is decorated in part with dynamic grotesque vines and with an abbreviated variant of the Moses scenes in Munich. This vessel was delivered to Florence in 1589 for the wedding of Ferdinand I de' Medici and Christine of Lorraine. A large ewer (Florence,

Pitti), the walls of which are decorated with allegories of the *Four Elements* after drawings by Fontana, also deserves mention.

A particular speciality of the Saracchi workshop were bird-shaped vessels and grotesque bird-dragons, which in some cases actually had genuine heron feathers on their heads, and such pieces were the most original and independent work produced by the workshop. Like almost all hardstone vessels, the 'herons', as they were called in inventories, were display pieces for princely *Kunstkammern*. The two largest pieces, of rock crystal, 438 and 409 mm high, come from the *Kunstkammer* of Ferdinand, Count of Tyrol (*reg* 1564–95), at Schloss Ambras and are now in the Kunsthistorisches Museum, Vienna. Two smaller bird-dragons of rock crystal and one of brown jade are also in the same museum, the latter with the escutcheon of the Archbishop of Salzburg, Wolf Dietrich von Raitenau. In the Museo degli Argenti in Florence there are also two bird-dragons of rock crystal and one of jade. The flanks of one of the crystal birds (*see* MILAN, fig. 4) are adorned with hunting scenes after sketches by Etienne Delaune (*c.* 1519–1583). Another rock crystal bird (Stuttgart, Württemberg. Landesmus.) shows marine scenes with *Neptune* and *Amphitrite*.

From the 1590s four sons of Giovanni Ambrogio Saracco also worked in the workshop: Gabrielo Saracco as a hardstone engraver, Pietro Antonio Saracco as a goldsmith, and Gasparo Saracco and Costanzo Saracco, one of whom was also a hardstone engraver and the other a goldsmith. No specific works can be linked to any of them. Gabrielo was Court Jeweller to the Duke of Mantua from 1617, and in the second decade of the 17th century asked high prices for work set with gemstones. The third generation continued the style of the Saracchi workshop and their work can be seen in a large fantastical vessel of rock crystal with two spouts and two handles, covered in grotesques (Vienna, Ksthist. Mus.). The mounts date this piece to the early 17th century. The altar crosses of rock crystal (Munich, Residenzmus.; Vienna, Schatzkam.) are probably also from this late period. It can be seen from these pieces that the workshop's style coarsened in the late period, and scenic or figural intaglios became rarer. The Saracchi workshop was, however, over at least four decades a well-known and extremely productive workshop for hardstone engraving in Milan, second only to the Miseroni workshop.

BIBLIOGRAPHY

P. Morigia: *La nobilità di Milano* (Milan, 1595), pp. 292–4

E. Kriss: *Meister und Meisterwerke der Steinschneidekunst der italienischen Renaissance* (Vienna, 1929), pp. 111–22, 182–7

R. Distelberger: 'Die Saracchi-Werkstatt und Annibale Fontana', *Jb. Ksthist. Samml. Wien*, lxxi (1975), pp. 95–164

——: 'Anmerkungen zu einigen Bergkristallarbeiten der Saracchi-Werkstatt nach Vorlagen von Annibale Fontana', *Die Weltkunst*, xix (1979), pp. 1244–5

RUDOLF DISTELBERGER

Sarcophagus. Chest for inhumation. The term (from anc. Gr. *sarkophagous*: 'flesh eating', from a type of limestone thought to consume the bodies laid in it) is generally applied to substantial or decorated types of coffin, of which there are examples from many different contexts worldwide.

The reuse of Classical sarcophagi as convenient and economical repositories for more recently deceased persons was characteristic of the Italian Renaissance, but it was not an innovation. The arms of an unidentified late medieval member of the Medici family appear, flanking an *agnus dei*, on a new pentroofed lid placed on an ancient Roman sarcophagus of *Meleager* (Florence, Baptistery). Similarly, *c.* 1443, an effigy of *Giuliano Davanzati* was carved in low relief, on a new lid for an Early Christian (3rd century AD) strigillated (i.e. ornamented with decorative fluting) sarcophagus, centred with a panel of *Christ the Good Shepherd*, and with lions' heads at either end. Copies or pastiches of earlier, purely decorative types of sarcophagus were also popular, to indicate familiarity and some identification with antiquity: some were strigillated, while in 1464 an ovoid one, like a wicker basket, was carved, probably by Donatello's workshop, for *Niccolo and Fioretta Martelli* (Florence, S Lorenzo); its curvaceous lid bore the coat of arms and a laudatory inscription on a Roman-style tablet with floating ribbons.

The earliest specifically Renaissance sarcophagus was created by Jacopo della Quercia for the tomb of *Ilaria del Carretto* (1405–1407/8; Lucca, S Martino; *see* JACOPO DELLA QUERCIA, fig. 2); it imitates a Roman type, being decorated with winged putti, which stand the full height of its sides and support great swags of fruit which loop down between them. This fidelity to a Classical model firmly identifies Jacopo as a protagonist of the Renaissance style in Italy.

In the second and third decades of the 15th century a favourite Roman design, showing a pair of winged putti in flight, supporting a wreath between them, was adapted to Renaissance usage: first in Piero di Niccolò Lamberti's tomb of *Onofrio Strozzi* (1418; Florence, Santa Trìnita), and a decade later by Buggiano (perhaps with the inspiration of Donatello and Brunelleschi), in the sarcophagus of *Giovanni di Bicci de' Medici and his wife Piccarda* (*c.* 1429–33; Florence, S Lorenzo). Both sarcophagi display the family coat of arms in the central wreath, but Buggiano placed the whole group on the lid, and sculpted two other putti on the sides, supporting tablets with laudatory inscriptions. Ghiberti adapted the same motif, but with more mature and fully draped angels, for his two bronze sarcophagi, one for the remains of three early Christian martyrs, *SS Protus, Hyacinth and Nemesis* (*c.* 1427; Florence, Bargello), and the other for *St Zenobius* (1432–42; Florence Cathedral). In the latter the angels are shown three deep on either side, thus creating an illusion of depth that is quite unlike the Classical prototypes.

Donatello and his partner Michelozzo adapted ancient precedent for having a narrative relief on the front of a sarcophagus, by inserting panels of *rilievo schiacciato*. Examples include the *Assumption of the Virgin* on their tomb of *Cardinal Rinaldo Brancaccio* (1426–8; Naples, S Angelo a Nilo; *see* MICHELOZZO DI BARTOLOMEO, fig. 1). The monument to *Bartolomeo Aragazzi* (fragments, Montepulciano Cathedral) included two panels carved by Michelozzo, one of which specifically imitated a Classical scene of the deceased taking leave of his family, a type normal on Greco-Roman gravestones. Flying angels in low relief, supporting tablets bearing laudatory inscriptions, became the norm for Florentine tombs: for instance,

Bernardo Rossellino's tomb of *Leonardo Bruni* (*c.* 1444–51; for illustration *see* ROSSELLINO, (1)), or Desiderio da Settignano's tomb of *Carlo Marsuppini* (*d* 1453; both Florence, Santa Croce; *see* DESIDERIO DA SETTIGNANO, fig. 1). Sculptors occasionally inserted a profile portrait of the deceased into the medallion held up by the putti (e.g. Rossellino's tomb of *Neri Capponi*, *c.* 1457; Florence, Santo Spirito); this, too, reflected Roman practice, although there the deceased had usually been shown frontally. Many variations of elements such as putti, coats of arms, inscriptions and so forth have been recorded.

The luxurious porphyry-clad sarcophagus of *Piero I de' Medici and Giovanni de' Medici*, erected by Lorenzo the Magnificent and Giuliano de' Medici in the open doorway between the Medici Chapel and the Old Sacristy in S Lorenzo, Florence, constitutes an exception. Designed by Verrocchio (*c.* 1470; *see* VERROCCHIO, ANDREA DEL, fig. 2), it has no figural decoration, but only a terse Latin inscription and luxuriant bronze mounts of acanthus leaves, and cornucopias, the whole surmounted by the Medici device of a diamond: the sarcophagus is surrounded by a simulated rope network, cast realistically in bronze and serving to divide the chapel from the sacristy.

The Stoic ideal of austerity was also proclaimed by tomb-chests such as those of *Francesco Sassetti* and his wife *Nera Corsi* (1483; Florence, Santa Trìnita), where black marble was used, notably for its funereal connotations, but also perhaps punning on the wife's name. In this novel design, ascribed to Giuliano da Sangallo, bucrania replaced the more vivacious putti. In North Italy the Gothic tradition of decorating sarcophagi with narrative panels persisted, as in the tomb of the condottiere *Bartolomeo Colleoni* (*d* 1475) by Giovanni Antonio Amadeo and his workshop, in the Colleoni Chapel, Bergamo (*see* AMADEO, GIOVANNI ANTONIO, fig. 1). Other examples are the funerary monument of *Giovanni Stefano Brivio* (Milan, S Eustorgio) by Tommaso Cazzaniga (*fl c.* 1470–1504), and that of *Camillo Borromeo* in Palazzo Borromeo, Isola Bella, Lake Maggiore.

In Rome, a standard type of tomb for the burial of great prelates came to conflate the sarcophagus with the representation of the bier, bearing an effigy of the deceased, laid out as though for burial; originally, in the 'humanist tombs' of Tuscany, such as the monument to *Leonardo Bruni* (see above), the bier was placed on top of the tomb, being quite distinct from it. To economize on labour and space, the two were subsequently combined, so that the effigy lay directly on the tomb-chest. During the High Renaissance, the effigy was made less funereal by portraying the deceased propped up on one elbow, as though asleep; this may be seen in Andrea Sansovino's funerary monuments of *Cardinal Ascanio Sforza* and *Cardinal Girolamo Basso della Rovere* (both 1505–7; Rome, S Maria del Popolo). Subsequently, effigies were given open eyes. The funereal grandeur of a plain sarcophagus, with minimal architectural mouldings or ornaments, appealed to Michelangelo for his Medici tombs (Florence, S Lorenzo; *see* MICHELANGELO, fig. 4), and also to Cardinal Thomas Wolsey, who chose a black touchstone one for his tomb by Benedetto da Rovezzano; this sarcophagus was expropriated by Henry VIII for his own tomb (and was

eventually used as part of the monument to *Horatio, 1st Viscount Nelson* (*d* 1805) in St Paul's Cathedral, London).

BIBLIOGRAPHY
E. Panofsky: *Tomb Sculpture* (New York, 1964/*R* London, 1992)
B. Myers: *Sculpture: Form and Method* (London, 1965)
R. Butler: *Western Sculpture: Definitions of Man* (New York, 1975)
Sculpture, Newsweek Books (New York, 1975)
R. Wittkower: *Sculpture* (London, 1977)
G. Bazin: *A Concise History of World Sculpture* (London, 1981)
CHARLES AVERY

Sarto, Andrea del [Agnolo, Andrea d'] (*b* Florence, 16 July 1486; *d* Florence, 29 Sept 1530). Italian painter and draughtsman. He was the leading painter in Florence in the early years of the 16th century, and, under the influence of Leonardo da Vinci, Fra Bartolommeo, Michelangelo and Raphael, he elaborated and perfected the classical style of the High Renaissance. In the second decade of the 16th century his art anticipated aspects of Mannerism, while his direct, immediate works of the 1520s became important models for the more naturalistic Tuscan artists of the Counter-Reformation. He painted mainly religious works, including both altarpieces and major cycles of frescoes. His portraits, distinguished by a dreamily poetic quality, are among the most individual of the High Renaissance.

1. Life and work. 2. Working methods and technique. 3. Influence, critical reception and posthumous reputation.

1. LIFE AND WORK.

(i) To 1510. (ii) 1511–18. (iii) From 1519.

(i) To 1510. The son of a tailor (hence 'del Sarto'), the incorrect use of the surname Vannucchi by some late sources (e.g. M. G. Cinelli's amplified edition (1677) of Francesco Bocchi's *Le bellezze della città di Firenze* (1591)) comes from the misreading of his monogram as AV, whereas it in fact represents two interlocking 'A's. According to Vasari, himself briefly a pupil of del Sarto's in the mid-1520s, at the age of seven del Sarto was apprenticed to a goldsmith, but because of his outstanding talent for drawing soon transferred to the otherwise unknown painter Gian Barile, and from there to the workshop of Piero di Cosimo. He became an independent artist on 12 December 1508 when he enrolled in the Arte dei Medici e Speziali, the painters' guild, and set up shop with Franciabigio in the Piazza del Grano. About 1510 they moved to a group of buildings known as La Sapienza (between the convents of SS Annunziata and S Marco), where several other artists had studios, including the sculptors Francesco Rustici and Jacopo Sansovino. Del Sarto soon received numerous commissions: from the Servi di Maria (to whom the convent of the SS Annunziata belonged) and the Compagnia di S Giovanni Battista, known as the Compagnia dello Scalzo, both of which orders became lifelong patrons, from other religious orders and from individual collectors and merchants, some of whom carried his reputation abroad. It was thus that his later patron Francis I, King of France (*reg* 1515–47), first came across his work.

Del Sarto's early paintings were strongly influenced by Piero di Cosimo, especially in the sweeping, luminous landscapes, at times summary and barren, at others enlivened by contorted tree trunks, bushes and grassy back-

1. Andrea del Sarto: *Punishment of the Gamblers* (1509–10), fresco from the *Life of St Filippo Benizi*, atrium, SS Annunziata, Florence

grounds. He also copied the cartoons (1504–6; destr.) of Leonardo's *Battle of Anghiari* and Michelangelo's *Battle of Cascina*, which had been made for wall paintings (destr.) in the Sala del Consiglio in the Palazzo Vecchio, Florence. From Leonardo he adopted the use of *sfumato* to enrich his colours and enhance the relationship between contoured forms and the surrounding space.

Michelangelo's influence is evident in the monumentality of the figures and in the more or less direct quotations that can be seen in his earliest paintings and drawings and throughout his subsequent work. The madonnas of Raphael's Florentine period (c. 1504–8), for example the *Small Cowper Madonna* (Washington, DC, N.G.A.), were another source of inspiration to del Sarto, whose early madonnas

(e.g. the *Madonna of the Goldfinch, c.* 1506; Rome, Gal. Barberini) share Raphael's interest in the rhythm of the figures and in the expression of emotion. More or less contemporary with this painting is the predella *Lamentation with Four Saints* (*c.* 1506–7, Rome, Gal. Borghese), which reflects his interest in Perugino's art and was indeed believed to be by Perugino until Longhi reattributed it. Another fundamental model for del Sarto, as for his partner Franciabigio, whose style in their early years was close enough to have caused persistent scholarly disagreement over attribution, was the work of Fra Bartolommeo. His modern way of painting and soft, luminous palette appealed greatly to del Sarto's sensibility.

Del Sarto's first large commission was from the Compagnia dello Scalzo, for a cycle of 12 monochrome fresco paintings in the Scalzo cloister, Florence, depicting episodes from the *Life of St John the Baptist* (detached, but *in situ*). He continued to work on this cycle throughout his career: documented payments for single scenes span the period 1515–26, yet the style of the *Baptism* suggests that he began work on the series as early as 1507–8. In these early years he also painted an *Annunciation* (Florence, Cenacolo di S Salvi) in a tabernacle beside the church of Orsanmichele, and the *Mary Magdalene Carried to Heaven by Angels*, on a pilaster of the church itself (*in situ*). In 1509–10, commissioned by the order of the Servi di Maria, he painted five frescoes of the *Life of St Filippo Benizi* in the atrium of SS Annunziata, Florence (*in situ*; see fig. 1); a series that includes several direct quotations from the art of Michelangelo. An altarpiece, *Noli me tangere* (*c.* 1509; Florence, Cenacolo di S Salvi), painted for the Augustinian church of S Gallo, Florence, is stylistically close to the frescoes of this series, and may have been painted shortly before them. The poses of the figures, their relationship to the landscape and the palette dominated by harmonies of green–brown, saturated red and violet–blue are similar in both. In such works, which represent the climax of del Sarto's early style, the sharp clarity of 15th-century drawing and perspective are softened to a more harmonious and natural vision.

(ii) 1511–18. By 1511 del Sarto was a well-established and sought-after artist. In that year Jacopo Sansovino returned from Rome and joined the artists at La Sapienza. Del Sarto enjoyed a close friendship with Sansovino, and Vasari tells us that he perfected his art by drawing and painting from wax models that Sansovino gave him for this purpose. They occasionally collaborated, as in 1515 when they worked together on the temporary façade for Florence Cathedral that formed part of the decorations for Pope Leo X's entry into the city.

In 1511 del Sarto received an important commission from the Vallombrosan monks at S Salvi, Florence, to fresco the end wall of their refectory. Beneath the large arch that frames the wall he painted the *Trinity* and the four protector saints of the order. Due to internal problems at the monastery, the intended painting of the *Last Supper* was not executed until 1526–7 (*see* §(iii) below).

It is probable that del Sarto visited Rome *c.* 1511, perhaps with his pupils Pontormo and Rosso Fiorentino (Berti). Indeed, this seems to be suggested by a new maturity, a greater monumentality and a highly individual development from classicism towards aspects of Mannerism that is evident in the colour and figures of his fresco of the *Journey of the Magi* (Florence, SS Annunziata), paid for in December 1511, and in the famous *Birth of the Virgin* (1513–14; SS Annunziata, atrium; see colour pl. 2, XXVIII2). In the latter work the scene is set in the contemporary context of an elegant bourgeois home. The rich surroundings, dominated by a canopied bed and decorated with classicizing architectural elements, impart a monumental quality that could have been inspired by the grandeur of Raphael's frescoes in the Stanza della Segnatura in the Vatican Palace. However, the painting is pervaded with humour and irony, in the grace and coquettishness of the women and the ambiguous smiles of the putti. These take it beyond the classical balance of the Florentine Renaissance ideal and lend it an unstable and modern quality that is enhanced by the artist's use of soft natural colours. This impressive work became the touchstone for the other Marian scenes painted in the atrium of SS Annunziata by Franciabigio (*Marriage of the Virgin*, 1513), Pontormo (*Visitation*, 1515) and Rosso Fiorentino (*Assumption of the Virgin*, 1513–14). These artists, and also Andrea di Giovanni di Lorenzo Feltrini, all worked with del Sarto in the period between 1511 and his visit to France in 1518–19. They represented the 'avant garde' of Florentine art, aptly described by Berti as the SS Annunziata school, and their style anticipated all the features of Florentine Mannerism.

In this period del Sarto painted an impressive series of works that are as revolutionary in their originality of composition and colour as those by Pontormo and Rosso at the same date. Three altarpieces—*Archangel Raphael with Tobias and St Leonard* (1512; Vienna, Ksthist. Mus.), the *Annunciation* (1512; Florence, Pitti) and the *Marriage of St Catherine* (*c.* 1513; Dresden, Gemäldegal. Alte Meister)—clearly reveal this originality. In the last-named painting, which is indebted to Raphael's *Madonna del Baldacchino* (1508; Florence, Pitti) and to the altarpieces produced by Fra Bartolommeo *c.* 1510–12, the splendid group of laughing figures beneath the green drapes of the canopy are united by a new subtlety and complexity of emotion, close to the art of Correggio.

Also belonging to this phase are the *Holy Family with St Catherine* (1514; St Petersburg, Hermitage), and the two panels from the *Story of Joseph* (1515; both Florence, Pitti), painted for the nuptial chamber of Pierfrancesco Borgherini and Margherita Acciaioli, a project on which Francesco Granacci, Bacchiacca and Pontormo also participated. The *Holy Family* (1515–16; Paris, Louvre) transforms Raphaelesque prototypes into an unstable and dramatic composition, while the daring *Madonna and Child with the Young St John the Baptist* (1517; Rome, Gal. Borghese) was the direct model for Pontormo's large altarpiece, *Virgin and Saints* (1518), in S Michele Visdomini, Florence.

Meanwhile del Sarto worked on the frescoes for the Scalzo cloister in Florence, and these follow the same stylistic evolution as the panel paintings. Proceeding in an anticlockwise direction from the figure of *Charity* (*c.* 1513), they are as follows: the *Allegory of Justice* (1515); the *Preaching of St John the Baptist* (1515); the *Baptism of the People* (1517); and the *Arrest of St John the Baptist* (1517).

2. Andrea del Sarto: *Disputation on the Trinity*, oil on panel, 2.32×1.93 m, *c.* 1518 (Florence, Palazzo Pitti)

They show such a lively awareness of the Roman artistic scene, dominated by Michelangelo and Raphael, that another visit by del Sarto to Rome at around this date seems probable (Monti). The works of this period culminate in the most famous of del Sarto's altarpieces: the *Madonna of the Harpies* (1517; Florence, Uffizi) and the *Disputation on the Trinity* (*c.* 1518; Florence, Pitti; see fig. 2). The restoration of these works (the *Madonna of the Harpies* in 1984; the *Disputation* in 1985) removed the disguising layers of coloured varnish to reveal rich colours that give the classicizing figures a spectacularly vibrant and natural quality. Both altarpieces convey a complex theological message. The iconography of the *Madonna of the Harpies* has always remained somewhat obscure but it possibly represents the Virgin triumphant over evil, as described in the apocalyptic vision of St John (Natali, 1984). The latter saint is depicted together with St Francis, the patron saint of the nuns of S Francesco dei Macci, who had commissioned the work in 1515. In the *Disputation on the Trinity*, SS Augustine, Lawrence, Peter Martyr and Francis, with Mary Magdalene and St Sebastian kneeling at their feet, are the protagonists of an impassioned debate led by St Augustine, while God the Father, holding the cross, looks down from a stormy sky that probably alludes to the Holy Spirit (exh. cat., Florence, 1986, pp. 26–41).

In 1518 Francis I, impressed by the artist's works he had acquired through his Florentine agents, invited del Sarto to Paris to be court painter. Among those works he owned was a *Lamentation* (untraced), known from three drawings (Florence, Uffizi) and from an engraving (1516) by Agostino dei Musi. In Paris del Sarto completed several paintings, of which only *Charity* (1518; Paris, Louvre; see fig. 3) survives. It is a pyramidal composition that owes

more to Michelangelo than to Leonardo (though critics usually relate it to the latter's *Virgin, Child, St Anne and a Lamb* (*c.* 1515; Paris, Louvre; *see* LEONARDO DA VINCI, fig. 5), which del Sarto would have been able to study at the French court), and possesses an affected, Mannerist elegance. Shortly before accepting King Francis's invitation, del Sarto had married Lucrezia del Fede, widowed in 1516, whom he had apparently admired since *c.* 1513, for her face appears in the *Nativity* in the cloister of SS Annunziata (Baldinucci). Vasari depicted del Sarto as idolizing this woman and being completely dominated by her personality. In any event he used her as the model for many of his madonnas and female saints, thus following his preference for models from within the circle of his family (another was Maria del Berrettaio, Lucrezia's daughter) and friends. Perhaps this helps explain the deep, pulsing humanity in his sacred figures and in his portraits. Among these, the *Portrait of a Young Lady* (*c.* 1513; Madrid, Prado) and the *Portrait of a Sculptor* (1515–16; London, N.G.) reflect the refined, nervous freedom of expression typical of the work of these years.

(iii) From 1519. After his return to Florence in 1519, a further change can be seen in del Sarto's style: the calculated expression, complex and artificial compositions, and elegantly refined poses seen, for example, in the *Holy Family* tondo (*c.* 1518–19, Paris, Louvre) and the *Virgin and Child with the Young St John the Baptist and Two Angels* (*c.* 1518–19; London, Wallace Col.), convey emotion with greater directness and immediacy. Some works,

3. Andrea del Sarto: *Charity*, oil on canvas, 1.85×1.37 m, 1518 (Paris, Musée du Louvre)

such as the *Lamentation* (*c.* 1520; Vienna, Ksthist. Mus.), prefigure the Baroque style. The dramatic and theatrical expression in all del Sarto's work of this period remains the constant factor in his continuous search for satisfying expressive formulae, a search documented in his intense production of preparatory drawings.

In the years 1519–21 del Sarto, and his usual group of colleagues—Franciabigio, Andrea di Cosimo Feltrini and Pontormo—received a commission from Pope Leo X to decorate the salon of the villa at Poggio a Caiano that had been built by the Pope's father, Lorenzo de' Medici. The fresco cycle, for which the humanist Paolo Giovio supplied the programme, was created to glorify the Medici by depicting episodes from Roman history that were to be seen as paralleling events in the lives of family members. The project was interrupted by the death of Leo X in 1521 and only completed much later (1578–82) by Alessandro Allori. The scene painted by del Sarto, the *Tribute of Animals to Caesar*, refers to the exotic animals sent to Lorenzo de' Medici by the sultan of Egypt. A spiral rhythm unifies the myriad of small, inventively imagined and captivating details.

In 1522–3 del Sarto returned to work in the Scalzo cloister and painted the *Dance of Salome* (1522); the *Beheading of St John the Baptist*, *Herod's Feast*, the allegorical figures of *Hope* and *Faith*, and the *Annunciation to Zaccharias* (all 1523). The cycle was completed later by the *Visitation* (1524) and the *Birth of St John the Baptist* (1526), works that are painted with fewer figures and with a new Michelangelesque monumentality, something first remarked by Vasari. The famous fresco of the Porta Pinti *Madonna* (lost in the 19th century but known from many copies, e.g. a fine 16th-century replica, U. Birmingham, Barber Inst.) belongs to this period. Several preparatory drawings survive to justify its fame, among which is the outstanding *Young St John the Baptist Laughing* (Melbourne, N.G. Victoria).

At this stage del Sarto adopted a heroic scale for his compositions, inspired by the late work of Raphael and his Roman followers and by Michelangelo, who was then working on the New Sacristy of S Lorenzo in Florence. Nevertheless, he still retained the more intimate qualities of gentleness and humanity. Examples of this approach include the *Madonna della scala* (*c.* 1522–3; Madrid, Prado), painted for Lorenzo Jacopi; the *Young St John the Baptist* (1523; Florence, Pitti) for Giovan Maria Benintendi; the *Lamentation* (1524; Florence, Pitti; see colour pl. 2, XXVIII1), painted for the high altar of S Piero a Luco in the Mugello; the famous fresco known as the *Madonna del sacco* (1525; Florence, SS Annunziata, great cloister) and the *Virgin in Glory with Four Saints* (*c.* 1526; Florence, Pitti), painted for SS Lorenzo e Onofrio di Gambassi (in the Val d'Elsa). This last work was commissioned by Becuccio 'bicchieraio' (It.: 'glass tumbler-maker'), whose lively portrait (*c.* 1528; Edinburgh, N.G.) was originally included in the predella, together with the equally lively one of his wife (Chicago, A. Inst.) (Conti).

The monumentality of del Sarto's work around the mid-1520s reached its most spectacular point in two impressive panels of the *Assumption of the Virgin* (both Florence, Pitti). The first, never completely finished, was painted *c.* 1522–4 for Bartolommeo Panciatichi; the second, for S

Antonio at Cortona, was commissioned by Margherita Passerini in 1526. Equally spectacular is the fresco of the *Last Supper* (1526–7; Florence, S Salvi; see fig. 4), which formed part of the decorations commissioned in 1511. In this work del Sarto distanced himself from local tradition and used a new iconography, possibly influenced by Leonardo's *Last Supper* in S Maria delle Grazie, Milan, and Raphael's treatment of the same subject (untraced, recorded in engravings by Marcantonio Raimondi). The spacious and luminous composition, well-constructed and solemn, is enlivened by the splendid freshness of the colours and the varied poses of the figures (many derived from northern prints, especially those by Albrecht Dürer (1471–1528)), which represent the whole range of psychological reactions to the words of Christ as related in St John's Gospel.

In the last two years of his life, notwithstanding troubled times and the siege (1530) of Florence by the army of Charles V, Holy Roman Emperor (*reg* 1519–56), del Sarto's abundant production continued. The majority of his works from this period survive and include some outstanding portraits, such as that of *Becuccio 'bicchieraio'* (*c.* 1528; Edinburgh, N.G.) and *Girl Reading Petrarch* (*c.* 1528; Florence, Uffizi; see colour pl. 2, XXVIII3), in both of which the sitter's personality is conveyed with great immediacy in the large, quick brushstrokes that characterized his late style. There is also the *Self-portrait* frescoed on a tile (Florence, Uffizi). Other late works are the Vallombrosan altarpiece, *Four Saints* (1528; Florence, Uffizi); the large altarpiece (1528; Berlin, Gemäldegal.; destr. 1945) for S Domenico at Sarzana, of which only the crowning panel depicting the *Annunciation* (Florence, Pitti) remains; the *Holy Family* (1528; New York, Met.); the *Madonna and Child* (Florence, Pitti); the Medici *Holy Family* (Florence, Pitti), painted during the siege of Florence for Ottaviano de' Medici; the polyptych of the *Madonna of St Agnese* (Pisa Cathedral); and the *Virgin in Glory with Four Saints* (1529–30; Florence, Pitti), executed for the Vallombrosan Badia at Poppi and left uncompleted at the artist's death. These late works are characterized by a tendency towards a more abstract and sculptural treatment and a more subdued palette than is evident in paintings from a few years earlier. They possess a monumental harmony of form and colour that was to inspire Tuscan Counter-Reformation artists in the late 16th century.

On 29 September 1530 del Sarto died of the plague that had been introduced into Florence by the besieging army. He was buried in SS Annunziata by the Compagnia dello Scalzo; his pupil Domenico Conti, who inherited his drawings, erected a memorial stone in his honour. This was removed shortly afterwards because proper authorization had not been obtained, but in 1605 the Prior of SS Annunziata had a marble bust of the painter made by Giovanni Battista Caccini and placed in the cloister that del Sarto had decorated.

2. WORKING METHODS AND TECHNIQUE. According to the Florentine tradition, del Sarto made a series of preparatory drawings for each of his paintings, and his working process became a model for the artists of the 16th century. A significant number of these drawings have

4. Andrea del Sarto: *Last Supper* (1526–7), fresco, refectory, convent of S Salvi, Florence

survived. Starting with the rapid notation of a first idea (which might be very far from the final solution), he then made studies of individual figures, checking them against a live model—usually a studio assistant clothed in everyday dress, assuming the chosen pose (e.g. preparatory drawing (Florence, Uffizi) for the untraced Puccini *Pietà*). Antique sculptures provided another source, as can be seen, for example, in his study (Florence, Uffizi) of a figure from the *Laokoon* group, to be used for the figure of Isaac in the *Sacrifice of Isaac* (Cleveland, OH, Mus. A.), or the work of contemporary sculptors, such as Michelangelo, Sansovino or Rustici, as in the study (Florence, Uffizi) of Michelangelo's *David* (Florence, Accad.; *see* ITALY, fig. 22) for a figure in the *Baptism of the People*. The initial idea for the figure composition was then developed into a sequence of studies, drawn in rapid, soft strokes of black or red chalk, leading to the final version (e.g. the five studies (London, BM) for the fresco known as the *Madonna del sacco*). The use of a cartoon is proved, as in the Scalzo frescoes, either by traces of charcoal or by incised contours.

The creative freedom revealed by del Sarto's drawings is equally characteristic of his painting. The restoration (1985–6) of several paintings in Florence provided fascinating insights into this (see exh. cat., Florence, 1986, pp. 330–57). The partial removal of the thick layers of 19th-century varnishes and glues permitted viewers to appreci-ate the artist's refined, brilliant use of colours. With age the increasing transparency of oil paint often reveals pentimenti, which provide information on his working methods. There are cases (e.g. the Medici *Holy Family* or the *Disputation on the Trinity*) when del Sarto decided at the last moment that his composition required greater space, and the wood support, after having been cut and assembled, was then enlarged by a further strip of wood. The technique of painting in oils, which by then was common in Florence, allowed the artist to achieve a convincing optical effect by omitting the final layers of paint: often the shaded parts of figures or of landscape have been left thus, and the effects of shadow and distance have been created through the tonality and intensity of the colours. This can be seen in parts of the Panciatichi and Passerini *Assumptions* and the *Virgin in Glory with Four Saints*. The final harmonious equilibrium of his altarpieces and frescoes is therefore the result of experi-mental research that extended beyond the preparatory drawings, to the painting process itself.

3. INFLUENCE, CRITICAL RECEPTION AND POSTHUMOUS REPUTATION. Andrea del Sarto's work was much admired by his Florentine contemporaries, many of whom were profoundly influenced by him. Apart from Franciabigio, all the following reflect his style to a

greater or lesser degree: Giovanni Antonio Sogliani, Domenico Puligo, the 'Master of the Kress Landscapes' and Francesco Granacci. Many Florentine artists trained with him: initially Pontormo and Rosso Fiorentino, and later, Pier Francesco Foschi (1502–67), Jacopino del Conte, Francesco Salviati, Giorgio Vasari and Jacone (d 1553). Other minor pupils, about whom little is known, include Andrea Sguazzella, who accompanied del Sarto to France in 1518 and remained there for many years, and Antonio Solosmeo (fl 1525–36), who was also a sculptor and in 1527 signed and dated an altarpiece for the Badia of S Fedele at Poppi. In the next generation, many copied del Sarto's work, especially that group of artists employed on the *studiolo* of Francesco I de' Medici that included Maso da San Friano, Carlo Portelli, Poppi, Giovan Battista Naldini and Giovanni Balducci (c. 1560–1631). By the end of the 16th century the appreciation of del Sarto's art had reached its height: artists of the Counter-Reformation such as Santi di Tito (1536–1602) and Jacopo da Empoli (1551–1640) tended to look back to his work more than to that of Raphael. Outside Tuscany Federico Barocci was influenced by his art.

Critical acclaim came first from Vasari and then, notably, from Francesco Bocchi who, in *Discorso sopra l'eccellenza dell'opere di Andrea del Sarto, pittore fiorentino* (1567; Florence, Bib. Uffizi, MS n.9) and *Le bellezze della città di Firenze* (1591), exalted the perfection and fascination of del Sarto's works. The Medici helped to add to his renown by avidly collecting his works through several generations, beginning with Cosimo I and Francesco I and continuing into the 17th and 18th centuries with the Grand Duke Ferdinando II, his brothers Cardinal Leopoldo (a passionate collector, in del Sarto's case especially of his drawings) and Cardinal Carlo, followed by the Grand Prince Ferdinando, son of Cosimo III. After the Medici their successors, the three Grand Dukes of Lorraine, who ruled Tuscany from the mid-18th century to the mid-19th, were equally enthusiastic. Consequently, all the works of del Sarto (with the exception of the panel, *Christ the Redeemer* (c. 1515; Florence, SS Annunziata), set into the tabernacle door and the polyptych of the *Madonna of S Agnese* (Pisa Cathedral)) have been kept in galleries for centuries.

The evaluation of del Sarto as an artist has been affected by the image created and perpetuated by Vasari's biography, which gave a picture of an exceptionally gifted master with an easy and spontaneous talent but a timid nature, dominated by an adored but tyrannical wife. This image encouraged romantic fantasies, even inspiring a play by Alfred de Musset (*Andrea del Sarto*, 1833) and a dramatic monologue by Robert Browning ('Andrea del Sarto', 1855). Sigmund Freud's biographer, Ernest Jones, made a fascinating psychoanalytic study of the artist (1913). Vasari's comment on del Sarto's work ('without fault') had a similarly potent effect and became almost the trademark of the artist. However, while in the 17th and 18th centuries the phrase carried a positive value, which emphasized the harmony, elegance and natural qualities of his painting (e.g. Baldinucci), in the Romantic period and up to the middle of the 20th century it acquired the negative connotation of academic correctness. This judgement, which applied to the paintings and not the drawings, which have always been highly acclaimed and appreciated, espe-

cially since Berenson's study (1903), was supported by the physical condition of most of the artist's works, both in fresco and on panel. Layers of grime and coloured varnish obscured the original effect and imparted a dull, flat aspect to the pictures. This led to del Sarto being classified, alongside Fra Bartolommeo, with the followers of the Florentine Renaissance as an artist opposed to the early Mannerists, Pontormo and Rosso Fiorentino.

The 20th-century view of del Sarto was established largely by three monographs: Freedberg (1963), Shearman (1965) and Monti (1965), the first two representing in many respects a definitive assessment of the corpus and chronology of the artist's work. This view, based on biographical documents and on the works themselves, underwent revision in the light of the restoration carried out during the 1980s, which enabled a truer assessment of his gifts as a painter and showed him to be far removed from academic pedantry. The 500th anniversary celebration of del Sarto's birth began with the anthology by Petrioli Tofani on the artist's drawings (1985) and culminated in the autumn of 1986 with two exhibitions, the first ever dedicated to the artist: *Hommage à Andrea del Sarto* (Paris, Louvre) and *Andrea del Sarto (1486–1530): Dipinti e disegni a Firenze* (Florence, Pal. Pitti).

BIBLIOGRAPHY

EARLY SOURCES
G. Vasari: *Vite* (1550); ed. C. Ricci (1927), iii, pp. 179–219; (rev. 2/1568); ed. G. Milanesi (1878–85), v, pp. 5–60
F. Bocchi: *Le bellezze della città di Firenze* (Florence, 1591; enlarged by M. G. Cinelli, 1677)
F. Baldinucci: *Notizie* (1681–1728); ed. F. Ranalli (1845–7), ii, pp. 72–82
L. Biadi: *Notizie inedite della vita d'Andrea del Sarto, raccolte da manoscritti, e documenti autentici* (Florence, 1829; *Supplemento*, 1832)

GENERAL
B. Berenson: *The Drawings of the Florentine Painters*, i (London, 1903), pp. 268–96
——: *Florentine School* (1963), pp. 7–10
J. Shearman and C. Coffey: *Maestri toscani del cinquecento* (Florence, 1978), pp. 23–32
Firenze e la Toscana dei Medici nell'Europa del cinquecento, 5 vols (exh. cat. by P. Prini and others, Florence, Pal. Strozzi and elsewhere, 1980), i, pp. 58–63, ii, pp. 255–7
S. Béguin: *Le XVIe Siècle florentin au Louvre* (Paris, 1982), pp. 20–26
J. Cox-Rearick: *Dynasty and Destiny in Medici Art* (Princeton, 1984)
Florentine Drawings of the Sixteenth Century (exh. cat. by N. Turner, London, BM, 1986), pp. 79–90

MONOGRAPHS
H. Guinness: *Andrea del Sarto* (London, 1899)
F. Knapp: *Andrea del Sarto* (Leipzig, 1907)
I. Fraenckel: *Andrea del Sarto* (Strasbourg, 1935)
S. J. Freedberg: *Andrea del Sarto*, 2 vols (Cambridge, MA, 1963) [with full bibliog.]
R. Monti: *Andrea del Sarto* (Milan, 1965, rev./1981)
J. Shearman: *Andrea del Sarto*, 2 vols (Oxford, 1965) [with full bibliog.]
A. Petrioli Tofani: *Andrea del Sarto: Disegni* (Florence, 1985)
S. Padovani: *Andrea del Sarto* (Florence, 1986)
Andrea del Sarto (1486–1530): Dipinti e disegni a Firenze (exh. cat., Florence, Pitti, 1986); reviews by J. Shearman in *Burl. Mag.*, cxxix (1987), pp. 498–502; A. Angelini in *Prospettiva*, xlv (1986), pp. 85–92
Hommage à Andrea del Sarto (exh. cat. by D. Cordellier, Paris, Louvre, 1986)
A. Natali and A. Cecchi: *Andrea del Sarto* (Florence, 1989)

SPECIALIST STUDIES
E. Jones: 'The Influence of Andrea del Sarto's Wife on his Art', *Applied Psycho-Analysis*, i (London, 1913)
P. N. Ferri: *I disegni della R. Galleria degli Uffizi, IV/iii: Andrea del Sarto* (Florence, 1916)

R. Longhi: 'Precisioni nelle gallerie italiane: I. R. Galleria Borghese', *Vita Artistica*, ii (1927), pp. 85–7

G. Incerpi: 'I restauri sui quadri fiorentini portati a Parigi', *Florence et la France: Florence, 1977*, pp. 215–35

A. Braham: 'The Bed of Pierfrancesco Borgherini', *Burl. Mag.*, cxxi (1979), pp. 754–65

S. J. Freedberg: 'A Recovered Work of Andrea del Sarto with Some Notes on a Leonardesque Connection', *Burl. Mag.*, cxxiv (1982), pp. 281–8

S. Padovani and S. Meloni Trkulja: *Il Cenacolo di Andrea del Sarto a San Salvi* (Florence, 1982)

M. Aronberg Lavin: 'Andrea del Sarto's *St John the Baptist*', *Burl. Mag.*, cxxv (1983), p. 162

S. Béguin: 'A propos de la *Sainte Famille* en tondo d'Andrea del Sarto', *Firenze e la Toscana dei Medici nell'Europa del '500*, iii (Florence, 1983), pp. 871–6

L. Berti: 'Per gli inizi del Rosso Fiorentino', *Boll. A.*, lxviii (1983), pp. 45–60

A. Conti: 'Andrea del Sarto e Becuccio bicchieraio', *Prospettiva*, xxxiii–xxxvi (1983–4), pp. 161–5

A. Natali: 'La *Pietà* del Perugino e la *Madonna delle arpie* di A. del Sarto', *Gli Uffizi studi e ricerche, i: Restauri* (Florence, 1984), pp. 46–54

J. K. Lydecker: 'The Patron, Date, and Original Location of Andrea del Sarto's Tobias Altarpiece', *Burl. Mag.*, cxxvii (1985), pp. 349–55

M. Ciatti and M. Seroni: 'Il San Giovanni Battista di Andrea del Sarto: Tecnica pittorica, indagini e restauro', *OPD Restauro*, i (1986), pp. 72–6

S. Padovani: 'Andrea del Sarto: Ipotesi per gli inizi', *A. Christ.*, lxxvi (1988), pp. 197–216

C. Lowenthal: 'In Search of Andrea del Sarto's *Head of an Angel*', *Drawing*, xvii/1 (May–June 1995), p. 13

D. Carl: 'Der Vertrag mit Andrea del Sarto fur die Fresken des Atriums der SS Annunziata in Florenz vom 30 Juli 1509', *Mitt. Ksthist. Inst. Florenz*, xl/3 (1996), pp. 371–4

D. Franklin: 'A Proposal for Early Andrea del Sarto: Altarpiece Painted for the Church of S Giusto, Pistoia, Italy', *Burl. Mag.*, cxxxiv (1997), pp. 106–8

L. A. Waldman: 'A Document for Andrea del Sarto's Panciatichi Assumption', *Burl. Mag.*, cxxxix (1997), pp. 469–70

G. R. Goldner: 'Two New Drawings by Andrea del Sarto', *Master Drgs*, xxxvi/1 (1998), pp. 29–32

SERENA PADOVANI

Sassetta [Stefano di Giovanni di Consolo] (*b* Siena or Cortona, *c*. 1400; *d* Siena, 1 April 1450). Italian painter and illuminator. He was the most original painter in Siena in the 15th century. Working within the Sienese tradition, he introduced elements derived from the decorative Gothic style and the realism of such contemporary Florentine innovators as Masaccio. Most of his surviving works are panel pictures, notably those from the altarpiece painted for S Francesco, Borgo San Sepolcro.

1. Life and work. 2. Working methods and technique.

1. LIFE AND WORK.

(i) Early life and the Arte della Lana Altarpiece, before 1431. The name Sassetta appears to have been associated with him, mistakenly, only since the 18th century (Pecci, 1752), but it is generally used. He was the son of Giovanni di Consolo of Cortona (Bacci, 1936) and is firmly documented first in 1426 in Siena but was probably active there earlier. His influences included Taddeo di Bartolo (1362/3–1422), Martino di Bartolommeo (*fl* 1389; *d c.* 1435), Benedetto di Bindo (1380/5–1417), Gregorio di Cecco (1390/5–1424) and other artists who were links between the great Sienese painters of the early 14th century —Simone Martini (*c*. 1284–1344), Ambrogio Lorenzetti (*fl c.* 1317) and Pietro Lorenzetti (*fl c.* 1306–45)—and the art of the 15th-century Renaissance.

Sassetta showed awareness of the new style from his earliest known work, the altarpiece commissioned by the guild of wool merchants, the Arte della Lana, *c*. 1426. The altarpiece was dismantled, but according to an 18th-century manuscript (Carli, *c*. 1750), its central panel (untraced) showed a monstrance held by angel musicians above a landscape with two fortified castles. An inscription in the background was addressed to the 'Patres' (Fathers). Its interpretation by Scapecchi (1979) is generally accepted. The Fathers were probably the church councillors who met in Siena Cathedral on 21 July 1423, and it was to commemorate this event that the Arte della Lana commissioned the altarpiece, for S Maria del Carmine, Siena (Moran, 1980). The work was moved from the Carmine to S Pellegrino in 1463, and it may have been dismantled as early as 1777, when the chapel was razed.

Various small panels are generally accepted as belonging to the Arte della Lana Altarpiece. The predella included the *Vision of St Thomas Aquinas* (Rome, Pin. Vaticana), *St Thomas in Prayer* (Budapest, Mus. F.A.), the *Miracle of the Sacrament* (Barnard Castle, Bowes Mus.), the *Last Supper* (Siena, Pin. N.), the *Burning of a Heretic* (Melbourne, N.G. Victoria) and *St Anthony Beaten by Devils* (Siena, Pin. N.). Several panels from the pinnacles and pilasters are in Siena (Pin. N.). It has been suggested that the *Angel of the Annunciation* (Massa Marittima, Pin. Com.) and the *Virgin Annunciate* (New Haven, CT, Yale U. A.G.) belonged to the altarpiece, as well as two landscapes, *Castle by the Sea* and *City by the Sea* (Siena, Pin. N.), usually attributed to Ambrogio Lorenzetti (Zeri, 1973). Despite their residual links to Sienese Gothic tradition, the surviving panels of Sassetta's altarpiece represent the most modern painting in Siena during the first three decades of the 15th century. The architectural perspectives in the *Last Supper*, for example, are no longer Gothic but are simplified in a classical manner, and the serene, luminous landscapes, as in *St Anthony Beaten by Devils*, show a skilful handling of setting and space.

(ii) Middle years, 1431–44. Sassetta is documented in Siena in 1431 as captain of the Compagnia di Si Pietro a Ovile, and in 1433 and 1434 he was a witness of several baptisms. During this decade his work, and that of such Sienese contemporaries as Domenico di Bartolo and Vecchietta, most closely reflected the new Florentine ideas of perspective and naturalism. This interest is apparent in his second important commission, the great altarpiece of the *Madonna of the Snow* (Florence, Pitti; see fig. 1) commissioned by Lodovicha Bertini (*d* 1432), wife of the sculptor Turino di Matteo, for the altar of S Bonifacio in Siena Cathedral and finished before the end of 1432. The central panel shows the *Virgin and Child Enthroned with Saints and Angels*. The predella, much damaged, has seven scenes illustrating the *Miracle of the Snow* and the consequent building of S Maria Maggiore in Rome. There are echoes of Gothic taste in the triple-arched frame, but in the central panel the treatment of space and perspective is strongly unified, with the focal point in the hand of the Virgin. This is the point of convergence of the lines of the ornate paving and those implied by the gestures of St Francis and St John the Baptist. Sassetta also suggests

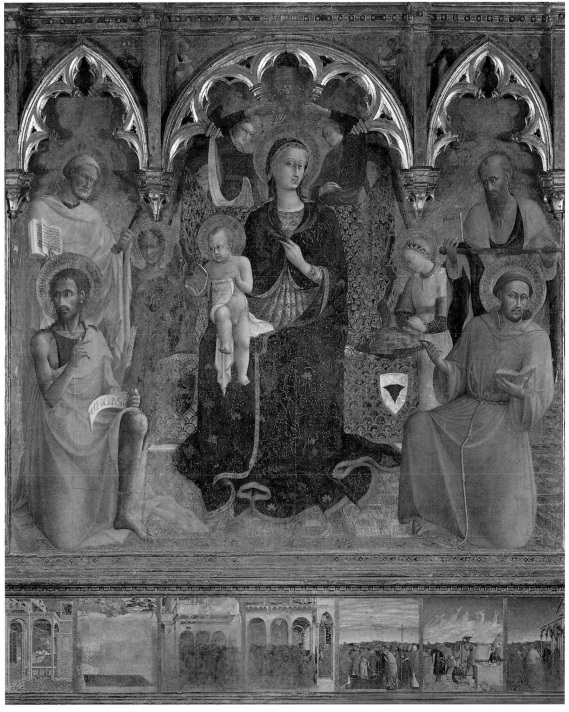

1. Sassetta: *Madonna of the Snow*, tempera on panel, 2.41×2.23 m, 1432 (Florence, Palazzo Pitti)

depth by using foreshortening, as in the raised knee of the Child and the book held out by St Francis. A number of details contribute to the naturalistic atmosphere, for example the right-hand angel making a snowball or the firm grip with which St Peter holds the keys. In the predella too there are wonderful details, such as the irregular clouds in the *Building of the Basilica*, which sweep the luminous sky like tongues of flame. These inventions, remarkable in the context of 15th-century Sienese painting, clearly demonstrate Sassetta's awareness both of the revolutionary art of Masaccio, and of the work of other Florentine painters, such as Fra Angelico, Masolino da Panicale, Paolo Uccello, even Domenico Veneziano, whose work combines strength and naturalism.

The same influences are brought to bear in the small panel, part of the great *Crucifix* that Sassetta painted in 1433 for the Sienese church of S Martino, depicting *St Martin Dividing his Cloak with the Beggar* (Siena, Col. Chigi–Saracini). The beautifully described figure of the beggar directly reflects Masaccio's shivering naked man in *St Peter Baptizing the Neophytes* in the Brancacci Chapel (Florence, S Maria del Carmine). Two other fragments of the *Crucifix*, representing the *Virgin* and *St John Mourning*, also survive (Siena, Col. Chigi–Saracini). The work was documented by several Sienese scholars, including della Valle (1786), who described it in some detail. Its destruction in 1820 by the brothers of S Martino, who sawed it up for 'wood to make doors', is recorded by Romagnoli. Like the *Madonna of the Snow*, it was remarkable for its demonstration of naturalistic and perspectival elements that already reflected the Renaissance, and for its chromatic delicacy and sensitivity to narrative that are part of the Sienese artistic tradition.

The two miniatures of a Missal (Siena, Bib. Com. Intronati, MS. G.V.7) attributed to Sassetta by Schoenburg-Waldenburg (1975) should perhaps be seen in relation to the S Martino *Crucifix*. Particularly significant is the *Crucifixion with St John and the Virgin* against a gold background framed by decorative geometrical elements. While there are Gothic inflections, especially in the drapery folds of the mourners, the crucified Christ, depicted frontally with his bowed head realistically foreshortened, is impressively handled.

A work generally dated to the mid-1430s is the altarpiece of the *Virgin and Child with Two Angel Musicians* (Cortona, Mus. Dioc.) painted for S Domenico, in Cortona. Stylistically it is linked with the *Madonna of the Snow*, although it shows more freedom from 14th-century artistic canons. Even in the carpentry there is greater simplicity: there are no longer small trilobate arches in the main compartments, and the vertical thrust of the pinnacles is countered by the circular surrounds of the scenes they bear. The artist's interest in sculptural and geometric values can be seen in the figures, for example in the oval face of St Michael the Archangel and the cylindrical necks of St Catherine and the Virgin.

A number of images of the Virgin, datable between 1432 and 1440, are usually associated with the Cortona Altarpiece, notably two pictures of the *Virgin and Child with Angels* (New York, Met.; Siena, Pin. N.) and the *Virgin of the Cherries* (Grosseto, Mus. Archaeol.). In these paintings, as in the Cortona Altarpiece, Sassetta's enthusiasm for the ideas of the early Florentine Renaissance is apparent in the tendency to translate objects into geometric forms, as in the cylindrical limbs of the Child, roundly turned like wood or ivory.

Two small paintings of the *Adoration of the Magi* (Siena, Col. Chigi–Saracini) and the *Journey of the Magi* (New

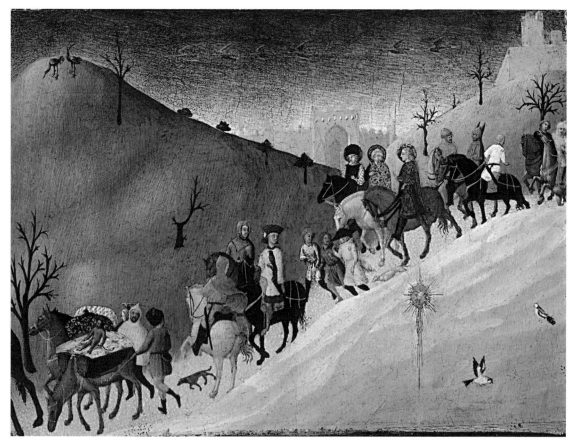

2. Sassetta: *Journey of the Magi*, tempera on panel, 216×298 mm, ?after 1433 (New York, Metropolitan Museum of Art)

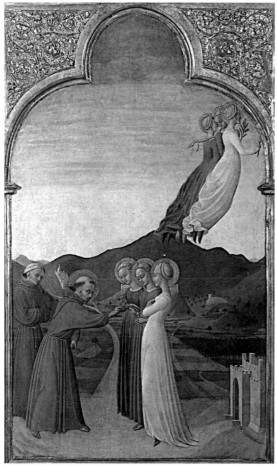

3. Sassetta: *Mystic Marriage of St Francis*, tempera on panel, 950×580 mm, 1440s (Chantilly, Musée Condé, Château de Chantilly)

attributed to Sassetta or his circle should be assigned to that Master.

Throughout the 1440s Sassetta remained in Siena (Milanesi, 1854), even for his most demanding project, the great altarpiece commissioned in 1437 for S Francesco in Borgo San Sepolcro. The work was entirely painted in Siena, although Sassetta did supervise its installation in San Sepolcro before the end of June 1444. He was paid 510 florins, the highest recorded fee for an altarpiece in Siena in the 15th century.

The S Francesco Altarpiece was dismantled in the 19th century, but the main elements survive. Like Duccio's *Maestà* (1311), it was designed to be seen from both sides, and its central panel (Paris, Louvre) depicts the *Virgin and Child Surrounded by Angels*. On the front the altarpiece had five sections: there was the central *Virgin and Child* and side panels with four saints (Florence, I Tatti; Paris, Louvre). On the back the main panel showed *St Francis in Glory* (Florence, I Tatti; see colour pl. 2, XXIX1) and at the sides, in two rows, were eight panels depicting scenes from his life, now all in London (N.G.) except for the *Mystic Marriage of St Francis* (Chantilly, Mus. Condé; see fig. 3). Other small panels, parts of the predella, the top and the pilasters, are in Berlin (Gemäldegal.), Cleveland, OH (Mus. A.), and Moscow (Pushkin Mus. F.A.). The San Sepolcro altarpiece reveals Sassetta in his full artistic maturity. After assimilating the innovations of Masaccio, he concentrated on defining a gentler form of realism. The panels in London and Chantilly show clearly that, without flouting the formal conventions of his time, Sassetta softened the severe Florentine style with a subtle fusion of abstraction and imaginative touches reminiscent of the 14th century. Other works (all untraced) executed by Sassetta during the seven years he worked on the San Sepolcro Altarpiece (Milanesi, 1854) included commissions for the main civic bodies of Siena, the Ospedale di S Maria della Scala, the Opera del Duomo and the Comune.

(iii) *Late works, 1447–50.* In 1447 Sassetta was given a major Sienese civic commission, the fresco decorations for the new city gates, started by Taddeo di Bartolo shortly before his death in 1422. The frescoes (destr.) for the Porta Romana (formerly Porta Nuova) were Sassetta's last work. He had completed the design and begun painting the angels in the underside of the arch and preparing the surface for the *Coronation of the Virgin* by 1450, when he died. The work was finished nine years later by Sano di Pietro using Sassetta's drawings. The fresco, much damaged by exposure, has been detached and installed under the porch of S Francesco in Siena. The surviving fragments show clearly the strong sculptural quality of Sassetta'a angels and the comparative lifelessness of Sano's figures. Sassetta's angels are skilfully painted to be viewed from below, following the curve of the arch. Probably close in date to the Porta Romana fresco is a panel of *St Bartholomew*, one of two (Siena, Pin. N.) surviving from an altarpiece for S Pietro in Castelvecchio, Siena, left incomplete by Sassetta and finished after his death, again by Sano di Pietro (Pietrasanta, 1971).

York, Met.; see fig. 2) are of controversial date. Pope-Hennessy's suggestion (1939) that they were parts of one composition is supported by the similarity of the figures in the two scenes: the three Magi, the man holding the hooded falcon, even the two greyhounds. The clear relationship between these two panels and the great *Adoration of the Magi* by Gentile da Fabriano (1423; Florence, Uffizi; see GENTILE DA FABRIANO, fig. 3) led E. Carli (1957) to give it an early date, before the end of 1429, noting that Gentile was in Siena in 1425–6. Other writers (Volpe, 1982; Angelini, 1986) justifiably suggest a date a few years later, after the works of 1432–3. The realism of certain details, such as the migrating cranes, which also appear in the *St Francis and the Wolf of Gubbio* (London, N.G.), certainly make it unlikely that the work dates from before 1430. These writers regard the *Magi* panels, which are characterized by evocative, shadowy tones receding into depth, as a critical point in Sassetta's creative development, leading to the powerful, almost abstract language of his last works. They should be associated with the Cortona Altarpiece. The *Magi* panels show that Sassetta had much in common with the MASTER OF THE OSSERVANZA (for illustration *see* MASTERS, ANONYMOUS, AND MONOGRAMMISTS, §I), and in fact certain works once

2. WORKING METHODS AND TECHNIQUE. Sassetta was a master of the traditional 15th-century technique of

tempera on panel. In the Cortona altarpiece, however, certain technical details differ from the common practice. Restoration has revealed that no fabric was applied between the primer and the support panels. The modelling was freely executed, without first filling in the figures with flat colour, a sign of great confidence. The faces were prepared using an old-fashioned technique employing *verdaccio*. In his panel painting he shows great skill in the Sienese tradition of working the gold backgrounds and haloes to give depth and volume even to a flat and abstract surface.

The only surviving examples of Sassetta's work in fresco are the fragments from the Porta Romana decorations. For these he prepared a sketch in two copies and a very detailed drawing that was transferred to the plaster by pouncing (exh. cat., 1981). He used lapis lazuli, unusual in frescoes, for the sky and for some details of clothing, giving an effect of luminous transparency similar to that achieved in his panel painting.

UNPUBLISHED SOURCE

Siena, Bib. Com. Intronati [MS. of G. G. Carli: *Notizie di belle arti, c.* 1750, C.VII.20]

BIBLIOGRAPHY

G. A. Pecci: *Ristretto delle cose più notabile della città di Siena* (Siena, 1752), p. 93
G. della Valle: *Lettere senesi sopra le belle arti* (Rome, 1785–6), iii, p. 44
E. Romagnoli: *Biografie cronologiche de' bell'artisti senesi* (Siena, before 1835/*R* Florence, 1976), iv, pp. 419–35
G. Milanesi: *Documenti per la storia dell'arte senese* (Siena, 1854–6), i, p. 48; ii, pp. 198, 242–5
S. Borghesi and L. Banchi: *Nuovi documenti per la storia dell'arte senese* (Siena, 1898), pp. 119–20, 142–4, 145, 166–9
R. Langton-Douglas: 'A Forgotten Painter', *Burl. Mag.*, iii (1903), pp. 306–18
F. Mason-Perkins: 'Quattro tavole inedite del Sassetta', *Ras. A.*, iii (1907), pp. 45–7
B. Berenson: *A Sienese Painter of the Franciscan Legend* (London, 1909)
G. De Nicola: 'Sassetta between 1423–1433', *Burl. Mag.* (1913), i, pp. 208–15; ii, pp. 276–85; iii, pp. 332–6
P. Bacci: *Francesco di Valdambrino* (Siena, 1936), pp. 347–51
J. Pope-Hennessy: *Sassetta* (London, 1939)
R. Longhi: 'Fatti di Masolino e di Masaccio', *Crit. A.* (1940); also in *Opera Completa* (Florence, 1956/*R* 1975), viii, pp. 5, 9, 43; n. 5
C. Brandi: *Quattrocentisti senesi* (Milan, 1949), pp. 7–26
F. Zeri: 'Towards a Reconstruction of Sassetta's Arte della Lana Triptych', *Burl. Mag.*, xciv (1952), pp. 36–41
E. Carli: *Il Sassetta e il Maestro dell'Osservanza* (Milan, 1957)
A. Pietrasanta: 'A "lavorii rimasti" by Stefano di Giovanni called Sassetta', *Connoisseur*, 177 (1971), pp. 95–9
F. Zeri: 'Ricerche sul Sassetta: La pala dell'Arte della Lana (1423–1426)', *Quad. Emblema*, ii (1973), pp. 22–34
G. Schoenburg-Waldenburg: 'Problemi proposti da un messale della Biblioteca di Siena', *Commentari*, xxvi/3–4 (1975), pp. 267–75
P. Scapecchi: *Chiarimenti intorno alla pala dell'Arte della Lana* (Genoa, 1979)
G. Moran: 'The Original Provenance of the Predella Panel by Stefano di Giovanni (Sassetta) in the National Gallery of Victoria', *A. Bull. Victoria*, xxi (1980), p. 33
L. Mencaraglia: 'L'indovinello del Sassetta', *Bull. Sen. Stor. Pat.*, i (1981), p. 40
Mostra di opere d'arte restaurate nelle provincie di Siena e Grosseto (exh. cat., ed. A. M. Giudicci; Siena, Pin. N., 1981), pp. 116–27
C. Volpe: 'Stefano di Giovanni, detto "Sassetta"', *Il gotico a Siena* (exh. cat., ed. G. Chelazzi Dini; Siena, Pal. Pub.; Avignon, Mus. Petit Pal.; 1982–3), pp. 383–92
Il Sassetta e i pittori toscani tra XIII e XV secolo (exh. cat. by A. Angelini, Siena, Pal. Chigi–Saracini, 1986), pp. 33–4
Painting in Renaissance Siena 1420–1500 (exh. cat. by K. Christiansen, L. B. Kanter and C. B. Strehlke, New York, Met., 1988–9), pp. 63–90
P. Torriti: *La Pinacoteca Nazionale di Siena* (Genoa, 1990), pp. 168–76
G. Landolfi and M. P. Winspeare: *Sassetta: Guida ai beni storici e artistici* (Livorno, 1994)
M. Israels: 'New Documents for Sassetta and Sano di Pietro at the Porta Romana, Siena', *Burl. Mag.*, cxl/1144 (1998), pp. 436–44

MARCO TORRITI

Sassetti, Francesco (di Tommaso) (*b* Florence, 1 March 1421; *d* Florence, ?31 March 1490). Italian patron. He became general manager of the Medici banking empire in 1463, and his relationship with the Medici shaped his life and informed his taste. His first major achievement as a patron was the purchase of a villa in Florence, which he rebuilt on a magnificent scale between *c.* 1460 and *c.* 1466 (now Villa La Pietra, Via Bolognese 120). Special features of the villa are its plan, which is a more regular version of the Palazzo Medici in Florence, and its two chapels, which were praised by Marsilio Ficino. Around 1466 he bought the patronage rights of a chapel in the Badia Fiesolana, for which he commissioned a terracotta altarpiece with the Medici *SS Cosmas and Damian* (Florence, Misericordia), attributed to Andrea della Robbia. He also bought a site for a town palace on what is now the Via Tornabuoni, but a crisis in the Medici bank's fortunes left him without funds to build on it.

Sassetti did, however, complete his family chapel in Santa Trinita. He acquired the patronage rights in 1478 and frescoes and an altarpiece by Domenico Ghirlandaio (*see* GHIRLANDAIO, (1), fig. 2) were completed by Christmas 1485. The touchstone tombs of Sassetti and his wife Nera Corsi have been attributed to Giuliano da Sangallo and Bertoldo di Giovanni. The patron's presence is seen everywhere: in three portraits of Sassetti himself; in the depiction of his family, friends and Medici employers; in the representation of places he frequented in Florence; and in the proliferation of coats of arms and personal emblems, often forming visual puns on the device of a sling with *sassetti* (little stones). In a religious sense, Francesco Sassetti is represented by his patron saint Francis of Assisi, whose life formed the subject of Ghirlandaio's frescoes. His special interest in antiquity and the learned advice of his librarian Bartolomeo Fonzio is evident in the tomb decoration, drawn from Roman coins and ancient sarcophagi, and in Latin inscriptions in the altarpiece, which derive from Fonzio's records. In 1488 Sassetti recorded his last wishes (*ultime volontà*) for his wife and children. This document was published by Aby Warburg in 1907 as a paradigmatic expression of the mind of a Renaissance patron.

BIBLIOGRAPHY

A. Warburg: 'Francesco Sassettis letztwillige Verfügung' (1907); also in *Gesammelte Schriften*, ed. G. Bing, i (Leipzig and Berlin, 1932/*R* Nedeln, 1969), pp. 129–58, 353–65
F. Saxl: 'The Classical Inscription in Renaissance Art and Politics', *J. Warb. & Court. Inst.*, iv (1940–41), pp. 19–46
A. de la Mare: 'The Library of Francesco Sassetti', *Cultural Aspects of the Italian Renaissance: Essays in Honour of Paul Oskar Kristeller*, ed. C. H. Clough (Manchester, 1976), pp. 160–201
E. Borsook and J. Offerhaus: *Francesco Sassetti and Ghirlandaio at Santa Trinita, Florence* (Doornspijk, 1981)
A. Lillie: 'Francesco Sassetti and his villa at la Pietra', *Oxford, China and Italy: Writings in Honour of Sir Harold Acton*, ed. E. Chaney and N. Ritchie (London, 1984), pp. 83–93
——: *Florentine Villas in the 15th Century: A Study of the Strozzi and Sassetti Country Properties* (diss., U. London, 1986)

AMANDA LILLIE

Savin, Paolo [Polo] **di Matteo** (*fl* Venice, 1506–19). Italian sculptor. A wood sculptor (*intaiador*) by profession,

Savin was a friend of Antonio Lombardo. When Lombardo abandoned his work on Cardinal Zen's chapel in S Marco, Venice, in 1506, he must have recommended Savin to the Procurators of S Marco as his successor. In July 1506 Savin and Giovanni Battista Bregno were commissioned to produce six Virtues to be cast in bronze for the sides of the tomb of *Cardinal Zen*, four of which were completed by 1507. Savin seems to have gradually replaced Antonio Lombardo, furnishing models for two statues of *St Peter* and *St John the Baptist* for the altar, a model for the relief of the *Resurrection* for the antependium (1508–12) and finally models for the sarcophagus and its effigy (completed in 1519). These were cast in bronze by Pietro di Giovanni Battista Campanato (or delle Campane). Savin's style is derived from that of the Lombardo family but is clumsy and reveals a mediocre talent. The two saints for the Zen chapel are of higher quality than the rest of his work, perhaps the result of the participation of other artists or possibly because Savin was completing models actually begun by Antonio Lombardo. Savin fell into obscurity and no more is known of him.

BIBLIOGRAPHY

L. Planiscig: *Venezianische Bildhauer der Renaissance* (Vienna, 1921), pp. 282–7

B. Jestaz: *La Chapelle Zen à Saint-Marc de Venise* (Wiesbaden, 1986)

BERTRAND JESTAZ

Savoia, Pio di. *See* PIO.

Savoldo, Giovanni Girolamo [Giovan Gerolamo] (*fl* 1506–48). Italian painter. Although called 'da Brescia' by himself and others, he is not known to have lived in Brescia, and the term may indicate his family origin or he may just have left the city in his youth. From at least 1521, until his death, he lived in Venice and is thus regarded stylistically as a painter of Venice, rather than of Brescia. More than any of his contemporaries, he specialized in pictures of single figures, both sacred and secular. Their imposing volume, which sometimes almost fills the frame, harks back to the 15th century, but they are made modern and animated by the use of vivid colours (often in masses of a single hue) and the importance given the environment by subtle lighting. He also painted wide-format portraits, which would have appeared similarly modern to his contemporaries. After his death, he sank into total obscurity and has been reinstated as one of the masters of the High Renaissance only in the 20th century.

1. LIFE AND WORK.

(i) Before 1530. Savoldo's training, the sources of his style and chronology have been difficult to determine because of the stylistic unity of his work. The discovery of documents (see 1990 exh. cat.) has improved our knowledge of his chronology. The idea of a Lombard influence in his style is supported by his family ties with Brescia and his quiet, solid realism. However, it is negated by his use of powerful colour, remote from the grey tones of Vincenzo Foppa and Moretto, and by his emphasis on the human figure and rejection of such favourite Lombard subjects as the still-life. Several factors support the suggestion that his initial training was in the conservative Venetian style typified by Alvise Vivarini. His earliest

certain works were produced in Venice and share the approach of the late phase of Cima, Bartolomeo Montagna and others in preserving traditional compositions, but use softer modelling.

Savoldo is first recorded in Parma in 1506 (named as 'Master'), when Cima may have been present there. He next appeared in 1508 in Florence, where he applied for membership of the painters' guild, but he had no further connection with either place. Only from 1520 does he regularly appear in documents. In that year he signed and dated the *Hermit Saints Anthony and Paul* (Venice, Accad.), the pendant to which is *Elijah* (Washington, DC, N.G.A.), judging from its identical size, style and linked iconography: the three figures are venerated as precursors of the Carmelite Order. Only the *Entombment* (Vienna, Ksthist. Mus.) is agreed by all to antedate the *Hermit Saints Anthony and Paul* and differs little from it. A second, similar *Entombment* (sold Strasbourg, Gersaint auction, 17 Nov 1989) shows an homage to Raphael and may well be of an earlier date.

Savoldo was in Venice by 1521, when he took over the commission for the large altarpiece of the *Virgin and Child with Six Saints* for the Dominican church of S Niccolò, Treviso (*in situ*), from a painter who had absconded. In 1524 he was commissioned to paint a high altarpiece for S Domenico, Pesaro, another Dominican church in a small city under Venetian influence. The resulting commission for the *Virgin and Child with Four Saints* (Milan, Brera) may well have been prompted by the friars' wish to rival the local Franciscans' high altarpiece by Giovanni Bellini of the *Coronation of the Virgin* (Pesaro, Mus. Civ.), which portrays all of the same saints, except for the replacement of St Francis by St Dominic. Savoldo's altarpiece may have had as a pinnacle the *Dead Christ* (Cleveland, OH, Mus. A.), analogous to Bellini's *Lamentation* (Rome, Vatican, Pin.), which formed the gable to the *Coronation*. Together with the *Transfiguration* (*c.* 1525; versions Milan, Ambrosiana and Florence, Uffizi), the *Dead Christ* is one of his most notable achievements of this period.

On several occasions Savoldo was patronized by Brescian families. In 1527 the Averoldo family commissioned him to paint a *St Jerome*, which may be the signed painting (London, N.G.) generally (but not universally) assigned to that date. The same year the Venetian Pietro Contarini bequeathed four paintings by Savoldo of the *Flight into Egypt* to a chapel he was founding in SS Apostoli, Venice. This seemingly puzzling donation of several works with the same theme may have been because the patron intended the pictures to be sold and the proceeds to be spent on the chapel. Four paintings of the *Rest on the Flight* may survive from this project, all of about this date. Three versions (Dubrovnik Cathedral; sold Monaco, Christies, 22 June 1991, lot 123; Venice, priv. col.; see 1990 exh. cat., figs I.11, I.12, I.13 respectively), are of similar scale and composition, the first two recorded in private collections at an early date; a fourth, larger version (ex-Albani priv. col., Milan; see 1990 exh. cat., fig. I.14) was perhaps the earliest treatment, whose success evoked the others. Any of them may have been among the surviving paintings ordered by Contarini. In 1527 the artist

1. Giovanni Girolamo Savoldo: *Shepherd with a Flute*, oil on canvas, 970×780 mm, *c.* 1527 (Los Angeles, CA, J. Paul Getty Museum)

made a will, perhaps on the occasion of his marriage to a Flemish widow.

During the 1520s Savoldo was led by such works as Titian's *Assumption of the Virgin* (Venice, S Maria Gloriosa dei Frari; for illustration *see* ALTARPIECE) to create a powerful pattern of figures silhouetted against pale air, though his works are quieter than Titian's and do nothing to resolve the duality of form and space. It is possible that he was experimenting with solutions to this problem in the paintings of the *Rest on the Flight*. Borrowing heavily from Venetian prints and northern European sources, in these works the figures are unusually small in proportion to the whole and are bilaterally balanced by complex architecture. Savoldo seems to have resolved the problem in the *Shepherd with a Flute* (*c.* 1527; Los Angeles, CA, Getty Mus.; see fig. 1), where perhaps for the first time the massive protagonist is also influenced by his surroundings and their subtle colour tone. Thereby Savoldo creates a Giorgionesque pastoral meditation, although the bulk of the shepherd's silhouette harks back to the 15th century.

(ii) 1530 and after. Savoldo's only recorded pupil, Paolo Pino, reported that his master was also patronized by Francesco Maria Sforza, the last Duke of Milan. This must have been between 1531 and 1535, the only stable and prosperous phase of the Duke's reign. Vasari wrote that there were in the mint at Milan 'four paintings of nights and fires' by Savoldo (he noted only one other painting by the master). Since the mint was under ducal control, these works must have been part of Savoldo's ducal patronage and the peak of his career. *St Matthew* (New York, Met.; see fig. 2) evidently belonged to the same cycle: it is one of only three surviving night scenes (there are also two

nocturnal pictures of the *Virgin and Child*, Rome, Margherita Mainoni priv. col.; ex-Mario Crespi priv. col., Milan; see 1990 exh. cat., figs I.17, I.18 respectively), and the saint is patron of public finance. A second painting from the cycle may be *Tobias and the Angel* (Rome, Gal. Borghese; see colour pl. 2, XXIX2), which is not a nocturne, but is of the same size and of a subject that also has financial connotations. In the *St Matthew* the saint's single candle lights his brilliant red robe and leaves everything else in a negative black: one light source determines the whole field.

In 1532 Marcantonio Michiel reported that a few of Savoldo's works were in private collections in Venice, but apart from some copies of a *Clemency of Scipio* (e.g. Florence, priv. col., see 1990 exh. cat., p. 46), the original of which was owned by Andrea Odoni, these are all lost. In about the same period as his work for the Duke of Milan, Savoldo may have visited Genoa, since two paintings (*Temptation of St Anthony*, Moscow, Pushkin Mus. F.A.; *Adoration of the Shepherds*, Turin, Gal. Sabauda) that belong stylistically to this date have separate, early Genoese provenances. In the Moscow *Temptation of St Anthony* and the other version of the same subject (San Diego, CA, Timken A.G.) Savoldo made literal borrowings from Hieronymus Bosch (*c.* 1450–1516)—Netherlandish painting would have been particularly accessible in Genoa. These two versions of the *Temptation* are exceptional, since the artist generally avoided energetic subjects. Instead he preferred, among standard religious themes, ones evoking quiet meditation, such as the Rest on the Flight into Egypt, the Adoration of the Shepherds and the Deposition.

More paintings survive from Savoldo's later years, when he was modestly successful. Portraits of this date are more elaborate: the so-called '*Gaston de Foix*' (*c.* 1532; Paris, Louvre) refers, in the inclusion of two mirrors, to the *paragone* argument, then current, that painting can equal sculpture by showing all views of a figure. The sitter, dressed in armour, is reflected in the mirrors, which make up his whole environment, so that the space repeats the figure, yet light fills the painting. In 1536 Savoldo was commissioned to paint the *Adoration of the Child* (Brescia, Pin. Civ. Tosio–Martinengo) for a Brescian family's chapel, and he repeated it in close variants for two other churches (Venice, S Giobbe; Terlizzi, S Maria della Rosa). Savoldo's late works are less bold, and he creates quieter images, evening scenes or grey interiors that are closer to Lombard painting than his earlier work. Notable among these is the *St Mary Magdalene* (Florence, Pitti), a revision of earlier versions of the same subject. The *Flute-player in a Room* (Brescia, Pin. Civ. Tosio–Martinengo) does not show the date 1539, as once suggested, but is of about that year. The figure, set against a plain grey wall, has a sensitivity of feeling close to Lotto's. Savoldo's last years are documented by notices of esteem from neighbours and former pupils; he may have retired before the last of these in 1548.

2. STYLE, WORKING METHODS AND POSTHUMOUS REPUTATION. Savoldo's corpus of about 40 paintings (about half of them signed, documented or variant versions of these that are) and 10 drawings is so consistent in style

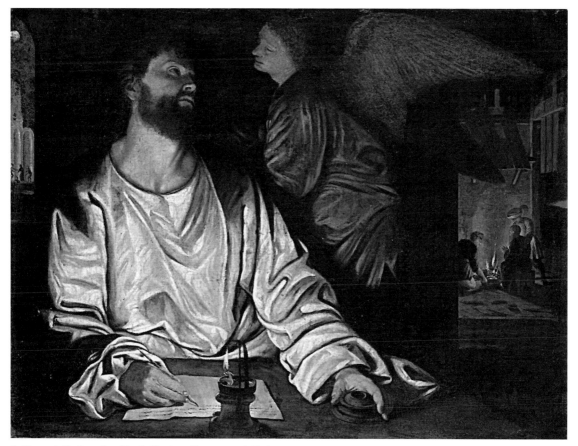

2. Giovanni Girolamo Savoldo: *St Matthew*, oil on canvas, 0.93×1.24 m, 1534–5 (New York, Metropolitan Museum of Art)

that there has been little controversy over attribution. The only wrong attribution to have considerable impact was Longhi's of the *Reclining Venus* (Rome, Gal. Borghese), which was widely endorsed until the discovery of a monogram led to its being accepted as the work of Girolamo da Treviso (ii). As a consequence, the suggestion that Savoldo's style was derived from Florentine painting from the circle of Piero di Cosimo and Fra Bartolommeo was abandoned. All his paintings are in oil on canvas or wood, the latter used for works destined for churches. Almost all of the known drawings are of heads in black chalk, careful preparations for paintings (e.g. the drawing of the *Head of Jerome* (Paris, Louvre) for the London painting of the same subject).

Unusually for a 16th-century painter Savoldo painted very few altarpieces; his favoured subject being one or a few figures in quiet poses. Vasari noted that he did not produce large works and added that he was 'capricious and sophistic' in his 'fantasies'. His usual type of figure is a stable individual interacting contemplatively with his surroundings, which, although distinct, are linked to the figure by atmospheric tone. Smooth thick paint in local colours and with strong contours helps the figure to dominate the picture surface, as does a psychological expression of assurance and mild urbanity in peasants and musicians alike. The visual effect may be somewhat conservative, closer to Giovanni Bellini than Giorgione,

who could create a unified field in which figures are as much incidents within the space as trees. Savoldo never began to approach Titian's free mobility of figures through space, yet he showed a constant skilled ability to adjust his work to harmonize with contemporary developments.

Pino reported in 1548 that Savoldo had done few works and gained little fame, with the exception of his time in the employ of the Duke of Milan. After an obscure career, he was completely forgotten; it may be unique that every signed work cited by 17th- and 18th-century writers was wrongly attributed (though not by all of them) to other painters. (The small scale and shadowed location of several of these signatures, a factor in their neglect, may also suggest a psychological reading of Savoldo's character.) His name survived only through four or five works that were never moved. From about 1850 Cavalcaselle, Mündler and others reconstructed his oeuvre using these works, the rediscovered signatures and the many variant versions. In the early 20th century lively critical analysis, notably by Venturi and Longhi, led to the inclusion of his works in exhibitions. He was one of the last artists to be raised to the ranks of the major High Renaissance masters, and in 1990 the retrospective of his work held in Brescia and Frankfurt am Main, which included most of his known paintings and drawings, greatly increased both his familiarity and reputation.

BIBLIOGRAPHY

Thieme–Becker

P. Pino: *Dialogo della pittura* (Venice, 1548); ed. A. Pallucchini (Venice, 1946), pp. 70, 129, 145

G. Vasari: *Vite* (1550, rev. 2/1568); ed. G. Milanesi (1878–85), vi, pp. 507–8

M. A. Michiel: *Notizie d'opera del disegno* (MS before 1552); ed. T. Frimmel as *Der Anonimo Morelliano* (Vienna, 1888), p. 84

C. Ridolfi: *Meraviglie* (1648); ed. D. von Hadeln (1914–24), i, pp. 271–2

M. Boschini: *Carta del navegar pittoresco* (Venice, 1660), p. 365

———: *Minere della pittura veneziana* (Venice, 1664), p. 487

J. Burckhardt: *Der Cicerone* (Leipzig, 1855; rev. 2 with contribution by O. Mündler, 1869), p. 995

J. Crowe and G. B. Cavalcaselle: *History of Painting in Northern Italy* (London, 1871; rev. 2 with notes by T. Borenius, 1912), iii, pp. 308–20

G. Ludwig: 'Archivalische Beiträge zur Geschichte der venezianischen Malerei', *Jb. K.-Preuss. Kstsamml.*, xxvi (1905), pp. 117–23

L. Venturi: *Giorgione e il Giorgionismo* (Milan, 1913), pp. 215–23

D. von Hadeln: 'Notes on Savoldo', *A. Amer.*, xiii (1925), pp. 72–81

S. Ortolani: 'Di Giangirolamo Savoldo', *Arte*, xxviii (1925), pp. 163–73

R. Longhi: 'Questiti caravaggeschi: I precedenti', *Pinacoteca*, i (1928–9), pp. 285–94

G. Nicco Fasola: 'Lineamenti del Savoldo', *Arte*, xliii (1940), pp. 51–81

G. Gamulin: 'Un nuovo dipinto di G. G. Savoldo', *Commentari*, vi (1955), pp. 254–7

A. Boschetto: *Giovan Gerolamo Savoldo* (Milan, 1963)

R. Bossaglia: 'La pittura del cinquecento', *Storia di Brescia*, ii (Milan, 1964), pp. 1011–1101

A. Ballarin: *Gerolamo Savoldo*, I Maestri del colore (Milan, 1966)

C. Boselli: *Regesto artistico dei notai roganti in Brescia dall'anno 1500 all' anno 1560* (Brescia, 1977), i, p. 67; ii, pp. 32–4, 87–8

Giovanni Gerolamo Savoldo, pittore bresciano: Atti del convegno: Brescia, 1983

H. Slim: 'Giovanni Girolamo Savoldo's *Portrait of a Man with Recorder*', *Early Music*, v (1985), pp. 398–406

C. Gilbert: *The Works of Girolamo Savoldo: The 1955 Dissertation with a Review of Research, 1955–85* (New York, 1986)

Giovanni Gerolamo Savoldo (exh. cat., Brescia, Monastery of S Giulia; Frankfurt am Main, Schirn Ksthalle; 1990) [complete doc. and bibliog. to 1989]

C. Gilbert: 'Newly Discovered Paintings by Savoldo in Relation to their Patronage', *A. Lombarda*, 96/97 (1991), pp. 29–46

F. Frangi: *Savoldo* (Florence, 1992)

Le Siècle de Titien (exh. cat., Paris, 1993), p. 536, no. 149 [entry by C. Legrand]

C. Gilbert: 'Savoldo, Cima, Parma and the Pio Family', *Venezia Cinquecento*, iv/8 (1994), pp. 113–25

W. M. Griswold: 'Some Newly-discovered Drawings in the Metropolitan Museum of Art: Beccafumi, Savoldo and Tibaldi', *Apollo*, cxl/393 (1994), pp. 24–8

L. Gelfand: 'Girolamo Savoldo in the Cleveland Museum of Art: A Question of Mistaken Identities', *Apollo*, cxli/397 (1995), pp. 14–19

A. Martin: *Savoldos sogenanntes Bildnis des Gaston de Foix* (Sigmaringen, 1995)

CREIGHTON E. GILBERT

Savoretti, Giovanni. See GIOVANNI DA ORIOLO.

Savoy, House of. Dynasty of rulers, patrons and collectors. They were counts of Savoy from the 11th century and dukes of Savoy from the 15th century, and in the 16th century the family established a distinguished court at Turin, which became the centre for the House of Savoy's politically motivated display and art patronage notable for its cultural and artistic cosmopolitanism.

During the 14th and 15th centuries the House of Savoy ruled a domain spanning the western Alps from north of Lake Geneva to the Mediterranean Sea. Its heraldic devices, a white cross on a red field (Savoyard cross), a love-knot (*nodi Sabaudi*; a cord, ribbon or vine looped in a figure 8), and the motto FERT, serve to identify the objects of its typically late medieval patronage. During the 14th century the House regularly commissioned frescoes, manuscripts, tapestries, metalwork and other accessories of courtly life from artists and craftsmen both within and outside its domain, a pattern that persisted in the next century. Little tangible evidence, however, survives from this period. For the 15th century there is voluminous evidence. Even where the identity of a specific donor is debatable, as, for example, with a stained-glass window in the Cistercian convent at Romont (Vaud), a capital with a shield-bearing angel (Avigliana, S Giovanni), a reliquary bust of *St Victor* (Valais, St Maurice d'Agaune) and frescoes at Chillon, Corsier, Payerne, Chavornay, Moudon (Vaud), Abondance (Chablais) and elsewhere, innumerable works blazoned with the Savoyard cross testify to the extensive artistic activity the family encouraged throughout its domain.

Amadeus VIII, Count of Savoy (*reg* 1391–1434), was an illustrious figure. He became 1st Duke of Savoy in 1416, and in 1439 he was elected Pope Felix V (*reg* 1439–49) by the Council of Basle. A notable patron, his support of the arts was extensive and diverse. During the second half of the century financial and political difficulties beset the family; its most significant patronage involved manuscripts. Louis, 2nd Duke of Savoy (*reg* 1434–65), is associated with a lavish Book of Hours (Paris, Bib. N., MS. lat. 9473) made *c.* 1440–60. Its principal artists, the eponymous Master of the Hours of Duke Louis and the Master of the Saluces Hours (London, BL, Add. MS. 27697), influenced an active regional school of miniature painting. Charles I, 5th Duke of Savoy (*reg* 1482–90), turned his attention to unfinished manuscripts in the family collection, and commissioned Jean Colombe (*fl* 1463–98) to complete (*c.* 1485) the miniatures in the Très Riches Heures of Jean, Duc de Berry (Chantilly, Mus. Condé, MS. 65), and in Amadeus VIII's Apocalypse (Escorial, Bib. Laurentina MS. E. Vit. 5), and to add some decoration to a two-volume *Histoire du Saint Graal* (Brussels, Bib. Royale Albert 1er, MS. 9246, and Paris, Bib. N., MS. fr. 91). The celebrated Turin–Milan Hours (Turin, Bib. N. U., MS. K. IV. 29; destr. 1904; Turin, Mus. Civ. A. Ant., MS. 47), a portion of the Très Belles Heures of the Duc de Berry, famous for miniatures attributed to Jan van Eyck (*c.* 1395–1441), was part of a donation to the university library of Turin (now Bib. N. U.) in 1720; the date of its acquisition by the House of Savoy, like that of the recovery of the Savoy Hours, is unknown but may have been during the 15th century.

The wars in the early 1530s with the canton of Bern deprived the House of Savoy of its lands in the Vaud and its special position in Geneva, while provoking military occupations by both Imperial and French armies. At the time of the restitution of the family states at the Treaty of Câteau-Cambrésis in 1559, the lands of Emanuel-Philibert, Duke of Savoy (*see* (1) below), consisted of a number of distinct juridical units straddling the Alps: the French-speaking duchy of Savoy with its capital at Chambéry, the seat of the court; the duchy of the Genevois; the counties of Bresse and of Nice; the alpine duchy of Aosta; and the Italian-speaking principality of Piedmont. The Duke's strategic decision in 1562 to transfer the seat of his court from Chambéry to Turin in Piedmont, thus placing his capital behind the Alps, a curtain against the French menace, concentrated ducal urban patronage on an undev-

eloped Italophone city. The structure of the court and its cultural affinities, however, continued to reflect the polyglot nature of the states of the Duke of Savoy, with strong links to Paris and the Italian cities and, thanks to juridical and dynastic ties, to the courts of Lisbon, Madrid, Munich and, especially, Vienna; cultural and artistic cosmopolitanism became the dominating motif of the Turin court.

See also TURIN.

BIBLIOGRAPHY

L. Tamburini: *Le chiese di Torino dal rinascimento al barocco* (Turin, n.d.)

C. Rovere: *Descrizione del Reale Palazzo di Torino* (Turin, 1858)

A. Dufour and F. Rabut: 'Notes pour servir à l'histoire des Savoyards de divers états', *Mémoires et documents publiés par la Société Savoisienne d'histoire et d'archéologie: Les Peintres et les peintures*, xii (1870) and xv (1875); *Les Sculpteurs et les sculptures*, xiv (1873); *Les Orfèvres et les produits de l'orfèvrerie*, xxiv (1886) [documents]

Gotico e rinascimento in Piemonte (exh. cat., ed. V. Viale; Turin, Pal. Carignano, 1938–9)

M. Viale: 'Essai d'une reconstruction idéale des tapisseries ayant appartenu à la Maison de Savoie', *La Tapisserie flamande au XVIIe et XVIIIe siècles* (Brussels, 1960)

E. J. Beer: *Die Glasmalerei der Schweiz aus den 14. und 15. Jahrhundert* (Basle, 1965)

C. Gardet: *De la peinture du moyen âge en Savoie, 1: Du XIe au XVe siècle* (Annecy, [1965])

A. Peyrot: *Torino nei secoli* (Turin, 1965)

F. Cognasso: *I Savoia* (?Rome, 1971)

N. Gabrieli: *Galleria Sabauda: Maestri italiani* (Turin, 1971)

L. Mallè: *Le arti figurative nel Piemonte*, 2 vols (Turin, 1973)

G. Pérouse: *Le Vieux Chambéry* (Lyon, 3/1974)

R. Oursel: *Art en Savoie* (Paris, 1975)

M. Bordes, ed.: *Histoire de Nice et du pays niçois* (Toulouse, 1976)

F. Cognasso: *Storia di Torino* (Florence, 1978)

Giacomo Jaquerio e il gotico internazionale (exh. cat., ed. E. Castelnuovo and G. Romano; Turin, Pal. Madama, 1979)

U[mberto] II] di S[avoia, King of Italy]: *Le medaglie della Casa di Savoia* (Rome, 1980)

I rami incisi dell'archivio di corte: Sovrani, battaglie, architetture, topografia (exh. cat., ed. I. Ricci Massabo; Turin, Pal. Madama, 1981–2)

M. Ruggiero: *Storia del Piemonte* (Turin, 1983)

R. Devos and B. Grosperrin: *La Savoie de la Réforme à la Révolution française* (1985), iii of *Histoire de la Savoie*, ed. J.-P. Leguay (Rennes)

P. Guichonnet, ed.: *Histoire d'Annecy* (Toulouse, 1987)

F. Avril: 'Le maître des Heures de Saluces: Antoine de Lonhy', *Rev. A.*, 85 (1989), pp. 9–34

A. Paravicini Bagliano, ed.: *The Manuscripts of the House of Savoy* (Stuttgart, 1989)

C. Roggero Bardelli, M. Grazia Vinardi and V. Defabiani: *Ville sabaude*, Ville Italiane, ed. P. Fausto Bagatti Valsecchi (Milan, 1990)

La Maison de Savoie en Pays de Vaud (exh. cat., ed. B. Andenmatten and D. de Raemy; Lausanne, Mus. Hist., 1990)

C. Sorrel, ed.: *Histoire de Chambéry* (Toulouse, 1992)

A. Cifani and F. Monetti, with G. Ferraris: *I piacere e le grazie: Collezionismo, pittura di genere e di paesaggio fra sei e settecento in Piemonte*, 2 vols (Turin, 1993)

SHEILA EDMUNDS, ROBERT ORESKO

(1) Emanuel-Philibert [Emanuele Filiberto], 10th Duke of Savoy (*b* Chambéry, 8 July 1528; *reg* 1553–80; *d* Turin, 30 Aug 1580). One of the foremost military captains of his age, his victory, at the head of Habsburg forces, over the French at Saint-Quentin (1557) led directly to the Treaty of Câteau-Cambrésis (1559), his marriage to Marguerite of France (1523–74), sister of Henry II, King of France (*reg* 1547–59), and herself an important patron of humanist culture, and his restoration to his patrimonial estates, which had been largely occupied by French and Habsburg armies from the 1530s. The enormous task of reconstructing the Sabaudian state provides the framework within which his patronage must be viewed, and much of it had, accordingly, a very practical nature. The decision,

implemented early in 1563, to establish the seat of the court at Turin was dictated by military considerations, but it had significant implications for patronage, encouraging a much more polyglot court culture and linking the growth of the city to the aspirations and fortunes of the House of Savoy. Initially, however, military defence took precedence, and one of the Duke's earliest, most important and durable commissions was for a design from Francesco Paciotto for the Turin citadel (1563–6; destr.; *see* TURIN), constructed by Francesco Horologgi, which subsequently became a model for a sequence of pentagonal citadels erected throughout Europe.

The decision to move the capital to Turin demanded building programmes to house the court, and the practical needs of providing an architectural framework and a ducal garden for an expanding court and of presenting the city emblematically as a sovereign capital were henceforth weighty constants in the dynasty's patronage. During his years of exile, the Duke had been exposed to the courts of his Habsburg kinsmen, and once settled in Turin he moved quickly to attract artists and craftsmen with the skills necessary to produce the elements essential to the courtly culture of the 16th century. Late in 1561 Alessandro Cesati, from *c.* 1540 Incisore e Mastro delle Stampe at the papal mint, entered Savoyard service and produced a medal with portraits of Emanuel-Philibert and Marguerite on obverse and reverse. In the same year Gian Paolo Negroli delivered three sets of armour for the Duke. By 1564 the ceramicists Antonio Nani and Orazio Fontana (*c.* 1510–76), both from Urbino, had undertaken work for the court of Turin, Fontana remaining for at least one year in Sabaudian service. The French element was represented by Etienne Bordier, who made furniture for the court, and by the sculptor Barthélemy Prieur (*c.* 1536–1611), a protégé of Anne, Duc de Montmorency, whose wife, Madeleine, was a daughter of the legitimized Tende branch of the Savoy dynasty. The city of Turin itself was celebrated in the *Plan of Turin* (1572) by Giovanni Caracca (Jan Kraeck, *d* 1607), who from 1567 held the post of court painter.

As well as direct, individual commissions, the Duke also provided the necessary encouragement for projects. A devout Catholic, he supported the Society of Jesus, and in 1567 the Jesuits opened their first college in Turin. In 1557 the first stone was laid, in the Duke's presence, of the Jesuit church of SS Martiri, designed by Pellegrino Tibaldi, a protégé of Carlo Borromeo, Archbishop of Milan and a pioneering disseminator of what became viewed as a Jesuit architectural style; thus the Duke contributed to an important architectural innovation in Turin without assuming full responsibility for it. Galeazzo Alessi's visit to Turin documents the Duke's interest in leading contemporary architects, as does his relationship with Andrea Palladio, who dedicated two volumes of *I quattro libri dell'architettura* (Venice, 1570) to him. The Duke's interest in the decorative arts is confirmed by Cipriano di Michele Piccolpasso, who praised his practical knowledge of the craftsmanship of armour and weapons and his patronage of ceramics. Traces of his affinity with the Veneto are a payment to Titian for a portrait of the young Duke in 1548, Vasari's account of a *Venus and Cupid* seen in Paris Bordone's studio in Venice in 1566

and destined for the Duchess Marguerite, and purchases of marbles and bronzes there in 1573.

Despite such individual acquisitions, the strong impression of Emanuel-Philibert's patronage remains that of the Duke furnishing, in a literal sense, a court restored after 25 years of exile and installed in a city that had no previous courtly tradition. Between 1561 and 1573 another court artist, Giacomo Vighi ('Argenta', d 1573), was dispatched to Paris, Vienna and Prague to make portraits of the princely relations of the House of Savoy. In 1574 Orazio Muti, resident in Rome, sold to the Duke a sizeable assemblage that typified princely buying in bulk: series of marble busts and medals of Roman emperors, 124 engraved gems, marble tables and reliefs and paintings attributed to Parmigianino, Correggio, Rosso Fiorentino, Giuseppe Salviati and even Raphael and Michelangelo. These were delivered only in 1583, three years after the Duke's death. However large-scale and indiscriminate such bold campaigns of acquisition may have been, their fruit formed the essential core from which the Sabaudian collections of paintings, coins and medals, gemstones and curiosities grew.

The Duke's decision in 1578 to transfer the Holy Shroud, the most precious religious relic in the dynasty's possession, from Chambéry to Turin, had great significance for the patronage of the House of Savoy. Ostensibly it was done to spare Carlo Borromeo the journey over the Alps to venerate the Shroud, and his visit to Turin became a high-point in the visual iconography of both the Dukes of Savoy and the Borromeo family. The public exposition of the Shroud henceforth played a key role in the religious festivities of the capital and became a popular subject for genre painters, while the problem of housing the sacred relic became a subject of architectural debate at the court of Turin for over a century. A prince of great literary and scientific culture, Emanuel-Philibert was hampered by financial and logistical constraints in his patronage, but he nevertheless managed to support and to define a number of aesthetic interests, fundamental to his role as the re-creator of the Sabaudian state, which his successors, with greater resources at their disposal, were able to exploit.

BIBLIOGRAPHY

A. Manno: *I principi di Savoja, amatori d'arte* (Turin, 1879)

Torino, viii/7–8 (1928), pp. 67–79, 81–6 [special issue dedicated to Turin during the reign of Emanuel-Philibert]

A. Caviglia: 'Profilo religioso di Emanuele Filiberto e la SS Sindone', *Emanuele Filiberto*, ed. C. Rinaudo (Turin, [1928]), pp. 359–92

P. Egidi: *Emanuele Filiberto, II: 1559–1580* (Turin, 1928)

A. Segre: *Emanuele Filiberto, I: 1528–1559* (Turin, 1928)

L. Venturi: 'Emanuele Filiberto e l'arte figurativa', *Studi pubblicati della Regia Università di Torino nel IV centenario della nascita di Emanuele Filiberto* (Turin, 1928)

L. Terreaux, ed.: *Actes du Congrès 'Marguerite de Savoie': Culture et pouvoir au temps de l'humanisme et de la renaissance: Paris and Geneva, 1978*

P. P. Merlin: 'Emanuele Filiberto e la nascita di una capitale', *Torino sabauda*, ed. V. Castronovo (Turin, 1992), pp. 341–60

ROBERT ORESKO

Sbraghe, Nicola di Gabriele. *See* NICOLA DA URBINO.

Scalcagna. *See* MICHELE DA FIRENZE.

Scamozzi. Italian family of artists. They were originally from the Valtellina region of Lombardy. Later members

included two architects active mainly in the Veneto: (1) Giandomenico Scamozzi, originally from the province of Sondrio, who emigrated in 1546 to Vicenza, aged 20, and obtained citizenship by 1570, and his more famous son (2) Vincenzo Scamozzi, born in Vicenza in 1548 and who *c.* 1580 moved to Venice, where he lived until his death in 1616.

(1) Giandomenico [Giovan Domenico] **Scamozzi** (*b* Arigna, Sondrio, 1526; *d* Vicenza, 1582). Surveyor, carpenter and architect. He was well known in his lifetime as a surveyor of land and buildings, but he also had technical interests, inventing a type of double-armed chain, the 'Scamozziana', which was used in the vaulting of Vicenza Cathedral (*c.* 1581–2). In view of his long experience as a surveyor he probably collaborated on the *Pianta Angelica* (Rome, Bib. Angelica), a topographical view of Vicenza drawn up in 1580 for Pope Gregory XIII. The most complete documentary evidence of his architectural activity is found in a dedicatory letter written by Lodovico Roncone of Vicenza for an edition of Sebastiano Serlio's *Tutte le opere d'architettura* published in Venice in 1584. This volume also attributes to Scamozzi an extensive index of the subjects covered. Both index and a 'Discorso' on architecture added to the edition of 1600 can have been conceived by Giandomenico in outline only, since the additions of his son Vincenzo are clearly identifiable and constitute the most substantial part of the two texts, but they nevertheless show an interesting and unexpected attention to architectural theory on his part. Among his works mentioned by Roncone, the most important one that is still identifiable is the villa built for the Ferramosca family at Barbano, near Vicenza, although a drawing of the project by Vincenzo (*see* (2), §1(i) below), who was then beginning his architectural career, indicates that it was a collaborative work.

Giandomenico's most representative work was once considered to be the Palazzo Bisognini, Vicenza, an attribution now considered erroneous. Early assessments of his architectural activity, largely based on this building, saw him as an interpreter of the style of Serlio. Later, however, with fewer building projects attributed to his name and with the recognition of Vincenzo's authorship of the 'Discorso', Giandomenico Scamozzi was regarded less as a builder and scholar than an expert surveyor who was occasionally employed, mostly by bourgeois patrons, for modest building operations.

(2) Vincenzo Scamozzi (*b* Vicenza, 2 Sept 1548; *d* Venice, 7 Aug 1616). Architect, theorist and writer, son of (1) Giandomenico Scamozzi. He was one of the leading architects of the Veneto region in the late 16th century and the early 17th, succeeding Jacopo Sansovino and Andrea Palladio (some of whose works he completed) and preceding Baldassare Longhena. Scamozzi's architecture has been described as derivative and Palladian as well as conservative and academic, but it is possible to see in his designs the seeds of a Serlian revival. His theoretical writings reveal an unexpected interest in various architectural styles observed in the regions of Italy and Europe that he visited.

1. Architectural career. 2. Theory and writings.

1. ARCHITECTURAL CAREER.

(i) Early years in Vicenza, before 1580. Scamozzi spent the first 30 years of his life in Vicenza, where he may have studied at the Seminario Vescovile and Accademia Olimpica; he also studied mathematics with his father. The apparently privileged nature of his early years of study has been proposed (see Puppi) as an explanation for his detached and intellectualizing approach to architecture and his sense of proud intellectual superiority, often interpreted as presumptuous arrogance, for which he was noted throughout his career, even during the early years of his training. A treatise on perspective written in 1575 (untraced) was probably the first product of this period of intense study. Meanwhile Scamozzi had begun his professional apprenticeship with his father, with whom he collaborated on the Villa Ferramosca at Barbano, near Vicenza, completed before the end of 1568. Vincenzo's drawing for his project (London, RIBA, XIV.5), which shows the structure of the building, demonstrates a student's attempt to combine Palladian teaching with the reconstruction of the classical villa as deduced from literary sources.

Scamozzi's first independent works, three buildings begun in the period 1574–7, produced the basic prototypes of designs that he later elaborated repeatedly. At the Villa Verlato (1574), Villaverla, near Vicenza, he transferred the Palladian model for an urban palace to the context of a suburban building. In the Palazzo Trissino (*c.* 1576; later Palazzo Trento; now the headquarters of the Cassa di Risparmio), commissioned by Pier Francesco Trissino in 1576 for a site near the cathedral of Vicenza, on the other hand, he drew on Serlian models. (The palazzo was enlarged between 1621 and 1629 by adding four arch spans to the façade, thereby altering the original symmetry of the composition.) Meanwhile, in the Rocca Pisani (1576), near Lonigo, he combined Palladian and Serlian models in an original interpretation of the centralized plan preferred by Giandomenico Scamozzi. Variations on the same square plan were subsequently adopted by him both in villas of modest dimensions and in small ecclesiastical buildings (*see* §(ii) below).

The Rocca Pisani (see fig. 1), an unusual building, isolated at the top of a hill, should be examined in the context of his subsequent return to the theme rather than the monumental precedent of Palladio's Villa Rotonda (begun *c.* 1565/6; *see* PALLADIO, ANDREA, fig. 5), near Vicenza, which Scamozzi completed after Palladio's death in 1580. The privileged position of the Rocca, offering views in all directions and, in its turn, visible from all directions, contributed to the centripetal design. Instead of the projecting porticos of the Villa Rotonda, the central openings of the Rocca Pisani's external walls—an Ionic loggia with crowning pediment on the south side and Serlian openings on the other three sides—are all flush with the walls, where they create voids converging around the cylinder of the central hall. The Rocca Pisani also represented an important turning point in Scamozzi's career, since it permitted him to make early contact with the Pisani, an important family of the Venetian nobility, where he later obtained his most important commission (*see* §(ii) below).

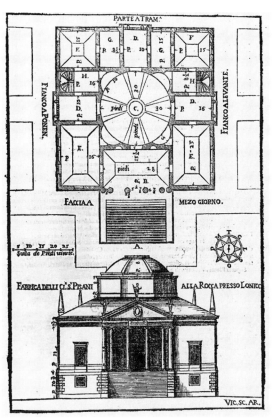

1. Vincenzo Scamozzi: Rocca Pisani, near Lonigo, 1576; wood engraving from his *L'Idea dell'architettura universale* (Venice, 1615), pt I, Book III, p. 273

In 1578 Scamozzi left Vicenza on a two-year study that took him south to Naples and Pozzuoli and then to Rome, where he remained for more than a year, attending mathematics classes with Cristoforo Clavio at the Collegio Romano and, at the end of his stay, printing three plates illustrating his proposed reconstructions of important ancient monuments. Those showing the restoration of the Colosseum and the baths of Antonino are untraced; but that of the baths of Diocletian, engraved by Marco Cartari in 1580, was rediscovered (Los Angeles, CA, Getty Cent.) and published in 1991 (L. Olivato, intro. facs. edn, *Discorsi sopra l'antichità di Roma*). The engraving shows a bird's-eye view of the architectural complex, partly in elevation, partly in plan only. When Scamozzi returned from Rome in 1580, he settled permanently in Venice, although he returned to Rome several times between 1585 and 1598 in connection with his work, passing through North Italy (Sabbioneta, Florence, Bergamo, Genoa). He also travelled to northern Europe, including Hungary, Poland, Germany and France (1599–1600), and to Salzburg in 1603–4 to prepare the plan for the new cathedral.

(ii) Venice and the Veneto, 1580 and after. Scamozzi's appearance on the cultural scene of Venice, almost coinciding with Palladio's death, led to his appointment to the editorial task of preparing the *Discorsi sopra l'antichità di Roma* (Venice, 1582), a commentary on a series of views

of Rome by Giovan Battista Pittoni. In this he had the indirect approval of the dedicatee, Jacopo Contarini, previously a supporter of Palladio. Scamozzi then obtained his most important commission in Venice, the Procuratie Nuove, through Marc'Antonio Barbaro, a friend of Contarini and an important patron of Palladio. The Procurators of S Marco, who were responsible for rebuilding work in the area around the square, had established in 1581 a programme for new housing and offices for the three Procuratie. This involved the extension of Sansovino's two-storey Libreria Marciana (*see* VENICE, §IV, 5(i)) towards the Grand Canal to align with the façade of his Zecca (mint), and the replacement of existing buildings along the south side of the Piazza S Marco. Barbaro was elected to the commission of three procurators supervising the works, and it was with his support that Scamozzi was appointed to carry out, on this most important urban site in Venice, an accomplished and grandiose project that attempted to revive the classical language of architecture.

Scamozzi's scheme, however, which surpassed the limits set by the original programme, met with opposition from the other two members of the commission, Andrea Dolfin and Federigo Contarini. Although Scamozzi won the competition (1582) for the design of the Procuratie Nuove, two other alternative proposals remained under consideration; these were brought forward again in 1596, when, after the death of Barbaro the previous year, and after construction had been under way for more than a decade, Dolfin and Contarini attempted to bring about a complete revision of the plan for the area around S Marco. It was eventually decided that the façade of the Procuratie Nuove should be placed further back in order to continue the line established by the end arcade of the Libreria, with the inevitable result that Sansovino's external articulation had also to be continued (*see* VENICE, fig. 2). The principal element of novelty introduced by Scamozzi, probably between 1584 and 1587, had been the addition of a third storey to the buildings. His intention was to do the same with the Libreria (already modified by the extension of the façade towards the jetty in order to accommodate additional offices for the procurators), but doing so would have involved the destruction of Sansovino's Ionic frieze, magnificent with its putti and festoons (still extant), and its replacement by a frieze of more conventional height, such as he had used (1583–8) for the Procuratie Nuove. As a consequence of the decisions of 1596, the addition of the third storey was limited to the residential wing of the Procuratie facing the main square, despite the continuing difficult problem of connecting the new façade with the *voltatesta* of the Libreria. Later in 1596 Scamozzi worked out a scheme (Paris, Louvre, drg no. 5448) to resolve these difficulties, and approval was given that same year, but even here his instructions were not accurately followed, and for reasons of economy and speed of execution his plan was abandoned. The work was finally completed in the mid-17th century by Longhena.

Any evaluation of Scamozzi's work on the Procuratie project, which occupied the central part of his career, but from which he felt obliged to distance himself in part for the purposes of his treatise, must take into account the conditions to which he was subjected. The resistance Scamozzi encountered there, however, was not an isolated case. During the same period he suffered the rejection of two designs (1588) for the Rialto Bridge, one with a single arch and the other with three; the destruction of his partially completed church of the Celestia near the Arsenal; and his dismissal from work on S Nicolò da Tolentino (designed 1590), Venice, by the Theatine monks who had commissioned the work. Scamozzi had already submitted a large number of plans for this project when he was accused of having used incorrect construction techniques in the foundations of the first pier of the dome, which had proved both costly and ineffective. Neither of the characteristic elements of his design—the apsidal transepts and the vast central dome—were subsequently constructed, while his exterior was only partially completed; the classicist, porticoed façade by Andrea Tirali (1657–1737) was added only in 1706–14. This series of failures cannot be explained merely by a climate of hostility towards Scamozzi within the Venetian capital. Important projects by him for buildings outside Venice, for example Salzburg Cathedral (designed 1603–4; built 1614–28), were completely altered during construction, while work on others dragged on long after his death, inevitably involving substantial changes, as in the new Palazzo Comunale at Bergamo (designed 1611; finally completed only in 1927–8).

Two large projects completed according to Scamozzi's designs therefore constitute precious sources of evidence: the Teatro Ducale (1588–90) at Sabbioneta, near Mantua, commissioned by Vespasiano Gonzaga, Duke of Sabbioneta, and the Palazzo Contarini degli Scrigni, Venice, which was under construction in 1608. The theatre at Sabbioneta (see fig. 2) offers an ideal comparison with the Palladian model of the Teatro Olimpico, Vicenza, for which Scamozzi had designed the monumental perspective street backdrops in 1584. At Sabbioneta, Scamozzi

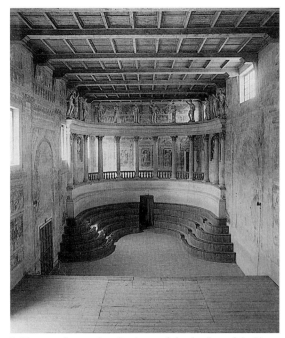

2. Vincenzo Scamozzi: auditorium and ducal gallery of the Teatro Ducale, Sabbioneta, 1588–90

abandoned the Palladian idea of re-creating the classical theatre, producing instead a prototype of modern theatrical space that was for the first time an autonomous building with its own façade (for further discussion *see* SABBIONETA). For the Palazzo Contarini on the Grand Canal, which has a flat, pilastered classical façade, Scamozzi formulated an original version of the traditional Venetian type of residential building, achieved through a combination of Serlian models and a formal vocabulary derived from Sansovino but reduced to the level of superficial decoration. This had considerable influence on the following generation of architects, particularly Longhena.

Other projects of the 1580s and after included several designs that echoed the centralized plans of Scamozzi's early work. His treatise, for example, includes three villa designs based on the Rocca Pisani: that for the Bardellini family (1594; destr.) in the Treviso region, the Villa Molin (1597), near Padua, and a villa (1608; unexecuted) at Dolo, near Venice. The same model was used in several church plans commissioned by Cardinal Federico Cornaro, which were designed to be integrated into monasteries: S Gaetano (1581), Padua, S Michele (1588–90), Este, and a church design (1588; unexecuted) for Ognissanti, Padua.

2. THEORY AND WRITINGS. The work in which Scamozzi expressed most completely his conception of architecture, outside the limitations and compromises of professional practice, was his treatise *L'idea della architettura universale*, which occupied him from 1591 onwards. It was originally conceived in twelve books, subsequently reduced to ten, but only six were published in 1615; the material prepared for the remaining four books was dispersed after Scamozzi's death, although some of the unpublished designs appeared in a Dutch edition of the treatise (Amsterdam, 1661) and later in the better known French edition (Leiden, 1713).

The ambitious programme for the work, which represents the last example of treatise writing in the Renaissance tradition, envisaged the collection and review of all knowledge on the subject of architecture, presented within an original framework that rejected the traditional encyclopedic structure based on Vitruvius. It did not, however, as in some modern treatises, attempt to divide the two fundamental polarities of the discipline, theory and practice. For Scamozzi, the mediating element between the abstract and universal principles, on which the 'science' of architecture was founded, and the concrete and specific product of the 'art' was constituted by the 'idea': a mental concept resulting from a complex package of theoretical and empirical knowledge, which was then translated to the material sphere by means of the design. The treatise aimed to illustrate this ideal working method, setting out the various steps in the study of sources and the selection of a nucleus of rational principles, which were epitomized in the rules for the construction of the five orders of architecture; it concluded with the presentation of a series of concrete solutions for the form and function of different building types, as represented by the author's own designs. Despite the unified concept of the work, however, its organization is confused and overcrowded. The treatise was reprinted several times, but its dissemination was largely in the form of later abridged editions and in the

separate publication, in various translations, of abbreviated editions of Book VI on the five orders (in Dutch, 1657, following a complete edition in 1640; in German, 1665; in English, 1669; in French, 1685). Taken out of its original context, this fragment of Scamozzi's monumental theoretical work was thus transformed into an example of the kind of bookish and popular treatise writing that he himself had constantly condemned.

Like Palladio in *I Quattro libri dell'architettura*, Scamozzi included in his treatise a vast selection of his own designs, providing an important record of his unexecuted, altered and destroyed work, especially private buildings. Only three of the villas included in the treatise (Villa Verlato, Villa Molin and Rocca Pisani) still survive, and of the eight designs for palaces, four were never built; his contribution (c. 1602) to the Palazzo Strozzi–Nonfinito (begun by Bernardo Buontalenti in 1593), Florence, was only partially executed; the Palazzo Godi, Vicenza, was constructed with major modifications; the palace for Galeazzo Trissino (now Vicenza Town Hall) on the Corso (now Corso Palladio) at Vicenza was begun in 1599 and completed only in 1668; while that for Pier Francesco Trissino near Vicenza Cathedral had already been enlarged by the second half of the 17th century. The plates reveal Scamozzi's original concepts for his projects, expressed as a simplification of the building structure into a regular grid described by basic geometric figures and articulated on the exterior by the presence of a classical order or the repetition of a series of apertures.

Scamozzi has been judged as an imitator of Palladio (Temanza), as a corrupter of the Palladian style in the direction of the Baroque (Scolari) and as the founder of an eclectic and proto-Neo-classical academic style (Barbieri, 1952). On the other hand, attention has been drawn to the co-existence in his theoretical work of 'Baroque and rationalism' (Jannaco), together with the emergence of pragmatic 'technical interests' (Puppi). There are also ideas that originate from Neo-Platonic culture, most notably Scamozzi's emphasis on the role of the 'idea' in the artistic process. Scamozzi's architecture also contains elements of a Serlian revival, while the development of the theoretical aspects of his treatise shows the influence exerted by such works as Giorgio Vasari's *Vite* and Daniele Barbaro's commentaries on Vitruvius, of which Scamozzi possessed his own carefully annotated copies. Also evident is an interest in Gothic architecture, unprecedented in an architect of the 16th century, but attested by a diary (Vicenza, Mus. Civ. A. & Stor.) kept by Scamozzi during his travels in Northern Europe, in which are recorded the principal monuments he visited, with some correction of their irregularities. This heterogeneous collection of influences eventually appeared in his treatise. His eclecticism was therefore the translation into the field of architecture of attempts, culminating in the work of Giulio Camillo (c. 1480–1544), to reach a universal synthesis of knowledge.

Scamozzi had personal contact with Inigo Jones (1573–1652) in 1613–14 during the latter's visit to Italy with Thomas Howard, 2nd Earl of Arundel (1585–1646), and several of Scamozzi's drawings, as well as Palladio's, were collected by Jones and Howard. As a result, Scamozzi's abstract and linear style lived on in the subsequent development of international Palladianism, especially in

Chiswick House (1725–9), London, by Richard Boyle, 3rd Earl of Burlington (1566–1643), rather than in the severe and orthodox school of Vicenza.

WRITINGS

V. Scamozzi, ed.: *Discorsi sopra le antichità di Roma* (Venice, 1592/*R* Milan, 1991, intro. L. Olivato)
G. Scamozzi and V. Scamozzi, eds: *Tutte le opere d'architettura . . . di Sebastiano Serlio et un indice copiosissimo . . . raccolto da M. Gio. Domenico Scamozzi* (Venice, 1584, rev. 1600 with added *Discorso/R* Bologna, 1987)
V. Scamozzi: *L'idea della architettura universale* (Venice, 1615/*R* Ridgewood, NJ, 1964, Bologna, 1982)

BIBLIOGRAPHY

A.-C. d'Aviler and S. du Ry: *Oeuvres d'architecture de Vincent Scamozzi* (Leiden, 1713)
T. Temanza: *Vite dei più celebri architetti e scultori veneziani che fiorirono nel secolo decimosesco* (Venice, 1778); ed. L. Grassi (Milan, 1966), pp. 409–74
F. Scolari: *Della vita e delle opere dell'architetto Vincenzo Scamozzi* (Treviso, 1837)
F. Franco: 'La scuola scamozziana di stile severo', *Palladio*, i (1937), pp. 59–70
G. Loukomsky: 'Disegni dello Scamozzi a Londra', *Palladio*, iv (1940), pp. 65–74
F. Barbieri: *Vincenzo Scamozzi* (Vicenza, 1952)
C. Jannaco: 'Barocco e razionalismo nel trattato d'architettura di Vincenzo Scamozzi', *Stud. Seicent.*, ii (1961), pp. 47–60
G. Zorzi: 'La verità su Gian Domenico Scamozzi, architetto valtellinese del secolo XVI, imitatore del Palladio', *A. Lombarda*, v (1961), pp. 20–40
W. Timofiewitsch: 'Das Testament Vincenzo Scamozzis vom 2 September 1602', *Boll. Cent. Int. Stud. Archit. Andrea Palladio*, vii (1965), pp. 316–28
——: 'Die Grundrisszeichnung Vincenzo Scamozzis in Salzburger Museum Carolino Augusteum', *Festschrifts Karl Oettinger* (Erlangen, 1968), pp. 411–32
F. Barbieri: 'Giandomenico e Vincenzo Scamozzi', *Vicenza illustrata*, ed. N. Pozza (Vicenza, 1976), pp. 308–23
L. Puppi: 'Venezia: Da Palladio a Longhena', *Longhena* (exh. cat., ed. O. Selvafolta; Lugano, Villa Malpensata, 1982), pp. 15–30
S. Mazzoni and O. Guaita: *Il teatro di Sabbioneta* (Florence, 1985)
M. Tafuri: *Venezia e il rinascimento: Religione, scienza, architettura* (Turin, 1985), pp. 246–71
F. Barbieri: *Vicenza: Città di palazzi* (Milan, 1987), pp. 105–17
——: 'Gli Scamozzi de Arigna', *Architetture palladiane: Dalla pratica del cantiere alle immagini del trattato* (Vicenza, 1992), pp. 299–305

NADIA MUNARI

Scardeone, Bernardino (*b* Padua, 1478; *d* Padua, 29 May 1574). Italian ecclesiastic and historiographer. Educated in Padua, he later entered the clergy and was elected a canon of Padua Cathedral in 1556. He wrote a number of religious works but is best remembered for his book on the antiquities and illustrious men of Padua. This Latin work was granted a licence to print in Venice in 1557 but was published in Basle in 1560. Following the tradition of earlier municipal chronicles, Scardeone described the origins and cultural heritage of Padua, paying considerable attention to its ancient monuments and transcribing many inscriptions from tombs. He also devoted a chapter to the artists of Padua, from the 14th century to his own day, including Andrea Mantegna, Francesco Squarcione, Andrea Riccio and Tiziano Minio. This was the first attempt, outside Florence, to compose a local compendium of artistic biographies. Although the accounts of the lives of individual artists, particularly the earlier ones, often have an anecdotal or legendary quality, they are nevertheless a valuable source for the study of Paduan art, especially that of the 15th century. The frontispiece of this volume is a view of Padua by an anonymous artist: it offers the first accurate compilation of visual data on the city's buildings.

WRITINGS

De antiquitate urbis Patavii et claris civibus Patavinis (Basle, 1560)

BIBLIOGRAPHY

N. C. Papadopoli: *Historia gymnasii patavinii post ea quae hactenus de illa scripta sunt ad haec nostra tempora plenius et emendatius deducta*, ii (Venice, 1726)
G. Volpi: *La libreria di Volpi e la stamperia Cominiana illustrate con utili e curiose annotazioni* (Padua, 1756), p. 196
G. Tiraboschi: *Storia della letteratura italiana*, vii (Venice, 1796), p. 319
F. S. Dondi Dell'Orologio: *Serie cronologico-storica dei canonici di Padova* (Padua, 1805), p. 196
G. Vedova: *Biografie degli scrittori padovani*, ii (Padua, 1836), pp. 255–9
J. Schlosser Magnino: *La letteratura artistica* (Vienna, 1924/*R* Florence, 1977), pp. 365–79
G. Mazzi: 'Iconografia di Padova ai tempi del Cornaro', *Alvise Cornaro e il suo tempo* (exh. cat., Padua, Pal. Ragione, 1980), pp. 178–94, 232–52

DONATA BATTILOTTI

Scarpagnino [Abbondi], **Antonio** (*b* Milan, 1465–70; *d* Venice, 26 Nov 1549). Italian architect. He was active in Venice from October 1505, when he was appointed as a mason by the Salt Office (in effect the Venetian Board of Works). His first assignment was to take over the rebuilding of the Fondaco dei Tedeschi (which had been damaged by fire) from Giorgio Spavento; his work there does not seem, however, to have had a substantial influence on the appearance of the structure, which was inspired by Fra Giaconolo. In 1507 he was apparently involved in building S Sebastiano and Santo Spirito on the Giudecca. The former, completed in 1547, has an aisleless nave with six side chapels and a domed choir reached through a small vestibule. The tripartite façade has a double order of paired columns and, for the first time in a Venetian church, windows capped by alternate triangular and segmental pediments.

In 1513 Scarpagnino worked on the restoration of the wooden Ponte di Rialto. Around this time he became the State Architect of Venice and in this capacity later reconstructed the Rialto market, which was completely destroyed by fire in January 1514. The choice of Scarpagnino's plan—rather than the scheme proposed by Fra Giovanni Giocondo for a square piazza enclosed by concentrically arranged buildings—seems to have been dictated by a preference for tradition, and possibly by the difficulties of obtaining sufficient freeholds in order to clear the site. The small church of S Giovanni Elemosinario, also greatly damaged in the same fire, was restored by Scarpagnino in the same period. Both the market and the church use a simplified architectural language, emphasizing the strong functional character of the buildings: the main part of the market has the form of a long arcade, roofed with vaults in place of the former wooden beamed ceilings, overlooking the piazza in front of the old church of S Giacometto, while S Giovanni, which has a cross in square plan and barrel-vaulted arms, retained its original form, surrounded by the shops of the market.

On returning from Legnago (1515), where he had gone to work on the fortifications, Scarpagnino was involved in some building operations at the Doge's Palace (*see* VENICE, §IV, 4(i)). He may have been partly responsible for the *piano nobile* of the internal façade overlooking the small Cortile dei Senatori, the Doge's private chapel of S Nicolò,

the portal of the Sala della Cancelleria and the one giving access to the great staircase (the Scala d'Oro), as well as the Sala dello Scrutinio and the Sala del Senato. In 1520 he was appointed to restore the Ponte della Pietra in Verona. From that date, his activity as a restorer extended also to Vicenza, where he worked on the renovation of the pavement of the old Loggia del Capitaniato (1521), and took part in the restoration of the Palazzo della Ragione (1527 and 1532). His exact contribution to the reconstruction of S Fantin, Venice is now difficult to identify. He probably demolished a part of the church built from 1545 onwards and changed the orientation of the building, which was completed in 1557–62, after his death.

In October 1527 Scarpagnino was appointed as overseer of the Scuola Grande di S Rocco (*see* VENICE, §V, 1 and 4), replacing Sante Lombardo. At first he was involved in the internal reconstruction of the great edifice that housed the meetings of the Scuola and in the building of the adjacent hostel, but in 1536 he had to confront the problem of completing the main façade, begun by Pietro Buon. The façade was archaic in style, with much decorative use of polychrome marbles. On this, Scarpagnino superimposed two orders of *all'antica* free-standing Corinthian columns on high bases, in the form of a triumphal arch (see fig.). He did not attain a completely classical style, for the structure retains elements of late 15th-century taste. The stairs he designed to give access to the upper hall are the first instance of an imperial staircase. Two parallel flights under barrel vaults lead to a landing, where a single central flight with a dome above, turns through 180° to continue upwards. Traditional architectural vocabulary characterizes the houses of Castelforte S Rocco (begun 1548), situated near the *scuola* and forming part of the same property. These three-storey buildings with crossed stairways were intended as houses to rent, with spaces for cellars and laundries as well as accommodation for servants in the attics.

Scarpagnino's work for the *scuole grandi* was not limited to S Rocco: the design of an altar in the great hall of the Scuola di S Marco is attributed to a collaboration between

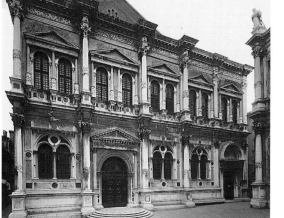

Antonio Scarpagnino: façade (begun by Pietro Buon (ii)) of Scuola Grande di S Rocco, Venice, 1536

him and Sansovino. Other Venetian works attributed to him include the Palazzo Loredan in Campo Francesco Morosini, the house of Doge Andrea Gritti in Campo S Francesco della Vigna, and the Palazzo dei Camerlenghi on the Isola Realtina. Scarpagnino's work typifies the early Renaissance in Venice: while exhibiting familiarity with the vocabulary of the new style, he failed to master the overall concept of the harmonious interplay of parts and the clarity of design that was already well understood in Rome. His monumental staircase at the Scuola di S Rocco, however, is an epoch-making work in a genre in which pioneering advances are generally ascribed to Spanish architects.

BIBLIOGRAPHY

DBI: 'Abbondi, Antonio'; Thieme–Becker: 'Abbondi, Antonio'
P. Paoletti: *L'architettura e la scultura del rinascimento in Venezia*, 2 vols (Venice, 1893)
A. Alberti and R. Cessi: *Rialto: L'isola, il ponte, il mercato* (Bologna, 1934)
E. T. Trincanto: *Venezia minore* (Milan, 1948)
U. Franzoi and D. Di Stefano: *Le chiese di Venezia* (Venice, 1976)
M. Tafuri: *Venezia e il Rinascimento* (Turin, 1985), pp. 125–54
S. Maso: 'Intorno ad Antonio Proto: Il lavoro, la vita', *Quad. Pal. Te*, v (1986), pp. 59–66
D. Calabi and P. Morachiello: *Rialto: Le fabbriche e il ponte* (Turin, 1987)
E. Concina: *Fondaci: Architettura, arte e mercatura tra Levante, Venezia e Alemagna* (Venice, 1997)

MANUELA MORRESI

Scavezzi, Prospero. *See* ANTICHI, PROSPERO.

Scheggia [Giovanni di ser Giovanni Guidi] (*b* San Giovanni Valdarno, nr Arezzo, 1406; *d* Florence, 1 Nov 1486). Italian painter. The son of a notary, grandson of Mone di Andreuccio who practised the art of *cassaio* (furniture maker) in Castel San Giovanni, and younger brother of MASACCIO, he spent some time as a mercenary soldier. From December 1420 and through the following year Giovanni is recorded in Florence in the workshop of Bicci di Lorenzo. In 1426 he is mentioned in the *estimo* and in 1427 in the *catasto* (land registry declaration) written jointly with his brother. Surviving documents and works suggest that he was in close collaboration with Masaccio's workshop. In October 1426 he appears as guarantor of Masaccio in an agreement for the completion of the altarpiece of the Carmine church in Pisa. In 1427 he shared Masaccio's workshop in the Piazza Sant' Apollinare (now San Firenze). In 1429 Giovanni paid a three soldi tax based on his own professional activity. In 1430 he enrolled in the Compagnia di S Luca, where he appears as Scheggia ('Splinter'), a nickname given in Tuscany to individuals of slight stature or who are somehow connected with wood.

On 23 October 1433 Giovanni matriculated in the Arte dei Medici e Speziali, after having enrolled (1432) in the Arte de Maestri di Pietra Legname. The documentary material has increased with research (Haines, 1999) into his artistic production, the movements of his shop and his network of relationships with other artists and artisans. The *Virgin and Child with SS John the Baptist, Anthony Abbot, Julian and James* (priv. col.), which recalls the style of Masaccio, is datable to the 1430s or 1440s. It shows close similarities with Giovanni's only signed work, the fragmentary fresco dated December 1456 or 1457 (Magherini Graziani) depicting the *Martyrdom of St Sebastian* in

Scheggia: *Story of Lionora dei Bardi and Filippo Buondelmonti*, tempera on panel, 0.44×1.47 m, 1450–70 (Grazzina, Alberto Bruschi private collection); front of a *forziero* (nuptial chest)

S Lorenzo, San Giovanni Valdarno. The frescoes of the adjoining bay depicting scenes from the *Life of St Anthony Abbot* are datable in the early phase, while the *St Francis* and *St Bernard* of Siena date from the artist's maturity. Bellosi (see 1969 exh. cat., and 1999) recognized the same hand in the signed fresco and in works previously attributed to the anonymous painter designated the Master of the Adimari Cassone (Longhi), also known as the Master of Fucecchio (Pudelko). The former name refers to a *spalliera* depicting a wedding scene (Florence, Accad.), while the second derives from the altarpiece from the collegiate church of Fucecchio, near Empoli, depicting the *Virgin and Child in Glory with SS Sebastian, Lazarus, Mary Magdalene and Martha* (Fucecchio, Mus. Civ.). The panel depicting a game of 'civettino' (a kind of boxing; Florence, Pal. Davanzati), which recent restoration has reclaimed as a birth salver with a scene of children boxing on the back (see Francolini, 1999), has been assigned to the Master of the Adimari Cassone.

Scheggia's known works primarily consist of *colmi* (little tabernacles) depicting the *Virgin and Child* intended for private devotion (e.g. that for Marco Parenti, 1451, made by Giuliano da Maiano; see Haines, 1999), birth salvers and paintings for furniture, including panelling and *forzieri* decorated with single figures on the inside of the lid (e.g. Avignon, Mus. Petit Pal.) or depicting a narrative scene (e.g. formerly Grassina, nr Florence, Alberto Bruschi priv. col.; see fig.). Between 1436 and 1440 Scheggia collaborated on the intarsia designs for the cupboards on the south wall of the Sagrestia delle Messe (new sacristy) in Florence Cathedral. The testimony of Brunelleschi's biographer Antonio Manneto indicates that Scheggia was on close terms with the architect. For the birth of Lorenzo de' Medici on 1 January 1449, Scheggia was commissioned to paint a birth salver depicting the *Triumph of Fame* (New York, NY Hist. Soc.); on the reverse is the diamond ring emblem flanked by the arms of Piero de' Medici and Lucrezia Tornabuoni. During this period he shared a workshop with the embroiderer Luca di Piero, continuing to work with his son Antonfrancesco until the latter's death in 1476. Among the chests with wall panelling inventoried in 1492 in the Medici town house on the Via Larga, Florence (all untraced), was a *spalliera*, recorded as by Scheggia, that depicted a famous joust of Lorenzo's in 1469. A panel (40×43 cm) with the figure of *Justice*, to be related to the other *Virtues* that have appeared on the Florentine art market, has been donated to the Palazzo Davanzati. In 1469 Scheggia declared to the tax officials that he was infirm. His last report is dated 1480. He died in 1486, and was buried in Santa Croce.

BIBLIOGRAPHY

G. Magherini Graziani: *Masaccio: Ricordo delle onoranze rese in San Giovanni in Valdarno nel dì XXV Ottobre MCMIII in occasione del V Centenario della sua nascita* (Florence, 1904), p. 118

R. Longhi: 'Ricerche su Giovanni di Francesco', *Pinacotheca*, I/i (1928), p. 38; repr. in '*Me pinxit' e quesiti caravaggeschi* (Florence, 1968), p. 25

G. Pudelko: 'Studien über Domenico Veneziano', *Mitt. Ksthist. Inst. Florenz*, iv (1934), pp. 163–4, no. 1

P. Dal Poggetto: *Museo di Fucecchio* (Florence, 1969), pp. 10–12, pl. III

Mostra d'arte sacra della diocesi di San Miniato (exh. cat., ed. L. Bellosi and others; San Miniato, Semin. Dioc., 1969), no. 42

Arte nell'Aretino (exh. cat., ed. A. M. Maetzke; Arezzo, S Francesco, 1974), pp. 88–91, fig. 117

J. Shearman: 'The Collections of the Younger Branch of the Medici', *Burl. Mag.*, cxvii (1975), pp. 12–27

M. Haines: *La sacrestia delle Messe del Duomo di Firenze* (Florence, 1983), pp. 62–3, 107

U. Procacci: 'Le portate al catasto di Giovanni di ser Giovanni detto lo Scheggia', *Riv. A.*, xxxvii (1984), pp. 235–68 [ed. by M. Haines]

M. Visonà and A. Bruschi: 'Note su Giovanni di ser Giovanni detto "Scheggia", fratello di Masaccio', *Quad. Padano*, vii/2 (1986), pp. 21–5

E. Callman: 'Apollonio di Giovanni and Painting for the Early Renaissance Room', *Ant. Viva*, xxvii/3–4 (1988), p. 8

MARA VISONÀ

Schiavo, Paolo [Paolo di Stefano Badaloni] (*b* Florence, 1397; *d* Pisa, 1478). Italian painter. He enrolled in the Arte dei Medici e Speziali in Florence on 8 December 1429. According to Vasari, he was a follower of Masolino; this is confirmed by those works securely attributable to him, though they date from a later phase of his activity. They include a signed and dated fresco of the *Virgin and Child Enthroned with Saints* (1436; Florence, S Miniato al Monte); a fresco of the *Crucifixion Adored by Nuns* (1447–8; Florence, convent of S Apollonia; see fig.), also signed and dated; a panel of the *Assumption* (1460) and frescoes of the *Adoration of the Magi*, the *Annunciation* and various saints (all Quarto, nr Florence, S Maria Assunta). Other frescoes include *Stories of St Stephen* (*c*. 1436–40; Collegiata, Castiglione Olona); frescoes in the left-hand chapel of the church of S Michele a Castellaccio di Sommaia, near Florence; and a signed *Virgin and Child with Saints* (Monte San Michele, Greve in Chianti). Two street tabernacles by Schiavo survive: the Tabernacolo delle Mozzette, near San Piero a Sieve, contains a *Virgin and Child with Saints* (*c*. 1437–8) while the Tabernacolo dell'Olmo at Castello, near Florence, bears an *Annunciation* and *Saints* (1447).

From 1420 until the mid-1430s Schiavo worked mostly on a small scale, as exemplified by the predella panels of

Paolo Schiavo: *Crucifixion Adored by Nuns* (1447–8), fresco, convent of S Apollonia, Florence

the *Visitation, Nativity, Adoration of the Magi* (all Philadelphia, PA, Mus. A.), an *Annunciation* (Berlin, Gemäldegal.), an altarpiece with the *Virgin and Child* (Cambridge, Fitzwilliam) and the panel of *Christ in the Garden and St Jerome in Penitence* (Altenburg, Staatl. Lindenau-Mus.). This last shows a notable affinity with the work of Masaccio, whom Schiavo undoubtedly knew.

He was active in Florence and its territories as well as in Pisa, where he lived for a time. In January 1462 he painted a small altarpiece of the *Virgin and Child with Saints* (dispersed) for the nuns of S Domenico in that city. At this time he probably also painted a *Christ on the Cross* (Pisa, Mus. N. S Matteo). Schiavo's stay in Pisa was not permanent however, as his various Florentine works dating from this period attest.

Schiavo was a versatile artist: he was also active as a manuscript illuminator and supplied cartoons for embroiderers. His considerable skill as a draughtsman can be seen in the *sinopie* discovered after several of his frescoes were detached (e.g. Virgin and saints on the façade of SS Apostoli, Florence). While the re-use of stock drawings both by Schiavo himself and by his busy workshop makes his paintings easily recognizable, it also complicates the question of chronology. The repetitive and stereotyped appearance of many of his works may also be attributed to this practice. Schiavo's works have been listed by Offner, Longhi, Berenson and Boskovits, although their

research is continually being augmented by new discoveries. His son Marco was also a painter who lived and worked in Pisa (Milanesi).

BIBLIOGRAPHY
Colnaghi; *DBI*; Thieme–Becker

G. Vasari: *Vite* (1550, rev. 2/1568), ed. G. Milanesi (1878–85), ii, p. 266

G. Milanesi: *Nuovi documenti per la storia dell'arte toscana* (Florence, 1901), p. 142

R. Offner: *Italian Primitives at Yale University* (New Haven, 1927), pp. 22–7

M. Salmi: 'Gli affreschi della Collegiata di Castiglione d'Olona', *Dedalo*, ix (1928–9), pp. 3–30

——: 'Recensione a R. Offner, "Italian Primitives at Yale", 1927', *Riv. A.*, xi (1929), pp. 267–73

R. Longhi: 'Fatti di Masolino e di Masaccio', *Crit. A.*, v (1940), p. 187

L. Berti: 'Notizie brevi su inediti toscani', *Boll. A.*, xxxvii (1952), pp. 178–81

R. Linnenkamp: 'Opera sconosciuta di Paolo Schiavo a Castellaccio', *Riv. A.*, xxxiii (1958), pp. 27–33

U. Procacci: *Sinopie e affreschi* (Florence, 1960)

B. Berenson: *Florentine School* (1963), pp. 165–6

M. Boskovits: *Tableaux des débuts de la Renaissance toscane* (Budapest, 1969)

Arte in Val di Chiana (exh. cat., ed. L. Bellosi, G. Cantelli and M. Lenzini Moriondo; Cortona, Fortezza Girifalco, 1970), pp. 20–21

A. Padoa Rizzo: 'Aggiunte a Paolo Schiavo', *Ant. Viva*, xiv (1975), pp. 3–8

R. Fremantle: *Florentine Gothic Painters* (London, 1975), pp. 523–32

G. Moran: 'Un affresco di Paolo di Stefano al Monte San Michele', *Gallo Nero* (1977), pp. 7–9

A. Padoa Rizzo: 'Paolo Schiavo all'Antella', *Ant. Viva*, xxii (1983), pp. 3–6

——: 'Pittori e miniatori a Firenze nel quattrocento', *Ant. Viva*, xxv/5–6 (1986), pp. 5–7

M. C. Improta and A. Padoa Rizzo: 'Paolo Schiavo fornitore di disegni per ricami', *Riv. A.*, 4th ser., v (1989), pp. 26–56

M. Boskovits: 'Ancora su Paolo Schiavo: Una scheda biografica e una proposta di catalogo', *A. Crist.*, lxxxiii/770 (1995), pp. 333–40

M. Sframeli: 'Ricamato da mano angelico: Un attribuzione settecentesca per l'*Incoronazione della Vergine* di Paolo Schiavo, *A. Crist.*, lxxxiii/770 (1995), pp. 323–31

ANNA PADOA RIZZO

Schiavon [Fattorini]. Italian family of potters of Croatian origin. The name Fattorini was used only after 1516. The name Schiavon was the nickname for Filippo Rimiteri (*b* Zagreb, 1403; *d* ?Montelupo), who left Croatia to become a potter in Italy. His sons Stefano and Piero (*d* Cafaggiolo, *c.* 1507) made maiolica pitchers but moved to the Medici villa in Cafaggiolo near Florence where they established the CAFAGGIOLO CERAMIC FACTORY in 1498. The family were in charge of this highly successful workshop for over 100 years. Stefano had several sons, including Jacopo (*b* Cafaggiolo, *c.* 1490; *d* Cafaggiolo, after 1576), who was in charge of the factory from 1568 and who worked with his brothers Domenico, Michele, Alessandro, Matteo and Giovanni. Works by Jacopo include several fine *istoriato* (narrative) dishes and a roundel depicting *Judith and her Maidservant* (London, V&A). Works by the family are signed with an SP monogram.

BIBLIOGRAPHY

G. Guasti: *Di Cafaggiolo e d'altre fabbriche di ceramiche in Toscana* (Florence, 1902, rev. Bologna, 1973)

G. Cora and A. Fanfani: *La maiolica di Cafaggiolo* (Florence, 1982)

CARMEN RAVANELLI GUIDOTTI

Schiavone, Andrea [Meldolla, Andrea; Medulić, Andrija] (*b* ?Zara [now Zadar], ?*c.* 1510; *d* Venice, 1 Dec 1563). Dalmatian painter, draughtsman and etcher, active in Italy. He belonged to a prominent family who had settled in Zara but were originally from Méldola in the Romagna. He may have been taught painting either in Zara or in Venice by Lorenzo Luzzo or Giovanni Pietro Luzzo, who were active in both cities. According to another theory, he was trained in the Venetian workshop of Bonifazio de' Pitati, but this would not account for his later proficiency as a fresco painter. As an etcher, he seems to have been essentially self-taught, working initially from drawings by Parmigianino. By the late 1530s Schiavone seems to have been established in Venice. In 1540 Giorgio Vasari commissioned from him a large battle painting (untraced), 'one of the best [works] that Andrea Schiavone ever did' (Vasari, 1568). Schiavone's first surviving paintings and etchings probably date from *c.* 1538–40; they show that he was strongly influenced by Parmigianino and Central Italian Mannerists in figural and compositional modes, but was also a strikingly daring exponent of Venetian painterly techniques; he employed an equally free technique in etching. Several paintings, for example the large-scale *Four Women in a Landscape* (priv. col., see Richardson, fig. 14) and the small-scale *Two Men* (priv. col., see Richardson, fig. 23), carry his 'technique of spots, or sketches' (Vasari) so far that the subjects have not been identified.

During the 1540s Schiavone developed this style in paintings of increasing size and complexity, such as the *Conversion of St Paul* (Venice, Fond. Querini–Stampalia) and the organ shutters of *David* and *Daniel* (Venice, S Giacomo del Orio). His etchings, too, became increasingly elaborate and technically inventive, culminating in his only signed and dated work, the very large *Abduction of Helen* (B. 81) of 1547. This combines elements from Giulio Romano's *Battle of Constantine* (Rome, Vatican, Sala di Constantino), Titian's *Battle of Cadore* (ex-Doge's Palace, Venice; destr.) and Mannerist engravings of battle scenes with Schiavone's own inventions in a torrential flow of horses, humans and banners, all fusing with, and submerged in, a dense atmospheric tone. Very close stylistically, and probably close in date, is the painting of the *Adoration of the Magi* (Milan, Ambrosiana; see colour pl. 2, XXX1), in which the rhythmic flow is achieved by the deformation of figures and architecture and the assertively liquid texture of the paint. The use of colour is complex and unorthodox, spicing harmony with dissonance.

Schiavone's principal surviving frescoes (Venice, S Sebastiano, Grimani Chapel) date from *c.* 1548–50; they are astonishing in their impressionistic use of the medium. The frescoes on the façade of Palazzo Zen, Venice (destr.), may have been contemporary, to judge by Boschini's vivid description. Schiavone's paintings of the 1540s translated Mannerist and Parmigianesque elements into an intensely Venetian painterly idiom to novel and compelling effect. They shocked some contemporaries and stimulated others: Paolo Pino (1548) stigmatized Schiavone's *empiastrar* (use of impasto) as 'worthy of infamy'; and in the same year Pietro Aretino, in a letter to Schiavone, both praised his invention and complained of his lack of 'finish', reporting that Titian was amazed 'at the technique you demonstrate in setting down the sketches of stories'. In the 1540s Schiavone was clearly important for his younger contemporaries Jacopo Tintoretto and Jacopo Bassano, above all in demonstrating a radically free manipulation of the paint medium to provide a shorthand for form.

Around 1550, Schiavone, pursuing greater sobriety and control, moderated the turbulence both of his compositions and of his brushwork and increasingly turned to Raphael and Titian for compositional models. Examples of this phase include the *Judgement of Midas* (Hampton Court, Royal Col.), the *Marriage of Cupid and Psyche* (New York, Met.), the *Holy Family with St Catherine* (Vienna, Ksthist. Mus.) and several of Schiavone's finest and most formal etchings, such as the *Holy Family with Saints* (B. 63, 64). In the mid-1550s Schiavone enriched this more monumental style with a renewed virtuosity of brushwork, a more finely gauged gamut of paint textures, complex and resonant colour harmonies and (often) a darkening tonality. By these means he effected a fusion of form with a dense atmosphere in a pictorial fabric whose elements tend to lose their separate identities. This development can be seen in such works as his nocturnal *Sacra conversazione* (British Govt A. Col.), the organ shutters of the *Annunciation*, *St Peter* and *St Paul* (all Belluno, S Pietro) and the *Pietà* (Dresden, Gemäldegal. Alte Meister). This style reached an apogee in three tondi painted for the ceiling of the sala of Jacopo Sansovino's Libreria Marciana in Venice: the *Force of Arms*, *The Priesthood* and *The Empire* (final payment 10 February 1556; all *in situ*), much admired by 16th- and 17th-century writers, and in the altarpiece of *Christ and the Disciples on the Way to Emmaus*

for the Pellegrini Chapel in S Sebastiano, Venice (after 24 June 1557; *in situ*). Schiavone's paintings of *c.* 1552–7 incorporate darkening tonalities, vibrating textures, open brushwork and dematerialized form—features that are, even taken separately, innovative—into vibrant and complex works that in the 16th century were paralleled only (at a somewhat later date) by some of Titian's late works. Their colouristic and textural richness and forceful chiaroscuro often engender a compelling expressive power. In arriving at this style, Schiavone drew on a close study of Titian and Giorgione.

In Schiavone's final years (*c.* 1557–63) he received substantial public and professional recognition; his works of this date are notably diverse in character and intention. They include mythological paintings in a light decorative vein, for example two scenes from the *Aeneid* (both Vienna, Ksthist. Mus.), astonishing in the nonchalant freedom of their handling; two grandiose *Philosophers* (both *c.* 1560; Venice, Lib. Marciana), irrationally and perversely majestic; some religious paintings that seem relatively perfunctory; and others of a visionary intensity or tragic depth of feeling unmatched in his oeuvre. Among the latter are an *Ecce homo* (Padua, Mus. Civ.), two paintings of *Christ before Pilate* (Hampton Court, Royal Col.; Vienna, Ksthist. Mus.) and the superb large *Christ before Herod* (Naples, Capodimonte; see fig.); the last two simultaneously recall Giorgione and prefigure Rembrandt. Two important commissions of this period now survive only in fragments. One was the painted choir-loft of the church of the Carmine, Venice, eulogized by 17th-century writers. A compositional drawing (Vienna, Albertina) and three parapet panels (now organ-loft parapets) survive. The panels show Schiavone's painterly daring at its farthest reach: all nocturnes, they represent the *Annunciation*, the *Adoration of the Shepherds* and the *Adoration of the Magi* in brushwork of astounding variegation and vitality. A very large painting of a *Miracle of St Mark*, commissioned by Tommaso Rangone for the Scuola di S Marco some time after 21 June 1562, may never have been completed; a fragment of a *Kneeling Woman and Child* cut from this canvas is preserved (Vienna, Ksthist. Mus.), though in poor condition; a compositional drawing for the whole also survives (Windsor Castle, Berks, Royal Lib.). After *c.* 1553, Schiavone produced fewer etchings, but they remained expressively powerful and innovative in their technical freedom, while becoming increasingly extreme in their luminism.

Schiavone's great historical importance was recognized in the 17th century (Gigli, Boschini) but somewhat lost sight of since. First, in the 1540s he introduced Mannerist modes and motifs into Venetian circles: in this, he was significant especially for the formation of Jacopo Tintoretto and Jacopo Bassano. Even more importantly, he pushed the Venetian painterly mode to an 'impressionistic' extreme unprecedented in large-scale paintings of that date, an extreme that implied a revised conception of what a painting is. In etching he was similarly innovative. His technique was unlike that of any contemporary: unsystematically he used dense webs of light, fine, multi-directional hatching to create a tonal continuum embracing form, light, shadow and air. He might enhance that continuum by lightly coating the plate with ink, punctuate

Andrea Schiavone: *Christ before Herod*, oil on canvas, 1.30×2.09 m, *c.* 1558–62 (Naples, Museo e Gallerie Nazionali di Capodimonte)

it with accents or contrasts in drypoint, or use other unprecedented expedients to enrich his prints' pictorial dimension. His etchings are the only real equivalent in printmaking of later 16th-century Venetian painterly modes, and his technical experiments were emulated by 17th-century etchers such as Jacques Bellange, Giovanni Benedetto Castiglione and Rembrandt. Schiavone's mature paintings (c. 1553–63), in which his inventive handling of paint created rich, subtle and complex pictorial fabrics, were influential for Jacopo Bassano, Palma Giovane, El Greco and other lesser artists of the next generation. Still more significantly, they provided precedents for Titian's late style; and in themselves, they often attain visual beauty and expressive power of a very high order.

BIBLIOGRAPHY

Thieme–Becker

M. Pittaluga: *L'incisione italiana nel cinquecento* (Milan, n.d.)

P. Pino: *Dialogo della pittura* (Venice, 1548); ed. R. and A. Pallucchini (Venice, 1946)

G. Vasari: *Vite* (1550, rev. 2/1568); ed. G. Milanesi (1878–85), vi, p. 596

P. Aretino: *Lettere sull'arte di Pietro Aretino* (before 1556); ed. F. Pertile, C. Cordie and E. Camesasca (Milan, [c. 1958]), ii, p. 221

F. Sansovino: *Venetia, citta nobilissima* (Venice, 1581); ed. D. G. Martinioni (Venice, 1663)

G. C. Gigli: *La pittura trionfante* (Venice, 1615)

C. Ridolfi: *Le meraviglie* (Venice, 1648); ed. D. von Hadeln, 2 vols (Berlin, 1914–21)

M. Boschini: *La carta del navegar pitoresco* (Venice, 1660); ed. A. Pallucchini (Venice and Rome, 1966)

——: *Le ricche minere della pittura veneziana* (Venice, 1674)

A. von Bartsch: *Le Peintre-graveur* (1803–21), xvi [see Meldolla] [B.]

Bryan's Dictionary of Painters and Engravers, ed. W. Stanley (2/London, 1849) [see Meldolla]

P. J. Mariette: *Abecedario pittorico*; ed. P. de Chennevières and A. de Montaiglon, *Archvs A. Fr*, ii (1854–6)

G. Ludwig: 'Archivalische Beiträge zur Geschichte der venetianischen Malerei', *Jb. Preuss. Kstsamml.*, xxiv (1903), Beiheft, pp. 87–8

L. Fröhlich Bum: 'Andrea Meldolla, gennant Schiavone', *Jb. Ksthist. Samml. Wien*, xxxi (1913–14), pp. 137–200 [pioneering biog.; some eccentric attribs]

L. Donati: 'Delle stampe di Andrea Meldolla, detto lo Schiavone', *Archv Stor. Dalmazia*, iii (1927), pp. 183–92, 211–20; iv (1927), pp. 13–44

——: 'Ancora sull'arte di Andrea Schiavone', *Archv Stor. Dalmazia*, vii (1929), pp. 494–502; ix (1930), pp. 110–27

G. Praga: 'Della patria e del casato di Andrea Meldolla', *Archv Stor. Dalmazia*, ix (1930), pp. 80–94

V. Moschini: 'Capolavori di Andrea Schiavone', *Emporium*, xcvii (1943), pp. 237–42

H. Tietze and E. Tietze-Conrat: *The Drawings of the Venetian Painters in the 15th and 16th Centuries* (New York, 1944)

G. Fiocco: 'Nuovi aspetti dell'arte di Andrea Schiavone', *A. Ven.*, iv (1950), pp. 33–42

R. Pallucchini: *La giovinezza del Tintoretto* (Milan, 1950)

K. Priatelj: *Andrija Medulic* (Split, [c. 1956])

B. Berenson: *Venetian School*, i (London, 1957), pp. 159–62 [see Meldolla]

S. J. Freedberg: *Painting in Italy, 1500–1600*, Pelican Hist. A. (Harmondsworth, 1971, rev. 2/1983), pp. 532–4

C. Karpinski: 'Some Woodcuts after Early Designs of Titian', *Z. Kstgesch.*, xxxix (1976), pp. 259–74

F. L. Richardson: *Andrea Schiavone* (Oxford, 1980) [standard monograph]; review by P. Rossi: 'In margine a una monographia su Andrea Schiavone e qualche aggiunta al catalogo del artista', *A. Ven.*, xxxiv (1980), pp. 78–95 [thoughtful review with some dubious attribs]

The Genius of Venice (exh. cat., ed. J. Martineau and C. Hope; London, RA, 1983) [good colour pls]

FRANCIS L. RICHARDSON

Schiavone, Giorgio (di Tommaso) [Ćulinović [Chiulinovich], Juraj] (*b* Scardona [Skradin], nr Sebenico [Šibenik], now in Croatia], ?1433–6; *d* Sebenico, 6 Dec 1504). Dalmatian painter active in Italy. He was the most important painter from Dalmatia (western Croatia) in the 15th century. In Italy, he usually signed his work *Sclavonus* (It. Schiavone: 'the Slavonian'). It is generally agreed that his small secure oeuvre, which includes five signed works, was painted in Padua while he was training under Francesco Squarcione. Giorgio Schiavone is an important representative of the Paduan school and one of the few whose artistic personality is well defined.

1. PADUA, 1456–61. He is recorded in Venice on 28 March 1456, when he signed a contract with Squarcione to study painting for three and a half years. His tenure with Squarcione, whose workshop was in Padua, was not an apprenticeship, rather a period of advanced training; it has been suggested (Prijatelj and Furlan) that he trained earlier under Dujam Vušković (*fl c.* 1442–60) in Sebenico. Squarcione's tuition was based on the study of an assemblage of stucco reliefs, medals and a prized collection of drawings, including finished studies that his students copied assiduously (Lazzarini and Moschetti, Doc. LVIII). Such exercises help to explain the incisive modelling and meticulous finish of Schiavone's panels. Squarcione painted little himself, but relied heavily on the labour of his pupils. He probably recruited Schiavone to replace Marco Zoppo, who had left the workshop six months earlier.

An eclectic artist, Schiavone was exceptionally skilled at appropriating pictorial sources. The *Virgin and Child* (c. 1456; Turin, Gal. Sabauda) shows his rapid adoption of the shop style. (This work is often dated to the late 1450s, but the figure types lack the monumentality of Schiavone's mature style.) The painting, a half-length figure beneath a festooned, Renaissance arch, surrounded by putti, is a type popularized by Squarcione's workshop; it is a vulgarization of the *all'antica* vocabulary used by Mantegna in the frescoes in the Ovetari Chapel (Padua, Eremitani; *see* MANTEGNA, ANDREA, fig. 1). Schiavone derived his arch from a stucco relief in the style of Donatello, a copy of which Squarcione evidently owned. His Paduan training is reflected in the depiction of multicoloured marbles and such *trompe l'oeil* elements as the fly and *cartellino*, features that recurred throughout his oeuvre. The Virgin's half-closed eyes and chubby, graceless hands are also typical of his work. Squarcione's influence is apparent in the treatment of clouds and such accessories as the platter of fruit and the festoon. The picture also includes a bare tree, a common motif in works from Squarcione's school. Schiavone's panel closely resembles Zoppo's *Virgin and Child* (c. 1455; Paris, Louvre; *see* ZOPPO, MARCO, fig. 1), suggesting an immediate transfer of duties from one pupil to the other.

Schiavone was soon entrusted with portrait painting. The *Portrait of a Man* (Paris, Mus. Jacquemart-André), a miniature on parchment, is probably among his earliest productions, as the inscription is in the minuscule letters used in the *Virgin and Child* at Turin; his later signatures are in majuscule letters (De Nicolò Salmazo, 1990). The depiction of the head is unusually descriptive for an Italian portrait, including such details as the temporal veins. Detailed naturalism is typical of Flemish art, however, and it suggests a northern influence on Schiavone's development. (The attribution of this work to Schiavone is rejected by some writers, e.g. Ruhmer.)

Schiavone was the dominant artist in Squarcione's shop by *c.* 1458, when he painted the polyptych of the *Virgin and Child with Saints* (London, N.G.) for the Frigimelica Chapel in S Nicolò, Padua. This was probably commissioned by Bonifacio Frigimelica (*fl* 1444–52), a doctor of law. The altarpiece recalls many Paduan sources. The general conception reflects Mantegna's *St Luke* altarpiece (1453–4; Milan, Brera). The angel reliefs on the Virgin's throne and the *Pietà* above derive from Donatello's altar in the Santo (1449–50; Padua, S Antonio). The figure of John the Baptist is borrowed from Squarcione's *St Jerome* altarpiece (1449–52; Padua, Mus. Civ.). The diverse quotations are integrated stylistically, however, and the altarpiece inaugurates the mature phase of Schiavone's work. The figures of SS Anthony of Padua and Peter Martyr, with elongated bodies and smallish heads, are his stock figure types for male saints. The Christ Child and putti, with broad foreheads and long torsos, are characteristic of his later paintings. The use of strong yellows, reds and dark greens is also typical. Although his distinctive drapery recalls that of Mantegna, it is less classicizing and more tubular; in this respect Schiavone is closer to Zoppo. His stylistic development is demonstrated by the monumental Virgin, which has none of the forced quality of his earlier *Virgin and Child.*

In the triptych of the *Virgin and Child with Saints* (*c.* 1460; central panel, Berlin, Gemäldegal.; wings, Padua Cathedral, Sacristy) executed for S Francesco, Padua, there is a greater concern for spatial depth and pictorial unity, evident in its continuous landscape, perspectively coherent pavement and the diagonal arrangement of figures. Schiavone adopted these principles from Mantegna's San Zeno Altarpiece (1456–9; Verona, S Zeno). Such carefully observed passages as the books and wooden sandals and the technical execution of the drapery have parallels in the central panel of Squarcione's *St Jerome* altarpiece. A new influence can be detected in Schiavone's depiction of the Virgin, whose towering, rotating figure assumes majestic proportions. This has been attributed to an awareness of Piero della Francesca, transmitted by Ferrarese artists, especially Cosimo Tura.

Schiavone's mature style is epitomized by his *Virgin and Child with Angels* (*c.* 1461; Baltimore, MD, Walters A.G.; see fig.). Silhouetted against a dark background, the Virgin's ovoid head strongly evokes the work of Piero della Francesca. A simplified, balanced composition replaces the cluttered Squarcione-like style of the mid-1450s, recalling contemporary paintings of the *Virgin and Child* by Tura (Venice, Accad.) and Squarcione himself (Berlin, Gemäldegal.). A comparison between this painting and Schiavone's *Virgin and Child* at Turin attests to the remarkable development of his pictorial language in a relatively brief period.

A number of works attributed to Schiavone are usually assigned to his Paduan years. A small *Virgin and Child with Saints* (Paris, Mus. Jacquemart-André), the attribution of which is based on a comparison with the altarpiece at London, and the slightly later *St Jerome* and *St Alessio* (both Bergamo, Gal. Accad. Carrara) are almost certainly autograph. More problematic are three paintings of the *Virgin and Child* (London, N.G.; Amsterdam, Rijksmus.; Venice, Correr) and another *Virgin and Child with Saints*

Giorgio Schiavone: *Virgin and Child with Angels*, tempera on panel, 690×567 mm, *c.* 1461 (Baltimore, MD, Walters Art Gallery)

(priv. col., see 1983 sale cat., lot 24), which is often attributed to Squarcione; certain of these works are likely to be by Schiavone's imitators, for instance the *Virgin and Child* at London (Davies and Wilenski). By the time Schiavone left Squarcione, he had heavily influenced the workshop style. A *Pietà* (ex-Kaiser-Friedrich Mus., Berlin, destr.; see Boskovits, fig. 3) in the manner of Squarcione is an adaptation of Schiavone's *Pietà* panel in the altarpiece at London. Schiavone also influenced the early works of Carlo Crivelli, who may have accompanied him on his return to Dalmatia.

2. DALMATIA, 1461–1504. Although Schiavone's contract expired in February 1460, he may have remained with Squarcione until mid-1461. He had returned to Dalmatia by 19 November 1461, residing at Zara (now Zadar), and by 1463 he had settled in Sebenico. In that year, he married Elena, the daughter of the sculptor and architect Giorgio da Sebenico (*fl c.* 1441–73), and agreed to train a pupil. Before leaving Padua, Schiavone took Squarcione to arbitration, seeking compensation for his labour. Also at issue were certain items, including drawings, which Schiavone brought to Dalmatia. (A drawing by (?Antonio) Pollaiuolo is often erroneously said to have been among these works.) The dispute continued for many years. All the items were eventually recovered by an emissary, who kept them after Squarcione's death. Schiavone is documented in Padua in 1474 and again in 1476, when he bought a house there.

Although documents identify Schiavone as a painter throughout this period, his productivity was apparently limited. He may have introduced certain Paduan motifs to his father-in-law's workshop (Kokole). In 1489 he exe-

cuted a painted emblem for a confraternity and contracted to paint a *Virgin and Child with Saints* (destr.) for the Didomerović Chapel in Sebenico Cathedral. At an unknown date, he apparently began an altarpiece (destr.) for the Grizanić Chapel, also in the cathedral; this was finished by Niccolò Braccio da Pisa between 1536 and 1538. The attribution of works to Schiavone's Dalmatian period remains speculative. A *Virgin and Child Enthroned* (Šibenik, St Lovro) is often cited as a possible late work (*DBI*; Höfler, fig. 287).

BIBLIOGRAPHY

DBI: 'Ćulinović, Juraj'
V. Lazzarini and A. Moschetti: *Documenti relativi alla pittura padovana del XV secolo* (Venice, 1908), pp. 38ff, 47–9 and Docs XLV, XLIX, L, LXI [documentation]
V. Miagostovich: 'Notizie inedite su Giorgio Schiavone', *L'Arte*, xvi (1913), pp. 474–7 [documentation]
P. Kolendić: 'Slikar Juraj Ćulinović u Šibeniku', *Vjesnik Arheol. & Hist. Dalmat.*, xliii (1920), pp. 117–90 [documentation]
R. Wilenski: *Mantegna (1431–1506) and the Paduan School* (London, 1947)
M. Davies: *The Earlier Italian Schools*, London, N.G. cat. (London, 1951, 2/1961/R/1986), pp. 464–8
K. Prijatelj: 'Profilo di Giorgio Schiavone', *A. Ant. & Mod.*, ix (1960), pp. 47–63 [unreliable]
I. Chiappini di Sorio: 'Giorgio Schiavone a Zara', *A. Ven.*, xv (1961), p. 201 [documentation]
Andrea Mantegna (exh. cat., ed. G. Paccagnini; Mantua, Pal. Ducale, 1961), pp. 98–101
Crivelli e i crivelleschi (exh. cat., ed. P. Zampetti; Venice, Pal. Ducale, 1961), pp. 1–7
E. Ruhmer: *Marco Zoppo* (Verona, 1966)
Da Giotto a Mantegna (exh. cat., ed. L. Grossato; Padua, Pal. Ragione, 1974), nos 89–90
I. Furlan: 'Giorgio Ćulinović', *Dopo Mantegna* (exh. cat., Padua, Pal. Ragione, 1976), pp. 29–31
A. Sartori: *Documenti per la storia dell'arte a Padova* (Vicenza, 1976), p. 415 [documentation]
F. Zeri: *Italian Paintings in the Walters Art Gallery*, i (Baltimore, 1976), pp. 205–7
K. Prijatelj: 'La pittura del rinascimento in Dalmazia e in Istria', *L'umanesimo in Istria*, ed. V. Branca and S. Graciotti (Florence, 1983), pp. 223–34
Catalogo di importanti dipinti antichi (sale cat., Florence, Sotheby Parke Bernet, 29 Sept 1983), lot 204
M. Boskovits: 'Giovanni Bellini: Quelques suggestions sur ses débuts', *Rev. Louvre*, 6 (1986), pp. 386–93
A. De Nicolò Salmazo: 'La pittura rinascimentale a Padova' and 'Schiavone, Giorgio', *La pittura in Italia: Il quattrocento*, 2 vols, ed. F. Zeri (Milan, 1987), i, pp. 179ff; ii, p. 753 [colour pls]
J. Höfler: *Die Kunst Dalmatiens* (Graz, 1989), pp. 213, 299–302
A. De Nicolò Salmazo: 'Padova' and 'Giorgio Schiavone', *La pittura nel Veneto*, 2 vols, ed. M. Lucco, ii (Milan, 1990), pp. 524–5, 765–6 [colour pls]
S. Kokole: 'Notes on the Sculptural Sources for Giorgio Schiavone's *Madonna* in London', *Venezia A.*, iv (1990), pp. 50–56

KEITH SHAW, THERESA SHAW

Script. System or style of writing. Scripts are historical phenomena, their appearance reflecting their date and use. Scripts are identifiable, and their particular features enumerated, as a consistent graphic representation of notations or letters of the alphabet. All scripts pass through periods of immaturity, maturity and decline; they generally mature quickly and decline slowly. A frequent misunderstanding concerning writing is that individual scribes wrote a script or scripts. A script is a model in the mind of a scribe, and what an individual scribe writes is a hand. Michelangelo and Queen Elizabeth I (*reg* 1558–1603) wrote not an italic script but very different italic hands.

1. Introduction. 2. Development.

1. INTRODUCTION. The history of scripts in the West begins in late antiquity, and from this period until the present a large number of scripts have been isolated and identified, some lasting longer than others. Much writing awaits precise examination and analysis, especially from the 12th century to the Renaissance. The basic unit of an alphabetically based script is the letter. Individual letters are constructed with a more or less precise series of movements of a pen loaded with ink. Well-defined movements are called strokes, and the order and nature of strokes and movements are determined by the kind of script being written. Stroke order, or the sequence of strokes and movements in writing, are referred to as either the ductus or the structure of a letter or script. Analysis of ductus or structure depends on the presumption that the pen was moved consistently to produce more or less identical marks.

In late antiquity writing was probably mostly executed with either a reed or quill pen. Throughout the Middle Ages and long after, most writing was executed with a quill. The quill is a very versatile and subtle tool with a natural affinity with parchment. Ink does not flow from a quill in a thin stream (as in the modern fountain pen) but in a rush. Writing with a quill on parchment is a matter of deftly directing a puddle of ink on to the writing support. This feature of the quill contributes much to the richness of early writing as well as allowing an accomplished scribe to manipulate the quill and ink flow to create subtle variations in form. The nib of a quill pen can be cut wide or narrow, sharp or blunt. The angle of the nib-tip in relation to the shaft of the quill can vary from square to oblique. The manner in which the quill is held in the hand and the position of the writing support, whether flat or at an angle, might vary in large or small ways in the writing of a particular script as well as in the writing of different scripts.

The fundamental graphic characteristic of Western writing is the contrast between thick and thin strokes of the quill. A thin stroke is formed by the movement of the quill along the axis of the nib-tip. A thick stroke is formed by the movement of the quill along the axis of the shaft of the quill, the difference between the two being 90°. The regular movement of the quill from one axis to the other produces a curved stroke, with a mark going from thick to thin or vice versa. The angle between a thin stroke and the horizontal line of writing is referred to as pen angle or writing angle. A steep pen angle can be as much as 45°, a shallow one 5–10°. Not all thin-to-thick or thick-to-thin strokes are produced in this way. A quill can be manipulated during the making of a stroke or movement, either by rotating the shaft of the quill or by moving the hand to change the pen angle, or by applying pressure to the nib-tip to make a mark wider than the width of the nib in repose. In addition, the quill can be moved so that only the corners of the nib-tip are in contact with the writing support, making a thin line, or the quill rocked in the hand so that a greater or lesser part of the nib-tip is in contact with the writing support. A quill can make either a downwards (a pulling movement) or upwards (a pushing movement) stroke, although most writing comprises a

series of the more natural downwards movements. Indications of a script in decline are in the frequent use of unnatural strokes or movements, obvious evidence of the manipulation of the quill, visible changes and alterations in pen angle and numerous extraneous or superfluous marks or strokes (see fig., line 3 above).

There are essentially two kinds of scripts, formal and informal. A formal script is made by a series of strokes in which the pen is lifted at the completion of each stroke. An informal script, a cursive script, is formed from a more or less continuous series of movements of the pen. There is often a good deal of overlap between formality and informality in the work of individual scribes. This is largely, but not entirely, due to the speed with which the pen is moved across the support. As success in writing is due to the clarity of the model in the mind of the scribe, his mental application at the moment of writing and the speed with which the writing is executed, the intrusion of informal qualities into formal writing is easily explained.

A script may contain one or two kinds of letters, minuscule and majuscule. A script used for writing a continuous text is referred to as a text script; that used for headings or titles (see fig., lines 1–2) is known as a display script and was often in one or more colours. Display scripts or majuscules used with minuscules were not always written letters but were often drawn, with the elements of the letters built up from two or more strokes of the pen (rarely a brush). Minor initials in manuscripts were also frequently drawn and can therefore be related to display scripts (see the initial letter in fig.).

BIBLIOGRAPHY

H. Degering: *Lettering* (London and Berlin, 1929/*R* 1965)
Two Thousand Years of Calligraphy (exh. cat. by D. Miner, V. I. Carlson, P. W. Filby, Baltimore, MD, Walters A.G., 1965)
N. Gray: *Lettering as Drawing* (Oxford, 1971)
B. Bischoff: *Paläographie des römischen Altertums und der abendländischen Mittelalters* (Berlin, 1979); Eng. trans. by D. Ó. Crónin and D. Ganz (Cambridge, 1990)
J. I. Whalley: *The Pen's Excellencie: Calligraphy of Western Europe and America* (Tunbridge Wells and New York, 1980)
D. Jackson: *The Story of Writing* (London and New York, 1981)
S. Knight: *Historical Scripts* (London, 1984)
N. Gray: *A History of Lettering* (Oxford, 1986)
M. P. Brown: *A Guide to Western Historical Scripts from Antiquity to 1600* (Cambridge, 1990)

MICHAEL GULLICK

2. DEVELOPMENT. By the 14th century there was a reaction against the absurd elaboration of Gothic scripts, not only because they represented things French, but because they had become divorced (like literature and art) from their Classical roots in Greece and Rome. Petrarch made important experiments in reforming his own writing to distance it from intricate forms of Gothic, which, he remarked in a letter, were difficult to read and produced by artists rather than scribes. This was an early sign of the growing movement among contemporary scholars towards the plainness and clarity of an ideal *littera antiqua*. Although ancient Rome itself provided no models of Classical minuscules, many of the long-neglected Classical texts already recovered, as well as those continually being found by such avid scholarly collectors as Coluccio Salutati (1330–1406), Niccolò Niccoli (*c*. 1364–1437) and Poggio Bracciolini (1380–1459), were written in Caroline minus-

cule. This admirably round, clear script formed the basis for humanistic minuscule (see fig.). When the new invention of printing made its appearance in Italy, introduced in rapid succession by the Germans Konrad Sweynheim (*d* 1477) and Arnold Pannartz (*d* 1476), the brothers Johann Emerich (*fl* 1487–1508) and Wendelin of Speier and the Frenchman Nicolas Jenson (*c*. 1420–80), the first types to be cut imitated this local script; hence the appearance of Caroline minuscule, by way of its humanist adoption, is familiar in the 20th century in the form of what typographers call 'roman' type.

Although by 1500 printing had spread to France, the Netherlands and England, writing by hand did not disappear, but there was a change of emphasis. Formal writing of texts was no longer in such demand, except by a relatively few wealthy patrons, but the need for competent scribes increased with the growth and power of Renaissance Italy. Every important town had its chancery, or administrative department, for the drawing up of documents and the writing, dispatch and receipt of letters; not only was a staff of penmen required for each, but (even more important) a fast and legible script that would allow them to deal efficiently with their workload. Here the cursive version of humanistic minuscule (later the model for printer's italic) came into its own, combining the greatest speed with the most legibility in a way that has never been equalled, and proving itself so useful to Renaissance civil servants that it came to be known as *cancelleresca corsiva* (chancery cursive). Beginning life (like

Humanistic minuscule script, from Cicero: *Letters to Atticus*, 1408 (Berlin, Staatsbibliothek Preussischer Kulturbesitz, MS. Hamilton 166, fol. 96*r*); one of the earliest humanistic minuscule scripts, written by Poggio Bracciolini

most cursives) as a poor relation, used only for notes and personal letters, it had, by 1500, supplanted *littera antiqua* as a bookhand. When the Venetian printer Aldus Manutius needed a compressed, clear typeface, economical in space and paper, for his projected series of small, inexpensive editions of Latin classics (begun 1501), chancery cursive was a natural choice as a model.

Throughout the 16th century, as printing became more distanced from calligraphic influence, general interest in writing and calligraphy grew, helped greatly (paradoxically) by printing itself. It was now possible (as Ludovico Arrighi did in his *Operina* of 1522) for an accomplished scribe and writing-master to publish or even print his own writing manual, in type designed by himself and with alphabetical woodcut illustrations; in this way the scribe's method and ideas could reach a vastly wider public. By the end of the century more than 20 of these manuals had appeared, produced by such masters as Giovannantonio Tagliente (*Presente libro*, 1524), and Giovanbattista Palatino (*Libro nuovo d'imparare a scrivere*, 1540), so that the possibility of acquiring at least the basic skills of fine writing was no longer limited to a relatively select body of professional scribes. All these manuals concentrated on the popular humanistic cursive, with the result that it began to acquire elaborate loops and flourishes. In Giovan Francesco Cresci's *Essemplare di piu sorti lettere*, printed in 1560 and re-issued in 1578, it had already begun to lose its 'edged-pen' character. Although his illustrations were still from woodcuts, the rapidly growing influence of engraving in copper as a more exact means of reproduction was already having its effect, resulting, during the 17th to 19th centuries, in the almost total loss of the edged pen, with its disciplined thicks and thins, and the dominance of copperplate script and its variants, which was formed by pointed, flexible nibs producing swelling variations in line by pressure alone.

BIBLIOGRAPHY

E. Johnston: *Writing and Illuminating, and Lettering* (London, 1906)
P. J. Smith: *Lettering: A Handbook of Modern Alphabets* (London, 1936)
J. H. Benson: *The First Writing Book: Arrighi's Operina* (New Haven, 1954)
A. Fairbank and B. Wolpe: *Renaissance Handwriting: An Anthology of Italic Scripts* (London, 1960)
J. Wardrop: *The Script of Humanism* (Oxford, 1963)
S. Morison: *Politics and Script* (Oxford, 1972)
A. S. Osley: *Scribes and Sources* (London, 1980)
S. Harvard: *An Italic Copybook: The Cataneo Manuscript* (New York, 1981)
K. A. Atkins: *Masters of the Italic Letter* (Harmondsworth, 1988)

JOHN R. NASH

Scultori [Mantovano]. Italian family of artists. They specialized in engraving, and their association with Giorgio Ghisi, the leading Mantuan engraver of the time, led Vasari and subsequent authorities mistakenly to assume that their surname was Ghisi. Giovanni Battista Scultori (*b* Mantua, 1503; *d* Mantua, 1575) worked in the studio of Giulio Romano, who was in Mantua from 1524 to 1546, and assisted in the extensive stuccowork in the Palazzo del Te. Between 1536 and 1540 Scultori engraved 20 plates (according to Bartsch), or 21 (according to Albricci), most of which bear the monogram IBM. To these must be added a signed frieze of two horses' heads (Cambridge, Fitzwilliam). However, the unsigned *Hercules and Antaeus* (B. 12)

seems closer to the work of his son Adamo Scultori (*b* Mantua, *c.* 1530; *d c.* 1585).

Giovanni Battista's style of engraving has its roots in that of Marcantonio Raimondi, probably through study with Raimondi's follower Agostino dei Musi, who was in Mantua *c.* 1530. The sources of the prints are almost all Scultori's own designs or drawings by Giulio Romano. Most of the subjects are Classical or military rather than religious and show a preoccupation with detail. Scultori came to engraving when he was already an accomplished draughtsman and sculptor, and his prints have a vigorous, sculptural quality with deeply cut lines that exaggerate tonal contrasts. Some of his best works, such as *David Cutting off the Head of Goliath* (B. 6) and *Mars and Venus* (B. 13), are filled with figures and details of furniture, rocks, armour and drapery, while the latter print also contains a cat, a dog and two doves. In others, such as the *Warrior in Antique Armour on Horseback* (B. 15) and the *Standard-bearer* (B. 16), the monumental figures and flying draperies stand out like sculptures against rather simple backgrounds. Scultori apparently taught Ghisi, whose early work shows his influence and who engraved two plates of subjects from the Trojan Wars after his designs. He also trained his son Adamo Scultori and daughter Diana Scultori (*b* Mantua, *c.* ?1535; *d* Rome, after 1588) in engraving, but neither of them possessed the talent, vigour or originality of their father.

Adamo Scultori appears to have attempted to emulate Ghisi, but his engravings are very uneven in quality. Bartsch lists 129 prints by Adamo. The set of 72 studies of figures after those by Michelangelo in the Sistine Chapel (B. 27–98) is probably his best-known work, but the figures are stiff and show Adamo's difficulties with foreshortening. Most of the other prints are after Giulio Romano and other artists around Mantua, or after the Antique. He usually signed his works with a monogram consisting of a large A with a small inscribed *s*. He also was active as a publisher, apparently in Rome, between *c.* 1577 and 1580.

Diana Scultori engraved several plates after works by her father, which she signed '*Diana filia*' or '*filia eius*'. According to d'Arco and Albricci, the date 1542 appears on the first state of the *Temperance of Scipio* (B. 33), making the generally accepted date of her birth doubtful. In 1565 the architect Francesco da Volterra arrived in Mantua, and he and Diana were subsequently married. By 1575 they were in Rome, where they settled. Albricci divides Diana's work into three periods: Mantuan, early Roman and later Roman. Some of her early works and some of her latest, executed after her husband's death, are signed *Diana Mantovana*, and in Rome she often added 'civis volterrana'. Her engravings vary in technique and competence, and many are somewhat flat, with a narrow range of tone and repetitive lines. She made many engravings after the work of Giulio Romano in the Palazzo del Te. Perhaps the most interesting of these is the large print in three parts, the *Marriage of Psyche* (B. 40), which was executed in Rome in 1575. Another of her most successful works, the *Adulteress under the Archway to the Temple* (B. 4), was made in the same year. From 1575 Diana worked after a number of different artists and in several different styles, with varying success. Bartsch lists 46 prints by her, Albricci 62. Because of the several styles in which she worked, the attribution

of later, unsigned prints is difficult. Diana was well regarded by her peers and is the subject of an undated bust portrait (B. 121), engraved by Cherubino Alberti (1553–1613).

BIBLIOGRAPHY

A. von Bartsch: *Le Peintre-graveur* (1803–21) [B.], xv [incl. cat. rais.]
G. Gori Gandellini: *Notizie istoriche degli intagliatori* (2/Siena, 1808)
C. d'Arco: *Di cinque valenti incisori mantovani del secolo XVI e delle stampe da loro operate* (Mantua, 1840)
——: *Delle arti e degli artefici di Mantova*, 2 vols (Mantua, 1857)
J. D. Passavant: *Le Peintre-graveur* (Leipzig, 1860–64), vi, pp. 134–7
P. J. Mariette: 'Catalogue de l'oeuvre gravé des Ghisi', *Nouv. Est.*, 9 (1968), pp. 367–85
G. Albricci: 'Prints by Diana Scultori', *Prt Colr*, 12 (March–April 1975), pp. 17–21
——: 'The engravings of G. Battista Scultori', *Prt Colr*, 33–4 (Sept–Dec 1976), pp. 10–62 [cat. rais.]
S. Ferrara: *Catologo generale della raccolta di stampe antiche della Pinacoteca Nazionale di Bologna*, pt vi (Bologna, 1977), nos 160–270
Incisori mantovani del '500: Giovan Battista, Adamo, Diana Scultori e Giorgio Ghisi dalle collezioni del Gabinetto Nazionale delle Stampe e della Calcografia Nazionale (exh. cat. by S. Massari, Rome, Calcografia N., 1980)
S. Boorsch and J. Spike, eds: *Italian Artists of the Sixteenth Century* (1987), 31 of *The Illustrated Bartsch*, ed. W. Strauss (New York, 1978–)

MICHAL LEWIS, R. E. LEWIS

Sebastiano del Piombo

Sebastiano del Piombo [Luciani, Sebastiano; Venetus, Sebastianus; Veneziano, Sebastiano; Viniziano, Sebastiano] (*b* ?Venice, 1485–6; *d* Rome, 21 June 1547). Italian painter. He was one of the most important artists in Italy in the first half of the 16th century, active in Venice and Rome. His early, Venetian, paintings are reminiscent of Giovanni Bellini and to a lesser extent of Giorgione. With his move to Rome in 1511 he came under the influence of Raphael and then of Michelangelo, who supplied him with drawings. After the death of Raphael (1520), he was the leading painter working in Rome and was particularly noted as a portrait painter. In his finest works, such as the *Pietà* (1513; Viterbo, Mus. Civ.) and the *Flagellation* (1516–24; Rome, S Pietro in Montorio), there is a remarkable fusion of the Venetian use of colour and the grand manner of Central Italian classicism.

1. Life and work. 2. Working methods and technique.

1. LIFE AND WORK.

(i) Early years: Venice, to 1510. (ii) Beginnings in Rome, 1511–15. (iii) Maturity: Rome, 1516–27. (iv) Rome: the Sack and after, 1527–36. (v) Last years: Rome, after 1537.

(i) Early years: Venice, to 1510. He was probably born in Venice as he often used the signature 'Sebastianus Venetus'. Vasari's statement that in his youth Sebastiano was much admired for his lute playing and other social graces suggests that he was from an upper middle-class family rather than the artisan background traditional for artists at this date. He began training as a painter at a relatively mature age—probably about 18–20—and it was he who decided to enter the studio of Giovanni Bellini and then to leave it, as Titian did later, for that of Giorgione.

The first paintings attributed to Sebastiano display the influence of both, as well as great freedom and capacity for technical and iconographic innovation. As there are no signed or documented works by Sebastiano from his time in Venice, attributions relating to this period are based on stylistic evidence and are disputed. Two paintings in Venice, however, are traditionally assigned to him: the altarpiece of *St Giovanni Crisostomo with Saints* (begun 1510; S Giovanni Crisostomo; see colour pl. 2, XXXI2), and the doors to the organ, with *St Louis of Toulouse* and *St Sinibaldus* (*c.* 1508–9; interior) and *St Bartholomew* and *St Sebastian* (exterior), in S Bartolomeo a Rialto. These can be dated accurately, because they were commissioned by Alvise Ricci, who was vicar of S Bartolomeo a Rialto from October 1507 until 1509. By extrapolation, based on these two paintings, it is possible to deduce Sebastiano's activity in the preceding three or four years. Many writers regard as a key work of this period the *Sacra conversazione* (Venice, Accad.). It seems to have no logical place in Sebastiano's development, however, and the comparisons made by Pallucchini (1935) and Hirst (1981) with his first painting of note, the *Portrait of a Young Woman* (*c.* 1505; Budapest, Mus. F.A.), demonstrate clearly its different formal root.

Sebastiano is increasingly often credited with the large and very ambitious *Judgement of Solomon* (Kingston Lacy, Dorset, NT; see fig. 1). This was formerly attributed to Giorgione, although its great size and monumental impact are not characteristic of his work. The restoration and cleaning of the *Judgement* in the 1980s permitted a reassessment of the chronology and evolution of Sebastiano's ideas. There is evidence that the painting was reworked, but many parts of the original composition, for example the old priest on the right-hand side and the architectural background, indicate a date of *c.* 1505. Particularly notable is the introduction of antique elements, such as the classical colonnade. Described by Ridolfi (1648) as 'unfinished', the painting was probably abandoned by Sebastiano some time before 1507. The judicial subject of the painting supports Hirst's hypothesis (1978) that the work was intended for the Palazzo Loredan (1502–9; now Palazzo Vendramin–Calergi), which was commissioned by Andrea di Nicolo Loredan, who was elected president of the Consiglio dei Dieci in 1506. According to Hirst, the *Judgement* was closely followed by *The Lovers* (untraced) of which a copy (New York, priv. col., see Hirst, 1981, p. 30) survives as well as an 18th-century engraving by Domenico Cunego, who took it to be the work of Giorgione. Also close in date to the *Judgement of Solomon* is the *Sacra conversazione* (New York, Met.; attributed to Domenico Mancini). The painting has certain areas of extraordinary modernity, as in the relaxed brushwork of the fringe to the Virgin's white veil, and together with the *Judgement* was a source of inspiration to two young painters, Cariani and Dosso Dossi, who was probably in Venice in 1510.

A new direction can be observed in the shutters to the organ in S Bartolomeo a Rialto, first attributed to Sebastiano by Scanelli (1657). There is principally a change in technique, from the earlier smooth surface to the application of paint in heavy brushstrokes, and also in style; the figure of St Sebastian on the outer doors clearly indicates Sebastiano's knowledge of such Classical precedents as the *Apollo Belvedere* (Rome, Vatican), as suggested by Wilde (1974); the new fiery colouring recalls descriptions of Giorgione's frescoes (largely destr.) on the façade of the Fondaco dei Tedeschi in Venice. A departure of a different nature can be observed in the *St Giovanni Crisostomo with Saints* (begun 1510), the altarpiece of S

1. Sebastiano del Piombo: *Judgement of Solomon*, oil on canvas, 2.08×3.15 m, *c.* 1505 (Bankes Collection, Kingston Lacy, Dorset, NT)

Giovanni Crisostomo, Venice, not yet cleared of its 19th-century overpainting. The compositional arrangement breaks with tradition by depicting the central figure in profile rather than full-face, an idea taken up three years later by Giovanni Bellini in his altarpiece for the same church. Other ideas in this painting were also adopted by Venetian painters, for example the group of three female figures to the left presenting simultaneously three different viewing angles of the faces. It is an obvious prototype for the similar group in Titian's fresco of the *Miracle of the Speaking Infant* in the Scuola del Santo in Padua painted a year later. Documents found by Gallo (1953) and Hirst (1981) show that the altarpiece was begun only in the summer of 1510; its date of completion is not known. Also dated 1510 is his *Salomé* (London, N.G.). The beautiful dress of Salomé appears again in the contemporary *Wise Virgin* (Washington, DC, N.G.A.) by Sebastiano, while the same intense colouring occurs in the mountain background of Giorgione's *Three Philosophers* (Vienna, Ksthist. Mus.; *see* GIORGIONE, fig. 3), which, according to Michiel (1525), was finished by Sebastiano (though, if so, his intervention was minimal). Probably also from this period, late 1510, is the unfinished *Sacra conversazione* (Paris, Louvre).

(ii) Beginnings in Rome, 1511–15. In early 1511 the Siennese banker Agostino Chigi came to Venice. When he returned to Rome in August, he took with him the painter he probably considered to be the best in Venice, Sebastiano. On his arrival in Rome, Sebastiano painted the frescoes in the lunettes of the Garden Loggia of Chigi's villa, later known as La Farnesina; these consisted of mythological scenes set in the heavens. Beneath these a cycle of myths relating to water was probably intended: instead there is a large figure of *Polyphemus* facing towards the *Galatea* painted by Raphael (see colour pl. 2, XXII1), which possibly supplanted one by Sebastiano (Angelini, 1986). The cycle was curtailed for reasons not known, perhaps because of flooding (Hirst, 1981). Restoration has revealed that Sebastiano's work was completed within a month. The frescoes are referred to as already complete in a pamphlet (Blosio Palladio) printed on 27 January 1512. The technical and stylistic innovation of these frescoes was noted by Vasari. Observations made during restoration (Angelini, 1986) indicate that Sebastiano did not use the traditional technique of transferring the cartoon by pouncing, but painted free-hand in the Venetian manner, with colours of chemical composition and intensity hitherto unknown in Rome.

In this period Sebastiano also produced masterfully coloured works on canvas, for example the *Adoration of the Shepherds* (Cambridge, Fitzwilliam), painted either in Venice or immediately after his arrival in Rome (possibly the latter) and the wonderful portrait of *Cardinal Ferry Carondelet and his Secretary* (Madrid, Mus. Thyssen-Bornemisza) executed in Rome early in 1512. The latter is perhaps the first Italian example of a portrait type, derived from Flemish models, in which the subject is depicted engaged in his usual business, in a setting and with companions emphasizing his public persona; it was painted six years before Raphael's *Leo X with Two Cardinals* (Florence, Uffizi; for illustration *see* MEDICI, DE', (7)).

Another Giorgionesque type Sebastiano painted in Rome is the *Portrait of a Man at Arms* (Hartford, CT, Wadsworth Atheneum), a work that is stylistically linked to the Carondelet painting. Before it was overpainted by Sebastiano this was undoubtedly evocative of such portraits by Giorgione as the *Gattamelata* (Florence, Uffizi). Sebastiano's reputation as a portrait painter burgeoned as a result of such works (Paolo Giovio, 1524). Other works from 1512 include the *Portrait of a Woman, 'La Fornarina'* (Florence, Uffizi) and, according to Tempestini (1991), also perhaps the large and beautiful *Dead Adonis* (Florence, Uffizi; see colour pl. 2, XXXI1). Probably commissioned by Chigi (Hirst, 1981), this latter painting may be contemporary with the *Polyphemus* (Rome, Villa Farnesina), given that the campanile of St Mark's in the background is shown without the spire, which was added in 1514. Michelangelo's painting on the Sistine Chapel ceiling was unveiled in October 1512, and there can be no doubt that the large female figures in Sebastiano's *Dead Adonis* show his study of Michelangelo's work as well as the methods of Raphael. Sebastiano's admiration of Michelangelo did not initially prevent his appreciation of Raphael, rather the change of interest was gradual.

Nevertheless, Sebastiano became a close friend of Michelangelo after his arrival in Rome. Vasari records that Michelangelo praised Sebastiano's paintings and provided the cartoon (untraced) for his most famous work, the *Pietà* (Viterbo, Mus. Civ.; see fig. 2). This was commissioned by Monsignor Giovanni Botonti for S Francesco, Viterbo, and probably painted *c.* 1513. The face of the Virgin is similar to that of the *Dorotea* (ex-Berlin, Kaiser-Friedrich Mus.; destr.), datable to shortly after 1512. There

is no sign of the tendency towards simplification and abstraction that is already evident in the later *Virgin and Child* (London, Pouncey priv. col., see Hirst, 1981, pl. 25) and that is more clearly apparent in such works as the *Deposition* (1516; St Petersburg, Hermitage) and others closely related, for example the *Portrait of a Young Man* (Budapest, Mus. F.A.) or the portrait of *Cardinal Antonio del Monte* (Dublin, N.G.). A document discovered by Hirst (1981) suggests that the altarpiece was installed in 1516. There is at least one partial study (Vienna, Albertina) by Michelangelo for the hands of the Virgin, identified by Wilde (1953). It has been suggested that the composition of the *Pietà* reflects the devotional ideas of the Theatines (Hartt, 1963). At any rate, it is certain that by portraying the mother as physically detached from her son, unlike more traditional treatments of the subject, Sebastiano put emphasis on the dead body of Christ, presenting it as a focus for the meditation of the faithful.

(iii) Maturity: Rome, 1516–27. As a result of the success of the *Pietà*, in 1516 the Florentine merchant Pierfrancesco Borgherini commissioned Sebastiano to decorate his chapel in S Pietro in Montorio, Rome. Michelangelo's assistance with the *Pietà* was not publicly known, but Borgherini knew Michelangelo well, and it is probable that a decisive factor in his choice of Sebastiano was his assumption that Michelangelo would be involved in the commission. As early as August 1516 Michelangelo supplied a drawing of the *Flagellation* (London, BM) for the chapel, as well as early sketches for the *Transfiguration*. The *Prophets* on the spandrels, for which Sebastiano prepared cartoons (Kroměříž, Kroměříž Castle, and Washington, DC, N.G.A.), were probably executed in March 1517. The development of the cartoons for the *Prophets* was closely followed by the portrait of *Cardinal Bandinello Sauli and Three Companions* (Washington DC, N.G.A.), signed and dated 1516.

A hiatus in work on the Borgherini chapel occurred when, towards the end of 1516, probably on Michelangelo's recommendation, Sebastiano was commissioned by Cardinal Giulio de' Medici to paint a large altarpiece, the *Raising of Lazarus* (London, N.G.; see fig. 3). The painting was to be sent, with the *Transfiguration* (Rome, Pin. Vatican; *see* RAPHAEL, fig. 6), commissioned from Raphael shortly before, to the cathedral in his own bishopric of Narbonne. According to Vasari, Sebastiano's *Lazarus* was intended to compete with Raphael's painting and was executed with the help of Michelangelo; their collaboration, once secret, was now openly encouraged by Giulio de' Medici with the express aim of exploiting the rivalry between Michelangelo and Raphael. There is a sketch for the figure of Lazarus (Bayonne, Mus. Bonnat) and two other drawings (London, BM), which Michelangelo probably provided for this work. The *Raising of Lazarus* was completed by 1 January 1519 and was an immediate success. Raphael was anxious to avoid comparison between his work and Sebastiano's, but in April 1520 the *Lazarus* was exhibited with the *Transfiguration* of Raphael, who had died only days before. Perhaps because of the drama of Raphael's early death, his altarpiece remained in Rome and that of Sebastiano eventually went to Narbonne.

2. Sebastiano del Piombo: *Pietà*, oil on panel, 2.7×2.3 m, *c.* 1513 (Viterbo, Museo Civico)

3. Sebastiano del Piombo: *Raising of Lazarus*, oil on panel transferred to canvas and remounted on board, 3.81×2.90 m, 1519 (London, National Gallery)

By May 1519 Sebastiano had resumed work on the Borgherini Chapel, painting the vault in the apse with his *Transfiguration*; it is highly probable that its conception predates the *Transfiguration* of Raphael, which was started in July 1518 but later radically modified. The chapel was completed and revealed to the public only in March 1524. Work had been delayed because of an outbreak of the plague in 1522, and also perhaps by the use of the oil on plaster technique, which was slower than fresco. Sebastiano's ambitions for the Borgherini Chapel were intensified by his failure in 1520 to secure the decoration of the Sala dei Pontefici in the Vatican following the death of Raphael. He sought the commission with the assumption of assistance from Michelangelo, but Pope Leo X ordered Michelangelo to work exclusively on the tomb of Julius II, and Sebastiano had to abandon any hope of securing the project.

There is no doubt, however, that after the death of Raphael, Sebastiano was generally regarded as the best artist in Rome. The years between 1516 and 1527 were the busiest and most productive of his career; besides his public works, he established himself as a portrait painter of repute. The unprecedented scale, power and self-assurance of his portraits is evident in *The Violinist* (1518; Paris, G. de Rothschild priv. col., see Lucco, 1980, fig. 49), *Christopher Columbus*, signed and dated (1519; New York, Met.), the damaged *Francesco Arsilli* (Ancona, Pin. Com.) and *The Humanist* (Washington, DC, N.G.A.). He also received important public or semi-public commissions. The *Holy Family with John the Baptist and a Benefactor* (London, N.G.), based on Michelangelo's sketch (Rotterdam, Mus. Boymans–van Beuningen), may be the painting he executed for Pierfrancesco Borgherini some time between 1517 and 1520 to replace one by Andrea del Sarto, with which Borgherini was not satisfied. Other works from this period include the *Visitation* (Paris, Louvre), which was sent to France; the *Martyrdom of St Agatha* (1520; Florence, Pitti), executed for Cardinal Ercole Rangone (*d* 1527); the *St Anthony Abbot* (early 1520s; Compiègne, Mus. Mun. Virenel); and *Christ Carrying the Cross* (Madrid, Prado), exported almost immediately to Spain, where many paintings were derived from it.

It is likely that Sebastiano left Rome during the plague of 1522, and little is known of him from 1522 to 1523. One commission, however, probably dates from this time. An associate of the Dutch Pope Adrian VI (*reg* 1522–3), Cardinal Enckenvoirt (*d* 1534), asked Sebastiano to paint his chapel in S Maria dell'Anima, Rome; owing to Sebastiano's procrastination, the work (destr.) was completed by Michiel Coxcie only in 1531. A portrait of *Cardinal Enckenvoirt* and one of *Adrian VI*, both mentioned by Vasari, are untraced.

Adrian VI had little interest in art, but prospects for artists in Rome improved in 1523, when he was succeeded by Cardinal Giulio de' Medici as Clement VII. The Cardinal had commissioned the *Raising of Lazarus*, and under his reign other Florentine patrons of Sebastiano also returned to Rome. They included Giovanni Botonti, who had commissioned the *Pietà* of Viterbo and who in 1524 commissioned a *Flagellation* (Viterbo, Mus. Civ.). Also from this period, the portrait of *Anton Francesco degli Albizzi* (1525; Houston, TX, Mus. F.A.) and that of *Pietro*

4. Sebastiano del Piombo: *Andrea Doria*, oil on panel, 1.53×1.07 m, 1526 (Rome, Galleria Doria–Pamphili)

Aretino (ruined; 1525; Arezzo, Pal. Com.) were highly praised by Vasari (1568). Works painted for the Pope at this time include the *Madonna del Velo* (or *Holy Family with St John the Baptist*; Prague, N.G., Šternberk Pal.), of which many copies were made (e.g. Castle Ashby, Northants). The work is derived from Raphael's *Holy Family* (Chantilly, Mus. Condé), but Sebastiano intensified the monumental aspects of the composition, giving it greater solemnity and weight. A later, smaller version (*c.* 1540; Naples, Capodimonte) is even more striking. Also for Clement VII in 1526 Sebastiano completed the powerful portrait of *Andrea Doria* (Rome, Gal. Doria–Pamphili; see fig. 4) and the beautiful likeness of *Clement VII* (Naples, Capodimonte), in which the Pope is portrayed as still youthful, without the beard he wore after the Sack of Rome. In 1526 Sebastiano was commissioned by the heirs of his first Roman patron, Agostino Chigi, to paint a large *Assumption* for Chigi's funerary chapel in S Maria del Popolo, Rome; of this first project, there remains only a fine drawing (Amsterdam, Rijksmus.). The enormous painting was to be executed in oils on marble slabs; the lengthy preparation process was interrupted by the Sack of Rome in 1527.

(iv) Rome: the Sack and after, 1527–36. The Sack of Rome in May 1527 dealt a decisive blow to Roman society and its artists, most of whom fled. Sebastiano, however,

remained with the Pope and his court in Rome in Castel Sant'Angelo and probably also in his next refuge, in Orvieto. In March 1528 he sent three portraits of the Gonzaga family (untraced) to Isabella d'Este in Mantua, where he stayed. In June he was in Venice, perhaps his first visit in nearly 17 years, though he was not impressed with the two leading painters, Titian and Pordenone. He had returned to Rome by early 1529 and probably accompanied the Pope to Bologna for the coronation of Charles V (*reg* 1519–56), from November 1529 to March 1530. A drawing (London, BM) survives from a commission for a double portrait of the two rulers but it was never painted.

In 1530 Sebastiano made a gift to the Pope of a *Christ* painted using a new technique of oil on stone, though the work is now unidentifiable (possibly that in Naples, Capodimonte). Soon after he began a commission, mentioned in Agostino Chigi's will ten years earlier, for a painting to be placed under the *Sibyls* by Raphael in S Maria della Pace in Rome, though the subject was now specified as that of the *Resurrection*. At the same time a new contract was drawn up for the commission for the chapel of S Maria del Popolo, with the new subject of the *Birth of the Virgin*. Only in 1532 does the correspondence between Michelangelo and Sebastiano mention sketches for the two paintings, and work on the *Birth of the Virgin* probably did not begin before the end of the 1530s, while the *Resurrection* never started.

In April 1531 Sebastiano was engaged in painting a new portrait of *Clement VII*, this time with a beard (Vienna, Ksthist. Mus.), of which the Pope immediately requested another version on stone, perhaps that in the Getty Museum in Los Angeles; another (untraced) was obtained by Baccio Valori, whose portrait (Florence, Pitti) Sebastiano was preparing at the time. A third was sent to Florence for Giuliano Bugiardini to copy. Also in the early 1530s Sebastiano executed the *Portrait of a Gentleman* (Princeton, NJ, Barbara Piasecka Johnson priv. col.), the *Portrait of a Lady* (Harewood House, W. Yorks) and the *Portrait of a Woman* (Barcelona, Mus. A. Catalunya).

In 1531 Sebastiano acquired the lucrative office of the Keeper of the Papal Seals, the *Piombo*, the nickname by which he is best known. His new position required him to become a friar (despite his marriage and two children) and to accompany the Pope everywhere (e.g. to Marseille in the autumn of 1533). According to Vasari, with his new status Sebastiano became lazy and avoided painting; certainly his artistic activity was much curtailed.

In 1532 Sebastiano painted one of his most famous portraits, that of *Giulia Gonzaga* (untraced), known only through copies (e.g. Florence, Uffizi). The following year Ferrante Gonzaga commissioned a painting from Sebastiano for the funeral chapel of Charles V's chancellor, Francisco de los Cobos, in S Salvador, Ubeda. To ensure the permanency of the image, Sebastiano insisted on using the technique of oil on slate for the work, a *Pietà* (Seville, Casa Pilatos), which was completed only in 1539. He also persuaded Clement VII to try to make Michelangelo paint the *Last Judgement* in the Sistine Chapel in this medium (see colour pl. 2, VII3) and even had the wall prepared. This led, in 1534, to a definitive split in his 20-year friendship with Michelangelo. The sketch of Christ (Paris, Louvre) that Sebastiano had obtained from Michelangelo

for the *Pietà* for Ubeda was the last fruit of their partnership.

(v) Last years: Rome, after 1537. In 1537 Sebastiano completed *Christ Carrying the Cross* (St Petersburg, Hermitage) for another Spanish patron, Ferdinando da Silva, Conde de Cifuentes. Also in the late 1530s he began to work on the *Birth of the Virgin* in S Maria del Popolo in Rome (*in situ*). It was completed only after Sebastiano's death by Francesco Salviati in 1556 and is similar in style to the originally planned *Assumption* and to Sebastiano's large altarpiece of the *Holy Family* which was sent to Burgos Cathedral in Spain, where it was probably in place by 1528. The work also has stylistic similarities with the late version of the *Madonna del Velo* (*c*. 1540; Naples, Capodimonte) and with the beautiful tondo with the *Head of a Woman* (Fort Worth, TX, Kimbell A. Mus.). Filippo Sergardi, the executor of Agostino Chigi's estate, before his death in 1541 commissioned Sebastiano to paint a mural of the *Visitation* in S Maria della Pace, Rome (dismembered and detached before 1614), the surviving fragments (Alnwick Castle, Northumb.) of which are impressive for their simplified forms and intense expressiveness, qualities that anticipate so much of the painting of the late 16th century. Closely linked to these paintings is one of Sebastiano's last works of the 1540s, the powerful and austere *Christ Carrying the Cross* (Budapest, Mus. F.A.).

Sebastiano's fame as a portrait painter continued in his last years, although he appears to have been less productive. Works that belong stylistically to the 1540s include the monumental *Portrait of a Woman* (Longford Castle, Wilts, see Hirst, 1980, pl. 192) and the unfinished *Double Portrait*, on stone (Parma, G.N.), depicting either Clement VII and a companion (Hirst, 1981) or Pope Paul III with his nephew, Alessandro Farnese (Ramsden, 1983). To this group of paintings probably also belong the *Judith* (ex-Kaiser-Friedrich-Mus., Berlin; destr.) and *A Lady as St Agatha* (London, N.G.), which, with the signature 'F(rater) Sebastianus Ven(etus)', must by definition be after 1531. The attribution to Sebastiano of the portrait of *Cardinal Reginald Pole* (1540s; St Petersburg, Hermitage) seems untenable in view of the strong echoes of Raphael in its style. Sebastiano was buried in S Maria Maggiore, Rome, but at the instigation of Daniele da Volterra his remains were transferred to the Accademia di S Luca, Rome, in 1561.

2. WORKING METHODS AND TECHNIQUE. Despite his reliance on sketches by Michelangelo, Sebastiano was himself an accomplished draughtsman, and many of his drawings survive (e.g. Florence, Uffizi; London, BM; Paris, Louvre; Windsor Castle, Berks, Royal Lib.). These range from such sketches for individual figures as the beautiful nude (Paris, Louvre) for the *Martyrdom of St Agatha* (Florence, Pitti) to elaborate compositional *modelli* like that (Paris, Louvre) for the *Birth of the Virgin* in S Maria del Popolo, Rome. His Venetian training is apparent in the use of black chalk for his drawings, most of which are on coloured paper and have white heightening. He is known to have used clay models for some figures.

Sebastiano painted on a wide range of supports and in a variety of media. Early works, such as the organ shutters for S Bartolomeo a Rialto, Venice, are in the traditional Venetian materials of oil on canvas. For other works he used oil on panel, for example the *Pietà* for Viterbo and the portrait of *Ferry Carondelet* (Madrid, Mus. Thyssen-Bornemisza). His decorations for Chigi's villa in Rome are in true fresco, a technique he abandoned after the *Transfiguration* (from 1516) in S Pietro in Montorio, Rome. For the *Flagellation* in the same church he switched to an oil medium for murals. He also used oil on stone, as in the portrait on slate of *Baccio Valori* (Florence, Pitti). Close scrutiny of the *Flagellation* reveals his unusual method of preparation, in which he incised virtually every form in the hardened surface rather than in the soft *intonaco*. The increasing tendency to formal simplicity and clarity in Sebastiano's work is echoed in his use of colour, which changed from the rich tones of his early paintings in Venice to a sombre palette with bright accents, as in the late mural, the *Visitation* (fragments, Alnwick Castle, Northumb.) for S Maria della Pace, Rome.

BIBLIOGRAPHY

EARLY SOURCES

Blosio Palladio: *Sububanum Augustini Chisii . . . Romae* (1512)
P. Giovio: *De viris illustribus* (1524); also in G. Tiraboschi: *Storia della letteratura italiana* (Parma, 1772–82)
M. A. Michiel: *Notizia d'opere di disegno* (Venice, 1525); ed. G. Frizzoni (Bologna, 1884)
G. Vasari: *Vite* (1550, rev. 2/1568); ed. G. Milanesi (1878–85), v, pp. 565–60
C. Ridolfi: *Meraviglie* (1648); ed. D. von Hadeln (1914–24)
F. Scanelli: *Il microcosmo della pittura* (Cesena, 1657)

GENERAL

J. Wilde: *Italian Drawings in the Department of Prints and Drawings in the British Museum: Michelangelo and his Studio* (London, 1953)
——: *Venetian Art from Bellini to Titian* (Oxford, 1974)
P. Partner: *Renaissance Rome, 1500–1559: A Portrait of a Society* (Berkeley and Los Angeles, 1976)
A. Chastel: *The Sack of Rome, 1527* (Princeton, 1983)
E. Ramsden: *'Come Take this Lute': A Quest for Identities in Italian Renaissance Portraiture* (Salisbury, 1983)

MONOGRAPHS

G. Bernardini: *Sebastiano del Piombo* (Bergamo, 1908)
P. D'Achiardi: *Sebastiano del Piombo* (Rome, 1908)
L. Dussler: *Sebastiano del Piombo* (Basel, 1942)
R. Pallucchini: *Sebastian Viniziano* (Milan, 1944)
M. Lucco: *Sebastiano del Piombo: Opera completa* (Milan, 1980)
M. Hirst: *Sebastiano del Piombo* (Oxford, 1981)

SPECIALIST STUDIES

E. Benkard: *Die venezianische Fruehzeit des Sebastiano del Piombo, 1485–1510* (Frankfurt, 1907)
R. Pallucchini: 'La formazione di Sebastiano del Piombo', *Crit. A.*, i (1935)
R. Gallo: 'Per la datazione della pala di San Giovanni Crisostomo di "Sebastian Viniziano"', *A. Ven.*, vii (1953), p. 152
F. Hartt: 'Power and the Individual in Mannerist Art', *The Renaissance and Mannerism: Studies in Western Art*, ii (Princeton, 1963)
M. Hirst: 'The Kingston Lacy "Judgement of Solomon"', *Giorgione, Atti del convegno internazionale di studio per il 50 centenario della nascita: Castelfranco Veneto, 1978*, pp. 257
C. Davis: 'Un appunto per Sebastiano del Piombo ritrattista', *Mitt. Ksthist. Inst. Florenz*, xxvi/3 (1982), pp. 383–5
M. Hirst: 'Sebastiano del Piombo', *The Genius of Venice, 1500–1600* (exh. cat., ed. J. Martineau and C. Hope; London, RA, 1983), pp. 209–11
C. Gardner von Teuffel: 'Sebastiano del Piombo, Raphael and Narbonne: New Evidence', *Burl. Mag.*, cxxvi (1984), pp. 765–6
A. Gentili and C. Bertini: *Sebastiano del Piombo: La pala di San Giovanni Crisostomo* (Venice, 1985)

A. Angelini: 'La Loggia della Galatea alla villa Farnesina a Roma: L'incontro delle scuole toscana, umbra e romana (1511–1514)', *Tecnica e stile: Esempi di pittura murale del rinascimento italiano*, ed. E. Borsook and F. Superbi (Milan, 1986)
K. Laing and M. Hirst: 'The Kingston Lacy "Judgement of Solomon"', *Burl. Mag.*, cxxviii (1986), p. 809
C. Gardner von Teuffel: 'An Early Description of Sebastiano's "Raising of Lazarus" at Narbonne', *Burl. Mag.*, cxxix (1987), pp. 185–6
——: 'Raffaels römische Altarbilder: Aufstellung und Bestimmung', *Z. Kstgesch.*, l/1 (1987), pp. 1–45
M. Lucco: '"Il Giudizio di Salomone" di Sebastiano del Piombo a Kingston Lacy', *Eidos*, 1 (1987)
R. Preimesberger: 'Tragische Motive in Raffaels "Transfiguration"', *Z. Kstgesch.*, l/1 (1987), pp. 88–115
E. Bermejo: 'Una Flagelación de Sebastian del Piombo, en Madrid', *Archv Esp. A.*, lxi/241–4 (1988), pp. 419–22
S. Deswarte-Rosa: 'Domenico Giuntalodi, peintre de D. Martinho de Portugal à Rome', *Rev. A.* (1988)
E. Howard: 'New Evidence on the Italian Provenance of a Portrait by Sebastiano del Piombo', *Burl. Mag.*, cxxx (1988), pp. 457–9
J. Juncic: 'Joachimist Prophecies in Sebastiano del Piombo's Borgherini Chapel and Raphael's Transfiguration', *J. Warb. & Court. Inst.*, li (1988), pp. 66–84
L. Puppi: 'La "Morte di Adone" di Sebastiano del Piombo', *Letture di storia dell'arte*, ed. R. Varese (Ancona, 1988)
C. M. Brown: 'A Further Document for Sebastiano's Ubeda "Pietà"', *Burl. Mag.*, cxxxvii (1990), pp. 570–71
R. Roggeri: 'I ritratti di Giulia Gonzaga contessa di Fondi', *Civiltà Mant.*, 28–9 (1990), pp. 61–86
A. Tempestini: 'Sebastiano del Piombo tra Venezia e Roma: l' "Adone morto" degli Uffizi', *Uffizi. Stud. & Ric.*, vii (1991)
M. Lucco: 'Some Observations on the Dating of Sebastiano del Piombo's S Giovanni Crisostomo Altarpiece', *New Interpretations of Venetian Renaissance Painting*, ed. F. Ames-Lewis (London, 1994), pp. 43–9
A. Schiavo: 'Affinità fra due disegni e altrettante simili opere di Michelangelo', *Urbe*, liv/6 (1994), pp. 241–8

MAURO LUCCO

Sebastiano di Giacomo di Bologna da Conegliano. *See* FLORIGERIO, SEBASTIANO.

Segala [Segalino; Segalla], **Francesco** (*fl* Padua, 1559; *d* Padua, 14 May 1592). Italian sculptor. He is documented for the first time in 1559, on the occasion of his wedding in Padua. By then he appears to have been a successful sculptor. Nothing is known about his training. The earliest work that can be connected with him is the bust of *Girolamo Michiel* (Padua, S Antonio), probably produced in 1558 or 1559. He was a member of Alvise Cornaro's circle in Padua, and stylistic features suggest the influence during his apprenticeship of Tiziano Minio, Agostino Zoppo and, less strongly, of Danese Cattaneo. From about 1564 the influence of Jacopo Sansovino is apparent, as in the bronze statuette of *St Catherine* (1564; *in situ*) on the font in S Antonio, Padua, the eleven terracotta figures (1564–5) in the oratory of S Prosdocimo in S Giustina, Padua, ten of which survive, and the statue of *St John the Baptist* (1565) in the baptistery of S Marco, Venice. These are distinguished by soft modelling and flowing contours.

From about 1575, influenced by Girolamo Campagna, Segala developed a more classical, academic and sober style. Characteristic works are the stucco figures (1578–9) in the Sala dei Marchesi (and perhaps those in the Sala dei Capitani) of the Palazzo Ducale, Mantua, the two marble statues of *Abundantia* and *Caritas* (*c.* 1581) for the Scala d'Oro of the Doge's Palace, Venice, and the tomb of *Tiberio Deciano* (after 1581) in S Maria del Carmine, Padua. Apart from the large-scale tomb sculptures in stucco, bronze and marble on which he collaborated, notably in

Padua, Segala produced small sculptures in bronze, such as *Omphale* (*c.* 1565; Padua, Mus. Civ.), and wax, such as the relief portrait of *Archduke Ferdinand of Tyrol* (1579; Vienna, Ksthist. Mus.).

BIBLIOGRAPHY

L. Pietrogrande: 'Francesco Segala', *Boll. Mus. Civ. Padova*, xxxi–xliii (1942–54), pp. 111–36; xliv (1955), pp. 99–119; l (1961), pp. 29–58

C. Semenzato: 'Francesco Segala', *Dopo Mantegna: Arte a Padova e nel territorio nei secoli XV e XVI* (exh. cat., Padua, Pal. Ragione, 1976), pp. 144–5

B. Boucher: 'Francesco Segala', *The Genius of Venice, 1500–1600* (exh. cat., ed. C. Hope and J. Martineau; London, RA, 1983), p. 385

THOMAS HIRTHE

Sellaio, Jacopo del [Jacopo di Arcangelo di Jacopo] (*b* Florence, *c.* 1441; *d* Florence, 1493). Italian painter. He is first mentioned in his father's *catasto* (land registry declaration) of 1446 as a child of five. By 1460 he had joined the Compagnia di S Luca in Florence, and in October 1473 he appears in their records sharing a studio with Filippo di Giuliano (*fl* 1473–91). His first documented commission, of 10 December 1477, was for two panels with an *Angel Annunciate* and a *Virgin Annunciate* for S Lucia dei Magnoli in Florence (*in situ*; see fig.). For the same church he was asked to clean and restore a painting of *St Lucy* (*in situ*) usually attributed to Pietro Lorenzetti (*fl c.* 1306–45). Sellaio's paintings show a brittle, linear technique and a light, pastel palette, clearly indebted to Botticelli. Vasari describes both Sellaio and Botticelli as fellow pupils of Fra Filippo Lippi.

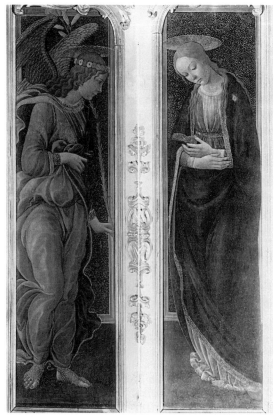

Jacopo del Sellaio: *Angel Annunciate* and *Virgin Annunciate*, oil on panel, 1.47×0.36 m, 1477 (Florence, S Lucia dei Magnoli)

Vasari names three paintings by Sellaio in Florence: two in S Frediano and one in S Maria del Carmine. The latter work has been identified with a commission for which payment was made in 1484 and of which fragments, depicting the martyred St Sebastian, have survived (see Pons, 1992). Sellaio's association with the Carmine is further documented by his appointment on 1 January 1484, as *capitano* for the Compagnia di S Maria delle Laudi, which owned a chapel in the Carmine and whose secretary was Neri di Bicci. Eighteenth-century descriptions of S Frediano list a *Pietà* and a *Crucifixion*, which critics have associated with the two paintings by Sellaio seen there by Vasari. On 8 February 1483 Sellaio was commissioned to paint a *Pietà* for the chapel of the Compagnia di S Frediano (nicknamed La Brucciata) in the church of the same name. Payments for the altarpiece continued until 1489, and it was not finished when Jacopo died, for in 1506 his son Arcangelo del Sellaio (*c.* 1477/8–1530), who had inherited his father's studio, was asked to complete the work within one year. In 1517 there was a dispute over the cost, and Giuliano Bugiardini and Ridolfo Ghirlandaio were called in to arbitrate. At about that time a predella was provided by Arcangelo di Jacopo, only recently identified by Pons (1996), who convincingly assigned to this painter the body of works previously ascribed to the anonymous Master of the Miller Tondo. Mackowsky (1899) convincingly identified the main panel with a *Pietà with Saints* (ex-Kaiser-Friedrich Museum, Berlin, inv. no. 1055; destr.), in which the figure of St Fredianus is derived from the same saint in Lippi's Barbadori Altarpiece (Paris, Louvre). Sellaio's other work for S Frediano, a huge *Crucifixion with the Virgin, St John and Six Saints*, survives in the 17th-century church of that name. Funds for its original site, a chapel dedicated to St Lawrence, were in place by 1486. Sellaio's altarpiece and its newly identified predella (see Pons, 1990) were in all likelihood underway by the end of the decade.

The two *Annunciation* panels, the *Crucifixion* in S Frediano and the destroyed *Pietà* formed the basis for a large number of attributions to Sellaio (see Berenson). The impact of Filippo Lippi on his style is difficult to assess, Botticelli's influence being more apparent in early works, such as the *Annunciation* panels. Sellaio's linear style is both more rigid and more flaccid than that of his contemporary, and his narrative scenes, often set in beautifully rendered landscapes, more anecdotal. In religious works, such as the *Penitent St Jerome* (*c.* 1485; Stockholm, N. Mus.) and the *Trinity with Saints and Donors* (*c.* 1480–85; Tokyo, N. Mus. W.A.), the principal subject is surrounded by a number of miniature scenes, unrelated to the main figures but presumably included as an aid to Christian devotion.

Sellaio's delicate colour sense and feeling for narrative are put to more effective use in such secular scenes as those he painted for *cassoni* and other items of domestic furniture, as in the pair of panels illustrating the story of *Cupid and Psyche* (Cambridge, Fitzwilliam; and New York, Hester Diamond priv. col.). Sellaio also illustrated the *Trionfi* of Petrarch in four beautiful panels (Fiesole, Mus. Bandini).

The dating of Sellaio's works presents various problems, but throughout the 1470s and 1480s he appears to have been frequently dependent on Botticelli as a source of

inspiration. The face of the Christ Child in a *Virgin and Child* (Florence, Gal. Corsini), for example, is copied from that in Botticelli's Bardi Altarpiece (1484–5; Berlin, Gemäldegal.); indeed, the style of the two masters came so close at this time that one work, the *Virgin of the Sea* (*c.* 1485–90; Florence, Accad.), continues to be attributed to Botticelli, or even Filippino Lippi, although Berenson rightly ascribed it to Sellaio. The professional relationship between the two painters still requires further study, as indeed does the entire career of Sellaio himself.

BIBLIOGRAPHY

G. Vasari: *Vite* (1550, rev. 2/1568); ed. G. Milanesi (1878–85), ii, pp. 627, 642–3

H. Mackowsky: 'Jacopo del Sellaio', *Jb. K. Preuss. Kstsamml.*, xx (1899), pp. 192–202, 271–84 [cat. of works]

O. H. Giglioli: 'L'antica Cappella Nenti nella Chiesa di Santa Lucia dei Magnoli a Firenze e le sue pitture', *Riv. A.*, iv (1906), pp. 184–8

H. P. Horne: 'Jacopo del Sellaio', *Burl. Mag.*, xiii (1908), pp. 210–13

G. Bacci: 'La Compagnia di S Maria delle Laudi e di S Agnese nel Carmine di Firenze', *Riv. Stor. Carmelitano*, iii (1931–2), p. 118

L. H. Heydenreich: 'Ein In-Memoriam-Bild des Jacopo del Sellaio', *Schönes Heim*, I/1 (1952), pp. 252–3

B. Berenson: *Florentine School*, i (1963), pp. 195–9

C. L. Baskins: 'Jacopo del Sellaio's *Pietà* in San Frediano', *Burl. Mag.*, cxxxi (1989), pp. 474–8

N. Pons: 'Una predella e altre cose di Jacopo del Sellaio', *Paragone*, 487 (1990), pp. 46–52

——: 'La pala del Sellaio per il Carmine: Un ritrovamento', *Ant. Viva*, xxix/213 (1992), pp. 5–10

——: 'Arcangelo di Jacopo del Sellaio', *A. Crist.*, lxxxiv/776 (1996), pp. 374–88

——: 'Jacopo del Sellaio e le confraternite', *La Toscana al tempo di Lorenzo il Magnifico: Politica, economia, cultura, arte: Università di Firenze, Pisa e Siena, 1992*, i (Pisa, 1996), pp. 287–95

ELIOT W. ROWLANDS

Sellari, Girolamo. *See* CARPI, GIROLAMO DA.

Semino. Italian family of painters and draughtsmen. Antonio Semino (?1485–?1555), who introduced Renaissance elements into Genoese artistic traditions, trained his sons (1) Andrea Semino and (2) Ottavio Semino, who subsequently participated in fresco and stucco decorative schemes in Genoese palaces and villas. There is still controversy over their contributions to certain works and as to their graphic oeuvre, but they clearly had very distinct personalities: Andrea was intellectual and reserved, Ottavio violent and extroverted.

(1) Andrea Semino (*b* Genoa, ?1526; *d* Genoa, 1594). Among his earliest known works are panels depicting the *Nativity*, the *Dream of St Joseph* and the *Annunciation to the Shepherds* and a stucco-and-fresco decoration of the *Life of the Virgin* (1567; all Genoa, S Caterina di Portoria). He became a popular painter of devotional altarpieces, for example the *All Saints* (1580; Genoa-Multedo, S Maria dell'Uliveto), but also executed decorative schemes in which stucco figures and cornices alternate rhythmically with panels of fresco painting. A versatile interpreter of Giovanni Battista Castello's spatial and compositional schemes, Andrea Semino successfully carried on the tradition, notably in cycles depicting warriors and battle scenes (e.g. 1560, Genoa, Pal. Pallavicini–Pessagno; 1569, Genoa, Pal. Campanella; 1593–4, Genoa, Banca d'America e d'Italia). He also worked in Savona and later Milan but by 1575 was back in Genoa, executing lyrical portraits in

the Bolognese style (e.g. 1579; Genoa, Gal. Pal. Bianco). At his death in 1594, he was buried in S Maria del Carmine in Genoa in a tomb he had prepared for himself in 1578.

(2) Ottavio Semino (*b* Genoa, ?1527; *d* Milan, 1604). Brother of (1) Andrea Semino. During the 1550s and 1560s he created several decorative façades in collaboration with his brother, but he also worked alone. In 1557 he was in Rome, in 1564 in Milan, and in 1567 in Pavia, where he created a *Last Supper* (*in situ*) in the refectory of the Certosa. In Genoa, between 1565 and 1571, he executed frescoes of historical–mythological subjects (e.g. Genoa, Pal. Cambiaso) that recall the fashion prevailing in Rome before its sack in 1527 but which he vulgarized and trivialized in order to satisfy the taste of the newly rich members of the Genoese middle class for public ostentation and private eroticism. After a further stay in Milan in the early 1570s, he returned to Genoa, where his fresco depicting the *Fall of the Giants* (1578; Genoa, Pal. Lercari–Parodi) was criticized from the outset for the dead, Michelangelo-like quality of its nudes. He created further decorative frescoes in Genoese palaces with his brother and then moved back to Milan. Ottavio Semino's technique shows him to have been a follower of Perino del Vaga and familiar with the engravings of the Fontainebleau school. He favoured colours that show Venetian influence, explicable by his familiarity with frescoes (*c.* 1533; destr.) by Girolamo da Treviso (ii) and Pordenone on the façade of the Palazzo Andrea Doria at Fassolo and with the Venetian paintings assembled by his friend Valerio Corte (1530–80).

BIBLIOGRAPHY

R. Soprani: *Vite* (1674); enlarged, ed. C. G. Ratti (1768–9)

F. Caraceni Poleggi: 'La committenza Borghese e il manierismo a Genova', *La pittura a Genova e in Liguria*, i (Genoa, 1970/R 1987)

Restauro degli affreschi di Andrea e Ottavio Semino (exh. cat. by A. de Floriani, Genoa, Pal. Cambiaso, 1978)

Les Dessins à Gênes du XVI au XVIII siècle (exh. cat. by M. Newcome and C. Monbeig Goguel, Paris, Louvre, 1985)

ELENA PARMA

Semolei, il. *See* FRANCO, BATTISTA.

Seregni (di Bonardo), Vincenzo (*b* Seregno, nr Milan, ?1504; *d* Milan, 12 Jan 1594). Italian architect. He trained as a stonecutter and engraver at the Cathedral Works in Milan, where he was apprenticed to Cristoforo Lombardo. His name first appears in records documenting the construction of the cathedral on 9 September 1535, when he was required to accompany Lombardo to Candoglia to select some marble, probably for the north transept door, the Porta verso Compedo. He is also recorded in September 1537 at a meeting to discuss the construction of this doorway, for which a drawing by Seregni survives (1536–7; Milan, Castello Sforzesco, vol. ii, fol. 16). The care taken on the sculptural decoration of this doorway is shown by the detailed relief of the *Annunciation* carved on it (now in Milan, S Maria in Camposanto), attributable to Seregni.

On 21 November 1547 Seregni was appointed architect to the cathedral, working with Lombardo, and was given special responsibility for the channelling of rain-water and for the external roof covering of the *tiburio* and vaults. A printed sheet (ex-Bib. Ambrosiana, Milan), erroneously

dated 1537, is probably associated with the occasion of this appointment and reveals his ideas on the construction of gutters covered in marble for draining rain-water from the cathedral and the construction of the vaults and staircases. It also contains his proposals for two bell-towers *c.* 20 m high to flank the planned façade of the cathedral. In 1548–9 Ferrante Gonzaga instigated a project for the reorganization of the city's central square, for which Seregni provided a drawing (Milan, Castello Sforzesco, vol. ii, fol. 2) that includes a complete ground-plan of the cathedral. From the mid-16th century Seregni was in charge of the production of all necessary drawings for the cathedral and effectively became responsible for all work on the site. In 1556, after Lombardo's death, he was put in charge of the works and supervised the roofing and organization of the east end of the cathedral, where he also arranged a dignified setting for the altar and adapted the episcopal throne of Archbishop Filippo Archinto in the choir (drawing in Milan, Castello Sforzesco, vol. ii, fol. 3).

The important role played by Seregni in the cathedral probably prompted his subsequent employment on the reconstruction of the Olivetan convent of S Vittore. Here his proposal for the Great Tribune incorporated a monumental dome at the west end of the church. This reveals the influence of his Lombard background, which combined a knowledge of Late Gothic models and Milanese buildings such as the churches of S Maria delle Grazie and S Maria della Passione. Although S Vittore was subsequently built according to designs attributed to Galeazzo Alessi, Seregni's presence on the site is documented in 1552–3 from work carried out on the construction of the convent cloisters.

The cultural climate of Milan between 1547 and 1554 under the rule of Ferrante Gonzaga probably encouraged Seregni to expand his theoretical knowledge, in particular of the treatises of Cesare Cesariano and Sebastiano Serlio, from which he acquired a more precise knowledge of and ability to utilize the Classical orders, as well as a greater interest in the organic unity of plans. This new knowledge, which allowed him to become more experimental, is perceptible in the design he submitted for the tomb of *Giovanni del Conte* in the church of S Lorenzo, and also in the catafalque in the cathedral for the funeral of Charles V, Holy Roman Emperor (*reg* 1519–56), in 1559, for which the drawings survive (Milan, Bib. Ambrosiana). The same classical interests are visible in the first floor of the so-called Cloister of the Two Columns in the church of S Simpliciano (1553–9), traditionally attributed to Seregni. The influence of Serlio is also visible in the oval room that forms part of Seregni's design for the Cannobian Schools, Milan (Milan, Castello Sforzesco, vol. i).

An exuberantly decorative style of architecture was introduced in Milan through Alessi's work on the courtyard (1553–8) of the Palazzo Marino; his characteristic festoons, historiated tablets and naturalistic and figurative elements were unprecedented among Milanese architects. Seregni drew on this new vocabulary but also modified some of Alessi's features in his decorative schemes. His window-frames changed from being simple rectangular openings to areas of decorative variations incorporating broken pediments with busts in their centre and with garlands and flanking anthropo-zoomorphic figures. As a result of such work, Seregni was appointed in 1561 by Pope Pius IV as architect for the Palazzo dei Giureconsulti, Milan (see fig.). Here he incorporated a ground-floor with loggias comprising a series of arches springing from paired Tuscan columns that can be interpreted as a series of Serlian motifs. This supports a more densely articulated upper floor of decorated windows and stylized Ionic pilasters. The new building set the style for the restructuring of the whole area around the medieval Broletto and prefigured the vast Portici Settentrionali on the Piazza del Duomo. Seregni's design for the Palazzo Medici (begun 1565; inc.; destr. 19th century) superimposed Tuscan and Ionic orders, and, as at the Palazzo Giureconsulti, incorporated windows crowned with exuberant decoration in stone.

Other works attributed to Seregni include the church of S Maria presso S Celso (1556–63), where he was present for work on the façade, and the Seminario Maggiore (1565), where he carried out work on the refectory and upper dormitory. From 1564 to 1565 he is recorded as a member of the Collegio degli Ingegneri, Architetti ed Agrimensori, Milan. In 1567 he was dismissed from his position at the Cathedral Works and replaced, on the initiative of Archbishop Carlo Borromeo, by Pellegrino Tibaldi. He nevertheless continued to work both in and around Milan, and between 1570 and 1582 he undertook the reconstruction of the Certosa di Garegnano and of the church of S Giovanni in Conca (destr.). He then worked at Voghera in the convent of S Ambrogio and at Saronno on the construction of the aisles of the sanctuary of the Virgin. As late as 1590 he was called on, with Ambrogio Alciati, to judge Martino Bassi's designs for the reconstruction of the dome of the church of S Lorenzo, Milan. Seregni had a son who also became an architect (*fl*

Vincenzo Seregni: Palazzo dei Giureconsulti, Milan, begun 1561

1582–1608), and who in honour of the architectural profession was christened Vitruvio.

BIBLIOGRAPHY

C. Baroni: *Documenti per la storia dell'architettura lombarda nel rinascimento e nel barocco*, i (Florence, 1940) [for documents on S Lorenzo and S Maria presso S Celso]; ii (Rome, 1968) [for documents on the Certosa di Garegnano, S Simpliciano, S Vittore, the Palazzo dei Giureconsulti, the Scuole Cannobiane and the Seminario Maggiore]

R. Wittkower: *Gothic versus Classic: Architectural Projects in 17th-century Italy* (London, 1974)

M. Rosci: 'Il palazzo dei Giureconsulti e l'urbanistica del cinquecento a Milano', *Galeazzo Alessi e l'architettura del Cinquecento*, ed. C. Maltese (Genoa, 1975), pp. 493–500

A. Scotti: 'Per un profilo dell'architettura milanese (1535–1560)', *Omaggio a Tiziano: La cultura artistica milanese nell'età di Carlo V* (exh. cat., Milan, Pal. Reale, 1977), pp. 98–107, 110–21

——: 'I disegni cinquecenteschi per il duomo di Milano: Vincenzo Seregni nel tomo II della Raccolta Bianconi', *Il disegno di architettura: Atti del convegno: Milan, 1989*

AURORA SCOTTI TOSINI

Serlio, Sebastiano (*b* Bologna, 6 Sept 1475; *d* ?Fontainebleau, ?1553–5). Italian architect, theorist and painter, active also in France. He wrote one of the most influential architectural treatises of the Renaissance, although he began his career as a painter. After a period of study in Rome, he moved to Venice, where he established a reputation as an architectural adviser, and then to France, where he executed his only complete buildings. His treatise comprised volumes (published separately and in some cases posthumously) on aspects of architectural theory, and its visual emphasis gave it an important influence, especially in northern Europe. It also charted Serlio's stylistic development: his artistic formation occurred in the circle of Bramante in Rome, where his chief mentor was Baldassare Peruzzi; in Venice he adapted Roman themes to Venetian circumstances and building types and began to show an enjoyment of the more bizarre traits of Mannerism; finally, in France he absorbed features of the French native tradition. A woodcut portrait of Serlio in Torello Sarayna's *De origine et amplitudine civitatis Veronae* (Verona, 1540) shows a weather-beaten profile with a long nose, thickset features and a determined expression. He may also be depicted by the imposing, black-bearded figure portrayed in Lorenzo Lotto's *Portrait of an Architect* (1535; Berlin, Gemäldegal.).

1. Life and work. 2. Influence.

1. LIFE AND WORK.

(i) Architectural career. (ii) Writings.

(i) Architectural career. It is now known that Serlio's father, Bartolomeo Serlio, was not a painter (as is widely believed) but a furrier. Serlio received his first training as a perspective painter and is mentioned, in the will of Beatrice da Manfredi da Reggio, as a painter in Pesaro, where he had been for three years. He moved *c.* 1514 to Rome, where he seems to have frequented the circles of Bramante's artistic heirs and may have worked in the Vatican workshops. He was evidently much impressed by Bramante's work, later including several of Bramante's Roman projects in Book III of his treatise as examples of a revival of the 'good architecture'. In his own published designs he took over themes from Bramante, such as the elevation of the Cortile del Belvedere in the Vatican (see colour pl. 1,

XVI) and the arched window flanked by two smaller upright rectangular windows, later to become known as the Serlian window. It was Baldassare Peruzzi, however, who exerted the strongest influence on Serlio in Rome. Although six years younger, Peruzzi seems to have acted as Serlio's teacher and guide, especially in the study of Roman ruins. For instance, the two artists together surveyed the Theatre of Marcellus in 1519. By 1520 Serlio had returned to Bologna, where he was again active as a painter. Peruzzi was also in Bologna in 1522–3, and Serlio probably accompanied him back to Rome in 1523. Later, Benvenuto Cellini accused Serlio of publishing Peruzzi's work under his own name, an accusation subsequently repeated by other authors, such as Giovanni Paolo Lomazzo, but Serlio himself openly acknowledged his debt to Peruzzi.

Recent documentary discoveries have invalidated the assumption that Serlio fled from Rome at the time of the Sack of 1527. He was in fact living again in Bologna between 1525 and 1527. In 1527/8 he moved to Venice, and there is strong evidence that he took with him a number of drawings by or after Peruzzi. He was in Venice by 1 April 1528, when he made his will; one of the witnesses was Lorenzo Lotto, with whom Serlio was to remain in touch until the end of his stay in Venice. In the same year he applied to the Venetian Senate for copyright privileges for a series of burin engravings of the Classical orders, nine of which were executed, to Serlio's designs, by Agostino dei Musi. In 1528 he was living in the parish of S Giustina, but he later moved to a house on the Fondamenta di S Caterina belonging to Francesco Priuli and Federico Priuli, where he was still lodging in 1537. During the following decade he evolved the plan for his treatise and began to prepare the two initial volumes. Meanwhile, he acted as an adviser and minor designer on a variety of Venetian projects. In 1531, for example, he designed a coffered ceiling (destr.) for a room then known as the Sala della Libreria, in the Palazzo Ducale. In 1532 Marcantonio Michiel recorded that he had seen in the house of Andrea Odoni a painting by Giovanni Cariani with an architectural background by Serlio. Some time before 1535, Serlio advised on the design of a ceiling for the newly built Scuola Grande di S Rocco. In 1535 he was one of the signatories, together with Titian and the humanist Fortunio Spira, to Fra Francesco Zorzi's report on Jacopo Sansovino's design for S Francesco della Vigna. He gave advice to the patrician Francesco Zen (*d* 1538) on the design of his palace near the church of the Crociferi.

Serlio was also consulted in other towns in the Veneto region. For example, the designs of two villas near Vicenza, those of Federico Priuli at Treville and Giangiorgio Trissino at Cricoli, may have benefited from his expertise. In 1539 he was paid for his project for the restoration of the basilica in Vicenza, but his ideas were not implemented; in the same year, however, he did erect a wooden theatre in the courtyard of the Palazzo Porto–Colleoni, Vicenza, which he describes in Book II of his treatise. At about this time he visited Verona to study the antiquities, commenting in his Book III that he considered this city the most beautifully situated in all Italy. Serlio's friends in Venice were discriminating and influential. They included his publisher, Marcolini, the poet Pietro Aretino, the patricians

Gabriele Vendramin, Marcantonio Michiel and Francesco Zen, and the Paduan Alvise Cornaro. His wife, Francesca Palladia, was a lady-in-waiting to Bona Sforza, Queen of Poland. Aretino claimed that Serlio was as well versed in religion and virtuous living as in Vitruvian studies and the knowledge of antiquity. Nonetheless, he had difficulty in attracting patronage in Venice and was forced to seek sponsorship further afield.

In 1541 Serlio made the journey to France with his wife and numerous children, arriving at the court of Francis I, where he came under the patronage of the King's sister, Marguerite of Navarre. In December of that year he was appointed royal painter and architect in charge of the château of Fontainebleau. Here Serlio designed the Grotte des Pins (1541–3; sometimes attributed to Primaticcio) and the Sal du Bal (begun 1541), although he claimed that the latter was modified in execution by the French mason. For Francis I (reg 1515–47) he also designed two army camps, one in Piedmont and one in Flanders, of which no visual record survives. Between 1542 and 1546 he built a house, La Grande Ferrare (destr.), at Fontainebleau for Cardinal Ippolito II d'Este, who was Papal Legate at the French court. Its appearance is recorded in the manuscripts of Book VI of Serlio's treatise, although the patron had been unwilling to allow its inclusion. Only the entrance gateway survives, a capriciously rusticated Mannerist portal. Serlio's most notable surviving building is the château of Ancy-le-Franc (c. 1541–50), near Tonnerre in Burgundy, built for Comte Antoine de Clermont-Tonnerre. The château as built differs considerably from the versions depicted in the manuscripts of Book VI of the treatise. Serlio, by now accustomed to French architectural conventions, complained that his patron had obliged him to follow an Italianate design, changing the small windows above the cornice, and asking for orders rather than rustication on the exterior façades. The château stands around four sides of a courtyard, with square towers at the angles. The courtyard elevation returns to the theme of Bramante's Cortile del Belvedere for the Vatican, though here surmounted by French-style Mannerist dormers and a steeply pitched roof.

After the death of Francis I in 1547, Serlio was replaced as royal architect by Philibert de L'Orme and moved out of his royal lodgings into La Grande Ferrare. In 1549 Marguerite of Navarre also died, and in 1550 Serlio moved to Lyon. There he met the antiquary and art dealer Jacopo Strada, who described him as very old, living in poverty and suffering from gout. Designs for three projects executed in these years survive in graphic form only; these were the Bourse in Lyon (Vienna, Österreich. Nbib.), the Place des Marchands, also in Lyon, and a château in Provence known as Rosmarino (both depicted in Book VII of the treatise).

(ii) *Writings*. From the outset the motivation behind Serlio's treatise was didactic. In 1528, when he applied to the Venetian Senate for copyright privileges for his engraved illustrations of the orders, he described himself as 'professor di architettura' and declared his intention to issue plates of the five orders in order to improve architectural knowledge. He also planned to publish perspective views of buildings and 'various pleasing antiqui-

ties', although only two additional architectural engravings, each with the monogram SB, can be linked with this stage of the project. By 1537, however, when Serlio again applied to the Senate for copyright privileges, the undertaking had become far more ambitious, and Serlio was planning to publish several illustrated books on architecture, and hoping also to provide a Latin edition so that the books could be read outside Italy. The first instalment of the treatise was Book IV, the *Regole generale*. Published in Venice in 1537, it was dedicated to Ercole II d'Este, Duke of Ferrara, and formulated the earliest Renaissance codification of the five orders.

Serlio's starting-point was Vitruvius' De architectura. In Rome, Serlio had noticed many departures from Vitruvian rules in the buildings of the ancients; he subsequently pointed these out in more detail in Book III, remarking, for instance, that the cornice on the entablature of the Doric order of the Theatre of Marcellus is much higher than Vitruvius recommends. Serlio advised his contemporaries not to imitate such errors in their own works, urging that 'unless reason persuades us otherwise, we must take Vitruvius' doctrine as our guide and infallible rule'. Serlio's aim was to clarify and illustrate Vitruvius' rules and to give advice on their use, not to create a new system. He insisted, nevertheless, on the architect's freedom to depart from the rules when his own judgement determined. Book IV discusses each of the five orders in turn, from the Tuscan, through the Doric, Ionic and Corinthian, to the Composite, in each case suggesting modern applications. (The Composite order was not mentioned by Vitruvius, but Serlio includes it because of its frequent use in antiquity.) Fundamental to the success of the volume was its wealth of practical solutions to the problem of how to apply the orders to contemporary needs. Serlio's commonsense recommendations soon became widely used formulae. For instance, he illustrates several designs for Venetian palace fronts, with Serlian windows to allow plenty of light deep into the long central halls (see fig. 1). By the end of the 16th century this type of façade was to be found all over Venice.

In bringing Vitruvian theory up to date, Book IV attempts to elucidate the ambiguities, inconsistencies and confusions in Vitruvius' original text. Nonetheless, Serlio was not afraid to develop or even depart from Vitruvius' ideas, offering, for example, a range of rusticated orders. Such flexibility gave him the licence to express the incipient Mannerism that runs through Book IV, and which he was to develop further in France. He was not opposed to invention, provided that the architect was aware of his departures from Vitruvian principles. Ornament, he felt, should spring initially from the function of the building, but for the sake of art decoration might go beyond functional necessity. This relaxed attitude is evident in Serlio's suggestions for chimney-pieces, for which there were no antique precedents, either Vitruvian or archaeological. His bizarre, often witty designs are a vivid illustration of his own fertile imagination.

The second volume to be published was Book III, *Delle antichità*, published in Venice in 1540 and dedicated to Francis I, King of France. In the prospectus in Book IV Serlio had stated that Book III would illustrate by means of plan, elevation and section the antique buildings of

1. Sebastiano Serlio: design for the façade of a Venetian palace, 1540; from his *Tutte l'opere d'architettura et prospetiva* (Venice, 1619) (London, British Library)

Rome, as well as those of Italy and beyond. His aim was to provide a useful corpus of ancient Roman buildings, plus a few High Renaissance masterpieces, to serve as a source of ideas for architects and builders. A similar technique had been recommended by Raphael in a letter to Pope Leo X written when he was beginning to make a complete graphic record of ancient Rome. Serlio may have been aware of Raphael's methods and intentions. Raphael had realized that orthogonal projection must be used to allow accurate representation and to eliminate the distortions of perspective. Serlio, however, used a mixture of orthogonal projection and perspective recession, often combining the two in one illustration. His section of the Pantheon (see fig. 2), for example, is shown entirely orthogonally, except for the niche and oculus, which are seen in perspective. Shading is used to give a more vivid impression. Thus accuracy is sacrificed for the sake of instant realism. In his illustration of the circular Temple of Vesta at Tivoli, Serlio used the graphic convention, later perfected by Palladio, of placing the section and elevation on two halves of the same plate, with the plan beneath, drawn to the same scale. Nevertheless, although the exterior is shown in orthogonal projection, the interior is shown in perspective. The irregular cutting away of the front elevation to reveal the section at one side adds to the picturesque effect. There is no rigid consistency in the presentation of Book III. The buildings are generally shown complete, rather than ruined, with imaginary recon-

struction where necessary. A touch of nostalgia is added in the details, which are roughly cut away to appear like ruined fragments.

The illustrations of Roman buildings were based on drawings that Serlio had brought from Rome, which, as Serlio acknowledged, depended heavily on Peruzzi's example. Some, such as the plan of the Pantheon, are even based on known drawings by Peruzzi. The drawings of Pula and Verona were acquired during his years in Venice. Serlio apologized for deficiencies in the measurements of the theatre at Pula, adding that the monument had been surveyed by a draughtsman who was 'more skilled in drawing than in mathematics', thereby implying he had used drawings by another hand. *Delle antichità* concludes with a three-page essay on the antiquities of Egypt, based on information supplied by a Venetian friend Marco Grimani, Patriarch of Aquileia, who also furnished him with drawings of the pyramid at Cairo. Of the buildings of ancient Greece, however, Serlio knew litle, apart from what he could learn from Vitruvius. The only Greek building illustrated is a fanciful hypostyle hall 'with a hundred columns'.

Books I and II of the treatise, on geometry and perspective respectively, were issued in Paris in 1545 and were dedicated, like Book III, to Francis I. At the end of Book II Serlio included a small but highly influential section on stage design entitled 'Trattato sopra le scene'. Compositions based on the idea of stage sets had been popular subjects for artists since the developments in perspective of the early 15th century, and Peruzzi was one of the finest exponents of such scenes. Serlio had also witnessed attempts in Rome to revive antique theatrical settings, for example at Peruzzi's Villa Farnesina (*see* PERUZZI, BALDESSARE, fig. 1) and Bramante's Cortile del Belvedere, while Raphael's Villa Madama had been designed to incorporate a hillside theatre; in Padua, Alvise Cornaro's house had been the setting for open-air plays. Serlio himself particularly admired the stage sets of Girolamo Genga for Francesco Maria I della Rovere, Duke of Urbino, and he himself had built a wooden theatre in the

2. Sebastiano Serlio: section of the Pantheon, Rome, 1540; from his *Tutte l'opere d'architettura et prospetiva* (Venice, 1619) (London, British Library)

courtyard of the Palazzo da Porto–Colleoni in Vicenza. The stage designs illustrated in Serlio's Book II were the first published reconstructions of the three types of scenery described by Vitruvius: Comic, Tragic and Satiric. The Comic scene reveals an urban piazza with a heterogeneous assembly of buildings, both Gothic and Classical, modest and ostentatious. In the Tragic scene, also an urban setting, the buildings are uniformly grand and classical in style, and prosaic details are replaced by antique statuary and obelisks (see fig. 3). The Satiric scene, by contrast, depicts a rustic landscape with rocks, trees and thatched cottages. Palladio and Inigo Jones were among the later architects who learnt from Serlio's advice on theatrical design.

Book V of the treatise, on temples, was published in Paris in 1547 and was dedicated to Marguerite of Navarre. The intention was to provide not a compendium of antique examples but a series of suggestions for the modern church architect. There is a touch of pragmatism in Serlio's decision to concentrate on small churches, because he had seen so many larger churches left unfinished. Nevertheless, most of the projects are highly idealized. Serlio himself had had no ecclesiastical commissions to give him practical experience. Like Alberti, he clearly preferred the centralized plan, but in addition to the circle and the Greek cross he offered an oval plan, a hexagon, a pentagon and two octagonal designs. Serlio's oval plan, based on a theme explored by Peruzzi, was the first such church design to be published, anticipating its popularity in the 17th century, when the oval was used, for example, by Gianlorenzo Bernini (1598–1680) for S Andrea Quirinale, Rome (1661). His last few projects are variations on the Latin cross. His aesthetic preference was for churches with chapels and niches excavated from the thickness of the walls, in the tradition of such ancient Roman models as the Pantheon.

Book VI, on domestic architecture and dedicated to Henry II, remained unpublished until 1966, although two manuscript versions exist (1541–6 and 1546–53; see Writings below). In it Serlio illustrated a wide spectrum of residential buildings, from housing for the poor to the grandest royal palace, in both town and country. Few architects at this time were involved in the design of housing for the poor. Alvise Cornaro had considered the question of popular housing in his manuscript treatise on architecture, but without providing such graphic information. Equally radical, in the context of the Renaissance architectural treatise, was Serlio's willingness to embrace the French architectural tradition as well as the classical Italian manner, whether antique or Renaissance. He in no way regarded French models as inferior and even illustrated Alvise Cornaro's own house in Padua, the Odeo Cornaro, with a steeply pitched roof and French-style Mannerist dormers, presumably as a suggested improvement. He particularly admired French domestic planning and intended to combine French comfort with Italian style and ornament, as he had done in his house for the Cardinal of Ferrara at Fontainebleau, where he adapted the plan of the 15th-century French town-house type, with a *corps de logis* at the back of a walled forecourt, a gallery wing on the left and a wing of minor apartments on the right. Serlio often illustrates French and Italian alternative schemes side by side, the French design with high, steeply pitched roofs or gables and ornately decorated dormers, the Italian one plainer, more horizontal in emphasis and more correct in classical detail. In the later, revised version of Book VI in Munich, even the French alternatives are more Italianate in style, probably in order to please his French patrons, who wanted a more academic approach and a more Italian manner.

Book VI shows Serlio at his most creative. While some of his schemes were realistic and sensible, others were huge and fantastic, such as the palace in the form of an amphitheatre. The most prophetic of his domestic designs were his projects for Italian-style villas. One of his themes for this type of house consisted of a symmetrical plan with a central hall flanked by suites of living rooms on either side, in the Venetian manner. Typically he would raise the *piano nobile* above a basement storey and place a loggia at the front or rear of the building. Schemes of this type closely resemble Palladio's early villa designs. Another popular theme in Book VI was the villa with a circular, domed, central hall, a formula that anticipated Palladio's Villa Rotonda, near Vicenza.

A manuscript of Book VII, on accidents and unusual situations in building, was purchased from Serlio by Jacopo Strada, and published by him in Frankfurt am Main in 1575. It contains a further innovation among Serlio's domestic schemes, namely the first published advice on

3. Sebastiano Serlio: design for a Tragic stage scene, 1545; from his *Tutte l'opere d'architettura et prospetiva* (Venice, 1619) (London, British Library)

how to restore and update an older house to suit modern tastes and needs. Serlio also prepared two further texts in France. One was a series of 30 rusticated Mannerist doorways known as the *Extraordinario libro di architettura*, his only book to be published with copper engravings rather than woodcut plates. The other was *Della castratametatione di Polibio*, an edition of Polybius' text that may have been intended as a possible eighth volume in Serlio's treatise, although its form and scope are rather different. Strada claimed that he had it printed as Book VIII in Frankfurt am Main in 1576. No printed copies are known, but the final manuscript is now in Munich (Bayer. Staatsbib.).

The most widely used complete edition of Serlio's works in Italian, *Tutte l'opere d'architettura et prospetiva*, a quarto edition published in Venice in 1619, included Books I–V and Book VII, with the *Extraordinario libro* inserted to form the missing sixth book. Numerous other editions appeared during the 16th century and later, testifying to the great popularity of the work. The books were soon translated into other languages: Book IV was translated into Dutch by Pieter Coecke van Aelst and published as early as 1549 in Antwerp, and also into French, in 1545; Book III was translated into French in 1550; Books I and II were published in Flemish and French in 1553, and in German in 1608. Books I–V were issued in English in London in 1611, translated from Coecke van Elst's Dutch translation, probably by Robert Peake.

2. INFLUENCE. Serlio was an enthusiastic and effective communicator, but he was also a pioneer, providing the first architectural treatise of the Renaissance to convey its content chiefly by visual means. His texts played a subsidiary role, being conceived merely as explanations and commentaries to accompany the woodcut plates. Although two early 16th-century editions of Vitruvius' *Ten Books on Architecture*—those of Fra Giovanni Giocondo (Venice, 1511) and Cesare Cesariano (Como, 1521)—had already been provided with illustrations, these were subordinate to the written text. Other illustrated architectural treatises existed in manuscript form, including that of Francesco di Giorgio Martini, which in many ways anticipates Serlio's treatise, though the influence was possibly transmitted through Peruzzi rather than directly. Serlio would also have known the fine architectural sketchbooks of High Renaissance Rome, such as those of Giuliano da Sangallo. Despite these, however, Serlio must take the credit for publishing the first wide-ranging, fully illustrated architectural treatise of the Renaissance. The writings of Leon Battista Alberti were read by discerning, educated patrons but were inaccessible to those with no classical education. By contrast, Serlio's volumes, with their bold, lively illustrations, could be used by craftsmen simply as pattern books, in the long-established medieval tradition. Thus his publications became the single most effective channel through which Renaissance architecture spread across Europe.

Outside Italy, in particular, Serlio's treatise had widespread and immediate success. As early as the 1550s the town hall of Poznań in western Poland, built by Giovanni Battista Quadro, reflected decorative motifs from his

books, while the Ottoheinrichsbau of Heidelberg Castle, built in the same decade, reveals the influence of Serlio's treatise in its tiers of Classical orders. The town hall (1560–64) at Antwerp by Cornelis Floris (1513/4–75) uses Serlian motifs in its decorated centrepiece; in England the plan of Wollaton Hall (1580–88) by Robert Smythson (1534/5–1614) was inspired by Serlio's woodcuts in his Book III of Poggio Reale in Naples; while in Scotland the ground-plan of Heriot's Hospital (begun 1628), Edinburgh, is based on Serlio's château of Rosmarino in Provence. Even unpublished schemes from Book VI were circulated and made their impact. Provincial builders in northern Europe used Serlio's books as traditional pattern books, drawing on his rich store of lively Mannerist decoration. However, their interest was eclectic and undogmatic: they would often draw on a wide range of illustrated books, including those of northern authors such as Wendel Dietterlin (1550/1–99) and Adriaen de Vries (*c.* 1545–1606). Only the more sophisticated northern architects, such as Philibert de L'Orme (1585–1646) and Inigo Jones (1573–1652), investigated the underlying discipline of the orders, and perfected their understanding both through visits to Italy and through the study of other, more erudite, Italian theorists, such as Alberti and Palladio. Yet even de L'Orme was able to appreciate the significance of Serlio's contribution, considering him the first to have given the French their knowledge of antique buildings.

Serlio's contribution to posterity has tended, however, to be overshadowed by the greater sophistication of Palladio's *I quattro libri dell'architettura*. Yet even before Serlio's first books appeared, his drawings seem to have been known to architects and patrons in Venice and the Veneto, and both there and in France he had a profound influence on the native architectural tradition. Palladio himself incorporated some of Serlio's ideas into his designs, such as the two-storey arcade with the Serlian motif for his own basilica in Vicenza. He also took over Serlio's didactic innovations, making the illustrative content the principal focus of his treatise and intertwining theory and practice. Serlio's pioneering exposition of the hierarchy of the five orders and his stress on the architect's own judgement transformed Vitruvian classicism, rendering it both more systematic and more flexible.

UNPUBLISHED SOURCES

Munich, Bayer. Staatsbib. [MS. of *Della castratametatione di Polibio*]

WRITINGS

Regole generale di architettura sopra le cinque maniere de gli edifici cioè Thoscano, Dorico, Ionico, Corinthio, et Composito (Venice, 1537) [Book IV; It. text]
Delle antichità: Il terzo libro nel quale si figurano e descrivono le antichità di Roma e le altre che sono in Italia e sopra Italia (Venice, 1540) [It. text]
Sesto libro (MS. 1541–6; New York, Columbia U., Avery Archit. & F.A. Lib); ed M. N. Rosenfeld (Cambridge, MA and London, 1978); and (MS. 1546–53; Munich, Bayer. Staatsbib.); ed. M. Rosci as *Delle habitationi di tutti li gradi degli homini . . .*, 2 vols (Milan, 1966)
De geometrie: Il primo libro d'architettura (Paris, 1545) [It. and Fr. texts]
De perspective: Il secondo libro di prospettiva (Paris, 1545) [It. and Fr. texts]
Quinto libro d'architettura nel quale se tratta di diverse forme di tempii (Paris, 1547) [It. and Fr. texts]
Extraordinario libro di architettura (Lyon, 1551) [It. and Fr. texts]
Il settimo libro d'architettura nel quale si tratta di molti accidenti (Frankfurt am Main, 1575) [It. and Lat. texts]
The Book of Architecture by Sebastiano Serlio (London, 1611); facs. ed. A. E. Santaniello (New York, 1980) [Eng. trans. of Books I–V]; Eng. trans. as *Sebastiano Serlio on Architecture, i: Books I–IV of Tutte L'Opere d'architettura et prospetiva* (New Haven and London, 1996)

Tutte l'opere d'architettura et prospetiva di Sebastiano Serlio bolognese (Venice, 1619/*R* Farnborough, 1964) [contains Books I–V, Book VII and the *Extraordinario libro*]

BIBLIOGRAPHY

G. P. Lomazzo: *Idea del tempio della pittura* (Milan, 1590), p. 17

A. B. Amorini: *Elogio di Sebastiano Serlio architetto bolognese* (Bologna, 1823)

B. Cellini: 'Della architettura', *La vita di Benvenuto Cellini*, ed. A. J. Rusconi and A. Valeri (Rome, 1901), pp. 797–8

G. C. Argan: 'Sebastiano Serlio', *L'Arte*, n. s., x (1932), pp. 183–99

W. B. Dinsmoor: 'The Literary Remains of Sebastiano Serlio', *A. Bull.*, xxiv (1942), pp. 55–91, 115–54

R. Krautheimer: 'The Tragic and Comic Scene', *Gaz. B.-A.*, n. s. 6, xxxiii (1948), pp. 327–46

A. Blunt: *Art and Architecture in France*, Pelican Hist. A. (Harmondsworth, 1953, rev. 4/1982), pp. 72–9

P. Aretino: *Lettere sull'arte*, ed. E. Camesasca, 2 vols (Milan, 1957)

——: *Lettere: Il primo e il secondo libro*, ed. F. Flora (Milan, 1960), pp. 240–42

C. Gould: 'Sebastiano Serlio and Venetian Painting', *J. Warb. & Court. Inst.*, xxv (1962), pp. 56–64

W. Timofiewitsch: 'Ein Gutachten Sebastiano Serlios für die Scuola di San Rocco', *A. Ven.*, xvii (1963), pp. 158–60

M. Rosci: *Il trattato di architettura di Sebastiano Serlio: Commento al sesto libro* (Milan, 1966); review by M. N. Rosenfeld in *A. Bull.*, lii (1970), pp. 319–22

W. Wolters: *Plastische Deckendekorationen des Cinquecento in Venedig und im Veneto* (Berlin, 1968)

C. Lewis Kolb: 'Portfolio for the Villa Priuli: Dates, Documents and Designs', *Boll. Cent. Int. Stud. Archit. Andrea Palladio*, xi (1969), pp. 353–69

M. N. Rosenfeld: 'Sebastiano Serlio's Late Style in the Avery Library Version of the Sixth Book on Domestic Architecture', *J. Soc. Archit. Historians*, xxviii (1969), pp. 155–72

S. Wilinski: 'La serliana', *Boll. Cent. Int. Stud. Archit. Andrea Palladio*, xi (1969), pp. 399–429

W. Wolters: 'Sebastiano Serlio e il suo contributo alla villa veneziana prima del Palladio', *Boll. Cent. Int. Stud. Archit. Andrea Palladio*, xi (1969), pp. 83–94

L. Olivato: 'Per il Serlio a Venezia: Documenti nuovi e documenti rivisitati', *A. Ven.*, xxv (1971), pp. 284–91

L. Puppi: 'Un letterato in villa', *A. Ven.*, xxv (1971), pp. 72–91

D. Howard: 'Sebastiano Serlio's Venetian Copyrights', *Burl. Mag.*, cxv (1973), pp. 512–16

M. N. Rosenfeld, ed.: *Sebastiano Serlio on Domestic Architecture . . . The Sixteenth-Century Manuscript of Book VI in the Avery Library of Columbia University* (Cambridge, MA, and London, 1976)

H. Gunther: 'Studien zum venezianischen Aufenthalt des Sebastiano Serlio', *Münch. Jb. Bild. Kst*, xxxii (1981), pp. 42–94

E. Concina: 'Fra oriente e occidente: Gli Zen, un palazzo e il mito di Trebisonda', *'Renovatio Urbis': Venezia nell'età di Andrea Gritti, 1523–1538*, ed. M. Tafuri (Rome, 1984), pp. 265–90

M. Tafuri: *Venezia e il rinascimento* (Turin, 1985)

A. Jelmini: *Sebastiano Serlio: Il trattato di architettura* (Locarno, 1986) [incl. list of principal edns of the treatise and further bibliog.]

J. Guillaume, ed.: *Les Traités d'architecture de la Renaissance* (Paris, 1988), pp. 207–62

C. Thoenes, ed.: *Sebastiano Serlio: Sesto seminario internazionale di storia dell'architettura: Milan, 1989*

L. Olivato: 'Sebastiano Serlio a Ferrara', *Duca Ercole I e il suo architetto Biagio Rossetti: Architettura e città nella Padania tra Quattro e Cinquecento: Rome, 1993*, pp. 89–93

F. Lemerle: 'Genèse de la théorie des ordres: Philandrier et Serlio', *Rev. A.*, ciii (1994), pp. 33–41

V. Hart and A. Day: 'A Computer Model of the Theatre of Sebastiano Serlio, 1545', *Computers & Hist. A.*, v, pt 1 (1995), pp. 41–52

☐

Sermoneta, Girolamo Siciolante da. *See* SICIOLANTE, GIROLAMO.

Sesto, Cesare da. *See* CESARE DA SESTO.

Settignano, Desiderio da. *See* DESIDERIO DA SETTIGNANO.

Settignano, Simone da. *See* CIOLI, (1).

Severo (di Domenico Calzetta) da Ravenna (*fl c.* 1496–*c.* 1543). Italian sculptor. His father, Domenico Calzetta, was probably a sculptor, and he may have been related to the two painters of the same name working in the circle of Mantegna in Padua: Pietro Calzetta (*c.* 1455–?86) and Francesco Calzetta (*fl* 1492–1500). Severo appears to have divided his time between Padua, Ferrara and Ravenna, where he was first recorded in 1496. From 1511, when he made statues for the visit to Ravenna of Pope Julius II, he appears to have remained in that city; the last notice of him there is in 1525. Severo's only securely documented work is the signed, ascetic marble figure of *St John the Baptist*, commissioned in 1500 for the entrance to the chapel of S Antonio in Il Santo, Padua (*in situ*). In his treatise *De sculptura* (1504), the Neapolitan art theorist Pomponius Gauricus singled out Severo for special mention at the end of his section on bronze sculpture, suggesting that by that date he was an established bronze sculptor, although no specific work is mentioned.

A bronze group of *Neptune and a Dragon* (New York, Frick), formerly attributed to the Master of the Dragon, has been attributed (Planiscig) to Severo by comparison with a single bronze *Dragon* (New York, Frick) signed O. SEVERI. RA, which closely corresponds with the signature on *St John the Baptist*. Other works, many formerly attributed to Andrea Riccio and Bartolomeo Bellano or their assistants, that are now attributed (Avery and Radcliffe) to Severo include *St John the Baptist* (Oxford, Ashmolean), in which the distinctive linear drapery style and sensitively modelled tapered hands resemble those of the Paduan marble figure, *Queen Tomyris with the Head of Cyrus* (New York, Frick) and *St Christopher* (Paris, Louvre), which, reunited with its lost *Christ Child* (Washington, DC, N.G.A.), establishes a child-type for Severo.

A signed *Kneeling Satyr* (priv. col., see Avery and Radcliffe, fig. 5), a version of a composition commonly ascribed to Riccio, has provided a second firmly attributable work around which several similar bronze *Satyrs* of *c.* 1500 have been grouped; their predating Riccio's versions suggests that they served as his model rather than vice versa, as hitherto assumed. The distinctive chiselled hair, tapered fingers and facture common to all Severo's bronzes have been recognized also in *Corpus Christi* (Cleveland, OH, Mus. A.) and *St Sebastian* (Paris, Louvre).

BIBLIOGRAPHY

W. Bode: *Die italienischen Bronzestatuetten der Renaissance* (Berlin, 1907; Eng. trans. by J. D. Draper, New York, 1980)

L. Planiscig: 'Severo da Ravenna (der Meister des Drachens)', *Jb. Ksthist. Samml. Wien*, n. s., ix (1935), pp. 75–86

Italian Bronze Statuettes (exh. cat., ed. J. Pope-Hennessy; London, V&A, 1961), nos 72–3

B. Jestaz: 'Une statuette de bronze: Le Saint Christophe de Severo da Ravenna', *Rev. Louvre*, xxii/2 (1972), pp. 67–78

A. Sartori: *Documenti per la storia dell'arte a Padova* (Vicenza, 1976), pp. 36–7

U. Middeldorf: 'Glosses on Thieme–Becker, III, Severo da Ravenna', *Festschrift Otto von Simson* (Frankfurt am Main, 1977), p. 290

C. Avery and A. Radcliffe: 'Severo Calzetta da Ravenna: New Discoveries', *Studien zum europäischen Kunsthandwerk: Festschrift Yvonne Hackenbroch* (Munich, 1983), pp. 107–22

S. Blake McHam: *The Chapel of St Anthony at the Santo and the Development of Venetian Renaissance Sculpture* (Cambridge, 1994), pp. 40, 66, n. 4, 95, 115, 130–31

☐

Sezze, Paolo di Mariani di Tuccio Taccone da. *See* PAOLO ROMANO.

Sforza. Italian family of rulers and patrons. The family ruled Milan from 1450 until 1535, with two interruptions (1499–1512; 1515–21) when they were ousted by the French (*see* MILAN, §§I, 2 and II, 1). The founder of the dynasty was (1) Francesco Sforza I who married (3) Bianca Maria, the illegitimate daughter of Filippo Maria Visconti, Duke of Milan (*see* VISCONTI (5)), and declared himself Duke in 1450. The Sforza court brought several notable artists and architects to Milan; in particular (5) Ludovico Sforza employed Leonardo da Vinci during an 18 year period and also utilized Donato Bramante on various architectural projects in Milan. With the death (1535) of (8) Francesco Sforza II, Milan passed to the Habsburgs. (2) Alessandro Sforza, Lord of Pesaro, the brother of Francesco I, was a notable architectural patron in Pesaro, while (6) Cardinal Ascanio Maria Sforza financed the new cathedral at Pavia as well as collecting books and manuscripts.

BIBLIOGRAPHY

L. Beltrami: *Il Castello di Milano sotto il dominio dei Visconti e degli Sforza* (Milan, 1894)
G. Clausse: *Les Sforzas et les arts en Milanais, 1450–1530* (Paris, 1909)
F. Wittgens: 'La pittura lombarda nella seconda metà del quattrocento', *Stor. Milano*, vii (1956), pp. 749–836
C. Santoro: *Gli Sforza* (Varese, 1968)
G. A. dell'Aqua: *Gli Sforza a Milano* (Milan, 1978)
E. S. Welch: *Art and Authority in Renaissance Milan* (New Haven, 1995)

E. S. WELCH

(1) Francesco I Sforza [Attendolo], Duke of Milan (*b* San Miniato, 23 July 1401; *reg* 1450–66; *d* Milan, 8 March 1466). He was the son of the condottiere Muzio Attendolo and established himself as one of the most important military figures in 15th-century Italy. In 1441 he married (3) Bianca Maria, the illegitimate daughter of Filippo Maria Visconti, Duke of Milan. Following Filippo Maria's death in 1447 and a short-lived attempt by the Milanese to create a republic (the Ambrosian Republic), Sforza declared himself Duke in 1450. His sponsorship of the arts was primarily directed towards religious and civic building projects. During the first ten years of his rule his patronage was dominated by the need to reconstruct and restore major Visconti fortresses, particularly the Castello Sforzesco, Milan, which had been destroyed during the Ambrosian Republic. Francesco also took up the traditional ducal sponsorship of the building of Milan Cathedral, and the Certosa di Pavia (*see* PAVIA, §2).

Francesco's personal contribution was the construction of the Ospedale Maggiore in Milan. His intention to create a new hospital based on Tuscan models was first expressed in 1451, but building did not begin until 1456, when the Florentine FILARETE was chosen as its architect. The resulting fusion of Tuscan design and local Lombard craftsmanship created one of the most eminent buildings in the city. Francesco's support of Filarete has always been considered his most significant achievement as a patron. The architect, called to Milan in 1452, was appointed Cathedral Master in 1454, despite local opposition. He was also involved in the design for the central tower of the Castello Sforzesco. Filarete hoped that Sforza would

act as an enlightened patron and expressed his gratitude by dedicating his *Trattato di architettura* (1461–4) to Francesco. The work, devised as a series of conversations between the architect, his patron, and the Sforza heir, (4) Galeazzo Maria Sforza, includes a description of an ideal city named Sforzinda, but many of Filarete's commissions in Milan, including the hospital and the castle tower, are also mentioned. Filarete's hopes for Sforza support were eventually unfulfilled. He left Milan in 1465 abd rededicated his treatise to Piero dei Medici.

Sforza's use of Tuscan artists and architects caused dissent among the Lombard artistic community. Another Florentine, BENEDETTO FERRINI, was a long-serving military engineer and architect to Francesco and also acted as intermediary in an abortive attempt to procure a marble sculpture and a pair of stucco *Virgins* from Desiderio da Settignano in Florence. He was often in conflict with Sforza's official supervisor of works, the Cremonese Bartholomeo da Gadio (1414–84), who felt that traditional Lombard methods of construction were more stable and better suited to Sforza's plans.

While it may be an accident of documentation, Francesco seems to have been less supportive of painters. His secular commissions were confined to the restoration of interior decorations ordered by the Visconti, and there were few major religious commissions. Between 1463 and 1469 Bonifacio Bembo is recorded as painting an altarpiece in the chapel of SS Daria e Grisante, S Agostino, Cremona, in honour of the saints whose feast day coincided with the day of Sforza's marriage. A pair of detached frescoed portraits of the married couple (Cremona, S Agostino) can be associated with this project. The painter Vincenzo Foppa also enjoyed Francesco's patronage: in 1461 the Duke wrote to the priors of Genoa Cathedral asking them to treat the artist with more consideration. In 1463 Foppa was at work on an image of the *Virgin and Child* (untraced) for the Duke.

BIBLIOGRAPHY

M. Caffi: 'Di alcuni maestri di arte nel secolo XV in Milano poco noti o male indicati', *Archv Stor. Lombardo*, v (1878), pp. 83–4
L. Belhami: *La 'Ca' del Duca' sul Canal Grande ed altre reminiscenze Sforzesche in Venezia* (Milan, 1900)
R. Giollo: *Bartholomeo Gadio e l'architettura militare* (Milan, 1935)
J. R. Spencer, ed.: *Filarete's Treatise on Architecture*, 2 vols (New Haven, 1965)
J. Spencer: 'Francesco Sforza and Desiderio da Settignano: Two New Documents', *A. Lombarda*, xiii (1968), pp. 131–3
L. Grassi: 'Il glorioso albergo de' poveri di Dio sotto Francesco Sforza, duca quarto di Milano', *La Ca' Grande* (Milan, 1981), pp. 23–44
M. B. Verga: 'Documenti per Benedetto Ferrini: Ingegnero ducale sforzesco, 1453–1479', *A. Lombarda*, n.s., lx (1981), pp. 49–102
F. Caglioti: 'Francesco Sforza e il Filelfo, Bonifacio Bembo e 'compagni': Nove prosopopee inedite per il ciclo di antichi eroi ed eroine nella Corte Ducale dell'Arengo a Milano (1456–c.61), *Mitt. Ksthist. Inst. Florenz*, xxxviii/2–3 (1994), pp. 183–217
F. Petrucci Nardelli: 'La biblioteca Visconteo Sforzesco: Ubicazione e disposizione del materiale librario', *Bibliofilia*, xcvii/1 (Jan–April 1995), pp. 21–33
E. S. Welch: *Art and Authority in Renaissance Milan* (New Haven, 1995)

E. S. WELCH

(2) Alessandro Sforza, Lord of Pesaro (*b* Cotignola, Oct 1409; *d* La Fosse, Ferrara, April 1473). Half-brother of (1) Francesco I Sforza. He ruled Pesaro as papal vicar from 1445 to his death, although he was principally a mercenary soldier and worked for Florence, the Papacy,

Naples, Venice and Milan. In spite of this, however, his economic resources seem always to have been weak, which affected his patronage. During the early part of his rule in Pesaro he was primarily concerned with consolidating his newly acquired territory and improving the fortifications of Pesaro (*see* PESARO (i), §1). He moved into the town palace that had been the residence of his predecessors, the Malatesta, and spent approximately 25 years substantially altering and enlarging it. In 1469 he began constructing the Villa Imperiale outside Pesaro (*see* PESARO (i), §3). Although both the town palace and the villa incorporated pre-existing structures, certain architectural elements of both buildings, as well as the plan of the Imperiale, reveal that Alessandro had carefully studied the most modern palaces of his day: the Palazzo Medici, Florence, the Palazzo Piccolomini, Pienza, the Palazzo Venezia, Rome, and the Palazzo Ducale, Urbino. The similarities between the entrance portals at the town palace and the villa and between the elevation of the palace portico and that of the villa courtyard are not to be understood as uninspired repetitions, but rather as expressions of Alessandro's established image of his social and political position. Alessandro was not an active patron of the pictorial arts, although he acquired a few works by Rogier van der Weyden (*c.* 1399–1464), for example the Sforza Triptych of *Christ on the Cross* (mid-1440s; Brussels, Mus. A. Anc.; probably by an assistant), Melozzo da Forlì and Antoniazzo Romano, and he attempted to patronize Mantegna. He was, however, a keen book collector, for which he was praised by Vespasiano da Bisticci, who also described the room that Alessandro built in the town palace especially to house his library.

BIBLIOGRAPHY

Vespasiano da Bisticci: *Vite di uomini illustri* (1480s; Bologna, Bib. U., MS. 1452); ed. A. Greco (Florence, 1970); Eng. trans. by W. G. Waters and E. Waters as *Renaissance Princes, Popes and Prelates: The Vespasiano Memoirs* (London, 1926/R New York, 1963)

A. Olivieri: *Memorie di Alessandro Sforza* (Pesaro, 1785)

G. Vaccaj: *Pesaro: Pagine di storia e di topografia* (Pesaro, 1909), pp. 73–102

L. Valle: *Il canzoniere di Alessandro Sforza* (Genoa, 1917)

C. H. Clough: 'A Note of Purchase of 1467 for Alessandro Sforza's Library in Pesaro', *Stud. Oliveriana*, xiii–xiv (1965–6), pp. 171–8

G. Mulazzani: 'Observations on the Sforza Triptych in the Brussels Museum', *Burl. Mag.*, cxiii (1971), pp. 252ff

S. Eiche: *Alessandro Sforza and Pesaro: A Study in Urbanism and Architectural Patronage* (diss., Princeton U., NJ, 1982)

——: 'Towards a Study of the *famiglia* of the Sforza Court of Pesaro', *Ren. & Reformation*, ix (1985), pp. 79–103

——: 'The Villa Imperiale of Alessandro Sforza at Pesaro', *Mitt. Ksthist. Inst. Florenz*, xxix (1985), pp. 229–74

——: 'La corte di Pesaro dalle case malatestiane alla residenza roveresca', *La corte di Pesaro*, ed. M. R. Valazzi (Modena, 1986), pp. 13–55

P. Castelli: 'La kermesse degli Sforza pesaresi', *Mesura ed arte del danzare: Guglielmo Ebreo da Pesaro e la danza nelle corti italiane del XV secolo*, ed. P. Castelli, M. Mingardi and M. Padovan (Pesaro, 1987), pp. 13–33

S. Eiche: 'The Sforza Antiquities: Two Wills and a Collection', *Mitt. Ksthist. Inst. Florenz*, xxxi (1987), pp. 162–7

——: 'Architetture sforzesche', *Pesaro tra medioevo e rinascimento, Historica Pisaurensia*, ii, ed. M. R. Valazzi (Venice, 1989), pp. 269–303

SABINE EICHE

(3) Bianca Maria Sforza [née Visconti], Duchess of Milan (*b* Settimo Milanese, 31 March 1425; *d* Melegnano, 28 Oct 1468). Wife of (1) Francesco I Sforza. She was the illegitimate and only child of Filippo Maria Visconti, Duke of Milan (*see* VISCONTI (5)), and, after her marriage in

1441, used her influence to win Milan's acceptance of the Sforza family. One of her many acts of patronage was to send the portrait painter ZANETTO BUGATTO to study under Rogier van der Weyden in Brussels in 1460. Her piety led to the construction of numerous new churches, which were innovative in design. In 1460 she founded S Nicola, Milan, attached to S Maria Incoronata, a church built by her husband nine years earlier. Also in 1460 she gave S Maria Bressanoro, Castelleone, one of the earliest centrally planned churches of the Renaissance in Italy, to Fra Amedeo Menez de Sylva, a Portuguese Observant Franciscan; S Maria della Pace, Milan, was begun for him by Bianca Maria in 1466. S Pietro in Gessate, Milan, also built at her command, dates from *c.* 1475. Her patronage was not confined to Milan: she donated a gold votive image and an illuminated Missal to S Antonio in Padua in thanksgiving for the recovery of her son (5) Ludovico Sforza from illness. At her death, there were numerous artists, including Bugatto and members of the Vaprio family, among her creditors.

BIBLIOGRAPHY

M. Caffi: 'Creditori della duchessa Bianca Maria Sforza', *Archv Stor. Lombardo*, iii (1876), pp. 534–42

——: 'Bianca Maria Visconti e San Antonio da Padova', *Archv Stor. Lombardo*, xiii (1886), pp. 400–13

W. Terni de Gregory: *Bianca Maria Visconti, duchessa di Milano* (Bergamo, 1940)

C. Gould: 'The Early History of Leonardo's *Vierge aux Rochers* in the Louvre', *Gaz. B.A.*, cxxiv/1511 (1994), pp. 216–22

E. S. Welch: *Art and Authority in Renaissance Milan* (New Haven, 1995)

——: 'Women as Patrons and Clients in the North Italian Courts', *Woman, Culture and Society in the Italian Renaissance* (Oxford, 1999)

E. S. WELCH

(4) Galeazzo Maria Sforza, Duke of Milan (*b* Fermo, 14 Jan 1444; *reg* 1466–76; *d* Milan, 27 Dec 1476). Son of (1) Francesco I Sforza and (3) Bianca Maria Sforza. Lacking a juridical right for his father's conquest of the duchy of Milan, his ten-year rule was dominated by the need to legitimize Sforza control. He emphasized his Visconti descent through his mother by supporting such traditional Milanese projects as the construction of Milan Cathedral and the Certosa di Pavia. His greatest contributions, however, concerned the building of a new residence within the Castello Sforzesco in Milan and the redecoration of the Castello in Pavia. Between 1469 and 1474 a series of programmes for fresco cycles was drawn up. At the Castello in Pavia there were to be scenes of court life—hunting, public audiences, banquets, the Duke dressing—and portraits of courtiers and servants; those at the Castello Sforzesco were to depict similar images of hunting, court life and ceremony, including a display of the annual procession of the Sforza army on the feast of St George. These works, however, have not survived; indeed, in the case of the Milanese frescoes, they may never have been executed. Some decorative paintings in the chapel and halls of the Castello Sforzesco commissioned by Galeazzo Maria do, however, remain.

Galeazzo Maria's innovative ideas were rarely carried out, usually due to lack of funds. In 1473 he attempted to find a sculptor to create a bronze equestrian monument to Francesco Sforza I and also tried to found a lazzaretto. More successful was his support for the construction of the Observant Franciscan monastery of S Maria degli

Angeli in Abbiategrasso (now ruined) and the building and decoration of votive chapels (both destr.) near Vigevano and in Santa Maria da Carravaggio.

The painters and architects who worked for Galeazzo Maria were, in the main, those who had worked for his parents. He employed the painter Bonifacio Bembo (*see* BEMBO, (1)) on numerous occasions in Pavia and Milan and VINCENZO FOPPA to produce a polyptych (untraced) for S Maria delle Grazie, Monza, in 1466; the rest of Foppa's work for the court was done in conjunction with such conservative artists as Bembo and ZANETTO BUGATTO. One of the most important ducal commissions carried out by the three painters was the polyptych (untraced) intended as the centrepiece of Galeazzo Maria's new chapel in the Castello in Pavia. This was an enormous construction with over 200 painted panels and contained sacred relics collected by the Visconti dukes. From Cristoforo de Predis (*see* PREDIS, (1)) he commissioned miniatures and manuscripts, notably a New Testament (Turin, Bib. Reale, Varia 124).

Galeazzo Maria was assassinated by three of his own courtiers in 1476. His will requested the construction of two votive churches, a mausoleum in the shape of the Florentine or Pisan Baptistery and bronze tombs for himself and his wife. None of his wishes was carried out, and the loss or destruction of most of the work he commissioned must be ascribed to his family's efforts to erase his memory.

BIBLIOGRAPHY

L. Beltrami: 'Il Lazzaretto di Milano', *Archv Stor. Lombardo*, ix (1882), pp. 400–41

G. Marangoni: 'La cappella di Galeazzo Maria Sforza nel castello di Milano', *Boll. A.: Min. Pub. Istruzione*, i (1921–2), pp. 176–86, 227–36

M. B. Verga: 'Documenti per Benedetto Ferrini: Ingegnero ducale sforzesco, 1453–1479', *A. Lombarda*, n. s., lx (1981), pp. 49–102

P. L. De Vecchi: 'Committenza e attività artistica alla corte degli Sforza negli ultimi decenni del quattrocento', *Milano nell'età di Ludovico il Moro. Atti del convegno internazionale: Milano, 1983*, ii, pp. 503–15

G. Lubkin and S. Eiche: 'The Mausoleoum Plan of Galeazzo Maria Sforza', *Mitt. Ksthist. Inst. Florenz*, xxxii (1988), pp. 547–53

E. Samuels Welch: 'Galeazzo Maria Sforza and the Castello di Pavia, 1469', *A. Bull.*, lxxi (1989), pp. 352–75

——: 'The Image of a Fifteenth-century Court: Secular Frescoes from the Castello di Porta Giovia, Milan', *J. Warb. & Court. Inst.*, liii (1990), pp. 367–92

G. Lubkin: *A Renaissance Court: Milan under Galeazzo Maria Sforza* (Berkeley, 1994)

E. S. Welch: *Art and Authority in Renaissance Milan* (New Haven, 1995)

E. S. WELCH

(5) Ludovico (Maria) Sforza [Ludovico il Moro], Duke of Milan (*b* Abbiategrasso, 3 Aug 1452; *reg* 1494–99; *d* Loches, Touraine, 27 May 1508). Son of (1) Francesco I Sforza and (3) Bianca Maria Sforza. In 1480, several years after the death of his brother (4) Galeazzo Maria Sforza in 1476, he succeeded in gaining control of the regency but did not become duke in name until his nephew Gian Galeazzo Sforza died in 1494. His commissions, both public and private, were divided between Lombard and Tuscan masters. Milanese architects were responsible for many of his most important projects, including the construction of the Lazzaretto (1488–1513) and S Maria presso S Celso (begun 1491 by Giovanni Giacomo Dolcebuono) in Milan, and a farm complex, known as the Sforzesca, outside Vigevano. Several prominent Lombard

sculptors, in particular GIOVANNI ANTONIO AMADEO, were commissioned to work on the façade of the Certosa di Pavia (*see* PAVIA, §2). Of the artists Ludovico encouraged to come to Lombardy, an undated letter reveals that he was considering Botticelli, Filippino Lippi, Perugino and Ghirlandaio as court artists. About 1482 LEONARDO DA VINCI arrived in Milan, where he attempted, often unsuccessfully, to serve Ludovico's household for 18 years. As court painter, Leonardo is documented as having portrayed two of Ludovico's mistresses, Lucrezia Crivelli and Cecilia Gallerani. The latter may be identified with the painting *Portrait of a Lady with an Ermine* (*c.* 1490–91; Kraków, Czartoryski Col.; *see* LEONARDO DA VINCI, fig. 3). Much of his work was for such courtly ephemera as the designs for the spectacle *Festa del Paradiso*, composed in 1490. Another commission of which nothing survives was for a bronze equestrian statue honouring Ludovico's father, which Leonardo worked on in the 1490s. The large terracotta model for this was eventually sikd to Ercole d'Este. A surviving work by Leonardo for the Duke is the Sala delle Asse (1498) in the Castello Sforzesco, Milan, where motifs of golden knots are interspersed among vegetation and heraldic shields.

Other Tuscans at work in Milan during the 1490s included DONATO BRAMANTE. As a painter, Bramante produced an allegorical figure of *Argus* (1490–93) in the Castello Sforzesco (*in situ*). The development of the piazza, tower and castle at Vigevano in the 1490s, one of the most important campaigns of urban planning in the Renaissance, was the work of Bramante, working perhaps with Leonardo, under Ludovico's supervision. Ludovico also took day-to-day responsiblity for projects financed by his brother (6) Cardinal Ascanio Maria Sforza, for example Bramante's work on the new cathedral in Pavia and the monastic quarters (commissioned 1497) at S Ambrogio, Milan. The illuminator GIOVANNI PIETRO BIRAGO was also active in Ludovico's court, producing, among others, several copies (e.g. London, BL. Grenville MS. 7251) of Giovanni Simonetta's life of Francesco Sforza I, the *Sforziada*.

Ludovico's plans were destroyed by the invasion of Louis XII, King of France (*reg* 1498–1515), in August 1499. Ludovico escaped, to return in February 1500, but following his final defeat and capture in April that year, he was confined to a prison in France for the remainder of his life.

BIBLIOGRAPHY

E. Salmi: 'La Festa del Paradiso di Leonardo da Vinci e Bernardo Bellincioni', *Archv Stor. Lombardo*, xxxi/1 (1904), pp. 75–89

F. Malaguzzi Valeri: *La corte di Ludovico il Moro: La vita privata e l'arte a Milano nella secunda metà del quattrocento*, 4 vols (Milan, 1913–23)

S. Lang: 'Leonardo's Architectural Designs and the Sforza Mausoleum', *J. Warb. & Court. Inst.*, xxxi (1968), pp. 218–33

A. M. Brivio: 'Bramante e Leonardo alla corte di Ludovico il Moro', *Studi Bramanteschi. Atti del congresso internazionale: Roma, 1970*, pp. 1–24

C. Pedretti: 'The Sforza Sepulchre', *Gaz. B.-A.*, lxxxix (1977), pp. 121–31

R. Schofield: 'Ludovico il Moro and Vigevano', *A. Lombarda*, n. s., lxii/2 (1981), pp. 93–140

M. Garberi: *Leonardo e il Castello Sforzesco di Milano* (Florence, 1982)

Ludovico il Moro: La sua città e la sua corte (1480–1499) (exh. cat., Milan, Archv Stato, 1983)

Milano e gli Sforza: Gian Galeazzo Maria e Ludovico il Moro (1476–1499) (exh. cat., ed. G. Bologna; Milano, Castello Sforzesco, 1983)

Milano nell'età di Ludovico il Moro. Atti del convegno internazionale: Milano, 1983

C. J. Moffat: *Urbanism and Political Discourse: Ludovico Sforza's Architectural Plans and Emblematic Imagery at Vigevano* (diss., Los Angeles, UCLA, 1992)

L. Giordano: 'L'autolegittimazione di una dinastia: Gli Sforza e la politica dell' immagine', *Artes* [Pavia], i (1993), pp. 7–33

P. L. Mulas: '"Cum apparatu ac triumpho quo pagina in hoc licet aspicere": l'investitura ducale di Ludovico Sforza, il messale Arcimboldi e alcuni problemi di miniatura Lombarda', *Artes* [Pavia], ii (1994), pp. 5–38

V. L. Bush: 'The Political Contexts of the Sforza Horse', *Leonardo da Vinci's Sforza Monument Horse: The Art and the Engineering*, ed. D. C. Ahl (London, 1995), pp. 79–86

A. Cole: *Virtue and Magnificence: Art of the Italian Renaissance Courts* (New York, 1995)

L. Giordano, ed.: *Lucovicus dux* (Vigevano, 1995)

G. Lopez: 'Un cavallo di Troia per Milano', *Achad. Leonardo Vinci: J. Leonardo Stud. & Bibliog. Vinciana*, viii (1995), pp. 194–6

E. S. Welch: *Art and Authority in Renaissance Milan* (New Haven, 1995)

E. S. WELCH

(6) Cardinal Ascanio Maria Sforza (*b* Milan, 3 March 1455; *d* Rome, 28 May 1505). Son of (1) Francesco I Sforza and (3) Bianca Maria Sforza. He was destined for an ecclesiastical career at an early age. He became a protonotary in 1465 and the apostolic administrator of Pavia in 1479 with the promise of the bishopric, although he also played an important role at the Sforza court. He was banished to Perugia in 1477 for supporting his brother (5) Ludovico Sforza against his sister-in-law, Bona Sforza, but in 1480, when Ludovico gained control of the regency, he returned to favour. In 1484, under Pope Sixtus IV, he became Cardinal of S Vito in Macello and later occupied one of the most powerful positions in the curia as vice-chancellor of Pope Alexander VI. Educated in the humanistic tradition, Ascanio Maria was an important collector of manuscripts and books and a major ecclesiastical patron in Lombardy. Among the illuminated texts associated with his name are Cicero's *Rhetorica ad Herennium* (Milan, Castello Sforzesco, MS. 772), probably executed for him as a child, and the *Liber musices* (*c*. 1484–96; Milan, Castello Sforzesco, MS. 2146) by Florentius de' Fasolis. Other manuscripts bearing his insignia include a Bible (Rome, Vatican, Bib. Apostolica, MS. Vat. lat. 35), Juvenal's *Satires* (Rome, Vatican, Bib. Apostolica, MS. Vat. lat. 1658) and the *Vita Sfortiae* (*c*. 1458; Paris, Bib. N., MS. lat. 11088) by Lorenzo Bonincontri (1410–83). Some important printed books were also dedicated to the Cardinal, such as the *Storia di Milano* (1485; pubd Milan, 1503) by Bernardino Corio (1459–1519).

As Bishop of Pavia, Ascanio Maria financed much of the construction of the city's new cathedral, forcing its dignitaries to accept Bramante as master of the works, despite their preference for the local architects Giovanni Antonio Amadeo and Cristoforo Ronchi (*fl* 1488–95). Disputes over the cathedral's plan were frequent, and both Leonardo da Vinci and Francesco di Giorgio Martini, then at work in Milan, were consulted as to its design. The Cardinal's role in the reconstruction of the monastery annexed to S Ambrogio in Milan was equally important: in 1497 he commissioned Bramante to provide new quarters for the Cistercian monks, one of the most important Renaissance buildings in Milan. Bramante may also have exercised some influence on the design of the cloisters of Ascanio Maria's abbey at Chiaravalle, for which he painted a *Christ at the Column* (*c*. 1480–90; Milan, Brera). Ludovico Sforza and his advisers were often responsible for the day-to-day supervision of Ascanio's Lombard commissions, but he followed their progress closely from Rome and during frequent visits to Milan.

In July 1499 Ascanio Maria was forced to come to the rescue of Ludovico, who had fled Milan after an attack by troops of Louis XII, King of France (*reg* 1498–1515). The Cardinal recovered the city in February 1500 and assumed the regency in Ludovico's name, but in April of that year he was imprisoned by Venetian troops and then sent to France. In 1502 he returned to Rome, where he continued to campaign for the restoration of Sforza rule until his death, possibly from the plague.

BIBLIOGRAPHY

L. Beltrami: *Bramante a Milano* (Milan, 1912)

F. Malaguzzi Valeri: *La corte di Ludovico il Moro: La vita privata e l'arte a Milano nella secunda metà del quattrocento*, 4 vols (Milan, 1913–23)

E. Pellegrin: *La Bibliothèque des Visconti e des Sforza* (Paris, 1955)

G. Mulazzani: 'A Confirmation for Bramante: The Christ at the Column of Chiaravalle', *A. Bull.*, liv (1972), pp. 141–5

G. Bologna: 'Un fratello del Moro letterato e bibliofilo: Ascanio Maria', *Milano nell'età di Ludovico il Moro: Atti del convegno internazionale: Milano, 1983*, pp. 293–332

M. Pellegrini: 'Ascanio Sforza: La creazione di un cardinale "di famiglia"', *Gli Sforza, la chiesa Lombarda, la corte di Roma: Strutture e practiche beneficiane del ducato di Milano* (Naples, 1989), pp. 215–89

E. S. WELCH

(7) (Ercole) Massimiliano Sforza, Duke of Milan (*b* Milan, Jan 1493; *reg* 1512–15; *d* Paris, 4 June 1530). Son of (5) Ludovico Maria Sforza. He was named after his godfather, the emperor Maximilian I. On his father's defeat by the French in 1499–1500, he became a refugee in Germany but returned to Italy in 1512 and was restored to power in Milan with the help of a Swiss mercenary army. He made his solemn entry into the city on 29 December 1512. The patronage of art formed part of Massimiliano's upbringing at his father's court in Milan, where, for example, educational texts such as Aelius Donatus' *Liber Jesus* and *Ars Minor* (both Milan, Castello Sforzesco) were copied for him and illuminated, by artists including Giovanni Pietro Birago and Boccaccio Boccaccino, with scenes in which the young prince appears as a focus of attention. A pleasure-loving and extravagant ruler, against whom the Milanese unsuccessfully rebelled in 1513, he made his brief reign memorable for the splendid entertainments given at his court (to which he invited his aunt, Isabella d'Este, early in 1513) and for his lavish expenditure—he was reputed to have spent some 30,000 ducats on the ducal wardrobe alone in 1514. In the following year his Swiss forces were defeated by the French under Francis I at the Battle of Marignano on 14 September 1515, whereupon he accepted a pension from Francis and retired to France.

BIBLIOGRAPHY

G. Treccani degli Alfieri, ed.: *Storia di Milano*, viii (Milan, 1957), pp. 133–88

Milano e gli Sforza: Gian Galeazzo Maria e Ludovico il Moro (1476–1499) (exh. cat., ed. G. Bologna; Milan, Castello Sforzesco, 1983), pp. 71–5

JANET SOUTHORN

(8) Francesco II Sforza, Duke of Milan (*b* Vigévano, 4 Feb 1495; *reg* 1521–35; *d* Castello di Porta Giovia, Milan, 1–2 Nov 1535). Son of (5) Ludovico Maria Sforza. Following his father's fall from power in Milan in 1499–

1500, Francesco II became a refugee in Germany. On the defeat of his brother, (7) Massimiliano Sforza, in 1515 Francesco II fled to Trent, where he lived in poverty until 1521, when, through the intervention of Girolamo Morone (?1450–1529), chancellor to both Massimiliano and Francesco II, the Sforza were returned to power as part of the treaty of 8 May between Pope Leo X and Emperor Charles V (*reg* 1519–56). Francesco II entered Milan on 20 November 1521. In 1533 he married the young Christine of Denmark (1522–90), the subject of a portrait (1538; London, N.G.) by Hans Holbein the younger (1497/8–1548), but died without issue, whereupon the duchy of Milan passed to the Habsburgs.

Francesco II's 14-year reign was a time of economic decline and political uncertainty in Milan, which was not conducive to major art patronage. His own health, moreover, was poor and his temperament was said to be melancholic. Yet as the grandson and namesake of (1) Francesco Sforza I, he enjoyed a reputation for military prowess to which the poet Ludovico Ariosto referred when praising him in *Orlando Furioso* (XXVI.li; XXXIII.xlv). He lived up to this to some extent by his patronage of the military architects Giovanni Maria Olgiati and Michele Sanmicheli. Francesco II requested the services of Sanmicheli as an inspector of fortresses from the Venetian Republic in December 1530, and he worked for him in Lombardy from February to May 1531. According to Vasari, Francesco II was also a patron of Titian, who was said to have painted the Duke's portrait and that of his courtier Massimiano Stampa, a friend and correspondent of Pietro Aretino (both untraced). Francesco II's name is particularly associated, however, with that of the Brescian painter GIOVANNI GIROLAMO SAVOLDO, whose pupil, Paolo Pino, recorded that Savoldo, who otherwise had few regular patrons, had been protected and provided for by him.

BIBLIOGRAPHY

Michaud

P. Pino: *Dialogo di pittura* (Venice, 1548); ed. E. Camesasca (Milan, 1954), pp. 23, 79 n. 18

G. Vasari: *Vite* (1550, rev. 2/1568); ed. G. Milanesi (1878–85), vi, pp. 344–5, 507 n. 4; vii, p. 450

E. Langenskiöld: *Michele Sanmicheli: The Architect of Verona* (Uppsala, 1938), pp. 11–12

Stor. Milano, viii (Milan, 1957), pp. 233, 293, 308–33

JANET SOUTHORN

Sforza, Antonio Maria. *See under* ANTONIO MARIA DA VILLAFORA.

Siciolante (da Sermoneta), Girolamo [Gerolamo] (*b* Sermoneta, ?1521; *d* Rome, 1575). Italian painter. After a possible apprenticeship with Leonardo Grazia da Pistoia (1502–?1548), he became an assistant to Perino del Vaga. His earliest known work is an altarpiece of the *Virgin and Child with SS Peter, Stephen and John the Baptist* (1541; Sermoneta, Castello Caetani), commissioned by Camillo Caetani (1495–1554) for SS Stefano e Pietro, Valvisciolo. It is an immature work, derived from Leonardo Grazia and Perino and also reminiscent of late 15th-century compositions by Pietro Perugino. The figures are bulky, stiffly posed and crowded together. Their heavy drapery fits loosely about their bodies, and their faces have delicate features like figures by Leonardo Grazia and Perino. The most striking aspect of the painting is the powerful colour combination of citric orange, blue-grey, blue-green, golden yellow and salmon pink.

Under the influence of Perino, Siciolante soon developed a more assured style, and he became prominent among the artists working in the papal court in Rome. In 1543 he joined the Accademia di S Luca and in the following year the Accademia dei Virtuosi al Pantheon. During 1544 he assisted Perino at Castel Sant'Angelo, Rome, painting frescoes of scenes from Roman antiquity in the Loggia of Pope Paul III (fragmentary; *in situ*). The next year he was in Piacenza in the employ of the Pope's son Pier Luigi Farnese, Duke of Parma.

In 1548 Siciolante completed a monumental altarpiece of the *Virgin and Child Enthroned with Six Saints and a Donor* for S Martino Maggiore, Bologna, which remains *in situ* with its original, elaborate architectural frame. The composition is similar to a late 15th-century Emilian type, with the Virgin, Child and two saints on a high platform above four seated saints and the donor Matteo Malvezzi (*c.* 1464–1547). The design was dictated by Malvezzi, who had earlier attempted to commission a similar one from Michelangelo. Siciolante prepared a large squared study for the painting (Paris, Louvre). In the S Martino altarpiece Siciolante showed a more accomplished and distinctive style. Although the figures are still stocky, the drapery reveals more of their forms, the bodies are better articulated, their poses more varied, and they are no longer crowded together. Their vibrant colours stand out against the grey architecture, and naturalistic details enhance the sculptural solidity of the forms. Siciolante's precise realism, adapted from late 15th-century models, contrasts with the decorative elegance of the progressive Mannerist style he learnt from Perino. Such deliberate archaism became characteristic of his work.

In 1554 Siciolante was named president (*consolo*) of the Accademia di S Luca for two years. As taste in religious art in Rome became more doctrinaire during the Counter-Reformation, his retrograde style was favoured by aristocratic patrons. The 1560s were probably his most productive period. He completed several large altarpieces for Roman churches, including a *Martyrdom of St Catherine* (*c.* 1566–7; S Maria Maggiore) and a *Crucifixion* (1564–5; S Maria di Monserrato), and also finished major cycles of frescoes, notably scenes from the *Life of the Virgin* (*c.* 1565; S Tommaso a Monte Cenci). His most important commission, from Pope Pius IV, was for frescoes celebrating the *Defence of the Faith* (1563–5; Rome, Vatican, Sala Regia) in collaboration with artists including Taddeo Zuccaro, Giuseppe Salviati and Livio Agresti da Forlì (*c.* 1508–79). The team established rules for figure scale, colouring and architectural background to give homogeneity to their compositions and to unify the decoration. Siciolante's contribution, the *Donation of Pepin* (see fig.), completed in 1565, is above the door to the Sistine Chapel. It is a historical allegory in which the 8th-century kings Pepin the Short and Aistolf are shown with members of Pius IV's court. The muscular figures in antique and contemporary costumes are larger in scale and more monumental in form than figures in his earlier work, a result of the influence of Michelangelo, which was a major feature of Siciolante's mature style.

Girolamo Siciolante: *Donation of Pepin* (completed 1565), fresco, Sala Regia, Vatican, Rome

In his last years Siciolante painted other major altar-pieces for Roman churches, notably the *Crucifixion* for the Massimi Chapel in S Giovanni in Laterano (1573; *in situ*). Among his late works the S Giovanni *Crucifixion* is outstanding in design, colour and expression. A slate-blue sky casts a chill over the landscape, setting off the unusual combination in the figures' garments of grey-green, acid red and cream. Colour also enhances the pattern of drapery of the Virgin, Mary Magdalene and St John the Evangelist, which is worked into large relief-like forms with soft undulating folds, revealing the figures' broad bodies. The *Crucifixion* is a conventional composition, a traditional devotional image of enduring quality. His last work was to assist in painting and gilding the wooden ceiling of S Maria in Aracoeli, Rome. While Siciolante left no school, his art revived pictorial values that were taken up by Late Mannerist painters in Rome, such as Scipione Pulzone.

BIBLIOGRAPHY
G. Vasari: *Vite* (1550, rev. 2/1568); ed. G. Milanesi (1878–85), vii, pp. 571–3
G. Baglione: *Vite* (1642); ed. V. Mariani (1935), pp. 23–4
A. Venturi: *Storia* (1901–40), ix, pp. 547–92
F. Zeri: 'Intorno a Gerolamo Siciolante', *Boll. A.*, xxxvi (1951), pp. 139–49
B. Davidson: 'Some Early Works by Girolamo Siciolante da Sermoneta', *A. Bull.*, xlviii (1966), pp. 55–64
O. Raggio: 'Vignole, Fra Damiano et Gerolamo Siciolante à la chapelle de la Bastie d'Urfé', *Rev. A.* [Paris], xv (1972), pp. 29–52
R. Bruno: 'Girolamo Siciolante, revisioni e verifiche ricostruttive', *Crit. A.* (1973), no. 130, pp. 55–71; (1974), no. 133, pp. 66–80; no. 135, pp. 71–80; no. 136, pp. 31–47
L. Mortari: 'Gerolamo Siciolante a Palazzo Spada', *Commentari*, xxvi (1975), pp. 89–97
Gli affreschi di Paolo III a Castel Sant'Angelo: Progetto ed esecuzione, 1543–1548 (exh. cat. by F. M. Aliberti Gaudioso and others, Rome, Mus. N. Castel S Angelo, 1981–2)
J. Hunter, T. Pugliatti and L. Fiorani: 'Siciolante da Sermoneta (1521–1575): Storia e critica', *Quad. Fond. Camillo Caetani*, iv (1983)
J. Hunter: 'Transition and Uncertainty in the Middle Years of Girolamo Siciolante da Sermoneta', *Stor. A.*, lix (1987), pp. 15–27
——: 'The Drawings and Draughtsmanship of Girolamo Siciolante da Sermoneta', *Master Drgs*, xxvi (1988), pp. 3–40
——: *Girolamo Siciolante: Pittore da Sermoneta (1521–1575)* (Rome, 1996)
JOHN HUNTER

Siena. City in Italy, situated at a height of 322 m in the hills of southern Tuscany between the valleys of the Arbia and the Elsa. It was founded by at least the 3rd century BC, the date of the earliest archaeological evidence, and became a *colonia* under Augustus (*reg* 27BC–AD14). It flourished particularly during the medieval period, when its merchants and bankers developed business interests in many parts of Europe and the Near East. From the second half of the 13th century to the mid-14th, Siena (see fig. 1) was one of the most important centres for the arts in Europe, especially in the areas of painting, sculpture and goldsmiths' work.

I. History and urban development. II. Art life and organization. III. Buildings.

I. History and urban development.

1. History. 2. Urban development.

1. HISTORY. According to legend, Siena was founded in the 8th century BC by Ascius and Senius, the sons of Remus, who fled from Rome after their father was murdered by Romulus; another tradition attributes the city's origin to the Gallic tribe of the Senones, who halted there during their invasion of Rome in the 5th century BC. Remains datable to the 3rd and 2nd centuries BC show that Siena was an Etruscan centre, while its name apparently derives from that of a powerful Etruscan family, the Saina, later Latinized as Saena. The city became Roman during the Republican period, and Augustus founded a military colony there *c.* 29 BC. Christianity was traditionally introduced by Ansanus, who was martyred in Siena in AD 303 and was later venerated as the first patron of the city. The diocese of Siena was established in the mid-5th

1. Siena, view from the campanile of the cathedral, showing the Campo and the Palazzo Pubblico

century, but it was suppressed during the Lombard invasions and finally re-established only in the mid-7th century.

Siena was ruled by counts from the time of Charlemagne (*reg* 768–814), but from the 10th century the power of the bishops increased. Between 1053 and 1056, after subduing some of the great feudal families, they received a charter from the Emperor, Henry III (*reg* 1039–56), legitimizing their temporal powers over the city and episcopal territories. At first Siena was governed by the bishop together with the imperial counts, but later the counts were replaced by three consuls elected from the patricians and the people. In 1147 the Bishop–Count Raniero was expelled, and a lay government was installed, thus forming the Comune.

Under the Comune, despite frequent internal conflicts between the nobles, merchants and lower classes, the territory of Siena expanded considerably. Siena aligned itself with the Ghibelline (pro-imperial) party in opposition to the Guelph (pro-papal) city of Florence, its main commercial rival. Conflicts with Florence led to Siena's victory at the Battle of Monteaperti (1260), but this resulted in the ex-communication of the Sienese by the Pope and the loss of many important banking interests, including the custom of the Apostolic See. A number of rich merchants therefore went over to the Guelphs, and after Siena had been defeated by Florence at Colle Val d'Elsa in 1269 a Guelph government was installed. The Council of Thirty-Six (1271–80), followed by that of the Fifteen (1280–85) and finally by the Nine (the *Noveschi*), maintained the Guelph political orientation and friendly relationship with Florence, and Siena entered its most prosperous and best-governed period, acquiring its most important monuments.

Wars, a famine in 1326 and the Black Death of 1348 led to the overthrow of the Nine in 1355, and class conflicts and changes of government continued until 1399, when Siena finally submitted to the rule of Giangaleazzo Visconti, 1st Duke of Milan. After his death, however, government again returned to the people, until the old Council of Nine was reinstalled in 1480. Pandolfo Petrucci, who ruled as absolute lord from 1502 to 1512, revived the economy and favoured the arts, but his sons Borghese and Fabio, who succeeded him, were forced to flee the city. Siena's internal conflicts continued, with factions backed by the Pope and the Emperor until 1532, when Charles V (*reg* 1519–56) had the city garrisoned. In 1552 the Spanish were driven out by the people, who formed an alliance with the French and the Florentine exiles under the command of Piero Strozzi (*d* 1558). A large-scale war followed; in 1554 an army under the command of Gian Giacomo de' Medici (1495–1555), Marchese di Marignano, besieged the city, which surrendered the following year. On 15 July 1559, with the Treaty of Câteau-Cambrésis, Siena became part of the Medici domain. When Cosimo I de' Medici, Grand Duke of Tuscany, entered Siena on 30 October 1560, the population had been reduced by the siege from 22,500 to little more than 10,000. Under the Medici, the city again prospered, and the population increased.

2. URBAN DEVELOPMENT. Renaissance civic architecture in Siena began with the work of the Florentines Bernardo Rossellino, who inspired the designs of the Palazzo Piccolomini and the Palazzo Piccolomini 'delle Papasse', built for Pope Pius II, and Giuliano da Maiano, who designed the Palazzo Spannocchi and the Palazzo di S Galgano. Notable Sienese architects were Antonio Federighi, whose works included the Logge del Papa, the suburban Palazzo dei Diavoli and the classicizing canopy of the Cappella di Piazza, and Francesco di Giorgio Martini, to whom the basilica of the Osservanza outside the city is attributed. The latter's follower, Giacomo Cozzarelli, was the principal architect of the Palazzo del Magnifico and Santo Spirito.

The greatest 16th-century Sienese architect was BALDASSARE PERUZZI, who worked mostly in Rome; after his return to Siena in 1527, he was responsible for improving the fortifications, the Palazzo Pollini and other works. Other Sienese architects included Bartolommeo Neroni ('il Riccio') and Antonio Maria Lari. In 1547 Charles V's vicar, Don Diego Hurtado de Mendoza, had many of the towers of the city demolished or lowered and used the materials to construct a fortress, destroyed in 1552 when the Spanish were expelled. Some new churches were built, including S Maria di Provenzano (1595; see fig. 2), and many others were remodelled, for example S Martino (2c) and S Vigilio (annexed to the Jesuit monastery; 1q above). The Prefettura (the governor's palace) was erected in the cathedral square, and the Palazzo Chigi Zondadori (2r) and the rear façade of the Loggia della Mercanzia (2s) were built on the perimeter of the Campo. A fine axonometric plan drawn in 1595 by Francesco Vanni (print in Siena, Bib. Com. Intronati) faithfully

2. Siena, plan of city: (a) Cathedral; (b) Palazzo Pubblico; (c) S Martino; (d) S Cristoforo; (e) S Giorgio; (f) S Donato; (g) Ospedale di S Maria della Scala; (h) Campo; (i) Piazza del Mercato; (j) Palazzo Sansedoni; (k) S Francesco; (l) S Domenico; (m) S Maria dei Servi; (n) S Agostino; (o) S Niccolò al Carmine; (p) S Maria di Provenzano; (q) S Vigilio; (r) Palazzo Chigi Zondadori; (s) Loggia della Mercanzia; (t) Piazza Salimbeni and Rocca dei Salimbeni; (u) Forte di S Barbara

reproduces the urban layout of the time; at the bottom is the Forte di S Barbara (2u), with its four powerful ramparts, the reconstruction of which was begun in 1561 by Cosimo de' Medici.

BIBLIOGRAPHY
R. Langton Douglas: *A History of Siena* (London, 1902)
E. Guidoni: *Il Campo di Siena* (Rome, 1971)
J. Hooks: *Siena: A City and its History* (London, 1979)
L. Bortolotti: *Siena* (Bari, 1983)
P. Anselm Riedl and M. Seidel, eds: *Die Kirchen von Siena*, Italienische Forschungen, 2 vols (Munich, 1985–)

II. Art life and organization.

Siena's importance as a centre for the arts in the later Middle Ages is reflected in the employment of Sienese artists in many other cities besides their own. In the 15th century the sculptor Jacopo della Quercia worked in Lucca, Ferrara and Bologna, and Francesco di Giorgio Martini, a sculptor and painter, was active as an architect at the court of Urbino and was also called to Naples and Milan; in the 16th century Baldassare Peruzzi worked in Rome.

Siena also welcomed artists from other places. Such sculptors as Lorenzo Ghiberti and Donatello worked in Siena during the 15th century, as did Michelangelo in the early 16th. During the 15th and 16th centuries the city was often visited by such painters as Gentile da Fabriano, Luca Signorelli, Pietro Perugino and especially Bernardino Pinturicchio and Sodoma.

The artists, like all artisans, belonged to different guilds (*arti*), but information about these is of relatively late date. In the statutes (*breve*) of the painters' guild, which goes back to 1355, the preamble solemnly proclaims the religious aims of their activity: 'Inasmuch as by the grace of God we are called upon to make manifest to rude men, who know not letters, the miraculous works done by virtue and in virtue of the Holy Faith . . .'. The *breve* of the goldsmiths' guild dates from 1361, and that of the master stonemasons from 1441; these were not necessarily the first such documents to be promulgated, but they are the earliest to survive. The statutes contain detailed rules regarding not only the practice of the trade, relations between masters, apprentices and workmen and the activity of tradesmen from outside the city but also about the religious ceremonies in which members were required to participate. These rules are followed by lists of the artists enrolled at the time and for a few years thereafter.

Art in all its forms was considered an essential element in the life of the city. The most important patrons were the Opera di S Maria, which commissioned works for the cathedral, and the Comune, which commissioned works for the Palazzo Pubblico and the Ospedale di S Maria della Scala (see fig. 3 below). Other important commissions came from the religious orders for their churches and convents; parish churches were enriched with paintings and sculptures, and lay confraternities and guilds vied with each other in the embellishment of their altars. Thus from 1423 to 1426 the members of the wool guild (the Arte della Lana) taxed their earnings to commission a polyptych from Sassetta for their chapel in S Pellegrino (dismembered; for locations *see* SASSETTA). In 1442 the grocers' guild (the Pizzicaioli) commissioned a splendid altarpiece for the hospital church of S Maria della Scala (also

dismembered: New York, Met.; Cleveland, OH, Mus. A.; Detroit, MI, Inst. A.; Amsterdam, Rijksmus.; Madrid, Mus. Thyssen-Bornemisza; priv. cols); Matteo di Giovanni was commissioned by the bakers' guild in 1478 to paint an altarpiece for S Domenico; in 1510 the shoemakers ordered an altarpiece painted on canvas for the church dedicated to their patrons, SS Crispino and Crispiniano; and in 1534 the master stone masons commissioned frescoes by Bartolommeo Neroni for their altar in the cathedral.

Even civic officers, such as those in charge of the treasury (Biccherna) and the chiefs of the tax office (Gabella), had the wooden covers of the registers of their six-month terms of office decorated with charming portraits or religious, historical and allegorical scenes, often commissioned from the most prominent painters of the time, such as Vecchietta, Domenico Beccafumi and Francesco Vanni. This custom, which began in 1258, continued until *c.* 1458–60 when the wooden covers were replaced by leather bindings. Subsequently paintings of this type, with inscriptions, were done on small panels (*tavolette*) and later on canvas. There survive 136 examples, with a few *tavolette* from other offices of the Comune and the hospital (most in Siena, Pal. Piccolomini, Archv Stato). Similar panels also survive from the registers of guilds.

Private artistic commissions, except for the handsome palaces built by the leading families between the 12th and the 16th century, were relatively few. Prominent examples include those of the Tolomei, Sansedoni, Piccolomini and Spannocchi families. Originally these houses probably did not contain works of art of exceptional value, except for the Palazzo Petrucci (or del Magnifico), in which frescoes were executed by Girolamo Genga, Signorelli and Pinturicchio (detached and dispersed 1844; now Siena, Pin. N.; London, N.G.; New York, Met.), and the Palazzo Agostini (now Bindi–Sergardi), which has a ceiling decorated with frescoes by Domenico Beccafumi. Surviving paintings from Sienese private houses of the period are rare.

In a few cases private citizens contributed to the enrichment of churches, usually in memory of relatives or for the benefit of their souls. For example, Giovanna, widow of the painter Simone Martini, offered a chalice and a missal to the Dominican convent 'for her soul, that of her husband and of her other late relatives'; and on 25 March 1430 Donna Ludovica, the widow of Turino di Matteo (formerly Master of Works at the Cathedral), commissioned from Sassetta the great altarpiece of the *Madonna of the Snow* for the cathedral (1432; now Florence, Pitti; *see* SASSETTA, fig. 1).

The most generous donors to the cathedral were the higher clergy. In 1437 Cardinal Antonio Casini had a new chapel (destr.) decorated by Jacopo della Quercia, a fragmentary relief from which survives (Siena, Mus. Opera Duomo). Cardinal Francesco Todeschini–Piccolomini (later Pope Pius III) had a library built next to the cathedral to house the books belonging to his uncle, the humanist Pope Pius II. It was decorated after his death (1503) with frescoes by Pinturicchio, and statues were ordered for the Piccolomini Altar in the cathedral from Michelangelo.

A new church, S Maria delle Nevi in Via Montanini, was commissioned by Giovanni Cinughi, Bishop of Pienza, and his heirs had a beautiful altarpiece painted for it in

1477 by Matteo di Giovanni. Many families also enriched their favourite chapels with fine works of art, especially in conventual churches. For example, the Guelfi, Pecci and Branchini commissioned works for S Domenico, the Piccolomini and Saracini for S Francesco and the Verdelli and Chigi for S Agostino.

BIBLIOGRAPHY

G. Milanesi: *Documenti per la storia dell'arte senese*, i (Siena, 1854)
L. Borgia and others: *Le biccherne: Tavole dipinte delle magistrature senesi* (Rome, 1984)
G. Freuler: 'Sienese Quattrocento Painting in the Service of Spiritual Propoganda', *Italian Altarpieces, 1250–1550: Function and Design*, ed. E. Borsook and F. S. Gioffredi (Oxford, 1994), pp. 81–118
M. Seidel: 'The Social Status of Patronage and its Impact on Pictorial Language in Fifteenth-century Siena' *Italian Altarpieces, 1250–1550: Function and Design*, ed. E. Borsook and F. S. Gioffredi (Oxford, 1994), pp. 119–38

III. Buildings.

1. Cathedral decoration. 2. S Maria della Scala decoration. 3. Palazzo Pubblico decoration.

1. CATHEDRAL DECORATION. Inside the 13th- and 14th-century cathedral, two long-term projects were initiated that continued into the Renaissance period: the historiated marble pavement, begun in 1369 and completed in the mid-16th century (see colour pl. 2, XXX2), and the carving of the wooden choir stalls, which continued for 35 years in the second half of the 14th century; additions were made during the 15th century, then in the 16th they were completely renovated.

The baptistery font (1416–31) was traditionally believed to be designed by Jacopo della Quercia, who made the marble statues of *Prophets* for its tabernacle. The gilded bronze reliefs depicting scenes from the *Life of St John the Baptist* and the six *Virtues* for the sides of the font were made by the Florentines Lorenzo Ghiberti and Donatello, and by Jacopo della Quercia, Turino di Sano (*fl* 1395–1424) and other Sienese sculptors. In 1437, when he was Master of the Works, Jacopo della Quercia was commissioned by Cardinal Antonio Casini (*fl* 1409; *d* 1439) to carry out the marble decoration for the chapel of S Sebastiano in the cathedral, of which a lunette depicting the *Presentation of the Cardinal to the Virgin and Child by St Anthony Abbot* survives (Siena, Mus. Opera Duomo). Donatello also executed works for the cathedral, including the bronze statue of *St John the Baptist* (1457). His brother Bartolomeo and Urbano di Pietro da Cortona made reliefs of the *Life of the Virgin* for the chapel of the Madonna delle Grazie (destr. *c.* 1660), which are now scattered in various parts of the cathedral and its museum. Antonio Federighi's work for the cathedral (from 1439 until after 1486) included the two ornate classicizing holy water stoups at the main entrance (before 1467). Among other sculptors working there in the 15th century were Giovanni di Stefano (the marble *St Ansanus* in the chapel of S Giovanni Battista, *c.* 1482–7), Francesco di Giorgio Martini (two of the bronze angels now flanking the high altar ciborium) and Neroccio di Bartolomeo de' Landi. Wooden sculptures of this period include four seated *Patron Saints of Siena* by Francesco di Valdambrino, fragments of which survive (1409; Siena, Mus. Opera Duomo), and a mourning *Virgin and St John* (1415) by Domenico di Niccolò dei

Cori, now in S Pietro Ovile, Siena. In June 1501 Michelangelo signed a contract to add 15 statues to the Piccolomini family altar, but only four were made. Domenico Beccafumi made eight bronze angels holding candlesticks (1548–51) to stand against the nave arcade piers, facing the altar.

BIBLIOGRAPHY

H. Keller: 'Die Bauplastik des Sieneser Doms', *Röm Jb. Bib. Hertz.* (1937), i, pp. 139–221
E. Carli: *Gli scultori senesi* (Milan, 1980)
G. A Johnson: 'Activating the Effigy: Donatello's Pecci Tomb in Siena Cathedral', *A. Bull.*, lxxvii/3 (1995), pp. 445–9

ENZO CARLI

2. S MARIA DELLA SCALA DECORATION. The mid-14th-century Ospedale di S Maria della Scala (see fig. 2g above), so-called from its position opposite the cathedral, with a flight of steps leading to the cathedral square, was a powerful charitable institution, the financial importance of which in the past ranked second to (and at times even surpassed) that of the Comune. After the cathedral, it was the largest patron of art in the city until the end of the 18th century. It is a huge architectural complex, almost a city within the city.

During the 14th century the hospital was extended at the rear by two enormous longitudinal hostels (*pellegrinai*). The left-hand one, begun before 1327, has six rib-vaulted bays (the vaults rebuilt *c.* 1404). The arches and vault webs were decorated with portraits of saints in 1439–40 by the Bolognese painter Agostino di Marsiglio (*fl c.* 1439–64) and assistants, while between 1441 and 1444 three noted Sienese painters added a cycle of frescoes on the walls, depicting subjects related to the hospital. (Those of the last bay, added *c.* 1575–80, were by Pietro di Achille Crogi (*fl* 1569–77) and Giovanni di Rafaello Navesi (*fl* 1560–77).)

The 15th-century frescoes are the most interesting works in the complex, both for their artistic quality and for the originality of their subjects. They include: the *Allegory of the Blessed Sorore and the Education of the Foundlings* (1441) by Vecchietta; the *Blessed Agostino Novello Confers the Investiture on the Rector of the Hospital* (1442) by Priamo della Quercia (*fl*1438–67); and *Reception and Marriage of Foundlings* (1441–2), *Care and Management of the Sick, Distribution of Alms, Pope Celestine III Granting Autonomy to the Hospital* (all 1442), *Extension of the Hospital* (1442–3; see fig. 3) and *Dinner Offered to the Poor* (1443–4) by Domenico di Bartolo, who in 1444 also painted a fresco of the *Madonna of Mercy* for the old chapel of the Relics. This work, later called the *Madonna del Manto*, was moved in 1610, with its wall, to the chapel of the Sacro Chiodo (later the Sagrestia Grande), where it was placed in a canopied marble tabernacle dating from 1475.

The sacristy was entirely frescoed in 1446 by Vecchietta, with images on the ceiling of *Christ Blessing, Evangelists, Doctors of the Church* and *Prophets*, and on the walls scenes from the Old and New Testaments and a *Last Judgement*. Vecchietta also worked as a sculptor for the hospital for many years, producing for its church a bronze ciborium (h. 4.06 m, 1467–72; transferred to the cathedral, 1506), and in 1476 he made a bronze statue of the *Risen Christ*

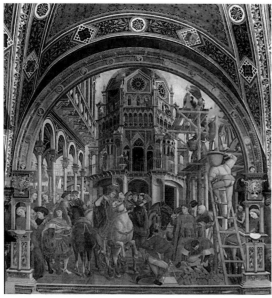

3. Siena, Ospedale di S Maria della Scala, Sala del Pellegrinaio, *Extension of the Hospital*, fresco by Domenico di Bartolo, 1442–3

BIBLIOGRAPHY

L. Banchi: *I rettori dello Spedale di S. Maria della Scala di Siena* (Bologna, 1877)
H. W. van Os: *Vecchietta and the Sacristy of the Siena Hospital Church: A Study in Renaissance Symbolism* (The Hague, 1974)
D. Gallavotti Cavallero: *Lo Spedale di Santa Maria della Scala in Siena: Vicenda di una committenza artistica* (Pisa, 1975) [bibliog.]
U. Morandi and A. Cairola: *Lo Spedale di Santa Maria della Scala in Siena* (Siena, 1975)
'Siena: La fabbrica del Santa Maria della Scala: Conoscenza e progetto', *Boll. A.*, lxxi (1986) [whole issue]
D. Gallavotti Cavallero and A. Brogi: *Lo spedale grande di Siena* (Florence, 1987)
Santa Maria della Scala dall'ospedale al museo (Siena, 1995) [six essays on the art and history of the hospital]

ENZO CARLI

for the chapel in which he wished to be buried (now main altar of the church; *see* VECCHIETTA, fig. 2).

The construction of this church, S Maria Annunziata, began in 1466–7 with the enlargement of the old church. The project was realized largely by Francesco di Giorgio Martini. The building consists of a large hall with, above the 13th-century structure, an upper storey with ten large single-light windows framed in *pietra serena* (a bluish sandstone) in a neat Renaissance design inspired by Filippo Brunelleschi. The interior has a gilded and painted coffered ceiling (1470–75), probably designed by Francesco di Giorgio, who also frescoed a *Coronation of the Virgin* in the apse, which was later covered with a large fresco by the Neapolitan painter Sebastiano Conca (1680–1764): a scenographic perspective view of the *Piscina probatica (Pool at Bethesda)*. To the right of the presbytery is an organ built by the Sienese Giovanni d'Antonio, called 'Piffero'; this is one of the earliest organs in Tuscany (1519), with a beautiful front attributed to Baldassarre Peruzzi and carved by Ventura di ser Giuliano Turapilli (*d* 1522) and Giovanni Castelnuovo. On either side of Vecchietta's *Risen Christ* are bronze candelabra in the form of angels, made by Accursio Baldi of Monte San Savino (1585). The most important work of the 16th century was the rebuilding of the Madonna del Manto Chapel (1512), with decoration by Domenico Beccafumi, whose first documented work is the lunette with the fresco of the *Meeting of Joachim and Anna* (1513). The triptych of the *Trinity with SS Cosmas, John the Baptist, John the Evangelist and Damian*, which he painted at the same time for the altar, is now in the Pinacoteca Nazionale di Siena.

During the 14th and 15th centuries many other frescoes, mostly devotional, were painted in other parts of the hospital. Numerous paintings on both panel and canvas, by leading Sienese painters, are now mostly in the Pinacoteca or dispersed in various Italian and foreign collections.

3. PALAZZO PUBBLICO DECORATION. As the centre of Sienese government, the Palazzo Pubblico was, with the cathedral, the chief site of civic patronage. Before the fall of the Republic in 1555, a large number of Siena's most distinguished painters contributed to the decoration of the palace, producing panels and especially frescoes. Although the Republic never had an official painter, the documents indicate that particular artists were favoured with repeated commissions. Taddeo di Bartolo worked for the Comune from 1406 to 1414. Sano di Pietro received numerous commissions from 1439 to *c.* 1461, as did Sodoma from 1529 to 1539.

Most of the decoration was religious in subject-matter, testifying to a rich and complex interweave of the political and religious quite unlike the modern separation of Church and State. As protectress of Siena, the Virgin often appears, as do the four patrons of the city, SS Ansanus, Sabinus, Crescentius and Victor; SS Peter and Paul were also frequently represented.

Alongside these subjects two other themes occur: Roman and what may be loosely termed communal subject-matter. Although the former may have arisen from Siena's claim to have been founded by Ascius and Senius, the twin sons of Remus, Roman heroes and subjects that provided models of civic virtue were generally selected. The communal themes, not always strictly separable from the religious, were varied and ranged from *pitture infamante* (images of false witnesses, rebels and other malefactors), depictions of subject territories and justice themes, to illustrations of the consequences of good and bad government.

In spite of a number of major studies, however, numerous problems surround the decoration of the palace. Many documents, particularly the early ones, lack precision, and much has been lost; the building has been modified over the centuries, and there is evidence of extensive 19th-century restorations, which included the introduction of elements and perhaps even inscriptions that were not there originally.

Physical and documentary evidence indirectly suggests that the erection of a new chapel on the first floor (completed 1405–6) led to a major reorganization of the central section of the palace on this level. As a result, a number of decorative projects were carried out, and the main problems concern lost works in this area. In August 1406 the Sienese government decided that Taddeo di Bartolo should paint the new chapel and that on its completion he should provide decoration and pictures for

the 'saletta nuova'. In June 1407 Martino di Bartolomeo (*fl* 1389; *d* 1434–5) was commissioned to paint the vaults of the 'sala nuova', now called the Sala di Balia, and in December he was paid for painting the vaults between the chapel and the Concistoro. The document also states that Spinello Aretino was to paint the rest of the room (his scenes include the *Story of Pope Alexander III*). This work seems to have been carried out during 1408, the same year that Taddeo di Bartolo painted *St Christopher* in the Anticappella. Just before this last commission, Taddeo had completed his frescoes of the *Life of the Virgin* in the chapel (1406–Dec 1407) and fulfilled a commission of October 1407 to paint *Christ* and *St Thomas* (perhaps an *Incredulity of Thomas*) in the Sala del Concistoro. It was only in 1414, however, that the artist added the *Roman Heroes* (see fig. 4), *Cardinal and Political Virtues*, *Judas Maccabaeus*, the *Blessed Ambrogio Sansedoni*, *Aristotle* and *Roman Gods with a Map of Rome* to the frescoes of the Anticappella, described in the documents as the pictures of the 'salette ante Concistorium'. This phrasing suggests that the reference of 1406 to the 'saletta nuova' is to the Anticappella and not to the Sala di Balia as Southard thought, and the documents also indicate that the Sala del Concistoro at this period, and earlier, was not the room now known by that name and frescoed by Domenico Beccafumi but was probably in the area indicated on an early 17th-century plan (see Brandi, fig. 480).

After this flurry of activity, civic patronage turned largely to other items of decoration: a door (1426) between the chapel and the Sala di Balia by Domenico di Niccolò de' Cori; choir-stalls (1415–28) for the chapel by the same artist; an inlaid wooden chair (1426), probably for the Sala del Mappamondo, by Mattia di Giovanni, called Bernacchino (1403–33), and an intarsia door for the sacristy by the same artist two years later; the iron gate of the chapel (1437–45) by Niccolò di Paolo, Giacomo di Vita (*fl* 1402–45) and his son Giovanni; the marble and bronze holy water stoup for the chapel (1438) by Giovanni di Turino; and a series of tapestries produced by Giachetto di

4. Siena, Palazzo Pubblico, Anticappella, *Roman Heroes: Curius Dentatus, Furius Camillus and Scipio Africanus*, fresco by Taddeo di Bartolo, 1414

Benedetto from 1442 onwards. In 1446 Bernardo Rossellino (Bernardo di Matteo) made a marble doorframe, which is now in the Sala del Concistoro. The fresco of the *Name of Jesus* (1425) by Battista da Padova in the Sala del Mappamondo is the only surviving painting of importance from this period.

Sano di Pietro is first recorded in the palace in 1446, working on the figure of an emperor (untraced) in the Sala di Balia. In 1448 he executed figures of *St Peter of Alexandria*, the *Blessed Andrea de' Gallerani* and the *Blessed Ambrogio Sansedoni* in the Sala di Biccherna. Between 1448 and 1452 he produced a new predella for the first floor chapel, apparently to stand below Simone Martini's polyptych. A payment to Sano in 1450 mentions only a figure of *St Bernardino* in the Biccherna and 'other works', but the total sum is a significant 415 lire. In 1450 or 1460–61, Sano frescoed the figure of *St Bernardino* in the Sala del Mappamondo, below the *Battle of Val di Chiana*. Thereafter he was responsible for a panel of the *Apparition of the Virgin to Pope Calixtus III* (1450 or 1456; Siena, Pin. N.) for the Stanza del Biado; a *Virgin and Child* (1459; untraced) for the second floor loggia; an *Annunciation* (1459; untraced) for the dining-room; and a figure of *St Catherine of Siena* (?after 1461) for the Sala di Biccherna, later repainted by Ventura Salimbeni. An ambiguous document suggests that Vecchietta executed a fresco of *St Catherine* for the Sala del Mappamondo in 1460. The *Battle of Poggio Imperiale*, in the same room, was created by Giovanni di Cristofano Ghini (*fl* 1480–88) and Francesco di Andrea (*fl* 1466–80) in 1480, to the right of the *Battle of Val di Chiana*.

Before the collapse of the Republic, the last great works for the palace were created by Sodoma and Beccafumi. In 1529 Sodoma executed frescoes of *St Ansanus* and *St Victor* for the Sala del Mappamondo, to be followed in 1533 by the *Blessed Bernardo Tolomei* for the same room. Around 1532 he painted frescoes of the *Imperial Eagle* and the *Resurrection* for the Stanza del Biado; once part of the same project, these two sections have been separated. His workshop produced a fresco of the *Virgin and Child with SS Galganus, Michael and John the Baptist* for the third office of the Biccherna in 1537, and the following year, in the Cappella di Piazza, he executed a half-length *Virgin and Child with the Four Patron Saints of Siena* that was originally flanked by *St Bernardino* and *St Sebastian*.

The greatest decorative project, by DOMENICO BECCAFUMI, was the ceiling in the room now identified as the Concistoro (1529–35). The scenes of civic virtue from Valerius Maximus' stories of *Factorum et dictorum memorabilium* and allegorical figures based on Cicero's *De officiis* show illusionistic effects (see fig. 5 and colour pl. 1, IX1).

After the fall of the Republic, decorative works continued to be commissioned for the Palazzo, although few of the cycles are of high quality. Four main projects may be singled out: those in the Sala del Capitano, the Sala di Biccherna, the third office of the Biccherna and the Sala del Risorgimento. These were all collaborative projects, and each involved many figures and scenes. The ceiling and lunettes of the Sala del Capitano, now the city council chamber, on the second floor, were decorated in the last years of the 16th century and the first years of the 17th. The subject-matter is a complex combination of events

5. Siena, Palazzo Pubblico, Concistoro, ceiling frescoes by Domenico Beccafumi showing scenes of civic virtue from Valerius Maximus' *Factorum et dictorum memorabilium* (detail), 1529–35

from Sienese history, scenes from the lives of local saints and *beati*, and religious and secular allegories. The principal artists were Ventura Salimbeni, Rutilio Manetti (1571–1639), Vincenzo Rustici (1556–1632) and Francesco Vanni (1563–1610).

BIBLIOGRAPHY

F. Donati: 'Il Palazzo del Comune di Siena: Notizie storiche', *Bull. Sen. Stor. Patria*, xi (1904), pp. 311–54

A. Cairola and E. Carli: *Il Palazzo Pubblico di Siena* (Rome, 1967)

E. C. Southard: *The Frescoes in Siena's Palazzo Pubblico, 1289–1539: Studies in Imagery and Relations to Other Communal Palaces in Tuscany*, Outstanding Diss. F.A. (New York, 1979)

C. Brandi, ed.: *Palazzo Pubblico di Siena: Vicende costruttive e decorazione* (Milan, 1983)

R. Starn and L. Partridge: *Arts of Power: Three Halls of State in Italy, 1300–1600* (Berkeley, CA, 1993)

H. B. J. MAGINNIS

Signorelli, Luca (d'Egidio di maestro Ventura de') (*b* Cortona, *c*. 1450; *d* between Oct and Dec 1523). Italian painter and draughtsman. Overcoming the handicap of lifelong residence in the provincial town of Cortona, in the 1480s he obtained early recognition as a leading artist in Central Italy from fellow artists and major patrons, including Pope Sixtus IV and Lorenzo de' Medici. Yet rapid evolution of taste, dominated by a sense of constant progress in truth to nature, led to his eclipse, beginning in the 1490s, together with his contemporaries Botticelli and Perugino, in favour of younger masters such as Filippino Lippi and Leonardo da Vinci. He was still respected for his skill in anatomical drawing and the expressive and dramatic effects for which he used it; this most notably produced Michelangelo's homage to Signorelli (Vasari reported that Michelangelo praised his frescoes at Orvieto highly and borrowed certain motifs from them for his *Last Judgement* in the Sistine Chapel, Rome; see colour pl. 2, VII3).

1. Life and work. 2. Critical reception and posthumous reputation.

1. LIFE AND WORK.

(i) Introduction. (ii) Paintings. (iii) Drawings.

(i) Introduction. The usually accepted birth date for Signorelli of 1450 is based on the earliest reports of his work in 1470. Vasari's statement that he died aged 82 requires an earlier birth date, 1441 or, if tied to Vasari's inaccurate death date of 1525, 1443, but is probably due to the exaggeration of the age of the elderly at that time.

Signorelli's life focused on his native Cortona, in southeast Tuscany near the Umbrian border. His family owned property there from the 13th century. Earlier records are lost, but he frequently served on various town councils from 1479 until his death; this reflects his acceptability to the Medici family (Cortona being subject to Florence). His town also made him an envoy on occasion, notably to Gubbio in 1484 to explore with Francesco di Giorgio the plans for S Maria del Calcinaio, Cortona (*see* FRANCESCO DI GIORGIO MARTINI, fig. 3). In 1491 he was one of the few non-Florentines invited to a meeting to discuss plans

for Florence Cathedral, but he did not attend. In 1515 he contracted to paint an altarpiece for a doctor in return for past and future medical services; he had made a similar exchange for a house in 1504 and in 1509 another for a granddaughter's dowry as a nun.

Various informal links with other artists are known: Signorelli dined at Bramante's house in Rome with Perugino, Pinturicchio and Caporali (who recorded it); he was godfather to Pinturicchio's son in 1509; he borrowed money from Michelangelo in 1513, claiming his life had been in danger as a Medici supporter (in 1518 Michelangelo sought repayment), and he received small loans from Guillaume de Marcillat in 1517 and 1521.

Florence and Rome mark the extremities of Signorelli's area of activity. He worked in almost every town of central Tuscany and western Umbria: Volterra, Siena, Arezzo, Sansepolcro, Città di Castello (which made him a citizen) and Perugia, as well as in villages. As a youth he worked in Loreto and in 1507–8 in Arcevia, also delivering small works to Fabriano and Urbino. Some such pattern was inevitable for an ambitious artist who decided not to migrate to Florence, and his career is comparable with that of Piero della Francesca.

Signorelli's oeuvre consists of frescoes, altarpieces and smaller easel paintings. All the large frescoes date from two periods: 1472–84 (when he did little else) and 1497–1509. The easel paintings consist of domestic pictures of the Virgin and Child, banners for confraternities and a few portraits and scenes derived from Classical mythology. They are often held to be of the period 1487–1500, but none is dated, and this may reflect a simplistic view of their external similarity; the only document referring to a domestic *Virgin and Child* is from 1505. The altarpieces are often dated and give the best impression of the artist's development, although they are limited in their repertory of form. The predellas form a separate group with a richer range, but these are often by assistants and have been detached, so losing their dates (Berenson noted 25 detached predella panels).

(ii) Paintings.

(a) 1450–88. (b) 1488–1502. (c) 1502–23.

(a) 1450–88. The earliest preserved work, a fresco fragment of *St Paul* (1474; Città di Castello, Pin. Com.), in its translucency, simple cylindrical form and aloof expression, confirms early reports that Signorelli was a pupil of Piero della Francesca, as stated in *Summa arithmetica* (Venice, 1494) by Luca Pacioli, who had personal links with Piero. Vasari reported a lost work of 1472 in Arezzo (but gave the date only in the second edition of the *Vite*). Both Città di Castello and Arezzo are in Piero's area; the inference thus arises that Signorelli sought Piero as a master, Cortona having no artists, and afterwards obtained work in the area with his master's support.

Signorelli's first certain advance, his part in the fresco project (1481–2 in the Sistine Chapel, Rome (*see* ROME, §V, 1(iii)(b)), for Pope Sixtus IV, was probably due to Perugino's support. Originally, three Florentine painters and Perugino, thought to have been the leader, were contracted for the work. Two of the scenes, however,

were by Signorelli (Vasari, 1550). One was overpainted in 1571 (Stastny, 1979), but the *Testament of Moses* is agreed to be by Signorelli and collaborators. These appear to be Bartolomeo della Gatta and the anonymous GRISELDA MASTER (*see* MASTERS, ANONYMOUS, AND MONOGRAMMISTS, §I), who worked with Signorelli in later projects.

The *Testament of Moses* is often dated 1483, on the grounds that Signorelli is not mentioned in the contract documents and consequently must have arrived later to replace the original painters, who are known to have left by then. However, it is widely agreed that Signorelli also contributed figures to Perugino's *Christ Giving the Keys to St Peter* (*see* PERUGINO, fig. 1), part of the same fresco cycle in the chapel (namely the two apostles behind Christ, some portraits and the stone-throwing background group, analogous to the *Conversion of Saul* in the Santa Casa, Loreto); on technical grounds, these cannot be later additions. His absence from the documents may be due to missing records or because he worked as an assistant, as did Pinturicchio, Piero di Cosimo and Bartolomeo della Gatta, also mentioned as participants by Vasari. This would accord with Signorelli's lack of previous fame and the fact that many of the important figures in his *Testament* are by other artists.

Signorelli, who seems to have been the leader of the team for the *Testament*, painted the actual will-writing scene in the right foreground and the small scene of Moses Shown the Promised Land in the right background. The Griselda Master painted the scene of Moses Appointing Joshua his Successor (except for the figure of Moses, which is by Signorelli) and the small background scene on the left depicting the *Death of Moses*; he also contributed two women in profile to Signorelli's group in the right

1. Luca Signorelli: *Virgin and Child with Saints*, panel, ?1484 (Perugia, Museo dell'Opera del Duomo)

2. Luca Signorelli: *Court of Pan*, oil on canvas, 1.94×2.57 m, *c*. 148 (Berlin, Kaiser-Friedrich Museum, destr. 1945)

foreground as if in exchange for Signorelli's addition of Moses to the Joshua scene. Bartolomeo della Gatta was responsible for the central group of figures, including the nude, which is close to his *St Roch Pleading with the Virgin* (1479; Arezzo, Gal. & Mus. Med. & Mod.). The exceptionally large scenes in the Sistine Chapel cycle are often the work of more than one artist; this was carried to an extreme in the *Testament of Moses* to the extent that it lacks any narrative centre for its several incidents: there may have been pressure to finish. Also close to the Sistine frescoes, and perhaps Signorelli's first masterpiece, is a processional standard (Milan, Brera) showing the *Virgin and Child* and the *Flagellation*.

Vasari was also the first (2/1568) to attribute to Signorelli the frescoes in the sacristy of S Giovanni in the Santa Casa at Loreto, dating them in the papacy of Sixtus IV (*reg* 1471–84), an attribution now universally accepted. Vasari described only minor parts in the dome, not the major groups on the walls of *Christ and Doubting Thomas*, the *Conversion of Saul* and the ten apostles arranged in pairs. This is Signorelli's most important youthful work and marks a dramatic change in style, stimulated by the most recent Florentine sculpture, notably Verrocchio's *Incredulity of Thomas* group (*c*. 1466–83) at Orsanmichele (*see* VERROCCHIO, ANDREA DEL, fig. 1). Powerful, mature males in heavy robes show angular movement, often bending at the waist, thus digging into and dominating

their space. The frescoes have been dated either *c*. 1478 or *c*. 1483 (i.e. either before or just after the Sistine work): after 1485 Loreto's budget was all used for military purposes. Although the earlier date is often cited, it seems less plausible that after this impressive commission from Sixtus IV, Signorelli would have had only a minor role in the Sistine Chapel when working for the same patron.

Signorelli's first surviving altarpiece, the *Virgin and Child with Saints* (Perugia, Mus. Opera Duomo; see fig. 1), made for Perugia Cathedral, once bore the date 1484; it was ordered by Bishop Jacopo Vannucci (who was from Cortona). The characterful, contrasted figures move in pockets of space just large enough to hold them. A still-life motif of flowers in a glass quotes from the Portinari Altarpiece by Hugo van der Goes (*c*. 1440–82) (Florence, Uffizi). As this is known to have reached Florence in May 1483, Signorelli must have stayed there in that year; both the speed and the intimacy of the derivation preclude indirect knowledge. The pot-bellied angel is also a Florentine citation, from Antonio Rossellino's tomb of *Jacopo di Lusitania, Cardinal of Portugal* (Florence, S Miniato). This accords with Vasari's report that Signorelli went to Florence to see the work of living and older masters, but suggests that the visit was somewhat earlier than is often proposed.

Signorelli's time in Florence must in any case have preceded the death of Lorenzo de' Medici in 1492 for

whom, again according to Vasari, he painted two important works: the *Court of Pan* (ex-Kaiser-Friedrich Mus., Berlin, destr.; see fig. 2) and the *Virgin and Child*, known as the Medici Tondo (Florence, Uffizi). The *Court of Pan* is often dated later than the Perugia Altarpiece, but is very similar: a 'pagan altarpiece' is given the same composition and figural types as the Christian version. Its specific theme has been much debated, chiefly with regard to its possible political and neo-Platonic references (see Seidel, 1984; Freedman, 1985). It is the best visual complement of Botticelli's *Birth of Venus*, probably of the same date (*c.* 1484; Florence, Uffizi; *see* BOTTICELLI, SANDRO, fig. 3) and also a Medici commission. The Medici tondo is similar to the *Pan* in figural qualities and use of space. The nudes behind the Virgin recall those in Signorelli's most notable portrait, the *Jurist* (Berlin, Gemäldegal.), in which two nude men, gazing downwards before an antique ruin, represent pagan earthliness, in contrast to the Christian virtue implied by the clothed women (by the Griselda Master) who gesticulate upwards in front of a circular temple. The presentation of nudes as pagans in relation to Judeo-Christian revelation was also used in the *Testament of Moses* and in an earlier Medici commission, Filippo Lippi's *Adoration of the Magi* (Washington, DC, N.G.A.). The undated *Circumcision* (London, N.G.) probably dates from this period. Nearly all these works include small figures in grisaille separately framed, which recall the work of Rogier van der Weyden (*c.* 1399–1464).

(b) 1488–1502. Vasari's longest description of a painting by Signorelli is of a *St Michael Weighing Dead Souls*

(destr.), formerly in Arezzo. Its patron, a lawyer named Francesco Accolti, died in 1488, so the work fills a gap to the next known dates. The description of its imagery suggests motifs present in later works.

Signorelli painted two works for Volterra in 1491: the *Virgin and Child Enthroned with Saints* (Volterra, Pin. Com.) is largely by assistants, perhaps because Signorelli was busy with the *Annunciation* (Volterra, Pin. Com; see colour pl. 2, XXXIII1.), which shows a striking shift in style: the dynamic figures, thick ornament and glowing, gemlike light perhaps show him moving in parallel with his lifelong associate and friend, Pinturicchio. This was the first of several occasions on which Signorelli executed more than one work during a visit to a town.

From 1493 to 1498 Signorelli was employed at Città di Castello to paint three altarpieces. The *Adoration of the Magi* (1493–4; Paris, Louvre) was followed by the *Adoration of the Shepherds* (1496; London, N.G.) and the *Martyrdom of St Sebastian* (1498; Città di Castello, Pin. Com.). The first two are characterized by crowded decoration, but in the *St Sebastian* emphatic, deep spaces counterbalance the dynamic crowds; a unique motif is a view up a rising city street, which parallels the path of an arrow. The painting was much admired; in 1500 Raphael copied one of its figures in a drawing (Oxford, Ashmolean, 501*r*), and soon after Piero di Cosimo imitated the rising street in his *Immaculate Conception* (Florence, Uffizi).

An early report led to the Bichi Chapel in S Agostino, Siena, being dated to 1498, but there are strong grounds for placing it earlier (Seidel, 1984). Signorelli produced the

3. Luca Signorelli: *Woman and Demon*, detail from the *Damned* (1500–03), fresco, chapel of S Brizio, Orvieto Cathedral

painted parts of its altarpiece and smaller frescoes collaborating with Francesco di Giorgio, who was responsible for the sculpture at the centre of the altarpiece and for larger frescoes. For the large project to fresco the cloister of the monastery of Monte Oliveto Maggiore, near Siena, Signorelli produced nine scenes from the *Legend of St Benedict*. It was begun after the spring of 1497 when the patron, Abbot Airoldi, was elected; the work certainly took more than a year, but was abandoned when Signorelli took on the project at Orvieto in 1499.

The frescoes illustrating the *End of the World* in the new chapel (known as the chapel of S Brizio) in Orvieto Cathedral, are well documented (for illustration *see* ISTORIA). They are Signorelli's most complex and famous work. In 1499 he was contracted to finish the vault, abandoned 50 years before by Fra Angelico; the board liked the result and in 1500 assigned the decoration of the rest of the chapel to Signorelli. It was finished in 1503, with a break in 1502 when funds were lacking. In the scenes, which include the *Last Judgement* (in several parts, including the *Damned*; see fig. 3 and colour pl. 2, XXXII1), the *Appearance of the Antichrist* and the *Resurrection of the Flesh* Signorelli explored the dramatic possibilities of the nude. By giving the demons near human form, but by colouring them with every shade of putrefying flesh, he made his cataclysmic vision fearful. Through his dynamic use of form and figural energy in the crowded scenes he created active compositional rhythms. Vasari wrote that Signorelli 'showed the way to represent nudes in painting as if alive'. Beneath the main scenes are remarkable small-scale grisaille scenes, which illustrate the underworld as described by pagan poets and Dante (the poets appear in the centre of each group of grisailles). Throughout the chapel the contours are often incised with a stylus; they were probably marked through a cartoon and in the grisailles correspond with the work of assistants, one of whom was his nephew, Francesco Signorelli (*d* 1559).

(c) *1502–23*. The *Lamentation over the Dead Christ* (1502; Cortona, Mus. Dioc.) inaugurated a late phase, in which Signorelli produced many altarpieces for Cortona and nearby towns. Three altarpieces were made in 1507–8 for Arcevia (then called Rocca Contrada), a village in the Marches; for one of these, the *Baptism* (Arcevia, S Medardo), he was required to paint only the three main figures and was paid 19 days later. These late altarpieces seem to hark back to his successes of the 1480s, although the surfaces are enriched with more ornament, notably in the costumes. A quasi-iconic approach to the figure emerged, with many strict profiles, full faces and silhouettes set against blank ground, as in the *Crucifixion with the Magdalene* (Florence, Uffizi) and the processional banner for Sansepolcro with the *Crucifixion* and *SS Anthony and Eligius* (Sansepolcro, Pin.). A large fresco cycle of the *Life of Christ* (Morra, S Crescentino) must post-date the rebuilding of the church in 1507. The grisaille *Allegory of Fertility* (Florence, Uffizi) and an analogous drawing (Florence, Uffizi, 133F) have been often assigned to these years.

More clearly of this late style are several tondi, such as the *Holy Family*, called the Parte Guelfa Tondo (Florence, Uffizi). A commission of 1505 for a *Madonna* specifies

that the artist was free to select the figures other than the Virgin. These may have been saints, as has been assumed (Mancini), or, more plausibly, smaller figures such as those in the Medici Tondo. For the same patron Signorelli painted a *Deposition* (destr.) also copied from an earlier composition, as the document specifies.

Signorelli's iconographic inventiveness also emerged in the unusual pious themes of some of his later works, for instance the *Holy Family Meeting Elizabeth, Zachariah and John the Baptist* (Berlin, Gemäldegal.), where the two boys' gestures prefigure the *Baptism*, and the Parte Guelfa Tondo, which shows Christ as a boy of about five. The *Institution of the Eucharist* (1512; Cortona, Mus. Dioc.) shows Judas at the front of the composition and denied the host, slipping into his purse a coin visually identical with it. The *Deposition Contemplated by Saints* (Cortona, S Niccolò) is comparable with the same subject by Carpaccio (Berlin, Gemäldegal.). A contract of 1521 refers to the 'mystery' of the Presentation in the Temple and suggests that such concerns were in the minds of both artist and patron; it seems to anticipate certain of the traits introduced into religious works of art after the Council of Trent.

A trip to Florence in July 1508 evidently produced no work. Documents are lacking for the last quarter of that year, when he may have been in Rome (and attended Bramante's dinner). It has also been suggested (Shearman, 1972) that at this time he painted a fresco (destr.) in the Vatican Stanze, overpainted soon after by Raphael. Vasari reported that Signorelli, Piero della Francesca, Bartolomeo della Gatta and Bramantino had painted there; as often, he is confused about dates. Bramantino and three other artists were paid for work there from October to December 1508. The absence of Signorelli from these records does not prove that he was not there with them; yet, if Vasari's reported names are accepted, there must also have been an earlier campaign that included Bartolomeo della Gatta (*d* 1502, largely inactive in painting after 1487), and Signorelli could be more plausibly linked with him, perhaps around the time they collaborated in the Sistine Chapel. This view is confirmed by the single surviving detail of his work in the Stanza d'Eliodoro, a grisaille figure seated on a keystone (Nesselrath, fig. 3), since it is identical with two in Signorelli's early *Flagellation*. At the early date too the artist had favour from Sixtus IV, in contrast to his later eclipse in Rome and nearly everywhere. In a theoretical discussion of the civilizing effects of painting, Paolo Cortesi in *De cardinalatu* (1510) imagined that Julius II might order images of the gods from Luca (as noted by Mancini, 1903), but did not state whether this happened.

After negotiations in 1506 about a design for the floor mosaic of Siena Cathedral, in 1509 Signorelli shared with Pinturicchio and others his last major fresco cycle in the Palazzo del Magnifico, Siena, the palazzo of the ruling Petrucci family. There he painted four of eight Classical scenes and allegories, of which two survive, the *Triumph of Chastity: Love Disarmed and Bound* and *Coriolanus Persuaded by his Family to Spare Rome* (both London, N.G.); reflections of the two others are recorded in a drawing of the *Festival of Pan* (London, BM, 236) and in a majolica plate showing the *Calumny of Apelles* (Amsterdam, Rijksmus.). In these frescoes he applied to secular

themes the brilliance of his evocation of crowds, shifting from fierceness to a tone of romantic, vibrating drama.

Signorelli's late works were mostly for local patrons and included many altarpieces for small villages, such as that of the *Coronation of the Virgin* (Foiano di Chiana, Collegiata di S Martino), his last datable work. Many of these altarpieces are largely shop work, but a surviving drawing of the *Dead Christ* (Paris, Fond. Custodia, Inst. Néer.) for the *Deposition* (1516; Umbertide, Santa Croce) shows Signorelli's personal late style.

(iii) Drawings. Signorelli almost invariably used black chalk for his figure studies, sometimes heightened with white or with wash. He was apparently one of the first Italians to prefer that medium to pen and exploited its immediacy and tonal effects. His example was of importance to Michelangelo.

An early style, in which smooth contours define large blank areas, is illustrated by the *Head of a Youth* (Stockholm, Nmus.), a black chalk drawing pricked for transfer, which was used for the figure of St John the Baptist in the 1484 *Virgin and Child with Saints*. Another early drawing is the study of a *Figure Seen from Behind* (ex-Calman priv. col., London, see Berenson, 1938, fig. 118), used for the woman on the right of the *Circumcision*. Signorelli's middle-period drawing style is vigorously nervous, as evidenced in drawings made as preparatory studies for work at Orvieto: the belligerent *Four Male Nudes* (Florence, Uffizi, 1246E), used at Orvieto for a grisaille scene illustrating Lucan, and the *Flagellant* (Paris, Louvre, 1797), usually linked to the *Flagellation* fresco at Morra but also used for the grisaille scene of *St Peter Parenzo* at Orvieto. A few autograph drawings for late works, such as the *Dead Christ* (Paris, Fond. Custodia, Inst. Néer.) for the Umbertide *Deposition* and the *Christ at the Column* (Florence, Uffizi, 224), which is a reverse image of the Morra *Flagellation*, show a soft, atmospheric line system, similar to Michelangelo's late style.

2. CRITICAL RECEPTION AND POSTHUMOUS REPUTATION. Signorelli's early high standing is evidenced by Giovanni Santi's inclusion of him, as one of the youngest painters, in his list of leading artists of all Italy (1488; see Bek, 1969), but Cortesi's citation of him as 'worthy in painting and in imitating nature truly' (*De cardinalatu*, 1510) seems, ironically, to be an effort to block its decline. Vasari's *Vita*, with a benign, personal tone towards Signorelli—who was his father's cousin and who encouraged Vasari to paint in his youth—is of great importance, since thereafter he dropped from view. Vasari's definition of Signorelli's position as the last Quattrocento figure, on the brink of the High Renaissance and so able to affect Michelangelo, remained fundamental to his standing. In the late 18th century, when an interest in art of the age before Raphael emerged, Signorelli was unusually favoured through G. della Valle's book of large engravings of Orvieto Cathedral (1791), which emphasizes his frescoes. In 1813 the Nazarene painter Peter Cornelius (1783–1867) wrote from Orvieto to his colleague Overbeck (1789–1869) that Signorelli equalled Raphael, thus giving him the status of a Pre-Raphaelite *par excellence*.

Berenson found in his nudes a notable instance of his 'life-enhancing tactile values'. Cézanne (1839–1906), who made hundreds of drawings after Old Master paintings, repeatedly copied Signorelli's drawings (and only his in such quantity), using reproductions in Charles Blanc's books. The works of Max Beckmann (1884–1950) echoed the *Court of Pan*: for both artists, energetic yet stiffly angular body forms were evidently congenial. Sigmund Freud (1856–1939), on the first page of *The Psychopathology of Everyday Life* (1901), took as the starting-point of his exposition the fact that he had forgotten Signorelli's name, although he had admired his work very much on a visit to Orvieto. E. M. Forster sent two characters in *A Room with a View* (1908) to look at Signorelli's paintings in the National Gallery, London. For subsequent generations, however, he has retreated from the status of a forceful stimulus to a historical reference.

BIBLIOGRAPHY

EWA; Thieme–Becker

G. Vasari: *Vite* (1550, rev. 2/1568); ed. G. Milanesi (1878–85), iii, pp. 683–96

R. Vischer: *Luca Signorelli und die italienische Renaissance* (Leipzig, 1879)

L. Fumi: *Il duomo di Orvieto e i suoi restauri* (Rome, 1891)

Exhibition of the Work of Luca Signorelli and his School (exh. cat. by R. Benson, London, Burlington F.A. Club, 1893)

M. Cruttwell: *Luca Signorelli* (London, 1899)

G. Mancini: *Vita di Luca Signorelli* (Florence, 1903)

L. Dussler: *Luca Signorelli*, KdK (Stuttgart, 1927)

B. Berenson: *The Drawings of the Florentine Painters* (Chicago, 1938), pp. 328–36

M. Salmi: *Luca Signorelli* (Novara, 1953)

Mostra di Luca Signorelli (exh. cat. by M. Moriondo, Cortona and Florence, 1953) [with good selective bibliog.]

A. Martindale: 'Luca Signorelli and the Drawings Connected with the Orvieto Frescoes', *Burl. Mag.*, ciii (1961), pp. 216–20

P. Scarpellini: *Luca Signorelli* (Milan, 1964) [with exhaustive bibliog. for 1953–61]

E. Carli: *Il duomo di Orvieto* (Rome, 1965)

M. Moriondo: *Signorelli* (Florence, 1966)

L. Bek: 'G. Santi's "Disputa de la pictura": A Polemical Treatise', *Anlct. Romana Inst. Dan.*, v (1969), pp. 75–102

G. Kury: *The Early Work of Luca Signorelli, 1465–1490* (New York, 1978) [with exhaustive bibliog. on that phase to 1973]

S. Ferino: 'Timoteo Vitis Zeichnungen zum verlorenen Martinszyklus in der Kapelle des Erzbischofs Arrivabene im Dom von Urbino', *Mitt. Ksthist. Inst. Florenz*, xxiii (1979), pp. 127–44

P. Stastny: 'A Note on Two Frescoes in the Sistine Chapel', *Burl. Mag.*, cxxi (1979), pp. 777–83

G. Agosti: 'Precisioni su un Baccanale perduto del Signorelli', *Prospettiva*, xxx (1982), pp. 70–77

Disegni umbri del rinascimento da Perugino a Raffaello (exh. cat. by S. Ferino Pagden, Florence, Uffizi, 1982)

C. Gilbert: 'Bramante on the Road to Rome', *A. Lombarda*, lxvi (1983), pp. 5–14

M. Seidel: 'Signorelli um 1490', *Jb. Berliner Mus.*, xxvi (1984), pp. 181–256

L. Freedman: 'Once More Luca Signorelli's Pan Deus Arcadiae', *Ksthist. Tidskr.*, liv (1985), pp. 152–9

C. Gilbert: 'Signorelli and Young Raphael', *Stud. Hist. A.*, xvii (1986), pp. 109–24

S. Meltzoff: *Botticelli, Signorelli and Savonarola* (Florence, 1987)

L. B. Kanter: *The Late Works of Luca Signorelli and his Followers, 1489–1559* (PhD thesis, New York, Inst. F. A., 1989; Ann Arbor, 1991)

R. San Juan: 'The Illustrious Poets in Signorelli's Frescoes', *Warb. Court. Inst.*, lii (1989), pp. 71–84

L. B. Kanter and D. Franklin: 'Some *Passion* scenes by Luca Signorelli after 1500', *Mitt. Ksthist. Inst. Florenz*, xxxv (1991), pp. 171–92

C. B. Cappel: 'On "la testa proportionalmente degradata": Luca Signorelli, Leonardo and Piero della Francesca's *De prospectiva pingendi*', *Florentine Drawing at the Time of Lorenzo the magnificent: Papers from a Colloquium held at the Villa Spelman: Florence, 1992*, pp. 17–43

L. B. Kanter: 'Some Documents, a Drawing and an Altarpiece by Luca Signorelli', *Master Drgs*, xxx (1992), pp. 415–19

A. Nesselrath: 'Art Historical Findings during the Restoration of the Stanza dell'Incendio', *Master Drgs*, xxx (1992), pp. 31–60

G. Santarelli: 'La sagrestia dipinta da Luca Signorelli: Un suggestivo ambiente di *sacra conversazione*', *Santuario di Lorento: Sette secoli di storia arte devozione*, ed. F. Grimaldi (Rome, 1994), pp. 89–101

'Il senso della morte e l'amore della vita' nel periodo orvietano di Luca Signorelli, 1499–1504 (exh. cat. by E. della Casa, Orvieto, Pal. Pop., 1994)

J. Reiss: Luca Signorelli: The San Brizio Chapel, Orvieto (New York, 1995)

——: 'Luca Signorelli's *Rule of Antichrist and the Christian Encounter with the Infidel*', *Reframing the Renaissance: Visual Culture in Europe and Latin America, 1450–1650*, ed. C. Farago (New Haven and London, 1995), pp. 282–91, 341–3

——: *The Renaissance Antichrist: Signorelli's Orvieto Frescoes* (Princeton, 1995)

G. Testa, ed.: *La cappella nova* (Milan, 1996) [exhaustive conservation reports, docs and bib. for the Orvieto work]

T. Henry: 'New Documents for Signorelli's *Annunciation* at Volterra', *Burl. Mag.*, cxl/1144 (1998), pp. 474–8

C. Gilbert: 'Signorelli's *Pan*', *Studi di storia dell'arte in onore di M. L. Gatti Perer* (Milan, 1999), pp. 147–53

CREIGHTON E. GILBERT

Silla, Giacomo. *See* LONGHI, SILLA.

Silvestro (di Giacomo da Sulmona) dell'Aquila (*fl* 1471; *d* L'Aquila, 1504). Italian sculptor and painter. He was probably the son of the goldsmith Giacomo di Paolo Sulmona, recorded as resident in L'Aquila by 1467. Silvestro is first documented in 1471, sharing a workshop with Giovanni Biascuccio, and again at the end of the decade in partnership with the Florentine Francesco Trugi. The earliest documented work by the sculptor is a tabernacle with *St James* (untraced) commissioned by the ecclesiastical authorities of Tornimparte on 12 February 1476. In 1476 he was also commissioned to execute, in L'Aquila Cathedral, a funerary monument (damaged 1703) to *Amico Agnifili, Bishop of L'Aquila* (*reg* 1431–76). A contract for materials dated 15 September 1476 allows a partial reconstruction of the original form of the marble monument. The surviving sepulchre with an effigy of *Agnifili* was flanked by niche figures (untraced) of *St George* and *St Maximian*. The lunette sculpture specified in the document can perhaps be identified with a relief of the *Virgin and Child* (L'Aquila, S Marciana).

Agnifili's tomb was close in type to Florentine models such as Desiderio da Settignano's tomb of *Carlo Marsuppini* (*c.* 1453–60; Florence, Santa Croce; *see* DESIDERIO DA SETTIGNANO, fig. 1). Silvestro's work frequently invites comparison with that of Florentine sculptors. Most frequently he has been considered a follower of Antonio Rossellino, but his wood sculpture of *St Sebastian* (1478; L'Aquila, Mus. N. Abruzzo) differs in significant respects from Rossellino's marble version of the same subject (Empoli, Mus. Collegiata). Silvestro's work is anatomically more correct, and his figure shows none of the contrapposto of Rossellino's figure. Silvestro's *St Sebastian* is perhaps closer to the bronze *David* by Verrocchio (Florence, Bargello; *see* VERROCCHIO, ANDREA DEL, fig. 3). The familiarity with contemporary Florentine sculpture suggests a period of residence in Tuscany, and Silvestro may have been in Florence in the late 1460s or early 1470s.

Silvestro was also known as a painter, and, although none of his works in this medium survives, comparisons can be made between his sculpture and contemporary painting. The niche figures of Silvestro's marble *Camponeschi* tomb (L'Aquila, S Bernardino), for example, recall, in the treatment of the draperies, figures from Central Italian art. The *Camponeschi* tomb, with its effigies of mother and child, was erected by Maria Pereira Camponeschi, a member of the House of Aragon, as a monument to her daughter Beatrice who had died before November 1491 aged 15 months. The work was under way by 1496, when an overseer was appointed. Close in date is the more ornamental repository for the bones of S Bernardino in the same church. The work was commissioned by Jacopo di Notar Nanni and was under construction when he made his will in 1500. The work follows the form of a sepulchral monument. In the upper register the donor is presented to the Virgin by S Bernardino. The four lower niche figures represent *SS Peter, Francis, Paul and Anthony of Padua*. Those in the upper niches represent *SS John the Baptist, John the Evangelist, Sebastian and Catherine*. The design is undoubtedly Silvestro's. It is evident, however, that he controlled a large workshop, and many assistants including Salvato Romano and Angelo di Marco, Silvestro's nephew and heir, worked on the monument, which was completed in 1505. Silvestro also produced numerous statues of the *Virgin and Child* in wood (1490; Ancarano, Madonna della Pace) and terracotta (1490s; L'Aquila, S Bernardino). Silvestro should not be identified with the goldsmith of the same name recorded in Florence in 1439–40.

BIBLIOGRAPHY
Thieme–Becker
A. Venturi: *Storia* (1901–40)

G. De Nicola: 'Silvestro dell'Aquila', *L'Arte*, xi (1908), pp. 1–16

L. M. Bongiorno: 'Notes on the Art of Silvestro dell'Aquila', *A. Bull.*, xxiv (1942), pp. 232–43

C. Seymour: *Sculpture in Italy, 1400–1500*, Pelican Hist. A. (Harmondsworth, 1966), pp. 163–4, 274

Simone da Settignano. *See* CIOLI, (1).

Sinibaldi. *See* MONTELUPO, DA, (1).

Sinopia. Red earth pigment, also known as porphyry or *terra di Sinope*. The term is more commonly used for a preparatory underdrawing in FRESCO painting (see fig.) in which the whole pictorial composition is drawn, usually in *sinopia*, directly on to the wall or on to the rough plaster (*arriccio*).

The red earth (sinopite) from which *sinopia* was obtained is found in Egypt, in the Balearic Islands and in Cappodocia (Turkey). After purification, it was taken to Sinop, a town on the Turkish coast of the Black Sea, where it was sold. According to Pliny, *sinopia* was one of the only four colours used by the Greeks. It was certainly highly prized by the ancient Greeks and Romans since they took care to maintain the quality of the product, but by the medieval period the term was applied to other, inferior red earth colours. Cennini, in his treatise of *c.* 1390, described *sinopia* as a 'natural colour ... lean [i.e. greaseless] and dry in character', and said it could be ground very fine to form an excellent pigment for painting on panels or plaster, either fresco or *a secco*. In the medieval period this pigment was widely employed not only by painters but also by

Sinopia by an Umbrian painter, Palazzo Trinci, Foligno (*c.* 1424)

builders and carpenters, who used it to coat the cords (*fili di sinopia*) that served to trace straight lines when stretched and sprung against walls or wooden beams.

Originally mural compositions had been sketched directly on to the plaster that was to be painted. The use of a *sinopia*, which was common from the mid-13th century to the 1430s (when it was largely replaced by the CARTOON), may have been adopted from the practice of mosaicists of making a preparatory drawing on the setting-bed. Cennini recommended that *sinopia* be used to draw figures on the *arriccio*; he advised painters not to add glue to the pigment and to make a preliminary charcoal sketch to be brushed off afterwards.

Fresco painting was carried out in sections known as *giornate* that were freshly plastered every day (*see* FRESCO, §1). The use of a *sinopia* underdrawing enabled the painter to refer to the whole composition as he painted the *giornate*. In establishing the *sinopia*, the artist would use a stylus to trace the perimeter of the composition and any internal lines; he would then work up the drawing with a brush. During this process he could keep an eye on the overall balance of the composition and make any changes in the original plan that might occur to him on seeing the full-size composition on the wall. The work was then completed with a final coat of plaster (the *intonaco*), on to which the main features of the composition were again sketched before the application of the paint.

In the Renaissance period the *sinopia* pigment was no longer used for drawing on the *arriccio*. It was replaced by other colours such as black, cinnabar or vermilion, red earth and yellow ochre. Sixteenth-century writers do not therefore speak of *sinopia* when referring to this type of underdrawing, and it is only since the mid-20th century

that the term *sinopia* has been widely used for underdrawings made with other pigments.

During the 1950s and 1960s frescoes were frequently detached from the wall using the *strappo* method, in which only the thin layer of plaster that carried the paint was lifted off, leaving the underlying plaster intact (*see* FRESCO, §2). This process brought to light a great number of *sinopie*, some of which are particularly interesting for the study of early drawing. The *sinopie* may be quite schematic, and even differ considerably from the final fresco; or finely drawn and corresponding closely to the finished work. By the later 20th century the practice of detaching frescoes, especially by the *strappo* method, was considered undesirable, so the discovery of *sinopie* became increasingly rare.

BIBLIOGRAPHY
Pliny: *Natural History* IX, xxxiii, 117, xxxv, 30–32, 36, 40, 50
C. Cennini: *Il libro dell'arte* (*c.* 1390); Eng. trans. and notes by D. V. Thompson jr as *The Craftsman's Handbook: 'Il libro dell'arte'* (New Haven, 1933/*R* New York, 1954)
G. Vasari: *Vite* (1550, rev. 2/1568); ed. G. Milanesi (1878–85)
Frescoes from Florence (exh. cat. by U. Procacci and others, London, Hayward Gal., 1969)
P. Mora, L. Mora and P. Philippot: *Conservation of Wall Paintings* (London, 1984)
 GIANLUIGI COLALUCCI

Sixtus IV, Pope. *See* ROVERE, DELLA, (1).

Sixtus V, Pope. *See* PERETTI, (1).

Soderini, Piero (di Tommaso) (*b* Florence, 14 May 1452; *d* Rome, 13 June 1522). Italian politician and patron. He belonged to a rich Florentine family that had been important in the city's public life since the 13th century. In addition to vast landholdings, the Soderini were active in commerce. Piero was a member of the powerful silk and wool guilds and was a business partner of the Medici. In 1476 he married the noblewoman Argentina Malaspina of Fosdinovo, increasing the family's already large patrimony. As a young man, he frequented the Neo-Platonic circle of Marsilio Ficino and was taught by the humanist Giovanni Antonio Vespucci (*b* 1434), a follower of Girolamo Savonarola. His political career mainly involved diplomatic duties, for which he went to France in 1493 and 1498. He was active in Florentine affairs after the downfall of the Medici in 1494, and in 1502 he became the first *Gonfaloniere* (chairman of the *signoria*) to be elected for life.

Soderini is mentioned in contemporary records as interested in the arts, and he had dealings with many important artists. In 1501 he commissioned Michelangelo to carve the marble *David* (Florence, Accad.; *see* ITALY, fig. 22) that was placed in the Piazza della Signoria in Florence. He then had Michelangelo execute a second *David* in bronze (untraced), at the request of the French general, Pierre de Rohan. In 1503–4, for the Florentine republic, he commissioned Leonardo da Vinci and Michelangelo to paint frescoes of battle scenes (the battles of Anghiari and Cascina respectively) for the new council chamber of the Palazzo della Signoria. Although Leonardo's fresco was destroyed and Michelangelo's was never executed, the designs for them were highly influential. Soderini asked Michelangelo in 1508 to execute a statue of Hercules and Cacus as a pendant for the *David*, a

project realized later by Baccio Bandinelli (*see* BANDINELLI, BACCIO, fig. 2). In 1510, also for the council chamber, he commissioned a large painting of the *Virgin and Child with Saints* from Fra Bartolommeo. Only the monochrome underpainting of this was executed (Florence, Mus. S Marco). According to Vasari, he had Morto da Feltre decorate his office in the Palazzo della Signoria with grotesques (destr.). Milanesi, in his edition of Vasari, noted that Lorenzo di Credi painted two portraits of Soderini (Florence, Gal. Panciatichi; Florence, Casa Bartolommei). Benedetto da Rovezzano made a beautiful marble tomb for him in 1510 (Florence, S Maria del Carmine). This was never used, however, as Soderini was exiled from Florence when the Medici returned in 1512; he eventually settled in Rome, where he is buried, in S Maria del Popolo.

BIBLIOGRAPHY

G. Vasari: *Vite* (1550, rev. 2/1568); ed. G. Milanesi (1878–85), iii, pp. 258, 404–5, 494; iv, pp. 45–9, 212, 484; v, 140; vii, pp. 121–5, 133, 268

R. Cooper: *Piero Soderini, Gonfaloniere a vita 1502–12* (diss., U. London, 1965)

H. Butters: 'Piero Soderini and the Golden Age', *It. Stud.*, xxxiii (1978), pp. 56–70

R. Cooper: 'Piero Soderini: Aspiring Prince or Civic Leader?', *Stud. Med. & Ren. Hist.*, n. s., i (1978), pp. 69–126

H. Butters: *Governors and Government in Early Sixteenth-century Florence 1502–1519* (Oxford, 1985), pp. 83–5

F. Hartt: 'Leonardo and the Second Republic', *J. Walters A.G.*, xliv (1986), pp. 95–116

DONATELLA PEGAZZANO

Sodoma [Bazzi, Giovanni Antonio] (*b* Vercelli, 1477; *d* Siena, 15 Feb 1549). Italian painter. He worked mainly in Siena and was the dominant painter of the Sienese school in the early 16th century. He painted frescoes, altarpieces and panel paintings for private collectors; he was patronized by religious institutions, the civic authorities in Siena and by noble patrons. His art unites the vivid and detailed naturalism of a North Italian artistic tradition with a new spaciousness and classical sense of form that reflects his study of the art of Central Italy. He had little competition in Siena, where his only rival, in his later years, was Domenico Beccafumi. He was a flamboyant and eccentric personality, whose character was later blackened by Vasari.

1. Early work, 1490–mid-1508. 2. Middle years, late 1508–28. 3. Last period, after 1529.

1. EARLY WORK, 1490–MID-1508. Sodoma was the son of Giacomo, a shoemaker from Biandrate, and of Angelina di Nicolò from Bergamo. On 28 November 1490, until about 1498, he was apprenticed to Giovanni Martino Spanzotti in Vercelli. He probably collaborated with Spanzotti on the frescoes of the *Life of Christ* in S Bernardino, Ivrea. By about 1500 he was in Siena, brought there, according to Vasari, by agents of the Spannocchi, the Sienese bankers, who had a branch in Milan. This information is confirmed by Sodoma's familiarity with the art of Leonardo da Vinci and his circle, which he must have known in Milan, where he went after 1498. A document of 1 March 1502 shows that he had already executed the altarpiece for the Cinuzzi Chapel in S Francesco in Siena, the monumental *Descent from the Cross* (Siena, Pin. N.). Here the Lombard–Piedmontese tradition of the 15th century is expressed in an accurate and incisive

design, in soft *sfumato* effects deriving from Leonardo and in the enamel-like colouring that had no precedents in Sienese or perhaps even in Tuscan painting. The delicate elegiac tone of the fainting Virgin is already typical of Sodoma, while an echo of Pietro Perugino's manner is perceptible in the face of St John. Slightly earlier than the Cinuzzi *Descent from the Cross* are two canvas banners of the *Crucifixion* attributed to Sodoma (Siena, Pin. N. and Montalcino, Mus. Dioc. A. Sacra).

On 10 July 1503 Sodoma was commissioned to paint the fresco decoration in the refectory of the Olivetan convent of S Anna in Camprena, near Pienza; the work was finished by 25 June 1504. It consists of a grotesque frieze on the window wall, in which five panels showing scenes from the *Life of St Anne* alternate with five tondos with busts of saints, a large tripartite scene of the *Miracle of the Loaves and Fishes* on the end wall, and a *Pietà* on the entrance wall; this is flanked by a scene showing *St Benedict Blessing the Constitutions of the Olivetan Congregation* and another of *St Anne and the Virgin and Child Adored by Two Olivetan Monks*.

Sodoma was then commissioned by the Olivetans to continue and complete the *Stories of St Benedict* in the large cloister of the monastery of Monte Oliveto Maggiore (near Siena), where the artist is recorded on 5 August 1505. Luca Signorelli had already painted nine scenes on this subject on the western side of the cloister in 1497–8 before he abandoned the undertaking. Records of payments made to Sodoma follow one another in swift succession until 22 August 1508. As well as painting *Christ at the Column*, *Christ Carrying the Cross* and *St Benedict Giving the Rule to the Olivetans* in the passage between the cloister and the church, Sodoma painted 26 scenes with vivacity and psychological penetration illustrating in detail as many episodes in the life of St Benedict as are narrated in the second book of St Gregory the Great's *Dialogues*. In these frescoes the artist achieved a compositional and narrative style in which the fresh and detailed naturalism of the illustrative tradition of the late 15th century in North Italy is matured and developed through the emergence of forms and through a breadth and unity of space that are wholly of the new century. These scenes are separated by small pilasters, with candelabras and grotesques, which are fundamental in the development of this ornamental motif. A number of tondi on panel are assigned to the period 1501 to 1505, for example the *Adoration of the Child* (Siena, Pin. N.), which is tied to the Tuscan tradition of this kind of composition; another with the same subject (Vercelli, Mus. Civ. Borgogna); and the Louvre tondo whose subject has been interpreted as *Charity* or *Love and Chastity*.

2. MIDDLE YEARS, LATE 1508–28. In October 1508, through the good offices of Sigismondo Chigi, Sodoma went to Rome, where he was commissioned to paint frescoes on the ceiling of the Stanza della Segnatura in the Vatican. Raphael, who subsequently worked in the same room, respected the decorative framework and the eight small trapezial scenes with mythological subjects and episodes from Roman military history that Sodoma executed. A *cassone* panel showing the *Rape of the Sabine Women* (Rome, Pal. Barberini), which originally came from

the Palazzo Chigi near SS Apostoli in Rome, also belongs to this period. About 1510 Sodoma decorated the ceiling of a room in the palace of Sigismondo Chigi in Via del Casato, Siena, with canvases of mythological subjects, of which four survive (New York, Met. and Worcester, MA, A. Mus.). In Siena, on 28 October 1510, Sodoma married Beatrice de' Galli, the daughter of an inn-keeper; their daughter, Faustina (*bapt* 16 Aug 1512), was married in 1542 to the artist's favourite pupil, Bartolomeo Neroni. The three panels representing *Judith* (Siena, Pin. N.), *Lucrezia* (Hannover, Kestner-Ges.) and *Charity* (destr. Berlin 1945), which may have been part of the decoration of a room in the palace of Pandolfo Petrucci, the 'magnificent' tyrant of Siena, probably date from 1511–12. At the same time Sodoma was commissioned by Sigismondo Chigi to paint an altarpiece for S Bartolomeo alle Volte, near Siena; this has been identified as the panel showing the *Virgin and Child with Four Saints* (Turin, Gal. Sabauda). On 9 November 1513 Sodoma signed a contract to paint the façade of Agostino Bardi's palace in Siena, for which his advance payment was a horse with a black velvet saddlecloth and gilded stirrups worth 30 gold ducats. Sodoma had a passion for horses, and he entered his own, ridden by other jockeys, for the Palio races in Siena in 1512, 1513 and 1514. Both the façade decoration of the Casa Bardi and that of the Palazzo Borghesi, which Domenico Beccafumi painted in competition with Sodoma, have been lost.

After the Bardi façade, Sodoma probably painted the fresco of the *Flagellation* in the cloister of S Francesco in Siena. The figure of Christ, which was admired both for its intense pathos and for the soft modelling similar to that of Leonardo, was detached from the wall in 1841 (Siena, Pin. N.). In 1514–15 Sodoma was at Piombino, and it was from there that on 18 June 1515 he was recommended to Lorenzo de' Medici, Duke of Urbino, by Jacopo Sesto, Duca di Piombino. In Florence one of his horses ran in the Palio held on the feast of St Barnabas and won. He painted a fresco of the *Last Supper* in the refectory of the Olivetan convent in Florence, and between 30 November 1515 and 17 February 1516 he met the Medici Pope Leo X, who conferred on him the title of Cavaliere.

Sodoma's most famous work, the decoration of one of the rooms in Agostino Chigi's sumptuous villa, later known as the Villa Farnesina, in Rome, is given the date 1516. The frescoes he painted represent the *Marriage of Alexander and Roxanne* (see colour pl. 2, XXXII2) and the *Family of Darius before Alexander* (both *in situ*). The marriage scene is derived from the description by Lucian of Samosata (AD 117–80) of a panel painting by Aetion. There was a drawing (destr.) by Raphael of the same subject, which is known through copies and which was engraved by Giovanni Jacopo Caraglio. The version closest to Raphael and sometimes attributed to him is in Vienna in the Albertina (1515–16). The style of the fresco by Sodoma is the nearest he approached to that of Raphael, although Sodoma's painting is more theatrical and more crowded in detail, reminiscent of northern art, than the serene and classical work by Raphael. The execution is however extraordinarily refined in the richness of the chromatic combinations, and the marvellous figure of

Roxanne represents Raphael's womanly ideal graced with the charm of Leonardo's light.

In 1518 Sodoma was once more in Siena, where he played a pre-eminent part in the collaboration with Girolamo del Pacchia (1477–1533) and Beccafumi in painting the cycle of scenes from the *Life of the Virgin* in the oratory of S Bernardino. A little later he executed some frescoes in the oratory of the former Compagnia di Croce underneath S Agostino, two of which—the *Agony in the Garden* and the *Descent into Limbo*—were detached in 1842 (Siena, Pin. N.).

On 3 May 1525 Sodoma was commissioned to paint the banner of the Compagnia di S Sebastiano in Camollia with the image of *St Sebastian* on one side (see fig. 1) and the *Virgin and Child Adored by St Sigismund and St Roch and Members of the Confraternity* on the other (Florence, Pitti). The work was so admired that on 6 November 1531 the artist received 10 ducats more than the original 20 stipulated in the contract. Eventually the Compagnia, which had refused to sell it for 300 gold scudi to some merchants from Lucca, was forced to cede it to the Grand Duke Leopold in 1786 for 200 zecchini. In contrast to the praise lavished on it previously, *St Sebastian* is regarded by many art historians today as sentimental. The same feeling characterizes *St Catherine Swooning* and the *Vision of St Catherine of Siena* which, together with the crowded scene of the *Execution of Nicolò di Tuldo*, form fresco decoration in S Domenico, Siena, painted by Sodoma in 1526; they are among the artist's most celebrated works.

1. Sodoma: *St Sebastian*, banner painted on canvas on both sides, 2.02×1.43 m, 1525 (Florence, Palazzo Pitti)

3. LAST PERIOD, AFTER 1529. Having become a sort of official painter to the Sienese Republic, in 1529 Sodoma was engaged to paint in fresco the figures of *St Victor* and *St Ansano* and in 1533 the figure of the *Blessed Bernardo Tolomei* in the Sala del Mappamondo in the Palazzo Pubblico (*in situ*) and also, in the same Palazzo, a *Resurrection* and a *Virgin with Two Saints* (*c.* 1535). At the end of 1530 he painted a fresco in the Cappella degli Spagnoli in Santo Spirito of an impetuous *St James of Compostela Riding over the Bodies of the Defeated Saracens*, a work that was admired by Charles V (*reg* 1519–56) when he visited Siena in 1536. The great fresco of the *Nativity* above the Porta San Viene (later Pispini) is documented in the years 1530–32, and to the same period belongs a *Pietà*, known as the *Madonna of the Raven*, in a tabernacle on the exterior of the Casa Bambagini Galletti. In 1537 he painted a large fresco of the *Virgin with the Four Patron Saints of Siena* in the Cappella di Piazza, of which only the charcoal drawing survives *in situ*.

Towards the end of 1537 Sodoma returned to Piombino, and from there he went to Volterra, where he executed a canvas for a ceiling showing the *Fall of Phaethon* (untraced) for Lorenzo di Galeotto de' Medici. A beautiful sepia sketch for it survives (Florence, Uffizi). In 1539 he was in Pisa, where the Opera del Duomo (Cathedral Works) commissioned two panels from him, one of a *Pietà*, the other of the *Sacrifice of Isaac*, both of which are in the apse of the Cathedral. In 1542 he painted an altarpiece showing the *Virgin with Six Saints* for the oratory of the Spina (now Pisa, Mus. N. S Matteo; see fig. 2). After a brief stay in Lucca, Sodoma returned to Siena in 1545. The artist's last years in the city where Beccafumi, his slightly younger rival, had by now become established, are obscure. The mediocre *Road to Calvary* in S Giacomo in Salicotto and the tearful *Pietà* (Rome, Gal. Borghese), both of which betray signs of a senile decadence, probably date from this period.

Apart from his activity as a fresco painter, Sodoma executed many panel paintings: various small-scale Madonnas; panels for biers, such as the four small ones ordered by the Compagnia di S Giovanni della Morte, Siena, of *St John the Baptist*, *Virgin and Child*, a *Dead Christ* and *St Bernardino of Siena* (*in situ*); and altarpieces, two of the most famous of which are the *Adoration of the Magi* (*c.* 1528) for S Agostino, Siena, and the *Holy Family with St Leonard* (*c.* 1533; Siena, Pal. Pub.), a work much praised by Annibale Carracci (1560–1609) (Mancini).

BIBLIOGRAPHY

G. Vasari: *Vite* (1550, rev. 2/1568); ed. G. Milanesi (1878–85), vi, pp. 379–408
G. Mancini: *Considerazioni sulla pittura* (1641–2); ed. L. Salerno (Rome, 1956), i, p. 192
L. Bruzza: *Notizie intorno alla patria e ai primi studi del pittore G. A. Bazzi, detto il Sodoma* (Turin, 1862)
R. H. Hobart Cust: *Giovanni Antonio Bazzi, Hitherto Usually Styled Sodoma* (London, 1906)
A. Segard: *G. A. Bazzi, dit le Sodoma* (Paris, 1910)
L. Gielly: *G. A. Bazzi, dit le Sodoma* (Paris, 1911)
H. Hauvette: *Le Sodoma* (Paris, 1911)
Mostra delle opere di G. A. Bazzi, detto il Sodoma: Catalogo (exh. cat. by E. Carli, Vercelli, 1950)
M. T. Marciano Agostinelli Tozzi: *Il Sodoma* (Messina, 1951)
A. Hayum: *Giovanni Antonio Bazzi, 'il Sodoma'* (New York, 1976)
E. Carli: *Il Sodoma* (Vercelli, 1979)

2. Sodoma: *Virgin with Six Saints*, 1542 (Pisa, Museo Nazionale di S Matteo)

F. Sricchia Santoro: 'Ricerche senesi, 4: Il giovane Sodoma', *Prospettiva*, xxx (1982), pp. 43–58
P. Zambrano: 'La Deposizione Cinuzzi del Sodoma: Una nuova proposta di datazione', *Paragone*, 479–81 (1990), pp. 83–93
W. Loseries: 'Sodoma e la scultura antica', *Umanesimo a Siena: Letteratura, arti figurative, musica*, ed. E. Cioni and D. Fausti (Siena, 1994), pp. 345–81
——: 'Sodoma's *Holy Family* in Baltimore: The "Lost" Arduini Tondo', *Burl. Mag.*, cxxxvi/1092 (March 1994), pp. 168–70
P. Zambrano: 'A New Scene by Sodoma from the Ceiling of Palazzo Chigi at Casato di Sotto, Siena', *Burl. Mag.*, cxxxvi/1098 (1994), pp. 609–12

ENZO CARLI

Sogari, Prospero. *See* SPANI, (2).

Sogliani, Giovanni Antonio (*b* Florence, 1492; *d* Florence, July 1544). Italian painter. He trained with Lorenzo di Credi, to whom he remained closely attached; he is recorded as an executor of Lorenzo's will in 1531. After collaborating on works in the style of Lorenzo, from 1515 he had an independent shop and began to develop his own style. In the *St Martin* for Orsanmichele in Florence, for example, he complemented his master's manner with a *sfumato* reflecting contemporary Florentine painting. The attribution of another work of this period, the *Last Supper* in the convent of S Maria di Candeli, Florence, has been disputed, but it is certainly characteristic of Sogliani (Vertova). The remarkable altarpiece of the *Martyrdom of St Acazio* (Florence, S Lorenzo) of 1521 reflects the work of Andrea del Sarto.

Vasari recorded that Sogliani was a follower of Fra Bartolommeo, and this is confirmed by the style of the monumental figures in such works as *St Bridget Imposing the Rule* (1522), the *Trinity with SS James, Mary Magdalene and Catherine* (both Florence, Mus. S Salvi), as well as the *Allegory of the Immaculate Conception* (Florence, Accad.) and the altarpiece of the *Virgin and Child with SS Jerome and Anselm* for S Maria at Ripa, near Empoli. From 1528 Sogliani executed paintings for Pisa Cathedral (all *in situ*), including the *Sacrifice of Abel*, the *Sacrifice of Cain* (both 1533), and an altarpiece of the *Virgin and Child Enthroned with Saints* (1539–41; initially commissioned from Perino del Vaga). He also completed the *Virgin and Child with Saints* (1536) that was left unfinished by del Sarto. In 1531, for S Maria delle Grazie, Anghiari, he executed the paintings (*in situ*) of *Christ Washing the Feet of the Disciples* and the *Last Supper*, a variation on del Sarto's work in S Salvi, Florence. The *Supper of St Dominic*, a large fresco in the refectory of S Marco in Florence, was painted in 1536. According to Vasari, its conservative style was imposed by the Dominican patrons, who rejected Sogliani's more modern design.

BIBLIOGRAPHY

G. Vasari: *Vite* (1550, rev. 2/1568); ed. G. Milanesi (1878–85), v, pp. 123–32

A. E. Popham: 'Sogliani and Perino del Vaga at Pisa', *Burl. Mag.*, lxxxvi (1945), pp. 85–90

R. Bacou: 'A Group of Drawings by Sogliani', *Master Drgs*, i (1963), pp. 41–3

L. Vertova: 'The "signed" Franciabigio of S Maria di Candeli', *Burl. Mag.*, cxiv (1972), pp. 472–5

A. Muzzi: 'La contesa fra Sogliani e i Domenicani di San Marco', *Atti del corsivo 'Dal disegno all'opera compiuta': Torgiano, 1987*, pp. 51–7

ANDREA MUZZI

Soiaro, il. *See* GATTI, BERNARDINO.

Solari [Solario] (i). Italian family of artists. The older branch included architects and sculptors who for three generations held numerous important positions in the ducal building projects in Lombardy: (1) Giovanni Solari, his sons (2) Guiniforte Solari and (3) Francesco Solari, and Guiniforte's son (4) Pietro Antonio Solari were all involved in work on the Certosa di Pavia and on Milan Cathedral. As a result, their individual contributions are often difficult to distinguish. These artists represented the Late Gothic tradition, partly in conscious opposition to the Renaissance architecture that was appearing in Milan from the middle of the 15th century. A second branch of the family, also based in Lombardy, was headed by the mason Bertolo Solari. Among his sons were the architect and sculptor (5) Cristoforo Solari, the painter (6) Andrea Solario, Alberto Solario (*d* 1512) and Pietro Solari, both masons and engineers.

(1) Giovanni Solari (*b* ?Campione, 1410; *d* Milan, 1480 or 1484). Architect. His participation in important building projects of the 15th century in Lombardy is fully documented, but none of his works has been authenticated. In particular, Giovanni's role in the planning of the Certosa di Pavia and in the design of the lantern (*tiburio*) in Milan Cathedral is still disputed. From 1428 to 1462 he was in charge of the construction of the church (originally commissioned in 1396 by Giangaleazzo Visconti) and the conventual buildings of the Certosa. Appointed ducal master builder in 1450 by Francesco Sforza and commissioned to complete the church that had barely been started, Giovanni may have effected a change of plan in relation to the original design; the construction of a monumental apse on a cruciform plan, with each arm terminating in a triconch, was completely new to Lombard architecture. From 1452 to 1470 Giovanni held the post of master builder of Milan Cathedral (initially with Filarete, and from 1459 with his son (2) Guiniforte); during this time he was presumably concerned with the lantern. From 1470 to 1480–81 he carried out various lesser works in the duchy, including works at the castle (ruined) in Novara (Lombardy) and at the ducal palace (destr.) in Milan.

(2) Guiniforte Solari (*b* 1429; *d* Milan, 7 Jan 1481). Architect and sculptor, son of (1) Giovanni Solari. His career is essentially linked with three great ducal construction projects: the Certosa di Pavia (*see* PAVIA, §2), Milan Cathedral and the Ospedale Maggiore in Milan. After working with his father on the Certosa (from 1452) and Milan Cathedral (from 1459), he took over the function of master builder of the two buildings from 1462 and 1471 respectively. The eastern parts of the Certosa church were erected in the 1460s together with the transept, choir and the cloister under the supervision of father and son, while in the 1470s they completed the lantern of Milan Cathedral. This temporary collaboration has made it difficult to distinguish between their work, although the lantern is attributed by most authors to Guiniforte. The structure and design of the lantern involved the transition from the square crossing to the octagonal vaulting by means of squinches. This design became the subject of vehement discussion after work was commenced in about 1470 but was retained for the version carried out in 1490–99 by Giovanni Antonio Amadeo and Giovanni Giacomo Dolcebuono. The lantern of the church at the Certosa di Pavia was begun in 1473 and follows the same principle. Guiniforte is known to have also worked on the sculpture of the cloister. It is likely that the exterior of the church, which is characterized by a ring of buttresses and a double dwarf gallery, and above all the unexecuted design for the façade (as represented in Ambrogio Bergognone's fresco of 1492–4 in the south transept apse) can be ascribed to Guiniforte. In 1465 he took over from Filarete as master builder of the Ospedale Maggiore (begun 1456), Milan. Diverging from Filarete's original conception he completed the main façade with Gothic two-light windows set back above the ground-floor arcade. He also built the adjoining sides, some inner courtyards and the rear façade.

The long portico, the so-called Coperto dei Figini, that was built in 1472 to Guiniforte's design (destr. 1868) has urbanistic relevance, a new feature in Milan. Although no reliable contemporary record has come to light, Guiniforte's name is traditionally also linked with two typologically and stylistically related Milanese churches: S Pietro in Gessate (*c.* 1460–76) and S Maria delle Grazie (1463–80). Both these churches have a nave and aisles flanked by side chapels and they are characterized by clear, uniform spatial

planning and simplified structural elements. Plain, round columns are used instead of compound piers in the nave; the transverse arches of the nave are supported by pilaster strips starting above the arcade, a system already used in 12th- and 13th-century Lombard churches. Other secure works by Guiniforte include the oratory of the Passione (1472) at S Ambrogio, Milan, and the castle (ruined) at Pizzighettone (Lombardy), while such buildings as S Maria Incoronata and S Maria della Pace (both in Milan) are frequently ascribed to him on stylistic grounds.

(3) Francesco Solari (*fl* 1464–70). Architect and sculptor, son of (1) Giovanni Solari. He was appointed ducal architect in 1464. Francesco worked in the workshop of Milan Cathedral and also as sculptor on its cloister and at the church of the Certosa di Pavia (*see* PAVIA, §2), the Ospedale Maggiore and the palazzo for Isabella da Robecca (destr.) in the Piazza Camposanto near Milan Cathedral. A relief of the *Virgin* signed by Francesco survives in S Angelo, Milan.

(4) Pietro Antonio Solari (*b c.* 1450; *d* Moscow, 1493). Architect and sculptor, son of (2) Guiniforte Solari. From 1476 he worked with his father in the architectural workshop of Milan Cathedral, but after Guiniforte's death in 1481 he became master builder of all the buildings for which his father had been responsible (although he shared the responsibility with Giovanni Antonio Amadeo at the Certosa di Pavia, and at Milan Cathedral). Three churches in Milan, del Carmine, S Maria Incoronata and S Maria della Pace, are ascribed on stylistic grounds to Pietro Antonio (together with Guiniforte). The only authenticated sculpture is the tomb of *Marco de' Capitani, Bishop of Alexandria* (1484; Alessandria Cathedral), with a somewhat crudely executed recumbent effigy. Pietro Antonio's architectural work can be securely identified only in Moscow, where he was summoned in 1490 by Ivan III, Grand Duke of Muscovy. His known buildings there include a wooden palace (destr.), three gate towers of the Kremlin walls (the Nikol'skaya, Spasskaya and Borovitskaya towers) and the Faceted Palace (1487–91; Granovitaya Palata).

BIBLIOGRAPHY

Thieme–Becker
Annali della fabbrica del Duomo di Milano dall'origine fino al presente, 9 vols (Milan, 1877–85)
F. Malaguzzi-Valeri: 'I Solari architetti e scultori lombardi dal XV secolo', *It. Forsch. Ksthist. Inst. Florenz*, i (1906), pp. 59–168
J. S. Ackerman: 'The Certosa of Pavia and the Renaissance in Milan', *Marsyas*, v (1947–9), pp. 23–37
A. M. Romanini: 'L'architettura viscontea nel XV secolo', *Stor. Milano*, vi (1955), pp. 611–84
——: 'L'architettura milanese nella seconda metà del quattrocento', *Stor. Milano*, vii (1956), pp. 601–18
V. Lasareff: 'Le opere di Pietro Antonio Solari in Russia ed i rapporti artistici italo-russi nel tardo quattrocento', *Arte e artisti dei laghi lombardi*, ed. E. Arslan, i (Como, 1959), pp. 423–40
A. M. Romanini: *L'architettura gotica in Lombardia*, 2 vols (Milan, 1964)
M. G. Albertini Ottolenghi, R. Bossaglia and F. R. Pesenti: *La Certosa di Pavia* (Milan, 1968)
P. Cazzola: 'Pietro Antonio Solari architetto lombardo in Russia', *A. Lombarda*, xiv (1969), pp. 45–52
F. Ferrari da Passano and A. M. Romanini: *Il Duomo di Milano*, 2 vols (Milan, 1973)
C. R. Morschek jr: *Relief Sculpture of the Façade of the Certosa di Pavia, 1473–1499* (New York and London, 1978)
R. Schofield: 'Giovanni Ridolfi's Description of the Façade of the Certosa di Pavia in 1480', *La scultura decorativa del primo rinascimento. Atti del I convegno internazionale di studi: Pavia, 1980*, pp. 95–102
M. Rossi: 'I contributi del Filarete e dei Solari per il tiburio del Duomo di Milano', *A. Lombarda*, lx (1982), pp. 15–23
L. Patetta: *L'architettura del quattrocento a Milano* (Milan, 1987)
M. P. Zanoboni: 'Il contratto di apprendistato di Giovanni Antonio Amadeo', *Nuova Riv. Stor.*, lxxix/1 (1995), pp. 143–50

A. E. WERDEHAUSEN

(5) Cristoforo Solari [il Gobbo] (*b* Milan, *c.* 1468–70; *d* Milan, May 1524). Sculptor and architect, cousin of (4) Pietro Antonio Solari. He received his early training from Pietro Antonio, to whom he was apprenticed for five years from 12 November 1483. Cristoforo worked in Venice in the early 1490s, but by 1493 he was back in Milan, where he was briefly employed by Ludovico Sforza and the Fabbrica (Cathedral Works) of S Maria presso S Celso. In 1494 he returned to Venice, probably with his brother (6) Andrea Solario. There he was employed by Giorgio Dragan, a Venetian sea-captain, to make the sculptural decoration for his altar (untraced), dedicated to St George, in S Maria della Carità (suppressed 1807; incorporated into the Galleria dell'Accademia). Although Solari is known to have executed other works during this second Venetian period, none has been identified. In 1495, once again in Milan, Cristoforo was appointed by Ludovico to replace Antonio Mantegazza (*d* 1495) as joint chief architect (with Giovanni Antonio Amadeo) of the façade of the Certosa di Pavia. This work was interrupted in 1497 when Ludovico commissioned Solari to carve the funerary monument to his consort *Beatrice d'Este* in S Maria delle Grazie, Milan. Only the effigies of *Beatrice* and *Ludovico* survive (in the Certosa di Pavia; see fig.) from this work, which Solari never finished, although he seems to have worked on it almost exclusively until Ludovico's fall in 1499.

The lack of documentation for Solari in late 1499 and 1500 suggests that he may have left Milan after Ludovico's fall, perhaps travelling to Rome, where his brothers Alberto (1461–1514) and Pietro (1450–*c.* 1493) were already established. On 18 February 1501, having returned to Milan, he was appointed Magister a Figuris of the cathedral, and subsequently executed or had executed various sculptures for the cathedral: attributes for the large roundels of the *Doctors of the Church* for the lantern, the figures of *Adam* and *Eve* (1504; Milan, Mus. Duomo), the *Flagellation* (inscribed CHRI. GOBI MLNO. OPUS) in the south sacristy, and *Job* (or *Lazarus*; Milan, Mus. Duomo), inscribed CHRI. GOB. on the pedestal, but perhaps not entirely autograph. In 1506 Solari was nominated to share the post of general architect with Amadeo, replacing Giovanni Giacomo Dolcebuono, who retired in that year. Relations between Amadeo and Solari must have been strained, as they officially signed a truce in 1508. Later, Leonardo da Vinci, Amadeo, Andrea da Fusina and Solari gave advice on the choir stalls of the cathedral. Solari was thus closely involved in one of the most important phases in the cathedral's history, which included the construction of the nave following the solution to the problem of the lantern by Amadeo and Dolcebuono.

Solari also worked for other patrons in this period. In 1502 he designed a wall monument ordered by the heirs of Arasmo Brasca for S Eufemia, Milan, although the

Cristoforo Solari: marble effigies of *Ludovico Sforza* and *Beatrice d'Este*, l. 1.85 m, 1497–9 (Certosa di Pavia)

unpublished contract for this work indicates that Cristoforo had no hand in its actual execution. In the same year he made six marble medallions with classical images (some extant), commissioned by Charles II d'Amboise for his château at Meillant, near Bourges; from August 1504 Solari worked for Gian Giacomo Trivulzio for a year. Several lengthy absences from the cathedral workshops indicate his involvement with large-scale and time-consuming projects for private clients. In 1509 he began work on the extremely elaborate free-standing tomb of the *Bishop of Tournai*. Newly discovered documents show that the work on this project proceeded slowly and was not completed until 1514 at the earliest.

Cristoforo's surviving sculpture reveals that he quickly abandoned his master Pietro Antonio Solari's Late Gothic style. He became known in Venice for his ability to represent antique themes in the antique manner; certainly his *Adam* indicates a close study of Roman models. Documents suggest that in his early projects for funerary monuments Cristoforo tried to combine the more modern approach represented by Gian Cristoforo Romano's tomb of *Giangaleazzo Visconti* (begun 1491; Certosa di Pavia) with the traditional Milanese tomb type. The tomb of the *Bishop of Tournai* (destr.) was more innovative, although not necessarily classicizing, and may have been stylistically similar to the later efforts of Agostino Busti. Solari's sculpture is extremely difficult to evaluate as very few autograph works survive, but he was regarded by his contemporaries as one of the finest artists of his time.

Cristoforo's architectural works were also influenced by Roman models. In 1505 he designed the courtyard of S Maria presso S Celso, Milan. This is the first example in Lombardy of the typically Roman motif of an arched minor order enclosed by a major order with a flat entablature (the 'partito romano'). The idea of making the base mouldings of the pedestals of the major order identical to and contiguous with those of the minor order is probably derived from Bramante's cloister at S Maria della Pace, Rome, while the use of bronze capitals was an antique idea (according to Pliny they were used in the first version of the Pantheon). The cloister of S Pietro al Po in Cremona was also begun in 1505 but not completed according to Solari's plan. Solari again used the 'partito romano', but with a Doric major order. The capitals are like those of Bramante's Tempietto, Rome, and his spiral staircase in the Belvedere (Vatican Palace). The order lacks the metope and triglyph frieze, as does that of the Colosseum. The Doric capitals, with three annulets and a neck, were of a type recommended by Alberti. A drawing (Paris, Louvre) of a church façade has been attributed to Cristoforo on the basis of its stylistic affinities to his atrium at S Celso, his courtyard of S Pietro al Po and certain antique structures. It is thought to represent Cristoforo's design for S Maria delle Grazie at Castelnuovo Fogliani; the design of the nave of the church itself is consistent with Cristoforo's style.

In 1513 and 1514 Cristoforo was documented in Rome, where he settled the estate of his brother Alberto. In 1514 he was commissioned to construct a funerary chapel in S Cecilia (remade) for Cardinal Carretto. By December 1514 Cristoforo was back in Milan, where he tried to be readmitted to the Fabbrica as *Magister a Figuris*. As before, he continued to work for private clients: in 1516 Alfonso I d'Este commissioned him to carve a *Hercules and Cacus* group; three years later Isabella d'Este hired him to design a monumental fountain for her park in Mantua.

Concerns similar to those of his earlier building projects are evident in Cristoforo's architectural works from the last years of his career. For example the Doric half columns in the loggia of the Casa Rabia (1516; destr.) in Milan included floral ornament between the neck and echinus, which indicates a knowledge of Roman Doric, such as that on the Basilica Emilia. Cristoforo's predilection for Doric is further exemplified by the powerful half columns built (according to unpublished contracts of 1510 and 1519) to his design in the crossing of S Maria della Passione, Milan. The building history of the apse of Como Cathedral remains unclear, but it is known that in 1519 Solari's model was chosen to replace that of Tommaso Rodari. The model (Como, Arcivescovado) comprises a lower order of fluted Doric half columns and an upper order of unfluted pilasters, while the cornice is supported by brackets set into the frieze as at the Colosseum, the Palazzo Venezia and the cloister of S Maria della Pace, Rome.

In the courtyard of the Palazzo Salvatico on Via San Marillio (begun 1520), Milan, the lower order comprises unfluted Doric half columns with a full Doric entablature. According to the contract, the upper order (executed later to a different design) should have comprised fluted Corinthian half columns; this unusual combination was

paralleled in Solari's wooden model of the apse of Como Cathedral. The palace itself gives a valuable indication of Milanese interest in Vitruvius. It comprises a vestibule, courtyard and atrium and generally matches Vitruvius's description of a *villa pseudourbana*: the architect and theorist Cesare Cesariano mentioned with approval the octagonal atrium, which demonstrates a knowledge of Roman 16th-century architectural theory of the circles of Antonio da Sangallo the younger and Baldassare Peruzzi and of such Roman buildings as the Pantheon (for the oculus), the Baths, the Domus Aurea (for the octagon) and the Basilica of Constantine (for the coffering). In 1519 Cristoforo had been appointed general architect of Milan Cathedral, again as Amadeo's colleague and co-worker, and he held this position until his death in May 1524; he was succeeded as general architect by Girolamo della Porta (*fl* 1490–1519).

BIBLIOGRAPHY

G. Biscaro: 'I Solari da Carona', *Boll. Svizzera It.* (1912), pp. 61–77
S. Gatti: 'Il Palazzo di G. A. Salvatico a Milano: Contributo allo studio della corrente classicheggiante nell'architettura lombarda del primo cinquecento', *Quad. Ist. Stor. A. Med. & Mod.*, ii (1976)
C. Simoncini: 'C. Solari detto il Gobbo architetto e scultore della veneranda fabbrica del Duomo di Milano', *Civil. Ambrosiana*, i (1984), pp. 336–44
A. E. Werdehausen: 'Il chiostro di S Pietro al Po', *I Campi e la cultura artistica cremonese del cinquecento*, ed. M. Gregori (Milan, 1985), pp. 400–03
G. Agosti: 'La fama di Cristoforo Solari', *Prospettiva*, xlvi (1986), pp. 57–65
L. Patetta: *L'architettura del quattrocento a Milano* (Milan, 1987)
A. M. Schulz: 'Cristoforo Solari at Venice: Facts and Suppositions', *Prospettiva*, liii–lvi (1988–9), pp. 309–16
C. L. Frommel: 'Bramante e il disegno 104 A degli Uffizi', *Disegno di Architettura*, ed. P. Carpeggiani and L. Patetta (Milan, 1989), pp. 161–8
C. Zucchi: *Architettura dei cortili milanesi, 1535–1706* (Milan, 1989)
C. L. Frommel: 'Il progetto del Louvre per la chiesa dei Fogliani e l'architettura di Cristoforo Solari', *Quaderno di studi sull'arte lombarda dai Visconti agli Sforza* (Milan, 1990), pp. 52–63
M. T. Fiorio: 'L'altro termine del paragone: Riflessi leonardeschi sulla scultura milanese', *Achad. Leonardi Vinci: J. Leonardo Stud. Bibliog. Vinciana*, vii (1994), pp. 107–12
J. Shell and G. Sironi: 'Ambrogio de' Predis, Cristoforo Solari and the Monument to Erasmo Brasca', *Rac. Vinc.*, xxvi (1995), pp. 159–83

RICHARD SCHOFIELD, JANICE SHELL

(6) Andrea Solario [Solari] (*b* Milan, *c.* 1465; *d* Milan, before 8 Aug 1524). Painter, brother of (5) Cristoforo Solari. The only painter in the family, he does not seem to have had an independent studio but worked with his four brothers. The documentation for Andrea, which consists mainly of records of payment for work done in France and of litigation and property transactions in Lombardy, has little bearing on his art. His surviving oeuvre consists of approximately 50 paintings and 20 drawings (London, BM; Rome, Gab. N. Stampe; Windsor Castle, Royal Lib.). These include a number of signed paintings dating from 1495 to 1515. The earliest signed and dated painting, the *Virgin and Child with Saints* (1495; Milan, Brera), shows the influence of Antonello da Messina and was originally in Murano, which supports the suggestion that Andrea accompanied his brother Cristoforo to Venice *c.* 1490. Returning to Milan after 1495, he soon established his reputation as a leading painter there. Early in 1507 he was called to France to decorate the chapel of Cardinal Georges I d'Amboise's château at Gaillon, the palace of the archbishops of Rouen in Normandy. Andrea was at Gaillon until at least September 1509, and surviving documents record payments he received for his work there, which included a series of frescoed portraits of the Amboise family (destr. in French Revolution). Other paintings presumably made for the Cardinal, such as the *Salome* (New York, Met.), indicate Andrea's important role in the introduction of the Renaissance style to France. After his return to Milan, Andrea worked briefly for Cardinal d'Amboise's nephew and heir, Charles II d'Amboise, Governor of Milan. Subsequently he probably visited Rome; a tablet bearing his name was set up in S Girolamo della Carità in 1514. Also suggestive of a trip to Rome are drawings datable to this time and the fact that Andrea adopted antique sources for paintings, such as the *Rest on the Flight into Egypt* (1515; Milan, Mus. Poldi Pezzoli).

In Solario's oeuvre there is little marked stylistic change, but there is a gradual evolution from the sharp precision of his early works towards a softer, more graceful manner, with a persistent strain of naturalism. His distinctive style combines brilliant colour and a sculptural approach to form, perhaps derived from Cristoforo, with influences from Antonello and Leonardo. His art also betrays a remarkably keen understanding of works by the early Flemish masters, which he could easily have encountered in Venice, Milan and France. Also reflecting northern models was his use of a technique combining oil and tempera, as in the *Lamentation* (*c.* 1507–9; Paris, Louvre).

Some of Solario's most characteristic works are half-length devotional images of the Virgin, such as the *Madonna of the Green Cushion* (*c.* 1509; Paris, Louvre; see fig.), a composition with a sweet grace derived from Leonardo. Others, including an *Ecce homo* (versions: Milan,

Andrea Solario: *Madonna of the Green Cushion*, tempera and oil on panel, 595×475 mm, *c.* 1509 (Paris, Musée du Louvre)

Mus. Poldi Pezzoli; Philadelphia, PA, Mus. A.), *Christ Carrying the Cross* (Rome, Gal. Borghese) and *St John the Baptist's Head* (1507; Paris, Louvre), played a decisive role in the development of devotional art in North Italy. Using Leonardo's new dramatic language of gesture and expression, as well as his formal devices of chiaroscuro and *sfumato*, Andrea transformed traditional iconographic types. He was also a portrait painter of distinction, creating such memorable likenesses as those of *Giovanni Cristoforo Longoni* (1505; London, N.G.) and *Girolamo Morone* (Milan, Gallarati Scotti priv. col.), as well as a few entrancing female portraits (Milan, Castello Sforzesco, wrongly ascribed to Giovanni Antonio Boltraffio).

Vasari noted devotional pictures and portraits by Andrea in many Milanese collections. The clients whose identities can be established belonged either to monastic orders or to the political and cultural élite formed by the French rulers of Milan and their Italian supporters. At his death, probably of plague, Andrea left unfinished a major work, the altarpiece of the *Assumption of the Virgin* (Pavia, Mus. Certosa), completed (1576) by Bernardino Campi.

Although he was mentioned by Vasari and by other relatively early writers, including Lomazzo (1584), Andrea remained a shadowy figure, and his works were often wrongly attributed to better-known masters, such as Bernardino Luini. Because of the uncertainty surrounding his identity, his achievement long went unrecognized. His oeuvre was reconstructed only in the 19th century (Mündler), and he continues to be misunderstood as a mere follower of Leonardo (Suida).

BIBLIOGRAPHY

Thieme–Becker: 'Solari, Andrea'

G. Vasari: *Vite* (1550, rev. 2/1568); ed. G. Milanesi (1878–85), iv, p. 120

G. P. Lomazzo: *Trattato dell'arte della pittura* (Milan, 1584); ed. R. P. Ciardi (Florence, 1973), p. 201

O. Mündler: *Essai d'une analyse critique* (Paris, 1850), pp. 115–23, 194–5, 203–4

——: 'Beiträge zu Jacob Burckhardt's Cicerone: Abteilung Malerei', *Jb. Kstwiss.*, xi (1869), pp. 266, 289–90

K. Badt: *Andrea Solario: Sein Leben und seine Werke* (Leipzig, 1914)

W. Suida: *Leonardo und sein Kreis* (Munich, 1929), pp. 197–201, 290–93

M. Davis: *National Gallery Catalogues: The Earlier Italian Schools* (London, 1961)

L. Cogliati Arano: *Andrea Solario* (Milan, 1965)

B. Berenson: *North Italian Painters of the Renaissance* (1968), i, pp. 410–12

Andrea Solario en France (exh. cat. by S. Béguin, Paris, Louvre, 1985)

D. A. Brown: *Andrea Solario* (Milan, 1987)

L. Cogliati Arano: 'Andrea Solario en France: Mostra al Département des Peintures, Parigi, Louvre', *Rac. Vinc.*, xxii (1987), pp. 182–200

F. Moro: 'Andrea Solario', *La pittura nel Veneto: Il quattrocento*, ii (Milan, 1990), pp. 766–7

D. A. Brown: 'A Cleopatra by Solario', *Rac. Vinc.*, xxiv (1992), pp. 55–9

DAVID ALAN BROWN

Solari (ii). *See* LOMBARDO.

Solario, Antonio [lo Zingaro] (*b* ?Venice; *fl* 1502–14). Italian painter. He is mentioned in a document dated 21 April 1502 at Fermo, as 'magister Antonius Joanis Pieri de Soleriis de Venetiis habitator Firmi', which suggests that he was from Venice and had lived in Fermo for some time. The document refers to the commission to complete a polyptych for S Giuseppe da Copertino (popularly known as S Francesco), Osimo, left unfinished at his death by Vittorio Crivelli. This painting, identified as the polyptych in S Francesco, Monte San Pietrangeli (Castelli, p. 96), shows no sign of intervention by Solario, however. His altarpiece of the *Virgin and Child with Saints*, also for S Giuseppe in Osimo (*in situ*), is documented between 1503 and 1506. On the basis of its similar style, he has also been credited with the *Virgin and Child with SS Bernard, Catherine, Jerome and Lucy* in S Maria del Carmine in Fermo.

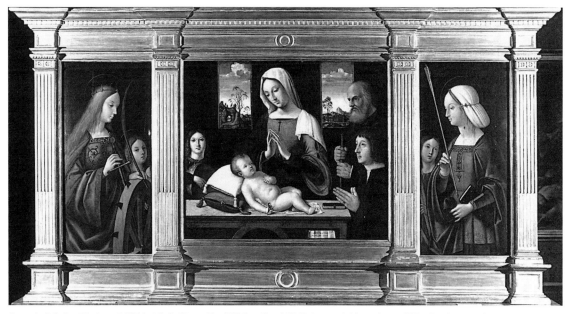

Antonio Solario: *Virgin and Child with the Donor Paul Withypoll and SS Catherine of Alexandria and Ursula*, oil on panel, 1514; central panel 775×889 mm (Bristol, City of Bristol Museum and Art Gallery); side panels 840×400 mm (London, National Gallery, on deposit at Bristol, City of Bristol Museum and Art Gallery)

Antonio probably trained in Venice, and the Fermo altarpiece is clearly influenced by Giovanni Bellini. There is also a resemblance to the work of Girolamo Genga in the face of St Lucy. Antonio's other securely dated works are the *Head of St John the Baptist* (1508; Milan, Pin. Ambrosiana), the *Lady Playing the Violin* and *Salomé* (both 1511; Rome, Gal. Doria–Pamphili) and the triptych of the *Virgin and Child with the Donor Paul Withypoll and SS Catherine of Alexandria and Ursula* (see fig.). The identity of the donor, a London merchant tailor, and the material of the main panel, apparently oak, suggest Antonio may have worked in England.

Within the framework of these documented works, it is possible to reconstruct Solario's career. His early work is represented by the *Virgin and Child Enthroned* (1490s; Cison di Valmarino), showing the influence of Bellini and Lombard painters of the school of Donato Bramante. Venetian models, including Bellini and possibly Vittore Carpaccio, are evident in the *Virgin and Child with the Infant St John the Baptist* (London, N.G.). He may have worked in Montecassino in 1518, and there is a major fresco cycle in Naples attributed to him, 20 scenes from the *Life of St Benedict* for the cloister of SS Severino e Sosio (now Naples, Archv Stato). The date generally given for these (1515) is, however, insufficiently documented; in fact they may date from any time after his period in the Marches. The nickname 'lo Zingaro' (the Gypsy) may refer to Solario's itinerant career.

BIBLIOGRAPHY

Thieme–Becker
B. de Dominici: *Vite*, i (1742), pp. 118–41
G. A. Moschini: *Memorie della vita di Antonio de Solario* (Venice, 1828)
E. Modigliani: 'Antonio da Solario, Veneto, detto lo Zingaro', *Boll. A.*, xii (1907), pp. 1–21
B. Berenson: *Venetian Painting in America* (London, 1916), pp. 45–9
S. Falcke: 'A Triptych by Antonio da Solario', *Burl. Mag.*, lxix (1936), p. 231
M. Davies: *The Earlier Italian Schools*, London, N.G. cat. (London, 1951, 2/1961/R 1986), pp. 492–4
F. Heinemann: *Giovanni Bellini e i Belliniani* (Venice, 1962), i, pp. 35, 303; ii, pp. 33, 46, 270
P. Castelli: 'Antonio Solario', *Lorenzo Lotto nelle Marche: Il suo tempo, il suo influsso* (exh. cat., ed. I. Chiappini, P. Dal Poggetto and P. Zampetti; Ancona, Gesù, S Francesco alle Scale, Loggia dei Mercanti, 1981), pp. 94–9
D. A. Brown: *Andrea Solario* (Milan, 1987), pp. 17, 30, 61, 63, 161, 171, 206
M. Lucco: 'A. Solario', *La pittura in Italia: Il cinquecento*, ed. G. Briganti, ii (Milan, 1989), pp. 842–3

MARIA CRISTINA CHIUSA

Sormani, Leonardo (*b* Savona; *fl* Rome, 1551; *d* Rome, *c*. 1589). Italian sculptor and restorer. While earlier sources incorrectly state that he was from Sarzana, more recent documentation accurately cites his birthplace as Savona. The biographical information pertaining to Sormani remains incomplete, but it is suggested that he worked as an apprentice in his father's workshop in Carrara after spending his early childhood in Savona. Sormani worked in Rome from 1551 until his death, remaining there except for a brief return visit to Carrara in 1561–2, possibly concerning the death of his father. In addition to minor restoration and sculptural work in Rome during the earlier years of his career, Sormani is credited with an extensive amount of sculpture in the basilica of S Maria Maggiore, Rome. In 1574 Cardinal Felice Peretti (later Pope Sixtus V) commissioned a tomb for Pope Nicholas IV in S Maria Maggiore from his architect Domenico Fontana. Fontana designed the structure of the tomb itself, and Sormani completed the marble sculptures that stand within its three rectangular niches. Sormani executed for the central, more prominent niche a seated statue of *Pope Nicholas IV*, wearing the traditional papal tiara and cope and gesturing with his right hand. The sculpture of the Pope is flanked by the allegorical figures of *Religion* on the left and *Justice* on the right. The tomb was originally placed on the left side of the high altar but was moved to the left of the main entrance in 1746, when Pope Benedict XIV refurbished the basilica, under the direction of Ferdinando Fuga, for the Holy Year of 1750.

Also prior to his election as Pope Sixtus V, Cardinal Peretti commissioned the construction of a small chapel to be added to the basilica of S Maria Maggiore. After his election in 1585, this became a funerary chapel, known as the Sistine Chapel, for Sixtus and his predecessor, Pope Pius V. Fontana was employed for the design of the chapel and the tombs. Sormani had begun sculptural work for the chapel before the election of Sixtus V, and he worked on the sculptures intermittently from 1583 to 1589. Sormani first completed the standing figures of *St Peter* and *St Paul* in 1587–8, to the design of the sculptor Prospero Antichi; these face each other from niches in the narrow side walls of the rear arm of the chapel. He then executed the figure of *Pope Pius V*, which is placed in the central arched niche of his tomb on the chapel's left wall. Unlike the kneeling figure of *Sixtus V* in the other tomb, the figure of *Pius V*, wearing the papal tiara and cope, is seated, smiling and raising his right hand in a traditional gesture of papal blessing. Modelled stiffly and, at times, awkwardly, Sormani's sculptures in S Maria Maggiore are considered academic and to conform to the dictates of the Council of Trent.

Sormani completed the figure of *Moses Striking the Rock* (1587–8), also begun by Antichi, for the fountain in Piazza S Bernardo, Rome. This fountain marked the termination of the Aqua Felice, also successfully completed by the architect Fontana under the direction of Sixtus V. The colossal fountain was designed with three prominent arches, the central one encasing the oversized, rather fierce figure of *Moses*, under an inscription glorifying the Pope. Later fabrications suggest that Antichi committed suicide in response to the violent criticism of this figure, but it was actually Sormani who completed its design. Until his death, Sormani continued doing minor work in Rome under the direction of Sixtus V. He assisted in the construction of the model for the bronze statue of *St Peter* that was placed in 1587 at the top of Trajan's Column in the Forum of Trajan, Rome, and sculpted one of the original tritons (replaced 1874) for the fountain at the southern end of the Piazza Navona. He received his last recorded payment in 1589, for assisting Fontana with the restoration of *Castor and Pollux* on the Monte Cavallo Fountain on the Quirinal Hill in Rome.

BIBLIOGRAPHY

Thieme–Becker
F. Titti: *Descrizione delle pitture, sculture e architetture* (Rome, 1763/R 1978)
A. Venturi: *Storia*, x (1937)
T. Magnusson: *Rome in the Age of Bernini*, i (Stockholm, 1982)
C. Pietrangeli, ed.: *Santa Maria Maggiore a Roma* (Florence, 1988)

RAYNE ROPER

Sorte, Cristoforo (*b* Verona, 1506 or 1510; *d* after 1594). Italian painter, cartographer, engineer and theorist. The son of Giovanni Antonio, an engineer in the service of Bernardo Cles (1485–1539), Cardinal-Bishop of Trent, he learnt painting in childhood and furthered his education at the court of the Gonzaga in Mantua. According to his own account in the *Osservazioni nella pittura* (written in February 1573, and published in 1580), he refined his knowledge of foreshortening under the guidance of Giulio Romano while engaged in a commission from Federico Gonzaga, 1st Duke of Mantua, to fresco a room in the Palazzo Ducale overlooking the lake of the city. None of his paintings is known to survive, but this concise treatise contains sufficient detailed information to place him within the tradition of late Mannerism. It explains the techniques of watercolour, gouache, fresco and oil painting, also giving recipes for colours and dealing with stylistic questions involved in landscape painting; examples of subject-matter are derived from the repertory of Classical mythology and, true to the spirit of the Counter-Reformation, there are also allusions to the theme of divine light with emphatic reference to the Bible.

Sorte's admiration for Veronese and Tintoretto is clear; he also stated that he was a close friend of the Cremonese painter Giulio Campi. Another passage records that he passed on Giulio Romano's methods of perspective painting to the Brescian painters Cristoforo Rosa (1520–77) and Stefano Rosa (1530–72); the brothers used them in frescoing the illusionistic setting for Titian's *Wisdom* (1560) in the vestibule of the Libreria Marciana in Venice and, apparently, in the lost decoration of the wooden ceiling of S Maria dell'Orto, Venice. As a demonstration of his skill as an illusionistic decorator, Sorte reproduced a twisted (solomonic) column, which has been identified as the one frescoed on the ceiling of a room on the ground floor of the Palazzo Ducale, Mantua. The preface, by his friend Bartolomeo Vitali da Desenzano, praises his skilled use of colour in a topographical map of the province of Verona, in which the density of the woodlands and the 'fearfulness of the mountains' could be discerned and fertile areas distinguished from sterile ones.

Sorte also mentioned his competence in hydraulic matters; early in the treatise there is an Aristotelian discourse on the origin of rivers. He was frequently employed by the Republic of Venice and its dependencies Brescia and Verona in connection with vast land reclamation projects designed to increase the agricultural productivity of the *terraferma*. In 1556 he planned the first land reclamations around Treviso and the territories of Este and Monselice. As a cartographer his commissions included a map of the imperial Tyrol (1558–9) for Emperor Ferdinand I (*reg* 1558–64) and some topographical and architectural reliefs (1563–4) for the Rectors of Verona. In 1571 he designed the decorations for the visit to Bussolengo of the princes of Austria. He also made numerous plans (Venice, Archv Stato and Bib. N. Marciana) of the hydraulic engineering works in the Veneto, of which the most important were those for Peschiera (1571), Verona (1574) and Padua (1586). Because of his hydraulic expertise he was commissioned, in 1580–81, to create a grotto with a fish pond for Battista da Porto in the garden of the Villa da Porto–Colleoni, Thiene, near Vicenza.

Sorte knew Sforza Pallavicino (1520–85), Captain General of the Venetian troops, and was also closely associated with the group of Venetian patricians headed by Marc'Antonio Barbaro. This influential support led to his being appointed to carry out an investigation of the damage suffered by the Palazzo Ducale, Venice, after the fire of 1577. Although his proposal for its total reconstruction (1578) was rejected, Sorte secured the commission to design the wooden cornices of the new ceilings in the Sala del Senato and the Sala del Maggior Consiglio (1578). For the Sala del Senato he also executed five maps showing the territorial extent of the *terraferma* (1585; see Wolters, pp. 260–61). With Barbaro and Vincenzo Scamozzi he (unsuccessfully) reproposed, in 1577–8, the Palladian solution for a new triple-arched Rialto Bridge. He later produced a relief of the proposed site for the Procuratie Nuove in Piazza S Marco, Venice.

UNPUBLISHED SOURCES

Venice, Archv Stato [numerous writings, accounts and drawings]
Venice, Bib. N. Marciana, MS. it. IV. 169 (5265) [*Trattato dell'origine de' fiumi*]
——, MS. it. VI. 188 (10039), n. 43; MS. it. VI. 189 (10031), n. 12 [topographical drawings of Peschiera (1571) and Bergamo (1575)]

WRITINGS

Osservazioni nella pittura (Venice, 1580, rev., enlarged, Verona, 1594); repr. in *Trattati d'arte del cinquecento fra manierismo e controriforma*, i, ed. P. Barocchi (Bari, 1960), pp. 271–301, 349–50, 526–39
Modo d'irrigare la campagna di Verona e d'introdur più navigationi per lo corpo del felicissimo Stato di Venetia (Verona, 1593)
Per la magnifica città di Verona, sopra il trattato ultimo del Magnifico Signor Theodoro da Monte (Venice, 1594)

BIBLIOGRAPHY

G. Bora: 'La prospettiva della figura umana—gli "scurti"—nella teoria e nella pratica pittorica lombarda del cinquecento', *La prospettiva rinascimentale: Codificazioni e trasgressioni, Atti del convegno: Milano, 1977*, p. 298
Testimonianze veneziane di interesse palladiano (exh. cat., Venice, Archv Stato, 1980), pp. 42, 69, nos 86, 181
Laguna, lidi, fiumi: Cinque secoli di gestione delle acque (exh. cat., Venice, Archv Stato, 1983), pp. 61–2, nos 114, 117
G. Conforti: *Cristoforo Sorte* (diss., U. Venice, Istituto Universitario di Architettura, 1985)
Ambiente scientifico veneziano tra cinque e seicento: Testimonianze d'archivio (exh. cat., Venice, Archv Stato, 1985), pp. 51–2, no. 69
D. Calabi and P. Morachiello: *Rialto: Le fabbriche e il ponte* (Turin, 1987)
W. Wolters: *Storia e politica nei dipinti di Palazzo Ducale: Aspetti dell'autocelebrazione della Repubblica di Venezia nel cinquecento* (Venice, 1987), pp. 36–7, 161, 260–61
G. Conforti: 'Cristoforo Sorte', *L'architettura a Verona nell'età della Serenissima (sec. XV–sec. XVIII)*, eds P. Brugnoli and A. Sandrini, ii (Verona, 1988), pp. 177–83 [with excellent bibliog.]
A. Belluzzi: 'La palazzina di Margherita Paleologa nel castello di Mantova', *Giulio Romano* (Milan, 1989), pp. 385–7
V. I. Stoichita: 'Peindre le feu?: La ville en flammes dans la peinture des XVe et XVIIe siècles', *Z. Schweiz. Archäol. & Kstgesch.*, lii/1 (1995), pp. 35–7

ANTONIO MANNO

Spada, lo. *See under* MARASCALCHI, PIETRO DE'.

Spalliera [from It. *spalla*: 'shoulder', backrest of a piece of furniture]. Term applied to Tuscan 15th- and early 16th-century painted wall panels. Originally the term denoted panels that were set into the wall panelling at head or shoulder height above the backrest of a piece of furniture. It was later extended to include panel paintings set into the wall and was an integral part of the wainscoting. With few exceptions, *spalliere* are characterized by their

size and shape—larger than *cassone* panels and proportionally higher, but still two to three times as long as high. A good example is the panel known as the *Adimari Wedding* (630×1800 mm; Florence, Accad.), now attributed to Scheggia and possibly dating from the 1450s. These pictures were installed above a piece of furniture, such as one or more *cassoni*, a bed or a *lettuccio* (a high-backed bench with a chest below the seat that doubled as a narrow bed). Schiaparelli (1908) distinguished between *spalliere* and so-called *cornice* pictures: the latter were installed higher up the wall so as to form a frieze above the wooden moulding (*cornice* in Italian), thus forming a separate register between the wooden panelling and the bare wall just below the ceiling, as is seen in Domenico Ghirlandaio's fresco of the *Birth of the Virgin* (Florence, S Maria Novella; see fig. 1). This distinction is lost once the panel has been removed from the wall, and the term *spalliera* is now applied to both. The upward migration of pictures from chest to wall was necessitated by the increasing acceptance of the idea that the perspective within a composition ought to be constructed to work from a spectator's viewpoint. Furthermore, whether cause or result, by the third quarter of the 15th century, paintings were much more highly esteemed in the domestic setting and quality was deemed more desirable, as attested by a higher proportion of panels by leading artists made specifically for domestic settings.

1. FUNCTION AND ARRANGEMENT. Just how and when *spalliere* were introduced is obscure, because none has survived *in situ*, and it is difficult to distinguish them from painted decorative panels. An early reference occurs in 1458 in the *ricordi* of Bernardo di Stoldo Rinieri (Florence, Archv Stato, Conventi soppressi, 95.212), who listed among the things ordered for his wedding a pair of chests (*forzieri*) with backrests (*spalliere*) painted by Apollonio di Giovanni. Giovanni Rucellai (*Giovanni Rucellai ed il suo zibaldone*, ed. A. Perosa, London, 1960, i, p. 32) recorded a pair of 'very magnificent' chests (*forzieri*) with long, low historiated panels above *spalliere* for the wedding of his son Bernardo in 1466. Both used the word in conjunction with chests, so that the panels were presumably at roughly shoulder height above the chests, as is illustrated in a woodcut of *c.* 1500 (see W. Bode: *Die italienischen Hausmöbel der Renaissance*, Leipzig, n.d., fig. 92). Occasionally a single long panel was placed above two or even three chests, an arrangement recorded in the Medici inventory of 1492, where such a *spalliera*, probably painted by Scheggia, was set above three chests. A Florentine panel of *The Hunt* (1460s; Toulouse, Mus. Augustins) has similar proportions (280×2360 mm) and probably served the same purpose. Although inventories list many more chests without *spalliere* than with them, it may well be that so few early examples have been identified because most were indistinguishable from *cassone* panels.

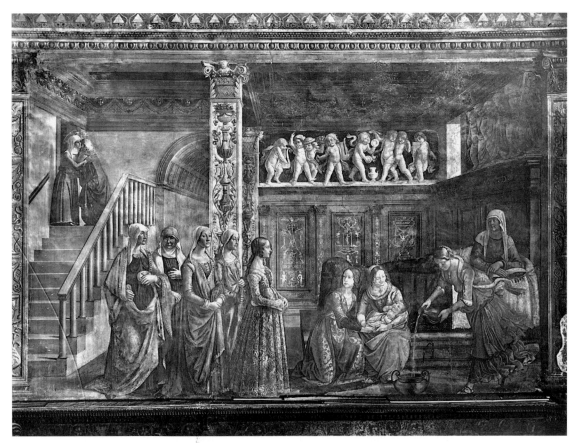

1. Domenico Ghirlandaio: *Birth of the Virgin* (1486–90), fresco showing a *spalliera* on the wall, S Maria Novella, Florence

Spalliera panels set immediately above chests may well have been the intermediate stage between narratives painted on the front of chests and paintings set above the wall panelling.

Evidence of painted panels being used in conjunction with a *lettuccio*, a *cassapanca* (a high-backed bench with storage space beneath the seat) or other furniture comes later. In 1469–70 the Florentine Mercanzia ordered paintings of the *Virtues* (all Florence, Uffizi), six by Piero del Pollaiuolo and one, of *Fortitude*, by Sandro Botticelli (*see* BOTTICELLI, SANDRO, fig. 1). According to the Anonimo Magliabecchiano, they were placed above the benches on which the officials of the Mercanzia, the Six, presided. Their vertical format is misleading; the panels were no doubt linked by complex mouldings and wooden framing, which would have created the continuous effect seen in a set of *cassone* panels depicting the *Seven Virtues* and the *Seven Liberal Arts* (*c.* 1450–70; Birmingham, AL, Mus. A.; Barcelona, Mus. A. Catalunya), in which figures are seated in the niches of a wall. The grander scale of the Mercanzia *Virtues* is appropriate to the official hall and follows the scale of the frescoes they replaced. The height at which they were installed can be estimated from the steep perspective of the figures.

By the 1480s and well into the 16th century *spalliera* panels were an important part of the interior furnishings of luxurious Tuscan homes; they were usually commissioned when a house was refurbished for a new bride. The perspective *View of a Harbour* (Berlin, Bodemus.; see fig. 2) shows how *spalliere* were integrated into the domestic interior by the 1490s. The harbour is seen through a loggia above imitation marble revetments and recalls ancient Roman wall paintings. The heavy cornice and complex framing elements along the sides serve both as an extension of the painted structure and, simultaneously, as a continuation of the room's cornice, mouldings and panelling. The narrow painted sides of the vertical frame show that it projected forward much as the headboard of the bed does in Ghirlandaio's *Birth of the Virgin*.

Reconstructions of the arrangement of such panels in a room are hampered by the often limited knowledge of whether sets are complete; a room could have had a single picture, two to four related pictures or several unrelated ones. Some idea of how panels were installed may be gleaned from the Ghirlandaio fresco in S Maria Novella. Others evidently were framed more elaborately: the colonnettes that divided the long Medici panel into three parts echoed the divider of the Singing Galleries then in Florence Cathedral (Florence, Mus. Opera Duomo), where Donatello used paired free-standing columns (see colour pl. 1, XXVIII2) and Luca della Robbia used pilasters (*see* ROBBIA, DELLA, (1), fig. 1). Painted framing elements in some Florentine works, for example two allegorical scenes of a woman with putti (London, N.G., see fig. 3; Paris, Louvre) from the school of Botticelli, support the thesis that similar wooden elements were regularly employed in the domestic setting.

Occasionally *spalliera* panels were combined with other wall panels of a different shape, for example the set painted by Bartolomeo di Giovanni for the marriage of Lorenzo di Giovanni Tornabuoni and Giovanna di Maso Albizzi in 1487. Here three standard panels with the *Story of the*

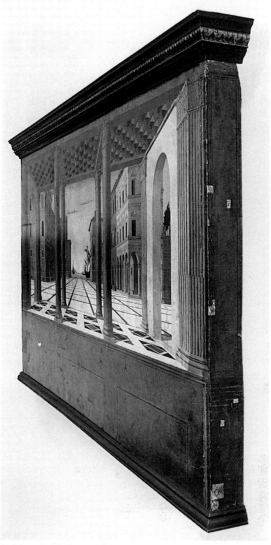

2. *View of a Harbour*, *spalliera* panel in tempera, 1.24×2.34 m, *c.* 1490 (Berlin, Bodemuseum, Gemäldegalerie)

Argonauts (Cape Town, Natale Labia priv. col.) were augmented by two narrow vertical ones with standing figures of *Venus* and *Apollo* (both priv. col., see Fahy, 1984, p. 234, pls 233–4). Jacopo del Sellaio's *David* (Philadelphia, PA, Mus. A.) and the Master of the Apollo and Daphne Legend's *Daniel* (New Haven, CT, Yale U., A.G.) may have been arranged in the same way. They are a first step towards a greater complexity and variety that culminated, in 1510, in the lavish nuptial chamber of Pierfrancesco Borgherini decorated with scenes from the *Life of Joseph* (London, N.G.).

2. SUBJECT-MATTER. Artists were slow to free themselves of the *cassone* tradition, so that *spalliere* often differ from them only in format. This dependence is strong in such panels as the pair illustrating the *Battle of Anghiari* and the *Taking of Pisa* (*c.* 1480; both Dublin, N.G.) and, despite a greater sense of depth, this is also evident in the

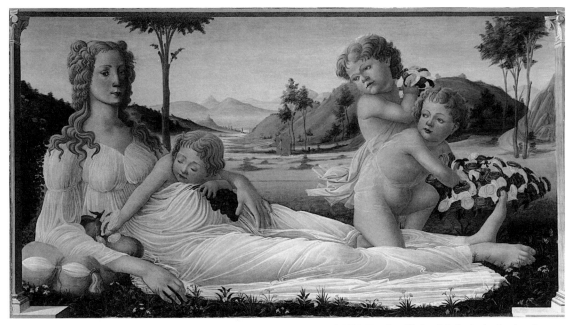

3. School of Botticelli: *Allegory*, tempera and oil on panel, 921×1727 mm, *c.* 1475–1500 (London, National Gallery); the framing elements may indicate that the panel was once installed as part of a domestic wall panelling

works of Biagio di Antonio, Filippino Lippi and Sellaio. Sellaio introduced a new lyricism to his favourite subjects, such as the *Story of Orpheus* (Kiev, Mus. W. & Orient. A.; Rotterdam, Mus. Boymans–van Beuningen).

As in *cassoni* subject-matter, there was a sharp turn to misogyny during the second half of the 15th century, introduced in stories such as 'Patient Griselda' and 'Nastagio degli Onesti' (Boccaccio, *Decameron*, X.10; V.8), and, when old favourites are used, in a shift of emphasis from female virtue to civic duty—from Lucretia's sacrifice to Brutus's vow to overthrow tyranny (e.g. Botticelli, *History of Lucretia*, Boston, MA, Isabella Stewart Gardner Mus.) or from the chastity of Susanna to the judgement of Daniel (e.g. Master of the Apollo and Daphne Legend, the *Story of Susanna*, Baltimore, MD, Walters A.G.; Chicago, IL, A. Inst.; Liverpool, Walker A.G.).

Spalliere had begun to evolve their own compositions and iconography and gradually to replace painted *cassoni* by the 1480s. Botticelli's reinterpretations of established compositions were the most original and inventive. In the *Nastagio* series (three panels, Madrid, Prado; see colour pl. 1, XIV2) from his shop, possibly variants of the set in the Palazzo Vespucci in Florence mentioned by Vasari, he not only combined several episodes in one scene as had been done earlier on *cassoni* but also used a frieze of tree tops, which was a common feature in earlier wall paintings (e.g. Florence, Pal. Davanzati). His autograph *Mars and Venus* (*c.* 1485; London, N.G.; *see* BOTTICELLI, SANDRO, fig. 6) is a masterly conflation of the couple traditionally painted separately inside the lids of a pair of *cassoni*. Although Piero di Cosimo rejected tradition in his fantastic renderings of complex allegorical themes, most of the early 16th-century masters, such as Francesco Granacci and Jacopo da Pontormo, were not wholly free either of established compositions or subjects. They emphasized

the importance of the family line by illustrating scenes of the *Birth of St John* or the *Story of Joseph* (e.g. Granacci, Florence, Uffizi; Pontormo, London, N.G.).

In Siena, where painted *cassoni* were not a firm tradition, painted *spalliere* developed more independently than in Florence. Although many of the same artists painted both, *spalliere* derived from *cassoni* are the exception. A good example is a pair of *spalliere* by Bernardino Fungai illustrating scenes from the *Life of Scipio* (St Petersburg, Hermitage; Moscow, Pushkin Mus.). Late 15th-century Sienese wall decoration often featured a series of large, standing allegorical figures of Virtues or famous men or women. Though inspired by North Italian baronial frescoes, they are variously combined to express contemporary themes of personal or civic virtue. The earliest figures are associated with Neroccio de' Landi (e.g. *Claudia Quinta*, Washington, DC, N.G.A.) and Francesco di Giorgio; Girolamo di Benvenuto (1470–1526), Andrea di Niccolò, Bernardino Fungai, the Griselda Master and Domenico Beccafumi continued the type.

See also CASSONE, §1.

BIBLIOGRAPHY

Museum catalogues are among the best and most up-to-date sources. They are not listed below, but most examples cited in the above entry are in collections with catalogues. *See also* the bibliographies of individual artists.

G. Vasari: *Vite* (1550, rev. 2/1568); ed. G. Milanesi (1878–85), iii, p. 312

A. Schiaparelli: *La casa fiorentina e i suoi arredi* (Florence, 1908, rev. 2/1983) [with add. notes]

P. Schubring: *Cassoni, Truhen und Truhenbilder der italienischen Frührenaissance*, 2 vols (Leipzig, 1915, suppl. 1923) [Schubring recognized that many of the panels he included were, in fact, *spalliere*]

J. Shearman: 'The Collections of the Younger Branch of the Medici', *Burl. Mag.*, cxvii (1975), pp. 12–27

C. L. Joost-Gaugier: 'A Rediscovered Series of *Uomini famosi* from Quattrocento Venice', *A. Bull.*, lviii (1976), pp. 185–95

M. Laclotte: '*Une Chasse* du quattrocento florentin', *Rev. A.*, xl–xli (1978), pp. 65–70

A. Braham: 'The Bed of Pierfrancesco Borgherini', *Burl. Mag.*, cxxi (1979), pp. 754–65

V. Tatrai: 'Il Maestro della storia di Griselda a una famiglia senese di mecenati dimenticata', *Acta Hist. A. Acad. Sci. Hung.*, xxv (1979), pp. 27–66

M. Trionfi Honorati: 'A proposito del *lettuccio*', *Ant. Viva*, xx/3 (1981), pp. 30–49

K. Christiansen: 'Early Renaissance Narrative Painting in Italy', *Met. Mus. A. Bull.*, xli/2 (1983) [whole issue]

E. Callmann: 'The Patron of Botticelli's Saint Zenobius Panels', *A. Bull.*, lxvi (1984), pp. 492–6

E. Fahy: 'The Tornabuoni–Albizzi Panels', *Scritti di storia dell'arte in onore di Federico Zeri* (Milan, 1984), pp. 233–48

L. Vertova: 'Cicli senesi di virtù: Inediti di Andrea di Niccolò e del Maestro di Griselda', *Scritti di storia dell'arte in onore di Federico Zeri* (Milan, 1984), pp. 200–12

A. Barricault: *Spalliera Paintings of Renaissance Tuscany* (University Park, PA, 1994)

ELLEN CALLMANN

Spani. Italian family of sculptors, architects and goldsmiths.

(1) Bartolomeo Spani (*bapt* Reggio Emilia, 7 March 1468; *d* Reggio Emilia, 1539). He was a pupil of Antonio Casotti. He worked in his own city and other towns in Emilia, and as a young man he made a trip to Rome (1488–91), where he saw the work of Mino da Fiesole, Andrea Bregno and Andrea Sansovino. Various funerary monuments executed by Spani bear traces of this Roman influence, for example the tombs in Reggio Emilia Cathedral of *Bishop Buonfrancesco Arlotti* (*d* 1508) and *Canon Gasparino Lanzi*, the latter now in fragments; the tomb of *Francesco Molza* (1516) in Modena Cathedral; that of *Ruffino Gabboneta* (*d* 1527) in S Prospero in Reggio Emilia; and that of *Bertrando Rossi* (1531–6) in the church of the Madonna della Steccata in Parma. His compositional schemes in particular were influenced by Sansovino. He encouraged in his own region a taste for decorative architectural details that was characteristic of the Tuscan and Lombard artists who were in Rome in the early 16th century. His architectural work included the courtyard of the Palazzo Vescovile in Reggio Emilia. He was also active as a goldsmith. Bartolomeo's son Andrea Spani was a sculptor and goldsmith and collaborated with his father. Bartolomeo's other son, Girolamo Spani, was a sculptor, goldsmith and architect, active in the first half of the 16th century. His surviving works include the old clock-tower in Reggio Emilia (probably 1541–4).

(2) Prospero Spani [Sogari; il Clemente] (*b* Reggio Emilia, 16 Feb 1516; *d* Reggio Emilia, 25 May 1584). Nephew of (1) Bartolomeo Spani. He was the pupil of Antonio Begarelli, whose influence is apparent in the tomb of the *Santo vescovo* (1544) in the crypt of Parma Cathedral. Later he adopted schemes inspired by Michelangelo for various tombs, for example the monument to *Bishop Filippo Zoboli* (1554; Reggio Emilia, S Nicolò), which is influenced by the closed triumphal arches of Michelangelo's Medici tombs (Florence, S Lorenzo, New Sacristy;

see colour pl. 2, V1). It includes seated female figures flanking a portrait set into an oval niche, elements that recur in Spani's other funerary monuments. The memorial to *Bishop Andreasi* (Mantua, S Andrea), commissioned for the Mantuan church of the Carmine by the Bishop's nephews in 1549, is composed of a sarcophagus supported by two sphinxes and a bronze swan, with a bust of the Bishop set into the base of an urn. The figures of *Faith* and *Charity*, which flank the urn, are close in style to the work of Michelangelo. The influence of Michelangelo is most apparent in the *Christ with the Cross* (Reggio Emilia Cathedral), which imitates Michelangelo's *Risen Christ* (Rome, S Maria sopra Minerva), and in his statues of *Adam* and *Eve* (commissioned 1552, installed 1557) over the main entrance of Reggio Emilia Cathedral. These figures are clearly based on Michelangelo's *Dawn* and *Evening* from the tomb of *Lorenzo de' Medici, Duke of Urbino* (Florence, S Lorenzo, New Sacristy).

Although Spani worked on the reconstruction of the whole façade of the cathedral from 1544 until his death, this was never in fact completed. In 1561 he was commissioned to build the monument to *Bishop Ugo Rangone* (Reggio Emilia Cathedral). The austere classical architecture of the memorial frames the varied sculptural elements. A full-length seated figure of the Bishop is placed above the sarcophagus, which is flanked by putti; two urns rest on the base, which carries two coats of arms of the Bishop and two figural low reliefs. The monument to *Canon Fossa* (Reggio Emilia Cathedral) was completed in 1566: its marble base was removed when it was transferred to its present location in 1788. It consists of two caryatids flanking a massive urn and is surmounted by a portrait of Fossa. The figures are elongated in a manner reminiscent of the work of Parmigianino and Girolamo Mazzola Bedoli, with whom Spani was associated. The monument to *Cherubino Sforziano* (Reggio Emilia Cathedral) can also be dated to 1566. Sforziano was a clockmaker at the court of Emperor Charles V (*reg* 1519–56); his memorial includes an enormous sculpted hour-glass, both a symbol of his profession and a *memento mori*. In 1577 Spani began a ciborium for the chapel of the Holy Sacrament in Reggio Emilia Cathedral, from a design by Lelio Orsi; this was completed by Spani's pupils in 1586. Spani also worked as a goldsmith.

BIBLIOGRAPHY

Bénézit

A. Venturi: *Storia*, x (1936), pp. 556–66

Mostra di Bartolomeo Spani e della sua bottega (exh. cat. by N. Artioli, Reggio Emilia, Mus. Civ. & Gal. A., 1968)

C. Gandolfi: 'Le sculture metafisiche di Prospero Spani detto il Clemente', *Mus. Ferrar.: Boll. Annu.*, iv (1974), pp. 134–43

Dizionario enciclopedico UTET di Pietro Fedele, xvii (1982)

MARIA CRISTINA CHIUSA

Spanzotti (da Casale), Giovanni Martino (*fl* 1480–*c.* 1523). Italian painter and sculptor. Of Lombard origin and son of a painter, Pietro, he is first mentioned as a witness in a document of 1480 in Casale Monferrato. He is recorded in 1481 in Vercelli, where he is known to have produced works, many untraced, until 1498. His early activity influenced the development of Piemontese painting in the second half of the 15th century, in its rejection of the traditional Late Gothic, French style in favour of

the innovations of Renaissance art. These were accessible to him through his considerable contacts with Bolognese figurative painting, in particular the work of Francesco del Cossa and, through intermediaries such as Bonascia, that of Piero della Francesca. A striking example of his ability to absorb such influences is the Tucher *Virgin and Child* (probably before 1475; Turin, Mus. Civ. A. Ant.), where the carefully measured space recalls Cossa's style. This device is even more apparent in the fresco depicting the *Adoration of the Child* in S Francesco, Rivarolo Canavese, and in the *Assumption of the Virgin* in the parish church of Conzano. An earlier, signed triptych depicting the *Virgin and Child Enthroned with SS Ubaldo and Sebastian* (Turin, Gal. Sabauda; *see* TURIN, fig. 1) exploits the contrast of the gold background of the upper part of the composition with the measured perspective that sets the figures unmistakably on the ground plane of the picture.

Between 1486 and 1491, in S Bernardino, Ivrea, Spanzotti executed an important fresco cycle depicting 21 scenes from the *Life of Christ*. Here the artist achieved a new formal and colouristic elegance, comparable to that found in south Netherlandish art, while retaining the spatial lessons of Piero della Francesca, as in the scene of the clearly articulated and measured *Annunciation*. The group of eight wooden sculptures known as the Pietra dell'Unzione (ex-Sacro Monte, Varallo; Varallo Sésia, Pin.) are attributed to the same period. The second fresco cycle in S Bernardino, Ivrea, reveals new developments in Spanzotti's style. The influences of Bramante and Bramantino, evident in the dramatic composition of the *Crucifixion*, and of Piero della Francesca, recognizable in the horseman on the right of the composition, are combined with more recent references to Lombard art and are characterized by a lively narrative quality destined to have a profound effect on 16th-century Piemontese painting, up to the time of Gaudenzio Ferrari.

In other contemporary works, such as two depictions of the *Pietà* (Rome, Mus. N. Castel S Angelo; Sommariva Perno, Tavoleto Sanctuary), Spanzotti's style is reduced to essentials in order to convey intense religious emotion. Between his return, in 1498, to Casale Monferrato and a move in 1502 to Chivasso, the polyptych for S Francesco, Casale Monferrato, was installed. Now scattered (Turin, Accad. Albertina; Milan, Brera; London, N.G.), it appears to be a workshop product (not uncommon at this stage in Spanzotti's career) and points especially to the collaboration of Defendente Ferrari. The *Baptism* (Turin, Cathedral) commissioned in 1508 was also a collaborative effort. Probably executed by Defendente to Spanzotti's design, it preserves the austere figurative manner of the older master. During these years workshop participation increased, to the point, sometimes, of reducing the normal quality of Spanzotti's craftsmanship to a more facile application of decorative effects. This is evident in the *Adoration of the Magi* (c. 1510; ex-Contini–Bonacossi priv. col., Florence), probably painted with Defendente, who reproduces, in some figures, the intensely absorbed atmosphere of Spanzotti's securely attributable *Christ Among the Doctors* (Turin, Mus. Civ. A. Ant.). In 1511 Spanzotti is documented in Turin, where he was to gain citizenship in 1513. He lived there until 1523 when he painted, in S Domenico,

in an already obsolete manner, the *Charity of St Anthony Pierozzi*.

The pattern of Spanzotti's stylistic development, from the influence of Piero della Francesca and Francesco del Cossa to the later Lombard borrowings derived from Bramante and Bramantino and the Ligurian influences from such painters as Ludovico de Donati, points the way for the development of Piemontese art in the first half of the 16th century, as seen not only in the work of Defendente Ferrari but also in that of the Master of Crea, and including the young Gaudenzio Ferrari and Sodoma, who was trained in his workshop between 1490 and 1498.

BIBLIOGRAPHY

L. Ciaccio: 'Gian Martino Spanzotti da Casale, pittore fiorito fra il 1481 e il 1524', *L'Arte*, vii (1904), pp. 441–56

A. Baudi Di Vesme: 'Nuove informazioni intorno al pittore Martino Spanzotti', *Atti Soc. Piemont. Archeol. & B. A.*, ix (1918)

A. M. Brizio: 'Giovanni Martino Spanzotti', *Misc. Fac. Lett. U. Torino*, i (1936), pp. 107–27

G. Répaci Courtois: 'La Pietra dell'Unzione di Martino Spanzotti', *Crit. A.*, xv/99 (1968), pp. 27–42

G. Romano: 'Orientamenti della pittura casalese da G. M. Spanzotti alla fine del cinquecento', *Quarto congresso di antichità e d'arte della Società Piemontese d'Archeologia e Belle Arti: Casale Monferrato, 1974*, pp. 281–314

——: 'Fortuna critica di Martino Spanzotti ad Ivrea', *Ricerche sulla pittura del quattrocento in Piemonte* (Turin, 1985), pp. 81–9

P. Venturoli: 'Martino Spanzotti e alcune Assunzioni della Vergine in Piemonte e in Lombardia', *Ricerche sulla pittura del quattrocento in Piemonte* (Turin, 1985), pp. 97–101

UGO RUGGERI

Spavento, Giorgio (*fl* 1486; *d* Venice, 17 April 1509). Italian architect and engineer. He was one of a group of Lombard craftsmen who dominated Venetian architecture in the period preceding the outbreak of the Cambrai Wars in 1509. He apparently came from Lake Como and was trained as a woodworker. He is first recorded in Venice in 1486, when he was appointed architect (*proto*) to the Procurators of S Marco, a post he held until his death. In this capacity he built the sacristy of S Marco and the adjoining chapel of S Teodoro. The rear façade of the chapel and sacristy on the Rio della Canonica shows a stately simplicity remarkable in Venice at that time, with a grid of panelled pilaster strips and a notable absence of ornament.

Spavento's technical skills were widely sought after. In 1489 he supplied a model for repairs to the campanile of S Marco. In 1496 he began to work in the Doge's Palace where the new east wing was already in progress. After Antonio Rizzo fled in disgrace in 1498, Spavento's part must have increased. In that year he also succeeded Rizzo as technical consultant for the restoration of the Palazzo della Ragione (the 'Basilica') in Vicenza. In 1502 he advised on repairs to the old, wooden Rialto Bridge in Venice and the Ponte delle Navi in Verona and was put in charge of the Lidi (coastal defences) of Venice. In these years he also served as architect to Venice's naval Ospedale di Gesù Cristo and erected the adjoining church of S Nicolò di Castello, consecrated in 1503. This consciously Byzantine Greek-cross church was demolished soon after 1810. The private chapel dedicated to S Nicolò in the Doge's Palace, which he rebuilt after 1506, still exists, though in altered form.

Giorgio Spavento: façade of the Fondaco dei Tedeschi, Venice, 1505–8

The two most important surviving buildings with which Spavento was associated are both late works, largely executed by others. In 1505 he supplied two models for the rebuilding of the Fondaco dei Tedeschi, the German merchants' colony in Venice, which had been destroyed by fire. Although a model by a German named Hieronymus was preferred, Spavento was put in charge of the building's execution, soon to be assisted by Antonio Scarpagnino. The building (see fig.) is of the traditional Venetian *fondaco* (trading centre) type. It originally had towers at either end of the façade and chimneys over the spaces between the paired windows. It was decorated in fresco by Giorgione and Titian. The simple, square piers in the arcaded courtyard are characteristic of Spavento's robust, economical style. The second of these late works, often cited as his masterpiece, is the nearby church of S Salvator, which was rebuilt for the Augustinian Canons Regular, with financial assistance from the State. Spavento's model was selected by the canons in 1506, but from 1507 the building was largely executed under the direction of Tullio Lombardo. Consisting of three intersecting, domed Greek crosses contained within a cruciform plan, the design marks the culmination of the Byzantine revival in early Renaissance Venice. The innovative, carefully proportioned plan seems to be Spavento's invention. The Corinthian and Ionic pilaster orders in the nave, however, show an interest in *all'antica* language not evident elsewhere in Spavento's documented work, and more typical of Tullio's style.

Since Spavento often worked in collaboration with others, it is difficult to disentangle his own contribution: centralized areas, sparse decoration and lucid grid-like compositions are continuing themes in his work; although he used Byzantine spatial systems, he avoided details from Roman antiquity, preferring plain, panelled pilasters. Not being a mason, he was less concerned with architectural ornament than his main rivals, specializing instead in large-scale design and in solving structural problems. Spavento was highly regarded in Venice and was described by the Venetian diarist Marin Sanudo as 'homo de grande inzegno' (a man of great ability).

BIBLIOGRAPHY

H. Simonsfeld: *Der Fondaco dei Tedeschi in Venedig* (Stuttgart, 1887)

P. Paoletti: *L'architettura e la scultura del rinascimento in Venezia*, i (Venice, 1893)

M. Dazzi, M. Brunetti and G. Gerbino: *Il fondaco nostro dei Tedeschi* (Venice, 1941)

F. Barbieri: *The Basilica of Andrea Palladio* (1970), ii of *Corpus Palladianum* (University Park, PA, 1970–79)

J. McAndrew: *Venetian Architecture of the Early Renaissance* (Cambridge, MA, 1980)

M. Tafuri: *Venezia e il rinascimento* (Turin, 1985)

☐

Spazio, Bernardo (*b* Pello Superiore, nr Como; *d* 1564). Italian architect. He came from a large family of masons

and is first documented in Genoa in 1543 in connection with the early Renaissance palazzo of Antonio Doria, Acquasola. His independent work as an architect dates between *c.* 1556 and 1564, when he became part of the circle of Galeazzo Alessi, which created a new High Renaissance palace style for the Genoese patriciate and republic, particularly on the Strada Nuova (now Via Garibaldi; *see* GENOA, §1). From *c.* 1556 Spazio worked on Alessi's Roman High Renaissance church of S Maria Assunta (1552–1603) in Carignano. He is the documented architect of the Palazzo di Pantaleo Spinola (1558–64; now Palazzo Gambaro), which he designed in an austere, undecorated, tripartite block with central window-balustrade grouping, a heavy Doric segmental entrance portal and projecting wings. Spazio's other major work is the Villa Grimaldi Fortezza (1559–64) in San Pier d'Arena, so called owing to its massive pyramidal roof. The villa forms part of the 'Alessian triad' in this once open coastal suburb, along with Bernardino da Cantone's Villa Lercari ('la Semplicità'; 1558–63) and Domenico Ponzello and Giovanni Ponzello's Villa Imperiale–Scassi ('la Bellezza'; *c.* 1560). Similar in tripartite design to the Palazzo Spinola, the villa, now with a central open loggia, was sited overlooking the garden, landscape and sea views. Both the exterior, which was originally frescoed with *trompe l'oeil* Doric and Ionic half columns, cornices and balustrades (destr.), and the interior sculpted decorations imitated the classical structure and festive Mannerist decorations of Alessi's Villa Giustiniani (1548–55; *see* ALESSI, GALEAZZO, fig. 1), Albaro. Spazio's contribution to the expanding spatiality of Genoese High Renaissance palazzi, apparent in the atrium–*scala*–courtyard sequence of the Palazzo Spinola and the giant *piano nobile* salon (l. 18 m) of the Villa Grimaldi, influenced contemporary Genoese palace designs and the Genoese Baroque style.

BIBLIOGRAPHY

Thieme–Becker

E. de Negri and others: *Il catalogo delle ville genovesi* (Genoa, 1967)

M. Labò: *I palazzi di Genova di Pietro Paolo Rubens e altri scritti d'architettura* (Genoa, 1970)

E. Poleggi: *Strada Nuova: Una lottizzazione del cinquecento a Genova* (Genoa, 1972)

Galeazzo Alessi e l'architettura del cinquecento: Atti del convegno internazionale di studi: Genoa, 1974

L. Magnani: *Il Tempio di Venere: Giardino e villa nella cultura genovese* (Genoa, 1987)

GEORGE L. GORSE

Sperandio (Savelli) (*b* Mantua, ?1425; *d* Venice ?1504). Italian medallist, architect, sculptor, painter, bronze and cannon caster. He was the son of a Roman goldsmith, Bartolommeo di Sperandio Savelli. In *c.* 1437 the family left Mantua to settle in Ferrara, where Sperandio was probably trained in goldsmithing by his father. Sperandio is first mentioned as a goldsmith at Ferrara in 1445 and again in 1447. He appears to have returned to Mantua at some point and to have been employed by Borso d'Este, Marchese of Ferrara, by the early 1460s. His medals of *Giovanni II Bentivoglio, Prince of Bologna*, *Bartolommeo Pendaglia*, merchant at Ferrara, *Giustiniano Cavitelli*, jurisconsult at Cremona, and *Antonio Sarzanella de' Manfredi of Faenza* have been assigned to the early years of his first period in Ferrara (1462–77). The medal depicting *Francesco Sforza, Duke of Milan* (*c.* 1466), shows the sitter in three-quarter view (the only *en face* medallic work by Sperandio). It does not appear to have been executed from life, but from a painting or drawing. After Borso d'Este's death and Ercole d'Este's accession to the duchy (1471), Sperandio appealed to him for assistance, and sent him, unsolicited, a medal with Ercole's portrait; the piece is probably the one mentioned in Ercole's inventory of 1471. Sperandio signs his letter 'Sperandio of Mantua, goldsmith living in Ferrara'. The appeal seems to have led to continuation of his employment, as records of 1475 show a payment to him for two marble busts executed for the duke (one in Paris, Louvre).

In 1477 Sperandio responded to a call from Carlo II Manfredi, Lord of Faenza, to work on the sculpture of the Faenza Cathedral; a five-year contract mentioned that he was to work in bronze, marble, terracotta, lead, goldsmithing, drawing, painting, and whatever else he was proficient at. His stay, however, was cut short by the revolution of 1477, in which Carlo was overthrown by his brother Galeotto and work on the cathedral came to a halt. Of two medals made there, portraying *Carlo II Manfredi* and *Galeotto Manfredi*, Carlo's piece lacks a reverse design. Sperandio was in Bologna for the next ten years or so, where he was employed to work on medals, sculpture and terracottas. In this period he made 18 medals. These include one of *Galeazzo Marescotti*. Its reverse depicts the Bolognese nobleman with his right hand resting on an open book, another volume in his left hand, surrounded by pieces of armour, a fortress in the background. His medals of this period also include a portrait of *Andrea Barbazza* (*c.* 1479; see fig.).

The medal of *Federigo da Montefeltro, Duke of Urbino*, was greatly praised by Goethe (1749–1832), who had a specimen in his collection; he ranked Sperandio even higher than Pisanello. Despite Sperandio's artistic ability he became poor during his stay in Bologna and was forced to depend on charity. He left Bologna for a second stay in

Sperandio: *Andrea Barbazza*, bronze medal, diam. 114 mm, *c.* 1479 (London, Victoria and Albert Museum)

Ferrara (1491–4), where he cast two medals, of *Jacopo Trotti*, an Este secretary, and of *Covella Sforza, Lady of Pesaro*. After a brief stay in Padua, he spent two years in Mantua as cannon founder and architect. In commemoration of the battle of Fornovo (1495) he made two medals, one of *Francesco II, Lord of Mantua*, the other of *Agostino Barbarido, Doge of Venice*. During his last years Sperandio was employed in Venice as a cannon founder for the arsenal (1496–1504).

Sperandio was one of the most prolific medallists of the Renaissance, but his work is of uneven quality. While some portraits are impressive in their forceful conception, others are dry and unimaginative. Moreover, his reverse compositions are often ill-proportioned, copied from other artists and do not always bear relevance to the sitter. Except for one piece, all his medals are signed OPVS SPERANDEI. He also executed narrative bronze plaquettes, including a *Flagellation* (Washington, D.C., N.G.A.) and a *Resurrection* (Berlin, Skulpgal.). In 1482 he completed the monument to the Antipope *Alexander V* (*d* 1410; Bologna, S Francesco) and in 1490 he made a model for the reconstruction of the campanile of S Petronio, Bologna. A bronze equestrian statue of *Francesco Gonzaga* (Paris, Louvre) and a terracotta *Annunciation* (Faenza Cathedral) have also been attributed to him.

BIBLIOGRAPHY

Forrer; Thieme–Becker

W. K. F. [Weimarische Kunstfreunde; i.e. J. W. von Goethe and H. Meyer]: 'Beiträge zu Geschichte der Schaumünzen aus neuerer Zeit', *Jena. Allg. Lit.-Z.*, i–viii (1810); ed. and trans. E. Gans and M. Knight as Goethe's *Italian Medals. . .* (San Diego, 1969)

J. Friedländer: *Die italienischen Schaumünzen des 15. Jahrhunderts, 1430–1530* (Berlin, 1882), pp. 59–78

A. Armand: *Les Médailleurs italiens* (Paris, 1879, rev. 2/1883–7), i, pp. 63–76; ii, p. 288; iii, pp. 14–17

A. Venturi: 'Sperandio da Mantova', *Archv/ Stor. A.*, ii (1888), pp. 385–97; iii (1889), pp. 229–34

H. Mackowsky: 'Sperandio Mantovano', *Jb. Kön.-Preuss. Kstsamml.*, xix (1898), pp. 171ff

C. von Fabriczy: *Medaillen* (Leipzig [1904]), pp. 42–5

G. F. Hill: 'Three Pen Studies by Sperandio', *Burl. Mag.*, xvi (1909), pp. 24 ff; xix (1911), p. 138

E. F. Bange: *Bildwerke der christlichen Epochen, italienische Bronzen der Renaissance und des Barock* (Berlin and Leipzig 1922), pp. 36, 83

G. Habich: *Die Medaillen der italienischen Renaissance* (Stuttgart, 1922), pp. 53–6

G. F. Hill: *Corpus* (1930), i, pp. 89–104

M. Weinberger: 'Sperandio und die Frage der Franciaskulpturen', *Munchn. Jb. Bild. Kst*, vii (1930), pp. 292–318

A. Rubbiani: 'La tomba di Alessandro V', *Riv. Com.*, xxii/11–12 (1935), pp. 29 ff

J. Pope-Hennessy: *Renaissance Bronzes from the Samuel H. Kress Collection* (London, 1965), p. 70

G. F. Hill and G. Pollard: *Renaissance Medals from the Samuel H. Kress Collection in the National Gallery of Art* (London, 1967), pp. 26ff

U. Middeldorf and D. Stiebral: *Renaissance Medals and Plaquettes* (Florence, 1983), pp. xxxi–xxxiii

G. Pollard: *Medaglie italiane del rinascimento*, Florence, Bargello cat., 3 vols (Florence, 1985)

G. Boccolari: *La Medaglia di Casa d'Este* (Modena, 1987), pp. 68, 76, 82

C. Lloyd: 'Reconsidering Sperandio', *Stud. Hist. A.*, xx (1987), pp. 99–113

L. Syson: 'Sperandio of Mantua', *The Currency of Fame: Portrait Medals of the Renaissance*, ed. S.K. Scher (New York, 1994), pp. 91–102

MARK M. SALTON

Spilimbergo, Irene di (*b* Udine, 1540; *d* Venice, 15 Dec 1559). Italian painter. Reputed to have studied for two years with Titian in Venice, she painted portraits as well as historical and religious subjects (e.g. the *Flight into Egypt*, ex-Count F. di Maniago col.), but few works have been identified. Lanzi wrote that her majestic figures, soft gradations of colour and use of glazing were reminiscent of Titian (Ellet). A three-quarter-length portrait of her sister, *Emilia di Spilimbergo* (Washington, DC, N.G.A.), with a landscape background, has been attributed to her. A pendant portrait of *Irene di Spilimbergo* (Washington, DC, N.G.A.) is thought to be by Titian. After her death, at 19, a volume of eulogies in her praise by poets including Lodovico Dolce and Torquato Tasso was published in 1561.

BIBLIOGRAPHY

E. F. L. Ellet: *Women Artists in All Ages and Countries* (New York, 1859)

F. Heinemann: 'La bottega di Tiziano', *Tiziano e Venezia: Convegno internazionale di studi: Venice, 1976*, p. 438

G. Greer: *The Obstacle Race: The Fortunes of Women Painters and their Work* (London, 1979), pp. 70–72, 182–3

C. Petteys: *Dictionary of Women Artists* (Boston, 1985) [with bibliog.]

☐

Spinelli [Spinello]. Italian family of artists. They were active in Tuscany in the 14th and 15th centuries. Like his brother and father, Luca di Spinello worked as a goldsmith and two of his sons were artists: the painter Spinello Aretino (1350/52–1410) and the goldsmith and sculptor Niccolò Spinelli. Spinello was one of the most popular, prolific and important Tuscan painters of the late 14th century and early 15th. Niccolò, who settled in Florence, was the oldest contestant in the 1401–2 competition to make the bronze doors of the Baptistery in Florence. He married the daughter of the painter Andrea di Nerio, who probably trained Spinello. Spinello's son, (1) Parri Spinelli, was also a painter. Niccolò's two sons, Cola Spinelli (1384–1458) and Forzore Spinelli (1397–1477), were goldsmiths in Florence. Forzore's son, (2) Niccolò di Forzore Spinelli, was a medallist who produced numerous large portrait medals.

(1) Parri Spinelli [Guasparri di Spinello] (*b* Arezzo, 1387; *d* Arezzo, *bur* 9 Jan 1453). Painter, draughtsman and goldsmith. Although many of his frescoes are lost, an impressive number of drawings has survived. He is first recorded in Siena, once in 1405 as recipient of a payment made to his father for work in the cathedral, and again in 1407, when he was named as an assistant in Spinello Aretino's contract for the frescoes in the Sala di Balía in the Palazzo Pubblico. His idiosyncratic style and eccentric figures, which appear to be in a state of frenzied animation, bear little or no relation to his father's sober, more monumental approach, although both painters had the same delicacy of handling. However, he derived gothicizing elements from his father and developed them to an exaggerated degree. Vasari wrote that Parri was apprenticed to Lorenzo Ghiberti, and he probably spent several formative years in Florence after Spinello's death; his uncle Niccolò had a goldsmith's workshop there with his sons Cola Spinelli (1384–1458) and Forzore Spinelli (1397–1477), who were also both goldsmiths. Parri was certainly influenced by Ghiberti and his followers, and by the paintings of Lorenzo Monaco, whose graceful figures with attenuated proportions reappear even more sinuously in his own works. By 1419 he was back in Arezzo and

apparently never left again. His brother Baldassare stated in their joint tax declaration of 1427 that Parri had been ill for eight years and was unable to work; in 1431 he was declared to be 'infirm of mind'.

Whatever this means—Vasari described Parri as a melancholic and a solitary—he was not denied an active career in his native city, although some records show him to have been an erratic worker. His earliest surviving mature work, the fresco of the *Madonna della Misericordia* (*c.* 1428; Arezzo, S Maria delle Grazie), shows a passion for elaborately patterned surfaces, elongated figures and looping drapery. This reappears in his only surviving panel painting, the altarpiece of the *Madonna della Misericordia* (Arezzo, Pin.), commissioned in 1435 by the Confraternità della Misericordia for SS Lorentino e Pergentino, and completed in 1437. Several frescoes in S Domenico, including a *Crucifixion and Scenes from the Life of St Nicholas* and a fragmentary composition with a pair of *Musical Angels*, are probably from the same period; their lively colours and elongated, rhythmically swaying figures epitomize Vasari's accurate analysis of Parri's art. A near-monochrome fresco of the *Crucifixion* (Arezzo, Pal. Com.) is datable to the 1440s; the intensity of grief is expressed even in the gnarled wood of the cross and the convoluted drapery. Its *sinopia* displays a summary but powerful variant on the scene. Late works include a *Crucifixion and Saints* (1444; Arezzo, Conservatorio di S Caterina) and a *Madonna della Misericordia with SS Donatus and Gregory X* (1448; Arezzo, Pal. Fraternità dei Laici), which was painted for an important audience chamber. Vasari stated that Parri far surpassed his father in the art of drawing. His highly refined and sometimes bizarre style is evident in such drawings as *Hercules Leaning on his Club* (Washington, DC, N.G.A.; see fig.). Executed in pen and ink, apparently rapidly, the drawings do not appear to come all from the same sketchbook (Florence, Uffizi, and elsewhere). Parri's calligraphic hand may also be seen in the figures of the Virgin Annunciate and Archangel incised on an incense boat (Arezzo, Gal. & Mus. Med. & Mod.), for which he presumably provided the design.

BIBLIOGRAPHY

Bolaffi; Thieme–Becker

G. Vasari: *Vite* (1550, rev. 2/1568), ed. G. Milanesi (1878–85), ii, pp. 275–85

——: *Vita di Parri Spinelli*, ed. M. Salmi (Florence, 1914)

C. Refice: 'Parri Spinelli nell'arte fiorentina del sec. XV', *Commentari*, ii (1951), pp. 196–200

P. P. Donati: 'Notizie e appunti su Parri Spinelli', *Ant. Viva*, ii/1 (1964), pp. 15–23

B. Degenhart and A. Schmitt: *Süd- und Mittelitalien* (1968), i of *Corpus der italienische Zeichnungen, 1300–1450* (Berlin, 1968–), ii, pp. 303–10; iv, pls 223–32

M. J. Zucker: 'A New Drawing by Parri Spinelli and an Old One by Spinello', *Master Drgs*, vii (1969), pp. 400–04

Frescoes from Florence (exh. cat. by L. Berti and P. Dal Poggetto, London, Hayward Gal., 1969), pp. 120, 123–31 [good pls]

M. J. Zucker: *Parri Spinelli: Aretine Painter of the 15th Century* (diss., New York, Columbia U., 1973)

R. Fremantle: *Florentine Gothic Painters* (London, 1975), pp. 533–42

I disegni antichi degli Uffizi: I tempi del Ghiberti (exh. cat., Florence, Uffizi, 1978), pp. 36–47

Lorenzo Ghiberti: 'Materia e ragionamenti' (exh. cat., Florence, Accademia, 1978), pp. 112–16

M. J. Zucker: 'Parri Spinelli Drawings Reconsidered', *Master Drgs*, xix (1981), pp. 426–41

L. Borri Cristelli: 'Considerazioni su un affresco attribuito a Parri Spinelli', *A. Crist.*, lxxxiii/767 (1995), pp. 91–100

Parri Spinelli: *Hercules Leaning on his Club*, pen and brown ink on paper, 281×154 mm, mid-1440s (Washington, DC, National Gallery of Art)

M. J. Zucker: 'Drawings by Parri Spinelli, the Gothic El Greco', *Drawing*, xvii/1 (1995), pp. 7–12

FRANK DABELL

(2) Niccolò di Forzore Spinelli [Niccolò Fiorentino] (*b* Florence, 23 April 1430; *d* Florence, before 23 April 1514). Medallist, second cousin of (1) Parri Spinelli. Only a few documents and contemporary references mark the progress of his career. In 1468 a 'Nicolas de Spinel', usually identified with this artist, was employed as a seal-engraver at the court of Charles the Bold, 4th Duke of Burgundy (*reg* 1467–77). He was in Flanders *c.* 1505, when Leonardo da Vinci wrote that Niccolò had advised him about a method of diverting a stream (see J. P. Richter: *The Literary Works of Leonardo da Vinci*, ii (London, 1883, rev. 2, Oxford, 1939, p. 183)). On 26 May 1484 Niccolò was paid to repair and re-cut the great silver seal (destr.) of the Arte de' Guidici e Notai of Florence. He was buried in S Maria Novella.

Niccolò di Forzore Spinelli's identity as a medallist is established by only five signed pieces (Hill, 1930, nos 922–

6). Payment for one of these, a medal of *Alfonso d'Este* (Hill, 1930, no. 923; see fig.), is recorded in 1492, the date on the medal. One of the other signed pieces, that of Silvestro Daziari, Bishop of Chioggia (*d* 1487; Hill, 1930, no. 922), is dated 1485. A forceful portrait of *Lorenzo de' Medici* (Hill, 1930, no. 926) is combined with a surprisingly crude personification of *Florence* on the reverse.

The five signed pieces epitomize the particular character of Niccolò's work. Whatever the size of the medal, the portrait is distinctive and confident, dominating the circular field, although in most cases the lettering is not as elegant. Each head is strongly individualized and modelled in fairly high relief. The economical style includes the essential contours and features, while conveying a feeling for the plasticity of flesh and the bone structure that brings the subjects to life, despite their presentation in strict and impersonal profile. Few other Renaissance medallists were able to produce so evocative a series of portraits, but this was, perhaps, to be expected in the environment of Quattrocento Florence. By contrast, the reverses of Niccolò's medals are mostly either clumsy, derivative, repetitive or inappropriate. At best, they exhibit a rough charm, as in the case of the *Three Graces*, which appropriately forms a pendant to the beautiful portrait of *Giovanna Albizza Tornabuoni* (Hill, 1930, no. 1021). This same reverse, however, is repeated on other medals (e.g. Hill, 1930, nos 1047, 1050), where its significance is not clear. Similarly, figures of *Hope, Fortune*, an *Eagle on a Tree* and *Charity*, rendered with a certain heavy vigour, are frequently repeated with little concern for their compatibility with the obverse.

In addition to the signed pieces, about 160 medals have been associated stylistically with Niccolò. Not all are his work, and Hill (1930) attempted to impose some order by dividing them into seven categories. In terms of both quality and style, there is a remarkable consistency in most of the group. It includes a series of portraits that seem to be centred in Rome and to have been made between *c.*

Niccolò di Forzore Spinelli: *Alfonso d'Este* (reverse), bronze medal, diam. 70 mm, 1492 (London, British Museum)

1480 and 1486 (Hill, 1930, nos 927–44). Particularly impressive are the portraits of *Girolamo Callagrani, John Kendal, Giovanni P. di Pavia*, and two female portraits, *Teodorina Usodimare-Cibo* and *Peretta Usodimare* (Hill, 1930, nos 931, 934, 938, 943, 944). It appears that Niccolò produced a series of portraits of Frenchmen (Hill, 1930, nos 945–54) at the time of the French invasion of Italy in 1494–5. They vary in quality and are best represented by the medals of *Jean Matharon de Salignac* (*d* 1495), *Béraud Stuart d'Aubigny* (*d* 1507) and an *Unknown Man* (Hill, 1930, nos 952–4).

The most significant group of medals, both in size and chronology, Hill subdivided into those produced before 1500 and those made between 1500 and 1514. Among these are many of outstanding quality, in particular the portraits of women such as *Nonnina Strozzi, Camilla Buondelmonti Salviati, Caterina Sforza-Riario*, and *Giovanna Albizza Tornabuoni* and *Lodovica Tornabuoni* (Hill, 1930, nos 957, 1012, 1014, 1015, 1069). Among his male portraits, the most impressive are those of the philosophers *Marsilio Ficino* and *Giovanni Pico della Mirandola* (Hill, 1930, nos 974, 998), churchmen such as *Fra Domenico Riccio* and *Girolamo Santucci* (Hill, 1930, nos 1009, 1013), or merchants and private citizens such as *Filippo Strozzi, Giovanni Tornabuoni* and *Alessandro di Gino Vecchietti* (Hill, 1930, nos 1018, 1023, 1027).

If the entire group of medals attributed to Niccolò is representative of an impressive Florentine school of medallic production rather than the oeuvre of one man, the extraordinary quality of the few medals mentioned above, together with the signed pieces and others not included, might be taken as outstanding examples of work around which the rest should be graded.

BIBLIOGRAPHY

G. F. Hill: *Medals of the Renaissance* (London, 1920; rev. and enlarged by G. Pollard, 1978), pp. 74–80
——: *Corpus*, i (1930), pp. 243–76
G. F. Hill and G. Pollard: *Renaissance Medals from the Samuel H. Kress Collection at the National Gallery of Art* (London, 1967), pp. 49–56
V. Johnson: 'Nelle medaglie la societè toscana alla fine della Repubblica e alla fine del Granducato', *Velia Johnson: Dieci anni di studi di medaglistica, 1968–78* (Milan, 1979), pp. 76–82
G. Pollard: *Italian Renaissance Medals in the Museo Nazionale del Bargello*, i (Florence, 1984), pp. 410–77
Eredità del Magnifico (exh. cat., Florence, Bargello, 1992), nos 29, 41, 44
The Currency of Fame: Portrait Medals of the Renaissance (exh. cat., ed. S. K. Scher; Washington, DC, N.G.A.; New York, Frick; 1994), pp. 132–6, 382

STEPHEN K. SCHER

Spinelli, Andrea (*b* Parma, 15 Feb 1508; *d* Venice, 24 May 1572). Italian medallist, sculptor, bookbinder and dealer. He was an industrious student of the goldsmith Gianfrancesco Bonzagni, to whom he was related. In 1533 he produced a medal (see fig.) celebrating the foundation of the Venetian church of S Francesco della Vigna (begun by Jacopo Sansovino). This event was also commemorated in a medal (e.g. Brescia, Pin. Civ. Tosio–Martinengo) by a pupil of Vittore Gambello. Both works depict Doge Andrea Gritti, who laid the foundation-stone of the church in 1534, as well as showing Sansovino's design. Spinelli's medal contains a bust of Gritti on its face with the inscription 'Gritti DVX Venetiar MDXXIII'. The Doge is shown facing to the left, bearded and clothed in a cap and robe. A portion of the chest and cap extends over part of

Andrea Spinelli: medal commemorating the foundation of the church of S Francesco della Vigna, Venice, bronze, diam. 36 mm, 1533 (Washington, DC, National Gallery of Art)

one of the two circles encompassing the bust. On the reverse of the medal is an inscription, surrounded by maple leaves, to 'DIVI Francisci MDXXXIIII', and, in the exergue, the signature 'An Sp F' (Andrea Spinelli Fecit), together with the date. The design on the reverse is from a perspective drawing of the church, which intersects the inner of the two circles, as the bust of the Doge does on the obverse side. The inscription within the two circles surrounding the design also appears on both sides. The medal, cast in bronze, has a predominantly light brown patina, although part of it has a covering of black lacquer. An unusual spot or mark is visible behind the neck of the Doge.

Spinelli created another medal (1538; Washington, DC, N.G.A.) to commemorate Antonio Mula's election in that year as a member of the Council of Ten for the third time and a Councillor for the fourth time. On the face of the medal is a bust of Mula, the Duke of Crete, in 1536, peering towards the left and clothed in a robe. On the reverse is *Concordia Fratrvm*, signed 'Sp F.' in the exergue. Mula and another man are dressed in full-length robes and are standing facing each other with their right hands joined. The medal is struck in bronze, has a dark brown patina and contains raised circles in order to make the inscription visible. Both sides have a pearled border engulfing the figures. A third important medal attributed to Spinelli depicts Doge Pietro Lando (*reg* 1539–45), as well as kneeling senators being blessed by Christ. On the reverse of the medal is the crowned figure of Venice, accompanied by a lion.

On 24 May 1540 Spinelli succeeded Pietro Benintendi as chief coin-engraver at the mint in Venice, at which he had been working since 1535. By 1543 he and his son Giacomo Spinelli had started their own small business in the San Giuliano district of Venice. It is believed that Giacomo predeceased his father by many years. It has also been suggested that another son, Marcantonio Spinelli, succeeded his father at the mint in Venice as the chief engraver when Andrea and Giacomo went into private business; eventually Marcantonio also worked in the family workshop. As well as producing medals, for which they employed apprentices, the Spinellis finished bookbindings and dealt in books and engravings. A sculpture, cast in bronze, of the *Risen Christ* (commissioned 9 Dec 1541; executed 1544) has also been attributed to Andrea.

BIBLIOGRAPHY
C. von Fabriczy: *Italian Medals* (London, 1904), pp. 80–81
The Salton Collection: Renaissance and Baroque Medals and Plaquettes (exh. cat. by M. Salton, Brunswick, ME, Bowdoin Coll. Mus. A., 1965), cat. no. 63
Sculpture in Miniature: Collection of Gilt and Gold Medals and Plaquettes (exh. cat. by A. S. Ciechanowiecki, Louisville, KY, Speed A. Mus., 1969), p. 58
U. Middeldorf and D. Stiebral: *Renaissance Medals and Plaquettes* (Florence, 1983), pp. LXIX–LXX

MARY MARGARET McDONNELL FORD

Spinelli, Domenico di Niccolò. *See* DOMENICO DI NICCOLÒ.

Spinola. Italian family of patrons. One of the foremost patrician families of Genoa, descended from Guido (Guidone) Spinola (*fl* 1102–26), it acquired wealth and power through banking and mercantile activities. Members included political, ecclesiastical and military leaders as well as several Doges of Genoa. Many were important patrons. Oberto Spinola founded the family church of S Luca, Genoa, in 1188. Battista Spinola (*d* 1470) commissioned Vincenzo Foppa to paint an altarpiece (*c*. 1480; destr.) for S Domenico, Genoa, and Luca Spinola commissioned Luca Cambiaso to paint the altarpiece of *St Benedict Enthroned* for Genoa Cathedral (1562; *in situ*). The magnificent residences built for members of the family include the Palazzo Spinola 'dei Marmi' (1445–59; for Giacomo Spinola), the Palazzo di Taddeo Spinola (1531) and the Palazzo Cattaneo Adorno (1584–8; for Lazzaro and Giacomo Spinola). Bernardino da Cantone designed a palace (1558–66; now Banca d'America e d'Italia) for Angelo Giovanni Spinola, which has frescoes of scenes from the *Life of Alexander the Great* (*c*. 1593) by Bernardo Castello (ii) and Andrea Semino. In collaboration with Giovanni Battista Castello (i), Cantone also designed a palace (1563–6; Palazzo Doria since 1723) for Giambattista and Andrea Spinola. The Palazzo Pallavicina-Pessagno (formerly Palazzo Tomaso Spinola), designed by Castello, has façade frescoes by Semino and contains frescoes by Cambiaso depicting episodes from the history of the Spinola family. Eliano Spinola, an early connoisseur of antiquities, assembled a collection in the 15th century that included medals, Greek coins and vases.

BIBLIOGRAPHY
N. Battilana: *Genealogia delle famiglie nobili di Genova*, 3 vols (Genoa, 1825–33)
A. M. G. Scorza: *Le famiglie nobili Genovesi* (Genoa, 1924), pp. 234–9
P. Boccardo: 'Per l'iconografia del "Trionfo" nella Genova del rinascimento: I portali Doria e Spinola', *Stud. Stor. A.*, 4 (1981–2), pp. 39–54
G. Rotondi Terminiello, F. Simionetti and G. Rosato: *La Galleria Nazionale di Palazzo Spinola, Genova* (Rome, 1991)

□

Squarcione, Francesco (*b* Padua, *c*. 1395; *d* Padua, after May 1468). Italian painter, teacher, draughtsman and printmaker. He is a controversial figure. His mediocre qualities as a painter are less contentious than his role as the head of a school for painters, possibly the earliest private establishment devoted to teaching painting and distinct from the workshop system of instruction through apprenticeships.

Having been recorded as a tailor and embroiderer, Squarcione is first referred to as a painter in 1426, when he executed an altarpiece (untraced) for the Olivetan monastery at Venda, south of Padua. He was then living near the Santo in Padua, where he later established his school. Soon after completing this altarpiece, Squarcione

left Padua. According to Scardeone, who knew Squarcione's lost autobiography, he travelled throughout Italy and Greece (i.e. the Byzantine empire). After returning to Padua, Squarcione took on his first pupil, Michele di Bartolommeo, in 1431. Apart from a *Crucifixion* (untraced), completed in 1439 for a Venetian patron, he undertook few commissions at this time. His purchase in 1440 of a neighbouring house to form a second place of study was therefore probably a result of recent success in teaching rather than in painting. In 1441 Squarcione's name first appears in connection with the Paduan painters' guild. Throughout the 1440s he was concerned with minor artistic works in Paduan churches and was sufficiently important to be received by the Holy Roman Emperor Frederick III (*reg* 1452–93) in 1452. From the 1440s Squarcione occasionally lived in Venice, where he executed two paintings (untraced), which are recorded in an inventory dated 1466 of the Scuola di S Marco. In 1463 he made designs for intarsia panels for the Santo, Padua, and two years later constructed a model of Padua for the city authorities. He made his final will in May 1468.

Two paintings survive that are clearly connected with Squarcione. One is an altarpiece (Padua, Mus. Civ.), formerly in the Carmine in Padua, commissioned by Leone de Lazzara in 1449 and completed in 1452. The central panel shows St Jerome seated in his study with a landscape behind. Four side panels each contain a saint standing on a pedestal. The figures are imaginatively posed and sensitively characterized, though the draughtsmanship is weak. The elegant drapery style suggests that the artist had studied the work of Pisanello. The second work, a signed but undated *Virgin and Child* (Berlin, Gemäldegal.), is stylistically rather different. This features a number of spatial devices, such as the foreground ledge and classicizing swags, indications that the artist was influenced by Tuscan artists interested in pictorial space, such as Donatello. The influence of Fra Filippo Lippi, active in Padua during the 1430s, is evident in the Virgin's delicate profile and the Child's pose. The contrast between the Renaissance motifs in the Berlin *Virgin and Child* and the Gothic features of the Lazzara altarpiece has led to the suggestion that the two works may not be by the same painter. However, comparison of such details as the hair and sky confirms that the same artist painted both. Frescoes of the *Life of St Francis* on the façade of S Francesco in Padua (only *sinopie* survive) were ascribed to Squarcione by Scardeone. A painting (untraced) by Squarcione listed in a Florentine inventory suggests his reputation extended beyond the Veneto.

As Squarcione adopted several pupils, apparently compelling them to undertake commissions in his name, the possibility remains that none of these works was executed by Squarcione himself. Evidence indicates that he chose his most talented pupils for adoption in order to take advantage of their skills for financial gain. Mantegna, who was adopted c. 1441, implies in a document of 1448 that he deserted Squarcione because of unreasonable exploitation. Another case of exploitation applies to MARCO ZOPPO, whose contract of adoption was made in 1455 and annulled later the same year. Zoppo left, notwithstanding the prospect of inheriting Squarcione's considerable estate.

Further documents reveal some of Squarcione's teaching methods. The contract of 1431 with Michele di Bartolommeo and subsequent contracts such as that of 1467 state that the pupil was allowed to study Squarcione's *exempla*, drawings that acted as models. His collection included a drawing (untraced) by (?Antonio) Pollaiuolo that showed some nude figures probably related to Squarcione's 'system for the naked body' mentioned in the contract of 1467. It was allegedly stolen by a former pupil, Giorgio Schiavone, but recovered by Squarcione's son in 1474. Squarcione also possessed a collection of antiquities that were employed as models. Documents of 1455 refer to reliefs kept in his workshop and to plaster used 'for shaping figures'. Vasari explained this by referring to Squarcione's collection of casts made from antique statues. Another feature of Squarcione's teaching was a method used for foreshortening figures and constructing perspectival views. But doubt exists about the extent of his knowledge of linear perspective: in 1465 a pupil maintained that although Squarcione promised to show him the true method of perspective, he was actually incapable of teaching it.

By the 16th century Squarcione's reputation as a teacher who had helped to shape the character of North Italian painting was firmly established. According to Scardeone, Squarcione was considered the best teacher of his time and was called 'the father of painters', having had 137 pupils. As a Paduan, Scardeone probably exaggerated Squarcione's significance. The works connected with him do not suggest that Squarcione offered his pupils anything original. Indeed the work of Dario da Treviso, one of Squarcione's pupils during the early 1440s, is very old-fashioned and provides no hint of the painterly devices that Squarcione later claimed to teach. It seems likely, therefore, that Squarcione's reputation rested principally on the achievements of his most talented pupils whose ideas he exploited. This explains why pupils turned against him and why documents indicate that he was deceitful in financial matters. Nonetheless his school brought together many notable painters and facilitated the exchange of artistic ideas.

BIBLIOGRAPHY

G. Vasari: *Vite* (1550, rev. 2/1568); ed. G. Milanesi (1878–85), iii, p. 85
B. Scardeone: *Historiae de urbis patavinae antiquitate et claris civibus patavinis* (Padua, 1560), pp. 370–71
G. Fiocco: 'Il museo immaginario di Francesco Squarcione', *Mem. Accad. Patavina Sci. Lett. & A.*, lxxi (1958–9), pp. 1–16
——: *L'arte di Andrea Mantegna* (Venice, 1959), pp. 59–72
M. Muraro: 'A Cycle of Frescoes by Squarcione in Padua', *Burl. Mag.*, ci (1959), pp. 89–96
V. Lazzarini: *Documenti relativi alla pittura padovana del secolo XV*, notes A. Moschetti, intro. M. Muraro (Bologna, 1974)
A. Schmitt: 'Francesco Squarcione als Zeichner und Stecher', *Münchn. Jb. Bild. Kst*, n. s. 3, xxv (1974), pp. 205–9
M. Muraro: 'Francesco Squarcione pittore "umanistica"', *Da Giotto al Mantegna* (exh. cat., ed. L. Grossato; Padua, Pal. Ragione, 1974), pp. 68–74, no. 80
P. A. Sartori: *Documenti per la storia dell'arte a Padova*, ed. C. Fillarini (Vicenza, 1976)
B. Aikema: 'The Fame of Francesco Squarcione', *Ateneo Ven.* (1977), pp. 133–7
M. Boskovits: 'Una ricerca su Francesco Squarcione', *Paragone*, xxviii/325 (1977), pp. 40–70
P. Sambin: 'Per la biografia di Francesco Squarcione: Briciole documentarie', *Med. & Uman.*, xxxiv (1979), pp. 443–65
R. Lightbrown: *Mantegna* (Oxford, 1986), pp. 15–29

THOMAS TOLLEY

Stagi, Stagio (*b* Pietrasanta, Tuscany, 1496; *d* Pisa, May 1563). Italian sculptor and architect. Active throughout his life in north-west Tuscany, he headed a busy workshop that he inherited from followers of his father, Lorenzo Stagio (*b* ?1455; *d* after 23 April 1506). He may have been trained by Lorenzo's associates Giuliano di Taddeo and Bastiano di Giovanni Nelli of Carrara (both *fl* 1506–7). Lorenzo Stagi was trained in the workshop of Matteo Civitali and collaborated with him on various commissions in and around Lucca. It was once thought that Stagio worked with Civitali on the statues for Genoa Cathedral, but he would have been too young; his father's participation in the Genoa works as a member of the Civitali workshop during the 1490s is, however, plausible.

In July 1521 Stagio Stagi was commissioned to make a marble holy water stoup for Pietrasanta Cathedral. The success of this work resulted in a companion piece a few months later. Reliefs of animals, garlands, putti and a figure of *St John the Baptist* decorate the basins and exemplify Stagio's training in the traditions of the Civitali family workshop. He also made the pilasters (1522) in Pietrasanta Cathedral to support a tabernacle that included angels carved earlier by Donato Benti.

Around 1524 Stagio settled in Pisa, where he remained for the rest of his life, and set up a workshop. He assisted Pandolfo di Bernardo Fancelli of Florence on the decoration of various altars in Pisa Cathedral, the most noteworthy of which is the altar of S Biagio, and on Fancelli's death (1526) he assumed the main role in completing the decoration of the church. Between March 1528 and 1533 he constructed two chapels, one dedicated to SS John the Baptist and George and the other, decorated with rich, multicoloured marbles, to the Virgin and St Clement; he erected a further six chapels between 1535 and 1546. In 1546 he began work on the high altar, a commission on which he worked until his death.

Additional documented works by Stagio include the marble inlay for the exterior of the bell-tower of Pietrasanta Cathedral (1538) and the funerary monument of *Filippo Decio* (1534–5; Pisa, Camposanto). The latter includes an elaborate base, which is clearly derived from the tomb of *Giovanni Chellini* (*d* 1462) by Bernardo Rossellino in S Domenico, San Miniato al Tedesco, and late 15th-century tombs in Rome. The tomb of *Bishop Mario Maffei* (*d* 1537) in Volterra Cathedral has also been attributed to Stagio, although this is not generally accepted. Numerous, often anonymous, marble tabernacles, holy water basins and shrines in the Versilia and Garfagnana regions of Tuscany reflect the extent and legacy of the Stagi workshop. Stagio's works are characterized by a clarity and crispness in carving and a classicizing compositional severity that shows the influence of Civitali and a lingering, late 15th-century aesthetic. Stagio's sons Bernardino (*d* ?1585) and Giuseppe (*d* ?1573) were members of his workshop, and Bartolomeo Ammanati trained in the Stagi studio in Pisa during the 1520s. Niccolò Tribolo joined the workshop in Pisa in 1527–8 and assisted on the early altars in the cathedral.

BIBLIOGRAPHY

S. Varni: *Di Maestro Lorenzo e Stagio Stagi di Pietrasanta* (Genoa, 1868)

G. Milanesi: *Notizie di Lorenzo e di Stagio Stagi* (Florence, 1881)

C. Arù: 'Scultori della Versilia', *L'Arte*, xii (1909), pp. 269–87

J. Pope-Hennessy: *Italian High Renaissance and Baroque Sculpture* (London, 1963, rev. 3/New York, 1985)

Le vie del marmo (Prato, 1992)

STEVEN BULE

Starnina, Gherardo (di Jacopo) (*b* Florence, ?*c*. 1360; *d* Florence, before Oct 1413). Italian painter. A pupil of Antonio Veneziano, he is first mentioned in 1387 in the records of the Compagnia di S Luca in Florence. Starnina was in Toledo in 1393, possibly with his former master, and in Valencia in 1395, 1398, 1399 and 1401. Documents indicate that he executed numerous commissions for frescoes and panel paintings in both towns, but no surviving works can be connected with certainty to these records.

In the autumn of 1404 Starnina completed frescoes in the chapel of St Jerome, S Maria del Carmine, Florence. The surviving fragments, in the refectory, depict large figures of saints standing in tabernacles. An engraving (1823) by Jean-Baptiste Séroux d'Agincourt records two of the lost scenes. In February 1409 Starnina was employed to decorate a chapel in S Stefano, Empoli (two fragments of an ornamental band with busts of saints, Empoli, Mus. S Andrea). A fresco (destr.) of *St Dionysius* on the façade of the Palazzo di Parte Guelfa, Florence, frescoes in the Castellani Chapel, Santa Croce, Florence depicting scenes from the *Life of St Anthony Abbot* and the *Thebais* (*c*. 1410; Florence, Uffizi) are also attributed to Starnina.

Before the discovery of the frescoes in S Maria del Carmine (Procacci) and S Stefano (Baldini), the Castellani Chapel frescoes determined the way Starnina's work was seen by scholars. The similarity of these frescoes to works by Agnolo Gaddi (*fl* 1369–96) was recognized, and Starnina was regarded as a pupil and assistant of this painter. Only Toesca had pointed to the figure of *Dionysius*, still faintly visible in 1929, emphasizing its Late Gothic features and discerning in it the hand of Starnina. Knowledge of the fragments in S Maria del Carmine and S Stefano put discussion of Starnina on a new basis. Berti and Bellosi pointed to the close relationship of these frescoes to works by the MASTER OF THE BAMBINO VISPO (*see* MASTERS, ANONYMOUS, AND MONOGRAMMISTS, §I), and by van Waadenoijen and Syre proposed that Starnina and this anonymous master were one and the same. Consequently Starnina appeared in a completely different light: he was no longer seen entirely in the tradition of Agnolo Gaddi, but as an artist who took ideas from various sources and moulded them into an individual, homogeneous and progressive style. The identification of Starnina with the Master of the Bambino Vispo has been widely, but not unanimously, accepted by scholars. Boskovits, for example, still sees Starnina as a pupil of Agnolo Gaddi, whose style changed markedly in Spain and then in Florence. Boskovits identified the anonymous master with the Spaniard Miguel Alcaniz (*fl* 1408–47).

Several attempts have been made to reconstruct Starnina's Spanish oeuvre. Various works in Toledo have been unconvincingly attributed to him and may well be the work of Spanish painters from the circle of Antonio Veneziano. A *Last Judgement* (Munich, Alte Pin.), regarded as a major work by the Master of the Bambino Vispo, may have been produced during Starnina's stay in Valencia. While characteristically Valencian with regard to format and iconography and revealing a Late Gothic influence in its articulation of forms, its depiction of space and the three-dimensional quality of the figures are Florentine in origin. Soon after 1401 Starnina left Spain and returned to

Florence, where he produced the frescoes in the chapel of St Jerome, S Maria del Carmine and, between 1404 and 1407, the *St Lawrence* altarpiece for the chapel donated by Cardinal Angelo Acciaiuoli (1349–1408) in the Certosa del Galluzzo, near Florence (fragments, Berlin, Bodemus.; Douai, Mus. Mun.; Dresden, Gemäldegal.; Frankfurt am Main, Städel. Kstinst. & Städt. Gal.; Milan, Mus. Poldi Pezzoli; Rome, Gal. Colonna; Rotterdam, Mus. Boymans–van Beuningen; Stockholm, Nmus.; see fig.). The frescoes (1409) in S Stefano were Starnina's final large commission. Alongside these major works, a series of other paintings can also be attributed to Starnina, including a fresco depicting the *Raising of Lazarus* (Florence, Mus. Opera Santa Croce), a *cassone* panel depicting an *Equestrian Combat* (Altenburg, Staatl. Lindenau-Mus.), a *Madonna of Humility* (Oxford, Christ Church Lib.) and a *Virgin and Child with Angels and Saints* (Florence, Accad.).

There is a stylistic ambivalence in all Starnina's works. They combine characteristic features of Florentine painting, such as concern for spatial depiction and a three-dimensional portrayal of the figures, with elements of the Late Gothic style that he absorbed in Spain. Starnina probably played an important role in transmitting these Gothic forms to Florentine painting—to Lorenzo Monaco, for example. Starnina was one of the most important painters of his time in Florence, as is demonstrated by the large number of works produced in his circle and by his successors. His interest in tackling problems of figure grouping and spatial depiction anticipate concerns that were of prime importance to Masaccio.

Gherardo Starnina: *Carthusian Saint (?Hugh of Lincoln) and St Benedict*, right panel of the *St Lawrence* altarpiece, tempera on panel, 995×710 mm, 1404–7 (Stockholm, Nationalmuseum)

BIBLIOGRAPHY
J. Séroux d'Agincourt: *Histoire de l'art par les monumens, depuis sa décadence au IVe siècle jusqu'à son renouvellement au XIVe siècle*, ii (Paris, 1823), pl. CXXI
A. Schmarsow: *Wer ist Gherardo Starnina?* (Leipzig, 1912)
P. Toesca: *La pittura fiorentina del trecento* (Verona, 1929), pp. 52, 67
C. Gamba: 'Induzioni sullo Starnina', *Riv. A.*, xiv (1932), pp. 55–74
U. Procacci: 'Gherardo Starnina', *Riv. A.*, xv (1933), pp. 151–90; xvii (1935), pp. 333–84; xviii (1936), pp. 77–94
U. Baldini: *Itinerario del Museo della Collegiata* (Empoli, 1956), pp. 14–15
L. Berti: *Masaccio* (Milan, 1964), pp. 137–8, n. 152
L. Bellosi: 'La mostra di affreschi staccati al Forte Belvedere', *Paragone*, xvii/201 (1966), pp. 73–9
J. van Waadenoijen: 'Proposal for Starnina: Exit the Maestro del Bambino Vispo?', *Burl. Mag.*, cxvi (1974), pp. 82–91
M. Boskovits: 'Il Maestro del Bambino Vispo: Gherardo Starnina o Miguel Alcaniz?', *Paragone*, xxvi/307 (1975), pp. 3–15
C. Syre: *Studien zum 'Maestro del Bambino Vispo' und Starnina* (diss., U. Bonn, 1979)
J. van Waadenoijen: *Starnina e il gotico internazionale a Firenze*, Istituto Universitario Olandese di Storia dell'Arte, xi (Florence, 1983)

CORNELIA SYRE

Statuette [Fr.: 'little statue']. Type of sculpture, smaller than life-size, usually figural and free-standing; often a reduced version of a larger work.

1. Introduction. 2. 15th century. 3. 16th century.

1. INTRODUCTION. The statuette was a significant element of sculptural production during most of Classical antiquity. Made in various materials, of which marble, bronze and terracotta were the most common, it served both sacred and secular functions. Inexpensive terracottas dedicated as votives in sanctuaries outnumber other types of figurines, but statuettes in precious materials, apparently commissioned as decorative objects, are also known.

Lacking the technical skills to work on a larger scale, early Greek sculptors created statuettes from necessity. A painted terracotta centaur found in a tomb at Lefkandi (*c.* 900 BC; Eretria, Archaeol. Mus.) represents one of their first surviving efforts. A cast-bronze statuette of a nude male, the 'Mantiklos Apollo' (*c.* 700–*c.* 675 BC; Boston, MA, Mus. F.A.), and a group of deities found at Dreros on Crete, made of thinly hammered bronze surmounting a wooden core (*c.* 700 BC; Herakleion, Archaeol. Mus.), illustrate the early achievements in bronze. Several lively bronze figures of athletes made in the early 5th century BC document the continued role of the statuette as a trend-setter into the Early Classical period (*c.* 480–*c.* 450 BC). Overshadowed during the 5th century BC by statuary of human scale, the statuette rose again to prominence in the Hellenistic era, when the popularity of the private house as a locus for sculptural display spurred the making of small-scale statues. Extensive finds of statuettes at Delos and Rhodes document this trend.

The statuette was also important in the Roman world. Household gods (*lares*) were a favourite subject. Hundreds of bronze statuettes rendering figures according to traditional typologies have been discovered in such provincial areas as Gaul and Germany. Although often artistically mediocre, these statuettes disseminated the formal language of classicism throughout the Empire. Other statuettes of higher quality inspired the small Renaissance bronzes made by Antico and other sculptors.

BIBLIOGRAPHY
S. Boucher: *Recherches sur les bronzes figurés de Gaule préromaine et romaine* (Paris, 1976)

J. Boardman: *Greek Sculpture: The Archaic Period* (London, 1978)
——: *Greek Sculpture: The Classical Period* (London, 1985)

ELIZABETH BARTMAN

2. 15TH CENTURY. During the Renaissance the sculptor's repertory was increased by the revival of the bronze statuette. Ancient Greek, Roman or Etruscan votive figures of deities and animals showed how attractive and durable such small bronze figurines could be, as well as providing a source of imagery and showing how the nude could be rendered. The only things akin to such statuettes in the Middle Ages had been figures that were integral components of religious precious metalwork (e.g. images of the Virgin and St John to flank crucifixes), and so their early history is tentative: statuettes gradually emerged from such quasi-architectural contexts as small niches on shrines to become free-standing objects of art in their own right. They adorned the desks and libraries of such humanists as Cosimo de' Medici and Piero I de' Medici and were made for practical purposes (e.g. as paperweights) or to adorn lamps or inkstands or simply as miniature representations of things dear to the owner—famous antiquities, patron saints, handsome men and women or favourite horses. The attraction of the small-scale and domestic commission for artist and patron alike was that pagan subjects and Classical nudity were acceptable (which they were not at this stage in monumental, and therefore public, sculpture).

(i) Central Italy. The earliest datable Renaissance statuettes come from the workshop of Donatello and Michelozzo di Bartolomeo, probably being cast by Maso di Bartolommeo. None, however, is by the hand of the master, although works attached to a feature in an architectural context, for example the putti on the font in Siena Cathedral (*c.* 1416–31; *in situ*), prove that Donatello was perfectly capable of making statuettes. His followers all over Italy, however, rapidly made up for his omission: Bertoldo di Giovanni and Antonio Pollaiuolo are famed for this type of work, each producing masterpieces on a miniature scale (e.g. the former's *Bellerophon and Pegasus, c.* 1483; Vienna, Ksthist. Mus.; *see* BERTOLDO DI GIOVANNI, fig. 2; and the latter's *Hercules and Antaeus, c.* 1475–80; Florence, Bargello; *see* POLLAIUOLO, (1), fig. 2).

Specialists in statuettes also emerged to meet the increasing demand for these artefacts (e.g. Adriano Fiorentino and Desiderio da Firenze). Andrea del Verrocchio's *Putto and Dolphin* (late 1460s–early 1470s; Florence, Pal. Vecchio; see colour pl. 2, XXXVIII2), though not quite a statuette (h. 670 mm), inspired generations of sculptors who specialized in statuettes (e.g. Giambologna). In Siena, following Donatello's two periods of activity there, such sculptors as Vecchietta and Francesco di Giorgio Martini also worked on a small scale in bronze. While as early as the 1440s in Rome, Antonio Filarete made an important contribution with his splendidly modelled reduction (1440–45; Dresden, Skulpsamml.) of the Classical equestrian statue of *Marcus Aurelius* (Rome, Piazza del Campidoglio) and another showing *Hector* (*c.* 1458–60; Madrid, Mus. Arqueol. N.), also on horseback.

(ii) North Italy. Bronze statuettes seem first to have been produced in the north of Italy to supplement the antiquities that were then being excavated and avidly collected. The mania for collecting seems to have been strongest in this region, inspired by the humanism of the University of Padua, and perhaps because antiquities from the Byzantine Empire were available through the maritime network of Venice, especially after the fall of Constantinople (now Istanbul) in 1452. The genuinely Renaissance statuette evolved out of this minor industry of copying or faking, hence the penchant for subjects from Classical mythology; nevertheless, the work of the earliest true specialist in statuettes, Bartolomeo Bellano, is predominantly religious in its subject-matter, for example *David with the Head of Goliath* (version, New York, Met.) or *St Jerome with the Lion* (Paris, Louvre).

Bellano encouraged such able pupils as Andrea Riccio and, perhaps, Severo da Ravenna. Severo was the next great sculptor specializing in bronze in Padua; his repertory extended from figures to domestic artefacts, and his oeuvre has now been disentangled from that of Riccio: most famous are Severo's group of *Neptune and a Dragon* (New York, Frick) and a variety of satyrs, but he also produced statuettes of saints (e.g. *St John the Baptist*, Oxford, Ashmolean; and *St Sebastian*, Paris, Louvre). Riccio, arguably the most gifted exponent of the statuette in the whole Renaissance, recreated for his intensely intellectual patrons in the University of Padua a series of Classical nymphs, satyrs, handsome nude shepherd boys, animals and monsters, as well as weirdly shaped lamps, grotesque masks and even erotica. His masterpiece of secualr subjects is, however, the *Shouting Horseman* (London, V & A), which shows a knowledge of Leonardo da Vinci's equestrian projects and his experiments with facial expression. All Riccio's bronzes were imbued with a nervous vivacity, conveyed by his subtle modelling in the wax, conscientious chasing of every detail and hammering of every exposed surface. This technique imparted a Leonardesque *sfumato* effect, instead of a high polish.

The Paschal Candlestick (1507–16; Padua, S Antonio; *see* RICCIO, ANDREA, fig. 2) is Riccio's masterpiece, and the repertory that it provides, even—surprisingly—of mythological figures, enables the attribution to this artist of many other similar independent statuettes that are neither signed nor documented. Andrea Riccio's style is quite unlike the angular, agonized style of Bellano and reverts to a canon of slim, well-proportioned figures, with smallish heads and normally of calm, Classical demeanour, very intellectually conceived and deeply spiritual.

A completely different interpretation of antiquity had meanwhile appeared in Mantua, at the court of the Gonzaga, introduced by the bronze sculptor Piero Jacopo Alari, nicknamed 'Antico' from his penchant for direct copies of Classical statuary (*see* ANTICO, fig. 1), by contrast with Riccio's free variations. Antico burnished the surfaces of his nude figures to a high polish, blackened and then partially gilded them, sometimes even inlaying their eyes with silver. These luxury products appealed to such demanding, princely patrons as Ludovico Gonzaga and Isabella d'Este, but fail, perhaps, to engage the emotions of a spectator who is not obsessed with Antiquity.

3. 16TH CENTURY. Less attention was paid to the production of statuettes during the High Renaissance, because of Michelangelo's obsession with marble statuary. Nevertheless, he seems to have modelled one or two of the bronze statuettes himself (e.g. *Hercules with the Apples of the Hesperides* (London, V & A; see Joannides), while some of his models (notably *Samson Slaying Two Philistines*; Rotterdam, Mus. Boymans–van Beuningen) were copied by others in bronze. Furthermore, Leonardo da Vinci and his close associate Giovanni Francesco Rustici were interested in the medium, because of its relationship to the modelled, rather than carved, sculpture that they practised. Leonardo noted making a small model in wax of a horse; Rustici produced a bronze statuette of *Mercury* for a Medici fountain (Cambridge, Fitzwilliam). Francesco da Sangallo also produced a notable statuette of *St John the Baptist* (New York, Frick).

(i) Florence and Rome. With the departure of Michelangelo from Florence in 1534, artists again turned to the statuette as a valid branch of sculpture and one suited to the aims of the Medici, by then established as dukes, for it provided a link with their 'democratic' forebears, as well as handsome ornamentation for their private studies and agreeable and prestigious diplomatic gifts. Such rivals of Michelangelo as Baccio Bandinelli and Benvenuto Cellini (*see* CELLINI, BENVENUTO, fig. 3) produced excellent statuettes in the Mannerist idiom *c.* 1540, while his followers of the younger generation, Niccolo Tribolo and Pierino da Vinci, also created notable examples.

Still younger sculptors who came to maturity around the date of Michelangelo's death in 1564, for example Giovanni Bandini, Valerio Cioli, Bartolomeo Ammanati and Vincenzo Danti, all famous for their monumental contributions to the decoration of the city of Florence, were also capable of brilliant work on a small scale (e.g. in the *studiolo* of Francesco I de' Medici in the Palazzo Vecchio; *see* STUDIOLO, fig. 2). They were active at the period when Giambologna made his momentous appearance on the Florentine art scene and perfected the bronze statuette as a medium of sculptural expression. He addressed a far wider range of subjects than had his predecessors, extending his repertory beyond the standard nude figures of Classical deities (e.g. *Mercury*, Bologna, Mus. Civ.; or *Venus Urania*, Vienna, Ksthist. Mus.) to struggling groups, for example the *Labours of Hercules* series (Vienna, Ksthist. Mus.; see fig.), or equestrian ones (e.g. *Nessus Abducting Deianeira*, San Marino, CA, Huntington Lib. & A.G.; Dresden, Skulpsamml.). He portrayed real people, animals and country-folk, with a positively Breughel-like delight (e.g. *The Fowler*, Paris, Louvre); and treated a number of religious themes, notably the crucified Christ. For compositional subtlety, sensuous tactile values and sheer technical virtuosity, Giambologna's statuettes have never been surpassed. Diffused as diplomatic gifts by his patrons, and later through purchase by collectors, they spread his style all over Europe.

In Rome, meanwhile, the principal exponent of high-quality statuettes was Guglielmo della Porta, who produced several designs of crucifixes and a *Christ in Limbo* (Vienna, Ksthist. Mus.). Leone Leoni, the Milanese sculptor and goldsmith, also executed a number of statuettes, sensitively

Giambologna: *Hercules and a Centaur*, bronze, h. 402 mm, after 1576 (Vienna, Kunsthistorisches Museum)

modelled in the wax before casting and then carefully chased.

(ii) North Italy. Several little-known goldsmiths and sculptors contributed to the success of the bronze statuette in North Italy in the first third of the 16th century, notably Vittor Camelio, Maffeo Olivieri, Desiderio da Firenze, Antonio Lombardo, Francesco da Sant'Agata and Giovanni Fonduli da Crema (e.g. *Seated Nymph*, London, Wallace). Their collected oeuvre represents an important and characteristic, though all too often neglected, aspect of High Renaissance art. Thus, when Jacopo Sansovino arrived in Venice after 1527, he found a thriving artistic tradition and technical infrastructure at his disposal, which he utilized chiefly for narrative reliefs and statuettes, as these could be modelled rapidly in wax and the tedious process of casting and chasing delegated to juniors: for the altar-rail in S Marco he made the *Four Evangelists*. He also signed a group of the *Virgin and Child* (Cleveland, OH, Mus. A.).

It was really left to Jacopo's numerous assistants to benefit from the tradition, chief among whom was Alessandro Vittoria, who found statuettes to be an ideal vehicle for his combination of Michelangelesque muscularity with Sansovino's suaver, Raphaelesque modelling and the Man-

nerist elongation and spiralling poses of Parmigianino, some of whose works he owned: his work ranges in size and subject from a signed *St Sebastian* (New York, Met.) down to little figures of *Winter* (versions, *c.* 1585; Vienna, Ksthist. Mus.; Toronto, Royal Ont. Mus.), an old man muffled up in heavy robes.

Others of Jacopo's immediate circle, Tiziano Minio and Danese Cattaneo, also produced statuettes, often depicting Classical marine deities, for example Minio's *Neptune* (London, V&A) and Cattaneo's *Venus Marina* (Vienna, Ksthist. Mus.). The Campagna brothers and Nicolò Roccataglata, Francesco Segala and Tiziano Aspetti are all credited with the production of an amazing range of statuettes and other types of bronze domestic artefacts. In Verona the foundry run by Giuseppe de Levis, his sons and nephews, conveniently applied signatures and dates to a broad range of functional items, giving an idea of how such a business operated over a whole century. The dearth of such objects produced in other Italian centres suggests that the Venetians gained a virtual monopoly over the manufacture and distribution of such useful items throughout the peninsula; this lasted well into the 17th century and probably even later, as such items were easy to reproduce from moulds and did not demand quite the degree of finish of statuettes proper. In Milan a similar repertory of ornamental bronzes was produced by Annibale Fontana.

BIBLIOGRAPHY

J. Montagu: *Bronzes* (London, 1963)
A. F. Radcliffe: *European Bronze Statuettes* (London, 1966)
H. R. Weihrauch: *Europäische Bronzestatuetten, 15.–18. Jahrhundert* (Brunswick, 1967)
Renaissance Master Bronzes from the Collection of the Kunsthistorisches Museum, Vienna (exh. cat. by M. Leithe-Jasper, Washington, DC, N.G.A.; Los Angeles, CA, Co. Mus. A.; Chicago, IL, A. Inst.; 1986)
P. Joannides: 'Michelangelo bronzista: Reflections on his Mettle', *Apollo*, cxlv/424 (1997), pp. 11–20

CHARLES AVERY

Stefano, Francesco di. *See* PESELLINO.

Stefano, Giovanni di. *See* GIOVANNI DI STEFANO.

Stefano (di Giovanni) da Verona [Stefano da Francia; Stefano da Zevio] (*b* 1374–5; *d c.* ?1438). Italian painter. He was the son of Jean d'Arbois (1365–99). Vasari first called him Stefano da Verona; in documents he appears as Stefano di Giovanni. The name da Zevio (Stephanus de Gebeto), adopted by local historians, arose from a confusion with Altichiero. Local historians, probably because of Vasari's chronological incoherence in calling him a student of both Agnolo Gaddi (1369–96) and Liberale da Verona, were also responsible for the creation of other apocryphal Stefanos (Stefano jr, Stefano sr, Vincenzo di Stefano).

Fruet published documents that shed light on Stefano's antecedents but which also pose problems. In 1399 a dowry contract was signed in Treviso between Stefano and Tarsia. Stefano is called a painter and is identified as the son of the deceased 'Johannis de Herbosio, provincie francie', possibly, Jean d'Arbois, a painter who worked at the court of Philip the Bold, Duke of Burgundy (*reg* 1363–1404), and is also probably to be identified with the 'Giovanni degli Erbosi' who was in Pavia in 1399 according

to Comi and Robolini (end of the 18th century). In 1394 and 1398 Stefano was in Mantua, where he was called 'Master Stefano of France'. He was in Treviso again in 1402, 1404 and 1410. Between 1396 and 1421 he is mentioned frequently in documents in Padua, where he lived, apparently with another wife, Alba, and held the position of steward of the painters' guild. He was settled in Verona with his original wife Tarsia between 1425 (when he was aged 50) and 1433. It may be Stefano who was mentioned in the will of Tommaso Salerno of Verona in 1438. In 1434 and 1438 he was at Castel Bragher in the Trentino.

This biographical outline must be accepted with reservations: the bigamy suggested by the two dowry contracts is very rare in the Middle Ages, and it is improbable that Stefano lived for 25 years in Padua without leaving a trace of his artistic activity. It is likely that he was trained in Lombardy at the end of the 14th century, at that time a centre for artists from throughout Europe who were attracted by workshops such as that of Milan Cathedral. Before 1399 Jean d'Arbois was in Pavia, where Michelino da Besozzo also worked. A Lombard training would seem to be confirmed by the fact that his work shows no trace of the influence of Veronese painters such as Altichiero (1369–93), Martino da Verona and Jacopo da Verona, while the influence of his father explains the French elements in his style; it is no longer necessary to suggest he travelled north of the Alps (Fiocco, L. Venturi).

Stefano's earliest attributed work mixes northern and Lombard traits, although executed in a totally Italian spirit. The lack of perspective, the play of curves and the delicacy of treatment of the figures and settings, executed according to decorative formulae rather than to observation of nature, have affinities with illuminated manuscripts. The stylistic influence of Michelino is evident in the repetition of colour combinations to create rhythms and the technically refined use of gold and a *pastiglia* relief. Boskovits's reattribution to Michelino of the *Virgin and Child with St Catherine in a Rose Garden* (Verona, Castelvecchio), is now widely accepted by the majority of art historians, so it would appear that Stefano's earliest surviving work is the fresco of *Angels* (Verona, S Fermo), mentioned by Vasari. It lacks any attempt to apply the laws of perspective, but a rhythmic elegance is created by the flowing scrolls carried by the angels. Vasari described several signed frescoes by Stefano in the churches and on palace façades in Verona (all destr.), particularly praising his fresco technique and saying that Donatello admired Stefano's work when he visited the city. A signed fresco of *St Augustine Enthroned* (Verona, S Eufemia) is now virtually illegible but was copied by Nanin, as was a fresco fragment of the *Adoration of the Child* (Verona, Castelvecchio), attributed to Stefano (though recently reattributed to Giovanni Badile or Michelino da Besozzo) and formerly in SS Cosme e Damiano; the colour range of the latter is limited and an almost enamelled effect is achieved.

Vasari also described frescoes by Stefano in Mantua. Those in S Domenico have been destroyed and the *St Francis Receiving the Stigmata* in S Francesco is almost illegible. In the same church Stefano painted the *Evangelists* in the vault of a chapel, which are now known only from photographs. The influence of Michelino, particularly in

the figures, suggests that they were early works. The *Virgin and Child with Angels* (Rome, Gal. Colonna), attributed to Stefano, is a work of great chromatic refinement in which the attenuated, tapered figures and curved lines create a rhythmic effect.

The signed and dated *Adoration of the Magi* (?1435; Milan, Brera; see fig.) is a mature work in which Stefano's stylistic links with Michelino are abandoned. In place of the decorative abstraction of his earlier works it displays a greater sense of narrative and a more anecdotal depiction of objects due, no doubt, to the subject-matter. The more naturalistic approach, evident in his treatment of animals, is already inherent in the Colonna *Virgin and Child*. In these two panels, Stefano created rich chromatic effects while still using gold highlights and *a pastiglia* decoration to enrich the pictorial surface. At the end of his career he remained faithful to the Late Gothic style of which he was one of the most interesting exponents.

Stefano's graphic work displays the same formal qualities as his paintings. The rapid drawing style, boldly drawn with the pen (e.g. the *Allegory of Charity*, Florence, Uffizi, 1101E), allowed the artist great freedom of invention. While maintaining certain formal characteristics of Lombard art, such as the constrained contours and bracketed compositions, Stefano used line with a rare sense of brio, favouring secular themes (e.g. *Study of Figures*, Florence,

Stefano da Verona: *Adoration of the Magi*, tempera on panel, 730×470 mm, ?1435 (Milan, Pinacoteca di Brera)

Uffizi, 1104E and 1106E; *Allegory of Dialectic and Grammar*, Milan, Bib. Ambrosiana, F214, inf. 20; *Reading Virgin*, Paris, Louvre, 9831). The chronology of the drawings is difficult to establish, however, and the connection between them and paintings is not always clear.

Stefano was barely influenced by Pisanello, who worked in Verona at the same time. However, the Pisanello-style *Declaration of Love* (Paris, Fond. Custodia, Inst. Néerlandais), a drawing recently reattributed to Giovanni Badile (see Guzzo in Badile bibliog.), bears witness to the extent to which more modest artists responded to the elaborate visual language evolved by the great Veronese master for the courts of Italy. The influence of Stefano on the young Pisanello, hypothesized in the older literature, must be reconsidered in the light of more recent research, which has placed more emphasis on the art of Gentile da Fabriano and Michelino da Besozzo in the genesis of Pisanello's early style. Nevertheless the fact that the *Virgin and Child with a Quail* (Verona, Castelvecchio) and the *Virgin and Child Enthroned*, known as the Palazzo Venezia Madonna (Rome, Pal. Venezia), were once attributed to both Pisanello and to Stefano proves that the question of reciprocal influences must remain open (see Boskovits, 1998).

BIBLIOGRAPHY

Thieme–Becker

G. Vasari: *Vite* (1550, rev. 2/1568); ed. G. Milanesi (1878–85), i, pp. 641–2; iii, pp. 628–33

P. Nanin: *Disegni di varie dipinture a fresco in Verona* (Verona, 1864), pp. 5, 67–8

A. Venturi: *Storia* (Milan, 1901–40/*R* 1967), vii/1, pp. 282–350

L. Venturi: *Le origini della pittura veneziana* (Venice, 1907), pp. 72–80

P. Toesca: *La pittura e la miniatura nella Lombardia* (Milan, 1912, rev. Turin, 2/1966), pp. 187, 189, 191n., 195–7, 208, 217

R. Brenzoni: *Stefano da Verona ed i suoi affreschi firmati* (Verona, 1923)

R. van Marle: *Italian Schools* (1923–38), vii, pp. 270–94

E. Sandberg-Vavalá: *La pittura veronese del trecento e del quattrocento* (Verona, 1926), pp. 274–308

G. Fiocco: 'Disegni di Stefano da Verona', *Proporzioni*, i (1950), pp. 50–64

G. Degenhart: 'Di una pubblicazione su Pisanello e di altri fatti', *A. Ven.*, viii (1954), pp. 96–118

Da Altichiero a Pisanello (exh. cat. by L. Magagnato, Verona, Castelvecchio, 1958), pp. 37–50

L. Magagnato: *Arte e civiltà del medioevo veronese* (Turin, 1962), pp. 100–06

L. Castelfranchi Vegas: *Il gotico internazionale in Italia* (Milan, 1966), pp. 27–8

B. Berenson: *Central and North Italian Schools* (London, 1968), pp. 417–18

M. T. Cuppini: 'L'arte gotica a Verona nei secoli XIV e XVI', *Verona e il suo territorio*, iii/2 (Verona, 1969), pp. 333–6

G. Fruet: 'Stefano da Verona e Stefano di Francia', *Civil. Mant.*, xxvi (1971), pp. 101–15

R. Longhi: *Lavori in Valpadana dal trecento al primo quattrocento (1934–1964)* (Florence, 1973), pp. 144–7

G. L. Mellini: 'Stefano di Giovanni', *Maestri della pittura veronese* (Verona, 1974), pp. 51–8

E. Moench: 'Stefano da Verona: La Quête d'une double paternité', *Z. Kstgesch.*, xlix (1986), pp. 220–28

M. Boskovits: *Arte in Lombardia tra gotico e rinascimento* (exh. cat., Milan, 1988)

E. Moench: 'Verona', *La pittura veneta: Il Quattrocento*, i (Milan, 1990), pp. 157–63

——: 'Stefano da Verona: La Mort critique d'un peintre', *Hommage à Michel Laclotte* (Paris, 1994), pp. 78–100

E. Karet: 'Stefano da Verona's Brera *Adoration of the Magi*: Patronage, Politics and Social History', *A. Lombarda*, 2–4 (1995), pp. 13–26

F. M. Aliberti Gaudioso, ed.: *Pisanello: I luoghi del gotico internazionale nel Veneto* (Milan, 1996), pp. 46–7, 102–4, 293

M. Boskovits: 'Le milieu du jeune Pisanello: Quelques problèmes d'attribution', *Pisanello: Actes du colloque: Paris, 1996* (Paris, 1998), i, pp. 91–3, notes 25–40

E. Moench: 'Verona: Gli anni venti del Quattrocento', *Pisanello* (exh. cat., ed. P. Marini; Verona, Musei Civ., 1996), pp. 62–6

ESTHER MOENCH

Stefano di Giovanni di Consolo. *See* SASSETTA.

Stradanus, Joannes [Johannes] [Straat Jan van der; Straet, Jan van (der); Strada, Giovanni della; Stradano, Giovanni; Stratensis, Giovanni] (*b* Bruges, 1523; *d* Florence, 3 Nov 1605). Flemish painter and draughtsman, active in Italy. The traces of his Flemish artistic heritage were much appreciated in the refined Mannerist circle, led by Vasari, in which he was active in Florence. He was especially skilled as a designer of tapestry cycles.

1. EARLY LIFE AND TRAINING: FLANDERS, 1523–45. According to Borghini, who knew his subject personally, Stradanus's first teacher was his father, Jan van der Straet (*d* 1535), an otherwise unknown painter in Bruges. After his father's death, he was apprenticed for two years to Maximilian Franck (1490–1547). From 1537 to 1540 Stradanus trained in Antwerp under Pieter Aertsen (1507/8–75). According to van Mander, Stradanus became a master in Antwerp *c.* 1545. In the same year he left for Italy, having heard of the excellence of the Italian painters. He travelled by way of Lyon, where he worked with Corneille de Lyon (1500/10–75).

Although no works can be ascribed to Stradanus with any certainty before his arrival in Italy, Van Puyvelde dated the following works before 1546: the triptych with the *Presentation in the Temple*, the *Birth of the Virgin* and the *Marriage of the Virgin* (Bruges, St Sauveur); the *Good Samaritan* (Bruges, St Janshosp.); and a series of 17 drawings of scenes from the *Life of the Virgin* (all Windsor Castle, Berks, Royal Lib.), which served as designs for the title-page and plates engraved by Adriaen Collaert (*c.* 1560–1618) in Antwerp. However, it is possible that Stradanus executed both the triptych and the *Good Samaritan* in Italy, and Thiem has dated the series of drawings *c.* 1580 on the basis of their style.

2. ESTABLISHED CAREER: ITALY, 1546–75. After leaving Lyon, Stradanus travelled to Florence via Venice, where he remained for six months. During his first stay in Florence (1546–50), he designed tapestry cartoons for Cosimo de' Medici's tapestry factory, the Arazzeria Medicea. According to Borghini, he also left the city during this period to paint frescoes in the palace in Reggio Emilia of one of the pope's commissaries (though this has been disputed). From 1550 to 1553 Stradanus probably stayed in Rome, where he certainly collaborated with Daniele da Volterra in the Belvedere (1550–51), even though his precise contribution can no longer be determined, nor can his duties as assistant to Francesco Salviati, with whom he also worked for several months. What is certain is that Salviati's work deeply influenced the development of Stradanus's own style. The series of black chalk drawings (Florence, Uffizi, F 17325–32), after Michelangelo's *Last Judgement* in the Sistine Chapel, Rome (see colour pl. 2, VII3), probably date from this period.

On his return to Florence, Stradanus made a few independent tapestry cartoons, but from 1557 onwards he worked under Vasari's supervision on the decoration of the Palazzo Vecchio (*see* FLORENCE, §IV, 8), producing both frescoes and at least 132 tapestry cartoons. He painted frescoes, for instance, with Vasari of *Allegories of Female Virtues* (1561–2) in the Quartiere di Eleonora di Toledo (*in situ*), and provided two panels for the subsequent decoration of the *studiolo* of Francesco I, including *The Alchemists* (signed and dated *Ioannes Stratensis Flandrus* 1570; *in situ*; see fig. 1), which reveals his Flemish training under Aertsen.

In 1563 Stradanus was an officer of the Accademia del Disegno, a post he occupied again in 1586 and 1591. He contributed a painting to a project organized by the Accademia in 1564 in honour of Michelangelo's obsequies: *Michelangelo Welcomed in Venice in 1529 by a Deputation in the Name of the Doge and the Senate* (untraced). The following year he assisted in the decoration for the Triumphal Entry of Joanna of Austria into Florence, making an arch over the Canto de' Tornaquinci. Between 1567 and 1577, while still working on the decoration of the Palazzo Vecchio, Stradanus produced a series of cartoons of *Hunting Scenes* (dispersed) for tapestries (Florence, Pal. Vecchio) originally intended to decorate 20 rooms of Cosimo's villa at Poggio a Caiano. The success of the Poggio a Caiano project probably encouraged Stradanus to design a further two series of *Hunting Scenes* (see fig. 2), this time to be engraved. Both series, consisting of 44 and 61 prints respectively, were engraved by Philip Galle (1537–1612) and others (Antwerp, 1578; Hollstein,

1. Joannes Stradanus: *The Alchemists*, panel, h. 1.17×0.85 m, 1570 (*studiolo* of Francesco I, Palazzo Vecchio, Florence)

2. Joannes Stradanus: *Bird Hunt*, pen and brown ink, with blue wash and white and brown highlights, on paper washed with light blue, 202×294 mm, *c.* 1576 (private collection; sold Monaco, Sotheby's, 1 March 1987, lot 521)

iv, nos 528–67), and they were later combined into a single series of 104 prints published by Galle under the title *Venationes, ferrarum, arium, piscium, pugnae* (*c.* 1596; Hollstein, nos 571–678).

Stradanus also painted altarpieces for several Florentine churches, for instance the *Ascension* in the Arsini Chapel of Santa Croce (1569; *in situ*), part of the cycle of altarpieces in the minor chapels of Santa Croce, begun in 1568 under Vasari's supervision. As part of the same project, Stradanus painted the *Baptism* in the Baccelli Chapel of S Maria Novella (*c.* 1572; *in situ*), of which Galle also made an engraving. Stradanus's signed and dated altarpiece of the *Crucifixion* for the chapel of the Crocifissione of SS Annunziata (1569; *in situ*) is flanked by frescoes ascribed to him of *Isaiah* and *Habakkuk*. A signed and dated autograph copy of the altarpiece (1581; Arezzo, Mus. Casa Vasari) was originally in the main hospital of S Maria Nuova, Florence. Galle also made an engraving of this work.

From 1571 onwards, Stradanus apparently worked on his own, to judge from a letter from Vasari to Francesco de' Medici: 'Of Maestro Giovanni Strada Fiamingo I prefer not to speak, for he has not been in my painters' shop for a long time'. In 1574 Stradanus bought a house in the Via Colonna, Florence. His altarpiece of *Christ Driving the Money-changers from the Temple* for the chapel of the Cambi Settimana in Santo Spirito, Florence (*in situ*), must have been painted between 1571 and 1576, in what was by then a new and wholly independent style.

3. LATER YEARS: FLANDERS AND ITALY, 1576 AND AFTER. According to Borghini, Stradanus went to Naples in 1576 at the request of John of Austria. He is supposed to have accompanied him on a journey to Flanders and remained there until John's death in 1578. No works are known from this presumed period in Flanders. After a short stay back in Florence, Stradanus apparently returned to Naples. There he frescoed a chapel in the monastery of Monte Oliveto with the *Mysteries of the Virgin* and the *Miracles of Christ*. He also produced an oil painting of the *Ascension* for the monastery (*in situ*) and started decorating a chapel above the dormitory. This work was finished by

his son Scipione Stradanus (*fl* until 1612). According to Colnaghi, Joannes Stradanus also painted four canvases in oil during his stay in Naples: *Rebecca, Bathsheba, Susanna* and *Venus with the Three Graces* (all untraced).

In 1583 Girolamo de' Pazzi commissioned Stradanus to decorate the chapel of his villa in Parugiano near Montemurlo in Prato. For Cardinal Alessandro de' Medici, Stradanus painted two altarpieces for the chapel of the Palazzo della Gherardesca in Florence, the *Adoration of the Shepherds* (1586) and the *Adoration of the Magi* (1587; both Lucca, priv. col., see Sasse van IJsselt, 1981, figs 15–16); these were originally part of a decorative programme of frescoes in the chapel. The frescoes and those in the interior court have also been attributed to Stradanus and dated *c.* 1585–7 (see Sasse van IJsselt, 1981). Shortly afterwards (1587–8) Stradanus was commissioned by Luigi Alamanni to illustrate Dante's *Inferno* as well as a few episodes from the *Purgatorio*; facsimile reproductions of the watercolours from the manuscript (Florence, Bib. Medicea–Laurenziana) were published in 1893 by G. Biagi. In 1602 Stradanus was relieved of his responsibilities at the Accademia del Disegno on account of his advanced age. After his death, his son Scipione erected a tomb for him in the chapel of St Barbara in SS Annunziata, the chapel of the Flemish Compagnia di S Barbara, of which both Stradanus father and son were members.

BIBLIOGRAPHY

Colnaghi; Hollstein: *Dut. & Flem.*

G. Vasari: *Vite* (1550, rev. 2/1568); ed. G. Milanesi (1878–85), viii–ix

R. Borghini: *Il riposo* (Florence, 1584/*R* Milan, 1967), pp. 579–84

K. van Mander: *Schilder-boeck* ([1603]–1604)

F. Baldinucci: *Notizie* (1681–1728); ed. F. Ranalli (1845–7), ii, pp. 591–6

A. Venturi: *Storia* (1901–40), ix/6 (1933), pp. 424–37

J. A. F. Orbaan: *Stradanus te Florence, 1553–1605* (diss., U. Rotterdam, 1903)

L. Dami: 'Un ciclo d'affreschi di Giovanni Stradano', *Ant. Viva* (1914), pp. 253–5

F. Antal: 'Zum Problem des niederländischen Manierismus', *Krit. Ber.* (1928–9), pp. 207–56

A. Welcher: 'A Wedding Gift by Stradanus to Christina of Lorraine: The Retreat of the Turks from Vienna', *Graph. Kst.* (1936), pp. 103–6

L. Van Puyvelde: *The Flemish Drawings in the Collection of His Majesty the King at Windsor Castle* (London, 1942), nos 135–85

——: 'The Flemish Drawings in the Royal Collection at Windsor Castle, IV', *Burl. Mag.*, lxxx (1942), p. 66

G. Thiem: 'Studien zu Jan van der Straat, genannt Stradanus', *Mitt. Ksthist. Inst. Florenz*, viii (1957–9), pp. 88–111, 155–66

Mostra di disegni fiamminghi e olandesi (exh. cat. by E. K. J. Reznicek, Florence, Uffizi, 1964), nos 30–35

R. Kultzen: *Jagddarstellungen des Jan van der Straet auf Teppichen und Stichen des 16. Jahrhunderts* (Hamburg and Berlin, 1970)

W. Bok-van Kammen: *Stradanus and the Hunt* (diss., Baltimore, MD, Johns Hopkins U., 1977)

M. B. Hall: *Renovation and Counterreformation: Vasari and Duke Cosimo in Sta Maria Novella and Sta Croce, 1565–1577* (Oxford, 1979)

E. Allegri and A. Cecchi: *Palazzo Vecchio e i Medici* (Florence, 1980)

D. van Sasse van IJsselt: 'Il Cardinale Alessandro de' Medici committente dello Stradano: La decorazione della cappella e del cortile del Palazzo della Gherardesca a Firenze, e *La generosità di San Nicola*', *Mitt. Ksthist. Inst. Florenz*, xxiv (1980), pp. 203–50

F. Stricchia Santoro: 'Antonio Tempesta fra Stradano e Matteo Brill', *Relations artistiques entre les Pays-Bas et l'Italie à la Renaissance: Etudes d'histoire de l'art publiées par l'Institut historique belge de Rome* (Rome, 1980), pp. 228–37

Firenze e la Toscana dei Medici nell' Europa del cinquecento, 3 vols (exh. cat., Florence, Pal. Vecchio and elsewhere, 1980), i, pp. 212–13 [drawings]; ii, p. 397 [paintings]; iii, pp. 70–84 [tapestries]

S. Lecchini Giovannoni: 'L'ultima cena de Giovanni Stradano', *Paragone*, ccclxxxi (1981), pp. 77–83

D. van Sasse van IJsselt: 'Tre disegni dello Stradano per la decorazione della cappella della Gherardesca a Firenze', *Mitt. Ksthist. Inst. Florenz*, xxv (1981), pp. 380–82
——: 'Een serie tekeningen van Johannes Stradanus met scenes mit het leven van de Heilige Giovanni Gualberto', *Oud-Holland*, ci (1987), pp. 148–70
——: 'Johannes Stradanus: De decoraties voor intochten en uitvaarten aan het hof vau de Medici te Florence', *Oud-Holland*, civ, (1990), pp. 149–79
——: 'Stradanus Drawings for the *Life of Appolonius of Tyana*', *Master Drgs*, xxxii (1994), pp. 351–9
A. Baroni Vannucci: *Jan van der Straet, detto Giovanni Stradano: Flandrus pictor et inventor* (Milan, 1997)

K. M. RUTGERS

Strazzarolo da Aviano, Girolamo di Bartolomeo. *See under* GIROLAMO DA TREVISO (i).

Strozzi. Italian family of bankers and patrons. From the time of their election to the city government in 1284 until the Medici regime exiled four of the Strozzi in 1434, they were one of the most powerful families in Florentine politics. The size of the family, which in 1427 was divided between about 40 households, their entrenchment in Florentine patrician circles, their political skill and the wealth of a few individuals ensured their survival under the domination of the Medici.

(1) Palla (di Nofri) Strozzi (*b* Florence, 1372; *d* Padua, 1462). He knew Latin and Greek and, through his collection of manuscripts and by bringing the Greek scholar Manuel Chrysoloras (*c.* 1350–1415) to Florence in 1397, he had a great influence on the development of humanist studies. By 1427 he had become the richest man in Florence, and his rural properties were the most extensive of any Florentine's before the purchases of Lorenzo de' Medici in the last decades of the 15th century. Two of his villas—Poggio a Caiano and Petraia—were later acquired by the Medici. By 1428 he owned five of the eight houses in a block between the Corso degli Strozzi (later Piazza Strozzi), Via Porta Rossa and Via Larga de' Legnaiuoli (later Via Tornabuoni), where he intended to build a new palace.

Although widely respected for his wisdom and virtue, Palla was banished to Padua in 1434. The only fruits of his artistic patronage in Florence to survive are the sacristy of Santa Trìnita and its two altarpieces, Gentile da Fabriano's *Adoration of the Magi* (Florence, Uffizi); *see* GENTILE DA FABRIANO, fig. 2) and the *Deposition* (Florence, Mus. S Marco) by FRA ANGELICO, begun by LORENZO MONACO. Palla's father Nofri Strozzi had commissioned and started building a new sacristy for the church in 1417–18. Palla seems to have finished the sacristy and its chapel by 1421 and then proceeded to enlarge the space by adding a second smaller sacristy and chapel next to it between 1423 and 1424. The marble interior doorway and the façade of the sacristy with its tabernacle windows were probably designed by Lorenzo Ghiberti and may be related to a payment that Palla made to Ghiberti in 1426. Gentile's *Adoration of the Magi* was almost certainly originally placed on the altar in the main sacristy chapel, and, though signed and dated in 1423, it may have been begun as early as 1420. Fra Angelico's *Deposition* was probably intended for the smaller sacristy chapel.

(2) Filippo (di Matteo di Simone) Strozzi [the elder] (*b* Florence, 4 July 1428; *d* Florence, 14/15 May 1491). In 1441 he left for Valencia and Barcelona to work for his cousin Niccolo di Lionardo Strozzi, following him to Naples in 1446. When Niccolo moved to establish a new branch of the Strozzi bank in Rome in the early 1450s, Filippo was left in charge in Naples. He settled permanently in Florence in 1471, and the continuing success of the Strozzi bank under Filippo's shrewd management during the last quarter of the 15th century is in marked contrast to the decline of the Medici bank in the same period. Filippo was exiled between 1458 and 1466, during which time the ban originally placed on his father was extended to him and his brothers. His artistic patronage thereafter helped to achieve the revival of the family's status.

From 1466 Filippo embarked on a series of architectural projects: the reconstruction of a villa, the Palagione, at Capalle (1475–6; 1486–7); contributions to his sister's villa with the neighbouring convent at Le Selve (1476–8); a garden loggia overlooking the Bay of Naples (1480–81); and major building campaigns for the hermitage of Lecceto (1478–80; 1487–9), for the villas of Santuccio (1483–6) and Maglio (1485–7) and for a house next to the site of his palace in Florence (1482–7). Many of Filippo's artistic commissions were for the furnishing and decoration of these buildings.

Giuliano da Maiano and Benedetto da Maiano (*see* MAIANO, (1) and (2)) made various intarsia *cassoni* and daybeds for Filippo, including a particularly splendid one incorporating a view of Naples, which he ordered from Benedetto in 1473 as one of a series of prestigious gifts for the Duke of Calabria and the Neapolitan court. Apart from Benedetto's bust of *Filippo Strozzi* (terracotta *modello*, Berlin, Skulpgal.; marble bust, probably by workshop, Paris, Louvre), for which he was paid in 1475, the sculptor also made a tomb (untraced) for Filippo's brother Lorenzo Strozzi that was sent to Naples in 1480 and a water stoup (1482) for Lecceto. From Mino da Fiesole, Filippo purchased a marble roundel with the heads of *Totila* and *Charlemagne* carved in relief in 1473. In 1487 Filippo commissioned Domenico Ghirlandaio to paint the main altarpiece for Lecceto (main panel untraced; central predella panel with the *Nativity* attributed to Sebastiano Mainardi, Rotterdam, Mus. Boymans–van Beuningen). Neri di Bicci painted an altarpiece and tabernacle for Le Selve (1482), *Christ on the Road to Calvary* for Lecceto (1488) and a *Crucifix* for Santuccio (1487). In 1489 Biagio d'Antonio was paid for his fresco of *St John the Baptist in the Wilderness* for the oratory at Santuccio and for the inscription around the choir in the church at Lecceto. Bernardo Rosselli (1450–1526) decorated ceilings and incised *sgraffito* on the façade at Santuccio (1483–4), painted a frieze around the campanile and the *Pietà* (1488) on the altar frontal at Lecceto, as well as decorating Filippo's study (1483) in Florence, painting chests and gilding picture frames.

Filippo first commissioned the frescoes for his chapel in S Maria Novella, Florence, from Filippino Lippi (*see* LIPPI, (2), and fig. 4) in 1487, though the cycle was only completed in 1502, after Filippo's death. Four Old Testament patriarchs—*Adam*, *Noah*, *Abraham* and *Jacob*—are depicted in the vault, while narrative scenes from the lives

of his patron saint, St Philip, and St John the Evangelist, the saint to whom the chapel is dedicated, are represented on the side walls. The decoration of the altar wall with Filippino's stained-glass window and illusionistic architecture is non-narrative but refers to Filippo's victory over death. The tomb of *Filippo Strozzi* (1491–7) is incorporated into this iconographical scheme in an unusual position behind the altar. Carved by Benedetto da Maiano, the black basanite sarcophagus is surmounted by a white marble *Virgin and Child with Angels*, set against a porphyry background and enclosed within a white marble arch.

Filippo planned to have a palace built in Florence from 1474, when he started to acquire a site. Although construction began in 1489, only the half inherited by his sons Lorenzo Strozzi and Filippo Strozzi the younger (1489–1538) was completed in 1505, while building continued sporadically on the half inherited by the eldest son Alfonso Strozzi until 1548. Vasari attributed the design to Benedetto da Maiano, but documents refer only to his models for hooks and lamps and his carving two small console capitals for the palazzo. The surviving wooden model of the palace (Florence, Bargello, on loan to Florence, Pal. Strozzi) is thought to be the first documented model and was made by Giuliano da Sangallo (*see* SANGALLO, (1)) between 1489 and 1490. On the basis of this, construction began. A second documented model, incorporating many columns, made between 1490 and 1493, has been associated with CRONACA, who began work as head mason in February 1490, was named *capomaestro* from 1497 and continued to work at the palazzo until 1504. Sangallo may have provided the initial design, which was modified by Cronaca, who then proceeded to design the courtyard and cornice. As a larger, more symmetrical and more magnificent version of the Palazzo Medici in Florence, the Palazzo Strozzi may be interpreted as either a tribute or a challenge to the Medici. Filippo Strozzi the younger was responsible for creating a piazza on the east side of the palazzo to the design of BACCIO D'AGNOLO. By 1534 the Piazza Strozzi was described as complete.

BIBLIOGRAPHY
V. da Bisticci: *Vite di uomini illustri del secolo XV* (MS.; 1480s); ed. P. d'Ancona and E. Aeschlimann (Milan, 1951)
G. Pampaloni: *Palazzo Strozzi* (Rome, 1963)
R. Goldthwaite: *Private Wealth in Renaissance Florence: A Study of Four Families* (Princeton, 1968)
E. Borsook: 'Documenti relativi alle cappelle di Lecceto e delle Selve di Filippo Strozzi', *Ant. Viva*, ix/3 (1970), pp. 3–20
——: 'Documents for Filippo Strozzi's Chapel in S Maria Novella and Other Related Papers—I', *Burl. Mag.*, cxii (1970), pp. 737–55; 'II, The Documents', pp. 800–04
L. Belle: *A Renaissance Patrician: Palla di Noferi Strozzi, 1372–1462* (diss., U. Rochester, NY, 1972)
R. Goldthwaite: 'The Building of the Strozzi Palace: The Construction Industry in Renaissance Florence', *Stud. Med. & Ren. Hist.*, x (1973), pp. 99–174
J. R. Sale: *The Strozzi Chapel by Filippino Lippi in Santa Maria Novella* (diss., Philadelphia, U. PA, 1976)
F. W. Kent: ' "Più superba di quella de Lorenzo": Courtly and Family Interest in the Building of Filippo Strozzi's Palace', *Ren. Q.*, xxx (1977), pp. 311–23
C. Elam: 'Piazza Strozzi: Two Drawings by Baccio d'Agnolo and the Problems of a Private Renaissance Square', *I. Tatti Stud.*, i (1985), pp. 105–35
H. Gregory: *A Florentine Family in Crisis: The Strozzi in the Fifteenth Century* (diss., U. London, 1981)
R. Jones: 'Palla Strozzi e la sagrestia di Santa Trinita', *Riv. A.*, xxxvii (1984), pp. 9–106
A. Lillie: *Florentine Villas in the Fifteenth Century: A Study of the Strozzi and Sassetti Country Properties* (diss., U. London, 1986)
D. Lamberini, ed.: *Palazzo Strozzi metà millennio, 1489–1989* (Rome, 1991).

AMANDA LILLIE

Strozzi, Zanobi (di Benedetto di Caroccio degli) (*b* Florence, 17 Nov 1412; *d* Florence, 6 Dec 1468). Italian illuminator and ?painter. He was the most important illuminator in the circle of Fra Angelico and made a fundamental contribution to the imagery of early Renaissance choir-books. The most important of these are the documented group illuminated (1446–60) for the convent of S Marco, Florence, which provided illustrative models for later generations of artists. His work as a panel painter needs to be reassessed.

Strozzi very probably received his training under Fra Angelico, in both manuscript and panel painting; there is no evidence of a stylistic link with Battista di Biagio Sanguigni (1393–1451), in whose bottega Strozzi worked in his youth. One of his earliest correctly identified works is the manuscript miniature of the *Mystic Marriage of St Catherine* (1447; Florence, Gal. Corsini priv. col.). A specialist in sacred themes, Zanobi softened the severe style of his predecessors, introducing lively details from everyday life and a new interest in the Antique. He used contemporary architectural motifs and naturalistic, animated landscapes. In the figure drawing there is a notable sense of movement in the draperies and the chromatic range is rich, with a preference for iridescent fabrics. The borders of his miniatures, with foliage and figures, were always illuminated by FILIPPO DI MATTEO TORELLI.

The high-points of the S Marco choir-books are found in the miniatures of the *Nativity*, the *Slaughter of the Innocents* and the *Stoning of St Stephen*. The two versions of the *Annunciation* (Florence, Mus. S Marco, corale 515, fol. 42r, before 1449 and corale 516, fol. 3r, before 1453, respectively) reveal different approaches to composition. In the *Birth of the Virgin* (corale 516, fol. 63v), the introduction of a figure in motion coming from a side entrance defines a prototype that was widely repeated until a more monumental approach was reintroduced by Domenico Ghirlandaio. In the *Conversion of St Paul* (corale 515, fol. 22v), the very naturalistically portrayed movement of the racing warrior may have been inspired by battle scenes on ancient sarcophagi. Suggestions of Fra Angelico's work are strikingly evident in the two renderings of the *Madonna of Mercy* (corale 528, fol. 5r, and corale 515, fol. 177v). The austerely sacred character of *St Augustine and the Angel* (corale 521, fol. 1r) is moderated by the liveliness of the country setting. The image of *St Michael and the Dragon* (Graduale B, fol. 68r) is rendered in a courtly style reminiscent of Pisanello.

Among other important liturgical works is the Antiphonal (*c*. 1453–5; Florence, Bib. Medicea–Laurenziana, MS. 43) for the Badia of Florence, in which the miniature of the *Agony in the Garden* (fol. 47r) is combined with the *Last Supper* in an extended rectangular format, almost anticipating Cosimo Rosselli's fresco (1481–2) in the Sistine Chapel, Rome. Also among Strozzi's dated illustrations (1457) is a *Glory of St Giovanni Gualberto* (Venice, Fond. Cini, no. 2151), based on the iconography of the Ascension; Torelli was paid for the border friezes. Between

1463 and 1468 Zanobi worked for Florence Cathedral on a series of choir-books. His illustrations show some advanced naturalistic elements, for example in the *Clerics Singing* (Florence, Bib. Medicea–Laurenziana, MS. Edili 149, fol. 61*v*), and a new iconography in the *Adoration of the Magi* (Florence, Bib. Medicea–Laurenziana, MS. Edili 150, fol. 87*v*; see fig.), where he introduced the image of the procession winding through the countryside, as in Benozzo Gozzoli's frescoes (completed 1461) for the Medici Palace, Florence (see colour pl. 1, XXXV). In some of the miniatures evidently designed by Zanobi, the inferior execution indicates the intervention of collaborators.

Even in Books of Hours, Strozzi introduced new subjects. For example, in the important Adimari Hours (Baltimore, MD, Walters A.G.) such thematic rarities as the *Proof of the True Cross* (fol. 163*r*) and a *Vesperbild* (fol. 162*v*) occur. He made few contributions to non-liturgical genres: one example is in a copy of Gratian's *Decretals* (Cortona, Bib. Com., MS. 77), which has a miniature of the *Author Offering his Work to the Pope* (fol. 1*r*). A problematic codex is the dispersed *Silio italico* (Venice, Bib. N. Marciana, MS. lat. XII. 68; St Petersburg, Hermitage) by Silius Italicus. The incipit page in the Venice portion (fol. 3*r*) is attributed to Strozzi; the illustration of *Mars on a Chariot Drawn by Two Red Horses* has been attributed by Toesca to Pesellino, but this is disputed. Other folios assigned to Pesellino but showing numerous connections with the works of Strozzi include those in the St Petersburg part, with miniatures of *Silius Italicus, Scipio, Hannibal* and *Nicholas V*.

BIBLIOGRAPHY

G. Vasari: *Vite* (1550, rev. 2/1568); ed. G. Milanesi (1878–85), i

P. D'Ancona: 'Un ignoto collaboratore di Beato Angelico (Zanobi Strozzi)', *L'Arte*, xi (1908), pp. 81–95

——: *La miniatura fiorentina dall'XI al XVI secolo*, 3 vols (Florence, 1914)

P. Toesca: 'Francesco Pesellino miniatore', *Dedalo*, xii (1932), pp. 85–91

L. Collobi Ragghianti: 'Zanobi Strozzi pittore', *Crit. A.*, xxxii (March 1950), pp. 454–73; xxxiii (May 1950), pp. 17–27

——: 'Studi angelichiani', *Crit. A.*, n. s., ii/7 (1955), pp. 22–47

——: 'Considerazioni su Zanobi Strozzi riconsiderato', *Crit. A.*, n. s. 2, vi/36 (1959), pp. 417–28

M. Levi D'Ancona: 'Zanobi Strozzi Reconsidered', *La Bibliofilia*, 61 (1959), pp. 1–38

——: *Miniatura e miniatori a Firenze dal XIV al XVI secolo* (Florence, 1962)

M. G. Ciardi Dupré Dal Poggetto: 'Note sulla miniatura fiorentina del quattrocento e in particolare su Zanobi Strozzi', *Ant. Viva*, xii/4 (1973), pp. 3–10

A. Garzelli: *Miniature fiorentine del rinascimento, 1440–1525: Un primo censimento*, 2 vols (Florence, 1985)

——: 'Zanobi Strozzi, Francesco di Antonio del Chierico e un raro tema astrologico nel libro d'ore', *Renaissance Studies in Honor of Craig Hugh Smyth* (Florence, 1985), ii, pp. 237–44

D. Gordon: 'Zanobi Strozzi's *Annunciation* in the National Gallery', *Burl. Mag.*, cxl/1145 (1998), pp. 517–24

ANNAROSA GARZELLI

Studiolo [It.: 'little study']. Term generally used in 15th- and 16th-century Italy to describe a private domestic room, especially that of a ruler or other distinguished figure. It was not the bedchamber, which usually had a semi-public character, but a smaller, inner room, to which no-one but the owner had automatic access. Earlier *studioli* were used as studies or libraries. Later examples were essentially private museums. The contents were customarily the owner's most precious possessions—books, jewels, *objets d'art* and other artefacts—which would be shown to favoured guests.

Both the name and the function of the *studiolo* testify to the intellectual qualities of the ideal Renaissance prince. Humanists imagined him as the antithesis of the illiterate medieval robber-baron; and the name of his inner sanctum indicated that one aspect of the ideal was that of the inquiring scholar. The power of this model was contemporaneously described in some extraordinary paintings, as flattering to the scholar-poets who frequented Renaissance courts as to the princes themselves. Antonello da Messina's *St Jerome in his Study* (c. 1460–65; London, N.G.; see ANTONELLO DA MESSINA, fig. 1) is shown reading with quiet dignity among the paraphernalia of the scholar but surrounded by imposing architecture, symbolic birds and plants, startling perspectives and distant views, all of which suggest the power of the intellect over the natural world. Botticelli's *St Augustine's Vision of the Death of St Jerome* (1480; Florence, Ognissanti; see colour pl. 1, XIV1), on the other hand, vigorously postulates the thrusting strength of the pursuit of new knowledge and ideas, in a room of classically austere architecture. In complete contrast is *St Augustine's Vision of St Jerome* by Vittore Carpaccio (1502–8; Venice, Scuola S Giorgio degli Schiavoni), which seems to represent the poetical aspect of literary composition, in a setting of delicate charm; the arrangement of the little church that contains the painting, with a deep frieze of scenes from the lives of *St George* and *St Jerome* above panelled walls, also reflects the decoration of actual *studioli*. Cosimo de' Medici had such a room, known as a *scrittoio*, in the old Palazzo Medici, Florence.

By the mid-15th century *studioli* had become more elaborate, with complex decorative schemes incorporating

Zanobi Strozzi: *Adoration of the Magi*; miniature from a choir-book, 1463–8 (Florence, Biblioteca Medicea–Laurenziana, MS. Edili 150, fol. 87*v*)

humanistic themes. The first of this new courtly type was at the Palazzo Belfiore (destr.), near Ferrara. Begun by Lionello d'Este and completed after his death in 1450 by his brother Borso d'Este, the Belfiore *studiolo* was decorated with paintings of the muses (dispersed) according to a programme devised by their tutor, the humanist scholar Guarino da Verona.

One of the most famous *studioli* is probably that of Federigo II da Montefeltro from the Palazzo Ducale, Urbino (1476; Urbino, Pal. Ducale). He represented the ideal of the multi-talented ruler: a successful soldier outside his dukedom, a benevolent ruler within, a statesman and a bibliophile, and an enlightened patron of scholarship and of the arts. His portraits, especially those with his son, probably by Justus of Ghent (*fl c.* 1460–80)—one (*c.* 1476; Urbino, Pal. Ducale; *see* URBINO, fig. 1) in armour and elaborate robes but seated and reading, and the other (*c.* 1480; London, Hampton Court, Royal Col.) attending a humanist lecture—reveal aspects of his character and interests. These are more fully defined by the decoration of his exquisite, windowless *studiolo*. The overall arrangement was probably planned by Francesco di Giorgio Martini. Its chief feature, the extraordinary intarsia (see fig. 1), is articulated by elements of Classical architecture, framing allegorical figures in feigned niches, views of architecture and landscape and, most remarkably, passages of specific *trompe-l'oeil* depicting cupboards, both ajar and

open to reveal books, armour and other objects, and benches bearing musical instruments. The deep frieze above the panelling originally contained imaginary portraits of philosophers, prophets, poets and other worthies (Urbino, Pal. Ducale; Paris, Louvre) by Justus of Ghent; the intricately coffered and gilt ceiling still displays fields with the Duke's personal emblems and mottoes. Federigo also had a *studiolo* in his palace at Gubbio, of which the intarsia panelling survives (New York, Met.).

The general features of the Urbino *studiolo* were much copied. The *studiolo* and grotto of Isabella d'Este (*see* ESTE, (6)) in the Corte Vecchia of the Palazzo Ducale, Mantua, has similar ceilings, inlaid panelling and deep friezes intended for paintings. Isabella knew the Belfiore *studiolo* of her Este uncles, and she too employed a humanist scholar, Paride Ceresara, to devise a programme for her rooms. The works she commissioned for them included mythologies by Lorenzo Costa (i), Perugino and Correggio, and, as the jewel of the group, Andrea Mantegna's ravishing *Parnassus* (all Paris, Louvre; see colour pl. 2, II3). The Este family was generally eager to acquire works by famous artists. Isabella's brother Alfonso d'Este I, Duke of Ferrara (*see* ESTE , (8)), attempted to obtain for his *studiolo* or Camerino d'Alabastro paintings by several distinguished artists including Raphael, Fra Bartolommeo and Giovanni Bellini. Bellini created for him the charmingly bucolic *Feast of the Gods* (1514; Washington, DC, N.G.A.), but

1. *Studiolo* of Federigo II da Montefeltro, Palazzo Ducale, Urbino, Italy; intarsia on north wall, 1476

died shortly after. Alfonso then turned to Bellini's pupil Titian to complete the scheme; this he did, with his great series of *Bacchanals* (also repainting the background of the Bellini to complement them)—the *Worship of Venus* (1519; see TITIAN, fig. 3) and the *Bacchanal of Andrians* (*c.* 1524–5; see TITIAN, fig. 5; both Madrid, Prado) and *Bacchus and Ariadne* (1520–23; London, N.G.; see TITIAN, fig. 4). Thus Alfonso's *studiolo* became, until its despoliation in 1598, a monument to his taste and munificence in patronage.

More elaborately decorative (but hardly as distinguished) were the artistic contents of the *studiolo* of Francesco I de' Medici (1570–75; *in situ*; see fig. 2) in the Palazzo Vecchio, Florence. This tiny room was originally accessible only down a hidden spiral staircase; windowless like the Urbino *studiolo*, it was unlike that example in its secrecy, the introversion hiding behind the public mask, and in its encrusted opulence. Mosaics, marble, bronzes, frescoes, oil-paintings on canvas and on slate, gilded wood and painted stucco were all combined in a whole that gives the spectator the impression of moving inside a work of brilliant craftsmanship. Francesco I was much interested in particular crafts and industries, and depictions of them are among the various scenes, which symbolize, on each wall, one of the Four Elements. The decorative scheme was under the direction of Giorgio Vasari, who contributed individual paintings to it (see VASARI, (1), fig. 8), along with a host of minor Florentine Mannerists (for illustration see STRADANUS, JOHANNES, fig. 1). Besides the paintings, the most considerable contributions to the decoration were the exquisite small bronzes of gods and goddesses provided by Giambologna and Bartolomeo Ammanati. The

2. *Studiolo* of Francesco I de' Medici, Palazzo Vecchio, Florence, 1570–75

insistent variety of Francesco's *studiolo* suggests the dominance of art over intellect, of the executant over the patron. The cupboards behind the pictures contained objects that tended towards the curious. The *studiolo* had become the *Kunstkammer* or *Wunderkammer*.

BIBLIOGRAPHY

L. Berti: *Il principe dello studiolo: Francesco I dei Medici e la fine del rinascimento fiorentino* (Florence, 1967)
E. Pucci: *Il Palazzo Vecchio* (Florence, 1968)
C. Hope: 'The Camerino d'Alabastro of Alfonso d'Este', *Burl. Mag.*, cxiii (1971), pp. 641–50, 712–21
E. Verheyen: *The Paintings in the Studiolo of Isabella d'Este at Mantua* (Mantua, 1971)
W. Liebenwein: *Studiolo: Die Entstehung eines Raumtyps und seine Entwicklung bis um 1600* (Berlin, 1977)
J. Fletcher: 'Isabella d'Este, Patron and Collector', *Splendours of the Gonzaga* (exh. cat., ed. D. Chambers and J. Martineau; London, V&A, 1981–2), pp. 51–64
O. Impey and A. MacGregor, eds: *The Origins of Museums: The Cabinet of Curiosities in Sixteenth- and Seventeenth-century Europe* (Oxford, 1985)
L. Cheles: *The Studiolo of Urbino: An Iconographic Investigation* (Wiesbaden, 1986)
H. Boström: 'The Studiolo: Background and Tradition', *Nmus. Bull.*, xl/2 (1987), pp. 53–68
C. Elam and C. Strehlke: [review of *Le muse e il principe* (exh. cat., ed. A. M. Molfino; Milan, Mus. Poldi Pezzoli, 1991)], *Burl. Mag.*, cxxxiii (1991), pp. 860–64
Met. Bull., ciii (1996) [special issue devoted to the *studiolo* on the occasion of the reinstallation in the Met. of Federigo da Montefeltro's *Studiolo* at the Ducal Palace at Gubbio]
D. Thornton: *The Scholar in his Study: Ownership and Experience in Renaissance Italy* (New Haven, 1997) □

Suardi, Bartolomeo. *See* BRAMANTINO.

Summonte, Pietro (*b* Naples, 10 April 1463; *d* Naples, 14 Aug 1526). Italian writer. He was a pupil of the Umbrian humanist Giovanni Pontano (1426–1503) with whom he collaborated closely, acting as his amanuensis in the Neapolitan Academy. Like Pontano, he took an active part in the political life of Naples. In 1498 he was nominated elector of the people and from 28 September 1504, in an honorary capacity, a functionary in the Naples Customs Office, retaining the right to draw a salary. In 1514 he was Chancellor of the city. Between 1520 and 1525 he occupied his first teaching post as lecturer in humanities at Naples University.

Summonte's surviving literary output is somewhat sparse, comprising two couplets and a six-line verse in Latin, and the *Disfida di Barletta*, a poem of 23 couplets, addressed to an Italian condottiere, Ettore Fieramosca (*d* 1515). Of much greater importance was his work as an editor, in which capacity he supervised the publication of Pontano's *Opere* (Venice, 1505–12), *Arcadia* (Naples, 1504) by Jacopo Sannazaro (1455–1530), the *Rime* (Naples, 1506) of Benedetto Gareth ('il Cariteo'; *c.* 1450–1514) and the works of other Neapolitan humanists. Summonte owes his reputation in art history to one of his surviving letters, which he sent on 20 March 1524 to his friend Marcantonio Michiel, who had asked for information on Neapolitan art for his *Vite de' pittori e scultori moderni*, a work that remained unpublished owing to the appearance in 1550 of Vasari's *Vite*. Despite a certain brevity, the letter is the most important documentary source on Neapolitan art from the 14th century to the first quarter of the 16th, owing to its invaluable first-hand accounts

and to Summonte's unusual critical acumen. This enabled him to articulate the stylistic differences between Italian and Flemish art, to perfect the historiographical concept of the 'school' and give proper emphasis to such minor arts as, for example, tapestry, embroidery, illuminated manuscripts, medals and leatherwork.

UNPUBLISHED SOURCES

Naples, Bib. N. [poetical works]
Padua, Mus. Civ. Bib. [lett. to Michiel]
Turin, AS [lett. to Michiel]

BIBLIOGRAPHY

C. von Fabriczy: 'Summontes Brief an M. A. Michiel', *Repert. Kstwiss.*, xxx (1907), pp. 143–68
N. Mancinelli: *Pietro Summonte, umanista napoletano* (Rome, 1923)
F. Nicolini: *L'arte napoletana del Rinascimento e la lettera di Pietro Summonte a Marcantonio Michiel* (Naples, 1925)
C. De Frede: *I lettori di umanità nello studio di Napoli* (Naples, 1960), pp. 142–9
F. Bologna: *La coscienza storica dell'arte d'Italia* (Turin, 1982), pp. 81–4

RICCARDO NALDI

T

Taccola [Vanni]**, Ser Mariano (di Jacopo)** (*b* Siena, 4 Feb 1382; *d* Siena, before 1458). Italian engineer, writer–artist and wood-carver. His nickname Archimedes of Siena acknowledges his reputation for mechanical ingenuity. His illustrations of engines and other mechanical devices, with descriptions in Latin, were among the first of many in the development of the so-called Theatres of Machines of the military architect Agostino Ramelli (1531–?1600) and others. Examples of his wood-carvings (*c.* 1415–28) are among the 36 wooden busts preserved as relocated parts of the choir-stalls in Siena Cathedral but cannot be identified. Taccola began technical writing and illustration in 1419, producing *De ingeneis*, which includes, in Book II, a rare transcription of the *Liber ignium* of Marcus Graecus and, in a sequel to Book II, quotations from Filippo Brunelleschi concerning the need for inventors to maintain secrecy as well as describing some practical methods for executing river works and mills. He illustrated Brunelleschi's inventions in Book III; in Book I he reported his own findings from hydraulic tests he had made in 1427 on the River Tiber and in Genoa on harbour works and mills.

In 1449 Taccola produced *De machinis*, a collection of drawings, with texts, of civil and military engines. Various copies and adaptations were made of this work, including one (Paris, Bib. N.) by Paolo Santini (active *c.* 1455), and in the 1470s–80s Francesco di Giorgio (1439–1501) copied and adapted Taccola's engine drawings and translated his texts in several of his own sketchbooks, copybooks and treatises; an almost complete compendium (London, BL) of Taccola's works was composed by an anonymous Sienese engineer at about the same time. (Two further copies are in Florence, Bib. N. Cent., and Venice, Bib. N. Marciana.) As late as the 1530s Antonio da Sangallo (ii) filled his sketchbooks with copies of Taccola's devices, despite their having been superseded by new guns and cannons, providing a line of descent from Taccola's innovations to those of the 16th century.

In 1432 Taccola appeared in Siena before the Holy Roman Emperor, King Sigismund of Hungary and Bohemia (*reg* 1410–37). He dedicated to the Emperor Books III–IV of *De ingeneis*, and was named *familiaris* and *comites palatini*. He was one of the Humiliates, was secretary of the Studio, or Domus Sapientiae (later the University of Siena), until 1434, and his reports were pronounced to the sound of trumpets as he stood before the Palazzo del Notaio, Siena. He was appointed to the office of estimator in 1434. His abilities as civil and hydraulic engineer were formally recognized in 1441, when he was made superintendent of streets.

WRITINGS
De ingeneis liber primus leonis, liber secundus draconis (begun 1419; Munich, Bayer. Staatsbib., Cod. CLM 197, part 2); i–ii and Addenda ed. G. Scaglia, F. D. Prager and U. Montag (Wiesbaden, 1984); *Liber tertius de ingeneis ac edifitiis non usitatis; Liber quartus de edifitiis cotidianis* (Florence, Bib. N. Cent., Cod. Palat. 766); iii ed. J. H. Beck (Milan, 1969); iii–iv ed. F. D. Prager and G. Scaglia in *Mariano Taccola and his Book 'De ingeneis', Books III and IV* (Cambridge, MA, and London, 1972)
De machinis (1449; Munich, Bayer. Staatsbib., Cod. CLM 28800); ed. G. Scaglia, 2 vols (Wiesbaden, 1971)

BIBLIOGRAPHY
B. Degenhart and A. Schmitt: *Corpus der italienischen Zeichnungen, 1300–1450, Mariano Taccola*, iv (Berlin, 1982)
G. Scaglia: 'Drawings of Machines, Instruments and Tools', *Fortifications, Machines and Festival Architecture*, i of *The Architectural Drawings of Antonio da Sangallo the Younger and his Circle*, ed. C. L. Frommel and N. Adams (New York, Cambridge, MA, and London, 1994), pp. 81–97

GUSTINA SCAGLIA

Taccone, Paolo (di Mariani di Tuccio). *See* PAOLO ROMANO.

Tadda [Taddeo]**, Francesco di.** *See* FERRUCCI, (3).

Taddei, Taddeo (*b* Florence, 23 Jan 1470; *d* Prato, 5 March 1528). Italian merchant and patron. He came from a prominent Florentine family of cloth merchants, associates of the Medici. He frequented humanist literary circles and was a friend of the writer Pietro Bembo, possibly through whom he met Raphael, who arrived in Florence in 1504. According to Vasari, he often entertained Raphael at his house, and in gratitude Raphael gave him two paintings. One of these has been identified as the *Madonna of the Meadow* (Vienna, Ksthist. Mus.), apparently dated 1505. Taddei owned, and may have commissioned, a marble tondo that Michelangelo left unfinished in 1505, the *Virgin and Child with the Infant St John the Baptist*, the Taddei Tondo (London, RA). His contact with Michelangelo continued in 1520, when Cardinal Giulio de' Medici appointed him to supervise the building of the New Sacristy at S Lorenzo in Florence. Also datable to the 1520s is the Palazzo Taddei on Via Ginori in Florence, designed and built by Baccio d'Agnolo. A fresco of the *Crucifixion* was executed in a tabernacle on the façade by Giovanni Antonio Sogliani in about 1520–25. (It is now on the house on the corner opposite.)

BIBLIOGRAPHY
G. Vasari: *Vite* (1550, rev. 2/1568); ed. G. Milanesi (1878–85), iv, pp. 311–86

A. Cecchi: 'Raffaello fra Firenze, Urbino e Perugia (1504–1508)', *Raffaello a Firenze: Dipinti e disegni delle collezioni fiorentine* (exh. cat., Florence, Pitti, 1984), pp. 40–41 [with bibliog.]

ALESSANDRO CECCHI

Taddeo da Ferrara. *See* CRIVELLI, TADDEO.

Tamagni, Vincenzo (*b* San Gimignano, 10 April 1492; *d* San Gimignano, *c.* 1530). Italian painter. He was a pupil of Sodoma, whom he assisted on the frescoes in the monastery of Monte Oliveto Maggiore, near Siena. In 1510–12 he executed frescoes of the *Virgin and Child with Saints and Others* in the ex-pharmacy of the Ospedale di S Maria della Croce at Montalcino (Siena) and these show clearly the influence of Sodoma. He then moved to Rome, where he entered the shop of Raphael and probably worked on the decoration of the Loggetta of Cardinal Bernardo Bibbiena in the Vatican; his frescoes of 1516 in the apse of S Maria at Arrone (Terni) reflect contemporary Roman ideas, in particular from Raphael's Vatican *Stanze* and from Baldassare Peruzzi. He then assisted in the decoration of the Vatican *Logge*, where, on the basis of the frescoes at Arrone, several scenes can be attributed to him, including the *Anointing of David*, the *Adoration of the Magi* and the *Last Supper*. According to Vasari, he also decorated façades (destr.) of numerous Roman houses.

On his return to San Gimignano in 1522, Tamagni executed a *Virgin and Child Enthroned* for S Gerolamo, and in 1523 the *Birth of the Virgin* for S Agostino. Also from this period is the *Assumption of the Virgin* in the Badia at Isola (Siena) and the *Virgin and Child with Saints* in the parish church of Pomarance, signed and dated 1525. About this date he returned to Rome, where he completed three ceiling frescoes at Villa Lante, of illustrious men and women surrounded by grotesque decoration. After the Sack of Rome in 1527, he returned to San Gimignano, where he executed works including the *Mystic Marriage of St Catherine* (San Gimignano, Bib. Com.) and the *Meeting of Joachim and Anne* (S Salvatore, Istia d'Ombrore, Grosseto), signed and dated 1528.

BIBLIOGRAPHY

G. Vasari: *Vite* (1550, rev. 2/1568); ed. G. Milanesi (1878–85), iv, pp. 489–92

A. Venturi: *Storia* (1901–40), IX/v, pp. 413–22

D. E. Rust: 'The Drawings of Vincenzo Tamagni da San Gimignano', *Stud. Hist. A.* (1968), pp. 70–93

N. Dacos Crifò: 'Vincenzo Tamagni a Roma', *Prospettiva*, 7 (1976), pp. 46–51

N. Dacos: *Le Logge di Raffaello: Maestro e bottega di fronte all'antico* (Rome, 2/1986)

GENNARO TOSCANO

Tamagnino, Antonio. *See* PORTA, DELLA, (1).

Tarvisium. *See* TREVISO.

Tasso, Giovan Battista di Marco del (*b* Florence, 1500; *d* Florence, 8 May 1555). Italian wood-carver, architect and sculptor. He was descended from a family of wood-carvers and intarsia-makers. In 1519 he went to Rome with his contemporary Benvenuto Cellini, but he returned to Florence soon afterwards to dedicate himself to carving. Many of his works are lost, due to the ephemeral nature of their functions and the perishability of their materials:

they included temporary displays, galley poop–decks (e.g. the splendid ones that he made for Andrea I Doria) and even beds (e.g. the one mentioned in the inventory of Cellini's possessions). However, his best-known works are still *in situ*: the ceiling (see fig.) and benches of the Biblioteca Medicea–Laurenziana, which he executed in collaboration with other craftsmen, following a design by Michelangelo for the ceiling.

The turning-point in Tasso's career occurred *c.* 1540, when he began working on art forms that were regarded by contemporary theorists as more elevated than wood-carvings. A letter (dated 31 Aug 1546) by Niccolò Martelli (1498–1555; see Collareta) supports the attribution to Tasso of the marble monument to *Cardinal Luigi de' Rossi* (Florence, S Felicita). He also gained fame as an architect with the Loggia del Mercato Nuovo (1546/7–51) and even worked as a military engineer (e.g. the fortifications of the Porta a Pinti (1552), Florence). In 1545 Tasso erected the walls of a workshop in the garden of Cellini's house, in which the latter cast his bronze sculpture of *Perseus* (Florence, Loggia Lanzi; see CELLINI, BENVENUTO, fig. 6). The 'consecration' of Tasso's new status took place in 1547, when Benedetto Varchi invited him, together with the foremost Florentine artists of the time, to express his opinion on the nobility of the arts and, more specifically, on whether painting was superior or inferior to sculpture. For some time Tasso's fortunes had been rising, as a result of the protection of the ducal steward Pier Francesco Riccio (*c.* 1490–1564), and the artist became increasingly influential, even on the choice of the artists and craftsmen who worked for Cosimo I. His architecture, however, was criticized by Vasari, partly because of the hostility that the latter encountered from those in Tasso's circle. Despite this criticism, Tasso won the Duke's confidence and was entrusted with numerous tasks, the most notable being the restructuring and enlargement of the Palazzo Vecchio (1549–55), during which he worked on the apartment above the Dogana with the Terrazzo di Eleonora, the Quartiere degli Elementi with the Loggiato di Saturno, and the gate on Via dei Leoni. After Tasso's death, one of his sons, Filippo, entered Cellini's workshop in 1555.

BIBLIOGRAPHY

C. Anzivino and P. Sanpaolesi: *Jacopo Barozzi* (Vignola, 1974), pp. 93–4 [contains bibliog. in entry ed. by C. Davis]

E. Allegri and A. Cecchi: *Palazzo Vecchio e i Medici: Guida storica* (Florence, 1980), pp. 7–19

M. Collareta: 'Una restituzione al Tasso legnaiolo', *Paragone*, 411 (May 1984), pp. 81–90

A. Morrogh: *Disegni di architetti fiorentini, 1540–1640* (Florence, 1985), pp. 30–31

ALESSANDRO NOVA

Tatti, Jacopo. *See* SANSOVINO, (1).

Temperelli, Cristoforo [Temperello, il]. *See* CASELLI, CRISTOFORO.

Tempesta, Antonio (*b* Florence, 1555; *d* Rome, 5 Aug 1630). Italian painter, draughtsman and printmaker. Enrolled at the Accademia del Disegno in Florence on 8 December 1576, he was a pupil of Santi di Tito (1536–1602), then of Joannes Stradanus, with whom he worked under Giorgio Vasari on the interior decoration of the

Giovan Battista di Marco del Tasso and others: ceiling (1524/7–1549/50) of the Biblioteca Medicea–Laurenziana, Florence, after a design by Michelangelo

Palazzo Vecchio in Florence. He then went to Rome, where he again had links with artists from the Netherlands. He and Matthijs Bril (1550–83) were commissioned by Pope Gregory XIII to paint the *Transfer of the Relics of St Gregory of Nazianzus* (1572) and other religious scenes in the loggias on the third floor of the Vatican Palace. In Tempesta's frescoes in the Palazzina Gambara at the Villa Lante in Bagnaia (1578–9), the hunting and fishing scenes, sweeping landscapes and urban backdrops again reveal the influence of Netherlandish art. From 1579 to 1583 Tempesta participated in the decoration of the Palazzo Farnese in Caprarola, notably of the Scala Regia. He is also known to have collaborated on the frescoes in the Villa d'Este at Tivoli.

At S Stefano Rotondo in Rome in 1583–5 Tempesta, again working for Pope Gregory XIII, executed a series of frescoes on the entrance wall and interior of the chapel of SS Primus and Felicianus. Subjects include the *Massacre of the Innocents*, and the *Seven Sorrows of the Virgin*, in which the Virgin is surrounded by seven swords, each with a tondo at the tip. This motif, rare in Italy, was derived from the south Netherlandish artist Bernard van Orley (*c*. 1488–1541). In the frescoes in the interior of the chapel, which depict the martyrdom of the two saints, the architectural settings are impressive, and Tempesta's interest in depicting nature, particularly animals, is evident. Other works by Tempesta, including hunting and battle

scenes, are in the Palazzo Giustiniani and the *casino* of the Palazzo Rospigliosi, both in Rome. He also produced panel paintings, including two versions of the *Crossing of the Red Sea* (Budapest, Mus. F.A.; Rome, Gal. Doria–Pamphili), the *Journey of the Three Magi* (Catania, Mus. Civ. Castello Ursino), *Pearl-diving in India* (Paris, Louvre), *Tournament on the Piazza del Castello in Turin* (1620; Turin, Gal. Sabauda) and a *Resurrection* (1620–25; Florence, S Felicità).

Between 1589 and 1627 Tempesta made over 1000 prints, which were widely circulated in Europe during his lifetime. Apart from single sheets, these were mainly series of engravings and book illustrations. These prints were often used as models by later artists.

BIBLIOGRAPHY

Thieme–Becker

A. Bartsch: *Le Peintre-graveur* (1803–21), xvii [B.]

F. Borroni: 'Antonio Tempesta incisore', *La Bibliofilia*, lii (1950), pp. 241–63

G. Briganti and others: *La Villa Lante di Bagnaia* (Milan, 1961), pls 84–8, 90–92

F. Sricchia Santoro: 'Antonio Tempesta fra Stradano e Matteo Bril', *Festschrift S. Sulzberger* (Brussels, 1980), pp. 227–37

L. Holm Monssen: 'Antonio Tempesta in Santo Stefano Rotondo', *Boll. A.*, lxvii (1982), pp. 107–20

——: 'The Martyrdom Cycle in San Stefano Rotondo', *Acta Archaeol. & A. Hist. Pertinentia Ser. Altera*, iii (1983), pp. 11–106

A. Vannugli: 'Gli affreschi di Antonio Tempesta a S. Stefano Rotondo e l'emblematica nella cultura del Martirio presso la Compagnia di Gesù', *Stor. A.*, xlviii (1983), pp. 101–16

V. Birke: 'Towards a Tempesta Catalogue', *Prt Q.*, ii (1985), pp. 205–18
A. Cecchi: 'La Pêche des perles aux Indes: Une peinture d'Antonio Tempesta', *Rev. Louvre*, xxxv (1986), pp. 45–57

C. HÖPER

Tempio Malatestiano. *See under* RIMINI, §1.

Terranova, Matteo da (*fl* 1509–27). Italian illuminator. Between 1509 and 1524 numerous references appear in the account books of Montecassino Abbey to payments received by Matteo and his assistant Aloise da Napoli for the decoration of manuscripts. The Psalters in the collection (Montecassino Abbey, Lib., MSS H, I, L, M, N, O, P, Q) as well as a number of choir-books can be firmly attributed to these artists. From Montecassino Matteo went to Perugia and in 1527 was working as illuminator for the monastery of S Pietro, again with his assistant and also intermittently with Francesco Boccardi (*d* 1547), son of Giovanni Boccardi. In the same year Matteo decorated three Graduals (Perugia, S Pietro dei Cassinensi, MSS E, F and G), which are among his finest works. A Psalter executed for the monastery (Perugia, S Pietro dei Cassinensi, MS. Z) displays the characteristic features of his work: the brick-red colour of the flesh, the hair curling in snakey locks and the lively, gesticulating figures. Although a modern note states that this was a collaborative effort with Francesco Boccardi, the continuity of style suggests that Matteo was the only illuminator.

BIBLIOGRAPHY
Thieme–Becker
P. A. Caravita: *I codici e le arti a Monte Cassino*, i (Montecassino, 1869), pp. 442–55
D. O. Piscicelli Taeggi: *Le miniature nei codici cassinesi* (Montecassino, 1887)
P. D'Ancona: *La miniatura fiorentina*, 3 vols (Florence, 1914), i, pp. 106–7; ii, p. 933
U. Gnoli: *Pittori e miniatori nell'Umbria* (Spoleto, 1923), pp. 199–200

□

Terribilia [Morandi]. Italian family of builders and architects. The family name was Morandi, but the two most important members, (1) Antonio and his son (2) Francesco, were known as 'Terribilia'. The Morandis were active in Bologna, where they owned a furnace and a business supplying building tools and instruments. Antonio's father, Bernardino Morandi, and brother Giovanni Morandi probably worked as masons and joiners.

(1) Antonio Terribilia [Morandi; Tribilia] (*b* Bologna, 1500–08; *d* Bologna, 1568). He worked initially as a mason but gradually ascended the hierarchy of the architectural profession and was nominated an architect after completing (1563) the Palazzo dell'Archiginnasio, Bologna, his most important work. His mature work showed a modest influence of contemporary Roman Mannerist architecture on traditional Bolognese forms. The first part of his career was dedicated to ecclesiastical works in Bologna: the reconstruction of the church of S Procolo (1536) and its campanile (1556); works, including two new cloisters, in S Giovanni in Monte (1542); the Pepoli (now Preziosissimo) Chapel in S Domenico in Monte (1551); and later, the reconstruction of the dome of S Giacomo (1562). Terribilia's work on these churches was rather prosaic, dictated in part by the guidelines of the religious orders he served.

In 1549 Terribilia was appointed *ingigniero* of the basilican church of S Petronio in succession to Jacopo Vignola, a post he held until his death. Work on the façade, to the Tuscan Gothic design of 1518 by Domenico Aimo, began in 1561; it progressed slowly, however, and only the lower part was completed. Also in 1549 Terribilia received his first secular commissions, for the Palazzo Bonasoni (1549–56) and the Palazzo Orsi (1549–60). Terribilia designed both palazzi in the Bolognese manner, each having an arcaded ground-floor, but he deviated from the traditional model by concentrating the decoration, of grotesques and pilasters, on the window-frames of the upper storeys, leaving the surrounding wall as unadorned brick. The greater architectural refinement of these works, and Terribilia's distinctive sculptural decoration, show the influence of Vignola, who had returned to Bologna from Rome in 1543.

Terribilia's most important work was the Palazzo dell'Archiginnasio (1562–3; damaged 1943–4; rebuilt 1950; now a library and museum), adjacent to S Petronio; for many years it was believed to have been by Vignola, who had designed the nearby Facciata dei Banchi in 1548 (executed 1565–8). The Archiginnasio was intended to house the various schools of the university, scattered around the city, in a single building under the control of the Roman Catholic Church. The building is of the Bolognese palazzo type, with a storey of classrooms over an arcaded loggia; an elegant courtyard, with two storeys of arcades, lies behind, with the chapel of S Maria Annunziata dei Bulgari and an anatomy theatre. Terribilia later continued the design in the reconstruction of the contiguous 13th-century Ospedale della Morte (1565; now Museo Civico), but without the emphasis on the sculptural decoration.

The design of several other minor palazzi in Bologna have been attributed to Terribilia: the Palazzo Zoppi, the Palazzo Leoni, and the Palazzo Fava Ghisilieri, with arcaded ground-floors in the Bolognese manner, and the Palazzo Buoi and the Palazzo Fava da S Domenico, in the Roman manner. All these are dated between 1550 and 1580, and the attributions are based mainly on the design of the window surrounds (Roversi). It was, perhaps, the effect of *terribilità* (It.: 'fearfulness') in the decoration of heraldic beasts on the Archiginnasio that led to his nickname.

(2) Francesco Terribilia [Morandi] (*b* Bologna, 1528; *d* Bologna, 1603). Architect, son of (1) Antonio Morandi, also called Terribilia. Francesco Terribilia was one of the main architects active in Bologna in the late 16th century; with Domenico Tibaldi, he was connected with the urban reforms in Bologna initiated by the papal government following the Council of Trent (1545–63). Terribilia was appointed architect of the basilican church of S Petronio, Bologna, in 1568, probably replacing his father, a post he held until his death. S Petronio had been started in 1390 to the design of Antonio di Vincenzo; it was modelled on Tuscan examples, although with a northern Gothic flavour. Its late start meant that Gothic design survived into the Renaissance, and caused controversy between 'classicists' and 'Goths' over the correct way to complete it. Domenico Aimo's Gothic design of *c.* 1518 for the main

façade of S Petronio had been left partially finished in the 1540s; Terribilia and Tibaldi were commissioned to produce designs for its completion. Terribilia's design (Bologna, Mus. S Petronio) was a more austere version of that by Aimo, with Florentine vertical rectangular panels, although with a more horizontal emphasis. Both designs were shown to Palladio, who preferred that by Terribilia; on a visit to Bologna in 1572, Palladio collaborated with Terribilia on another design (Bologna, Mus. S Petronio). This also incorporated elements of the design by Aimo, but deployed typically Palladian features within a Gothic structure. None of these designs was executed.

Terribilia began vaulting the nave of S Petronio at the apse end in 1587, but he was challenged by a tailor, Carlo Carazzi, 'il Cremona', after only one bay was constructed. Cremona asserted that Terribilia was using the 'Roman' rather than the 'German' system of proportion, which would involve the medieval principles of triangulation. Cremona's challenge found such popular support that work came to a halt. In 1589 Cardinal di Montalto from the Curia in Rome decided to arbitrate: the architect Martino Longhi I was despatched to Bologna and found in favour of Terribilia. This did not satisfy the Bolognese Senate, however, who commissioned a wooden model of each proposal from Floriano Ambrosiano and a comparative drawing (Bologna, Mus. S Petronio) in 1591. Pope Clement VIII eventually resolved the problem by forbidding work to continue; work on the vaulting did not recommence until 1648, with a compromise solution that involved dismantling Terribilia's vault and rebuilding it 5 m higher.

The Palazzo Ruini–Ranuzzi (now the Giustizia) was completed by Terribilia in 1584, based on a sketch (1572) by Palladio. Its powerful, flat, pilastered façade broke with the Bolognese tradition of arcaded ground-floors. The Palazzo Caprara (now Prefettura) has been attributed to Terribilia; it has a dignified Roman façade (1541) in the manner of the Palazzo Farnese by Antonio da Sangallo (ii). In the 1580s Tibaldi and Terribilia supervised the restoration and remodelling of the Palazzo Comunale, which included a new cistern (1587; Bologna, Pin. N.) in the courtyard designed by Terribilia. Terribilia has also been attributed with the design of several minor palazzi in Bologna: the Fava da S Domenico (begun 1573) and the modest Lambertini (1570s; now Liceo Minghetti), with Roman façades; and the Prati (1580s), with a Bolognese arcaded ground-floor.

BIBLIOGRAPHY

G. Zucchini: *Disegni antichi e moderni per la facciata di S Petronio* (Bologna, 1933)

C. Ricci and G. Zucchini: *Guida di Bologna* (Bologna, 1968)

R. Wittkower: *Gothic versus Classic* (London, 1974)

G. Manzini: 'Antonio Morandi, il 'Terribilia'', *Il Carrobbio*, ix (1983), pp. 244–55

G. Roversi: *Palazzi e case nobili del '500 a Bologna* (Bologna, 1986)

M. Kiene: 'Bologna: Fassade des Archiginnasio', *Röm. Jb. Kstgesch.*, xxiii/24 (1988), pp. 267–71

N. Miller: *Renaissance Bologna*, University of Kansas Humanistic Studies, lvi (New York, 1989)

Terzi [Tércio; Terzio], **Filippo** [Felipe; Filipe] (*b* Bologna, *c.* 1520; *d* Lisbon, 10 April 1597). Italian architect and engineer, active in Portugal. When he was still a child, his family moved to the della Rovere court at Pesaro, where he became a pupil of Rainieri del Monte at the famous school of mathematics and military engineering. He was subsequently involved in numerous works as a member of the team of engineers of the Duchy of Urbino; his name appears on a list (1542) of builders of the Ducal stables in Pesaro. Between 1550 and 1560 he constructed retables in the church of Corpus Domini at Pesaro (destr.), built the campanile at Orciano di Pesaro and collaborated in the decoration of various other churches. In 1563 he appears officially as 'engineer and architect of the court'; in this capacity he contributed to the realignment of the Piazza Ducale (now Piazza del Popolo), Pesaro, and collaborated on the fortifications at Senigallia, Pesaro and Urbino and hydraulic works at Pesaro and Fano. He designed the Villa Miralfiore, outside Pesaro, for Guidobaldo II della Rovere, Duke of Urbino. Other works by Terzi from this period are the Palazzo Comunale (1564–71), Fossombrone, and the fortress at Urbino (1571–4).

In 1575 and 1576 Terzi was in Rome working for the papal court, and it was there that the Portuguese Ambassador persuaded him to enter the service of Sebastian, King of Portugal (*reg* 1557–78). He moved to Lisbon in 1576 and at once began directing various municipal works in the city. He spent the rest of his career there, becoming the most gifted architect in Portugal in the second half of the 16th century. During the following century his work remained influential in Portugal and its colonies in Brazil and India, owing to both the examples of his buildings and their detailing (the entrance loggia, the façade towers) and through the schools of architecture that he instituted.

BIBLIOGRAPHY

EWA; *LK*; *Macmillan Enc. Architects*

Viterbo; p. 229; iii, pp. 93–101, 423–4

W. C. Watson: *Portuguese Architecture* (London, 1908)

H. Trinidade Coelho and G. Battelli: *Filippo Terzi, architetto e ingegnere militare in Portogallo, 1577–97: Documenti inediti dell'Archivio di Stato di Firenze e della Biblioteca Oliveriana di Pesaro* (Florence, 1935)

G. Fiocco: 'Il chiostro grande del Convento del Cristo a Tomar e l'opera di Filippo Terzi', *Riv. A.*, xx (1938), pp. 355–79

L. A. Maggiorotti: *Architetti in Portogallo* (1939), iii of *Architetti e architettura militari*, 3 vols, L'Opera del Genio Italiano all'Estero (Rome, 1933–9)

R. Brito: 'Felipe Tércio e a Ponte Real de Coimbra', *Arquiv. Coimbro*, x (1947)

R. dos Santos: 'A vinda de Felipe Terzio para Portugal', *Belas A.*, n. s., iii (1951)

——: *L'Art portugais* (Paris, 1953)

G. Kubler and M. Soria: *Art and Architecture in Spain and Portugal and their American Dominions, 1500 to 1800*, Pelican Hist. A. (Harmondsworth, 1959)

G. Bresciani Alvarez: 'Un architetto pesarese in Portogallo, Filippo Terzi', *Atti Congr. Stor. Archit.*, xi (1965), pp. 355–74

R. C. Smith: *The Art of Portugal* (London, 1968)

G. Kubler: *Portuguese Plain Architecture: Between Spices and Diamonds, 1521–1706* (Middletown, CT, 1972)

As relações artísticas entre Portugal e Espanha na época dos descobrimentos: Simpósio Luso-Espanhol de História da Arte: Coimbra, 1983 [articles by A. Bustamente García and F. Marías, R. Moreira and S. Deswarte-Rosa]

JAVIER RIVERA

Terzio [de Terciis; de Tertio; Terro; Terzi; Terzo], **(Giovanni) Francesco** (*b* Bergamo, *c.* 1523; *d* Rome, 20 Aug 1591). Italian painter and draughtsman. His date of birth is deduced from his will, drawn up in 1551, in which he gave his age as around 28 years. He presumably trained in Bergamo during the 1530s and 1540s. In 1550 he painted

a large canvas of the *Crucifixion* for SS Bartolomeo e Stefano, Lallo, near Bergamo, in which the style is close to the late work of Lorenzo Lotto. A letter from Terzio to Pietro Aretino, written in Milan and dated 11 July 1551, contains many allusions to an otherwise undocumented sojourn in Venice. Shortly afterwards Terzio went to Vienna, where he joined the court of Ferdinand I, King of Hungary (*reg* 1625–46) and Bohemia (*reg* 1627–46), later Holy Roman Emperor (*reg* 1637–57). He remained in Austria for over 25 years, making frequent journeys to Prague (where he designed a fountain for the castle) and a few brief visits to Lombardy. Ambitious and astute, he worked assiduously for the Habsburgs and was particularly active in the 1560s, producing a considerable number of their portraits as well as of other illustrious figures linked with the Austrian royal house, for instance *Andrea Doria* and *Ferrante Gonzaga*. Most of these portraits are in Schloss Ambras, Innsbruck, or the Kunsthistorisches Museum, Vienna. In his portraiture Terzio sought to emulate Titian, but his works display a tedious formal rigidity. The block-like, wooden figures appear frozen in pompous official poses, with no attempt at conveying psychological insight; the *Portrait of a Bearded Man* (Bergamo, Gal. Accad. Carrara) is alone in his output in not adhering slavishly to these clichés.

Terzio returned to Italy in the mid-1570s. In 1579 he painted a *Virgin and Child in Glory with Saints* for S Francesco, Bergamo (it was later moved to another church in Bergamo, S Pancrazio). In 1581 he was active in Milan, where he produced a canvas of *Christ among the Apostles* (ex-S Simpliciano, Milan; Milan U., Fac. Teol.). In the same year he went to Venice, where he assisted in the restoration of the interior of the Doges' Palace after the fire of 1577, painting a canvas depicting the *Victory of the Venetians over Roger II of Sicily*. Around 1590 he produced the canvas of the *Nativity* (Bergamo, Carmine church). Terzio spent the last two years of his life in Rome, where he is recorded as a member of the Accademia di S Luca.

BIBLIOGRAPHY
F. M. Tassi: *Vite dei pittori, scultori e architetti bergamaschi*, i (Bergamo, 1793), pp. 173–81
P. Locatelli: *Illustri bergamaschi*, ii (Bergamo, 1869), pp. 222–6
M. Pistoi: 'Francesco Terzi', *I pittori bergamaschi dal XIII al XIX secolo: Il cinquecento*, ii (Bergamo, 1976), pp. 591–637 [with extensive bibliog.]
 MARCO CARMINATI

Tessari [del Santo], **Girolamo** (*b* Padua *c.* 1480; *d* Padua, after 1561). Italian painter. He was the son of a painter, Battista Tessari; his nickname del Santo, by which he is better known, derives from the place where he lived, the Santo quarter of Padua, near the church of S Antonio. His earliest known works are frescoes in the Scuola di S Antonio: the *Miracle of the Glass* (1511) and the *Death of St Anthony* (1513). These reveal the influence of Venetian painting, particularly the art of Giovanni Bellini, and of the late works of Mantegna, as well as familiarity with contemporary works in Padua: Titian's frescoes in the Scuola di S Antonio, and Romanino's *Virgin and Child with Saints* (Padua, Mus. Civ.) in S Giustina.

Tessari produced his best works in the second decade of the 16th century, including frescoes depicting scenes from the *Life of the Virgin* (Padua, Scoletta del Carmine),

the canvas depicting the *Virgin and Child with St Bernard and a Donor* (Milan, Mus. Poldi Pezzoli), the *Lamentation* and the *Virgin and Child with SS Benedict and Justine* (both Padua, Mus. Civ.). Works from the 1520s include another fresco in the Scuola di S Antonio, Padua, and the *Miracle of the Mule* (1524). From this period, in which he probably painted the fresco of the *Entombment with Saints* in the Benedictine convent at Praglia, Girolamo was increasingly influenced by Domenico Campagnola. In the 1530s he painted an altarpiece (1532; *in situ*) for the parish church of Lissaro di Mestrino, near Padua, and worked on the decoration of the oratory of S Rocco and of the oratory of the Redentore (both Padua). His last known work, executed between 1542 and 1546, was the fresco decoration (damaged) in the great cloister of S Giustina, Padua.

BIBLIOGRAPHY
G. Briganti, ed.: *La pittura in Italia: Il cinquecento* (Milan, 1988), ii, pp. 849–50
P. Joannides: 'A Raphaelesque Moment in the Veneto', *A. Crist.*, 739 (1990), pp. 267–71
Da Bellini a Tintoretto (exh. cat., Padua, 1991), pp. 120–35
 MAURO LUCCO

Theatre. Place or structure for drama and performance.

1. Introduction. 2. Renaissance Italy.

1. INTRODUCTION. Architectural theatre structures developed after years of experiment during which performances were conducted in flexible impermanent environments or in buildings designed for other purposes. When dramas involved communities in state celebration of occasional religious festivities, climatic and seasonal considerations dictated the time of performance. The ancient theatres of Greece and Rome, the impermanent medieval rounds, processional wagon stages and the public playhouses of northern Europe were roofless, relying on favourable weather conditions and daylight to illuminate the performances. As social conditions and patterns of leisure changed, performances were also given in the winter season, and theatres became enclosed. They were lit by candles and oil. Although in general theatrical practitioners determine on-stage technical requirements, the structure and decoration of the auditorium and exterior is determined by the patrons. From the 16th century aristocratic patronage influenced the design of glittering courtly interiors and palatial exteriors throughout Europe.

In the mid-16th century the application of the laws of pictorial perspective to the scenic representation of place changed the structure of the contemporary theatre and allowed architects to unify what had been an amorphous relationship between stage and auditorium. In Italy the medieval conventions and emblematic symbolic simultaneous stage were rejected in favour of the classically inspired concept of the dramatic unities and of verisimilitude. The symbolic abstract stage was replaced by one with scenery constructed and painted in perspective and in naturalistic proportion to the actor. The actor was bound in a strict mathematical relationship with his patron, all of which was unified by geometry. This formula determined the relationship between the stage and the auditorium and the construction of theatres for three centuries. Initially a curtain divided the stage from the

audience, but later the architectural feature known as the proscenium arch was designed to function as a frame to the theatrical picture and divide the stage from the auditorium. Early perspective settings were three-dimensional plastic illusionistic representations of the scene; by the end of the 16th century the painter replaced the architect as set designer, and static three-dimensional illusion was replaced by movable two-dimensional scenery painted three-dimensionally. The laws of perspective still governed the relationship between the actor, the scenery and the audience, even if few in the auditorium could view the scenery through the proscenium arch from the best vantage point. To accommodate the desire for spectacle, stages became deeper. To effect rapid transformations fly towers were built above the stage and excavations below the stage facilitated the development of traps and lifts.

BIBLIOGRAPHY

E. K. Chambers: *The Elizabethan Stage*, 4 vols (Oxford, 1923)
M. Bieber: *The History of the Greek and Roman Theater* (Princeton, NJ, 1939/*R* 1961)
W. Beare: *The Roman Stage: A Short History of Latin Drama in the Time of the Republic* (London, 1950, rev. 3/1978)
B. Hewitt, ed.: *The Renaissance Stage: Documents of Serlio, Sabbattini and Furttenbach* (Florida, 1958)
W. Tydeman: *The Theatre in the Middle Ages* (Cambridge, 1960)
W. L. Wiley: *The Early Public Theatre in France* (Cambridge, MA, 1960)
J. White: *The Birth and Rebirth of Pictorial Space* (London, 1972)
A. M. Nagler: *The Medieval Religious Stage* (New Haven, 1976)
G. C. Izenour: *Theater Design* (New York, 1977)
F. Penzel: *Theatre Lighting before Electricity* (Middletown, CT, 1978)
G. Wickham: *Early English Stages, 1300–1660*, 3 vols (London, 1981)
R. Leacroft and H. Leacroft: *Theatre and Playhouse* (London, 1984)

GRAHAM F. BARLOW

2. RENAISSANCE ITALY. By 1450 in Italy the rediscovery of Classical drama inspired the emulation of the stylistic qualities of the Classical authorities, an adherence to their critical precepts and the construction of appropriate theatre spaces in which to stage new dramas. Initially the plays were produced in Latin, but soon indigenous vernacular dramas based on Classical precedent succeeded them.

The rest of Europe, however, continued to perfect its medieval theatrical techniques for many years before absorbing Italian influences. Italian architects and painters applied pictorial perspective to scenery, thus unifying stage and auditorium and enabling playwrights to observe the three dramatic unities of time, place and action, and verisimilitude in any one of three genre categories: tragedy, comedy or pastoral. These innovations led to the rejection of the emblematic abstract simultaneous staging techniques of the medieval period in favour of appropriate naturalistic scenic representation of place in the relevant genre. The static three-dimensional perspective scenes could be erected in a great hall or courtyard or on a temporary stage. From *c*. 1580, however, there was a gradual development away from such static three-dimensional perspective scenery to the two-dimensional changeable perspective scenery designed for the courtly intermezzi. This architectural and scenic style was gradually adopted all over Europe in the early years of the 17th century, first at courts and then in specifically designed public theatres. The influence of the Italian architects and scenographers engaged throughout Europe resulted not only from their work but also from the publication of their designs, which were quickly plundered, and treatises on architecture, perspective painting and stage-management techniques for lighting and effects.

The distinguishing feature of theatres devised for intermezzi and the masque was that the stalls area in the auditorium was left empty during performances so that the actors could descend from the stage, pass beyond the bounds of the proscenium arch and dance with members of the audience before returning to the scenic world on stage. In France, while the public theatre companies synthesized old and new styles by arranging their medieval emblematic scenes in perspective, the court imported Italian architects and designers to construct theatres and design spectacular scenery and costumes for plays, operas and ballets.

BIBLIOGRAPHY

Vitruvius: *On Architecture*, Eng. trans. by M. H. Morgan as *The Ten Books on Architecture* (Cambridge, MA, 1926)
G. R. Kernodle: *From Art to Theater: Form and Convention in the Renaissance* (Chicago, 1944)
B. Hewitt, ed.: *The Renaissance Stage: Documents of Serlio, Sabbattini and Furttenbach* (Florida, 1958)
L. B. Campbell: *Scenes and Machines on the English Stage during the Renaissance* (London, 1960)
A. M. Nagler: *Theatre Festivals of the Medici, 1539–1637* (New Haven, 1964)
A. Nicoll: *The Development of the Theatre* (London, 1966)
J. White: *The Birth and Rebirth of Pictorial Space* (London, 1972)
R. Leacroft and H. Leacroft: *Theatre and Playhouse* (London, 1984)

GRAHAM F. BARLOW

(i) Architecture. (ii) Stage design. (iii) Costume.

(i) Architecture. Italian Renaissance theatre design was characterized by two different developments: the attempt to reconstruct the antique theatre with its *scaenae frons* (front of the stage building) as described by Vitruvius, and the elaboration of a stage area with a central perspective. After the rediscovery of Vitruvius's *On Architecture* (*see* VITRUVIUS, §2) by Poggio Bracciolini in the library of St Gall Abbey *c*. 1415, commentated editions (1486, 1511 and 1540) and illustrated Italian translations (1521 and 1556) were published. Attempts to reconstruct the Vitruvian theatre were encouraged by the excavation and measurement of antique buildings, for example the theatre of Marcellus (ded. *c*. 13–*c*. 11 BC) studied by Antonio da Sangallo the younger and Sebastiano Serlio, or the Teatro Berga (second half of the 1st century AD) in Vicenza examined by Daniele Barbaro and Palladio.

The development from the medieval simultaneous stage to the modern consecutive stage gave rise first to the arcade screen (*see* §(ii) below) and ultimately to a new type of building, a spatial entity incorporating a stage area and separate audience accommodation; this had a determinative effect on all subsequent theatre architecture. In the 15th and 16th centuries theatres were set up in large halls or in the courtyards of palaces. The 1497 Venetian edition of the plays of Terence depicts a theatre that combines stage and auditorium (*see* §(ii) below). The viewer looks from the stage, flanked by *versurae* (large rooms used either for storing props or as foyers during intervals), towards the semicircular tiers of seating rising to form an amphitheatre, the antique *cavea*, where the audience sat. The roof is supported by a circle of pillars. A theatre, the ground-plan of which survives (London, Soane Mus., Codex

Coner), was built on Rome's Capitoline Hill in 1513. A reconstruction shows tiered seating that, with the pit for standing spectators, accommodated 3000 people.

The northern façade of the Villa Farnesina (after *c.* 1506) in Rome by Baldassare Peruzzi (*see* PERUZZI, BALDASSARE, fig. 1) and the Loggia Cornaro (1524) in Padua by Giovanni Maria Falconetto (*see* FALCONETTO, GIOVANNI MARIA, fig. 2) were both built with five axes on a façade flanked by projections and used for theatrical performances. In his design for a theatre in the Villa Madama in Rome *c.* 1518, Raphael went the furthest in approximating to Vitruvius' Roman theatre. The theatre was to have a *cavea*, a semicircular orchestra, a narrow platform stage and a *scaenae frons* with a loggia of columns in front and a central opening.

After Palladio had constructed several temporary theatre buildings in Venice and Vicenza in the 1560s, he designed the first permanent modern theatre in Vicenza: the Teatro Olimpico (1580; *see* PALLADIO, ANDREA, §I). It combines a *cavea* with a semi-oval ground-plan and a stage dominated by a classic *scaenae frons* (see fig. 1; *see also* §(ii) below). The fact that this form of stage was becoming outdated even as it was being built may be indicated by Scamozzi's insertion of seven receding vistas behind the enlarged openings in the *scaenae frons*. In the Teatro Olimpico the antique-inspired theatre derived from Vitruvius was combined with the perspective stage, which had been developing simultaneously.

The development of the perspective stage had received a crucial impetus from Donato Bramante's stone choir at S Maria presso S Satiro in Milan (*c.* 1482; *see* BRAMANTE, DONATO, §I, 2(ii)(a) and fig. 1), where centralized perspective created a fictitious area of space in a flat recess by means of strongly aligned architectural elements. In the following decades Peruzzi had perfected the perspective stage in Rome. The first datable design for a deep stage with a backdrop (1515; Turin, Bib. Reale) just predates the frescoes in the Sala delle Prospettive in the Villa Farnesina (1516–17). Two other drawings by Peruzzi (both 1531; Florence, Uffizi) and a report by M. C. da Lodi (1531; Cruciani, pp. 510–21) permit a full reconstruction of the theatre used for the production of Plautus's *Bacchidi* in front of the Palazzo Cesarini in Rome in 1531 (*see* §(ii) below).

Scamozzi's theatre in SABBIONETA (1588–90; *see* SCAMOZZI, (2), fig. 2) is the first permanent theatre with an angularly framed perspective stage. The auditorium and the stage are separate as SEBASTIANO SERLIO had suggested, but the flat proscenium is enclosed in a set consisting of houses. The rising stage has angular structures forming a street that ends in a vista. Only the proscenium and the front area can be used. The ideal viewing-point, determined by the perspective construction of the back of the stage, lies above the *cavea* level with the prince's box. Bernardo Buontalenti also built a raised prince's podium in a central position in the Teatro Mediceo

1. *Scaenae frons* of the Teatro Olimpico, Vicenza, by Andrea Palladio and Vincenzo Scamozzi, 1580–84

(1586) at the Uffizi, Florence (*see* BUONTALENTI, BERNARDO, §3). With lavish scene-changing equipment and movable sets, this building heralded the Baroque theatre.

BIBLIOGRAPHY

H. Janitschek: 'Das capitolinische Theater vom Jahr 1513', *Repert. Kstwiss.*, v (1882), pp. 259–70

G. Schöne: 'Die Entwicklung der Perspektivbühne', *Theatergeschichtliche Forschungen*, xliii (Leipzig, 1933/*R* Liechtenstein, 1977)

L. Magagnato: *Teatri italiani del cinquecento* (Venice, 1954)

H. Kindermann: *Das Theater der Renaissance*, ii of *Theatergeschichte Europas* (Salzburg, 1959)

J. Jacquot, ed.: *Le Lieu théâtral à la Renaissance* (Paris, 1964, rev. 1968)

K. Neiiendam: 'Le Théâtre de la Renaissance à Rome', *Anlct. Romana Inst. Dan.*, v (Rome, 1969), pp. 157–97

C. L. Frommel: 'Raffaello e il teatro alla corte di Leone X', *Boll. Cent. Int. Stud. Archit. Andrea Palladio*, xvi (1974), pp. 173–87

K. W. Forster: 'Stagecraft and Statecraft', *Oppositions*, ix (1977), pp. 63–87

F. Cruciani: *Teatro nel rinascimento, Roma 1450–1550* (Rome, 1983)

G. Pochat: *Theater und Bildende Kunst* (Graz, 1990)

ROLAND WOLFF

(ii) Stage design. Up until the 17th century, stage design was intimately bound up with the architecture of the theatre. As well as designing temporary theatre structures, such artists as Leonardo, Mantegna, Giulio Romano, Raphael, Baldassare Peruzzi, Palladio and Bernardo Buontalenti also designed the built-in stage sets. The attempt to reconstruct the Vitruvian stage with its *scaenae frons* and the use of perspective painting on the stage converged in the *scaena fissa* that corresponds to the Classical unity of action, time and space. In the second half of the 15th century, the single-set arcade screen, which is known to have been used in Ferrara in 1486, evolved out of the mansions of the medieval simultaneous stage. The illustrations of contemporary editions of the plays of Terence show portico buildings with draped entrances, from which a street extends out upon which the action takes place. Simple supports hold up an entablature with Renaissance ornamentation, and single entrances may project so that the central area is emphasized. On the other hand, Baldassare Peruzzi's wooden theatre (1513) on the Capitoline Hill, Rome, had a two-storey *scaenae frons*. The back wall was structured into five axes by colossal pilasters, while two bays on either side to left and right enclosed the flat acting surface, in the manner of antique *versurae*. However, it is unclear exactly how Peruzzi's stage plan (London, Soane Mus.) was combined with the *scaenae frons*. Raphael's use of painted vistas in his theatre (*c.* 1518) in the Villa Madama, Rome, is also an unresolved question.

Daniele Barbaro's *I dieci libri dell'architettura di M. Vitruvio*, his edition of Vitruvius's *On Architecture*, illustrated Palladio's reconstruction of a two-storey antique *scaenae frons* (*see* BARBARO, (1)), and in 1580–84 a comparable one was constructed for the Teatro Olimpico in Vicenza. In contrast to previous attempts at reconstruction, a portico was replaced with a rhythmic construction of columns with recesses for statues and openings. The openings representing the *porta regia* and the *hospitalia*, which in Vitruvius's edition showed painted vistas of towns, were now described by Vincenzo Scamozzi in *Idea dell'architettura universale* (Venice, 1615) as containing street fronts foreshortened by perspective; these were derived from the three-dimensional stage that was developing concurrently.

From about 1500, stages using perspective consisted of a fixed set on a rising floor, generally representing a street front or a square. In either case, two wooden frames held in tension were fixed together at an obtuse angle to form the corner of a house. Three of these angular frames were assembled on either side of the stage in a funnel shape so that between them there could be entrances, or alleyways. Along with the vista that formed the back of the stage, they were either painted with a view based on a central perspective or were given a sculptural finish using stucco. The squared-off stage thus emphasized the perspective effect. Vitruvius, in his essay on architecture, discusses not only the *scaenae frons* but also this technique of painting stage sets to create the effect of perspective. Because of a pronounced foreshortening, the action of the play could take place only at the front area of this stage set, and like the arcade screen, the stage was extended by a flat platform. The two plates (*c.* 1520) in the Palazzo Strozzi in Florence depicting a perspective stage design with a painted prospect on the back, Peruzzi's designs for Plautus's *Bacchides* (1531; Florence, Uffizi, and Stockholm, Nmus.) and Scamozzi's design (1588; Florence, Uffizi, 191A) for the theatre in SABBIONETA, near Mantua (*see* SCAMOZZI, (2) and fig. 2), all give a good impression of the appearance of the perspective stage. The buildings represented in these stage designs conform to the High Renaissance taste for the powerful forms of the Roman Empire.

In *Trattato sopra le scene*, included at the end of Book II of *Tutte l'opere d'architettura et prospettiva* (Paris, 1545) SEBASTIANO SERLIO described three types of perspective stage that he categorized after Vitruvius: the tragic stage (*see* SERLIO, SEBASTIANO, fig. 3), which would have buildings appropriate for people of high social standing; the comic stage, depicting simple dwellings and inns (see fig. 2); and the satyric stage, the scenery of which should be executed in the style of landscape painting. Despite the vanishing point being displaced towards the back of the

2. *The Comic Stage* by Sebastiano Serlio; from Book II (Paris, 1545) of his *Tutte l'opere d'architettura et prospettiva di Sebastiano Serlio bolognese* (London, British Museum)

stage, acting would be practicable only on the front area, preferably on the proscenium. Unlike Serlio, Francesco Salviati and Scipione Chiaramonti (1565–1652) achieved a greater effect of distance in their stage designs by progressively reducing the size of their buildings as they receded. Around 1600 Guido Ubaldus (1545–1607) developed a method of construction for the representation of the corners of houses on one-sided framing sets by arranging them along the perspective lines going towards the vanishing-point.

There were a variety of interpretations of Vitruvius's description of the *periaktoi* (Gr.: 'revolving triangular prism') as rotating devices with three types of decoration, and it was unclear as to where these were to be set up. In his sketches (Florence, Uffizi) for stage designs, Antonio da Sangallo the younger represents the *periaktoi* above a set framed by angular buildings, and in the ground-plan for a Classical stage he represents them in the *hospitalia*. On the perspective stage they would have had only a token character, illusionistically extending the *scaenae frons*. Similarly, in Barbaro's edition of Vitruvius, triangular prisms are indicated in the ground-plan and painted buildings in the elevation of the *scaenae frons*. In his designs for the Teatro Olimpico, Palladio may have considered installing such a device behind the *porta regia* and the *hospitalia*, and Barbaro, in his *Prattica della prospettiva* (Venice, 1568), called for rotating prisms with three sides corresponding to the three categories of stage. Jacopo Vignola extended this concept by designing a stage on which there were five rotating prisms and which allowed the actors to extend the space of their performances right to the very back.

As well as the *periaktoi*, which were hard to use and limited in their effect, the Renaissance *scaena fissa* was enlivened and extended by a variety of devices. In the first half of the 15th century Brunelleschi developed cumbersome theatre machines for the appearances of the *sacre rappresentazioni*, and in 1490 Leonardo developed a device to open and close a mountain. In the late 16th century, with increasing importance being given to *intermezzi* between performances, theatrical machines and changeable sets were further developed by BERNARDO BUONTALENTI, and were partly built into the stage of the Teatro Mediceo (1586) in the Palazzo degli Uffizi. The often painterly character of the perspective stage, with its unified surface, was increasingly interrupted by the placement of movable scenery to form the backdrops for the *intermezzi*; this prepared the way for the illusionistic sets of the Baroque theatre. As theatres began to be enclosed in a confined space, artificial light became more important; it had already been introduced deliberately by Peruzzi to enhance the perspective effect of his stage design. There was use of both direct and indirect lighting, as well as coloured and moving lights; Buontalenti even had footlights for his performances. There were also discussions about the possibility of darkening the auditorium.

BIBLIOGRAPHY

L. de' Sommi: *Quattro dialoghi in materia di rappresentazioni sceniche* (1556); ed. F. Marotti (*R*/Milan, 1968) [first pubd entirely 1968]
Vitruvius: *On Architecture*; Eng. trans. by M. H. Morgan as *The Ten Books on Architecture* (Cambridge, MA, 1914/*R* New York, 1960)
D. Barbaro: *I dieci libri dell'architettura di M. Vitruvio* (Venice, 1556)
J. Vignola: *Le due regole della prospettiva pratica*, ed. I. Danti (Rome, 1583)
S. Serlio: *Tutte l'opere d'architettura et prospettiva di Sebastiano Serlio bolognese* (ed. G. D. Scamozzi, Venice, 1619/*R* Ridgewood, NJ, 1964)
A. d'Ancona: *Origini del teatro italiano*, i and ii (Turin, 1891)
V. Mariani: *Storia della scenografia italiana* (Florence, 1930)
C. L. Frommel: 'Baldassare Peruzzi als Maler und Zeichner', *Beihft Röm. Jb. Kstgesch.*, xi (1967–8)
G. Niggestich-Kretzmann: *Die Intermezzi des italienischen Renaissanceth-eaters* (diss., U. Göttingen, 1968)

ROLAND WOLFF

(iii) Costume. Like stage designs, costumes were also differentiated according to categories, with rules for the appropriate colours and forms of dress. The lavish, and in some cases extremely magnificent, costumes always respected the relationships among the characters being portrayed. Historical allusions were borrowed from Roman antiquity, for example in the form of a toga-like garment or armour and weapons. Contemporary costumes were not used for Classical plays; it was only in the *commedia dell'arte*, which was just being established in the late 16th century, that realistic contemporary costumes and props were employed. The actors also wore leather masks to typify their figures. While the stage design was executed in matt colours, the costumes stood out by virtue of their golden materials and bright, powerful colours. The discarded wardrobes of princely houses were used by costumiers as their basic stock; exotic accessories, wigs, masks, jewellery and garish make-up contributed to the complete transformation of the performer.

BIBLIOGRAPHY

A. Warburg: 'I costumi teatrali per gli intermezzi del 1589', *Gesammelte Schriften*, ed. A. Warburg, i (Berlin, 1932), pp. 259–300, 394–438
S. M. Newton: *Renaissance Theatre Costume and the Sense of the Historic Past* (London, 1975)

ROLAND WOLFF

Thiene. Italian family of nobles and patrons. The family settled in Vicenza from Athens *c.* 1080, came to prominence in the 14th century, was ennobled in 1469 and is still extant. Lodovico Thiene commissioned a house (*c.* 1489; rest. 1872) adjacent to the Contrà Porti, Vicenza (1489–95), from Lorenzo da Bologna, but work was suspended when Lodovico went into voluntary exile in Mantua. His son Giovanni Galeazzo (*d* before 1542) maintained the association with Mantua and apparently commissioned drawings from Giulio Romano for the renovation of the house, but work ceased on Giovanni Galeazzo's death. Gaetano Thiene (St Cajetan; 1480–1547; can 1671) founded the Theatine Order, though many of his relations had Reformist inclinations.

Giovanni Galeazzo's son, Marcantonio Thiene (*d*1560), was, according to his friend ANDREA PALLADIO, 'very learned in architecture'. Constructing a new palazzo in Vicenza adjacent to the family's existing house, in 1542 he used designs apparently by Giulio Romano but in 1546 he resolved to pursue a more radical approach. The resulting Palazzo Thiene (now Banco Popolare; 1542–58) is Palladio's most impressive palazzo in Vicenza (though there is controversy over the attribution) and the principal act of patronage of the family (*see* VICENZA, §1). The drawings (Palladio, Book II) show the influence of Giulio Romano and of contemporary Roman architecture, such as the Palazzo della Cancelleria (*c.* 1485) and Palazzo Caprini (*c.*

1510) by Donato Bramante, in both the treatment of the façade and the planning; only two sides were executed.

Palladio's Villa Thiene (later Villa Valmarana, now town hall; begun 1546), in Quinto Vicentino, was commissioned by Marcantonio Thiene and his brother Adriano Thiene (*d* 1550). It has a pedimented brick façade articulated with paired pilasters facing the piazza; a pilastered portico faces the garden. The drawings (Palladio, *I quattro libri dell'architettura* [Venice, 1570], Book II) show a building modelled on Palladio's reconstruction of an ancient villa but the executed work was much reduced. Ottavio Thiene (*d* before 1576), the son of Marcantonio, did not continue work on the Villa Thiene but beautified the gardens and added a labyrinth (destr.).

A collateral branch of the Thiene family was based in Cicogna, Padua, from *c.* 1539. According to Palladio (*I quattro libri*, Book II), Francesco Thiene (*d* 19 Dec 1556) commissioned the Villa Thiene (1556–63), Padua, but it was executed by his sons Teodoro Thiene and Odoardo Thiene. Marco Thiene, Francesco's nephew, accompanied Giangiorgio Trissino and Palladio to Rome in 1545. Odoardo, who was a *principe* of the Accademia Olimpica, Vicenza, had been the driving force behind the villa, and works were delayed and later stopped after his flight to Switzerland in 1567 for religious reasons (from 1561 he had been closely connected with Calvinist circles in Vicenza). The drawings (*I quattro libri*, Book II) show a magnificent villa with a two-storey loggia enclosed by a semicircular arcade; only an arcaded portico remains.

Orazio di Francesco Thiene and his nephew Francesco di Sartorio Thiene (*d* 1593) came from the branch from Porta Castello, Vicenza. Palladio made sketches for the Palazzo Thiene al Castello (now Palazzo Bonin) at Corso, Vicenza, for Francesco di Sartorio in 1572; this was later executed by Vincenzo Scamozzi for Enea Thiene, the son of Orazio di Francesco.

BIBLIOGRAPHY

A. Palladio: *I quattro libri dell'architettura* (Venice, 1570)
Libro d'oro della nobiltà italiana, Collegio Araldico, iv (Rome, 1916–19)
P. Carpeggiani, S. Grandi Varsori and P. Morseletto: *Il Palazzo Thiene Bonin Longare, sede dell'Associazione industriale della provincia di Vicenza* (Vicenza, 1982)
G. Arnaldi, ed.: *Storia di Vicenza*, iii (Vicenza, 1989)

For further bibliography *see* PALLADIO, ANDREA.

☐

Thoryson, Peter. *See* TORRIGIANI, PIETRO.

Tibaldi [Pellegrini]. Italian family of artists. Tebaldo Tibaldi (1490–1563) was a builder from Puria di Valsolda, Lombardy, who may have worked in Bologna before settling there *c.* 1530. He was involved, together with Giovanni Antonio di Milano, in the construction of S Gregorio, Bologna (1523–35), as well as of the dormitory of S Michele in Bosco outside the city (1533). Among his children were (1) Pellegrino Tibaldi and (2) Domenico Tibaldi, of whom the more notable was Pellegrino, a leading Mannerist artist successful both as a painter and as an architect. Pellegrino's frescoes reveal the strong influence of Michelangelo, while as an architect he fulfilled the requirements of the Counter-Reformation. Domenico

was primarily an engraver but also worked as an architect and painter.

BIBLIOGRAPHY

Thieme–Becker
C. C. Malvasia: *Felsina pittrice* (1678); ed. G. Zanotti (1841)

(1) Pellegrino Tibaldi (*b* Puria di Valsolda, 1527; *d* Milan, 27 April 1596). Painter and architect.

1. Painting, to 1564. 2. Architecture. 3. Painting, 1565–96.

1. PAINTING, TO 1564. Pellegrino Tibaldi's early paintings show the influence of Bagnacavallo and of other Bolognese followers of Raphael, but his actual teacher is unknown. Vasari's claim that his own works in S Michele in Bosco, Bologna, formed Tibaldi's artistic education is hardly borne out by the latter's first efforts. The *Mystic Marriage of St Catherine* (*c.* 1545; Bologna, Pin. N.) is, in its classical, hierarchical simplicity, clearly inspired by Raphael's manner as interpreted by his Bolognese imitators; although it also bears delicate marks of Parmigianino's grace, the power of its expressive dignity and the architectural background hint at Tibaldi's future development. Tibaldi's *Adoration of the Shepherds* (*c.* 1546; Cento, Pin. Civ.) shows an attempt at more elaborate composition, but its overtly Mannerist elements—perhaps derived from Vasari, as well as from Parmigianino—were not sufficiently digested to be fully integrated into the design.

Tibaldi's move to Rome *c.* 1547 marks a sudden and remarkable maturing of his style. He assisted Perino del Vaga in the decoration (1545–9) of the apartments of Pope Paul III in the Castel Sant'Angelo, taking over the commission on Perino's death (1547). The magnificent frescoed figure of *St Michael*, an elaborate exercise in contorted contrapposto, is still imbued with the graceful energy of Raphael and Parmigianino, but filtered through Perino's complexity. This and the adjacent illusionistic doorway in the Sala del Consiglio are almost certainly by Tibaldi, and their novelty of conception, power of realization and immediacy of execution announce his artistic independence.

In 1549 Tibaldi produced his *Adoration of the Shepherds with a Sibyl* (Rome, Gal. Borghese), an ambitiously sophisticated composition of vigorously disposed, muscular figures accentuated with patches of strong colour and shafts of golden light and evidently derived from Michelangelo's Sistine Chapel frescoes. Also in 1549 he worked on the decorations for the funeral of Pope Paul III (untraced), and *c.* 1550 he decorated the façade and loggia of the villa of the Bolognese Monsignor Giovanni Poggi (destr.; now site of Villa Giulia) on the Pincio outside the Porta del Popolo. From 1550 to 1553 Tibaldi collaborated with Marco Pino on the frescoes of the vault of Daniele de Volterra's della Rovere Chapel in Trinità dei Monti (*in situ*, but damaged) and frescoed a colourful *Battle Scene* on the vault of the chapel of St Denis in S Luigi dei Francesi (*in situ*). Probably in 1551–2 he painted a delightful fresco decoration in the Vatican Belvedere (*in situ*) for Julius III. Late in 1553 he completed the frescoed figures of *SS Peter and Andrew* (destr.) in S Andrea, Via Flaminia, for the same patron.

In 1554 Tibaldi was in Loreto at the command of Cardinal Otto Truchsess von Waldburg, decorating the

chapel of St John the Baptist (now the chapel of the Assumption) in the sanctuary of the Santa Casa with frescoes and stuccos on the vault, an altarpiece of the *Baptism* with a portrait of the donor (all destr.) and lateral frescoes of *St John the Baptist Preaching* and the *Beheading of St John the Baptist* (detached but damaged; Loreto, Pal. Apostolico). Probably early in 1555 he was summoned back to Bologna by Giovanni Poggi, now a cardinal, to execute a series of decorative cycles in the Palazzo Poggi (now the University). The earliest seems to be the frieze showing scenes from the *Life of St Paul* (Bologna, Bib. U.) set in an elaborate architectonic framework distinctly reminiscent of his work with Perino del Vaga. On the staircase of the Biblioteca Universitaria is a fresco of *Artemisia* (detached from a chimney-piece), while downstairs are two rooms (now the Istituto delle Scienze) with ceilings showing scenes from *The Odyssey*, which are Tibaldi's pictorial masterpieces. The barrel vault of the larger room (the Sala dell'Accademia Clementina; see fig. 1) is divided by a cruciform arrangement of *quadri riportati* in richly architectural stucco frames, with, at the corners, painted colonnades open to blue sky derived from Raphael's Vatican Logge. On these colonnades perch four male nudes, specific references to individual nudes from Michelangelo's Sistine Chapel ceiling, seen from below and

1. Pellegrino Tibaldi: ceiling decoration (*c.* 1555), fresco and stucco, the larger Sala d'Ulisse, Palazzo Poggi (now Sala dell'Accademia Clementina, Istituto delle Scienze, Università degli Studi), Bologna

animated by exaggerated gestures and a lively breeze. In the central *quadro*, the *Blinding of Polyphemus*, the figure of the cyclops is a direct imitation of the Sistine Adam (see colour pl. 2, V2), tensed in pain and with decoratively writhing limbs; the artificial rocky background, the febrile figure of Ulysses and the geometric foreground still-life elaborate a superb scene. Of the others, the *Loosing of the Winds* is notable for the humour of its depiction of Neptune in his chariot, influenced perhaps by Rosso Fiorentino's drawings of the *Loves of the Gods* (engraved by Giovanni Jacopo Caraglio in 1526–7). This humorous vein was intensified in the second room. Here Tibaldi combined a vigorous ensemble of white and gold garlands, pediments and busts, all in stucco, with frescoes painted in a fluid, brilliant and colourful style. His energetic *Ulysses*, with his bristling beard and improbably muscular limbs, leaps through his exploits with theatrical panache, in scenes enlivened by such memorable passages as, in the *Stealing of the Cattle of Helios*, the identical startled glance of heifer and sailor. The central illusionistic vision of four *genii* scattering flowers (see colour pl. 2, XXXIII3) recalls Perino's oculus of angels in the Sala dei Pontefici of the Vatican Palace but is given a more naturalistic solidity.

Tibaldi also designed and decorated the Poggi Chapel in S Giacomo Maggiore, Bologna (probably 1556–8; *in situ*). The vault has small frescoes and stucco decoration (most probably designed by Tibaldi and executed by Prospero Fontana), and the altarpiece of the *Baptism* (perhaps begun by Tibaldi but completed in a flaccid manner by Fontana in 1561) is flanked by the frescoed figures of *Cardinal Poggi* on one side and other male members of the family on the other, kneeling before painted colonnades. The large arched spaces of the side walls are filled with Tibaldi's frescoes of the *Conception of St John the Baptist* and *St John the Baptist Preaching*. Both compositions contain complex groups of figures with inflated gestures along with dynamic airborne male nudes, disposed in an elaborate iconography, which led to the subject-matter of the frescoes being obscured in subsequent centuries. Such muscular vigour recalls Tibaldi's *Adoration* of 1549, while the humour of the *Odyssey* decorations (perhaps considered unsuitable here) surfaces only in some vivid physiognomies in the crowds.

In 1558 Tibaldi went to Ancona, where he was commissioned by the municipality to restore and redecorate the Loggia dei Mercanti with frescoes of eight colossal *Virtues* above the stucco cornice (completed 1561; *in situ*, damaged but restored) surrounding the figure of *Justice* in the centre of the vault. During the same period he painted for an altar in S Agostino, Ancona, a panel of the *Baptism with Saints* (Ancona, Pin. Com., damaged) with weighty figures and a mournful landscape, solidly composed and with strong, but lifeless colours. By contrast, the predella panels, especially the *Visitation* (Urbino, Pal. Ducale) and the *Beheading of St John the Baptist* (Milan, Brera), are graceful and delicate. Also in Ancona, Tibaldi decorated the *salone* of the Palazzo Ferretti with an architectural stucco ceiling and a painted frieze of Olympian gods and Roman histories (*in situ*); and he may have designed the funerary monument (1558) to *Count Giovanni Ferretti* in S Ciriaco al Monte, Ancona, a church in which he provided

a stucco tondo of *Christ* (1560; untraced) for the high altar.

2. ARCHITECTURE. It was evidently through the Ferretti family that Tibaldi met Cardinal Carlo Borromeo, an encounter that heralded a new phase of architecture in his career. His first known essay in architecture had been Cardinal Poggi's chapel (1556–8) in S Giacomo Maggiore, Bologna. Here the fluted columns, corner niches, high arches and shallow vault create a dynamic framework for the frescoes, dissolving the wall plane in a manner analogous to that of Raphael in the Chigi Chapel (1513–15) in S Maria del Popolo, Rome. After meeting Cardinal Borromeo, Tibaldi became involved, perhaps during 1561–3, in the rebuilding of the fortifications of Ancona and Ravenna. By early 1564 he was with Borromeo in Rome, where, as his later work attests, he must have studied the latest architectural developments, particularly those of Michelangelo. It is clear that Borromeo was grooming him to carry out his own architectural plans and that he may have chosen Tibaldi partly for his inexperience, in order to keep greater control. His choice was certainly justified, for Tibaldi soon showed a talent for architecture as prodigious as that for painting, and an even more abundant wealth of invention.

Borromeo sent Tibaldi to Milan, his new archdiocese. Tibaldi immediately began the construction of the Collegio Borromeo (completed 1592) in Pavia, of which the most successful and original feature is the courtyard. This consists of two tiers of coupled Doric columns, joined by architraves and supporting arcades, devoid of ornament apart from simple mouldings and the balustrade between the bases of the upper colonnade. Despite a slight resemblance to Palladio's basilica in Vicenza (1549), Tibaldi's austere composition derives rather from two Milanese prototypes, the upper storey of Cristoforo Lombardo's courtyard in the Palazzo Stampa di Soncino (1534) and the lower one of Galeazzo Alessi's courtyard in the Palazzo Marino (begun 1558). Tibaldi's combination of these two models, stripped of their ornament, creates an elegant and coherent effect. The wide arches and spaces between the columns illuminate the groin-vaulted porticos. The entrance façade is, by contrast, varied and restless, with its unity broken by decoratively diverse openings. The longer south façade, on the other hand, uses the repetition of a limited range of these details to create a more colossal impression, particularly impressive in the alternation of pedimented windows with higher pedimented niches.

In 1565 Carlo Borromeo himself went to Milan. Part of his plan for the reform of his archdiocese included its architectural systematization, and he began at the centre, in the cathedral precinct. Tibaldi's first work there was the courtyard of the Canonica (designed 1565, built 1572; *see* MILAN, fig. 3). The original designs (Milan, Castello Sforzesco) propose an elaborate and festive arrangement with syncopated rhythms and rich rustication, reminiscent of Giulio Romano's Cavallerizza (1540s) in the Palazzo Ducale, Mantua. In one, a specific motif from the wings of the Collegio, of coupled arched windows under a single pediment, is doubled in the upper loggia to create a superstructure of twin triangular pediments enclosed in one large segmental one, a development of Michelangelo's

superimpositions in the Porta Pia. In the building as executed, however, inside the lower portico Tibaldi incorporated a double entrance arch with superimposed pediments. The loggie are much plainer, with tall, single, rusticated pilasters, both Tuscan and Ionic, between arches with enriched keystones, triple below and sculpted above, topped by an entablature with projecting blocks above the capitals and keystones.

The crisp architectural detail of the Canonica is reflected in Tibaldi's chaste portal to the adjacent Palazzo Arcivescovile and its rigorously plain octagonal stable building. In 1567 he replaced Vincenzo Seregni, against the will of the Fabbrica committee, as official architect of the cathedral. Soon the interior was transformed by his series of huge, columned aediculae on the side altars of the nave and by his reconstruction of the crypt, the high altar and the choir. The altar, for which Tibaldi designed a domed and columned *tiburio* supported by sculpted angels, is raised behind a flight of sloping steps that give it the illusion of greater height; it is set above a circular crypt (the *scurolo*) in which the central ring of columns (supporting a vault lavishly decorated with stuccos; design, Milan, Bib. Ambrosiana) and surrounding ambulatory recall Early Christian structures. The choir, containing two tiers of lavishly carved fixed stalls and a cathedra, is bounded by two great carved wooden organ-cases and an enclosing wall decorated with marble reliefs. Tibaldi's partly executed design (Milan, Castello Sforzesco) for the façade (later rebuilt) is even more impressive, with vast free-standing Corinthian columns in front of half-columns and a low upper storey between obelisks, the whole composition flanked by tall towers. The scheme would have meant the demolition of part of the Palazzo Ducale, and Borromeo was unable to persuade the Spanish governor to agree to it.

In 1567 Borromeo forced the Jesuits to accept Tibaldi's designs for their new church of S Fedele, in Milan, instead of those of their own architect, P. Giovanni Tristano. Tibaldi's magnificent and original creation (see fig. 2) was clearly inspired by the grandiose effect of Michelangelo's S Maria degli Angeli, Rome (begun 1563). Tibaldi attempted to emulate the colossal scale of the ancient Roman columns by setting his free-standing pinkish granite columns on tall pedestals. His employment of grey and white stucco details in the entablature and vault, including wave and Greek-key patterns, rosettes and coffered bands, serves to emphasize his Classical sources. The nave is of two bays with high arches framing side chapels articulated in a triumphal arch rhythm, separated by projecting piers from a domed crossing, shallow transepts and a deep apsed choir. The composition, united by order, colour and detail, disposes the separate functional parts of the church as clearly as Galeazzo Alessi's S Barnaba, Milan (1557), and Jacopo Vignola's church of Il Gesù, Rome (1568; *see* ROME, fig. 13), while subordinating them to the essentials of preaching space and altar. A similarly monumental style characterizes the exterior, which is executed in pink marble and terracotta plaster and animated with half columns, niches and pediments; statues and reliefs, in accordance with Borromeo's *Instructiones fabricae* (Milan, 1577), were reserved for the main façade (completed to Tibaldi's design in the 19th century).

2. Pellegrino Tibaldi: S Fedele, Milan, interior looking east, begun 1569

After the plague of 1576, Borromeo persuaded the Senate of Milan to accept Tibaldi's designs for their votive church of S Sebastiano (begun 1577; completed 1617). The project was of great simplicity, circular in plan, with Roman Doric pilasters between arched chapels, a small apse and a coffered dome. The exterior was to have been equally simple, with superimposed Roman Doric and Ionic pilasters and a plain cupola, but it was substantially altered in execution by Martino Bassi and Fabio Mangone (1587–1629). More elaborate, and more in keeping with Borromeo's *Instructiones*, was Tibaldi's design (1577) for S Gaudenzio, Novara (begun 1579). The Latin-cross plan and giant half columns flanking superimposed niches in the nave recall Palladio's church of the Redentore, Venice (1576–7; *see* PALLADIO, ANDREA, fig. 7). The similarities are probably due to both architects' coincidental responses to similar influences and problems, and their works create quite different impressions. In S Gaudenzio the dominance of the longitudinal axis is emphasized by the repetition of half columns and arches in the presbytery and choir, drawing the eye towards the east end. The grey, pink and white colouring, more strongly contrasted than in S Fedele, gives accent and unity to the whole, to tremendously impressive effect. The exterior, with its elaborate arrangement of niches, pediments and giant pilasters, clearly shows the influence of Michelangelo's St Peter's and of Roman imperial remains. S Gaudenzio is typical of Tibaldi's mature style, being visually conceived, rich in form but basically simple in organization. He had shown himself capable of a classic chasteness in the interiors of S Cristoforo (1565), Lodi, and the sanctuary of the Madonna (1575), Caravaggio, and of a functional austerity in the octagonal chapel of the Lazzaretto (1576), Milan; the imperial grandeur of S Gaudenzio was to reappear in the sanctuaries at Rho (1581) and at Saronno (1584).

In 1584 Borromeo died, and the collective resentment of Milanese architects and architectural committees towards Tibaldi's dominance broke out. He was gradually replaced in all his major commissions by Bassi, his chief critic, and others such as Giuseppe Meda (*d* 1599) and Lelio Buzzi.

3. PAINTING, 1565–96. Tibaldi created no pictorial works in Milan, apart perhaps from some designs (Milan, Bib. Ambrosiana) for stained-glass windows in the cathedral. However, on more than one occasion he returned to Bologna to execute paintings, including a *Lucretia* (late 1560s; Bologna, Pin. N.), a fresco of *Silence* for the Palazzo Comunale (1569; Bologna, Mus. Civ.) and a frescoed chimney-piece depicting the *Blinding of Polyphemus* (1570; Bologna, Pal. Sanguinetti–Vizani). They show an increasingly stagnant, academic style, with inflated forms summarily described and geometrically disposed, though still with some compositional ingenuity.

Summoned by Philip II (*reg* 1556–98), in 1586 Tibaldi left Milan for Spain to replace Federico Zuccaro in the decoration of the Escorial. His first undertaking was to complete the retable of the high altar of the chapel with a central panel showing the *Martyrdom of St Lawrence* and, below it, the remaining two of the seven surrounding panels, a *Nativity* and an *Adoration of the Magi* (all *in situ*). His work so pleased the King that he was set to decorate the walls of the cloisters of the great Patio de los Evangelistas with 46 large arched frescoes showing scenes from the *Life of the Virgin* and the *Passion* (probably 1588), culminating in a *Last Judgement* (and obliterating most of the already executed work of Zuccaro). He was assisted in this enormous undertaking by artists already at work in the palace, notably Luis de Carabajal (1534–1607) and Diego de Romulo Cincinato (*c.* 1580–1625/6); this may have contributed to the development in his style of a didactic religiosity similar to that of one of his other predecessors there, Luca Cambiaso, and evidently agreeable to their pious patron. However, Tibaldi's scenes are distinguished not only by his flair for powerful composition but also by his inventive colouring, which enlivens the broad groupings and massive figures. His other major work in the Escorial was the decoration of the barrel vault of the library with allegorical frescoes (begun 1591–2) of the *Liberal Arts and Sciences*. The scheme was devised by José de Sigüenza. Bulky female figures are seen from below and set within architectonic frames, flanked by Michelangelesque nudes and surrounded by imaginary portraits of Classical poets and philosophers.

Early in 1596 Tibaldi returned to Milan at the behest of the new archbishop, Carlo Borromeo's cousin Federico, but he died almost immediately, without being able to contribute to Federico's plans for the city. However, Tibaldi's architectural legacy was taken up in Milan by the most dynamic of early Baroque architects, Francesco Maria Ricchini (1584–1658), and through the work of Giovanni Ambrogio Mazenta (1565–1635) was transferred to Bologna. There Tibaldi's pictorial work had already influenced such artists as Fontana, Lorenzo Sabatini, Orazio Samacchini, Bartolomeo Passarotti and Tommaso Laureti and, most importantly, the Carracci family: pupils at the Carracci Academy were set to study Tibaldi's Poggi Chapel

frescoes, and his Palazzo Poggi ceilings directly inspired one of the first masterpieces of the Baroque, the Galleria in the Palazzo Farnese, Rome by Annibale Carracci (1560–1609).

BIBLIOGRAPHY

G. Vasari: *Vite* (1550, rev. 2/1568); ed. G. Milanesi (1878–85), vii, pp. 416–19

C. C. Malvasia: *Felsina pittrice* (1678); ed. G. Zanotti (1841)

A. Venturi: *Storia* (1901–40), IX/vi, pp. 519–77

W. Hiersche: *Pellegrino de'Pellegrini als Architekt* (Parcheim, 1913)

M. L. Gengaro: 'Dal Pellegrino al Ricchino: Costruzioni lombarde a pianta centrale', *Boll. A.*, xxx (1936), p. 202

C. Baroni: *Il collegio Borromeo* (Pavia, 1937)

G. Rocco: *Pellegrino Pellegrini: L'architetto di San Carlo e le sue opere nel duomo di Milano* (Milan, 1939)

G. Briganti: *Il manierismo e Pellegrino Tibaldi* (Rome, 1945)

M. Tafuri: *L'architettura del manierismo nel cinquecento europeo* (Rome, 1966), pp. 72–6

A. Peroni: 'Architetti manieristi nell'Italia settentrionale: Pellegrino Tibaldi e Galeazzo Alessi', *Boll. Cent. Int. Stud. Archit. Andrea Palladio*, ix (1967), p. 272

S. J. Freedberg: *Painting in Italy, 1500–1600*, Pelican Hist. A. (Harmondsworth, 1971, rev. 2/1983), pp. 390–94

A. Scotti: 'Architettura e riforma cattolica nella Milano di Carlo Borromeo', *Arte*, 18–19/20 (1972), pp. 55–90

——: 'Disegni di architettura', *Il seicento lombardo: Catalogo dei disegni, libri, stampe* (exh. cat., Milan, 1973)

L. Heydenreich and W. Lotz: *Architecture in Italy, 1400–1600*, Pelican Hist. A. (Harmondsworth, 1974), pp. 296–9

C. Fraccaro: 'Due nuovi documenti per Callisto Piazza e Pellegrino Tibaldi a Lodi', *Archv Stor. Lodi.*, cxiii (1994), pp. 301–10

W. M. Griswold: 'Some Newly-discovered Drawings in the Metropolitan Museum of Art: Beccafumi, Savoldo and Tibaldi', *Apollo*, cxl/393 (Nov 1994), pp. 24–8

V. Fortunati Pietrantantonio, ed.: *Pittura bolognese del '500* (Bologna, 1986)

V. Romani: *Problemi di michelangiolismo padano: Tibaldi e Nosadella* (Padua, 1988)

G. Panizza: *L'architettura: Pellegrino Pellegrini* (Milan, 1990)

V. Romani: *Primaticcio, Tibaldi e la questione delle 'Cose del cielo'* (Padua, 1997)

NIGEL GAUK-ROGER

(2) Domenico Tibaldi (*b* Bologna, 18 April 1541: *d* Bologna, *c.* 1583). Engraver, architect and painter, brother of (1) Pellegrino Tibaldi. He is thought to have been a pupil of his brother and to have assisted him on various fresco commissions in Bologna, notably the decoration in 1565 of the sacristy of S Michele in Bosco; two allegorical figures (Bologna, Pin. N.) from this scheme, attributed to Pellegrino, may be by Domenico. No other paintings likely to be his have been identified.

Domenico Tibaldi's reputation as an architect rests chiefly on his reconstruction of the choir of the cathedral of S Pietro, Bologna, for Cardinal Gabriele Paleotti. He created a square, cross-vaulted chapel, considerably higher than the medieval nave, with giant Corinthinan columns in the corners. Low arches in the walls, supported by a smaller Corinthian order, lead to apses on either side and to a deeper apse accommodating the new choir to the east. Originally a fourth arch opened on the west to a narrow passage, decorated with Corinthian pilasters and a rich frieze, leading between the closed rectangular chapels of the Paleotto and Boncompagni families to the nave. This arrangement, together with Tibaldi's proposed recasting of the nave arches in Roman arcades with the same small order and frieze, was recorded in a drawing (Florence, Uffizi). In the actual rebuilding of the nave, based on designs by Giovanni Ambrogio Mazenta in 1605–13,

Domenico's magnificent altar space, so reminiscent of Pellegrino's Poggi Chapel in S Giacomo, Bologna, and S Fedele, Milan, was opened out to provide a fitting climax to the interior.

The most distinguished of Tibaldi's other architectural works was the palazzo he designed for Lorenzo Magnani opposite S Giacomo, Bologna. Here he transformed the traditional Bolognese palazzo, with its arcaded ground floor and distinct *piano nobile*, into a subtle critique both of Palladio's direct classicism and of Bartolomeo Ammanati's and Jacopo Vignola's sophisticated Mannerism. A simple disposition of rusticated arches on the ground floor is surmounted by giant Composite pilasters. These are set between superimposed pedimented and square windows, and the whole façade is enriched by an accumulation of precisely profiled details. These include projecting rustication in the spandrels of the arches, panelled pedestals to the pilasters joined by an architraved band interrupted by balustrades under the main windows, a narrow stone frame with convex curved corners surrounding each pair of windows, and at each end a projecting pier, pilaster and section of entablature reinforcing the closing half-member.

Tibaldi's chief occupation was engraving, but only eight signed prints have survived, and his manner is not sufficiently distinguishable from that of other practitioners in Bologna, such as Cornelis Cort (1533–78) and Francesco Bricci (1575–1623), to make anonymous works certainly attributable. Of his known engravings, the largest is that of an elaborate *Palazzo* (1566) on two plates, after a design by Galasso Alghisi; the most distinctive is that of the *Neptune Fountain* (1570) in Bologna, designed by Tommaso Laureti and with figures by Giambologna. He also engraved a *Trinity* (1570) after Orazio Samacchini and a portrait of *Gregory XIII* (1572) after Bartolomeo Passarotti, as well as a *St Mary Magdalene* by Titian. Perhaps his most unusual example is a *Stigmatization of St Francis* (1567–8), which combines elements from two different engravings of the same subject by Cort, of 1567–8, after Girolamo Muziano. Tibaldi engraved two of his own designs, the *Rest on the Flight into Egypt* and *Peace*, in which elaborate compositions with flights of winged figures, angels and *genii* are enhanced by his sensitive and delicate touch. However, his greatest distinction in this field is as the teacher of Agostino Carracci (1557–1602).

BIBLIOGRAPHY

C. C. Malvasia: *Le pitture di Bologna* (Bologna, 1686); ed. A. Emiliani (Bologna, 1969), p. 226

P. de Bouchard: *Bologne* (Paris, 1909), pp. 57–8

A. Foratti: *La chiesa di San Pietro in Bologna dal secolo XV al XVII* (Bologna, 1914), pp. 12–25

D. DeGrazia Bohlin and B. Bohn: *Italian Masters of the Sixteenth Century (1980)*, 39 [XVIII/i] of *The Illustrated Bartsch*, ed. W. Strauss (New York, 1978–) [B.]

For further bibliography *see* § (1) above.

NIGEL GAUK-ROGER

Tiberio d'Assisi. *See* ASSISI, TIBERIO D'.

Tintoretto [Robusti]. Italian family of painters and draughtsmen. They were active in Venice, where the career of (1) Jacopo Tintoretto spanned the mid- to late 16th century. Criticized for his unorthodox professional practices, Jacopo developed a style that was highly idiosyncratic

and worked with astonishing rapidity. By 1553 he had married Faustina, daughter of Marco Episcopi (or dei Vescovi), a prominent figure in the Scuola Grande di S Marco in Venice. Three of their eight children, (2) Marietta Tintoretto, (3) Domenico Tintoretto and Marco Tintoretto (1561–1637), became artists and were among the many assistants in their father's busy workshop. Marietta, though her career is only scantily documented, seems to have specialized in portrait painting. Domenico adopted his father's style and assisted him on some of his most prestigious commissions, such as that for decorations in the Doge's Palace. He also received several independent commissions, but after Jacopo's death his painting declined.

(1) Jacopo Tintoretto (*b* Venice, 1519; *d* Venice, 31 May 1594). He was the most prolific painter working in Venice in the later 16th century and is recorded away from his native city only in 1580 in connection with a commission for the ruling Gonzaga family at Mantua. In his early career he struggled to achieve recognition, which finally came in 1548 with a work commissioned by the Scuola Grande di S Marco. In his mature years he worked extensively on decorations for the Doge's Palace (*see* VENICE, §IV, 4(ii)) and for the meeting-house of the Scuola Grande di S Rocco, on which he was occupied from 1564 until 1567 and between 1575 and 1588 (*see* VENICE, §V, 4). In addition to his religious and mythological works, Jacopo also painted many portraits of prominent Venetians. He was, however, never wholly accepted by the leading aristocratic families that dominated Venetian cultural life, and to some extent this hindered his patronage. The swift, abbreviated style that characterizes much of his work caused controversy among contemporaries, and the lack of conventional finish was seen by some as merely a result of carelessness or overhasty execution. Despite a long and busy career, Jacopo Tintoretto apparently never became rich, and in 1600 his widow submitted a plea to the Venetian State for financial help to support her family.

I. Life and work. II. Working methods and technique. III. Character and personality. IV. Critical reception and posthumous reputation.

I. Life and work.

1. Before 1548. 2. 1548–55. 3. 1556–74. 4. 1575 and after.

1. BEFORE 1548. His father, Giovanni Battista Robusti, was a cloth-dyer, a common and respectable occupation in Renaissance Venice. Nonetheless, the Robusti do not appear to have enjoyed higher citizen (*cittadino originario*) status. Jacopo's adopted nickname, meaning 'the little dyer', advertised rather than concealed his artisan background. The details of Tintoretto's artistic training are not known, although early sources report that he was expelled from Titian's workshop after a short period, as a result either of the jealousy (Ridolfi, 1642) or incomprehension (Boschini, 1660) of his master. The marked distance from Titian's chromatic idiom in Tintoretto's earliest works (e.g. the *Holy Family with St Jerome and the Procurator Girolamo Marcello*, 1537–40; ex-priv. col., Lucerne, see Pallucchini and Rossi, p. 292; and the *Holy*

Family with SS Zacharias, ?Elizabeth, John, Catherine and Francis, 1540; priv. col., see Pallucchini and Rossi, p. 295) suggests that these romanticizing elaborations have a factual basis. The linear and dynamic values of the paintings indicate that Tintoretto was apprenticed to an artist working in Venice, but influenced by Central Italian Mannerism. Bonifazio de' Pitati, Paris Bordone and Andrea Schiavone have variously been suggested as his teachers.

Jacopo Tintoretto was practising as an independent master as early as 1539. Ridolfi mentioned his collaboration with Andrea Schiavone and other 'painters of lesser fortune' in the production of *cassone* panels. While the connection with Schiavone is certainly important on a formal level, it is also indicative of Tintoretto's lack of artistic standing at this stage. The sets of *cassone* panels attributable to Tintoretto (e.g. those depicting six scenes from the *Old Testament, c.* 1543–4; Vienna, Ksthist. Mus.; see fig. 1) are characterized by a rapid, rough technique in which all form is radically abbreviated. This visual shorthand was, to some extent, an established feature of *cassone* painting in 16th-century Venice and reflected the economic strictures governing the production of this type of work. Tintoretto's introduction of an analogous technique into the realm of monumental painting distinguished him from his contemporaries.

Tintoretto's *prestezza* (rapid, abbreviated technique) is prominent in a sequence of large religious narrative paintings, including *Christ among the Doctors* (*c.* 1540–42; Milan, Mus. Duomo), the *Adoration of the Shepherds* (*c.* 1544–5; two versions, Cambridge, Fitzwilliam; Verona, Castelvecchio), the *Supper at Emmaus* (*c.* 1545–6; Budapest, Mus. F.A.) and *Christ and the Adulteress* (*c.* 1546–7; Dresden, Gemäldegal. Alte Meister). These *laterali* (horizontal paintings) were probably made to hang on the side walls of Venetian chapels, and Tintoretto's art is at its most progressive in his early period within this relatively new picture type in Venice. These works typically feature active figure groups, set in a forward plane to maximize an effect of formal monumentality and narrative intensity. The figures are shown in dynamic, twisting or foreshortened poses reminiscent of contemporary Mannerist painting but typically have more mass and energy and lack the courtly elegance of, for example, Parmigianino or Francesco Salviati. The earlier compositions are symmetrical, with the protagonists placed centrally. In subsequent works, such as the two versions of *Christ Washing the Feet of the Disciples* (*c.* 1547–8; Madrid, Prado; Gateshead, Shipley A.G.), the insistent off-centre perspective reflects Tintoretto's concern to make his painting respond to its intended location. It originally hung on the right wall of the presbytery at S Marcuola, Venice, and the perspective assumes that the viewer is positioned to the right, that is, in the nave. The central dramatic exchange between Christ and the Apostle Peter is, accordingly, placed at the extreme right of the pictorial field, at the point nearest the congregation.

Although Tintoretto produced as many as ten façade frescoes in Venice (L. Foscari, *Affreschi esterni a Venezia* (Milan, 1936), pp. 61–7, 132), knowledge of this activity is limited to the surviving fragments from the Palazzo (Ca') Soranzo (1540–45; Venice, Cojazzi priv. col., see Palluc-

1. Jacopo Tintoretto: *Belshazzar's Feast* (detail), oil on panel, 290×1560 mm, *c.* 1543–4 (Vienna, Kunsthistorisches Museum); one of a series of *cassone* panels depicting scenes from the *Old Testament*

chini and Rossi, p. 299) and some 18th-century engravings by Anton Maria Zanetti (1706–78) of the paintings on this building and on the Ca' Gussoni (1550–52). Nonetheless, the evidence again suggests a concern with formal monumentality at the expense of more traditional Venetian decorative and chromatic values. The Ca' Gussoni frescoes were closely based on Michelangelo's sculptures of *Dawn* and *Dusk* in the Medici Chapel in S Lorenzo, Florence, and it is likely that Tintoretto owned small models of these works. A group of early drawings after the Medici figures (*Day*, Oxford, Christ Church Lib. and Paris, Louvre; *Dusk*, U. London, Courtauld Inst. Gals and Florence, Uffizi) and other sculptures by Michelangelo (*Samson and the Philistines*, eight sheets, including Cambridge, MA, Fogg, and Berlin, Kupferstichkab.; *St Damian*, Sarasota, FL, Ringling Mus. A.) confirms Tintoretto's early interest in the Florentine artist. His complementary concern with Classical and contemporary sculpture is stressed by early sources (Borghini; Ridolfi, 1642; Boschini, 1660).

When Tintoretto was commissioned to produce paintings of a more mainstream type, his style was comparatively timid. The *Apollo and Marsyas* (1545; Hartford, CT, Wadsworth Atheneum) is probably identifiable with one of the two ceiling paintings commissioned by Pietro Aretino for his house and for which he thanked Tintoretto in a letter of 15 February 1545. The work is relatively conventional, as are Tintoretto's earliest portraits, which

typically utilize schemes that recall Titian (e.g. the *Portrait of a Man Aged 25*, 1545; London, Hampton Court, Royal Col.). Their small size and non-official character (e.g. the head and shoulders *Portrait of a Bearded Man*, 1546; Florence, Uffizi; and the *Portrait of a Gentleman*, 1546–8; Madrid, Prado) indicate the limited social range of Tintoretto's portrait clientele at this stage.

Tintoretto painted very few altarpieces before 1548. The conservative *Christ Blessing with SS Mark and Gall* (1540–45; Venice, Mus. Dioc. S. Apollonia) and *St Demetrius with Zuan Pietro Ghisi as Donor* (1544–7; Venice, S Felice) feature static figures set in the traditional vertical space. Ridolfi mentioned the artist's exhibition of ready-made paintings at the Rialto, a common strategy for struggling painters. Tintoretto did, however, gain early support from the smaller, non-noble confraternities. The *Presentation in the Temple* (1540–43; Venice, S Maria del Carmelo) may have been commissioned by the Scuola dell'Arte dei Pescivendoli (the trade guild of the fishmongers), and a frieze (destr.) in the meeting-house of the Scuola dell'Arte dei Sartori (the trade guild of the tailors) also dates from this period.

In 1547 Tintoretto painted his earliest known version of the *Last Supper* (Venice, S Marcuola), a subject he depicted at least eight times during his career. With the exception of the versions for the Scuola di S Rocco (1578–81) and the Benedictines of S Giorgio Maggiore (1591–2),

these paintings were commissioned by parish-based Scuole del Sacramento. These small, socially humble confraternities were committed to the upkeep of the reserved sacrament. The paintings they typically commissioned were *laterali* to decorate either the chapels where the sacrament was kept or the Scuola's church meeting-place. The S Marcuola *Last Supper* follows established models and has a symmetrical composition, with the table parallel to the picture plane. However, the newly popular location—in a small parish church—is reflected in the figure types of the apostles. Tintoretto's rapid brushwork emphasizes the rough textures of their drapery, flesh and hair. Comparisons with Leonardo's prototype (1494–8; Milan, S Maria delle Grazie) show that Tintoretto de-individualized the apostles in order to stress their shared social and spiritual characteristics. This, like the limits set on the apostles' vocabulary of expression and gesture, allowed the painter to create a convincing image of popular religious experience.

2. 1548–55. The canvas of *St Mark Rescuing the Slave* (1547–8; Venice, Accad.; see fig. 2), commissioned from Tintoretto by the Scuola Grande di S Marco, was initially rejected and sent back to the painter. This reaction suggests the unprecedented nature of the image in the Venetian tradition, and it was this work that finally brought the artist recognition throughout Venice. Every element in the picture serves to amplify the subject's dramatic and emotional impact. Full bodily movement replaces facial expression as the prime indicator of individual response, while different incidents within the story are shown simultaneously so as to reinforce narrative meaning. In *St Roch Healing the Plague Victims* (1549; Venice, S Rocco), commissioned by the rival Scuola Grande di S Rocco, Tintoretto used chiaroscuro for the first time as an important compositional device. The distribution of light draws attention to the sick at the expense of St Roch himself, and while this inversion of accepted pictorial convention has formal precedents in Central Italian Mannerism, here its significance is expressive and ascetic rather than arbitrary and aesthetic. More generally, the essentially communicative and moral intention of Tintoretto's formal manipulations distance his work from contemporary Mannerism.

Tintoretto's work in the following years has been described as 'an expression of orthodoxy' (Tietze), and a new deference to established pictorial values in Venice is already noticeable in, for example, *St Martial in Glory with SS Peter and Paul* (1548–9; Venice, S Marziale), which uses a conservative pyramidal design. In the paintings decorating the organ shutters at the church of the Madonna dell'Orto, Venice (outer doors: the *Presentation of the Virgin*, 1552–3; inner doors: the *Martyrdom of St Paul* and *St Peter's Vision of the Cross*, 1556), glowing reds and golds

2. Jacopo Tintoretto: *St Mark Rescuing the Slave*, oil on canvas, 4.16×5.44 m, 1547–8 (Venice, Galleria dell'Accademia)

replace the cool colours that predominate in earlier works. The *Presentation of the Virgin* is also typical of this phase in its explicit reference to Titian's well-known version of the subject (1538; Venice, Accad.). Ridolfi's anecdote about Tintoretto's eclectic ambition to combine Michelangelo's *disegno* with Titian's *colore* is relevant only in this period. Paintings such as the *Original Sin* and *Cain Killing Abel* (both 1550–53; Venice, Accad.), from the cycle of paintings commissioned by the Scuola della Trinità, demonstrate a continuing Michelangelesque interest in the nude in movement, but the figures are set in Venetian-style landscapes that bind them within a naturalistic ambience of light and air.

A group of cabinet paintings with mythological or apocryphal subjects (e.g. *Susanna and the Elders*, 1550–55; several versions, including Paris, Louvre, and Vienna, Ksthist. Mus.; the *Rescue of Arsinoë*, 1554–6; Dresden, Gemäldegal. Alte Meister; *Venus, Vulcan and Mars*, 1550–55; Munich, Alte Pin.) also draws on established Venetian models. The female protagonists typically assume complex, diagonal postures, abandoning the traditional arrangement of form in order to accord with the underlying axis of the picture frame, and the paintings are generally highly finished and detailed, employing bright and varied colours. Tintoretto's portraits from this period are characterized by precise individualization, bold chiaroscuro and the suggestion of rapid movement (e.g. the *Portrait of Lorenzo Soranzo*, 1553; Vienna, Ksthist. Mus.). Portraits of important patricians (e.g. that of the *Soranzo Family*, *c.* 1550–65; Milan, Castello Sforzesco, and *Nicolò Priuli*, *c.* 1549; Venice, Ca' d'Oro) testify to the increasing social range of his patronage.

By 1553 Tintoretto had contributed a painting (probably showing *Pope Alexander III Excommunicating Barbarossa*) (*c.* 1553; destr. 1577) to the prestigious Alexander cycle in the Sala del Maggiore Consiglio in the Doge's Palace and assumed the task of supplying votive pictures for retiring officials of the Magistrato del Sale at the Palazzo dei Camerlenghi (e.g. *St Louis of Toulouse with St George and the Princess*, 1552; Venice, Accad.). Paolo Veronese, however, dominated the field of official commissions at this time, and his success elicited a prompt response from Tintoretto, who, in a series of small ceiling paintings (*Susanna and the Elders, Esther and Ahasuerus, Judith and Holofernes, Solomon and the Queen of Sheba, Joseph and Potiphar's Wife* and the *Finding of Moses*, all *c.* 1554–5; Madrid, Prado) and in several portraits (e.g. the *Portrait of a Bearded Man, c.* 1553–5; Montreal, Mus. F.A.), showed his willingness to experiment with the newcomer's decorative use of colour. Tintoretto's interest was not merely aesthetic, however, and Ridolfi reported that he 'stole' Veronese's commission for an altarpiece for the church of the Crociferi by promising to paint in his rival's manner. The resulting painting, the *Assumption of the Virgin* (*c.* 1554–5; Venice, Accad.), distinctly recalls the work of Veronese in style, employing opaque patches of strong local colour to connect planes and deny movement into depth.

3. 1556–74. In the later 1550s Tintoretto renewed his experiments with pictorial space, as can be seen in a number of portraits that combine complex, foreshortened architectural settings and landscape backgrounds, for example the *Portrait of a Soldier Aged 30* (1555–60; Vienna, Ksthist. Mus.). In the *Pool of Bethesda* (1559; Venice, Scu. Grande S Rocco; see colour pl. 2, XXXIV2), the compressed space becomes a metaphor for the sufferings of the crowd of lepers who struggle within it. The painting demonstrates Tintoretto's increasing interest in large-scale compositions in which individual form is subordinated to broader sequences, where the overall sense is articulated by a reduced number of key movements or gestures. In the enormous choir paintings (*c.* 1560–63) at the Madonna dell'Orto this devaluation of individual form is implemented through chiaroscuro. In the *Last Judgement*, from this cycle, free-floating figures are arranged in contrasting subgroups of twos or threes, with broken strips of light closely following their forms. Their illuminated movements thus act as directional pointers, encouraging the eye to move quickly across them.

In the cycle of paintings commissioned by Tommaso Rangone for the Scuola Grande di S Marco in 1562—the *Finding of the Body of St Mark* (Milan, Brera; see fig. 3), the *Removal of the Body of St Mark* and *St Mark Saving the Saracen* (both Venice, Accad.)—space is created solely to enhance the scenic or dramatic effect. In both the *Finding* and the *Removal* the linear logic of the emptied, boxlike perspective vistas is undermined by an irrational play of light and shade. Both paintings suggest the simultaneous existence of different levels of reality through the use of a range of pictorial techniques. The detailed modelling of the foreground group in the *Removal* contrasts strikingly with the sketchily rendered piazza and the fleeing Alexandrians beyond, while in the *Finding*, the most commanding physical presence is that of the visionary figure of St Mark, whose miraculous appearance brings about a radical confusion of material and spiritual realities.

Tintoretto further developed this visionary-epic style of religious narrative in the paintings (1565–7) for the Sala

3. Jacopo Tintoretto: *Finding of the Body of St Mark*, oil on canvas, 4.05×4.05 m, 1562–6 (Milan, Accademia di Belle Arti di Brera)

4. Jacopo Tintoretto: *Last Supper*, oil on canvas, 2.21×4.13 m, *c.* 1556–7 (Venice, S Trovaso)

dell'Albergo of the Scuola Grande di S Rocco and in such other Scuola paintings as the *Descent into Limbo* and the *Crucifixion* (both 1568; Venice, S Cassiano). Vasari reported that Tintoretto gained the initial commission for the Sala dell'Albergo paintings only by 'illegal' means: he donated and installed the ceiling canvas of *St Roch in Glory* (1564; *in situ*), so undermining the proposed competition. The painting's overt reference to Titian's famous *Assumption of the Virgin* (1516–18; S Maria Gloriosa dei Frari; for illustration *see* ALTARPIECE) perhaps reflects an attempt to appeal to the conservative tastes of the members of the Scuola. In the following year Tintoretto was admitted to membership of the confraternity and thereafter played an active role in its organizational and devotional life. The security of his position seems to have encouraged the experimental style in such subsequent paintings as the *Crucifixion* (1565; *see* VENICE, fig. 12), the *Road to Calvary*, the *Ecce homo* and *Christ before Pilate* (all 1566–7; *in situ*). The composition of the enormous *Crucifixion* is conceived as a flattened circle, arranged around the iconic figure of Christ. The picture holds in suspension different realities: the naturalistic depiction of physical effort in the groups raising the thieves' crosses contrasts with the spiritual effort embodied in the hieratic group of mourners at the centre. The combination of idealized pathos with raw artisan action allows the painting the socially inclusive, epic quality that became a feature of Tintoretto's subsequent work at S Rocco.

In this period Tintoretto also received further commissions from the Scuole del Sacramento for paintings of the *Last Supper*. In the S Felice version (1559; Paris, St-François-Xavier) one edge of the table continues to lie parallel to the picture plane, but its form recedes into depth, with Christ removed to the further end. Despite the apparent symmetry of the composition, important concessions are made to the painting's location—on the left wall of the Cappella Maggiore—and to its patrons. The gesture of the apostle at the foreground left facilitates visual entry from that point, and the traditionally sacred space is used to include contemporary portraits of the Scuola's Guardian (erased probably as early as June 1560; Pallucchini and Rossi, i, p. 179), Scrivener and Vicar. In the S Simeon Grande painting (*c.* 1561–3), the asymmetry is much more radical, with the table set at an oblique angle to the picture plane and Christ removed from his traditional central position. In the versions at S Trovaso (*c.* 1556–7; see fig. 4) and S Polo (*c.* 1570) Tintoretto most radically broke with the compositional frontality that traditionally reinforced in the Last Supper the quality of a hieratic and timeless icon.

In the S Trovaso painting, made to hang on the right wall of the chapel, the shift in compositional axis is undertaken in accordance with an imagined viewer positioned obliquely to the picture plane, at the chapel entrance. This subjectivizes the image, suggesting that the composition unravels as an extension of the observer's own sight line. The Last Supper is set in a dingy basement, crowded with apostles who are shown less as biblical patriarchs than as contemporary Venetians of the lower classes. This reflects the expected social scope of the painting's viewing public. However, other planes of reality are also suggested. The artisan apostles are set in the foreground, nearest to the transition point between fictive and real space. As the eye moves into depth, gestures, responses and figure types are increasingly removed from these naturalistic coordinates. In the S Polo version the intrusion of the outside world into the hieratically fixed space of the Last Supper is again emphasized, by the inclusion of a servant, two beggars, a donor portrait and a landscape. The centrifugal composition explodes outwards from the dynamic central figure of Christ, forcing the viewer's attention back to the subsidiary figures towards the edges of the picture.

In the context of patrician patronage Tintoretto's mature style was very different. After the election of Doge Girolamo Priuli (*reg* 1559–67), who was a friend of Rangone, Tintoretto's career as a state painter flourished. He took over from Titian the role of producing ducal portraits (e.g. *Doge Girolamo Priuli, c.* 1559; three versions, Los Angeles, CA, Getty Mus.; Detroit, MI, Inst. A.; Venice, Accad.) and was subsequently commissioned to produce a whole range of official imagery. Tintoretto's first ceiling decoration for the Venetian State, the canvases depicting *Doge Girolamo Priuli with ?St Mark, Peace and Justice,* surrounded by four *Old Testament* scenes and the *Seasons* (*c.* 1564–5, Venice, Doge's Pal., Sala dell'Atrio Quadrato), is characterized by a tightness of handling and high finish that combine with strong local coloration to generate a primarily decorative effect. A similar restraint is evident in such official votive pictures as the *Virgin and Child with SS Sebastian, Mark and Theodore, Venerated by Three Treasurers* (*c.* 1567; Venice, Accad.), which utilize orderly, decorous compositions and where relatively static forms are placed parallel to the picture plane.

The style of Tintoretto's mature portraits is as varied as that in his narrative paintings. The public context of the official portraits (e.g. *Doge Pietro Loredan, c.* 1567–70; two versions, Melbourne, N.G. Victoria; Budapest, Mus. F.A.) precluded expressive experimentation, but the portraits of figures from the Venetian intellectual–artistic milieu (e.g. *Jacopo Sansovino, c.* 1566; Florence, Uffizi; see colour pl. 2, XXXIII2) are less formal, and their style and technique are adapted to the personality and interests of the sitter. Nonetheless, the public–private distinction increasingly broke down. In the *Venetian Senator* (*c.* 1570; Lille, Mus. B.-A.), the focusing of concentration on the face and the simplicity of pose and setting newly suggest an inwardness that stands in expressive contrast to the sitter's public office.

4. 1575 AND AFTER. Tintoretto's most prolific period was the final two decades of his life. In addition to his extensive work at the Scuola Grande di S Rocco (1575–88), he played a major role in the redecoration of the Doge's Palace after the fires of 1574 and 1577. The range of his patronage also broadened following Titian's death in 1576, with commissions from the courts at Prague (*c.* 1577–8), Mantua (1578–80) and the Escorial (1583 and 1587). While such foreign expansion may have been an attempt to take on Titian's mantle as Venetian painter to the aristocracies of Europe, Tintoretto's production of religious paintings, mythologies and portraits for a local clientele did not diminish.

(i) The meeting-house of the Scuola Grande di S Rocco. (ii) Other works.

(i) The meeting-house of the Scuola Grande di S Rocco. Following his work (1565–7) on the Sala dell'Albergo, Tintoretto was commissioned to decorate the rest of the meeting-house in a piecemeal fashion. The artist himself played an active role in generating a demand for paintings and developing an iconographic programme. His series of petitions (July 1575–March 1577) offering to provide paintings for the Sala Superiore ceiling at a greatly discounted price culminated with a proposal (Nov 1577) to execute paintings for the walls and any further work the Scuola might require. He undertook to produce three paintings a year in return for an annuity of 100 ducats. The production of cheap paintings at speed played an important role in determining the style and technique subsequently employed. It was apparently Tintoretto's suggestion that the initial ceiling painting should show the *Brazen Serpent* (1575–6), an Old Testament type of the *Crucifixion* that could stand as an introduction to the Sala dell'Albergo *Passion* cycle. The large ceiling canvases that followed allude to the Christian Sacraments of Baptism (1577; *Moses Striking the Rock*) and the Eucharist (1577; *Gathering of the Manna*). The placing of the latter nearest to the altar, however, suggested a new longitudinal emphasis orientated away from the Sala dell'Albergo. The paintings feature complex, foreshortened figure groups silhouetted against a broken, flickering light that emanates from a supernatural source deep within the picture. Space is arbitrary, with local recessions replacing any continuous perspective system. Landscape is reduced to a schematic minimum, with the effect of further loosening naturalistic form.

The decision to commission paintings for the walls necessitated an iconographic reorientation, five transversal axes being established by the correspondences between the *Old Testament* scenes on the ceiling and those from the *Life of Christ* on the walls (1578–81). The iconographic connection was reinforced by the partial repetition in the wall sequence of the compositional schemes in the central ceiling paintings. The rotating composition of the *Brazen Serpent* is broadly repeated in the *Ascension* and *Resurrection* below, while the diagonal horizon in the *Gathering of the Manna* is picked up in the related wall scenes showing *Miracle of the Loaves and Fishes* and the *Raising of Lazarus.* Moreover, individual forms originating in the three central ceiling canvases reappear, albeit with variations, in thematically related wall scenes (e.g. God in the *Brazen Serpent* is partially repeated in the Christ of the *Ascension*).

The iconographic and formal dominance of the ceiling also has the effect of freeing the paintings on the walls from the lateral scansion traditional to narrative cycles in Venice, allowing each painting an unprecedented independence from its neighbour. In many paintings, compositional dislocation is taken to new extremes (e.g. the *Nativity* and the *Agony in the Garden*). Working in conjunction with the dominant chiaroscuro, which subdues local colour and simplifies form throughout the cycle, the episodic space subdivides each composition into distinct temporal and narrative units, isolating separate moments within the text. Thus, conventional sequential representation is replaced by narrative simultaneity, requiring the viewer to reconstruct the connecting links.

The wall scenes are, typically, heavily populated, while individual figures are radically abbreviated. Facial expression is concealed through foreshortenings and cast shadows, and the range of movements and gestures employed is relatively limited and repetitious. These formal devices negate any individuality and generate a sense, instead, of the shared material and spiritual status of those who experience Christ's miracles. In many of these works the figure of Christ, displaced from the compositional centre, occupies a secondary position towards the picture margins,

5. Jacopo Tintoretto: *Flight into Egypt*, oil on canvas, 4.22×5.79 m, 1583–7 (Venice, Scuola Grande di S Rocco, Sala Terrena)

while the role of the recipients of miraculous salvation is promoted, for example in the *Pool of Bethesda* (see colour pl. 2, XXXIV2) and the *Last Supper*. As in the earlier S Polo version of the *Last Supper*, that in the Sala Superiore also includes beggars, one of whom is, by a trick of perspective, placed next to Christ. An ideal of sacred poverty is a leitmotif throughout the cycle.

The prominence given to groups of the sick, poor and hungry in the wall paintings of this room was probably designed to refer to the charitable activities of the Scuola, but the pictorial inversions also suggest Tintoretto's reformist insistence on the essential equality of man in Christ. The form of Christianity conceived in the Sala Superiore overturns all social distinctions and is, in this sense, both open and popular. In keeping with this emphasis, the eight wall scenes in the Sala Terrena (Aug 1581–Aug 1587) stress the poverty of the Holy Family. Although it has sometimes been assumed that the iconography of the Sala Terrena paintings is confused, the focus on Christ's infancy acts as a precursor to the Christocentric theme of the paintings in the rooms above. The secondary emphasis on the Virgin is wholly in keeping with the teachings of the Counter-Reformation. Two smaller canvases may show the prophetic meeting between the Virgin and St Elizabeth in Egypt (as recorded in the apocryphal gospel of St James), while the *Assumption of the Virgin* prefigures the *Ascension of Christ* in the Sala Superiore above.

In the *Annunciation* visionary spirituality dynamically obtrudes into the context of artisan life, and analogous social relocations of the sacred narrative inform the *Flight into Egypt* (see fig. 5) and the *Adoration of the Magi*. Fluid variations of style and technique characterize the Sala Terrena cycle, suggesting the interpenetration of different levels of reality. The sketchy treatment of the visionary landscapes in the Marian paintings contrasts with the closely detailed naturalism of the *Flight into Egypt*. Colour and light are also manipulated with a new expressive freedom. The drained, monochromatic tones of the *Massacre of the Innocents* contrasts with the explosive golds of the *Assumption*.

The detailing of physiognomy and costume in the *Adoration of the Magi* and the *Presentation in the Temple* suggests workshop participation. However, unlike in the contemporary cycles painted for aristocratic patrons, Tintoretto's own hand remained dominant at the Scuola. In his final petition of 1577 he stressed that his work was undertaken 'to show my great love for this venerated Scuola of ours, and the devotion I have for the glorious St Roch'. His personal involvement in the life of the confraternity continued long after the decorations were complete. But concerted opposition to Tintoretto within the Scuola is recorded as late as February 1578. This may have had a basis in artistic taste and cultural position rather than private animosity. The *cittadini originarii* who dominated the Venetian Scuole Grandi typically emulated their

aristocracy in artistic matters, and it seems likely that Tintoretto's assertively independent style, with its popularizing emphasis on the original communal ideals of the confraternity, was not to the taste of certain of the more socially ambitious members. In addition to the total of two painted ceilings and twenty-eight wall paintings executed for the meeting-house, Tintoretto also painted the altarpiece of the *Vision of St Roch* (1588; *in situ*) and a painting for the Scuola staircase landing showing the *Visitation* (1588).

(ii) Other works. A new degree of stylistic and technical variability is evident in Tintoretto's later work. In *laterali* for Venetian parish churches (e.g. six histories of *St Catherine*, 1582–5, Venice, Patriarcato, on deposit; *Christ Washing the Feet of the Disciples*, 1588–90, Venice, S Moisè), Tintoretto utilized a broken chiaroscuro, disjointed spatial arrangements, a limited, sombre palette and a rough surface finish. At the Doge's Palace, he developed a richly coloured decorative modification of this style, using heavy forms set in a forward plane to control spatial recession and emphasize the highly polished picture surfaces. In four political allegories depicting the *Three Graces and Mercury, Bacchus, Ariadne and Venus, Minerva Rejecting Mars* and the *Forge of Vulcan* (1577–8; Sala dell'Anticollegio), which were originally painted for the Atrio Quadrato, relief-like forms generate complex decorative patterns that are read at the picture surface. Similarly conservative stylistic modulations were exacted in the sequence of votive and ceiling paintings subsequently executed in the important State rooms of the Doge's Palace (1577, Sala delle Quattro Porte; 1579–*c.* 1582, Sala del Maggiore Consiglio; *c.* 1581–2, Sala del Collegio; *c.* 1582, Sala del Senato). The large-scale votive pictures emulate the static prototypes of Giovanni Bellini and Titian. *Doge Andrea Gritti before the Virgin and Saints* in the Sala del Collegio is broadly dependent on Titian's painting of the same subject (1531; destr. 1574). Analogous restrictions on expressive movement, volume and depth are evident in the large ceiling canvases showing *Jupiter Proclaiming Venice Queen of the Adriatic* (Sala delle Quattro Porte), the *Triumph of Doge Nicolò da Ponte* (Sala del Maggiore Consiglio) and the *Triumph of Venice as Queen of the Sea* (Sala del Senato). The lucid colour, compositional symmetries and an elegance reminiscent of Veronese in the figure types stand in sharp contrast to the energy, obscurity and instability that characterize the main ceiling paintings in the Sala Superiore at S Rocco.

Similar variations are evident in his altarpiece commissions. The *Temptation of St Anthony* (1577; Venice, S Trovaso), painted for Antonio Milledonne, Secretary to the Senate, utilizes the 'patrician' modulation of Tintoretto's style and is very close in its formal arrangement to the *Origin of the Milky Way* (*c.* 1577–8; London, N.G.), painted for Rudolf II, Holy Roman Emperor (*reg* 1576–1612). The complex but studied contrapposto poses of the figures in the former are clearly articulated within a confined forward plane. In contrast, the *Baptism* (*c.* 1580; Venice, S Silvestro), commissioned by the Scuola dell'Arte dei Peateri (trade guild of the bargemen), is a radically abbreviated composition, all detail and colour in the landscape being dissolved in an explosion of heavenly

light. The chiaroscuro achieves an equivalent simplification in the figures of the two protagonists, broad masses of light and shade reducing their forms to expressive silhouettes.

When Tintoretto adopted a similarly abridged style in an altarpiece for the patrician Bonomo family at S Francesco della Vigna, Venice, his work was substituted for one by the conservative painter Francesco Santacroce (1516–84). Tintoretto's rejected painting, probably identifiable with the *Martyrdom of St Lawrence* (1569–76; priv. col.), utilizes roughly sketched forms dissolved by an arbitrary and broken chiaroscuro, within an amorphous, irrational space. Late works such as the *Flagellation* (1585–90; Vienna, Ksthist. Mus.), the *Crowning with Thorns* (1585–90; London, priv. col., see Pallucchini and Rossi, p. 599) and *St Michael and Satan* (1585–90; Dresden, Gemäldegal. Alte Meister) are in a similar style, although their original patrons and locations are not known.

The variety of Tintoretto's late style is indicative of his relatively unimpeded movement among different classes of patrons, institutions and picture types in a desire to fulfil the maximum number of commissions. His avoidance of exclusive relationships with patrons is apparent in the lack of priority accorded to socially exalted clients. Around 1580, for example, Tintoretto himself painted the altarpiece for the Scuola dell'Arte dei Peateri but left the series of battle paintings for Guglielmo Gonzaga, 3rd Duke of Mantua, to his workshop. Titian and Veronese rarely ignored the privileges of rank in such a manner. One possible reason for Tintoretto's independent policy might lie in his continuing distance from the more fashionable sectors of the aristocratic cultural establishment in Venice and abroad. Tintoretto's expected State stipend (*sansaria*), granted in 1574, was apparently never paid, and despite his extensive employment in an official capacity during his late period, he failed to achieve a dominance comparable to Titian's in this area. Veronese was generally more successful with aristocratic patrons and won the competition (1579–82) to paint the huge *Paradise* in the Sala del Maggior Consiglio of the Doge's Palace. Documents reveal that Tintoretto worked under very restrictive conditions for the Gonzaga and, although he produced two paintings for Philip II, King of Spain (*reg* 1556–98) the *Nativity* (1583; Madrid, Escorial); and the '*Judgement*' (1587; untraced), it was Veronese who was invited to take up a lucrative position at the Spanish court in 1585.

While both Titian and Veronese extended their private portrait clientele beyond the confines of Venetian territory, the vast majority of Tintoretto's later portraits were commissioned by local sitters to hang in public buildings. When he visited Venice, Sir Philip Sidney chose to have his portrait painted by Veronese. In his later portraits of elderly Venetian officials, Tintoretto managed to turn the constraints of their public function to artistic advantage. In those of unknown sitters in the Prado, Madrid (*c.* 1580), and the National Gallery of Ireland, Dublin (1575–80), and those of *Vincenzo Morosini* (1511–88) painted *c.* 1580 (London, N.G.; see fig. 6) and the *Procurator Alessandro Gritti* (1578–82; Barcelona, Mus. B.A. Cataluña), Tintoretto suggested a tension between personal frailty and public power, his uncompromising attention to the lined

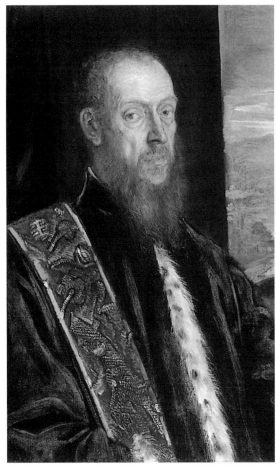

6. Jacopo Tintoretto: *Vincenzo Morosini*, oil on canvas, 845×515 mm, *c.* 1580 (London, National Gallery)

and pasty flesh of his sitters contrasting with the rich brocades and ermines denoting their high office.

Tintoretto's career ended on a note of triumph. After Veronese's death in 1588, he finally gained the coveted commission for the painting of the *Paradise* (1588–90), which Veronese had not begun, in the Doge's Palace and between 1591 and 1594, he was commissioned to produce a series of important paintings for Palladio's S Giorgio Maggiore (the *Deposition*, the *Last Supper* and the *Gathering of the Manna*; *see* VENICE, §IV, 1(ii)). The *Last Supper* (1591–2; see colour pl. 2, XXXIV1), in the choir, brings to a climax the series of works Tintoretto had painted of the subject combining elements from the version at S Polo, S Rocco and S Margherita. Traditionally, depictions of the Last Supper were made for monastic refectories, where the non-liturgical context mitigated against explicit sacramental meanings. In the chapel setting, however, these could come to the fore. In Tintoretto's earlier Last Suppers (S Trovaso, S Felice) the traditional moment of the Annunciation of the Betrayal was maintained as the central focus, but in subsequent versions (S Polo, S Rocco, S Margherita), this was replaced by the Institution of the Eucharist. At S Giorgio the swirling angels and flickering, supernatural light stress the ritual moment. As in earlier

versions, the table is positioned in accordance with the oblique viewpoint of the congregation. However, its recession parallel to the altar wall now serves to enhance the painting's liturgical meaning. The table appears as an extension of the High Altar itself, while Christ and the Apostles become prototypes for the priest and the communicants. Tintoretto's final *Last Supper* is, then, not wholly representative of his earlier, popularizing versions painted for the lay Scuole del Sacramento. The shifts in emphasis, however, suggest his ability (remarked by early sources, such as Boschini) to modulate the style and content of his paintings according to their specific contexts.

II. Working methods and technique.

Ridolfi reported Tintoretto's practice of arranging 'little models of wax and clay' in artificially illuminated 'little houses', sometimes suspending them from strings, in order to generate compositional ideas. The use of such models was by no means peculiar to Tintoretto, but when seen in relation to the marked lack of surviving compositional drawings attributable to him, it seems likely that the technique was a particularly important one. Such compositional drawings as are known probably followed, rather than preceded, the use of stages and figurines, given their closeness to the finished paintings, as in the drawing (Berlin, Kupferstichkab.) related to *Venus, Vulcan and Mars* (1550–1; Munich, Alte Pin.). In most cases, however, Tintoretto probably bypassed this stage altogether.

The majority of the *c.* 130 sheets of drawings attributable to Tintoretto show single figures in dynamic poses, presumably made at an intermediate point, after the arrangement of the composition but before the painting stage. Most of these figure studies were produced with a specific painting in mind, the poses being repeated fairly closely in the finished work (e.g. *Two Clothed Male Figures*, Florence, Uffizi; *Clothed Male Figure*, Windsor Castle, Berks, Royal Lib.; *Seated Male Figure*, U. London, Courtauld Inst. Gals, all in relation to the *Crucifixion*, *c.* 1555; Venice, Accad.). It would be easy to exaggerate the importance of drawings such as these in Tintoretto's artistic process. The complex poses were probably dependent on the given narrative invention and for each crowded composition only a few subsidiary figures were drawn. Their peripheral or transitional function is suggested again by their increasingly radical formal abbreviations (e.g. compare *Walking Male Nude*, Florence, Uffizi, with *Male Nude*, Vienna, Albertina).

As with compositional drawings, the number of known *bozzetti* by Tintoretto is small. He seems only to have produced oil sketches on demand. The three sketches (*c.* 1564–7, Madrid, Mus. Thyssen-Bornemisza; *c.* 1579–82, Paris, Louvre; *c.* 1588–9, copy, Madrid, Prado) for the *Paradise* in the Doge's Palace resulted from the series of competitions organized by the Venetian State. Recent technical examination of Tintoretto's paintings has confirmed his abridgement of the process of production. The *Last Judgement* (*c.* 1560–3; Venice, Madonna dell'Orto) and *Christ Washing the Feet of the Disciples* (*c.* 1563–5; London, N.G.) were constructed using complex, uneven paint layers, the random irregularity of the paint structure

suggesting that compositional arrangement was simultaneous with the act of painting. In this process the brushstroke itself took on an integral, form-creating significance rather than passively recording prior artistic decisions. However, Tintoretto's use of this abbreviated technique was by no means constant. The *ad hoc* treatment of the *Last Judgement* wholly contrasts with the orderly paint structure and high finish in the *Presentation of the Virgin* (1552–3; Venice, Madonna dell'Orto), in which gold leaf on the risers of the steps reasserts a connection with traditional methods of picture making.

Picture type and patron seem to have played an important role in creating this discontinuity. Many of Tintoretto's upright, round-topped altarpieces have a more traditional technical construction, employing relatively tight handling and high finish (e.g. *St George and the Dragon, c.* 1555–60; London, N.G.), while within the new horizontal format, the technique employed is more experimental. Paintings for aristocratic clients are typically highly finished (e.g. the *Origin of the Milky Way, c.* 1577–8; London, N.G.), while those for more humble patrons are looser in execution. Expensive ultramarine pigment is extensively used in paintings for aristocratic patrons, while in the cut-price works for S Rocco this prestigious pigment is much less in evidence.

Tintoretto apparently used such technical adaptability to gain coveted commissions. In June 1564 he conceived, executed and installed the ceiling painting depicting *St Roch in Glory* (Venice, Scuola di S Rocco) in under three weeks. In defence of accusations of subverting the proposed competition, Tintoretto pleaded that 'this was his way of designing and he knew no other, and that designs and models ought to be done thus in order to avoid deception' (Vasari). In 1571 the Venetian Senate commissioned Titian to produce a picture commemorating the Battle of Lepanto (1571) for the Doge's Palace. His characteristic delay allowed Tintoretto a chance to submit a petition for the commission, proposing as his sole reward the expectation of the next available State stipend. In a second petition Tintoretto drew attention both to his forfeited fee (500 ducats) and to his completion of the work in just ten months. The contrast between Tintoretto's rapid and cheap production of the battle painting (destr. 1577) and the expensive delays in Titian's completion of his *Battle of Spoleto* (1537; destr. 1577) cannot have been lost on the Senate.

Tintoretto's low pricing was evidently made viable by his rapidity of execution, and he employed many assistants to achieve his prolific output. However, while Titian's pupils were closely dependent on their master, reproducing successful autograph works or working closely from his designs, the personal control exercised by Tintoretto in his workshop was much less strict. The structure and organization seems to have been unusually fluid and devolved, the resultant autonomy facilitating the rapid production and vast output. Tintoretto's assistants were encouraged to produce independent remodellings and enlargements, albeit within the master's idiom. Although workshop replicas do exist, enlarged variants are more common (e.g. *St John the Baptist, c.* 1554–6; St Petersburg, Hermitage, based on the original painting in S Zaccaria, Venice). Few complete autograph designs for paintings

undertaken by the workshop are known, and those that do survive differ so markedly from the final works that they cannot be considered as working models (e.g. *Alvise Mocenigo Adoring the Redeemer*, preparatory study, *c.* 1571–4, New York, Met.; painting, *c.* 1581–2, Venice, Doge's Pal., Sala del Collegio). After 1580 relatively few paintings can be attributed to Tintoretto alone.

Foremost among Tintoretto's assistants were his children, Domenico, Marco and Marietta. He also employed an amorphous group of local painters, including Giovanni Galizzi, Antonio Vassilacchi, Lionardo Corona and Andrea Michieli, and Netherlandish artists, including Marten de Vos (1532–1603), Pauwels Francke (1538–1615) and Lodewyk Toeput (*c.* 1550–1605). The Netherlandish painters seem to have developed Tintoretto's penchant for naturalistic detail, landscape and still-life. His Italian followers, on the other hand, executed large, heavily populated compositions using a pictorial language based on Tintoretto's but typically incorporating elements derived from the work of other leading masters in Venice, such as Veronese, Jacopo Bassano and Palma Giovane. Tintoretto's reliance on his workshop reflected the traditional craftsmanlike assumption of the lack of distinction between the products of master and workshop.

Tintoretto's style lent itself to rapid replication and expansion, given its economy of form. A single drawing could supply formal ideas for more than one painting (e.g. *Male Nude with a Staff*, Rotterdam, Mus. Boymans–van Beuningen, in relation to both the *Martyrdom of St Lawrence*, 1585–90, Oxford, Christ Church Pict. Gal.; and the *Rape of Helen, c.* 1588–9, Madrid, Prado). The figure in *St Jerome* (*c.* 1574–5; Vienna, Ksthist. Mus.) reverses that of one of those in the *Philosophers* (1570–71) in the Libreria Marciana (*see* VENICE, §IV, 5(ii)), itself a variant on another painting.

It is often assumed that Tintoretto was fundamentally opposed to the mass production of paintings. However, the evidence suggests that, on the contrary, he specifically organized his artistic practice to increase his potential output. Nevertheless, his appetite for work was less a matter of eccentricity than is often assumed. Owing to his lack of ready support from powerful groups within the aristocracies in Venice and abroad, the artist seems to have adopted policies of low pricing, rapid production and increased output, which eventually secured him artistic dominance.

III. Character and personality.

Tintoretto's private life conformed in many ways to the type of the respectable Venetian citizen. He was a stable, family man running a successful local business. In marrying the daughter of a leading figure in the Scuola Grande di S Marco, Tintoretto gained entry to the pious, civic-minded and essentially conservative world of the non-noble confraternities. He became an active member of the Scuola di S Rocco himself, and the majority of his religious paintings were commissioned by Venetian confraternities. His special relationship with the Scuole del Sacramento, however, suggests that he shared their more progressive commitment to Catholic reform.

Tintoretto was also recorded as a member of two literary academies (the Accademia Pellegrina in 1551 and the Accademia Veneziana Seconda in 1593–4), indicating an active participation in the intellectual life of the city. Both of these organizations were, like the Scuole, dominated by non-nobles, and most of Tintoretto's known friends also came from this social rank. Ridolfi (1642) mentioned Vincenzo Riccio (*d* 1567), Paolo Ramusio (1532–1600) and Bartolomeo Malombra who, despite their exclusion from the patrician Libro d'Oro (Golden Book), won considerable fame in middle-class humanist literary circles. Tintoretto was also friendly with the Florentine polymath Antonio Francesco Doni (1513–74) and the playwright Andrea Calmo (1510–70). These men developed a spontaneous literary style, analogous to Tintoretto's painting technique. The work of both men was aimed at a wider public than was the case with writers enjoying patrician or aristocratic patronage. An indication of Tintoretto's attitude to aristocratic pretensions was given in an anecdote reporting that his ambitious wife insisted on his dressing in patrician regalia. In order to tease her, the painter deliberately dragged his toga in the muddy street (Ridolfi, 1642; Mariette).

Like Doni, Tintoretto experienced a difficult relationship with the influential circle of artists, writers and connoisseurs who gathered around the older and more established figures of Pietro Aretino and Titian. The latter's opposition to Tintoretto is constantly reiterated in Ridolfi's account, and Aretino's relations with the painter seem to have markedly deteriorated after 1548. Vasari praised Tintoretto's artistic and social accomplishments, stating that 'he has delighted in all the arts, and particularly in playing musical instruments, besides being agreeable in his every action', but he attacked his individualism in art, complaining that he worked 'in a fashion of his own and contrary to the use of other painters'.

IV. Critical reception and posthumous reputation.

Tintoretto's reputation has always been controversial. While opposition from patrons was probably generated by his unusual painting style, that among his fellow artists was a result of his professional conduct. Criticisms of Tintoretto in the contemporary literature derive from these controversies. Pietro Aretino commended Tintoretto's realism in two letters to the painter (1545, 1548), but his interest did not disturb his fundamental commitment to Titian. The second letter ends on a negative note, advising the painter to control his undue 'haste to have done'. The suggestion that Tintoretto's *prestezza* was the product of carelessness was repeated by Aretino's friends and followers. Francesco Sansovino criticized (1556, 1561) the lack of finish in Tintoretto's *Pope Alexander III Excommunicating Barbarossa* as 'the result of his great speed', while Lodovico Dolce criticized (1557) a number of Tintoretto's works, his supposed follies acting as a foil to offset the splendours of Titian's genius.

Vasari clearly drew on the critical consensus of the circle of Aretino in Venice in his account of Tintoretto, which was destined to become the cornerstone of the academic–classical censure in the following centuries. Vasari criticized Tintoretto as 'swift, resolute, fantastic and extravagant', asserting that he worked 'haphazardly, without *disegno*, as if to prove that art is but a jest'. Vasari's negative reaction to Tintoretto's lack of finish contrasted with his positive assessment of Titian's late style. While Titian's loose brushwork could be understood in terms of a progressive courtly aesthetic, and its apparent randomness interpreted as a product of sophisticated dissimulation (*sprezzatura*), Tintoretto's spoke only of an undignified desire to save time and effort. Like Vasari, Federico Zuccaro was particularly concerned to raise the social status of artists. He also shared Vasari's identification of Tintoretto as a potential enemy to this process. Reflecting his concern to preserve the social exclusivity of art, Zuccaro mocked Tintoretto's depiction of the saints in the depiction of *Paradise*, stating that they 'appear like common people in the market place'.

Other contemporaries, however, evaluated Tintoretto's work more positively. For Andrea Calmo and Cristoforo Sorte his *prestezza* was taken as being indicative of special artistic competence, distinguishing artistic creation from the mechanical act of painting. The celebrations offered by the Venetians Carlo Ridolfi (1642, 1648) and Marco Boschini (1660, 1664, 1674) were more selfconsciously polemical, being adopted in reaction to the strictures of Central Italian theorists. Ridolfi's *Vita* became (and remains) the single most important historical source for Tintoretto, while Boschini was the first to offer a coherent aesthetic challenge to the classical–academic criticisms. However, Boschini ultimately remained dependent on the image of the painter developed by his arch-enemy Vasari, merely reversing the latter's negative judgements of Tintoretto's artistic unconventionality. In the process, Boschini further exaggerated the academic projection of Tintoretto as an eccentric and instinctual individualist, describing his artistic personality in terms of 'a flash of lightning, a thunderbolt or an arrow'.

Outside Venice, the negative or lukewarm comments of a succession of writers, including Joachim von Sandrart (1606–88) and André Félibien (1619–95), indicated Tintoretto's low standing within the academic theoretical framework that considered Central Italian *disegno* superior to Venetian *colorito*. Even Roger de Piles (1635–1709), whose commitment to painterly Rubénisme in art might have generated a sympathetic response, had mixed feelings, suggesting that 'from the inequality of his mind came the inequality of his works'.

During the Enlightenment the notion that Tintoretto lacked intellectual and artistic control became a commonplace. Even the Venetian Anton Maria Zanetti the younger did little more than elucidate the theme (1771), suggesting that Tintoretto's 'furious enthusiasm' had caused him to go beyond the limits of truth and reality. Critics such as Joshua Reynolds (1723–92) resurrected Vasari's careful distinction between Tintoretto and Titian.

In the earlier part of the 19th century Tintoretto was rehabilitated by writers with new aesthetic interests and sensibilities. For Ruskin (1819–1900) (1846, 1853), Tintoretto epitomized 'Imagination Penetrative', the highest formative principle by which the greatest artists transform outward circumstance. Those in possession of this faculty do not 'stop at outward images of any kind' and thus Ruskin celebrated the non-naturalistic aspects of Tinto-

retto's art. Ruskin's stress on the moral and spiritual content of Tintoretto's work—on his imaginative transformation of the real—allowed him to affirm the painter as a 'purist' illustrator of the central Christian texts, akin to the Gothic artists he idolized. Tintoretto's imagined commitment to spiritual values in the context of the secular, materialist world of late Renaissance Venice could thus stand as a romantic paradox bearing analogies to the experience of Ruskin and other intellectuals and artists in Victorian England.

Ruskin's theoretical division between the spiritual–moral and the material–aesthetic presupposed an analogous division between the artist and his society. This dual division proved essential to the many subsequent writers who rediscovered Tintoretto within the Ruskinian framework. John Addington Symonds likened Tintoretto to a poet for whom 'the intellectual life is paramount, and the body subordinate'. Even the positivist Hippolyte Taine reverted to the language of romantic hyperbole in his description of Tintoretto's 'habits' as 'those of all savage, violent geniuses out of harmony with the world'.

In the 20th century the romantic projection of Tintoretto's artistic personality has proved hard to dislodge. While in England the Ruskinian tradition was extended by Newton, German criticism emphasized aspects of Tintoretto's painting style, such as light (Thode) and colour (von der Bercken) as the agents through which his art exacted a 'spiritualization of reality' (Thode). Other writers, however, were more concerned to establish a precise position for Tintoretto in the history of art, stressing his debt to Central Italian Mannerism (Dvořák). Nevertheless, this switch of critical attention from content to form did not prove incompatible with earlier, essentially non-historical models of the artist, and in some cases led to an intellectually myopic concern to locate Tintoretto's work within an abstracted stylistic network (Freedberg).

Marxist analyses of Tintoretto have attempted to explain the artist in terms of class conflict and social alienation (Vipper; Hauser, 1952, 1965), projecting him as 'the rejected champion of a bourgeoisie attacking the patrician aesthetics of fixity and being' (Sartre, 1964, 1966). This position—still dependent in certain ways on Ruskin's romantic outsider—contrasts strongly with the findings of a number of late 20th-century historians who, through concentrating on specific aspects of Tintoretto's activity, emphasized his cultural centrality in the context of 16th-century Venice (de Tolnay, 1960; Levey; Rosand; Hills). It is possible, though, to argue for a reconciliation of these contrasting views, allowing Tintoretto to have played a central role within Venetian culture, while emphasizing his primary connection with those non-noble sections of society that in the later 16th century remained more faithful to the traditional, communal ideals of the Republic than their patricians. The opposition that Tintoretto faced in an age dominated by the aristocracy can thus be understood as a response to the non-exclusive social values permeating his artistic practice.

BIBLIOGRAPHY

EWA; Mariette

EARLY SOURCES

P. Aretino: *Lettere sull'arte* (Venice, 1545–9); ed. E. Camesasca, intro. F. Pertile, ii (Milan, 1957)

A. Calmo: *Il rimanente de le piacevole et ingeniose littere* (Venice, 1548); ed. V. Rossi (Turin, 1888)

G. Vasari: *Vite* (1550, rev. 2/1568); ed. G. Milanesi (1878–85), vi, pp. 587–94

A. F. Doni: *Tre libri di lettere* (Venice, 1552)

F. Sansovino: *Tutte le cose notabili e belle che sono in Venetia* (Venice, 1556, rev. 3/1663)

L. Dolce: *Dialogo della pittura . . . intitolato l'Aretino* (Venice, 1557); Eng. trans. by M. W. Roskill in *Dolce's 'Aretino' and Venetian Art Theory of the Cinquecento* (New York, 1968)

C. Sorte: *Osservazioni nella pittura* (Venice, 1580)

R. Borghini: *Il riposo* (Florence, 1584); ed. M. Rosci (Milan, 1967)

F. Zuccaro: *Lettera a prencipi e signori amatori del disegno, pittura, scultura et architettura . . . con un lamento della pittura* (Mantua, 1605); ed. P. Barocchi in *Scritti d'arte del cinquecento*, II/iv (Milan and Naples, 1971)

C. Ridolfi: *Vita di Giacopo Robusti detto il Tintoretto* (Venice, 1642); Eng. trans. by C. Enggass and R. Enggass (University Park, PA, 1984)

——: *Maraviglie* (1648); ed. D. von Hadeln (1914–24)

M. Boschini: *La carta del navegar pitoresco* (Venice, 1660); ed. A. Pallucchini (Rome and Venice, 1966)

——: *Le minere della pittura* (Venice, 1664)

——: *Le ricche minere della pittura veneziana* (Venice, 1674)

J. von Sandrart: *Teutsche Academie* (1675–9); ed. A. R. Peltzer (1925)

A. Félibien: *Entretiens*, iii (Paris, 1679)

R. de Piles: *Abrégé de la vie des peintres* (Paris, 1699)

J. Reynolds: *Discourses on Art* (London, 1771); ed. R. R. Wark (San Marino, 1959/*R* New Haven and London, 1975)

A. M. Zanetti: *Della pittura veneziana e delle opere pubbliche de' veneziani maestri* (Venice, 1771, rev. 1792)

GENERAL

J. Ruskin: *Modern Painters*, ii (London, 1846); ed. E. T. Cook and A. Wedderburn (London, 1903)

——: *The Stones of Venice*, ii (London, 1853); ed. E. T. Cook and A. Wedderburn (London, 1903)

H. Taine: *Voyage en Italie*, 2 vols (Paris, 1866); Eng. trans. by J. Durand (New York, 1869)

J. A. Symonds: *The Renaissance in Italy*, 7 vols (London, 1875–86)

M. Dvořák: 'Über Greco und den Manierismus', *Jb. Kstgesch.*, i (1921–2), pp. 22–42; Eng. trans. by J. Coolidge as 'El Greco and Mannerism', *Mag. A.*, xxxiv (1953), pp. 14–23

L. Coletti: 'La crisi manieristica nella pittura veneziana', *Convivium*, xiii (1941), pp. 109–26

H. Tietze and E. Tietze-Conrat: *The Drawings of the Venetian Painters in the Fifteenth and Sixteenth Centuries*, 2 vols (New York, 1944)

A. Hauser: *The Social History of Art*, ii (London, 1952)

——: *Mannerism: The Crisis of the Renaissance and the Origin of Modern Art* (London, 1965)

S. J. Freedberg: *Painting in Italy, 1500–1600*, Pelican Hist. A. (Harmondsworth, 1971)

S. Sinding-Larsen: *Christ in the Council Hall: Studies in the Religious Iconography of the Venetian Republic* (Rome, 1974)

D. Rosand: *Painting in Cinquecento Venice: Titian, Veronese, Tintoretto* (New Haven and London, 1982, rev. 1997))

MONOGRAPHS

H. Thode: *Tintoretto* (Bielefeld and Leipzig, 1901)

D. von Hadeln: *Zeichnungen des Giacomo Tintoretto* (Berlin, 1922)

L. Coletti: *Il Tintoretto* (Bergamo, 1940/*R* 1951)

E. von der Bercken: *Die Gemälde des Jacopo Tintoretto* (Munich, 1942)

H. Tietze: *Tintoretto: The Paintings and Drawings* (London, 1948)

B. R. Vipper: *Tintoretto* (Moscow, 1948); Italian trans., abridged, as 'Tintoretto e il suo tempo' in *Rass. Sov.* (1951), viii, pp. 50–57; ix, pp. 63–73; x, pp. 52–77; xi, pp. 53–60

R. Pallucchini: *La giovinezza del Tintoretto* (Milan, 1950)

E. Newton: *Tintoretto* (London, 1952)

C. Bernari and P. de Vecchi: *L'opera completa del Tintoretto* (Milan, 1970)

P. Rossi: *Jacopo Tintoretto: I ritratti* (Venice, 1974)

——: *I disegni di Jacopo Tintoretto* (Florence, 1975)

R. Pallucchini and P. Rossi: *Tintoretto: Le opere sacre e profane*, 2 vols (Venice, 1982)

K. M. Swoboda: *Tintoretto: Ikonographische und stilistische Untersuchungen* (Munich and Vienna, 1982)

A. L. Lepschy: *Tintoretto Observed: A Documentary Survey of Critical Reactions from the 16th to the 20th Century* (Ravenna, 1983) [with extensive bibliog.]

R. Krischel: *Tintoretto* (Hamburg, 1994)

T. Nichols: *Jacopo Tintoretto: Tradition and Identity* (London, 1999)

SPECIALIST STUDIES

The Scuola di S Rocco

R. Berliner: 'Forschungen über die Tätigkeit Tintorettos in der Scuola Grande di San Rocco', *Kstchron. & Kstmarkt*, xxxi (1920), pp. 468–97

C. De Tolnay: 'L'interpretazione dei cicli pittorici di San Rocco', *Crit. A.*, vii (1960), pp. 341–76

E. Huttinger: *Die Bilderzyklen Tintorettos in der Scuola di S. Rocco zu Venedig* (Zurich, 1962)

K. M. Swoboda: 'Die grosse Kreuzigung Tintorettos im Albergo der Scuola di San Rocco', *A. Ven.*, xxv (1971), pp. 145–52

J. Grabski: 'The Group of Paintings by Tintoretto in the "Sala Terrena" in the Scuola di San Rocco in Venice and their Relationship to the Architectural Structure', *Artibus & Hist.*, i (1980), pp. 115–31

F. Valcanover: *Jacopo Tintoretto and the Scuola Grande di San Rocco* (Venice, 1983)

G. Romanelli, A. Gallo and A. Manno: *Tintoretto: La Scuola di San Rocco* (Milan, 1994)

M. E. Massimi: 'Jacopo Tintoretto e i confratelli della Scuola Grande di San Rocco: Strategie culturali e committenza artistica', *Venezia Cinquecento*, v/9 (1995), pp. 5–169

Others

D. F. von Hadeln: 'Beiträge zur Tintorettoforschung', *Jb. Kön.-Preuss. Kstsamml.*, xxxii (1911), pp. 1–58

J. Wilde: 'Die Mostra del Tintoretto zu Venedig', *Z. Kstgesch.*, vii (1937), pp. 140–53

D. R. Coffin: 'Tintoretto and the Medici Tombs', *A. Bull.*, xxxiii (1951), pp. 119–25

J.-P. Sartre: 'Le Séquestré de Venise', *Temps mod.*, no. 141 (1957), pp. 762–800; Eng. trans. by W. Baskin in *Essays in Aesthetics* (London, 1964)

C. Gilbert: 'Tintoretto and Michelangelo's St. Damian', *Burl. Mag.*, ciii (1961), pp. 16–20

M. Muraro: 'Affreschi di Jacopo Tintoretto a Ca' Soranzo', *Scritti di storia dell'arte in onore di Mario Salmi*, iii (Rome, 1963), pp. 103–16

M. Levey: 'Tintoretto and the Theme of Miraculous Intervention', *J. Royal Soc. A.*, cxiii (1965), pp. 707–25

J.-P. Sartre: 'Saint-Georges et le dragon', *L'Art*, xxx (1966), pp. 33–52

P. Eikemeier: 'Der Gonzaga-Zyklus des Tintoretto in der alten Pinakothek', *Münchn. Jb. Bild. Kst* (1969), pp. 75–137

C. De Tolnay: 'Il Paradiso del Tintoretto: Note sull'interpretazione della tela in Palazzo Ducale', *A. Ven.*, xxiv (1970), pp. 103–10

C. Gould: 'The Cinquecento at Venice, III: Tintoretto and Space', *Apollo*, xcvi (1972), pp. 32–7

K. M. Swoboda: 'Die Apostelkommunion in den Bildern Tintorettos', *Jb. Österreich. Byz.*, xxi (1972), pp. 251–68

N. Penny: 'John Ruskin and Tintoretto', *Apollo*, cxlvi (1974), pp. 268–73

J. Plesters and L. Lazzarini: 'The Examination of the Tintorettos', *The Church of Madonna dell'Orto*, ed. A. Clarke and P. Rylands (London, 1977), pp. 7–26

C. Gould: 'An X-ray of Tintoretto's "Milky Way"', *A. Ven.*, xxxii (1978), pp. 211–13

J. Plesters: 'Tintoretto's Paintings in the National Gallery', *N.G. Tech. Bull.*, iii (1979), pp. 3–24; iv (1980), pp. 32–48; viii (1984), pp. 24–34

S. Marinelli: 'La costruzione dello spazio nelle opere di Jacopo Tintoretto', *La prospettiva rinascimentale*, ed. M. Dolai (Florence, 1980), pp. 319–30

J. Schulz: 'Tintoretto and the First Competition for the Ducal Palace "Paradise"', *A. Ven.*, xxxiii (1980), pp. 112–26

P. Hills: 'Piety and Patronage in Cinquecento Venice: Tintoretto and the Scuole del Sacramento', *A. Hist.*, vi (1983), pp. 30–43

D. Knopfel: 'Sui dipinti di Tintoretto per il coro della Madonna dell'Orto', *A. Ven.*, xxxvii (1984), pp. 149–54

H. MacAndrew and others: 'Tintoretto's "Deposition of Christ" in the National Gallery of Scotland', *Burl. Mag.*, cxxvii (1985), pp. 501–17

F. Valcanover: 'Il restauro del Paradiso di Jacopo Tintoretto', *Venezia A.*, i (1987), pp. 96–9

The Cinquecento (exh. cat., ed. C. Whitfield; London, Walpole Gal., 1991), pp. 44–7

P. Hills: 'Tintoretto's Marketing', *Venedig und Oberdeutschland in der Renaissance*, ed. B. Roeck, K. Bergdoff and A. J. Martin (Venice, 1993), pp. 107–20

R. M. Hagen and R. Hagen: 'Der dritte Voyeur sass vor der Leinwand', *Art* [Hamburg], 4 (1994), pp. 76–81

R. Krischel: *Tintoretto und die Skulptur der Renaissance in Venedig* (Weimar, 1994)

T. Nichols: 'Tintoretto's Poverty', *New Interpretations of Venetian Renaissance Painting*, ed. F. Ames-Lewis and A. Bednarek (London, 1994)

Jacopo Tintoretto e i suoi incisori (exh. cat., ed. M. A. Chiari Moretto Weil; Venice, Doge's Pal., 1994)

Jacopo Tintoretto: Ritratti (exh. cat. by P. Rossi and others, Venice, Accad., 1994)

Uffizi: Le due LEDE del Tintoretto restaurate (exh. cat., Florence, Uffizi, 1994)

Jacopo Tintoretto (1519–94): Il grande collezionismo mediceo (exh. cat. by M. Chiarini, S. Marinelli and A. Tartuferi, Florence, Pitti, 1994–5)

R. Echols: 'Giovanni Galizzi and the Problem of the Young Tintoretto', *Artibus & Hist.*, xvi/31 (1995), pp. 69–110

R. Krischel: 'Reiseerfahrungen des Jacopo Tintoretto: Trips to Padua and Mantua in Search of Inspiration and Painting Commissions', *Wallraf-Richartz Jb.*, lvii (1996), pp. 133–59

G. Marini: 'Tintoretto and Printmaking: Print Reproductions of the Artist's Work', *Prt Q.*, xiii (1996), pp. 187–9

T. Nichols: 'Tintoretto, *prestezza del fatto*, and the *poligrafi*: A Study in Literary and Visual Culture of Cinquecento Venice', *Ren. Stud.*, x/1 (1996), pp. 72–100

——: 'Price, Prestezza and Production in Jacopo Tintoretto's Business Strategy', *Venezia Cinquecento*, vi/12 (1996), pp. 207–33

L. Puppi and P. Rossi, eds: *Jacopo Tintoretto nel quarto centario della morte* (Venice, 1996)

TOM NICHOLS

(2) Marietta Tintoretto (*b* Venice, *c.* 1554; *d* Venice, *c.* 1590). Daughter of (1) Jacopo Tintoretto. She was taught by her father and assisted him in his workshop. It is said that while young, he had her dress like a boy and follow him everywhere. As his favourite daughter, Jacopo also had her married to a local jeweller to keep her near him. Marietta does not appear to have received commissions for major religious paintings, and, like other women artists in this period, she worked primarily as a portrait painter. Apart from a *Self-portrait* (Florence, Uffizi), no work can be assigned to her with certainty. The three portraits attributed to her in Madrid (Prado) include a possible self-portrait. The only surviving painting that may be signed by her is a *Portrait of Two Men* (Dresden, Gemäldegal. Alte Meister), which bears the initials MR. Ridolfi wrote that her portrait of the antiquarian and collector Jacopo Strada attracted the attention of Emperor Maximilian II (*reg* 1564–76), who enquired about her employment as court painter. However, this may be a mistaken reference to her father's portrait of Strada's son *Ottavio Strada* (Amsterdam, Stedel. Mus.). Philip II of Spain (*reg* 1556–98) apparently showed a similar interest in Marietta's work. A few small religious paintings are attributed to her, including two pictures of the *Virgin and Child* (both Cleveland, OH, Mus. A.), and her work as an assistant is thought to be evident in certain of her father's paintings (e.g. *St Agnes Reviving Licinio*, *c.* 1578–9; Venice, Madonna dell'Orto). Two drawings after models (Milan, Rassini priv. col.) are also assigned to her and were probably executed while she was in her father's workshop.

BIBLIOGRAPHY

C. Ridolfi: *Vita di Giacopo Robusti detto il Tintoretto* (Venice, 1642); Eng. trans. by C. Enggass and R. Enggass (University Park, PA, 1984)

E. Conrat-Tietze: 'Marietta, fille du Tintoretto', *Gaz. B.-A.*, ii (1934), pp. 258–62

P. Rossi: *Jacopo Tintoretto: I ritratti* (Venice, 1974), pp. 138–9 [details of attributions to Marietta]

D. Bachmann and S. Piland: *Women Artists: An Historical, Contemporary, and Feminist Bibliography* (Metuchen, NJ, 1978), pp. 65–6

E. H. Fine: *Women and Art* (Montclair, NJ, 1978), pp. 13–14

□

(3) Domenico Tintoretto (*b* Venice, 1560; *d* Venice, 1635). Son of (1) Jacopo Tintoretto. He was taught by his

father and assisted him in his workshop. At the age of 17 he was admitted to the Venetian painters' guild, and he is recorded in the confraternity of painters from 1594. He began his career by helping his father to execute the paintings in the Sala del Collegio and Sala del Senato in the Doge's Palace, Venice. Following this he worked independently at the palace, on the Sala dello Scrutinio and the Sala del Maggiore Consiglio. His training with his father helped him in his own compositions, several of which, such as the *Battle of Salvore*, or the *Second Conquest of Constantinople*, are heroic battle themes with complex groupings and dramatic poses. In the last two decades of the 16th century Domenico concentrated on religious commissions in Venice, including a *Last Supper* and *Crucifixion* (both *c.* 1583) for S Andrea della Zirada (both *in situ*), a *Marriage of the Virgin* for S Giorgio Maggiore (*in situ*) and a *Crucifixion* for the Scuola dei Mercanti. During this early period as an independently commissioned painter he continued to collaborate with his father on occasions, notably on the *Paradise* (1588–90) in the Sala del Maggiore Consiglio in the Doge's Palace.

Domenico was also an accomplished portrait painter (e.g. *Portrait of a Young Man*, 1585; Kassel, Schloss Wilhelmshöhe) and in 1591 the Scuola dei Mercanti in Venice ordered two large portrait groups from him (both Venice, Accad.). In 1592 he went to Ferrara to paint a portrait of Margaret of Austria, later Queen of Spain, and in 1595 he went from Venice to Mantua at the invitation of Vincenzo I Gonzaga, 4th Duke of Mantua, to execute a portrait commission. Some of his most impressive civic portraits were also painted in the last decade of the 16th century, such as that of *Doge Marino Grimani* (*c.* 1595; Cincinnati, OH, A. Mus.). Like many of his others, this is framed by landscapes and vegetation and reveals the influence of his father's assistants, Lodewyk Toeput (*c.* 1550–1605) and Pauwels Francke (1538–1615). In secular works of this period, such as *Venus, Adonis and the Three Graces* (1585–90; Chicago, IL, A. Inst.), Domenico translated his father's structures and compositions into his own individual language, allowing more room for landscape and background details. In these mythological scenes he displayed the same preoccupation with the topography of Veneto that is evident in his portraits of this period. Domenico's style is furthest from that of his father in his drawings, in which the quick, expressive lines that Jacopo used to suggest figures are replaced in Domenico's drawings with clearly rounded limbs and torsos in chiaroscuro. A good example is his *Recumbent Nude* (Ames priv. col.; see Sutton, p. 276) in which he experimented with light as a means of defining form.

At the end of Domenico's career, after the death of his father, there is a notable change in his style. The phosphorescent colours and intricate compositions that he had so aptly borrowed from Jacopo in earlier works gradually disappeared. Later paintings, such as the altarpiece of the *Virgin Interceding with Christ for the Cessation of the Plague* (1631; Venice, S Francesco della Vigna), lack the vitality of the religious panels of the 1580s. Nevertheless, they effectively communicated Counter-Reformation messages and coincided with the naturalism popular in Rome in the 17th century.

BIBLIOGRAPHY
C. Ridolfi: *Vita di Giacopo Robusti detto il Tintoretto* (Venice, 1642); Eng. trans. by C. Enggass and R. Enggass (University Park, PA, 1984)
W. Suida: 'Clarifications and Identifications of Works by Venetian Painters', *A. Q.* [Detroit], ix/4 (1946), pp. 282–99
D. Sutton: 'Sunlight and Movement: Splendours of Venetian Draughtsmanship', *Apollo*, c (1974), pp. 274–81
P. Rossi: 'Per la grafica di Domenico Tintoretto', *A. Ven.*, xxix (1975), pp. 205–11
R. Pallucchini: *La pittura veneziana del seicento* (Milan, 1981)
R. Pallucchini and P. Rossi: *Tintoretto: Le opere sacre e profane* (Milan, 1982)
P. Rossi: 'Per la grafica di Domenico Tintoretto, II', *A. Ven.*, xxxviii (1984), pp. 57–71

□

Tisi, Benvenuto. *See* GAROFALO.

Titian [Vecellio, Tiziano] (*b* Pieve di Cadore, *c.* ?1485–90; *d* Venice, 27 Aug 1576). Italian painter, draughtsman and printmaker. The most important artist of the VECELLIO family, he was immensely successful in his lifetime and since his death has always been considered the greatest painter of the Venetian school. He was equally pre-eminent in all the branches of painting practised in the 16th century: religious subjects, portraits, allegories and scenes from Classical mythology and history. His work illuminates more clearly than that of any other painter the fundamental transition from the 15th-century tradition (characterized by meticulous finish and the use of bright local colours) to that of the 16th century, when painters adopted a broader technique, with less defined outlines and with mutually related colours.

Titian was based in Venice throughout his professional life, but his many commissions for royal and noble patrons outside Venice and Italy, notably for Philip II of Spain (*reg* 1556–98), contributed considerably to the spread of his fame. His work was a vital formative influence on the major European painters of the 17th century, including Rubens (1577–1640) and Velázquez (1599–1660).

I. Life and painted work. II. Graphic arts. III. Working methods and technique. IV. Critical reception and posthumous reputation.

I. Life and painted work.

1. Training and early work, to 1515. 2. Early success, 1516–mid-1540s. 3. 'Late style', mid-1540s and after.

1. TRAINING AND EARLY WORK, TO 1515. The evidence for the year of Titian's birth is conflicting and has been much disputed. He was brought as a child to Venice, where, according to Dolce, he was first apprenticed to a painter and mosaicist, Sebastiano Zuccati (*d* 1527), and then successively to Gentile Bellini, Giovanni Bellini and finally was associated with Giorgione. A votive picture of *Jacopo Pesaro Presented to St Peter* (Antwerp, Kon. Mus. S. Kst) is probably the most primitive in style of the undocumented early works and therefore among the very earliest, although the presence in it of Pope Alexander VI does not suffice to date the picture before his death in 1503, as has been claimed. The earliest surviving paintings that are precisely datable are three frescoes of scenes from the *Life of St Anthony* (Padua, Scuola di S Antonio), documented as of 1511. As they are almost Titian's only surviving works in fresco, they are of limited value as touchstones of his early style as a painter of easel pictures. Vasari (1568) mentioned works dating from a little before

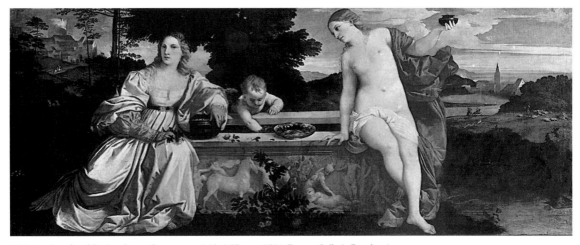

1. Titian: *Sacred and Profane Love*, oil on canvas, 1.18×2.79 m, *c.* 1514 (Rome, Galleria Borghese)

this, but one, a *Tobias*, is not certainly identifiable, and the other, the *Triumph of Christ*, is not a painting but a woodcut (*see* §II, 2 below). Also before 1511, Titian is stated by Vasari to have shared work with Giorgione on frescoes, now almost entirely destroyed (fragments Venice, Ca' d'Oro), on the exterior of the Venetian headquarters of the German merchants, the Fondaco dei Tedeschi, for which Giorgione was paid in 1508. Titian's altarpiece of *St Mark Enthroned with SS Cosmas, Damian, Roch and Sebastian* (Venice, S Maria della Salute) is roughly datable because it includes St Roch who was invoked against the plague, of which there had been an outbreak in 1510.

Probably Titian's earliest surviving masterpiece is the *Sacred and Profane Love* (see fig. 1), which includes the arms of both the Aurelio and Bagaretto families and can therefore be associated with a wedding between members of the families that took place in 1514. Although the precise meaning of the picture is uncertain, its extraordinary and original beauty is not in dispute. The gorgeously dressed girl on the left (presumably representing the bride) is contrasted with the nude on the right, presumably Venus, whose flesh is set off by the crimson cloak that flutters to the right of her. Further contrast is provided by the simulated marble relief between the figures and by the panoramic landscape with horsemen, sheep, picturesque buildings and different formations of cloud (of which Titian was a great master). Three other technically similar and therefore probably roughly contemporary paintings of major importance are the *Noli me tangere* (London, N.G.), the '*Three Ages of Man*' (*Daphnis and Chloe*; see fig. 2) and the *Baptism* (Rome, Mus. Capitolino). In all of these, as in the *Sacred and Profane Love*, the figures and the landscape are lyrically interrelated.

Despite the existence of these few landmarks, it is difficult to define Titian's early work, not only because so few pictures are datable, but also because the contemporary work of such painters as DOMENICO MANCINI, GIULIO CAMPI and GIOVANNI CARIANI is even less defined, and liable to be confused with his. Confusion with the work of GIORGIONE has been particularly controversial. Michiel noted that Titian finished or altered a painting of *Venus* by Giorgione, probably the picture now

at Dresden (Gemäldegal. Alte Meister). As Giorgione died unexpectedly in 1510, the *Venus* was presumably a late work, left unfinished. However, his share of it—the figure of Venus and the drapery on which she reclines—shows a sharper touch than the evident work of Titian in the landscape: while the *Portrait of a Man* (*see* GIORGIONE, fig. 2), probably of 1510, suggests that the two painters were already developing on different lines. The portrait is

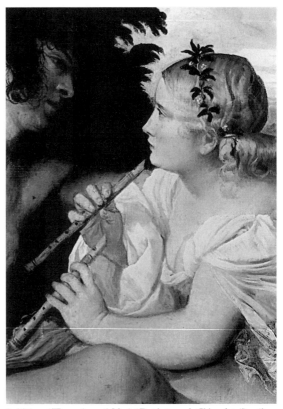

2. Titian: '*Three Ages of Man*' (*Daphnis and Chloe*, detail), oil on canvas, 0.90×1.51 m, *c.* 1514 (Duke of Sutherland: on loan to Edinburgh, National Gallery of Scotland)

delicate in touch and with thin pigment, while roughly contemporary works undoubtedly by Titian such as the *St Mark Enthroned* or the *Holy Family with a Shepherd* (London, N.G.) have vigorous brushwork and relatively thick impasto. There is an increasing tendency to attribute to the young Titian such pictures as *Christ and the Adulteress* (Glasgow, A.G. & Mus.), the *Concert* (Florence, Pitti) or the *Concert champêtre* (see colour pl. 2, XXXVI3), which were formerly regarded as borderline between him and Giorgione. In the one instance where the two worked together, at the Fondaco dei Tedeschi, 16th-century opinion judged Titian's contribution superior.

Giorgione's premature death and the departure in 1511 of his partner, Sebastiano del Piombo, for Rome left the young Titian without a serious rival at Venice except for the very old Giovanni Bellini. Titian's status was confirmed in 1513, when he was granted permission to contribute to the redecoration of the Doge's Palace, which he began only in the 1520s (*see* §2(i)(a) below).

2. EARLY SUCCESS, 1516–MID-1540s.

(i) Religious and mythological pictures. (ii) Portraits.

(i) Religious and mythological pictures.

(a) Venice. (b) Ferrara and Mantua. (c) Urbino. (d) Elsewhere.

(a) Venice. In 1516 a huge architectural frame of marble was installed behind the high altar of S Maria Gloriosa dei Frari at Venice, and on 20 May 1518 Titian's highly dramatic altarpiece of the *Assumption of the Virgin* (for illustration *see* ALTARPIECE) was placed in it. The great height of the vault of the Gothic church conditioned the proportions of the picture, which is unusually high in relation to its width. The gigantic height of the altarpiece—nearly 7 m—and its dynamic spiral composition were unprecedented in Venice; and Titian's pre-eminence among Venetian painters can be traced to the impact of this work. Dolce noted, however, that the older painters and the unlettered public were at first outraged at the novelty of the picture. This may well be the first recorded instance of a work of art provoking controversy by virtue of its revolutionary visual qualities. The extreme agitation of the Apostles on the ground was less probably the cause of the offence than the portrayal of the Virgin, whose feminine curves are conspicuous. Titian would have seen Mantegna's large fresco of the *Assumption* (*c.* 1455) in the Ovetari Chapel in the church of the Eremitani at Padua (*in situ*). Mantegna's treatment was unusually animated for its period and evidently exercised some influence on Titian's rendering. His main inspiration, however, seems to have come through a meeting with Fra Bartolommeo, probably at Ferrara in the spring of 1516. Inspired, in his turn, by the dynamism of Raphael's frescoes in the Stanza d'Eliodoro as well as by Michelangelo's Sistine Chapel Ceiling (both Rome, Vatican; see colour pl. 2, V2), Fra Bartolommeo painted several large and dramatic altarpieces at this period, as well as some very dramatic designs for an *Assumption* (now known only in his drawings; Munich, Staatl. Graph. Samml.).

In the second of Titian's altarpieces for the Frari, the Pesaro *Madonna* (*Virgin and Child Enthroned with Saints and Members of the Pesaro Family*, 1519–26; *in situ*; see colour pl. 2, XXXV2), the main novelty is directed to achieving an effect of dynamism in a static subject by shifting the Virgin's throne to an asymmetrical position in order to catch the gaze of the spectator from the central aisle. This acknowledgment of the spectator's existence was one reason why the picture inspired such Baroque masters as Annibale Carracci (1560–1609) and Rubens, who executed variants on it, as did Paolo Veronese. Titian first painted a coffered vault as a background, but replaced it with two huge pillars with clouds, a setting that also proved highly influential (*see also* PESARO).

Although Titian is not known to have visited Rome by this date, some awareness of Raphael's and Michelangelo's work, obtained through intermediaries, is apparent not only in the Frari *Assumption* but also in several other paintings from this time. An obvious instance is the *Virgin and Child with SS Francis and Aloysius and the Donor, Alvise Gozzi* (1520; Ancona, Pin. Com.), which evidently owes the principles of its composition to Raphael's *Madonna of Foligno* (1511–12; Rome, Pin. Vaticana). Similarly, in the last of the three great early altarpices for Venice, the *Death of St Peter Martyr* for SS Giovanni e Paolo (1526–30; destr. 1867, known from copies and prints), the most conspicuous figure apparently derives from a figure in Raphael's fresco of the *Deliverance of St Peter* (*c.* 1512; Rome, Vatican, Stanza d'Eliodoro). The *St Peter Martyr* altarpiece was considered by Vasari and most writers who saw it to be Titian's greatest work. According to Pino, Palma Vecchio competed against Titian for this commission, and, according to Ridolfi, so also did Pordenone.

The next major undertaking for Venice after the *St Peter Martyr* altarpiece was a huge picture of the *Presentation of the Virgin* (finished by 1538) for the Scuola della Carità (*in situ*, now Venice, Accad.). The composition is of the processional type, which was traditional in Venice for pictures of this subject, and it includes portraits of members of the Scuola. The elaborate architecture in the

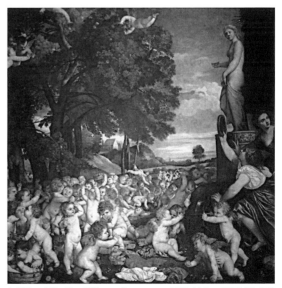

3. Titian: *Worship of Venus*, oil on canvas, 1.72×1.75 m, 1519 (Madrid, Museo del Prado)

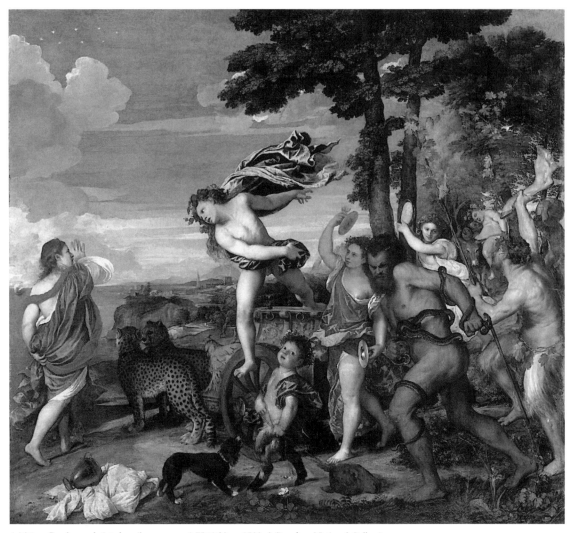

4. Titian: *Bacchus and Ariadne*, oil on canvas, 1.75×1.90 m, 1522–3 (London, National Gallery)

background was perhaps designed, or at least inspired, by Sebastiano Serlio, who had come to Venice after the Sack of Rome in 1527 and had become a close friend of Titian.

Also dating from the mid-1530s is the altarpiece of the *Virgin and Child with Saints* (Rome, Pin. Vaticana) from S Nicolo ai Frari at Venice. This was originally painted with the Virgin enthroned, but the final form is a two-tiered composition with the Virgin on clouds above the standing saints, who are disposed with striking asymmetry and considerable recession in the picture space. Raphael had used a comparable but less extreme system in his *St Cecilia* altarpiece (c. 1513–16; Bologna, Pin. N.).

More important at this time was Titian's work for the Doge's Palace in Venice, nearly all of which was destroyed in the fire of 1577. The appearance of his first painting there, of the humiliation of Frederick Barbarossa (1523) is not recorded. The *Battle of Spoleto* (or *Battle of Cadore* 1538; destr. 1577), for which he was granted permission in 1513, is known from copies, engravings and preliminary drawings (Paris, Louvre). Elements of its design were evidently derived, indirectly, from Leonardo's *Battle of*

Anghiari (destr.) for Florence, as well as from the fresco by Raphael's workshop of the *Victory of Constantine at the Milvian Bridge* (Rome, Vatican, Sala di Costantino). Titian's composition became, in its turn, the inspiration for some of Rubens's battle pictures (e.g. Munich, Alte Pin.). One more altarpiece, the dramatic *Christ Crowned with Thorns* (Paris, Louvre), was painted for S Maria delle Grazie, Milan, in 1540–42, and it too owes something to the *Laokoon* group. A second version (Munich, Alte Pin.) dates from the end of Titian's life.

(b) *Ferrara and Mantua*. Concurrently with his work on the three great early Venetian altarpieces Titian was working for the courts at Ferrara and Mantua. His début as the preferred painter of princes came in the spring of 1516 when he stayed for more than a month in the Este castle at Ferrara at the expense of Alfonso I, Duke of Ferrara (*see* ESTE, (8)). The *Tribute Money* (Dresden, Gemäldegal. Alte Meister), one of the noblest of all depictions of the adult Christ, was probably painted at this time.

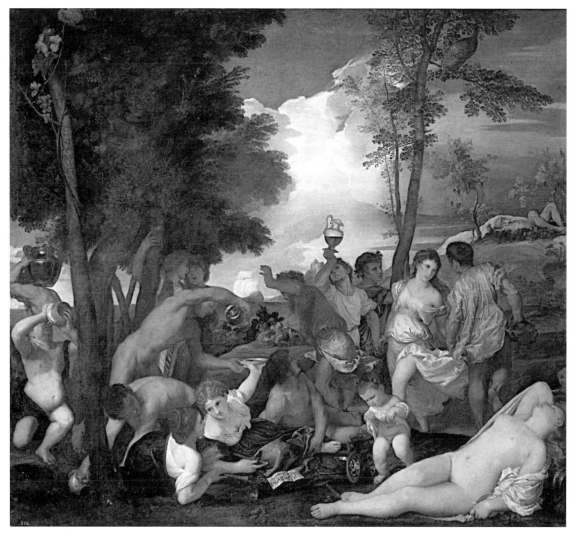

5. Titian: *Bacchanal of the Andrians*, oil on canvas, 1.75×1.93 m, mid-1520s (Madrid, Museo del Prado)

For several years before this Alfonso had been planning a series of paintings for his *camerino*, a small room in the castle at Ferrara, evidently in emulation of the *studiolo* of his sister Isabella d'Este (*see* ESTE, (6)) at Mantua. Alfonso's scheme consisted of bacchanalian subjects illustrating passages from Ovid and Philostratus the younger, which he selected himself. Like Isabella, he wanted a single contribution from each of the leading contemporary painters. He obtained works from Dosso Dossi and Giovanni Bellini. Michelangelo refused to surrender the promised painting, and Raphael and Fra Bartolommeo both died after planning their contributions. Titian was asked to fill the breach. Two of his pictures were based on the designs of the painters he replaced. The first, the *Worship of Venus* (see fig. 3), follows Fra Bartolommeo's sketch for his unexecuted painting, while the second, *Bacchus and Ariadne* (see fig. 4), derives, at least in part, from Raphael's *modello* for his picture of a similar, but not identical, subject. The third painting for the *camerino*, the *Bacchanal of the Andrians* (see fig. 5), was probably ordered

from Titian in the first place. Its main pictorial debt is to Michelangelo's cartoon for the *Battle of Cascina* (destr.), part of which was at Mantua where Titian went in 1519. Titian's dependence on the designs of his predecessors also reflects the fact that there was otherwise no pictorial tradition for the representation of these subjects. His three works are brilliantly painted, with a lavish use of ultramarine pigment and with sensuous painting of both the naked bodies and of the occasional silken garments. The landscape backgrounds are also marvellously vivid and lyrically beautiful. Despite his limited knowledge of Classical art at first hand, Titian's bacchanals are amazingly successful, imaginative evocations of the spirit of antiquity, as well as one of the greatest peaks of Italian Renaissance art. It was probably at the end of the series that Titian repainted most of the background of Bellini's bacchanal, the *Feast of the Gods* (Washington, DC, N.G.A.), in order to make it harmonize with his own.

In addition to these crucial contributions to the *camerino* of Alfonso d'Este, Titian painted portraits of the Duke

and of his mistress, *Laura Dianti* (*see* §(ii) below). It was his skill as a portraitist that contributed more than any other factor to his success in his lifetime, his ability to combine a degree of flattery with a good likeness. Since the princely families of Italy were interrelated, success with one led to the patronage of others. Alfonso's sister, Isabella d'Este, and her son Federico II Gonzaga offered him patronage at Mantua as did Isabella's daughter, Eleanora, Duchess of Urbino, at her court. The patronage of other notables was secured, in many cases, through Titian's friendship with PIETRO ARETINO, who from the 1530s had constituted himself, in effect, Titian's publicity agent. Having pleased influential patrons with portraits, Titian followed up his success with religious or mythological pictures. According to Vasari, 'there is hardly any nobleman of repute, nor prince, nor great lady, who has not been portrayed by Titian'.

Federico II Gonzaga, 1st Duke of Mantua (*see* GONZAGA, (8)), was one of the most enlightened of 16th-century patrons. In addition to Titian, Federico employed Correggio and Giulio Romano, who was court artist at Mantua from *c.* 1525. Titian's *Entombment* (see fig. 6) is similar in treatment, and in its thundery lighting, to the *Bacchanal of the Andrians* and therefore datable to the same period, the mid-1520s. It would thus have been among Titian's earlier work for Federico. In its drama and

the depth of the emotion conveyed, this is one of the greatest Renaissance religious pictures. The most admired of the Mantua Titians, however, was a series of 11 pictures of *Roman Emperors* (a 12th was added by Giulio Romano). Drawing on medals and busts, they dated from 1536–40 and were destroyed in Spain in 1734. Federico inherited a taste for antique subjects from his parents who owned works by Mantegna, such as the *Triumph of Caesar* (London, Hampton Court, Royal Col.). To judge from copies of the *Emperor* series (e.g. drawings by Ippolito Andreasi; Düsseldorf, Kstmus.), Titian infused great variety into these half-length figures: young and old, in profile, three-quarter face of full face, from the side or the back and with many different arrangements of drapery.

(c) Urbino. Titian's work for the court of Urbino started early in the 1530s. The Duke of Urbino, Francesco Maria I della Rovere (*see* ROVERE, DELLA, (3)), like his brother-in-law, Federico II Gonzaga, was on intimate terms with Titian, as their letters indicate. Titian worked for Francesco Maria until his death in 1538 and afterwards for his son, Guidobaldo II della Rovere. Most of Titian's pictures for Francesco Maria were portraits (*see* §(ii) below). A notable execption was the *Venus of Urbino* (Florence, Uffizi; see colour pl. 2, XXXV3). This shows a new attitude towards the nude, no longer generalized to the extent that it was

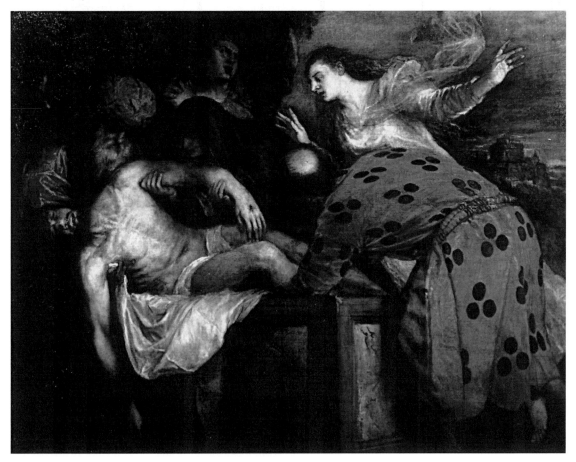

6. Titian: *Entombment*, oil on canvas, 1.48×2.05 m, mid-1520s (Paris, Musée du Louvre)

in Giorgione's *Sleeping Venus* (Dresden, Gemäldegal. Alte Meister; *see* GIORGIONE, fig. 4). Titian's version is given what is virtually a genre setting, and the sitter is less a goddess than a woman. She reclines naked on sheets, her head on pillows and her lapdog asleep at the foot of the bed. She wears a ring and a bracelet and turns to look at the spectator. To emphasize that the scene is of the real world there are two servants at the back of the room, inspecting the inside of a chest. There is a pronounced erotic element due to the combination of the naked body and realistic accessories, but the way the body is painted is idealized—the outlines very slightly smoothed, and irregularities in the flesh eliminated.

(d) Elsewhere. Although much of his energy throughout the 1520s and 1530s was given to work for Ferrara, Mantua, Urbino and Venice, Titian occasionally painted works for other cities. These included the Ancona *Virgin and Child* mentioned above and an altarpiece of the *Resurrection* (see fig. 7), dated 1522, for SS Nazaro e Celso,

Brescia. One panel of the altarpiece shows an elaborate foreshortened figure of St Sebastian, derived, again through intermediaries, from the antique sculpture group of the *Laokoon* (Rome, Vatican, Mus. Pio-Clementino). Also from the early 1520s is an *Annunciation* for Treviso Cathedral (*in situ*), in which the angel, unusually, advances from the back of the room.

(ii) Portraits. Titian, more than any other painter, was responsible for the development of the art of portraiture in the first half of the 16th century. The change involved enlarging the field from the head-and-shoulders format that was normal in 15th-century portraits, to half-length and full-length figures, thereby permitting the inclusion of adjuncts—furniture, musical instruments, a servant, a horse or a dog—to suggest the sitter's interests or his importance. It also entailed new problems of pose, in particular to do with the sitter's hands. In this, as in every other respect, Titian was pre-eminently resourceful. The hands were occupied with a book, a pair of gloves or the

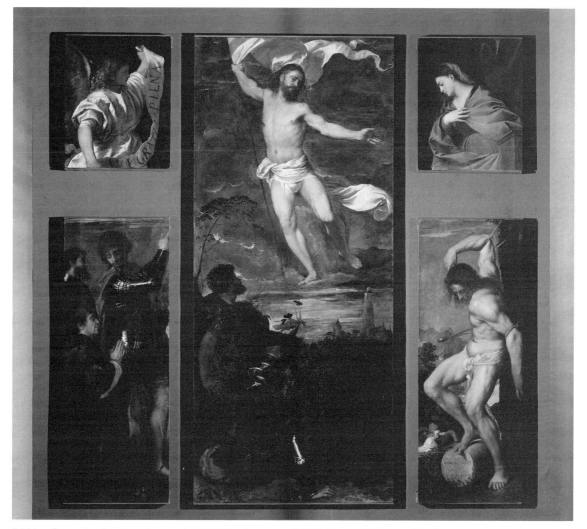

7. Titian: *Resurrection* altarpiece, oil on panel, 2.78×1.22 m (centre panel), 1522 (Brescia, SS Nazaro e Celso)

hilt of a sword. The subject was shown frontally, from one side, or even from the back, looking over his shoulder. Whereas most of the surviving portraits from the 15th century are of men, from this period onwards the number of portraits of female sitters increased. In most of Titian's early portraits the sitters are unidentified—he did not yet move among the great—and the works are not precisely dated. In some, such as the *Portrait of a Man* ('*Ariosto*', London, N.G.), perhaps a self-portrait, Titian retained the device of a ledge in the foreground, which had been used by Giorgione. In the *Portrait of a Woman* ('*La Schiavona*', London, N.G.), the ledge includes a raised portion incorporating a pseudo-antique profile relief of the sitter. Gloves feature prominently in two other early portraits of young men (Garrowby Hall, N. Yorks; Paris, Louvre), while an older male subject at Hampton Court (Royal Col.) fingers a book. In all of these portraits except the female one, the sitter's face is shown at an angle. The colours are generally restrained, although in the Garrowby Hall portrait the glimpses of the sitter's scarlet tunic and sleeves are contrasted effectively with the black silk of his robe.

In the portrait of *Federico II Gonzaga* (1520s; Madrid, Prado; see colour pl. 2, XXXV1) the field is extended to three-quarter length. The young ruler is shown with one hand on a dog and the other concealed. The colouring, too, a sumptuous blue velvet doublet and red breeches, is more vivid than in the earlier portraits. In the *Laura Dianti* (Kreuzlingen, Heinz Kisters priv. col.), the colouring is brighter still and a second figure, a Moorish page, is added as a foil. The pair of portraits of *Francesco Maria della Rovere, Duke of Urbino*, and his Duchess, *Eleanora Gonzaga* (both Florence, Uffizi), are datable to the mid 1530s. Both are three-quarter length, but Titian's sketch (Florence, Uffizi) (*see* §II,1 below) for the Duke's portrait—the only surviving study for a Titian portrait—shows the sitter at full length. In contrast with the portrait of the Duchess's brother, *Federico Gonzaga* (Madrid, Prado), who is shown in civilian clothes and with an expression of aristocratic confidence, Francesco Maria is depicted as a soldier, in armour, baton in hand. Titian's portrait of a young woman, '*La Bella*' (Florence, Pitti), and the *Portrait of a Girl in a Fur Cape* (Vienna, Ksthist. Mus) are assumed to represent the same sitter. She was evidently also the model for the *Venus of Urbino* and was presumably Francesco Maria's mistress. Probably the greatest of all the half-length standing portraits, perhaps dating from as late as the 1540s, is the enigmatic '*Young Englishman*' (Florence, Pitti).

The pinnacle of Titian's worldly success was reached when he found favour with Emperor Charles V (*reg* 1519–56), and, some years later, worked for Pope Paul III (*see* FARNESE, (1)). In 1533, three years after their first meeting, the Emperor created Titian Count Palatine and Knight of the Golden Spur and tried in vain to persuade him to come to Spain. The first paintings for the Emperor were portraits (some destr.), of which the full-length portrait of *Charles V with his Hunting Dog* (?1532; Madrid, Prado) seems to be merely a copy of one by Jakob Seisenegger (1505–67). In 1543 Titian met Pope Paul III, a devoted patron of Michelangelo, at Bologna. This led in 1546 to the artist's only known visit to Rome. There he met Michelangelo, who, according to Vasari, censured his draughtsmanship but praised his colouring.

3. 'LATE STYLE', MID-1540s AND AFTER. During the mid-1540s a major change can be seen in Titian's painting, marking the beginning of the 'late style'. If the great *Ecce homo* (Vienna, Ksthist. Mus.), finished in 1543 for Giovanni d'Anna, a Flemish merchant resident in Venice, is compared with a similar composition, the *Presentation of the Virgin*, finished only five years previously, the difference is clear. The greater agitation in the intensely dramatic later work can be attributed to the more tragic subject, but the stylistic difference is apparent in the darker tones and more summary handling.

(i) Religious and mythological pictures. (ii) Portraits.

(i) Religious and mythological pictures.

(a) Work for Charles V. (b) Work for Philip II and related late paintings.

(a) Work for Charles V. Before the end of 1547, Titian was summoned by Charles V to join him at Augsburg, a journey across the Alps in winter. There he painted, among other subjects, the *Last Judgement* or *Trinity*, known as '*La Gloria*' (Madrid, Prado), which was not finished until 1554 and was later taken by the Emperor to his retreat at the monastery of Yuste in Spain. It differs fundamentally from the Landauer Altarpiece (Vienna, Ksthist. Mus.) by Albrecht Dürer (1471–1528) and Michelangelo's *Last Judgement* (Rome, Vatican, Sistine Chapel; see colour pl. 2, VII3), both of which have been cited as partial prototypes, in not showing a frontal presentation. Instead, the Old Testament figures in the foreground look up towards the Trinity at an angle, and the spectator follows the direction of their gaze.

During this first visit to Augsburg, Titian was commissioned by the Emperor's sister, Mary, Queen of Hungary, the regent of the Netherlands, to paint four large pictures of legendary Greek figures, *Tityus, Sisyphus* (both Madrid, Prado), *Tantalus* and *Ixion* (both untraced), the '*Furias*'. These were destined for Mary's château at Binche (Belgium). Although intended as wall decoration, they are in an heroic style, with the figures filling most of the canvas, similar to the series of ceiling paintings of Old Testament subjects—*Cain and Abel*, the *Sacrifice of Isaac* and *David and Goliath*— that Titian had painted a few years earlier for Santo Spirito in Venice (Venice, S Maria della Salute). In both series some influence from Giulio Romano's frescoes at Mantua (e.g. Palazzo del Te), as well as from Correggio's cupola paintings at Parma (e.g. in the cathedral), may be traced.

(b) Work for Philip II and related late paintings. On his way back from Augsburg, Titian stopped at Innsbruck to paint portraits (untraced) of the family of Ferdinand I, King of Bohemia and Hungary (*reg* 1526–62), the brother of Charles V. Soon after he returned to Venice, he received a further summons, to go to Milan to meet the Crown Prince, the future King Philip II of Spain, who was to be his principal patron for the rest of his life. From this meeting the only result was a portrait (untraced), and it was not until Titian was again summoned to Augsburg, in

8. Titian: *Rape of Europa*, oil on canvas, 1.78×2.05 m, *c.* 1560 (Boston, MA, Isabella Stewart Gardner Museum)

1550, that he and the young prince worked out an elaborate programme of pictures that the artist would paint in Venice and send to Spain. The most important was a series of canvases of subjects taken, like the Ferrara bacchanals, from Classical literature (Ovid). Referred to as the '*poesie*', they were evidently planned in pairs. The strong erotic element was presumably also specified. The *poesie*, interspersed with pictures of religious subjects, were sent at intervals throughout the 1550s and first half of the 1560s. As with the Ferrara series Titian drew for inspiration on Central Italian models: on Michelangelo in the case of the first, the *Danaë* (Madrid, Mus. Prado; an earlier version is in Naples, Capodimonte), on Raphael for the next, *Venus and Adonis* (1553; Madrid, Prado), and probably on Benvenuto Cellini's relief of *Perseus and Andromeda* from his statue of *Perseus* (Florence, Loggia Lanzi; *see* CELLINI, BENVENUTO, fig. 6) for the picture of that subject (London, Wallace). For the *Diana and Actaeon* (*see* ITALY, fig. 16), which is probably the masterpiece of the series, and the *Death of Actaeon* he seems to have drawn primarily on Classical sculpture. The other surviving *poesie* are the *Diana and Callisto* (Duke of Sutherland, on loan

to Edinburgh, N.G.; see colour pl. 2, XXXVI1) and the *Rape of Europa* (see fig. 8). In two of the series, *Diana and Actaeon* and the *Rape of Europa*, Titian made brilliant use of a colouristic device that he had also used to great effect in the *Bacchus and Ariadne*: a crimson cloak fluttering like a flame against an ultramarine sky.

When the style and technique of the *poesie* for Philip are compared with those of the earlier series for Ferrara, the differences conform with the general trend of Titian's development. The mood in the later series is more fiery, the colours deeper and more closely interrelated and the execution more summary. The dimensions of the canvas in the two series are nearly the same but the figures in the later one are larger in relation to the surround. In the *poesie* as in the earlier series, the landscape element is prominent, and in the last of the series, the *Death of Actaeon*, it is treated with a freedom that no other painter attempted again until the 19th century. The religious paintings for Philip included a huge *Last Supper* (Madrid, Escorial, Nuevos Mus.).

Three important altarpieces for churches in Venice and the mainland are datable to the late 1540s and the 1550s.

The first, the *Pentecost* (S Maria della Salute), was painted for Santo Spirito (destr. 1656) as a replacement for an earlier altarpiece by Titian, which had deteriorated. The arrangement of the Salute picture is traditional (compare with, for example, the picture of the same subject by Luca Signorelli in Santo Spirito, Urbino), but executed with brilliant, opalescent colours. The second, the *Martyrdom of St Lawrence* (Venice, S Maria Assunta dei Gesuiti), is important as being Titian's first night scene. It dates from the mid- or late 1550s, as does the third, the splendid *Crucifixion* (Ancona, S Domenico).

Throughout his last years and almost to the time of his death Titian continued to send most of his output to Philip II. Some of these paintings, such as the *Venus of Pardo* (Paris, Louvre) and the *Religion Succoured by Spain* (Madrid, Prado), had been started many years previously and were now reworked. Others, such as the *St Lawrence* (Madrid, Escorial), were repetitions of compositions he had delivered to other patrons. Many others were found unfinished in his studio at his death. These included the huge canvas for Doge Antonio Grimani, '*La Fede*' (Venice, Doge's Pal.), which had been commissioned as early as 1555. Not delivered in Titian's lifetime, it escaped the first fire at the Doge's Palace (1574). The figure of the kneeling Doge on the right is magnificently painted in Titian's style of the late 1550s. The standing figure of St Mark on the left also appears to be the work of Titian himself, but from a later date. The central figure of Faith is probably at least in part of studio execution. During his last years Titian also executed a few works for the Venetian mainland, including three paintings of allegorical and mythological subjects for Brescia (1568; destr. 1575).

The technique of Titian's late works has been described as proto-Impressionist. Vasari may have been nearer the mark when he described Titian's final style as looking like *macchie* ('blots'). It is not a systematic exploration of the effects of light on colour and form, rather all forms become blurred. The great last *Pietà* (see fig. 9), for example, composes well from a normal viewing distance, but the brushstrokes make little sense when seen from a few centimetres. To some extent this late style may be due to failing eyesight. Certainly the effects of old age on Titian's painting did not escape comment during his lifetime. A dealer, Niccolò Stoppio, reported in 1568 that Titian's hand trembled so much that he was unable to finish any pictures and left them to assistants. The curious form of signature, *Titianus fecit fecit*, on the late *Annunciation* (Venice, S Salvatore) has been interpreted as Titian's defiant rebuttal of such insinuations (Ridolfi).

Nevertheless, a number of paintings dating from the last 10 or 15 years of Titian's life are recognized as masterpieces: the Salvatore *Annunciation*, the *St Sebastian* (St Petersburg, Hermitage), the Escorial *St Lawrence*, the *Flaying of Marsyas* (Kroměříž Castle) and, above all, the last *Pietà*. The *Pietà*, in particular, is one of the most moving of all representations of the subject. All the paintings are very dark in tone, fiery in mood and appear to be unfinished when seen from close quarters. His art was truly humanist. His figures, whether in a religious or a secular context, tend to be slightly more handsome and graceful than the average, but are still creatures of flesh and blood. To see this, they need only be compared with

9. Titian: *Pietà*, oil on canvas, 3.53×3.48 m, 1573–6 (Venice, Galleria dell'Accademia)

those of his two great successors: the aristocratic abstractions of Paolo Veronese or the faceless figures of Jacopo Tintoretto.

The same is true of his exquisitely beautiful background landscapes. They are more freshly observed than those of previous painters with the possible exception of Giovanni Bellini, but the incidental irregularities of nature have been softened.

As Titian's career spanned more than 65 years he was certainly very old when he died. There was plague in Venice at the time of his death, but the fact that he was buried the following day, in S Maria Gloriosa dei Frari, suggests that he did not die of the plague. Several other members of the VECELLIO family were painters, including one of Titian's sons, Orazio Vecellio. Titian kept a large workshop, and Jacopo Tintoretto and El Greco were among the artists said to have trained there.

(ii) Portraits. In the 1540s Titian produced the three most elaborate of all his portraits: the group of *Pope Paul III with his Grandsons* (1546; Naples, Capodimonte), the larger group of the male members of the *Vendramin Family* (London, N.G.) and the life-size equestrian portrait of *Charles V at Mühlberg* (Madrid, Prado), painted on the occasion of the Emperor's victory over the Lutherans at Mühlberg early in 1547. In the earlier, more modest group portrait, *Bishop Georges d'Armagnac and his Secretary* (late 1530s; Alnwick Castle, Northumb.), the kneeling secretary is allowed only a subordinate place; most of the picture is occupied by the ample form of the seated bishop. The Vendramin group—three adults, six children and a dog—is more complex, and the design suffered somewhat when it was truncated on the left. The contrasts of psychology between the members of the different generations of the family are very effective, however, as well as pictorial contrasts of different colours, mainly red and black, and different textures of the robes.

Painted during Titian's visit to Rome, the design of the group of *Pope Paul III with his Grandsons* evidently derives from that of Raphael's *Pope Leo X and Two Cardinals* (Florence, Uffizi; for illustration *see* MEDICI, DE', (7)). At this time Titian would not have seen Raphael's original, which was already in Florence, but would have known Andrea del Sarto's copy (Naples, Capodimonte) at Mantua. Titian's picture is more vivid and also more loosely constructed. The stooping figure, Ottavio Farnese, has been seen as sycophantic, and as an indication of unreliability. However, since the Pope is known to have been very softly spoken, a more likely explanation is that Ottavio Farnese was trying to hear what he was saying, and Titian brought out the irritation and impatience of old age in the expression of the Pope. In this portrait, which is unfinished, the range of colours is restricted, the white of the Pope's robe setting off the different shades of crimson.

In comparison with the grandiloquence and bravura of equestrian portraits of rulers painted in the 17th century, Titian's great portrait of Charles V appears a model of verisimilitude and restraint. No allegorical figures underline the Emperor's victory, even though Aretino has advocated their inclusion. The enemy is not even shown. Like the Christian champion he felt himself to be, the Emperor rides undaunted from the wood, assured of sufficient divine protection to challenge and defeat the forces of hell.

Of the later single portraits, mention should be made of an oddity, the full-length portrait of *Giovanni Acquaviva, Duca d'Atri* (*c.* 1552; Kassel, Schloss Wilhelmshöhe). The work is splendid in execution and in its scarlet and gold colouring, but the sitter appears so grotesquely over-dressed as to suggest some satirical intent on Titian's part. Three single portraits from the later period are outstanding, both visually and psychologically. Titian's first portrait of *Pope Paul III* (see fig. 10) follows the type created by Raphael in his portrait of *Pope Julius II* (London, N.G.), with the sitter shown from an angle, at three-quarter length, in an armchair. By using a slightly higher viewpoint than Raphael, Titian was able to look down on the Pope's outstretched right hand, which seems to claw the velvet pouch he wears, thereby complementing the suspicious mood suggested by the facial expression. The colours are restricted to a combination of whites and marvellous dull reds with light highlights. The full-length *Philip II in Armour* is an official image, since Philip, unlike his father, was not primarily a soldier. The richly damascened black and gold armour is painted with extraordinary virtuosity, but the very free technique, almost anticipating impressionism, was not appreciated by the sitter who attributed it to haste in a letter to his aunt Mary of Hungary. Of the very late portraits, the most arresting is that of the antiquarian *Jacopo Strada* (1567–8; Vienna, Ksthist. Mus.), a man Titian apparently disliked. The sitter's fiery expression is emphasized by his gesture, brandishing a statuette so that his left arm, with its brilliant scarlet satin sleeve, cuts diagonally across his body.

II. Graphic arts.

1. DRAWINGS. Dolce mentioned Titian's facility as a draughtsman during his student days, but, as he made little use of them in the preparatory stages of painting (*see* §III below), there are relatively few drawings from his maturity. As with other Old Masters, the touchstone of authenticity consists of those drawings that connect with authentic paintings, while not corresponding so closely as to be considered sketch copies by later artists after the paintings. In Titian's case, these include two in pen and ink: one for the Brescia *St Sebastian* (Berlin, Kupferstichkab.) and the other for the portrait of *Francesco Maria della Rovere* (both Florence, Uffizi). There are two drawings mainly in black chalk: one (London, BM) is for an Apostle in the Frari *Assumption of the Virgin*, the other (Paris, Ecole B.-A.) is for the *Sacrifice of Isaac* (Venice, S Maria della Salute). In addition, there are studies for lost paintings, including the *Battle of Spoleto* (e.g. Florence, Uffizi; Paris, Louvre) and the votive picture of Doge Andrea Gritti (Florence, Uffizi), formerly in the Doge's Palace, and a few others possibly connected with known paintings.

The main category of drawings for which the attribution to Titian is still controversial consists of finished studies in pen and ink representing undulating landscapes with prominent bushes in the middle distance, buildings in the far distance and relatively small figures in the foreground. This genre seems to have started in the circle of Giorgione and to have been connected with the production of woodcuts. Two drawings of this type (both London, BM) are signed Domenico Campagnola, who appears to have been the most active exponent of it. The example of this type most confidently attributed to Titian is a sheet (New York, Met.), which appears to be a study for part of a large composite woodcut of the *Sacrifice of Isaac* (Berlin, Kupferstichkab.), which, in its third state, bears an inscription

10. Titian: *Pope Paul III*, oil on canvas, 1.06×0.85 m, 1543 (Naples, Museo e Gallerie Nazionali di Capodimonte)

attributing it to Titian. In certain parts of the Metropolitan sheet there is a lack of continuity in the ink lines, and this seems to support the theory that such works are not drawings but are counterproofs taken from the woodcuts that were later touched up by hand with fraudulent intent (Dreyer). Nevertheless, there can be little doubt that Titian did execute drawings of this type.

2. PRINTS. The success at Venice, early in the 16th century, of the engravings and woodcuts of Jacopo de' Barbari and Dürer evidently fired the young Titian. His *Triumph of Christ* (e.g. Paris, Bib. N., Cab. Est.), a huge woodcut procession made from ten blocks, was dated by Vasari to 1508 and is therefore among Titian's earliest works in any medium. Suggestions that this print dates from a few years later are not based on solid evidence. The enormous and highly dramatic woodcut of the *Crossing of the Red Sea* (e.g. London, BM), which has been described as the greatest woodcut ever made (1983 exh. cat.), was widely influential. It is known from an inscribed edition dated 1549 but is assumed to have originated many years earlier. A chiaroscuro woodcut of *St Jerome* (e.g. London, BM) is inscribed with the names of Titian as designer and of Ugo da Carpi as cutter. A number of other prints have been attributed to Titian by some writers. Despite his relatively small output, there can be no doubt that Titian's importance in the history of woodcut is almost as great as it is in painting. Late in his career he encouraged the reproduction of his paintings by engravers, including Niccolò Boldrini, Giulio di Antonio Bonasone, Giovanni Jacopo Caraglio, Cornelis Cort (1533–78), Giulio Fontana and Martino Rota.

III. Working methods and technique.

Most of Titian's early works are on panel, including the enormous Frari *Assumption of the Virgin*. Another large work of this period, the Frari Pesaro *Madonna*, is, however, on canvas. Although later he painted more often on canvas, he did not entirely abandon panel, which he used, for example, for the *Christ Crowned with Thorns* (1546–50; Paris, Louvre). The choice of support was probably determined by the size of the work and its intended location. Canvas, which could be rolled, was more suitable for large works that had to be shipped long distances. Both panel and canvas supports were prepared with a layer of light-coloured gesso.

The painting procedure developed by Titian was revolutionary in its day. Vasari, who disapproved, described it in his *Vita* of Titian as 'working merely with paint, without the intervention of preliminary drawings on paper'. Modern scientific analysis, as well as an eye-witness account of Titian's method of painting by Palma Giovane, support Vasari's contention that drawing played no more than a minor part in Titian's procedure. The transfer from panel, for instance, of the *Madonna of the Cherries* (Vienna, Ksthist. Mus.) in the late 19th century revealed only summary lines of underdrawing. The same proved to be true when a later work, the *Vendramin Family*, dating from the 1540s, was cleaned in 1973–4. In this case there was a great deal of underdrawing in dark paint, but it was very sketchily done and did not always correspond with

the final outline as painted. On the other hand, when the *Bacchus and Ariadne* (1522–3) was cleaned in 1967–9, there was hardly any indication of underdrawing. It was found that this picture was painted on a thin gesso ground, originally light in colour, although subsequently darkened. This is evidence against the theory that Titian generally used a red-brown ground. It also became clear that Titian was prepared on occasion to improvise on the canvas. Ariadne's scarlet scarf, for instance, is painted over the blue pigment of the sea behind her. In the Pesaro *Madonna* the architectural background was drastically altered more than once, but the figures were not painted until the architecture had assumed its final form. The definitive colour effects were sometimes obtained by underpainting of a different colour from that of the top layer. In the *Virgin and Child with SS John the Baptist and Catherine* (London, N.G.), for instance, dating probably from the 1530s, St Catherine's yellow dress has a pink underpainting.

Something of Titian's preparations may be seen with the naked eye in the portrait group of *Pope Paul III with his Grandsons*, since this picture is clearly unfinished. Crowe and Cavalcaselle (1881) described the process:

> Laid on first with broad sweeps of brush in the thinnest of shades, the surfaces appear to have been worked over and coloured more highly with successive layers of pigment of similar quality, and modelled in the process to a delicate finish. The shadows were struck *in* with the same power as they were struck *out* in chips in the statues of Michelangelo. The accessories were all prepared in well-marked tints, subject to toning down by glazing, smirch or scumble. White in light, dark in shadow, indicate forms, the whole blended into harmony by transparents, broken at last by flat masses of high light, and concrete touch.

Palma Giovane gave a famous description of Titian's painting method, though being born *c.* 1548 he could have known Titian only at the very end of the latter's life. Palma's account was repeated by Boschini (1674):

> Palma Giovane told me ... that Titian was in the habit of laying in his pictures with a mass of colour, which served as a bed or base for what he was going to construct above it. And I myself have seen some of these, worked with rapid strokes of a brush steeped in solid colour, in some areas with a mass of red earth, which was intended for the middle tones, in others with white lead. Then with the same brush, and red, black and yellow pigment he modelled a highlight; and in this way he fashioned, with four strokes of the brush, the nucleus of a beautiful figure. ... When he had completed these expert preliminaries he turned the picture to the wall and sometimes left it there for several months without looking at it; and when at last he wished to resume work he examined it rigorously as though it were a mortal enemy, in order to detect in it some feature which was not in keeping with his lofty intention. ... For the finishing touches he rubbed the edges of the highlights with his fingers, blending them with the half tones, and harmonising one colour with another. At other times he would slide his finger to make a dark accent in a corner and thereby reinforce it, or a spot of red like a drop of blood to enliven an unaccented passage, and in this fashion he brought his painted figures to a state of perfection. And Palma assured me that in the final stages he worked more with his fingers than his brush.

This description makes no mention either of preliminary sketches or of underdrawing. Instead Titian seems to have evolved a roughly equivalent system in terms of paint. Just as one method of drawing starts with a maze of imprecise lines from which the definitive outline ultimately emerges, so Titian seems to have arrived at the final result by a process of refining both the area and the colour of successive layers of pigment. Early in his career he also compensated for his minimal use of drawing by working from the live model at the painting stage. A letter of 14 October 1522 from Alfonso d'Este's agent in Venice about the *Bacchus and Ariadne* mentions that Titian was still using live models at least six weeks after starting on the canvas. Since Palma makes no mention of this, the conclusion is that by the end of his life Titian had abandoned the practice.

IV. Critical reception and posthumous reputation.

During the 20th century Titian has been among the most generally revered of all Old Masters. In previous centuries, however, Raphael was regarded as the greatest of all painters. The reasons for this reversal are complex and not easy to define, but the most cogent factor has probably been the changing attitude to the art of antiquity. As long as the Antique was considered the fountain-head of all excellence in the visual and literary arts, artists whose practice reflected this view were thought superior to those who were content to copy nature. In the 16th century a dispute began concerning the primacy in painting of draughtsmanship or painting (*see* DISEGNO E COLORE). The exponents of *disegno* looked to the art of antiquity for guidance, whereas those who favoured *colore* modelled their art more directly on nature. Raphael was seen as the purest exponent in modern times of the antique ideal and was idolized by the advocates of *disegno*, who included the leading theorists of art: Vasari in the 16th century, Giovanni Pietro Bellori (1613–96) in the 17th and Anton Raphael Mengs (1728–79) in the 18th.

With the decline in the prestige of antiquity, Raphael's fame also started to decline, and that of Titian, as the exponent of the rival, *colore* faction, rose correspondingly. Titian in fact had also been influenced by the art of antiquity, but he was promoted as the great student of nature by Dolce and others in opposition to the school of Rome and the Antique. Among artists there was, nevertheless, some divergence between theory and practice. Whatever the attitudes towards Raphael of Rubens, Anthony van Dyck (1599–1641) and Velázquez, for instance, there is no doubt that in their painting all three were more affected by Titian. Similarly, in the 19th century, Delacroix (1798–1863) referred to Raphael as 'the greatest of all painters' but wrote with more appreciation of Titian (*Journal*, 1 March 1859).

Titian's fame and influence were disseminated through the collections of his work located outside Venice as well as in it. The export to Spain of most of his output in the last 25 years of his life made works available to Velázquez and other Spanish painters, as well as to such visiting artists as Rubens; and by the middle of the 17th century this tremendous holding was augmented by examples of Titian's earlier period. Two of the Ferrara bacchanals, the *Worship of Venus* and the *Andrians*, arrived in Madrid in the 1630s from Rome, where, following their confiscation from Ferrara at the end of the 16th century, they had already exerted a vital influence on such resident artists as Poussin (1594–1665). In the 17th century there were likewise important examples of Titian's work in collections in England, France and the Netherlands. Although before the 20th century there were reservations concerning Titian's standing outside Venice, his supremacy in relation to other Venetian painters has never been seriously challenged.

BIBLIOGRAPHY

EARLY SOURCES

M. Sanudo: *I Diarii* (1496–1533); ed. R. Fulin, 58 vols (Venice, 1879–1903)

Anonimo Morelliano [Marcantonio Michiel]: *Notizie d'opere di disegno* (*c.* 1532); Eng. trans. (London, 1903)

P. Pino: *Dialogo di pittura* (Venice, 1548); also in *Trattati d'arte del cinquecento*, ed. P. Barocchi (Bari, 1960), i, pp. 95–139

G. Vasari: *Vite* (1550, rev. 2/1568); ed. G. Milanesi (1878–85), vii, pp. 425–68

L. Dolce: *L'Aretino, ovvero dialogo della pittura* (Venice, 1557); ed. M. Roskill (New York, 1968)

F. Sansovino: *Venetia città nobilissima et singolare* (Venice, 1581); ed. G. Martinoni (Venice, 1663/*R* Venice, 1968)

R. Borghini: *Il Riposo* (Florence, 1584); ed. M. Rosci (Milan, 1968)

P. Aretino: *Lettere* (Paris, 1609); rev., abridged as *Lettere sull'arte*, (Milan, 1956–7)

'Tizianello': *La vita del insigne Tiziano Vecellio* (1622/*R* Venice, 1809)

C. Ridolfi: *Le Maraviglie dell'arte* (Venice, 1648); ed. D. von Hadeln (Berlin, 1914–24); Eng. trans., ed. J. Bondanella and others as *The Life of Titian* (University Park, PA, 1996)

M. Boschini: *La carta del navegar pitoresco* (Venice, 1660); ed. A. Pallucchini (Venice, 1966)

——: *Le minere della pittura* (Venice, 1664); rev. as *Le ricche minere della pittura* (Venice, 1674)

A. Cloulas, ed.: 'Documents concernant Titien conservés aux archives de Simancas' *Mél. Casa Velazquez*, iii (1967), pp. 197–286

GENERAL

B. Berenson: *Venetian School* (1957)

J. Steer: *Venetian Painting: A Concise History* (London, 1970)

J. Wilde: *Venetian Art from Bellini to Titian* (Oxford, 1974)

D. Rosand: *Painting in Cinquecento Venice: Titian, Veronese, Tintoretto* (New Haven and London, 1982, rev. 1997)

MONOGRAPHS

J. A. Crowe and G. B. Cavalcaselle: *Life and Times of Titian* (London, 1877, rev. 2/1881)

G. Gronau: *Titian* (Berlin, 1900; Eng. trans., London, 1904)

W. Suida: *Tizian* (Leipzig, 1933)

H. Tietze: *Tizian* (Vienna, 1936)

G. A. Dell'Acqua: *Tiziano* (Milan, 1955)

R. Pallucchini: *Tiziano*, 2 vols (Florence, 1969)

E. Panofsky: *Problems in Titian: Mostly Iconographic* (London, 1969)

H. E. Wethey: *The Paintings of Titian*, 3 vols (London, 1969–75) [fullest account for reference]

C. Hope: *Titian* (London, 1980) [best short account]

EXHIBITION CATALOGUES AND SYMPOSIA

Tiziano e Venezia. Atti del convegno: Venice, 1976

Titianus Cadorinus. Atti del convegno: Pieve di Cadore, 1976

Disegni di Tiziano e della sua cerchia (exh. cat. by K. Oberhuber, Venice, Fond. Cini, 1976) [drawings]

Tiziano e il disegno veneziano del suo tempo (exh. cat. by W. Rearick, Florence, Uffizi, 1976) [drawings]

Titian and the Venetian Woodcut (exh. cat. by M. Muraro and D. Rosand, Washington, DC, N.G.A. and Int. Exh. Found., 1976)

Tiziano e il manierismo europeo (exh. cat. by R. Pallucchini, Florence, 1978)

Da Tiziano a El Greco: Per la storia del manierismo a Venezia, 1540–1590 (exh. cat., Venice, Doge's Pal., 1981)

The Genius of Venice, 1500–1600 (exh. cat., ed. C. Hope and J. Martineau; London, RA, 1983)

Titian, Prince of Painters (exh. cat., Venice, Doge's Pal.; Washington, DC, N.G.A.; 1990–91)
Le Siècle de Titien (exh. cat., Paris, Grand Pal., 1993)

SPECIALIST STUDIES

Drawings

T. Pignatti and M. A. Chiari: *Tiziano: Disegni* (Florence, 1979)
M. A. Chiari Moretto Wiel: *Tiziano: Corpus dei disegni autografi* (Milan, 1989)

Materials and technique

A. Lucas and J. Plesters: 'Titian's Bacchus and Ariadne: The Materials and Technique', *N.G. Tech, Bull.*, 2 (1978)
F. Valcanover and L. Lazzarini: 'La Pala Pesaro: note techniche', *Quad. Sopr. Beni A. & Stor. Venezia*, 8 (1979)

Other

M. Jaffe: 'The Picture of the Secretary of Titian', *Burl. Mag.*, cviii (1966), pp. 114–26
P. Fehl: 'Realism and Classicism … in Titian's Flaying of Marsyas', *Czechoslovakia Past and Present*, ii (The Hague, 1969)
C. Hope: 'The Camerini d'Alabastro of Alfonso d'Este', *Burl. Mag.*, cxiii (1971), pp. 641–50, 712–21
D. Goodgal: 'The Camerino of Alfonso I d'Este', *A. Hist.*, i/2 (1978)
P. Dreyer: 'Tizianfälschungen des sechzehnten Jahrhunderts', *Pantheon* (1979); review by D. Rosand in *Master Drgs*, 3 (1981)
C. Gould: 'The Earliest Dated Titian?', *Artibus & Hist.*, 13 (1986)
C. Hope: 'Titian, Philip II and Mary Tudor', *England and the Continental Renaissance: Essays in Honour of J. B. Trapp*, ed. E. Chaney and P. Mack (Woodbridge, 1990), pp. 53–65
Titian 500: Washington, 1990
Le siècle de Titien: L'âge d'or de la peinture à Venise (exh. cat., Paris, Grand Pal., 1993)
R. Goffen: 'The Problematic Patronage of Titian's *Venus of Urbino*', *J. Med. & Ren. Stud.*, xxiv/2 (Spring 1994), pp. 301–21
C. Hope: 'A New Document about Titian's Pietà, *Sight and Insight: Essays on Art and Culture in Honour of E. H. Gombrich at 85* (London, 1994), pp. 152–67
P. Joannides: 'Two Topics in the Early Work of Titian', *Apollo*, cxl/392 (1994), pp. 17–27
D. Rosand: 'Titian's *Saint Sebastian*', *Artibus & Hist.*, xv/30 (1994), pp. 23–39
P. Carabell: 'Finito and Non-finito in Titian's Last Paintings', *Res*, 28 (Autumn 1995), pp. 78–93
B. Cole: 'Titian and the Idea of Originality in the Renaissance', *Craft of Art: Originality and Industry in the Italian Renaissance and Baroque Workshop*, ed. A. Ladis, C. Wood and W. U. Eiland (Athens, GA, 1995), pp. 86–112
L. Freedman: *Titians Portrait's through Aretino's Lens* (University Park, PA, 1995)
Tiziano: Amor Sacro e Amor Profano (exh. cat. by M. G. Bernardini, Rome, Pal. Espos., 1995)
F. Mozzetti: *Ritratto di Pietro Aretino* (Modena, 1996)
R. Goffen, ed.: *Titian's VENUS OF URBINO* (Cambridge and New York, 1997)
R. Goffen: *Titian's Women* (New Haven and London, 1997)
I. Tobben: *DIE SCHINDUNG DES MARSYAS: Nachdenken über Tizian und die Gefährlichkeit der Künste: Ein Essay* (Berlin, 1997)
Titian and Rubens: Power, Politics and Style (exh. cat. by H. T. Goldfarb, D. Freedberg and M. B. Mena Marqués, Boston, MA, Isabella Stewart Gardner Mus., 1998)

CECIL GOULD

Tito, Santi di (*b* Sansepolcro, 6 Oct 1536; *d* Florence, 2 July 1602). Italian painter, draughtsman and architect. His art is of fundamental importance to the history of Florentine painting in the transitional period between Mannerism and Baroque. He rejected the virtuosity of Mannerist painters and returned to an earlier Renaissance tradition that emphasized clear narrative and the expression of a purer, more genuine religious sentiment. His most important works are altarpieces and frescoes; his private commissions included devotional paintings, mythological scenes and portraits. Although he was less important as an architect, here too he upheld an ideal of purity and simplicity that parallels the style of his paintings.

1. LIFE AND PAINTED WORK.

(i) Florence, Rome and Venice, to c. 1575. Santi di Tito completed his training in Florence, where he studied with Bastiano da Montecarlo (dismissed by Vasari as 'uomo senza disegno'), then with Agnolo Bronzino and Baccio Bandinelli. He was admitted to the Compagnia di S Luca in 1554. In 1555 he was in contact with Vasari (then court artist to Cosimo I de' Medici) and as late as 1557 is again documented with Bastiano. In this early period Santi experimented with the different elements that were to determine his style. The first work that may confidently be attributed to him, an *Adoration of the Magi* (before 1558; Fiesole, S Domenico), which had been begun by Giovanni Antonio Sogliani, is deeply indebted to the Florentine tradition of Andrea del Sarto and Fra Bartolommeo.

Between 1558 and 1564 Santi worked in Rome. The first frescoes he painted there, oval medallions of the *Four Seasons* and narrative panels illustrating the *Parable of the Vineyard* (Rome, Giardini Vaticani Casino Pio IV), remain within this Florentine tradition. The later ones—a *Crucifixion*, scenes from the *Acts of the Apostles* (both Rome, Pal. Salviati, chapel) and the stories of *Nebuchadnezzar* (Rome, Vatican, Cortile Belvedere)—show a tendency towards the more Raphaelesque style of Taddeo Zuccaro.

In March 1564 Santi returned to Florence and in July gained admittance to the Accademia del Disegno (founded 1563), for which he thereafter performed a variety of duties. From 1564, with other artists of the Accademia, he was regularly employed by Vasari. Two paintings, a *Virgin with Saints* (Florence, Ognissanti) and an impressive *Nativity* (Florence, S Giuseppe), both done before 1568, indicate a return to local stylistic tradition. In their simplicity and naturalism they are quite distinct from the complex poses and precious colouring advocated by Vasari, whose projects evidently required Santi to modify his style to one that was more sophisticated and graceful. This compromise is seen in his fresco of the *Construction of Solomon's Temple* (1571; Florence, Annunziata, chapel of St Luke), the small paintings the *Discovery of Purple*, the *Origin of Amber* and the *Crossing of the Red Sea* (1571–2), which were painted to decorate the *studiolo* of Francesco I in the Palazzo Vecchio (*in situ*), and in the great altarpiece of the *Resurrection* (*c.* 1572; Florence, Santa Croce; see fig. 1). His court portraits (e.g. *Don Pietro Medici*, Florence, Uffizi), which recall those by Bronzino and Francesco Salviati, show some of his best qualities.

The influence of Venetian art (Santi evidently visited the city in 1571–2) and more particularly of Paolo Veronese may be seen in Santi's *Feast in the House of Simon* (Florence, SS Annunziata, refectory). Having become a member of the oratory of St Thomas Aquinas in 1568, he painted the *Vision of St Thomas Aquinas* (1573; Florence, S Salvi). The dramatic complexity and spatial effects of this work and of his *Supper at Emmaus* (1574; Florence, Santa Croce) similarly point to his Venetian experience, while the realism of the figures perhaps also suggests a first-hand knowledge of Lombard painters.

1. Santi di Tito: *Resurrection, c.* 1572 (Florence, Santa Croce)

(ii) Florence, c. 1575–87. After Vasari's death (1574), Santi received fewer court commissions and worked increasingly for the churches of Florence, for private clients and for oratories and confraternities. He was now able to give more time to painting devotional works. The many drawings related to the *Holy Family* and the *Pietà* (e.g. Florence, Uffizi; Munich, Alte Pin.) indicate that these were his preferred subjects. In 1578 he was granted Florentine citizenship and built a house to his own design in the Via delle Ruote (*see* §2 below).

Santi's *Pentecost* (*c.* 1575; Dubrovnik, Dominican church) marks an abandonment of the experimental style of the early 1570s in favour of an increasingly simple and accessible narrative style, in keeping with the demands of the Counter-Reformation church for works that would both instruct and move the most humble spectator. These ideas were promulgated in Florence by the Provincial Synod of 1573 and later supported by critics as influential as Raffaelle Borghini. Many of Santi's paintings exemplify this approach, among them the *Raising of Lazarus* (1576; Florence, S Maria Novella), the *Martyrdom of St Stephen* (1579; Florence, SS Gervasio & Protasio) and the *Assumption* (1587; Fagna, S Maria). Santi's narrative clarity is largely derived from his progression through several preparatory sketches to one or more highly finished drawings, squared for transfer, as in the drawing (Florence, Uffizi) for the *Nativity* (1583; destr., ex-S Maria del

Carmine, Florence); other important examples survive (Florence, Uffizi; Rome, Pal. Farnese; Paris, Louvre). Such preparation was standard Mannerist practice and showed Santi's adherence to the ideal of *disegno*, but his striving to achieve greater naturalism led him away from Mannerism and back to the art of Andrea del Sarto and Raphael, which influenced both his style of composition and the poses of individual figures. This return to an early 16th-century tradition constitutes his 'reform' of Florentine painting. He was searching for a means to express a purer religious sentiment, a quest that is clearly demonstrated in a series of drawings of heads (Florence, Uffizi) and in various aspects of his painted works. Simple and devout paintings, such as the *Pietà with Saints* (Scrofania, Compagnia del Salvatore) and the *Annunciation* (Scrofania, S Biagio), both dating from 1575–80, adopt the clear structures of early 16th-century paintings. The *Circumcision* (1579; Casciana Alta, parish church) includes direct quotations from the prints of the *Life of the Virgin* by Albrecht Dürer (1471–1528) and the frescoes of scenes from the *Life of St Dominic* (1570–82; Florence, S Maria Novella) contain echoes of Domenico Ghirlandaio. These references to earlier art accord with the views of Counter-Reformation theorists, such as Giovanni Andrea Gilio da Fabriano and Gabriele Paleotti, who exalted 'primitive' and Nordic paintings as expressions of a more genuine devotion. There is more feeling too in Santi's later portraits (e.g. *Portrait of an Unknown Gentleman*, Florence, Uffizi), which have a humanity and warmth that suggests the art of Bartolomeo Passarotti (1529–1592) and Annibale Carracci (1560–1609).

(iii) Florence, 1588–1602. In his final period Santi responded to the new interest in light and colour that was being developed by younger Florentine artists, such as Lodovico Cigoli (1559–1613), Gregorio Pagani (1558–1605), Jacopo da Empoli (1551–1640) and Domenico Passignano (1559–1638). Three paintings, all of 1588, herald this new phase: *St Nicholas of Tolentino* (Sansepolcro, Pin.), *St John the Baptist Preaching* (Lima, Ortiz de Zevallos priv. col., see Spalding, 1982, fig. 70) and the *Crucifixion* (Florence, Santa Croce). Monumental in composition, they are also richer in colour and more realistic in their treatment of light and shade. These aspects of his style culminated in the *Agony in the Garden* (1591; Florence, S Maria Maddalena dei Pazzi; see fig. 2), the *Miracle of the Loaves and Fishes* (1592; Florence, SS Gervasio & Protasio) and the *Vision of St Thomas Aquinas* (1593; Florence, S Marco). The *Miracle of St Clement* (1592; Sansepolcro, Pin.) is among his less careful paintings, which are probably associated with his being overburdened with commissions. A new mood of subdued yet vibrant emotion is present in such works as the *Pentecost* (1598; Prato, S Spirito) and in the series of *Madonnas in Glory* (*c.* 1600; e.g. Montevettolini, S Michele; Dicomano, S Maria; Prato, Cassa di Risparmio; Florence, S Stefano a Ponte). His last known work, an *Annunciation* (*c.* 1602; Florence, S Maria Novella), revives an archaic composition and is tempered by delicate passages of light, in which some critics have seen a reflection of the works of Caravaggio.

(iv) Workshop and critical reception. Santi's importance was universally recognized. He was an acclaimed teacher,

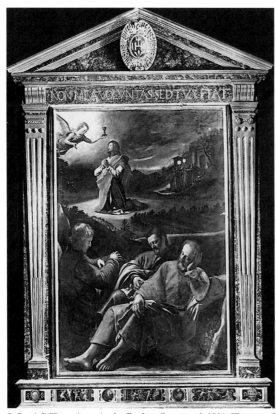

2. Santi di Tito: *Agony in the Garden*, oil on panel, 1591 (Florence, S Maria Maddalena dei Pazzi)

admired by artists as diverse as Cigoli and Passignano. Many young Florentine artists entered his workshop, among them Pagani, Agostino Ciampelli (1565–1630), Andrea Boscoli (*fl* 1550–1606), Ludovico Buti (*c.* 1560–1603), Antonio Tempesta and his own son, Tiberio di Tito (1573–1627). When, in 1602, the Accademia del Disegno established rules for the protection of Florence's artistic patrimony, he was mentioned as the foremost of the leading artists whose signatures were required to sanction the exportation of works of art.

2. ARCHITECTURE. Santi's activities as an architect are poorly documented, and much of his work has been distorted by later alterations. Only the original façades survive of the oratory of St Thomas Aquinas (1568–9), his own house in the Via delle Ruote and the Palazzo Dardinelli–Fenzi (both *c.* 1580). The famous door of the artist's house, with its jambs placed at a slanting angle rather like a painterly conceit, was included in Santi's architectural repertory as a concession to the Mannerist love of the bizarre. All the other elements in these early buildings, however, tend towards an ideal of purity and simplicity, directly in conflict with the architectural notions introduced into Florence by Bartolomeo Ammannati and Vasari. The substantially intact Palazzo Anchini (after 1583), Florence, with a courtyard that has been attributed to Michelozzo, clearly exemplifies these characteristics. There are three surviving examples of Santi's villa architecture: the Villa Montrone at Peretola; the Villa Le Corti

at San Casciano, Val di Pesa; and the Villa I Collazzi at Giogoli, the grandeur of which has led to its being attributed to Michelangelo. The Capponi tempietto at Semfonte (1594–7) and the convent of S Michele alla Doccia (now Villa Doccia), on which Santi worked in 1599, are the best documented of his architectural works. For the tempietto he planned to embellish an octagonal oratory with a portico, but this was never carried out; for the convent, however, the work of linking and enriching a series of existing buildings was completed in exact accordance with his plan.

BIBLIOGRAPHY

G. Vasari: *Vite* (1550, rev. 2/1568); ed. G. Milanesi (1878–85), v, p. 124; vii, pp. 91, 309–10, 619–20

R. Borghini: *Il Riposo* (Florence, 1584), pp. 106, 115–16, 187–8, 194, 198, 205, 619–23

G. Baglione: *Vite* (1642); ed. V. Mariani (1935), pp. 41, 65, 153–4, 319, 332

F. Baldinucci: *Notizie* (1681–1728); ed. F. Ranalli (1845–7), ii, pp. 534–54

G. Briganti: 'Un libro su Santi di Tito', *Crit. A.*, iii (1938), pp. xvii–xix

R. Chiarelli: 'Contributi a Santo di Tito architetto', *Riv. A.*, xxi (1939), pp. 126–55

G. Fagnoni Spadolini: 'Una villa restaurata: I Collazzi', *Ant. Viva*, i/3 (1962), pp. 30–40

W. Vitzthum: *Lo studiolo di Francesco I a Firenze* (Milan, 1965)

L. Berti: *Il principe dello studiolo: Francesco I dei Medici e la fine del rinascimento fiorentino* (Florence, 1967), pp. 73, 77–8, 179–81, 196

E.R.M.: 'A Deposition of Christ by Santi di Tito', *Minneapolis Inst. A. Bull.*, lvii (1968), pp. 49, 67

S. J. Freedberg: *Painting in Italy, 1500 to 1600*, Pelican Hist. A. (Harmondsworth, 1971), pp. 428–31

P. Moschella: 'L'oratorio di San Tommaso d'Aquino di Santi di Tito a Firenze', *Boll. Ingeg.*, xix/10 (1971), pp. 22–5

J. Spalding: 'A Drawing by Santi di Tito for his Lost Carmine *Nativity*', *Master Drgs*, xiv (1976), pp. 278–80

M. Collareta: 'Tre note su Santi di Tito', *An. Scu. Norm. Sup. Pisa*, vii/1 (1977), pp. 351–69

I. Bigazzi: 'La scala del Palazzo Nonfinito', *Michelangelo*, vii/25 (1978), pp. 25–8

A. Godoli and A. Natali: 'Santi di Tito e la Maestà di Antonio Vecchietti', *Ant. Viva*, xix/4 (1980), pp. 12–17

J. Spalding: *Santi di Tito* (New York and London, 1982)

M. Gregori: 'Ut pictura poesis: Rappresentazioni fiorentine della *Gerusalemme liberata* e della *Divina commedia*', *Paragone*, xxxiv/401–3 (1983), pp. 107–21 (108–11)

J. Spalding: 'Santi di Tito and the Reform of Florentine Mannerism', *Stor. A.*, xlvii (1983), pp. 41–52

S. Lecchini Giovannoni: 'Studi e disegni preparatori di Santi di Tito', *Paragone*, xxxv/415 (1984), pp. 20–36

Disegni di Santi di Tito (1536–1603) (exh. cat. by S. Lecchini Giovannoni and M. Collareta, Florence, Uffizi, 1985)

Il seicento fiorentino, 3 vols (exh. cat., Florence, Pal. Strozzi, 1986–7), i, pp. 82–4; ii, pp. 67–9; iii, pp. 161–3

M. P. Mannini: 'Il patrimonio sconosciuto: Santi di Tito e Alessandro Allori nella villa Spini a Peretola, Firenze', *A. Crist.*, lxxii/763 (1994), pp. 271–8

MARCO COLLARETA

Tivoli. Italian hill town, 37 km east of Rome, set above the cascades of the River Aniene. As Tibur, it was a favourite retreat of wealthy Romans escaping the summer heat. Villas were built there, the most famous being that of the emperor Hadrian (*reg* 117–38). It was sacked by the Ostrogoths early in the 6th century AD, but rebuilt and traded to Pope Hadrian I (*reg* 772–95) by Charlemagne in 787. An attack by Emperor Otto III (*reg* 996–1002) was repulsed in 1001, and Tivoli remained an imperial free city until its annexation to the Papal States in 1816. Pius II built the Rocca Pia (1458–64) with four massive round crenellated towers. Pope Julius III granted the governor-

ship of Tivoli to Ippolito II d'Este, Cardinal of Ferrara, who built the fabulous Villa d'Este (*see* §1 below).

BIBLIOGRAPHY
V. G. Pacifici: 'Tivoli nel settecento', *Atti & Mem. Soc. Tiburtina Stor. & A.*, xlv (1972), pp. 97–173; xlvi–xlvii (1973–4), pp. 127–79
M. Vendittelli: 'Testimonianza sulla cattedrale di Tivoli nel medioevo', *Atti & Mem. Soc. Tiburtina Stor. & A.*, lvii (1984), pp. 73–114
S. Carocci: *Tivoli nel basso medioevo: Società cittadina ed economia agraria* (Rome, 1988)
E. B. SAREWITZ

1. VILLA D'ESTE. Villa on the edge of the town, famous for its fine gardens with their spectacular fountains and waterworks. Ippolito II d'Este was appointed governor of Tivoli in 1550. He decided to transform the governor's residence located in a portion of an old rundown Benedictine monastery attached to S Maria Maggiore into a lavish villa with splendid gardens devised by PIRRO LIGORIO. Although some gardens and vineyards were purchased below the monastery at this time, little was accomplished on the project for the next decade as the Cardinal was diverted by political affairs. The villa itself is, in architectural terms, somewhat plain. Ligorio did, however, execute a fine staircase loggia on the garden front. This is bordered on either side by ranges of private rooms, which are largely frescoed with such works as an *Allegory of Nature* by the school of Federico Zuccaro and the *Labours of Hercules* by the school of Girolamo Muziano. In addition, the Audience Hall was frescoed by Muziano himself with views of the gardens.

Between 1560 and 1566 additional land was acquired for the new gardens. In 1560 the first efforts were made to lay on sufficient water for the fountains, which were, and are, the particular glory of the gardens (*see* LIGORIO, PIRRO, fig. 2). An aqueduct was built to tap the springs on nearby Monte S Angelo, and in 1564–5 a great conduit was tunnelled under the town of Tivoli to divert water from the Aniene into the garden. The terrain of the valley was remodelled (1563–5) to create a steep slope falling off directly in line with the old monastery and another lesser slope to the north-east. The removed earth was used to form a flat terrace at the south-west, with the existing city wall acting as a retaining wall. A plentiful water supply and a natural gravity flow induced by the different levels provided a play of water for the numerous fountains.

By using ancient statues, some excavated from Hadrian's Villa, and contemporary fountain sculpture, Ligorio devised an elaborate iconographical garden layout celebrating the Cardinal. An ancient statue of *Hercules* standing above the Fountain of the Many-headed Dragon on the hillside along the central walk to the palace identified the garden with the mythological Garden of the Hesperides. According to contemporary historians, Hercules was reputed to be the mythological ancestor of the Estes and had been the ancient deity of Tivoli. A water organ, derived from ancient examples and played by the action of the water, was located in the Fountain of Nature. Another fountain, that of the Owl and Birds, was animated by a water-driven mechanism. Throughout the garden were hidden spurts of water, activated by different devices so as to drench visitors unexpectedly. Water therefore stimulated senses of sight, sound and touch. Work continued on the fountains, pools and grottoes, as well as the formal

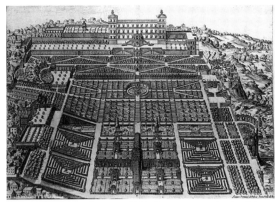

Tivoli, Villa d'Este, begun *c.* 1560; from an engraving by Etienne Dupérac, 1573 (London, British Museum)

landscaping, until 1572. In September of that year the Fountain of the Dragons was erected in honour of a visit by Pope Gregory XIII. This is set within a great horseshoe staircase set on the main axis leading from the villa and consists of a group of dragons, set on a circular pool, spouting water. The theme echoes the figure of a dragon on the Pope's coat of arms.

An engraving dated 1573 (see fig.) presumably illustrates the original design for the villa and gardens. It depicts features, such as the belvederes rising at the ends of the villa or the Fountain of Neptune in the lower southern corner, that were never realized. In the 17th century a few changes and additions were made in the garden. The great wooden cross-pergola beyond the public entrance, depicted in the 1573 engraving, was replaced by the circle of gigantic cypress trees that is still the major horticultural attraction of the garden. In 1660 Gianlorenzo Bernini (1598–1680) designed the Fountain of the Bicchierone on the central axis above the Fountain of the Dragon and added a naturalistic cascade below the Water Organ. The villa became the property of the Italian state in 1918 and has since been restored. Its spectacular setting combined with the extravagance of its waterworks has assured the garden a pervasive influence on formal garden design throughout Europe since the 16th century.

BIBLIOGRAPHY
T. Ashby: 'The Villa d'Este at Tivoli and the Collection of Classical Sculptures which it Contained', *Archaeologia*, lxi (1908), pp. 219–56
D. R. Coffin: *The Villa d'Este at Tivoli* (Princeton, 1960)
R. W. Lightbown: 'Nicolas Audebert and the Villa d'Este', *J. Warb. & Court. Inst.*, xxvii (1964), pp. 164–90
C. Lamb: *Die Villa d'Este in Tivoli* (Munich, 1966)
D. R. Coffin: *The Villa in the Life of Renaissance Rome* (Princeton, 1979), pp. 311–40
M. L. Madonna: 'Il genius loci di Villa d'Este: Mito e misteri nel sistema di Pirro Ligorio', *Natura e artificio*, ed. M. Fagiolo (Rome, 1979), pp. 192–226
——: 'Pirro Ligorio e Villa d'Este: La scena di Roma e il mistero della Sibilla', *Il giardino storico italiano*, ed. G. Ragioneri (Florence, 1981), pp. 173–96
C. Benocci: 'I sistemi simbolici dei giardini delle ville d'Este a Roma e a Tivoli', *Duca Ercole e il suo architetto Biagio Rosseti: Architettura e città nella Padania tra Quattro e Cinquecento* (Rome, 1995), pp. 39–46
D. Dernie: *The Villa d'Este at Tivoli* (London, 1996)
DAVID R. COFFIN

Toccagni, Callisto de. *See* PIAZZA, (1).

Todeschini, Giulio (*b* Brescia, *c.* 1524; *d c.* 1603). Italian architect. He trained initially as a painter in Milan and Venice. He first worked as an architect in Desenzano del Garda, where he designed the porticos of the Palazzo del Comune (*c.* 1560). His Palazzo del Provveditore (1585), with its rusticated arcades, smooth Doric pilasters and entablature without a frieze, resembles a timid reflection of Michele Sanmicheli's Palazzo degli Honorij (later Palazzo Guastaverza; 1553–4) in Verona. Todeschini also rebuilt S Maria Maddalena (begun 1586), Desenzano, an example of severe simplicity in compliance with the principles of the Counter-Reformation, with elegant Doric columns supporting round arches.

In Brescia, Todeschini replaced the engineer Ludovico Beretta as Superintendent of Buildings in 1572. He rejected a plan (1575) by Andrea Palladio and Francesco Zamberlan (1529–after 1606) to build a third floor on the Palazzo Comunale della Loggia, where a second floor had already been added (1550–60) to the original scheme (1490–1510), on the grounds that the existing walls were too thin to support the additional load and that the proposed third order would disrupt the strict adherence to the rules of classical architecture and the proportions of the façade. Owing to his technical expertise, Todeschini was also consulted on questions of military architecture, such as the restoration of the old castle (1584) and the construction of the new one (1586–8), designed by Giulio Savorgnan (1516–95). He may have designed S Gaetano (1588–98; rebuilt 1692–1745), Brescia, and he drew up the plans for the triumphal arches erected in the city (1595) in honour of Cardinal Giovanni Antonio Morosini.

UNPUBLISHED SOURCES

Venice, Bib. N. Marciana, Cod. it., cl. VII, 1155 (7453) & 1913 (9047) [*Scritture sul vecchio e nuovo castello di Brescia: Preventivo di spesa derivante dal progetto di Giovanbattista Bonhomi* (1586); *Scrittura sullo stato di avanzamento dei lavori* (1588); *Rilievi in qualità di proto del castello* (1589)]

BIBLIOGRAPHY

P. Fontana: *Il sontuoso apparato, fatto dalla magnifica città di Brescia, nel felice ritorno dell'Illu. (et) Reverendiss. Vescovo suo, il cardinale Morosini . . .* (Brescia, 1591)
U. Papa: 'L'architetto Giulio Todeschini da Brescia, 1524–1603', *Emporium*, xiii (1901), pp. 352–65
A. Peroni: 'L'architettura e la scultura nei secoli XV e XVI', *Storia di Brescia*, ed. G. Treccani degli Alfreri, ii (Brescia, 1961), pp. 864–70
A. Manno: 'Un compromesso fra "vecchi" e "giovani": Il nuovo castello di Brescia (1580–1611)', *Stud. Ven.*, n. s., xiii (1987), pp. 255–84
F. Robecchi: 'Fonti inedite per la storia del castello di Brescia e delle fortezze del territorio fra XVI e XVII secolo', *Il colle armato: Storia del castello di Brescia*, ed. I. Gianfranceschi (Brescia, 1988), pp. 187–203

ANTONIO MANNO

Tommaso, Bartolomeo di. *See* BARTOLOMEO DI TOMMASO.

Tommaso da Ravenna. *See* RANGONE, TOMMASO.

Tommaso di Ser Giovanni di Mone Cassai. *See* MASACCIO.

Torbido [il Moro], **Francesco (di Marco India)** (*b* Venice, 1482–5; *d* Verona, 1561–2). Italian painter. According to Vasari, he was taught by Giorgione. He moved from Venice to Verona around 1500 and was certainly trained in the workshop of Liberale da Verona. In 1514 he is recorded as living with the noble Giusti family in Verona. The *Portrait of a Young Man with a Rose* (Munich, Alte Pin.), signed and dated 1516, displays a soft finish and dreamy countenance, and the *Portrait of a Man and Woman* (Berea Coll., KY) has similar Giorgionesque qualities. The signed *Portrait of a Man* (*c.* 1520; Milan, Brera) is more tightly painted, recalling Lorenzo Lotto rather than Giorgione. In the *Virgin and Child with Five Saints* (*c.* 1520; Verona, S Zeno) the more finished forms, bright colour and twisting poses reveal an interest in Mannerism; the same characteristics are evident in the altarpiece depicting the *Virgin in Glory with the Archangel Raphael and S Giustina* (1523; Verona, S Fermo). Between 1526 and 1530 he produced four frescoes of saints in the Fontanella Chapel, S Maria in Organo, Verona, of which the muscular, energetic forms of *St John the Baptist* and *St Jerome* are similar to those in his slightly earlier altarpieces. In the *Mystic Marriage of St Catherine* (ex-Potsdam, Neues Pal.; see Repetto Contaldo (1984), fig. 15) painted for the same chapel, gesture and pose are agitated and emotional, as found in the work of Correggio.

Torbido's frescoes in the choir of Verona Cathedral depicting the *Assumption of the Virgin*, to designs by Giulio Romano, were commissioned by Bishop Giovanni Matteo Giberti (1495–1543) and completed in 1534; (for the Catholic Reform context of this pre-Trent commission, see Serafini). Subsequent works in the Abbazia di Rosazzo (1535) reveal powerful forms and sharp foreshortenings. *St Barbara in Glory with SS Anthony and Roch* (late 1530s; Verona, S Eufemia) shows an increased use of chiaroscuro, intense colour, calmer poses and a less polished finish than the altarpieces of the 1520s. At the beginning of 1546 Torbido was back in Venice, where he executed four scenes from *Genesis* (untraced) for the Scuola della SS Trinità. In 1557 he returned to Verona. Torbido's early assimilation of Mannerism was an important influence on his son-in-law Battista dell'Angolo del Moro and on del Moro's contemporaries Paolo Farinati, Giambattista Zelotti, Anselmo Canneri and Paolo Veronese.

BIBLIOGRAPHY

G. Vasari: *Vite* (1550, rev. 2/1568); ed. G. Milanesi (1878–85), v, pp. 287, 291–6
C. Ridolfi: *Meraviglie* (1648); ed. D. von Hadeln (1914–24), ii, pp. 118–19
B. dal Pozzo: *Le vite de' pittori, scultori e architetti veronesi* (Verona, 1718), pp. 27–8
G. Gerola: 'Questioni storiche di arte veronese, 8: Torbido, Moro e dall'Angolo', *Madonna Verona*, iv/3 (1910), pp. 145–57
D. Viana: *Francesco Torbido detto il Moro, pittore veronese* (Verona, 1933)
B. Berenson: *Central and North Italian Schools* (1968), i, pp. 430–31
M. Repetto Contaldo: 'Francesco Torbido: Da Giorgione alla "Maniera"', *A. Ven.*, xxxvi (1982), pp. 62–80
——: 'Francesco Torbido detto il Moro', *Saggi & Mem. Stor. A.*, xiv (1984), pp. 43–82, 133–68
A. Serafini: 'Gian Matteo Giberti e il Duomo di Veroni 2: Gli affreschi di Francesco Torbido', *Venezia Cinquecento*, xv (1998), pp. 21–142

DIANA GISOLFI

Torelli, Filippo [Pippo] **di Matteo** (*b* Florence, 1409; *d* Florence, 2 May 1468). Italian illuminator. He trained in the bottega of Michele di Giovanni Guarducci (1387–1453) between 1438 and 1442. From 1446 he decorated a series of choir-books for the Capitolo di S Marco, among which the Gradual (1456–7; Venice, Fond. Cini, no. 2151) from S Pancrazio is of special interest for its introduction

of the 'heroic putto'. He also decorated several manuscripts for Florence Cathedral: for example, two Psalters (Florence, Mus. Opera Duomo, N. II, 3 and O, 4), which were illustrated by Zanobi Strozzi, with whom he continued to collaborate, and an Antiphonary (Florence, Mus. Opera Duomo, U. 46) for which he was paid in 1450–51. Between 1454 and 1463 Torelli worked on the borders of two Graduals (Florence, Bib. Medicea–Laurenziana, MSS Edili 149 and 151), also for the cathedral. Here the figure style recalls the work of Ser Ricciardo di Nanni, who was his pupil, and of Francesco di Antonio del Chierico. In the same period Torelli participated in the decoration of the choir-books (Florence, Archivio del Capitolo di S Lorenzo, Corale K. 209) for the Badia of Fiesole.

The illustration of Livy's *Fourth Decade* (Florence, Bib. Medicea–Laurenziana, MS. Plut. 63.12), documented in 1458 by a letter from Vespasiano da Bisticci to Piero de' Medici, shows that Torelli contributed to humanist as well as liturgical books, although only in the decoration of borders. In 1467–8 he began the decoration of an Evangeliary (Florence, Bib. Medicea–Laurenziana, MS. Edili 115), which was completed by Ser Ricciardo di Nanni. The ornamental friezes, the distortion of the figures and the zoomorphic treatment of plant motifs reflect earlier illumination; but Torelli's images are also sometimes enriched by more sculptural forms and greater naturalism that go beyond the limits of decoration. Torelli thus transformed the conventional white-vine scrolls into arabesques of leaves and fruits with putti and animals (e.g. Brussels, Bib. Royale Albert 1er, MS. IV. 229). This type of decoration, reminiscent of the work of lacemakers, embroiderers and goldsmiths, was widely appreciated throughout the 15th century and the beginning of the 16th, especially in the work of Ser Ricciardo di Nanni, Francesco di Antonio del Chierico and Francesco Boccardi (*d* 1547).

BIBLIOGRAPHY

M. Levi d'Ancona: *Miniatura e miniatori a Firenze dal XIV al XVI secolo* (Florence, 1962), pp. 186–91

A. Garzelli: *Miniatura fiorentina del rinascimento, 1440–1525: Un primo censimento*, i (Florence, 1985)

PATRIZIA FERRETTI

Torino. *See* TURIN.

Tornabuoni. Italian family of patrons. One of the most powerful merchant families of 15th-century Florence, the Tornabuoni were closely connected with the Medici. Both families were involved in banking and had literary and scholarly interests that brought them into association with the most distinguished humanist scholars of the day.

(1) Giovanni Tornabuoni (*b* Florence, 1428; *d* Florence, 1497). He was the son of Francesco Tornabuoni and Selvaggia degli Alessandri and married Francesca Pitti (*d* 1477) in 1466. His sister Lucrezia was the mother of Lorenzo the Magnificent. Around 1450 he had a palazzo built by Michelozzo di Bartolomeo (in the Via Tornabuoni, Florence, but now much altered and known as the Palazzo Corsi). It was modelled on the palazzo that Michelozzo had recently built for the Medici. In 1465 he became head of the Medici bank and supervised the family's financial interests in Rome, where he mainly resided until 1487, for part of that time as treasurer to Pope Sixtus IV. He met Domenico Ghirlandaio in Rome (*see* GHIRLANDAIO, (1)), who in 1481 depicted him with his son, (2) Lorenzo Tornabuoni, in a fresco in the Sistine Chapel. He granted Ghirlandaio a contract, dated 1 September 1485, to paint frescoes of scenes from the *Life of the Virgin* and the *Life of St John the Baptist* in the family chapel in S Maria Novella, Florence. The detailed description of the patron's requirements given in this contract conveys the new interest in richly detailed landscape backgrounds. The frescoes were unveiled in 1490 and include portraits of Giovanni, his wife and numerous relatives and friends. The scene of *Zachariah in the Temple* contains portraits of Marsilio Ficino, Angelo Poliziano and Cristoforo Landino, evoking the humanist circles in which Giovanni moved. Ghirlandaio also designed the stained glass for the chapel and painted the vast high altarpiece (e.g. central panel of the *Virgin in Glory with Four Saints*; Munich, Alte Pin.). Vasari mentioned many other works commissioned from Ghirlandaio, including a tondo with an *Adoration of the Magi* (Florence, Uffizi) and a cycle of frescoes (untraced) for a villa near Florence then owned by the Tornabuoni, usually identified as the present Villa Lemmi.

In 1477 Giovanni commissioned Verrocchio to create a tomb (e.g. four *Virtues*; Paris, Mus. Jacquemart-André) for his wife, who had died in childbirth in Rome. The low relief of the *Death of Francesca Tornabuoni* that was to be carved on the base (Florence, Bargello) was erroneously said by Vasari to have been commissioned by Francesco Tornabuoni. Similarly it was Giovanni, not Francesco, who had the tomb of *Giovanfrancesco Tornabuoni* carved by Mino da Fiesole in the church of S Maria sopra Minerva, Rome. Giovanni's portrait appears not only in frescoes but also in a medal attributed to Sperandio (Florence, Bargello).

(2) Lorenzo Tornabuoni (*b* Florence, 1465; *d* Florence, 1497). Son of (1) Giovanni Tornabuoni. He married Giovanna degli Albizzi (1468–88) in 1486. As a cousin of Lorenzo the Magnificent he moved in Florentine Neo-Platonic circles. He was educated by Angelo Poliziano, who dedicated *L'Ambra* and *La Selva* to him. We know from the Medici archives that at the age of 14 Lorenzo was already reading Greek manuscripts of the *Iliad* and the *Odyssey* (Fahy). According to some critics, the youth depicted in the frescoes painted in the Villa Lemmi (*Youth Presented to the Visual Arts*; Paris, Louvre), attributed to SANDRO BOTTICELLI, was the young Lorenzo. A series of panels depicting the story of *Jason*, painted by Bartolomeo di Giovanni, Biagio d'Antonio and Pietro del Donzello (Paris, Mus. A. Déc.; Cape Town, priv. col., see Fahy, pls 233–9), may have been connected with Lorenzo's marriage, perhaps as decorations for a nuptial chamber.

In 1491 Lorenzo Tornabuoni commissioned from Ghirlandaio an altarpiece representing the *Visitation* (Paris, Louvre) for his chapel in S Maria Maddalena dei Pazzi, Florence. Two portraits of him exist, one on a medal by Niccolò di Giovanni Fiorentino and the other a panel painting, attributed to Francesco Botticini (Stockholm, Kun. Slottet). In 1497, having been accused, with Bernardo del Nero, of plotting to restore Piero de' Medici to Florence, he was tried and beheaded.

BIBLIOGRAPHY

G. Vasari: *Vite* (1550, rev. 2/1568); ed. G. Milanesi (1878–85), ii, p. 444; iii, pp. 118, 258, 260, 262, 269

A. Reaumont: 'Il monumento Tornabuoni del Verrocchio', *G. Erud. A.*, ii (1873), pp. 167–8

G. Milanesi: 'Documenti inediti', *Il Buonarroti*, ser. 3, ii (1887), p. 336 [prints contract between Giovanni Tornabuoni and Ghirlandaio]

R. Ridolfi: 'Giovanna Tornabuoni e Ginevra de' Benci nel coro di S Maria Novella in Firenze', *Archv Stor. It.*, vi (1890), pp. 426–56

V. Chiaroni: 'Il Vasari e il monumento sepolcrale del Verrocchio per Francesca Tornabuoni', *Studi vasariani. Atti del convegno: Firenze, 1952*, pp. 144–5

D. S. Chambers: *Patrons and Artists in the Italian Renaissance* (London, 1970), pp. 170–75

A. Luchs: *Cestello: A Cistercian Church of the Florentine Renaissance* (New York, 1977), pp. 21, 37–64, 159

E. Fahy: 'The Tornabuoni-Albizzi Panels', *Scritti di storia dell'arte in onore di Federico Zeri*, ed. F. Porzio (Milan, 1984), i, pp. 233–48

K. Rådström: 'Un gruppo di dipinti fiorentini nel Palazzo Reale di Stoccolma', *Ant. Viva*, xxv (1986), pp. 9–13

DONATELLA PEGAZZANO

Torrigiani, Bastiano (*b* Bologna; *d* Rome, 5 Sept 1596). Italian sculptor. He was active in the Roman workshop of Guglielmo della Porta after 1573, and assumed control of the studio after della Porta's death in 1577. He executed bronze sculptures for the Cappella Gregoriana in St Peter's, the Cappella del Presepio in S Maria Maggiore, both in Rome, and the Cappella del Coro in S Agostino in Bologna. His best-known works are the colossal bronze figures (1585–7) of *St Peter* and *St Paul* cast for the tops of the columns of Trajan and Marcus Aurelius. Perhaps Torrigiani's greatest contribution was in portraiture, notable examples being a bust of *Gregory XIII* and three busts of *Sixtus V* (Berlin, Bodemus.; Macerata Cathedral; London, V&A). These and other works by Torrigiani are generally regarded as among the most significant sculptures produced in Rome between the death of Paul III in 1549 and the sculpture of Gianlorenzo Bernini (1598–1680), capturing the zeal of the early years of the Council of Trent. The busts demonstrate an indebtedness to Michelangelo's art and 16th-century Venetian painted portraits, such as those by Titian, in their emphasis on surface texture and the strong presence of the sitter—influences that Torrigiani would have inherited through his training and association with della Porta.

BIBLIOGRAPHY

Thieme–Becker

J. Pope-Hennessy: *Italian High Renaissance and Baroque Sculpture*, iii (London, 1963), pp. 305–6

U. Schlegel: *Italienische Skulpturen* (Berlin, 1989)

STEVEN BULE

Torrigiani, Pietro [Piero] **(di Torrigiano d'Antonio)** [Thoryson, Peter; Torrejano, Pedro; Torrisani, Petrus; Torrisany, Petir; Tourrisan, Pierre; Turrisan, Petrus; Turrizani, Petrus; Master Peter; Magistro Petro] (*b* Florence, 22 Nov 1472; *d* Seville, July or August 1528). Italian sculptor, active also in France, the Netherlands, Spain and perhaps Portugal. He is famous both as the man who broke Michelangelo's nose and as the Florentine artist who is generally credited with introducing the Italian Renaissance style to England. He was a brilliant and versatile sculptor and also one of the first Italian Renaissance artists to work outside of Italy.

1. Life and work. 2. Critical reception and influence.

1. LIFE AND WORK. Pietro was the son of Torrigiano Torrigiani, a member of a family of wine producers

(*vinatieri*) in the area around Florence. According to Giorgio Vasari, the young Torrigiani was a pupil of Bertoldo di Giovanni, in the 'academy' of Lorenzo de' Medici, where he studied drawing and marble, bronze and terracotta sculpture. Vasari considered Torrigiani's early works 'very beautiful', but described his personality and appearance as haughty (*superbo*), powerful and robust, violent and overbearing. Torrigiani's envy of Michelangelo, his contemporary and rival in the academy, led to the famous fight (recorded twice by Vasari and by Benvenuto Cellini) while the two sculptors were boasting about whose skill was greater in drawing Masaccio's figures in the Brancacci Chapel in S Maria del Carmine, Florence (see colour pls 2, II2 and 2, III2). Vasari records that this incident (which must have occurred before 1492) so incensed Lorenzo de' Medici that Torrigiani was forced to flee Florence.

On 18 August 1492, in Bologna Torrigiani promised to make a terracotta bust (untraced) of the physician Stefano della Torre. Shortly afterwards, according to Vasari, he settled in Rome to work with Andrea Bregno and Bernardo Pinturicchio and their workshops on the stucco decorations of the Torre Borgia in the Vatican Palace for Pope Alexander VI (*reg* 1492–1503). During this period Torrigiani must have encountered the Florentines Piero and Antonio del Pollaiuolo, who were responsible for the tombs of *Pope Sixtus IV* (completed 1493) and *Pope Innocent VIII* (completed 1498; both Rome, St Peter's) that influenced Torrigiani's later tombs in England. By 1498 Torrigiani was resident in the house of Stefano Coppi, then rector of S Salvatore alla Suburra, Rome, who came from San Gimignano, Tuscany. Torrigiani's will, dated 18 September 1498, appoints Coppi his executor and mentions that 50 ducats were due to Torrigiani for a head (*testa*) he made of *Pope Alexander VI*; this piece Ferrajoli tentatively, but probably incorrectly, associated with a terracotta bust in Berlin (Berlin, Bodemus.). About this time Torrigiani probably made the earliest surviving works attributed to him, the marble busts of *Christ* (San Gimignano, Mus. A. Sacra) and *St Fina*, and a terracotta bust of *St Gregory*, the last two presented by Coppi to the Ospedale di S Fina in San Gimignano (both *in situ*).

Documents discovered in Florence, Rome and Avignon (Darr, 1992) establish that between 1493 and 1506 Torrigiani remained active in Rome, Florence and elsewhere in Italy and southern France and that he may not have left for northern Europe and England until after early 1506. Between 1496 and 1502, Cardinal Adriano Castellesi, the papal secretary for the Spanish Pope Alexander VI, commissioned one 'Magistro Petro, Scarpelino Florentino', also called 'Petrus Scarpelinus florentinus' (Pietro Torrigiani), and other Florentine artists to complete various marble monuments for S Giacomo degli Spagnoli, now called Nostra Signora del Sacro Cuore, on Piazza Navona in Rome. This was founded in 1450 by Bishop Alfonso Paradinas of Seville (*d* 1485) and was the first church built in Rome after the papacy left Avignon and returned to Rome. Documented over seven years, the works Magistro Petro Scarpelino Florentino created include the church's marble doorways (1499–1500) now on the Piazza Navona façade, a polychome and gilded marble Singing Gallery or *Cantoria* (1500–02), a marble altar

dedicated to Francisco Gundisalvo de Valladolid (1501), various wall tombs and monuments to Pietro Suarez Guzmán (c. 1500), to Don Diego Valdes (c. 1501), and probably the heraldic putti on that to Ferdinando de Córdoba (c. 1490–95), all three now removed to the cloister of S Maria di Monserrato. A stairway, a royal coat of arms for Spain, and stone window frames for the church (all destr.) are also documented to the same Magistro Petro. His patrons, two of them cardinals influential with England and Spain, help explain the important commissions Torrigiano would later receive.

Vasari stated that in order to earn better wages during these years, Torrigiani enlisted in Cesare Borgia's army in the war of Romagna (1499–1500); he then joined the Florentines in the battle against Pisa (autumn 1499) and later fought at Garigliano (28 Dec 1503) with Piero de' Medici and the French forces. Heralded as a valiant soldier, he returned to Florence, presumably in early 1504. Several works have been attributed to him during this period, for example a polychrome *Virgin and Child* in SS Annunziata degli Zoccolanti, Fossombrone (on loan to Palazzo Ducale, Urbino), which is associated with a commission for an altarpiece that Torrigiani received on 13 January 1500. Some works attributed to the MASTER OF THE UNRULY CHILDREN and the MASTER OF THE DAVID AND ST JOHN STATUETTES (*see* MASTERS, ANONYMOUS, AND MONOGRAMMISTS, §I) may be by Torrigiani. The earliest surviving documented work identified as 'Pietro Turrisani' is the marble life-size statue of *St Francis* carved by 5 June 1501 for Cardinal Francesco Todeschini–Piccolomini for the Piccolomini Altar in Siena Cathedral (*in situ*; was completed by Michelangelo). Piccolomini was Cardinal Protector of England from 1492 to 1503, when he was elected Pope as Pius III (*d* 1503). He maintained close contacts with the Tudor court, and he and his family were probably instrumental in securing Torrigiani's English appointment. Vasari reported that, before going to England, Torrigiani made for Florentine merchants numerous drawings, some in competition with Michelangelo, and many small marble and bronze sculptures 'with nobility and good style' (all untraced). In 1503 Torrigiani married Felice di Francesco Mori (*d* 1541) in Florence, and they had their only child there, a son Torrigiano (*b* 29 Aug 1503; *d* 1528).

Through his contacts with Cardinals Castellesi, Piccolomini and others in Rome, and the Baroncelli and other Florentine merchants, Torrigiani found employment that led to his journey to northern Europe. On 19 February 1504 he was commissioned by Francesco and Giovanni Baroncelli to sculpt with Clement Delamotte, a local painter and glazier, three statues for a *Crucifix with the Virgin and St John* (untraced) for the church of the Cordeliers (destr.) in Avignon. Torrigiani may have met Francesco Baroncelli in Rome in 1503–4, when Baroncelli, head of the Florentine 'nation' in Avignon, led a papal delegation to Rome to meet with the new Pope, Julius II. Documents in Avignon indicate, however, that 'Petrus Torrissani' did not continue to travel north, but returned to Rome and on 26 January 1505/6 purchased two large blocks of marble which Michelangelo owned. These new documents and attributed works establish that Torrigiani travelled regularly between Florence, Bologna and Rome,

and the more distant Romagna, the Marches, and even Avignon, before he departed for the Low Countries and England, where he remained active until he moved to Spain either *c.* 1522, when Charles V (*reg* 1516–56) visited his aunt, Catherine of Aragon, and Henry VIII (*reg* 1509–47) in London, or *c.* 1525, when he made a terracotta bust (untraced) of Empress Isabella of Portugal, according to Francisco d'Hollanda, presumably for her marriage in 1526 to Charles V in Seville. According to Vasari, Torrigiani was so incensed over an inadequate payment from the Spanish Duque de Arcos that he destroyed a terracotta statue of the *Virgin and Child*; he was imprisoned for the sacrilege and then starved himself to death. The tale remains unsubstantiated, but estate documents referring to Torrigiani's widow indicate that he died in the summer (July or August) of 1528.

2. CRITICAL RECEPTION AND INFLUENCE. An unsympathetic image of Torrigiani and his work has largely been created by Vasari and other supporters of Michelangelo and by the dispersal and relative inaccessibility of Torrigiani's mature sculptures. His monuments in England and Spain are significant for Italian art, however, in their continuing reflection of the sculptural styles of such Florentine sculptors as Verrocchio, Pollaiuolo, Benedetto da Maiano, the della Robbia and Bertoldo. Torrigiani's modelled and carved works, especially his sepulchral monuments in Westminster Abbey, London, and his *St Jerome* of 1525 (Seville, Mus. B.A.), are among the best Florentine Renaissance sculptures anywhere and demonstrate the talent of this artist and his role in disseminating disparate Italian Renaissance styles, techniques and new uses of materials throughout Europe.

BIBLIOGRAPHY
Thieme–Becker
F. de Hollanda: *Da pintura antigua* (Lisbon, 1548); Eng. trans. by A. F. G. Bell as *Four Dialogues on Painting* (London, 1928)
G. Vasari: *Vite* (1550, rev. 2/1568); ed. G. Milanesi (1878–85), iv, pp. 255–65
B. Cellini: *Vita* [c. 1558–67]; Eng. trans. based on various editions by J. A. Symonds, 2 vols (London, 1887/*R* 1959), pp. 18–19
A. Higgins: 'On the Work of Florentine Sculptors in England in the Early Part of the Sixteenth Century: With Special Reference to the Tombs of Cardinal Wolsey and King Henry VIII', *Archaeol. J.*, li (1894), pp. 129–220, 367–70
A. Venturi: *Storia* (1901–40), x, pp. 278–83
C. Justi: 'Torrigiano', *Jb. Preuss. Kstsamml.*, xxvii (1906), pp. 249–81
R. S. Scott: 'On the Contracts for the Tomb of the Lady Margaret Beaufort, Countess of Richmond and Derby', *Archaeologia*, xlvi (1914/15), pp. 365–76
A. Ferrajoli: 'Un testamento dello scultore Pietro Torrigiano e ricerche sopra alcune sue opere', *Boll. A.*, ix (1915), pp. 181–92
C. Cochin: 'Un lien artistique entre l'Italie, la Flandre et l'Angleterre, Pietro Torrigiano en Flandre', *Rev. A. Anc. & Mod.*, xxxvi (1915–19), pp. 179–82
C. R. Beard: 'Torrigiano or Da Maiano', *Connoisseur*, lxxxiv (1929), pp. 77–88
L. Dimier: 'Pierre Torrigiani: Artiste florentin en Avignon', *Bull. Soc. N. Antiqua. France* (1937), pp. 95–6
F. Grossmann: 'Holbein, Torrigiano and Some Portraits of Dean Colet', *J. Warb. & Court. Inst.*, xiii (1950), pp. 202–36
J. Pope-Hennessy: *Italian Renaissance Sculpture* (New York, 1958, rev. 3/1985), pp. 304–5, 359
H. J. Dow: 'Two Italian Portrait Busts of Henry VIII', *A. Bull.*, xlii (1960), pp. 291–4
J. Pope-Hennessy: *Catalogue of Italian Sculpture in the Victoria and Albert Museum*, ii (London, 1964), pp. 399–401

J. Hernández Díaz: 'Presencia de Torrigiano en el cinquecento europeo', *Archv Hispal.*, lvi (1973), pp. 311–27

B. H. Meyer: 'The First Tomb of Henry VII of England', *A. Bull.*, lviii (1976), pp. 358–67

A. P. Darr: 'The Sculpture of Torrigiano: The Westminster Abbey Tombs', *Connoisseur*, cc (1979), pp. 177–84

——: *Pietro Torrigiano and his Sculpture for the Henry VII Chapel, Westminster Abbey* (diss., New York U., 1980)

——: 'From Westminster Abbey to the Wallace Collection: Torrigiano's *Head of Christ*', *Apollo*, cxvi (1982), pp. 292–8

——: 'Santa Fina', *Capolavori e restauri* (exh. cat., Florence, Pal. Vecchio, 1986), pp. 96–8

C. Galvin and P. G. Lindley: 'Pietro Torrigiano's Portrait Bust of King Henry VII', *Burl. Mag.*, cxxx (1988), pp. 892–902

——: 'Pietro Torrigiano's Tomb for Dr Yonge', *Ch. Mnmts*, 3 (1988), pp. 42–60

P. G. Lindley: 'Una grande opera al mio re: Gilt-bronze Effigies in England from the Middle Ages to the Renaissance', *J. Brit. Archaeol. Assoc.*, 143 (1990), pp. 112–30

——: 'Playing Check-mate with Royal Majesty? Wolsey's Patronage of Italian Renaissance Sculpture', *Cardinal Wolsey: Church, State and Art*, ed. S. J. Gunn and P. G. Lindley (Cambridge, 1991), pp. 261–85

A. P. Darr: 'New Documents for Pietro Torrigiani and Other Early Cinquecento Florentine Sculptors Active in Italy and England', *Kunst des Cinquecento in der Toskana*, ed. M Cämmerer (Munich, 1992), pp. 108–38

——: 'Verrochio's Legacy: Observations Regarding his Influence on Pietro Torrigiani and Other Florentine Sculptors', *Verrocchio and Late Quattrocento Italian Sculpture*, ed. S. Bule, A. P. Darr and F. S. Gioffredi (Florence, 1992), pp. 125–39

ALAN PHIPPS DARR

Toscani, Giovanni (di Francesco) (*b* 1370–80; *bur* Florence, 2 May 1430). Italian painter. He matriculated in the Florentine Compagnia di S Luca in 1424, but it seems that already in 1420 he was inscribed on the rolls of the company (Orlandi). In 1423 and 1424 he received payments for decorating the Ardinghelli Chapel in Santa Trìnita, Florence (Milanesi). In the *catasto* (land registry declaration) of 1427, Toscani described himself as a *cassone* painter ('cofanaio').

Bellosi (1966) realized that the two poorly preserved, but surviving fragments of the fresco decoration in the Ardinghelli Chapel, showing *St Nicholas of Bari in Glory* and the *Pietà*, were close in style to the paintings grouped together (Salmi, Offner) under the name of the Master of the Griggs Crucifixion. However, subsequent work on Toscani has led to the view that the Griggs *Crucifixion* (New York, Met.) after which the anonymous master is named should be excluded from Toscani's work; its painter was evidently interested in early Renaissance innovations and had a close affinity with the youthful works of Fra Angelico, whereas Toscani's documented works are closer to the gothicizing style of Lorenzo Monaco and Lorenzo Ghiberti. Among the assistants who worked with Ghiberti (contracts of 1403, 1407) on the north doors of the Florence Baptistery (*see* GHIBERTI, (1), fig. 2) is a Giovanni di Francesco who could be Toscani. Paintings by Toscani such as the *Virgin and Child* (Buffalo, NY, Albright–Knox A.G.) or the triptych of the *Virgin and Child with Saints* (Florence, Gal. Osp. Innocenti) probably can be dated *c.* 1410–20. While they show the influence of late Orcagnesque models, they also reveal an assimilation of a Gothic style that is more tender and more advanced than that of Lorenzo Monaco. The *cassone* panel of the *Court of Love* (Madison, U. WI, Elvehjem A. Cent.) and one illustrating a scene from Boccaccio's *Decameron* (Edinburgh, N.G.) are also likely to date *c.* 1410–20. Other *cassoni* panels

attributable to Toscani include two depicting the celebrations of the feast day of St John the Baptist (Cleveland, OH, Mus. A.; Florence, Bargello).

Of the painters active in Florence in the 1420s, Giovanni Toscani was one of the most intelligent and original interpreters of the great changes in style that occurred following Gentile da Fabriano's arrival there and in the wake of Masaccio's revolutionary innovations. Among Toscani's works of that decade the decoration of the Ardinghelli Chapel must have been particularly important. Some panels from the chapel's altarpiece also survive (dispersed), and attempts to reconstruct it have been helped by the discovery of a 17th-century description of the altarpiece (Padoa Rizzo). Fragments include a predella panel of the *Stigmatization of St Francis and a Miracle of St Nicholas of Bari* (Florence, Accad.), the *Adoration of the Magi* (ex-Dodge priv. col., Italy, see 1988 exh. cat., pp. 70–71), the *Baptism of Christ and the Martyrdom of St James* (Philadelphia, PA, Mus. A.), the right-hand panel of *SS John the Baptist and James the Great* (Baltimore, MD, Walters A.G.) and gables with the *Crucifixion* (Florence, Accad.) and the *Annunciation* (Rome, Carandini priv. col., see Padoa Rizzo).

BIBLIOGRAPHY
G. Vasari: *Vite* (1550, rev. 2/1568); ed. G. Milanesi (1878–85), i, p. 629; ii, p. 20

G. Milanesi: 'Le vite di alcuni artefici fiorentini scritte da Giorgio Vasari', *G. Stor. Archv. Tosc.*, iv/3 (1860), pp. 178–210 (207–9)

M. Salmi: *Masaccio* (Rome, 1932), p. 134

R. Offner: 'The Mostra del Tesoro di Firenze sacra, II', *Burl. Mag.*, lxiii (1933), pp. 170–73

W. Paatz and E. Paatz: *Kirchen* (1940–54), v, pp. 251, 358

S. Orlandi: *Beato Angelico* (Florence, 1964), pp. 171, 181

L. Bellosi: 'Il Maestro della Crocifissione Griggs: Giovanni Toscani', *Paragone*, xix/193 (1966), pp. 44–58

——: 'Due note per la pittura fiorentina di secondo trecento', *Mitt. Ksthist. Inst. Florenz*, xvii (1973), pp. 179–94 (189)

M. Boskovits: *Un'Adorazione dei Magi e gli inizi dell'Angelico* (Berne, 1976), p. 38

M. Eisenberg: 'The Penitent St Jerome by Giovanni Toscani', *Burl. Mag.*, cxviii (1976), pp. 275–83

F. Zeri: *Italian Paintings in the Walters Art Gallery*, i (Baltimore, 1976), pp. 29–31

L. Bellosi: *Il Museo dello Spedale degli Innocenti a Firenze* (Milan, 1977), p. 233

A. Padoa Rizzo: 'Sul polittico della cappella Ardinghelli in Santa Trinita di Giovanni Toscani', *Ant. Viva*, xxi/1 (1982), pp. 5–10

Arte in Lombardia tra Gotico e Rinascimento (exh. cat., Milan, Pal. Reale, 1988), pp. 196–7 [entry by L. Bellosi]

G. Bonsenti: *Beato Angelico* (Florence, 1998), pp. 10, 115–16

LUCIANO BELLOSI

Tosini, Michele [Ghirlandaio, Michele di Ridolfo del] (*b* Florence, 8 May 1503; *d* Florence, 28 Oct 1577). Italian painter. He studied with Lorenzo di Credi and Antonio del Ceraiolo (*fl* 1520–38) before entering the workshop of Ridolfo Ghirlandaio. By 1525 he was frequently collaborating with Ghirlandaio, and their closeness is reflected in Tosini's adopted name. Tosini began painting in the early 16th-century Florentine style of Fra Bartolommeo and Andrea del Sarto (e.g. the *Virgin of the Sacred Girdle*, *c.* 1525; Florence, S Marco). His acceptance of Mannerism was slow, but by the 1540s the influence of Francesco Salviati and Agnolo Bronzino was observable in his work.

After 1556 Tosini worked for Giorgio Vasari in the fresco decoration of the Salone dei Cinquecento in the Palazzo Vecchio, Florence. Through Vasari's example,

Tosini adopted a vocabulary derived from the work of Michelangelo and painted some of his best-known works in this manner (e.g. *Night*, *c.* 1560; Rome, Gal. Colonna, and *Leda*, *c.* 1560; Rome, Gal. Borghese). He executed several important commissions late in his career: the fresco decoration of three city gates of Florence (1560s), the altar in the chapel at the Villa Caserotta (1561), near San Casciano Val di Pesa, and the paintings on the sides and back of the tabernacle of the high altar of S Maria della Quercia (1570), Viterbo. According to Vasari, Tosini headed a large workshop that executed numerous altarpieces and paintings.

BIBLIOGRAPHY
G. Vasari: *Vite* (1550, rev. 2/1568); ed. G. Milanesi (1878–85), vi, pp. 543–8
C. Gamba: 'Ridolfo e Michele di Ridolfo del Ghirlandaio—II', *Dédalo*, ix (1929), pp. 544–61
B. Berenson: *Florentine School*, i (1963), pp. 149–50
D. Franklin: 'Towards a New Chronology for Ridolfo Ghirlandaio and Michele Tosini', *Burl. Mag.*, cxl/1144 (1998), pp. 445–55
H. J. Hornik: *Michele di Ridolfo del Ghirlandaio (1503–1577) and the Reception of Mannerism in Florence* (PhD diss., University Park, PA State Univ., 1990)
——: 'The Testament of Michele Tosini', *Paragone*, xlvi (1995), pp. 156–67

GENETTA GARDNER

Tourrisan, Pierre. *See* TORRIGIANI, PIETRO.

Tozzo, il. *See* LARI, ANTONIO MARIA.

Tramello, Alessio (*b* Piacenza prov., before 1470; *d* Piacenza, *c.* 1528). Italian architect. He may have trained under Giovanni di Domenico Battagio, whose style was derived from Donato Bramante; Tramello's own monumental works belong to the same school. Two of his most impressive and original buildings are the Benedictine church of S Sisto (1499–?1511) and the Olivetan monastery of S Sepolcro (?1498–1510/11), both in Piacenza and both erected by Tramello to his own designs. The Benedictines stipulated that he must respect the existing foundations of the medieval church of S Sisto and incorporate the eight granite columns (which now support the vaults of the nave and aisles) remaining from an earlier project of 1494. The church is a cruciform basilica with a barrel-vaulted nave of five bays flanked by aisles and outer chapels. The aisle bays are square and surmounted by domes; the arcade leading to the outer chapels is supported on cruciform piers, and each chapel consists of a straight bay with an apse. The main transept has apsed arms, but there is a second transept just behind the façade, with a central dome, and here the arms are planned as domed Greek crosses.

The Olivetan monastery of S Sepolcro has three features of particular interest: a three-aisled library, a secret passage (a covered walk parallel to the loggias of the cloisters) and its entrance (known as the 'House of the Commendatory Abbot'), which has an incomplete façade characterized by enormous lozenges and circles. The church of S Sepolcro was built by Tramello for the first time in 1498 together with the monastery but was subsequently modified following the 'neo-Byzantine' scheme of S Salvador at Venice and construction began in 1513. A design by Tramello for the church of S Sepolcro at Piacenza is kept in the parish archive of the Olivetan monastery of S Vittore al Corpo in Milan. Like S Sisto, it has a nave flanked by aisles and apsed outer chapels, but here the nave consists of two square groin-vaulted bays separated by narrow barrel-vaulted bays (see fig.). The square aisle bays behind the latter are domed. There is an apse at each end of the transept, as at S Sisto, and the use of piers without capitals in the main elevation, which stresses the verticality of the composition, was also foreshadowed in the earlier building.

Between 1502 and 1507 Tramello built the smaller court of Palazzo Landi in Piacenza and in the same period constructed the double loggia in the courtyard of the Pallavicino palace in the City of Cortemaggiore (1479). For the Olivetans he planned and built the church and monastery of the Annunziata (begun 1517; destr.) at Villanova near Lodi, Milan. It is possible that he designed unrealized projects for the church and monastery of S Vittore al Corpo in Milan. For the Benedictines of Reggio nell'Emilia he produced designs for the church of SS Pietro and Prospero, also not commissioned, which combined the schemes of S Sisto and of S Sepolcro (Reggio nell'Emilia, archivio di stato, arch. Benedettino). The Cappella del Salvatore in the benedictine convent of S Maria Teodote in Pavia, seems to take up once again the Tramellian *tempietti* in the head of the first transept of S Sisto at Piacenza. In 1520–23 he erected the church of S Benedetto (or S Marco) in Piacenza, which in 1547 was incorporated in the pentagonal fortress (destr.) built for Pier Luigi Farnese, 1st Duke of Parma. It is likely that Tramello also built the church of S Benedetto (from 1527; destr.) in Crema, near Cremona, possibly to a design by Paolo Sacca (*d* 1537). Tramello's last surviving work, which he both designed and supervised, is the civic church of Piacenza, S Maria di Campagna (1522–6). The plan, in the form of a Greek cross, is developed from the scheme he used at S Sepolcro. A square, domed central bay is surrounded by pairs of shallower bays, with small domed square chapels at the corners. The exterior presents a strong contrast between the bare arms of the Greek cross and the complexity of the central lantern, with its two tiers

Alessio Tramello: S Sepolcro, Piacenza, interior of nave looking west, 1513

of windows, and the four smaller lanterns of the corner chapels. The interior shows Tramello's ability to play the smaller spaces of the four chapels against the larger space of the Greek cross and to exploit the luminosity of the dome frescoed by Pordenone. One of the finest provincial architects of the Renaissance in Italy, Tramello was made syndic of the Guild of Builders of Piacenza (1508) and in 1527 received a special tribute from the city to which he had contributed so many palazzi and churches.

BIBLIOGRAPHY

Macmillan Enc. Architects
P. Gazzola: *Opere di Alessio Tramello architetto piacentino* (Rome, 1935)
J. Ganz: *Drei Sakralbauten in Piacenza und die oberitalienische Architektur um 1500* (Frauenfeld, 1968)
L. H. Heydenreich and W. Lotz: *Architecture in Italy, 1400–1600*, Pelican Hist. A. (Harmondsworth, 1974)
B. Adorni: *Alessio Tramello* [in preparation]
M. Giuffredi, ed.: *Santa Maria di Campagna: Una chiesa bramantesca* (Reggio Emilia, 1995)

BRUNO ADORNI

Trent Castle. *See* BUONCONSIGLIO CASTLE.

Treviso [anc. Tarvisium]. Italian city and capital of the Trevisan Marches, the largest and most important territory in the Veneto. The city lies about 30 km north of Venice, to which it is connected by the Terraglio, an ancient road widened and embellished by Napoleon. Treviso stands at the confluence of the Sile and Cagnano (Botteniga) rivers, amid abundant springs at the centre of a fertile alluvial plain famous for its wine production. The original nucleus of the city was expanded to three times its size in the late medieval and Renaissance periods, becoming a rectangular, walled city orientated east–west, with surrounding streams channelled through large moats. The city's picturesque aspect derives from these moats and many smaller canals, as well as from its arcaded streets (e.g. Calmaggiore) of brick buildings with frescoed façades.

Archaeological evidence from the Bronze and Iron ages (from the 13th century BC) as well as substantial finds from Greek and Roman antiquity attest to the lengthy but modest development of the settlement that became the Roman municipium of Tarvisium by 46 BC. The city grew with surprising consistency during the 4th–6th centuries AD, profiting from a gradual abandonment of the Roman cities of Aquileia, Altino and Oderzo in the wake of successive invasions. An increasingly powerful bishopric from at least AD 396, Treviso became a duchy under the Lombards, with a mint founded by AD 773. Charlemagne entered Treviso in AD 776, establishing a hereditary line of Lombard–Frankish counts. The city was sacked by the Hungarians (AD 899, 911); under King Berengarius of Italy (*d* 924) it was briefly capital of the marquisate of Friuli; but in AD 952 its long association with the Holy Roman Empire was reaffirmed by its formal annexation by Emperor Otto I (*reg* 936–73). The first decrees of the essentially independent *comune* date from 1162, and in 1164 Emperor Frederick I (*reg* 1152–90) granted its civic government important rights, including the construction of houses with covered street arcades and the erection of an enlarged circuit of city walls (completed 1219). The office of Podestà (imperial governor) dates from 1176.

A brief republic was proclaimed in Treviso in 1312–18, but contention between the lords of Verona and Padua for control of the city induced the *comune* to call in its Austrian overlords, who reaffirmed its rank as an imperial city in 1319. The Trevisan March was subsequently ceded to Venice (1339) as the first of its many mainland territories, among which Treviso enjoyed pride of place for nearly five centuries until 1797. Important churches of the 15th century include the Venetian Gothic basilica of S Maria Maggiore (1473–4; rebuilt 1946–53), with a marble Tempietto (1492) enclosing an early devotional fresco (1352) by Tomaso da Modena.

The history of Trevisan art and architecture is exemplified particularly in the cathedral. Apart from surviving Romanesque portions, it contains work from many subsequent periods, notably the east end (1481–8) by members of the Lombardo family; the chapel of the Holy Sacrament (1501–13) by Antonio Maria da Milano, with sculpture by Giovanni Battista Bregno and his brother Lorenzo Bregno (for discussion and illustration *see* BREGNO, (3) and (4)); and the chapel of the Annunciation (1519–23) by Martino Lombardo, frescoed in 1520 by Pordenone. Treasures in the cathedral include the tomb of *Bishop Zanetti* (late 1480s) by Pietro Lombardo; the altarpiece of the *Virgin and Child Enthroned with SS Sebastian and Roch* (1487) by Girolamo da Treviso (i); a superb *Annunciation* (early 1520s) by Titian; an *Adoration of the Shepherds* (*c*. 1540s) by Paris Bordone; and the marble *St John the Baptist* (*c*. 1565) by Alessandro Vittoria.

The wars of the League of Cambrai (1508–16) caused every able-bodied citizen of Treviso to work throughout the summer of 1509 on a surviving 4.8 km circuit of modernized city walls with 13 bastions (completed 1513) traditionally attributed to Fra Giovanni Giocondo of Verona, supervised by Lorenzo di Ceri and Barolomeo d'Alviano. The Porta S Quaranta (1517) is attributed to Alessandro Leopardi, and the Porta S Tomaso (1518) to Guglielmo Bergamasco (Scarpellino; *fl* 1515–50). Notable buildings of the mid-16th century include the Palazzo Spineda (remodelled early 18th century).

Treviso was the birthplace of such Renaissance artists as Girolamo da Treviso (i) and Paris Bordone, while Cima, Giorgione and Titian came from the surrounding area. Most of these masters are well represented in Treviso's fine Museo Civico Luigi Bailo, a complex of historical buildings incorporating also the Biblioteca Comunale (with important manuscript holdings). The Biblioteca Capitolare of the cathedral (catalogued 1135) was one of the richest in North Italy until its partial destruction in 1944.

BIBLIOGRAPHY

Enc. Catt.; *Enc. It.*
L. Coletti: *Catalogo delle cose d'arte e d'antichità di Treviso* (Rome, 1935)
Veneto, Guida Italia TCI (Milan, 4/1954), pp. 416–31
F. Roiter: *Favolosa Marca: Itinerari nella provincia di Treviso* (Treviso, 1976)
T. Basso and A. Cason: *Treviso ritrovata: Immagini della città scomparsa* (Treviso, 1977)
G. Anselmi: *Treviso: Guida turistica* (Treviso, 3/1985)
I. Sartor: *Treviso lungo il Sile: Vicende civili ed ecclesiastiche in San Martino* (Treviso, 1989)
I. Puccinelli: 'Treviso romana e altomedievale', *Venezia A.*, 4 (1990), pp. 19–28

DOUGLAS LEWIS

Treviso, Dario da. *See* DARIO DA TREVISO.

Treviso, Girolamo da. *See* GIROLAMO DA TREVISO (i) and (ii).

Treviso, Vincenzo da. *see* DESTRE, VINCENZO DALLE.

Trezzo, Jacopo (Nizolla) da, I (*b* Milan, 1515–19; *d* Madrid, 23 Sept 1589). Italian medallist, sculptor, gem-engraver and jeweller. Nothing is known of his background and early life. His family apparently came from Trezzo-sull Adda but were living in Milan at the time of his birth. By 1550 he had achieved a level of fame that deserved mention in the first edition of Vasari's *Vite*. His activities in Milan, in which city he lived until 1555, included gem-engraving and the fabrication of objects in precious and semi-precious stones for Cosimo I, Duke of Florence. Several letters in archives in Florence, dated 1552, 1572 and 1575, describe this work and the difficulties Trezzo experienced in receiving payment. Between 1548 and 1578 Jacopo produced eleven medals, including variants, eight of which are signed. The first of these is the medal of the Cremonese engineer *Gianello delle Torre*, of which one example (Florence, Bargello) bears the date 1548. Although not signed, it has been attributed both to Trezzo and to Leone Leoni. Stylistic evidence strongly favours Trezzo as the author of the medal: the portrait is forceful, and the details of hair, beard and drapery are delicately modelled without being fussy. The reverse, showing *Fountain of the Sciences*, is a masterpiece of relief sculpture with expressive movement, strong modelling, subtle variations in relief and a precise but lively depiction of faces, water, and drapery.

While in Milan, Trezzo produced two signed medals (both London, V&A), doubtless commissioned by the Governor of Milan, Ferrante Gonzaga. One was of Gonzaga's wife, *Isabella de Capua, Princess of Molfetta* (*d 1559*), and the other of their daughter, *Ippolita Gonzaga (1535–63)*, dated by the age of the subject to 1552. The obverse of the latter was copied from a medal made a year earlier by Leoni with some changes in the drapery and jewellery and with a perceptible loss of refinement in the portrait. The reverse, however, showing *Aurora in a Chariot Riding across the Heavens*, is handled with considerable skill in its modelling and suggestion of space. The medal of *Isabella de Capua* recalls the placid strength of the *Gianello delle Torre* medal, as well as having similar drapery.

In 1555 Trezzo moved to the Low Countries, probably to Brussels, in the service of Philip II of Spain (*reg* 1556–98), who had also become the ruler of Milan. The documentation of Trezzo's move indicates that he carved two seals for Philip in 1557. He also produced his most beautiful medallic portrait, that of *Mary I of England* (*reg* 1553–8; London, BM), who married Philip in 1554. Her features are given an extraordinary alertness, while the details of her costume are rendered with a precision that is nonetheless subordinate to the form of the body beneath and to the overlapping layers of drapery. The reverse shows Mary in the guise of Peace setting fire to a pile of arms with her left hand and holding aloft palm and olive branches in her right, while suppliants kneel behind her beneath a rain-cloud. The medal, which is signed, resembles that of delle Torre. Its pendant is a medal of *Philip*

II, signed and dated 1555, of which there are two variants (Florence, Bargello). The portrait of Philip does not have the intensity of that of Mary, nor does its reverse equal that of the Ippolita Gonzaga medal, which it resembles in subject-matter, the *quadriga* of Apollo replacing Aurora's chariot.

In 1559 Trezzo followed Philip to Spain, where he apparently spent the rest of his life. Trezzo's son Jacopo da Trezzo II (*d* Madrid, 16 Jan 1607) was also a sculptor.

BIBLIOGRAPHY

Forrer
G. Vasari: *Vite* (1550); ed. G. Milanesi (1878–85)
A. Armand: *Les Médailleurs italiens* (2/1883–7), i, pp. 241–3; iii, pp. 114–15
I. B. Supino: *Il medagliere mediceo nel R. Museo Nazionale di Firenze* (Florence, 1899), pp. 140–42
G. F. Hill and G. Pollard: *Renaissance Medals from the Samuel H. Kress Collection at the National Gallery of Art* (London, 1967), pp. 83–4
G. F. Hill: *Medals of the Renaissance* (London, 1920; rev. and enlarged by G. Pollard, 1978), p. 97
V. Johnson: 'La medaglia italiana in Europa durante i secoli XV e XVI', pt 2, *Velia Johnson: Dieci anni di studi di medaglistica, 1968–78* (Milan, 1979), pp. 51–68
Splendours of the Gonzaga (exh. cat., ed. D. Chambers and J. Martineau; London, V&A, 1982), pp. 182–3
G. Pollard: *Italian Renaissance Medals in the Museo Nazionale del Bargello* (Florence, 1985), iii, pp. 1238–51
The Currency of Fame: Portrait Medals of the Renaissance (exh. cat., ed. S. K. Scher; Washington, DC, N.G.A.; New York, Frick; 1994), pp. 158–61, 383–4

STEPHEN K. SCHER

Tribilia, Antonio. *See* TERRIBILIA, (1).

Tribolo, Niccolò [Niccolò di Raffaello de' Pericoli; il Tribolo] (*b* ?Florence, 1500; *d* ?Florence, 7 Sept 1550). Italian sculptor, engineer and garden designer. He was apprenticed in Florence first as a wood-carver with Giovanni d'Alesso d'Antonio and then as a sculptor with Jacopo Sansovino, whom he continued to assist well into the second decade of the 16th century. Vasari listed many works (most now untraced) from Tribolo's youth, among which was his earliest fountain; an old terracotta copy (London, V&A) shows this unpretentious and slightly old-fashioned work to have featured two children and a spouting dolphin that foreshadow the blithe charm of his later masterpieces.

Tribolo was famously unassertive and often adapted his art to suit established or collaborative projects. His plump and lissom putto (marble, *c.* 1523–4) on the lower right of Baldassare Peruzzi's tomb of *Hadrian VI* (Rome, S Maria dell'Anima) indicates his exposure both to antique sculpture and to contemporary Roman work, especially that of Michelangelo's maturity. In 1525–7 he collaborated on façade sculpture for S Petronio, Bologna, where his portal relief of *Joseph Interpreting Pharoah's Dreams* combines recollections of the antique *Laokoon* (Rome, Vatican, Mus. Pio-Clementino) and Michelangelo with an archaizing quality inspired by Jacopo della Quercia's sculptures on the middle portal.

Although the influence of Jacopo's grandeur persists in most of Tribolo's later history reliefs, in his next two works he turned away from this epic world: late in 1527 he made the model for a marble angel now at the entrance to the high altar of Pisa Cathedral. This engaging work, which he probably also undertook to carve (though it was

finished and signed by Silvio Cosini, who changed the head), is important for its contribution to the development of free-standing sculpture with continuous multiple viewpoints. Enhanced by the sweeping rhythms of the draperies, the figure pushes Michelangelesque contrapposto to an extreme. By contrast his marble statue of *Nature* (Paris, Louvre; *see* ITALY, fig. 40), designed in Florence *c.* 1528 as a stand for an antique vase, is a static, symmetrical composition, intended to be viewed frontally, despite its swarm of animated putti, birds, frogs and other animal and vegetable fantasies; the figure is based on the antique *Diana of Ephesus* (Fontainebleau, Château), and the work can be regarded as a prototype for the great fountains of Tribolo's last years.

Tribolo was among the team of sculptors to work on the basilica of the Santa Casa at Loreto, where he collaborated on several works and in 1533 completed Andrea Sansovino's marble high relief of the *Marriage of the Virgin* (began 1527). He also produced wax models for niche figures of prophets (untraced) in the basilica; these evidently impressed Clement VII sufficiently for him to send Tribolo back to Florence to help Michelangelo complete the Medici tombs in S Lorenzo (see colour pl. 2, V1), though this work was interrupted in 1534 because of the Pope's death. In 1536 Tribolo entered the service of Duke Alessandro de' Medici, producing for him a monumental carved Medici escutcheon with two Victories (marble; Prato, Mus. Com.) and numerous large-scale ephemeral decorations, the latter also for the Duke's successor, Cosimo I. Around this time he was called to Bologna to provide huge marble reliefs of the *Assumption of the Virgin* (payment 1537–8) for the church of the Madonna di Galliera. Tribolo's original arrangement was of a broad lower section depicting the Apostles, with the Virgin soaring above (probably separately compartmented), her smaller scale enhancing the effect of a receding apparition. The reliefs were moved to a chapel in S Petronio in the 18th century and reassembled as a single scene in a coarse and inappropriate Baroque setting. Nevertheless, it remains one of the best history reliefs of the second quarter of the 16th century.

In 1538 Tribolo returned to Florence at the request of Cosimo I to realize the allegorical Mannerist garden at the Medici villa at Castello. Concurrently he worked on a colossal marble Medici escutcheon for one of the bastions of S Miniato, Florence (unfinished; a Victory and some trophies, Florence, Pal. Alessandri), and a model (London, Wallace) for a monument to Cosimo's father, *Giovanni delle Bande Nere* (Florence, Piazza S Lorenzo), the only one of his much-admired models to survive (the commission was later transferred to Baccio Bandinelli). Vasari's account of the elaborate iconographical programme of the gardens at Castello states that a series of portrait and allegorical sculptures was intended to glorify the Medici virtues that nourished the state, the geographical features of which were also to be personified in sculpture. Among the earliest works to be undertaken were marble statues of river gods representing the *Arno* and the *Mugnone* (both untraced), the latter accompanied by a personification of *Fiesole* (Florence, Bargello), one of Tribolo's boldest works. The Fountain of the Labyrinth (Villa Petraia, nr Florence), the first of the two great marble and bronze fountains of the central axis of the garden, initiated the final phase of Tribolo's career, when the demands on his time were such that he had to content himself with making models, leaving much of the execution of the finished works to his pupils. Among the more talented of them was Leonardo's nephew Pierino da Vinci, who was with Tribolo *c.* 1542–6 and carved the exquisite upper part of the fountain.

During his dozen years' service with Cosimo I, Tribolo undertook an extraordinary miscellany of tasks. These included decorations for state occasions, firework displays, theatrical costumes and décor as well as water conservation and other hydraulic projects. More specifically, he was also responsible for the design and supervision of the monumental tomb of *Matteo Corte* (marble, 1544–8; Pisa, Campo Santo), which was executed by Antonio Lorenzi (*d* 1583); the installation of Michelangelo's sculpture in the Medici Chapel at S Lorenzo (1546); the design and installation of the elaborate pavement in the Biblioteca Laurenziana at S Lorenzo; new gardens for the Medici villa at Poggio a Caiano, near Florence; and the continuing work at Castello. The most influential accomplishment of his last years, however, was the laying out of the Boboli Gardens behind the Pitti Palace in Florence (*see* FLORENCE, §IV, 9(iii)). A painting (1599; Florence, Mus. Firenze com'era) by Giusto Utens (*d* 1609) shows this scheme as originally set out before later additions to the south destroyed the logic of the composition. The symmetrical architectonic layout of the big urban palace was continued into the gardens along an impressive receding central axis. The scheme was to be taken up again in the following century in the gardens of the Tuileries and the Luxembourg Palace in Paris for Maria de' Medici and was to be an essential component in the design of the gardens of the château of Versailles in the 1660s.

So well organized was Tribolo's workshop that his Fountain of Hercules at Castello (see fig.), now judged to be his masterpiece, was executed largely by assistants from his models, much of it posthumously. Larger, more richly decorated and with a more copious flow of water than the Fountain of the Labyrinth, it consists of an octagonal marble basin and two tazze decorated with marble and bronze putti, masks and claws. The whole is topped by a heroic bronze group of *Hercules and Antaeus*, which contrasts in typical fashion with the animated denizens of Tribolo's fairyland below. The monumental bronzes for Castello were cast in a somewhat perfunctory fashion in the 1560s: the *Hercules and Antaeus* and a colossal *Appennine* by Bartolomeo Ammanati's assistants and the small statue of *Florence* by Giambologna's. They nevertheless retain important vestiges of Tribolo's models. His last documented and entirely autograph work is a small, exuberant twisting figure of *Pan* (1549; Florence, Bargello), shown playing on the pipes. It has been described as one of the most beautiful Florentine bronzes of the Renaissance (Dupré) and should also be seen as an indispensable paradigm for the evolution of the free-standing statue in the art of Giambologna and his contemporaries. Vasari gives his date of death as 7 September 1550; other sources give 20 August 1550.

BIBLIOGRAPHY
G. Vasari: *Vite* (1550, rev. 2/1568); ed. G. Milanesi, vi (1881), pp. 55–117
B. H. Wiles: 'Tribolo in his Michelangesque Vein', *A. Bull.*, xiv (1932), pp. 59–70

Niccolò Tribolo: Fountain of Hercules, marble and bronze, Villa di Castello, near Florence, *c.* 1550

——: *Fountains of the Florentine Sculptors* (Cambridge, MA, 1933)

J. Holderbaum: 'Notes on Tribolo', *Burl. Mag.*, xcix (1957), pp. 336–43, 369–72

J. Pope-Hennessy: 'A Small Bronze of Tribolo', *Burl. Mag.*, ci (1959), pp. 85–9

M. Ciardi Dupré: 'Presentazione di alcuni problemi relativi al Tribolo scultore', *A. Ant. & Mod.*, 7 (1961), pp. 244–7

J. Pope-Hennessy: *Catalogue of Italian Sculpture in the Victoria and Albert Museum*, ii (London, 1964), pp. 436–9

H. Keutner: 'Niccolò Tribolo und Antonio Lorenzi: Die Äskulapbrunnen im Heilkrautergarten der Villa Castello bei Florenz', *Studien zur Geschichte der europäischen Plastik: Festschrift für Theodor Müller* (Munich, 1965), pp. 235–44

W. Aschoff: *Studien zu Niccolò Tribolo* (Berlin, 1967)

C. Lloyd: 'Drawings Attributable to Tribolo', *Master Drgs.*, vi (1968), pp. 243–5

C. Avery: *Florentine Renaissance Sculpture* (London, 1970)

D. R. Wright: *The Villa Medici at Olmo a Castello* (diss., Princeton U., NJ, 1976; microfilm, Ann Arbor, 1981)

W. Aschoff: *Studien zu Niccolò Tribolo* (diss., Frankfurt am Main, U. Frankfurt am Main, 1994)

C. Acidini Luchinat and G. Galletti: *La villa e il giardino della Petraia a Firenze* (Florence, 1995)

A. Butterfield and D. Franklin: 'A Documented Episode in the History of Renaissance *Terracruda* Sculpture', *Burl. Mag.*, cxl/1149 (1998), pp. 819–24

JAMES HOLDERBAUM

Trissino, Giangiorgio [Giovan Giorgio], Count (*b* Vicenza, 1478; *d* Vicenza, 1550). Italian writer, scholar, amateur architect, patron and teacher. He was an active and well-known man of letters who did much to promote the new learning and the principles of Renaissance architecture in the Veneto region, running an informal residential school mostly for the sons of the local aristocracy at his home near Vicenza, where his most famous pupil was ANDREA PALLADIO. Trissino was a keen scholar of linguistics and rhetoric and was very familiar with both Greek and Latin texts. He attempted to revive the Greek epic and introduced Greek tragedy into Italy through his *Sofonisba* of 1514–15. Later he drew on Plautus and Pindar respectively for his comedy *I Simillimi* (1548) and his *Canzoni*. His interest in Greek forms of language culminated in his attempt to hellenize Italian spelling and pronunciation.

Trissino also produced books on grammar and an *Ars Poetica* and even tried to develop a common language in Italy. He also translated Horace and wrote pastoral and other poems in Latin. These include the heroic epic poem *Italia liberata dai Goti* which appeared finally in 1547, dedicated to the Emperor Charles V (*reg* 1519–56). Trissino stated that from his vast knowledge of ancient literature he chose Aristotle and Homer as his two main influences. The poem tells of the expulsion of the Goths from Italy by Belisarius, a commander under Justinian I (*reg* 527–65), which ensured the survival of the classical tradition in Italy. Perhaps more interesting to Trissino was the fact that this act aligned Italy to the Eastern empire, and hence to contact with ancient Greek civilization. Charles V was seen as the new Justinian, charged with the task of ridding the Eastern empire of the infidel. In 1538 Trissino added a loggia of his own design to his villa at Cricoli. This was the first known structure in Vicenza to show an understanding of the principles of Roman Renaissance architecture. This project led to his first meeting with Andrea di Pietro della Gondola, a local stonemason involved in the work, for whom Trissino became both mentor and patron. Trissino set about educating him solely in the theory and practice of Classical architecture and in 1540 renamed him Andrea Palladio. This education made Palladio the first of a new type of humanist architect who was a specialist in his own field.

WRITINGS

S. Maffei, ed.: *Tutte le opere di Giovan Giorgio Trissino* (Verona, 1729)

BIBLIOGRAPHY

J. S. Ackerman: *Palladio* (Harmondsworth, 1966, rev. 1976), pp. 20–25, 31–2

R. Wittkower: *Architectural Principles in the Age of Humanism* (London, 1973), pp. 51–64, 71, 94

DANA ARNOLD

Trivulzio, Gian Giacomo (*b* 1441; *d* 1518). Italian soldier, patron and collector. He was a member of a leading patrician family and inherited considerable estates from his father Antonio Trivulzio, who had been a prominent figure in the Ambrosian Republic. He was a favourite of Galeazzo Maria Sforza, Duke of Milan, and became a noted condottiere, serving, among others, Ferdinand I, King of Naples (*reg* 1458–94). In 1495 he transferred his services to Charles VIII, King of France (*reg* 1483–98), and in 1499 took the duchy of Milan for Louis XII (*reg* 1498–1515). Although Trivulzio was considerably rewarded and made Marchese di Vigerano, his relations with the French Crown were strained, due to his own difficult nature and the rivalry within the French regime in Milan. The French continued to rely on his military skills, however, and he remained a prominent and wealthy figure.

Trivulzio's patronage was extensive, although he was considered very mean by his contemporaries. He constructed an elaborate palace (destr. *c.* 1920) in Milan, begun in 1469 and radically altered and lavishly decorated *c.* 1485.

He had a considerable interest in antiquity, and his palace was decorated with ancient inscriptions; he also collected and commissioned manuscripts of Classical texts. Trivulzio's leading position in Milan after 1500 is demonstrated by three of his commissions: firstly the set of 12 tapestries (Milan, Castello Sforzesco) illustrating *The Months*, designed by Bramantino and made in a workshop probably established by Trivulzio between 1501 and 1510. The unusual iconography of these tapestries illustrates Trivulzio's interest in the Classical world, his involvement in agriculture and his aim of glorifying his family by the elaborate use of heraldry.

Trivulzio also seems to have been much concerned with the construction of a funerary monument. Leonardo da Vinci made an estimate for an elaborate marble tomb (*c.* 1510), surmounted by a bronze equestrian statue of Trivulzio; a number of extant drawings by the artist (Windsor Castle, Royal Lib.) have been associated with this project, which was not executed. Trivulzio opted instead for a novel kind of funerary chapel, designed by Bramantino and consisting of a complex (*c.* 1512) forming the façade of the church of S Nazaro Maggiore, Milan. This incorporates an octagonal chapel that provided ample space for the family tombs. The complex is an amalgam of traditional Milanese elements and ideas derived from ancient Greek and Roman architecture and illustrates both Trivulzio's empathy with Bramantino's interest in the Antique and his aim of promoting his own interests and those of his family.

BIBLIOGRAPHY

C. de Rosmini: *Dell'istoria intorno alle militari imprese e alla vita di Giano Giacomo Trivulzio detto il Magno*, 2 vols (Milan, 1815)
E. Motta: *Libri di Casa Trivulzio* (Como, 1890)
C. Baroni: 'Leonardo, Bramantino ed il mausoleo di G. Giacomo Trivulzio', *Rac. Vinc.*, xv–xvi (1934–9), pp. 201–70
K. Clark: *The Drawings of Leonardo da Vinci in the Collection of His Majesty the King* (London, 1935); rev. 2 with C. Pedretti as *The Drawings of Leonardo da Vinci in the Collection of Her Majesty the Queen*, 2 vols (London, 1969)
G. Castelfranco: 'Il preventivo di Leonardo per il monumento sepolcrale di G. G. Trivulzio', *Boll. A.*, n. s. 1, iii (1955), pp. 1–8
M. Valsecchi: *Gli arazzi dei Mesi del Bramantino* (Milan, 1968)
N. Forti Grazzini: *Gli arazzi dei Mesi Trivulzio: Il committente, l'iconografia* (Milan, 1982)

CHARLES ROBERTSON

Trometta [Trombetta; Martinelli, Niccolo] (*b* Pesaro, *c.* 1540; *d* Rome, *c.* 1610). Italian painter. He probably began his apprenticeship in his native Pesaro, but, while young, he moved to Rome, where he studied in the workshop of Taddeo and Francesco Zuccaro. The work of Taddeo most influenced his style, and, with Cherubino Alberti, Giovanni Maria Ricci and Cesare Nebbia, Trometta became one of the leading members of the Zuccaro workshop, participating in the decoration of the Casino of Pope Pius IV in 1561–3. By January 1565 he was established as an independent master, when he was commissioned to decorate a chapel in S Maria della Consolazione. In the same month he agreed to fresco the choir vault in S Maria in Aracoeli, Rome, as part of the restoration of that church ordered by Pius IV in 1561. Trometta's decorative scheme, executed between 1566 and 1568, is one of the best-preserved and most extensive of mid-16th-century ecclesiastical decorations in Rome and comprises a central oval of the *Virgin and Child with Angels* flanked by rectangular

sections depicting *Augustus and the Sibyl* and *Augustus Sacrificing at the Altar*, as well as subsidiary sections. The style reflects the Mannerism of the Zuccaros and of Francesco Salviati, but retains a provincial naivety of Trometta's own.

About 1570 Trometta returned to Pesaro, where he painted a series of large altarpieces, including the *Last Supper* for the church of the Sacrament (now Tavullia, S Lorenzo) and the *Virgin and Child with SS John the Baptist and Nicholas of Bari* for S Maria della Scala della Porta (Budapest, Mus. F.A.), which betray the additional influence of Federico Barocci. After his final move to Rome *c.* 1580, he undertook further ecclesiastical decorations, notably the chapel of the Crucifix (*c.* 1591) and the chapel of St Francis (1595), both in S Maria dell'Orto, but the works of his last period show a marked decline.

BIBLIOGRAPHY

J. A. Gere: 'Drawings by Niccolo Martinelli, il Trometta', *Master Drgs*, i/4 (1963), pp. 3–18
A. Szobor: 'Un Tableau de Pesaro retrouvé de Niccolo Martinelli dit le Trometta', *Bull. Mus. Hong. B.-A.*, xxxiv–xxxv (1970), pp. 85–92
M. Frattarelli: 'Gli affreschi della volta del coro della chiesa di S Maria in Aracoeli in Roma di Niccolo Trometta', *Not. Pal. Albani*, x/2 (1981), pp. 49–53
B. Montevecchi: 'Un ommaggio ai della Rovere', *Quad. Gal. N. Marche*, iii (1981), pp. 65–9

□

Trotti, Giovanni Battista [il Malosso] (*b* Cremona, 1556; *d* Parma, 11 June 1619). Italian painter and architect. He was the last important exponent of Cremonese Mannerism. He was a pupil of Bernardino Campi and inherited his workshop. The cold, brilliant colours and enamel-like surfaces of Trotti's first recorded works, the *Sacrifice of Melchidesek* and the *Gathering of Manna* (both Pralboino Parish Church), closely follow Bernardino's style. More influential, however, were the works of Antonio Campi, seen, for example, in the detailed use of light in the *Beheading of St John the Baptist* (1590; Cremona, Mus. Civ. Ala Ponzone), and especially Bernardino Gatti. From the latter, Trotti derived the elements of Correggio's style that appear in his work from the early *Annunciation* (Casalmaggiore, S Chiara). First-hand knowledge of Correggio's work in Parma is reflected in the *Nativity* (1584; Carate Brianza, SS Ambrogio e Simpliciano). He also absorbed a special interest in landscape from the Flemish painters he met in Parma.

From 1587 Trotti participated in the decoration of S Pietro al Po, Cremona. His busy workshop executed an impressive series of commissions in Cremona and the neighbouring regions, for example at Salò Cathedral (*c.* 1590) and S Sisto, Piacenza (1603). To cope with the enormous quantities required many of his designs were executed by pupils, but he signed the finished paintings. In the early 17th century he was employed as a painter, architect and interior designer by members of the Farnese family in Parma, for example on the decoration of the Palazzo del Giardino (now Palazzo Ducale), and was awarded the title Cavaliere. He often returned to Cremona, for example to work on the cathedral's Altar of the Holy Sacrament, design decorations in honour of Philip III, King of Spain (*reg* 1598–1621), and Margaret of Austria, and supervise his workshop, especially in the decoration of the oratory of the Risen Christ in S Luca, Cremona.

BIBLIOGRAPHY

C. Baroni: 'Il Malosso e il suo ambiente', *Emporium*, 615 (1946), pp. 109–22

A. Puerari: *La Pinacoteca di Cremona* (Florence, 1951), pp. 97–102

M. di Giampaolo: 'Per il Malosso disegnatore', *A. Illus.*, vii (1974), no. 57, pp. 18–35

——: 'Una scheda per il Malosso', *Ant. Viva*, xv/5 (1976), pp. 20–21

——: 'A Drawing by Malosso at Oxford and Some Additions to his Oeuvre', *Master Drgs*, xv (1977), pp. 28–31

I Campi e la cultura artistica cremonese del cinquecento (exh. cat., ed. M. Gregori; Cremona, Mus. Civ. Ala Ponzone, 1985), pp. 238–48

M. Tanzi: 'Qualche aggiunta al Malosso e alla sua cerchia', *Prospettiva*, 40 (1985), pp. 82–5

——: 'Malosso e "dintorni": Dipinti e disegni', *Prospettiva*, 61 (1991), pp. 67–74

A. Dallaj: 'Gli "heroi austriaci", Cremona e il Malosso: I disegni per gli apparati del 1598', *Quad. Pal. Te*, ii (1995), pp. 34–47

MARCO TANZI

Tura, Cosimo [Cosmè] (*b* Ferrara, ?1430; *d* Ferrara, April 1495). Italian painter. He was court painter to the Este family of Ferrara from 1458 until the mid-1480s. He was the first and one of the greatest representatives of the Ferrarese school of painting, but many of his most important works, including the decoration of the library of Pico della Mirandola (1463–94), have been either destroyed or dismantled, and some of his large-scale altarpieces are divided between collections. His career is well recorded and provides a vivid illustration of the role and duties of a 15th-century court artist.

1. Life and work. 2. Critical reception and posthumous reputation.

1. LIFE AND WORK.

(i) To 1459. (ii) 1459–70. (iii) 1471–95.

(i) To 1459. Tura is first recorded in Ferrara in a notarial act of 28 July 1431, in which 'Cosimo, the son of Domenico, the shoemaker' is described as an infant, which would set the date of his birth some time within the previous year. The first indications of an artistic career occurred in 1451 when, in association with the painter Galasso di Matteo Piva, Tura was called in to appraise a set of trumpet banners painted by Jacopo Turolo. The following year his name appeared among the regular salaried members of the Este household where he is documented as having designed a jousting helmet decorated with Borso d'Este's *imprese* of the unicorn and palm tree for the St George's Day horse race; he also painted a banner for the tailors' guild (which he was asked to repaint four years later), and worked with the manuscript illuminator Giorgio d'Alemagna and the carver Giovanni Carlo di Bretagna on 17 small coffers (*coffinetti*) decorated with, among other things, religious scenes and heraldic devices of Duke Borso.

Between 1453 and 1456 Tura is absent from the ducal records. Venturi proposed that he had spent this time in Padua and, perhaps, Venice. The former suggestion is based on the observation that several aspects of Tura's painting style seem to be derived from the mannered classicism of Francesco Squarcione and the Paduan school. Specifically, there are similarities with the work of Mantegna and Niccolò Pizzolo in the Ovetari Chapel in the church of the Eremitani, Padua (*see* MANTEGNA, ANDREA, fig. 1), which has prompted some critics to suggest that Tura worked on or, at least, carefully studied these

paintings. The proposed stay in Venice is surmised from a passage in Tura's first will (14 January 1471), in which he leaves money to the poor of Venice. It has also been suggested that during this visit he was influenced by the recently completed mosaic designed by Andrea Castagno in the Mascoli Chapel in S Marco.

In 1456 Tura was in Ferrara and by 1457 he is listed as living in the Castello and earning a regular salary from the court of 15 lire per month. His only documented ducal commission for this year is for tapestry designs containing the coat of arms and devices of the Duke, which were subsequently woven by the Fleming Livino di Giglio. Tura's first documented painting was a *Nativity* (1458; untraced), commissioned by the ducal bailiff Vincenzo de' Lardi, and placed in the Old Sacristy of Ferrara Cathedral. The work must have been part of a portable altar since it was transferred to the main sacristy of the cathedral during the 18th century. According to 18th-century descriptions, it consisted of several small figures.

In 1458 Borso d'Este appointed Tura official court painter, doubled his salary and placed him in charge of the decoration of the ducal villa at Belfiore. It is difficult to assess Tura's contribution to the fresco cycle of the *Nine Muses* (destr.), originally intended for the *studiolo* of Borso's father Lionello d'Este. Three contemporary documents

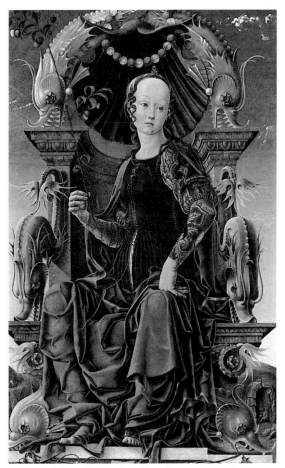

1. Cosimo Tura: *Enthroned Goddess*, oil on panel, 1160×710 mm, 1459–63 (London, National Gallery)

relate to the project: a letter of 5 November 1457 from Guarino da Verona to Lionello d'Este, offering a series of iconographic suggestions regarding the form and attributes of the Muses; Cyriac of Ancona's description of 1449 of the finished paintings of *Clio* and *Melpomene* he had seen in the studio of the former court painter, Angelo del Macagnino; and the statement made by the Ferrarese humanist Ludovico Carbone that Tura was responsible for finishing the series of the Muses begun by Angelo del Macagnino. Unfortunately the information contained in these letters is not wholly consistent, thus making it difficult either to make connections with extant works of art or to reconstruct the iconographic programme. However, two panels have been proposed as possible components of the decorative scheme: Tura's *Enthroned Goddess* (London, N.G.; see fig. 1), variously identified as Venus, Spring and the nymph Erato; and the painting usually called *Charity* (Milan, Mus. Poldi Pezzoli) but perhaps intended to represent the muse Terpsichore. (Only the lower half of the latter painting, showing three dancing children, appears to be by Tura.)

Resting on these suggestions is the identification of Tura's first datable works and our understanding of the whole chronology of his oeuvre. If the two paintings in London and Milan are characteristic of Tura's early work, they show him to be an artist much more closely linked to the local tradition of Ferrarese painting and the style of Angelo del Macagnino and Michele Pannonio than had hitherto been suspected. As a result, stylistically similar works such as the *Virgin and Child with SS Apollonia and Jerome* (Ajaccio, Mus. Fesch), dated by Longhi and Ortolani to the 1490s, should be radically redated to the late 1450s or early 1460s. The transition from this softer, and slightly awkward style—via perhaps the *Pietà* (Venice, Correr), the *Crucifixion* (Washington, DC, N.G.A.), the *Ecce homo* (Vienna, Kunsthistorisches Mus.) and the *Portrait of a Young Man* (New York, Met.)—to the highly formalized structure and figures of Tura's earliest extant documented work, the organ shutters (1469; Ferrara, Mus. Duomo) for Ferrara Cathedral, seems plausible.

(ii) 1459–70. In 1459 Tura made designs for tapestries that were probably commissioned as part of the festivities surrounding the visit of Galeazzo Maria Sforza to the Este court. It is also possible that Borso d'Este, constantly beseeching papal favour, may have been making preparations in the hope of receiving a much grander guest, since Galeazzo Maria was travelling in the cortège of Pope Pius II. On 6 August 1462 Tura was paid for two tournament costumes for Alberto Maria d'Este, which were covered with gold lilies, silver daisies and images of sieves with water running through them (the last probably being one of Alberto Maria's *imprese*). On 7 March and 14 July 1464 he was paid for further tournament costumes for Alberto Maria d'Este and Niccolò d'Este, and the following year he decorated three pairs of horse trappings to be given as a gift by Duke Borso to his favourite, Cavaliere Teofilo Calcagnini.

Tura's absence from the ducal records between 1466 and 1467 suggests that during this period he was engaged in the decoration of the library (destr.) of Pico della Mirandola in the castle of Mirandola. A detailed description

of the cycle is given in a dialogue by the Ferrarese humanist Lelio Gregorio Giraldi. The decoration was apparently arranged in six panels, each divided into three registers and surmounted by a lunette. It depicted the history of poetry arranged chronologically from ancient to modern times. The lunettes contained triumphs of the different poetical ages, and the scheme was bound together by a frieze consisting of crowns, armorial devices and foliage.

By 31 December 1467 Tura had returned to Ferrara, involved, again, with tapestry decoration. Late in 1467 he also received a commission from the brothers Uberto Sacrati, Bartolommeo Sacrati and Pietro Sacrati to decorate the walls of their family chapel in S Domenico, Ferrara, with the 'entire story of the New Testament' and provide an altarpiece of the *Adoration of the Magi* (both frescoes and altarpiece destr.).

On 11 June 1469 Tura was paid for painting the organ shutters (Ferrara, Mus. Duomo) for the great organ in Ferrara Cathedral. Together with the severely damaged frescoes of the Salone dei Mesi in the Palazzo Schifanoia, Ferrara (see below), the organ shutters represent the best of Ferrarese painting during the last half of the 15th century. On the outside of the doors is an emotionally turbulent and pictorially dynamic depiction of *St George and the Dragon* (see fig. 2) set in a landscape. On the inside is a dramatically different, serene image of the *Annunciation* (see colour pl. 2, XXXVI2), set beneath a classicizing triumphal arch. Stylistically related to the organ shutters, and therefore probably also datable to the late 1460s, are the *Virgin and Child* (Venice, Accad.) and two tondi (both Ferrara, Pin. N.) depicting scenes from the *Life of St Maurelius*, painted for the chapel of St Maurelius in S Giorgio fuori le Mura, Ferrara.

On 30 May 1469 Tura signed a contract to decorate the chapel of Belriguardo (destr.), near Voghiera. The terms

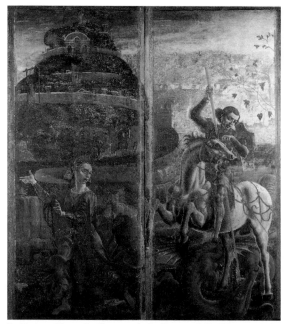

2. Cosimo Tura: *St George and the Dragon*, 349×305 mm, 1469 (Ferrara, Museo del Duomo); outside of the organ shutters from Ferrara Cathedral

are interesting not only because they stipulate wages and provisions for Tura and his two anonymous assistants, the responsibility for materials and a time schedule, but also because they indicate that the patron, Borso d'Este, intended to devise the iconographic programme himself. The progress of Tura's work is well documented, including notations of his various trips to Venice to buy gold and colours. Six months after beginning the project, Tura was sent by Borso to Brescia to look at the Malatesta Chapel in the Broletto (town hall). It is unclear whether Borso intended Tura to study the decoration of the chapel as a whole or just the frescoes by Gentile da Fabriano. Either way, it is a reflection of Borso's conservative taste that he chose to send his court painter to study work painted some 50 years earlier.

An accurate picture of the subject-matter and disposition of the decoration, in what appears to have been a free-standing, centrally-domed, cruciform building, is given in a contemporary description (31 March 1471) of the programme, supplied by Baldassare d'Este and the Venetian artist Antonio Orsini when they were called on to evaluate the project. The paintings were executed in oil and represented God the Father, in the small dome of the lantern, with eight semi-circular half-lengths of Evangelists and Doctors of the Church arranged beneath. The architectural components of the chapel were heavily decorated with animal and vegetal reliefs, and highlighted by a continuous frieze of 145 sculpted and gilt seraphim.

Despite repeated attempts to attach Tura's name to some aspect of the Salone dei Mesi frescoes in the Palazzo Schifanoia, Ferrara, the stylistic evidence of Tura's oeuvre makes this unlikely. Baruffaldi's suggestion was based on the assumption that as court painter Tura must have played a role. He proposed that Tura was responsible for the cartoons and that the rest of the work was executed by other painters. However, this overlooks the fact that between 1468 and 1470, the probable date for the Schifanoia cycle, Tura was engaged in a number of other projects, including the decoration of the Belriguardo chapel. Moreover, stylistically, compositionally and, more tentatively, conceptually, the Schifanoia frescoes bear no more than a generic resemblance to any of Tura's known works.

(iii) 1471–95. On 14 January 1471 Tura made the first of his three wills. His instructions indicate unexpected wealth and properties. In 1464 Tura had bought a two-storey house between the Via Centoversuri and Via Boccanale in Ferrara. In his first will he made provision for the erection and decoration of a church dedicated to SS Cosmas and Damian in which he wanted to be buried, stipulated that his 50 books and all of his drawings were to be left to a certain 'Domenicus filius Jacobi Valerij' and left large legacies to the poor of Venice and to those nearest to him. In August 1471 Borso d'Este died, and Tura was paid 20 lire for constructing the ducal catafalque. His official court title seems to have been changed or augmented to court portrait painter with the succession of Ercole I d'Este. Tura's first recorded duty for the new Duke was to supply designs for a 36-piece silver set (to be executed by the Venetian goldsmith Giorgio Alegretto da Ragusa), intended for the celebration of the Duke's impending marriage to Eleanora of Aragon. The decoration, recorded

in detail in the register of the Guardaroba, consisted largely of ducal *imprese* and devices, but two of the flasks had the unusual iconography of 'wild men', and the garlands used were described as *all'antica*. In 1472 Tura executed portraits of *Ercole I* and of *Lucrezia d'Este* (both untraced) to be sent to Eleanora of Aragon in Naples. During the late summer he provided a coloured sketch for a tapestry, to be woven by Giovanni Mille and Rubinetto da Francia for

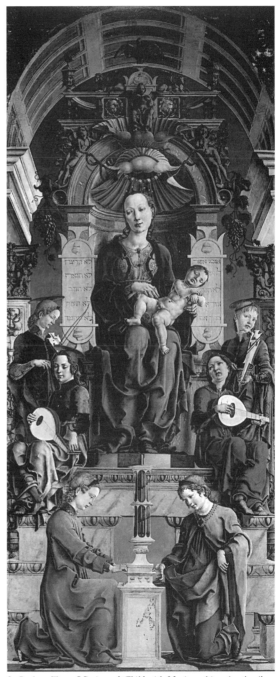

3. Cosimo Tura: *Virgin and Child with Music-making Angels*, oil on panel, 2.34×1.01 m, *c.* 1474 (London, National Gallery); central panel of the Roverella Altarpiece

the marriage bed of Ercole I and Eleanora. Between 1472 and 1474 he seems to have been occupied almost exclusively with tapestry designs.

The year of the death of Bishop Lorenzo Roverella (1474) provides the approximate date for Tura's next major commission, the Roverella altarpiece for S Giorgio fuori le Mura, Ferrara. Baruffaldi records the original location (on the wall in front of the chapel containing Tura's St Maurelius tondi) and the disposition of the panels within the altarpiece. The *Virgin and Child with Music-making Angels* (London, N.G.; see fig. 3) comprised the central portion of the altarpiece and the *SS Paul and Maurelius with the Kneeling Niccolò Roverella* (Rome, Gal. Colonna) was the right wing of the polyptych. The left wing illustrated SS George and Peter, below whom the kneeling Bishop Roverella was shown knocking on the Gates of Paradise. Only a fragment of this, the *Head of St George* (San Diego, CA, Mus. A.), has survived. The central panel was surmounted by the lunette of the *Lamentation* (Paris, Louvre). Two additional half-lengths of SS Benedict and Bernardo have been lost. In his reconstruction of the Roverella altarpiece, Longhi suggested that the *Circumcision* (Boston, MA, Isabella Stewart Gardner Mus.), the *Adoration of the Magi* (Cambridge, MA, Harvard U., Fogg) and the *Flight into Egypt* (New York, Met.) are three of a proposed seven tondi that formed the predella of the altarpiece. In addition to the fact that this contradicts Baruffaldi's observation that the predella was composed of scenes from the lives of SS Benedict and Bernardo, the use of historiated roundels in a predella is unprecedented. Thus, although these tondi belong to the same stylistic period as the Roverella altarpiece, it seems unlikely that they existed as a part of it. In the altarpiece, Tura's painting technique has become appreciably harder and more stylized. The figures seem to have lost all trace of human warmth both in their colouring and their emotional states. Other paintings which can be dated to this period are the *St Jerome* (London, N.G.; see fig. 4) with its corresponding fragment, the *Crucified Christ* (Milan, Brera), the *Annunciation, St Francis* and *St Maurelius* (all Washington, DC, N.G.A.), the *Virgin and Child* (Rome, Gal. Colonna) and the *St John on Patmos* (Genoa, Gnecco priv. col.; see Molajoli, pp. 86–7, no. 27).

In 1475 Tura made further tapestry designs. Between 1475 and 1483 the weaver Rubinetto da Francia is recorded as working on an altarcloth; it is possible that Tura's *Lamentation* antependium (Cologne, Neven-Dumont priv. col., see Molajoli, p. 88, no. 28; copy, Cleveland, OH, Mus. A.) dates from this period. Also in 1475 he was commissioned by Ercole I d'Este to make a series of paintings for a small portable altar. The frame was carved by Bernardo da Venezia and the niello decoration executed by Amadio da Milano. Apparently Ercole was dissatisfied with Tura's work and ordered him to repaint it. The contract stipulates a central Virgin and Child flanked by four standing saints. Several suggestions have been offered as to which extant panels might have belonged to this altar. These include the four panels in Washington mentioned above and the *Virgin and Child* (Bergamo, Gal. Accad. Carrara). In 1476 Tura was involved in a lawsuit with the Ferrarese notary Giacomo Pinzerna.

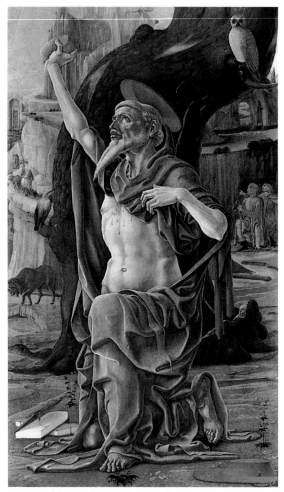

4. Cosimo Tura: *St Jerome*, oil on panel, 1010 × 572 mm, 1471–95 (London, National Gallery)

In 1477 Tura was commissioned to paint three portraits of the year-old prince, *Alfonso I d'Este* (all untraced). The first was completed on 27 July, while the other two were not finished until October. One of these portraits passed via the Canonici collection into the collection of Baruffaldi's father, and the critic recalls it as 'exemplary above all others'. In the same year Tura was asked to complete a set of seven female nudes (untraced), four of which had been worked on previously. It is unclear if this is another case of Tura having to repaint or perhaps 'update' work of his own or of others. Ruhmer suggested that these figures might relate to work Tura had done previously at Belfiore and proposed that the brush drawing of a *Seated Winged Female Figure* (Berlin, Kupferstichkab.), which he called *Charity*, might be a preliminary study for one of the paintings from this series.

In addition to supplying tapestry cartoons for a door curtain to be woven by Giovanni Mille, and a mule blanket, to be woven in several copies by Rinaldo da Bretagna, in 1479 Tura was paid by Eleanora of Aragon for a portrait of *Lucrezia d'Este* (untraced) to be sent to Lucrezia's fiancé, Annibale Bentivoglio. In 1480 Tura painted a portrait of *Isabella d'Este* (untraced) for her intended

spouse, Francesco Gonzaga, Marchese of Mantua, and was paid for a cartoon depicting a story of Solomon. In 1481 he is recorded collaborating with the intarsia worker Tasto Tortoletto and, between 1483 and 1485, he was engaged in making designs for an elaborate silver service for Ludovico Sforza, Duke of Milan.

In a letter to Ercole I (8 January 1490), complaining of poverty and the unpaid debts due to him, Tura mentions two paintings for which payment is outstanding. The first, a *St Anthony of Padua* (untraced), was painted for the Monsignor of Adria and cost 25 ducats, which indicates either that the painting was small or that Tura's reputation as an artist had suffered to the extent that he was no longer able to command adequate fees. The second, an altarpiece for S Niccolò, Ferrara, commissioned by the ducal secretary Francesco Nasello and worth 60 ducats, has been identified with Tura's *St Anthony of Padua* (formerly called *St Giacomo della Marca*, Modena, Gal. & Mus. Estense). This association is slightly problematic as Tura does not mention the subject of his painting for Nasello. He claimed to have painted 'similmente' for Monsignor of Adria, but it is doubtful that this refers to the subject-matter of the painting. Moreover, Tura mentioned that Nasello's picture had been coloured with gold at his own expense and the Modena *St Anthony* has neither gold ground nor details. In support of this attribution, however, the painting can be dated stylistically to *c.* 1484, thereby complementing Tura's note recording that he finished these paintings six years before the date of his letter, and the painting's provenance can be traced back to the church of S Niccolò, Ferrara. If the painting is part of the altarpiece painted for Nasello, it is Tura's last documented work and shows him as having developed a style of painting so mannered and tense as to verge on the repellant. A number of small panels, stylistically related to the Modena *St Anthony*, although not quite so austere, have been variously arranged by critics to form reconstructions of the dispersed altarpieces Tura painted during the mid-1480s. These include *St James the Great* (Caen, Mus. B.-A.), *St Dominic* (Florence, Uffizi), *St Anthony of Padua* (Paris, Louvre) and perhaps *St Christopher* and *St Sebastian* (both Berlin, Bodemus.).

In 1485 Tura received his last court commission for a bust-length portrait of Beatrice d'Este to be sent to her betrothed, Ludovico Sforza. In 1486 he was moved from his lodgings into one of the gate-towers of the city wall near Porta Cosmaria, Ferrara, and lived with a certain Teofilo di Jacopo Cesena, apparently a painter or apprentice. From this time until his death virtually all the documents pertaining to Tura centre on his complaints about poverty. In 1487 he wrote a second will, asking to be buried in S Giorgio. On 18 April 1491 he wrote his third and final will. He was buried, according to the request in his third will, in S Lorenzo, Ferrara.

2. CRITICAL RECEPTION AND POSTHUMOUS REPUTATION. At the height of his career Tura's fame had spread as far as the courts of Milan and Urbino. Filarete, in his *Trattato di architettura* (1458–64), listed Tura with Fra Filippo Lippi, Piero della Francesca, Squarcione and Vincenzo Foppa as one of the masters fit to paint in the courtyard of the Casa Regia of his imaginary city of Sforzinda. Giovanni Santi, in his *La vita e le geste di Federico da Montefeltro* (*c.* 1488–92), named Tura and Ercole de' Roberti as the two exemplars of Ferrarese painting. Tura's fortunes, however, were directly linked to his patron Borso d'Este, after whose death in 1471 the artist progressively lost commissions to his more fashionable contemporaries. By the middle of the 16th century, only some 50 years after his death, his name was all but forgotten and he was only summarily mentioned by Vasari. Girolamo Baruffaldi was the first to restore his reputation during the 18th century, citing him as the founder and greatest representative of the Ferrarese school. Despite the relative paucity of surviving works, now scattered in different collections, archival work by scholars such as Cittadella, Campori and Venturi has contributed greatly to our understanding of his career.

BIBLIOGRAPHY

EARLY SOURCES

A. Averlino [il Filarete]: *Trattato di architettura* (1458–64); ed. A. M. Finoli and L. Grassi (Milan, 1972), i, p. 258

G. Santi: *La vita e le gesta di Federico di Montefeltro duca d'Urbino* (MS.; *c.* 1488–92); ed. Luigi Michelini Tocci (Rome, 1985), p. 674

T. V. Strozzi: 'Ad Cosmum pictorem', *Carmina, eroticon libri iv* (Venice, 1513)

G. Vasari: *Vite* (1550, rev. 2/1568); ed. G. Milanesi (1878–85), ii, p. 142; iii, p. 92

L. G. Giraldi: *Opera, quae extant omnia* (Basle, 1580)

G. Baruffaldi: *Vita di Cosimo Tura pittore ferrarese del secolo XV scritta dall'Archiprete Girolamo Baruffaldi, corredata di note* (MS.; 1702–37); ed. G. Petrucci (Bologna, 1836)

C. Cittadella: 'Cosimo Tura', *Catalogo istorico de' pittori e scultori ferraresi . . .* (Ferrara, 1782), i, pp. 47–57; ii, pp. 210–12; iv, p. 308

G. Baruffaldi: *Vite de' pittori e scultori ferraresi*, ed. G. Boschini (Ferrara, 1844–6), pp. 63–85

GENERAL WORKS

Enc. It.; *EWA*; Thieme–Becker

L. N. Cittadella: *Notizie relative a Ferrara . . .* (Ferrara, 1864)

——: *Documenti ed illustrazioni risguardanti la storia artistica ferrarese* (Ferrara, 1868)

G. Campori: *L'arazzeria estense* (Modena, 1876)

G. Gruyer: *L'Art ferrarais à l'époque des princes d'Este* (Paris, 1897)

A. Venturi: *Storia* (1901–40), VII/iii, pp. 506–58

E. Gardner: *The Painters of the School of Ferrara* (London, 1911)

J. A. Crowe and G. B. Cavalcaselle: *The History of Painting in Northern Italy*, ed. T. Borenius (London, 1912), pp. 221–31

N. Barbantini: *Catalogo della esposizione della pittura ferrarese del Rinascimento* (Ferrara, 1933), pp. 44–63

S. Ortolani: *Cosmè Tura, Francesco del Cossa, Ercole de' Roberti* (Milan, 1941)

B. Nicolson: *The Painters of Ferrara* (London, 1951), pp. 9–12, 18

C. Padovani: *La critica d'arte e la pittura ferrarese* (Rovigo, 1954)

B. Berenson: *Central and North Italian Schools* (1968), i, pp. 55–60, 297–8

R. Longhi: *Officina ferrarese* (Florence, 1975) [incl. *Officina ferrarese* (1934), *Ampliamenti nell'officina ferrarese* (1940), *Nuovi ampliamenti* (1940–55) and *Note brevi* (1955)]

MONOGRAPHS

L. N. Cittadella: *Ricordi e documenti intorno alla vita di Cosimo Tura detto Cosmè, pittor ferrarese del secolo XV* (Ferrara, 1866)

A. Neppi: *Cosmè Tura* (Milan, 1953)

M. Salmi: *Cosmè Tura* (Milan, 1957)

E. Ruhmer: *Tura Paintings and Drawings* (London, 1958)

P. Bianconi: *Tutta la pittura di Cosmè Tura* (Milan, 1963)

E. Riccomini: *Cosmè Tura* (Milan, 1965)

R. Molajoli, ed.: *Cosmè Tura e i grandi pittori ferraresi del suo tempo: Francesco Cossa e Ercole de' Roberti*, Opera Completa (Milan, 1974)

S. Campbell: *Cosmè Tura of Ferrara: Style, Politics and the Renaissance City, 1450–1495* (New Haven and London, 1997)

J. Manca: *Cosmè Tura: The Life and Art of a Painter in Estense Ferrara* (New York, 1999)

SPECIALIST STUDIES

A. Venturi: 'L'arte nel periodo di Borso d'Este', *Riv. Stor. It.*, ii/4 (1885)

——: 'Cosmè Tura e la Cappella di Belriguardo', *Buonarroti*, 3rd ser., ii (1885), pp. 55–64

G. Campori: 'I pittori degli Estensi nel secolo XV', *Atti & Mem. RR. Deput. Stor. Patria Prov. Moden. & Parm.*, 3rd ser., iii (1886), pp. 526–604

F. von Harck: 'Verzeichnis der Werke des Cosma Tura', *Jb. Preuss. Kstsamml.*, ix (1888), pp. 34–40

A. Venturi: 'Cosma Tura genannt Cosmè, 1432 bis 1495', *Jb. Preuss. Kstsamml.*, ix (1888), pp. 3–33

——: 'L'arte ferrarese nel periodo di Ercole d'Este', *Atti & Mem. Stor. Patria Prov. Romagna*, vi (1888), pp. 91–119, 350–422; vii (1889), pp. 368–412

G. Gruyer: 'Cosimo Tura (1432?–1495)', *Art*, liii (1892), pp. 141–8, 173–9

A. Venturi: 'Documento per la determinazione approssimativa della data della nascità di Cosmè Tura', *Archv. Stor. A.*, vii (1894), pp. 52–3

H. J. Hermann: 'Die Gemälde des Cosimo Tura in der Bibliothek des Pico della Mirandola', *Jb. Ksthist. Samml. Allhöch. Ksrhaus.*, xix (1898), pp. 207–16

C. Padovani: 'Cosmè Tura', *Riv. Ferrara*, xi (1933), pp. 11–21

A. Neppi: 'Alla mostra della pittura ferrarese del Rinascimento: Rettifiche e di attribuzione, relative al Tura, al Cossa, all'Ortolano, e al Garolfalo', *Riv. Ferrara*, ii (1934), pp. 185–91

O. Härtzsch: *Katalog der echten und fälschlich zugeschriebenen Werke des Cosimo Tura* (Hamburg, 1935)

H. Beenken: 'Angelo del Maccagnino und das Studio von Belfiore', *Jb. Preuss. Kstsamml.*, li (1940), pp. 147–62

O. Härtzsch: 'Cosimo Tura', *Pantheon*, xxvi (1940), pp. 153–61

D. G. Shepherd: ' *The Lamentation*: A Tapestry Antependium Designed by Cosimo Tura', *Bull. Cleveland Mus. A.*, xxxviii (1951), pp. 40–42

E. Ruhmer: 'Zur plastischen Tätigkeit des Cosimo Tura', *Pantheon*, xviii (1960), pp. 149–53

M. Baxandall: 'Guarino, Pisanello and Manuel Chrysolaras', *J. Warb. & Court. Inst.*, xxviii (1965), pp. 183–204

W. Zanini: 'Les Tapissiers franco-flamands à la cour des Este', *Vasari*, xxii–xxiii (1965), pp. 1–3

M. Guidoni and A. Marino: 'Cosmus Pictor. Il nuovo organo di Ferrara: Armonia, storia e alchimia della creazione', *Stor. A.*, iv (1969), pp. 388–416

A. K. Eörsi: 'Lo studiolo di Lionello d'Este e il programma di Guarino da Verona', *Acta Hist. A. Acad. Sci. Hung.*, xxvi (1975), pp. 15–52

M. Boskovits: 'Ferrarese Painting about 1450: Some New Arguments', *Burl. Mag.*, clxxviii (1978), pp. 370–85

J. Bentini, ed.: *San Giorgio e la principessa di Cosmè Tura: Dipinti restaurati per l'officina ferrarese* (Bologna, 1985)

J. Dunkerton: 'Cosimo Tura as Painter and Draughtsman: The Cleaning and Examination of his *Saint Jerome*', *N.G. Tech. Bull.*, xv (1994), pp. 42–53

S. J. Campbell: 'Pictura and scriptura: Cosme Tura and Style as Courtly Performance: Humanist Criticism of Painting at the Ferrarese Court', *A. Hist.*, xix (1996), pp. 267–95

S. Campbell: *Cosmè Tura of Ferrara. Style, Politics and the Renaissance City, 1450–1495* (New Haven and London, 1997)

R. Stemp: 'Two Sculptures Designed by Cosmè Tura', *Burl. Mag.* cxli (1999), pp. 208–15

KRISTEN LIPPINCOTT

Tura, Pietro del. *See* ARETINO, PIETRO.

Turin [It. Torino; *anc.* Augusta Taurinorum]. Italian city and capital of Piedmont. It is situated at the confluence of the River Po with Doria Riparia, 120 km north-west of Genoa. Turin was formerly the capital of the Duchy of Savoy, the Kingdom of Sardinia and the first capital of the Kingdom of Italy.

1. History and urban development. 2. Art life and organization. 3. Cathedral.

1. HISTORY AND URBAN DEVELOPMENT. Founded under Emperor Augustus in *c.* 28 BC as a colonial settlement for military veterans, the orthogonal street layout of the Roman *castrum* forms the nucleus of modern Turin. The Roman settlement was an almost perfect square, with each of its walls approximately 700 m long and penetrated by at least one gate. The town was divided into four parts by the north–south road (*cardo*) and the east–west road (*decumanus*), which ran from the four main gates to cross at right angles at the centre of town, which was the site of the forum. Although the Roman achievement was modest, the vigour of the brick construction and the rationality of the street grid were a prominent source of inspiration for subsequent urban development.

During the Middle Ages the regular grid of streets was altered by the introduction of shorter, diagonal passageways connecting such principal buildings as the cathedral and the Palazzo di Città. Most of them were located in the north-west corner of the city. The Roman walls were reinforced with towers under the *comune*. The east gate, which connected the city to the River Po, was radically rebuilt in 1317–19, when it became the fortified Castello degli Acaja (now Palazzo Madama). The castle was further enlarged at the beginning of the 15th century. This square fortress with a cylindrical tower at each corner, the fragmented grid of orthogonal streets and the Roman walls were the only distinguishing aspects of the city when Duke Charles V (*reg* 1535–6) lost it to the French in 1536. During their 25-year occupation, the French reinforced the fortifications by raising a wall of earth almost as tall as the brick ones and by building a bastion at each of the four corners of the city, with a fifth at the centre on the eastern wall around the castle. In order to build the bastions and defend them effectively, the suburbs and the nearby monasteries were razed. The fortification campaign thus deprived Turin of its suburbs and, through its menacing new walls, endowed it with a ferocious aspect.

In the mid-16th century Turin was still a medieval city, only marginally touched by the ideals of Renaissance architecture. Apart from the French fortification that was built in response to the use of cannon in siege warfare, the only significant Renaissance building was the cathedral (1491–6; *see* §3 below), commissioned by Archbishop Domenico della Rovere from the Tuscan architect Meo da Caprino. Close to the Porta Palatina, the cathedral has a longitudinal nave flanked by aisles and chapels and vaulted with pointed arches. The large, white, undetailed and unadorned upper areas dominate the dark chapels, decorated at a later date. The façade has an insipid silhouette but some successful marble relief decoration around the portals (see fig. 2 below). The east end of the church abutted the bishop's palace, subsequently replaced by the palace of the Dukes of Savoy.

The fortunes of Turin changed radically after 1559 with the Treaty of Câteau-Cambresis, which obliged the French to return the duchy of Piedmont-Savoy to the Duke of Savoy. Emanuel-Philibert, 10th Duke of Savoy (*reg* 1553–80), established the capital of his duchy in Turin by transferring the administrative centre from Chambéry, French Savoy. The political and geographical circumstances of the duchy, caught between French and Spanish territories, required able self-defence. One of the Duke's first commissions was the construction of a citadel (1563–6; destr.), designed by FRANCESCO PACIOTTO and built by Francesco Horologgi. Paciotto proposed a pentagonal fortress, placed in the south-west corner of the city. It was to have three bastions orientated towards the countryside, defending the approach to the city from the west, and two

bastions facing the city, ready to subjugate it in case of rioting against the Duke's rule. This perfect polygon, influenced perhaps by the Fortezza Alessandra (1533–6; by Antonio da Sangallo (ii); now Fortezza di Basso) in Florence and by the pentagonal Villa Farnese (from 1521; by Antonio da Sangallo (ii) and Baldassare Peruzzi) in Caprarola, fascinated military architects in the 16th century. It was the first of a number of five-sided citadels, which included Antwerp (begun 1567; destr. 1874), also by Paciotto, Parma (1591) and Ferrara (1618). This splendid fortress established Turin as a mighty *piazzaforte*, and, despite the duchy's neutrality, acted as a provocation to Piedmont's neighbours. It also demonstrated the Duke's interest in architectural and urban renewal, which his successors eventually carried on.

BIBLIOGRAPHY

C. Promis: *Storia della antica Torino* (Turin, 1869)

V. Comoli Mandracci: *Torino* (Bari, 1983)

M. Pollak: *Turin, 1564–1680: Urban Design, Military Culture and the Creation of the Absolutist Capital* (Chicago and London, 1991)

MARTHA POLLAK

2. ART LIFE AND ORGANIZATION. Piedmontese art began to be influenced by Renaissance themes and forms with the work of GIOVANNI MARTINO SPANZOTTI, court painter to Charles II, Duke of Savoy, in 1507. Influenced by Vincenzo Foppa, Piedmontese artists continued to work on *vero naturale* (It.: 'natural truth'), of which one of the most important examples is Spanzotti's *Virgin Enthroned with SS Ubaldo and Sebastian* (see fig. 1). Spanzotti's work influenced many Piedmont artists, notably Defendente Ferrari, who trained in the former's workshop and who added to his mentor's style elements taken from wider European Renaissance culture, evident, for example, in the *Assumption of the Virgin* (1516), painted for the Confraternity of the Holy Shroud at Cirié, near Turin.

1. Giovanni Martino Spanzotti: *Virgin and Child Enthroned with SS Ubaldo and Sebastian*, tempera on panel, 1.35×1.33 m, before 1475 (Turin, Galleria Sabauda)

The political turbulence and French occupation of Piedmont during the early 16th century hindered further artistic development until after 1563, when Emanuel-Philibert, moved the capital of the duchy from Chambéry to Turin, where the university was reopened and where the most important administrative offices came to be concentrated. During these years the cultural policy of the Savoy dynasty favoured contact with artists from Central Italy, facilitating the spread of the Mannerist style. In 1605 Federico Zuccaro moved to Turin, where Charles-Emanuel I, 11th Duke of Savoy (*reg* 1580–1630), entrusted him with the interior decoration of the gallery (1605–7; destr. 1659) that linked the old Palazzo del Vescovo to the Castello (*see* ZUCCARO, (2), §1).

BIBLIOGRAPHY

Piemonte (Turin, 1991)

LISA PAROLA

3. CATHEDRAL. Until the end of the 15th century the episcopal seat of Turin occupied three churches: S Salvatore, S Giovanni Battista and S Maria. The chair of the first Catholic bishop of Turin was probably in S Maria: in September AD 398 the council of the Milanese archdiocese was held in that basilica. The basilica of S Salvatore stood on the right-hand side of S Maria, under the left aisle of the present cathedral; between the two was the baptismal church of S Giovanni, under the present nave. S Giovanni was probably the cathedral first mentioned by Gregory of Tours (586–7). It was perhaps in Lombard times that it was enlarged and the three churches were joined together; in 680 a new Catholic bishop, Rusticus, was installed; he died in 691.

At the beginning of the 11th century Landolfo, Bishop of Turin, made a pilgrimage to Saint-Jean d'Angely in France, to worship some relics, supposedly of St John the Baptist, that were discovered between 1010 and 1021. He obtained one of these, and when he returned to Turin he reconstructed all or part of the church of S Giovanni to produce a nave-and-aisles structure divided by pillars, with a raised presbytery, a timber roof and a porticoed façade. In 1039 there was evidently a *lipsanotheca* (reliquary) in S Giovanni, and documents dated 1425 and 1434 indicate that it still had its baptistery; a crypt was mentioned in 1435, and the bell-tower was built in 1468. The roof was restored between 1353 and 1379, and the apse was reconstructed in 1395, but the rest of the Romanesque structures survived until between 1490 and 1492, when S Giovanni, S Salvatore and S Maria were all destroyed.

The first stone of the new cathedral was laid in 1491, and it was finished in late 1496 and consecrated in 1505 (see fig. 2). Its Renaissance design was by MEO DA CAPRINO. The three marble portals are either by Meo himself or by the Florentine Sandrino di Giovanni, who also produced a holy-water basin inside the church. The interior has a nave and aisles, the nave arcade piers faced with half columns, which rise to clerestory level, where they support the transverse arches of a seven-bay barrel vault. There is also an apsidal-ended transept and a deep rectangular choir. Works of art in the cathedral include an important full-size 19th-century copy of Leonardo's *Last Supper*; the late 15th-century tomb of *Giovanna d'Orlie*; the altarpiece of *SS Crispin and Crispinian* (now attributed

2. Turin Cathedral by Meo da Caprino, 1491–6

to Giovanni Martino Spanzotti); a *Baptism of Christ* (1508) by Spanzotti, now in the sacristy; and the tomb of *Bishop Claudio of Seyssel* with sculptures (1526) by Matteo Sammicheli, also in the sacristy.

BIBLIOGRAPHY
F. Rondolino: *Il duomo di Torino illustrato* (Turin, 1898)
S. Solero: *Il duomo di Torino e la R. Cappella della Sindone* (Pinerolo, 1956)
G. Gentile: 'Ruoli e figure professionali nei documenti di alcuni cantieri piemontesi del Tre e Quattrocento', *Ric. Stor. A.*, 55 (1995), pp. 21–8
ROBERTO CORONEO

Turini, Baldassare (*b* Pescia, nr Pistoia, 1486; *d* Rome, 15 Oct 1543). Italian courtier and patron. From an early age he was in contact with the Medici family in Florence, and in particular with the young Cardinal Giovanni de' Medici. When Giovanni was elected Pope Leo X in 1513, he made Turini his chamberlain and, in 1518, papal datary. Turini lost this position after Leo's death in 1521, but subsequently became papal secretary when another Medici pope was elected (Clement VII, 1523); he retained the post for the rest of his life. From 1535 Turini also received the papal ministry of 'Magister Viarum' and was in charge of road-building and maintenance in Rome.

Turini owned a number of houses in Rome and Pescia and was thus probably quite wealthy. From about 1520 he seems to have lived as an agent of the Medici in their unfinished palace in Rome (now the Palazzo Madama). He was in contact with many artists, not only on behalf of the Medici but also to secure works of art for himself, including commissions from Francesco Francia and Leonardo da Vinci. On the Janiculum in Rome he commissioned Giulio Romano to build a villa for him (now the Villa Lante), which was decorated by Polidoro da Caravaggio, Maturino da Firenze (*d* 1528) and probably Vincenzo Tamagni. Turini was on good terms with Raphael and acted as his testamentary executor, as appears in the inscription on Raphael's tomb in the Pantheon in Rome. He acquired *c.* 1514 his unfinished panel of the *Madonna and Child Enthroned with Saints* (the '*Madonna del baldacchino*', 1508; Florence, Pitti), which was completed by an

unknown painter and served as the altarpiece for the Turini Chapel in Pescia Cathedral. The chapel was designed by Giuliano di Baccio d'Agnolo, while the tomb monument with Turini's statue was executed by Raffaele da Montelupo *c.* 1540.

BIBLIOGRAPHY
C. L. Frommel: 'Der römische Palastbau der Hochrenaissance', *Röm. Forsch. Hrg. Bib. Hertziana*, xxi/2 (1973), p. 228
D. R. Coffin: *The Villa in the Life of Renaissance Rome* (Princeton, 1979)
H. Lilius: 'Villa Lante al Gianicolo: L'architettura e la decorazione pittorica', *Acta Inst. Romani Finland.*, x (1981)
G. Stenius: 'Baldassare Turini e le sue case romane sulla base dei documenti', *Opuscula Inst. Romani Finland.*, i (1981), pp. 71–82
C. Conforti: 'Baldassare Turini da Pescia: Profilo di un committente di Giulio Romano architetto e pittore', *Quad. Pal. Te*, 2 (1985), pp. 35–43
C. Conforti: 'Architettura e culto della memoria: La commitenza di Baldassare Turini datario di Leone X', *Baldassare Peruzzi: Pittura, scena e architettura nel cinquecento*, ed. M. Fagliolo and M. Madonna (Rome, 1987), pp. 603–28
J. L. DE JONG

Turino di Sano (*fl* Siena, 1382–1427). Italian sculptor and goldsmith. He was married in 1382 and had three sons: Barna, a wood-carver; Lorenzo (*b* 1407; *fl* 1456), a goldsmith; and Giovanni, or Nanni (*c.* 1385–1455), who was also a sculptor and goldsmith. Mentioned in Pisa in 1394, Turino di Sano's earliest documented work in Siena was the design of an engraved seal with the image of the Virgin (1410; untraced). In 1413 he was commissioned to execute a silver statue of *St Crescentius* (untraced) for Siena Cathedral.

On 16 April 1417 he and his son Giovanni di Turino were authorized to design two bronze reliefs for the Siena Baptistery font (*in situ*), which were not delivered until July 1427. The two reliefs depict the *Birth of St John the Baptist* (*c.* 1417–18) and *St John the Baptist Preaching* (*c.* 1419–20) and are both relatively conservative in design and eclectic in nature. Evident familiarity with current developments in Florence can be seen in the *Birth of St John the Baptist*, which is replete with motifs borrowed from Lorenzo Ghiberti's first set of bronze doors (1403–24) for the Baptistery in Florence (*see* GHIBERTI, (1), fig. 2).

Turino and Giovanni then worked on three bronze statuettes representing *Virtues* (completed 1431) for the base of the font, the other *Virtues* having been commissioned from Donatello and Goro di Ser Neroccio. These are among the earliest known bronze statuettes of the Renaissance. Contemporary with them are the two bronze putti designed for the tabernacle of the font: more classicizing in style than the *Virtues*, they are less dynamic and ambitious than neighbouring figures by Donatello. They also made the gilded monogram of Jesus (1425) on the façade of the Palazzo Pubblico, Siena. A number of wooden sculptures tentatively attributed to Turino di Sano include two polychromed statues of *St Anthony Abbot* (Siena, S Domenico, and oratory of the Arciconfraternità della Misericordia) and a figure of *St John the Baptist* (Montalcino, Mus. Dioc. A. Sacra).

Giovanni di Turino also worked independently of his father. In 1426 he completed the marble reliefs of *Evangelists*, begun by Giovanni da Imola, for the new pulpit in Siena Cathedral. He made three bronze statuettes of *Prudence, Justice* and *Temperance* for the font in the Baptistery, Siena (all 1430–31; *in situ*). The exuberant and

decorative use of line in their draperies shows the influence of Donatello and of Ghiberti, of whom, according to Vasari, Giovanni was a 'faithful friend'. He also made the bronze door with a scene of the *Baptism of Christ* for the font. With his brother Lorenzo di Turino, he made the bronze *She-wolf with Romulus and Remus* (1429–30; Siena, Pal. Pub.). A water-stoup by Giovanni in the Palazzo Pubblico, Siena, dates from 1438.

BIBLIOGRAPHY

Thieme–Becker

G. Vasari: *Vite* (1550, rev. 2/1568); ed. G. Milanesi, iii, pp. 289, 304–7

G. Milanesi: *Documenti per la storia dell'arte senese* (Siena, 1854–6), ii, pp. 62, 67, 86, 129, 131

P. Schubring: *Die Plastik Sienas im Quattrocento* (Berlin, 1907), p. 21

P. Bacci: *Jacopo della Quercia: Nuovi documenti e commenti* (Siena, 1929), pp. 71, 119, 176, 216, 228

I. Machetti: 'Orafi Senesi', *La Diana*, iv (1929), pp. 67–70

E. Carli: *La scultura lignea senese* (Milan, 1951), pp. 64–7

——: *Gli scultori senesi* (Milan, 1980)

ELINOR M. RICHTER

Turrisan [Turrizani]**, Petrus**. *See* TORRIGIANI, PIETRO.

Tuscany, Grand Dukes of. *See* MEDICI, DE'.

Tusculum. *See under* FRASCATI.

U

Uberti, Lucantonio degli (*b* Florence; *fl* Venice, 1503; *fl* Florence, 1557). Italian printmaker. In Venice between 1503 and 1526 he engraved numerous woodcut book illustrations: his monogram, known in 17 variations, appears in *c.* 60 different volumes, printed in Venice. Among his most famous works is the edition (*c.* 1517) in nine blocks of Titian's woodcut *Triumph of Christ*. Uberti's return to Florence *c.* 1550 is suggested by the presence of wood-engravings in the Venetian fashion in certain Florentine texts, such as the *Historia di S Antonio di Padova* (1557). Apart from his woodcuts, seven engravings (and a dubious eighth) are attributed to him (e.g. B. 1, 2 [390] and Patellani, pp. 48–55), which, in a graphic language that is still late 15th century, are inspired by works by Perugino, Leonardo da Vinci, Marcantonio Raimondi and Albrecht Dürer (1471–1528).

BIBLIOGRAPHY
Bolaffi
G. Patellani: 'Lucantonio degli Uberti', *Quad. Conoscitore Stampe*, xx (1974), pp. 46–55
M. Zucker: *Early Italian Masters*, 25 [XIII/ii] of *The Illustrated Bartsch*, ed. W. Strauss (New York, 1980) [B.]
C. Karpinski: '*Il Triofo della fede*: L''affresco' di Tiziano e la silografia di Lucantonio degli Uberti', *A. Ven.*, xlvi (1994), pp. 6–13
FELICIANO BENVENUTI

Ubertini, Francesco. *See* BACCHIACCA.

Ubriachi. *See* EMBRIACHI.

Uccello, Paolo [Paolo di Dono] (*b* Florence, *c.* 1397; *d* Florence, 10 Dec 1475). Italian painter, draughtsman, mosaicist and designer of stained glass. His work vividly illustrates the principal issues of Florentine art during the first half of the 15th century. Trained within the tradition of the Late Gothic style, he eventually became a leading exponent of the application of linear perspective based on the mathematical system established by Filippo Brunelleschi and Leon Battista Alberti. It is the merging of these two diametrically opposed tendencies that forms the basis of Uccello's style. As well as painting on panel and in fresco (many of his works in this medium have been severely damaged), he was also a master mosaicist and produced designs for stained glass.

1. Life and work. 2. Working methods and technique. 3. Critical reception and posthumous reputation.

1. LIFE AND WORK.

(i) Training and early work, *c.* 1412–43. (ii) Middle years, 1443–*c.* 1460. (iii) Late works, *c.* 1460–75. (iv) Lost works.

(i) Training and early work, c. 1412–43. The documents are relatively informative about Uccello's life and movements, but less so about his artistic output. His proper name was Paolo di Dono, but he was commonly referred to as Uccello. According to Vasari, this was simply a sobriquet adopted as a result of the painter's love of birds (It. *uccello*: 'bird'), but it seems that the name also had some legal sanction, since it occurs in official documents and in the signatures on the fresco of *Sir John Hawkwood* (Florence Cathedral; see fig. 1 below) and on one of the panels of the *Rout of San Romano* (Florence, Uffizi). Uccello's father, Dono di Paolo, was a barber–surgeon from Pratovecchio, who became a Florentine citizen in 1373 and married in 1387. Uccello's date of birth is deduced from his tax returns, beginning with that of 1427, when his age is given as 30, although a slight degree of variance is apparent in subsequent returns; discrepancies of this type are not unusual at this date. Uccello spent most of his life in Florence, apart from visits to Venice (1425–*c.* 1430), Padua (1445–6) and Urbino (1465–8/9). He married Tommasa di Benedetto Malifici, apparently rather late in life. A son, Donato, was born in 1453 and a daughter, Antonia, in 1456.

It is usually stated that Uccello was recorded as an assistant (*garzone*) in Lorenzo Ghiberti's workshop in 1404 or 1407, but this is a misreading, and the artist's apprenticeship with Ghiberti is now thought to have been from 1412 until 1416 (Beck, 1980). Uccello's affiliation with Ghiberti undoubtedly established the basis of his early style. The large workshop employed by the sculptor for his many projects in Florence also included Masolino and Donatello. During Uccello's years in the shop, work was proceeding on the first set of bronze doors for the Florentine Baptistery (*see* GHIBERTI, (1), fig. 2) and on the bronze *St John the Baptist* for Orsanmichele (*in situ*). Ghiberti was one of the main Florentine exponents of the Late Gothic style, with its emphasis on decorative quality derived from line, colour and pattern. The figure style of the north doors of the Baptistery and the friezes that teem with animal life would have appealed to Uccello, given his proclivity for such subject-matter, as recounted by Vasari. By the time he left Ghiberti's workshop, however, Uccello had gained a certain independence. In 1414 (not 1424 as often interpreted) he joined the Compagnia di S Luca, and

in 1415 he was a member of the Arte dei Medici e Speziali, being referred to as painter.

Between 1425 and 1427 Uccello was in Venice working as a mosaicist in S Marco. The evidence for this rests in the inquiry made by the authorities of Florence Cathedral in 1432 into the artist's performance while employed as a master mosaicist at S Marco. The full extent of Uccello's work there is not known, and only a figure of *St Peter* (destr.; see Salmi, 1950) is documented. It is sometimes argued that Uccello was involved with the design of the narrative scenes of the *Life of the Virgin* in the Mascoli Chapel, S Marco.

The identification of Uccello's earliest works is difficult because of the dearth of information following his departure from Ghiberti's workshop. Attempts to establish an oeuvre for the artist during the 1420s have not been convincing (e.g. Volpe, 1980). It is likely that the opportunities presented by his work as a mosaicist in Venice reinforced those stylistic tendencies already inculcated by Ghiberti. The earliest works reliably attributed to Uccello, therefore, are the frescoes on the east wall of the Chiostro Verde of S Maria Novella, Florence, which are usually dated to the early 1430s. The frescoes represent scenes from Genesis and are part of an extensive scheme of decoration in the cloister to which Uccello himself further contributed at a later date. From the first campaign, the frescoes of the *Creation of the Animals and the Creation of Adam* and the *Creation of Eve and the Fall* in the opening bay are by Uccello. The style of the figures and the handling of the landscape are not dissimilar to Masolino's, whereas the care taken over the animals and foliage recalls Ghiberti and also to some extent Gentile da Fabriano. The poses of Adam and Eve are inspired by their counterparts in the comparable panel of Ghiberti's second set of bronze doors for the Florentine Baptistery (see colour pl. 1, XXXI2), while ultimately the drapery of the figure of God the Father is dependent on *St Matthew* at Orsanmichele (*see* GHIBERTI, (1), fig. 3).

The one documented work dating from the 1430s is the commemorative fresco of *Sir John Hawkwood*, painted in 1436 on the north wall of Florence Cathedral (see fig. 1). Uccello's fresco, depicting the English condottiere (*c.* 1320–94) on horseback, replaced the image commissioned from Agnolo Gaddi and Giuliano Pesello (*c.* 1367–1446) in 1395 and was matched in 1456 by Andrea del Castagno's companion fresco commemorating *Niccolò da Tolentino* (*d* 1435; *see* ANDREA DAL CASTAGNO, fig. 4). Uccello in fact painted the fresco of Hawkwood twice, since the cathedral authorities were for some reason dissatisfied with his first attempt. Possibly the problem was one of technique. Nonetheless, the final result is an important link in the evolution of the equestrian monument. In the fresco, Uccello addressed the problems of perspective and three-dimensionality posed by Masaccio in the *Trinity* (Florence, S Maria Novella; see colour pl. 2, III1) or by Donatello in the tondi in the Old Sacristy, S Lorenzo. It demonstrates his growing interest in perspective and his tendency to render natural forms as a series of geometrical shapes, particularly in the horse and rider. The artist used two viewpoints: the horse and rider are seen as if on a level with the spectator, but the sarcophagus is seen sharply from below. Such a discrepancy might have been the result

1. Paolo Uccello: *Sir John Hawkwood* (1436), fresco, Florence Cathedral

of a change of design requested by the cathedral authorities (Even, 1985).

Uccello made three cartoons (destr.) for circular stained-glass windows positioned in the octagon below the cupola of Florence Cathedral. The work was part of a large project started in the early 1430s in which Ghiberti, Donatello and Castagno were also involved. Uccello was commissioned in 1443 to submit designs for scenes of the *Ascension*, the *Resurrection*, the *Nativity* and, in 1444, the *Annunciation*. Of these, only the *Nativity* and the *Resurrection*, executed by the glass painters Bernardo di Francesco and Angelo di Lippo respectively, survive; the *Annunciation* (destr. 1828) was executed by Bernardo di Francesco alone, and a design by Ghiberti was used for the *Ascension*. Uccello worked again in partnership with Bernardo di Francesco for the cathedral authorities in 1456.

(ii) Middle years, 1443–c. 1460. Uccello's paintings of the 1440s and 1450s reveal his determination to come to terms with recent developments in Florentine art. The frescoes executed for S Miniato al Monte and a second series for S Maria Novella emphasize his growing preoccupation with the ideas expounded by Alberti regarding the representation of space. Alongside the purely theoret-

ical influence of Alberti, it is likely that Donatello's example profoundly affected Uccello in the matter of translating Alberti's ideas into practice. The bolder modelling of the four saints' heads decorating the corners of the painted clockface at the west end of Florence Cathedral (1443; *in situ*) shows the influence of Donatello's marble sculpture.

In 1445–6 Uccello visited Padua at the behest of Donatello (Vasari). There, he frescoed a series of giants (destr.) in *terra verde* in the entrance to the Casa Vitaliani. These are a serious loss as regards the connection between Central and North Italian art at that date. They may have been similar in style to the heads adorning the clockface in Florence Cathedral, and, according to Vasari, they influenced Andrea Mantegna's early work in the Ovetari Chapel (Padua, Eremitani; *see* MANTEGNA, ANDREA, fig. 1).

The fresco cycle (badly damaged) in the cloister of S Miniato al Monte is devoted to scenes of monastic life and was most probably painted towards the close of the 1440s. The receding lines of the buildings bear witness to Uccello's concern to depict space three-dimensionally, a feature that also characterizes his next frescoes.

Uccello's second fresco cycle in the Chiostro Verde, S Maria Novella, illustrates the *Story of Noah* and decorates the east side of the cloister. Uccello painted the *Flood and the Recession of the Flood* (see fig. 2) in a lunette, with the *Sacrifice of Noah and the Drunkenness of Noah* below. Suggested dating for these scenes varies considerably, ranging between the mid-1440s and the first half of the 1450s. The style of Donatello's relief panels on the altar

of the Santo, Padua, with their steep perspective and use of movement to augment the drama, may have been in Uccello's mind as he was painting the *Flood*. This scene shows Uccello's style at its most advanced and no longer dependent on Alberti. Undeniably, however, the establishment of separate vanishing-points that yet serve to fuse together two separate incidents, the recession into space, the range of characterization, the display of imagination and even the technique are close to Alberti's prescriptions for compositional procedure. There has been an attempt to identify the figure standing in the right foreground of the fresco as Alberti (Ames-Lewis, 1974; Eisler, 1974), while the figure of Noah leaning out of the ark has been identified as Uccello (Joost-Gaugier, 1974). Vasari was inspired to write one of his most vivid descriptions of the dramatic detail of the scene, where for once Uccello's somewhat academic concept is quickened by a forceful depiction of the cataclysm overwhelming mankind.

During the later stages of his career Uccello explored the tension between the formal decorative aspects of his art and the more scientific principles that he first adopted during the 1430s and developed during the 1440s. Nowhere is this tension more apparent than in the three panels illustrating the *Rout* (or *Battle*) *of San Romano* (London, N.G.; Florence, Uffizi; Paris, Louvre). These were first recorded in a Medici inventory of 1492 and evidently formed part of a decorative scheme in the newly built Palazzo Medici in Florence. They are usually dated to the mid-1450s. The paintings were originally in a room

2. Paolo Uccello: *Flood and the Recession of the Flood* (*c.* 1445–55), fresco, Chiostro Verde, S Maria Novella, Florence

3. Paolo Uccello: *Rout of San Romano*, oil on panel, 1.81×3.20 m, mid-1450s (London, National Gallery)

in which two other paintings by Uccello and one by Pesellino were also hung. Later the room was used as a bedroom by Lorenzo de' Medici. The Rout of San Romano was a military action that took place on 1 June 1432 in the war between Florence and Lucca. The panel in London (see fig. 3) shows Niccolò da Tolentino, the Florentine commander, directing the attack against Sienese forces, who had formed an alliance with Lucca. The Uffizi panel depicts the unhorsing of the Sienese commander, Bernardino della Carda, while the panel in Paris (see colour pl. 2, XXXVII1) portrays another Florentine commander, Michele da Cotignola, bringing up the reserve troops in a surprise attack against the Sienese (Griffiths, 1978). Uccello displayed his finest skills in these three battle scenes. The sightlines are established by the array of weapons, the movement of horses and the debris of war scattered on the ground. Yet, although the eye does penetrate into the background landscapes, Uccello discouraged any such movement into depth by overlaying the constituent elements, so that lances, banners, assorted headgear, plate armour, horses' flanks and kicking hooves create a network of interlocking shapes across each of the panels. What characterizes these paintings, therefore, is the dualism resulting from an application of geometric principles, which evokes both a unified space and a sense of pattern resulting from a fascination for the geometry contained within individual forms. The means at Uccello's disposal is pre-eminently scientific, but the effect is unrelievedly decorative, to the extent that the panels are often likened to tapestry.

(iii) Late works, c. 1460–75. A similar dualism underlies those works that are generally considered to be late, including *St George and the Dragon* (*c.* 1465; Paris, Mus. Jacquemart-André; see colour pl. 2, XXXVII2), to which

a document of 1465 may allude (Beck, 1979). A group of payments made to Uccello in Urbino between 1465 and 1468 almost certainly relates to the predella panels of the *Profanation of the Host* (Urbino, Pal. Ducale), painted for the altarpiece of the *Institution of the Eucharist* (Urbino, Pal. Ducale), which is probably by Justus of Ghent (*fl c.* 1460–80). Another late work is the *Hunt in the Forest* (Oxford, Ashmolean; see fig. 4). These panels are all considerably smaller in scale than previous works. Their bright colouring and figural types—the heads with pointed noses but no chins—are distinctive, and Uccello's exploration of mathematical principles remains relentless.

The *Hunt* best exemplifies the degree of sophistication that Uccello could bring to his compositional methods. The wood is neatly divided into equal parts; the orthogonals are represented by branches lying in the undergrowth; the eye is drawn to the central vanishing-point by the fleeing stags and galloping hounds but at the same time is presented with a number of secondary viewing points, formed by compartments of space defined by the tree trunks. Within this firmly structured ambience, the huntsmen, some shown running at full stretch like athletes on a Greek vase, create a ribbon of colour intertwined with the trunks of the trees. It would be hard to find a better example of Uccello's dualism in the simplicity of structure and the complicated dramatic invention. It is sometimes suggested that the *Hunt* was painted while Uccello was in Urbino (1465–7), but it is more likely to have been done *c.* 1470 in Florence.

Although in many ways these late pictures are the summation of Uccello's art, they are essentially in a style that had fallen behind developments in Florentine art. The *Hunt* and the predella panels in Urbino are supreme works by an experimental artist who had brought the stylistic virtues of the 1440s and 1450s to a pitch of the greatest

4. Paolo Uccello: *Hunt in the Forest*, tempera on panel, 730×1770 mm, *c.* 1470 (Oxford, Ashmolean Museum)

refinement. Uccello made a vital contribution to the literal realization of space within the confines of a painting, but by the end of his life younger artists were already beginning to find means other than mathematics for this purpose, and the use of aerial perspective was being developed.

The artist made two wills, the first in 1425, presumably before travelling to Venice, and the second in 1475, a month before he died. His final tax return in 1469 includes the plea 'I find myself old and ailing, my wife is ill, and I can no longer work'—a statement that is echoed by Vasari, who added that because of Uccello's predilection for perspective 'he came to live a hermit's life, hardly knowing anyone and shut away out of sight in his house for weeks and months at a time'. Nevertheless, there is some tentative evidence that he may still have been active as a painter during the 1470s (Beck, 1979). He was buried in his father's grave in Santo Spirito, Florence.

(iv) Lost works. Only a few lost works by Uccello are recorded in documents; more are mentioned in the early biographies of the artist. For the early style of Uccello the fresco of the *Annunciation* (destr.), formerly in S Maria Maggiore, Florence, may have been significant because of its possible relationship with paintings of that subject by Masolino and Masaccio (Spencer, 1955). Vasari described the fresco cycle of scenes from the *Life of St Benedict*, formerly in the cloister of S Maria degli Angeli, Florence, in sufficient detail to suggest that in it Uccello made full use of his narrative powers. The *Battle of Dragons and Lions* (untraced), listed in the Medici inventory of 1492 and also described briefly by Vasari, is further testimony to Uccello's interest in animals. It has been argued that contemporary Florentine engravings reflect the type of composition devised by Uccello (Salmi, 1950). The most serious loss is the fresco of giants, formerly in the Casa Vitaliani, Padua, which may have influenced Mantegna.

2. WORKING METHODS AND TECHNIQUE.

(i) Frescoes and panels. Nearly all Uccello's frescoes have been damaged, and understanding of the scenes is often enhanced by reference to 19th-century line-engravings such as those published by Giovanni Rosini (*Storia della*

pittura italiana, 1839–54) and Seroux d'Agincourt (*Histoire de l'art*, 1810–23). On the other hand, the parlous condition of the frescoes has necessitated restoration, which in turn has revealed the underlying *sinopie*, thereby providing additional information about Uccello's preparatory methods. In the case of the scenes of the *Creation* in S Maria Novella, the gain is one concerning pictorial content, but in the case of the *Nativity and the Annunciation to the Shepherds* from S Martino alla Scala, the *sinopia* provides a perfect demonstration of the laying-in of grid lines. It is possible that the deterioration of Uccello's frescoes was in some cases, although not necessarily in all, hastened by the use of mixed media. At S Miniato al Monte, for example, oil was adopted as the medium (Saalman, 1964). The frescoes are normally described as having been executed in *terra verde*. It can be seen from surviving examples that this creates a predominantly chiaroscuro effect relieved only by subdued local colours.

Uccello seems to have specialized in this monochrome technique, which was advocated by Alberti, and it contrasts strongly with the vivid colours he used for the panels. Technical information for panel paintings is sparse. For the transference of the design to the surface of the painting, Uccello seems to have used both squared drawings for enlargement and pricked cartoons. Given the precise structure of the compositions, it is likely that Uccello relied on such detailed preparatory methods as well as the greater freedom inherent in the *sinopia*.

(ii) Drawings. Few drawings can be firmly attributed to Uccello, although Vasari stated that the painter left 'whole chests full of drawings'. Of particular interest are the squared study for the upper half of the fresco of *Sir John Hawkwood*, the portrait of a man in profile facing left (given by Hartt to Castagno; see *A. Q.* [Detroit], xix (1956), pp. 162–73) and the squared and pricked study of a soldier on horseback (all Florence, Uffizi; see Degenhart and Schmitt, 1960, nos 302, 307, 309). These are drawings made in preparation for paintings, and the portrait study constitutes valuable evidence for the unresolved problem of Uccello's painted portraits. Uccello also made a number of studies of objects seen in perspective amounting to

exercises in geometry; these include the drawing of a *mazzocchio* (Florence, Uffizi) and an even more elaborate drawing of a cup (Florence, Uffizi). Several drawings of animals are, not surprisingly, attributed to Uccello. Vasari claimed to have owned several drawings by the artist.

(iii) Perspective. Discussion of Uccello all too often concentrates on the issue of perspective, stressing the mathematical aspects and tending to overlook the general philosophical or intellectual connotations that the term *prospettiva* had in 15th-century Florence. Perspective was not simply a mathematical exercise but a new way of recording, and therefore of looking at the world. Uccello's depiction of himself on the panel known as the *Founders of Florentine Art* (Paris, Louvre) alongside such artists as Filippo Brunelleschi and Donatello as well as the astronomer and geographer Paolo dal Pozzo Toscanelli has a certain significance in this matter. The various ways in which Uccello applied his knowledge of perspective, including bifocal perspective, show that he was not content to stick rigidly to the system enshrined in Alberti's *De pittura* (1435). Central to an understanding of Uccello's use of perspective is his concern to assess its theoretical formulation in the context of natural phenomena. His conclusion seems to have been that while one-point perspective assisted in a more convincing pictorial rendering of the world, it was at the same time restricting and ultimately false because it demanded a fixed viewing point not in accordance with nature. Uccello's experiments in perspective and his constant deployment of mathematical principles in his works are in essence an examination of this dilemma.

(iv) Studio practice. Uccello does not seem to have maintained a large studio. Only a single individual, Antonio di Papi, is recorded as an assistant, in the documents for work carried out at S Miniato al Monte (Saalman, 1964). On the whole, Uccello's paintings do not show evidence of collaboration. Yet it is clear that a number of painters were influenced by his distinctive style and, accordingly, may have received some training in his workshop. Of those followers, the Prato Master is perhaps the most individual. His animated style and light tonality are best displayed in the scenes from the *Lives of the Virgin and St Stephen* (Prato Cathedral) or the *Virgin and Child* (Dublin, N.G.). Another hand that can be isolated is that of the painter known as the Karlsruhe Master, named after the panel of the *Adoration of the Child* (Karlsruhe, Staatl. Ksthalle), to whom several works, including *Christ on the Cross with Four Saints* (Madrid, Mus. Thyssen-Bornemisza) and the *Scenes from Monastic Legends* (Florence, Accad.), can be attributed (Pope-Hennessy, 1950). Many of the works by these two masters have at one time or another been incorporated into Uccello's oeuvre, but without any real justification (*see* MASTERS, ANONYMOUS, AND MONOGRAMMISTS, §I: KARLSRUHE MASTER and PRATO MASTER).

3. CRITICAL RECEPTION AND POSTHUMOUS REPUTATION. In Landino's preface (1481) to Dante's *Divine Comedy*, Uccello is described as a 'good composer and varied, great master of animals and landscapes, skilful

in foreshortening, because he understood perspective well'. Vasari (2/1568) was more concerned with evaluation than bald description:

> The most captivating and imaginative painter to have lived since Giotto would certainly have been Paolo Uccello, if only he had spent as much time on human figures and animals as he spent, and wasted, on the finer points of perspective. Artists who devote more attention to perspective than to figures develop a dry and angular style because of their anxiety to examine things too minutely; and, moreover, they usually end up solitary, eccentric, melancholy and poor, as indeed did Paolo Uccello himself.

However, Vasari was not totally dismissive of Uccello's art, admiring the painter's facility for landscape and the depiction of animals.

Vasari's analysis of Uccello's art is echoed by Berenson (1896), who declared that Uccello 'almost entirely sacrificed what sense of artistic significance he may have started with, in his eagerness to display his skill and knowledge'. For Berenson, Uccello's achievements lay more in the realm of mathematics than in art, but, in the light of subsequent research into the use of linear perspective by artists, he missed the essential point. Pope-Hennessy (1950) discerned that the dualism in Uccello's work is not between art and science 'but between two imperfectly reconciled visual traditions and two incompletely synthesized attitudes to art'. He recognized that Uccello was both an imaginative decorative painter and a remarkable naturalist, as is evident in the Chiostro Verde frescoes. Although Uccello's reputation has remained intact since the 15th century, it is true to say that, as with Piero della Francesca, there has been a quickening of interest in his work in the 20th century, mainly because of its appeal to modern sensibilities. Clark (1983) compared Uccello's achievement to that of Georges Seurat (1859–1891) and likened his methods to those of the Cubists. He described Uccello as an artist in whose work there is 'a synthesis of his Gothic fantasy and Euclidian logic: a synthesis so complete that we can never be certain whether a happy passage of design is a triumph of taste or of calculation'.

BIBLIOGRAPHY

EARLY SOURCES

C. Landino: *Comento di Cristoforo Landino fiorentino sopra la Comedia di Dante Alighieri poeta fiorentino* (Florence, 1481); preface in *Scritti critici e teorici*, ed. R. Cardini, i (Rome 1974), pp. 100–164; extract in O. Morisani: 'Art Historians and Art Critics III: Cristoforo Landino', *Burl. Mag.*, xcv (1953), pp. 267–70; Eng. trans. of extract in C. Gilbert: *Italian Art, 1400–1500* (Englewood Cliffs, 1980), pp. 191–2

G. Vasari: *Vite* (1550, rev. 2/1568), ed. G. Milanesi (1878–85), ii, pp. 203–17

GENERAL

Colnaghi; *EWA*; Thieme–Becker

J. A. Crowe and G. B. Cavalcaselle: *A History of Painting in Italy* (London, 1864, rev. 2/1911, ed. L. Douglas), iv, pp. 106–22

B. Berenson: *The Florentine Painters of the Renaissance* (London, 1896), pp. 33–41

A. Venturi: *Storia* (1901–40/R 1967), VII/i, pp. 331–45

R. van Marle: *Italian Schools* (1923–38), x, pp. 203–50

M. Davies: *The Earlier Italian Schools*, London, N.G. cat. (London, 1951, 2/1961/R 1986), pp. 525–33

J. White: *The Birth and Rebirth of Pictorial Space* (London, 1956, 2/1967), pp. 202–7

E. Borsook: *The Mural Painters of Tuscany from Cimabue to Andrea del Sarto* (London, 1960, rev. Oxford, 2/1980), pp. 71–9

B. Degenhart and A. Schmitt: *Corpus der italienischen Zeichnungen, 1300–1450*, I/ii (Berlin, 1960), pp. 379–414 [detailed disc. of Uccello's drgs]

B. Berenson: *Florentine School* (1963), i, p. 209

H. W. Janson: 'The Equestrian Monument from Cangrande della Scala to Peter the Great', *Sixteen Studies* (1970), pp. 159–68 [disc. of *Sir John Hawkwood*]

H. Saalman, ed.: *The Life of Brunelleschi by Antonio Tuccio Manetti* (Philadelphia, 1970), pp. 18–19, n. 24 [identifies Uccello's self-portrait in the *Founders of Florentine Art*]

MONOGRAPHS

W. Boeck: *Paolo Uccello* (Berlin, 1939); review by M. Wackernagel in *Pantheon*, xxvii (1941), pp. 102–10

M. Pittaluga: *Paolo Uccello* (Rome, 1946)

J. Pope-Hennessy: *The Complete Work of Paolo Uccello* (London, 1950, rev. 2/1969); review by C. Gilbert in *A. Q.* [Detroit], xxxiii (1970), pp. 441–3

E. Sindona: *Paolo Uccello* (Milan, 1957)

E. Carli: *Tutta la pittura di Paolo Uccello* (Milan, 1959; Eng. trans., 1963)

P. D'Ancona: *Paolo Uccello* (Eng. trans., London, 1960)

E. Flaiano and L. Tongiorgi Tomasi: *L'opera completa di Paolo Uccello* (Milan, 1971)

F. Borsi and S. Borsi: *Paolo Uccello* (1992); Eng. trans. by E. Powell (London, 1994)

J. Darriulat: *Uccello: Chasse et perspective* (Paris, 1997)

SPECIALIST STUDIES

E. Campani: 'Uccello's *Story of Noah* in the Chiostro Verde', *Burl. Mag.*, xvii (1910), pp. 203–10

G. J. Kern: 'Der Mazzocchio des Paolo Uccello', *Jb. Preuss. Kstsamml.*, xxxvi (1915), pp. 13–38

M. Marangoni: 'Gli affreschi di Paolo Uccello a San Miniato al Monte a Firenze', *Riv. A.*, xii (1930), pp. 403–17

G. Poggi: 'Paolo Uccello e l'orologio di S. Maria del Fiore', *Miscellanea di storia dell'arte in onore di I. B. Supino* (Florence, 1933), pp. 323–36

W. Paatz: 'Una *Natività* di Paolo Uccello e alcune considerazioni sull'arte del maestro', *Riv. A.*, xvi (1934), pp. 112–48

G. Pudelko: 'The Early Works of Paolo Uccello', *A. Bull.*, xvi (1934), pp. 231–59

M. Salmi: *Paolo Uccello, Andrea del Castagno, Domenico Veneziano* (Milan, 1938), pp. 7–49, 101–14

R. G. Mather: 'Documents, Mostly New, Relating to Florentine Painters and Sculptors of the Fifteenth Century', *A. Bull.*, xxx (1948), pp. 62–4

M. Salmi: 'Riflessioni su Paolo Uccello', *Commentari*, i (1950), pp. 22–33

C. Grayson: 'A Portrait of L. B. Alberti', *Burl. Mag.*, xcvi (1954), pp. 177

J. K. Spencer: 'Spatial Imagery of the Annunciation in Fifteenth Century Florence', *A. Bull.*, xxxvii (1955), pp. 273–80

D. Gioseffi: 'Complementi di prospettiva, 2', *Crit. A.*, v (1958), pp. 102–39

A. Parronchi: 'Le fonti di Paolo Uccello', *Studi su la 'dolce' prospettiva* (Milan, 1964), pp. 468–532

H. Saalman: 'Paolo Uccello at San Miniato', *Burl. Mag.*, cvi (1964), pp. 558–63

M. Aaronberg Lavin: 'The Altar of Corpus Domini in Urbino: Paolo Uccello, Joos van Ghent, Piero della Francesca', *A. Bull.*, xlix (1967), pp. 1–24

M. Meiss: 'The Original Position of Uccello's *Sir John Hawkwood*', *A. Bull.*, lii (1970), p. 231

H. E. Mittig: 'Uccellos Hawkwood Fresko: Platz und Wirkung', *Mitt. Ksthist. Inst. Florenz*, xiv (1970), pp. 235–9

R. L. Mode: 'Masolino, Uccello and the Orsini *Uomini famosi*', *Burl. Mag.*, xciv (1972), pp. 369–78

E. Sindona: 'Introduzione alla poetica di Paolo Uccello: Relazioni tra prospettiva e pensiero teoretico', *L'Arte*, xvii (1972), pp. 7–100

F. Ames-Lewis: 'A Portrait of L. B. Alberti by Uccello?', *Burl. Mag.*, cxvi (1974), pp. 103–4

C. Eisler: 'The Portrait of L. B. Alberti', *Burl. Mag.*, cxvi (1974), pp. 529–30

C. Joost-Gaugier: 'Uccello's "Uccello": A Visual Signature', *Gaz. B.-A.*, n.s. 6, lxxxiv (1974), pp. 233–8

C. Griffiths: 'The Political Significance of Uccello's *Battle of San Romano*', *J. Warb. & Court. Inst.*, xxxxi (1978), pp. 313–16

J. Beck: 'Paolo Uccello and the Paris *St George*, 1465: Unpublished Documents 1452, 1465, 1474', *Gaz. B.-A.*, n.s. 6, xciii (1979), pp. 1–5

——: 'Uccello's Apprenticeship with Ghiberti', *Burl. Mag.*, cxxii (1980), p. 837

C. Volpe: 'Paolo Uccello a Bologna', *Paragone*, xxxi (1980), pp. 3–28

C. Lloyd, ed.: *Paolo Uccello's 'Hunt in the Forest'* (Oxford, 1981)

K. Clark: 'Paolo Uccello and Abstract Painting', *The Art of Humanism* (London, 1983), pp. 43–76

Y. Even: 'Paolo Uccello's *John Hawkwood*: Reflections of a Collaboration between Agnolo Gaddi and Giuliano Pesello', *Source*, iv/4 (1985), pp. 6–8

J. O'Grady: 'An Uccello Enigma', *Gaz. B.-A.*, n.s. 6, cv (1985), pp. 99–103

P. A. Rossi: 'La *Madonna* di Dublin', *Crit. A.*, li (1986), pp. 40–50

E. Oy-Marra: *Florentiner Ehrengrabmäler der Frührenaissance* (Berlin, 1994)

V. Gebhart: *Paolo Uccello: Die Schlacht von San Romano: Ein Bilderzyklus zum Ruhme der Medici* (Frankfurt am Main, 1995)

J. L. Schefer: *The Deluge, the Plague* (Ann Arbor, 1995)

J. Bloedé: *Paolo Uccello et la représentation du mouvement: Regards sur la BATTAILE DE SAN ROMANO* (Paris, 1996)

CHRISTOPHER LLOYD

Udine, Giovanni da. *See* GIOVANNI DA UDINE.

Udine, Girolamo da. *See* GIROLAMO DA UDINE.

Udine, Martino da. *See* PELLEGRINO DA SAN DANIELE.

Ugo da Carpi. *See* CARPI, UGO DA.

Ul, Sebastiano d'. *See* VALENTINIS, SEBASTIANO DE'.

Ulocrino (*fl c.* 1485–1530). Italian sculptor. The identification of this artist, who signed his bronze plaquettes VLOCRINO, has prompted a number of proposals, the most ingenious (Molinier) being that his name was formed from the Greek *oulos* and the Latin *crinis*, meaning 'curly-haired', and is therefore a pseudonym for Andrea Briosco, known as Andrea Riccio on account of his curly hair; this identification has been refuted on stylistic grounds, while it is accepted that this artist may also have been curly-haired.

Ulocrino's classicizing and clearly modelled compositions include religious plaquettes of *St Jerome*, *St Cecilia* and *St Gerasimus* and mythological scenes of *Apollo and Marsyas* and the *Death of Meleager* (all Berlin, Bodemus.). A plaquette showing *Aristotle and Alexander of Aphrodisias* (London, V&A) is a rare treatment of a literary subject, and it has been suggested that the composition depends on an illuminated frontispiece to an edition of Aristotle's *Works* (Venice, 1483; New York, Pierpont Morgan Lib., ChL 907), probably executed by Girolamo da Cremona. Stylistically, Ulocrino's compositions are related to Paduan plaquette sculpture of the early 16th century.

BIBLIOGRAPHY

E. Molinier: *Les Plaquettes: Catalogue Raisonné*, i (Paris, 1886), pp. 176–84

E. F. Bange and F. Goldschmidt: *Reliefs und Plaketten* (1922), ii of *Die italienischen Bronzen der Renaissance und des Barock* (Berlin, 1914–22), pp. 57–8, nos 418–27, 430

J. Pope-Hennessy: 'The Italian Plaquette', *Proc. Brit. Acad.*, l (1964), pp. 63–76

D. R. Morrison: '*Aristotle and Alexander of Aphrodisias* by Ulocrino', *Aristotle Transformed: The Ancient Commentators and Their Influence*, ed. R. Sorbi (London, 1990), pp. 481–4

□

Unghero, Nanni [Giovanni d'Alesso d'Antonio] (*b* Florence, *c.* 1490; *d* Florence, 31 May 1546). Italian carpenter, wood-carver, architect and military engineer. He trained in carpentry with his father and by 1510 had his own workshop. Through the patronage of Baccio d'Agnolo, architect of the Florentine Opera del Duomo (Cathedral Works), Nanni may have gained his first known commis-

sion, for two altars (1510; destr.) in the cathedral, as well as work on the palace and villas that Baccio built for the Bartolini family in the second decade of the century.

Nanni also became known for his sculpture in wood; Vasari related that he carved a number of figures after designs by Jacopo Sansovino, with whom he carved his one surviving statue, the *St Nicholas of Tolentino* (Florence, Santo Spirito). This formed the centrepiece of an altar (1513–18) containing wooden putti (destr.) after designs by Sansovino and painted panels by Franciabigio. Nanni and Sansovino also worked together at the Bartolini family's suburban villa of Valfonda in those years, and Sansovino took on Niccolò Tribolo as an apprentice after he had worked with Nanni.

From the 1520s Nanni concentrated more exclusively on architecture and engineering. In 1520 he restored the choir-stalls of the cathedral (destr.) and later renewed those of SS Annunziata, Florence (1528–39; destr.). The best example of his architectural style is the organ-case and altar of S Salvatore in SS Annunziata. The marble framework employs a basic architectural vocabulary derived from Giuliano da Sangallo and resembles Baccio d'Agnolo's Palazzo Serristori façade (1523) in its decorative motifs.

The uncertain state of Tuscan politics in the 1520s and 1530s gave scope for Nanni's abilities as a military architect: he was engaged on fortifications for Pisa (the citadel), Pistoia (Palazzo Capitano, Fortress of S Barbara), Arezzo and Borgo San Sepolcro and built the Fortezza da Basso in Florence (1535–7) after designs by Antonio da Sangallo the younger. He was made master builder of the Parte Guelfa in 1531 and was an engineer for Cosimo I from 1538 to 1544. Nanni's development from carpentry to sculpture and architecture mirrored that of Baccio d'Agnolo and the Sangallo family and illustrates the lack of rigid divisions between the guilds in Florence at the time.

BIBLIOGRAPHY

G. Vasari: *Vite* (1550, rev. 2/1568); ed. G. Milanesi (1878–85), vi, pp. 56–7

P. Tonini: *Santuario di SS Annunziata di Firenze* (Florence, 1876), p. 59

J. Balogh: 'Nanni Unghero', *Az Országos Magyar Szépművészeti Múzeum Évkönyvei* [Yearbook of the Museum of Fine Arts, Budapest], iv (1924–6), pp. 91–115

F. Gurrieri: 'La fortezza rinascimentale di S Barbara a Pistoia: Una conferma per Nanni Unghero', *Boll. A.*, lxi (1976), pp. 12–20

L. B. Salimbeni: 'Una "fabbrica" fiorentina di Baccio d'Agnolo', *Palladio*, xxvii/2 (1978), pp. 7–28

M. Gianneschi and C. Sodini: 'Urbanistica e politica durante il principato di Alessandro de' Medici, 1532–37', *Stor. Città*, x (1979), pp. 5–34

BRUCE BOUCHER

Urbania. *See* CASTEL DURANTE.

Urbano (di Pietro) da Cortona (*b* Cortona, ?1426; *d* Siena, 8 May 1504). Italian sculptor. He was first mentioned working as an assistant to Donatello in September 1447 when he and Giovanni da Pisa (i), Antonio Chellini and Francesco del Valente (*fl* 1446; *d* after 1464) were each paid for the execution of an Evangelist's symbol and a relief of an angel for the high altar of the Santo, Padua (although which sculptor did which pieces is not specified). Soon afterwards Urbano apparently worked in Perugia, designing the tomb of the university professor *Ubaldo*

Bartolini (Perugia University) and the wall tomb of *Archbishop Andrea Giovanni Baglioni* (*d* 1451; Perugia Cathedral), before establishing himself permanently in Siena. In July 1451 he was commissioned to design two marble statues of saints for the Loggia di Mercanzia (Loggia di S Paolo), Siena, which were never carved. In 1462 Urbano carved a marble bench for the loggia ornamented with personifications of the four Cardinal Virtues.

In October 1451 Urbano and his brother Bartolommeo began the decoration of the chapel of the Madonna delle Grazie (destr. 1661) in Siena Cathedral. Sixteen marble reliefs (Siena Cathedral) depicting scenes from the *Life of the Virgin* originally intended to ornament the pilasters, the symbol of St Matthew and a tondo of the Virgin from the pediment survive (Siena, Mus. Opera Duomo). The rigid lines of the drapery and the stereotyped figures reveal an artist of a conservative and eclectic nature, whose manner, influenced by Donatello, was unlikely to have much of a following among his Sienese contemporaries.

In 1456 Urbano designed a terracotta figure of *St Bernardino* (Siena, Osservanza) whose pose is reminiscent of Donatello's statues of saints on the high altar of the Santo, Padua. In 1457 he was sent to Florence by the Sienese authorities to deliver monies owed to Donatello for the bronze *St John the Baptist* (Siena Cathedral). The marble wall tomb (Siena, S Francesco) of Cristoforo Felici, former Operaio of the cathedral, is dated 1462 or 1463, although the final payment was delayed until 1487.

In March 1470 Urbano was paid for a lunette of *St Catherine and Two Angels* for the oratory of Caterina, Siena (*in situ*); together with many other Sienese masters, Urbano had been employed on the decoration of the oratory from 1468 to 1474. In 1470–72 Urbano decorated the newly constructed Palazzo Piccolomini, Siena, and in September 1481 he received his last important commission from the Sienese authorities, to design a marble intarsia of the *Persian Sibyl* for the cathedral pavement; the final payment was made in October 1483. Urbano acted as arbitrator in a dispute between Giovanni di Stefano and his workmen in 1497–8.

Also attributed to Urbano, but with a lesser degree of certainty, are a relief of the *Virgin Suckling the Infant Christ* (Montarioso, Seminario Archivescovile), formerly in S Francesco, Siena, and a number of polychromed stucco reliefs of the Holy Family based on a prototype by Donatello (Berlin, Skulpgal.; Florence, Mus. Bardini; London, V&A).

BIBLIOGRAPHY

Thieme–Becker

G. Milanesi: *Documenti per la storia dell'arte senese*, 3 vols (Siena, 1854–6)

R. H. H. Cust: *The Pavement Masters of Siena, 1369–1562* (London, 1901)

P. Schubring: *Urbano da Cortona: Ein Beitrag zur Kenntnis der Schule Donatellos und der Sieneser Plastik im Quattrocento* (Strasbourg, 1903)

J. Pope-Hennessy: 'Some Donatello Problems: Three Stucco Reliefs', *Essays on Italian Sculpture* (London, 1959, R/1968), pp. 60–64

V. Herzner: 'Donatello in Siena', *Mitt. Ksthist. Inst. Florenz*, xv (1971), pp. 161–86

E. Carli: *Il Duomo di Siena* (Genoa, 1979)

——: 'Un tondo di Urbano da Cortona', *Antol. B.A.*, xxi–xxii (1984), pp. 11–14

R. Munman: 'Urbano da Cortona: Corrections and Observations', *Verrocchio and Late Quattrocento Italian Sculpture* (Florence, 1992), pp. 225–41

ELINOR M. RICHTER

Urbino [anc. Urvinum Mataurense]. Italian hilltop city in the Marches. Set in a relatively isolated position east of

the Appenines, *c.* 12 km south-west of Pesaro, Urbino (population *c.* 16,000) achieved an extraordinary cultural importance in the 15th and 16th centuries, especially under the rule of Federigo II da Montefeltro (*see* MONTEFELTRO, (1)), who built the great Palazzo Ducale that dominates the walled city.

1. History and urban development. 2. Art life and organization. 3. Centre of maiolica production. 4. Palazzo Ducale.

1. HISTORY AND URBAN DEVELOPMENT. Renaissance tradition held that the city was founded 100 years after Rome by Metaurus Suassus Umbro, who is mentioned in an inscription on the Porta Valbona (1621), but the city's Latin name refers more directly to the nearby River Mataurum (now River Metauro), while its more ancient remains date back to the 3rd and 2nd centuries BC. The Roman city, bisected by its *cardo maximus* and *decumanus*, spread over the summit of the hill surrounded by walls in *opus quadratum* of local stone, of which some traces remain.

Urbino subsequently became the seat of a garrison of Goths and was captured by Belisarius in AD 538. It then became part of the Byzantine province of Ravenna, passing to the Lombards (AD 751) and finally to the Church (AD 774). In the 12th and 13th centuries a new circuit of walls was built, extending the city further to the north-east, the only side on which it could expand within the slopes of the surrounding hills. In 1234 the city came into the hands of the Montefeltro family, and the walls withstood a siege (1284–5) by the papal army. Churches built in the 14th century include S Domenico, with a Renaissance portal (1449–52) designed by Maso di Bartolommeo and realized by Pasquino da Montepulciano, with Fra Carnevale supervising the building.

At the beginning of the rule of Federigo II da Montefeltro (1444), Urbino was still divided internally into quarters based on the Roman plan, with the Piazza Maggiore (now Piazza Duca Federico) on what may have been the site of the ancient forum, with the supposed medieval Palazzo del Conte Antonio to the south-east and the cathedral on the other side. The Castellare, a medieval building that, in view of its light construction, is unlikely to have served a defensive purpose, occupied the third site of the Piazza Maggiore and was later incorporated into the new Palazzo Ducale. The position of such medieval public buildings as the Palazzo dei Priori and Palazzo del Podestà, which are mentioned in documents, and the ancient cathedral and other buildings, has been credibly reconstructed by Negroni.

The city was then radically transformed by the construction of Federigo's great hilltop Palazzo Ducale (begun ?1454; see figs 3 and 4 below; *see also* §4 and fig. 5 below), starting with the east range flanking the built-up area along the road (widened in 1563; now Piazza Rinascimento; see fig. 4s below) where S Domenico stands, and extending west down into the valley on a powerful substructure. At the lower level, looking to the Mercatale, a market square outside the city walls, there is the Data, the great ducal stables extending on two levels along the slope below the palace; the Data were constructed with a wide bastion containing spiral ramp inside by FRANCESCO DI GIORGIO MARTINI as part of his work there.

The Piazza Maggiore was ultimately defined on two sides by the entrance façade of the palace ('Facciata ad Ali'), which was linked by the Castellare to the new cathedral (begun *c.* 1480) by Francesco di Giorgio on the side of the old one, but with a new orientation (see fig. 4 below). Francesco also built the convent of S Chiara on the south-eastern slopes of the city and the church of S Bernardino (*see* FRANCESCO DI GIORGIO MARTINI, fig. 2) facing it on an adjacent hill (both begun *c.* 1482). In addition, the medieval city walls were extended by Federigo, with a new stretch, the Risciolo, extending downhill from his new palace to the 14th-century fortress of Albornoz. New fortifications, begun in 1507 under Federigo's successors, with contributions from Federigo Commandini, perfected his plans; they were mostly completed by 1525, with 12 demi-bastions. The new cathedral was not completed until 1604, when the dome was added, probably by Muzio Oddi.

Urbino was briefly occupied by Cesare Borgia in 1502–3, and in 1508, on the death of Federigo's son Guidobaldo da Montefeltro, the city passed to his chosen heir, Francesco Maria I della Rovere.

BIBLIOGRAPHY
F. Bianchini: *Memorie concernenti la città di Urbino* (Rome, 1724/R Bologna, 1978)
F. Ugolini: *Storia dei conti e duchi d'Urbino*, 2 vols (Florence, 1859)
E. Cabrini: *Urbino e i suoi monumenti* (Florence, 1899)
L. Moranti: *Bibliografia urbinate* (Florence, 1959)
G. De Carlo: *Urbino: La storia di una città e il piano della sua evoluzione urbanistica* (Padua, 1966)
G. Franceschini: *I Montefeltro* (Milan, 1970)
C. H. Clough: *The Duchy of Urbino in the Renaissance* (London, 1981)
F. Mazzini: *I mattoni e le pietre di Urbino* (Urbino, 1982)
L. Benevolo and P. Boninsegna: *Urbino* (Rome and Bari, 1986)
M. Bruscia, ed: *La Data (Orto dell'Abbondanza) di Francesco di Giorgio Martini* (Urbino, 1990)
F. Negroni: *Il duomo di Urbino* (Urbino, 1993)
FRANCESCO PAOLO FIORE

2. ART LIFE AND ORGANIZATION. The city was renowned for the brilliance of its Renaissance court under Federigo II da Montefeltro (*reg* 1444–82; *see* MONTEFELTRO, (1)), which was immortalized in Baldassare Castiglione's eulogy to the ideal courtier, *Il libro del cortegiano* (Venice, 1528). Throughout the reign of the Montefeltro family and their heirs, the della Rovere, until 1631, Urbino was recognized as a centre of learning and culture. According to his librarian and biographer Vespasiano da Bisticci, Federigo encouraged artists from all over Italy and beyond to come to his court and add to the decoration of the city's churches and the embellishment of his new Palazzo Ducale (*see* §4 below), which Castiglione described as the most beautiful palace in Italy.

Several important artists were born in the region of Urbino, studied there or worked there, including Bramante, Giovanni Santi (1435/40–94) and his son RAPHAEL, Federico Zuccaro, TIMOTEO VITI and FEDERICO BAROCCI, who painted several religious works in the cathedral and elsewhere in Urbino in the early 17th century. Important visitors to the city during the reign of Federigo included Ottaviano Nelli, Leon Battista Alberti, Luca della Robbia, Maso di Bartolommeo, Paolo Uccello, Piero della Francesca, Melozzo da Forlì and Luca Signorelli.

Justus of Ghent (*fl c.* 1460–80), the only major Netherlandish painter working in 15th-century Italy, ran a workshop in Urbino in the 1470s and painted portraits of Federigo and his son Guidobaldo (see fig. 1) and an altarpiece of the *Communion of the Apostles* (Urbino, Pal. Ducale), as well as a series of *Famous Men* (Urbino, Pal. Ducale; Paris, Louvre) in the *studiolo* of the palazzo (*see* §4 below); some of the latter have been attributed to Pedro Berruguete (*c.* 1450–1500), who is also thought to have been in Urbino in the 1470s. In the 16th century TITIAN had particularly close relationships with Francesco Maria I della Rovere and Guidobaldo II della Rovere, successors to the Montefeltro; Titian's *Last Supper* and *Resurrection* (1542–4), parts of a standard painted for the Confraternity of Corpus Christi, still hang in the Galleria Nazionale delle Marche at the Palazzo Ducale, together with masterpieces by Piero della Francesca, Raphael and others. This collection also reflects the strong tradition of maiolica work at Urbino during the later Renaissance period (*see* §3 below).

Many of the art works produced at the Renaissance court of Urbino were later dispersed to Rome, Florence and even further afield. Federigo da Montefeltro's library of Classical, medieval and contemporary texts, a collection of over 1000 manuscripts, was dispersed into papal collections and, through Vittoria della Rovere, Grand Duchess of Tuscany and daughter of Claudia de' Medici, to collections in Florence. Likewise, many of the sumptuous paintings, pieces of sculpture, maiolica, carpets, tapestries and ornate pieces of furniture listed in contemporary inventories of ducal property were removed when, on the death of Francesco Maria II della Rovere in 1631, the Duchy of Urbino was taken over by the papacy and ducal possessions divided between surviving heirs.

BIBLIOGRAPHY
J. Dennistoun: *Memoirs of the Dukes of Urbino* (London, 1851, rev. 1909)
G. Gronau: *Documenti artistici urbinati* (Florence, 1936)
C. H. Clough: 'Federigo da Montefeltro's Patronage of the Arts, 1468–1482', *J. Warb. & Court. Inst.*, xxxvi (1973), p. 137
G. Cerboni Biairdi, G. Chittolini and P. Floriani, eds: *Federico di Montefeltro: Lo stato / le arti / la cultura*, 3 vols (Rome, 1986)
L. Cheles: *The Studiolo of Urbino: An Iconographic Investigation* (Wiesbaden, 1986)

ANABEL THOMAS

1. Justus of Ghent: *Federigo da Montefeltro and his son Guidobaldo*, 1340×755 mm, *c.* 1476 (Urbino, Palazzo Ducale)

3. CENTRE OF MAIOLICA PRODUCTION. Urbino was a prominent centre for the production of maiolica during the 16th century. Pottery had been produced in Urbino from medieval times but became celebrated in the 16th century for its fine *istoriato* (narrative) maiolica. Although CASTEL DURANTE served as the training ground for many maiolica painters, the best of them worked in the ducal capital of Urbino. Artists schooled in both places were also active in such other Italian cities as Pesaro and Venice and beyond the peninsula in Lyon and Nevers, where the Urbino style took hold. *Istoriato* wares captured the imagination of both middle-class and aristocratic patrons, including Isabella d'Este. Although these labour-intensive, painted wares constituted only a small percentage of the output of the factories, they have been better preserved and are traditionally more highly valued than any other type of maiolica.

The *istoriato* style developed soon after 1500 and by 1515 had spread throughout Central Italy. At first FAENZA was particularly noted for these wares; between 1525 and 1575, however, the potteries in the duchy of Urbino were unsurpassed in this mode. The narrative style became fully developed in the 1520s with the influx into Urbino of such prominent and talented artists as Nicola di Gabriele Sbraghe (formerly incorrectly identified as Nicola Pellipario; *see* URBINO, NICOLA DA) and FRANCESCO XANTO AVELLI of Rovigo. The artist Guido Durantino, who adopted the name Fontana, ran an extremely successful workshop with his sons, Camillo Fontana and Orazio Fontana, and later his nephew, Flaminio Fontana, and may have enjoyed the patronage of Guidobaldo II, Duke of Urbino; in 1565 Orazio founded his own workshop (see colour pl. 1, XXX2). The only other documented shop that made marked wares in any notable quantity was that of Guido di Merlino, whose circle of painters in the 1540s included the prolific FRANCESCO DURANTINO.

Other artists working in the *istoriato* tradition in Urbino included the anonymous 'Milan Marsyas' and 'Coal-Mine' painters, Francesco Urbini and Camillo Gatti (*fl* 1545–51).

Characteristic Urbino *istoriato* wares depict subjects drawn from literature, history, the Bible, Classical mythology and, occasionally, contemporary life. The restricted palette of the 15th century was replaced by a broader range of brilliant colours, including orange, yellow, green, turquoise, blue, purple and black. Some *istoriato* wares were sent on to Gubbio for the addition of the red and gold lustres for which that city's workshops were famous. Many painters in Urbino were inspired by woodcuts from illustrated books and engravings after the works of such painters as Raphael, Mantegna, Albrecht Dürer (1471–1528) and Rosso Fiorentino, copying individual figures and even whole compositions from these models (see fig. 2); Xanto was especially noted for this tendency. Other design sources included architecture, painting and sculpture, which artists knew either first hand or from prints and drawings.

Around 1560 a new genre appeared in Urbino in which ornamental grotesques, in the style made popular by Raphael, were spread liberally over the white, tin-glazed surfaces of dishes. They were also applied to more elaborate forms of vases and basins sometimes based on contemporary silverwares, which had become popular in the mid-16th century. Grotesques were frequently used as auxiliary decoration to frame smaller *istoriato* scenes in roundels or cartouches. The production of these wares was dominated firstly by the Fontana workshop and later by that of the PATANAZZI family from *c*. 1580 into the 17th century (e.g. flask, probably from the workshop of Antonio Patanazzi, *c*. 1579; London, BM). In addition to the *istoriato* and white-ground grotesque wares, both shops produced such sculptural pieces as inkstands and salt

2. Maiolica dish painted with the *Muses and Pierides* from a print by Giovanni Jacopo Caraglio after Rosso Fiorentino, diam. 460 mm, workshop of Guido Durantino, probably made by Camillo Gatti, *c*. 1545–50 (Cambridge, Fitzwilliam Museum)

cellars decorated with whimsical genre scenes or mythological figures.

BIBLIOGRAPHY
G. Vanzolini, ed.: *Istorie delle fabbriche di maioliche metaurensi* (Pesaro, 1879)
C. D. E. Fortnum: *Maiolica: A Historical Treatise on the Glazed and Enamelled Earthenwares of Italy* (Oxford, 1896)
J. V. G. Mallet: 'In botega di Maestro Guido Durantino in Urbino', *Burl. Mag.*, cxxix (1987), pp. 284–98
T. Wilson: *Ceramic Art of the Italian Renaissance* (London, 1987)
Italian Renaissance Pottery: Papers Written in Association with a Colloquium at the British Museum, London: 1987
B. Talvacchia: 'Professional Advancement and the Use of the Erotic in the Art of Francesco Xanto', *16th C. J.*, xxv/1 (1994), pp. 121–53
WENDY M. WATSON

4. PALAZZO DUCALE. The residence of the dukes of Urbino, which dominates the city, was begun by Federigo II da Montefeltro (*see* MONTEFELTRO, (1)) in the mid-15th century and was the work of several masters, notably Luciano Laurana and Francesco di Giorgio Martini. The building now houses the Galleria Nazionale delle Marche. Although Federigo took power in Urbino in 1444, he was not awarded the title of duke until 1474; construction of the palace was provided for in the agreement he signed with the *comune* on entering the city, but its starting date remains uncertain. According to the anonymous *Memorie* (1723), Federigo began his new residence in 1454. In 1466 Laurana sent a model for the building from Mantua.

The Palazzo Ducale developed within clearly defined limits of the existing city (see fig. 3): medieval buildings to the south, S Domenico to the east, the medieval walls towering over the valley to the west, and another medieval building, the Castellare, to the north in the Piazza Maggiore (now Piazza Duca Federico; see fig. 4r below). The originality of the Palazzo Ducale, which was progressively built to fill all the available space, lay in its great size and an articulation that surpassed even that of contemporary Florentine palaces, although it adopted numerous elements of their style and architectural language, especially the arcaded central court. The interior was large enough to accommodate both the state administration and the court. In describing it as a city in the form of a palace, Baldassare Castiglione captured the significance of its form and organization as well as the character of the architectural synthesis which expressed the will of a lord who was both a condottiere and a humanist.

In the *Ordini et offici*, describing the '*famiglia*' of Federigo in the early 16th century, the 'master' architects mentioned are: LUCIANO LAURANA, FRANCESCO DI GIORGIO MARTINI and Baccio Pontelli, besides Fra Carnevale (known as a painter) and Sciro Sciri (a military engineer). Laurana came to the court in 1466 and remained until 1472; Francesco di Giorgio was certainly there from 1476 to 1485; and Pontelli, present from 1479, probably helped him to complete the palace until Federigo's death in 1482. Laurana was appointed supervisor for the project in 1468. Numerous other masters worked on the palace in those years, probably including Bramante; they were engaged in different parts of the work but often collaborated. The precise role of each one is thus unknown; it is particularly hard to distinguish between the work of Laurana and Francesco di Giorgio, and the attribution of the architectural decoration is equally problematical. The most likely

3. Urbino, Palazzo Ducale, Facciata dei Torricini, after 1466

hypotheses about the architectural decoration are those by Rotondi, which are referred to here.

(i) Palazzetto della Jole. This refers to the whole southern part of the palace (see fig. 4a), including the wing fronting the Cortile del Pasquino and those on three sides (east, south and west) of the Cortile d'Onore. This, the oldest part of the palace, was mainly built before the arrival of Laurana; before its completion Federigo and his wife lived in the east range facing S Domenico, which was created by joining a central two-storey building with a medieval house to the south. The appearance of this brick wing was not unlike that of other noble residences in north-central Italy. It was crowned with battlements; the first floor has a series of arched two-light windows, of which the last three at the south end were added after 1474, as shown by the carved initials F. D. ('Federicus Dux') and by their more mature design.

Inside, two rooms on the first floor show important decorations: the Sala degli Affreschi (4c) and the Sala della Jole (4d). In the Sala degli Affreschi there are remains of painted decoration representing ancient warriors in Renaissance dress. Below these figures is a band with escutcheons, attributed to Giovanni Boccati. In the whole range the corbels of the vaults embracing lunettes—where they are not replaced by later cloister vaults—appear to be of

the oldest type used in the palace. Bartolommeo Genga later added a suite of rooms (1554–7) on the second floor, begun in the 15th century. The Sala della Jole has a monumental chimney-piece supported by piers featuring *Hercules* and *Jole*, and an architrave carved with a *Triumph of Bacchus and Ariadne* surmounted by a fascia of putti and festoons. A trabeated portal on pilasters leads to the grand staircase, and outside there is a similar portal decorated with military motifs. The Florentine–Riminese taste of the decorations points to Pasquino da Montepulciano as the designer and Michele di Giovanni da Fiesole (*b* 1418) as the sculptor.

(ii) Scalone d'Onore. The construction of the Scalone d'Onore or grand staircase (4e) played a decisive role in determining the width of the main range (north wing of the Cortile d'Onore). Placing the staircase in the corner, however, created major difficulties in designing both the east façade and the north, looking on to the Piazza Maggiore. On the east it was necessary to vary the rhythm of the arched two-light windows, replacing them with differently spaced single-light ones. More importantly, the four rectangular windows introduced to light the staircase on the north façade were not uniform in size and position with the large aediculated windows on the *piano nobile* of the 'Facciata ad ali' (*see* §(viii) below). The negative effect

4. Urbino, first-floor plan of the Palazzo Ducale, begun *c.* 1454: (a–c) Palazzetto della Jole: (b) Sala degli Affreschi; (c) Sala della Jole; (d) Scalone d'Onore; (e) main range; (f) Sala Grande; (g) Sala degli Angeli; (h) Sala delle Udienze; (i) *studiolo*; (j) Cortile d'Onore; (k) Facciata dei Torricini, overlooking the Mercatale; (l) Cortile del Pasquino; (m) Giardino Pensile; (n) Castellare; (o) 'Facciata ad Alì', overlooking the Piazza Duca Federico (formerly Piazza Maggiore) and the new cathedral; (p) Piazza Rinascimento (enlarged in 1563); from M. L. Polichetti, ed.: *Il palazzo di Federico da Montefeltro: Restuari e ricerche* (Urbino, 1985)

was minimized by leaving the *piano nobile* façade incomplete, perhaps for that reason.

The interior treatment of the staircase was monumental and novel: for the first time a single entrance flight was built, in line with the north arcade of the courtyard, followed by two exceptionally wide and well-lit flights at right angles to it. A free-standing column faces the main internal wall on the second landing, and the corners are adorned with matching pilasters with candelabra attributed by Rotondi to Ambrogio d'Antonio Barocci and his associates. The staircase is believed to have been built before 1474: the initials F. C. ('Fredericus Comes') appear in the ceiling medallions except for the first and last flights, where the initials F. D. were probably introduced later, as was the complete Montefeltro coat of arms on the second landing.

(iii) Main range. The main range (4f), the north wing of the Cortile d'Onore between the grand staircase and the Facciata dei Torricini, contains the most important public spaces of the court and ends with private quarters, with windows and loggias between the towers facing the valley to the west. In the basement are the main kitchen, the furnace and the duke's bathroom, *calidarium*, *frigidarium* and dressing-room; other service rooms communicate with the lowest loggia between the towers. The plan of the bathrooms and their simple decoration of Doric pilasters can be attributed to Francesco di Giorgio. On the ground floor are the barrel-vaulted entrance hall, guard room and library; the latter was decorated with four panels representing the *Liberal Arts* (destr.) and still has ceiling decoration of Federigo's eagle radiating flames. Towards the Facciata dei Torricini is an apartment considered by some to be that of Ottaviano Ubaldini, Federigo's 'brother'; it is quite similar to Federigo's on the floor above, except for two small rooms, the Tempietto delle Muse and the Cappella del Perdono, the purpose and attribution of which are problematic. The Tempietto is a small rectangular space with a niche at the end, covered by a barrel vault divided into squares. Until 1632 there were painted panels on the walls representing the *Nine Muses, Apollo* and *Pallas*, some of which are attributed to Timoteo Viti (e.g. the *Muse Thalia with Apollo*; now Florence, Gal. Corsini) and Giovanni Santi. The adjoining barrel-vaulted Cappella del Perdono strongly evoked the Antique in its marble inlay and decoration attributed to Ambrogio Barocci. The inscription in the frieze over the portal suggests a date before 1480. The numerous attributions of the architectural design to Bramante cannot be confirmed.

The first-floor corridors over the courtyard arcades lead to the Sala Grande (4g; erroneously called the Sala del Trono), the Sala degli Angeli (4h) and Sala delle Udienze (4i); this sequence of public spaces leads to the smaller, private spaces of Federigo's apartment, with his bedchamber, *studiolo* and antechamber. At each end of the Sala Grande are side entrance portals framed by pilasters and entablatures, with different designs inside and out. Two Ionic chimney-pieces attributed to Francesco di Giorgio project into the vast rectangular space covered by a vaulted ceiling (see fig. 5); their detailing dates them to 1471–4. The passage from the Sala Grande towards Federigo's apartment is marked by accentuated decoration, which extends to the doors, with their wooden inlays of perspectives and symbolic motifs. In the Sala degli Angeli there is a striking architraved chimney-piece on brackets by Domenico Rosselli, who also designed the room's three doors with segmental pediments and who, with a pupil of Pietro

5. Urbino, Palazzo Ducale, interior of the Sala Grande, 1471–4

Lombardo, built the chimney-piece in the Sala delle Udienze (probably designed by Francesco di Simone Ferrucci). This latter room is perhaps the most richly decorated, together with that thought to have been Federigo's bedroom.

The Sala delle Udienze leads to the *studiolo* (4j), a small room clad with intarsia work and, up to the ceiling, with panels painted with 28 *Portraits of Famous Men*. These portraits (some now Paris, Louvre) were painted by Justus of Ghent and Pedro Berruguete in strict unity with the illusionistic architectural framework of the intarsia decoration below, probably executed by the Florentine Giuliano and Benedetto da Maiano, looking to Botticelli for the *Virtù* and to Francesco di Giorgio for the *Squirrel* panel. Within the open doors of the *trompe l'oeil* cupboards created in inlaid wood, objects appropriate for study and war are displayed with great three-dimensional effectiveness; the room has often been interpreted as a humanistic microcosm of the duke. The frieze bears the date 1476, probably indicating the completion of the work (for further discussion and illustration *see* STUDIOLO, fig. 1).

(iv) Cortile d'Onore. The layout of the palace as a whole is determined by Laurana's grand, rectangular courtyard, the Cortile d'Onore (4k), surrounded by arcades or columns (1467–72; for further discussion and illustration *see* LAURANA, LUCIANO). The corners of the courtyard are emphasized by L-shaped piers articulated by half columns set against pilasters of a major order, the capitals of which

touch at the angle. The effect is to create a firm and clear separation of the court's façades, looking at Brunelleschi's and Alberti's architecture together. On the upper floor, above the arcades, completed by Francesco di Giorgio, pilasters and counter pilasters divide the amply fenestrated walls. According to Rotondi, the eulogy to Federigo inscribed on the frieze was added after 1482. An attic storey above the *piano nobile* was added to the court in the time of Guidobaldo II della Rovere (*reg* 1538–74), by Filippo Terzi and Giulio da Thiene (1551–1619).

(v) Facciata dei Torricini. According to Rotondi, the west wing of the Palazzetto della Jole was already finished when Laurana began construction of the section with the *torricini* after 1466. This façade (4l and see fig. 3 above) was angled outward towards the road leading from Rome, allowing it to be connected to the Castellare. The façade was completed before 1474, as evidenced by the initials F. C. on the arch of the second loggia between the towers. The two cylindrical towers are crowned with corbelled merlons surrounding octagonal spire-capped turrets. Inside are spiral stairways for rapid vertical communication between Federigo's apartment and the lower floors, terminating in a secret escape door. The small size of the towers indicates that they did not have a real defensive function, but they can be clearly seen from a distance, and their intention seems to have been celebratory.

This function is emphasized in the interior, where the loggias, the upper ones having arches on free-standing

columns, recall the triumphal arch between the towers of the Castel Nuovo, Naples, to which Federigo was attached from the beginning of his military career. The architectural decoration is particularly fine, as are the second loggia capitals, executed by Francesco di Simone Ferrucci *c.* 1470. The trabeated windows later used throughout the palace were perhaps first fitted on this façade. On the side overlooking the Terrazza del Gallo is another two-arched loggia on two storeys, contemporary with the body of the towers.

(vi) Cortile del Pasquino. Just behind the medieval structures of the Palazzetto della Jole, at the southern end of the palace, the Cortile del Pasquino (4m) was laid out with loggias on two sides: one at ground level with three arches on pillars, and the other with a loggia on the first floor, which was a later addition, as shown by the masonry. This had seven spans, of which two were originally blocked up and alternated with the open arches (at present the first three exterior bays are also blocked up). The capitals of the pillars with pilasters are similar to those of the corner pilasters on the first floor of the Cortile d'Onore. Baldi believed that a circular tempietto was planned for the centre of the court. An existing underground space has been interpreted as the tempietto's burial chamber (Rotondi) but seems to be a cistern (Polichetti).

(vii) Giardino Pensile and Castellare. When Laurana left Urbino in 1472, only the wing facing the Piazza Maggiore and some foundations for the court could possibly have been built between the block with the towers and the Castellare. Francesco di Giorgio is therefore credited with the construction of the underground quarters with stables and snow pit, and the mechanism for collecting water under the hanging garden, as well as the regularization of this whole northern part of the palace. The resulting trapezoid court, artificially converted into a garden, the Giardino Pensile (4n), was surrounded by a wall with windows facing the valley, topped by a walkway between the duke's apartment and the new quarters in the Castellare (4o). On the eastern side of the court a portico with simple arches on pillars was completed with a cylindrical structure projecting at the angle with the Castellare, containing a spiral ramp for use by horses; this was a functional counterpart of the grand staircase and solved the difficult problem of the junction with the Castellare, which is at an angle to the palace. The *piano nobile* of the Castellare was remodelled, and from 1477 it became the duchess's apartment.

(viii) 'Facciata ad Ali'. The entrance forecourt (4p), known as the 'Facciata ad Ali' ('façade with wings') because it embraces two sides of what used to be the Piazza Maggiore (on the third side is the new cathedral), is the focus of the whole varied organism of the palace. It is designed in an innovative *all'antica* style, with a plinth storey faced with flat, rusticated stone punctuated by doors and windows. The brick *piano nobile*, with large trabeated windows on stone pilasters, may have been intended to be lightly stuccoed. The walls were originally topped with battlements, which were hidden when the roof was raised under Guidobaldo II della Rovere. The façade displays other unusual features, including a corner pier above which the string course juts out to form a sort of capital; the alternating rhythm of the ground-floor portals and first-floor windows; and the interruption of the stonework with the change in rhythm of the last three windows on the *piano nobile* in line with the end portal of the second wing of the façade. The rhythm was varied not only because of the grand staircase in the corner but also because the Sala Grande is off-centre, as is the palace entrance, on axis with the court, which is also off-centre. The architect nevertheless also had to resort to wholly or partly false windows and doors to balance the composition. The successful result, which inspired numerous imitations in the Renaissance, is attributable to Francesco di Giorgio; it is certainly after 1474, as seen from the inscription FE DUX on the apron below the windows on the *piano nobile*. Francesco di Giorgio is also credited by Vasari with the sculpted panels depicting the *Arts of War*, placed as backrests to the benches at the base of the façade. According to Rotondi, these panels were executed by Ambrogio Barocci, as was probably the architectural decoration of the façade.

BIBLIOGRAPHY

Memorie istoriche concernenti la devoluzione dello stato di Urbino alla sede apostolica (Amsterdam, 1723)

B. Baldi: 'Descrizione del palazzo ducale di Urbino', *Memorie concernenti la città di Urbino*, ed. F. Bianchini (Rome, 1724)

A. Venturi: 'Studi sul palazzo ducale di Urbino', *L'Arte*, xvii (1914), pp. 414–73

L. Serra: 'Le varie fasi costruttive del palazzo ducale di Urbino', *Boll. A.*, x (1931), pp. 1–11, 433–47

M. Salmi: *Piero della Francesca e il palazzo ducale di Urbino* (Florence, 1945)

P. Rotondi: *Il palazzo ducale di Urbino*, 2 vols (Urbino, 1950–51; Eng. trans., London, 1969)

G. Marchini: 'Il palazzo ducale di Urbino', *Rinascimento*, ix/1 (1958), pp. 43–78

——: 'Aggiunte al palazzo ducale di Urbino', *Boll. A.*, i–ii (1960), pp. 73–80

L. H. Heydenreich: 'Federico da Montefeltro as a Building Patron: Some Remarks on the Ducal Palace of Urbino', *Studies in Renaissance and Baroque Art Presented to A. Blunt* (London, 1967), pp. 1–6

G. Eimer: 'Francesco di Giorgio Fassadenfries am Herzogpalast in Urbino', *Festschrift Ulrich Middeldorf* (Berlin, 1968)

P. Rotondi: *Francesco di Giorgio nel palazzo ducale di Urbino* (Novilara, 1970)

Urbino e le Marche prima e dopo Raffaello (exh. cat., ed. M. G. Ciardi Duprè and P. Dal Poggetto; Urbino, Pal. Ducale, 1983)

G. Bernini Pezzini: *Il fregio dell'arte della guerra nel palazzo ducale di Urbino: Catalogo di rilievi* (Rome, 1985)

M. L. Polichetti, ed.: *Il palazzo di Federico da Montefeltro: Restauri e ricerche* (Urbino, 1985)

C. Ceri Via: 'Ipotesi di un percorso funzionale e simbolico nel palazzo ducale di Urbino attraverso le immagini', *Federico di Montefeltro*, ed. G. Cerboni Baiaroli, G. Chittolini and P. Floriani (Rome, 1986), ii, pp. 47–64

L. Cheles: *The Studiolo of Urbino: An Iconographic Investigation* (Wiesbaden, 1986)

F. P. Fiore: 'Le residenze ducali di Urbino e Gubbio: Città in forma de palazzo', *Archit.: Stor. & Doc.*, ii (1989), pp. 5ff

Piero e Urbino: Piero e le corti rinascimentali (exh. cat., ed. P. Dal Poggetto; Urbino, Pal. Ducale, 1993)

F. P. Fiore and M. Tafuri: *Francesco di Giorgio architetto* (Milan, 1994)

N. Guidobaldi: 'Court Music and Universal Harmony in Federico da Montefeltro's Studiolo in Urbino', *Musikalische Ikonographie*, ed. H. Heckmann, M. Holl and H. J. Marx (Hamburg, 1994), pp. 111–20

C. H. Clough: 'Art as Power in the Decoration of the Study of an Italian Renaissance Prince: The Case of Federico Da Montefeltro', *Artibus & Hist.*, xvi/31 (1995), pp. 19–50

W. Lutz: *Luciano Laurana und der Herzogspalast von Urbino* (Weimar, 1995)

FRANCESCO PAOLO FIORE

Urbino (da Crema), Carlo (*b* Crema, *c.* 1510–20; *d* Crema, after 1585). Italian painter, draughtsman and theorist. He has been identified, and is principally of interest, as the author of the Codex Huygens (New York, Pierpont Morgan Lib., MS. M.A. 1139), a collection of studies of proportion and perspective based, in part, on the notebooks of Leonardo da Vinci. Urbino's earliest works were frescoes (destr.) depicting scenes from *Jerusalem Delivered* for the Palazzo Zurla, Crema, and altarpieces painted between 1554 and 1557 in S Maria presso S Celso, Milan. Contact with the school of Leonardo and also with Gaudenzio Ferrari is evident in the decoration of the Taverna Chapel, S Maria della Passione, Milan, and in the organ shutters in the same church. He subsequently worked with Bernardino Campi, for whom he made preparatory drawings for paintings executed by his partner and for fresco cycles in the Palazzo Ducale, Sabbioneta, and the chapel of St Cecilia in S Sigismondo, Cremona. In the frescoes in the sanctuary of S Maria in Campagna, Pallanza, executed with Aurelio Luini (1530–93), he demonstrated the skills in perspective seen in the drawings of the Codex Huygens, although the execution in paint is disappointing. His painting technique is generally poor, as is evident both from such earlier works as the *Incredulity of Thomas* (Milan, Brera), influenced by Ambrogio Figino, and such later work as the *Calvary* (Crema, S Maria della Croce). A better executed result is achieved in the frescoes painted in 1580 in S Pietro, Quintano. Drawings for a treatise on terms and caryatids (London, V&A) have been attributed to Urbino.

BIBLIOGRAPHY

E. Panofsky: *The Codex Huygens and Leonardo da Vinci's Art Theory* (London, 1940)
M. Di Giampaolo: 'Bernardino Campi a Sabbioneta e un'ipotesi per Carlo Urbino', *Ant. Viva*, xiv/3 (1975), pp. 30–38
G. Bora: 'Note Cremonesi, II: L'eredità di Camillo e i Campi (continuazione)', *Paragone*, xxviii/327 (1977), pp. 54–88
S. Gatti: 'Due contributi allo studio del pittore Carlo Urbino, *A. Lombarda*, 47–8 (1977), pp. 99–107
U. Ruggeri: 'Disegni di Oxford', *Crit. A.*, xlii/154–6 (1977), pp. 98–118
——: 'Carlo Urbino e il Codice Huygens', *Crit. A.* xliii/157–9 (1978), pp. 167–76
G. Bora: 'Un ciclo di affreschi, due artisti e una bottega a Santa Maria di Campagna a Pallanza', *A. Lombarda*, 52 (1979), pp. 90–106
S. Marinelli: 'The Author of the Codex Huygens', *J. Warb & Court. Inst.*, xliv (1981), pp. 214–29
M. Kemp: *The Science of Art: Optical Theories in Western Art from Brunelleschi to Seurat* (New Haven and London, 1990), pp. 74–6

UGO RUGGERI

Urbino, Nicola da. *See* NICOLA DA URBINO.

Utili, Giovanni Battista dei. *See* BERTUCCI, (1).

Ut pictura poesis [Lat.: 'as is painting so is poetry']. The phrase is derived from the *Ars poetica* (361) of Horace (65–8 BC). It has subsequently been used to suggest a general similarity between the arts of painting (and sometimes, by extension, sculpture) and poetry. From the 16th century it was the motto of theorists who wished to elevate the status of painting to that of poetry and the other liberal arts.

See also PARAGONE .

1. ORIGINS. In Horace the phrase *ut pictura poesis* introduces a specific analogy: repeated pleasure is afforded not by pictures that have to be scrutinized closely, but by those that can be appreciated at a distance; the same, Horace suggests, is true of poetry, in which broad effects are most successful. The distinction between paintings that are to be seen from different distances may have been derived from Aristotle, who used it as a parallel to the different forms of rhetoric appropriate to judicial enquiries and public assemblies (*Rhetoric* 1447a7–14). Occasional references to painting are also found in Aristotle's *Poetics*, in which, having distinguished arts that use colour and form from those that rely on the voice (1447a15–25), he draws parallels between painting and poetry on the basis of the common practice of imitation; the shared tendency to heroize the subject, and the analogy between design in painting and plot in drama.

The parallel between painting and poetry is more explicitly articulated in the formulation attributed by Plutarch to Simonides (556–468 BC): 'painting is mute poetry and poetry a speaking picture' (*Moralia* 346). Plutarch used the saying to commend writers of vivid historical prose whose colourful narrative allowed the reader to picture the events described. But the parallel could also be to the disadvantage of painting, as in the *Republic*, in which Plato dismisses painters along with poets as the purveyors of an inferior reality. Although the aesthetic writings of Philostratos (*Imagines*) and Lucian of Samosata (*Imagines*) imply that paintings may be read like poetry, the comparison of the two arts was employed in antiquity chiefly to elucidate the qualities of literary language.

2. THE RENAISSANCE. It was only during the 15th century in Italy that painting and poetry came to be considered on a more equal footing and the parallel between them used for their mutual explication. Leon Battista Alberti (*Della pittura*) noted that painters and poets have many ornaments in common and advised artists to emulate the inventions of poets as the sculptor Pheidias had learnt from Homer. Leonardo da Vinci considered invention and measure to be principles that governed both poetry and painting. But in his *Paragone* he drew out the implications of Simonides' maxim to the advantage of painting: 'Poetry is the science of the blind and painting of the deaf. But painting is nobler than poetry in that it serves the nobler sense' (*Trattato della pittura* 15). Leonardo's comparison of the two arts emphasizes that the function of both is to imitate nature, and it was primarily on this basis that the analogy continued to be employed.

In the 16th century the kinship of painting and poetry was a commonplace. But while Florentines, such as Benedetto Varchi in his *Due lezzioni* of 1549, used the comparison primarily as a means of contrasting the two arts, Venetian writers emphasized their unity. Lodovico Dolce, the friend and spokesman of Pietro Aretino, published his *Dialogo della pittura intitolato l'Aretino* in 1557. Dolce had published a translation of the *Ars poetica* in 1537 and was influenced by the work of Bernadino Daniello (*d c.* 1565) on poetry; he thus emphasized the reciprocal nature of the relationship between painting and

poetry and even suggested that the *Aretino* might be of value to students of literature as well. The dialogue argues that practitioners of both arts may draw with equal benefit from one another's work because they are alike committed to the imitation of nature, to the use of invention, design and colouring, and to the maintenance of decorum. Giovanni Paolo Lomazzo, in his *Trattato dell'arte de la pittura* (Milan, 1584), asserted that the sisterhood of painting and poetry lay in the shared need for inspiration in the rendering of the emotions. But he went beyond previous authors in specifying practical ways in which painters might learn from poets in depicting the actions of animals and the emotions of men.

BIBLIOGRAPHY

L. Dolce: *Dialogo della pittura intitolato l'Aretino* (Venice, 1557)

G. P. Lomazzo: *Trattato dell'arte de la pittura* (Milan, 1584)

J. P. Richter, ed.: *The Literary Works of Leonardo da Vinci*, 2 vols (London, 1883, 2/1939)

W. G. Howard: '*Ut pictura poesis*', *Pubns Mod. Lang. Assoc*, xxiv (1909), pp. 40–123

J. H. Hagstrum: *The Sister Arts* (Chicago, 1958)

R. W. Lee: '*Ut pictura poesis*': *The Humanist Theory of Painting* (New York, 1967)

N. Goodman: *Languages of Art* (New York, 1968)

M. W. Roskill: *Dolce's 'Aretino' and Venetian Art Theory of the Cinquecento* (New York, 1968) [contains text and trans. of the *Aretino*]

S. Alpers and P. Alpers: '*Ut pictura poesis*? Criticism in Literary Studies and Art History', *New Lit. Hist.*, iii (1972), pp. 437–58

C. Grayson, ed.: *Leon Battista Alberti on Painting and on Sculpture* (London, 1972)

W. Steiner: *The Colors of Rhetoric* (Chicago, 1982)

W. J. T. Mitchell: *Iconology: Image, Text, Ideology* (Chicago, 1986)

Cah. Mus. N. A. Mod., xxxviii (1991) [special issue with seven articles devoted to *ut pictura poesis*]

J. Craven: '*Ut pictura poesis*: A New Reading of Raphael's Portrait of *La Fornarina* as a Petrarchan Allegory of Painting, Fame and Desire', *Word & Image*, x (1994), pp. 371–94

N. E. Land: *The Viewer as Poet: The Renaissance Response to Art* (University Park, 1994)

MALCOLM BULL

V

Vacca, Flaminio (*b* Rome, 1538; *d* Rome, 26 Oct 1605).
Italian sculptor of Spanish descent. Although an accomplished artist, he has been neglected and at times categorically condemned by critics. His few surviving works reveal the influence both of Classical models, to which he was passionately devoted, and of the Florentine manner derived from Michelangelo. He studied with the Florentine Vincenzo de' Rossi, who was in Rome between 1546 and 1560, and at first worked on restorations and adaptations of antique sculptures, for example on an *Apollo* for Ferdinando I de' Medici (Florence, Uffizi). Around 1572 he was listed among the members of the Congregazione dei Virtuosi al Pantheon. His period of greatest creative productivity began in the last years of the pontificate of Pope Gregory XIII. In 1583 he carved the Pope's coat of arms in the two large marble escutcheons for the Collegio del Gesù, the rich curves of which are meticulously carved in the Florentine style of Bartolomeo Ammanati. In 1587–8 he worked with Pietro Paolo Olivieri to complete an *Angel* and a low relief of *Joshua and his Army* for the Acqua Felice fountain, the latter work showing his interest in late Roman reliefs. The two sculptors, together with Domenico Fontana (1543–1607) and Leonardo Sormani, also took part in the restoration (1588–90) of *Castor and Pollux* in the Monte Cavallo Fountain in Piazza del Quirinale. During this period Vacca also sent a tabernacle (1589) to the church of S Lorenzo in Spello, outside Rome.

In 1588 Vacca produced one of his most demanding works, the *St Francis of Assisi*, for the Sistine Chapel in S Maria Maggiore, Rome. This work reveals a Mannerist taste, together with a certain stylized expressionism in the manner of de' Rossi. In contrast, the signed figures of *St John the Baptist* (see fig.) and *St John the Evangelist* (1592–3) in S Maria Vallicella (or Chiesa Nuova) display a soft, shadowy quality, modifying the Mannerist style that Vacca had learnt both from his teacher and from Baccio Bandinelli. On the other hand, the *Angel* in the Cappella degli Angeli in Il Gesù, which dates from the end of the decade, is characterized by a freedom of modelling and an elegance of line; another *Angel* in the same chapel was begun by Olivieri and completed by Vacca. Vacca also executed a signed *Lion* (between 1570 and 1590; now Florence, Loggia Lanzi), commissioned by Grand Duke Ferdinando I for the Villa Medici in Rome; it was moved to Florence in 1787. It is a finely made statue that shows a return to the classical mode, a work of great vitality and virtuoso realism.

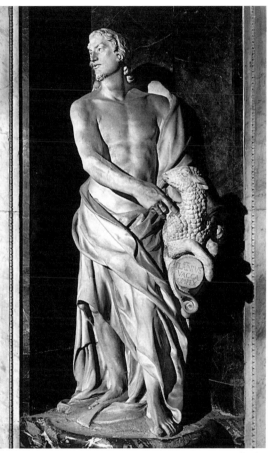

Flaminio Vacca: *St John the Baptist*, 1592–3 (Rome, S Maria Vallicella)

Vacca's passion for antiquity also found expression in his *Memorie di varie antichità trovate in diversi luoghi della città di Roma*, written in 1594 and published in 1704 as an appendix to a text by Famiano Nardini. These notes are particularly interesting as a history of archaeological excavations in Rome.

Vacca also produced highly admired portraits, with a concern for accuracy in physiognomy and psychology. His *Self-portrait* (signed and dated 1599; formerly Rome, Pantheon; now Rome, Protomoteca Capitolina) is modelled with great sensitivity to the play of light, revealing an expression of contained anxiety and a rigorous simplicity. The same characteristics appear in the bust of *Baldassare*

Ginanni (*c.* 1599; Rome, S Agostino), which has been attributed to Vacca. In 1599 he was elected head of the Accademia di S Luca in Rome.

WRITINGS

app.: F. Nardini: *Roma antica* (Rome, 1704)

BIBLIOGRAPHY

Thieme–Becker

G. Baglione: *Vite* (1642); ed. V. Mariani (1935), pp. 71–2

A. Venturi: *Storia* (1901–40), pp. 690–92

V. Martinelli: 'Flaminio Vacca, scultore e antiquario romano', *Stud. Romani*, ii (1954), pp. 154–64

S. Pressouyre: *Nicolas Cordier: Recherches sur la sculpture a Roma autour de 1600* (Rome, 1984)

C. D'Onofrio: *Le fontane di Roma* (Rome, 1986)

S. Lombardi: 'Flaminio Vacca', *Roma di Sisto V* (exh. cat., ed. M. L. Madonna; Rome, Pal. Venezia, 1993)

ANA MARIA RYBKO

Vaga, Perino del. *See* PERINO DEL VAGA.

Valdambrino, Francesco di. *See* FRANCESCO DI VALDAMBRINO.

Valentinis [Valentini], **Sebastiano de'** (*fl* Udine and Gorizia, *c.* 1540–60). Italian etcher, painter and gilder. He was formerly identified as Sebastiano d'Ul because of a misreading of the signature 'SEBASTIANO D'.VL' that appears in one of his prints. His etchings are in certain aspects akin to the contemporary graphic art of Paolo Farinati and Battista del Moro (1514–74) in Verona, but with obvious northern European influences, perhaps from the Danube school. Only three of his works are known: the *Rest on the Flight into Egypt* (see exh. cat., 1983, no. 45) and *Prometheus* (1558; see exh. cat., 1983, no. 46), both of which are signed, and the recently discovered large print of the *Turkish Army* (1558; London, BM).

BIBLIOGRAPHY

Bolaffi

V. Rossitti: *Dizionario degli incisori friulani* (Udine, 1981), pp. 85–7

D. Landau: 'Printmaking in Venice and the Veneto', *The Genius of Venice* (exh. cat., ed. J. Martineau and C. Hope; London, RA, 1983), pp. 342–3

FELICIANO BENVENUTI

Valentino, Duca di. *See* BORGIA, (3).

Valeriano, Giuseppe (*b* L'Aquila, Aug 1542; *d* Naples, 15 July 1596). Italian architect and painter, active also in Spain, Portugal, Germany and Malta. He was in Rome from the early 1560s and *c.* 1570 executed the decoration of the Cappella dell'Ascensione, including an altarpiece showing the *Ascension*, in Santo Spirito in Sassia, Rome. His painting style, though provincial, shows the influence of Mannerism and of the successors in Rome of Pellegrino Tibaldi and Michelangelo. Also characteristic is an exaggerated expressiveness and a peculiar imbalance in the depiction of figures and space. He worked partly in collaboration with Scipione Pulzone and Gaspare Celio (1571–1640).

Valeriano, however, is more important for his work as an architect. The first buildings that can be securely attributed to him were designed in Spain, where he went in 1573, becoming a member of the Jesuit Order there the following year. He came into contact with Juan de Herrera (*c.* 1530–97), whose work on the Escorial, near Madrid,

clearly influenced him in his own work on the Collegio Romano in Rome after he returned to Italy in 1580. Despite the traditional attribution to Bartolomeo Ammanati, the design of the Collegio Romano, founded by Pope Gregory XIII, is now regarded as Valeriano's, in collaboration with a team that included Giacomo della Porta.

In 1584 Valeriano produced plans for the new building of the Collegio Massimo (now the University), Naples, and started work there on his masterpiece, the Gesù Nuovo, the largest Jesuit church in southern Italy. The building has a basically centralized plan, with a dome over the crossing, tunnel-vaulted transepts and cupolas over the corner chapels; the longitudinal axis was emphasized by a one-bay extension of the nave on both entrance and choir sides. Originally painted white, with features picked out in *piperno*, the local volcanic stone, they have since been covered in rich marble. His church of the Gesù (begun 1589), Genoa, has a similar plan, and the wall surfaces of its spacious interior are articulated with pilasters. In 1591 Valeriano worked on the enlargement of the Michaelskirche, Munich, and in 1592 he produced plans for Jesuit buildings in Lisbon, Malta, L'Aquila, Marsala and Palermo.

BIBLIOGRAPHY

G. Baglione: *Vite* (1642); ed. V. Mariani (1935), pp. 83–4

A. Rodriguez y Guttiérrez de Ceballos: 'Juan de Herrera y los Jesuitas Villalpando, Valeriano, Ruiz, Tolosa', *Archv Hist. Soc. Iesu*, xxxv (1966), pp. 285–321

P. Pirri: *Giuseppe Valeriano S.I.: Architetto e pittore, 1542–1596* (Rome, 1970)

A. Blunt: *Neapolitan Baroque and Rococo Architecture* (London, 1975), pp. 37–9

A. Ceccarelli: 'Giuseppe Valeriano, padre gesuita: Architetto progettista della Chiesa e Collegio di S Ignazio di Cosenza', *Boll. A.*, xliv/2 (1979), pp. 29–60

R. Bösel: *Jesuitenarchitektur in Italien (1540–1773): Die Baudenkmäler der römischen und der neapolitanischen Ordensprovinz* (Vienna, 1985)

S. Benedetti: 'La prima architettura gesuitica a Roma: Note sulla chiesa dell'Annunziata e sul Collegio Romano', *L'architettura della Compagnia di Gesù in Italia, XVI-XVIII secolo: Milan, 1990*, pp. 57–68

I. Di Resta: 'Il Collegio Romano', *L'architettura della Compagnia di Gesù in Italia, XVI-XVIII secolo: Milan, 1990*, pp. 81–5

L. Salviucci Insolera: 'Giuseppe Valeriano, pittore ed architetto gesuita', *A. Crist.*, lxxxii/764–5 (1994), pp. 465–72

RICHARD BÖSEL

Valle, Andrea da (*b* Koper, Istria; *d* Venice, ?1577). Italian architect. He worked principally in Padua, where he is first recorded in 1531, when he began a long association with the basilica of S Giustina. In 1533 he assisted Giovanni Maria Falconetto, then working on the chapel of the Santo at the basilica of S Antonio; by 1539 he had established his own workshop. His work at the Villa dei Vescovi (the villa of the bishops of Padua), Luvigliano, executed under the supervision of Bishop Alvise Cornaro, dates from the same period. Da Valle's first important works date from the 1540s and show his developing style more clearly. The first of these was the cloister of S Gregorio, Bologna, which was followed by the double cloisters (completed by 1562) at S Vitale, Ravenna. Both latter cloisters are harmonious essays in a refined style similar to that of Palladio, which was to remain characteristic of da Valle's work. In 1547 he proposed a scheme for the completion of the choir and apses of Padua Cathedral. He was not immediately successful, but following opposition to the proposed appointment of Jacopo Sansovino, the chapter

asked da Valle to execute the work, which was loosely based on an original proposal by Michelangelo. Work began in 1551 on da Valle's appointment as *proto* (chief architect).

The clarity and monumentality of form of the cathedral apses were even more clearly expressed in da Valle's most important work, the grandiose basilica of S Giustina. Work had begun on the basilica in 1532, to a model (1521–2) by Alessandro Leopardi, with Matteo da Valle (probably a relative) as *proto*. Matteo died shortly afterwards and was replaced as *proto* by Andrea Moroni. Andrea da Valle, who had been associated with the project since 1531, worked as Moroni's assistant until the latter's death in 1560, when he himself became *proto*, a title he retained until his own death. Da Valle's contribution to the early stages of S Giustina cannot, however, be accurately gauged. The original Greek-cross plan was modified at an early stage to form the complex Latin cross that was built. The plan has a central nave and two aisles, flanked by rows of side chapels. Beyond the crossing there is a deep central apse, flanked in turn by smaller apsidal chapels, while the transepts also have apsidal ends and are flanked by smaller chapels. The overall form is loosely modelled on S Antonio, but on a considerably grander scale. The interior is most imposing, with a highly unified appearance; the whole is finished in a refined classical style that has affinities with Palladio's churches, although on a more monumental scale. The east end is surmounted by a cluster of four domes (again referring to the basilicas of S Antonio and S Marco, Venice), all set on high drums containing windows. The choir and apses are thus brightly lit, in contrast with the nave, which is roofed with three large, shallow, windowless domes and where the light is far more subdued. The complex east end is almost certainly da Valle's work, as are the domes, although the roof was not complete at his death.

In 1577 da Valle, together with other leading architects of the day, was invited by the Venetian government to inspect and report on the damage inflicted on the Doge's Palace by the fires of 1574 and 1577. However, this is the last record of him, and he must have died shortly thereafter. Although highly regarded in his own time, his reputation did not extend much beyond his native Republic and was later eclipsed by that of Palladio, with whose work that of da Valle has some affinity.

BIBLIOGRAPHY
Portoghesi
G. Cappelletti: *Storia di Padova dalle sue origini fino al presente*, 2 vols (Padua, 1872 and 1875)
A. Venturi: *Storia* (1901–40)
E. Lovarini: 'Di Andrea da Valle, architetto', *Riv. Italia*, xiii/6 (1910)
E. Rigoni: *L'architetto Andrea Moroni* (Padua, 1939)
R. Pepi: *L'abbazia di S Giustina* (Padua, 1966)
G. Bresciani Alvarez: *La basilica di S Giustina* (Castelfranco Veneto, 1970)

RICHARD J. GOY

Valle, Cardinal **Andrea della** (*b* 30 Dec 1463; *d* Rome, 4 Aug 1534). Italian prelate and patron. From a Roman family of jurists, physicians and scholars linked to the nobility, he became Bishop of Cotrone in 1496 and of Mileto in 1508. He enlarged the complex of family properties in the centre of Rome in order to reconstruct the della Valle palazzo, which had been razed in 1484 at the order of Pope Sixtus IV. The new palazzo on the Via Papale (now Corso Vittorio Emmanuele) was built (1517) by Lorenzo Lotti. The architrave of the entrance portal still bears della Valle's name. Originally the Palazzo della Valle presented a well-designed principal façade (later extended by several bays by the Bufalo family) built on three storeys with a series of handsome aedicule windows and an interior courtyard with a Doric arcade. Within the palazzo, the rooms on the *piano nobile* are embellished with capitals and fireplaces sculpted with the della Valle coat of arms. The ceilings were decorated with fine stuccowork and illusionistic paintings, attributed to Raffaello dal Colle, of which some in the principal reception room survive.

After his election as cardinal in 1517, della Valle began a second palazzo, which was largely completed by 1536, after his death. Although most of this palazzo was later subsumed in the Teatro della Valle (1819–22), part of it survives in the Palazzo Capranica, which displays on its exterior façade finely worked rustication and handsome ground-floor windows, the sills of which are supported by carved brackets. Two plans for this palazzo by Antonio Sangallo the younger survive (Florence, Uffizi, A.982, A.1274), but from *c.* 1526 work was directed by Lorenzo Lotti. The statue garden in the second palazzo is well documented in 16th-century prints and drawings, notably the drawing (Madrid, Escorial) by Francisco de Holanda (1517–84) and the engraving (Bober and Rubinstein, p. 480) by Hieronymus Cock (*c.* 1510–70) after the drawing (untraced) of *c.* 1530 by Maarten van Heemskerck (1498–1574) (*see* ROME, fig. 2). The della Valle collection was highly prized by contemporaries, including Vasari, both for the quality of individual pieces and for the decorative unity of the display. The inventory, drawn up in 1584, when Ferdinand I de' Medici purchased the sculpture, indicates the scope and extent of the collection, which included celebrated pieces such as the hanging *Marsyas*, a Roman copy of a Greek statue of the 3rd century BC (Florence, Uffizi); *Apollo*, a Roman copy of a Hellenistic work (Florence, Poggio Imp.); and *Minerva*, a Roman copy of a Greek statue of the 4th century BC (Florence, Pitti). Antique reliefs from the collection were installed on the rear façade of the Villa Medici, Rome; della Valle's famous coin collection was dispersed.

BIBLIOGRAPHY
DBI
G. Vasari: *Vite* (1550, rev. 2/1568); ed. G. Milanesi (1878–85), iv, pp. 579–80
G. A. Mansuelli: *Galleria degli Uffizi: Le sculture*, i–ii (Florence, 1958–61)
C. L. Frommel: *Der römische Palastbau der Hochrenaissance* (Tübingen, 1973), ii, pp. 336–54
P. P. Bober and R. Rubinstein: *Renaissance Artists and Antique Sculpture* (Oxford, 1986), pp. 479–80

DIANA NORMAN

Valmarana. Italian family of patrons. First noted in Vicenza in the 11th century, the family was among the oldest and most powerful of the city's ruling dynasties; the title Count was awarded in 1540 by the Holy Roman Emperor Charles V (*reg* 1519–56). The family occupied an important position in the Lisiera region, where, by 1555, it had control over the rivers and bridges. Giovanni Francesco Valmarana (*d* 1566) commissioned from

ANDREA PALLADIO the Villa Valmarana (1563–?4; now Villa Scagnolari; partly destr. 1945; reconstr.) at Lisiera. The drawings show a block with a two-storey loggia, but the villa was only partly constructed, probably due to the death of Giovanni Francesco.

Giovanni Francesco's brother Giovanni Alvise (Luigi) Valmarana (d 1558) was a friend of Palladio, whose design for the loggia of the Palazzo della Ragione (also known as the Basilica) in Vicenza he supported in 1549. Giovanni Alvise's widow was responsible for the family's principal act of patronage: the commissioning of the Palazzo Valmarana (1565–71; now Palazzo Braga) in Vicenza, one of the most important of Palladio's palazzi. The façade (see PALLADIO, ANDREA, fig. 6) is dominated by a giant order of pilasters, and the planning is functional; however, only the front part was executed. The Valmarana family had owned a house there since 1487, and Palladio's work incorporated parts of the existing building.

Giovanni Alvise's son, Leonardo Valmarana (?1548–?1613), who inherited the estates of both his father and uncle, played an important part in the completion and decoration of the Palazzo Valmarana, later commissioning Domenico Fontana (1543–1607) to execute the statues on the façade. He also involved Palladio in the design of the Valmarana funerary chapel (1576) in the church of Santa Corona, Vicenza. As director of Vicenza's Accademia Olimpica in 1583, he commissioned the statues for Palladio's Teatro Olimpico (1580).

Giuseppe di Bernardino Valmarana (1524–80), from a different branch of the family, commissioned the Villa Valmarana (1541–3; now Villa Bressan) in Vigardolo. This is an early work by Palladio, with an unarticulated pedimented brick façade with a single central Serlian motif opening to a loggia; it differs slightly from his drawing (see ARCHITECTURAL DRAWING, fig. 3). The Valmarana family, still resident in Vicenza and Venice, has owned the Villa Rotonda (c. 1565/6–70; see PALLADIO, ANDREA, fig. 5, and VICENZA, §2) since 1911 and has recently undertaken its restoration.

BIBLIOGRAPHY
Libro d'oro della nobilità italiana, iii (Rome, 1914–15)
G. Arnaldi, ed.: *Storia di Vicenza*, iii (Vicenza, 1989)

Valori, Baccio [Bartolomeo] (*b* Florence, 1477; *d* Florence, 20 Aug 1537). Italian politician and patron. From a noble Florentine family, he was the son of Filippo Valori, a rector of the university of Pisa and a friend of Angelo Poliziano and Marsilio Ficino. Baccio Valori was active in political affairs, in opposition to the government of Piero Soderini, and later served as a councillor to Cardinal Silvio Passerini (1470–1529), who was regent in Florence under Cardinal Ippolito de' Medici and Alessandro de' Medici. He then went to Rome, where Clement VII appointed him as his general commissioner. He supported the surrender to the Medici of the army of the Florentine republic in 1530 and achieved his greatest political power as a councillor during the reign of Alessandro de' Medici as Duke of Florence. After the assassination of the Duke, he allied himself with other Florentine exiles against the rise to power of Cosimo I de' Medici. Their forces were defeated in the battle of Montemurlo in 1537, and he was

imprisoned and condemned to death by Cosimo. He is depicted as a prisoner in a fresco in the Sala di Cosimo in the Palazzo Vecchio in Florence.

Valori had contacts with some of the most important artists of his time. According to Vasari, in 1530–31 he commissioned from Michelangelo a marble figure of *Apollo* taking an arrow from his quiver. This work (Florence, Bargello) later entered the collection of Cosimo I, probably at the time of Valori's execution. Valori's frequent contacts with Michelangelo are confirmed by their correspondence. In a letter of 1532 he asked the artist for some drawings for his house and referred to a work thought to be the *Apollo*: 'I do not wish to solicit you further about my statue, because I am quite certain, because of the affection I know you have for me, that there is no need to ask about it.' The *Apollo* was probably in Valori's house in Florence, in Borgo degli Albizi, which was later described, with the works of art it contained, by Borghini. In Rome, Valori knew Benvenuto Cellini, who mentions him in his autobiography, and patronized Sebastiano del Piombo, who painted an intense portrait of him on slate (Florence, Pitti). According to Vasari, he was also painted by Giuliano Bugiardini, with Clement VII.

BIBLIOGRAPHY
G. Vasari: *Vite* (1550, rev. 2/1568); ed. G. Milanesi (1878–85), v, p. 576; vi, p. 206; viii, p. 190
R. Borghini: *Il Riposo* (Florence, 1584); ed. M. Rosci (Milan, 1967), i, pp. 587–8, 621–2
P. Barocchi and R. Ristori, eds: *Il carteggio di Michelangelo* (Florence, 1973), iii, pp. 301, 329, 331–2, 335, 344, 348, 364, 386; iv, p. 394
C. de Tolnay: *Michelangelo, Sculptor, Painter, Architect* (Princeton, 1975), pp. 201–2
Palazzo Vecchio: Committenza e collezionismo medicei (exh. cat., Florence, Pal. Vecchio, 1980), p. 265, n. 495
M. Hirst: *Sebastiano del Piombo* (Oxford, 1981), pp. 103, 110–11, 113
 DONATELLA PEGAZZANO

Vanni, Mariano. *See* TACCOLA, MARIANO.

Vannocci, Oreste. *See* BIRINGUCCI, (2).

Vannucci, Pietro di Cristoforo. *See* PERUGINO.

Vaprio, Giovanni Zenone da. *See* GIOVANNI ZENONE DA VAPRIO.

Varallo, Sacro Monte. Observant Franciscan foundation and pilgrimage site in Piedmont, Italy.

1. Architecture. 2. Decoration.

1. ARCHITECTURE. Situated in the diocese of Novara, the Sacro Monte occupies about 12 wooded ha on top of a spur rising *c.* 160 m above the town of Varallo (see fig. 1). The monument's primary feature is 44 chapels, in which scenes from or associated with the Life of Christ are rendered as life-size dioramas, consisting of groups of figures in various materials against painted background scenes. These chapels are either free-standing or grouped within secondary structures to suggest their scenes' shared locations, are evenly distributed around the summit, and are connected in approximately chronological order of their events by a main path. Their sequence concludes at a central piazza and the monument's secondary feature, a

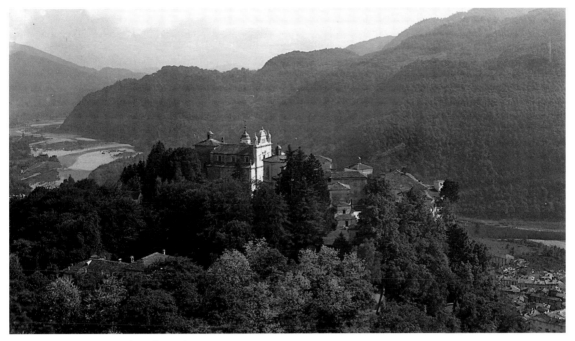

1. Varallo, Sacro Monte, view from the north

basilica dedicated to the Virgin of the Assumption. Reflecting a succession of conceptions and programmes, the whole combines a monastic retreat, a delightful park and a penitential vehicle.

The earliest architecture of the Sacro Monte was designed by Brother Bernardino Caimi (*d* 1499), whose intention was to re-create the plans and salient features of the holy sites of Jerusalem in a series of chapels. An early source (the acts of concession) confirms that three structures were complete by 1493: the reproduction of the Holy Sepulchre and a contiguous hermitage, and two additional chapels. A pilgrim's guide to the sanctuary (1514) describes some two dozen chapels ('*capeleta*' or '*luoco*'), of which there survive the complexes of Nazareth, Bethlehem and the Sepulchre (with modifications); the chapels of the Way to Calvary and the Stone of Unction (with different subjects); those of the Last Supper and the Pentecost (with entirely different functions); and the Sepulchre of the Virgin (abandoned). These earliest structures, simple in construction (of rock-faced rubble and hewn timber) and vernacular in style, provided little more than shelter for their ensembles and passageways for the visitor.

The chapels of the Procession of the Magi and Calvary (begun before 1519; completed by 1528) signalled a departure from the earlier style towards a more generic and grand representation of the sites. Caimi's scheme became confused, and progress was halted until Giacomo d'Adda commissioned Galeazzo Alessi to reorganize the entire Sacro Monte (*see* ALESSI, GALEAZZO). Prepared between 1565 and 1569, Alessi's studies of a comprehensive plan and 34 new or redesigned chapels, along with an articulate preface and careful notations, are contained in the *Libro dei misteri* (Varallo, Bib. Civ.), a single volume of 318 folios. The project generally respects the earliest

structures and even acknowledges the topographic conceit, but it subsumes these within a textually based, temporally ordered narrative from the Fall to the Last Judgement and phrases it with an unprecedented formal sophistication. Contemporary with the *Libro*, the monumental portal and the first chapel in this new scheme, that of the Fall of Man (or of Adam and Eve), were the only structures carried out according to Alessi's plans. Built between 1572 and 1576 with funds provided by d'Adda, most of the new chapels in the Sacro Monte's lower area (from the Fall to the Entry into Jerusalem) correspond to the *Libro* at least in subject and location. And several conceptions—the temporal sequence, the urbanistic entity in the upper area, the isolation and regulated viewing of the ensembles by screens—became principles of the Sacro Monte's later development. But, as Alessi himself recognized, the scheme was inherently difficult, its materials (now marble and carved stone) costly, and the requisite skills lacking in the local builders. Worse, by submerging the monastic sense in one of Mannerist delectation, his brilliant solution exacerbated conflicts with the Observants and conflicted with a Counter-Reformation desire for clarity, simplicity and directness. There were two different efforts to address these practical, but also increasingly ideological, problems. The first was initiated by d'Adda himself, who, sometime during the 1570s (but probably 1578–80; Longo, 1985) engaged Martino Bassi to draw up versions of the *Libro*'s plans for the overall organization, especially the upper area (which became 'Jerusalem' explicitly) and several individual chapels. Bassi's studies (Milan, Bib. Ambrosiana) considerably simplify, clarify and (as their preface notes) avoid anything that might distract from the devotional purpose.

The balance of the architecture was planned during the episcopate of Carlo Bascapè (1593–1615); Bascapè, influenced by S Carlo Borromeo's views on religious art and

by his belief in direct episcopal intervention in artistic as well as administrative matters, gave precise instructions for the sanctuary's remaining arrangement. His architectural consultants were Domenico Alfani (1593 to 1602) and then, probably, Giovanni d'Enrico (d 1644). The six interior chapels of Pilate's Palace were ready for decoration by 1608, and the basilica—its presbytery and crossing complete—was dedicated in 1649. Realized after Bascapè's death, but hardly less determined by him, were those of the Arrest and First Presentation to Pilate (before 1617); two of the three free-standing chapels that form the Piazza dei Tribunali, the Second Presentation to Pilate and the marble reproduction of the Scala Santa (before 1628); the Crucifixion (before 1637); the Deposition (before 1641); and, protracted from a foundation around 1570, the Transfiguration (after 1647). Uniform in style and consistent in relation to the site and their ensembles, these structures represent a final tempering of Alessi's project in the light of Observant tradition, Counter-Reformation ideology and practicality. Even when departing considerably in style, the later architecture of the Sacro Monte, which includes the chapel of Annas (1737), the basilica's nave (1708–20s), tribune and crypt (designed by Benedetto Innocente Alfieri; executed by Giovanni Battista Morondi, 1730s) and façade (designed by Giovanni Ceruti, 1891–6), still reflects the basic scheme and ideas promoted by Bascapè.

2. DECORATION. The earliest decoration of the Sacro Monte was intended to reinforce identification of its chapels with the holy sites of Jerusalem and to encourage visualization of their relative events. Initially, in the three structures completed by 1493, this seems to have included reproductions of objects and relics (first mentioned in the guide of 1514 and purportedly then extant). An early source suggests that by 1495 the decoration featured figural representations that brought to mind the religious dramas or *misteri*, and the guide of 1514 mentions sculpted representation at three sites, painted representation at another four, and, in one instance, both forms. Corresponding to these citations, there survive wooden statues of two types: earlier and more conventional in style, the carved and polychromed figures of the *Stone of Unction* group (Varallo, Pin.) and, with modifications, the Sepulchre's *Christ* (to which can be added the Calvary's *Christ* and the *Risen Christ* of the piazza's fountain); somewhat later and more distinctive are the cloth-draped and wigged mannequins of the *Annunciation* and *Last Supper* (to which can be added the basilica's *Death of the Virgin*).

None of the cited paintings was preserved much beyond the 16th century, but there remain traces of fresco ornament on the interior and exterior of several chapels and, unique as a record of the earliest figural painting, the frescoes of the *Sepulchre of the Virgin* (Varallo, Pin.). This early decoration is essentially vernacular: the first type of sculpture is an elaboration of a regional type, the second apparently an adaptation of a popular and ephemeral one, and the painting a provincial interpretation of recent Milanese style.

In the second decade of the 16th century there is a new concern with completeness and consistency as well as a new stylistic sophistication. This can be seen in the more differentiated description and characterized expression of such wooden figures as the *Disrobing of Christ*, in the introduction of polychromed terracotta in the figures of the *Nativity* and *Adoration of the Shepherds*; and in the frescoes of the *Disrobing* (presently surrounding the *Pietà*), which are compatible in style and increasingly coordinated in scale and composition with the sculpture. These developments, traditionally and convincingly attributed to Gaudenzio Ferrari, most likely date to c. 1514–20 and culminate in his decoration of the *Crucifixion* (begun probably c. 1520; *see* fig. 2) and the *Adoration of the Magi* (largely completed by 1528), in which terracotta figures and panoramic frescoes are combined in ensembles of extraordinary size (37 figures and 200 sq. m of painting in the former), narrative richness and visual coherence. With these ensembles, which provided the model for later decoration, figural representation displaced topographic reproduction as the primary significance of the Sacro Monte.

In the following period decoration was interrupted, with the exception of some works that can be dated to the early 1540s and that are still legible to varying degrees. In one interior space of the original Pilate's Palace, Bernardino Lanino painted a fresco of *Christ before Pilate* (surviving sections, Varallo, Pin.); in the other interior space of the palace, an anonymous sculptor returned to completely carved wood for the three figures of a *Flagellation* (one destr.; two integrated into the later version of the subject). At the same time, Lanino added a fresco version of the *Pentecost* (Varallo, Pin.), a virtual altarpiece, to the chapel dedicated to that event. These exceptions suggest an attempt, albeit a limited one, to revive the decoration at Varallo: Ferrari's style is the basis of Lanino's frescoes and even of the statues' types, but they revert to conventional formats, differing scales and separate existences.

A true revival of the decoration began with the implementation of Galeazzo Alessi's plan. Between 1570 and the early 1580s painted plaster figures loosely based on the vignettes in his *Libro dei misteri* (*see* §I above) were introduced to the new chapels, from the *Fall of Man* to the *Entry into Jerusalem*, as they were completed (the latest figures of this type, included in the *Miracle of the Widow's Son*, date from 1589). Accompanying frescoes followed between the late 1570s and 1594. These ensembles, however, remain modest works in a provincial Mannerist style, secondary to both Gospel and the abstract order of Alessi's scheme.

The decoration of one chapel in this series, depicting the *Massacre of the Innocents*, signalled a further stage in the revival. Set up between 1587 and 1590 and attributed to Giacomo Paracca (b c. ?1557), its figures are many (originally about 36), startlingly rude in the characterization of soldiers, mutilated babies and desperate mothers, and, although relatively coarse in finish, they are again in polychromed terracotta. Its frescoes, commissioned from Giovanni Battista della Rovere (1561–1627/30) in 1590 (and executed in collaboration with his brother Giovanni Mauro della Rover, 1575–1640), cover every surface, including the vault (c. 100 sq. m); the complex and illusionistic composition suggests an agitated crowd about a large atrium and asserts the contemporary Milanese style.

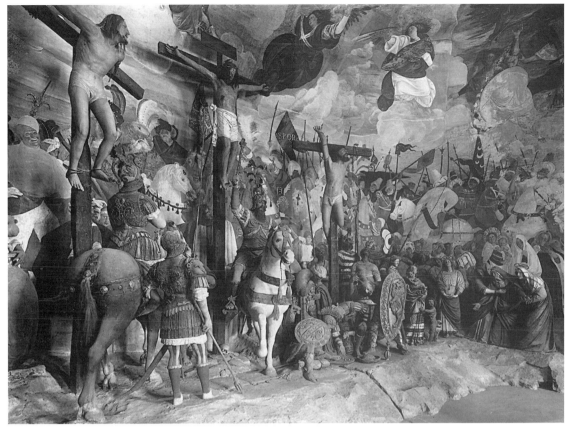

2. Varallo, Sacromonte, Chapel XXXVIII, *Crucifixion* by Gaudenzio Ferrari, wood, terracotta and fresco, *c.* 1520–26

After Bascapè's appointment as Bishop of Novara in 1593, the revival of artistic ambitions for Varallo coincided with a Tridentine concern for accuracy and respect for stylistic precedent and visual continuity, quickly returning the decoration to the highest level. The renovation or repair of extant ensembles included the definitive revision of the *Fall* and the addition of figures to the *Massacre* (*c.* 1594–5; both with statues by Michele Prestinari (*fl* 1594–1634) and paintings by Domenico Alfani), and modifications of the *Visitation* and *Temptation* (*c.* 1598) by Jean de Wespin (*c.* 1569–1615), called Tabacchetti. The decoration of the new chapel of the Way to Calvary was the first to be realized entirely according to Bascapè's orders. Between 1599 and *c.* 1601 Tabacchetti created the requisite procession with 44 terracotta figures and 9 horses. They are almost caricatural in type and extravagant in attitude, but superb in manufacture and are arranged relative to three principal viewpoints. The ensemble was completed by Morazzone (1573–1625/6) with frescoes that augment the crowd below and fill the vault above with illusionistically framed Old Testament archetypes (this was largely executed by *c.* 1605, but was still awaiting completion in 1616). Throughout, as Bascapè had instructed, there are references to the scene that now properly followed, Ferrari's *Crucifixion*. However, the most active period of decoration at Varallo dates from the next 30 years, when there is an almost complete coincidence of the chapel's architecture with the representation, coordination of sculpture and painting (at points they merge), unity of composition and integrity of expression.

BIBLIOGRAPHY

Pre-19th-century guides are excluded except important ones that have been reprinted. Also excluded are writings on the principal artists, which can be found under the individual biographies.

G. Alessi: *Libro dei Misteri: Progetto di pianificazione urbanistica, architettonica e figurativa del Sacro Monte di Varallo in Valsesia* (1565–9); ed. S. Stefani Perrone, intro. A. M. Brizio, 2 vols (Bologna, 1974)

G. B. Fassola: *La Nuova Gierusalemme o sia il Santo Sepolcro di Varallo* (Milan, 1671/R 1973)

M. Cusa: *Nuova guida storica, religiosa ed artistica al Sacro Monte di Varallo ed alle sue adiacenze* (Varallo, 1857–63/R 1984)

F. Tonetti: *Museo storico ed artistico valsesiano*, 4 vols (Varallo, 1883–91/R vols ii–iv, 1973)

S. Butler: *Ex voto: An Account of the Sacro Monte or New Jerusalem at Varallo Sesia* (London, 1888)

E. Motta: *Il beato Bernardino Caimi fondatore del Sacro Monte di Varallo: Documenti e lettere inedite* (Milan, 1891)

P. Galloni: *Sacro Monte di Varallo: Atti di fondazione; B. Caimi fondatore* (Varallo, 1909/R 1973)

——: *Sacro Monte di Varallo: Origine e svolgimento delle opere d'arte* (Varallo, 1914/R 1973)

A. Durio: 'Francesco Sesalli e la prima "Descrittione" del Sacro Monte di Varallo', *Boll. Stor. Prov. Novara*, xxi (1927), pp. 167–379

——: *Bibliografia del Sacro Monte di Varallo e della chiesa di Santa Maria delle Grazie annessa al Santurario* (Novara, 1930)

——: 'Bibliografia del Sacro Monte di Varallo: Omissioni e aggiornamento, 1600–1943', *Boll. Sezione Novara*, xxxvii (1943), pp. 75–100

M. Bernardi: *Il Sacro Monte di Varallo* (Turin, 1960)

M. L. Gatti Perrer: 'Martino Bassi, il Sacro Monte di Varallo e S Maria presso San Celso a Milano', *A. Lombarda*, ix/2 (1964), pp. 21–57

C. Debiaggi: *Dizionario degli artisti valsesiani dal secolo XIV al XX* (Vqrallo, 1968)

——: 'Le cappelle dell'Ascensione, dell'Apparizione di Gesù ai Discepoli e l'originaria topografia del Sacro Monte di Varallo', *Boll. Stor. Prov. Novara*, lxix/2 (1978), pp. 56–81

——: *A cinque secoli dalla fondazione del Sacro Monte di Varallo: Problemi e ricerche* (Varallo, 1980)

M. Cometti: 'Bibliografia del Sacro Monte di Varallo', *Aspetti storici ed artistici del Sacro Monte di Varallo* (exh. cat., ed. M. G. Cagna and others; Varallo, Bib. Civ. and Archv Stato, 1980)

J. Bober: 'Storia e storiografia del S Monte di Varallo: Osservazioni sulla "prima pietra" del S Sepolcro', *Novarien*, xiv (1984), pp. 3–18

G. Gentile: 'La storia del Sacro Monte nei documenti: Note per una lettera della mostra', *Il Sacro Monte di Varallo: Mostra documentaria* (exh. cat., ed. M. G. Cagna Pagnone; Varallo, Archv Stato, 1984), pp. 79–93

W. Hood: 'The Sacro Monte of Varallo: Renaissance Art and Popular Religion', *Monasticism and the Arts*, ed. T. G. Verdon (Syracuse, NY, 1984), pp. 291–311

P. G. Longo: 'La proposta religiosa del Sacro Monte di Varallo', *Novarien*, xiv (1984), pp. 19–98

——: 'Il Sacro Monte di Varallo nella seconda metà del XVI secolo', *Da Carlo Borromeo a Carlo Bascapè: Atti della giornata culturale: Arona, 1984*, pp. 83–182

Iconografia del Sacro Monte di Varallo: Disegni, dipinti e incisioni dal XVI al XX secolo (exh. cat., ed. M. Cometti Valle; Varallo, Bib. Civ., 1984)

G. Gentile: 'Il Sacro Monte di Varallo nella pietà di Carlo Borromeo: Sviluppi spirituali e catechetici di una tradizione devozionale', *Boll. Stor. Prov. Novara*, lxxvi (1985), pp. 201–31

G. Testori and S. Stefani Perrone: *Artisti del legno: La scultura in Valsesia dal XV al XVIII secolo* (Borgosesia, 1985)

P. G. Longo: 'Fonti documentarie sui Francescani a Varallo tra XV e XVI secolo', *Sacro Monte di Varallo: Spunti storici e devozionali: Atti del convegno culturale: Varallo, 1986*, pp. 29–108

S. Stefani Perrone, ed.: *Questi sono i Misteri che sono sopra el Monte di Varalle (in una 'Guida' poetica del 1514)* (Borgosesia, 1987)

J. Bober: 'Sulla "preistoria" del Sacro Monte di Varallo', *Sacri Monti: Devozione, arte e cultura della Controriforma: Atti del convegno internazionale: Gazzada (Varese), 1990*, pp. 119–30

S. Stefani Perrone: 'La Gerusalemme delle origini nella secolare vicenda edificatoria del Sacro Monte di Varallo', *Sacri Monti: Devozione, arte e cultura della Controriforma: Atti del convegno internazionale: Gazzada (Varese), 1990*, pp. 27–57

A. Nova: 'Popular Art in Renaissance Italy: Early Response to the Holy Mountain at Varallo', *Reframing the Renaissance: Visual Culture in Europe and Latin America, 1450–1650*, ed. C. Farago (New Haven and London, 1995), pp. 112–26

JONATHAN BOBER

Varano. Italian family of patrons. They emerged as Lords of Camerino, a commune in the Marches, a province of the Papal States, in the second half of the 13th century. Their ascendancy was built on property held in the city and its surrounding *contado*, or jurisdiction, on occasional high public offices and on their alliance with the Guelph cause. Despite Camerino's importance as a market town and a centre of production for textiles, and later paper, much of the Varano wealth depended on their service as condottieri, often for the papacy. The dynasty tried to buttress its position through marriage with other ruling dynasties in the region; in 1451 Giulio Cesare da Varano (*reg* 1444–1502) married Giovanna Malatesta. The family received formal recognition as papal vicars (hereditary vicars after 1468) and then dukes (from 1515), but it never became one of the major Italian powers, and its lordship over Camerino was interrupted by family rivalry, internal dissent and foreign interference. Divisions within the dynasty and external intervention drove them into exile between 1433 and 1444, and Alexander VI ousted them from the city between 1502 and 1503. The principal male line ended with Giovanni Maria da Varano (*reg* 1503–27), and, after brief periods of rule by the della Rovere and Farnese families, Camerino returned to direct papal rule in 1545.

The Varano attracted many artists, craftsmen and men of letters to Camerino. During the 14th century the family's properties in the centre of the city and next to the cathedral were converted into a palace, which was greatly extended in two campaigns (1465–75 and 1489–99) by Giulio Cesare. Craftsmen were imported from elsewhere in the Marches and from Tuscany, while labour services were demanded of the local population. The second phase was possibly directed by Baccio Pontelli and Rocco da Vicenza (*fl c.* 1500). The Palazzo Ducale, which now houses part of the University and the Biblioteca Valentiniana, has been much modified and largely stripped of its furnishings and decorations, but early descriptions and inventories suggest that it was intended to rival the palaces of contemporary and neighbouring dynasties, such as that of the Montefeltro of Urbino. Tapestries and intarsia panelling formed part of its decoration; some of the latter, the work of Luca di Firenze (1471) is preserved in the Museo Diocesano. Under the direction of Giulio Cesare and his son Giovanni Maria, its principal public rooms were frescoed with representations of members of the Varano family, its allies, dynastic coats of arms and laudatory captions (*elogie*) composed by the churchman and scholar Varino Favorino (*c.* 1450–1537). The courtyard is decorated with the devices of the Varano and Malatesta families, and a bust of *Giulio Cesare* crowned the main entrance. Following contemporary fashion, the lord of Camerino had a *studiolo* in his palace, commissioned a portrait medal and attracted the praise of men of letters. He also contributed to work on the façade of S Venanzio (1480) and embellished the Varano chapel, dedicated to S Ansovino, in the cathedral; both church and cathedral were largely rebuilt in the 19th century. Giulio Cesare's other projects included the central hospital of S Maria della Misericordia (1479) and the monastery of S Pietro di Muralto (1484), for which he commissioned an altarpiece from Crivelli.

The Varano family directed and inspired enough architectural, artistic and literary activity in the city to ensure that their lordship (especially the rule of Giulio Cesare) was long regarded as a 'golden age' in the region, but their resources, and those of the other leading families of Camerino, were insufficient to create a distinct, long-lasting school.

BIBLIOGRAPHY

P. Litta: *Famiglie celebri italiani*, vii (Milan, 1819), table 4

B. Feliciangeli: 'Cenni storici sul palazzo dei Varano a Camerino', 'Sulle condizioni economiche e demografiche di Camerino e sulla ricchezza della famiglia Varano', *Atti & Mem. Reale Deput. Stor. Patria Marche*, n.s., viii (1912), pp. 21–61

R. Romani: 'Il Palazzo Varano a Camerino', *Rassegna Marchigiana*, vi (1927–8), pp. 374–84

S. Corradini: 'Il palazzo di Giulio Cesare Varano e l'architetto Baccio Pontelli', *Stud. Maceratesi*, iv (1969), pp. 186–220

P. Zampetti: *Paintings from the Marches* (London, 1971), pp. 67–130

A. Bittarelli: 'Varino Favorino e i suoi "Elogia"', *Stud. Picena*, xliv (1977), pp. 215–29

——: *Camerino: Viaggio dentro la città* (Macerata, 1978)

J. E. Law: 'City, Court and *contado* in Camerino, *c.* 1500', *City and Countryside in Late Medieval and Renaissance Italy: Essays Presented to Philip Jones*, ed. T. Dean and C. Wickham (London, 1990), pp. 171–82

P. L. Falaschi: 'Il Palazzo Ducale dei Varano e i Giardini Rinascimentali', in *Atti dell'Incontro L'Orte Botanico e il Verde di Camerino* (Camerino, 1989), pp. 5–15

B. Teodori: 'Restauri e nuove acquizione nel Palazzo de Da Varano a Camerino', in *Atti dell'Incontro L'Orte Botanico e il Verde di Camerino* (Camerino, 1989), pp. 31–50

——: 'Atti della Giornata di Studi Malatestiani a Camerino', *Studi Malatestiani*, v (Rimini, 1990).

JOHN LAW

Varchi, Benedetto (*b* Florence, March 1503; *d* Florence, Dec 1565). Italian humanist and theorist. After travels in the 1530s during which he studied Aristotle and frequented the circle of Pietro Bembo he settled permanently in Florence in 1543. A chronicler and writer, he became one of the most active members of the Accademia Fiorentina, writing many commentaries on the works of Dante and Petrarch. He was in close contact with artists: he exchanged numerous sonnets with Agnolo Bronzino and Bartolomeo Ammanati and, according to Vasari, advised Niccolò Tribolo on iconographic matters. He also helped Benvenuto Cellini revise the manuscript of his *Vita*. Varchi's writings on art comprise a short discourse of unknown date entitled *Della beltà e grazia* ('Of beauty and grace'); two lectures delivered in 1547 in S Maria Novella, Florence, and published in 1549 as *Due lezzioni*; an unpublished treatise on proportion; and the funeral oration for Michelangelo (Florence, 1564).

Della beltà e grazia synthesizes commonplaces of Renaissance aesthetics stemming from Marsilio Ficino's commentary on Plato's *Symposium* and disseminated in the 16th century through various *trattati d'amore* and commentaries on Petrarch's *Canzoniere*. The funeral oration for Michelangelo summarizes his life, describes his Platonic standpoint and presents his work as crowning the development of Tuscan art from the time of Cimabue. The two lectures are Varchi's most important contribution to art history. In the first, a commentary on Michelangelo's sonnet *Non ha l'ottimo artista alcun concetto*, Varchi expounds the principles of natural creation after the example of artistic creation, which he defines as the reproduction of an image retained in the artist's imagination. He concludes with a eulogy of Michelangelo based on the Platonic doctrine of love. The second lecture, a series of three discussions based on Book VI of Aristotle's *Nicomachean Ethics*, sets out to assess the nobility of the various arts, the operations of which, according to Aristotelian psychology, are situated in the lower part of the rational soul, their domain being confined to the universe of particulars. In the first discussion medicine triumphs over the arts in general. In the second, despite the unifying principle of *disegno*, Varchi invokes the Aristotelian concept of substance—the fusion of form and matter (*Metaphysics*, 1029a)—in declaring himself in favour of sculpture. The last discussion compares painting and poetry, opposing the two disciplines in terms of content but underlining their common imitative properties. The text concludes with eight letters from artists, including Vasari, Bronzino,

Tribolò, Jacopo Pontormo, Benvenuto Cellini, Francesco da Sangallo, Battista di Marco del Tasso and Michelangelo, whose views on the matter Varchi had requested.

While bearing witness to the immense reputation of Michelangelo, the two lectures present a theory as yet ill defined, halfway between traditional Aristotelianism and empirical admiration. They nevertheless had considerable influence on subsequent comparative discussions of the arts (*see* PARAGONE), and their introduction of Aristotelian categories in this debate prepared the way for the ideas of Vincenzo Danti and Federico Zuccaro.

UNPUBLISHED SOURCES

Florence, Bib. Riccardiana, fols 84–108 [*Trattato della proportioni e proportionalità*]

WRITINGS

Due lezzioni di M. Benedetto Varchi (Florence, 1549); ed. in part by P. Barocchi in *Trattati d'arte del cinquecento* (Bari, 1962), i, pp. 1–82; also in P. Barocchi, ed., *Scritti d'arte del cinquecento* (Milan, 1971–3), i, pp. 493–544

Orazione funerale . . . nell'essequie di Michelagnolo Buonarroti (Florence, 1564)

Libro della beltà e grazia; in *Lezzioni di M. Benedetto Varchi* (Florence, 1590); ed. P. Barocchi, *Trattati d'arte del cinquecento* (Bari, 1962), i, pp. 83–91

BIBLIOGRAPHY

E. Panofsky: *Idea: Ein Beitrag zur Begriffgeschichte der älteren Kunsttheorie* (Leipzig, 1924; Eng. trans., 1968), pp. 115–21

U. Pirotti: *Benedetto Varchi e la cultura del suo tempo* (Florence, 1971)

S. Rossi: *Dalle botteghe alle accademie* (Milan, 1980), pp. 83–122

L. Mendelsohn: *Paragone: Benedetto Varchi's Due Lezzioni and Cinquecento Art Theory* (Ann Arbor, 1982)

F. Quiviger: 'Benedetto Varchi and the Visual Arts', *J. Warb. & Court. Inst.*, 1 (1987)

T. Frangenburg: 'Perspectivist Aristotelianism: Three case-studies of Cinquecento Visual Theory', *J. Warb. & Court. Inst.*, liv (1991), pp. 137–58

FRANÇOIS QUIVIGER

Varignana, Domenico da. *See* AIMO, DOMENICO.

Varnucci, Bartolomeo di Antonio (*b* Florence, 1410; *d* Florence, 1479). Italian illuminator and stationer. He is documented from 1440, when he enrolled in the Arte de' Medici e Speziali, and began to work for the Badia in Florence with his brother Giovanni. When the latter died, Bartolomeo entered the bottega of his younger brother, Chimenti. Bartolomeo was not an innovator and was of second rank compared to such skilled illuminators as Francesco d'Antonio del Chierico, Gherardo di Giovanni di Miniato del Foro, Monte di Giovanni di Miniato del Foro and Attavante degli Attavanti. His handling of volume, the sculptural quality of his scrolls and his use of large, densely hatched areas in landscapes, beards and hair, are reminiscent of contemporary sculpture; the influence of Donatello's low reliefs is especially evident in Bartolomeo's use of the 'heroic putto' (e.g. initial S, Florence, Bib. Medicea–Laurenziana, MS. S Marco 616, fol. 4*r*).

Bartolomeo worked mainly on liturgical manuscripts and Books of Hours, sometimes in collaboration with other artists. For example he came into contact with Battista di Niccolò da Padova and Ser Ricciardo di Nanni while working on the four-volume Lectionary (Florence, Bib. Medicea–Laurenziana, MSS Edili 141–7) for Florence Cathedral. Among his large-scale works are two Missals (Florence, Bib. Medicea–Laurenziana, MSS Edili 103–4), also commissioned by the cathedral authorities, in June

1456 and March 1458, respectively. His other patrons included the Stamperia (press) di Ripoli, for which between 1474 and 1480 he produced four *Libri di compagnia*, two copies of the *Life of St Catherine* and a Psalter written by Frate Matteo da Pistoia. In his Books of Hours the repetitiveness of certain compositional schemes marks Bartolomeo as a conservative artist; nonetheless, his works do not lack original illustrative ideas (e.g. Catania, Bib. Reg. U., MS. F. 109, fol. 56*r*; Rome, Bib. Casanatense, MS. 244, fol. 155*r*).

BIBLIOGRAPHY

M. Levi d'Ancona: *Miniatura e miniatori a Firenze dal XIV al XVI secolo* (Florence, 1962), pp. 29–37

A. Garzelli: *Miniatura fiorentina del Rinascimento, 1440–1525: Un primo censimento*, i (Florence, 1985), pp. 29–31

PATRIZIA FERRETTI

Vasari. Italian family of artists and writers. As a prototype of the intellectual artist, (1) Giorgio Vasari, more than any other, determined the shape taken by court display and church decoration in Rome and Florence in the late Renaissance. As the author of the *Vite* ('Lives'), he founded critical art historiography. He was also one of the earliest collectors of Old Master drawings, which he mounted in his famous *Libro de' disegni*. His nephew (2) Giorgio Vasari *il giovane*, an expert in mathematics, perspective, military architecture and cosmography, is best known for his work as an essayist and for organizing his uncle's private papers.

(1) Giorgio Vasari (*b* Arezzo, 30 July 1511; *d* Florence, 27 June 1574). Painter, draughtsman, architect, writer and collector.

I. Life and work. II. Working methods and technique. III. Writings. IV. Collection. V. Character and personality.

I. Life and work.

1. Training and early works, before 1537. 2. First major commissions, 1537–53. 3. Years of maturity, 1553–74.

1. TRAINING AND EARLY WORKS, BEFORE 1537. From a family of potters (*vasaio*, hence Vasari), Giorgio was the son of Antonio Vasari (*d* 1527) and Maddelena Tacci (*d* 1558). Information on his training should be treated with caution, as it is based almost exclusively on his autobiography. From 1520 to 1524 he was taught Latin, and probably ancient mythology and religion, by Antonio da Saccone, otherwise unknown, and Giovanni Pollastra (1465–1540), who undoubtedly shaped his literary inclinations. Giorgio's predilection for learned, allegorical subjects in his paintings and his ability to express himself in writing were unusual for a painter of his time. He received his first training as a painter in Arezzo from Guillaume de Marcillat, who had been employed in Rome at the Vatican and knew the works there by Michelangelo and Raphael. Vasari's accomplishments attracted the attention of the Cardinal of Cortona, Silvio Passerini (1470–1529), the tutor of Alessandro and Ippolito de' Medici, and he took Vasari with him to Florence in 1524. There he was taught with the two Medici by Pierio Valeriano (1477–1558). Vasari continued his artistic training in Florence in the workshops of Andrea del Sarto and Baccio Bandinelli, working with Francesco Salviati.

The expulsion of the Medici in 1527 ended Vasari's first stay in Florence. He returned to Arezzo, where he met Rosso Fiorentino, who provided him with a drawing for a painting of the *Resurrection* (untraced). In 1529 Vasari was again in Florence; he joined the workshop of Raffaello da Brescia (again with Salviati) and began an apprenticeship as a goldsmith with Vittorio Ghiberti. In October he went to Pisa to paint a fresco (untraced) and met the Olivetan monk Don Miniato Pitti, who was later of great importance to him. In 1530 he returned to Arezzo by way of Modena and Bologna, where he collaborated on the decorations for the coronation of Charles V (*reg* 1519–56). A year later, at the invitation of Cardinal Ippolito de' Medici, he went to Rome, where he entered his service in January 1532. With Salviati, he studied works of ancient and contemporary Roman art and architecture. It was at this time that he met Paolo Giovio, who was later to obtain important commissions for him and to encourage him to write his *Vite*.

In the summer of 1532 Vasari returned to Florence, where he offered his services to Alessandro and Ottaviano de' Medici. Vasari's earliest surviving work, the *Entombment* (Arezzo, Mus. Casa Vasari), was painted for Ippolito in this period. It shows clearly the influence of Rosso and of northern graphic art as well as Bandinelli's style of drawing. The painting earned Vasari the admiration of the Duke of Florence, Alessandro de' Medici, through whom he received further commissions, many arranged by Ottaviano, including portraits of *Lorenzo il Magnifico* (see fig. 1) and *Alessandro de' Medici* (both 1534; Florence, Uffizi). These portraits are important particularly for the use of complicated symbolism. In the portrait of *Lorenzo il*

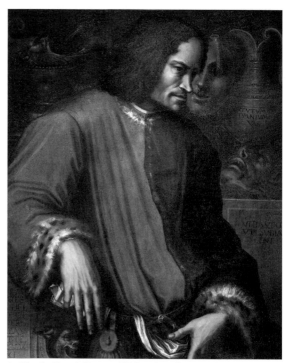

1. Giorgio Vasari: *Lorenzo il Magnifico*, oil on panel, 900×720 mm, 1534 (Florence, Galleria degli Uffizi); posthumous portrait

Magnifico, for which a drawing by Vasari (the earliest known) has survived (Florence, Uffizi), a number of inscriptions allude to the virtue of the sitter, an idea no doubt devised by a literary adviser, probably Giovio. In the portrait of *Alessandro de' Medici*, on the other hand, the symbolic meaning is conveyed by objects alluding to the aims and ambitions of the Duke. The complex meaning of the work would not have been fully comprehensible without the explanation given by Vasari in a letter to Ottaviano, the first of many such accounts.

In 1535 Ippolito de' Medici died. Since Vasari's new patron, Alessandro de' Medici, was mainly interested in fortifications, the artist now began to study architecture. The first result of these studies was the organ base (*in situ*) for the cathedral of Arezzo, in which he mixed 15th-century motifs with those from the architecture of Michelangelo. In 1536 Vasari collaborated on the temporary decorations for the entry of Charles V into Florence. He executed this large commission quickly, with the aid of many assistants, demonstrating a talent for organization that he put to good use later in his career, when he was in charge of large-scale projects for his court patrons. The following year he produced several works for Arezzo, including a *Deposition* (Arezzo, SS Annunziata), again influenced by Rosso, and frescoes for S Rocco (detached; Arezzo, Gal. & Mus. Med. & Mod.; Monte San Savino, S Chiara). These earliest surviving frescoes show Vasari's virtuoso technique; they have a freshness and lightness often lacking in his panel paintings.

2. FIRST MAJOR COMMISSIONS, 1537–53.

(i) 1537–40. With the murder of Alessandro de' Medici in 1537, Vasari lost his second princely patron. He decided to give up the precarious existence of the court artist and earn his living from art alone. Through his former teacher Pollastra, he went to work for the monks at Camaldoli. There he painted a *Virgin and Child with SS John the Baptist and Jerome* (1537; *in situ*), frescoes (destr.) and an altarpiece of the *Nativity* (1538; *in situ*), a night scene of which the lighting effects were much admired. He interrupted the works at Camaldoli by a journey to Rome made in early 1538, accompanied by his assistant Giovanni Battista Cungi. A year earlier he had expressed the wish to return to Rome, where, as he wrote in a letter, the study of ancient and modern works had brought contemporary art to perfection, an idea he developed later, in the *Vite*. Vasari stated that he executed more than 300 drawings in Rome, many in the newly excavated villa of Nero, the Domus Aurea. He claimed that this trip influenced his painting of the *Assumption* for S Agostino in Monte San Savino (1538–9; *in situ*), but the work is, in fact, based on elements from two paintings of the subject by Andrea del Sarto (both Florence, Pitti). The combining of his own pictorial ideas with those of others remained characteristic of Vasari's oeuvre.

In 1539, through Don Miniato Pitti, Vasari was commissioned to execute works for S Michele in Bosco, near Bologna: *Abraham and the Three Angels* (untraced), *Christ in the House of Mary and Martha* (*in situ*), the *Feast of St Gregory* (with Cristofano Gherardi; Bologna, Pin. N.) and frescoes with scenes from the *Apocalypse* (*in situ*), after

Albrecht Dürer (1471–1528). In Bologna he studied works by Parmigianino and also Raphael's *St Cecilia* (Bologna, Pin. N.), from which he did a drawing of a *Standing Man* (Florence, Uffizi). The influence of his stay in Bologna is evident in a stylistic change in his painting, which lost its hard, metallic quality and gained a new elegance and ornamental refinement.

In 1540 Vasari painted the high altar at Camaldoli, depicting the *Descent from the Cross* (1540; Camaldoli, SS Donato e Ilariano; see fig. 2). While there, he met Bindo Altoviti, who commissioned from him a painting for his chapel in SS Apostoli, Florence. As Vasari hoped this work would aid his return to Florence, he prepared it with great care. The painting, an *Immaculate Conception* (*in situ*; see fig. 3), was derived from a composition by Rosso. The success of Vasari's composition is indicated by the large fee he received and by the numerous replicas. His treatment of the theme became an iconographic model followed in Central Italian art until the early 17th century. The popularity of such paintings illustrating learned programmes is also attested by Vasari's *Penitent St Jerome*, first executed for Ottaviano de' Medici in 1541 and repeated several times for other patrons (Chicago, A. Inst.; Florence, Pitti; Leeds, C.A.G.; Vincigliata, Graetz priv. col.). Apart from the didactic paintings on Christian or allegorical subjects for which he is known, Vasari also painted works with more frivolous, mainly erotic, themes. Most are

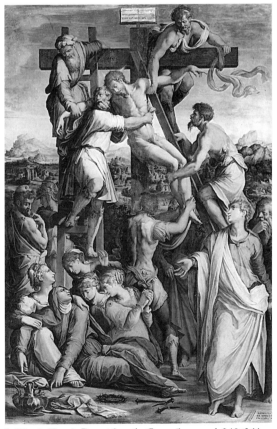

2. Giorgio Vasari: *Descent from the Cross*, oil on panel, 2.10×3.11 m, 1540 (Camaldoli, SS Donato e Ilariano)

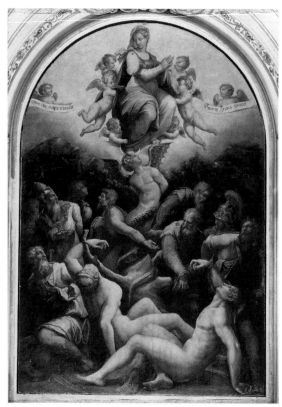

3. Giorgio Vasari: *Immaculate Conception*, oil on panel, 3.45×2.37 m, 1541 (Florence, SS Apostoli)

untraced, but there are echoes in some individual figures in the later decorations in the Quartiere degli Elementi of the Palazzo Vecchio.

(ii) 1541–5. At the invitation of Pietro Aretino, Vasari went to Venice in 1541. On the journey he viewed art and visited fellow artists in a number of North Italian cities. In Mantua he visited Giulio Romano, and in Ferrara he stayed with Garofalo. In Venice in 1542 (with Cungi, Gherardi and others) he painted the stage-set for Aretino's *La talanta* and decorated the walls of the room in which it was performed. This work was crucial in the development of his interior decorations. Through Michele Sanmicheli, he was commissioned to do nine ceiling paintings in the Palazzo Corner Spinelli in Venice (dispersed). For his host, Francesco Leoni, he painted a *Holy Family with St Francis* (Los Angeles, CA, Co. Mus. A.), his most lavish and perhaps his best version of the subject.

On his return to Tuscany, Vasari began decorating the house he had acquired in Arezzo in 1541 (for illustration *see* AREZZO). In the autumn of 1542 he went to Rome, where he painted a *Deposition* for Bindo Altoviti (untraced; drawing Paris, Louvre; replica Siena, Col. Chigi–Saracini). The painting earned Michelangelo's approval; it also brought Vasari into contact with Cardinal Alessandro Farnese, and in early 1543 he painted *Justice* (Naples, Capodimonte) for the Cardinal's Rome residence, the Palazzo della Cancelleria. This learned allegory was clearly intended to catch the attention of the Cardinal and indeed

opened the way for the commission of the Cancelleria frescoes in 1546. In the meantime, Vasari painted, among other works, a *Deposition* for S Agostino (Rome, Gal. Doria–Pamphili), a variant of the Camaldoli composition, showing the influence of Michelangelo and Salviati.

In 1544 Vasari went to Naples, where, again for the Olivetans, he painted the *Presentation of Christ*, for the high altar of S Anna dei Lombardi (Naples, Capodimonte), and, with Raffaello dal Colle and others, decorated their refectory, with dazzling white stucco and colourful grotesques (*in situ*), which clearly owe much to Venetian influences. Vasari painted many other works in Naples, including the *Crucifixion* for S Giovanni a Carbonara (*in situ*). The powerful religious expressiveness of this work, unique in his oeuvre, clearly reflects the wishes of the patron, the theologian Girolamo Seripando (1493–1563). In October 1545 Vasari returned to Rome, where he executed the remaining Neapolitan commissions: 18 panels with scenes from the *Old Testament* and the *Life of St John the Baptist* for the sacristy of S Giovanni a Carbonara, and the organ doors for Naples Cathedral (*in situ*). During this period Titian was in Rome, and Vasari accompanied him to places of interest.

(iii) 1546–53. In March 1546 Vasari received from Alessandro Farnese the commission for the decoration of a hall in the Cancelleria. These frescoes were completed in an extremely short time (100 days), hence the name of the room, Sala dei Cento Giorni. Vasari was therefore obliged to use a large number of assistants, and he was not satisfied with the result; but this first large court fresco cycle did give him useful experience for later commissions. The cycle depicts the *Deeds of Pope Paul III*, the Cardinal's grandfather, in a complex setting of fictive architecture, the most striking elements of which are the staircases leading the eye from the room into each scene.

According to Vasari's own account, it was during this period, and encouraged by Giovio, that he began writing the *Vite*, although he must have begun collecting material long before. In the months after his return to Florence in autumn 1546, he worked primarily on the *Vite*, probably completing the text by the autumn of 1547. In October he went to Rimini, to paint the *Adoration of the Magi* for S Maria di Scolca (main panel, Rimini, S Fortunato). He also painted the *Stigmatization of St Francis* for S Francesco there (1548; *in situ*) and a *Deposition* for the Camaldolese abbey of Classe, near Ravenna (Ravenna, Accad. B.A.). Also in 1548 he visited Urbino, where he probably saw the ducal collection.

In the summer of the same year Vasari completed the decoration of his house in Arezzo, begun in 1542. It is characteristic of his self-confidence that he lavished as much effort on his own house as on those of his patrons. This may also reflect the influence of the elaborately decorated houses of Andrea Mantegna and Giulio Romano, which he had seen in Mantua in 1541. On the ceiling of the Sala della Fama, he painted the figure of *Fame*, surrounded by personifications of the arts: *Poetry*, *Painting*, *Sculpture* and *Architecture*. It was a pictorial expression of the equality of the arts, an idea he elaborated later in a letter to Benedetto Varchi on the PARAGONE, and in the introduction to the *Vite*. His ideas on art theory

were also reflected in the decoration of the other rooms. The Sala del Trionfo della Virtù, painted in 1548, includes monochrome frescoes illustrating well-known anecdotes about artists recorded by Pliny. Also in 1548 Vasari's work for Cardinal Giovanni Maria del Monte (later Pope Julius III) began with plans for a country house near Monte San Savino (probably never executed).

At the end of 1549 Vasari married Nicolosa Bacci (1536–84) from Arezzo. The match was negotiated by his friend Vincenzo Borghini, the prior of the Ospedale degli Innocenti. In April 1550 the first edition of the *Vite* was published. By this time Vasari was again in Rome, working with Bartolomeo Ammanati on the design of the del Monte Chapel in S Pietro in Montorio, commissioned by Julius III. Other works of the time include the *Beheading of St John the Baptist* for S Giovanni Decollato (*in situ*), designs for the Villa Giulia, frescoes (destr.) for the loggia of the Villa Altoviti, frescoes (Rome, Pal. Venezia) for the loggia of the Palazzo Altoviti, and a painting of *Patience* (Florence, Pitti) for Bernardo Minerbetti, Bishop of Arezzo (1507–74). At Minerbetti's request, Vasari used in this work a motif from Michelangelo, a variation of a figure from the *Crucifixion of St Peter* (Rome, Vatican, Cappella Paolina). Numerous copies of this 'invention' testify to its success.

3. YEARS OF MATURITY, 1553–74. In 1553 Vasari designed decorations for the façade and interior (*in situ*)

of the palazzo of Sforza Almeni (*d* 1566), aide to Cosimo I, who played an important role in the negotiations that brought Vasari back to the service of the Medici in 1554, a post that he retained until the end of his life. These frescoes were executed mainly by Gherardi, after a programme by Cosimo Bartoli (Davis, 1980). Vasari and Gherardi collaborated on another major fresco decoration in these years, for the Compagnia del Gesù in Cortona (*in situ*). Vasari's activities during 1554 also included plans and a wooden model for the completion of S Maria Nuova in Cortona, begun in 1550.

(i) Palazzo Vecchio. (ii) Other architectural commissions and ephemeral decorations. (iii) Other painted works.

(i) Palazzo Vecchio. Vasari's first major task for Cosimo was the remodelling of the Palazzo Vecchio in Florence as a ducal residence. His work there, as architect and painter, occupied a large part of his creative energy from 1555 to 1572. It was the most extensive palace decoration executed to a coherent programme in 16th-century Italy and the prototype for the residence of an absolute ruler. In many cases Vasari only produced designs (see fig. 4), and the execution of the paintings was left largely to his numerous assistants. The programmes, devised with Bartoli and Borghini, were so complex that by 1558 Vasari decided to produce a written explanation of the decoration, the *Ragionamenti* (*see* §III, 2 below). Works began in 1555, in the Quartiere degli Elementi on the second floor and

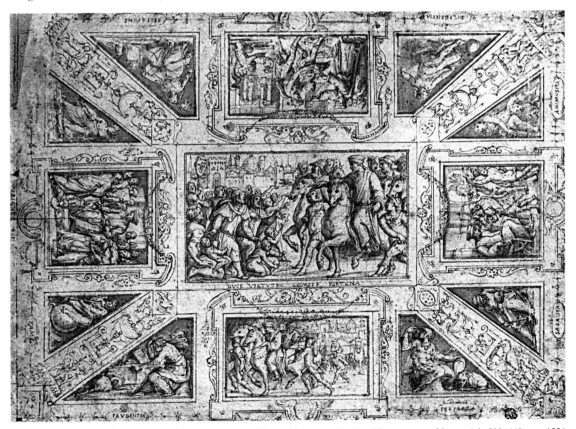

4. Giorgio Vasari: *Study for the Ceiling of the Sala di Cosimo il Vecchio, Palazzo Vecchio, Florence*, pen and brown ink, 320×440 mm, 1556 (Paris, Musée du Louvre)

5. Giorgio Vasari: *Apotheosis of Cosimo I* (1565), oil on panel, ceiling of the Salone del Cinquecento, Palazzo Vecchio, Florence

in the Quartiere di Leone X on the first, with collaborators including Gherardi and Joannes Stradanus.

The *Genealogy of the Gods* was chosen as the theme for the Quartiere degli Elementi; the Quartiere di Leone X was to illustrate the *History of the House of Medici*, with individual rooms devoted to depictions of the deeds of important family members (for illustration *see* MEDICI, DE', (2) and (14)). The programme was without parallel in earlier history paintings, and in his *Ragionamenti* Vasari further emphasized the encomiastic theme, pointing out that everything depicted in the rooms devoted to the gods had its counterpart in the rooms below, in the deeds of the Medici. These links were not represented visually, however, and may have been an interpretation after the event.

The choice of subject for the Quartiere di Leone X differed fundamentally from the historical themes represented in Italian family palazzi. Feats of arms were largely ruled out as a theme for the Medici, but, as Vasari had learnt in the Cancelleria, acts of patronage were also suitable for pictorial representation. In 1550, in the *Vite*, he had already stressed the special role of the Medici in the rebirth of the arts. It is not surprising, therefore, that scenes illustrating this idea appear in most of the rooms. Vasari's interpretation of the history of the Medici remained the model until the 17th century. From about 1562, work began on the decorations of the Quartiere del Duca Cosimo (largely destr.) and the Quartiere di Eleonora, the paintings for which were executed mainly by Stradanus.

The first phase of work in the Palazzo Vecchio culminated in the remodelling and decoration of the Salone del Cinquecento (see colour pl. 2, XXXVII3), the great hall built by Cronaca in 1495. In 1560 Vasari submitted a model for the project to Michelangelo, who suggested raising the ceiling. Work began in 1563 and was completed in 1571. The general theme of the decoration is the history

of Florence from its foundation in 70 BC. Scenes of the wars against Pisa and Siena occupy two side walls and the major part of the ceiling. The subject for the central ceiling panel, originally a personification of Florence in Glory, was changed to the *Apotheosis of Cosimo I* (see fig. 5); the Grand Duke thus appears as the culmination of the whole of Florentine history. Vasari executed the 42 panels of the ceiling with many collaborators, including Prospero Fontana, Giovan Battista Naldini, Stradanus and Jacopo Zucchi.

(ii) Other architectural commissions and ephemeral decorations. Vasari received his three largest architectural commissions in 1559–62: the Uffizi in Florence, buildings for the Order of the Cavalieri di S Stefano in Pisa, which involved the remodelling of the town centre, and the dome of the Madonna dell'Umiltà in Pistoia. The Uffizi, a building to house the offices of 13 administrative authorities then scattered about Florence, was an expression of the political unity that Cosimo I had imposed on his state. The plans for the project, documented from 1559, were possibly based on a sketch by Cosimo. Vasari designed two long wings, stretching from the Piazza della Signoria to the river, where they terminate in a linking wing (see fig. 6). Each authority was provided with a complex of rooms on the ground-floor, the mezzanine and the main floor, with direct access from the portico. The arrangement of the offices is reflected in the articulation of the façade, divided into units of three bays. On the ground-floor the entrance to each unit is marked by pairs of Doric columns, flanked by piers; on the main floor the central window of the unit is emphasized by a segmental pediment. The upper floor (loggia), which was not connected to the rooms below, was probably originally intended for the use of the Duke. It was given a new function in 1565, as part of the passage (Corridoio Vasariano) linking the Palazzo Vecchio to the Palazzo Pitti across the river. Construction of the Uffizi began in 1560, but it was still unfinished when Vasari died. The building was completed in the 1580s by Bernardo Buontalenti.

In 1561 Vasari was given the house he occupied in Borgo Santa Croce by Cosimo. His many projects for the Duke at this time left him little opportunity for other work and he had to decline an invitation to decorate the Sala Regia in the Vatican in the same year. In this year he also began planning the buildings in Pisa for the Order of the Cavalieri di S Stefano, founded by Cosimo, and the remodelling of the town centre. These projects, mainly concerned with rebuilding older palazzi, were intended to eradicate traces of the governmental seat of the Republic of Pisa. Work began in 1562 with the remodelling of the Palazzo dei Cavalieri, for which Vasari designed a *sgraffito* façade. He also designed the church of S Stefano (1565–9) and its interior decoration; later he painted its altarpiece. The Canonica and the Palazzo dell'Orologio, planned and begun by Vasari, were completed in the 17th century.

Vasari's third great architectural project, and technically the most difficult, was the dome of the Madonna dell'Umiltà in Pistoia (1563–8). One of the largest domes in 16th-century Italy, it is a double-shell construction with a complex system of internal ribs.

Other architectural commissions in this period included building the passage linking the Palazzo Vecchio, the

6. Giorgio Vasari: the Uffizi, Florence, 1560–1580s

Uffizi and the Palazzo Pitti and, not least, the radical remodelling of S Maria Novella and Santa Croce in Florence. In 1566 Vasari designed a magnificent ciborium for Santa Croce. Vasari's work for the Medici court also involved temporary decorations, notably for the wedding in 1565 of Francesco I de' Medici to Joanna of Austria (1547–78) and for the baptism of their daughter Eleonora de' Medici in 1568.

(iii) Other painted works. Owing to the quantity of projects, during these years, Vasari made increasing use of collaborators, even for works for himself, such as the family altar in the parish church of Arezzo. For the main panel of this altarpiece he used the *Calling of SS Peter and Andrew*, originally painted for Julius III in 1551 (Arezzo, Badia); the side panels were left to Stradanus and Poppi. From at least 1561 he was collecting material for the new edition of the *Vite*, the first volume of which was printed in 1564; the second and third volumes were delayed until 1568. He made two journeys in connection with his revisions. In May 1563 he went to Arezzo, Cortona, Assisi, Loreto, Ancona and Venice. On a second, longer trip, in April and May 1566, he visited numerous towns in central and northern Italy, including Parma, where he saw works by Correggio. In Cremona he stayed with the family of Sofonisba Anguissola, and in Venice he visited Titian.

In early 1567 Vasari was again in Rome, to deliver to Pius V the *Adoration of the Magi* he had ordered for Santa Croce in Bosco Marengo. The Pope then commissioned the *Last Judgement* for the high altar there (both *in situ*). The same year Vasari began frescoing the walls of the *salone* in the Palazzo Vecchio. He took on so many other commissions as well that in December 1568 Borghini felt called on to write to him: 'It has sometimes seemed to your friends that you take on too many jobs, which are then not done by your hand and cannot bring you the glory befitting you' (Frey, ii, p. 411). Works of these years also included the *Forge of Vulcan* (Florence, Uffizi) for Francesco de' Medici, the *Coronation of the Virgin* for the parish church of Arezzo (Arezzo, Badia), the *Assumption* (Florence, S Maria Assunta), the *Standard of St Roch* (Arezzo, Gal. & Mus. Med. & Mod.) and the *Last Supper* (Figline, Ospedale Serristori). He also produced a series of altarpieces for S Maria Novella and Santa Croce in Florence, remodelled by him in 1565, and, some time after 1569, he frescoed the *salone* of his house in Florence (see fig. 7). Here, as at his house in Arezzo, he depicted ancient legends about artists, but he was now emphasizing the role of *disegno*, which he had defined as the father of the three sister arts in the 1568 edition of his *Vite* (*see* §III, 1(ii) below), by representing him in the centre of the main fresco as a three-headed figure on the threshold between

7. Giorgio Vasari: *Apelles and the Shoemaker* (*c.* 1569), fresco, Casa Vasari, Florence

the realms of nature and of art. He was obliged to use assistants to help him in this work.

Vasari went to Rome in February 1570 to see three chapels in the Vatican that Pius V had commissioned him to decorate. On his return to Florence, he worked with Borghini on the plans for a small room, the *studiolo*, in the Palazzo Vecchio for Cosimo's son Francesco (*see* STUDIOLO, fig. 2). His painting for the *studiolo*, *Perseus Freeing Andromeda* (see fig. 8), reflects the cheerful sensuality of his earlier works. Other projects included the plans for decorating the dome of Florence Cathedral, for which again Borghini drew up the programme. Vasari returned to Rome in December to begin decorating the Vatican chapels. The frescoes in all three chapels (*in situ*) were largely executed by collaborators such as Zucchi and Alessandro Fei, while Vasari painted the altarpieces: a *Coronation of the Virgin* for the chapel of S Michele (main panel Livorno, S Caterina) and the *Martyrdom of St Stephen* (Rome, Pin. Vaticana) and the *Death of St Peter Martyr* (Vienna, Ksthist. Mus.) for the chapels dedicated to these saints.

In 1571, after completing the chapels, Vasari was awarded a knighthood by the Pope. He returned to Florence, where he completed the frescoes in the Salone del Cinquecento in the Palazzo Vecchio and prepared to decorate the cathedral dome. At the end of 1571 he painted the *Battle of Lepanto* in the Sala Regia (Vatican).

8. Giorgio Vasari: *Perseus Freeing Andromeda* (1570), oil on slate, 1.17×1.00 m, *studiolo* of Francesco I, Palazzo Vecchio, Florence

Returning briefly to Florence in May, he began the frescoes in the cathedral dome and designed the Loggia in Arezzo. By November he was continuing his work in the Sala Regia, where he painted a second scene of the *Battle of Lepanto*, the *Massacre of the Huguenots*, the *Return of Gregory XI* and *Gregory IX Excommunicating Frederick II*, assisted by Lorenzo Sabatini, Giacomo Coppi and Denys Calvaert (*c.* 1540–1619). He also designed frescoes (some destr.) for the staircases of the Vatican Palace, executed by Donato da Formello. Another project in the Vatican, however, Vasari's design for the ceiling of the Cappella Paolina, was rejected by Gregory XIII. Back in Florence in 1573, Vasari continued the decoration of the cathedral dome, which was incomplete at his death. He was buried in the family chapel in Arezzo parish church.

II. Working methods and technique.

Vasari could manage his immense workload only with the aid of assistants; the large number of painters who worked for him contributed significantly to the dissemination of his style. For most of his paintings and frescoes he provided drawings (which he regarded as the real creative process); the contribution of the workshop was limited mainly to the execution, with little scope for initiative. This working method emphasized the importance of drawing, or design (*disegno*). In the introduction to the *Vite*, he described at length the stages of the design process, and there are examples of each stage in his work: sketches capturing an initial idea; carefully executed drawings (see fig. 9) and full-scale cartoons, which only needed

9. Giorgio Vasari: *Prudence*, pen and brown ink and brown wash, heightened in white, on blue paper, 345×260 mm, *c.* 1544–5 (Paris, Institut Néerlandais)

to be traced on to the work surface. He appears to have kept the drawings and cartoons in his workshop for repeated use. There are numerous examples in his oeuvre of the repetition of single figures and of compositions. The drawing of a *Standing Man* (Florence, Uffizi) was used in Camaldoli and in the Cancelleria; the composition of his drawing of *St Michael* (1541; Munich, Alte Pin.) was repeated exactly, nearly 30 years later, on the ceiling of the chapel of S Michele in the Vatican; the allegories created for the refectory of Monteoliveto reappear in the Cancelleria and the Palazzo Vecchio. This economical reuse of drawings was another factor that contributed to Vasari's ability to complete large commissions quickly.

III. Writings.

1. The *Vite*. 2. Other writings.

1. THE 'VITE'.

(i) First edition. (ii) Second edition. (iii) Critical reception.

(i) First edition.

(a) Introduction. (b) Classification. (c) *Disegno* and other central themes. (d) Technique. (e) Sources.

(a) Introduction. Vasari's *Vite* (*Le vite de più eccellenti architetti, pittori, et scultori* ...) was published, amid widespread interest, in 1550, by the Florentine printer Lorenzo Torrentino (*d* 1563). The work, two volumes with more than a thousand pages, was dedicated to Cosimo I de' Medici. It contains a general preface (*proemio*), an introduction to architecture, sculpture and painting, and three parts consisting of artists' biographies, each with its own *proemio*. The first part comprises 28 lives (from Cimabue to Lorenzo di Bicci), the second 54 (from Jacopo della Quercia to Pietro Perugino), the third 51 (from Leonardo da Vinci to Michelangelo, the only living artist included). As Vasari also discussed pupils and assistants in many of the lives, however, the number of artists mentioned is considerably higher. The work ends with remarks addressed to 'artists and readers', and there are several indices, which give access to the contents in unusual detail.

Vasari's fame rests principally on this book, of which the second, enlarged edition, published in 1568, was the basis of all subsequent editions and translations. For this work Vasari is considered the father of art history. The *Vite* is more than just a chronological sequence of biographies (as had already existed), it is the first critical history of artistic style. History for Vasari was more than the mere compiling of annals or chronicles: just as general historians aimed to teach men wisdom in conducting their lives, he wished 'to be of service to art'; he wanted not merely to 'say what has been produced and achieved, but to distinguish the better from the good, the excellent from the highly competent, and to describe with some care the ways in which artists and sculptors conceive, depict and treat their subjects, as well as their inventions and fancies'.

Vasari's view of the past was not impartial. It is the view of an artist who has learnt that perfection in art cannot be taken for granted: once achieved it can be lost

again. He described the process of the rebirth of art, the *rinascita*, to make clear to his readers the value of artistic heritage. Many of his statements need to be understood in the light of this concern for the survival of art. He thought that, although art is the responsibility of the artist, it is nevertheless not his burden alone. He knew from experience how capricious patrons could be and was too conscious of their influence on the practical conditions of artists' lives to omit them from his book. The *Vite* was addressed to anyone interested in art and its history, as collector, patron or artist. This viewpoint, far removed from that of today, should be borne in mind when considering Vasari's achievement, which consisted in compiling, classifying and evaluating a copious amount of material.

Vasari's influential division of the history of art into epochs was based on a biological concept of history familiar since antiquity: the comparison between the ages of a human being and the development of a state. Vasari used it to present his history of the rebirth of the arts since Cimabue in three periods. These are defined in the introductions to the three biographical parts of the *Vite*: art had risen slowly to the height of perfection in antiquity and then declined gradually from the time of Constantine on, through the invasions of the barbarians, the Goths, and then was destroyed completely. The Goths determined the subsequent forms taken by art, in particular architecture, which Vasari therefore called 'German' or 'Gothic'. He and his contemporaries saw little of merit in the Gothic style. For him, it was only with Cimabue, Giotto and other artists of the 14th century that there was a rebirth of art, an art 'wholly and principally an imitation of nature'. This first phase, *primi lumi*, was followed by the period of growth and improvement (*augumento*) and was finally succeeded by the third epoch, which extended to Vasari's own time, the time of perfection (*perfezione*), attained with Michelangelo. The idea of the perfecting of art through its increased resemblance to nature was not an invention of Vasari's; it too was found in antiquity, for example in a passage of Cicero's *Brutus* that Vasari used almost verbatim (without acknowledgement).

(b) Classification. Vasari applied this model to the art of his own age and also used it as a means of classifying the art of the past. In his view and that of his contemporaries, the art of Raphael and Michelangelo had equalled and even surpassed that of antiquity. Thus artists of earlier times could be judged and classified in terms of their closeness to this ideal, to the *perfetta regola*. Vasari was aware that this classification did not automatically coincide with an order based on date; for example, he observed that Donatello, although of the second period chronologically, could be regarded as belonging to the third on the basis of his achievements.

In addition to the absolute criterion, the *perfetta regola dell'arte*, Vasari posited as a second, relative standard the peculiarity of time, *la qualità de' tempi*. In this way, earlier art, which could only be described as imperfect if judged by the criteria of the present, could nevertheless be praised. He justified this procedure in the second part of the *Vite*, where he wrote of the works of Andrea Pisano and others: 'anyone who pays regard to the abilities of that time ...

will consider them not only beautiful ... but admirable and will feel an infinite satisfaction at the sight of these first beginnings, these sparks of the good that began to glow in works of painting and sculpture.' Here too he pointed to his general principle of historiography, that one should take account of time, place, circumstances and persons in judging historical facts.

Vasari's commitment to judging art from a relative historical standpoint is shown by his return to this point in his concluding remarks to artists in the edition of 1568:

> I may seem to have been over generous in praising some older or more recent masters I can only reply that I believe I have not praised such artists unconditionally, but always conditionally, with due regard to place, time and other such considerations. In truth, although Giotto was undoubtedly very praiseworthy in his own day, I do not know what people would have said about him and other old masters had they lived at the time of Michelangelo. What is also worth noting is that the artists of our century, who have attained the highest degree of perfection, would not be in the position they hold today had not those who came before us been what they were.

After its clumsy beginnings, which Vasari excused because of the lack of knowledge and good examples, art was perfected in the second phase according to his classification, corresponding roughly to the 15th century. In this epoch 'all things are done better, with more invention and design, with a more beautiful style and greater industry.' Vasari used the three concepts of style (*maniera*), invention (*invenzione*) and design (*disegno*) to describe the progress of art of this time. He also borrowed the concepts of rule, order and measure (*regola, ordine, misura*) from the theory of architecture and applied them to the other arts. In the third epoch, according to Vasari, art attained perfection; until then it had been dry and pedantic, lacking lightness, grace and an indefinable quality that could not be gained by study. The impetus to surpass the second stylistic stage came, he wrote, from the contemporary discovery of antique statues. He maintained, however, that the achievements of 15th-century art, which he saw as founded entirely on study, deliberation and calculation, were still valid. He attempted to express this in a famous statement: 'What rule lacks is a certain freedom (*licenzia*), which, without itself being a rule, is governed by rule and can exist without creating confusion or disrupting order.' This abstract definition becomes more comprehensible if it is read with a passage from his life of Michelangelo, who had made in the new sacristy of S Lorenzo 'fine cornices, capitals, pedestals, doors, tabernacles' that were 'entirely different from that which people had earlier respected as measure, order and rule, according to general custom.' Michelangelo had thereby broken the chains that had caused 'everyone to continue always along the habitual road'. Freedom, however, was not arbitrary; it was restricted by the judgement of the eye (*giudizio dell'occhio*); the eye thus assumed the function of the rule, becoming the ultimate authority.

In the biographies of individual artists the theme of artistic development gives way to an emphasis on the individuality of the artist, his personal style, his works and his character. The same interest in the individual was given

10. Giorgio Vasari: *Self-portrait*, woodcut, 200×135 mm; from the *Vite* (2/1568)

visual expression by the portraits at the beginning of each *vita*, already planned for the 1550 edition but realized only in 1568 (see fig. 10).

(c) Disegno *and other central themes.* The developmental model and the individual biographies are, however, only a framework for Vasari's discussion of the artists' works. To understand these properly, the reader needed to know how they were made and to be aware of the possibilities and aims of the various artistic genres. To improve the reader's awareness of these, in his first preface Vasari discussed a theme popular in his day: the comparison (*paragone*) of sculpture with painting (*see* PARAGONE). He was not concerned with proving that one was superior to the other (although his sympathy clearly lay with painting), rather, he had other objectives. First, he wanted to introduce *disegno* (*see* DISEGNO E COLORE), the fundamental concept of the whole of the *Vite*, the common 'father' of all the arts, which he defined fully in the second edition of 1568 (*see* §(ii) below). With the concept of *disegno* Vasari not only set aside the rivalry between the three visual arts, but found for the first time a viable basis for uniting them and allowing them to be discussed on equal terms. Equally important for Vasari, however, were the arguments brought forward in this debate, through which he was able to present a series of points that could be used not to demonstrate the superiority of this or that art, but to assert the importance of visual art as a whole, and so justify the subject of his book.

Another theme that runs through the whole work is the relationship between artist and patron. Vasari contrasted, for example, the covetousness of contemporary patrons with the generous attitudes of patrons in antiquity. As an artist, he was all too aware of the essential role of patrons, and he repeatedly emphasized their influence in fostering or obstructing artists and therefore art:

> in our age greater and much better works would be achieved than in antiquity, if the endeavours of artists were granted their just reward. But the fact that the masters of art have to struggle more to escape hunger than to achieve fame, this fact oppresses their spirits and deprives them (shame and disgrace on those who could help but do not care!) of the opportunity to make themselves known.

Vasari contrasted these complaints with the role he ascribed to the Medici in the development of the *rinascita*. Indeed, one of the themes underlying the whole of the *Vite*, from the life of Giotto to that of Michelangelo, is the support given to art by the members of this family.

(d) Technique. Vasari also considered that knowledge of the technical or craft aspects of the three arts was essential for judging works. Without this, it was not possible to appreciate an artist's achievement properly. In the *Vite* the introductions to the three arts, known as the *teoriche*, are devoted to setting out this technical knowledge. The work is not a technical manual like that of Cennino Cennini. For example, at the beginning of the section on architecture Vasari explained that technical details had been omitted, since Vitruvius and Leon Battista Alberti had already written on them at length; he proposed instead to discuss how beautiful buildings should be constituted. He then sketched briefly the range of artistic skills perfected in his day, from architecture to painting, from bronze-casting to mosaic, from the techniques of vaulting to stained-glass windows. The reader should have knowledge of the difficulties and terminology of these techniques in order to understand, while reading the ensuing historical survey, how the perfection of artistic skill had been achieved. By placing this summary of artistic activities before the historical account, Vasari showed from the very beginning the goal towards which the artists' efforts were leading. This goal was the artistic practice of his own time. Thus it is clear that Vasari by no means intended, as is sometimes suggested, to present the epoch of art history he was describing as already complete. Also apparent here is his concern not to become tedious or pedantic, but to offer something of value to both layman and artist. In the discussion of the five architectural orders, for example, Vasari defined them only briefly before going on to characterize in detail Gothic architecture as an aberration.

Simultaneously in the introductions Vasari developed a number of aesthetic categories, thus establishing the criteria by which well-made art was to be recognized and judged. Each of the three *teoriche* contains a section in which the components of good architecture, sculpture or painting are discussed. He was not providing a complete system of aesthetics or art theory; his account was based on the statements of Leon Battista Alberti and other earlier theoreticians. However, by combining sections devoted to the judgement of the eye with others describing the

technical aspects of art, Vasari offered a new perspective to the reader, especially to one who was not an artist. Like the production of art, the judging of art follows rules that can be learnt. These rules not only help in the recognition of good or perfect contemporary art but also help to assess the degree to which earlier art approached perfection and so to classify it. Vasari also implied that an account of earlier art was not a task merely for the chronicler, but one requiring the application of aesthetic, specifically art-historical, criteria. He implied the same when he remarked that he did not simply follow his written sources but was always careful to check their observations against the evidence of his own eyes.

(e) Sources. Little is known of Vasari's sources for the first edition. In the text he mentioned Vitruvius and Cesare di Lorenzo Cesariano, the architectural treatises of Alberti and Sebastiano Serlio, Lorenzo Ghiberti's *Commentari* and unspecified writings by Raphael and Domenico Ghirlandaio. Other works available to him included Antonio Manetti's life of Filippo Brunelleschi, Francesco Albertini's guide to Florence (*Memoriale di molte statue e pitture . . . di Florentia*; Florence, 1510), Pietro Aretino's letters, Antonio Billi's *Libro* and a lost source that was also used by Anonimo Magliabechiano and by Giovanni Battista Gelli.

(ii) Second edition. The references to sources in the second edition of the *Vite* are more plentiful than in the first and are supplemented by the author's correspondence. He made extensive use of the histories of Paulus Diaconus (*b c.* AD 720–24; *d* 799), the chronicle by Giovanni Villani (*d* 1348) and Matteo Villani (*d* 1363), as well as other local chronicles, Antonio Filarete's architectural treatise and much more. In Michelangelo's *vita* he incorporated excerpts from Ascanio Condivi's life of the artist of 1553 without acknowledgement. He drew extensively on inscriptions and obtained further details from his friends and correspondents, such as Fra Marco de' Medici in Verona, G. B. Grassi, Danese Cattaneo, Cosimo Bartoli (1503–72) and, above all, Raffaele Borghini (*c.* 1537–88), but little has survived in written form.

This second edition, published by Giunti in three volumes in 1568, was much larger than the first: about 1500 pages, two thirds devoted to the third epoch alone, with about 30 new biographies. Some of the new chapters hardly deserve the title of biography since they are mainly accounts of the history of particular artistic genres. For example, there is a history of gem-cutting in the life of Valerio Belli, and the life of Marcantonio Raimondi has a short history of prints and engravings. Such passages permitted Vasari to give information about a number of artists to whom he did not devote biographies of their own. The discussion of artists in terms of a common technique in the 1568 edition was not completely new but developed out of an idea already present in the first edition, which gave a summary of the history of oil painting in the *teoriche*. The fact that in the second edition these digressions are not in the technical introductions—the logical place for them—but appear later was due to the process of revision. For the first edition Vasari had delivered a largely complete manuscript to the printer, but the first

parts of the second edition were already being published (1564) while other sections were still being revised.

The broadening of Vasari's range of interests is undoubtedly connected to his position at the Medici court, where he was responsible for all kinds of artistic activities. This probably prompted the long descriptions of temporary decorations in the second edition. A detailed description of the wedding festivities of 1565–6, written by Giovan Battista Cini (1528–86), was printed at the end of the new chapter on the members of the Accademia del Disegno. Such events, and the decoration of the Palazzo Vecchio, required the most diverse artistic skills; this may account for the references in the second edition to many artistic genres hardly mentioned in 1550.

Where links through common techniques were not possible, Vasari grouped artists according to national, regional or local affiliations. There are sections on Italian and Netherlandish artists and on those from Friuli, North Italy, Verona etc. These classifications signalled a change in structure from the first edition of the *Vite*, although the title was retained. This change was required to incorporate the enormously increased volume of information. Vasari had been considering organizing the work into these 'collective' lives from as early as 1550. Also new were the references to private collections, especially to the drawings in Vasari's own *Libro de' disegni* (*see* §IV below). He was aware that such collections illustrated his conception of art history as a history of style. Underlying this is the increased importance of the concept of *disegno* in the second edition. He defined it, at the start of the essay on painting, as follows:

> Seeing that Design, the parent of our three arts, Architecture, Sculpture, and Painting, having its origin in the intellect, draws out from many single things a general judgement, it is like a form or idea of all the objects in nature, most marvellous in what it compasses, for not only in the bodies of men and of animals but also in plants, in buildings, in sculpture and in painting, design is cognizant of the proportion of the whole to the parts and of the parts to each other and to the whole. Seeing too that from this knowledge there arises a certain conception and judgement, so that there is formed in the mind that something which afterwards, when expressed by the hands, is called design, we may conclude that design is not other than a visible expression and declaration of our inner conception and of that which others have imagined and given form to in their idea. . . . What design needs, when it has derived from the judgement the mental image of anything, is that the hand, through the study and practice of many years, may be free and apt to draw and to express correctly, with the pen, the silver-point, the charcoal, the chalk, or other instrument, whatever nature has created. For when the intellect puts forth refined and judicious conceptions, the hand which has practised design for many years, exhibits the perfection and excellence of the arts as well as the knowledge of the artist. (trans. Maclehose)

The second edition contains a wealth of new data, and errors from the first edition were corrected, although new ones were added (Kallab). The moving spirit behind the revisions and the collection of new material was Borghini. While the first edition owed much to Paolo Giovio's rhetorical model of historiography, the second edition bears the stamp of Borghini's factual approach. Borghini

wanted Vasari to write a general history of Italian painting and sculpture. According to Borghini, Vasari's efforts should not concentrate on biographical details of the artists, but on the discussion of their works, including detailed information on their location and subject. Vasari's journey of 1566 may have been in response to Borghini's request. Vasari also supplied details on medieval architecture; moreover, the famous definition of *disegno* of 1568 was probably also developed in discussion with Borghini, if not actually edited by him. Borghini's influence should not be overestimated, however, as the essential ideas and opinions in the second edition remain Vasari's own. Many of the changes follow directions already indicated in the first edition, but the framework of the first edition is still visible in the second. It is significant that Vasari made virtually no changes to the introductions.

The inclusion of living artists is often cited as the most important new feature in the second edition, but such an extension was already contemplated in the first edition. It is not so much the inclusion of living artists that significantly distinguishes the second edition from the first, but the problem of concluding the historical narrative. The first edition ended with Michelangelo as the living embodiment of perfection in art; art history had reached its climax but not its end. With the master's death in 1564, Vasari had to formulate a future for art or concede that art history had indeed come to an end. The author was almost forced to look round for alternatives. The solution was to distinguish between the means of art—*disegno*, perfected by Michelangelo—and the constant goals of art (Alpers). This is illustrated by a passage inserted in the *vita* of Raphael in 1568. Vasari argued that Raphael realized he could not equal Michelangelo in the depiction of the naked body, i.e. in *disegno*, but that progress in painting was nevertheless possible in *invenzione*, the narrative element in art. Thus Raphael had given up imitating Michelangelo in *disegno* and striven to excel him in other areas, a practice Vasari endorsed: 'artists who devoted themselves solely to studying Michelangelo . . . created a harsh, difficult manner without charm or colour and with little invention, whereas, had they striven to develop and perfect the other parts of their art, they would have done themselves and the world a service.'

This more critical view can be found in Michelangelo's *vita* of the second edition; in it Vasari argued that while the master wanted to paint only the human body, artists who chose the other way, based on the charm of colours or new *invenzioni*, were also among the masters of the first rank. This new attitude to Michelangelo and the emphasis on tendencies embodied by Raphael and Titian clearly reveals the influence of Pietro Aretino and Lodovico Dolce (Roskill). In a separate, revised edition of the life of Jacopo Sansovino, published in 1570, Vasari conceded that Sansovino had surpassed Michelangelo in some respects (Davis, 1981 exh. cat., p. 295).

Vasari departed from his original concept of the *Vite* only in some parts of the second edition; elsewhere he intensified his criticism of the Venetians' lack of mastery of *disegno*. He also acceded only partially to Borghini's desire that he write a general history of art. His Tuscan bias is clearly discernible, and this became a target for critics of the next generation. Despite the defects and

errors of detail for which Vasari can be criticized, his achievement as an art historian cannot be overestimated. The *Vite* remains a fundamental work of art history, the essential source for the study of the Italian Renaissance.

(iii) Critical reception. Vasari's enduring reputation is based far more on the *Vite* than on his own artistic works. In the 16th century its worth was recognized by writers such as Raffaele Borghini and Giovanni Battista Armenini (*c.* 1525–1609), but it also became a focus for criticism. Gian Paolo Lomazzo, for example, felt called on to defend Vasari against the accusation of partisanship, a charge repeated in 1573 by Johann Fischart (*c.* 1545–1589/90), who took exception to Vasari's disparaging account of German art (evidence of how quickly and widely the *Vite* were disseminated). Criticism of the *Vite*, mainly by the Venetians and Bolognese, reached a peak in the 17th century, in the works of Conte Carlo Malvasia (1616–93) and Giulio Cesare Gigli.

The interest with which Vasari's work was read and the controversy that it engendered are demonstrated by the marginal notes in copies of the *Vite* by such artists as Federico Zuccaro, Annibale Carracci (1560–1609), Francisco de Holanda (1517–84) and El Greco (*c.* 1541–1614), or by connoisseurs such as Sebastiano Resta (1635–1714). The strongest evidence of its impact, however, is provided by the many editions published and the numerous histories of art modelled on it in the following century, including the *Schilder-boeck* ([1603]–1604) of Karel van Mander I (1548–1606), the *Arte de la pintura* (1649) of Francisco Pacheco (1564–1644) and the *Teutsche Academie* (1675) of Joachim von Sandrart (1606–88). Few of these matched Vasari for originality or critical intelligence.

2. OTHER WRITINGS. Vasari's other writings are less significant, although they do contain important information about his own art. His letter to Varchi concerning the *paragone* has been mentioned. The *Ragionamenti*, his explanation of the paintings in the Palazzo Vecchio, was published posthumously by his nephew (2) Giorgio Vasari *il giovane*, in 1588, from a non-autograph manuscript (Florence, Uffizi). This text was known in Vasari's lifetime, however, and is mentioned several times in the *Vite*. It is the first of a series of similar descriptions of complex palazzo decorations published by artists or their advisers in the last quarter of the 16th century. Vasari may have been influenced by the tradition of published descriptions of festivities—he himself published a description of this kind, concerning the baptism of Eleonora de' Medici in 1568 (*see* §I, 3(ii) above)—or he may have been continuing his old habit of explaining his paintings on profane subjects in detailed letters to his patrons.

Vasari's letters, some of which are of considerable literary quality, were part of an extensive body of writings that has survived only in part (Arezzo, Mus. Casa Vasari; New Haven, CT, Yale U. Lib.). These writings, which include his *Ricordanze* as well as the *Zibaldone* (a collection of notes mainly about his paintings but also the *Vite*), offer a wealth of information, not yet fully explored, on Vasari's own works and the artistic life of his time.

IV. Collection.

Vasari collected, to some extent systematically, examples of the art both of his predecessors and of his contempo-

raries. This collection was confined largely to drawings, which he assembled and mounted in his famous *Libro de' disegni* (of which there were probably at least seven volumes). Since the *disegno* represented for Vasari the true intellectual achievement of the artist, first formed in the mind and then transferred to the paper, it was only natural for him to acquire examples of this direct expression of artistic achievement. He began the collection during his apprenticeship (1528–9) with Vittorio Ghiberti (ii), who gave him a group of drawings by Lorenzo Ghiberti and artists of the 14th century, probably from Lorenzo's collection. The value Vasari placed on his drawings is shown by the care with which he mounted them in the *Libro* (*see* fig. 11), with woodcut portraits from the *Vite* and fanciful marginal drawings. The collection began to be dispersed soon after Vasari's death: one volume was given to Francesco I de' Medici, others later came into the possession of Niccolò Gaddi. In the 17th century the volumes began to be broken up. Today most of the pages are in the Louvre, Paris, and the Uffizi, Florence, while others are in Oxford, Stockholm and other collections. In cases where Vasari's marginal drawings have been removed from the pages (as in the Uffizi), their provenance from his collection is hardly provable.

The rest of Vasari's collecting was more haphazard. Apart from a plaster statue of *Venus* by Bartolomeo Ammanati (Arezzo, Mus. Casa Vasari), his most important pieces were: a terracotta head of the emperor *Galba*

11. Page from Vasari's *Libro de' disegni*, with an *Allegorical Scene* (pen and grey-brown ink, 198 x 187 mm), formerly attributed to Vittore Carpaccio, mounted below a portrait of the artist; the mount itself is drawn in pen and brown ink and brown wash, over black chalk, and is inscribed *Anno 1495*, 571 x 442 mm, assembled after 1568 (London, British Museum)

(Arezzo, Mus. Casa Vasari) by Andrea Sansovino; Rosso Fiorentino's *modello*, owned by Pollastra, for the ceiling decoration proposed for SS Annunziata in Arezzo (untraced); a painting of the *Virgin and Child* by Parmigianino, bought in Bologna in 1540 (untraced); the head and an arm of Michelangelo's large model for the statue of *St Cosmas* in the New Sacristy (Florence, S Lorenzo); and Niccolò Tribolo's terracotta copy (London, V&A) of Michelangelo's *Night*, also from the New Sacristy.

V. Character and personality.

Passages in Vasari's letters and in the *Vite* reveal much of his character. In the earliest surviving letter, written on his visit to Rome in 1532, he expressed his desire to be one of those who receive pensions and other rewards for their art. He devoted much of his energy to this end, with considerable success. Giovio described him, in 1543, as a capable, efficient painter able to take quick decisions, qualities that must have commended him to impatient patrons such as Alessandro Farnese (and later to the Medici). Vasari's negotiations with Francesco Bacci, the father of his future wife, are particularly illuminating about his ambitions. Clearly reluctant to be tied to provincial Arezzo by his wife or her parents, Vasari instructed his intermediary, Borghini, to make clear to the Bacci family that it was essential for his professional life for him to work away from home. This craving for fame and money was criticized by contemporaries, including Ottaviano de' Medici and Borghini.

Vasari's pride in his success and in the social status his work had brought him is clear from an episode he related in the *Vite*. When the painter Jacone (*d* 1553) asked him in a provocative manner how he was, Vasari replied:

> I am well, my dear Jacone. I used to be poor like all of you, and now I have three thousand scudi and more. You used to think me foolish, but now the monks and priests consider me an excellent man. I used to serve you and now this servant serves me and leads my horse. I used to wear the clothes poor artists wear, and now I am dressed in velvet. I used to go on foot and now I ride on horseback. So, my dear Jacone, I really am well, may God preserve you.

Not surprisingly his ambition aroused the envy of some artists (e.g. Benvenuto Cellini); but he was on friendly terms with a greater number, notably Michelangelo, Gherardi, Salviati and Fontana. The fact that on several occasions he produced drawings for Fontana's paintings suggests that for all his ambition he was also capable of selfless friendship.

WRITINGS

Le vite de più eccellenti architetti, pittori, et scultori italiani, da Cimabue insino a' tempi nostri: Descritte in lingua Toscana, da Giorgio Vasari pittore aretino. Con una sua utile & necessaria introduzzione a le arti loro (Florence, 1550)

Descrizione dell'apparato fatto nel Tempio di S. Giovanni di Fiorenza per lo battesimo della Signora prima figliuola dell'Illustrissimo, et Eccellentissimo S. Principe di Fiorenza, et Siena Don Francesco Medici [. . .] (Florence, 1568)

Le vite de' più eccellenti pittori, scultori, e architettori [. . .] (Florence, 1568)

Ritratti de' più eccellenti pittori, scultori et architettori contenuti nelle vite di M. Giorgio Vasari [. . .] (Florence, 1568) [very rare edition of portraits from the *Vite*; see C. Davis in 1981 exh. cat., pp. 257–9]

Vita del Gran Michelangelo Buonarroti [. . .] (Florence, 1568) [rare edition of the *Vita* of Michelangelo; see U. Procacci in 1981 exh. cat., pp. 284ff]

Vita di M. Iacopo Sansovino scultore & architetto eccellentissimo della Serenissima Repubblica di Venetia (?Venice, 1570) [see C. Davis in 1981 exh. cat., pp. 293–5]

Ragionamenti [. . .] sopra le inventioni [. . .] dipinte in Firenze nel Palazzo di loro Altezze Serenissime [. . .] (Florence, 1588)

K. Frey and H. W. Frey, eds: *Der literarische Nachlass Giorgio Vasaris*, 3 vols (Munich, 1923–40/*R* Hildesheim, 1982)

A. del Vita, ed.: *Lo Zibaldone di Giorgio Vasari* (Rome, 1937)

modern editions of the 'vite'

G. Vasari: *Opere*; ed. G. Milanesi, 9 vols (Florence, 1878–85, 2/1906/*R* 1981) [incl. *Vite* of 1568, *Ragionamenti* and letters; superseded by later edns, but often cited; useful notes]

——: *La vita di Michelangelo nelle redazioni del 1550 e del 1568*; ed. P. Barocchi, 5 vols (Milan and Naples, 1962–7) [definitive edn; comprehensive commentary]

——: *Le Vite [. . .]*; ed. P. della Pergola, L. Grassi and G. Previtali, 9 vols (Milan 1962–6) [reliable edn of *Vite* of 1568]

——: *Le vite de' più eccellenti pittori, scultori e architettori nelle redazioni del 1550 e 1568*; ed. R. Bettarini and P. Barocchi, 6 vols [text] (Florence, 1966–87) [crit. edn, only one containing complete texts of both edns, including original indices; *Commento secolare* assembles notes from most older edns]

——: *Le vite de' più eccellenti architetti, pittori, et scultori italiani da Cimabue insino a' tempi nostri nell'edizione per i tipi di Lorenzo Torrentino Firenze 1550*; ed. L. Bellosi and A. Rossi (Turin, 1986) [reliable edn of *Vite* of 1550]

translations

L. Schorn and E. Förster, trans.: *Leben der ausgezeichnetsten Maler, Bildhauer und Baumeister von Cimabue bis zum Jahre 1567*, 6 vols in 8 parts (Stuttgart and Tübingen, 1832–49/*R* Worms, 1983)

L. Maclehose, trans.: *Vasari on Technique*, ed. G. B. Brown (London, 1907/*R* New York, 1960)

G. du C. de Vere, trans.: *Lives of the Most Eminent Painters, Sculptors and Architects*, 10 vols (London, 1912–15/*R* London, 1996)

A. Chastel, ed. and trans.: *Les Vies des meilleurs peintres, sculpteurs et architectes*, 12 vols (Paris, 1981–9) [detailed notes include latest res.; xii, *Vasari illustré*, illustrates 205 works mentioned in the *Vite* and many drgs from Vasari's *Libro*]

BIBLIOGRAPHY

EARLY SOURCES

G. Gaye, ed.: *Carteggio inedito d'artisti dei secoli XIV, XV, XVI*, ii (Florence, 1840), pp. 502–18 [Vasari's will]

G. degli Azzi and A. del Vita: 'Documenti vasariani', *Il Vasari*, iv (1931), pp. 216–31

N. V. Palli D'Addario: 'Documenti vasariani nell'Archivio Guidi', *Convegno: 1981*, pp. 363–89

R. Williams: 'Notes by Vincenzo Borghini on Works of Art in San Gimignano and Volterra: A Source for Vasari's *Lives*', *Burl. Mag.*, cxxvii (1985), pp. 17–21

R. G. Babcock and D. J. Ducharne: 'A Preliminary Inventory of the Vasari Papers in the Beinecke Library', *A. Bull.*, lxxi (1989), pp. 300–04

P. J. Jacks: 'The Composition of Giorgio Vasari's *Ricordanze*: Evidence from an Unknown Draft', *Ren. Q.*, xlv (1992), pp. 739–84

MONOGRAPHS

[No single work encompasses the full range of Vasari's activity]

Studi vasariani. Atti del convegno internazionale per il IV centenario della prima edizione delle 'Vite' del Vasari: Firenze, 1950 [cited as *Atti: 1950*]

Il Vasari storiografo e artista. Atti del congresso internazionale nel IV centenario della morte, Arezzo: Firenze, 1974 [cited as *Atti: 1974*]

T. S. R. Boase: *Giorgio Vasari: The Man and the Book* (Princeton, 1979); review by M. Baxandall in *TLS* (Feb 1980), p. 111

Giorgio Vasari: Principi, letterati e artisti nelle carte di Giorgio Vasari. Pittura vasariana dal 1532 al 1554 (exh. cat., Arezzo, Casa Giorgio Vasari; Arezzo, S Francesco; 1981) [cited as 1981 exh. cat.; detailed bibliog.; separate appendices; *Indici, con aggiunte e revisioni*, ed. C. Davis and M. D. Davis (Florence, 1982)]

Giorgio Vasari tra decorazione ambientale e storiografia artistica. Convegno di studi: Arezzo, 1981 [cited as *Convegno: 1981*]

P. Barocchi: *Studi vasariani* (Milan, 1984)

U. Baldini: *Giorgio Vasari, pittore* (Florence, 1994)

R. Le Mollé: *Giorgio Vasari: L'homme des Médicis* (Paris, 1995)

P. L. Rubin: *Giorgio Vasari: Art and History* (New Haven and London, 1995)

P. Jacks: *Vasari's Florence: Artists and Literati at the Medicean Court* (Cambridge, 1998)

ILLUSTRATIONS

A. Paolucci and A. M. Maetzke: *La casa del Vasari in Arezzo* (Florence, 1988)

L. Corti: *Vasari: Catalogo completo dei dipinti* (Florence, 1989) [not complete cat. rais.; not all works illus.]

U. Muccini: *Il Salone del Cinquecento in Palazzo Vecchio* (Florence, 1990)

U. Muccini and A. Cecchi: *Le Stanze del Principe in Palazzo Vecchio* (Florence, 1991)

PAINTINGS

P. Barocchi: *Vasari pittore* (Milan, 1964) [suppl.: 'Complementi al Vasari pittore', *Atti & Mem. Accad. Tosc. Sci. & Lett., 'La Colombaria'*, xiv (1963–4), pp. 251–309]

E. A. Carroll: 'Lappoli, Alfani, Vasari and Rosso Fiorentino', *A. Bull.*, xlix (1967), pp. 297–304

N. Rubinstein: 'Vasari's Painting of *The Foundation of Florence* in the Palazzo Vecchio', *Essays in the History of Architecture Presented to Rudolf Wittkower* (London, 1967), pp. 64–73

E. Pillsbury: 'Three Unpublished Paintings by Giorgio Vasari', *Burl. Mag.*, cxii (1970), pp. 94–101

M. Guillaume: 'Vasari au Musée de Dijon', *Mém. Acad. Sci., A. & B.-Lett. Dijon*, cxxxi (1970–72), pp. 277–84

P. Fehl: 'Vasari's *Extirpation of the Huguenots*', *Gaz. B.-A.*, lxxxiv (1974), pp. 157–284

H. Röttgen: 'Zeitgeschichtliche Bildprogramme der katholischen Restauration unter Gregor XIII., 1572–1589', *Münchn. Jb. Bild. Kst*, xxvi (1975), pp. 85–122

U. Davitt Asmus: *Corpus Quasi Vas. Beiträge zur Ikonographie der italienischen Renaissance* (Berlin, 1977), pp. 41–113

C. Davis: 'The Pitfalls of Iconology, or How it Was that Saturn Gelt his Father', *Stud. Iconog.*, iv (1978), pp. 79–84

——: 'Per l'attività del Vasari nel 1553: Incisioni degli affreschi di Villa Altoviti e la Fontanalia di Villa Giulia', *Mitt. Ksthist. Inst. Florenz*, xxiii (1979), pp. 197–224

E. Allegri and A. Cecchi: *Palazzo Vecchio e i Medici* (Florence, 1980) [best general work on the Palazzo Vecchio, incl. drgs and docs]

C. Davis: 'Frescoes by Vasari for Sforza Almeni, "Coppiere" to Duke Cosimo I', *Mitt. Ksthist. Inst. Florenz*, xxiv (1980), pp. 127–202

——: 'New Frescoes by Vasari: *Colore* and *Invenzione* in Mid-16th-century Florentine Painting', *Pantheon*, xxxviii (1980), pp. 153–7

M. Campbell: 'Il ritratto del *Duca Alessandro de' Medici* di Giorgio Vasari: Contesto e significato', *Convegno: 1981*, pp. 339–61

P. L. De Castris: 'Napoli 1544: Vasari e Monteoliveto', *Boll. A.*, lxvi (1981), pp. 59–88

E. McGrath: '*Il senso nostro*: The Medici Allegory Applied to Vasari's Mythological Frescoes in the Palazzo Vecchio', *Convegno: 1981*, pp. 117–34

E. Parma Armani: 'Fonti per il *Convito per le nozze di Ester e Assuero* di Giorgio Vasari in Arezzo', *Stud. Stor. A., U. Genova, Ist. Stor. A.*, iii (1981), pp. 61–75

P. Tinagli Baxter: 'Rileggendo i *Ragionamenti*', *Convegno: 1981*, pp. 83–93

F. H. Jacobs: 'Vasari's Vision of the History of Painting: Frescoes in the Casa Vasari, Florence', *A. Bull.*, lxvi (1984), pp. 399–416

R. Roani Villani: 'Un'eco della rafaellesca *Incoronazione della Vergine* de Monteluce in un dipinto del Vasari nella Badia aretina', *Paragone*, xxxv/407 (1984), pp. 57–62

D. L. Clark: 'Vasari's *Temptation of St Jerome* Paintings: Artifacts of his Camaldoli Crisis', *Stud. Iconog.*, x (1984–6), pp. 97–118

L. D. Cheney: 'Vasari's *Chamber of Abraham*: A Religious Painted Ceiling in the Casa Vasari of Arezzo', *16th C. J.*, xviii (1987), pp. 355–80

——: 'Vasari's Depiction of Pliny's *Histories*', *Explor. Ren. Cult.*, xv (1989), pp. 97–120

V. Markova: 'Un *Baccanale* ritrovato di Giorgio Vasari, proveniente dalla Galleria Gerini', *Kunst des Cinquecento in der Toskana* (Munich, 1992), pp. 237–41

R. Starn and L. Partridge: *Arts of Power: Three Halls of State in Italy, 1300–1600* (Berkeley, 1992), pp. 203–12

C. Acidini Lucinat: 'Il giudizio universale, dal Battistero alla Cupola', *La cattedrale di Santa Maria del Fiore*, ii of *Alla riscoperta del Duomo di Firenze*, ed. T. Verdon (Florence, 1993), pp. 40–63

L. Cheney: 'Vasari and Naples: The Monteolivetan Order', *Parthenope's Splendor: Art of the Golden Age in Naples*, ed. J. C. Porter and S. S. Munshower (University Park, PA, 1993), pp. 48–124

J. Kliemann: *Gesta dipinte: La grande decorazione nelle dimore italiane dal quattrocento al seicento* (Cinisello Balsamo, 1993) [Cancelleria, pp. 37–51; Palazzo Vecchio, pp. 69–78]

U. Baldini: *Giorgio Vasari pittore* (Florence, 1994)

J. Kliemann: 'Programme ou interpretation? A propos des fresques de Vasari à la Cancelleria', *A travers l'image: Lecture iconographique et sens de l'oeuvre*, ed. S. Deswarte-Rosa (Paris, 1994), pp. 75–92

M. P. Cattolico: 'Un capolavoro "inedito": Il *Giudizio Universale* della cupola del duomo di Firenze", *Kermes*, viii/23 (May–Aug 1995), pp. 8–9

L. D. Cheney: 'Giorgio Vasari's Sala dei Cento Giorni: A Farnese Celebration', *Explorations Ren. Cult.*, xxi (1995), pp. 121–50

S. Gregory: 'Dürer's *Treatise on Fortifications* in Vasari's Workshop', *Prt Q.*, xii/3 (1995), pp. 275–9

L. Corti: 'La *Pietà* per Bindo Altoviti', *Quad. Semin. Stor. Crit. A. Pisa*, vi (1996), pp. 147–64

ARCHITECTURE, EPHEMERAL DECORATION AND APPLIED ARTS

G. Capovilla: 'Giorgio Vasari e gli edifici dell'Ordine Militare di S Stefano in Pisa (1562–1571) (con lettere inedite del Vasari)', *Stud. Stor.*, xvii (1908), pp. 305–79; xviii (1909), pp. 581–602; xix (1910), pp. 27–55, 147–226

P. Barocchi: 'Il Vasari architetto', *Atti Accad. Pontaniana*, vi (1958), pp. 113–36

V. Cazzato: 'Vasari e Carlo V: L'ingresso trionfale a Firenze del 1536', *Atti: 1974*, pp. 179–204

M. Fossi: 'Il Vasari e la basilica dell'Umiltà di Pistoia', *Atti: 1974*, 127–141

J. Lessmann: *Studien zu einer Baumonographie der Uffizien Giorgio Vasaris in Florenz* (diss., U. Bonn, 1975)

M. T. Bartoli: 'La Badia delle SS Flora e Lucilla in Arezzo', *Stud. & Doc. Archit.*, vi (1976), pp. 27–37

E. Pillsbury: 'Vasari's Staircase in the Palazzo Vecchio', *Collaboration in Italian Renaissance Art: In Memoriam Charles Seymour, Jr* (New Haven and London, 1978), pp. 125–42

M. B. Hall: *Renovation and Counter-Reformation: Vasari and Duke Cosimo in Sta Maria Novella and Sta Croce, 1565–1577* (Oxford, 1979)

E. Codini Karwacka: 'Piazza dei Cavalieri ed edifici adiacenti', *Livorno e Pisa: Due città e un territorio nella politica dei Medici* (exh. cat. by M. Mirri and others, Pisa, Arsenale Galee, Arsenale Mediceo, 1980), pp. 223–41

A. Nova: 'The Chronology of the Del Monte Chapel in S Pietro in Montorio in Rome', *A. Bull.*, lxvi (1984), pp. 150–54

R. Lunardi: 'La ristrutturazione vasariana di Santa Maria Novella: I documenti ritrovati', *Mem. Domenicane*, n. s. 19 (1988), pp. 403–19

A. Nova: *The Artistic Patronage of Pope Julius III (1550–1555): Profane Imagery and Buildings for the Del Monte Family in Rome*, Outstanding Diss. F.A. (New York and London, 1988)

P. Roselli: 'La vicenda costruttiva delle Logge Vasari ad Arezzo', *QUASAR*, i (1989), pp. 31–42

J. von Henneberg: 'The Church of Santo Stefano dei Cavalieri in Pisa: New Drawings', *Ant. Viva*, xxx/1–2 (1991), pp. 29–42

——: 'Of Altars and Drawings: Vasari's Projects for S Stefano dei Cavalieri in Pisa (?)', *Master Drgs*, xxx (1992), pp. 201–9

C. Conforti: *Giorgio Vasari architetto* (Milan, 1993)

L. Satkowski: *Giorgio Vasari, Architect and Courtier* (Princeton, 1993)

F. Colalucci: 'Le pitture della cappella di S Caterina in S Maria Maggiore: I Cesi, Vasari Siciolante e la Controriforma', *Boll. Mnmt., Mus. & Gal. Pont.*, xiv (1994), pp. 113–61

C. Conforti: 'Momenti di un sodalizio artistico e professionale: Giorgio Vasari e Bartolomeo Ammannati', *Bartolomeo Ammannati, scultore e architetto (1511–1592)*, ed. N. Rosselli del Turco and F. Salvi (Florence, 1995), pp. 139–46

T. Verdon: '"Ecce homo": Spazio sacro e la vittoria dell'uomo', *La cupola di Santa Maria del Fiore*, iv of *Alla riscoperta di Piazza del Duomo in Firenze* , ed. T. Verdon (Florence, 1995), pp. 89–113

A. M. Testaverde: 'Episodi di architettura effimera e stereotipi iconografici di Firenze tra i secoli XVI–XVIII', *Iconographie et arts du spectacle*, ed. J. de la Gorce (Paris, 1996), pp. 29–58

DRAWINGS

G. Thiem: 'Vasaris Entwürfe für Gemälde in der Sala Grande des Palazzo Vecchio zu Florenz', *Z. Kstgesch.*, xxiii (1960), pp. 97–135

Mostra di disegni del Vasari e della sua cerchia (exh. cat., ed. P. Barocchi; Florence, Uffizi, 1964)

G. Thiem: 'Neuentdeckte Zeichnungen Vasaris und Naldinis für die Sala Grande des Palazzo Vecchio in Florenz', *Z. Kstgesch.*, xxxi (1968), pp. 143–50

The Age of Vasari (exh. cat., ed. M. Milkovich and D. A. Porter; Notre Dame, IN, Snite Mus. A.; Binghamton, SUNY; 1970)

C. Monbeig-Goguel: *Maîtres toscans nés après 1500, morts avant 1600: Vasari et son temps* (1972), i of *Inventaire général des dessins italiens du Louvre* (Paris, 1972–)

G. Thiem: 'Neue Funde zu Vasaris Dekorationen im Palazzo Vecchio', *Atti: 1974*, pp. 267–73

E. Pillsbury: 'The Sala Grande Drawings by Vasari and his Workshop: Some Documents and New Attributions', *Master Drgs*, xiv (1976), pp. 127–46

A. Cecchi: 'Borghini, Vasari, Naldini e la *Giuditta* del 1564', *Paragone*, xxviii/323 (1977), pp. 100–07

——: 'Nuove acquisizioni per un catalogo dei disegni di Giorgio Vasari', *Ant. Viva*, xvii/1 (1978), pp. 52–61

J. Kliemann: 'Zeichnungsfragmente aus der Werkstatt Vasaris und ein unbekanntes Programm Vincenzio Borghinis für das Casino Mediceo in Florenz: Borghinis *invenzioni per pitture fatte*', *Jb. Berlin. Mus.*, xx (1978), pp. 157–208

C. Monbeig-Goguel: 'Chronique vasarienne', *Rev. A.*, lvi (1982), pp. 65–80

——: 'Drawings by Vasari and his Circle in the Collection of the Louvre: An Examination and New Findings', *Drawing*, xi/1 (1989), pp. 1–6

A. Cecchi: 'Disegni inediti o poco noti di Giorgio Vasari', *Kunst des Cinquecento in der Toskana* (Munich, 1992), pp. 242–8

A. Nova: 'Salviati, Vasari and the Reuse of Drawings in their Working Practice', *Master Drgs*, xxx (1992), pp. 83–108

F. Härb: 'Theorie und Praxis der Zeichnung bei Giorgio Vasari', *Zeichnungen aus der Toskana: Das Zeitalter Michelangelos* (exh. cat., ed. E. G. Güse and A. Perrig; Saarbrücken, Saarland Mus., 1997), pp. 147–64

VASARI AS HISTORIAN, WRITER AND COLLECTOR

W. Kallab: *Vasaristudien* (Vienna and Leipzig, 1908) [fundamental study of Vasari's sources]

J. Schlosser Magnino: *Die Kunstliteratur* (Vienna, 1924); rev. as *La letteratura artistica*, ed. O. Kurz (Florence, 1964/R 1979), pp. 287–346

E. Panofsky: 'Das erste Blatt aus dem *Libro* Giorgio Vasaris: Eine Studie über die Beurteilung der Gotik in der italienischen Renaissance', *Städel-Jb.*, vi (1930), pp. 25–72 [Eng. trans. in E. Panofsky: *Meaning in the Visual Arts* (New York, 1955), pp. 169–235]

P. Barocchi: 'Il valore dell'antico nella storiografia vasariana', *Il mondo antico nel rinascimento. Atti del V Convegno internazionale di studi sul rinascimento: Firenze, 1956* (Florence, 1958), pp. 217–36

J. Rouchette: *La Renaissance que nous a léguée Vasari* (Bordeaux, 1959)

S. Alpers: 'Ekphrasis and Aesthetic Attitudes in Vasari's *Lives*', *J. Warb. & Court. Inst.*, xxiii (1960), pp. 190–215

E. H. Gombrich: 'Vasari's *Lives* and Cicero's *Brutus*', *J. Warb. & Court. Inst.*, xxiii (1960), pp. 309–11

W. Prinz: 'Vasaris Sammlung von Künstlerbildnissen', *Mitt. Ksthist. Inst. Florenz*, xii (1966) [suppl.]

E. H. Gombrich: 'The Leaven of Criticism in Renaissance Art', *Art, Science and History in the Renaissance*, ed. C. S. Singleton (Baltimore, 1967), pp. 3–42

M. W. Roskill: *Dolce's 'Aretino' and Venetian Art Theory of the Cinquecento* (New York, 1968), pp. 63–5

R. Bettarini: 'Vasari scrittore: Come la Torrentiniana diventò Giuntina', *Atti: 1974*, pp. 485–500

W. Kemp: 'Disegno: Beiträge zur Geschichte des Begriffes zwischen 1547 und 1607', *Marburg. Jb. Kstwiss.*, xix (1974), pp. 219–40

L. Ragghianti Collobi: *Il 'Libro de' disegni' del Vasari*, 2 vols (Florence, 1974)

Z. Waźbiński: 'L'Idée de l'histoire dans la première et la seconde édition des *Vies* de Vasari', *Atti: 1974*, pp. 1–25

C. Goldstein: 'Vasari and the Florentine Accademia del Disegno', *Z. Kstgesch.*, xxxviii (1975), pp. 145–52

G. Dalli Regoli: 'Sul *Libro de' disegni* di Giorgio Vasari', *Crit. A.*, xli/146 (1976), pp. 39–43

L. Ragghianti Collobi: 'Aggiunte per il *Libro de' disegni* del Vasari', *Crit. A.*, n. s. 23, cliv–vi (1977), pp. 165–86

P. Barocchi: 'Storiografia e collezionismo dal Vasari al Lanzi', *Stor. A. It.*, ii (1979), pp. 5–82

C. Monbeig-Goguel: 'A propos de Vasari, historien et collectionneur: Giulio Romano et Giorgio Vasari, le dessin de la *Chute d'Icare* retrouvé', *Rev. Louvre*, xxix (1979), pp. 273–6

L. Riccò: *Vasari scrittore: La prima edizione del libro delle 'Vite'* (Rome, 1979)

M. Cristofani: 'Vasari e le antichità', *Prospettiva*, xxxiii–vi (1983–4), pp. 367–9

M. Winner: 'Il giudizio di Vasari sulle prime tre stanze di Raffaello in Vaticano', *Raffaello in Vaticano* (exh. cat., Rome, Musei Vaticani, 1984), pp. 179–93

P. De Vecchi: 'Raffaello nelle *Vite* del Vasari', *A. Crist.*, lxxiii (1985), pp. 258–62

H. Wohl: 'The Eye of Vasari', *Mitt. Ksthist. Inst. Florenz*, xxx (1986), pp. 537–68

R. Le Mollé: *Georges Vasari et le vocabulaire de la critique d'art dans les 'Vite'* (Grenoble, 1988)

R. Barolsky: *Michelangelo's Nose: A Myth and its Maker* (University Park, PA, 1990)

P. Rubin: 'What Men Saw: Vasari's Life of Leonardo da Vinci and the Image of the Renaissance Artist', *A. Hist.*, xiii (1990), pp. 34–46

P. Barolsky: *Why Mona Lisa Smiles and Other Tales by Vasari* (University Park, PA, 1991)

J. Kliemann: 'Giorgio Vasari: Kunstgeschichtliche Perspektiven', *Kunst und Kunsttheorie, 1400–1900*, ed. P. Ganz and others (Wiesbaden, 1991), pp. 29–74

R. Panichi: *La tecnica dell'arte negli scritti di Giorgio Vasari* (Florence, 1991)

P. Barolsky: *Giottos Father and the Family of Vasari's Lives* (University Park, PA, 1992)

A. Conti: 'Osservazioni e appunti sulla *Vita* di Leonardo di Giorgio Vasari', *Kunst des Cinquecento in der Toskana* (Munich, 1992), pp. 26–36

D. Cast: 'Reading Vasari Again: History, Philosophy', *Word & Image*, ix (1993), pp. 29–38

H. Maginnis: 'Giotto's World through Vasari's Eyes', *Z. Kstgesch.*, lvi (1993), pp. 385–408

M. Collareta: 'L'historien et la technique: Sur le rôle de l'ofèrvrerie dans les *Vite* de Vasari', *De l'Antiquiét au XVIIIe siècle*, i of *Histoire de l'histoire de l'art* (Paris, 1995), pp. 163–76

R. Stapleford: 'Vasari and Botticelli', *Mitt. Ksthist. Inst. Florenz*, xxxix (1995), pp. 396–408

B. J. Watts: 'Giorgio Vasari's *Vita di Michelangelo Buonarroti* and the Shade of Donatello', *The Rhetorics of Life-Writing in Early Modern Europe: Forms of Biography from Cassandra Fedele to Louis XIV*, ed. T. F. Mayer and D. R. Woolf (Ann Arbor, 1995), pp. 63–96

M. Winner: 'Ekphrasis bei Vasari', *Beschreibungskunst—Kunstbeschreibung: Ekphrasis von der Antike bis zur Gegenwart*, ed. G. Boehn and H. Pfotenhauer (Munich, 1995), pp. 259–78

J. Clifton: 'Vasari on Competition', *16th C. J.*, xxvii/1 (1996), pp. 23ń41

B. Roggenkamp: *Die Töchter des 'Disegno': Zur Kanonisierung der drei Bildenden Künste durch Giorgio Vasari* (Münster, 1996)

L. Bartoli: 'Rewriting History: Vasari's *Life of Lorenzo Ghiberti*', *Word & Image*, xiii (1997), pp. 245–52

M. Hirst: 'Michelangelo and his First Biographers', *Proc. Brit. Acad.*, xciv (1997), pp. 63–84

R. Williams: *Art, Theory and Culture in Sixteenth-century Italy: From Techne to Metatechne* (Cambridge, 1997)

CRITICAL RECEPTION AND REPUTATION OF THE 'VITE'

R. Dos Santos: 'Un Exemplaire de Vasari annoté par Francisco de Olanda', *Atti: 1950*, pp. 91ff

G. L. Pinette: 'Über deutsche Kunst und Künstler (Fischarts Kritik an Vasari)', *Jb. Vorarlberg. Landesmusver.* (1966), pp. 9–21

M. Capucci: 'Dalla biografia alla storia: Note sulla formazione della storiografia artistica nel seicento', *Stud. Seicent.*, ix (1968), pp. 81–125

L. Puppi: 'La fortuna delle *Vite* nel Veneto dal Ridolfi al Temanza', *Atti: 1974*, pp. 405–37

R. Salvini: 'L'eredità del Vasari storiografo in Germania: Joachim von Sandrart', *Atti: 1974*, pp. 759–71

H. Belting: 'Vasari und die Folgen: Die Geschichte der Kunst als Prozess?', *Historische Prozesse*, ed. K.-G. Faber and C. Meier (Munich, 1978), pp. 98–126

S. A. Vosters: 'Lampsonio, Vasari, van Mander y Pacheco', *Goya*, clxxxix (1985), pp. 130–39

M. Hochmann: 'Les Annotations marginales de Federico Zuccaro à un exemplaire des *Vies* de Vasari: La Réaction anti-vasarienne à la fin du XVIe siècle', *Rev. A.*, lxxx (1988), pp. 64–71

E. Grasman: 'La controversia fra il Vasari ed il Malvasia nella letteratura artistica del settecento', *Il luogo ed il ruolo della città di Bologna tra Europa continentale e mediterranea: Atti del Colloquio C.I.H.A.: Bologna, 1990*, ed. G. Perini (Bologna, 1992), pp. 529–38

G. Perini, ed.: *Gli scritti dei Carracci*, intro. by C. Dempsey (Bologna, 1990) [incl. transcription of the *postille* to the *Lives*]

X. De Salas: *El Greco y el arte de su tiempo: Las notas de El Greco a Vasari* (Madrid, 1992)

D. Cast: 'Speaking of Architecture: The Evolution of a Vocabulary in Vasari, Jones and Sir John Vanbrugh', *J. Soc. Archit. Hist.*, lii (1993), pp. 179–88

D. Kemper: 'Litterärhistorie - romantische Utopie - kunstgeschichtliche Poesie: Drei Modelle der Renaissancerezeption, dargestellt anhand gedruckter und ungedruckter Vasari—Übersetzungen 1778–1832', *Romantik und Renaissance: Die Rezeption der italienischen Renaissance in der deutschen Romantik*, ed. S. Vietta (Stuttgart and Weimar, 1994), pp. 116–39

H. B. J. Maginnis: 'Matters of Money: Vasari on Early Italian Artists', *Source*, xiv/1 (1994), pp. 6–9

M. O. Renger: 'A Medieval Basis for Vasari's Libro', *Shop Talk: Studies in Honour of Seymour Slive, Presented on his Seventy-fifth Birthday*, ed. C. P. Schneider, W. W. Robinson and A. I. Davis (Cambridge, MA, 1995), pp. 204–6, 386–7

JULIAN KLIEMANN

(2) Giorgio Vasari, *il giovane* (*b* Arezzo, 6 Nov 1562; *d* Florence, 17 Nov 1625). Essayist and architect, nephew of (1) Giorgio Vasari. He obtained Florentine citizenship in 1591 and was subsequently given numerous high-ranking posts within the Medici administration. In Arezzo, where he was appointed ambassador in 1614 to Cosimo II de' Medici, Grand Duke of Florence, he built a monastery, possibly to the commission of Bishop Usimbardi. After Bartolomeo Ammanati's death, he worked on the church of S Maria in Gradi, for which he designed the main altar (1607). In Florence he produced plans (not executed) for the façade of the cathedral, a pulpit in the church of Santo Spirito and the chapel of S Lorenzo (1604). Vasari *il giovane* admired the serenity of Filippo Brunelleschi's works and in his own designs showed considerable graphic and structural ingenuity.

In the extensive collection of Vasari's building plans (Florence, Uffizi) a clear attempt may be seen to reduce the whole field of ancient and modern architecture to a single modular system. His plan for an ideal city, while not based on any social doctrine, reveals a strong desire for order and centralization: the main streets follow the directions of the eight winds and converge in a single piazza dominated by the prince's palazzo and the law courts. The plan is a coherent representation of Medici absolutism (although this is not expressly stated by Vasari), with its public buildings—churches, monasteries, hospitals, centres of civil and ecclesiastical authority, multiple dwellings, a university, an arsenal and a port—all part of a heliocentric city dominated by the prince, of whom the architect is a faithful functionary.

UNPUBLISHED SOURCES

Florence, Bib. Riccardiana [MS. of *Libro di fortificatione . . .*(1570); MS. of *Studio di varii instrumenti per misurare la vista* (1600)]

WRITINGS

Città ideale . . . disegnata l'anno 1598 (1598; Florence, Uffizi, MS. 4529–4594); ed. V. Stefanelli (Rome, 1970)

Piante di chiese, palazzi e ville di Toscana e d'Italia . . . (1598; Florence, Uffizi, MS. 4715–4944); ed. V. Stefanelli (Rome, 1970)

Porte e finestre di Firenze e di Roma (Florence, Uffizi, MS. 4715A–4944A); ed. F. Borsi and C. Acidini in *Il disegno interrotto: Trattati medicei d'architettura* (Florence, 1980), pp. 295–321

BIBLIOGRAPHY

R. Klein: 'L'Urbanisme utopique de Filarte à Valentin Andrae', *La Forme et l'intelligible: Ecrits sur la Renaissance et l'art moderne* (Paris, 1970), pp. 310–26; Eng. trans. (New York, 1979), pp. 89–101

L. Olivato: 'Profilo di Giorgio Vasari il Giovane', *Riv. Ist. N. Archeol. & Stor. A.*, n. s., xvii (1970), pp. 181–229

——: 'Testimonianze della cultura architettonica spagnola (e araba) nel Rinascimento italiano: Alcuni disegni di Giorgio Vasari il Giovane', *Actas del XXIII Congreso internacional de historia del arte: Granada, 1976–8*, ii, pp. 378–84 [Contains the drawings (Florence, Uffizi) of

buildings in Spain and Tunis, including the Cathedrals of Seville and Toledo and the Alcazar at Toledo]

<div style="text-align: right">ANTONIO MANNO</div>

Vasaro, Giovanni [Zoan] **Maria** (*b* ?Faenza; *fl c.* 1475–1550). Italian ceramics painter. Although he was probably a native of Faenza, as his decorative repertory would suggest, he was active at the beginning of the 16th century in Castel Durante. His most famous signed work, a goblet (1508; ex-Met., New York), was made in honour of Pope Julius II. From this and other works that can be attributed to him on stylistic grounds, it is evident that he specialized in symmetrical compositions for plates, with a border of grotesques, trophies and musical instruments surrounding a central cavetto. Although his life and work are poorly documented, a survey of the maiolica of this period indicates that his work was very influential on maiolica artists who worked around Castel Durante during the first half of the 16th century.

BIBLIOGRAPHY

B. Rackham: 'Der Majolikmaler Giovanni Maria von Casteldurante', *Pantheon*, i (1928), pp. 435–45; ii (1929), pp. 88–92

<div style="text-align: right">CARMEN RAVANELLI GUIDOTTI</div>

Vassilacchi, Antonio [Aliense] (*b* Melos, 1556; *d* Venice, 15 April 1629). Italian painter of Greek descent. He arrived in Venice not later than 1571, when his father was supplying provisions to the Venetian fleet. It is unlikely that he had received any artistic training in Greece; probably his first teacher was Paolo Veronese, in whose workshop in Venice he was involved in the copying of drawings and paintings. In 1574, together with Veronese and Jacopo Tintoretto, he was employed decorating the triumphal arch (destr.) erected on the Venice Lido, after designs by Andrea Palladio, for the arrival of Henry III, King of France (*reg* 1574–89). He worked with Benedetto Caliari on the frescoes in the bishop's residence at Treviso (*c.* 1579) and, with Dario Varotari, on the decoration of the Villa Emo Capodilista at Montecchia, near Padua. In these works he adopted the dramatic chiaroscuro effects of Tintoretto, rather than following the painterly effects of his master, Veronese; of all Venetian Mannerists he followed Tintoretto most closely.

In 1584 Vassilacchi first worked in the Doge's Palace, painting a series of *Virtues* and some grisailles on the ceiling of the Sala dello Scrutinio, the most interesting of these being *Pietro Ziani Rejecting the Office of Doge* and the *Death of Ordelafo Falier during the Battle of Zara*, in which he emphasized the violence of the scenes by highlighting anatomy and using dramatic contrasts of light and shade.

A vivid *Resurrection* (Venice, S Marziale) dates from 1586; equally melodramatic is the *Punishment of the Serpents* (1588; Venice, S Angelo Raffaele), in which the serpentine figures, agitated drapery and the dramatic use of light reveal his debt to Tintoretto. In 1591–2 Vassilacchi collaborated with Tintoretto and his son Domenico on the decoration of the Scuola dei Mercanti; Vassilacchi's surviving works from this commission are a *Visitation* (Venice, Semin. Patriarcale) and an *Adoration of the Shepherds* (Loreo, parish church). In this last work his style is more tranquil; the intimacy of the pastoral scene is probably influenced by the work of Jacopo Bassano.

In 1593–4 Vassilacchi worked on a series of 11 canvases of the *Life of Christ* and the *Passion* for S Pietro, Perugia, which constitutes his masterpiece. The large, theatrical compositions are inspired by Tintoretto's works for the Scuola di S Rocco in Venice: the light is intensely expressive, particularly in the nocturnal scenes; the compositions display considerable spatial complexity; and the uncompromising realism demonstrates his interest in the work of Flemish painters.

An *Adoration of the Magi* was painted *c.* 1600 for the Sala del Consiglio dei Dieci in the Doge's Palace. In his later works Vassilacchi softened the Mannerist tension, perhaps under the influence of Domenico Tintoretto and Palma Giovane, with whom he collaborated on the decoration (1602–5) of Salò Cathedral. He also worked with Antonio Foler on the frescoes (before 1616) of the Villa Barbarigo, Noventa Vicentina. His late works, such as the *Portrait of Federico Contarini* (1613; Venice, Le Zitelle) and the *Birth of the Virgin* (1623; Padua, S Maria in Vanzo), show him to have abandoned the dynamic movement of Mannerism and adopted the quieter mood in painting promoted after the Council of Trent.

BIBLIOGRAPHY

Thieme–Becker

G. Boccassini: 'Profilo dell'Aliense', *A. Veneta*, xii (1958), pp. 111–25

R. Pallucchini: *La pittura veneziana del seicento*, i (Milan, 1981), pp. 44–6

Da Tiziano a El Greco: Per la storia del manierismo a Venezia, 1540–1590 (exh. cat., ed. R. Pallucchini; Venice, Doge's Palace, 1981), p. 231

<div style="text-align: right">MASSIMO GEMIN</div>

Vecchi, Giovanni (Liso) de' [Giovanni dal Borgo] (*b* Borgo San Sepolcro, 1536/7; *d* Rome, 13 April 1615). Italian painter. Often classified as an Italian Mannerist, he may have been a disciple of the painter Raffaello dal Colle in Rome. It is likely that he worked alongside Giuseppe Ceracchi at the Palazzo Belvedere in the Vatican in Rome during the early 1560s, and he may have been closely associated there with Santi di Tito between *c.* 1562 and 1564. He was almost certainly the painter called 'Giovanni dal Borgo' who worked at the Villa d'Este in Tivoli in 1568. He is first documented in Rome as a member of the Accademia di S Luca in 1570 and during the first half of that decade was employed on two enterprises initiated by Alessandro Farnese: the religious decoration of the oratory of the Gonfalone in Rome, and the secular work at the Villa Farnese at Caprarola, where he worked within the ambience of Federico Zuccaro and Jacopo Bertoia. According to Giovanni Baglione, de' Vecchi executed frescoes at Caprarola in the Sala del Mappamondo (*c.* 1574) and in the Sala degli Angeli (*c.* 1575–6). There is little doubt that he designed the frescoes in both rooms. In the Sala del Mappamondo he certainly executed most of the allegorical figures (e.g. *Asia* and *Africa*) and the ornamentation, while in the Sala degli Angeli he probably executed the decorative and allegorical lunettes. The ceiling fresco there, the *Fall of the Angels*, was formerly also attributed to him.

De' Vecchi painted religious subjects, primarily in fresco, in churches throughout Rome, for example the *Adoration of the Shepherds* (fresco, 1574–5; S Eligio degli Orefici; *in situ*). In 1578 he became a member of the Congregazione dei Virtuosi al Pantheon, but during this period he appears to have returned intermittently to Borgo

San Sepolcro. Among his few surviving pictures there are two oil paintings dating from the first half of the 1580s: the *Nativity of the Virgin* and the *Presentation in the Temple* (both Sansepolcro, Mus. Civ.). Both pictures display an acute and artificial manipulation of pictorial space, a capriciousness in details of gesture and expression, and a vivacious colouring that suggests the influence of early 16th-century Venetian art. These, together with the frescoes at Caprarola, exemplify de' Vecchi's Mannerist style.

In 1578 he was commissioned to paint a fresco cycle of the *Legend of the Cross* at the oratory of the Crocifisso di S Marcello, Rome. Although he executed only part of this programme, his first painting, *St Helena Ordering the Search for the True Cross* (*c.* 1580; see fig.), which is perhaps somewhat old-fashioned in its conception, is notable for showing a tentative abandonment of Mannerist principles and a new inclination towards greater psychological depth and naturalism. De' Vecchi's most important commission of the 1580s was for frescoes, begun in 1583, depicting the *Four Doctors of the Latin Church* on the vault pendentives at Il Gesù in Rome. He may also have designed a fresco for the cupola. His work was overpainted (1675–6) by Giovanni Battista Gaulli (1639–1709), but two of the pendentives were recorded in a painting of *Urban VIII Visiting Il Gesù during the Centenary Celebrations of the Jesuit Order, 1639* (oil on canvas, 1641; Rome, Pal. Braschi), executed by Andrea Sacchi (*c.* 1599–1661), Jan Miel (1599–1664) and Filippo Gagliardi (*d* 1659).

During the 1580s and 1590s de' Vecchi participated in the decoration of a number of chapels and executed a series of frescoed altars in Rome, including *St Francis Receiving the Stigmata*. His mature style is embodied in one of his last major paintings, *Pope Gregory the Great's Procession with the Miraculous Icon of the Virgin Mary during the Plague of 590* (oil on slate; S Maria in Aracoeli; *in situ*). This picture has an intense mystical quality, expressed by concentrated chiaroscuro and heightened colour. Much of the artist's previous use of descriptive incident and detail has been eliminated, and the sentiment of the picture is substantially more sombre and meditative than decorous or rhetorical. This is perhaps the most pious work of de' Vecchi's late career and may support suggestions that he became increasingly responsive to the mood of the Counter-Reformation.

BIBLIOGRAPHY

G. Baglione: *Vite* (1642); ed. V. Mariani (1935), pp. 25, 96, 104, 121–8, 155

R. Roli: 'Giovanni de' Vecchi', *A. Ant. & Mod.*, 29 and 31–2 (1965), pp. 45–56, 324–34

S. J. Freedberg: *Painting in Italy, 1500–1600*, Pelican Hist. A. (Harmondsworth, 1970), pp. 443–4, 447–8

A. Pinelli: 'Pittura e controriforma: "Convenienza" e misticismo in Giovanni de' Vecchi', *Ric. Stor. A.*, 6 (1977), pp. 49–64

J. Heideman: 'A New Dating of De' Vecchi's "Procession" Painting in Santa Maria in Aracoeli in Rome', *Paragone*, xxxix/455 (1988), pp. 51–61

P. Tosini: 'Rivedendo Giovanni de' Vecchi: Nuovi dipinti, documenti e precisazioni', *Stor. A.*, lxxxii (1994), pp. 303–47

L. Partridge: 'The Room of Maps at Caprarola, 1573–75', *A. Bull.*, lxxvii/3 (1995), pp. 413–44 □

Vecchietta [Lorenzo di Pietro di Giovanni] (*bapt* Siena, 11 Aug 1410; *d* Siena, 6 June 1480). Italian painter, sculptor, goldsmith and architect.

1. BEFORE *c.* 1465. He was formerly believed to have been born *c.* 1412 in the Tuscan town of Castiglione d'Orcia, but del Bravo has identified him with the Lorenzo di Pietro di Giovanni who was baptized in Siena in 1410. His name appears in a list of the members of the Siena painters' guild in 1428. From the evidence of later works, he is generally supposed to have been apprenticed to Sassetta, but his early work has not been identified. Between *c.* 1435 and 1439 he executed for Cardinal Branda Castiglione (1350–1443) a series of frescoes at Castiglione Olona, near Varese in Lombardy. He has been considered an assistant of MASOLINO DA PANICALE in this enterprise, but the scenes of the martyrdoms of SS Lawrence and Stephen in the apse of the Collegiata, below Masolino's vault frescoes, show that Vecchietta's closely packed compositional style was already fully formed. He also painted the frescoes (partially published by Bertelli) in the chapel of the Cardinal's palace in the town, depicting the Evangelists (vault) and friezes of male and female saints (side walls). Although abraded and fragmentary, they nevertheless indicate the naturalistic effects of atmospheric lighting and foreshortening that, more than any other Sienese painter of his day, he had learnt from Masolino and the Florentine painters. In 1439, aided by Sano di Pietro, he painted the figures of a wooden *Annunciation* group (untraced) for the high altar of Siena Cathedral.

Vecchietta's earliest surviving documented work is the *Allegory of the Blessed Sorore and the Education of the Foundlings* (1441) in the Ospedale di S Maria della Scala,

Giovanni de' Vecchi: *St Helena Ordering the Search for the True Cross* (*c.* 1580), fresco, oratory of the Crocifisso di S Marcello, Rome

Siena; it is the only fresco to be preserved of four he painted there, and the first of several major commissions for the hospital (*see* SIENA, §III, 2). It contrasts with the neighbouring frescoes by Domenico di Bartolo in its orderly and rational approach to the architectural setting (in which a Roman triumphal arch is set in front of an aisled nave) and in its subtly graded coloration. In 1442, styled for the first time by his nickname, he is documented as carving and painting a *Risen Christ* (untraced) for the high altar of Siena Cathedral. Although his paintings and sculpture are usually considered separately, the two functions reinforced each other throughout his remaining career. For example, the measured approach to monumentality in his fresco of the *Lamentation* (1.90×2.08 m, 1445–8; Monteriggioni, Mus. Semin. Arcivescovile), formerly in the Martinozzi Chapel in S Francesco, Siena, is also evident in the contemporary painted wood *Pietà* (h. 960 mm) at S Donato, Siena, which has a similar composition.

Vecchietta worked in both miniature and monumental styles, so that works carried out in the same years for the sacristy of the Ospedale di S Maria della Scala, Siena, show differing forms of expression. The painted panels of the sacristy's reliquary cabinet (2.73×1.87 m with doors closed, 1445–9; Siena, Pin. N.) are by at least two artists, but those on the exterior bearing local Sienese saints are closer to Vecchietta's style: *Blessed Agostino Novello* and *Blessed Catherine of Siena* are certainly autograph panels. The *Passion* scenes on the interior are by a gifted miniaturist in his workshop. Although damaged, the frescoes of 1446–9 show a contrasting spaciousness. Christ blessing, Evangelists, Doctors of the Church and Prophets are depicted on the vault of the sacristy, while on the walls are Old and New Testament scenes and the *Last Judgement*; van Os (1974) has shown how the imagery is employed to illustrate the articles of faith in the Creed. This is also the subject of the ceiling frescoes of the baptistery in Siena (1450–53), which revert to an ostensibly miniaturist precision of placement, but cleaning has revealed that the brushwork was carried out with remarkable freedom. Tawny russet hues predominate. Benvenuto di Giovanni, recorded in 1483 as working in the baptistery, may have executed the frescoes of the *Miracles of St Anthony of Padua*.

The lunette fresco of the *Madonna of Mercy* (mid-1450s) in the Ufficio del Sale, Palazzo Pubblico, Siena, again shows a free brushstroke deployed to characterize a number of figures. A delicate range of pinks now predominates, but otherwise this fresco has a grave overall expression in common with the altarpiece of the *Virgin and Child with Saints* (see fig. 1) from the Villa Monselvoli, Siena. The restraint of these iconic works co-exists with a fresher approach to narrative in such smaller-scale paintings as the *biccherna* panel of the *Coronation of Pius II* (590×405 mm, 1460; Siena, Pal. Piccolomini, Archv Stato), the pope who was to be Vecchietta's next main patron, and the predella of the altarpiece of the *Virgin and Child with Saints* (*c.* 1461–2; now Pienza, Mus. Cattedrale) from S Niccolò a Spedaletto, Pienza. An especially delightful *plein-air* quality permeates the predella panel of monks building a church, a scene from the *Life of St Benedict* (295×450 mm; Sant'Anna in Camprena, Monastery).

Bellosi, possibly referring to a record from 1460 of a debt owed by 'Master Lorenzo di Pietro and Benvenuto and Francesco, painters', has divided responsibility for a group of lively predella panels among three artists, claiming the *Miracle of St Louis of Toulouse* (Rome, Pin. Vaticana) for Vecchietta, the *Miracle of St Anthony of Padua* (Munich, Alte Pin.) for Benvenuto di Giovanni and the *Sermon of St Bernardino of Siena* (Liverpool, Walker A.G.) for the young Francesco di Giorgio Martini. The style of all three scenes, in which the painstaking perspective established in the Pellegrinaio fresco appears again, is, however, that of Vecchietta, whose self-portrait is discernible in the Liverpool panel (he also appears in the *Madonna of Mercy* fresco and in his late altarpiece in Siena; see §2 below). Panels assumed to be from the same predella, two representing flagellants (Ajaccio, Mus. Fesch, and Bayonne, Mus. Bonnat) and two embodying Franciscan allegories (both Munich, Alte Pin.), are also more likely to be by Vecchietta than by Francesco di Giorgio.

The brilliant modulation of light and shade and the perfect integration of figure and setting that characterize the fresco of *St Catherine of Siena* (Doc. 1460 but dated 1461, the year of Catherine's canonization) in the Sala del Mappamondo in the Palazzo Pubblico, Siena, and the signed triptych of the *Assumption of the Virgin with Four Saints* (*c.* 1462; see colour pl. 2, XXXVIII1) in Pienza Cathedral can be attributed chiefly to Vecchietta's growing experience of sculpture. His grave and even bleak marble niche figures of *SS Peter and Paul* (1458–62) on the Loggia della Mercanzia, Siena, show strong influence of Donatello, the *St Paul* being based on Donatello's *St Mark* for Orsanmichele, Florence. The taut play of line in these statues, however, is entirely Vecchietta's own.

2. AFTER *c.* 1465. Vecchietta's work became increasingly diversified. As early as 1460 he had travelled to Rome to obtain Pius's approval for the model of his design for the Piccolomini Loggia in Siena. He served as a fortifications expert throughout the Sienese territories (1467–70) and provided Siena Cathedral with silver reliquary busts of saints (1472–6; all untraced). This technical agility was best realized in the production of large-scale bronze sculptures, the chief undertakings of his late career, which necessitated numerous assistants. The tomb effigy of the humanist and jurist *Mariano Sozzini* (d 1467) for S Domenico, Siena (now Florence, Bargello; Bellosi attributes the work to Francesco di Giorgio), shows an unflinching naturalism in the shrivelled face and crinkly drapery; a 16th-century source ascribes the *Sozzini* to Vecchietta, and Bellosi is unconvincing in reattributing it to Francesco di Giorgio Martini. Vecchietta's most elaborate work in bronze is the multi-figured ciborium (1467–72; transferred to the high altar of Siena Cathedral in 1506, replacing Duccio's *Maestà*) made for the high altar of S Maria della Scala, Siena. Supported on a stem embellished with putti and music-making angels, the tempietto-shaped body of the ciborium is in the form of the Holy Sepulchre in Jerusalem. It is topped by a statuette of the *Risen Christ*, superb in contrapposto and balancing precariously on a chalice. Pfeiffer explained the whole as a Dominican apologetic of the veneration due to the Holy Blood. A painted model for the ciborium survives (Siena, Pin. N.).

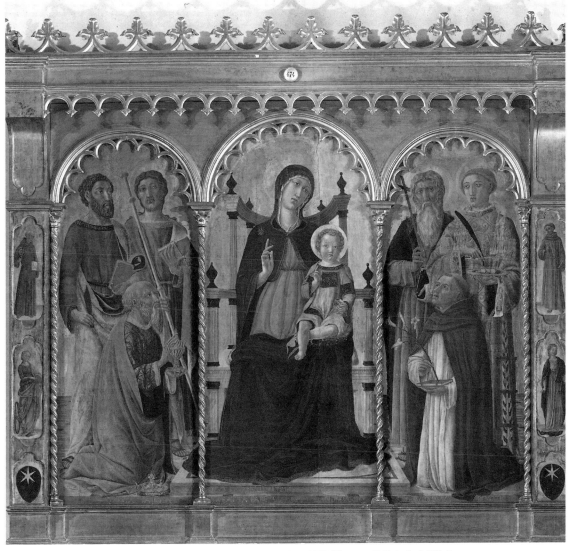

1. Vecchietta: *Virgin and Child with Saints*, tempera on panel, 1.56×2.30 m, 1457 (Florence, Galleria degli Uffizi)

In the highly detailed, signed bronze relief of the *Resurrection* (543×412 mm, 1472; New York, Frick), Vecchietta drew on his experiences as a painter. The piece is both too richly worked and too weighty to have served as a tabernacle door as is sometimes claimed.

Vecchietta's signed wood figures of *St Anthony Abbot* (dated 1475; *in situ*) and *St Bernardino of Siena* (Florence, Bargello) were both made for Narni Cathedral. While the latter is relatively restrained, the former, well over life-size, is at once brooding and familiar, a massive volumetric study like most of his late works.

In 1477 Vecchietta succeeded in his petition of the previous year to build a burial chapel to his own design for himself and his wife in S Maria della Scala, Siena. On the altar was placed the great bronze figure of the *Risen Christ* (see fig. 2), which now adorns the high altar of the church. Behind hung his panel of the *Virgin and Child with SS Peter, Paul, Lawrence and Francis* (Siena, Pin. N.), the two last being the name-saints of Vecchietta and his wife Francesca. It is remarkable that he signed the bronze as painter and the panel as sculptor, in a way that proclaims his mastery of both media and also their inter-reliance. Despite the damaged condition of the painting, the original splendour of the figures grouped harmoniously within their golden apse can still be estimated. Vecchietta's final commission (1480) was for painted wood reliefs of the *Death of the Virgin* and *Assumption of the Virgin* (Lucca, Villa Guinigi), but he lived to execute only the first, the *Assumption* being completed by Neroccio de' Landi. This is a final instance of how Vecchietta helped to mould two generations of Sienese artists, but his greatest legacies were the works for his own chapel. It has been noted that the unprecedented, life-size bronze figure must have lingered in Michelangelo's mind when he planned the *Risen Christ* in S Maria sopra Minerva, Rome.

BIBLIOGRAPHY

Thieme–Becker
G. Vasari: *Vite* (1550, rev. 2/1568); ed. G. Milanesi (1878–85), iii, pp. 69–81

2. Vecchietta: *Risen Christ*, bronze, h. 1.83 m, 1476 (Siena, S Maria della Scala)

G. Milanesi: *Documenti per la storia dell'arte senese*, 3 vols (Siena, 1854–6)
C. del Bravo: *Scultura senese del quattrocento* (Florence, 1970), pp. 60–91
H. W. van Os: *Vecchietta and the Sacristy of the Siena Hospital Church: A Study in Renaissance Religious Symbolism* (The Hague, 1974)
A. Pfeiffer: *Das Ciborium im Sieneser Dom: Untersuchungen zur Bronzeplastik Vecchiettas* (diss., Marburg, Philipps-U., 1975)
H. W. van Os: 'Vecchietta and Blessed Sorore: A Vexed Question in the Iconography of the Saints in Sienese Painting', *Festschrift Wolfgang Braunfels* (Tübingen, 1977), pp. 281–7
——: 'Vecchietta and the Persona of the Renaissance Artist', *Studies in Late Medieval and Renaissance Painting in Honor of Millard Meiss*, i (New York, 1977), pp. 445–54
P. Torriti: *La Pinacoteca Nazionale di Siena: I dipinti dal XII al XV secolo* (Genoa, 1977), pp. 351–63
I. Lavin: 'The Sculptor's "Last Will and Testament"', *Allen Mem. A. Mus. Bull.*, xxxv (1977–8), pp. 4–16
E. Carli: *Gli scultori senesi* (Milan, 1980), pp. 42–4, pls 264–82
Pienza e La Val d'Orcia: Opere d'arte restaurate dal XIV al XVII secolo (exh. cat., ed. A. Bagnoli and L. Martini; Pienza, Pal. Piccolomini, 1984), pp. 42–50
S. Hansen: *Die Loggia della Mercanzia in Siena* (Worms, 1987)
Scultura dipinta: Maestri di legname e pittori a Siena, 1250–1450 (exh. cat., ed. A. Bagnoli and R. Bartalini; Siena, Pin. N., 1987), pp. 172–80
C. Bertelli: 'La cappella del Palazzo Branda Castiglioni', *Arte in Lombardia tra gotico e rinascimento* (exh. cat., Milan, Pal. Reale, 1988), pp. 297–303
Painting in Renaissance Siena, 1420–1500 (exh. cat. by K. Christiansen and C. B. Strehlke, New York, Met., 1988), pp. 15–18, 258–63
Francesco di Georgio e il rinascimento a Siena, 1450–1500 (exh. cat., ed. L. Bellosi, Siena, Sant'Agostino, 1993)

JAMES DAVID DRAPER

Vecchietti, Bernardo (*b* Florence, 31 March 1514; *d* Florence, 20 Dec 1590). Italian patron and collector. His father, Giovanni di Bernardo Vecchietti, had enriched the family and bought a country seat, the Villa Il Riposo, near Florence. Bernardo's main claim to fame was his discovery of Giambologna. He was host to Giambologna for about 14 years (1552–66) and introduced him to Prince Francesco de' Medici. He played an important role in spreading an awareness of Giambologna's small bronzes, created first for Vecchietti himself and then for a large Florentine and international clientele; he also secured Medici commissions for the sculptor for monumental works in Florence.

Vecchietti embarked on his career as a diplomat under Cosimo I de' Medici, and made frequent visits to Venice (those of 1554–5 and 1557 are recorded), where he bought jewellery for the Medici court, and to Rome (1570), where he purchased several antiques. He acquired a specialist knowledge of jewellery, and played an increasingly prominent role as artistic adviser in the reign of Francesco I de' Medici, who in 1578 made him a senator. He organized the decoration of the cupola of Florence Cathedral, promoting Federico Zuccaro, to whom the commission was awarded in 1575. He was instrumental in the enrichment of Florence by monumental sculptures, among them Giambologna's *Rape of a Sabine* (1583; Florence, Loggia Lanzi; *see* GIAMBOLOGNA, fig. 2) and an equestrian statue of *Cosimo I de' Medici* (1587–93; Florence, Piazza della Signoria). He transformed the medieval family residence at 2 Via de' Vecchietti into a Renaissance palazzo (using Giambologna's designs from 1578), and enriched the Villa Il Riposo, where he employed Giambologna, Gregorio Pagani and, after 1584, Santi di Tito. He gave paintings to the family church of S Donato (destr.) and was granted the rights of patronage to a chapel in S Maria Novella, which was modernized (1575) by the Medici. This suggests the closeness of his relationship with the court, and his support for the Medici interest in the new religious art of the Counter-Reformation. In 1587, on the recommendation of Ferdinand I de' Medici, he organized the funeral of Francesco I.

At the Villa Il Riposo, Vecchietti created a rich art collection; Giambologna contributed to its development as a studio and museum from 1552 to 1566, and after 1584. The collection was rich in small sculptures. Vecchietti was particularly attracted by the sculptor's models and ensured the survival of a large number of Giambologna's sketch models in wax and clay (e.g. *Hercules and the Hydra*, *c.* 1579; Florence, Pal. Vecchio). He also had a collection of celebrated Old Master drawings, cartoons and pictures, among them a cartoon for Leonardo da Vinci's *Leda* (destr.) and Michelangelo's cartoon for the *Battle of Cascina* (destr.). Raffaele Borghini, in a dialogue entitled *Il riposo* (1584), described the collections and recorded the discussions on art that took place at the villa. The Villa Il Riposo was important in the history of collecting, and Borghini described not only its contents but also the didactic aims of its creator. Many of the sculptor's models were bought by William Locke (1732–1810) of Norbury Park in the late 18th century, and were admired by English artists and collectors in the early 19th (for the later history of the Vecchietti collection, see Avery, 1987, p. 241).

BIBLIOGRAPHY
R. Borghini: *Il Riposo* (Florence, 1584); facs., ed. M. Rosci (Milan, 1967), 2 vols
S. Platt: *Villa Il Riposo: The Concept and the Reality*, Pius XII Institute, Rosary College, River Forest, IL (Oct 1968), p. 9
C. Avery: 'Bernardo Vecchietti and the Wax Models of Giambologna', *La Ceroplastica nella scienza e nell'arte: Atti del congresso internazionale: Firenze, 1975*, pp. 461–76

D. Heikamp: 'The Grotto of the Fata Morgana and Giambologna Marble Gorgon', *Ant. Viva*, xx (1981), pp. 12, 30, n. 2

A. Natali: 'Candior Animus', *Ant. Viva*, xx/4 (1981), pp. 22–31

M. Bury: 'Bernardo Vecchietti, Patron of Giambologna', *I Tatti Stud.*, i (1985), pp. 13–56

C. Avery: *Giambologna* (Oxford, 1987)

Z. WAŹBIŃSKI

Vecchio Bolognese, il. *See* AIMO, DOMENICO.

Vecellio. Italian family of artists. They came from Pieve di Cadore and can be traced back to the 13th century. The family, which included numerous notaries, magistrates and mayors, became wealthy and prominent locally. There were artists in two branches, one descended from Conte Vecellio, a notary who served as the town mayor, military leader and ambassador to Venice, and one from his brother Giovanni Antonio Vecellio (*d* 1497).

The son of Conte Vecellio, Gregorio Vecellio (*c.* 1455–1530), who was a civic official in Cadore, had two sons who were painters. The elder, (1) Francesco Vecellio, trained as a painter in Venice, where the family name was linked with the timber trade. He was joined there by his younger brother Tiziano Vecellio (*see* TITIAN), who became the leading painter in Venice and one of the most important artists in Italy in the 16th century. Titian trained his second son, (2) Orazio Vecellio, who painted in his father's style.

(3) Cesare Vecellio belonged to the branch of the family descended from Giovanni Antonio. He trained in Titian's workshop and remained there until the latter's death in 1576, when he began to work independently. His younger brother, Fabrizio Vecellio (*b* early 1520s), was also a painter. (4) Marco Vecellio, the son of Titian's second cousin, was a mediocre follower of the master's style, as was Marco's son Tiziano Vecellio, or 'Tizianello' (1570–1650), who wrote a biography of Titian (*La vita del insigne Tiziano Vecellio*, 1622). Tommaso Vecellio (1576–*c.* 1629), Marco's nephew, who worked in Pieve di Cadore, was another mediocre follower of Titian. Francesco, Cesare, Orazio and Marco were the family members allowed to use the appellation 'di Tiziano'. Titian's assistant GIROLAMO DENTI was also permitted to use this signature.

BIBLIOGRAPHY

G. Vasari: *Vite* (1550, rev. 2/1568); ed. G. Milanesi (1878–85)

S. Ticozzi: *Vite dei pittori Vecelli di Cadore* (Milan, 1817)

J. A. Crowe and G. B. Cavalcaselle: *Life and Times of Titian* (London, 1877, rev. 2/1881)

Mostra dei Vecellio (exh. cat. by F. Valcanover, Belluno, Mus. Civ., 1951)

R. Pallucchini: *Tiziano* (Florence, 1969)

G. Fabbiani: 'Artisti cadorini', *Archv Stor. Belluno, Feltre & Cadore*, 190 (1970)

F. Heinemann: 'La bottega di Tiziano', *Tiziano e Venezia. Atti del convegno: Venezia, 1976*

M. Roy Fisher: *Titian's Assistants During the Later Years* (New York and London, 1977)

SERGIO CLAUT

(1) Francesco Vecellio (*b* Pieve di Cadore, 1475; *d* Pieve di Cadore, 1559–60). Painter. He trained in Venice in the workshop of Giovanni Bellini, whose influence is evident in the altarpiece he painted for Santa Croce, Belluno, the *Virgin and Child Enthroned with Saints* (Berlin). He served in the Venetian army *c.* 1508–9, and when he returned to painting he came under the influence of his brother Titian, with whom he began to collaborate on, for example, the frescoes showing the *Miracle of the Miser's Heart* and the *Miracle of the 'Navicella'* (1511) in the Scuola di S Antonio in Padua and the polyptych of the *Virgin and Child Enthroned* (central panel, Sédico, parish church). The Sédico Altarpiece may have been planned by Titian, but was certainly executed by Francesco and is his best work. He did not develop further artistically, however, and his later work continued to reflect Titian's early style, often with poorly assimilated influences from other artists. Contemporary with the Sédico Altarpiece is the delightful *Virgin and Child* (Vicenza, Mus. Civ.). However, a painting of 1518 for Pieve di Cadore, demonstrating the loyalty of the people of Cadore to Venice, is untraced. This conservative tendency is clear in his altarpiece of the *Virgin and Child Enthroned with Saints* (1524; S Vito di Cadore, parish church), with its echoes of Palma Vecchio. In his organ shutters (*c.* 1530) for S Salvatore, Venice (*Transfiguration, Resurrection, St Augustine, St Theodore*), he attempted, somewhat awkwardly, more dramatic compositions of a Mannerist type. He left Venice in 1534 to look after the family's affairs in Pieve di Cadore, where he continued to execute such modest local commissions as the *Virgin and Child Enthroned* (Venas di Cadore, parish church), the *Madonna with SS Titian and Anthony Abbot* (S Vito di Cadore, church of the Difesa), the *Madonna with SS John the Baptist and Andrew* at Candide, the *Madonna with SS Roch and Sebastian* at Dommegge e Vallesella, and a beautiful *Virgin and Child* (Pieve di Cadore, Casa Policardi). Meanwhile, contacts with Venetian clientele were dwindling. Around 1540, Francesco executed an *Annunciation* (Venice, Accad.) in the church of S Nicolo di Bari, Venice, which seems to be a reductive transcription of the Titianesque workshop version in the Scuola de S Rocco. Also dating from this time are the organ doors of S Salvatore, which are an unrealistic attempt to manoeuvre dramatic Mannerist figurative compositions, far removed from the taste of the artist.

BIBLIOGRAPHY

G. Fiocco: 'Profilo di Francesco Vecellio', *A. Ven.*, vii (1953), pp. 39–44

F. Valcanover: 'Il polittico Vecelliano di Sédico', *Archv Stor. Belluno, Feltre & Cadore*, 130 (1955), pp. 25–31

M. Lucco: 'Francesco Vecellio', *Proposte di restauro* (Castelfranco, 1978), pp. 49–52, 119–20

S. Claut: 'Il furto delle opere d'arte nel 1797 e la dispersione del patrimonio artistico', *Archv Stor. Belluno, Feltre & Cadore*, lxix/302 (1998), p. 72

SERGIO CLAUT

(2) Orazio Vecellio (*b c.* 1515; *d* Venice, before 23 Nov 1576). Painter, nephew of (1) Francesco Vecellio. The second son of Titian, he trained in his father's workshop and accompanied him to Rome in 1545 and to Augsburg in 1548. Vasari mentioned him favourably, particularly his portrait of the musician *Battista Ceciliano* (untraced), executed in Rome. Other sources and his few surviving works suggest, however, that he was an inadequate painter, perhaps with a talent for adapting or copying his father's works, as in, for example, a *Venus and Adonis* (untraced). In the 1550s he painted the polyptych in S Andrea, Serravalle (Vittorio Veneto), representing the *Virgin and Child Enthroned with SS Andrew and Peter*, the *Annunciation*, and the *Coronation of the Virgin*. The *Assumption of the Virgin* in Sargnano parish church

(Belluno) can also be ascribed to him, but the donor is a later addition.

Titian held Orazio in high esteem, and in 1564, certainly owing to his father's influence, he competed successfully against Jacopo Tintoretto and Paolo Veronese for the commission to paint the *Battle of Castel Sant'Angelo* (destr. 1577) for the Sala del Gran Consiglio in the Doge's Palace in Venice. His limitations as a painter are obvious both in the congested altarpiece (*c.* 1559) in the church at Sorisole (Bergamo) and in the reliquary shutters in S Biagio, Calàlzo (Belluno), painted in 1566, which are stiff compositions, probably adapted from models by Titian and Jacopo Bassano. Works executed in collaboration with his father include the large *Flight from Egypt* (St Petersburg, Hermitage) and the *Mystic Marriage of St Catherine* (London, Hampton Court, Royal Col.). Among the late works are two conventional altarpieces in the church of Fregona, and a banner for the church of Castel Roganzuolo (1574–6).

BIBLIOGRAPHY

G. Vasari: *Vite* (1550, rev. 2/1568); ed. G. Milanesi (1878–85), vi, p. 588

G. Cadorin: *Dello amore ai veneziani di Tiziano Vecellio* (Venice, 1833)

J. A. Crowe and G. B. Cavalcaselle: *Life and Times of Titian* (London, 1877, rev. 2/1881)

SERGIO CLAUT

(3) Cesare Vecellio (*b* Pieve di Cadore, 1521; *d* Venice, 2 March 1601). Painter and engraver, relative of (1) Francesco Vecellio. He was also a distant relation of Titian. Probably after training in Cadore with Francesco, he joined Titian's workshop in Venice. He travelled with Titian, visiting Augsburg in 1548, and remained in the shop until Titian's death in 1576. His independent works showed great decorative skill, particularly his scenes from the *Life of the Virgin* (1577) and the *Deposition*, both for S Maria Assunta, Lentiai (Belluno; *in situ*). In these paintings, he seemed to turn away from Titian and to look towards the work of Andrea Schiavone and Jacopo Tintoretto. In the neighbouring church of Bardies, Cesare Vecellio signed the frescoes showing *Scenes from the Life of S Anthony Abbot*. Apart from occasional visits to Venice, he was active mainly in Cadore and Belluno, where he decorated a room in the Palazzo Piloni with the *Four Seasons*, and the *Rape of the Sabines* (untraced), known due to a surviving print (*c.* 1685), probably by Giacomo Gallinari.

Probably Cesare's most successful work in terms of style and the use of colour is the altarpiece of the *Virgin and Child with SS Sebastian and Gregory the Great, and Giovanni Loredan* (1584; Belluno Cathedral). This work is directly derived from Paolo Veronese's altarpiece of the same name painted for the church of S Sebastiano in Venice. Here, with his usual Mannerist themes, he demonstrated an unusual awareness of the real world, both in his use of light and in the disposition and depiction of figures. His gift for portraiture is also shown in other works, such as the altarpieces in Tarzo (Treviso) and Borgo Valsugana (Trento), in which the naturalistic effects are worthy of Leandro Bassano at his best. For the parish church of Pieve di Cadore he executed an important painting, the *Surrender of Cadore to Venice* (1599). He also painted the shutters of the old organ there (*St Peter, St Paul*, the *Annunciation*) and a lavish, but lifeless altarpiece

of the *Last Supper*, which is dominated by a background of classical architecture inspired by Andrea Palladio and derived from a Titianesque model (Milan, Brera). Many other works are in churches of the Cadore region and there is a *Trinity* in Milan (Brera).

Cesare also worked as an engraver, producing, for example, the *Adoration of the Name of Jesus* (*c.* 1575). He published the first illustrated costume book, *De gli habiti antichi et moderni di diverse parti del mondo* (Venice, 1590), with 450 woodcuts by Cristoforo Guerra, based on drawings by Vecellio. The edition of 1598 has 503 prints, but there are fewer illustrations in later editions (Madrid, 1794; Paris, 1856–9). He also published a book on embroidery and lacemaking, the *Corona delle nobili et virtuose donne* (Venice, 1591), which was reissued in many editions, as late as 1891. Cesare Vecellio hand-painted the woodcuts in his books and in the books of the library of his Bellunese patrons the Piloni counts, now dispersed.

BIBLIOGRAPHY

F. Vergerio: *La chiesa monumentale di Santa Maria di Lentiai* (Alassio, 1931)

L. Alpago Novello: *Gli incisori bellunesi* (Venice, 1939–40)

G. Fiocco: 'Note su Cesare Vecellio', *Lettere ed arti* (1946)

F. Valcanover: *Le venti tavole del soffitto di S. M. Assunta di Lentiai di Cesare Vecellio* (Belluno, 1956)

M. Lucco: 'Cesare Vecellio', *Arte del '600 nel Bellunese* (Padua, 1981)

S. Claut: 'Feltre e Belluno', *La pittura del Veneto: Il Cinquecento*, ed. M. Lucco, ii (1998), pp. 721–3, 733–4

SERGIO CLAUT

(4) Marco Vecellio (*b* Pieve di Cadore, 1545; *d* Venice, 1611). Painter, relative of (3) Cesare Vecellio. He too was distantly related to Titian and worked in his shop in Venice. He gained Titian's respect and permission to use the denomination 'di Tiziano' with which he signed his numerous works after Titian's death in 1576. In 1566, using cartoons by Titian, he collaborated with Girolamo Denti and Emanuele d'Augusta on the frescoes of the *Life of the Virgin and Christ* (destr.) in the arch-diaconal church of Pieve di Cadore. Until *c.* 1600 he was active chiefly in Cadore and the Veneto, producing repetitive works in dull, monotonous colours in a debased version of Titian's style. It is unlikely, therefore, that he painted the colourful and lively polyptych at SS Addolorata, Pieve di Zoldo, which has been attributed to him. He was on good terms with Doge Leonardo Donà (*reg* 1606–12), and in the early 17th century he executed many works in important Venetian churches (e.g. the *Annunciation*, S Giacomo a Rialto), and the votive painting of *Doge Donà* (S Giovanni Elemosinaro). For the Doge's Palace, Venice, he painted vast canvases including *Pope Clement VII and the Emperor Charles V* in the Sala del Consiglio dei Dieci, the *Masters of the Mint* in the Sala del Senato, the *Virgin and Child with St Mark and Doge Donà* in the Sala della Bussola, and the *Naval Battle at Cape Maleo* in the Sala dello Scrutinio. He also executed a series of portraits of members of the Querini family (Venice, Fond. Querini-Stampalia).

BIBLIOGRAPHY

M. Boschini: *Le minere della pittura veneziana* (Venice, 1664)

D. M. Federici: *Memorie trevigiane sulle opere di disegno* (Venice, 1803)

M. Dazzi and E. Merkel: *Catalogo della Fondazione Scientifica Querini-Stampalia* (Venice, 1979)

I Madruzzo e l'Europa, 1539–1658: I principi vescovi di Trento tra Papato e Impero (exh. cat. by L. Dal Prà, Trent, Castello Buonconsiglio, 1993)

SERGIO CLAUT

Velathri. *See* VOLTERRA.

Vendramin, Gabriele (*b* Venice, 1484; *d* Venice, 15 March 1552). Italian collector. A Venetian nobleman, he was descended from Doge Andrea Vendramin (*reg* 1476–8) and was related to Doge Andrea Gritti (*reg* 1523–38). His wealth came from trade in soap and from land revenues. His palazzo in the parish of S Fosca was frequented by *virtuosi*, and his contacts included many learned patricians. He was the brother-in-law of Taddeo Contarini and knew two other great collectors, Antonio Pasqualino and Michele Contarini. Enea Vico and Hubertus Goltzius (1526–83) praised his collection of medals (Vico, 1555), and Antonio Francesco Doni in *I marmi* described a visit to his collection, where Vendramin showed him an ancient bronze lion, among many rare pieces. Sebastiano Serlio mentioned him as a connoisseur of architecture, and Marcantonio Michiel visited and described his collection in 1530. Vendramin was appointed to his only public office, the minor role of Consigliere della Città, in 1550. His will, a codicil of which was witnessed by Titian, placed his collection in trust.

After Vendramin's death, the collection remained in the Palazzo S Luca in the care of his eldest nephew, Luca. After family disputes about the sale of coins to Venetian merchants, inventories were finally drawn up in 1567–9. The paintings were appraised by Jacopo Tintoretto and Titian's son Orazio Vecellio, and the antiquities by Alessandro Vittoria, Jacopo d'Antonio Tatti Sansovino and Tomaso da Lugano (*fl c.* 1556). Guglielmo Gonzaga, 3rd Duke of Mantua, tried unsuccessfully to acquire some of the antiquities through the mediation of Titian in 1570 and against a background of further conflicts between the heirs and other descendants of Vendramin. These prolonged disputes resulted in a new inventory of the collection in 1601. In 1615 Vincenzo Scamozzi reported that the collection was preserved under seal in the Palazzo S Luca, but it was progressively dispersed during the 17th century, and certain paintings were acquired by Nicolas Régnier (1591–1667). The two inventories of 1567–9 and 1601 permit identification of some of the pieces from Vendramin's collection: the most famous are *La vecchia* and *The Tempest* by Giorgione (both *c.* 1506–10; Venice, Accad.; for the latter see colour pl. 1, XXXIII2); the *Vendramin Family* by Titian (1547; London, N.G.), which shows Gabriele, his brother Andrea, and the latter's sons kneeling before a reliquary of the True Cross, which was involved in two miracles and was given by a mid-14th century ancestor; and Jacopo Bellini's book of drawings (London, BM; *see* BELLINI, (1), fig. 3). He also possessed important Netherlandish paintings: a diptych (Rome, Gal. Doria–Pamphili) attributed to Jan Gossart (*c.* 1478–1532) and a portrait of a man (perhaps that in Genoa, Pal. Rosso), then believed to be a self-portrait by Albrecht Dürer (1471–1528).

UNPUBLISHED SOURCES

Venice, Casa Goldoni, Archivio Vendramin [1567–9 and 1601 inventories]

BIBLIOGRAPHY

M. Michiel: *Notizia d'opere di disegno* (MS.; *c.* 1520–40); ed. G. Frizzoni (Bologna, 1884); Eng. trans. by P. Mussi, ed. G. C. Williamson, as *The Anonimo* (London, 1903/*R* New York, 1969)

S. Serlio: *Il terzo libro* (Venice, 1540)

A. F. Doni: *I Marmi*, iii (Venice, 1552), fol. 40

E. Vico: *Discorsi sopra le medaglie de gli antichi* (Venice, 1555), pp. 16, 88

H. Goltzius: *C. Julius Caesar, sive historiae imperatorum Caesarumque Romanorum ex antiquis numismatibus restituatae* (Bruges, 1563)

V. Scamozzi: *L'idea dell'architettura universale* (Venice, 1615)

A. Rava: 'Il "camerino delle anticaglie" di Gabriele Vendramin', *Nuo. Archv Ven.*, xxxix (1920), pp. 155–81

D. Battilotti and M. T. Franco: 'Regesti di committenti e dei primi collezionisti di Giorgione', *Ant. Viva*, xvii/4–5 (1978), pp. 64–8

S. Settis: *La 'Tempesta' interpretata, i committenti, il soggetto* (Turin, 1978), pp. 129–33

J. Anderson: 'A Further Inventory of Gabriel Vendramin's Collection', *Burl. Mag.*, cxxi (1979), pp. 639–48 [incl. 1601 inventory]

I. Favaretto: *Arte antica e cultura antiquaria nelle collezioni venete al tempo della serenissima* (Rome, 1990), pp. 79–82

D. Battilotti and M. T. Franco: 'La committenza e il collezionismo privato', *Tempi di Giorgione*, ed. R. Maschio (Rome, 1994), pp. 204–99

MICHEL HOCHMANN

Veneto, Bartolomeo. *See* BARTOLOMEO VENETO.

Veneziano, Agostino. *See* MUSI, AGOSTINO DEI.

Veneziano, Baptista. *See* FRANCO, BATTISTA.

Veneziano, Bonifazio. *See* PITATI, BONIFAZIO DE'.

Veneziano, Domenico. *See* DOMENICO VENEZIANO.

Veneziano, Jacometto. *See* JACOMETTO VENEZIANO.

Veneziano, Sebastiano. *See* SEBASTIANO DEL PIOMBO.

Venice [It. Venezia]. Capital of the Veneto region of Italy. The city is built on an archipelago of about 100 islets in the centre of the extensive Venetian lagoon (see fig. 1). It has been renowned since the Middle Ages for its art and architecture and it owes the survival of much of its historic fabric to its isolated position.

I. History and urban development. II. Art life and organization. III. Centre of production. IV. Buildings. V. Scuole.

I. History and urban development.

1. Before 1453. 2. 1453 and after.

1. BEFORE 1453. Venice was founded in the 7th century AD by inhabitants of cities in the Roman Empire, who were fleeing barbarian invasions on the mainland. The earliest settlement was only one of a confederation of twelve similar settlements in the lagoons that once stretched from the Po Delta around the Gulf of Venice to modern Trieste. The first capital of this confederation was Heraclea and the second Malamocco, the latter within the Venetian lagoon. Internecine strife and frequent flooding led to a final transfer of the government of the confederation to Rivo Alto (Rialto) in AD 810, with a chapel to the patron saint, firstly S Todaro. Nineteen years later, the body of the Evangelist St Mark was brought to Rivo Alto from Alexandria; his immediate adoption as the new patron saint confirmed that Rivo Alto was to be the new permanent capital, and his symbol, the winged lion, became that of Venice. Gradually, Venice grew to eclipse all other members of the confederation, although the closest ones (Torcello, Murano and Chioggia) benefited from their proximity to the capital.

1. *Map of Venice* by Jacopo de' Barbari, woodcut in six blocks, 1.35×2.82 m, *c*. 1500 (Venice, Biblioteca Nazionale Marciana); aerial view showing the Grand Canal with the Rialto Bridge, the Piazza S Marco (lower centre), the Arsenal (far right), the Isola S Giorgio (bottom centre), SS Giovanni e Paolo (right of the Rialto Bridge)

The archipelago on which the city was to grow measured about 1.5×5 km. Initial settlement was scattered, although gradually two nuclei, Rialto and S Marco, emerged to form the centre of the city. Rialto developed market functions very early as a result of its location in the centre of the archipelago and of the lagunar network of deep channels. S Marco was settled because it guarded the entrance to the Grand Canal and commanded a great natural harbour with direct access to the sea. The seat of government first took the form of a fortified castle, destroyed by fire in 976, but immediately rebuilt on a larger scale.

Other islets settled in the 10th century included S Pietro di Castello, S Zaccaria, SS Apostoli, and S Giorgio Maggiore. Other island-parishes were founded in all parts of the archipelago in the 9th, 10th and 11th centuries, many of them along the Grand Canal. As the city grew in the 11th century, some parishes became important local centres, with their own markets and the houses (later palaces) of their leading families, the core of the patriciate. By 1200 there were over 70 parishes, each centred on its own *campo* (field or square), with a well for fresh water. Two distinct communications networks developed. The commercial one was formed by the natural watercourse of the Grand Canal, the city's main artery, and by the dozens of subsidiary canals (*rii*) and the navigable channels of the lagoon. The terrestrial network, consisting of the parish squares, their surrounding streets (*calli*) and timber bridges linking the islets allowed land communication on horseback or on foot.

The Venetians had little access to building materials; the first structures were of timber, their roofs thatched with osiers from the lagunar margins. Since these buildings were light, foundations were not a significant consideration. Later, though, as the city grew, more permanent materials were necessary. Bricks were first obtained from the nearby ruins of Roman Altinum and then from brickfields near Mestre. Timber was originally cut from the coastal forests, but these stocks were soon depleted,

and it was then obtained from further afield, chiefly from the forests of the Friuli and the colony of Istria. From the latter also came Istrian limestone, an essential complement to the local brick, while a richer effect was achieved by using Verona or Carrara marble, or Greek marble from ancient ruins. With the building of more substantial structures, timber rafts became necessary as foundations.

By the 10th century Venice had established important commercial links with Constantinople (now Istanbul) and in the 10th and 11th centuries was granted trading privileges by Byzantine emperors. The important shipbuilding industry was taken under state control at the Arsenal (founded 1104) and greatly expanded. These factors facilitated the Republic's subsequent powerful commercial and territorial expansion eastwards. Venice's growth as capital of a great trading empire is inseparable from the growth of S Marco as its spiritual and political centre, and that of Rialto as its commercial heart.

By 1200 Venice had a population of around 100,000 and was one of the largest cities in western Europe; it comprised a constellation of island-parishes from Mendigola in the west to S Pietro in the east. A further boost to development followed the taking of Constantinople (1204) during the Fourth Crusade; as a result, a vast booty of sculptures and artefacts was brought back to Venice. Rialto was well established by this time as the hub of Venice's retail and commercial trade. Bulk goods were unloaded at the adjacent quays, some of which had specialist functions indicated by their present names: Riva del Vin (wine); Riva del Ferro (iron and steel); Riva del Carbon (coal). Banks and insurance offices were centred on the little square in front of S Giacomo; gold and jewellery were worked in the adjacent Ruga degli Orefici, while near by were the fruit, fish and vegetable markets. The focal role of the area around S Marco was considerably enhanced in the 13th century; in 1264 the piazza was paved for the first time, and in 1277 the Zecca (Mint) was moved here from Rialto, so that all major offices of state

were concentrated here. In 1310 great granaries were built near by to house the city's emergency grain supplies.

The structure of the Venetian constitution was largely established by the end of the 13th century. The doge, elected by a complex procedure designed to avoid nepotism, stood at the head of several councils (including the Senato, Collegio and Consiglio dei Dieci) whose members were selected for short terms of office from the Maggior Consiglio. The latter was an assembly of several hundred Venetians eligible for election. In the *Serrata* or 'closing' of this council in 1297, its membership was restricted to the nobles, who thus gained the right to lifelong and hereditary participation in governing the state.

In the east of the city, the Arsenal developed as another specialized zone. It was centred on the original basin of the Arsenale Vecchio, but by 1300 even this large basin was inadequate, and a great new extension was begun, the Arsenale Nuovo, completed *c.* 1325. This became Venice's great naval base and shipbuilding quarter, surrounded by high walls and defensive towers. It was highly organized and rigidly specialized and by the mid-15th century it was probably the largest industrial complex in Europe, employing several thousand men on a rationalized production-line system. Completed ships were fitted out in the Arsenale Vecchio before entering the Bacino and then the Adriatic.

The plan (*c.* 1350, but considerably earlier in origin; Venice, Bib. N. Marciana) by Paolino da Venezia provides the earliest clear representation of the city; about 100 parish and monastic churches are shown, as well as the important satellite islands of Giudecca and Murano and many monastery-islets in the lagoon. Venice was by this time a true metropolis, with every major feature of its urban form clearly established, with the six urban districts (*sestieri*). The entire lagoon now formed an extension of the city, and many of these further satellites had specialized functions: Torcello was a religious centre and seat of a bishopric; Chioggia produced salt and was the headquarters of the sea-fishing fleet; Murano produced glass (*see* §III, 3 below). The lesser islands produced fruit, vegetables and wine, all of which were sold at Rialto.

Fourteenth-century expansion, which included the acquisition of Treviso in 1339, was abruptly halted by the plague, the Black Death, of *c.* 1348, which killed up to half the city's population. It was followed by war (1378–80) against Venice's great rival, Genoa, culminating in the siege of Chioggia, which brought Venice for the first (and only) time to the brink of violent conquest. The Genoese were repulsed, and there was a long period of recovery, which continued until the mid-15th century. After 1400, the Republic expanded on the Italian mainland, occupying much of the Po plain and the present Veneto, including VICENZA in 1404, PADUA and VERONA in 1405 and Ravenna in 1442. By the 1420s Venice was once again the wealthiest city in western Europe and capital of a trading empire that embraced much of the eastern Mediterranean.

Many public works were undertaken to improve the metropolis. The department of the Piovego, in particular, had responsibility for building and maintaining bridges, quays and canals and for enforcing building codes. Many new wells were built to alleviate water shortages, and a long programme of paving all principal streets and squares

was begun. Building techniques became more refined and specialized as experience with larger and higher structures grew. By the late 14th century, all larger buildings were often supported on timber piles driven into the underlying clay (e.g. the south wing of the Doge's Palace). Two vital constructional principles needed to be followed by Venetian architects: the load of a building had to be minimized and it had to be spread as evenly as possible on the foundations. Brick remained the basic building material, with widespread use of white Istrian stone for almost all detailing, especially of windows, balconies and doorways. Floors and roofs were of timber, and vaults were rarely constructed owing to the dangers of settlement. For the same reason, campanili often collapsed or had to be rebuilt. The increased population led to higher buildings and acute land shortages in the city centre. Many streets were extremely narrow, but additional space was gained on upper floors by jetties (*barbacani*) and by building over streets (*sottoporteghi*). The frequent fires led to the development of the characteristic Venetian chimney-pot, incorporating a cinder-trap.

Several specialized building types evolved, of which the *palazzo-fondaco* (or *fontego*) of the merchant noble is the most distinctive and widespread. The *fondaco* element was a warehouse with adjacent offices: it was typically centred on a long hall, the *androne*, which usually ran the entire depth of the building and was directly accessible from the canal. On the first floor was the apartment of the noble and his family; the plan reflected that of the ground floor, with a great hall or *portego* above the *androne*. As land became scarce, older two-storey palaces were replaced by new ones on three or four floors, with servants' rooms and kitchens usually located in the attic. Towards the rear of the palace there was a courtyard containing a well, and an external stair giving direct access to the living accommodation above. Many such palaces lined the Grand Canal but they were also built in parish squares throughout the city. Among 15th-century examples is the Ca' d'Oro (1421–40), the most richly decorated of all. The many foreign communities also had their own *fondachi* combining the function of warehouse with that of lodgings for local representatives and travelling merchants. The Fondaco dei Tedeschi was the largest, but Arabs, Greeks and Turks also had their own warehouses.

2. 1453 AND AFTER. Venice's period of greatest prosperity survived the fall of Constantinople in 1453 to continue into the later 15th century, although there was an outbreak of plague in 1478; in the 16th century, although expansion continued, Venice was beset by crises, notably a fire on the Rialto in 1514 (see below) and further epidemics, particularly severe in 1527 and 1575. There was, however, considerable building activity in all spheres. Much of the work was done by foreigners, of whom the most notable after *c.* 1470 were Pietro Lombardo and Mauro Codussi. Lombardo brought an idiosyncratic Renaissance style to Venice, while Codussi developed a more classical, monumental version. The definitive picture of Venice in this period is Jacopo de' Barbari's extraordinarily detailed woodcut dated 1500 (see fig. 1 above). The city centre was now densely built up; beyond was a slightly less

dense secondary zone, while only at the perimeter was there open space, chiefly orchards and monastic gardens.

In the 1480s a great era of new works began at S Marco with the rebuilding of the east wing of the Doge's Palace, after a fire in 1483 had destroyed the ducal apartments. These works were begun by Antonio Rizzo and included his Scala dei Giganti, the ceremonial stair from which new doges were proclaimed (see fig. 9 below). In the Piazza S Marco the Procuratie Vecchie were rebuilt in the 1510s to replace the earlier procurators' apartments; a little earlier the Torre dell'Orologio was built, forming a gateway where the Merceria, the chief business street, enters the piazza (for further discussion see BUON (ii)).

The early, decorative Lombard style is exemplified by such buildings as the Palazzo Dario (1487), the Scuola Grande di S Giovanni Evangelista (c. 1478–81), the façade of the Scuola Grande di S Marco, rebuilt after a fire in 1485 (begun by Lombardo but completed by Codussi in the early 1490s; see §V, 3 and fig. 11 below), and S Maria dei Miracoli (c. 1489) by Lombardo (for illustration see LOMBARDO, (1)). Codussi introduced a more disciplined approach, and his S Michele in Isola (begun 1469; see CODUSSI, MAURO, fig. 1) is the first fully Renaissance structure in the lagoons. His later work, such as S Maria Formosa (begun 1492) and S Giovanni Crisostomo (begun 1497), exhibits an elegant vocabulary and a mastery of interior spaces, while his Palazzo Corner Spinelli (c. 1490) and the Palazzo Loredan (later Vendramin Calergi; begun c. 1502; see CODUSSI, MAURO, fig. 2) show his development towards a monumental, self-assured style in which a traditional plan is faced with a Roman, classical façade.

The Piazzetta was transformed in the early 16th century; the old markets were removed, and Jacopo Sansovino's magnificent Libreria Marciana was built (see §IV, 7 below), to balance the Doge's Palace situated opposite. By setting the library back from the campanile, Sansovino considerably widened this end of the Piazza, establishing its final shape and dimensions (see fig. 2). Sansovino also designed the adjacent Zecca (Mint), begun c. 1537. This building,

with its strong modelling and rustications symbolic of its function, marked a further stage in the aggrandizement of the S Marco area. Sansovino's third work at S Marco is the Loggetta (c. 1537–42; see SANSOVINO, (1), fig. 3) at the base of the campanile, built as a meeting-place for the nobility. In 1574 and 1577 serious fires destroyed most of the interior of the south and east wings of the Doge's Palace, necessitating an extensive programme of internal rebuilding. The last in this long series of civic works were Vincenzo Scamozzi's procurators' houses, the Procuratie Nuove (see SCAMOZZI, (2); completed after 1640 by Baldassare Longhena), which followed the new corner of the Piazza established by Sansovino and continued Sansovino's elevation along the south side of the square. Thus by 1600 the Piazza had assumed its definitive form; the Prigioni Nuovi (new prisons), connected to the Doge's Palace by the Ponte dei Sospiri (1603), were built at about the same time.

Rialto, the city's financial heart, was almost entirely destroyed in a disastrous fire in 1514, and only S Giacomo escaped serious damage. The urgent necessity to rebuild quickly in order to avoid disruption to trade meant that there were no urbanistic innovations, and the old street-pattern was retained. Several buildings were completely rebuilt by Antonio Scarpagnino, including the Fabbriche Vecchie (c. 1520) and the Palazzo dei Dieci Savi (1521). A little later, Sansovino's Fabbriche Nuove followed (1552–5), and finally in 1588 a competition was held for a new stone Rialto Bridge. Despite proposals by Palladio and Sansovino, the winner was Antonio da Ponte, whose daring single-span arch of 28 m was completed in 1591 (see fig. 3). In the early 16th century there was further expansion of the Arsenal, with the enclosure of the great Arsenale Nuovissimo, later developed as shipbuilding yards. Many other works from 1539 to 1583 modernized and rationalized ship production.

Sixteenth-century development directly reflected population patterns. In 1500 Venice was still one of Europe's largest cities, with nearly 150,000 inhabitants. There was further expansion until the disastrous plague of 1575, which killed up to 40% of the population. Attempts were made to increase land by reclamation around the perimeter of the city; the Zattere quays were built in 1519, but the major expansion was to the north and west. To the north, the Fondamente Nuove were built after 1589, extending the city 200 m into the lagoon. In this period, too, northern Cannaregio was further developed with palaces, houses and terraces. To the west, an even larger zone was reclaimed by 1600, between Santa Croce and the Mendigola peninsula. This land, the Terreni Nuovi, was developed with a regular arrangement of parallel canals and rectangular islets.

The Jewish Ghetto, established by decree in 1526, was the first in Europe. By 1600 it was one of the most notable seats of Jewish culture, with 5000 inhabitants. Initially confined to a single islet, isolated at night, it spread over two adjacent islands as numbers grew. Housing densities became the highest in the city, with houses of up to eight storeys. Five synagogues represented Jews of diverse origins. Other foreign communities also retained their identity in the city, notably the Greeks, with their own church, S Giorgio dei Greci (begun 1539). Later, the

2. Venice, Piazza S Marco, showing the Procuratie Vecchie (1490s) to the left, S Marco (begun c. 1063) and the campanile centre and the Procuratie Nuove (late 16th century to mid-17th) to the right

3. Venice, Rialto Bridge, by Antonio da Ponte, completed 1591

Armenians made a spiritual and cultural base at S Lazzaro in the lagoon.

The city's satellite communities, including Murano and the Giudecca, were rapidly developed by the nobility after 1500. Suburban villas were built on these islands, often with large gardens for which there was no space in the city centre. This early *villeggiatura* grew in importance as the patriciate increasingly left the city in the summer for these villas. The Palazzo Trevisan (*c.* 1556) at Murano is one of the few surviving examples of such houses; similar buildings with extensive gardens lined the northern shore of the Giudecca. After mid-century, though, the nobility turned to the mainland, acquiring great country estates and building much larger villas. The first ones lined the Brenta Canal, between the lagoon and Padua; among them was Palladio's Villa Foscari ('La Malcontenta'), begun *c.* 1558. Dozens were built throughout the 16th and 17th centuries, culminating in such palatial houses as Villa Pisani at Stra (*c.* 1730–60).

Sebastiano Serlio's architectural treatise (*see* SERLIO, SEBASTIANO), first published in Venice 1537–47, had a great impact on his own and succeeding generations, notably on Jacopo Sansovino, whose first major palace, Palazzo Dolfin (begun 1538), reflects this influence. The later Palazzo Corner at S Maurizio (begun 1545) marks the culmination of this stage of the monumental Venetian Renaissance. These palaces are characterized by imposing stone façades with superimposed Classical orders and are paralleled by such works as Michele Sanmicheli's Palazzo Corner at S Polo (*c.* 1550) and his Palazzo Grimani (1556; *see* SANMICHELI, MICHELE, fig. 2), one of the finest in the city. Many other palaces were built in the 16th century, and although several were clad with stone, none was as monumental as these. The façades usually followed more traditional forms; Palazzo Balbi (*c.* 1582–9) is a prominent example, with Baroque influence already visible.

Important churches of the early 16th century include Giorgio Spavento's masterpiece, S Salvatore (begun 1506), still early Renaissance in style and with a noble, imposing interior. A little later, Sansovino's ecclesiastical works included S Martino (1553), much of S Francesco della Vigna (1534) and S Giuliano (1553), and he also worked on the vast Scuola Grande della Misericordia, which was never completed. His contemporary, Scarpagnino, worked on the Scuola Grande di S Rocco (for illustration *see* SCARPAGNINO, ANTONIO) and rebuilt the Fondaco dei Tedeschi after its destruction by fire in 1505. The two most notable later 16th-century churches are Palladio's S Giorgio Maggiore and Il Redentore (*see* PALLADIO, ANDREA, fig. 7). The former was a reconstruction of a former monastery, and Palladio's work included the cloister and refectory as well as the church, while the latter was built to commemorate the end of the plague of 1575. Both interiors are essays in the manipulation of light and space, while the façades, with their giant orders and superimposed pediments, develop Palladio's façade of 1562 at S Francesco della Vigna.

BIBLIOGRAPHY

E. R. Trincanato: *Venezia minore* (Milan, 1948)
J. McAndrew: *Venetian Architecture of the Early Renaissance* (Cambridge, MA, 1960)
S. Muratori: *Studi per una operante storia urbana di Venezia* (Rome, 1960)
G. Perocco and A. Salvadori: *Civiltà di Venezia*, 3 vols (Venice, 1973–6)
W. Wolters: *La scultura veneziana gotica, 1300–1460*, 2 vols (Venice, 1976)
D. Howard: *The Architectural History of Venice* (London, 1980)
G. Bellavitis and G. Romanelli: *Venezia*, Le città nella storia d'Italia (Rome, 1985)
P. Maretto: *La casa veneziana nella storia della città* (Venice, 1986)
G. Gianighian: 'La casa veneziana complessa del Rinascimento: Un'invenzione contra il consumo di territorio', *D'une ville à l'autre: Structure matérielles et organisation de l'espace dans les villes européennes, XIIIe–XCVIe siècle*, ed. J.-C. Maire Vigueur (Rome, 1989), pp. 557–90
R. J. Goy: *Venetian Vernacular Architecture: Traditional Housing in the Venetian Lagoon* (Cambridge, 1989)
H. A Millon and V. M. Lampugnani: *Renaissance from Brunelleschi to Michelangelo: The Representation of Architecture* (London, 1994)
E. Concina: *Storia dell'architettura di Venezia* (Milan, 1995); Eng. trans. as *A History of Venetian Architecture* (Cambridge, 1998)
P. F. Brown: *Venice and Antiquity* (New Haven and London, 1997)

R. J. Goy: *Venice, the City and its Architecture* (London, 1997)
G. Romanelli, ed.: *Venice: Art and Architecture*, 2 vols (Cologne, 1997)
G. Mazzariol and A. Dorigato: *Venetian Palazzi* (New York, 1998)

RICHARD J. GOY

II. Art life and organization.

1. Before 1453. 2. 1453 and after.

1. BEFORE 1453. In the late 14th century and the early 15th, Venice was conservative in its social and economic structures. The chief patrons were the state (e.g. the decoration of S Marco and the Doge's Palace, religious communities and churches, the confraternities (*scuole*; *see* §V below) and private individuals. Important areas of artistic production in this period were in manuscripts and ceramics (*see* §III, 1 and 2 below), while painting was revived around the mid-14th century. GENTILE DA FABRIANO, who came to Venice in 1408, initiated the Late Gothic phase in Venetian painting that was continued by such artists as JACOBELLO DEL FIORE, MICHELE GIAMBONO, Antonio Vivarini (*see* VIVARINI, (1)) and Jacopo Bellini (*see* BELLINI, (1)); in the work of the latter, an increasingly Renaissance character is evident.

For the most part, artists were not distinguished from craftsmen, but in the latter half of the period there were some, for example Jacopo Bellini and Jacobello del Fiore, who aspired to a higher status. Painters, stone-carvers and wood-carvers were artisans who were obliged to belong to guilds, and who typically carried on business in family partnerships. Painters formed one branch of their guild, the Arte dei Dipintori, which also included leather gilders, painters of curtains and wooden chests, and decorators of playing cards. In documents, painters were often referred to as 'pittori di santi', as their main activity was painting altarpiece panels with figures of the Virgin and saints, both for churches and private houses.

Wood-carvers ('intagliatori di legno') belonged to another, separate guild, and there were many disputes over demarcation between the two. Wood-carvers produced altarpieces and frames for painted panels, statues of saints, choir-stalls and many other objects. Their work was usually painted and gilded. All craftsmen working and trading in stone and marble belonged to the Arte dei Tagliapietre. The guild statutes made no distinction between trading in stone and marble, stonemasonry and stone-carving, and a single family partnership might combine all these activities, as did that of Giovanni Buon and his son Bartolomeo Buon, who were in partnership between 1423 and 1443, even though individual members of the workshop might specialize in one activity.

In this period the painters', stone-carvers' and wood-carvers' guilds laid down few regulations on apprenticeship and entry to the guild. The length of apprenticeship for painters varied, but the stone-carvers' guild stipulated a period of at least five years in 1449. There were no mastership tests before the 16th century, and an apprentice who had finished his term and paid a fee was admitted as a master. The ease of entry to the guild reflects the short supply of skilled artisans following the Black Death of *c.* 1348. Paintings were not permitted to be sold in Venice except from the shops of members of the Arte dei Dipintori. The exception to this was the fair at Ascension, which was a free market to which foreigners both brought their wares and came to buy, and at which works of art and antiques changed hands.

Neither painters' nor sculptors' workshops were in any particular area of Venice. A stone-carver's workshop was a yard attached to his house; stone-carvers tended to work to order and did not stock finished articles for sale in the same way as a painter. In Venice family partnerships were the usual type of business association both for merchants and artisans, and it is noticeable that the practice of painting and sculpting ran in families: the Bellini, Vivarini and del Fiore (painters), dalle Masegne and Buon (sculptors); the Gruato family produced five generations of sculptors (documented between 1350 and 1478). The guild dues were lower for the sons of existing members, and premises, tools, stocks and drawings were passed on from father to son. Workshops were not large, with probably no more than two or three family members and a few apprentices and other assistants. Slaves might work at their master's craft, and women may also have helped; they are mentioned in some guild statutes, although not in the painters' or sculptors'.

The government of Venice regulated guilds and craftsmen. In order to promote the growth of crafts and industries in the city, it encouraged skilled craftsmen to settle in Venice and took measures to keep Venetian masters in the city. In 1381 a law was passed threatening anyone who persuaded a master craftsman to leave Venice with six years' imprisonment. Care was taken that there were always master mosaicists in the city to repair the mosaics in S Marco and add to them. When the last remaining mosaic master, Jacobello della Chiesa, died in 1424, the Senate sent to Genoa to fetch his former colleague back to Venice. The gold and more brilliantly coloured tesserae were made in the glass furnaces of Murano (*see* §III, 3 below). There was no Venetian school of fresco painting in the 14th century and, conscious of the high prestige of the medium in the rest of Italy, the Venetian government commissioned the Paduan Guariento (*fl* 1338–67/70) to paint a large fresco of *Paradise* (now in the Sala dell' Armamento) for the newly built Sala del Maggior Consiglio, the largest council-chamber in the Doge's Palace. He was required to train two Venetian apprentices while he carried out the work from 1365–68. Although many foreign craftsmen (e.g. painters from Florence and stone-carvers from Florence and north Italy) came to work in Venice between 1400 and 1450, there was no significant opposition to them from the guilds.

BIBLIOGRAPHY
P. Paoletti: *L'architettura e la scultura del rinascimento in Venezia*, 3 vols (Venice, 1893)
L. Testi: *La storia della pittura veneziana*, 2 vols (Bergamo, 1909)
M. Muraro: *Pitture murali nel Veneto e tecnica dell'affresco* (Venice, 1960), pp. 25–32
E. Favaro: *L'arte dei pittori in Venezia e i suoi statuti*, Università di Padova, Pubblicazioni della Facoltà di Lettere e Filosofia, lv (Florence, 1975)
W. Wolters: *La scultura veneziana gotica, 1300–1460*, 2 vols (Venice, 1976)
D. Rosand: *Painting in Cinquecento Venice: Titian, Veronese, Tintoretto* (New Haven and London, 1982), pp. 1–46
S. Connell: *The Employment of Sculptors and Stonemasons in Venice in the Fifteenth Century*, Outstanding Diss. F.A. (New York and London, 1988)

SUSAN CONNELL

2. 1453 AND AFTER.

(i) Painting. (ii) Sculpture. (iii) Patronage.

(i) Painting. During the later 15th century a distinct school of painting developed in Venice. It was characterized by the exploration of colour and light and by the sensuous rendering of surface texture. As in the preceding period, painters continued to be organized in the Arte dei Pittori, and many of them were also in family workshops. During the second half of the 15th century the leading artists working in this way were the VIVARINI and the BELLINI families, while during the 16th century TITIAN, Jacopo Tintoretto (*see* TINTORETTO, (1)), PAOLO VERONESE and Francesco Bassano the elder (*see* BASSANO) were all working with members of their families. Some painters gained considerable social status: members of the Bellini family held offices in the Scuola Grande di S Marco, and Jacopo Tintoretto was granted membership of the Scuola Grande di S Rocco as part of his remuneration. Gentile and Giovanni Bellini and, later, Titian were appointed official painters of the Republic. Both Gentile and Titian were knighted.

Many artists who were not native Venetians made a significant contribution to the city's art. For example, the decade (1443–53) spent by Donatello in nearby Padua played a pivotal role for Venetian sculptors and painters. In the second half of the 15th century the most influential painters from outside Venice were Andrea Mantegna, who was working in Padua in the 1450s, and the Sicilian Antonello da Messina, who was in Venice in 1475–6. Although Giovanni Bellini had probably experimented with oil paint before Antonello's visit, it was the latter's use of this medium that determined the Venetian's subsequent development. As head of the local school, Bellini influenced many painters, including Cima da Conegliano, Francesco Bissolo and Giovanni Mansueti. His art also affected the German Albrecht Dürer (1471–1528), who visited Venice in 1495 and 1505–7. In the early 16th century Palma Vecchio was the leading member of a colony of Lombard artists in Venice that also included Giovanni Cariani and Giovanni Girolamo Savoldo. Around 1540 Giorgio Vasari and other Florentines visited the city, and in the 1560s the young El Greco (*c.* 1541–1614) spent several years in the workshops of Titian and Tintoretto.

Initially, predominantly religious paintings were produced, mainly altarpieces for Venice's churches, votive pictures and devotional images for private use. Formats of altarpieces varied, but the medieval polyptych was gradually replaced by the Renaissance *pala*, usually representing a *Sacra conversazione*, as in Giovanni Bellini's S Giobbe Altarpiece (Venice, Accad.; *see* BELLINI, (3), fig. 3). This format was established in the 1470s, but polyptychs continued to be produced throughout the 16th century. Votive pictures usually represented donors kneeling in front of a saint or the Virgin (e.g. *see* BELLINI, (3), fig. 1). Large numbers of devotional images, mostly half-length representations of the Virgin and Child, were executed in workshops, not necessarily to commission. According to statistics of *c.* 1600, practically every Venetian household owned such pictures. Religious images were produced by all painters throughout the period, and such variations of

the *Sacra conversazione* as Titian's Pesaro *Madonna* (1519–26; Venice, S Maria dei Frari; see colour pl. 2, XXXV2) remained popular. Increasingly, altarpieces also depicted narrative events, the most influential example being Titian's *Death of St Peter Martyr* (1526–30; Venice, SS Giovanni e Paolo; destr. 1867). During the late 15th century and the early 16th, however, narrative themes were predominantly represented on canvas in large-scale cycles. The most prominent of these was the series of historical–political paintings for the Sala del Maggior Consiglio in the Doge's Palace, begun by Gentile Bellini in 1474. Other council chambers were given similar decorative schemes, as part of a campaign that continued for almost a century and involved all major Venetian painters. When many of the paintings were destroyed by fires in 1574 and 1577 they were immediately replaced, either by Veronese (see fig. 10 below) and Tintoretto and their workshops, or by painters of a younger generation, including Palma Giovane, the leading painter of his day (*see* §IV, 4(ii) below).

The *scuole* (*see* §V below) modelled themselves on the patrician government in organization and artistic taste. The wealthy *scuole grandi*, in particular, decorated their assembly halls with narrative sequences similar to those of the Doge's Palace, preferring to commission artists previously employed by the state, but focusing on religious–social subjects related to their own social function. Around 1500 Gentile Bellini, Vittore Carpaccio and others were meticulously illustrating contemporary life, as shown by the canvases for the Scuola Grande di S Giovanni Evangelista (1494–1506; Venice, Accad.; see colour pl. 1, VIII3). Other schemes, for example Carpaccio's cycle of the mid-1490s for the Scuola di S Orsola (Venice, Accad.; *see* CARPACCIO, (1), fig. 4 and colour pl. 1, XIX1), were painted for the *scuole piccole*. From the 1540s such programmes often also included lavishly carved and gilded compartmentalized ceilings with paintings. All the leading painters produced ceiling paintings for private, public and religious buildings. Paolo Veronese was particularly renowned for his canvases in the Doge's Palace (1553 and later; *see* VERONESE, PAOLO, fig. 2) and in S Sebastiano (*c.* 1555). The largest cycle of narrative paintings, comprising approximately 60 canvases, was executed by Tintoretto (*see* TINTORETTO, (1)) and his workshop for the Scuola Grande di S Rocco (1565–88; see colour pl. 2, XXXIV2). In the second half of the 16th century these paintings had their counterparts in frescoes of allegorical and mythological subjects that were painted in villas on the Venetian mainland. Many of them, for example those of *c.* 1561 in the Villa Barbaro at Maser, were produced by Veronese (*see* VERONESE, PAOLO, fig. 3 and colour pl. 2, XXXIX1) and his compatriot Giambattista Zelotti. In Venice itself frescoes were also common and were painted by such artists as PORDENONE, but they deteriorated quickly in the lagoon's damp climate. It is probable that young artists painted frescoes on façades in order to advertise their art, and Giorgione and Titian's work at the Fondaco dei Tedeschi may be an example of this.

In the late 15th century the private portrait gained popularity, in addition to the already established official state portrait. The Bellini are usually credited with its introduction, but Netherlandish portraits, several of which

were held in Venetian collections, were also influential. During the 16th century portraits increased in size, and three-quarter or even full-length representations were favoured, in proportion to the sitter's growing sense of self-importance. Titian and LORENZO LOTTO created the psychologically most intense likenesses (e.g. *see* TITIAN, fig. 10), both of single sitters and of groups. The numerous portraits (including self-portraits) of painters in this period demonstrate their changing status from that of craftsmen to artists (see fig. 4). The increasing popularity of the private portrait led to the development of a fashion for representations of imaginary semi-nude female sitters; these in turn led to the theme of the Reclining Venus (see colour pl. 2, XXXV3). Such erotic subjects, reserved for private viewing, had been introduced by Giorgione in the *Sleeping Venus* (?1508–10; Dresden, Gemäldegal. Alte Meister; *see* GIORGIONE, fig. 4) and were elaborated by many painters, most notably Palma Vecchio. Similarly, landscape became increasingly prominent in Venetian painting. Initially used as a backdrop in paintings by Giovanni Bellini, for example in his *Agony in the Garden* (*c.* 1465; London, N.G.), and, above all, CIMA DA CONEGLIANO, landscape later played a major role in the pastorals and *poesie* of the 16th century, as can be seen in Titian's *Rape of Europa* (*c.* 1560; Boston, MA, Isabella Stewart Gardner Mus.; *see* TITIAN, fig. 8). Giorgione's *Tempest* (Venice, Accad.; see colour pl. 1, XXXIII2) is an outstanding example of this new genre. From the second quarter of the 16th century mythological narratives, often in a landscape setting, quickly gained popularity. Working in Venice, Titian supplied numerous mythologies to such princely patrons as Alfonso I d'Este and Philip II of Spain.

Preparatory drawings appear to have played a minor role in Venice, and they were not necessarily regarded as part of the process of making a picture. This led Vasari to accuse Venetian artists of 'not being capable of making designs'. On the other hand, as Venice was a leading centre of the early printing industry, prints, woodcuts and engravings were produced in large numbers (*see* §III, 1 below). The prints were mostly reproductions of paintings, frescoes and drawings, which could thereby reach a wide audience. Prints by German artists were particularly popular. Closely connected to the Germans was Jacopo de' Barbari (see fig. 1 above), who at the end of the 15th century improved engraving techniques and was able to pull many impressions from one plate. He inspired younger engravers, including Giulio and Domenico Campagnola.

(ii) Sculpture. Most sculptors in Venice of this period were also active as architects (and vice versa). Although some specialized in figure-carving, all were members of the masons' guild, the Arte dei Tagliapietra. In 1460 masons were in such demand that the Venetian government attracted foreign craftsmen by granting them citizens' status. By 1491, however, local craftsmen felt threatened by the predominance of foreign (mostly Lombard) masons and complained about foreign competition, mentioning as many as 126 non-Venetian masters and their 50 apprentices as opposed to only 40 Venetian masters. The leading Lombards were Pietro Lombardo and his sons Antonio Lombardo and Tullio Lombardo. Numerous other sculptors were active in the city, but few works are signed or documented, and many projects were workshop productions. Among the identifiable sculptors of the early 16th century are Giovanni Buora (before 1450–1513), Giovanni Battista and Lorenzo Bregno, Antonio Minello and GIOVANNI MARIA MOSCA PADOVANO, whose work was related to the style of the Lombardo family, and Bartolomeo di Francesco Bergamasco (*d* 1527/8). Throughout the period, sculpture in Venice was made largely by non-Venetians: Jacopo Sansovino and DANESE CATTANEO came from Tuscany, and Nicolò Roccatagliata (*fl* 1593–1636) was from Genoa. Others came from the Venetian mainland: Antonio Rizzo and Girolamo Campagna (1549–*c.* 1625) were from Verona, Andrea Riccio and Tiziano Aspetti (*c.* 1559–1606) from Padua, and Alessandro Vittoria was from Trent. Like painters, many sculptors and masons (e.g. the Lombardo and the Bregno families) worked in family businesses. Some workshops were of an impressive size: Pietro Lombardo employed 25 masons (including stonecutters and sculptors) on at least one occasion. Workshops were located all over the city, often near a canal to facilitate the transport of stone. Temporary workshops were set up on site for larger undertakings. At times, projects necessitated the collaboration of sculptors and painters. In 1476 Antonio Rizzo carved a pulpit with reliefs (destr. 1485) for the Scuola Grande di S Marco, after designs by Gentile Bellini. During the late 16th century Alessandro Vittoria and the painter Palma Giovane, who were close friends, collaborated on several occasions, for example on the altar of the Merciai (the mercers' guild; *c.* 1584; Venice, S Giuliano; *see* VITTORIA, ALESSANDRO, fig. 2).

4. Palma Giovane: *Self-portrait*, oil on canvas, 1.28×0.96 m, *c.* 1590 (Milan, Accademia di Belle Arti di Brera)

Venetian sculpture remained essentially Gothic until the death (*c.* 1464–7) of Bartolomeo Buon, when the Renaissance style was introduced by ANTONIO RIZZO in such works as the altars of St Paul and St James (1465–9; Venice, S Marco). Although numerous sculpted altarpieces decorated Venice's churches, the major genre of Venetian sculpture developing during the late 15th century was the ducal tomb. The first monument of the period was produced by members of the Bregno family for *Doge Francesco Foscari* (*c.* 1460; Venice, S Maria Gloriosa dei Frari; for illustration *see* BREGNO, (1)). It is still a predominantly Gothic work, but a new type emerged in the 1470s, combining Roman triumphal arch motifs with traditional elements. During the late 15th century and the early 16th most ducal tombs were produced in the Lombardo workshop, the foremost example being Tullio Lombardo's monument to *Doge Andrea Vendramin* (*c.* 1488–94; Venice, SS Giovanni e Paolo; *see* LOMBARDO, §II(2), fig. 1). Tullio's avid pursuit of the Antique reflects Venetian artistic taste of *c.* 1500, when the interest in Classical art had become widespread. In 1504 Pomponius Gauricus published his treatise *De sculptura*, in which he praised Tullio Lombardo as the leading artist–sculptor of his day. The vogue for *all'antica* sculpture manifested itself in many small bronzes and reliefs but, paradoxically, it found its most rigorous expression in Tullio Lombardo's marble relief altarpiece of the *Coronation of the Virgin* (*c.* 1500–02) in S Giovanni Crisostomo.

Sculptural monuments embellished many of Venice's public spaces. One of the most outstanding examples is the bronze equestrian statue of *Bartolomeo Colleoni* (commissioned 1480; *see* VERROCCHIO, ANDREA DEL, fig. 4) in the Campo SS Giovanni e Paolo. It was designed by the Florentine Andrea del Verrocchio and completed after his death (1488) by the Venetian Alessandro Leopardi. Leopardi also contributed to the sculptural decoration of the Piazza S Marco and its surrounding: the three bronze flag staff bases (1505–6, Venice, Piazza S Marco; for illustration *see* LEOPARDI, ALESSANDRO) and the two giant *Moors* (1497–9) on the clock tower, which are possibly by Leopardi, are part of a complex programme designed to express Venice's glory. Moreover, they attest to the status of bronze as the most prestigious material for sculpture, a view also endorsed by Gauricus. In the wake of Donatello's activity, Padua developed an important bronze industry, led by Bartolomeo Bellano and, later, ANDREA RICCIO, who excelled in making small bronzes, mostly for humanists' collections. At the end of the 15th century such works also gained popularity in Venice. Monumental bronzes were also produced; the tomb and altar with life-size figures (1503–22) by Antonio Lombardo (*see* LOMBARDO, §II(3)) and PAOLO DI MATTEO SAVIN in the Zen Chapel, S Marco, were the largest bronze works in Venice of the early 16th century. The most important Venetian sculpture of Jacopo Sansovino, chief architect and sculptor of the Venetian Republic in the mid-16th century, was also executed in bronze. Under Sansovino the sculptural programme of the S Marco precinct was continued with four bronze statues for the Loggetta of the Campanile (*see* SANSOVINO, (1), fig. 3) and bronze reliefs as well as statues for the choir of S Marco. The sculptural decoration required for Sansovino's buildings was produced in his

5. Alessandro Vittoria: gilded stucco vault (detail; 1577–9), Scala d'Oro, Doge's Palace, Venice

workshop, where the most gifted member was Alessandro Vittoria. Vittoria and, later, Girolamo Campagna (*c.* 1549–1625) were entrusted with prestigous state commissions. Vittoria introduced stucco for the vault decorations of Sansovino's staircase in the Doge's Palace (the Scala d'Oro; see fig. 5) and in the Libreria Marciana as well as the figures in the chapel of the Rosary in SS Giovanni e Paolo. Apart from marble and bronze, he also used clay for numerous portrait busts, the counterparts to portraits from the workshops of Tintoretto or Palma Giovane. Campagna designed the bronze statuary for the high altars of two of Palladio's churches: Il Redentore (1589–90) and S Giorgio Maggiore (1592–3).

(iii) Patronage. Although many Venetian artists worked for European courts, Venetian art itself was not centred around the taste of a court or one dominant family. The ideology of the state, however, influenced the pattern for corporate and private patronage. The central institutions responsible for state patronage were S Marco and the Doge's Palace. Many artists sought state patronage, as it increased their reputation and provided them with a pension. While it was customary for the doge (and other government officials) to commission a votive or devotional picture for the Doge's Palace, only a few doges, for example Agostino Barbarigo (*see* BARBARIGO) and ANDREA GRITTI, were major patrons in their own right. The example set by the patrician government at the Doge's Palace was followed by the *scuole* as well as by several religious orders, including the Hieronymites at S Sebastiano. Occasionally, the state or corporate patrons organized competitions. The commission for the *Colleoni* monument (*see* §(iii) above) probably resulted from a competition,

and in the 16th century the Scuola Grande di S Rocco launched two competitions: in 1516 for the high altar of S Rocco and in 1564 for the pictorial decoration of its assembly halls (see §V, 4 below).

Religious images were commissioned by all types of patrons, but most were made for laymen. From c. 1500 private individuals ordered an increasing number of secular paintings for domestic settings. Various private collections existed during the late 15th century and the early 16th. Several of these, including the well-known ones of Andrea Odoni and Gabriele Vendramin, were described by the patrician and connoisseur MARCANTONIO MICHIEL in the first half of the 16th century. Giorgione was among the first to work almost exclusively for this new market, executing paintings of ambiguous or erotic subject-matter. When at the end of the 15th century humanist schools were founded in Venice, patrons also became increasingly interested in works of Classical art. In 1523 Cardinal Domenico Grimani bequeathed his collection of antiquities to the state, and it was displayed in the Doge's Palace. When in 1593 Domenico's nephew Giovanni Grimani left 200 antique marble works to the Republic, the entire collection was moved to the Libreria Marciana, and the Statuario Pubblico was established in 1596 as the first public archaeological museum.

The guidebook of 1581, *Venetia città nobilissima et singolare*, by Francesco Sansovino (see SANSOVINO, (2)) is an invaluable source of information on the art life and organization of 16th-century Venice.

BIBLIOGRAPHY

Pomponius Gauricus: *De sculptura* (1504); ed. and Fr. trans. by A. Chastel and R. Klein (Geneva, 1969)

F. Sansovino: *Dialogo di tutte le cose notabili che sono in Venetia* (Venice, 1561)

——: *Venetia città nobilissima et singolare* (Venice, 1581); ed. G. Stringa (Venice, 1604); ed. G. Martinioni (Venice, 1663)

F. Frizzoni, ed.: *Anonimo Morelliano: Notizie d'opere di disegno* (Bologna, 1884) [notes of Marcantonio Michiel]

P. Paoletti: *L'architettura e la scultura del rinascimento a Venezia* (Venice, 1893)

P. Molmenti: *La storia di Venezia nella vita privata dalle origini alla caduta della Repubblica*, 3 vols (Bergamo, 1927–9)

J. Schulz: *Venetian Painted Ceilings of the Renaissance* (Berkeley and Los Angeles, 1968)

W. Stedman Sheard: *The Tomb of Doge Andrea Vendramin in Venice by Tullio Lombardo* (diss., New Haven, CT, Yale U., 1971)

O. Logan: *Culture and Society in Venice, 1470–1790: The Renaissance and its Heritage* (London, 1972)

M. Perry: 'The Statuario Pubblico of the Venetian Republic', *Saggi & Mem. Stor. A.*, viii (1972), pp. 75–253

G. Perocco and A. Salvadori: *Civiltà di Venezia*, 3 vols (Venice, 1974–6)

M. Maek-Gerard: 'Die "Milanexi" in Venedig', *Wallraf-Richartz-Jb.*, xli (1980), pp. 105–30

T. Pignatti, ed.: *Le scuole di Venezia* (Venice, 1981)

The Genius of Venice, 1500–1600 (exh. cat., ed. J. Martineau and C. Hope; London, RA, 1983)

N. Huse and W. Wolters: *Venedig: Die Kunst der Renaissance* (Munich, 1986; Eng. trans., 1988)

S. Connell: *The Employment of Sculptors and Stonemasons in Venice in the Fifteenth Century*, Outstanding Diss. F. A. (New York and London, 1988)

P. Fortini Brown: *Narrative Painting in the Age of Carpaccio* (New Haven, 1988)

D. Chambers and B. Pullan, eds: *Venice: A Documentary History, 1450–1630* (Oxford, 1992)

M. Hochmann: *Peintres et commanditaires à Venise (1540–1628)* (Rome, 1992)

P. Humfrey: *The Altarpiece in Renaissance Venice* (New Haven, 1993)

P. Humfrey: 'The Bellini, the Vivarini and the Beginnings of the Renaissance Altarpiece in Venice', *Italian Altarpieces, 1250–1550: Function and Design*, ed. E. Borsook and F. S. Gioffredi (Oxford, 1994), pp. 139–76

P. F. Brown: *The Renaissance in Venice: A World Apart* (London, 1997)

From Tempera to Oil Paint: Changes in Venetian Painting, 1460–1560 (exh. cat. by A. Wallert and C. von Oosterhout, Amsterdam, Rijksmus., 1998)

JOACHIM STRUPP

III. Centre of production.

1. Manuscripts, books and prints. 2. Ceramics. 3. Glass. 4. Tapestry.

1. MANUSCRIPTS, BOOKS AND PRINTS. Illuminated manuscripts from Venice reflect its unique political structure as well as the nature of its institutions. Venetian guilds and confraternities were closely scrutinized by the Republic, a situation reflected in the production of official manuscripts. The *mariegole*, containing guild regulations, open with images of patron saints or scenes relating to the organization. The *ducali*, which record the vows (*promissioni*) of each newly elected doge and list the duties (*commissioni*) of Venetian governors of subject cities, open with images of the doge, St Mark, Venice personified or a patron saint. Other secular manuscripts from the Veneto include illustrated romances, chronicles of Venetian history and scientific treatises, for example the Carrara Herbal (c. 1400; London, BL, Egerton MS. 2020), made in Padua with many plants observed directly from nature.

In the late 14th century the reformed monastic orders, especially the Benedictines of S Giustina, Padua, and the Camaldolites of S Michele, Murano, commissioned new choir-books, which continued to be produced in the Veneto until the 16th century; they show styles ranging from extravagant Late Gothic to fully Renaissance compositions with classicizing decorative and figural components.

Manuscript illumination in Venice from 1400 to 1440 was dominated by CRISTOFORO CORTESE, who painted many religious, literary and Classical texts, including works by such authors as Cicero, Seneca and Terence, demonstrating the spread of humanism in the Veneto. Leonardo Bellini (see BELLINI, (4)) was prominent from the later 1450s to the 1480s. He executed *ducali*, including the *promissione* of Doge Cristoforo Moro (1463; London, BL, Add. MS. 15816), and humanist texts with noble Venetian coats of arms. His works incorporate Renaissance elements, while the *Old Testament* miniatures in the Hebrew Rothschild Miscellany (Jerusalem, Israel Mus., MS. 180/51) contain exceptional landscapes. More fully classicizing works were produced in Venice and Padua in the 1450s and 1460s under Mantegna's influence by such illuminators as the Tiptoft Master, the Master of the Victoria and Albert Petrarch, FRANCO DEI RUSSI, GIROLAMO DA CREMONA, the scribe BARTOLOMEO SANVITO and perhaps Mantegna himself. Frontispieces framed with Classical architecture and bearing faceted initials imitating Roman epigraphic letters appeared. Illusionistic effects were achieved through painting the area near the edge of the text to look like a torn piece of parchment with monuments and landscapes behind.

The arrival of printing in Venice in 1469 intensified the Classical Revival in Veneto–Paduan illumination, in part because Latin authors predominated in the earliest editions

(see below). Generous spaces were left blank by the printers for initial letters to be added by hand. Some were completed by well-established illuminators such as Franco dei Russi and Girolamo da Cremona, just as they would have illuminated manuscripts. Younger artists who matured in the 1470s, such as Giovanni Vendramin, the MASTER OF THE PUTTI (*see* MASTERS, ANONYMOUS, AND MONOGRAMMISTS, §I), the London Pliny Master, the Pico Master (*fl* 1469–94) and Antonio Maria da Villafora, specialized in decorating printed books, executing frontispieces with Classical architecture and mythical creatures. The compositions were frequently drawn in pen with only touches of wash for colour, harmonizing well with the printed page. Painted coats of arms often appear, but sometimes the shield is blank, suggesting that the decoration was prepared speculatively. In the 1490s the use of woodcuts presaged the end of the illuminator's trade. The great printer Aldus Manutius (*d* 1515), however, occasionally still printed on parchment, and copies of his editions were illuminated in the early 16th century. BENEDETTO BORDON painted a few ecclesiastical manuscripts and many *ducali* in these years, including the Evangeliary (1523–5; Dublin, Chester Beatty Lib., MS. 107) for S Giustina, Padua. Finally, from 1520 to 1570, there survive over 40 *ducali* showing the influence of Titian, from the workshop of an illuminator with the initials *T*˙. *Ve.*

The Venetian printing industry grew rapidly after printing with movable type arrived in Venice in 1469. By 1500 over 200 firms had printed at least one book, with more than 3000 editions, making Venice the greatest centre for printing in Europe. Venetian incunabula (books printed before the end of 1500) were distinguished by their large size, handsome layout and beautifully designed type. A Frenchman, Nicolas Jenson, was the most successful printer in the 1470s and set high standards for design, particularly in editions of Classical texts set with Roman type. A market for printed ecclesiastical and legal books soon developed, but these were usually set with Gothic types. Large woodcut initials and borders appeared in Venetian books printed in 1476–8 by the Germans Erhard Ratdolt (*fl* 1462–*c*. 1518), Bernard Mahler and Peter Löslein (*fl* 1476–8), but in general printers in Venice resisted illustrating books with figural woodcuts until *c*. 1490. In the transitional period, frontispieces and initials were left blank and individual copies were completed by illuminators (see above).

In the early 1490s there was a rapid increase in the number of Venetian books with woodcut frontispieces and narrative scenes. Initially these were simple outline woodcuts in two principal styles by artists designated the 'Popular Designer' and the 'Classical Designer' (Hind), who were probably illuminators and may perhaps be identified as the Pico Master and Benedetto Bordon respectively. Elegant architectural frontispieces and vivacious vignettes by the Popular Designer appear in editions between 1489 and 1494, while after 1493 the style of the Classical Designer predominates. Initially 'Classical style' woodcuts were also simple outline cuts, although the figure style was more monumental and reminiscent of paintings by Mantegna. The culmination of this style is represented by the beautiful woodcuts in the *Hypnerotomachia Poliphili* (Venice, 1499) by Francesco Colonna,

which have been attributed to a wide variety of artists, including Bordon. It was printed by Aldus Manutius, the most distinguished printer in Venice from the mid-1490s until his death in 1515. His fame rests on his many editions in Greek and on the handsome design of small volumes printed in innovative cursive types, now known as italic.

By the end of the 15th century artists in the Veneto were also producing woodcuts and engravings independent of printed books. Classicizing engravings of the 1470s and 1480s by ANDREA MANTEGNA, and woodcuts and engravings by Albrecht Dürer (1471–1528) in the 1490s, profoundly influenced all subsequent printmakers in northern Italy. Both achieved volumetric effects by modelling figures with parallel strokes or with crosshatching. Works continuing this style include the magnificent multi-block woodcut *Map of Venice*, designed by Jacopo de' Barbari (*c.* 1500; 12 extant copies, e.g. London, BM; original blocks in Venice, Correr; see fig. 1 above); a series of the *Triumph of Caesar* designed by Benedetto Bordon and cut by a German, Jacob of Strassburg (*fl* 1494–1530); and engravings by Giulio Campagnola, whose pastoral imagery additionally reflects the paintings of Giorgione.

Titian introduced a looser woodcut style after 1510, and woodcutters emulated the longer, broader lines of his drawings. His large multi-block woodcut of the *Crossing of the Red Sea* was published by Bernardino Benaglio, whose request for a privilege to print cites UGO DA CARPI as the cutter. Da Carpi in turn probably invented the chiaroscuro woodcut (see colour pl. 1, XXI), using multiple blocks and colours of ink in imitation of wash drawings. Domenico Campagnola and Niccolò Boldrini also sometimes collaborated with Titian and spread his sweeping style in landscapes with religious or secular subjects.

Venice remained an important centre of fine printing throughout the 16th century. After 1500 illustrations in Venetian books also shifted from outline woodcuts to prints with fine modelling lines that heightened the three-dimensional qualities of figures and objects; engravings also occasionally replaced woodcuts for full-page illustrations. Title-pages with architectural elements, classicizing decorative motifs, allegorical figures and even narrative scenes in fictive reliefs became common. Illustrated technical treatises of high quality included the *De humani corporis fabrica libri septem* by the anatomist Andreas Vesalius (1514–64), prepared in Italy but printed in Basle (1543) by Johannes Oporinus. It is not known who produced the accompanying woodcuts of partially dissected human figures set in landscapes, although the designs apparently originated in the circle of Titian, and his pupil Jan Steven van Calcar (?1499–?1546) appears to be responsible for some of the illustrations. The woodcuts by Andrea Palladio illustrating Daniele Barbaro's translation of Vitruvius, *I dieci libri dell'architectura* (Francesco Marcolini, 1556), and Palladio's own *I quattro libri dell'architettura* (Domenico de' Franceschi, 1570) are impressive for their archaeological expertise and balanced designs. In literature, the elegant, Mannerist engravings for Ludovico Ariosto's *Orlando furioso* (Francesco de' Franceschi, 1584) by Girolamo Porro (*fl* 1574–1604) are among the most elaborate illustrations of any Venetian Renaissance book. These works epitomize the combined

intellectual, artistic and entrepreneurial character of book and print production in Renaissance Venice.

BIBLIOGRAPHY

Prince d'Essling [V. Maséna]: *Les Livres à figures vénitiens de la fin du XVe siècle et du commencement du XVIe (1469–1525)*, 6 vols (Florence, 1907–14)
Catalogue of Books Printed in the XVth Century, London, BM cat., v (London, 1924) [with facs. of typefaces]
A. M. Hind: *An Introduction to a History of Woodcut* (London, 1935)
M. Sander: *Le Livre à figures italien depuis 1467 jusqu'à 1530*, 6 vols (New York, 1941–5)
R. Pallucchini: *La pittura veneziana del trecento* (Venice, 1964)
G. Mariani Canova: *La miniatura veneta del rinascimento* (Venice, 1969)
J. Schulz: 'The Printed Plans and Panoramic Views of Venice (1486–1797)', *Saggi & Mem. Stor. A.*, vii (1970), pp. 13–108
G. M. Zuccolo Padrono: 'Il Maestro "T". Ve" e la sua bottega: Miniature veneziane del XVIo secolo', *A. Ven.*, xxv (1971), pp. 53–71
R. Mortimer: *Italian Sixteenth-century Books*, Harvard U. Lib. cat., 2 vols (Cambridge, MA, 1974)
Early Italian Engravings from the National Gallery of Art (exh. cat. by J. Levenson, K. Oberhuber, J. Sheehan, Washington, DC, N.G.A., 1976)
L. V. Gerulaitis: *Printing and Publishing in Fifteenth-century Venice* (Chicago, 1976)
Titian and the Venetian Woodcut (exh. cat., ed. D. Rosand and M. Muraro; Washington, DC, N.G.A., 1976)
M. Lowry: *The World of Aldus Manutius* (Ithaca, NY, 1979)
L. Armstrong: *Renaissance Miniature Painters and Classical Imagery: The Master of the Putti and his Venetian Workshop* (London, 1981)
G. Dillon: 'Sull libro illustrato del quattrocento: Venezia e Verona', *La stampa degli incunaboli nel Veneto*, ed. N. Pozza (Vicenza, 1984), pp. 81–96
J. J. G. Alexander: 'Initials in Renaissance Illuminated Manuscripts: The Problem of the So-called "Litera Montiniana"', *Renaissance- und Humanistenhandschriften* (Oldenbourg, 1989), pp. 145–55
L. Armstrong: 'Il maestro di Pico: Un miniatore veneziano del tardo quattrocento', *Saggi & Mem. Stor. A.*, xvii (1990)
J. M. Massing: 'The Triumph of Caesar by Benedetto Bordone and Jacobus Argentoratensis', *Prt Q.*, vii (1990), pp. 11–39
M. Lowry: *Power, Print, Profit: Nicolaus Jenson and the Rise of Venetian Publishing in Renaissance Europe* (Cambridge, 1990)
G. Mariani Canova: 'La miniatura nei libri liturgici marciani', *Musica e liturgia a San Marco: Testi e melodie per la liturgia delle ore dal XII al XVII secolo: Dal graduale tropato del duecento ai graduali cinquecenteschi*, ed. G. Cattin, 4 vols (Venice, 1990–92), i, pp. 149–88
L. Armstrong: 'The Impact of Printing on Miniaturists in Venice after 1469', *Printing the Written Word: The Social History of Books, ca. 1450–1530*, ed. S. Hindman (Ithaca, NY, 1991), pp. 174–202
The Painted Page: Italian Renaissance Book Illumination, 1450–1550 (exh. cat., ed. J. J. G. Alexander; London, RA, 1994)
G. Mariani Canova: 'La miniatura a Venezia dal Medioevo al Rinascimento', *Storia di Venezia: Temi, L'arte*, ii (Rome, 1995), pp. 769–843
H. K. Szepe: 'Bordon, Dürer and Modes of Illuminating Aldines', *Aldus Manutius and Renaissnce Culture: Essays in Memory of Franklin D. Murphy* (Florence, 1998), pp. 185–200
L. Pon: 'Prints and Priveleges: Regulating the Image in 16th-century Italy', *Harvard U. A. Mus. Bull.*, vi (1998), pp. 40–64

LILIAN ARMSTRONG

2. CERAMICS. Ceramic production flourished in Venice from the Middle Ages. During the 14th century the already numerous craftsmen formed the *Fraglia* and decorated their wares with *sgraffito* designs of Middle Eastern origin. During the 15th century the ornamental repertory widened to include courtly designs, plant motifs and heraldic animals. Towards the end of the 15th century the so-called *graffito a fondo abbassato* was introduced, which involved removing slip from the ground in order to leave an image in relief. Wares decorated *alla porcellana* ('in the style of porcelain') and *alla damaschina* ('in the style of Damascus wares') showed the lasting influences of East Asian pottery imported into Venice. The technique of painting on a pale-blue ground (*berrettino*) is documented from the late 15th century. Venetian potters were in regular contact with potters from other Italian centres of production; their *sgraffito* work seems to imitate examples from Padua and Ferrara, while the maiolica resembles that of Faenza, partly because the Faenzan potters enjoyed special concessions in the markets of the Veneto region.

The most important 16th-century Venetian workshops included those of Maestro Ludovico, Maestro Jacopo da Pesaro (*fl* 1507–46) and Maestro Domenico (*fl* 1540–68). Wares were decorated with medallions, coats of arms, mythological scenes, portraits, wreaths *alla porcellana* (e.g. plate, 1516; London, BM), arabesques and trophies. The palette was often very bright, with a rich use of yellow–orange, blue and green. Typical 16th-century Venetian wares include rounded, pot-bellied pharmaceutical jars known as *a palla* (ball-shaped).

BIBLIOGRAPHY
A. Alverà Bortolotto: *Storia della ceramica a Venezia* (Milan, 1981)

LUCIANA ARBACE

3. GLASS.

(i) Before 1500. (ii) 1500–99.

(i) Before 1500. Various reasons have been proposed for the rise of glassmaking in Venice. Some historians have suggested that it may have been due to the presence of important late Roman centres in the Veneto; others have emphasized the presence of numerous monastic communities in Venice and on the islands in the lagoon that could initiate and promote vigorous experiments in glass technology. The widespread use of mosaic decoration in the Veneto also suggests that furnaces must have already been in operation in order to produce glass tesserae. Finally there were constant commercial, political and cultural relations between Venice and the Middle East, where the tradition of artistic glass manufacture had continued since Classical times with no breaks or periods of decline.

Between the 11th and 13th centuries the Venetian glassmakers were called *fioleri*, from *fiola*, a type of round-bellied bottle with a narrow neck. This indicates that during this period Venetian glass manufacture must have been mainly concerned with the production of objects for domestic use. On the nearby island of Murano there was already an established and rapidly expanding glass industry, the growing success of which helped to accelerate the process whereby the island became independent of Venice; in fact it had already obtained substantial guarantees of independence. The thriving industry needed an organizational structure, and from 1224 the glassmakers belonged to the Corporazione dei Vetrai, which in 1271 adopted a statute, the Capitulare de Fiolaris (also known as the *mariegole*), which was renewed in 1441. This strictly regulated apprenticeships, sales, imports and exports, and above all Venetian craftsmen were forbidden to move to other cities to establish or work in glasshouses for fear of creating rival centres of production. Yet although these rules were often reaffirmed, they were destined to be more and more easily evaded as the demand for Venetian glass increased in the rest of Italy and Europe. In 1291 an edict issued by the Magistrature of the Venetian Republic closed all the glasshouses in Venice and transferred them to Murano for fear of furnace fires. This also helped the

guild's protectionist system and furthered Venice's monopoly of the production of blown glass.

From its origins, Venetian glass was of a sodaic type as the flux that was mixed with the silica (extracted from sand) was obtained from the ashes of vegetable materials. Depending on the chromatic effect desired, metallic oxides could be added to the frit, or manganese dioxide could be used as a decolourizing agent. Soda glass is a very ductile material, and the instruments used for working the metal were few and simple: apart from the blowpipe, moulds were sometimes used, as well as iron pincers for modelling details, and special scissors. The basic tools remained substantially unchanged, despite the increased complexity of the manufactured pieces.

The first datable pieces from the second half of the 15th century provide indisputable evidence of the high degree of technical perfection and the exquisite stylistic refinement achieved during the period by the Murano craftsmen. Most of the objects (goblets, cups, beakers, plates, bowls) were made of deep-blue, emerald-green or red glass, with rich and vivid polychrome enamelling and gilding. The style of decoration between 1460 and 1480 shows a clear relationship with, if not actually a derivation from, contemporary painting and manuscript illumination. The prevalence of brilliant colours and gold, as well as the recurrent friezes, with crowns, scrolled botanical motifs and medallions enclosing portraits, or even scenes of processions, Triumphs of Venus and Fountains of Love, were undoubtedly derived from manuscript illumination. The Barovier Cup (1470–80; Murano, Mus. Vetrario; see colour pl. 1, VI3), a wedding cup, is made in deep-blue glass and decorated with polychrome enamelling with portraits of the bride and groom enclosed in two medallions. The remaining space is occupied by scenes of the cavalcade towards the Fountain of Love and women bathing in the fountain. The figurative inventions, choice of subjects, stylistic solutions and the highly refined sense of colour can also be seen in relation to the Venetian school of painting and the intense activity in those years of such artists as Vittore Carpaccio and Giovanni Bellini. There was also a group of painters in Murano who must have had an influence on glass design. This was led by the circle of Bartolomeo Vivarini and his brother Alvise Vivarini together with Alvise's daughter Armenia Vivarini, who was perhaps also a painter; in the 16th century she entered the glassmaking trade and is thought to have invented a particular type of *acquereccia* (ornamental water jug), decorated with a miniature reproduction of a ship. Original sources and documents contain the names of many famous master glassmakers, but as the craftsmen of Murano did not sign their works, it is difficult to identify the maker of any piece with reasonable accuracy.

Techniques of glassmaking at Murano remained essentially the same until about 1450, when ANGELO BAROVIER invented a new type of transparent glass that used not only manganese dioxide as a decolourizing agent, which counteracted the impurities that had sullied the old glass, but also special preparations and processes. This colourless metal was very pure and so closely resembled rock crystal that it was called *cristallo*. The exceptional qualities of this product brought such fame to Barovier that he received insistent and flattering invitations to the courts of the

Medici and Francesco Sforza, Duke of Milan. Very soon the method of producing the new glass became widely known and practised, and numerous other craftsmen joined the inventor in producing *cristallo* to supply the enormous demand. Enamelled decoration was also applied to articles made in the new glass in very brilliant colours, highlighted with gold. Rather than figurative subjects this ornamentation consisted of decorated bands with dots and scrolls in the form of vines, tiles or scales. Specific pieces were commissioned to commemorate important events in aristocratic families, the designs including noble coats of arms or heraldic symbols. The latter type of decoration can be seen in two gourd-shaped, *cristallo* pilgrim-flasks (see fig. 6), one of which presents the enamelled coat of arms of the Bentivoglio family, while the other bears the arms of the Sforza family. They were made in 1492 on the occasion of the marriage between Alessandro Bentivoglio and Ippolita Sforza. Another example is the *cesendello* (a cylindrical, hanging lamp) in *cristallo* decorated with small points and polychrome enamel and gold imbrication, bearing the coat of arms of the Tiepolo family (late 15th century or early 16th; Murano, Mus. Vetrario).

In the late 15th century the Murano craftsmen sought new technical solutions: typical of this period is 'chalcedony' glass (so called because of its likeness to the hardstone of that name). This glass is dull red in colour with polychrome venation obtained by adding metallic compounds to the vitreous mixture (e.g. pitcher, *c.* 1500; London, BM; see colour pl. 2, XXXVIII3). Numerous contemporary paintings provide ample pictorial evidence of the presence and use of such glass objects in Venice and elsewhere during this period. Since glass is a material that does not change significantly with age (which means the date of manufacture cannot be deduced from the state of the material) and the techniques and even the designs used by the Murano glassmakers remained almost unchanged over the centuries, such iconographic references assist with the identification and dating of glass articles.

6. Two glass pilgrim-flasks, with enamel and gilt decoration, showing the coats of arms of the Bentivoglio and Sforza families, Murano, 1492 (Bologna, Museo Civico)

(ii) 1500–99. At the end of the 15th century and the beginning of the 16th the production of *lattimo* (milk glass) became widespread. This white, opaque glass, already known to the ancient Romans, was often used to imitate Chinese porcelain. In some documents it is referred to as *vetro porcellano* (porcelain glass). The decoration of *lattimo* was usually figurative and was clearly influenced by such contemporary painters as Giovanni Bellini, Vittore Carpaccio and Bartolomeo Montagna, with frequent representations of sacred subjects or portraits of men and women. *Lattimo* glass was also used for a different decorative effect, which was inspired by the ancient Roman practice of decorating glass with twisted, white canes applied to the edges of dishes and bowls. The Murano masters imbedded filaments of *lattimo* glass into the transparent molten glass to obtain a decoration of parallel streaks. As the technique developed it became possible to incorporate threads of *lattimo* glass that were rolled into spirals or woven, thus creating pieces decorated with *retortoli* (twists) or *reticelli* (nets). During the 16th century glassmakers using this technique, which by analogy with goldsmith's work was called *filigrana* (filigree) decoration, produced astonishing results in Murano. Numerous examples of this technique exist (see fig. 7).

During the 16th century the taste for rich polychrome decoration finally declined. Owing mainly to the discovery and spread of *cristallo* the Murano glassmakers began to produce works that gave more prominence to the material itself rather than the decoration. The finest pieces produced in the 16th century are undoubtedly represented by an important series of *cristallo* chalices and goblets. These are transparent, without any decoration, graceful with thin, blown or moulded pillar stems. The forms were no longer based on metal models but determined directly by the

characteristics of the material and by the particular technical and executive procedures involved in working glass. The elegance of line is perfectly suited to the unrivalled transparency of the glass.

In this period the main stylistic emphasis was on the line and harmony of form, and pictorial decoration was relegated to a very secondary role. It can be found, for example, on a few plates, inspired by subjects drawn from well-known engravings of the period (which in turn repeated themes depicted by such famous painters as Raphael). These were executed on the back surface using the technique of cold painting (with lacquer or oil paint) rather than enamelling. This form of decoration is extremely perishable, and it has often almost completely worn off. In the last decades of the 16th century colour appeared sporadically in the decoration of goblets, but this was limited to azure-blue edging or applied threading in wing-like designs on the stem. Another important product of 16th-century technical experimentation was 'ice glass', so called because of the cracked appearance of the material. The effect was obtained by immersing the white-hot metal in water while it was still being worked and blowing it, sometimes with the help of moulds, into simple forms such as goblets, fruit stands and baskets, which were sometimes decorated with applied masks or lions' heads (e.g. basket, 1550–1600; Murano, Mus. Vetrario). It was perhaps the emphasis on purity of line that favoured the introduction of another decorative technique using very light diamond-point engraving. The subjects included plant motifs, geometrical figures, arabesques, grotesques, satyrs and mythological figures. The pioneer of this technique was probably Vincenzo d'Angelo del Gallo, who *c.* 1550 obtained exclusive rights to the process.

The production of mirrors is closely related to the art of glassmaking and also dependent on it. Mirrors, in fact, were often adorned with delicate engravings either on the plate itself or on the frame (when the latter was not made in carved wood or in other forms of worked glass). While glass mirrors were probably invented in Germany, the del Gallo brothers obtained the patent in 1507, and it was thanks to the Venetians in the late 15th century and the early 16th that this type of product came into wide production and use. Glass mirrors were valued not only for their practical effectiveness but also for their high decorative quality. The practice of the glassmakers of Murano was to blow rough glass plates, which because of the technical difficulties were rather small, by the same method used for window panes. They were passed on to the *specchieri* (mirror-makers), who had their workshops in Venice itself. These craftsmen squared the plates, polished them and applied a thin coating of tin or mercury. Finished with precious carved-wood or engraved-glass frames, such mirrors became important elements in the furnishing of aristocratic homes.

Another thriving sector of Venetian glassmaking was in the production of glass beads, which were imitation pearls made of coloured vitreous paste, used for necklaces, for decoration of garments and for rosaries. They were produced in rough form in Murano and finished in Venice with the flame of a lamp, so that they were also called *perle a lume* (lamplight pearls).

7. Glass pitcher with *reticello* decoration, h. 198 mm, Murano, 1550–1600 (Murano, Museo Vetrario)

BIBLIOGRAPHY

G. Lorenzetti: *Murano e l'arte del vetro soffiato* (Venice, 1953)

L. Zecchin: *Murano e l'arte del vetro, guida al Museo Vetrario di Murano* (Venice, 1953)

Glass from the Corning Museum of Glass (Corning, 1955, rev. 1974)

A. Gasparetto: *Il vetro di Murano* (Venice, 1958)

G. Mariacher: *Il vetro soffiato* (Milan, 1960)

——: *Vetri italiani del cinquecento* (Milan, 1963)

——: *Vetri italiani del seicento e del settecento* (Milan, 1965)

——: *L'arte del vetro dalle origini al rinascimento* (Milan, 1966)

——: *Vetri di Murano* (Milan and Rome, 1967)

——: *Specchiere italiane e cornici da specchio dal XV al XIX secolo* (Milan, 1969)

R. Barovier Mentasti: *Il vetro veneziano* (Milan, 1982)

Mille anni di arte del vetro a Venezia (exh. cat., Venice, Correr, 1982)

A. Dorigato: *Vetri: Rinascimento e barocco* (Novara, 1985)

PAOLA D'ALCONZO

4. TAPESTRY. Because it was such a lively trading centre, Venice was one of the few Italian cities where independent tapestry workshops could prosper on a fairly continuous basis in post-medieval times. The earliest recorded workshop is that of the master weavers Giovanni of Bruges and Valentino of Arras in 1421. Many authors believe that this workshop, or another contemporary local one, wove the *Passion* cycle (*c.* 1420–30; Venice, Mus. S Marco; *see* ITALY, fig. 36) for the cathedral of S Marco from cartoons by Zanino di Pietro; more recently the cartoons have also been attributed to Niccolò di Pietro or his circle, although others believe the tapestries were woven north of the Alps. By the 1460s the weaver–merchant Rinaldo Boteram (pseud. di Gualtieri) from Brussels had also established a shop in Venice, apparently mainly to sell imported Flemish tapestries. Renaissance documents often mention Venice as a source of ready-made, probably mostly Flemish, tapestries, so there were most likely other shops in addition to that of Boteram.

Tapestry weavers apparently continued to work in Venice almost continuously throughout the 16th century; *The Pentecost* (*c.* 1510–20) in S Maria della Salute in Venice may be one of their products. Cartoons for lost tapestries were designed by, among others, Titian (four *Theological Virtues* for Senator Carlo Zane, woven in 1562 by the Flemish master Lazzaro Canaam; *fl* 1562–72) and Domenico Tintoretto (an eight-piece *Life of St Lorenzo Giustiniani* for Caterino Malipiero, ordered from Girolamo de Bassi in 1596). Two families of weavers—Angelo di Battista Clemente from Friuli and his sons and the possibly Flemish Zinquevie—were active at this time.

BIBLIOGRAPHY

M. Viale Ferrero: *Arazzi italiani del Cinquecento* (Milan, 1963), pp. 14, 45

W. Wolters: 'Über die Wandteppiche von S Marco in Venedig und ihren Meister', *Pantheon*, xxiii (1965), pp. 75–83

R. Pallucchini and others: 'Arazzi dei secoli XV e XVI', *Il Tesoro e il Museo*, ed. H. R. Hahnloser, ii of *Il Tesoro di San Marco* (Florence, 1971), pp. 233–58

M. Stucky-Schürer: *Die Passionsteppiche von San Marco in Venedig* (Berne, 1972)

G. Delmarcel and J.-K. Steppe: 'Les Tapisseries du Cardinal Erard de la Marck, prince-évêque de Liège', *Rev. A.*, xxv (1974), pp. 43, 54

B. Boucher: 'Jacopo Sansovino and the Choir of St Mark's', *Burl. Mag.*, cxviii (1976), pp. 234–9

CANDACE J. ADELSON

IV. Buildings.

1. S Giorgio Maggiore. 2. SS Giovanni e Paolo. 3. S Maria Gloriosa dei Frari. 4. Doge's Palace. 5. Libreria Marciana.

1. S GIORGIO MAGGIORE. The Benedictine monastery, located opposite the Doge's Palace on the island of S Giorgio (see fig. 1 above), was founded in AD 982. The present church, begun by ANDREA PALLADIO in 1566 (see colour pl. 2, XI2), was the fifth on the site, according to Francesco Sansovino, replacing one consecrated in 1419. When Venice was occupied by Napoleon in 1797, the monastery became a garrison for French, and later Austrian, troops whose tenure damaged the buildings. The library, archive and most portable works of art were removed from the island and never fully restituted. Restored to the Benedictines, the church was reconsecrated in 1808. The monastery has been physically rehabilitated through the benefaction of Conte Vittorio Cini, whose Fondazione Giorgio Cini, which supports the arts and humanities, was established in the monastery in 1951.

(i) Architecture. (ii) Decoration.

(i) *Architecture.* The main period of work on the monastic buildings was during the 16th century, although according to Vasari the first library (destr.) was constructed in 1433 by Michelozzo. The dormitory, completed by Giovanni Buora around 1513 and situated behind the east end of the old church, has a tripartite semicircular arched façade in the Lombard–Venetian style facing the Riva degli Schiavoni. The cloister of the Laurels was begun *c.* 1516 by Buora's son, Andrea (*d c.* 1556), and, with a new chapter house, was completed in the late 1530s. Work on a new refectory was initiated in the 1540s but was delayed until 1560 when Palladio's presence at the monastery was first recorded on 3 July. In two years Palladio had completed the structure, which was composed of an anteroom, stairway and barrel-vaulted hall including three large thermal windows (since blocked).

In 1565 Palladio made a wood model (untraced) for a new church. The cruciform plan incorporates a spacious barrel-vaulted nave with a domical crossing, an enlarged transept (to accommodate the participants in the rituals for the feast of St Stephen, co-titular saint of the church) and an elongated apsidal choir behind the presbytery. The interior elevation consists of a monumental Composite order of engaged columns and pilasters raised on pedestals, carrying an imposing entablature, applied to a brick fabric covered in white stucco and illuminated by thermal windows. The church, including the quadrangular space of the presbytery but not the apsidal choir, was completed under Palladio's supervision in 1575. A year after Palladio's death in 1580, the church was in use. Construction on the apsidal choir was in progress by 1583 and completed by 1589. It has been proposed that the elongated apse, separating the choir entirely from the presbytery, was the result of a new plan by Palladio for the church and monastery, coinciding with the 1579 initiation of the cloister of the Cypresses (Isermeyer). The relation of the executed façade to Palladio's designs has been the source of much discussion (Cooper). Istrian stone was first collected for the façade in 1597, and work was begun in 1599 but was not completed until 1610. A monumental Composite order on high pedestals supports a pediment crowning the nave; this is interlocked with a lower, horizontal temple front, which coincides with the aisles. Below this, single-storey Corinthian pilasters frame triangular pedimented aedicules containing sculptural decoration celebrating the history of the church.

(ii) Decoration. The principal decoration for the refectory, the monumental *Marriage at Cana* (6.69×9.90 m; Paris, Louvre), was commissioned in 1562 from Paolo Veronese and finished in 1563. An extensive campaign of decoration on the church was undertaken in the 1590s, employing some of the leading artists of Venice. Work on the two-tier ornamented, walnut choir-stalls was begun in 1594 by Gasparo de' Gatti. Forty-eight panels in high relief narrating the *Life and Miracles of St Benedict* are inscribed and dated 1598 by the Flemish sculptor Albert van der Brulle. The high altar (1592–4) by Girolamo Campagna, after a design by Antonio Vassilacchi, is a singular example for this date of a freestanding tabernacle with a bronze figural group (*God the Father on the Globe of the World Supported by the Four Evangelists*). It is flanked in the presbytery by two contemporary *laterali* (1590–4) by Jacopo Tintoretto, the *Gathering of the Manna* and the *Last Supper* (see colour pl. 2, XXXIV1), completing a eucharistic cycle. Jacopo, his son Domenico and their workshop completed a number of altarpieces that fill marble frames designed by Palladio, including the *Resurrection with St Andrew, Vincenzo Morosini and his Family* (accompanied by busts from the workshop of Alessandro Vittoria), the *Coronation of the Virgin with SS Benedict, Gregory, Maurus and Placidus* and the *Martyrdom of St Stephen*, as well as one of Jacopo's final works, the *Entombment* (1594) in the chapel of the Dead.

One of the last works of Jacopo Bassano, the *Adoration of the Shepherds* (before 1592), is sited across the nave from his son Leandro's *Miracle of the Immobility of St Lucy* (1596). In the nave, Campagna's marble *Virgin and Child with Angels* faces a 15th-century polychrome wooden *Crucifixion*, which survives from the earlier church.

BIBLIOGRAPHY

F. Sansovino: *Venetia, città nobilissima et singolare* (Venice, 1581; ed. G. Martinioni, Venice, 1663)
E. Cicogna: *Delle iscrizioni veneziane*, iv (Venice, 1834/*R* Bologna, 1969)
G. Damerini: *L'isola e il cenobio di San Giorgio Maggiore* (Venice, 1956)
C.-A. Isermeyer: 'Il primo progetto del Palladio per S Giorgio secondo il modello del 1565', *Boll. Cent. Int. Stud. Archit. Andrea Palladio*, xxii (1980), pp. 259–68
T. E. Cooper: *The History and Decoration of the Church of San Giorgio Maggiore in Venice* (diss., Princeton U., NJ, 1990) [extensive bibliog.]
G. Frasson: 'Nuovi contirbuti per la storia del cenobio di San Giorgio Maggiore di Venezia', *Archv Ven.*, cxlv (1995), pp. 139–47

TRACY E. COOPER

2. SS GIOVANNI E PAOLO. The principal Dominican church in Venice, also known as S Zanipolo. The Dominicans were granted a site in Venice in 1234 by Doge Jacopo Tiepolo (*reg* 1229–49). The first church, of which no trace survives, was constructed by 1293 and had already been chosen by several doges, including Ranier Zeno (*reg* 1253–68) and both Jacopo and Lorenzo Tiepolo (*reg* 1268–75), as their place of burial. In 1333–4 fund-raising began for a new church, which was consecrated in 1430. The building takes the form of a basilica, laid out on a Latin cross plan with a five-bay nave flanked by aisles, a domed crossing and five contiguous apsed chapels at the east end. Work had reached the crossing by 1368—the date inscribed on the transverse arch of the north transept.

As early as 1362 the tomb of *Doge Giovanni Dolfin* (*reg* 1356–61) was located on the south wall of the presbytery, followed by the adjacent tomb (*c.* 1368) of *Doge Marco Cornaro* (*reg* 1365–8), for which Nino Pisano (*fl* 1334–60s) carved a *Virgin and Child*. The most splendid of the presbytery monuments is that of *Doge Michele Morosini* (*reg* 1382), combining mosaic, sculpture and fresco. In 1390 the State contributed 10,000 ducats towards the building of the church and the construction of the chapel of S Domenico (now del Rosario). The church roof was complete by 1417, while between 1420 and 1430 the monks' choir and the organ loft (dismantled 1690) were raised in the fifth bay of the nave. The earliest side chapel, begun 1448, was that of S Lodovico Bertrando (now of the Addolorata), designed in an elegant Gothic style that is visible in the linear complexities of the windows and the terracotta ornament under the eaves.

In 1458 the main portal was redesigned, with the addition of a cluster of non-structural columns (purchased from the church of S Andrea di Torcello) in the manner of the portals of S Marco, or of the Arco Foscari at the Doge's Palace (see fig. 9 below). Bartolomeo Buon (i) supervised the work, which partly obscured the previous Gothic arcuated façade. Precocious classical elements such as a cornice and frieze, and volutes within the Gothic foliage of the capitals, indicate that carvers from both Florence and Milan were involved in the project, which was complete by 1464. Later in the decade Pietro Lombardo executed the tomb of *Doge Pasquale Malipiero*, followed by his masterpiece, the tomb of *Doge Pietro Mocenigo*. By the end of the century a further Renaissance element was added: the hemispherical dome over the crossing, already visible in Jacopo de' Barbari's aerial view of Venice of *c.* 1500 (see fig. 1 above).

In the first decade of the 16th century, the decision was taken to designate SS Giovanni e Paolo a pantheon for the condottieri Dionigi Naldo da Brisighella, Nicolò Orsini and Leonardo da Prato, heroes of the League of Cambrai War (1508–16). The theme is echoed in the lowest register of the stained-glass window in the right transept, where the soldier saints Theodore and George are depicted, together with SS John and Paul. Although warriors' tombs (e.g. that of *Jacopo Cavalli, d* 1384) had existed in the church from the 14th century, Verrocchio's equestrian bronze statue of *Bartolomeo Colleoni* (see VERROCCHIO, ANDREA DEL, fig. 4), erected in 1494 in front of the church, may have provided a more immediate stimulus for this decision. The tradition of commemorating military heroes in this church was continued in the following centuries. In the same spirit, the sculptor and architect Alessandro Vittoria supervised the building and redecoration of the chapel of the Rosary (1582–1608) to honour the victory of the Battle of Lepanto (1571). The chapel, together with paintings by Vittoria's contemporaries and altarpieces by Titian and Giovanni Bellini, was burnt down in 1867 (reopened in 1959). Meanwhile massive late Renaissance tombs by Girolamo Grapiglia (*fl*1572–1621) were built for the doges *Leonardo Loredan* and *Alvise Mocenigo* in the presbytery and on the west wall respectively.

BIBLIOGRAPHY

F. Z. Boccazzi: *La basilica dei Santi Giovanni e Paolo in Venice* (Venice, 1965) [with bibliog.]
H. Dellwing: *Studien zur Baukunst der Bettelorden im Veneto* (Munich, 1970)

L. Puppi: *La grande vetrata della basilica di San Giovanni e Paolo* (Venice, 1985)

C. R. Puglisi: 'The Cappella di San Domenico in Santi Giovanni e Paolo', *A. Ven.*, xl (1986), pp. 230–8

PHILIP RYLANDS

3. S MARIA GLORIOSA DEI FRARI. The visually coherent Franciscan church belies a complex history of construction that spanned nearly 200 years. In the second quarter of the 13th century the Order received an abandoned Benedictine abbey from Doge Jacopo Tiepolo (*reg* 1229–49), who agreed to reconstruction and improvements on the site near the canal of the Frari ('brothers'). Despite three distinct building phases, the church and its two attached cloisters preserve the simplicity that is attributed to a design of Nicola Pisano (Vasari).

The building was begun in 1250; by 1280 the first Gothic structure, a hall church with an aisleless nave, suitable for preaching, was complete. Sixty years later, the prosperous Franciscans had so increased their following that they required a larger, more ambitious structure with arcaded aisles. In 1340, aided by patrons of the Gradenigo, Giustiani and Savelli families, they began a new church adjacent to the still functioning older building. Jacopo Celega (*d* before March 1386), the architect of the imposing campanile, began work in 1361 and may have supervised the entire second construction. Records show that his son, Pietro Paolo (*d* 1417), was still working on the project in 1396 when the campanile, one of the highest in Venice, was completed and the lead roof installed.

In the early 15th century, the friars engaged builders to complete the new church, in particular the last three bays towards the present entrance façade. With minor changes, the style and spirit of the 1340 design were continued. The older church was demolished in 1415 as the new one neared completion. At approximately the same time, large altars and sepulchral monuments were placed along the aisle walls between the windows, obliterating a wealth of 14th-century frescoes. The aesthetics of the interior also suffered from the inclusion of tie-beams across the nave and between the arcade arches; this distracting maze of wood was an essential addition to counter potential damage occasioned by the settling of the church's pilings in the lagoon mud.

The present cruciform church comprises a vaulted nave with massive columns dividing it from the aisles. Nearly all the window and door openings rise to pointed arches, with only a few openings in the upper parts indicating the later preference for round-headed arches. On the façade, small round windows, symmetrically placed, echo the large rose window. The original designer confined exterior decoration to discreet blind arcading at the upper edge of the brick walls. During the Renaissance phase, sections of ornamental brick serving to heighten the structure were added at the top of the façade, as were the three airy, decorative, finial forms placed above them. These find visual consonance with those above the left side entrance, a form that acts as a buttressing mass for the campanile. The later ornamental additions do not depart significantly from the style of the earlier church, thus ensuring the coherence of the exterior design.

One of the greatest architectural glories of the church is the octagonal apse with multi-level, bifurcated glass and carved, wooden altar screen, a rare inclusion in an Italian church. The large, round-arched opening of the screen frames the high altar, above which is the *Assumption of the Virgin* (1518; for illustration *see* ALTARPIECE) by Titian, a large, dramatic composition manifesting the theme of the church's name, which was commissioned by Father Germano, a prior of the Frari monastery. Carved stone sculptures by Pietro Lombardo complete the decorative programme of the apse. The vast transept area, of equal length to the nave, contains six unusually shaped chapels, three on either side of the main altar space. The plan of each chapel terminates in a point, thus creating a lively exterior line at the east end. Venetian confraternities and nobility hired artists to decorate individual chapels. In a left aisle chapel, the Pesaro family commissioned a painting by Titian, now known as the Pesaro *Madonna* (1519–26; see colour pl. 2, XXXV2). In the nave, immediately preceding the transept, is a three-tiered wooden choir-stall carved in 1468 by the Venetian Marco Cozzi (*d* 1485), a commission of the Correr family. Among the other well-known monuments and works of art in the church are the tombs of *Titian* (1838–52) by Pietro and Luigi Zandomeneghi, of *Doge Francesco Foscari* by Antonio and Paulo Bregno (*c.* 1460; for illustration *see* BREGNO, (1)) and of *Doge Niccolò Tron* (*c.* 1476–80; for illustration *see* RIZZO, ANTONIO), a triptych (1488) by Giovanni Bellini and a wooden statue of *John the Baptist* (1438) by Donatello.

BIBLIOGRAPHY

J. White: *Art and Architecture in Italy*, Pelican Hist. A. (Harmondsworth, 1966)

U. Franzoi and D. di Stefano: *Le chiese di Venezia* (Venice, 1976)

PHILANCY N. HOLDER

4. DOGE'S PALACE.

(i) Architecture and sculpture. (ii) Painting and decoration.

(i) Architecture and sculpture. The palace, situated in the Piazzetta between S Marco and the Grand Canal, was rebuilt and remodelled repeatedly during its history, as is reflected in its mixture of Byzantine, Gothic and Renaissance features. The present building, constructed largely in the 14th and 15th centuries, replaced a 9th-century fortified castle on the same site. The new structure was to serve both as the official residence of the doge and as the seat of government, a dual purpose that influenced every aspect of the building, including the style and iconography of its decoration. In a city the very existence of which depended on the balance of commercial and diplomatic ties with both the Near East and western Europe, the palace was designed to serve both practical and diplomatic purposes, by flattering and overwhelming its visitors and at the same time instructing them on the unique qualities of the city they were visiting. The unknown architects who began the reconstruction of the building designed it as a replica of a Byzantine palace in order to impress visitors from Constantinople.

The Byzantine source of the design partly explains the strangely top-heavy structure, with a loggia and delicately traceried gallery appearing to support the solid walls of the upper storeys. The main façade facing the Grand Canal (begun *c.* 1340) has an arcade composed of 36 short, thick columns, above which 71 columns form a gallery

8. Venice, Doge's Palace, main façade, begun c. 1340

(see fig. 8). The shapes of the arcade and gallery arches, as well as the tracery that originally decorated the windows, show the architects' attempt to combine Gothic elements with the eastern design. The wall above, covered with a diaper pattern of white Istrian stone and rose-coloured Verona marble, adds to the colourful exoticism of the building, as does the delicate crenellation that crowns this façade. Although constructed as late as the 15th century, the adjoining wing facing the Piazzetta was designed in a similar style, while the façade facing the Rio di Palazzo, begun c. 1484 by Antonio Rizzo and completed c. 1510 by Pietro Lombardo, is an odd, piecemeal structure, marked by an irregular fenestration and an uneven cornice. The diamond-patterned stonework at basement level is unusual in Venice and the idea was probably imported from the mainland, reflecting the city's increasing involvement with the rest of Italy at that time.

The sculptural decoration of the two principal façades is medieval in its encyclopedic character. Although some of the capitals are simply ornamental, most of them as well as the larger sculptures in this area are allegorical, designed to impress upon the city leaders their obligation to justice and virtue. The capital of the corner column by the Porta della Carta is decorated with an allegorical figure of *Justice*, while a larger 15th-century sculpture of the *Judgement of Solomon* appears above. On the other two corners 14th-century sculptures depicting the *Drunkenness of Noah* and *Adam and Eve* serve as reminders of human weakness. The column capitals (many of which have been replaced or are badly worn) were carved with such

personifications of Virtue and Justice as *Moses*, *Solon*, *Aristotle* and *Numa Pompilius*, and images of the *Planets* and the *Months*, according to an iconographic programme derived from Gothic cathedrals.

The Porta della Carta, situated between the palace and S Marco, forms the main entrance to the courtyard and palace. It was begun by Giovanni Buon and his son Bartolomeo Buon in 1438, and with its mixture of Gothic and proto-Renaissance elements provides the most important surviving example of the Venetian style of that time (for illustration *see* BUON (i), (1)). Its present name refers to the government's practice of posting proclamations on the doorway, though it was originally referred to as the 'Golden Doorway' on account of its extensive gilding. Despite being stripped of its gold and polychromy the doorway remains rich in detail and iconography. Extending the iconography of the façade sculpture, a figure of *Justice* crowns the doorway, while *St Mark*, the patron saint of Venice, appears in a roundel below. In the canopied niches placed against the side pillars are statues of Virtues: *Prudence*, *Charity*, *Temperance* and *Fortitude*. Immediately above the door a relief showing *Doge Francesco Foscari Kneeling before the Lion of St Mark* reproduces an earlier sculpture that was destroyed during the revolutionary turmoil of 1797. It symbolizes the divine approval of the Republic, a theme that was often represented inside the palace.

The Porta della Carta leads through a vaulted corridor known as the Porticato Foscari to the Arco Foscari (see fig. 9), which was built in the 15th century and embellished

9. Venice, Doge's Palace, courtyard, showing the Arco Foscari (begun 15th century) in the centre and the Scala dei Giganti (begun after 1483) to the right

by later doges. The structure serves both as an impressive triumphal arch leading to the palace courtyard and as a transept façade for S Marco. Many of its important architectural elements, such as the two superimposed orders and the columns, pinnacles and figure sculpture above, are derived from the west façade of S Marco. Sculptures by Rizzo of *Adam* and *Eve* (replaced by copies) echo the religious tone of the basilica. Thus the Arco Foscari reveals two tendencies prominent in 15th-century Venetian civic architecture: the desire to establish richly decorated focal points along major visual and ceremonial axes, and the willingness to combine elements from different styles to achieve the greatest possible richness of colour and texture.

The courtyard was built in several stages from the late 15th century to the mid-16th. Its principal architect was Rizzo, who began to rebuild the courtyard after it was destroyed by fire in 1483, and who continued to work on it until 1498, when he fled the city after being found to have embezzled money from the palace workshop treasury. He was succeeded by Pietro Lombardo, who generally followed Rizzo's plan. Rizzo's structure, which is seen most clearly in the façade facing the Grand Canal, displays the Venetian Gothic interest in rich surface elaboration marked by irregular rhythms (caused in part by the need

to work around the existing interior spaces and fenestration) and rich textural effects. However, it also shows Classical borrowings in many of its decorative elements such as garlands, arms, armour and inlaid roundels. The final result is a pleasing mixture of syncopated rhythms and richly varied textures, although the effect of his work has been somewhat obscured by sculpture added in the 16th and 17th centuries.

The courtyard served as a large gathering place for the citizens and provided an elegant setting for the impressive Scala dei Giganti (see fig. 9), built by Rizzo after the earlier staircase was destroyed in the fire of 1483. The structure fulfilled several functions, serving as the grand entrance to the palace, the site of major ceremonies such as the coronation of the doge and as the major sculptural focus of the palace. Its role, therefore, was not only practical but also symbolic, as is apparent from the design. Rizzo deliberately emphasized the staircase by giving it a different scale and decoration in relation to the surrounding walls. The massive staircase leads into the palace through three arches of the first floor arcade, recalling a Roman triumphal arch. A small prison used to house traitors and enemies of the state was situated below the stairs, so that the doge could ceremonially tread on them as he entered and exited the palace. Colossal statues of *Mars* and *Neptune*, sculpted by Jacopo Sansovino

and his pupils in the 16th century, crown the staircase on either side and proclaim the military and naval power of Venice (*see* SANSOVINO, (1) and fig. 4).

The staircase and the Arco Foscari separate the main courtyard from the Cortile dei Senatori, a small area built *c.* 1520 in which members of the Senate gathered during state ceremonies. Antonio Scarpagnino, the presumed architect of at least part of the internal façade, harmonized it with the main courtyard by repeating many of the forms found there. This audience area, together with the staircase and the rest of the courtyard, reflects the sense of theatre that characterized the Doge's Palace, where the city's major events were acted out.

Much of the palace was destroyed by fire in 1574 and 1577, and many influential citizens of Venice, including Palladio, proposed rebuilding it in a grandiose Renaissance style. Palladio found the building particularly hideous: 'The fabric was in a barbarous style because, to say nothing of the ugliness of the orders, it was very weak, having the solid part above the void, and the thick and heavy part above the narrow.' Jacopo Sansovino was the only leading Venetian architect to support the city leaders' decision to rebuild the palace in its original form.

BIBLIOGRAPHY

G. Fogolari: *Il Palazzo Ducale* (Milan, 1949)
G. Mariacher: *Il Palazzo Ducale* (Florence, 1950)
L. Serra: *The Doge's Palace* (Rome, 1951)
E. Bassi and E. Tricanato: *Il Palazzo Ducale nella storia e nell'arte di Venezia* (Milan, 1960)
D. Pincus: *The Arco Foscari: The Building of a Triumphal Gateway in Fifteenth Century Venice* (New York, 1976)
P. Lauritzen: *Palaces of Venice* (New York, 1978)
D. Howard: *The Architectural History of Venice* (New York, 1981)
H. Honour: *The Companion Guide to Venice* (Englewood Cliffs, 1983)
W. Wolters: *Der Bilderschmuck des Dogenpalastes: Untersuchungen zur Selbstdarstellung der Republik Venedig im 16. Jahrhundert* (Wiesbaden, 1983)
E. Bianchi, N. Righi and M. C. Tezaghi: *Il Palazzo Ducale di Venezia* (Milan, 1997)
U. Franzoi: *Le prigioni di Palazzo Ducale a Venezia* (Milan, 1997)
F. Roiter: *Il Palazzo Ducale* (n.p., [1997])

JANE NASH MALLER

(ii) Painting and decoration. The decorative programme of the interior of the Doge's Palace was designed to represent the most illustrious moments in the history of the Venetian Republic and to impress its visitors with the splendour of the city. Though originally decorated in the 14th, 15th and early 16th centuries by leading artists from both the city and the mainland, including GENTILE DA FABRIANO, Pisanello, Giovanni Bellini (*see* BELLINI, (3)), Carpaccio and Titian, most of the existing decoration postdates the fire of 1577, which gutted the palace destroying most of the earlier masterpieces.

The Scala dei Giganti (*see* §(i) above) leads into a loggia, which in turn opens on to the Scala d'Oro that leads to the main halls of the palace. The latter staircase was completed in the mid-16th century and received its name from the rich gold stucco decoration on its vaulted ceiling. The decorative scheme was designed by Alessandro Vittoria and is a simplified version of the decoration planned by Jacopo Sansovino for the bronze door of the sacristy of S Marco. The ceiling contains a profusion of decorative motifs—foliage, crowns, busts of heroes, philosophers, orators, and personifications of history, politics, religion,

law and science—intended to overwhelm the visitor with a host of references to Venetian glories rather than to present a unified allegorical programme.

The staircase leads to a vestibule (the Atrio Quadrato) with a ceiling painting (*c.* 1654–5) by Jacopo Tintoretto showing Doge Girolamo Priuli (*reg* 1559–67) receiving the sword and balance, emblems of Venice, from Justice, while the Virgin and Priuli's patron saint, Jerome, pray for the prosperity of his reign. The theme of the painting echoes the emphasis on Justice seen in the palace's exterior decoration, while the heavenly setting of the scenes implies divine approval of the Venetian Republic. Beyond the vestibule is a succession of state rooms. The Sala delle Quattro Porte, which served first as the seat of the College and then as a vestibule of honour, was partially designed by Palladio. The decoration of the room, which includes a statue by Vittoria of *Vigilance*, illustrates the power and virtues of the Venetian Republic. The stuccoed ceiling was painted by Jacopo Tintoretto with an allegory of the *Triumph of Venice* (1577) surrounded by smaller compartments in which are depicted the regions and cities under Venetian control. On one wall is a canvas by Titian and his nephew Marco Vecellio showing *Doge Antonio Grimani Adoring Faith*, while Andrea Vicentino's *Entrance of Henry III into Venice in 1574* appears on another.

The Sala dell'Anticollegio was given a particularly rich decoration in order to impress the foreign ambassadors who would wait here before an audience with the doge. The ceiling contains one of Veronese's finest works, *Venice Distributing Honours and Rewards*, painted in 1586–7. Four works painted by Tintoretto in 1577–8 in the vestibule were moved into this room in 1714: *Bacchus, Ariadne and Venus*, the *Three Graces and Mercury*, the *Forge of Vulcan* and *Minerva Rejecting Mars*. A fireplace by Vincenzo Scamozzi and Veronese's lavish *Rape of Europa* (1580) completed the decoration of this room.

Just beyond is the Sala del Collegio, the main audience hall, where the doge, six councillors, three chiefs of the Criminal Courts, the appointed sages of the Republic, and the three heads of the Council of Ten sat on state occasions. The ceiling is decorated with a series of paintings commissioned from Veronese in 1574 illustrating the power and virtues of Venice, including the large *Venice Enthroned with Justice and Peace* and a painting of *Mars and Neptune* symbolizing the military and naval power of the city. Smaller paintings of the *Virtues*, represented as richly dressed female figures, complete the painted decoration of the ceiling. On the walls below are illustrations by Veronese and Tintoretto of four 16th-century doges celebrating military victories or giving thanks to religious figures for their successes or, in one case, for deliverance of the city from the plague.

The Sala del Senato is similarly decorated with paintings illustrating divine protection of Venice and the development of her culture. The central compartment of the ceiling shows the *Triumph of Venice as Queen of the Sea*, designed by Tintoretto and executed by his pupils. Another painting by Tintoretto's school portrays Doge Loredan praying to the Virgin for help in defeating the Turks and stopping the plague. A canvas over the door by Palma Giovane shows Doge Pasquale Cicogna asking Christ to

save the city from famine and pestilence (for illustration *see* PALMA, (3)), while yet another shows Venice's victorious battle against the League of Cambrai.

The Sala del Consiglio dei Dieci was the site of the meetings of the ten magistrates appointed to protect the city and its government from political enemies. It contained three paintings by Veronese dated 1553–4: *Jupiter Expelling the Vices* (Paris, Louvre; replaced *in situ* by 17th-century copy), an allegory of the justice meted out by the Council; *Juno Bestowing Gifts on Venice*, suggesting the bounty the city enjoyed thanks to her conquest of vice; and *Youth and Age* (*see* VERONESE, PAOLO, fig. 2), also known as *Proserpina and Pluto*, an allegorical reference to the old and new domains of the Republic.

Other government chambers were also lavishly decorated in the 15th and 16th centuries, as were the doge's private rooms. The most monumental decoration was reserved, however, for the Sala del Maggior Consiglio, a vast room that could hold as many as 3000 people. This was the site of the legislative meetings of the lower house of the Venetian government, which numbered up to 1600 members; elections and banquets were also held here. After most of the 14th- and 15th-century masterpieces were destroyed in the fire of 1577, Veronese and Tintoretto were called in to redecorate the room with historical and mythological scenes illustrating the wars, victories and growth of Venice. On the ceiling are paintings showing *Venice, Queen of the Sea Presenting the Doge with an Olive Branch*, probably by Tintoretto and his pupils, and a *Triumph of Venice* (1579–82; see fig. 10) that was painted by Veronese. The walls are decorated with scenes of the

12th-century conflict between Emperor Frederick Barbarossa (*reg* 1152–90) and Pope Alexander III, in which Venice achieved prestige as a diplomatic negotiator, as well as events of the Fourth Crusade (1204). Other battle scenes complete the wall decoration. Above is a frieze by Domenico Tintoretto depicting the first 76 doges of Venice. Only Marino Falier, who was executed for treason, is omitted. In his place is a black curtain, a reminder that even the most powerful man in Venice was subject to justice. All of these decorations are overpowered by Jacopo and Domenico Tintoretto's enormous (if not entirely compositionally satisfying) image of *Paradise* (1588–90), which gained fame as the largest painting on canvas (7.62×21.34 m) in the world. It filled the wall behind the thrones of the doge and the heads of government, and thus acted as a final, overwhelming reminder of the divinely privileged position the Venetians gave themselves.

BIBLIOGRAPHY

S. Sinding-Larsen: *Christ in the Council Hall: Studies in the Religious Iconography of the Venetian Republic* (Oslo, 1974)
T. Pignatti: *The Golden Century of Venetian Painting* (New York, 1979)
H. Honour: *The Companion Guide to Venice* (Englewood Cliffs, 1983)
R. W. Rearick: *The Art of Paolo Veronese* (New Haven, 1986)
D. Rosand: *Painting in Cinquecento Venice: Titian, Veronese and Tintoretto* (New Haven, 1986)

For further bibliography *see* §(i) above.

JANE NASH MALLER

5. LIBRERIA MARCIANA. Located in the Piazzetta opposite the Doge's Palace, it was commissioned by the Procurators of S Marco following bequests to the Republic of two distinguished private libraries—Francesco Petrarch's in 1362 and Cardinal Bessarion's in 1468. In 1812 the building was requisitioned by Napoleon and much of its contents transferred to the Doge's Palace and never fully restituted. It was restored in 1929, with the Biblioteca Nazionale Marciana occupying the first floor as well as the adjacent Zecca and one wing of the Procuratie Nuove.

(i) Architecture. The library was designed by Jacopo Sansovino in the Roman Renaissance style and is noted for the pictorial quality of its Istrian stone façade as well as the festive character of its decoration, paralleling its civic role and scenographic position. Raised on a three-step podium, it has a two-storey, twenty-one bay façade employing a repeated Serlian motif, with a triple arcade at each end. Crowned by a balcony, the façade has an Ionic order superimposed over the Doric order of the ground-floor. Entrance to the library is through a monumental portal in the central bay, up a grand stairway to a square vestibule preceding a long, rectangular *salone* (reading room).

Construction began by 1537 at the corner by the campanile, following the initial demolition of hostelries and shops in the Piazzetta. The setting back of the library in relation to the campanile had a profound impact on the realignment of the public space of Piazza S Marco. In 1539 a competition was held for the design of the corner of the building according to Vitruvian principles, and Sansovino's model was judged victorious. His fortunes were reversed, however, when the vaulting he had insisted upon against local advice collapsed in the first bay of the

10. Venice, Doge's Palace, Sala del Maggior Consiglio, ceiling painting by Paolo Veronese: *Triumph of Venice*, oil on canvas, 1579–82

salone in 1545. He was jailed, lost his salary and position for almost two years and was required to pay for repairs. A wood-beam ceiling was constructed instead, but the coved interior reflected Sansovino's original intention. Work under Sansovino halted early in 1556 with sixteen bays completed; in 1582 the last five bays and a subsequent programme of modification to its interior were entrusted to Vincenzo Scamozzi (*see* SCAMOZZI, (2)), who was also responsible for the Procuratie Nuove on the south side of the Piazza (see fig. 2 above), next to the Libreria. Scamozzi, critical of the library's proportions and its juncture with the Zecca, urged the addition of a third storey, but his recommendations were rejected in 1588 and Sansovino's design was preserved. From 1588 to 1590 Scamozzi was occupied with work on the interior, and in 1591 he began the transformation of the vestibule from a patricians' school for humanistic studies to a museum housing the collection of Patriarch Giovanni Grimani's antiquities, bequeathed to the Republic in 1587 and installed in 1596.

(ii) Decoration. The allegorical and mythological decoration of the exterior was largely executed in the 1550s and continued the vein of politically charged allusions found in the nearby Loggetta (*see* SANSOVINO, (1), fig. 3). The arcade, with its vaulting of interlocking framed compartments in gilded and painted stucco, came to serve as the patricians' afternoon meeting-place. Sansovino directed Bartolomeo Ammanati, Alessandro Vittoria, Danese Cattaneo and others in the execution of the architectural sculpture. Vittoria and assistants were responsible for the *Feminone* (1553–5), two monumental caryatids flanking the entrance portal. The only one of the Olympian deities and heroes of the balustrade sculptures to be completed before Sansovino's death was Ammanati's *Neptune* (lost mid-18th century); the remainder were done under Scamozzi, including six by Girolamo Campagna (1549–by June 1625) between 1588 and 1591.

The interior decoration was begun in 1556 when seven painters, including Giuseppe Salviati, Andrea Schiavone and Paolo Veronese, were commissioned to paint the *salone* ceiling. Twenty-one tondi with allegorical subjects are framed in geometric compartments similar to the portico decoration; Veronese's *Music* was awarded a gold chain in a competition (1556) judged by Titian and Sansovino. The walls originally followed an architectural scheme of decorative pilaster enframements designed by Sansovino, with a painted series of philosophers in niches executed by artists already active in the *salone*, including Veronese. The majority, however, were by Jacopo Tintoretto, who had been excluded from the ceiling commissions. Ridolfi praised Tintoretto's 'stupendous figure' of *Diogenes*, 'so boldly coloured that he seems distinct from the niche where he is painted'.

Vittoria's contract of 1560 testifies to work begun on the stucco framework and reliefs of the stairway, which consists of two barrel-vaulted flights. The tripartite interlocking framework alternates rectangular compartments containing stuccos with simulated gold mosaic backgrounds and octagonal paintings by Battista Franco in the first flight, and by Battista del Moro (*c.* 1514–before 1574), in the second. Representations of astrological, mythological and allegorical figures and personifications of the

natural sciences and liberal arts terminate with a stucco figure of *Vera Sapienza* at the entry to the vestibule. A fictive architectural soffit was painted (1559–60) in the vestibule by the Brescian *quadratura* specialists Cristoforo and Stefano Rosa. Titian subsequently painted the ceiling octagon, usually thought to represent an *Allegory of Wisdom*, although formerly identified as *History* (Ridolfi). Jacopo Tintoretto and Domenico Molin had executed four portraits of procurators and four paintings of philosophers by 1562, when they were commissioned to paint two paintings each. These were accompanied by six fictive bronze chiaroscuro paintings and a frieze with putti and garlands. The vestibule lost its original character when it was remodelled as a museum in the 1590s.

BIBLIOGRAPHY

F. Sansovino: *Venetia, città nobilissima et singolare* (Venice, 1581); ed. G. Martinioni (Venice, 1663)
V. Scamozzi: *L'idea della architettura universale*, 2 vols (Venice, 1615/*R* Ridgewood, NJ, 1964)
C. Ridolfi: *Meraviglie* (1648); ed. D. von Hadeln, 2 vols (1914–24/*R* 1965)
G.-A. Moschini: *Guida per la città di Venezia*, 2 vols (Venice, 1815)
M. Zorzi: *La Libreria di San Marco* (Milan, 1987) [comprehensive history and bibliog.]
C. Hope: 'The Ceiling Paintings in the Libreria Marciana', *Nuovi studi su Paolo Veronese*, ed. M. Gemin (Venice, 1990), pp. 290–8
T. Hirthe: 'Zum Programm des Bibliothekssaals der Libreria Marciana in Venedig', *Iconographie der Bibliotheken* (Wiesbaden, 1992), pp. 107–58
M. L. Ricciardi: *Biblioteche dipinte: Una storia nelle immagini* (Rome, 1996)
TRACY E. COOPER

V. Scuole.

Religious confraternities, formed in the 13th century and dedicated to a patron saint, the *scuole* met for church services, for the funerals of their members and for their yearly banquets. Venice had a large number of these institutions, which took various forms: they included organizations attached to the city's trade guilds (*arti*), which acted for the benefit of practitioners of a particular trade; those formed for immigrant communities; for such groups as the lame or blind; or for specific purposes, for instance the accompaniment of condemned criminals. Income from fees, property and investment was used to aid members and their families. Most confraternities remained small in membership and restricted in function; the role of these *scuole piccole* in the patronage of Venetian art is not fully defined but was certainly less important than that of the *scuole grandi*, the largest, wealthiest and most prestigious of the *scuole*, which are discussed in detail below.

1. Introduction. 2. Scuola Grande di S Giovanni Evangelista. 3. Scuola Grande di S Marco. 4. Scuola Grande di S Rocco. 5. Scuola Grande di S Maria della Misericordia. 6. Scuola Grande di S Maria della Carità. 7. Scuola Grande di S Teodoro.

1. INTRODUCTION. Six *scuole grandi* were recognized by the middle of the 16th century: the Scuola di S Maria della Carità, the Scuola di S Marco and the Scuola di S Giovanni Evangelista were established in 1261 in the aftermath of the flagellant movement, which had swept Italy in the previous year; the Scuola di S Maria della Misericordia was established in 1308; the Scuola di S Rocco was recognized as a *scuola grande* in 1489; and the Scuola di S Teodoro was the last to be recognized, in 1552. Between the early 15th century and the late 16th,

major sums were spent on the construction and decoration of their meeting-houses; after the Venetian government itself, these confraternities were probably the most important source of large-scale artistic commissions in Renaissance Venice. Their commissions greatly encouraged the development of a Venetian Renaissance artistic style, but the artistic productions were also closely related to the purpose and values of these religious brotherhoods.

Already by the 14th century, the *scuole grandi* had begun to outstrip other Venetian confraternities in size and prestige. The Scuola di S Marco, named after Venice's patron saint, was given an upper limit of 600 brothers; the others were allowed to enrol 550 members. That the large confraternities were able find well over 3000 men willing to pay the entrance fee and annual dues, as well as to participate in the various ceremonies is itself an indication of the prestige these institutions enjoyed in Venetian society. By the later 14th century the *scuole grandi* had developed a system of internal government. At the top were four major offices including the leader (*guardian grande*), his assistant (*vicario*), a record keeper (*scrivano*) and a master of the novices (*guardian da matin*); assisting them in maintaining contact with the brothers scattered across Venice were the deacons (*degani*), two of whom represented each of the six *sestieri* of Venice. The officers and deacons met regularly as a committee (*banca*) to discuss policy, to raise and allocate money, and later to commission works of art. At the beginning of the 15th century the offices had become important enough to be reserved by law to native-born citizens of Venice; in the 16th century, these positions conferred great prestige on those elected to serve their confraternities.

In the course of the 14th century, the *scuole grandi* began to shift their devotional emphasis away from personal devotions towards a more civic orientation. Much of their wealth was accumulated through gifts and bequests. Some of this was used to support the poorer brothers and their families through the distribution of alms or the provision of inexpensive housing to those on small incomes; to establish small hospitals, which provided physical and spiritual care for those without families; and to provide dowries to the daughters of poor brothers so that they could marry and live honourably. From the 14th century part of their wealth was used to acquire adequate meeting-houses. Originally the brothers had rented rooms from ecclesiastical establishments, but after 1300 they began to purchase vacant land or underused buildings. These early meeting-houses were probably fairly small, like the disused old meeting-house of the Scuola di S Maria della Misericordia in Cannaregio (*see* §5 below), but they included at least one large meeting-room (*sala*) to accommodate the whole brotherhood in general and religious meetings, often another large meeting-room (*androne*) for processions and flagellant sessions and usually also a small committee-room (*albergo*) for the meetings of the *banca*. The construction of meeting-houses forced the *scuole grandi* into fixed locations. The Scuola di S Giovanni Evangelista settled close to S Giovanni Evangelista in the *sestiere* of S Polo; the Scuola di S Marco, established first in the *sestiere* of Santa Croce, was after 1438 located next to SS Giovanni e Paolo in the *sestiere* of Castello; the Scuola di S Maria della Carità was established adjacent to the monastery of S Maria della Carità in the *sestiere* of Dorsoduro; the Scuola di S Maria della Misericordia was adjacent to S Maria della Misericordia Abbey in the *sestiere* of Cannaregio; the Scuola di S Rocco near S Maria Gloriosa dei Frari in the *sestiere* of S Polo after 1478; and the Scuola di S Teodoro opposite S Salvatore in the *sestiere* of S Marco.

From the early 15th century the *scuole grandi* began to enlarge and renovate their old meeting-houses, or to build large new ones as well as to decorate the rooms with splendid paintings. Some of the best architects in Venice worked to give the confraternities suitably magnificent meeting-houses, and some of the best painters decorated the walls with paintings illustrating biblical incidents or narratives appropriate to the brotherhoods. Most of the great commissions initiated by the *scuole grandi* occurred between the early 15th century and the later 16th, the period when they were especially wealthy and active as Christian institutions. Of the six, the Scuola di S Giovanni Evangelista, the Scuola di S Marco and the Scuola di S Rocco were most actively involved as patrons. Indeed, the two former were especially competitive in the building and decoration of their meeting-houses.

2. SCUOLA GRANDE DI S GIOVANNI EVANGELISTA. This *scuola* was pioneering in using art to reflect its growing status in Venetian society. In the first quarter of the 15th century it carried out major structural renovations of its meeting-house, probably enlarging its main meeting-hall and decorating it with an ornate ceiling. Since it owned a famous, miracle-working relic of the True Cross, the confraternity decided in 1414 to commission a series of paintings commemorating the recent miracles of this relic; in 1421 it also commissioned a series of paintings illustrating scenes from the Old and New Testaments. These innovative projects may have acted as precedents, encouraging the other *scuole grandi* to increase their public profile.

In the second half of the 15th century the Scuola di S Giovanni Evangelista became involved in a form of artistic competition with the Scuola di S Marco. In the 1460s it commissioned from Jacopo Bellini, the most important painter in Venice at this time, paintings illustrating scenes from the New Testament, of which four have survived: the *Annunciation*, the *Birth of the Virgin* (both Turin, Gal. Sabauda), the *Marriage of the Virgin* and the *Epiphany* (both New York, Stanley Moss priv. col.). From the 1480s the *scuola*, responding to the innovative activities of the Scuola di S Marco (*see* §3 below), spent more money, first to create a new style of Renaissance meeting-house and then to decorate it. In 1481 Pietro Lombardo created a courtyard by erecting a marble screen with classicizing motifs to enclose the *calle* between the meeting-house and the nearby church. In the 1490s the confraternity greatly expanded its meeting-house. Mauro Codussi, architect to the Scuola di S Marco, supervised the raising of the floor and enlargement of the windows of its main meeting-room; a new entrance (1512) was added, together with a double-branched monumental staircase (1498) suitable for grand processions like that being built at the Scuola di S Marco. As a result, the confraternity's cramped medieval

quarters were transformed into a spacious and elegant Renaissance meeting-house.

To complement these structural works, the Scuola di S Giovanni Evangelista commissioned equally rich pictorial decoration. For the walls of the Sala dell'Albergo, a number of leading painters in the emerging Venetian Renaissance style received commissions to paint a new series of large paintings (all Venice, Accad.). These illustrate the miracles of its relic and also celebrate the confraternity as an important institution in Venice. In 1494 Vittore Carpaccio painted the *Patriarch of Grado Curing a Demoniac*, while Giovanni Mansueti painted the *Miracle of the True Cross at the Campo di S Lio*. In 1496 Gentile Bellini was engaged to paint his celebrated *Procession of the True Cross in the Piazza S Marco* (see colour pl. 1, X3), illustrating a great public procession and depicting the Piazza S Marco in minute detail as it appeared in the late 15th century; in 1500 he began the *Miracle of the True Cross at the Bridge of S Lorenzo* (see BELLINI, (2), fig. 1; and in 1501 he painted the *Miraculous Healing of Pietro dei Ludovici*. Lazzaro Bastiani painted the *Donation of the Relic of the True Cross* (*c.* 1495) commemorating the donation of the relic in 1369 by Philippe de Mézières, Chancellor of Cyprus, to Andrea Vendramin, *guardian grande* of the Scuola di S Giovanni Evangelista. In the early 1500s Benedetto Diana painted *A Child Fallen from a Ladder Is Miraculously Saved* and Giovanni Mansueti painted the *Miraculous Cure of the Daughter of Ser Benvegnudo da San Polo*, both glorifying the miracles worked by the relic while in the possession of the *scuola*, thus emphasizing the supernatural power in the confraternity's control. Also celebrated are the confraternity's officers, whose portraits appear in many of the paintings, and Venice itself, which is illustrated in great detail.

After *c.* 1510 the Scuola di S Giovanni Evangelista was less involved in major commissions of art, perhaps because it was largely satisfied with its meeting-house, or perhaps because it had little spare capital as a result of the growing fiscal demands of the state. In the 17th century it was engaged in making expensive repairs and modifications to its meeting-house and in commissioning new paintings, but the confraternity was no longer able to afford the work of leading artists.

3. SCUOLA GRANDE DI S MARCO. The confraternity began its institutional existence in the *sestiere* of Santa Croce but in 1438 moved to the north-east corner of the city, where it built a new meeting-house on a site located next to SS Giovanni e Paolo. The early form of this building is not known owing to its destruction by fire in 1485. In the 1460s, perhaps responding to innovations pioneered by the Scuola di S Giovanni Evangelista, the officers of the Scuola di S Marco commissioned for the main meeting-room a series of paintings illustrating scenes from the Old and New Testaments (all destr.): in 1466 a *Crucifixion* and *Christ Driving the Money-changers from the Temple* from Jacopo Bellini; the *Crossing of the Red Sea* and the *Passage through the Desert* from his son Gentile; in 1468 a painting from Bartolomeo Vivarini and Andrea da Murano, the subject of which is unclear; and in 1470 scenes from the *Story of David* and *Noah's Ark* from Giovanni Bellini, although his failure to complete the

works eventually led to the withdrawal of the commission, which was given to Bartolomeo Montagna.

The fire of 1485 provided the *scuola* with the opportunity to rebuild and redecorate. Unlike the Scuola di S Giovanni Evangelista, which had to adapt an old building located on a circumscribed piece of land, the Scuola di S Marco could begin again and with more undeveloped land available to the rear of its first building. The first stage was the rebuilding of the meeting-house itself (begun 1487), but on a larger scale to ensure that the *scuola* retained its image of primacy in Venice. By 1490 the main construction work on the new meeting-house was sufficiently complete for the embellishment of the building to begin. Pietro Lombardo and Giovanni di Antonio Buora (1450–1513) directed the construction of the lower part of the façade (begun 1489; see fig. 11), incorporating some sculptures saved from the old meeting-house, while Pietro's son Tullio created the low-relief panels (1489–90) at street level, two containing the *Lions of St Mark* flanking the main door into the meeting-house, and two illustrating *St Mark Healing Anianus* and *St Mark Baptizing Anianus* (see LOMBARDO, §II(2)). Unique in the sculptural embellishment of the *scuole grandi*, the monumental and classicizing approach of these panels looked forward to the stylistic developments of the High Renaissance in Venice. Further innovations followed in the mid-1490s, when MAURO CODUSSI (who had become chief architect in 1490) pioneered the development of the type of ornate, double-branched monumental internal staircase (destr. 1812, reconstructed 1952), ideal for processions, connecting the ground-floor meeting-room with the Sala Grande. These innovations in scale and style represented a departure from the older conception of a meeting-house.

In the early 16th century, perhaps in response to the series of paintings of the True Cross in the Scuola di S Giovanni Evangelista, the Scuola di S Marco decided to decorate its Sala dell'Albergo. Capitalizing on the local importance of St Mark as Venice's patron saint and urged on by Gentile Bellini, the most famous Venetian painter of the time who was by then an officer in the confraternity, the *banca* chose as the theme of the paintings famous events from the *Life of St Mark*. In 1506 Gentile Bellini began the first painting, *St Mark Preaching in Alexandria* (Milan, Brera), which his brother Giovanni finished in 1507. In 1515 Giovanni Bellini signed a contract to paint the *Martyrdom of St Mark in Alexandria* (Venice, Accad., on dep. Osp. Civ.), which his pupil Vittore Belliniano finished in 1526. Three further paintings illustrating scenes in this series were executed *c.* 1518–26 by Giovanni Mansueti: *St Mark Healing Anianus* (Venice, Accad.), *St Mark Baptizing Anianus* (Milan, Brera) and *Episodes from the Life of St Mark* (Venice, Accad.). After a short hiatus, large canvases, illustrating additional miracles performed by St Mark, were commissioned for the upstairs Sala Grande. Many leading Venetian artists were employed: in 1523–4 Palma Vecchio to paint *St Mark Saving Venice from the Ship of Demons* (*in situ*); in 1534 Paris Bordone to paint the *Presentation of the Ring to the Doge* (Venice, Accad.; see BORDONE, PARIS, fig. 1); and in 1548 Tintoretto to paint the *St Mark Rescuing the Slave* (Venice, Accad.; see TINTORETTO, (1), fig. 2), followed in 1562 by the *Finding of the Body of St Mark* (Milan, Brera; see TINTORETTO, (1),

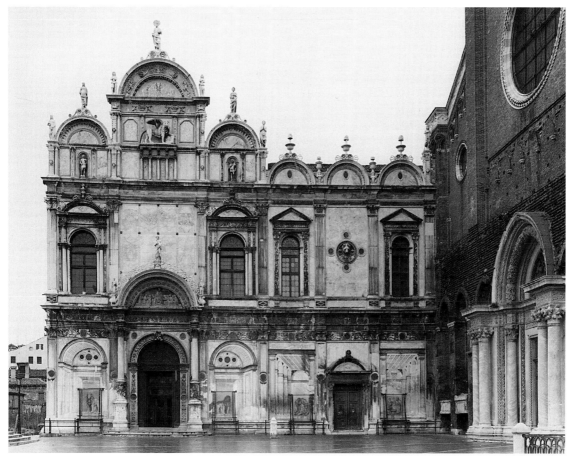

11. Venice, Scuola Grande di S Marco, façade (1489–95); lower part by Pietro Lombardo and Giovanni di Antonio Buora, upper part by Mauro Codussi and sculptural reliefs by Tullio Lombardo

fig. 3), the *Removal of the Body of St Mark* (Venice, Accad.) and *St Mark Saving the Saracen* (Venice, Accad.). Other paintings followed, completing the decoration of the Sala Grande. The cycle celebrated the apostolate and martyrdom of St Mark in Alexandria, the translation of his relics to Venice and some of the miracles he worked in Venice; they also reminded both the brothers and other Venetians of the civic religious power of the confraternity's and the city's patron saint. The portraits of many officers and visual representations of Venice in a number of paintings celebrated the importance of the *scuola grande* and created a vicarious link between the past and present united in the life and works of this saint.

In the 17th century the Scuola di S Marco completed the embellishment of its Sala Grande with many ornate panels and striking paintings. Although no longer a functioning confraternity (it is now the Ospedale Civile), the meeting-house remains as it appeared in the late 18th century, with the scenes from the *Life of St Mark* still *in situ* in the small committee meeting-room. The accumulated commissions represent a conscious investment in art as a means of venerating a patron saint and promoting the confraternity. Only one other *scuola* was able to follow its example: the Scuola Grande di S Rocco.

4. SCUOLA GRANDE DI S ROCCO. Founded in the aftermath of the plague of 1478, it rapidly gained the status of a *scuola grande*. Originally it had few resources, but veneration of St Roch and the fear generated by repeated visitations of the plague, notably those of 1478, 1527 and 1571, encouraged many Venetians to make bequests and gifts to it; by the end of the 16th century it was the richest of all Venice's *scuola grandi*. It was the only *scuola grande* to build its own church, S Rocco (begun 1489; consecrated 1508; rebuilt 18th century), which is located next to S Maria Gloriosa dei Frari. This was followed by the construction of a meeting-house on vacant land across the square from the church. Work was begun on this in 1517 and continued until the end of the 16th century. The early work was entrusted to Pietro Buon or possibly Bartolomeo Buon, who laid out the basic structure including the grand staircase and raised the first storey. From 1527 Antonio Scarpagnino continued the work, bringing a more classicizing style to the upper storey. The meeting-house is similar in its asymmetrical design to that of the Scuola di S Marco, but in a more flamboyant style, especially its richly carved façade (for illustration *see* SCARPAGNINO, ANTONIO).

12. Venice, Scuola Grande di S Rocco, Sala dell'Albergo, *Crucifixion* by Tintoretto, oil on canvas, 5.36×12.24 m, 1565

After the mid-16th century the building was ready for work to begin on the decoration of the rooms. In 1565 the confraternity commissioned Tintoretto (*see* TINTORETTO, (1)) to paint a huge *Crucifixion* (see fig. 12) in the Sala dell'Albergo of the meeting-house; in 1566–7 he painted three more scenes from the Passion, *Christ before Pilate*, the *Way to Calvary* and a *Pietà*, as well as secondary works on the ceiling (all *in situ*). In 1575 Tintoretto began the decorative programme of the Salone Maggiore with ceiling paintings illustrating the various charitable functions of the brotherhood while the walls were covered with New Testament scenes (see colour pl. 2, XXXIV1), thus introducing the Passion narrative of the Sala dell'Albergo. Between 1583 and 1587 Tintoretto returned to the *scuola* to decorate the lower-level meeting-room with paintings illustrating the *Life of the Virgin* (*see* TINTORETTO, (1), fig. 5). Since Tintoretto painted the vast majority of the paintings, the rooms have a unity of style not found in the meeting-houses of the other *scuole grandi*. Still a functioning confraternity, the Scuola di S Rocco maintains its meeting-house much as it was in its heyday around 1600.

5. SCUOLA GRANDE DI S MARIA DELLA MISERICORDIA. Founded in 1308, it was located well away from the centre of Venice on a severely circumscribed site in Cannaregio. In the 1440s, apparently in response to the innovations of the Scuola di S Marco, the Scuola della Misericordia enlarged its meeting-house by extending the front wall towards the Campo della Misericordia, and by adding a new façade decorated by a large *Madonna of Mercy* (London, V&A; see fig. 13), which is attributed to Bartolomeo Buon or to his workshop (*see* BUON (i), (1)). This building (the so-called Scuola Vecchio della Misericordia) is the best surviving example of a confraternity meeting-house dating from the early 15th century. The limitations of the site and lack of funds prevented further enlargements during the 15th century.

In 1509, having decided to erect a completely new meeting-house on its land on the other side of the canal, the confraternity commissioned Pietro and Tullio Lombardo to begin work, but the project was dogged by financial problems and administrative indecision and was never carried out. Only after the disasters of the War of the League of Cambrai and the plague of 1527 did the Scuola della Misericordia feel confident enough to consider beginning the project again. The *banca* wanted a large meeting-house and commissioned Jacopo Sansovino to build it, beginning in 1535. Sansovino planned a large building with many Roman stylistic details, an artistic coup against the other *scuole grandi*, but the confraternity did not have sufficient funds to sustain the project. The building work was repeatedly interrupted by the problems in Venice during the 16th century or by the changing ideas of the *banca*. In 1544, for instance, it rejected Sansovino's plan to have vaulted ceilings in the new meeting-house,

13. Venice, Scuola Grande di S Maria della Misericordia, *Madonna of Mercy* attributed to Bartolomeo Buon, marble, installed on the façade in 1451 (London, Victoria and Albert Museum)

preferring instead the traditional flat ceilings that could be decorated with paintings; the *banca* also opened a new competition for the structure and decorative details of the monumental, two-branched staircase, a sign that the confraternity had again rejected the advice of its architect. When Sansovino died in 1570, the brick walls had just been erected; only after many more tribulations and an embarrassing merger with the wealthy Scuola Piccola di S Maria dell'Orto, were the roof, the upper room and staircase set in place to allow the formal translation (1589) of the confraternity from its old to its new meeting-house.

This meeting-house, monumental in its conception, was clearly too expensive for the resources of the Scuola della Misericordia. There is no evidence to suggest that the confraternity ever commissioned a series of paintings to celebrate either of its meeting-houses with scenes from the life of its patron saint or miracles worked by a relic. Clearly, the resources at the disposal of the *scuola*, greatly diminished by demands made by the state and by the cost of supporting its poor brothers during the later 15th century and the 16th, were inadequate to meet the expense of erecting the largest meeting-house in the city, which remains unfinished and little decorated.

6. Scuola Grande di S Maria della Carità. This was an ancient and wealthy *scuola grande* with a fine meeting-house close to the centre of the city. The state of the confraternity's archives and the many structural alterations to the building, most notably those in the early 19th century, when the meeting-house was altered to become Venice's Galleria dell'Accademia, make it very difficult to assess the confraternity's contribution as a patron. The *scuola* was located next to the monastery of S Maria della Carità, from which it first rented rooms and later purchased land and buildings. By 1343 it had two large meeting-rooms, one above the other, perhaps creating the original model of the *androne* or lower meeting-room and the *sala* or main meeting-room. Traces of fresco can still be seen near the cornice of the *sala*, which suggests that the room may originally have been decorated with frescoes.

Like the other *scuole grandi* in the mid-15th century, the Scuola della Carità improved its meeting-house, which was extended into the Campo della Carità in order to build an *albergo* for the meetings of the *banca*. This was decorated with a triptych by Antonio Vivarini and Giovanni d'Alemagna, the *Virgin and Child with SS Jerome and Gregory, Ambrose and Augustine* (1446; Venice, Accad.; see fig. 14), and a ceiling of elaborate panels. Possibly at this time the *scuola* erected the Gothic façade seen in the background of the *Stonemason's Yard* (1726–7; London, N.G. by Canaletto (1697–1768). In the early 16th century the confraternity was considering further improvements, mainly decorations for its Sala dell'Albergo. In 1534 Titian was commissioned to paint a very large *Presentation of the Virgin* (1534–8; *in situ*), a work of complex design and symbolism, to cover one entire wall of the Sala dell'Albergo, where the *banca* usually distributed alms and made the annual selection of the young women who would receive the confraternity's dowry contributions; thus the subject-matter reflected the confraternity's charitable activities, reinforced by the many portraits of officers shown looking on as the young Virgin ascends the steps to the

14. Venice, Scuola Grande di S Maria della Carità, *Virgin and Child with SS Jerome and Gregory, Ambrose and Augustine* by Antonio Vivarini and Giovanni d'Alemagna, oil on canvas, 3.44×4.77 m, 1446 (Venice, Galleria dell'Accademia)

temple. Additions to the decoration of the room were Giampietro Silvio's *Marriage of the Virgin* (1540–3) and Girolamo Denti's *Annunciation* (1557–61; both parish church of Venice, Accad., on dep. Mason Vicentino). After the 1560s the *scuola* apparently did not make any more major additions to its meeting-house. Although it considered the possibility of constructing an ornate staircase like those of the other *scuole grandi*, this project was not begun until the mid-18th century.

7. Scuola Grande di S Teodoro. The old *scuola piccola* in honour of S Teodoro, traditionally Venice's patron saint alongside St Mark, was the last to be elevated to the status and responsibilities of a *scuola grande*, in 1552. It was successful in enrolling many new brothers from the rich merchants residing near the Rialto Bridge. In 1555, well after the other confraternities had set out the definitive Venetian style of a confraternity meeting-house, the Scuola di S Teodoro decided to erect a meeting-house, but it was not until 1576 that the necessary land opposite the newly constructed S Salvador was acquired. Under the supervision of Simone Sorella, the meeting-house was gradually constructed following the established plan of a large

meeting-room on the ground floor connected by a double-branched staircase to the vast and elegant upper meeting-room and committee room. The surviving meeting-house is on a scale similar to those of the Scuola di S Giovanni Evangelista and the Scuola di S Marco. Inside, the decoration includes paintings with scenes from the *Life of St Theodore*, commissioned during the 17th and 18th centuries. Although the confraternity commissioned paintings from famous artists of the later 17th century and the early 18th, these works did not have the great cultural impact of the commissions of the other confraternities, and this confraternity never became as famous as the other five. The confraternity was dissolved during the Napoleonic occupation; the meeting-house is now used for exhibitions and concerts.

BIBLIOGRAPHY

P. Paoletti: *La Scuola Grande di San Marco* (Venice, 1929)
R. Gallo: 'La Scuola Grande di San Teodoro in Venezia', *Atti Ist. Ven. Sci., Lett. & A.*, cxx (1961–2), pp. 461–5
L. Sbriziolo: 'Le confraternite veneziane di devozione: Saggio bibliografico e premesse storiografiche', *Riv. Stor. Chiesa Italia*, xxi (1967), pp. 167–97
B. Pullan: *Rich and Poor in Renaissance Venice: The Social Institutions of a Catholic State to 1620* (Oxford, 1971)
P. L. Sohm: 'The Staircases of the Venetian Scuole Grandi and Mauro Coducci', *Architectura* [Milan], viii (1978), pp. 125–49
S. Gramigna and A. Perissa: *Scuole di arti, mestieri e devozione a Venezia* (Venice, 1981)
R. Maschio: 'Le scuole grandi a Venezia', *Storia della cultura veneta dal primo quattrocento al Concilio di Trento*, ed. G. Arnaldi and M. Pastore Stocchi, III/iii (Vicenza, 1981)
T. Pignatti, ed.: *Le scuole di Venezia* (Milan, 1981)
P. L. Sohm: *The Scuola Grande di San Marco, 1437–1550: The Architecture of a Venetian Lay Confraternity* (New York, 1981)
R. Mackenney: 'Devotional Confraternities in Renaissance Venice', *Voluntary Religion*, ed. W. Shiels and D. Wood, Stud. Church Hist. (Oxford, 1986), pp. 85–96
P. F. Brown: *Venetian Narrative Painting in the Time of Carpaccio* (New Haven, 1988)
G. Romanelli: *Scuola grande di San Rocco* (Milan, 1995)

WILLIAM B. WURTHMANN

Ventura di Andrea Vitoni. *See* VITONI, VENTURA DI ANDREA.

Venusti, Marcello [Mantovano, Marcello] (*b* Como, ?1512–15; *d* Rome, 14 Oct 1579). Italian painter. Although he may have studied in Mantua, the earliest notices of the artist date from his participation in the workshop of Perino del Vaga in Rome in the 1540s. His first important commission, to copy Michelangelo's *Last Judgement* (Rome, Vatican, Sistine Chapel; see colour pl. 2, VII3), came from Cardinal Alessandro Farnese in 1548; the small-scale painting (Naples, Capodimonte) is a valuable document of the appearance of the fresco before Daniele da Volterra added draperies. It secured Venusti's reputation and began his long friendship with Michelangelo, who allowed him to execute numerous small-scale paintings based on his designs, usually of religious subjects. Venusti often added the settings to Michelangelo's figure studies and elaborated details to create devotional works with the intensity of miniature paintings. Among those recorded by Vasari and later sources are a large-scale *Annunciation* (Rome, S Giovanni in Laterano, sacristy), based on a Michelangelo drawing owned by Tommaso de Cavalieri (Florence, Uffizi, no. 229F), and an *Annunciation* for the

Cesi Chapel in S Maria della Pace in Rome (replica, Rome, Pal. Barberini; Michelangelo's drawing, New York, Pierpont Morgan Lib.). A *St Jerome* was engraved in 1558 by Sebastiano da Reggio (*fl c.* 1550–60).

Numerous small paintings based on Michelangelo's 'presentation drawings' (highly finished drawings; for illustration *see* PRESENTATION DRAWING) have been attributed to Venusti, but his only signed and dated work is a *Holy Family* (1563; Leipzig, Mus. Bild. Kst.). Many Michelangelesque chalk drawings have been wrongly attributed to him; his own drawings, mostly in pen and wash, reveal a sweetness and suavity that distinguish him from the master and other imitators. Similar qualities are found in his independent paintings, among which are *Nativity with a Circle of Putti* (Rome, S Silvestro al Quirinale) and *St Bernard* (Rome, Vatican Mus.).

BIBLIOGRAPHY

G. Vasari: *Vite* (1550, rev. 2/1568); ed. G. Milanesi (1878–85), v, pp. 625, 632; vii, pp. 272–5
G. Mancini: *Considerazioni sulla pittura* (*c.* 1618); ed. A. Marucchi (Rome, 1956)
G. Baglione: *Vite* (1642); ed. V. Mariani (1935)
F. Scanelli: *Il microcosmo della pittura* (Cesena, 1657)
A. Bertolotti: *Artisti lombardi a Roma*, 2 vols (Milan, 1881)
A. Venturi: *Storia* (1901–40) IX, vi, pp. 475–94
C. de Tolnay: 'Marcello Venusti as Copyist of Michelangelo', *A. America*, xxviii (1940), pp. 169–76
F. Zeri: *Pittura e controriforma* (Turin, 1957)
J. Wilde: 'Cartoonists by Michelangelo', *Burl. Mag.*, ci (1959), pp. 370–80
P. Borland: 'A Copy by Venusti after Michelangelo', *Burl. Mag.*, ciii (1961), pp. 433–4
A. Perrig: 'Michelangelo und Marcello Venusti: Das Problem der Verkündigungs- und Olberg Konzeption Michelangelos', *Wallraf-Richartz-Jb.*, xxiv (1962), pp. 261–94
B. Davidson: 'Drawings by Marcello Venusti', *Master Drgs*, xi (1973), pp. 3–18
Quadri romani fra '500 e '600 (exh. cat., ed. C. Strinati; Rome, Pal. Venezia, 1979)
L. Russo: 'San Bernardo Schiaccia il Demonio', *Bull. Mnmt., Mus. & Gal. Pont.*, iv (1983), pp. 173–8
J. M. Ruiz Manero: 'Obras y noticias de Girolamo Muziano, Marcello Venusti y Scipione Pulzone en España', *Archv Esp. A.*, lxviii/272 (1995), pp. 365–80

JANIS CALLEN BELL

Verdizotti [Verdezotti; Verdizzotti], **Giovanni** [Zuan] **Maria** (*b* Venice, 1525; *d* Venice, 1600). Italian printmaker, draughtsman and writer. He is mainly remembered for his friendship with Titian, who, in 1556, introduced him to Vasari. After the death in that year of Pietro Aretino, he probably became Titian's secretary. According to Ridolfi, Verdizotti specialized in painting small scenes of landscapes with tiny figures, but no painted work can be attributed with certainty to him. The most secure work in his rather obscure oeuvre is the signed drawing of *Cephalus and Procris* (pen and ink; Brunswick, Herzog Anton Ulrich-Mus.), which shows an intelligent adherence to Titian's graphic style as seen in the master's preparatory drawings (Berlin, Kupferstichkab.; Frankfurt am Main, Städel. Kstinst. & Städt. Gal.) for the *Resurrection* polyptych (1521–2; Brescia, SS Nazaro e Celso).

Verdizotti probably also executed the drawing of a *Bear Devouring a Rabbit in a Landscape* (pen and ink and wash; Florence, Uffizi), which carries the motto *naturam ars vincit*. This work is very similar in style to the woodcuts that illustrate his *Cento favole* (Venice, 1570). Similarly, the putative portrait of *Titian* (pen and ink; Haarlem, Teylers

Mus.) is close to the Brunswick *Cephalus and Procris*. Another drawing with a plausible attribution to Verdizotti is the *Landscape with Houses* (pen and ink; Milan, Bib. Ambrosiana). In 1597 Verdizotti published his *Vite de' Santi Padri* in Venice, illustrating it with woodcuts of his own design. In the preface to this work, it is mentioned that he had a canonry at Castelcucco, near Treviso. Among the large corpus of pen drawings inspired by Titian, the *Study of a Tree* (pen and ink; Madrid, Real Acad. S Fernando, Mus.) can be assigned to Verdizotti, but the *Study of Rocks and Trees* in the same collection does not appear to be his and is probably of a later date.

BIBLIOGRAPHY

G. Vasari: *Vite* (1550, rev. 2/1568); ed. G. Milanesi (1878–85), vii
L. Dolce: *Dialogo della pittura* (Venice, 1557); ed. M. W. Roskill (New York, 1968)
C. Ridolfi: *Meraviglie* (1648); ed. D. von Hadeln (1914–24), ii
N. L. Cittadella: 'Torquato Tasso e Giovanni Verdizzotti', *Ateneo Ven.*, v (1871), pp. 287–98
D. von Hadeln: *Die Zeichnungen des Tizian* (Berlin, 1924)
H. Tietze and E. Tietze-Conrat: *The Drawings of the Venetian Painters in the 15th and 16th Centuries* (New York, 1944)
G. Venturini: 'Giovanni Maria Verdizzoti, pittore e incisore, amico e discepolo di Tiziano', *Boll. Mus. Civ. Padova*, lix (1970), pp. 33–73
H. E. Wethey: *Titian and his Drawings with Reference to Giorgione and Some Close Contemporaries* (Princeton, 1987)

UGO RUGGERI

Vergelli, Tiburzio (*b* Camerino, 1555; *d* ?Loreto, 7 April 1610). Italian sculptor. He may have been trained as a bronze sculptor in Recanati at the Fonderia Recanatese and is first recorded in 1572 as an assistant of Girolamo Lombardo in Loreto. In 1576 he was paid for work on the frames and reliefs of the four bronze doors of the Santa Casa in the basilica of S Maria in Loreto. He assisted Antonio Calcagni in 1582 in casting bronzes for the Massilla–Rogati Chapel in the same church and collaborated with Antonio Lombardo II (*c.* 1564–between 1608 and 1610) in 1583 on the group of the *Virgin and Child* for the basilica's façade. In 1585 he was commissioned by the Camerino town council to execute a bronze seated statue of *Sixtus V* (completed 1589; Camerino, Piazza Cavour). The dull characterization of the Pope is relieved by Vergelli's attention to ornamental detail in the throne and the reliefs of female allegories decorating the base.

In 1590 the Governatore of the Santa Casa allocated to Vergelli the north door of the basilica: it was inaugurated in 1598. This bronze door, divided into ten rectangular panels framed by scrolled foliage and oval reliefs, complements Antonio Calcagni's right door, both iconographically and stylistically. Although the decoration of the earlier doors of the Santa Casa by the Lombardo family is reminiscent of that of Lorenzo Ghiberti's Florentine Baptistery doors, Vergelli's use of oval reliefs containing statuettes of Virtues or low-relief scenes and his pictorial treatment of space and mass in the large reliefs are distinctive of his own more florid style. The richly ornamented font in the basilica, abundantly decorated with swags of fruit, reliefs, statuettes of Virtues, and angels, and surmounted by a group depicting the *Baptism*, was completed between 1600 and 1607 by Vergelli and his assistants. A bronze group of the *Virgin and Child with the Infant St John* (London, V&A) relates closely to the group of *Charity* on the font, suggesting a similar date.

BIBLIOGRAPHY

M. Santori: *Sisto V e la sua statua a Camerino* (Camerino, 1905)
G. Pauri: *I Lombardi–Solari e la scuola recanatese di scultura* (Recanati, 1915), pp. 53–4
C. Ricci: 'Statue e busti di Sisto V', *L'Arte*, xix (1916), pp. 163–74
A. Venturi: *Storia*, x, pt 2 (1936), pp. 735–46
K. Weil Garris: *The Santa Casa di Loreto: Problems in Cinquecento Sculpture*, 2 vols (New York and London, 1977), pp. 101, 348
A. Radcliffe: 'Tiburzio Vergelli, Giambologna, and a Rare Bronze Group from Recanati', *Antol. B.A.*, 24–27 (1984), pp. 21–5
P. Dal Poggetto, ed.: *Le arti nelle Marche al tempo di Sisto V* (Milan, 1992)
M. Giannatiempo Lopez: 'I bronzi lauretani: La felice stagione scultorea', *Santuario di Loreto: Sette secoli di storia arte devozione*, ed. F. Grimaldi (Rome, 1994), pp. 127–39

ANTONIA BOSTRÖM

Verino, Benedetto. *See under* MASTERS, ANONYMOUS, AND MONOGRAMMISTS, §I: MASTER OF THE DIE.

Verona. Italian city in the Veneto on the River Adige *c.* 60 km west of Venice. It has substantial Roman remains, and its position at the crossing of three important trade routes gave it significant economic strength, which is reflected in numerous fine medieval buildings. From the mid-16th century Michele Sanmicheli left a lasting influence on architectural styles in the city.

1. History and urban development. 2. Art life and organization.

1. HISTORY AND URBAN DEVELOPMENT. The pre-Roman settlement, at a fording point on the Adige, is thought to have been situated mainly on the hill of S Pietro on the left bank of the river. The Roman city was founded on the right bank of the river in the mid-1st century BC and had reached the height of its development by *c.* AD 265. With the advent of Christianity in the city new architectural forms such as basilicas were established. Nonetheless, following the war with the Goths in the 5th century, the city fell into a rapid decline, houses destroyed in battles being rebuilt with poorer materials, and areas formerly occupied by citizens given over to pasture and tillage. The city recovered to some extent in the 9th century, when Archdeacon Pacificus (*d* 846) founded new churches and restored damaged old ones; but it was only from the 12th century that buildings were of a quality to leave a lasting impression on the urban topography.

From 1136 to 1277 (with a brief interlude of tyranny) Verona was a commune, the Palazzo del Comune being built beside the ancient Forum from 1193 (rest. 1925), while prominent families built themselves tower-houses. Under the rule of the della Scala (Scaligeri), from the accession of Alberto I della Scala (*d* 1301) in 1277 until 1387, Verona expanded to nearly six times the size of the Roman city, and it remained within these expanded limits until the end of World War I. The della Scala, and after them the Visconti (1387–1405), developed Verona as a military stronghold with the construction of several fortresses. Continuous and violent civil strife of the 12th and 13th centuries must have forced the citizens to make defensive alterations to their houses, which studies indicate must have been particularly fine at that time. Following brief domination by the Carraresi and then by the Visconti, in 1405 Verona came under the sway of the Venetian Republic, and except for a few years of imperial rule (1509–16) it remained under Venetian control until 1797.

This control was reflected in much of the architecture of the city. From this period, particularly in the early Renaissance, one can find Venetian architectural elements, such as the grouping of pointed arched windows.

The first important public architectural project under the Venetians was the construction (1452–66) of S Bernardino, still on Gothic lines but with some Renaissance decorative elements. The Loggia del Consiglio, begun in 1476 on the Piazza dei Signori by masons from Lombardy, is a more complete example of Renaissance architecture. In 1517, after the brief imperial occupation of the city, Venice ordered the demolition of all the houses and churches that lay outside the town walls in order to guarantee better defences. Between 1520 and 1525 the city walls to the left of the river were rebuilt, and from 1530 MICHELE SANMICHELI was responsible for renewing the defences on the right bank, where he built a series of bastions.

In 1530 Venice ordered the Cittadella to be dismantled, and in 1535 Sanmicheli was entrusted to develop the site. A new street, the Corso Porta Nuova, was built along the moat of the Cittadella, with a gate, the Porta Nuova (1535–40). Sanmicheli also built the Porta Palio (c. 1547), in a style that freely re-created the forms of antiquity. After entering Porta Brà, the Corso Porta Nuova was deflected towards the Arena by Sanmicheli's Palazzo degli Honori. The stretch of Roman street between the Porta Borsari and the Arco dei Gavi was enriched by Sanmicheli's Palazzo Canossa (c. 1530; see SANMICHELI, MICHELE, fig. 1) and Palazzo Bevilacqua (before 1534; see fig.). These, with their full range of classical details and rich articulation, are the high-point of Veronese Renaissance architecture. They contrast with the many painted façades, a marked feature of the city, which include those by Girolamo dai Libri at the Casa Cristani and those by Giovanni Maria Falconetto, including the Casa Trevisani–Lonardi. These fresco schemes tend to reproduce antique reliefs set against brilliantly coloured backgrounds. The work of Sanmicheli left such an impression on Verona that much architecture in the following decades followed patterns established by him.

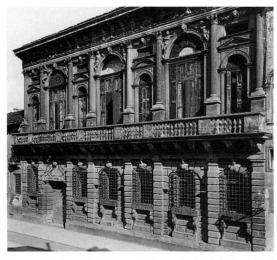

Verona, façade of the Palazzo Bevilacqua by Michele Sanmicheli, before 1534

BIBLIOGRAPHY

T. Sarayna: *De origine et amplitudine civitatis Veronae* (Verona, 1540)
S. Maffei: *Verona illustrata* (Verona, 1732/*R* 1975)
G. B. da Persico: *Descrizione di Verona e della sua provincia* (Verona, 1820–21/*R* 1974)
G. Biadego: *Verona* (Bergamo, 1909)
A. da Lisca: *La fortificazione di Verona dai tempi romani al 1866* (Verona, 1916)
Michele Sanmicheli (exh. cat., ed. P. Gazzola; Verona, Pal. Canossa, 1960)
L. Puppi, ed.: *Ritratto di Verona: Lineamenti di una storia urbanistica* (Verona, 1978)
L. Franzoni: 'Il collezionismo dal cinquecento all'ottocento', *Cultura e vita civile a Verona*, ed. G. P. Marchi (Verona, 1979), pp. 597–656
Palladio e Verona (exh. cat., ed. L. Magagnato; Verona, Gran Guardia, 1980)

2. ART LIFE AND ORGANIZATION. Only from the fuller records from the early 15th century is it possible to assess the economic and social position of artists and craftsmen in Verona. The registry of births and deaths, and the records of land valuations (*Campioni d'Estimo*), the first of which dates from 1409, show that stone-carvers were generally better off than other artists such as painters; that they had many opportunities for work during the 15th century is shown by the influx of masons from Lombardy, who made up at least a quarter of the total. The apogee of sculpture in Verona seems to have been the later Middle Ages.

Conditions for glassmakers were difficult throughout the Veneto owing to the privileged position of the glass-workers of Murano, who were protected by Venice. For similar reasons ceramicists had to yield to the dominance of Faenza. Embroiderers, however, were generally prosperous. Verona produced some excellent embroiderers, for example Paolo da Verona (*fl c.* 1470), whom Vasari praised for his scenes from the *Life of St John the Baptist*, executed in Florence for sacred vestments to a design by Antonio Pollaiuolo. Engraving and marquetry were practised by Fra' Giovanni da Verona, Fra' Vincenzo dalle Vacche (*fl* 16th century) and members of the Giolfino family.

The first numismatic collection in Verona was evidently started by the della Scala family, who were the first serious patrons of art in the city, extending patronage to Dante Alighieri as well as summoning painters to work at court, among them Giotto. Although in the 15th century the more peaceful conditions guaranteed by Venetian overlordship did not lead to a great flowering of architecture and public art, the influence of Venice was felt in the city. Towards the last quarter of the century, with the work on the Loggia del Consiglio, a group of fine sculptors spread the taste for sculptured decoration on portals and altars and, perhaps under the influence of Andrea Mantegna, disseminated a taste for classical values.

The city churches received much painted decoration in the 15th and 16th centuries, with work by Giovanni Badile (S Maria della Scala; 1443–4; *see* BADILE, (1)) and, around 1500, by Domenico Morone (*see* MORONE, (1)), who executed all the important fresco commissions (e.g. S Maria in Organo, SS Nazaro e Celso) and was the main influence on the next generation of painters, including his son Francesco, Girolamo Dai Libri and the slightly younger Gian Francesco Caroto (*see* CAROTO, (1)). Paolo Veronese, who was born in the city, left one surviving work, the Bevilacqua–Lazise Altarpiece for S Fermo

Maggiore (*c.* 1548; Verona, Castelvecchio), before his departure for Venice, and painted two other altarpieces in 1566 (*Martyrdom of St George*, S Giorgio Maggiore; and *Virgin and Child with SS Anthony and John*, Marogna Chapel, S Paolo), during a return visit to Verona. The leading painters later in the 16th century were Domenico Brusasorci (S Stefano; *see* BRUSASORCI, (1)) and Battista dell'Angelo del Moro (*c.* 1515–73), who worked with, among others, PAOLO FARINATI.

The collection of archaeological remains is documented in Verona as early as 1496, possibly linked to the presence at that time of Mantegna. In addition to the few small epigraphic collections made by craftsmen, antiquities were of interest to some noble families, but it was not until the second half of the 16th century that the collections of Mario Bevilacqua (1536–93), Agostino Giusti (1546–1615) and Girolamo Canossa (1532–91) took shape. Bevilacqua, in particular, assembled a collection of fine ancient sculpture that remained intact at the Palazzo Bevilacqua for more than two centuries until it was moved to the Glyptothek, Munich, in 1811. No less important was his art collection, for which the painter Orlando Flacco (*b* 1530) acted as consultant. Giusti enriched the famous garden of his palazzo with a fine epigraphic collection, and Canossa's art collection was admired for its antique gems and for a picture gallery containing Raphael's *Holy Family (Madonna della Perla)* (now Madrid, Prado).

BIBLIOGRAPHY

G. Vasari: *Vite* (1550, rev. 2/1568); ed. G. Milanesi (1878–85), iii, p. 299
A. Avena: 'L'arte vetraria in Verona', *Madonna Verona*, v (1911), pp. 112–27
A. Mazzi: 'Gli estimi e le anagrafi inedite dei pittori veronesi del secolo XV, *Madonna Verona*, vi (1912), pp. 43–60
——: 'Gli estimi e le anagrafi inedite dei miniatori e pittori veronesi del secolo XV', *Madonna Verona*, vi (1912), pp. 85–93
——: 'Gli estimi e le anagrafi dei lapicidi veronesi del secolo XV', *Madonna Verona*, vi (1912), pp. 221–8; vii (1913), pp. 25–38
A. Avena: 'Ceramisti e ceramiche in Verona nel secolo XV e nel XVI', *Madonna Verona*, x (1916), pp. 111–25
G. Schweikhart: *Fassadenmalerei in Verona vom 14. bis zum 20. Jahrhundert* (Munich, 1973)
M. T. Cuppini: 'L'arte a Verona tra XV e XVI secolo', *Verona & Territ.*, iv/1 (1981), pp. 241–522
L. Rognini: *Tarsie e intagli di fra Giovanni a Santa Maria in Organo di Verona* (Verona, 1985)
Miniatura veronese del rinascimento (exh. cat., ed. G. Castiglioni and S. Marinelli; Verona, Castelvecchio, 1986)
K. Pomian: *Collectionneurs, amateurs et curieux* (Paris, 1987)

LANFRANCO FRANZONI

Verona, Giovanni da. *See* GIOVANNI DA VERONA.

Verona, Liberale da. *See* LIBERALE DA VERONA.

Veronese, Bonifazio. *See* PITATI, BONIFAZIO DE'.

Veronese [Caliari]**, Paolo** (*b* Verona, 1528; *d* Venice, 19 April 1588). Italian painter and draughtsman. With Titian and Tintoretto he makes up the triumvirate of great painters of the late Renaissance in Venice. He is known as a supreme colourist and for his illusionistic decorations in both fresco and oil. His large paintings of biblical feasts executed for the refectories of monasteries in Venice and Verona are especially celebrated. He also produced many altarpieces, history and mythological paintings and por-

traits. His compositional sketches in pen, ink and wash, figure studies in chalk, and chiaroscuro modelli and *ricordi* form a significant body of drawings. He headed a family workshop that remained active after his death (*see* CALIARI; for Veronese's adoption of this name *see* §III below).

I. Life and work. II. Working methods and technique. III. Character and personality. IV. Critical reception and posthumous reputation.

I. Life and work.

1. Verona, to 1553. 2. Venice and Verona, 1553–60. 3. Maser, Verona and Venice, 1560–73. 4. Late works, 1574–88.

1. VERONA, TO 1553.

(i) Training and first works. Paolo was the son of Gabriele, a stonecutter (whose father was also a stonecutter, from Lombardy), and Caterina. Borghini and Ridolfi named Antonio Badile IV as Veronese's master, and *Paulus eius discipulus seu Garsonus 14* is recorded as a member of Badile's household in 1541 (Verona, Archv Stato). Vasari named Giovanni Caroto as Paolo's teacher, and it is likely that training with Caroto followed the initial apprenticeship with Badile, since a 'Paulus' is no longer a member of Badile's household in 1544 (Gisolfi Pechukas, 1976, 1982).

Veronese's earliest works confirm roles for both Badile and Caroto in his training and reflect the richness of the artistic ambience of Verona during the 1540s. Verona was a Roman town and a site of antiquarian studies during the Renaissance, including a book by Caroto (1546 edn and original drgs; Verona, Bib. Civ.). Fresco cycles (*c.* 1500) by Giovanni Maria Falconetto and Domenico Morone in S Nazaro, the cathedral and the library of S Bernardino offered Veronese important examples of illusionistic cycles that intended to re-create ancient wall decoration. Paintings by Francesco Morone and Cavazzola, executed in the first two decades of the 16th century and shining with pure colours illumined by light that mimics sunlight, probably inspired his palette. Nicola Giolfino's decorations (*in situ*) of the 1520s in the Cappella S Francesco, S Bernardino (*in situ*), were examples that successfully orchestrated architectural settings with background views, and Francesco Torbido's translation in 1534 of Giulio Romano's designs offered a powerful illusion of the *Assumption of the Virgin* in the choir of the cathedral (*in situ*). Other influences included a book of drawings by Parmigianino then in the Muselli Collection, older contemporaries of Veronese such as Domenico Brusasorci and Battista dell'Angolo del Moro, who adopted Mannerist conventions of anatomy, and Caroto, who worked in a High Renaissance style well into the 1550s (Gisolfi Pechukas, 1976, 1982).

Veronese's earliest known works are two oil sketches, similar to each other in size, technique and style, for works described by Ridolfi as 'beginnings' (Gisolfi Pechukas, 1976, 1982): the *Raising of the Daughter of Jairus* (*c.* 1546; Paris, Louvre, reserve), which is the *bozzetto* for a lost painting formerly in the Cappella degli Avanzi, S Bernardino, Verona (original stolen and replaced by a copy, 1696), and the *Virgin and Child Enthroned with SS Louis of Toulouse and John the Baptist* (*c.* 1546; Florence, Uffizi, reserve; see fig. 1), a *bozzetto* for the damaged Bevilacqua–Lazise Altarpiece (*c.* 1546; ex-S Fermo Maggiore, Verona;

1. Paolo Veronese: *Virgin and Child Enthroned with SS Louis of Toulouse and John the Baptist*, oil study for the Bevilacqua–Lazise Altarpiece, 500×360 mm, *c.* 1546 (Florence, Galleria degli Uffizi, reserve)

Verona, Castelvecchio). The surviving works show morphological similarities to Badile's documented works of the 1540s, while the clear light and colour are closer to Caroto (e.g. frescoes of archangels, 1530; S Maria in Organo, Verona). Other decipherable influences include Parmigianino's drawings, Michelangelo's *Joel* (via an engraving) and the altarpiece of *St Nicholas* (1535) by Torbido and Battista dell'Angolo del Moro in S Fermo Maggiore.

The two oil sketches are at the centre of a group of very early works that may be dated to the late 1540s (Gisolfi Pechukas, 1982). This includes the *Magdalene Laying aside her Jewels* (London, N.G.), the *Lamentation* (Verona, Castelvecchio), the *Mystic Marriage of St Catherine* (New Haven, CT, Yale U. A.G.), the *Holy Family with the Infant John the Baptist* (Amsterdam, Rijksmus.) and the *Portrait of a Woman with her Son and Dog* (Paris, Louvre). These works share with the oil sketches their somewhat elongated figure types with mannered gestures, a simple division of foreground 'stage' and background view, a cool palette and blue skies streaked with thin white clouds, and architectural details derived from works by Sanmicheli. To this group may be added another painting of the *Mystic Marriage of St Catherine* (Tokyo, N. Mus. W.A.), datable to 1547 by the joint coat of arms (Gisolfi, 1995).

Three modestly sized canvases for a ceiling, possibly from a palazzo in or near Verona, may date from *c.* 1550 (Gisolfi Pechukas, 1987). The allegories of *Peace* and *Hope* (Rome, Mus. Capitolino) and the *Allegory of the Arts*

(Rome, Pin. Vaticana) share the *di sotto in sù* foreshortening of Veronese's subsequent ceiling decorations, but the figures are still delicately proportioned and simply clad, and the blue skies are streaked with thin clouds as in the earliest pictures. The boldness of his later series is not yet evident.

(ii) First commissions outside Verona. In 1551 Veronese's first altarpiece for a Venetian church was installed: a *Sacra conversazione* for the Giustiniani Chapel of S Francesco della Vigna. Compositionally it is a variation on Titian's Pesaro *Madonna* (1519–26; Venice, S Maria Gloriosa dei Frari; see colour pl. 2, XXXV2) and on Badile's *Virgin and Child Enthroned with Saints* (1544; ex-Santo Spirito, Verona; Verona, Castelvecchio). St Catherine's gorgeous brocade mantle is an early example of Veronese's rich overlaying of pigments. (See Gisolfi Pechukas, 1976; Sponza in *Paolo Veronese Restauri*, 1988; Gisolfi, 1989–90 on the modification of the background architecture in this painting.)

The surviving fresco fragments of 1551 from the Villa Soranzo (destr. 1816) by Sanmicheli (about 14; Castelfranco, Cathedral sacristy; Venice, Semin. Patriarcale; Vicenza, Mus. Civ. A. & Stor.) are not by Veronese only but by his compatriots Battista Zelotti and Anselmo Canneri as well, and close study of early descriptions, records and related drawings indicates collaboration of the three on an equal basis. Reconstruction of the decoration of the Loggia, Sala and two Camere at the villa reveals a system of feigned architecture, statuary and reliefs in monochrome, setting off 'real' landscape views and coloured figures (Schweikhart, 1971; Gisolfi Pechukas, 1987; Gisolfi, 1989–90). As in the earlier examples of Falconetto and Morone in Verona, the intent was probably to re-create ancient Roman illusionistic decorations. The large fragment of *Time and Fame* (1551; Castelfranco Cathedral sacristy) was probably the ceiling of the 'Camera C' (Crosato Larcher, 1977) and demonstrates Veronese's early mastery of *di sotto in sù* foreshortening and effects of sunlight on fabric and flesh. The tumbling figure of Fame is indebted to Giulio Romano's design of angels, executed by Torbido (1534) in the vault of the choir of Verona Cathedral. Fame's elongated proportions recall Parmigianino's figures, while the muscular Time resembles Correggio's figure of St Peter in the *Vision of St John on Patmos* (1520–23; dome fresco, S Giovanni Evangelista, Parma). In addition, Veronese's fragment of a *Putto Straddling a Baluster* (Vicenza, Mus. Civ. A. & Stor.) is close in style to Correggio's boldly foreshortened putti in the Camera S Paolo, Parma, further suggesting that Veronese had recently visited Parma.

In 1552 Cardinal Ercole Gonzaga commissioned Veronese, Domenico Brusasorci, Paolo Farinati and Battista dell'Angolo del Moro to paint altarpieces for four altars in Mantua Cathedral. Veronese's resultant *Temptations of St Anthony* (1552; Caen, Mus. B.-A.), his first fully documented commission, is unique among his early works for its warm tonality and sensuality. The softness of flesh and atmosphere must have been inspired by Correggio's canvases of similar tonality, perhaps the *Antiope* (Paris, Louvre), then in Mantua.

2. VENICE AND VERONA, 1553–60.

(i) Major decorative commissions. In 1553 Veronese moved to Venice. He had been invited by Giovanni Battista Ponchino to collaborate with him and with Giambattista Zelotti on the decoration of the Sala del Consiglio dei Dieci in the Doge's Palace (see VENICE, §IV, 4(ii)). The themes of the three ceilings decorated in 1553–4—the Sala del Consiglio dei Dieci, and the adjacent Stanza della Bussola and Stanza dei Tre Capi—were devised by Daniele Barbaro (Sansovino). Veronese's work predominates. In the large Jupiter Expelling the Vices (1553–4; Paris, Louvre), designed as the central oval for the Consiglio dei Dieci ceiling, he developed the influence of Giulio Romano. The Vices, muscular male figures who hurtle from the heavens, are sharply foreshortened though their descent, seen through the oval frame, is not as threatening as the Fall of the Giants in Giulio Romano's Sala dei Giganti (1530–32; Mantua, Pal. Ducale; see colour pl. 1, XXXV1). The violent action is held in equilibrium by precise balancing and juxtaposition of forms, movements and colour areas.

The smaller oval canvas of Youth and Age (also known as the Rape of Proserpina, 1553–4; see fig. 2), in a corner of the ceiling, is an outstanding early work. The female figure of Youth is shown in brilliant sunlight beside a Michelangelesque figure of Age. The main colour areas of blue, white and gold are enhanced by judicious touches of vermilion. Ideal forms are seen in an ideal climate, in a perfect harmony of form, light and colour. The entire ceiling of the much smaller Stanza della Bussola was entrusted to Veronese. The central canvas of St Mark and the Theological Virtues (Paris, Louvre) recalls details of Correggio's Assumption of the Virgin (Parma Cathedral; see CORREGGIO, fig. 4), but the motion is less frenzied because of Veronese's careful balancing of forms and juxtaposing of poses; the scene is characteristically suffused with bright sunlight, reflecting on luminous flesh and shiny fabric.

Zelotti painted the central panel in the Stanza dei Tre Capi, and Veronese was responsible for two smaller canvases with themes of virtue and vice, Peace Comforting the Innocent and the Allegory of Nemesis (both in situ). In the former the female figure of Peace or Victory is seen from behind, with a male figure in white discreetly placed below and behind her; the harmonious disposition of form and colour creates the serenity for which Veronese is celebrated. The composition is an elegant reversal of the Allegory of Nemesis, in which the victorious female looms over the crouching male in the foreground.

In 1555 Veronese was employed by the Veronese prior Bernardo Torlioni (d 1572), who was rector of S Sebastiano, Venice, from 1555 to 1572, to paint the ceiling of the church's sacristy and, in 1556, the ceiling of its nave (see Pignatti, 1966, regarding earlier monochromes). His decoration of this church in fresco, secco and oil continued until at least 1570. The central canvas of the sacristy ceiling represents the Coronation of the Virgin, and the four surrounding canvases depict the Evangelists. The magnificent paintings of Esther Brought before Ahasuerus, the Triumph of Mordecai and the Coronation of Esther on the nave ceiling show these scenes from the Life of Esther in di sotto in sù foreshortening and bright sunlight. In each of the three, background architecture is foreshortened to the extent that the receding element forms a vertical division of the composition. The Coronation of Esther moves furthest in a new direction. The chief change is in the more complex light: the sunlight not only illuminates different textures but dances between metal, satin and shining locks of blond hair in a rich interplay. Tea (1920) noted Veronese's use of adjacent colours, not black, to create delicate shadows that depict colour as seen in clear daylight, an observation that seems to have been inspired particularly by these ceiling pieces. It is possible that Giovanni Antonio Fasolo collaborated with Veronese on this project.

The Feast in the House of Simon (Turin, Gal. Sabauda), painted for the refectory of SS Nazaro and Celso in Verona, is Veronese's first surviving supper scene, and his first of several commissions from the Benedictines of the Cassinese congregation (Gisolfi and Sinding-Larsen, 1998). Its dating is debated: Ridolfi and most later writers placed it c. 1559; von Hadeln (1914) suggested 1553; and Sancassani (1973–4) argued that a payment of January 1556 referred to the work as in progress. (This fits with a placement after the Anointment of David (Vienna, Ksthist. Mus.) and the Presentation of Christ (Dresden, Gemäldegal. Alte Meister), which on stylistic grounds belong to c. 1554 and c. 1555 respectively.) An architecture of Corinthian columns and acanthus frieze sets the scene in the pharisee's home. The space is rather shallow. Mary Magdalene anoints Christ's feet, while his discourse with Simon and

2. Paolo Veronese: Youth and Age (1553–4), oil on canvas, 2.86×1.50 m, ceiling painting in the Sala del Consiglio dei Dieci, Doge's Palace, Venice

forgiveness of her sins cause amazement among the guests. The composition is more complex than in Veronese's earliest biblical paintings, the figures more robust and the costume richer. Ridolfi emphasized the beauty of the architectural frame and of two satyrs that must then have adorned the framework covering the now vacant upper corners of the canvas.

In 1557 Veronese was one of seven artists each of whom painted three roundels for the ceiling of the Libreria Marciana (*see* VENICE, §IV, 5(ii)), and he was awarded the gold chain for the finest tondo, his allegory of *Music*. Titian and Sansovino were judges in the contest (Ridolfi); perhaps this is why the frankly classical *Music* won. Recalling the fresh, relaxed classicism of early Titian, it stands out among the generally mannered compositions of other competitors and differs, too, from Veronese's other roundels. In *Geometry and Arithmetic* the figure types remain close to those of the S Sebastiano ceilings, the two females assuming poses that complement and reflect the frame of the roundel; in the allegory of *Honour*, however, the experiments with Mannerist devices, the elongated repoussoir figures and rather confused composition, are clearly intentional.

Around 1557 Veronese decorated in fresco the Palazzo Trevisano in Murano. This work is now damaged and partially lost, but cleaning in the early 1980s revealed landscapes in fairly good condition in the upper room, the Sala dell'Olimpo (Romano, 1981 and 1983). The illusionistic complex includes the feigned architecture, landscape 'views' and Olympian visions (in the vault) that were components of the decorations at the Villa Soranzo and in examples by Veronese's contemporaries, for instance the work of Brusasorci and the Caroto brothers at the Villa del Bene (1551) at Volargne, near Verona.

During 1558 Veronese continued decorating S Sebastiano with the frescoes of *St Sebastian Reproving Diocletian* and the *Martyrdom of St Sebastian*, which cover walls on the north and south sides of the monks' choir above the atrium of the church. Both scenes are conceived as dramas enacted on a shallow stage and are framed by ornate painted architecture, possibly executed by Veronese's brother Benedetto Caliari. The foreground space in which the action takes place is also defined by architecture, repoussoir figures directing the viewer's attention and architecture allowing room for a spacious expanse of sky as a backdrop. Also for S Sebastiano, Paolo designed the organ (1558) and painted on the external shutters the *Presentation of Christ* and on the interior the *Pool of Bethesda* (1560); he designed the high altar and painted (probably in 1560) the altarpiece of *St Sebastian with the Virgin and Child and Other Saints*. The architecture of both organ and altar is rich and apparently based on Sanmicheli's style, as demonstrated, for example, in the Cappella Pellegrini of S Bernardino in Verona. Painted and actual architecture of the organ are coordinated so that, whether the shutters are open or closed, painted architecture continues the organ's exterior architecture in both perspective and vocabulary.

(ii) Early portraits. Veronese's many portraits raise difficult problems of attribution and dating. The pendants *Giuseppe da Porto and Son* (Florence, Pitti) and *Livia da Porto Thiene and Daughter* (*c.* 1554; Baltimore, MD, Walters A.G.) are,

together with the *Portrait of a Woman with her Son and Dog* (Paris, Louvre), generally accepted as both early and authentic. The da Porto portraits are full-length, standing portraits, which suggests that Veronese knew works by Moretto or Giovanni Battista Moroni. Contemporary with these is probably the Budapest *Portrait of a Gentleman* (Mus. F.A.; see Rearick, Venice, Cini, exh. cat., 1988, and Gisolfi, 1989–90). The *Portrait of a Gentleman* (Los Angeles, CA, Getty Mus.), a full-length portrait of a sitter of nonchalant yet restrained elegance against an architectural setting, develops the theme of the portrait of *Giuseppe da Porto*. Gaetano Zancon (1771–1816) engraved it as a self-portrait of Veronese (see Ticozzi, 1977 exh. cat., pl. 91, p. 32) in 1802; if this identification is accepted, it suggests an early date for the painting, as the man is far less bald than the self-portrait included in the *Marriage of Cana* (1562–3; Paris, Louvre; *see* §3(ii) below), but Rearick (Washington exh. cat., 1988) gave a late date of 1578 (see Gisolfi, 1989–90, pp. 32–3).

3. MASER, VERONA AND VENICE, 1560–73. According to Ridolfi, in 1560 Veronese was invited to accompany Girolamo Grimani, Procurator of S Marco, to Rome. The greater monumentality of his work after this time, resulting from his study of antiquity and masterpieces of the High Renaissance, supports Ridolfi's dating. Smith (1977) suggested that the visit may have been arranged by Daniele Barbaro and perhaps Andrea Palladio to allow Veronese to study antique villa decoration in preparation for his commission to provide frescoes at the Villa Barbaro (now Villa Volpi) at Maser, near Treviso.

(i) Decorative frescoes: the Villa Barbaro at Maser. It seems likely that Veronese's work on the decorations for the Villa Barbaro at Maser were done *c.* 1561, after his return from Rome. Daniele Barbaro and his brother Marc'Antonio employed Palladio as architect, perhaps Alessandro Vittoria as sculptor and Veronese as painter. Undoubtedly the brothers devised the iconographical programme for the frescoes with themes that celebrate the agrarian, pastoral, cultured and Christian life (see Ackerman, 1982). The illusionistic effects are brilliantly executed in the main rooms. In the central Sala a Crociera a painted arcade of Palladian proportion and vocabulary frames landscape views *all'antica* that include ruins, travellers, animals and streams and recall Vitruvius' description of appropriate villa decoration (*On Architecture*, VII.v). The horizon of the painted landscapes coincides with that of the living landscape seen through the front window from a middle point in the room, and the feigned balustrades continue the stone balustrade framing the front window before each landscape view. Painted banners and lances rest in corners, as if casually deposited; musicians playing various instruments project from painted niches set between the arches.

In each of the five rooms adjacent to the Sala a Crociera the illusion is further developed. Ceilings open up to offer views of appropriate deities and allegories; Bacchus teaches man the use of the grape in the Stanza di Bacco; other pleasures are celebrated in *Abundance* in the Stanza degli Sposi; *Faith* and *Charity* are above in the Stanza della Lucerna; and there is an allegory of *Abundance, Fortitude*

and Envy in the Stanza del Cane. The celebration of the virtues and rewards of country life culminates in the vault of the main Sala di Olimpo at the end of the Crociera, where *Universal Harmony* (Lewis, 1987; Crosato, 1983) or *Divine Love* (Jackson Reist, 1985) presides, surrounded by the key residents of Olympus and deities symbolic of the four elements. The walls of each room have landscape views, feigned architectural elements carefully coordinated with real ones and feigned statuary. These views, which often evoke the atmospheric grandeur of Roman ruins, derive from prints by Hieronymus Cock (*c.* 1510–70) of 1551 and Battista Pittoni of 1561, the dates of which confirm the dating of the frescoes to *c.* 1561 (Oberhuber, 1968). Humorous touches enliven every room: a dog and a cat occupy ledges in the Stanza del Cane; cleaning utensils rest on a sill in the Stanza degli Sposi. In the Stanza di Bacco vines seen in landscape views show their upper branches in lunette and cove 'windows' above; in the Stanza della Lucerna a putto seen through a ceiling oval holds a real lantern. In the Sala a Crociera and in smaller rooms visible from the main ones family members are depicted at doorways that match the actual doors (see colour pl. 2, XXXIX1) and, in the Sala di Olimpo, Signora Giustiniani Barbaro, accompanied by a child, a servant and two pets, surveys her household from the balcony (see fig. 3). Undoubtedly Veronese and his patrons knew Pliny the elder's passage praising humour in the decorations of Spurius Tadius, which included 'splendid villas approached across marshes, men tottering and staggering along carrying women on their shoulders for a bargain, extremely wittily designed' (*Natural History* XXXV.ix.116–17).

(ii) Subject pictures and altarpieces. In 1562–3 Veronese painted the vast *Marriage at Cana* (6.69×9.90 m; Paris, Louvre), the most ambitious of his banquet scenes, for the refectory of S Giorgio Maggiore, Venice. Vasari wrote with enthusiasm of its dimensions and of its 'more than 150' figures, its 'variety of costumes' and its *'invenzione'*. At the centre of the immense activity is the silent figure of Christ, and in the right foreground are the servants, the water jars and the steward who tastes the new wine. Bride and groom are seated at the left in splendid array, while in the centre foreground a quartet performs; Boschini (1674) identified the players as Veronese (viola), Francesco Bassano (flute), Jacopo Tintoretto (violin) and Titian (bass viol). The crowded composition is made possible by a deep setting and relatively high viewpoint; this depth, the heavy grandeur of the architecture and the complexity of the composition may reflect Veronese's experience of Raphael's Stanze in the Vatican during his visit to Rome in 1560. Rosand (1973) stressed the symbolism of the lamb being carved just above Christ's head and considered the elaborate costumes to reflect contemporary theatre, and Fehl (1981) related the rich yet decorous treatment of the subject to Pietro Aretino's *La humanità di Christo* (Venice, 1535). Cooper saw the choice of Veronese for this commission by the erudite Benedictines of the Cassinese Congregation as significant (Cooper, 1991).

3. Paolo Veronese: *Members of the Barbaro Household* (detail; *c.* 1561), fresco, Sala di Olimpo, Villa Barbaro, Maser

In the middle of the 1560s Veronese produced a series of large subject pictures that unite noble figures and stately architecture in compositions of theatrical grandeur. These paintings form a link between the *Marriage at Cana* and the more elegantly structured banquet scenes of the early 1570s. They include the *Martyrdom of St Sebastian* and *SS Mark and Marcellianus Led to Martyrdom* (both 1565; Venice, S Sebastiano, choir), the celebrated *Mystical Marriage of St Catherine* (*c.* 1565–75; Venice, Accad.), one of Veronese's most richly painted canvases, and *Christ Preaching in the Temple* (*c.* 1565; Madrid, Prado; for debate on dating of this picture see Levey, 1960, and Gisolfi Pechukas, 1982).

In 1566 Veronese returned to Verona to marry Elena Badile, daughter of his first teacher. Two altarpieces for churches in Verona are assigned to this year, the *Martyrdom of St George* for S Giorgio Maggiore and the *Virgin and Child with SS Anthony and John* for the Marogna Chapel in S Paolo (both *in situ*). The pen sketches (Los Angeles, CA, Getty Mus.) for *Christ Preaching in the Temple* and the *Martyrdom of St George* exemplify Veronese's mature, rapid compositional drawings (*see* §II, 2 below).

This work culminated in the *Feast in the House of Levi* (1573; see fig. 4), which, through a series of adjustments unifying its greater width, improved on the composition of the quite similar *Supper of Gregory the Great* (1572; Vicenza, Sanctuario di Monte Berico). In both paintings the architectural setting, Palladian in proportion and detail, creates a triptych-like division of the canvas, and steps leading past the side areas direct attention to the centre. The steps resemble those leading to the raised sanctuaries sometimes found in Romanesque churches of North Italy, thus associating the centre with the sanctuary and the table with the altar (Rosand, 1973). The lighter and more elegant composition of these later banquet scenes is achieved partly through the choice of a lower viewpoint than in the *Marriage at Cana*, so that the surface of the table is barely visible and one rhythmic line of celebrants crosses the canvas.

The *Feast in the House of Levi* was commissioned as a *Last Supper* for the refectory of SS Giovanni e Paolo in Venice. A tripartite arcade frames the whole, presenting the upper room as an open loggia with the banisters of the lateral staircases leading the eye to Christ at the centre, framed by the arch. The sacred figures are thus isolated from the wealth of incident around them but the picture nonetheless attracted the attention of the Inquisition, which sensed heresy in having 'drunken buffoons, armed Germans, dwarfs and similar scurrilities' present at the Last Supper (see Fehl, 1961, for a complete transcript of the trial). In his defence before the tribunal of the Inquisition on 28 July 1573, Veronese claimed for the painter the creative freedom of the 'poet and the madman', also pointing out that he had depicted the incidental figures and anecdotal details outside the realm of sacred elements. That his depiction conforms to ideals of decorum was reaffirmed by Fehl (1961). Yet Veronese was ordered to correct his composition, to which he ultimately responded by changing its title to *Feast in the House of Levi*, a subject requiring 'a great company of publicans' (Luke 5:29) (Fehl and Perry, 1984).

(iii) Later portraits. A few portraits may be tentatively placed in Veronese's mature period. The tender *Portrait of a Lady* ('*La bella Nani*'; Paris, Louvre) in cool blues and silvers, which resembles the portrait of Signora Barbaro at Maser, and the three-quarter-length seated portrait of *Daniele Barbaro* (Amsterdam, Rijksmus.), shown holding an edition of Vitruvius dated 1556, were probably executed in the early 1560s. There may have followed the grander *Portrait of a Man in a Fur* (Florence, Pitti; see colour pl. 2, XXXVIII4) and the *Portrait of a Man* (Rome, Gal. Colonna), their later dating suggested by a bolder brushwork and darker tonality (Gisolfi, 1989–90). It should be noted, however, that Rearick (Washington exh. cat., 1988) placed the *Portrait of a Lady* and the *Portrait of a Man in a Fur* around 1550.

4. Paolo Veronese: *Last Supper*, renamed the *Feast in the House of Levi*, oil on canvas, 5.55×12.80 m, 1573 (Venice, Galleria dell'Accademia)

Some of Veronese's finest portraits are included within major subject pictures of his maturity, such as the quartet of artists in the *Marriage at Cana*, noted above. An entire contemporary family bears witness to the *Supper at Emmaus* (*c.* 1560; Paris, Louvre); while the somewhat stiff group of family members at the right may have been executed by Benedetto, the two little girls playing with a dog in the foreground are justly famous examples of Veronese's sympathetic portrayals. The *Cuccina Family Presented to the Virgin by the Theological Virtues* is one of four canvases commissioned to decorate a room of the family palazzo on the Grand Canal (*c.* 1570–72; Dresden, Gemäldegal. Alte Meister). The sitters are sumptuously dressed, shown with gestures of affection and with the inevitable pet puppy. Veronese's most significant contributions to the art of portraiture may in fact be the skilful and sensitive group portraits incorporated in biblical and votive paintings.

4. LATE WORKS, 1574–88.

(i) Further commissions for the Doge's Palace. Directly after the fire in the Doge's Palace in 1574, Veronese received payments towards the cost of paintings he was to do for the Sala del Collegio (Zorzi, 1953; Schulz, 1968). The ceiling celebrates the Venetian State and her relationship to Ecclesia, the central canvases showing *Venice Enthroned with Justice and Peace*, *Mars and Neptune* and the *Old Testament Sacrifice and the Eucharist* (for discussion of the iconography see Sinding-Larsen, 1974 and 1988), while the smaller surrounding canvases represent allegories of the *Virtues*. These allegorical figures and scenes are set in the heavens and viewed through a rich gilded wood framework. The *di sotto in sù* perspective and the palette recall the Consiglio dei Dieci ceiling but with the bright daylight effect of Veronese's pieces in the earlier decorations modified: the angle of light is lower, and the pink reflections suggest an afternoon rather than a midday light. It is generally thought that Benedetto Caliari assisted his brother in the Sala del Collegio, but the conception is certainly Paolo's. The wall painting over the tribunal representing an *Allegory of the Battle of Lepanto*, with Christ at the centre (Sinding-Larsen, 1974), and the flanking monochrome niche figures of *St Sebastian* and *St Justine* are also Veronese's, executed, probably with Benedetto, *c.* 1581.

In 1579–82, after the fire of 1577 in the Doge's Palace, a competition was held to select an artist to execute the huge *Paradise* in the Sala del Maggior Consiglio. Veronese and Francesco Bassano (ii) were awarded the commission jointly, presumably in 1582, but the piece had not been executed when Veronese died in 1588 and Tintoretto (always resourceful in these matters) obtained the commission. De Tolnay (1970) argued that Tintoretto's painting is based to some extent on the original oil sketches (Veronese's: Lille, Mus. B.-A.; on this issue see also Schulz, 1980, and Sinding-Larsen, 1984). Between 1579 and 1582 Veronese and his assistants (particularly Benedetto) executed the large ceiling canvas of the *Triumph of Venice* above the ducal throne in the same Sala (*see* VENICE, fig. 10). He prepared the complex vision with *di sotto in sù* foreshortening, rich architecture and ebullient figures in a

beautifully executed modello in pen with white highlighting on brown paper (Harewood House, W. Yorks; see Cocke, 1984, no. 88). Here Veronese went beyond his earlier ceiling decorations: the motion, excitement and activity are used to convey uplifting emotion, as in Baroque art.

(ii) Other mythological paintings. New directions and a more complex development are seen in Veronese's works of the 1580s. The *Triumph of Venice* is proto-Baroque, and this direction was developed ultimately by Giambattista Tiepolo (1696–1770). Related to this are such late mythological works as the *Choice of Hercules*, the *Allegory of Wisdom and Strength* (both *c.* 1580; New York, Frick) and *Mars and Venus* (*c.* 1580; New York, Met.). As with the contemporary *Rape of Europa* (Venice, Doge's Pal., Anticollegio), the sunny palette of the Doge's Palace ceiling paintings is still operative, the light is still full and the shadows delicate, but the paintings show a new richness of detail, as in the worldly objects cast at the feet of Wisdom, and sumptuous treatment of drapery.

(iii) Other religious works. A more radical change is evident in Veronese's late religious works. Here he abandoned for the first time since the *Temptations of St Anthony* (1552) the sunny palette and clear light learnt and adapted from artists of Verona. In a series of depictions of the Pietà and in his last altarpiece, the *Miracle of St Pantaleon* (see fig. 5), he experimented with chiaroscuro effects to heighten pathos. Perhaps the most powerful of these is the *Dead Christ with the Virgin and an Angel* (*c.* 1581; St Petersburg, Hermitage; x-rays show the head of a second angel on the left), originally executed for the church of SS Giovanni e Paolo, Venice, and recorded there by Borghini in 1584. As in other late religious works, Veronese has substituted nocturnal light for his usual daylight. A pale light, which could be moonlight, enters from the right and gently highlights the angel's blond ringlets and rose drapery, the Virgin's head and Christ's knee, hand and loincloth. The setting is reduced to a piece of drapery beneath Christ, and the viewer is asked to meditate on his sacrifice. Veronese's repetition of this emotional theme may reflect the instruction of the Council of Trent that religious art should inspire piety. In pursuing this more profound religious feeling, Veronese dispensed with the decorative richness of his secular pieces. He did not abandon his lifelong research on the interaction of light and colour; rather he progressed to a new phase, the study of nocturnal light.

Several other versions of the Pietà exist, usually assigned to the 1580s, and assistance from Veronese's shop has been suggested in each case. They include the *Dead Christ with Two Angels* (Berlin, Gemäldegal.; Boston, MA, Mus. F.A.) and two versions of the *Dead Christ with an Angel and a Donor* (Switzerland, priv. col.; Houston, TX, Mus. F.A.; see Pignatti, 1984). The surviving late altarpiece that matches the St Petersburg Pietà in quality and character is not thematically related. In the *Miracle of St Pantaleon* (1587; Venice, S Pantalon; see fig. 5), commissioned by Bartolommeo Borghi, who is shown in the picture supporting the sick child, the masterful brushwork, nocturnal setting and 'moonlight' entering from the right recur. The red-rose drapery of the saint is the primary colour and this

5. Paolo Veronese: *Miracle of St Pantaleon*, oil on canvas, 2.27×1.60 m, 1587 (Venice, S Pantalon)

reflects the pale light, through a brilliant use of lead white blending in highlights and red lakes for shadows.

II. Working methods and technique.

1. PAINTINGS. Veronese's working methods were first described by Boschini (1660), whose account mentions specific materials: orpiment; red lead; *giallolino* (probably lead-tin yellow) and lakes. Analysis of pigment from Veronese's work has confirmed use of these materials and shown the use of all the other finest pigments then available in Venice—ultramarine, azurite, malachite, verdigris, litbarge, realgar, vermilion, carbon black and lead white. In addition, it is clear that Veronese used, particularly in fresco, all the earth colours and ochres. Tests show that his medium for paintings on canvas was linseed oil and/or walnut oil (Mills and White, 1978, 1981 and 1983).

Study by Lazzarini (1983 and 1984) of paint layers in works executed in oil on canvas shows that Veronese consistently used a preparation of gesso and animal glue, thinly applied. Boschini described him as first laying out the composition, applying the middle tones for each area, then adding shadows and highlights. The cross-sections

of paint samples show, as Lazzarini stressed, a complex variety of practice. In a few cases traces of burnt ochre or carbon black under the paint layers indicate the remains of a drawing (see Spezzani, 1992). Sometimes there is a thin layer of priming above the preparation, but not always. Some areas, such as sky, may show only the preparation, a thin layer of pigment, and varnish. Other areas, particularly of brocades and other types of drapery, may show preparation, four or five or even six layers of pigment, and varnish. Boschini's assertion that Veronese favoured the use of red lakes to shadow draperies seems well supported: red lakes appear regularly in complex samples from draperies and are sometimes mixed with other pigments, such as lead white or ultramarine and lead white. Plesters (1966) noted that pure ultramarine was sometimes used as a glaze; Lazzarini (1983) published a cross-section from Veronese's Giustiniani Altarpiece illustrating this. Penny and Spring (1995) show examples in which the less expensive smalt or indigo are used as underlayers to a glaze of ultramarine. Lazzarini emphasized Veronese's liking for malachite and azurite; samples from the *Feast in the House of Levi* show azurite used to model malachite, with yellow lead and white lead mixed for highlighting (Lazzarini and Scire, 1984). In Veronese's fresco painting the 'cream' of slaked lime is used for highlighting (Gisolfi Pechukas, 1987). Sometimes the pigment below it, still wet, was allowed to 'bleed' into the highlight. (See also *Paolo Veronese: Restauri*, 1988 exh. cat.)

2. DRAWINGS AND OIL SKETCHES. Veronese used both drawings and oil sketches in preparing paintings; it seems that drawings were also made in his shop to record completed compositions. The inventory of the house of the *eredi di Paolo Veronese* mentions a small chest full of pictorial drawings (*disegni pittoreschi*) and oil sketches (*dipinti in carta*) (Gattinoni, 1914). At least three kinds of preparatory drawing are known. Chiaroscuro drawings on tinted paper include the *Temptation of St Anthony* (1552; Paris, Louvre), which has been associated with the altarpiece for Mantua Cathedral (Rosand, 1966). Black chalk studies, heightened with white, for individual figures include those for the allegorical figures on the ceiling of the Sala del Collegio in the Doge's Palace (London, BM; Paris, Louvre; Rotterdam, Mus. Boymans–van Beuningen). There are also many compositional sketches in pen or pen and wash. In these spontaneous drawings, such as the sheet of studies (*c.* 1566; Los Angeles, CA, Getty Mus.; see fig. 6) for the *Martyrdom of St George* (Verona, S Giorgio Maggiore), Veronese experimented with swiftly drawn figures and groupings, often patterning an entire sheet with searching studies. In the late drawings, such as the sheet of studies (1587; Paris, Louvre) for the *Miracle of St Pantaleon*, his touch is yet lighter and freer. In the very early instance of the Bevilacqua–Lazise Altarpiece, two preparatory works survive, both the chiaroscuro drawing and the oil sketch. Comparison of the compositions with the surviving altarpiece shows that the oil sketch was the penultimate work (Gisolfi Pechukas, 1982). This suggests a logical progression, from preliminary sketches to finished chiaroscuro drawing to oil sketch to painting; as it is the only known instance in which both a chiaroscuro drawing and an oil sketch survive for an extant painting,

6. Paolo Veronese: *Studies for the Martyrdom of St George*, pen and brown ink and brown wash, 289×229 mm, 1566 (Los Angeles, CA, J. Paul Getty Museum)

it is not clear that this elaborate process was always followed. There are examples of preparatory works of all types from all phases of Veronese's career.

Chiaroscuro drawings seem to have been used in Veronese's workshop not only as modelli, but as *ricordi* of works completed (Tietze and Tietze-Conrat, 1944). The function of several such drawings is disputed and a clear sorting remains to be done. The questions raised in regard to authorship of chiaroscuro drawings of lesser quality are related to unsolved matters regarding workshop practice.

3. WORKSHOP. Veronese ran a large family workshop in Venice, employing his brother Benedetto Caliari and his own sons Carlo and Gabriele (*see* CALIARI) as well as various other assistants and apprentices, including his nephew Alvise dal Friso (1559–1611) and Francesco Montemezzano (1540–1602). Benedetto's assistance is first documented in 1556 at S Sebastiano (Pignatti, 1966, p. 124) and is thought to have been considerable at Maser in 1561. Given their age, the earliest possible date for Veronese's sons joining the workshop is 1580. The degree of workshop participation in individual works both before and after 1580 is, however, often a matter of dispute. Crosato Larcher (1967, 1969 and 1977) made significant contributions in identifying the hands of Benedetto, Carlo and Gabriele, but many, particularly late, works are clearly collaborative or are of disputed attribution. Furthermore, Veronese's family continued to produce works in his manner under the label *Haeredes Pauli* after his death. These works made use of existing drawings, stock figural

types and typical compositions by the master. Thus the definition of a work by Veronese can vary: sometimes it is entirely by the master's hand; in other cases there is some workshop participation; in others the design may be by Veronese but the execution largely by assistants; in works signed *Haeredes Pauli* the entire execution is by others possibly following or 'recycling' Paolo's preparatory studies. Unsurprisingly, there is much disagreement about the degree of Veronese's authorship in many works and those where several versions of the same composition exist. Works by associates and copyists further confuse questions of attribution.

III. Character and personality.

The picture given by early sources is appealing but not detailed. Vasari (2/1568) emphasized Veronese's youth and early success in Venice, implying that he was considered precocious. Borghini (1584) drew attention to Veronese's fame, his humble origins and his financial success, aspects that are celebrated at greater length by Ridolfi (1648), who also described his important patrons and quoted some 'memorable sayings' attributed to Veronese:

> that it was impossible to judge paintings well without a good knowledge of the art; that the ability to paint was a gift from heaven and that to try to paint without natural talent was to sow seed in the waves; that the most worthy qualities in an artist were simplicity and modesty; and that saints and angels must be painted by excellent artists since they should arouse wonder and emotion.

The same sayings are quoted by Boschini (1674), who also commented that Veronese had a 'noble and open character, as is shown in his work; he dressed with dignity and bore himself as a great lord', adding that there were no scandals about Paolo. Boschini also reported that Veronese liked to go to the Piazza S Marco to observe the exotic clothing of foreigners from all parts of the world, especially the Armenians, from whom he got ideas for his vestments, turbans and 'Persian' shoes. Documentary evidence is purely factual and provides little concerning Paolo's personality. Contracts and statements about money are brief and to the point, indicating a businesslike and straightforward approach. His financial success itself shows a talent for administering business, while a couple of letters from the late 1580s show a real humanity and warmth. His testimony before the Inquisition in 1573, besides demonstrating a practical ability to deal appropriately with others and to protect himself, bears witness to his standing as a man of faith. Ridolfi and Boschini reported that Veronese died after catching a cold in an Eastertide procession, and both writers used this to give him a virtuous end. Ridolfi praised his character as trustworthy, caring and circumspect and stressed that he instructed his children in the faith and in moral discipline. According to the sayings attributed to Veronese, he recognized his gifts as God-given. He also made the most of these gifts, sharing his success with his family and frankly enjoying his well-being. The portrait of a sane and life-loving artist is consistent with the harmony and richness of Paolo's art.

Veronese's adoption of the name Caliari might, like his love of finery, be considered vain. Fiocco (1928) pointed

out that the name was adopted, and Trecca (1940) noted that it belonged to a noble family in Contrada S Paolo of Verona. It was used by Paolo and his family only after he had achieved success in Venice. Trecca's review of documents indicates that the name first appears in a contract of 1555 for the *Transfiguration* at Montagnana (*in situ*), where Veronese is referred to as 'Mis. Paulo Caliaro Veronese' but signs himself *Paullo veronese*. The use of Caliari in signatures seems to begin around 1575.

IV. Critical reception and posthumous reputation.

1. VASARI, RIDOLFI AND OTHER EARLY SOURCES. Veronese's commissions, from church and state, rulers and nobility, Venetians and foreigners, attest to his recognition and fame during his lifetime. Vasari praised his work at Soranzo for its *disegno*, the *Feast in the House of Simon* for its 'life-like portraits and unusual perspectives . . . two dogs so fine that they seemed alive . . . and further away some excellently painted cripples', the ceiling of S Sebastiano as a 'most rare' work and other works there as 'most praiseworthy'. He ended his account with a description of the *Musica* on the Libreria Marciana ceiling, using Veronese's winning of the gold chain to illustrate his youthful achievement of success. Borghini said that Veronese's works were 'much praised by everyone' and that Paolo did not 'cease to work with great profit to painting'.

Ridolfi (1594–1658) in his *Meraviglie dell'arte* includes a long biography of Veronese and a catalogue of his works. The account begins with a homage to painting as the mirror 'in which all the works of the Creator can be seen in brief', and proceeds to describe Paolo as one of the most illustrious painters of the 'modern era' and to praise Verona for its antiquities, its fine site and for having produced this renowned artist. The initial emphasis on naturalism and on the significance of Veronese's birthplace is supplemented in descriptions of paintings by praise of colour, particularly of vestments, and of perspective. Ridolfi especially admired Veronese's *Youth and Age* and quoted Palma Giovane as saying 'in that case Paolo reached the highest degree of perfection, drawing together the most learned ancient style with the nobility of his own'. In summing up the merits of Veronese's art, Ridolfi modified the creed of naturalism with which he began, saying that painters must depart from the defects of nature and that Veronese painted nature 'più bella'. Beyond this approval of idealization Ridolfi stressed that Veronese had profited by practising 'the Venetian manner, which has given light to every painter improving the way of colouring'. Boschini, in *La carta del navegar pitoresco* (1660), praised Veronese's intellect, invention, colour, drawing and brushwork. Other writers of the 16th and 17th centuries admired his work for the prized qualities of *disegno*, *invenzione* and *colorito*.

2. LATER WRITERS AND CRITICS. Joshua Reynolds (1723–92), being essentially opposed to Venetian *invenzioni*, attacked Veronese's art as 'ornamental' or decorative:

> Such as suppose that the great stile might happily be blended with the ornamental, that the simple, grave and majestic dignity of Raffaelle could unite with the glow and bustle of a Paulo, or Tintoret, are totally mistaken The subjects of the Venetian painters are mostly such as give them an

opportunity of introducing a great number of figures; such as feasts, marriages, and processions, publick martyrdoms, or miracles. I can easily conceive that Paul Veronese, if he were asked, would say that no subject was proper for an historical picture, but such as admitted at least forty figures; for in less a number, he would assert, there could be no opportunity of the painter's shewing his art in composition, his dexterity of managing and disposing the masses of light and groups of figures, and of introducing a variety of Eastern dresses and characters in their rich stuffs.

John Ruskin (1819–1900) was more kindly disposed towards Veronese's naturalism and humour. After praising Veronese's dogs, particularly in the *Supper at Emmaus* (c. 1560; Paris, Louvre), he added, 'Neither Titian nor Velasquez ever jest; and though Veronese jests gracefully and tenderly, he never for an instant oversteps the absolute facts of nature'. Berenson emphasized that 'Paolo was the product of four or five generations of Veronese painters' and wrote of his 'cheerfulness, his frank and joyous worldliness' (1894). Over 60 years later he wrote a broader appreciation:

> When I contemplate Veronese's paintings, I experience a satisfaction so full and perfect that I feel seized by it in all of my being, in my senses, my feelings, my intellect, and then, all things considered, I love him at least as much as I love any other painter who has ever painted (Ojetti and others, 1960).

In his initial emphasis on Veronese's origins and in his later appreciation of Paolo's intellect, Berenson anticipated the emphasis in later scholarship on the artist's training and on structure and decorum in his art.

3. INFLUENCE. Prints after Veronese were executed during his lifetime by Agostino Carracci (1557–1602), including one after the *Mystic Marriage of St Catherine* (see Ticozzi, 1977 exh. cat., pl. 5, pp. 11 and 63). His influence on Annibale Carracci (1560–1609) is apparent in such works as the latter's San Lodovico Altarpiece (c. 1588; Bologna, Pin. N.). Peter Paul Rubens (1577–1640), Anthony van Dyck (1599–1641), Mattia Preti (1613–99), Pietro da Cortona (1596–1669) and Luca Giordano (1634–1705) are among the many other 17th-century artists stylistically indebted to Veronese; those who made prints after him include Nicolas Cochin (1610–49), Giuseppe Maria Mitelli (?1634–1718), Valentin Le Febre (1642–80/81) and Charlotte Catherine Patin (b 1660). Andrea Zucchi (1679–1740) was one of Veronese's chief engravers in the 18th century (see Ticozzi, 1977). The artist for whom his example was crucial, however, was Giambattista Tiepolo. Tiepolo re-created Veronese in a late Baroque mode: the clearly recognizable models are lightened, the palette is whitened, figures become less dominant, clouds more so, the illusion more unified. The oeuvre is parallel: altarpieces, ceiling decorations, frescoed villas and supper scenes. While Reynolds deplored Veronese's 'decorative' art, he considered that Tiepolo used it with understanding, high originality and appropriately brilliant technique to provide the last great chapter of Venetian painting.

In 1797 Napoleon's agents took some of Veronese's finest works to Paris. The presence in the Louvre of major works of the highest quality by Paolo is important in the

history of French art. The journals and correspondence of Eugène Delacroix (1798–1863) include repeated musings on Veronese, and in a letter of 1859, he observed, 'There is a man who makes simple that which we are always being told is impossible—Paul Veronese. In my view he is probably the only one to have grasped the secrets of Nature' (A. Joubin, ed.: *Correspondance générale d'Eugène Delacroix*, Paris, 1936–8, iv, p. 94). Not surprisingly, John Rewald's *History of Impressionism* (New York, 1961, pp. 76 and 462) records the practice by Henri Fantin-Latour (1836–1904) and Berthe Morisot (1841–95) of copying Veronese in the Louvre and the admiration that Auguste Renoir (1841–1919) had for his work in Venice.

UNPUBLISHED SOURCES

Verona, Archv Stato [census inf. and wills]

BIBLIOGRAPHY

EARLY SOURCES

P. Pino: *Dialogo della pittura* (Venice, 1548)
G. Vasari: *Vite* (1550, rev. 2/1568); ed. G. Milanesi (1878–85), vi, pp. 369–74
A. Guisconi [pseud. of F. Sansovino]: *Tutte le cose notabili e belle che sono in Venetia* (Venice, 1556)
L. Dolce: *Dialogo della pittura* (Venice, 1557); ed. M. Roskill in *Dolce's 'Aretino' and Venetian Art Theory of the Cinquecento* (New York, 1968)
F. Sansovino: *Venetia città nobilissima e singolare* (Venice, 1581)
R. Borghini: *Il Riposo* (Venice, 1584), pp. 561–3
C. Ridolfi: *Meraviglie* (1648); ed. D. von Hadeln (1914–24), i, pp. 296–352
M. Boschini: *La carta del navegar pitoresco* (Venice, 1660); ed. A. Pallucchini (Venice, 1966) [incl. the 'Breve instruzione' of *Le ricche miniere. . .* (Venice, 1674)]
——: *Le ricche miniere della pittura veneziana* (Venice, 1674); ed. A. M. Zanetti as *Descrizione di tutte le pubbliche pitture della città di Venezia o sia rinnovazione delle ricche miniere dal 1674* (Venice, 1733)
B. dal Pozzo: *Le vite de' pittori, scultori e architetti veronesi* (Verona, 1718), pp. 77–114
E. A. Cicogna: *Delle iscrizioni veneziane*, 6 vols (Venice, 1824–53), iv, p. 128
P. Caliari: *Paolo Veronese: Sua vita e sue opere* (Rome, 1888)
G. Biadego: *Di Giambettino Cignaroli pittore veronese: Notizie e documenti* (Venice, 1890)
D. Zannandreis: *Le vite dei pittori, scultori, ed architetti veronesi* (Verona, 1890), pp. 161–77

GENERAL

J. Reynolds: *Discourses on Art* (London, 1778/R New York, 1961)
J. Ruskin: *Modern Painters*, v (New York, 1886)
B. Berenson: *Venetian Painters of the Renaissance* (1894), in *Italian Painters of the Renaissance* (London, 1952)
G. Ludwig and others: 'Archivalische Beiträge zur Geschichte der venezianischen Kunst', *It. Forsch. Ksthist. Inst. Florenz* (Berlin, 1911), iv, pp. 139–45
D. von Hadeln: *Venezianische Zeichnungen der Spätrenaissance* (Berlin, 1926), pp. 26–32
H. Tietze and E. Tietze-Conrat: *Drawings of the Venetian Painters in the Fifteenth and Sixteenth Centuries*, 2 vols (New York, 1944)
B. Berenson: *Venetian School* (1957), i, pp. 129–39
L. Crosato: *Gli affreschi nelle ville venete del cinquecento* (Treviso, 1962)
J. Schulz: *Venetian Painted Ceilings of the Renaissance* (Berkeley, 1968)
S. J. Freedberg: *Painting in Italy, 1500–1600*, Pelican Hist. A. (Harmondsworth, 1971)
S. Sinding-Larsen: *Christ in the Council Hall: Studies in the Religious Iconography of the Venetian Republic* (Rome, 1974)
W. R. Rearick: *Maestri veneti del cinquecento*, Biblioteca di Disegni VI (Florence, 1980)
Da Tiziano a El Greco per la storia del manierismo a Venezia, 1540–1590 (exh. cat., ed. R. Pallucchini; Venice, Doge's Pal., 1981)
J. Ackerman: 'The Geopolitics of Venetian Architecture in the Time of Titian', *Titian: His World and his Legacy*, ed. D. Rosand (New York, 1982), pp. 41–7
P. Spezzani: *Riflettoscopia e indagine non distruttive: Pittura e grafica* (Milan, 1992)
F. Ames-Lewis, ed.: *New Interpretations of Venetian Renaissance Painting* (London, 1994)

MONOGRAPHS AND EXHIBITION CATALOGUES

P. Osmond: *Paolo Veronese: His Career and Work* (London, 1927)
G. Fiocco: *Paolo Veronese* (Bologna, 1928, 2/1934)
D. von Hadeln: *Paolo Veronese* (MS.; before 1935); ed. G. Schweikhart (Florence, 1978)
Mostra di Paolo Veronese: Catalogo delle opere (exh. cat., Venice, Ca' Giustinian, 1939)
R. Pallucchini: *Veronese* (Bergamo, 1940)
G. Trecca: *Paolo Veronese e Verona* (Verona, 1940)
L. Vertova: *Veronese* (Milan, 1953)
T. Pignatti: *Le pitture di Paolo Veronese nella chiesa di San Sebastiano in Venezia* (Milan, 1966)
R. Marini: *L'opera completa del Veronese*, foreword by G. Piovene (Milan, 1968)
T. Pignatti: *Veronese*, 2 vols (Venice, 1976) [with catalogue raisonné, comprehensive bibliography and excellent plates]
Paolo Veronese e i suoi incisori (exh. cat., ed. P. Ticozzi; Venice, Correr, 1977)
Palladio e la maniera (exh. cat., ed. V. Sgarbi and others; Vicenza, Santa Corona, 1980)
Palladio e Verona (exh. cat., ed. L. Magagnato and others; Verona, Pal. Gran Guardia, 1980)
K. Badt: *Paolo Veronese* (Cologne, 1981)
R. Cocke: *Veronese's Drawings* (Ithaca, NY, 1984)
R. Pallucchini: *Veronese* (Milan, 1984)
The Art of Paolo Veronese, 1528–1588 (exh. cat., ed. W. R. Rearick; Washington, N.G.A., 1988)
Paolo Veronese: Disegni e dipinti (exh. cat., ed. W. R. Rearick and others; Venice, Fond. Cini, 1988)
Paolo Veronese: Restauri (exh. cat., ed. G. Nepi Sciré and others; Venice, Accad. Pitt. & Scul., 1988) [*Quaderni della Soprintendenza ai beni artistici e storici di Venezia XV: Venezia 1988*]
Veronese e Verona (exh. cat., ed. S. Marinelli and others; Verona, Castelvecchio, 1988)
M. Gemin, ed.: *Nuovi studi su Paolo Veronese* (Venice, 1990)
F. Pedrocco and T. Pignatti: *Veronese catalogo completo* (Florence, 1991, rev. Venice, 2/1995)
Les Noces de Cana de Véronèse: Une Oeuvre et sa restauration (exh. cat., Paris, Louvre, 1992–3)
D. Rosand: *Painting in Sixteenth-century Venice: Titian, Veronese, Tintoretto* (Cambridge and New York, 1997)

SPECIALIST STUDIES

G. Biadego: 'Intorno a Paolo Veronese: Note biografiche', *Atti Ist. Ven. Sci., Lett. & A.*, lvii (1898–9), pp. 99–111
D. von Hadeln: 'Wann ist Paolo Veronese geboren?' *Kunstchronik*, n. s., xxii (1910–11), pp. 257–60
A. Bevilacqua-Lasize: 'Un quadro di autore controverso al museo civico di Verona', *Madonna Verona*, v (1911), pp. 106–11
G. Gattinoni: *Inventario di una casa veneziana del secolo XVII (la casa degli eccellenti Caliari eredi di Paolo Veronese)* (Mestre, 1914)
D. von Hadeln: 'Veronese und Zelotti', *Jb. Kön.-Preuss. Kstsamml.*, xxxv (1914), pp. 168–220; xxxvi (1915), pp. 97–128
E. Tea: 'Il cromatismo di Paolo Veronese', *L'Arte*, xxiii (1920), pp. 59–75
T. Borenius: 'A Group of Drawings by Paul Veronese', *Burl. Mag.*, xxxviii (1921), pp. 54–9
D. von Hadeln: 'Drawings by Paul Veronese', *Burl. Mag.*, xlvii (1925), pp. 298–304
A. M. Brizio: 'Nota per una definizione critica dello stile di Paolo Veronese: I', *L'Arte*, xxix (1926), pp. 213–42
L. Coletti: 'Paesi di Paolo Veronese', *Dedalo*, vi (1926), pp. 377–410
G. Fiocco: 'Paolo Veronese und Farinati', *Jb. Ksthist. Samml. Wien*, i (1926), pp. 123–6
D. von Hadeln: 'Some Portraits by Paolo Veronese', *AIA J.*, xv (1927), pp. 239–52
A. M. Brizio: 'Nota per una definizione critica dello stile di Paolo Veronese: II', *L'Arte*, xxxi (1928), pp. 1–10
——: 'Rileggendo Vasari', *Emporium*, lxxxix (1939), pp. 123–30
R. Gallo: 'Per la datazione delle opere del Veronese', *Emporium*, lxxxix (1939), pp. 145–52
E. Arslan: 'Nota su Veronese e Zelotti', *Belle A.*, i (1948), pp. 227–45
R. Brenzoni: *La prima opera di Paolo Veronese: 'La suocera di Pietro (Simeone)' del 1546 e la sua singolare vicenda* (Verona, 1953)
G. Zorzi: 'Nuove rivelazioni sulla ricostruzione . . . del Palazzo Ducale', *A. Ven.*, vii (1953), pp. 123–51

U. Moussalli: 'Le Processus d'élaboration et de création dans les grands ateliers vénitiens du XVIIème siècle, notamment chez Véronèse', *Venezia e l'Europa: Atti del XVIII Congresso internazionale di storia dell'arte: Venezia, 1955*, pp. 285–8

E. Tea: 'Paolo Veronese e il teatro', *Venezia e l'Europa: Atti del XVIII Congresso internazionale di storia dell'arte: Venezia, 1955*, pp. 262–4

S. Béguin: 'La Fille de Jaire de Véronèse au Musée du Louvre', *Rev. des A.*, vii (1957), pp. 165–9

R. Brenzoni: 'Architetti e scultori dei laghi lombardi a Verona', *Arte e artisti dei laghi lombardi*, ed. E. Arslan, 2 vols (Como, 1959–64), i, pp. 89–130

A. M. Brizio: 'La pittura di Paolo Veronese in rapporto con l'opera del Sanmicheli e del Palladio', *Boll. Cent. Int. Stud. Archit. Andrea Palladio*, ii (1960), pp. 19–25

C. Gould: 'An Early Dated Veronese and Veronese's Early Work', *Burl. Mag.*, cii (1960), p. 489 [letter]

M. Levey: 'An Early Dated Veronese and Veronese's Early Work', *Burl. Mag.*, cii (1960), pp. 107–11; see also C. Gould, ibid., p. 489

P. Ojetti and others: *Palladio, Vittoria e Veronese a Maser* (Milan, 1960)

P. Fehl: 'Veronese and the Inquisition: A Study of the Subject Matter of the So-called *Feast in the House of Levi*', *Gaz. B.-A.*, 6th ser., lviii (1961), pp. 325–54

T. Pignatti: *Le pitture di Paolo Veronese nella chiesa di San Sebastiano in Venezia* (Milan, 1966)

J. Plesters: 'Ultramarine Blue, Natural and Artificial', *Stud. Conserv.*, xi (1966), pp. 62–91

D. Rosand: 'An Early Chiaroscuro Drawing by P. Veronese', *Burl. Mag.*, cviii (1966), pp. 421–2

L. Crosato Larcher: 'Per Carletto Caliari', *A. Ven.*, xxi (1967), pp. 108–24

A. Caiani: 'Un palazzo veronese a Murano: Note e aggiunte', *A. Ven.*, xxii (1968), pp. 47–59

L. Magagnato: 'I collaboratori veronesi di Andrea Palladio', *Boll. Cent. Int. Stud. Archit. Andrea Palladio*, x (1968), pp. 170–87

K. Oberhuber: 'Hieronymus Cock, Battista Pittoni und Paolo Veronese in Villa Maser', *Munuscula Discipulorum: Kunsthistorische Studien Hans Kauffmann zum 70. Geburtstag* (Berlin, 1968), pp. 207–25

——: 'Gli affreschi di Paolo Veronese nella Villa Barbaro', *Boll. Cent. Int. Stud. Archit. Andrea Palladio*, x (1968), pp. 188–202

J. Schulz: 'Le fonti di Paolo Veronese come decoratore', *Boll. Cent. Int. Stud. Archit. Andrea Palladio*, x (1968), pp. 241–54

L. Crosato Larcher: 'Note su Benedetto Caliari', *A. Ven.*, xxiii (1969), pp. 115–30

N. Ivanoff: 'La tematica degli affreschi di Maser', *A. Ven.*, xxxiv (1970), pp. 210–13

M. Kahr: 'The Meaning of Veronese's Paintings in the Church of San Sebastiano in Venice', *J. Warb. & Court. Inst.*, xxxiii (1970), pp. 235–47

C. de Tolnay: 'Il *Paradiso* del Tintoretto, note sull'interpretazione della tela in Palazzo Ducale', *A. Ven.*, xxiv (1970), pp. 103–10

A. Ballarin: 'Considerazioni su una mostra di disegni veronesi del "500"', *A. Ven.*, xxv (1971), pp. 92–118

R. Cocke: 'An Early Drawing by Paolo Veronese', *Burl. Mag.*, cxiii (1971), pp. 726–33

G. Schweikhart: 'Paolo Veronese in der Villa Soranza', *Mitt. Ksthist. Inst. Florenz*, xv (1971), pp. 187–206

R. Cocke: 'A Preparatory Drawing for the "Triumph of Mordecai" in S Sebastiano Venice', *Burl. Mag.*, cxiv (1972), pp. 322–5

——: 'Veronese and Daniele Barbaro: The Decoration of Villa Maser', *J. Warb. & Court. Inst.*, xxxv (1972), pp. 226–46

D. Rosand: 'Theatre and Structure in the Art of Paolo Veronese', *A. Bull.*, lv (1973), pp. 217–39; rev. in *Painting in Cinquecento Venice* (New Haven, 1982), pp. 145–81

G. Sancassani: 'Un autografo di Paolo Veronese per la cena in casa di Simone fariseo', *Atti & Mem. Accad. Verona*, xxv (1973–4), p. 85

M. Monteverdi: 'Ipotesi su un modello di Paolo Veronese', *Crit. A.*, xx/138 (1974), pp. 33–8

P. Ticozzi: 'Le incisioni da opere del Veronese nel Museo Correr', *Boll. Mus. Civ. Ven.*, xx (1975), pp. 6–62, figs 1–180

D. Gisolfi Pechukas: *The Youth of Veronese* (diss., U. Chicago, 1976)

W. R. Rearick: *Tiziano e il disegno veneziano del suo tempo* (Florence, 1976), pp. 157–62

R. Cocke: 'Three Fragments from the Villa Soranza', *Mitt. Ksthist. Inst. Florenz*, xxi (1977), pp. 211–18

L. Crosato Larcher: 'Nuovi contributi per la decorazione della Soranza', *A. Ven.*, xxxi (1977), pp. 72–9

R. Smith: 'A Matter of Choice: Veronese, Palladio and Barbaro', *A. Ven.*, xxxi (1977), pp. 60–62

J. Mills and R. White: 'Organic Analysis in the Arts: Some Further Paint Medium Analyses', *N.G. Tech. Bull.*, ii (1978), pp. 71–6

J. Thornton: *Renaissance Color Theory and Some Paintings by Veronese* (diss., U. Pittsburgh, 1979)

R. Cocke: 'The Development of Veronese's Critical Reputation', *A. Ven.*, xxxiv (1980), pp. 96–111

J. Schulz: 'Tintoretto and the First Competition for the Ducal Palace *Paradise*', *A. Ven.*, xxxiv (1980), pp. 112–26

P. Fehl: 'Veronese's Decorum: Notes on the *Marriage at Cana*', *Art, the Ape of Nature: Studies in Honor of H. W. Janson* (New York, 1981)

J. Mills and R. White: 'Analyses of Paint Media', *N.G. Tech. Bull.*, v (1981), pp. 66–8

S. Romano: 'I paesaggi di Paolo Veronese in Palazzo Trevisan', *A. Ven.*, xxxv (1981), pp. 150–51

L. Crosato Larcher: 'Considerazioni sul programma iconografico di Maser', *Mitt. Ksthist. Inst. Florenz*, xxvi/1 (1982), pp. 211–56

D. Gisolfi Pechukas: 'Two Oil Sketches and the Youth of Veronese', *A. Bull.*, lxiv (1982), pp. 388–413

R. Bacou: 'Ten Unpublished Drawings by Veronese Recently Acquired by the Cabinet des Dessins du Louvre', *Master Drgs*, xxi (1983), pp. 255–62, pls 1–10

L. Lazzarini: 'Il colore nei pittori veneziani tra il 1480 e il 1580', *Boll. A.* (1983), suppl., pp. 135–44

J. Mills and R. White: 'Analyses of Paint Media', *N.G. Tech. Bull.*, vi (1983), pp. 65–7

S. Romano: 'Gli affreschi di Paolo Veronese', *Boll. A.* (1983), suppl., pp. 119–32

P. Fehl and M. Perry: 'Painting and the Inquisition at Venice: Three Forgotten Files', *Interpretazioni veneziane: Studi di storia dell'arte in onore di Michelangelo Muraro* (Venice, 1984)

L. Lazzarini and G. Nepi Sciré: 'Il restauro del Convito in Casa di Levi di Paolo Veronese', *Quad. Sopr. Beni A. & Stor. Venezia*, xi (1984) [whole issue]

T. Pignatti: 'Una nuova *Pietà* di Paolo Veronese', *A. Ven.*, xxxviii (1984), pp. 146–8

S. Sinding-Larsen: 'The Paradise Controversy: A Note on Argumentation', *Interpretazione veneziana, studio di storia dell'arte in onore di Michelangelo Muraro*, ed. D. Rosand (Venice, 1984)

I. Jackson Reist: 'Divine Love and Veronese's Frescoes at the Villa Barbaro', *A. Bull.*, lxvi (1985), pp. 614–35

D. Gisolfi Pechukas: 'Veronese and his Collaborators at La Soranza', *Artibus & Hist.*, xv (1987), pp. 67–108

D. Lewis: 'Classical Texts and Mystical Meanings: Daniele Barbaro's Program for the Villa Maser', *Festschrift für Erik Forssman zum 70. Geburtstag* (Hildesheim, 1987), pp. 289–307, 531–4

D. Gisolfi Pechukas: 'Paolo Veronese e i suoi primi collaboratori', *Nuovi studi su Paolo Veronese: Convegno internazionale di studi: Venezia, 1988*, ed. M. Gemin (Venice, 1990), pp. 25–35

S. Sinding-Larsen: 'Paolo Veronese tra rituale e narrativo: Note a proposito di un disegno per il Palazzo Ducale', *Nuovi studi su Paolo Veronese: Convegno internazionale di studi: Venezia, 1988*, ed. M. Gemin (Venice, 1990), pp. 36–41

D. Gisolfi: '"L'anno veronesiano" and Some Questions about Early Veronese and his Circle', *A. Ven.*, xliii (1989–90), pp. 30–42

T. E. Cooper: 'Un modo per 'La Riforma Cattolica'?: La scelta di Paolo Veronese per il refettorio di San Giorgio Maggiore', *Crisi rinnovamento nell'autunno del Rinascimento a Venezia*, ed. V. Branca and C. Ossola (Florence, 1991), pp. 271–92

A. Augusti Ruggeri and S. Savini Branca: *Chiesa di San Sebastiano: Arte e devozione* (Venice, 1994)

R. Cocke: 'Civic Identity and the Venetian Art Market: Jacopo Bassano and Paolo Veronese', *New Interpretations of Venetian Renaissance Painting*, ed. F. Ames-Lewis (London, 1994), pp. 91–7

L. Gnocchi: *Paolo Veronese fra artisti e letterati* (Florence, 1994)

P. Humfrey: 'Some Thoughts on Writing a History of Venetian Altarpieces', *New Interpretations of Venetian Renaissance Painting*, ed. F. Ames-Lewis (London, 1994), pp. 9–16

D. Gisolfi: 'A New Early Veronese in Tokyo', *Burl. Mag.* (Nov 1995), pp. 742–6

N. Penny and M. Spring: 'Veronese's Paintings in the National Gallery: Technique and Materials: pt. I', *N.G. Tech. Bull.*, xvi (1995), pp. 4–29

R. Wollheim: 'The Shape of the Story', *Mod. Painters*, viii/3 (1995), pp. 56–9

J. Habert: *Véronèse: Une Dame vénitienne dite la Belle Nani* (Paris, 1996)

N. Penny, M. Spring and A. Roy: 'Veronese's Paintings in the National Gallery: Technique and Materials: pt. II', *N.G. Tech. Bull.*, xvii (1996), pp. 32–55

D. Gisolfi: 'The School of Verona in American Collections', *Artibus & Hist.*, xxxiv (1996), pp. 177–91

W. R. Rearick: 'Cabinet of Wonders: Veronese's Use of Drawing Paper', *On Paper*, i (1997), pp. 2–3

D. Gisolfi and S. Sinding-Larsen: *The Rule, the Bible, and the Council: The Library of the Benedictine Abbey at Praglia* (Seattle, 1998)

DIANA GISOLFI

Verrocchio, Andrea del [Andrea di Michele di Francesco Cioni] (*b* Florence, 1435; *d* Venice, ?30 June 1488). Italian sculptor, painter, draughtsman and goldsmith. He was the leading sculptor in Florence in the second half of the 15th century, and his highly successful workshop, in which Leonardo da Vinci trained, had a far-reaching impact on younger generations. A wide range of patrons, including the Medici family, the Venetian State and the city council of Pistoia, commissioned works from him. Exceptionally versatile, Verrocchio was talented both as a sculptor—of monumental bronzes, silver figurines and marble reliefs—and as a painter of altarpieces. He was inspired by the contemporary interest in the Antique and in the study of nature, yet, approaching almost every project as a new challenge, developed new conceptions that often defied both traditional aesthetics and conventional techniques. His fountains, portrait busts and equestrian sculpture are indebted to an iconographic tradition rooted in the early 15th century and yet they are transformed by his original outlook. His funerary ensembles are unique, so that, despite the great admiration they inspired, they had no imitators. Though a highly important artist in his own right, Verrocchio has often had the misfortune of being seen as in the shadow of his pupil Leonardo.

I. Life and work. II. Working methods and technique. III. Character and personality. IV. Critical reception and posthumous reputation.

I. Life and work.

1. Sculpture. 2. Painting.

1. SCULPTURE.

(i) Training and early career, before *c.* 1477. (ii) Mature and late works, *c.* 1477 and after.

(i) Training and early career, before c. *1477.* The son of a brickmaker, Michele di Francesco Cioni (*d* 1452), Verrocchio is mentioned first in 1452, when a record of a court case indicates that he was arrested and then fully acquitted for accidentally killing a woolworker by the name of Antonio di Domenico. He is next documented as the pupil of Antonio di Giovanni Dei (1406–?1480), in whose workshop on the Via Vaccherecia in Florence he worked from 1453 to 1456. Dei was a member of a large family that owned and managed several busy goldsmiths' workshops, but he did not actually practise as a goldsmith. A successful businessman, he was able to secure his pupils profitable commissions and help launch their careers. Andrea subsequently became associated with another family of goldsmiths, headed by Francesco di Luca Verrocchio and his son Giuliano Verrocchio, from whom he seems to have taken his name. His training as a sculptor in marble remains highly controversial, although two early sources, *Il codice dell'Anonimo Gaddiano [Magliabechiano]* and *Il libro di Antonio Billi*, state that he was involved in the execution of Desiderio da Settignano's tomb of *Carlo*

Marsuppini (*d* 1453; Florence, Santa Croce; *see* DESIDERIO DA SETTIGNANO, fig. 1), and it has also been suggested that he worked in the studio of Antonio Rossellino and Bernardo Rossellino in the early 1460s (Seymour).

As a metalworker, Verrocchio was a member of the goldsmiths' guild, apparently from the late 1450s, but in his first surviving *catasto* (tax-return) in 1457 he noted that commissions for bronze artefacts were scarce, and he appears to have been determined to widen his activities and to vie for profitable undertakings in architecture and painting. In 1461, with Desiderio da Settignano, Giuliano da Maiano and Giovannini di Meuccio di Contaldino (*fl* 1442–73), he competed unsuccessfully for the commission for the chapel of the Madonna della Tavola (destr.) at Orvieto Cathedral. From the outset of his career he also embarked on prestigious projects in various media for influential patrons. Between 1465 and 1467 he designed the tomb of *Cosimo de' Medici* (Florence, S Lorenzo) in stone and brass, and towards 1466 he was awarded the

1. Andrea del Verrocchio: *Incredulity of Thomas*, bronze, h. 2.30 m, *c.* 1466–83 (Florence, Orsanmichele)

commission for the bronze group of the *Incredulity of Thomas* (Florence, Orsanmichele; see fig. 1). In 1468 he received partial payment for a monumental bronze candlestick for the Palazzo della Signoria, Florence (Amsterdam, Rijksmus.). In the same year the Florentine Cathedral workshop commissioned him to execute the copper ball for the lantern of Florence Cathedral (erected 1471; destr. 1600), and, probably in 1469 (Covi, 1981 and 1983), he made a visit to Venice and Treviso to purchase copper for this project. He enrolled in the sculptors' guild in 1469 and in the painters' guild in 1472.

The monumental bronze group of over life-size figures of Christ and St Thomas in the *Incredulity of Thomas* and the marble and bronze tomb of *Piero I and Giovanni de' Medici* (completed 1472; Florence, S Lorenzo, Old Sacristy; see fig. 2) are the most original of Verrocchio's early documented works, and both reveal the influence of his experience of Venetian art. The *Incredulity of Thomas* was commissioned by the Tribunale di Mercanzia to replace Donatello's *St Louis of Toulouse* (1423; Florence, Mus. Opera Santa Croce) in a niche on the exterior east wall of Orsanmichele, and the choice of Verrocchio to contribute to the sculptural decoration of a building already enriched by works of the great early Renaissance sculptors suggests his growing prestige. The challenge of creating a dramatic ensemble rather than sculpting single figures of one or two of the guild's patron saints encouraged him to take an original approach. In a composition inspired (Covi, 1983) by a mosaic of the *Incredulity of Thomas* (*c*. 1200; Venice, S Marco), he placed the figure of Christ in the middle of the frame on an elevated step and that of the apostle outside and below it to the left. Such an alignment allowed him to retain the prescribed sizes of the figures without overcrowding the relatively narrow space allotted to them. More interestingly, it enabled him to stage the emotionally charged encounter between the two on a diagonal and thereby create a dynamic instead of a static picture. Compositionally and dramatically, the axis of the scene is the wound that Christ exposes with his upraised arm, on one side, and his hand, which holds open the tear in the garment, on the other. St Thomas's tentatively outstretched right hand and his intense gaze lead the spectator towards this focal-point and into the niche. The figures form a united and balanced picture, although the figure of Christ was cast several years before that of St Thomas, which was completed only in 1483. Christ's draperies are sharper and less flowing than those of St Thomas, the facial features more elongated and the posture less graceful.

Even more unusual is Verrocchio's tomb of *Piero I and Giovanni de' Medici*, with its equally unusual location in the arched opening that connects the chapel of the Madonna (formerly the chapel of the Sacrament) and the Old Sacristy at S Lorenzo. Presenting two equal views on both sides, it is a free-standing double funerary monument, unprecedented in its use of secular imagery. Its exceptional artistic effect depends on the geometrical contrast between the severity of its main components and the naturalistic richness of the varied ornament. Thus the simple white marble base is juxtaposed with the sumptuous red porphyry sarcophagus with green serpentine medallions. The smooth, polished surfaces of these structures, in turn, contrast with the swirling, rugged shapes of the decorative

2. Andrea del Verrocchio: tomb of *Piero I and Giovanni de' Medici*, marble, porphyry, serpentine and bronze, h. 4.50 m, completed 1472 (Florence, S Lorenzo, Old Sacristy)

elements underneath, between, on and above them: bronze tortoises below the base, bronze lions' feet connecting the base and the sarcophagus, bronze acanthus leaves in the corners of the latter, and a screen of bronze interlacing ropes filling the entire space between the tomb and the arch itself. The animal and plant forms, including those carved in marble on the intrados, are so filled with life and motion that they animate the whole ensemble.

Two of Verrocchio's free-standing bronze sculptures, ordered by the Medici family probably in the late 1460s or early 1470s, deserve special mention: the *Putto with a Dolphin* (Florence, Pal. Vecchio; see colour pl. 2, XXXVIII) and *David* (Florence, Bargello; see fig. 3). They were described by Verrocchio's brother Tommaso (*b* 1441) in the inventory he made (1496) of the works Andrea executed for the Medici (Fabriczy, 1895). Both were conceived as dainty statuettes, despite their medium size (670 mm and 1.26 m respectively), and they epitomize Verrocchio's critical and interpretative approach to the ideals and forms of Classical antiquity. The *Putto with a Dolphin*, a rotating fountain figure apparently exhibited in the Villa Medici at Careggi during the 15th century, represents a boy, with a dolphin clutched to his chest, balancing on his left leg and turning his head to the right. Verrocchio here re-created a theme well known in Roman art yet with a new quality of realism and movement. The serpentine pose, so characteristic in the Baroque but rare in the Renaissance, promotes a sense of continuous

3. Andrea del Verrocchio: *David*, bronze, h. 1.26 m, *c.* 1475 (Florence, Museo Nazionale di Bargello)

breathtaking motion and allows the spectator to view the statue from multiple viewpoints. Verrocchio's originality is most apparent in his portrayal of the putto's delight at being able to control his playful swerve. His apparent sudden awareness of his own strength complements the suddenness of his twisting motion and lends the image a quality of truthfulness to life, which the artist counterbalances against his Classical sources.

Where the design of the *Putto with a Dolphin* presented Verrocchio with the opportunity to pay tribute to and try to outdo a popular antique image, that of *David* offered him the chance to challenge Donatello's celebrated bronze of the same subject (Florence, Bargello; see colour pl. 1, XXIX1). Verrocchio's invocation both of the Classical models that influenced Donatello and of Donatello's *David* itself is evident in the dignified countenance of his frontal figure. Standing in a contrapposal pose, his left arm on his waist, the *David* carries on the tradition of a distant and near past. However, more concrete and accurate, it represents a totally novel approach. Instead of showing, as had Donatello, a heroic nude embodying general ideals of beauty, grace and youth, he portrayed a given young hero whose tight leather tunic reveals a bony but taut torso. Depicting a dramatic moment, he thus replaced Donatello's languorous and passive figure with an audacious conqueror, with a trace of a supercilious smile. The finely crafted statue is distinguished by a wealth of surface details: the corkscrew curls that crown the

young face, the skin-tight tunic with its decorative borders and fringes, the thin ribs and firm stomach showing through the fabric, the bulging veins of the right arm, and the pleats formed by the sweeping movement of the hips.

A terracotta relief of the *Virgin and Child* (Florence, Bargello) was probably designed by Verrocchio in the mid-1470s and is close in style to the bronze *Putto with a Dolphin*. It is the only relief of this subject whose attribution to Verrocchio is unanimous. Influenced by similar images by Filippo Lippi and Alesso Baldovinetti, it is distinguished by the liveliness of the handling and the sweetness of the mood.

(ii) Mature and late works, c. 1477 and after. In 1477, after a contest in which he and three other sculptors submitted models, Verrocchio undertook to carve the marble cenotaph for *Cardinal Niccolò Forteguerri* (Pistoia Cathedral) for the cathedral workshop at Pistoia. His relationship with the authorities was difficult and may have caused the lengthy delays that resulted in the monument remaining unfinished at his death. From the start of the project, there was tension: although Verrocchio's model was preferred, his request for 350 florins was considered too high so the committee reopened negotiations with Piero del Pollaiuolo, who had also competed. It was only after the intervention of Lorenzo de' Medici in 1478 that the job was reassigned to Verrocchio.

The *Forteguerri* cenotaph displays the only extant monumental figure designed by Verrocchio in marble. The work is now much altered, yet its original appearance can be deduced from a terracotta model (London, V&A), probably by Verrocchio, for the complete monument. This presents Christ in majesty within a mandorla, carried by four wingless angels, in the upper part, and, below, Niccolò Forteguerri (*d* 1473), surrounded by a triangle of the three cardinal virtues: Faith, Hope and Charity. Its iconographical and formal schema are traditional. They recall both Maso di Banco's painting above the tomb of *Bettino Bardi* (Florence, Santa Croce) and Nanni di Banco's relief above the Porta dell Mandorla (completed 1421; Florence Cathedral). Verrocchio's originality lies in the composition's greater unity and naturalism (Passavant). The figures are no longer differentiated by size, and they are so animated as to create a sense of dynamism that is most noticeable in the four angels, who seem to lift and support a heavy mandorla. In the completed monument, seven of the nine figures exhibited in the lunette framework—Christ, the four angels supporting the mandorla, and Faith and Hope—are recorded as having been carved in Verrocchio's workshop. The work was completed by Lorenzetto Lotti and Giovanni Francesco Rustici and then in 1753 disastrously given a Baroque character by Gaetano Masoni.

On 27 July 1477 Verrocchio was commissioned by the Guild of the Cloth Refiners, which supervised works at the Florentine Baptistery, to execute a silver relief of the *Beheading of St John the Baptist* for the silver altar in the Baptistery (Florence, Mus. Opera Duomo; *see* ITALY, fig. 31). He had won the commission in a contest in which Antonio del Pollaiuolo also participated, Verrocchio submitting two models, Pollaiuolo three. Verrocchio was subsequently also assigned the task of casting some of the

silver figurines for the altar itself. The relief, which is on the right side of the antependium of the altar, is Verrocchio's only extant work in silver on such a small scale (310×420 mm). It is also the only surviving sculptural project that he carried out in two different techniques: low relief for the architectural background and modelling in the round for the human figures.

The commission itself was unique in the artist's career in that it had been planned as a collaborative enterprise; it was part of a larger programme, and four storiated reliefs for the dossal of the altar were also intended. The scene of the beheading is set in an L-shaped courtyard formed by a palace wall, articulated by closed-in arches. At the centre is the executioner, naked except for a loin cloth and seen from the back, who raises his arms as if about to inflict the final fatal blow with his sword. To the left, kneeling on the ground, is the bearded figure of the saint and three agitated young Roman soldiers, one of whom is carrying the salver. To the right are two other witnesses, one attempting to prevent the violent death and one trying to hasten it. Angrily facing one another, they seem ready to fight. Verrocchio stressed the theatricality of this climactic episode. Focusing the viewer's attention on the muscular body of the executioner, he strove to draw it then to the various other protagonists and to their reactions to him: fright, horror and rage. Verrocchio's concern with the dramatic content of the scene is reflected in the different hand gestures and facial expressions, and yet he pays no less attention to other anatomical features: every aspect of the body, for instance John's veined left arm and the executioner's taut ribcage, is meticulously detailed.

Of equally small size and delicate proportions are two undocumented works in terracotta that have been acknowledged, almost unanimously, as products of Verrocchio's maturity: the damaged relief of the *Lamentation* (290×430 mm; ex-Kaiser-Friedrich Mus., Berlin, destr.; see Adorno, fig. 119) and the free-standing statuette of the *Sleeping Youth* (360×580 mm; Berlin, Bodemus.). The former seems to have been prepared as an independent artefact and not as a full-scale model for a bronze. It may have been intended as part of the cenotaph for *Niccolò Forteguerri* or of the monument to a Venetian doge (untraced) that Vasari mentioned. Verrocchio's authorship of the relief has been accepted by scholars on the basis of the monumentality of the composition, the emotional undercurrent of the scene, and the fine and detailed way in which the figures' bodies, clothes and faces are delineated. Christ's pathetically lifeless head, touched by Mary's sorrowful, aged face, crowns a pyramidal construction at the bottom of which are the grieving Magdalene and Nicodemus, kneeling on either side. They are framed by mourning figures who extend the triangle into a rectangle, and, with varied poses, enrich the seemingly simple composition. The multiple folds of the draperies reinforce the subtle complexity of forms, emphasizing the illusion of three-dimensionality and also echoing the agitated state of the mourners.

The precision and finish of the *Lamentation* also distinguishes the *Sleeping Youth*. The sculpture was inspired by that of the Hellenistic *Dying Gaul* (Roman copy, ?1st century BC; Rome, Mus. Capitolino), yet it was also studied from life and shows a specific state of mind. The boy,

recumbent and asleep, may represent both innocence and relaxation. His smooth face, firm chest and bony limbs are the attributes of his tender years, while his closed eyes, the head leaning on the right arm, the dreamy face, and the drooping hands invoke an atmosphere of withdrawal and tranquillity. It is not clear whether the figure was destined to form part of a sculptural group, and it has been suggested that it was prepared as a model for the young soldier in the *Resurrection* (Florence, Bargello), a polychrome terracotta relief associated either with Verrocchio or his workshop.

Verrocchio also undertook two commissions for lifesize portrait busts, one in marble and one in terracotta. The marble *Woman Holding Flowers* (Florence, Bargello; see ITALY, fig. 19) is almost unanimously recognized as an authentic work from the late 1470s. Its format, a halffigure bust, including arms and hands, was unusual at that date and recalls that of a specific type of antique statue used to depict Roman officials. It enabled the artist to endow his subject with a regal stance and demeanour and to show aristocratic hands with long, elegant fingers. Of special note is the hair with its side-curled ends, the faint trace of a smile and the finely detailed clinging dress, tied at the waist. A similarly impressive personality emanates from the terracotta portrait bust of *Giuliano de' Medici* (Washington, DC, N.G.A.), perhaps the one listed in Tommaso's inventory of 1496. A debt to Classical statues is apparent in the forceful tilt of the head with its arrogant mien. Its indebtedness to Renaissance ideals may be visible in the realism with which the artist delineated each physiognomic trait.

Vasari recorded that in the late 1470s Verrocchio designed the sepulchral monument of *Francesca Tornabuoni* (destr.) for the church of S Maria sopra Minerva, Rome. A marble relief of a birth and death scene (Florence, Bargello) has been associated with this tomb, but neither this association nor the attribution of the relief are certain. From the close of the 1470s until his death, Verrocchio devoted most of his time and energy to the planning and casting of the colossal bronze monument to *Bartolomeo Colleoni* (Venice, Campo SS Giovanni e Paolo; see fig. 4). The condottiere Colleoni had bequeathed part of his wealth to the Venetian state, with the provision that a bronze equestrian statue should be erected to his memory. Alessandro Leopardi and Bartolommeo Bellani (?1400–?1492), who had collaborated with Donatello on the monument to *Gattamelata* (1447–53; Padua, Piazza del Santo; for illustration see DONATELLO, fig. 4), took part in the competition for the commission, for which Verrocchio prepared a true-to-life, life-size wooden model covered with black leather. Verrocchio was awarded the commission in 1480, and probably in 1486 went to Venice to supervise the statue's execution.

The monument crowned Verrocchio's career and is the most forceful of 15th-century equestrian monuments. Inspired more by Venetian precedents than by Florentine counterparts, it is a realistic depiction of a contemporary and ferocious condottiere, not the idealized representation of a military commander that is seen in the Roman *Marcus Aurelius* (2nd century AD; Rome, Piazza del Campidoglio) and in Donatello's *Gattamelata*. It also differs from these famous representations in being, typically for Verrocchio,

4. Andrea del Verrocchio: monument to *Bartolomeo Colleoni* (*c.* 1479–92), bronze, h. 3.95 m, Campo SS Giovanni e Paolo, Venice

an animated rather than a static group. The conception of the rider and horse is based on Andrea del Castagno's fresco of *Niccolò da Tolentino* (1456; Florence Cathedral; *see* CASTAGNO, ANDREA DEL, fig. 4) and on the unattributed early 15th-century equestrian monument to *Paolo Savelli* (*d* 1405) (Venice, S Maria dei Frari). Yet one of the horse's forelegs is freed from any support, and its head is turned to the left. The resulting contrapposto movement, echoed by that of the rider, accentuates the forward thrust of the two figures, which, united, seem to embody the notion of unyielding, domineering strength, a quality also expressed by their facial expressions. In 1488 Leopardi was commissioned to cast the sculpture, and it was erected in 1494. On his death Verrocchio seems to have been working on a fountain ordered by Matthias Corvinus, King of Hungary (*reg* 1458–90).

2. PAINTING. Verrocchio's work as a painter continues to raise problems of attribution; his *Virgin and Child with SS John the Baptist and Donatus* in the Donato de' Medici Chapel of Pistoia Cathedral is his only extant documented painting, and was the product of a collaboration with Lorenzo di Credi (*see* LORENZO DI CREDI, fig. 1). However, Verrocchio had ambitions as a painter early in his career. In 1468 he designed a decorative pennant (untraced) for Lorenzo de' Medici, and in 1469 competed unsuccessfully with Antonio del Pollaiuolo, Piero del Pollaiuolo and Sandro Botticelli for the painting of the *Virtues* at the Università dei Mercatanti in Florence. An undocumented half-length *Virgin and Child* (*c.* 1468; Berlin, Bodemus.) may be dated to this early period. A small work (720×530 mm), it is, nonetheless, a monumental image in which the two voluminous figures, seen in three-quarter profiles, fill most of the picture plane and are set against a landscape background. These figures are placed on opposing diago-

nals that meet in the centre, where the Virgin's left hand holds the infant's right foot, and are echoed by the distant hill behind the Virgin, and a steeper cliff in the middle ground behind Christ. Verrocchio's sculptural approach to the figures gives them an imposing grandeur: as if carved in the round, they form the shape of a rising pyramid that looks more solid and dense than the distant mountains. Light and shade enhance the illusion of plasticity. Yet the picture is tender in feeling, with the Virgin and Christ bound together by expression and gesture in a moment of rare intimacy. In mood it is reminiscent of the terracotta relief of the *Virgin and Child* from the mid-1470s.

In 1474 Verrocchio made another tournament standard, this time for Giuliano de' Medici; a triangular-shaped drawing in silverpoint and bistre (Florence, Uffizi) of a reclining female and a putto in a flowery meadow may be a preparatory sketch for this commission. Verrocchio's most famous painting, the altarpiece of the *Baptism* (Florence, Uffizi; see fig. 5), was probably begun in the mid-1470s and was painted for S Salvi, Florence. It is the first large altarpiece in Florence to represent the scene, which had previously been the subject of sculptural and pictorial cycles and predellas. Its symmetrically balanced composition is traditional, with the figure of the Baptist on the right and those of the two attending angels on the left, flanking the centrally placed figure of Christ. Yet Verrocchio's image is nonetheless highly original. Christ and St John seem to move forward and face each other from opposite directions, thus forming a sculptural entity that is as impressive and imposing as the *Incredulity of Thomas* at Orsanmichele. They appear to be completely

5. Andrea del Verrocchio: *Baptism*, tempera on panel, 1.77×1.51 m, *c.* 1475–85 (Florence, Galleria degli Uffizi); some alterations possibly made by Leonardo da Vinci

self-absorbed and self-contained, as if oblivious to the presence of the angels, the sound of water and the birds. The bond that unites them at the very moment of baptism accentuates their prominence and their concentrated expressions create a sense of tension that heightens the viewers' experience of the sacredness of this instant. Apparently in the 1480s areas of the picture, which include the angel seen in profile, much of the landscape, and Christ's face, were changed, repainted or added by the young Leonardo da Vinci.

Tobias and the Angel (London, N.G.; see fig. 6) is accepted by most critics as an autograph painting from the late 1470s. Depicting the young Tobias, accompanied by Raphael, on his journey home, the picture focuses on the figures' energetic surge as they advance from right to left towards the forefront, and their closeness as they walk arm in arm, their gazes almost locked together. Most remarkable, however, is the physical beauty that they seem to embody. It permeates their delicate faces, their elegantly colourful clothes, their graceful stride and gestures. Raphael's walk, his stretched left leg, and bent right arm are those of a ballet dancer. The landscape background is more detailed than that of the *Virgin and Child*. Sharper and perhaps harsher at the same time, it includes sections of rivers and fortresses, which extend far below the protagonists whose upper bodies are thus silhouetted against the sky.

Verrocchio's inclination to aggrandize the human figure at the expense of the background does not appear to typify the paintings completed later in his life. In the documented altarpiece of the *Virgin and Child with SS John the Baptist and Donatus* (Pistoia Cathedral), commissioned in 1474

by Bishop Donato de' Medici and executed almost entirely by Lorenzo di Credi, the different elements—protagonists, architecture and scenery—acquire a balance that is lacking in the *Baptism*, the *Virgin and Child* and *Tobias and the Angel*. They are interrelated in size and proportions to create a unity where no detail, no matter how important, overshadows another. The composition consists of three spatial tiers, beginning with the plane close to the spectator where the saints are seen standing, proceeding through an elaborate throne in which the Virgin and the infant are seated in mid-ground, and ending with a rich view of mountains, forests and winding paths at the back. Within a triangular alignment that brings the figures together both formally and emotionally, a series of subtle relationships emerges. St Donatus, on the right, gazes at St John the Baptist, on the left, who looks at us while pointing his finger at the Christ Child. The seated mother and infant draw our attention back to the standing saints. Whereas the Virgin's legs project towards St Donatus, her face turns to St John the Baptist, who appears to gain more prominence as the infant's blessing is directed at him as well. Regular and irregular forms blend into a harmonious whole. The severe lines that define the architecture in horizontal and vertical parallels contrast with the undulating lines that separate the landscape from the sky. Likewise, the harsh and angular surface of the marble is juxtaposed with the soft texture and round shapes of the leaves and flowers.

Other pictures associated with Verrocchio, the attributions of which remain controversial, include paintings of the *Virgin and Child* in the National Gallery of Art, Edinburgh (the Ruskin *Madonna*), the National Gallery, London, the Metropolitan Museum of Art, New York, and the Städelsches Kunstinstitut, Frankfurt am Main.

II. Working methods and technique.

1. SCULPTURAL TECHNIQUES AND USE OF PREPARATORY STUDIES. Vasari praised Verrocchio's versatility as goldsmith, sculptor and painter. Nevertheless, his contemporaries seem to have valued him most for his ingenuity and technical ability as a metal-caster and an engineer. The contract for the gilt copper ball to crown the lantern of Florence Cathedral laid down that he was to supervise the purchase of metal in Venice and perhaps to study methods of hammering it in Treviso and Pordenone. The ball was hammered into shape and gilded by the mercury process.

As a goldsmith and silversmith, Verrocchio used an assemblage technique, a method favoured in the 14th century. The silver *Beheading of St John the Baptist* contains many separately cast elements; the kneeling saint, his executioners and the soldiers. He also used the same process for his larger-scale statues, casting different parts of free-standing statues and reliefs separately. The *David* was cast in two sections: the figure of the hero and the severed head of Goliath; the figures were extensively chiselled after casting. In the group in the *Incredulity of Thomas* Verrocchio did not cast those sections that were not intended to be seen: the figures of Christ and St Thomas have no back, and in this they follow Donatello's *St Louis of Toulouse*. However, he paid particular attention

6. Andrea del Verrocchio: *Tobias and the Angel*, tempera on panel, 840×660 mm, late 1470s (London, National Gallery)

to the parts of the hands that are exposed to the viewer. For the drapery in the *Putto with a Dolphin* he used cloth dipped into hot wax and arranged on the wax figure, a technique also used by Donatello in his *Judith and Holofernes* (Florence, Piazza della Signoria) (Cannon-Brookes).

Verrocchio was equally skilled in a variety of media and often approached one medium as he would another. His training as a goldsmith reveals itself in his love of polychromy, and the tomb of *Cosimo de' Medici* in white marble and red and green porphyry is distinguished by the richness and colour of the materials. This was developed in the tomb of *Piero I and Giovanni de' Medici*, where the combination of a variety of coloured stones with bronze decoration is strikingly original. This work has frequently been likened to a jewel box or reliquary. In Verrocchio's multifaceted art small or medium works sometimes acquire the characteristics of monumental projects while many of his large productions exhibit the traits of small artefacts. His bronze *David*, finely and precisely detailed, has the quality of a small and precious object, admired more for its delicacy than for its dramatic impact. It suggests Verrocchio's skill as goldsmith first and sculptor second. His mastery as a marble carver is revealed in the only documented examples of his work in this medium, the faces of Christ and Faith on the *Forteguerri* monument; here the surfaces attain a degree of softness that distinguishes them from the shiny hardness characteristic of many contemporary reliefs and statues (Seymour).

The preparatory work for sculpture that was produced in Verrocchio's workshop included *bozzetti* in wax or clay, terracotta modelli and drawings; *bozzetti* were also used to win contracts from prospective clients. It is not always clear whether Verrocchio's terracottas were intended as independent works or as modelli; a marble relief of the *Virgin and Child* (Florence, Bargello) is a studio variant of the terracotta relief in the same museum. Vasari described how Verrocchio, using a special plaster, cast moulds of natural forms such as hands, feet, knees, legs, arms and torsos in order to study them at length. Few drawings by Verrocchio survive, but he was a fine draughtsman, and a pen-and-ink sheet with *Studies of a Child* (Paris, Louvre) is vivid and spontaneous. He also made a group of delicately modelled black chalk cartoons of heads, which were pricked for transfer and were intended for panel paintings; these include the *Head of a Woman* (Oxford, Christ Church), the *Head of an Angel* (Florence, Uffizi) and another *Head of an Angel* (Berlin, Kupferstichkab.); Vasari mentioned a group of drawings of women's heads by Verrocchio that he owned and that had influenced Leonardo. Drapery studies acquired a new importance in Verrocchio's studio; Vasari described how Leonardo made clay models of figures, draping them with rags dipped in plaster, and then drew them on prepared linen, in brown or black and white, a practice that was adopted by several artists associated with Verrocchio's studio (Popham).

2. WORKSHOP. Verrocchio, whose diligence is frequently praised by Vasari, was outstandingly successful in maintaining an independent firm, which branched out into two studios: one in Florence and one in Venice. His prosperous Florentine studio was strikingly self-sufficient, and, unlike Antonio del Pollaiuolo, who collaborated with various goldsmiths' firms on the Via Vacchereccia, and Donatello, who had managed two sculptors' workshops with Michelozzo, he remained the sole proprietor of his multifaceted studio. The only joint enterprise in which he participated was for the silver altar of the Baptistery. His involvement in public art activities in co-operation with other masters was limited as well: in 1468 he served on the committee that appraised Giovanni di Bartolommeo's and Bartolomeo di Fruosino's contributions to the casting of the base for the ball of the cathedral lantern. In 1473 he was a member of a committee that evaluated the marble pulpit (Prato Cathedral) of Antonio Rossellino and Mino da Fiesole.

Verrocchio's studio included Perugino, Francesco di Simone Ferrucci, Agnolo di Polo, Giovanni Francesco Rustici, Leonardo da Vinci and Lorenzo di Credi. Within his firm Verrocchio gave considerable latitude to his artists. During his second stay in Venice in the 1480s, he allowed Lorenzo di Credi, who was never granted the rank and privileges of an associate, to take full responsibility for his working facilities near the Opera del Duomo, Florence. It was probably at that time that the latter executed the altarpiece *Virgin and Child with SS John the Baptist and Donatus*, and Leonardo da Vinci retouched and overpainted the altarpiece of the *Baptism*. Verrocchio's will of 1488 made Lorenzo an heir and executor, in place of the former's brother Tommaso, and attests to Verrocchio's wish that Lorenzo complete all the projects left unfinished at his death and take care of his affairs and of some of his relatives. It is clear that the younger man did indeed regard himself as a veritable companion and family member of his master. Rather than bury Verrocchio in the church of the Madonna dell'Orto in Venice, Lorenzo took it on himself to transfer the body to Florence and lay it to rest at the Cioni family vault at S Ambrogio, as the artist had requested.

As was common practice in the 15th century, Verrocchio hired specialized artisans, who did not become part of his regular workforce, for the execution of special engineering feats. When the gilt copper ball for the lantern of Florence Cathedral had been completed he is reported to have enlisted the services of three stonecutters, Lucca di Piero, Salvestro di Paolo di Stefano and Giovanni di Tomé. During the design of the bronze equestrian monument to *Bartolomeo Colleoni*, he is known to have engaged the assistance of a woodcutter by the name of Francesco di Giovanni. Giovanni di Andrea di Domenico, a goldsmith who was chosen by Lorenzo di Credi as the most likely candidate to conclude the casting of this colossal statue, may also have been one of the craftsmen whom Verrocchio employed on a temporary basis.

III. Character and personality.

The scant information about Verrocchio's personal life in the primary sources often relates to untypical events. For example, the record of the court case in 1452, following Verrocchio's accidental killing of a woolworker, contrasts with the more general picture of an apparently uneventful, if busy, life. The assumption that this private man was a homosexual—denied by Cruttwell but supported by Sey-

mour—cannot be verified and largely originates from his relation with the young Leonardo. Three tax declarations from 1457, 1470, and 1480 suggest that Verrocchio devoted himself almost entirely to his art. Without a family of his own, his only concern was with his stepmother, Mona Nannina, his younger brother Tommaso, and later with the latter's unmarried daughters as well as with other unmarried nieces. A document dated 5 November 1490—a tribunal action in litigation involving Tommaso and Lorenzo di Credi—includes a list of articles left in Verrocchio's Florentine workshop: a lute, an Italian Bible, Franco Sacchetti's *Cento novelle*, Petrarch's *Trionfi* and Ovid's *Heroides*, and these attest to his intellectual pursuits. That Verrocchio was indeed a musician, or a lover of music, is confirmed by Vasari. Though his interests were varied, he was primarily a practical man and left no theoretical works. Unlike many of his fellow artists, Verrocchio did not take part in the public life of Florence and neither did he aspire to better his social standing. Despite his originality as an artist, he essentially appears as a master craftsman who plied his trade within the closed circle of his workshop. Seemingly as uninterested in wealth as he was in fame, he did not seek to develop his practice into a prosperous business establishment and made no investments in real estate, as did several of his competitors.

IV. Critical reception and posthumous reputation.

Although Verrocchio has always been considered one of the most renowned artists in 15th-century Florence, his achievements have been underestimated. He has been branded by posterity as Leonardo da Vinci's master, and the constant comparison of his style with that of his illustrious apprentice has impeded an accurate evaluation of his art. In his own lifetime, however, Verrocchio was a celebrated artist. In 1476 his bronze *David* was purchased from the Medici by the powerful members of the Florentine Signoria, for no less than 150 florins. They chose to exhibit it on the landing of the staircase in front of the Sala del Orologio in the Palazzo della Signoria (now the Palazzo Vecchio). Verrocchio's terracotta models were also prized, and in 1483 the same influential officers bought, for 40 ducats and 200 denari, the model that the artist had made of the figure of *St Thomas* for the bronze *Incredulity of Thomas* from the Tribunale di Mercanzia so as 'not to allow the sketch and source of so beautiful a work be damaged and perish' (Pope-Hennessy). Documents indicate that they decided to place this figure in the council chamber of the Università de' Mercantanti. Verrocchio's high reputation in the 1480s is also suggested by his influence on other artists; Perugino quoted the pose and gesture of Verrocchio's St Thomas in one of the apostles in his fresco *Christ Giving the Keys to St Peter* (Rome, Vatican, Sistine Chapel; *see* PERUGINO, fig. 1), as did Filippino Lippi in the *Virgin Enthroned with SS John the Baptist, Bernard, Victor and Zenobius* (completed 1486; Florence, Uffizi; *see* LIPPI, (2), fig. 1). Many copies of his sculptures were made, among them terracotta portrait busts of *Lorenzo de' Medici* (Boston, MA, Mus. F.A.; Washington, DC, N.G.A.) and of young boys (London, V&A; Berlin, Bodemus.) or stucco reliefs of the *Virgin and Child* (Oberlin Coll., OH, Allen Mem. A. Mus.).

Nonetheless, Vasari's admiration for Verrocchio was tempered by his description of his style as 'rather harsh and somewhat coarse'. Since Vasari, there has been a growing tendency to compare him unfavourably not only with Leonardo but also with Donatello and his contemporary Antonio del Pollaiuolo. Thus Hartt described Pollaiuolo's style as 'easy' and 'vivacious', but Verrocchio's as 'more solemn' and 'clumsier'. Even those art historians of the 20th century who have crusaded on Verrocchio's behalf are not immune to this tendency. While emphasizing the versatility and novelty of his creations, Cruttwell praised him, above all, as the organizer of a workshop where greater and more gifted artists trained. Covi, while focusing on the important lessons that he had learnt in Venice, saw him as 'one of the earliest essential links in the transmission' to Florence of Venetian ideals. Because Verrocchio failed to complete several of his major projects and collaborated extensively with other artists, some scholars have tended to rob him of any independent contribution. His works are often divided into two categories: those recognized as superior and thus ascribed, at least in part, to Leonardo da Vinci, and those viewed as inferior or inadequate and thereby attributed to Lorenzo di Credi or to less skilled followers. Seymour attempted to destroy the idea of Verrocchio as a mere 'hyphen' or 'hinge' between two ages and two artistic centres. Nonetheless, an unbiased evaluation of Verrocchio's achievements remains to be made.

BIBLIOGRAPHY

EARLY SOURCES

P. Gauricus: *De sculptura* (Florence, 1504)
F. Albertini: *Memoriale di molte statue e pitture di Florentia* (Florence, 1510)
G. Vasari: *Vite* (1550; rev. 2/1568); ed. G. Milanesi (1878–85)
C. Frey, ed.: *Il libro di Antonio Billi esistente in due copie nella Biblioteca nazionale di Firenze* (Berlin, 1892)
C. von Fabriczy: 'Il codice dell'Anonimo Gaddiano [Magliabechiano] nella Biblioteca nazionale di Firenze', *Archv Stor. It.*, ser. 5, xii (1893), pp. 15–94, 275–334; repr. (Farnborough, 1969)
——: 'Andrea del Verrocchio ai servizi dei Medici', *Archv Stor. A.*, ser. 2, i (1895), pp. 163–76 [reprints of 1496 inventory made by Tommaso, with annotations]

GENERAL

EWA
J. Pope-Hennessy: *Italian Renaissance Sculpture* (Oxford, 1958, rev. 3/1986), pls 76–85, pp. 293–9 [with annotated bibliog.]
F. Hartt: *A History of Italian Renaissance Art: Painting, Sculpture, Architecture* (London, 1970, rev. 2/1987), p. 319

MONOGRAPHS

M. Cruttwell: *Verrocchio* (London, 1904) [includes documents]
L. Planiscig: *Andrea del Verrocchio* (Vienna, 1941)
G. Passavant: *Verrocchio: Sculptures, Paintings and Drawings* (London, 1969)
C. Seymour jr: *The Sculpture of Verrocchio* (Greenwich, CT, 1971)
P. Adorno: *Il Verrocchio* (Florence, 1991) [with bibliog.]
A. Butterfield: *The Sculptures of Andrea del Verrocchio* (New Haven and London, 1997)

VERROCCHIO AND LEONARDO

J. Thiis: *Leonardo da Vinci: The Florentine Years of Leonardo and Verrocchio* (London, 1913)
W. R. Valentiner: 'Leonardo as Verrocchio's Co-worker', *A. Bull.*, xii (1930), pp. 43–89
E. Möller: 'Leonardo e il Verrocchio: Quattro rilievi di capitani antichi lavorati per Re Mattia Corvino', *Rac. Vinc.*, xiv (1930–34), pp. 3–38
A. Bertini: 'L'arte del Verrocchio', *L'Arte*, xxxviii (1935), pp. 433–73
W. R. Valentiner: 'Two Terracotta Reliefs by Leonardo', *A. Q.*, vii (1944), pp. 2–22
A. E. Popham: *The Drawings of Leonardo da Vinci* (New York, 1945)

W. R. Valentiner: 'On Leonardo's Relation to Verrocchio', *Studies of Italian Renaissance Sculpture* (New York, 1950), pp. 113–78

G. Scaglia: 'Leonardo's Non-inverted Writing and Verrocchio's Measured Drawing of a Horse', *A. Bull.*, lxiv/1 (1982), pp. 32–44

D. A. Brown: *Leonardo da Vinci: Origins of a Genius* (New Haven and London, 1998)

SPECIALIST STUDIES

H. Mackowsky: 'Das Lavabo in San Lorenzo zu Florenz', *Jb. Kön.-Preuss. Kstsamml.*, xvii (1896), pp. 239–44

C. Gamba: 'Una terracotta del Verrocchio a Careggi', *L'Arte*, vii (1904), pp. 59–61

C. Sachs: *Das Tabernakel mit Andreas del Verrocchio Thomasgruppe an Or San Michele zu Florenz* (Strasbourg, 1904)

C. Gamba: '*La Risurrezione* di Andrea Verrocchio al Bargello', *Boll. A.*, xxv (1931–2), pp. 193–8

C. Kennedy, P. Bacci and E. Wildner: *The Unfinished Monument by Andrea del Verrocchio to the Cardinal Niccolò Forteguerri at Pistoia* (Northampton, MA, 1932)

L. Planiscig: 'Andrea del Verrocchios Alexander-Relief', *Jb. Ksthist. Samml. Wien*, vii (1933), pp. 89–96

W. R. Valentiner: 'Verrocchio's Lost Candlestick', *Burl. Mag.*, lxii (1933), pp. 228–32

E. Moller: 'Verrocchio's Last Drawing', *Burl. Mag.*, lxvi (1935), pp. 192–5

A. Lipinsky: 'Das Antependium des Baptisteriums zu Florenz', *Münster*, ix/5–6 (1956), pp. 133–45

C. A. Isermeyer: *Verrocchio und Leopardi: Das Reiterdenkmal des Colleoni* (Stuttgart, 1963)

D. A. Covi: 'Four New Documents Concerning Andrea del Verrocchio', *A. Bull.*, xlviii/1 (1966), pp. 97–103 [excellent documentary analysis]

G. Passavant: 'Beobachtungen am Silberaltar des Florentiner Baptisteriums', *Pantheon*, xxiv (1966), pp. 10–23

J. G. Phillips: 'The Lady with the Primroses', *Bull. Met.*, xxvii (1969), pp. 385–95

F. Cannon-Brookes: 'Verrocchio Problems', *Apollo*, xcix (1974), pp. 8–19

J. Clearfield: 'The Tomb of Cosimo de' Medici in San Lorenzo', *Rutgers A. Rev.*, ii (1981), pp. 13–30

D. A. Covi: 'Verrocchio and the Palla of the Duomo', *Art, the Ape of Nature: Studies in Honor of H. W. Janson*, ed. M. Barasch and L. Freeman Sandler (New York, 1981), pp. 151–69

——: 'Verrocchio in Venice', *A. Bull.*, lxv/2 (1983), pp. 253–73

D. A. Brown: 'Verrocchio and Leonardo: Studies for the Giostra', *Florentine Drawing at the time of Lorenzo the Magnificent: Papers from a Colloquium held at the Villa Spelman: Florence, 1992*, pp. 99–109

S. Bule, ed.: *Verrocchio and Late Quattrocento Sculpture* (Florence, 1992)

L. Dolcini, ed.: *Verrocchio's Christ and St Thomas: A Masterpiece of Sculpture from Renaissance Florence* (New York, 1992)

J. Eisler: 'Dans l'atelier de Verrocchio', *Bull. Mus. Hong. B.-A.*, 80–81 (1994), pp. 77–90, 183–91

B. P. Strozzi: 'An Unpublished Crucifix by Andrea del Verrocchio', *Burl. Mag.*, cxxvi/1101 (Dec 1994), pp. 808–15

L. Taylor-Mitchell: 'A Florentine Source for Verrocchio's Figure of *St Thomas* at Orsanmichele', *Z. Kstgesch.*, lvii/4 (1994), pp. 600–9

D. A. Covi: 'The Italian Renaissance and the Equestrian Monument', *Leonardo da Vinci's Sforza Monument Horse: The Art and the Engineering* (London, 1995), pp. 40–56

A. Butterfield: 'The Candelabrum by Andrea del Verrocchio', *Bull. Rijksmus.*, xliv/2 (1996), pp. 120–22

J. Fenton: 'Verrochio: The New Cicerone', *Leonardo's Nephew: Essays on Art and Artists* (New York, 1998), pp. 50–67

YAEL EVEN

Vespasiano da Bisticci (*b* ?Florence, *c.* 1421; *bur* Florence, July 1498). Italian bookseller, stationer (*cartolaio*) and writer. He was one of six children of Filippo (*d* 1426), a wool chandler, the eldest of whom, Jacopo (*d* 1468), became a successful doctor after partnering Bernardo Cennini (*b* 1415) as a goldsmith until *c.* 1446. Vespasiano himself recorded that he had no formal education in Latin; by 1434 he was already working for the stationer and binder Michele Guarducci, whose double shop was on the corner of the Via del Proconsolo, the centre of the Florentine book trade, opposite the Palazzo del Podestà (now the Bargello). Humanists such as Niccolò Niccoli,

the avid book collector, frequented the shop and encouraged Vespasiano in his studies. By the 1440s he was acting as a bookseller in his own right, although he did not become a partner in the shop until shortly before Guarducci's death in 1451. He exploited the commercial possibilities of manuscripts, especially of the classics and the Church Fathers, written and decorated in the new 'humanistic' style developed in Florence by Niccoli, Poggio Bracciolini and their circle. This was the result of having seen how much demand there had been for such books among the dignitaries and scholars who had assembled in Florence from all over Europe for the Council of Reunion between 1439 and 1443.

Vespasiano made his first known independent sale of a book in 1442, to Pietro Donato, Bishop of Padua; by 1444 he was organizing the transcription of Classical and other texts for the visiting Englishman William Gray, Bishop of Ely, and in 1445–6 Cosimo il Vecchio de' Medici entrusted him with important commissions for purchasing and binding books for the new library of S Marco. By 1446 he was being praised by Girolamo Aliotti, Abbot of SS Fiora e Lucilla at Arezzo, for his remarkable bibliographical knowledge, which shows that he had a more than local reputation. In the 1450s and early 1460s Vespasiano produced a great many luxury books in the new style for Cosimo's sons Piero and Giovanni and also worked for Alfonso I, King of Sicily and Naples (*reg* 1442–58), as well as for many lesser clients from Florence and outside. In the early 1460s, at Cosimo's request, he undertook to provide a new library for the Badia of San Domenico di Fiesole. The surviving accounts and manuscripts show that between April 1462 and June 1464 he provided at least 111 manuscripts, most but not all of them newly copied. Vespasiano's most important client for bespoke manuscripts in his later years was Federigo II da Montefeltro, Count and later Duke of Urbino. Vespasiano advised Federigo on the formation of his library and provided a large proportion, running into several hundreds, of the manuscripts that were newly produced for it between about 1465 and 1480. The most famous of these is the two-volume Urbino Bible (Rome, Vatican, Bib. Apostolica, MSS Urb. lat. 1–2), copied in humanistic script, completed in June 1478 by the French scribe Hughes de Comminelles and illuminated by a galaxy of the finest contemporary Florentine illuminators, led by Francesco d'Antonio del Chierico.

Vespasiano also produced copies of texts for which there was a heavy demand—Latin Classical and patristic texts, Greek texts in new humanist translations and works by contemporary humanists, especially Leonardo Bruni—to be sold ready-made in his shop to casual customers (a novelty at this time). These manuscripts were generally copied in humanistic script and given comparatively simple 'white-vine' decoration, sometimes including painted wreaths left blank in which the eventual purchaser could have his own arms painted. When one of these manuscripts was sold to a foreign client, such as the French cardinal Jean Jouffroy (1461–73) or the Englishman Robert Flemming (*c.* 1415–83), Proctor of the King of England at the Roman curia, Vespasiano had one of his scribes (rarely the original scribe of the manuscript) write in a note saying that Vespasiano had produced it. These advertisements,

anticipating printers' colophons, have been found in 14 manuscripts. Numerous other manuscripts have notes by owners recording their purchase from Vespasiano and several times, as in the Urbino Bible, scribes state that they were working for him. Most of the leading Florentine scribes and illuminators of his day worked for Vespasiano at one time or another as independent artisans, on a piece-work basis.

With the introduction of printing into Italy in 1465, Vespasiano's trade was particularly badly affected, especially since he apparently refused to sell printed books, unlike most of his Florentine contemporaries. Thus, probably late in 1478, soon after the Urbino Bible had been completed, he gave up his shop and withdrew to the family villa at Antella outside Florence to start a new career as a writer. In 1480 he referred to writing as 'a new thing to me and alien to my profession' but from then on he wrote steadily. The bulk of his best-known work, now generally known as the *Vite di uomini illustri*, was apparently composed over a number of years in the 1480s but was not published until the 19th century. There is one main manuscript (Bologna, Bib. U., MS. 1452), with many autograph additions and corrections, but there are also numerous small presentation manuscripts containing selections of lives sent by Vespasiano to such friends as Filippo Strozzi (the latest of these dates from *c.* 1497), or important single lives, such as the *Vita* of Federigo da Montefeltro, presented to his son Guidobaldo, Duke of Urbino, and the *Vita* of Vespasiano's great friend and mentor Giannozzo Manetti (1396–1459). The *Vite* are in Italian and Vespasiano repeatedly claimed only to be providing material for others to use in more formal lives in Latin. They are in essence reminiscences of his friends and former clients, ranging from King Alfonso I and Pope Nicholas V through cardinals, bishops and distinguished clerics to eminent and not so eminent Florentines. The writing is lively and disorganized, prejudiced and full of anecdotes but the text also includes valuable facts that have often been substantiated from other sources. Vespasiano was noted among his friends as a collector of the latest news. His Florentine *Vite* and other evidence show that he was a supporter of the *via di mezzo* ('the middle way') and that despite his great debt to and affection for Cosimo il Vecchio de' Medici he was very unhappy with developments under Cosimo's successors.

WRITINGS

Vite di uomini illustri (1480s; Bologna, Bib. U., MS. 1452); ed. A. Greco (Florence, 1970); Eng. trans. by W. G. Waters and E. Waters as *Renaissance Princes, Popes and Prelates: The Vespasiano Memoirs* (London, 1926/*R* New York, 1963)

BIBLIOGRAPHY

G. M. Cagni: *Vespasiano da Bisticci e il suo epistolario*, Temi e testi, xv (Rome, 1969)

A. Garzelli: *La bibbia di Federico da Montefeltro* (Rome, 1977)

A. C. de la Mare: 'New Research on Humanistic Scribes in Florence', *Miniatura fiorentina del rinascimento*, ed. A. Garzelli, i (Florence, 1985), pp. 395–600 [lists Vespasiano's MSS]

——: 'Vespasiano da Bisticci e i copisti fiorentini di Federico', *Federico di Montefeltro: La cultura*, ed. G. Cerboni Baiardi, G. Chittolini and P. Floriani, Europa delle corti. Biblioteca del Cinquecento, xxx (Rome, 1986), pp. 81–96

——: 'Vespasiano da Bisticci as Producer of Classical Manuscripts', *Medieval Manuscripts of the Latin Classics: Production and Use*, eds C.A. Chavannes-Mazel and M. M. Smith (Los Altos Hills and London, 1996), pp. 166–207

A. C. DE LA MARE

Vespucci. Italian family of merchants and patrons. The family originally came from Peretola, moving to Florence during the 14th century. They settled in the parish of S Lucia a Ognissanti, where they grew rich through trade and financial dealing. According to Vasari, at the end of the 15th century and in the first half of the 16th the Vespucci distinguished themselves as patrons. Simone Vespucci (*c.* 1438–1500), the Podestà of Monte S Savino, sponsored Andrea Sansovino at the beginning of his career, bringing him to Florence and providing for his artistic education. In his house near the Ponte Vecchio, he had a collection of Sansovino's drawings and modelli. The family also had a large house in Via de' Servi, bought in 1499 by Guidantonio Vespucci (1434–1501; not Giovanni Vespucci, as Vasari says), who commissioned decorations for his new rooms from Piero di Cosimo and Botticelli, an artist closely associated with the Vespucci. Piero di Cosimo painted Bacchanalian scenes with 'fauns, satyrs, woodland gods and putti and bacchanti' (Vasari). These works may perhaps be identified as the *Discovery of Honey* (Worcester, MA, A. Mus.) and the *Misfortunes of Silenus* (Cambridge, MA, Fogg). Botticelli painted 'very lively and beautiful figures' (Vasari), perhaps the scenes from the *Life of Virginia* (Bergamo, Gal. Accad. Carrara) and the scenes from the *Life of Lucrezia* (Boston, MA, Isabella Stewart Gardner Mus.).

For the Vespucci Chapel in the church of the Ognissanti, Domenico Ghirlandaio and Davide Ghirlandaio painted the fresco of the *Madonna of Mercy* (*c.* 1470–71), which includes members of the Vespucci family. Among them is Amerigo Vespucci (1451–1512), the famous explorer, who, according to Vasari, also appears in a drawing by Leonardo. In the same church Botticelli painted *St Augustine's Vision of the Death of St Jerome* (1480; see colour pl. 1, XIV1), and some scholars believe that it was Giorgio Antonio Vespucci (1434–after 1499), the tutor of Lorenzo di Pierfrancesco de' Medici, who procured for Botticelli the commission of the *Primavera* (*c.* 1478; Florence, Uffizi; *see* BOTTICELLI, SANDRO, fig. 2). Tradition has it that Simonetta Vespucci (1453–75), who married Marco di Piero Vespucci *c.* 1468, served as a model for the *Primavera* and for other works by the painter. Niccolò Vespucci (1474–*c.* 1535), the Cavaliere of Rhodes, was a man of culture and an art patron. In his house near the Ponte Vecchio, he was host to Ludovico Ariosto and later also to the young Vasari, whose artistic career he afterwards continued to sponsor. Niccolò was painted by Giulio Romano in one of the frescoes in the Sala di Costantino in the Vatican Palace, Rome.

BIBLIOGRAPHY

G. Vasari: *Vite* (1550, rev. 2/1568); ed. G. Milanesi (1878–85), iii, pp. 255, 311–12; iv, pp. 26, 141; v, pp. 510, 530; vii, p. 7

A. M. Bandini: *Vite di Amerigo Vespucci* (Florence, 1898), pp. 2–14, 67–94

R. Langton Douglas: 'The Contemporary Portraits of Amerigo Vespucci', *Burl. Mag.*, lxxxiv (1944), pp. 34–56

——: *Piero di Cosimo* (Chicago, 1946)

G. Arciniegas: 'Come nacque la Primavera', *Confer. Assoc. Cult. It.*, x (1963)

C. Rosselli del Turco: *I Vespucci* (Florence, 1985)

DONATELLA PEGAZZANO

Vetraio [Vetraro], **il** . *See* BEMBO, (3).

Vetri, Domenico (di Polo di Angelo) de' [Domenico di Polo] (*b* Florence, *c.* 1480; *d* Florence, *c.* 1547). Italian medallist and gem-engraver. Vasari stated that he was a disciple of the gem-engraver Giovanni delle Corniole (*c.* 1470–*c.* 1516), and it is known that he studied the same craft with Pier Maria Serbaldi da Pescia, whose atelier he entered in 1501. He appears to have spent his entire career as court medallist for Alessandro de' Medici (1510–37), 1st Duke of Florence from 1531 (e.g. 1534; Pollard, nos 321–2) and Cosimo I de' Medici (1519–74), Duke of Florence from 1537 and Grand Duke of Tuscany from 1569 (e.g. Pollard, nos 327–32). None of his works is signed, but a group of medals and several cameos and gems (e.g. *Head of Hercules*, Florence, Uffizi) have been attributed to him, after having been separated by de la Tour from the work of Francesco dal Prato. His medal showing a figure of *Florence* (Pollard, nos 332–32a) and, for Cosimo, another with the sign of *Capricorn* (1537; Pollard, no. 330) on the reverse serve as a basis for the attribution of others.

All of de' Vetri's medals were originally struck, either in bronze or silver, and are between 29 and 44 mm in diameter. In most of his surviving medals of the Medici, he established an official portrait and varied it with several interchangeable reverses, most commonly an allegorical figure derived directly from ancient Greek and Roman coinage. His portraits have the precision of the gem-cutter, but are not dry and lifeless, unlike many mint-struck pieces, and the reverses are well-balanced and delicate, though somewhat limited in invention.

BIBLIOGRAPHY
Forrer
H. de la Tour: 'Domenico di Polo, médailleur et graveur sur pierres fines du duc Alexandre de Médicis', *Procès-verbaux et mémoires, Congrès international de numismatique: Paris, 1900*, pp. 382–99
C. Johnson: 'Ancora sul "Corpus" di medaglie di Cosimo I de Medici', *Medaglia*, 14 (1977), pp. 7–28
K. Langedijk: *The Portraits of the Medici* (Florence, 1981), pp. 233–40, 495–500
G. Pollard: *Italian Renaissance Medals in the Museo Nazionale del Bargello*, ii (Florence, 1985), pp. 647–72

STEPHEN K. SCHER

Vicentino [Michieli], **Andrea** (*b* Vicenza, ?1542; *d* Venice, ?1617). Italian painter. He probably trained in Vicenza with Giambattista Maganza (*c.* 1509–86). His mature style, however, was largely dependent on his subsequent experience of the dominant stylistic idioms at Venice in the later 16th century. Those of Paolo Veronese, Jacopo Tintoretto, Jacopo Bassano and Palma Giovane were particularly influential. He arrived in Venice in the mid-1570s and registered in the Venetian painters' guild in 1583. In this period he assisted Tintoretto at the Doge's Palace in Venice, making significant contributions to the ceiling decorations in the Sala del Senato and Sala dello Scrutinio. In the latter, he painted a replacement for Tintoretto's *Battle of Lepanto* (destr. 1577), displaying considerable skill in his organization of a crowded composition through an all-dominant chiaroscuro. His style is closely dependent on Tintoretto, but his technique remains more literal, and his forms have a heavy, static quality closer to Veronese.

Vicentino's proven ability as a history painter subsequently won him further important state commissions. Paintings such as the *Arrival of Henry III at Venice* (*c.* 1593; Venice, Doge's Pal., Sala delle Quattro Porte) had an important documentary value for Vicentino's patrons, as a kind of visual proof that the event actually had occurred. He was also active as a religious painter, both at Venice and on the mainland. Such altarpieces as the *Madonna of the Rosary* (1590s; Treviso Cathedral), *God the Father with Three Theological Virtues* (1598; Gambarare) and *St Charles Borromeo* (*c.* 1605; Mestre) confirm that he played an important role in the renovation of provincial altars in accordance with the requirements of the Counter-Reformation. His style in this context is more closely dependent on the visionary luminism of the late styles of Tintoretto and Jacopo Bassano.

BIBLIOGRAPHY
C. Ridolfi: *Meraviglie* (1648); ed. D. von Hadeln (1914–24), i, pp. 147–9
Palladio e la Maniera (exh. cat. by V. Sgarbi, Vicenza, S Corona, 1980), pp. 130–35
P. Fantelli: 'Andrea Vicentino', *Da Tiziano a El Greco* (exh. cat., ed. R. Pallucchini; Venice, Doge's Pal., 1981), pp. 234–5
La pittura in Italia: Il Cinquecento, ed. G. Briganti (Milan, 1983), pp. 135, 190, 205, 214, 772

TOM NICHOLS

Vicentino, (Giuseppe) Niccolò (*b* Vicenza; *fl c.* 1540–*c.* 1550). Italian woodcutter and printer. He signed five chiaroscuro woodcuts, each after a different artist and all undated. Probably the earliest is a two-block woodcut of *Hercules and the Lion* (B. 119, 17) after Giulio Romano. *Cloelia* (B. 96, 5) after Maturino (*d* ?1528) or Giulio Romano, in three blocks, is still rather crudely cut and registered, and probably the next chronologically. A very cursive, elegant line manifests itself in subsequent works, such as *Ajax and Agamemnon* (B. 99,9) after Polidoro da Caravaggio, the *Sacra Conversazione with St Catherine* (B. 64, 23) after a design attributed to Camillo Boccaccino and *Christ Healing the Lepers* (B. 39, 15) after Parmigianino. An unsigned *Adoration of the Magi* (B. 30, 3) and *The Cardinal and the Doctor* (B. 144,6) can also reasonably be ascribed to him.

Vicentino's hand is doubtless one of several discernible in a large group of anonymous chiaroscuros based on designs by Parmigianino that may represent the products of a workshop supervised by Vicentino. Vasari related how Parmigianino had certain chiaroscuros cut by Antonio da Trento, and that many other designs were printed after the painter's death by 'Joannicolo Vicentino'. A group of ten small anonymous two-block chiaroscuros after silver-point drawings by Parmigianino (Chatsworth, Derbys; Windsor Castle, Royal Lib.; Florence, Uffizi) as well as the *Twelve Apostles* (B. 69, 1–70, 12), in which two cutting hands are visible, are presumably part of this output, along with about a dozen more anonymous chiaroscuros. That Vicentino had a workshop is further suggested by the fact that a large number of the Parmigianino drawings related to the chiaroscuros remained together and that Andrea Andreani seems to have acquired many of the blocks and reprinted them later in the 16th century.

BIBLIOGRAPHY
G. Vasari: *Vite* (1550, rev. 2/1568); ed. G. Milanesi (1878–85), v, p. 421
A. von Bartsch: *Le Peintre-graveur* (1803–21), xii
C. Karpinski: *Italian Chiaroscuro Woodcuts*, 48 [XII] of *The Illustrated Bartsch*, ed. W. Strauss (New York, 1983), pp. 26–7, 41, 85, 144, 150, 154, 182, 189

JAN JOHNSON

Vicentino, Valerio. *See* BELLI, VALERIO.

Vicenza. Italian city, capital of the province of the same name. It is situated in the Veneto at the foot of Monte Berico *c.* 65 km west of Venice. The city is best known as the home of Andrea Palladio, and it contains many examples of his work, including, just outside the city, the influential Villa Rotonda (begun 1565).

1. History and urban development. 2. Villa Rotonda.

1. HISTORY AND URBAN DEVELOPMENT. The history of Vicenza dates back to the Palaeo-Venetian culture associated with the ancient Euganean city of Este. Around the 1st millennium BC the first small settlement was established on the low alluvial hills where the River Astico, flowing from the north, joined the meandering course of the Retrone, which flowed from the south-west. This topography determined the future direction of Vicenza's urban development. At that time the Astico, which followed the course of the present Astichello, silted up to the north to form a huge lake, the Lacus Pusterlae; it is recalled in the name Laghetto given to the suburb that gradually grew up in the middle of the ancient basin. When Este had entered its final decline, the future city of Vicenza gradually consolidated its autonomy, only to be absorbed by the irresistible expansion of Rome in the mid-2nd century BC: situated on the Via Postumia, which also passed through Piacenza, Cremona and Verona, the settlement formed a link in the chain of communication between Genoa and the eastern outpost of Aquilea.

The Veicentinos are first mentioned in a Latin inscription of 135 BC, and between the last republican phase and the 2nd century AD the settlement was referred to as Vicetia. Later, in the 3rd and 4th centuries AD, this name alternated indiscriminately with Vicentia, by which it became exclusively known in the 5th century. From *c.* 200 to *c.* 150 BC Roman Vicenza was a small town limited to the hilltops, centred on the typical perpendicular axes of the *cardo* running north–south (now Contrà Porti del Monte and Contrà Pescheria) and the *decumanus* running east–west (now Corso Andrea Palladio), incorporating the urban section of the Via Postumia. In 89 BC Vicenza obtained its *ius latii*, and in 49 BC it became a *municipium*.

Rome left an indelible mark on Vicenza, especially in the street layout, which has never been substantially altered and which determined the city's development. Inside the perimeter, minor *cardines* and *decumani* subdivided the settlement into a precise rectangular grid. In 1954 a large three-branched covered passageway (cryptoporticus) was discovered under the new presbytery of the cathedral. Traces of Roman roads in that area had been known for a long time, and stone tablets and fragments of mosaic pavements had also been found there. Subsequent excavations under Palazzo Trissino–Baston (now the Residenza Municipale) have revealed the forum, adjacent to the *decumanus* on the south side. Other remains include those of a huge aqueduct at Lobia and of a theatre (1st–2nd century AD) in the Berga quarter, both of which were well known to the humanists of Vicenza and which Palladio studied in 1540–50.

In the 5th and 6th centuries Vicenza was devastated by successive barbarian raids and invasions by Lombards, Franks and Huns. More complete fortifications were built in the 10th and 11th centuries, which respected and expanded the original Roman plan of the city. The expansion was not extensive, however, taking in only the areas immediately adjacent, including the lowlands of the Isola to the east, as far as the banks of the Bacchiglione, and the quarter surrounding the Berga Theatre across the Retrone. Thus, the medieval radial scheme was grafted on to the ancient grid system. Today the walls are reduced to a few fragments, but the ring appears intact in the perspective map of Vicenza (the *Pianta Angelica*; Rome, Bib. Angelica; see fig. 1), made in 1580. Its route corresponded to the present Contrà Pedemuro S Biagio, Contrà delle Barche and Contrà Mura Pallamio.

After the stable period of Paduan rule, the dynamic Scaligeri became rulers of Vicenza (1311–87). The four centuries of peace (1404–1797) that the subsequent Venetian rule granted Vicenza proved exceptionally fruitful. From *c.* 1435–40, after a necessary phase of adjustment, the quality of building, both public and private, began to improve. The streets were adorned with residences, built in the Gothic style in clear imitation of Venice, beginning in the Barche quarter along the Bacchiglione, its river port in direct contact with ships arriving from Venice. The cultural influence of Venice was stronger and the results more striking than in any other city of the Veneto. The façades were decorated with polychrome frescoes, and the capitals of the pilasters on the mullioned windows were frequently gilded. Over the city towered the great Palazzo della Ragione (*c.* 1450–60), created by reconstructing and uniting the old Palazzo Vetus and Palazzo Communis. The walls were clad in marble, and at the north-eastern corner rose the 82 m Torre di Piazza.

Apart from rebuilding the cathedral (mid-15th century) and works at S Maria in Foro and the oratory of S Cristoforo for the church of S Chiara (*c.* 1450) in the Berga district, there was little in the way of ecclesiastical archi-

1. Vicenza, perspective plan known as the *Pianta Angelica*, pen and ink, 1.3×1.4 m, 1580 (Rome, Biblioteca Angelica)

tecture during this period. Little was done, either, to the city's fortifications; in fact, they subsequently remained more or less as established by the Scaligeri, apart from minor alterations to Porta Monte in order to enclose better the Berga district, and the addition of Porta S Bartolo (1435). The latter was an isolated outpost of the fortifications (see fig. 2) of the Pusterla quarter, which were never completed despite the commands (1508–9) of Bartolomeo d'Alviano. The emphasis on secular building in Vicenza continued throughout the 16th century, helped by the stay in the city of Pietro Lombardo from *c.* 1467 to 1474, when competent workshops were set up in Pedemuro S Biagio by skilled Lombard craftsmen, notably Bernardino da Milano (1477–1504), Tommaso da Milano (1475–1510), Tommaso's son Rocco da Vicenza (*fl* 1494–1526) and Giacomo da Porlezza.

An important role was played by the architect Lorenzo da Bologna, evidently a follower of Leon Battista Alberti, who was in Vicenza from 1476 to 1489. Under his influence, the rules of Renaissance architecture were grafted on to Late Gothic schemes in the city, for example Palazzo Arnaldi–Tretti and Palazzo Negri de' Salvi, and new architectural solutions were tried, for example Palazzo Thiene (*c.* 1489; *see* LORENZO DA BOLOGNA) in Contrà Porti by Lorenzo himself. Old houses were embellished with elegant portals in response to the new fashion, which found exuberant expression in the altars of churches, for example the Garzadori Altar in S Corona. A typical case is the altar (destr. 19th century) of S Bortolo, which began to be updated in 1447; it incorporated local sculpture by the Pedemuro workshops and paintings by BARTOLOMEO MONTAGNA and his followers.

In the 16th century Vicenza's tenacious aspiration towards civic perfection, encouraged by the cultural leadership of GIANGIORGIO TRISSINO, took a decisive turn with the revival of classicism. In fact it was through Trissino's patronage that this tendency was consolidated, thanks to the professional skills of Andrea di Pietro della Gondola, who in 1523–4 moved from Padua to the workshop of the Pedemuro craftsmen of Vicenza, and who from 1538–40 worked independently under the name Palladio, which was bestowed on him by Trissino (*see* PALLADIO, ANDREA). Palladio's structures 'alla Romana', erected to celebrate the entrance into the city of Bishop Ridolfi in September 1543, were in anticipation of the ideal Vicenza; after only a few minor experiments, the style passed from the status of ephemeral decoration to that of permanent construction. In addition to the loggias around the Palazzo della Ragione (also known as the Basilica; 1548; *see* PALLADIO, ANDREA, fig. 3) and the Loggia del Capitaniato (early 1570s), both public buildings, Palladio undertook many important projects for private clients, to be fitted into the urban fabric of the city in the course of four decades, along with lesser but similar initiatives (*see* PALLADIO, ANDREA, figs 2 and 6). The intention was to set up a masterfully varied series of model examples of classical orthodoxy, without altering the rectangular Roman street plan. Though strikingly successful, the results of this comprehensive programme were only partial. Nevertheless, while the ideal city was never actually built, the vision was realized in the Teatro Olimpico (1580), designed by Palladio for the Accademia Olimpica. There, the ideal city was represented in the scenery created by Vincenzo Scamozzi for the opening

2. Vicenza, view from the slopes of Monte Berico showing the fortifications; detail from an altarpiece by Marcello Fogelino: *Madonna of the Stars*, oil on canvas, *c.* 1525 (Vicenza, S Corona)

performance (*Oedipus rex*; 1585), which presented, in the guise of Boiotian Thebes, the dream of Vicenza. It thus had the character of a paradigm, and therefore the stage set was not dismantled after the event but was permanently preserved.

BIBLIOGRAPHY

G. Mantese: *Memorie storiche della chiesa vicentina*, 5 vols (Vicenza, 1952–82)
F. Barbieri, R. Cevese and L. Magagnato: *Guida di Vicenza* (Vicenza, 1953, rev. 1956)
E. Arslan: *Catalogo delle cose d'arte e di antichità d'Italia: Vicenza: Le chiese* (Rome, 1956)
Illuministi e Neoclassici a Vicenza (Vicenza, 1972), pp. xi–xvi
E. Franzina: *Vicenza: Storia di una città, 1404–1866* (Vicenza, 1980)
F. Barbieri: *Vicenza: Storia di una avventura urbana* (Milan, 1982)
——: *Vicenza, città di palazzi* (Milan, 1987)
Storia di Vicenza, 3 vols (Vicenza, 1987–90)

FRANCO BARBIERI

2. VILLA ROTONDA. South-east of Vicenza is the famous suburban villa (also known as the Villa Rotunda, Villa Almerico–Valmarana or Villa Capra) that was designed by Andrea Palladio (*see* PALLADIO, ANDREA, fig. 5) for Cardinal Paolo Almerico, a Referendary to Pope Pius IV. Almerico and his father had purchased land in the area of the Valle Silenzio from 1533, and circumstantial evidence suggests building of the villa was begun *c.* 1565–6. The interior decoration was under way in the 1570s, although the villa was not fully completed at the time of Palladio's death in 1580.

The villa is attractively located in the countryside outside Vicenza, but Palladio nonetheless included the villa among his designs for city palazzi. He described the site in terms of the charm of the landscape and its vistas

> upon a gently sloping hilltop flanked on one side by the navigable Bacchiglione River, from the other it is surrounded by other pleasant hills which resemble a large theatre Therefore, because it enjoys beautiful vistas from every side, some of which are near by, others more distant, others that reach the horizon, loggias have been made on all four façades.

This setting is usually considered the determining element of the quadrilateral symmetry that characterizes the design of the villa.

The interior rooms of the villa are arranged around a central two-storey rotunda. The villa is remarkable for its four identical façades, marked by pedimented porticos and flights of steps leading up from the ground-level. The whole unit is surmounted by a low stepped dome, a form usually associated with antique or religious architecture and introduced by Palladio to villa design here for the first time. The dome was executed to Palladio's design by Vincenzo Scamozzi, who claimed to have completed the building after Palladio's death. The main north-west entrance is accentuated by the addition of two statues on the pedestals flanking the approach staircase. Palladio named Vincenzo Rubini (*fl* 1550–60) as the sculptor responsible. Figures on the angles of the pediments on all fronts were added by Giovanni Battista Albanese in 1606. The regularity of the design of the villa represents a fulfilment of Palladio's theories of ideal form and proportion, even though he had already prepared a similar plan for the unexecuted Villa Trissino at Meledo. The villa as built differs from the illustration in Palladio's *I quattro libri dell'architettura* in both plan and elevation: the central vault

is lower, windows and doors have been given frames, and the four passages leading to the central rotunda are not all of equal width.

The interior rooms of the main floor contain stucco chimney-pieces, elegant stucco cornices and compartmented ceilings incorporating large figurative frescoes with small-scale grotesques (*c.* 1599–1600) attributed to Anselmo Cavera, Alessandro Maganza and his son. Figural stuccowork is attributed to Ottaviano Ridolfi (*fl* 1567–92) and Agostino Rubini. The walls of the four axial halls leading to the central rotunda were frescoed *c.* 1695–1705 by Louis Dorigny.

The unusual planning of the villa together with its representation in *I quattro libri* have made it one of the most famous villas ever built. Consequently, it has provided a source for many imitations, notably Vicenzo Scamozzi's Rocca Pisana (1576), Lonigo (*see* SCAMOZZI, (2), fig. 1), and, in England, Mereworth Castle (1722), Kent, by Colen Campbell (1676–1729), and Chiswick House (1725), near London, by Richard Boyle, 3rd Earl of Burlington (1694–1753).

BIBLIOGRAPHY

C. Rowe: 'The Mathematics of the Ideal Villa: Palladio and Le Corbusier', *Archit. Rev.* [London], ci (1947), pp. 101–4; repr. with addendum in C. Rowe: *The Mathematics of the Ideal Villa and Other Essays* (Cambridge, MA, 1976), pp. 1–27
W. Lotz: 'La Rotonda: Edificio civile con cupola', *Boll. Cent. Int. Stud. Archit. Andrea Palladio*, iv (1962), pp. 69–73; Eng. trans. in W. Lotz: *Studies in Italian Renaissance Architecture* (Cambridge, MA, 1977), pp. 190–96
J. Ackerman: *Palladio's Villas* (Locust Valley, NY, 1967), pp. 68–72
C. A. Isermeyer: 'Die Villa Rotonda von Palladio', *Z. Kstgesch.* (1967), pp. 207–21
C. Semenzato: *La Rotonda di Andrea Palladio*, Corpus Palladianum, i (Vicenza, 1968; Eng. trans., 1969)
C. M. Sicca: 'La fortuna della Rotonda', *La Rotonda: Novum corpus Palladianum* (Milan, 1988), pp. 169–204
La Rotonda, Centro Internazionale di Studi di Architettura 'Andrea Palladio' di Vicenza (Milan, 1988)
B. Boucher: *Palladio* (Tosino, 1994), pp. 390–99

CAROLYN KOLB

Vico, Enea (*b* Parma, 29 Jan 1523; *d* Ferrara, 18 Aug 1567). Italian engraver. He trained in Parma and by 1541 was in Rome, where he became a pupil of Tommaso Barlacchi (*fl* 1527–42). In 1541–2, in collaboration with Barlacchi, he produced his first work, a series of 24 engravings with grotesque decorations in imitation of antique paintings (B. 467–90). In Rome, Vico was also influenced by the printmakers Agostino dei Musi, Antonio Salamanca and, above all, Marcantonio Raimondi. Vasari recorded that in 1546, following a short period in Florence, where he made engravings for Grand Duke Cosimo I de' Medici after works by Michelangelo, Vico applied to live in Venice. He remained there until 1563, when he was summoned to the court of Alfonso II d'Este, Duke of Ferrara, where he lived until his death.

About 500 prints by Vico are recorded. Notable among his single engravings are those based on Michelangelo's *Leda and the Swan* (B. 26) and on his *Judith and Holofernes* (1546; B. 1) and the *Prophet Isaiah* (B. 11) from the frescoes in the Sistine Chapel (Rome, Vatican). Many of his prints are after Raphael, including those of the *Annunciation* (B. 2), *Entombment* (1543; B. 7), *Lamentation* (1548; B. 8), *Tarquinius and Lucretia* (B. 15) and the *Toilet of Venus*

(1546; B. 19). He also made engravings after Parmigianino, for example *Lucretia* (B. 17), *Mars and Venus* (B. 21, 27), *Woman Spinning* (B. 39) and *Proserpina Turning Ascalaphus into an Owl* (B. 45), as well as after Raimondi (B. 4, 6, 16, 36, 37), Titian (B. 3), Perino del Vaga (B. 25, 38, 46), Rosso Fiorentino (B. 30) and Francesco Primaticcio (B. 31). Vico's engravings of the *Academy of Baccio Bandinelli* (B. 49; *see* ITALY, fig. 42), showing a group of artists working by candle-light, was based on a work by Bandinelli, and his *Rhinoceros* (1548; B. 47) on one by Albrecht Dürer (1471–1528). Series of engravings by Vico include 42 allegorical figures after Francesco Salviati (B. 50–91), 8 depictions of ancient Greek philosophers (B. 92–9) and 99 of ethnic costumes (B. 134–232). Among his portraits, that of *Cosimo I de' Medici, Grand Duke of Tuscany* (B. 239), the two of *Henry II, King of France* (B. 247, 250) and the two of *Charles V, Holy Roman Emperor* (B. 251, 255) are particularly noteworthy; the *Army of Charles V Crossing the Elbe* (B. 18) is a tumultuous, oval landscape with a great number of figures, surrounded by allegorical female forms and animals.

Vico's interest in antiquity, particularly medals and engraved gems, made him important as a scholar. He made prints of antique statues in the collection of Cardinal Andrea della Valle in Rome in 1541 (B. 42–4). He produced 85 prints after ancient medals in *Le imagini con tutti i riversi trovati et le vite degli Imperatori tratte dalle medaglie e dalle historie degli antichi* (1548, 2/1554; B. 322–406) and

63 portraits of empresses in its companion volume, *Augustarum imagines* (1557, 2/1558; B. 257–319). In 1560 he made ten prints with medals of *Julius Caesar* (B. 407–16), and in 1567 an engraving of the *Column of Antonius and a Roman Obelisk* (Vienna, Albertina; see fig.). His *Ex antiquis cameorum et gemmae delineata* consists of 34 prints after antique gems and cameos (B. 100–133); he also made engravings of antique friezes (B. 455–66), candlesticks (B. 491–4), vases (B. 420–33) and trophies (B. 434–49). Vico's work is of inestimable value for identifying ancient works of art, particularly gems and cameos.

BIBLIOGRAPHY

Thieme–Becker

G. Vasari: *Vite* (1550, rev. 2/1568); ed. G. Milanesi (1878–85), v, pp. 427–31

A. von Bartsch: *Le Peintre-graveur*, xv (1813), pp. 273–370 [B.]

J. D. Passavant: *Le Peintre-graveur*, vi (Leipzig, 1864), pp. 121–4

Fortuna di Michelangelo nell'incisione (exh. cat., ed. M. Rotili; Benevento, Mus. Sannio, 1964), pp. 62–4, fig. 16

Mostra di stampe popolari venete del '500 (exh. cat., ed. A. Omodeo; Florence, Uffizi, 1965), pp. 46–7, no. 41 (1–24); p. 57, figs 35–42

E. Lemburg-Ruppelt: 'Der Berliner Cameo des Dioskurides und die Quellen', *Röm. Mitt.*, xci (1984), pp. 89–113

O. J. Neverov: 'La serie dei "Cammei e gemme antichi" di Enea Vico e i suoi modelli', *Prospettiva* [Florence], xxxvii (1984), pp. 22–32

C. HÖPER

Vidolenghi, Leonardo (*b* Marzano, Pavia; *fl* 1446–1501). Italian painter. In 1462 he witnessed a document in Pavia concerning Vincenzo Foppa. The only work attributable with certainty to Vidolenghi is a fresco on a pilaster representing the *Virgin and Child with SS Lucius and Lucy* in the church of S Maria del Carmine, Pavia; signed and dated 1463, it shows that he had become at least partly familiar with Foppa's artistic innovations. It testifies not only to the strength of his Pavian background but also to his contacts with the stained-glass masters of Milan and Pavia. This is confirmed by a document of 1463, probably concerning the execution of a window, which mentions a previous commission that he undertook with Bassiano Benlafaremo (*fl* 1463–71), for the church of S Tecla (later S Agostino), Genoa.

In spite of this definite link with Liguria, scholars have tended to reject the identification of Vidolenghi with the Leonardo da Pavia who signed and dated the *Virgin and Child with Saints* (1466; Genoa, Pal. Bianco), a work that is still clearly related to the Late Gothic culture of Bonifacio Bembo and other Lombard painters of the period. Before 1476 Vidolenghi painted a *Maestà* (untraced) for the church of S Giorgio de' Catassi, Pavia. In 1490 he was among the group of various artists called to Milan to decorate the Sala della Balla of the Castello Sforzesco for the wedding (1491) of Ludovico Sforza, Duke of Milan, and Beatrice d'Este. Tanzi attributed to Vidolenghi the *Virgin and Child with SS Julius and Anthony Abbot* (Pavia, S Maria del Carmine) and the frescoed polyptych on the inside wall of the façade of S Pietro in Ciel d'Oro, Pavia.

BIBLIOGRAPHY

C. J. Ffoulkes and R. Maiocchi: *Vincenzo Foppa of Brescia, Founder of the Lombard School: His Life and Work* (London and New York, 1909), pp. 21–2, 37–8, 239–40, 256

F. Malaguzzi Valeri: 'Maestri minori lombardi del quattrocento', *Ant. Viva*, xi (1911), pp. 199–200

R. Maiocchi: *Codice diplomatico di Pavia dall'anno 1330 all'anno 1550*, 2 vols (Pavia, 1937–49)

F. Mazzini: *Affreschi lombardi del quattrocento* (Milan, 1965), pp. 450–51

Enea Vico: *Column of Antonius and a Roman Obelisk*, engraving, 536×324 mm, 1567 (Vienna, Graphische Sammlung Albertina)

M. Tanzi: 'Da Vincenzo Foppa al Maestro delle Storie di Sant'Agnese (1458–1527)', *Pittura a Pavia dal romanico al settecento*, ed. M. Gregori (Milan, 1988), pp. 76–7

VITTORIO NATALE

Vignola, Jacopo [Giacomo] **(Barozzi da)** (*b* Vignola, 1 Oct 1507; *d* Rome, 7 July 1573). Italian painter, architect and theorist. Following three decades of diversified and mainly collaborative artistic activity, he emerged in the 1550s as the leading architect in Rome after Michelangelo and was in papal service for over three decades. His masterpieces (notably the Villa Farnese at Caprarola and the church of Il Gesù in Rome) were produced as house architect to the wealthy and powerful Farnese family. In an era of experimental and sometimes dramatically personal styles, his palaces, villas and churches manifested a cool and methodically reductive classicism that became a model of orthodoxy for a generation of architects during the Counter-Reformation. His *Regola delli cinque ordini d'architettura* (1562), a concise illustrated tract on the five orders (see fig. 1), enjoyed immense popular and academic success throughout Europe and was the most influential book on classical architecture until the advent of Modernism.

1. Life and work. 2. The treatises.

1. LIFE AND WORK.

(i) Early work, before 1543. (ii) Bologna, 1543–*c*. 1549. (iii) Late work, after *c*. 1549.

(i) Early work, before 1543. Vignola was born to a family of artisans: although the occupation of his father Barto-

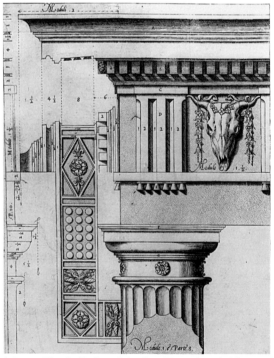

1. Jacopo Vignola: Doric capital and entablature from the Theatre of Marcellus (13 or 11 BC), Rome; from his treatise *Regola delli cinque ordini d'architettura* (Rome, 1562), pl. XIII

lomeo is unknown, one brother, Guarnerio (*b c.* 1510; *d* before 1 Sept 1564), was a painter while another, Giovanni Angelo (*fl c.* 1550–?1570) was, apparently, a stone-carver. According to his earliest biographers Giorgio Vasari and Ignazio Danti, Jacopo was sent as a youth to Bologna, where he was apprenticed to an unnamed painter. Poorly taught, he was unable to win much success in painting and so turned to the study of architecture and perspective. This change of direction may have been encouraged by the example of the painter-architects Baldassare Peruzzi and Sebastiano Serlio, both of whom were in Bologna during the early 1520s and profoundly affected Vignola's architectural thought. Indeed, he seems to have worked for Peruzzi, for his name appears on a list of assistants on the back of an undated drawing by the older master (Florence, Uffizi, MS. A., fol. 104*v*). It is possible that Vignola executed architectural designs at this time (the dovecote of the Villa Isolani at Minerbio, nr Bologna, 1536, may be his work), but the only sure evidence of his activity comes from the pictorial arts. For Francesco Guicciardini, Papal Governor of Bologna (1482–1540), he produced perspectival compositions, which Fra Damiano Zambelli da Bergamo (1480–1549) translated into coloured wood intarsia panels, such as the *Finding of Moses* (1534; New York, Met.). Vignola was married *c.* 1530. He had three sons, Bartolomeo Barozzi (*b* Bologna, 1532), Giacinto Barozzi (*b* ?Bologna, *c.* 1534; *d* after 1 July 1584), who became an architect and theorist, and assisted his father in numerous projects, and Luigi Barozzi (*b* Bologna, 1535).

In the late 1530s Vignola moved to Rome, where he supported his family as a painter and draughtsman in a series of collaborative enterprises that brought him significant architectural experience. In November 1538 he is recorded in the Vatican as a painter of furniture and banners in association with the Ferrarese architect Jacopo Melighino, who was a favourite of Paul III. Melighino worked with Antonio da Sangallo the younger at St Peter's and elsewhere, and Vasari stated that Vignola assisted him as a designer. In February 1541 he collaborated with Perino del Vaga on the construction and decoration of theatre sets for a performance of Niccolò Machiavelli's *Clizia* at the Palazzo Farnese. About this time Vignola became involved with the Accademia della Virtù, a private society of intellectuals led by Claudio Tolomei, which planned to publish a definitive annotated and illustrated edition of Vitruvius. The Accademia, Vasari reported, employed Vignola 'to measure thoroughly all of the antiquities of Rome'. Although this ambitious project never came to fruition, its impact on the artist was substantial for not only did it engage him in a systematic study of ancient architectural remains and expose him to a thoroughly up-to-date critical reading of Vitruvius, it also introduced him to a circle of influential patrons. At the age of 33 the provincial painter was qualified to receive major architectural assignments and in March 1541 Paul III appointed him architect of the basilica of S Petronio in Bologna.

Before taking up this post, however, Vignola fulfilled obligations that he had undertaken with Francesco Primaticcio for Francis I, King of France (*reg* 1515–47). In 1540 Primaticcio was commissioned to produce bronze

copies of famous antique Roman statues to decorate the royal château of Fontainebleau. He engaged Vignola to supervise the making of plaster moulds of ten works in the papal collection of the Belvedere. In the summer of 1541 Vignola travelled to France, where, receiving a monthly stipend of 20 livres, he helped to direct the casting operation until its completion in 1543. Only five of the bronzes survive—the *Apollo Belvedere*, *Ariadne*, *Knidian Venus*, *Commodus as Hercules* and the *Laokoon* (Fontainebleau, Château). The royal account books refer to Vignola as a painter and Danti stated that he furnished Primaticcio with perspective designs for pictorial decorations at Fontainebleau, although no convincing attributions have been made. Similarly, Vasari claimed that Vignola was taken to France to assist with architectural projects, but his achievements there remain a matter of conjecture.

(ii) Bologna, 1543–c. 1549. In September 1543 Vignola presented himself to the Fabbricieri (Board of Trustees) of S Petronio in Bologna and became architect of the civic basilica (*see* BOLOGNA, §IV, 2). He shared the position with Jacopo Ranuzzi (*d* 1549), an undistinguished local architect who had political backing: from the outset there were bitter hostilities between the two men. The principal task at this time was to decorate the façade in stylistic harmony with the Gothic church. On 17 December 1543 Vignola submitted a lengthy critique of earlier designs, including Ranuzzi's, and the following year he drafted his own proposal, of which two variations are known (Bologna, Mus. S Petronio). His project (see fig. 2) insists on the Classical orders as an indispensable element of architectural composition. The façade is treated as a flat plane articulated by a grid of Corinthian pilasters and entablatures corresponding to the widths and heights of the interior chapels, aisles and nave. Overtly Gothic elements, such as pointed arch windows, gables with tracery and pinnacles, are rigorously subordinated to Vitruvian logic.

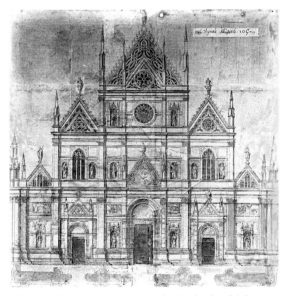

2. Jacopo Vignola: proposed design for the façade of S Petronio, Bologna, pen and ink, 1544 (Bologna, Museo di San Petronio)

He presented his façade drawings to Paul III during one of several visits to Rome in 1545 and, according to Danti, they received a written commendation from Giulio Romano. Nevertheless, his project was not endorsed by the Fabbricieri and Ranuzzi's criticism compelled Vignola to compose a detailed defence on 1 February 1547. Within days Alessandro Manzuoli, an associate of the now defunct Accademia della Virtù in Rome, recommended Vignola's talents in a letter (Parma, Archv Stato) to Pier Luigi Farnese, 1st Duke of Parma and Piacenza, with the lament that 'such a fine mind may be lost if not kept continuously exercised'.

Frustrated at S Petronio, Vignola took on a variety of private and public commissions in Bologna during the late 1540s. The eccentric Palazzo Bocchi, begun in 1545 but altered within a decade and never finished, is ascribed to him by Danti with the observation that he was 'following the disposition [*l'humore*] of the patron'. The philosopher and humanist Achille Bocchi (1488–1562) intended the building as the practical and emblematic home of a private academy. For the façade (the initial design of which is recorded in an engraving, 1545; priv. col., see Schmidt, p. 84), Bocchi produced a sculptural programme as well as the unusual selection of inscriptions in Hebrew (Psalm 120:2) and Latin (Horace: *Epistles* I:i). He undoubtedly encouraged the slightly incongruous mixture of architectural motifs derived from Sangallo, Serlio and Giulio Romano. In 1547 Vignola built an innovative columnar portal in the courtyard of the Palazzo Comunale and a bridge (destr.) over the River Samoggia on the Via Emilia. The bridge, known from a drawing submitted to the municipal authorities (Bologna, Archv Stato), had piers pierced by round openings, like that of the Ponte Sisto in Rome, and three arches shaped inventively as half-ovals. On 5 May 1548 he signed a contract for the rehabilitation of the Canale Navile, the navigable waterway connecting Bologna with the River Po. This important and successful piece of civil engineering entailed the excavation of *c.* 6 km of channel between Bologna and the village of Corticella; he constructed three locks, one of which was elliptical, and laid out the urban port.

Vignola was awarded Bolognese citizenship on 1 February 1549 but soon he had little reason to remain in the city. In July the Fabbricieri began to pressure him to relinquish his post at S Petronio and in November the death of Paul III deprived him of papal support. Vasari claimed, moreover, that Vignola was very poorly rewarded for his work on the Canale Navile. It is little wonder that around this time he welcomed the patronage of Cardinal Marcello Cervini (later Pope Marcellus II; *reg* 1555), another former member of the Accademia della Virtù, for whom he produced a set of working drawings (Berlin, Kstbib.) for a fortified villa (not executed) featuring a circular courtyard. Towards the end of 1549 or in early 1550 Vignola left Bologna for Rome.

(iii) Late work, after c. *1549.*

(a) Papal commissions. (b) Farnese family commissions.

(a) Papal commissions. Vignola settled permanently in Rome and soon entered papal service. His first major work

was the Villa Giulia (Villa di Papa Giulio; 1551–5) or, more precisely, its *casino* (see fig. 3). Located above the Via Flaminia just outside the Porta del Popolo, the villa suburbana consists of a small U-shaped palace, the *casino*, to which is attached a rectangular walled garden court terminating in a loggia and a sunken neo-antique nymphaeum. The complex was built for Julius III and apparently conceived by Vasari in consultation with Michelangelo in the winter of 1550; Vignola is recorded at work there from February 1551 until March 1555. From a lost master-plan attributable to him, it is known that two arcaded wings were to have extended laterally from the *casino* and the garden court was to have been lozenge-shaped. These remarkable features were discarded soon after construction began and in 1552 Bartolomeo Ammanati was commissioned to redesign much of the court and nymphaeum. Apart from assisting in hydraulic work for the fountains, Vignola was concerned only with the construction and decoration of the *casino*.

The building's two-storey façade was innovative for its rational integration of all parts into an expressive unit. Divided vertically into thirds by pilasters—rusticated Tuscan below, Composite above—the façade is dominated physically and symbolically by the centre, where the arched entrance portal is framed by engaged columns and by niches in a variation of the triumphal arch motif. This motif is repeated on the *piano nobile* by a central balcony, suitable for papal appearances, flanked by niche-windows. The entrance leads to an elegant Corinthian room that gives on to the barrel-vaulted, semicircular arcade embracing the garden court. The court façade is dominated by pilasters, with the Composite order carried over from the front on the *piano nobile*, and the Ionic order on the ground floor in triumphal arches derived from Bramante's upper Corte di Belvedere court in the Vatican (see colour pl. 1, XVI1). Two colonnades in a minor order with flat entablatures inserted between the triumphal arch units subtend long rectangular fields for painted decoration.

The little church of S Andrea (1551–3) on the Via Flaminia was also commissioned by Julius III. Free from collaborative constraints, in S Andrea Vignola realized a work with powerful theoretical implications. In terms of scale and function it is little more than a wayside chapel

for pilgrims, but like the Old Sacristy at S Lorenzo, Florence (1419–28; *see* BRUNELLESCHI, FILIPPO, figs 2–3), or the Tempietto, Rome (after 1502; *see* BRAMANTE, DONATO, fig. 4), S Andrea addressed the practical and intellectual concerns of an epoch. The church is rectangular in plan with a projecting altar room opposite the entrance. The interior walls are subdivided by Corinthian pilasters, above which rise warped pendentives carrying an oval cornice and dome. By effectively uniting an oblong space focused on the altar with a dome that extends over the entire nave, Vignola succeeded in reconciling the traditional liturgical demand for axiality with the humanistic ideal of centrality. S Andrea was the first church to employ an oval dome, a feature that won great favour in the 17th century. The façade, which ingeniously recalls the Pantheon in Rome, has Corinthian pilasters, disposed outwardly in diminishing intervals in order to accentuate the centre, carrying a pediment set into a flat wall of brick before an oval drum capped by a stepped dome.

As papal architect, Vignola received commissions for diverse projects in Rome and the Papal States. In 1552 he directed construction inside the Vatican Palace. He provided plans for the Castellina, Norcia (1554–64), a diminutive but finely executed square fortress with angle bastions. It was probably for Julius III that Vignola developed a highly original project (not executed) for the church of S Giovanni dei Fiorentini in Rome. Known only from drawings by other artists, it centred on an oval nave ringed by a continuous aisle with shallow radiating chapels. Fronted on the street by a porch, the exterior had Doric half columns, an attic with 12 obelisks and buttresses surrounding a high fenestrated drum, and a ribbed oval cupola crowned by an ornate, windowless lantern. Considered within the long planning history of this building, involving Jacopo Sansovino, Antonio da Sangallo, Baldassare Peruzzi and Michelangelo, Vignola's plans represent a unique synthetic response to the problem of longitudinal versus centralized designs.

After the death of Julius III in 1555, Vignola worked in Perugia, where he designed a chapel (destr.) for the church of S Francesco and advised on Vincenzo Danti's bronze portrait statue of *Julius III* (1555; Perugia Cathedral). Ignazio Danti credits Vignola with buildings for Marchese Ascanio della Corgna in the Umbrian towns of Castiglione del Lago and Città della Pieve. The pontificate of Marcellus II was too brief to occasion building commissions, but Vignola's creative energies were exploited extensively by Pius IV. On the death of Michelangelo, Pius IV appointed Vignola as fellow architect of St Peter's with Pirro Ligorio, whose early departure left Vignola in charge from 1567. His attention was focused on the execution of Michelangelo's plans and virtually none of the present basilica was actually conceived by him (*see* ROME, §V, 1(ii)(a)).

During the 1560s Vignola was prolific as a church designer in Latium and Rome. Just outside Capránica di Sutri he built the church of S Maria del Piano (1559–65) with a simple box-like exterior and a pedimented Ionic façade. Until its partial collapse and reconstruction in the 17th century, the nave was oblong, with a cube of space covered by a cupola at the centre and exedrae at either end. He also planned the small parish churches of Mazzano Romano (*c*. 1567; destr. after World War II) and S Lorenzo,

3. Jacopo Vignola: façade of the Villa Giulia, Rome, 1551–5

Sant'Oreste al Soratte (1568), which has an aisleless vaulted Doric nave with side chapels. For the collegiate church at Fara in Sabina he produced the elegant marble tabernacle (1563) in the form of a domed peripteral tempietto. Elsewhere he provided a fountain model for Viterbo (1566) and dispensed drawings and expertise for work on the communal palaces of Rieti (1563), Cittaducale (1569), Velletri (1572) and Camerino (1573).

At the Vatican Vignola laid out a conclave chapel in the Belvedere (1559 or 1565) and probably built the chapel of St Pius V in the Torre Pia (1566–72), both on oval plans. The most inventive and influential of these modest ecclesiastical structures was the confraternal church of S Anna dei Palafrenieri (1565–76) at the Vatican. Vignola's son Giacinto directed construction there from 1565 to 1574. The plan puts an oval nave within a rectangular shell, reserving the four residual corner spaces for service functions. Eight embedded columns with alternating wide and narrow intercolumniations encircle the central space. Here Vignola resolutely abandoned the High Renaissance preference for simple, geometrical shapes and the ideal of providing legible mutual relationships between interior and exterior. Although it was only vaulted in the 18th century, S Anna must be counted as an inspirational model for the dynamic centralized churches of such early Baroque masters as Gianlorenzo Bernini (1598–1680), Francesco Borromini (1599–1667) and Carlo Rainaldi (1611–91). In June 1572 Vignola presented Gregory XIII with a masterplan for the church of the Escorial (Spain), incorporating ideas from Galeazzo Alessi, Pellegrino Tibaldi, Andrea Palladio and others. The scheme was forwarded to Philip II, King of Spain (*reg* 1556–98).

(b) Farnese family commissions. While in papal service, Vignola was also principal architect to Cardinal Ranuccio Farnese and Cardinal Alessandro Farnese, the grandsons of Paul III. Between May 1550 and March 1552 he supervised the construction of the monumental tomb of *Paul III* designed by Guglielmo della Porta. At the same time Cardinal Ranuccio, as the principal occupant of the unfinished Palazzo Farnese, employed Vignola to direct construction there. His responsibilities at the great palace centred mainly on the execution of plans by Michelangelo, but over the next two decades he made significant contributions to the appearance of the interior by designing doorframes, fireplaces, wooden ceilings and furniture, including the so-called Farnese Table (1565–70; New York, Met.). Cardinal Alessandro provided Vignola with his greatest commissions, beginning at Caprarola, a small hill town *c.* 55 km north-west of Rome. This was a Farnese fiefdom overlooked by an unfinished pentagonal fortress with bastions built by Antonio da Sangallo the younger and Baldassarre Peruzzi during the early 1520s. Preparations for new construction were under way by May 1557 and within a year Vignola drew up a definitive project for a grand residential villa (*see* CAPRAROLA, VILLA FARNESE, and fig.). Begun in April 1559, he supervised its construction closely until the end of 1564 and then intermittently until his death, by when it was substantially complete.

The Villa Farnese at Caprarola is Vignola's greatest achievement, testifying to the full range of his talent as an urban planner, engineer, architect and painter. From the start he conceived the villa in scenic and symbolic terms. For visibility and traffic a long straight street on axis with the main entrance was cut through the medieval town. From the street the approach continues by way of semicircular ramps to a trapezoidal piazza and then by flights of stairs, ending with a drawbridge before a rusticated Doric portal. For those arriving by carriage or on horseback Vignola provided smooth access by excavating a tunnel from the piazza through the pre-existing scarp and into a circular turning space beneath the central courtyard. Ascent to the upper floors is facilitated by a large and comfortable spiral staircase with paired Doric columns inspired by Bramante's ramp staircase in the Cortile del Belvedere at the Vatican (*see* BRAMANTE, DONATO, fig. 5). The functional transformation of a military stronghold into a grand summer residence thus began below ground. On the exterior, however, motifs of fortification were made to serve the image of neo-feudal princely power: the arrowhead bastions remained in place, their tops converted into open-air *piano nobile* terraces, on which stand the three upper floors of the pentagonal palazzo, its corner bays projecting slightly to embrace an austere grid of pilasters, Ionic for the *piano nobile* where they enclose the arches of a formerly open gallery, and Composite for two short upper floors reserved for servants and retainers. Directly behind the implacable façades Vignola orchestrated on the main floor a sequence of a dozen spacious rectangular staterooms and a circular chapel, set in a space that is the counterpart to the staircase, most of which was lavishly decorated with frescoes by Taddeo Zuccaro (*see* ZUCCARO, (1)), Federico Zuccaro, Jacopo Bertoia and others. Vignola himself was responsible for the architectural perspectives adorning the ground-floor Sala di Giove.

The most extraordinary feature of the Villa Farnese is the perfectly round interior courtyard. This form had been considered for Caprarola by Sangallo and it had been used by Vignola himself in his Villa Cervini project, but such examples fail to anticipate the consummate power of this solution. The absolute geometry of the circle is in stark contrast to the shifting, ambiguous prospects of the pentagonal exterior. Keyed to the five wings and corners by ten bays of superimposed arches, the cylindrical elevation has rusticated piers on the ground floor and paired Ionic half columns on the *piano nobile*. The scheme characteristically draws on and deftly conjoins two authoritative designs in Rome by Bramante—the Palazzo Caprini (House of Raphael; destr.) and the upper Belvedere court façades in the Vatican.

While at Caprarola, Vignola was called in as a consultant regarding the Palazzo Farnese at Piacenza, begun in 1558 or 1559 by Francesco Paciotto for Ottavio Farnese, 2nd Duke of Parma and Piacenza, and his wife, Margaret of Parma. Wresting control from Paciotto, Vignola presented an elaborate revised project that was accepted in 1561; construction proceeded to his orders until 1568, when it was abandoned for lack of funds. Despite efforts to finish the palace in the late 1580s, it remains an immense torso encompassing only about one-third of its intended site (112×88 m). The most compelling legacy of Vignola's work at Piacenza is a series of drawings (Parma, Archv Stato; Windsor Castle, Royal Lib.), many by his son

Giacinto who assisted him there in 1561. It is apparent from these that Vignola wished the building to serve as a fortress (with scarped basement, moat, drawbridge and tower), an urban palace (with central arcaded courtyard, two grand staircases and a three-storey main façade containing more than 100 windows) and a villa suburbana (with open loggias facing extensive rear garden). For the courtyard at the heart of this ambitious project, Vignola planned a permanent neo-antique theatre with a semi-oval *cavea* (Lat.: 'auditorium') set into the northern range and open to the sky. As a self-sustaining structure in brick and stone, the design is derived from Vitruvius and the ruins of Classical Rome rather than Raphael's hillside amphitheatre for the Villa Madama, Rome (1518). As such, it represents a significant conceptual advance in the evolution of the modern European theatre. During his visit to Piacenza in 1564 Vignola made drawings for other works, including the compact Palazzo Radini Tedeschi, Piacenza (now Palazzo Malvicini-Fontana; priv. col., see Adorni), which was only partly completed to his intentions, and the imposing Facciata dei Banchi, Bologna (see fig. 4), his most important essay in urban renovation. Stretching some 96 m across the east side of the Piazza Maggiore, this façade of tall Composite pilasters, heavy unbroken entablature and a high attic masks the 15 bays and two incoming streets of a low Gothic portico. In one masterful stroke Vignola unified, reproportioned and modernized the large civic square.

The commission for Il Gesù, Rome (1568–75), Vignola's most ambitious and influential church, came from Cardinal Alessandro Farnese, who underwrote the cost of its construction for the Society of Jesus. Farnese stipulated that the church must have a single vaulted nave with side chapels. Vignola's response was in part conditioned by his project of S Maria in Traspontina, Rome (1566; not executed), and perhaps by S Maria degli Angeli, Assisi (1568), which Danti said he laid out. These are Latin-cross churches with a nave and two aisles, relatively shallow transepts and domed crossings. At Il Gesù the elimination of side aisles allowed for enlarged lateral chapels and a broader nave that turns the cupola into a highly visible culminating element. The innovative plan brought these ecclesiastically differentiated parts into unprecedented visual and spatial unity. Overall cohesion was enhanced by lining the interior with paired Composite pilasters without pedestals and a continuous belt-like entablature. Lowered entrance arches rendered the six nave chapels unobtrusive; above their flattened oval vaults are screened-off galleries. Under Vignola's direction, Il Gesù was constructed to the height of the main entablature; the barrel vault of the nave and the dome were built later, and higher than he had intended, by Giacomo della Porta.

In the following decades, Il Gesù profoundly influenced the Roman church designs of della Porta, Martino I Longhi and Carlo Maderno, while as the home church of the Jesuit Order it became a prototype for countless churches world-wide. Vignola's initial façade project for Il Gesù (*see* ROME, fig. 13), recorded in the foundation medal of 1568, features giant Corinthian pilasters topped by a high pedimented attic with obelisks. The emphatically horizontalizing design follows from his S Maria in Traspontina project and from the façade he built at S Maria dell'Orto,

4. Jacopo Vignola: Facciata dei Banchi, Bologna, 1565

Rome (1564–7). In these a single order of pilasters masks the entire width of the church and, with the central entrance accentuated by columns, the higher nave is covered as a subordinate element. Such a conception failed to please Cardinal Farnese, whose munificence the façade was to celebrate, and in 1570 Vignola produced a more elaborate second design that acknowledged the authority of traditional Roman double-order aedicular schemes. In 1571 this design was rejected and Cardinal Farnese turned from his architect of 20 years to award the commission to a younger man, Giacomo della Porta (*see* ROME, fig. 14).

Notwithstanding the setback at Il Gesù, Vignola was productive in his final years. Cardinal Farnese continued to employ him at Caprarola where, as well as work at the villa itself, he furnished projects for road works (1571), town houses (1571) and a hospital (1572). In addition, he worked on the Palazzo Comunale at Grotte di Castro (1568; see *La vita e le opere*) and submitted plans for fortresses at Isola Farnese (1567 and 1569) and Montalto di Castro (1570). He also visited important country estates, among them the Villa Gambara, Bagnaia (now Villa Lante, 1568; *see* GARDEN, fig. 1), Villa Tuscolana, Frascati (now Villa Vecchia; 1569) and Castel Gandolfo (1570), although the extent of his involvement at these locations is unclear.

When Vignola died, the artists of Rome honoured him with a burial in the Pantheon. He left no workshop and, having been poorly equipped by nature for success as a building entrepreneur, much less a courtier, he had acquired neither wealth nor high social rank. Solitary and hard-working, proud but unpretentious, he had devoted himself wholly to the discipline of building well according to exacting architectural principles. His legacy was a handful of monuments, many begun or finished by others, that provided rich rewards for architects willing to study them, and a small corpus of powerful theoretical writings accessible to all.

2. THE TREATISES. Vignola wrote two books. The *Regola delli cinque ordini d'architettura* is undated but may be assigned to 1562 on the evidence of a letter (Parma, Archv Stato) from his son Giacinto dated 12 June of that year offering a copy to Ottavio Farnese. The extremely rare first edition consists of 32 single-sided folio engravings, a title-page with a portrait of *Vignola*, a 10-year copyright from Pius IV, a dedication to Cardinal Alessandro Farnese with an introductory epistle and 29 illustrations of the five orders, including the Salomonic column and a cornice design. Almost immediately eight of the principal plates were reworked to provide the names of architectural components. For a second edition Vignola seems to have prepared five additional illustrations of four portals and a fireplace executed for the Farnese family; whether he oversaw their publication is not known. In subsequent editions by others the copyright page is invariably replaced by a synoptic illustration of the five columns. The *Regola* is neither a humanistic introduction to architecture nor a simple pattern-book. Intended for 'those who may have had some introduction in art', its narrowly focused argument is supremely graphic, the text being reduced to brief captions. It was the first book to demonstrate a universal method (or rule) for proportioning each of the five orders, including all component parts,

according to a module equal to the radius of the column. Moreover, the ratios between the heights of pedestal, column and entablature in each order remain the same (4:12:3), facilitating the application of columnar decoration to any given elevation. The system is fundamentally empirical and arbitrary in that it is not derived from pure mathematics or archaeological fact: the forms of Vignola's orders have been taken directly from esteemed Classical examples, but various details within them have been adjusted to fit the rule.

The extraordinary success of the *Regola* was due to the clarity and precision of Vignola's system, the impeccable illustrations and the folio format, which rendered the book useful to workmen. A recent bibliography enumerates more than 500 editions, including translations in ten languages (Bassi and Marini, 1985). Of these, nearly all served as academic textbooks, which partly explains how the treatise and its author came to be widely thought of as fundamentally pedantic. Vignola's second book, *Le due regole della prospettiva pratica* (Rome, 1583), was published posthumously by Ignazio Danti, who prefaced it with a biography of the architect. Again Vignola's text is spare, consisting only of a series of succinct statements demonstrating the two principal methods (rules) of Renaissance perspective: Albertian artificial perspective (*costruzione legittima*) and the distance-point method. Although it broke no new ground, *Le due regole* became the definitive statement on Renaissance perspective, thanks in part to the long and learned commentary added by Danti.

WRITINGS

Regola delli cinque ordini d'architettura (Rome, 1562); ed. E. Bassi and P. Marini, *Trattati di architettura*, v/2 (Milan, 1985)
I. Danti, ed.: *Le due regole della prospettiva pratica . . . con i comentarij del R. P. M. Egnatio Danti* (Rome, 1583) [with biog. of Vignola by Danti]

BIBLIOGRAPHY

Macmillan Enc. Architects; Thieme–Becker; *DBI*
G. Vasari: *Vite* (1550, rev. 2/1568); ed. G. Milanesi (1878–85), v, p. 432; vii, pp. 105–8, 130, 407
H. Willich: *Giacomo Barozzi da Vignola* (Strasbourg, 1906)
Memorie e studi intorno a Jacopo Barozzi pubblicati nel IV centenario della nascità: Vignola, 1908
G. P. Stevens: 'Notes on the Villa di Papa Giulio, Rome', *J. Amer. Inst. Architects* (1914), pp. 539–40
G. Giovannoni: *Saggi sulla architettura del rinascimento* (Milan, 1931, rev. 1935)
W. Lotz: 'Vignola: Zeichnungen', *Jb. Preuss. Kstsamml.*, lix (1938), pp. 97–115
——: *Vignola: Studien* (Würzburg, 1939)
J. Coolidge: 'Vignola's Character and Achievement', *J. Soc. Archit. Historians*, ix/4 (1950), pp. 10–14
W. Lotz: 'Die ovalen Kirchenräume des Cinquecento', *Röm. Jb. Kstgesch.*, vii (1955), pp. 9–99
M. Walcher Casotti: *Il Vignola*, 2 vols (Trieste, 1960)
M. Lewine: 'Vignola's Church of Sant'Anna de' Palafrenieri in Rome', *A. Bull.*, xxxxvii (1965), pp. 199–229
P. Dreyer: 'Beiträge zur Planungsgeschichte des Palazzo Farnese in Piacenza', *Jb. Berlin. Mus.*, vii (1966), pp. 160–203
J. K. Schmidt: 'Zu Vignolas Palazzo Bocchi in Bologna', *Mitt. Ksthist. Inst. Florenz*, 13 (1967), pp. 83–94
T. Falk: 'Studien zur Topographie und Geschichte der Villa Giulia in Rom', *Röm. Jb. Kstgesch.*, xiii (1971), pp. 101–78
W. Lotz and L. H. Heydenreich: *Architecture in Italy, 1400–1600*, Pelican Hist. A. (Harmondsworth, 1974)
C. Thoenes: 'Vignola e il teatro Farnese a Piacenza', *Boll. Cent. Int. Stud. Archit. Andrea Palladio*, xvi (1974), pp. 243–56
La vita e le opere di Jacopo Barozzi da Vignola, 1507–1573, nel quarto centenario della morte: Vignola, 1974 [good illus., bibliog.]
K. Schwager: 'Ein Ovalkirchen-Entwurf Vignolas für San Giovanni dei Fiorentini', *Festschrift für Georg Scheja* (Sigmaringen, 1975), pp. 151–78

R. J. Tuttle: 'A New Attribution to Vignola: A Doric Portal of 1547 in the Palazzo Comunale in Bologna', *Röm. Jb. Kstgesch.*, xvi (1976), pp. 207–20

K. Schwager: 'La chiesa del Gesù del Vignola', *Boll. Cent. Int. Stud. Archit. Andrea Palladio*, xix (1977), pp. 251–71

E. Kieven: 'Eine Vignola-Zeichnung für S Maria in Traspontina', *Röm. Jb. Kstgesch.*, xix (1981), pp. 245–7

W. Lotz: *Studies in Italian Renaissance Architecture* (Cambridge, MA, 1981)

B. Adorni: *L'architettura farnesiana a Piacenza, 1545–1600* (Parma, 1982)

C. Thoenes: 'Vignolas "Regola delli cinque ordini"', *Röm. Jb. Kstgesch.*, xx (1983), pp. 345–76

P. Dreyer: 'Vignolas Planungen für eine befestigte Villa Cervini', *Röm. Jb. Kstgesch.*, xxi (1984), pp. 365–96

C. Thoenes: 'Versuch über Architektur und Gesellschaft im Werk Vignolas', *Krit. Ber.*, xv/3–4 (1987), pp. 5–19

B. Adorni: 'Una piccola chiesa, un camino, delle abitazioni: Nuovi disegni del Vignola e del Paciotto', *Dis. Archit.* (1989), pp. 199–204

R. J. Tuttle: 'Vignola's Facciata dei Banchi in Bologna', *J. Soc. Archit. Historians*, lii (1993), pp. 68–87

D. Heikamp: 'Federico Zuccari in Florenz: Fiende und Freunde', *Ars naturam adiuvans: Festschrift für Matthias Winner* (Mainz, 1996), pp. 346–51

R. J. Tuttle: 'Vignola and the Villa Giulia, Rome', *Casabella*, lxi/646 (1997), pp. 50–69

——: 'On Vignola's Rule of the Five Orders of Architecture', *Paper Palaces* (New Haven and London, 1998), pp. 199–218, 358–65, 386–7

RICHARD J. TUTTLE

Villa. Type of house, originally built as a country retreat for a wealthy patron; the term later applied also to smaller detached suburban or urban houses in garden settings. Villas appeared in Italy from the 2nd century BC and were the product of increasing wealth as a result of Rome's recently acquired empire. In ancient Rome the Latin word *villa* referred to a house in the country as opposed to a town house (*aedes*); the term *villa suburbana* was commonly applied to a house close to but outside a town. Some Roman villas were luxury retreats but these were not typical; the great majority were farms (*villae rusticae*) or the centres of landed estates, where the residence was known as a *villa urbana*, and even the most palatial examples were likely to have an agricultural base. After the fall of the Roman Empire, the villa virtually disappeared as a building type until the revival of economic prosperity and security in the early Renaissance period, when the word villa usually applied to a country estate or semi-rural retreat, the equivalent of the *villa suburbana*.

JOHN PERCIVAL

1. Introduction. 2. History and development. 3 Decoration. 4. Literature and theory.

1. INTRODUCTION. The revival of the ancient Roman villa in 15th-century Italy was anticipated by changing social habits that can be traced back to much earlier times. These included the custom, common to royalty and the feudal aristocracy, of retreating on occasion to a hunting-lodge (e.g. the Castel del Monte owned by Frederick II, Holy Roman Emperor (*reg* 1212–50), in Apulia); the idea of temporary seclusion in a monastery; and, above all, the practice of *villeggiatura*—the voluntary withdrawal from cities to avoid the summer heat. As feudal power declined and mercantile fortunes grew in the 13th century, prosperous townspeople had begun to invest money in land and to build houses on their newly acquired farms or vineyards. By the mid-15th century the powerful Strozzi family, for example, had no fewer than 32 houses in the Florentine countryside. As well as enabling their owners to enjoy the delights of *villeggiatura*, these rural residences could be used as retreats in time of plague, as centres for the collection and distribution of agricultural produce (especially important under the increasingly widespread sharecropping system), as places of intellectual and physical refreshment and as residences for different members of an extended family.

The term villa was not widely used until the 15th century; it usually implied not only the house (the *casino*) but also its surroundings, including gardens, farm buildings, housing for the farmworkers, and the agricultural estate. Many villas were situated deep in the countryside, although within reach of a city—which explains their absence in much of southern Italy. During the 16th century in such areas as Lombardy and the Veneto, where there was an active programme of land reclamation encouraged by the State, villa building was carried out in conjunction with a programme of agricultural improvement. Other villas built at this time conformed more closely to the pattern of the ancient Roman *villa suburbana*: a detached house amid gardens built close to a city (sometimes even within its walls) and serving either as the full-time residence of a wealthy individual or as a pleasure house for a pope or prince—rarely, if ever, slept in except by important visitors before they made a triumphal entry into a city. By the 16th century rich merchants, noblemen and princes had begun to lavish as much attention on their rural houses as on their urban palazzi, using them as status symbols and for extravagant entertainment, including theatrical performances; several villas, especially those near Rome, were also used to house collections of antique sculpture.

2. HISTORY AND DEVELOPMENT. The villa emerged as a social phenomenon long before it acquired an architectural character of its own. For most of the 15th century there was little to distinguish a villa from a farmhouse or semi-fortified palazzo. For example, Cosimo de' Medici's villas at Careggi (remodelled 1434–1450s), Caffagiolo and Il Trebbio (both 1420s) were all built around courtyards and retain towers or machicolation, either from earlier buildings on the site or deliberately added by their architect, MICHELOZZO DI BARTOLOMEO, as an assertion of quasi-feudal authority. The villa known as La Sforzesca (1480–86) at Vigevano in Lombardy was placed behind high walls, while the early 16th-century Villa Giustinian (now the Villa Ciani–Bassetti) at Roncade in the Veneto, probably by Tullio Lombardo, was set in a farm courtyard surrounded by crenellated walls and entered through a formidable gate-house, as was the Palazzo Rossi (after 1482) at Pontecchio near Bologna.

For those villa owners who lacked seigneurial pretensions, more modest houses sufficed. In the 15th century villas were usually smaller and plainer than urban palazzi, and in such houses as the mid-15th century *casino* built by Cardinal Bessarion on the Appian Way, just within the walls of Rome, or Filippo Strozzi the elder's villa (1483–6) at Santuccio, near Florence (an enlargement of an earlier building), the most striking architectural feature is an arcaded upstairs loggia leading from the main reception room or *sala*. In the relatively modest hipped-roofed villa (*c.* 1460) built for Giovanni de' Medici at Fiesole, attributed to Michelozzo, much of the ground floor is taken up by a

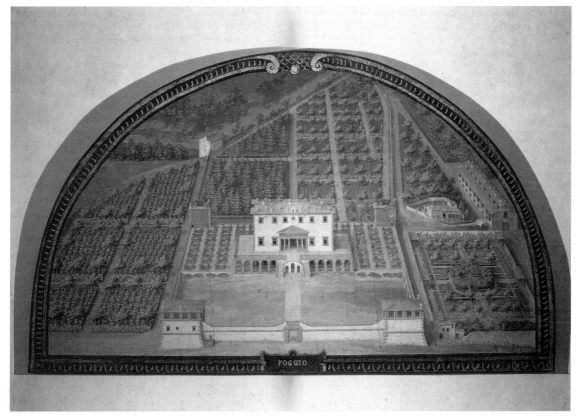

1. Villa Medici, Poggio a Caiano, by Giuliano da Sangallo, begun 1485; lunette by Giusto Utens, 1598–9 (Florence, Museo di Firenze com'era)

loggia leading directly into the terraced gardens, which concealed cellars, stables and wine-presses. There are loggias on both floors of the Villa da Porto–Colleoni (1441–53; now Villa Thiene) at Thiene, near Vicenza, where the block containing the *sala* is enclosed between two castellated towers. This tripartite arrangement of a loggia and *sala* (often bisecting the house) flanked by minor rooms remained an important feature of the planning of many villas. Loggias were in effect semi-outdoor rooms designed to allow the owner and his guests to enjoy the shade and breezes and to survey the walled garden, which was often planted with fruit trees and might contain a lake or fish-ponds. Sometimes a loggia for outdoor dining was built in the garden itself, for example the round-arched late-15th century loggia (*in situ*) at the otherwise destroyed villa of Caterina Cornaro (*see* CORNARO, (2)) at Altivole, near Treviso. Thus feudal magnificence gradually gave way to a delight in the pleasures of nature.

The architecture of Classical antiquity had little effect on the overall design of Italian villas until the last years of the 15th century. Little was known about the layout of ancient Roman villas, apart from what could be gleaned from such literary accounts as Pliny the younger's *Letters* and the remains of Hadrian's palatial villa at Tivoli (then unexcavated); there was total ignorance about the external appearance of these buildings. When architects and their patrons first seriously turned their attention to the creation of a villa *all'antica*, the emphasis was therefore on the evocation of classicism through symmetrical planning,

careful detailing and appropriate proportions, rather than the strict imitation of ancient models. The first villa to be designed throughout on the new principles was that begun in 1485 by Lorenzo de' Medici to the designs of Giuliano da Sangallo (see fig. 1; *see also* POGGIO A CAIANO, VILLA MEDICI and SANGALLO, DA, (1), §1(ii)); it was symmetrically laid out and proportioned according to simple mathematical ratios, with a loggia treated as a temple-front *in antis* at the centre of the entrance front—the first appearance of this feature in Renaissance villa architecture.

Italian Renaissance villas are of three main types: those built around courtyards, those in which the house consists of a main block with wings, and those with the accommodation fitted into a single compact block. All these plans have medieval precedents. An early example of the courtyard villa is the house (begun 1487; destr.) built for Ferdinand I, King of Naples (*reg* 1458–94), at Poggio Reale, probably to the designs of Giuliano da Maiano (*see* MAIANO, DA, (1)). Its courtyard was colonnaded, as in an ancient Roman villa, and there were low towers at the corners—a motif borrowed 200 years later by William Kent at Holkham Hall, Norfolk, England. The second, far more common, plan was employed in the house now known as the Villa Farnesina in Rome, built *c.* 1505–10 by Pope Julius II's banker, Agostino Chigi, to the designs of Peruzzi (*see* PERUZZI, BALDASSARE fig. 1). The internal layout is less rigorously symmetrical than at Poggio a Caiano, but the façades (originally painted with frescoes) are meticulously proportioned, with a Tuscan pilaster

order on each floor, a stucco frieze under a hipped roof and an arched loggia between the two wings on the garden side. The third, compact type of plan was used in the smaller and slightly later Villa Lante on the Janiculum, Rome, built to the designs of Raphael and Giulio Romano for an official in the court of Pope Leo X (*see* GIULIO ROMANO); this attractive building provided a prototype for countless smaller villas until the 19th century.

The influence of antiquity first began to affect the surroundings of the Italian villa in the early 16th century. In 1504 Pope Julius II employed Bramante to add a courtyard in imitation of an ancient Roman garden in front of the Belvedere, a pleasure house built by Innocent VIII close to the Vatican in 1487 (*see* ROME, §V, 1(iii)(a); *see also* BRAMANTE, DONATO, §I, 3(ii)(a)). The terraced Cortile del Belvedere (see colour pl. 1, XVI1) was flanked by arcades housing the Pope's important collection of Classical statuary and terminated in a theatre-like semicircular exedra. At the Villa Madama near Rome (begun *c.* 1518, not completed), Raphael made an even more ambitious attempt to re-create a villa of the type described by Pliny the younger, with a large circular courtyard, a formal garden containing an outdoor theatre, nymphaeum and grotto, and a small grove to the rear. In its highly artificial mingling of plantations and water the villa garden thus became a poetic extension of the house.

Raphael and his followers brought a new element of monumentality to villa architecture. The vaulted garden loggia (*see* RAPHAEL, fig. 9) at the Villa Madama was intended to recapture the vanished grandeur of ancient Roman buildings, as was the new building (1530s) at the Villa Imperiale, Pesaro, by Girolamo Genga (for illustration *see* GENGA, (1); *see also* PESARO, §3). In the Palazzo del Te (1525–35) at Mantua, Giulio Romano went even further in the evocation of antiquity by following the Roman model of four single-storey ranges of building around a courtyard. From the outside there is an effect of massive rusticity, with an extensive use of the Doric order, heavily emphasized keystones and voussoirs, and massive blocks of masonry (*see* GIULIO ROMANO, fig. 3), while within there is a series of profusely decorated rooms with frescoes of writhing, lascivious gods and goddesses. A monumental loggia similar to that at the Villa Madama (where Giulio Romano had worked) leads from the courtyard into the garden, the focal point of which is a massive exedra.

The spirit of artifice so evident in the Palazzo del Te reached its apogee in a group of mid-16th-century villas built by popes and members of the great papal families in and around Rome. The Villa Giulia (1551–5; *see* VIGNOLA, JACOPO, fig. 3), erected for Julius III to the designs of Vignola, Bartolomeo Ammanati and other architects, presents a reticent face to the outside world, but the garden front of the *casino* is semicircular and faces a screen beyond which lies a sunken nymphaeum. A similar contrast exists at the Villa Medici on the Pincian Hill, Rome,

2. Villa Medici, Rome, remodelled by Bartolomeo Ammanati for Cardinal Ferdinando de' Medici, 1576–86

remodelled in 1576–86 by Ammanati for Cardinal Ferdinando de' Medici, who owned a notable sculpture collection; here the garden front is decorated with stucco embellishments and antique reliefs (see fig. 2). The most spectacular Roman villa of this period is the massive pentagonal Villa Farnese (see CAPRAROLA, VILLA FARNESE), begun to the designs of Vignola in 1559. This is a Renaissance equivalent of the medieval *castello*: a centre of territorial power dominating its surroundings. It was built on foundations intended for a fortified castle, and behind its forbiddingly monumental façades are suites of ceremonial rooms designed for the formal entertainment of large numbers of guests, with a circular courtyard in the centre; a smaller, private *casino* with its own garden, including a water cascade, was built 400 m away to allow the quiet seclusion traditionally associated with villa life.

The gardens of late 16th-century Roman villas were among the most ambitious and inventive ever created (see GARDEN, §II). At the Villa d'Este (begun 1560; see TIVOLI) they spread in terraces down the hillside from the relatively plain house and owe much of their effect to the copious use of fountains and the play of water designed by Pirro Ligorio (see LIGORIO, PIRRO, fig. 2), who had been employed by Ippolito II d'Este to excavate the ruins of Hadrian's Villa a short distance away. The garden of the Villa Lante (begun *c.* 1568; see BAGNAIA, VILLA LANTE), attributed to Vignola, is arranged as a series of parterres down the hillside, with the most elaborate in front of the two residential pavilions (see GARDEN, fig. 1).

The influence of Roman-style villas soon spread to other parts of Italy. In Genoa and its surroundings, the Umbrian-born Galeazzo Alessi designed several suburban villas for the wealthy mercantile élite of the Republic, for example the Villa Giustiniani (1548; now Villa Cambiaso; see ALESSI, GALEAZZO, fig. 1) and the Villa Pallavicino (*c.* 1555; see fig. 3), set among terraced gardens that take full advantage of the hilly topography of the area (see ALESSI, GALEAZZO, §2(iii)). The façades of these compact, beautifully proportioned buildings represent a more sculptural and ornamental development of the Farnesina type. The Venetian villa also achieved prominence in the mid-16th century as the nobility of the Veneto began to develop their estates on the mainland. Here the architecture owed

3. Villa Pallavicino, Genoa, by Galeazzo Alessi, *c.* 1555

much to the spread of High Renaissance ideas by the humanists Alvise Cornaro, designer of the Villa dei Vescovi (late 1530s) near Padua, and Giangiorgio Trissino, who designed a villa at Cricoli, near Vicenza, for his own use.

Trissino later patronized Andrea Palladio, who became one of the most accomplished, and certainly the most famous, of all Italian villa architects. The Venetians believed that they, alone among all the Italians, had never submitted to the barbarians and were in consequence the true heirs of the Romans: Palladio's villas embody this attractive myth in a powerfully monumental form. His first villas (e.g. the Villa Godi–Malinverni at Lonedo, 1537–42; see PALLADIO, ANDREA, fig. 1) represent a refinement and regularization of the local vernacular tradition and are notable chiefly for their simple balanced porportions and symmetrical plans. Farm buildings, including stables, *barchesse* (barns with attached arcades) and dovecots, are successfully incorporated into the layout, and the main rooms are placed over a basement that (sometimes together with the top floor) is given over to storage space and service quarters. After he had been to Rome at Trissino's expense in 1541, Palladio began to incorporate elements taken from the architecture of antiquity, notably the porticoed temple-front, either engaged (e.g. Villa Barbaro, 1549–58; for illustration see MASER, VILLA BARBARO); projecting (e.g. Villa Foscari at Malcontenta, late 1550s); *in antis* (e.g. Villa Badoer, *c.* 1556–60, at Fratta Polesine; see fig. 4); or two-storey (e.g. Villa Cornaro, early 1550s, at Piombino Dese; see PALLADIO, ANDREA, fig. 4). Since the main rooms were usually placed on the *piano nobile*, the opportunity was taken to give nobility to the composition by the provision of a broad temple-like flight of steps leading up to the portico; this effect was often heightened (e.g. Villa Barbaro and Villa Emo Fanzolo, late 1550s) by linking the farm buildings to the main block by arcaded loggias. Palladio showed equal dexterity in the internal layout of his villas. The plans are usually square and compact, with a central axis containing a *sala* approached through a vestibule or *entrata* and flanked by smaller rooms of varying shapes, sometimes influenced by Palladio's study of the ruined baths of ancient Rome. The *sala*—the formal focus of the house—could be rectangular or cruciform (e.g. Villa Barbaro and Villa Foscari) or even circular, as in the most famous of all his villas, the Villa Rotonda (begun *c.* 1565–6; see VICENZA, §2). Placed on a hilltop just outside Vicenza, the Villa Rotonda has porticos on each of its four fronts and a dome crowning the whole composition (see PALLADIO, ANDREA, fig. 5); this arrangement inspired Scamozzi at Rocca Pisani (1576), near Lonigo (see SCAMOZZI, (2), fig. 1), and continued to influence villa architects until the 20th century.

3. DECORATION. The rooms in 15th-century villas were relatively lightly furnished. Pictures and tapestries were more commonly found in urban palazzi than in villas, where the main embellishment took the form of frescoed walls. There are still remnants of frescoes by well-known late 15th-century artists in villas near Florence, for example those by Antonio del Pollaiuolo in the Villa della Gallina at Arcetri, which show dancing nudes against a background, as in antique vase painting, and those by Filippino

4. Villa Badoer, Fratta Polesine, by Andrea Palladio, *c.* 1556–60

Lippi inside the loggia of the Villa Medici at Poggio a Caiano. Fresco decoration remained the most significant feature of villa interiors until the 18th century. As in ancient Roman villas, the subjects of these frescoes are an indication of their owners' cultural interests and way of life: frescoes (1471) in the Palazzo di Schifanoia at Ferrara by Francesco del Cossa, for example, glorify the court of Borso d'Este, Duke of Ferrara, and the astrological influences that allegedly governed it (*see* FERRARA, fig. 2). Myth was frequently employed to reinforce the grandeur of the owner and his family, for example in the *sala* at Poggio a Caiano (decorated by Pontormo in the 16th century) and in the interiors of the Villa d'Este at Tivoli, where frescoes of the legend of Hercules are used to glorify the family. In the much smaller Villa Poiana (*c.* 1550), near Vicenza, Palladio's *sala* is decorated with figures of Roman military heroes in an attempt to give it the character of an atrium.

The evocation of a Classical Golden Age, free from mundane concerns, became a constant preoccupation from the late 15th century. The superb frescoes of the *Story of Cupid and Psyche* and of the *Legend of Galatea* (see colour pl. 2, XXII1) by Raphael and others at the Villa Farnesina, Rome, were carefully chosen to underline the building's function as a pleasure house, far removed in character from the more austere humanist retreats of the 15th century. The decorative scheme was modelled to some extent on the descriptions of Pliny the younger's villas in his *Letters* and thus included *trompe l'oeil* landscape painting, especially in the main garden loggia and in the upstairs *sala delle prospettive*; here the intention was to blend the interior of the house with the garden, itself an

artificial retreat set apart from everyday concerns. Landscapes by Dosso Dossi, some of them seen through pergolas supported by caryatids, also appear in the original building at the Villa Imperiale, Pesaro.

With increasing archaeological knowledge of such ancient Roman interiors as the Domus Aurea of Nero, Rome, *grottesche* began to be incorporated (*see* GROTESQUE). In the garden loggia of the Villa Madama, for example, the iconographical scheme includes representations of the *Seasons* and the *Elements*, along with scenes from Ovid, whose *Metamorphoses* remained a popular source for villa decoration throughout the 16th century and the early 17th. As well as mythological themes, the internal decoration of late 16th-century villas sometimes included representations of scenes of villa life, for example those by Giovanni Antonio Fasolo (*c.* 1570) in the Villa Caldogne near Vicenza. Veronese's famous frescoes in Palladio's Villa Barbaro at Maser constitute a quasi-Virgilian celebration of rural life in general (see colour pl. 2, XI1), a theme that continued until the 18th century.

4. LITERATURE AND THEORY. Vitruvius, the only ancient Roman writer on architecture whose writings have survived, had little to say about the design of country residences. The main literary influence from antiquity came from descriptions of villas—notably those by Pliny the younger of his villas at Laurentum and Tusculum—and from such writers as Cato and Virgil who dealt with aspects of rural life and husbandry; they helped to establish a mythology of villa life in which the wise man deliberately sought relief for limited periods in the countryside from

the pressures of the city. This Classical literary tradition, celebrated in such works as the Hypnerotomachia Poliphili (Venice, 1499), played a powerful part in encouraging both the growth and the eventual architectural form of the Italian Renaissance villa. The first Italian writer to discuss the architecture and planning of villas was Leon Battista Alberti. In his *De re aedificatoria* (written *c.* 1452; pubd Florence, 1485; V.xiv–xviii; IX.ii–iv), Alberti gave advice on the design of country and suburban villas. Ideally both should be placed on hills, to enable the owners to enjoy the benefits of fresh air in the hot Italian summer climate, to command the view and to be visible to strangers. Villas should be more festive in their architectural and decorative character than town houses; their general appearance should be welcoming, and battlements and fortifications were not appropriate. There should be a central courtyard (*sinus*), which could be covered over. The reception rooms should be of varying shapes and sizes, but their proportions, like those of the architectural elevations, should be related to one another and to the canonic, often mathematical, proportions of ancient buildings. Loggias were appropriate, both close to the house and in the gardens, which might themselves be embellished with vases, grottoes, vines and clipped trees. The interiors could be decorated with statuary and pictures of heroic deeds or, in houses intended purely for the pursuit of pleasure, with landscapes and scenes of country sports. Alberti's account anticipates in certain respects the Italian Renaissance villa as it actually developed in the late 15th century and the 16th.

The first architectural treatise to provide plans and elevations of villas was by Sebastiano Serlio. In his unpublished 'Sixth Book' and in the seventh book of his *Architettura* (Venice, 1584) he included several of his own designs for houses in the country, some of them of a highly unusual character (e.g. one shaped like a cross); in his third book he also publicized such notable recent buildings as the Villa Madama. Serlio's influence was matched and even surpassed by that of Palladio, whose comments (II.xii–xiii) in his *Quattro libri dell' architettura* (Venice, 1570) on the siting and design of villas (based on his own very successful practice of villa architecture) supplemented, without contradicting, those of Alberti a century earlier. Palladio stressed the importance of running water in the vicinity of a villa and recommended sites either on hills or close to navigable rivers. The architect should integrate farm buildings and storage space into the overall design and should arrange housing for the farmer and labourers close to the gates. In general the architecture of a rural villa (in contrast to that of a *villa suburbana* or town house) should be plain and simple, but dignity and grandeur could be imparted to the exterior by the inclusion of a temple-front, which Palladio believed (II.xvi) might have been a feature of the houses of the ancients, as it was of their temples and public buildings. Inside, the main architectural emphasis should be on the *sala*, which, since it was used 'for entertainments, banquets, weddings and similar recreations. . .should be much bigger than the other [rooms]'. These ideas were developed by Scamozzi in Book 3 of his *Idea dell'architettura universale* (Venice, 1615). He emphasized that the building of villas would encourage landowners to visit their estates more often, which would result in greater profit. He also produced designs for villas of varying size. Some were compactly planned, but others, described as 'onorevoli' or even 'magnifiche', were supplied with accommodation as plentiful as that in urban palaces.

BIBLIOGRAPHY

G. Masson: *Italian Villas and Palaces* (London, 1959)
——: *Italian Gardens* (London, 1961)
J. Ackerman: *Sources of the Renaissance Villa*, Studies in Western Art, ii (Princeton, 1963)
I. Barsali: *La villa a Lucca* (Rome, 1964)
G. L. Tomasi: *Le ville di Palermo* (Palermo, 1965)
C. L. Frank: *The Villas of Frascati* (London, 1966)
E. de Negri and others: *Le ville genovesi* (Genoa, 1967)
L. Heydenreich and others: 'La villa: Genesi e Sviluppi', *Boll. Cent. Int. Stud. Archit. Andrea Palladio*, xi (1969)
G. Cuppini and A. M. Matteucci: *Ville del bolognese* (Bologna, 1969)
H. Acton: *Tuscan Villas* (London, 1973)
P. E. Foster: *A Study of Lorenzo de' Medici's Villa at Poggio a Caiano* (diss., New Haven, CT, Yale U., 1974)
R. Palluchini and others: *Gli affreschi nelle ville venete* (Venice, 1978)
M. N. Rosenfeld, ed.: *Sebastiano Serlio on Domestic Architecture* (Cambridge, MA, and London, 1978)
D. Coffin: *The Villa in the Life of Renaissance Rome* (Princeton, 1979)
J. Dixon Hunt: *Garden and Grove* (London, 1986)
A. R. Lillie: *Florentine Villas in the Fifteenth Century: A Study of the Strozzi and Sassetti Country Properties* (diss., U. London, 1986)
M. Muraro: *Venetian Villas* (New York, 1986)
J. Ackerman: *The Villa: Form and Ideology of Country Houses* (London, 1990)
P. Holberton: *Palladio's Villas: Life in the Renaissance Countryside* (London, 1990)
P. Thornton: *The Italian Renaissance Interior: 1400–1600* (London, 1991)
P. van der Ree, G. Schmienk and G. Steenbergen: *Italian Villas and Gardens* (Amsterdam, 1992)

GEOFFREY C. TYACK

Villa Barbaro, Maser. *See* MASER, VILLA BARBARO.

Villafora, Antonio Maria da. *See* ANTONIO MARIA DA VILLAFORA.

Villamena, Francesco (*b* Assisi, 1564; *d* Rome, 7 July 1624). Italian engraver. According to tradition, he was a pupil of Cornelis Cort (1533–78), whose engravings he copied, and was associated in his youth with Agostino Carracci (1557–1602). He made few original engravings but reproduced designs of artists including Raphael, Paolo Veronese, Federico Barocci, Girolamo Muziano and Giulio Romano. His output also included frontispieces and book illustrations. Closely related to such northern late adherents of Mannerism as Hendrick Goltzius (1558–1617) and Jacques Bellange (*c.* 1575–1616), he employed an elegant and expressive calligraphic style with perfect control of the burin. In addition to religious and historical subjects, he executed portraits, notably a series of genre figures (Rome, Gab. N. Stampe). In 1594 he executed a series of engravings illustrating scenes from the *Life of St Francis*. His oeuvre comprised at least 100 plates.

BIBLIOGRAPHY

K. Oberhuber: *Renaissance in Italien. 16. Jahrhundert* (Vienna, 1966), pp. 31, 208–10
A. Grelle: 'Francesco Villamena', *Claude Mellan, gli anni romani* (exh. cat., ed. S. Bonsignori; Rome, G.N.A. Ant., 1989–90), pp. 128–43
F. T. Camiz: 'The Roman "Studio" of Francesco Villamena', *Burl. Mag.*, cxxxvi/1097 (1994), pp. 506–16

FRANÇOISE JESTAZ

Villa Orsini. *See* BOMARZO, SACRO BOSCO.

Vincenzo da Treviso. *See* DESTRE, VINCENZO DALLE.

Vincenzo di Biagio. *See* CATENA, VINCENZO.

Vinci, Leonardo da. *See* LEONARDO DA VINCI.

Vinci, Pierino da. *See* PIERINO DA VINCI.

Vincidor, Tommaso (di Andrea) [il Bologna] (*b* Bologna; *d* Breda, 1534–6). Italian painter. He is first mentioned in a document drafted in Rome in 1517. According to Vasari, he was a pupil of Raphael and was among the artists who worked with him on the frescoes in the Vatican Logge. In 1520 he travelled to Flanders, carrying a letter of recommendation from Pope Leo X, to prepare cartoons for tapestries—to be woven in Brussels—for the Sala di Costantino and the Sala del Concistoro in the Vatican. In Flanders he met Albrecht Dürer (1471–1528), who mentioned him in his *Journal of Travels in the Low Countries* (travels made between 1520 and 1521). Vincidor made a portrait of Dürer (untraced; copy by Willem van Haecht II (1593–1637), Antwerp, Rubenshuis).

On the basis of the written descriptions of the tapestry cartoons for the Sala di Costantino that Vincidor sent Leo X in 1521, the following works have been firmly attributed to him: the drawings of *Playing Putti* (Munich, Staatl. Graph. Samml.) and the *Adoration of the Shepherds with Leo X Kneeling* (Paris, Louvre), in which the figures of the putti, surrounded by animals and festoons of flowers and fruit, are clearly derived from Raphael, although other elements would seem to owe more to Dürer. The *Playing Putti* theme is reproduced in a suite of four prints (1532) by the MASTER OF THE DIE (*see* MASTERS, ANONYMOUS, AND MONOGRAMMISTS, §I). Vincidor's hand has been identified in the panel (transferred to canvas) of the *Circumcision* (Paris, Louvre) and in some of the frescoed scenes in the Vatican Logge, including the *Meeting of Jacob and Rachel* and the *Creation of Eve*. Some fragments of tapestry cartoons for the Sala del Concistoro have also been attributed to Vincidor, including those depicting the *Feet and Head of a Warrior* and a *Head of a Woman* (Oxford, Ashmolean). He is mentioned in 1534 in a register of the Castle of Breda, where he was working for Hendrik III of Nassau-Breda (1483–1538). According to the same account, he was dead by 1536.

BIBLIOGRAPHY
F. Filippini: 'Tommaso Vincidor da Bologna, scolaro di Raffaello e amico del Dürer', *Boll. A.*, viii/7 (1929), pp. 309–24
N. Dacos: 'Tommaso Vincidor: Un Elève de Raphaël aux Pays-Bas', *Relations artistiques entre Pays-Bas et l'Italie à la Renaissance: Etudes dédiées à Suzanne Sulzberger* (Brussels and Rome, 1980), pp. 61–99 [with full bibliog.]
T. Campbell: 'Pope Leo X's Consistorial *Letto de Paramento* and the Boughton House Cartoons', *Burl. Mag.*, cxxxviii/1120 (1996), pp. 436–45
Roma e lo stile classico di Raffaello 1515–27 (exh. cat. by K. Oberhuber, Mantua, 1999)

ANNA MARIA FERRARI

Viniziano, Sebastiano. *See* SEBASTIANO DEL PIOMBO.

Visconti. Italian dynasty of rulers and patrons. As Lords and later Dukes of Milan, they dominated the politics of North Italy from the mid-14th century to the mid-15th, when the related SFORZA dynasty succeeded to the duchy. From 1311 Matteo I Visconti (*d* 1322) held the joint offices of Captain General and Imperial Vicar of Milan and gained control of most of western Lombardy. In 1327 his son Galeazzo I Visconti (*reg* 1322–8) was expelled from Milan by Ludwig of Bavaria (*reg* 1294–1347). Galeazzo's son Azzone Visconti (*reg* 1328–39) recovered the Imperial Vicariate in 1329 and subsequently regained control of the surrounding cities. Azzo was succeeded by his uncles Lucchino Visconti (*reg* 1339–49) and Giovanni Visconti, Archbishop of Milan (*reg* 1349–54).

In 1349 the heirs of Matteo I the Great were granted the perpetual hereditary right to the title Lord of Milan. This provided surety for the position of the family but did not prevent rivalry and dispute between different family members. A balance was kept by exile, occasional murder and various agreed divisions of responsibility. After the death of Archbishop Giovanni, the lordship of Milan passed to three of his nephews; when one of them, Matteo II (*reg* 1354–5), died in 1355, the rule of the Milanese state was divided between his brothers, Bernabò Visconti (*reg* 1354–85) and Galeazzo II Visconti (*reg* 1354–78), with only Milan held in common. In 1385 Giangaleazzo Visconti (*reg* 1378–1402), son of Galeazzo II, captured and overthrew his uncle, Bernabò, to assume sole rule of the dominions of Milan.

In 1395 Gian Galeazzo was created Duke of Milan. The title and rule of the city was inherited by his sons Galeazzo Maria Visconti (*reg* 1402–12) and (1) Filippo Maria Visconti, the last Visconti ruler of Milan. With the fall of the Ambrosian Republic (1447–50), the rule and dukedom of Milan went to FRANCESCO I SFORZA, husband of Filippo Maria's illegitimate daughter. In the 16th century members of a collateral branch of the family, (2) Prospero Visconti and (3) Pirro Visconti, also contributed as patrons to Milan's art life.

BIBLIOGRAPHY
G. Fiamma: *Opusculum de rebus gestis ab Azzone, Luchino ed Iohanne Vicecomitibus ab anno MCCCXXVIII usque ad annum MCCCXLII* (after 1342), Rerum Italicarum Scriptores, xii/4 (Bologna, 1938)
P. Azario: *Liber gestorum in Lombardia* (*c.* 1362), Rerum Italicarum Scriptores, xvi/4 (Bologna, 1939)
P. Giovio: *Vite duodecim vicecomitum mediolani principum* (Paris, 1549)
C. Magenta: *I Visconti e gli Sforza nel castello di Pavia e loro attinenze con la Certosa e la storia cittadina*, 2 vols (Milan, 1883)
L. Beltrami: *La Certosa di Pavia* (Milan, 1891, rev. 3/1924)
E. Pellegrin: *La Bibliothèque des Visconti et des Sforza ducs de Milan au XVe siècle* (Paris, 1955); *Supplément* (Florence, 1969)
L. Green: 'Galvano Fiamma, Azzone Visconti and the Revival of the Classical Theory of Magnificence', *J. Warb. & Court. Inst.*, liii (1990), pp. 98–113
K. Sutton: 'Milanese Luxury Books: The Patronage of Bernabò Visconti', *Apollo*, cxxxiv (1991), pp. 322–6
——: 'Giangaleazzo Visconti as Patron: A Prayerbook Illuminated by Pietro da Pavia', *Apollo*, cxxxvii (1993), pp. 89–96
E. S. Welch: *Art and Authority in Renaissance Milan* (New Haven, 1995)

KAY SUTTON

(1) Filippo Maria Visconti, 3rd Duke of Milan (*b* 23 Sept 1392; *reg* 1412–47; *d* Milan, 14 Aug 1447). Filippo Maria became Duke of Milan after his brother's assassination. His long career was devoted to the reconstruction of the Visconti dominions in Lombardy, and numerous wars with Venice and Naples punctuated his reign. He was known as an eccentric recluse who rarely left his

fortified castle in Milan. Nevertheless, he maintained a large court and supported numerous humanist writers, in particular Pier Candido Decembrio and Francesco Filelfo. His early patronage followed that of his father, supporting the construction of Milan Cathedral and the Certosa di Pavia.

In 1431 the Duke corresponded with the painter Pisanello concerning an unidentified and unfinished work of art. In 1440 the artist appeared before the Duke, this time, however, as a prisoner of war captured in Verona. A portrait drawing (Paris, Louvre, Cabinet des Dessins, 2482) and Pisanello's medal of *Filippo Maria Visconti* (Paris, Bib. N.) are usually associated with this period. A lost fresco cycle in the castle at Pavia, mentioned by the architect and writer Cesare Cesariano in 1512, was probably also painted at this time. It may have represented images of women playing games and was possibly the iconographic source for the fresco of the *Giuochi Borromei* in the Palazzo Borromeo, Milan.

The greater part of the works made for Filippo Maria that have survived are small-scale and seem to have been for his personal use. The Duke was reported to have paid his secretary, Marziano da Tortona, 1500 scudi for tarot cards painted with images of gods and animals. These cannot be identified, but a set of cards (New Haven, CT, Yale U., Beinicke Lib.) displaying Visconti imprese and coins with Filippo Maria's monogram (examples, London, BM) has survived.

In 1426 the Duke had ordered an unusually detailed inventory to be compiled of the library in the castle at Pavia, and he subsequently became an important collector of manuscripts. There are dedication miniatures showing the Duke in Galassio da Correggio's *Historia Angliae* (Paris, Bib. N., MS. lat. 6041) and a translation of Suetonius' *Vitae imperatorum* (Paris, Bib. N., MS. it. 131), both attributed to the MASTER OF THE VITAE IMPERATORUM (*see* MASTERS, ANONYMOUS, AND MONOGRAMMISTS, §I). His most impressive commission, however, was the continuation by Belbello da Pavia of an illuminated Book of Hours (Florence, Bib. N., Landau Finaly 22; for illustration *see* BELBELLO DA PAVIA) begun by the de Grassi for Giangaleazzo Visconti. According to Pier Candido Decembrio's biography of Filippo Maria, the Duke carried out some large-scale building in Milan, such as the enlargement and decoration of his fortress. During the three years of the Ambrosian republic that followed the Duke's death, however, the castle was sacked and much of the Visconti heritage destroyed, rendering a full assessment of Filippo Maria's patronage impossible.

BIBLIOGRAPHY

P. C. Decembrio: *Vita di Filippo Maria Visconti* (Milan, 1625); trans., ed. E. Bartolini (Milan, 1983)
G. Biscaro: 'Pisanus pictor alla corte di Filippo Maria Visconti nel 1440', *Archv. Stor. Lombardo*, n. s. 3, xv (1901), pp. 171–4
E. Pellegrin: *La Bibliothèque des Visconti et des Sforza, ducs de Milan au 15ème siècle* (Paris, 1955)
F. Cognasso: *I Visconti* (Varese, 1966)
M. Meiss and E. W. Kirsch: *The Visconti Hours* (London, 1972)
A. Cadei: *Belbello, miniatore lombardo: Artisti del libro alla corte dei Visconti* (Rome, 1976)
G. Mulazzani: *I tarocchi viscontei e Bonifacio Bembo: Il mazzo di Yale* (Milan, 1981)
A. Cadei: *Studi di miniatura lombarda: Giovannino de Grassi e Belbello da Pavia* (Rome, 1984)

E. S. Welch: *Secular Fresco Painting at the Court of Galeazzo Maria Sforza* (diss., U. London, 1987)
——: *Art and Authority in Renaissance Milan* (New Haven, 1995)
E. S. WELCH

(2) Prospero Visconti (*b* ?Milan, 1543–4; *d* Tortona, before 10 March 1592). A member of a collateral branch of the former ruling dynasty of Milan, he was among the most prominent figures in Milanese cultural life in the late 16th century. He was a respected scholar, interested in ancient and modern history and in languages, including Greek and Hebrew, and a poet in both Latin and Italian. From a poem by the Lombard writer Bernardino Baldini (1515–1600/01), which praises Visconti's mastery of both the historian's pen and the sculptor's chisel, it would appear that he was also an amateur sculptor. His interests and his particular concern with the local history of Milan and Lombardy were reflected in his library, which included manuscripts written on lime-tree bark (*tiglia*) in a medieval Lombard dialect. He had a notable collection of Classical antiquities, including an extensive series of medals. The library and the collection were housed in his palace in Via Lanzone, Milan, which was built *c.* 1589–91 by the architect and engineer Giuseppe Meda (*d* 1599). Visconti also acted as art agent in Milan for William V, Duke of Bavaria (*reg* 1579–98), and his wife Renée of Lorraine. During the 1570s he regularly supplied the Duke with antique gems and statuary, paintings, carved and painted portraits of Italian cardinals and Spanish governors of Milan, armour, inventions for jousts and tournaments, vases, crystalware and such curiosities as a rare conch shell, as well as musical scores and political news from Italy.

BIBLIOGRAPHY

G. Borsieri: *La nobiltà di Milano di P. Morigi . . . il supplimento in questa nova impressione del Sig. Girolamo Borsieri* (Milan, 1619)
F. Picinelli: *Ateneo dei letterati milanesi* (Milan, 1670)
H. Simonsfeld, ed.: 'Mailander Briefe zur bayerischen und allgemeinen Geschichte des 16. Jahrhunderts', *Hist. Kl. Kön. Bayer. Akad. Wiss.*, xxii (1902), pp. 231–575
G. Treccani degli Alfieri, ed.: *Stor. Milano*, x (Milan, 1957)
JANET SOUTHORN

(3) Conte **Pirro Visconti** (*d* Milan, before 1619). A member of the former ruling dynasty of Milan, his sympathies with the Spanish government of the day were reflected in the award to him of the Spanish Order of S Giacomo. His interest in art is evident from the dedication to him by the artist and art critic Giovanni Paolo Lomazzo of his *Poésie* (Milan, 1589). As a patron, Visconti was responsible for bringing the Procaccini family of artists from Bologna to Milan, having met Camillo Procaccini (*c.* 1555–1629) in Bologna *c.* 1580 and invited him first to Rome and then to Milan. Camillo worked on Visconti's estate at Lainate, north of Milan, providing mosaic decoration (1585–9) for a building that adjoined a grand fountain (destr.), which Visconti had commissioned, perhaps from Francesco Brambilla the younger. A contemporary, Girolamo Borsieri, described the fountain as one of the wonders of the world and also commented that Visconti possessed a collection of paintings that, though not large, was 'exquisite'. It included Correggio's *Agony in the Garden* (*c.* 1555; London, V&A), which Visconti bought for 400 scudi and later sold to the Governor of Milan for

750 doppie (Lomazzo). Pirro's son Fabio Visconti inherited most of the collection.

BIBLIOGRAPHY

G. P. Lomazzo: *Idea del tempio della pittura* (Milan, 1590); ed. R. Klein, 2 vols (Florence, 1974)
G. Borsieri: *La nobiltà di Milano di P. Morigi . . . il supplimento in questa nova impressione del Sig. Girolamo Borsieri* (Milan, 1619), pp. 69–70
G. Melzi d'Eril: 'Federico Borromeo e Cesare Monti: Collezionisti milanesi', *Stor. A.*, xv–xvi (1972), pp. 293–306
Lombard Paintings, c. 1595–c. 1630: The Age of Federico Borromeo (exh. cat., ed. P. Cannon-Brookes; Birmingham, Mus. & A.G., 1974)

JANET SOUTHORN

Visentin, Giovanni. *See* DEMIO, GIOVANNI.

Viterbo. Italian city in Lazio, between the Cimino Mountains and the valley of the River Tiber. A provincial capital, episcopal see and university town, it was the seat of the popes in the 13th century.

An Etruscan and then a Roman settlement, the site was fortified in AD 773 by the Lombard leader Desiderius (*reg* 756–74), taken by the Franks and ceded by them to the Church in 787. It was established as a commune in 1095, when the town walls were begun; with the creation of the bishopric in 1192 Viterbo became the principal rival of Rome in the region. From the early 13th century it was dominated by two rival families, the Guelph Gatti and the Ghibelline Tignosi. In 1257 Pope Alexander IV (*reg* 1254–61), in conflict with both the Empire and the Roman aristocracy, moved to Viterbo, which became the official papal residence until the death of Nicholas III in 1280. The riots following the election of Martin IV (*reg* 1281–5) led to the excommunication of the city and the departure of the papal court. This hastened the decline of the commune, which gradually became subject to Rome. Some members of the Vico family resisted, but Giovanni Vico was defeated in 1354 by the papal legate Cardinal Gil Alvarez Carrillo de Albornoz (1310–67), after which the city lost its autonomy.

The most significant urban and artistic development in the city occurred between the foundation of the commune and the 16th century. The 15th-century palazzi built by such members of the Roman patriciate as the Chigi and Farnese families foreshadowed the opulent villas in the rural environs, of which JACOPO VIGNOLA was to be the principal architect, as at the Villa Farnese (1557–84) at Caprarola. Vignola designed the Palazzo Chigi (after 1562) at Soriano, the Villa Lante (1556–78) at Bagnaia and influenced the unique Sacro Bosco, the garden below Bomarzo created from 1552 for Pier Francesco Orsini (*d* 1585; *see* BOMARZO, SACRO BOSCO). In the suburbs of Viterbo is the Renaissance church of S Maria della Quercia, completed in 1525; the three terracotta lunettes (1507–8) on the portals are by Andrea della Robbia.

Paintings in S Maria Nuova, such as those of Matteo Giovannetti (*c.* 1300–68/9), show that in 14th-century Viterbo artists were under the influence of Siena; but the work of FRANCESCO D'ANTONIO DA VITERBO and Antonio da Viterbo (*c.* 1450–*c.* 1480) in the 15th century shows contact with the art of Umbria–Tuscany. This later trend is particularly evident in the frescoes (1469) by Lorenzo da Viterbo (?1437–after 1476) in the Mazzatosta Chapel in S Maria della Verità. In the 16th century,

however, with Sebastiano del Piombo's magnificent *Pietà* (1517; *see* SEBASTIANO DEL PIOMBO, fig. 2) and *Flagellation* (1524–5; both Viterbo, Mus. Civ.), painters in Viterbo increasingly looked to Rome.

BIBLIOGRAPHY

C. Pinzi: *I principali monumenti di Viterbo* (Viterbo, 1911)
V. Scriattoli: *Viterbo nei suoi monumenti* (Rome, 1920)
A. Gottardi: *Viterbo nel duecento* (Viterbo, 1955)
I. Faldi: *I pittori viterbesi* (Rome, 1972)
A. M. Corbo: 'Chiese e artisti viterbesi nella prima metà del secolo XV', *Commentari*, i–iii (1977), pp. 162–71
B. Barbini and P. Petrassi: *Il Palazzo dei Priori a Viterbo* (Rome, 1983)
Il quattrocento a Viterbo (exh. cat. by R. Cannata and C. Strinati, Viterbo, Mus. Civ., 1983)

GIUSEPPE PINNA

Viterbo, Francesco d'Antonio (Zacchi) da. *See* FRANCESCO D'ANTONIO DA VITERBO.

Viterbo, Pier Francesco da. *See* PIER FRANCESCO DA VITERBO.

Viti, Timoteo (*b* Urbino, 1469; *d* Urbino, 1523). Italian painter. According to Vasari and Malvasia, he was apprenticed to Francesco Francia in Bologna between 1490 and 1495. While there is no documentary proof of this, constant aspects of Viti's style would seem to confirm an apprenticeship in Bologna. In 1503 he was in Urbino, painting the banners of Cesare Borgia, then lord of the city. In 1504 the Montefeltro returned to Urbino, and the young painter, together with Girolamo Genga, was commissioned by Bishop Arrivabene to decorate the chapel of S Martino in the cathedral. This cycle included a central panel by Viti, stylistically indebted to Perugino, showing *SS Thomas Becket and Martin Worshipped by Bishop Arrivabene and Duke Guidobaldo da Montefeltro* (Urbino, Pal. Ducale). Similar in style and probably from this period is the *Virgin and Child with Two Saints* (ex-Urbino Cathedral; Milan, Brera). Also painted for the cathedral was *Mary Magdalene* (1508; Urbino, Pal. Ducale). For the Tempietto delle Muse of the Palazzo Montefeltro, Viti painted the *Muse Thalia with Apollo* (Florence, Gal. Corsini), a composition that originally included two other figures.

Around 1511, perhaps during a visit to Rome, Viti saw works by Raphael, which for a while had a strong influence on him, as can be seen in the large altarpiece of *Christ Appearing to Mary Magdalene, SS Michael the Archangel and Anthony Abbot* (*c.* 1512) for the church of S Angelo Minore in Cagli (Pesaro). In later works (e.g. the *Annunciation with SS John and Sebastian*; Milan, Brera), he rejected Raphael's influence and looked back to the art of the late 15th century. In his last works (e.g. the *Mary Magdalene*, 1521; Gubbio Cathedral) his style became heavier, perhaps because of the increasing intervention of pupils.

BIBLIOGRAPHY

G. Vasari: *Vite* (1550, rev. 2/1568); ed. G. Milanesi (1878–85), iv, pp. 492–9
C. C. Malvasia: *Felsina pittrice* (1678); ed. G. Zanotti (1841), i, pp. 54–5
L. Pungileoni: *Elogio a Timoteo Viti* (Urbino, 1835)
Urbino e le Marche prima e dopo Raffaello (exh. cat., ed. M. G. C. Duprè dal Poggetto and P. dal Poggetto; Urbino, Pal. Ducale, 1983), pp. 157–8, 279–85, 315–20 [with bibliog.]
L. Arcangeli: 'Viti, Timoteo', *La pittura in Italia: Il cinquecento*, ed. G. Briganti, ii (Milan, 1987, rev. 1988), pp. 864–5 [with bibliog.]

MARCO CARMINATI

Vitoni, Ventura di Andrea (*b* Pistoia, 1442; *d* ?Pistoia, 1522). Italian architect and sculptor. He is first recorded as a master carpenter at Pistoia Cathedral in 1464. In 1473 he began a long association with the nunnery of S Giovanni Battista, Pistoia, where he worked until about 1485. In around 1483 the abbess founded another nunnery in Pistoia, dedicated to S Chiara, and Vitoni worked there for many years, most notably on the church. The work shows strong Florentine influences, which are combined with Vitoni's own skills, demonstrated in the building's attractive proportions. Owing to the restricted site, he designed an aisleless nave with a coffered ceiling and a dome at the east end; circular windows in the drum show Brunelleschi's influence. The church was completed in 1498, and Vitoni began work on the adjacent cloisters in the same year. He returned to S Giovanni Battista at about this time, where the church itself was rebuilt after 1500. Here the central space is octagonal, and the cupola owes much to the Pazzi Chapel in Florence, traditionally attributed to Brunelleschi, even down to the detailing of the radiating ribs. The upper orders of the interior again recall Brunelleschi; they are finely worked but rather fussily detailed. The octagon is dated 1513 on the trabeation.

In 1492 Giuliano da Sangallo won a competition for the new church of S Maria dell'Umiltà and asked Vitoni to prepare a wooden model. Sangallo's other commitments prevented him from building the church himself, and the work was executed by Vitoni, who made several visits to Florence to discuss progress with Sangallo. The building (see fig.) owes much more to Vitoni, however, and is perhaps his most important work. Construction began in 1495 and was completed by *c*. 1509. Vitoni was strongly influenced by Michelozzo's S Maria delle Grazie, Pistoia, itself based on the Pazzi Chapel (which has also been attributed to Michelozzo). Spatially, Vitoni was influenced by Sangallo's sacristy at Santo Spirito, Florence, together with its vestibule by Cronaca. Yet overall Vitoni lacked the clear vision of Michelozzo and Sangallo's precision of detailing. The church is an unusual structure, consisting of a spacious rectangular atrium and an octagonal nave, with a niche for the altar. The atrium has a coffered barrel vault, with a frieze and other details of pinkish marble. The octagon itself has four superimposed orders, the lowest in the form of an open arcade. All the detailing is in *pietra serena* (grey limestone), with white plastered walls. The scale is monumental, reminiscent of Romanesque baptisteries rather than the intimate refinement of the Pazzi Chapel. Much of the detailing, though, is crowded and awkwardly resolved, particularly in the altar niche, which cuts arbitrarily into the perforation of the second order windows.

Several other works in Pistoia are associated with Vitoni. His interventions at the cathedral were confined to the remodelling of the entrance portico, including the vaulting, decorated *c*. 1505 by Andrea della Robbia. Another later work was the little oratory of the Crocefisso della Morte, completed just before 1500. Two other secular works can be attributed to him with certainty; one is the Palazzo Comunale, where he rebuilt the main entrance doorway, and the other is the Palazzo Panciatichi, built for his close friend Gualtieri Panciatichi. His last important commission was at the Ospedale del Ceppo, where he built a new portico in the form of a spacious, attractive colonnade across the face of the older building. It was completed in 1514 and decorated by Giovanni della Robbia, with characteristic tondi as well as a bold, continuous frieze of coloured terracotta.

Vitoni was effectively Pistoia's city architect for several decades. Although in some examples his designs are elegant (notably the Ospedale del Ceppo and S Chiara), elsewhere his work shows a certain lack of refinement and an inability to appreciate fully the classical restraint of his Florentine mentors. Nevertheless, Vitoni, almost alone, introduced Renaissance architecture to Pistoia.

BIBLIOGRAPHY

Venturi

H. Strack: *Central- und Kuppelkirchen der Renaissance in Italien* (Berlin, 1882)

C. Stegman and H. von Geymüller: *Die Architektur der Renaissance in Toskana*, 10 vols (Munich, 1890–1908)

O. H. Giglioli: *Pistoia nelle sue opere d'arte* (Florence, 1904)

G. Marchini: *Giuliano da Sangallo* (Florence, 1942)

Ventura Vitoni e il rinascimento a Pistoia (exh. cat., ed. M. C. Buscioni; Pistoia, Mus. Civ., 1977)

Pistoia: Una città nello stato mediceo (exh. cat., Pistoia, Fortezza S Barbara, 1980)

N. Andreini Galli: *Ville pistoiese* (Lucca, 1989)

□

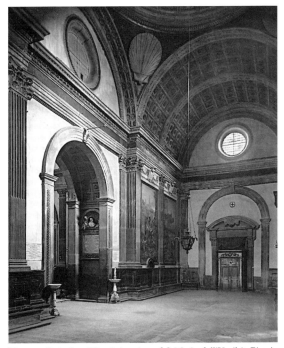

Ventura di Andrea Vitoni: interior of S Maria dell'Umiltà, Pistoia, 1495–*c*. 1509

Vitruvius (*fl* later 1st century BC). Roman architect, engineer and writer, renowned for his treatise in ten books, *On Architecture* (Lat. *De architectura*), the only text on architectural theory and practice to have survived from Classical antiquity.

1. *On Architecture*. 2. Influence.

1. 'ON ARCHITECTURE'.

(i) The text. (ii) The ten books.

(i) The text. On Architecture is a didactic treatise on the subject of architecture in all its branches as understood in Classical antiquity. Vitruvius' claim to represent accurately the theory and practice of ancient Greek and Roman architecture has been challenged by modern scholars, but his influence on later architects and students of Classical architectural styles, particularly in the Italian Renaissance was enormous (*see* §2 below). A revival of scholarly interest in Vitruvius' treatise, with several international colloquia during the 1980s, may also reflect renewed interest in Classical styles among architects, and an important new edition of the text, with French translation and commentary, has been undertaken.

The text of *On Architecture* presents two main obstacles. The first involves the corruptions of and lacunae in the original text that accumulated in the course of its transmission from antiquity. These are inevitably numerous, since Vitruvius' work abounds in technical terms and exotic proper names. As a consequence, there are considerable differences, even between the texts of modern printed editions. The two most popular English translations, for example (Morgan and Granger), differ significantly, being based on different Latin texts. A further problem concerns the illustrations. *On Architecture* was originally 'published' in parallel columns on papyrus scrolls, one scroll for each of its ten books, and the illustrations essential to the content of the treatise were either simple drawings inserted into the text or more elaborate figures appended to it. In most cases these illustrations did not survive the process of manuscript copying. Since the publication of the earliest printed editions, editors have needed either to reconstruct the drawings as indicated by the text or to find illustrations appropriate to otherwise obscure passages. Hence, the exact nature of Vitruvius' influence on architects from the Renaissance onwards often relates to specific printed editions.

The second obstacle stems from Vitruvius' literary style, which ranges from the laconic to the bombastic, often without full control of either. Vitruvius' stylistic shortcomings have often obscured his meaning, in terms both of detail and of broader questions. It has, for example, often been noted that the matter and the organization of the individual books vary greatly. For this reason *On Architecture* has been considered by its severest critics as nothing more than a compendium composed by an embittered, unsuccessful and unemployed architect. Perhaps anticipating such criticism, Vitruvius spoke in his own defence in the Preface to Book VII (all quoted passages are from Morgan's translation): 'From their commentaries [of earlier authors] I have gathered what I saw was useful for the present subject, and formed it into one complete treatise, and this principally because I saw that many books in this field had been published by the Greeks, but very few indeed by our countrymen.'

The overall organization of the treatise reflects the division of architecture into three parts: Books I–VIII deal with *aedificatio*, the science of building; Book IX with *gnomonice*, the art of making sundials; and Book X with *machinatio* or mechanics. The preface of each of the books is designed as a literary introduction, sometimes anecdotal, sometimes expository, to the more technical material presented in the particular book.

(ii) The ten books. The Preface to Book I dedicates *On Architecture* to the Emperor Augustus, thus indicating a date of 17 BC or later. Vitruvius avowed his thanks for Augustus' patronage and his hope of educating him concerning the discipline of architecture. Elsewhere in *On Architecture* there is evidence that Vitruvius was writing for a readership of other knowledgeable patrons and for professional architects themselves. It was Vitruvius' contemporary M. Terrentius Varro (116–27 BC) who seems to have been the first Roman to raise the study of architecture to the level of the Liberal Arts, dedicating a book to it in his encyclopedic *Disciplinarum libri*. Vitruvius' work was no doubt, in addition to its other claims, intended to raise the social status of the profession.

The first chapter of Book I defines a broad range of subjects appropriate to the education of the architect: he should be literate, able to draw and have a knowledge of geometry, optics, arithmetic, history, philosophy (including physics), music, medicine, law and astronomy. Though he should be educated in all the arts, the architect must not be expected to excel in each. Here Vitruvius made an important distinction between practice and theory, stating that the arts were each dualities composed of the work itself (*opus*) and its theoretical dimension (*ratiocinatio*). For the architect, the theory of architecture should suffice. However, despite the great influence that Vitruvius' treatise was to have over architectural design, it does not accord practice (*fabrica*) and theory the usual relation to one another found in dualist systems. Theory is presented not as a preparatory basis for the work in the form of design, but rather as a way of explaining or justifying the effect produced by the work. Hence, the importance of theory lies in the relation of the architect to his patron, and the treatise provides the means of appreciating the subject for those who are not professional architects.

In the second chapter the fundamental principles of both architectural practice and theory are laid out. These are: Order (*ordinatio*), Arrangement (*dispositio*), Eurhythmy (*eurythmia*), Symmetry (*symmetria*), Propriety (*decor* or *decorum*) and Economy (*distributio*). It has been noted (see Watzinger) that the six fundamental principles of architecture listed by Vitruvius actually consist of three distinct concepts, each divided into pairs according to the opposition of artistic practice and theory, or 'process' and 'product'. These are: Order/Symmetry; Arrangement/Eurhythmy; and Economy/Propriety. Certain phrases demonstrate that Vitruvius conceived of the design process as essentially synthetic, consisting of different components and their 'adjustment[s] according to quantity'. Products, on the other hand, he saw as unities subject to analysis, 'fashioned with quality'. Hence, Order is 'an adjustment according to quantity' by which the whole is constructed, whereas Symmetry, the 'proper arrangement between members of the work', is its qualitative result. Arrangement is the quantitative 'putting of things in their proper places', and Eurhythmy its qualitative result. Finally, Economy involves the architect's quantitative consideration of the appropriateness of the site and what the client

can afford, and Propriety is the quality that results. Of the six principles, Propriety alone receives further analysis, being divided into three parts: religious custom or prescription (*statio*), social usage or habit (*consuetudo*) and natural causes (*natura*). If this passage constitutes Vitruvius' theory of architecture (see Watzinger), his exposition leaves much to be desired. Nevertheless, the application of these principles elsewhere in his treatise is more or less consistent, indicating that, whatever the source of the theory, Vitruvius made it his own. In any case, Vitruvius' discussion is an important source for the study of ancient architectural theory.

The remainder of Book I deals with the selection of the site for a city and its buildings. The site itself should be healthy, with a temperate balance of the four Empedoclean elements of moisture, heat, air and earth. Having ascertained that the city can be supplied by roads, rivers or sea ports, the architect should lay out encircling walls and towers. Then, setting up a gnomon in the centre of the site, he should determine from the sun's course the cardinal directions and sources of the eight winds. The text provides sufficient detail here for the illustration to be reconstructed (see fig. 1). Having determined the cardinal directions, the architect can lay out streets and alleys. Book I ends with a discussion of the proper sites for the forum and for the temples.

Book II is devoted to the materials used in construction. This book shows Vitruvius at his most original and for this reason seems to break the continuity between Book I and Book III, so that some scholars have considered it to be a later, ill-fitting addition. It presents a thorough attempt to relate materials used in building to their occurrence in nature and also views human technology as a product of man's natural inclination to learn through imitation. Like his contemporary Lucretius, Vitruvius was, therefore, inclined to discover the authority for current practices in the remote, natural origins of human culture. For example, the control of fire and the society of the hearth preceded even the development of language, a fact that lends antiquity and dignity to the profession of architecture.

In discussing the methods of building masonry walls with a concrete core, Vitruvius distinguished two types, one faced with irregular stones laid in an irregular pattern (*opus incertum*), the other employing regular wedges laid in a reticulate pattern (*opus reticulatum*). In a passage that has received much attention from archaeologists, Vitruvius preferred the more ancient *opus incertum* to the contemporary *opus reticulatum*. In declaring his allegiance to the 'Ancients' he explained the contemporary preference for *opus reticulatum* as an aesthetic rather than a structural choice. While archaeology has verified Vitruvius' relative chronology, it has also confirmed the impression that he may have been a pious antiquarian out of touch with the reasoning behind contemporary practice. Economics rather than aesthetics probably dictated the choice of *opus reticulatum*, especially since walls of both types were normally faced with stucco or marble. Furthermore, Vitruvius' misgivings about the structural properties of *opus reticulatum* do not seem to be borne out in surviving examples.

Current practices occasionally won the approval of this conservative author, however. One passage in Book II (II.viii.17) gives an invaluable glimpse of contemporary Roman multistorey city housing:

> In these tall piles reared with piers of stone, walls of burnt brick, and partitions of rubble work, and provided with floor after floor, the upper storeys can be partitioned off into rooms to very great advantage. The accommodations within the city wall being thus multiplied as a result of the many floors high in the air, the Roman people easily find excellent places in which to live.

Given Vitruvius' evident approval of this type of construction, his conservatism cannot be simply regarded as indiscriminate.

Books III and IV are both concerned with temple architecture. Book III begins with a discussion of Symmetry in temples and in the human body, and the first chapter contains the famous passage constructing the ideally proportioned 'Vitruvian Man'. In resuming the discussion of the organization of architecture according to type and returning to theory, Book III appears to continue from Book I rather than from Book II. It proceeds to a classification of temples according to plan and to a discussion of the *eustyle*, or 'well-proportioned' elevation. Vitruvius acknowledged the source for his ideas here to be the 2nd-century BC Greek architect Hermogenes, and this has led many commentators to infer that he followed Hermogenes closely in his treatment of the Ionic order, which in retrospect (III.v.15) he declares to have been the subject of Book III.

Accordingly, Book IV contains a discussion of material not treated by Hermogenes: the Corinthian and Doric orders, and the rules for Etruscan temples. Vitruvius' treatment of the Doric order (IV.iii) begins with the observation that the 'Ancients', among whom he numbers Hermogenes and Pytheos, considered this order unsuitable for temples because of such inherent design problems as

1. Vitruvius: design for a sundial (gnomon), to be used in determining the optimum site for a city; from his *Ten Books on Architecture*, translated by M. H. Morgan (Cambridge, MA, 1914), Bk I, p. 30

the uneven spacing of triglyphs at the corners of a Doric building. Given Vitruvius' earlier discussion of ideal, *eustyle* proportion in the Ionic order, his treatment of Doric proportions is perfunctory, though informative. It covers the subject of such Doric refinements as curvature on the stylobate and entasis, which are considered necessary to correct optical illusions and are therefore subject to the general principle of Symmetry. Chapter seven briefly deals with the construction of an Etruscan temple using modular measurements and chapter eight is devoted to circular temples and other variations, as determined by Decorum (IV.viii.6): 'For we must not build temples according to the same rules to all gods alike, since the performance of the sacred rites varies with the various gods.'

Book V deals with the remaining public building types: fora, basilicas, theatres, baths and palaestrae. It concludes with a brief discussion of harbours, breakwaters and shipyards. The treatment of fora begins by contrasting the Greek agora with the Roman forum, the latter requiring two-storey buildings with wider intercolumniations, thanks to the custom of staging gladiatorial combats in the forum. In treating basilicas and their proportions in general, Vitruvius gave specific dimensions for his own (unlocated) building at Fano. The discussion of theatres again distinguishes between the Roman type and the Greek; both descriptions follow a treatment of harmonics based on the theories of Aristoxenos (*fl c.* 300 BC) and the amplification of the voice by means of bronze vessels. In the designs for both Roman and Greek theatres Vitruvius employed a circle containing a 12-sided polygon to determine the relation of the *orchestra* to the *cavea* (auditorium) and the stage building. In the Roman figure four equilateral triangles are inscribed within the circle, 'as the astrologers do in a figure of the twelve signs of the zodiac, when they are making computations from the musical harmony of the stars', and each fifth point is connected (representing the diapason). In the Greek figure three squares are inscribed: each fourth point is connected (the diatesseron). Excavation has shown that many ancient Greek theatres were designed according to the principle given by Vitruvius, but no Roman theatres have as yet been found conforming to this scheme. The passage is thus better understood as an attempt to propose new architectural principles than as evidence of Vitruvius' lack of knowledge of current practice.

Book VI is concerned with such private building types as the Roman town house (*domus*) and farm house (*villa*), and the Greek house, though a treatment of the luxury villa is noticeably absent. The material evidence from excavations at Pompeii and elsewhere in Italy has confirmed Vitruvius' account of the design of both *domus* and *villa* types, and the arrangement and proportioning of rooms of the grand houses from Pompeii conform closely to his rules. This is important evidence that he was intimately familiar with Italian domestic design as it had evolved from the 3rd–1st centuries BC. Appealing to the principle of Decorum, Vitruvius justified building on a grand scale for the houses of prominent public figures. In contrast with moralists who condemned contemporary luxury as vanity, Vitruvius noted the many public uses such houses afforded, as places for public meetings, private trials and judgements, and other functions.

Book VII addresses the interior decoration of houses, including floors, stuccoed walls and frescoes. In addition to its valuable information concerning contemporary practice, Book VII is notable for Vitruvius' historical summary of representational wall painting (VII.v.1–4) and his tirade against the decadence of the current fashion for the grotesque (VII.v.3–4). As well as providing an important document for post-Classical arguments in favour of the natural as opposed to the imaginary in art, this passage has also been important for the classification and dating of Pompeian wall painting.

Book VIII is devoted to hydrology and hydraulics and is essentially both a continuation of the study of building on certain sites and a transition to the last two books, which deal with the construction of water clocks and sundials (IX) and with mechanics (X). In addition to the ways of locating good water, Book VIII deals with aqueducts, wells and cisterns. Although Vitruvius provided technical specifications for constructing water systems with lead pipes, he strongly recommended against the use of lead for health reasons (VIII.vi.10–11). The extensive Introduction to Book IX concerns the workings of the heavens, and this book as a whole is extremely important for the history of ancient mathematics. Book X, on the subject of mechanics and ballistics, is perhaps the closest of all the books to Vitruvius' own area of expertise as a military engineer. Yet the extended treatment of mechanical advantage was also no doubt a subject of the greatest importance to contemporary civil architects and builders.

On Architecture is important both for the history of architecture and its theory, thanks to Vitruvius' conscientious habit of citing his sources; although he wrote as a historian, he had the viewpoint of a practising architect.

WRITINGS

M. H. Morgan, trans.: *The Ten Books on Architecture* (Cambridge, MA, 1914/*R* New York, 1960)

F. Granger, ed. and trans.: *On Architecture*, 2 vols (London and Cambridge, MA, 1931, 1934) [ed. from Harleian MS. 2767]

S. Ferri, ed.: *Vitruvio: Architettura, dai libri* I–VII (Rome, 1960) [with commentary]

C. Fensterbusch, ed. and trans.: *Vitruvii: De architectura libri decem* (Berlin, 1964) [with Ger. trans.]

J. Soubiran, ed. and trans.: *Vitruve: De l'architecture, Livre* IX (Paris, 1969) [with Fr. trans. and commentary]

L. Callebat, ed. and trans.: *Vitruve: De l'architecture, Livre* VIII (Paris, 1973) [with Fr. trans. and commentary]

L. Callebat and P. Fleury, eds and trans.: *Vitruve: De l'architecture, Livre* X (Paris, 1986) [with Fr. trans. and commentary]

P. Fleury, ed. and trans.: *Vitruve: De l'architecture, Livre* I (Paris, 1990) [with Fr. trans. and commentary]

BIBLIOGRAPHY

Macmillan Enc. Architects; Pauly–Wissowa

C. Watzinger: 'Vitruvstudien', *Rhein. Mus. Philol.*, lxiv (1909), pp. 203–23

A. Boethius: 'Vitruvius and the Roman Architecture of his Age', *Dragma M. P. Nilson dedicatum* (Lund, 1939), pp. 114–43

P. Ruffel and J. Soubiran: 'Vitruve ou Mamurra?', *Pallas*, xi (1962), pp. 123–79

P. Gros: 'Vitruve: L'Architecture et sa théorie à la lumière des études récentes', *Aufstieg und Niedergang der römischen Welt*, ii (Berlin, 1982), pp. 659–95

Vitruv-Kolloquium des deutschen Archäologen-Verbandes: Darmstadt, 1982

L. Callebat and others, eds: *Vitruve, De architectura: Concordance*, 2 vols (Hildesheim, Zurich and New York, 1984)

H. Knell: *Vitruvs Architekturtheorie: Versuch einer Interpretation* (Darmstadt, 1985)

Munus non Ingratum: Proceedings of the International Symposium on Vitruvius' 'De architectura' and the Hellenistic and Republican Architecture: Leiden, 1989

EUGENE DWYER

2. INFLUENCE.

(i) c. 1350–c. 1500. In spite of the relatively wide circulation of *On Architecture* north of the Alps in the medieval period, until about the middle of the 14th century there was apparently just one copy in the Italian peninsula, in the library of Montecassino. Shortly after 1350 Petrarch brought a copy from France and showed it to Boccaccio and other literary friends, so it became known in North Italy and in Florence (see Ciapponi, 1960). Thus, long before Poggio Bracciolini 'rediscovered' the treatise at St Gall in 1416, a favourable climate existed for a new interest in the Vitruvian text.

In the 15th century, almost 15 centuries after it was written, *On Architecture* increasingly began to affect architectural practice in a way it had never done before, enjoying a uniquely delayed influence. The new humanist interest in Greek and Latin writings obviously extended to Vitruvius. In addition, the admiration for the unsurpassed architecture of the ancient Romans encouraged the belief that there was a lost body of knowledge, a set of principles and laws according to which ancient architecture had been created that could be found in Vitruvius' treatise—the only one that survived from the whole Greco-Roman world, and one written by an architect. Moreover, basing architecture on a set of rules meant giving this discipline a scientific dignity on a par with the liberal arts, lifting it from the artisanal sphere and giving architects the higher social position to which they had aspired at least since the time of Filippo Brunelleschi in the early 15th century. At first Vitruvius' treatise seemed to hold great promise for the humanists. As few architects had a literary education, however, the Latin language, the obscurity of the text (corrupted by successive manuscript transcriptions) and the loss of the original illustrations made it inaccessible to most of them. Even those who could read the treatise found inconsistencies in the most interesting part, the section on the orders in books III and IV, which made it hard to apply in practice.

Alberti was the first humanist to study architectural theories. Initially, perhaps in 1440 at the suggestion of Lionello d'Este, Marchese of Ferrara, he may have planned to write a commentary on *On Architecture*. Soon, however, he became dissatisfied with the obscurities and imprecisions of the ancient text and began a work of his own, *De re aedificatoria* (Florence, 1485), which he finished in 1452 (*see* ALBERTI, LEON BATTISTA). Alberti criticized Vitruvius' language and also his notion of the encyclopedic education necessary for architects, but he nonetheless adopted several elements from *On Architecture* in his own work. Some were purely formal, such as the division into ten books and the use of many of the same headings, though in a different order. He also followed Vitruvius' indications to reconstruct the types of ancient buildings. In particular, he proposed a plan for a house with a courtyard inspired by the *domus*, showing a comprehension of that type of dwelling that long remained unequalled. Drawing on Vitruvius' books III and IV, he described the various kinds of columns, including the 'Italic' (later known as the Composite), which was not mentioned by Vitruvius; Alberti thus laid the basis for the Renaissance system of orders that became canonical in the following century (*see*

§ii) below). He also used the Latin treatise to interpret the variety of evidence provided by ancient architecture itself; and he was the first to expound, first in writing and then in actual practice, the project of enriching Vitruvius' descriptions with the analysis of monuments.

It is possible (though unproven) that, even before Alberti, Brunelleschi had read *On Architecture* and that in studying ancient Roman monuments his knowledge of the treatise helped him to distinguish the various types of columns. In fact, in using well-defined Corinthian and Ionic capitals with fragments of trabeation, Brunelleschi indicated that he had an idea of two essential aspects of the orders described by Vitruvius: the distinction of the types of columns and the trilithic system. In this sense he can be considered the first of the Vitruvian architects.

The first attempts to create houses based on the types described in *On Architecture* may have been almost as early. Initially, it seems, only the names of the principal parts of the *domus* were used; but later efforts were made to make the plans conform to Vitruvian types. For example, in 1432 Francesco Pizzolpasso (documented after that date as owning a codex of Vitruvius) used the word 'atrium' for the entrance hall of a palazzo built in the 1420s for Cardinal Branda Castiglione Olona near Varese (see Morresi, 1986; Onians, 1988); and in the Este villa of Belriguardo, near Ferrara, finished in 1435, the elevation remains Gothic while the plan seems inspired by the Vitruvian description of the Greek house (see Kehl, 1992). The type of palazzo with a court surrounded by porticos, the Renaissance equivalent of the *domus* that later became common, was then unusual. In fact, in the 1450s Flavio Biondo (*Roma triumphans*), describing the form of the ancient Roman house, cites as modern examples the palace of Bernabò Visconti in Milan and the cloisters of convents, which he thought had preserved the ancient form of the *domus* because such dwellings had often been converted to house the original monasteries of religious orders.

In the second half of the 15th century, perhaps thanks to Alberti's criticisms, the spread of *On Architecture* increased. It was circulated in many manuscript copies (see fig. 1), held in the libraries of the most important courts and owned by great patrons and literary men of all kinds, including philologists (e.g. Ermolao Barbaro and Angelo Poliziano), authors of treatises on government (e.g. Francesco Patrizi of Siena) and, less frequently, cultured architects interested in architectural theory. During the years when Alberti was writing *De re aedificatoria*, Lorenzo Ghiberti, who owned a copy of *On Architecture*, inserted in his *Commentarii* passages from his own translation of it. A copy made by Buonaccorso Ghiberti in his *Zibaldone* of other parts translated by Lorenzo shows that he was seeking information on types of temples, orders and their proportions, the *domus* and its rooms—subjects for which Vitruvius was studied throughout the Renaissance.

FILARETE, in his treatise finished in 1464, referred to Book III of *On Architecture* for the proportions of the human figure and the temple, and introduced a chapter on the analogy between architecture and the human body, in which he combined elements of Vitruvius' exposition with Greek and Christian sources. In his unpublished

1. *Vitruvius* (holding stonecutting tools); decorated initial from a manuscript copy of *On Architecture*, Book I (Eton, Berks, Eton College Library, MS. 137, fol. 1*r*)

writings of the mid-1480s Francesco di Giorgio Martini further extended the significance of Vitruvius' analogies as a basis for justifying proportions. He used a passage from Vitruvius on the human body as a model of proportion, the theme of man as microcosm and the anecdote of Dinocrates, to propose a correspondence between the human body and cities, forts and castles, and—recalling medieval allegories—between the human body, plants, and sections of churches.

Francesco di Giorgio Martini was one of the first architects to produce an extensive translation of *On Architecture*. First, with the help of humanist friends, he translated selected passages to use in the first edition of his own treatises; then (mid-1480s) he made a translation of almost the whole work, one of the first to survive. With his numerous descriptions of ancient monuments, he began the long process of comparing Vitruvius' writings with the realities of Roman architecture, and his exposition of the typology of houses and of the orders was inspired by Vitruvius. One of Francesco di Giorgio's most obvious misunderstandings—he confused Doric and Ionic capitals—shows how difficult it still was for an architect to connect Vitruvius' descriptions with the forms of ancient architecture. In the same period (1488) Giuliano da Sangallo, assisted by no less a literate architectural dilettante than Lorenzo de' Medici, took his inspiration from Vitruvius' description of the *domus* in designing a palace for Ferdinand I of Naples, attempting to recreate a plan in the antique style. He also proposed, for the first time, the interpretation of the atrium as a hall in basilican form (see Biermann, 1970). Giuliano, who evidently read Latin and knew Alberti's treatise as well as *On Architecture*, enriched the application of the Vitruvian orders, making use again of the Tuscan order in the courtyard of the Palazzo Scala, and giving a new importance to the Ionic (at Poggio a Caiano and Cestello), which was formerly confined to secondary positions (see Tönnesmann, 1983;

Guillaume, 1988, pp. 135–50). The difficulty of the text, however, still made the treatise inaccessible to most architects.

In most of the manuscript copies of *On Architecture* made in Italy in the second half of the 15th century (the Vatican library alone has more than a dozen), copious marginal notes give clues to the culture and interests of those who were reading it. The notes, almost always in Latin, concern not only geographical and historical curiosities but also the vocabulary of ancient architecture—especially the types of dwellings, the orders and their rules of proportion. Now and then sketches appear in the margins, mostly referring to the scientific, astronomical and geometrical topics rather than the specifically architectural ones. It would appear that very few skilled draughtsmen were reading the treatise. The work of two or three generations of humanists and architectural scholars was needed before architects could make more than sporadic use of the text.

The first printed edition of *On Architecture*, with emendations, was produced by a philologist, Sulpizio da Veroli, between 1486 and 1492. The initiative came from the circle of Cardinal Raffaele Riario, who was especially interested in Vitruvius' treatment of the theatre. In the same climate, the façade of the Cardinal's Roman palazzo (*c.* 1485–*c.* 1511), later called the Palazzo della Cancelleria (*see* ROME, §V, 6(i)), was clad with Travertine slabs—a direct evocation of the *opus isodomum*, the most admired ancient stonework described by Vitruvius.

ii) After c. 1500. In the 16th century Vitruvius' treatise became more comprehensible thanks to the work of Fra Giovanni Giocondo, who, after more than two decades of preparation, published the first abundantly illustrated edition (Venice, 1511). A humanist philologist who knew Latin and Greek, he was at the same time an architect and student of ancient architecture and of Latin and Greek texts on scientific disciplines. For his edition of Vitruvius, he drew on his knowledge in all these areas (rarely united in one person) and put what he learnt from ancient texts to immediate use in his own architectural work, for example in the building of the Pont Nôtre-Dame in Paris (see Ciapponi, 1984). Fra Giocondo's emendations to the text, sometimes conjectural, are for the most part still accepted by modern scholarship; and his drawings, reproduced as woodcuts, created a precedent for illustrated treatises on architecture in the following decades (for illustration *see* GIOCONDO, GIOVANNI). They gave readers considerable help in understanding the text and they clarified the architectural orders so that errors like Francesco di Giorgio's became impossible. Less useful in making the treatise correctly comprehensible was the first translation into the vernacular (Como, 1521) by the Lombard architect CESARE CESARIANO. Like that of Fra Giocondo, this edition was illustrated, and it was provided with a full commentary. Though the comments are learned, the figures are often inspired less by Classical architecture than by the *all'antica* architecture of 15th-century North Italy. One of the main merits of this translation is its graphic reconstruction of the types of dwellings, for which the author used Alberti's treatise (without citing it) and his

own knowledge of courtyard houses in various North Italian cities of Roman foundation.

In Rome, Vitruvius' treatise had a direct influence on architectural practice from the early 16th century, especially on the development of a vocabulary based on the system of orders. Bramante, drawing on Vitruvius' text, which he knew from his Milanese period, as well as on Alberti and on his direct observation of ancient structures, used the complete Doric order in the Tempietto (after 1502) at S Pietro in Montorio, Rome, and in the spiral stairway of the Cortile del Belvedere (*c.* 1505) in the Vatican he placed in orderly sequence the types of columns—Tuscan, Doric, Ionic and Composite, which was not then clearly distinguished from the Corinthian (*see* BRAMANTE, DONATO, figs 4 and 5).

In the second decade of the 16th century Raphael, in particular, gave greater importance to the Ionic order. Antonio da Sangallo (ii) showed an early tendency to follow the Vitruvian text more rigidly, even in the canons of proportionality. The standard system of orders, which was elaborated first in the Roman architecture of the first part of the 16th century, was later codified in the treatises of SEBASTIANO SERLIO (1537), JACOPO VIGNOLA (1562) and Andrea Palladio (1570), and remained for centuries the foundation of Western architectural language. This was not taken entirely from Vitruvius, however. The Corinthian style was partly invented by 16th-century architects on the basis of examination of Roman monuments; the Composite order was first described by Alberti; and even the Tuscan, to which Vitruvius devoted only a few summary remarks, was partly re-created by Renaissance architects. Certain fundamental concepts are nevertheless obviously Vitruvian: trabeation, the numerical proportioning of elements, their definition by set types and the meanings associated with each type of column could not have been arrived at through the mere study of ancient monuments without reference to the text of Vitruvius.

At the same time the generation after Bramante, especially Antonio da Sangallo (ii), tended to draw inspiration from Vitruvius' description of Roman and Greek houses not only in the generic reference to the type of house with a courtyard, but also in trying (as Palladio did later) to re-create the principal parts of the *domus* (at times in accordance with distorted restorations). Thus in the Palazzo Farnese (1514–16; *see* PALAZZO, fig. 2) and some other palace schemes, Antonio reintroduced an atrium in the form of a basilican hall from Fra Giocondo's version of the Vitruvian *domus*; the same type of atrium reappeared in Raphael's plans for the Villa Madama (1518), Rome; and Giulio Romano built one in the Palazzo del Te (from 1526), Mantua, as did Michele Sanmicheli in the Palazzo Grimani (1556), Venice.

Antonio da Sangallo (ii) and his brother Battista da Sangallo thought of themselves as true Vitruvians and were so judged by their contemporaries. They owned the principal editions of *On Architecture*, which they both tried to translate (when he died in 1548 the latter had almost finished an illustrated translation, which he intended to publish), and they used Vitruvian theory to criticize the work of other architects, from Raphael's plan for St Peter's (*c.* 1529) to Michelangelo's cornice for the Palazzo Farnese

(1546). According to the explicit testimony of his brother, Antonio wanted to follow the 'rule of Vitruvius' in the Palazzo Farnese. For him, following the rule meant drawing on the plans described in the treatise to re-create the *domus*, villas and theatres for modern use and aiming to adopt Vitruvius' syntax and proportions in the use of the orders. He tried to establish types of details (especially in the 1530s and 1540s) by translating the appropriate passages of *On Architecture* into drawings, with many misunderstandings and some adaptations to ideas taken from ancient architecture. He also sought to interpret and extend the Vitruvian principle of truth and naturalness of the architectural elements (see Guillaume, 1988, p. 52). His whole approach was singularly consonant with Vitruvius' prescriptive aims.

At the same time Antonio da Sangallo (ii) and his assistants, as well as others, were directly studying ancient architecture to compare the reality with the precepts of Vitruvius, and to fill the gaps in the treatise with what could be learned from analysis of the monuments. Very soon the systematic analysis of these structures, surveyed and restored through the medium of scale drawings along lines proposed by Raphael (*c.* 1519), showed how ill-founded was the naive, *a priori* notion (expressed by Antonio in the preface to his own translation of Vitruvius) that Roman architecture of the Imperial age, being later than Vitruvius, necessarily followed his precepts. In fact most of the time, for example in defining a type of archaic Ionic base, Vitruvius referred to models remote in time and space, using the writings of Greek theorists rather than contemporary Roman practice.

There were different reactions to the contradictions between the descriptions of Vitruvius and the reality of ancient buildings. Raphael, when he was appointed architect for St Peter's in 1514, read Vitruvius in an Italian translation made at his request by Marco Fabio Calvo. In it he found 'great light, but not enough of it' and drew freely on ideas derived from ancient architecture. Baldassare Peruzzi observed that ancient buildings offered a great variety of solutions and that those described by Vitruvius were not always the best; he used his own judgement in the choice of elements. Serlio, in book III of his treatise (1540) tried to follow Vitruvius dogmatically in studying ancient architecture to distinguish the positive aspects from those to be condemned. Antonio da Sangallo sometimes tried to eliminate contradictions by bending his interpretation of the text to fit what he saw in the ancient monuments.

The Accademia della Virtù, a private society of intellectuals, was more critical and flexible in its approach. In its programme of Vitruvian studies (1542) it proposed to compare ancient monuments and their details with the rules in *On Architecture* and wherever there was divergence to seek the particular reasons for it. To this end Vignola was engaged to do scale drawings of Roman monuments. The academy's programme marked the high point of research on Vitruvius and closely related studies of ancient architecture in 16th-century Rome. The group, led by Claudio Tolomei, intended to prepare and publish 17 works on *On Architecture* and antiquarian studies: the corrected Latin text, a translation, a set of illustrations much fuller than that of Fra Giocondo, lexicons and

various accessory materials, and annotated surveys of monuments. Because the project lacked financial backing, however, they managed only to organize a series of weekly meetings in which each member of the group in turn read his commentary on one part of the treatise. It took three or four years to complete the study of the whole work. This initiative recalls other early experiences of collective teaching or study of architectural theory based on the reading of Vitruvius: Fra Giocondo's public lectures on *On Architecture*, given in Paris at the beginning of the century, in which he supplemented his comments with drawings, and the group readings organized by Michelangelo and Giovan Francesco da Sangallo, together with other artists and *letterati*, in Florence in 1520.

Meanwhile in Venice, Daniele Barbaro, with the help of Palladio for the main illustrations, had prepared his own annotated translation of *On Architecture*, published in 1556 (see fig. 2). Thanks to his scientific education, Barbaro, who tackled all the ten books of the treatise with equal interpretative zeal, produced the first printed translation showing a full comprehension of the Latin text (*see* BARBARO, (1)). His version was unrivalled for a couple of centuries, until the 18th-century version of Galiani. Basing himself on Barbaro's translation, Palladio continued the attempt begun in the previous century to recreate *all'antica* types of palazzi, villas and theatres derived from Vitruvian descriptions (*see* THEATRE). To the revival of the atrium of the *domus* he added, both in theory and practice, that of the hall with four columns (see Wittkower). Vignola's

contemporary *Regola delli cinque ordini d'architettura* (Rome, 1562), based on a study of ancient monuments that resulted from Vignola's involvement with the Accademia della Virtù, has little connection with the precepts of Vitruvius, however: only for the Tuscan order does the author mention having referred to *On Architecture*, for lack of ancient examples. But the result of Vignola's work, a simple rule drawing together a long series of relationships between the elements of the five orders, is close to the spirit if not the letter of Vitruvius.

After the publication of Vignola's *Regola* and Palladio's *I quattro libri dell'architettura* (Venice, 1570), Vitruvius' treatise lost its pre-eminent position by comparison with new standard works annotated with examples of ancient or modern architecture. At the same time the founding of the design academies reduced its importance as an introduction to architectural theory. Interest in Vitruvius revived later, however, in all the periods of renascent classicism, especially in the 18th century with Galiani's translation. The reading of Vitruvius' treatise was then heavily influenced by the interpretations given by Renaissance architects and literary men.

BIBLIOGRAPHY

EARLY SOURCES

G. Giocondo: *M. Vitruvius, per iucundum solito castigatior factus, cum figuris et tabula, ut iam legi et intellegi possit* (Venice, 1511)

C. Cesariano: *Di Lucio Vitruvio Pollione de architectura libri dece traducti de Latino in Vulgare* (Como, 1521); ed. F. Piel, with intro. by C. H. Krinsky (Munich, 1969)

D. de Sagredo: *Medidas del romano* (Toledo, 1526); ed. F. Marías and A. Bustamente (Madrid, 1986)

G. Philander: *In decem libros M. Vitruvii Pollionis de architectura annotationes* (Rome, 1544)

D. Barbaro: *I dieci libri dell'architettura di M. Vitruvio* (Venice, 1556); ed. M. Tafuri (Milan, 1987)

G. Poleni: *Exercitationes vitruvianae primae* (Padua, 1739)

GENERAL

E. Forsmann: *Dorisch, Ionisch, Korintisch: Studien über das Gebrauch der Säulenordnungen in der Architektur des 16.–18. Jahrhunderts* (Stockholm, 1961)

R. Wittkower: *Architectural Principles in the Age of Humanism* (London, 1962)

R. Weiss: *The Renaissance Discovery of Classical Italy* (Oxford, 1969, rev. 1988)

A. Tönnesmann: *Der Palazzo Gondi in Florenz* (Worms, 1983)

J. Onians: *Bearers of Meaning: The Classical Orders in Antiquity, the Middle Ages and the Renaissance* (Princeton, 1988)

SPECIALIST STUDIES

F. Pellati: 'Vitruvio nel medio evo e nel rinascimento', *Boll. Reale Ist. Archeol. & Stor. A.*, v/4–5 (1932), pp. 111–18

——: 'Vitruvio e il Brunelleschi', *Rinascita*, ii (1939), pp. 343–65

H. Koch: *Vom Nachleben des Vitruv* (Baden Baden, 1951)

P. G. Hamberg: 'G. B. da Sangallo detto il Gobbo e Vitruvio con particolare riferimento all'atrio di palazzo Farnese a Roma e all'antico castello reale di Stoccolma', *Palladio*, viii (1958), pp. 15–21

L. A. Ciapponi: 'Il *De architectura* di Vitruvio nel primo umanesimo', *Italia Med. & Uman.*, iii (1960), pp. 59–99

R. Krautheimer: 'Alberti and Vitruvius', *Acts of the 20th International Congress of the History of Art: New York, 1961*, ii, pp. 42–53

C. H. Krinsky: 'Seventy-eight Vitruvius Manuscripts', *J. Warb. & Court. Inst.*, xxx (1967), pp. 36–70

H. Biermann: 'Das Palastmodell Giuliano da Sangallos für Ferdinand I, König von Neapel', *Wien. Jb. Kstgesch.*, xxiii (1970), pp. 154–95

J. Onians: 'Alberti and φιλδρετε : A Study in their Sources', *J. Warb. & Court. Inst.*, xxxiv (1971), pp. 96–114

P. N. Pagliara: 'L'attività edilizia di Antonio da Sangallo il giovane: Il confronto tra gli studi sull'antico e la letteratura vitruviana', *Controspazio*, iv/7 (1972), pp. 19–55

2. Illustration printed opposite the opening text page of D. Barbaro: *I dieci libri dell'architettura di M. Vitruvio* (Venice, 1556)

V. Juřen: 'Fra Giovanni Giocondo et le début des études vitruviennes en France', *Rinascimento*, 2nd ser., xiv (1974), pp. 101–15

V. Fontana and P. Morachiello: *Vitruvio e Raffaello: Il 'De architectura' di Vitruvio nella traduzione inedita di Fabio Calvo ravennate* (Rome, 1975)

L. A. Ciapponi: 'Vitruvius', *Catalogus translationum et commentariorum*, ed. F. E. Cranz (Washington, DC, 1976), iii, pp. 399–409

C. Thoenes: 'Spezie e ordine di colonne nell'architettura del Brunelleschi', *Filippo Brunelleschi: La sua opera e il suo tempo: Convegno internazionale di studi: Firenze, 1977*, ii, pp. 459–69

L. Cervera Vera: *El codice de Vitruvio hasta sus primeras versiones impresas* (Madrid, 1978)

V. Juřen: 'Politien et Vitruve (Note sur le MS. Lat. 7382 de la Bibliothèque nationale)', *Rinascimento*, 2nd ser., xviii (1978), pp. 285–92

L. Marcucci: 'Regesto cronologico e critico' and 'Giovanni Sulpicio e la prima edizione del *De architectura* di Vitruvio', *Stud. & Doc. Archit.*, viii (1978), pp. 29–184, 185–95

M. Tafuri: 'Cesare Cesariano e gli studi vitruviani del quattrocento', *Scritti rinascimentali di architettura* (Milan, 1978), pp. 388–92

L. Vagnetti: 'Per una coscienza vitruviana', *Stud. & Doc. Archit.*, viii (1978), pp. 15–24

G. Scaglia: 'A Translation of Vitruvius and Copies of Late Antique Drawings in Buonaccorso Ghiberti's "Zibaldone"', *Trans. Amer. Philos. Soc.*, lxix (1979), pp. 3–30

S. Deswarte: 'Francisco de Hollanda et les études vitruviennes en Italie', *A introdução da arte da renascença na península ibérica: Actas do simpósio internacional: Coimbra 1981*, pp. 227–80

F. P. Fiore: 'Cultura settentrionale e influssi albertiani nelle architetture vitruviane di Cesare Cesariano', *A. Lombarda*, 64 (1983), pp. 43–52

L. A. Ciapponi: 'Fra Giocondo da Verona and his Edition of Vitruvius', *J. Warb. & Court. Inst.*, xlvii (1984), pp. 72–86

A. Bustamante and F. Marías: 'La Révolution classique: De Vitruve à l'Escorial', *Rev. A.*, 70 (1985), pp. 29–40

F. P. Fiore: 'La traduzione di Vitruvio di Francesco di Giorgio', *Archit.: Stor. & Doc.*, i (1985)

G. Scaglia, ed.: *Il Vitruvio magliabechiano di Francesco di Giorgio Martini* (Florence, 1985)

M. Morresi: 'Pier Candido Decembrio, Francesco Pizzolpasso e Vitruvio', *Ric. Stor. A.*, 28–9 (1986), pp. 217–23

P. N. Pagliara: 'Vitruvio da testo a canone', *Memoria dell'antico nell'arte italiana*, ed. S. Settis, iii (Turin, 1986), pp. 3–85

A. Cerutti Fusco: 'La restituzione grafica di testi antichi nei primi decenni del cinquecento: Interesse antiquario, studi vitruviani e "inventioni"', *Saggi in onore di Guglielmo De Angelis d'Ossat*, ed. S. Benedetti and G. M. Mariani (Rome, 1987), pp. 301–12

F. Zöllner: *Vitruvs Proportionsfigur: Quellenkritische Studien zur Kunstliteratur: 15. und 16. Jahrhunderts* (Worms, 1987)

J. Guillaume, ed.: *Les Traités d'architecture de la Renaissance* (Paris, 1988) [relevant essays: pp. 49–59, 135–50, 179–206, 207–26, 307ff]

P. Kehl: 'Belriguardo, una villa principesca nel hinterland di Ferrara', *C.E.S.R. XXe colloque d'histoire de l'architecture: Tours, 1992*

<div align="right">PIER NICOLA PAGLIARA</div>

Vittore di Matteo. *See* BELLINIANO, VITTORE.

Vittoria, Alessandro (*b* Trent, ?1525; *d* Venice, 27 May 1608). Italian sculptor, stuccoist and architect. He was a pupil and collaborator of Jacopo Sansovino and in the second half of the 16th century became one of the most important sculptors active in Venice. He was by temperament more of a modeller than a carver, and his stuccos, bronzes and terracottas are characterized by a verve and warmth that his work in marble tends to lack. His fluent, innovative and expressive style is in many ways opposed to Sansovino's thoughtful, classicizing, High Renaissance idiom. Vittoria's portrait sculpture is particularly fine. In his altars and funerary monuments he gradually evolved a dynamic relationship between sculptural and architectural elements that was more fully explored by artists of the Baroque. Comparatively little is known of Vittoria's work as an architect. Although he is known to have been active also as a painter, none of his paintings has been identified. His workshop was clearly extensive. His principal collab-

orators were his nephews Agostino Rubini (*b c.* 1560; *d* before 1595) and Vigilio Rubini (*b c.* 1558; *d* after 1608), sons of his sister Margherita and the Vicentine sculptor Lorenzo Rubini (*fl* 1550–68), and a third nephew, Andrea dell'Aquila (*b c.* 1565; *d* after 1608).

1. Life and work. 2. Working methods and technique.

1. LIFE AND WORK.

(i) Training and early years, to *c.* 1560. (ii) The 1560s and 1570s. (iii) Later works, from *c.* 1580. (iv) Bronze statuettes.

(i) *Training and early years, to* c. *1560.* Alessandro was the son of Vigilio Vittoria, a tailor in Trent. It is likely, given the correspondences between his early works and those of the Paduan sculptors Vincenzo and Giovanni Girolamo Grandi, that he trained with them during their time in Trent (1534–42). In July 1543 he went to Venice, where he lived, with only two interruptions, for the rest of his life. There he entered the workshop of Jacopo Sansovino and soon assisted him with two great projects in bronze for S Marco: the door of the sacristy and the figurated reliefs for the singing-galleries to right and left of the choir. The overt emotionality of these works was the most significant influence on Vittoria's development as an artist.

Vittoria continued to work for Sansovino during the 1540s but by 1550 was an independent master. His earliest known sculpture, the marble statuette of *St John the Baptist* (h. *c.* 600 mm; Venice, S Zaccaria, right-hand stoop), dates from that year. It was originally commissioned by the monks of S Geremia, Venice, but payment was never fully made, and Vittoria bought it back in 1565. It remained in his possession until he died, and his will of 1608 included 'my little St John' as a bequest to the nuns of S Zaccaria. The *St John* occupies a key position in Vittoria's career. The figure is conceived within a closed silhouette and steps slightly forward in the act of baptism. The skin is stretched taut over the gaunt body, so that each bone and muscle protrudes. As in later works, the drapery patterns are clear and simple; the particularized features of the face foreshadow Vittoria's calling as a portraitist. The exploration of a highly emotional state of being—in this case of the saint's asceticism—remained a constant feature of Vittoria's artistic approach, as did his preference for small-scale figures: in an age dominated by Michelangelesque gigantism, Vittoria's most personal creations tended to be statuettes and under life-size figures.

After finishing the *St John* and carving some decorative figures for Sansovino's Libreria di S Marco, Venice, Vittoria returned to Trent, most likely attracted by the possibilities for work occasioned by the convening of the Council of Trent. In April 1551 he was paid for work on decorations (destr.) for the triumphal entry into the city by the future Philip II of Spain. By December 1551 he was in Vicenza, where he remained until early 1553. Around this time he and Sansovino had a bitter falling-out. The exact reasons for this remain obscure, but it seems Vittoria had tried to take away an important commission from Sansovino in 1552, and it would not be surprising if the quarrel arose from rivalry between the former pupil and his master.

Vittoria's main project in Vicenza was the stucco decoration of rooms in Andrea Palladio's Palazzo Thiene

(now Banca Popolare), where the ceilings chart the development of his decorative idiom. The earlier ones, while rich and vigorous, merely follow and articulate the architectural layout. But in the Sala degli Dei the ceiling was conceived as one large high relief, and the cartouches, garlands and figures are not only more imaginative and graceful but powerful sculptural presences in their own right. This was probably the first programme in Italy to be carried out in strapwork, while the busts of Roman historical characters in the Sala dei Principi mark the first appearance of the portrait bust in Vittoria's work. It was also at this time that he made a series of portrait medals, including two of the writer *Pietro Aretino* (both lead; Munich, Staatl. Münzsamml.).

It was as a result of Aretino's mediation that in early 1553 Vittoria was reconciled with Sansovino, and by May of that year he was back in Venice. The two large caryatids known as the *Feminone* (1553–5), at the entrance to the Libreria Sansoviniana, were carried out with a good deal of studio assistance; they were Vittoria's first essay in large-scale stone sculpture and are not among his most successful works. As Sansovino's closest collaborator during the 1550s, he worked on a number of projects in Venice that were headed by Sansovino, including the bronze statue of *Tommaso Rangone* (1556–7) over the portal of S Giuliano; the marble *Pietà* (1557–8) in the lunette of the Venier tomb in S Salvatore; and, most important, the stuccos (1556; 1559–60) over the monumental staircase of the Libreria Sansoviniana and those (1557–9) over the Scala d'Oro (*see* VENICE, fig. 5) in the Doge's Palace. These sumptuous decorations further extend the principles applied in the Palazzo Thiene: the vaults over the staircases are treated as sculpture, with the result that the frescoes, which in both cases are by Battista Franco, are overwhelmed by the massive stuccos surrounding them. The Scala d'Oro was the ceremonial entrance to the palace, and Vittoria's stuccos display the richness and splendour of the Venetian state. The panels, with svelte, elongated figures in elegant contrapposto, also reveal his assimilation of a vocabulary formed by Central Italian Mannerists such as Parmigianino; he continued to refine and experiment with figures in contrapposto throughout his career. He acquired Parmigianino's *Self-portrait in a Convex Mirror* (Vienna, Ksthist. Mus.) in 1560 and also bought drawings by Parmigianino in 1558 and 1581.

Vittoria's independent projects of the 1550s include four stone statues (1555–8) on the tomb of *Alessandro Contarini* in S Antonio, Padua; the *Mercury* (stone, 1558–9) on the Piazzetta façade of the Doge's Palace, Venice; a stone *Angel* (commissioned 1555; Verona, Pal. Vescovile, courtyard); and the marble bust of *Giovanni Battista Ferretti* (1557; Paris, Louvre; mid-18th-century copy *in situ*) for his tomb in S Stefano, Venice. Meanwhile he continued his association with Palladio at the Villa Pisani (now Villa Placco) in Montagnana, where he executed stucco statues of the *Four Seasons* (1554–5; *in situ*).

(ii) The 1560s and 1570s. The 1560s marked the start of the period during which Vittoria reached full artistic maturity. His marble portrait busts of *Benedetto Manzini* for S Geminiano (now Ca' d'Oro), Venice (*in situ*), and

the procurator *Marc'Antonio Grimani* (Venice, S Sebastiano) date from 1560–61. The sitters are shown full of energy and movement, forceful and alert, in their cross-movements of shoulders, heads and glances manifesting Vittoria's concern for contrapposto and the *figura serpentinata*. The bust of *Grimani*, placed on the left-hand wall of his family chapel, is accompanied by small marble statues of *St Anthony Abbot* and *St Mark* (both completed 1561), in niches to either side of the altar; together, they form Vittoria's first altarpiece. In November 1561 Vittoria was commissioned to work on the altar in the Montefeltro Chapel, S Francesco della Vigna, Venice. Carved of Rovigo stone, the statues of *St Anthony Abbot*, *St Sebastian* and *St Roch* (completed by 1564; *in situ*) show him in full command as a sculptor of life-size figures. He was not, however, responsible for their architectural setting. Other projects of this decade include the two marble caryatids (terracotta model of right-hand caryatid, Padua, Liviano), eventually placed on Vittoria's tomb in S Zaccaria, Venice; a stone statue of *St Thomas* (Venice, Semin. Patriarcale) with the features of Tommaso Rangone, who commissioned it for the portal of the convent of S Sepolcro, Venice; a marble bust of *Priamo da Lezze*, placed on the family monument in S Maria Assunta (the Gesuiti), Venice, in the 1580s; and a marble bust of *Niccolò Massa* (Venice, Ateneo Veneto) for S Domenico di Castello, Venice.

Vittoria's most ambitious undertaking of the 1560s, however, was the altar of the *Zane Family* in S Maria Gloriosa dei Frari (the Frari), Venice. This was described by Vasari in the second edition of the *Vite* and must therefore have been under way by 1566–8; Vasari's testimony resulted in the long-held belief that it was complete by 1568, but Leithe-Jasper (1963) showed that the centrepiece of the work, a marble, over life-size *St Jerome*, was not begun until at least 1570. The complex originally consisted of a large stucco relief of the *Assumption of the Virgin*, set above five large statues of saints, one of which was of marble and in the round, the other four of stucco and in varying degrees of relief. The altar was dismantled in the mid-18th century by the monks of the Frari, and only the architectural frame of the altar, two angels on top of the pediment, two of the stucco figures and the central marble *St Jerome* survive. This is a serious loss, representing as it does Vittoria's first attempt to set up dynamic relationships between the various components of an altar, a theme he would further explore in the 1570s and 1580s.

The *St Jerome* of the altarpiece bears the features of Giulio Contarini (*c.* 1500–1580), whose marble bust and tomb monument (1570–72; *in situ*) Vittoria executed for S Maria del Giglio, Venice. In 1569 Contarini had bought a house in the Calle della Pietà for Vittoria; he lived there for the rest of his life. Vittoria responded to his patron's generosity by carving one of his finest portraits, also the prototype for most of his later sepulchral monuments (including his own): a bust set above an inscribed commemorative plaque, flanked by caryatids or putti.

During 1574 Vittoria paid Andrea Palladio's son Marcantonio (*c.* 1538–after 1600) for work on the four great stucco *Evangelists* set into the inner façade of S Giorgio Maggiore, Venice, which was designed by Palladio himself. These statues formed the earliest component of the decoration of the church, and their spiralling, ecstatic

rhythms show the increased expressiveness and poetic quality of Vittoria's figural language at this time. Despite this, however, he was not successful in his attempt to be awarded the commission for the high altar of the church, losing out to his younger competitor Gerolamo Campagna. During the 1570s he supervised the decoration of the chapel of the Rosary in SS Giovanni e Paolo.

It was during the 1570s that Vittoria brought his portrait style close to perfection. From the busts of *Contarini* and *Giuseppe Grimani* (marble, 1573; Venice, S Giuseppe di Castello) to that of *Tommaso Rangone* (bronze, *c.* 1575; Venice, Ateneo Veneto) for S Geminiano, Venice (Vittoria's only bronze bust), there is a steady progression in which the size and breadth of the torso are increased, the contrapposto of head and torso is more intense and complex, and the richness of chiaroscuro contrasts is deeper. The busts also increase in expressive power, for example those of *Ottaviano Grimani* (marble; Berlin, Skulpgal.; see fig. 1), *Orsato Giustiniani* (marble; Padua, Mus. Civ.) and *Sebastiano Venier* (marble; Venice, Doge's Pal.).

In 1576 Vittoria was at work on the altar for the Scuola di S Fantin (now the Ateneo Veneto), Venice, the major element of which was the marble *St Jerome* (now Venice, SS Giovanni e Paolo); in September that year he fled to Vicenza to avoid the plague but completed the work after his return to Venice (by April 1577). This later *St Jerome*—kneeling and exhausted from his penances, a strong contrast with the heroic stance of the saint in the Frari altar—reveals an increasing pathos in Vittoria's work, as well as a change in his sculptural technique to a less detailed, more astringent manner.

In 1579 two of the most prominent statues in Venice were executed by his workshop to Vittoria's design: the

1. Alessandro Vittoria: *Ottaviano Grimani*, marble, 1570s (Berlin, Skulpturengalerie mit Frühchristlich-Byzantinischer Sammlung)

stone *Justice* and *Venice* set over the great windows on the western and southern façades of the Doge's Palace. The marble statues of *Faith*, *Charity* and the *Risen Christ* (Brescia, Mus. Civ. Cristiano) for the tomb monument of *Bishop Domenico Bollani* in S Maria Rotondo, Brescia, must also have been substantially complete by 1579, the year of Bollani's death. Although *Faith* and *Charity* seem largely to be products of the workshop, the *Risen Christ* is autograph. (The monument was ruined in 1708 when a tower of the church collapsed; *Faith* and *Charity* survived intact, but the *Christ* is now without arms or legs.) From the early 1580s onwards Vittoria left more and more tasks to his workshop.

(iii) Later works, from c. *1580.* In 1581 Vittoria paid his nephew and assistant Andrea dell'Aquila for carving the stone *Christ* over the entrance to the Frari, an indication of the increasing role of the workshop. Nonetheless Vittoria produced some of his greatest works during the 1580s, including a second altar for the Scuola di S Fantin. Probably dating from the first half of the decade, it depicts the *Crucifixion*, for which Vittoria supplied bronzes of the *Virgin* and *St John* (Venice, SS Giovanni e Paolo), each a little over 1 m high. Weighed down by the heavy folds of her robes but even more by her grief, the sorrowing *Virgin* has her hands clasped tightly together as she stares downward, providing a counterbalance to the figure of *St John*, who is portrayed with his arms spread wide and his neck strained upwards to gaze at Christ.

Between 1578 and 1583 Vittoria and his workshop were also engaged on two projects at S Giuliano, Venice, where in the 1570s he had succeeded Sansovino as architect in charge of rebuilding the church. In 1583 Vittoria paid Ottaviano Ridolfi (*fl* 1567–92) for executing to his design the stucco decorations of the ceiling of the chapel of the Sacrament. Although the two small bronzed terracotta figures of the *Virgin* and *St John* in the side niches of the altar of this chapel have been attributed to Vittoria, Davis (1985) showed that they are signed by Agostino Rubini.

During this period Vittoria devoted his personal attention to another altar in the church, that of the Merciai (the grocers' guild; see fig. 2). The architecture, which consists of an elaborately carved altar table decorated with reliefs and herms surmounted by an aedicular structure of paired Corinthian columns supporting a complex broken segmental pediment, was designed by him and built by Francesco Smeraldi (*c* 1540-1614); Vittoria executed the lateral statues of *St Catherine of Alexandria* and *Daniel* (marble; completed 1584). At Vittoria's instigation, Palma Giovane painted the *Assumption of the Virgin* above the altar. This design constitutes one of Vittoria's finest achievements. The statues are not set into niches, as are those of S Francesco della Vigna or the Frari, but stand free from the double columns behind them. Inward-turning, in contrapposto poses, they are shown looking upwards as if drawn towards the scene depicted in Palma's painting. The result is a new synthesis between the painting, sculpture and architecture of an altar that was widely developed in the Baroque art of the 17th century.

In 1583–4 Vittoria oversaw the execution of the two *Angels* and the *Virgin* that crown the pediment of the Scuola di S Fantin. He also designed the façade of the

2. Alessandro Vittoria and Francesco Smeraldi: altar of the Merciai, showing Vittoria's statues of *St Catherine of Alexandria* and *Daniel*, marble, h. 1.3 m, completed 1584 (Venice, S Giuliano)

Scuola, providing the two-storey structure with a strongly sculptural effect achieved through the alternation of projecting and recessive elements: windows surmounted by deeply carved pediments supported by colonettes are framed by projecting units composed of a pair of columns separated by a shallow niche. Vittoria's experience as a stuccoist no doubt influenced his striving after such effects of relief and chiaroscuro. Around this time the marble and stone monument to the *Lezze* family in the Gesuiti, Venice, was under construction; its close resemblance to the Scuola makes its attribution to Vittoria quite likely, particularly as the Palazzo Balbi, built between 1582 and 1590 under Vittoria's supervision, features similar, though reduced, effects.

The so-called Pala Fugger (early 1580s; Chicago, IL, A. Inst.), a bronze relief of the *Annunciation* made for Johann Fugger, a member of the famous German banking family, was inspired by Titian's painting of the same subject (Venice, S Salvatore). The composition is simple: Gabriel rushes in from the left as the Virgin, kneeling, turns suddenly to gaze directly at him; above, two groups of angels play in clouds as a tiny dove descends towards the Virgin. The great height of the relief contrasts powerfully with the smooth background, a contrast emphasized by the turbulent draperies and clouds.

The terracotta bust of *Doge Nicolò da Ponte* (Venice, Semin. Patriarcale; see fig. 3), perhaps Vittoria's greatest portrait, was made around 1584 for S Maria della Carità, Venice. In being his only depiction of a doge in ducal regalia, his only half-length and by far his largest portrait,

it sums up Vittoria's aims as a portraitist, the foremost of which was to bring to the sitter a sense of movement. He used one of his favourite devices, an asymmetrical base, so that the Doge seems to lean towards the right, the direction in which he looks. This effect, counterbalanced by the way his shoulders recede in depth to the left, is further enforced by the contrasting drapery patterns on the robe: the folds are flat and vertical on the right, but deeply cut and diagonal on the left. The huge scale of the portrait is enhanced by the depth with which the torso projects in front and to either side of the socle. In the face, below the Doge's wrinkled flesh, every bone and muscle is apparent. Da Ponte, who was in his 90s when the bust was modelled, is shown vigorous and alert, old but wise.

After 1585, the autograph production of portrait busts declined sharply. While those of *Pietro Zen* (terracotta, *c.* 1585; Venice, Semin. Patriarcale) and *Giovanni Donà* (marble, after 1585; Venice, Ca' d'Oro), executed for SS Giovanni e Paolo, Venice, are by Vittoria himself, the busts of *Giovanni Battista Peranda* (marble, 1586; Murano, S Maria degli Angeli) for S Sepolcro, Venice, *Vincenzo Morosini* (marble, 1588; Venice, S Giorgio Maggiore) and *Tommaso Contarini* (marble, mid-1580s; Venice, Madonna dell'Orto) are by the workshop.

Although the altar Vittoria designed for the Scuola dei Luganegheri (the guild of sausage-makers) in S Salvatore is usually dated to 1600, it more likely dates from *c.* 1590. In the composition and placing of the marble statues of *St Sebastian* and *St Roch*, Vittoria continued the affective relationship between architecture and sculpture begun at the altar of the Merciai in S Giuliano. The figure of *St*

3. Alessandro Vittoria: *Doge Nicolò da Ponte*, terracotta, 1.00×0.78 m, *c.* 1584 (Venice, Seminario Patriarcale)

Sebastian, writhing in pain against the column behind him, is one of the most moving in all Venetian sculpture.

In 1591 the death of his second wife, Veronica Lazzarini (whom he had married in 1567), caused Vittoria to restrict his activities still further. For the marble busts of *Alvise Tiepolo* (1594; Venice, S Antonin), *Lorenzo Cappello* (*c.* 1595; Trent, Castello Buonconsiglio) and *Domenico Duodo* (1596; Venice, Ca' d'Oro), for example, only a standard torso was used in each case. From 1602 to 1605 Vittoria oversaw the work on his tomb monument in S Zaccaria, Venice, which was largely carried out by his nephews Vigilio Rubini and Andrea dell'Aquila, to whom he bequeathed his drawings, models and tools.

(iv) Bronze statuettes. Vittoria's bronze statuettes, although an important aspect of his output, have never been thoroughly studied, with the result that basic problems of attribution and chronology persist. They include some of his most beautiful works and demonstrate how medium affects aesthetic: unlike the marble statues, which tend to command only one main viewpoint and which always reflect the shape of the original block of stone, the bronzes are more overtly three-dimensional. *St John the Baptist* (Venice, S Francesco della Vigna), for instance, steps and leans forward as his shoulders twist in opposite directions from his hips and his raised right arm stretches above and behind him. Similarly, the opposed torsion between the head and right arm of *Neptune* (London, V&A) gives to the body a spiralling motion that continues through the arched neck of the attendant seahorse and on to the back of the statuette. The compositional movement is fully three-dimensional, and the figure is designed to be viewed from many angles. Other bronze statuettes securely attributable to Vittoria are *Jupiter* (1560s; Ecouen, Mus. Ren.), *St Sebastian* (1566; New York, Met.), *Winter* (*c.* 1585; Vienna, Ksthist. Mus.) and *Diana* and *Apollo* (Berlin, Skulpgal.).

2. WORKING METHODS AND TECHNIQUE. Although Vittoria made many references to drawings in his wills, not one has been securely identified, so that little is known about his working procedure. It is reasonable to assume that he followed the standard practice of first making sketches and then working up clay, wax or terracotta models, before beginning the actual carving. One terracotta model (Padua, Liviano) survives—that for the right caryatid on Vittoria's own tomb in S Zaccaria. Although the terracotta portraits are usually described as full-scale models for marble versions, they are much more likely to be independent works, produced to meet a demand. They also demonstrate that 16th-century Venetian patrons were willing to commission in a humble medium, in order to enjoy brilliant artistic effects.

BIBLIOGRAPHY

G. Vasari: *Vite* (1550, rev. 2/1568); ed. G. Milanesi (1878–85), vii, pp. 518–20
T. Temanza: *Vite dei più celebri architetti e scultori veneziani* (Venice, 1778/ R 1966), pp. 475–98
R. Predelli: 'Le memorie e le carte di Alessandro Vittoria', *Archv Trent.*, xxiii (1908), pp. 8–74, 129–265 [Vittoria's account book and other source material; Venice, Archv Stato]
L. Planiscig: *Venezianische Bildhauer der Renaissance* (Vienna, 1921), pp. 435–524

G. Gerola: 'Nuovi documenti veneziani su Alessandro Vittoria', *Atti Ist. Ven. Sci., Lett. & A.*, lxxxiv/2 (1924–5), pp. 339–59
V. Moschini: 'Aspetti del gusto artistico del Vittoria', *Riv. Mens. Città Venezia*, xiii (1934), pp. 125–40
A. Venturi: *Storia* (1901–40), xiii, pp. 64–179
M. Leithe-Jasper: *Alessandro Vittoria: Beiträge zu einer Analyse des Stils seiner figürlichen Plastiken unter besonderer Berücksichtigung der Beziehungen zur gleichzeitigen Malerei in Venedig* (diss., U. Vienna, 1963)
J. Pope-Hennessy: *Italian High Renaissance and Baroque Sculpture* (1963, 2/1970), iii of *Introduction to Italian Sculpture* (Oxford, 1955–63)
C. Semenzato: 'Il Vittoria', *Rinascimento europeo e rinascimento veneziano*, ed. V. Branca (1967), iii of *Civiltà europea e civiltà veneziana* (Venice, 1963–73), pp. 275–80
C. Davis: 'Shapes of Mourning: Sculpture by Alessandro Vittoria, Agostino Rubini, and Others', *Renaissance Studies in Honour of Craig Hugh Smyth*, ii (Florence, 1985), pp. 163–71
T. Martin: 'Grimani Patronage in S Giuseppe di Castello: Veronese, Vittoria and Smeraldi', *Burl. Mag.*, cxxxiii (1991), pp. 825-33
——: *Alessandro Vittoria and the Portrait Bust in Renaissance Venice: Remodelling Antiquity* (New York, 1998)

THOMAS MARTIN

Vivarini. Italian family of painters. Descended from a family of glassworkers active in Murano, (1) Antonio Vivarini became prominent in Venetian painting *c.* 1440, producing many joint works with his brother-in-law GIOVANNI D'ALEMAGNA. Antonio also often collaborated with his younger brother (2) Bartolomeo Vivarini, and the family dynasty remained important until the death of Antonio's son (3) Alvise Vivarini.

Giovanni d'Alemagna must, as his various signatures show, have been of German origin, but he was completely integrated into the family workshop, and attempts by earlier art historians to attribute to him supposedly German elements in his joint works with Antonio seem misjudged. The question of northern influence on the works is not resolved. Giovanni's name often appears before that of Antonio in documents and signatures and his role in the workshop was surely an important one.

A major part of the workshop's production was of tiered polyptychs in elaborately carved Gothic frames made by a number of different wood-carvers but of similar design. Developed by Antonio and Giovanni, these were, in the 1440s, very fashionable in Venice, but the market for them continued in various provincial centres under Venetian influence—the Marches, Puglia and to a lesser extent Istria—until the 1470s, and in these areas the Vivarini workshop enjoyed a virtual monopoly, producing a large number of works, many of low quality and probably entirely by studio assistants. In the late 1480s and the 1490s Bartolomeo opened up a new market for such works in the small centres around Bergamo.

This element of mass-production should not obscure the creative originality of the family. Each had, at least for a while, a substantial degree of success in Venice and the Veneto. There are also certain iconographic and stylistic habits which continue across the shifts in style and make the fact that a work is by the Vivarini as apparent to a 20th-century viewer as it would have been to the client who commissioned it. Comparison with the Bellini family reveals that the Vivarini were less innovative both stylistically and iconographically.

BIBLIOGRAPHY

Thieme–Becker
J. Crowe and G. Cavalcaselle: *A History of Painting in North Italy*, i (London, 1871, rev. T. Borenius, 2/1912), pp. 17–71 [with Borenius's notes, good for basic research]

L. Testi: *Storia della pittura veneziana*, ii (Bergamo, 1915) [Antonio and Bartolomeo only; out of date but, in the absence of monographs, still useful for both artists]

R. Longhi: *Viatico per cinque secoli di pittura veneziana* (Florence, 1946), pp. 8–10 [perceptive notes on all three artists]

V. Moschini: *I Vivarini* (Milan, 1946)

B. Berenson: *Venetian School*, i (London, 1957), pp. 195–203 [not always reliable in distinguishing the late work of Antonio from Bartolomeo]

R. Pallucchini: 'I Vivarini', *Saggi & Mem. Stor. A.*, iv (1962) [whole issue, standard work with a cat. and a corpus of plates for all three artists]

F. Zeri: 'Antonio e Bartolomeo Vivarini: Il polittico del 1451 già in San Francesco a Padova', *Ant. Viva.*, xiv/4 (1975), pp. 3–10

<div style="text-align:right">JOHN STEER</div>

(1) Antonio Vivarini (da Murano) (*fl* Venice, 1440; *d* between 1476 and 24 April 1484). Because of the collective nature of much Vivarini workshop activity, connoisseurs have remained unusually confused about Antonio's work, and attributions, particularly as regards his late work, are often misleading. After Giovanni d'Alemagna's death in 1450, Antonio probably continued to produce independent works but also collaborated with (2) Bartolomeo; from *c.* 1460 he ran the workshop alone.

1. EARLY WORK AND COLLABORATION WITH GIOVANNI D'ALEMAGNA, 1440–50. Antonio's first work, a signed polyptych (1440; Parenzo, S Eufrasiana), reveals the originality of his style *vis-à-vis* the Venetian Gothic of the preceding decades. The saints, who flank the Virgin and a Man of Sorrows on two tiers, are still Gothic in their generalized types but are fully realized as solids in space. The linear rhythms of Gothic art are almost entirely absent, and the Virgin in particular is conceived, with almost Byzantine frontality, as a simple, cone-like solid, complementing the plain apsidal architecture of the throne on which she sits. This style, which Longhi compared with Masolino's, is already a long way from the lyricism and decorative linearity of Jacobello del Fiore, but its origins are not easy to determine. Longhi's comparison is useful insofar as it situates Antonio in relation to the fully fledged Renaissance style of, for example, Masaccio or Donatello; nothing is known of Masolino's work in the Veneto, so his actual influence, if any, cannot be quantified.

Antonio's collaboration with Giovanni d'Alemagna is first recorded in 1441, and between then and Giovanni's death in 1450 they executed a series of major commissions in Venice and Padua which are probably the most original Venetian paintings of the decade. These works are so homogeneous in style that it is as fruitless as it is alien to their workshop practice to try to distinguish their hands. However, the signature 'Johannes' on a *St Jerome* (1444; Baltimore, MD, Walters A.G.) provides a basis for considering Giovanni's own style, which was flatter and more decorative than that of Antonio and without his overriding drive towards three-dimensional form. On this basis it is probably right to associate with Antonio the more realistic tendencies in their joint style and with Giovanni the more decorative tendencies. This is in no way to diminish Giovanni's share or the leading role he played in the workshop itself, as it must have been in large part to their decorative splendour that their Venetian works of the 1440s owed their success.

This can be seen in the three reliquary altars (1443) executed for the Benedictine convent of S Zaccaria, Venice (now the chapel of S Tarasio attached to the rebuilt church), which, with Castagno's apse frescoes of the year before, remain *in situ*. The commission, because of the convent's ceremonial connections with the Doge, was one of major importance. The altars, which are signed by their carvers as well, are Gothic complexes of great elaboration in which decorative and narrative carvings play as important a part as the paintings. The painted saints are of exceptional richness, the bright colours of their robes enhanced by damasked surfaces in stamped gold and embossed accessories in gilded gesso. However, they are not formally subsumed into the decorative rhythms of the altarpiece as a whole. Each panel opens up a consistent space behind the frame, and within it the saints are presented as palpable, three-dimensional presences, consistently illuminated by a real light. They are represented as if standing on plinths, an honorific device common in sculpture but in Venetian painting peculiar to the Vivarini circle, but they do so in such a relaxed way that their human reality is paradoxically enhanced. They are still types rather than individuals, but the clear purpose of the style is to present them as physical presences to the worshipper. A similar intention is evident in the *Coronation of the Virgin* (1444; Venice, S Pantalon), where the vault of heaven is conceived as a semicircular apse crowded with, and made up from, figures.

In the great tripartite canvas for the Scuola della Carità (3.44×4.77 m, 1446; Venice, Accad.; for illustration *see* VENICE, fig. 14) the Virgin and Child, accompanied by the four fathers of the Church, are set in a unified space, half throne, half crenellated courtyard, enthroned in the former Sala dell'Albergo immediately above the heads of the governors of the Scuola. The Virgin is of a more courtly type than the figure in the Parenzo Polyptych, probably a result of the demands of the Scuola rather than of stylistic development, and a particular feature is the extensive use of yellow paint hatched with black to simulate gold fictively. This skill, which appears to have been specific to the Vivarini workshop, may well have been invented by them and is perhaps associated with Giovanni, as it largely disappeared after his death. Its cheapness in comparison with gold leaf must have been an important factor in enabling the Vivarini to create in the 1440s works that embody the aristocratic values of the neighbouring north Italian courts in a manner economically as well as stylistically satisfactory to Venetian patrons.

The stylistic range of the joint workshop, even within a single work, was, however, considerable, and different types of commission produced different results. In the polyptych for the Franciscan Observants at Padua (1447; Prague, N.G.; see fig.) the saints, who flank a central *Nativity*, still stand on plinths but they are more active and individualized than in the more courtly Venetian works. *St Bartholomew*, with his firm, natural stance and toga-like robe is directly influenced by Castagno's saints on the vault of S Tarasio. The realism and humanity of these figures suggest a considerable understanding of the values of Tuscan 15th-century art, while by contrast the flatter and more decorative style of the central *Nativity*, like a comparable *Adoration of the Magi* (Berlin, Gemäl-

Antonio Vivarini and Giovanni d'Alemagna: polyptych with the *Nativity* and *Saints*, tempera, centre panel 1.31×0.60 m, side panels 1.14×0.31 m, 1447 (Prague, National Gallery)

degal.), is close to the decorative Late Gothic style. These two works may well have been influenced by German art.

Other narrative scenes of the *Life of St Monica*, the fragments of an altar from S Stefano, Venice, signed by the brothers-in-law (dispersed, panels in Detroit, MI, Inst. A.; Venice, Accad.), show a more straightforward narrative style, anecdotal in the Venetian tradition, with simple, empirically constructed settings. There is no concern with linear perspective or with the innovative, complex narrative modes found in Jacopo Bellini's sketchbooks (*see* BELLINI, (1), figs 2–4). In four elaborate scenes of female martyrdoms (two in Bergamo, Gal. Accad. Carrara; Bassano del Grappa, Mus. Civ.; New York, Met.) *all'antica* details are prominent. These details are in the style of a Late Gothic sketchbook and were probably demanded by the patron. The scenes are very decorative, the bright colours of the buildings negating the perspective.

In 1447 Antonio Vivarini and Giovanni d'Alemagna registered in the Paduan painters' guild, and in 1448 they were commissioned by the heirs of Antonio Ovetari to paint half of his chapel in the Eremitani, Padua, alongside Niccolò Pizzolo and Mantegna. In the event, only the vault of the chapel was executed (destr. 1945), and it included elaborate foliated decoration in simulated gold;

the Evangelists demonstrated the same physical and human values as the saints in the Prague Polyptych, and the nude angels were related to similar figures painted by Castagno on the S Tarasio vault. Nonetheless, the vault as a whole must have looked out of date in comparison with Mantegna's scenes on the walls (*see* MANTEGNA, ANDREA, fig. 1). On Giovanni d'Alemagna's death, Antonio Vivarini abandoned the commission and returned to Venice, where he executed a number of polyptychs in collaboration with Bartolomeo (*see* §(2) below).

2. AFTER 1450. Alongside his extensive work with Bartolomeo, Antonio probably executed a number of independent works just before or after Giovanni's death. Among these is the small-scale polyptych for the Benedictine abbey of Praglia in the Euganean Hills (?*c.* 1448; Milan, Brera) where the *Virgin and Child* are softened and humanized variants of the much earlier figures in the Parenzo Polyptych and the saints are of great dignity, each embodying in pose and expression his own kind of authority.

This style is continued on a grand scale in the nearly life-size *St Peter* and *St Paul* who formed, with a *St Ursula and her Virgins* (all Brescia, Nuo. Semin. Dioc.), part of a

polyptych for a church in Brescia. Usually dated early, these panels are more likely to be from the 1450s, as the saints are close to another pair (Prague, N.G.), which probably formed part of the high altarpiece of S Francesco in Padua signed by the brothers in 1451, and show Antonio's own style at its most mature. The figures stand directly on the ground without plinths; gold is used only in the background and for a limited number of suitable details; and the colours, strong in the male saints and soft for the virgins, are gently modelled by a palpable light which explores texture as well as form. In the *St Ursula* scene, the virgins, clustering around the saint, disappear one behind another into the distance until only the tops of their heads show, a device of considerable optical subtlety which suggests their numbers—11,000 according to the legend. This sophisticated style cannot easily be categorized as either Gothic or Renaissance, but exists between the two. Antonio's means belong optically and psychologically to a new age but his ends are still directed primarily towards devotion.

That in the mid-1450s Antonio was still held in high esteem in Venice is shown by the commission of 1456, apparently without Bartolomeo, to paint a high altar for the church of the Carità. This is lost, unless the *Virgin and Child Enthroned* (Milan, Mus. Poldi Pezzoli), surely of this period, was its centre. The exquisite and intimate *Virgin and Child* (Venice, Accad.) is also best dated at this time.

This style was continued, with an increasing sharpness of outline, in the elegant male saints on the lower tier of a polyptych (Rome, Vatican, Pin.; see colour pl. 2, XXXIX3) for the Confraternity of St Anthony Abbot at Pesaro, signed and dated by Antonio in 1464. The figures on the upper tier of the polyptych are, however, by a different and inferior hand; the distinction is important, because this hand seems also to have executed all the surviving parts of the last dated work from Antonio's studio, the polyptych for S Maria Vetere, Andria, of 1467 (dispersed; panels in Bari, Pin. Prov.; Andria, S Maria Vetere). Unfortunately, this work has been taken as a measure for Antonio's last style and a number of inferior workshop pieces, for example *SS John the Baptist and Augustine* (Venice, Accad.), have wrongly been seen as representative of his own late work. Conversely, others of higher quality have been wrongly attributed to Bartolomeo (Steer, 1982).

BIBLIOGRAPHY

G. Fogolari: 'La chiesa di Sta Maria della Carità di Venezia: Documenti inediti di Bartolomeo Bon, di Antonio Vivarini, di Ercole del Fiore e di altri artisti', *Archv Ven.-Trident.*, v (1924), pp. 77–9
R. Longhi: 'Una eventualità relativa a una Madonna di Antonio Vivarini', *Paragone*, xi/123 (1960), pp. 32–3
F. d'Arcais: *Antonio Vivarini* (Milan, 1966)
F. Zeri: 'Un "San Gerolamo" firmato di Giovanni d'Alemagna', *Studi di storia dell'arte in onore di Antonio Morassi* (Venice, 1971), pp. 40–49
J. Steer: *Alvise Vivarini: His Art and Influence* (Cambridge, 1982) [monograph with cat. of accepted and rejected works; full pls]; review by J. Fletcher in *Burl. Mag.*, cxxv (1983), pp. 99–101, and by A. de Nicolo Salamazò in *A. Ven.*, xxxix (1985), pp. 41–6

JOHN STEER

(2) **Bartolomeo Vivarini** (*fl* Venice, *c.* 1440; *d* after 1500). Brother of (1) Antonio Vivarini. The date of 1432, sometimes given for his birth, is derived from an inscription, almost certainly faked, on an inferior *Virgin and Child* (ex-Hugh Lane col., untraced). Bartolomeo was still alive in 1500 when he judged an altarpiece in S Marco, Venice (Paoletti, 1893), with his brother and the Bellini.

Bartolomeo's style was, from the beginning, distinct from that of his brother. He appears to have been trained in Padua in the orbit of Squarcione, probably in the late 1440s. Line, wiry and in his later works omnipresent, dominated his conception of form, which never showed Antonio's sense of physical substance and became increasingly schematic.

Bartolomeo emerged in 1450 when he signed jointly with Antonio a large-scale polyptych (Bologna, Pin. N.) for the Certosa di Bologna, a commission of some importance as it was given by Nicholas V in honour of Cardinal Albergati. A second joint polyptych, dated 1451 (fragments Prague, N.G.), was for the high altar of the Observant Franciscans in Padua. It is always assumed that Bartolomeo joined the family workshop because of Giovanni d'Alemagna's death, but, given the importance of these commissions, concurrent with the Ovetari frescoes, it is likely that a third partner would have been needed.

While it is probably impossible to distinguish the hands of the brothers in the Bologna Polyptych, since they may both have worked on the same figure and at least one studio hand is also involved, the type of the central *Virgin and Child*, with the Child asleep on the Virgin's lap and her hands joined over him in prayer, is repeated by Bartolomeo in several depictions of the Virgin in the following decade. From the very beginning, therefore, Bartolomeo's role in the production of such polyptychs would seem to have been substantial, even dominant.

Most of these polyptychs were done for provincial sites in the Marches and Puglia and vary greatly in quality; those in Osimo (Pal. Mun.) and Corridonia (Mus. Coll. SS Pietro & Paolo), for example, are probably entirely by assistants. The brothers' last jointly signed and dated work (1458; Arbe, S Eufemia) is typical of the genre. The dominant hand is again that of Bartolomeo, who seems to have painted both the central *St Bernardino* and the *Virgin and Child* above. At the sides, a continuous ground plane unites the saints, except where, as with St Christopher, tradition demanded a miniature landscape. The background is still gold.

Bartolomeo's first dated independent work is the *St Giovanni Capistrano* (1459; Paris, Louvre) and thereafter his practice seems to have developed rapidly. During the 1460s and 1470s he was regularly employed on commissions in Venice itself, almost all of them for altarpieces. In 1467 he was commissioned with Andrea da Murano to paint two canvases (destr.) for the Scuola di S Marco, but this is the only occasion in which he is recorded tackling this kind of work and it is evident that his subject-matter was limited; there are no portraits and no signs in his works of humanist or intellectual interests.

Nevertheless, from 1464 until the late 1470s Bartolomeo enjoyed great success in Venice, painting a series of works for major altars in the Certosa di S Andrea, the Frari and SS Giovanni e Paolo, often under the patronage of leading Venetian families such as the Morosini and the Corner, as well as producing smaller but high-quality works for the *scuole piccole* and for parish churches. In these, Bartolomeo brought the Vivarini altarpiece up to date, gradually replacing Gothic frames with Renaissance

ones and sometimes gold backgrounds with sky. This last development is by no means consistent, however, and it was surely partly to his adaptability that Bartolomeo owed his success. At this period he had cornered the market for altarpieces in Venice, apparently excluding even the Bellini, before Giovanni's triptych for the church of the Frari (1488; *in situ*).

Bartolomeo also continued to work in the Marches and Puglia. The *Virgin and Child Enthroned with Four Saints* (1476; Bari, S Nicola) updates the arrangement of Antonio's tripartite canvas for the Scuola della Carità, placing the figures in a crenellated courtyard with an evening sky behind and setting the whole in a Renaissance frame. The reference to Antonio's work is unmistakable, and it is a nice point whether Bartolomeo was simply copying his brother or fulfilling a patron's demand for a similar kind of work.

The saints in Bartolomeo's best altarpieces are more psychologically intense than those of his brother and strongly characterized as contrasting types. Contemplative rather than dramatic, they nonetheless give out a sense of nervous interior life, which adds a new dimension to the devotional ends they are designed to serve. This is apparent in the Ca' Morosini Polyptych (1464; Venice, Accad.), in which the delicately outlined and subtly coloured *St John the Baptist* (see fig.) is an example of Bartolomeo's work at its most refined.

This style is developed to produce the powerful saints in the works of the 1470s, who, often seen from a low viewpoint, tower over the worshipper. Examples are the surviving figures from the polyptych of *St Augustine* (1473; Venice, SS Giovanni e Paolo)—which, particularly in the way they are lit, reveal the influence of Giovanni Bellini's *St Vincent Ferrer* altarpiece in the same church (see colour pl. 1, XI1)—and the paired saints in the *St Mark* triptych (1474; Venice, Frari). Although still in a Late Gothic frame, this shows Bartolomeo's style at its most advanced, with St Mark seated on an early Renaissance throne, angels with swags and the diagonally grouped saints standing out against the sky and set in a continuous space. These saints are psychologically alive and their common mood gives unity to the altarpiece.

By contrast, in the polyptych for the Arte dei Tagliapietra (1477; Venice, Accad.), the saints, although strongly characterized and on a continuous ground plane, are still placed in separate compartments against a gold ground. Local colour is also strong and one guesses that Bartolomeo was responding to the demands of the stonecutters for a traditional polyptych in bright colours.

During the mid-1470s, the period of his greatest success, Bartolomeo also painted an important and original *Sacra conversazione* (1475; ex-Certosa di Padua; Lussingrande, S Antonio Abate) in which saints and angels, with God the Father above, surround the Virgin and Child set in a landscape. The style of this work appears, perhaps because of its Paduan provenance, to be more linear than in the Venetian altarpieces and the relationship between Bartolomeo and Crivelli is at its strongest. During the 1480s, however, Bartolomeo's works became increasingly linear and schematic and their quality declined, coinciding with a decline in his Venetian practice. He developed a new area of patronage in the small towns and villages around

Bartolomeo Vivarini: *St John the Baptist*, tempera on panel, 1.08×0.36 m, from the Ca' Morosini Polyptych, 1464 (Venice, Galleria dell'Accademia)

Bergamo, which vied with one another in the scale and splendour of the altarpieces that they commissioned from him (see Griffiths). The last Bergamask altarpieces (e.g. Bergamo, Gal. Accad. Carrara; Milan, Bib. Ambrosiana) are, for all their gilded splendour, distressingly arid; even the colours have lost their edge.

As well as altarpieces, Bartolomeo painted a large number of pictures of the Virgin and Child, mostly, after an initial Paduan phase, very like each other. He also painted a few smaller devotional images, such as the small *Sacra conversazione* (1465; Naples, Capodimonte) in which the Virgin is seated on a Renaissance-style throne and courtly elements from Giovanni d'Alemagna and Antonio are fused with Paduan features. It was perhaps, given its comparatively small scale, for private devotion.

BIBLIOGRAPHY
P. Paoletti: *L'architettura e la scultura del rinascimento in Venezia* (Venice, 1893), pp. 105, 107
A. Griffiths: *Bartolomeo Vivarini* (MA thesis, Courtauld Inst., U. London, 1976) [useful on patronage, the market for Vivarini paintings outside Venice and frame makers]

P. Humfrey: 'Bartolomeo Viviarini's St James polyptych and its Provenance', *J. Paul Getty Mus. J.*, xxii (1994), pp. 11–20
C. Zicari: 'Il polittico del Vivarini retorna a Morano', *Calabria Lett.*, xliii/79 (July–Sept 1995), pp. 66–7

JOHN STEER

(3) Alvise [Luigi] **Vivarini** (*b* 1442–53; *d* 1503–05). Son of (1) Antonio Vivarini. He is first mentioned in the wills of his mother in 1457 and 1458. He emerged as an independent artist in 1476 when he was enrolled in the Scuola della Carità, Venice, and signed a polyptych (Urbino, Pal. Ducale) for the Franciscans of Montefiorentino in the Marches. In 1488, conscious of the family prestige, he petitioned to work alongside the Bellini in the Sala del Gran Consiglio of the Doge's Palace. He was allotted three canvases, but at his death two were incomplete and one only begun. Vasari mentioned these historical scenes (destr. 1577) and also referred to him as the 'unhappy Vivarini', confirming an impression, conveyed in documents, that he became ill in his last years. Perhaps for this reason, he died poor and in debt.

Alvise's artistic personality was more pronounced than that of his uncle. He was aware of the work of the more advanced artists, particularly sculptors, and strove to keep his own art up to date. His style was formed under the influence of both his uncle and his father, but from the first he learnt from the work of Giovanni Bellini. There are, however, no literary references to him (Fletcher, 1983) and no known humanist connections such as the Bellini family enjoyed. In the Montefiorentino Polyptych, which has a traditional Vivarini Gothic frame, the Virgin with the Child sleeping on her lap are types taken directly from his uncle. However, they are realized with a sense of substance as solid forms in space. As in Giovanni Bellini's *St Vincent Ferrer* altarpiece (Venice, SS Giovanni e Paolo; see colour pl. 1, XI1), light is reflected back from the smooth surfaces of the forms and acts as a spiritual metaphor. The saints, particularly St John, are informed by a new principle of dramatic expression conveyed through movement.

Alvise's range was more extensive than that of his father and uncle. The tiny *St Jerome* (Washington, DC, N.G.A.) is a personal variation on a Bellinesque invention, the saint in a landscape with an emotive light effect, and landscape also plays an important part in his *Christ Carrying the Cross* (Venice, SS Giovanni e Paolo), probably a banner, in which a full-length Christ pathetically drags his cross through an arid landscape. Alvise also contributed, with Giovanni Bellini and Lazzaro Bastiani, to the narrative scenes decorating the Scuola di S Girolamo; his canvas known only from a tiny engraving suggests that he made a significant contribution to the development of such painting (Steer, 1982, p. 112).

In the 1480s Alvise responded strongly to the influence of Antonello da Messina, as can be seen in his *Virgin and Child Enthroned* (1483; Barletta, S Andrea). The linear qualities of the 1470s have been replaced by a broader, more volumetric style, in which light alone defines and models the forms, simplifying them as in Antonello's works to shining solids of great purity. Through this formal perfection, the traditional image is given for the worshipper a fresh spiritual meaning.

1. Alvise Vivarini: *Risen Christ*, tempera on panel, 1.45×0.76 m, 1498 (Venice, S Giovanni in Bragora)

During the same decade Alvise made important contributions to the *sacra conversazione*. In his first treatment of the subject, for S Francesco, Treviso (1480; Venice, Accad.), the horizontal format and the enclosed interior space are in the family tradition, but Alvise's understanding of Renaissance principles is apparent in the certainty of the spatial construction and the sculptural grouping of the figures, who exist with absolute assurance as solids in space. Their quiet gestures—the hands were studied from life on a sheet of drawings (Paris, Fond. Custodia, Inst. Néer.)—give a muted eloquence to the scene, and an evening light endows it with a poetic quality. The essence of the subject, the intersection of the human and divine in a moment of contemplation, is perfectly realized.

Alvise's second treatment of the subject was a full-scale, round-topped altarpiece of the *Virgin and Child Enthroned with Saints* (ex-Kaiser-Friedrich Mus., Berlin, destr.) for S

2. Alvise Vivarini: *Portrait of a Middle-aged Man*, oil on panel, 622×470 mm, 1497 (London, National Gallery)

Maria dei Battuti, Belluno. The architectural setting was continuous with the frame of the painting and stylistically close to Codussi's architecture. From a rediscovered list (Lucco) it can probably be dated 1486, but whether in enthroning the Madonna under a golden dome it followed the form of Antonello's lost S Cassiano Altar or was a pioneering work remains unresolved. It also shows the influence of the wall tombs of Pietro Lombardo and Antonio Rizzo.

Alvise does not appear to have worked much in Venice before 1488, but from the 1490s on he received varied and important commissions, taking part, as did Cima, in the refurbishing of S Giovanni in Bragora, painting a banner for the Scuola di S Marco and beginning a large-scale altarpiece in the Frari (*in situ*; see colour pl. 2, XXXIX2) for the Milanese *scuola*, completed after his death by Basaiti.

Alvise's *Risen Christ* (1498; Venice, S Giovanni in Bragora; see fig. 1) is a fine example of his late work, showing an increasing use of movement as a means of dramatic expression; one notes the spiralling upward movement of Christ and the terrified flight of the soldiers. The signed and dated *Virgin and Child with SS Jerome, Mary Magdalene and a Saint Bishop* (1500; Amiens, Mus. Picardie), formerly attributed to Marco Basaiti by Berenson, shows a contemplative subject being turned into a dramatic dialogue. In these moves towards a more dynamic and dramatic style he anticipated the artists of the early 16th century, although how far he actually influenced them, as argued by Steer (1982), remains a matter of debate. Berenson's high opinion of Alvise's significance

was based on the attribution to him of a *St Giustina* (Milan, Bagatti–Valsecchi priv. col.), which is by Giovanni Bellini. However, Gilbert's (1956) view that the original qualities in his late works were due to assistants, notably Jacopo dei Barberi, is misjudged.

Alvise also practised as a portrait painter, closely following Antonello da Messina, although with a more forthright approach to both appearance and personality. A *Portrait of a Middle-aged Man* (1497; London, N.G.; see fig. 2) develops the static portrait bust familiar in Messina's work by showing the sitter's hand and emphasizing the turn of the body. In this it prepares the way for the more dynamic portraiture of the 16th century.

BIBLIOGRAPHY

G. Vasari: *Vite* (1550, rev. 2/1568); ed. G. Milanesi (1878–85), iii, pp. 158–9
B. Berenson: *Lorenzo Lotto: An Essay in Constructive Art Criticism* (London, 1895, rev. 2/1905) [important historiographically but out of date]
C. Gilbert: 'Alvise e compagni', *Scritti in onore di Lionello Venturi*, i (Rome, 1956), pp. 277–308 [presents a view of Alvise's late work challenged by Steer, 1982]
J. Steer: 'Some Influences from Alvise Vivarini in the Art of Giorgione', *Burl. Mag.*, ciii (1961), pp. 220–25 [controversial]
R. Longhi: 'Ritorni e progressi su Alvise', *Paragone*, xx/1 (1969), pp. 38–42 [new attributions to Alvise; some questioned by Steer, 1982]
F. Zeri: 'Primazie di Alvise Vivarini', *Ant. Viva*, xiv/2 (1975), pp. 3–8
——: 'Aggiunta ad Alvise Vivarini', *Ant. Viva*, xv/1 (1976), pp. 3–5
M. Lucco: 'Due problemi antonelliani', *Antol. B.A.*, iii (1979), pp. 27–33 [attribution to Alvise of an *Assumption of the Virgin* at Noale]
P. Humfrey: 'Cima da Conegliano, Sebastiano Mariani and Alvise Vivarini at the East End of S Giovanni in Bragora', *A. Bull.*, xxxiv (1980), pp. 350–63
J. Steer: *Alvise Vivarini: His Art and Influence* (Cambridge, 1982) [monograph with cat. of accepted and rejected works; full plates]; review by J. Fletcher in *Burl. Mag.*, cxxv (1983), pp. 99–101, and by A. de Nicolo Salmazò in *A. Ven.*, xxxvii (1983), pp. 248–50
P. Humfrey: 'The Life of St Jerome Cycle from the Scuola di San Gerolamo in Cannaregio', *A. Ven.*, xxxix (1985), pp. 41–6

JOHN STEER

Volpaia. Italian family of clockmakers, astronomers and architects. Lorenzo di Benvenuto Volpaia (*b* Florence, 1446; *d* 1512) made his reputation in Florence as a clockmaker. In 1490–94 he constructed a public clock for the Palazzo Comunale and from 1500 to 1511 he was the official in charge of its regular maintenance and repair. In 1497 he began constructing a clock for the cathedral and in 1511 he also renewed that in the Torre del Saggio in the Mercato Vecchio. In about 1510 he made a complex planisphere, a clock which also indicated the movements of the planets, for the Capitani di Parte della Signoria. Various other works were undertaken to improve the clock of the Palazzo Comunale, and Lorenzo was assisted by his son Camillo di Lorenzo Volpaia (*d* 1560), who was primarily an astronomer; later Camillo's son Girolamo took over this responsibility. Morelli identified Lorenzo and his sons as the authors of a number of surviving drawings for other mechanical devices and inventions, and Lorenzo has also been associated with Alesso Baldovinetti's frescoes (destr. 1760) in the Gianfigliazzi Chapel at Santa Trìnita, Florence.

Of Lorenzo's sons, Benvenuto di Lorenzo Volpaia (*b* Florence, 1486; *d* 1550) is the most prominent. He was trained by his father as a clockmaker, although his later career seems to have included architecture, surveying and

map-making, at which he excelled, according to Vasari. He worked with his brother Fruosino di Lorenzo Volpaia (*fl* 1532; *d* Frankfurt) for a time. In 1521 Benvenuto became the official in charge of the clock in the Mercato Nuovo and in 1549 renewed that in the Servite nunnery of SS Annunziata. In 1529, in association with Niccolò Tribolo, a prominent figure at the Medici court, he executed what was perhaps his most intriguing work. He was commissioned by Pope Clement VII to prepare a model of Florence, to be used as a source of information for Clement in the forthcoming conflict between the Imperial army and the Medici. It was to be a three-dimensional model, based on accurate surveys which themselves took several months. The heights of all the city's towers were measured, as well as the elevations of the surrounding hills, for a distance of one mile around the city. The cupola of the cathedral was used as the datum or focus for the survey. To reduce its weight, the completed model was made of cork, and all of the features were accurately carved to scale. The overall size was four braccia (about 2.4 m) square, and it was in several pieces. When complete, it was smuggled out of the city and taken to Perugia. The Pope made constant use of the model during the ensuing ten-month siege of the city by the Imperial army, thus closely following the military events. In 1531 Benvenuto became superintendent of the Belvedere fortress, where he became an associate of Michelangelo.

BIBLIOGRAPHY
G. Vasari: *Vite* (1550, rev. 2/1568); ed. G. Milanesi (1878–85)
J. Morelli: *Codici manoscritti volgari della Libreria Naniana* (Venice, 1776)
U. Dorini: 'L'Orologio dei pianeti di Lorenzo di Volpaia', *Riv. A.*, vi (1909), pp. 137–44

□

Volterra [Etrus. Velathri; Lat. Volaterrae]. Italian city in Tuscany, *c.* 55 km south-west of Florence and *c.* 28 km east of the Tyrrhenian port of Vada. It is situated on a steep outcrop overlooking the valleys of the rivers Era and Cècina and strategically controlling the north–south routes of the Val d'Elsa. A centre of Villanovan culture in the 9th–7th centuries BC, Velathri became one of the most powerful Etruscan principalities in the 7th century BC. In the Middle Ages control of Volterra was disputed between Siena, Pisa and Florence, the last finally conquering the city in the war over the acquisition of the alum mines in 1472. Volterra remained under Florentine control until the unification of Italy in 1861. Within the 13th- and 15th-century walls the city has largely retained its medieval appearance, but the *balze* (chasms in the clayey soil on which it was built) have caused the disappearance of both Etruscan monuments and of the older medieval churches. Artists born in Volterra include the painter Daniele Ricciardelli, called Daniele da Volterra.

After the fall of the Roman Empire, Volterra fell under the domination of the Lombards and the Franks. It had become a bishopric in the 5th century AD, and in the 11th and 12th centuries imperial privileges reinforced the power of the bishop alongside that of the count; the bishopric became hereditary with the Pannochieschi family (1150–1239). The commune, which had its own consuls from 1150 and a podestà from 1193, succeeded in affirming its authority only in the 13th century, but in 1348 the tyrannical signoria of Ottaviano Belforte was imposed.

Florentine support for the commune ended in a definitive seizure of power in 1361, and, despite important attempts at rebellion (for example that of 1472), Volterra's fortunes were linked with those of Florence until Italian unification.

In the 15th century palazzi were built, including the Pilastri–Bargiotti, Biondi, Campani, Incontri and Contugi (now Ricciarelli), and the churches of S Lino, S Pietro in Selci and S Girolamo. The Palazzo Solaini (now Minucci), attributed to Antonio da Sangallo (i), and the façade of the Palazzo Viti, attributed to Bartolommeo Ammanati, date from the 16th century. From then on, however, activity centred on rebuilding and redecorating existing structures rather than on constructing new buildings. Characteristic features of the palazzi are small windows for children beneath the main ones.

When the city was retaken by Florence in 1472, Lorenzo de' Medici extended the defences by joining the Rocca Vecchia to the Rocca Nuova. The former, founded 1342–3, has a trapezoidal plan with a semi-elliptical tower in the centre; the Rocca Nuova is square, with angle towers. They were linked by a double curtain wall, and their dominant position at the top of the town has defined its subsequent appearance.

Volterra did not develop an independent artistic tradition, and its considerable artistic patrimony consists mainly of works by outsiders, notably from Pisa, Siena and Florence, each of which exerted their influence in succession: Pisa from the 11th to the 13th century, Siena in the 14th and Florence from the second half of the 15th century.

BIBLIOGRAPHY
C. Ricci: *Volterra* (Bergamo, 1905)
E. Carli: *Volterra nel medioevo e nel rinascimento* (Pisa, 1979)
F. Lessi and U. Bavani: *Arte a Volterra* (Pisa, 1980)
Momenti dell'arte a Volterra (exh. cat., ed. M. Burresi and A. Caleca; Volterra, Pal. Minucci–Solaini, 1981)
E. Fiumi: *Volterra e S Gimignano nel medioevo*, ed. G. Pinto (Siena, 1983)
ALESSANDRA ANSELMI

Volterra, Daniele da. *See* DANIELE DA VOLTERRA.

Volterra, Francesco da [Capriani, Francesco] (*b* Volterra, 1535; *d* Rome, 15 Sept 1594). Italian architect. He started as a *falegname* (It.: 'joiner') and developed his career as an architect mainly in Rome; he was recorded there in 1559. He continued the late Renaissance manner of Giacomo da Vignola; Giacomo della Porta regarded him as among the foremost architects of his time. He became a member of the Accademia di San Luca in 1594. He was seldom able to complete his commissions, however, which all passed to Carlo Maderno (1555/6–1629) after his death. His first architectural commissions came from Cesare Gonzaga in 1563–64, for alterations to the Galleria in the Palazzo Ducale, Mantua, and to the Palazzo Ducale, Palazzo della Comunità, and cathedral of S Pietro, Guastalla (all altered), and improvements to the town plan. He returned to Rome in 1570 to work for Cardinal d'Este; he has been credited with the design of the Fountain of the Dragon at the Villa d'Este, Tivoli. His connections with the Gonzaga family gave him invaluable access to the Curia; although he was recommended for court architect at Mantua in 1583, he preferred to remain in Rome. Da Volterra left Rome only in 1580 to renovate the cathedral

in Volterra, to which he added an elaborately carved ceiling.

The church of S Giacomo degli Incurabili, Rome, also commissioned by Cardinal Antonio Maria Salviati, is da Volterra's most important and influential work; he employed an oval plan (long axis *c.* 25.5 m, short axis *c.* 18.7 m) in a major ecclesiastical building, which may have been a development of designs for oval churches by Vignola, particularly for S Andrea (1554). A series of drawings (1590; Stockholm, Nmus.; 1595–6; Vienna, Albertina) shows the development from a conventional rectangular plan to a longitudinal oval with transepts and then to the final unified oval plan surrounded by chapels. The double pilasters that originally articulated the side chapels gave way to single pilasters, emphasizing the longitudinal axis, and the exterior underwent a similar change, the articulated side façades being replaced by unadorned and unarticulated walls to form a simple shell for the interior. The façade to the Via del Corso followed Vignola's unexecuted design (1568) for Il Gesù, Rome, of a two-storey façade constrained by volutes. Da Volterra gave it a resolutely vertical emphasis, with modest volutes; he reduced it to a flat plane framed with pilasters and with engaged columns to the entrance portico. Maderno completed the vaulting and the façade, and the church was consecrated in 1602. This new design became a model for oval churches in the 17th and 18th centuries.

Salviati also commissioned da Volterra to build a palazzo (1592–8; destr. 1659) in the Piazza Collegio Romano, Rome. The block (33.5 m long, 26.8 m deep) had a three-storey façade; the courtyard (18.8 sq. m) had loggias and a fountain. The design of the Salviati Chapel (1600) in S Georgio, with a polychromatic marble interior, is usually attributed to da Volterra but was executed after his death and may therefore have been significantly altered by Maderno. Volterra also executed various projects for Cardinal Nicola Caetani: a funerary monument in the basilica of Loreto, Marches, statuary and the entrance portal for the Ninfa gardens, Rome (destr.), and the palace at Cisterna, Latium (altered), all in 1578. The unexecuted project for the Palazzo all'Orso (1581; Florence, Uffizi) for Cardinal Enrico Caetani followed Antonio Sangallo (ii)'s design of Palazzo Farnese (1541–46; *see* PALAZZO, fig. 2, and SANGALLO, DA (4), fig. 2); the plain three-storey façade was relieved only by a projecting balcony over the main entrance, similar to that of the Palazzo Salviati alla Lungara by Sangallo. The Caetani Chapel (*c.* 1590) in the church of S Pudenziana had an oval sail vault over a rectangular plan with a polychrome marble interior; it was finished by Maderno in 1601.

Other works in Rome designed by da Volterra include the convent and church of S Chiara a Casa Pia (1582; destr. 1883), which had a plain pilastered façade similar to S Giacomo degli Incurabili; the rebuilding (1585–91) of the church of the Orfanelli, S Maria in Aquiro; the new convent of S Susanna (1587–96; destr.); and the Ospizio di S Luigi dei Francesi (1588; destr. 1798). Volterra also supervised the execution of the nave and four chapels (1591–4) of Giacomo della Porta's design for S Andrea della Valle. Later works were finished and modified by Maderno: the convent (1588–91) and church (1591) of S Silvestro in Capite (destr.), which had a barrel-vaulted nave and oval dome; the Palazzo Lancelotti (begun 1591, finished 1621) built for Cardinal Scipio Lancelotti (1527–98); and the Lancelotti Chapel (1594; destr. 1640s) in S Giovanni in Laterano.

BIBLIOGRAPHY

H. Hibbard: *Carlo Maderno and Roman Architecture, 1580–1630*, Stud. Archit., x (London, 1971)

L. H. Heydenreich and W. Lotz: *Architecture in Italy, 1400–1600*, Pelican Hist. A. (Harmondsworth, 1974)

A. C. Beccarini: 'La cappella Caetani nella basilica di Santa Pudenziana in Roma', *Quad. Ist. Stor. Archit.*, 25 (1975), pp. 143–58

M. Tafuri: 'Francesco Capriani', IXX (1976), pp. 189–95

S. Benedetti and G. Zander: *L'arte in Roma nel secolo XVI*, Storia di Roma, xxix/1 (Bologna, 1990)

L. Marcucci: *Francesco da Volterra: Un protagonista dell'architettura post-tridentina* (Rome, 1991)

ZILAH QUEZADO DECKKER

Voltri, Nicolò da. *See* NICOLÒ DA VOLTRI.

Z

Zaccagni. Italian family of architects, builders and engineers. Bernardino Zaccagni (*b* Torrechiara, nr Parma, *c.* 1460; *d* Parma, *c.* 1530) and his sons Benedetto Zaccagni (*b* 26 Nov 1487; *d* 26 Jan 1558), also known as il Torchiarino, and Gian Francesco Zaccagni (*b* 21 Feb 1491; *d* 1543) were active in Parma from the late 15th century to the 16th. Bernardino's name is linked with the most important architectural works produced in Parma in the early 16th century. Between 1498 and 1507 he completed the Benedictine church of S Benedetto, Parma, which was begun in the local vernacular by Pellegrino da Pontremoli in 1491. Its graceful gabled façade, articulated by four elongated pilaster strips, betrays an ignorance of the rules of the Classical orders. Bernardino's Benedictine church (1507–9) at Pedrignano, near Parma, also seems alien to the Renaissance climate and may have been inspired by local Lombardic churches. In 1514 he designed the church of S Alessandro, Parma, which was largely remodelled in 1622 by Giovanni Battista Magnani.

From 1510 to 1519 Bernardino worked with Pietro Cavazzolo on the Benedictine church of S Giovanni Evangelista (begun 1490), Parma. He may have completed the side chapels near the monastery and constructed the groin vaults and the low dome on an octagonal drum over the crossing, which pays naive homage to the Romanesque Parma Cathedral. It is not clear if he worked only on the construction of the church, or if he also assisted in its design. In 1525 he also took part with his son Gian Francesco in the construction of the adjoining monastery of S Giovanni Evangelista, completing the crossing to the east of the large cloister.

Bernardino and Gian Francesco were also involved in the building of a new church to replace the 14th-century oratory of S Maria della Steccata, Parma, which was partly financed by the city as a civic temple (*see* PARMA, §2). Bernardino's design, dated 4 April 1521, which is in the form of an inscribed cross, was initially accepted, but some doubts must have arisen as to the capabilities of the Zaccagni, for almost as soon as construction began in 1521 a commission of experts was summoned to give an opinion on the model. In 1524 Gianfrancesco d'Agrate (*fl* 1515–47) offered an alternative plan, proposing a gallery in place of the existing attic, and in 1525 Zaccagni was dismissed from the project, ostensibly because of a crack that appeared in the large niche on the south side of the building. In April 1526 Antonio da Sangallo (ii) gave his opinion on the church (*see* PARMA, §2) and left a sketch plan for the dome, a fair copy of which was made by

Marco Antonio Zucchi (1469–1531). The design was ultimately realized by Gianfrancesco d'Agrate and Paolo Sanmicheli da Porlezza (1487–1559), a cousin of Michele Sanmichele, although Vasari attributed the church to Bramante; there is also a view that Leonardo da Vinci, who was in Parma at times during this period, may have been the architect. Zaccagni therefore probably confined himself to elaborating the ideas of others in this last important commission, a fact also suggested by the contrast between the design of S Maria della Steccata and his earlier work. Bernardino's older son Benedetto was chiefly active as a military engineer, working for Pier Luigi Farnese, 1st Duke of Parma, on the fortifications of Parma and Nepi.

BIBLIOGRAPHY

Thieme–Becker
M. Salmi: 'Bernardino Zaccagni e l'architettura del rinascimento a Parma', *Boll. A.*, v–viii (1918), pp. 85–169
L. Testi: 'Bernardino Zaccagni e l'architettura del rinascimento a Parma', *Archv Stor. Prov. Parm.*, n. s., xviii (1918), pp. 147–242
B. Adorni, ed.: *L'abbazia benedettina di San Giovanni Evangelista a Parma* (Milan, 1979)
——: *Santa Maria della Steccata a Parma* (Parma, 1982)
A. Ronchini: 'Il Torchiarino da Parma', *Atti & Mem. RR. Deput. Stor. Patria Prov. Moden. & Parm.*, n.s. 2, iii (1985), pp. 473–80

BRUNO ADORNI

Zacchi, Francesco d'Antonio. *See* FRANCESCO D'ANTONIO DA VITERBO.

Zacchi, Giovanni (*b* Bologna or Volterra, 1512–15; *d* ?Rome, *c.* 1565). Italian medallist and sculptor. Son of the sculptor Zaccaria Zacchi (1473–1544) of Volterra, he spent almost his entire career in Bologna, working primarily for the Farnese family. One of his earliest and best-known medals (e.g. Florence, Bargello; see Pollard, p. 1292) was modelled in 1536 and shows the 82-year-old Venetian Doge *Andrea Gritti*. It is signed IO. ZACCHUS. F. on the reverse, which has a figure of Fortune holding a cornucopia and a tiller and standing on a globe encircled by a three-headed serpent. On only one other medal, that of *Fantino Cornaro of Episcopia* (Turin, Mus. Civ. A. Ant.), does Zacchi give this full signature.

Other medals, signed either IO. F. or simply IO, are attributed to the artist on stylistic grounds, but such attributions make sense both chronologically and geographically. One of these, signed IO. F. (e.g. Florence, Bargello; see Pollard, p. 1293), is of *Guido Ascanio Sforza* (1518–64) and must also be from *c.* 1536, since Sforza was made Cardinal of Santafiora in 1534 and was Legate of

Bologna from 1536 to 1540. Two additional medals bear the same form of signature, those of *Onofrio Bartolini de' Medici* (e.g. London, BM) and *Giambattista Malvezzi of Bologna*. The third type of signature, IO, is found on only one medal, that of *Girolamo Veralli* (e.g. London, BM), but it is close in style to the other medals already mentioned and can be ascribed to Zacchi. Two additional unsigned pieces, showing *Cardinal Giovanni Maria del Monte Sansovino* (later Pope Julius III) and *Fabio Mignanelli* (1496–1557; Florence, Bargello; see Pollard, pp. 1292–5), Bishop of Lucera from 1540 and Vice-Legate of Bologna from 1541, can also be included in Zacchi's oeuvre on stylistic grounds.

Although no specific medals can be identified, it is quite possible that Zacchi's long association with the Farnese family brought him into contact with Pope Paul III. It is probable that he did work in Rome near the end of his career, since he is last recorded in 1555 fashioning a series of medals of noble Roman ladies for Cardinal Alessandro Farnese.

Zacchi was the recipient of two letters (*Lettere*, Venice, 1538–57) from Pietro Aretino and is also mentioned in two others, all dating from the autumn of 1552. The latter were addressed to Ersilia Cortesi del Monte, the wife of the only nephew of Julius III, and mention a medal (untraced) that Zacchi had made of her.

In the development of the medallic art in Bologna, the first dominant name is Sperandio of Mantua, who represents the broad, forceful, sculptural style of the 15th century. He was followed by the noted painter Francesco Francia, who possibly designed and engraved dies for the very fine portrait coins of the lord of Bologna, Giovanni II Bentivoglio, but whose medallic work has not been entirely clearly defined. Whether the medals formerly ascribed to him are his work or that of others (they are now referred to merely as the Bolognese school) they are more refined and sensitive in portraiture, modelling and composition than the medals of Sperandio and clearly provided inspiration for Zacchi, who represents the peak of medallic development in Bologna in the 16th century. Zacchi's medals are all cast and from around 57 to 77 mm in diameter, and his subjects are usually churchmen. He combined forceful relief in the truncation of the bust, the profile of the beard and the projection of the beretta with subtle modelling in the drapery and in the characterization of the face. The profile and the features are handled with great refinement. In all his medals the bust of the sitter is set firmly and confidently in the field, the various levels of relief giving the entire composition a plasticity that is perfectly balanced with the delicately rendered details of hair, clothing and facial features. The lettering, too, is in good proportion to the field and the scale of the bust on the obverse.

Zacchi is only slightly less successful with the reverses of his medals. Despite the compositions being sometimes rather awkward, the subjects are executed with a combination of vigorous movement and fine and delicate detailing and modelling. The Fortuna on the reverse of the *Andrea Gritti* medal is posed majestically, albeit somewhat precariously, on a globe encircled by a rather strange three-headed serpent. The globe and the serpent, this time with only one head, appear again on the *Fabio Mignanelli* medal, but in a less interesting presentation. Perhaps the most energetic and exciting of Zacchi's reverses occurs on the medal of *Girolamo Veralli*, where a prancing, long-necked griffin-like creature twists its neck around the trunk of a palm tree, at the top of which a smaller beast, also griffin-like, stands with outspread wings. This richly narrated scene, filled with movement and texture, combines with a fine obverse portrait to make it one of Zacchi's most successful works.

BIBLIOGRAPHY

Forrer; Thieme–Becker

A. Armand: *Les Médailleurs italiens* (2/1883–7), i, p. 143; iii, pp. 50, 56

I. B. Supino: *Il medagliere mediceo del R. Museo Nazionale di Firenze* (Florence, 1899), pp. 96–7

G. F. Hill: 'Notes on Italian Medals, XVII. Giovanni Zacchi and the Bolognese School', *Burl. Mag.*, xxv (1914), pp. 335–41

——: *Medals of the Renaissance* (London, 1920; rev. and enlarged by G. Pollard, London, 1978), p. 63

G. Habich: *Die Medaillen der italienischen Renaissance* (Stuttgart and Berlin, 1924), p. 108

F. Pertile and E. Camesasca, eds: *Lettere sull'arte di Pietro Aretino*, 3 vols (Milan, 1957–60), pp. 298, 408, 410, 413, 414, 527–8

G. Pollard: *Italian Renaissance Medals in the Museo Nazionale del Bargello*, iii (Florence, 1985), pp. 1292–5

STEPHEN K. SCHER

Zacchia, Lorenzo , *il giovane* (*b* Lucca, *bapt* 27 Dec 1524; *d c.* 1587). Italian painter. He was a cousin of the Lucchese painter Ezechia da Vezzano, known as Zacchia *il vecchio* (*fl* 1510–60), who probably brought him up and from whom he learnt to paint in the Florentine High Renaissance style. However, his *Adoration of the Shepherds* (1576; Lucca, Mus. & Pin. N.) is in an obviously mature style that owes something to the Mannerist compositions of Bronzino, particularly to his altarpiece (1564) on the same subject for S Stefano dei Cavalieri, Pisa. Two other reliably datable works, from the 1580s, feature typical Counter-Reformation themes: a *Virgin and Child with SS Louis and John the Evangelist* (1585; Lucca, S Paolino) and a *Crucifixion with SS Lawrence and Julian* (1587; Lucca, S Anastasio). Lorenzo treated these subjects in a style closer to that of Zacchia *il vecchio* and Fra Bartolommeo.

Some questions remain to be answered on Lorenzo's career: a group portrait known as *The Concert* (ex-art market, Munich) is one of the few works signed by him, yet the style of the painting is uncharacteristically Venetian and it seems to date from 1523, a year before his documented baptism (Borelli). Possibly the inscribed date is incomplete or was added later by someone other than the artist.

BIBLIOGRAPHY

T. Borenius: 'Italian Pictures in the Rijksmuseum', *Burl. Mag.*, lix (1931), p. 71

J. Pope-Hennessy: 'Zacchia il vecchio and Lorenzo Zacchia', *Burl. Mag.*, lxxii (1938), pp. 213–23

E. Borelli: *Nel segno di Fra Bartolomeo* (Lucca, 1983), pp. 41–5, 166–77

G. Briganti, ed.: *La pittura in Italia: Il cinquecento*, 2 vols (Milan, 1987, rev. 1988), p. 866

□

Zaganelli, Francesco (di Bosio) [Francesco da Cotignola] (*b* Cotignola, nr Ravenna, 1470–80; *d* Ravenna, between 31 Jan and 3 Dec 1532). Italian painter. He was possibly a pupil of Marco Palmezzano in Forlì. He primarily studied Ferrarese painting, which permeates his oeuvre and may account for certain eccentricities of style.

He shared a workshop in Cotignola with his brother Bernardino Zaganelli (*fl* 1499–1509). Their first known joint work was the *Virgin and Child Enthroned with SS John the Baptist and Florian and Three Angels* (signed and dated 1499; Milan, Brera). Their last, the *Holy Family* (1509; Bergamo, Gal. Accad. Carrara), is unusual in the prominence accorded to St Joseph. The fan-shaped trees that rise above the wooded landscape in this painting are also found in the one work definitely assigned solely to Bernardino, *St Sebastian* (signed and dated 1506; London, N.G., together with the original lunette).

Francesco is documented in Ravenna from 1513, with his wife and orphaned niece, and from this period date the *Baptism* (signed and dated 1514; London, N.G.), painted for S Domenico, Faenza, and the *Immaculate Conception* (signed and dated 1513; Forlì, Pin. Civ.), which includes the pleasing motif of the angel leaning on his lute. The *Nativity* (after 1520) and *Crucifixion* (*c.* 1530; both Ravenna, Accad. B.A.) were mentioned by Vasari and mark the high-points of Francesco's late career. In the *Crucifixion* the expressive poses of the group of weeping women and the figure of John, the attention to detail and the setting of luminous colours against earthy ones are particularly striking. After his brother's death, Francesco responded to new stimuli, including German woodcuts. He was a painter of limited technical skill and worked in an old-fashioned tempera technique, but his work, notwithstanding its provincial limitations, is characterized by a fertile imagination.

BIBLIOGRAPHY

Thieme–Becker

G. Vasari: *Vite* (1550, rev. 2/1568); ed. G. Milanesi (1878–85), v, pp. 255–6

C. Gnudi: 'I Cotignola', *Mostra di Melozzo e del quattrocento romagnolo* (exh. cat. by C. Gnudi and L. Becherucci, Forlì, Pal. Mus., 1938), pp. 126–39

R. Roli: 'Sul problema di Bernardino e Francesco Zaganelli', *A. Ant. & Mod.*, 31–2 (1965), pp. 223–43

A. Paolucci: 'L'ultimo tempo di Francesco Zaganelli', *Paragone*, xvii (1966), no. 193, pp. 59–73

B. Berenson: *Central and North Italian Schools* (London, 1897, rev. 1932); rev. as *Italian Pictures of the Renaissance*, 3 vols (London, 1968)

La Pinacoteca Comunale di Ravenna: Opere dal XIV al XVIII secolo (Ravenna, 1988)

R. Zama: *Gli Zaganelli (Francesco e Bernardino) pittore: Catalogo generale* (Rimini, 1994)

ANDREW JOHN MARTIN

Zambono, Michele. *See* GIAMBONO, MICHELE.

Zanguidi, Jacopo. *See* BERTOIA, JACOPO.

Zanino di Pietro [Giovanni di Francia; Giovanni di Pietro Charlier] (*fl* Bologna, 1389; *d* Venice, by 1448). Italian painter. With Niccolò di Pietro and Jacobello del Fiore, Zanino di Pietro was one of the major Venetian painters of the first quarter of the 15th century. His activity in Bologna, repeatedly documented between 1389 and 1406, was of crucial importance for the pungent narrative style and naturalistic details of his earliest signed painting, a folding *Crucifixion* triptych painted for the Franciscan convent of Fonte Colombo (Rieti, Mus. Civ.). The inscription describes the artist as *h[ab]itator ve[n]eciis i[n] contrata sa[nc]te a[ppol]linaris*, and it is therefore datable to *c.* 1405, when Zanino seems to have moved permanently to Venice.

Whether the triptych reflects the work of Gentile da Fabriano, who was active in Venice by 1408, or whether Zanino was instrumental in transmitting an Emilian style to Gentile cannot be answered satisfactorily. Zanino's subsequent paintings reveal the influence of both Gentile and Michelino da Besozzo, who was active in Venice by 1410. The most important are two polyptychs in the Museo Diocesano, Camerino, and the convent of the Beato Sante, Mombarroccio, both in the Marches, the iconostasis of Torcello Cathedral and the fresco decoration of the tomb of the *Beato Pacifico* (1437; Venice, S Maria Gloriosa dei Frari).

Padovani has demonstrated that Zanino di Pietro is identical with the Giovanni di Francia who, in 1429, signed a painting of the *Virgin and Child* (Rome, Pal. Venezia). Previously, Giovanni di Francia had been considered an inferior follower of Zanino. This identification is further evidence of the stagnation and decline of Zanino's work after *c.* 1410. After 1420 Zanino was employed principally as a decorator. In 1426 he gilded a pulpit in the church of the Carità, Venice, and in 1431 he was commissioned to decorate the façade of the Ca' d'Oro.

The most ambitious works plausibly attributed to Zanino are the designs for a set of tapestries with scenes from the *Passion* for S Marco (Venice, Mus. S Marco; *see* ITALY, fig. 36), the date of 1420–30 and attribution of which are highly controversial. They have also been attributed to Niccolò di Pietro.

BIBLIOGRAPHY

DBI

R. Longhi: *Viatico per cinque secoli di pittura veneziana* (Florence, 1946), p. 49

F. Zeri: 'Aggiunte a Zanino di Pietro', *Paragone*, xiii/153 (1962), pp. 56–60

S. Padovani: 'Una nuova proposta per Zanino di Pietro', *Paragone*, xxxvi/419–23 (1985), pp. 73–81

KEITH CHRISTIANSEN

Zanobi degli Strozzi. *See* STROZZI, ZANOBI.

Zaroto. *See* LUZZO, LORENZO.

Zavattari [Zavatari]. Italian family of painters. The earliest member of the family documented as a painter was Cristoforo (di Francesco) Zavattari (*fl* Milan, 1404–9; *d* Milan, before 24 Jan 1414). Members of the family continued to work as painters in Lombardy until the mid-16th century. In 1404 Cristoforo was employed by the Fabbrica (Cathedral Works) of Milan Cathedral to examine and assess the value of stained-glass windows executed by Niccolò da Venezia (*fl* 1391–1415); in 1409 he gilded a capital destined for one of the pilasters in the cathedral's apse and several other figures. In February 1417 Cristoforo's son, Franceschino (di Cristoforo) Zavattari (*fl* Milan, before 1414; *d* Milan, 1453–7), was employed by the cathedral deputies to design and paint a large number of stained-glass windows, illustrating New Testament scenes; although he began work on the windows and was paid for what he did, nine months later the project was given to Maffiolo da Cremona for completion.

The most important surviving work by members of the Zavattari family is the cycle of frescoes, consisting of five registers of scenes from the *Life of Queen Teodolinda* (see

fig.) in the Teodolinda Chapel, Monza Cathedral. An elaborate inscription dated 1444 in the fourth register specifies that all but the vault was painted by the family. Modern scholars have identified between two and four distinct hands at work in the frescoes thought to have been executed by the Zavattari family. However, a contract of 10 March 1445 complicates the problem considerably. According to this document, Franceschino Zavattari and his sons Gregorio (di Franceschino) Zavattari *fl* before 1445; *d* Milan, after 23 Nov 1498) and Giovanni (di Franceschino) Zavattari (*fl* before 1445; *d* Milan, 1479) had, in the course of the year, to complete half of the unfinished work in the chapel; if the authorities were satisfied, the painters were to finish the decorations in 1446. It is certainly possible that the Zavattari had signed earlier contracts providing for the execution of the first three registers of frescoes, though no such contracts have been found. The date on the inscription (1444) presents greater difficulties, though it is conceivable that the final digit has been altered in the course of restoration. The decorations for the chapel were previously thought to have been commissioned by Filippo Maria Visconti, 3rd Duke of Milan; in fact, the work done in 1445 and 1446—presumably the fourth and fifth registers—was ordered by the cathedral building authorities and a representative of the comune of Monza.

The Teodolinda fresco cycle is the most important of the few surviving examples of Lombard painting of the first half of the 15th century. The effect of these spirited narrative scenes, packed with incidental anecdotal detail and rich decoration, is generally homogeneous, despite the intervention of at least three painters, one of them——Franceschino—considerably older than the others. Not surprisingly, the decorations reveal considerable familiarity with the art of Gentile da Fabriano, Masolino and especially of Pisanello, all three of whom had worked in Lombardy. The frescoes are, however, completely lacking in the monumental quality that characterizes the best work of the Zavattari family's more famous contemporaries: they are like a series of miniatures painted on a large scale.

In 1450 Ambrogio (di Franceschino) Zavattari (*fl* Milan, before 1456; *d* Milan, 26 Dec 1512), Franceschino's third son, and another painter, Giovanni Pietro Landriani, rented a studio in Pavia. In 1453 Ambrogio, Franceschino and Gregorio were painting at the Certosa di Pavia, though none of the works executed survives. In 1456 Ambrogio gilded a keystone depicting *St John the Evangelist* for the deputies of Milan Cathedral; three years later he painted a *Maestà* for the cathedral's high altar.

In May 1460 Gregorio Zavattari was once again in Monza. It is possible that he executed the fresco of *St Catherine of Alexandria* (Monza Cathedral) at this time. A

Zavattari family: fresco from the series *Life of Queen Teodolinda* (?1444–6), Teodolinda Chapel, Monza Cathedral

second fresco in Monza Cathedral, a *Virgin and Child*, of less certain attribution, may be by Gregorio as well. In December 1462 Gregorio and Giovanni Zavattari and Giacomo Vismara agreed to decorate the apse of S Vittore al Corpo, Milan; Ambrogio Zavattari (Vismara's son-in-law) later joined in the project (destr.), which was completed in 1464. In 1466–7 Giovanni Zavattari painted a fresco (destr.) in the refectory of the Olivetan monastery at Baggio. In 1475 Gregorio painted his only documented independent work, the signed and dated fresco of the *Virgin and Child* in the Santuario della Madonna dei Miracoli, Corbetta. This is an attractive but weak picture that makes no concessions to contemporary artistic trends.

Three of Giovanni's four sons were painters: Francesco (di Giovanni) Zavattari (*b* Milan, before 1459; *d* Milan, after 21 May 1484), Guido (di Giovanni) Zavattari (*b* Milan, before 1459; *d* Milan, 1510) and Gerolamo (di Giovanni) Zavattari (*b* Milan, after 1459; *d* Milan, between Nov 1522 and May 1525). In 1479 Francesco and his uncle Gregorio were commissioned by Bianca Trivulzio to paint frescoes of scenes from the *Life of St Margaret* (destr.) in S Margherita, Milan. In the same year Francesco Zavattari, Guido Zavattari and Giorgio della Chiesa undertook the decoration (destr.) of the vault of the chapel of the Immaculate Conception in S Francesco Grande, Milan. In 1487–8 Gregorio painted 'certain pictures'—no doubt frescoes (destr.)—for a confraternity chapel in Santa Croce, Milan. In 1506 Guido painted an altarpiece and a lectern for Giovanni Battista Barbavara. Nothing is known of Gerolamo's activity as a painter, though his life is fairly well documented. The career of Giovanni Angelo (di Ambrogio) Zavattari (*fl* Milan, *c.* 1500–50), the only one of Ambrogio's sons to become a painter, is obscure.

Other works attributed to the Zavattari include a large polyptych of the *Virgin and Child with Saints* (Rome, Mus. N. Castel Sant'Angelo; Rome, priv. col., see 1984 exh. cat., pp. 8–9), for which both the specific attribution and the dating present considerable problems, a *Virgin of Humility* (untraced, see 1984 exh. cat., p. 61, pl. 53), an *Assumption of the Virgin* (ex-priv. col., Rome), a *Crucifixion with Saints* (Milan, S Cristoforo sul Naviglio), a fresco of the *Virgin and Child* (Bosco in Sesto S Giovanni, Santuario della Madonna) and a fresco fragment depicting a scene from Petrarch's *Triumphus cupidinis* (Angera, Rocca). It is extremely difficult to assess the validity of these attributions; all the paintings are in poor condition. While the attributed works have some qualities in common with the Teodolinda frescoes, that work, and the style of the Zavattari in general, must have influenced dozens of Milanese painters.

In addition to these large-scale works, three packs of tarot cards have been associated with the Zavattari: the Tarocchi Brambilla (Milan, Brera), the Tarocchi Colleoni or Baglioni (Bergamo, Gal. Accad. Carrara; New York, Pierpont Morgan Lib.) and the Tarocchi Visconti di Modrone (New Haven, CT, Yale U., Beinecke Lib.). All of the cards are closer in style to Bonifacio Bembo, to whom they have traditionally been attributed. Similarly the illustrations in the *History of Lancelot* (1449; Florence, Bib. N. Cent., Cod. Palatino 556), recently attributed to Franceschino Zavattari, have been more convincingly given to Bembo.

BIBLIOGRAPHY
G. Algeri: *Gli Zavattari* (Rome, 1981) [with bibliog.]
Il polittico degli Zavattari in Castel Sant'Angelo: Contributi per la pittura tardogotica lombarda (exh. cat., Rome, Mus. N. Castel S Angelo, 1984) [with bibliog.]
J. Shell: 'La cappella di Teodolinda', *Il Duomo di Monza* (Milan, 1988)
JANICE SHELL

Zelotti, Battista [Giambattista; Gian Battista] (*b* Verona, *c.* 1526; *d* Mantua, 28 Aug 1578). Italian painter. According to Ridolfi, he was trained with Paolo Veronese in the workshop of Antonio Badile IV in Verona. Much of Zelotti's work was executed for prestigious villas and palazzi in and near Vicenza. Although works of uncertain attribution have often been assigned traditionally to Veronese, owing to his greater fame, a clearer picture of the distinctions between the two artists during their early years has emerged in the later 20th century (Gisolfi, 1990).

Probably the earliest collaboration between Zelotti and Veronese, in association with Anselmo Canneri, was the decoration (1551) of the Villa Soranzo (destr.), near Castelfranco Veneto. Of the surviving fresco fragments, Zelotti's *Temperance* and *Putto with an Apple* (both Castelfranco Veneto Cathedral) are executed with flatter faces and less bold foreshortening than appear in Veronese's fragments (Gisolfi, 1987). In 1553–4, working with Veronese and Giovanni Battista Ponchino, Zelotti painted in oil the compartments of the ceilings in the Sala del Consiglio dei Dieci and the Sala dei Tre Capi in the Doge's Palace, Venice, in the former of which his putto frieze and *Venice Surmounting the Globe* are skilfully executed. In the latter the central octagon of *Time, Truth and Innocence* shows Zelotti's masterful depiction of cool light playing over the figures. Further Venetian commissions included three of the ceiling tondi in the reading-room at the Libreria Marciana (1556–7) and the decoration, with Veronese, of the Palazzo Trevisan, Murano (1557) and frescoed decorations of façades now known only from Zanetti's engravings of 1760 (Zanetti; Gisolfi, 1996).

Two important fresco series on the mainland date from the 1550s: the decoration of the Palazzo da Porto–Colleoni at Thiene and Palladio's Villa Godi–Malinverni at Lonedo (*see* PALLADIO, ANDREA, fig. 1). In both, Zelotti depicted rather grandiose forms in bright colours in illusionistic settings. The *Mucius Scaevola* at Thiene and the female figures perched over cornices at Lonedo are still very close in style to Veronese. In the 1560s Zelotti worked at the Villa Roberti, Brugine (*c.* 1560), and Palladio's Villa Emo, Fanzolo, and Villa Foscari, Malcontenta. Zelotti contributed significantly to the decoration of the Benedictine Abbey at Praglia, including frescoes, altarpiece and organ-shutters (now Padua, Mus. Civ.) in the church (see Carpanese and Trolese), and a cycle of 24 canvases in tempera on the ceiling and walls (the nine wall canvases now in the refectory) of the library (see reconstruction in Gisolfi and Sinding-Larsen). The library cycle is datable close to the Villa Caldogno frescoes of *c.* 1570, and is important as a program of Benedictine self-identification commissioned just after the Council of Trent (Gisolfi and Sinding-Larsen). Fresco decorations at the nearby Castello del Cataio, Battaglia, date from 1570–73 (Palluchini).

BIBLIOGRAPHY
G. Vasari: *Vite* (1550, rev. 2/1568); ed. G. Milanesi (1878–85), vi, pp. 369–74

C. Ridolfi: *Meraviglie* (1648); ed. D. von Hadeln (1914–24)

B. dal Pozzo: *Le vite de' pittori, scultori e architetti veronesi* (Verona, 1718), pp. 130–37

A.M. Zanetti: *Varie pitture a fresco de' principali maestri veneziani ora la prima volta con le stampe pubblicate* (Venice, 1760), plates 15–18

B. Berenson: *Venetian School* (1957), i, pp. 203–5

L. Crosato: *Gli affreschi nelle ville venete del cinquecento* (Treviso, 1962)

J. Schulz: *Venetian Painted Ceilings of the Renaissance* (Berkeley, 1968), pp. 93–5, 97–9, 125

R. Pallucchini: 'Giambattista Zelotti e Giovanni Antonio Fasolo', *Boll. Cent. Int. Stud. Archit. Andrea Palladio*, lx (1968), pp. 203–28

F. Zava Boccazzi: 'Considerazioni sulle tele di Battista Zelotti nel soffitto della libreria di Praglia', *A. Ven.*, xxiv (1970), pp. 111–27

C. Carpanese and S. Trolese: *L'abbazia di Santi Maria di Praglia* (Milan, 1985)

D. Gisolfi Pechukas: 'Veronese and his Collaborators at "La Soranza"', *Artibus & Hist.*, xv (1987), pp. 67–108

——: 'Paolo Veronese e i suoi primi collaboratori', *Nuovi studi su Paolo Veronese* (Venice, 1990), pp. 24–35

K. Brugnolo Meloncelli: 'Precisioni cronologiche sulle opere di Battista Zelotti', *Venezia A.*, v (1991), pp. 49–62

D. Gisolfi: 'Tintoretto e la Facciate Affrescale di Venezia' *Jacopo Tintoretto nel quarto centario della morte*, ed. P. Rossi and L. Puppi (Padua, 1996), pp. 111–14, 315–16

D. Gisolfi and S. Sinding-Larsen: *The Rule, the Bible and the Council: The Library of the Benedictine Abbey at Praglia* (Seattle, 1998)

DIANA GISOLFI

Zen, Giovanni Battista (*b* Venice, 1439; *d* Padua, 8 May 1501). Italian cardinal and patron. He was the nephew of Pope Paul II, whose patronage, with that of his successors, assured Zen a brilliant ecclesiastical career. He was renowned for his haughtiness, wealth and munificence; his status is reflected in the buildings and furniture that he commissioned. In Rome he had a palace (destr. 19th century) built next to the portico of St Peter's, and he furnished and decorated the 'casino' of Cardinal Bessarion. His episcopal palace in Vicenza was enriched by a double loggia (1494) built over the courtyard in an advanced style.

In his will, Zen left considerable sums for the rebuilding of the choir of Vicenza Cathedral and that of the church of S Fantin in Venice; for the construction of a commemorative chapel in the basilica of S Antonio (Il Santo), Padua; and for his funerary monument in S Marco, Venice. Zen, inspired by Donatello's high altar in Il Santo, ordered an altar laden with bronze statues to be built in each of these churches, but only the directives concerning his tomb were fulfilled, and these not precisely. A chapel was adapted by Tullio Lombardo in S Marco with a bronze baldacchino sheltering statues of the *Virgin*, *St Peter* and *St John the Baptist*, executed by Antonio Lombardo and Paolo Savin, and a bronze tomb by Savin and Giovanni Battista Bregno. This ensemble was the most important bronzework of the Italian Renaissance to follow Donatello's high altar in Padua.

BIBLIOGRAPHY

P. Paoletti: *L'architettura e la scultura del Rinascimento in Venezia* (Venice, 1893)

G. G. Zorzi: 'Contributo alla storia dell'arte vicentina', *Miscellanea di storia Veneto tridentina* (1926), pp. 103–21

G. Soranzo: 'Giovanni Battista Zen', *Riv. Stor. Chiesa Italia*, xvi (1962), pp. 249–74

B. Jestaz: *La Chapelle Zen à Saint-Marc de Venise* (Stuttgart, 1986)

——: 'Il caso di un cardinale veneziano: Le committenze di Battista Zen a Roma e nel Veneto', *Arte, committenza ed economia a Roma e nelle corti del Rinascimento* (Turin, 1995), pp. 331–52

BERTRAND JESTAZ

Zenale, Bernardo (*b* Treviglio, *c.* 1464; *d* Milan, 10 Feb 1526). Italian painter and architect. In 1481 Zenale was already a qualified master and a member of the Scuola di S Luca, the painters' guild, in Milan. In 1485 he and BERNARDINO BUTINONE were hired by Simone da San Pellegrino and other officials of S Martino, Treviglio, to paint a large altarpiece for the high altar (*in situ*); the carving of the frame was subcontracted to Ambrogio and Giovanni Pietro Donati. By January 1491 the altarpiece had been installed, and Zenale and Butinone made a final payment to the Donati brothers. The two-tiered polyptych, in an elaborate pedimented frame, shows the Virgin and Child, St Martin and the beggar and other saints. The architectural setting for each group, shown in steep perspective, is festooned with swags and encrusted with decorative patterning.

During the 1480s and early 1490s Zenale frequently worked with Butinone: from these years date the decorations, including Dominican saints, for the nave of S Maria delle Grazie, Milan (*in situ*), the frescoes of the *Life of St Ambrose* in the chapel of Ambrogio Griffi in S Pietro in Gessate, Milan (*in situ*), and the frescoes (destr.) for a confraternity at Mozzánica, near Treviglio. In December 1490 the painters were ordered to assist in the ornamentation of the Sala della Balla in the Castello Sforzesco, which was being prepared for the nuptial celebrations of Lodovico Sforza and Beatrice d'Este.

In 1494 Zenale received a payment from the Confraternity of S Maria Assunta della Passione in S Ambrogio, Milan, for a triptych of the *Virgin and Child with SS Ambrose and Jerome* (Milan, Mus. Sacro S Ambrogio); only the central panel is by his hand. In 1501–2 he executed an altarpiece for the Scuola di Santa Maria at Cantù, near Como. The central panel is of the *Virgin and Child* (Los Angeles, CA, Getty Mus.; see fig.); other panels that have been associated with the ensemble include *SS Francis and John the Baptist* (Milan, Fond. Bagatti Valsecchi), *SS Stephen and Anthony of Padua* (Milan, Mus. Poldi Pezzoli) and the tondi of *St Jerome* and *St Ambrose* (Milan, Mus. Poldi Pezzoli). In 1503 he was contracted by the church of S Martino, Treviglio, to provide designs (untraced) for an organ case to be carved by Benedetto Canzoli. In 1502 and 1506 he was painting in S Maria presso S Celso, Milan.

Initially, Zenale was influenced by Butinone, who for his part appears to have been much impressed by Ferrarese masters of the 1460s and 1470s. By the turn of the 16th century, however, Zenale's style had become more 'modern'. The central panel of the Cantù Altarpiece has none of the decorative extravagance that characterized the earlier Treviglio Altarpiece, and the figures, more naturally posed, are placed in front of a Leonardesque landscape. Although Zenale was interested in Leonardo's achievement, his debt to the Florentine is slight; his later manner owes more to Vincenzo Foppa, Ambrogio Bergognone and other Lombard contemporaries. Few securely attributable works of his have survived, but it seems that his style did not undergo dramatic changes between 1500 and his death. A group of paintings (*c.* 1510 and later) that were formerly attributed to him, including the *Circumcision* (Paris, Louvre), the *Virgin and Child with St Domenico, the Blessed Alano della Rupe and ?Donors* (Oleggio, Mus. A. Relig.) and the *Virgin and Child*, called the Noseda *Madonna* (Milan, Brera), are by the painter called the

Bernardo Zenale: *Virgin and Child*, oil on panel, 1430×855 mm,
1501–2 (Los Angeles, CA, J. Paul Getty Museum)

Master XL by W. Suida (*Leonardo und sein Kreis*, Munich,
1929).

It is not known when Zenale began to work as an
architect; all the documents attesting to his activity in that
field are from the second and third decades of the 16th
century. By 1513 he had returned to S Maria presso S
Celso to work on a model (destr.) of the church; by April
1514 he was, with Antonio da Lonate, general architect to
the building. In 1519 the deputies of Milan Cathedral
nominated him to oversee the construction of a wooden
model of the cathedral (Milan, Mus. Duomo); in August
1522 he succeeded Giovanni Antonio Amadeo as one of
its two general architects. Towards the end of his life he
wrote a treatise on the theory of perspective (untraced).

BIBLIOGRAPHY
Zenale e Leonardo: Tradizione e rinnovamento della pittura lombarda (exh.
 cat., Milan, Mus. Poldi Pezzoli, 1982) [good text with complete bibliog.]
J. Shell: *Painters in Milan, 1490–1530* (diss., New York U., 1986), pp.
 1259–418
P. C. Marani: *Leonardo e i Leonardeschi a Brera* (Florence, 1987)
JANICE SHELL

Zenone da Vaprio, Giovanni. *See* GIOVANNI ZENONE
DA VAPRIO.

Zingaro, lo. *See* SOLARIO, ANTONIO.

Zoan [Giovanni] **Andrea** (*fl c.* 1475–?1519). Italian en-
graver and painter. A painter named Zoan Andrea is
recorded in a letter of September 1475 written to Ludovico
II Gonzaga, 2nd Marchese of Mantua, by Simone Ardizoni
da Reggio, a painter and engraver. Simone claimed that he
and Zoan Andrea had been brutally assaulted on the orders
of Andrea Mantegna. Mantegna was enraged to hear that
the two had remade some of his prints. Their exact crime
is not clear, but it has been suggested that they had re-
engraved Mantegna's original plates. Given this connec-
tion with Mantegna's circle of engravers, it is likely that
Zoan Andrea can be identified with the anonymous artist
who signed himself ZA on 20 engravings, the earliest of
which show a strong dependence on Mantegna, both in
technique and composition. The three monogrammed
engravings closest to Mantegna are of *Hercules and Dei-
anira* (B. 2509.005), *Judith and Holofernes* (B. 2509.001)
and an *Ornamental Panel* (B. 2509.045), in all of which
cross-hatching is used extensively.

Later in his career, Zoan Andrea must have moved to
Milan, since engravings signed ZA are based on drawings
by Leonardo and his Milanese pupils, for example a *Portrait
Bust of a Lady* (B. 2509.026). In Milan he met the
illuminator and engraver Giovanni Pietro Birago, after
whose drawings he made engravings for three in a series
of twelve decorative panels, one of which bears his
monogram.

A signed engraving dated 1505 of the *Virgin and Child
on a Grassy Bank* (B. 2509.030) belongs to a group of five
that Zoan copied from prints by Albrecht Dürer (1471–
1528). However, he does not appear to have been influ-
enced by Dürer; his late style is characterized by an unusual
combination of strong outlines and delicate cross-hatched
shading. Typical of this period are several engravings of
secular subjects, in some cases openly erotic, such as the
Two Lovers (B. 2509.022), in which the painstaking repro-
duction of moiré fabric is particularly striking.

If it is true that Zoan Andrea is the author of an
engraving of the *Emperor Charles V* (B. 2509.028), his
career must have lasted at least until 1519, the date of the
Emperor's accession. None of the engravers active in
Venice who signed themselves ZA or *ia* (in Gothic letters)
can be identified with Zoan Andrea. The attribution of
some drawings in the style of Mantegna to Zoan Andrea
is conjectural. Despite the fact that he was called a painter
in 1475, no paintings have been attributed to him.

BIBLIOGRAPHY
V. Massena, Prince d'Essling-C. Ephrussi: 'Zoan Andrea et ses homony-
 mes', *Gaz. B.-A.*, n.s. 3, v (1891), pp. 401–15; vi (1891), pp. 225–44
P. Kristeller: *Andrea Mantegna* (Berlin, 1902), pp. 530, 534 [doc.]
J. Byam Shaw: 'A Group of Mantegnesque Drawings, and their Relation
 to the Engravings of Mantegna's School', *Old Master Drgs*, xliv (1937),
 pp. 57–60
A. M. Hind: *Early Italian Engraving*, v (London, 1948)
L. Donati: 'Del mito di Zoan Andrea e di altri miti grandi e piccoli', *Amor
 Libro*, vi (1958), pp. 3–12, 97–102, 147–54, 231–6; vii (1959), pp. 39–
 44, 84–8, 163–8
H. Gollob: 'Ein Beitrag zur Zoan Andrea-Frage', *Gutenberg Jb.*, xxxiv
 (1959), pp. 165–70
K. Oberhuber: 'Neuentdeckungen', *Albertina Inf.*, iv (1970), p. 6
J. Levenson, K. Oberhuber and J. Sheehan: *Early Italian Engravings from
 the National Gallery of Art* (Washington, DC, 1973), pp. 265–71, 274

M. J. Zucker: *Early Italian Masters, Commentary (1984)*, 25 [XIII/ii] of *The Illustrated Bartsch*, ed. W. Strauss (New York, 1978–), pp. 255–303
[B.]
MARCO COLLARETA

Zoppo. *See* BENEDETTO DI BINDO.

Zoppo, Marco [Marco di Ruggero; Lo Zoppo] (*b* Cento, nr Bologna, ?1432; *d* Venice, ?1478). Italian painter.

1. Life and work. 2. Working methods and technique. 3. Critical reception and posthumous reputation.

1. LIFE AND WORK. The earliest dated notice of Zoppo is an agreement of 24 May 1455 concerning his legal adoption by the Paduan painter Francesco Squarcione. The document indicates that at the time it was drawn up Zoppo had been living in Squarcione's house for about two years and at 23 years old was already recognized as a painter of considerable ability. According to the agreement, Squarcione, who was childless and had recently become a widower, acknowledged Zoppo as his sole heir in return for Zoppo's work in painting.

The contract, however, was short-lived. By October of the same year, Zoppo had left Squarcione and was living in Venice. Two documents record the terms by which the adoption agreement was to be annulled and the arrangements drawn up not only to compensate Zoppo for work he had executed for which Squarcione had received payment, but also to cover Squarcione's costs for having provided Zoppo with lodging and artists' materials. Clearly Zoppo quickly discovered that the conditions placed on him by Squarcione were not to his advantage. Like other young artists who came into contact with Squarcione, most notably Andrea Mantegna, who had a similar experience in the late 1440s, Zoppo soon realized that his success as an artist rested on gaining his freedom, even though this could be achieved only by relinquishing his rights to Squarcione's substantial estate.

The signatures on Zoppo's mature works invariably acknowledge his Bolognese origin, but what may be his earliest surviving painting, a *Virgin and Child with Angels* (Paris, Louvre; see fig. 1) is signed OPERA DEL ZOPPO DI SQUARCIONE, a clear indication that it was executed *c.* 1455, at the time Zoppo was adopted by Squarcione. Although it seems likely that Zoppo received some initial training in Bologna before his Paduan period, this early *Virgin and Child* provides little evidence for such a theory, indicating instead how fully he had absorbed characteristics of Paduan art associated with Squarcione and his pupils.

No documents concerning Zoppo have come to light between the time he moved to Venice in 1455 and 1461 when he was in Bologna. A series of payments for decorative work in the church of S Petronio in Bologna dated 1461–2 indicates that he had probably been established in the city for some time. A document of July 1462 shows that he sold some land near Bologna, suggesting that he may have been planning another move, possibly back to Venice. None of the works likely to have been painted by Zoppo in Bologna is dated, making their chronology difficult to establish. On stylistic grounds, the earliest is the large *Crucifix* (Bologna, S Giuseppe). Ruhmer (1966) suggested that this is Zoppo's earliest surviving work, datable before he went to Padua. Although its

1. Marco Zoppo: *Virgin and Child with Angels*, oil and tempera on canvas, 892×725 mm, *c.* 1455 (Paris, Musée du Louvre)

format is old-fashioned, being reminiscent of many 13th-century crucifixes, with half-length figures of the Virgin and St John the Evangelist in quatrefoils at either end of the horizontal beam and a skull beneath Christ's feet, the articulation of Christ's torso and particularly the expressive qualities of Christ's head indicate knowledge of Donatello's *Crucifix* from the altar of the Santo in Padua, which Zoppo would have known. The *Crucifix* from S Giuseppe therefore probably dates from the late 1450s.

The most important of Zoppo's surviving Bolognese works is the altarpiece in the church of S Clemente, the chapel of the Collegio di Spagna. One of Zoppo's most impressive works, it is a polyptych with the Virgin and Child in the central panel with two saints on either side, three predella panels and 12 small-scale saints set into the frame. The upper part of the altarpiece consists of three elaborate gables in the Venetian style set with painted roundels of the Christ, the Archangel Gabriel and the Virgin Annunciate, features which suggest that Zoppo was looking back to altarpiece designs favoured in North Italy much earlier in the 15th century.

By the late 1460s Zoppo had apparently returned to Venice where he probably spent the remainder of his life. In Venice in 1473, for example, he acted as a witness to the will of a member of the Trevisan family. The first work he executed on his return was probably the main altarpiece for the church of S Giustina, dated 1468. Only fragments of this work survive, including a panel of *St Augustine* (London, N.G.) and one of *St Paul* (Oxford, Ashmolean), but its form has been partially reconstructed from a description of the altarpiece by Francesco Sansovino (1581). These saints seem better characterized than the figures from the S Clemente altarpiece, and the

foreshortening of details such as books and other attributes shows a more assured handling. The varied poses of the figures suggest that Zoppo may have been inspired by Jacopo della Quercia's sculpture decorating the main doorway of S Petronio, Bologna (see colour pl. 1, XXXIV3).

In 1471 Zoppo completed a major altarpiece of the *Virgin and Child with SS John the Baptist, Francis, Paul and Jerome* destined for the church of S Giovanni Battista in Pesaro (Berlin, Bodemus.). This work differs from his earlier altarpieces in that the principal figures are shown in an integrated setting in the manner of a Venetian *sacra conversazione*, an indication that Zoppo was anxious to keep abreast of recent developments in altarpiece design.

2. WORKING METHODS AND TECHNIQUE. Zoppo's early dependence on Paduan art is most apparent in *Virgin and Child* (Paris, Louvre). In this painting the infant angels surrounding the Virgin reflect the artist's knowledge of Donatello's bas-reliefs from the Santo altar in Padua, which most of Squarcione's pupils seem to have studied enthusiastically. Devices such as swags of leaves and fruit and illusionistic *cartellini* attached to a ledge in the foreground of the painting, providing space for a signature, feature in many works by artists connected with Squarcione. They appear, for example, in Mantegna's *St Euphemia* (1454; Naples, Capodimonte), painted shortly before the Louvre *Virgin and Child*.

Zoppo's mature work also reveals his continuing interest in Mantegna. Armstrong (1976) pointed out that the pose of the *Virgin and Child* (Washington, DC, N.G.A.; see fig. 2), probably dating from *c.* 1470, reflects the arrangement of the equivalent figures in Mantegna's altarpiece from S Zeno in Verona, completed *c.* 1460. Technical details in his work also indicate Zoppo's debt to Mantegna's example, as in the use of delicate cross-hatching to build up a sense of form, and stippling for areas of flesh and drapery.

Compared with Mantegna's figure style, however, Zoppo's is much more nervous and contorted, characteristics shared with Ferrarese artists such as Cosimo Tura. The expressive qualities of some of his later work may have been influenced by the exaggerated style of local sculptors, such as Niccolò dell'Arca, who was active in Bologna from *c.* 1462. But it was art from Venice that was mostly responsible for shaping the character of his mature work. Already in the S Clemente altarpiece the poses of the principal saints show that he had paid careful attention to Andrea del Castagno's frescoes in S Zaccaria, Venice. The arrangement of the figures also suggests that during his first period in Venice Zoppo came into contact with Bartolomeo Vivarini, whose feeling for vivid colour he shared. In his second Venetian period he was increasingly attracted by the softer, more luminous style of Giovanni Bellini. The atmospheric landscape in the background of the altarpiece of 1471 painted for Pesaro may be related to Bellini's example, and indeed the entire composition of this work is closely connected with Bellini's near-contemporary altarpiece of the *Coronation of the Virgin*, also destined for Pesaro (Pesaro, Mus. Civ.). In Zoppo's last works, such as the *Virgin and Child* (Altenburg, Staatl. Lindenau-Mus.), the pose of the main figure and the tonal

2. Marco Zoppo: *Virgin and Child*, panel, 408×299 mm, *c.* 1470 (Washington, DC, National Gallery of Art)

range suggest that he was affected by the work of Antonello da Messina, who was active in Venice during the early 1470s.

A large corpus of drawings, attributable to Zoppo, sheds valuable light on his working methods. He was perhaps introduced to the importance of drawing while with Squarcione; the adoption agreement specifically mentions drawing as one of the techniques practiced in the Squarcione workshop. Zoppo's drawings, executed mostly in pen and ink, fall into several categories. Some are copies of works of art, such as the *Fainting Virgin Supported by Two Holy Women* (London, BM; Popham and Pouncey, no. 263), which is taken from Mantegna's engraving of the *Entombment*. There is also a series of tender studies of the Virgin and Child with several compositions to each page (London, BM; Popham and Pouncey, no. 261), all apparently drawn from life. Although the emphasis is on the figures, which are rapidly executed and usually heavily worked with much prominent hatching, there are hints of settings behind the figures which indicate that Zoppo was experimenting with ideas for paintings. In contrast, a complete volume of 50 drawings, which include studies for heads and non-religious scenes with antique motifs, survives (London, BM; Popham and Pouncey, no. 260). Unlike the Virgin and Child studies, these drawings are highly finished and may have been a commission from a collector with humanist interests.

3. CRITICAL RECEPTION AND POSTHUMOUS REPUTATION. Several sources indicate that Zoppo was

highly regarded in humanist and courtly circles during his lifetime. A letter dated 16 September 1462 written by Zoppo to Barbara Gonzaga, wife of Marchese Ludovico Gonzaga of Mantua, discusses two pairs of *cassoni* which the Marchesa had commissioned from him. One of the excuses Zoppo offers for not being able to finish the commission on time is that he was anxious to complete the painting in a manner which would be fit to stand comparison with the work of Mantegna, court artist to the Gonzaga. Zoppo was on good terms with Mantegna from the time he had been in Squarcione's workshop, and the tradition of friendship between the two artists is twice referred to by Vasari in his *Vita* of Mantegna. One of Mantegna's friends, the humanist Felice Feliciano, was also interested in Zoppo. In a letter addressed to the artist, Feliciano compares Zoppo with Euphranor, one of the celebrated artists of antiquity. According to Pliny's *Natural History*, Euphranor was a sculptor, theorist and painter, and though not a prolific artist was praised for his indefatigable industry. Feliciano may have had Pliny's account in mind when he made the comparison. Zoppo was likened to another famous artist of antiquity, Phidias, by Raffaello Zovenzonio, a pupil of the humanist Guarino, in a poem that compliments him on the still-life details in his paintings.

Although Zoppo died too young to have many followers, his work continued to be admired. In the 16th century Francesco Sansovino praised the S Giustina Altarpiece in Venice, and in the 17th century Malvasia commented on Zoppo in *Felsina pittrice*. Some idea of Zoppo's standing at this time can be gained from Malvasia's discussion of a *Virgin and Child* (probably the one at Altenburg), which, according to Malvasia, had been considered a work by Albrecht Dürer (1471–1528) until the discovery on it of Zoppo's signature. Zoppo's *Dead Christ with SS John the Baptist and Jerome* (London, N.G.) was also attributed to Dürer in the 17th century. By the end of the 18th century, however, Zoppo's work was sufficiently well known for drawings to be attributed to him. But understandably, the high quality of some of his drawings often resulted in them being erroneously attributed to Mantegna. Since 20th-century connoisseurship has succeeded in establishing Zoppo as the author of these drawings, such mistaken attributions may now be interpreted as a tribute to Zoppo's distinction as a draughtsman.

BIBLIOGRAPHY

G. Vasari: *Vite* (1550, rev. 2/1568), ed. G. Milanesi (1878–85), iii, p. 405

C. C. Malvasia: *Felsina pittrice* (1678), ed. A. Arfelli (1961), i, p. 34

C. Ricci: 'Un sonetto artistico del sec. XV.', *A. & Stor.*, xvi/4 (1897), pp. 27–8

R. Fry: 'Marco Zoppo: Eight Studies of the Virgin and Child', *Vasari Soc.*, n.s., ii (1906–7), pp. 11–12, pls 15–16

T. Borenius: 'On a Dismembered Altarpiece by Marco Zoppo', *Burl. Mag.*, xxxviii (1921), pp. 9–12

C. Dodgson: *A Book of Drawings Formerly Ascribed to Mantegna* (London, 1923)

I. B. Supino: 'Nuovi documenti su Marco Zoppo pittore', *Archiginnasio*, xx/3–4 (1925), pp. 128–32

G. Fiocco: 'Felice Feliciano amico degli artisti', *Archv Ven.-Trident.*, ix (1926), pp. 194–6

C. Dodgson: 'Un libro di disegni di Marco Zoppo', *Miscellanea di storia dell' arte in onore di Igino Benvenuto Supino* (Florence, 1933), pp. 337–51

A. E. Popham and P. Pouncey: *Italian Drawings in the Department of Prints and Drawings in the British Museum: the Fourteenth and Fifteenth Centuries*, 2 vols (London, 1950)

G. Fiocco: 'Notes sur les dessins de Marco Zoppo', *Gaz. B.-A.*, n.s. 6, xliii (1954), p. 228

S. P. Newton: 'Costumi tedeschi e borgognoni nel libro di Marco Zoppo', *Commentari*, ix/3 (1958), pp. 155–60

E. Ruhmer: *Marco Zoppo* (Vicenza, 1966)

J. J. G. Alexander: 'A Virgil Illuminated by Marco Zoppo', *Burl. Mag.*, cxi (1969), pp. 514–17

L. Armstrong: *The Paintings and Drawings of Marco Zoppo* (New York, 1976)

M. T. Fiorio: 'Marco Zoppo et le livre padouan', *Rev. A.*, 53 (1981), pp. 65–73

Marco Zoppo (Cento 1433–1478 Venezia): Atti del Convegno internazionali di studi sulla pittura del quattrocento padano: Cento, 1993

Padua in the 1450s: Marco Zoppo and his Contemporaries (exh. cat. by H. Chapman, London, British Mus., 1998)

THOMAS TOLLEY

Zuan da Milano. *See* RUBINO, GIOVANNI.

Zuccaro [Zuccari; Zucchero; Zuccheri]. Italian family of artists. The painter Ottaviano Zuccaro (*b* nr Urbino, *c.* 1505) had two sons, (1) Taddeo Zuccaro and (2) Federico Zuccaro, who were leaders in the development of a classicizing style of painting that succeeded High Mannerism in Rome in the late 16th century. Apart from important commissions for churches, the brothers participated in some of the most significant decorative projects of the period, including the Sala Regia in the Vatican and the Villa Farnese at Caprarola. Federico's travels contributed to the spread of the Mannerist style throughout Italy and Europe; less inventive than Taddeo, his work had a more conventional academic quality that made it easier to emulate.

(1) Taddeo Zuccaro (*b* S Angelo in Vado, Marches, 1 Sept 1529; *d* Rome, 2 Sept 1566). Painter and draughtsman. Taught to draw by his father, at the age of 14 he went alone to Rome where, according to Vasari, he was employed in various workshops and studied independently, particularly the works of Raphael. Through assisting Daniele de Porri (1500–77), who had trained in Parma, he learnt of the work of Correggio and Parmigianino. He first became known for his paintings on façades, notably scenes from the *Story of Furius Camillus* on the palazzo of a Roman nobleman Jacopo Matteo, executed in 1548. Vasari claimed that Taddeo's façade decorations equalled those of Polidoro da Caravaggio; none survives, although some are documented in drawings (e.g. London, BM; Paris, Louvre) and show his assimilation of Polidoro's style.

Taddeo's earliest extant works date from 1553, when he collaborated with Prospero Fontana on the decoration (part destr.) of the villa of Pope Julius III outside the Porta del Popolo in Rome; Taddeo's contributions included scenes of *The Seasons* in the loggia of the nymphaeum. In these, clarity of form and space, natural proportions and idealization of human form demonstrate his affinity with the classicism of the High Renaissance. He also assimilated the sculptural sensibility of Mannerism, derived from Michelangelo. This awareness of sculptural form can be seen in his drawings, complex compositions that inventively blend stylistic conventions of the High Renaissance with figures of refined expression, gesture and pose derived from the art of such painters as Parmigianino, Bronzino, Francesco Salviati and Giorgio Vasari.

Other works by Taddeo from this period include the *Crucifixion* altarpiece (1553–6; untraced; copy Rome, Gal. Pallavicini) and scenes of the *Passion* (*c.* 1556) for the Mattei Chapel in S Maria della Consolazione, Rome, one of his most significant surviving works (see fig. 1). The frescoes of the *Life of St Paul* in the Frangipani Chapel in S Marcello al Corso, Rome, were commissioned in 1557, painted mostly in 1560 and completed by Federico. These commissions show Taddeo's assimilation of the High Renaissance and Mannerist styles of such painters as Sebastiano del Piombo and Michelangelo, and in particular his debt to Michelangelo's frescoes in the Pauline Chapel (Rome, Vatican; for a drawing showing Taddeo copying Michelangelo's *Last Judgement*, see ROME, fig. 3). Likewise, Taddeo's altarpiece for the Frangipani Chapel, the *Conversion of Saul* (1563; *in situ*), reflects Michelangelo's painting of that subject in the Pauline Chapel (*see* MICHELANGELO, fig. 6). It was characteristic of Taddeo, according to Freedberg, to employ descriptive naturalism within a Mannerist stylization. His *Parnassus* (1559; Ilo Nuñes priv. col., see Gere, 1969, pl. 109) for the Casino (destr.) of the Palazzo Bufalo in Rome and the two fresco cycles of the *Life of Alexander* (both 1560; one Bracciano, Castello Orsini; the other Rome, Pal. Mattei di Gove), with their careful observation of reality, study of details and analysis of nature, demonstrate this.

Works of Taddeo's maturity, such as the fresco of the *Death of the Virgin* (1564–5; Rome, Trinità dei Monti,

Pucci Chapel), in which he was continuing the decoration begun by Perino del Vaga, and the *Christ in Glory* (1559; Rome, S Sabina, apse), anticipate Baroque painting, the classicism of Annibale Carracci (1560–1609) and the naturalism of Caravaggio (1571–1610) (Freedberg). The combination of naturalism and Mannerist ornamental elements in Taddeo's style was well suited to the requirements made of art by the Counter-Reformation. Thus the *Dead Christ Supported by Angels* (1564–5; Urbino, Pal. Ducale; version, Rome, Gal. Borghese), commissioned by the Farnese in 1559 for the chapel of their villa at Caprarola, although Mannerist in style is yet a sincere expression of piety.

In 1563, after the death of Francesco Salviati, Taddeo finished the decorations for the Sala dei Fasti Farnesiani in the Palazzo Farnese in Rome. Shortly after this success, he worked with Vasari on a major papal commission, painting the *Donation of Charlemagne* (see fig. 2), the *Battle of Tunis* and two allegorical figures (all 1564) on an overdoor decoration in the Sala Regia in the Vatican. His most ambitious undertaking, however, was the decoration of Cardinal Alessandro Farnese's villa at Caprarola, which he began *c.* 1559. It was continued after his death by Federico. According to Vasari, this important commission was a major turning-point in Taddeo's career. It brought him prestige and economic security as well as recognition for his artistic talents and ability to manage a large

1. Taddeo Zuccaro: *Flagellation* (*c.* 1556), fresco, Mattei Chapel, S Maria della Consolazione, Rome

2. Taddeo Zuccaro: *Donation of Charlemagne* (1564), fresco, Sala Regia, Vatican, Rome

workshop and execute a major enterprise. The theme of the decorations is the accomplishments of the Farnese family. In the *piano nobile* and the *salone* there are scenes painted in the vaults and fictive easel paintings and simulated tapestries on the walls. The fusion of fictive and real painting, architecture and sculpture anticipates the illusionism of Baroque art.

The scenes in the ceiling vaults illustrate family history (see colour pl. 2, XL1); the end walls depict specific events in the lives of Cardinal Farnese's father and brothers and four episodes in the Cardinal's career as Secretary of State under his grandfather Pope Paul III. The decorative cycles present a propagandistic vision of the Cardinal's mission to establish peace between the Habsburg and Valois rulers. The iconographical programme was devised by humanist scholars, including Paolo Manuzio (1512–74), Onofrio Panvinio and Annibal Caro. Vasari quoted from Caro's instructions to Taddeo in his detailed description of the paintings: 'The subjects the cardinal has directed me to give you for the painting of the palace of Caprarola cannot be described adequately in words, because they comprise not only the ideas, but the arrangement, attitudes, colouring and other particulars.' Taddeo's implementation of the programme was a *tour de force* of illusionism recalling Giulio Romano's frescoed cycle in the Sala di Costantino in the Vatican Palace in Rome, executed with a *sprezzatura* (apparent ease) that appealed to an educated audience. Influenced by antiquity, the High Renaissance and such contemporary painters as Salviati, Vasari and Jacopo Zucchi, he created a powerful propagandistic statement in the Mannerist style. In addition to paintings and frescoes, Taddeo also produced decorative art work in collaboration with his brother Federico (*see* §(2) below).

The biographies of Taddeo by Vasari and Baglione comment briefly on his personal life and at length on his

many commissions. Vasari described his style as fluent and very vigorous, without a trace of crudeness, and praised him for his full compositions and his treatment of heads, hands and nudes. Taddeo is buried in the Pantheon in Rome, close to his mentor Raphael.

(2) Federico Zuccaro (*b* Sant' Angelo in Vado, Marches, 1540–42; *d* Ancona, 6 Aug 1609). Painter, draughtsman and writer, brother of (1) Taddeo Zuccaro.

1. Life and painted work. 2. Decorative art with Taddeo, the Accademia di S Luca and writings.

1. LIFE AND PAINTED WORK. Having been invited to Rome by his brother, between 1555 and 1563 he worked with Taddeo on various projects including the Villa Farnese at Caprarola and the Pucci Chapel in Trinità dei Monti, Rome. Many of Federico's drawings for both commissions show Taddeo's influence. According to Vasari, Taddeo supervised his brother's early work, which created friction between them. In 1558, for example, when they collaborated on painting the façade of the house of Tizio da Spoleto with scenes from the *Life of St Eustace*, Taddeo retouched some of his brother's paintings, so offending Federico. Already at 18 Federico was commissioned to paint many works at the Vatican: the *Transfiguration*, the *Marriage at Cana* and other scenes from the *Life of Christ* for the decorations (part destr.) of the Casino of Pius IV; an *Escutcheon of Pius IV* flanked by *Justice* and *Equity* (1562) for the Tribunale della Ruota Romana and 16 scenes from the *Life of Moses* at the Belvedere.

The brothers' rivalry became less intense after 1564, when Federico went to Venice to execute commissions for Cardinal Giovanni Grimani, including paintings of *Justice* (untraced), the *Adoration of the Magi*, the *Resurrection of Lazarus* and the *Conversion of Mary Magdalene* (untraced) all for the Grimani Chapel in S Francesco della Vigna. His stay in Venice and a study trip through Lombardy with the architect Andrea Palladio were the first of a series of journeys he made over a period of almost 45 years. In Florence in 1565 Federico was admitted to the Accademia del Disegno and executed hunting scenes for the festive decorations celebrating the marriage of Francesco de' Medici and Joanna of Austria. He then proceeded to Rome to assist Taddeo on the commissions for Trinità dei Monti, S Marcello, the Sala Regia (Vatican) and at the Villa Farnese at Caprarola. After Taddeo's death, in 1566, Federico continued these projects and painted *Henry IV before Gregory VII* in the Sala Regia. He also decorated the ceilings of the Sala della Gloria and Sala della Fama in the Villa d'Este at Tivoli for Ippolito II d'Este, Cardinal of Ferrara, and in 1568–70 carried out Taddeo's commission for S Lorenzo in Damaso, Rome—the altarpiece of the *Coronation of the Virgin with SS Lawrence, Paul, Peter and Damasus* (*in situ*).

Federico travelled to Orvieto in 1570 to paint *Christ Healing the Blind Man* and *Christ Raising the Son of the Widow of Nain* for the cathedral. Between 1570 and 1573 in Rome he painted the *Conversion of the Empress Faustina*, the *Disputation of St Catherine*, *Christ Driving the Money-changers from the Temple* and *Ecce homo*, all for S Caterina dei Funari. For the oratory of S Lucia del Gonfalone in

1573 he collaborated on a cycle of scenes of the *Passion*, a major decorative commission involving many artists, including Jacopo Bertoia and Raffaellino da Reggio. The cycle was intended to create a powerful vision for the faithful to identify and empathize with Christ's suffering. Federico's paintings of *Prophets and Sibyls* and the *Flagellation* (see fig. 1) combined naturalistic design with the embellishment of classical forms.

In 1574 Federico travelled to the Netherlands, Spain and England. In London he executed many portraits, including those of *Robert Dudley, First Earl of Leicester* (destr.), *Mary, Queen of Scots* and a drawing of *Elizabeth I* (London, BM; see fig. 2). He continued to Antwerp, where he may have executed drawings for tapestries, and Nancy. Late in 1574 he returned to Florence, where he completed the frescoes of the *Last Judgement* in the dome of the cathedral, left unfinished at Vasari's death. He built a studio and house in Florence in Via Capponi and decorated them with allegorical motifs, myths and fables in the manner of Vasari's houses in Arezzo and Florence.

In 1580 Federico went to Rome to work on the fresco of the *Baptism of Cornelius*, continuing the decoration of the Pauline Chapel in the Vatican begun by Michelangelo. He also designed two works executed by assistants, the *Vision of St Gregory* and *Procession of St Gregory* (both untraced) for the Ghiselli Chapel at the Madonna del Baraccano in Bologna. These were much criticized for their Mannerist style, and Federico responded with satirical depictions of his detractors in the *Porta Virtutis* (untraced; engraving Oxford, Christ Church Pict. Gal.), for which he was expelled from Rome by Pope Gregory XIII in 1581.

2. Federico Zuccaro: *Elizabeth I*, black and red chalk, 309×222 mm, 1574 (London, British Museum)

Federico revisited Venice and was commissioned to execute the fresco of *Barbarossa Making Obeisance to the Pope* in the Sala del Maggior Consiglio of the Doge's Palace in 1582. Although he adopted aspects of Venetian colouring and design for this work, he disliked Venetian painting, particularly that of Jacopo Tintoretto, whom he later criticized in the *Lamento della pittura* (1605). For Francesco Maria II della Rovere, Duke of Urbino, he went to Loreto in 1583 to fresco the *Marriage of the Virgin*, the *Visitation*, the *Death of the Virgin*, the *Coronation of the Virgin*, and the *Virgin in Glory* for the Santa Casa. These frescoes also reflect Venetian influence, combined with naturalism and Mannerist classicism. Federico's patrons and friends finally secured a pardon from the Pope and he returned to Rome to work on the Pauline Chapel, where he painted the *Arms of Gregory III*, the *Pentecost* and the *Mission of the Apostles*. From 1585 to 1588 he was in Madrid working for King Philip II (*reg* 1556–98) on the decoration of the Patio de los Evangelistas and S Lorenzo at the Escorial. His frescoes in the great retable were criticized for their cold, academic Mannerist style, and they were replaced with paintings by his assistant, Bartolomé Carducho (1560–1608), who later became court painter.

After this, Federico returned to Italy, to work on a series of drawings (Florence, Uffizi) for Dante's *Divine Comedy*. In Rome he painted the vault and an altarpiece for the Vittori family in the Cappella degli Angeli at the Gesù in 1592 and began the decorations of the house he had bought on the Pincian Hill in 1590 (see colour pl. 2,

1. Federico Zuccaro: *Flagellation* (1573), fresco, oratory of S Lucia del Gonfalone, Rome

XL2). In 1594 he visited Lucca to execute the *Adoration of the Magi* for the cathedral. He completed frescoes of scenes from the *Life of St Hyacinth* and decorated the vault of the chapel of S Giacinto in S Sabina, Rome, in 1600. In 1604 he returned to his native town to paint the family altarpiece, the *Virgin and Child with the Zuccaro Family as Donors* (S Angelo in Vado, S Caterina). Federico Borromeo invited him to Pavia that year to paint the *Emissary of St Charles to Cardinal Borromeo* for the Collegio Borromeo and the Hall of the Zodiac in the Palazzo Marozzi, as well as a *Pietà* and a *Dead Christ with Angels* for the family chapel at Arona on Lake Maggiore. Federico also travelled to Bologna, Mantua, Turin (in 1605–7, for the Savoy court, he frescoed (destr.) the gallery connecting the Palazzo Madama with the new palace of Charles-Emanuel I) and Parma (the *Disrobing of Christ* painted in 1608 for S Rocco).

The impact of the Council of Trent (1543–63) and the resolutions of the Ecumenical Council contributed to Federico's development of a new, Counter-Reformation style, which Freedberg termed the 'Counter-Maniera'. Counter-Reformation officials required art with a strongly propagandistic religious content, in which stories of the saints demonstrated their piety and glorified the Christian faith. Images were to be painted in natural forms with emotional expressions, simple compositions and clear narrative—a truly anti-Mannerist style. Taddeo was perhaps slightly affected by these resolutions in his work for the Mattei and Frangipani chapels and in the Farnese decorative cycles. The decorations of the Pucci Chapel, which were completed by Federico in 1589, may also reflect such influence. Federico, however, adopted the 'Counter-Maniera' style more readily because it reflected a pragmatic and propagandistic sensibility that appealed to his taste for clarity, realism and devotional stimulation. The consequent differentiation between the brothers' styles is demonstrated in Federico's commissions for the Santa Casa of Loreto (1583) and for the Cappella di S Giacinto in S Sabina, Rome (1600). Mundy has characterized the difference as one between conveying metaphorical meaning through complex composition and monumental figures of expressive virtuosity (Taddeo), and conveying allegory, particularly religious allegory, through natural, proportionate forms whose symbolic function, once grasped, can be vividly appreciated (Federico).

2. DECORATIVE ART WITH TADDEO, THE ACCADEMIA DI S LUCA AND WRITINGS. Taddeo and Federico both worked on many types of art. In addition to religious and secular paintings and fresco cycles, the Zuccari designed trophies, maiolica (e.g. dish, London, V&A, from the maiolica wares given to Philip II of Spain by Guidobaldo II della Rovere, Duke of Urbino, in 1562) and such festive decorations as those for the obsequies of Emperor Charles V (*reg* 1519–56) in S Giacomo di Spagnuoli, Rome, in 1559, and a hunt scene (modello, Florence, Uffizi) for the entry of Joanna of Austria into Florence in 1565. The environment in which they worked was intensely competitive, and artists had little status. Competition was fearful, even to the point of law suits. Federico, who tended to be combative and arrogant, was involved in several such conflicts with patrons and fellow

artists. Following his banishment from Rome in 1581 by Pope Gregory XIII, he made annotations in his copy (Florence, Uffizi) of Vasari's *Vite* that reveal his jealousy of successful artists. The lack of professional status for artists prompted Federico to try to organize a Roman equivalent of Vasari's Florentine Accademia di Disegno. After 15 years of effort towards this end, and with the backing of Cardinal Federico Borromeo, he finally succeeded in establishing a reformed Accademia di S Luca, of which he was elected principe. The first meeting was held at the Palazzo Zuccari, the house that Federico designed and built on the Pincian Hill and which now holds the Biblioteca Hertziana. Instruction included lectures by Federico (recorded by his nephew Romano Alberti), the notes for which formed the basis of *L'idea de' pittori, scultori ed architetti* (published in Turin several years after it had been written). Inspired by the notion that correct theory would produce good art, Federico explained the rudiments of painting, discussed theories on art postulated by Aristotle, Aquinas, Alberti, Dürer, Pino, Vasari and Lomazzo, and expounded the metaphysical nature of *disegno*. This explanation is accompanied by a diagram that shows how an idea arises in the mind of an artist and is then translated into a drawing. His approach was influenced by the ideas of St Thomas Aquinas as expressed in *Summa theologiae* ('God, as a creator, also designs internally and externally') and included the belief that the artist's original idea was formed in his mind by God. The word *disegno* seemed to Federico to demonstrate this, containing within it the words for God (*Dio*) and sign (*segno*). The book, relatively ignored by art historians (but see Panofsky and Barasch), has been described by Freedberg as the 'most systematic and most lucid' account of the aesthetics of Mannerism.

WRITINGS OF FEDERICO ZUCCARO
Lettere a principe et signori amatori del disegno, pittura, scultura et architettura (Mantua, 1605); ed. D. Heikamp (Florence, 1961)
Lamento del pittura (Mantua, 1605)
L'idea de' pittori, scultori ed architetti (Turin, 1607); ed. D. Heikamp (Florence, 1961)
Il passagio per Italia con la dimora di Parma (Bologna, 1608); ed. Lanciarini (Rome, 1893)

BIBLIOGRAPHY
G. Vasari: *Vite* (1550, rev. 2/1568); ed. G. Milanesi (1878–85), vii, pp. 73–134
R. Alberti: *Origine e progresso dell' Accademia del Disegno di Roma* (Rome, 1607); ed. D. Heikamp (Florence, 1961)
G. Baglione: *Vite* (1642); ed. V. Mariani (1935), pp. 102–3, 121–5
W. Körte: *Der Palazzo Zuccari in Röm* (Leipzig, 1935)
J. Gere: 'The Decorations of the Villa Giulia', *Burl. Mag.*, cvii (1965), pp. 199–206
——: 'Two of Taddeo Zuccaro's Last Commissions Completed by Federico Zuccaro. I: The Pucci Chapel in Trinità dei Monti; II: The High Altarpiece in S Lorenzo di Damaso', *Burl. Mag.*, cviii (1966), pp. 286–93, 341–5
D. Heikamp: 'Federico Zuccaro a Firenze 1577–9', *Paragone*, xviii/207 (1967), pp. 44–68; xviii/209 (1967), pp. 1–34
E. Panofsky: 'Zuccari: The Aristotelian–Thomistic Trend', *Idea: A Concept in Art Theory* (Columbia, 1968)
J. Gere: *Taddeo Zuccaro* (Chicago, 1969)
O. Berendsen: 'Taddeo Zuccaro's Paintings for Charles V's Obsequies in Rome', *Burl. Mag.*, cxii (1970), pp. 809–10
H. Outram Evenett: *The Spirit of the Counter-Reformation* (Notre-Dame, 1970)
S. J. Freedberg: *Painting in Italy, 1500–1600*, Pelican Hist. A. (Harmondsworth, 1971, rev. 2/1983)
L. W. Partridge: 'The Sala d'Ercole in the Villa Farnese at Caprarola', *A. Bull.*, liii (1971), pp. 467–86; liv (1972), pp. 50–62

A. Garzetti: *Museo di Orvieto, Museo dell' Opera del Duomo* (Bologna, 1972)

C. Strinati: 'Gli anni difficili di Federico Zuccari', *Stor. A.*, 20–22 (1974), pp. 95–117

G. Smith: *The Casino of Pius IV* (Princeton, 1977)

L. W. Partridge: 'Divinity and Dynasty at Caprarola: Perfect History in the Room of Farnese Deeds', *A. Bull.*, lx (1978), pp. 449–530

K. Hermann-Fiore: 'Die Fresken Federico Zuccaris in seinem römischen Kunstlerhause', *Rom. Jb. Kstgesch.* (1979), pp. 36–112

I. Cheney: 'Les Premières Décorations: Daniele da Volterra, Salviati et les frères Zuccari', *Le Palais Farnese, Ecole française de Rome* (1981), pp. 243–67

I. Faldo: *Il Palazzo Farnese di Caprarola* (Turin, 1981)

K. Hermann-Fiore: '*Disegno* and *Giuditio*; Allegorical Drawings by Federico Zuccaro and Cherubino Alberti', *Master Drgs*, xx (1982), pp. 247–56

I. Gerards-Nelissen: 'Federigo Zuccaro and the Lament of Painting', *Simiolus*, xiii (1983), pp. 45–53

M. Barasch: 'Zuccari: The Theory of Disegno', *Theories of Art: From Plato to Winckelmann* (New York, 1985)

L. Cheney: *The Paintings of the Casa Vasari* (New York, 1985)

E. J. Mundy: *Renaissance into Baroque: Italian Master Drawings by the Zuccari, 1550–1600* (Cambridge, MA, 1990)

J. A. Gere: 'Taddeo Zuccaro: Addenda and Corrigenda', *Master Drgs*, xxxiii/3 (1995), pp. 223–323 [whole issue]

D. Spengler: 'A Drawing and a Self-portrait by Federico Zuccaro', *Burl. Mag.*, cxxxvii/1112 (Nov 1995), pp. 750–52

LIANA DE GIROLAMI CHENEY

Zucchi, Jacopo (*b* Florence, *c.* 1540; *d* Rome, before 3 April 1596). Italian painter and draughtsman. He was trained in the studio of Vasari, whom he assisted in the decoration of the Palazzo Vecchio, Florence, as early as 1557. He accompanied Vasari to Pisa in 1561, from when dates his earliest known drawing, *Aesculapius* (London, BM). Between 1563 and 1565 he was again in Florence and is documented working with Vasari, Joannes Stradanus and Giovan Battista Naldini on the ceiling of the Sala Grande (Salone dei Cinquecento) in the Palazzo Vecchio; a drawing of an *Allegory of Pistoia* (Florence, Uffizi) is related to the ceiling allegories of Tuscan cities. In 1564 Zucchi entered the Accademia del Disegno and contributed to the decorations erected for the funeral of Michelangelo. He travelled to Rome with Vasari and was his chief assistant on decorations in the Vatican in 1567 and 1572, where he executed frescoes of scenes from the *Life of St Peter Martyr* in the chapel of S Pio V.

Zucchi settled in Rome permanently from 1572 and was appointed artist-in-residence to the Medici court in Rome by Cardinal Ferdinando de' Medici. After 1576 he decorated several rooms in the Villa Medici, including a vault depicting the *Eight Winds* and other mythological figures; also associated with the Villa is a design (London, BM), probably for a (small) ceiling or vestibule, and seven studies for a long gallery (London, RIBA and V&A). In S Clemente, Rome, he painted the *Virgin and Child with St John* (1570–90) in the chapel of the Rosary; frescoes (late 16th century) in the baptistery are also attributed to him. Another important patron was Orazio Rucellai, for whom he painted ceiling frescoes (1586–90) in the Palazzo Ruspoli, Rome. Some 30 drawings attributed to Zucchi include pen sketches, brush and gouache composition sketches and decorative architectural drawings. His painted work also comprises cabinet pictures (e.g. the *Bath of Bathsheba*; Hartford, CT, Wadsworth Atheneum) and altarpieces (e.g. the *Foundation of S Maria Maggiore*, late 1570s; Rome, Pin. Vaticana). His early style owes much to Vasari, but later works display considerable individual accomplishment.

BIBLIOGRAPHY
Colnaghi; Thieme–Becker

H. Voss: 'Jacopo Zucchi: Ein vergessener Meister der florentinisch-römischen Spätrenaissance', *Z. Bild. Kst.*, xxiv (1913), pp. 151–62

P. Barocchi: 'Complimenti al Vasari pittore', *Atti & Mem. Accad. Tosc. Sci. & Lett., 'La Colombaria'*, n. s. 14, xxviii (1964), pp. 286–8

C. Monbeig-Goguel: *Vasari et son temps: Maîtres toscans nés après 1500, morts avant 1600*, Paris, Louvre, Cab. Dessins cat. (Paris, 1972), pp. 219–37, nos 360–428

E. Pillsbury: *Jacopo Zucchi: His Life and Works* (diss., U. London, 1973)

——: 'Drawings by Jacopo Zucchi', *Master Drgs*, xii/1 (1974), pp. 3–33

——: 'The Sala Grande Drawings by Vasari and his Workshop: Some Documents and New Attributions', *Master Drgs*, xiv/2 (1976), pp. 127–46

Florentine Drawings of the Sixteenth Century (exh. cat. by N. Turner, London, BM, 1986), pp. 200–03, nos 151–3

G. Briganti, ed.: *La pittura in Italia: Il cinquecento* (Milan, 1987, rev. 2/1988), ii, pp. 869–70

A. Giovannetti: 'Sugli esordi di Jacopo Zucchi: Lo stato dell'arte e una novità', *Paragone*, xlv/529–33 (1994), pp. 101–6

A. Vannugli: 'Per Jacopo Zucchi: Un *Annunciazione* a Bagnoregio ed altre opere', *Prospettiva*, 75–6 (1994), pp. 161–73

S. Eiche: 'Un Dessin inconnu de Jacopo Zucchi pour la villa Médicis', *Rev. A.*, 108 (1995), pp. 61–4

S. J. TURNER

Black and White Illustration Acknowledgements

We are grateful to those listed below for permission to reproduce copyright illustrative material and to those contributors who supplied photographs or helped us to obtain them. The word 'Photo:' precedes the names of large commercial or archival sources who have provided us with photographs, as well as the names of individual photographers (where known). It has generally not been used before the names of owners of work of art, such as museums and civic bodies. Every effort has been made to contact copyright holders and to credit them appropriately; we apologize to anyone who may have been omitted from the acknowledgements or cited incorrectly. Any error brought to our attention will be corrected in subsequent editions. Where illustrations have been taken from books, publication details are provided in the acknowledgements below.

Line drawings, maps and plans are not included in the list below. All of the maps were produced by Oxford Illustrators Ltd, who were also responsible for some of the line drawings.

Abate, Nicolò dell' *1* Photo: Scala, Florence; *2* Trustees of the National Gallery, London

Adriano Fiorentino Philadelphia Museum of Art, Philadelphia, PA (Given by Mr and Mrs George D. Widener)

Agostino di Duccio © Board of Trustees, National Gallery of Art, Washington, DC (Andrew W. Mellon Collection)

Alberti, Leon Battista *1* National Gallery of Art, Washington, DC (Samuel H. Kress Collection); *2* Photo: AKG Ltd, London; *3, 5, 8* Photo: Scala, Florence; *7* Bildarchiv Foto Marburg

Albertinelli, Mariotto *1* Photo: Archivi Alinari, Florence; *2* Photo: Scala, Florence

Ammanati, Bartolomeo *1* Photo: Scala, Florence; *2* Photo: Charles Avery

Angelico, Fra *1* Kimbell Art Museum, Fort Worth, TX; *2, 4, 6* Photo: Scala, Florence; *3, 5* Photo: Archivi Alinari, Florence

Anguissola, Sofonisba By kind permission of the Earl Spencer/Photo: Courtauld Institute of Art, London

Anselmi, Michelangelo Soprintendenza per i Beni Artistici e Storici di Modena e Reggio Emilia

Antico *1* Photo: Ursula Edelmann; *2* Kunsthistorisches Museum, Vienna

Antique, the *1* Bibliothèque Nationale de France, Paris; *2* Photo: Archivi Alinari, Florence

Antonello da Messina *1, 4* Trustees of the National Gallery, London; *2* Kunsthistorisches Museum, Vienna; *3* © RMN, Paris

Antonio da Trento Detroit Institute of Arts, Detroit, MI

Apollonio di Giovanni Art Institute of Chicago, IL/© 1996 (Mr and Mrs Martin A. Ryerson Collection; no. 1933.1006)

Architectural drawing *1* Biblioteca Medicea Laurenziana, Florence; *2* Photo: Archivio Fotografico Vasari, Rome; *3* Photo: British Architectural Library, RIBA, London

Ascoli Piceno Photo: Conway Library, Courtauld Institute of Art, London

Arezzo Photo: Tim Benton, Cambridge

Aspertini, Amico Photo: Archivi Alinari, Florence

Attavanti, Attavante Bibliotèque Royale Albert1er, Brussels

Bacchiacca National Gallery of Scotland, Edinburgh

Baccio d'Agnolo Photo: Scala, Florence

Bagnaia, Villa Lante Photo: Scala, Florence

Baldovinetti, Alesso *1* Photo: Scala, Florence; *2* Trustees of the National Gallery, London

Bambaia Museo d'Arte Antica, Castello Sforzesco, Milan

Bandinelli, Baccio *1* Photo: © RMN, Paris; *2–3* Photo: Charles Avery

Bandini, Giovanni Photo: Scala, Florence

Barbari, Jacopo de' Ashmolean Museum, Oxford

Barbaro: (1) Daniele Barbaro Rijksmuseum, Amsterdam

Bardi (i): Donato de' Bardi Photo: Archivi Alinari, Florence

Barocci, Federico *1* Photo: Scala, Florence; *2* Trustees of the National Gallery, London; *3* Photo: Archivi Alinari, Florence; *4* Photo: © RMN, Paris

Baroncelli, Niccolò Museo Civico, Padua

Bartolomeo della Gatta Photo: Archivi Alinari, Florence

Bartolomeo di Giovanni Photo: Archivi Alinari, Florence

Bartolomeo Veneto Trustees of the National Gallery, London

Bartolommeo, Fra *1* Metropolitan Museum of Art, New York (Rogers Fund, 1906; no. 06.171); *2* Photo: Archivi Alinari, Florence; *3* Photo: © RMN, Paris

Basaiti, Marco Gabinetto Fotografico, Soprintendenza a Beni Artistici e Storici, Venice

Bassano, (1): Jacopo Bassano *1* Museo Biblioteca Archivio, Bassano del Grappa/Photo: Foto Bozzeto Cartigliano; *2* Royal Collection, Windsor Castle/© Her Majesty Queen Elizabeth II

Bassi, Martino Photo: Archivi Alinari, Florence

Battaggio, Giovanni di Domenico Photo: Archivi Alinari, Florence

Beccafumi, Domenico *1–2* Museo dell'Opera del Duomo, Siena

Bedoli, Girolamo Mazzola Photo: Archivi Alinari, Florence

Begarelli: (1) Antonio Begarelli Galleria e Museo Estense, Modena

Belbello da Pavia Photo: Scala, Florence

Bellano, Bartolomeo Photo: Archivi Alinari, Florence

Giotto *1–2, 4–10* Photo: Archivi Alinari, Florence; *3* Photo: Overseas Agenzia Fotografica, Milan

Giovanni Antonio da Brescia Photo: © RMN, Paris

Giovanni da Modena Photo: Scala, Florence

Giovanni di Consalvo Photo: Archivi Alinari, Florence

Giovanni di Paolo *1* Photo: Archivi Alinari, Florence; *2* Metropolitan Museum of Art, New York (Rogers Fund, 1906; no. 06.1046)

Giraldi, Guglielmo Biblioteca–Pinacoteca Ambrosiana, Milan

Girolamo da Treviso (ii) Photo: Gabinetto Fotografico Nazionale, Istituto Centrale per il Catalogo e la Documentazione, Rome

Girolamo da Cremona © Cleveland Museum of Art, Cleveland, OH (Gift of the Right Reverend William A. Leonard through Florence Sullivan, 1930.661)

Giulio Romano *1, 4* Photo: Scala, Florence; *2* Photo: © RMN, Paris; *3* Kunstmuseum, Düsseldorf; *5* Photo: © RMN, Paris; *6* Photo: Archivi Alinari, Florence

Gozzoli, Benozzo *1* Trustees of the National Gallery, London; *2* Photo: Scala, Florence

Granacci, Francesco Photo: Giraudon, Paris

Grigi, Guglielmo de' Gabinetto Fotografico, Soprintendenza per i Beni di Artistici e Storici, Venice/Photo: Reale Fotografia Giacomelli, Venice

Grotesque V & A Picture Library, London

Guindaleri, Pietro British Library, London (Harley MS. 3567)

Istoria Photo: Bildarchiv Foto Marburg

Italy *5, 9* Photo: Overseas Agenzia Fotografica, Milan; *6, 10, 13, 18–20, 22, 31, 33, 36, 39* Photo: Scala, Florence; *7, 8, 11* Photo: Archivi Alinari, Florence; *12* National Gallery of Art, Washington, DC (Andrew W. Mellon Collection); *14* Syndics of the Fitzwilliam Museum, Cambridge; *15* Vatican City, Vatican Museums, Rome; *16* National Gallery of Scotland, Edinburgh; *17* Trustees of the National Gallery, London; *21, 23, 26, 32* V & A Picture Library, London; *24* Photo: Osvaldo Böhm, Venice; *25* Henry E. Huntington Library and Art Gallery, San Marino, CA; *27–28, 42* © British Museum, London; *29* Trustees of the Wallace Collection, London; *30* J. Paul Getty Museum, Los Angeles, CA; *34–35* Museo degli Argenti, Florence; *37* Minneapolis Institute of Arts, Minneapolis; *38* Photo: Bridgeman Art Library, London; *40* Photo: © CNMHS, Paris; *41* Staatliche Museen zu Berlin, Preußischer Kulturbesitz

Jacobello del Fiore *1* Photo: Archivi Alinari, Florence; *2* Photo: Scala, Florence

Jacopo della Quercia *1* Conway Library, Courtauld Institute of Art, London; *2–3* Photo: Scala, Florence; *4* Photo: Gabinetto Fotografico, Soprintendenza ai Beni Artistici e Storici, Bologna

Jacopo del Sellaio Photo: Archivi Alinari, Florence

Lamberti: (1) Niccolò di Piero Lamberti Photo: Scala, Florence

Landi, Neroccio de' Pinacoteca Nazionale, Siena (inv.m. 282 datato 1476)

Laurana, Francesco *1* Photo: Archivi Alinari, Florence; *2* Photo: Scala, Florence

Laurana, Luciano Photo: Archivi Alinari, Florence

Leonardo da Vinci *1* Gabinetto Fotografico, Soprintendenza per i Beni Artistici e Storici, Florence; *2* Trustees of the National Gallery, London; *3* National Museum, Kraków; *4, 6–7* Royal Collection, Windsor Castle/© Her Majesty Queen Elizabeth II; *5* Photo: © RMN, Paris; *8* © British Museum, London; *9* Museum of Fine Arts, Budapest

Leoni, Leone *1* Museo del Prado, Madrid; *2* Photo: Archivi Alinari, Florence

Leopardi, Alessandro Conway Library, Courtauld Institute of Art, London

Liberale da Verona Photo: Hans Joachim Eberhardt

Libri, dai: (2) Girolamo dai Libri Photo: Archivi Alinari, Florence

Ligorio, Pirro *1–2* Photo: Scala, Florence

Lilli, Andrea Photo: Scala, Florence

Lippi: (1) Filippo Lippi *1* Photo: RMN, Paris; *2* Bayerische Staatsbibliothek, Munich; *3–4* Photo: Scala, Florence

Lippi: (2) Filippino Lippi *1* Galleria degli Uffizi, Florence/Photo: Bridgeman Art Library, London; *2* Photo: Scala, Florence; *3* Photo: Bardazzi Fotografia, Florence; *4* Photo: Scala, Florence

Lomazzo, Giovanni Paolo Art Museum, Princeton University, Princeton, NJ (Gift of Frank Jewett Mather, jr)

Lombardo: (1) Pietro Lombardo Photo: Osvaldo Böhm, Venice

Lombardo: (2) Tullio Lombardo *1* Photo: Osvaldo Böhm, Venice; *2* Photo: Sarah Blake McHam; *3* Conway Library, Courtauld Institute of Art, London

Lombardo: (5) Girolamo Lombardo Conway Library, Courtauld Institute of Art, London

Lorenzo di Credi *1* Photo: Gabinetto Fotografico, Soprintendenza per i Beni Artistici e Storici, Florence; *2* Photo: Scala, Florence

Lorenzo Monaco *1* Photo: Overseas Agenzia Fotografica, Milan; *2, 4* Photo: Archivi Alinari, Florence; *3* Syndics of the Fitzwilliam Museum, Cambridge

Loreto *1* Photo: Father Floriano Grimaldi; *2* Conway Library, Courtauld Institute of Art, London; *3* Photo: Archivi Alinari, Florence

Lotto, Lorenzo *1* Photo: Soprintendenza per i Beni Artistici e Storici, Naples; *2, 4* Photo: Archivi Alinari, Florence; *3* Royal Collection, Windsor Castle/© Her Majesty Queen Elizabeth II

Luini, Bernardino Photo: Archivi Alinari, Florence

Machiavelli, Zanobi Photo: Archivi Alinari, Florence

Maiano: (1) Giuliano da Maiano Photo: James Austin, Cambridge

Maiano: (2) Benedetto da Maiano Photo: Scala, Florence

Mainardi, Bastiano Indianapolis Museum of Art, Indianapolis, IN (Gift of Mrs Booth Tarkington in memory of her husband)

Mannerism Photo: Archivi Alinari, Florence

Mantegazza V & A Picture Library, London

Mantegna, Andrea *1* Photo: Overseas Agenzia Fotografica, Milan; *2* Photo: Scala, Florence; *3, 5* Photo: © RMN, Paris; *4* Staatliche Museen zu Berlin, Preußischer Kulturbesitz; *6* Trustees of the National Gallery, London

Mantua Photo: Foto Giovetti, Mantua

Marmitta, Francesco National Gallery of Scotland, Edinburgh

Masters, anonymous, and monogrammists, I:

Master of the Barbarigo Reliefs Photo: Osvaldo Böhm, Venice

Master of the Mascoli Altar Photo: Archivi Alinari, Florence

Master of the Osservanza Photo: Archivi Alinari, Florence

Stratonice Master Photo: Maurizia Tazartes

Master of the Unruly Children V & A Picture Library, London

Masters, anonymous, and monogrammists, II:

Master of 1419 Cleveland Museum of Art, Cleveland, OH (Gift of the Hanna Fund, 1954.834)

Masaccio *1* Trustees of the National Gallery, London; *2* Staatliche Museen zu Berlin, Preußischer Kulturbesitz; *3* Museo e Gallerie Nazionali di Capodimonte, Naples/Photo: Overseas Agenzia Fotografica, Milan; *4* Photo: Scala, Florence; *5* Photo: Archivi Alinari, Florence

Mascherino, Ottaviano Photo: Archivi Alinari, Florence

Maser, Villa Barbaro Centro Palladiano, Vicenza
Masolino *1* Photo: Scala, Florence; *2* Photo: Gabinetto Fotografico, Soprintendenza per i Beni Artistici e Storici, Florence; *3–4* Photo: Archivi Alinari, Florence
Matteo di Giovanni Photo: Fotografia Lensini Fabio, Siena
Mazzoni, Guido Photo: Archivi Alinari, Florence
Medici, de': (2) Cosimo de' Medici Photo: Scala, Florence
Medici, de': (7) Leo X Photo: Scala, Florence
Medici, de': (14) Cosimo I de' Medici Photo: Scala, Florence
Melone, Altobello (da) Trustees of the National Gallery, London
Melozzo da Forlì *1* Vatican Museums, Vatican City, Rome; *2* Photo: Archivi Alinari, Florence
Michelangelo *1–5, 8–9* Photo: Scala, Florence; *2* Photo: Giraudon, Paris; *6* Photo: Archivi Alinari, Florence; *7* © British Museum, London
Michelino da Besozzo Pierpont Morgan Library, New York
Michelozzo di Bartolomeo *1, 3* Photo: Archivi Alinari, Florence; *2* Photo: Scala, Florence
Milan *1, 3* Photo: Archivi Alinari, Florence; *2* V & A Picture Library, London; *4* Photo: Scala, Florence
Mino da Fiesole *1* Staatliche Museen zu Berlin, Preußischer Kulturbesitz/Skulpturensammlung, Berlin/Photo: Jörg P. Anders, 1989; *2* Conway Library, Courtauld Institute of Art, London
Mocetto, Girolamo Trustees of the National Gallery, London
Montagna: (1) Bartolomeo Montagna *1* Vicenza, Museo Civico d'Arte e Storia; *2* Photo: Archivi Alinari, Florence
Montorsoli, Giovanni Angelo Photo: Scala, Florence
Moretto *1* Pinacoteca Civica Tosio–Martinengo, Brescia; *2* Trustees of the National Gallery, London
Moroni, Andrea Museo Civico, Padua
Moroni, Giovanni Battista *1* Trustees of the National Gallery, London; *2* Photo: Bridgeman Art Library, London
Muziano, Girolamo Vatican Museums, Vatican City, Rome
Naldini, Giovan Battista Photo: Scala, Florence
Nanni di Banco Photo: Scala, Florence
Nanni di Bartolo Photo: Archivi Alinari, Florence
Naples *1, 3, 5* Photo: Scala, Florence; *2, 4* Photo: Archivi Alinari, Florence; *6* Conway Library, Courtauld Institute of Art, London
Neri di Bicci *1* National Gallery of Canada, Ottawa; *2* Photo: Archivi Alinari, Florence; *3* Photo: Scala, Florence
Niccolò dell'Arca Photo: Gabinetto Fotografico, Soprintendenza ai Beni Artistici e Storici, Bologna
Niccolò di Pietro Metropolitan Museum of Art, New York (Rogers Fund, 1923; no. 23.64)
Ornament & pattern V & A Picture Library, London
Orsi, Lelio *1* Trustees of the National Gallery, London; *2* Photo: © RMN, Paris
Paciotto, Francesco Soprintendenza per i Beni Artistici e Storici, Parma
Padua *1* Museo Civico, Padua; *2* Photo: Archivi Alinari, Florence
Palazzo *1–2* Photo: Archivi Alinari, Florence
Palladio, Andrea *1–3, 5* Bildarchiv Foto Marburg; *4* British Library, London; *6* British Architectural Library, RIBA, London; *7* Gabinetto Fotografico, Soprintendenza ai Beni Artistici e Storici, Venice/Photo: Osvaldo Böhm, Venice
Palma: (1) Palma Vecchio *1* Kunsthistorisches Museum, Vienna; *2* Trustees of the National Gallery, London
Palma: (3) Palma Giovane Gabinetto Fotografico, Soprintendenza ai Beni Artistici e Storici, Venice/Photo: Real Fotografia Giacomelli, Venice
Parma Photo: Scala, Florence
Parmigianino *1* Kunsthistorisches Museum, Vienna; *2* Metropolitan Museum of Art, New York (Gustavus A. Pfeiffer Fund, 1962; no. 62.135); *3* Photo: Scala, Florence; *4* Kunsthistorisches Museum, Vienna
Passarotti, Bartolomeo Private Collection of the Marquess of Linlithgow and on loan to the Hopetoun House Preservation Trust, Hopetoun House, nr Edinburgh
Pastiglia V & A Picture Library, London
Pastorini, Pastorino National Gallery of Art, Washington, DC
Pavia *1* Photo: Scala, Florence; *2* Photo: Archivi Alinari, Florence
Penni: (1) Giovan Francesco Penni Soprintendenza per i Beni Ambientali, Architettonici, Artistici e Storici, Salerno
Perino del Vaga Photo: Archivi Alinari, Florence
Perugino *1* Photo: Scala, Florence; *2* Photo: © RMN, Paris; *3* Bayerische Staatsgemäldesammlungen, Munich; *4* Trustees of the National Gallery, London
Peruzzi, Baldassare *1* Photo: Archivi Alinari, Florence; *2, 4* Photo: Scala, Florence; *3* Photo: Nicholas Adams
Pesaro British Library, London (no. Maps C25.d.12)
Pesellino Courtauld Institute Galleries, London (Gambier-Parry Collection)
Pienza *1* Photo: Archivi Alinari, Florence; *2* Conway Library, Courtauld Institute of Art, London
Pier Francesco Fiorentino Museo dell'Opera di Santa Croce, Florence
Pierino da Vinci Vatican Museums, Vatican City, Rome
Piero della Francesca *1* Trustees of the National Gallery, London; *2–3* Photo: Scala, Florence
Piero di Cosimo *1* National Gallery of Art, Washington, DC (Samuel H. Kress Collection); *2* Trustees of the National Gallery, London
Pietro di Giovanni d'Ambrogio Brooklyn Museum of Art, Brooklyn, NY (Bequest of Helen Babbott Sanders; no. 78.151.9)
Pinturicchio, Bernardino *1* Trustees of the National Gallery, London; *2* Photo: Scala, Florence
Pisanello *1, 4* Photo: © RMN, Paris; *2* Photo: Scala, Florence; *3* British Museum, London; *5* V & A Picture Library, London
Pitati, Bonifazio de' Gabinetto Fotografico, Soprintendenza ai Beni Artistici e Storici, Venice
Poccetti, Bernardino Gabinetto Disegni e Stampe degli Uffizi, Florence
Polidoro da Caravaggio Courtauld Institute Galleries, London
Pollaiuolo: (1) Antonio Pollaiuolo *1* Trustees of the National Gallery, London; *2* Photo: Scala, Florence; *3* © British Museum, London
Pollaiuolo: (2) Piero Pollaiuolo *1* Staatliche Museen zu Berlin, Preußischer Kulturbesitz; *2* Photo: Archivi Alinari, Florence
Pontelli, Baccio Photo: Archivi Alinari, Florence
Pontormo, Jacopo da *1* Photo: Scala, Florence; *2* Photo: Archivi Alinari, Florence
Pordenone *1* Photo: Scala, Florence; *2* Photo: Elio Ciol, Casarsa della Delizia
Porta, della: (3) Guglielmo della Porta Photo: Dr Markus Völkel
Porta, Giacomo della *1* Photo: Scala, Florence; *2* British Library, London (no: 62. g.3(1))
Pouncing Trustees of the National Gallery, London
Predis, de: (1) Cristoforo de Predis Trustees of the Wallace Collection, London
Predis, de: (2) Giovanni Ambrogio de Predis Trustees of the National Gallery, London
Presentation Drawing Courtauld Institute Galleries, London
Previtali, Andrea Private collection, Scotland

Stefano da Verona Photo: Scala, Florence
Strada: (1) Jacopo Strada Bayerisches Haupstaatsarchiv, Munich (Plansammlung 7931)
Stradanus, Joannes *1* Photo: Scala, Florence; *2* Sotheby's, London
Strozzi, Zanobi Photo: Bardazzi Fotografia, Florence
Studiolo *1–2* Photo: Archivi Alinari, Florence
Tasso, Giovan Battista di Marco del Photo: Archivi Alinari, Florence
Theatre *1* Photo: Overseas Agenzia Fotografica, Milan; *2* © British Museum, London
Tibaldi: (1) Pellegrino Tibaldi *1* Gabinetto Fotografico, Soprintendenza per i Beni Artistici e Storici, Bologna; *2* Photo: Gabinetto Fotografico Nazionale, Istituto Centrale per il Catalogo e la Documentazione, Rome
Tintoretto, Jacopo *1* Kunsthistorisches Museum, Vienna; *2* Photo: Osvaldo Böhm, Venice; *3, 5* Photo: Scala, Florence; *4* Gabinetto Fotografico, Soprintendenza ai Beni Artistici e Storici, Venice; *6* Trustees of the National Gallery, London
Titian *1* Photo: Gabinetto Fotografico Nazionale, Istituto Centrale per il Catalogo e la Documentazione, Rome; *2, 7* Photo: Scala, Florence; *3, 6* Bridgeman Art Library, London; *4* Trustees of the National Gallery, London; *5* Museo del Prado, Madrid; *8* Isabella Stewart Gardner Museum, Boston, MA; *9* Gabinetto Fotografico, Soprintendenza di Artistici e Storici, Venice; *10* Soprintendenza per i Beni Artistici e Storici, Naples
Tito, Santi di *1–2* Photo: Archivi Alinari, Florence
Tivoli British Library, London
Tramello, Alessio Photo: Bruno Adorni
Tribolo, Niccolò Photo: Scala, Florence
Tura, Cosimo *1, 3–4* Trustees of the National Gallery, London; *2* Photo: Scala, Florence
Turin *1* Archivio Fotografico, Soprintendenza per i Beni Artistici e Storici del Piemonte, Turin/Galleria Sabauda, Turin; *2* Photo: Archivi Alinari, Florence
Uccello, Paolo *1–2* Photo: Scala, Florence; *3* Trustees of the National Gallery, London; *4* Ashmolean Museum, Oxford
Udine, Giovanni da Photo: Scala, Florence
Urbino *1* Photo: Scala, Florence; *2* Syndics of the Fitzwilliam Museum, Cambridge; *3* Photo: James Austin, Cambridge; *5* Yale University Press Photo Library, London/Photo: Istituto Nazionale Lucce, Rome
Vacca, Flaminio Photo: Archivi Alinari, Florence
Varallo, Sacro Monte *1–2* Photo: Archivi Alinari, Florence
Vasari, Giorgio *1–3, 5, 7–8* Photo: Scala, Florence; *4* Photo: © RMN, Paris; *6* Conway Library, Courtauld Institute of Art, London; *9* Fondation Custodia, Collection Frits Lugt, Institut Néerlandais, Paris; *10* Photo: Dr J. Kliemann; *11* © British Museum, London
Vecchi, Giovanni de' Photo: Gabinetto Fotografico Nazionale, Istituto Centrale per il Catalogo e la Documentazione, Rome
Vecchietta *1–2* Photo: Scala, Florence
Venice *1* Museo Correr, Venice; *2* Photo: Anthony Kersting, London; *3* Conway Library, Courtauld Institute of Art, London; *4, 12* Photo: Scala, Florence; *5, 14* Photo: Archivi Alinari, Florence; *6* Museo Civico Medievale, Bologna (neg. Ab2, inv. no. 1364-1365); *7* Museo Vetrario di Murano, Venice; *8–11* Photo: Osvaldo Böhm, Venice; *13* V & A Picture Library, London
Verona Photo: Archivi Alinari, Florence
Veronese, Paolo *1* Photo: Gabinetto Fotografico, Soprintendenza per i Beni Artistici e Storici, Florence; *2–3* Photo: Scala, Florence; *4–5* Photo: Gabinetto Fotografico, Soprintendenza per i Beni Artistici e Storici, Venice; *6* J. Paul Getty Museum, Los Angeles, CA
Verrocchio, Andrea del *1–3, 5* Photo: Scala, Florence; *4* Photo: Osvaldo Böhm, Venice; *6* Trustees of the National Gallery, London
Vicenza *1* Biblioteca Angelica, Rome; *2* Photo: Franco Barbieri
Vico, Enea Graphische Sammlung Albertina, Vienna
Vignola, Jacopo *1* British Architectural Library, RIBA, London; *2* Photo: Archivi Alinari, Florence; *3* Photo: Scala, Florence; *4* Overseas Agenzia Fotografica, Milan/Photo: A. Villani, Bologna
Villa *1* Photo: Scala, Florence; *2* Photo: Archivi Alinari, Florence; *3* Photo: Archivio Fotografico, Servizio Beni Culturali-Comune, Genoa; *4* Architectural Association, London/Photo:Theo Armour
Vitoni, Ventura di Andrea Photo: Archivi Alinari, Florence
Vitozzi, Ascanio Photo: Archivi Alinari, Florence
Vitruvius *1* British Library, London (no. 2261.f.14); *2* Provost and Fellows, Eton College/Photo: Conway Library, Courtauld Institute of Art; *3* British Library, London (no: 59. f.23)
Vittoria, Alessandro *1* Staatliche Museen zu Berlin, Preußischer Kulturbesitz; *2* Photo: Osvaldo Böhm, Venice; *3* Photo: Archivi Alinari, Florence
Vivarini: (1) Antonio Vivarini National Gallery, Prague
Vivarini: (2) Bartolomeo Vivarini Gabinetto Fotografico, Soprintendenza per i Beni Artistici e Storici, Venice
Vivarini: (3) Alvise Vivarini *1* Photo: Reale Fotografia Giacomelli, Venice; *2* Trustees of the National Gallery, London
Zavattari Photo: Scala, Florence
Zenale, Bernardo J. Paul Getty Museum, Los Angeles, CA
Zoppo, Marco *1* Photo: © RMN, Paris; *2* National Gallery of Art, Washington, DC (Samuel H. Kress Collection)
Zuccaro: (1) Taddeo Zuccaro *1* Gabinetto Fotografico Nazionale, Istituto Centrale per il Catalogo e la Documentazione, Rome/Photo: Witt Library, Courtauld Institute of Art, London; *2* Photo: Scala, Florence
Zuccaro: (2) Federico Zuccaro *1* Photo: Gabinetto Fotografico Nazionale, Istituto Centrale per il Catalogo e la Documentazione, Rome; *2* © British Museum, London

Colour Plate Acknowledgements

Volume 1

PLATE I.

1. Niccolò dell'Abate: *Concert* (*c.* 1550; detail), frescoed frieze, Palazzo Poggi, Bologna (Photo: Scala, Florence

2. Leon Battista Alberti: façade of S Maria Novella, Florence, *c.* 1458–70 (Photo: Scala, Florence

PLATE II.

1. Mariotto Albertinelli: *Adoration of the Child*, predella panel from the S Martino Altarpiece, 1503 (Florence, Galleria degli Uffizi/Photo: Scala, Florence

2. Bartolomeo Ammanati: Courtyard of the Palazzo Pitti, Florence, 1560–77 (Photo: Scala, Florence

PLATE III.

1. Fra Angelico: *Annunciation*, *c.* 1440–45, fresco, north corridor, monastery of S Marco, Florence (Photo: Scala, Florence

2. Fra Angelico: *Mocking of Christ*, *c.* 1440–45, fresco, Cell 7, monastery of S Marco, Florence (Photo: Scala, Florence

PLATE IV.

1. Antonello da Messina:*Pirate of Lipari*, oil on panel, 300x250 mm, later 1460s (Cefalù, Museo Mandralisca/Photo: Scala, Florence

2. Antonello da Messina:*Pietà*, oil on panel, 740x510 mm, 1475–80 (Madrid, Museo del Prado/Photo: Scala, Florence

PLATE V.

1. Bacchiacca:*Arrrest of Joseph[rquote]s Brothers* from the scenes from the *Life of Joseph*, *c.* 1517 (Rome, Galleria Borghese/Photo: Scala, Florence

2. Alesso Baldovinetti: *Virgin and Child with Saints*, tempera on panel, 1.76x1.66 m, *c.* 1454 (Florence, Galleria degli Uffizi/Photo: Scala, Florence

PLATE VI.

1. Federico Barocci: *'Il Perdono' (Vision of St Francis)*, oil on canvas, 4.27x2.36 m, *c.* 1577 (Urbino, S Franceso/Photo: Scala, Florence

2. Federico Barocci: *Francesco-Maria II della Rovere*, oil on canvas, 1130x930 mm, *c.* 1573 (Florence, Galleria degli Uffizi/Photo: Scala, Florence

3. Barovier Cup, glass wedding goblet with enamel decoration, h. 180 mm, 1560–80 (Murano, Museo Vetrario/Photo: Bridgeman Art Library, London

PLATE VII.

1. Fra Bartolommeo: *Christ and the Four Evangelists*, oil on canvas, 2.82x2.04 m, 1516 (Florence, Palazzo Pitti/Photo: Scala, Florence

2. Fra Bartolommeo: *Mystic Marriage of St Catherine of Siena*, oil on panel, 3.51x2.67 m, 1512 (Florence, Galleria dell'Academia/Photo: Scala, Florence

3. Marco Basaiti: *Virgin and Child with a Donor*, *c.* 1496–*c.* 1500 (Venice, Museo Correr/Photo: Scala, Florence

PLATE VIII.

1. Jacopo Bassano: *Entombment*, oil on canvas, 2.7x1.8 m, 1574 (Padua, S Maria in Vanzo/Photo: Scala, Florence

2. Jacopo Bassano: *Rest on the Flight into Egypt*, oil on canvas, 1.18x1.58 m, *c.* 1547 (Milan, Pinacoteca Ambrosiana/Photo: Scala, Florence

PLATE IX.

1. Domenico Beccafumi: *Posthumius Tiburtius Has His Son Killed*, (1529–1532, 1535) ceiling fresco, Sala del Concistoro, Palazzo Pubblico, Siena (Photo: Scala, Florence

2. Domenico Beccafumi: *Stigmatization of St Catherine with SS Benedict and Jerome*, tempera on panel, 2.12x1.62 m, 1514–15 (Siena, Pinacoteca Nazionale/Photo: Scala, Florence

PLATE X.

1. Jacopo Bellini: *St Jerome*, tempera on panel, 960x640 mm, *c.* 1440 (Verona, Musei Civici di Verona/Photo: Scala, Florence

2. Jacopo Bellini: *Madonna of Humility*, oil on panel, 602x401 mm, *c.* 1430 (Paris, Museé du Louvre/Photo: Scala, Florence

3. Gentile Bellini: *Procession of the True Cross in Piazza S Marco*, oil on canvas, 3.67x7.45 m, 1496 (Venice, Galleria dell' Accademia/Photo: Scala, Florence

PLATE XI.

1. Giovanni Bellini: *St Vincent Ferrer* polyptych, tempera on panel, 720x670 mm, *c.* 1464–8 (Venice, SS Giovanni e Paolo/Photo: Scala, Florence

2. Giovanni Bellini: *Transfiguration*, oil on panel, 1.15x1.54 m, *c.* 1478–9 (Naples, Museo e Gallerie Nazionali di Capodimonte/Photo: Scala, Florence

2. Desiderio da Settignano: *Virgin and Child*, marble, h. 610 mm, ?late 1450s (Turin, Galleria Sabauda/Photo: Scala, Florence

3. Deruta plate with arms of the Montefeltro family, maiolica, diam. 400 mm, before 1508 (Pesaro, Museo Ceramiche/Photo: Scala, Florence

PLATE XXVIII.

1. Domenico Veneziano: detail of the main panel of the *St Lucy* altarpiece, tempera on panel, 2.09x2.13 m (whole panel), mid-1440s (Florence, Galleria degli Uffizi/Photo: Scala, Florence

2. Donatello: *Singing Gallery* (*Cantoria*), marble and mosaic inlay, 3.48x5.70 m, 1439 (Florence, Museo Opera del Duomo/Photo: Scala, Florence

PLATE XXIX.

1. Donatello: *David*, bronze, h. 1.58 m, 1450s (Florence, Museo Nazionale del Bargello/Photo: Scala, Florence

2. Giovanni Maria Falconetto: Odeo Cornaro, Padua, 1530 (Photo: Scala, Florence

3. Dosso Dossi: *Stregoneria* ('Sorcery') or *Allegory of Hercules*, oil on canvas, 1.43x1.44 m, *c.* 1538 (Florence, Galleria degli Uffizi/Photo: Scala, Florence

PLATE XXX.

1. Florentine Arazzi tapestry with grotesques, 2.33x3.53 mm (maximum dimensions), *c.* 1546–9 (Florence, Galleria degli Uffizi/Photo: Scala, Florence

2. Orazio Fontana (workshop): maiolica dish with Raphaelesque decoration, diam. 665 mm, part of the table service made for the Duke of Urbino, 1565–71 (Florence, Museo Nazionale del Bargello/Photo: Scala, Florence

3. Vincenzo Foppa: *St Jerome*, tempera on panel, 460x310 mm, before 1460 (Bergamo, Accademia Carrara di Belle Arti/Photo: Scala, Florence

PLATE XXXI.

1. Francesco di Giorgio Martini: S Maria del Calcinaio, Cortona, begun 1485 (Photo: Scala, Florence

2. Lorenzo Ghiberti: *Gates of Paradise* (*c.* 1426–52), gilded bronze, Baptistery, Florence (Photo: Scala, Florence

3. Gentile da Fabriano: *Flight into Egypt*, predella panel from the *Adoration of the Magi*, tempera on panel, 1.73x2.20 m, 1423 (Florence, Galleria degli Uffizi/Photo: Scala, Florence

PLATE XXXII.

1. Domenico Ghirlandaio: *Last Supper* (1480), fresco, church of the Ognissanti, Florence (Photo: Scala, Florence

2. Domenico Ghirlandaio: *Ludovica Tornabuoni*, detail from the *Birth of the Virgin* (1486–90), fresco, Tornabuoni chapel, S Maria Novella, Florence (Photo: Scala, Florence

PLATE XXXIII.

1. Giorgione (or ?Titian): *Virgin and Child with SS Roch and Anthony*, oil on canvas, 920x1330 mm, *c.* 1509 (Madrid, Museo del Prado/Photo: Scala, Florence

2. Giorgione: *The Tempest*, oil on canvas, 830x730 mm (Venice, Galleria dell[rquote]Accademia/Photo: Scala, Florence

3. Giambologna: allegorical fountain of the *Appenines* (1570–80), brick and volcanic lava, h. 11m, Pratolino, near Florence (Photo: Scala, Florence

PLATE XXXIV.

1. Giovanni di Paolo: *Last Judgement*, tempera on panel, 420x2350 mm, *c.* 1463 (Siena, Pinacoteca Nazionale/Photo: Scala, Florence

2. Giotto: *Flight into Egypt* (*c.* 1303–6), fresco, Arena Chapel, Padua (Photo: Giraudon, Paris

3. Jacopo della Quercia: relief panels with the story of *Adam and Eve* from the left side of the Porta Magna (1425–30), S Petronio, Bologna (Photo: Scala, Florence

4. Italian Renaissance painted armoire, 2270x1800x580 mm, Siena, early 16th century (Florence, Palazzo Davanzati/Photo: Scala, Florence

PLATE XXXV.

1. Giulio Romano: *Fall of the Giants* (1532–4), fresco, Sala dei Giganti, Palazzo del Té, Mantua (Photo: Scala, Florence

2. Benozzo Gozzoli: detail of one of the processions in the *Journey of the Magi* (1459–61), fresco, Palazzo Medici, Florence (Photo: Scala, Florence

PLATE XXXVI.

1. Leonardo da Vinci: *Annunciation*, oil and tempera on panel, 980–2170 mm, from the Convent of Monte Oliveto, Florence, *c.* 1473 (Florence, Galleria degli Uffizi/Photo: Scala, Florence

2. Leonardo da Vinci: [rquote]*La Belle Ferroni[=233]re*[rquote], oil and tempera on panel, 630x450 mm, 1490s (Paris, Musée du Louvre/Photo: Scala, Florence

3. Leonardo da Vinci: [rquote]*Mona Lisa*[rquote], oil and tempera on panel, 770x530 mm, *c.* 1500–3 (Paris, Musée du Louvre/Photo: Scala, Florence

PLATE XXXVII.

1. Leonardo da Vinci: *Virgin of the Rocks*, oil on panel, transferred to canvas, 1.97x1.20 m, begun 1483 (Paris, Musée du Louvre/Photo: Scala, Florence

2. Liberale da Verona: *Martyrdom of St Sebastian*, panel, 1980x950 mm, late 1480s (Milan, Pinacoteca di Brera/Photo: Scala, Florence

PLATE XXXVIII.

Filippo Lippi: *Coronation of the Virgin*, tempera on panel, 2.00x2.87 m, 1439–47 (Florence, Galleria degli Uffizi/Photo: Scala, Florence

Flippino Lippi: *Crucifixion of Peter* (*c.* 1485), fresco, Brancacci Chapel, S Maria del Carmine, Florence (Photo: Scala, Florence

PLATE XXXIX.

1. Filippo Lippi: *Virgin and Child with Scenes from the Life of the Virgin*, tempera on panel, diam. 1.35 m, 1452–3 (Florence, Palazzo Pitti/Photo: Scala, Florence

2. Lorenzo di Credi: *Annunciation*, oil on panel, 880x710 mm, late 1490s (Florence, Galleria degli Uffizi/Photo: Scala, Florence

3. Lorenzo Lotto: *Virgin and Child with Saints* (the Recanati Altarpiece), oil on panel, 2.27x1.08 m, completed 1508 (Recanati, Pinacoteca Civica/Photo: Scala, Florence

4. Bernardino Luini: *Virgin and Child of the Rose Garden*, panel, 630x700 mm (Milan, Pinacoteca di Brera/Photo: Scala, Florence

PLATE XL.

1. Lorenzo Lotti: *Messer Marsilio and his Wife* oil on canvas, 710x840 mm, 1523 (Madrid, Museo del Prado/Photo: Scala, Florence

2. Lorenzo Monaco: *Adoration of the Magi*, tempera on panel, 1.15x1.7 m, early 1420s (Florence, Galleria degli Uffizi/Photo: Scala, Florence

Volume 2

PLATE I.

1. Andrea Mantegna: frescoed vault (1465–74) of the Camera degli Sposi, Palazzo Ducale, Mantua (Photo: Scala, Florence

2. Andrea Mantegna: *Court Scene* (1465–74), fresco, Camera degli Sposi, Palazzo Ducale, Mantua (Photo: Scala, Florence

PLATE II.

1. Andrea Mantegna: *Death of the Virgin*, tempera on panel, 540x420 mm, 1462 (Madrid, Museo del Prado/Photo: Scala, Florence

2. Masaccio: *Expulsion from Paradise* (*c*. 1427), fresco, Brancacci Chapel, S Maria del Carmine, Florence (Photo: Scala, Florence

3. Andrea Mantega: *Parnassus*, tempera on canvas, 1.50x1.92 m, 1495/6–7 (Paris, Musée du Louvre/Photo: Scala, Florence

PLATE III.

1. Masaccio: *Trinity* (*c*. 1425–7), fresco, S Maria Novella, Florence (Photo: Scala, Florence

2. Masaccio: *Distribution of the Goods of the Church* (*c*. 1427), fresco, Brancacci Chapel, S Maria del Carmine, Florence (Photo: Scala, Florence

3. Maso di Bartolomeo: gilded bronze reliquary, inlaid with bone and tortoiseshell, for the Capella del Sacro Cingo, Prato Cathedral (Prato, Museo Opera del Duomo/Photo: Scala, Florence

PLATE IV.

1. Masolino: *St Peter Preaching* (*c*. 1425), fresco, Brancacci Chapel, S Maria del Carmine, Florence (Photo: Scala, Florence

2. Masolino: *Marriage of the Virgin* (1435), fresco, Collegiata, Castiglione Olona, Lombardy (Photo: Scala, Florence

3. Michelangelo: *Holy Family* (Doni Tondo), tempera on panel, diam. 1.2 m, 1503 or 1507 (Florence, Galleria degli Uffizi/Photo: Scala, Florence

4. Melozzo da Forli: *Music-making Angels*, fresco transferred to canvas, 1479–80 (Rome, Pinacoteca Vaticana/Photo: Scala, Florence

PLATE V.

1. Michelangelo: tomb of *Giuliano de' Medici*, (1519–1533), marble, h.1.73 m, New Sacristy, S Lorenzo, Florence (Photo: Scala, Florence

2. Michelangelo: *Creation of Adam* (1508–10), fresco, Sistine Chapel, Vatican, Rome (Photo: Scala, Florence

PLATE VI.

1. Michelangelo: *Delphic Sybil* (1511–12), fresco, Sistine Chapel, Vatican, Rome (Photo: Scala, Florence

2. Michelangelo: *Prophet Jonah* (1511–12), fresco, Sistine Chapel, Vatican, Rome (Photo: Scala, Florence

PLATE VII.

1. Michelangelo: *Studies for the Libyan Sibyl*, red chalk, 289x214 mm, 1508–12 (New York, Metropolitan Museum of Art/Photo: Metropolitan Museum of Art, Purchase, Joseph Pulitzer Bequest, 1924; no. 24.197.2

2. Michelangelo: *Moses*, marble, h. 2. 35 m, from the tomb of *Julius II*, *c*. 1515–16 (Rome, S Pietro in Vincoli/Photo: Scala, Florence

3. Michelangelo: *Last Judgement* (1536–41), fresco, Sistine Chapel, Vatican, Rome (Photo: Scala, Florence

PLATE VIII.

1. Milanese rock crystal vase by Annibale Fontana, enamelled gold with gilt metal mounts, 394x184 mm (Florence, Museo Argenti/Photo: Scala, Florence

2. Mino da Fiesole: *Piero de' Medici*, marble, h. 500 mm, 1453 (Florence, Museo Nazionale del Bargello/Photo: Scala, Florence

3. Bartolomeo Montagna: *Virgin and Child with Four Saints and Music-making Angels*, panel transferred to canvas, 4.60x2.40 m, mid-1480s (Vicenza, Museo Civico d'Arte e Storia/Photo: Scala, Florence

4. Monte di Giovanni del Fora: illumination in the *Life of Lorenzo the Magnificent* (Florence, Biblioteca Laurenziana, MS Plut. 61-3, fol. 2r/Photo: Scala, Florence

PLATE IX.

1. Moretto: *St Nicholas of Bari Presenting Pupils of Galeazzo Rovelli to the Virgin and Child* (the Rovelli Altarpiece), oil on canvas, 2.45x1.92 m, 1539 (Brescia, Pinacoteca Civica Tosio–Martinengo/Photo: Scala, Florence

2. Neri di Bicci: *Coronation of the Virgin with Saints*, panel, 1560 (Florence, Galleria dell'Ospedale degli Innocenti/Photo: Scala, Florence

3. Giovanni Battista Moroni: *Antonio Navagero*, oil on canvas, 900x1150 mm, 1565 (Milan, Pinacoteca di Brera/Photo: Scala, Florence

4. Niccol[=242] di Forzore Spinelli: bronze medal with portrait of *Lorenzo the Magnificent*, diam. 91.6 mm, 1450 (Florence, Museo Nazionale del Bargello/Photo: Scala, Florence

PLATE X.

1. Lelio Orsi: *St George and the Dragon*, oil on canvas, 600x485 mm, early 1560s (Naples, Museo e Gallerie Nazionali di Capodimonte/Photo: Scala, Florence

2. Gasparo Padovano (attrib.): *Aristotle Seated*, frontispiece (367x257 mm) from Aristotle: *Historia animalium, De partibus animalium, De generatione animalium*, translated by Theodore of Gaza, written by Bartolomeo Sanvito, from Rome, *c*. 1473/4–80 (Rome, Vatican, Biblioteca Apostolica, MS. Vat. Lat. 2094, fol. 8r/Photo: Vatican Museums

PLATE XI.

1. Andrea Palladio: Villa Barbaro, Maser, 1554–8 (Photo: Scala, Florence

2. Andrea Palladio: S Giorgio Maggiore, Venice, 1566–75; fa[=231]ade 1599–1610 (Photo: Scala, Florence

PLATE XII.

1. Palma Vecchio: *Virgin and Child with Saints and Two Donors*, oil on panel, 1.34x2.10 m, mid-1520s (Naples, Museo e Gallerie Nazionali di Capodimonte/Photo: Scala, Florence

2. Palma Giovane: *Conquest of Constantinople*, oil on canvas, 5.75x6.25 m, c. 1578 (Venice, Doge's Palace, Sala del Maggiore Consiglio/Photo: Scala, Florence

PLATE XIII.

1. Parmigianino: *Holy Family*, oil on panel, 1192x889 mm, c. 1524 (Madrid, Museo del Prado/Photo: Scala, Florence

2. Parmigianino: *Turkish Slave Girl*, oil on panel, 680x530 mm, 1530s (Parma, Galleria Nazionale/Photo: Scala, Florence

3. Parmigianino: *Virgin and Child with SS Mary Magdalene, St John the Baptist and the Prophet Zachariah*, oil on panel, 730x600 mm, late 1520s (Florence, Galleria degli Uffizi/Photo: Scala, Florence

4. Bartolomeo Passarotti: *The Botanist*, oil on canvas, 1010x828 mm, late 1560s (Rome, Galleria Spada/Photo: Scala, Florence

PLATE XIV.

1. Perino del Vaga: *Jove Hurling Thunderbolts at the Giants* (c. 1530), fresco, Palazzo Doria–Pamphili, Fassolo, Genoa (Photo: Scala, Florence

2. Perugino: *Francesco delle Opere*, tempera on panel, 520x440 mm, 1494 (Florence, Galleria degli Uffizi/Photo: Scala, Florence

3. Perugino: *Lamentation*, oil on panel, 2.14x1.95 m, 1495 (Florence, Palazzo Pitti/Photo: Scala, Florence

PLATE XV.

1. Baldassare Peruzzi: fictive perspective view (1517–18), fresco, Sala delle Prospettive, Villa Farnesina, Rome (Photo: Scala, Florence

2. Piero della Francesca: *Resurrection*, fresco, 2.80x2.25 m, after 1458 (Sansepolcro, Museo Civico/Photo: Scala, Florence

PLATE XVI.

1. Piero della Francesca: *Legend of the True Cross* (late 1440s–mid-1450s), fresco, S Francesco, Arezzo (Photo: Scala, Florence

2. Piero della Francesca: *Virgin and Child* (the Brera Altarpiece), oil on panel, 2.48x1.70 m, ?mid-1470s (Milan, Pinacoteca di Brera/Photo: Scala, Florence

PLATE XVII.

1. Piero della Francesca: *'Madonna del Parto'* (Virgin with Two Angels; ?late 1450s), detached fresco, cemetary chapel (formerly S Maria a Momentana), Monterchi (Photo: Scala, Florence

2. Bernardino Pinturicchio: *Delphic Sibyl* (c. 1509), ceiling decoration, vault of the presbytery, S Maria del Popolo, Rome (Photo: Scala, Florence

3. Piero di Cosimo: *Liberation of Andromeda*, oil on panel, 710x1230 mm, c. 1515–20 (Florence, Galleria degli Uffizi/Photo: Scala, Florence

PLATE XVIII.

1. Pisanello: *Lionello d'Este*, tempera on panel, 295x184 mm, 1441 (Bergamo, Galleria dell'Accademia Carrara/Photo: Scala, Florence

2. Antonio del Pollaiuolo: *Hercules and the Hydra*, tempera on panel, 170x120 mm, after c. 1460 (Florence, Galleria degli Uffizi/Photo: Scala, Florence

3. Jacopo da Pontormo: *Cosimo de[rquote] Medici il Vecchio*, oil on panel, 870x650 mm, 1519 (Florence, Galleria degli Uffizi/Photo: Scala, Florence

PLATE XIX.

1. Pordenone: *Conversion of Saul* (1523), tempera on canvas, 4.48x2.24 m, organ shutter, Spilimbergo Cathedral (Photo: Scala, Florence

2. Jacopo da Pontormo: *Annunciation* (1525–8), fresco, Capponi Chapel, S Felicita, Florence (Photo: Scala, Florence

PLATE XX.

1. Francesco Primaticcio: fresco decoration for the Chambre de la Duchesse d'Etampes at Fountainebleau, 1541–4 (Fountainebleau, Musée National du Château de Fontainebleau/Photo: Scala, Florence

2. Raphael: Borghese *Entombment*, oil on panel, 1.84x1.76 m, 1507 (Rome, Galleria Borghese/Photo: Scala, Florence

PLATE XXI.

1. Raphael: *Parnassus* (c. 1508–10), fresco, Stanza della Segnatura, Vatican, Rome (Photo: Scala, Florence

2. Raphael and Giovanni da Udine: fresco decoration (1516) in the bathroom (*Stufetta*) of Cardinal Bernardo Bibbiena, Vatican, Rome (Photo: Scala, Florence

PLATE XXII.

1. Raphael: *Triumph of Galatea* (c. 1512), fresco, Villa Farnesina, Rome (Photo: Scala, Florence

PLATE XXIII.

1. Raphael: *Madonna della Sedia*, oil on panel, diam. 710 mm, c. 1514 (Florence, Palazzo Pitti/Photo: Scala, Florence

2. Raphael: *Donna Velata*, oil on canvas, 850x640 mm, c. 1514 (Florence, Palazzo Pitti/Photo: Scala, Florence

PLATE XXIV.

1. Andrea della Robbia: *Annunciation*, tin-glazed terracotta, 1.54x2.85 m, c. 1490 (Florence, Ospedale degli Innocenti, cloister/Photo: Scala, Florence

2. Luca della Robbia: *Singing Gallery* (*Cantoria*; detail), marble, 3.28x5.60 m (whole) for the organ loft of Florence Cathedral, marble, 1431–8 (Florence, Museo dell'Opera del Duomo/Photo: Scala, Florence

PLATE XXV.

1. Gerolamo Romanino: *Raising of Lazarus* (early 1540s), fresco, chapel of the SS Sacramento, S Giovanni Evangelista, Brescia (Photo: Scala, Florence

2. Cosimo Rosselli (attrib.): *Crossing of the Red Sea* (*c.* 1482), fresco, Sistine Chapel, Vatican, Rome (Photo: Scala, Florence)

PLATE XXVI.

1. Rosso Fiorentino: *Virgin and Child Enthroned with Four Saints*, tempera on panel, 1.72x1.41 m, 1518 (Florence, Galleria degli Uffizi/Photo: Scala, Florence

2. Rosso Fiorentino: *Marriage of the Virgin*, oil on panel, 3.25x2.47 m, 1523 (Florence, S Lorenzo/Photo: Scala, Florence)

3. Francesco Salviati: *Charity*, oil on panel, 1.56x1.22 m, *c.* 1545 (Florence, Galleria degli Uffizi/Photo: Scala, Florence)

4. Francesco Salviati: *Story of David* (*c.* 1553), fresco, Gran Salone, Palazzo Sacchetti, Rome (Photo: Scala, Florence)

PLATE XXVII.

1. Giuliano da Sangallo: Villa Medici, Poggio a Caiano, begun *c.* 1485 (Photo: Scala, Florence

2. Jacopo Sansovino: *Virgin and Child*, polychromed papier m[=226]ch[=233] relief with gilding, 1133x838 mm, *c.* 1527–50 (Fort Worth, TX, Kimbell Art Museum/Photo: Kimbell Art Museum)

PLATE XXVIII.

1. Andrea del Sarto: *Lamentation*, oil on panel, 2.39x1.99 m, 1524 (Florence, Palazzo Pitti/Photo: Scala, Florence

2. Andrea del Sarto: *Birth of the Virgin* (1513–14), fresco, atrium, SS Annunziata, Florence (Photo: Scala, Florence)

3. Andrea del Sarto: *Girl Reading Petrarch*, oil on panel, 870x690 mm, *c.* 1528 (Florence, Galleria degli Uffizi/Photo: Scala, Florence

PLATE XXIX.

1. Sassetta: *St Francis in Glory*, panel, 1.90x1.22 m (central panel), 1.79x0.58 m (wings), back of the main panel of the S Francesco Altarpiece, 1437–44 (Florence, Villa I Tatti/Photo: Scala, Florence)

2. Giovanni Girolamo Savoldo: *Tobias and the Angel*, oil on canvas, 960x1240 m, 1534–5 (Rome, Galleria Borghese/Photo: Scala, Florence

PLATE XXX.

1. Giorgio Schiavone: *Adoration of the Magi*, oil on canvas, 1.85x2.22 m, *c.* 1547 (Milan, Pinacoteca Ambrosiana/Photo: Scala, Florence

2. Siena Cathedral, inlaid mosaic pavement showing *Abdis Bringing Elia's Message to Acab*, after Domenico Beccafumi, 1524 (Photo: Scala, Florence

PLATE XXXI.

1. Sebastiano del Piombo: *Dead Adonis*, oil on canvas, 1.89x2.95 m, 1512 (Florence, Galleria degli Uffizi/Photo: Scala, Florence

2. Sebastiano del Piombo: *St Giovanni Crisostomo with Saints*, oil on canvas, 2.00x1.65 m, begun 1510 (Venice, S Giovanni Crisostomo/Photo: Scala, Florence

PLATE XXXII.

1. Luca Signorelli: *Damned* (1500–03), fresco, chapel of S Brizio, Orvieto Cathedral (Photo: Scala, Florence

2. Sodoma: *Marriage of Alexander and Roxanne* (between 1509 and 1516), fresco, Villa Farnesina, Rome (Photo: Scala, Florence

PLATE XXXIII.

1. Luca Signorelli: *Annunciation*, panel, 2.58x2.06 m, 1491 (Volterra, Pinacoteca Communale/Photo: Scala, Florence

2. Jacopo Tintoretto: *Jacopo Sansovino*, oil on canvas, 700x650 mm, *c.* 1566 (Florence, Galleria degli Uffizi/Photo: Scala, Florence

3. Pellegrino Tibaldi: *Four Genii*, ceiling decoration (*c.* 1555), fresco and stucco, the smaller Sala d'Ulisse, Palazzo Poggi (now Istituto delle Scienze, Università degli Studi, Bologna) (Photo: Scala, Florence)

PLATE XXXIV.

1. Jacopo Tintoretto: *Last Supper* (1592–4), fresco, choir of S Giorgio Maggiore, Venice (Photo: Scala, Florence)

2. Jacopo Tintoretto: *Pool of Bethesda*, (1578–81), fresco, meeting-house, Scuola Grande di S Rocco, Venice (Photo: Scala, Florence)

PLATE XXXV.

1. Titian: *Federico II Gonzaga, Duke of Mantua*, oil on panel, 1250x990 mm, 1520s (Madrid, Museo del Prado/Photo: Scala, Florence

2. Titian: *Virgin and Child Enthroned with Saints and Members of the Pesaro Family*, (the Pesaro *Madonna*), oil on canvas, 4.78x2.66 m, 1519–26 (Venice, S Maria Gloriosa dei Frari/Photo: Scala, Florence)

3. Titian: *Venus of Urbino*, oil on canvas, 1.19x1.65 m, 1530s (Florence, Galleria degli Uffizi/Photo: Scala, Florence)

PLATE XXXVI.

1. Titian: *Diana and Callisto*, oil on canvas, 1.87x2.05 m, *c.* 1559 (Duke of Sutherland, on loan to Edinburgh, National Gallery of Scotland/Photo: National Gallery of Scotland

2. Cosimo Tura: *Angel of the Annunciation*, tempera on canvas, 4.13x1.68 m, from the inside of the organ shutters from Ferrara Cathedral, 1469 (Ferrara, Museo del Duomo/Photo: Scala, Florence

3. Titian (?attrib.): *Concert champêtre*, oil on canvas, 1.05x1.36 m, *c.* 1510 (Paris, Musée du Louvre/Photo: Scala, Florence

PLATE XXXVII.

1. Paolo Uccello: *Rout of San Romano*, tempera on panel, 1.83x3.17 m, mid-1450s (Paris, Musée du Louvre/Photo: Scala, Florence

2. Paolo Uccello: *St George and the Dragon*, oil on canvas, 565x743 mm, *c.* 1465 (Paris, Musée Tacquemart-André/Photo: Scala, Florence

3. Giorgio Vasari and assistants: Salone del Cinquecento, Palazzo Vecchio, Florence, 1563–71 (Photo: Scala, Florence)

PLATE XXXVIII.

1. Vecchietta: *Assumption of the Virgin with Four Saints*, tempera on panel, 3.6x2.7 m, *c.* 1462 (Pienza Cathedral/Photo: Scala, Florence

2. Andrea del Verrocchio: *Putto with a Dolphin*, bronze, h. 1.25 m, late 1460s or early 1470s (Florence, Palazzo Vecchio/Photo: Scala, Florence

3. Venetian [lquote]chalcedony[rquote] glass jug, h. 333 mm, from Murano, *c.* 1500 (London, British Museum/Photo: [=169] British Museum

4. Paolo Veronese: *Portrait of a Man in a Fur (?Daniele Barbaro)*, oil on canvas, 1.40x1.07 m, *c.* 1550 (Florence, Palazzo Pitti/Photo: Scala, Florence

PLATE XXXIX.

1. Paolo Veronese: illusionistic frescoes (*c.* 1561), Villa Barbaro, Maser (Photo: Scala, Florence

2. Alvise Vivarini (and Marco Basaiti): *St Ambrose Enthroned with Saints*, panel, 5.0x2.5 m, 1503 (Venice, S Maria Gloriosa dei Frari/Photo: Scala, Florence

3. Antonio Vivarini: polyptych with *St Anthony Abbot and other Saints*, tempera on panel, 530x300 mm (upper lateral part), 800x500 mm (upper central part), 1.05x1.3 m (lower part), 1464 (Rome, Pinacoteca Vaticana/Photo: Scala, Florence

PLATE XL.

1. Taddeo Zuccaro: *Marriage of Ottavio Farnese* (begun *c.* 1559), fresco, Villa Farnese, Caprarola (Photo: Scala, Florence

2. Federico Zuccaro: *Wisdom* (begun *c.* 1592), fresco, Casa Zuccaro (now Biblioteca Hertziana), Pincian Hill, Rome (Photo: Scala, Florence

Appendix A

LIST OF LOCATIONS

Every attempt has been made in compiling this encyclopedia to supply the correct current location of each work of art mentioned, and in general this information appears in abbreviated form in parentheses after the first mention of the work. The following list contains the abbreviations and full forms of the museums, galleries and other institutions that own or display art works or archival material cited in this encyclopedia; the same abbreviations have been used in bibliographies to refer to the venues of exhibitions.

Institutions are listed under their town or city names, which are given in alphabetical order. Under each place name, the abbreviated names of institutions are also listed alphabetically, ignoring spaces, punctuation and accents. Square brackets following an entry contain additional information about that institution, for example its previous name or the fact that it was subsequently closed. Such location names are included even if they are no longer used, as they might be cited in the encyclopedia as the venue of an exhibition held before the change of name or date of closure. The information on this list is the most up-to-date available at the time of publication.

Adelaide, A.G. S. Australia
 Adelaide, Art Gallery of South Australia

Aix-en-Provence, Mus. Granet
 Aix-en-Provence, Musée Granet

Ajaccio, Mus. Fesch
 Ajaccio, Musée Fesch

Alba, Pal. Com.
 Alba, Palazzo Comunale

Albenga, Mus. Dioc.
 Albenga, Museo Diocesano

Alençon, Mus. B.-A. & Dentelle
 Alençon, Musée des Beaux-Arts et de la Dentelle

Alessandria, Pal. Cuttica
 Alessandria, Palazzo Cuttica

Alessandria, Pin. Civ.
 Alessandria, Pinacoteca Civica

Algiers, Mus. N. B.-A.
 Algiers, Musée National des Beaux-Arts

Allentown, PA, A. Mus.
 Allentown, PA, Art Museum

Altenburg, Staatl. Lindenau-Mus.
 Altenburg, Staatliches Lindenau-Museum

Alzano Lombardo, Mus. Basilica S Martino
 Alzano Lombardo, Museo della Basilica di San Martino

Amiens, Mus. Picardie
 Amiens, Musée de Picardie

Amsterdam, Rijksdienst Beeld. Kst
 Amsterdam, Rijksdienst Beeldende Kunst

Amsterdam, Rijksmus.
 Amsterdam, Rijksmuseum [includes Afdeeling Aziatische Kunst; Afdeeling Beeldhouwkunst; Afdeeling Nederlandse Geschiedenis; Afdeeling Schilderijen; Museum von Asiatische Kunst; Rijksmuseum Bibliotheek; Rijksprentenkabinet]

Amsterdam, Stedel. Mus.
 Amsterdam, Stedelijk Museum

Ancona, Mus. Dioc.
 Ancona, Museo Diocesano

Ancona, Pin. Com.
 Ancona, Pinacoteca Comunale [Francesco Podesti e Galleria d'Arte Moderna]

Angera, Rocca

Angers, Mus. B.-A.
 Angers, Musée des Beaux-Arts

Ann Arbor, U. MI
 Ann Arbor, MI, University of Michigan

Ann Arbor, U. MI, Mus. A.
 Ann Arbor, MI, University of Michigan, Museum of Art

Antwerp, Kon. Mus. S. Kst
 Antwerp, Koninklijk Museum voor Schone Kunsten

Antwerp, Mus. Mayer van den Bergh
 Antwerp, Museum Mayer van den Bergh

Antwerp, Rubenshuis

Aranjuez, Jard. Príncipe
 Aranjuez, Jardín del Príncipe

Arezzo, Casa Giorgio Vasari
 Arezzo, Casa di Giorgio Vasari [houses Museo e Archivio Vasariano]

Arezzo, Gal. & Mus. Med. & Mod.
 Arezzo, Galleria e Museo Medioevale e Moderno

Arezzo, Mus. Dioc.
 Arezzo, Museo Diocesano

Arezzo, Pal. Com.
 Arezzo, Palazzo Comunale

Arezzo, Pal. Fraternità dei Laici
 Arezzo, Palazzo della Fraternità dei Laici

Arezzo, S Francesco

Asciano, Mus. A. Sacra
 Asciano, Museo di Arte Sacra

Ascoli Piceno, Mus. Dioc.
 Ascoli Piceno, Museo Diocesano

Ascoli Piceno, Pin. Civ.
 Ascoli Piceno, Pinacoteca Civica

Asolo, Mus. Civ.
 Asolo, Museo Civico

Assisi, S Rufino, Mus. Capitolare
 Assisi, San Rufino, Museo Capitolare

Assisi, Tesoro Mus. Basilica S Francesco
 Assisi, Tesoro del Museo della Basilica di San Francesco

Athens, N.G.
 Athens, National Gallery [and Alexander Soutzos Museum]

Atlanta, GA, High Mus. A.
 Atlanta, GA, High Museum of Art

Austin, U. TX, A. Mus.
 Austin, TX, University of Texas at Austin, University Art Museum [name changed to Huntington A.G. in 1980]

Avignon, Mus. Petit Pal.
 Avignon, Musée du Petit Palais

Baltimore, MD, Mus. A.
 Baltimore, MD, Baltimore Museum of Art

Baltimore, MD, Walters A.G.
 Baltimore, MD, Walters Art Gallery

Barcelona, Mus. A. Catalunya
 Barcelona, Museu d'Art de Catalunya

Barcelona, Mus. B.A. Cataluña
 Barcelona, Museo de Bellas Artes de Cataluña [now Mus. A. Catalunya]

Bari, Castello Svevo

Bari, Pin. Prov.
 Bari, Pinacoteca Provinciale

Barnard Castle, Bowes Mus.
 Barnard Castle, Bowes Museum

Basle, Kstmus.
 Basle, Kunstmuseum [incl. Kupferstichkabinett]

Bassano del Grappa, Bib. Civ.
 Bassano del Grappa, Biblioteca Civica

Bassano del Grappa, Mus. Civ.
 Bassano del Grappa, Museo Civico

Bayonne, Mus. Bonnat
 Bayonne, Musée Bonnat

Belluno, Mus. Civ.
 Belluno, Museo Civico

Benevento, Mus. Sannio
 Benevento, Museo del Sannio

Berchtesgaden, Schlossms.
 Berchtesgaden, Schlossmuseum [Verwaltung Wittelsbacher Ausgleichsfonds Munich]

Berea Coll., KY
 Berea, KY, Berea College

Bergamo, Accad. Carrara B.A.
 Bergamo, Accademia Carrara di Belle Arti

Bergamo, Bib. Civ. A. Mai
 Bergamo, Biblioteca Civica A. Mai

Bergamo, Gal. Accad. Carrara
 Bergamo, Galleria dell'Accademia Carrara [Pinacoteca]

Bergamo, Pal. Ragione
 Bergamo, Palazzo della Ragione

Berlin, Altes Mus.
 Berlin, Altes Museum [formerly Museum am Lustgarten; houses Kupferstichkabinett; Sammlung Zeichnungen und Druckgraphik; Wechselausstellungen]

Berlin, Bodemus.
 Berlin, Bodemuseum [houses ägyptisches Museum und Papyrussammlung; Frühchristlich-Byzantinische Sammlung; Gemäldegalerie; Münzkabinett; Museum für Ur- und Frühgeschichte; Skulpturensammlung]

Berlin, Dt. Staatsbib.
 Berlin, Deutsche Staatsbibliothek [united with the Staatsbib. Preuss. Kultbes. as Staatsbib. 1 Jan 1992]

Berlin, Freie U.
 Berlin, Freie Universität

Berlin, Schloss Charlottenburg
 Berlin, Galerie der Romantik [in Schloss Charlottenburg]

Berlin, Gemäldegal.
 Berlin, Gemäldegalerie [at Dahlem]

Berlin, Kaiser-Friedrich Mus.
 Berlin, Kaiser-Friedrich Museum [destr.; rebuilt as Bodemus.]

Berlin, Kstbib.
 Berlin, Kunstbibliothek [of SMPK; formerly at Charlottenburg, now at Tiergarten]

Berlin, Kstbib. & Mus.
 Berlin, Kunstbibliothek Berlin mit Museum für Architektur, Modebild und Grafik-Design

Berlin, Kupferstichkab.
 Berlin, Kupferstichkabinett [formerly at Dahlem, since 1994 at Tiergarten]

Berlin, Schloss Charlottenburg

Berlin, Skulpgal.
 Berlin, Skulpturengalerie mit Frühchristlich-Byzantinischer Sammlung [at Dahlem]

Berlin, Staatl. Museen Preuss. Kultbes.
 Berlin, Staatliche Museen Preussischer Kulturbesitz [admins ägyp. Mus.; Alte N.G.; Altes Mus.; Antikenmus.; Bodemus.; Gal. Romantik; Gemäldegal.; Gipsformerei; Kstbib.; Kupferstichkab.; Mus. Dt. Vlksknd.; Mus. Ind. Kst; Mus. Islam. Kst; Mus. Ostasiat. Kst; Mus. Vlkernd.; Mus. Vor- & Frühgesch.; Neue N.G.; Pergamonmus.; Schinkelmus.; Schloss Charlottenburg; Schloss Köpenick; Skulpgal.; Staatsbib.; Tiergarten, Kstgewmus.]

Berlin, Staatsbib.
 Berlin, Staatsbibliothek zu Berlin Preussischer Kulturbesitz

Berlin, Staatsbib. Preuss. Kultbes.
 Berlin, Staatsbibliothek Preussischer Kulturbesitz [united with the Dt. Staatsbib. to form Staatsbib. in 1992]

Berlin, Tiergarten, Kstgewmus.
 Berlin, Kunstgewerbemuseum

Berne, Kstmus.
 Berne, Kunstmuseum

Besançon, Mus. B.-A. & Archéol.
 Besançon, Musée des Beaux-Arts et d'Archéologie

Binghamton, SUNY
 Binghamton, NY, State University of New York

Birmingham, Mus. & A.G.
 Birmingham, City of Birmingham Museum and Art Gallery

Birmingham, AL, Mus. A.
 Birmingham, AL, Museum of Art

Bloomington, IN U.
 Bloomington, IN, Indiana University

Bloomington, IN U. A. Mus.
 Bloomington, IN, Indiana University Art Museum

Bologna, Archv Stato
 Bologna, Archivio di Stato

Bologna, Bib. Com. Archiginnasio
 Bologna, Biblioteca Comunale dell'Archiginnasio

Bologna, Bib. U.
 Bologna, Biblioteca Universitaria

Bologna, Compagnia Lombardi
 Bologna, Compagnia dei Lombardi

Bologna, Mus. Civ.
 Bologna, Museo Civico

Bologna, Mus. Civ. Med.
 Bologna, Museo Civico Medievale e del Rinascimento [in Palazzi Fava Ghisilardi]

Bologna, Mus. S Domenico
 Bologna, Museo di S Domenico

Bologna, Mus. S Petronio
 Bologna, Museo di S Petronio

Bologna, Mus. S Stefano
 Bologna, Museo di S Stefano [della Basilica Stefaniana]

Bologna, Pal. Archiginnasio
 Bologna, Palazzo dell'Archiginnasio

Bologna, Pal. Arcivescovile
 Bologna, Palazzo Arcivescovile

Bologna, Pal. Com.
 Bologna, Palazzo Comunale, Collezioni Comunali d'Arte

Bologna, Pal. Pepoli
 Bologna, Palazzo Pepoli

Bologna, Pal. Pepoli Campogrande
 Bologna, Palazzo Pepoli Campogrande

Bologna, Pal. Podestà
 Bologna, Palazzo del Podestà

Bologna, Pal. Poggi
 Bologna, Palazzo Poggi

Bologna, Pal. Sanguinetti
 Bologna, Palazzo Sanguinetti

Bologna, Pin. N.
 Bologna, Pinacoteca Nazionale

Bonn, Rhein. Friedrich-Wilhelms-U.
 Bonn, Rheinische Friedrich-Wilhelms-Universität

Bordeaux, Gal. B.-A.
 Bordeaux, Galerie des Beaux-Arts

Bordeaux, Mus. B.-A.
 Bordeaux, Musée des Beaux-Arts

Boston, MA, Isabella Stewart Gardner Mus.
 Boston, MA, Isabella Stewart Gardner Museum

Boston, MA, Mus. F.A.
 Boston, MA, Museum of Fine Arts

Boston, MA, Pub. Lib.
 Boston, MA, Public Library

Bracciano, Castello Orsini
 Bracciano, Castello degli Orsini

Bremen, Ksthalle
 Bremen, Kunsthalle

Brescia, Mus. Civ. Armi Marzoli
 Brescia, Museo Civico delle Armi Luigi Marzoli

Brescia, Mus. Civ. Crist.
 Brescia, Museo Civico Cristiano

Brescia, Nuo. Semin. Dioc.
 Brescia, Nuovo Seminario Diocesano

Brescia, Pin. Civ. Tosio--Martinengo
 Brescia, Pinacoteca Civica Tosio--Martinengo

Brest, Mus. Mun.
 Brest, Musée Municipal [Musée des Beaux-Arts]

Brisbane, Queensland A.G.
 Brisbane, Queensland Art Gallery

Bristol, Mus. & A.G.
 Bristol, City of Bristol Museum and Art Gallery

Brit. Royal Col.
 British Royal Collection

Brno, Morav. Gal.
 Brno, Moravian Gallery (Moravská Galerie v Brnê)

Bruges, St Janshosp.
 Bruges, St Janshospitaal

Brunswick, Herzog Anton-Ulrich Mus.
 Brunswick, Herzog Anton-Ulrich Museum

Brunswick, ME, Bowdoin Coll. Mus. A.
 Brunswick, ME, Bowdoin College Museum of Art

Brussels, Bib. Royale Albert 1er
 Brussels, Bibliothèque Royale Albert 1er [Koninklijke Bibliotheek Albert I]

Brussels, Mus. A. Anc.
 Brussels, Musée d'Art Ancien

Bucharest, Mus. A.
 Bucharest, Museum of Art of RSR (Muzeul de Arta al RSR) [now N. Mus. A.]

Bucharest, N. Mus. A.
 Bucharest, National Museum of Art of Romania (Muzeul National de Artă a României) [formerly called Mus. A.; admins Mus. A.; Mus. A. Col.; Mus. Med. Roman. A.; Mus. Roman. Music]

Budapest, Mus. F.A.
 Budapest, Museum of Fine Arts (Szépmű vészeti Múzeum)

Budapest, N.G.
 Budapest, Hungarian National Gallery (Magyar Nemzéti Galéria)

Budapest, N. Mus.
 Budapest, Hungarian National Museum (Magyar Nemzéti Múzeum)

Budapest, N. Széchényi Lib.
 Budapest, National Széchényi Library (Országos Széchényi Könyvtár)

Budrio, Pin. Civ. Inzaghi
 Budrio, Pinacoteca Civica D. Inzaghi

Buenos Aires, Mus. N. B.A.
 Buenos Aires, Museo Nacional de Bellas Artes

Buffalo, NY, Albright–Knox A.G.
 Buffalo, NY, Albright–Knox Art Gallery [formerly Albright A.G.]

Buonconvento, Mus. A. Sacra Val d'Arbia
Buonconvento, Museo d'Arte Sacra della Val
d'Arbia

Buxton, Mus. & A.G.
Buxton, Buxton Museum and Art Gallery

Caen, Mus. B.-A.
Caen, Musée des Beaux-Arts

Cagliari, Mus. Archeol. N.
Cagliari, Museo Archeologico Nazionale

Cambridge, Fitzwilliam
Cambridge, Fitzwilliam Museum

Cambridge, Trinity Hall

Cambridge, U. Lib.
Cambridge, University Library

Cambridge, MA, Fogg
Cambridge, MA, Fogg Art Museum

Cambridge, MA, Harvard U., Houghton Lib.
Cambridge, MA, Harvard University,
Houghton Library

Camerino, Mus. Pin. Civ.
Camerino, Museo della Pinacoteca Civica

Capua, Mus. Prov. Campano
Capua, Museo Provinciale Campano

Carpi, Mus. Civ.
Carpi, Museo Civico

Carrara, Accad. B.A. & Liceo A.
Carrara, Accademia di Belle Arti e Liceo
Artistico

Caserta, Pal. Reale
Caserta, Palazzo Reale [Palazzo Reggia]

Casole d'Elsa, Pal. Com.
Casole d'Elsa, Palazzo del Comune

Castell'Arquato, S Maria, Mus.
Castell'Arquato, S Maria, Museo

Castiglion Fiorentino, Pin. Com.
Castiglion Fiorentino, Pinacoteca Comunale

Catania, Bib. Reg. U.
Catania, Biblioteca Regionale Universitaria

Catania, Mus. Civ. Castello Ursino
Catania, Museo Civico di Castello Ursino

Cava dei Tirreni, Mus. Badia SS Trinità
Cava dei Tirreni, Museo della Badia della SS
Trinità di Cava

Cefalú, Mus. Mandralisca
Cefalú, Museo Mandralisca

Cento, Pin. Civ.
Cento, Pinacoteca Civica

Certaldo, Pal. Pretorio
Certaldo, Museo del Palazzo Pretorio
Vicariale

Cesena, Bib. Malatestiana
Cesena, Biblioteca Malatestiana

Chaalis, Mus. Abbaye
Chaalis, Musée de l'Abbaye de Chaalis

Chambéry, Bib. Mun.
Chambéry, Bibliothèque Municipale

Chambéry, Mus. B.-A.
Chambéry, Musée des Beaux-Arts

Chambéry, Mus. Benoit-Molin
Chambéry, Musée Benoit-Molin

Chantilly, Mus. Condé
Chantilly, Musée Condé, Château de Chantilly

Chapel Hill, U. NC, Ackland A. Mus.
Chapel Hill, NC, University of North
Carolina, Ackland Art Museum

Charlottesville, U. VA
Charlottesville, VA, University of Virginia

Chartres, Mus. B.-A.
Chartres, Musée des Beaux-Arts

Châteauroux, Mus. B.-A.
Châteauroux, Musée des Beaux-Arts

Chicago, IL, A. Inst.
Chicago, IL, Art Institute of Chicago

Chiusi, Mus. Cattedrale
Chiusi, Museo della Cattedrale

Cincinnati, OH, A. Mus.
Cincinnati, OH, Cincinnati Art Museum

Cingoli, Mus. Civ.
Cingoli, Museo Civico

Città di Castello, Pin. Com.
Città di Castello, Pinacoteca Comunale
[Palazzo Vitelli alla Cannoniera]

Cividale del Friuli, Mus. Archeol. N.
Cividale del Friuli, Museo Archeologico
Nazionale

Cleveland, OH, Mus. A.
Cleveland, OH, Cleveland Museum of Art

Coburg, Veste Coburg
Coburg, Kupferstichkabinett der
Kunstsammlungen der Veste Coburg

Cologne, Wallraf-Richartz-Mus.
Cologne, Wallraf-Richartz-Museum

Colorno, Pal. Ducale
Colorno, Palazzo Ducale

Columbia, U. MO, Mus. A. & Archaeol.
Columbia, MO, University of Missouri,
Museum of Art and Archaeology

Columbus, OH, Mus. A.
Columbus, OH, Museum of Art [formerly
Gal. F.A.]

Columbus, OH State U.
Columbus, Ohio State University

Como, Civ. Mus. Archeol.
Como, Civico Museo Archeologico ['Giovio']

Como, Mus. Civ. Stor. Garibaldi
Como, Museo Civico Storico G. Garibaldi

Conegliano, Mus. Civ. Castello
Conegliano, Museo Civico del Castello

Copenhagen, Nmus.
Copenhagen, Nationalmuseum

Copenhagen, Stat. Mus. Kst
Copenhagen, Kongelige Kobberstiksamling,
Statens Museum for Kunst

Copenhagen, Stat. Mus. Kst
Copenhagen, Statens Museum for Kunst

Copenhagen, Thorvaldsens Mus.
Copenhagen, Thorvaldsens Museum

Coral Gables, FL, U. Miami, Lowe A. Mus.
Coral Gables, University of Miami, Lowe Art
Museum

Cortona, Bib. Com.
Cortona, Biblioteca Comunale

Cortona, Fortezza Girifalco
Cortona, Fortezza del Girifalco [Fortezza
Medicea]

Cortona, Mus. Dioc.
Cortona, Museo Diocesano

Cremona, Bib. Stat. & Lib. Civ.
Cremona, Biblioteca Statale e Libreria Civica

Cremona, Gal.
Cremona, Galleria

Cremona, Mus. Civ. Ala Ponzone
Cremona, Museo Civico Ala Ponzone [in
Palazzo Affaitati]

Cremona, Osp. Nuovo
Cremona, Ospedale Nuovo

Cremona, Pal. Com.
Cremona, Palazzo Comunale

Dallas, TX, Mus. F.A.
Dallas, TX, Museum of Fine Arts

Darmstadt, Hess. Landes- & Hochschbib.
Darmstadt, Hessische Landes- und
Hochschulbibliothek Darmstadt

Denver, CO, A. Mus.
Denver, CO, Denver Art Museum [Museum
of Fine Arts]

Deruta, Pin. Com.
Deruta, Pinacoteca Comunale [Museo
Comunale d'Arte]

Detroit, MI, Inst. A.
Detroit, MI, Detroit Institute of Arts

Dijon, Mus. B.-A.
Dijon, Musée des Beaux-Arts

Douai, Mus. Mun.
Douai, Musée Municipal [La Chartreuse]

Dresden, Gemäldegal. Alte Meister
Dresden, Gemäldegalerie Alte Meister [in
Zwinger]

Dresden, Skulpsamml.
Dresden, Skulpturensammlung [in
Albertinum]

Dublin, Chester Beatty Lib.
Dublin, Chester Beatty Library and Gallery of
Oriental Art

Dublin, N.G.
Dublin, National Gallery of Ireland

Düsseldorf, Kstakad.
Düsseldorf, Kunstakademie [Hochschule für
Bildende Künste]

Düsseldorf, Kstmus.
Düsseldorf, Kunstmuseum im Ehrenhof

Ecouen, Mus. Ren.
Ecouen, Musée de la Renaissance, Château

Edinburgh, N.G.
Edinburgh, National Gallery of Scotland

Edinburgh, Royal Mus. Scotland
Edinburgh, Royal Museum of Scotland
[formed 1 Oct 1985 by union of Royal Scot.
Mus. and N. Mus. Ant.]

Edinburgh, Royal Scot. Mus.
Edinburgh, Royal Scottish Museum [name
changed to Royal Mus. Scotland on 1 Oct
1985]

El Paso, TX, Mus. A.
El Paso, TX, Museum of Art

Empoli, Mus. Dioc.
Empoli, Museo Diocesano

Empoli, Mus. S Andrea
Empoli, Museo della Collegiata di S Andrea

Eretria, Archaeol. Mus.
Eretria, Archaeological Museum

Erice, Mus. Civ. Cordici
Erice, Museo Civico Antonio Cordici

Essen, Villa Hügel

Esztergom, Mus. Christ.
Esztergom, Museum of Christianity
(Keresztény Múzeum)

Eton, Berks, Coll.
Eton, Berks, Eton College

Eton, Berks, Coll. Lib.
Eton, Berks, Eton College Library

Evanston, IL, Northwestern U.
Evanston, IL, Northwestern University

Fabriano, Pin. Civ. Mus. Arazzi
Fabriano, Pinacoteca Civica e Museo degli
Arazzi

Faenza, Mus. Int. Cer.
 Faenza, Museo Internazionale delle
 Ceramiche

Faenza, Pin. Com.
 Faenza, Pinacoteca Comunale

Fano, Pin. Civ. & Mus. Malatestiano
 Fano, Pinacoteca Civica e Museo Malatestiano

Feltre, Mus. Civ.
 Feltre, Museo Civico

Fermo, Pin. Com.
 Fermo, Pinacoteca Comunale

Ferrara, Castello Estense

Ferrara, Civ. Bib. Ariostea
 Ferrara, Civica Biblioteca Ariostea [Palazzo
 Paradiso]

Ferrara, Gal. Civ. A. Mod.
 Ferrara, Galleria Civica d'Arte Moderna e
 Centro d'Attività Visive [Palazzo dei
 Diamanti]

Ferrara, Mus. Civ. A. Ant. Pal. Schifanoia
 Ferrara, Museo Civico d'Arte Antica del
 Palazzo Schifanoia

Ferrara, Mus. Duomo
 Ferrara, Museo del Duomo

Ferrara, Pal. Schifanoia
 Ferrara, Palazzo Schifanoia

Ferrara, Pin. N.
 Ferrara, Pinacoteca Nazionale [Pinacoteca
 Nazionale del Palazzo dei Diamanti]

Fiesole, Mus. Bandini
 Fiesole, Museo Bandini

Fiesole, Pal. Mangani
 Fiesole, Palazzo Mangani

Figline Valdarno, Vecchio Pal. Com.
 Figline Valdarno, Vecchio Palazzo Comunale

Florence, Accad.
 Florence, Galleria dell'Accademia

Florence, Accad. B.A. & Liceo A.
 Florence, Accademia di Belle Arti e Liceo
 Artistico

Florence, Accad. Dis.
 Florence, Accademia del Disegno

Florence, Archv Stato
 Florence, Archivio di Stato

Florence, Arcisp. S Maria Nuo.
 Florence, Arcispedale di S Maria Nuova

Florence, Badia Fiorentina

Florence, Banca Tosc.
 Florence, Banca Toscana

Florence, Bargello
 Florence, Museo Nazionale del Bargello

Florence, Bib. Convento dei Servi all'Annunziata
 Florence, Biblioteca del Convento dei Servi
 all'Annunziata

Florence, Bib. Marucelliana
 Florence, Biblioteca Marucelliana di Firenze

Florence, Bib. Medicea-Laurenziana
 Florence, Biblioteca Medicea-Laurenziana

Florence, Bib. N. Cent.
 Florence, Biblioteca Nazionale Centrale [incl.
 Biblioteca Medicea-Palatino-Lotaringia]

Florence, Bib. Riccardiana
 Florence, Biblioteca Riccardiana

Florence, Bib. Uffizi
 Florence, Biblioteca della Galleria degli Uffizi

Florence, Casa Buonarroti
 Florence, Museo della Casa Buonarroti

Florence, Cenacolo Andrea del Sarto S Salvi
 Florence, Cenacolo di Andrea del Sarto a San
 Salvi

Florence, Cenacolo S Apollonia
 Florence, Cenacolo di Sant'Apollonia

Florence, Cent. Di
 Florence, Centro Di

Florence, Certosa del Galluzzo, Pin.
 Florence, Certosa del Galluzzo, Pinacoteca

Florence, Chiostro Scalzo
 Florence, Chiostro dello Scalzo

Florence, Depositi Gal.
 Florence, Depositi delle Gallerie Fiorentine

Florence, Fond. Longhi
 Florence, Fondazione R. Longhi

Florence, Fond. Romano
 Florence, Fondazione Salvatore Romano

Florence, Forte Belvedere
 Florence, Forte di Belvedere

Florence, Fortezza Basso
 Florence, Fortezza da Basso

Florence, Gal. Osp. Innocenti
 Florence, Galleria dell'Ospedale degli
 Innocenti

Florence, Gal. Panciatichi
 Florence, Galleria Panciatichi

Florence, Giard. Gherardesca
 Florence, Giardino della Gherardesca

Florence, I Tatti
 Florence, Villa I Tatti [Harvard University
 Center for Italian Renaissance Studies]

Florence, Loggia Lanzi
 Florence, Loggia dei Lanzi

Florence, Misericordia

Florence, Mus. Archeol.
 Florence, Museo Archeologico di Firenze
 [houses Etruscan Museum col.]

Florence, Mus. Bardini
 Florence, Museo Bardini

Florence, Mus. Bigallo
 Florence, Museo del Bigallo

Florence, Mus. Firenze com'era
 Florence, Museo di Firenze com'era [Museo
 Storico Topografico di Firenze com'era]

Florence, Mus. Horne
 Florence, Museo Horne

Florence, Mus. Ognissanti
 Florence, Museo di Ognissanti

Florence, Mus. Opera Duomo
 Florence, Museo dell'Opera del Duomo

Florence, Mus. Opera Santa Croce
 Florence, Museo dell'Opera di Santa Croce

Florence, Mus. Opificio Pietre Dure
 Florence, Museo dell'Opificio delle Pietre
 Dure [e Laboratori di Restauro d'Opere
 d'Arte]

Florence, Mus. Osp. Innocenti
 Florence, Museo dell'Ospedale degli
 Innocenti

Florence, Mus. S Marco
 Florence, Museo di S Marco [houses library]

Florence, Mus. S Salvi
 Florence, Museo S Salvi [in ex-convent]

Florence, Mus. Stibbert
 Florence, Museo Stibbert

Florence, Pal. Alessandri
 Florence, Palazzo degli Alessandri

Florence, Pal. Arcivescovile
 Florence, Palazzo Arcivescovile

Florence, Pal. Capponi
 Florence, Palazzo Capponi

Florence, Pal. Congressi
 Florence, Palazzo dei Congressi

Florence, Pal. Davanzati
 Florence, Palazzo Davanzati [Museo della
 Casa Fiorentina Antica]

Florence, Pal. Medici–Riccardi
 Florence, Palazzo Medici–Riccardi

Florence, Pal. Nonfinito
 Florence, Palazzo Nonfinito

Florence, Pal. Parte Guelfa
 Florence, Palazzo di Parte Guelfa

Florence, Pal. Salviati
 Florence, Palazzo Salviati

Florence, Pal. Serristori
 Florence, Palazzo Serristori

Florence, Pal. Strozzi
 Florence, Palazzo Strozzi

Florence, Pal. Vecchio
 Florence, Palazzo Vecchio [houses Collezione
 Loeser; Museo delle Opere d'Arte
 Recuperate]

Florence, Pitti
 Florence, Palazzo Pitti [houses Appartamenti
 Monumentali; Collezione Contini-Bonacossi;
 Galleria d'Arte Moderna; Galleria del
 Costume; Galleria Palatina; Museo degli
 Argenti; Museo delle Carrozze; Museo delle
 Porcellane]

Florence, Poggio Imp.
 Florence, Poggio Imperiale

Florence, S Lorenzo, Archv Capitolare
 Florence, S Lorenzo, Archivio Capitolare

Florence, Sopr. Gal.
 Florence, Soprintendenza alle Gallerie
 [admins Pal. Vecchio; Pitti]

Florence, Uffizi
 Florence, Galleria degli Uffizi [incl. Gabinetto
 dei Disegni]

Foligno, Pin. Civ.
 Foligno, Pinacoteca Civica [Pinacoteca
 Comunale; housed with Mus. Archeol.]

Folkestone, Mus. & A.G.
 Folkestone, Museum and Art Gallery

Fontainebleau, Château
 Fontainebleau, Musée National du Château de
 Fontainebleau

Fontanellato, Mus. Rocca Sanvitale
 Fontanellato, Museo della Rocca Sanvitale

Forlì, Abbazia S Mercuriale
 Forlì, Abbazia di San Mercuriale

Forlì, Oratorio S Sebastiano & Pal. Alberteni
 Forlì, Oratorio San Sebastiano and Palazzo
 Alberteni

Forlì, Pal. Mus.
 Forlì, Palazzo dei Musei

Forlì, Pin. Civ.
 Forlì, Pinacoteca Civica

Fort Worth, TX, Kimbell A. Mus.
 Fort Worth, TX, Kimbell Art Museum

Fossombrone, Mus. Civ. Vernarecci
 Fossombrone, Museo Civico A. Vernarecci

Frankfurt am Main, Mus. Ksthandwk
 Frankfurt am Main, Museum für
 Kunsthandwerk

Frankfurt am Main, Schirn Ksthalle
 Frankfurt am Main, Schirn Kunsthalle

Frankfurt am Main, Städel. Kstinst. & Städt. Gal.
 Frankfurt am Main, Städelsches Kunstinstitut
 und Städtische Galerie

Frankfurt am Main, U. Frankfurt am Main
Frankfurt am Main, Johann Wolfgang
Goethe-Universität

Fucecchio, Mus. Civ.
Fucecchio, Museo Civico

Gabiano, Castello Negrotto Cambiaso

Gazzada, Mus. Villa Cagnola
Gazzada, Museo di Villa Cagnola [Cagnola
Foundation]

Geneva, Mus. A. & Hist.
Geneva, Musée d'Art et d'Histoire

Genoa, Archv Mun., Pal. Tursi
Genoa, Archivio Municipale di Genova,
Palazzo Tursi

Genoa, Arcivescovado

Genoa, Bib. Berio
Genoa, Biblioteca Berio

Genoa, Gal. Pal. Bianco
Genoa, Galleria di Palazzo Bianco [Civica
Galleria]

Genoa, Mus. Accad. Ligustica B.A.
Genoa, Museo dell'Accademia Ligustica di
Belle Arti

Genoa, Mus. Osp. Civ.
Genoa, Museo degli Oggetti d'Arte e
Ceramiche degli Ospedali Civili [Museo degli
Ospedali Civili di Genoa]

Genoa, Mus. S Agostino
Genoa, Museo di S Agostino

Genoa, Pal. Bianco
Genoa, Palazzo Bianco

Genoa, Pal. Cambiaso
Genoa, Palazzo Cambiaso

Genoa, Pal. Campanella
Genoa, Palazzo Campanella

Genoa, Pal. Rosso
Genoa, Palazzo Rosso

Genoa, Pal. Spinola
Genoa, Galleria Nazionale del Palazzo
Spinola

Genoa, Sopr. Beni A. & Stor. Liguria
Genoa, Soprintendenza per i Beni Artistici e
Storici della Liguria

Genoa, Teat. Carlo Felice
Genoa, Teatro Carlo Felice

Genoa, U. Studi
Genoa, Università degli Studi

Glasgow, A.G. & Mus.
Glasgow, Art Gallery and Museum
[Kelvingrove]

Glasgow, Burrell Col.
Glasgow, Burrell Collection

Glens Falls, NY, Hyde Col.
Glens Falls, NY, Hyde Collection

Göteborg, Kstmus.
Göteborg, Göteborgs Konstmuseum

Gotha, Forschbib.
Gotha, Forschungsbibliothek [in Schloss
Friedenstein]

Gotha, Landesbib.
Gotha, Landesbibliothek [in Schloss
Friedenstein]

Gotha, Mus. Nat.
Gotha, Museum der Natur

Grand Rapids, MI, A. Mus.
Grand Rapids, MI, Art Museum

Graz, Alte Gal.
Graz, Alte Galerie

Graz, Steiermärk. Landesmus.
Graz, Steiermärkisches Landesmuseum
Joanneum [admins Alte Gal.; Jagdmus.;
Landeszeughaus; Mus. Kstgew.; Mus. Vor- &
Frühgesch.; Neue Gal.; Steiermärk.
Landesmus.; Steier. Vlkskndmus.; Stainz,
Schloss; Trautenfels, Schloss]

Greenville, SC, Bob Jones U. Gal. Sacred A.
Greenville, SC, Bob Jones University Gallery
of Sacred Art and Bible Lands Museum

Grenoble, Mus. B.-A.
Grenoble, Musée des Beaux-Arts

Grosseto, Mus. Archeol.
Grosseto, Museo Archeologico e d'Arte della
Maremma

Grottaferrata, Mus. Abbazia S Nilo
Grottaferrata, Museo dell'Abbazia di San Nilo

Gualdo Tadino, Pin. Com.
Gualdo Tadino, Pinacoteca Comunale

Gubbio, Mus. Duomo
Gubbio, Museo del Duomo

Gubbio, Mus. & Pin. Com.
Gubbio, Museo e Pinacoteca Comunali

Gubbio, Pal. Com.
Gubbio, Palazzo Comunale

Haarlem, Teylers Mus.
Haarlem, Teylers Museum

Hagerstown, MD, Washington Co. Hist. Soc.
Mus.
Hagerstown, MD, Washington County
Historical Society Museum

Hamburg, Ksthalle
Hamburg, Hamburger Kunsthalle [incl.
Kupferstichkabinett]

Hamburg, Mus. Kst & Gew.
Hamburg, Museum für Kunst und Gewerbe

Hannover, Kestner-Ges.
Hannover, Kestner-Gesellschaft

Hannover, Kestner-Mus.
Hannover, Kestner-Museum

Hannover, Niedersächs. Landesmus.
Hannover, Niedersächsisches Landesmuseum
[Niedersächsische Landesgalerie; formerly
called Provmus.]

Hanover, NH, Dartmouth Coll., Hood Mus. A.
Hanover, NH, Dartmouth College, Hood
Museum of Art [name changed from Hopkins
Cent. A.G. in 1985]

Hartford, CT, Wadsworth Atheneum

Havana, Mus. N.
Havana, Museo Nacional

Havana, Mus. N. B.A.
Havana, Museo Nacional de Bellas Artes [in
Palacio de Bellas Artes]

Heidelberg, Ruprecht-Karls-U.
Heidelberg, Ruprecht-Karls-Universität
Heidelberg

Herakleion, Archaeol. Mus.
Herakleion, Archaeological Museum

Honolulu, HI, Acad. A.
Honolulu, HI, Honolulu Academy of Arts

Houston, TX, Mus. F.A.
Houston, TX, Museum of Fine Arts

Houston, TX, Sarah Campbell Blaffer Found.
Houston, TX, Sarah Campbell Blaffer
Foundation

Imola, Bib. Com.
Imola, Biblioteca Comunale [e Istituti
Culturali Annessi]

Imola, Pin. Civ.
Imola, Pinacoteca Civica [Raccolta d'Arte
Comunale]

Impruneta, Mus. Santuario
Impruneta, Museo del Santuario [in S Maria
dell'Impruneta]

Indianapolis, IN, Mus. A.
Indianapolis, IN, Museum of Art [incl.
Clowes Fund Collection of Old Master
Paintings]

Innsbruck, Schloss Ambras
Innsbruck, Kunsthistorisches Museum,
Sammlungen Schloss Ambras

Isola Bella, Mus. Borromeo
Isola Bella, Museo Borromeo

Jerusalem, Israel Mus.
Jerusalem, Israel Museum [houses Art and
Archaeology Library; Bezalel National Art
Museum; Bronfman Biblical and
Archaeological Museum; Ruth Young Wing;
Shrine of the Book]

Jesi, Pin. Civ.
Jesi, Pinacoteca Civica

Kansas City, MO, Nelson–Atkins Mus. A.
Kansas City, MO, Nelson–Atkins Museum of
Art [name changed from W. Rockhill Nelson
Gal. c. 1980]

Karlsruhe, Staatl. Ksthalle
Karlsruhe, Staatliche Kunsthalle [houses
Kupferstichkabinett]

Kassel, Landesbib.
Kassel, Landesbibliothek

Kassel, Schloss Wilhelmshöhe
Kassel, Schloss Wilhelmshöhe

Kiev, Mus. W. & Orient. A.
Kiev, Museum of Western and Oriental Art

Kirchheim im Schwaben, Schloss Fugger
Kirchheim im Schwaben, Schloss der Fugger

Kraków, Czartoryski Col.
Kraków, Czartoryski Collection (Zbiory
Czartoryskich) [Czartoryski Museum; housed
in N. Museum at Czartoryski Palace; part of
Czartoryski Found.]

Kraków, N. A. Cols
Kraków, National Art Collections
(Państwowe Zbiory Sztuki na Wawelu)
[Wawel Castle]

Kraków, N. Mus.
Kraków, National Museum (Muzeum
Narodowe w Krakowie) [admins Cloth Hall
Gall.; Czartoryski Col.; Czartoryski Lib.;
Hutten-Czapski Col.; Matejko House Mus.;
N. Mus.; New Building; Szołayski House;
Zakopane, Szymanowski Museum]

Krefeld, Kaiser Wilhelm Mus.
Krefeld, Kaiser Wilhelm Museum

Kreuzlingen, Heinz Kisters

Kroměříž, Archbishop's Pal.
Kroměříž, Archbishop's Palace
(Arcibiskupský Palác)

Kroměříž Castle
Kroměříž, Kroměříž Castle (Státní Zámek)

L'Aquila, Mus. N. Abruzzo
L'Aquila, Museo Nazionale d'Abruzzo

Lausanne, Mus. Hist.
Lausanne, Musée Historique de Lausanne [in
Ancien-Evêché]

Lawrence, U. KS
Lawrence, KS, University of Kansas

Lawrence, U. KS, Spencer Mus. A.
Lawrence, KS, University of Kansas, Spencer
Museum of Art

Leeds, C.A.G.
Leeds, City Art Gallery

Le Havre, Mus. B.-A.
Le Havre, Musée des Beaux-Arts

Leiden, Bib. Rijksuniv.
Leiden, Bibliotheek der Rijksuniversiteit
Leiden

Leiden, Rijksuniv.
Leiden, Rijksuniversiteit

Leipzig, Mus. Bild. Kst.
Leipzig, Museum der Bildenden Künste

Le Mans, Mus. Tessé
Le Mans, Musée de Tessé [Musée des Beaux-
Arts]

Le Puy, Mus. Crozatier
Le Puy, Musée Crozatier [Jardin Henri-Vinay]

Lille, Mus. B.-A.
Lille, Musée des Beaux-Arts [in Palais des
Beaux-Arts]

Lisbon, Arquiv. N.
Lisbon, Arquivo Nacional da Torre do
Tombo

Lisbon, Fund. Gulbenkian
Lisbon, Fundação Calouste Gulbenkian
[admins Mus. Gulbenkian]

Lisbon, Mus. Gulbenkian
Lisbon, Museu Calouste Gulbenkian
[Fundação Calouste Gulbenkian]

Lisbon, Mus. N. A. Ant.
Lisbon, Museu Nacional de Arte Antiga
[Museu das Janelas Verdes]

Liverpool, Walker A.G.
Liverpool, Walker Art Gallery

Ljubljana, N.G.
Ljubljana, National Gallery (Narodna
Galerija)

Lodi, Mus. Civ.
Lodi, Museo Civico

Lodi, S Cristoforo
Lodi, Chiesa di San Cristoforo

Lodi, Tesoro Incoronata
Lodi, Tesoro dell'Incoronata

London, BL
London, British Library

London, BM
London, British Museum

London, Burlington F.A. Club
London, Burlington Fine Arts Club [no
longer exists]

London, Christie's
London, Christie, Manson & Woods Ltd

London, Colnaghi's
London, P & D Colnaghi & Co. Ltd

London, Hayward Gal.
London, Hayward Gallery

London, Helikon Gal.
London, Helikon Gallery [closed]

London, Matthiesen F.A.
London, Matthiesen Fine Art

London, N.G.
London, National Gallery

London, Queen's Gal.
London, Queen's Gallery

London, RA
London, Royal Academy of Arts [Burlington
House; houses RA Archives & Library]

London, RIBA
London, Royal Institute of British Architects
[houses RIBA drgs col.]

London, Soane Mus.
London, Sir John Soane's Museum

London, Soc. Antiqua.
London, Society of Antiquaries of London

London, Sotheby's
London, Sotheby and Co. c. 1945–17 Sept
1975 Sotheby & Co.; 17 Sept 1975–17 July
1984 Sotheby Parke Bernet & Co.; since 17
July 1984 Sotheby's]

London, St Paul's Cathedral

London, U. London, Courtauld Inst.
London, University of London, Courtauld
Institute of Art

London, V&A
London, Victoria and Albert Museum [houses
National Art Library]

London, Wallace
London, Wallace Collection

London, Watney Col.
London, Watney Collection

London, Westminster Abbey

Loreto, Archv Stor. S Casa
Loreto, Archivio Storico della Santa Casa

Loreto, Pal. Apostolico
Loreto, Palazzo Apostolico ed Archivio
Storico della Santa Casa

Loreto, Santuario S Casa, Bib.
Loreto, Santuario della Santa Casa, Biblioteca

Los Angeles, CA, Co. Mus. A.
Los Angeles, CA, County Museum of Art
[incl. Robert Gore Rifkind Center for German
Expressionist Studies]

Los Angeles, CA, Getty Mus.
Los Angeles, CA, J. Paul Getty Museum

Los Angeles, CA, Norton Simon A. Found.
Los Angeles, CA, Norton Simon Art
Foundation

Los Angeles, CA, Norton Simon Found.
Los Angeles, CA, Norton Simon Foundation

Los Angeles, UCLA
Los Angeles, University of California

Los Angeles, UCLA, Res. Lib.
Los Angeles, University of California,
Research Library

Louisville, KY, Speed A. Mus.
Louisville, KY, J.B. Speed Art Museum

Lovere, Gal. Accad. B.A. Tadini
Lovere, Galleria dell'Accademia di Belle Arti
Tadini

Lucca, Archv Stato
Lucca, Archivio di Stato

Lucca, Bib. Stat.
Lucca, Biblioteca Statale di Lucca

Lucca, Mus. & Pin. N.
Lucca, Museo e Pinacoteca Nazionale [in
former Palazzo Mansi]

Lucca, Pal. Prefettura
Lucca, Palazzo della Prefettura [Palazzo
Provinciale]

Lucca, Villa Guinigi
Lucca, Museo Nazionale di Villa Guinigi

Lugano, Col. Thyssen-Bornemisza
Lugano, Collection Baron Thyssen-
Bornemisza [in Villa Favorita, Castagnola]: see
also Madrid, Mus. Thyssen-Bornemisza

Lugano, Villa Malpensata

Lyon, Bib. Mun.
Lyon, Bibliothèque Municipale

Lyon, Mus. A. Déc.
Lyon, Musée des Arts Décoratifs

Lyon, Mus. B.-A.
Lyon, Musée des Beaux-Arts

Maastricht, Bonnefantenmus.
Maastricht, Bonnefantenmuseum [Stichting
Limburgs Museum voor Kunst en Oudheden]

Macerata, Pin. & Mus. Com.
Macerata, Pinacoteca e Musei Comunali
[Civica Pinacoteca]

Madison, U. WI
Madison, WI, University of Wisconsin

Madison, U. WI, Elvehjem A. Cent.
Madison, WI, University of Wisconsin,
Elvehjem Art Center

Madrid, Bib. N.
Madrid, Biblioteca Nacional [housed with
Mus. Arqueol. N.; incl. Sala de la Biblioteca
Nacional]

Madrid, Bib. U. Complutense
Madrid, Biblioteca de la Universidad
Complutense de Madrid

Madrid, Escorial
Madrid, El Escorial

Madrid, Escorial, Nuevos Mus.
Madrid, El Escorial, Nuevos Museos

Madrid, Mus. Arqueol. N.
Madrid, Museo Arqueológico Nacional
[housed with Bib. N.]

Madrid, Mus. Thyssen-Bornemisza
Madrid, Museo Thyssen-Bornemisza [in Pal.
Villahermosa]

Madrid, Pal. Liria, Col. Casa Alba
Madrid, Palacio Liria, Colección Casa de Alba

Madrid, Pal. Real
Madrid, Palacio Real de Madrid [Palacio de
Oriente]

Madrid, Prado
Madrid, Museo del Prado [Museo Nacional de
Pintura y Escultura]

Madrid, Real Acad. S Fernando
Madrid, Real Academia de Bellas Artes de San
Fernando

Madrid, Real Acad. S Fernando, Mus.
Madrid, Real Academia de Bellas Artes de San
Fernando, Museo

Mainz, Altertmus. & Gemäldegal.
Mainz, Altertumsmuseum und
Gemäldegalerie

Malibu, CA, Getty Mus.
Malibu, CA, J. Paul Getty Museum

Mantua, Archv Stato
Mantua, Archivio di Stato

Mantua, Bib. Com.
Mantua, Biblioteca Comunale

Mantua, Ist. Gonzaga
Mantua, Istituto dei Gonzaga

Mantua, Mus. Civ. Pal. Te
Mantua, Museo Civico Palazzo del Te

Mantua, Pal. Ducale
Mantua, Palazzo Ducale

Mantua, Pal. Te
Mantua, Palazzo del Te

Mantua, Pal. Vescovile
Mantua, Palazzo Vescovile

Marburg, Philipps-U.
Marburg, Philipps-Universität

Marseille, Mus. B.-A.
Marseille, Musée des Beaux-Arts [Palais de Longchamp]

Massa Marittima, Pin. Com.
Massa Marittima, Pinacoteca Comunale

Matelica, Mus. Piersanti
Matelica, Museo Piersanti

Mdina, Cathedral Mus.
Mdina, Cathedral Museum

Melbourne, N.G. Victoria
Melbourne, National Gallery of Victoria [Victorian A. Cent.]

Memphis, TN, Brooks Mus. A.
Memphis, TN, Memphis Brooks Museum of Art [Brooks Memorial Art Gallery]

Merion Station, PA, Barnes Found.
Merion Station, PA, Barnes Foundation

Messina, Mus. Reg.
Messina, Museo Regionale di Messina [Civico Museo Peloritano; Museo Nazionale]

Messina, Pal. Com.
Messina, Palazzo Comunale

Miami Beach, FL, Bass Mus. A.
Miami Beach, FL, Bass Museum of Art

Milan, Ambrosiana
Milan, Pinacoteca Ambrosiana

Milan, Archv Capitolare
Milan, Archivio Capitolare [in Mus. Sacro S Ambrogio]

Milan, Archv Stato
Milan, Archivio di Stato

Milan, Bib. Ambrosiana
Milan, Biblioteca Ambrosiana

Milan, Bib. Capitolare
Milan, Biblioteca Capitolare

Milan, Bib. N. Braidense
Milan, Biblioteca Nazionale Braidense

Milan, Brera
Milan, Pinacoteca di Brera [Accademia di Belle Arti di Brera]

Milan, Civ. Mus. Archeol.
Milan, Civico Museo Archeologico

Milan, Crespi Col.
Milan, Crespi Collection

Milan, Finarte

Milan, Fond. Bagatti Valsecchi
Milan, Fondazione Bagatti Valsecchi

Milan, Mus. Civ. Milano
Milan, Museo Civico di Milano

Milan, Mus. Duomo
Milan, Museo del Duomo

Milan, Mus. Poldi Pezzoli
Milan, Museo Poldi Pezzoli

Milan, Mus. Sacro S Ambrogio
Milan, Museo Sacro di S Ambrogio

Milan, Pal. Borromeo
Milan, Palazzo Borromeo

Milan, Pal. Reale
Milan, Palazzo Reale

Milan, Semin. Vescovile
Milan, Seminario Vescovile

Milan, Tesoro Duomo
Milan, Tesoro del Duomo [Sacrestia Meridionale del Duomo]

Milan, U. Cattolica
Milan, Università Cattolica del Sacro Cuore

Minneapolis, MN, Inst. A.
Minneapolis, MN, Minneapolis Institute of Arts

Modena, Archv Stor.
Modena, Archivio Storico

Modena, Bib. Estense
Modena, Biblioteca Estense

Modena, Gal. & Mus. Estense
Modena, Galleria e Museo Estense

Modena, Mus. Stor. & A. Med. & Mod.
Modena, Museo di Storia e Arte Medioevale e Moderna

Modena, Pal. Musei
Modena, Palazzo dei Musei [houses Archv Stor.; Bib. Civ. Stor. A.; Bib. Estense; Bib. U; Gal. Campori; Gal. & Mus. Estense; Gal. Poletti; Mus. Archeol. Etnol.; Mus. Lapidario; Mus. & Medagliere Estense; Mus. Risorgimento; Mus. Stor. & A. Med. & Mod.]

Mönchengladbach, Schloss Rheydt
Mönchengladbach, Schloss Rheydt, Städtisches Museum

Monserrat, Mus.
Monserrat, Museo de la Abadía de Monserrat

Montalcino, Mus. Civ.
Montalcino, Museo Civico [housed with Mus. Dioc. A. Sacra]

Montalcino, Mus. Dioc. A. Sacra
Montalcino, Museo Diocesano d'Arte Sacra

Monte Acuto, Villa Blasi Foglietti

Montefortino, Pin. Com.
Montefortino, Pinacoteca Comunale [Palazzo Comunale]

Montepulciano, Mus. Civ.
Montepulciano, Museo Civico

Monterchi, Scu. Via Reglia
Monterchi, Scuola di Via Reglia

Monteriggioni, Mus. Semin. Arcivescovile
Monteriggioni, Museo del Seminario Arcivescovile

Montpellier, Mus. Fabre
Montpellier, Musée Fabre [Musée des Beaux-Arts]

Montreal, Cent. Can. Archit.
Montreal, Centre Canadien d'Architecture

Montreal, Mus. F.A.
Montreal, Museum of Fine Arts [Musée des Beaux-Arts]

Montserrat, Mus. Abadía
Montserrat, Museo de la Abadía de Montserrat [Monastery of S María]

Moscow, Obraztsov Col.
Moscow, Obraztsov Collection

Moscow, Pushkin Mus. F.A.
Moscow, Pushkin Museum of Fine Arts (Muzey Izobrazitelnykh Iskusstv Imeni A.S. Pushkina)

Munich, Alte Pin.
Munich, Alte Pinakothek

Munich, Bayer. Nmus.
Munich, Bayerisches Nationalmuseum [incl. Staatliches Museum für Angewandte Kunst, Neue Sammlung]

Munich, Bayer. Staatsbib.
Munich, Bayerische Staatsbibliothek

Munich, Haus Kst
Munich, Haus der Kunst

Munich, Konrad O. Bernheimer

Munich, Ludwig-Maximilians-U.
Munich, Ludwig-Maximilians-Universität

Munich, Residenzmus.
Munich, Residenzmuseum

Munich, Staatl. Antikensamml.
Munich, Staatliche Antikensammlungen

Munich, Staatl. Graph. Samml.
Munich, Staatliche Graphische Sammlung

Munich, Staatl. Münzsamml.
Munich, Staatliche Münzsammlung München

Münster, Westfäl. Landesmus.
Münster, Westfälisches Landesmuseum für Kunst und Kulturgeschichte

Münster, Westfäl. Wilhelms-U.
Münster, Westfälische Wilhelms-Universität

Murano, Mus. Vetrario
Murano, Museo Vetrario

Nancy, Mus. B.-A.
Nancy, Musée des Beaux-Arts

Nantes, Mus. B.-A.
Nantes, Musée des Beaux-Arts de Nantes

Naples, Archv Stato
Naples, Archivio di Stato

Naples, Bib. Girolamini
Naples, Biblioteca dei Girolamini [in Church of the Girolamini]

Naples, Bib. N.
Naples, Biblioteca Nazionale

Naples, Capodimonte
Naples, Museo e Gallerie Nazionali di Capodimonte [Museo Borbonico]

Naples, Mus. Archeol. N.
Naples, Museo Archeologico Nazionale

Naples, Mus. N. Cér.
Naples, Museo Nazionale della Ceramica Duca di Martina [in Villa Floridiana]

Naples, Pal. Reale
Naples, Palazzo Reale

Naples, Pin. Pio Monte della Misericordia
Naples, Pinacoteca del Pio Monte della Misericordia [Palazzo del Monte]

Narni, Pin. Com.
Narni, Pinacoteca Comunale

Newark, U. DE
Newark, DE, University of Delaware

New Haven, CT, Yale U.
New Haven, CT, Yale University

New Haven, CT, Yale U. A.G.
New Haven, CT, Yale University Art Gallery

New Haven, CT, Yale U., Beinecke Lib.
New Haven, CT, Yale University, Beinecke Library

New Haven, CT, Yale U. Lib.
New Haven, CT, Yale University Library

New York, Brooklyn Mus.
New York, The Brooklyn Museum

New York, Christie's Int.
New York, Christie's Manson and Woods International

New York, Columbia U.
New York, Columbia University

New York, Columbia U., Avery Archit. & F.A. Lib.
New York, Columbia University, Avery Architectural and Fine Arts Library

New York, Cooper-Hewitt Mus.
New York, Cooper-Hewitt Museum, Smithsonian Institution; National Museum of Design

New York, Frick
New York, Frick Collection

New York, Hisp. Soc. America
New York, Hispanic Society of America

New York, Kress Found.
New York, Samuel H. Kress Foundation [col. now dispersed; many pieces in Washington, DC, N.G.A.]

New York, Met.
New York, Metropolitan Museum of Art

New York, NY Hist. Soc.
New York, New-York Historical Society

New York, Piero Corsini
New York, Piero Corsini

New York, Pierpont Morgan Lib.
New York, Pierpont Morgan Library

New York, Pub. Lib.
New York, Public Library [formed 1895 by amalgamation of Astor & Lenox libraries]

New York, Salander-O'Reilly Gals
New York, Salander-O'Reilly Galleries, Inc.

New York, Sotheby's
New York, Sotheby's [until 17 July 1984 called Sotheby Parke Bernet & Co.]

New York U., Inst. F.A.
New York, New York University, Institute of Fine Arts

Nivå, Nivaagaards Malsaml.
Nivå, Nivaagaards Malerisamling (Nivaagaards Art Collection)

Nocera Umbra, Pin. Com.
Nocera Umbra, Pinacoteca Comunale

Norfolk, VA, Chrysler Mus.
Norfolk, VA, Chrysler Museum

Northampton, MA, Smith Coll. Mus. A.
Northampton, MA, Smith College Museum of Art

Notre Dame, IN, Snite Mus. A.
Notre Dame, IN, University of Notre Dame, Snite Museum of Art

Nottingham, A.G.
Nottingham, University Art Gallery

Nuremberg, Ger. Nmus.
Nuremberg, Germanisches Nationalmuseum

Oberlin Coll., OH, Allen Mem. A. Mus.
Oberlin, OH, Oberlin College, Allen Memorial Art Museum

Oleggio, Mus. A. Relig.
Oleggio, Museo di Arte Religiosa

Omaha, NE, Joslyn A. Mus.
Omaha, NE, Joslyn Art Museum

Orléans, Mus. B.-A.
Orléans, Musée des Beaux-Arts

Orvieto, Mus. Opera Duomo
Orvieto, Museo Opera del Duomo

Orvieto, Pal. Pop.
Orvieto, Palazzo del Popolo

Osimo, Mus. Sacro Dioc.
Osimo, Museo Sacro Diocesano

Oslo, N.G.
Oslo, Nasjonalgalleri

Ottawa, N.G.
Ottawa, National Gallery of Canada

Oxford, Ashmolean
Oxford, Ashmolean Museum

Oxford, Bodleian Lib.
Oxford, Bodleian Library

Oxford, Christ Church Pict. Gal.
Oxford, Christ Church Picture Gallery

Padua, Bib. Capitolare
Padua, Biblioteca Capitolare

Padua, Bib. Semin.
Padua, Biblioteca del Seminario

Padua, Cassa di Risparmio

Padua, Liviano

Padua, Loggia Cornaro

Padua, Mus. Antoniano
Padua, Museo Antoniano

Padua, Mus. Civ.
Padua, Museo Civico

Padua, Pal. Ragione
Padua, Palazzo della Ragione

Padua, Scu. Carmine
Padua, Scuola del Carmine

Padula, Mus. Archeol. Prov. Lucania Occident.
Padula, Museo Archeologico Provinciale della Lucania Occidentale [in Certosa]

Palermo, Gal. Reg. Sicilia
Palermo, Galleria Regionale della Sicilia [Galleria Nazionale della Sicilia; Palazzo Abatellis]

Palermo, Mus. Reg.
Palermo, Museo Regionale di Palermo [Museo Nazionale Archeologico]

Paris, Bib. Arsenal
Paris, Bibliothèque de l'Arsenal

Paris, Bib. Inst. France
Paris, Bibliothèque de l'Institut de France

Paris, Bib. N.
Paris, Bibliothèque Nationale

Paris, Bib. N., Cab. Est.
Paris, Bibliothèque Nationale, Cabinet des Estampes

Paris, Bib. N., Cab. Médailles
Paris, Bibliothèque Nationale, Cabinet des Médailles [et Antiquités]

Paris, Ecole B.-A.
Paris, Ecole des Beaux-Arts

Paris, Ecole N. Sup. B.-A.
Paris, Ecole Nationale Supérieure des Beaux-Arts

Paris, Fond. Custodia, Inst. Néer.
Paris, Fondation Custodia, Institut Néerlandais [Frits Lugt Collection]

Paris, Gal. Petit
Paris, Galerie Petit [closed 1933]

Paris, Grand Pal.
Paris, Grand Palais [Galeries Nationales d'Exposition du Grand Palais]

Paris, Heim
Paris, Heim et Cie, Marcel

Paris, Inst. France
Paris, Institut de France

Paris, Louvre
Paris, Musée du Louvre

Paris, Louvre, Cab. Dessins
Paris, Musée du Louvre, Cabinet des Dessins

Paris, Mobilier N.
Paris, Mobilier National

Paris, Mus. A. Déc.
Paris, Musée des Arts Décoratifs

Paris, Mus. Cluny
Paris, Musée de Cluny

Paris, Mus. Jacquemart-André
Paris, Musée Jacquemart-André

Paris, Mus. Marmottan
Paris, Musée Marmottan

Paris, Petit Pal.
Paris, Musée du Petit Palais

Paris, Wildenstein Inst.
Paris, Wildenstein Institute

Parma, Archv Stato
Parma, Archivio di Stato

Parma, Bib. Palatina
Parma, Biblioteca Palatina

Parma, G.N.
Parma, Galleria Nazionale [in Pal. Pilotta]

Parma, Pal. Com.
Parma, Palazzo Comunale

Parma, Pal. Pilotta
Parma, Palazzo della Pilotta [houses G.N.; Mus. Bodoniano; Mus. N. Ant.]

Parma, Pin. Stuard
Parma, Pinacoteca Giuseppe Stuard

Pasadena, CA, Norton Simon Mus.
Pasadena, CA, Norton Simon Museum

Passariano, Villa Manin

Pavia, Mus. Certosa
Pavia, Museo della Certosa [in Pal. Ducale]

Pavia, Pin. Malaspina
Pavia, Pinacoteca Malaspina [in Castello Visconteo]

Pavia, Semin. Vescovile
Pavia, Seminario Vescovile [formerly monastery of Pusterla/S Maria Teodote]

Perugia, Archv Stato
Perugia, Archivio di Stato

Perugia, Bib. Augusta
Perugia, Biblioteca Augusta

Perugia, G.N. Umbria
Perugia, Galleria Nazionale dell'Umbria

Perugia, Mus. Opera Duomo
Perugia, Museo dell'Opera del Duomo

Perugia, Osp. Misericordia
Perugia, Ospedale della Misericordia

Perugia, Rocca Paolina, Sale Cannoniera
Perugia, Rocca Paolina, Sale della Cannoniera

Pesaro, Mus. Civ.
Pesaro, Museo Civico

Pescia, Pal. Vescovile
Pescia, Palazzo Vescovile

Philadelphia, PA, Free Lib.
Philadelphia, PA, Free Library of Philadelphia

Philadelphia, PA, Mus.
Philadelphia, PA, Philadelphia Museum [col. now dispersed]

Philadelphia, PA, Mus. A.
Philadelphia, PA, Museum of Art

Philadelphia, PA, Rosenbach Mus.
Philadelphia, PA, Rosenbach Museum

Philadelphia, U. PA
Philadelphia, PA, University of Pennsylvania

Piacenza, Archv Stato
Piacenza, Archivio di Stato di Piacenza

Piacenza, Coll. Alberoni
Piacenza, Collegio Alberoni

Piacenza, Mus. Civ.
Piacenza, Museo Civico [Palazzo Farnese]

Pienza, Mus. Cattedrale
Pienza, Museo della Cattedrale

Pisa, Arsenale Galee
Pisa, Arsenale delle Galee

Pisa, Camposanto

Pisa, Mus. N. S Matteo
Pisa, Museo Nazionale di S Matteo

Pistoia, Fortezza S Barbara

Pistoia, Mus. Cap.
Pistoia, Museo Capitolare

Pistoia, Mus. Civ.
Pistoia, Museo Civico [Palazzo Comunale, Palazzo Pubblico]

Pistoia, Pal. Vesc.
Pistoia, Palazzo dei Vescovi

Pittsburgh, PA, Carnegie
Pittsburgh, The Carnegie [admins Carnegie Lib.; Carnegie Mus. A.; Carnegie Mus. Nat. Hist.; Carnegie Music Hall; Carnegie Sci. Cent.]

Pittsburgh, PA, Carnegie Inst.
Pittsburgh, PA, Carnegie Institute [name changed to The Carnegie autumn 1985]

Pittsburgh, PA, Carnegie Mus. A.
Pittsburgh, PA, The Carnegie Museum of Art

Pittsburgh, PA, Frick A. Mus.
Pittsburgh, PA, Frick Art Museum

Poggio a Caiano, Mus. Villa Medicea
Poggio a Caiano, Museo Villa Medicea

Pordenone, Mus. Civ. Pal. Ricchieri
Pordenone, Museo Civico di Palazzo Ricchieri

Portland, OR, A. Mus.
Portland, OR, Portland Art Museum

Potsdam, Bildergal.
Potsdam, Bildergalerie [in Park Sanssouci]

Potsdam, Neues Pal.
Potsdam, Neues Palais [in Park Sanssouci]

Poznań, N. Mus.
Poznań, National Museum (Muzeum Narodowe w Poznaniu)

Prague, N.G.
Prague, National Gallery (Národní Galerie) [admins Convent of St Agnes; Convent of St George; Czech & Eur. Graph A.; Mun. Lib.; Šternberk Pal.; Trade Fair Pal.; Valdštejn Riding Sch.; Zbraslav Castle]

Prague, N.G., Convent of St George
Prague, National Gallery, Convent of St George

Prague, N.G., Kinský Pal.
Prague, National Gallery, Kinský Palace

Prague, N.G., Šternberk Pal.
Prague, National Gallery, Šternberk Palace

Prague, N. Mus.
Prague, National Museum (Národní Muzeum) [admins Cent. Office Museology; Hist. Mus.; Mus. Czech. Music; Mus. Nat. Sci.; Mus. Phys. Training & Sport; Náprstek Mus. Asian, Afr. & Amer. Cult.; N. Mus.]

Prague, Rudolphinum

Prato, Bib. Roncioniana
Prato, Biblioteca Roncioniana

Prato, Cassa di Risparmio

Prato, Mus. Com.
Prato, Museo Comunale [in Pal. Pretorio]

Prato, Mus. Opera Duomo
Prato, Museo dell'Opera del Duomo

Pratolino, Villa Demidoff

Princeton U., NJ
Princeton, NJ, Princeton University

Princeton U., NJ, A. Mus.
Princeton, Princeton University, Art Museum

Providence, RI, Brown U.
Providence, RI, Brown University

Providence, RI Sch. Des., Mus. A.
Providence, RI, Rhode Island School of Design, Museum of Art

Raleigh, NC Mus. A.
Raleigh, NC, North Carolina Museum of Art

Ravenna, Accad. B.A.
Ravenna, Accademia di Belle Arti

Ravenna, Bib. Com. Classense
Ravenna, Biblioteca Comunale Classense

Ravenna, Loggetta Lombard.
Ravenna, Loggetta Lombardesca

Ravenna, Mus. N.
Ravenna, Museo Nazionale

Ravenna, Pin. Com.
Ravenna, Pinacoteca Comunale

Recanati, Mus. Dioc.
Recanati, Museo Diocesano

Recanati, Pin. Civ.
Recanati, Pinacoteca Civica

Reggio Calabria, Mus. N.
Reggio Calabria, Museo Nazionale [della Magna Grecia]

Reggio Emilia, Mus. Civ. & Gal. A.
Reggio Emilia, Musei Civici e Gallerie d'Arte

Rennes, Mus. B.-A. & Archéol.
Rennes, Musée des Beaux-Arts et d'Archéologie

Rieti, Mus. Civ.
Rieti, Museo Civico

Rimini, Pal. Arengo
Rimini, Palazzo dell'Arengo

Rimini, Pin. Com. & Mus. Civ.
Rimini, Pinacoteca Comunale e Museo Civico

Rome, Acad. France
Rome, Académie de France

Rome, Accad. N. Lincei
Rome, Accademia Nazionale dei Lincei

Rome, Accad. N. S Luca
Rome, Accademia Nazionale di S Luca

Rome, Archv Congregazione Oratorio
Rome, Archivio della Congregazione dell'Oratorio

Rome, Bib. Accad. N. Lincei & Corsiniana
Rome, Biblioteca dell'Accademia Nazionale dei Lincei e Corsiniana

Rome, Bib. Angelica
Rome, Biblioteca Angelica

Rome, Bib. Casanatense
Rome, Biblioteca Casanatense

Rome, Calcografia N.
Rome, Calcografia Nazionale [Calcografia di Roma]

Rome, Carmelite Coll.
Rome, Carmelite College [Sassone]

Rome, Casa Gen. Gesuiti
Rome, Casa Generalizia dei Gesuiti

Rome, Castel S Angelo

Rome, Gab. N. Stampe
Rome, Gabinetto Nazionale delle Stampe

Rome, Gal. Borghese
Rome, Galleria Borghese

Rome, Gal. Colonna
Rome, Galleria Colonna

Rome, Gal. Pallavicini
Rome, Galleria Pallavicini [in Pal. Rospigliosi–Pallavicini]

Rome, Gal. Spada
Rome, Galleria Spada [in Pal. Spada]

Rome, G.N.A. Ant.
Rome, Galleria Nazionale d'Arte Antica [admins Pal. Barberini; Pal. Corsini]

Rome, G.N.A. Mod.
Rome, Galleria Nazionale d'Arte Moderna [e Arte Contemporanea; in Palazzo delle Belle Arti]

Rome, Grotte Vaticane

Rome, Ist. N. Graf.
Rome, Istituto Nazionale per la Grafica

Rome, La Sapienza
Rome, Università degli Studi di Roma 'La Sapienza'

Rome, Margherita
Rome, La Margherita

Rome, Mus. Capitolino
Rome, Museo Capitolino

Rome, Mus. Conserv.
Rome, Museo dei Conservatori [in Pal. Conserv.]

Rome, Mus. N. Castel S Angelo
Rome, Museo Nazionale di Castel Sant'Angelo

Rome, Mus. N. Romano
Rome, Museo Nazionale Romano [Museo delle Terme]

Rome, Pal. Barberini
Rome, Palazzo Barberini [Galleria Nazionale del Palazzo Barberini]

Rome, Pal. Braschi
Rome, Palazzo Braschi [houses Galleria Comunale d'Arte Moderna]

Rome, Pal. Cancelleria
Rome, Palazzo della Cancelleria

Rome, Pal. Conserv.
Rome, Palazzo dei Conservatori [houses Mus. Conserv., Sale Conserv. and Pin.; adjoining are Pal. Conserv., Braccia Nuovo and Pal. Conserv., Mus. Nuovo]

Rome, Pal. Corsini
Rome, Palazzo Corsini [G.N.A. Ant.]

Rome, Pal. Espos.
Rome, Palazzo delle Esposizioni

Rome, Pal. Farnese
Rome, Palazzo Farnese

Rome, Pal. Gesù
Rome, Palazzo al Gesù [Palazzo Cenci-Bolognetti]

Rome, Pal. Massimo alle Colonne
Rome, Palazzo Massimo alle Colonne

Rome, Pal. Mattei
Rome, Palazzo Mattei

Rome, Pal. Mattei di Gove
Rome, Palazzo Mattei di Gove

Rome, Pal. Montecitorio
Rome, Palazzo di Montecitorio [Camera dei Deputati]

Rome, Pal. Quirinale
Rome, Palazzo del Quirinale

Rome, Pal. Rospigliosi–Pallavicini
Rome, Palazzo Rospigliosi–Pallavicini [houses Gal. Pallavicini]

Rome, Pal. Salviati
Rome, Palazzo Salviati

Rome, Pal. Venezia
Rome, Palazzo Venezia

Rome, Pantheon

Rome, Pin. Vaticana
Rome, Pinacoteca Vaticana

Rome, Protomoteca Capitolina

Rome, St Peter's

Rome, Vatican, Appartamento Borgia
Rome, Vatican, Appartamento Borgia

Rome, Vatican, Bib. Apostolica
Rome, Vatican, Biblioteca Apostolica Vaticana [Vatican Lib.]

Rome, Vatican, Bib. Apostolica, Archv Capitolare S Pietro
 Rome, Vatican, Biblioteca Apostolica Vaticana, Archivio Capitolare S Pietro

Rome, Vatican, Braccio Carlo Magno
 Rome, Vatican, Braccio di Carlo Magno

Rome, Vatican, Braccio Nuo.
 Rome, Vatican, Braccio Nuovo

Rome, Vatican, Cortile Belvedere
 Rome, Vatican, Cortile del Belvedere

Rome, Vatican, Cortile Pigna
 Rome, Vatican, Cortile della Pigna

Rome, Vatican, Gal. Arazzi
 Rome, Vatican, Galleria degli Arazzi

Rome, Vatican, Gal. Candelabri
 Rome, Vatican, Galleria dei Candelabri

Rome, Vatican, Medagliere

Rome, Vatican, Mus. Gregoriano Etrus.
 Rome, Vatican, Museo Gregoriano Etrusco

Rome, Vatican, Mus. Gregoriano Profano
 Rome, Vatican, Museo Gregoriano Profano

Rome, Vatican, Mus. Pio-Clementino
 Rome, Vatican, Museo Pio-Clementino

Rome, Vatican, Mus. Pio-Crist.
 Rome, Vatican, Museo Pio-Cristiano

Rome, Vatican, Mus. Sacro
 Rome, Vatican, Museo Sacro

Rome, Vatican, Mus. Sacro Bib. Apostolica
 Rome, Vatican, Museo Sacro della Biblioteca Apostolica

Rome, Vatican, Mus. Stor. A. Tesoro S Pietro
 Rome, Vatican, Museo Storico Artistico Tesoro di S Pietro

Rome, Vatican Pal.
 Rome, Vatican Palace

Rome, Vatican, Sala di Costantino

Rome, Vatican, Sala Regia

Rome, Vatican, Stanza d'Eliodoro

Rome, Vatican, Stanza della Segnatura

Rome, Vatican, Stanze di Raffaello

Rome, Villa Farnesina
 Rome, Villa Farnesina

Rome, Villa Medici
 Rome, Villa Medici

Rotterdam, Mus. Boymans
 Rotterdam, Museum Boymans [name changed to Museum Boymans—van Beuningen 1958]

Rouen, Mus. B.-A.
 Rouen, Musée des Beaux-Arts

Rovigo, Accad. Concordi
 Rovigo, Accademia dei Concordi

Saarbrücken, Saarland Mus.
 Saarbrücken, Saarland Museum

Saint-Denis Abbey

Saint-Lô, Mus. B.-A.
 Saint-Lô, Musée des Beaux-Arts [Musée de Saint-Lô, Musée d'Art; in Hôtel de Ville]

St Petersburg, Hermitage
 St Petersburg, Hermitage Museum (Muzey Ermitazh)

Salerno, Mus. Duomo
 Salerno, Museo del Duomo [Mus. Dioc. Prov. since 1992]

Salerno, Mus. Prov.
 Salerno, Museo Provinciale

San Diego, CA, F.A. Gal.
 San Diego, CA, Fine Arts Gallery of San Diego

San Diego, CA, Mus. A.
 San Diego, CA, San Diego Museum of Art

San Diego, CA, Timken A.G.
 San Diego, CA, Timken Art Gallery

San Francisco, CA, de Young Mem. Mus.
 San Francisco, CA, M. H. de Young Memorial Museum

San Gimignano, Bib. Com.
 San Gimignano, Biblioteca Comunale

San Gimignano, Mus. A. Sacra
 San Gimignano, Museo d'Arte Sacra

San Gimignano, Mus. Civ.
 San Gimignano, Museo Civico [in Pal. Pop.]

San Gimignano, Pin. Civ.
 San Gimignano, Pinacoteca Civica [in Pal. Pop.]

San Marino, CA, Huntington Lib. & A.G.
 San Marino, CA, Huntington Library and Art Gallery

San Miniato, Mus. Dioc. A. Sacra
 San Miniato, Museo Diocesano d'Arte Sacra

San Miniato, Pal. Com.
 San Miniato, Palazzo Comunale

San Miniato, Semin. Dioc.
 San Miniato, Seminario Diocesano

San Severino Marche, Pin. Com. 'P. Tacchi Venturi'
 San Severino Marche, Pinacoteca Comunale 'P. Tacchi Venturi'

San Simeon, CA, Hearst Found.
 San Simeon, CA, Hearst Foundation

Sansepolcro, Casa Piero
 Sansepolcro, Casa di Piero della Francesca

Sansepolcro, Mus. Civ.
 Sansepolcro, Museo Civico

Sansepolcro, Pin.
 Sansepolcro, Pinacoteca

São Paulo, Mus. A. Assis Châteaubriand
 São Paulo, Museu de Arte de São Paulo Assis Châteaubriand

Sarasota, FL, Ringling Mus. A.
 Sarasota, FL, John and Mable Ringling Museum of Art

Sassocorvaro, Pal. Com.
 Sassocorvaro, Palazzo Comunale

Sassoferrato, Gal. A. Mod.
 Sassoferrato, Galleria d'Arte Moderna

Savona, Pin. Civ.
 Savona, Pinacoteca Civica

Schallaburg, Schloss
 Schallaburg, Schloss Schallaburg

Schwerin, Staatl. Mus.
 Schwerin, Staatliches Museum

Senigallia, Pal. Vescovile
 Senigallia, Palazzo Vescovile

Sermoneta, Castello Caetani

Seville, Casa Pilatos
 Seville, Casa de Pilatos

Seville, Mus. B.A.
 Seville, Museo de Bellas Artes

Sèvres, Mus. N. Cér.
 Sèvres, Musée National de Céramique

Sibiu, Brukenthal Mus.
 Sibiu, Brukenthal Museum (Muzeul Brukenthal)

Siena, Archv Stato
 Siena, Archivio di Stato

Siena, Bib. Com. Intronati
 Siena, Biblioteca Comunale degli Intronati

Siena, Bib. Piccolomini
 Siena, Biblioteca Piccolomini [Libreria Piccolomini; in Siena Cathedral]

Siena, Col. Chigi-Saracini
 Siena, Collezioni Chigi-Saracini [in Pal. Chigi-Saracini]

Siena, Magazzini del Sale

Siena, Monte Paschi
 Siena, Monte dei Paschi [banking inst.; in Palazzo Salimbeni, Palazzo Spannocchi, Palazzo Tantucci]

Siena, Mus. Castelli
 Siena, Museo Aurelio Castelli [attached to Convento dell'Osservanza]

Siena, Mus. Opera Duomo
 Siena, Museo dell'Opera del Duomo [Museo dell'Opera della Metropolitana]

Siena, Osp. S Maria della Scala
 Siena, Ospedale di S Maria della Scala

Siena, Osservanza

Siena, Pal. Piccolomini, Archv Stato
 Siena, Palazzo Piccolomini, Archivio di Stato

Siena, Pal. Pub.
 Siena, Palazzo Pubblico

Siena, Pal. Reale
 Siena, Palazzo Reale

Siena, Pin. N.
 Siena, Pinacoteca Nazionale di Siena

Simancas, Archv Gen.
 Simancas, Archivo General de Simancas

Sorrento, Mus. Correale Terranova
 Sorrento, Museo Correale di Terranova

Southampton, C.A.G.
 Southampton, City Art Gallery

South Hadley, MA, Mount Holyoke Coll. A. Mus.
 South Hadley, MA, Mount Holyoke College Art Museum

Spello, Pin. Com.
 Spello, Pinacoteca Comunale

Spoleto, Mus. Civ.
 Spoleto, Museo Civico

Stockholm, Kun. Husgerådskam.
 Stockholm, Kungliga Husgerådskammar med Skattkammar och Bernadotte-Bibliotek [Royal collections]

Stockholm, Kun. Slott
 Stockholm, Kungliga Slott

Stockholm, Nmus.
 Stockholm, Nationalmuseum

Stockholm U., Kstsaml.
 Stockholm, Stockholms Universitetum, Konstsamling

Storrs, U. CT, Benton Mus. A.
 Storrs, CT, University of Connecticut, William Benton Museum of Art

Strasbourg, Mus. B.-A.
 Strasbourg, Musée des Beaux-Arts

Stuttgart, Württemberg. Landesmus.
 Stuttgart, Altes Schloss, Württembergisches Landesmuseum

Stuttgart, Staatsgal.
 Stuttgart, Staatsgalerie

Syracuse, Pal. Bellomo
 Syracuse, Museo Nazionale del Palazzo Bellomo [Museo Regionale del Palazzo Bellomo]

Tempe, AZ State U., Northlight Gal.
 Tempe, AZ, Arizona State University, Northlight Gallery

Terni, Mus. & Pin. Civ.
 Terni, Museo e Pinacoteca Civica

Tivoli, Villa d'Este

Tokyo, N. Mus.
 Tokyo, National Museum (Kokuritsu Hakubutsukan)

Toledo, OH, Mus. A.
 Toledo, OH, Museum of Art

Toronto, A.G.
 Toronto, Art Gallery of Toronto [name changed to A.G. Ont. in 1966]

Toronto, A.G. Ont.
 Toronto, Art Gallery of Ontario

Toronto, Royal Ont. Mus.
 Toronto, Royal Ontario Museum [also admins Canadian Building]

Tortona, Pal. Vescovile
 Tortona, Palazzo Vescovile

Toulouse, Mus. Augustins
 Toulouse, Musée des Augustins

Tours, Mus. B.-A.
 Tours, Musée des Beaux-Arts

Trapani, Mus. Reg.
 Trapani, Museo Regionale Pepoli

Trent, Bib. Com.
 Trent, Biblioteca Comunale

Trent, Mus. Dioc.
 Trent, Museo Diocesano

Trent, Mus. Prov. A.
 Trent, Museo Provinciale d'Arte [Antica, Medievale, Moderna e Contemporanea]

Treviso, Bib. Com.
 Treviso, Biblioteca Comunale

Treviso, Mus. Civ. Bailo
 Treviso, Museo Civico Luigi Bailo

Treviso, Pal. Trecento
 Treviso, Palazzo dei Trecento

Trieste, Mus. Civ. Stor. & A.
 Trieste, Museo Civico di Storia ed Arte ed Orto Lapidario

Tulsa, OK, Philbrook A. Cent.
 Tulsa, OK, Philbrook Art Center

Turin, Accad. Albertina
 Turin, Accademia Albertina di Belle Arti

Turin, Archv Stato
 Turin, Archivio di Stato di Torino

Turin, Bib. N. U.
 Turin, Biblioteca Nazionale Universitaria

Turin, Bib. Reale
 Turin, Biblioteca Reale di Torino

Turin, Cassa di Risparmio

Turin, Gal. Sabauda
 Turin, Galleria Sabauda

Turin, Mus. Civ.
 Turin, Museo Civico di Torino [admins Borgo & Castello Med.; Gal. Civ. A. Mod.; Mus. Civ. A. Ant.; Mus. Micca]

Turin, Mus. Civ. A. Ant.
 Turin, Museo Civico d'Arte Antica

Turin, Mus. Egizio
 Turin, Museo Egizio di Torino

Turin, Pal. Madama
 Turin, Palazzo Madama

Udine, Castello, Salone Parlamento
 Udine, Castello, Salone del Parlamento

Udine, Mus. Civ.
 Udine, Museo Civico [in castle]

Udine, Pal. Arcivescovile
 Udine, Palazzo Arcivescovile

University Park, PA State U.
 University Park, PA, Pennsylvania State University

Urbino, Bib. U.
 Urbino, Biblioteca Universitaria

Urbino, Pal. Ducale
 Urbino, Palazzo Ducale [houses Galleria Nazionale delle Marche]

Utrecht, Catharijneconvent
 Utrecht, Rijksmuseum Het Catharijneconvent [houses col. of former Aartsbisschoppelijk Mus.]

Vaduz, Samml. Liechtenstein
 Vaduz, Sammlungen der Fürsten von Liechtenstein

Valencia, Mus. B.A.
 Valencia, Museo de Bellas Artes [Museo Provincial de Bellas Artes; Museo de San Pio V]

Vallo della Lucania, Mus. Dioc.
 Vallo della Lucania, Museo Diocesano

Varallo, Bib. Civ.
 Varallo, Biblioteca Civica

Varallo, Mus. Civ. Pietro Calderini
 Varallo, Museo Civico Pietro Calderini

Varallo, Pin.
 Varallo, Pinacoteca

Varese, Mus. S Maria del Monte
 Varese, Museo di S Maria del Monte [in monastery]

Velletri, Mus. Capitolare
 Velletri, Museo Capitolare

Venice, Accad.
 Venice, Galleria dell'Accademia

Venice, Accad. Pitt. & Scul.
 Venice, Accademia di Pittura e Scultura [18th C. acad.; in Fontegheto della Farina]

Venice, Ala Napoleonica

Venice, Archv Stato
 Venice, Archivio di Stato [in convent bldgs of S Maria Gloriosa dei Frari]

Venice, Ateneo Veneto

Venice, Bib. Correr
 Venice, Biblioteca del Civico Museo Correr

Venice, Bib. N. Marciana
 Venice, Biblioteca Nazionale Marciana [in Palazzi della Libreria Vecchia e della Zecca]

Venice, Casa Goldoni
 Venice, Casa di Goldoni [Museo Teatrale ed Istituto di Studi Teatrali; also houses archv]

Venice, Col. Cini
 Venice, Collezione Cini

Venice, Correr
 Venice, Museo Correr

Venice, Doge's Pal.
 Venice, Doge's Palace [Palazzo Ducale]

Venice, Fond. Cini
 Venice, Fondazione Giorgio Cini, Istituto di Storia dell'Arte [Isola di S Giorgio Maggiore]

Venice, Fond. Cini, Bib.
 Venice, Fondazione Giorgio Cini, Istituto di Storia dell'Arte, Biblioteca

Venice, Fond. Querini–Stampalia
 Venice, Fondazione Querini–Stampalia

Venice, Frari
 Venice, Santa Maria Gloriosa dei Frari

Venice, Gal. Farsetti
 Venice, Galleria Farsetti

Venice, Gal. Querini–Stampalia
 Venice, Galleria Querini–Stampalia [Pinacoteca Querini–Stampalia]

Venice, Ist. U. Archit.
 Venice, Istituto Universitario di Architettura

Venice, Lib. Marciana
 Venice, Libreria Marciana

Venice, Mus. Archeol.
 Venice, Museo Archeologico

Venice, Mus. Dioc. S Apollonia
 Venice, Museo Diocesano d'Arte Sacra, S Apollonia

Venice, Mus. Opera Pal.
 Venice, Museo dell'Opera del Palazzo [in Doge's Pal.]

Venice, Mus. S Marco
 Venice, Museo di San Marco

Venice, Pal. Grassi
 Venice, Palazzo Grassi

Venice, Pal. Pesaro
 Venice, Palazzo Pesaro

Venice, Pal. Ruzzini–Priuli, S Maria Formosa
 Venice, Palazzo Ruzzini–Priuli, S Maria Formosa [Palazzo Priuli, S Maria Formosa]

Venice, Scu. Grande S Giovanni Evangelista
 Venice, Scuola Grande di S Giovanni Evangelista

Venice, Scu. Grande S Rocco
 Venice, Scuola Grande di S Rocco

Venice, Semin. Patriarcale
 Venice, Seminario Patriarcale

Venice, Tesoro S Marco
 Venice, Tesoro di San Marco

Vercelli, Mus. Civ. Borgogna
 Vercelli, Museo Civico Borgogna

Verona, Bib. Capitolare
 Verona, Biblioteca Capitolare

Verona, Bib. Civ.
 Verona, Biblioteca Civica

Verona, Castelvecchio
 Verona, Museo Civico di Castelvecchio

Verona, Gran Guardia

Verona, Musei Civ.
 Verona, Musei Civici di Verona [admins Castelvecchio; Mus. Affreschi; Mus. Archeol. Teat. Romano; Mus. Lapidario Maffeiano; Pal. Forti]

Verona, Mus. Miniscalchi Erizzo
 Verona, Museo Miniscalchi Erizzo

Verona, Pal. Canossa
 Verona, Palazzo Canossa

Verona, Pal. Gran Guardia
 Verona, Palazzo della Gran Guardia

Verona, Pal. Vescovile
 Verona, Palazzo Vescovile [Archbishop's Pal.]

Vicenza, Mus. Civ. A. & Stor.
 Vicenza, Museo Civico d'Arte e Storia

Vienna, Akad. Bild. Kst.
 Vienna, Akademie der Bildenden Künste

Vienna, Albertina
 Vienna, Graphische Sammlung Albertina

Vienna, Gemäldegal. Akad. Bild. Kst.
 Vienna, Gemäldegalerie der Akademie der Bildenden Künste

Vienna, Ksthist. Mus.
 Vienna, Kunsthistorisches Museum [admins Ephesos Mus.; Ksthist. Mus.; Mus. Vlkerknd.; Nbib; Neue Gal. Stallburg; Samml. Musikinstr.; Schatzkam.; houses Gemäldegalerie; Neue Hofburg;

Kunstkammer; Sammlung für Plastik und
Kunstgewerbe]

Vienna, österreich. Mus. Angewandte Kst
Vienna, österreichisches Museum für
Angewandte Kunst

Vienna, österreich. Nbib.
Vienna, österreichische Nationalbibliothek
[Hofbibliothek]

Vienna, Schatzkam.
Vienna, Schatzkammer

Viggiù, Mus. Enrico Butti
Viggiù, Museo Enrico Butti

Vignola, Rocca

Villeneuve-lès-Avignon, Mus. Mun.
Villeneuve-lès-Avignon, Musée Municipal
Villeneuve-lès-Avignon

Viterbo, Mus. Civ.
Viterbo, Museo Civico

Vittorio Veneto, Mus. Cenedese
Vittorio Veneto, Museo del Cenedese

Volterra, Mus. Dioc. A. Sacra
Volterra, Museo Diocesano di Arte Sacra [in
Palazzo Vescovile]

Volterra, Pal. Priori, Gal. Pittorica
Volterra, Palazzo dei Priori, Galleria Pittorica
[since 1982 housed in Pal. Minucci–Solaini]

Volterra, Pin. Com.
Volterra, Pinacoteca Comunale [Palazzo dei
Priori]

Warsaw, N. Lib.
Warsaw, National Library

Warsaw, N. Mus.
Warsaw, National Museum (Muzeum
Narodowe)

Washington, DC, Howard U., Gal. A.
Washington, DC, Howard University, Gallery
of Art

Washington, DC, N.G.A.
Washington, DC, National Gallery of Art

Washington, DC, Smithsonian Inst.
Washington, DC, Smithsonian Institution
[admins Anacostia Neighborhood Mus.;
Freer; Hirshhorn; N. Air & Space Mus.; N.
Mus. Afr. A.; N. Mus. Amer. A.; N. Mus. Nat.
Hist.; N.P.G.; N. Zool. Park; Renwick Gal.;
Cooper-Hewit Mus.]

Weimar, Goethe-Nmus.
Weimar, Goethe-Nationalmuseum [Nationale
Forschungs- und Gedenkstätten der
Klassischen Deutschen Literatur in Weimar]

Weimar, Goethe-Nmus. Frauenplan
Weimar, Goethe-Nationalmuseum am
Frauenplan

Wiesbaden, Mus. Wiesbaden
Wiesbaden, Museum Wiesbaden

Williamstown, MA, Clark A. Inst.
Williamstown, MA, Sterling and Francine
Clark Art Institute

Williamstown, MA, Williams Coll. Mus. A.
Williamstown, MA, Williams College Museum
of Art

Windsor Castle, Royal Lib.
Windsor, Windsor Castle, Royal Library

Wolfenbüttel, Herzog August Bib.
Wolfenbüttel, Herzog August Bibliothek

Worcester, MA, A. Mus.
Worcester, MA, Worcester Art Museum

York, C.A.G.
York, City Art Gallery [until 1892 called F.A.
& Ind. Exh. Bldgs]

Zagreb, Slika Gal.
Zagreb, Slika Gallery (Galerija Slika Grada)
[now Gal. Contemp. A.]

Zagreb, Yug. Acad. Sci. & A.
Zagreb, Yugoslav Academy of Sciences &
Arts (Jugoslavenska Akademija Znanosti i
Umjetnosti)

Zurich, Ksthaus
Zurich, Kunsthaus Zürich

Zurich, Landolthaus

Zurich, Schweiz. Landesmus.
Zurich, Schweizerisches Landesmuseum

Appendix B

LIST OF PERIODICAL TITLES

This list contains all of the periodical titles that have been cited in an abbreviated form in italics in the bibliographies of this encyclopedia. For the sake of comprehensiveness, it also includes entries of periodicals that have not been abbreviated, for example where the title consists of only one word or where the title has been transliterated. Abbreviated titles are alphabetized letter by letter, including definite and indefinite articles but ignoring punctuation, bracketed information and the use of ampersands. Roman and arabic numerals are alphabetized as if spelt out (in the appropriate language), as symbols (e.g. A + '⟨A plus⟩'). Additional information is given in square brackets to distinguish two or more identical titles or to cite a periodical's previous name (where such publishing information was known to the editors).

A. America
Art in America [cont. as *A. America & Elsewhere*; *A. America*]

A. America & Elsewhere
Art in America and Elsewhere [prev. pubd as & cont. as *A. America*]

A. & Ant.
Art and Antiques

A. Ant. & Mod.
Arte antica e moderna

A. Bavar.
Ars Bavarica

Abh. Heidelberg. Akad. Wiss.
Abhandlungen der Heidelberger Akademie der Wissenschaften

A. Bull.
Art Bulletin

A. Bull. Victoria
Art Bulletin of Victoria

Academia: Bol. Real Acad. B.A. San Fernando
Academia: Boletín de la Real academia de bellas artes de San Fernando

Acad. Inscr. & B.-Lett.: C. R. Séances
Académie des inscriptions et belles-lettres: Comptes rendus des séances

Accad. & Bib. Italia
Accademie e biblioteche d'Italia

Achad. Leonardi Vinci: J. Leonardo Stud. & Bibliog. Vinciana
Achademia Leonardi Vinci: Journal of Leonardo Studies and Bibliography of Vinciana

A. Crist.
Arte cristiana

Acropoli

Acta

Acta Archaeol. & A. Historiam Pertinentia
Acta ad archaeologicam et artium historiam pertinentia

Acta Hist. A. Acad. Sci. Hung.
Acta historiae artium Academiae scientiarum Hungaricae

Acta Inst. Romani Finland.
Acta Instituti Romani Finlandiae

Acta U. Upsaliensis: Figura
Acta Universitatis Upsaliensis: Figura

Actum Luce

A. Doc.
Art Documentation

A. & Dossier
Art et dossier

A. Emilia
Arte in Emilia

A. Figurativa
Arte figurativa

A. Figurative
Arti figurative: Rivista d'arte antica e moderna

A. France
ii) Arts de France

Africa
Africa: Journal of the International Institute of African Languages and Cultures

A. Friuli, A. Trieste
Arte in Friuli, arte a Trieste

A. Hist.
Art History

AIA J.
AIA [American Institute for Architects] Journal [cont. as *Architecture* [USA]]

A. Illus.
Arte illustrata: Rivista d'arte antica e moderna

Albertina Inf.
Albertina Informationen

A. & Libris
De arte et libris

Allen Mem. A. Mus. Bull.
Allen Memorial Art Museum Bulletin

A. Lombarda
Arte lombarda

A. Medit.
Arte mediterranea

Amor Libro
Amor di libro

Amtl. Ber. Kön. Kstsamml.
Amtliche Berichte aus den Königlichen Kunstsammlungen [cont. as *Berlin. Mus.: Ber. Staatl. Mus. Preuss. Kultbes.*; *Berlin. Mus.: Ber. Ehem. Preuss. Kstsamml.*]

An. Archit. Cent.
Annali di architettura del Centro internazionale di studi di architettura Andrea Palladio

An. Bib. Stat. & Lib. Civ. Cremona
Annali della Biblioteca statale e libreria civica di Cremona

An., Econ., Soc., Civilis.
Annales, économies, sociétés, civilisations

An. Fac. Filos. & Lett. U. Milano
Annali della Facoltà di filosofia e lettere dell'Università di Milano

An. Fac. Lett. & Filos. U. Napoli
Annali della Facoltà di lettere e filosofia dell'Università di Napoli

An. Ist. Stor. It.-Ger. Trento
Annali dell'Istituto storico italo-germanico in Trento

Anlct. Romana Inst. Dan.
Analecta Romana Instituti Danici

An. Liceo Class. [G. Garibaldi' Palermo
Annali del Liceo classico [G. Garibaldi' di Palermo

Annu. Rep. & Bull., Walker A.G., Liverpool
Annual Report and Bulletin, Walker Art Gallery, Liverpool

An. Scu. Norm. Sup. Pisa
Annali della Scuola normale superiore di Pisa

An. Scu. Norm. Sup. Pisa, Lett., Stor. & Filos.
Annali della Scuola normale superiore di Pisa, lettere, storia e filosofia

An. Soc. Hist. & Archéol. Gatinais
Annales de la Société historique et archéologique du Gatinais

Antol. B.A.
Antologia di belle arti

Ant. Viva
Antichità viva: Rassegna d'arte

Antwerpen
Antwerpen: Tijdschrift der stad Antwerpen

An. U. Valencia
Anales de la Universidad de Valencia

Apotheca

Appennino Camerte
Appennino camerte

Aquileia Nostra
Aquileia nostra: Bollettino dell'Associazione nazionale per Aquileia

Archaeol. J.
Archaeological Journal

Archaeologia

Archeol. Class.
Archeologia classica

Archiginnasio

Archit.: Cron. & Stor.
L'architettura: Cronache e storia

Archit. Des.
Architectural Design

Archit. Dig.
Architectural Digest

Architects' J.
Architects' Journal

Archit. Hist.
Architectural History [Society of Architectural Historians of Great Britain]

Archit.: Stor. & Doc.
Architettura: Storia e documenti

Archit.: Z. Gesch. Baukst
Architectura: Zeitschrift für Geschichte der Baukunst

Archv Esp. A.
Archivo español de arte [prev. pubd as *Archv Esp. A. & Arqueol.*]

Archv Esp. A. & Arqueol.
Archivo español de arte y arqueología [cont. as *Archv Esp. Arqueol.*; *Archv Esp. A.*]

Boll. Numi.
Bollettino di Numismatica

Boll. Reale Ist. Archeol. & Stor. A.
Bollettino del Reale istituto di archeologia e storia dell'arte

Boll. Sezione Novara
Bollettino di Sezione Novara

Boll. Soc. Lett. Verona
Bollettino della Società di lettere di Verona

Boll. Soc. Pavese Stor. Patria
Bollettino della Società pavese di storia patria

Boll. Soc. Piemont. Archeol. & B.A.
Bollettino della Società piemontese di archeologia e belle arti

Boll. Stat. Com. Ferrara
Bollettino statistico del comune di Ferrara

Boll. Stor. Cremon.
Bollettino storico cremonese

Boll. Stor. Foligno
Bollettino Storico della Città di Foligno

Boll. Stor. Piacent.
Bollettino storico piacentino

Boll. Stor. Pisa.
Bollettino storico pisano

Boll. Stor. Prov. Novara
Bollettino storico per la provincia di Novara

Boll. Stor. Svizzera It.
Bollettino storico della Svizzera italiana

Boll. Svizzera It.
Bollettino della Svizzera italiana

Brit. J. Aesth.
British Journal of Aesthetics

Bull. A. Inst. Chicago
Bulletin of the Art Institute of Chicago

Bull. Allen Mem. A. Mus.
Bulletin of the Allen Memorial Art Museum

Bull. Assoc. Difesa Firenze Ant.
Bullettino dell'associazione per la difesa di Firenze antica

Bull. Assoc. F.A. Yale U.
Bulletin of the Associates in Fine Arts at Yale University

Bulletin de l'Association des Historiens de l'Art Italien

Bull. Bibliopb.
Bulletin du bibliophile [cont. as *Bull. Bibliopb. & Bibliothécaire*]

Bull. Cleveland Mus. A.
Bulletin of the Cleveland Museum of Art

Bull. Detroit Inst. A.
Bulletin of the Detroit Institute of Arts

Bull. Fogg A. Mus.
Bulletin of the Fogg Art Museum [prev. pubd as *Fogg A. Mus.: Notes*]

Bull. Inst. Hist. Belge Rome
Bulletin de l'Institut historique belge de Rome

Bull. Inst. Royal Patrm. A.
Bulletin de l'Institut royal du patrimoine artistique

Bull. John Rylands Lib.
Bulletin of the John Rylands Library

Bull. LA Co. Mus. A.
Bulletin of the Los Angeles County Museum of Art

Bull. Liaison Cent. Int. Etud. Textiles Anc.
Bulletin de liaison du Centre international d'étude des textiles anciens

Bull. Met.
Bulletin of the Metropolitan Museum of Art

Bull. Mus. Hong. B.-A.
Bulletin du Musée hongrois des beaux-arts /A Szépművészeti múzeum közleményei [cont. as *Bull. Mus. N. Hong. B.-A.*]

Bull. Mus. & Mnmts Lyon.
Bulletin des musées et monuments lyonnais

Bull. Mus. N. Varsovie/Biul. Muz. N. Warszaw.
Bulletin du Musée national de Varsovie/Biuletyn Muzeum narodowego w Warszawie

Bull.: NC Mus. A.
Bulletin: North Carolina Museum of Art

Bull.: Philadelphia Mus. A.
Bulletin: Philadelphia Museum of Art [prev. pubd as *Philadelphia Mus. A.: Bull.*; *PA Mus. Bull.*]

Bull. Rijksmus.
Bulletin van het Rijksmuseum

Bull. Sen. Stor. Patria
Bullettino senese di storia patria

Bull. Soc. Hist. A. Fr.
Bulletin de la Société de l'histoire de l'art français

Bull. Soc. N. Antiqua. France
Bulletin de la Société nationale des antiquaires de France

Bull. V&A
Bulletin of the Victoria and Albert Museum

Bull. Walters A.G.
Bulletin of the Walters Art Gallery

Buonarroti

Burl. Mag.
Burlington Magazine

Cah. Acad. Auquetin
Cahiers de l'Académie Auquetin

Cah. Mus. N. A. Mod.
Cahiers du Musée national d'art moderne

Calabria Lett.
Calabria Letteraria

Capitolium

Carmelus

Carrobbio

Casabella

Castellum
Castellum: Rivista dell'Istituto italiano di castelli

Cent. Ted. Stud. Ven.: Quad.
Centro tedesco di studi veneziani: Quaderni

Chieron

Ch. Mnmts
Church Monuments

Chron. A. & Curiosité
Chronique des arts et de la curiosité [cont. as *Beaux-A.: Chron. A. & Curiosité, Arts* [Paris]]

Cincinnati A. Mus. Bull.
Cincinnati Art Museum Bulletin

Civil. Ambrosiana
Civiltà ambrosiana

Civil. Mant.
Civiltà mantovana

Colour

Com. Bologna
Comune di Bologna

Comitatus

Commentari

Commentary

Comment. Ateneo Brescia
Commentari dell'Ateneo di Brescia

Comp. Stud. Soc. & Hist.
Comparative Studies in Society and History

Computers & Hist. A.
Computers and the History of Art

Connoisseur

Contrib. Ist. Stor. A. Med. & Mod.
Contributi dell'Istituto di storia dell'arte medioevale e moderna

Controspazio

Convivium
Convivium: Årskrift for humaniora kunst og forskning

Copé

Corr. Dir. Acad. France
Correspondance des directeurs de l'Académie de France à Rome

Country Life

Crit. A.
Critica d'arte

Crit. Stor.
Critica storica

Cron. A.
Cronache d'arte

Cronaca

Cron. Archeol.
Cronache di archeologia [prev. pubd as *Cron. Archeol. & Stor. A.*]

Cron. Archeol. & Stor. A.
Cronache di archeologia e di storia dell'arte [cont. as *Cron. Archeol.*]

Cultura

Curator

Daidalos

Das Münster

Dawn

Dedalo

Der Cicerone

Design

Dial. Stor. A.
Dialoghi di Storia dell'Arte

Die Weltkunst

Dis. Archit.
Il disegno di architettura

Domus

Drawing

Dresdn. Ksthl.
Dresdner Kunstblätter

Early Music

Eidos

El Artista

Emporium

Esercizi

Explorations Ren. Cult.
Explorations in Renaissance Culture

Faenza
Faenza: Bollettino del Museo internazionale delle ceramiche in Faenza

Felix Ravenna

Fides & Hist.
Fides et historia

Fimantiquari

F.M.R. Mag.
F.M.R. Magazine

Fond. Stud. Stor. A. Roberto Longhi, Firenze: An.
Fondazione di studi di storia dell'arte Roberto Longhi, Firenze: Annali

Fort

Gartenkst [Worms]
Gartenkunst [Worms]

Gaz. B.-A.
Gazette des beaux-arts [suppl. is *Chron. A.*]

Genava
Genava: Bulletin du Musée d'art et d'histoire de Genève, du Musée Ariana et de la Société auxiliaire du musée, la Bibliothèque publique et universitaire

Genders

Gentile da Fabriano: Boll. Mens. Celeb. Centen.
Gentile da Fabriano: Bollettino mensile per la celebrazione centenaria

Geog. Mag.
Geography Magazine

Georges Bloch J. Kstgesch. Semin. U. Zürich
Georges Bloch J. Kstgesch. Semin. U. Zürich

Gesta

Getty Mus. J.
J. Paul Getty Museum Journal

Goya

Grafica A.
Grafica d'Arte

Graph. Kst.
Graphische Künste

G. Stor. Archv. Tosc.
Giornale storico degli archivi toscani

G. Stor. Lett. It.
Giornale storico della letteratura italiana

Gutenberg Jb.
Gutenberg Jahrbuch

Harvard Lib. Bull.
Harvard Library Bulletin

Hist. Kl. Kön. Bayer. Akad. Wiss.
Historische Klasse der Königlichen bayerischen Akademie der Wissenschaften

Idea: Jb. Hamburg. Ksthalle
Idea: Jahrbuch der Hamburger Kunsthalle [prev. pubd as *Jb. Hamburg. Kstsamml.*]

Il Carrobbio

Illus. Bresc.
Illustrazione bresciana

Illus. Fiorentino
Illustratore fiorentino

Illus. Vatic.
Illustrazione vaticana

Il Santo

Il Vasari

Imagination

Imago

Incontri

Indica

Insula Pulcheria

Interv. Rest.: G.N. Pal. Spinola
Interventi di restauro: Galleria nazionale del Palazzo Spinola

Int. Studio
International Studio

Italia Med. & Uman.
Italia medioevale e umanistica

I Tatti Stud.
I Tatti Studies

It. Cult.
Italian Culture

It. Forsch. Kstgesch.
Italienische Forschungen zur Kunstgeschichte

It. Forsch. Ksthist. Inst. Florenz
Italienische Forschungen des kunsthistorischen Instituts in Florenz

Itinerari
Itinerari: Contributi alla storia dell'arte in memoria di Maria Luisa Fero

It. Stud.
Italian Studies

J. Aesth. & A. Crit.
Journal of Aesthetics and Art Criticism

J. Amer. Inst. Architects
Journal of the American Institute of Architects

Janus

Jb. Berlin. Mus.
Jahrbuch der Berliner Museen

Jber.: Schweiz. Landesmus. Zürich
Jahresbericht: Schweizerisches Landesmuseum in Zürich

Jb. Hamburg. Kstsamml.
Jahrbuch der Hamburger Kunstsammlungen [cont. as *Idea: Jb. Hamburg. Ksthalle*]

Jb. Kön.-Preuss. Kstsamml.
Jahrbuch der Königlich-preussischen Kunstsammlungen [cont. as *Jb. Preuss. Kstsamml.*]

Jb. Ksr.-Kön. Zent.-Komm. Erforsch. & Erhaltung Kst- & Hist. Dkml.
Jahrbuch der K.-K. [Kaiserlich-Königlichen] Zentral-Kommission für Erforschung und Erhaltung der Kunst- und historischen Denkmale

Jb. Kstgesch.
Jahrbuch für Kunstgeschichte [prev. pubd as *Jb. Ksthist. Inst.*; *Kstgesch. Jb. Ksr.-Kön. Zent.-Komm. Erforsch. & Erhaltung Kst- & Hist. Dkml.*; cont. as *Wien. Jb. Kstgesch.*]

Jb. Ksthist. Inst. Graz
Jahrbuch des Kunsthistorischen Institutes der Universität Graz

Jb. Ksthist. Samml. Allhöch. Ksrhaus.
Jahrbuch der kunsthistorischen Sammlungen des allerhöchsten Kaiserhauses [cont. as *Jb. Ksthist. Samml. Wien*]

Jb. Ksthist. Samml. Wien
Jahrbuch der kunsthistorischen Sammlungen in Wien [prev. pubd as *Jb. Ksthist. Samml. Allhöch. Ksrhaus.*]

Jb. Kstwiss.
ii) Jahrbuch für Kunstwissenschaft [1923–30; prev. pubd as *Mhft. Kstwiss.*; merged with *Z. Bild. Kst* & with *Repert. Kstwiss.* to form *Z. Kstgesch.*]

Jb. Max-Planck-Ges. Förderung Wiss.
Jahrbuch der Max-Planck-Gesellschaft zur Förderung der Wissenschaften

Jb. österreich. Byz.
Jahrbuch der österreichischen Byzantinistik [prev. pubd as *Jb. österreich. Byz. Ges.*]

Jb. Preuss. Kstsamml.
Jahrbuch der preussischen Kunstsammlungen [prev. pubd as *Jb. Kön.-Preuss. Kstsamml.*]

J. Brit. Archaeol. Assoc.
Journal of the British Archaeological Association

Jb. Vorarlberg. Landesmusver.
Jahrbuch des Vorarlberger Landesmuseumsvereines

Jb. Wien. Goethe-Ver.
Jahrbuch des Wiener Goethe-Vereins

Jb. Zentinst. Kstgesch.
Jahrbuch des Zentralinstituts für Kunstgeschichte

J. Gdn Hist.
Journal of Garden History

J. Hist. Col.
Journal of the History of Collections

J. Hist. Ideas
Journal of the History of Ideas

J. Med. & Ren. Stud.
Journal of Medieval and Renaissance Studies

J. Paul Getty Mus. J.
J. Paul Getty Museum Journal

J. Playing Card Soc.
Journal of the Playing Card Society

J. Royal Soc. A.
Journal of the Royal Society of Arts

J. Soc. Archit. Hist.
Journal of the Society of Architectural Historians [prev. pubd as *J. Amer. Soc. Archit. Hist.*]

J. Walters A.G.
Journal of the Walters Art Gallery

J. Warb. & Court. Inst.
Journal of the Warburg and Courtauld Institutes [prev. pubd as *J. Warb. Inst.*]

J. Warb. Inst.
Journal of the Warburg Institute [cont. as *J. Warb. & Court. Inst.*]

Kalòs
Kalòs: Invito al collezionismo

Keramos
Keramos: Zeitschrift der Gesellschaft der Keramikfreunde e.V.

Kermes

Krit. Ber.
Kritische Berichte

Kst & Altert.
Kunst und Altertum

Kstchron. & Kstlit.
Kunstchronik und Kunstliteratur [suppl. of *Z. Bild. Kst*]

Kstchron. & Kstmarkt
Kunstchronik und Kunstmarkt: Wochenschrift für Kenner und Sammler

Kstgesch. Ges.
Kunstgeschichtliche Gesellschaft

Kstgesch. Jb. Ksr.-Kön. Zent.-Komm. Erforsch. & Erhaltung Kst- & Hist. Dkml.
Kunstgeschichtliches Jahrbuch der K.-K. [Kaiserlich-Königlichen] Zentral-Kommission für Erforschung und Erhaltung der Kunst- und historischen Denkmale [cont. as *Jb. Ksthist. Inst.*; *Jb. Kstgesch.*; *Wien. Jb. Kstgesch.*]

Ksthist. Tidskr.
Konsthistorisk tidskrift [Art historical magazine]

Kstmus. Årsskr.
Kunstmuseets årsskrift [Art Museum's yearbook]

Kunstchronik

Kunstfreund

Kunstschrift

La Balzana

La Bibliofilia

La Diana

L'Adige

L'Architettura

La Romagna

L'Art
L'Art: Revue hebdomadaire illustrée

L'Arte

L'Arte
L'Arte: Rivista di storia dell'arte [prev. pubd as *Archv Stor. A.*; cont. as *L'Arte: Riv. Stor. A. Med. & Mod.*]

Leonardo, Saggi & Ric.
Leonardo, saggi e ricerche

Letteratura

Lett. Vinc.
Lettura vinciana

Libri & Doc.
Libri e documenti

Libro & Stampe
Il Libro e le stampe

Liburni Civitas
Liburni civitas

L'Italia

L'Oeil

Lotus Int.
Lotus International [prev. pubd as *Lotus*]

Machiavelli Stud.
Machiavelli Studies

Madonna Verona

Mag. A.
Magazine of Art [incorp. suppl. *RA Illus.* until 1904]

Manuscripta
Manuscripta: Information about and Studies on Manuscripts

Marburg. Jb. Kstwiss.
Marburger Jahrbuch für Kunstwissenschaft

Marmo

Marsyas

Maso Finiguerra

Master Drgs
Master Drawings

Mber. Kön. Preuss. Akad. Wiss. Berlin
Monatsberichte der Königlich preussischen Akademie der Wissenschaften zu Berlin

Medaglia

Meded. Ned. Hist. Inst. Rome
Mededelingen van het Nederlands historisch instituut te Rome [Reports of the Dutch Historical Institute in Rome; cont. as *Meded. Ned. Inst. Rome*]

Meded. Ned. Inst. Rome
Mededelingen van het Nederlands instituut te Rome [prev. pubd as *Meded. Ned. Hist. Inst. Rome*]

Med. & Human.
Medievalia et humanistica

Med. & Uman.
Medioevo e umanesimo

Mél. Archéol. & Hist.
Mélanges d'archéologie et d'histoire

Mél. Archéol. & Hist.: Ecole Fr. Rome
Mélanges d'archéologie et d'histoire: L'Ecole française de Rome

Mél. Casa Velázquez
Mélanges de la Casa Velázquez

Mél. Ecole Fr. Rome: It. & Medit.
Mélanges de l'Ecole française de Rome: Italie et Méditerranée

Melozzo Forlì
Melozzo da Forlì

Mém. Acad. Inscr. & B.-Lett.
Mémoires de l'Académie des inscriptions et belles-lettres

Mém. Acad. Sci., A. & B.-Lett. Dijon
Mémoires de l'Académie des sciences, arts et belles-lettres de Dijon

Mem. Amer. Acad. Rome
Memoirs of the American Academy in Rome

Mem. Amer. Philos. Soc.
Memoirs of the American Philosophical Society

Mem. Domenicane
ii) Memorie Domenicane

Mem. Ist. Ven. Sci., Lett. & A.
Memorie dell'Istituto veneto di scienze, lettere ed arti

Mem. Reale Accad. Sci. Torino
Memorie della Reale accademia delle scienze di Torino

Mém. Soc. Emul. Doubs
Mémoires de la Société d'émulation du Doubs

Mem. Stor. Dioc. Brescia
Memorie storiche della diocesi di Brescia

Mem. Stor. Dioc. Milano
Memorie storiche della diocesi di Milano

Mem. Stor. Forogiuliesi
Memorie storiche forogiuliesi

Met. Mus. J.
Metropolitan Museum Journal

Mhft. Kstwiss.
Monatshefte für Kunstwissenschaft [cont. as *Jb. Kstwiss.*]

Michelangelo

Milano

Millennium

Minneapolis Inst. A. Bull.
Minneapolis Institute of Arts Bulletin

Misc. A.
Miscellanea d'arte: Rivista mensile di storia dell'arte medievale e moderna [cont. as *Riv. A.*]

Misc. Bib. Hertz.
Miscellanea bibliothecae Hertzianae

Misc. Fac. Lett. U. Torino
Miscellanea della facoltà di lettere dell'Università di Torino

Misc. Fiorent. Erud. & Stor.
Miscellanea fiorentina di erudizione e storia

Misc. Stor. It.
Miscellanea di storia italiana

Misc. Stor. Sen.
Miscellanea storica senese

Misc. Stor. Ven.
Miscellanea di storia veneta [cont. as *Misc. Stor. Ven.-Trident.*; reverts to *Misc. Stor. Ven.*]

Misc. Var. Lett.
Miscellanea di varia letteratura

Misc. Volterrana
Miscellanea volterrana

Mitt. Ges. Vervielfält. Kst
Mitteilungen der Gesellschaft für vervielfältigende Kunst [prev. pubd as *Chron. Vervielfält. Kst*]

Mitt. Ksthist. Inst. Florenz
Mitteilungen des Kunsthistorischen Instituts in Florenz

Mitt. österreich. Inst. Geschforsch.
Mitteilungen des österreichischen Instituts für Geschichtsforschung [prev. pubd as *Mitt. Inst. österreich. Geschforsch.*; cont. as *Mitt. Inst. österreich. Geschforsch. & Archvwiss. Wien.*; reverts to *Mitt. Inst. österreich. Geschforsch.*]

Mnmts Hist.
Monuments historiques [prev. pubd as *Mnmts Hist. France*]

Mnmts Hist. France
Monuments historiques de la France [cont. as *Mnmts Hist.*]

Mnmts Piot
Monuments Piot [Fondation Eugène Piot]

Mod. Lang. Notes
Modern Language Notes [cont. as *MLN*]

Mod. Painters
Modern Painters

Münchn. Jb. Bild. Kst
Münchner Jahrbuch der bildenden Kunst

Münchn. Jb. Kstgesch.
Münchner Jahrbuch der Kunstgeschichte

Mus. Ferrar.: Boll. Annu.
Musei ferraresi: Bollettino annuale

Mus. Notes: Mus. A., RI
Museum Notes: Museum of Art, Rhode Island

Mus. Stud.
Museum Studies [Art Institute of Chicago]

Napoli Nob.
Napoli nobilissima: Rivista bimestrale di arte figurativa, archeologia e urbanistica

New Lit. Hist.
New Literary History

New Repub.
New Republic

N.G. Tech. Bull.
National Gallery Technical Bulletin

Nmus. Bull.
Nationalmuseum bulletin

Nmus. Skrser.
Nationalmuseet skriftserie [National Museum writing series]

Noncello
Il Noncello: Collana di monografie pordenonensi

Notizie

Not. Pal. Albani
Notizie del Palazzo Albani: Rivista quadrimestrale di storia dell'arte [Università degli studi di Urbino]

Nouv. Est.
Nouvelles de l'estampe

Nouv. Rev.
Nouvelle Revue

Nouv. Rev. Fr.
Nouvelle Revue française

Nova Hist.
Nova historia

Novarien

Numi. & Ant. Class.
Numismatica e antichità classiche

Numi. Chron.
Numismatic Chronicle

Nuova Antol.
Nuova antologia

Nuova Riv. Misena
Nuova rivista misena

Nuova Riv. Stor.
Nuova rivista storica

Nuovo Archv Ven.
Nuovo archivio veneto [prev. pubd as *Archv Ven.*; cont. as *Archv Ven.–Trident.*]

Nuovo G. Lett. Italia
Nuovo giornale de' letterati d'Italia [prev. pubd as *G. Lett. Italia*]

NY Rev. Bks
New York Review of Books

Old Master Drgs
Old Master Drawings

On Paper

Oppositions

Opuscula Inst. Romani Finland.
Opuscula Instituti Romani Finlandiae

Opusculum

Osservatorio A.
Osservatorio delle arti

Oud-Holland

Oxford A. J.
Oxford Art Journal

Padova

Padova & Territ.
Padova e il suo Territorio

Pageant

Pagine Istria.
Pagine istriane

Palladio

Pallas

Pantheon
Pantheon: Internationale Zeitschrift für Kunst [cont. as *Bruckmanns Pantheon*]

Pap. Brit. Sch. Rome
Papers of the British School at Rome

Paragone

Parma Econ.
Parma economica

Period. Soc. Stor. Prov. & Ant. Dioc. Como
Periodico della Società storica per la provincia e antica diocesi di Como [cont. as *Period. Stor. Comense*]

Phoebus
Phoebus: Zeitschrift für bildende Kunst

Physis

Pinacotheca

Plaisirs France
Plaisirs de France

Prato
Prato: Storia e arte

Presenza Romagnola
Presenza romagnola

Proc. Amer. Philos. Soc.
Proceedings of the American Philosophical Society

Proc. Brit. Acad.
Proceedings of the British Academy

Proporzioni
Proporzioni: Studi di storia dell'arte

Prop. & Ric.
Proposte e ricerche

Prov. Lucca
Provincia di Lucca

Prov. Treviso
Provincia di Treviso

Prt Colr
Print Collector

Prt Colr Q.
Print Collector's Quarterly

Prt Q.
Print Quarterly

Quad. Accad. Chigiana
Quaderni dell'Accademia chigiana

Quad. Conoscitore Stampe
Quaderni del conoscitore di stampe

Quad. Fond. Camillo Caetani
Quaderni della Fondazione Camillo Caetani

Quad. Gal. N. Marche
Quaderni della Galleria nazionale delle Marche

Quad. Guarneriani
Quaderni Guarneriani

Quad. Ist. N. Stud. Rinascimento Merid.
Quaderni dell'Istituto nazionale di studi sul Rinascimento meridionale

Quad. Ist. Stor. A. Med. & Mod.
Quaderni dell'Istituto di storia dell'arte medievale e moderna

Quad. Ist. Stor. Archit.
Quaderni dell'Istituto di storia dell'architettura

Quad. Italo-Sviz.
Quaderni italo-svizzeri

Quad. Padano
Quadrante padano

Quad. Pal. Te
Quaderni del Palazzo del Te

Quad. Pal. Venezia
Quaderni del Palazzo Venezia

Quad. Ric. Sci.
Quaderni della ricerca scientifica

Quad. Semin. Stor. Crit. A. Pisa
Quaderni del Seminario di Storia della Critica d'Arte, Scuola Normale

Quad. Sopr. Beni A. & Stor. Venezia
Quaderni della Soprintendenza di beni artistici e storici di Venezia

Quad. Stor. U. Padova
Quaderni per la storia dell'Università di Padova

QUASAR
QUASAR: Quaderni di storia dell'architettura e restauro

Quellenschr. Kstgesch.
Quellenschriften für Kunstgeschichte

Racar
Racar: Revue d'art canadienne

Rac. Vinc.
Raccolta vinciana

Rass. A.
Rassegna d'arte [cont. as *Rass. A. Ant. & Mod.*]

Rass. Archv Stato
Rassegna degli archivi di stato

Rass. A. Sen.
Rassegna d'arte senese

Rass. A. Umbra
Rassegna di arte umbra

Rass. Bibliog. A. It.
Rassegna bibliografica dell'arte italiana

Rass. Graf.
Rassegna grafica

Rass. It. A.
Rassegna italiana dell'arte

Rass. March.
Rassegna marchigiana

Rass. Sov.
Rassegna sovietica

Rass. Stud. & Not.
Rassegna di studi e di notizie

Rec. A. Mus., Princeton U.
Record of the Art Museum, Princeton University
Register
Rendi. Accad. N. Lincei, Cl. Sci. Mor., Stor. & Filol.
Rendiconti dell'Accademia nazionale dei Lincei, classe di scienze morali, storiche e filologiche [prev. pubd as *Rendi. R[eale] Accad. N. Lincei, Cl. Sci. Mor., Stor. & Filol.*]
Rendi. Pont. Accad. Romana Archeol.
Rendiconti della Pontificia accademia romana di archeologia
Ren. Mitt.
Renaissance Mitteilungen
Ren. News
Renaissance News [cont. as *Ren. Q.*]
Ren. Q.
Renaissance Quarterly [prev. pubd as *Ren. News*; later incorp. into *Stud. Ren.*]
Ren. & Reformation
Renaissance and Reformation
Ren. Stud.
Renaissance Studies
Repert. Kstwiss.
Repertorium für Kunstwissenschaft [prev. pubd as *Jb. Kstwiss.* [1868–1873]; merged with *Jb. Kstwiss.* [1923–30] & *Z. Bild. Kst* to form *Z. Kstgesch.*]
Representations
Res
Res: Anthropology and Aesthetics
Restauro
Rev. A.
Revue de l'art
Rev. A. Anc. & Mod.
Revue de l'art ancien et moderne
Rev. Belge Archéol. & Hist. A.
Revue belge d'archéologie et d'histoire de l'art [prev. pubd as *Rev. Belge Archéol. & Hist. A./ Belge Tijdschr. Oudhdknde & Kstgesch.*]
Rev. Bénédictine
Revue bénédictine
Rev. des A.
Revue des arts
Rev. Esthét.
Revue d'esthétique
Rev. Louvre
Revue du Louvre et des musées de France
Rev. Roum. Hist. A.
Revue roumaine d'histoire de l'art
Rhein. Philol.
Rheinische Philologie
Ric. Stor. A.
Ricerche di storia dell'arte
Riv. Stor. Lazio
Rivista Storica del Lazio
Ric. Stor. Pesaro
Ricerca storica di Pesaro
Ric. Stor. Relig. Roma
Ricerche della storia religiosa di Roma
Riv. A.
ii) Rivista dell'arte [cont. as *Bolaffi A.*]

Riv. Archeol.
Rivista di archeologia
Riv. Coll. Araldica
Rivista del Collegio di araldica
Riv. Com.
Rivista del comune
Riv. Ferrara
Rivista di Ferrara
Riv. Ist. N. Archeol. & Stor. A.
Rivista dell'Istituto nazionale d'archeologia e storia dell'arte [prev. pubd as *Riv. Reale Ist. Archeol. & Stor. A.*]
Riv. Italia
Rivista d'Italia
Riv. It. Numi.
Rivista italiana della numismatica
Riv. Mens. Città Venezia
Rivista mensile della città di Venezia
Riv. Reale Ist. Archeol. & Stor. A.
Rivista del Reale istituto d'archeologia e storia dell'arte [cont. as *Riv. Ist. N. Archeol. & Stor. A.*]
Riv. Semest. Stor. A.
Rivista semestrale di storia dell'arte
Riv. Staz. Spermntl Vetro
Rivista della stazione sperimentale del vetro
Riv. Stor. Chiesa Italia
Rivista di storia della chiesa in Italia
Riv. Stor. It.
Rivista storica italiana
Riv. Venezia
Rivista di Venezia
Roma
Romagna A. & Stor.
Romagna arte e storia
Röm. Hist. Mitt.
Römische historische Mitteilungen
Röm. Jb. Bib. Hertz.
Römisches Jahrbuch der Bibliotheca Hertziana
Röm. Jb. Kstgesch.
Römisches Jahrbuch für Kunstgeschichte [prev. pubd as & also known as *Kstgesch. Jb. Bib. Hertz.*]
Röm. Qschr.
Römische Quartalschrift
Sabazia
Saggi & Mem. Stor. A.
Saggi e memorie di storia dell'arte
Santo
Schede Umanistiche
Schweiz. Münzbl.
Schweizer Münzblätter
Scriptorium
Sculp. Rev.
Sculpture Review
Semiolus
Serapis
Signature
Signature: A Quadrimestrial of Typography and Graphic Arts
Simiolus
16th C. J.
Sixteenth Century Journal
SMI Rev.
SMI Review

Smith Coll. Mus. A. Bull.
Smith College Museum of Art Bulletin
Source: Notes Hist. A.
Source: Notes in the History of Art
Speculum
Städel-Jb.
Städel-Jahrbuch
Stanford It. Rev.
stanford italian review
Stor. A.
Storia dell'arte
Stor. A. It.
Storia dell'arte italiana: Dal medioevo al quattrocento
Stor. Archit.
Storia dell'architettura
Stor. Città
Storia della città
Stor. Cult. Ven.
Storia della cultura veneta
Stor. Sicilia
Storia della Sicilia
Strenna Romanisti
Strenna dei romanisti
Strenna Stor. Bologn.
Strenna storica bolognese
Stud. Albornot.
Studia Albornotiana
Stud. A. Urbin.
Studi artistici urbinati
Stud. & Bibliog. An. Bib. Stat. & Lib. Civ. Cremona
Studi e bibliografie degli Annali della biblioteca statale e libreria civica di Cremona
Stud. Boccaccio
Studi sul Boccaccio
Stud. Class. & Orient.
Studi classici ed orientali
Stud. Conserv.
Studies in Conservation: The Journal of the International Institute for Conservation of Historic and Artistic Works
Stud. & Doc. Archit.
Studi e documenti di architettura
Stud. & Doc. Stor. & Dir.
Studi e documenti per la storia e diritto
Stud. & Doc. Stor. Pal. Apostol. Vatic.
Studi e documenti per la storia del Palazzo apostolico vaticano
Stud. Iconog.
Studies in Iconography
Stud. Maceratesi
Studi maceratesi
Stud. Med.
Studi medievali
Stud. Med. & Ren. Hist.
Studies in Medieval and Renaissance History
Stud. Oliveriana
ii) Studi Oliveriana
Stud. Piemont.
Studi piemontesi
Stud. Ren.
ii) Studies in the Renaissance [later incorp. *Ren. Q.*]
Stud. Romagn.
Studi romagnoli

Stud. Romani
Studi romani
Stud. Seicent.
Studi seicenteschi
Stud. & Skiz. Gemäldeknd.
Studien und Skizzen zur Gemäldekunde [prev. pubd as *Bl. Gemäldeknd.*; cont. as *Neue Bl. Gemäldeknd.*; *Gemäldekunde*]
Stud. Stor.
ii) Studi storici
Stud. Stor. A.
Studi di storia delle arti
Stud. Stor. A. [Todi]
Studi di Storia dell'Arte [Todi]
Stud. Stor. A., U. Genova, Ist. Stor. A.
Studi di storia delle arti, Università di Genova, Istituto di storia dell'arte
Stud. Trevi.
Studi trevisani
Stud. Warb. Inst.
Studies of the Warburg Institute
Technol. & Cult.
Technology and Culture
Temps Mod.
Temps modernes
Text
Text: Transactions of the Society for Textual Scholarship
Textile Hist.
Textile History
Third Eye
The Third Eye
TLS
The Times Literary Supplement
Torre
Torre: Revista general de la Universidad de Puerto Rico
Town Planning Rev.
Town Planning Review
Trans. Amer. Philos. Soc.
Transactions of the American Philosophical Society
Trans. RIBA
Transactions of the Royal Institute of British Architects
Uffizi, Stud. & Ric.
Gli Uffizi, studi e ricerche
Ur
Urbanistica
Urbe
L'Urbe: Rivista romana di storia, arte, lettere, costumanze
V&A Mus. Bull.
Victoria and Albert Museum Bulletin
V&A Mus. Yb.
Victoria and Albert Museum Yearbook
Veltro: Riv. Civiltà It.
Veltro: Rivista della civiltà italiana
Venezia A.
Venezia arti: Bollettino del dipartimento di storia e critica delle arti dell'Università di Venezia
Venezia Cinquecento
Venezia cinquecento
Verona Illus.
Verona illustrata
Verona & Territ.
Verona e il suo territorio

Viator

Vita A.
Vita d'arte

Vita Artistica

Vita Veron.
Vita veronese

Vjesnik Arheol. & Hist. Dalmat.
Vjesnik za arheolgiju i historiju dalmatinsku [Bulletin of Dalmatian archaeology and history]

Wallraf-Richartz-Jb.
Wallraf-Richartz-Jahrbuch

Walpole Soc.
Walpole Society

Wien. Jb. Kstgesch.
Wiener Jahrbuch für Kunstgeschichte [prev. pubd as *Jb. Kstgesch.*; *Jb. Ksthist. Inst.*; *Kstgesch. Jb. Ksr.-Kön. Zent.-Komm. Erforsch. & Erhaltung Kst. & Hist. Dkml.*]

Woman's A. J.
Woman's Art Journal

Word & Image

Xenia
Xenia: Semestrale di antichità

Yale It. Stud.
Yale Italian Studies

Yale U. A.G. Bull.
Yale University Art Gallery Bulletin

Yale U. Lib. Gaz.
Yale University Library Gazette

Z. Bild. Kst
Zeitschrift für bildende Kunst [incorp. suppl. *Kstchron. & Kstlit.*; merged with *Jb. Kstwiss.* & with *Repert. Kstwiss.* to form *Z. Kstgesch.*]

Z. Kstgesch.
Zeitschrift für Kunstgeschichte [merger of *Z. Bild. Kst* with *Repert. Kstwiss.* & with *Jb. Kstwiss.*]

Z. Kstwiss.
Zeitschrift für Kunstwissenschaft [prev. pubd as & cont. as *Z. Dt. Ver. Kstwiss.*]

Z. Numi.
Zeitschrift für Numismatik

Z. Schweiz. Altertknd.
Zeitschrift für schweizerische Altertumskunde

Z. Schweiz. Archäol. & Kstgesch.
Zeitschrift für schweizerische Archäologie und Kunstgeschichte

Appendix C

LISTS OF STANDARD REFERENCE BOOKS AND SERIES

LIST A

This list contains, in alphabetical order, the abbreviations used in bibliographies for alphabetically arranged dictionaries and encyclopedias. Some dictionaries and general works, especially dictionaries of national biography, are reduced to the initial letters of the italicized title (e.g. DAB) and others to the author/editor's name (e.g. Thieme-Becker) or an abbreviated form of the title (e.g. Macmillan Enc. Archit.). Abbreviations from List A are cited at the beginning of bibliographies or bibliographical subsections, in alphabetical order, separated by semi-colons; the title of the article in such reference books is cited only if the spelling or form of the name differs from that used in this dictionary or if the reader is being referred to a different subject.

Bénézit
 E. Bénézit, ed.: *Dictionnaire critique et documentaire des peintres, sculpteurs, dessinateurs et graveurs*, 10 vols (Paris, 1913–22, rev. 3/1976)

Bolaffi
 Dizionario enciclopedia dei pittori e degli incisori italiani, dall'XI al XX secolo, 11 vols (Turin, 1972–6) [pubd by Bolaffi]

Bryan
 M. A. Bryan: *Bryan's Dictionary of Painters and Engravers*, 2 vols (London, 1816); rev. and enlarged under the supervision of G. Williamson, 5 vols (London, 1903–5)

Colnaghi
 D. E. Colnaghi: *A Dictionary of Florentine Painters from the 13th to the 17th Centuries* (London, 1928)

DBI
 Dizionario biografico degli italiani (Rome, 1960–)

Enc. A. Ant.
 Enciclopedia dell'arte antica, classica e orientale, 7 vols and suppls (Rome, 1958–73)

Enc. Catt.
 Enciclopedia cattolica, 12 vols (Florence, 1948–54)

Enc. It.
 Enciclopedia italiana di scienze, lettere ed arti, 39 vols and suppls (Milan, 1929–81)

Enc. Spettacolo
 Enciclopedia dello spettacolo, 9 vols and suppl. (Rome, 1954–66)

EWA
 Enciclopedia universale dell'arte, 15 vols (Rome, 1958–67); Eng. trans. as *Encyclopedia of World Art* (New York, 1959–68)

Forrer
 L. Forrer: *Biographical Dictionary of Medallists*, 8 vols (London, 1902–30)

Grove 6
 S. Sadie, ed.: *The New Grove Dictionary of Music and Musicians*, 20 vols (London, rev. 6/1980)

LK
 Lexikon der Kunst: Architektur, bildende Kunst, angewandte Kunst, Industrieformgestaltung, Kunsttheorie (Leipzig, 1968–)

Mariette
 P.-J. Mariette: 'Abecedario de P.-J. Mariette et autres notes inédites de cet amateur sur les arts et les artistes', *Archv A. Fr.*, ii (1851–3), iv (1853–4), vi (1854–6), viii (1857–8), x (1858–9), xii (1859–60)

Meissner
 G. Meissner, ed.: *Allgemeines Künstler-Lexikon: Die bildenden Künstler aller Zeiten und Völker*, 3 vols (Leipzig, 1983–90/*R* Munich, 1992) [see also Thieme–Becker below]

Michaud
 L.-G. Michaud, ed.: *Biographie universelle ancienne et moderne*, 84 vols (Paris, 1811–57)

Pauly–Wissowa
 G. Wissowa, W. Kroll and K. Mittelhaus, eds: *Paulys Realencyclopädie der klassischen Altertumswissenschaft*, 10 vols and suppls (Stuttgart, 1894–1978)

Portoghesi
 P. Portoghesi, ed.: *Dizionario enciclopedico di architettura e urbanistica*, 6 vols (Rome, 1968–9)

PSB
 Polski słownik biograficzny, 34 vols (Wrocław, 1935–)

RDK
 O. Schmitt and others, eds: *Reallexikon zur deutschen Kunstgeschichte* (Stuttgart, Metzler and Munich, 1937–)

SKL
 C. Brun: *Schweizerisches Künstler-Lexikon/ Dictionnaire des artistes suisses*, 4 vols (Frauenfeld, 1905–17/*R* Nendeln, 1967)

Thieme–Becker
 U. Thieme and F. Becker, eds: *Allgemeines Lexikon der bildenden Künstler von der Antike bis zur Gegenwart*, 37 vols (Leipzig, 1907–50) [see also Meissner above]

Series List

This list comprises the abbreviations used in this encyclopedia for publisher's series; they are arranged in alphabetical order by title. Series titles appear in bibliographical citations in roman, immediately before the publication details.

LIST B

A. Amer.
 Artes Americanae

Acta Archaeol. & A. Hist. Pertinentia
 Acta ad archaeologiam et artium historiam pertinentia

Beitr. Kstgesch.
 Beiträge zur Kunstgeschichte

Brit. Archaeol. Rep., Suppl. Ser.
 British Archaeological Reports,
 Supplementary Series

Chiese Roma Illus.
 Chiese di Roma illustrate

Class. A.
 Classica dell'arte

Corp. Vitrearum Med. Aevi
 Corpus vitrearum medii aevi

Diamanti A.
 I diamanti dell'arte

Guida Italia TCI
 Guida d'Italia del Touring club italiano

Italia Romanica
 Italia romanica

It. Forsch. Ksthist. Inst. Florenz
 Italienische Forschungen des
 kunsthistorischen Instituts in Florenz

Klass. Kst Gesamtausgaben
 Klassiker der Kunst in Gesamtausgaben

Maestri Colore
 I maestri del colore

Opera Completa
 Opera completa

Outstanding Diss. F.A.
 Outstanding Dissertations in the Fine Arts

Pelican Hist. A.
 Pelican History of Art

Quellenschr. Kstgesch. & Ksttech.
 Quellenschriften für Kunstgeschichte und
 Kunsttechnik

Saggi & Stud. Stor. A.
 Saggi e studi di storia dell'arte

Sources & Doc. Hist. A.
 Sources and Documents in the History of
 Art

Stor. Milano
 Storia di Milano

Stor. Pitt. It.
 Storia della pittura italiana

Stud. Church Hist.
 Studies in Church History

Stud. Hist. A.
 Studies in the History of Art

Tatti Stud.
 I Tatti Studies: Essays in the Renaissance

Tutta Pitt.
 Tutta la pittura/All the Paintings

Appendix D

Contributor List

Adams, Doug
Adams, Nicholas
Adelson, Candace J.
Adorni, Bruno
Alberton Vinco da Sesso, Livia
Alessi, Cecilia
Aluffi-Pentini, Stefano
Amaturo, Matilde
Ames-Lewis, Francis
Anderson, Jaynie
Andres, Glenn M.
Anselmi, Alessandra
Anthes Jr, William L.
Arbace, Luciana
Armstrong, Lilian
Arnold, Dana
Avery, Charles
Bösel, Richard
Bacci, Mina
Baker, Donna T.
Bambach Cappel, Carmen
Banti, Enrica
Barbieri, Franco
Barcham, William L.
Barlow, Graham F.
Barolsky, Paul
Barovier Mentasti, Rosa
Bartman, Elizabeth
Bartoli, Roberta
Battilotti, Donata
Bauer-Eberhardt, Ulrike
Baxter, Ronald
Bayer, Andrea
Beamish, Gordon Marshall
Bell, Janis Callen
Bellosi, Luciano
Benati, Daniele
Benvenuti, Feliciano
Bernabei, Franco
Bernasconi, John G.
Beyer, Andreas
Biass-Fabiani, Sophie
Binaghi Olivari, M. T.
Bober, Jonathan
Bober, Phyllis Pray
Boch, Stella von
Bohn, Babette

Bollati, Milvia
Bonito, Virginia Anne
Bonn, Mary
Bora, Giulio
Borga, Ludovico
Borgo, Margot
Borsellino, Enzo
Boström, Antonia
Boucher, Bruce
Bradshaw, Marilyn
Branstator, Robin A.
Brook, Anthea
Brown, Beverly Louise
Brown, C. M.
Brown, David Alan
Bruschi, Arnaldo
Bule, Steven
Bull, Malcolm
Burkart, Bettina
Cadogan, Jean K.
Caldwell, Dorigen
Calkins, Robert G.
Callmann, Ellen
Campbell, Ian
Capobianco, Fernanda
Cappelletti, Francesca
Carli, Enzo
Carminati, Marco
Caron, Linda
Carpeggiani, Paola
Carrington, Jill E.
Casadio, Paolo
Cassese, Giovanna
Cassidy, Brendan
Castiglioni, Gino
Cetello, Angela
Cecchi, Alessandro
Cerutti Fusco, Annarosa
Chambers, D. S.
Chappell, Miles L.
Charles, Kathryn A.
Chatfield, Judith
Cheney, Iris
Chiarelli, Renzo
Chiarini, Marco
Chiarlo, Carlo Roberto
Chiusa, Maria Cristina
Christiansen, Keith

Cianchi, Marco
Civai, Alessandra
Claut, Sergio
Coffin, David R.
Colalucci, Gianluigi
Colbert, Charles
Collareta, Marco
Colle, Enrico
Connell, Susan
Conti, Alessandro
Cook, Cathy S.
Cooper, Tracy E.
Corbeiller, Clare le
Coroneo, Roberto
Coté, Cynthia
Covi, Dario A.
Cox-Rearick, Janet
Crum, Roger J.
Cucciari, Daniela
Czarnecki, James
D'Alconzo, Paola
D'Onofrio, Mario
Dabell, Frank
Dagnino, Anna
Damiani, Giovanna
Darr, Alan Phipps
Davenport, Michael
David, Massimiliano
Davies, M. C.
Davies, Paul
Deckker, Zilah Quezado
De Girolami Cheney, Liana
De Grazia, Diane
De la Coste-Messelière, Marie-Geneviève
De la Mare, A. C.
Della Torre, Stefano
Dempsey, Charles
De Winter, Patrick M.
Di Castro Moscati, Daniela
Di Giampaolo, Mario
Dillon, Gianvittorio
Distelberger, Rudolf
Donati, Valentino
Draper, James David
Dugdale, Alice
Duke, James O.
Dwyer, Eugene

Eberhardt, Hans-Joachim
Edmunds, Sheila
Eiche, Sabine
Ekserdjian, David
Elam, Caroline
Emison, Patricia
Evans, Mark L.
Even, Yael
Fama, Giovanna
Farago, Claire
Fassio, Matilde
Favro, Diane
Feinberg, Larry J.
Ferrari, Anna Maria
Ferretti, Patrizia
Finaldi, Gabriele
Fioravanti Baraldi, Anna Maria
Fiore, Francesco Paolo
Fiorio, Maria Teresa
Fletcher, Doris
Ford, Mary Margaret McDonnell
Frabetti, Alessandra
Fracchia, Carmen
Frangi, Francesco
Franzoni, Lanfranco
Friedman, Joan Isobel
Frommel, Christoph Luitpold
Frosinini, Cecilia
Gardner, Genetta
Garofoli, Marina
Garzelli, Annarosa
Gauk-Roger, Nigel
Geddes, Helen
Gemin, Massimo
Gentilini, Giancarlo
Ghirardi, Angela
Ghisetti Giavarina, Adriano
Gibbs, Robert
Giffi, Elisabetta
Gilbert, Creighton E.
Gill, Meredith J.
Giordano, Luisa
Gisolfi, Diana
Giusti, Annamaria
Goode, Patrick
Gorse, George L.

Gould, Cecil
Goy, Richard J.
Grimaldi, Floriano
Grindstaff, B. K.
Griswold, William
Gullick, Michael
Höper, C.
Hamilton, Paul C.
Harness, Jessica
Harprath, Richard
Hawkins, Lucinda
Hearnden, Warren
Hemsoll, David
Herz, Alexandra
Hess, Catherine
Hessert, Marlis von
Hicks, Carola
Hills, Helen
Hirthe, Thomas
Hochmann, Michel
Holder, Philancy N.
Holderbaum, James
Hood, William
Hope, Charles
Howe, Eunice D.
Hubert, Hans
Hughes, Anthony
Hughes, Quentin
Humfrey, Peter
Hunt, John Dixon
Hunter, John
Jacks, Philip J.
Jestaz, Bertrand
Jestaz, Françoise
Johnson, Jan
Jong, J. L. de
Kaplan, Paul H. D.
Keller, Fritz-Eugen
Kemp, Martin
Kempers, B.
Kent, F. W.
Kiefhaber, Susanne
Kliemann, Julian
Klinger, Linda S.
Kockelbergh, Iris
Kolb, Carolyn
Kowalczyk, Jerzy
Krahn, Volker

Kraye, Jill
Kruft, Hanno-Walter
Land, Norman E.
Lattuada, Riccardo
Law, John
Lazzaro, Claudia
Lehmann-Brockhaus, Ursula
Leoncini, Luca
Leone de Castris, Pierluigi
Leslie, Michael
Levenson, Jay A.
Lever, Jill
Lewis, Douglas
Lewis, Michal
Lewis, R. E.
Lightbown, R. W.
Lillie, Amanda
Lippincott, Kristen
Lisot, Elizabeth A.
Lloyd, Christopher
Looney, Dennis
Luca, Elena de
Lucco, Mauro
Luchs, Alison
Möseneder, Karl
MacDougall, Elisabeth Blair
Mack, Rosamond E.
Maginnis, H. B. J
Maller, Jane Nash
Mancinelli, Fabrizio
Mandel, Corinne
Manno, Antonio
Marani, Pietro C.
Martin, Andrew John
Martin, Thomas
Martineau, Jane
Massari, Stefania
Massinelli, Anna Maria
Mattevi, Maria Angela
Matthew, Louisa C.
McClintock, Kathryn Marie
McGuire, William
McHam, Sarah Blake
Meek, Harold
Melville-Jones, John R.
Menichella, Anna
Merkel, Ettore
Mezzatesta, Michael P.
Michel, Olivier
Miller, Naomi
Millidge, Shirley
Milne, Louise S.
Moench, Esther
Mongellaz, Jacqueline
Morgan, Sarah
Moro, Franco
Morresi, Manuela
Morscheck Jr, Charles R.
Moskowitz, Anita F.
Munari, Nadia
Musto, Ronald G.
Muzzi, Andrea

Myers, Donald
Nagel, Alexander
Naldi, Riccardo
Nash, John R.
Natale, Vittorio
Natali, Antonio
Neilson, Nancy Ward
Nepi Scirè, Giovanna
Neri Lusanna, Enrica
Nesbitt, Judith
Nichols, Tom
Norman, Diana
Norris, Andrea S.
Nova, Alessandro
Nuttall, Paula
O'Malley, Michelle
Oakes, Catherine
Och, Marjorie A.
Oldfield, David
Olszewski, Edward J.
Oresko, Robert
Ostrow, Steven F.
Pace, Claire
Padoa Rizzo, Anna
Padovani, Serena
Pagden, Sylvia Ferino
Pagliara, Pier Nicola
Panvini Rosati, Franco
Paoletti, John T.
Parma, Elena
Parola, Lisa
Partridge, Loren
Pasini, Pier Giorgio
Passoni, Riccardo
Pavone, Mario Alberto
Pedrocco, Filippo
Pegazzano, Donatella
Pelta, Maureen
Penny, Nicholas
Percival, John
Perissa Torrini, Annalisa
Pescarmona, Daniele
Peterson, Sara
Petrucci, Francesca
Pfleger, Susanne
Phillips, Maria A.
Pillsbury, Edmund P.
Pinna, Giuseppe
Pinney, Rosie-Anne
Poke, Christopher
Pollak, Martha
Pollard, J. G.
Pons, Nicoletta
Pyle, Cynthia M.
Quast, Matthias
Quinterio, Francesco
Quiviger, François
Radke, Gary M.
Rangoni, Fiorenza
Ravenelli Guidotti, Carmen
Regoli, G. Dalli
Riccardi-Cubitt, Monique

Richards, John
Richardson, Francis L.
Richter, Elinor M.
Rivera, Javier
Robertson, Charles
Robertson, Clare
Roio, Nicosetta
Romano, Serena
Roper, Rayne
Rosenberg, Charles M.
Rossi, Lorenza
Rotondi Terminiello,
 Giovanna
Rowlands, Eliot W.
Rubinstein, Ruth Olitsky
Ruggeri, Ugo
Rutgers, K. M.
Rybko, Ana Marie
Rylands, Philip
Salton, Mark M.
Sambo, Elisabetta
Santi, Bruno
Sarewitz, E. B.
Satzinger, Georg
Scaglia, Gustina
Scarpellini, P.
Scher, Stephen K.
Schofield, Richard
Schultz, Bernard
Schweikhart, Gunter
Scotti Tosini, Aurora
Seidmann, Gertrud
Shaw, Keith
Shaw, Theresa
Shell, Janice
Sica, Maria
Signorini, Rodolfo
Sikorski, Darius
Soldini, Nicola
Southorn, Janet
Spantigati, Carlenrica
Sparti, Donatella L.
Spilner, Paula
Sricchia Santoro, Fiorella
Steer, John
Stefani, Chiara
Stephens, Lynda
Strupp, Joachim
Suffield, Laura
Summers, David
Sutton, Kay
Syre, Cornelia
Tabarroni, Giorgio
Talvacchia, Bette
Tanzi, Marco
Taylor, J. W.
Tazartes, Maurizia
Tempestini, Anchise
Thomas, Anabel
Thomas, John
Tolley, Thomas
Toniolo, Federica

Torriti, Marco
Toscano, Gennaro
Towey, Jeannette
Tripps, Johannes
Tuohy, Thomas
Turner, Ailsa
Turner, S. J.
Tuttle, Richard J.
Tyack, Geoffrey C.
Vannugli, Antonio
Vargas, Carmela
Varriano, John
Venturini, Lisa
Verdon, Timothy
Verellen, Till R.
Visioli, Monica
Visonà, Mara
Ważbiński, Z.
Wardle, Patricia
Warma, Susanne Juliane
Watson, Wendy M.
Welch, E. S.
Werdehausen, A. E.
Whitaker, Lucy
Wilkins, David G.
Wilson, Carolyn C.
Witcombe, Christopher L. C.
 E.
Wohl, Hellmut
Wolff, Roland
Wolters, Wolfgang
Wright, Joanne
Wundham, Manfred
Wurthmann, William B.
Yorke, James
Zerner, Henri
Zuraw, Shelley

Index

This index comprises a selective listing of references in the *Encyclopedia of Italian Renaissance Art*. It has been compiled to be useful and accessible, enabling readers to locate both general and highly specific information quickly and easily. Colour plate references appear as large roman numerals. The index contains cross-references to direct the reader from various spellings of a word or from similar terms; an arrow (→) indicates that the term is to be found under a sub-heading following the main entry; for example, for the cross-reference.